ENCYCLOPEDIA OF WORLD ART

VOL. VIII

INDO-IRANIAN ART – LANDSCAPE ARCHITECTURE

ENCICLOPEDIA UNIVERSALE DELL'ARTE

Sotto gli auspici della Fondazione Giorgio Cini

ISTITUTO PER LA COLLABORAZIONE CULTURALE
VENEZIA – ROMA

ENCYCLOPEDIA
OF
WORLD ART

McGRAW-HILL BOOK COMPANY, INC.
NEW YORK, TORONTO, LONDON

ENCYCLOPEDIA OF WORLD ART: VOLUME VIII

Revised printing 1971

Paper for plates and text supplied by Cartiere Burgo, Turin — Engraving by Zincotipia Altimani, Milan — Black-and-white and color plates printed by Istituto Italiano d'Arti Grafiche, Bergamo — Text printed by "L'Impronta," Florence — Binding by Stabilimento Stianti, San Casciano Val di Pesa, Florence — Book cloth supplied by G. Pasini & Co., Milan.

Printed in Italy

Library of Congress Catalog Card Number 59-13433
International Standard Book Number 07-019465-3

INTERNATIONAL COUNCIL OF SCHOLARS

ABBREVIATIONS

Museums, Galleries, Libraries, and Other Institutions

Antikensamml.	— Antikensammlungen
Antiq.	— Antiquarium
Bib. Nat.	— Bibliothèque Nationale
Bib. Naz.	— Biblioteca Nazionale
Brera	— Pinacoteca di Brera
Br. Mus.	— British Museum
Cab. Méd.	— Cabinet des Médailles (Paris, Bibliothèque Nationale)
Cleve. Mus.	— Cleveland Museum
Conserv.	— Palazzo dei Conservatori
Gall. Arte Mod.	— Galleria di Arte Moderna
IsMEO	— Istituto Italiano per il Medio ed Estremo Oriente
Kunstgewerbemus.	— Kunstgewerbemuseum
Kunsthist. Mus.	— Kunsthistorisches Museum
Louvre	— Musée du Louvre
Medagl.	— Medagliere
Met. Mus.	— Metropolitan Museum
Mus. Ant.	— Museo di Antichità
Mus. Arch.	— Museo Archeologico
Mus. B. A.	— Musée des Beaux-Arts
Mus. Cap.	— Musei Capitolini
Mus. Civ.	— Museo Civico
Mus. Com.	— Museo Comunale
Mus. Etn.	— Museo Etnologico
Mus. Naz.	— Museo Nazionale
Mus. Vat.	— Musei Vaticani, Vatican Museums
Nat. Gall.	— National Gallery
Öst. Gall.	— Österreichische Galerie
Pin. Naz.	— Pinacoteca Nazionale
Prado	— Museo del Prado
Rijksmus.	— Rijksmuseum
Samml.	— Sammlung
Staat. Mus.	— Staatliche Museen
Staatsbib.	— Staatsbibliothek
Städt. Mus.	— Städtisches Museum
Tate Gall.	— Tate Gallery
Uffizi	— Uffizi Gallery
Vict. and Alb.	— Victoria and Albert Museum
Villa Giulia	— Museo di Villa Giulia

Reviews and Miscellanies

AAE	— Archivio per la Antropologia e la Etnologia, Florence
AAnz	— Archäologischer Anzeiger, Berlin
AAs	— Artibus Asiae, Ascona, Switzerland
AB	— Art Bulletin, New York
AbhAkMünchen	— Abhandlungen der Bayerischen Akademie der Wissenschaften, Munich
AbhBerlAk	— Abhandlungen der Berliner Akademie der Wissenschaften, Berlin
AbhPreussAk	— Abhandlungen der preussischen Akademie der Wissenschaften, Berlin; after 1945: Abhandlungen der Deutschen Akademie der Wissenschaften zu Berlin, Berlin
ABIA	— Annual Bibliography of Indian Archaeology, Leiden
ABME	— 'Αρχεῖον τῶν Βυζαντινῶν Μνημείων τῆς 'Ελλάδος, Athens

AC	— Archeologia Classica, Rome
ActaA	— Acta Archaeologica, Copenhagen
ActaO	— Acta Orientalia, Leiden, The Hague
AD	— Antike Denkmäler, Deutsches Archäologisches Institut, Berlin, Leipzig
AEA	— Archivio Español de Arqueología, Madrid
AEArte	— Archivio Español de Arte, Madrid
AErt	— Archaeologiai Értesitö, Budapest
AfA	— Archiv für Anthropologie, Brunswick
AfO	— Archiv für Orientforschung, Berlin
AfrIt	— Africa Italiana, Bergamo
AJA	— American Journal of Archaeology, Baltimore
AM	— Mitteilungen des deutschen archäologischen Instituts, Athenische Abteilung, Athens, Stuttgart
AmA	— American Anthropologist, Menasha, Wis.
AmAnt	— American Antiquity, Menasha, Wis.
AN	— Art News, New York
AnnInst	— Annali dell'Instituto di Corrispondenza Archeologica, Rome
AnnSAntEg	— Annales du Service des Antiquités de l'Egypte, Cairo
AntC	— L'Antiquité Classique, Louvain
AntJ	— The Antiquaries Journal, London
AnzAlt	— Anzeiger für die Altertumswissenschaft, Innsbruck, Vienna
AnzÖAk	— Anzeiger der Österreichischen Akademie der Wissenschaften, Vienna
APAmM	— Anthropological Papers of the American Museum of Natural History, New York
AQ	— Art Quarterly, Detroit
ArndtBr	— P. Arndt, F. Bruckmann, Griechische und römische Porträts, Munich, 1891 ff.
ARSI	— Annual Report of the Smithsonian Institution, Bureau of Ethnology, Washington, D.C.
ArtiFig	— Arti Figurative, Rome
ASAtene	— Annuario della Scuola Archeologica Italiana di Atene, Bergamo
ASI	— Archivio Storico Italiano, Florence
ASWI	— Archaeological Survey of Western India, Hyderabad
AttiDeSPa	— Atti e Memorie della Deputazione di Storia Patria
AttiPontAcc	— Atti della Pontificia Accademia Romana di Archeologia, Rome
Atti3StArch	— Atti del III Convegno Nazionale di Storia dell'Architettura, Rome, 1938
Atti5StArch	— Atti del V Convegno Nazionale di Storia dell'Architettura, Florence, 1957
AZ	— Archäologische Zeitung, Berlin
BA	— Baessler Archiv, Leipzig, Berlin
BABsch	— Bulletin van de Vereeniging tot bevordering der kennis van de antieke Beschaving, The Hague
BAC	— Bulletin du Comité des Travaux Historiques et Scientifiques, Section d'Archéologie, Paris
BAcBelg	— Bulletin de l'Académie Royale de Belgique, Cl. des Lettres, Brussels
BACr	— Bollettino di Archeologia Cristiana, Rome
BAEB	— Bureau of American Ethnology, Bulletins, Washington, D.C.
BAER	— Bureau of American Ethnology, Reports, Washington, D.C.

BAFr — Bulletin de la Société Nationale des Antiquaires de France, Paris

BAmSOR — Bulletin of the American Schools of Oriental Research, South Hadley, Mass.

BArte — Bollettino d'Arte del Ministero della Pubblica Istruzione, Rome

BByzI — The Bulletin of the Byzantine Institute, Paris

BCH — Bulletin de Correspondance Hellénique, Paris

BCom — Bullettino della Commissione Archeologica Comunale, Rome

Beazley, ABV — J. D. Beazley, Attic Black-figure Vase-painters, Oxford 1956

Beazley, ARV — J. D. Beazley, Attic Red-figure Vase-painters, Oxford, 1942

Beazley, EVP — J. D. Beazley, Etruscan Vase-painting, Oxford, 1947

Beazley, VA — J. D. Beazley, Attic Red-figured Vases in American Museums, Cambridge, 1918

Beazley, VRS — J. D. Beazley, Attische Vasenmaler des rotfigurigen Stils, Tübingen, 1925

BEFEO — Bulletin de l'Ecole Française d'Extrême-Orient, Hanoi, Saigon, Paris

BerlNZ — Berliner Numismatische Zeitschrift, Berlin

Bernoulli, GI — J. J. Bernoulli, Griechische Ikonographie, Munich, 1901

Bernoulli, RI — J. J. Bernoulli, Römische Ikonographie, I, Stuttgart, 1882; II, 1, Berlin, Stuttgart, 1886; II, 2, Stuttgart, Berlin, Leipzig, 1891; II, 3, Stuttgart, Berlin, Leipzig, 1894

BHAcRoum — Bulletin Historique, Académie Roumaine, Bucharest

BICR — Bollettino dell'Istituto Centrale del Restauro, Rome

BIE — Bulletin de l'Institut de l'Egypte, Cairo

BIFAN — Bulletin de l'Institut Français d'Afrique Noire, Dakar

BIFAO — Bulletin de l'Institut Français d'Archéologie Orientale, Cairo

BInst — Bullettino dell'Instituto di Corrispondenza Archeologica, Rome

BJ — Bonner Jahrbücher, Bonn, Darmstadt

BM — Burlington Magazine, London

BMBeyrouth — Bulletin du Musée de Beyrouth, Beirut

BMC — British Museum, Catalogue of Greek Coins, London

BMCEmp — H. Mattingly, Coins of the Roman Empire in the British Museum, London

BMFA — Museum of Fine Arts, Bulletin, Boston

BMFEA — Museum of Far-Eastern Antiquities, Bulletin, Stockholm

BMImp — Bullettino del Museo dell'Impero, Rome

BMMA — Bulletin of the Metropolitan Museum of Art, New York

BMQ — The British Museum Quarterly, London

BNedOud — Bulletin van de Koninklijke Nederlandse Oudheidkundige Bond, Leiden

BPI — Bullettino di Paletnologia Italiana, Rome

BrBr — H. Brunn, F. Bruckmann, Denkmäler griechischer und römischer Skulptur, Munich

Brunn, GGK — H. Brunn, Geschichte der griechischen Künstler, 2d ed., Stuttgart, 1889

Brunn, GK — H. Brunn, Griechische Kunstgeschichte, Munich, I, 1893; II, 1897

BSA — Annual of the British School at Athens, London

BSEI — Bulletin de la Société des Etudes Indochinoises, Saigon

BSOAS — Bulletin of the School of Oriental and African Studies, London

BSPF — Bulletin de la Société Préhistorique Française, Paris

BSR — Papers of the British School at Rome, London

Cabrol-Leclercq — F. Cabrol, H. Leclercq, Dictionnaire d'archéologie chrétienne et de liturgie, Paris, 1907

CAF — Congrès Archéologique de France, Paris, 1841–1935

CahA — Cahiers Archéologiques, Fin de l'Antiquité et Moyen-Age, Paris

CahArt — Cahiers d'art, Paris

CAJ — Central Asiatic Journal, Wiesbaden

CEFEO — Cahiers de l'Ecole Française d'Extrême-Orient, Paris

CIE — Corpus Inscriptionum Etruscarum, Lipsiae

CIG — Corpus Inscriptionum Graecarum, Berolini

CIL — Corpus Inscriptionum Latinarum, Berolini

CIS — Corpus Inscriptionum Semiticarum, Parisiis

Coh — H. Cohen, Description historique des Monnaies frappées sous l'Empire Romain, Paris

Collignon, SG — M. Collignon, Histoire de la sculpture grecque, Paris, I, 1892; II, 1897

Comm — Commentari, Florence, Rome

Cr — La Critica, Bari

CRAI — Comptes Rendus de l'Académie des Inscriptions et Belles-Lettres, Paris

CrArte — La Critica d'Arte, Florence

CVA — Corpus Vasorum Antiquorum

DA — N. Daremberg, N. Saglio, Dictionnaire des antiquités grecques et romaines, Paris, 1877–1912

Dehio, I-V — G. Dehio, Handbuch der deutschen Kunstdenkmäler, Berlin, I, Mitteldeutschland, 1927; II, Nordostdeutschland, 1926; III, Süddeutschland, 1933; IV, Südwestdeutschland, 1933; V, Nordwestdeutschland, 1928

Dehio, DtK — G. Dehio, Geschichte der deutschen Kunst, 4 vols., Berlin, 1930–34

Dehio-VonBezold — G. Dehio, G. von Bezold, Die kirchliche Baukunst des Abendlandes, Stuttgart, 1892–1901

DissPontAcc — Dissertazioni della Pontificia Accademia Romana di Archeologia, Rome

EA — Photographische Einzelaufnahmen, Munich, 1893 ff.

EAA — Enciclopedia dell'Arte Antica, Rome, I, 1958; II, 1959; III, 1960; IV, 1961

EArt — Eastern Art, London

EB — Encyclopaedia Britannica

ΕΕΒΣ — Ἐπετερὶς Ἑταιρεία Βυξαντινῶν Σπουδῶν, Athens

Ἐφημ — Ἀρχαιολογικὴ Ἐφημερίς, Athens

EI — Enciclopedia Italiana, Rome, 1929 ff.

EphDR — Ephemeris Dacoromana, Rome

Ἐργον — Τὸ ἔργον τῆς ἀρχαιολογικῆς ἑταιρείας, ed. A. K. Orlandos, Athens

ESA — Eurasia Septentrionalis Antiqua, Helsinki

Espér — E. Espérandieu, R. Lantier, Recueil général des Bas-Reliefs de la Gaule Romaine, Paris

FA — Fasti Archaeologici, Florence

FD — Fouilles de Delphes, Paris

Friedländer — Max Friedländer, Altniederländische Malerei, Berlin, 1924–37

Furtwängler, AG — A. Furtwängler, Antiken Gemmen, Leipzig, Berlin, 1900

Furtwängler, BG — A. Furtwängler, Beschreibung der Glyptothek König Ludwig I zu München, Munich, 1900

Furtwängler, KlSchr — A. Furtwängler, Kleine Schriften, Munich, 1912

Furtwängler, MP — A. Furtwängler, Masterpieces of Greek Sculpture, London, 1895

Furtwängler, MW — A. Furtwängler, Meisterwerke der griechischen Plastik, Leipzig, Berlin, 1893

Furtwängler Reichhold — A. Furtwängler, K. Reichhold, Griechische Vasenmalerei, Munich

GBA — Gazette des Beaux-Arts, Paris

GJ — The Geographical Journal, London

HA — Handbuch der Archäologie in Rahmen des Handbuchs der Altertumswissenschaft..., herausgegeben von Walter Otto, Munich, 1939–53

HBr — P. Herrmann, F. Bruckmann, Denkmäler der Malerei des Altertums, Munich, 1907

Helbig-Amelung — W. Helbig, W. Amelung, E. Reisch, F. Weege, Führer durch die öffentlichen Sammlungen klassischer Altertümer in Rom, Leipzig, 1912–13

HIPBC — A Handbook for Travellers in India, Pakistan, Burma and Ceylon, London, 1955

HJAS — Harvard Journal of Asiatic Studies, Cambridge, Mass.

Hoppin, Bf — J. C. Hoppin, A Handbook of Greek Black-figured Vases with a Chapter on the Red-figured Southern Italian Vases, Paris, 1924

Hoppin, Rf — J. C. Hoppin, A Handbook of Attic Red-figured Vases Signed by or Attributed to the Various Masters of the Sixth and Fifth Centuries B.C., Cambridge, 1919

HSAI — J. H. Steward, ed., Handbook of South American Indians, 6 vols., Bureau of American Ethnology, Bull. 143, Washington, D.C., 1946–50

IAE — Internationales Archiv für Ethnographie, Leiden

IBAI — Bulletin del l'Institut Archéologique Bulgare, Sofia

IFAN — Institut Français Afrique Noire

IG — Inscriptiones Graecae, Berolini

ILN — Illustrated London News, London

IPEK — Ipek, Jahrbuch für prähistorische und ethnographische Kunst, Berlin

JA — Journal Asiatique, Paris

JAF — Journal of American Folklore, Lancaster, Pa.

JAOS — Journal of the American Oriental Society, Baltimore

JAS — Journal of the African Society, London

JBORS — Journal of the Bihar and Orissa Research Society, Patna, India

JdI — Jahrbuch des deutschen archäologischen Instituts, Berlin

JEA — Journal of Egyptian Archaeology, London

JhbKhSammlWien — Jahrbuch der kunsthistorischen Sammlungen in Wien, Vienna

JhbPreussKSamml — Jahrbuch der preussischen Kunstsammlungen, Berlin

JHS — Journal of Hellenic Studies, London

JIAI — Journal of Indian Art and Industry, London

JIAN — Journal International d'Archéologie Numismatique, Athens

JISOA — Journal of the India Society of Oriental Art, Calcutta

JNES — Journal of Near Eastern Studies, Chicago

JPS — Journal of the Polynesian Society, Wellington, New Zealand

JRAI — Journal of the Royal Anthropological Institute of Great Britain and Ireland, London

JRAS — Journal of the Royal Asiatic Society, London

JRS — Journal of Roman Studies, London

JS — Journal des Savants, Paris

JSA — Journal de la Société des Africanistes, Paris

JSAH — Journal of the Society of Architectural Historians, Charlottesville, Va.

JSAm — Journal de la Société des Americanistes, Paris

JSO — Journal de la Société des Océanistes, Paris

KbNed — Kunstreisboek voor Nederland, Amsterdam 1960

Klein, GrK — W. Klein, Geschichte der griechischen Kunst, Leipzig, 1904–07

KS — Communications on the Reports and Field Research of the Institute of Material Culture, Moscow, Leningrad

Lippold, GP — G. Lippold, Die griechische Plastik (W. Otto, Handbuch der Archäologie, II, 1), Munich, 1950

Löwy, IGB — E. Löwy, Inschriften griechischer Bildhauer, Leipzig, 1885

MAAccIt — Monumenti Antichi dell'Accademia d'Italia, Milan

MAARome — Memoirs of the American Academy in Rome, Rome, New York

MAF — Mémoires de la Société Nationale des Antiquaires de France, Paris

MAGWien — Mitteilungen der anthropologischen Gesellschaft in Wien, Vienna

Mâle, I — E. Mâle, L'art religieux du XII° siècle en France, Paris, 1928

Mâle, II — E. Mâle, L'art religieux du XIII° siècle en France, Paris, 1925

Mâle, III — E. Mâle, L'art religieux de la fin du moyen-âge en France, Paris, 1925

Mâle, IV — E. Mâle, L'art religieux après le Concile de Trente, Paris, 1932

MALinc — Monumenti Antichi dell'Accademia dei Lincei, Milan, Rome

Mattingly-Sydenham — H. Mattingly, E. Sydenham, C. H. V. Sutherland, The Roman Imperial Coinage, London

MdI — Mitteilungen des deutschen archäologischen Instituts, Munich

MdIK — Mitteilungen des deutschen Instituts für ägyptische Altertumskunde in Kairo, Wiesbaden

Mél — Mélanges d'Archéologie et d'Histoire (Ecole Française de Rome), Paris

MemLinc — Memorie dell'Accademia dei Lincei, Rome

MGH — Monumenta Germaniae Historica, Berlin

MIA — Material and Research in Archaeology of the U.S.S.R., Moscow, Leningrad

Michel — A. Michel, Histoire de l'art depuis les premiers temps chrétiens jusqu'à nos jours, Paris 1905–29

MInst — Monumenti dell'Instituto di Corrispondenza Archeologica, Rome

MJhb — Münchner Jahrbuch der bildenden Kunst, Munich

MLJ — Modern Language Journal, St. Louis, Mo.

MnbKw — Monatsberichte über Kunstwissenschaft

MPA — Monumenti della pittura antica scoperti in Italia, Rome

MPiot — Fondation Eugène Piot, Monuments et Mémoires, Paris

MPontAcc — Memorie della Pontificia Accademia Romana di Archeologia, Rome

NBACr — Nuovo Bullettino di Archeologia Cristiana, Rome

NChr — Numismatic Chronicle and Journal of the Royal Numismatic Society, London

NedKhJb — Nederlandsch Kunsthistorisch Jaarboek, 1945ff.

NedMon — De Nederlandse Monumenten van Geschiedenis en Kunst, 1911 ff.

NIFAN — Notes de l'Institut Français d'Afrique Noire, Dakar

NR — Numismatic Review, New York

NSc — Notizie degli Scavi di Antichità, Rome

NZ — Numismatische Zeitschrift, Vienna

OAZ — Ostasiatische Zeitschrift, Vienna

OIP — Oriental Institute Publications, Chicago

ÖJh — Jahreshefte des Österreichischen archäologischen Instituts, Vienna

ÖKT — Österreichische Kunsttopographie, Vienna

OMLeiden — Oudheidkundige Mededeelingen van het Rijksmuseum van Oudheten te Leiden, Leiden

OpA — Opuscola Archaeologica, Lund

OudJb — Oudheidkundig Jaarboek, Leiden

Overbeck, SQ — J. Overbeck, Die antiken Schriftquellen zur Geschichte der bildenden Künste bei den Griechen, Leipzig, 1868; reprint, Hildesheim, 1958

Oxy. Pap. — The Oxyrhunchus Papyri, by B. P. Grenfell, A. S. Hunt, H. I. Bell et al., eds., London, 1898 ff.

ΠΑΕ — Πρακτικά τῆς ἐν Ἀθήναις Ἀρχαιολογικῆς Ἑταιριας, Athens

PEQ — Palestine Exploration Quarterly, London

Perrot-Chipiez — G. Perrot, C. Chipiez, Histoire de l'art dans l'Antiquité, Paris, I, 1882; II, 1884; III, 1885; IV, 1887; V, 1890; VI, 1894; VII, 1898; VIII, 1903; IX, 1911

Pfuhl — E. Pfuhl, Malerei und Zeichnung der Griechen, Munich, 1923

PG — J. P. Migne, Patrologiae cursus completus, Series Graeca, 162 vols., with Latin trans., Paris, 1857–66

Picard — C. Picard, Manuel d'Archéologie, La Sculpture, Paris, I, 1935; II, 1939; III, 1948; IV, 1, 1954

PL — J. P. Migne, Patrologiae cursus completus, Series Latina, 221 vols., Paris, 1844–64

PM — B. Porter and R. L. B. Moss, Topographical Bibliography of Ancient Egyptian Hieroglyphic Texts, Reliefs and Paintings, 7 vols., Oxford, 1927–51, 2d ed., 1960 ff.

Porter — A. Kingsley Porter, Romanesque Sculpture of the Pilgrimage Roads, Boston, 1923

Post — Charles Post, A History of Spanish Painting, 10 vols., Cambridge, Mass., 1930 ff.

ProcPrSoc — Proceedings of the Prehistoric Society, Cambridge

PSI — Pubblicazioni della Società Italiana per la ricerca dei papiri greci e latini in Egitto, Florence, 1912 ff.

QCr — Quaderni della Critica, Bari

RA — Revue Archéologique, Paris

RAA — Revue des Arts Asiatiques, Paris

RACr — Rivista di Archeologia Cristiana, Rome

RArte	— Rivista d'Arte, Florence
RArts	— Revue des arts, Paris
RBib	— Revue Biblique, Paris
RDK	— Reallexicon zur deutschen Kunstgeschichte, Stuttgart, 1937 ff.
RE	— A. Pauly, G. Wissowa, Real-Enzyklopädie der klassischen Altertumswissenschaft, Stuttgart, 1894 ff.
REA	— Revue des Etudes Anciennes, Bordeaux
REByz	— Revue des Etudes Byzantines, Paris
REG	— Revue des Etudes Grecques, Paris
Reinach, RP	— S. Reinach, Répertoire des Peintures Grecques et Romaines, Paris, 1922
Reinach, RR	— S. Reinach, Répertoire des Reliefs Grecs et Romains, Paris, I, 1909; II and III, 1912
Reinach, RS	— S. Reinach, Répertoire de la Statuaire Grecque et Romaine, Paris, I, 1897; II, 1, 1897; II, 2, 1898; III, 1904; IV, 1910
Reinach, RV	— S. Reinach, Répertoire des Vases peints, grecs et étrusques, Paris, I, 1899; II, 1900
REL	— Revue des Etudes Latines, Paris
RendAccIt	— Rendiconti della R. Accademia d'Italia, Rome
RendLinc	— Rendiconti dell'Accademia dei Lincei, Rome
RendNapoli	— Rendiconti dell'Accademia di Archeologia di Napoli, Naples
RendPontAcc	— Rendiconti della Pontificia Accademia Romana di Archeologia, Rome
RepfKw	— Repertorium für Kunstwissenschaft, Berlin, Stuttgart
REthn	— Revue d'Ethnographie, Paris
RhMus	— Rheinisches Museum für Philologie, Frankfort on the Main
RIASA	— Rivista dell'Istituto d'Archeologia e Storia dell'Arte, Rome
RIN	— Rivista Italiana di Numismatica, Rome
RlDKg	— Reallexicon zur deutschen Kunstgeschichte, Stuttgart, 1937
RLV	— M. Ebert, Real-Lexicon der Vorgeschichte, Berlin, 1924–32
RM	— Mitteilungen des deutschen archäologischen Instituts, Römische Abteilung, Berlin
RN	— Revue Numismatique, Paris
Robert, SR	— C. Robert, Die antiken Sarkophag-Reliefs, Berlin, 1890 ff.
Roscher	— W. H. Roscher, Ausführliches Lexikon der griechischen und römischen Mythologie, Leipzig, 1884–86; 1924–37
RQ	— Römische Quartalschrift, Freiburg
RScPr	— Rivista di Scienze Preistoriche, Florence
RSLig	— Rivista di Studi Liguri, Bordighera, Italy
RSO	— Rivista degli Studi Orientali, Rome
Rumpf, MZ	— A. Rumpf, Malerei und Zeichnung (W. Otto, Handbuch der Archäologie, IV, 1), Munich, 1953
SA	— Soviet Archaeology, Moscow, Leningrad
SbBerlin	— Sitzungsberichte der preussischen Akademie der Wissenschaften, Berlin
SbHeidelberg	— Sitzungsberichte der Akademie der Wissenschaften zu Heidelberg, Heidelberg
SbMünchen	— Sitzungsberichte der bayerischen Akademie der Wissenschaften zu München, Munich
SbWien	— Sitzungsberichte der Akademie der Wissenschaften in Wien, Vienna
Schlosser	— J. Schlosser, La letteratura artistica, Florence, 1956
Scranton, Greek Walls	— R. L. Scranton, Greek Walls, Cambridge, Mass., 1941
SEtr	— Studi Etruschi, Florence
SNR	— Sudan Notes and Records, Khartoum
SPA	— A Survey of Persian Art, ed. A. U. Pope and P. Ackerman, Oxford, 1938
SymbOsl	— Symbolae Osloenses, Oslo
Tebtunis	— The Tebtunis Papyri, B. P. Grenfell, A. S. Hunt, et al., eds., London, 1902 ff.
ThB	— U. Thieme, F. Becker, Künstler Lexikon, Leipzig, 1907–50
TitAM	— Tituli Asiae Minoris, Vindobonae, 1901–44
TNR	— Tanganyika Notes and Records, Dar-es-Salaam
Toesca, Md	— P. Toesca, Il Medioevo, 2 vols., Turin, 1927
Toesca, Tr	— P. Toesca, Il Trecento, Turin, 1951
TP	— T'oung Pao, Leiden
UCalPAAE	— University of California, Publications in American Archaeology and Ethnology, Berkeley

USMB	— United States National Museum, Bulletin, Washington, D.C.
Van Marle	— R. van Marle, The Development of the Italian Schools of Painting, The Hague, 1923–38
Vasari	— G. Vasari, Vite, ed. Milanesi, Florence, 1878 ff. (Am. ed., trans. E. H. and E. W. Blashfield and A. A. Hopkins, 4 vols., New York, 1913)
Venturi	— A. Venturi, Storia dell'Arte Italiana, Milan, 1901 ff.
VFPA	— Viking Fund Publications in Anthropology, New York
Vollmer	— H. Vollmer, Allgemeines Lexikon der bildenden Künstler des XX. Jahrhunderts, Leipzig, 1953
Warburg	— Journal of the Warburg and Courtauld Institutes, London
Weickert, Archaische Architektur	— C. Weickert, Typen der archaischen Architektur in Griechenland und Kleinasien, Augsburg, 1929
Wpr	— Winckelmannsprogramm, Berlin
WürzbJ	— Würzburger Jahrbücher für die Altertumswissenschaft, Würzburg
WVDOG	— Wissenschaftliche Veröffentlichungen der Deutschen Orient-Gesellschaft, Leipzig, Berlin
ZäS	— Zeitschrift für ägyptische Sprache und Altertumskunde, Berlin, Leipzig
ZfAssyr	— Zeitschrift für Assyriologie, Strasbourg
ZfbK	— Zeitschrift für bildende Kunst, Leipzig
ZfE	— Zeitschrift für Ethnologie, Berlin
ZfKg	— Zeitschrift für Kunstgeschichte, Munich
ZfKw	— Zeitschrift für Kunstwissenschaft, Munich
ZfN	— Zeitschrift für Numismatik, Berlin
ZfSAKg	— Zeitschrift für schweizerische Archäologie und Kunstgeschichte, Basel
ZMG	— Zeitschrift der deutschen morgenländischen Gesellschaft, Leipzig

Languages and Ethnological Descriptions

Alb.	— Albanian
Am.	— American
Ang.	— Anglice, Anglicized
Ar.	— Arabic
Arm.	— Armenian
AS.	— Anglo-Saxon
Bab.	— Babylonian
Br.	— British
Bulg.	— Bulgarian
Chin.	— Chinese
D.	— Dutch
Dan.	— Danish
Eg.	— Egyptian
Eng.	— English
Finn.	— Finnish
Fr.	— French
Ger.	— German
Gr.	— Greek
Heb.	— Hebrew
Hung.	— Hungarian
It.	— Italian
Jap.	— Japanese
Jav.	— Javanese
Lat.	— Latin
Mod. Gr.	— Modern Greek
Nor.	— Norwegian
Per.	— Persian
Pol.	— Polish
Port.	— Portuguese
Rum.	— Rumanian
Rus.	— Russian
Skr.	— Sanskrit
Sp.	— Spanish
Swed.	— Swedish
Yugo.	— Yugoslav

Other Abbreviations (Standard abbreviations in common usage are omitted.)

Abh.	— Abhandlungen
Acad.	— Academy, Académie
Acc.	— Accademia
Adm.	— Administration

Ak.	— Akademie	K.	— Kunst
Allg.	— Allgemein	Kat.	— Katalog
Alm.	— Almanacco	Kchr.	— Kunstchronik
Amm.	— Amministrazione	Kg.	— Kunstgeschichte
Ann.	— Annals, Annali, Annuario, Annual, etc.	Kunsthist.	— Kunsthistorische
Ant.	— Antiquity, Antico, Antiquaire, etc.	Kw.	— Kunstwissenschaft
Anthr.	— Anthropology, etc.	Lett.	— Letteratura, Lettere
Antr.	— Antropologia, etc.	Lib.	— Library
Anz.	— Anzeiger	ling.	— linguistica, lingua, etc.
Arch.	— Architecture, Architettura, Architettonico, etc.; Archives	Lit.	— Literary, Literarische, Littéraire, etc.
Archaeol.	— Archaeology, etc.	Mag.	— Magazine
attrib.	— attributed	Med.	— Medieval, Medievale, etc.
Aufl.	— Auflage	Meded.	— Mededeelingen
Aufn.	— Aufnahme	Mél.	— Mélanges
B.	— Bulletin, Bollettino, etc.	Mém.	— Mémoire
b.	— born	Mem.	— Memorie, Memoirs
Belg.	— Belgian, Belga, etc.	Min.	— Minerva
Berl.	— Berlin, Berliner	Misc.	— Miscellany, Miscellanea, etc.
Bern.	— Berner	Mit.	— Mitteilungen
Bib.	— Bible, Biblical, Bibliothèque, etc.	Mnb.	— Monatsberichte
Bibliog.	— Bibliography, etc.	Mnbl.	— Monatsblätter
Bur.	— Bureau	Mnh.	— Monatshefte
Byz.	— Byzantine	Mod.	— Modern, Moderno, etc.
C.	— Corpus	Mon.	— Monuments, Monumento
ca.	— circa	Münch.	— München, Münchner
Cah.	— Cahiers	Mus.	— Museum, Museo, Musée, Museen, etc.
Cal.	— Calendar	N.	— New, Notizia, etc.
Cap.	— Capital, Capitolium	Nachr.	— Nachrichten
Cat.	— Catalogue, Catalogo, etc.	Nat.	— National, etc.
Chr.	— Chronicle, Chronik	Naz.	— Nazionale
Civ.	— Civiltà, Civilization, etc.	Notit. dign.	— Notitia Dignitatum
cod.	— codex	N.S.	— new series
col., cols.	— column, columns	O.	— Oriental, Orient, etc.
Coll.	— Collection, Collana, Collationes, Collectanea, Collezione, etc.	Ö.	— Österreichische
		obv.	— obverse
		öffentl.	— öffentlich
Comm.	— Commentaries, Commentari, Communications, etc.	Op.	— Opuscolo
		Pap.	— Papers
Cong.	— Congress, Congresso, etc.	per.	— period
Cr.	— Critica	Per.	— Periodical, Periodico
Cron	— Cronaca	Pin.	— Pinacoteca
Cuad.	— Cuadernos	Pr.	— Prehistory, Preistoria, Preystori, Préhistoire
Cult.	— Culture, Cultura, etc.	Proc.	— Proceedings
D.	— Deutsch	Pub.	— Publication, Publicación
d.	— died	Pubbl.	— Pubblicazione
Diss.	— Dissertation, Dissertazione	Q.	— Quarterly, Quaderno
Doc.	— Documents, etc.	Quel.	— Quellen
E.	— Encyclopedia, etc.	R.	— Rivista
Eccl.	— Ecclesiastic, Ecclesia, etc.	r	— recto
Ep.	— Epigraphy	Racc.	— Raccolta
Esp.	— España, Español	Rass.	— Rassegna
Est.	— Estudios	Rec.	— Recueil
Et.	— Etudes	Recens.	— Recensione
Ethn.	— Ethnology, Ethnography, Ethnographie, etc.	Rech.	— Recherches
Etn.	— Etnico, Etnografia, etc.	Rel.	— Relazione
Etnol.	— Etnologia	Rend.	— Rendiconti
Eur.	— Europe, Europa, etc.	Rép.	— Répertoire
ext.	— extract	Rep.	— Report, Repertorio, Repertorium
f.	— für	Rev.	— Review, Revue, etc.
fasc.	— fascicle	Rl.	— Reallexicon
Fil.	— Filologia	Rom.	— Roman, Romano, Romanico, etc.
Filos.	— Filosofia, Filosofico	rv.	— reverse
fol.	— folio	S.	— San, Santo, Santa (saint)
Forsch.	— Forschung, Forschungen	S.	— Studi, Studies, etc.
Gal.	— Galerie	Samml.	— Sammlung, Sammlungen
Gall.	— Gallery, Galleria	Sc.	— Science, Scienza, Scientific, etc.
Geog.	— Geography, Geografia, Geographical, etc.	Schr.	— Schriften
Giorn.	— Giornale	Schw.	— Schweitzer
H.	— History, Historie, etc.	Script.	— Scriptorium
hl.	— heilig, heilige	Sitzb.	— Sitzungsberichte
Holl.	— Hollandisch, etc.	s.l.	— in its place
Hum.	— Humanity, Humana, etc.	Soc.	— Social, Society, Società, Sociale, etc.
I.	— Istituto	Spec.	— Speculum
Ill.	— Illustration, Illustrato, Illustrazione, etc.	SS.	— Saints, Sante, Santi, Santissima
Ind.	— Index, Indice, Indicatore, etc.	St.	— Saint
Inf.	— Information, Informazione, etc.	Sta	— Santa (holy)
Inst.	— Institute, Institut, Instituto, etc.	Ste	— Sainte
Int.	— International, etc.	Sto	— Santo (holy)
Ist.	— Istituto	Sup.	— Supplement, Supplemento
J.	— Journal	s.v.	— under the word
Jb.	— Jaarboek	Tech.	— Technical, Technology, etc.
Jhb.	— Jahrbuch	Tecn.	— Tecnica, Tecnico
Jhrh.	— Jahreshefte	Tr.	— Transactions

trans.	— translator, translated, etc.	VAT	— Vorderasiatische Tafen
Trav.	— Travaux	Verh.	— Verhandlungen, Verhandelingen
u.	— und	Verz.	— Verzeichnis
Um.	— Umanesimo	Vf.	— Verfasser
Univ.	— University, Università, Université, etc.	Wien	— Wiener
Urb.	— Urban, Urbanistica	Yb.	— Yearbook
v	— verso	Z.	— Zeitschrift, Zeitung, etc.

NOTES ON THE ENGLISH EDITION

Standards of Translation. Contributors to the Encyclopedia, drawn from the outstanding authorities of over 35 different countries, have written in many languages — Italian, Spanish, French, German, Russian, etc. To ensure faithful translation of the author's thought, all articles have been translated into English from the original language, checked for the accuracy of technical terms and accepted English forms of nomenclature by English and American art historians, and correlated with the final editorial work of the Italian edition for uniformity and coherence of the over-all presentation. Naturally the McGraw-Hill Book Company, Inc., assumes full responsibility for the accuracy and completeness of all translations. Those articles written in English appear in the words and style of the authors, within the bounds of editorial attention to consistency and stylistic and organizational unity of the work as a whole. Article titles are in most cases parallel to those in the Italian edition, though occasionally they have been simplified, as *Dravidian Art* for *Dravidiche Correnti e Tradizioni.*

New Features. Although generally the English-language edition corresponds to the Italian version, a small number of purely editorial changes have been made in the interest of clear English-language alphabetization and occasional deletions or amplifications solely in the interest of clarity. Three major differences between the two editions do exist, however:

A considerable number of cross-references have been added in many places where it was felt that relating the subject under consideration to other pertinent articles would be of value to the reader.

A more extensive article on the Art of the Americas was projected for Volume One of the English edition with an entirely new text and many plates in black and white and color. This article was designed to give the completest possible coverage within the existing space of some 100,000 words to a subject which, because of its interest to the English-speaking public, was entrusted to a group of well-known American scholars, each expert in his respective area.

Some 300 separate short biographies have been added to the English edition to provide ready access to data on the lives, works, and critical acceptance of certain artists identified with schools, movements, and broad categories of historical development that are treated in the longer monographic articles. These articles are unillustrated, but works of the artists are represented in the plates accompanying the longer articles.

Bibliographies. The bibliographies of the original Italian edition have been amplified at times to include titles of special interest to the English-speaking world and English-language editions of works originally published in other languages.

In undertaking these adaptations of the Italian text and preparing original material for the English edition, the publisher has been aided by the generous advice and, in many cases, collaboration of the members of the Editorial Advisory Committee.

CONTRIBUTORS TO VOLUME VIII

Filippa Maria ALIBERTI, Direzione Generale, Belle Arti, Rome
Giancarlo AMBROSETTI, Rome
Giulio Carlo ARGAN, University of Rome
Michael AVI-YONAH, Hebrew University, Jerusalem
John AYERS, Assistant Keeper, Victoria and Albert Museum, London
Bellarmino BAGATTI, Studium Biblicum Franciscanum, Jerusalem
Eugenio BATTISTI, University of Genoa
Gianguido BELLONI, Vice Director, Musei Civici d'Arte, Archeologia e Numismatica, Milan
Leonardo BENEVOLO, Rome
Sergio BOSTICCO, University of Florence
Mario BUSSAGLI, University of Rome
Michelangelo CAGIANO DE AZEVEDO, Università Cattolica del Sacro Cuore, Milan
Schuyler Van Rensselaer CAMMANN, University of Pennsylvania, Philadelphia
Guglielmo CAPOGROSSI, Rome
Roberto CARITÀ, Soprintendente ai Monumenti e Gallerie per le provincie di Sassari e Nuoro, Sardinia
Ferdinando CASTAGNOLI, University of Rome
Ernesta CERULLI, Istituto per le Civiltà Primitive, University of Rome
André CHASTEL, University of Paris
Marco CHIARINI, Florence
George CŒDÈS, Membre de l'Institut; Honorary Director, École Française d'Extrême-Orient, Paris
Piero CORRADINI, University of Rome
Maurice S. DIMAND, formerly, Metropolitan Museum of Art, New York City
Gillo DORFLES, University of Trieste
Klaus FISCHER, Kabul, Afghanistan
Fausto FRANCO, Venice
Giovanni GARBINI, University of Rome
Roman GHIRSHMAN, University of Teheran; Membre Correspondant de l'Institut de France; Directeur des Missions Archéologiques Françaises en Iran
Hermann GOETZ, University of Heidelberg
Godfrey St. G. M. GOMPERTZ, Aldworth, Reading, England
Lloyd GOODRICH, Director, Whitney Museum of American Art, New York City
† Douglas H. GORDON, Hingham, Norfolk, England
Pierre GRIMAL, University of Paris
Will GROHMANN, Berlin
Joseph GUTMANN, Hebrew Union College, Jewish Institute of Religion, Cincinnati, Ohio
Madeleine HALLADE, Musée Guimet, Paris
Louis HAMBIS, École Pratique des Hautes Etudes, Sorbonne, Paris
Tom HARRISSON, Curator, Sarawak Museum, Kuching, Sarawak, Federation of Malaysia

Robert HEINE-GELDERN, Institut für Völkerkunde, University of Vienna
Julius S. HELD, Barnard College, Columbia University, New York City
Henry R. HOPE, Indiana University, Bloomington, Ind.
John M. JACOBUS, Jr., University of California, Berkeley
† Ernst KÜHNEL, Director, Islamic Section, Staatliche Museen, Berlin
Takeshi KUNO, Staff Member, Tokyo National Institute of Cultural Properties Research, Tokyo
Lionello LANCIOTTI, University of Rome
Fritz LOW-BEER, New York City
John W. McCOUBREY, University of Pennsylvania, Philadelphia
Richard B. K. McLANATHAN, New York City
Taiji MAEDA, Tokyo Geijutsu Daigaku, Tokyo
Fernanda DE' MAFFEI, Rome
Guido MANSUELLI, Soprintendente alle Antichità, Bologna
Giovanni MARIACHER, Director, Musei Civici, Venice
Guglielmo MATTHIAE, University of Rome
Paolo MATTHIAE, Rome
Agnes MONGAN, Curator of Drawings, Fogg Art Museum, Cambridge, Mass.
Anton MOORTGAT, Freie Universität, Berlin
Peter MURRAY, Courtauld Institute of Art, University of London
Bernard S. MYERS, formerly, The City College, New York City
Francesco NEGRI ARNOLDI, Rome
Liam DE PAOR, Department of History, University College, Dublin
Enrico PARIBENI, Soprintendenza, Foro Romano e Palatino, Rome
Antonio PRIORI, Rome
Robert ROSENBLUM, Princeton University
Luigi SALERNO, Soprintendenza ai Monumenti, Rome
Margaretta M. SALINGER, Metropolitan Museum of Art, New York City
Gianroberto SCARCIA, Accademia dei Lincei, Rome
Giuseppe SCAVIZZI, Rome
Guido SCHOENBERGER, Jewish Museum, New York City
Italo SIGNORINI, Rome
Peter C. SWANN, Keeper, Department of Eastern Art, Ashmolean Museum, Oxford
Shuzo TAKIGUCHI, Tokyo
Shin'ichi TANI, Tokyo Geijutsu Daigaku, Tokyo
Jeanne TERWEN, Rijksmuseum voor Volkenkunde, Leiden
Kojiro TOMITA, Curator of Asiatic Art, Museum of Fine Arts, Boston
Giorgio VIGNI, Ministero della Pubblica Istruzione, Rome
Geoffrey WEBB, London
Marcus WHIFFEN, Arizona State University, Tempe, Arizona
Giuseppe ZAMMERINI, Rome

ACKNOWLEDGMENTS

The Institute for Cultural Collaboration and the publishers express their thanks to the collectors and to the directors of the museums and galleries listed below for permission to reproduce works in their collections and for photographs supplied.

The Institute also acknowledges the kind permission of H. M. Queen Elizabeth II to reproduce works belonging to the Crown.

AIX-EN-PROVENCE, France, Musée Granet
AMSTERDAM, Koninklijk Instituut voor de Tropen
AMSTERDAM, Stedelijk Museum
AOMORI, Japan, Gengo Echigoya Coll.
AOSTA, Italy, Museo Archeologico
AQUILA, Italy, Museo Nazionale d'Arte Abruzzese
ATHENS, Benaki Museum
ATHENS, National Museum

BALTIMORE, Museum of Art
BASEL, Kunstmuseum
BEIRUT, Lebanon, American University, Museum of Archaeology
BERLIN, Museum für Völkerkunde
BERLIN, Staatliche Museen
BERN, Kunstmuseum, Paul-Klee-Stiftung
BOLOGNA, Pinacoteca Nazionale
BOMBAY, Prince of Wales Museum
BOSTON, Isabella Stewart Gardner Museum
BOSTON, Museum of Fine Arts
BRESCIA, Italy, Museo Cristiano
BRESCIA, Italy, Pinacoteca Civica Tosio-Martinengo

CAIRO, Egyptian Museum
CAIRO, Museum of Islamic Art
CALCUTTA, Indian Museum
CAMBRIDGE, England, Fitzwilliam Museum
CAPUA, Italy, Museo Provinciale Campano
CHANTILLY, France, Musée Condé
CHICAGO, Art Institute
CINCINNATI, Art Museum
COLOGNE, Lackmuseum Herbig-Haarhaus
COPENHAGEN, Nationalmuseet

DAMASCUS, National Museum
DELPHI, Greece, Archaeological Museum
DERBYSHIRE, England, Trustees of the Chatsworth Settlement
DJAKARTA, Indonesia, Museum
DRESDEN, Gemäldegalerie

FERRARA, Italy, Museo dell'Opera del Duomo
FERRARA, Italy, Pinacoteca Nazionale
FLORENCE, Accademia
FLORENCE, Museo Archeologico
FLORENCE, Museo Bardini
FLORENCE, Museo Nazionale di Antropologia e Etnologia
FLORENCE, Museo Storico e Topografico
FLORENCE, Pitti

FLORENCE, Pitti, Museo degli Argenti
FLORENCE, Uffizi

HAMBURG, Museum für Völkerkunde
HIKONE, Japan, Naosuke Ii Coll.

INNSBRUCK, Tiroler Volkskunstmuseum

JERUSALEM, Hebrew University Coll.
JERUSALEM, Palestine Archaeological Museum
JERUSALEM, Reifenberg Coll.

KABUL, Afghanistan, Museum
KAMAKURA, Kanagawa prefecture, Japan, Kawabata Coll.
KANSAS CITY, Mo., Nelson Gallery of Art and Atkins Museum
KASSEL, Germany, Staatliche Kunstsammlungen
KYOTO, Japan, National Museum
KYOTO, Japan, Nomura Coll.

LEIDEN, Rijksmuseum voor Volkenkunde
LENINGRAD, The Hermitage
LIVERPOOL, Public Museums
LONDON, British Museum
LONDON, National Gallery
LONDON, Victoria and Albert Museum
LONDON, Wallace Coll.
LOS ANGELES, County Museum
LUCERNE, Switzerland, Kofler-Truniger Coll.
LUCKNOW, India, Provincial Museum
LUND, Sweden, Antikmuseet

MADRID, Museo Arqueológico Nacional
MARSEILLES, Musée Archéologique
MATHURA, India, Archaeological Museum
MILAN, Brera
MILAN, Castello Sforzesco
MILAN, Pinacoteca Ambrosiana
MODENA, Italy, Museo del Duomo
MUNICH, Bayerisches Nationalmuseum
MUNICH, Bayerische Staatsbibliothek
MUNICH, Museum für Völkerkunde

NAPLES, Museo di Capodimonte
NAPLES, Museo Nazionale
NEW DELHI, National Museum
NEW YORK, Brooklyn Museum
NEW YORK, Frick Coll.
NEW YORK, Solomon R. Guggenheim Museum

NEW YORK, N. Heeramaneck Coll.
NEW YORK, F. Low-Beer Coll.
NEW YORK, Metropolitan Museum
NEW YORK, Museum of Modern Art
NUMAZU, Japan, Tanaka Coll.

ODAWARA, Japan, Asano Coll.
ORVIETO, Italy, Museo dell'Opera del Duomo

PADUA, Italy, Museo Civico
PARIS, Coll. David-Weill
PARIS, Louvre
PARIS, Musée d'Art Moderne
PARIS, Musée de Cluny
PARIS, Musée Guimet
PARIS, Musée de l'Homme
PATNA, India, Archaeological Museum
PEKING, Jupéon Museum
PERUGIA, Italy, Galleria Nazionale dell'Umbria
PERUGIA, Italy, Musei Civici
PESARO, Italy, Cathedral Treasury
PHILADELPHIA, Museum of Art
PHILADELPHIA, University Museum
PHNOM PENH, Cambodia, Musée Albert Sarraut
PISA, Museo Nazionale
PRINCETON, N.J., University Art Museum

RAVENNA, Italy, Museo Nazionale
ROME, Biblioteca Casanatense
ROME, Galleria Borghese
ROME, Galleria Doria Pamphili
ROME, Galleria Nazionale
ROME, Lateran Museums
ROME, Museo d'Arte Orientale
ROME, Museo Nazionale Romano
ROME, Museo di Palazzo Venezia
ROME, Museo Pigorini
ROME, Palazzo dei Conservatori, Museo Nuovo
ROME, Palazzo dei Conservatori, Pinacoteca Capitolina
ROME, Vatican Library
ROME, Vatican Museums

SAINT-GERMAIN-EN-LAYE, France, Musée des Antiquités Nationales
SEATTLE, Art Museum
SEATTLE, Thomas Burke Memorial Washington State Museum
SEOUL, National Museum of Korea
SIENA, Italy, Palazzo Pubblico
SIENA, Italy, Pinacoteca
SRINAGAR, Kashmir, Sri Pratap Singh Museum

TEHERAN, Archaeological Museum
TEHERAN, Gulistan Palace, Imperial Library
TERVUEREN, Belgium, Musée Royal de l'Afrique Centrale
TOKYO, Brasch Coll.
TOKYO, Princess Chichibu Coll.
TOKYO, Fujiwara Coll.
TOKYO, Hara Coll.
TOKYO, Hosokawa and Hara Coll.
TOKYO, Hatakeyama Kazukiyo Coll.
TOKYO, Matsudaira Coll.
TOKYO, Mitsui Coll.
TOKYO, Muto Coll.
TOKYO, Nagao Museum
TOKYO, Takeo Nakazawa Coll.
TOKYO, National Museum
TOKYO, Nezu Museum
TOKYO, Sakai Coll.
TOKYO, Mosaku Sorimachi Coll.
TOKYO, Keiji Takakuma Coll.
TOKYO, University of Arts
TOKYO, Yamanouchi Coll.
TORONTO, Royal Ontario Museum, J. H. Hirshhorn loan
TRIESTE, Italy, Museo Sartorio

URBINO, Italy, Galleria Nazionale delle Marche

VENICE, Accademia
VERONA, Italy, Museo di Castelvecchio
VIENNA, Museum für Völkerkunde

WASHINGTON, D.C., Freer Gallery of Art
WASHINGTON, D.C., National Gallery

ZURICH, Schweizerisches Landesmuseum

PHOTOGRAPHIC CREDITS

The numbers refer to the plates. Those within parentheses indicate the sequence of subjects in composite plate pages. Italic numbers refer to photographs owned by the Institute for Cultural Collaboration.

AB ORREFORS GLASBRUK, Orrefors, Sweden: 58 (2, 3)
AERO-PHOTO, Paris: 437 (1–2)
AERO PICTORIAL LTD, London: 444 (2)
ALINARI, Florence: 81 (1–2); 82 (1–2); 83; 85; 86 (2); 95; 98 (2); 100 (1–2); 102 (1–2); *103*; *104*; 105; *118*; 171 (1–2, 4–5); 172 (2–4); 173 (2, 4); 174 (3–4); 176 (2–5); 177 (2–4); 178 (1–4); *179*; 181 (2–4); 182 (1–4); 183 (1–4); 184 (1, 3–4); 185 (1–4); 186 (2–4); 187 (1,3); 188 (3–4); 191 (1–5); 192 (1–4); 193 (1–2); 194 (1, 3); 195 (1, 3); 196 (1–3); 197 (1, 3); 198 (1–5); 199 (1, 3–4); 200 (1–2); 201 (1–2); 202 (2, 4); 203 (1–3); 204 (1, 3); 205 (1, 3); 206 (1–4); 207 (1–5); 208 (1–3); 209 (1–3); 210 (1–3); 213 (3); 214 (1, 3); 215 (1–3); 216 (1–3); 217 (1); 218 (2–3); 219 (1, 2, 4); 220 (1–3); *221*; 223 (2–4); 224 (1–4); 225 (1, 3–4); 226 (1–6); 227 (1–2, 4); 228 (1–2); 229 (2–4); 231 (2); 232 (1); 242 (4–6); 245; 246 (1); 424 (3); 425 (1–2); 426 (1–3); 427 (2); 429 (1); 430 (1–2); 431 (1–4); 432 (2); 434 (1–2); 435 (1); 440 (1–2); 441 (1); 445 (1, 3–5)
ALPINER KUNSTVERLAG WILHELM STEMPLE, Innsbruck, Austria: 99 (4)
ANDERSON, Rome: 82 (3); 86 (1); 97 (1); 111 (2); 173 (1, 3); 174 (1–2); 176 (1); 177 (1, 5); 178 (5); 186 (1); 187 (2, 4); 202 (3); 205 (2); 208 (4); 213 (2); 214 (2); 217 (2); 219 (3); 220 (4); 223 (1); 225 (2); 227 (3); 231 (1); 232 (2); 429 (2); 433 (2); 441 (2)
ARCHIEF INDISCH INSTITUT, Amsterdam: 23 (4); 24 (2); 25 (3)
ARGIROPULO NOVOSTI PRESS AGENCY, London: 389 (1)
ARTE E COLORE, Milan: 5; 6; 11; *222*; *359 (1–4)*; *362*; *403*
ARTEK STANDARD, Helsinki: 50 (3)
"L'AUTOMOBILE," Rome: 43 (1)

BALLO, Aldo, Milan: 52 (1); 56 (1); 57 (2)
BENRIDO COMPANY LTD., Kyoto: *269, 270, 299, 304, 314*; *317*; *319*
BILDARCHIV FOTO MARBURG, Marburg, Germany: 335 (2); 439 (2–3)
BOUTRELLE, Adrien, New York: 40 (1)
BRITISH EUROPEAN AIRWAYS: 48 (1)
BROGI, Florence: 194 (2); 195 (2); 204 (2); 218 (1)

CAISSE NATIONALE DES MONUMENTS HISTORIQUES, Paris: 72; 108 (3); 237 (3); 438 (2–3)
CALZOLARI, Mantua, Italy: 106 (1); 428 (2)
CHRYSLER CORPORATION, New York: 46 (1)
CHUZEVILLE, Paris: *119*; *130*
COOPER, A.C., London: 152 (4)
COUNCIL OF INDUSTRIAL DESIGN, London: 57 (3)
COUNTRY LIFE, London: 99 (1, 3); 109 (2)
COURTAULD INSTITUTE OF ART, London: 342 (1–2)

DE ANTONIS, Rome: 27 (2); 31; 41; 42; 78 (3); *129*; *143*; *144*; *152 (3)*; *153*; *154*; *157*; *167*; *168*; 211 (1–2); 239 (1); 240 (4); 242 (1–2); 243 (1); 244 (2–3); 249 (4); 259; 260; 279; *280*; *290*; *293*; *294*; *300*; *303*; *313*; *348*; *383*; *402*; *415 (1)*
DEPARTMENT OF ARCHAEOLOGY, GOVERNMENT OF INDIA, New Delhi: 1; 3 (1); 7 (1); 10; 15; 63; 64; 65; 66; 67 (1–2); 68; 70 (1–4); 89 (3); 113 (2); 165; 166; 169; 251; 252; 253; 254 (1–2); 255; 256; 257 (1–3); 258 (2)
DEUTSCHE FOTOTHEK, Dresden: 213 (1)

DEUTSCHES ARCHÄOLOGISCHES INSTITUT, Athens: 237 (2)
DEUTSCHES ARCHÄOLOGISCHES INSTITUT, Rome: 230 (2); 346
DRÄYER, Walter, Zurich: 238 (2)
DREYFUSS, Henry, New York: 54 (3)

ENTE PROVINCIALE DEL TURISMO, Caserta, Italy: 175 (1)
ENTE PER LE VILLE VENETE, Venice: 435 (2); 442 (2)

FARID SHAFEI: 88 (1–2)
FICARELLI, M., Bari, Italy: 172 (1)
FIORENTINI, Venice: 107
FLEMING, London: *384*
FOTOGRAMMA, S.R.L., Milan: 54 (1); 56 (2); 61
FOTOTECNICA UNIONE, Rome: 96 (3)

GABINETTO FOTOGRAFICO NAZIONALE, Rome: 338 (2–3); 442 (1)
GARRIGNES, Tunis: 146 (2)
GARZÓN, Granada: 149
GIRAUDON, Paris: 4 (2); 7 (2); 9; 22; 69 (1–2); 71 (1–3); 73; 75 (1–2); 76; 201 (3); 243 (2–4); 347; 438 (1,4)
GOETZ, Hermann, Heidelberg, Germany: 89 (1–2); 446 (1–2)

HIRMER VERLAG, Munich: 92; 97 (3); 240 (2–3); 439 (1)

ISTITUTO CENTRALE DEL RESTAURO, Rome: 188 (1)
ISTITUTO DI PATOLOGIA DEL LIBRO, Rome: 175 (3)

JONALS CO., Copenhagen: 57 (10)

KEMPTER, Munich: *117*
KERSTING, A.F., London: 340 (1)
KNOLL ASSOCIATES, INC., Zeeland, Mich.: 51 (1)
KOCH, Lucerne, Switzerland: 120 (1–2)
KOLONIAAL INSTITUT, Amsterdam: 26 (3)
KONINKLIJKE LUCHTVAART MAATSCHAPPIJ: 48 (2)
KONINKLIJK INSTITUT VOOR DE TROPEN, Amsterdam: 23 (1–3); 24 (1); 25 (2)
KUNSTMUSEUM, Bern, Switzerland, Paul-Klee-Stiftung: *393*; *394*

LANGKJAER, Stockholm: 54 (2)
LAVAUD, Paris: *12 (1–2)*
LEHNERT & LANDROCK, Cairo: 77 (2)
LEKEGIAN: 162 (1)
LOKE WAN-THO, Singapore: 366; 367; 368 (2); 369 (2); 372 (1–2); 374 (2); 375; 376

MARAINI, Fosco: 448 (1–4); 449
MAS, Barcelona: 91 (5–6); 113 (1); 148 (2–3); 443 (1–3)
MINISTRY OF WORKS, London: 339
MUSÉE GUIMET, Paris: 2 (2); 3 (2); 4 (1); 8 (1–2); 13 (1–2); 14; 30 (2–3); 34 (1–2); 35; 241 (1–3); 365; 368 (1); 369 (1); 370; 371 (1–2)
MUSEUM OF MODERN ART, New York: 59 (1)

NATIONAL BUILDINGS RECORD, London: 341 (1)

OFALAC, Mansourah: 150 (2)
ORLANDINI, V., Modena, Italy: 171 (3)

PALMAS, Milan: 112 (3)
PIETINET, Helsinki: 50 (3)
POZZAR, Trieste, Italy: 112 (1)
PRINCE OF WALES MUSEUM, Bombay: 258 (3)
PUCCI-GIARDINA, G., Rome: 433 (1)

RAMPAZZI, Turin: 94; 423 (1)
RAZAVI, Teheran: 125 (2-3); 140 (1); 141 (2)
ROOKS PHOTO: 51 (2)
ROSTAMY, Teheran: 126
ROYAL COMMISSION ON HISTORICAL MONUMENTS, England: 340 (2)

SACHSSE, Bonn: 422 (1-2)
SAKAMOTO, M.: 345 (1-4); 418
SALA, Dino, Milan: 54 (4)
SAVIO, Oscar, Rome: 43 (2); 53 (1); 79; 80; 93; 96 (1-2); 98 (1); 101; 106 (2); 175 (4); 180; 190 (2-3); 229 (1); 233; 234; 239 (4); 358; 409 (1-4); 410 (1-2); 411 (2); 412
SCHMIDT-GLASSER, Helga, Stuttgart: 108 (2)
SCHULMAN, Julius, Los Angeles, Calif.: 116 (2)
SIMONE DI SAN CLEMENTE, Florence: 164 (1); 374 (1)
SIRÉN, Osvald, Stockholm: 114 (1)

SKELL, Orpington: 407
SOPRINTENDENZA ALLE ANTICHITÀ, Turin: 230 (1, 3)
SOPRINTENDENZA ALLE GALLERIE, Florence: 428 (1)
SOPRINTENDENZA ALLE GALLERIE, Naples: 108 (1)
SOPRINTENDENZA AI MONUMENTI DELLA CAMPANIA, Naples: 175 (2)
STEINKOPF, Walter, Berlin (Dahlem): 401 (1-2); 404; 405 (1-2)
STEINLEHNER, J., Afrika-Foto-Archiv, Munich: 162 (2)
STOLLER, Ezra, Rye, N.Y.: 450 (5)
SUNAMI, Soichi, New York: 391 (3)
SYNERGETICS INC., Raleigh, N.C.: 62 (2)

UNITED PRESS PHOTO, New York: 47
UNIVERSITY OF ROME, Gabinetto di Storia dell'Arte Medievale: 335 (1); 336; 337 (1)

VATICAN LIBRARY, Rome: 189
VICTORIA AND ALBERT MUSEUM, London: 110 (1-2); 111 (1)

WILLIAMS, Lawrence S., Upper Darby, Pa.: 46 (5)

ZABBAN, Roberto, Milan: 45 (4)

CONTENTS - VOLUME VIII

INDO-IRANIAN ART. Relations between northern India and the Iranian world or, more specifically, between the Indus Valley (see INDUS VALLEY ART) and occasionally the Ganges Valley and Iran, date back to very ancient times. Contacts were established mainly through the regions between the Indus and the Oxus (Amu Darya) rivers, such as Gandhara, through the provinces of Kapisa and Bactria (see BACTRIAN ART), which occupied the eastern part of the Iranian plateau, and at times through Drangiana (Seistan) and Arachosia.

Throughout the turbulent history of this vast zone, from the Achaemenian period until the arrival of the Arabs (ca. 6th cent. B.C. to 8th cent. of our era), these provinces were constantly changing hands, becoming either incorporated into northern India or annexed to Iran, to which their climate, way of life, and ethnic ties more closely related them.

Commercial exchanges and diplomatic relations alternated continually with conquests or migrations of populations who crossed the Hindu Kush and reached the Indus and the Punjab through the Kabul Valley. Historical events, trade, the exchange of man power and of religious beliefs were so many channels through which the art of Achaemenian, Parthian, and Sassanian Iran entered India. Thus elements of Achaemenian art (see IRANIAN PRE-SASSANIAN ART CULTURES) appear in ancient Indian art (from ca. 3d cent. B.C. to 1st cent. of the present era), while Parthian art influenced the Greco-Buddhist or Gandhara style (see GANDHARA), which flourished from the Oxus to the Punjab during the first centuries of our era, and to a certain extent the so-called "Mathura" style (see MATHURA), which flourished from the late 1st to the 4th century. It was during the Sassanian period (see SASSANIAN ART), however, that Iranian art made its most appreciable impact on India, particularly in the province of Kapisa, where an influx of Iranian culture promoted the flowering of a local style, called "Irano-Buddhist," which developed and evolved in the great monastic center of Bamian (3d to early 7th cent.; see AFGHANISTAN). Apart from its individuality, this style is of particular interest and significance for its relation to the art of the regions beyond the Oxus, in Sogdiana and Khwarizm (qq.v.), and for its influence on the art of Serindia (see ASIA, CENTRAL).

Bamian seems to have been the center for the transformation and diffusion of Iranian influence mixed with Indian elements, which appears in the frescoes of Kizil, Su-bashi, and Kumtura (late 4th–8th cent.) and which subsequently was modified and spread as far as China and even Japan. Toward the end of the 6th and during the 7th century, a fresh wave of Sassanian artistic influence, together with the stimulus provided by the art of Gupta (see GUPTA, SCHOOL OF) and Pala (see PALA-SENA SCHOOLS) India, gave rise to the development of a more sophisticated, rather baroque style, which might be termed "Sassano-Gupta." With this style, embodying an amalgamation or juxtaposition of contrasting tendencies, are associated the works of art discovered in a little monastery in Fondukistan and some late sculptures at Bamian.

SUMMARY. Historical relations between Iran and northern India (col. 2). Contributions of Achaemenian Iran to the art of ancient India (col. 3). Contributions of Parthian Iran to the Greco-Buddhist style and to that of Mathura (col. 5). The Irano-Buddhist school of Bamian (col. 8). Relations between Gupta and post-Gupta India and Sassanian Iran: the Sassano-Buddhist style of Fondukistan (col. 14). Reflections of Indo-Iranian art in the art of Serindia (col. 15).

HISTORICAL RELATIONS BETWEEN IRAN AND NORTHERN INDIA. "India, in centuries and perhaps millenniums B.C., was an integral part of an 'Ancient East' that extended from the Mediterranean to the Ganges Valley. In this ancient world there prevailed a common type of culture, which may well have had a continuous history" A. K. Coomaraswamy, in his *History of Indian and Indonesian Art*, thus emphasizes the ties which have bound India to Iran from the remote past. Excavations, many quite recent, have demonstrated the similarities that existed between the civilizations of Susa and Mesopotamia and those which flourished from the 4th to the 2d millennium at Harappa and Mohenjo-daro in the Indus Valley, in Baluchistan, and in southeastern Afghanistan (recent excavations at Mundigak). The migrations of the Aryans (or Indo-Iranians) toward the Punjab, during the 2d millennium B.C., still may be considered the source of the tie that existed between Iran and India. However, relations between the two regions were not permanently established until the end of the 4th century B.C., when the Achaemenids conquered and occupied the Indus Valley. This conquest may have been begun by Cyrus (558–529 B.C.) and continued by Darius immediately upon his accession. At all events, Bactria, Kapisa, Gandhara, the Punjab, and Sind became satrapies of the Great King, and it was as successor to the Persians that Alexander the Great laid claim to the suzerainty over these regions at the time of his expedition into India (327–325 B.C.). After the death of the Macedonian conqueror, cordial relations were established between the Seleucids and the Maurya emperors, who had extended their dominion as far as the southern part of the Hindu Kush by means of an agreement. The sojourn at Pataliputra of Seleucus's ambassador Megasthenes, between 304 and 297 B.C., attests to the reciprocal feelings of good will and suggests that exchanges took place between the two courts — exchanges that were expressed in the realm of art. Relations with India were maintained during the period of turmoil attendant on the decline of Seleucid power in the eastern part of the Iranian plateau, though often these were of a less cordial nature [Antiochus III's expedition up the Indus, 206 B.C.; conquests of Demetrius and Menander (Melinda), 2d cent. B.C.]. For about two hundred years, from the middle of the 3d century, India saw the establishment of a series of Greco-Bactrian and then Indo-Greek dynasties, which undoubtedly left a Hellenic stamp, tinged with Iranism, on the regions extending from the Oxus River to the Punjab and sometimes even beyond. The penetration of Iranian culture into India was promoted by the invasion of the Śakas, Scythian tribes who came from beyond the Oxus in about 130 B.C. Having settled for a time in Drangiana (which had become Sakastan), where they were exposed to the influence of Parthian Iran, these tribes finally reached the Indus Valley in about 75 B.C., under their leader Maues. From about 30 B.C. to the mid-1st century, first under Azes and then under Gondophares, a Śaka ruler of Parthian origin, they seem to have extended their dominion from Kapisa to Sind and to the eastern Punjab.

The arrival of the Yüeh-chih (probably another tribe of Iranian Scythians) opened a new era of contact between India and Parthian Iran, with subsequent artistic influences. Although established in Bactria by 130 B.C., the Yüeh-chih did not extend their dominion to the southern part of the Hindu Kush until about one hundred years later. The clan of the Kushans (see KUSHAN ART), having established its supremacy in the latter part of the 1st century of our era, under Kujūla Kadphises and his son Wima Kadphises, founded a powerful dynasty which immediately unified under its rule the provinces extending from Mathura to the north of Bactria. The great Kushan rulers, Kaniṣka in particular, brought peace and prosperity to these regions, where various composite cultures flourished side by side. The eclecticism of the dynasty is demonstrated by its coins, on which Greek inscriptions are combined with hybrid Iranian motifs, and Iranian divinities (such as Mithra) alternate with Hercules, the Buddha, sometimes Śiva, or with the symbols of these. Protectors of Buddhism (q.v.), the Kushans promoted the construction of numerous monasteries and religious monuments, thereby stimulating the development of a complex style known as Greco-Buddhist.

With the rise of the Sassanian dynasty in Iran relations with India were revived, although established on a different basis. After the conquest of Bactria by Ardashīr I (226–41), the Kushans were driven back to the southern part of the Hindu Kush and seem to have recognized the Sassanian supremacy. The subsequent diffusion of Sassanian culture is attested by the magnitude of its influence on the art of northwestern India (Irano-Buddhist school of Bamian). Although the Ephthalite invasion, in the mid-5th century, hardly affected the artistic production of this school in the region of the Hindu Kush, it caused tangible and irreparable damage in Gandhara and the Punjab, where most of the monasteries were totally destroyed.

The Ephthalites were driven out of Bactria by a coalition of the Turks and the Sassanians under Khusrau (Khosrau, Chosroes) I, who remained master of the province. Before 597, however, under their khan Tardu, the Turks had in turn driven the Persians out of Bactria, which was renamed Tokharistan. According to Hsüan-tsang, who visited the regions to the north and south of the Hindu Kush about 630, the Turkish rulers were favorably disposed toward Buddhism, whose vitality is attested by the works of art (PLS. 4, 6, 7, 11) found in the little monastery at Fondukistan (from coins of Khusrau II, it can be dated between 590 and 628). It was not until the arrival of the Arabs, in the latter half of the 7th century, that the development of Buddhist art in this region finally ceased.

Although it was primarily historical events which brought India and Iran into contact, several other factors contributed to the establishment of relations between the two countries. The discoveries made in such places as Taxila and Begram have proved the intensity of the commercial and other exchanges which went on between northwestern India, or Kapisa, and western Asia from before the beginning of the Christian Era. Regions where Iranian influence was paramount were situated along the road which ran from the Indus River to Balkh (anc. Bactra) and there joined the immense caravan route, called the "Silk Route," which linked China to Iran and to the Mediterranean world beyond. Even when traffic followed the maritime route, it continued to unite India with the Iranian border; beyond the Persian Gulf the route rejoined the great caravansaries of Dura-Europos and Palmyra — frontier zones where Roman and Parthian civilizations existed side by side. The regions open to continual Iranian influence were those closest to Iran, where geographical conditions imposed a similar mode of living and the art reflected a gradual penetration of religious beliefs. Although most of the regions which had once constituted satrapies of the ancient Achaemenian empire eventually drifted away from Iran and, chiefly through their adoption of Buddhism, entered the India orbit, the traces of their former heritage have remained very much in evidence.

CONTRIBUTIONS OF ACHAEMENIAN IRAN TO THE ART OF ANCIENT INDIA. A. K. Coomaraswamy (1927) frequently refers to the cultural and religious affinity between the ancient civilizations of Iran and India. This would account for the similarities in various decorative and symbolic motifs, in certain aspects of the mythology, and, more especially, in the importance of the worship of the sun and of fire. Numerous representations of the Devī (earth divinity or mother goddess) in the art of ancient India stem from this affinity of religious beliefs. Beginning with the nude goddess depicted on a small gold plaque found in a Vedic funeral mound (8th–7th cent. B.C.) at Lauriya Nandangarh, an assortment of terra cottas found between Pataliputra and Taxila perpetuate in a variety of forms the theme of the goddess as bestower of fertility [discoveries made at the Bhir mound in Taxila and at Mathura; the winged goddess from Basarh (anc. Vaisali), etc.]. These works, dating chiefly from the Maurya and Śuṅga periods, were the prototypes of later representations: those of Lakṣmī and especially those of Māyā (the Buddha's mother) as she is represented in the bas-reliefs on the stupas of Bharhut and Sanchi (ca. 2d cent. B.C.–1st cent. of our era) and, on a monumental scale, on the façade of the chaitya at Manmoda. The depiction of fire altars on seals and coins is further evidence of contact between India and Iran.

The influence of Achaemenian Iran is more readily discernible in the architectural and decorative fields; sometimes there are similarities in technique. However, Indian art had already passed through the preliminary stages of development by the time perishable materials were abandoned in favor of stone. Thus, we must base our judgment on its mature aspect and can only make conjectures as to its formation and the gradual process of adoption and incorporation of Iranian artistic traditions into its own.

Aśoka's palace at Pataliputra, built about the mid-3d century B.C., seems to have equaled in splendor the Achaemenian palaces at Susa and Ecbatana (mod. Hamadān). The remains of a great hall with stone columns are reminiscent, in their disposition, of the hypostyle halls at Persepolis. An indebtedness to Iran is palpable in the aspect of the tall pillars, or lats, scattered singly throughout the various provinces of Aśoka's empire, on which this pious Buddhist had his edicts inscribed (II, PL. 399). The beautiful polish of the stone implies an Iranian technique, probably introduced by the Iranian artists who worked at Aśoka's court. The bell capital is of a Persepolitan type: the effect of fluting, obtained from the carving around it of elongated lotus petals, is similar to that on Achaemenian capitals and bases. This type of bell capital was long retained in India, where it evolved and gradually assumed a more purely Indian form. Used to frame doors and gateways (e.g., the stupa at Bharhut), it also dominated the shafts of the columns in the rock-carved chaityas dating from the beginning of our era or possibly even later (Bedsa, Karli; II, PL. 410; VII, PL. 451). The Persepolitan combination of capital and protomas of animals, the latter functioning as a support for the architrave, was also taken over in India in a modified form. In the chaityas, now and then on the toranas, and in carved architectural details protomas of animals or (more often) crouching animals figured above bell capitals. Numerous examples of this combination are to be found in the relief carvings at Bharhut, Sanchi, Mathura, and Jaggayyapeta and among the carved ivories from Begram, Afghanistan, with representations of toranas. The animals often were winged and addorsed and served a decorative rather than structural purpose.

Together with a variety of obviously indigenous motifs, ancient India's decorative repertory contained many Iranian elements, or rather elements that had come to it through Iran. It was, in fact, through Achaemenian art that motifs of a far more distant and more ancient origin reached India (e.g., Hittite, Assyrian, Hellenic), and although the earliest evidence of their penetration into India is in works of stone of the Śuṅga period, they may have appeared much earlier in objects of wood, clay, ivory, and other perishable materials.

To this assortment of imported motifs belongs the majority of the mythical animals which abound in the relief carvings on the toranas and balustrades of stupas and which reappear on the collection of Indian carved ivories that came to light

at Begram: animals in profile with their heads turned to face the viewer, animals face to face or back to back, winged lions, griffins, and many others. The variety of imported motifs also includes decorative elements: the tree of life, the palmette, certain rosettes, perhaps the blue lotus depicted in profile, the saw-tooth molding, and the typically Iranian graded crenelation disposed in a frieze. Even composite themes were transmitted to India, such as the four-horse solar chariot, or chariot of Sūrya. These motifs often were modified slightly, as in the case of the flowing vase from ancient Mesopotamia, which reappeared as a vase of lotus flowers. As J. Hackin has suggested: might not the monster-tamers depicted on the ivories discovered at Begram be the ultimate descendants of the legendary Sumerian heroes, Gilgamesh and Enkidu, or of the enigmatic divinities of Luristan grappling with wild beasts?

The graded crenelations and the palmettes reappear almost unaltered at Mathura (2d-3d cent.), together with a host of winged monsters from Iran, which also appear in the more southern Amaravati style. These monsters, particularly the lion, as well as the motifs of the tree of life and the vase of abundance, eventually were transmitted as far as southeast Asia.

CONTRIBUTIONS OF PARTHIAN IRAN TO THE GRECO-BUDDHIST STYLE AND TO THAT OF MATHURA. The constant intercourse between India and Iran during the centuries preceding and following the beginning of the Christian Era brought a continual influx of Parthian artistic ideas into India. At the same time the establishment of Greco-Bactrian and Indo-Greek dynasties in the area between the Oxus and the Punjab certainly promoted the spread of Hellenic culture; however, it affected only the thin upper stratum of the population and was itself strongly admixed with Iranian elements, as is evident from the coins of this period: miscellaneous Greek deities among various Iranian divinities (Artemis-Anahita, the sun gods, and various bearded divinities). The contacts between India and Iran were multiplied by the arrival of the Scythians (Śakas) and then the Parthians, who had settled for a time in Drangiana before reaching the Indus. According to E. Herzfeld (1935), the frescoes at Kuh-i-Khwaja (Seistan) would seem to date back to the time of Gondophares (beginning of our era). These frescoes, of combined Greek and Iranian inspiration, may have influenced the art of the neighboring regions, but it is impossible to estimate the extent of their effect upon the Greco-Buddhist painting of northwestern India, since this painting is almost entirely unknown. It is, in fact, only on the coins of the Śaka and Parthian dynasties (III, PL. 399) and of the Kushan dynasty which succeeded them (PL. 409), that traces remain of this contact with Iran. Its influence and inspiration is manifest in the type of costume (long, flared mantle and high, supple boots), in certain poses, and in various details (circular or rayed halos, flames issuing from the shoulders of King Wima Kadphises and his successors). Such Iranian divinities as Mithra are included in the complex pantheon represented on the coins of the great Kushans, on some of which Kaniṣka himself is shown in the act of placing grains of incense on a fire altar.

The proximity of Iran affected religious beliefs and consequently art. Kaniṣka, who was one of the great protectors of Buddhism, and who had Buddhist monasteries and stupas built throughout his kingdom, had extremely eclectic tastes; this fact is confirmed by the recent discovery of the fire temple at Surkh Kotal in Bactria (II, PL. 86), which presumably can be attributed to him. Besides the Jandial temple near Taxila, which Sir John Marshall (1951) dates in the first century of our era, and which has been identified as a sanctuary of Ahura Mazda, other vestiges of Mazdaism would seem to subsist at Kunduz, while the old temple at Multan, near the Indus, appears to have been administered by Magi. Alfred Foucher (1942-48) drew particular attention to the influence exerted by Iranian Mazdaism on Buddhism, in consequence of which Buddhism evolved from a Hinayana to a Mahayana form. The whole conception of the Buddha as a human being was thereby altered; henceforth he was a deity. This evolution, which also brought about an expansion of the Buddhist pantheon,

is reflected in the art of the Kushan epoch. Although anecdotal representations of episodes in the life of the Buddha Śākyamuni continued to multiply in relief carvings on minor stupas, the veneration for them tended to diminish in favor of more impersonal, more superhuman images of the Buddha and the bodhisattvas. This impersonal type of cult image became ever more frequently reproduced on stupas (at Hadda and Taxila) and in the painted vaults and niches of Buddhist sanctuaries (at Bamian). Halos, which perhaps were copied from Iran and its solar divinity, indicate this superhuman quality of the Buddhas and the bodhisattvas. At Paitava and Shotorak, near the Hindu Kush, flames issue from the shoulders of the Buddhas Śākyamuni and Dīpaṅkara (PL. 2) and from the bodhisattvas. Jacques Meunié (1942) has suggested that the purpose of these flames was "to materialize in the eyes of the faithful the holiness and majesty of the person represented"; at Bamian they appear even on "human beings of great importance, such as certain kings of Persia." These flames and the flakes of fire bordering the halos on the steles at Paitava and Shotorak are strongly reminiscent of the veneration for the cults of fire and of light in this region.

The influence of Parthian Iran is manifest in the Greco-Buddhist style, or style of Gandhara (q.v.), which flourished under the Kushans, particularly between the Oxus and the Punjab, probably from the end of the 1st century of our era to about the middle of the 5th. The composition of this style appears increasingly complex; the influence of Parthian Iran is intermingled with elements of Alexandrian and Syrian Hellenism and with those of Roman origin, while themes and forms from the art of ancient India also appear. It is seldom easy to trace the origin or course of Hellenic themes and motifs, since these circulated throughout the whole of Asia Minor and were reproduced and exchanged over a period of several hundred years, from southern Russia to India, from Alexandria, and even from Rome, to the Scythian world of Transoxiana.

In the constant ferment of civilizations in and beyond what may conveniently be called the Near East, certain motifs and traditions persisted, although gradually they were transformed. Frequently, through the agency of Parthian Iran and under a Greco-Iranian aspect, they came to be incorporated into the art of northwest India, where they were further modified and transmitted to nearby Mathura, to Serindia, and through the latter to China and even to Japan.

A. Foucher (1905-22) perceived the relationship between the school of Gandhara and the contemporary schools of Antioch, Palmyra, Susa, and Seleucia, and pointed out the similarities between the Parthian city of Dura-Europos and that of Sirkap (Taxila). Sir John Marshall drew attention to the similarities between the palace at Sirkap (ca. 1st cent. of the present era) and the Parthian palaces at Ashur, Dura, and Nippur. However, it is chiefly Daniel Schlumberger's recent research in this field that has revealed the magnitude of the Parthian contribution to Kushan art and defined its nature. This archaeologist sees in Greco-Buddhist art "the Indian descendant of Greco-Iranian art," the former having derived from the latter its predilection for frontal representation and monotonous alignment. The existence of analogies between Parthian art at Palmyra, Dura-Europos, and Hatra and the art of the Kushan epoch in Bactria, Kapisa, northwest India, and to a lesser extent, Mathura, thus has been firmly established. Indeed, a striking similarity is often apparent in the treatment of drapery folds or acanthus leaves, in the use of the same motifs, and, for instance, in the profile of a laurel-leaf molding at Palmyra, which reappears as far away as Mathura.

Elements related to those of Iran are more prevalent in the regions closest to Iran, such as Kapisa and Bactria. At Shotorak the vine scroll and the eglantine with five petals (VI, PL. 25) were frequently reproduced, and there, as at Paitava, bearded donors are represented in the costume of the cold regions, worn by both Scythians and Iranians: a belted, pleated tunic, long trousers reaching down to soft shoes, and often a flared mantle of the type worn by the Parthians and the Kushans and also the fashion at Dura-Europos. The female donors were dressed according to a western fashion which

continued in Sassanian Iran: a long gown with sleeves, and a voluminous shawl fastened over the left shoulder, leaving the right one bare (PL. 3).

The spirit of Parthian Iran also pervades the fragments of a frieze found at Airtam, near Termez (anc. Tarmita). This extremely beautiful piece of carving (of the 1st or 2d cent. of our era), which probably came from a Buddhist monument, shows a row of musicians or bearers of garlands and necklaces, emerging from a border of acanthus leaves that separate the figures. The frontal representation, the alignment, the sturdy forms, and the rather heavy features of the beautiful, serenely smiling faces are all characteristics which relate this frieze to works of Greco-Iranian tradition. The arched squinches supporting the domes at Kunduz and Haibak (II, PL. 87) were derived directly from Iran, whose influence is also abundantly manifest in the fire temple at Surkh Kotal, in Bactria. Since its discovery by Schlumberger in 1952, this site has been the object of a series of excavations (II, PLS. 86, 87, 89). The vast ensemble is situated on the top of a hill and bounded by a rampart. The central temple stands in a rectangular court, which is enclosed on three sides by fortified walls, with the fourth side opening onto a monumental stairway that descends, in three stages, to the level of the plain some 800 ft. below. The complex also includes a secondary temple which is probably of a later date. The main temple would seem to date back to the time of the great Kushans, that is, to about the 2d century of our era, although more precise information on this point undoubtedly will be provided by an important inscription which has been discovered.

Schlumberger has clearly specified the relationship of this complex to the Buddhist monuments of the period and to Iranian tradition. His analysis covers the method of construction, the plan, details of architectural decoration, and similarities of costume, pose, and theme in the sculpture. As to the method of construction, "the association of unbaked bricks for the foundations, of freestone limited to certain organs, and of great heavy beams for the roof ceases to appear unusual when one recalls the Achaemenid monuments, which provide excellent examples thereof" (*JA*, 1952, p. 448). Originally, the square cella of the main temple was surrounded on three sides by an ambulatory; the roof was supported on four columns placed at the corners of the platform of the fire altar. To Schlumberger, this plan suggested comparison with the fire temples at Susa, Persepolis, Hatra (Mesopotamia), and Kuh-i-Khwaja. With regard to the architectural decoration, whereas the Attic bases of both the columns and the engaged pillars, distributed around the walls of the cella, are of Hellenistic origin and Greco-Buddhist tradition, the merlons are essentially Iranian, and their loopholes in the form of arrowheads are copied directly from Achaemenian and Parthian examples.

Of the sculptures that have come to light, the most interesting are the badly damaged remains of three large statues which must have represented the investiture of the king by the god, a theme of Iranian tradition. Here again, Schlumberger noticed a correspondence between these three statues at Surkh Kotal and three statues found in the dynastic temple at Mathura, at the other extremity of the Kushan empire, and, indeed, in both costume and pose the Mathura statues bear a striking resemblance to the Surkh Kotal group. Each of the Mathura figures wears a long tunic with a wide galloon down the front, long trousers reaching to heavy felt boots, and a flared mantle which is held together across the chest with a clasp of double cabochons and which opens and stands out from the waist, giving the figure a pyramidal silhouette. These tunics and long trousers were the costume of the Scythian horsemen, worn by the Kushans during the 2d and 3d centuries and later adopted by the Parthians. The flared mantle, similar to those of the Surkh Kotal statues (II, PL. 89), reappears at Dura-Europos, at the other extremity of the Iranian empire, where Parthian fashions often were adopted. Likewise, the wide galloon down the front of the tunic, a handsome example of which is preserved on a statue at Surkh Kotal, recalls the ribbons which embellished the costumes at Dura-Europos and Kuh-i-Khwaja and which reappear on the statue of Sūrya at Khair Khaneh (Kabul region,

ca. 5th–6th cent.). The effect of grandeur and stability induced by the rigidly frontal and hieratic pose of the Surkh Kotal statues is equally and similarly obtained by the statues of the Kushan kings at Mathura; even the divergent position of the feet is common to both groups (PL. 1). A corresponding quality of grandeur and vigor marks the few extant Parthian statues (e.g., the bronze statue from Shami, PL. 141), in which the same frontal representation and often even the same conception of form may be noted (particularly on the steles). As Schlumberger expressed it, Parthian art did not aim to create "an illusion": bodies were flattened out, their natural volume disregarded, and clothing was merely outlined on a convex mass (many of the Buddhas on the Greco-Buddhist steles were conceived in the same manner). A small figure carved in high relief on a merlon, seated with elbows and knees turned outward, is of the same style and is related to the statue of an enthroned king at Mathura with a fire altar on its base.

The art of Surkh Kotal thus constituted one of the more important manifestations of the great movement of Iranian, or rather Greco-Iranian, art that spread to the west as far as Palmyra and Dura-Europos and to the east as far as the Indus Valley, Mathura, and Kashmir (terra cottas of Harwan), and even beyond. A low relief from Mathura (to which the merlon figure of Surkh Kotal is also related) showing the god Sūrya crouched in his chariot and the horses deployed to either side of the axletree belongs to a series of representations of the same type. Henri Seyrig, in a study on the "spread eagle" chariot (as he called it, in reference to the position of the horses), and Mario Bussagli, in a study on the frontal representation of the divine chariot (1955), both have noted the persistence of this arrangement in India (at Bodhgaya and Khandagiri) and Serindia, to which the motif was transmitted, as well as in the more westerly regions. According to Bussagli, the frontal representation of this Iranian motif in India might correspond to an ancient indigenous tendency, encouraged by the Iranian influence of the Śakas, which may itself have come from the predilection for frontal representation noted in the art of Luristan and Sumer. Foucher (1942–48) also remarked on the persistence of Iranian influence in the representations of Sūrya, identified with Mithra. The white marble statue of Sūrya in the Brahmanic sanctuary at Khair Khaneh in the Kabul region (ca. 5th–6th cent.) appears to be descended directly from an Iranian prototype; not only the costumes of the god, his two assistants, and a donor, but even the gesture of a worshiper who offers the deity a beribboned crown are in the Iranian tradition. The bead molding, which emphasizes the details of the costume, reflects a fashion that became popular in the Sassanian period. This fashion, which also was transmitted to Bamian, spread to India with the development of the Gupta style. This accounts for the beaded medallions of lotus flowers and the ornamental fasciae on columns. It was Hackin who first pointed out the similarities between the figures of the group at Khair Khaneh and others found at Bhumara (in India; late 6th cent.?) with the characteristic Sassanian ribbons.

THE IRANO-BUDDHIST SCHOOL OF BAMIAN. The establishment of the Sassanian dynasty in Iran by Ardashīr I (226–41) appears to have had immediate repercussions on the art of the neighboring regions, particularly at Bamian, which came within the confines of the vast Sassanian empire upon the annexation of Bactria by the Sassanians during the 3d century. This dynasty promoted in Iran a revival of national traditions which extended to the arts in the form of a return to Achaemenian principles of symmetry and stability — notwithstanding their previous modification by outside influences. Ancient Iranian traditions, new Sassanian forms, and contributions from various other regions (particularly from Roman Syria) all penetrated to Bamian, there to amalgamate with the iconographic traditions of Indian Buddhism, with elements derived from the Gandhara style, and, later on, with the influence of Gupta India. The fusion of all these elements gave rise to a highly individual local style which Hackin, because of its predominantly Sassanian qualities, called "Irano-Buddhist."

INDO-IRANIAN ART

As a major stopping place on the road from Bactria to Taxila, where caravans crossing the Hindu Kush stopped to rest and revictual, the fertile valley of Bamian was renowned especially for its great monastic establishment, which flourished from the 2d to the 8th century. Nothing remains of the monasteries built at the foot of the great sandstone cliff dominating the valley to the north, their domes having long since been damaged by the fall of loose rock. The Buddhist monks, however, profiting from the facility with which the sandstone could be worked, carved enormous images of seated and standing Buddhas (PL. 10) and a network of monasteries out of the cliffs all around and beyond the valley. Most of the monasteries comprised a vast assembly hall, a sanctuary, and a few cells for the monks. A large number of them were uncovered and explored between 1923 and 1933 by the Godards and Hackin, aided after 1930 by J. Carl. Giuseppe Tucci recently directed the investigation of another group of caves a little farther off.

The sculpture contributes but little to the knowledge and understanding of the art of Bamian. Neither the colossal standing Buddhas (one 120 ft. high, the other 175 ft. high; PL. 10) nor the various seated Buddhas are of much interest apart from the influence they had on the art of nearby and distant regions through the small-scale copies carried by pious pilgrims. The numerous Buddhas in high relief which occupied the large niches in the sanctuaries and the coffers in some of the domes all have disappeared. The few heads recovered seem to correspond either to the models in stucco found at Hadda (those of Cave G) or to some of a later date found at Fondukistan.

An examination of the various monasteries at Bamian reveals the characteristics of the Irano-Buddhist style of architecture and painted and relief decoration, to which the sanctuary exacavated in the nearby valley of Kakrak (PL. 8) is also related. According to B. Rowland (1938), the paintings found at Bamian may be regarded collectively as having been executed within a short period of time and at a relatively late date. On the contrary, it seems more probable, as Hackin repeatedly had occasion to argue, that the processes of carving out and decorating the monasteries and of decorating the niches of the colossal carved Buddhas went on continuously throughout the long period of occupation of this site. Although it remains almost impossible to put a definite date to any of the work at Bamian, careful study reveals an evolution in its style, the main lines of which still seem to be those set forth by Hackin. To a framework of Greco-Buddhist traditions were added Sassano-Iranian elements which were initially predominant in the local style evolving from this fusion. Subsequently, Gupta Indian influence came to balance and at length outweigh that of Iran, thereby modifying the character of the later work. As a group, the caves in the vicinity of the 120-ft. Buddha at the eastern end of the valley (commonly designated by letters) are earlier than those near the 175-ft. Buddha on the far side, to the west (designated by Roman numerals). The colossal image of the 120-ft. Buddha probably was begun toward the 2d century of our era, while the most recent work (around the 175-ft. Buddha), from the later period of activity on this site, would seem to be of the 6th or even the 7th century.

The sanctuaries and assembly halls are simple in plan, either rectangular, circular, or octagonal; some have quite an elaborate type of ceiling (cells of Group F, Caves V and XV) composed of beams superimposed diagonally across the corners of a square to form successive tiers of squares progressively diminishing in size (PL. 13). This type, which also was used in the region of the Pamirs, would seem to be of western origin and to have come from Armenia, Anatolia, and Georgia. Most of the sanctuaries, however, have vaulted ceilings of Iranian type, which underwent a clearly discernible evolution here at Bamian. Thus, whereas in Cave G, which appears to be the oldest, a representation of arched squinches effects the transition from the square sanctuary to the dome (an expedient which was applied in some of the halls of Group E), in the majority of the caves, for which either a circular or an octagonal plan seems generally to have been adopted, the transition from the vertical surface of the walls to the dome is effected by one

or two courses of corbeling. This corbeling subsequently assumed increasing importance in a number of the caves near the 175-ft. Buddha (I, II, and XI), tending to raise considerably the level of the dome, which then became flatter. On the other hand, it appears that the decoration of the oldest caves (C, D), which had consisted primarily of paintings, was later replaced by ornament in relief (I, XI). In a recent study Bussagli discusses the adoption by the monks at Bamian of the octagonal plan traditional in Iranian architecture.

The art of Bamian was essentially religious and dedicated to the service of Buddhism in its Hinayana form (see BUDDHISM). The tendency toward constant repetition of the same or similar aspects of the Buddha, which recalls the endless reproduction of the figure of the Master on the stupas at Hadda and Taxila, appears early. Through these frescoes it is possible to trace the formation and development of the Irano-Buddhist style and, despite the confusing interspersion of hybrid elements, to distinguish the main lines of its evolution.

Apart from the Iranian contribution of the arched squinches, the decoration of Cave G, with its clay heads from the central stupa (resembling those at Hadda), its garland motif, and the Buddhas painted in the dome, is in the Hellenistic and Greco-Buddhist tradition. Only a donor displays the regional costume of a long tunic with double revers, which reappears in Serindia.

Sassanian influence, which probably penetrated toward the end of the 3d century, is first manifest in various details of the decoration and thereafter in the iconography, in the costumes, and even in the style of painting. Traces appear in Groups C and D, near the 120-ft. Buddha, in the typically Iranian ribbons of pleated material that widen out at the ends. These ribbons, or kusti, apparently were an emblem of dignity in Iran. They are found on the diadems, vestments, and sometimes even the mounts of gods and monarchs and are also used as architectural decoration; they figure as often in the great relief carvings on the rocks (at Naqsh-i-Rustam, Shapur, and Taq-i-Bustan) as in Sassanian goldwork. Transmitted to Bamian, where they enjoyed an equal vogue, they first appeared as accessories in the decoration of the painted domes of the assembly halls and sanctuaries of Group C, where they framed a vaselike motif — an Iranian element — above the arches surrounding the standing Buddhas or were strewn over a background studded with little flowers. In costume, pose, and gesture the seated and standing Buddhas in this group remain within the Greco-Buddhist tradition, but their halos — composed of concentric circles of different colors — and the bold contrast of tones is characteristic of the Irano-Buddhist school. These details, and the entire composition in the dome of Sanctuary C, later transmitted to Serindia, to Kirish, and to Sim-Sim, and, in a more fully developed form, to Kizil (Cave of the Pigeons; I, PL. 480).

The influence of Iran is still more apparent in the decoration of Group D. In the vestibule, the beaded moldings and the motifs in the medallions on the flat ceiling are unmistakably of Iranian origin: the winged horse, the often repeated boar's head, and the extremely beautiful composite design of two birds, back to back, heads turned to face the spectator, holding in their beaks a string of pearls. On the ceiling of the sanctuary, which has an unusually large number of simulated beams, are a series of heads in relief; these vigorous masks of mustached men with sinuous beards and conical caps also are descended from an Iranian tradition, though one of more ancient origin.

The painted decoration of the niche sheltering the 120-ft. Buddha attests to a renewal of influence from Iran. The soffit of this niche is covered with a vast composition, the subject matter of which is derived directly from the cults practiced in Parthian Iran and western Asia and, in particular, in the caravansaries of Palmyra and Dura-Europos, to which several details can be traced. The painting shows a towering solar or lunar divinity in a chariot drawn by four winged horses grouped in pairs and shown in profile on either side of the chariot. The large halo encircling the divinity is bordered with short rays, recalling the rayed halos of Iranian tradition. The figure was first identified as a lunar divinity, because of a whitish crescent

perceived within the lower part of the halo. A closer examination, carried out under better conditions at the time that Carl was making a copy of the composition, has shown that this supposed crescent is merely a space left blank between the halo and the voluminous cloak that unfurls in a semicircle around the god. Since the identification of this figure as a lunar divinity thus would seem to have lost its foundation, it is perhaps equally plausible to regard him as a solar divinity, unless the flight of geese depicted in the upper register is to be considered a reference to the role of the lunar god as escort of the souls of the departed to paradise. As Hackin pointed out, in the paintings of Central Asia, and notably in those at Kizil, geese symbolizing these souls frequently were shown hovering around the moon. The veneration of the sun god in his chariot, as M. Rostovtzeff has noted (1938), is of very ancient origin, going back to the dawn of Iranian history; in the Vedas Mithra is also described as riding in a chariot. The representation of the sun god in his chariot would seem to have originated from a Greek prototype modified by Greco-Iranian artists (ca. 3d cent. B.C.), while representations of the Indian Sūrya, of the type found at Bodhgaya, probably were derived from the Greco-Iranian model.

The disposition of the horses deployed to either side of the chariot, common to Bodhgaya and Mathura and preserved in this composition, was not adopted for representations of the sun god at Dura-Europos, but it reappears in Sassanian portrayals of this theme. His armament and costume relate the divinity at Bamian to the solar and lunar gods deeply venerated and often represented at Dura-Europos and Palmyra and in Parthian and Sassanian Iran. He holds a long sword and a spear and wears a great cloak which is fastened across his chest with a clasp and which falls behind from his shoulders. The same mode of adjusting the cloak across the chest and the same cabochon clasp with which it is held are noted on the figure of a winged genie in a mosaic at Bishapur (latter half of 3d cent.). The long tunic with the galloon down the middle is a variant of the tailored garment worn throughout the Iranian plateau regions and in both Russian Turkistan (e.g., Pyandzhi-kent, Varakhsha) and Chinese Turkistan (e.g., Kumtura, Kizil; I, PL. 479). On either side of the central motif of the divinity in his chariot is a row of donors on a balcony. The bearded faces and vigor of these figures are reminiscent of Iran, while various details are derived directly from Sassanian art. Kusti flutter from the shoulders of each donor and from those of the bodhisattva in the center of either row. According to Hackin, the coiffure is the same as that on Sassanian coins of the 4th and 5th centuries, notably those with the image of Bahrām II. Particularly characteristic is the diadem with a large sphere in the center.

The hieratic conception, rigid pose, and bold coloring of a bodhisattva painted on the soffit of the niche of a seated Buddha (Group E; PL. 13) attest to the presence of Iranian stylistic tendencies in the Irano-Buddhist school at Bamian; the immobile pose and intense gaze lend this figure a certain mystic strength. The details of the coiffure and of the costume are Iranian, while the chaitya arch that frames the bodhisattva and the balconies, each dominated by a figure, are typical of the Greco-Buddhist style. The constant juxtaposition of Indian and Iranian elements at Bamian was due partly to the consistent dealings there with both India and Iran and partly to the fact that artists of both schools frequently worked side by side. A typical example of this cooperation is a bodhisattva of Group I (published by Rowland) in a rigid pose, with costume of Indian fashion, who holds a stem with three flowers like the plants of Sassanian landscapes; at the same time, the conventional use of a fluttering ribbon resembles the kusti of Shāpur I and Bahrām II at Naqsh-i-Rajab and Bishapur. The scarf wound sketchily around the body is another detail characteristic of the Irano-Buddhist art of Bamian; the motif of this perennial strip of gossamer, with its unrealistic undulations, may be seen on the figure of a stringed-instrument player at Pyandzhikent (Russian Turkistan, 7th cent.) and appeared in the later works of Tun-huang (q.v.; II, PL. 398), at the eastern terminus of the Silk Route.

The influence of Gupta Indian art often was blended quite felicitously into the already assimilated influence of Iran. The essentially Indian motif of a balcony with figures half-concealed (first used at Bharhut) appeared constantly. In Group I (PL. 12) a troupe of supple and lively, if rather heavy, female dancers and musicians appear in an otherwise austere and schematic composition with rows of medallions each containing a Buddha. These fair and dark-skinned female figures of different ethnic types display the familiar Iranian ribbons, which here float more naturally. The figures seem to wear tight-fitting, low-cut corselets exposing their breasts (I, PL. 476); like the braided coiffure, this fashion is encountered frequently in Central Asia, at Tumshuk, Kizil, Kumtura, and Shorchuk.

The same amalgamation of Indian and Iranian elements and features of the fully developed Irano-Buddhist style stands out in the paintings that embellish the dome of one of the sanctuaries in the nearby valley of Kakrak. The iconography has remained extremely simple: the same Buddhas are constantly associated and repeated in a sort of monotonous "litany," which nevertheless is not lacking in a certain austere grandeur (PL. 8). This composition at Kakrak assumes the aspect of a mystic diagram, or mandala. In the center of the dome is a huge image of Maitreya seated in the Indian style and surrounded by a circle of smaller seated Buddhas. Around this central motif is a broad fascia enclosing a series of lesser circles of small Buddhas, each grouped about a larger seated Buddha; more Buddhas of the same type occupy the spaces between the circles, all of which have borders of beading. The lower register comprises a row of Buddhas seated under a succession of pedimented arches supported on small, beribboned columns. Gupta India's contribution is manifest in the suppleness of the bodhisattva, draped in the toga of the great Buddhas, which leaves the chest and right shoulder bare, and tracing the prescribed symbolic gestures (mudra); the beauty of the graceful and expressive hands is likewise an Indian attribute, at Kakrak as at Bamian. The essence of Irano-Buddhist art is manifest in the robustness, rather stocky proportions, and square faces of these Buddhas, in the almost diagrammatic regularity of the composition, and in the boldness of the colors. The bodhisattva and all the Buddhas are surrounded by large, multicolored halos, which recurred constantly at Bamian and which later were transmitted to Central Asia. Warm tones are dominant: deep cinnabar for the monastic robes of the multiple Buddhas and yellow ochre for the flesh and various details. Touches of brown and milk-white appear here and there, while the warm tones contrast with patches of fairly bright greens and blues, primarily in the background. The influence of Iran is felt at Kakrak in the diadem of cabochons and crescents worn by the bodhisattva and especially in the princely figure, called the "hunter-king," seated among the Buddhas under the arches in the lower register. This figure, probably a local princeling, is dressed in baggy trousers and boots and has a diadem with three crescents, each encompassing a white disk. Hackin compared this diadem to that on a Kushan-Sassanian coin found at Ghazni; it reappears on several bodhisattvas at Bamian and on a bejeweled Buddha depicted in the niche of the 175-ft. Buddha. The princely diadems at Kizil are similar.

The majority of the caves near the 175-ft. Buddha seem to belong to a later period (6th and even early 7th cent.) and are marked by an increase in relief decoration (Caves I and XI). Below the flattened dome are two rows of superimposed arches; those in the lower row are trefoil and correspond to the type frequently used on the stupas at Hadda and Taxila. A beautiful rinceau of leaves separates and borders the two rows; Buddhas in high relief appear under the arches, which are supported on short, squat pilasters, remnants of the Greco-Buddhist style; the Indian motif of the balustrade also is reproduced. Besides the perennial flowing vase of Mesopotamian and Assyrian origin placed above the arches, some curious grotesque masks (PL. 9), their mustaches and eyebrows treated as foliage scrolls, also would seem to be of ancient origin (masks of Luristan and the Gorgon's head); they foreshadow one of the aspects assumed by the Indian kīrtimukha (grotesque mask) at the beginning of the post-Gupta period, when foliage decoration was partic-

ularly prevalent (e.g., at Bhumara). The greater part of the relief decoration in the dome of Cave XI has survived intact. An elaborate network of hexagonal coffers, each containing a small seated Buddha, surrounds a central octagon with another seated Buddha. In spirit the composition is close to that at Kakrak, while this system of coffering is reminiscent of that observed in various Syrian monuments, at Dura-Europos and Baalbek in particular (ceiling of the Temple of Bacchus); subsequently, hexagons were used as decorative motifs in Sassanian art, in textiles and stuccowork of the late period (Bishapur, Ctesiphon). Hackin also found some curious heads with pointed hats in this dome at Bamian, which he compared to certain images of priests from Dura-Europos; their headdress, too, reappears on a few Sassanian coins (on the son of a king) and on the priests represented around a fire altar at Pyandzhikent. The complexity of the elements which penetrated to Bamian thus is demonstrated vividly in Sanctuaries I and XI, where Iranian motifs of widely diverse epochs mingle with motifs of Indian and even Roman west Asian origin; some perpetuate themes from the immemorial past (e.g., the vase of abundance), while others anticipate new themes (masks with mustaches and eyebrows of leaf scrolls).

The decoration in the upper part of the niche of the 175-ft. Buddha seems to have been executed during the final period of activity at Bamian. Although certain parts have disappeared completely, enough remains to give an idea of the compositional scheme and figure style. Under the arris of projection of the niche are contiguous, oval medallions containing genies and their companions, in groups of three, flying toward the Buddha to present him with flowers and garlands. High in the vault, above ornamental bands of draperies and flowers, looms a pantheon of huge seated Buddhas and bodhisattvas, encircled with multicolored halos. Here again, Iranian inspiration is conspicuous in such details as the beribboned vases, the diadems with three crescents, and the flying ribbons. A donor bearing a tray of offerings wears a long, tight-fitting tunic with revers, high boots, and a baldric holding a short dagger — an ensemble worn throughout the regions between Iran and Serindia, examples of which recur at Pyandzhikent, Kizil, and Kumtura. It is, however, the influence of Gupta India that predominates in this composition, manifesting itself in the presence of the female figures with strongly inflected posture, in the theme of the flying figures, in the predominance of Indian fashion, as exemplified by the bare torsos and gossamer draperies, and in the affectation of the hands, which are extremely elegant, expressive, and slender. The slight mannerist tendency discernible here and there is a reflection of the sensibility of Ajanta (q.v.).

The art of Bamian, founded on Greco-Buddhist traditions and subsequently permeated by elements proceeding chiefly from Sassanian Iran, evolved an Irano-Buddhist style. It assimilated and blended a variety of influences, and attaining full maturity (late 4th and 5th cent.?), revealed its truly individual character in such works as the "beautiful Bodhisattva" of Group E and the dome at Kakrak. A fresh influx of Gupta Indian influence (6th cent.?) subsequently modified the style, causing it to assume what might be described as a Sassanian-Gupta aspect, which was to be expressed in the slightly later work at Fondukistan (PLS. 4, 6, 7, 11). The art of Bamian, religious in nature, was principally concerned with the exaltation of the Buddha and the bodhisattvas; indeed, from the hieratic representation of these superhuman beings to the timeless quality of the schematic compositions with their endless repetitions, everything seems to serve this purpose. It is the predisposition toward repetition and the formalism pervading the art of Bamian which make it, if not the direct prototype, a close ancestor of subsequent manifestations of Buddhist art: the theme of the Thousand Buddhas, which first appeared in Chinese art of the Wei dynasty and reached full development in depictions on the walls and ceilings of sanctuaries in Central Asia (at Turfan and Tun-huang); the mystic diagrams, or mandalas, which spread through the esoteric Buddhism of Nepal, Tibet, and Japan. In accord with its religious purpose, Bamian's art was preeminently symbolic and decorative, seldom including anything in a picturesque or anecdotal vein; representations of donors were rare, while the vivacious

aspect of the musicians in Group I, or in the niche of the Great Buddha, were absolutely exceptional. The color range employed at this site varied: the warm tones used at Kakrak reappear in some of the paintings in Group I at Bamian, while a certain ponderousness is created by the abundance of browns and greens on the domes of Groups C and D. In the main, however, light, refined color prevails; intense pink contrasts and harmonizes with bright blue, grey, and white (e.g., fresco of the "beautiful Bodhisattva"). The style and type of the figures vary considerably — a diversity due to the passage of time, no doubt, but also to the heterogeneousness of the artists who worked at Bamian.

RELATIONS BETWEEN GUPTA AND POST-GUPTA INDIA AND SASSANIAN IRAN: THE SASSANO-BUDDHIST STYLE OF FONDUKISTAN. It was apparently with the radiation of Irano-Buddhist art that elements of pose and dress, derived from Sassanian Iran, were transmitted to Central Asia. Some of these details reappear in India itself, at Ajanta. Here, however, their presence is due not to stylistic influence but to the recollection of Iranian visitors to the region. The figures in a libation scene on the ceiling of Vihara I at Ajanta exhibit the physical type and costume of Iranians and even hold Iranian objects (goblet and flask). Their heads, covered with the characteristic felt caps, are portrayed with a scrupulous attention to ethnic authenticity, giving them a slightly burlesque aspect; moreover, the masculine tunic and boots and the long feminine gown with pleated ribbons create a bulging, deformed contour which is alien to the classic Indian silhouette. This fresco at Ajanta, and another in which figures the typical Iranian, or Phrygian cap, constitute visual proof of the exchange between India and Sassanian Iran, of which the embassy sent by Khusrau to the Chalukya king of the Deccan, in the 7th century, is but one instance. It was owing to these relations that Ajanta came to exert its influence on the later paintings at Bamian and, to a marked degree, on those at Fondukistan.

Excavations carried out by Hackin in 1937 brought to light a collection of paintings and sculptures in a small monastery at Fondukistan, between Bamian and Begram. The style of these works, as well as some coins found here in funerary urns (drachma with the effigy of Khusrau II, and pieces of the Napki type, 5th–6th cent.) would seem to date the creative activity at this site in the early 7th century. The monastery had a square sanctuary with a central stupa of the usual type and deep, arched niches in the walls. The rinceaux of molded clay framing the arches are very similar to those which adorn Caves I and XI at Bamian, a fact which would indicate their proximity in time. The niches were filled with sculptures, while their walls and the wall spaces between niches were covered with paintings. The coarse material of the sculpture is the same as that used at Bamian and often in Central Asia: clay mixed with chopped straw and plant or animal fibers; a wooden armature served to support the amalgam for the head, the torso, and the arms (PL. 4). The images of the Buddha, bodhisattvas, and devata have a distinctive style, dominated by Pala Indian elements which have been somewhat exaggerated. Bussagli (1953) accurately pointed out the affinity of these sculptures produced at Fondukistan with those executed in Central Asia; the figures in the great relief carvings at Tumshuk (I, PL. 472) show a corresponding tendency toward affectation. In this case, however, the art of Serindia, hitherto constantly inspired by that of the Afghan region, influenced the work of the artists at Fondukistan; this seems to be confirmed by a comparison of the ornamental elements. The details of the diadems, for example, harmoniously assembled at Tumshuk, appear to be somewhat modified and dissociated on similar ones at Fondukistan, indicating a slightly later date for the latter (PLS. 6, 7). The facial type, with arched eyebrows, and the treatment of the hair (PL. 11), generally arranged in short, separate locks, are factors which contribute to the unusual aspect of the images on this site. A similar novel effect is achieved in the late heads of Bamian and in others found in Kashmir (chiefly at Ushkur), which again show this rising mannerist tendency. Conversely, the princely couple found in a niche comes from an entirely different sphere of influence: the tight-

fitting tunic with revers, adorned with medallions, recalls Sassanian dress and materials.

The boldly colored frescoes exhibit a similar complexity of trends. The elegance, skill, and knowledge of the human body which are manifest in a nude figure seem to derive from the frescoes at Ajanta. In a portrayal of Maitreya an essentially Indian suppleness in the pose and hands combines with a certain ponderousness of form and stolidity of the face, around which float the characteristic ribbons constantly reproduced at Bamian. The theme and details of a panel representing a solar and a lunar divinity, standing side by side, belong in quite a different category and are a reflection of the ancient cults which were perpetuated in this region. The details of the costume and attributes of these divinities are Iranian, while the lunar deity's diadem, bearing three crescents, repeats those of Bamian and Kakrak.

Before disappearing from this region, Buddhism thus stimulated the flowering of yet another distinctive style of art in a monastery at Fondukistan. Despite the fact that they too embodied elements of a widely divergent nature, the products of this art remained within the main stream of evolution which progressed from northern India and nearby Kashmir (see KASHMIR ART) to Serindia.

REFLECTIONS OF INDO-IRANIAN ART IN THE ART OF SERINDIA. This rapid review of the various styles of art that flourished successively in northwestern India and the Afghan region has demonstrated the tremendous influence of the Indo-Iranian culture, which pervaded this area throughout almost ten centuries. Echoes of it continued to reverberate through the later art of India until the advent of the Moslem era, which brought a wave of Iranian culture of an entirely different kind to bear upon the age-old traditions of India.

Symbolic and decorative motifs adopted directly from the Iranian world, or transmitted through its agency, enriched the repertory of Indian art from its first inception; indeed, its versatility is early attested by the Buddhist monuments of the 2d century B.C. (balustrades at Sanchi and Bharhut; see BUDDHIST PRIMITIVE SCHOOLS). Two esthetic ideals were thus confronted from the earliest times and throughout numerous styles. The Iranians, on the one hand, sought to impart a quality of impassive majesty and stability to their sculpture, which was in most cases dependent upon architecture; figures, whether represented in profile or fullface, were rigidly posed and had no effective volume, since they were outlined rather than modeled; the clothes appeared to be superimposed on the body, which they neither fitted nor revealed. The Indians, on the other hand, with their innate, sensual feeling for life and living things, preferred the animated pose, sought to reproduce the plastic qualities of a figure, and closely observed nature; their costume and soft, diaphanous drapery, which either exposed or suggested the body, promoted the representation of the nude. From time to time new styles were born of this constant dialogue between the eminently official and formal art of Iran and the more human and more deeply religious art of India. Such was the case at Bamian, where the Iranian and Indian esthetics were forcibly associated and their eventual compromise and fusion gave rise to a hybrid style of original aspect. This new style in turn influenced the artistic production of various localities in Serindia, to which Indian and Iranian forms, modes, and motifs often penetrated through Bamian's agency. A number of similarities already have been pointed out between the frescoes on the latter site and those at Kizil, which are nevertheless of a more episodic and picturesque nature (PL. 14). Although a certain affinity to Sassanian art noted in the art of Tumshuk does not extend much beyond the similarity of a few ornamental motifs, the association of Indian and Iranian elements and motifs is widely encountered in Serindia, notably in the frescoes executed before Chinese T'ang influence became predominant in this region, probably toward the beginning of the 8th century. The composition in the dome of Sanctuary C at Bamian was evidently the prototype for those at Kirish, Sim-Sim, Kizil, and elsewhere. The tripartite diadems with floating ribbons constantly reappear at Su-bashi, Duldur-akhur, Kizil, and Kumtura, and even figure on a Chinese stele. The familiar chaitya arch returns, though somewhat modified, while the theme of the musicians appearing at half-length on a balcony has likewise remained in vogue, together with that of the carpets hung over a balustrade (also from Bamian), which has here become a decorative motif. The tendency to treat thrones and other architectural elements as decoration began at Bamian; the bead motif used there to outline series of arches and to border medallions becomes so much *pointillé* ornamentation at Kizil. Sassanian motifs are to be seen in the rich costumes of donors and in the decoration; these include medallions bordered with bead molding and enclosing a boar's head or birds adorned with ribbons. Numerous other examples could be cited, among which are the flames issuing from the shoulders of various personages, the multicolored halos, and the enduring prestige of representations of the solar and lunar divinities. Portrayed from Kumtura to Tun-huang, these divinities are always conceived frontally, but the quadriga gradually disappears; at Kumtura only the heads and front legs of the horses are shown, while at Kizil even these are omitted. On the other hand, the deities of the wind and the flight of geese associated with the lunar deity at Bamian are repeated frequently. The analogies are not limited to theme or details, but include the invariably angular pose, the sense of form, and the technique. The ponderous flight of the genii in the Cave of the Painter at Kizil is identical to the flight of the figures at Bamian, whose faces also were to become typical in Central Asia. Rowland (1938) observed that shadows of orange pigment, as seen at Bamian, appear also in the later caves at Kizil; in fact, the coloring at the two sites is similar.

Until the diffusion of Chinese influence, in Serindia as at Bamian, color was applied in a composition for its own sake; it served neither to model form as in India, nor to emphasize particular details of a design as in China. On the contrary, a wide range of color was boldly and yet harmoniously contrasted and combined to produce a preeminently decorative effect. The Irano-Buddhist art at Bamian contained many elements which subsequently became characteristic of the art of Central Asia; indeed, there exists a definite correspondence between the art of Bamian and that of the immense region extending beyond both the Pamirs and the Oxus. Even in the frescoes on a site such as Pyandzhikent (8th cent.), which derive from a different source and produce quite another effect, certain details of costume and some of the decorative motifs betray a distant connection: the medallions bordered with bead molding; the conventional floating scarf of a harpist, whose instrument is similar to those of the musicians at Bamian. However, it was chiefly toward China that elements of Indian and Iranian origin were transmitted, with the propagation of Buddhist art and its iconography. Thus the cross-legged pose, the schematic draperies, the multicolored halos and those with flames, and the framework of beams treated as decoration are encountered in the sculpture and painting of the Wei dynasty, while a number of other Indo-Iranian motifs, including the diadems and ornaments, were transmitted in T'ang art.

Indo-Iranian art thus continued its progress toward the east, a progress extensive in time as in space. Just as the Iranian cameo representing a bearded personage holding a flower turned up at Oc Eo in Indochina alongside Indian and Chinese objects, so Indo-Iranian art eventually reached the shores of the Pacific. Henceforth, tripartite diadems and waving scarves in Japan and ornamental trees of life or vases of abundance in Java alike reflect its radiation, while even comparatively late relief carvings in Burma seem to preserve qualities reminiscent of Sassanian ornamentation.

BIBLIOG. P. Gardner, The Coins of the Greek and Scythic Kings of Bactria and India in the British Museum, London, 1886; A. Stein, Zoroastrian Deities on Indo-Scythian Coins, Babylonian and O. Record, I, 1887, pp. 155–66; A. Foucher, L'art gréco-bouddhique du Gandhâra, 2 vols., in 4, Paris, 1905–51; Y. I. Smirnov, Vostochnoye serebro (Oriental Silverwork), St. Petersburg, 1909; W. Andrae, Hatra, II, Leipzig, 1912; U. Monneret de Villard, Sull'origine della doppia cupola persiana, Arch. e arti decorative, I, 1921, pp. 315–24; A. Stein, Serindia, 5 vols., Oxford, 1921; A. Stein, The Thousand Buddhas: Ancient Buddhist Paintings from the Cave-temples of Tun-huang, London, 1921; E. J. Rapson, ed., The Cambridge History of India, I, London, New York, 1922; A. von Le Coq,

Die buddhistische Spätantike in Mittelasiens, 7 vols., Berlin, 1922–33; L. Delaporte, La Mesopotamie; Les civilisations babylonienne et assyrienne, Paris, 1923 (Eng. trans., New York, 1925); V. A. Smith, The Oxford History of India, 2d ed., Oxford, 1923; F. Cumont, Fouilles de Doura-Europos, Paris, 1926; O. M. Dalton, The Treasure of the Oxus, 2d ed., London, 1926; A. K. Coomaraswamy, History of Indian and Indonesian Art, London, New York, 1927; A. Godard, Y. Godard, and J. Hackin, Les antiquités bouddhiques de Bâmiyân, Paris, Brussels, 1928; L. Bachhofer, Early Indian Sculpture, 2 vols., Paris, 1929; J. J. Barthoux, Les fouilles de Haḍḍa, III: Figures et figurines, Paris, 1930; E. Herzfeld, Die sasanidischen Quadrigae Solis et Lunae, Archäol. Mitt. aus Iran, II, 1930, pp. 128–31; E. Herzfeld, Kushano-Sassanian Coins, Calcutta, 1930; J. P. Vogel, La sculpture de Mathurâ (Ars Asiatica, XV), Paris, Brussels, 1930; J. Marshall, Mohenjo-daro and the Indus Civilization, 3 vols., London, 1931; M. I. Rostovtsev, L'art gréco-iranien, RAA, VII, 1931–32, pp. 202–22; G. Yazdani, Ajantā, 3 vols., London, 1931–46; R. Grousset, L'Iran extérieur: son art, Paris, 1932; M. I. Rostovtsev, Caravan Cities, Oxford, 1932; W. Andrae and H. Leuzen, Die Partherstadt Assur, Leipzig, 1933; J. Hackin, Iranian Influences in Buddhist Art, TASJ, 2d ser., X, 1933, pp. 21–24; J. Hackin and J. Carl, Nouvelles recherches archéologiques à Bâmiyân, Paris, 1933; J. Hackin, L'oeuvre de la Délégation archéologique française en Afghanistan (1922–1932), Tokyo, 1933; R. Kak, Ancient Monuments of Kashmir, London, 1933; D. Schlumberger, Les formes anciennes du chapiteau corinthien en Syrie, en Palestine, en Arabie, Syria, XIV, 1933, pp. 283–317; J. Allan, T. Wolseley Haig, and H. H. Dodwell, The Cambridge Shorter History of India, Cambridge, New York, 1934; B. M. Barua, Barhut, 3 vols., Calcutta, 1934–37; H. Ingholt, Palmyrene Sculptures in Beirut, Berytus, I, 1934, pp. 32–43; A. K. Coomaraswamy, La sculpture de Bodhgayâ (Ars Asiatica, XVIII), Paris, Brussels, 1935; J. Hackin, Recherches archéologiques en Asie centrale (1931), RAA, IX, 1935, pp. 124–43, X, 1936, pp. 65–72; E. Herzfeld, Archeological History of Iran, Oxford, 1935; I. A. Orbeli, and K. B. Trever, Sasanidskii metall (Sassanian Metalwork), Moscow, Leningrad, 1935; A. U. Pope, Some Interrelations between Persian and Indian Sculpture, Indian Art and Letters, IX, 1935, pp. 101–25; R. Dussaud, La renaissance du style oriental en Syrie aux IIᵉ et IIIᵉ siècles, AAs, VI, 1936, pp. 191–202; R. Ghirshman, Les fouilles de Châpour, RAA, X, 1936, pp. 117–22, XII, 1938, pp. 12–19; J. Hackin and J. Carl, Recherches archéologiques au col du Khair Khaneh, Paris, 1936; M. I. Rostovtsev, The Sarmatae and Parthians, in Cambridge Ancient History, XI, Cambridge, 1936, pp. 91–130; H. Seyrig, Armes et costumes iraniens de Palmyre, Syria, XVIII, 1937, pp. 1–53; K. B. Trever, Novye sasanidskie bliuda Ermitazha (New Sassanian Dishes of the Hermitage), Moscow, Leningrad, 1937 (Rus. and Fr. text); R. Dussaud, The Bronzes of Luristan, in SPA, I, pp. 254–77; A. Foucher, Les satrapies orientales de l'Empire achéménide, CRAI, 1938; M. I. Rostovtsev, Dura-Europos and Its Art, Oxford, 1938; B. Rowland, The Wall-paintings of India, Central Asia and Ceylon, Boston, 1938; R. du Mesnil du Buisson, Les peintures de la synagogue de Doura-Europos, Rome, 1939; C. Fabri, Buddhist Baroque in Kashmir, Asia, XXXIX, 1939, pp. 593–98; J. Hackin, L'art indien et iranien en Asie Centrale: Bâmyân, Paris, 1939; J. and R. Hackin, Recherches archéologiques à Begram, 2 vols., Paris, 1939; H. Seyrig, La grande statue parthe de Shami et la sculpture palmyréenne, Syrie, XX, 1939, pp. 177–94; P. Stern, Art de l'Inde, in Histoire universelle des arts, IV, Paris, 1939, pp. 106–78; W. van Ingen, Figurines from Seleucia on the Tigris, Ann Arbor, London, 1939; J. Hackin, Buddhist Monastery of Fondukistan, J. Greater India Soc., VII, 1940, pp. 1–14, 85–91; J. Marshall and A. Foucher, The Monuments of Sanchi, 3 vols., Calcutta, 1940; H. Seyrig, Ornamenta palmyrena antiquiora, Syria, XXI, 1940, pp. 277–328; K. B. Trever, Pamiatniki greko-baktriyskogo iskusstva (Monuments of Greco-Bactrian Art), Moscow, Leningrad, 1940; L. Bachhofer, On Greeks and Śakas in India, JAOS, LXI, 1941, pp. 223–50; K. Erdmann, Das iranische Feuerheiligtum, Leipzig, 1941; R. Grousset, L'Inde jusqu'à la conquête timourine (Histoire générale, Glotz Coll., X, 1, Les Empires), Paris, 1941; E. Herzfeld, Iran in the Ancient East, London, New York, 1941; D. Levi, The Evil Eye and the Lucky Hunchback, in Antioch-on-the-Orontes, III, Princeton, 1941, pp. 220–32; A. Foucher, La vieille route de l'Inde de Bactres à Taxila, 2 vols., Paris, 1942–48; J. Meunié, Shotorak, Paris, 1942; K. Erdmann, Die Kunst Irans zur Zeit der Sasaniden, Berlin, 1943; R. de Mecquenem and others, Archéologie susienne (Mém. de la Mission archéol. en Iran, XXIX), Paris, 1943; M. Chandra, The History of Indian Costume from the 3d to the end of the 7th Century A.D., JISOA, XII, 1944, pp. 1–97; A. Christensen, L'Iran sous les Sassanides, 2d ed., Copenhagen, 1944; W. H. Moreland and A. C. Chatterjee, A Short History of India, 2d ed., London, New York, 1944; R. Ghirshman, Begram: Recherches archéologiques et historiques sur les Kouchans, Cairo, 1946; E. Herzfeld, Early Historical Contacts between the Old-Iranian Empire and India, in India Antiqua: A Volume of Oriental Studies Presented ... to Jean Philippe Vogel, Leiden, 1947, pp. 180–84; V. S. Agrawala, Gupta Art, Lucknow, 1948; R. Ghirshman, Les Chionites-Hephtalites, Cairo, 1948; L. Ashton, ed., The Art of India and Pakistan (exhibition cat.), London, 1949; M. Bussagli, Brevi note sui Kuṣāṇa, Rend-Linc, 8th ser., IV, 1949, pp. 446–53; E. J. van Lohuizen de Leeuw, The "Scythian" Period: An Approach to the History, Art, Epigraphy and Paleography of North India from the 1st Century B.C. to the 3d Century A.D., Leiden, 1949; A. C. Soper, Aspects of Light Symbolism in Gandharan Sculpture, AAs, XII, 1949, pp. 252–83, 314–30, XIII, 1950, pp. 63–85; J. Auboyer, Arts et styles de l'Inde, Paris, 1951; R. Ghirshman, L'Iran des origines à l'Islam, Paris, 1951 (Eng. trans., Iran, Harmondsworth, 1954); G. S. Ghurye, Indian Costume, Bombay, 1951; J. Marshall, Taxila, 3 vols., London, 1951; D. Schlumberger, La Palmyrène du Nord-Ouest, Paris, 1951; R. Ghirshman, Cinq campagnes de fouilles de Suse (1946–1951), Rev. d'Assyriologie, XLVI, 1952, pp. 1–18; R. Henkl, The Clay Images from Fondoukistan, J. Royal Asiatic Soc. of Bengal (Letters), XVIII, 1952, pp. 179–83; D. Schlumberger, Le temple de Surkh Kotal en Bactriane, JA, CCXL, 1952, pp. 433–53, CCXLII, 1954, pp. 161–87, CCXLIII, 1955, pp. 269–79; J. Starcky, Palmyre, Paris, 1952; M. Bussagli, L'influsso clas-

sico ed iranico sull'arte dell'Asia centrale, RIASA, N.S., II, 1953, pp. 171–92; M. Bussagli, L'irrigidimento formale nei bassorilievi del Gandhāra in rapporto alll'estetica indiana, AC, V, 1953, pp. 67–83; R. Curiel and D. Schlumberger, Trésors monétaires d'Afghanistan, Paris, 1953; B. Rowland, The Art and Architecture of India, London, 1953; M. Sprengling, ed., 3d Century Iran: Sapor and Kartir, Chicago, 1953; R. E. M. Wheeler, The Indus Civilization, Cambridge, 1953 (2d ed., London, 1960); J. Hackin et al., Nouvelles recherches archéologiques à Begram, Paris, 1954; H. Ingholt, Palmyrene Sculptures from Hatra (Mem. Conn. Acad. of Arts and Sciences, XII), New Haven, 1954; U. Monneret de Villard, L'Arte iranica, Milan, 1954; Zhivopis drevnego Pyandzhikenta (Paintings of Ancient Pyandzhikent), I, Moscow, 1954; M. Bussagli, The "Frontal" Representation of the Divine Chariot, East and West, VI, 1955, pp. 9–25; M. Bussagli, Mostra d'arte iranica (exhibition cat.), Milan, 1956; M. Bussagli, Osservazioni sulla persistenza delle forme ellenistiche dell'arte del Gandhâra, RIASA, N.S., V–VI, 1956–57, pp. 149–247; R. Ghirshman, Bichâpour, II: Les mosaïques sassanides, Paris, 1956; L. Petech, Afghanistan, Subcontinente indiano, in Civiltà dell'Oriente, I, Rome, 1956, pp. 583–755; H. Ingholt, Gandhāran Art in Pakistan, New York, 1957; A. M. Belenitsky, Nouvelles découvertes de sculpture et de peintures murales à Piandjikent, Arts Asiatiques, V, 1958, pp. 163–82; G. Glaesser, Painting in Ancient Pjandžikent, East and West, VIII, 1958, pp. 199–215; A. M. Belenitsky, Neue Denkmäler der vorislamischen monumentalen sogdischen Kunst, in Akten des XXIV. Int. Orientalisten-kongresses (Munich, 1957), Wiesbaden, 1959, pp. 512–15; J. Hackin, J. Carl, and J. Meunié, Diverses recherches archéologiques en Afghanistan (1933–1940), Paris, 1959.

 Madeleine HALLADE

Illustrations: PLS. 1–14.

INDO-MOSLEM SCHOOLS.

This term refers to certain Islamic creations on Indian soil that differ from the great Moghul tradition. The productions of these schools reflect and embody the encounter of Islamic esthetic tradition with the more tenacious elements of Indian tradition, elements that managed to survive in the environment of the new religion. The so-called "Indo-Moslem schools" are of great interest not only because of the frequently high quality of their creations but also because, more than any other cultural phenomenon, they mark the variations and progressive adaptations of the Indian converts to Islam, who found it easy to accept the orthodox Moslem way of thinking and conception of the world. The sources of inspiration of these Indo-Moslem schools — which arose from violent conflicts and altogether disrupted the social and cultural milieu of India — are predominantly Iranian and Central Asian (Turkish). For this reason, too, the violent meeting of different traditions in a world like pre-Moghul Moslem India — a world in formation and development — is of great interest. In other cases the Indo-Moslem schools affected the development of peripheral or semiprovincial traditions, which also have an interest for the esthetic evolution of the Indian subcontinent. See INDIAN ART; ISLAM; MOGHUL SCHOOL; and TIMURID ART.

SUMMARY. General character (col. 18). The process of style development (col. 18). Earliest phases (col. 19). The art of the Delhi sultanate (col. 20). The art of the north Indian provincial sultanates (col. 23). The art of the sultanates of the Deccan (col. 26).

GENERAL CHARACTER. Indo-Moslem art is fundamentally different from and antagonistic to the Hindu and Buddhist art of India preceding it (see BUDDHISM; HINDUISM), but it is linked to it in innumerable ways: by common geographic, even ethnic, background; by the use of the same materials; by the employment of Hindu masons, painters, and other artisans; and by the infiltration of Hindu taste via Hindus converted to Islam and the Hindu women in the royal and aristocratic zenanas (women's quarters). It is basically a branch of Islamic art in its essential typology and remained faithful to the forms inherited from Iran and Turkistan during the first century of Moslem rule in India, with the cautious addition of later innovations in southwestern Asia and North Africa. The contemporaneous Hindu traditions were absorbed whenever they did not clash with the religious prejudices of the Moslems. The Indo-Moslem style developed in different ways in various parts of India, and later on these variants influenced one another.

THE PROCESS OF STYLE DEVELOPMENT. The Islamic styles which developed in the West were imported by conquerors or

immigrants. Conquerors, however, had been few: the Arabs in Sind in the early 8th century, the Ghaznevids and Ghorids in northern India about 1200, and the Great Moghuls in the 16th century. The invasions of the Mongols in the 13th–14th century, of Tamerlane in 1398–99, of Nādir Shah in 1739, and of the Afghans in the late 18th century proved to be abortive, and also created a prejudice against the civilizations of the invaders. Much more important was the influence of peaceful immigration. Most of the immigrants were military adventurers not interested in art, and the importation of new Persian, Turkish, and Egyptian (Ayyubid and Mameluke) ideals of art was the work of a handful of highly cultured statesmen of foreign extraction. Art was also used as a means of social distinction when the subject Hindus had succeeded too well in imitating their masters. The Indians themselves did not wish to imitate Islamic art too closely, for this would have been an admission of provincial inferiority, and hardly any Indian sultan or emperor would have been prepared to acknowledge such an inferior cultural status.

The situation was different with regard to the influence of Hindu art on the conquerors. The Moslems formed a diminutive ruling class of soldiers, with a sprinkling of scholars and religious teachers. They were forced to rely on indigenous labor. Good artists from other Moslem countries would be attracted by any successful ruler, especially if he showed a real appreciation of their work. But an ambitious ruler would want numerous, grandiose, and costly fortresses, palaces, mosques, furniture, apparel, illustrated manuscripts, etc., and the most the few Moslem artists could do was to provide general designs and supervise their execution by Hindu artisans. The latter were highly skilled and brought a great tradition of their own. It was inevitable that most minor details would be left to them, so long as they avoided whatever might appear idolatrous or obscene to the Moslem planners: anthropomorphous figures, and especially representations of deities and nude women.

As both the Hindu and Moslem regimes were more or less theocratic, every conquest required the destruction of the royal temples of the overthrown Hindu dynasties, the temples of other Indian rallying centers, and the great places of pilgrimage and the erection of mosques, symbols of victory which also served the religious needs of the Moslem garrisons. The successive conquests were so sweeping that at first there was no time for extensive building programs. The pillars, doors, beams, and ceilings of the destroyed temples were rearranged into mosques after the most objectionable sculptures had been eliminated. From using Hindu spoils to the conscious introduction of Hindu motifs into Indo-Moslem art was but a step.

Another channel of Hindu art was the great zenanas, with their many Hindu ladies only superficially converted to Islam and faithful to their native costumes, jewelry, and articles of daily use. Even when these women adopted Islamic fashions, there were still the maidservants, singing and dancing girls, jesters, and astrologers who did not. This unobtrusive but lasting influence became stronger when relations with the Hindus were peaceful; when there was war, the differences became accentuated. Eventually not only the exterior aspects but also the spirit of the arts of the two cultures mingled and fused into a new entity.

EARLIEST PHASES. A distinct Indo-Moslem style did not develop until the foundation of the Mameluke sultanate of Delhi about the beginning of the 13th century. However, Arab art of the Abbasside caliphate (see ABBASSIDE ART) had maintained a foothold in Sind since the 8th century, especially at its capital, Brahmanabad. Remnants of fortifications, a mosque, ivory "chessmen" (parts of a piece of furniture), and potsherds recall the finds at Samarra. Abbasside ornaments survived in the Hindu art tradition, for example, in the "Ghazni throne" of the rajas of Pugal and in the Hirmā Devī temple of Manali (16th cent.).

The capital of the Ghaznevid empire (see GHAZNEVID ART), which comprised Afghanistan, Sind, and the Punjab (10th–12th cent.), was Ghazni. The only remaining monuments are the tombs of Mahmūd (998–1030) and of Ibrāhīm (1059–99), the

minarets of Mas'ūd III (1099–1115) and of Bahrām Shah (1117–53), the ruins of the Gōsha-i Mas'ūdī palace, and some tombs, all in a style related to Samanid-Seljuk art (see SELJUK ART). The door of Mahmūd's tomb (now at Agra), which is supposed to have been part of Mahmūd's loot from the Somnath temple in Saurashtra, is in the best Samanid tradition. Ghazni, however, reveals the hand of Hindu masons, and the murals of the palace of Lashkari Bazaar anticipate many characteristics of Rajput painting in India (see RAJPUT SCHOOL). Early Rajput applied art has often proved to be a late echo of the Seljuk-Ghaznevid tradition.

THE ART OF THE DELHI SULTANATE. The first mosque was the Quwwat-ul-Islam at Lalkot, begun in 1193 by expanding the court of a former Jain temple with the spoils from other Hindu shrines and adding a Seljuk façade where pure Hindu flower arabesques form the background for quotations in Arabic from the Koran. Beside it is a huge tower of victory, begun in 1199, the world-famous Qutb Minār (PLS. 15, 164). The Ghorid minaret of Jam (Iran) is a copy of it. The first three stories of the Qutb Minār are of tapering tent shape, fluted, with projecting balconies resting on beautiful muqarna (stalactite) niches, and attractive friezes of inscriptions from the Koran, Islamic arabesques, and Hindu ornaments. Another mosque, the Arhai-dīn-kā-Jhōnpra, was erected in 1200 at Ajmer, with a rich screen of trefoil and five-scalloped arches and fluted buttresses at the corners. Sultan Iltutmish (1211–36) expanded the Quwwat-ul-Islam in 1230; the screen here does not have Hindu ornamentation. Iltutmish also completed the Qutb Minār, but the top two stories had to be rebuilt by Fīrūz Shāh III Tughlaq in 1368. The top was renovated in 1503 and 1828; at present the tower is 238 ft. high. Iltutmish also built a mosque at Budaun in 1223, of rather heavy proportions. His tomb, behind the Quwwat-ul-Islam, is cubic in form and was once covered by a dome; inside it is decorated with remarkable Hindu-Islamic arabesques. The oldest mausoleum, of 1231, is that of his eldest son at Mahipalpur (4 mi. southwest), an underground chamber (therefore called "Sultān Ghārī") of Hindu spoils embedded in the flooring of a fortified court of simple Hindu colonnades, with marble mihrab and entrance.

Of the still surviving buildings of the later Mameluke sultans, the most important ones are those erected under Balban: the heavily renovated mausoleums of the saints Bahā-ud-Dīn Zaqariā (1262) and Shams-ud-Dīn Tabrīzī (1276), both at Multan, the small mosque at Jalali, and the badly damaged mausoleum of Balban (1266–87) at Mahrauli. The famous palaces of that time — Daulat Khāna, Kōshak-i Safīd, Kōshak-i Lāl, and Kilokheri — no longer exist, having been used as quarries by later rulers. The vast figural murals in the palace of Kilokheri, erected by Kai-Kūbād (1287–90), were later destroyed by Fīrūz Shāh III Tughlaq.

Under the Khiljī (1290–1320) and Tughlaq (1320–1414) dynasties Indo-Moslem art at last broke away from the Seljuk tradition. The defence against the Mongols of Persia, the setting up of a highly efficient war machine, and the conquest of almost the whole of India inspired an art of megalomaniac dimensions, pronouncedly military, and of increasingly Indian character. A'lā-ud-Dīn (1296–1316) laid out a new town, Siri (1313), northeast of Lalkot. His plan to expand the Quwwat-ul-Islam mosque to three times its size never proceeded beyond the foundations, and the A'lai Minār, intended to reach a height of almost 500 ft., reached only the first turn of its winding staircase. Only the south arcade with its entrance, the A'lai Darwāza, was completed. It is a cube with a low dome, four doorways, genuine and blind windows, red sandstone walls carved with Islamic and Hindu ornaments, panels of white, yellow, and black marble or of bluish schist, flowering cusped arches, Hindu flower-garland arches, and pillars. A'lā-ud-Dīn's son Khizr Khan erected a mausoleum of the same type for the saint Nizām-ud-Dīn Auliyā; under Fīrūz Shāh III Tughlaq this was transformed into a congregation hall (Jam'at Khāna) by the addition of two similar wings. Most provincial buildings of this time are crude constructions from Hindu spoils; only

a few are of artistic interest, such as the mosques at Anhilwara (mod. Patan; 1305), Cambay (1314), and Broach in Gujarat and the one at Daulatabad (1315) in the Deccan.

Ghiyās-ud-Dīn Tughlaq (1320–25) inaugurated the pure military style in the fortress, palace, and mausoleum of Tughlak-abad (5 mi. east of Lalkot); his son Muḥammad ibn-Tughlaq built the fort at Adilabad to protect the dam of the artificial lake which provided the fortress and its moat with water. The mighty fortifications encircle a hillock 65 to 98 ft. high. In the lower citadel there are still ruins of a vast palace. South of it, connected by a dyke, the mausoleum of Ghiyās-ud-Dīn Tughlaq stands in the midst of a small but strong fort. Like the walls and bastions, it has sloping walls of red sandstone, sparsely decorated with sculptured ornaments, deriving its esthetic effect mainly from the color contrast of the panel friezes of white and black marble. In its circumvallation, halls of pure Hindu character with Hindu pillars, lintel beams, and eaves of sandstone slabs have been inserted. Ghiyās-ud-Dīn Tughlaq also built the mausoleum of Rukn-i ʿĀlam at Multan, of octagonal ground plan and sloping corner buttresses.

Muḥammad ibn-Tughlaq (1325–51) moved the capital in 1327 to Deogiri (mod. Daulatabad) in the northern Deccan, in order to control the north and south from this immensely strong fortress (on an extinguished volcano) near the most important passes. Returning to Delhi in 1332, he connected Lalkot and Siri by the town of Jahanpanah, where he built a palace, the Bijai Mandal. This very strong private palace, consisting of a zenana on the top floor, ascending zigzag passages for palanquins, and some garden pavilions of simple massive forms, once probably painted in gorgeous colors, still exists; all that is left of the audience hall of huge wooden pillars, called Chihīl Sutūn (Forty Pillars) or Hazār Sutūn (Thousand Pillars), is the flooring.

Muḥammad's pious successor Fīrūz Shāh III Tughlaq (1351–88), who salvaged at least northern India from the chaos created by the megalomania of his uncle, was a great builder, founder, and resettler of many towns and village colonies, such as Jaunpur, Shahpur, Hissar, and Dholka. He surrounded Delhi with many garden palaces and hunting lodges, such as the Kotila-i Fīrūz Shah, Hauz-i Khās, Boli Bakhtiyāri-kā Mahal, and Kōshak-i Shikār. They are cheaply built of rubble, roughly cut stones, and mortar, and covered with plaster, once, however, nicely painted; their forms are more elegant, rich, and involved than under Fīrūz Shah's predecessors. Persian (Timurid) influence makes itself felt alongside more Hindu forms; inscription friezes and ornaments of carved stucco are rare. The most interesting palaces are those of the Kotila and the Hauz-i Khās. The first is a summer palace, the main buildings of which — a Hawā Mahal (wind-exposed step pyramid of halls and terraces), a mosque (PL. 16), and a zenana — skirt the banks of the Jamuna River; a garden with a well surrounded by cool underground chambers, a reception hall, offices, and the barracks of the guards are situated near the strong entrance gate. The Hauz-i Khās is a palace on the banks of an artificial lake (west of Siri), with its southwestern corner flanked by two wings of domed halls and open colonnades, behind which gardens and courts housed the royal ladies. Fīrūz Shah was buried in the principal hall, and the garden pavilions were later given over to professors and students of theology. Fīrūz Shah built no mosques at Delhi, but he did build several dargahs (places of pilgrimage around the tombs of saints): at Mahrauli (south of Lalkot) that of Quṭb-ud-Dīn Bakhtiyār Kākī (1355); at Nizam-ud-Din a new tomb (later rebuilt) for the great Auliyā saint, Niẓām-ud-Dīn, altering the older one into a congregation hall; at Siri that of Roshān Chirāgh-i Delhī (1374); and at Paharganj (near the present New Delhi station) the Qadam-i Sharīf, a small shrine for a relic of the prophet Mohammed inside a strong fort.

The three Delhi mosques of his reign were built by his prime ministers, Khan Jahān Tēlingānī and his son Khan Jahān Jūnān Shah. That at Nizam-ud-Din (1370/71) has four courts separated by colonnades; that at Begampur (PL. 17) is a huge structure raised on a high platform, with a Persian aiwan (vaulted hall) behind the main entrance, an arched pylon in front of the maqṣura (hall in front of the principal mihrab), and a charming ladies' mosque; the small Kalā(n) Masjid (near the Turkoman Gate) stands on a high substructure of shops, the rent from which once served for its maintenance. Other buildings of the time are at Dholka and Mangrol in Gujarat, Sarhind in the Punjab, and the Bihār-i Sharīf.

From then on, monuments were erected by the nobles who set up or overthrew the last Tughlaqs, or who became practically independent in the provinces, for example, the Lāl Gumbad and Kharēra Īdgāh at Delhi, the mosques and tombs of the Khanzāda amirs of Mewat, the Jilvānī-Auhadīs of Bayana, the Dandānīs of Nagaur, and the Malikshāhs of Kalpi in Bundel-khand. Echoes of the Tughlaq style survive in the architecture of the sultanates of Jaunpur, Malwa, Gujarat, and the Deccan.

The Sayyid dynasty (1414–51) and originally also the Lōdī dynasty of Delhi (1451–1526) had started as vassals of the Timurids of Central Asia in Delhi and the Punjab. They broke with the Tughlaq art tradition, again building mosques and tombs with vertical walls and high domes, sometimes also with heavy, but no longer tapering, buttresses. They decorated them with purely Central Asian inscriptions and arabesque friezes of deeply carved and painted stucco, enriched by an admixture of encaustic tiles, niches, and battlements of irregular shapes. The type of mausoleum that Khan Jahān Tēlingānī had first introduced in 1372 now became the rule: it consisted of an octagonal ground plan, surrounded by an open colonnade covered inside by fluted domes and outside crowned by small chattrīs (Hindu pavilions) of broad eaves and high domes resting on slim pillars. Hindu pillar bases and capitals, brackets, lintels, eaves, balconies, and chattrīs now became an integral part of most buildings. The edifices of the Sayyid dynasty are confined to Delhi (the township of Mubarakpur) and the tombs at Khairpur (now Lodi Gardens) as well as Mubarakpur. The Lōdīs, who annexed the kingdom of Jaunpur up to the frontier of Bengal and north-central India, have left a consider-able number of monuments. Those in the Delhi area include the mausoleum of Sikandar Lōdī (PL. 16); the small, beautifully decorated Lōdī Mosque at Khairpur, built by Abū-Amjad in 1494; the Mōth-kā Masjid at Siri (PL. 18); and other buildings at Mahrauli and Siri. In Sarhind, Sikandra, Agra (two Lōdī foundations), Bayana, Dholpur, and Sambhal are other buildings of the Lōdīs.

The Lōdī style survived the first conquest of northern India by the Moghul emperors Bāber (1526–30) and Humāyūn (1530–40), as seen especially in the Jamālī Masjid and the small, beautiful mausoleum of Maulānā Jamāl Khan at Mahrauli (PL. 18). It experienced a splendid revival under the Pathan emperors of the Sūr dynasty (1540–54) before it was incorporated into Moghul architecture between 1554 and 1575. Shēr Shah (1540–45) not only built many towns and fortresses, such as Patna, Rohtas in Bihar, Kanauj, Shergarh, and Rohtas in the Punjab, but also erected fine buildings in Monghyr, Patna, Chainpur, Sasaram, Rajgarh, and Merta. Best known are his imperial citadel Purana Qila at Delhi, with the grandiose Qila-i Kohna Masjid (PL. 18) and the gates (e.g., the Lāl Darwāza) of the town connected with it (PL. 19); and his own grandiose mausoleum and the tombs of his family at Sasaram and Chainpur in Bihar. They represent a synthesis of all the achievements of the preceding Moslem dynasties of northern India. The mighty walls and huge bastions of Purana Qila are decorated outside with slabs of red and yellow sandstone and white and black marble (as in Tughlaq times) and with the Sūr coat of arms (Solomon's seal); within, the fort has Lōdī friezes of richly cut stucco. The Qila-i Kohna Masjid, near the old riverside, is a large-scale repetition of the (Sayyid) Muḥammadī Mosque (PL. 17) and the (Lōdī) Mōth-kā Masjid, both at Siri, and of the Jamālī Masjid at Mahrauli. Its decoration is a mixture of styles: Hindu pillars, brackets, and lotus ceilings; Khiljī arches and panels; Tughlaq multicolored stone intarsia; Lōdī inscriptions and arabesques; Central Asian encaustic tile friezes; and Mameluke marble mosaic, probably introduced by Egyptian emigrees after the fall of the Mameluke empire in 1517. Shēr Shah's mausoleum at Sasaram, a huge dome resting on an octagon surrounded by open colonnades, is on a platform in

the center of an artificial lake which is reached by a causeway; at one time the great emperor's tomb was richly embellished with green, yellow, and blue glazed tiles. The mausoleum of his successor Islām (Salīm) Shah at Sasaram was never completed. The tombs of Shēr Shah's relatives at Chainpur are much simpler. Of later Sūr buildings the tomb and mosque of 'Īsā Khan (1547) near Nizam-ud-Din (Delhi) and the tomb of the governor Fath Jang (1547) at Alwar are best known. The former is of the octagonal type, in the center of an octagonal fortified garden; the latter is a domed cube surrounded by two stories of open galleries, covered by fluted cupola ceilings.

The Moghul emperors (after 1526, and more precisely from Akbar's reign, 1556–1605) introduced the Timurid art of Turkistan and the Safavid style of Persia that derived from it. But like the earlier conquerors of India they were soon forced to employ indigenous architects, masons, and painters. The earliest example of Sūr architecture for the Moghuls is the Rām (originally Ārām) Bāgh at Agra, the next the tomb of Adham Khan at Mahrauli (1562). The decoration of white (and also black) marble panels on red sandstone walls was soon adopted, as in Delhi in the Arab Serai, 1561; the Khair-ul-Manāzil Madrasah, 1561–62 (X, PL. 109); and the mausoleum of the emperor Humāyūn, ca. 1568–80 (X, PL. 111). The mosaic of Shēr Shah's Qila-i Kohna Masjid recurs in part of the decoration of the exquisite tomb of Ataga Khan at Delhi (d. 1562; PL. 89) and in the maqsūra of the Great Mosque (1571–80) at Fatehpur Sikri. Thereafter the Lōdī-Sūr style was integrated into the eclectic Moghul art of the late 16th and early 17th centuries, as were all the Islamic and northern Hindu styles of the time.

Of painting and the minor arts under the Delhi sultanate very little is known. The *History of Fīruz Shah* mentions that the pious emperor had figural paintings removed from the walls and doors of the Delhi palaces, but nothing is preserved. The so-called "Kanauj throne" of the Bikaner maharajas, with its many carved wooden panels, may be regarded as the sole piece so far known of 15th-century furniture (V, PL. 458). Encaustic tiles and potsherds have been excavated at Adilabad. There is a brass aquamanile in Boston (Mus. of Fine Arts) and a lion tapestry (14th cent.?) in Ahmadabad (Calico Mus. of Textiles).

THE ART OF THE NORTH INDIAN PROVINCIAL SULTANATES. Kashmir, a Moslem state from 1339, had never been subject to Delhi. Bengal and the Deccan had become independent under Muhammad ibn-Tughlaq in 1345–46; after the sack of Delhi by Tamerlane in 1398, Jaunpur, Malwa, and Gujarat also became independent sultanates. These sultanates, antagonistic to Delhi and closely linked with the traditions of their respective provinces, cultivated local art styles.

This was not so pronounced in the case of Delhi's most dangerous adversary, the Sharqī sultanate of Jaunpur (1394–1479), which ruled over the Ganges plains between Delhi and Bengal. Most of its monuments are found at Jaunpur (northwest of Benares) with its strong citadel, the Ātala Masjid (PL. 19); the huge Jāmi' Masjid (1438–48, enlarged 1478); and the Lāl Darwāza Masjid (ca. 1457), built by the queen Bībī Rājī near the royal palace of the same name, which no longer exists. Although Hindu spoils were extensively used in these mosques, they represent a further development of the mosque of Khan Jahān Jūnān Shah at Begampur; the Timurid aiwans and arched pylons dominate the buildings; in the ornamentation Khiljī motifs (especially floral scallops along the arches) interpreted in a "baroque" spirit and mosaic of innumerable small encaustic tile cubes are characteristic.

The architecture of Malwa is much more complex. It too derived from the late Tughlaq tradition, but here vertical walls of yellow limestone, even of white marble, were retained, as well as some Khiljī decorative motifs; to this were added many elements from other architectural styles: contemporary Persian (especially huge aiwans, high hemispherical domes, corner turrets, etc.), Mameluke (columns, "Gothic" arches), and Rajput (projecting eaves, perforated stone screens, pillars, and lintels). The chief centers are Dhar and Mandu in south Malwa and Chanderi in north Malwa. In Dhar, the first capital of Malwa, the Lāt Masjid, which enclosed a Hindu iron column, was erected from Hindu spoils by Dilāwar Khan (1392–1406). Mandu, the later capital, was founded on an almost inaccessible spur of the Vindhyas by Hōshang (1406–35), the actual creator of the Malwa style; he also founded Chanderi at the foot of a former Rajput hill fort. Other Malwa monuments are found at Udaipur, Singhapur, Ujjain, Kalyada, Mandasor, and Narsinghgarh. Examples of the earlier, simple style of Hōshang are his mausoleum of white marble, the Old Palace, mosque of Malik Mughīs ud-Dunyā (1432), Hindōla Mahal (audience hall with Tughlaq tapering buttresses), and Delhi Gate (1411), all at Mandu, and the Jāmi' Masjid at Chanderi. The classic style of Mahmūd I (1435–69) is seen at Mandu in the Ashrafī Mahal (madrasah, tomb, and tower of victory, of which little remains), great audience hall ("Gada Shah's Shop"), Northern Palace (Egyptian influence), and Jahāz Mahal (zenana); at Chanderi, in the Kōshak Mahal and Shāhzādī-kā Rauza. The Jāmi' Masjid (on a high platform) at Mandu was begun by Hōshang and completed by Mahmūd I. Examples of the late, ornate style under Ghiyās-ud-Dīn (1469–1500), Nāsir-ud-Dīn (1500–11), and Mahmūd II (1511–31) are the vast zenana town, Lāl Mahal, Chappan Mahal, Palace of Bāz Bahādur and Rūpmatī's Pavilion, "Gadā Shah's House" (with the only surviving murals), all at Mandu, and the various mosques and palaces in other places, especially the Jal Mahal (water palace) at Kalyada near Ujjain. A Moghul echo of the Malwa style is the mausoleum of the saint Muhammad Ghaus at Gwalior (1563). Recently two illustrated manuscripts have been discovered, the *Ni'mat-nāma* of Ghiyās-ud-Dīn (London, India Office Lib.) and the *Bustān* of Nāsir Shah Khiljī (New Delhi, Nat. Lib.).

The architecture of Gujarat, Bengal, and Kashmir, however, evolved from Hindu prototypes. In the Gujarat sultanate (1401–1573) pure Islamic architecture was confined to buildings in brick and plaster, such as the mausoleum of 'Azam and Mu'azzam at Sarkhej, near Ahmadabad (1457), the gigantic mausoleum of Daryā Khan (1453) at Ahmadabad, an unknown tomb at Champaner, and the palace of Mahmūd III (1538–54) at Mehmadabad. Otherwise Hindu architecture (first used as spoils) was adapted, because excellent Hindu masons were available in great number. Hindu shrines, placed atop one another, became minarets; Hindu cult halls, set side by side, became the naves of mosques; the entrances of Hindu sanctuaries became mihrab niches. Only the ogival arches (or at least the central arch) of the mosque façade follow a purely Islamic pattern, the transition to the much lower nave of Hindu columns and corbeled ceilings behind them being achieved by means of an upper story of balconies and open galleries. All Hindu forms and ornaments were retained, though purified of idolatrous figures and enriched by Islamic arabesques and Arab inscriptions.

In principle the style of Gujarat had already been anticipated in the Khiljī and Tughlaq mosques at Anhilwara, Sidhpur, Cambay, Broach, Dholka, and Mangrol, but it assumed definitive shape under Ahmad I (1411–41), founder of the new capital Ahmadabad and of Himatnagar (mod. Ahmadnagar in Gujarat). The early, simple style is exemplified in Ahmadabad by the mosque of Ahmad I (1414; constructed partly of Hindu spoils) within the Bhadr, or royal fort; the mosques of the Rani (in the Mirzapur quarter), Sayyid 'Ālam, and Haibat Khan, all of 1412; the Jāmi' Masjid (1423/24); and the Tīn Darwāza, or Triple Gateway (ca. 1425), of the palace square. Ahmad I also built a mosque in Himatnagar. Representative of the transitional style under Muhammad II (1448–51) and Qutb-ud-Dīn Ahmad II (1451–58) in or near Ahmadabad are the mausoleum of Ahmad I; the Tombs of the Queens (Rānī-kā Hujrā, ca. 1440); the mosques of Qutb-ud-Dīn (ca. 1450) and Malik 'Ālam (ca. 1450–60); the tombs (and mosques) of Shakar Khan (1450), Sheik Ahmad Khatri (1446–51; at Sarkhej), Malik Sha'bān (1452/56), and Sheik Burhān-ud-Dīn (at Batwa); and Kankariya Lake. There were two types of mosque, one with ogival arches, the other with Hindu pillars and lintels; ornaments were still sparsely used and had not yet become stereotyped.

The classic style flourished under Maḥmūd Bēgadā (1458–1511) and Muẓaffar II (1511–26). Maḥmūd Bēgadā expanded Ahmadabad, founded the second capital Champaner (1482/84) at the foot of the former Rajput mountain fortress of Pawagarh, and founded or rebuilt Mehmadabad, Baroda, Mustafabad (now Junagarh), and Jalor. In Ahmadabad are the mosques of Dastūr Khan (1486), Muhāfiz Khan (1492), and Bābā Lulū'ī, the Gumti Masjid (ca. 1510; in the Isanpur quarter), the mausoleums of Sīdī 'Usmān (1460; in the Usmanpur quarter), Bībī Achyut Kūkī (1472), and Shah 'Ālam (1475), and the step-well of Bāi Harī (1500). Another well of 1500 is in Adalaj. Other buildings of this period are the royal palaces and lake at Sarkhej; the sluices of Kankariya Lake; at Champaner the Jahānpanāh citadel with ruins of royal palaces, Jāmi' Masjid (1508/09), Nīla Gumbaz, several tombs, the Sat Manzil, and a hunting lodge perched at the top of a deep gorge halfway up to Pawagarh; the Kevadā and Halol mosques; at Mehmadabad the Bhamaria well (with underground chambers) and the mausoleum of Mubārak Sayyid (1484); at Jalor the Tōpkhāna Masjid. The architecture during this time was well balanced, its conception grand, its ornamentation rich but not yet exuberant; after about 1500, however, it became increasingly rich and elegant and was finally smothered in a wealth of decoration. The most famous examples of this elaborate style are the tombs of Rani Rūpvatī (1500) and Rani Sipari (1514) at Ahmadabad and the mausoleum of the Nagīna Masjid at Champaner. To the late, degenerating style (1526–97) belong the mausoleum of Sultan Sikandar at Halol (1526) and the following buildings at Ahmadabad: mosques in the Sarangpur quarter (1528), of Shah Khūb Sayyid (1538), Sīdī Sayyid (1572; PL. 19), and Muḥammad Ghaus (1562); and the mausoleums of Sheik Ḥasan Muḥammad Chishtī (1566) in the Shahpur quarter and Abū-Turāb (1597). The Khan Sarovar (artificial lake; 1589–94) at Anhilwara is another example of the late style and was constructed under Moghul rule as was the mausoleum of Sheik Salīm Chishtī at Fatehpur Sikri (1571–80).

Gujurat painting, which we know only from a few original miniatures, remnants of murals at Champaner (since destroyed), copies in contemporaneous Jain manuscripts (mainly the *Kālakācāryakathā*), and echoes in a 16th/17th-century manuscript from Marwar, seems to have been a late offshoot of the "Baghdad" school, possibly via Delhi. Glazed and unglazed pottery has been discovered in Baroda and other places, and printed textiles have been excavated in Egypt.

Architecture under the Bengal sultanate (1287/1345–1576) also developed from Hindu art, but from brick prototypes and not limestone. Stone had to be brought by boat from the quarries of Rajmahal, where the Ganges skirts the easternmost spurs of the central Indian mountain ranges. Massive brick walls decorated with delicate reliefs of intricate Hindu ornaments (generally leaf scrolls) or with richly carved inserted stone slabs and *bangaldār* (curved) roofs (inspired by the bamboo roofs of the local village huts) are the characteristics of this art. Its centers were Gaur at the head of the Ganges Delta, capital of Bengal in 1211–1354 and 1442–1576, and, in the interior, Pandua (14 mi. to the north), both vast cities surrounded by broad moats and high dikes. The only remnants of the first Gaur period are the Seljuk mihrab of the mausoleum of Zafar Khan Ghāzī (rebuilt 1493–1518) at Tribeni (Hooghly district) and the Sālik Mosque at Basirhat (1305). At Pandua Sikandar Shah (1358–89) built the gigantic Adīna Masjid, and Jalāl-ud-Dīn Muḥammad (1414–31) built the Eklākhī Mosque in classic style.

Most monuments at Gaur belong to the second period. Nāṣir-ud-Dīn Muḥammad (1442–59) restored the town, erected the tomb of A'lā-ul-Haq at Pandua, the mosque at Satgaon, and the Sāth Gumbaz Masjid at Bagerhat (1459, echoes of Tughlaq style); Rukn-ud-Dīn Bārbak (1459–74) built the imposing Dakhil Darwāza (palace entrance) in Gaur. After Yūsuf Shah (1474–81), Bengalese art became mannered and effeminate (Tāntipāra, Daras Bārī, Nattan, Chamkhan, and Gunmant mosques, all in Gaur). The mosques of Bābā Ādam Shahīd at Vikrampur (1483) and of Muẓaffar Shah (1490–93) at Kusumbha and the Fīrūz Mīnār at Gaur (1486) show how the style became progressively decadent, ending in empty repetition. However, in the 16th century there was a renaissance, overelaborate and flamboyant, as seen in the Choṭā Sonā (Little Golden) Masjid (1493–1518) and Barā Sonā (Great Golden) Masjid (1526) — the two best-known Moslem buildings in Bengal — and the tomb of Ākhī Sirāj-ud-Dīn (1510), all at Gaur; the mosques of Bara Goali, Tribeni, and Masjidkur (1493–1518), Malda (1533–38, 1566), and Bhaga (1523/24); and finally the Sonā Masjid of Pandua (1585). The only painting we know is a portrait of Sultan A'lā-ud-Dīn Fīrūz Shah (1532), attributed to the school of the Persian master Bihzād. The Gaur-Pandua style (lotus columns, *bangaldār* roofs) first influenced Moghul architecture during the reign of Shah Jahān (1628–58), who had been governor of Bengal before he became emperor.

In Kashmir the Hindu-Buddhist background was still different. There were few Hindu ruins of the 8th–10th century, and a living tradition of indigenous wood and imported Persian brick and tile architecture persisted (see KASHMIR ART). Some Hindu temple ruins were transformed into tombs, such as the ziara of Bumazuv on the road to Pahlgam; the shrine of Mādīn Shah near Srinagar, simply a temple ruin roofed in; and especially the mausoleum of the mother of Sultan Zain-ul-'Ābidīn (1417–67) in Srinagar, a brick construction (decorated with encaustic tiles randomly spaced) with a high dome and supplementary turrets, which rests on Hindu foundations. Other mosques (e.g., at Pampur) and ziaras (the most famous one that of Shah Hāmadān in Srinagar) are huge blockhouses with a sod-covered sloping roof and a curious *ma'zīna* (low minaret) ending in a spire; probably they are adaptations of a late type of Buddhist temple, crowned by a *chattrāvalī*, such as is still found in Tibet (though without the latter). In the Jāmi' Masjid of Srinagar, originally founded by Sikandar Būtshikān (1390–1416), these spired blockhouses form the four aiwans of a mosque of Persian ground plan. Almost all these wooden constructions had burned down and been rebuilt time and again; except for minor details they retained the original design.

THE ART OF THE SULTANATES OF THE DECCAN. In the southern Deccan, the area farthest away from Delhi, the Hindus had recovered from their defeat by the Khiljī and Tughlaq sultans and rallied under the Rāyas of Vijayanagar. The Bahmanī sultans of the northern Deccan (1347–ca. 1528), who were equally antagonistic to Delhi, nevertheless regarded Vijayanagar as their principal enemy. In search of a style of their own, they adopted contemporary Persian art, but the influence of the Indian milieu — through the royal and aristocratic zenanas, Hindu converts to Islam, Hindu vassals and mercenaries, courtesans, and artisans — resulted in a strong admixture of Hindu motifs, especially in secular architecture and the minor arts. (See DECCAN ART.) The Bahmanī sultans strengthened their hold over the country by a net of mighty fortresses built according to the most modern methods evolved in southwestern Asia during the Crusades.

Zafar Khān Ghāzī (1347–58) moved the capital to the center of the new kingdom, Gulbarga. The earliest buildings still followed the Tughlaq style, but Muḥammad I (1358–75), who first gave to the state its characteristic organization, introduced the Persian style in the Jāmi' Masjid, which was built by a Persian architect from Qazvin. It is one of the very few mosques in India without court or minarets and has an open hall covered by 68 domes surrounded by vaults, all resting on broad keel arches supported by low piers. The royal tombs to the east and west of Gulbarga are of pure Ilkhan type (see ILKHAN ART): cubes decorated with two stories of blind keel-arch niches and crowned by a hemispherical dome flanked by four turrets. During the rule of the tolerant Fīrūz Shah (1397–1422) Hindu motifs (among them the Deccan coat of arms, a lion holding diminutive elephants in his claws) began to infiltrate. Fīrūz Shah built a summer residence at Firozabad on the Bhima River. Aḥmad I Wālī (1422–36) transferred the capital to Bidar in 1428, but it was not completed until 1532. In Bidar, which is partly surrounded by a triple moat cut into the rock, the Persian taste dominated, as is evidenced in buildings covered with brightly painted encaustic tiles: the Takht Mahal, Shāh

Burj, Lāl Bāgh, Sōla Khumba Masjid, and the later series of royal tombs at Ashtur. During the reign of Aḥmad I the mausoleum of the saint Banda Nawāz (Gēsū Darāz) was built at Gulbarga; the huge freestanding arch, six stories high, was added later by Aḥmad III.

Aḥmad II (1436–58) built a madrasah with a Takht-i Kirmānī (hall for Shiite festivals) in Bidar, the garden palace of Niʿmatabad (now destroyed), and the Chānd Minār at Daulatabad (1436), a slim tower encircled by broad balconies. Under Aḥmad III (1461–63) and Muḥammad III (1463–82) the Gagan, Tarkash, Chīnī, and Nagīna mahals were added to the royal palace at Bidar; these represent the zenith of Bahmanī art. The actual power at this time was in the hands of the prime ministers, the most important of whom, Maḥmūd Gāwān (1466–81), built the great madrasah (1472), of purely Persian style, in Bidar. To the period of decadence belong the buildings erected at Bidar under Maḥmūd (1482–1518), a powerless tool in the hands of his quarreling nobles: the Sharza Darwāza (with tile pictures of the sun behind a lion rampant), the New Palace, and the Rangīn Mahal, which is richly decorated with walls of encaustic tiles, Hindu carved wooden pillars and ceiling, and door frames incrusted with mother-of-pearl.

Some illustrated manuscripts of late Bahmanī times have been traced but are not yet published. These reveal the same mixture of an essentially Persian art with some Hindu influences. Minor arts are so far known only from literary references.

During Maḥmūd's reign the Bahmanī empire broke up into the five sultanates of Bidad, Berar, Ahmadnagar, Bijapur, and Golconda. To these must be added the principality of Khandesh, which had been independent since 1382/88.

The art of the Fārūqī dynasty of Khandesh (1382/88–1600) was dependent on the neighboring areas of Gujarat, Malwa, and the Deccan. The principal stronghold of the Fārūqīs was the mountain fortress of Asirgarh, and their capital was Burhanpur; however, several princes were buried at Thalner on the Tapti River, the original family fief. In Burhanpur (1400/01) are the Jāmiʿ Masjid (by Raja ʿAlī Khan), the Bībī Masjid, and the mausoleum of Nādir Shah (Nāṣir Khan, 1399–1457). At Thalner the mausoleum of Mīrān Mubārak I (1441–57) is remarkable for its beauty. The Barā Darwāza at Chikalda has a huge arch like that of the Banda Nawāz shrine at Gulbarga.

The art of the Niẓāmshāhs of Ahmadnagar (1490–1633) was also rather eclectic but with a stronger Deccan accent. Like the Bahmanīs, they built many fortresses, though mainly as a protection against the Moghuls. Their first capital, Ahmadnagar (founded ca. 1490 by Aḥmad Niẓāmshāh Bahrī), was one of the finest works of military engineering in India; because it was subjected to many sieges, it is badly damaged. The best buildings are the Dāmarī Masjid, in a mixed Deccan-Gujarat style, and, outside the Fort, the tomb of Salābat Khan and the Fāriā (Pērī) Bāgh, both in the Moghul style. The second capital, Daulatabad (the former Deogiri), has two sets of Niẓāmshāhī palaces on the terrace of the Lower Fort, between the rock-cut moat surrounding the old Hindu Deogiri and the town (PL. 20). The palace proper is rather small, as befits the powerless boy kings kept there by Negro and Marāṭhā regents; the Chīnī Mahal, which is an imitation of the Hindōla Mahal at Mandu, was once completely covered with brightly colored encaustic tiles. The town Khirki (which later became the Moghul capital Aurangabad), founded in 1610 by the regent Malik ʿAmbar, contains two mosques of this time, the Jāmiʿ and Kala masjids, both in the Bijapur style.

Painting is represented by the manuscript of the *Tārīkh-i Ḥusain Shāhī* at Poona, which is a history of Ḥusain I (1553–65) and describes the great victory over the Vijayanagar kingdom at the battle of Talikota in 1565; the style of the manuscript is partly Turkoman, partly Vijayanagar-Hindu. To the court of Murtaẓā I Diwāna (1565–86) we may possibly ascribe part of the Deccan *Rāgmālā* miniatures (Coll. Maharaja of Bikaner), in a very elegant style (the rest being decidedly of Bijapur origin).

The Barīdshāhs (1492/1528–1618), who originally were prime ministers of the Bahmanī sultans, ruled over Bidar, the former Bahmanī capital. They have left few monuments of their own. In their tombs at Bidar the usual domed cube is transformed into a towerlike open hall resting on four pilasters, the dome of which is borne by a high cornice of friezes with inscriptions.

The two Deccan styles of great importance were those of the sultanates of Bijapur (ʿAdilshāhs; 1490–1686) and Golconda (Quṭbshāhs; 1512–1687). The art of each of these sultanates can be divided into three phases: the aftermath of the Bahmanī tradition (until ca. 1570–80); the period of typological and esthetic Hinduization from the decline of Vijayanagar (until the middle of the 17th cent.); and the period of growing Moghul influence (throughout the 17th cent.).

The first ʿĀdilshāhs, in a difficult position between the Hindus of Vijayanagar and their Moslem colleagues, could not build much. Yūsuf (1490–1510), who resided at Raichur, erected the Shaykh Rauza at Gulbarga; Ismāʿil (1510–34) settled in the Arh Qila (citadel) of Bijapur, and Ibrāhīm I (1534–57) built a small mosque there; his minister ʿAin-ul-Mulk built a mosque (1556) in the suburb of Ainapur; all these are in the late Bahmanī style. Under ʿAlī I (1557–80) an intensive building activity began at Bijapur. Most of the fortifications of the town were constructed at this time; the ʿAdālat Mahal and the lofty Gagan Mahal (used as an audience hall) were built within the Arh Qila; the Jāmiʿ Masjid (1565–70), Chānd Baori (a pond constructed by the queen Chānd Bībī in 1579), palace and mosque of Mustafā Khan (d. 1581), and ʿAlī I's mausoleum were erected. Probably the water palace at Kumatgi (with Persian murals) also dates from this period. The style of these buildings is still that of the Bahmanī period, but enlarged to grandiose proportions; Vijayanagar-Hindu elements are added to it, richly carved wooden pillars and brackets in the ladies' balconies of the Gagan Mahal, Hindu eaves and peacock brackets at Kumatgi, and Hindu female figures in the frescoes there. In the *Nujūm-al-ʿUlūm* manuscript (Dublin, Chester Beatty Lib.), we find side by side almost pure Vijayanagar female figures and ornaments and Turkoman male figures.

Ibrāhīm II (1580–1626; PL. 21) erected the following buildings at Bijapur: the Ānand Mahal (ladies' audience hall, 1580) and the Jal Mandir (water pavilion), both in the Arh Qila; the Mihtar Mahal (a small mosque with high gateway, 1620); the Andū Masjid (1608); the mosques of the queen Malika-i Jahān (1587) and Ikhlās Khan (1597); and the Tāj Baōri (another pond, built by the queen Tāj Sultana). To the west of Bijapur Ibrāhīm II constructed the new palace town of Torwa (Nauraspur) after 1599, which contains the palaces of the sultan's Hindu dancing girls, the Sangīt Mahal (PL. 20), and Nārī Mahal; to the east, the ruined tomb of Malika-i Jahān. In these the Hindu element predominated (especially in the Jal Mandir, Mihtar Mahal, and Andū Masjid); it then became more and more integrated until at last it determined the general taste of Bijapur art, notwithstanding another strong influx of Islamic motifs from Arabia, Persia, and the Moghul empire. Architectural forms lost their technical functions and assumed a predominantly sculptural character, with an exuberance of richly modeled details, restless "baroque" outlines, pronounced chiaroscuro effects, and a dreamy unreality.

Painting too followed the same pattern: first the semi-Vijayanagar style (see DRAVIDIAN ART), of ʿAlī I's reign (the *Rāgmālā* miniatures in Bikaner; *Mālavī Rāginī*, Baroda); then the Moghul style, which was developed during Akbar's reign, but with a copious addition of gilding; and finally the later Safawid style of Riẓā-i-ʿAbbāsī (q.v.). Examples of minor arts include a very interesting ivory box with portraits of the young Ibrāhīm, Chānd Bībī, and Ikhlās Khan, as well as textiles and china.

Under Muḥammad (1626–56) the taste of the Moghul empire began to make itself felt. The Ibrāhīm Rauza (mausoleum of Ibrāhīm II; IV, PL. 132) represents the most extreme Hinduization of Bijapur art, but its wall decorations reveal Ottoman influence, which is most in evidence in Muḥammad's tomb at Bijapur, the Gōl Gumbaz (X, PL. 156). This immense domed hall (135 sq. ft. in area, 200 ft. high, with a dome 124 ft. in diameter) was inspired by the Hagia Sophia in Istanbul and is one of the mightiest buildings in the world. Other edifices of this reign are the Sat Manzil (Seven Stories) and the mosques of Chinch Diddī and Bukhārī, all in the Arh Qila at Bijapur; the Champak

Mahal, for favorite Hindu queens; the Āthār Mahal, a Persian garden palace clumsily painted with murals in the style of Paolo Veronese, later transformed into a Moslem sanctuary; the mosques the "Two Sisters" and Rangīn; and the mosque in the suburb of Shahpur. Painting succumbed more and more to Moghul influence, distinguished merely by stronger outlines, much gilding, and depiction of the local costume.

To the period of decline (1656–86) belong the last additions to the impressive fortification system, which permitted the town to survive seven sieges by the Moghul emperors. 'Alī II, whose unfinished mausoleum in the Arh Qila was intended to be even more impressive than the Gōl Gumbaz, was buried by the side of his father. Sikandar ended his days as a Moghul prisoner. Only the palace of Khawāss Khan, regent for the last boy king, survives from this dreary period. 'Adilshāhī monuments are, of course, found over the whole length and breadth of the Bijapur kingdom, but with few exceptions they are either utilitarian or small and simple.

In the eastern Qutbshāhī kingdom of Golconda, art developed on parallel lines. However, as it was farther from the Moghul empire as well as from the sea routes to southwestern Asia, other Islamic style influences hardly penetrated and Hindu art was more extreme and persistent. The late Bahmanī style dominated the early Qutbshāhī period (1512–50), especially in the Fort at Golconda, founded by Sultan Qulī (1512–43). The Fort is on a steep granite hill, surrounded by 87 bastions and mighty gates, and encloses the Jāmi' Masjid, Naqqar Khāna (music gallery), Sila Khāna (armory), palaces, and the Bālā Hissār (citadel at the summit). The period of Hindu influence set in with Ibrāhīm (1550–80). He expanded the Fort from 1550 to 1559 in order to make room for his vast palaces; the Lower Fort and the town, which had no natural defences, were strengthened by mighty granite bastions (e.g., Ibrāhīm Burj) and gates (e.g., Makkī Darwāza) behind a broad moat and the artificial Langar Lake. On the plain east of Golconda a garden city began to develop near the Husain Sagar (lake) and the Purāṇa Pūl (Old Bridge) over the Musi River. In the new palaces, the mosques of Mustafa Khan (1562) and Mullā Khiyālī (1570), and finally in Ibrāhīm's tomb in Golconda, the Bahmanī tradition reached another peak of refined elaboration, but for the first time Hindu elements of style and ideals appeared, especially the bulbous dome emerging from a circle of lotus petals.

The reigns of Muḥammad Qulī (1580–1612), Muḥammad (1612–25), 'Abdullāh (1625–72), and Abū'l-Ḥasan (1672–87) represent the golden age of Golconda art: at Golconda are the mausoleums of Jamshīd (1543–50), Muḥammad Qulī, Muḥammad, 'Abdullāh, and of the princesses Hayātbakhsh Begam (1617) and Fāṭima Khānum (1673), and the 'Ambar Khāna (treasury); at Hyderabad, the town founded in 1589 south of the Purāṇa Pūl, are the Chār Minār (1591; 186 ft. high), the Jāmi' (1598), Mushīrābād (1611–25), Pēmatī (1662), Sāliha Bībī (1656/57), and Tolī (1761) masjids, the Bādshāhī 'Ashūr Khāna (1593–97), and the Gōsha Mahal Hauz (ca. 1672–87); at Bhagnagar (between the two towns) are the mosque of Bhāgmatī and the garden palace of Tāramatī; finally, at Janwada are the mosque and tomb of the princess Ḥusaina Begam. In Muḥammad Qulī's tomb the Hindu element is confined to arcaded porches. But thereafter Islamic and Hindu elements fused into a bizarre style — overelaborate, restless, and full of chiaroscuro effects, with far-projecting balconies, galleries of miniature pavilions, bulbous domes, and onion-shaped minaret cupolas in the form of lotus buds or open lotus flowers. The sole exception is the Bādshāhī 'Ashūr Khāna, with its walls of encaustic tiles painted in a modified Ottoman taste.

Early Qutbshāhī painting is lost but can to some degree be reconstructed from the painted cotton chintzes (pintados) exported from Masulipatam in the 17th century. The earliest known illustrated manuscripts are the *Hātifī* of Patna (1576) and the *Khāwar-nāma* (1645; Bombay, Prince of Wales Mus.). Most miniatures (brought to Europe by Dutch merchants) belong to the last years of 'Abdullāh and the reign of Abū'l-Ḥasan (i.e., after the sack of Hyderabad by the Moghuls in 1656). Their style is very similar to that of late Bijapur, but

the Vijayanagar style also continued to be used for portraits of famous Hindu courtesans.

Both the Bijapur and Golconda styles disappeared before the end of the 17th century, but they had a decisive influence on Moghul architecture after the reign of Aurangzēb and on painting at the court of the Nizams of Hyderabad in the 18th century.

Moghul art, which superseded the earlier Indo-Moslem styles, was strongly dependent on them only from about 1560 to 1620. Its later "imperial" style, an original creation, absorbed little from Bengal and the Deccan and definitively ousted all older traditions in the late 17th and early 18th centuries.

BIBLIOG. S. Carr, The Archaeology and Monumental Remains of Delhi, Calcutta, 1876; J. H. Ravenshaw, Gaur: Its Ruins and Inscriptions, London, 1878; A. Führer, Sharqi Architecture of Jaunpur, London, Calcutta, 1889; J. Burgess, On the Muhammedan Architecture of Bharoch, Cambay, Dholka, etc., in Gujarat, London, 1896; J. Burgess, The Muhammedan Architecture of Ahmedabad, 2 vols., London, 1900–05; E. Barnes, Dhar and Mandy, Bombay, 1902; J. Burgess and H. Cousens, Architectural Antiquities of Northern Gujerat, London, 1903; H. Cousens, Brahmanābād-Mansūra in Sind, Archaeol. Survey of India, Ann. Rep., III, 1903–04, pp. 131–144, VIII, 1908–09, pp. 79–87; G. R. Hearn, The Seven Cities of Delhi, London, 1906; J. H. Nicholls, Muhammedan Architecture of Kashmir, Archaeol. Survey of India, Ann. Rep., VI, 1906–07, pp. 161–70; M. Zafar Hasan, Balban's Mosque at Jalālī, Archaeol. Survey of India, Ann. Rep., XIV, 1914–15, pp. 151–54; H. Cousens, Bijāpūr and Its Architectural Remains, Bombay, 1916; F. Wetzel, Islamische Grabbauten in Indien aus der Zeit der Soldatenkaiser, Leipzig, 1918; G. P. Baker, Calico Painting and Printing in the East Indies in the 17th and 18th Centuries, London, 1921; M. Zafar Hasan, A Guide to Nizam ud-din, Calcutta, 1922; R. M. Riefstahl, Persian and Indian Textiles, New York, 1923; A. Godard and S. Flury, Ghaznī, Paris, 1925; W. Haig, Architecture of Hyderabad, Indian Art and Letters, I, 1925, pp. 103–05; J. F. Blakiston, The Jāmi Masjid at Badāun and Other Buildings in the United Provinces, Calcutta, 1926; J. A. Page, A Historical Memoir on the Qutb, Delhi, Calcutta, 1926; S. A. Asgar Bilgrami, Landmarks of the Deccan, Hyderabad, 1927; H. Heras, The Aravidu Dynasty of Vijayanagar, I, Madras, 1927; M. B. Carde, Guide to Ghanderi, Gwalior, 1928; G. Yazdani, The Great Mosque of Gulbarga, Islamic Culture, II, 1928, pp. 14–21; Cambridge History of India, III–V, Cambridge, Eng., 1928–37; H. Cousens, Antiquities of Sind, Calcutta, 1929; Sha Rocco (pseud.), A Guide to Golconda, Hyderabad, 1929; G. Yazdani, Mandū: The City of Joy, Oxford, 1929; H. G. Srivastava, Excavations at Bijai Mandal, Archaeol. Survey of India, Ann. Rep., 1930–34, pp. 146–49; H. Goetz, Bilderatlas zur Kulturgeschichte Indiens in der Grossmoghul-Zeit, Berlin, 1931; M. H. Kuraishi, List of Ancient Monuments Protected by Act VII of 1904 in the Provinces of Bihar and Orissa, Calcutta, 1931; R. C. Kak, Ancient Monuments of Kashmir, London, 1933; H. Goetz, Peinture indienne: Les écoles du Dekkan, GBA, XIII, 1935, pp. 275–88; A. U. Pope, Some Interrelations between Persian and Indian Architecture, Indian Art and Letters, IX, 1935, pp. 101–25; M. Zafar Hasan, Sirī: A City of Delhi Founded by Alā ud-dīn Khaljī, Archaeol. Survey of India, Ann. Rep., 1935–36, pp. 137–43; T. W. Arnold and J. V. S. Wilkinson, eds., The Library of A. Chester Beatty: Catalogue of the Indian Miniatures, I, London, 1936; N. Nazim, Bijapur Inscriptions, Delhi, 1936; S. Kramrisch, A Survey of Painting in the Deccan, London, 1937; J. A. Page, A Memoir on Kotla Firoz Shah, Delhi, 1937; B. Gray, Deccani Painting, BM, LXXIII, 1938, pp. 74–76; J. A. Page, Guide to the Qutb, Delhi, 1938; E. Schroeder, An Aquamanile and Some Implications, Ars Islamica, V, 1938, pp. 9–20; M. A. Chaghtai, Nagaūr: A Forgotten Kingdom, B. of the Deccan College Research Inst., II, 1940–41, pp. 166–83; H. Goetz, The Fall of Vijayanagar and the Nationalisation of Muslim Art in the Deccan, J. of Indian H., XIX, 1940, pp. 249–55; H. Goetz, Indo-Muslin Architecture in Its Islamic Setting, J. of the Univ. of Bombay, N.S., VIII, 4, 1940, pp. 40–51; P. Brown, Indian Architecture, II: The Islamic Period, Bombay, 1943; H. Waddington, 'Adilābād, Ancient India, I, 1946, pp. 60–82; S. A. A. Naqvi, Sultān Ghārī, Delhi, Ancient India, III, 1947, pp. 4–10; G. Yazdani, Bidar: Its History and Monuments, London, 1947; L. Ashton, ed., The Art of India and Pakistan (exhibition cat.), London, 1950; H. Goetz, Decorative Murals from Champaner, J. of the Univ. of Bombay, N.S., XIX, 1950, pp. 94–101; R. E. M. Wheeler, Five Thousand Years of Pakistan, London, 1950; D. Schlumberger, Les palais Ghaznavides de Lashkari Bazar, Syria, XXIX, 1952, pp. 251–70; H. Goetz, The Deer Park Palace of Sultan Mahmud III, J. of the Gujarat Research Soc., XV, 1953, pp. 92–98; H. Goetz, Vestiges of Muslim Painting under the Sultans of Gujarat, J. of the Gujarat Research Soc., XVI, 1954, pp. 212–20; K. Fischer, Firozabad on the Bhima, Islamic Culture, XXIX, 1955, pp. 246–53; H. Goetz, Some Early Indo-Muslim Textiles, O. Art, N.S., I, 1955, pp. 22–27; O. C. Gangoly, Three New Acquisitions of Indian Paintings, B. of the Baroda Mus., XII, 1955–56, pp. 15–18; J. Terry, Indo-Islamic Architecture, London, 1957; S. Toy, The Strongholds of India, London, Melbourne, 1957; W. G. Archer, Central Indian Painting, London, 1958; D. Barrett, Painting of the Deccan, 16th–17th Century, London, 1958; R. Skelton, Documents for the Study of Painting at Bijapur in the Late 16th and Early 17th Century, Arts Asiatiques, V, 1958, pp. 97–125; A. Bombaci and U. Scerrato, Summary Report on the Italian Mission in Afghanistan, East and West, X, 1959, pp. 3–56; R. Ettinghausen, The Būstan Manuscrip† of Sultān Nāsir Shāh Khaljī, Mārg, XII, 3, 1959, pp. 42–43; J. Irwin, Golconda Cotton Paintings of the Early 17th Century, Lalit Kalā, V, 1959, pp. 11–48; R. Skelton, The Ni'mat Nāma: A Landmark in Malwa Painting, Mārg, XII, 3, 1959, pp. 44–50.

Hermann GOETZ

Illustrations: PLS. 15–22.

INDONESIA. The Republic of Indonesia, which gained independence in December, 1949, comprises in the main the group of islands situated to the southeast of the Asian continent, extending from the Malay Peninsula to Australia and surrounded by the South China Sea, the Pacific Ocean, and the Indian Ocean. The northern and northwestern area of Borneo and the eastern half of Timor (with adjacent small islands) are not a part of the Republic. However, they are included in the following geographical discussion of the region. The principal Indonesian islands are Sumatra, Java, Borneo, and Celebes. The art of Bali, also, has attracted particular attention, and various other islands are of special interest in the field of primitive art.

SUMMARY. General considerations (col. 31). Nias and the Batu Islands (col. 32). Mentawei Islands (col. 32). Engano (col. 33). Sumatra (col. 33). Java and Madura (col. 34). Bali (col. 35). Lombok (col. 36). Sumbawa (col. 36). Eastern group of the Lesser Sunda Islands (col. 36). South West Islands and South East Islands (col. 37). Borneo (col. 37): *Kalimantan; Sarawak, Brunei, and North Borneo.* Celebes (col. 39). Moluccas (col. 39). Modern Indonesia (col. 40): *Djakarta; Bogor.*

GENERAL CONSIDERATIONS. The Indonesian archipelago owes its importance largely to its location near the straits utilized in the

island of Bali, east of Java, the evolved Javanese art succeeded in maintaining itself, though it was more and more impregnated with an indigenous character. The art of Bali remained faithful to the cults and legends drawn from Hinduism, but these also were altered by autochthonous contributions.

<div align="right">Madeleine HALLADE</div>

Following the Dutch conquest of Java in the 17th century, Indonesia was opened to European influences which, although not determinative, became noticeable in architecture and in some forms of handicrafts. Only in the years since its independence has Indonesia integrated into its life those aspects of international civilization which have greatly modified the appearance of the country.

<div align="right">* *</div>

BIBLIOG. See bibliog. for INDONESIAN CULTURES.

NIAS AND THE BATU ISLANDS. The island of Nias abounds in wooden sculptures, ancestor images (PL. 25), and figures serving apotropaic or magic purposes. The practice of erecting megalithic monuments survived until recently. In southern Nias these monuments were frequently given artistic forms, the menhirs being replaced by obelisks and the dolmenlike structures by well-shaped stone benches. Ancestor images of stone, some of superhuman size, and fantastically stylized stone animal figures are found in southern and central Nias. The large stone stairs giving access to the hilltop villages of southern Nias are works of true artistic merit, as are the

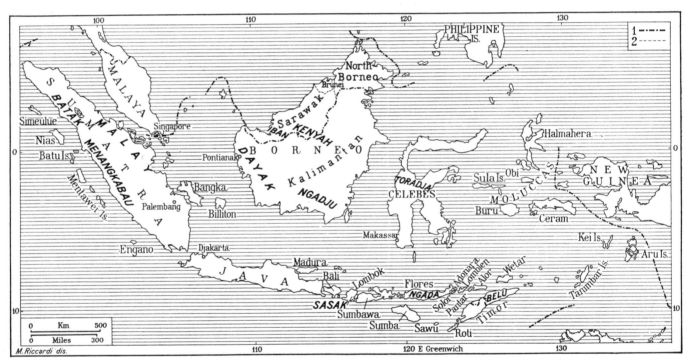

Indonesia, showing principal art-producing tribal groups (names in slanting bold-face capitals). *Key:* (1) Modern national boundaries; (2) internal boundaries of former British Borneo.

maritime routes between India and China. By virtue of the contacts thus afforded, particularly the settlement of Indian colonists along the coasts, the great religions of India and Indian designs and traditions were introduced during the first centuries of the Christian Era (see INDIA, FARTHER). A strongly Indianized civilization was added to and often superimposed upon the native Malayo-Polynesian beliefs and customs. Indianization developed principally in Sumatra and Java, especially from the 7th century in the prosperous kingdom of Śrivijaya and under the Śailendra dynasty. Although there are a few works dated to an earlier period, it is possible to trace the evolution of art in the two centers only from the time when the monuments and sculptures were executed in durable materials. This art, serving the great religions of India (see BUDDHISM; HINDUISM) and clearly marked by Indian artistic influences, developed over many centuries, shaped more and more by local tendencies (particularly after the 10th century). Its evolution was arrested or transformed by the introduction of Islam, the influence of which was intensified during the 15th and 16th centuries; from that time the ancient traditions survived occasionally in monuments of an entirely different type, such as mosques and palaces (*kraton*). On the small

houses of southern chiefs, supported by large wooden columns and covered by powerful towering roofs; some of the relief decorations on the inner walls and columns of these houses correspond to motifs characteristic of the early Buddhist art of India. Together with the floral designs in relief on some megalithic monuments, these decorations suggest that the flowering of art in southern Nias and in the Batu Islands may have been stimulated by slight contact with Indian culture, probably not later than the 3d century of our era.

BIBLIOG. E. E. W. G. Schröder, Nias, 2 vols., Leiden, 1917; J. P. Kleiweg de Zwaan, Het eiland Nias en zijn bewoners, Nederlandsch-Indië Oud en Nieuw, XI, 1926–27, pp. 322–41, 355–72; P. Wirz, Het oude Nias, Nederlandsch-Indië Oud en Nieuw, XIII, 1928–29, pp. 163–74, 197–207; R. Heine-Geldern, Survivance de motifs de l'ancien art bouddhique de l'Inde dans l'île de Nias, Artibus Asiae, XXIV, 1961, pp. 299–306.

MENTAWEI ISLANDS. The lintels and walls of the large communal houses are decorated with paintings representing men, animals, scenes of hunting and fighting, and the like. Ornamental designs, consisting of spirals and plaited bands, correspond to those found in various regions of Sumatra.

BIBLIOG. A. Maass, Die primitive Kunst der Mentawai-Insulaner, ZfE, XXXVIII, 1906, pp. 433–55; P. Wirz, Het eiland Sabiroet en zijn bewoners, Nederlandsch-Indië Oud en Nieuw, XIV, 1929–30, pp. 337–48.

ENGANO (Enggano). The native population of Engano and its very archaic culture have become extinct. Specimens of its art, surviving only in museums, consist of wood carvings, human figures and heads, and figures of birds. The style, unique in Indonesia, resembles that of the Cook Islands in Polynesia.

BIBLIOG. E. Modigliani, L'isola delle donne, Milan, 1894; J. Keuning, Holzschnitzereien von der Insel Enggano, Nachr. der Gesellschaft für Natur- und Völkerkunde Ostasiens, LXXXIII, 1958, pp. 10–17.

SUMATRA. The Pasemah plateau in southwestern Sumatra is rich in stone sculptures and reliefs of a highly dynamic style, representing single persons or groups, men riding on buffaloes (PL. 25) or elephants, and the like; similar subjects appear in paintings of the same style on the inner walls of some of the stone cist graves and chamber tombs of the region. The weapons, ornaments, and bronze drums depicted in the sculptures indicate a date in the second half of the 1st millennium B.C., possibly extending into the first centuries of the Christian Era.

Among the Batak, wood carving (ancestor images, protective figures, masks, staffs, or so-called "magic wands") is richly developed (PLS. 26, 28). The country also abounds in ancient and recent stone sculpture (PL. 24), the outstanding works of Batak monumental art being the magnificent sarcophagi of the region of Lake Toba. Personal ornaments, sword hilts, scabbards, and other brass castings are richly decorated with ornamental designs and frequently with representations of buffalo heads and lizards as well. In the 19th century Batak goldsmiths still produced fine ornaments decorated by the granulation technique. Textile art, formerly distinguished by splendid *ikat* cloth, has badly deteriorated. The houses of the Toba and Karo Batak excel in their graceful roof forms and their carved or painted decoration (PL. 23).

The decorative designs of Sumatra Malayan wood carvings and metal objects generally take the form of stylized plant motifs derived from the art of the Hindu-Buddhist period. The most artistic silverwork is produced by the Malays of the Riouw Islands. In textile art the finest examples are the gold and silver brocades, which occasionally are combined with decorations in *ikat* technique. The weaving and embroidery of the Kroë region, in southwestern Sumatra, with such motifs as the soul boat (X, PL. 431), perpetuate designs and styles dating from the pre-Hindu period. The houses of the Menangkabau (Minangkabau) area of Sumatra, with multiple roofs which telescope into one another and with carved and painted decorations, merit special mention (PL. 23).

BIBLIOG. E. H. Giglioli, Notes on the Ethnographical Collections Formed by Dr. E. Modigliani during His Recent Explorations in Central Sumatra and Engano, IAE, 1893, pp. 109–31; J. Freiherr von Brenner, Besuch bei den Kannibalen Sumatras, Würzburg, 1894; W. Volz, Nord-Sumatra, I: Die Batakländer, Berlin, 1909; C. W. P. de Bie, Verslag van de ontgraving der steenen kamers in de doesoen Tandjoeng Ara, Pasemah hogvlakte, Tijdschrift voor Indische Taal-, Land- en Volkenkunde, LXXII, 1932, pp. 626–35; A. N. J. Th. à Th. van der Hoop, Megalithic Remains in South Sumatra, Zutphen, 1932; K. Helbig, "Sichtbare" Religion im Batakland auf Sumatra, ZfE, LXV, 1933, pp. 231–41; H. W. Vonk, De "batoe Tatahan" bij Air Poear (Pasemah-landen), Tijdschrift voor Indische Taal-, Land- en Volkenkunde, LXXIV, 1934, pp. 296–300; R. Heine-Geldern, The Archaeology and Art of Sumatra, Wiener Beiträge zur Kulturgeschichte und Linguistik, III, 1935, pp. 305–31; G. L. Tichelman and P. Voorhoeve, Steenplastiek in Simaloengoen, Medan, 1938; F. M. Schnitger, Forgotten Kingdoms in Sumatra, Leiden, 1939; A. J. de Lorm and G. L. Tichelman, Beeldende kunst der Bataks, Leiden, 1941.

Robert HEINE-GELDERN

Palembang. The great artistic activity which characterized Sumatra from the 7th century to the 13th, and even into the 14th, was particularly evident during the height of power of the kingdom of Śrīvijaya, which had its capital in the Palembang region, on the Musi River. The radiation of this activity was felt as far as Ligor in the northern part of the Malay Peninsula, where several monuments of a similar character were erected. Nonetheless, the evolution of Sumatran art most often resembled that of Javanese art, the contacts between the two regions having multiplied unceasingly. The Palembang region was an important center of Buddhist culture. Among the oldest objects which have been discovered there is a large image of the Buddha in granite (5th–6th cent.), probably imported from the island of Bangka to the northeast.

Gedong Sura. The site of Gedong Sura, to the southeast, as well as others in this region, has provided beautiful stone and bronze

sculpture (8th–14th cent., perhaps 15th cent.). According to F. M. Schnitger, a group of funerary temples was constructed at Gedong Sura during the 16th century.

Malayu and Jambi. Various remains of monuments have been discovered at the site of Malayu, farther to the north, while at Jambi, near the mouth of the Batang Hari River, seven groups of ruins have been brought to light, of which one, the Stano, or royal mausoleum, could have been a Moslem edifice. The importance of the other (Buddhist) temples leads one to suppose that they formed part of a great city. These temples were built between 1050 and 1250. To the west, near the source of the river, the site of Sungei Langsat has yielded a great image of the deified king Ādityavarman.

Muara Takus. Farther to the north, in the high valley of the Kampar River, the ruins of Muara Takus (11th–12th cent.) were included in a part of the city surrounded by a wall of earth; the best preserved edifice is the Maligai stupa.

Padang Lawas. Numerous monuments in ruins are found in the area of Padang Lawas on the Upper Baruman River and its tributary, the Panei; probably located here was a kingdom bearing the latter name, which is mentioned in the inscriptions at Tanjore and must have been subject to the king of southern India in 1024. The Si Pamutung, the three sanctuaries of Bahal, and others of these temples are among the largest in Sumatra; according to F. M. Schnitger, the large temples date from the 11th and 12th centuries. Numerous monuments have been restored by the Dutch archaeological services, and many sculptures from Sumatra are preserved in the museum at Palembang.

BIBLIOG. See bibliog. for INDONESIAN CULTURES.

Madeleine HALLADE

JAVA AND MADURA. Of the early art known in these islands, there are bronze drums and richly decorated ceremonial battle-axes which date from the late prehistoric Dông-so'n period. Western and central Java are rich in stone sculptures, more or less primitive in character, occurring in large accumulations at such places as Artya Domas near Bogor (Buitenzorg). Apart from the genuinely primitive works, which cannot be dated but might be truly prehistoric, others show some Hindu-Buddhist influence. The production of sculpture in this style continued at least until the 14th century. Some stone statues and stone reliefs of eastern Java may date from the last centuries before Christ or from the first millennium of our era.

BIBLIOG. W. F. Stutterheim, Pictorial History of Civilization in Java, Weltevreden, 1926; H. R. van Heekeren, Megalithische overblijvselen in Besoeki, Djawa, XI, 1931, pp. 1–18; J. Röder, Steinplastik aus dem Goenoeng Kidoel, Cultureel Indië, II, 1940, pp. 16–20; G. L. Tichelman, Primitive steenplastiek op Java, Cultureel Indië, II, 1940, pp. 21–23.

Robert HEINE-GELDERN

Two regions of the island of Java were successively the chief areas of artistic development: first, the central region, from the end of the 7th to the middle of the 10th century, then the eastern region, from that time until the 16th century.

The earlier period, called "Indo-Javanese" or, after the geographical area, "Central Javanese," was marked by the ascendancy of the dynasty of the Buddhist Śailendras, who reigned during the 8th century in the region; this ascendancy resulted in the spread of Buddhism and the building of numerous monuments consecrated to it. Meanwhile, other sanctuaries were dedicated to the Hindu divinities, for Hinduism also had been introduced from India during the first centuries of our era. Two archaeological zones may be distinguished in central Java. The plateau of Dieng, in the northern part, appears to have been occupied for nearly five centuries. Some forty Śaiva monuments were built there, of which the earliest may date to the end of the 7th or the first half of the 8th century. The principal remains are those of eight temples (candi; Jav., caṇḍi), which survive in an old crater: candis Bhīma, Dvaravati, and Gaṭotkatja, each separate; the Arjuna group (candis Arjuna and Semar); and candis Śrīkaṇḍi, Sembadra, and Puntadeva. In another crater is the group of temples of Gedong Sanga, while a little to the south are found Candi Perot and Candi Pringapus.

The most important groups of remains or monuments are found in the southern zone of central Java, distributed in the plains of Kedu and of Prambanam (a little more to the east). Borobudur (ca. 750–850) is the great Buddhist monument of the Kedu plain (PLS. 30, 33; III, PL. 485); not far off are candis Mendut and Pawon (PL. 34), probably its dependent temples. At the Hindu Candi Banon many sculptures of excellent quality have been found. In the Pram-

banam plain are grouped other Buddhist monuments: Candi Kalasan (consecrated 778, according to an inscription); Candi Sari, a monastery (vihara) of similar age; and Candi Sajiwan; then the great ensembles built later, candis Sewu (PL. 34) and Plaosan, built probably at the end of the 9th century and perhaps at the beginning of the 10th. The growth of power of the kings of Mataram engendered a revival of Saivism during the second half of the 9th century that was manifested in the great Hindu temple complex of Prambanam, Lara Jongrang, which was probably erected at the end of the 9th or the beginning of the 10th century.

Eastern Java became the center of development of civilization and art when the capital was moved to the area during the reign of Siṇḍok (ca. 929–47), thus initiating what is called the "Eastern Javanese" period. Not far from the coast is the Gunung Gangsir (ca. 950), and near Mount Penanggungan sepulchral bathing places were erected at Djalatunda (end of 10th cent.) and Belahan (11th cent.). New construction, which seems to have been less frequent during the ascendancy of the kingdom of Kediri (12th cent.) on the middle course of the Brantas River, became more common at the end of the second decade of the 13th century.

Lying east of the Brantas, Singhasāri became the capital in the 13th century and remained so until the end of the century. The majority of its monuments are Hindu; examples are Candi Singhasāri and, a little to the south, Candi Kidal. Nearby is Candi Jago, consecrated to a Buddhism mixed with Saivism.

At the end of the 13th century the capital was shifted again, this time to Majapahit, south of the Brantas delta and west of Penanggungan. The power of the kingdom of Majapahit was manifested during the 14th century by an abundance of new construction scattered throughout eastern Java; among the chief monuments may be noted Candi Jabung (Buddhist) and Candi Keḍaton in the east, Candi Surawana to the west, Candi Simping and Candi Sawentar in the south. Of particular importance is the large complex of Panataran, also in the south, probably begun in the 12th century but with principal monuments of the Majapahit period.

In the middle of the 15th century, from Mount Lawu (to the west) and from Mount Merbada and Mount Wilis as far as Penanggungan (to the east), the mountains scattered in the interior of the island became places consecrated to late Hinduism mingled with indigenous cults. Religious edifices, such as Candi Sukuh on Mount Lawu, were erected; some of these persisted even after the definitive establishment of Islam. Following the end of the kingdom of Majapahit (beginning of 16th cent.) and the growth of power among the Moslem sultanates, palaces, mosques, and tombs were built. Some monuments conserved stylistic traditions of the preceding period in eastern Java; examples are the minaret in Kudus and the mosque in Sendangduwur on the northern coast. Until the middle of the 18th century immense and magnificent palaces (kraton) were built of timber in Jogjakarta and Surakarta, cities of central Java.

The Dutch archaeological services have restored a large number of Javanese monuments; numerous sculptures are preserved in various museums in Java itself, particularly in the museum at Djakarta (formerly Batavia), while others may be found in the museums and private collections of many lands, particularly in those of the Netherlands, in Amsterdam (Koninklijk Instituut voor de Tropen) and in Leiden (Rijksmuseum voor Volkenkunde).

BIBLIOG. See bibliog. for INDONESIAN CULTURES.

Madeleine HALLADE

With the establishment of Islam, the art of Java and Madura came to be expressed chiefly in textiles, particularly those decorated by the batik technique, and in masks, wayang (shadow-play) puppets, metalwork, and weapons. Many krises are of high artistic quality. Ornamental wood carving has been dominated by stylized plant ornaments derived from the ancient Indian lotus motif; it is seen at its best in the exuberant interior decorations of houses at Kudus and Japara.

Robert HEINE-GELDERN

BALI. The tiny island of Bali was influenced very early by Hindu culture, in the earliest period probably by India directly, and later through the intermediary of the Javanese kingdoms. Before the 10th century there existed on the island a society with an Indo-Balinese culture which was independent of Java and had adopted Buddhism and Saivism. Then, under Siṇḍok and in particular under Erlaṅga (Airlangga; 991–1049?), closer relations between Bali and Java introduced Javanese culture into Bali and favored the predominance of Hinduism. These relations were intensified under the kings of Majapahit (14th–15th cent.) and, in the face of the invasion by Islam, the island became the refuge for Javanese faithful to their beliefs and to their older traditions.

Several sculptures of the 8th–10th centuries (contemporary with the Central Javanese period) have been discovered on Bali, some of which must have belonged to wooden temples which have disappeared, although others may have been imported from the large neighboring island. The oldest monuments, which are not earlier than the Eastern Javanese period, are found in the southern part of the island. These include the tomb complex of Tampaksiring (end of 11th cent.), the cave of Goa Gajah (13th cent.?) in which the entrance has the appearance of a kala, or monster's head, and the temple and bathing place of Ye Ganga near Perean (ca. 14th cent.). The style of these monuments is related to that of central Java.

The more typically Balinese temples (pura) are particularly numerous, and many are very recent. In each village they are dedicated respectively to the village itself, to the dead, and to the sea. The most important temples are in the south, though some are found in the north. Among those of the late period (17th cent. to date) characteristic of the architecture of the south are the Pura Kehen near Bangli, the Pura Sempidi near Tabanan, the Pura Satria near Denpasar (or Badung), and the Pura Dasar near Klungkung. In the northern region are the temples of Singaraja, Sangsit, Bila, Jagaraja, and others. Although elements borrowed from the Eastern Javanese style continue to exist, the originality of Balinese art is more and more strongly affirmed in such temples as these by the increasing importance of the entrances and by the local, and often fantastic, sculptures which adorn them.

Madeleine HALLADE

A notable survival of the Dông-so'n period is a huge bronze drum, of hourglass shape and richly decorated, preserved in a temple at Pedjeng.

In the present day, wood and stone sculpture in the traditional style continues to flourish, and figures of gods, demons, men, and animals are still being produced. The reliefs found on the doors of princely mansions are of high artistic quality (PL. 37). Paintings in the traditional style on wood and cotton, as well as the illustrations of palm-leaf manuscripts, represent scenes from myth and epic and from the ancient literature. Silverwork, kris hilts, and textiles are outstanding among the minor arts. The textiles made in the village of Tenganan are unique in that they are decorated by the double ikat technique (warp and weft ikat; PL. 40). The designs include geometric and flower patterns as well as figures in wayang style.

Completely new styles in painting and sculpture, which came into vogue about 1930, soon inspired many native artists to produce works of great charm and originality.

BIBLIOG. W. O. J. Nieuwenkamp, Bali en Lombok, 3 vols., Edam, 1906–10; W. O. J. Nieuwenkamp, Zwerftochten op Bali, 2d ed., Amsterdam, 1923; P. A. J. Moojen, Kunst op Bali, The Hague, 1926; W. O. J. Nieuwenkamp, Bouwkunst van Bali, The Hague, 1926; W. O. J. Nieuwenkamp, Beeldhouwkunst van Bali, The Hague, 1928; M. Covarrubias, Island of Bali, New York, 1947; R. Goris and P. L. Dronkers, Bali, Djakarta, n.d.

LOMBOK. The art of the descendants of Balinese conquerors who came in the 18th century conforms to that of Bali. The princely pleasure seat at Narbada, with terraced gardens, waterworks, and bathing places, is noteworthy. The art of the Mohammedan Sasak, the indigenous population, is of little consequence.

BIBLIOG. W. O. J. Nieuwenkamp, Bali en Lombok, 3 vols., Edam, 1906–10.

SUMBAWA. A few sarcophagi, discovered in the western part of the island, are decorated with human and animal figures in relief, corresponding in style to those of eastern Java and probably of the same date. Six bronze drums of late Dông-so'n style, found on the small island of Sangeang, off the coast of Sumbawa, are now in the museum at Djakarta.

The art of the present population is little known. Ornamental wood carvings utilize mainly plant motifs and bird and serpent (naga) figures. The very fine krises and ceremonial weapons, as well as the elaborate gold crown, set with diamonds, of the sultans of Sumbawa may have been imported from Java or Celebes rather than of local manufacture.

BIBLIOG. J. Elbert, Die Sunda-Expedition des Vereins für Geographie und Statistik zu Frankfurt am Main, II, Frankfurt am Main, 1912.

EASTERN GROUP OF THE LESSER SUNDA ISLANDS. This group comprises the islands of Sumba, Flores, and Timor and the smaller islands of Sawu, Roti, Adonara, Solor, Lomblen, Pantar, and Alor. Unlike the people of Lombok and Sumbawa, who are Mohammedan, the inhabitants of the eastern group adhere to tribal beliefs, with the exception of considerable numbers of Christian converts. Accordingly, the local arts belong to those indigenous styles which did

not come under the influence of Javanese art. Exceptions are the flower patterns of Javanese derivation on a few textiles and the decoration on bamboo receptacles in western Timor.

The island of Sumba has magnificent megalithic tombs and monuments, which are richly decorated with ornamental designs as well as with human and animal figures in relief or in the round (PLS. 24, 25). In Flores occur ancestor images of wood and some of stone, while the island of Alor abounds in dragonlike cult figures of serpents, many decorated with spiral motifs in openwork. Some of the houses of the Ngada in central Flores and of the Belu in central Timor are particularly rich in ornamental carvings. Fine personal ornaments of gold, silver, and brass have been produced in Sawu and Flores in recent times.

The bronze or brass drums of hourglass shape (mokkos), used as currency on the island of Alor until the early part of the 20th century (see COINS AND MEDALS; III, PL. 416) are not of local manufacture but were imported from Java. The oldest ones, decorated in a degenerate version of the Dông-so'n style, are related to the drum of Pedjeng in Bali, while later mokkos have motifs corresponding to the Eastern Javanese style of the Hindu-Buddhist period or, in some cases, derived from the European baroque.

Sumba combs of tortoise shell, horn, or wood, as well as spoons of wood, horn, or coconut shell from Timor, are notable for their rich openwork decoration. Among textiles decorated by the ikat technique, those from Sumba (PL. 40) and Timor are outstanding.

Three ceremonial bronze axes of the Dông-so'n period with unusually rich decorations have been discovered on the island of Roti.

BIBLIOG. W. O. J. Nieuwenkamp, Iets over Soemba en de Soemba-weefsels, Nederlandsch-Indië Oud en Nieuw, VII, 1922–23, pp. 294–313; W. O. J. Nieuwenkamp, Kunst van Timor, Nederlandsch-Indië Oud en Nieuw, IX, 1924–25, pp. 362–92; W. O. J. Nieuwenkamp, Zwerftochten door Timor en onderhoorigheden, Amsterdam, 1925; H. Fiedler, Die Insel Timor, Friedrichssegen an der Lahn, 1929; P. Arndt, Die Religion der Nad'a (West-Flores), Anthropos, XXVI, 1931, pp. 353–405, 697–739; J. G. Huyser, Mokko's, Nederlandsch-Indië Oud en Nieuw, XVI, 1932, pp. 225–36, 279–86, 309–19, 337–52; E. Vatter, Ata Kiwan: Unbekannte Bergvölker im tropischen Holland, Leipzig, 1932; C. du Bois, The People of Alor, Minneapolis, 1944; J. van Bekkum, Manggaraische Kunst, Leiden, 1946; B. A. G. Vroklage, Ethnographie der Belu in Zentral-Timor, 3 vois., Leiden, 1952.

SOUTH WEST ISLANDS AND SOUTH EAST ISLANDS. These easternmost island groups of Indonesia abound in wooden sculptures, images of ancestors and protective deities. Some are boldly stylized, their features reduced to the simplest possible forms, while others manifest an impressive realism; all are typical examples of the survival of the ancient Indonesian monumental style into recent times. By contrast, the ornamental designs of the region, spirals and their derivatives, are characteristic of the Indonesian ornamental style of Dông-so'n origin. Among the works most representative of this style are the decorative wood carvings (PL. 26) and the openwork scrolls of combs, carved of bone or ivory, of the Tanimbar Islands.

Only in the Kei Islands, where a large proportion of the population is Moslem, were the old designs to some extent displaced by plant motifs of Malayan style.

BIBLIOG. J. F. Snelleman, Houtsnijwerk van Groot-Kei, Nederlandsch-Indië Oud en Nieuw, V, 1920–21, pp. 326–32; P. Drabbe, Het leven van den Tanembarees (IAE, XXXVIII, Sup.), Leiden, 1940.

BORNEO. The political division that exists between Kalimantan, which pertains to the Republic of Indonesia, and the remaining area of the island (Sarawak, Brunei, and North Borneo), is not readily applied to the art. In some cases tribal groups as well as motifs extend across the border and related trends may be pointed out in different areas.

Kalimantan. Among the scarce monuments of the Hindu-Buddhist period the most noteworthy is a bronze statue of the Buddha from Kota Bangun in eastern Borneo. Gold objects of this period include Buddhist and Hindu images, incense burners, and jewelry. The island abounds in ancient earthenware and porcelain vases of Chinese and Indochinese origin, which are highly appreciated and treasured by the native tribes.

The art of the native peoples today manifests a variety of styles and of subjects. The Olo Ngadju in the southeast erect memorial and sacrificial posts carved with reliefs of men and animals, characteristically surmounted by figures in the round (PL. 26; X, PL. 133). Their paintings on wooden boards depict the boats of the gods, the soul boat, the abodes of the deceased, and the celestial tree. The neighboring Ot Danom excel in designs on bamboo depicting scenes with many figures which represent the death rites, mythological subjects, and the like. Masks of southern Borneo represent human or demoniac faces, those of western Borneo mostly animals.

Excellent carved figures of hornbills, used in certain ceremonies, are produced by the Iban group, settled in the northwest on both sides of the border. The ornamental designs these people execute on bamboo are influenced by the Malayan floral style of Indian origin; by contrast the patterns of their ikat cloths display the genuine old Indonesian style of textile decoration at its very best.

The art of the central Borneo tribes (PL. 29; IX, PL. 244), such as the Kayan and Kenyah, who extend into Sarawak as well, surpasses all other primitive styles of Indonesia in the variety and refinement of its ornamental designs. Characteristic of this area are richly decorated funerary huts, supported by two wooden columns and having two stylized animals, so-called "dogs" (aso), on the roof. The art of the Moslem coastal population conforms to the general Malayan and Javanese patterns.

BIBLIOG. A. R. Hein, Die bildenden Künste bei den Dayaks auf Borneo, Vienna, 1890; M. C. Schadee, Bijdrage tot de kennis van de ethnographie van de Westerafdeeling van Borneo, IAE, IX, 1896, pp. 62–89; F. D. K. Bosch, Oudheden in Koetei, Oudheidkundige Dienst: Oudheidkundig Verslag, 1925, pp. 132–46; J. M. Elshout, De Kenja-Dajaks uit het Apo-Kajangebied, The Hague, 1926; D. W. Buys and others, ed., Midden-Oost-Borneo-expeditie 1925, Weltevreden, 1927; H. F. Tillema, Apo-Kajan: Een filmreis naar en door Centraal-Borneo, Amsterdam, 1938; T. Harrisson, Gold and Indian Influences in West Borneo, J. of the Malayan Branch Royal Asiatic Soc., XXII, 4, 1949, pp. 33–110.

Robert HEINE-GELDERN

Sarawak, Brunei, and North Borneo. In this area the indigenous arts have survived with particular vigor, partly for historical reasons, partly because of the great size of the island and its lack of internal communications. Although this situation is undergoing rapid change, particularly as a result of the labors of missionaries, it is still possible to find here a "living museum" of primitive art.

In recent years valuable information concerning earlier art forms in this area has been recovered. A magnificent set of wall paintings has been found in the Great Caves of Niah, about halfway up the western coast of the island. Though crude in conception, they manifest at least two themes which persist into the present. The first is the curving and twisting line, representing in one case probably the same rhinoceros hornbill that dominates many contemporary designs, particularly among the Iban or Sea Dayaks of the southwest. The second is the repeated representation of the soul boat, or ship of the dead, on the deck of which figures dance with arms akimbo. The latter motif has become stylized almost beyond recognition in this area, though it survives strongly among the Ngadju in southeast Borneo, where the resemblance between Ngadju patterns and Dông-so'n designs has often been pointed out. The wall paintings discovered at Niah in 1958 provide a link between the ancient Dông-so'n and the living present; they are associated with actual carved soul boats lying on the cave floor, which contain human remains and are surrounded by objects of the early metal age along with very early Chinese ceramics imported from the mainland.

In the far hinterland of the Kelabit uplands, at the junction of the Sarawak, North Borneo, and Kalimantan borders, other evidence of prehistoric art forms is provided by megalithic remains. The contemporary inhabitants preserve a living megalithic culture but do not execute the same designs that appear on the older forms, which they attribute to a pre-Kelabit people. A classic example of this early design in stone is a nearly life-size figure spread-eagled across a boulder, represented with elongated ears and a headdress of Buddhist type; the swirled and curved treatment of the feet is paralleled in the decoration of modern bark coats worn by warriors on the Baran and Bahau rivers.

Undoubtedly Chinese influences were, both directly and indirectly, constantly intermixed with the local art for as much as two thousand years. Particularly among the Iban, patterns occur which closely correspond to those on Chou bronzes, though here executed most often in textiles and tattooing.

Mohammedanism was introduced very late (14th cent.) and in diluted form. Its effects on the art were limited, though, along the coastal fringe, the convoluted and spiralistic treatment of human representations branched out into a different symbolism.

In the present day, although only three or four wood carvers (in the village of Long Jigan on the Tinjar River) are to be viewed as professional artists, almost every individual has some sort of artistic skill, evidenced in the decoration on the walls of long houses, tattoo patterns, wooden images and door carvings of apotropaic significance, dance shields, magnificently carved coffins, and carved prows of boats, as well as in the decoration of many objects such as parangs, bamboo pipes, woven mats, seat pads, or boxes for blow-pipe darts.

While there is great variety from tribe to tribe (for example, in the decoration of wooden plank surfaces), a continuous thread of

approach and expression is a striking feature of the design. Certain types of baskets with elaborate red "tendril" patterns are produced in almost identical form by fifteen to twenty different groups. Perhaps the chief distinction to be drawn in different areas (though they overlap) lies in the preference for either animal or vegetal motifs, and here tribal lore plays a considerable part. The Sea Dayaks produce some of their finest art in great wooden carvings of the rhinoceros hornbill, the tribal ancestor, and the northwestern peoples are mainly oriented to animal mythology, whereas the Land Dayaks in the extreme southwest prefer vegetal themes, a tendency which increases toward the east in Kalimantan. However, it is clear that deep trends out of the past are widespread. Perhaps the most overwhelming impression produced by the art is the predominance of spiraling or curving lines and forms, which prevails throughout a very large part of the country, notably in the dynamic design of the Kenyah, Kayan, and Kelabit.

BIBLIOG. H. L. Roth, The Natives of Sarawak and British North Borneo, II, London, 1896; A. C. Haddon and L E. Start, Iban or Sea-Dayaks Fabric, Cambridge, 1936; P. M. Synge, Beauty in Borneo, in Borneo Jungle (ed. T. Harrisson), London, 1938, pp. 151–207; T. Harrisson, World Within, London, 1959.

Tom HARRISSON

CELEBES (Sulawesi). Noteworthy among prehistoric monuments is the rock painting representing a boar, probably of the mesolithic era, discovered in a cave in southwestern Celebes. Central Celebes abounds in menhir statues and in large stone vats which originally served as tombs but which have been robbed of their contents. Some of the vats are decorated with reliefs, mostly depicting stylized human faces, which may date from a late phase of the Dông-so'n period. A large and richly decorated bronze drum of continental origin, probably from the first 500 years of the Christian Era, is preserved on the small island of Salayar, south of Celebes.

Representative of the Hindu-Buddhist period is a fine bronze image of the Buddha, half life size, now in the museum at Djakarta. It was found on the Karama River near the western coast; its style indicates that it must have been imported from southern India or Ceylon, probably between A.D. 200 and 500.

At Minahassa, in the extreme northeast, are found a number of sarcophagi (waruga) that date from the 15th to the 19th century. These sarcophagi are monolithic rectangular receptacles with lids in the form of house roofs, and many are richly decorated with ornamental designs and with human and animal figures in relief.

The various tribes of central Celebes, now partly Christianized, are usually grouped together under the name Toradja. Wood carving (human figures, bulls' heads, etc.) and ornamental design are well developed among them; the houses, rice sheds (PL. 23), and covered bridges of the Saadang Toradja excel in the graceful form of their roofs as well as in their carved and painted decorations. The western Toradja produce large ikat shrouds with geometric patterns derived from interlinked human figures. Some of the northern Toradja dress in bark cloth decorated with painting or appliqué work.

The art of the Makassarese, Buginese, and other Moslem peoples of Celebes (wood carving, metalwork, krises and other ceremonial weapons, textiles) forms a subdivision of the general art style of the Moslem peoples of Indonesia; ornamental designs of Indian origin are favored.

BIBLIOG. N. Adriani and A. C. Kruyt, Geklopte boomschors als kleeding-stof op Midden-Celebes, IAE, XIV, 1901, pp. 139–91; P. and F. Sarasin, Reisen in Celebes, 2 vols., Wiesbaden, 1905; A. Grubauer, Unter Kopfjägern in Central-Celebes, Leipzig, 1913; F. D. K. Bosch, Het bronzen Buddhabeeld van Celebes' Westkust, Tijdschrift voor Indische Taal-, Land- en Volkenkunde, LXXIII, 1933, pp. 495–513; W. Kaudern, Megalithic Finds in Central Celebes (Ethnographical Studies in Celebes, V), Göteborg, 1938; A. C. Kruyt, De West-Toradjas op Midden-Celebes, 5 vols., Amsterdam, 1938; W. Kaudern, Art in Central Celebes (Ethnographical Studies in Celebes, VI), Göteborg, 1944; H. R. van Heekeren, Rock-paintings and Other Prehistoric Discoveries near Maros (South West Celebes), Dinas Purbakala Republik Indonesia (Archaeol. Service of Indonesia), Laparan Tahunan, 1950, pp. 22–35; N. Adriani and A. C. Kruyt, De Bare's sprekende Toradjas van Midden-Celebes, 2d ed., 5 vols., Amsterdam, 1950–51.

MOLUCCAS. In the western part of Ceram a very original version of the ornamental art of Indonesia, based on the spiral and its derivatives, appears in wood carving and the decoration of bamboo objects. Bark loincloths and jackets from Ceram and Halmahera are richly decorated with painted ornaments, some of which are related to those of the northern Toradja of Celebes. Halmahera plaited ceremonial mats, which display geometric designs and human figures, are of excellent artistic quality. Peculiar to the Moluccas are wooden shields with inlay of shells and mother-of-pearl in geometric patterns. Ancestor figures (PL. 27) are striking here, as elsewhere. The art of the Moslems manifests the same characteristics as in other regions of Indonesia.

BIBLIOG. J. G. F. Riedel, De sluik- en kroesharige rassen tusschen Selebes en Papua, The Hague, 1886; K. Martin, Reisen in den Molukken, Leiden, 1894; J. Fortgens, Schets van de vlechtkunst der Tabaroe's van Halemahera, Nederlandsch-Indië Oud en Nieuw, XV, 1930–31, pp. 1–22; A. E. Jensen, Die drei Ströme (Ergebnisse der Frobenius-Expedition in die Moiukken und nach Holländisch Neu-Guinea, II), Leipzig, 1948.

Robert HEINE-GELDERN

MODERN INDONESIA. No single influence can be said to determine the development of modern Indonesia, in spite of the Dutch occupation for nearly three and a half centuries and the concomitant growth of a group of mixed population. Having conquered some Javanese territory, the Dutch built Batavia (now Djakarta) in 1619 to further the growth of their commerce; it was a walled city on a Dutch model, with canals and brick houses. In the course of years, however, adaptation to tropical life produced the tendency to adopt as a model the Javanese open house, with the rooms opening onto galleries and arcades and with service quarters generally behind the house and connected to it by an open corridor.

European influence on architecture was sporadic from the 17th to the 19th century. It may be noted in the Dutch-style fortifications of Bantam (Fort Speelwijck, 1685), of Makassar (Celebes), and of the Moluccas, as well as in the simple Protestant churches (Ambon has an example). Sometimes it is limited to specific elements of decoration, as in several mosques built at Djakarta about 1760 in late Régence style, in a minaret and an adjacent structure for the mosque at Bantam, perhaps the work of a Dutch Moslem, and in the outer wall of the kraton (palace) in the same city. Unlike the architecture, local furniture, made by Chinese craftsmen under Dutch direction, was almost always inspired by European models; the rich production of the 17th and 18th centuries is characterized by European structural design decorated with carved plant motifs of Indonesian origin. Louis XIV, XV, and XVI, Queen Anne, Chippendale, Sheraton, and Adam styles were also widely copied in valuable Indian woods. This rather heavy and provincial output, originally destined for Europeans, afterwards found its way also into the kampong.

Active in painting in the 19th century was the Javanese Raden Saleh (Sjarif Bastaman, 1814–80), of European education and training, a portraitist and landscapist in the romantic tradition of Géricault and Delacroix. But a local center of artistic activity developed under direct European influence only in the 20th century, spurred, no doubt, in the 1930s by exhibitions of works from the collection of P. A. Regnault, which included such artists as Picasso, Campigli, Chirico, Chagall, and Ensor. The group of Indonesian painters born in the decade 1910–20 includes the names of Affandi (X, PLS. 418, 419), Hendra, Henk Ngantung, S. Sudjojono, and Agus Djayasuminta; their work reflects sentiment and instinctive enthusiasm but lacks stylistic vigor and is frequently weak in technique. (See ORIENTAL MODERN MOVEMENTS.)

The artistic tradition of Bali, strongly dictated by the cultural requirements of Hinduism, has retained both autonomy and originality in its representations of gods and goddesses, demons, and religious themes in general. One might speak of "European influence" in those temple bas-reliefs, strikingly grotesque, which depict Dutchmen on bicycles, in automobiles, or drinking beer; of more serious significance is the influence, particularly since 1925, of European and American artists who have been attracted to Bali, including Walter Spies, Rudolf Bonnet, and Miguel Covarrubias. The Balinese Anak Agung Gde Sobrat was the pupil of Spies and drew inspiration from him. Genre scenes, inspired by the activities of everyday life, have continued to increase in favor both in painting and in sculpture. One may observe in the latter medium a fairly consistent use of elongated and sharply stylized animal or human figures, a tendency fostered by I Tegelan and Ida Bagus Ketut Gelodog about 1930. Portraits made for the souvenir trade bring to mind the idealized Florentine portraits of the Cinquecento.

Jeanne TERWEN

In the years following World War II, and particularly since independence, Indonesia has undergone radical transformation. The most modern experiments of international architecture have been called into service to meet problems of urbanization and architectural needs. Many cities have been enlarged and modernized; examples are Jogjakarta and Bandung, the latter with new commercial centers and residential quarter, two large hotels, and monumental government buildings. A completely new city was created at Sumberdjaja in southern Sumatra (1952). In addition to the significant new building at Djakarta and Bogor (see below), examples may be singled out in the buildings of Stanvac Oil Company and the large new hospital in Palembang, southern Sumatra (both 1958), the Bank of Indonesia in Jogjakarta (1950), a Protestant church in Ambon (1952–56), an institute for the handicapped in Solo (1950), and the

Red Cross Institute in Malang. The Gajah Mada University was built at Jogjakarta in 1945 and the University of Indonesia (distributed among Bogor, Bandung, and Djakarta) in 1952, followed by at least ten other important educational centers in the next decade. The same period was marked by numerous new factories as well as airport, harbor, and other facilities.

* *

Djakarta (Batavia). The present name dates from 1948. Batavia was founded on the marshy coast of Java, following the conquest by J. P. Coen of the town of Jakarta (1619), which has almost completely disappeared. Batavia bore a Dutch stamp, with its canal system for the swamp, a walled *enceinte* and a rectangular fort to the north, a square with a city hall in Dutch style, Protestant churches forming a central core, and rows of Dutch houses. Slowly but continually, especially during the 19th and 20th centuries, the city spread out to the south. During the 19th century a type of "colonial" house, with galleries and arcades consonant with the demands of the climate, was widely used; these were substantially on an Indonesian plan, though the Europeans furnished the luxury of columns as external decoration. Remaining 17th- and 18th-century monuments are few: the town hall of 1712; the Portuguese Buitenkerk (1695), and some country houses. There are also many houses in colonial style, the President's palaces at Konigsplein and Rijswijk, as well as the Willemskerk (1839) on the central square and the Neo-Gothic house of the painter Raden Saleh at Tjikin. Among modern buildings are the Parliament, the Ministries (particularly that of foreign affairs, erected in 1958), the Central Hospital near the School of Medicine, and numerous office buildings (Bank of Java, Pasaad-Musin Corporation, state salt and soda agencies, Central Trading Co.). Noteworthy also are Tandjung (1952), the new residential area; the satellite suburb of Kebajoran (1958); and the Christian University of Indonesia (1953).

Bogor (Buitenzorg). In the middle of the 18th century, Buitenzorg grew up around the summer residence of the Governor-General, in the cool mountain area south of Batavia; in 1948 the city changed its name to Bogor. The architects were inspired by the English Blenheim Castle (Oxfordshire). In the northern part there still remains a suggestion of the older Pabatonweg, the original avenue of entrance. In 1834 the summer residence was destroyed by an earthquake; it was rebuilt on its former foundation, one story less in height.

English inspiration is also to be observed in the park, achieved under the Lieutenant-Governor Sir Thomas Raffles (1811–16). Characteristic of the city are the old avenues with tall trees and numerous 19th-century colonial houses. In the mid-20th century the city underwent substantial urban development; among the most modern edifices is the President's Palace (1952), which rises in the midst of a great botanical garden.

BIBLIOG. A. A. Gobius, Gids voor Buitenzorg, Batavia, 1905; F. de Haan, Priangan, II, Batavia, 1912; V. I. van de Wall, De Nederlandsche oudheden in de Molukken, The Hague, 1928; V. I. van de Wall, Indische landhuizen en hun geschiedenis, Batavia, 1932; F. de Haan, Oud Batavia, 2 vols., Bandung, 1935; R. Bonnet, Beeldende Kunst in Gianjar, Djâwâ, XVI, 1936, pp. 60–71; V. I. van de Wall, Het Hollandse koloniale barockmeubel, Antwerp, The Hague, 1940; M. Covarrubias, Island of Bali, New York, 1947; H. A. Breuning, Het voormalige Batavia, Amsterdam, 1954; Ministry of Information of Indonesia, Arts and Crafts in Indonesia, Djakarta, 1958; New Trends in Art, Indonesia, III, 6, 1958, pp. 10–12; F. W. S. van Thienen, ed., Algemene Kunstgeschiedenis, 2d ed., V, Antwerp, 1959, pp. 74–88 at 85; V. I. van de Wall, Korte Gids voor Oud-Banten, Batavia, n.d. Indonesia (ed. in Eng.), 1954 ff.

Jeanne TERWEN

Illustrations: 1 fig. in text.

INDONESIAN CULTURES.

The areas reached by the spread of Indonesian cultures are not strictly limited to the archipelago of Indonesia (q.v.) but include also Madagascar (see MALAGASY REPUBLIC), and extend eastward as far as the Philippines (q.v.) and the mountainous region of Formosa (see CHINA) with the neighboring island of Botel Tobago.

In order to understand the origin and history of Indonesian art styles, it is necessary to free oneself of the conception that styles change, as in the case of European art, with relative rapidity. In archaic cultures such as those of Indonesia, where the artist is strongly bound by tradition and finds little scope for innovations, styles may survive for thousands of years if not disturbed by outside influences. The art of Indonesian tribes is not exactly the same as it was two thousand years ago, of course — there were always changes and internal developments — but the

essential characteristics of the respective styles survived. This makes it possible to trace the current art styles of Indonesia to their distant prehistoric origins.

A glance at the map will show that the mountain ranges and river valleys branching off fanlike from eastern Tibet and western China provided natural migration routes for prehistoric peoples. These routes were bound to lead to the sea and eventually into Indonesia. Therefore it is to the north, to continental southeastern Asia and to China, that one must look in order to discover the origins of the earlier art styles of Indonesia.

The first sections deal with these earlier styles, which preceded the introduction of Hindu-Buddhist art, and at the same time with tribal arts surviving in modern times. Here the emphasis is on their relationships, sources, and parallels; the distribution of tribal arts and an outline of their products are discussed in the article on INDONESIA. The succeeding sections deal with the Hindu-Buddhist art that evolved following the penetration of the Indian religions in the early centuries of the Christian Era, particularly with the great monuments and sculptures of Java and Sumatra and, to a lesser extent, Borneo; the two major periods or styles take their names from the central and eastern sections of Java, where they were centered, although art (see also INDIA, FARTHER). In a third or "late" period, beginning in the 15th century, Moslem influences have become mixed with the earlier traditions.

The art of Bali, which pursued somewhat independent directions, is discussed separately, as are the minor arts, in which Moslem characteristics found their fullest expression. More recent developments under the impact of Western civilization are discussed more fully under INDONESIA and the article ORIENTAL MODERN MOVEMENTS.

See also INDIA, FARTHER.

SUMMARY. Ancient cultures and modern tribal art (col. 42): *The monumental style. The art of the Dông-so'n culture. The ornamental styles: a. The Dông-so'n influence; b. Chinese influence of the later Chou period; c. Painting; d. Sculpture; e. Megalithic monuments and sarcophagi; f. Architecture; g. Textile art. Marginal Indonesian cultures: a. Formosa; b. Botel Tobago; c. Nicobar Islands; d. Madagascar.* Hindu-Buddhist art (col. 59): *Historical background. Religious beliefs. Evolution of the art styles. Central Javanese period: a. Architecture and its decoration; b. Principal monuments; c. Sculpture. Eastern Javanese period: a. Architecture and its decoration; b. Principal monuments; c. Sculpture.* Late period (col. 83). Art of Bali (col. 83). Minor arts (col. 85). European influences (col. 86). Conclusion (col. 86).

ANCIENT CULTURES AND MODERN TRIBAL ART. *The monumental style.* Archaeological and linguistic evidence indicates that the original home of the peoples with Austronesian (or Malayo-Polynesian) languages lay in southwestern China and in the northern part of central Indochina, around the middle Mekong River, and that they entered Indonesia with a late neolithic culture by way of the Malay Peninsula, probably in the 2d millennium B.C.

Some of the primitive stone ancestor figures of Sumatra and Java may conceivably be of the Neolithic age, but there is no way of dating them. Since the ancient artists used primarily wood and other perishable materials, it is not surprising that no single known art object can be ascribed with certainty to the Neolithic period. It is nevertheless possible to discern the probable characteristics of the neolithic art style in Indonesia on the basis of its connections with the custom of erecting megalithic monuments.

Megalithic cultures, comparable and related to those of the hill tribes of Assam and Burma, are, or were until recently, flourishing on the islands of Nias, Flores, Sumba, and Timor, on the Tanimbar Islands, in parts of Celebes, among the Kelabit of Borneo, and among some of the hill tribes of northern Luzon. As no excavations have been undertaken at Indonesian megalithic monuments, with the exception of stone cist graves in Sumatra and Java and megalithic tombs of eastern Java (all of which date from the Bronze or the Iron Age), circumstantial evidence must be utilized in order to establish the date of the introduction of the megalithic complex into Indonesia.

It is well known that the Munda languages of India are related to the Mon-Khmer languages of southeastern Asia, that Mongoloid racial features occur among the Munda tribes, and that their cultures manifest many traits also observed in southeastern Asia, including types of megalithic monuments and the rituals which accompany their erection. It is also in the Munda region that quadrangular and tanged stone adzes have been found, of types common in southeastern Asia but totally lacking in the rest of India. This evidence reinforces the conclusion that the migration of those who carried into India these linguistic, racial, and cultural traits originating in southeastern Asia took place in the late Neolithic. This means that at least in Assam and Burma, and probably in other regions of Indochina as well, the custom of erecting megalithic monuments must have existed already in the Neolithic period. Therefore, chronologically, there is no objection to the assumption that the megalithic complex reached Indonesia in the course of the Austronesian neolithic migration.

There are also indications of the age of the megalithic complex in Indonesia itself. The spread of megalithic cultures to the Lesser Sunda Islands, in eastern Indonesia, must have taken place before the routes for tribal migrations were interrupted by the establishment of organized Hindu-Buddhist states on the islands of Sumatra, Java, and Bali. Furthermore, the existence of megalithic monuments on those three islands and the survival there of numerous conceptions and customs derived from the megalithic complex show that in western Indonesia, too, Hindu-Buddhist civilization was preceded by megalithic cultures. This would date the introduction of the megalithic complex at least as early as the beginning of the Christian Era; an earlier, i.e. neolithic, date is suggested by the fact that those influences of Bronze Age art which are so conspicuous in most of Indonesia are either absent or of little importance in the art styles of such megalithic cultures as Nias, northern Luzon, and the northern part of central Celebes.

In order to make clear the art style connected with the megalithic complex, it is necessary to refer to the hill tribes of Assam and western Burma, where the complex has undergone fewer modifications than in Indonesia and where, above all, the style in question survives in its pure form, untouched by all those later influences which spread over most of the Indonesian islands (see ASIA, SOUTH: TRIBAL STYLES). Among the Naga and Kuki-Chin tribes of Assam and western Burma megalithic monuments (menhirs, dolmens, stone platforms) are erected, either as memorials to the dead or by wealthy men as memorials to themselves, in the course of "feasts of merit" which entail an enormous expenditure in sacrificial animals, rice, and rice beer in order to entertain the members of the clan or village. These feasts and the erection of megaliths raise the host to a higher social rank, entitle him to various privileges, and are intended not only to keep the memory of his name alive but also to assure his soul of a preferential lot after death. At the same time they are intended to promote the fertility of herds and fields and are linked to a very pronounced "wealth complex." The core of the rituals accompanying the erection of megaliths is the sacrifice of bulls, which, although the motivation for the practice varies, is thought to be particularly important from the eschatological point of view. Among some of the tribes there is a close connection between head hunting and megaliths, the heads being either temporarily deposited on stone monuments or suspended on menhirs, or a menhir being erected as a memorial for every head taken. Like the feasts of merit and the erection of megaliths, head hunting raises a man's social status and assures his soul of a better lot in the hereafter; taking of heads is thought to promote magically the fertility of the fields as well.

These beliefs are reflected in the art of the tribes concerned (I, PL. 495), which is almost wholly sculptural. Purely ornamental designs are of the simplest geometric character, quite insignificant when they exist at all, but there is an abundance of symbols carved on house fronts, village gates, and wooden monuments. There are rows of women's breasts as symbols of fertility and wealth, rosettes as symbols of the sun and the moon, weapons and rows of human heads as memorials of achievements in war and head-hunting, and innumerable bulls' heads as memorials of feasts of merit and of the erection of megaliths. The front pillars of some houses are adorned with figures of elephants, tigers, lizards, and hornbills, in relief or in the round, some displaying a simple but striking realism while others are stylized almost into geometric forms. Both these tendencies can also be observed in human figures in the round, though figures of ancestors, set on graves or memorial platforms, are always strictly frontal and are generally more or less stylized.

The ideas underlying the sculpture are exactly the same as those fundamental to the feasts of merit and the erection of megalithic monuments. Menhirs and wooden statues, or menhirs and wooden monuments with relief representations of bulls' heads, are actually interchangeable, having the same commemorative function. The motifs frequently carved in wood, particularly the ubiquitous bulls' heads, were occasionally sculptured on the megalithic monuments themselves; so close are the links between this art and the megalithic complex that both may be assumed to have been introduced into Assam and Burma at the same time, that is, in the late Neolithic period.

Since the art style was used largely for memorials, whether of ancestors or of the achievements in ritual or war by the living or the dead, it may be called the "monumental style" in the strict sense of the Latin *monumentum*. In the best works, particularly in some of the powerful and skillfully stylized bulls' heads, it is monumental also in the esthetic sense of the word. Megalithic monuments and living remnants of the monumental style are found not only in Assam and Burma but also in the central and eastern regions of Indochina; there can be little doubt that this style once extended over most of continental southeastern Asia.

In Indonesia the art styles of most tribes are dominated to such an extent by rich, curvilinear ornamental designs that they are fundamentally different from the art of the hill tribes of Assam and Burma. There are, however, a few regions where the ornamental designs did not penetrate at all or where they exercised only a slight influence. This is particularly true of the mountain region of northern Luzon and the island of Nias, but the art styles of these two areas, though undoubtedly related to that of the mainland tribes, do not lend themselves to easy comparisons. The sculptural art of the hill tribes of Luzon, almost totally restricted to the representation of ancestors (PL. 27) and other human figures, seems to have undergone a process of impoverishment; on the other hand, the art of Nias came for some time under early Indian influence and underwent what might be called a process of incipient sophistication.

More significant is a third area, in which the monumental style, with a few ornamental additions, survives almost in its pure form, that is, among the northern Toradja tribes of central Celebes. Bulls' heads and such symbols of fertility as women's breasts and male and female genitals abound in the art of these tribes, the stylistic rendering being the same as in that of the Naga of Assam. The fact that these closely related variants of a single art style are found in regions more than two thousand miles apart suggests, of course, that the style must be of considerable antiquity. In addition there are numerous indications of an earlier and far wider expansion. Single motifs corresponding to those of the continental tribes and of north central Celebes, such as women's breasts, figures of lizards and hornbills, bulls' heads, and a human figure standing between the horns on a bull's head, occur also within such highly ornamental and curvilinear styles as those of the Batak of Sumatra and the Saadang Toradja in southwestern central Celebes. The masks of the Batak show unmistakable traits of the monumental style, as do the majority of ancestor images in the non-Moslem regions of Indonesia (PLS. 27, *left*, *right*; 28). Obviously remnants of an older style, they survived within the strongly ornamentalized styles of a later period because of their religious or symbolic connotations. The inevitable conclusion seems to be that, contrary to prevailing opinions, it is not the magnificent ornamental designs of the Batak or Dayak which represent the original Indonesian art; rather, at an earlier period the Indonesians

possessed a purely sculptural, monumental, and symbolic art, closely corresponding to that of the hill tribes of Assam and Burma, probably very poor (or perhaps lacking altogether) in ornamental designs. Since the curvilinear ornamental styles were introduced between 700 and 200 B.C., in the early metal age, the preceding monumental style must have been that of neolithic Indonesia. There can be little doubt that in Indonesia, as on the continent in southeastern Asia, the style was originally linked to the megalithic complex.

The art of the Dông-so'n culture. The contrast between the current art styles of most Indonesian tribes, with their wealth of curvilinear ornamental designs, and the monumental style which must have preceded them is so striking that a purely local development of the current styles from the monumental is inconceivable, and it is necessary to search for foreign influences that may have caused this complete change in style. Such influences are to be found in Chinese art of the later Chou period (ca. 7th–3d cent. B.C.), which are discussed below, and even more clearly in the art of the Dông-so'n culture, which stemmed from Yunnan and eastern Indochina. (See ASIATIC PROTOHISTORY.)

The character of Dông-s'on art can be understood only in relation to its origins. In the last quarter of the 9th and the early part of the 8th century B.C. China, which at that time comprised only the northern part of its present area, was constantly engaged in fighting the inroads of "western barbarians," a struggle which culminated in 771 B.C. in the capture of the Chinese capital by one of these tribes. The account of these troubles reflects one of those ethnic migrations which from time to time upset the political and cultural systems of the ancient world. This is confirmed by archaeological evidence. In this period new types of weapons, tools, personal ornaments, and designs, all of Western origin, appeared in eastern Asia where they were previously unknown. In them may be discerned influences of the early Iron Age cultures of the Caucasus, of the Cimmerian and Thracian areas of southern Russia and southeastern Europe, and of the Hallstatt culture of the Middle and Lower Danubian regions. Several Indo-European, as well as Caucasian, tribes must have participated in this migration. In Central Asia some of the invaders kept their ethnic identity until medieval times, while those who penetrated farther east were probably soon absorbed by the local population. Since this migration started from the areas bordering the Black Sea, it may be called the "Pontic migration." Apparently some of the invaders turned south after reaching the western borderlands of China. Following the river valleys, they reached Yunnan and northern Vietnam without passing through what was then the political and cultural area of China. They gave rise, perhaps in the 8th century B.C., to the first metal-using culture of southeastern Asia, called "Dông-s'on" after the village in northern Annam, near the border of Tonkin, where it was first identified as a distinct entity. It was essentially a bronze-using culture, but at least in its final phases iron was also known and occasionally used. Numerous Chinese imports of the later Chou and Han periods show that its bearers were in contact with China.

From its centers in Yunnan and northern Vietnam the Dông-so'n culture, or at least its influence manifested by the use of bronze, spread to Laos, Cambodia, Siam, and Burma, and eventually to Indonesia and to the northern coast of New Guinea, probably mainly from northern Vietnam and the lower Mekong region. The first Dông-so'n influences must have reached Indonesia at some time between 700 and 300 B.C. The Dông-so'n culture persisted in northern Vietnam until the country was forcibly Sinicized about the middle of the 1st century of our era. In Cambodia and southern Vietnam it must have come to an end in the 1st or, at the latest, the 2d century through the foundation of Hindu colonial kingdoms.

Dông-so'n art, as known through the decorations of numerous bronze objects, lacks all those complex and highly sophisticated designs so conspicuous in the contemporaneous art of the later Chou period of China, but shares with it some of the motifs of Western origin that were introduced in the course of the Pontic migration. There is, however, an important difference: In China these Western designs, incorporated into an already existing rich ornamental art, underwent various adaptations and modifications; Dông-so'n art, on the other hand, had been preceded in southeastern Asia by the monumental style, with its lack of ornament. Since the Western ornamental designs had no competition from indigenous ones, they were accepted with little or (in many instances) no change at all. Designs of Caucasian and Hallstatt origin predominate. The former comprise S-shaped double spirals and motifs which represent either twisted strings or strings and bands plaited from two strands. The most conspicuous among the designs derived from the Hallstatt culture are the meander in its classic form, rows of circles linked to one another by oblique tangents, rows of unconnected

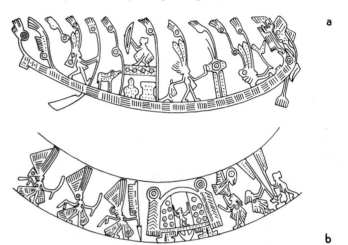

Dông-so'n style, incision on drums from Tonkin: (*a*) Soul boat; (*b*) the feast of the dead (*after V. Goloubew, 1929*).

circles, saw-tooth patterns, and the so-called "ladder" pattern. A somewhat more pretentious design, a band consisting of linked double spirals, may be derived from the Cimmerian or Thracian regions of Europe.

All these patterns are found on the most important works of art surviving from the Dông-so'n culture, namely, the large bronze drums or (more correctly) drum-shaped gongs, the oldest of which come from Yunnan and northern Vietnam and date probably from the second half of the 1st millennium B.C. The center of the tympanum is invariably marked with a large star. This is surrounded by concentric zones, some of which are filled with ornamental designs, while others show rows of birds or quadrupeds. The larger and more elaborate drums have one zone depicting houses, dancing men wearing large feather headdresses, and musicians playing mouth organs or beating drums, scenes which probably represent either the great annual feast in memory of the dead or the life of the souls in the hereafter. On the bulging upper side of the drums are pictures of boats, manned by crews wearing feather headdresses; on the basis of comparisons with recent paintings from Borneo this motif has been identified as a representation of the boat which is thought to carry the souls of the dead to their final abode (FIG. 46; see also ESCHATOLOGY).

Bronzes of the Dông-so'n culture and the contemporaneous stone sculptures and grave paintings of the Pasemah plateau of southern Sumatra (PL. 25) are the oldest Indonesian art objects that can be definitely ascribed to a particular period. Some of the Dông-so'n bronzes found in Indonesia, however, were not local products but must have been imported from Indochina. This is the case, for example, of a bronze vessel of unusual shape from the island of Madura and of a similar one from Sumatra; both are apparently imitations of baskets, and both are decorated with spiral designs. In addition the neck of the one from Madura has rows of magnificently stylized figures of deer and peacocks. Its continental origin is indicated by the finding in Cambodia of a vessel of identical shape and decoration. Some bronze drums found in Java and Sumatra are so similar to the oldest types of northern Vietnam that they may be as-

sumed to have originated there. Eastern Indonesia is partic-
ularly rich in ancient bronze drums imported from Indochina.
These show, however, some deterioration of the original de-
signs of plumed warriors and, at the same time, greater so-
phistication in the figures of men and animals which are of types
not found on the oldest drums and reveal Chinese and Indian
influences. They obviously date, not from the Dông-so'n
period proper, but from the first centuries of the Christian

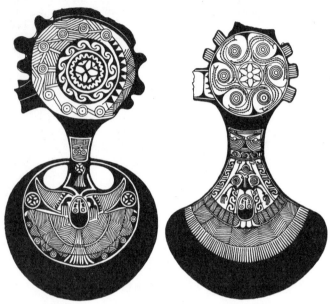

Bronze axes from Roti (*after J. Teillers, Ethnographica in het Museum van het Bataviaasch Genootschap van Kunsten en Wetenschappen, 1910*).

Era, when the coastal regions of eastern Indochina were al-
ready under Chinese and Hindu domination.

The art of bronze casting was introduced into Java and
Bali, and probably into other islands as well. Casting molds
for socketed axes and lance heads have been found in Java.
On some of the islands bronze tools, weapons, and bracelets
of the Dông-so'n period occur in fairly large numbers, but
works of art of indubitably local origin are few. The most
important work is a bronze drum kept in a temple at Pedjeng
(Bali), which differs from the drums of the mainland not only
in its enormous height (ca. 6 ft.) but also in its shape and
decoration. It is undoubtedly a magnified equivalent in bronze
of the wooden drums of hourglass shape still in use on various
Indonesian islands. The star in the center of its tympanum
is surrounded by broad curvilinear bands derived from spirals,
while its sides are decorated with stylized heart-shaped human
faces. Several tympanums of similar drums, as well as stone
molds for casting drums of this type, have been discovered in
Java and Bali. The type survives in the *mokkos*, bronze or
brass drums of hourglass shape which until the 20th century
were used as currency on the island of Alor (see COINS AND
MEDALS; III, PL. 416).

An enormous bronze socketed ax from Celebes, apparently
ceremonial, is decorated with a stylized human face and with
ornamental designs of Dông-so'n character. Three ceremonial
axes from the small island of Roti, with blade and handle cast
in one, excel in their rich decoration, including tangent circles,
spiral bands, stars, whorl motifs, and stylized human figures
(FIG. 47). A curious type of battle-ax, apparently ceremonial,
is peculiar to Java; its large crescent-shaped blade and short
handle are cast in one piece, while its decoration comprises
fantastically stylized bird figures and small S-shaped double
spirals.

A few small bronze figures of men and animals in the round,
found in Java, have been tentatively ascribed to the local branch
of the Dông-so'n culture. A bronze find made at Kuwu (Su-
matra) contained 4 bracelets with decorations in Dông-so'n
style and 14 small human figures representing men with extended

arms. The latter are remarkably similar to several from the
early Iron Age Koban culture of the Caucasus; one Sumatran
and one Caucasian figure share even such a very special detail
as a horizontal S-shaped double spiral on the body.

Despite their small number, these and a few other bronzes
indicate that the continental models were not simply copied but
that local variants of Dông-so'n art developed in Indonesia.
Such characteristic motifs of far Western origin as double spirals,
spiral bands, plaited strings, and tangent circles are still pres-
ent, but they are combined in a way different from that found
in Indochina; moreover, new and original designs were added,
such as the stylized bird figures on the ceremonial axes from
Java and the heart-shaped faces on the drum of Pedjeng.

Apart from the art of bronze casting, there are good reasons
to assume that the innovations introduced into Indonesia dur-
ing the Dông-so'n period also included various artistic activities
using perishable materials, goldwork, the art of weaving, certain
house types, a type of plank-built boat, and, apparently, some
new religious conceptions and rituals, as well as the custom
of burying the dead in urns or stone cists.

The relation between the ornamental designs of the Batak,
Dayak, and other modern Indonesian tribes and those of the
Dông-so'n culture of northern Vietnam was first pointed out
by V. Goloubew in 1929. He concluded that the Indonesians
had created the Dông-so'n culture prior to their emigration
from the continent and eventually introduced it into the archi-
pelago. This erroneous notion was so widely accepted that it
seems to be ineradicable. Archaeological and linguistic evi-
dence shows that the Indonesians came, not from the coast of
northern Indochina, but from its interior by way of the river
valleys and the Malay Peninsula, and with a neolithic and not
a bronze-using culture. Moreover, Chinese reports make it
clear that when northern Vietnam first appeared in history in
the 3d century B.C., it was inhabited not by Indonesians but
by the ancestors of the modern Vietnamese. It may therefore
be assumed that the spread of the Dông-so'n culture and art
to Indonesia was largely due to the ancient Vietnamese; various
facts indicate that these people must have been keen mariners.
Other contemporaneous movements, originating among the
peoples on the lower Mekong and perhaps also among those
of Siam and Burma, all speakers of Mon-Khmer languages,
may have contributed to a certain extent to the expansion of
Dông-so'n influences in the islands. In no instance, however,
can there have been a question of large-scale migrations, but
rather of small groups of immigrants which, while exercising
a profound influence on local culture, were soon absorbed by
the local populations. To a certain extent the manner in which
the Dông-so'n culture spread to Indonesia may be compared
to that of the expansion of the Indian civilization that followed
it in the first centuries of the Christian Era.

The Dông-so'n style must have deeply impressed the peoples
of Indonesia, precisely because of their former dearth of pure
ornament. Its arrival seems to have resulted in a sudden
flowering of decorative art; the few ancient objects so far found
give the merest indication of this phenomenon, but its results
survive in the recent art styles of Indonesian tribes.

The ornamental styles. The term "ornamental styles" has
been chosen here to indicate the art styles of Indonesia in which
ornamental designs predominate, with the exception, however, of
those of the Moslem peoples and of Bali, the decorative designs
of which are in the main derived from the art of the Hindu-
Buddhist period.

The character of the ornamental styles is in every respect
opposite to that of the monumental style which preceded them.
This fundamental difference concerns not only outward sty-
listic aspects but the very meaning of the art. While the monu-
mental style was used almost exclusively in memorials and
symbols, the ornamental styles are applied not only in religious
art but also in the purely esthetic decoration of secular objects.

The ornamental styles prevail in the following areas: the
Batak region of Sumatra; the Mentawei Islands; Borneo, with
the exception of the Moslem coastal regions; Celebes, with the
exception of the Moslem regions (in the northern part of central

Celebes, however, mixed with the predominant monumental style); most of the Moluccas and of the southern island chain from Flores and Sumba to the Tanimbar Islands; and the territory of the primitive tribes of Mindanao, particularly the region around the Davao Gulf. Stray motifs of the old Indonesian ornamental styles survive also in the arts of most Moslem peoples, particularly in those of Menangkabau in Sumatra and of the Moro in the Philippines, but also in Java. On the other hand, through Malayan and Javanese influences, patterns of Indian derivation were adopted into many local variants of the ornamental styles. In some instances the two stylistic groups blend into each other so that it is difficult to draw a dividing line. It may be assumed that, in one way or another, all ornamental styles of Indonesia are derived either from the art of the Dông-so'n culture or (as in the case of central Borneo and central Flores) from that of later Chou China. However, the degree of affinity varies; in some instances a direct derivation from Dông-so'n art can hardly be doubted, while in others Dông-so'n influence may have penetrated indirectly and long after the Dông-so'n culture itself had vanished.

a. The Dông-so'n influence. Since knowledge of the ornamental art of the Dông-so'n culture is derived wholly from bronzes, the survival of its stylistic tradition may be most easily recognized in metalwork. It is true that bronze has been superseded by brass, that the shapes of most modern objects differ from those of the Dông-so'n culture, and that different motifs have been added. Batak brass objects, for example, are frequently adorned with representations of bulls' heads and lizards adopted from the old monumental style. Nevertheless, such characteristic designs as the S-shaped double spiral, the twisted string, and the two-strand plaited string are so conspicuous as to leave no doubt concerning the Dông-so'n origin of Batak metal art. The same applies to brasswork from central Celebes, to Batak gold jewelry, and to gold ornaments from the island of Flores.

Dông-so'n ornamental designs are by no means restricted to metalwork. They are found on all kinds of materials: wood, bamboo, textiles, and even on megalithic monuments. Thus S-shaped double spirals are found in almost all local branches of the ornamental styles. They appear singly, in rows, or in the form of heart-shaped designs consisting of two spirals opposed to each other. Rows of triangles in saw-tooth patterns play an important role as border designs, as on the ancient bronze drums. While designs based on the spiral or derived from it are ubiquitous, the more elaborate ones have no counterparts in the decoration of the ancient bronzes, which cannot match the magnificent scrolls of Tanimbar ivory combs, or the delicate and intricate designs of Batak (PL. 23), Tanimbar (PL. 26), and Ceram wood carvings, with their fantastic interlacery of bands and spirals. This wealth of highly complex designs is probably due only in part to local developments. The nature of Dông-so'n wood carving is unknown, but there is every reason to assume that its designs were far more elaborate than those on the metal objects. It is evident that for technical reasons the ancient metallurgists were forced to restrict themselves to the reproduction of the simpler motifs, just as among modern Indonesian tribes the designs in metalwork are simpler than those used in wood carving. In Indonesian ornamental styles a phytomorphic aspect is frequently given to spirals and bands of connected spirals by the addition of small tendrillike appendages. The decorations of at least one bronze dagger hilt from Dông-so'n show the same peculiarity and seem to reflect a tendency that must have existed in Dông-so'n wood carving.

The diversity of Indonesian ornamental styles and the puzzling problems they pose may be exemplified by conditions in eastern Indonesia. While the art styles of Ceram, Alor, and the Tanimbar group are completely dominated by spirals and their derivatives, in central Celebes and on the islands of Timor and Sumba, side by side with spirals and other curvilinear designs, are found a wealth of purely geometric motifs, mainly in wood carving and bamboo decoration, but also in ornaments carved on megalithic tombs in Sumba (PLS. 24, 25) and, in the

northern part of central Celebes, in painting on bark cloth. This mixed curvilinear and geometric style finds its richest expression in the carved and painted decorations of Saadang Toradja houses in the southwestern part of central Celebes (PL. 23). Such designs as meanders, rows of triangles, and rows of circles are certainly of Dông-so'n derivation. For some reason the geometric, nonspiral elements of Dông-so'n art seem to have appealed to these tribes; even some curvilinear designs of Dông-so'n origin, such as the plaited band, have be-

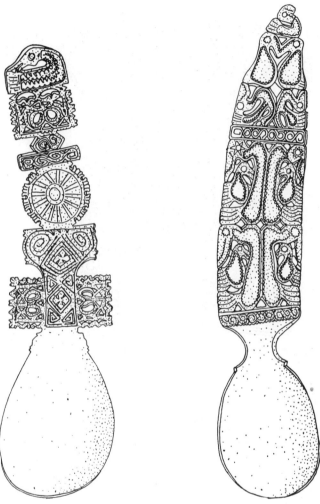

Decorative art of Timor; horn spoons with openwork ornament.

come rectilinear and angular. Other motifs clearly were adopted from the monumental style, even when in modified form. Thus the bull's head survives in its original character in the wood carvings of the northern Toradja and even on the front posts of Saadang Toradja houses, and appears at the same time in flat relief and painting in a stylized ornamental version. Finally, these styles, particularly that of the Saadang Toradja, are rich in flower patterns of Indian origin, which must have been copied from Javanese, Malayan, or Bugi textiles.

Bamboo is a major art medium in Indonesia; some of the finest designs are found on cylindrical receptacles for tobacco, lime, and the like. Though occasionally produced by pyrography, such designs are generally created either by incision or by cutting away portions of the outer layer of the bark so that the untouched parts form the design. In order to make the design stand out more clearly, the surrounding surface is frequently colored either black or red. In general, the designs conform more or less to the local ornamental style. Only in the western part of Timor is a completely different, geometric and floral style used in the decoration of bamboo receptacles; but in this case, according to the natives' own testimony, they were inspired by the patterns of imported Javanese textiles.

b. Chinese influence of the later Chou period. Among all the ornamental styles of Indonesia, that of some tribes of central Borneo is outstanding. Its main bearers are the Kayan and Kenyah on the upper reaches of the Kayan, Mahakkam, and Kapuas rivers and in the interior of Sarawak. The style is seen also in several other tribes, but with present knowledge it is not possible to delineate the exact area of its expansion. In former times it may have reached as far as the coast. The techniques in which it finds expression comprise wood carving, bamboo decoration (FIG. 53), painting on house walls and

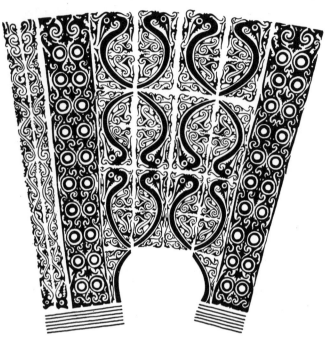

Tattoo motifs from central Borneo (*after A. W. Nieuwenhuis, 1904–07*).

shields (IV, PL. 175), the carving of bone and hartshorn, embroidery, beadwork, copper and silver inlay on sword blades, and tattooing. The last named has a connection with the art of wood carving, since the patterns are first carved on wooden blocks used to stamp color on the skin as a guide to the tattooer (FIG. 51).

Insofar as the art of central Borneo is based on the spiral and its derivatives, it is of course related to some extent to the other ornamental styles of Indonesia. It differs from them, however, in its greater freedom from symmetry, in the variety and intricacy of its patterns, in the extreme delicacy of its lines, and, above all, in its masterly integration of different motifs into an organic and harmonious over-all design. Comparison of some of these designs with the strictly symmetrical arrangement of ornaments in Tanimbar carvings, with the rich but repetitious designs from Ceram, and with the mechanical side-by-side placement of disparate and unconnected motifs in the art of the Saadang Toradja of Celebes reveals the very different spirit that prevails in the art of central Borneo. Not even the magnificent ornamental carvings of the Batak can match their refinement and artistic freedom.

The art of central Borneo lacks all those basic and most characteristic Dông-so'n designs which are so important in the rest of Indonesia, such as the simple S-shaped double spiral, the twisted string, the two-strand plaited string, the plaited band, and the saw-tooth motif. Instead it is dominated by spiral designs and particularly by a zoomorphic motif, the so-called "dog" (*aso*), which is well-nigh ubiquitous in central Borneo, although it is unknown in the rest of Indonesia. It appears in the decoration of bamboo objects, in wood carvings, in the decoration of house walls, on painted shields, in tattoo patterns, and even in beadwork, embroidery, and appliqué on textiles. *Aso* figures are placed on the roofs of houses and on graves. The *aso* is always stylized and highly ornamentalized,

its wide-open jaws ending in hooks or scrolls. There is a strong tendency for the whole figure to disintegrate into mere ornamental designs. The figure may lose its legs, the elongated body taking on the aspect of a serpent or dragon; frequently the body disappears completely, leaving only the head with its large eye and hooked jaws. The surface of bamboo receptacles and of panels on the interior walls of houses may be covered with a fantastic maze of spirals and curved lines interspersed with *aso* heads. The variety of designs derived from this single motif is endless.

The fundamental differences between the art of central Borneo and the ornamental styles of the rest of Indonesia cannot be due merely to divergent local developments; they indicate a difference in origin. An art style of such refinement and sophistication could not possibly have developed independently in the cultural surroundings of central Borneo without an initial stimulus from the art of some higher civilization. This hypothetical parent style must have shared some traits with that of the Dông-so'n culture, but it must have possessed far more complex designs as well as certain zoomorphic ornamental motifs foreign to the Dông-so'n style. These traits are to be found in Chinese art of the later Chou period. (Cf. CHINESE ART, *Chou period.*)

Between the art of central Borneo and that of the later Chou period there was a gap of more than two millenniums, during which there must have occurred considerable change due to local developments and to adaptation to the cultural surroundings. Moreover, apart from some lacquer paintings on wood, the decorative art of later Chou China is known only through objects of metal and jade; as pointed out in other connections, the use of different materials of course necessitates some difference in designs. At present the characteristics of later Chou ornamental wood carving are not known; equally unknown are the designs then applied in tattooing, which, according to literary sources, was practiced by some of the ancient peoples of southern China. Despite this lack of knowledge, it can be shown that to a considerable extent the art of central Borneo and later Chou art are similar in general character and share a number of highly specific traits and motifs, only a few of which can be listed here.

The stylistic similarity between the patterns of Borneo and those inlaid in silver or gold on later Chou bronze objects is particularly striking. In the latter a thin line running parallel to the contour of the main design adds frequently to its daintiness and grace. Even this trait, apparently minor but in fact highly characteristic, appears in the wood carving of central Borneo and particularly in designs on bamboo (FIG. 53). A Bornean tattoo pattern consisting of a comma-shaped design with the head of a hornbill on its upper end (FIG. 51) has a counterpart in silver inlay on a Chinese bronze. But it is particularly in the *aso* motif that Chinese influence comes clearly to the fore. A variety of the *aso*, with its head turned backward and the whole figure having the aspect of a horizontal letter S, corresponds closely to Chinese jade carvings which are interpreted as representing tigers or, perhaps, leopards. Two opposed *aso* figures sharing a common head, as well as a broad S-shaped band with an *aso* head at each end, may be compared to well-known Chinese motifs. Finally, decisive evidence is provided by a variety of the *aso* in which one hind leg protrudes above its back. This grotesque design may be understood only by a comparison with the curiously twisted animal figures on Chinese bronze mirrors, dating from the 4th and 3d centuries B.C., according to Karlgren. The heads and necks of these fantastically stylized figures, representing either tigers or dragons, are shown in profile, while the body is seen from above with the legs spread on both sides.

In summary, it may be concluded that the *aso* designs are derived from Chinese motifs. This, however, does not exclude the possibility of some influence derived from Hindu-Buddhist naga figures in the serpentlike versions. Hindu-Buddhist influence is beyond doubt perceptible, also, in the magnificently carved sword hilts of wood or hartshorn. Many among them show a human figure either on a *makara* or seated on a demonic head; the latter was originally a scene from the Buddhist *Sutasoma-Kalmāṣapāda* legend, representations of which were

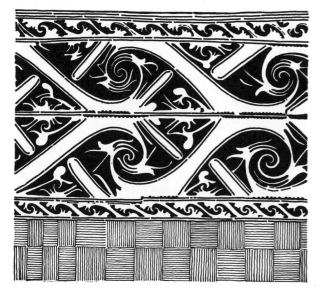 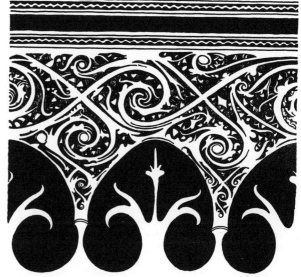

Designs on bamboo containers from central Borneo (*after A. W. Nieuwenhuis, 1904–07*).

widely used as warrior charms in southeastern Asia. Certain details indicate that these motifs were probably introduced in the 14th century, when Borneo lay under the political supremacy of the Javanese kingdom of Majapahit. The motifs were adapted to the local style, however. Ornamental lines spread like roots or creepers over the bodies and faces of the figures, in many instances completely dissolving the latter into a tangle of hooks and scrolls.

Like the ornamental art of central Borneo, that of the Ngada in central Flores seems to be of Chinese later Chou origin; the carvings on Ngada house fronts and sacrificial posts, interlacing scrolls with the same characteristic double contours as in China and Borneo, are remarkably similar to some designs in inlay on Chinese bronze objects.

The Chinese influences that stimulated the development of the art of central Borneo and of the Ngada may be dated approximately to the 4th century B.C., more or less contemporaneous with the spread of the Dông-so'n culture in the archipelago. Since archaeological research on the islands of Borneo and Flores is only beginning, it is not surprising that no Chinese objects of the period in question have been found there. Moreover, it is conceivable that no Chinese art objects of such durable materials as bronze or jade were ever exported to Indonesia, but that later Chou influences were introduced by small groups of people from the coastal regions of China, who settled in the islands for commercial or other reasons and there produced their traditional designs in wood or bamboo. Precisely in this manner, and through the medium of nondurable materials (wood, bamboo, textiles), Malayan and Javanese ornamental designs of Indian origin spread in more recent times to many tribes in Borneo, Celebes, and eastern Indonesia.

c. Painting. The many-figured festive scenes and representations of the soul boat on the ancient bronze drums of the Dông-so'n culture (FIG. 46) cannot have been created solely to be cast in bronze; they must have been preceded by similar scenes painted on wood or some other material. This suggests the possibility that the paintings of human and animal figures, boats, and the like, found in the Mentawei Islands and among the Batak of Sumatra, the Ngadju in the interior of southeastern Borneo, and the Saadang Toradja of Celebes may be derived from this hypothetical painters' art of the Dông-so'n culture. (It is significant in this connection that many-figured paintings representing myths and legends adorn the walls of men's houses on the Palau Islands, the one Micronesian group which, as its house forms and certain ornamental designs testify, was reached by Dông-so'n influences. See IX, PL. 543.)

The most adequately known pictorial works are those of the Ngadju of Borneo. Painted on large boards, they represent the land of the dead, the celestial tree said to have precious textiles as leaves and to bear agate beads as fruits, the boats in which the gods are thought to travel, and the boat in which the god Tempon Telon is believed to conduct the souls of the deceased to their final abode. The soul boat, called *banama tingang* ("hornbill boat"), has a hornbill's head on its prow and the bird's tail feathers on its stern. The mast is a version of the celestial tree with its textile leaves. The close correspondences between these Ngadju boat paintings and the boats represented on one of the oldest Dông-so'n bronze drums was first pointed out by Goloubew. The boat designs on the drum have tail feathers on the stern but lack the hornbill's head on the prow, its place being taken by the figures of hornbills coming down from above in flight and touching the prow with their beaks. The boat's cabin, containing a bronze drum and a precious jar, corresponds to the cabins of Ngadju boat paintings, with their cargoes of bronze gongs and precious jars, funeral gifts to the dead, while the archer on the drum, discharging an arrow from the cabin's roof, has his counterpart in the paintings in a man who is discharging a cannon on the roof of the cabin. This shows beyond any doubt that the Ngadju boat pictures are modernized versions of a motif that must have existed in the Dông-so'n culture even before it was reproduced on the bronze drums. There is, however, a marked difference in style. The warriors forming the boat's crew on the drum are shown in a simple, realistic manner. In the Ngadju paintings the god Tempon Telon and his companions are curiously stylized; their arms, hands, and legs resemble the legs of beetles rather than human limbs. Similarly stylized human figures, with limbs like those of beetles, occur in the paintings on the walls of Toba Batak houses and in the illustrations of Batak manuscripts (X, PL. 64). Since the possibility of any direct contact between the Batak of Sumatra and the Ngadju of Borneo can be ruled out, they must have derived this stylistic trait from some common source. A Chinese manuscript on silk, found in a tomb at Ch'ang-sha in the province of Hunan and tentatively dated to the 4th century B.C., indicates a possible source. The illustrations show demonic figures of practically the same style as those of Ngadju paintings, also with limbs resembling those of beetles. It may be that the Ngadju paintings, while originally of Dông-so'n derivation, were later modified by Chinese influences; it is equally conceivable that, except for the different stylization of human figures, the motif of the soul boat existed in later Chou Chinese painting in the same form as in the Dông-so'n culture, and that it was introduced into Borneo from China.

No trace of Chinese influence is found in the scenes painted on the beams and walls of houses of the Mentawei Islands, of the Karo Batak and of the Saadang Toradja (nor in the paintings of the Palau Islands in Micronesia); these have a simple realism

and may represent the original painters' style of the Dông-so'n culture. Some of the magnificent drawings of the Ot Danom on the upper reaches of the rivers of southern Borneo, incised into the surfaces of bamboo receptacles, represent the great feast in honor of the dead, with the celestial world shown above and the nether world below this central scene. Although far more elaborate, the latter deal with the same subject as do the representations of feasts on the tympanums of some of the oldest bronze drums. It seems possible, therefore, that these Bornean drawings are distantly rooted in Dông-so'n traditions.

d. Sculpture. The ancestor figures of wood (PLS. 25, 27) or, more rarely, of stone — whether in seated position or standing, whether boldly simplified with almost geometric features or more realistic and rounded in form — perpetuate for the most part the ancient monumental style that preceded the Dông-so'n. In the eastern islands, for instance in the Tanimbar group, parts of the surfaces may be covered with ornamental designs without, however, affecting the character of the sculptures themselves. It is only among the Batak of Sumatra and in Borneo that a more complicated situation is found.

In the carvings on Toba Batak houses (PL. 23) occur typical motifs of the monumental style, such as women's breasts and figures of lizards, side by side with sculptures that not only are covered with ornamental designs but have in themselves become ornaments. Ornamental versions of buffalo heads and of squatting human figures are so stylized that in many instances their basic form becomes hardly recognizable. It is difficult to tell whether this is due to the influence of the local ornamental style or to stimuli received from Hindu-Buddhist art, or, as seems most likely, to both. Foreign influences, mostly Hindu-Buddhist, are noticeable in some other sculptures, ancestor and protective figures of wood and stone, and masks, but the majority conform in essence to the monumental style. The so-called "magic wands" or priests' staffs, with numerous human and animal figures superimposed one upon the other (PL. 26), pose a special problem. They are probably derived from a very ancient style of eastern Asia, elements of which seem to have survived in China until the 1st millennium B.C. and may have been carried south in the Dông-so'n period.

In central Borneo the wooden statues intended to give protection against diseases and other ill fortune show the traits of the monumental style; at the same time ornamentalized human or demonic faces are carved on house posts, on the pillars supporting sepulchral huts, and on objects of daily use (PL. 42). Some of the memorial monuments of southern Borneo have numerous human and animal figures superimposed upon one another (PL. 26). They seem to be related in style to the Batak magic wands and may be of the same origin. The masks of central Borneo (PL. 29), representing fantastic demons of truly nightmarish quality, are typical products of the local ornamental style and differ fundamentally from the far simpler masks of the rest of Borneo.

e. Megalithic monuments and sarcophagi. In some areas of Indonesia even the megalithic monuments came under the influence of ornamental tendencies. This is particularly the case on the island of Sumba. Most of the tombs there consist of huge monolithic receptacles in the shape of the frustum of a pyramid covered with a large stone slab. In some instances the decoration consists merely in relief representations of bronze gongs, as symbols of wealth, and buffalo horns. Others are covered with rich ornamental designs of Dông-so'n derivation, interspersed with relief figures of horsemen or with such motifs of the old monumental style as lizards. Frequently the head of a buffalo is carved on one end of the covering slab and the animal's tail indicated at the opposite end. The whole tomb thus becomes a stylized buffalo figure, occasionally carrying on its back human figures of stone (PL. 24). This conforms to the old megalithic belief in the eschatological importance of the buffalo sacrifice. The simple menhirs of former times are replaced by even more fantastic monuments, richly ornamented, their sides carved into freely projecting scrolls or adorned with reliefs of men and animals, and frequently surmounted by full-round figures of men or birds (PL. 25).

Other instances of the development of stone sculpture within the ornamental styles of Indonesia include the house-shaped sarcophagi of the Minahassa district of northern Celebes, many of them richly decorated, and the sarcophagi of the Toba Batak (PL. 24), conforming to the local house type and with a large, magnificently stylized human face at one end.

f. Architecture. Three Indonesian house types of real artistic merit, all more or less related to one another, may be assumed to have been introduced during the Dông-so'n period. One of them, represented on the oldest bronze drums, has a saddle-shaped ridge with the ends protruding beyond the front and rear walls of the house, thus giving the roof the shape of a boat. This type survives in its purest form in the houses of the Toba Batak of Sumatra and those of the Saadang Toradja of Celebes. In the second type the roof consists of two parts, a lower hipped roof and above it a boat-shaped roof corresponding to the first type. Its antiquity in eastern Asia is attested by its representation on the oldest bronze mirrors from Japan. This second type occurs among the Karo Batak of Sumatra, where it has given rise, probably under Hindu-Buddhist influence, to even more complex storied roof forms (PL. 23). The third type has a multiplicity of boat-shaped roofs, linked horizontally as if telescoping into one another. There are indications that this type was also formerly widely distributed in eastern Asia; it survives in the wooden Buddhist architecture of Burma and Siam. In Indonesia it is restricted to the Menangkabau region of Sumatra (PL. 23).

g. Textile art. Textiles decorated by the *ikat* technique rank among the most attractive works of Indonesian art. In this technique the pattern is produced by tie-dyeing, not on the finished tissue, but before weaving, either on the warp or the weft or, occasionally, on both. Before immersion of the threads in the dye those portions which are not to be colored are wrapped with leaves or fibers, and this process is repeated for every color.

Except for the tread-looms of Indian derivation which are used in a few localities in Java and Sumatra, all Indonesian looms of whatever model are worked by hand, the warp being stretched with the help of a belt around the weaver's back. Cotton, certainly introduced from India in the first centuries of the Christian Era, is today the most common weaving material, but various kinds of indigenous plant fibers (*Musa textilis, Borassus flabellifer, Pandanus,* and others) are still being used on a number of islands.

The textile designs of Indonesia (PLS. 40, 41) may be roughly divided into two major groups. The first, characterized by flower patterns and their geometric derivatives and by stylized plant motifs, corresponding to the designs of textiles represented on ancient Javanese monuments, are obviously of Indian origin. Accordingly the patterns of this group predominate on the tissues of the Javanese, Malays, Balinese, Buginese, and others who were formerly within the realm of Hindu-Buddhist culture, or who at least came under its influence; they were adopted only to a slight extent by primitive tribes, occurring chiefly on some of the Lesser Sunda Islands.

The second group of designs, completely different, owes nothing whatsoever to Hindu-Buddhist art. Apart from a few simple patterns of technical origin this group comprises spirals and their derivatives, as well as human and animal figures. For the sake of convenience this second style of textile design may be termed "old Indonesian." It is found on the tissues of the Batak of Sumatra, of the primitive tribes of Borneo and Mindanao, of the Toradja of Celebes, and among most primitive tribes of the Lesser Sunda Islands, the Moluccas, the Tanimbar Islands, and elsewhere. It is significant that old Indonesian designs occur side by side with those of Indian origin on Malayan, Javanese, and Balinese fabrics, where they can only be survivals from an earlier period. They prove that the old Indonesian style of textile decoration, and consequently also weaving and the *ikat* technique, were known in Sumatra,

Java, and Bali prior to the establishment of Indian colonial cultures on those islands. However, this concerns only the warp *ikat* technique, the only one known to the peoples where the old Indonesian style prevails. Weft *ikat*, as found among Malays, Javanese, Balinese, and the Moslems of Lombok and northern Celebes, certainly came from India, where it is still practiced.

No indication as yet has been found that weaving was known in the Neolithic period; of course this is not positive proof to the contrary, but it seems likely that the neolithic Indonesians used only bark cloth, as some tribes do even today. Under no circumstances could the rich ornamental designs of Indonesian *ikats* have been derived from the neolithic monumental style with its dearth of ornament. From the foregoing it follows that warp *ikat* was introduced into Indonesia neither in the Neolithic nor in the Hindu-Buddhist period. Since the *ikat* technique is, or was, widely diffused throughout southern, central, and eastern Asia, the possibility that this technique came to Indonesia with the spread of the Dông-so'n culture must be considered. It is known that the bearers of the Dông-so'n culture in northern Vietnam practiced weaving, for remnants of textile wrappings adhere to some of the bronzes excavated at Dông-so'n. The nature of these tissues is not known. However, the spiral designs in the patterns of Indonesian *ikats*, which include the characteristic S-shaped double spiral, are unmistakable proof of Dông-so'n influence. Of course the weavers of the Dông-so'n period could have used only plant fibers, the material still employed in Mindanao and various other islands.

Limitations of space preclude a full survey of the wealth of Indonesian textile designs. Outstanding among them are those of Mindanao, of the Iban of northwestern Borneo (PL. 40) and some tribes of eastern Borneo (with a puzzling gap in central Borneo), of the western Toradja of Celebes (PL. 41), of the Batak of Sumatra, and of the islands of Sumba (PL. 40) and Timor. Human figures and figures of crocodiles are conspicuous by their wide distribution. In some instances they have been so stylized that they are recognizable only on the basis of detailed comparisons. On Batak *ikats* the crocodile figures have been reduced to mere lozenges, while some apparently purely geometric designs of western Toradja *ikats* have been shown to be derived from a pattern of interlinked human figures.

Future research will, no doubt, disclose subgroups of more closely interrelated textile styles. Even a superficial glance will show that some special relation exists between the style of Mindanao and that of the Iban, to which Timor *ikats* also manifest a fairly close relationship. Batak *ikats*, while sharing numerous single motifs with those of the islands farther east, differ from them in general character. In a class by themselves are some of the magnificent *ikats* of Sumba, which are characterized by figures of men, deer, horses, birds, serpents, and marine animals and by representations of stylized trees with human skulls fastened to their branches (PL. 40).

While some *ikats* serve as everyday or festive clothing, others are used only as ceremonial gifts at weddings and other celebrations. Larger and more elaborate specimens frequently are kept as heirlooms and used as wall decorations on festive occasions. The very large *ikats* of the western Toradja serve as shrouds, and those of Sumba as funerary gifts. Such motifs as human and crocodile figures indicate an association with some kind of religious symbolism, even though the original meaning may have been forgotten.

Ceremonial and religious connotations adhere also to a completely different class of textiles, found in the Kroë and Lampong districts of southern Sumatra. There are two varieties, embroidered ceremonial clothing and large cloths woven with floating weft that are used as ceremonial hangings. Both display the soul boat (X, PL. 431), human and animal figures, and the celestial tree. Their motifs are related to the paintings of the Ngadju of Borneo. Such ornamental designs as spirals indicate beyond any doubt that they are derived either from Dông-so'n or later Chou Chinese art.

The technique of basketry, with its remarkably refined products (II, PLS. 228, 229, 231, 234), is discussed in the article on BASKETRY.

Marginal Indonesian cultures. a. Formosa. A highly specialized variety of the monumental style exists among the Paiwan, the southernmost of the tribes with Indonesian languages who inhabit the mountain region of Formosa. Their works of art include human statues, as well as reliefs with human and animal figures, human heads, and snakes carved on wooden house beams and lintels, on menhirlike slabs of slate, and on knife sheaths, wooden vessels, and drinking cups. A few reliefs of the same style occur among the Rukai, near neighbors of the Paiwan. The art of the other hill tribes is of little importance.

b. Botel Tobago. The ornamental art of the Yami, inhabitants of the small island of Botel Tobago east of the southern tip of Formosa, is applied mainly to the decoration of boats. The designs consist of rows of triangles, zigzag lines, and human figures; the last have extended arms which end in spirals in place of hands. A circle enclosing a star is inscribed on either side of the boat near the bow. Plank-built boats of the same shape and the same unusual type of construction occur in the Solomon Islands, where they are decorated with similar designs. In general, the ornamental styles of Botel Tobago and of the Solomon Islands seem to be closely related. This is not due to Melanesian influences in Botel Tobago, as has been supposed, but, on the contrary, to Asiatic influence in the Solomons. The spirals and the rows of triangles used as border designs, very much the same as on the ancient bronze drums, indicate the Dông-so'n origin of the Yami style. Moreover, it is practically certain that the very special type of plank-built boat used in Botel Tobago and in the Solomons was introduced into eastern Asia in the Dông-so'n period. However, since Yami art differs from the ornamental styles of Indonesia, one must conclude that its development was stimulated by a separate wave of Dông-so'n influences from the mainland.

c. Nicobar Islands. In view of the geographical proximity of this archipelago to Sumatra and the affinity of its culture to that of Engano, it is not out of place to devote a few lines to its art, even though the Nicobarese language is not Indonesian but belongs to the Mon-Khmer family. Nicobarese sculptures, carved of soft wood, are intended to drive off evil spirits. The human and animal figures excel in their lively realism (PL. 27). It is difficult to determine their place within the general framework of Indonesian art history. Paintings on wooden boards or on the sheaths of palm leaves are suspended in the houses in order to give protection against the spirits of disease. The representations include men, animals, dances, legendary beings, houses, ships, sun, moon, and stars, and the like (PL. 39), executed in a simple, realistic style resembling that of Mentawei, Saadang Toradja, and, above all, Palau paintings (see MICRONESIAN CULTURES). It seems not unlikely that they, too, are somehow derived from Dông-so'n painting, even though little else in Nicobarese art or culture could possibly be of Dông-so'n origin.

d. Madagascar. The art of Madagascar (see MALAGASY REPUBLIC) is imperfectly known and has not yet been studied within a wider scope; nevertheless, a few facts which indicate its relationship to the art styles of Indonesia may be pointed out. Wooden memorial pillars, with figures of crocodiles carved in relief and surmounted by human statues, are definitely derived from the monumental style of Indonesia. In view of the megalithic character of the local cultures this is not surprising. The ornamental designs seen on shutters, beds (PL. 39), wooden plates and boxes, and other household objects are strikingly similar to those of the Saadang Toradja of Celebes and even more closely related to carvings on megalithic monuments in Sumba, with their S-shaped double spirals, plaited bands, rosettes, zigzag lines, and rows of triangles. A motif consisting of rows of squares cut by diagonal lines is as characteristic of Madagascar as of Sumba. This stylistic similarity extends also to the flat reliefs (in Sumba on stone, in Madagascar occasionally on stone but mostly in wood) that represent human figures, horsemen, bulls, crocodiles, or lizards. One may conclude that the art of Madagascar is derived from an Indonesian

art style which must have been very similar to that of Sumba, but which must still have retained strong remnants of the monumental style at the time of the migration to Madagascar (probably in the first half or about the middle of the first millennium of the Christian Era). The human and animal figures in the designs of Madagascar warp *ikats*, woven of raffia, may be compared to those of the Iban of Borneo, of Timor, and particularly of Sumba, while some of the purely geometric patterns correspond to those of Batak and western Toradja *ikat* cloths.

Robert HEINE-GELDERN

HINDU-BUDDHIST ART. Under the influence of artistic, iconographic, and religious traditions which stemmed from India, an Indonesian Hindu-Buddhist art developed in the two large islands of Java and Sumatra, to a lesser extent in Borneo, and with a remarkable later flowering in the small island of Bali. It is possible to trace this development from the time when buildings and sculptures were first executed in durable materials, that is, from the late 6th or 7th century; contacts with India had been established, however, before that time. With the adoption of Indian civilization and religion by the Indonesian sovereigns and their courts, there arose an art which remained for a long time related to that of India but which evolved with original tendencies in each region. The Indianized civilization remained that of the privileged classes. Under these circumstances indigenous traditions quickly began to mingle with those which had been imported; asserting themselves more and more, after the 10th century and especially in the 13th and 14th, they marked the later works with a clearly Indonesian character, which persisted even after the establishment of Islam in Java at the end of the 15th century.

Relationships may often be observed between this art and those which developed in southeastern Asia under the same Indian impulse. For example, both in the Khmer culture (see KHMER ART) and in Indonesia, the direction of art was influenced by the concept of the relation of royal to divine power, and by the rite of apotheosis which derived from this idea. Many similarities are due to common origin, but more precise borrowings can be detected as well. The expansion of the Javanese kingdom of Śrīvijaya transmitted forms developed in the islands into the Malay Peninsula as far as Ligor. There, at Jaya, in the area of the kingdom of Dvaravati (whose center was in lower Menam), have been found small buildings and sculptures very close in style to those of central Java. In the Khmer style of Phnom Kulên (first half of 9th cent.) are elements borrowed from Javanese art, among them *makara* heads with their characteristic pendants, which are found turned outward on the ends of lintels as in many series of small arches in Java. The folded-over belts, and especially the body belt of the same provenance, occur in the later style of Prah Kô (last quarter of 9th cent.). Other contributions are noted in the art of Champa (see CHAM, SCHOOL OF): on monuments of the late 9th century and first half of the 10th is repeated a very beautiful foliage scroll arranged in a climbing band on the walls of Candi Kalasan and Borobudur. These examples are sufficient to reveal the importance of the two islands situated on either side of the Sunda Strait and the broad distribution of their art.

Climatic conditions in the islands of Sumatra and Java have permitted the preservation only of the monuments and objects executed in stone or metal. For this reason the appearance of the wooden palaces and dwellings can be visualized only through their representation in relief carvings, and the same is true of costume and all the objects related to daily life. What we know of the former art of Indonesia is thus of an essentially religious character. In this field there are regrettable lacunae, since, alongside the images in stone and bronze, there must have existed others in wood or painted on cloth, just as wooden annexes accompanied the great edifices. Furthermore, many of the stone monuments of the earlier periods have been entirely destroyed, and those that remain have survived only in a damaged state. Monuments abandoned when capitals and centers of culture were moved, or when religious beliefs changed, suffered many depredations. To the effects of earthquakes and the encroachments of the exuberant vegetation must often be added the vandalism of the inhabitants, who used the stones and bricks for their own buildings. Prolonged effort on the part of many scholars and archaeologists was necessary to discover, reconstruct, and interpret the architectural and sculptural vestiges of this remarkable past.

These ancient monuments attracted interest late in the 18th century, and it was early in the 19th that the clearing of the ruins of Prambanam began. Historical, archaeological, and linguistic research has continued for more than a century. It is impossible to list here all the achievements. Particularly important, however, was the work of H. Kern, who was the first to learn Kawi, the language of all the old Javanese texts, and of J. L. A. Brandes (d. 1905), who studied the Javanese monuments. Later on N. J. Krom organized the Archaeological Service of the Dutch East Indies, while the work of restoration was directed by T. van Erp. As Krom's successor in the Javanese Archaeological Service, F. D. K. Bosch has continued studies in various fields. It is impossible not to admire the method (anastylosis) by which the monuments have been restored: patiently and skillfully, often under difficult conditions, many buildings have been reerected, stone by stone. The Ecole Française d'Extrême-Orient has followed the example of the Dutch Service and used the same technique. Through this painstaking work, out of crumbled ruins and piles of stone, the Javanese temples have been reborn in all their beauty and harmony.

Historical background. The spread of Indian culture to Indonesia during the first six centuries of the Christian Era is attested by various sources: Sanskrit inscriptions going back to the second half of the 4th century have been found in Java and Borneo; archaeological remains have been discovered in different parts of the archipelago (Buddhas of the Amaravati and Gupta styles in the Celebes, Java, and Sumatra, and Buddhist and Hindu images in Borneo). The existence of relations chiefly with India, but also with China, is confirmed also by various Chinese sources, such as the reports of embassies and the accounts of pilgrims who, on their voyages to or from India to visit the holy places of Buddhism, visited the islands of the "Seas of the South"; among the latter were Fa-hsien in 414 and Yi-ching (I-ching) in the late 7th century. Hinayana Buddhism seems to have been adopted at first, but Mahayana was preached from the mid-7th century by a monk who had come from Nalanda.

The geographical situation of Sumatra and Java on the straits ensured their prosperity. The two islands, especially Sumatra, were revictualing stations and navigational landmarks on the great sea route (Spice Route), which joined India and China and touched the countries situated along the coasts. The importance of Sumatra grew with the expansion of the kingdom of Śrīvijaya, which at first was limited to the southeastern part of the island at Palembang. From the late 7th century it spread in the wake of military expeditions sent northwest to the Strait of Malacca and southeast across the Sunda Strait against Java. Its expansion in the direction of the Malay Peninsula reached, in the 8th century, as far as the region of Ligor, where discoveries have been made of sanctuaries and statues dating back to this period that show Indonesian influence.

The middle and end of the 8th century in Java was a period of great power for the Buddhist Śailendra dynasty, which was based in the center of the island. The ascension of these monarchs favored the dissemination of the "Great Vehicle" of Mahayana Buddhism (which was already mixed with Tantric beliefs) and led to the construction of important Buddhist monuments, called candi (Jav., *caṇḍi*): Mendut, Borobudur, Kalasan, Sari, and later Sewu. In the 9th century the Śailendras assumed at least nominal sovereignty over the Śrīvijayas, and the younger son of one of them even governed that kingdom about 850–60. But while the strength of the Śailendras was increasing in Sumatra during the second half of the 9th century, it was declining in the center of Java. Buddhism survived, as is proved by the building of Candi Plaosan and Candi Sajiwan at about this time, but Hinduism (q.v.) was already becoming

more important. The monuments on the Dieng Plateau, the northern region of the center of Java, believed to date from the late 7th or early 8th century, reveal the presence of this religion even before the appearance of the Śailendras, who were favorable to Buddhism. Their decline was accompanied by a new vitality in Hinduism, as is proved by the construction of the huge temple complex of Lara Jongrang at Prambanam in the latter half of the 9th or early 10th century. In addition a certain syncretism established itself between the two religions, later a source of new forms.

In the late 9th century and the 10th a troubled and obscure period seems to have followed the prosperous age of the Śailendras, with the kingdom of Mataram uniting the center and east of the island. The ascension to the throne of King Siṇḍok (ca. 929) saw the removal of the capital to the east, the region which became the definitive center of the Hindu-Javanese civilization.

Continuous rivalry marked relations between the two islands, which were creating strong bonds with China and India. Embassies were sent to China, and relations, at first friendly, were established with the Cholas of India, but a raid by the Cholas of Tanjore against Sumatra followed during the first quarter of the 11th century.

The vigorous literary activity during this epoch and the preceding one was continued in the kingdom of Kediri, which followed in the late 11th and 12th centuries. The great epics of India and the religious texts, which were adapted and translated into old Javanese, remained a frequent source of inspiration for reliefs, plays, and dances until the 16th century in Java and until the present time in Bali. The themes borrowed from India were thus perpetuated.

The kingdom of Sumatra was prosperous and dominated the Malay Peninsula once again in the early 13th century, but its rule diminished in the middle of the century. During the long reign of the Javanese king Kṛtanāgara, however, there was a resurgence of the power of Java. After a brief Mongol expedition carried out by Kublai Khan in 1292, the king Rāden Vijaya, a descendant of Ken Angrok, who reigned under the name of Rājasa, founded the kingdom of Majapahit.

The power of Sumatra declined even further in the late 13th century, when the Tai (Thai) conquered the Malay Peninsula, and the Javanese controlled the straits as a result of an expedition in 1275. The arrival of Islam, propagated by traders about 1281, and the success of this new religion quickly led to the decline of the Indo-Malay culture in the north of the island. Buddhism, associated with Saivism, survived longer in the south of the island in the kingdom of Malayu.

Despite various rebellions, the kingdom of Majapahit prospered throughout the 14th century, reaching its high point in the period of Hayam Wuruk, who ruled under the name of Rājasanāgara (1350–89). Javanese sovereignty extended over a large part of the Malay Peninsula, and its influence was felt in Bali, where the viceroy was an uncle of Rājasanāgara. There was a great output of literature, and religious foundations were numerous. Upon the death of Rājasanāgara, however, a decline began that was accelerated in the first decades of the 15th century by rivalries and by the progress of Islam, which was aided by the growth of Malacca, a Moslem religious center and a commercial rival. The Hindu cults mixed with old native traditions survived only in the mountains (e.g., Penanggungan and Lawu), and the early 16th century saw the end of the kingdom of Majapahit (between 1513 and 1528) and the almost complete triumph of Islam. The Hindu culture — strongly mixed with Indonesian elements — persisted, however, in Bali.

The Arabs, who monopolized trade, became the allies and protectors of the small Malayan Islamic states until a new epoch began in the late 15th century. After the arrival of Vasco da Gama in 1498, the installation of the Portuguese on the Sunda Islands (taken from Malacca by Affonso de Albuquerque in 1510) was soon followed by that of the Dutch.

Religious beliefs. Since the art is essentially religious in character, it is necessary to give some information on the religions and beliefs of Indonesia. Buddhism and Hinduism (qq.v.), brought from India to the Indonesian archipelago by travelers and by the traders who settled in the islands in the first centuries of the Christian Era, often took on particular aspects as a result of contact with the indigenous beliefs. In 420 a monk from Kashmir, Guṇavarman, preached Buddhism successfully at the court. In the middle of the 7th century Dharmapāla, a monk who had studied at the great Buddhist monastery at Nalanda in Bihar, introduced advanced Mahayana teachings that were already mixed with Tantric ideas.

The conception behind the plans of the architectural ensembles was inspired by these beliefs. Thus the imposing monument of Borobudur (PLS. 30, 33, 36), which has both a cosmic and a dynastic significance, becomes a true microcosm. It was an architectural representation on a reduced scale of the cosmic

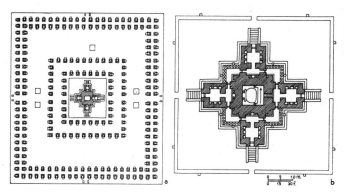

Java, Candi Sewu. (a) Plan; (b) plan of principal temple.

mountain which, according to Indian theories, rose in the center of the universe, and at the same time a huge, "three-dimensional mandala" (to quote P. M. Pott). The group of temples of Candi Sewu — though spread out horizontally — show a similar arrangement (FIG. 62). These Javanese monuments are related to the later mandalas of Nepal and of Tibet (qq.v.), those geometric and esoteric schemata intended to aid mystical meditation.

The development of Buddhism was favored by the Śailendra dynasty who reigned in central Java, and from there it was transmitted to Bali. In Sumatra, Buddhism became and remained the state religion from about the 7th to the 14th century, when the Sumatran kingdom of Śrīvijaya collapsed. Relations with Nalanda, source of the teachings, were still flourishing in the middle of the 9th century. Indeed, an inscription mentions that at this time a king of Sumatra was having a monastery built for his subjects who were going to stay as pilgrims in that great Buddhist center. These contacts explain how influences from the Pala and later the Sena style (see PALA-SENA SCHOOLS) reached the islands.

In spite of the predominance of Buddhism, Brahmanism or Hinduism came early and persisted under the Śailendras, as is proved by the Dieng Plateau temples and by inscriptions of 752 and 760 referring to the linga, the symbol of Śiva. The recrudescence of Hinduism in the 9th century and later is witnessed by the importance of the great temple complex of Lara Jongrang at Prambanam, with its temples dedicated to the three great divinities, Brahmā, Śiva, and Viṣṇu, and to their mounts. The Saiva sect quickly became the most important in Java, however. Śiva, who lived on a mountain, was readily integrated with popular beliefs, since the veneration of a god residing on a high mountain figured among the indigenous animist concepts that preceded the introduction of Indian culture. As in India, Śiva took on varied aspects, both benevolent and terrible. Among other deities, the sculptures reflect the favor accorded to Durgā, who is shown crushing the demon-buffalo, and to Śrī or Lakṣmī, who became associated in Java with the rice goddess. Kubera, god of wealth, shown holding a mangosteen, was popular among both Saiva and Buddhist sects.

To the religions that came from India were added beliefs (also common in part of Indochina) according to which royal power was assimilated with that of a god. The king was re-

garded as the earthly counterpart of a god whose name he borrowed. Thus the temple of Borobudur, with its terminal stupa, would have suggested the identification of the monarch with the Ādibuddha (the supreme Buddha), who, in addition, was assimilated there with Śiva, the "king of the mountain."

If a certain syncretism between Śiva and a native god showed itself from the very beginning, a great tolerance and often a comparable syncretism could be observed between Hinduism and Buddhism. From the middle of the 9th century Buddhist temples were to be found side by side with Saiva ones (as in the complex of Sewu beside that of Lara Jongrang at Prambanam), and the images seem to have been worshiped simultaneously by followers of both religions. The spread of Tantric beliefs was accompanied by a very complicated and often strange iconography. The favor shown to the Bhairava sect led to the representation of the gods in their frightening forms, but alongside these fearful divinities are others that possess a profound serenity and spirituality. Such is the Prajñapāramitā of Leiden (Rijksmus. voor Volkenkunde), which reveals the mystical aspect of Tantric Buddhism, capable of attaining the extremes in every direction of human thought.

Islam was first introduced in northwest Sumatra by Arab navigators. Its progress, which was slow in the 13th century, accelerated in the 15th, and the 16th century saw the first Moslem kingdom in Java. Buddhism disappeared completely, but Hinduism partially survived in the mountainous areas of the island, where it became mixed with the native beliefs in the mid-15th century. The success of Islam affected the purpose of the temples but had little influence on their design. Buildings returned to established formulas and often maintained an ancient aspect in spite of the change in their purpose. The chief effect on the art was the repression of anthropomorphic representation.

In Bali, Buddhism and Hinduism had long since been assimilated into the local culture, creating a complex of beliefs which became the official religion. Buddhism and its legends were quickly abandoned, while the survival of Hinduism was due largely to the popularity of the great Indian epics, the *Rāmāyaṇa* and the *Mahābhārata*, whose heroes became and have remained those of the theater, the dance, and the wayang shadow plays (see PUPPETS, MARIONETTES, AND DOLLS).

Evolution of the art styles. At the time when Indonesian art became historical — that is, following the 7th century of the Christian Era — the Indian art (q.v.) which provided its Hindu-Buddhist models had reached full maturity, apparent both in technical skill and in the consolidation of particular tendencies. Evolved from a long artistic history, and enriched by borrowings from western Asia and even from the Mediterranean world, the Gupta, post-Gupta, and Pala art of India revealed a superb feeling for form, tremendous inventive genius, great spiritual inspiration, and an often intensely human sensibility. By this time many of the forms created, architectural as well as iconographic, had become traditional, and principles regulating their appearance and proportions were beginning to be established. (See GUPTA, SCHOOL OF; PALA-SENA SCHOOLS.)

This whole conglomeration of traditions, symbols, forms, and esthetic tendencies passed from India into Indonesia, where the art, following its Indian antecedent, became in its turn traditional and symbolic. This vast heritage came in successive waves from different parts of India and Ceylon and left its mark in architecture, in bronze and stone sculpture, and in ornament.

The temples borrowed both their function and their appearance from India, with very little modification in the beginning. The typical Buddhist stupa — reliquary, commemorative monument, and object of veneration — was created in the form of a bell-shaped dome similar to those of Ceylon. The temples, as in India, were intended to enclose in a cell the images or symbols of Buddha and the Buddhist or Hindu gods which were the object of cult offerings or ablutions. The architectural scheme of the temple was Indian also. The main part of the edifice, which was square or rectangular, was raised on a platform and dominated by an imposing superstructure. The

only vault known and utilized was corbeled; it was formed of horizontal strata, which overlap progressively toward one another on the inside, thus diminishing little by little the space to be roofed over. This method of construction results in a roof of great height, especially when the size of the building is increased. The superstructure was decorated with architectural elements, such as arches or monuments executed in reduced scale, that were repeated, following the Indian tradition, in successive stories. The technique employed limited the architectural possibilities, with the result that important temple groups were created by erecting many small buildings and juxtaposing them around the principal temple, rather than by making the latter very large or by connecting it to its annexes. Indonesian architecture remained in this phase and did not copy the later Indian developments.

Indian prototypes also imposed limits on the sculpture. As a result of the conventions governing its creation, the image acquired a symbolic character, and the form became a kind of language which only the initiated could fully understand. The type and proportions of the figures were determined by the benevolent or terrible character of the gods and of various beings. Anatomical distortions, such as gods represented with multiple heads and arms or with animal elements (e.g., Gaṇeśa's elephant head), were deliberately employed for expressive purposes. The attitudes (*āsana*), seated or standing, were established by tradition; among them are figures seated "Indian" fashion (*padmāsana* and its variants), in relaxed poses (*lalitāsana*), and in the so-called "European" seated position that became common in post-Gupta India. The symbolic gestures (*mudrā*, or *hasta*) and the attributes appropriate for each Buddhist or Hindu deity were also prescribed. The details of Indian iconography (see BUDDHISM; HINDUISM) were thus taken over, as were the lotuses that served as supports and the thrones with their decoration and symbolism.

The themes also were borrowed from India, together with the secondary figures which complete the Indian pantheon. The mounts of the great gods of Hinduism — the bull Nandi of Śiva, and the bird Garuḍa of Viṣṇu — can be found, as well as the flying creatures (genies and celestial musicians, gandharvas and apsarases) and a great number of mythical beings, such as the half-human, half-bird kinnaras, and the rakshasas, frightful demonic figures who in eastern Java seem to have been guardians (*dvārapāla*s) of the sanctuaries. Indonesian sculpture adopted, besides, the techniques and many of the esthetic tendencies of Indian prototypes: the sense of volume and roundness in the deeply hollowed bas-reliefs; the preference for the stele, which led to a flattening in the poses of the figures and to development of movement across the stone rather than in depth; the suppleness of the body with its "three-bends" pose (*tribhaṅga*); and the poetic rendering of scenes, which relates the bas-reliefs of Borobudur to the frescoes of Ajanta. Finally, the similarity of dance attitudes, musical instruments, and many other details, show how deeply Indian culture affected Javanese secular as well as religious life.

Similar resemblances can be found in many of the elements of ornamentation. In richness and fantasy Javanese decoration equals that of India. The garlands, pendants, and foliage scrolls that were so popular in Gupta and post-Gupta India reappeared in Java, in addition to the vase with lotus flowers like those of Amaravati. The lion became fantastic and was shown crouching or standing erect. Two mythical creatures specifically adopted from the Indian decorative repertory were given new functions: the *kāla*, or monster's head (the Indian *kīrtimukha*) and the *makara*, an aquatic animal with a trunk, whose head alone was used in Indonesia; as in India, the two motifs were associated in the decoration of arches.

All these influences and borrowings exercised their greatest effect during the first era of Javanese and Sumatran art, which is consequently known as the Indo-Javanese period (late 7th–mid-10th cent.). Later new importations modified some of these first tendencies, but the art of the archipelago has always borne the imprint of this early Indian ancestry. The Indian elements appear to have been immediately adopted, quickly assimilated, and long retained. They seem never to have pro-

voked the profound reaction that occurred in Khmer art, which rapidly freed itself from Indian dominance and imposed a new esthetic, often contrary to that of India.

However, in Java and Sumatra, architecture and sculpture were never servile copies of Indian prototypes, and individual qualities showed themselves from the beginning. Even the earliest known temples and their sculptures are distinguished by the harmony of their proportions, by the fine balance maintained between a rich inventiveness and restraint, and by the refinement of ornament. A spirit of moderation controlled the production of the 8th and 9th centuries and separated it from the more exuberant Indian spirit. For example, where the *tribhanga* was used, it became less exaggerated without losing its suppleness; the Indian feminine grace was kept, but the hips and breasts have less fullness, and the silhouettes too are slimmer and more youthful. The character of the type was subtly changed. Until the 10th century facial expressions were serene and gentle, attitudes restrained, and compositions less crowded than in India. Harmony and rhythm were essentials of Indonesian art, especially in the first stage of its development; they give it the particular qualities that differentiate it from other art.

In architecture, as in ornament, borrowed Indian elements quickly acquired a new emphasis, either changing in form or finding new groupings. The string-wall of a stairway or the arches joining a monster's head with two *makara* are motifs known in Indian architecture, where they play a secondary role; in Java they become of primary importance by virtue of their proportion and richness of ornamentation. The monster's head (*kāla*) was modified by expansion of the crest of foliage which surmounts it. The *makara* was transformed even more, with its two horns curling back on its neck, a pendant falling from its raised trunk, and a little figure or lion placed in its open mouth. New combinations were created. All are imprinted with the feeling for harmony and rhythm which, together with fantasy, marks all Indonesian decoration, where real and mythical forms are in constant association.

The evolution of art in Java and Sumatra was a continuous process, without any violent breaks. Nevertheless, it can be divided, on the basis of developments in Java, into three periods corresponding to the changes in the center of civilization and to the swings of history. Each period was accompanied by a different orientation of the dominating influences. During the first period, called "Central Javanese," the majority of temples were built in the center of the island, which had become extremely prosperous under the Buddhist Śailendras. This period is also called "Indo-Javanese," since it is the time when the borrowings from India are most apparent. The period called "Eastern Javanese" corresponds to the epoch, after the middle of the 10th century, when the capitals had been moved to the east and the principal temples were constructed close to the towns of Singhasāri and Majapahit. In spite of a partial survival of Javanese art after the Moslem domination (end of 15th cent.), the island of Bali became the new center, where Javanese traditions mixed with existing local ones.

Sumatran art can be included in this scheme. It has some qualities peculiar to itself, especially in architecture, but the same tendencies and a parallel evolution often united the artistic production of the two islands.

Central Javanese Period. a. Architecture and its decoration. Many of the buildings of this period were Buddhist foundations, since the Śailendras had made Buddhism a state religion. Other temples, however, were Hindu, for this religion had survived on the Dieng Plateau and regained importance with the decline of the Śailendras. Except for Borobudur, which is in a class of its own, most buildings of this period were single sanctuaries, sometimes grouped together in an enclosure. Urns containing ashes have been recovered in the foundations of many of them, suggesting that they had a funerary purpose. The name "candi," given to all these monuments, also supports this theory; it is properly applied to a commemorative structure erected over the grave of the deceased, but it became generally applied to all the monuments.

During this period, volcanic rock (andesite or trachite) was used for all the temples; their construction reveals a highly developed technical skill. The plan of the sanctuaries is usually square, with a small entrance projecting on one side. At times this plan is transformed into a Greek cross by the addition of projecting niches to the other three sides. As in India, the edifice was constructed on a base decorated with moldings; but here the base extends sufficiently to provide a platform to which a staircase with a string-wall gives access. This platform, which permitted the ritual of circumambulation around the monuments, often has a low balustrade. The superstructure, composed of several floors, has a pyramidlike appearance derived from Indian prototypes at Mamallapuram (7th cent.); it is decorated with small arches surrounding niches and with monuments, reproduced on a small scale, placed on the platforms created by the pyramid form. In Buddhist sanctuaries these miniature structures take the form of stupas similar to those in favor in Ceylon in this period. The bell-shaped dome is mounted on a cylindrical pedestal and topped by a cubic element supporting a finial. The style evolved, however, and often the square plan is repeated in the different floors of the superstructure. Another form is also encountered; in this the first rectangular story is succeeded by another which is octagonal or circular, and which itself serves as a base for a large terminal stupa, or dagoba. This type is found at Candi Kalasan and was used in Sumatra at a later period.

The Javanese sanctuary, like the Indian temple, was designed to contain in an inner room the symbol or the image of the deity to whom it was consecrated. This principal image, placed against the wall of the cella, was often accompanied by stone or bronze statues of bodhisattvas or gods. The cella was usually small. Often there was incised decoration on the walls; sometimes there were niches or cavities for candles. Apparently there was no ceiling to separate the cella from the corbeled vault, the successive sections of which were thus visible. A trench, often very deep, contained the foundations. In some cases the cella was surrounded by a corridor which could connect not only with the entrance vestibule but also with the projecting chapels in sanctuaries where the Greek cross plan had been employed, as in Candi Sewu.

Throughout the first period the proportional height of the main part of the building and of the superstructure remained fairly low and no effect of height was attempted, as it was in the sanctuaries of Champa, for example. Even when, toward the end of the period, the temples were built taller (as in the Lara Jongrang group at Prambanam), the feeling of height was diminished by the strong horizontal emphasis. The main lines of the architecture were always emphasized by thick moldings and overhanging cornices, the latter creating a contrast between the light-catching projections and the deep shadows. In the moldings, often projecting markedly, straight lines and curves opposed each other, avoiding both monotony and slackness. The areas for sculpture and decoration were planned in advance. Sculpture was generally strictly confined, sometimes in niches or in recessed panels, sometimes framed by moldings, by undecorated bands, or by short decorative pilasters. The Pawon (PL. 34) and Mendut candis are excellent examples of the balanced distribution of motifs; the ornament is arranged in three parts on each face of the building, and rectangular panels are set in a frieze on the base between the moldings at the foot of the base and those of the cornice. In the great temple of Prambanam the decoration of the three stories of the pyramidal base combines fantasy and order by a regular succession and alternation of varied groups of figures and decorative motifs. The execution was not left to chance; the stones were cut according to the decoration they were to receive, so that the joints would not awkwardly mar a sculpture or molding. Whenever possible, the slabs used were of the shape necessary to contain an entire relief or ornamental design.

Certain elements of this architectural ornament acquired an exceptional importance in Java, as in the case of the arches that surmount or frame the doorways and niches. By the combination of the *kāla* and the *makara*, noted above, innumerable variants were created. In the most simple form, each curved

band that springs from a side of the head of the central monster ends in a *makara* head holding a pendant in its raised trunk. The heads of the *makara* are thus turned to the outside, but they may be faced in again by a new twist in the bands. The curves formed by the arches are usually very beautiful and are of great size when, starting from the summit of a niche or entrance way, they descend almost to its base. At Candi Kalasan they are almost monumental.

The head of the Javanese monster took on a characteristic look as a result of the breadth of the mask, the absence of a lower jaw, the largeness of the eyes, which were originally round and later spiraled, and the high growth of foliage that springs from the head and gives it a triangular shape. The stairways also became important structural and decorative elements, with the wide curve of their profile, the ornament of the side walls, and the distinctive side rail which began with the open mouth of a monster and ended in the raised head of a *makara* rendered in high relief. In an unusual fantasy, the raised trunk turns into a snake at Candi Merak. On the staircases, as on the arches, the head of the *makara* acquired distinctive characteristics, with its two horns at the base, one of them ornamented with pearls, a pearl pendant, and a motif which appears in its gaping mouth — either one or two figures, a crouching lion, or a bird. The eye, which was at first natural-istically shaped, became a spiral extended by foliage, as in the case of the *kāla*. *Makara* heads are also found on other elements — on the backs of thrones, as in India, or decorating the gar-goyles or *somasūtra*s which prevent the rainwater from dripping down the walls. Among other architectural decorative forms that are typically Central Javanese are the tiny stupas forming pinnacles, and the ornaments or antefixes with triangular tops which are spaced regularly along the cornices or which form angular designs.

The architectural sculpture is of excellent quality. The male and female figures, which were often placed standing against the side walls, borrowed from India the suppleness of their pose and the details of their costumes; for example, the belts, placed one over the other, occurring in the second style of post-Gupta sculpture (7th cent.) and also in Ceylon. However, here the rich ornament mixed and modified the elements taken from India. To the garlands, pendants, and stylized foliage so popular in the post-Gupta style, Javanese art added further motifs derived from the flora and fauna of the island.

Javanese buildings were not always isolated from one an-other; frequently they were grouped according to their partic-ular function, or according to the symbolic or cosmological concepts they embodied. On the Dieng Plateau, a sanctuary and its annexes were often included within the same enclosure; on this plateau and elsewhere stone platforms were sometimes used to support wooden buildings in which the priests lived, very close to the sanctuaries. Generally, though, large group-ings were created by the juxtaposition of sanctuaries and temples placed symmmetrically inside one or more enclosure walls according to a methodical plan. Although these complexes are not so large in general as the Khmer units, they reveal an equal preoccupation with order and logic. The vast monument of Borobudur and the ensembles of Sewu, Plaosan, and Lara Jongrang at Prambanam, in spite of the diversity of their plans, reveal the same careful organization of structures and sculpture to fulfill the same symbolic and iconographic role. Both the Borobudur and the Sewu candis were conceived as mandalas, and the Dhyani Buddhas are placed in niches or shrines oriented in the direction sacred to each. Veritable microcosms, these temples evoke the cosmological concepts of India. The arrange-ment of the sanctuaries at Prambanam is related to the hierarchy established among the great gods of Hinduism and makes immediately clear the primacy given to Śiva.

b. Principal monuments. The Dieng Plateau, situated at an altitude of 6,000 ft. in the north of central Java, contains a veritable Saiva religious city, which was a center of pilgrimage for several centuries. Steles have been found there, some of which are ascribed to the beginning of the 9th century, and there is a final date of 1210 painted on a rock. Of the forty or

so monuments that were built, the ruins of eight survive in the form of the stone foundations which must have supported wooden buildings according to the Hindu custom. The temples are relatively small and separated from one another, but some-times they are found in a group. The so-called "Arjuna group" consists of four principal sanctuaries, open to the west and placed on the same axis; Candi Arjuna, the most important, is located opposite its annex, while Candi Semar, a small build-ing intended to contain cult objects, is situated on another line. Both are enclosed by a wall.

The building of monuments continued throughout the Central Javanese period, but it seems that these on the Dieng Plateau are the oldest and simplest examples; they may date from the end of the 7th century or the first part of the 8th. Sev-eral distinct factors suggest this antiquity. The entrance ves-tibule forms a projection that is almost a distinct unit and hardly relates to the main part of the building, which is noticeably higher. The architectural decoration is generally exceptionally sober; the surface of the walls is often blank or, as in Candi Arjuna and Candi Bhīma, divided into panels by a simple molding. The center of each side is occupied by a narrow, shallow niche. There are two types of superstructure, the com-monest being that which remained in use in central Java — py-ramidal and with a marked setback at each story. The temples of the Pallava dynasty (India), such as the rathas of Mamalla-puram (7th cent.; IV, PL. 254), may have served as prototypes; but on the steps of the pyramid at Dieng, in place of the miniature buildings, there are small square ornamental aediculae which have moldings and are topped by a crowning stone. The other type of superstructure is found only in Candi Bhīma. There the setback of the more numerous stories is less pronounced and the superstructure is proportionally much higher. This type too is borrowed from an Indian system which became fully developed in the shikara, but it was quickly abandoned by the Javanese. At Candi Bhīma, decoration of the roof consists of three arch systems in each story; each arch (*kūḍu*) frames a bust or head in fine high relief. The corners at the higher levels have the circular, bulbous, ribbed, and flattened motif, the amalaka, which ornaments the Indian shikara. Numerous sculptures have been found near these temples; among the most beautiful are those from Candi Banon, which is now destroyed.

East and south of the Dieng Plateau are other monuments, among them the nine little groups of the temple complex of Gedong Sanga. Farther to the south, in the Kedu plain, there are other buildings, most of them Buddhist, but some, con-structed at the same period, Saiva; among the latter are Candi Perot, which contains an inscription dating from 852, and Candi Pringapus.

Candis Pawon and Mendut are situated near Borobudur, to which they must be related, since they are placed on the same axis. Both are fine examples of Central Javanese architecture. Candi Mendut is the bigger of the two. The temple — 43 ft. 7 in. square — rises from a high base which has on the northwest a projection corresponding to that of the entrance vestibule; the projection is reached by a large staircase. This base is or-namented with a succession of panels which contain alternately a regular decoration forming a kind of *jeu de fond* and a balanced but freer design in which one or more real or mythical people or animals are combined with sinuous scrolls of flowers and leaves. Three panels decorate the exterior of each side of the building; the center one generally contains bodhisattvas or images of Tārā beneath a stylized tree and flying figures. In the cella there are three monolithic statues (still *in situ*) about 9 ft. high; two bodhisattvas in a position of ease, Avaloki-teśvara and Mañjuśrī, frame a central figure of the preaching Buddha, seated in the "European" fashion with both legs down. These sober and imposing works are related to Indian post-Gupta sculpture, as is the ornament on the high-backed thrones.

The smaller candi, Pawon (PL. 34), is also symmetrical. On the exterior the center of each side contains a panel with a beautiful design of a stylized tree surrounded by kinnaras (half-woman, half-bird) and flying figures. On each side in a shallow niche stands a male or female figure. The principal motifs of Javanese decoration are grouped in this sanctuary,

where the *kāla* and *makara* and, in the superstructure, bell-shaped stupas are combined.

The most important works of the period are the monument of Borobudur and the great Hindu temple complex at Prambanam built a little later. Borobudur (PLS. 30, 33, 36; III, PL. 485) is a very distinctive building set on an immense pyramidal base, or *prāsāda*, and surmounted by an enormous stupa, the only one of its kind in Java. Borobudur has long been studied by scholars. For many, the esoteric nature of its symbolism (see above) is increased by the fact that the lower story of the pyramid has been deliberately masked by a new terrace placed against the front of the first. The reliefs thus concealed represented evil actions and the hells that corresponded to them, as described in the text of the *Karmavibaṅga*. According to the cosmic conception, this inferior world was situated at the edge of the mountain of iron surrounding the universe, the mountain being represented by the above-mentioned terrace. Some archaeologists believe that this double base is due mainly to a renewal of the foundations, erected so as to consolidate the ensemble; this theory would explain the alterations in the original plan that seem to have been made in the course of the work.

Recent studies by J. G. de Casparis tend to date Borobudur in the years around 825, since the writing of various short inscriptions found on the monuments corresponds to that of one dated 824. The construction and decoration of this vast edifice must have spread over several decades; a span of 35 years has been suggested, though it is not possible to calculate it precisely. An evolution is apparent in certain motifs of the ornament (in the type of *makara* and *kāla*, for example) and in the style of the reliefs. There are many elements similar to those found at candis Mendut, Pawon, and Kalasan, particularly the type of stupa and the appearance of many of the *kāla*s and *makara*s, but other elements are more like those of the later candis of Plaosan and Prambanam.

As restored in 1910 and 1911 by T. van Erp, Borobudur is composed of six layers of square terraces having 36 corners formed by redan-shaped projections, above which rise three circular platforms surrounding a central stupa 17 yd. in diameter. On the platforms are 72 little openwork stupas (III, PL. 485) placed in three ranks. The lowest terrace is about 121 yd. square, and the height of the ensemble (PL. 30) is about 114 ft. In the center of each face a stairway leads to the upper platform and to the intermediate terraces which permit circumambulation, or *pradakṣiṇā*, of the monument. The setback of the terraces leaves a space between them sufficient for a narrow gallery open to the sky, bordered on one side by a parapet and on the other by the supporting wall of the terrace above. This wall is ornamented with relief panels and niches containing Dhyani Buddhas, while the tiny stupas form pinnacles. The various Dhyani Buddhas occupy the niches on the face of the monument, each facing in the proper direction, performing the mudra appropriate to him, and seated in Indian fashion. Thus on the east face is Akṣobhya "calling the Earth as witness"; on the south face, Ratnasambhava with the mudra of giving; on the west, Amitābha in meditation; and on the north, Amoghasiddhi with a hand raised in protection (PL. 30). The statues of Vairocana, Dhyani Buddha of the zenith, represented with the preaching mudra, appear in the niches of the upper terrace and in the interiors of the open stupas on the circular platform. The number of reliefs (PLS. 33, 36) is immense; there are about 1300 panels on the supporting walls of the different terraces and on the inner face of the balustrade. The hells and the lower aspects of life were pictured on the buried story, while on the galleries above were represented the different routes to salvation — some by means of earthly life (the Jātakas and Avadānas), others by means of the celestial worlds. The representations of the Jātakas, or earlier lives of the Buddha, follow the text of the *Jātakamālā*; those of the last earthly life of the Buddha Śākyamuni illustrate the *Lalitavistara* and stop at the First Preaching of the doctrine at Benares. In its interpretation of the *Gaṇḍavyūha*, the second story depicts the travels of Sudhana in search of complete truth: he questions various bodhisattvas, then Śiva and Maitreya, to whose cult numerous panels on the galleries above are dedicated.

The total effect of Borobudur is one of considerable heaviness, for the central stupa seems too small for the immense base that bears it; perhaps the monument does not represent its originally projected culmination. Nevertheless, the excellent qualities of Javanese architecture can be seen throughout. The framing arch at the foot of the staircases (PL. 30) is among the most beautiful realizations of the *kālamakara* motif, which occurs also in profusion as a frame for the niches. The statues and reliefs are incorporated harmoniously into the ornament and into the lines of the architecture. The statues, inspired by Indian post-Gupta models, are heavy and present a puffy appearance peculiar to the Borobudur style, but the reliefs are of exceptional quality.

There are important groups of Buddhist and Hindu monuments in the plain of Prambanam situated farther to the east at what must have been the site of a large town. Many of these monuments belong to the last phase of the Central Javanese period.

According to a stele dated 778, Candi Kalasan was dedicated to Tārā. The square plan is transformed into a Greek cross by wide and deep extensions in the center of each side; three of the extensions served as chapels and the other as the principal entrance, oriented toward the west. Above the first story, an intermediate octagonal story provides a transition to the circular third floor, which originally must have been surmounted by a dagoba or stupa. The images of the cella have disappeared. According to J. L. A. Brandes, the lotus seat and footrest which have survived belonged to a Tārā in bronze; the statue must have been seated in "European" fashion and was about 19 ft. high. Candi Kalasan is most notable for the richness of its ornament, with its friezes and foliage decoration, and especially for the beautiful framing of the doorways and niches of the extensions. At each doorway an enormous *kāla* head, placed very high up and joined to the cornice of the roof, is dominated by a large bunch of stylized foliage amplified by flying and adoring companion figures. From this head descend bands ending in enormous *kāla* heads placed on each side of the door. This motif, on a smaller scale and differently arranged, recurs above the niches of the extensions, where there are more flying figures among plant ornaments. Above the figures is an architectural motif representing a kind of celestial palace of the type very popular in India at the end of the Gupta period and shortly after; this is yet another example of the connection between Javanese decoration and Indian prototypes. There are also large figures in the shallow niches which frame the doors, as well as on the roof stories.

Candi Sari has another form and a different purpose. A rectangular building of two stories, it has a roof consisting of three juxtaposed vaults, at the crest of which are aligned small stupas of the usual type; at each end of these vaulted parts a blind niche surmounts the false windows of the widest façades. By a corresponding tripartite division, each of the two stories has three adjoining rooms, which served as sanctuaries, on the ground floor, and as living rooms, on the second story. The building must have been a monastery, probably connected to Candi Kalasan. The windows and blind windows are topped by pediments and framed by standing figures, which are often extremely elegant and supple.

The complexes of candis Sewu and Plaosan, though both Buddhist, follow different schemes. Candi Sewu, or the so-called "Thousand Temples" (PL. 34; FIG. 62), which remained unfinished, is a vast ensemble of 250 separate constructions. Conceived as a mandala, it extends over a rectangular area surrounded by a wall, which is pierced in the center of each side by a passage framed by two *dvārapāla*s (temple guardians) with the terrible aspect of rakshasas. The large central temple dominates four series of small temples or shrines, placed so as to form four concentric squares on terraces of gradually decreasing height. The temples in the square nearest the center were dedicated to Vairocana, Dhyani Buddha of the zenith, while in the other squares the other Dhyani Buddhas were represented, the temples being oriented toward the cardinal point appropriate for each. The arrangement is thus similar to that at Borobudur, but here the entrances of the temples forming the third and fourth squares are placed facing each other, instead

of facing uniformly in the same direction on each side. The ample space between the third and fourth squares forms a courtyard in which, along the axial paths, two temples were placed; in this way monotony was avoided in spite of the regularity of the plan. The principal temple is in the form of a Greek cross, with its entrance vestibule and the chapels on the three sides opening both toward the outside and into a corridor that leads around the interior cella. Access to the cella is gained only by means of a door opposite the entrance vestibule, on each side of which there are three magnificently decorated niches with capitals in the form of kālā heads, pilaster bases in the form of a vase, and a beautiful motif of lotus flowers. This principal temple, similar in its arrangement to Candi Kalasan, also had in the superstructure an intermediary story supporting a large stupa. The statues in the niches and sanctuaries were numerous, and there must have been a very large statue in the cella. Outside the walled enclosure, an axial path led from each passage to an anterior temple. The remains of two of these four temples have been found at a distance of about 330 yd.: to the south, the foundation of Candi Bubrah, and to the east, Candi Asu, probably dedicated to Kubera.

Candi Lumbung, situated about a half mile to the south of Sewu, is of similar type, with a principal temple and 60 smaller temples laid out in a square.

Candi Plaosan belongs to the end of the Central Javanese period. It is composed of two rectangular edifices, which are divided into three sanctuaries. As at Sari, each must have had a floor used as a residence for monks. The two buildings of the monastery are surrounded by a rectangle of small temples and a double row of little stupas that were probably built to contain the ashes of dead monks. There are also other rectangular groups of small temples and stupas nearby.

The complex at Prambanam, Lara Jongrang, is the finest and most important Hindu monument from the end of the Central Javanese period. It seems to have been built at the same time as Plaosan, in the second half of the 9th century or the beginning of the 10th. Some of its characteristics anticipate those which appeared later, during the Eastern Javanese period. Prambanam, too, is a vast complex of large and small temples surrounded by several rectangular ramparts. Inside the first rampart the central group consists of three main temples placed side by side, dedicated to the three great gods of Hinduism. Opposite each building, somewhat to the east, are three secondary temples consecrated to the mounts of each of the gods. At each end of the intervening space stands a smaller temple. Outside the rampart of the central group and at a slightly lower level are three concentric squares formed by 156 small temples. This grouping is surrounded by another rampart, and at some distance the vestiges of a third have been discovered; this also had entrances on each of the four axes of the square.

Of the three main temples, that of Śiva, placed in the middle of the row, is clearly more important than those of Brahmā and Viṣṇu on either side. The plan of these buildings is a square with projections. The latter are particularly accentuated in the temple of Śiva, where three chapels and the entrance vestibule jut out, as at Kalasan and Sewu. The temples rise on a high pyramidal base. The terraces have a parapet-balustrade ornamented with niches and panels on the exterior and with reliefs on the inner face. A high point in architectural technique seems to have been reached in this Lara Jongrang complex, where the execution was exceptionally refined. Transformations and new tendencies that later increased began to appear here. Not only are the main temples raised on a high base, but the two smaller buildings as well. This elevation modified the appearance of the staircases, the profiles of which nevertheless remained curvilinear. The Śiva temple is divided into two false stories by a thick, flat molding, and the superstructure is proportionally higher than in temples of the type represented by candis Mendut and Pawon — tendencies which later developed further. The setback is still clearly marked, and the platforms thus created are filled with a series of aediculae, the shape of which seems to have been inspired by the modified stupas to be seen in Candi Sewu in similar positions; they consist of a bulbous, ribbed element on a tall, square base, topped by circular moldings and a cylindrical

finial recalling a linga. The same motif is used for the crowning stone of the temple.

The sculpture and ornament are as fine as the architecture. The temples and niches contained numerous statues corresponding to the many forms in the Hindu pantheon. In the central cella of the temple consecrated to Śiva Mahādeva, there is a large statue of the god on a pedestal with a waterspout for ablutions. The bull Nandi — from the sanctuary dedicated to him — is also an outstanding and beautifully balanced work. The decoration on the bases of the main temples is very symmetrically arranged. On the lowest level there is a series of panels divided into three parts; a central niche with a crouching lion is flanked on each side by a stylized tree between two mythical or real animals. Elsewhere, statues of divinities and groups of figures alternate, the former shown motionless, the latter in animated postures. In this decoration the tendencies of the two successive Javanese periods may be seen juxtaposed: supple and elegant figures with serene, gentle faces, similar to those at Borobudur, were represented side by side with figures of a quite different type, characterized by expressions and movements that are sometimes almost violent — precursors of a style which was to be seen later.

c. Sculpture. Javanese sculpture was abundant at all times but particularly so in the Central Javanese period, when figures were blended into the total architectural scheme. The sculpture, whether in stone or bronze, was usually of excellent quality, revealing a high level of technical skill. Like the architecture, it clearly shows the influence of Indian prototypes. The discovery in Java, Celebes, Borneo, and Sumatra of bronze and some stone images connected to the Amaravati and Gupta styles proves the penetration of these influences before the flourishing of art in central Java. These works were either imported from India or copied as closely as possible. Among the stone sculptures reproducing Indian models are two works found in Sumatra: a large Buddha, 11 ft. 9 in. high, found to the west of Palembang, which must have been carved at Bangka (5th or 6th cent.) in the Amaravati style; and a standing life-size Buddha, found at Jambi, still rather crude but showing Gupta characteristics. There were successive waves of Indian influences, but it is often difficult to determine exactly the origin of tendencies appearing in Indonesian art, as a certain parallelism existed in different sites in India in the same epoch. The influence of the Pala style, and later the Sena, seems to have been particularly strong. A refinement, even a certain preciousness, a spirituality that idealized the forms, a moderation and sweetness tending to become conventionalized — these are characteristics which are found in common in the art of Bengal and of Java. Many details were transmitted from one to the other, such as the random undulations of the Brahman ribbon and the long necklaces which hang across the chest, the roundish modeling, the curved lines of the silhouette, and the bulging appearance of the body. The parallels are numerous in the bronzes too: the casting technique; the types of nimbus and throne, with a similar treatment of the symbolic animals that decorate them; and even, in many cases, the repetition of the same motifs, such as the lion mounted on an elephant. After the establishment of the Buddhist university of Nalanda in Bengal and Nepal, which remained centers for the development of Tantric Buddhism, Ceylon held a great attraction for Buddhists and was an object of pilgrimage, and consequently the influence of its art was felt in Indonesia. Equally noticeable is the spread of Gupta and post-Gupta styles as a result of the transmission of forms developed both in Buddhist sites (Ajanta, Ellora, and others) and in Hindu localities of the Chalukya and Pallava dynasties (Mammallapuram, 7th cent.). The combination of a monster's head with the *makara* had been made at Ajanta before it occurred in Java. Some of the costume details (e.g., jewelry decoration, the metalwork belts, and the curving bands of tucked-up cloth) depicted in Java and Sumatra came from India. These borrowings from Indian civilization were both varied and important; they are revealed not only in the iconography and the costume but even in the furniture and musical instruments depicted in the reliefs.

As already noted, however, Indonesian art quickly asserted individual qualities. Throughout the first period these qualities are those which emanated from architecture: harmonious proportions, elegant form, balance between structure and the decoration — in short, the spirit of restraint characteristic of Javanese art (which, however, tended to diminish toward the end of the period, especially in the reliefs of Prambanam).

In addition to its religious purpose, sculpture in the Central Javanese period played a dominant part in the decoration of monuments, and the numerous large statues are integrated perfectly into the architecture. The works are grouped according to various types, but the same tendencies recur. The objects in stone (chiefly volcanic granite) include cult images and niche statues in the cellae, chapels, and small temples; isolated figures and groups in the round used for decoration and for religious purposes on the outside walls; scenes depicted in relief on balustrades and supporting walls (at Borobudur and Prambanam); and various celestial and ascetic beings that often appear in the ornament (gandharvas, apsarases, rishis). Among the bronzes there are large cult images (such as the Tārā of Kalasan); of the many medium-sized and small statuettes in bronze, only cult objects have survived, all executed with great care. The bronzes were cast by the lost-wax process and show a high level of technical skill. Their greenish patina is exceptionally beautiful, and the refinement of details is often exquisite.

Among the large stone statues executed in the round, those in the niches at Borobudur and the three cult images from Candi Mendut belong to the Indian post-Gupta tradition. The heaviness of the form, with its rather overblown quality, connects the Dhyani Buddhas of Borobudur with those added at about the same period to the façade of Cave XIX at Ajanta (q.v.). The imposing size of the sculpture at Mendut brings to mind the Buddhist statues of Ellora (7th cent.), but there is a restraint in treatment and a balance in proportions in the Javanese works which makes them much finer. The feeling for volume found in Indian sculpture reappears in Java, together with the predilection for creating images in the stele form, a preference which led to a flattening of the figures and their poses. Many works from the Dieng Plateau are among the most beautiful of this period — for instance, the heads from Candi Bhima, whose restrained expressiveness gives them the quality of portraits, and the images of the great Hindu gods from Candi Banon, among them Brahmā, Śiva, and Viṣṇu, shown standing with their mounts in the background. Refinement and elegance are the dominant qualities of these works, which are notable for the serenity of the faces, the naturalness of the attitudes (frontal but without stiffness), the simplicity of the supple modeling (rounded but without heaviness), and the richness of adornment. The last is abundant; there are diadems, necklaces, armbands and bracelets, and various kinds of belts with beautiful clasps. This finery adds a note of superfluity to the effect, but since the ornamentation is incised, it does not encumber the figure or spoil the main lines of the silhouette. The same delicacy is evident in such costume details as knots with the ends falling symmetrically from the belts, and a narrow scarf that hangs across the body. These characteristics of the Candi Banon statues also occur in other works of the period.

A similar idealization of form and softness of modeling, and the same slightly pensive, kindly smiling faces are to be found in the reliefs and in the decorative wall sculptures — such as those at Candi Sari — which were often posed in the subtle *tribhaṅga* attitude. But on the bases at Prambanam, alongside groups of figures of this type where the elegance is perhaps overly conventionalized, there are also others of a different type, in less graceful but more natural attitudes, more lively, with less poetic but more intense expressions. These two types apparently coexisted in this way from the end of the 9th century, both persistently reappearing in the art of eastern Java.

Other works of the Central Javanese period must also be noted, some that were found in Borneo and many fine examples discovered in Sumatra. The sculpture of Sumatra resembles the art of both Pala and central Java; the stone and bronze images display similar characteristics, with similar details of costume and ornament. The attire, despite its simplicity, still retains its importance and purity of form. These characteristics are displayed in a life-size Lokeśvara that is exceptionally restrained, from Bimgin (Djakarta Mus.), as well as in a group of much smaller bronze images, found near Palembang, representing Śākyamuni, Maitreya, and Avalokitésvara. The bulging chests of the two bodhisattvas connect these statues with the Pala style. Other works seem to have undergone Pallava influence.

The reliefs of Borobudur and Prambanam show the typical tendencies of the Central Javanese style and, at the same time, the evolution that was beginning to occur toward the end of the period. At Borobudur (PLS. 33, 36) they are arranged in a long succession of panels on the balustrades and supporting walls of the different terraces. In the first gallery, two rows arranged one above the other fill the entire wall; devoted to the last earthly life of the Buddha, to his earlier lives (Jātakas), and to pious legends (Avadānas), they constitute the finest group. At Borobudur, as in India, the relief is quite deep and reveals the same feeling for rounded forms. The designs are clear and often skillfully composed, with subtly balanced groups of figures, architectural elements that are always seen from the front, and trees with perfectly vertical trunks to set off the scenes. Trees and architecture are diminished proportionally according to the space available. The protagonists of a scene stand out, not by means of an increase in size but by being isolated, often raised on a platform or a throne, or sometimes framed by a canopied dais or an architectural element. Frequently a small pavilion was chosen for interior scenes. Other figures were grouped in immobilized poses; the secondary figures, pressed against one another, in many cases functioned only as a filler. The compositions are not overloaded, and there are even some empty spaces preserved. An impression of soothing calm and softness emanates from the reliefs because of the grace of the figures and the elasticity of their movements, which are never extreme. A poetic atmosphere of an idealized life is created by the languorous grace of the poses, by the serene, smiling, sometimes pensive expression of the faces, by the abundance of scenes of court life, and by the beauty of the setting for the various episodes. An idyllic charm pervades the landscapes, where animals are commingled with foliage: a ewe and its lamb romp on the grass, small animals climb along the conventionalized rocks or swim among lotuses, and birds fly among trees or perch on them. The love of nature that shows itself here remained a characteristic of the relief sculpture, in which landscape was to become more and more important. Although life was embellished and transformed, reality also found a place in the art of Borobudur, which was often human and sensitive. Many of the gestures and postures are natural, apparently having been closely observed in nature; the poses and facial expressions reveal acute sensibility. Also represented with precision are the details of everyday life, such as high-roofed houses of a particular local type and boats with sailors busy in the rigging.

The reliefs of the upper stories at Borobudur, devoted to the search for truth by Sudhana and to the cult of Maitreya, are rather different in style. The compositions are more crowded and the groups not so connected. Perhaps because of the variety of subject matter, architectural elements sometimes abound at the expense of the human figure, or again some scenes depict daily life more faithfully and the poses become more exaggerated. Perhaps some of these reliefs were executed later and mark the beginning of a change in style.

This evolution is seen clearly in the reliefs of Prambanam, where the more dramatic episodes of the legends of Kṛṣṇa and Rāma are depicted. Some of these reliefs are similar to those of Borobudur, while others are completely different. In the panels spread along the inner face of the balustrades many scenes are grouped, often following one another without divisions. The compositions, which are fuller and sometimes overcrowded, are generally less clearly arranged. The scenes give an impression of strength, roughness, and violent energy. Although some of the persons, such as the hero Rāma and his

brother, retain the idealized appearance seen at Borobudur, the type is cruder — the bodies are more contorted and their movements more stressed. Many of the faces have a distinct hardness, are of a different physical type, and often have aggressive and frightening expressions. The calm compositions of Borobudur, where horizontals and verticals predominate, were succeeded here by tumultuous groupings in which the figures are intermingled with animals and landscape, and the settings increase in importance; if there are masses of flowering trees, their trunks and roots are twisted and interlaced. Some of the figures take on a fantastic and even cruel appearance; such are the rakshasas, demonic giants fought by Rāma, and even sometimes the monkeys, his allies. The earlier grace is still found in some female figures, side by side with an aggressiveness that may be suggested even by the landscape itself or by grimacing sea monsters (as in the episode of the ocean stopping the monkeys before the island of Lanka). A realistic note distinguishes familiar scenes, which become more numerous, and the representations of everyday objects and local types of houses begin to multiply. A more popular and indigenous character thus seems to emerge in many of the episodes, where the protagonists, as a rule, no longer wear the rich diadems and ornaments of the court scenes of Borobudur. The same evolution is found later in the reliefs of Djalatunda.

Eastern Javanese period. After the center of the island was abandoned, for reasons that are still uncertain, eastern Java became the center of culture under the kingdoms which followed successively from the accession of Siṇḍok (ca. 929) until the arrival of Islam. Building seems to have been less active at first but intensified in the 13th and 14th centuries, especially in the period when the capital was first at Singhasāri and then at Majapahit; a decline seems to have set in at the beginning of the 15th century. During this period the dating of monuments is much more precise, for usually the name of the dead king to whom they were consecrated is known.

a. Architecture and its decoration. Differences between the monuments of this and the preceding period are clearly apparent, even though a continuity can be detected. There was a change in the purpose of the monuments which corresponded to a change in beliefs: the majority of the temples now built were Hindu and only a few Buddhist, and even in those few Buddhism was mixed with Saivism (as at Candi Jawi, dedicated to the cult of Śiva-Buddha). The funerary character is of even more importance in the monuments and sculpture than in those of the first period; not only the temples serve as mausoleums but also the bathing places, which sometimes have an architectural decoration and are embellished with sculptures, as at Djalatunda, Belahan, and Candi Tikus. The use of brick, which was almost standard in eastern Java, modified the appearance of the buildings. A transformation is also evident in the form of the sanctuaries and their component parts, in the concept of the total ensemble, and in the changes brought about in the ornament.

In spite of such differences, the derivation from the monuments of the Central Javanese period can always be discerned. The plan of the sanctuaries is in general the same; the square plan with an entrance on only one side predominates, though there are often false gates on the other sides. Sometimes the square plan was transformed into a modified Greek cross, as in Candi Singhasāri. The three distinct parts of the building were retained, but the effect of height was increased by proportionally raising the various components: the base, which projects very little, the temple itself, which is divided halfway up by a flat band varying in width and thickness, and especially the superstructure, the silhouette of which is transformed. The change of proportions was accomplished, however, without any loss of harmony.

The setback of the successive stories, which were more numerous, was less accentuated; often only superimposed moldings of flat bands were used, ornamented with acroteria at the center and at the corners. The crowning stone takes the form of a cube, and a similar member is found at the apex of the niches,

as in Candi Kidal. The silhouette of the stairways, high and projecting slightly, is completely changed. The broad curve of the thick balustrade, typical in central Java, gives way to a flat vertical band, scarcely rounded at the top and ending at the bottom in a flattened spiral. There, as elsewhere, the *makara* in very deep relief, so popular in the Central Javanese style, was abandoned, although gargoyles may appear. The customary arcade joining the *kāla* and the *makara*, which had known so many variants, was no longer used. Framed by a flat band, the narrow niches and doors became quite rectangular and were surmounted by a flat horizontal projecting slab which forms a lintel. The doorways are thus separated from the immense *kāla* head which continues to surmount them and which is attached to the cornice supporting the superstructure. Quite exceptionally, the temple of Nāga at Panataran retained a decoration in high relief, with large figures supporting the undulating bodies of serpents, but elsewhere the numerous figures which played both a decorative and a religious role in central Java did not reappear. Often long rows of reliefs of a uniform depth were set in the high bases (e.g., Candi Jago). In general the ornament remained abundant on the frames of doorways and niches and on the various bands. Though the erect lions of Candi Kidal were the successors of those of Candi Ngawen, and derived from India, more and more the motifs borrowed from Indian art gave way to different ones. In the medallions, for example, fantasy still mixed with a certain naturalism characterizes animals and various beings treated in flat relief, but their bodies are transformed by the use of curved strips and hooked spirals (Candi Panataran, Candi Kidal, and others).

The high bases of several stories supporting a building were still used (as in the central sanctuary of Panataran), but often they had variations, such as the lengthening of the square plan so that it became rectangular. At Panataran (PL. 35) the various monuments are arranged on terraces placed successively one behind the other; a certain symmetry is retained in the disposition, but it is only approximate. The great centralized groups in regular ranks, usual in central Java, were employed no more. Instead there were modified or new forms, such as the double stairways placed either parallel to the façade or on each side. The doorways followed the evolution of the temple architecture, which they reproduced in a simplified form. Two types can be distinguished: in one the opening of the entrance is covered by a roof; in the second the superstructure is interrupted above the entrance, so that the doorway is "cut out" and appears as a narrow passage between the two halves of the temple. The bathing places took on importance (Candi Tikus) and were connected to the temple groups (Panataran).

b. Principal monuments. Few buildings seem to have been built before the 13th century, or at least very few have survived. Among the remaining examples are the foundations of Gunung Gangsir, of Djalatunda, and of Belahan. Several monuments in Bali also go back to this time.

Candi Gunung Gangsir dates from about the middle of the 10th century. Built in brick, it continues the Central Javanese style, but an Eastern Javanese character is introduced in the height of its base, which projects very little and consequently did not permit circumambulation.

The royal bathing place of Djalatunda appears to have been the sepulcher of King Udayana, father of Erlanga (Airlangga). An inscription bears a date corresponding to A.D. 977. On one side of the rectangular bathing place is enclosed a terrace on a higher level. In the center of this, water channeled down from the mountain falls on the sides of a linga (the symbol of Śiva) and is then fed into the lower basin by gargoyles. The reliefs decorating the edges of the terrace refer to the legend of the five Pāṇḍava princes, and in particular the story of the last, Udayana. The style of the reliefs is unusual. (According to Bosch, they were influenced by works in terra cotta.) Certain details connect them to the reliefs at Prambanam, but they show a further stylistic evolution. The landscape becomes pervasive; flowers and foliage, only slightly stylized, display a fine naturalism, whereas other elements such as the rocks and clouds are quite conventionalized. This domination by nature seems

to correspond to a revival of the animist beliefs of the old Indonesian culture.

Another royal bathing place, that of Belahan, is the mausoleum of King Erlanga, which must go back to the middle of the 11th century. In the niches there still exist beautiful statues of Lakṣmī and Śrī, who pour the water into the basin. Also belonging to this complex is an excellent portrait statue of King Erlanga in the form of Viṣṇu mounted on the bird Garuḍa, a work which combines the styles of central and eastern Java.

The complex of Tampaksiring in Bali belongs to the 11th century. The funerary site consecrated to the youngest brother of Erlanga and his family, it consists of a cloister and a dozen candis sculptured in high relief in the rock to look like the constructed temples.

Building became more frequent during the 13th and 14th centuries, when the capitals were successively Singhasari (after the death of Ken Angrok in 1227) and Majapahit (14th cent.).

Candi Kidal is presumed to be the funerary temple of King Anūshapati, who was the son of Ken Angrok and who died in 1248 (FIG. 77). While deriving from the past, this monument shows clearly in its tall proportions and in its ornament the tendencies of the Eastern Javanese style. New and old features are juxtaposed; medallions decorated with an engraved motif (as at Panataran) can be seen on the main part of the edifice, and supporting lions are found at the corners of the base, as at Candi Ngawen of the first period. The superstructure, which is particularly high, encloses a square chamber located above the interior cella but completely closed and inaccessible. This second room, probably intended only to lighten the superstructure, is sometimes found in buildings of great height and size.

Candi Jago is a Buddhist monument consecrated by King Kṛtanāgara to his predecessor Viṣṇuvardhana, who died in 1268. The arrangement of the terraces supporting the temple is exceptional: the square base of the sanctuary is placed on two high rectangular platforms, which are very much extended in front; access is provided by two lateral stairways. The Indo-

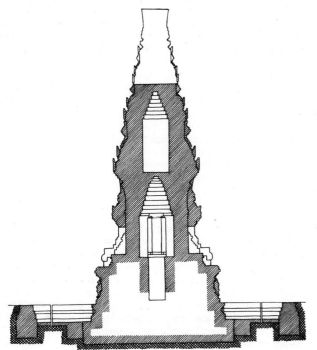

Java, Candi Kidal, section (*after W. F. Stutterheim, 1927*).

nesian character of the ornament and of the long rows of reliefs is marked. The figures, which are in very shallow relief, are depicted in silhouette. An image of King Kṛtanāgara appears in the cella. The principal image was an Amoghapāśa with eight arms, placed among representations of various Tantric Buddhist divinities.

Candi Singhasāri was associated with the posthumous cult of King Kṛtanāgara, who died in 1292. This temple had a more complex plan (FIG. 78). It rests on a particularly high base and is surrounded by four smaller sanctuaries, each placed at the middle of one side of the base. The principal cella occupies the center of the base and is thus on the same level as the cellae

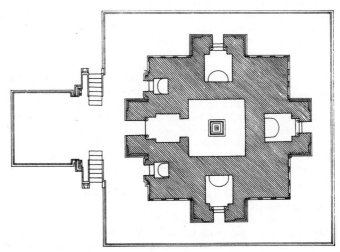

Java, Candi Singhasāri, plan (*after K. With, 1920*).

of the four secondary sanctuaries. In this unusual arrangement, with the cella in the base, the temple itself contains only an upper room that is inaccessible. The numerous sculptures of this Saiva monument are of fine quality and show clearly the persistence of influences of the Central Javanese style.

The complex of Panataran (PL. 35) is the most important of the eastern part of the island. Its construction was probably spread over several centuries, since the inscriptions bear dates ranging from 1197 to the 14th century, but most of the buildings must belong to the end of the 13th century and to the 14th. The complex, which is enclosed by an irregular wall, is composed of three parts lying one behind the other. In addition to stone bases, some richly decorated, there have survived the small "dated temple" (an example of the typical architecture of the period), the lower part of the beautiful temple of Nāga, and, at the very back, the high, multistoried pyramidal base of the principal temple. This was built a little later, in the 14th century, and the body and superstructure of the temple have disappeared. The plan of the base is a square with projections and a central extension on the lowest story of each side. This extension is more pronounced on the façade, where it is flanked by two stairways.

The abundant decoration of the monuments at Panataran is very characteristic of the tendencies of the period. The terrible beings with demonic aspect and the rakshasas in the round, which are placed, crouching or upright, on the sides of the stairways and the entrances, have become the customary guardians of the sanctuaries. The base of the main temple exhibits varied elements and motifs. On the outer face of the lower story, ornamented medallions alternate with rectangular panels containing reliefs with figures. A long row of bas-relief scenes stretches along the second story, above which are spaced fine ornamental motifs sculptured in high relief; a lion support alternates with the forepart of a serpent with head raised, and both creatures are framed with wings in shallower relief — a motif which was to increase in popularity.

In the bas-reliefs, flattened figures in angular attitudes are treated with uniform modeling. There, as elsewhere, their Indonesian aspect and the violence of the rakshasas contrasts with the idealized images of the sanctuaries, where for the most part Central Javanese traditions survive in spite of modifications. The medallions of the lowest story of the base are incised, as are some rectangular panels which illustrate episodes of the *Rāmāyaṇa*; the people or animals, the fantastic elements of the decoration or landscape, which are very stylized and

unreal, are shallowly cut on a flat ground and are silhouetted like the marionettes, or wayang, of the shadow theater. The exuberance of the ornament and the sometimes exaggerated attitudes of the entangled figures are happily counterbalanced by the cleanness of the moldings and cornices and by the sobriety of the undecorated parts. The main lines of the architecture and the decoration are thus kept clearly distinct and balanced. These qualities are also found in the monuments of the following epoch: Candi Jago, Candi Jabung, and others.

Candi Sawentar, which is undated, was probably consecrated to Viṣṇu, judging from the sculpture found there. Its proportions and the appearance of the various elements are typical of the sanctuaries built in the Eastern Javanese period under the Majapahit dynasty. The winged ornamentation, which was to become more popular, appears here on the sides of the stairway.

Candi Tikus, a royal bathing place, seems to belong to the 14th century. A monumental staircase descends on one side into the large quadrangular basin, in the middle of which there is a vast platform supporting a whole complex of little candis.

Candi Jabung, a Buddhist temple, contains an inscription of 1354. The body of the building is of an unusual type, being circular, with one real and three false doors; it is placed on a high base with projections.

There are other temples of which only the bases have survived; such is the case with Candi Kedaton, which was surrounded by terraces, and Candi Surawana, a funerary building for King Wengker, who died in 1388.

In Sumatra, while some monuments existed before the Eastern Javanese period (a fact proved by the sculptures and remains of ornament which correspond to the Central Javanese style), the existing ruins go back only to a period from the end of the 11th century to about the 14th. The ruins are sufficiently important to reveal the character of Sumatran architecture, in which brick was used almost exclusively. The forms developed in central Java continued — the bell-shaped stupa; the wall marking off the sacred area; the sanctuaries with a square plan and a doorway, sometimes set forward, on one of the sides; the pyramidal roof supporting a crowning stupa; the little stupas on the stepped terraces; and the stairway with balustrade ending in a makara head. Many of the Sumatran buildings were built before the great period of construction in eastern Java, but they are related to the Eastern Javanese style by certain details: in particular, the use of rectilinear moldings with angular cross sections for bases and cornices, and the presence of rakshasas with similar aspect beside the stairways. Some local forms were developed in the island from time to time, and the decoration of the monuments seems to have remained more sober than in Java.

The first mention of the site at Jambi goes back to 664, but the remains of buildings that have been found are scarcely older than the 11th or 12th century; their number shows that these temples must have been part of a large city. At Sungei Langsat, a base in the form of a Greek cross indicates that the evolution of architectural forms was similar in the two islands. An older base, in which moldings with a curved cross section alternated with angular moldings, had been overlaid by later masonry in which only angular cross sections were used.

Parallels with Javanese architecture can also be seen in the complexes of Muara Takus, farther west, and of Padang Lawas, in the northwest of the island. At Muara Takus ruins dating from the 11th and 12th centuries, according to F. M. Schnitger, are grouped in the same enclosure. The most important monument was a stupa, of which the circular molded foundation alone remains. This stupa stood on a base which itself was supported by a double extended terrace. Other buildings of the same group have notable features. The Maligai stupa is especially unusual. Probably the tomb of a Sumatran king, it looks like a very high tower of red brick raised on a projecting base. The badly damaged upper part was a bell-shaped dagoba having four crouching lions at the base. The neighboring terrace of Candi Bungsu supported a large stupa surrounded by smaller stupas, a grouping which recalls the upper terrace of Borobudur on a reduced scale. At the end of the same platform stands the base of another stupa, in which was found, together with gold

leaf and some cinders, a gold plaque with an inscription that F. D. K. Bosch has dated in the 12th century.

The region of Padang Lawas contains 16 sites, the majority of them Buddhist, as is usual in Sumatra, though a few were Saiva. The most important group, Si Pamutung, had four sanctuaries in the same enclosure; the principal one is the largest on the island. The construction of the monuments at Padang Lawas extended from the 11th century to the 13th or 14th. The reliefs on the base of Candi Pulo are in a style clearly later than that of the sculpture of the other sanctuaries. In the various ensembles the buildings, usually sanctuaries with square cellae, are raised on one or two terraces ornamented with panels. These terraces are not very high but are sufficiently wide to permit circumambulation. The superstructures, which consisted of several stories, were square, octagonal, or even circular. Small stupas were placed on each level, and a tall one crowned the building. Large makara heads, accompanied by rakshasas and sometimes by lions, terminated the projecting stairways. These buildings seem to have been more sober and more austere in effect than the Javanese buildings; the proportions are very subtle and give an impression of imposing size, although the dimensions are actually quite modest.

c. Sculpture. During the Eastern Javanese period sculpture was still abundant; cult images were numerous in the cellae and chapels, and relief panels were the usual ornament of the stepped bases. However, large decorative figures no longer appeared on the main structures. Despite an evolution, the traditions of the Central Javanese style persisted in the images of Buddhist and Hindu gods placed in the interiors of the sanctuaries. There was also a partial renewal of Indian influence; contacts with the continent remained lively, and new influences spread to the islands. At the same time a recrudescence of indigenous beliefs can be detected, manifested especially in the Indonesian appearance of secular figures and of the female figures ornamenting the bathing places (the figures in the museum of Mojokerto, for example) and in the violence and fantasy of the rakshasas which guard the entrances. This reappearance of native elements shows itself still further in the numerous bas-reliefs — in the types of people and the more awkward groupings, in the importance and appearance of the landscape, and in the fantastic elements which invade the panels and rob the human figures of their primacy.

The funerary character of many of the images was better established than in the preceding epoch. They usually represented a Buddhist or Hindu divinity with whom a dead king or a member of his family was identified. The gestures and attributes are those of the god, but the suggestion of the deified human appears in the face, which tended to become an idealized portrait. Belonging to this group of funerary works is the superb statue of Viṣṇu mounted on Garuḍa, coming from Belahan and dating from the beginning of the period (11th cent.). A statue of the consecration of King Erlanga, it combines opposed tendencies: those inherited from central Java and those which were now growing in importance. Viṣṇu, with the features of Erlanga, is seated in serene majesty on an enormous, aggressive Garuḍa. In a departure from the Indian tradition, which was more closely followed in central Java, the head of the previous types of Garuḍa, with its hooked beak, is replaced by a monstrous head with open jaws. Use of this new type continued, at Candi Kidal and Candi Kedaton, for example. With wings outspread, trampling and grasping serpents, the mythical bird has become an unleashed force, a fantastic animal which anticipates the fabulous and terrifying monsters still kept alive by the Balinese theater.

This presentation is fairly rare, however. In the Singhasāri and Majapahit styles, the figure of a deified king is set back against a high stele. The king-god, often with multiple arms, stands in a strictly frontal attitude and holds the appropriate attributes. Sometimes the face is cold and inexpressive; in the poorer pieces the posture is often rather stiff and awkward, and the proportions become heavy. Although the Central Javanese traditions can still be discerned, the elegance and unity of the form often have disappeared. The diadem, treated in

very high relief, weighs down the head; the jewels and the details of the costume — too numerous and too prominent — break up the surface unity. Many of these sculptures, nevertheless, are of excellent quality; among them are the more supple Buddhist figures of Candi Jago, which display in their faces and gestures of adoration a softness and spirituality (the stele of Sudhana, for example). Another fine work is a replica of the main image of Candi Jago, an eight-armed Amoghapāśa surrounded by Tantric divinities, which was sent to Sumatra in 1286 and consecrated anew by the Sumatran king Ādityavarman in 1347. The seated Prajñāpāramitā of Candi Singhasāri is very pure in form and of a rather frozen elegance, but in its perfect meditative serenity it reflects the mystical aspects of the beliefs. According to tradition the features are those of the wife of the first king of Singhasāri (first quarter of 13th cent.). On the tall steles the large standing image is framed in designs. In the Singhasāri style (13th cent.), the leaves and flowers of a lotus stem climb up each side to the top of the stele; this stem seems to spring from a bulb or from a vase, which is sometimes masked by two small figures. In the Majapahit style the background is simpler: short parallel superposed lines form a serrated halo that surrounds the image, the stiffness of which is often even greater than in the Singhasāri style.

In the sculpture of the cellae and chapels the many aspects of the Indian pantheon reappear: Hindu forms (especially Śaiva), and the forms of Tantric Buddhism, which is here very much mixed with Śaivism. In accordance with the beliefs of the sovereign who consecrated them, the steles and bronzes depict Śiva, Pārvatī, or Durgā as often as Viṣṇu and Śrī, or Harihara, who combines Śiva and Viṣṇu. Also represented are the Dhyani Buddhas, the bodhisattvas, and Tārā. Among many others, the works from Candi Singhasāri deserve to be mentioned. They are of fine quality and reveal the varied forms and tendencies in religious sculpture of the period. The Prajñāpāramitā in the Leiden Rijksmuseum voor Volkenkunde comes from this monument. Quite different is a Bhairava (the terrible aspect of Śiva), which is a portrait statue of King Kṛtanāgara, who encouraged this form of Śaivism. This statue — also in the Leiden Museum — represents a four-armed Śiva dancing on a pedestal surrounded by heads of the dead. His face is demonic, with bulging round eyes and two fangs emerging from his half-open mouth. Śiva's macabre and bloody trappings influenced the representations of Tantric Buddhism, which borrowed many forms from Śaivism in Sumatra as well as in Tibet. Skulls form Śiva's diadem and ear pendants, severed heads are threaded on a long necklace, and the god holds a cup shaped like a monster's head and a knife in the form of a *vajra* (thunderbolt). But this violence is tempered by the balance of the whole piece and the lack of vigor in the movement. The two feet placed on the ground retain the attitude which was used for the cosmic dance of Śiva in India prior to the mid-7th century, when it was abandoned for another that was more dynamic.

The spirit of moderation inherited from the Central Javanese style also permeates other statues: in the theme of Durgā whose *élan* is subdued (also from Singhasāri); in the Gaṇeśa of Bara, where preciousness is mixed with the macabre; and in the two-armed Bhairava of Sungei Langsat (14th cent.). In this last piece, which comes from central Sumatra, an immobility of pose and a roundness of form diminishes the effect sought in the portrayal, which is probably that of the Sumatran king Ādityavarman, who was initiated into the Bhairava sect in his youth during a stay at the court of Majapahit. In the terrible aspect of the Bodhisattva Mañjuśrī, with a small statue of Dhyani Buddha Akṣobhya in his high coiffure, the deified king is standing on a pedestal surrounded by skulls, and under his feet he crushes a human being. He is richly adorned: among the strings of pearls in his belt a monster's head thrusts forward, and his dress is bestrewn with skulls and crescent moons; serpents serve as ear pendants and encircle his arms and ankles.

A more dynamic sculpture is a dancing Heruka from Bahal II (Padang Lawas group, Sumatra), superbly carved in high relief in a panel on the base of a sanctuary. The supple and harmonious pose is close to Indian prototypes. This statue of a god particularly popular in the Vajrayāna sect is compared by F. M. Schnitger to works of the same kind in Bengal and Bihar, and because of the similarities he dates it in the 10th century. The head of a rakshasa in another sanctuary of Padang Lawas is beautifully proportioned. In contrast, the leaping and dancing figures on a base from the same complex (a 13th-cent. work in the stupa-shaped sanctuary of Pulo) show a verve and vigor which are much more uncontrolled; the grotesque heads, the hooked motifs that fill the background, the treatment in shallow relief, and even the style of the figures all spring from a different spirit and from tendencies that are more local and more popular. Such tendencies are found in some statues of stone and a few in terra cotta (particularly personages and rakshasas at entrances), and they are marked in the female figures that pour water from inclined pitchers into the bathing pools. They are particularly to be found in the reliefs of the period.

The decoration of bases with scenes in relief underwent considerable change in eastern Java. As a result of the height of these bases, often several stories, panels and friezes with many people were often placed one above the other. The reassertion of Indonesian tendencies grew stronger, and the evolution begun at Prambanam continued. The idealized, richly ornamented figures from Borobudur gave way to a slimmer type, often in more expressive but stiffer attitudes. The thinness of these figures was accentuated by the simple, short costumes, without draperies, which clung to the body. The rich diadems were usually replaced by bouffant coiffures which framed the almond-eyed faces. Though the relief was still deep and lively at Djalatunda (end of 10th cent.), it became uniform and projected less in the works of the later styles of Singhasāri (13th cent.) and of Majapahit (14th cent.). At Panataran, in Candi Jago, and other sites, the compositions became more awkward and the groupings cruder. The bodies were flattened, the broad shoulders strictly horizontal, the gestures angular, and the figures juxtaposed in lines, or intermingled without order in the more violent scenes. There was a tendency to treat the figures in silhouette, as can be seen in the decorative motifs of Candi Rimbi, and in the large base of Panataran (14th cent., PL. 35) and other reliefs of the same monument. This tendency became more and more frequent in the Majapahit style. The hooked motifs — stylizations of clouds and vegetation — were mixed with the diverse creatures and tended to overrun the surface. Several heroes, such as Arjuna, remained richly appareled, but many figures were of a more popular type. The fantastic appearance of the rakshasas was further increased. The themes were especially those of the great epics and legends taken from India, in particular those of the *Rāmāyaṇa* and of the *Mahābhārata*, which continued to be equally in favor in Bali. Popularized in Javanese versions of these poems, Rāma and the five Pāṇḍavas became practically national heroes and appeared in changed forms.

In spite of recurring tendencies, differences arose in the works at the various sites. At Candi Keḍaton, a certain degree of modeling was long retained; the scenes are animated and human beings are dominant. A certain realism is apparent in the expressive gestures and in well-observed details (such as the pose of an old man who leans on a long stick). At Candi Rimbi, the decoration spread as the human element became less important. At Candi Suravana flattened silhouetted figures, still expressive, are spaced out among fantastic forms along with a profusion of stiff and stunted trees, the carved foliage of which varies the effects and indicates the species. The figures are also varied; some are ornamented, while others, short and fat, have a more primitive look. Some more slender female figures possess a wholly indigenous grace. The tendencies found here occur later in Bali with a triumph of the decorative elements.

The reliefs from Trawulan in the museum of Mojokerto are in quite a different spirit; they are devoted especially to the representation of landscapes in which naturalistic trends can be discerned, and it seems that only a certain lack of skill hinders a search for definite realism. Human figures are rare and are rather lost in the natural setting. The landscape is at the same time intimate and immense; a vast distance is suggested by the

succession and overlapping of the rounded summits of mountains topped with trees, but rustic dwellings are pictured in their enclosures, and rocky streams wind through the valleys. Here the impression of immensity and solitude that emanates from the Chinese Sung landscapes seems to have been translated into a simple, popular language. It is possible that the embassies which were constantly exchanged between China and Indonesia effected some transmission of Chinese influence. (These relations were only temporarily interrupted by the expedition sent by Kublai Khan in 1292, and they multiplied thereafter.) This preoccupation with the elements of nature represents the culmination of a long line of works in which they were progressively introduced. The depiction of mountains, which had not occurred earlier, coincided with a resurgence of the native beliefs and cults of Indonesia in which the veneration of sacred places on mountain tops played an important part. This group of works remains, however, rather exceptional.

LATE PERIOD. The decline of the Majapahit kingdom, from the first half of the 15th century, led to a slowing down of artistic production. In the face of the progress of Islam, the Hindu cults lost their preeminence, and their votaries retired to the mountains, where indigenous cults had often been established and where the Hindu beliefs — in the Saiva form — began to mix with the ancient local religion and with its rites. On the mountain summits (Lawu, Penanggungan, and others), various temples were consecrated to this bastardized Hinduism. They usually took the form of terraces supporting sanctuaries, which have yielded examples of sculpture and decorative elements, as in the case of Candi Sukuh (mid-15th cent.) on Mount Lawu. The works of this site were still of good quality; for example, a rough masculine head is well proportioned, expressive, and sober.

In spite of the success of Islam, the earlier architectural traditions were maintained in Java. They can be seen in buildings designed for Moslem purposes, as in the minaret of Kudus and the mosque of Sendangduwur, brick constructions which retained the architectural characteristics of eastern Java. At Kudus, the very tall base with juxtaposed panels and superimposed cornices raises the central structure to a great height, and the horizontal band which divides it halfway up is retained. The two types of door already described are used in the various walls at Kudus and Sendangduwur. The abundant ornament making use of living forms has disappeared, although a large motif of outspread wings framing the gateway at Sendangduwur proves the persistence of earlier decorative elements. The strongest survivals of the earlier Indonesian traditions are to be found, however, in Bali (see below), where Hinduism remained the prevailing religion.

During this last period, mosques and the surviving later palaces (kraton) were built of wood. These structures followed a quite different tradition from the stone buildings, but one which could also have been ancient, as at all times wooden buildings had accompanied and completed those built in brick or stone. Palaces as well as small buildings had always been constructed of wood, and the reliefs at Borobudur depicted pavilions where thin columns held up roofs that were often overhanging. The kratons of Jogjakarta or of Surakarta, which go back no further than the 18th century, consist of a long succession of rectangular courts containing separate buildings. The halls and throne rooms are covered with a large, steeply sloping tiled roof; the central part is supported by very tall painted pillars, while a double rectangle of columns, also of wood, sustains the outer part of the overhanging roof.

ART OF BALI. Indian influences arrived early in this small island, whether transmitted directly or by way of the Central Javanese styles. While certain parallels with Javanese art may be discerned, as in the 11th-century complex of Tampaksiring and in various sculptures, the art quickly took on a local character. This hybrid aspect is manifested during the late period in a mélange of borrowed forms and indigenous tendencies. With the persistence of Hinduism in Bali, a religious architecture in wood still continues ancient traditions.

The temples (pura) of Bali, high wooden structures with superimposed roofs reminiscent of pagodas, are often called "merus" because they symbolize Mount Meru, the cosmic mountain. These structures preserve ancient forms which are perhaps distantly Indian in origin, though they have disappeared elsewhere; representations of them in Javanese reliefs show that they must once have existed in other parts of the archipelago. Sanctuaries of this type have multiplied in the island, generally accompanied by a group of lower buildings, also of wood. Sometimes, as in the Pura Ye Ganga near Perean (ca. 14th cent.), the lower part is made of brick. Brick was particularly used, however, for the enclosure walls and the gateways; the latter were greatly emphasized in Bali and were often of considerable size, even to the point of becoming the principal architectural element. The two types of entrances seen in eastern Java recur, in both cases with a narrow opening. The multiple stories of their superstructure give these doorways an effect of height which is increased by the steps, often numerous, above which they are elevated. Cornice moldings of the angular type survive on the walls as well as on the various parts of the doorways. The relief decoration also reappears, sometimes sparingly used, elsewhere in profusion. Representations either in the round or in relief of fantastic creatures seem often almost to overload the sides of the entrances. These motifs sometimes overflow to the ends of the superstructure and greatly enliven the silhouette. The ornament becomes increasingly independent of the architectural forms; the proliferation of this decoration and of the sculpture is in some cases so extreme that it seems decadent (Pura Bedji at Sangsit). Color effects are often sought, the various elements being painted in brilliant tones. This desire for color led at Pura Kehen to the insertion of Chinese porcelain plates in the masonry. The number of temples in Bali is very great; among them should be cited those of Sangsit, Bangli, Batur, and Kesiman.

Madeleine HALLADE

The outstanding examples of Balinese ornamental wood carving are the magnificent reliefs on the large wooden doors of temples and princely mansions. They consist of lotus motifs and "rococo" scrolls representing rocks, interspersed with figures from Indian myths and epics (PL. 37). Sculptures in the round of gods and mythical beings are mostly rather conventional and show a predilection for grotesque demonic figures; in contrast, human and animal figures are frequently of a lively and striking realism, tending toward humorous caricature.

The art of painting survived in Bali, while in Java it succumbed to Islam. Large paintings (PL. 32) in wayang style on wood or cotton cloth take their subjects from Indian mythology and epics and from the ancient romantic literature of Java. Illustrations of palm-leaf manuscripts, incised with an iron stylus, testify to the extreme grace and refinement of traditional Balinese art. Bali also possesses rich metal and textile arts comparable to the Javanese and Malayan production described below.

Unlike most areas where indigenous arts prevail, wider contact with the outside world led to an almost miraculous renascence in Bali. The art had not been crippled by the impact of Islam; sculpture and painting were still living arts, and, moreover, the whole population was imbued with a deep esthetic feeling. When, as a result of outside influences, the old traditional ties of society and culture began to loosen, the time was ripe for the creation of new expressions in art.

In painting the new trend was initiated by the influence of a German painter, Walter Spies, who lived in Bali from 1927 to 1940 and who had been inspired in his youth by the paintings of Henri Rousseau. Only one Balinese painter, Anak Agung Gde Sobrat, actually worked with Spies, although others may have seen his works. This very slight stimulus resulted in the practically explosive birth (ca. 1930) of a completely new and yet thoroughly Balinese school of painting. While it takes its subjects largely from daily life — the rice harvest, village scenes, festivals, and funerals, it draws also from the epics and legends. The art, which excels in its original com-

positions and decorative values, ranks among the outstanding interpretations of tropical nature and life.

At the same time, in 1930, two wood carvers, I Tegelan and Ida Bagus Ketut Gelodog, created a new style of sculpture which was immediately adopted by many other artists. Some of their works are realistic, others fantastically stylized, with extremely slender bodies and exaggeratedly thin arms and legs. They look very "modern" in the European sense, although none of these Balinese artists was familiar with modern European sculptures. In more recent years there seems to have been a tendency toward a syncretism of the new and traditional styles.

MINOR ARTS. When Islam replaced Hinduism and Buddhism, the building of temples and the sculpturing of images came to an end, but the old style survived in the minor arts and even reached new heights. With the spread of Islam it was, moreover, diffused to peoples who had never adopted Hindu-Buddhist culture.

Wood carving is completely dominated by stylized plant ornaments, baroque derivatives of the ancient Indian lotus motif. Similar plant scrolls are used in the decoration of metal objects, mostly of brass or silver, but with the addition of flower patterns of textile origin and, in Java, of human and animal figures in wayang style.

Excluding tribal arts, which are discussed in the first sections, three classes of art object deserve special notice, krises, wayang puppets, and textiles.

The oldest type of kris, with hilt and blade forged in one piece, the hilt being formed by a human figure in the style of primitive ancestor images, is traditionally ascribed to the time of the kingdom of Majapahit. Actually, it must be far more ancient and may be derived from a type of bronze dagger with a human figure as hilt which has been found at Dông-s'on. The kris with hilt of wood, ivory, or gold came into fashion prior to the foundation of Majapahit — in the 13th century at the latest, and perhaps earlier. The oldest types of such hilts seem to be those representing either a demon, originally perhaps the man-eater Kalmāṣapāda of Buddhist and Hindu legend, or the man-eagle Garuḍa. Both kinds are still widely found, but in many instances the figures have been so stylized that they have degenerated into a maze of branches and leaf patterns or have become more and more simplified, assuming almost geometric forms. Other varieties of kris hilts are probably of more recent origin. The blades have a distinctive pattern (*pamor*) which results from their being forged from several rods of iron, some of it meteoric in origin, and occasionally they have decorations inlaid with gold. It was probably during the expansion of Majapahit (14th cent.) that the kris spread from Java to the Malays of Sumatra, Malaya, and Borneo, to Bali, and to the Buginese and Makassarese of Celebes.

Because of their graceful stylization and their rich and delicate à jour decorations, the painted puppets cut from parchment for the shadow play (*wayang kulit*) rank among the most attractive products of Javanese art. Whether the shadow play originated in Java or was introduced from either China or India, the style of the puppets is no doubt derived from paintings more or less similar to those still found in Bali and particularly to those on the scrolls of the Javanese *wayang beber*. Since this style does not seem to be of Indian origin, it might have been derived from Dông-so'n painting, perhaps through the medium of ancient Javanese folk art. Its influence appears first in reliefs of the 13th century.

The techniques of textile decoration comprise brocading, *ikat*, *plangi* (tie-dyeing on the finished tissue), and batik. The outstanding gold brocades are those from Palembang in Sumatra. The origin of the Javanese batik technique has been the subject of much discussion, but the problem has not been solved; it was used in India, as well as in ancient China, and is still practiced by some hill tribes of southern China, northern Indochina, and the island of Hainan. In Indonesia, primitive varieties of the technique survive in western Java and among the Toradja of central Celebes. They may have been introduced from the mainland at the same time as the warp *ikat* technique (i.e.,

in the Dông-so'n period). It is possible that, like *ikat*, batik came to Java twice, first from the north and later from India. In any case it was developed in Java to a degree not surpassed anywhere else. In recent times it spread from Java to eastern Sumatra and to the Moros of the Sulu Islands. The designs of Javanese batiks excel in their variety and their high esthetic quality. They comprise flower and plant patterns of Indian origin, Chinese phoenixes, cloud designs, and even patterns derived from Dông-so'n spirals, but all of these have been stylized in a typically Javanese manner, while numerous motifs of local invention, such as wayang figures, peacocks, and birds' wings symbolizing Garuḍa, have been added.

EUROPEAN INFLUENCES. Although some effect of the Dutch baroque can be seen in Javanese wood carvings, and stray motifs of European origin may be found on such work as Sumba *ikats* and Madura kris hilts, early European influences were negligible on the whole. In the 19th century a Javanese painter, Raden Saleh (1814–80), achieved some fame, but his works are purely European in character and reveal the influence in his youth of the French school, particularly of Delacroix and Géricault. As in many other areas of the world, contacts with Western civilization in recent times have been detrimental to the indigenous art of the Indonesian peoples, with the exception of Bali, where, as noted above, conditions were particularly favorable. The developments of the 20th century, when modern Indonesian art began strongly to reflect a Western impact, are treated under ORIENTAL MODERN MOVEMENTS. The buildings constructed under Dutch and English influence and, more recently, in international style are outlined under INDONESIA.

CONCLUSION. An attempt has been made to trace the origins of the various art styles of Indonesia and to determine their sequence in time. Only on the basis of such a historical analysis can an understanding of the puzzling variety and the contradictory tendencies noticeable in Indonesian art be achieved.

There can be little doubt that the monumental style was introduced by the Indonesians themselves when they migrated to the islands, probably in the 2d millennium B.C. But the most decisive impulses, those which helped to create most of the local art styles of Indonesia, came from the Dông-so'n culture of Indochina at some time between 700 B.C. and the end of the pre-Christian era. During the same period, probably in the 4th century B.C., contacts with people from China resulted in the birth of those art styles which still survive in central Borneo and among the Ngada of Flores.

In the Christian Era the northern influences were superseded by those from India, which resulted in the creation of the Hindu-Buddhist art of Java, Sumatra, and Bali. Moslem influence was mainly negative, but the very fact that religious architecture and sculpture were suppressed may have spurred the creative spirit to seek outlets in the minor arts and thus have caused their flowering in recent centuries. It has long been recognized that the ancient art of Java, although derived from India, was not Indian but Javanese. The same applies to the ornamental styles of Indonesia, as well as to the new school of art of Bali. The foreign models were not simply copied but gave rise to new, original styles. Therefore all Indonesian art styles, of whatever period and origin, may be said to be genuinely Indonesian in the same sense that German and Italian Gothic are — despite the French origin of the Gothic style — German and Italian, and the French and German Renaissance styles are genuinely French and German, even though they resulted from stimuli emanating from Italy.

Robert HEINE-GELDERN

BIBLIOG. *Indigenous cultures: a. General works*: J. A. Loebèr, Geïllustreerde beschrijvingen van Indische kunstnijverheid, 8 vols., Amsterdam, 1903–16; J. E. Jasper and M. Pirngadie, De inlandsche kunstnijverheid in Nederlandsch-Indië, 5 vols., The Hague, 1912–30; R. Heine-Geldern, Eine Szene aus dem Sutasoma-Jātaka auf hinterindischen und indonesischen Schwertgriffen, IPEK, I, 1925, pp. 198–238; T. J. Bezemer, Indonesian Arts and Crafts, The Hague, 1931; G. P. Rouffaer, Beeldende kunst in Nederlandsch-Indië, Bijdragen tot de Taal-, Land- en Volkenkunde van Nederlandsch-Indië, LXXXIX, 1932, pp. 321–658; R. Heine-Geldern, Vorge-

schichtliche Grundlagen der kolonialindischen Kunst, Wien. Beiträge zur K. und Kulturgeschichte Asiens, VIII, 1934, pp. 5–40; J. A. Loebèr, Indonesische Frauenkunst, Wuppertal-Elberfeld, 1937; R. Heine-Geldern, L'art prébouddhique de la Chine et de l'Asie du Sud-Est et son influence en Océanie, RAA, XI, 1937, pp. 177–206; A. N. J. T. à T. van der Hoop, Indonesian Ornamental Design, Djakarta, 1949; F. A. Wagner, Indonesia: The Art of an Island Group, New York, 1959.

b. *Dông-so'n art*: W. O. J. Nieuwenkamp, De trom met de hoofden te Pedjeng op Bali, Bijdragen tot de Taal-, Land- en Volkenkunde van Nederlandsch-Indië, LXI, 1908, pp. 319–38; V. Goloubew, L'âge du bronze au Tonkin et dans le Nord-Annam, BEFEO, XXIX, 1929, pp. 1–46; R. Heine-Geldern, Bedeutung und Herkunft der ältesten hinterindischen Metalltrommeln, Asia Major, VIII, 1932, pp. 519–37; R. Heine-Geldern, The Drum Named Makalamau, India Antiqua: A Volume of Oriental Studies Presented by His Friends and Pupils to Jean Philippe Vogel, Leiden, 1947, pp. 167–79; R. Heine-Geldern, Das Tocharerproblem und die Pontische Wanderung, Saeculum, II, 1951, pp. 225–55; H. R. van Heekeren, The Bronze-Iron Age of Indonesia, The Hague, 1958.

c. *Ornamental motifs*: J. A. Loebèr, Timoreesch snijwerk en ornament, The Hague, 1903; A. W. Nieuwenhuis, Quer durch Borneo, 2 vols., Leiden, 1904–07; E. B. Haddon, The Dog-Motive in Bornean Art, JRAI, XXXV, 1905, pp. 113–25; J. A. Loebèr, Bamboe-snijwerk en weefsels op Timor, Bijdragen tot de Taal-, Land- en Volkenkunde van Nederlandsch-Indië, LXI, 1908, pp. 339–49; C. Hose and W. McDougall, The Pagan Tribes of Borneo, 2 vols., London, 1912; J. A. Loebèr, Sierkunst uit Midden Celebes, Nederlandsch-Indië Oud en Nieuw, I, 1916–17, pp. 243–61; P. M. van Walcheren, Ornamentiek bij de Toradja's, Nederlandsch-Indië Oud en Nieuw, I, 1916–17, pp. 147–57; H. F. E. Visser, Over ornamentkunst van Seram, Koloniaal Inst. te Amsterdam: Volkenkundige opstellen, I, 1917, pp. 91–104; O. D. Tauern, Patasiwa und Patalima: vom Molukkeneiland Seram und seinen Bewohnern, Leipzig, 1918; J. A. Loebèr, Bamboe-ornament van het eiland Borneo, Nederlandsch-Indië Oud en Nieuw, III, 1918–19, pp. 159–68, 189–202, 217–30; A. W. Nieuwenhuis, Kunst van Borneo in de verzameling W. O. J. Nieuwenkamp, Nederlandsch-Indië Oud en Nieuw, X, 1925–26, pp. 67–91; W. Hough, The Buffalo Motive in Middle Celebes Decorative Design, Proc. U. S. Nat. Mus., LXXIX, 29, Washington, 1932; G. L. Tichelman, Het snel-motief op Toradja-Foejas, Cultureel Indië, II, 1940, pp. 113–18; E. Banks, Sea Dayak Carving, J. Malayan Branch Royal Asiatic Soc., XIX, 1941, pp. 219–26; B. A. G. Vroklage, Eine alte Metallkunst in Lio auf Flores, IAE, XL, 1941, pp. 9–40; W. Kaudern, Art in Central Celebes (Ethn. S. in Celebes, VI), Göteborg, 1944; F. Manis, The Art of Anyi, Sarawak Mus. J., V, 1, 1949, pp. 10–13; T. Harrisson and F. Manis, Hairpins from Borneo Hill Peoples, Sarawak Mus. J., V, 2, 1950, pp. 242–55; E. R. Leach, A Kajaman Tomb Post from the Belaga Area of Sarawak, Man, L, 1950, pp. 133–36; T. Harrisson, Humans and Hornbills in Borneo, Sarawak Mus. J., V, 3, 1951, pp. 400–13.

d. *Painting*: F. Grabowsky, Der Tod, das Begräbnis, das Tiwah oder Totenfest und Ideen über das Jenseits der Dajaken, IAE, II, 1889, pp. 177–204; J. A. Loebèr, Merkwaardige kokerversieringen uit de Zuider- en Oosterrafdeeling van Borneo, Bijdragen tot de Taal-, Land- en Volkenkunde van Nederlandsch-Indië, LXV, 1911, pp. 40–52; P. te Wechtel, Erinnerungen aus den Ost- und West-Dusun-Ländern (Borneo), IAE, XXII, 1915, pp. 1–24, 43–58, 93–129; T. J. Bezemer, Plechtigheden en gebruiken bij en na de begrafenis in den Oost-Indischen Archipel, Nederlandsch-Indië Oud en Nieuw, II, 1917–18, pp. 177–90; H. Schärer, Die Gottesidee der Ngadju Dajak in Süd-Borneo, 1946.

e. *Sculpture*: G. W. W. C. Baron van Hoëvell, Einige weitere Notizen über die Formen der Götterverehrung auf den Süd-Wester und Süd-Oster Inseln, IAE, VIII, 1895, pp. 133–37; D. C. Worcester, The Non-Christian Tribes of Northern Luzon, Philippine J. Sc., I, 1906, pp. 791–875; C. Spat, Animisme en prae-animisme, Nederlandsch-Indië Oud en Nieuw, I, 1916–17, pp. 209–23, 271–90; J. G. Huyser, Bataksche ruiterbeeldjes: Bijdrage to de kennis der Batak plastiek, Nederlandsch-Indië Oud en Nieuw, XI, 1926–27, pp. 39–63; P. Wirz, De dans met den tooverstaf, Nederlandsch-Indië Oud en Nieuw, XI, 1926–27, pp. 130–43; C. T. Bertling, Hampatongs of Tempatongs van Borneo, Nederlandsch-Indië Oud en Nieuw, XII, 1927–28, pp. 131–41, 179–92, 223–36, 249–54; W. H. Rassers, Naar aanleiding van eenige maskers van Borneo, Nederlandsch-Indië Oud en Nieuw, XIII, 1928–29, pp. 35–64; H. F. Tillema, Doodenpalen, tiwah en lijkverbranding, Nederlandsch-Indië Oud en Nieuw, XVI, 1931–32, pp. 131–55; A. Møller, Beitrag zur Beleuchtung des religiösen Lebens der Niasser, IAE, XXXII, 1934, pp. 121–66; E. Vatter, Der Schlangendrache auf Alor und verwandte Darstellungen in Indonesien, Asien und Europa, IPEK, IX, 1934, pp. 119–48; G. L. Tichelman, Toenggal panaloean, de Bataksche tooverstaf, Tijdschrift voor Indische Taal-Land- en Volkenkunde, LXXVII, 1937, pp. 611–34; G. L. Tichelman and P. Voorhoeve, Steenplastiek in Simaloengoen, Medan, 1938; A. J. de Lorm, Bataksche maskers in de Haagsche volkenkundige verzameling, Cultureel Indië, I, 1939, pp. 48–53; G. L. Tichelman, Bataksche maskerplastiek, Cultureel Indië, I, 1939, pp. 378–88; P. Voorhoeve, Steenen beelden in Simaloengoen, Cultureel Indië, I, 1939, pp. 362–66; B. A. G. Vroklage, Beeldhouwwerk uit de Manggarai (West-Flores), Cultureel Indië, I, 1939, pp. 356–61, 389–94; H. T. Fischer, Over de wordingsgeschiedenis van de Bataksche tooverstaf, Tijdschrift voor Indische Taal-, Land- en Volkenkunde, LXXX, 1940, pp. 585–610; J. de Gruyter, Batacksche plastiek, Cultureel Indië, III, 1941, pp. 123–32; R. Horsky, Religiöse Holzplastik auf Nias, Ann. des naturhistorischen Mus. in Wien, LIII, 1942, pp. 374–98; G. L. Tichelman, Quelques observations sur la sculpture primitive au Simaloungoun, Anthropos, XLVI, 1951, pp. 209–20; G. L. Tichelman, Quelques données sur la crosse sacerdotale des Bataks, Ethnos, XVIII, 1953, pp. 7–20.

f. *Megalithic monuments and sarcophagi*: C. T. Bertling, De Minahasische "waroega" en "Hockerbestattung," Nederlandsch-Indië Oud en Nieuw, XVI, 1931–32, pp. 33–51, 75–94, 111–16; G. P. Rouffaer, Etnographie van de Kleine Soenda Eilanden in beeld, The Hague, 1937; F. M. Schnitger, Megalithen vom Batakland und Nias, IPEK, XV–XVI, 1941–42, pp. 220–52; G. L. Tichelman, Bataksche sarcophagen, Cultureel Indië, IV, 1942, pp. 246–61; A. Bühler, I megaliti di Sumba, Le vie del mondo, XIV, 1952, pp. 45–66.

g. *Architecture*: L. C. Westenenk, De Minangkabausche Nagari (Meded. Bur. voor de Bestuurszaken der Buitengewesten, 17), Weltevreden, The Hague, 1918; D. W. N. de Boer, Het Toba-Bataksche huis (Meded. Bur. voor de Bestuurszaken der Buitengewesten, 23), Weltevreden, The Hague, 1920; D. W. N. de Boer, Het Niassche huis (Meded. Bur. voor de Bestuurszaken der Buitengewesten, 25), Weltevreden, The Hague, 1920; W. Kaudern, Structures and Settlements in Central Celebes (Ethn. S. in Celebes, I), Göteborg, 1925; H. H. Bartlett, The Sacred Edifices of the Batak of Sumatra, Ann Arbor, 1934; P. Voorhoeve, Het stamhuis der Sitoemorangs van Lontoeng, Cultureel Indië, I, 1939, pp. 285–91.

h. *Textiles*: F. C. Cole, The Wild Tribes of Davao District, Mindanao, Field Mus. Nat. Hist.: Anthr. Ser., XII, 1913, pp. 49–203; A. W. Nieuwenhuis, Figuurknoopen, ikat-verven en weven in Oost-Indië, Nederlandsch-Indië Oud en Nieuw, I, 1916–17, pp. 5–16, 49–62; H. F. E. Visser, Tentoonstelling der Oost-Indische weefsel collectië van Kerckhoff, Nederlandsch-Indië Oud en Nieuw, III, 1918–19, pp. 17–32; B. M. Goslings, Scheringtechniek in Indische weefsels, Nederlandsch-Indië Oud en Nieuw, V, 1920–21, pp. 209–22, 228–40, 283–88; J. W. van Nouhuys, Een autochthon weefgebied in Midden-Celebes, Nederlandsch-Indië Oud en Nieuw, VI, 1921–22, pp. 237–43; B. M. Goslings, De beteekenis der invoering van den kam in het Indonesische weefgetouw, Nederlandsch-Indië Oud en Nieuw, VII, 1922–23, pp. 162–80 243–56, 275–91; J. M. van Nouhuys, Wasbatik in Midden-Celebes, Nederlandsch-Indië Oud en Nieuw, X, 1925–26, pp. 110–22; W. O. J. Nieuwenkamp, Eenige voorbeelden van het ornament op de weefsels van Soemba, Nederlandsch-Indië Oud en Nieuw, XI, 1926–27, pp. 258–88; A. C. Haddon and L. E. Start, Iban or Sea Dayak Fabrics and Their Patterns, Cambridge, 1936; A. Steinmann, Les "tissus à jonques" du Sud de Sumatra, RAA, XI, 1937, pp. 122–37; A. Steinmann, Enkele opmerkingen aangaande de z. g. scheepjes-doeken van Zuid-Sumatra, Cultureel Indië, I, 1939, pp. 252–56; A. Steinmann, Das kultische Schiff in Indonesien, IPEK, XIII–XIV, 1939–40, pp. 149–205; G. Tillmann, De motieven der Batakweefsels, Cultureel Indië, II, 1940, pp. 7–15; A. Bühler, Materialen zur Kenntnis der Ikattechnik (IAE, XLIII, Sup.), Leiden, 1943; P. Heerkens, Van katoen tot ikat-doek, Cultureel Indië, VI, 1944, pp. 1–19; J. H. Jager Gerlings, Sprekende weefsels: studië over ontstaan en betekenis van weefsels van eenige Indonesische eilanden, Amsterdam, 1952.

i. *Art of marginal cultures*: W. Svoboda, Die Bewohner des Nikobaren-Archipels, IAE, VI, 1893, pp. 1–38; H. H. Bartlett, The Carvings of the Paiwan of Formosa, Pap. Mich. Acad. of Science, Arts and Letters, X, 1928, pp. 53–58; Jen Shien-min, A Study of Men's Houses of the Tanan Rukai (in Chinese: Eng. summary), B. Inst. Ethn., Acad. Sinica (Taipei), 1, 1956, pp. 141–61; Jen Shien-Min, Wooden Carved Containers of the Paiwan Tribe (in Chinese: Eng. summary), B. Inst. Ethn., Acad. Sinica (Taipei), 2, 1956, pp. 129–36; T. Kano and K. Segawa, Illustrated Ethnography of Formosan Aborigines, I: The Yami Tribe, 2d ed., Tokyo, 1956; Jen Shien-min, Notes on a Paiwan Carver (in Chinese: Eng. summary), B. Inst. Ethn., Acad. Sinica (Taipei), 4, 1957, pp. 109–22; Chen Chi-lu and Tang Mei-chun, Woodcarving of the Paiwan Group of Taiwan (in Chinese), B. Dept. Archaeol. and Anthr., Nat. Taiwan Univ., XI, 1958, pp. 49–91.

j. *Art of Madagascar*: J. Sibree, Decorative Carving on Wood, Especially on Their Burial Memorials, by the Betsileo Malagasy, JRAI, XXI, 1891, pp. 230–44; A. and G. Grandidier, Histoire physique, naturelle et politique de Madagascar, III–IV, Paris, 1924; M. E. Ribard, Contribution à l'étude des aloalo malgaches, L'Anthropologie, XXXIV, 1924, pp. 91–102; E. G. Waterlot, La sculpture sur bois à Madagascar, L'Anthropologie, XXXV, 1925, pp. 133–34; P. Camboué, Aperçu sur les Malgaches et leurs conceptions d'art sculptural, Anthropos, XXIII, 1928, pp. 1–18; R. Linton, The Tanala: A Hill Tribe of Madagascar, Chicago, 1933; H. M. Dubois, Monographie des Betsileo (Madagascar), Paris, 1938; G. Tillmann, Het ikatten op Madagascar, Cultureel Indië, I, 1939, pp. 113–17.

Hindu-Javanese art: J. Groneman, Tjandi Prambanan op Midden-Java, na de ontgraving, Leiden, 1893; J. L. Brandès, Beschrijving van de ruine bij de desa Toempang genaamd Tjandi Djago, The Hague, 1904; J. L. Brandès, Beschrijiving von Tjandi Singasari en de Wolkentoone len van Panataran, The Hague, 1909; T. van Erp, 20th Century Impressions of Netherlands India, London, 1909; Inventaris der Hindoe-oudheden, Rapporten van de Oudheidkundige Dienst, 3 vols., The Hague, Djakarta, 1914–23; N. J. Krom and T. van Erp, Beschrijving van Barabudur, 5 vols., The Hague, 1920–31; K. With, Java: Brahmanische, buddistische und eigenlebige Architektur und Plastik auf Java, Hagen, 1920; M. Lulius van Goor, A Short Guide to the Ruined Temples in the Prambanan Plain, the Dieng Plateau and Gedong Sanga (Eng. trans., H. S. Banner), Weltevreden, 1922; N. J. Krom, Inleiding tot de Hindoe-Javaansche kunst, 2d ed., 3 vols., The Hague, 1923 (reviewed by M. Lulius van Goor and H. Parmentier, BEFEO, XXII, 1922, pp. 261–76); F. D. K. Bosch, A Hypothesis as to the Origin of Indo-Javanese Art, Rūpam, 17, 1924, pp. 6–41; W. F. Stutterheim, Voorloopige inventaris der oudheden van Bali, Oudheidkundige Verslag, Oudheidkundige Dienst van Nederlandsch-Indië, 1925, pp. 150–170, 1927, pp. 139–150; J. P. Vogel, The Relations between the Art of India and Java, in The Influences of Indian Art (ed. J. Strzygowski), London, 1925, pp. 35–86; N. J. Krom, L'art javanais dans les Musées de Hollande (Ars Asiatica, VIII), Paris, 1926; P. A. J. Moojen, Kunst op Bali, The Hague, 1926; N. J. Krom,

Barabuḍur, 2 vols., The Hague, 1927; W. F. Stutterheim, Pictorial History of Civilization in Java, Weltevreden, 1927; M. P. Verneuil, L'art à Java: les temples de la période classique indo-javanaise, Paris, 1927; F. D. K. Bosch, Archaeological Research in Java, Indian Art and Letters, N.S., III, 1929, pp. 79–100; F. D. K. Bosch, De beteekenis der reliefs van de derde en vierde gaanderij van Baraboedoer, Oudheidkundige Verslag, Oudheidkundige Diest van Nederlandsch-Indië, 1929, pp. 179–243; W. F. Stutterheim, The Meaning of the Kālamakara Ornament, Indian Art and Letters, N.S., III, 1929, pp. 27–52; W. F. Stutterheim, Oudheden van Bali, 2 vols., Singaradja, 1929–30; W. F. Stutterheim, Tjandi Baraboedoer, Weltevreden, 1929; R. Heine-Geldern, Weltbild und Bauform in Südostasien, Wien. Beiträge zur K. und Kulturgeschichte Asiens, IV, 1930, pp. 28–78; N. J. Krom, Hindoe-Javaansche geschiedenis, 2d ed., The Hague, 1931; P. Mus, Barabudur: les origines du stûpa et la transmigration, Essai d'archéologie religieuse comparée, BEFEO, XXXII, 1932, pp. 269–439, XXXIII, 1933, pp. 577–980, XXXIV, 1934, pp. 175–400; A. J. Bernet Kempers, The Bronzes of Nalanda and the Hindu-Javanese Art, B. Kern Inst., XC, 1933, pp. 1–88; J. R. van Blom, Tjandi Sadjiwan, Leiden, 1935; R. Heine-Geldern, The Archaeology and Art of Sumatra, in Sumatra: Its History and People (ed. E. M. Loeb), Vienna, 1935, pp. 305–31; W. F. Stutterheim, Indian Influences in Old-Balinese Art, London, 1935; F. M. Schnitger, Hindoe-oudheden aan de Batang Hari, Leiden, 1936; F. M. Schnitger, Oudheidkundige vondsten in Padang Lawas, Leiden, 1936; F. M. Schnitger, The Archaeology of Hindoo Sumatra, Leiden, 1937; N. J. Krom, Het Hindoe-tijdperk, Geschiedenis van Nederlandsch-Indië, I, Amsterdam, 1938, pp. 113–298; J. Blom, The Antiquities of Singasari, Leiden, 1939; P. Stern, L'art javanais, Histoire universelle des arts, IV, Paris, 1939, pp. 185–205; H. Marchal, Architecture comparée dans l'Inde et l'Extrême-Orient, Paris, 1944, pp. 196–222; R. Heine-Geldern, Prehistoric Research in the Netherlands Indies, Science and Scientists in the Netherlands Indies (ed. P. Honig), New York, 1945, pp. 129–67; G. Coedès, Les états hindouisés d'Indochine et d'Indonesie, Paris, 1948; H. Parmentier, L'art architectural hindou dans l'Inde et l'Extrême-Orient, Paris, 1948; F. D. K. Bosch, "Local Genius" en Oud-Javaanse kunst, Meded. der K. Nederlandsche Akad. van Wetenschappen, Afdeeling Letterkunde, N.S., XV, 1, 1952, pp. 1–25; J. G. de Casparis, Twintig jaar studie van de oudere geschiedenis van Indonesië, Oriëntatie, XLVI, 1954, pp. 626–64; M. Hallade, L'Asie du Sud-Est, Arts de l'Asie ancienne: thèmes et motifs, II, Paris, 1954, pp. 12–34; H. R. van Heekeren, Prehistoric Life in Indonesia, Djakarta, 1955; P. H. Pott, The Influence of Tantric Buddhism on Ancient Indonesian Civilization, Mārg, IX, 1956, pp. 53–64; W. F. Stutterheim, Chandi Barabudur: Name, Form and Meaning, Studies in Indonesian Archaeology, The Hague, 1956, pp. 1–62; A. J. Bernet Kempers, Ancient Indonesian Art, Cambridge, Mass., 1959 (bibliog.).

Art of the Moslem peoples and Bali: G. A. J. Hazeu, Eine Wajang Beber Vorstellung in Jogjakarta, IAE, XVI, 1904, pp. 128–35; J. Groneman, Der Kris der Javaner, IAE, XIX, 1910, pp. 90–109, 123, 161, XXI, 1913, pp. 129–37; H. L. Roth, Oriental Silverwork: Malay and Chinese, London, 1910; G. P. Rouffaer and H. H. Juynboll, Die indische Batikkunst und ihre Geschichte, 2 vols., Utrecht, Haarlem, 1914; H. H. Juynboll, Balinesische Farbenzeichnungen mit Darstellungen aus altjavanischen Schriften, IAE, XXIII, 1916, pp. 8–16; J. G. Huyser, Ornament van Indisch koperwerk, Nederlandsch-Indië Oud en Nieuw, I, 1916–17, pp. 224–31, 327–38, 537–45, II, 1917–18, pp. 133–41; J. G. Huyser, Het vervaardigen van krissen, Nederlandsch-Indië Oud en Nieuw, I, 1916–17, pp. 235–36, 547–61, II, 1917–18, pp. 26–37, 102–14, 357–76, 411–17, 439–47; J. W. van Nouhuys, Iets over metaalbewerking in den Indischen Archipel, Nederlandsch-Indië Oud en Nieuw, I, 1916–17, pp. 440–46; J. G. Huyser, Wajang-stijl, Nederlandsch-Indië Oud en Nieuw, IV, 1919–20, pp. 13–32; Noto Soeroto, Wayangbeeldkunst als grondslag eener Javaansche schilderschool, Nederlandsch-Indië Oud en Nieuw, IV, 1919–20, pp. 258–69; J. E. Jasper, Het stadië Koedoes en zijn oude kunst, Nederlandsch-Indië Oud en Nieuw, VII, 1922–23, pp. 3–30; H. H. Juynboll, Een Balineesche doek met voorstellingen uit een Oud-Javaansch heldendicht, Nederlandsch-Indië Oud en Nieuw, VII, 1922–23, pp. 49–64; J. G. Huyser, Koperwerk uit Midden-Sumatra, Nederlandsch-Indië Oud en Nieuw, X, 1925–26, pp. 357–70; J. A. Loebèr, Das Batiken: Eine Blüte indonesischen Kunstlebens, Oldenburg, 1926; H. T. Damste, Een geïllustreerde Bramara Sangoepati, Nederlandsch-Indië Oud en Nieuw, XIII, 1928–29, pp. 15–23; W. O. J. Nieuwenkamp, Beeldhouwkunst van Bali, The Hague, 1928; B. M. Goslings, Het batikken in het gebied der hoofdplaats Djambi, Nederlandsch-Indië Oud en Nieuw, XIV, 1929–30, pp. 140–52, 174–85, 217–23; J. G. Huyser, Broenei en Broenei-bronzen, Nederlandsch-Indië Oud en Nieuw, XIV, 1929–30, pp. 35–49, 115–30; J. W. van Dapperen, Krisheften, Nederlandsch-Indië Oud en Nieuw, XVI, 1931–32, pp. 99–110; J. W. van Dapperen, Tegalsch houtsnijwerk, Nederlandsch-Indië Oud en Nieuw, XVI, 1931–32, pp. 183–89; C. Lekkerkerker, Scherts en caricatuur in de Balische plastiek, Nederlandsch-Indië Oud en Nieuw, XVI, 1931–32, pp. 194–206; T. J. Bezemer, Javaansche maskers, Nederlandsch-Indië Oud en Nieuw, XVII, 1932, pp. 1–11; W. G. Broek, Maleisch zilverwerk, Nederlandsch-Indië Oud en Nieuw, XVII, 1932, pp. 64–73; R. Heine-Geldern, Über Kris-Griffe und ihre mythischen Grundlagen, OAZ, XVIII, 1932, pp. 256–92; J. G. Huyser, Oud koperwerk uit Siroekam, Nederlandsch-Indië Oud en Nieuw, XVII, 1932, pp. 161–64; B. M. Goslings, De Wajang op Java en Bali in het verleden en het heden, Amsterdam, 1938; W. H. Rassers, Inleiding tot een bestudeering van de Javaansche kris, Meded. K. Nederlandsche Akad. van Wetenschappen, Afdeeling Letterkunde, N.S., I, 8, Amsterdam, 1938; T. P. Galestin, Tantriilustraties op een Balisch doek, Cultureel Indië, I, 1939, pp. 129–36; J. Goedheer, De strijd om het onsterfelijkheidsdrank op een Balisch doek, Cultureel Indië, I, 1939, pp. 344–46; A. Maass, Die Kunst bei den Malaien Zentral-Sumatras, BA, XXII, 1939, pp. 1–62; G. Tillmann, Bijdrage tot het kapittel Broenei-bronzen, Cultureel Indië, I, 1939, pp. 217–26; T. P. Galestin, Eenige Balische illustraties bij het Oud-Javaansche gedicht Smaradahana, Cultureel Indië, V, 1943, pp. 76–87; J. P. W. Philipsen, Kain Djambi:

iets over de verziering der Djambi-batiks, Cultureel Indië, VII, 1945, pp. 114–22; C. C. F. M. le Roux, Madoereesche krisheften, Cultureel Indië, VIII, 1946, pp. 161–71; T. P. Galestin, Over oude illustraties van een Balisch verhaal, Indonesië, II, 1948, pp. 486–520; A. Bühler, Plangi, IAE, XLVI, 1952, pp. 4–35; A. Steinmann, Batik: A Survey of Batik Design, London, 1958.

European influences and modern Balinese art: J. T. Petrus Blumberger, Raden Saleh als portretschilder, Nederlandsch-Indië Oud en Nieuw, VII, 1922–23, pp. 321–23; R. Bonnet, Beeldende kunst in Gianjar, Djåwå, XVI, 1936, pp. 60–71; H. Paulides, Oud en nieuwe kunst op Bali: tegen den achtergrond van het Westen, Cultureel Indië, II, 1940, pp. 169–85; V. I. van de Wall, Beschrijving van eenige werken van Raden Saleh, Cultureel Indië, IV, 1942, pp. 159–67.

Madeleine HALLADE and Robert HEINE-GELDERN

Illustrations: PLS. 23–42; 8 figs. in text.

INDUSTRIAL DESIGN.

INDUSTRIAL DESIGN. This term is applied to the artist's plan for goods to be manufactured in series by fully mechanized processes. In contrast to handicrafts (q.v.), in which esthetic form is created in the process of fashioning the object and no two objects are quite identical, the artistic effect of machine-made products is achieved either in the original design or in a working model that serves as a pattern for succeeding objects in the series, which are produced without variation. The industrial designer may be responsible for the complete product, in the case of static objects such as glassware or furniture; in products with mechanical, electrical, or electronic operating parts, such as typewriters, automobiles, or radios, he may provide the envelope, the exterior form, for the combined inventions of many technicians. The discussion here is limited to objects that contain some three-dimensional elements; industrial-design processes related to the graphic arts (q.v.), to textiles (see TEXTILES, EMBROIDERY, AND LACE), etc., are treated elsewhere in these volumes. (See also DESIGN; DESIGNING, and the chapter *Machine technology* in AMERICAS: ART SINCE COLUMBUS, I, col. 328.)

SUMMARY. *The concept of series and the standard; Theoretical premises; Relationships among industrial design, handicrafts, and fine art; Relationship between industrial design and industrialized architecture; Novelty and obsolescence; The "symbolic" function of the industrial product; Styling; Fashion; Advertising; Teamwork; Duties and functions of the designer; Historical origins; William Morris and the Arts and Crafts movement; From Van de Velde to Muthesius; From the Bauhaus to the present; Teaching of industrial design.*

The concept of series and the standard. Industrial production involves production systems or processes used in operations of a repetitive nature in which each phase of work is precisely regulated and organized in such a way as to permit the reproduction of sets or series of objects (in contrast to craft production, in which control is slight or not at all precise and does not result in series of exact duplicates). The concept of series is basic to an understanding of the nature of industrial production. Series implies the possibility of reproducing a given model which possesses "in the greatest measure that collection of characteristics necessary to its use as a pattern in producing copies by series operations, and which is made up of standardized parts" (Ciribini, 1958). Such a model or matrix becomes the standard, or norm, in the production of the object.

Production in series refers to the method of production rather than the quantity of goods produced, provided the quantity is more than one. Some industrially produced items such as locomotives or ships are made in relatively limited numbers; others, like plastic dishes or household appliances, are mass-produced. But in all these cases the production process is one of repetition.

The concept of the standard, or norm, arose with the advent of the machine as an instrument capable of multiplying a given model indefinitely. This concept illustrates one of the most striking transformations in the attitude of the public toward a work of art: no longer does the object's uniqueness or the skill of the artisan matter; only the design is important — or rather the conception of the designer that existed before the

mechanical execution. A strictly serial production of copies, each identical with the next, was practically unknown before our own time; every product of handicraft, even when most accurately made to specification or constructed with the aid of machines such as the lathe and auger, always had limited precision and contained an element of chance in its form. The amount of imprecision admissible in objects produced in series is entirely different from the amount admissible for handicraft products; in the latter, inexactness, far from being a defect (as in industrially produced articles), is usually a positive value.

To conform to the standard, the industrial object must be planned as complete via the act of production; it must not undergo later manipulations. For this reason it is difficult to include a good deal of modern furniture under the category of industrially produced goods. Such furniture is only in part produced on a standard model, the finishing and hand polishing being done later.

Theoretical premises. Industrial design as we have defined it has its theoretical basis in certain esthetic principles found in Kant and still earlier in the English empiricists. For Kant there are two kinds of beauty: free beauty (*pulchritudo vaga*) and dependent beauty (*pulchritudo adhaerens*), the latter involving the purpose which the object is to serve. Purpose for Kant is an a priori principle of the esthetic faculty. It is identified with function, and the appropriateness of the object to its purpose (the "fitness" of the empiricists) is identified with its perfection. Kant discusses "painting," but within this category he includes the decorative arts, furniture, and interior decoration — genres in which the concept of purpose dominates.

The idea of functional beauty is usually considered anti-Kantian and closer to the eclectic naturalism of late-19th-century philosophy. But it should be pointed out that Kant adapted the idea of purpose to his own theory, holding that beauty could be contingent on purpose and that purpose could be implicit as well as explicit. (See ESTHETICS for a fuller treatment of Kantian esthetic theories.)

In the English empiricists, especially in Addison and Burke, we find an attitude toward the art object that can properly be called "functionalist." Burke states: "When we examine the structure of a watch, when we come to know thoroughly the use of every part of it, satisfied as we are with the fitness of the whole, we are far enough from perceiving anything like beauty in the watch-work itself In beauty . . . the effect is previous to any knowledge of the use; but to judge of proportion [for Burke an element of beauty], we must know the end for which any work is designed" (*A Philosophical Inquiry into . . . the Sublime and Beautiful*, 1756). This quotation indicates the distinction still made by Burke between beauty and proportion (as an element of beauty) on the one hand and fitness and knowledge of use on the other. We already glimpse here the beginnings of that long debate which sought to equate or to contrast the useful with the beautiful or to subordinate the useful to the beautiful while integrating the two concepts within that of function.

The concept of function underwent considerable expansion in the last decades of the 19th century and during the first half of the 20th. Originally understood in a strictly utilitarian or materialistic sense, the concept developed increasingly greater psychological overtones. This expansion of meaning has resulted in statements such as those of Paul Souriau that "there can be no conflict between the beautiful and the useful" (*La Beauté rationelle*, Paris, 1904, p. 198), and "a thing is perfect when it is in conformity with its purpose" (*ibid.*, p. 195). Such beliefs recall the early struggles of architectural rationalism when Adolf Loos was proclaiming his "Ornament und Verbrechen" (ornament and crime) and Louis Sullivan held that "form follows function." Numerous battles were waged by both architects and critics over the extent to which beauty in architecture should be subordinate to functionality; but these discussions are by now empty of significance, particularly with respect to industrial objects, whose real existence began much

later. Today it is generally accepted that the artistic component in an industrial product is only partly related to its material utility, and that industrial design as a whole cannot be brought entirely within the area of the so-called "fine arts." In the twenties, however, during the time of the Bauhaus, beauty and utility in industrial design were regarded as necessarily joined. That there could be utilitarian objects in which stylishness and advertising requirements were the sole determining factors was not considered possible.

Another common assumption previously held was that from the point of view of esthetic value an absolute comparison could be made among handicrafts, works of art, and industrial objects. This position, too, has undergone revision. The esthetic constants characteristic of an industrial object can most readily be identified by an analysis of the relationships among industrial design, handicrafts, and fine art; and between industrial design and industrialized architecture.

Relationships among industrial design, handicrafts, and fine art. It is undeniable that the forms of many industrial objects show obvious affinities to those of modern sculpture and painting. In fact, fine art has had an appreciable influence on industrial art, just as industrial design has in turn influenced fine art. If we accept the fact that a complete separation between applied and fine art can no longer be maintained, and if we accept modern architecture (even if prefabricated) as a form of art, then we must also accept industrially produced objects as art, at least in part.

Yet a clear distinction must be drawn between industrial design and handicraft design as separate genres, each with its own special requirements, in order to avoid regarding one as more valid or more artistic than the other. Handicrafts are increasingly becoming a subproduct of fine art, that is, taking on the characteristics of material preciousness and uniqueness that distinguish painting and sculpture. Handicrafts are being leveled to that type of production in which the touch of the hand is obviously of chief importance. Objects that are better and more easily made by machine, however, will scarcely be made by hand.

At this point some questions arise: Why is it that obvious analogies of form and inspiration could be drawn, not long ago, between industrial products and objects of art (e.g., the well-known early Eames chair, certain products of Aalto and Wirkkala; sculpture by Arp or Noguchi), but subsequently such similarities practically disappeared? Also, to what can we attribute the fact that during the Bauhaus period constructivist abstraction and neoplasticism in fine art showed clear resemblances to industrial forms, but today there is little affinity between industrial design and the free painting and constructions of such artists as Jean Fautrier, Antoni Tàpies, Alberto Burri, or César (Baldaccini)? One explanation serves for both these questions: In the representational arts the increasing use of the machine has resulted in the reproduction and dissemination on a vast scale of extremely poor material such as comic strips and cheap magazine illustrations, which have little in common with real modern art. Partly as a reaction against this flood of material, tendencies have developed in post-World War II art toward a greater expressive and formal freedom. This development in fine art has few points of contact with the necessarily sober and exact forms of contemporary industrial design.

Today the industrial object is the only product of any artistic content that is in contact with a wide public and not merely with an elite. For this reason it must be the responsibility of industrial design to encourage in the masses a sensitivity to good artistic form, which otherwise threatens to be overwhelmed by the widespread contemporary pseudo art disseminated by the machine. More than handicrafts or fine art, industrial design has the influence to educate the public and reawaken it to the genuine values of modern art and architecture.

Relationship between industrial design and industrialized architecture. This relationship has often been misunderstood and has frequently given rise to false interpretations and comparisons

The matter deserves clarification because of the ever-increasing expansion of architecture produced by industrial means. The concept of industrial design cannot be extended directly to architecture, city planning, complex organisms such as naval or railroad constructions, or giant industrial installations; although these structures derive from fully mechanized methods of work, they are not produced in series through repetitive operations. Included within industrial design, however, are all those elements of modern architecture produced by standardized means such as curtain walls, fixtures, installations, and fully prefabricated structures which need only be assembled and in which all the basic work has already been done in the factory. Among such prefabricated structures are the well-known geodesic domes and dymaxion houses of R. Buckminster Fuller (PL. 62) and the joints and other modular elements of Konrad Wachsmann's constructions (IV, PL. 196). An architecture composed entirely of prefabricated elements, or entire dwellings created by the repetition of a single basic unit, is theoretically possible in the not-too-distant future; the basic-unit method has been followed in the single-family plastic houses designed by J. Johansen in the United States, in the Monsanto Chemical Company's House of the Future, Los Angeles, and in the house of resin planned by J. Shein in France. Such architecture would, of course, fall entirely under industrial design.

But even if most future construction could be prefabricated, which is doubtful, the basic factors of planning and topographical layout would still place architecture partly outside industrial design. Close and significant relationships do exist, however, between industrial design and contemporary architecture.

Novelty and obsolescence. A highly debated problem is the role played by novelty of form in the industrial object. While novelty enters as a factor into all works of art, it is particularly important in industrial design. It is linked to concepts of information and the consuming of information as they apply to industrial forms.

The recently developed esthetics based on the theory of information, and the acceptance by certain scholars such as Max Bense and A. Moles of criteria borrowed from cybernetics to account for the phenomenon of a consuming or using up of information (that is, the concept that artistic forms undergo entropy and obsolescence due to overfamiliarity), have their sources in 18th-century esthetics, particularly in the work of the empiricists — a fact that has been insufficiently stressed. Basically the concept of entropy of communication (Norbert Wiener), when applied to objects of common use or to any other visual form, repeats in different words and with more precision ideas clearly hinted at by 18th-century English philosophers. In the modern formulation of the concept of entropy of information, it is held that the maximum amount of information is furnished by the message or form which, by its newness, unexpectedness, and unforeseeableness, produces the maximum amount of surprise (since the amount of information imparted is in direct proportion to its degree of unforeseeableness); so that when the message or form is repeated too often, the effectiveness of its stimulus gradually lessens until a minimum of information is obtained from it. Addison had already defined the problem when he stated that new and unusual things give delight to the imagination because they fill us with pleasurable surprise. We find in Burke the following: "Indeed beauty is so far from belonging to the idea of custom, that in reality what affects us in that manner is extremely rare and uncommon. The beautiful strikes us as much by its novelty as the deformed itself For as use at last takes off the painful effect of many things, it reduces the pleasurable effect in others in the same manner" (*op. cit.*). Here we already find the belief that novelty is the source of esthetic pleasure, while overexposure to a given form results only in boredom and aversion.

Various institutions in contemporary culture play a part in the speed of obsolescence of industrial forms (see below, discussions of styling, fashion, and advertising). Whether such speed is esthetically beneficial is difficult to say; it is, in any case, typical of the mid-20th century for purely artistic as well as so-called "useful" forms.

Concerning the role of novelty and obsolescence in industrial production as opposed to the fine arts, in industrial production novelty and exposure to form are primary factors; they are vital to the success of the product. In painting, sculpture, and architecture, however, obsolescence and aging are less significant; and unexpectedness alone is not sufficient to create validity in terms of the art form. Thus certain esthetic principles currently applied to the visual arts — for example, that aging adds beauty to a work — do not apply to industrial design. This particular principle is most fully embodied in the esthetics of Zen, in which the various states of artistic deterioration and incompleteness that add merit to a work are expressed by the terms *wabi* (Jap., apology) and *sabi* (Jap., rust tarnish). The same principle is common in Western esthetics as well, as in the familiar notion that the patina produced by aging adds to the beauty of an ancient sculpture. But the industrial object is made for an immediate practical and esthetic satisfaction that is strictly related to the object's purpose. While it is possible to imagine an increase in the value or beauty of an industrial object due to age, wear, or change in taste (as has already happened with products of the last century or with old locomotives and automobiles; PL. 43), such a change in value is the result of factors which are extrinsic to the object itself and which are therefore not relevant to our analysis of industrially produced work. Use of an industrial product as a piece of scrap in the construction of a work of fine art similarly has no bearing upon the purpose and value of the original object.

The "symbolic" function of the industrial product. "Symbolic" here refers to the manner in which the shape of an object clearly expresses its purpose and is not related to the theories of such philosophers as Ernst Cassirer or Susanne Langer, who hold that art is always a symbol of something. In our use of the term, an industrially produced object contains an element or elements that symbolize its function. These elements of meaning are introduced into the object's form, underscoring its general appearance and at the same time effectively serving to point out the characteristic function of the object. Frequently this function needs to be emphasized; it must be made to seem attractive or significant to the consumer. Occasionally, however, the function of the product is deliberately disguised or concealed by the outer form. This often occurs when the internal mechanism of the object might produce an adverse or undesirable psychological effect.

Styling. Styling serves to make a product more appealing by giving it a bright new form when its old appearance has ceased to please. Related to basic social and ethical requirements within the culture, styling and styling changes go hand in hand with changes in the symbolic elements of objects. Styling is to be distinguished from fashion, which, although exerting some influence on styling, is connected primarily with an ephemeral need for change and distinctiveness and is more directly related to the demands of the market.

Thus in a period when aerodynamics is of dominant interest, even static objects may be styled with aerodynamic forms, as numerous examples testify. Similarly, when angular lines predominate, semimobile or dynamic objects tend to be styled in an angular manner. Various stylistic changes have occurred in industrial design, from the early rationalistic, rectilinear surfaces to the aerodynamic forms of the 1930s and 1940s, the "enveloping forms and tactile surfaces" (Francastel, 1955) of the postwar period, and the later return to more angular and geometric shapes that at times resemble certain aspects of Art Nouveau (q.v.).

Styling is without doubt one of the most controversial aspects of industrial design, and the practice has been severely criticized. It is still held in low esteem, particularly in England, but is now widespread wherever industry has been highly developed. The concept originated in the United States, with its advanced level of industrialization and high standard of living, and it was there that styling first became established. Reyner Banham ("Machine Aesthetics," *Arch. Rev.*, 117, 1955, pp. 225–28) has stated that styling and most of the formal

aspects of industrial design can be placed in the category of popular art as defined by Leslie A. Fiedler ("The Middle against Both Ends," *Encounter*, August, 1955, pp. 16–23). There is some truth to this statement, for industrial design comes into contact with the masses as no other art form in our time. However, the popular art of the past was always in some way related to the fine arts. Today this relationship is almost nonexistent; the phenomenon of a popular art entirely divorced from cultivated art is the unhappy prerogative of our own age. Thus Pierluigi Spadolini's contention — that art in the past was confined to a narrow, aristocratic society and was therefore "a highly individualistic pursuit permitted to few" (1960, p. 85) — is questionable. It may be argued that although the art of antiquity was fostered by the privileged, its enjoyment was almost universal — certainly more widespread than today, when genuine art is restricted to a tiny elite.

Fashion. Fashion, as we have observed, is related to fluctuating needs (such as immediate market demands) for new and distinct forms — needs based on factors other than the more basic ethical and social requirements of the culture that shape the true style of a period. The instability of form of the industrial object, caused by (and causing) rapid consumption, reflects considerations of fashion, advertising, and competition.

A useful distinction has been made by L. D. Kalff ("La Mode dans l'esthétique industrielle," *Esthétique Industrielle*, 28, 1957) concerning the role of fashion in various types of industrial products. Kalff separates products whose forms are primarily functional and are derived from their technological character and products whose forms are decorative and are derived from their affective character. In the first category the author places high-tension wires, street lamps, trains, and other goods of a public rather than private nature, not generally found in stores; a few items for private consumption such as sports equipment, radiators, and ventilators are also included. In the second category are products whose forms are strongly decorative, such as automobiles and household appliances, and products whose functional character is entirely subordinate to the decorative, such as glassware and toilet articles. Where the product is impersonal and the element of personal competition of the consumer is lacking, as in the first category, fashion tends to play little or no role in the design. But in objects of a highly personal nature, as in the second category, fashion becomes extremely important; the relative impermanence of these objects plays a significant role in their submission to fashion. The distinctions drawn are somewhat arbitrary, but they also hold true for goods designed in limited numbers for governmental or industrial use as compared with goods produced in great quantities, which rapidly become obsolete. (A similar analysis has been made by Werner Graeff in *Über Formgebung*, Rat für Formgebung, Darmstadt, 1960, the official organ of German industrial design.)

The phenomenon of the custom-made object — that is, the object produced out of series — is also, somewhat paradoxically, related to fashion. Spadolini suggests that one reason why special models are produced is that they contain innovations that may later be extended to mass-produced objects of a similar type: The phenomenon "pertains only to objects whose use and enjoyment may be extended to other people; that is, automobiles are custom-made, but not electric razors" (1960, pp. 81–83). We can regard custom building, for example, as a prefashion phenomenon — an early stage of a fashion which has not yet become generalized.

Advertising. Rapid obsolescence of industrial forms in the 20th century is due in part to the enormous development of advertising (see PUBLICITY AND ADVERTISING), including advertising art and publicity directed toward the industrial object. The industrial object plays a special role in advertising, functioning both as advertising art and as indirect publicity for other items in the series. The product of industrial design, as we have seen, also partakes of certain aspects of pure art.

One difference between advertising art and pure art is that the latter advertises itself only, while the former directs attention primarily to some other product. Like pure art, the industrial product is self-advertising; but like advertising art, it functions as a representative of a class of objects, publicizing other identical objects. The industrial product in its advertising role is subject to all the laws governing advertising. It must therefore be highly informative and, to remain so, must continuously renew itself to avoid the information consumption that would render it ineffective; as advertising, the industrial object shows changes due more to fashion than to style.

It should not be assumed that the attribution of an advertising character to industrial design necessarily depreciates its artistic value. Rather the ready adaptability of the industrial product to changes of fashion permits to a high degree the anticipation of new trends, which is desirable in even more specifically artistic forms.

Teamwork. Another characteristic of industrial design that distinguishes it from other art forms is its necessary dependence upon specific requirements of industry. Although the thesis has often been advanced that a designer should be free of all outside restrictions and allowed to work independently, such a condition is obviously impossible; no industrial product can be the pure invention of the designer. Even when the designer is given a free hand, he still feels restricted by the possibility of the failure of his product, should it clash with public taste. While novelty in the industrial product is essential for sales, it must conform to the requirements of the market and production. In painting and sculpture the opposite is true: going against current taste is often the way to greatest success.

These special considerations in industrial design point to the necessity for teamwork. Although the designer may work alone as the creator of a given form, his invention can rarely be realized without the help of many people in direct contact with the various phases of production and the market. Group work, however, inevitably affects the designer's originality, freshness, and initiative. Some of the finest products, today as in the past, are the result of individual work done without outside interference. An example is a black paper knife designed by Nizzoli in 1959, which was given away as an advertisement by the Olivetti Company. It was produced in series with modern material, and though its functionality is somewhat doubtful, it fully meets the formal requirements demanded of an object of industrial design; and it approaches, in a surprising way, pure sculpture. But such an object is not typical of industrial design; it is rather an exception to the rule that teamwork and functional operation are necessities in industrial production.

Duties and functions of the designer. The duties and functions of an industrial designer within the framework of a single industry are extremely complex, but they can be summed up in a few essentials. First it should be emphasized that the designer is not merely a draftsman — a technician specializing in accurate finished renderings of a given subject — but a creative planner with true artistic ability, who has full knowledge of the task he is undertaking. One of his first duties, therefore, is to analyze and organize the data obtained from a vast team of scientists, technicians, engineers, statisticians, market analysts, and production specialists and to draw from this material the conclusions necessary to determine the type of product he must create. It is desirable that the designer have a technical staff at his command, not only to aid him in analyzing the pertinent data without which his creative imagination is ineffective, but also to help improve or change the product.

Demand for novelty in an item can be a by-product of scientific and technological discoveries or of new ways of using old tools and procedures. In this connection the designer has a truly creative function, both as an artist and an inventor. Through his knowledge of existing products and methods and the demands of the public, he may create an object in a new form, utilizing new technological advances or personally developing a technical innovation. Examples of technical innovations first introduced by designers are the extreme delicacy of certain watch mechanisms, the portability of transistor radios, and the

transparency of various coffee machines. With respect to the inventive role of the designer, Arthur BecVar has stated: "Design in its initial planning stage is the thinking about problems, not their solutions . . . finding out if the problem has been clearly stated and is understandable to the people concerned" ("The Designer's Answer," *Design Forecast*, 1, 1959, pp. 54–57).

One of the chief duties of the designer is, as we have seen, to create by means of styling and redesigning new models and forms for the market — new, at least, in their external appearance. Suitability of form must also be considered; an item that is not a redesign of a model already on the market must, from its first appearance, present all the necessary requirements of intelligibility and self-symbolization. It is indispensable that the product be immediately comprehensible to the public which is to use it and which has not yet seen it. The product must not be disguised in an inappropriate form or be easily confused with an already established product. In short, the object must possess from the start a distinct personality of its own. To achieve this is one of the designer's most critical tasks, and everything depends upon his ability to carry it out.

Historical origins. It has frequently been argued whether the term "industrial design" can be applied to products preceding the industrial revolution, and whether one can properly include within the category of industrial design objects made in antiquity with the use of rudimentary machinery. Many scholars have sought to classify ancient tools and objects such as shovels, picks, hammers, amphoras, bells, and furniture as examples of industrial design. Such an enlargement of the concept, however, does not seem justifiable. In the distant past the elementary employment of the machine always introduced some uncertainty into the repetitive aspects of the work. Products could not be made identical in every case, and no real standard could be established. For this reason industrial design as such began only with the advent of a genuine standardization of product, where tolerances were kept to a minumum. The initial stages of the industrial revolution must therefore be considered the prehistory of industrial design.

The earliest goods produced industrially from designs specifically adapted to the new system of production appeared in the late 18th and early 19th centuries. They seem to embody an erroneous concept of what we now call industrial design: An attempt was made to disguise the functional character of the object by imposing upon it decorative details conforming to the taste of the period. This practice ultimately led to a profound crisis concerning methods of production and the artistic validity of the objects produced. An example of this early approach is John Nash's Royal Pavilion (1818–19) in Brighton, England; cast iron, the chief material of early industrial achievement was used, and the pavilion was decorated in the Orientalizing taste then in fashion. The pheasant cage (1808) by Humphry Repton, which was to be part of the pavilion complex, was similarly designed. Furniture makers Thomas Chippendale (ca. 1718–79) and Thomas Sheraton (1751–1806) continued to draw inspiration for their decoration from pre-existing styles and ornamental motifs, although they were mindful of the functional requirements of their products. To Sheraton belongs credit for the first attempt to organize a system of mass production. Josiah Wedgwood (1730–95), who contributed many technical and chemical discoveries to the ceramics industry and who dedicated himself with great inventive zeal to its problems of production, trade, and transportation, was also aware of the attractions of ornamentation. This can be seen in his later work particularly, after he became associated in 1768 with the merchant Thomas Bentley, a man of taste and culture. The two partners engaged John Flaxman and other artists to produce pottery designs inspired by ancient Greek prototypes (X, PL. 289).

The incongruity of combining such ornamentation with qualities of technical perfection, efficiency, and functionality (which by themselves can give a product some esthetic merit) becomes clear in the objects shown at the Great Exhibition of 1851 in London. The esthetic values inherent in industrializa-

tion and standardized production were first expressed in works of engineering: in exposition buildings, transportation systems, and utilitarian constructions of all sorts — works that made full use of such new building materials as iron. Among the earliest examples of these engineering structures was the Severn Bridge in England (1779), the first to be built with a single span, constructed by J. Wilkinson and Abraham Darby; and Sunderland Bridge, Durham, England (1793), based on designs of Thomas Paine. In other countries as well, early use was being made of the new building materials produced by industry. Victor Louis's Théâtre Français of 1786 in Paris, with its iron-framed tile roof, is one of the important 18th-century constructions in cast iron. Among the French buildings with iron construction in the first half of the 19th century are Les Halles of Victor Baltard and the Bibliothèque Ste-Geneviève (1843–50) of Henri Labrouste (q.v.), both in Paris. Labrouste's Bibliothèque Nationale (1853), Contamin's Hall of Machines (1889), and Eiffel's tower (1889; V, PL. 99) are important later-19th-century French examples with metal construction. Labrouste's approach to building is recalled in his statement: "In architecture, form must always be appropriate to function A logical and expressive decoration must derive from the construction itself" (*Souvenirs d'Henri Labrouste*, Paris, 1928).

Such an attitude toward building was more common in the United States than in Europe during the 19th century. Before 1850 industrially prefabricated parts were in wide use in the United States for building, as in Alexander Parris's Boston Market (ca. 1825). In 1848 James Bogardus built one of the earliest commercial buildings with a cast-iron front; and in 1854, in the Harper Building, New York, he introduced the first American rolled-iron beams. The new architectural trends that were developing between 1850 and 1880 culminated in the work of Henry H. Richardson (q.v.), architect of the Marshall Field Wholesale Store in Chicago (1885–87; I, PL. 84), and the vital group of Chicago architects comprising William Le Baron Jenney, Holabird, Burnham, John Root, and the great Louis Sullivan (q.v.), teacher of Frank Lloyd Wright.

William Morris and the Arts and Crafts movement. William Morris (q.v.), guiding spirit of the Arts and Crafts movement in England, holds an equivocal position regarding the industrialization of art. His attitude was negative inasmuch as he essentially denied the machine, which he considered responsible for the artistic decline of the applied arts in his time; but his approach was also positive in that he saw and insisted upon the importance of giving esthetic dignity to even the most insignificant aspects of daily life. Morris emphasized that there is an artistic factor not only in pure art but in objects of common use as well. Unfortunately, his suspicion of the machine caused him to turn to handicrafts instead of industrial production as a means of educating the public through art. In this he was complying in full with the beliefs of John Ruskin (1819–1900) and the Pre-Raphaelites. The polemic that Ruskin and Morris long directed against machinework and technology is summed up in Ruskin's *The Seven Lamps of Architecture* (1849), in which he accuses the machine of having suppressed the joy of working. Morris was anticipating attitudes that were to be generally appreciated much later, when, in disgust at the meretriciousness of commercial products, he tried to teach his workmen to search out and exploit the individual beauty of different materials and when he personally saw to the designing of every detail in his Red House (built for him in 1859 by Philip Webb), from the wallpaper to the glassware. Morris's importance consists chiefly in the fact that he sought to give handicraft production a new vitality and direction of its own, refusing to imitate slavishly the designs of the past.

Although Morris himself never came to recognize the decisive importance of the machine as a new and revolutionary means of production even in the field of art, this awareness was present in some of his disciples such as Walter Crane (1845–1915), W. R. Lethaby (1857–1931), John D. Sedding (1837–91), Lewis F. Day (1845–1910), and Charles R. Ashbee (1863–1942). Day, who was very much a true designer, wrote in *Everyday Art* (1882): "Whether we like it or no, machinery

and steam-power, and electricity for all we know, will have something to say concerning the ornament of the future."

From Van de Velde to Muthesius. The rationalist tendency that characterized American architecture from the middle of the 19th century later appeared fully in European architecture with the work of H. P. Berlage (q.v.) in Holland, Adolf Loos (q.v.) in Austria, Tony Garnier and Auguste Perret (q.v.) in France, and Peter Behrens (q.v.) in Germany. This trend was not long in affecting industrial production as well, particularly when a number of modern architects such as Behrens also turned to industrial design. In 1907 Behrens became advertising and design consultant for the Allgemeine Elektricitäts-Gesellschaft (AEG; PL. 44) and in 1909 built the AEG Turbine Factory in Berlin (V, PL. 103).

Only an apparent contrast distinguishes the rationalism of the above group from the almost contemporaneous tendencies of Art Nouveau (q.v.). In 1903 Henri Van de Velde, who with Victor Horta was one of the leading exponents of Art Nouveau, had declared himself a supporter of "logical structure in products, logic without compromise in the use of materials and a proud honesty in working methods" (*Die Renaissance im modernen Kunstgewerbe*, Berlin, 1901). Art Nouveau was strongly influenced by the English Arts and Crafts movement and Pre-Raphaelitism. In 1891, when English handicrafts first appeared on the Belgian market, Serrurier-Bovy was already beginning to produce in his Liège factory furniture based on English models, and Van de Velde was starting his design career under the influence of William Morris. Van de Velde's decoration of Siegfried Bing's Paris shop in 1896 helped spread Art Nouveau to France, where in the work of Emile Gallé and Hector Guimard it developed in a highly imaginative and decorative way. Though Art Nouveau was, in many ways, closer in theory and practice to the Arts and Crafts movement than to the rationalist currents of the early 20th century, one of its chief merits in the development of modern industrial design was its insistence upon a close connection between decoration and structure in both architecture and design.

Germany and Austria also saw advances in modern design around the turn of the century. In 1903 the Wiener Werkstätten (Vienna) were founded by Josef Hoffmann (1870–1956) and Karl Moser (1860–1936). The Werkstätten flourished until about 1913 and were primarily concerned with the creation of furniture and household objects that would be functional yet artistic. In Germany the achievements of Morris and the Arts and Crafts movement and of architects such as Charles R. Mackintosh (q.v.) and Arthur H. Mackmurdo (1851–1942) were spread largely by the German architect Hermann Muthesius (1861–1927); Muthesius had been attached to the German embassy in London from 1896 to 1903 and had studied at first hand the problems involved in the industrialization of handicrafts in England. His return to Germany presaged the advent of a new German art style known as "Maschinenstil." Muthesius's active campaigning was partly responsible for the creation in 1907 of the Deutscher Werkbund, to which numerous architects belonged — including Hans Poelzig and others who tried to put industrial production on a firmer artistic basis.

The activities of these associations helped produce important changes in the art-training centers of Germany and Austria, as did the appointment in 1899 of Hoffmann as professor of architecture at the Vienna School of Arts and Crafts, later of Behrens as director of the Düsseldorf School of Arts and Crafts, and of Van de Velde as director of the Weimar Academy.

From the Bauhaus to the present. In 1919 Walter Gropius (q.v.), a former pupil of Van de Velde, replaced the latter as director of the Weimar Academy and transformed it into the Bauhaus. Until 1925 the Bauhaus was located in Weimar; then it moved to Dessau, where it remained until 1933, when it was closed by the Nazis. During the period of its existence the school epitomized the aims of the modern movement in architecture and design. Some of the greatest artists of the age were at one time on the faculty of the Bauhaus: the painters Klee, Kandinsky, Feininger, and Moholy-Nagy (qq.v.); architects and graphic artists Mies van der Rohe, Breuer (qq.v.), Max Bill, Hannes Meyer (who succeeded Gropius in 1928 as director), Gyorgy Kepes, Josef Albers, and Johannes Itten.

It is all too easy today to criticize the teaching methods of the Bauhaus. Such criticism is not altogether unjustified, especially with regard to the handicrafts orientation of the school and its emphasis on artistry instead of science and experimentation. But without the Bauhaus there might never have developed in our time so clear an awareness of the new requirements necessary for the evolution of architecture and industrial design. Gropius' teaching departed from premises which were distinctly social as well as artistic and which sought to create for the public an art capable of attaining a maximum esthetic result with a minimum of cost; his approach was based on a full acceptance of the machine and the necessity of furnishing industry with new and functional designs. Gropius sought, perhaps somewhat unrealistically, to achieve a complete integration of the arts by joining art instruction with scientific and technical training. In industrial design the important achievements of the Bauhaus are amply attested by such creations as Mies van der Rohe's metal chairs (PL. 50); the nickel handles by Gropius; the automobile Gropius designed for Adler (PL. 45); and the well-known chairs by Breuer made of chromed-steel tubing with cloth pieces stretched over the frame for seat, back, and arms (V, PL. 456). Today these objects may seem dated (as does some of the contemporaneous furniture created by the artists of de Stijl, e.g., Gerrit Rietveld's 1917 chair; PL. 50); nevertheless, they constitute the real point of departure for a machine art completely devoid of superimposed ornamentation such as appeared at that time in the furniture and objects of Art Nouveau. In the years that followed, certain kinds of ornamentation in machine-made objects became acceptable, and it was recognized that Gropius' functionality, with its social implications, was directed not toward the masses but toward an intellectual elite. However, without the purification of form and the rationalization of technical means carried out by the Bauhaus, the dubious ornamentation that is still found on many industrial objects would have been more widespread than it is.

The principles of the Bauhaus were not lost after the school was closed by the Nazis. Many of Germany's finest architects and designers were welcomed in the United States, where they once again took up their teaching. Moholy-Nagy became director of the Chicago School of Design, which under his leadership continued the Bauhaus principles; Mies van der Rohe went to the Illinois Institute of Technology, where he taught for many years; Kepes, one of the youngest of the Bauhaus group, was appointed to the Massachusetts Institute of Technology; Gropius received a post at Harvard; and Albers joined the faculty at Yale. The arrival in America of the great Bauhaus craftsmen was not destined to transform suddenly the quality of American industrial design and bring it closer to European taste and procedures. The United States, with its highly advanced industrialization and important contributions already made to modern architecture and industrial design, was not greatly affected by the Utopian zeal of the German artists. In the years between the two world wars, America had already seen the large-scale development of styling; considerable attention had been given to the external appearance of products. Large design-consulting studios for industry already existed in the United States, and appliances, airplanes, and automobiles designed by these studios anticipated in their extensive styling and mechanical perfection the products that were to appear in Europe after World War II.

Among the more important American designers was Walter D. Teague (d. 1960). During the many years of his activity, Teague's studio produced a variety of products from motorboats and clinical apparatus to utensils and gasoline stations. Henry Dreyfuss, for many years a consultant for the Bell Telephone Company, designed an entire series of telephones for Bell (PL. 54). Dreyfuss has also designed the "Super G Constellation" (1951) for the Lockheed Aircraft Corporation and the ocean liner "Independence," as well as alarm clocks, thermostats, fire extinguishers, and tractors (I, PL. 136). One of the most noted American designers of a slightly later generation is Charles

Eames, well known for his lounge chair of bent plywood and steel tubing produced by Herman Miller, Inc. (PL. 51), and designer of lamps, playing cards, and other highly original compositions in plastic and wood (PLS. 54, 55; I, PL. 135; V, PL. 457). Eero Saarinen (d. 1961), Breuer, and Philip Johnson are important names in architecture as well as in design. Their designs include diesel locomotives (Breuer, PL. 46), wooden and plastic furniture, and furniture capable of being mass-produced. Particularly well known for the last are the, firms of Miller and Knoll Associates, Inc., whose products also reach a European market (PL. 51; I, PL. 135). Other noted American designers are Peter Muller-Munk, Herbert Bayer, and J. C. Shalvoy. In the field of automobile design, except for a few distinguished examples such as the 1955 Studebaker by Raymond Loewy (a designer of many other products including motorboats and trains), the tendency, particularly since World War II, has been to make the body design increasingly more showy and complicated in response to consumer demands for the automobile as a status and power symbol (PL. 47). The American motorcar has become a typical example of the symbolizing tendency in industrial design that we have discussed. The form is not only made to express function; it is given psychological and emotional expressiveness as well.

The beginning of modern industrial design in Italy can be identified to some extent with the beginning of functional architecture in that country. Italy lacked the industrial tradition that in other countries goes back to the late 18th and early 19th centuries. It was only with the start of the rationalist battles centering around the Milan Triennale exhibitions before World War II (particularly the exhibition of 1936) that Italy became fully aware of modern functional architecture and design. Before this, Italian machine products, and even machines themselves (e.g., sewing machines, typewriters, steam engines), still showed decoration. In the 1930s the situation began to change. The Lancia "Aprilia" of 1937 and the ETR 200 electric trains of 1936 are among the few examples of their time whose forms show a certain maturity of design. At about this period several attempts at modern functional design were made with radios, such as those designed by L. Figini· and G. Pollini (1935) and by the Castiglioni brothers and Caccia Dominioni (1939) for Phonola. Only since World War II, however, has a full consciousness of design problems in both a practical and theoretical sense really shown itself in Italy. In about 1946 the necessity for a rapid and economical means of transportation gave birth to the celebrated Vespa motor scooter manufactured by Piaggio and Company (PL. 46). This was followed shortly afterward by the Lambretta "Innocenti." These two modest but imaginative models (which were to revolutionize the field of two-wheeled transportation in Europe), together with a few automobiles· of advanced design like the "Aurelia GT" and the "Cisitalia" by the designer Pininfarina served as examples for numerous other Italian industries and demonstrated the importance of esthetic quality in the sale of a product. During these same years Italian typewriters and sewing machines also underwent considerable design development. The "Lexicon" and later the "Lettera 22" typewriters designed by M. Nizzoli for Olivetti (PL. 56) are notable examples, as are the sewing machines designed by Nizzoli for Necchi (PL. 56), by M. Zanuso for Borletti, and more recently by A. Mangiarotti and B. Morassutti for Salmoiraghi. Also significant is the Italian development of packaging (PL. 61) and plastic products (PL. 60).

The first important Italian exhibition of industrial design was the Forma dell'Utile, conceived and arranged by the architects E. Peressuti and L. Belgioioso and held at the 9th Triennale in Milan, 1951. This exhibit was followed by a more important one held at the 10th Triennale of 1954, which was also the occasion of a large international design congress in which Max Bill, Walter D. Teague, Le Corbusier, and Konrad Wachsmann, among others, took part. At the 11th Triennale the work of about thirty of the world's major designers was shown. In 1955 a highly successful exhibition of Italian industrial design arranged by M. Zanuso and G. Dorfles was also held in London, in which were shown, among other products, Frua's Motom motorcycle, Zanuso's Borletti sewing machine and "Martin-

gala" easy chair, Nizzoli's "Lexicon" typewriter, 'glassware designed by F. Poli, fabrics manufactured by Jsa, and ceramics by the firm of Ginori. In 1954 the Rinascente department store in Milan began a series of competitions in industrial design (the Compasso d'Oro). Among the products which have won prizes are the "Atlantic" fishing reel manufactured by Alcedo, a series of steel skillets designed by R. Sambonet (PL. 57), a plastic pail by Menghi, a number of plastic objects designed by G. Colombini for Kartell, s.r.l. (PL. 60), an electromechanical clock designed for Solari by G. and N. Valle, J. R. Myer, and M. Provinciali (PL. 54), vases designed by Vianello, furniture by G. De Carlo, a water heater by Alberto Rosselli, and lamps made for Arteluce by G. Sarfatti. Two final indications of the progress industrial design has made in Italy in the 1950s are the creation of, Stile Industria (1954), a specialized periodical under the direction of Rosselli, and the establishment in 1956 of the Associazione per il Disegno Industriale (ADI), a regulating body for industrial design that has helped organize several national and international exhibitions.

In the United States since World War II there has been a tendency to concentrate upon styling, with the result that genuine originality of form resulting from new esthetic points of view has been absent. Something similar has also happened in the other highly industrialized nations. Even in the extremely design-sober countries of Scandinavia, and in Japan, with its ancient decorative tradition, the influence of America has been felt in the gaudy designs and perhaps excessive overmodeling of some products.

Great Britain is one of the most conservative countries in architecture as well as design, and its early industrialization easily met the demands of the public, even with production that kept the same character over a long period. In fact, just after the war there were only a few products in England that showed exaggerated styling. Among the finer postwar examples of English design are the locomotives of Misha Black, noted also for his household furnishings; furniture by Robin Day, Neville Ward, and Ian Bradbery; the radios of A. Bednall and J. White; television sets by Robin Day and Arthur F. Thwaites; the electrical appliances of D. S. Ogle and Roy F. Perkins; and metal household objects designed by P. H. Davies and Robert Cantor. In more recent years, however, England has begun to follow the lead of countries further advanced in industrial design and seems to have been particularly attracted by the example of Italy. Two exhibitions of Italian industrial design held in London in 1955 and 1956 were unexpected successes. Between 1958 and 1960 the British automobile industry also realized that public demand was turning toward the types of automobiles produced on the Continent; as a result, Morris, Hillman and Austin invited Pininfarina to design automobiles for them.

In Germany immediate attempts were made after the war to rectify the injustices committed against the great architects during the Nazi period and to regain lost ground as quickly as possible in architecture and design. But by the early 1960s Germany had not produced any really outstanding examples of industrial design. With its high level of industrialization it has, however, manufactured numerous objects of good design quality. Among them are the many products by Wilhelm Wagenfeld, including porcelain, glassware (PL. 58), plastic goods, flatware, and lamps (PL. 53); the products of the Max Braun Company, such as radios designed by Hans Gugelot and the air conditioner by D. Laing; the flatware of Hugo Pott; Max Bill's clock designed for Junghans; P. Sieber's pocket flashlight; Theo Häussler's transistor radio; and H. Ehring's fruit squeezer. Germany's most notable postwar contribution to industrial design is in the field of teaching, with the creation in 1954 of the Hochschule für Gestaltung founded in Ulm by Inge Scholl-Aicher with the aid of American funds. Max Bill, a Swiss, was asked to be the school's first director. Well known as an architect, sculptor, graphic artist, and art theorist, Bill had been one of the youngest members of the Bauhaus. His intention was to bring to the new German school the old functionalist spirit that had infused the Bauhaus. Unfortunately, Bill's approach led to disagreement with the rest of the faculty (including the painter Friedl Vordemberge-Gildewart, graphic artist O. Aicher, Hans

Gugelot, and critic and sociologist Tomas Maldonado), and he was forced to resign. Bill was succeeded by Maldonado, who sought to orient the instruction along critical and theoretical lines instead of stressing formal training as his predecessor had done. Maldonado was in turn succeeded by Gert Kalow.

France has made almost no important postwar contribution to industrial design, in spite of its high level of industrialization and strong theoretical interest in design problems. (Etienne Souriau, the most important contemporary French esthetician, has continued his father Paul's concern with industrial design, as have P. Francastel, M. Dufrenne, R. Huyghe, and others.) Exceptions to France's generally static level of industrial-design development are a few automobiles, notably the Citroën DS 19. However, through the efforts of the Esthétique Industrielle, the association founded and directed by Jacques Viénot until his death in 1959, France has held a number of competitions in industrial design and has introduced many excellent postwar products, such as Le Creuset's pots, the transformers and other metal objects of G. Gautier and R. de la Godelinais, B. Lacroix's lamps, T. Meunier's electric heaters, plumbing fixtures, and furniture by J. Abraham and H. de Looze, and Viénot's electric razor. Other important French designers are C. Defrance, A. Philippon, J. A. Motte, C. Gaillard, M. Mortier, P. Paulin, J. C. Hennin, and G. Pelletier.

The quality and reputation of Scandinavian design are well known everywhere; Swedish, Danish, and Finnish furniture and household objects are regarded throughout the world as almost unreachable ideals in design. The materials generally used are wood, ceramics, and glass, less frequently plastic and metal. Objects produced are usually the type for which the handicraft tradition still has validity. Many products retain a certain indication of "pleasure" in materials that recalls handicrafts, even when the items are conceived as series and produced by the most rigorously standardized means. Among the best-known Scandinavian designers are Arne Jacobsen (V, PL. 456) and Finn Juhl (both Denmark), who have created some extremely original furniture; Tapio Wirkkala (Finland), designer of many highly refined knives, forks, and spoons; Alvar Aalto (q.v.), Finland's finest architect and one of the most imaginative designers of furniture (PL. 50) and objects in bent plywood and plastics; Erik Herlöw and Tormod Olesen (both Finland), creators of Series R cast-iron enameled pots, among the best examples of contemporary utilitarian objects; and Kaj Franck (Finland), creator of many porcelain and glass objects for the home (VII, PL. 316). Among the Swedes, who also work with more distinctly mechanical objects such as calculators and heating apparatus, are Sigvard Bernadotte, Acton Bjørn (PLS. 54, 57), and Per Heribertson. Designing glassware and ceramics are Timo Sarpaneva and Toini Muona (both Finland), Herbert Krenchel and Kristian Vedel (both Denmark), and Sven Palmquist (Sweden; PL. 58; VII, PL. 325). Steel products of Folke Arnström (VII, PL. 325), Sven-Arne Gillgren, and Sigurd Persson (all Sweden) are also noteworthy. Important designers from Norway are Grete Prytz Korsmo, Willy Johansson, and Björn Engö (objects and furniture); Tore Hjertholm and Karl Korseth (furniture); and Birger Dahl (lamps).

A number of well-designed products have been made in Japan during the postwar years. The frequent accusation that Japan has not developed its own modern industrial design but has slavishly copied forms from the United States and Europe is not borne out. Japan's products compete economically with those of the West but have nevertheless maintained a distinct individuality of style, not only in the more traditional areas of housing and furniture but also in household objects and electrical appliances. While Japanese-produced electrical equipment and precision instruments do not yet show any striking originality of design compared with those of the West, Japanese products that were once handicrafts but are now fully industrialized show unmistakable national characteristics. Among the products noteworthy for distinction and precision of design and for excellence of execution are the furniture of Sori Yanagi (one of the best present-day Japanese designers; V, PL. 456), Isamu Noguchi (the well-known sculptor), and Kenzō Tange (perhaps Japan's best contemporary artist); the lamps of Yoshida, Saito,

and Tsutoma Shimozuma; the furnishings of Iwao Yamawaki, Riki Watanabe, and Kenmochi; and the glassware of Masakichi Awashima.

Teaching of industrial design. As with many of the newer disciplines of our time, the question of industrial-design instruction arose when the field had already reached a certain level of maturity. The earliest instruction was given by handicraft schools, which, firmly established within the craft tradition, often incorporated industrial design within their curriculums, frequently in an incomplete form or incorrectly. In England, where at the beginning of the 19th century there was already an awareness of the importance that machine products were to assume, schools were early established in connection with semihandicraft factories; they included instruction in what we would today call industrial design.

A similar development occurred in Germany. The Bauhaus, as discussed above, was first directed by Van de Velde, who worked fundamentally within a handicraft tradition, although he was acquainted with the developments of industrial art. It was under Gropius that the institution became a school of industrial design in the full sense of the term. The Bauhaus, along with other schools, not only trained students in the craftsmanlike handling of different materials but also gave specific instruction in designing for industry. Its teaching methods (for a more complete treatment see Argan, 1951) are, as we have seen, generally considered outdated today, mostly because they were pervaded by a prophetic and socially Utopian functionalist attitude that no longer corresponds to present-day conditions of life and work.

In Italy, notwithstanding the recent vigorous development of industrial design, no school yet exists devoted exclusively to training in this field. One exception is the sincere but modest attempts of the industrial arts school founded by Nino di Salvatore in Novara, which offers an introductory course in design. The department of architecture of the University of Florence offers a course in designing for industry, ably taught first by the architect Leonardo Ricci and later by Pierluigi Spadolini. But because of technical and material limitations, the course (as of 1962) has been rather a supplement to the architecture studies than a specific training in the theory and practice of design. In 1960, organization was also begun in the University of Venice for a department of industrial design.

Most American and European design institutes already in operation can be distinguished according to their scope, depending on whether they aim at developing designers who are at the same time graphic artists and architects or are specialized within a given area, or, on the other hand, aim at a complete integration of industrial design within the field of visual and literary communication, as is the case with the Hochschule in Ulm. Furthermore, some schools are primarily craft schools (most of those in Germany and Scandinavia) in which limited design courses are given in a particular area such as ceramics or woodwork.

In the United States, the five-year program of the University of Syracuse affords a fairly typical example of college-level industrial-design training. The program comprises, in addition to the required academic courses, design analysis of structural and form elements in natural and man-made objects; introduction to the use of basic tools and machines; development of manual dexterity and manual and visual sensitivity; development of expressiveness, using various means of design and presentation; market analysis, packaging, and display; development of a product design from its initial stages through the model stage to the final, definitive example; study of the physical properties of materials and the theoretical and practical aspects of their structures; mechanics and the mechanical transmission of power; the study of products for domestic, commercial, and industrial use through the determination of human needs, limitations of materials, and sales distribution; time and cost analysis; full-scale construction of working models; problems in advanced designing and commercial and industrial planning; professional practice: professional ethics and responsibilities of the designer and relations with clients; office organization and management:

contracts, letter writing, accounting, and billing; protection of designs: patents, copyrights, and trademarks; and professional organizations.

BIBLIOG. *a. General*: M. Casteels, L'art moderne primitif, Paris, 1930 (Eng. trans., London, 1931); H. Read, Art and Industry, London, 1934 (new ed., New York, 1954); N. Pevsner, Pioneers of the Modern Movement... London, 1936 (new ed., Harmondsworth, 1960); W. Dexel, Hausgerät das nicht veraltet, Ravensburg, 1938; H. Van Doren, Industrial Design: A Practical Guide, New York, 1940; S. Giedion, Mechanization Takes Command, New York, 1948; W. Wagenfeld, Wesen und Gestalt der Dinge um uns, Potsdam, 1948; W. D. Teague, Design This Day, New York, 1949; G. C. Argan, Walter Gropius e la Bauhaus, Turin, 1951; H. Bayer and W. Gropius, Bauhaus, 1919–28, Boston, 1952; M. Bill, Form, Basel, 1952; L. Mumford, Art and Technics, New York, 1952; E. Mundt, Art, Form, and Civilization, Berkeley, Los Angeles, 1952; Atti del Congresso Internazionale dell'Industrial Design, X Triennale di Milano, Milan, 1954 (writings of Argan, Paci, Wachsmann, Teague, Bill, Dorfles, Pizzorno, etc.); W. Braun-Feldweg, Normen und Formen industrieller Produktion, Ravensburg, 1954; S. Giedion, Space, Time and Architecture, 3d ed., Cambridge, Mass., 1954; Knoll Associates, Inc., Knoll Index of Contemporary Design, New York, 1954; G. Nelson, Chairs, New York, 1954; G. Nelson, Storage, New York, 1954; C. Singer and others, ed., A History of Technology, 5 vols., Oxford, 1954–58; J. Viénot, Les problèmes de l'esthetique contemporaine, Rev. d'Esthétique, VII, 1954, pp. 204–08; H. Dreyfuss, Designing for People, New York, 1955; G. Fuchs, Über die Beurteilung formschöner Industrie-Erzeugnisse, Essen, 1955; S. T. Madsen, Sources of Art Nouveau, New York, 1955; P. A. Michelis, Ἡ αἰσθητικὴ τῆς ἀρχιτεκτονικῆς τοῦ μπετὸν-αρμέ, Athens, 1955; P. L. Nervi, Costruire correttamente, Milan, 1955 (Eng. trans., Structures, G. and M. Salvadori, New York, 1956); J. A. Thuma, Schönheit der Technik, die gute Industrieform, Stuttgart, 1955; H. Van de Velde, Zum neuen Stil (ed. H. Curjel), Munich, 1955; F. Ahlers-Hestermann, Stilwende, 2d ed., Berlin, 1956; W. Braun-Feldweg, Gestaltete Umwelt, Berlin, 1956; P. Francastel, Art et technique aux XIXᵉ et XXᵉ siècles, Paris, 1955; G. C. Argan, Marcel Breuer, Milan, 1957; H. Dreyfuss, Industrial Design: A Pictorial Accounting, 1929–57, New York, 1957; G. Nelson, Problems of Design, New York, 1957; H. Spencer, ed., Designers in Britain, 5 vols., London, 1957; G. Ciribini, Architettura e industria, Milan, 1958; G. Dorfles, Le oscillazioni del gusto, Milan, 1958; E. Gomringer, Max Bill, Teufen, 1958; M. Labò, Gio Ponti, Milan, 1958; T. Maldonado, Le nuove prospettive industriali e la formazione del designer, Brussels, 1958; N. di Salvatore, Rapporti arte industria, Novara, 1958; G. Dorfles, Il divenire delle arti, Turin, 1959; P. A. Michelis, Βιομηχανικὴ αἰσθητικὴ καὶ αφηρημένη τέχνη, Athens, 1959; H. Teirlinck, Henry Van de Velde, Brussels, 1959; K. Wachsmann, Wendepunkt im Bauen, Wiesbaden, 1959; R. Banham, Theory and Design in the First Machine Age, London, New York, 1960; R. Marks, The Dymaxion World of Buckminster Fuller, New York, 1960; G. Morpurgo Tagliabue, L'esthétique contemporaine, Milan, 1960; P. Spadolini, Progettazione artistica per l'industria, Florence, 1960 (mimeographed).

b. Periodicals dealing largely with industrial design: Form, Stockholm, 1905 ff.; Design Q., Minneapolis, 1946 ff.; Design, London, 1949 ff.; Kontur, Stockholm, 1950 ff.; Esthétique Industrielle, Paris, 1951 ff.; Industrial Design, New York, 1954 ff.; Stile Industria, Milan, 1954 ff.; Design, Bombay, 1957 ff.

c. Periodicals dealing partly with industrial design: Architektur und Wohnform (formerly Innen-dekoration), Stuttgart, 1890 ff.; Arts and Architecture (formerly Calif. Arts and Arch.), Los Angeles, 1911; Werk, Bern, Zürich, 1914 ff.; Dansk Kunsthaandvaerk, Copenhagen, 1928 ff.; Domus, Milan, 1928 ff.; Bonytt, Oslo, 1941 ff.; Arhitektura, Zagreb, 1947 ff.; Bauen und Wohnen, Zürich, 1947 ff.; Baukunst und Werkform, Nürnberg, 1947 ff.; Comunità, Milan, 1947 ff.; Pirelli, Turin, 1948 ff.; Tvar, Prague, 1948 ff.; Arts ménagers et culinaires, Paris, 1949 ff.; Esso Rivista, Rome, 1949 ff.; Ark, London, 1950 ff.; Habitat, São Paulo, 1950 ff.; Civiltà delle macchine, Rome, 1953 ff.; Aujourd'hui, Boulogne-sur-Seine, 1955 ff.; MD, Stuttgart, 1955 ff.; L'Oeil, Paris, 1955 ff.; Project, Warsaw, 1956 ff.; Ideal-Standard, Milan, 1959 ff.; Alfa-Romeo, Milan, 1960 ff.; Italsider, Cornigliano, 1960 ff.

d. Periodicals on furnishings: Interiors, New York, 1888 ff.; House Beautiful, Boston, Chicago, 1896 ff.; Die Kunst und das schöne Heim, Munich, 1899 ff.; Mobilier décoration, Sèvres, 1920 ff.; Plaisir de France, Paris, 1934 ff.; Arte y Hogar, Madrid, 1944 ff.; Möbel-Kultur, Hamburg, 1949 ff.; Ameublement Informations, Paris, 1950 ff.; Das moderne Heim, Vienna, 1951 ff.; Rivista dell'arredamento, Milan, 1955 ff.; Artecasa, Milan, 1959 ff.

Gillo DORFLES

Illustrations: PLS. 43–62.

INDUS VALLEY ART. Like the contemporaneous Mesopotamiam and Egyptian civilizations, the first Indian civilization flourished, in its major centers, along the course of a great river. It has also been called both the "civilization of Mohenjo-daro" (for the locality in which the first of its great cities was discovered) and the "civilization of Harappa" (for the city whose cultural development during the 3d and 2d millenniums B.C. seemed easiest to trace). It is certain, however, that the area within which the civilization expanded

extends, both to the east and to the west, far beyond the geographic limits of the basin of the Indus (see ASIATIC PROTOHISTORY). The Harappa civilization is noteworthy for the plan of its towns based on an invariable and regular design that may be described, in modern terminology, as functional because it was intended to meet the practical needs of the inhabitants. In the plastic arts are found creations of great artistic value, notwithstanding their small dimensions; the freedom of their shapes seems far removed from the rigid patterns of primitive esthetics. In this tendency to symbolize reality in an illusory yet stylized manner, as shown in the recurrent use of animal figures, the Indus Valley civilization seems to foreshadow certain characteristics of Indian art (q.v.).

SUMMARY. The early background (col. 106). The civilization of the Indus Valley (col. 106). Chronology and expansion of the Harappa culture (col. 108). Social and technological background (col. 109). Arts and crafts of the Harappa culture (col. 111): *Stonework; Metalwork; Ceramics; Jewelry*. The Aryan invasions (col. 116). The end of the Harappa culture and its influence on the invaders (col. 117). Survivals of the Harappa culture (col. 119).

THE EARLY BACKGROUND. The earliest known inhabitants of the Indus Valley left evidence of their presence in the workshop sites at Rohri and Sukkur, places near the vast irrigation dam and railway bridge that now span the river. Here they made their early core and flake tools; from here the Harappans were to derive the cherty flint for their flake-blade knives. A number of microlithic sites, in the main associated with the hilly country bordering the lower Indus, also show the presence of mesolithic hunting and food-gathering peoples. Without doubt their settlements persisted side by side with the Harappa culture; one such community, whose tools were found on the banks of the Lyari River near Karachi, used Rohri chert and left typical Harappan flake blades and cores in addition to their traditional microliths of geometric style. This find produces the sole roughly datable instance of an early microlithic industry (ca. 2400–2000 B.C.).

About 2700 B.C. peasant farmers from the high plateau of Iran, who had been spreading through Baluchistan, made their way through the passes of the Kirthar Range and occupied the greater part of Sind surrounding the lower Indus. They were accompanied by potters whose work, manifesting an attractive diversity of painted decoration, has been called "Amri ware" after the site of that name (see CERAMICS). Though they possessed a small number of copper articles acquired by trade, these farmers were in a neolithic stage of cultural development. There is no indication that they could or did develop the urban civilization that displaced them, without the intervention of some considerable external stimulus. Amri pottery, while varying from place to place in its styles of decoration, is a clearly related cultural product, which is sometimes influenced by similar decorative styles employed in Baluchistan. Harappan pottery, at first existing side by side with Amri ware and finally succeeding it, manifests a new and quite unrelated tradition; there is no question whatsoever of the merging of one into the other by slow cultural development. Thus the Harappa culture came as an intruder into a congeries of peasant farming communities, bringing elements of civilization wholly unfamiliar to those who had inhabited the Indus Valley before its arrival; as a token of their artistic ability these early inhabitants left behind only painted pottery with a considerable measure of primitive charm.

THE CIVILIZATION OF THE INDUS VALLEY. The basic elements of that remarkable civilization, the Harappa culture, were introduced into the Indus Valley at a date which cannot be much earlier than 2600 B.C.; it is not now, and may never be, possible to know with complete certainty the manner in which these wholly different conceptions of life were brought to India. One thing is quite clear: there is not the slightest evidence for any slow and laborious evolution in India itself. This culture was urban from its start. Apparently it began with the founding of a modest town at Mohenjo-daro (PLS. 63, 64), then on the west bank of the Indus, now at some distance from

the river, which has many times shifted its course; the town grew into a remarkable city of considerable size. It has been contended that the Harappa culture arrived fully developed from the very start, but this is not so. It is likely that certain peoples from the lands at the head of the Persian Gulf determined to band together in order to establish a colony in new lands overseas. The first landfall which would offer a country worth settling would be the mouth of the river Indus if they came by sea, coasting along the northern shore of the Persian Gulf, as is most likely; the elements distinctive of the Harappa culture from its beginning in India would never have

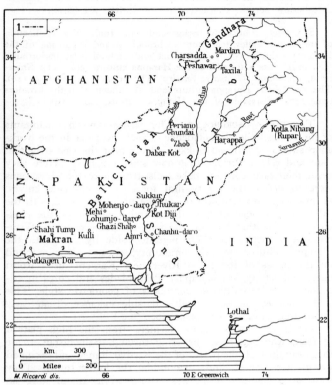

Chief archaeological sites of the Indus Valley civilization. *Key:* (1) Modern national boundaries.

survived a long overland trek in bullock carts. These peoples brought knowledge and ideas and had before them the stimulus of a new land. They were clearly accustomed to the use of sun-dried bricks; much of the building in the Indus cities — platforms, ramparts, in fact anything which required a solid infilling — was carried out in sun-dried brick. However, they also knew of fired brick. It is likely that in the country of their origin timber was too scarce to fire large quantities of bricks; in the Indus Valley, however, trees must have been plentiful, and, no doubt faced with heavy rainfall, the founders of the Harappa culture used available wood to produce the vast quantities of baked bricks which are so outstanding a feature of their towns and cities.

The recently excavated site of Kot Diji, near Khairpur in Sind, has brought to light an interesting settlement. This does not reveal, as has sometimes been thought, the Harappa culture in evolution; as suggested in the preliminary excavation report, the settlement was almost certainly in contact with the Harappan cities, from which it borrowed elements of pot decoration. As might be expected, the shards from the Kot Diji site so far published show resemblances to Amri ware from Ghazi Shah and to the earlier Harappan types of Chanhu-daro. Though present knowledge of this site is slight, the fact that it was burned, apparently by the Harappans, who then settled there, suggests certain tentative conclusions. The settlement was originally (ca. 2700 B.C.) one of Amrian peasant farmers. In pioneering communities such as Mohenjo-daro in its earlier days there are always dissident and independent

types who are expelled or who move on to new ground. Such may have settled at Kot Diji about 2500 B.C. and built a small fortified town, which preyed on Harappan communications and was in consequence attacked and burned (ca. 2250). As no doubt the surrounding area was under cultivation, the place was settled by the Harappans to occupy this point on the route between Harappa and Mohenjo-daro and was maintained probably until the 16th century B.C.

The Harappans must have been a mercantile people capable of considerable feats of organization; the felling of timber, the making and firing of bricks, and the erection of well-constructed houses by builders and carpenters all required great skill and competent direction. If the life span of Mohenjo-daro, the earliest and longest lived of the Indus cities, is somewhat arbitrarily divided into four periods marking its rise, greatness, stagnation, and decline, certain events can be assigned roughly to their position in those periods and the appearance of innovations and improvements can be charted.

In judging the artistic output of the Harappans, that of their contemporaries must be borne in mind. If the period of greatness is placed from 2350 to 2200 B.C., it would coincide with the dynasty of Akkad in Iraq; however, as all the pieces of statuary were found in late levels, 2–6½ ft. below the surface, they might well be much later, coinciding with the 1st dynasty of Babylon. But no clear parallels can be drawn with Babylonian art objects. The general impression gained of the Harappans is that of a mercantile people of considerable administrative ability, whose ruler — whether a single individual or a corporate body — was not a patron of the fine arts.

CHRONOLOGY AND EXPANSION OF THE HARAPPA CULTURE. The dating of the Harappa culture depends wholly on the discovery of various objects of Indus Valley origin and those having unmistakable Harappan traits in datable surroundings elsewhere. About a dozen seals, either from the Indus Valley or with clear Harappan affinities, have been found at Ur, Kish, Tell Asmar, Tepe Gawra, Lagash, and in Syria at Hama; they cover a period from about 2400 to 1750 B.C., the majority being of Sargonid date. Kidney-shaped bone inlays found at Tell Asmar and copies of conch-shell sections of similar shape found at Indus sites are all of Akkadian date, as are carnelian beads etched with a figure-eight pattern and gold disk beads with an axial tube. Similar gold beads appear at Tepe Hissar III together with the notched paste beads so common in Mesopotamia (q.v.). At Shah Tepe, not far from Tepe Hissar, notched paste beads reappear, accompanied by a square carnelian bead etched with a singular design of circles in radiating compartments. This uncommon type of etched bead also appears in the Royal Tombs of Ur. The fact that both it and the notched paste beads have been unearthed at Mohenjo-daro bears out the dating of 2400–1750 B.C. for the trade contacts already suggested by the seal data.

The earliest contact is represented by a fragment of steatite found at Mohenjo-daro which has carved decoration in imitation of woven reed matting. This is a portion of a Sumerian hut-pot, carved to portray the reed huts of early Mesopotamia with their walls of reed matting and their reed-bundle doorways; such small jars were common throughout Iraq from Susa westward to Mari in immediately pre-Akkadian times and are found in the Royal Tombs of Ur. A date of about 2450 B.C. would fit in well with the Period I level in which the fragment was found.

All the evidence now available, which will be canvassed more fully in a later section, indicates that the Harappa culture was brought to an end by a series of invasions from the Iranian plateau (ca. 1800–1400 B.C.). Late incised-stone vessels, possibly third-hand copies of the early naturalistic Sumerian hut-pots, are found in the upper levels of Mohenjo-daro; these may be imports from Kulli or Mehi in Baluch Makran. A date not earlier than 2100 B.C. would be appropriate for these late copies wherever found. Even allowing for the yet untouched depths at Mohenjo-daro, it is extremely doubtful whether the date of the founding of the Harappan city, as opposed to any earlier occupation, can be much, if at all, earlier than 2600 B.C.,

while it seems probable that this was the last among the Indus Valley cities to survive, being finally destroyed about 1550 B.C.

As their city grew in strength, the Harappans enlarged their hold upon the surrounding countryside. Small Harappan townships appear at Jhukar, Chanhu-daro, and Lohumjo-daro along that stretch of the Indus over which the Harappans held sway.

It is suggested that Period I (ca. 2600-2400 B.C.) was the formative period of the Harappa culture. All the various arts and crafts which gave it the right to be classified as a fully civilized community, producing such important public works as the Great Bath (PL. 64) and the Granary in the citadel area at Mohenjo-daro, achieved their highest degree of quality and perfection in Period II (ca. 2400-2150). Those who had instituted citadel rule during this period planted a colony at Harappa on the river Ravi, a tributary of the Indus, 350 miles to the north in the Punjab. About 2300 these colonists, no doubt led by members of the Harappan ruling class or dynasty, dispossessed peasant farmers connected to the Zhob people of Periano Ghundai II (see CERAMICS) and founded a city with a citadel and a granary on the same pattern as their parent city.

During the succeeding centuries (to ca. 2000 B.C.) Harappan settlements extended along the ancient river Sarasvati as far east as Rupar and Kotla Nihang in eastern Punjab. A settlement has been found as far south as Lothal in Gujarat. Trading posts in the Zhob at Dabar Kot and at Sutkagen-dor in Baluch Makran suggest contacts with the peasant farmers of the hill valleys of northern Baluchistan, while a Persian Gulf entrepôt facilitated trade with Sumer and Akkad.

Although some outward expansion may have taken place during Period III (ca. 2150-1800 B.C.), this was in general an era of stagnation marked by few, if any, improvements or innovations. It is possible that at this time the invasion of Mesopotamia by Guti barbarians may have brought outside contacts with that country to an end. Western contacts may have been reopened with the 1st dynasty of Babylon during the marked decline after 1800, in Period IV, at the same time that the pressure of invading forces drove a wedge into the region (ca. 1700). Those invaders, whose forays had penetrated during the previous century farther and farther into the Indo-Iranian borderlands, continued their attacks after that first impact until they eventually occupied the townships of Jhukar, Chanhu-daro, and Lohumjo-daro; only the city of Mohenjo-daro, because of its superior strength, was able to resist these attacks.

While no evidence shows that the Harappans dislodged by the invading Aryans ever retreated to make a fresh start in the Ganges-Jamuna Valley and to reproduce their culture, small provincial settlements, probably of a late period, have been uncovered on the western coast at Saurashtra (mod. Soruth) and near the mouth of the Narbada. Other settlements have been brought to light at Alamgirpur, about 16 miles west of Miraht (mod. Meerut), the only Harappan settlement east of the Jamuna known to this time. Though the settlements of Rupar in the Punjab and Lothal in Gujarat may have survived for several decades longer, the nucleus of the Harappan realm had ceased to exist by 1500 B.C.

SOCIAL AND TECHNOLOGICAL BACKGROUND. It has already been mentioned that an outstanding feature of the Indus towns and cities was the extensive use of baked brick (PLS. 63–65). There was a high standard of town planning; blocks of houses were divided by straight main thoroughfares and connecting side streets, while drainage works to draw off household waste water, sewage, and storm water indicate an appreciation of the value of controlled sanitation. The earliest drains (PL. 63) appear toward the end of Period I.

To support this urban civilization, with its civic functionaries, its leading families (who provided direction for affairs of state), its artisans and tradesmen, there had to be a prosperous economy which yielded a surplus sufficient to maintain social services and to purchase consumer goods. The vast granaries at Harappa and Mohenjo-daro bear witness that this economy was quite clearly based on a considerable grain production; some of the grain, as well as cotton, was almost certainly exported. Traces of a cotton material of plain weave — used to wrap certain copper articles — were providentially preserved by the action of metallic salts produced by the combination of the copper with alkalis in the damp soil.

Such an economy would presuppose the use of transport. Model cart frames and wheels in terra cotta and the marks of wheel ruts in the earth testify that the Harappan cart was of the same type as those found today in Sind; its wheel span was identical with that of its modern counterpart, and it differed only in having solid rather than spoked wheels. Overseas trade entails the use of small ships; evidence for the existence of river transport and coastal shipping is provided by one of the characteristic seals of this culture, which depicts a boat with a high central deckhouse or cabin.

At Harappa there are slave barracks on the north side of the citadel area, adjacent to the granary and to the grain-pounding platforms where the slaves turned out quantities of coarse flour. Certain small terra-cotta figurines of seated men, squatting with knees drawn up, some of them wearing a broad flanged collar, may be ex-voto offerings of slaves in lieu of an actual human sacrifice.

It seems likely that the community was ruled by an oligarchy and that its upper class was mercantile rather than priestly or warrior. Its mercantile system did not function in all its details from the start; weights and seals, which must have formed a very important part of trading practice, were found in such small quantities in those levels which may pertain to Period I that it is doubtful whether seals were introduced much before the earlier part of Period II, and weights much before the later part. The system of weights was unique. The weights themselves are cut and polished cubes of chert. The lower weights progress by doubling from 1 to 64, which is two-fifths of the next unit of the system, 160. From this point there is a new progression in decimal multiples of 16.

As will be shown in subsequent sections, the Harappans had a competent standard of metallurgy and a script which has survived only in brief inscriptions on seals, jars, and copper tablets and axes, but which must have been used for trade records and accounts as well, if for no other purpose. No public inscriptions, neither edicts nor dedications, have emerged if they ever existed. It is the lack of any classifiable document which makes the decipherment of this Indus script practically an impossibility.

Intercourse with the Sumero-Akkadian realm brought knowledge of the properties of bitumen in rendering a structure watertight. This knowledge was employed to advantage when building the Great Bath at Mohenjo-daro (PL. 64). A layer of asphalt 1 in. thick was introduced into the side walls and floor of the tank. Although the idea came from Iraq, the mastic employed at Mohenjo-daro was of an entirely different type from that used at Tell Asmar or Ur; obtained locally from sources on the Sind-Baluch border or in the Punjab, the Indian product is a refined rock asphalt with sufficient mineral content to permit application by troweling without the addition of any stiffening material.

The Great Bath is one of the few structures for which a religious purpose has been suggested. Ritual cleansing by bathing before participation in religious ceremonies is a well-attested custom. There is also the supposition, which may well be correct, that the Buddhist stupa which dominates the citadel was built immediately above the site of a temple; for this reason an imposing building between the stupa and the Great Bath was named by the excavators the "College of Priests." It is of course possible that the stupa does overlie a temple, but none of the buildings so far excavated in its vicinity, not even the "College of Priests," gives evidence of any other than a secular use. The truth is that knowledge of the Harappan religion is very slight. There are no temples, of which the architectural layout could afford some clue, nor are there texts, like the Babylonian Gilgamesh epic, to disclose religious concepts, nor even temple accounts which might reveal the practical administrative picture. Names of gods may be concealed in the seal inscriptions, but they cannot be

read. The best keys to the religious ideas and practices of the Harappans are the seals themselves. Some depict people in an attitude of worship. To what or to whom do they pay this tribute? Two worshipers, each backed by a snake of considerable size, kneel to the seated figure of the god, who is recognized as the horned god by comparison with a well-known seal in which he is shown surrounded by animals. This figure is sometimes depicted standing between branches of pipal (*Ficus religiosa*) and attended by a kneeling worshiper accompanied by a large spiral-horned goat, and in some instances by a row of priestesses. A kneeling figure also makes an offering to what must be a sacred tree. There was therefore a horned god, associated with a sacred pipal tree, which appears on seals and sealings; the pipal tree is also connected with bull leaping and with a sacred enclosure containing a pillar crowned with the horns and hair braid of the horned god. The quantity of female figurines suggests a mother goddess, though none of them has the sex exaggerations common to fertility goddesses. Figurines of oxen are related to the seals showing bull or buffalo baiting and sacrifice. In summary, the cult seems to be directed to a horned god and fertility goddess, accompanied by the sacred tree or grove and by the ritual baiting and sacrifice of cattle; the pattern is a familiar one.

ARTS AND CRAFTS OF THE HARAPPA CULTURE. *Stonework.* In the first place it should be borne in mind that at Mohenjo-daro no indigenous stone exists. Every pebble found at the site, alabaster, limestone, steatite, or sandstone, had to be imported, the nearest sources being Sukkur on the Indus and the Kirthar Range. In all, some seventeen or eighteen sculptured pieces of stone of all sizes (seals are not included) have been found at Harappa and Mohenjo-daro, particularly at the latter site (PLS. 66–68). The greater number seem to portray a seated or squatting male figure, possibly a god. These figures are of no great size; if the largest head found belonged originally to such a figure, the whole would have been roughly 2 ft. high, an average size being about 16 in. By far the best-preserved piece shows the head and shoulders of a bearded man. His hair is bound with a fillet having a circular ornament on the forehead (PL. 67). When examined in London in 1947, this figure was found to be of sandstone with a fired surface coating. In its general appearance there is nothing remotely resembling Sumerian or Babylonian types or artistic style; by far the closest parallels are to be found in the subject Asians, Sangari and Kadshi, portrayed on the chariot of Pharaoh Thutmosis IV.

The remaining male figures from Mohenjo-daro do not enhance the artistic reputation of the Harappan sculptors. The figures are ill-proportioned, the body and arms appearing small in comparison to the head and legs. Most of the details, notably the ears and hair, are schematic. Although no proper record was made by excavators, all these figures were found in late levels; none can be placed earlier than the latter half of Period III (ca. 1900 B.C.). In addition to these human figures, there are two limestone figurines of rams.

Two fragments of carved steatite, one showing only the hair portion of a woman's head and the other a small female image, were found at high, almost superficial levels. These are almost certainly of the early historic period and date to the time of the Buddhist occupation.

Since only two stone sculptures were found at Harappa, a considerable measure of uncertainty has always existed as to whether these two limestone statuettes can with confidence be assigned to the time of the Harappa culture. The first is a naked male torso with a somewhat protruding stomach, in which the body planes are rendered with much skill and sensitivity (II, PL. 8); the other is a male dancing figure which shows a mastery of balanced movement but has nothing of the anatomical perfection of the former. At first sight it would appear that there is no basis for an attribution to the Harappa culture. But no known stone images of the early historic period have separately carved detachable heads, as did the male torso. There are indications that the nipples of both figures were inlaid; circular depressions on the shoulders of the torso might also have been intended for inlays, though these would make

little sense. Inlays are a feature of the Harappa culture, and the sensitive rendering of some of the animals depicted on the seals indicates a possibility of an equal sensitivity in carvings in the round. There are, however, equally cogent arguments against such an attribution. Apart from the detachable head and the question of inlays, the male torso is a typical northern Indian carving of the early centuries of the Christian Era. Though they are the only sculptures found at Harappa, the torso and the dancer show not the slightest resemblance in subject, style, or artistic sensibility to any of those found at Mohenjo-daro. It would seem better to suspend judgment as to the provenance of these two sculptures until there is further evidence of Harappan origin, and to refrain from using them to support any particular argument concerning Indian art history, since numerous remains of the Buddhist period were also found at Harappa.

Possibly the most characteristic feature of the Harappa culture is a series of small stone tablets, averaging roughly 3 cm. square and 8 cm. thick, cut from steatite, and coated with an alkaline substance before firing. Perhaps these were used as seals; on the obverse is engraved a line of characters of the Harappan script and a picture, while on the reverse appears a narrow raised boss with a single incised line and a hole for a cord. The picture is almost always of an animal. The most common theme has been identified as the urus ox, depicted in profile with only one forward-pointing horn visible; the tiger, elephant, humped bull, buffalo, rhinoceros, and mountain goat are also represented (PL. 69). Religious or mythological subjects are not common, but there are a few late seals portraying a hero subduing tigers or a seated horned deity.

E. J. H. Mackay was of the opinion that the line of script constituted the seal element and that the picture was amuletic. There is no real evidence to support this idea. If the animals are regarded as totemic, conferring amuletic benefits, the disproportionate number of urus ox figures renders absurd such a supposition. Beyond the fact that these objects were used to seal and mark bales packed in matting, nothing is known about them. The very few sealings that remain survived mainly through accidental baking. Baked seal impressions, probably used as tokens, can be paralleled in early historic times. That any of these seals or sealings were regarded as luck-bringing or protective is doubtful, though any interpretation must of necessity be wholly speculative.

The actual execution of the seals is very uneven. As is only natural, only the finest examples are commonly used as illustrations, in particular the depiction of a humped and heavily dewlapped Brahmany bull, a magnificent specimen of the seal cutter's art. The high degree of anatomical skill displayed in a few outstanding seals has been put forward in argument to support an early date for the two Harappa statuettes carved with equal mastery. As the finest seals come from Mohenjo-daro, which has produced no statuary remotely resembling the competence of these statuettes, it is doubtful that this argument carries much weight.

Though humans or gods in human form are uncommon in the seal pictures, these subjects appear on what are possibly the most important and most interesting seals. One religious scene shows a goat with a human face standing behind a kneeling figure who worships a deity framed by pipal branches. Other seals show men tossed by a buffalo, a man spearing a buffalo, and a man leaping a bull in front of a sacred tree in an enclosure with a pillar bearing the horns of consecration of the horned god; this last is a most Minoan scene in all its details.

Metalwork. In spite of the surviving fragments of a few sickle blades, it is doubtful that metal was used extensively for agricultural tools; however thus restricted in scope, the metalwork of the Harappans in copper and bronze shows a knowledge of all the techniques in use during the 3d millennium B.C. Some of the small figures of humans and animals in bronze are the finest artistic works produced by this civilization. It is impossible to ascertain precisely how these figures were made; it is clear that they were molded, and probably a number of them were produced by the lost-wax process.

Two outstanding metal figures of women, possibly representing dancers, were found at Mohenjo-daro; the better preserved of the two has a remarkable quality of vitality (II, PL. 7). These ladies have been used as supporting evidence for assigning a 3d-millennium date to the Harappa statuettes. There is also a bronze image of the horned god, a squat dumpy figure with short, thick legs and with arms pressed close to his sides. The copper or bronze animals are for the most part striking representations of their particular kind.

Animal figures also served as ornamentation, although it is difficult to tell in what manner they were used. Two objects, without question derived from the same mold, depict what may be a bull standing on a bar, with a ring cast centrally onto its underside. The suggestion that these objects were rein rings receives little support from the fact that the space over the bar between the animal's legs, through which the rein would have to pass, is only $5/8$ in. wide. A bronze figure of a crouching goat tied to a post by a band of cloth is furnished with a tang, and so was fixed to something, possibly a stand. Mackay was of the opinion that the depiction might have formed part of a group with the goat as a sacrificial victim.

Three small two-wheeled carts cast in bronze have come to light, one at Harappa and two at Chanhu-daro. One from each site has a gabled canopy and is of much the same type as a modern ekka; drivers are seated in two of them. Presumably these toys would have been completed originally by bronze oxen to draw them, just as some of the terra-cotta oxen found in such great numbers must have been toys to draw the model carts, the terra-cotta frames of which can be picked up in equal abundance. (Cf. X, PL. 100.)

An animal-headed pin from Mohenjo-daro and a rod from Harappa are metal objects of considerable dating value. Though they may well have been copied by Harappan craftsmen, they were in fact more generally at home in the area of Asia Minor, the Caucasus, and the Caspian. Two antelope heads, back to back, spring from the bulbous head of the bronze pin from Mohenjo-daro. On the crossbar of the rod from Harappa stands a horned animal, probably a mountain goat, attacked by a dog. The pin, which was found at a depth that might indicate its context as the beginning of Period III (ca. 2150 B.C.), might well prove to be of later date, but the rod, unearthed from only about 2 ft. below the surface, is likely to be late in date, conceivably even post-Harappan. Though there are a number of early examples from Mesopotamia, the clearly related ones scattered from Mycenae to Tepe Hissar are dated about 2000 B.C.

Thin small tablets of copper, bearing on one side a design, usually an animal, and on the other a line of script, have been found at Mohenjo-daro. Their appearance is striking; the engraved outlines have filled with cuprous oxide and show up as a contrasting red against the copper background. While the designs are similar to those cut on the stone seals, there are some new forms. The exact purpose of these tablets is unknown. It has been suggested that they are amulets, but since they have no loop or hole for suspension, they must have been concealed in an amulet case, which seems unlikely. Their use as coins has been rejected because they vary in weight and conform to no standard. However, they may have been tokens denoting a payment obligation; this possibility is strengthened by the small seals from Harappa, very many of which have identical inscriptions on one face and on the other what appears to be a numeral, a fact again suggesting tokens. Moreover, this idea is supported by a much more recent example. At early historic period sites between Peshawar and Mardan, in the North-West Frontier Province of Pakistan, numbers of baked clay sealings impressed with intaglio seals of the Parthian and Kushan periods (50 B.C.–A.D. 300) have come to light. These are ovate or wedge-shaped lumps of clay, quite useless as anything but tokens. It is suggested that all these classes of objects served the same function, that of commercial tokens.

Though the majority of the less well-to-do citizens of the Indus townships must have contented themselves with pottery vessels and with the chert-blade knives which are recovered in such abundance as to justify the classification of this civili-

zation as chalcolithic, the more wealthy had copper and bronze household utensils in addition to these more expendable items. From the earliest times the Harappan coppersmiths must have known the art of producing simple pots, pans, and bowls. The deeper and more globular bowls were formed by a technique known as "raising": a flat disk of copper or bronze is continuously hammered on its outer side while the inner side is turned slowly around the surface of the metalworker's stake, and thus the metal is raised in a series of concentric rings. The simple shallow pans and bowls show hammer marks on the inside; these were made by the easier method of hollowing, or sinking, in which the metal is sunk to the required depth and shape by being hammered and turned over a circular depression in a block of wood.

Other more advanced techniques were used as well. A small pedestal jar, found at a level which indicates the middle of Period II (ca. 2300 B.C.), was without doubt cast by the lost-wax method. The process of lapping, joining sections of sheet metal, seems to have been employed only during Period IV (after 1800). This technique was used to affix the base to an elliptical jar, to form a copy in metal of what was without doubt the most elegant ceramic form produced by the Harappan potters. The same technique was used to join the upper and lower portions of sharply carinated bowls, each portion being fashioned separately by raising, then joined by lapping at the carinated shoulder.

Certain objects found in the lower levels undoubtedly date from the earliest times, from the first foundation of the Harappan settlement. The manufacture and use of metal flat axes, chisels, saws, knives, arrow- and spearheads, and fishhooks are implicit in the very nature of the Harappan culture as observable from the start; the building achievements and general way of life presuppose the use of such weapons of the chase and tools. Certain articles connected with human adornment, such as razors, pins, bracelets, and handled mirrors, also make their appearance quite early. The methods by which these articles were turned out are comparatively simple. Flat axes and mirrors were cast in open molds, chisels were hammered out from round or square-sectioned rods, while razors, knives, and heads of arrows and spears, of thin section, were chiseled from sheet metal. In each case the tool or weapon could have been shaped and hardened by annealing and cold hammering. It seems inconceivable that the Harappans did not know of the western Asiatic shaft-hole ax, widespread after 2500 B.C., though, as will be seen, even when this type was introduced in India by invaders, the use of the flat ax continued throughout the subcontinent up to the onset of the Christian Era.

Ceramics. Though images of stone are scarce at Harappan sites, there is no lack of terra-cotta figurines, both of humans and of animals; at Mohenjo-daro more than 500 human and 800 animal figures were unearthed (PL. 70; II, PL. 7), while Harappa produced nearly 700 human and only about 300 animal figures of this sort. By far the greatest number of the human figures are women, probably images of the mother goddess. When intact, all these mother-goddess figurines have a narrow loincloth and are adorned with one or, very rarely, several necklaces and, occasionally, with a girdle; most have also a high comblike headdress, with braids of hair arranged in various styles. At Harappa only one figure has as many as three necklaces, and at Mohenjo-daro only five have three or more; the most common by far are those having only a single ornamented collar round the throat. In a few instances the headdress includes two cuplike objects secured by bands, one on each side of the face; it is possible that these on occasion contained either incense or a lighted wick. One of the female figures is wrapped in a cloak or blanket. The comparatively scarce male figures, when complete, are naked. The horned figures probably represent a god while the occasional naked and bearded figure is almost certainly a votary.

At Harappa there are certain local types not found at Mohenjo-daro. A number of female figurines, undoubtedly representing priestesses or votaries, are shown with both arms raised to their heads, on which is a voluted object — possibly

a headdress, but more likely some sacred article. Mention has already been made of the squatting male figures peculiar to Harappa, which may represent slaves as ex-voto figures in lieu of human sacrifice discontinued on economic rather than humanitarian grounds. It is likewise possible that many of the animal figurines were votive; round the neck of one ox is a flanged collar similar to those worn by the slave figures; into the sides of the collar are thrust cone-shaped containers, perhaps for incense or some other form of offering. Rosetted headdresses are also an exclusive feature of the Harappa female figures. Chanhu-daro produced relatively few figurines of any kind, while a peculiar bulging type, of which a few came to light at Mohenjo-daro, may represent a pregnant woman and may have served a talismanic function, ensuring either pregnancy or a safe delivery. Such animal figurines as a climbing monkey pierced with holes out of alignment so that its movement on a string is checked, an ox with a movable head, birds (with open or closed wings) on pedestals, and bulbous bird-whistles in the form of a hen, were certainly toys.

Almost without exception these terra cottas have been well fired under oxidizing conditions so as to be fired pink throughout. Many of the human figures have a thin red slip, applied as a finish and preservative. It cannot be said that any of these crudely modeled figurines have much artistic merit. The plain, working potters who turned them out in large numbers probably catered to a clientele who demanded an object having certain religious and luck-bringing properties; the efficacy of the item was not reduced by its stylized appearance, restricted by the limited capability of its maker. A figure of a monkey (?) holding a young one on its knee has a certain naturalism and vital expression wholly lacking in any of the others. Distinct from these crudely modeled figures are a few well-modeled images of bulls, in which great care has been taken to reproduce the anatomy correctly and to finish the figure carefully by clever carving. These may be the product of a single individual who was a true artist. Comparable to these impressive animals is the small figure of a bull finely carved in steatite, a stone carved almost as easily as clay.

The pottery of the Harappa culture (see CERAMICS) was a very utilitarian style of ware. The museum at Mohenjo-daro at one time contained many shelves full of rather undistinguished pink pots in a limited range of shapes, of which the most elegant are the elliptical vases, Mackay's types R and S from Mohenjo-daro, and Wheeler's type XXIX from cemetery R37 at Harappa. The greater part of the household wares are bowls with slight variations of profile; pots with a variety of rim openings narrowing to bottle-necked types; dishes, with and without pedestal stands; pointed-base beakers (in the upper levels); and a certain number of storage jars, the largest being 3 ft. high.

There must have been a fair number of pots decorated with black paint on a polished red slip, but few have survived intact (PL. 70). Some of these are quite striking, with a bold pattern of intersecting circles (III, PL. 121), but the rather crowded designs of foliage, fringed circles, comb patterns, peacocks, and checkered squares generally present a scene of tasteless muddle. Some of the earliest wares found at Chanhu-daro, Lohumjo-daro, and Jhukar, painted in black, often on a cream slip, are much more attractive. Their simple and un-crowded decoration consists usually of a branching pipal tree growing from a small mound of earth, such as is found on Kulli shards from Baluch Makran, and a discontinuous horizontal zigzag with corner dots, such as is found in early Iranian wares from Tepe Giyan and Tepe Sialk.

Jewelry. It is clear from the necklaces, bracelets, and girdles shown on the terra-cotta figures that women of this region habitually adorned themselves with these trappings. One elaborately finished figure boasts an impressive girdle; by good fortune a girdle of this identical type was recovered complete (VI, PL. 243). Long narrow carnelian beads (3 ³/₄ in. in length) were strung in groups separated by narrow spacers flanked by small spherical beads. At one end is a flat hemispherical terminal of copper. Terminals and spacers, recovered in some numbers, are made of such varied substances as copper, bronze,

steatite, and faïence, while the terminals, which may be triangular, are occasionally of gold. The majority of the beads are of steatite or faïence, but there are also beads of various semiprecious stones, such as agate, carnelian, jasper, and amazonite from Gujarat, as well as scarce jade from central Asia or Burma and lapis lazuli from Afghanistan. The common shapes are barrel, cylindrical, and spherical. Most beads are plain but some are decorated, the favorite pattern being the trefoil featured on the robe of one of the pieces of statuary. Frequently these trefoils are produced by drilling or chiseling the surface of steatite barrel beads, but some are etched in white or, in rare instances, black, on carnelian barrels; the etching is done by drawing the pattern on the surface with an alkali solution such as carbonate of soda, then heating the bead to produce absorption of the alkali, and thus yielding a permanent pattern. This process was perhaps an invention of the Harappan civilization; examples found at Ur, Tell Asmar, and as far afield as Tepe Hissar all have typical Harappan patterns. This method of decorating beads, widespread in India during the early historic period, survives to the present day.

A very peculiar style of bead, a flat gold disk with an axial tube, formed part of a necklace unearthed at Mohenjo-daro. Such beads, also copied in faïence, are similar to some found at Ur and in Troy IIg, so that a date of about 2300 B.C. is suggested. Segmented beads of faïence, found particularly at Harappa in some numbers, though of a type which is widespread both in time and space, have been found by the application of spectrographic analysis to be identical in composition to similar beads from Knossos in Crete, dated to about 1600 B.C.

Bracelets and bangles, especially those of pottery, are common; many are so small that it appears doubtful they could have been worn. More costly examples appear in gold, silver, copper, bronze, faïence, and conch shell.

THE ARYAN INVASIONS. Toward the close of the 3d millennium B.C., following the fall of the dynasty of Akkad, which had held in subjection all its border peoples, there is evidence throughout western Asia of troubled times and of the incursion into settled lands of warlike barbarians, probably either of Aryan speech or led by an Aryan element. It was at this time that Guti barbarians from the north invaded Sumer and Akkad, and from about 2100 B.C. onward the sites on the high plateau of Iran passed into the hands of these warrior-dominated peoples. That some were Aryan in speech cannot be doubted; in the course of the tribal conflicts of those times, involving movements of peoples in the general area of Anatolia, the Caucasus, and Iran, it is clear that some of these folk, certainly with an ever-increasing Aryan component, were impelled eastward.

The desert country of Makran with its sparse oases and the narrow hill valleys of the Indo-Iranian borderland did not invite settlement by the invaders. There is little except devastation to mark their passage in those regions. About 1800 B.C. all the peasant farming communities of Baluchistan and Makran came to an end. The long-lived cultures of Kulli and Nal and the Periano Ghundai culture of the Zhob all disappeared, to be replaced only in occasional instances by pottery of a new and inferior type, marking the settlements of intruders with less efficient potters.

Archaeological proof of the arrival of the Aryans in India is as difficult to obtain as is that of their existence in the lands from which they came. As they left no literary remains inscribed on stone or clay, it cannot be asserted with certainty, but only deduced, that those who dispossessed the Harappans and destroyed their culture were peoples of Aryan speech. They came certainly from the Iranian plateau; they brought with them weapons of a type that can be associated with warrior peoples of that land, many of whom must be accounted as Aryan at this period. The period of invasion lasted a long time, possibly 400 or 500 years; it consisted of a series of incursions which may have grown in strength and intensity as did the Śaka and Islamic invasions of historical times. Though the coming of the Aryans to India has been the subject of a vast literature since the end of the 18th century, only in the 20th century were discoveries made that subsequent research has shown can

be associated with that incursion. Graves at Khurab in Persian Makran, still more graves at Shahi Tump in Baluch Makran, and settlements in the Indus Valley mark the advance of the earliest invaders and their arrival at their objective.

The first evidence of this contact in the borderlands is an ax found in a grave at Khurab. For a long time described by writers as a wand, this object has been shown to be a shaft-hole ax of a rather specialized type. It has a very narrow blade; the figure of a squatting camel appears on the back of the socket; the distance from the head of the camel to the edge of the blade is about $7\frac{1}{4}$ in. Axes of this type, with narrow blades and animal figures, come from Til Barsip (mod. Tell Ahmar) in Syria, Van, and Luristan (ca. 2100–1700 B.C.); the Khurab ax and its associated graves are likely to date to about 1900 B.C. or somewhat later. Farther to the east, at Shahi Tump, were unearthed a number of interesting graves containing a strange and poorly made pottery with clearly archaistic patterns (produced as burial goods rather than for daily use), as well as a shaft-hole ax of copper and compartmented seals. The seals have parallels in the cultures of Tepe Hissar III*b* and Anau III and so suggest a settlement founded about 1800 B.C. Other than the destruction they caused, no further traces of these invaders are found until their settlements in Sind are reached. At the site of Nal in southern Baluchistan the final habitations of intruders from the Zhob in the north were burned, and the whole Baluch culture of peasant farmers with distinctive pottery came to an end. The Harappan towns of Chanhu-daro, Lohumjo-daro, and Jhukar were taken over by those who are called the Jhukar people at a date which can be set theoretically at 1700 B.C. Sufficient material connected with this occupation was recovered at Chanhu-daro to give some substance to knowledge of these invaders and to provide a clue to their origins and stage of cultural development.

A shaft-hole ax and compartmented seals align the Jhukar people with the people whose graves have been found at Shahi Tump. Single-loop pins of a type found at Tepe Hissar III, tweezers at Anau III, a bead of whorl type (also characteristic of the cultures of northeast Iran) found at Lohumjo-daro, and an object originally thought to be a kohl jar but finally identified as a macehead with its parallel in Tepe Hissar III, all indicate that this people sprang from Iran early in the 2d millennium B.C. In addition, there are stamp seals which accord with this time and place of origin, including a seal from Jhukar, with a Maltese cross almost identical with one from Anau III, as well as continuous-loop and schematic bird patterns similar to some from the Hittite site Alaca Hüyük. These invaders must have been illiterate; nowhere is there an inscription of any kind whatsoever. Though some of the simpler elements of decoration on painted Jhukar ware are similar to those found on Harappa ware — for instance, the patterns based on intersecting circles, checkered squares, and barred-leaf foliage — the general appearance of the bold Jhukar patterns in black and red on cream is totally dissimilar. It may be that the Jhukar people pressed Harappan potters, particularly captive women, into their service; moreover, the general heritage of Iranian pottery design had persisted to some extent from Amri times. Even so, the Jhukar people had a very characteristic and quite unmistakable pottery of their own. Aside from this they produced nothing at all of real esthetic value; they were an even less artistic people than the Harappans.

THE END OF THE HARAPPA CULTURE AND ITS INFLUENCE ON THE INVADERS. It is probable that the obliteration of the Indus Valley civilization through the continued impact of fresh arrivals from the west took a fairly considerable time; it is likely that the total number of invaders was measured in tens rather than hundreds of thousands, and that the Harappans did not succumb everywhere and at once to their onslaught. This is the only picture that fits both the practical probabilities and a reasonable interpretation of the *Ṛgveda*. From this collection of very early hymns, written in the earliest form of Sanskrit, it is plain that there were dissensions among various groups of Aryan and semi-Aryan invaders and that compromises were made with the Harappans, with whom must be identified the

Asuras and the mercantile Panis, whose cities the Aryans overthrew with the aid of their god Indra.

It is likely that the city of Mohenjo-daro continued to maintain itself against the newcomers long after the destruction of the Harappan towns of Lohumjo-daro, Chanhu-daro, and Jhukar, which probably fell in that order during the period 1700–1600 B.C. Weapons foreign to Harappan types were discovered in the uppermost levels at Mohenjo-daro: an adze-ax of a type found at Hissar between 1800 and 1600 B.C.; dirks and daggers having a raised midrib and rivet holes for securing the hilt (frequently two holes at the base of the blade), implements which have parallels in Syria and Palestine dating from 2000 to 1900 B.C. It would appear that the dirks and daggers were either goods hidden while the city was undergoing assault or were loot cached, but not recovered, by an invader during the sack of the city. Nor need the adze-ax be assumed from its position to be a weapon of the final conquerors. It is far more likely that all these western weapons were acquired by the Mohenjo-daro people from their new neighbors, with whom they had temporarily come to terms, or that they were the property of westerners who had taken up residence in the city, possibly as mercenaries.

That Mohenjo-daro was finally assaulted and sacked is evident from the bodies found in various parts of the city; everywhere the circumstances indicate that these bodies, some of them bearing the marks of their death wounds, lay abandoned where they fell. Meanwhile, at a date which may well be somewhat earlier than the destruction of Mohenjo-daro, the city of Harappa, far to the north, came under pressure from the invading barbarians, as the blocking up of one of the city gates shows. Here the conquerors settled on the site, erecting ill-constructed hutments with bricks taken from the ruins of the Harappan houses. The characteristic painted pottery of these folk, called the "Ravi people" from the river by which they lived, can be recovered from the surface of the entire site, particularly from the citadel mound.

To provide track ballast for the railway the site of Harappa was stripped of bricks to such an extent that the upper levels, where Ravi pottery is relatively thick on the ground, elude scientific interpretation. There are signs of contact with the Harappa culture. In one of the pot burials were found articles which cannot well be regarded as gleanings from the site many centuries after it was abandoned by the Harappans; included are pieces of two triangular cakes and a pointed-base Harappan goblet. With other objects, these were embedded in the generally ashy contents, along with charred bones. Dishes on pedestal stands appear to have been adopted from the Harappans by the Ravi people as well as by those at Jhukar. Moreover, though the general appearance and decoration of Ravi ware is quite distinct, there are many similarities in decorative detail. Patterns derived from the Harappa culture include rayed-star forms, pipal leaves, vertically arranged eye forms, and leaves with stems radiating from a circle. The humped bulls, peacocks, fish, and antelopes which appear on Harappa ware and that of the Indo-Iranian border are common on Ravi pottery but are very rare in later times.

Recent excavations at Rupar in East Punjab and at the neighboring site of Bara have brought to light pottery with such elements of decoration as arrowheads between horns, fishlike objects with vertical hatching and forked tails, large irregular five-pointed stars, and a circular motif with triangular points, quite different from Harappa ware but characteristic of Ravi ware. As this pottery level divides the late Harappan from the level of painted gray ware (ca. 700–400 B.C.), it may be regarded as reasonably certain that the Ravi people were those who brought about the destruction of Harappa about 1600 B.C and that Mohenjo-daro did not fall until about fifty or so years later. It may well be also that in the people of Ravi II the Vedic Aryans can be recognized.

The single definite and abiding influence exercised by the Harappans on the invaders was in the matter of religion. The priestly caste of Brahmans would appear to derive directly from the Harappans, introducing from them such elements as phallic worship and the worship of Śiva, the three-faced

horned ithyphallic god. It is indeed unlikely that, short of complete extermination, the literate Harappan priesthood, with the entire tradition of the Indus civilization behind it, could fail to make a strong and lasting impression on the religious ideas and practices of India, no matter what invaders might penetrate the western passes through the ages.

In Sind the Jhukar culture degenerated into groups of fishers and hunters who reverted to a proto-neolithic style of living and are known only from their pottery, which is accompanied by microlithic flakes. They are named after the type sites of Trihni and Jhangar; there is some doubt as to which of these two groups is the earlier and to what period they should be assigned. Although both styles appear at Chanhu-daro, they were found in different localities, and there is as yet no evidence of sequence. The original discoverer of these wares considered Trihni the older. The greater part of the Jhangar pottery is handmade gray ware with incised decoration. A connection with the period of invasions is indicated by a triple jar found at Chanhu-daro, its three bowls joined by tubes. Since jars of this type were found at Shahi Tump in the late cemetery, in Iran at Tepe Sialk in the graves of Necropolis B, and at Shah Tepe, there is clearly a connection with the intruders from the Iranian plateau. It is likely, therefore, that these two groups of pottery, Trinhi and Janghar, may provide clues about the very enigmatic period from 1400 to 1100 B.C.

Pottery having a cream slip, bands of red paint, and a simple decoration of plain and wavy black circumferential lines, found in the Zhob at Periano Ghundai, gives an impression of association with Jhukar ware, while succeeding types with various forms of carelessly executed polychrome designs are likely to be contemporary with Trihni ware. Moreover, some of this ware found at Rana Ghundai can be classed as Loralai V, which is followed by the three phases of Loralai VI, the long and intermittent period that introduces early historic times.

These evidences of a retrogression into barbarism of a low type bring to a close all knowledge of the Indus civilization and of its immediate predecessors and successors.

SURVIVALS OF THE HARAPPA CULTURE. Although attempts have been made to suggest the survival of certain elements of the Harappa culture, it is doubtful whether any of the instances advanced are anything but fortuitous similarities. It is true that certain early cast coins of Ajodhya do possess most of the characteristics of the Harappan seals; one, indeed, has all of them, save that the animal, if viewed as an impression, faces the wrong way. The coin is square and, below an inscription, has an animal facing a manger. But even this striking similarity presents the insuperable difficulty that more than 1,200 years intervene, with no connecting link of any kind. Some motifs, such as the hero subduing wild beasts, are so common and enduring in the ancient world that late examples cannot be used with any confidence unless a succession can be shown in India to span the dark ages which separate the Indus civilization from historic times. It is true that this motif appears on Ravi pottery, but it is not found again until it occurs in the Mahadeo Hills in a rock painting which at the very earliest cannot be dated prior to 500 B.C.

Both seals and terra cottas are evidence for bull sacrifice and possibly for bull sports; the possibility of a connection with the Minoan religion has been suggested, and Crooke (1917) collected a number of Indian ritual practices in which bulls fight or are baited, including one in which cloth bows are plucked from bulls' horns. Such bows are depicted on rock bruisings at Kupgallu near Bellary. Some of the objects included in these bruisings appear to be mounted on T-shaped stands of the same form as the processional standards of the Harappa culture. Again, however, the interval of distance, time, and space makes speculation very hazardous. Bull sports are not so uncommon that diffusion might not have taken place at any time; though a connection is, of course, possible, bull sports are among those enduring practices which pervaded the whole ancient world.

The fact that such objects as shell bangles, knob-handled pot lids, etched carnelian beads, and painted pottery that were made in Harappan times can be found quite commonly on most early historic sites and are produced today demonstrates, with no other particular significance, the persistence of such elements in a society which has undergone little basic change. One such pattern, however, while possibly only coincidental, does suggest survival: terra-cotta birds which very closely resemble types found on Harappan sites, and all on pedestals in the Harappan manner, have come to light in the setting of early historic Gandhara (now in northwest Pakistan); these objects include a spread-winged bird from the Bālā Hissār, Charsadda, a closed-winged bird from Sar Dheri, and a bird rattle from Taxila, identical with Harappan bird whistles.

The more definite examples of survival are all connected with religious ideas and practices. The god seated in a yoga position, with a horned trisula-shaped headdress, ithyphallic, three-faced, and surrounded by animals to show him as Paśupati (Lord of Beasts), is without doubt the prototype of Śiva. His place in Hinduism (q.v.) and the attendant sexual symbols of linga and yoni are survivals from the religion of the Indus Valley which are wholly foreign to the religious ideas of the Rgveda. One very strange occurrence may be, again, only a coincidence, or it may have some inherited religious significance: the intentional longitudinal division of female terra-cotta figurines observed at Harappa and at early historic sites in Gandhara. Careful examination has shown that this splitting cannot be accidental. Painted pottery still made at Balreji in Sind has less specific significance in relation to the survival of this art than has been assumed. Similar pottery is made near Quetta in Baluchistan, at Gujargarhi near Mardan, and in the vicinity of Rawalpindi, all in northwest Pakistan; it is probable that this art of painting pots has continued in a sporadic fashion ever since its introduction by the peasant farmers of the Amri culture.

BIBLIOG. W. Crooke, Bull-baiting, Bull-racing, Bull-fights, Folklore, XXVIII, 1917, pp. 141–63; J. Marshall, Mohenjo-daro and the Indus Civilization, 3 vols., London, 1931; N. G. Majumdar, Explorations in Sind (Mem. Archaeol. Survey of India, XLVIII), Calcutta, 1934; E. J. H. Mackay, The Indus Civilization, London, 1935; R. J. Forbes, Bitumen and Petroleum in Antiquity, Leiden, 1936; A. Stein, Archaeological Reconnaissances in North-western India and South-eastern Iran, London, 1937; R. Ghirshman, Fouilles de Sialk près de Kashan, 2 vols., Paris, 1938–39; E. J. H. Mackay, Further Excavations at Mohenjo-daro, 2 vols., Delhi, 1938; K. N. Dikshit, Prehistoric Civilisation of the Indus Valley, Madras, 1939; D. H. and M. E. Gordon, Mohenjo-daro: Some Observations on Indian Prehistory, Iraq, VII, 1940, pp. 1–12; D. H. and M. E. Gordon, Survivals of the Indus Culture, JRAS of Bengal, VI, 1940, pp. 61–71; M. S. Vats, Excavations at Harappā, 2 vols., Delhi, 1940; R. F. S. Starr, Indus Valley Painted Pottery, Princeton, 1941; T. G. Aravamuthan, Some Survivals of the Harappa Culture, Bombay, 1942; E. J. H. Mackay, Chanhu-daro Excavations, New Haven, 1943; S. Piggott, Dating the Hissar Sequence: The Indian Evidence, Antiquity, XVII, 1943, pp. 169–82; H. Mode, Indische Frühkulturen und ihre Beziehungen zum Westen, Basel, 1944; G. Höltker, Das Herz- oder Nierenförmige Ornament auf einer Vase aus Mohenjo-daro, Ethnos, IX, 1946, pp. 1–34; D. E. McCown and E. J. Ross, A Chalcolithic Site in Northern Beluchistan, JNES, V, 1946, pp. 284–316; S. Piggott, Notes on Certain Pins and a Mace-Head from Harappā, Ancient India, IV, 1947–48, pp. 26–40; R. E. M. Wheeler, Harappā, 1946, Ancient India, III, 1947, pp. 58–130; E. J. H. Mackay, Early Indus Civilisations, London, 1948; S. Piggott, Prehistoric India, Harmondsworth, 1950; R. E. M. Wheeler, The Indus Civilization, London, 1953 (2d ed., 1960); D. H. Gordon, The Pottery Industries of the Indo-Iranian Border, Ancient India, X–XI, 1954–55, pp. 157–91; B. Subbarao, The Personality of India, Baroda, 1956 (2d ed. 1958); Before Mohenjo-daro, ILN, CCXXXII, 1958, pp. 866–67; D. H. Gordon, The Prehistoric Background of Indian Culture, Bombay, 1958 (2d ed., 1960; bibliog.); H. Mode, Das frühe Indien, Stuttgart, 1959 (bibliog.); R. E. M. Wheeler, Early India and Pakistan: to Ashoka, London, New York, 1959.

Douglas H. GORDON

Illustrations: PLS. 63–70; 1 fig. in text.

INGRES, JEAN-AUGUSTE-DOMINIQUE. The dominant figure of the French neoclassic school of the 19th century, Ingres was born in Montauban on Aug. 29, 1780. He received his first instruction in drawing from his father, Joseph Ingres, a sculptor of ornamental work versed also in architecture, painting, and music. In 1791 the young Ingres went to Toulouse, entering the Academy to study painting under Roques (winner in 1779 of the Grand Prix de Rome), sculpture under Vigna, and landscape painting under Briant. In the summer of 1797 Ingres set out for Paris with a letter of intro-

duction from Roques to David, who accepted the student into his atelier, then the largest, liveliest, and most famous on the Continent.

In October, 1799, Ingres entered the École des Beaux-Arts and, about three months later, won first prize in the category of half-figure painting. In March, 1800, he placed second in the preliminary contest for the Grand Prix de Rome, executing a painting (now lost) of the assigned subject, *Cincinnatus Receives the Deputies of the Senate*. A month later he entered the Prix de Rome competition officially, and in October received word that he had been awarded second prize. Ingres's painting of the subject chosen for the year, *Antiochus Sends His Son to Scipio*, is now known only through a photograph, the original having been destroyed by fire in 1871. In the spring of 1801 he entered the Prix de Rome preliminaries for a second time and was again classed second, but in September he carried off the first prize with *The Envoys from Agamemnon* (Paris, Mus. de l'École des Beaux-Arts).

Ingres exhibited for the first time at the *Salon* in September, 1802. In the summer of 1803 he was commissioned to paint for the city of Liège a portrait of *Bonaparte as First Consul* (Liège, Mus. B.A.), which was unveiled in the Liège town hall in 1805. In September, 1806, he exhibited at the *Salon* his portrait of *Napoleon I on the Imperial Throne* (Paris, Mus. de l'Armée); the three superb portraits of the Rivière family: father, mother, and daughter (PL. 73), all now in the Louvre; several portraits of friends; and his *Self-Portrait* (Chantilly, Mus. Condé). The *Salon* opening was delayed, but Ingrès received the Grand Prix money he had been awarded in 1801 for study in Rome (payment having been delayed by economic difficulties owing to political and military reverses at that time), and so he set out for the Eternal City without seeing how his paintings were hung. One can understand his bewilderment and rancor upon hearing how poorly hung, severely criticized, and stupidly judged were his entries.

The greeting given him by Joseph Benoît Suvée, the director of the French Academy, upon Ingres's arrival in Rome in October, 1806, was balm to his injured pride. He spent a few weeks in the Villa Medici, the new home of the French Academy (where it is still located), and Suvée then offered the young Montalbanais the small atelier of San Gaetano on the Pincio as a studio. It was there, probably shortly before the summer of 1807, that he painted two of his rare landscapes, the small circular views of Rome now in the Musée Ingres in Montauban.

During his four years as a pensioner at the Academy, Ingres copied the old masters, especially Raphael, and painted the famous turbaned nude with her back turned, called the *Grande baigneuse* or *Bather of Valpinçon* (Louvre), the so-called *Sleeper of Naples* (now lost), and *Oedipus and the Sphinx* (Louvre). Instead of returning to France when his term was completed, he took a studio at 40 Via Gregoriana. Two friends whose acquaintance he had made in Rome, the engraver Édouard Gatteaux and the government official Charles-Marie-Jean-Baptiste-François Marcotte d'Argenteuil, obtained for Ingres his first commissions in Italy; these two Frenchmen remained his loyal and devoted friends for life.

In 1811 Ingres sent his *Jupiter and Thetis* (PL. 71) to the Académie des Beaux-Arts, but the official criticism it received was even more devastating than the attack leveled upon the portraits he exhibited in the *Salon* of 1806. He was accused of misusing his talents and was exhorted to change his ways. In these circumstances, his friendship with Gatteaux and with Marcotte, director of Waters and Forests, served him in good stead. Through these friends Ingres met other French officials in Rome, among them the Baron de Tournon, prefect of Rome, and General Miollis, governor of the French-occupied city. Ingres was commissioned to paint the portraits of Marcotte's relatives, M. Bochet (Louvre) and Mme. Panckoucke, née Bochet (Louvre); a portrait of the Baron de Tournon's mother (Philadelphia, Coll. Henry P. McIlhenny); and a painting of *Vergil Reading the Aeneid* (Toulouse, Mus. des Augustins) for the Villa Aldobrandini, a commission secured through General Miollis. Ingres also painted a *Dream of Ossian* (Mont-

auban, Mus. Ingres) for a ceiling in the Quirinal Palace, to decorate the Emperor's bedroom for the latter's projected visit which was never realized. At this time, too, to have their portraits drawn, there sat for him not only many of his friends and fellow artists but also a succession of officials whose business had brought them to the Eternal City.

In 1813, on the advice of Mme. de Lauréal, whose acquaintance he had made in Rome, he wrote to her cousin, Madeleine Chapelle, a modest milliner of Guéret, asking her hand in marriage. Madeleine accepted the offer and journeyed alone to Rome, where they were married in December.

The following year Ingres was commissioned to paint a portrait of Queen Caroline Murat and her family, and so he went to Naples. Before the Murat portraits were completed, Napoleon was defeated, and the Bourbons returned to rule Naples; with the fall of the Empire, Ingres's official French patrons disappeared from Rome. However, the French Academy continued at the Villa Medici, and through the new director, Charles Thévenin, Ingres was given a commission for a *Christ Giving the Keys to St. Peter* (Louvre). English noblemen, free once again after the Napoleonic Wars to make the grand tour, flooded Rome; many of these visitors, learning of Ingres's talent as a portrait-draftsman, flocked to him. Although he disliked the work and begrudged the time it took, the artist accepted the commissions because he needed the modest income these sitters brought him. His paintings in the *Salon* of 1814, the *Don Pedro of Toledo* and several other portraits, were badly received. To the *Salon* of 1819 Ingres sent his *Grande Odalisque* (Louvre), commissioned by Queen Caroline Murat but never delivered, and *Roger Freeing Angelica* (Louvre; PL. 75), but once again his work was given a hostile reception.

During the decade 1810–20, in the Via Gregoriana studio, Ingres painted his first versions of many themes to which he was to return in later repetitions and variations: *The Betrothal of Raphael to the Niece of Cardinal Bibiena*, *Raphael and the Fornarina*, *Paolo and Francesca*, and *The Death of Leonardo da Vinci*.

In David's atelier in 1799 Ingres had made friends with Lorenzo Bartolini, then an unknown, ambitious sculptor, who later settled in Florence and became very successful. Bartolini urged Ingres to leave Rome and live in Florence; Ingres accepted the suggestion, at first even living with Bartolini and his family. During his four years in Florence, from 1820 to 1824, he was received warmly by three families who gave him commissions for both painted and drawn portraits: M. and Mme. LeBlanc (paintings in the Metropolitan Museum, New York); a member of the Gonin-Thomegeux family (Cincinnati, Taft Mus.); and M. and Mme. de Pastoret (Paris, private coll.). It was at this time, too, that he painted the portrait of Gouriev, the Russian Minister (Leningrad, The Hermitage) and made the portrait drawing of the Austrian Minister, the Comte de Bombelles (location unknown). During his leisure hours he copied Titian's *Venus* in the Uffizi (location of his copy unknown) and Raphael's *Self-Portrait* (Montauban, Mus. Ingres). He also painted, on commission for his native town, the *Vow of Louis XIII* (Cathedral, Montauban).

Although deeply sure of his powers as he slowly brought the *Vow of Louis XIII* to completion, he was uneasy about the reception the painting would be given when shown in Paris at the *Salon*. He went to Paris in the autumn of 1824 for the exhibition. To his astonishment, the painting was a tremendous success. The tide had turned: at the *Salon's* close, Ingres was presented the Cross of the Legion of Honor by Charles X himself and a few months later was elected a member of the Académie des Beaux-Arts. At the end of that year Ingres opened a studio in Paris and began to receive pupils. Over a hundred students flocked to follow his instruction, first among them being Eugène Emmanuel Amaury-Duval, who later became his biographer.

In 1826 Ingres was commissioned by the director of the museums of France to paint *The Apotheosis of Homer* (PL. 71) as a ceiling decoration in the Charles X Museum at the Louvre. The finished painting was put into place a year later. The artist was appointed a professor at the École des Beaux-Arts

in 1829; in 1832 he was made Vice President, and in 1833 President, of that institution for the year following each nomination.

Ingres had been commissioned in 1824 to paint, for the cathedral of Autun, a large altarpiece of *The Martyrdom of St. Symphorian*, a local saint. He worked on it for ten years, but the picture he produced was not one of his successes. Overloaded with archaeology, crowded with people, and coldly dramatic in composition, the painting was poorly received at the Salon of 1834. His feelings again injured, Ingres returned to Rome, where he succeeded Horace Vernet as director of the French Academy. He introduced many improvements at the Villa Medici, both in the physical plant of the school and in its courses of instruction. The master eventually finished the *Odalisque with Slave* (Cambridge, Mass., Fogg Art Mus.), which he had begun for M. Marcotte in 1834; *Antiochus and Stratonice* (Chantilly, Mus. Condé), which the Duc d'Orléans had commissioned the same year; and his first version of the *Virgin with the Host* (Moscow, Pushkin Mus.), for the Czarevitch.

He returned to Paris in the spring of 1841. His entry was triumphant. During the 1840s he completed some of his finest portraits: the original portrait of the Duc d'Orléans and several replicas of it; and the portraits of Mme. d'Haussonville (New York, Frick Coll.), Mme. Reiset (Cambridge, Mass., Fogg Art Mus.), Mme. Gonse (Montauban, Mus. Ingres), the Princess de Broglie (Paris, private coll.), and the Baronne James de Rothschild (Paris, Coll. Baron Édouard de Rothschild). He also began the decoration, commissioned in 1839 by the Duc de Luynes, of the Château de Dampierre with two large allegorical panels to be called *The Golden Age* and *The Iron Age*; the first was nearly complete when he left Dampierre for good in 1847, but only a sketch had been executed for *The Iron Age*.

In July, 1849, the artist's wife died, and he went traveling in the north of France to forget his sorrow. Two years later he finished his first portrait of Mme. Moitessier (Washington, D.C., Nat. Gall.; PL. 74) and in that same year (1851) he deposited the first big selection from his own collection in his native Montauban and resigned his professorship at the École des Beaux-Arts. Once again through his friends a marriage was arranged, this time with a relative of the Marcottes, the forty-three-year-old Delphine Ramel. The second marriage was as successful as the first.

During 1853 Ingres was chiefly occupied with the now destroyed *Apotheosis of Napoleon I*, a painting commissioned by the Préfecture to decorate Napoleon III's Salon in the Hotel de Ville. When the canvas was finished in February, 1854, the Emperor and Empress themselves came to the artist's studio to view it. The largest showing of Ingres's work during his lifetime occurred in 1855 at the Exposition Universelle. He was given a separate room in which to arrange 43 paintings and 25 of the cartoons for the stained glass of the Chapelle Royale in Dreux and the Chapelle of St-Ferdinand in Paris.

A year later he finished his second portrait of Mme. Moitessier (London, Nat. Gall.) and *The Source* (Louvre), a painting he had begun in Florence about 1820 and which he had kept in his studio during the intervening years. In 1861 he finished *Homer and His Guide* (Brussels, Coll. of H. M. the King of the Belgians) for King Leopold I of Belgium, and, in 1863, brought *The Turkish Bath* (Louvre; PL. 72) to its final form. His *Self-Portrait about the Age of 85* he sent in 1865 to Antwerp (Mus. Royal B. A.); it was a copy of the self-portrait he had painted at the age of seventy-nine for the Ramel family (Cambridge, Mass., Fogg Art Mus.). His last large religious canvas was *Christ among the Doctors*, commissioned by Louis Philippe in 1842 but only completed 20 years later. It was still in his studio at the time of his death and went, along with several thousand drawings, his notebooks, and his library, to the museum in Montauban.

Ingres died on Jan. 14, 1867. As late as six days before his death, he was still drawing and still seeking to learn from the old masters.

Agnes MONGAN

The unqualified antagonism that has been posited between Ingres, the defender of the classical tradition, and Delacroix, the recognized head of the romantic school, has proved of little help in arriving at a just evaluation of Ingres's art, for his art cannot be reduced to the defense of certain principles. His adversaries included some of the strictest academicians as well as the romantics; yet some of his themes fall completely within the sphere of the romantic idiom, while his art — on the borderline between neoclassic and romantic — did not succumb, despite its conservative element, to the movements spawned by romanticism. Throughout the 19th century, the name of Ingres was associated with every effort to reaffirm, despite trends to naturalism and realism, the value of drawing, plasticity of form, and the eternal, suprahistorical character of art. This search for the "idealistic" was manifest not only in contrast to or alongside impressionism (as, for example, in the so-called "nouveau humanisme" or in the work of Puvis de Chavannes), but it also existed within the framework of impressionism itself, in which the quest was continued for both the structure of color and light as well as for a precise sense of space based on sensory experience. Toward the end of the century both Renoir and Degas went through an Ingres period.

The extent to which the painting of Ingres differs from the intransigent neoclassicism of David is obvious: in Ingres's drawing there is a tendency toward purity and fluidity rather than firmness and vigor of line, and he used chiaroscuro not so much for the purpose of modeling plastic form as for delicate modulation of tones and halftones, while his color is often brilliant and produces extraordinary harmonies. David's ideal was the antique in its severest, most sculptural forms, and his classicism usually bears a moral or civic message.

Ingres's ideal model was Raphael, and his mode of expression is elegiac rather than epic. Ingres also looked to Reni, Domenichino, and Poussin, who especially influenced his historical and religious compositions. These works are pervaded by that same mixture of austerity and pensiveness that the 17th-century painters revealed, reflecting not so much a firm faith in the authority of classicism as a regret for a golden age that, though past forever, lives on as a symbol of inner choice and of aspiration toward unattainable perfection. In short, the classicism of Ingres is not a theory, nor the teaching of any school; it is the result of a profound feeling for history, a kind of contemplative spirituality that may, in fact, be related to a deep Christian piety and (particularly in his pictures of historical subjects) to a pathos that may be termed romantic. As the romantic writer Théophile Gautier said, "Ce n'est plus de l'archaïsme mais de la résurrection."

It is nevertheless true that Ingres was a pupil of David, but the classicism which Ingres sought he found not so much in works of art as in poetry, especially in Homer and Vergil. This again demonstrates that antiquity was for him a source of inspiration rather than an abstract doctrine.

Significantly, Ingres, the pupil of the most celebrated of neoclassical painters, examined with interest the works of English and German neoclassicists. He studied the publications of the collector Sir William Hamilton and borrowed from the line engravings of Flaxman (q.v.) and Tischbein. He admired their historic sense, which was certainly less eloquent and impassioned but more reserved and contemplative than David's. Flaxman, in turn, extolled above David's works Ingres's *Envoys from Agamemnon*, for which Ingres had won the Prix de Rome in 1801. Through classicism David attempted to place himself in harmony with the heroic spirit of the revolution and the Empire, whereas Ingres sought to recapture the memory of a wonderful bygone era. In 1806, when Ingres depicted Napoleon enthroned, showing him in a hieratic pose perhaps better suited to a painting of St. Louis, the picture appeared — with reason — "Gothic"; his disagreement with David, growing more bitter as time went on, might even have had a political basis. That Ingres was interested in the themes of the early romantic movement as well as in neoclassical subjects is, moreover, proven by the fact that he painted his *Dream of Ossian* in 1813, only a year after executing one of his most classical compositions, *Romulus and Acron*.

Outstanding in the evolution of the salient features of Ingres's art was his search for complete calm and formal purity.

Inventiveness of composition did not greatly interest him, for Ingres, in contrast to David, developed only a few themes, which he frequently repeated and elaborated. His compositions are impressive for their rhythmic unity of form and line and for the extreme clarity with which each detail of the painting is fitted into the ensemble. His portraits are posed very simply. His female nudes, which he saw as forms of great perfection, are only occasionally brought together as participants in an event, as for example, in *Roger Freeing Angelica* of 1819 (PL. 75). Complex compositions such as *The Turkish Bath* of 1862–63 (PL. 72) are, in large part, developments of formal themes that he often treated in pictures of bathers and odalisques. The symmetry of parts and the calculated crescendo of his great decorative compositions (*Apotheosis of Homer*, 1827; PL. 71) can be related more closely to structural devices in choral music (Ingres was a fine musician) than to architectonic principle. The extreme simplicity of some of his religious paintings — *Ste Germaine de Pibrac* (1856; Montauban, church of St-Étienne de Sapiac), for instance — even borders on the ingenuousness of the popular devotional image. At times it almost seems as though Ingres gave in to the temptations of conventional sentimentality, as if in defiance, or in order to show that nobility of form could redeem any kind of content.

The famous "dessin" of Ingres is no formal abstraction but the expressive means by which the artist re-creates his feeling for nature and history. The landscape drawings of his first Roman period are a good illustration of this process. The extreme precision of his draftsmanship eliminates all emotional accents, defines space with great clarity, and even indicates color. Just as the drawing supplies a unified contexture, so the color forms a basic tonal harmony within which each individual hue can attain perfection of tone without disturbing the unity of the whole composition. "Modeling," Ingres said, "should not be squared and angular; one should model round and without apparent internal particulars." Indeed, not limited to supplying description and structure, Ingres's drawing follows a rhythmic course sensitive to variations in feeling. It is this treatment of line that made Ingres's art appear "Gothic" to his contemporaries. In its outward coolness but inward emotion, his work appears to have some affinity with that of the Tuscan mannerists, and especially of Bronzino, who seems to have provided inspiration for such paintings as the *Grande baigneuse* (1808) and the *Petite baigneuse* (1828; PL. 71).

The "purism" of Ingres, which consists precisely in this expressiveness contained and almost sublimated within the tight, severe rhythms of his form and color, receives greater stress in his later works, especially in the portraits, and in religious compositions, such as *Christ among the Doctors* of 1862. On the one hand, these paintings recall the neoprimitivism and the subtle archaism of an artist like Sassoferrato, while on the other hand, they are part of the religious current of the mid-19th century that pervades the painting of the German Nazarenes, the Italian Puristi, and the early English Pre-Raphaelites. Yet, since *Christ among the Doctors*, which Delacroix judged "the sad outcome of an age past hope of redemption," was painted in the same year as *The Turkish Bath* (in which Raphaelesque curvilinear rhythms are united to Titianesque sensuality of color), it is apparent that the subject was only a vehicle for Ingres's search for purity of form. The fact that Ingres was engaged in such a search for perfection of form, necessitating clarification of his own inner motives and reassessment and refinement of his means of expression, helps to explain his reluctance, already mentioned, to indulge in compositional invention, in the grand effect, and in novel solutions to problems of form. It explains, above all, the acute *esprit de finesse* that pervades his painting and that has for so long seemed the expression of a strictly rational attitude toward form.

* *

BIBLIOG T. Silvestre, Histoire des artistes vivants, français et étrangers: Étude d'après nature (introd. and cat. by M. L. de Virmond), Paris, 1856 (repr. as Les artistes français, II: Éclectiques et réalistes, Paris, 1926); E. Galichon, Dessins de M. Ingres exposés au salon des Arts-Unis, GBA, IX,

1861, pp. 343–61, XI, 1861,. pp. 38–48; E. J. Délécluze, Louis David, son école et son temps: Souvenirs, 2d ed., Paris, 1863; C. Blanc, Ingres: sa vie et ses ouvrages, Paris, 1870; H. Delaborde, Ingres: sa vie, ses travaux, sa doctrine, d'après les notes manuscrites et les lettres du maître, Paris, 1870; E. E. Amaury-Duval, L'atelier d'Ingres, Paris, 1878 (2d ed., 1924); R. Balze, Ingres, son école, son enseignement du dessin, par un de ses élèves, Paris, 1880; H. Lapauze, Les dessins de J. A. D. Ingres du musée de Montauban, Paris, 1901; J. Momméja, Collection Ingres au musée de Montauban, Paris, 1905; B. d'Agen, ed., Ingres d'après une correspondance inédite, Paris, 1909; H. Lapauze, Ingres: sa vie et son œuvre (1780–1867) d'après des documents inédits, Paris, 1911; L. Frühlich-Bum, Ingres: Sein Leben und sein Stil, Vienna, Leipzig, 1924 (Eng. trans., M. V. White, London, 1926); L. Hourticq, Ingres: l'oeuvre du maître, Paris, 1928; B. Ford, Ingres Portrait Drawings of English People at Rome, 1806–1820, BM, LXXV, 1939, pp. 2–13; R. Longa, Ingres inconnu: 129 reproductions de croquis à la plume de musée de Montauban, Paris, 1942; A. Mongan, Ingres and the Antique, Warburg, X, 1947, pp. 1–13; Alain (pseud. E. Chartier), Ingres, Paris, 1949; J. Alazard, Ingres et l'ingrisme, Paris, 1950; H. Naef, Französische Meisterwerke aus Provinzmuseum, Du, Schweizerische Monatsschrift, XI, 7, 1951, pp. 7–34; G. Wildenstein, Ingres, London, New York, 1954; A. Mongan, Three Drawings by Ingres, AQ, XVIII, 1955, pp. 180–85; D. Ternois, Ingres aquarelliste, RArts, V, 1955, pp. 101–04; H. Naef, Ingres Portrait Drawings of English Sitters in Rome, BM, XCVIII, 1956, pp. 427–35; H. Naef, Paolo und Francesca: Zur Problem der schöpferischen Nachahmung bei Ingres, ZfKw, X, 1956, pp. 97–108; N. Schlenoff, Ingres: cahiers littéraires inédits, Paris, 1956; N. Schlenoff, Ingres: ses sources littéraires, Paris 1956 (bibliog. to 1953); G. Wildenstein, Les portraits du Duc d'Orléans par Ingres, GBA, VI ser., XLVIII, 1956, pp. 75–80; H. Naef, Ingres as Portraitist im Elternhause Bartolinis, Paragone, 83, 1957, pp. 31–38; H. Naef, Notes on Ingres Drawings, AQ, XX, 1957, pp. 181–90, XXI, 1958, pp. 407–14; H. Naef, Ingres' Portraits of the Marcotte Family, AB, XL, 1958, pp. 336–45; H. Naef, Two Unpublished Portrait Drawings of English Sitters by Ingres, BM, C, 1958, p. 81 ff.; N. Schlenoff, Ingres and the Classical World, Archaeology, XII, 1959, pp. 16–25; N. Schlenoff, Ingres and Italy, in Relations artistiques entre la France et les autres pays depuis le haut moyen âge jusqu'à la fin du XIXᵉ siècle (Actes du XIXᵉ Congrès international d'histoire de l'art), Paris, 1959, pp. 529–34; H. Schwartz, Ingres graveur, GBA, LIV, 1959, 329–42; D. Ternois, Les dessins d'Ingres au musée de Montauban: Les portraits (Inventaire général des dessins des musées de province, 3), Paris, 1959; M. J. Ternois, Les œuvres d'Ingres dans la collection Gilibert, RArts, 1959, pp. 120–30; L. Burroughs, A Portrait of Ingres as a Young Man, BMMA, XIX, 1960–61, pp. 1–7; G. Naef, Rome vue par Ingres, Lausanne, 1960; H. Naef, Vier Ingres Zeichnungen, Pantheon, XVIII, 1960, pp. 35–43; N. Schlenoff, Quatre grands peintures inconnues d'Ingres, B. de la Soc. de l'H. de l'Art Française, 1961, pp. 147–59. See also various articles in the Bulletin du Musée Ingres.

Illustrations: PLS. 71–76.

INLAY. Ornamental or figural work produced by setting together upon a flat surface variously shaped pieces of different materials such as marble, colored stones, ivory, and wood is generally called "inlay." The terms *tarsia*, *intarsia*, and *intarsiatura* are Italian words derived from the Arabic *tarsi*; all denote inlay but are usually employed, especially in Western art history, with more specific meaning. They refer to works of considerable size and of serious artistic purpose, executed on the basis of drawings or cartoons and therefore rather close in intention and effect to painting. Yet inlay refers particularly to the embellishment of furnishings or architecture and thus falls into the more general category of composite decoration obtained by such techniques as joining, inset, and damascening (see ENAMELS; GOLD- AND SILVERWORK; MEDIA, COMPOSITE; METALWORK). Some of these techniques are often the equivalent of inlaid work. Also there exists between inlay and mosaic a technical affinity so close that occasionally the two techniques are used simultaneously in the decoration of the same surface, as in a pavement. However, mosaic, with its small and uniform tesserae, produces effects of chiaroscuro and of color quite distinct from the unmodulated fields, flatness, and rigidity of line peculiar to inlay. But inlay effects are found in the art of stained glass (see STAINED GLASS).

SUMMARY. Antiquity (col. 126). The European West (col. 129). The East (col. 133). Tribal cultures (col. 134).

ANTIQUITY. In Egypt, from the time of the 1st dynasty, inlays of ivory and wood appeared in small coffers, decorated with geometric motifs, found in the royal necropolises at Abydos and Saqqara. Noteworthy are two coffers from the tomb of Hemaka; one is circular with inlays of different woods, and one rectangular, of wood and ivory. As far back as the 4th dynasty, inlay was used on furniture (IV, PL. 343), as in the sedan chair

of Hetepheres I, in which the ebony inlay is itself inlaid with hieroglyphs of gold.

At the same time in the Near East, during the predynastic period (ca. mid-3d millennium B.C.), inlay of semiprecious stones and shell — mother-of-pearl — set into a bed of bitumen was more common. The best example of this work is the so-called "Standard" of Ur (PL. 77; IX, PL. 471), a panel of fine workmanship showing complex and varied scenes. A frieze from al-'Ubaid depicting the milking of cows exhibits a similar technique, but with white as well as colored stones, as do also some panels from Kish and from Mari, which also have inserts of mother-of-pearl. Objects of common use but of finest workmanship, such as certain gaming boards (VI, PL. 5), some musical instruments (I, PL. 505), and de luxe furniture, all share in this technique of inlay incrustation that is proper to the art of the cabinetmaker. There are also some inlaid vases, such as those of Bismaya, in which the skirts of the musicians represented are of white stones set into the surface of the vase.

Such pieces were still being made in the first half of the 2d millennium, and in a great variety of techniques. That has been proved by various finds. Among these can be cited a panel from a wooden box bearing four birds in bone from a tomb at Jericho (PL. 77); an ivory panel from Chuga Zanbil; objects of glazed terra cotta from the early palaces of Crete, made to be inset into surfaces of another material; and the cosmetic boxes of an Egyptian princess of the Middle Kingdom, from Lahun, of ebony with ivory panels inlaid with carnelian, glass pastes of various colors, gold, and four tiny heads of the goddess Hathor made of stones and colored glass paste. All things considered, the procedure is comparable to the insertion of eyes of glass, or of precious stones, or even simply of white marble, in statues and in figures of animals, a very common practice in the entire ancient Oriental world and one subsequently taken over by the Greeks and Romans in their sculpture, both in marble and bronze. The technique is also comparable to the practice of adding finishing touches and descriptive elements to statues and bronzes. But generally all these adjuncts to sculpture do not constitute inlay in the strict sense of the term (see MEDIA, COMPOSITE).

In the category of cabinetmaking, on the other hand, inlaid objects of the highest quality may be found. The tomb of Tutankhamen has provided a rich collection of these in the form of small coffers — some with simple decorative motifs of pierced and gilded wood, enriched with hieroglyphs (first incised, then filled with colored paste), and others with delicately wrought scenes, as on a box inlaid with ivories that project slightly from the red ground, depicting the royal couple walking in a garden (PL. 77) — and in the form of furniture, chariots, and sarcophagi, all adorned with inlays of various woods, glass pastes, gold, and ivory. Small panels covered with inlays of glass paste were not infrequent. These objects continued to be produced up to the Ptolemaic period, though at a lower level of quality.

Within the realm of Cretan art there are small, precious figures of steatite inlaid with rock crystal, mother-of-pearl, wood, and gold, such as the bull-head protoma from Knossos, now in the Archaeological Museum, Heraklion (IV, PL. 64), and the leonine protoma of red jasper on white marble of the same provenance and also in Heraklion. Mycenaean civilization matches that output with small inlaid objects (IV, PL. 71), such as the tiny shields from Mycenae, now in the National Museum in Athens. As regards the oldest Greek culture, there are only literary allusions to objects such as those here described, generally in reference to articles imported from the East, where, in the 1st millennium, the craft tradition underlying this production was still maintained — a fact documented by ivory inlays from Assur and by yew and boxwood inlays from Gordion that were formerly parts of fittings and furniture.

Comparable to inlay are the revetments of glazed bricks (see CERAMICS) of palaces in Mesopotamia and Iran, the alabaster incrustations of the palaces of Crete, and the application of slabs of marble or of varicolored stone to interior and exterior walls, in imitation of structural stonework, in classical archi-tecture. According to Pliny the Elder (*Naturalis historia*, xxxvi, 47), this method of decoration was first applied by Mausolus of Caria in the first half of the 4th century B.C. However, the reference should be taken in a generic sense as indicating that the practice first arose and spread in the Near East and in the Hellenistic world generally and then passed to Rome, whence it spread to the entire ancient world. Πλάκωσις in Greek (*Thesaurus linguae Graecae*, s.v.), *incrustatio* in Latin, or, rarely, *loricatio* (Isidore of Seville, *Originum*, xix, 3; Vitruvius, *De architectura*, vii, 3, 3, 10; 5, 1; *Panegyricus*, xi, 11), are the terms by which this technique is known in the sources. It appeared in Rome about the middle of the 1st century B.C., and Pliny, in the passage cited, attributed its introduction to Mamurra. Certainly from that time revetments of marble or in imitation of marble were used in every period and in every type of building, both public and private. For example, there are the polychrome revetments of the House of the Relief of Orestes at Hercu-laneum, those of black marble ordered by Domitian for the imperial palace on the Palatine, the polychrome revetments of the later houses at Ostia, the *crustae* of the Aula Palatina at Trier, and the marble facing of numerous Early Christian and Byzantine churches that culminated in that ornamental place-ment of slabs at S. Vitale, Ravenna, which exploits the direction of the veining as well as the color.

Strictly speaking, however, inlaid work is called in Latin *opus sectile* or *opus interrasile* (Pliny, *op. cit.*, xxxv, 2). In the first instance; marble slabs are fitted together in jigsaw fashion, all the pieces being of equal thickness; in the second, a thinner slab is set into a larger, thicker piece. The following are some examples of the last type, the *opus interrasile*: slabs of slate from Pompeii decorated with satyrs and maenads (PL. 78), with a scene of offering to an image of Dionysus, and with a female figure leaning against a small pillar; the Colonna slab representing the founders of Rome and the goddess Roma (PL. 78), previously dated between the period of Augustus and that of the Antonines, but which, after careful study, can be placed about the middle of the 4th century; the fragments, formerly in the Hartwig Collection, now lost but recorded in photographs in the Deutsches Archäologisches Institut, Rome; the architectural fragments from Aezani; and the inlay of glass paste, formerly in the Stroganoff Collection, now in the Museo Nazionale Romano.

The term *opus sectile* is usually applied to the decoration of pavement with geometrical motifs (PL. 81). It used to be believed that such decoration was in fashion from the 1st century B.C. up to the Flavian period and then again from the 4th century on. However, a glance at the dating of some of the hundreds of extant pavements will reveal the error of this opinion. To the long list given under *Inkrustation* in the *RE* may be added a large group of Early Christian churches in Rome — from S. Adriano to S. Stefano Rotondo, from S. Lucia in Selci to the Lateran Baptistery, and from S. Giorgio in Velabro to S. Costanza and S. Agnese — as well as the pavements in Via Capo d'Africa and in the Curia of Diocletian in the Roman Forum; that of the Serapeum at Leptis Magna; in Constantinople, the pavement of St. John in Studion and fragmentary examples in the imperial palace; and the flooring of the episcopal chapel at Ravenna (Oratorio di S. Andrea), of St. Gabriel at Kos, of a Roman villa at Beth Guvrin in Israel, and others.

There are also examples of *opus sectile* that are representa-tional. Dating from the 3d century are a beautiful, delicate head of Helios from the Mithraeum under S. Prisca in Rome and a panel with a griffin, found in the vicinity of S. Pietro in Vincoli, now both in the Museo Nazionale Romano. Assigned to the 4th century (although perhaps to be dated later) are the inlays of the Basilica of Junius Bassus; these were executed by two different artists, since the representations of the tigers attacking a deer and a calf (PL. 79) and of the quadriga may be attributed to an artist of African background, and the little picture of Hylas surrounded by nymphs to a second artist of Hellenic bent. To the end of the 4th century or the beginning of the 5th are assigned the poorer, cruder examples, depicting sheep, in S. Ambrogio in Milan, and to the 5th and 6th centuries the inlays of many basilicas, such as S. Sabina in Rome, the

Basilica Eufrasiana in Parenzo (PL. 81), St. Demetrius in Salonika, and Hagia Sophia in Constantinople, all with motifs of liturgical significance, with chalices, dolphins, and aediculae. Also late in date is the splendid revetment of a room in a house at Ostia, with figural as well as geometric inlay.

Finally, note should be made of some inlaid work of special interest. One group consists of designs obtained with inlays of brick that are monochromatic, or, if differently baked bricks are used, at most dichromatic. These inlays appear especially throughout the 2d century, generally in a funerary context; there are examples in the necropolis of Ostia on the Isola Sacra and in the cemetery found beneath St. Peter's in Rome. Another group is made up of obsidian bowls found at Castellammare di Stabia; in these enamels small pseudo-Egyptian scenes, animals, and floral motifs are inserted, together with gold filigree, into the surface cavities (PL. 78). Clearly this work is from the beginning of the Christian Era, and the Alexandrian provenance of these precious little vessels is beyond question. A third and final example is the door "inlaid with marble slabs" mentioned by Eusebius (*De vita Constantini*, iii, 36), some idea of which may be had from a mosaic of Souzy-la-Briche (*Inventaire des mosaïques de la Gaule*, I, 924) that seems to picture precisely the wings of a double door, covered with *crustae* of multicolored marble.

Michelangelo CAGIANO DE AZEVEDO

THE EUROPEAN WEST. The architectural use of inlay of marbles and varicolored stones goes back to antiquity. The late-antique tradition was continued in Ravenna (S. Vitale, I, PL. 411; Baptistery of the Orthodox), and, more in the Western style, in the work of the Cosmati (q.v.), and in the decoration of Tuscan Romanesque buildings in Florence (Baptistery, I, PL. 302; S. Miniato; the Badia in Fiesole, III, PL. 388; and Alberti's shrine of the Holy Sepulcher, I, PL. 50, and his façade for S. Maria Novella, I, PL. 53). In richer, more detailed form the late-antique tradition was continued in Pisa, Lucca, Venice, and Pistoia. This kind of mural decoration fulfilled the desire for pictorial and decorative effects that was characteristic of both the Romanesque and the Gothic and which gave way to a more rigorously geometric and perspectival style during the Renaissance. Inlay of this type, found on ambos, baptismal fonts, and the like, was most widely used in Campania, in Latium, and in some periods in Tuscany.

Another unusual production of 14th-century and Renaissance Italy was what Vasari called "another kind of mosaic, made of marble fragments so joined together that they imitate subjects depicted in chiaroscuro" (Introduction to *The Lives*). He said it was found on pavements and even on the façades of buildings. Among the most famous examples are the pavements of the Baptistery of Florence (PL. 82) and of the Cathedral of Siena; the Siena pavement, which Vasari dated to the time of Duccio (it was actually begun in 1372), was the work of many 15th-century masters, among them Matteo di Giovanni and, at the beginning of the 16th century, of Beccafumi (PL. 86). Francesco di Giorgio (q.v.) prepared the cartoon for another "storied" pavement, that of the chapel of St. Catherine in S. Domenico in Siena. In all these works a black substance based on pitch was placed in the hollows prepared for it on slabs of marble. The pattern of black and white which resulted is particularly effective. Great compositions of exceptional power unfold beneath the feet of the spectator. Less striking is the effect of intarsiated pavements in Rome (Sala della Giustizia in Castel Sant'Angelo) and Florence (Laurentian Library, the pavement of which Vasari called a masterpiece of its kind).

In the baroque, the use of inlay in architecture was revived, and the polychromy of marble was exploited. Borromini's Cappella Spada in S. Girolamo della Carità in Rome is a masterpiece (II, PL. 313). The incrustation of tombs, altars, pulpits, and ciboria extended even to the addition of precious stones. In the 18th century, however, the art of marble inlay slowly declined.

Wood intarsia is even richer than marble inlay and was employed from the 14th century on. Boxes, coffers, and wooden objects had been generally covered with stucco or painted; the use of wood without such coating was something new and required the work of inlayers (*intarsiatori*) skilled in cutting thin pieces and in varying the colors by combining different types of woods, such as ebony, cypress, boxwood, and walnut. Initially the inlayers took special advantage of light woods (the spindle tree and boxwood) and dark (ebony and walnut) for contrast, but at the end of the 15th century they resorted to staining. Shadings were obtained by blackening the wood with a hot iron after the pieces had been glued on. The discovery of a procedure that permitted staining the wood by boiling was attributed by Vasari to Fra Giovanni da Verona (V, PL. 440), who supposedly used it in the choir of the abbey church at Monte Oliveto Maggiore, near Siena, in 1503. Actually credit belongs to Lorenzo and Cristoforo da Lendinara, who had already employed the technique as early as 1462 for the panels of the choir stalls in the basilica of S. Antonio at Padua.

Intarsia certosina work, in which small polygonal tesserae of wood, bone, ivory (see IVORY AND BONE CARVING), or mother-of-pearl are arranged in geometric forms, was in use up to the 15th century, especially in Lombardy and in the Veneto. For coffers, small caskets, and sacred furnishings, sculptural decoration was combined with this type of inlay.

Intarsia was first widely used in Siena. The names of masters famous in this field are known from the 14th century on. Some of their works have been preserved, such as the choir stalls of the Orvieto Cathedral, depicting figures of saints framed by rosettes and geometrical motifs (PL. 85), executed by the Sienese Giovanni Ammannati and his school. At the beginning of the 14th century, Domenico di Niccolò dei Cori made for the stalls of the chapel in the Palazzo Pubblico in Siena a series of panels illustrating the articles of the Credo. The panels seem to be literal renderings of paintings. His pupil, Mattia di Nanni, called Bernacchino, received between 1425 and 1430 numerous commissions for the Palazzo Pubblico, among them one for a *residenza*, or large backed chest-bench, adorned, it is believed, with five tondi, now lost, showing figures of famous men, and with two allegorical scenes. The latter have survived. One of these is a view of Siena, certainly inspired by some painting and recalling the ideal cities seen in medieval miniatures.

In the second half of the 15th century the development of the art of intarsia changed direction completely. It became linked to the researches of the Florentines, who were investigating a new definition of forms in space in terms of perspective. The discipline received decisive impetus during 1425–35 from the perspective demonstrations of Brunelleschi and Alberti. The starting point of these studies in perspective were city views in which the regular diminution of side walls, similar to that of theater wings, and the recession of paving stones was easily translated into linear forms. The intersection of vanishing lines and orthogonals established a network of simple shapes easily rendered in cutting wooden laminae. The urban perspectives were not only a favorite exercise of the intarsia workers but a clarification of the very reason for the existence of their art. The masters of perspective were both *prospettivisti* and *intarsiatori*. The 1492 inventory of Lorenzo the Magnificent lists in the great salon of the Palazzo Medici "a wooden bedstead of five and a half *bracce* with inlays and perspectives." There are extant several examples of *cassoni* ornamented with panels of this kind (Florence, Contini Bonacossi Coll.). This intarsia decoration with scenes of architecture in perspective, set in carved frames and used in coffers and chair backs, can be compared to the painted city views (in Baltimore, Walters Art Gall.; Berlin, Staat. Mus.; Urbino, Gall. Naz. delle Marche) that clearly derive from them. Another favorite field for intarsia was the geometry of solids. Paolo Uccello's studies of the structure of three-dimensional forms were intended, according to Vasari, to furnish *intarsiatori* with new and ingenious models, such as polyhedrons, books, and stars. From such exercises it is a short step to trompe-l'oeil and still life.

No works survive of the generation that could have profited directly from the instruction of Brunelleschi, but the names of many masters are known, especially those who worked under Antonio di Manetto on the cupboards of the sacristy of the

Cathedral of Florence. Among them was the brother of Masaccio, Giovanni Guidi, called Scheggia. But the redecoration by Giuliano da Maiano resulted in the disappearance of almost the entire work of his predecessors except, perhaps, for the upper part of the panel to the right, decorated with garlands set against a background in perspective. The intarsia by the Maiano brothers in the sacristy of Florence Cathedral explains their fame. In bringing up to date Manetto's scheme of decoration, the Maianos placed large figures in niches and scenes from the Gospels inside a vigorously architectonic framework (PL. 83). Vasari described Benedetto da Maiano's talent in the art of "combining woods stained different colors to produce perspectives, rinceaux, and other objects of fancy, introduced in the days of Filippo Brunelleschi and Paolo Uccello" (*Life of the Maiano*). The renown achieved by Benedetto brought him an invitation to Naples from Alfonso of Aragon and to Hungary from Matthias Corvinus.

The golden age of Florentine intarsia was about 1460–70. The chronicler Benedetto Dei counted at that period 84 intarsia workshops in the city. The most famous of these, after that of Benedetto da Maiano, was run by Francesco di Giovanni (called Francione), noted in Pisa after 1467 and said by Vasari to be the master of Giuliano da Sangallo. It was to a Florentine, Baccio Pontelli, that the Duke of Urbino turned for the decoration of his study. In 1475 Pontelli executed for that study a celebrated piece of decoration in trompe-l'oeil in which all three types of decorative intarsia are used: imaginary cabinets on the wall, false niches with figures, and an imaginary window (PL. 100). A view through a portico with double-storied pilasters, opening onto a landscape of lakes and mountains, suggests the author of the cartoon: Francesco di Giorgio, then in the employ of the Duke of Urbino, certainly furnished the design for this composition (PL. 80). Some years later, in Gubbio, the city from which the Montefeltros, dukes of Urbino, originated, there was executed another *studiolo* (New York, Met. Mus.), inspired by the Urbino decoration, that reached a level of matchless virtuosity. The finest example of intarsia, by then a complex and sophisticated art, was executed in Siena between 1482 and 1502 by Antonio Barili: the choir stalls of the Chapel of St. John the Baptist, featuring bust-length figures and landscape elements. Six panels are at San Quirico d'Orcia.

In northern Italy, the work of Piero della Francesca, artist-mathematician par excellence, was at the root of wood inlay decoration in the new style. Piero himself influenced the brothers Lorenzo and Cristoforo da Lendinara (PL. 86) and, through them, others. By contrast with their abstract, decorative work in the Modena Cathedral (1461 on), the brothers revealed in their compositions for the choir of the basilica of S. Antonio in Padua a less rigidly linear and more pictorial style. The technique of boiling wood to alter its color furnished more varied, gradated tones and made possible subtler light effects. Miniature arcades with alternating dark and light voussoirs frame views of a city with bridges, balconies, towers, and porticoes — an atmospheric portrait of Padua. The Lendinara brothers trained many pupils north of the Appennines. One pupil, Pier Antonio dell'Abate, son-in-law of Lorenzo, executed in about 1484 a series of choir stalls (for S. Corona in Vicenza), alternating still lifes with architectural perspectives in a style very close to that of the intarsia in Padua, on which he had probably collaborated. A similar development took place in Lombardy, which produced such noteworthy items as the cupboards of the sacristy of S. Maria delle Grazie in Milan, the stalls of the Certosa of Pavia (on which Bartolomeo da Modena worked from 1487, followed by Pantaleone dei Marchi, also from Modena), and the wooden aedicula, called the *coretto*, at Torrechiara in Tuscany, of which there is another example in the Victoria and Albert Museum, London (V, PL. 440).

Inlay combining still life and architectural perspective found its most splendid exponent in Fra Giovanni da Verona. Giovanni's teacher was certainly Fra Sebastiano da Rovigno, an Olivetan oblate with whom he was in Ferrara in 1477 and 1478. For the Convento di S. Elena in Venice Fra Sebastiano inlaid 34 stalls, a work that brought him considerable fame. They

are now in the sacristy of S. Marco. Fra Giovanni probably collaborated on the work, since he was in Venice in 1489 and 1490, just when his master was engaged in this important task. Doubtless, Giovanni mastered all the many possibilities that the cityscape offered to intarsia decoration, for he was able to develop this theme in his work for the choir of S. Maria in Organo, Verona (1492–99), revealing both technical ability and a fine poetic imagination. For the choir at Monte Oliveto Maggiore he executed 52 panels in two years (1503–05); only a fraction of the original number remain in place, 38 of them now being located in the Siena Cathedral. These panels exhibit extraordinary richness of invention: there are landscapes traversed by swallows in flight; perspective views with pheasants, cats, hoopoes, and other animals; fantastic architecture; and views of Monte Oliveto, Siena, and the Colosseum.

Fra Giovanni da Verona was called to Rome and commissioned by Julius II to decorate with intarsia the Stanza della Segnatura in the Vatican, a project he worked on from 1511 to 1513. But his work was removed during the pontificate of Paul III to make room for the monochrome paintings of Perino del Vaga, an occurrence that indicates an important change in taste and signals the end of the golden age of intarsia. The Florentine tradition of measure and elegance had lost its meaning for *intarsiatori* like Giovanni Francesco Capodiferro, who for the Cathedral of Bergamo used cartoons by Lorenzo Lotto to execute panels of extraordinary virtuosity but overloaded with motifs and without any formal unity (1524–30). This break with tradition is seen also in the work of Damiano Zambelli da Bergamo, another pupil of the famous Fra Sebastiano. In S. Bartolomeo in Bergamo, his native city, Damiano placed among Biblical scenes a view of Brescia, a view of the Piazza Vecchia in Bergamo, and a "Venetian" perspective, all of them retaining an echo of his master's style. But his masterpiece is the series of episodes from the lives of the saints that adorns the choir stalls of S. Domenico, Bologna (1528–40). For Fra Damiano city views were no longer inanimate descriptive motifs, bereft of people, but settings for scenes full of animation. This new tendency was continued by Fra Damiano's favorite pupil, Francesco Zambelli, who put together for the church of S. Lorenzo in Genoa a series of panels from which architecture disappears, giving place to landscape and figures. Still working in the old manner, in Tuscany the brothers Nicolò and Ambrogio Pucci composed in 1529 panels with "synthetic" city views set in half-open cupboards (now in Lucca, Pin. Naz. di Pal. Ducale).

As intarsia developed into "a new kind of painting" — that is, only a faithful transcription of the work of contemporary artists — it lost its essential character and, simultaneously, its decorative effectiveness. Inlay finally became a mere ornamental adjunct to coffers, tables, and pieces of cabinetwork.

But just when it lost its vigor in Italy, the technique of wood inlay came into favor and underwent interesting developments in southern Germany. Augsburg in particular became a center of production notable for both quantity and quality. One example stands out, the so-called "Wrangel Cabinet," 1569, now in the Kestner-Museum, Hanover. It is a cabinet whose doors are adorned with panels: ruins, geometrical solids, the most fanciful ornaments, fallen columns, swollen classical drapery, torsoes, busts, fantastic horses, broken vases, volutes and cylinders, perforated and cut forms comprise quaint scenes that are made more prominent by the coloration of the woods. This work is a triumph of cartouche design and of mannerist decoration.

Another kind of furniture inlay, featuring the use of rare marbles, began to be developed in Italy in the middle of the 16th century. The table designed by Giacomo Barozzi da Vignola (ca. 1570; New York, Met. Mus.; PL. 84) presents a surface of white marble incrusted with colored marbles and rare stones (*opus compaginatorum*) set in geometric and heraldic motifs. It was the intention of the makers of these *tavole intarsiate* to model themselves on the splendor of the antique, and in fact Roman marbles were generally used. *Tavolini di gioie*, inlaid with precious stones, were also produced; Vasari mentioned in this regard Bernardino di Profirio of Leccio, the head of

a particularly active Florentine workshop. This manufacture of luxury items came to be appreciated even outside Italy because of the gifts which the Medici made to foreign rulers. In the 17th century a rather large number of these objects were produced in a special workshop of the Medici Grand Dukes, known as the *Opificio delle pietre dure*. Colbert even sent for an Italian expert, Ferdinando Migliori, for the Gobelin manufactory to teach the French this technique.

But French marquetry, as used in cabinetwork, underwent a completely new development, partly because of the range of materials employed, varicolored and often precious — ivory, mother-of-pearl, tortoise shell, in combination with metal and wood. The tendency to render the panels more splendid emerged in the 16th century with the use of arabesques, but it was developed only with the so-called "mazarine" desks, on which there began to appear surfaces of violet wood with insets of tin or edgings of ebony, or even with inlays of red tortoise shell framed in copper. The small chests and cabinets made by André Charles Boulle (1642–1732; V, PL. 444), almost exclusively for Louis XIV, are the complex masterpieces of this sumptuous art, which was continued into the 18th century (PL. 87) by such Parisian cabinetmakers as Jean Henri Riesener (V, PL. 454), Jean François Leleu, and François Oeben (see FURNITURE). In woods there was a very wide range of choice: rosewood and violet wood, palisander and mahogany, as well as boxwood and olive. In forms, geometric ornament gave way to garlands, to baskets of flowers, and to "silhouettes" of pastoral subjects. Imitated in almost all Europe, this art of the great Parisian cabinetmakers and inlayers inspired, in Germany, the compositions of Abraham and David Roentgen, and, in Italy, the incrustation of Pietro Piffetti in Turin. Piffetti, from 1731 cabinetmaker to the King of Sardinia, inlaid furniture of precious woods with gold, ivory, and mother-of-pearl; the Queen's study in the Royal Palace in Turin contains fine examples of his art. The work of Giuseppe Maggiolini in Milan came somewhat later (V, PL. 451). Maggiolini, a protegé of the Archduke Ferdinand, decorated the Royal Palace (then being restored by Giuseppe Piermarini) with inlays that marked the passage from a rococo to a neoclassical style of ornamentation.

André CHASTEL

THE EAST. In China inlaying lacquer with mother-of-pearl seems to date back at least to the T'ang period (V, PL. 459). One of the earliest examples extant is a lute in the Shōsōin repository in Nara (PL. 90). In Japan, from the time of the Nara period, this type of inlay was very common, especially in combination with gold or black lacquer sprinkled with gold, and was used for boxes (*suzuri-hako*, *inrō*, and the like). Great masters of Japanese painting, such as Ogata Kōrin (q.v.) and Hon-ami Kōetsu, made use of inlay in the decoration of large, multipartite screens of painted lacquer. Save for one period — under the Ch'ing dynasty, in which screens of Coromandel lacquer inlaid with jade and other semiprecious stones were produced — the art of inlay soon fell into disuse in China.

The Moslems seem to have inherited the inlay technique from the Copts and from Sassanian Mesopotamia. They used it mainly for bronze, wood, and ivory work (V, PL. 458). Silver inlay on bronze flourished especially under the Seljuks, Ortuqids, Ayyubids, and Mamelukes in Persia, Iraq, Syria, and Egypt, some preferring a semiheraldic figural style, others geometrical and arabesque decoration. Among these objects are some of the greatest masterpieces of Islamic art. Later, silver or gold inlay on iron and blackened steel became more common, especially in Iran. An Indian variety is the biddery ware and Moradabad ware, probably developed in the 15th century but known mainly from 17th-, 18th-, and 19th-century hookahs, bowls, ewers, and dishes in the Moghul taste. Inlay (of various woods, ivory, bronze, or mother-of-pearl) in wood was common, though mainly combined with woodcarving, appliqué, and mosaic work. The transition between media is almost indistinguishable.

Least known is the East Persian (predominantly Timurid) school; somewhat better known is the Anatolian-Seljuk type, represented mainly at Konya; and best known is the school of Cairo. This type of inlay is found especially on the doors, ceilings,

and mimbars (pulpits) of Mameluke mosques and madrasahs in Egypt and Syria (al-Mu'ayyad, PL. 88; Ḥasan al-Kabir; 'Abd-al-Gharī Fakhrī) and in Istanbul (in the Sulaymāniya), where they had been imported. Very few of the smaller pieces have survived. A wooden casket inlaid with ivory figures, inscriptions, and arabesques (12th or 13th cent.) is preserved in the Royal Palace in Palermo, and some Indian travel chests of sandalwood, inlaid with ivory figures in a mixed Rajput and Deccan style, are in the Victoria and Albert Museum, London.

One of the most impressive forms of Indo-Moslem inlay work is that of semiprecious stones, or, more simply, of black marble in the white marble buildings of the Moghul emperor Shah Jahān (1628–58). Though in form it is a variety of the mosaic work in variously colored marbles, limestone, and schist in use under Shah Jahān's predecessors, Shēr Shah, Akbar, and Jahāngīr (16th–early 17th cent.), this type of inlay appears technically to be an adaptation of Florentine "mosaic" introduced by Italian and French adventurers. The change in technique occurred because the elements of the new designs were distributed much more sparsely over the white marble ground and because of the costliness of the stones inlaid (agate, carnelian, malachite, and others, generally no more than a quarter of an inch thick). Accompanied still by older modes of decoration in mosaic and relief, this new type of inlay appeared first in the mausoleum of I'timād-ud-Daula at Agra (1628; PL. 89). It predominates, however, in the decoration of the palaces of Shah Jahān at Agra, Delhi, and the Fort at Lahore, and in the Tāj Mahal. With the decline of the Moghul empire under Aurangzēb (1658–1707), this inlay work was gradually replaced by painting on marble and ultimately by painting on stucco designed to imitate marble.

The Jāt rajas of Bharatpur reused Moghul inlaid marble slabs for their garden palaces at Dig, and the maharaja Ranjit Singh of Lahore used slabs from the tomb of the empress Nūr Jahān for the Golden Temple of Amritsar.

Inlay has to some extent been used by the Jains in the decoration of their temples. The craft survives in the bazaar at Agra.

Hermann GOETZ

TRIBAL CULTURES. Inlay, as decoration applied to surfaces especially prepared for it, is not found among primitive peoples. Almost universally used, however, are insertions (of eyes, teeth, and so forth) in wooden figures, as well as appliqués — in designs that are mostly geometric, rarely figural — of pieces of mother-of-pearl and other material on the surfaces of vases, furnishings, cult objects, and weapons. Appliqué (see MEDIA, COMPOSITE) predominates particularly in Oceania, where, in the Solomon Islands (see MELANESIAN CULTURES), it reaches its highest level of artistic quality in the display shields of the island of Guadalcanal. Singularly pleasing effects are produced on these shields by the application on a ground covered with a resinous preparation of pieces of shell arranged in designs that are abstract, yet derived from the human figure. Equally effective are the appliqués of mother-of-pearl on the ceremonial vases and wooden arms of the Palau Islands (see MICRONESIAN CULTURES).

Inlay is not found among the cultures of pre-Columbian America; these civilizations produced, instead, works in the mosaic technique (see MOSAICS).

* *

BIBLIOG. *Antiquity*. *a. Egypt*: A. C. Mace, The Caskets of Princess Sat-Hathor-Iunut, BMMA, XV, 1920, pp. 151–56; H. Carter, The Tomb of Tut-Ankh-Amen, II, London, 1927, pp. 78–82; R. Engelbach, The so-called Coffin of Akhenaten, AnnSAntEg, XXXI, 1931, pp. 98–114; A. Lucas, Ancient Egyptian Materials and Industries, 3d ed., London, 1948, p. 514. *b. Near East*: C. L. Woolley, Ur Excavations, II: The Royal Cemetery, Oxford, 1934, pp. 262–83; H. Frankfort, The Art and Architecture of the Ancient Orient, Harmondsworth, 1954; A. Parrot, Le temple d'Ishtar, Paris, 1956, pp. 135–55; R. S. Young, The Tomb of a King of Phrygia Discovered Intact, ILN, CCXXXII, 1958, pp. 828–31; R. Ghirshman, Temples and Palaces of the Elamites: New Finds at Tshoha-Zanbil, ILN, CCXXXIV, 1959, pp. 1025–27. *c. Crete and Mycenae, Greece, Rome*: O. Deubner, RE, s.v. Inkrustation, sup., VII, cols. 285–93; C. Ricci, Appunti per la storia del musaico, BArte, VIII, 1914, pp. 273–77; O. Elia, Due pannelli decorativi pompeiani, BArte, IX, 1929, pp. 265–76; D. Krenker and E. Krüger, Die Trierer Kaiserthermen, Augsburg, 1929, pp. 306–19; H. Balducci, Basiliche protocristiane e bizantine di Coo, Pavia, 1936; E.

Strong, Sulle tracce della lupa romana, Scritti in onore di B. Nogara, Vatican City, 1937, pp. 475–509; O. Deubner, Expolitio, RM, LIV, 1939, pp. 14–41; G. Brett et al. The Great Palace of the Byzantine Emperors: First Report, Oxford, 1947, pp. 24–26; C. Cecchelli, Vita di Roma nel Medio Evo, 2 vols., Rome, 1951–52, pp. 601 ff.; G. and M. Sotiriou, ʿΗ βασιλικὴ τοῦ ἁγίου Δημητρίου τῆς Θεσσαλονίκης, Athens, 1952, p. 65; M. J. Vermaseren and C. C. van Essen, The Aventine Mithraeum, Antiquity and Survival, I, 1955, pp. 3–36 (esp. p. 28); O. Elia, Le coppe ialine di Stabiae, BArte, XLII, 1957, pp. 97–103; F. W. Deichmann, Frühchristliche Bauten und Mosaiken von Ravenna, Baden Baden, 1958; P. Toesca, Tarsie in marmo, Agenda ENIT 1958, Rome, 1958; F. Vollbach, Arte paleocristiana, Florence, 1959; S. Marinatos, Crete and Mycenae (Eng. trans., J. Boardman), London, New York, 1960; M. Schapiro and M. Avi-Yonah, Israel: Ancient Mosaics, Greenwich, Conn., 1960; P. A. Underwood, Work of the Byzantine Institute, 1957–59, Dumbarton Oaks Pap., XIV, 1960, pp. 205–22.

The European West: D. C. Finocchietti, Della scultura e tarsia in legno, Florence, 1873; C. Scherer, Technik und Geschichte der Intarsia, Leipzig, 1891; H. Havard, Les Boulle, Paris, 1893; V. Forcella, La tarsia e la scultura in legno, Milan, 1895; E. Fornoni, Le arti dell'intaglio e della tarsia in Bergamo, Bergamo, 1896; F. H. Jackson, Intarsia and Marquetry, London, 1903; P. Lugano, Di Fra Giovanni da Verona, maestro d'intaglio e di tarsia e della sua scuola, Siena, 1905; P. Lugano, Fra Giovanni da Verona e i suoi lavori alla camera della Segnatura, Rome, 1908; A. Schiapparelli, La casa fiorentina e i suoi arredi dei secoli XIV e XV, Florence, 1908; G. Fiocco, Lorenzo e Cristoforo da Lendinara e la loro scuola, L'Arte, XVI, 1913, pp. 273–88, 321–40; A. Pedrini, L'ambiente, il mobilio e le decorazioni del Rinascimento in Italia, Turin, 1925; P. Bacci, Due preziose "tarsie" del senese Mattia di Nanni di Stefano detto il Bernacchino, Bolzano, I, 4, 1927, pp. 180–83; M. Tinti, Il mobilio fiorentino, Milan, 1928; L. Serra, La tarsia e l'intaglio in legno, Rass. marchigiana, XII, 1934, pp. 129–65; F. Archangeli, Tarsie, 2d ed., Rome, 1943; P. Torriti, Il coro del Duomo di Orvieto e le sue sculture, Commentari, I, 1950, pp. 143–45; E. Carli, Scultura lignea senese, Milan, Florence, 1951; J. W. Evers, Intarsia, Utrecht, 1952; G. Marangoni, Storia dell'arredamento (1500–1850), 2d ed., Milan, 1952; A. Chastel, Marqueterie et perspective au XVᵉ siècle, Rev. des Arts, III, 1953, pp. 141–54; G. Kossatz, Die Kunst der Intarsia, Dresden, 1954; E. H. Pinto, Intarsia I, Apollo, LIX, 1954, pp. 147–51; J. G. Phillips, Early Florentine Designers and Engravers, Cambridge, 1955; L. Möller, Der Wrangelschrank und die Verwandten süddeutschen Intarsienmöbel des 16. Jahrhunderts, Berlin, 1956; A. Chastel, Cités idéales, L'Oeil, XXXVI, 1957, pp. 32–39; G. Morazzoni, Il mobilio veneziano del '700, 2 vols., Milan, 1958; Catalogue d'Exposition Louis XIV, Faste et décor (Pavillon de Marsan), Paris, 1960; O. Raggio, The Farnese Table: A Rediscovered Work by Vignola, BMMA, XVIII, 1960, pp. 213–31; H. Sturm, Egerer Reliefintarsien, Munich, Prague, 1961 (Eng. summary, pp. 265–72).

The East: E. W. Smith, Mughal Colour Decoration of Agra, Allahabad, 1901; G. Watt and P. Brown, Indian Art at Delhi, 1903, London, 1904; E. F. Strange, Catalogue of Japanese Lacquer, Victoria and Albert Museum, 2 vols., London, 1924–25; G. Migeon, Manuel d'art musulman, 2d ed., Paris, 1927; M. I. Rostovtsev, Inlaid Bronzes of the Han Dynasty, Paris, Brussels, 1927; R. Ettinghausen, Metal Work from Islamic Countries (exhibition cat.), Ann Arbor, 1943; M. S. Dimand, Handbook of Muhammadan Art, 2d ed., New York, 1947; J. Harada, The Shosoin, Tokyo, 1950; P. C. Swann, Introduction to the Arts of Japan, Oxford, 1958; E. A. Seguy, Les Laques de Coromandel, Paris, n. d.

Illustrations: PLS. 77–90.

INNESS, GEORGE. American painter (b. near Newburgh, N.Y., May 1, 1825; d. Bridge-of-Allan, Scotland, Aug. 3, 1894). Son of a prosperous merchant, he grew up in Newark, N.J. Because of delicate health he received little formal education. Except for brief study with the French-born landscapist Régis Gignoux in New York, he was self-taught, painting landscapes directly from nature. His early work, in the prevailing meticulous Hudson River school style, did not satisfy him; he later said that his eyes were opened by engravings after the old masters; "they were nature, rendered grand instead of being belittled." This revelation was confirmed by two early visits to Italy, in 1847 and 1850–52, and another to France, where, in 1854, he saw the work of the Barbizon painters. While retaining his native fidelity to facts, from the mid-1850s Inness evolved a more subjective romantic style: the panoramic viewpoint gave way to an intimate one, literalism to growing awareness of light, atmosphere, and mood. His style became broader, freer, more chromatic, and more painterly. This evolution was further stimulated by a four-year European visit (1870–74), with winters in Rome and summers in the Italian countryside and at Etretat in France.

In 1850 Inness married Elizabeth Hoyt; they had six children. For years he received little recognition except from a few patrons. Elected Associate of the National Academy of Design in 1853,

he was not made full Academician until 1868. The family led a somewhat nomadic existence, living in Brooklyn and New York, 1854–59; Medfield, Mass., 1859–64; Eagleswood, N.J., 1865–67; Brooklyn, 1867–70; New York, 1875–78. From the mid-1870s his fortunes improved. In 1878 he settled in Montclair, N.J., his permanent home thereafter, with painting trips to Virginia, California, Florida, and elsewhere.

Inness' mind was restless and inquiring. Strongly religious, he was converted in the 1860s to Swedenborgianism. For a time he painted religious subjects, and to him even pure landscape was an embodiment of the divine: "All things that we see will convey the sentiment of the highest art if we are in the love of God."

As he matured, he became concerned less with the objective facts of nature than with her moods and the subjective emotions they aroused (I, PL. 109). More and more he saw everything in terms of light, color, and tonal values. This development came largely from within, but it was assisted by the Barbizon example. In his latest phase the Barbizon viewpoint evolved into a dark, romantic tonalism suggestive of impressionism. Inness' emotionalism occasionally verged on sentimentality; while his emotional content was often fresh and moving, it was also sometimes banal. Nevertheless, he remains the most vital American romantic landscapist of his period and the one who had the strongest influence on the native landscape school.

Inness' paintings are in most American museums, with large groups in the Metropolitan Museum and the Art Institute of Chicago.

BIBLIOG. E. Daingerfield, George Inness, New York, 1911; Fifty Paintings by George Inness, New York, 1913; G. Inness, Jr., Life, Art, and Letters of George Inness, New York, 1917; E. McCausland, George Inness, New York, 1946.

Lloyd GOODRICH

INSTITUTES AND ASSOCIATIONS. Corporate institutions connected with the world of artists and art lovers have been created in many varying forms depending on their origin, their nature, and the demands (technical, economic, didactic, scholarly) they were organized to meet. Clearly, such organizations as simple trade associations or artists' and craftsmen's workshops differ greatly in character and purpose from schools and academies of art, societies of art lovers, and those modern institutions devoted to research and study in the field of art history. Still, for all their differences, these forms of artistic cooperation and organization are to some degree interdependent and often have historical links, so that it is far from easy to establish any clear-cut line of demarcation which would justify treating them under more than one heading. Each period of history has, in fact, its own forms, reflecting the standards and structure of the civilization from which they spring. In ancient times and during the Middle Ages, the typical form of association was the workshop or corporation, in which, side by side with the predominant practical purpose, are seen elements of a religious, social, or cultural nature. A great part was played by these institutions in the handing down of artistic experience. From the 16th to the 19th century the academies of art in various parts of Europe, acting with official support, worked to establish a system based on experience and to codify rules, while at the same time they encouraged a certain amount of study and reflection on artistic matters. It is only in recent times that these various activities have been differentiated and incorporated in separate bodies, resulting in modern societies of artists, schools of art, cultural societies, and institutes devoted to study and research. The rise of the latter type of institution as a means of increasing knowledge of the historical basis of problems connected with art is directly related to the predominant historicist tendencies of modern thought and culture. For closely related subject matter which amplifies and completes this discussion, see CRITICISM; EDUCATION AND ART TEACHING; HANDICRAFTS; HISTORIOGRAPHY; MUSEUMS AND COLLECTIONS; PRESERVATION OF ART WORKS; RESTORATION AND CONSERVATION; SOCIOLOGY OF ART.

SUMMARY. Organization of artistic and craft activities in primitive societies and in the ancient world (col. 137). Corporations, workshops, and schools in the Middle Ages and the Renaissance (col. 141). Art academies from the 16th to the 18th century (col. 150). The academy since the age of neoclassicism (col. 157). Origin and development of modern cultural and research organizations (col. 159). Schools and museums of industrial art (col. 161). Contemporary developments (col. 165). China (col. 166). Principal organizations related to study of art and development of artistic activities (col. 167).

ORGANIZATION OF ARTISTIC AND CRAFT ACTIVITIES IN PRIMITIVE SOCIETIES AND IN THE ANCIENT WORLD. It is impossible to picture accurately for remote, and even not so remote, periods of prehistory, the forms of collective cooperation in the execution of a work of art. The existence of such cooperation, at least in the technical sphere, is probably implicit in the scale of prehistoric rock decoration, in the sum of the experiences handed down through the ages, and in the continual use of schemes that presuppose some degree of specialization and education of artists; but it is impossible to establish how and to what extent this activity can be distinguished from that of groups composed of members of a family or from the realm of magic and religion. Certainly the craft of the stonecarvers and of the modelers in clay, with all its formal and decorative implications, must have had an enduring organizational structure of schools and workshops. On the other hand, in the art of pottery, one cannot ignore the indications that from Neolithic times this art was a feminine occupation carried on within the family unit. Only beginning with the more complex art of metallurgy can one speak with some certainty of embryonic specialized corporations, stable or wandering. Some light is thrown on this primitive world by the traditions and testimony of the organized societies of ancient times as revealed in the earliest written evidence, with its echoes of a legendary past; more informative, however, is the situation among primitive peoples of the present day or of the historical past.

In primitive communities groups of individuals often form special classes or castes bound by racial, religious, or political ties to the practice of certain crafts handed down from father to son. In West Africa the various crafts were almost everywhere in the hands of castes, often despised and also feared for the magic powers with which they were credited, but sometimes held in high esteem, as among the Akan group, where metalworkers and smiths possessed clearly defined social functions. In the same area, among the Ashanti of Ghana, the goldsmiths formed a sort of brotherhood in which the secrets of the trade were handed down from father to son.

In pre-Columbian America corporations of craftsmen existed among the Aztecs, but chronicles provide information only about the most active — the goldsmiths, the mosaicists, and the jewelers. These craftsmen were known as Toltecs because their artistic activities were regarded as something foreign to Aztec culture, a legacy inherited from the preceding Toltec civilization. This attribution is not purely legendary. After the fall of Tula, capital of the Toltecs, the population dispersed throughout the Valley of Mexico and continued to follow its own way of life, preserving its native techniques and artistic skills. According to Jacques Soustelle (*La vie quotidienne des Aztèques à la veille de la conquête espagnole*, Paris, 1955), the group of craftsmen responsible for the production of feather mosaics, prior to the incorporation of their village (Amatlán) and themselves into the Aztec capital and civilization, had been enemies, foreigners to be conquered. Even after their assimilation they continued to follow their own customs, remaining faithful to their group tradition and pledging their children to the tutelary gods of the guild for the continuance of their craft.

In Polynesia and Micronesia there were schools for the art of tattooing, and the great masters (called in Samoa *tufuga ta tatau*) were held in the highest esteem. Often their fame extended beyond the island or archipelago in which they practiced their art. In western Polynesia, for example, the school of Samoa was so famous that the young men of the Tonga Islands undertook long sea voyages in order to be tattooed there.

Conditions of this sort probably existed in the world of European and Eurasian protohistory. Many indications of this could be cited relating to the origins of the metallurgic cultures of central and western Asia, to the vast areas covered by the ancient steppe cultures, and to the European Iron Age.

Concerning prehistoric and protohistoric China there is additional material, derived from the analysis and sociological interpretation of literary documents of a later period. From these it is clear that groups of technicians and craftsmen, expert in the production of pottery and the fusion of metal, had from a very early date formed themselves into confraternities whose leaders, according to some scholars (Marcel Granet), even possessed political power. Legends concerning mythical rulers and heroes (Huang-ti, the great Yü) speak of associations of potters and bronzesmiths consisting, for the most part, of 72 or 81 members. The bronze caldrons and magic swords which they made became royal or dynastic symbols. Other legends of a somewhat later date reveal how the swordmakers received the secrets of their trade from a master or relative; clans of such founders of metal probably existed, especially in those regions of southern China that in the Chou dynasty saw the beginnings of the art of metallurgy.

Similar traditions persist in the mythology of the ancient peoples of the Western world. These traditions record the names not only of individual craftsmen, masters, and magicians like Daedalus, whose teachings, techniques, and "shop secrets" were passed on and spread over the course of time, but also of groups like the Cyclopes and Cabiri, sharing not so much an ethnic kinship as the secret of a special manual activity which they carried on with unique skill. Such myths and traditions seem to be an allusion to the origins of distinctive craft categories and workshops.

Written sources show more concretely that individual craftsmen took charge of important projects. In this category are Bezaleel, who directed the building of the Tabernacle in the Holy Land; Hiram, whose versatility in the arts led to his being put in charge of the construction of the Temple of Solomon; and the anonymous craftsman who made the throne of Solomon, which was subsequently copied or carried off by Nebuchadnezzar to Babylon. There were those craftsmen who worked on the temples of Mesopotamia, such as that of Khafaje, somewhat in the manner of the craftsmen engaged in building a medieval cathedral. In return for their services and the use of their particular skills, they were provided with the means of subsistence and the materials necessary for their work. Some form of association with a hierarchic structure seems to have existed at the Egyptian court, where such posts as Master of the King's Works and Superintendent of the Palace sometimes apparently were hereditary. Several classes of craftsmen, who probably formed corporate associations of some kind, are mentioned in the Code of Hammurabi. They were not protected by official regulations, however, and had a private character based on paternal instruction within the unit of the individual workshop. More highly developed was the form of association documented in the 15th and 14th centuries B.C. at Ugarit, where types of corporations existed with practical aims of a commercial nature and safeguards and privileges for members. The terms used to designate master and apprentice differ from the habitual "father" and "son," a fact which suggests that there the usual custom of handing down crafts from one generation to another of the same family was not practiced. At about the same time, according to recent interpretations of the tablets from Pylos (though the evidence is not entirely reliable), there seem to have been groups of craftsmen of various sorts, especially metalworkers, operating in the local courts of the Aegean area.

Archaeological evidence confirms this. At Tell el 'Amarna have been discovered the living quarters and working area of the workmen and craftsmen engaged in building the city. This temporary "city" has a hierarchic structure which seems intended to ensure its smooth working. Besides this unified structure, the existence of wooden models composed of separate parts, each of which seems to have been mass-produced, also indicates the presence of some sort of loose form of association between related workshops. Finally — and this is particularly important for the protohistory of the Iranian plateau — while in techniques and types of pottery even the smallest

localities show notable individuality, the areas of diffusion of certain types of bronzes are clearly much larger and more uniform. Information about wandering communities of craftsmen, some of which still survive (tinkers, gypsies), sheds light on the diffusion routes of cultural currents, particularly in connection with such highly composite cultures as the Neo-Assyrian, the Urartu, the Achaemenid, and the Celtic, in all of which are seen the influence of the Scythian migrations. The problem of metalworking is vital and significant. The discovery of a foundry in the palace at Phaistos and at Knossos (where there are also ceramic workshops), together with lists of objects produced and stored in the palace at Pylos, should be taken in conjunction with what is found in the world of the Homeric poems, which reflect the usages of the preceding civilization. The production of everyday objects was carried out in the family unit under the direct control of the head of the family, while objects requiring a difficult, refined, or specialized technique were bought or commissioned from wandering artists who enjoyed the protection of the law of hospitality. Not only the artists but also metal, their raw material, traveled. This is proved by the discovery in Sardinia of pigs of bronze bearing Cretan markings, and by the cargo of a Bronze Age ship, which foundered south of Cape Gelidonya, between Finike and Antalya, off the coast of Asia Minor, with a cargo of metal ingots and pigs (G. F. Bass and P. Throckmorton, "Excavating a Bronze Age Shipwreck," *Archaeology*, XIV, 1961, p. 78 ff.).

As for ceramic workshops, those of high standard were clearly not mobile, especially in ancient and classical Greece. The hereditary principle seems to have been widely abandoned, and the successful painter often opened his own workshop. Excluded from citizenship in aristocratic regimes, and accepted only with limitations in timocracies, such was the weight of the traditional disrepute in which artists were held that even after achieving full equality of rights under the democratic constitution of Athens, they tended at the first opportunity to become entrepreneurs. Phidias himself illustrates this tendency.

One form of temporary association of this period was the large group of artists and craftsmen which gathered together to build works commissioned by various cities. In most cases, however, these acts of civic patronage lacked the conscious purpose of a Pericles, whose appreciation of the propaganda value of good art, and of the contribution which his building program could make to artistic standards and organization, remained exceptional. Even in Hellenistic times, all the artists at Sparta were state slaves or foreigners, and this situation was repeated in Crete and Tanagra. A provision to this effect is contained in the constitutional proposals of Phaleas of Chalcedon.

The Hellenistic period was characterized by an intimate association between artist and prince. More important than the friendship and protection of the prince, who was himself often a person of artistic interests and culture, was the existence under his patronage of groups interested in art and in critical and literary problems — real academies, in fact, whose members had a common interest in the definition and stylistic resolution of certain problems. This is the highest point reached in the organization of artistic culture in antiquity. Not until Roman times were there real collegiate associations of artists, and even then such associations were conceived of from a utilitarian, "trade-union" point of view. In Rome itself the practice of an art was originally considered unworthy of an *ingenuus*, that is, a freeborn man. This explains why until the late Empire there were neither artistic organizations for such men nor any significant number of people devoting themselves to the arts, except for certain famous individuals whose interest was pure dilettantism (Fabius Pictor, Quintus Pedius, Nero, Hadrian, Marcus Aurelius, Alexander Severus, Valentinian I); even such persons as these were sometimes the object of criticism (Attalus III, Heliogabalus). The only exception was the instruction in painting (that is, design) given within the family to enable women to select or execute embroidery.

Alexander Severus set up a school of architecture with an ambitious program and a theoretical basis. This school was open to *ingenui*. Later state interventions in this school and provisions to encourage artistic teaching within the family were

emergency measures of a purely practical nature designed to meet the shortage of artists and the decline in technical standards. Architecture remained always the favored art. Under Constantine a grant (*stipendium*) was decreed for students of architecture, while those who acquired and passed on to their children any technical skill ancillary to architecture were granted certain tax concessions. Painters received similar favors under Valentinian I, being exempted from some tax burdens and granted the free use of state-owned studios (*pergulae*) and workshops.

The first workshops were organized on a strictly family basis, instruction being given by the paterfamilias to his children and to the slaves attached to the workshop. The development which took place between the late republican period and the end of the Empire brought with it an increase in the activities, and thus in the personnel, of the workshops, which came to be associated with a whole *gens* rather than an individual family; with their monopolistic privileges based on imperial concessions and benefits, they provided a fruitful source of revenue. In this way these workshops existed for many decades and were the centers at which whole generations of craftsmen were trained. Their activities were, or soon became, industrial in nature: a typical example is the production of Arretine ware, which imitated the example of the earlier factories of Megarian, Pergamene, and Etrusco-Campanian ware in its type of organization. The first names of proprietors to appear in the makers' stamps were all Italic, but the craftsmen were Greek or Oriental. One might perhaps mention here the existence of monopolies, often granted to members of the imperial family, in certain other nonartistic fields of production, such as the manufacture of lead pipes and bricks.

One incentive to artistic production was the life of the legions, which was reflected both in the execution of works of military interest (for which there were specialized craftsmen) and in the production of reliefs, mainly funerary. These were often carried out by Romanized barbarian artists working on the spot.

The new social structure that emerged at the end of the 3d century of our era, together with the tendency toward a closed economy, encouraged the development of the self-sufficient workshop run directly by the owner and intended to serve a limited area. Its activity did not normally include work of high artistic quality, for which outside artists were engaged. In the great houses, and particularly the imperial household, there were true examples of specialization in the execution, restoration, and maintenance of works of art, which were entrusted to slaves with specific titles such as *ad statuas* (of the statues) and *ad imagines* (of the pictures).

In general, then, Roman organized groups included workers considered exclusively as producers. Concerning artists in the strict sense the evidence of the existence of specialized associations is scanty and doubtful, though some did belong to one group or another. It is noteworthy that the associations most specifically connected with artistic work were those concerned with various aspects of the art of jewelry making. The first opportunity for the formation of an artistic tradition in Rome came with the creation of a state mint; but an autonomous Roman tradition of types and style did not appear before about 250 B.C., and even the fact that the issues of the mint gave important families an opportunity for self-glorification did not foster establishment of high artistic standards (see COINS AND MEDALS). Triumphal painting, too, normally entrusted to slaves, failed to rise above the level of occasional art, and there has been found no evidence of the formation of schools and associations.

Changes in Roman society and ethics after the 3d century B.C. restricted interest in art to the circle of a few great families and brought about the importation of such artists as Metrodorus, family artist and tutor to Lucius Aemilius Paulus (see PATRONAGE).

The lack of critical preparation on the part of the Roman public and the conservative nature of its tastes led to the setting up in Rome of workshops of sculptors in marble following the various currents of classicistic taste. These workshops appear to have been hereditary, but the number of local craftsmen

and assistants who received instruction in them must have been considerable. This situation persisted under the Empire, with the triumph of stylistic tendencies officially approved by the emperor and expressed in the work of certain groups of artists (e.g., the group at Aphrodisias in Asia Minor).

In the late-antique and Byzantine periods, the production of works of art became increasingly centered around the court and so more and more influenced by its bureaucratic organization. Such objects as tapestries, hangings, cloth, and jewelry were produced in great public workshops equipped according to their rank. All possible private initiative was thereby stifled.

Edicts of Constantine and his successors granted tax concessions to the craftsmen who came to Constantinople from every part of the Empire and were particularly generous toward those who brought with them their families and their workshops.

* *

Italo SIGNORINI, Lionello LANCIOTTI, Paolo MATTHIAE, and Giancarlo AMBROSETTI contributed portions of this section.

CORPORATIONS, WORKSHOPS, AND SCHOOLS IN THE MIDDLE AGES AND THE RENAISSANCE. Throughout the Middle Ages and thereafter the organization of artistic life, from both the economic and the legal point of view, was based in effect on three institutions: the guild, which gathered in one organization craftsmen of identical or similar occupation; the workshop, in which an individual master craftsman worked with his assistants, carrying on a legally recognized teaching activity; and the *ministerium*, or works department, of a great public or private undertaking, which cut across the various trades and employed craftsmen belonging to several guilds and workshops. These three institutions had the same fundamental character in that they were all formed by the free association of free men lending their services on the basis of contracts drawn up in accordance with the requirements of the law. There were naturally some intermediate institutions, such as the monastic scriptoriums, which produced illuminated manuscripts and functioned in a manner very similar to that of a workshop, though lacking the latter's economic purpose. The triple division, however, covers in practice all the activities of medieval craftsmen. It should be noted that the distinction between artists and craftsmen, which was to be made so haughtily in the Renaissance, had no economic justification in the Middle Ages. The greatest excellence and the most highly specialized workmanship were to be found within the guilds (even if the association to which the artists belonged was often in itself poorer than the associations of their patrons, for example the merchants). The lack of prestige accorded to artists was largely counterbalanced by a greater freedom of action and less control by the civil authorities. As the results show, the average level of individual work was generally much higher than that of the works produced by second- or third-rate artists of more recent times, since the disbanding of these corporate associations.

Detailed studies of the corporate institutions covering those higher forms of craftsmanship now understood by the word "art" are unfortunately almost nonexistent, and the relevant documentary material is unusually scanty before the 13th and 14th centuries. Any sort of group organization, however, inevitably exercises influence on style and on economic and geographic distribution. For this reason it is worth trying to deduce, from information about other bodies, the principles upon which the social organization of artists was based, until the economic blossoming of the towns and the emergence of larger numbers of private patrons produced a great expansion of artistic activity.

The continuity of the large-scale workshops of late antiquity is a factor of exceptional importance for the entire Middle Ages and also for much of the modern period. These workshops were organized and maintained by the imperial court, by the great monasteries, and by the cities. Such large workshops produced articles of high quality and value for a very small number of customers, or else realized vast collective undertakings covering many years or decades, or even, as in the case of the great cathedrals, never really coming to an end because of the requirements of maintenance. The importance of these groupings of artists derived from several factors. First, craftsmen were selected not on economic but on strictly artistic grounds, and members were chosen not only from a city, but from entire nations or even from all Europe. Second, in these organizations there was a close connection between those who commissioned and those who carried out the various projects, with the result that daring experiments were possible and figural style was immediately affected by such things as fashion, the study of ancient treatises, or the impact of poetic and literary images. These workshops also stimulated competition, encouraging patrons to strive to outstrip each other with products of richness and quality; at the same time the workshops provided a testing ground for new systems of work which then spread to lower, more popular levels of production. Almost all the major stylistic trends of the Middle Ages — the Carolingian, the Romanesque, and the Gothic — can be attributed in part to the positive influence of this method of organization. There is detailed information only about the works departments that existed in the towns — and actually only about the organizational and financial aspects of the building of certain cathedrals. Both from surviving important buildings and particularly from the very rapid adoption of successive improvements in Cistercian monasteries throughout Europe (for example, in methods of lighting and roofing) it can be deduced that an equally fruitful and complex group activity existed in the great religious and political centers of the early Middle Ages, and that its results were carried even to remote places by parties of specialized craftsmen. Such workshops combined the functions of a central planning authority — they were equipped with schools and with a generous supply of cultural aids, such as manuscripts and albums of drawings — with some of the functions of a central production unit, as they included smaller workshops capable of turning out and distributing some of the essential elements of construction: architectural decorations, capitals, and columns. Such a situation had already existed in Byzantium at the time of Justinian. The most famous cathedral works departments were only a reflection and a continuation of these centralized initiatives. Later their organization increased in complexity, eventually giving rise to such forms of association as Freemasonry, which went beyond purely artistic or economic matters to acquire an ideological *raison d'être*. Such great forms of organization present an extraordinarily happy synthesis of intellectual and practical elements.

At first the economic and spiritual control of these organizations was often vested in an enlightened bishop or abbot; one thinks in this connection of the extraordinary capacity for stimulating and encouraging artistic activity possessed by men like Abbot Suger. In time this role was taken over by the chapter — an assembly of canons with great legal autonomy — or by the civic authorities, especially in Italy. Gradually these institutions became more independent, even at the expense of the ecclesiastical power. The cathedral represented the interests of all classes, who shared the expenses of its construction and in return used it for their meetings and sought as an honor the right to representation. Moreover, as J. Gimpel pointed out, in the elaboration of plans and the carrying out of the work, the functions of the chapter were more or less comparable to those of a present-day department of city planning and urban renewal.

The problems were of the same nature: expropriation of property, finance, and the awarding of contracts. The difficulties which arose in the realization of large-scale projects were by and large similar to those which arise today. For this purpose the chapter appointed a supervisor whose job it was to run the department and keep the building accounts. It was thus necessary for him to be both a good businessman and an architectural expert. His responsibilities included the supplying of necessary materials (which sometimes had to be brought from a considerable distance), the taking on of new staff, and the paying of wages. Closely connected with the supervisor was the architect, who often enjoyed the highest prestige, being accorded even the dignity of a university title (Pierre de Montreuil, for example, was referred to in his epitaph as "docteur-ès-pierres"), and who had little connection with

the practical side of the work. Toward the middle of the 13th century Nicolas de Biard (quoted by Gimpel) wrote: "In large buildings it is usual to have a principal master who sees the work forward by words alone, but who rarely or never uses his hands, and who nevertheless receives a bigger salary than the others The master masons who have stick and gloves in their hands say to the others 'Cut here and here'; they themselves do not work at all, yet they receive larger salaries." The major architects, many of whom had reached this position from the humblest beginnings, occupied a clearly defined social position in the works departments of the cathedrals and belonged to a special class with exceptional privileges such as the use of specially reserved premises for working on their plans, maintenance at the chapter's expense, receipt of presents of clothing and furs, exemption from levies, receipt of monetary rewards, and the right to serve as consultants. Moreover, only well-known architects, by virtue of their continual travels, could keep up to date with the various technical advances achieved in other centers.

Beneath the architect there were various groups of specialized craftsmen, who jealously guarded their privileges and secrets. Among these were the *appareilleurs*, or stone dressers, who marked the stones to indicate how they were to be cut ("He it is," wrote Pierre du Colombier of this type of craftsman, "who prepares the area or layer of plaster on which he then draws in full scale the elevation of a vault or of another part of the building, with all the developments of which it is capable, and finally draws it in projection"); the master carpenters; the master masons, capable of reading the architect's drawings and of deducing an elevation from a plan; and the carvers and their assistants, divided into two categories, paid according to the type of stone used and naturally possessing a very different training and background. In England, for example, those who worked a particularly hard stone were called hard hewers; on the other hand, the freestone masons, or freemasons, worked an excellent limestone particularly well suited to the delicate work of carving. Stress has rightly been placed on the imaginative freedom displayed by the latter artists, whose work was sometimes unacceptable to the chapter because it flouted too openly the orthodox iconographic tradition. Finally came the masons, arranged in various classes down to the humble laborers and all recorded in the surviving account books.

Despite its multiplicity of functions, the works department was united by a bond of secrecy which gave it the distinctive appearance of a form of corporate association, even if temporary. The masons and carvers together formed a lodge, an organization which at times became a real confraternity with considerable commitments of a devotional and economic nature as well as in the field of mutual assistance. In the lodge important decisions concerning the members' work were made in general assemblies. The Regius manuscript (1390; cf. D. Knoop and G. P. Jones, 1949) recommends the following conduct to the apprentice. He must keep the counsels of his master to himself and not reveal them. He must not reveal to anyone what happens in the lodge nor what he hears or sees there. He must not pass on to anyone the counsels of the lodge nor those of the chamber but keep them to himself as a point of honor to avoid incurring blame on himself and shame on the trade. Secrecy is found even within the subdivisions of a craft; thus Etienne Boileau, provost of Paris after 1258, wrote in his *Livre des métiers* (paragraph VII of statute 48) that masons, stonecutters, plasterers, and others "may have all the assistants and apprentices that they want, provided that they show them absolutely nothing of their trade." These exhortations to secrecy explain the existence of special instructional works, usually beginning with a series of solemn religious formulas, handed down in manuscript form within the same workshop, literally for centuries; such is the *Painter's Manual of Mount Athos*, still in use in 1800, the notebook of Doxaras, the Russian *podlinnik*, the treatises of Armenia, the various books of formulas for colors, mosaics, and painted glass, and manuals on glass blowing. These are aspects of the medieval guild, an organization in some ways simpler than the cathedral companies.

There was, if not a continuity, at least a derivation of the medieval guild from earlier forms of craft associations such as the *collegia* of late antiquity and the Byzantine schools. All these forms of association were designed to meet the same economic and social needs, which can be summed up as follows: (*a*) they brought together craftsmen belonging to the same trade, protecting their rights with respect to each other and to their patrons or outside authorities, intervening on behalf of the craftsmen in disputes and legal cases; (*b*) they procured for their members certain exclusive privileges such as tax reductions and exemptions from military service or from particularly ignominious forms of punishment; (*c*) in cases of sickness, they came to the assistance of orphans and widows of poor craftsmen, and they assisted members in their old age; (*d*) they possessed assets of their own, received from such sources as subscriptions of members, donations, and fines; and (*e*) in the same way as a confraternity, they conducted their own religious rites, funeral services, and celebrations. Naturally, the power of the organization was in proportion to the number of its members and the size of their income, and therefore to the contributions that they could afford to pay. Such highly specialized crafts as those related to the arts were thus at a disadvantage, for though their products were expensive, the volume of production was small. Although the merchants established many foundations throughout the Middle Ages, before the Renaissance there were few buildings designed as meeting places for such craft associations; of the few examples which do exist most are chapels erected at the expense of associations of masons such as the *magistri comacini*. Another consequence of the relative poverty of artistic guilds is the absence of any significant iconographic tradition, with the exception of the representation of St. Luke painting the portrait of the Virgin, a widely diffused iconographic theme associated with the painters' guild. It was not until the late Renaissance that the order of importance of the guilds ceased to depend on economic and political factors and came instead to be based on esthetic and cultural considerations. It is interesting to note, however, the existence in the late Middle Ages of certain collective expressions of opinion in this sense; for example, the preamble to the statute of the Sienese guild of painters, dated 1355, exalts the profession as an ornament of sacred oratory and of grammar: "We are those who by the grace of God reveal to dullards who know no letters the wonderful things done by and in virtue of our Holy Faith."

Despite these aspirations, however, the social organization of even the most liberal artistic professions remained the same as that of other trades. It will suffice to survey in general terms the organization of those bodies — *collegia*, schools, guilds, and the like — to which artists have belonged at different epochs. From a historical and artistic point of view it matters little whether these corporations were subject to any form of pressure from the state — insistence on the principle of hereditary trades, compulsory relocation of craftsmen, or prohibitions against their free movement. Such pressure, in fact, mainly affected associations whose field of activity impinged upon the public good and in practice was restricted to the building trade, whose members were faced with certain obligations in connection with fires and with military and defense work. However, not even the Byzantine corporation concerned with the construction and adornment of buildings, which included among its members carpenters, smiths, painters, and marble cutters, functioned on the principle of heredity. Nor did the state regulate the use of the corporation's property. Indeed, this particular Byzantine association, in comparison with those established elsewhere, seems to have been fairly free from rules and regulations. The growth in importance of corporations, and the consequent promulgation of statutes, seems to have been brought about by economic factors and by the desire both to limit or suppress competition, particularly outside competition, and to control the pressure of the new generations. This promulgation of statutes occurred at a fairly late stage in the evolution of urban economy and, significantly, concerned largely craftsmen working on the production of luxury objects, whose work was in no way concerned with the public good: goldsmiths, tapestry makers, and *tailleurs d'images* — those crafts-

men who had most to fear from widespread competition. Municipal control made itself felt by these craftsmen in three ways: first, by passing sumptuary laws that limited the maximum value of certain products, particularly in the realm of dress and furnishings, and perhaps even prohibited the production of certain items; second, by applying to artists the same system of controls used for other guilds, whereby workshops of similar type had to be located in the same street or zone; third, by granting tax concessions to famous master craftsmen who taught extensively. The edicts of Theodosius (codified 5th cent.) show that membership in corporations concerned with the public good was compulsory and hereditary. The consequent stifling of experimentation and cross-fertilization of ideas occurring outside the specific field of activity of each individual trade must have seriously hampered the development of new techniques and styles. To fill the gap, some of the more important *collegia* (including perhaps the one concerned with building construction) had recourse to forced enrollments and even recruited from among prisoners. The *collegia* were organized according to imperial decree. Their members all followed the same trade; membership was compulsory and included even slaves. To understand the evolution of the 'guilds and the comparative flexibility with which the corporations adapted themselves to changes in the administrative situation of the cities, it is helpful to know that by law their organizational structure was modeled on that of the city, with patrons, magistrates, a senate, and the plebs, or people, and also official lists of officers and members, an annual register, and a roll of new members. According to the information assembled by P. S. Leicht, the administration was divided between the magistrates and the general assembly of members. In the larger colleges the place of the assembly was sometimes taken by a committee of decurions. Meetings took place in the "school," in the temple of the college, or in a public place. The prefect, or president, or, more often, the two prefects of the college remained in office for five years. Under them were the custodians, treasurers, secretaries, and an "actor," who served the college as its legal representative. The prefects, though elected by the assembly, in some cases had to be approved by the state. Sometimes the office of prefect was given to famous personages whose generosity might be expected to benefit the college; a similar munificence was expected from the patrons, to whom commemorative statues were often erected. The income of the college derived from the entrance fees and monthly subscriptions of members, from gifts (such as those made by officers upon election), from revenue on various assets (used for funerals and other charitable and religious purposes), and from the proceeds of fines for infringement of the college statutes. The advantages enjoyed by members, as laid down, for example, in Rome in the Codex Theodosianus (XIV, 2), included exemption from special levies and from military service, unrestricted permission to reside in the city, freedom from certain taxes, the possibility of achieving the rank of knight (with consequent exemption from torture), the possibility of enjoying monopolistic privileges, and the opportunity of acquiring materials in bulk through the college.

There is no reason to draw any sharp distinction between the Roman *collegia* and the schools of Byzantium, whose privileges were roughly the same. The records of the Prefect of Constantinople show clearly that in about the 9th and 10th centuries there were at least twenty-two corporations, some of them concerned with the production of artistic objects (jewelers, silk weavers and dyers, building constructors). These corporations had features which were already remarkably similar to those of the guilds. Admission was open only to citizens of the Empire who were capable of paying the entrance fee and was subject to the explicit approval of the assembly of members, the president, and the prefect of the city, to whom, as in Rome, the councils were legally subject. The corporations tended to limit as much as possible the number of admissions and to impose strict obligations on members, with very severe penalties which in some serious cases — such as the adulteration of goods, the falsification of weights and measures, and illegal competition — included the cutting off of the offender's

hands. Special permission and the completion to the satisfaction of the corporation of at least one major work were required before a member was allowed to set up a workshop of his own.

The president of the school was either nominated by the assembly, subject to the approval of the prefect of the city, or nominated on the authority of the latter. The prefect kept a careful list of all the objects produced, fixed their price, and determined their quality and quantity. For ease of control, workshops of similar nature were grouped in the same street or quarter, and those producing luxury objects, such as jewelry, were situated in the city center. In the event of disputes with a customer, the president of the guild intervened as mediator. The schools were allowed to own property, and they performed important religious activities as well as providing for the welfare of their members. Similar characteristics were to be seen in the early medieval schools established for the carrying out of modest commercial ventures in such Byzantine cities as Ravenna, where there is evidence of schools in the years 943 and 954. These schools were free associations of private individuals who joined together in the hope of obtaining concessions or other exclusive rights and were ruled by a *maior* or *capitularius* elected for life, with officers such as a *judex* or *vicarius* drawn from the membership. The freedom enjoyed by these associations was very great; moreover, in later documents their members are designated *vir honestus* (free man). The *Honorantiae Papiae*, compiled during the years 1004–24 to inform the emperor Henry II of the privileges enjoyed by the royal chancellery at Pavia, show that in this city, too, which was part of the Western Empire, there existed several guilds, called *ministeria*. These guilds, as A. Solmi established, were subordinate to the central administration and were organized around magistrates who both directed their activities and, though responsible to the state, did what they could to defend the privileges of the trade and to obtain acceptance for its products. The members of these *ministeria* were obliged to submit all their disputes to the jurisdiction of the king and the treasurer and were subject to general and special levies paid to the treasurer or the court for the privilege of practicing their trade. There must have been other associations of craftsmen free of central control; there are Lombardic documents dating back to the 7th century which speak of master builders at the head of small groups of craftsmen for whom they are exclusively responsible. Perhaps the subordinate position of the guilds in the *Honorantiae Papiae* derives from the fact that they had received monopolistic privileges from the royal chancellery. It is noteworthy that the word *artes* was used as early as 599 by Gregory the Great to describe those corporations having their own statutes.

With the development of urban life and the growth of local industry and initiative, the guilds increased in number, perhaps favored by greater specialization of work and by the fact that state-sponsored undertakings were ceasing to monopolize the activities of craftsmen and were being rivaled by private commissions. These associations, variously named according to the language and region (*arti, compagnie, paratici, gilde, gremios, Innungen, Zünfte, ministeria, fratelea, fraglie, università*, etc.), came into being in different ways: in some cases they were founded by the local authorities (evidently on the model of Rome and Byzantium); in others they began within the large works departments as a bond among those engaged in the same type of work and a means of defending their own economic interests and privileges. In return for official recognition, the guilds undertook to maintain a rigorous self-discipline and control over their members. As at Byzantium, the leading master craftsmen were exempted from taxation, in return for certain teaching duties. Entry to the guild was subject to the payment of a fee, the completion of an important work, and a decree of the guild giving the new member the right to set up in trade on his own. This permission sometimes must have been very difficult to obtain, for frequently young artists left their own cities to work under masters in other localities or to enter into partnership with them in order to practice their trade. The interests of members were strenuously defended against outsiders, who were often compelled to move

elsewhere. The types of guilds were many and varied; this account deals only with the situation in Italy and is based on the data collected by C. E. Ferri. Like earlier forms of association, the guilds had an administrative structure modeled on that of the city. They were ruled by an *abate, console, priore*, or *gastaldo* (administrator of the royal demesnes in the Lombard kingdom), assisted by a council and controlled by syndics. Under the head of the guild were such officers as the *camerario* (treasurer) and the *scrivano* (secretary), and possibly some messengers or beadles, whose job it was to collect dues, summon members to meetings, and so on. Every guild had its statutes and kept minutes of its meetings and up-to-date lists of members — valuable documents which make it possible to establish when a young master craftsman began to work on his own. The council of the guild exercised a strict and vigilant control over its members, and the penalties that it imposed were supported by the state; the council had the right of search and interrogation, of holding official inquiries into matters within its jurisdiction, and of receiving evidence in secret. Until the 13th and 14th centuries, the general chapters were usually located in churches and religious houses. The guilds organized solemn ceremonies and forms of corporate worship, helped aged workmen, widows, and orphans, and provided dowries for girls of marriageable age; the richer quilds founded hostels and hospitals for their members. The guilds also assumed responsibility for the unemployed and provided them with work. They took over both the social authority exercised by the large workshops of late antiquity and the protective role of the patrons of the *collegia*. Without them it might have been impossible for craftsmen to break away from the cathedral or palace works department, to form their own workshops and clientele, and thus to come into closer contact (even geographically) with the new demands of the lay world.

For the individual workshop, too, the first records go back to the early Middle Ages. The workshop was a typically capitalist organization requiring continuity of work and, therefore, the simultaneous execution of several works or projects, a notable specialization of trades, and a complex internal organization. By the end of the 13th century (particularly with Giotto) the medieval workshop had acquired the authority of the old large-scale workshop of Roman times, dealing with the popes, powerful religious orders, and rich merchants, and supplying not only plans of works but the skilled personnel necessary for their realization. These craftsmen were itinerant, sometimes following the head of the workshop from place to place and sometimes working without him, using his plans, cartoons, and other equipment. The merging of the role of master craftsman with that of contractor and businessman was one of the many effects of the parallelism between the organization of artistic activity and that of craft and manufacturing activity. The only essential distinction, from the economic point of view, is that art remained a luxury product, could not be duplicated, and so was not amenable to any sort of mass production. For this reason the strength and authority of important workshops was more moral than commercial; actually they assumed more and more an intellectual position. Their attempts to achieve dominance, or even monopoly, involved, among other things, the development of their didactic activity.

The most ancient documents on the organization of the workshop are probably the codex of Rothari, King of the Lombards, of Nov. 22, 643 (articles 144, 145), and the supplementary memorandum of Liutprand of Feb. 28, 713, where it is stated that the master builder is responsible for accidents which occur during the course of work and must therefore himself provide the necessary compensation (here the title "master" indicates the head of a workshop, not of a corporate association). According to U. Monneret de Villard and P. S. Leicht, each master builder was actually a contractor who had working with him people of similar interests, "which is not to be taken as evidence of a corporation, but simply of a link binding together different artists in a common undertaking." Only in an organization based on the workshop could projects — some of considerable size — be undertaken in other regions, as was to be true later of the wandering *magistri comacini* and *magistri antelami*.

Some sort of workshop structure, with active master craftsmen and assistants at various levels of specialization, must have existed within the large-scale organizations of late antiquity. One of the most interesting bits of evidence is provided by the salary tables for mosaicists set out in the edict of Diocletian. In order to be able to undertake a decoration by itself, a workshop had to consist of three groups of artists. The most highly paid was the *pictor imaginarius*, who enjoyed absolute authority and earned 175 sesterces a day. His job was to provide the design of the composition and any other graphic work required, whether of a formal or iconographic nature. Since mosaic decorations were employed mainly in public and sacred buildings, the *pictor imaginarius* had to be well informed about all the ceremonial and theological details connected with his decorations, so that even before undertaking the work he had to collaborate closely with courtiers and various important personages — a situation which was repeated in similar circumstances at least until the baroque period. The *pictor imaginarius* appears to have been a cultured man, at home in society, acquainted with the problems of iconography, and in command of a broad repertory of subjects to be made available to clients and patrons. It is not known whether in addition to the overall design he also provided detailed sketches for individual figures, but in workshops which carried out the entire work on their own this is highly likely, as the *imaginarius* was presumably also in charge of the job. Since the methods of work in late medieval and Renaissance workshops were undoubtedly traditional, these mosaic workshops probably used albums similar to the well-known ones of Jacopo Bellini or collections of cartoons, such as those utilized at various times in Giotto's workshop, with sketches and plans of entire schemes, drawings of individual parts, such as heads (especially if used as portraits), of whole figures in different costumes and attitudes, and of such details as arms and hands, jewels, cloth, and architectural decoration. One of the stylistic consequences of this method of work was the frequent repetition of the same movement or attitude and of identical arrangements, even if sometimes reversed, of hands, feet, and other parts.

While the *imaginarius*, having decided on the over-all composition, applied himself to the preparation of detailed drawings, the *pictor parietarius*, who earned a little less than half the salary of the *imaginarius* (75 sesterces a day), began to transfer the design to the wall. Some indication of his method of work is to be found in the sinopia drawings discovered, for example, beneath the mosaics in Milan, in Rome, and in the Church of S. Marco in Venice. These drawings are rare, indicating that direct sketches on the walls were used only in cases of special technical difficulty; it is significant that when such drawings appear there are usually later changes in the composition. Though the duties of the *parietarius* are fairly clear, it is difficult to discover what system he used to transform the design of the *imaginarius* into the finished composition, inserting the figures, details, and various other elements provided by his colleague, and dealing with the problems raised by the different dimensions and perspective and by the possible curvature of the wall. Perhaps he employed a type of cartoon. It seems clear that it was also his job to provide all the necessary supplementary details (backgrounds, general landscape elements, and even secondary figures), for there is often a distinct contrast of style between the protagonists of a scene and the figures which accompany them and also between their pictorial treatment and that of the background.

Last is the *musearius*, whose salary was 50 to 60 sesterces a day. A remarkable craftsman of unequalled technique, his job was to select, sometimes on the basis of directions given him by his colleagues, the pieces of colored glass forming the mosaic, which he usually obtained from oval blocks of glass. It is clear that the work of one *musearius* was not enough: as a workshop progressed from the planning state to the execution of the work, an ever-increasing number of unskilled workers became necessary. The creation of mosaics, however, was a complex operation (though not so complex as building construction). In the case of frescoes, the *pictor parietarius* needed only less specialized assistants to prepare his colors, and in

cases where a preexisting model such as a miniature was followed, the *pictor parietarius* could be head of the workshop, aided only by one or two skilled assistants and some apprentices.

This same organization, more as the result of practical considerations than of the influence of custom, lies at the basis of the late medieval workshop. Concerning workshops, information begins to be precise only about the 14th century, with the beginnings of a biographical historiography, followed later by the evidence of legal documents, when new economic conditions caused apprentices to try to break free from their masters before the stipulated time, as in the notorious series of suits involving Francesco Squarcione. The workshop fulfilled a definite educational function (see EDUCATION AND ART TEACHING), and the distribution of tasks was proportionate to the ability of the young men receiving instruction. Usually there were three categories of craftsmen, defined by law: the master, who was in charge of the workshop and at the same time taught those under him; the assistant; and the apprentice. Apprentices began work at the age of thirteen or fourteen. After five or six years they obtained certificates and were no longer considered apprentices; after three or four years more, if they passed an official test judged by the head of the guild, the councilors, and a notary, they were appointed masters and could set up their own workshops. In the training process the necessity of passing through these various stages, which in themselves constituted a process of selection, enabled the young aspirant to master all the techniques at different levels. Frequently these workshops had a family character, and the patrimony of drawings, cartoons, and other equipment was passed on from father to son, brother to brother, or even brother-in-law to brother-in-law. It was by no means uncommon, however, for an apprentice to remain, even after becoming a master, in the workshop where he had studied, eventually inheriting its good name and its property.

Eugenio BATTISTI

The practice of training in a workshop remained in force throughout the 15th century and was mentioned in the following way by Cennino Cennini about 1400: "Begin to submit yourself to the direction of a master for instruction as early as you can; and do not leave the master until you have to" (Cennino Cennini, *Il libro dell'arte* or *Trattato della pittura*, III, trans. D. V. Thompson, Jr., Yale Univ. Press, 1933). This form of association, as in the past, was the only one ratified by the law which guaranteed its position. In the 15th century, however, the workshop underwent a notable expansion and acquired a previously unknown flexibility. This was in part due to its routine, by then almost standardized, which brought the young man by various stages from the apprenticeship to the grade of master. "Know that there ought not to be less time spent in learning than this: to begin as a shopboy studying for one year, to get practice in drawing on the little panel; next, to serve in a shop under some master to learn how to work at all the branches which pertain to our profession; and to stay and begin the working up of colors; and to learn to boil the sizes and grind the gessos; and to get experience in gessoing anconas and modeling and scraping them; gilding and stamping; for the space of a good six years. Then to get experience in painting, embellishing with mordants, making cloths of gold, getting practice in working on the wall, for six more years; drawing all the time" (Cennini, CIV).

Sometimes apprentices received a salary; sometimes they themselves paid the master, depending on the latter's fame and on the amount of actual work they did. They lived with the master, who often adopted them as godsons (this was true of Giotto and his pupils Taddeo and Agnolo Gaddi in Florence, and of Squarcione in Padua with a large number of disciples, among them Marco Zoppo and Mantegna); this practice, however, often gave rise to exploitation. The number of pupils varied a great deal; in the case of Squarcione it is said to have reached 137 in a few years (as reported by B. Scardeone). The legal aspects of all matters relating to the profession were dealt with by the guilds, whose statutes had the force of law. In general, these statutes defended local interests against the intrusion of overindependent external elements; but in Genoa there existed a *Consortia de li Foresteri*, or guild of foreigners, with statutes dated 1393 and 1485, whose purpose was to legitimize and reinforce the position of such elements within the city. These 15th-century statutes contain nothing new, but it was in this period that most of the guild statutes were drawn up, either to codify traditional practice or to bring up to date earlier rules. In Rome, for example, there had been a *università*, or guild, for a long time; but it was not until 1406 that the guild of marbleworkers had its own statute, while the statute of the guild of painters, known as the Compagnia di S. Luca, dates from 1478. The latter statute laid down rules governing the relations between painters and the organization of the guild and contained provisions concerning meetings, fines, and so forth. Against the sentences of its court, which were promulgated on the Campidoglio, there was no appeal. However, the Roman *università* remained solely a professional organization and took no part in city government, where its consuls had no powers of representation. The Compagnia was presided over by a director, three councilors, and a treasurer; the payments made by members — the entrance fee was two gold ducats — were used for the celebrations prescribed by statute and for the payment of the rector and other officers charged with direction of the guild's affairs. The statute of the painters of Padua dates from 1441; it specifies the different types of assistants and apprentices between the ages of fourteen and twenty-five. Another known Paduan statute was that of the *fraglia*, or guild, of stonecutters, drawn up in 1494, which fixed the entrance fee (very high for craftsmen from other areas in order to protect local carvers), established regulations for the sale of carvings (for example, one could sell only works carried out in one's own workshop; dealing in works executed outside Padua was forbidden), and contained stipulations concerning workshops (each master could have no more than one apprentice, who had to undergo six years of training before becoming a master). In 1441, about a century after the painters and goldsmiths, the masons of Siena drew up their ordinances, which clearly defined the boundary between "the art of the carpenter and that of the stonecutter," according to an agreement reached "in the presence of the officers." Other 15th-century statutes include that of the carvers of Rome (1406), now lost, that of the stonecutters of Cortona (1414), the main purpose of which was to fix the religious festivals, and that of the *università* of painters of Cremona (1470). Particularly severe were the laws governing the length of the apprenticeship (ca. 6–10 years) and of the discipleship (ca. 10–12 years) and the financial and other arrangements existing between master and apprentice, which varied according to whether the young man was a pupil or merely an assistant. The contributions demanded by a guild were at times heavy (in 1472 Leonardo owed money to the Florentine painters' guild) and so, too, in many cases were the other obligations of membership.

ART ACADEMIES FROM THE 16TH TO THE 18TH CENTURY. At the beginning of the 16th century, as in the preceding period, the workshop was still the basic unit of artistic organization. Various artists have left much information concerning it. Some workshops grew to an impressive size, and those who studied there made considerable sums of money (as did Cellini, for example, between the ages of fifteen and eighteen). The apprentice ranked just below the assistant, who shared the profits of the master (Cellini, *Autobiography*, par. 22). The guilds, too, continued to exist, drawing up or improving their statutes (gold- and silversmiths of Rome, 1509; carpenters, goldsmiths, and painters of Bologna, in 1559, 1572, and 1602 respectively; and architects and engineers of Cremona, 1688). Nevertheless, even though to all appearances the relations between artists, both within the workshops and outside, were still controlled as before, a new factor, the growing interest in the individual, was leading many artists to regard the old ties of corporate association as no longer binding. One of the first controversies was connected with the name of Michelangelo and led eventually to the laws discussed below. In fact, the workshop was moving toward a crisis. Michelangelo had no school in the

traditional sense; his followers were either manual helpers or intellectual disciples, the latter, he boasted, being all of noble birth. Similarly, Leonardo started what seems to have been a small, select academy together with Francesco Melzi and G. A. Boltraffio, also retaining certain young men (e.g., Gian Giacomo Caprotti, called "Salai") as assistants with normal contracts. In view of the situation existing in the figural arts, the attitude of Michelangelo and Leonardo toward art and art education was clearly an innovation and reflects the great prestige of the literary and philosophical academies that had arisen in Florence and elsewhere in the first half of the 15th century. Leonardo was the first to protest against the typical routine of the workshop, which placed practical work above free interpretation. "Study knowledge first, and then follow the practice dictated by this knowledge." This view was echoed by Michelangelo, according to whom "one paints with the mind not the hand," and who considered sculpture to be a "scienza studiosa" (a learned science, not a mechanical or servile art). In this concept of art the link between master and pupil can only be an academy, a place of pure speculative study, where the relation between members is that formed by free research, without an ever-present authority, and where, in particular, the master no longer acts as contractor but allows his pupils to accept contracts and commitments with complete freedom.

A most important forerunner in the development of art academies was the school run by Bertoldo di Giovanni (q.v.), with the support of Lorenzo de' Medici, in the Giardini di S. Marco in Florence. This was the first institution to possess the essential characteristics of an academy, namely, erudite, learned training (which no longer consisted in manual assistance with the master's work, but in theoretical study alone) and disregard of the economic aspect of art and of the restrictions and limitations imposed by the guild system. It also had that connection with the court which to a greater or lesser degree was a permanent feature of the academy. Bertoldo's school was referred to by Vasari in very explicit terms, although doubts about its activities have recently been expressed by authoritative critics. Michelangelo is one of the many artists who are said to have studied there. The students, lodged at the court, probably had access to the Medici collections of ancient and modern art. Another later example of a school which bore the name academy (though the precise meaning of the word is debatable) was connected with Leonardo (Accademia Leonardi Vinci, as found in engravings by Leonardo or one of his close collaborators), who is said to have carried on a school in Milan at the court of Lodovico il Moro. Another such academy seems to have been run by Baccio Bandinelli in the Belvedere at the Vatican, as can be seen from two engravings, executed at different times, in which the master appears surrounded by a group of artists of all ages intent on copying ancient statues, studying anatomy, and so forth. The first real academy, however, was the Accademia del Disegno of Florence. Here, realizing that the guild had lost all importance and that the confraternity of artists "had entirely ceased to function," Vasari proposed a new system of organization intended to free artists from all corporate restrictions. A choice was to be made of the best artists, who would place themselves under the protection of the Grand Duke; architects, painters, and sculptors were to be united by a common interest in "disegno." This academy came into existence in 1563 with the support of the Grand Duke Cosimo I de' Medici and completely superseded the guild; the Compagnia di S. Luca became a subordinate body. The meetings of the academy were held in the chapter house of the Church of the SS. Annunziata, and its regulations, because of the authoritative support of the Duke, represented a victory over the local guilds, creating a situation in which the arts were at last clearly distinguished from the crafts and were freed from the legal ties by which the latter were bound. In 1571 a decree was published exempting painters and sculptors from the obligation of belonging to their respective guilds (Arte dei Medici e Speziali for painters, Arte dei Fabbricanti for sculptors). A similar step had already been taken in Rome: after several disputes between Michelangelo, Sangallo, and the guild, a brief of Paul III (1539) had freed

sculptors from these ties, though painters had to wait until the publication of a similar brief by Gregory XIII (1577). One of the fundamental purposes of the Accademia del Disegno was teaching. Each year three "visitors" were appointed whose duty it was to visit the workshops and to help the young artists. In addition to this practical instruction, which supplemented but did not supplant the workshop, theoretical classes in geometry and anatomy were organized and held in the hospital of S. Maria Nuova. Apart from this rather general information, little is known of the structure of the Accademia del Disegno. Its first heads were Cosimo and Michelangelo, its first lieutenant, Vincenzo Borghini. In view of the not strictly technical but broader cultural aims of the academy, membership was not confined to artists but was also open to art lovers and dilettanti. The academy occupied a position of some consequence in the life of Florence, and its views were solicited on matters of artistic interest; however, this aspect of the academy, though represented in the three persons who were its first leaders, was not clearly defined. Fundamentally, Vasari's purpose in founding the academy had been not to educate but rather to reestablish and exalt the dignity of the profession, in emulation of the literary academies, and to break with the guild by putting the artist under the exclusive control of the prince. Federico Zuccari, however, in a program drawn up in the period 1575–78, wanted the didactic role of the academy to be divorced from all other problems and given absolute preeminence; he suggested the creation of a studio for life classes (the first time such a suggestion had been made), the institution of regular courses on theory, and the establishment of prizes (it should be added, however, that Zuccari's emphasis on teaching, stressed by Pevsner, is denied by Mahon). But Zuccari soon lost interest in the Accademia del Disegno as he became preoccupied with the foundation of an academy in Rome. The Florentine institution soon disappeared from the scene, not to reemerge until after 1630.

The first attempt to found an academy of art in Rome was probably that of Lorenzo Sabatini, who, according to Carlo Cesare Malvasia, unsuccessfully applied for a papal brief authorizing him to set up such an institution. Another painter apparently involved in a similar project was Girolamo Muziano. A full account of his program is contained in the biography of this artist written toward the end of the 17th century by the Lombard Lodovico David. According to this account, Muziano was inspired by the example of Vincenzo Catena of Venice, who apparently left his possessions to the local guild so that a school might be founded at the Church of Sta Sofia. The way in which David's account of Muziano's program, which was never put into effect, anticipates later developments is a little suspicious, and its authenticity is doubted by Pevsner. It is certain, however, that in the pontificate of Gregory XIII Muziano began to hold meetings with his followers in the Church of SS. Luca e Martina. In 1577 he obtained from the Pope a bull of foundation; although, owing to a series of practical difficulties, nothing came of the project, the wording of this bull is significant: "Painters and sculptors of Rome have represented to us ... that the arts of painting, sculpture, and drawing were day by day declining in beauty and losing evermore of their glory and nobility, both because of the lack of proper instruction and of Christian charity, in which those who professed the fine arts could not perfect themselves for lack of teachers, and because artists still at the outset of their careers, urged by necessity or by the desire for gain, undertook important works which as a result were deprived of all adornment and lacking in that perfection which is proper to the arts" It was hoped that young artists, as well as learning about art, "would be diligently instructed in Christian doctrine, in piety, and in good behavior" These words reveal not only a crisis in the whole educational system of the period, but also a determination on the part of the Church to keep so important a branch of cultural activity firmly under its wing. It is revealing that when an academy of art was finally founded in Rome (1588) its "protector" was Cardinal Federigo Borromeo. Despite the swift success and wide diffusion of its methods, this Roman academy, known as the Accademia di

S. Luca, was informed by the same principles that had inspired the Accademia del Disegno of Florence, though with a more effective didactic role. Like its Florentine predecessor, it aspired to be a cultural organ of high quality, its members including not only artists but also art lovers and men of letters, rivaling in quality and interests the membership of corresponding literary academies from which it derived its structure. Certainly this was not all, but the opening meetings of the academy, conducted for some months solely by Zuccari, were extremely abstract and dogmatic in tone. In words steeped in rhetoric Zuccari lectured on the meaning of "disegno," a concept regarded as a universal value, a dogma to be defended by the academicians, who composed and recited poems and madrigals in its honor. The novelty of the school's orientation, namely its doctrinal basis, rested on very personal principles, and once Zuccari's presence was removed the academy ceased to flourish. The subjects for public discussion were chosen by Zuccari himself: "What are figure, movement, gesture, attitude?" "In what does the substance of good painting really consist?" "What is history, composition, grace, and beauty?" All this was accompanied by a practical teaching program for young artists in which were adumbrated such modern educational methods as the use of scholarships and the encouragement of travel for purposes of study. Zuccari himself put his own house at the disposal of needy students from outside Rome. Every Sunday in the plenary sessions of the academy the students worked under the supervision of its members, 12 of whom, chosen by lot and called assistants, followed the students' progress and fixed their weekly program. "For some one thing, for others another, according to their capabilities: that is, one will be told to do drawings by hand, another cartoons, another reliefs, another head, feet, and hands; another will spend the week drawing from the antique, or copying the façades of Polidoro; another will draw landscapes, houses, animals, and similar things; others at the appropriate time will draw from the nude with grace and intelligence, or make clay models, clothe them, and draw them carefully. Some will do architectural drawings, others perspective; and those who do best are always to be singled out with some favor and for that week to be made superior to the others and the lieutenant and to be obeyed and respected by the assistant" (R. Alberti). This was an almost conventional program, out-of-date, in fact, compared with that of Muziano (if genuine), whose proposals included the establishment of a collection of plaster casts, the sending of the better students to Venice and Lombardy to copy the works of the local masters, the creation of a special studio for life classes, and the institution of scholarships and annual prizes.

Artists in Rome were not legally obliged to join the Accademia di S. Luca; those who did, however, were bound by the academy's regulations. Several clauses in the academy's rules are reminiscent of those of the medieval guilds: "no student may hold a meeting in his house or keep a model; no member of the academy may presume to tamper with ancient carvings and pictures." Fines were imposed on those who appropriated the works of others, offered a work for sale below the price fixed by others, painted licentious pictures, or tried to attract other artists' pupils. At first the relationship of the academy to the guilds was not clearly defined; by 1596, however, relations were badly strained, one of the difficulties being that the head of the academy had to be accepted by the Compagnia di S. Luca as its head, too. Finally, Urban VIII recognized the academy "as an authority superior to the craft guilds," but other associations continued to exist outside the academy. In Rome, the Accademia dei Virtuosi, at the Pantheon, founded in 1543 at the instigation of Desiderio d'Auditorio, with aims of a purely religious or charitable nature, numbered Pope Paul III among its members; other members included Domenico Beccafumi, Pierino del Vaga, Raffaello da Montelupo, Antonio da Sangallo the Younger, and later, in the 17th century, Bernini, G. B. Gaulli (known as Bacciccio), Giovanni Lanfranco, Francesco Mochi, Claude Lorrain, and Velázquez. The only artistic activity of this academy was an annual exhibition of works of art, held in the porch of the Pantheon on the feast of St. Joseph, patron of the academy. Later the exhibitions became more frequent, particularly in the 17th century, when similar events took place in other parts of the city (at the churches of S. Giovanni Decollato and S. Bartolomeo). An association with similar characteristics, the Sta Unione or Compagnia degli Artisti, was started in Fano in 1535. This was a religious congregation, and its aim was the preservation of the public peace.

The academies of Florence and Rome attracted the attention of artistic circles in many places. Van Mander, for example, after his sojourn in Italy, founded in Haarlem a flourishing institution modeled on the Italian academies. Where the position of artists was not firmly established, however, their situation did not improve. In advocating the founding of academies, Van Mander deplored the fact that, except in Rome, the relations between painters were everywhere still at the corporative stage. In Genoa, for example, the guild imposed severe restrictions on artists who had not submitted themselves to the established routine and exercised complete control over the importation of paintings and the immigration of painters. In Bologna no separate organization for painters existed before 1589. In Venice it was not until 1682 that painters were able to break away from the guild and found their own association (Collegio dei Pittori); sculptors had to wait even longer, until 1723, before achieving their independence. Before their emancipation these artists, for political reasons, had had to submit to being classed with craftsmen and manual workers and had been subjected to the same regulations. In 1620 an academy of painting was founded in Milan by the same Federigo Borromeo who had earlier been protector of the academy in Rome. This foundation, however, which had a limited number of students (24) and was directed by three *magistri* and three priests, was not a spontaneous creation but with its avowedly Counter-Reformational aims represented in some sense the imposition upon art of a religious ideal; for this reason its history has little relevance to that of artistic institutions. Since academies of art, as noted above, were linked with the court, their period of greatest development did not come until the triumph of absolutism, the first academy with a really active life being the French academy of the second half of the 17th century. As for the two mother academies of Rome and Florence, both gradually declined and were replaced by numerous private schools which also, as in the 16th century, took the name of academy. In Bologna the Accademia degli Incamminati, founded about 1586, had blazed the trail, and from the time of the Carraccis there had never ceased to be private schools, notable among them that of Francesco Ghislieri, in which Francesco Albani and Guercino took part. In Milan Camillo and Giulio Cesare Procaccina "maintained an academy in their own house" (G. Mancini); Giovanni Carlo Doria did the same in Genoa (G. Marino); while in Rome Poussin was admitted to academies "which it is the practice to hold during the winter in various houses" (G. B. Passeri). Giovanni Baglione, too, often mentioned "academies which exist in Rome." The same situation prevailed in Modena, Venice, Lucca, and in other Italian cities. Even the academy in Haarlem, founded about 1600 by Van Mander in collaboration with Cornelis Cornelisz. and Hendrik Goltzius, was entirely private in character and in no way affected the relationship between the painter and the guild. Such schools were held in the artists' studios or in the house of a patron, who paid the costs. These schools were not restricted to the pupils of a particular master but were based on relations of protection and friendship and were easily accessible; an artist could even attend more than one academy at a time. The study of the nude was widespread — indeed, it was the principal objective of these schools — but other subjects were not overlooked; time was found for the scientific study of anatomy based on the examination of corpses and skeletons, and sometimes even for the study of still life.

The Académie Royale of Paris evolved differently. In France Italian artists had worked with complete freedom throughout the 16th century; indeed, in 1608 Henry IV refused to approve the founding of a new association of miniaturists on the grounds that, like all the other guilds, it would hinder the

freedom of action of artists. Restrictions on artistic activity had reached the point of prohibiting the importation of paintings from abroad. Attempts by the guilds, however, to curtail the privileges granted to certain court artists and to limit their very number continued to be frequent; after one such attempt in 1646 had gone as far as the parliament, the court reacted in 1648 by founding an academy intended to end, finally, all forms of corporate association. The rules of this academy followed those of the academies of Rome and Florence. The subjects to be taught were architecture, geometry, perspective, anatomy, and history, followed at a later stage by life classes. Though it was modeled on the Accademia di S. Luca in Rome and contained no substantial innovations, this French academy was to be far more successful, because it was based on a more systematic organization, with a full series of courses with set timetables to keep the pupils well-occupied. In addition, of course, it enjoyed the constant protection of the king and formed a sort of palace school, ever ready to meet the vast and multifarious needs of a great court during a period of expansion. There was no limit to the number of academicians. The officers were a protector, four vice-protectors, a director, and four rectors; the teaching was in the hands of twelve professors and six councilors. Dilettanti were admitted to membership as honorary academicians or councilors. The pupils were divided into four groups: *simples élèves* (ordinary pupils), *médaillistes* (medalists), *grand-prix* (six places reserved for protégés, who were entitled to study in Rome at the Académie de France), and *académiciens* (children of members of the academy). All the pupils were under the care of a master whose work was coordinated by a supervisor. The general direction of their studies is described as follows by Félibien des Avaux (*Entretiens sur les vies et sur les ouvrages des plus excellens peintres anciens et modernes*, Paris, 1666–88): "It is advisable after having drawn for some time from the drawings of the best masters, to study ancient statues and then to return to nature itself, which has taught all the painters who have ever lived." There was a definite emphasis on the importance of drawing at the expense of color: drawing was "the pole and compass which guide us." The courses and life classes were supervised by the professors, who worked on a monthly rota and determined the models to be copied. Classes were not the only activity of the academy; it also organized exhibitions and awarded prizes to the better students. Even in Paris, however, students did not spend all their time in the academy; certain parts of their training, painting, carving, and modeling, were not done there but in the studio or workshop of a master with whom they lived and worked in a way almost exactly like that of the Middle Ages. Membership in a workshop was essential; without a certificate from a master, no one could be admitted as a student to the academy. At the beginning the academy received no financial assistance from the monarchy and was entirely dependent on the contributions of its members; however, in 1655, not long after its foundation, it was granted a royal subsidy and was given space in the Collège Royal, while from 1661 on it enjoyed the open support of Colbert. The King's favors reached the point of exempting from military service the young men enrolled in the academy and allowing pupils to use for their studies the pictures in the royal collections. Relations with the guild and corporation, strained from the outset, were soon completely severed, and the guild founded its own academy (Académie de St-Luc), directed by Simon Vouet. In 1651 this merged with the Académie Royale. The academy's monopoly was such that private schools were soon forbidden, and the life course became a prerogative of the royal institution.

In 1689 there was introduced a monthly examination of all the drawings produced by the students, on the results of which some pupils were rejected and others promoted to more advanced classes. Prizes, at first consisting only of the remission of fees, later became a notable feature of the academy, particularly with the institution of the four Petits-Prix and the Grand-Prix, which entitled its recipient to a stay of four years at the Académie de France in Rome. To compete for the Grand-Prix, students had to present a sketch on a given theme, usually Biblical (a preliminary selection of candidates would have

been made on the basis of drawings). After a further selection the final verdict was given on the basis of the finished works, which were then exhibited to the public (first exhibition, 1667).

Closely linked with the Académie Royale was its offshoot in Rome, the Académie de France, where its best pupils stayed and worked. Founded in 1666, this institution had wide autonomy and was very effective as an educational instrument; it is also important as the first and most notable instance of a school established by a country in a foreign land in order to facilitate a more direct interchange of culture and to effect a more immediate acquaintance with the material of study. The foundation of the Académie de France by Colbert merely established on an institutional basis an already existing practice: scholarships for travel in Italy and study in Rome, the *bourse du Souverain*, had been awarded in Paris prior to 1666, the recipients including Poussin and Lebrun. In 1664 Colbert had founded in Rome an Académie des Inscriptions et Médailles, to which was later joined the academy of painting and sculpture; in 1671 the scope of the institution was extended to include architecture. No secret was made of the fact that one of the aims of the academy was to enrich French museums by sending back to France ancient statues, vases, coins, and artistic and bibliographical rarities, as Poussin had done during the reign of Louis XIII. In addition, painters and sculptors had the task of copying famous pictures and statues so that the royal collections might have copies of what they could not possess in the original. The students were 12 in number — 6 students of painting, 4 of sculpture, and 2 of architecture. Only in the 19th century did their number rise to 20, and a music student was also admitted. The methods of study were those of the Académie Royale. The students worked hard, and the results of their labors were frequently sent to Paris and shown to the public. It was a custom of the academy, and one which still survives, that its life class was open to all who wished to participate.

The spread of academies in Europe was sporadic until the advent of neoclassicism. Those that did come into existence modeled themselves on the Académie Royale. Even the academies of Rome and Florence felt the influence of the Parisian institution; in 1673 the Accademia del Disegno, following the lead of the Académie Royale, opened a school in Rome (directed by E. Ferrata and C. Ferri), organized exhibitions, and instituted prizes for its pupils. A few new academies were founded in Italy. According to Carlo Cesare Malvasia, Lodovico Carracci's attempts to start one in Bologna were unsuccessful; but an academy was founded at Perugia in 1573, and in the following century others were started in Lucca (1640) and Turin (1678). The Turin academy developed directly out of the local guild of painters, sculptors, and architects. In the early 18th century academies were founded in Bologna (1709, Accademia Clementina) and Ferrara (1737). In France the academies of Nancy, Bordeaux, and Toulouse date respectively from 1702, 1712, and 1726. In Germany are the academies of Nuremberg (1678, founded by J. von Sandrart), Berlin (founded 1696, but soon declined and was revived only after 1750), Charlottenburg (1696), Augsburg (two academies, one founded 1710 by J. S. Müller, and the Kaiserlich Franciszische Academia Liberalium Artium, 1715), and Dresden (1750); however, all these resembled the private academies of Italy rather than the Académie Royale. This was also the case in England in the first half of the 18th century. Sir Godfrey Kneller (q.v.) in 1711 became the first Governor of the Academy of Painting in London, which seems to have been primarily a studio where the pupils served as assistants to the master. In 1720 a second such academy was begun by John Vanderbank and the French-born artist Louis Chéron, but it lasted only a few years. Sir James Thornhill in 1724 began a private academy in his own home. It was only with the establishment of the Royal Academy of Arts in 1768 (actually initiated in 1760 as the Society of Artists) that a true confederation of artists came into existence in England. Elsewhere academies were founded in The Hague (1656), Utrecht (1696), Amsterdam (1718), Antwerp (this originated in 1665 as an offshoot of the guild, for life classes), Brussels (1711), Bruges (1717), Stockholm (1735), St. Petersburg (1724), Edinburgh

(1729), and Copenhagen (1784). Another important academy was that of Vienna, founded in 1692, which achieved considerable importance after 1730 through the activities of Jacob van Schuppen and attracted many of the best art students from all Germany.

THE ACADEMY SINCE THE AGE OF NEOCLASSICISM. The vast upheavals of the 18th century, both intellectual and political, brought about radical changes in the institutes of art education and led to a gradual fragmentation and differentiation of their aims. The widely accepted classicist theories of Winckelmann gave academies an eclectic atmosphere and an intellectualistic tendency (particularly through the great importance given to drawing, "the foundation of painting"), features which many academies still retain. At the same time, changes in outlook encouraged the development of a new interest in historical studies, particularly archaeology; these studies became detached from the old academies and found expression in separate institutions, later to become of great importance in the field of learning. The rise of mercantilism and the development of industry also presented new problems for art education and led gradually to types of schools and associations which were at the opposite extreme, theoretically speaking, from the traditional idea of an academy.

Academies continued to be founded in large numbers in the 18th century. In Germany all imitated the model of Paris and followed the conventional educational program: drawing from drawings, then from casts, and finally from life; lectures on anatomy, geometry, and perspective; and copying works in the local art galleries. In the elementary class in Berlin there were three stages: students first drew flowers, ornamentation, *idealisch Laub*, or ideal foliage, and parts of faces; then details of the human body; finally the entire human figure. In Paris the Ecole Royale des Elèves Protégés, founded in 1748, followed a composite program in its courses: copying of pictures, composition, history and mythology, and perspective and anatomy. In the Vienna academy (entirely reorganized in 1783), the elementary course was followed by courses in sketching from the antique, life drawing, and landscape; in addition to painting and sculpture, the academy had departments for engraving, ornament, and architecture. In the academy in Copenhagen, founded in 1784, the courses after the elementary one were arranged as follows: ornament drawing, sketching from the antique, and life drawing. The Moscow academy (founded in St. Petersburg in 1724) added to the usual subjects mathematics, geography, languages, history, and mythology; anatomy and life drawing were included only in 1760. All these schools aimed at providing as complete an education as possible, from the general as well as from the artistic point of view, and their extensive program occupied much of the pupils' time. In the Moscow academy, for example, the first timetable allowed for 31 hours of lectures and classes each week. Moreover, in addition to their activities as centers of study, many of these academies were the source of every initiative concerning the arts. The Regia Accademia of Parma, for example, founded in 1757, was responsible for the development of the Museo di Antichità, the art gallery, a school of art, and the Ufficio Governativo di Sopraintendenza Artistica; it also organized competitions and cultural activities of the most varied kinds. A similar influence was the Accademia di Belle Arti (the nucleus of the Brera), founded in Milan in 1776 by Maria Theresa of Austria in an effort to remedy the low level of artistic activity. This academy acquired casts of Greek and Roman sculpture, organized (after 1805) annual exhibitions on its premises, awarded prizes and scholarships for study in Rome, formed a library open to the public, and assembled a collection of pictures which gradually became of prime importance, partly as a result of the acquisition, through the Monti bequest, of the pictures of the 17th-century Galleria Arcivescovile. Other achievements initiated by this academy included, about 1803, the forming of a Gabinetto Numismatico (Department of Coins and Medals) and a Museo Patrio d'Archeologia (now included in Museo Archeologico). The Venice academy, first projected in 1679 but not founded until 1750, instituted four annual scholar-

ships entitling the holders to three years' study in Rome, where their work was for a time directed by Canova; it also made frequent additions to the galleries and acted as a consulting body for the restoration, buying, and selling of works of art. Particularly under the direction of Leopoldo Cicognara (from about 1808 on), the academy performed the task of approving the plans for new buildings, the arrangements for street decorations on festive occasions, and the layout of parks and gardens, thus taking over all the rights of the Collegio dei Pittori, which had fought the academy bitterly for many years and was forced to succumb. The importance of this academy is confirmed by the fact that all the great men of 18th-century Venice were members. In general, one can say that in the 18th century the academy really became in many cases the dominant artistic institution, embracing all the most active and enlightened forces; it originated all new developments and exercised full legal control, having by then fully absorbed in one institution both the tradition of the workshop and the authority of the guild, though in some places the latter continued to exist. The extreme suitability of the academy to that particular time in history is shown by the rapid increase in numbers which occurred in the space of a few decades in Europe and America and is recorded in the following foundations: (*a*) Germany: Mannheim, 1752; Bayreuth, 1756; Mainz, 1757; Stuttgart, 1762; Leipzig, 1764; Düsseldorf, 1767; Munich, 1770; Oehringen, 1771; Erfurt, about 1772; Hanau, 1772; Zweibrücken, 1773; Weimar, 1774; Kassel, 1777; Frankfurt, 1779; Halle, 1780; Karlsruhe, 1786; Gotha, 1787; (*b*) Italy: Venice, 1750; Genoa, 1751; Mantua, 1752; Naples, 1755; Parma, 1757; Verona, 1763; Carrara, 1769; Milan, 1776; (*c*) France: Montpellier, 1738; Rouen, 1741; Reims, 1748; Beauvais, 1750; Toulouse, 1750; Marseilles, 1752; Lille, 1755; Lyons, Nantes, Le Mans, 1757; Amiens, 1758; Tours, 1760; Grenoble, 1762; Aix, 1765; Saint-Omer, 1767; Dijon, 1767; Arras, 1770; Douai, 1770; Poitiers, 1771; Troyes, 1773; Besançon, 1773; Bayonne, 1779; Châtellerault, 1782; Langres, 1782; Mâcon, Saint-Quentin, Valenciennes, 1783; Toulon, 1786; Orléans, 1786; *d*) Spain: Madrid, 1752; Valencia, 1753; Barcelona, 1775; Saragossa, 1778; Valladolid, 1779; Cádiz, 1789; (*e*) England: London, 1768; (*f*) Holland: The Hague, 1750; Amsterdam, 1758; Rotterdam, 1773; (*g*) Belgium: Ghent, 1750; Tournai, 1756; Malines, 1761; Brussels, 1763; Liège, 1773; Mons, 1781; (*h*) Switzerland: Geneva, 1751; Zurich, 1773; (*i*) Mexico: Mexico City, 1785; (*j*) United States: Boston, 1780; New York, 1802; Philadelphia, 1805.

The instruction given in European academies well into the 19th century, however complex and well-organized, remained essentially faithful to the programs of the 16th and 17th centuries. Most of the course consisted in the study of works of art and was thus antiquarian, humanistic, and secondhand; imitation of classical art was still fundamental, even though it was integrated with life drawing. The reaction against this type of teaching began in Germany and can be considered a reaction of the romantic spirit against the intellectualistic attitude of the preceding age. In place of the analytical method of study used by the copyist, the romantics stressed the pupil's need for imaginative freedom. A desire to revise the traditional scheme was already part of the thinking of Johann Friedrich Overbeck, but the first practical expression of this reaction occurred in the Munich academy, where Johann Peter von Langer (director of the Munich academy until his death in 1824) and (after 1824) Peter Cornelius replaced the pedantic study of drawing after casts with a more direct method and a greater emphasis on color at the expense of drawing, which previously had been regarded as fundamental. Similar ideas also inspired the teaching of J. L. David (q.v.) at the Ecole des Beaux-Arts in Paris; David gave individual attention to his pupils, avoiding the disadvantages of the traditional system whereby students were taught by a large number of continually changing masters. Further innovations were made in the Düsseldorf academy, directed by Wilhelm Schadow (the successor in 1826 of Peter Cornelius, who had directed both the Düsseldorf and the Munich academies). In an attempt to remove the often excessive ascendancy of the teacher over the pupil and to create that community of works and aims cherished by

the Nazarenes as a romantic revival of the medieval workshop, there was instituted at the school a *Klasse der ausübenden Eleven*, in which the pupils spent five years in elementary courses and subsequently participated in the work of their master, attaining "that freer development which is produced by the interaction of different individual faculties and tendencies." But if "the Nazarenes dreamt of the spirit of community . . . what they were bound to attain was only the destruction of . . . collective education and the establishment of a purely individualistic system" (Pevsner, 1940).

With the advent of impressionism there was a general revolt by artists against the traditional methods of instruction; the impressionists emphasized the necessity of individual freedom and regarded all externally imposed laws as intolerable. As a result of this attitude art teaching began to be conceived of by some not as a means of intellectual discipline or as training in taste but solely as the handing on of certain technical skills.

After the middle of the 19th century dissatisfaction with the teaching given in the academies became widespread. In Italy, for example, there was a general demand that all academies be turned into schools of applied or industrial art and that architectural training be reorganized and taken out of the hands of the academies. (For fuller discussion of art teaching in the United States, see IV, col. 567 ff.)

ORIGIN AND DEVELOPMENT OF MODERN CULTURAL AND RESEARCH ORGANIZATIONS. For many years the study of art history was associated with the academy of art, which thus fulfilled a double function — that of producing artists and that of improving the level of art-historical education (even if on a somewhat limited scale). Historical problems, in which the fine arts were often involved, were really within the scope of the academies or institutes of science, letters, and the arts which — under various titles and involving either strictly local or more extensive fields of study — had come into being in Europe from the 16th century. The earliest bodies of this type were founded in Italy, and their number continued to increase until the end of the 19th century (Vicenza, 1555; Lucca, 1588; Acireale, 1671; Modena, 1683; Palermo, 1718; Naples, 1752; Venice, 1802; Arezzo, 1810; and others). From Italy they spread to all of Europe (e.g., Académie des Inscriptions et Belles-Lettres, founded in Paris in 1664) and then to America, where the academies of Boston (1780) and Philadelphia (1805) were established. In the second half of that century, however, the study of art history began to break away from these academies; the main cause was the founding of a series of organizations devoted to the study of ancient history and the new science of archaeology. As early as 1727 the Accademia Etrusca of Cortona, an institution of relatively modest ambitions, began to collect archaeological remains (as well as paintings of the Tuscan school) and actively promoted studies of ancient history of more than local relevance. In 1740 the Accademia delle Romane Antichità was founded in Rome by Pope Benedict XIV. This academy, which derived its inspiration from the 15th-century Accademia Pomponiana, had about thirty members who met monthly on the Campidoglio and lectured in turn mainly on historical subjects. The academy also sponsored discussions and publications. Its activities ended in 1757, but in 1810 it was revived through the enthusiasm and energy of the Frenchman J. M. de Gérando, who became its first president (its second was Canova). The revived academy had its own statutes and an academic body of 110 members, consisting of regular, honorary, and corresponding members (the latter numbered 40 and were drawn from the rest of Italy and from abroad). Through meetings and correspondence it practiced the international cooperation later continued by another Roman organization, the Istituto di Corrispondenza Archeologica (now the German Institute) founded by E. Gerhard. The academy, which met first in the Palazzo Corsini, on the Campidoglio from 1811, and finally in the Cancelleria (where it still meets), was at first financed by France but after 1816 once more received papal support. Its activities included the awarding of quadrennial scholarships and the publication of numerous works (the *Atti* of 1821, and subsequently *Disserta-*

zioni, Rendiconti, and *Memorie*). In comparison with the 18th-century academy, the scope was widened to include ancient history, archaeology, and the largely ignored period from the Middle Ages to the beginning of the Renaissance. The interest in Greece evident as early as the second half of the 17th century, together with the first excavations undertaken in Italy (ca. 1710), led to the founding in London (ca. 1733) of the Society of Dilettanti, which organized studies and excavations in Athens and Asia Minor, especially after 1764; in Naples, Charles III of Bourbon instituted in 1755 the Società Ercolanense with the intention of developing the archaelogical researches he had initiated in the area of Herculaneum.

The diffusion of the theories of Winckelmann, the founding of museums (the earliest of which, the British Museum, dates from 1759), and travels and excavations in the East all contributed to the creation of various institutes of archaeology, the most important of which, throughout the first half of the 19th century, was the Istituto di Corrispondenza Archeologica, founded in Rome in 1829. Subsequent foundations include the Association pour l'Encouragement des Etudes Grecques en France, of Paris (ca. 1850); the Society for the Promotion of Roman Studies, of London; and the Society for the Promotion of Hellenic Studies, also of London (founded in 1879). In the middle of the century there was founded the Ecole Française d'Athènes (1846), the first of a series of schools established in Rome and Athens by various countries.

Since the end of the 19th century the study of classical and modern art has been conducted by university institutes or by specialized bodies of an international character. Notable examples of the former are the Warburg Institute and the Institute of Classical Studies, both of London; of specialized bodies, the Institutes of Archaeology and History of Art of Paris and Rome are noteworthy. All these bodies possess libraries and collections of photographs and sponsor lectures, courses of instruction, and publications. There are in addition many institutes dedicated to particular fields of study. There are those concerned with Oriental studies (School of Oriental and African Studies, London; Oriental Institute of the Deutsche Akademie, Munich; the Oriental Institute of the University of Chicago; the Società Asiatica Italiana, founded in 1886; the Istituto Italiano per il Medio ed Estremo Oriente, Rome) and those devoted to local or national fields of inquiry (for example, in Italy, the Istituto di Studi Etruschi ed Italici, of Florence, which since 1926 has acted as coordinating body for studies on Etruscan civilization; the Centro Nazionale di Studi sul Rinascimento, Florence; the Società Magna Grecia, Rome, which is concerned with the ancient history of Sicily and southern Italy; the Istituto di Studi Romani, which studies Roman history and art; and the Fondazione Giorgio Cini, of Venice, which promotes in various ways the study of Venetian culture). Wherever the possibilities of study are greatest (Rome, Athens, Spain, some Eastern countries), there are numerous institutes for the study of culture, founded since the middle of the 19th century and fulfilling the role once occupied by the school for artists studying abroad. In these new institutions, as in the old, there are places for scholarship students. In Rome there are many such organizations dedicated to the study of archaeology and history of art with regular publications containing the results of their activities: the Academia Belgica, the American Academy in Rome (incorporating since 1913 the American School of Classical Studies, founded in 1894), the German Biblioteca Hertziana, the British School at Rome, the Danske Institut for Videnskab og Kunst i Rom, the Deutsches Archäologisches Institut, the Ecole Française de Rome, the Escuela Española de Historia y Arqueología en Roma, the Institutum Romanum Finlandiae, the Istituto Svizzero di Roma, the Nederlands Historisch Instituut te Rome, the Österreichisches Kulturinstitut in Rom, and the Svenska Institutet i Rom. Similar institutes exist in many other cities: in Florence, for example, there is the important Kunsthistorisches Institut; and in Athens, where institutes are active in the work of excavation, are found the American School of Classical Studies at Athens, the Ecole Française d'Athènes, and the Scuola Archeologica Italiana di Atene; and in Beirut is the Institut Français d'Archéologie.

SCHOOLS AND MUSEUMS OF INDUSTRIAL ART. In the second half of the 18th century, as a result of an impressive expansion in the crafts, another group of schools came into existence; their purpose can best be described as commercial. At Hagedorn, Meissen, and Leipzig (all in Germany) schools of art were started specifically to study particular spheres of industrial activity (such as pottery or printing) in which art played an important part; in addition, this ground was partially covered by departments of some of the academies of art, such as those of Berlin, St. Petersburg, Copenhagen, The Hague, and Dublin. In Naples three institutes of this kind, real centers of research in the applied arts, were founded during the reign of Charles III of Bourbon; these were the Reale Laboratorio degli Arazzi (1737), the Reale Laboratorio delle Pietre Dure (1738), and the Fabbrica di Ceramiche of Capodimonte (1739). Other important foundations were the Manufaktur Schule of Vienna, the Handwerkerschule of Karlsruhe, and the Ecole Royale Gratuite de Dessin of Sèvres, which opened in 1767 with 1,500 pupils. In all these schools artistic instruction consisted mainly in copying from drawings and prints and in the study of ornamentation, flowers, animals, and geometric motifs. In this new development, however, the greatest impulse came from France and England, the principal centers of that process of industrialization which was to transform the crafts. In the second half of the 18th century were founded the Paris Ecole des Ponts et Chaussées (1747) and the Ecole Polytechnique (1794); openly at variance with the Académie des Beaux-Arts, these schools reacted against the traditional concept of architecture and concentrated their attention on specific structural problems. The Conservatoire National des Arts et Métiers (founded 1794), though dealing with problems faced earlier by the German schools, tackled more realistically and on a larger scale than before the difficulties blocking the spread of knowledge about mechanical and industrial processes and those hindering the gradual transformation and expansion of small industries into large-scale production units. Apart from some rudiments of theory, the syllabus of the Conservatoire was essentially practical and included all the forms of craftsmanship suited to industrialization: metalwork, claywork (particularly as utilized in architecture), glass and mosaic work, textiles, typographical characters and printing in general, and engraving and photographic techniques. The instruction stressed the processes used in creating an object — glazing and firing a pot, fusing, blowing, coloring, and enameling glass — and gave a sound knowledge of the processes of stamping, rolling, pressing, and turning metals, of the mechanical working of various types of material, and of their decoration. The founding of the Ecole des Beaux-Arts by Napoleon in 1806 was a further step in the same direction. In England, too, though in a less organized and more experimental fashion, many branches of craft production, through the collaboration of designers and producers (e.g., John Flaxman and Josiah Wedgwood in the field of pottery), began to organize the means of mass production. The Great Exhibition of 1851, in London, confirmed the rivalry between France and England in this field and contributed to the development of industrial art in Europe, helping to bring about that linking of museums and schools of applied art which was the most significant development of the second half of the 19th century (Pevsner, 1937). This idea was originated by the German architect G. Semper; claiming that the machine was responsible for the decline of industrial art and wishing to improve and refine the sensibility of the working class, he suggested setting aside most of the exhibits of the Great Exhibition of London to create a permanent museum that would be a place of practical study where the variety of works of art would provide an abundance of excellent material to be copied and studied. The result of his plans was the creation of the South Kensington Museum of London, later renamed the Victoria and Albert Museum, which contained works of art and copies of works of art of the most varied nature and origin, ranging from wrought iron to the intricate woodwork of the façade of an English 16th-century house. From its foundation this museum had attached to it a school of design (for the applied arts), the purpose of which was to train teachers

for local schools. This example was soon followed in Germany. In 1873 the Kunstgewerbemuseum was set up in Berlin, with a notable collection of jewelry, ancient fabrics, and pottery and with an associated technical school. Similar institutions were founded in Jessen, Karlsruhe, Cologne, and Hamburg, while the museum in Munich was devoted particularly to industrial art. In Vienna the important Österreichisches Museum für Kunst und Industrie was founded in 1844 to house collections of precious metals, works in bronze, china and pottery, furniture, miniatures, and leatherwork (an Oriental Museum was added shortly thereafter); it later included a school with courses in design, drawing, plastic arts, pottery, and wall decoration. Other institutions of this type included the Museum of Applied Arts in Budapest; the Museum of Industrial Art in Geneva, with an attached school and collections of fabrics, embroidery, lace, pottery, and weapons; the Bontowski Museum of Art and Industry in Moscow; and the Stieglitz School at St. Petersburg. An important French contribution to this large movement was the creation in 1865 of the Union Centrale des Beaux-Arts Appliqués à l'Industrie. This organization, which was founded on the initiative and through the support of private individuals, had a library specializing in art and industry, arranged competitions and prizes, organized exhibitions of the industries of countries throughout the world, and collected material for a museum of decorative art and for particular sectors of the minor or exotic arts (Oriental art, textiles and tapestries, metalwork, weapons, furniture). Other French schools strove for higher standards in various fields: the Ecole Nationale des Arts Décoratifs, which taught geometrical and architectural design, decoration, and human-figure and animal drawing; the school of Lyons for workers in silk textiles; the national training school for workers in the steel industry and in wood; and the two great organizations of Gobelins and Sèvres, which had benefited from the collaboration of Falconet, Boucher, and Van Loo. In Italy, too, this union of school and museum enjoyed some favor. An industrial museum was founded at Turin, and the purpose of the Museo Vetrario in Murano (founded 1861, school added 1864), was to improve the quality and quantity of the products of the glass and pottery industries, both of which had suffered a serious decline during that century. To promote the national solution of such problems a new central organization, the Regio Museo Artistico Industriale di Roma, similar to those existing in other countries, was founded in 1873 in Rome, once again the capital; in 1876 a small school was added, with courses in pictorial decoration, wax modeling, and metal enameling. In 1907 this organization was enlarged and became the Istituto Nazionale Artistico Industriale di San Michele. The exceptional number of schools and museums of industrial art which were founded in Italy in the second half of the 19th century resulted from the many ancient and varied traditions of local craftsmanship which these museums and schools were meant to defend and protect, rather than from the beginning of any real expansion on an industrial scale. These institutions were thus conservative in character and often somewhat provincial, an aspect which can be attributed to the political situation of the country, only recently united. One of the first schools associated with a museum was the Reale Istituto d'Arte, Naples (1880), attached to the Museo Artistico Industriale (1878); a speciality of this school was the continuation of the local tradition of ceramics. Other foundations were the schools in Massa (sculpture, 1852), Urbino (1861; since 1922 specializing in the art of bookmaking), Padua (1867), Sesto Fiorentino (ceramics, 1873), Venice (1873), Cortina d'Ampezzo (1874), Novi (ceramics, 1875), Torre del Greco (the working of coral, 1878), Lanciano (1879), Gorizia (1880), Verona (1881), Syracuse and Acqui (1882), Cantù (1883), Bologna (1885), Sorrento (inlay, cabinetmaking, 1886), Penne and Pesaro (majolica, 1887), Sansepolcro (1888), Castelmassa (1890), Cascina (woodwork, 1896), and Galatina (1897). These schools, some of which were part-time or for girls only, usually did not deal with general cultural subjects; the length of the course was three to five years and the age of entry twelve to fourteen years.

In the 20th century more schools were founded, including those in Faenza (1916), attached to the local museum; Castelli

(1906); and Civita Castellana (1913) — all for ceramics. In 1924 they all came under the control of the Ministry of National Education.

The great period of development for schools of industrial art throughout Europe has been the 20th century. Some of the main stages in this development were the Turin exhibition of 1902; the law dealing with the organization of German schools of industrial art (1904); the Deutscher Werkbund, started in Munich in 1907; the founding of the British Institute of Industrial Design (London, 1919), which supplemented an already existing Design and Industries Association; the founding of the Bauhaus (1919); the Deville reform of schools of applied art in France; the Triennale of Milan, which began in 1918 at Monza as a biennial of the decorative arts; and the Milan university for the decorative arts, founded in 1922 (later the Istituto Superiore per le Industrie Artistiche, functioning as such until 1940). The Deutscher Werkbund, founded by H. Muthesius, H. Van de Velde, T. Fischer, F. Schumacher, R. Riemerschmid, F. Naumann, and K. E. Osthaus, and led by T. Heuss, brought together artists, people in industry, and craftsmen and aimed at improving the quality of the artistic product through publications, teaching, and the organization of such exhibitions as those of Cologne (1914) and Stuttgart (Weissenhof quarter, 1927; participants including L. Mies van der Rohe, W. Gropius, B. and M. Taut, H. Poelzig, P. Behrens, R. Döcker, H. Scharoun, L. Hilberseimer, A. Schneck, Le Corbusier, and J. J. P. Oud). The influence of this movement on German domestic architecture, furniture, furnishings, and household utensils was of the greatest importance. The Werkbund — which soon had corresponding organizations in Austria (1912, Österreichischer Werkbund; prominent supporters were J. Hoffmann and O. Strand), Switzerland (1913, Schweizerischer Werkbund), and Prague — broke away from the Arts and Crafts movement begun in England by William Morris, systematizing his somewhat abstract ideas though upholding his concept of art as a collaborative venture in which all efforts are coordinated in order to achieve quality in industrial work. The program of the Werkbund was carried on in the Bauhaus, which was formed by the merging of two institutions already existing in Saxony, the Sächsische Hochschule für Bildende Kunst and the Grossherzogliche Sächsische Kunstgewerbeschule. The Bauhaus, a school of architecture and applied art, was founded in Weimar in 1919 by W. Gropius (q.v.), who directed it for the next ten years. Gropius believed that industry should evolve from and not destroy craftsmanship. ("A deliberate return to the old system of crafts would be a mistaken display of atavism. Today, the gap between the crafts and industry is closing; indeed, these two must gradually merge into a new unity of production, which restores to each individual his sense of collaboration in the whole. In this new unity, the crafts will provide the experimental side of industry, creating the standards for industrial production.") The school aimed at increasing, by means of the machine, the production of the old class of craftsmen. The machine, they maintained, need not alter the quality of the object as it leaves the craftsman's hands, but would simply permit its unlimited reproduction. It was one of the purposes of the school to accustom the craftsman to the use of the machine. The Bauhaus had about two hundred students, and its courses lasted three and a half years. The students began with manual and technical work (*Werklehre*), proceeded to work of a more formal nature (*Formlehre*), and terminated with architecture, which continually intervenes, "mediating and conditioning the vital relationship between man and reality" (Argan). The Bauhaus, which soon numbered among its teachers some of the best artists in the country (Klee from 1921 and Kandinsky from 1922), exercised a great influence on furniture, textiles, wallpaper, upholstery, and printing, and left its mark, too, on the theater and on advertising. In 1925 the hostility of certain reactionary circles — including traditional or conservative craftsmen, the civil service, and big business — forced the school to move to Dessau, and in 1933, after Gropius had been succeeded as director by Hannes Mayer and Mies van der Rohe, the Bauhaus was closed by the Nazis. The Bauhaus concluded the series of attempts made since the middle of the

19th century to reestablish contact between the worlds of art and production, to create a class of workmen who were also inventors of forms, and to base artistic work on the principle of cooperation. In its revolt against "pure" art, that is art conceived as a mysterious inspiration vouchsafed to only a privileged élite, it was "the last act in the struggle of romanticism against classicism; and at the same time an example of the practical approach, a reaction against the esthetic theories of idealism" (Argan). One of the features of the school was its emphasis on cooperation, apparent not only in the community life led by teachers and pupils, who spent their free time together in various cultural activities, but also in the direct participation of the students in the school council and in the cooperative designing of models sold to industry to help support the school.

In mid-20th-century France artistic education comes under the control of the Conseil Supérieur de l'Enseignement des Beaux-Arts, composed of members of the ministry of national education, of the staff of the undersecretary of state for the fine arts, and of the staff of the secretary to the academies of fine arts. This council controls about thirty regional and municipal schools of applied art — the principal ones being in Bordeaux, Marseilles, Nancy, Grenoble, Lyons, and Rouen — and in addition the national schools of decorative art at Nice and Dijon, the school of applied art at Bourges, and the Ecole Nationale Supérieure des Art Décoratifs of Paris. In Italy the art schools for craftsmen are divided, according to the regulations of 1924, into schools of art (elementary) and institutes of art (advanced), numbering together about sixty. In Germany, the tendency since the beginning of the 20th century has been to combine courses in fine arts, crafts, industrial design, and industrial production (*Fortbildungsschulen, Gewerbeschulen* or *Fachschulen, Kunstgewerbeschulen,* and *Kunstakademien*); the *Fachschule* embraces both technical and industrial schools, while the schools of arts and crafts cover more and more the fine arts. The ideals of the Bauhaus and the union of academy and school of arts and crafts in Berlin have been important influences in this direction. In England the opposite tendency has prevailed, and the schools there tend to specialize in particular branches of knowledge. Compared with their Continental counterparts, even the least advanced of these schools (for pupils from twelve to sixteen years) have more varied and extensive courses. The oldest (founded 1884 by J. B. Fletcher) and most comprehensive is the Birmingham College of Arts and Crafts, which is divided into two schools with three-year courses. A special school for jewelers was founded in Birmingham in 1890 by the Jewellers' and Silversmiths' Association. Other specialized schools are at Kidderminster (carpets), Stourbridge and Brierley Hill (glass manufacture), Walsall (leather and other skins), and Wolverhampton. Others include the Burslem Art School, Stoke on Trent (pottery), the Manchester School of Art (with about 1200 students; like other schools in Lancashire and Yorkshire it is primarily for work in textiles), the Leicester College of Technology and Commerce, and the Wycombe Technical Institute. In London the London County Council has 26 schools of arts and crafts with specialized courses; among them are the North-Western Polytechnic, the Chelsea School of Art (graphic arts), the School of Photo Engraving, the Hammersmith School of Building, and the Shoreditch Technical Institute. The only school of art run by the government is the Royal College of Art, which has five separate branches of instruction: architecture, design and craft, painting and drawing, engraving, and sculpture. The best students from these schools proceed to the Central School of Arts and Crafts, in London, an advanced school founded in 1896 through the influence of the Arts and Crafts movement. The courses which it offers are architecture, illustration and printing, furniture, fashion, carving, modeling, painting, metalwork, and stained glass. Some of these courses prepare pupils for entry to a trade, others to an industry; a special class comprising students drawn from various courses studies industrial design. The work of this educational system is supplemented by a series of associations. The British Institute of Industrial Art, an official body founded in 1914, devotes itself primarily to

the organization of exhibitions of arts and crafts and of industrial art. On the other hand, the Design and Industries Association (founded in 1915 on the model of the German Werkbund) and the Industrial Art Committee of the Federation of British Industries (established 1921), both private bodies, are principally concerned with educating the sensibility and taste of the purchasing public. The Royal Society of Arts, first founded in 1754, entered a period of decline in the 19th century but was revived in 1924 with its original purpose of encouraging collaboration between industry, commerce, and the arts, and thus benefiting British arts and manufactures. The Society of Industrial Artists (1930) had similar aims, while numerous exhibitions and publications (e.g., the periodical *The Studio*) helped in the task of educating the public. Even the Royal Academy held an exhibition of industrial art at Burlington House (1935). Similar organizations, though on a somewhat smaller scale, played a leading part in other countries. In Sweden, for example, the evolution of modern taste was in many ways determined by the influence of the Swedish Society for Industrial Design, founded early in the 20th century.

CONTEMPORARY DEVELOPMENTS. Several of the functions which once belonged to academies of art are now largely performed by museums or galleries of modern art. This is particularly true in the United States. The Cleveland Museum of Art,, for example, relying entirely on private support, has a wide teaching program with courses for both young people and adults. Its Education Department, established in 1916, works with schools and groups organized according to the potential of the pupils. In addition, the Museum, whose courses are entirely free, collaborates with the University, with the Cleveland Institute of Art, and with other institutions, and plays an active part in the solution of such problems as urban development. American museums perform a leading role in bringing culture to the people and in experimenting with new educational methods, such as the mobile exhibition (e.g., the Artmobile, conceived and created in 1953 by the Virginia Museum of Fine Arts, Richmond), though certain European museums are also entering the field (e.g., the Ecole du Louvre in Paris). Attempts are currently being made to amalgamate the teaching activities of the museum (e.g., the J. B. Speed Art Museum of Louisville, Ky., and the New York Metropolitan Museum of Art) — now one of the most active forces in the community — with the similar activities of other institutions; the relations between these various bodies have been discussed at special congresses (e.g., Baltimore, 1949) dealing with elementary and secondary schools, colleges, universities, and technical schools, in addition to museums. Teaching activities also come within the scope of the College Art Association of America (which publishes the excellent *Art Bulletin* and the *College Art Journal*), an association which for a quarter of a century has linked art departments of colleges offering public courses aiming at "total education" — that is, balanced development, in what is virtually the old humanistic sense — of the individual and the community. These organizations, which attempt to combine the teaching of art history and criticism with the practice of art, have been influenced by the concept of "self-expression," which became popular about 1930 and was widely applied particularly in the teaching of art in the lower grades of the American school system. Although it is now generally acknowledged that this concept has little to do with art and functions primarily as an aid in the development of the personality, the tendency has spread. For example, in the state educational system of Mexico, the teaching of painting to young children was introduced by followers of the American educator John Dewey.

Another significant development in the last hundred years, in all fields of art, has been the frequency of national and international exhibitions. Some of these exhibitions, held at regular intervals in the same place, have acquired a certain autonomy and a definite line of development. Significant results have been achieved by the two largest Italian exhibitions of this kind, the Milan Triennale and the Biennale of Venice. The latter has become a well-known center for the study of contemporary art, possessing very complete photographic collec-

tions, publishing a periodical, and sponsoring other publications. The Triennale has had the greatest influence in Italy, being responsible for, among other things, the introduction of the current of functionalism. In 1949 it set up a Centro Studi Triennale, which specializes in modern art and is provided with a library, photographic collections, and various card indexes. The activity of the Triennale has also extended to the organization of congresses and to the construction of an experimental suburb on the outskirts of Milan.

One of the characteristic features of the mid-20th century is the tendency to create in every field national or international organizations, often under the patronage of the United Nations Organization, designed to coordinate the efforts of smaller bodies in specific fields. The purpose of these large organizations ranges from the safeguarding of professional interests to the promoting of educational aims and the conservation of works of art. In the field of conservation two organizations, the International Institute for the Conservation of Historic and Artistic Works, with headquarters in London, and the Istituto Centrale del Restauro, in Rome, deal with problems of restoration on a national and international level and are at the head of modern developments in this area, owing to scientific methods of work and up-to-date laboratory equipment. Attached to the Istituto Centrale of Rome (now under United Nations patronage) is an international school for the restoration of works of art. In France in the field of photographic documentation all the material concerning national monuments and works of art is centralized in the Archives Photographiques in Paris. Museums, too, have organized associations in which a large number of museums are represented and which function as research centers, some with the sole purpose of protecting the national artistic and cultural heritage (Associazione Nazionale dei Musei Italiani); others have broader functions — educational, for example (American Association of Museums). This tendency toward collective organization can be seen in every field: for example, all the institutions in Rome concerned with historical and artistic studies set up in 1945 a Union International des Instituts d'Archéologie, d'Histoire, et d'Histoire de l'Art, with headquarters in Rome. This collaboration has permitted the publication of the Biblioteca Historica Medii Aevi, of a catalogue of classical sources in Roman libraries, and of *Fasti archaeologici* (published by the Associazione Internazionale d'Archeologia Classica), and has also made possible the establishment of a photographic library of ancient Italian architecture and topography and of a similar library of post-antique art. The various activities of these bodies include the spread of modern tendencies and ideas (e.g., the Société Belge des Urbanistes et Architectes Modernistes, the Federazione delle Associazioni Italiane per l'Architettura Moderna, founded in 1950 in Milan) and more general cultural and professional pursuits (e.g., in the field of architecture, The Royal Institute of British Architects, the Union of Architects of the Rumanian People's Republic). The International Council of Societies of Industrial Design studies the problems of this specific field of the arts. The Union International des Architects, which was set up in 1948, has wide artistic, technical, cultural, and social aims, not least among which is the safeguarding of the interests of the profession. The Union's work is divided among various committees which organize exhibitions and international competitions, sponsor studies on town planning and the building industry (with special reference to the building of hospitals), and discuss the architect's education, his position in society, and the protection of artistic copyright.

Giuseppe SCAVIZZI

CHINA. In the Asiatic world it was only in China that the primitive forms of association of artist and craftsman (of the sort discussed above under *Organization of Artistic and Craft Activities in Primitive Societies and in the Ancient World*) were followed by artistic institutions of some complexity, whose intellectual and social significance makes them in some way comparable to those of Europe. Precise information is available mainly for the art of painting, the only art that the Chinese regarded as great, all the other artistic techniques including

sculpture being considered on the level of crafts. At the court of the Southern Sung (12th and 13th cent.) there was the so-called "Academy of Painting" (Hua-yüan), to which professional painters at the imperial court belonged. Until almost the end of the Sung dynasty this academy was a part of the (literary) Han-lin Academy. The latter, founded in 754, had been open to painters as early as the first century of its existence; but in the reign of T'ai-tsu (960–76), of the Northern Sung dynasty, an Office of Painting was founded, subordinate to the Han-lin Academy and modeled on various private academies, not subject to government control which had flourished during the period of the Five Dynasties (907–60). However, some scholars (e.g., Yonezawa) would place the origins of the Hua-yüan in the T'ang period (618–906). Whatever its origins, this academy gradually acquired more and more autonomy. It was organized in four grades, was responsible for the teaching of painting, arranged competitions, and above all gradually developed what came to be called the academic style. The Mongols (Yüan dynasty, 1260–1368) at first took away the academy's independence and then in 1287 reopened it. It continued to exist under the two subsequent dynasties (Ming and Ch'ing) but never reached the standard attained during the Southern Sung period. Most of the great painters remained aloof, and the academy declined to a small institution of salaried painters charged with the supervision of works ordered by the emperor.

Schools of painting existed with varying degrees of success in every period, and the same is true for the other arts. The study of pottery reveals the existence of common characteristics due to the work of groups of potters operating at the same kiln; sometimes these characteristics are found in different localities, as in the case of potters who, because of Mongol pressure, emigrated to the south in the 12th century but continued to produce in their new home the same type of objects as before.

The establishment of the Republic (1912) saw the formation of the National Research Institute, known also as the Academia Sinica. This body, which coordinated scientific and cultural activity, is known chiefly for the important archaeological excavations which it carried out prior to World War II. After 1949 the old group of the Academia Sinica moved to Formosa; it has to its credit a number of important publications. In mainland China the Academy of Sciences was founded in 1949 and reorganized in 1955; it has four sections (mathematics, physics, and chemistry; biology, geology, and geography; technology; and philosophy and social sciences) and possesses all the characteristics of a national research institute. There also exists in mainland China a Union of Chinese Artists and an All-China Federation of Literary and Art Circles, founded in 1949.

Lionello LANCIOTTI

PRINCIPAL ORGANIZATIONS RELATED TO STUDY OF ART AND DEVELOPMENT OF ARTISTIC ACTIVITY. The following list is indicative of the variety of institutions and their activities in the field of art studies. For more extensive listings and later reorganizations, see the publications cited under *Inventories of institutes, organizations, and societies* in the bibliography. Years which follow the names of institutions are the dates of founding. The universities, with their institutes of archaeology, art history, architecture, ethnology, and so forth, are omitted for the sake of brevity: see *Minerva Jahrbuch der gelehrten Welt, Abteilung Universitäten und Fachhochschulen, I: Europa,* Berlin, 1952, *II: Ausseneuropa,* Berlin, 1956. Museums, many of which offer educational programs, maintain specialized libraries, and publish books, monographs, catalogues, etc., are more extensively treated under MUSEUMS AND COLLECTIONS.

International institutions: Association Internationale des Critiques d'Art (AICA), Paris, organizes congresses. Associazione Internazionale d'Archeologia Classica, Rome (1945), pub. *Fasti archaeologici, Notiziario annuale.* Centro Internazionale di Studi per la Conservazione e il Restauro dei Beni Culturali, Rome (1959), pub. *Répertoire international des laboratoires, des musées et des ateliers de restauration, Climatisation et conservation dans les musées.* Comité International d'Histoire de l'Art, Paris (1930), assembles art historians from 21 countries, holds triennial congresses, pub. *Répertoire d'art et d'archéologie, Dictionnaire international d'art et d'archéologie,* and others. Fédération Internationale des Associations d'Études Classiques, Paris (1948), established under the auspices of UNESCO to encourage

research in classical antiquity, pub. bibliographies and dictionaries. International Association of Plastic Arts, Paris (1954), UNESCO. International Council of Museums (ICOM), Paris (1946), UNESCO, coordinates activities among museums of various nations, pub. *ICOM News.* The International Institute for Conservation of Historic and Artistic Works (IIC), London (1950), pub. *Studies in Conservation,* Abstracts of the Technical Literature on Archaeology and the Fine Arts. Union Académique Internationale, Brussels, pub. *Compte rendu, Corpus vasorum antiquorum, Tabula Imperii Romani,* and others. Union Internationale des Architects, Paris (1948).

Algeria: Académie d'Hippone, Bône, pub. *Bulletin, Comptes rendus des réunions.* Centre Algérien de Recherches Anthropologiques, Préhistoriques et Ethnographiques, Algiers. Société Archéologique, Historique et Géographique du Département de Constantine, Constantine (1852), pub. *Recueil des notices et mémoires, Bulletin mensuel.*

Argentina: Academia Nacional de Bellas Artes, Buenos Aires. Academia Provincial de Bellas Artes "Fernando Fader," Córdoba. Escuelas de Artes Plásticas, Buenos Aires. Escuela Superior de Bellas Artes Ernesto de la Cárcova, Buenos Aires (1921). Comisión Nacional de Museos y de Monumentos y Lugares Históricos, Buenos Aires (1940). Fundación Académica para el Estudio de la Historia y la Filosofía del Arte, Buenos Aires (1955). Instituto Bonaerense de Numismatica y Antigüedades, Buenos Aires (1872), pub. *Boletín.* Instituto de Estudios Históricos y Arqueológicos de Santa Fé. Instituto de Etnografía Americana de la Universidad Nacional de Cuyo, Mendoza, pub. *Anales.* Real Academia de Ciencias, Bellas Letras y Nobles Artes de Córdoba, Córdoba, pub. *Boletín.* Sociedad Central de Arquitectos, Biblioteca Alejandro Christophersen, Buenos Aires.

Australia: The Arts Council of Australia, Sydney (1943), promotes exposizions. Contemporary Art Society of Australia, Melbourne (1939). Royal Art Society of New South Wales, Sydney (1880). Royal Australian Institute of Architects, Sydney (1930), pub. *Architecture in Australia, Year Book.* Royal Queensland Art Society, Brisbane (1886). Royal South Australian Society of Artists, Adelaide (1856). Society of Artists, Sydney (1895). Victorian Artists' Society, Melbourne (1870), four expositions annually.

Austria: Akademie der Bildenden Künste, Vienna (1692). Akademie für Angewandte Kunst, Vienna (1867). Gesellschaft Bildender Künstler Wiens, Vienna (1861). Gesellschaft für Vergleichende Kunstforschung, Vienna (1932), pub. *Kunstwissenschaftliche Jahresgabe, Mitteilungen.* Internationale Sommerakademie für Bildende Künste, Salzburg. Österreichische Akademie der Wissenschaften, Vienna (1847), pub. *Mitteilungen der prähistorischen Kommission der Akademie, Der römische Limes in Österreich, Schriften der Balkankommission,* and others. Österreichische Byzantinische Gesellschaft, Vienna, pub. *Jahrbuch.* Österreichische Gesellschaft für Anthropologie, Ethnologie und Prähistorie, Vienna, pub. *Mitteilungen.* Österreichisches Archäologisches Institut, Vienna, pub. *Jahreshefte.* Österreichische Ingenieur- und Architektenverein, Vienna (1848), pub. *Österreichische Ingenieur-Zeitschrift.* Verein der Freunde Asiatischer Kunst und Kultur in Wien, Vienna (1925), pub. *Wiener Beiträge zur Kunst und Kulturgeschichte Asiens.* Verein für Volkskunde, Vienna (1894), pub. *Österreichische Zeitschrift für Volkskunde.* Wiener Gesellschaft zur Förderung der schönen Künste, Vienna. Wiener Secession, Vienna (1897). Zentralvereinigung der Architekten Österreichs, Vienna (1907).

Belgium: Académie Royale d'Archéologie de Belgique, Brussels, pub. *Annales, Bulletin, Revue belge d'archéologie et d'histoire de l'art.* Académie Royale des Beaux-Arts, Ecole supérieure des Arts Décoratifs, Ecole Supérieure d'Architecture de Bruxelles, Brussels (1711). Académie Royale des Sciences, des Lettres et des Beaux-Arts de Belgique, Brussels (1772), pub. *Annuaire, Bulletin de la classe des beaux-arts,* etc. Centre International d'Etude Ethnographique de la Maison dans le Monde, Brussels (1960), proposes to study the architecture of peoples of ethnological interest. Cercle Royal Archéologique, Littéraire et Artistique, Malines (1886). Institut Archéologique du Luxembourg, Arlon (1847). Institut Archéologique Liégeois, Liège (1850), pub. *Bulletin, Chronique archéologique.* Institut des Hautes Études de Belgique, Brussels (1849), with subsection of Oriental archaeology. Institut Orientaliste, Brussels (1936), pub. *Le Muséon, Bibliothèque du Muséon.* Koninklijke Vlaamse Academie voor Wetenschappen Letteren en Schone Kunsten van België, Brussels. National Hoger Instituut voor Bouwkunst en Stedebouw-Antwerpen, Antwerp. Société Archéologique, Namur (1845), pub. *Annales, Namurcum.* Société d'Art et d'Histoire du Diocèse, Liège, pub. *Bulletin, Leodium,* and others. Société d'Émulation pour l'Étude de l'Histoire et les Antiquités de la Flandre, Bruges, pub. *Annales.* Société d'Histoire et d'Archéologie de Gand, Ghent, pub. *Annales, Bulletin.* So-

ciété Royale Belge d'Anthropologie et de Préhistoire, Brussels (1882), pub. *Bulletin*. Société Royale de Numismatique de Belgique, Brussels (1841), pub. *Revue belge de numismatique et de sigillographie*. Société Royale des Beaux-Arts, Brussels (1893). Société Royale Paléontologique et Archéologique de l'Arrondissement Judiciaire de Charleroi, Charleroi, pub. *Bulletin, Documents et rapports*. Société Verviétoise d'Archéologie et d'Histoire, Verviers, pub. *Bulletin, Chronique*.

Bolivia: Asociación de Arquitectos de Bolivia, La Paz (1942). Círculo de Bellas Artes, La Paz (1912). Instituto Tiahuanacu de Antropología, Etnografía y Prehistoria, La Paz, conducts excavations. Sociedad Arqueológica de Bolivia, La Paz, pub. *Anales de la Arqueología de Bolivia*.

Brazil: Escola de Belas Artes de São Paulo, São Paulo (1925). Escola Nacional de Belas Artes, Rio de Janeiro (1816). Instituto Arqueológico, Histórico e Geográfico Pernambucano, Recife (1862), pub. *Revista*. Instituto Brasileiro Historia da Arte, Rio de Janeiro. Instituto de Antropologia e Etnologia do Pará, Belém, pub. *Monografias*, studies of Brazilian anthropology, archaeology, and others. Sindicato dos Compositores Artisticos, Musicais e Plásticos do Estado de São Paulo, São Paulo (1922), annual exhibitions. Sociedade Brasileira de Belas Artes, Rio de Janeiro.

Bulgaria: B"lgarska Akademiya na Naukite, Sofia (1869), which includes its Archeological Institute (1921), pub. *Izvestiya*, and its Ethnographic Institute (1947). B"lgarsko Arkheologichesko Druzhestvo, Sofia, pub. *Izvestiya*. Hudozhestvena Akademiya Hristo Pavlovich, Sofia. Saius na Artistite v B"lgariya, Sofia.

Burma: Burma Research Society, Rangoon (1947), encourages among foreigners studies in Burmese art history. State School of Fine Arts, Rangoon (1952). State School of Fine Arts, Music and Drama, Mandalay (1953).

Canada: The Alberta Association of Architects, Edmonton (1906). Alberta Society of Artists, Calgary (1931), pub. *Highlights*. Antiquarian and Numismatic Society of Montreal, Montreal (1862), pub. *Canadian Antiquarian and Numismatic Journal of Montreal*. Architects' Association of New Brunswick, St. John's. Architectural Institute of British Columbia, Vancouver (1914). Canadian Art Academy, Montreal. Canadian Arts Council, Montreal. Canadian Society of Graphic Art, Toronto. Canadian Society of Painters, Etchers and Engravers, Toronto (1916). Canadian Society of Painters in Water Colour, Toronto (1925). Contemporary Art Society, Montreal (1939). Ecole des Beaux-Arts de Montréal, Montreal. Ecole des Beaux-Arts de Québec, Quebec. Federation of Canadian Artists, Toronto (1941). Manitoba Association of Architects, Winnipeg (1906). Newfoundland Academy of Art, St. John's. Newfoundland Association of Architects, St. John's. Nova Scotia Association of Architects, Halifax. Ontario Association of Architects, Toronto (1890). Ontario College of Art, Toronto. Ontario Society of Artists, Toronto (1872). Province of Quebec Association of Architects, Montreal (1890), pub. *Year Book* and *Register*. Royal Architectural Institute of Canada, Ottawa (1907), pub. *Journal*. Royal Canadian Academy of Arts, Toronto (1880). Royal Society of Canada, Ottawa (1882). Saskatchewan Association of Architects, Regina. Sculptors' Society of Canada, Toronto (1932).

Chile: Museo Nacional de Bellas Artes, Santiago de Chile, pub. *Boletín*.

China (People's Republic): All-China Federation of Literary and Art Circles, Peiping (1949). Chung-kuo K'o-hsüeh Yüan, Peiping (1949), includes the Archaeological Institute.

China (Republic of). See *Taiwan*.

Colombia: Academia Colombiana de Bellas Artes, Bogotá (1930). Academia Colombiana de Historia, Bogotá (1943), pub. *Boletín de Historia y Antigüedades*. Escuela de Bellas Artes, Universidad Nacional de Colombia, Bogotá. Instituto Colombiano de Antropología, Bogotá (1952), administers the Museo Arqueológico Nacional, pub. *Revista colombiana de antropología, Revista colombiana de folklore*.

Costa Rica: Museo Nacional, San José, studies and publications on pre-Columbian archaeology.

Cuba: Academia Nacional de Arte y Letras, Havana (1910). Colegio Nacional de Arquitectos de Cuba, Havana (1933). Escuela Elemental de Artes Plásticas Aplicadas, Havana. Escuela Nacional de Bellas Artes "San Alejandro," Havana (1818). Junta Nacional de Arqueología y Etnología, Havana (1937), pub. *Regista*. Sociedad del Folklore Cubano, Havana (1923), pub. *Archivos de folklore cubano*. Sociedad Universitaria de Bellas Artes, Havana (1942).

Cyprus: Etaireia Kypriakon Spoudon, Nicosia (1936), studies relating to Cypriote archaeology, history, and folklore, pub. *Kypriakai spoudai*.

Czechoslovakia: Akademie Výtvarných Uměni, Prague (1799). Československá Akademie Věd, Prague (1952), to Section VI of which belong: Archeologický Ústav (1919), pub. *Archeologické rozhledy, Památky archeologické*; Odděleni pro Theorii a Dějiny Uměni (1952); Národopisný Ústav (1952); Orientální Ústav (1922). Hollar Sdruženi Českých Umělců Graficů, Prague (1917), pub. *Hollar*. Jednota Umělců Výtvarných, Prague (1898), pub. *Dilo*. Slezský Ústav Československé Akademie Věd, Opava. Slovenská Akadémia Vied, Bratislava (1953), including: Kabinet Téorie a Dejín Umenia, Bratislava; Archeologický Ústav, Nitra, pub. *Slovenskâ archeológia*; Národopisný Ústav, Bratislava. Spolek Výtvarných Umělců Mánes, Prague (1887). Umělecká Beseda, Prague (1863). Vysokà Škola Uměleckoprůmyslová, Prague (1885).

Denmark: Akademisk Arkitektforening, Copenhagen (1879), pub. *Arkitekten*. Dansk Billedhuggersamfund, Copenhagen (1905). Institutum Aegyptologicum Hafniensis, Copenhagen, pub. *Analecta Aegyptiaca*. Kongelige Akademi for de Skønne Kunster, Copenhagen (1754). Kongelige Danske Videnskabernes Selskab, Copenhagen (1742), pub. *Arkeologisk-kunsthistoriske meddelelser, Arkaeologisk-kunsthistoriske skrifter, Danske, Meddelelser, Oversigt*, and others. Det Kongelige Nordiske Oldskriftselskab, Copenhagen (1825), pub. *Aarbøger for nordisk oldkyndighed og historie, Nordiske fortidsminder*. Kunstnerforening af 18de November, Copenhagen (1843). Malende Kunstneres Sammenslutning, Copenhagen (1909). Ny Carlsberg Glyptotek, Copenhagen (1882), pub. *From the Collections*.

Ecuador: Academia de Bellas Artes "Remigio Crespo Toral," associated with the University of Cuenca, Cuenca (1868). Academia Ecuatoriana, Quito (1875), pub. *Memorias*. Escuela Nacional de Bellas Artes, associated with the Central University of Ecuador, Quito (1769).

Egypt: Deutsches Institut für Aegyptische Altertumskunde, Cairo, pub. *Mitteilungen*. Hellenic Society of Ptolemaic Egypt, Alexandria (1908). Idarit Hifz el-Assar el-Arabia, Cairo (1882). Institut d'Égypte, Cairo (1859), pub. *Bulletin*. Institut Dominicain d'Etudes Orientales, Cairo (1952). Institut Français d'Archéologie Orientale, Cairo (1880), pub. *Art islamique, Etudes sud-arabiques, Fouilles, Recherches d'archéologie, de philosophie et d'histoire*. Schweizerisches Institut für Aegyptische Bauforschung und Altertumskunde in Kairo, Cairo, pub. *Beiträge zur ägyptischen Bauforschung und Altertumskunde*. Société d'Archéologie Copte, Cairo (1932), pub. *Bulletin, Fouilles, Bibliothèque d'art et d'archéologie*, and others. Société Archéologique d'Alexandrie, Alexandria (1893), pub. *Bulletin, Mémoires, Monuments de l'Égypte gréco-romaine*. Society of Friends of Art, Cairo.

Ethiopia: Institut Ethiopien d'Études et Recherches, Section d'Archéologie, Addis Ababa.

Federal Republic of Cameroon: Institut des Recherches Scientifiques du Cameroun, Foumban, administers the Musée des Arts et des Traditions Bamoun.

Finland: Suomen Akatemia, Helsinki (1948). Suomen Itämainen Seura, Helsinki (1917), pub. *Studia orientalia*. Suomen Muinaismuistoyhdistys-Finska Fornminnesföreningen, Helsinki (1870), pub. *Suomen Museo, Suomen muinaismuistoyhdistyksen aikakausikiria, Kansatieteellinen arkisto*. Suomen Taideakatemia, Helsinki (1940). Suomen Taideyhdistys, Helsinki (1846). Suomen Taiteilijaseura-Konstnårsgillet i Finland, Helsinki (1864).

France: Académie d'Architecture, Paris (1840). Académie des Beaux-Arts, Paris (1803), part of the Institut de France (1795), pub. *Bulletin*. Académie des Inscriptions et Belles-Lettres, Paris (1663), part of the Institut de France, pub. *Comptes rendus, Mémoires, Monuments et mémoires (Monuments Piot)*, and others. Académie des Sciences, Agriculture, Arts et Belles-Lettres d'Aix, Aix-en-Provence (1808). Académie des Sciences, Arts et Belles-Lettres, Dijon, pub. *Annales de Bourgogne*. Académie des Sciences, Belles-Lettres et Arts de Besançon, Besançon, pub. *Procès-verbaux et Mémoires*. Académie des Sciences, Belles-Lettres et Arts de Bordeaux, Bordeaux (1712), pub. *Actes*. Académie des Sciences, Belles-Lettres et Arts de Clermont-Ferrand, Clermont-Ferrand, pub. *Bulletin historique et scientifique de l'Auvergne, Mémoires*. Académie des Sciences, Belles-Lettres et Arts de Lyons, Lyons (1700), pub. *Mémoires, Rapports*.

Académie des Sciences, Belles-Lettres et Arts de Savoie, Chambéry, pub. *Mémoires*. American Art Center, Paris. Byzantine Institut, Paris, pub. *Bulletin*. Centre d'Études et de Documentation Paléontologique (CEDP), Paris (1946), pub. *Bulletin trimestriel d'information*. Centre National de la Recherche Scientifique, Laboratoire de Recherches sur l'Émaillerie Médiévale, Limoges. Commission Départementale des Antiquités de la Côte d'Or, Dijon (1831), pub. *Mémoires*. Délégation Archéologique Française en Afghanistan, Paris, pub. *Mémoires*. École du Louvre, Paris (1882). Ecole Française d'Extrême-Orient, Paris (formerly Hanoi), pub. *Bulletin*. Ecole Nationale Supérieure de Céramique de Sèvres, Sèvres. École National Supérieure des Arts Décoratifs, Paris (1767). École National Supérieure des Beaux-Arts, Paris (1648). Féderation Internationale des Éditeurs de Médailles, Paris, pub. *Médailles*. Fondation Jacques Doucet, Paris (1918). Rhodania, Vienne (1919), promotes prehistoric, archaeological, and antiquarian research, pub. *Rhodania, Comptes rendus du Congrès*. Société Archéologique de Sens, Sens (1844), pub. *Bulletin*. Société Archéologique d'Eure-et-Loire, Chartres. Société Archéologique du Finistèrre, Quimper (1873), pub. *Bulletin*. Société Archéologique et Historique de Clermont-en-Beauvais, Clermont (1902), pub. *Bulletin, Mémoires*. Société Archéologique et Historique de l'Orléanais, Orléans (1848), pub. *Bulletins, Mémoires*. Société Archéologique et Historique du Châtillonnais, Châtillon-sur-Seine (1880), pub. *Bulletin*. Société Archéologique, Historique et Scientifique de Noyon, Noyon (1856), pub. *Bulletin mensuel, Mémoires*. Société Asiatique, Paris (1882), pub. *Journal asiatique, Cahiers*. Société d'Archéologie et de Statistique de la Drôme, Valence (1866), pub. *Bulletin*. Société d'Archéologie et d'Histoire Naturelle du Département de la Manche, Saint-Lô (1836), pub. *Notices, Mémoires*. Société d'Archéologie Lorraine et du Musée Historique Lorrain, Nancy (1848), pub. *Journal, Bulletin, Pays Lorrain, Mémoires*. Société de l'Histoire de l'Art Français, Paris (1880), pub. *Bulletin, Archives de l'art français*, and others. Société d'Émulation du Bourbonnais, Moulins (1846), pub. *Bulletin*. Société des Amis de la Cathédrale de Strasbourg, Strasbourg (1902), pub. *Bulletin*. Société des Amis du Louvre, Paris (1897), pub. *Bulletin*. Société des Antiquaires de la Morinie, Saint-Omer (1831). Société des Antiquaires de l'Ouest, Poitiers (1834), pub. *Bulletins, Mémoires*. Société des Antiquaires du Centre, Bourges (1867), pub. *Mémoires de l'Union des sociétés savantes de Bourges*. Société des Artistes Français, Paris (1882), pub. *Bulletin*, organizes annual expositions. Société des Artistes Indépendants, Paris (1884). Société des Études Juives, Paris (1880), pub. *Revue des études juives*. Société de Statistique, d'Histoire et d'Archéologie de Marseille et Provence, Marseille (1827), pub. *Provence historique*. Société d'Histoire, d'Archéologie et Littérature de Beaune, Beaune (1851), pub. *Mémoires, Journal de Beaune, Le Bourgogne*. Société d'Histoire et d'Archéologie de la Lorraine, Metz (1888, reorganized 1920), pub. *Annuaires, Les cahiers lorrains, Mémoires*. Société du Salon d'Automne, Paris (1903). Société Française d'Archéologie, Orléans (1843), pub. *Bulletin monumental, Congrès archéologiques de France*. Société Française d'Égyptologie, Paris, pub. *Revue d'égyptologie*. Société Française de Numismatique, Paris (1866), pub. *Revue numismatique, Bulletin menseul*. Société Historique, Archéologique et Littéraire de Lyon, Lyon (1878), pub. *Bulletin*. Société Historique et Archéologique de l'Orne, Alençon (1882), pub. *Bulletin*. Société Historique et Archéologique du Gâtinais, Fontainebleau (1883), pub. *Annales, Documents*. Société Historique et Archéologique du Périgord, Perigueux (1874), pub. *Bulletin*. Société Nationale des Antiquaires de France, Paris (1803), pub. *Annuaire, Bulletin, Mémoires, Mémoires de l'Académie Celtique, Mettensia*. Société Nationale des Beaux-Arts, Paris (1890). Société Savoyenne d'Histoire et d'Archéologie, Chambéry, pub. *Mémoires et documents*. Société Scientifique, Historique et Archéologique de la Corrèze, Brive (1878), pub. *Bulletin*. Union Central des Arts Décoratifs, Paris (1882).

Germany (Federal Republic and Democratic Republic): Akademie der Bildenden Künste, Munich (1770). Akademie der Bildenden Künste in Nürnberg, Nürnberg (1678). Akademie der Künste, Berlin (1954, continues the Preussische Akademie der Künste, 1696). Akademie der Wissenschaften in Göttingen, Göttingen, pub. *Abhandlungen, Göttingische Gelehrte Anzeigen, Nachrichten*. Archäologische Gesellschaft zu Berlin, Berlin (1841), pub. *Winckelmannsprogramm, Sitzungsberichte*. Bayerische Akademie der Schönen Künste, Munich, pub. *Gestalt und Gedanke*. Bayerische Akademie der Wissenschaften, Munich (1759), pub. *Abhandlungen, Sitzungsberichte*, and others. Bayerische Numismatische Gesellschaft, Munich, pub. *Jahrbuch für Numismatik und Geldgeschichte, Mitteilungen*. Berliner Gesellschaft für Anthropologie, Ethnologie und Urgeschichte, Berlin (1869). Deutsche Akademie der Künste, Berlin (1950), pub. *Sinn und Form*. Deutsche Akademie der Wissenschaften zu Berlin, Berlin (1700), pub. *Abhandlungen, Jahrbuch, Sitzungsberichte*, and others. Deutsche Akademie für Städtebau und Landesplanung, Düsseldorf. Deutsche Orient-Gesellschaft, Berlin (1898), pub. *Mitteilungen*. Deutscher Verein für Kunstwissenschaft, Berlin (1908), pub. *Denkmaler deutscher Kunst, Zeitschrift für Kunstwissenschaft, Schrifttum zur deutschen Kunst*. Deutsches Archäologisches Institut, Berlin (1829), with seats in Rome, Athens, Istanbul, Madrid, Cairo, and Baghdad, pub. *Jahrbuch, Frankfurt Anzeiger*, and others. Deutsches Institut für Merovingische und Karolingische Kunstforschung, Erlangen. Forschungsinstitut für Kunstgeschichte, Marburg. Gesamtverein der Deutschen Geschichts- und Altertumsvereine, Wiesbaden (1852), pub. *Blätter für deutsche Landesgeschichte*. Görres-Gesellschaft, Cologne, pub. *Historisches Jahrbuch, Jahresbericht*, and others. Heidelberger Akademie der Wissenschaften, Heidelberg (1909), pub. *Abhandlungen, Sitzungsberichte*. Hochschule für Bildende Künste, Berlin (1696). Institut für Kirchenbau und Kirchliche Kunst der Gegenwart, Marburg. Institut für Orientforschung, Berlin, pub. *Mitteilungen*. Institut für Völkerkunde, Göttingen. Johann-Gottfried-Herder-Institut, Marburg. Kunstgeschichtliche Gesellschaft, Berlin, pub. *Sitzungsberichte*. Mommsen-Gesellschaft, Göttingen. Numismatische Gesellschaft zu Berlin, Berlin, pub. *Berliner numismatische Zeitschrift*. Römisch-Germanische Kommission des Deutschen Archäologischen Instituts, Frankfurt am Main, pub. *Bericht, Germania*. Sächsische Akademie der Wissenschaften zu Leipzig (1846), pub. *Abhandlungen*. Staatliche Akademie der Bildenden Künste, Freiburg (1940). Staatliche Akademie der Bildenden Künste, Karlsruhe (1854). Staatliche Akademie der Bildenden Künste, Stuttgart (1762). Staatliche Akademie für Graphische Künste und Buchgewerbe in Leipzig, Leipzig. Staatliche Hochschule für Baukunst und Bildende Kunste, Weimar (1860). Staatliche Hochschule für Bildende Künste, Frankfurt am Main (1817). Staatliche Kunstakademie in Düsseldorf, Düsseldorf (1767), pub. *Jahresbericht*. Verband Deutscher Kunsthistoriker e.V., Cologne (1948). Verein für Nassauische Altertumskunde und Geschichtsforschung, Wiesbaden (1812), pub. *Nassauische Mitteilungen, Nassauische Heimatblätter*. Verein von Altertumsfreunden in Rheinlande, Bonn (1841), pub. *Bonner Jahrbücher*. Verein zur Erforschung der Rheinischen Geschichte und Altertümer, Mainz (1844), pub. *Mainzer Zeitschrift*. Württembergischer Geschichts- und Altertumsverein, Stuttgart (1843), pub. *Zeitschrift fur Württembergische Landesgeschichte, Fundberichte aus Schwaben*.

Great Britain: Architectural Association, London (1847), pub. *Architectural Association Journal*. Arts and Crafts Exhibition Society, London (1888). Arts Council of Great Britain, London (1940), pub. *Annual Report, Proceedings*. Art-Workers' Guild, London (1883), pub. *Annual Report*. Barber Institute of Fine Arts, Birmingham (1939). Berkshire Archaeological Society, Reading (1847), pub. *Berkshire Archaeological Journal*. Birmingham College of Arts and Crafts, Birmingham (1821). Brighton and Hove Archaeological Society, Brighton (1906), pub. *Brighton and Hove Archaeologist, Annual Report*. Brighton College of Arts and Crafts, Brighton (1865). Bristol and Gloucestershire Archaeological Society, Bristol, pub. *Transactions*. British Academy, London (1901), includes sections of Archaeology, Oriental Studies, Art History, pub. *Proceedings*. British Archaeological Association, London (1843), pub. *Journal*. British Numismatic Society, London (1903), pub. *British Numismatic Journal*. British School of Egyptian Archaeology, London (1905). British School of Master Glass-Painters, London (1921), pub. *Journal*, and others. Cambrian Archaeological Association, Cardiff (1846), pub. *Archaeologica Cambrensis*. Cambridge Antiquarian Society, Cambridge (1840), pub. *Proceedings, Reports*. Carmarthenshire Antiquarian Society, Carmarthen, pub. *Transactions*. Chelsea School of Art, London (1895). China Society, London (1906). City and Guilds of London Art School, London (1879). Contemporary Art Society, London (1910). Council of Industrial Design, London (1944), pub. *Design* and others. Council for the Encouragement of Music and the Arts (CEMA), Belfast (1943), pub. *Annual Report*. Courtauld Institute of Art, London (1931), pub. *Journal of the Warburg and Courtauld Institutes*. Cumberland and Westmoreland Antiquarian and Archaeological Society, Carlisle (1866), pub. *Transactions*. Dundee Institute of Art and Technology, Dundee (1889). East India Association, London (1866). Edinburgh College of Art, Edinburgh (1907). Egypt Exploration Society, London (1882), pub. *Excavation Memoirs, Archaeological Survey, Graeco-Roman Memoirs, The Journal of Egyptian Archaeology*. Glasgow School of Art, Glasgow (1840). Greenwich and Lewisham Antiquarian Society, Greenwich (1906). Heatherley School of Fine Art, London (1845). Honourable Society of Cymmrodorion, London (1751), pub. *The Transactions*. Incorporated Association of Architects and Surveyors, London (1925), pub. *Journal, The Parthenon*. Incorporated Institute of British Decorators and Interior Designers, London (1899). Institute of Archaeology, Liverpool, pub. *Annals of Archaeology and Anthropology*. Institute of Contemporary Arts, London (1948). International African Institute, London (1926), pub. *Africa*. Islamic Cultural Centre, London (1944), pub. *Islamic Quarterly*. Kent Archaeological Society, Maidstone (1875), pub. *Archaeologia Cantiana*. Leicester College of Art, Leicester. Library

of the Victoria and Albert Museum, London (1837), photograph library. London and Middlesex Archaeological Society, London (1885), pub. *Transactions*. London County Council Central School of Arts and Crafts, London (1896). London Society, London (1912), pub. *London Society Journal*. Manchester Regional College of Art, Manchester (1858). Monumental Brass Society, Croydon (1887), pub. *Transactions*. Museums Association, London (1889), pub. *Museums Journal*. National Art-Collection Fund, London (1903). National Housing and Town Planning Council, London (1900), pub. *British Housing and Planning Review, British Housing and Planning Year Book*. National Society for Art Education, Leicester (1888), pub. *Journal*. National Society of Painters, Sculptors and Engravers, London (1930), pub. catalogues of exhibitions. National Trust for Places of Historic Interest or Natural Beauty, London, pub. *List of Properties, Annual Report, News Bulletin*. New English Art Club, London (1886), pub. catalogues of annual exhibitions. Nottingham College of Arts and Crafts, Nottingham (1843). Palestine Exploration Fund, London (1865), pub. *Palestine Exploration Quarterly, Annual*, and others. Palestine Oriental Society, London, pub. *Journal*. Pastel Society, London (1898). Prehistoric Society, Oxford (1908), pub. *Proceedings*. Records Branch Kent Archaeological Society, Maidstone, pub. *Kent Records*. Royal Academy of Arts in London, London (1768). Royal Academy Schools, London (1768). Royal Anthropological Society, London (1870), pub. *Journal, Man*. Royal Archaeological Institute of Great Britain and Ireland, London (1843), pub. *Archaeological Journal, Proceedings*. Royal Asiatic Society of Great Britain and Ireland, London (1823), pub. *Journal*. Royal Cambrian Academy of Art, Conway (1881). Royal Central Asian Society, London (1901), pub. *Journal*. Royal College of Art, London (1837). Royal Drawing Society, London (1881), to encourage the development of children's drawing, pub. *Annual Report*. Royal Fine Art Commission, London (1924). Royal Incorporation of Architects in Scotland, Edinburgh (1916), pub. *Quarterly*. Royal India, Pakistan and Ceylon Society, London (1910), pub. *Art and Letters*. Royal Institute of British Architects, London (1834), pub. *Journal, Kalendar*, and others. Royal Institute of Oil Painters, London (1883). Royal Institute of Painters in Water Colours, London (1831). Royal Institution of Chartered Surveyors, London (1868). Royal Numismatic Society, London (1836), pub. *Numismatic Chronicle, Proceedings*. Royal Scottish Academy, Edinburgh (1826). Royal Society of Arts, London (1754), pub. *Journal*. Royal Society of British Artists, London (1823). Royal Society of British Sculptors, London (1904). Royal Society of Miniature Painters, Sculptors and Gravers, London (1894). Royal Society of Painter-Etchers and Engravers, London (1880). Royal Society of Painters in Water Colours, London (1804). Royal Society of Portrait Painters, London (1891), pub. catalogue of annual exhibition. Ruskin School of Drawing and of Fine Art, Oxford (1871). St. Martin's School of Art, London (1854). Slade School of Fine Art, London (1871). Society for Education through Art, London (1939), pub. *Athene*. Society for the Promotion of Hellenic Studies, London (1879), pub. *Journal of Hellenic Studies*. Society for the Promotion of Roman Studies, London, pub. *Journal of Roman Studies*. Society for the Protection of Ancient Buildings, London (1877), pub. *Annual Report*. Society of Antiquaries of London, London (1707), pub. *Archaeologia, Antiquaries Journal*, and others. Society of Antiquaries of Newcastle upon Tyne, Newcastle upon Tyne (1813), pub. *Archaeologia Aeliana, Proceedings*. Society of Antiquaries of Scotland, Edinburgh (1780), pub. *Proceedings*. Society of Graphic Artists, London (1920), pub. catalogues of exhibitions. Society of Industrial Artists, London (1930), pub. *Journal*. Society of Miniaturists, London (1895). Society of Portrait Sculptors, London (1953). Somersetshire Archaeological and Natural History Society, Taunton (1849), pub. *Proceedings*. Staffordshire Record Society, Stafford (1879), pub. *Staffordshire Historical Collection*. Standing Commission on Museums and Galleries, London (1931). Surrey Archaeological Society, Guildford, pub. *Surrey Archaeological Collections*. Sussex Archaeological Society, Lewes, pub. *Sussex Archaeological Collections*. Town and Country Planning Association, London (1899). Warburg Institute, London (1905), pub. *Journal of the Warburg and Courtauld Institutes, Studies, Mediaeval and Renaissance Studies*. West of England College of Art, Bristol (1853). Yorkshire Archaeological Society, York, pub. *Yorkshire Archaeological and Topographical Journal*.

Greece: Akadimia Athinon, Athens (1926), pub. *Praktika, Pragmatie, Mnemeia*. American School of Classical Studies at Athens, Athens (1881), pub. *Hesperia, Annual, Bulletin, Papers*. Anotati Scholi Kalon Technon, Athens (1836). Archæologiki Hetairia, Athens (1837), pub. *Archeologiki Ephimeris, Praktika*. Associations of the Federation of Plastic Arts, Athens (1937), including Eleutheroi Kallitechnai; Omas-Techni; Somateion Hellinon Glypton (1930); Syndesmos Hellinon Kallitechnon (1910); Syndesmos Skitsographon (1926). British School of Classical Studies at Athens, Athens (1886), pub. *Annual*.

Deutsches Archäologisches Institut, Athens (1876), pub. *Athenische Mitteilungen*. Ecole Française d'Athènes (or Institut de Correspondance Hellénique), Athens (1846), pub. *Bulletin de correspondance hellénique, Bibliothèque des Ecoles françaises d'Athènes et de Rome, Fouilles de Delphes, Exploration archéologique de Délos, Etudes thasiennes, Etudes crétoises, Recherches françaises en Turquie, Études péloponnésiennes*. Hetairia Byzantinon Spoudon, Athens (1919), pub. *Epeteris*. Scuola Archeologica di Atene e delle Missioni Italiane in Oriente, Athens (1909), pub. *Annuario*. Svenska Institutet i Athen, Athens, pub. *Skrifter*.

Guatemala: Instituto de Antropología e Historia, Guatemala City (1946), pub. *Antropología e historia de Guatemala, Boletines*. Universidad de San Carlos, Instituto de Bellas Artes, Guatemala City.

Haiti: Bureau d'Ethnologie, Port-au-Prince (1941), with two sections (Afro-Haitian ethnography and pre-Columbian archaeology), pub. *Bulletin*. Institut d'Ethnologie d'Haiti, Port-au-Prince. Société Haitienne des Lettres et des Arts, Port-au-Prince.

Hungary: Debreceni Tudomámyegyetem, Debrecen. Magyar Müvészeti Tanács, Budapest (1945). Magyar Néprajzi Társaság, Budapest (1889), pub. *Ethnographia, Ethnographia füzetei*. Magyar Régészeti Müvészettörténeti és Éremtani Társulat, Budapest, pub. *Archaeologiai értesitö, Müvészettörténeti értesitö, Erem, Numizmatikai közlöny*. Magyar Tudományos Akadémia, Budapest (1825), pub. *Acta orientalia, Acta historiae artium, Acta archaeologica*, and others. Nemzeti Szalon Müvészeti Egyesület, Budapest (1894), pub. *A Nemzeti Szalon almanachja, A Nemzeti Szalon Müvészeti Egyesület kiállitásának katalógusai*. Népmüvelési Intézet, Budapest (1951). Országos Magyar Iparmüvészeti Föiskola, Budapest (1880). Országos Magyar Képzömüvészeti Föiskola, Budapest (1871). Országos Néptanulmányi Egyesület, Budapest (1913), pub. *Magyar nyelvör*.

Iceland: Bandalag Íslenzkra Listamanna, Reykjavík (1928), includes, *inter alia*, Félag Íslenzkra Myndlistarmanna and Húsameistarafélag Íslands. Hid Islenzka Fornleifafélag, Reykjavík (1879), pub. *Árbók*.

India: Andhra Historical Research Society, Andhra (1922), pub. *Journal of Historical Research*. Archaeological Survey of India, New Delhi (1902), numerous pubs. Asiatic Society, Calcutta (1784), pub. *Journal*. Bharata Itihāsa Saṃśodhaka-Maṇḍala, Poona (1910), pub. *Journal*. Bombay Art Society, Bombay (1888). Indian Ceramic Society, Benares (1929), pub. *Transactions*. Indian Society of Oriental Art, Calcutta (1907), pub. *Journal*. Kalakṣetra, Madras, dedicated to the development of the arts. Kamarupa Anuśandhan Samiti, Gauhati (1912), pub. *Journal of Assam Research Society*. Lalit Kāla Akademi (National Academy of Art), New Delhi (1955), organizes exhibitions and research and coordinates the activities of other associations. Museums Association of India, Bombay (1943). Oriental Institute, Baroda (1915), pub. *Pracīna Gurjāra Granthamālā Journal*, archaeology series, and others. Viśveśvarānand Vedic Research Institute, Hosiarpur (1924), pub. *Viśva Jyoti*.

Indonesia: Dinas Purbakala Republik Indonesia, Djakarta, pub. *Laporan Tahunan*.

Iraq: American School of Oriental Research, Baghdad (1923), pub. *Bulletin*. British School of Archaeology in Iraq (Gertrude Bell Memorial), Baghdad (1923), pub. *Iraq*. Deutsches Archäologisches Institut, Baghdad. Institute of Fine Arts, Baghdad (1936). Iraq Academy, Baghdad (1940).

Ireland: Architectural Association of Ireland, Dublin, pub. *The Green Book*. Arts and Crafts Society of Ireland, Dublin (1894). Cork Historical and Archaeological Society, Cork (1891), pub. *Journal*. County of Louth Archaeological Society, Dundalk, pub. *Journal*. Friends of the National Collections of Ireland, Dublin (1924). Irish Society of Arts and Commerce, Dublin (1911). Royal Hibernian Academy of Painting, Sculpture and Architecture, Dublin (1823). Royal Institute of Architects of Ireland, Dublin (1839), pub. *RIAI Year Book*. Royal Irish Academy, Dublin (1786), with a committee on antiquities, pub. *Cunningham Memoirs, Proceedings*. Royal Society of Antiquaries of Ireland, Dublin (1849), pub. *Journal*.

Israel: American School for Oriental Studies and Research in Palestine, Jerusalem, pub. *Papers*. Association of Engineers and Architects in Israel, Tel Aviv (1921), pub. *Journal*. British School of Archaeology, Jerusalem, pub. *Supplementary Papers*. Israel Exploration Society, Jerusalem, pub. *Bulletin*. The Israel Oriental Society, Tel Aviv, pub. *Hamizrah Hehadesh* (the New East), Oriental notes and studies. Milfrid Israel House for Oriental Studies and Art, Hazorea.

Italy (including *Vatican City*): Academia Belgica, Rome (1939), pub. *Bulletin, Études de philologie, d'archéologie et d'histoire*, and others. Accademia Albertina di Belle Arti e Liceo Artistico, Turin (1652). Accademia di Archeologia, Lettere e Belle Arti di Napoli, Naples, pub. *Memorie, Rendiconti*. Accademia di Belle Arti, Florence (1801). Accademia di Belle Arti, Milan (1803). Accademia di Belle Arti, Parma. Accademia di Belle Arti, Perugia (1573). Accademia di Belle Arti e Liceo Artistico, Bologna (1709). Accademia di Belle Arti e Liceo Artistico, Naples (1838). Accademia di Belle Arti e Liceo Artistico, Palermo. Accademia di Belle Arti e Liceo Artistico, Rome. Accademia di Belle Arti e Liceo Artistico, Venice (1750). Accademia di Francia (Académie de France à Rome), Rome (1666). Accademia di Romania, Rome. Accademia di Scienze, Lettere ed Arti, Palermo, pub. *Atti, Bollettino*. Accademia di Spagna, Rome. Accademia d'Ungheria, Rome, pub. *Biblioteca, Janus Pannonius, Rendiconti*. Accademia Egiziana di Belle Arti, Rome. Accademia Ligustica di Belle Arti, Genoa. Accademia Nazionale dei Lincei, Rome (1603), pub. *Monumenti antichi, Rendiconti, Memorie, Notizie degli scavi*. Accademia Nazionale di San Luca, Rome (1588). Accademia Petrarca di Lettere, Arte e Scienze, Arezzo (1910), pub. *Atti e memorie*, etc. Accademia Polacca di Scienze e Lettere (Polska Akademia Nauk), Rome (1923). Accademia Tedesca, Rome. American Academy in Rome, Rome (1895), pub. *Memoirs, Papers*, and *Monographs, Annual Report*. Associazione Archeologica Romana, Rome (1902), pub. *Bollettino, Romana gens*. Associazione Nazionale dei Musei Italiani, Rome (1955), pub. *Musei e gallerie d'Italia*. Associazione Nazionale "Italia Nostra" per la Tutela del Patrimonio Artistico, Rome (1956), pub. *Italia nostra*. Associazione Nazionale per Aquileia,'Aquileia, pub. *Aquileia nostra*. Biblioteca Hertziana, Rome (1913), pub. *Römisches Jahrbuch, Römische Forschungen*. British School at Rome, Rome (1901), pub. *Papers*. Centro di Studi per la Storia dell'Architettura, Rome, pub. *Bollettino*. Centro Nazionale di Studi sul Rinascimento, Florence, pub. *Rinascimento*. Centro per le Antichità e la Storia dell'Arte del Vicino Oriente (Istituto per l'Oriente), Rome (1959), pub. *Oriens antiquus*. Comitato Nazionale per le Tradizioni Popolari, Rome, pub. *Lares*. Danske Institut for Videnskab og Kunst i Rom, Rome (1955), pub. *Analecta Romana Instituti Danici*. Deutsches Archäologisches Institut, Rome (1828–29, revived 1882), pub. *Römische Mitteilungen*. Ecole Française de Rome, Rome (1873), pub. *Mélanges d'archéologie et d'histoire, Bibliothèque des Ecoles françaises d'Athènes et de Rome*. Escuela Española de Historia y Arqueologia en Roma, Rome (1910), pub. *Cuadernos de trabajos*. Esposizione Biennale Internazionale di Venezia, Venice (1895), pub. *La Biennale di Venezia*. Fondazione Giorgio Cini, Istituto di Storia dell'Arte del Centro di Cultura e Civiltà, Venice (1954). Institutum Romanum Finlandiae, Rome (1953). Istituto di Archeologia e Storia dell'Arte, Rome (1922), pub. *Annuario bibliografico di archeologia, Bollettino, Rivista*. Istituto di Belle Arti delle Marche per la Decorazione e l'Illustrazione del Libro, Urbino (1863). Istituto di Studi Etruschi e Italici di Firenze, Florence (1931), pub. *Studi etruschi*. Istituto di Studi Romani, Rome (1925), pub. *Bollettino sistematico di bibliografia romana, Roma, Studi romani*. Istituto Internazionale di Studi Liguri, Bordighera, pub. *Rivista di studi liguri, Rivista Ingauna e Intemelia, Cahiers ligures de préhistoire*. Istituto Italiano di Numismatica, Rome (1912), pub. *Annali, Atti e memorie, Studi di numismatica*. Istituto Italiano di Preistoria e Protostoria, Rome (1956), pub. *Rivista di scienze preistoriche*. Istituto Italiano per il Medio ed Estremo Oriente (ISMEO), Rome (1933), pub. *Asiatica, East and West, Rome Oriental Series*. Istituto Nazionale d'Architettura (INARC), Rome (1958). Istituto Nazionale di Urbanistica, Rome, pub. *Urbanistica*. Istituto Portoghese di Roma, Rome. Istituto Statale d'Arte per la Ceramica G. Ballardini, Faenza. Istituto Svizzero di Roma, Rome (1949). Istituto Veneto di Scienze, Lettere ed Arti, Venice, pub. *Annuario, Atti, Memorie*. Kunsthistorisches Institut, Florence (1888), pub. *Italienische Forschungen, Jahresbericht, Florentiner Forschungen, Mitteilungen*. Kunsthistorisch Instituut der Nederlandse Universiteiten, Florence. Nederlands Historisch Instituut te Rome, Rome, pub. *Mededeelingen*. Norske Institutt i Roma for Forskere, Arkitekter og Kunstnere, Rome. Pontificia Accademia Romana di Archeologia, Rome (1740), pub. *Rendiconti, Memorie, Dissertazioni*. Pontificio Istituto di Archeologia Cristiana, Rome (1925), pub. *Rivista di archeologia cristiana*. Pontificio Istituto Orientale, Rome. Römisches Institut der Görres-Gesellschaft, Vatican City (1888), promotes historical and archaeological research in the archives, museums, and libraries of Italy, pub. *Studien zur Geschichte und Kultur des Altertums, Römische Quartalschrift*, and others. Scoala Româna din Roma, Rome, pub. *Ephemeris Dacoromana*. Scuola Superiore di Arte Cristiana Beato Angelico, Milan. Società Archeologica Comense, Como (1901), pub. *Rivista archeologica dell'antica provincia e diocesi di Como*. Società di Storia, Arte e Archeologia per le Provincie di Alessandria e Asti, Alessandria, pub. *Rivista*. Società Magna Grecia, Rome, pub. *Atti e memorie, Archivio storico per la Calabria e la Lucania*. Sodalizio tra Studiosi dell'Arte, Rome (1946), pub. *Colloqui*. Svenska Institutet

i Rom, Rome (1926), pub. *Skrifter*. Unione Internazionale degli Istituti di Archeologia, Storia e Storia dell'Arte, Rome (1946).

Japan: Bijutsu Kenkyūjo, Tokyo (1930), pub. *Bijutsu Kenkyū, Kokushigaku*. Kanazawa Bunko, Yokohama. Kenchiku Gakkai, Tokyo. Tokyo Geijutsu Daigaku Toshokan, Tokyo.

Jordan: Studium Biblicum Franciscanum, Jerusalem.

Lebanon: Académie Libanaise, Beirut (1937). Institut Français d'Archéologie, Beirut (1946), pub. *Syria*. Oriental Institute, Beirut (1933).

Mexico: Academia Mexicana, Mexico City. Academia San Carlos, Mexico City. Asociación de Ingenieros y Arquitectos de México, Mexico City (1868). Ateneo Nacional de Ciencias y Artes de México, Mexico City (1920), pub. *Boletín*. Escuela de Bellas Artes, Morelia. Escuela Nacional de Artes Plásticas, Mexico City (1781), pub. *Revista de artes plásticas*. Escuela Nacional de Bellas Artes, Mexico City. Instituto Nacional de Antropología y Historia, Mexico City (1850), pub. *Anales, Memorias*. Instituto Nacional de Bellas Artes y Letras, Mexico City (1947), pub. *México en el arte*. Sociedad de Arquitectos Mexicanos, Mexico City.

Netherlands: Academie van Beeldende Kunsten, The Hague. Academie van Bouwkunst, Amsterdam (1908). Academie voor Kunst en Industrie, Enschede. Bond Heemschut, Amsterdam (1911), conservation of the artistic heritage. Centraal Adviesbureau voor de Gebonden Kunsten en Industrieelen Vorm, Amsterdam. Genootschap Architectura et Amicitia (A. et A.), Amsterdam (1955), pub. *Forum*. International Association of Egyptology, Leiden, pub. *Annual Egyptological Bibliography*. International Society for Oriental Research, Leiden, pub. *Oriens*. Jan van Eyk-Academie, Maastricht. Koninklijk Oudheidkundig Genootschap, Amsterdam (1858), pub. *Jaarverslagen*. Maatschappij "Arti et Amicitiae," Amsterdam (1839), society of painters and sculptors. Maatschappij tot Bevordering der Bouwkunst Bond van Nederlandsch Architecten (BNA), Amsterdam (1842), pub. *Bouwkundig weekblad*. Pulchri Studio, The Hague (1847), art exhibitions. Rijksakademie van Beeldende Kunsten, Amsterdam (1870). Rijksbureau voor Kunsthistorische Documentatie, The Hague (1930), pub. *Annual Report, Bulletin*, and bibliographies. Rotterdamse Academie van Beeldende Kunsten en Technische Wetenschappen, Rotterdam. Vereeniging "Sint Lucas," Amsterdam (1880). Voor-Aziatisch Egyptisch Gezelschap "Ex Oriente Lux," Leiden, pub. *Jaarbericht, Mededeelingen*. Voorlopige Monumentenraad, The Hague (1946), pub. *Voorlopige Lijst, Geillustreerde beschrijving der nederlandsche monumenten, Kunstreisboek voor Nederland*.

New Zealand: Auckland Institute and Museum, Auckland (1933), pub. *Records*. Board of Maori Ethnological Research, Wellington (1926), pub. *Memoirs*. Elam School of Fine Arts, Auckland University College, Auckland. New Zealand Academy of Fine Arts, Wellington. New Zealand Institute of Architects, Wellington (1905, pub. *Year Book, Journal*. Polynesian Society, Wellington (1905), pub. *Journal, Memoirs*.

Norway: Bildende Kunstneres Styre, Oslo (1882). Foreningen til Norske Fortidsminnesmerkers Bevaring, Oslo (1844), pub. *Aarsberetning*. Indo-iransk Institutt, Oslo (1920). Norske Videnskaps Akademi i Oslo, Oslo (1857), pub. *Årbok, Skrifter, Avhandlinger*. Statens Kunstakademi, Oslo (1909).

Pakistan: Pakistan Museum Association, Peshawar (1949). Society of Arts, Literature and Welfare, Chittagong (1948). Varendra Research Society and Museum, Rajshahi (1910).

Panama: Archaeological Society of Panama, Panama, pub. pre-Columbian studies.

Paraguay: Sociedad Científica del Paraguay, Asunción, pub. *Revista*.

Peru: Academia de Artes Plásticas del Cuzco, Cuzco. Academia Lauretana de Ciencias y Artes, Lima. Academia Peruana, Lima, pub. *Revista*. Archivo Nacional del Perú, Lima, pub. *Revista*. Escuela Nacional de Bellas Artes, Lima. Instituto Arqueológico del Cuzco, Cuzco, pub. *Revista*. Instituto de Etnología y Arqueología, Lima, pub. *Publicaciones*. Instituto de Investigaciones de Arte Peruano y Americano, Lima (1943). Museo Nacional, Lima, pub. *Revista*. Patronato Nacional de Arqueología, Lima. Sociedad de Bellas Artes del Perú, Lima.

Philippines (Republic): Art Association of The Philippines, Manila (1948). Philippine Institute of Architects, Manila. Philippine Numismatic and Antiquarian Society, Manila (1929), pub. monographs.

Poland: Akademia Sztuk Pięknych, Warsaw. Akademia Sztuk Plastycznych, Kraków. Akademia Sztuk Plastycznych, Warsaw (1908). Państwowy Instytut Sztuki, Warsaw (1949), pub. *Materiały do studiów i dyskusja z zakresu teorii i historii sztuki, krytyki artystycznej oraz badań nad sztuką, Biuletyn historii sztuki, Przeglad artystyczny, Polska sztuka ludowa*. Polska Akademia Nauk (PAN), Warsaw (1952), art included as well as science, pub. *Nauka polska, Biuletyn obcojęzyczny PAN*, and others. Polskie Towarzystwo Miłośników Historii i Zabytków Krakowa, Kraków (1897). Polskie Towarzystwo Orientalistyczne, Warsaw (1953), pub. *Dawna kultura, Przegląd orientalistyczny*. Societas Archaeologica Polonorum, Wrocław, pub. *Acta*. Towarzystwo Archeologiczne we Wrocławie, Wrocław, pub. *Archaeologia*. Towarzystwo Przyjaciół Nauki i Sztuki w Gdańsku, Danzig (1922), pub. *Rocznik Gdański*.

Portugal: Acadêmia Nacional de Belas Artes, Lisbon (1932), pub. *Boletim, Inventário artístico de Portugal*. Associação dos Arqueólogos Portugueses, Lisbon (1863), pub. *Arqueologia e historia, Boletim*. Escola Nacional de Belas Artes, Porto (1836). Escola Superior de Belas Artes, Lisbon (1836). Instituto Português de Arqueologia, História e Etnografia, Lisbon, pub. *Ethnos*. Sociedade Nacional de Belas Artes, Lisbon (1901). Sociedade Portuguesa de Antropologia e Etnologia, Porto (1918), pub. *Trabalhos*.

Rhodesia: Rhodesian Society of Arts, Salisbury.

Romania: Academia de Arte Frumoase, Bucharest. Academia Republicii Populare Romîne, Bucharest (1948), including in its Section VIII archaeology and art history. Societatea Istorico-Archeologică Bisericească, pub. *Revista*. Societatea Numismatică, Bucharest, pub. *Buletinul*.

Saudi Arabia: The Arab Archaeological Society, Mecca.

Senegal: Institut Français d'Afrique Noire, Dakar, pub. *Notes, Bulletin*.

Spain: Academia de Ciencias Naturales y Artes, Madrid, pub. *Memorias*. Associación Amigos de los Museos, Barcelona (1933), pub. *Historiales*. Asociación Artístico-Arqueológica Barcelonesa, Barcelona, pub. *Boletín, Revista*. Asociación de Pintores y Escultores de España, Madrid (1910), pub. *Gaceta de Bellas Artes*. Ateneo Científico, Literario y Artístico, Madrid (1820), pub. *Ateneo, Hoja del Ateneo*. Ateneo Científico, Literario y Artístico, Mahon (Minorca; 1905), pub. *Revista de Minorca*. Centro de Estudios de Etnología Peninsular, Madrid, pub. *Revista de dialectología y tradiciónes populares*. Colegio Oficial de Arquitectos de Cataluña y Baleares, Barcelona (1931), pub. *Cuadernos de arquitectura*. Consejo Superior de Investigaciones Científicas (CSIC), Madrid (1940) is composed of eight divisions, parts of one of these divisions, the Patronato "Marcelino Menéndez Pelayo," including Instituto "Rodrigo Caro" de Arqueología y Prehistoria, pub. *Ampurias, Archivo de prehistoria levantina, Hispania antigua epigrafica*; Instituto Diego de Velázquez de Arte, pub. *Archivo español de arqueología, Archivo español de arte, Bibliografía de arte español, Boletín del Seminario de estudios de arte y arqueología, Revista de ideas estéticas*; Instituto Antonio de Agustín de Numismática, pub. *Numario hispánico*; Instituto "Benito Arias Montaño" de Estudios Hebraicos y Oriente Próximo, pub. *Sefarad*. Deutsches Archäologisches Institut, Madrid. Dirección General de Arquitectura, Madrid (1940), pub. *Revista nacional de arquitectura*. Instituto Amatller de Arte Hispánico, Barcelona (1941). Instituto Arqueológico del Ayuntamiento de Madrid, Madrid, pub. *Anuario de arqueología madrileña*. Institut d'Estudis Catalans, Barcelona (1907), pub. *Anuari, Memories de la Secció histórico-arqueológica*, and others. Real Academia de Bellas Artes de la Purísima Concepción, Valladolid (1802), pub. *Boletín*. Real Academia de Bellas Artes de San Fernando, Madrid (1744), pub. *Boletín*. Real Academia de Bellas Artes de San Jorge, Barcelona (1849). Real Academia de Bellas Artes de Santa Isabel de Hungría, Seville (1660), pub. *Boletín*. Real Academia de Bellas Artes de San Telmo, Málaga (1849). Real Academia de Bellas Artes y Ciencias Históricas de Toledo, Toledo (1916), pub. *Boletín*. Real Academia de Ciencias y Artes de Barcelona, Barcelona (1764), pub. *Nómina, Memorias, Boletín*. Real Academia de Ciencias, Bellas Letras y Nobles Artes, Córdoba (1810), pub. *Boletín*. Real Academia de Nobles y Bellas Artes de San Luis, Saragossa (1792), pub. *Boletín*. Real Sociedad Arqueológica Terraconense, Tarragona (1844), pub. *Boletín arqueológico*. Real Sociedad Vascongada de los Amigos del País, San Sebastián (1764), archaeological explorations of prehistoric caverns, pub. *Boletín*, and others. Servicio de Investigación Prehistórica de la Excelentísima Deputación Provincial, Valencia (1927), pub. *La labor del SIP y su museo, Trabajos Varios, Archivo de prehistoria levantina (Anuario)*. Sociedad Arqueológica Luliana, Palma, Majorca (1880), pub. *Boletín*. Sociedad el Museo

Canario, Las Palmas (1879), pub. *El Museo Canario*. Sociedad Española de Amigos del Arte, Madrid (1912), pub. *Arte español*. Sociedad Española de Antropología, Etnografía y Prehistoria, Madrid (1921), pub. *Acta y memorias*.

Sudan: Philosophical Society, Khartoum, also promotes archaeological and ethnological studies, pub. *Sudan Notes and Records*.

Sweden: Arkiv för Dekorativ Konst, Lund. Göteborgs Kungl. Vetenskaps- och Vitterhets-Samhälle, Göteborg (1778), pub. *Handlingar*. Kungl. Akademien för de Fria Konsterna, Stockholm (1735), pub. *Meddelanden*. Kungl. Gustav Adolfs Akademien för Folklivsforskning, Uppsala (1932). Kungl. Konsthögskolan, Stockholm (1735), pub. *Kungl. Konsthögskolan, Timplan, Kungl. Konsthögskolan, Elevkatalog*. Kungl. Vitterhets- Historie- och Antikvitets-Akademien, Stockholm (1786), pub. *Fornvännen, Handlingar, Årsbok*. Svenska Arkitekters Riksförbund, Stockholm (1936), pub. *Arkitekten*. Svenska Arkitektföreningen, Stockholm (1888), pub. *Byggmästaren*. Svenska Slöjdföreningen, Stockholm (1845), pub. *Form, Kontur*. Sveriges Allmänna Konstförening, Stockholm (1832), pub. *Sveriges Allmänna Konstförenings årspublikation*.

Switzerland: Académie Internationale de la Céramique, Geneva. Antiquarische Gesellschaft, Zürich (1832), pub. *Mitteilungen*. Bund Schweizer Architekten-Fédération des Architectes Suisses, Berne (1906), pub. *Schweizer Baukatalog, Werk*. École Cantonale des Beaux-Arts et d'Art Appliqué, Lausanne. Ecoles d'Art, Geneva. Geographisch-ethnographische Gesellschaft, Basel (1923), pub. *Korrespondenzblatt, Mitteilungen*. Gesellschaft Schweizerischer Maler Bildhauer und Architekten-Société des Peintres, Sculpteurs et Architectes Suisses, Berne (1865), pub. *Schweizer Kunst, Art suisse*. Historische und Antiquarische Gesellschaft zu Basel, pub. *Basler Chroniken, Basler Zeitschrift für Geschichte und Altertumskunde, Jahresbericht*. Schweizerischer Künstlerbund-Fédération Suisse des Artistes, Zürich (1926). Schweizerisches Institut für Kunstwissenschaft, Zürich. Schweizerische Vereinigung zur Erhaltung der Burgen und Ruinen, Zürich, pub. *Nachrichten*. Société des Arts, Geneva (1776). Société des Femmes Peintres, Sculpteurs et Décorateurs, Berne (1903). Société d'Histoire et d'Archéologie, Geneva (1838), pub. *Bulletin, Mémoires et documents*. Société Suisse des Ingénieurs et des Architectes, Zürich (1837), pub. *Schweizerische Bauzeitung, Bulletin technique de la Suisse romande, Rivista tecnica della Svizzera italiana*. Société Vaudoise d'Histoire et d'Archéologie, Lausanne (1902), pub. *Revue historique vaudoise*. Verband Schweizerischer Graphiker, Zürich (1938). Wirtschaftsbund Bildender Künstler, Zürich (1933), pub. *Mitteilungen*.

Syria: Institut Français de Damas, Damascus (1928), pub. *Bulletin d'études orientales, Documents, Mémoires*.

Taiwan (Republic of China): Academia Sinica, Taipeh (1912). National School of Arts, Panchiao (1955).

Thailand: Royal Institute, Bangkok (1933), institute of the arts and sciences, pub. *Journal*. Siam Society (formerly the Thailand Society), Bangkok (1904), encourages researches and artistic activity, pub. *Journals, Coinage of Thailand*, and others. University of Fine Arts, Bangkok.

Turkey: British Institute of Archaeology at Ankara, Ankara (1848), pub. *Anatolian Studies*. Deutsches Archäologisches Institut, Istanbul, pub. *Istanbuler Forschungen, Istanbuler Mitteilungen*. Güzel Sanatlar Akademisi, Istanbul (1882). Milletlerarasi Şark Tetkikleri Cemiyeti, Istanbul (1947). Russkii Arkheologicheskii Institut v Konstantinopel, Istanbul, pub. *Izvestiya*. Şark Ilimleri Tetkik Cemiyeti, Istanbul (1946). Türk Halk Bilgisi Dernegi, Istanbul (1846). Türk Tarih Kurumu, Ankara (1931), pub. *Türk Tarih Arkeologya ve Etnografya Dergisi*.

Union of South Africa: Institute of South African Architects, Johannesburg (1911), pub. *South African Architectural Record*. Michaelis School of Fine Art, Cape Town. South African Archaeological Society, Cape Town (1945), pub. *South Africa Archaeological Bulletin*. The South Africa National Society, Cape Town (1905), pub. *Year Book, Annual Report*. Suid-Afrikaanse Akademie vir Wetenskap en Kuns, Pretoria (1909), pub. *Tydskrif vir wetenskap en kuns, Tegnikon, Hertzog-Annale*.

Union of Soviet Socialist Republics: Akademiya Khudozhestv SSSR, Moscow (1947). Akademiya Nauk SSSR, Moscow (1724), the division of history includes a subdivision devoted to the history of art and one devoted to ethnography, pub. *Voprosy istorii* and others. Akademiya Stroitel'stva i Arkhitekturi SSSR, Moscow (1934). Gosudarstvennyi Institut dlya Iskusstva, Kharkov. Gosudarstvennyi

Institut dlya Iskusstva, Kiev. Gosudarstvennyi Institut dlya Prikladnych i Dekoratsionnych Iskusstv, Kaunas. Gosudarstvennyi Khudozhestvennyi Institut, Moscow. Gosudarstvennyi Khudozhestvennyi Institut, Vilna. Khudozhestvennyi Institut, Tartu. Institut dlya Arkhitektury, Moscow. Institut dlya Prikladnogo i Dekoratsionnogo Iskusstva, Moscow. Institut dlya Zhivopisi, Skulptury, Arkhitectury Imen J. Repina pri Vsesoyuznoi Akademii Khudozhestv, Leningrad. Máklas Akademija, Riga. Khudozhestvennyi Institut, Tartu. Many of the Academies of Science of individual republics of the USSR possess institutes devoted to art history, archaeology, or ethnography, depending on their divisions of social science.

United States of America: Alaska Historical Library and Museum, Juneau (1920). American Academy of Arts and Letters, New York (1904), pub. *Academy Papers, Proceedings*. American Academy of Arts and Sciences, Boston (1780), pub. *Bulletin, Memoirs, Proceedings*. American Anthropological Association, Washington, D.C. (1902), pub. *American Anthropologist, Bulletin, Memoirs*. American Antiquarian Society, Worcester, Mass. (1812), pub. *Proceedings, Monographs*. American Asiatic Association, New York (1898). American Association of Museums, Washington, D.C. (1906), pub. *Museum News, Museum Buildings*, and many others. American Craftsmen's Council, New York (1943), pub. *Craft Horizons*. American Ethnological Society, temporarily at Arizona State Museum, Tucson (1842). American Federation of Arts, New York (1909), pub. *Quarterly*; sponsors pub. of *The American Art Directory* (formerly *The American Art Annual*) and *Who's Who in American Art*. American Folklore Society, Inc., Philadelphia (1888), pub. *Journal, Memoirs*. American Institute of Architects, Washington. D.C. (1857), pub. *Bulletin, Journal*, and others. American Institute of Graphic Arts (AIGA), New York. The American Museum of Natural History, New York (1869). American Numismatic Society, New York (1858), pub. *Museum Notes, Numismatic Literature, Proceedings*, and others. American Schools of Oriental Research, New Haven (1900), pub. *Annual, Biblical Archaeologist, Bulletin, Journal of Cuneiform Studies*. American Society of Industrial Designers, Inc., New York (1944), pub. *Newsletter*, and others. Archaeological Institute of America, New York (1879), pub. *American Journal of Archaeology, Archaeology*. Art Association of Indianapolis, Indianapolis (1883), pub. *Annual Report, Bulletin*. The Art Institute of Chicago, Chicago (1879), pub. *Quarterly*. Art Students League of New York, New York (1875), pub. *News*. Brooklyn Institute of Arts and Sciences, New York (1823), which administers the Brooklyn Museum, pub. *Bulletin* and others. Buffalo Fine Arts Academy, Buffalo, N.Y. (1862), incorporating the Albright-Knox Art Gallery, pub. *Annual Report, Bulletin*. Byzantine Institute of America, Boston. Carnegie Institution of Washington, Washington D.C. (1902), with an archaeological section. Cleveland Institute of Art, Cleveland (1882), pub. *School Catalogue*. College Art Association of America, New York (1912), pub. *Art Bulletin, College Art Journal*. Cooper Union for the Advancement of Science and Art, New York (1859), with museum and picture reference library, pub. *Cooper Union Chronicle*. Detroit Institute of Arts, Detroit (1885), pub. *Bulletin, Art Quarterly, Proceedings*. Dumbarton Oaks Research Library and Collection of Harvard University, Washington, D.C. (1940), pub. *Dumbarton Oaks Papers*. Fine Arts Federation of New York, New York (1895). Frick Art Reference Library, The Frick Collection, New York (1935). Heye Foundation, Museum of the American Indian, New York (1916), pub. *Contributions*. Hispanic Society of America, New York (1904). Henry E. Huntington Library and Art Gallery, San Marino, Calif. (1919), pub. *The Huntington Library Quarterly*. Institute of Contemporary Art, Boston (1937), pub. *Bulletin, Newsletter*. Institute of Contemporary Arts, Washington (1947). International Graphic Arts Society (IGAS), New York (1951), pub. *IGAS*. Library of Congress, Washington, D.C. (1800), pub. *Guide, Pictorial Americana*. Mediaeval Academy of America, Cambridge, Mass. (1925), pub. *Speculum*, and others. The Metropolitan Museum of Art, New York (1870), pub. *Bulletin*, and others. Minneapolis Society of Fine Arts, Minneapolis (1883). Museum of Modern Art, New York (1929). National Academy of Design, New York (1825), which conducts an art school, pub. *Art Schools, National Academy Bulletin*. National Geographic Society, Washington, D.C. (1888), pub. *The National Geographic Magazine*. National Institute of Arts and Letters, New York (1898). National Sculpture Society, New York (1893), pub. *National Sculpture Review, Year Book*. National Society of Mural Painters, New York (1893), pub. *Newsletter*. New York Historical Society, New York (1804), pub. *Quarterly*. Pennsylvania Academy of the Fine Arts, Philadelphia (1805), pub. *Annual Report*. The Pierpont Morgan Library (1924), New York. Rhode Island School of Design, Providence (1877). School of American Research, Santa Fé (1907), pub. *El Palacio*. Smithsonian Institution, Washington, D.C. (1846), which administers the United States National Museum, pub. *Annual Report, Bulletins, Proceedings*; the Bureau of American Ethnology, pub. *Annual Report, Bulletins*;

the National Collection of Fine Arts; the Freer Gallery of Art, pub. *Annual Report, Oriental Studies, Ars Orientalis*, and others; and the National Gallery of Art. Society for American Archaeology, Washington, D.C. (1945), pub. *American Antiquity*. Society of Architectural Historians, New York (1940), pub. *Journal*. Wenner-Gren Foundation for Anthropological Research (1941), New York. In the United States the equivalent of the European art academy has frequently developed as a department of a university (see V, col. 567). In addition, since World War II, privately endowed, nonprofit foundations (e.g., The Ford Foundation) have played a large role with grants for development in fields related to the arts, and many state and local historical societies (e.g., Pennsylvania, Massachusetts, New York) offer exhibitions, maintain libraries, and preserve monuments and objects of historical importance, some of which are also of artistic interest. Other organizations have been formed by various national and religious groups in the United States to gather and disseminate through their publications information about their particular cultures (e.g., American-Jewish Historical Society, founded 1892, New York; American Swedish Historical Foundation, founded 1926, Philadelphia).

Uruguay: Sociedad "Amigos de Arqueología," Montevideo (1926), pub. *Revista*. Sociedad de Arquitectos del Uruguay, Montevideo (1914), pub. *Boletín, Arquitectura*.

Venezuela: Asociación Venezolana Amigos del Arte Colonial, Caracas (1942), pub. *Revista*. Escuela de Artes Plásticas y Artes Aplicadas "Cristóbal Rojas," Caracas (1936).

Yugoslavia: Akademija Likovnih Umjetnosti, Belgrade. Akademija Likovnih Umjetnosti, Zagreb. Akademija Primejenih Umjetnosti, Belgrade. Akademija Primejenih Umjetnosti, Zagreb (1949). Jugoslavenska Akademija Znanosti i Umjetnosti, Zagreb (1867). Restauratorski Zavod, Zagreb (1948). Slovenska Akademija Znanosti in Umetnosti, Ljubljana (1921), pub. *Arheološki vestnik*, and others. Srpska Akademija Nauka, Belgrade (1886), pub. *Starinar* and others. Umetnostno Zgodovinsko Društvo, Ljubljana (1920), pub. *Zbornik za umetnostno zgodovino*. Zavod za Arhitekturu i Urbanizam, Zagreb (1952).

* *

BIBLIOG. *Antiquity*: a. *Near East*: W. F. Petrie, Professions and Trades, Ancient Egypt, XI, 1926, pp. 73–84; E. W. Ware, Egyptian Artists' Signatures, Am. J. of Semitic Languages and Lit., XLIII, 1926 and 1927, pp. 185–207; I. Mendelsohn, Guilds in Ancient Palestine, BAmSOR, LXXX, 1940, pp. 17–21; I. Mendelsohn, Guilds in Babylonia and Assyria, JAOS, LX, 1940, pp. 68–72; C. Virolleaud, Les villes et les corporations du royaume d'Ugarit, Syria, XXI, 1940, pp. 148–51; I. Mendelsohn, Free Artisans and Slaves in Mesopotamia, BAmSOR, LXXXIX, 1943, pp. 25–29; V. G. Childe, What Happened in History, Harmondsworth, 1942, New York, 1946, pp. 85–88; R. De Langhe, Les textes de Ras Shamra-Ugarit et leurs rapports avec le milieu biblique de l'Ancien Testament, II, Paris, 1945, p. 378; W. S. Smith, A History of Egyptian Sculpture and Painting in the Old Kingdom, 2d ed., Oxford, 1949, pp. 351–56; A. Hauser, The Social History of Art (Eng. trans., S. Godman), I, London, New York, 1951, pp. 47–53; L. Koehler and W. Baumgartner, Lexicon in Veteris Testamenti libros, Leiden, 1953, p. 579; Cambridge Ancient History, III, Cambridge, 1954, pp. 96–98; C. H. Gordon, Ugaritic Manual, Rome, 1955, p. 200; H. Schmökel, I Sumeri, Florence, 1955, p. 125; C. H. Gordon, Ugaritic Guilds, Studies Presented to Hetty Goldman, New York, 1956, pp. 140–43; J. Vandier, Manuel d'archéologie égyptienne, III, Paris, 1958, pp. 3–13. b. *Greece*: E. Cavaignac, Etudes sur l'histoire financière d'Athènes au Ve siècle, Paris, 1908; P. Waltz, Les artisans et leur vie en Grèce, Rev. historique, CXVII, 1914, pp. 5–41; J. L. Benson, Geschichte der korinthischen Vasen, Basel, 1953; R. Bianchi Bandinelli, L'artista nell'antichità classica, AC, IX, 1957, pp. 1–17 at 6. c. *The Roman world*: J. P. Waltzing, Etude historique sur les corporations professionnelles chez les Romains, II, 1–2, Louvain, 1895–96; H. Gummerus, Die Römische Industrie, I: Das Goldschmied- und Juweliergewerbe, Klio, XIV, 1914–18, pp. 129–89; F. G. Lo Bianco, Civiltà romana: La organizzazione dei lavoratori, Rome, 1939; G. Becatti, Arte e gusto negli scrittori latini, Florence, 1951, pp. 1–8; J. Gagé, Fornix Ratumenus, B. de la Faculté des Lettres de Strasbourg, XXXI, 1953, pp. 163–80; P. De Francisci, Le arti nella legislazione del secolo IV, RendPontAcc, XXVIII, 1954 and 1955, pp. 63–73; W. Westermann, The Slave Systems of Greek and Roman Antiquity, Philadelphia, 1955; I. Calabi Limentani, Studi sulla società romana: Il lavoro artistico, Milan, 1958.

Middle Ages: a. *General works*: E. Boileau, Livre des métiers (ca. 1271), ed. G. P. Depping (Coll. des doc. inédits sur l'histoire de la France, LV), Paris, 1837; H. Geraud, Paris sous Philippe-le-Bel, Paris, 1837; J. J. Champollion-Figeac, Documents paléographiques relatifs à l'histoire de beaux-arts et des belles-lettres pendant le Moyen-âge, Paris, 1868; J. Labarte, Histoire des arts industriels au Moyen âge et à l'époque de la Renaissance, 2d ed., 3 vols., Paris, 1872–75; G. Fagniez, Études sur l'industrie et la classe industrielle à Paris au XIIIe et XIVe siècle, Paris, 1877; R. de Lespinasse and F. Bonnardot, ed., Le Livre des métiers d'Étienne Boileau, Paris, 1879; A. Franklin, Les corporations ouvrières de Paris du XIIe au XVIIIe siècle: Histoire, statuts, armoiries d'après de documents originaux ou inedits, Paris, 1884; G. Gonetta, Bibliografia statuaria delle corporazioni d'arti e mestieri

in Italia con saggio della bibliografia estera, Rome, 1891; E. Rodocanachi, Les corporations ouvrières à Rome, Paris, 1894; G. Monticolo, I capitolari delle arti veneziane, 3 vols., Rome, 1896–1914; A. Doren, Entwicklung und Organisation der florentiner Zünfte im 13. und 14. Jahrhundert, Leipzig, 1897; L. M. Hartmann, Zur Geschichte der Zünfte im frühen Mittelalter, Gotha, 1904; A. Stöckle, Spätrömische und byzantinische Zünfte, Leipzig, 1911; C. E. Ferri, Le antiche corporazioni italiane di mestiere, Milan, 1929; D. Knoop and G. P. Jones, The Medieval Mason, Manchester, 1933 (repr. 1949); G. M. Monti, Le corporazioni nell'evo antico e nell'alto medio evo, Bari, 1934; G. Mickwitz, Kartellfunktionen der Zünfte und ihre Bedeutung für die Entstehung des Zunftwesens, Helsinki, 1936; P. S. Leicht, Corporazioni romane e arti medievali, Turin, 1937; M. Wackernagel, Der Lebensraum des Künstlers in der florentinischen Renaissance, Leipzig, 1938; H. Pirenne, Les villes et les institutions urbaines, 4th ed., 2 vols., Paris, 1939; P. Koelner, Basler Zunftherrlichkeit, Basel, 1942; P. Charanis, Social Structure of the Later Roman Empire, Byzantion, XVII, 1944 and 1945, pp. 39–57; F. Antal, Florentine Painting and Its Social Background, London, 1948; A. Hauser, The Social History of Art (Eng. trans., S. Godman), 2 vols., London, New York, 1951; L. Mumford, Art and Technics, New York, 1952; L. F. Salzman, Building in England down to 1540, Oxford, 1952; A. P. Kazhdan, Tsekhi i gosudarstvennye masterskie v Konstantinopole v IX–X vv. (The Arts and Imperial Workshops in Constantinople during the 9th and 10th Centuries), Vizantiiskii Vremennik, VI, 1953, pp. 131–55; I. M. Kulisher, Storia economica del Medioevo e dell'età moderna (It. trans., G. Böhm, ed. G. Luzzatto), 2 vols., Florence, 1955; Schlosser, pp. 43–49; F. Dölger, Die frühbyzantinische und byzantinische beeinflusste Stadt: V–VIII Jahrhundert, Atti dei III Cong. int. di s. sull'alto Medioevo, Spoleto, 1959, pp. 91–100; J. Gimpel, Les bâtisseurs de cathédrales, Paris, 1959 (Eng. trans., C. F. Barnes, New York, 1961); R. Assunto, La critica d'arte nel pensiero medioevale, Milan, 1961. b. *Individual arts*: 1. *Architects and masons*: E. Tucher, Baumeisterbuch der Stadt Nürnberg (1464–1475) (ed. F. von Weech and M. Lexer), Stuttgart, 1862; H. Stein, Les architectes des cathédrales gothiques, Paris, 1909; E. Lefèvre-Pontalis, Répertoire des architectes, maçons, sculpteurs, charpentiers et ouvriers français au XIe et au XIIe siècle, B. monumental, LXXV, 1911, pp. 423–68; V. Mortet and P. Deschamps, Recueil de textes relatifs à l'histoire de l'architecture et à la condition des architectes en France au moyen âge, 2 vols., Paris, 1911–29; D. Knoop, G. P. Jones and D. Hamer, The Two Earliest Masonic Manuscripts, Manchester, 1938; G. P. Bognetti, Gli Antelami e la carpenteria di guerra, in Munera: Racc. di scritti in onore di A. Giussani, Milan, 1944, pp. 217–24; F. Frankl, The Secrets of the Medieval Masons, AB, XXVII, 1945, pp. 46–60; D. Knoop and G. P. Jones, The Genesis of Freemasonry, Manchester, 1948; P. Du Colombier, Les chantiers des cathédrales, Paris, 1953. 2. *The magistri comacini*: Regum Langobardorum leges de structoribus quas C. Baudius de Wesme primo edebat, Carolus Promis commentariis auxit, secundum editionem Augustae Taurinorum repetendos curavit J. F. Neigebauer, Munich, 1853; L. Marzari, I maestri comacini: 600–1800, 2 vols., Milan, 1893; U. Monneret de Villard, L'organizzazione industriale nell'Italia longobarda durante l'alto Medioevo, Arch. storico lombardo, XLVI, 1919, pp. 1–83 at 24; U. Monneret de Villard, Note sul memorato dei maestri comacini, Arch. storico lombardo, XLVII, 1920, pp. 1–161. 3. *Painters*: F. Baldinucci, Notizie dei professori del disegno, secolo II, decennale V, Florence, 1686 (Statuto of the Florentine painters); Il Breve dell'arte dei pittori senesi, in G. Milanesi, Documenti per la storia dell'arte senese, I, Siena, 1854, pp. 1–56; F. Odorici, Dello spirito di associazione di alcune città lombarde, ASI, N. S., XI, 1860, pp. 73–108 at 99 (Statuto di Cremona, 1470); F. Odorici, Lo Statuto della fraglia dei pittori di Padova del 1441, Arch. veneto, VII, 1874, pp. 327–51, VIII, 1874, pp. 117–33; M. Pangerl and A. Woltmann, Das Buch der Malerzege in Prag, Quellenschriften für Kg. und Kunsttechnik, XIII, Vienna, 1878; E. Müntz, Les arts à la cour des Papes, III, Paris, 1882 (Statuto of Rome); P. Molmenti, ed., Lo statuto dei pittori veneziani nel secolo XV, Venice, 1884; G. Monticolo, Il capitolare dell'arte dei pittori a Venezia, N. arch. veneto, II, 1891, pp. 321–56; A. Gaudenzi, Le Società delle arti in Bologna nel secolo XIII: i loro statuti e le loro matricole, Rome, 1898; U. Procacci, Di Jacopo di Antonio e delle Compagnie di pittori del Corso degli Adimari nel XV secolo, RArte, XXXV, 1961, pp. 3–70. 4. *Goldsmiths*: F. Odorici, Dello spirito di associazione di alcune città lombarda, ASI, N. S., XI, 1860, pp. 73–108 at 95 (Statuto of the Venetian goldsmiths, 1233); M. Dello Russo, Breve dell'arte degli orafi senesi, Naples, 1870; S. Varni, Appunti artistici sopra Levanto, Genoa, 1870 (Genoese goldsmiths' Statuti of 1248); J. Stockbauer, Die Nürnberger Goldschmiede-Ordnungen, Vierteljahrsschrift für Volkswirtschaft, LXX, 1881, pp. 94–121; N. Menčik, Pořádek bratrstva zlatnického v Praze a jeho stanovy z roku 1324 (The Goldsmith Brotherhood in Prague and Their Constitutions of 1324), Sb. der böhmischen Gesellschaft der Wissenschaften, 1891, pp. 257–79; F. Migliaccio, Il primo statuto per la nobile arte degli orefici, Arch. storico campano, II, 1893, pp. 397–418. 5. *Stonemasons* (see also *Architects and masons*): J. Neuwirth, Satzungen des Regensburger Steinmetzvereins von 1459, Vienna, 1888; H. Voltellini, Die Ordnungen der Wiener Bauhütte, Mnbl. des Vereins für Geschichte der Stadt Wien, VII, 42, 1925, pp. 60–64. 6. *Weavers*: J. A. Deville, Recueil des documents et statuts relatifs à la compagnie des tapissiers, 1258–1875, Paris, 1876 7. *Mosaic workers*: G. Bovini, Origine e tecnica del mosaico parietale paleocristiano, Felix Ravenna, 3d ser., 14, 1954, pp. 5–21; G. Volpe and others, La vita medievale italiana nella miniatura, Rome, 1960.

Modern period: academies, schools, and institutes: R. Alberti, Origine e progresso dell'Accademia del disegno de' pittori, scultori ed architetti di Roma . . ., Pavia, 1604; Capitoli dell'Accademia della Pittura, Verona, 1766; Stiftungsbrief und Gesetze der Hanauischen Zeichnung-Akademie, Hanau, 1774; C. F. Prange, Entwurf einer Akademie der bildenden Kunst, 2 vols., Halle, 1778; Redevoering bij de invijiding der nieuwe teekenzaal te Utrecht, Utrecht, 1778; Estatutos de la Real Academia de San Carlos de Nueva España, Mexico City, 1785; Histoire en inrichting der Koninklijken Akademie van Teeken-, Schilder en Bouwkunden, Ghent, 1794; F. Tonelli, Compendio storico letterario intorno alla R. Mantovana Accademia, Verona, 1801; R. van Eijnden and A. van der Willigen, Geschiedenis der vaderlandsche schilderkunst, 3 vols., Haarlem, 1816–40; K. F. Stark, Das Städelsche Kunstinstitut in Frankfurt am Main, Frankfurt, 1819; M. Missirini, Memorie per servire alla storia della Romana Accademia di San Luca fino alla morte di A. Canova, Rome, 1823; M. J. Girardin, Discours d'ouverture, Précis analytique des travaux de l'Académie Royale des Sciences, Belles-Lettres et Arts de Rouen, 1841, pp. 1–13; A. Pinchart, Recherches sur l'histoire et les médailles des Académie et des Ecoles de Dessin . . . en Belgique, Rev. numismatique belge, IV, 1848, pp. 184–275; A.-L. Paris, L'Ecole de Reims et le Musée, Reims, 1849; M. Staglieno, Memorie e documenti sulla Accademia Ligustica di Belle Arti, Genoa, 1862; F. J. van den Branden, Geschiedenis der Academie van Antwerpen, Kermisfeesten, Antwerp, 1864; M. Wiessner, Die Akademie der bildenden Kunst zu Dresden, Dresden, 1864; J. Caveda, Memorias para la historja de la R. Academia de S. Fernando, Madrid, 1867; E. Ridolfi, Relazione storica sul R. Istituto di Belle Arti in Lucca, Lucca, 1872; F. Asioli, Relazione sulla R. Accademia di Belle Arti in Modena, Modena, 1873; C. F. Biscarra, Relazione storica intorno alla R. Accademia Albertina di Belle Arti in Torino, Turin, 1873; A. Caimi, L'Accademia di Belle Arti in Milano, Milan, 1873; J. Cavallucci, Notizie storiche intorno alla R. Accademia di Belle Arti in Firenze, Florence, 1873; A. Dall'Acqua Giusti, L'Accademia di Venezia, Venice, 1873; P. Martini, La R. Accademia parmense di Belle Arti, Parma, 1873; Gli Istituti scientifici, letterari ed artistici di Milano, Memorie a cura della Soc. storica lombarda, Milan, 1880; K. Wörmann, Zur Geschichte der Düsseldorfer Kunst Akademie, Düsseldorf, 1880; J. Garnier, Notice sur l'École National des Beaux-Arts de Dijon, Dijon, 1881; L. Nieper, Die Königliche Kunst Akademie in Persner Kunstgewerbe Schule in Leipzig, Leipzig, 1881; A. Ferrarini, Origine e progressi della Scuola parmigiana di belle arti, Parma, 1882; J. Hasselblatt, Historische Überblick der Entwicklung der Kaiserlichen Russischen Akademie der Kunst in St. Petersburg, St. Petersburg, 1886; L. Looström, Den svenska Konstakademien, Stockholm, 1887; H. Delaborde, L'Académie des Beaux-Arts, Paris, 1891; H. Omont, Documents relatifs à l'établissement de l'Académie de sculpture et de peinture de Toulouse, Ann. du Midi, IV, 1892, pp. 542–56; A. Gatti, Notizie storiche intorno alla R. Accademia di Belle Arti in Bologna, Bologna, 1896; H. Müller, Die Königliche Akademie der Kunst zu Berlin, Berlin, 1896; Z. Montesperelli, Brevi cenni storici sulla Accademia di Belle Arti di Perugia, Perugia, 1899; A. Borzelli, L'Accademia del Disegno a Napoli, Napoli nobilissima, IX, 1900, pp. 71–76, 110, 111, 141–43, X, 1901, pp. 1–5, 22–26, 53–56, 105–07, 124–26, 138–41; V. Ernst, Die Kunstschule in Zürich, Zürich, 1900; J. A. Beringer, Geschichte der Mannheimer Zeichnungsakademie, Strasbourg, 1902; I. Valetta, L'Académie de France à Rome, Turin, 1903; F. Meldahl and P. Johansen, Det Kongelige Akademi for de Skønne Kunster, Copenhagen, 1904; A. von Ochelhäuser, Geschichte der Grossherzoglichen Badischen Akademie der bildenden Kunst, Karlsruhe, 1904; J. E. Hodgson and F. A. Easton, The Royal Academy and Its Members, London, 1905; C. R. Ashbee, Craftsmanship in Competitive Industry, Camden, 1908; H. Knackfuss, Geschichte der Königlichen Kunst Akademie zu Kassel, Cassel, 1908; E. von Steier, Die Königliche Akademie der bildenden Kunst zu München, Munich, 1909; E. K. Chambers, Report of the Departmental Committee on the Royal College of Art, London, 1911; H. T. Wood, A History of the Royal Society of Arts, London, 1913; H. Muthesius, F. Naumann and H. van de Velde, Die Werkbund-Arbeit der Zukunft, Jena, 1914; M. Dreger, Die Kaiserliche Königliche Akademie der bildenden Kunst in Wien in den Jahren 1892–1917, Vienna, 1917; W. D. McKay, A Historical Narrative, in The Royal Scottish Academy (ed. F. Rinder), Glasgow, 1917, pp. xxxi–cxxi; Almanach Akademie Výtvarných Umění v Praze, Prague, 1926; M. Maylender, Storia delle Accademie d'Italia, 5 vols., Bologna, 1926–30; League of Nations, La coopération intellectuelle et les beaux-arts (Cah. des relations artistiques, I), Paris, 1927; A. Abbott, Trade Schools on the Continent, London, 1932; J. P. Alaux, L'Académie de France à Rome, 2 vols., Paris, 1933; T. Munro, The Educational Functions of an Art Museum, B. Cleve. Mus. of Art, XX, 1933, pp. 141–46; E. M. O'R. Dickey and W. M. Keesy, Industry and Art Education on the Continent, London, 1934; N. Pevsner, Post War Tendencies in German Art Schools, J. of the Royal Soc. of Art, LXXXIV, 1935–36, pp. 248–62; F. A. Taylor, Art Training for Industry on the Continent, J. of the Royal Soc. of Art, LXXXIV, 1935 and 1936, pp. 64–87; N. Pevsner, An Enquiry into Industrial Art in England, Cambridge, New York, 1937; Ministero dell'Educazione Nazionale, Accademie e Istituti di cultura: cenni storici, Rome, 1938; J. H. Plantenga, De Academie van 's-Gravenhage en haar plaats in de kunst van ons land, The Hague, 1938; T. R. Adam, The Museum and Popular Culture, New York, 1939; F. Magi, Per la storia della Pontificia Accademia Romana di Archeologia, RendPontAcc, XVI, 1940, pp. 113–30; N. Pevsner, Academies of Art Past and Present, Cambridge, 1942; V. Golzio, Il R. Museo artistico industriale di Roma, Florence, 1942; T. Low, The Museum as a Social Instrument, New York, 1942; L. Powel, The Art Museum Comes to the School, New York, 1944; P. B. Cott, Museum Trends: Facilities for Study and Research, Art in America, XXXIV, 1946, pp. 207–12; W. M. Milliken, Museum Trends: The Museum as a Community Center, Art in America, XXXIV, 1946, pp. 221–26; G. L. Morley, Museum Trends: Exhibitions, Art in America, XXXIV, 1946, pp. 195–206; T. Munro, School Instruction in Art, Rev. of Educational Research, XVI, 1946, pp. 161–81; D. Mahon, Studies in Seicento Art and Theory, London, 1947; C. E. Slatkin, Aims and Methods in Museum Education, College Art J., VII, 1947, pp. 28–33; W. Pach, The Art Museum in America, New York, 1948; T. Munro, The Arts in General Education, Arts and Education, I, 1949, pp. 6–14; A. C. Ritchie and others, The Museum as an Educational Institution, College Art J., VIII, 1949, pp. 178–202; A. Chastel, L'École du Jardin de S. Marc, S. Vasariani, Florence, 1950; G. C. Argan, Walter Gropius e la Bauhaus, Turin, 1951; G. Rickey and others, The Training of the Artist in Colleges and Art Schools: A Symposium, College Art J., XIII, 1953, pp. 25–35; Mi-

nistero della Pubblica Istruzione, Ordinamenti delle Accademie e degli Istituzioni di cultura, Rome, 1956; A. Pica, Storia della Triennale di Milano, Milan, 1957; E. Crispolti, Premesse storiche dell'industrial design, Civiltà delle macchine, VI, 1958.

China: S. Tani, Origin and Growth of the Academy in China, Kokka, 274, 1915; Y. Yonezawa, The Origin of the Hua-yüan or Art Academy in the T'ang Dynasty of China, Kokka, 554, 1937, pp. 3-9; A. Wenley, A Note on the So-Called Sung Academy of Painting, HJAS, VI, 1941, pp. 269-72.

Inventories of institutes, organizations, and societies: American Art Directory, New York, 1961; E. O. Christensen, ed., Museums Directory of the United States and Canada, Washington, D.C., 1961; International Directory of Arts, 6th ed., Berlin, 1961; The World of Learning, 13th ed., London, 1963.

INTERIOR DECORATION AND DESIGN. The art of interior decoration is fundamentally different from that of architecture (q.v.), for its problem is not the definition of interior spaces but their adaptation to human needs. To make this adaptation artistically it is necessary to consider the relationship between the room's decoration and its furnishings as well as the whole visual effect. In this respect, the art of interior decoration includes the art of furnishing but should be treated separately from such individual elements as furniture, household objects, and tapestry and carpets (qq.v.). Interior design directly and effectively reflects the taste of an epoch, a culture, a social group (even mirroring a tradition of a particular family), or of personal predilection. Although conservative in primitive societies and at the folk level, it changes rapidly, almost as swiftly as fashion, in more evolved civilizations. In some famous historic and public buildings, such as palaces and churches, interior design assumes a monumental role, and its history and development are recorded together with that of architecture.

SUMMARY. The art of interior decoration and its relation to architecture and furnishings (col. 183): *Structural and functional elements. The formal definition of interior space. The relationship to furnishings. Design.* Historical development (col. 189): *Primitive interiors. Antiquity. The West. The East: a. The Iranian, Indian and Islamic world; b. China; c. Japan. Modern interiors.*

THE ART OF INTERIOR DECORATION AND ITS RELATION TO ARCHITECTURE AND FURNISHINGS. Because it echoes concepts not only of nature but also of life and social customs, the treatment of interior space differs greatly from civilization to civilization, and, within each civilization, from place to place and from class to class. Interior spaces are to a certain extent planned, arranged, and articulated at the moment of architectural conception. Except in very important buildings designed for public functions, the final determination and formal modification of interior spaces depends in large part upon the initiative and taste of the craftsmen — the cabinetmakers and stuccoworkers, for example — and upon the users themselves. In most cases the interior space reflects, in its formal configuration, the general attitudes and ideas concerning the space outside. This is true whether the limits of the space enclosed are enlarged by creation of a relationship between interior and exterior space, or whether there is an attempt to eliminate all apparent connection between them, thereby emphasizing the seclusion and privacy of an enclosed space. It must be noted, however, that while creation of such a relationship is often explicitly attempted or avoided in the actual construction of the buildings, in many cases it is produced, completely or in part, by psychological means and at times even by optical illusion. As a result, the outside space, observed as part of the space inside, is regarded not objectively but as space seen or imagined by a person within the room; even if the view of the outside is constantly seen from within, it is effective only in that it appears beyond the wall, inscribed inside the geometric form of a window, like a picture within its frame.

Unless the area concerned is to be set apart from worldly contact for ritual or functional reasons — as, for example, a tomb — the architectural designing of an interior almost always presents the same problem, which can be separated into the following aspects: (a) the determination of size and proportion, (b) exposure (ventilation, insulation, etc.), (c) functional distribution and articulation of the rooms, and (d) definition of form. Since the first three of these aspects are treated in the articles on TOWN PLANNING, ARCHITECTURE, and STRUCTURAL TYPES AND METHODS, the discussion here will be limited to the last.

Within the subject of enclosed space, or inhabited architecture, a distinction should be made between (1) functional aspects, in so far as they determine the size, the proportions, the distribution of rooms and their form, and (2) decorative aspects, in so far as these are conditioned by function, even though some elements may fall into both categories. Included in the first category — the functional aspects — are all the structural elements, whether their purpose is to delimit or to support, that receive formal definition in the interior (such as walls, piers, and columns); elements of communication between interior and exterior space (such as doors and windows); interior structural elements meant to subdivide the interior space or to determine, within the room, areas assigned to different functions; and elements that articulate or connect (such as stairs and corridors). Into the second category — the decorative aspects — fall elements of architectural decoration, hangings and wallpapers of various types, furnishings, furniture, and household objects.

Structural and functional elements. An essential factor in the shaping and determination of interior space is the treatment of the defining planes, or more specifically, the building plan. The structural plan is important not only because it pertains to the distribution of supports bearing the building's weight and the effective use of spaces for their specific purposes, but also because it is the essential agent in determining the size, proportions, modulation, and design of the space. However, the spatial limits of the plan may be integrated and modified by accessory elements, such as partitions, fixed and mobile dividing walls, screens, hangings, railings, balustrades, and by surface decoration.

Structural elements, even if common to both the exterior and interior of a building, generally have a different appearance inside, where material and ornamental forms are more delicate and more suitable for close viewing. Not uncommonly such elements assume symbolic significance, at times intentional, at other times unconscious. Illustrating intentional design is the decoration of domes with figures alluding to the heavens (in the physical, cosmological, astrological, or religious sense) and the decoration of columns and piers so as to suggest that they are supports not only of the physical building but also of the building as an idea, a spiritual construction. Less meaningful or even unconscious is the mental association of the wall with the horizon — a basic theme in wall decoration, though diversely expressed in different times and cultures.

Interior space in its actual or imaginary relationship to the outside is determined by the necessity for shelter from the elements and for the protection of property, the need for privacy, and the possibility of modifying this relationship according to circumstances. The size of openings to the outside and of such protective and screening devices as gratings, railings, shutters, blinds, and transparent or opaque curtains, is also governed by these factors. Besides serving a decorative function, achieved largely through the effects of transparency and diffusion of light, these devices affect the character of the ensemble, since they determine conditions of illumination. Doors, as building entrances, have symbolic and ritual significance, emphasized by the kind of decorative motifs used (often the permanent, stylized versions of ornaments first placed there on solemn or festive occasions); interior doors between rooms also retain a decorative character, frequently augmented by the use of frames of special materials, drapes, and especially by ornamentation of the doors themselves, which are often painted, carved, or inlaid. Molding, acting as surface delimitation or connection, is an element of caesura and of plastic unity; its function is fulfilled even when the molding is reduced to a mere painted trimming and becomes

intensified when contact with openings (such as doors and windows) is made. The architecture of the Renaissance reveals full awareness of — almost to the extent of theorization about — this function of articulating the relation between surface and void, for the molding of that period is clearly a plastic and spatial entity which establishes the perspective of openings in relation to walls. This may help to explain why the decoration of doors and windows, since the Renaissance, emphasizes perspective, as if to suggest the deep space beyond the closed door by the decoration on its surface.

Another functional element frequently developed for its great decorative value is the stairway. Structurally, its rapidly diminishing perspective presents a view that adds an element of variety to the building, in the context of more stable views. Decoratively, there often develops a complex idiom, generally based upon suggestions of perspectival recession or upon effects of movement.

The arrangement and decoration of interior spaces is particularly important in the areas for special family or social functions such as eating, receiving guests, worship, and study. The *studioli* of the Renaissance (PLS. 100, 103) and the boudoirs of the 18th century (PL. 108) are typical examples of rooms whose decoration alludes to or comments on their particular function. Areas and objects which are directly or indirectly considered symbolic because of their importance in social and family functions (their significance indicated by their shape or placement) include fireplaces and large, decorated, built-in stoves, and the bedroom and bed, which is often raised on a platform, isolated by curtains or a balustrade, or placed in an alcove (PLS. 100, 104, 108, 109). The placement, almost always permanent, of such objects in a room constitutes an important factor in the organization of space, which is also affected to a great extent by the interrelationship, sometimes preplanned, of the principal pieces of furniture.

The general shape of some interiors is linked, through practical necessity or by custom, with their specific functions; for example, the need to obtain a perfect and uniform transmission of sound and to permit the convergence of all lines of vision on a given point determines the form of the spatial cavity in theaters (PL. 106) and auditoriums (see ACOUSTICS) and in certain types of religious and public buildings. A more direct structural relationship between interior and exterior is established when the interior of an edifice is not subdivided, or when one space clearly predominates over other accessory spaces because of the public character of the building's functions, as in the case of churches, theaters, and government buildings. In these interiors the furnishings are generally determined directly by the architecture or are integral parts of it. Special planning for a specific type of building is also found in modern structures such as stations, offices, factories, and laboratories, in which function dictates unusual forms, offering extraordinary opportunities for the architect's imagination.

The interior furnishings of some vehicles, such as carriages and ships, are derived from those used in buildings. The need to concentrate equipment and furnishings within a small area and to protect them during movement, plus the use of materials such as wood and metal instead of masonry, endow these interiors with a special character and style of their own. These qualities are in turn reflected in architecture, which has been known to imitate, for example, the wooden stairs, galleries, and furnishings of a ship. Northern countries, especially the Netherlands, occasionally utilize such motifs in city dwellings and lodging houses.

The interior design and decoration of modern vehicles such as trains, ships, planes, and submarines becomes ever more difficult because of the specialized problems involved. The solutions — which may involve opening, reducing, or eliminating apertures, increasing or reducing the visible exterior, outfitting the space normally or eliminating the usual furnishings — are sometimes quite different from those developed for houses. Because it is completely bound up with technical, functional, and industrial problems, the structure and furnishing of such interiors has generally become the province of industrial design (q.v.).

The formal definition of interior space. The demarcation of interior space in architectural design is determined by a combination of factors, besides structure and function, that vary considerably according to culture and period but reflect, to a great degree, the relationship of the individual to his natural and social environment. This relationship can be expressed through various sculptural and pictorial techniques and materials and can be classified according to the use and type of delimiting surface involved: wall, ceiling, or floor.

Apart from being flat, curved, or, more rarely, irregular (its structural treatment dictated by the ground plan), the wall is normally a surface which can be embellished by descriptive or ornamental decoration executed in fresco or in stucco, or by objects attached to it, such as hangings, tapestries, paintings, reliefs, wallpaper, trophies, weapons, or arms. Wall decoration generally tends to create either of two effects: an illusory expansion toward outside space, canceling, so to speak, the limitation of the wall; or, quite the opposite, spatial segregation by accentuating that limit. In either case, there is usually an attempt to create a logical relationship between the structure and the wall decoration, achieved either by means of actual or simulated architectural supports and joints or by dividing the surface of the wall into variously proportioned and combined areas.

In producing the first effect — illusionistic expansion beyond the wall — the representational elements are the usual ones for simulating space: bands, cornices, or simple frames imitate in a more or less conventional manner an opening in the wall, beyond which appears further space — which may be architectural, naturalistic, or imaginary — with or without representation of figures. Sometimes one room seems to be followed by other, entirely imaginary rooms, set in perspective and often depicted full of people. In modern design, the wall is frequently covered with mirrors that seem to do away with the wall by reflecting the space within the room. Occasionally the illusion is carried to the point of simulating a completely different environment from the actual one. For example, a closed room may be transformed, by use of naturalistic decoration, into an open setting, a garden, a wood, or an arbor. The architectural design of the actual room may also be transformed by creating views into space or by using the artificial perspectives of theatrical scenography. Even when they are not meant to create the illusion of another environment, the most common ornamental motifs, predominantly geometric or floral in pattern, allude, sometimes only indirectly through stylized forms, to the fundamental contrast existing between architecture and nature. One of the most interesting features of wall decoration is the spectacular display of the imaginary and the inventiveness with which it is represented, making illusion almost an end in itself. Painting not only can simulate marble, wood, and textiles, and suggest landscapes and fantastic scenes, but can even imitate in chiaroscuro works of art made in other media, such as reliefs, statuary, and tapestries. There are even descriptions by ancient writers, both Western and Eastern, which emphasize the importance of the illusory artifice that, revealing itself as such, excites admiration but simultaneously destroys the efficacy of the illusion.

A particular type of wall decoration that is important because of the number and quality of examples of it and because it occurs in almost all cultures, is the large mural scene, often executed by the greatest masters. Because of their fixed position or by means of actual or simulated architectural forms, these representations are bound to the interior space of a building; although viewed naturalistically, they are not intended as illusory devices but as representations of religious, historical, secular, mythological, or commemorative scenes. Despite the fact that these depictions may be conceived as fantastic apparitions, as fictitious narrative, or as simple scenery, they are meant to edify and to instruct. The association of such representations with architectural space is of interest because this space is thought of as idealized, as a place in which miraculous and edifying events may be seen. The very fact that a fresco occasionally simulates a panel or relief confirms its character as an ideal representation in ideal space.

At the opposite extreme is spatial definition of walls without the use of representational elements. This category includes walls flatly painted in one color and with extremely stylized figural elements or with none at all, as well as modern wallpapers and wall paints whose rough texture, intricacy of design, and interlacing of lines and colors help to suggest a more or less definitive space that destroys the rigid limit of the wall and the visual impenetrability of the surface.

Accentuation of spatial delimitation, especially desirable for endowing small rooms with a character of intimacy or isolation, is obtained largely by using heavy ornamentation and drapery or facing that invites close inspection of the precious materials and fine workmanship involved. While the decoration of a large space normally has some connection with the architecture, or at least enters partly into the planning of a building, the decoration of a small space allows for better use of the various minor arts and is more immediately influenced by fashion, often because of the direct intervention of the client.

More than any other element within a room, the ceiling retains obvious traces of its architectural structure; not only are the vault and the dome undisguised structural forms, but even a flat ceiling often manifests more or less openly, at times by simulation, the structure of its beams. Great variety exists in the modes of spatial representation on ceilings. There is a kind of spatial reversal in certain Etruscan tombs that show the ceiling decorated with the tiles and the climbing plants that would ordinarily be visible on the roof outside. Classical coffered domes, so widely used, create effects of upward perspective movement. Almost inverting such an effect are Islamic stalactite ceilings, which hang down to fill the room space. Finally, the illusionistic decoration of Renaissance and baroque vaults frequently extends the architectural space of the room upward toward an imaginary opening to the sky. The tendency to cancel the ceiling entirely prevails over the opposite tendency, to weigh down and intrude upon room space; a culmination point of the trend to extend the ceiling is reached in baroque vaults that seem to pierce through the roof to reveal the heavens and their glories (PL. 105), almost transforming the interior of the architectural structure into an ideal space directly communicating with the metaphysical space of the paradise beyond.

No less complex is the treatment of the base level or floor, though the implicit reference to the ground generally renders any perspectival allusion to depth inappropriate. The technical and functional requirements — themselves a rather broad area of consideration — occasion the use of all manner of materials and techniques, ranging from marble slabs to inlays of colored marble, from brick work (recalling the primitive flooring of beaten earth) to ceramic tiles, and from mosaic to wood variously worked. In the spatial composition of a room, the floor is in direct relationship to the ceiling, often repeating or freely varying in its configurations the ceiling's structure. Moreover, whether they follow a rhythmic or a linear, perspective sequence, the divisions of the flooring can compress or expand the movement of spatial recession and thus even alter the apparent size of a room.

Psychologically, the floor is best rendered as a level plane and therefore is commonly decorated with geometric ornamentation and motifs, such as meanders and palmettes, that are strongly stylized and repetitive, but naturalistic elements (floral patterns suggesting a garden, for example) are also frequently used. Designs colored and stylized so as to suggest carpets are not uncommon, for carpets are a natural complement to the floor and, especially in Islamic countries, constitute its essential decoration. The need to retain the level appearance of the floor prevents the development of extensive narrative and naturalistic representation in floor decoration. This type of embellishment is also impractical because the floor can be seen only at close range and from a single point of view, which excludes any view of the whole and presupposes that the spectator moves on the same plane as the representation. Hence, floor decoration is generally limited to representations that are divisible (even though linked and continuous), limited in area, and usually enclosed within rectangular or round borders, and tends to have a symbolic or emblematic rather than narrative theme.

The relationship to furnishings. Fixed furnishings are an important element in the determination of interior space. Regardless of the material, which varies according to use, period, or culture, furnishings that are an integral part of the interior — for example, shelving and cabinets in libraries; choir screens, confessionals, stalls, and singers' galleries in churches; and shelving, cabinets, and partitions in modern homes and offices — are either absorbed into the architectural concept of the building, or, occasionally, made part of a scheme that is intentionally decorative. They are even at times designed to assume a predominant role in the entire spatial definition of the interior, as in many German and Italian baroque libraries, and in sacristies, where the walls are almost entirely covered by tall cabinets that are treated as an integral part of the architecture. Occasionally, fixed furnishings used for religions purposes, such as choir screens, cathedras (or episcopal chairs), and pulpits, become the center of interest within the place of worship, a significant interruption in the perspective of the nave; furnishings decorated with inlay work in Early Christian basilicas and with Cosmati work in medieval churches provide examples. At other times, such furnishings assume symbolic significance, as in the Old Sacristy of S. Lorenzo, in Florence, where a marble table in the center of the room emphasizes the geometric rhythm woven into the entire architectural composition. Common to both medieval and Renaissance interior decoration were wooden high-backed seats, set against walls, that served as benches, chests, and stalls. These marked off a clear division of the space into two parts, one area meant for use and another for mural decoration. Today fixed furnishings are usually considered part of the total design of the entire structure and, with the disappearance of the wall as a dividing member, these furnishings themselves become necessary elements in the subdivision of usable space, as, for example, dividers used in the home between living room and kitchen, entrance, or study, and partitions erected between the various parts of a modern office. At the same time an ever more limited role is assigned to mobile furnishings, which by their nature are less bound to the plan and structure of the building.

It is also true that the form which interior space at various times assumes has profoundly influenced the shape of furniture. Indeed, it would be possible to categorize all furniture according to two extremes: maximal or minimal occupation of interior space. In contrast to the light, inconspicuous furniture that fits appropriately into the clear, defined, and proportioned rooms of the Far East, the architectonic furniture of the Renaissance concretely occupies an interior space, assuming its lines and proportions, while the massive furniture of the baroque actually dominates its spatial environment. Modern furniture, on the other hand, tends to be linked with architecture because of the linear and structural character common to both; its design adheres primarily to function, secondary consideration being given to pure style and form, while the bright colors of its upholstery enliven the room. The modern concept of relating furniture to architecture evolved in part as a result of the progressive decline of craftsmanship and the parallel rise and development of industry; the standardized products of industry issue from a kind of planning that is akin to and consonant with that of architecture. The variety of furniture types is reduced to a few elements uniform in character, able to serve a wide variety of functions and to fit conveniently into the small interiors typical of modern buildings. Because of such standardization of furniture types, corresponding to a standardization of rooms, the participation of the user in arranging the interior space is decreased. This frustration of personal control is in part the cause of a misunderstood reevaluation of "period styles" that exists to a certain extent in modern society and an accompanying propensity for mixing styles and for antique collecting. Furniture from different periods is often combined, especially in the home, but it requires a well controlled creative imagination and a well oriented personal taste to obtain good results.

Design. The problem of consciously relating the actual architectural plan to the formal definition of interior spaces

is a relatively recent one. The traditional architecture of the Far East and especially of Japan, which emphasizes continuity between exterior and interior space, has supplied modern architects with a precedent to which they have willingly turned. In the West the first indications of a conscious, programmatic effort at formal definition of interior space are found in the 16th century, when Sebastiano Serlio studied architectural forms for fireplaces, doors, and other elements. This new interest continued to develop through the 18th century, especially in France, and by the beginning of the 19th century even the design of furniture, in keeping with the neoclassical principles of the Empire style, had developed a clearly architectural character (PL. 118).

Owing to such factors as the decline of craftsmanship, the transfer of furniture production to industry, and especially the new conception of architectural space, the approach to interior design has taken a decisive turn in the 20th century. The new conception completely eliminates the traditional distinction between a receptive space and the object contained within it, for it is founded on the principle of unlimited divisibility and, therefore, continuity of space (PL. 116).

The conscious distinction between exterior and interior accordingly loses all validity. In ever-increasing use are large window surfaces that almost completely destroy the wall and change the interior into a volume of light, establishing full equivalence and a virtual reciprocity of view between inside and outside. Even elements of light control tend to pass from the category of accessories to that of structure, as in the case of the *brise-soleil*. In turn, modern architectural practices, eliminating the carrying function of the wall, permit maximum flexibility of plan and hence the modification of interior spaces according to the practical needs of the inhabitants. On the one hand, there is a tendency to incorporate furnishings into the architecture, both through built-in elements (often provided for in the floor plan) and as a result of the progressive standardization of furniture through mass production. On the other hand, the adoption of functionality as the determining factor in the definition of form has led architects to concentrate their attention on interior space, which is no longer derived from the exterior structure, but itself now determines the entire structure. Consequently, the exterior becomes only a projection of the interior space, or a natural boundary to it.

<div style="text-align:right">Giulio Carlo ARGAN</div>

HISTORICAL DEVELOPMENT. *Primitive interiors.* Among prehistoric and primitive cultures there is no single criterion for the planning of the interior. While the structure of the interior is always conditioned by the external form and particularly by the degree of permanence of the dwelling, the interior decoration and design are determined primarily by economic factors, by social requirements, or by the symbolism characteristic of religious beliefs. Since these factors vary considerably from culture to culture, the amount of architectural elaboration and the richness of furnishings are equally varied. Furnishings are, moreover, often found only in an embryonic stage, and thus the analysis of primitive interiors tends to be confined to an examination of the architectural elements.

In some types of fixed habitation, especially in the long houses of the Salmon River Indians and the assembly houses and the men's houses in Micronesia and Melanesia, the architecture of the interior functionally predominates over the furnishings. Carved or painted posts and panels, decorated lofts, platforms running along the walls serving as bed niches, and benches are incorporated into the structure of the building or cut out of the walls; these complete or, more often, take the place of modest furnishings. However, in impermanent dwellings and particularly in tents, the plan and subdivision of interior space is not determined by the architectural structure or its fixed furnishings but by mobile elements such as mats, trellises, curtains, carpets, and skins, all occasionally decorated with great artistic imagination (PL. 91).

It would be impossible, generally, to discuss interior design if only the economic system of a particular people and the exter-

nal shape of their dwellings were considered, but an exception to the rule must be made in dealing with the rather simple dwellings of hunters and gatherers in tropical and subtropical regions. These are simple sheds or beehive structures in which the definition of the interior space is determined completely by the form of the external covering. The simplicity characteristic of these huts appears also in the dwellings of nomadic shepherds, whether the structure is a cabin that can be dismantled, as among the Teda of the Tibesti region, or a tent of more or less considerable size like those of the Tuaregs of the Sahara. Interior divisions are made by mats and coverings, and the furnishings consist of a few pallets placed on the ground and some utility objects. However, neither hunters of small game nor wandering shepherds seem ever to have produced art of great quality, though for different reasons: cultural poverty in one case and economic distress in the other (see PALEO-AFRICAN CULTURES).

The interiors found in agricultural societies and among hunters of big game and fishermen are more complex. Some primitive agricultural tribes live in large multifamily houses, such as the *malocas*, of the forest dwellers of the Amazon River. In these, partitioning of the interior space is a social necessity, but the partitions used are for the most part functional and lack artistic character. Other agricultural tribes, among them almost all the Bantu of central and southern Africa, the Melanesians, and the Maori of New Zealand (PL. 91), have architecturally simpler dwellings, but at least in some cases (the semi-Bantu of the Cross River and the Zulu of southern Africa) these have interior partitions with a certain degree of artistic refinement. Among the Maori, interiors, especially those in the houses of nobles and chiefs, are painted red and ornamented with elegant decorative motifs, predominantly of the stylized human figure, which bear a certain affinity to the decorations of the Haida of British Columbia. In contrast, the more highly civilized agricultural tribes in the Mexican-Andean zone evinced practically no interest in interior design, despite the impressiveness of their dwellings (which were fixed and sometimes made of masonry) and the advanced state of their other arts.

In some primitive societies religious factors are decisive in determining the structure of interiors. For example, there is often a close correspondence between complex partitioning of interiors and an elaborate concept of the universe. Among almost all primitive peoples the real and symbolic center of the house is the hearth, which at times even takes on a sacred character; among the Aztecs, for instance, the hearth was the symbol of the fire god. Elsewhere the same role of domestic center is performed by the central post supporting the roof. Among the Somali of Merca this post has particular cosmological significance, for they place at the top of it a wooden disk (IV, PL. 86) incised with motifs that, according to Leo Frobenius, symbolize the universe (see COSMOLOGY AND CARTOGRAPHY).

A more complex symbolism, involving both the interior and the exterior of a building, is found among the Dogon of the western Sudan region. The "great house" of a Dogon family represents an image of the primordial ancestral pair or of a man lying on his right side in an ithyphallic position, while various parts of the building are likened to different parts of the human body. Similar ideas are found among the Mossi of the Sudan and seem also to have inspired the complex structures found in Upper Volta, known as "castles" or "fortresses," in which the layout of the interior spaces, the decoration of the walls, the placement of the ceiling and door beams, and even the locks, are all determined by anthropological and cosmological conceptions. Among the Bantu of Rhodesia, doors, utensils, and furniture — what little there is of it — are decorated with female sexual symbols. A different symbolism prevails among the Pueblos of Arizona, whose kivas, the large circular or rectangular chambers used for public and religious ceremonies, are determined in form, structure, and decoration by the Pueblo belief that the entrance into the spirit world is located in these chambers.

<div style="text-align:right">* *</div>

Antiquity. While cabin and tent furnishings are rudimentary and to a great extent are an integral part of the very simple

structure, architecture in a more advanced state of development presents for the first time the problem of a distinction between architecture and furnishings, the latter understood as elements or objects added to the space which architecture isolates from the surrounding world for the purpose of making it practical, functional, and habitable.

In the fixed house made of masonry, which appeared in the entire Mediterranean basin during the pre-Hellenic period, the basic units, whether circular or rectangular in plan (see STRUCTURAL TYPES AND METHODS), were usually grouped about an area that served as the court or the square. Just as the square was the center of urban life, so the court was the center of the house, and the rooms served no other purpose than to provide a place for nightly rest and for protection from inclement weather. A small porch, which usually effected a transition between courtyard and rooms, served to filter the heat and light, an important function in the hot countries of the Mediterranean.

Examples of the oldest structures with interior articulations that might be classified as furnishings in the modern sense are found at Hattushash, the capital of the Hittite empire. These houses included mats, trellises, and a few objects that can be considered furniture, but what is more significant is that mats, skins, and textiles were hung between the supports of the interior to modify the bareness of the cell, adapting it to the necessities of life.

Egyptian houses and palaces, such as the palace at Tell el 'Amarna and the tomb or "labyrinth" of Amenemhet III (Herodotus, ii, 148), had rooms, courts, and gardens laid out in an axial arrangement that in itself relegated furnishings to a place of secondary importance. Formal elaboration of interiors was, moreover, confined to an ever richer ornamentation of ceilings, walls, and floors. Although this sumptuous decoration served to adorn the structural elements, it did not articulate or determine them, nor were the few furnishings intended to create a unified atmosphere; they were simply included as incidental items of use. The Pharaoh's throne constituted the sole exception, for it was placed so as always to be seen from the front, and its superabundance of ornament and complexity of structure made the throne the focal point of the room that contained it.

Similar characteristics were found in the Cretan palace, although the law of frontality was undeniably violated at times, as in the so-called "Throne Room" at Knossos (PL. 92). On the other hand, the placement of the hearth in the Mycenaean palace, which was organized around the megaron with the hearth at its center, relegated the throne to a position of minor importance, for the throne was placed against one of the room's long walls. Only in a later age, in temples that repeated the typical form of the megaron, was there a return to perfect axiality through placement of the god's image against the back wall opposite the entrance. In the Mycenaean palace the decoration of floors and especially of walls achieved effects of great splendor; there was a separation of ornament from structure, as seen in the great friezes of shields painted or hung on walls or in the thrones placed, often together with benches and similar furnishings, along the sides of the room. Four columns surrounding the hearth marked off a sacred enclosure to emphasize its determining function within the room. Hangings seem again to have served both as partitions within the space and as elements accenting the most important area or furnishing of the room. It was in the latter character, imbued with religious significance, that hangings passed into the classical and post-classical interior.

Another element transmitted by these early structures was the courtyard, which became, in the form of atrium and peristyle, the central space or introductory element in the articulation of the interior. The use of the interior court and the disposition of rooms around this court, as found particularly in the Roman house, was of great importance in the matter of furnishings. Each room was a unit in itself, opening not upon other rooms but generally upon such central spaces as the atrium and peristyle, and thus the interior decoration of each room was designed to be viewed directly from the central space of the court.

Concerning furnishings in the stricter sense (see FURNITURE), since only rarely and in few sites have any pieces been found in place, recourse must be had to funerary monuments for documen-

tation. Important for this purpose are the Etruscan Tomb of the Reliefs at Cerveteri (PL. 95) and the Roman sarcophagus from Simpelveld (J. H. Holwerda, "Romeinsche sarcophaag uit Simpelveld," IAE, XXXII, 1934, suppl., pp. 27–48). Since the function of the sarcophagus could have determined the arrangement of objects such as beds, chests, tables, and chairs along the sides to provide an empty central space for the body, the Cerveteri tomb affords a better indication of an original arrangement. The central space of the tomb is surrounded by cubicles with large klinai — beds — set in alcoves. Other pieces of furniture are distributed along the walls or set against the piers. Their placement undoubtedly mirrored faithfully the interior of a house, except that one important accessory is missing: the partitions and hangings that must have created smaller rooms within the spacious interior. Transennae, are documented archaeologically at Herculaneum. These movable screens, apparently not provided for in the construction of the building, created secondary rooms within the principal ones and isolated both space and furnishings in single smaller units. The furniture was placed along the walls, especially alongside doors and passageways, both for decorative effect and for emphasis on perspectival recession. Only a few small tables, fixed or movable, seem usually to have been placed in the center of the room as a focal point for directing attention to the symmetrical disposition of the other furnishings and decorative elements such as statues, reliefs, and inlay. Large objects such as beds were often put in an alcove that concealed their bulk, while the floor of the alcove was treated differently to underline its independence of the room.

The relative unimportance of furniture was compensated by abundant decoration of ceilings (PL. 96), walls, and floors with carved or painted ornamentation, with pictures, mosaics, figured inlays, or simple ornamental motifs. Among the Romans, wall painting with views, scenes, landscapes, and architecture (PL. 93) developed in a manner unknown to the Greeks, who articulated the wall with an endless series of minor variations of simulated marble incrustation. The lack of interest in furniture also helps to explain the development of great mosaic floor decorations, with and without figure motifs. Only hangings and wooden or marble screens, not bulky furniture, were placed against walls, for objects that blended with the wall's pictorial content were favored.

A similar emphasis on wall decoration existed in the late-antique period and in the Byzantine world, when even the nymphaea were represented as part of the interior decoration of the house, for they were depicted on the walls. The walls were also decorated with rich inlay work that disguised their structure or were pierced by many-apertured windows that permitted the outside world to enter the interior.

All the elements of Byzantine decoration, featuring wall hangings, side furniture, central throne, and axial arrangement of rooms, were carried over into the interiors of Christian places of worship. Arranged along the same axis as the area assigned to the faithful were the altar or martyrium (in churches or cathedrals built on a central plan) and the cathedra, altar, and choir (in churches with an elongated nave). Curtains closed the sanctuary from view at established moments in the liturgy. Other furnishings, if any, were set along the walls. Mosaics, inlay, and painting covered floors and walls.

Michelangelo CAGIANO DE AZEVEDO

The preceding section includes contributions by Giancarlo Ambrosetti.

The West. The period of decline in Europe following the dissolution of the Roman Empire caused a standstill in building construction and consequent retrogression in the development of interior design. Evidence dating back to the 6th and 7th centuries, the period of greatest disturbance in Europe, is too scanty and intermittent to permit any true reconstruction of interiors. It is known, however, that the barbarians for the most part restricted themselves to the easily transportable tent and that the settled population, engaged mainly in farming and pastoral activity, lived in wooden houses that had, occasionally, a masonry foundation and that consisted of a single room, probably

equipped only with a hearth. The house, then, like the tent, had a merely protective function.

Written sources, a few ivories, rare miniatures, and especially the remains of princely residences, permit some more exact deductions as regards the 8th and 9th centuries, a period when the Carolingian empire established itself in central Europe, laid down the foundations of the Holy Roman Empire, and gave initial impetus to the feudal system. Documents that refer only to the dwellings of the nobility can be supplemented by what is known about monastic establishments. From the latter the general aspect of the interiors of private homes can be deduced, since most of the monastery buildings were designated for housing, as can be seen, for example, in the 9th-century plan for the monastery of Saint-Gallen (see H. Reinhardt, *Der St. Galler Klosterplan*, Saint-Gallen, 1952). In contrast to the world of the monastery, life in the house of the feudal lord apparently took place primarily in one room — the main hall (corresponding roughly in function to the monastery's chapter room) which, according to the sources, had a simple rectangular plan and served not only for the reception of officials and for banquets, but also as a bedchamber of the lord. As seen in miniatures, heavy curtains closed off the bed on all four sides. In all probability a throne (III, PLS. 64, 68), or at least a chair of office, constituted the most notable piece of furniture. Cushions and precious silks decorated this seat and precious hangings probably covered the walls, which were otherwise cold and bare. Apparently there was a fondness for painted walls, as is indicated by the frescoes (now lost) of Charlemagne's palace at Aachen with scenes of war, by the murals representing the liberal arts and the seasons in the residence of Theodulf, bishop of Orléans, and by those of the imperial residence at Ingelheim, depicting figures, painted by order of Louis the Pious.

Splendor and color, evident even in church interiors, seem to have formed the dominant note in these rooms, but as a result the autonomous architectonic quality of the interior was weakened. That quality was better respected in monasteries, because of the asceticism inherent in monastic life. In these establishments different rooms were assigned for different aspects of daily life; besides the chapter room, there were also a refectory, one or more dormitories, and cells. Sobriety characterized the furnishings. Carolingian and Ottonian miniatures representing Evangelists in their studies (X, PL. 471) probably faithfully portray the interior of the cells (see FURNITURE).

The Byzantine world of the Middle Ages displayed particular lavishness in interior decoration. The 10th-century book of Constantine VII Porphyrogenitus, *De ceremoniis*, gives much information concerning the axial disposition of rooms, the placement of furniture, and the importance of the throne as a central focus, emphasized by the presence of hangings. The house of the Byzantine nobleman was apparently divided into numerous rooms, with a large reception room on the first or second floor, a porticoed façade, interior gardens, and baths. The proximity of the Orient undoubtedly influenced the formation of a taste for sumptuous interiors, a taste indulged also in religious edifices, where the predominance of decorative elements — first mosaics and later frescoes — indicates a tendency which ultimately led to the dissolution of the architectonic structure into light and color (I, PL. 411). Considering this development, it can be justly supposed that in the houses of the nobility mosaics were replaced by rich silks and damasks. The silken hanging that closes a doorway in the mosaic in S. Vitale showing Theodora and her court (Ravenna, 6th cent.; II, PL. 446) is an example of this taste, which reappears in the 11th-century mosaics at Daphne and in mosaics of the Palaeologian renaissance [the Kariye Camii (Kahrié Jami) at Constantinople; see BYZANTINE ART].

In Europe the political events that took place about the year 1000 — the consolidation of the feudal classes and the formation of the various nations — signaled a period of lively elaboration and rebirth in architecture, culminating during the 11th century in the Romanesque. The private dwelling began to gain greater importance in this period. Having developed initially from the fortified residence of the feudal lord, to which eventually was added a true domestic area, the private dwelling evolved within the next century into the town house and, in Italy, into the city hall, which may be considered a fundamental element in reconstructing the taste of this epoch.

It was in the Romanesque period that the various orientations peculiar to different countries manifested themselves. With the adaptation of the dwelling to its surroundings, various local tendencies developed, and there evolved a difference in taste in interior design between countries of the north and countries of the south. Rooms in northern countries were as a rule not so large, had smaller windows, were more closely grouped and more sheltered, and the use of wood facing for interiors became customary, especially in England. Rooms in Mediterranean countries, particularly in Italy, had more light and were more spacious and of a more fixed architectural plan.

Also in the Romanesque period there emerged, in private houses, a distinction in rooms according to their use, so that the main hall, though still the nucleus of the house, served simply as a place of reception, and the bedchamber was either moved into an alcove facing this hall or was completely separated from it. The first rudimentary furnishings of this period were developed for this room. They consisted of the bed with its curtains or canopy, a chest (later transformed into an actual platform at the foot of the bed; PL. 98; IV, PL. 104; VI, PL. 380) used for storage of clothing, and a little table built into the wall to support a light or small objects. With increasing frequency a fireplace was to be seen in the main hall (PL. 94); however, it had lost its symbolic and sentimental significance and functioned only as the center for the diffusion of heat. Miniatures show that various forms which differed from the traditional semicircular hood were tried out for the fireplace. The placement of fixed pieces of furniture began to be made with consideration of the interior atmosphere, and furniture assumed decorative as well as functional value. Ornate chairs, like those in chapter rooms or in church choirs, were placed along walls. The table, also ornate, was normally coupled with a high-backed bench (cf. copies from the *Hortus deliciarum* of Herrad von Landsberg, destroyed in 1870), and was reserved for the master of the house. When necessary, tables on stands were set up for guests. Seats were cut into window embrasures, and walls were seldom without some niche for the placement of objects. A light hanging from the center of the ceiling served for illumination (*Codex Aureus Epternacensis*, fol. 36, from Echternach, Nürnberg, Germanisches National Mus., ca. 1035–40). Of special importance to interior design is the introduction of tapestries, which not only decorated walls but actually served as walls, dividing large rooms into smaller areas. Walls were now frescoed with decorative motifs similar to those on textiles, and ceilings with exposed beams had colored ornamentation and moldings (cf. the ceiling painted with animals and narrative scenes, 13th cent.; Metz, Mus. Central). The kitchen, which the monks had always built as a separate room, was now set apart in secular dwellings as well. The hearth was open, and the absence of cabinets suggests that the various utensils were hung on the walls. There were bathrooms in the more imposing establishments. In the Castel del Monte near Andria the bedrooms, situated on the second floor, were furnished with a bath and an anteroom to it cleverly cut out of the corner towers.

The trend toward functional distribution of rooms was further developed in the Gothic period, during which furnishings increased in refinement. Visual evidence from this period is much more abundant and is supplemented by literary references. Based upon a subtle feeling for the verticality produced by the ogival vault, the structure of a Gothic interior encouraged, especially in the north, a greater decorative richness in furniture, which absorbed in its ornamentation and articulation suggestions from architecture. In England decoration in wood gained in favor; ceiling decoration became ever more refined, and furnishings in private houses, though not so sumptuous as those in Gothic churches, were often richly and imaginatively ornamented (PL. 99). For the first time, sideboards, derived from chests, appeared in the rooms; cupboards were frequently used, and the *prie-dieu* for private devotions was frequently placed in bedchambers, often in front of a small portable altar, a crucifix, or a statuette of the Virgin. The proper furniture for each

type of room was specified with progressively greater exactitude, and there developed at the same time a propensity for items of great value (once reserved exclusively for the Church) and of rarity, such as banquet tableware and Oriental silks, objects that added a note of refinement to the rooms. This tendency reached its peak in the late Gothic period, when the richness of setting was matched by that of costume. During this period, also, shops were equipped with shelves and counters, as can be seen from many miniatures (PL. 98) and from the fresco of Good Government by Ambrogio Lorenzetti in the Palazzo Pubblico, Siena.

Fernanda DE' MAFFEI

The taste for precious objects and fine furnishings that dominated northern Europe during the late Gothic period manifested itself also in Italy in the period immediately preceding the Renaissance. There is exact and ample information about the dwellings of the Florentine nobility and bourgeoisie of that period (PL. 100). All the walls of the house, even those of the bathrooms, were decorated, some with geometric motifs executed in freehand, others with isolated figures or picture cycles. Windows seldom had glass panes; more often they were curtained or screened with some transparent material. Brick flooring was replaced by painted or glazed tiling (VI, PL. 179). Wood ceilings retained their natural color, though colored ornamental motifs often stood out against the plain ground. Unity of interior design was created by the wood facing of the walls that reached a height of more than 20 in. above the floor. Acting as a backing for various pieces of furniture such as chests, beds, and benches, this facing was gradually enriched with complex moldings, inlay work, and pictures. Good examples are the *studiolo* of the Palazzo Ducale in Urbino (PL. 100) and the fresco *The Birth of the Virgin* by Ghirlandajo in S. Maria Novella in Florence (VI, PL. 184). In the Medici-Riccardi Palace on Via Larga (now Via Cavour), in Florence, the antechamber of Lorenzo the Magnificent had "a wainscoting of pine all around, XX *braccia* in width, IV *braccia* high, with cornices and bosses of walnut and inlay work and with a similarly inlaid chest at the entrance to the antechamber.... One part of this wainscoting functions as part of a day bed, another as part of a cupboard with two locks, and in addition there are set into the wainscoting the side pieces and the bolster of a bedstead."

Tapestries were placed on tables, chests, and the floor as well as on walls, and were often used along with wooden facing and painted wall decorations. As a novelty, in use not only at the Medici court but even in the houses of private families, works of art were employed as furnishings and arranged according to affinities of style, without regard for subject matter. Sacred scenes and allegories of a secular nature were grouped with ancient bas-reliefs and contemporary statues.

In the north, especially during the late Gothic period, there also prevailed a taste for precious objects and fine furnishings (PL. 99). However, there was often a stylistic difference between the furnished interiors and the architecture that enclosed them. In the south the plan of the buildings generally remained rigidly geometrical, and the external appearance of the structure was one of compactness, with windows set symmetrically, so that all the rooms had to have the same plan. In the north the interior literally broke through the architectural envelope in covered porches, turrets, and other projections. At times the asymmetrically placed windows almost completely replaced the solid exterior wall, and the exterior conformed in shape to the interior, while the walls between rooms became light trellises placed at will.

In northern Europe, in short, the distinction between interior and exterior formulated by the builders of late antiquity broke down because a relationship was established between closed interior spaces and those exterior ones formed by the city itself, both receiving an architectural treatment identical in tendency. Visual confirmation of this tendency can be found in still-preserved medieval towns and quarters, with their inextricable weaving of interior and exterior spaces into one single compact pattern, where streets, squares, courtyards, porticoes, entrance ways, and interiors all flow one into the other.

While construction in the north was moving toward this state of continuity, more regular systems of town planning were attempted in Italy, at the threshold of the modern era. Perspective, as conceived by Italian artists of the 15th century, introduced a procedural method in architectural planning that helped to disintegrate the earlier medieval concept of continuity. Though expressed in new terms, there reappeared with the Renaissance *palazzo* the classical dualism of interior as opposed to exterior, and on the basis of that dualism the relationship between the architect and the other planners involved in the realization of a buildings was defined. The architect created the parietal box of the building and some of the finishing touches that form the so-called "architectural decoration," that is, the architectural orders, the door and window frames, the balustrades, and the like. The rest — statues, pictures, and furnishings — could be handled by other specialists, and a certain degree of independence of the architectural framework could be taken for granted (this is in part expressed even in the Italian term *mobili*, literally "movables," that generally refers to household furnishings). Thus it was possible to separate systematically the interior decoration from the architecture, especially in those rooms not directly involved in the general composition of the building.

Strictly speaking, the architectural definition of interiors and façades may be understood as the application of certain finishing touches to a preexisting structure. Between the interior and the exterior detailing there is a neutral architectural support that makes it possible to conceive of the two resulting compositions as independent entities. One of the most important works of the early Renaissance, Leon Battista Alberti's Tempio Malatestiano (I, PL. 52) at Rimini, is in fact constructed about an older core covered outside and in by a new architectural envelope.

Whenever an interior space is considered as an independent unit, perspective furnishes a means of creating around it the illusion of more space by pictorially prolonging on the walls continued recession into depth. Perspective views either painted or outlined in low relief are frequently found on the walls of this period, from Milan — S. Maria presso S. Satiro by Bramante (II, PL. 340) — to Rome (the Farnesina by Baldassarre Peruzzi). These views produce the desired effect only when seen from a point along the axis of the room. Even ceiling decorations, like those of Mantegna in the Palazzo Ducale in Mantua (IX, PL. 329) are frequently subject to a vertical perspective view.

In the courtly, rational atmosphere of the Renaissance places of withdrawal were often created in isolated parts of the interior, either by means of partitions or through artificial constructions of wood. The *studiolo* of Federigo da Montefeltro in the Palazzo Ducale in Urbino (PLS. 80, 100), for example, is a complete room within a room, an autonomous, independently planned edifice that served to create, within a larger space, an area of different dimensions, for practical and perhaps for psychological reasons. For similar reasons dormitories in 15th-century monasteries were divided into cells that were occasionally narrow and dark, and were in contrast to the even luminosity of the otherwise undifferentiated, geometric interior. This is well illustrated in the famous panel by Antonello da Messina, representing St. Jerome in his study (I, PL. 311), where, in a manner that is not entirely a product of the imagination, the study is formed by a half-enclosed wooden structure placed in the midst of the great spatial void created by the architecture.

Rooms designed for intimacy (as even their names — studies, *camerini*, writing rooms — indicate) and furnished appropriately became ever more frequent in Renaissance *palazzi*. Their notable characteristics were indirect lighting, avoidance of general illumination, and deliberate proportional reduction of scale. Studies sometimes served as true private apartments, completely isolated from the rest of the palace, and were occasionally tiny, like the *grotta* of Isabella d'Este in the Castello di S. Giorgio in the Palazzo Ducale in Mantua or the *camerini* of Alfonso d'Este at Ferrara. Their ceilings were painted or gilded, their floors richly colorful, yet their relation to nature is in some cases rather more direct than in normal, full-scale buildings. In the south these exceptional rooms are the only ones, except

perhaps in the wooden houses of the common people, which can be said to have a unified interior decoration.

The imaginative palace decoration introduced by the Italian mannerists, which covered every wall with a sort of fresco tapestry, sought to reduce the restrictive effect of enclosing walls to an even greater degree than was possible with illusionistic perspective. The best results were obtained in city and country villas, especially with loggias that opened onto gardens, where such decorations as festoons of flowers and mythological scenes alluding to the seasons or to the hours of the day cleverly succeeded in creating a sense of unity with nature (PL. 101).

In the mannerist country villas of Italy, as in the renovated feudal castles of France — exposed to the weather, complex in structure, and serving diverse economic and social purposes — concern for façade was increasingly accompanied by attention to problems of adaptability and comfort. The best possible exposure was the subject of endless discussions by doctors and technicians. Widespread and rapid improvement of fireplaces made it possible to inhabit more rooms during the winter. The distribution of rooms became ever more varied, not only according to function but also according to exposure and to the extent of their use in winter or summer. Ceilings both of wood and of masonry were used, and even with the prevalence of the vault, quite noteworthy elaborations of plan were obtained.

Differences between north and south in the conception of interior space persisted in the baroque period. In northern Europe the development of interiors was characterized by opposition to the pomp represented by architectural symmetry. The transition to the ever more intimate and lively interiors of the rococo occurred almost spontaneously in a progressive breakdown of large salons into smaller rooms, with greater use of wood, stucco decoration, and, later, elegant textiles. Madame de Rambouillet — who at the end of the 16th century anticipated the rococo style with her enameled sideboards, loaded with Chinese porcelains, crystal vases, ebony framed mirrors, and small gilt caskets — is credited more than anyone else with having made a sharp distinction between official, residential, and service quarters. In about 1640 the plan of the usual *hôtel* included a vestibule, an anteroom used for dining, a reception room, a drawing room, an alcove, and several clothes closets. In time, drawing rooms, alcoves, and closets increased in number to the point that each inhabitant of the house had his private bedroom (except the servants, who were either housed in dormitories or in attics beneath the mansard roofs). Partitions, lofts, corridors, and service stairs helped realize this arrangement.

The baroque architects of Italy took little interest in changing the disposition of interiors in private buildings and limited themselves to designing rooms of rectangular plan, with vaults of uniform height. Though they frequently violated such Renaissance principles as the relative independence of basic structure and final detail or the geometric organization of interrelated elements, the deliberate aim of baroque architects was to keep interior space strictly architectonic. In exceptional instances, however, a preference for interiors of great complexity led to a dynamic fusion of the various spaces into one formal continuum that is esthetically resolved only when the entire interior space is viewed as a whole. In many baroque interiors the architectural details, the pictures, the sculpture, and the furnishings form a unified complex, in which the control of color was so great that often, or regularly in the case of Borromini's interiors, such artificial materials as plaster, stucco, and varnish were preferred to natural materials. But in general the practice of considering interior and exterior separately was not discontinued. Indeed, the distinction between the two aspects was reinforced because of the taut declarative character which each assumed. Such a contrast of interior and exterior may be found in the principal works of Borromini (q.v.) in Rome: S. Carlino alle Quattro Fontane, S. Ivo alla Sapienza, S. Andrea delle Fratte.

Baroque freedom of plan extended but slowly into the realm of the private dwelling. However, once firmly established at the beginning of the 18th century, it occasioned a rather drastic architectural change. The greatest variety in plan was now to be observed in the interior, not the exterior. This freedom was the result of the subordination of architecture to an increasingly artificial mode of decoration that was actually separated from its architectonic enclosure by hollow walls and false ceilings. Whereas the architecture, in its particular style, was accepted as something external and public, an owner considered it almost a social duty to shape the interior to his own liking, being aided in the endeavor by many practical guides and designs. There is often an odd contrast between the restrained exterior and the rich interior, as combined, for example, in the Petit Trianon at Versailles (V, PL. 421). The reign of Louis XV was particularly characterized by a desire for intimacy and comfort. The heating of rooms became a great preoccupation: hermetically sealed windows were tried; bathrooms became more numerous. This was the heyday of private studies (the study being considered even in treatises the most important room in a suite), of small rooms with secret passages for servants, and of the service corridor. The furniture was often made by the same craftsmen who made the room decorations and was frequently patterned on designs by the building's architect. The rococo period, which reached its artistic peak precisely in the field of interior decoration, also marked a high point in the very close collaboration of artists and craftsmen, a fusion of the work of architect, decorator, sculptor, wood carver, stuccoworker, and tapestry weaver (PLS. 108, 117; V, PL. 416). This type of art spread throughout Europe, although its center of diffusion, despite the multiplicity of stylistic developments, was always Paris. An extremely rich mode of decoration, it nevertheless fulfilled new economic requirements, since it utilized cheap materials easily worked by craftsmen of moderate skill. It required, moreover, a wall enclosure of the simplest kind.

The neoclassic reaction that took place about the middle of the 18th century against this aspect of the rococo was above all stylistic in character (PLS. 110, 111, 118). It developed throughout Europe almost simultaneously and produced a return to greater dignity in interiors: proportions were enlarged and unified and plans simplified even to the extent of a loss of intimacy in private life, often for the sole purpose of creating perspective views through doors and mirrors, repeated ad infinitum. Furniture regained autonomy; its forms became more rigid and geometric, so that it was seen in greater isolation and once again assumed an architectonic dignity. In contrast, an effort had been made during the rococo period to fuse furniture with general decoration as much as possible, fitting it into corners, merging it with curtains and other objects, and modeling it in organic forms. The artisan of the neoclassic period therefore sought and often effected a balance of style between interior and exterior. The penchant for an archaeological correctness in furniture prevailed in all of Europe except England, where, independently of this fashion, Chippendale, the Adam (q.v.) brothers, George Hepplewhite, and Thomas Sheraton enjoyed the greatest renown as interior decorators, following a declared policy of uniting "the useful to the pleasing." (See V, PLS. 448–450; VI, PL. 442; X, PLS. 270, 271.)

There were also attempts at proportioning according to human scale that today seem extraordinarily advanced, calling to mind comparable discussions of Le Corbusier. Juan de Villanueva's Casita de Abajo, built in 1773 at the Escorial by Charles III of Spain for his son Prince Carlos, is proportioned like a doll's house, adapted for use by a child, with furniture fitted harmoniously into the general ensemble, everything equally small in scale. Indeed, the principles laid down by Percier and Fontaine (1801–27) may here also be considered valid. "Furnishings are overly bound to the decoration of interiors in order that the architect may be indifferent to them. When, in spirit, decoration is separated from construction and does not operate in accord with it, decoration soon abandons itself to every form of absurdity and contradiction. Not only will it pervert the essential forms of the building; it will cause them to vanish. Mirrors placed without judgment and tapestries placed at random will open up voids where there should be solids, solids where there should be voids. Structure should

be to buildings what the skeleton is to the human body. It should be beautified without being masked completely. And it is the structure, varying according to country, clime, and type of building, that determines the character of the decoration. But whatever the size and importance of the building, the finished work will lack spiritual meaning if the decoration is not planned along with the construction, if the basic form of the building does not seem in accord with details, if, finally, one perceives that the building is the product of two wills in discord."

Shortly after these ideas were expressed, furnishings returned to a course of completely independent development, thereby avoiding, primarily for practical reasons, the problem of total accord.

In the 19th century, the romantic architect could refer to a variety of styles of the past, selecting or rejecting at will, a possibility widely exploited in the treatment of interiors as differentiated from that of exteriors. This era gave birth to the notion of "period furnishings," the adoption of which in the world of fashion remained independent of architecture proper. There also originated the idea of the "period room," which allowed the existence, side by side, of rooms furnished in contrasting styles (PL. 112).

It should also be noted that the production of furniture and furnishings on an industrial scale rendered it more difficult for the person of ordinary means to adapt furnishings to a given architectural setting, since the pieces were usually purchased ready-made from the store (see INDUSTRIAL DESIGN). Furthermore, temporary arrangements in rented apartments generally caused furnishings to become more ephemeral than buildings and to be subjected to many more transformations.

These circumstances helped confirm the academic distinctions between "building," "rooms," and "furniture" that theorists felt obliged to set up with almost scientific precision during this period. The paradoxical intermixture of stylistically diverse furnishings and bric-a-brac made evident the conventional character of this reference to past styles. The contradictions arising from the complex of conventions existing especially after the middle of the 19th century constituted, by the 20th century, a most important impetus in the campaign for the renewal of architecture and interior design.

Eugenio BATTISTI and Leonardo BENEVOLO

The East. a. The Iranian, Indian, and Islamic world. Interior decoration in India and the Islamic world has been largely determined by the fact that climate and socio-economic conditions have always favored outdoor life and a minimum of easily movable furniture. Rulers and nobles spent much of their life in military campaigns, hunting expeditions, and sports such as polo. Merchants spent years on caravan journeys. Pilgrims, ascetics, and dervishes were always on the move. Ladies preferred to stay in enclosed gardens. The tent, the open enclosure, and the open hall, therefore, were more important than the closed room, which served as refuge only during the hottest summer hours or during the winter. Furniture was continually moved in and out and could not be heavy. Even in mountain countries such as Nepal, Kashmir, Afghanistan, Iran, and Asia Minor, where the climate enforced a longer stay in closed rooms, this style of life was not basically altered. Furniture consisted mainly of chests, bedsteads (used also among other things as benches and seats of honor), low tables or footstools, folding reading-desks, carpets, and cushions.

The character and arrangement of rooms determined their shape and decoration. Normally, the house was planned around one or several inner courts (in Kerala and Malabar practically an atrium) onto which the rooms opened either directly or indirectly, across a surrounding terrace or gallery. Where this inner court was absent, there was at least one open gallery (*maqʻad, dālān*) overlooking the street or an open courtyard and sometimes projecting into one or several open or screened verandas. Because of the small amount of furniture, a distinction was seldom made between individual bedrooms (when belonging to a prince called *khwābgāh*), dining rooms, and drawing rooms,

but merely between common and reception rooms, and between private rooms and shops. For safety, staircases were generally very narrow, even in palaces. Doors were closed by curtains, except the entrance door which had a strong gate and a bench (mastaba) or niche for the guardian of the door (*bawwāb, dvārapāla*), and the access to the family (i.e., the ladies') court, which had a passage or corridor planned in such a manner that it was impossible to see the interior even when the door was wide open. Most of the rooms received their light through the door or a small window above it, or through a big window or balcony in the exterior wall, the opening being filled, however, with bricks set in openwork or with perforated stone slabs, or a wooden lattice. The walls were plain, except for numerous niches. The common rooms were generally on the top floor, which was reserved for the family, and the richly decorated reception rooms generally were on the first floor (*mandara, dīwānkhāna, bīrūn, khās, mahal, salāmlik*) if the house had several stories; otherwise they were in the back and central courts.

The common room (*ursī, balakhāna*) was merely a large room with elaborately decorated walls, accessible from a pillared porch, colonnade, or gallery. It usually served as a drawing room for the owner of the house and his intimate friends or for the harem (zenana), or alternately for both. It was therefore either richly painted (*rang mahal*) or covered with mirror mosaic, and small rooms used for sleeping often adjoined it. At times a square hall covered by a cupola was used, in Spain and in the Maghrib as *mashwar*, or council hall (such as the Sala de los Ambajadores in the Alhambra), in India for the common rooms of several Rajput palaces (Chitorgarh and Hindoli, for example). From the 18th century on, in Turkey, Iran, and Afghanistan, this room was usually closed on one, two, or three sides by glass windows set in a wooden framework.

There were three basic types of large reception room. The Indian type was a one- or two-storied hall (*śālā*) constructed in wood or stone and surrounded by a gallery. The Irano-Islamic type was a high-vaulted hall (liwan, *īvān*) opening on one side onto a garden or court, and often expanded into a combination of similar liwans opening onto a central court or dome. The Syro-Lebanese type was a flat-roofed hall running across the length of the building, lighted by windows or balconies at both ends. The garden pavilion was either an ordinary chamber open on one side, a variation of the Indian garden house, or a combination of several liwans set either back to back or around a central hall and opening onto the garden (*kōshk*, kiosk). The corners which had to bear the thrust of the liwan vaults served as storage nooks or small dressing rooms. These liwan combinations were also used for mausoleums, madrasahs, small mosques and even Hindu temples. There were in addition hypostyle halls of several stories combined with open terraces (*hawā mahal*) as well as underground retreats for the summer, often connected with a well (*takhtabosh, tākhāna, serdab*).

The Indian reception room consisted of an oblong (occasionally square, very rarely circular) hall surrounded by two rows of columns between which ran a narrow gallery. In most cases this gallery was lower than the central hall or stood on a platform interrupted at the principal entrances. In some cases it supported an upper gallery that was either open at both ends or closed by a grille. This main hall could serve many purposes: here were held audiences, dance performances, banquets, even religious ceremonies (in which case a chapel or even a full-size temple joined it at one end). In the lower gallery servants and spectators gathered, while from the upper gallery ladies, children, guests, and musicians could observe the ceremonies below without being seen. Halls of this kind go back to early Buddhist wooden architecture (see BUDDHIST PRIMITIVE SCHOOLS). The vimanas of South Indian temples (see DRAVIDIAN ART) and the rectangular mandapas of Marāṭhā wood temples (see DECCAN ART) are similar in type. From the latter there developed the *baradari*, a garden house or temple, consisting of a high central hall and a surrounding gallery of four oblong and four square rooms. In the course of that development the construction of these rooms changed time and again. First provided with wooden barrel vaults, they later

were given trabeated ceilings that rested on supporting stone beams or corbel brackets. From the 15th century on, they were covered with vaults of stone or brick and domes resting on arches. The columns in these rooms were heavily carved with figures, and the platform plinths, the parapets of the balconies, the entablatures, and the grilles of the upper gallery were also decorated.

The Irano-Islamic type of reception room developed from Assyro-Babylonian brick architecture (see MESOPOTAMIA). Its first representatives were the Arabo-Parthian audience halls at Hatra. Commonly used in Sassanian palaces, the liwan was employed in Islamic architecture in many variations and combinations. At Ukhaidir the Sassanian scheme was repeated, though after a much more elaborate plan. At Samarra, however, the liwans were connected by two halls that intersected beneath a central dome. Subsequently two open liwans, one at each end, or four liwans, one on each of four sides, of a court became the rule, and these combinations were used also in madrasahs and mosques. In Mameluke Syria and Egypt the most common reception room, located on the upper floor, was the qā'a (IX, PL. 272), a domed central hall (dūrqa'a) generally with a fountain in the center, faced on two sides by two slightly raised liwans (riwāqs) and on the two remaining sides by the entrance and a trellised bay window overlooking street, court, or garden. Later, the open liwans were placed behind a colonnade. In the course of this development the liwan lost its original character; the vault was replaced by a flat wooden ceiling and only an ogival front arch survived. Examples of this modified liwan are to be found in several durbar halls in India, at Mandu for example, or Warangal.

The reception room of Syro-Lebanese type goes back to the ancient Near Eastern bît-hilani house. Very common in Lebanon, but less common in Syria and Palestine, it has inspired the plan of most Venetian palaces.

Fireplaces were used only in palaces situated in cold countries, such as Turkey, Iran, Afghanistan, the Punjab, and the Punjab Himalaya, and were regarded as an exceptional luxury. They were rather low, had a conical flue and a chimney inside the wall. The normal source of heat was (and still is) a brazier (kāngrī), often placed beneath a table covered with a thick cloth under which people slipped their bodies up to the waist in order to keep warm. To offset the summer heat, fountains were used; these had many thin jets falling into one or several basins. In Iran and India a channel of water ran through the reception and common rooms, starting from an artificial waterfall with fish-scale ducts and interrupted by low basins and fountains. When water was scarce, the channel wound its way through a series of labyrinths. Garden houses were constructed atop water courses or in the center of a pool filled with fountains and waterfalls. In Hindu palaces fountains were sometimes also arranged in a canal inside the gallery that circled the big reception hall.

In Turkish council halls and common rooms, in the Egypto-Syrian qā'a, and in the Maghribi mashwar, a low stone bench ran along the liwan walls or beneath the windows. It was backed by a smooth stone dado, and both back and seat were covered with cushions. Such benches had been used previously in ancient Sumerian and Babylonian temples and palaces. In Iran and India, where the nobles either stood or sat on the floor, only a throne appeared in the room. It was not so much a seat as a platform, one that could be occupied by several persons or used for sleeping (V, PL. 458). In India no distinction was made between a seat of honor and a bed, stone platforms (chabutrās) under trees being used as resting places for travelers, as a village meeting place, as sleeping accommodations, and even as temples. And correspondingly, the throne itself (masnad, takht) was regarded as a sort of sanctuary and was venerated by the Hindus. From the late 16th century on, ceremonial chairs came into fashion for imperial princes and princesses, queens, begums, and other persons of rank.

In Egypt and Syria bay windows closed by a wooden latticework screen (mashrabiya) formed part of the qā'a. In Turkey these were developed into screened or glassed-in verandas or balconies. In India balconies and bay windows often linked both the private and the common rooms to the exterior world, forming a raised gallery or small room that on one side opened (often like a balcony) onto the hall and on the other side projected as a balcony over a court or garden. This was the place of honor in the common room reserved for the owner of the house or his first lady or ladies, and it could be used in the most manifold ways: to enjoy the view outside, to receive guests and petitioners, or to listen to musicians, buffoons, and dancers inside. For the sake of privacy the bay window had a screen (mashrabiya, jālī) with small windows. In many Indian miniatures rulers, nobles, and their wives are depicted in these jharokhās or bay windows. In the most elaborate examples, these windows were flanked by two rooms for the family and courtiers, opening at the front onto a court for visitors and entertainers, and at the back onto a room for servants bringing refreshments, the water pipe (narghile), the betel box, and so forth.

In the absence of cupboards wall niches played a most important role. Only objects that were not often used were stored away in chests. All other articles were left on the carpet-covered floor or placed in the wall niches. Ladies kept their jewels in "safes" — deep holes carved into the stone block at the bottom of a niche and accessible only through a narrow hole closed with a stone slab. In Indian palaces pavilions with "safes" like these are called naulākhī (literally 900,000, meaning a million). In the less important rooms all movable objects, such as crockery, toilet articles, books, textiles, and even oil lamps, were and still are put away in such niches. In ordinary Hindu houses little brass idols, or pictures of gods and saints, were set up in niches, and a burning oil lamp was placed before them. Wall niches were part of the decoration of reception rooms and were used to hold costly vases (especially those of Chinese porcelain), glassware, and metal vessels, or were themselves decorated with built-in mirrors, or with murals, or occasionally with mosaics, depicting religious or erotic subjects. Common to the ancient East, such niches are found in India depicted in the Ajanta frescoes. In Islamic art they were found in the caliphs' palaces at Samarra and appeared thereafter in an amazing variety of arrangements, sizes, and shapes (square and oblong, ending in round, ogival, keel, or cusped arches, trefoils, quatrefoils, etc.). The larger niches served for books and clothing or contained murals, and in libraries such niches — with stone shelves, separated by pilasters — covered the entire length of the walls. A special type are the noguldūn niches, which are set behind wooden or stucco boards cut out in the shape of the vases and flasks displayed therein. An inexpensive substitute for this special type were niches in which vases and bowls (with or without flower arrangements) were painted. From about the 17th century on, some of these wall niches were provided with doors, especially if the niche served as a bookcase or as a domestic chapel, eventually developing into the type of wall cupboard generally in use today.

Windows were normally closed by a latticework of stone (marble, sandstone, or alabaster), bricks, stucco, or wood, permitting the free circulation of air but admitting only a subdued light and no view of the outside. This latticework was made in the form of innumerable rows of lathe-turned rods, of simple grilles, or of bricks set chessboard fashion or crosswise, but the designs in most cases were complicated geometric patterns, stylized floral motifs, and in Hindu art also heraldic beasts and human figures. From early Islamic times on, this latticework was filled in by clear and colored glass panes. Because of their costliness, however, their use was limited to sanctuaries and royal palaces from the 11th to the 15th century, and became common only with the 18th century. In their stead the latticework was filled with thin, translucent slabs of marble, alabaster, or semiprecious stones. Where the climate was cold, the ordinary citizen fixed parchment or paper sheets behind the grille. Windows were constructed on two levels, the upper ones beneath the cornice, the lower ones at the level of the floor, the benches, or the bay windows.

Doors had two slender panels constructed of intersecting vertical and horizontal slats, with the interstices either boxed decoratively after the manner of a coffered ceiling (India) or

entirely faced with various woods, ivory, cast brass, or iron, arranged in complicated geometric patterns. Designs cut out in metal (of heraldic animals especially), embossed copper, or silver or gold sheets served as appliqués on this covering. Beginning with the 17th century, doors were also painted with flowers, landscapes, and human figures, and then lacquered. The top of the door frame was often adorned with a repetition of the cornice that decorated the room. Window shutters (used mainly in Iran and Turkey) were treated in a similar manner.

The common and reception rooms had to be richly decorated. In Hindu palaces statues were placed in front of the columns in these rooms, and the columns, brackets, and entablatures were covered with reliefs and statuary, especially of dancers, musicians, and erotic scenes, but also of the tutelary deities of the owners. The walls were covered with murals depicting mainly mythological and epic subjects, as well as all the conventional erotic subjects from lyric poetry. Literary sources often mention *citraśālā*s in the palaces of kings and nobles and in the houses of famous courtesans, which may well refer to decorations similar to the many genre scenes in the Ajanta caves (see AJANTA). However, all the examples that have survived date from recent centuries. Generally the walls were divided into horizontal friezes, the individual scenes being the size of ordinary miniatures, although sometimes they were as much as eight times as large. Very often the murals formed only a frieze immediately below the ceiling or the ceiling itself, in which case the murals were merely semifigural, ornamental patterns. In Islamic palaces figural paintings or reliefs were restricted to the harem and baths. It is mainly the palaces of the Ommiads, Abbassides, Fatimids, and Ghaznevids that furnish examples of figural scenes (see OMMIAD SCHOOLS, ABBASSIDE ART, FATIMID ART, GHAZNEVID ART). Under the Seljuks (see SELJUK ART), Ortuqids, Zangids, and Ayyubids, the cornice generally had figure carvings. Battle scenes, hunts, games, the pleasures of the table and of the garden, and erotic scenes formed the subject matter. In contrast, public rooms were decorated with floral, and geometric motifs and calligraphic benedictions (PL. 113). Originally, the medium used was Syro-Roman or Byzantine mosaic (*fusāīfisā*), then carved and painted stucco or wood. The typical Islamic style developed first under the Abbassides. Later, stylized flowers and flower arrangements executed in encaustic tiles, marble relief, or painting came into fashion. They were composed either like a tapestry or carpet, and were thus suggestive of the atmosphere of a tent, or were like a system of blind arches, the panels and cartouches filled with flowers, calligraphic inscriptions, and so forth, in alternation. Cornices and ceilings were no less richly decorated, often in *muqarna* (stalactite) work. At times, the whole domed ceiling dissolved into a complicated maze of *muqarna* motifs. These rich Islamic ceilings were taken over into the Mudejar style of Spain (see MOORISH STYLE), and comparable ceilings can be found even in Mexico and Peru.

A special type of decorated room is the *shīsh mahal* or *ainakhānā*, the walls of which are covered with mirror mosaic (*ainakarī*) in many patterns. Sometimes tiny mirrors were set into large panels of marble stucco or plaster, at other times the panels formed merely thin bands between the mirror pieces. The effect is very beautiful, especially when seen in candlelight or when it occurs in circular rooms and on domed ceilings. Beginning with the 18th century, mirrors — initially of looking-glass size but ultimately much larger — were mounted on walls and ceilings, especially in sleeping rooms. The stucco was originally kept white, but in the 18th century multicolored and gilded stucco were introduced.

This entire style of interior decoration began to disintegrate with the introduction of European furniture, for which the proportions of the rooms, the position of the windows, indeed the whole concept of the interior, proved unsuitable.

Hermann GOETZ

b. China. In China the conception of interior space includes magical, cosmological elements that, in the protohistoric period, found expression in a type of spatial organization called *Ming-t'ang*. This seems to have been an architectural complex composed of an empty square space, covered in the center by a round roof and enclosed not by actual walls but by four surrounding buildings or rooms oriented according to the four points of the compass. The central space of the *Ming-t'ang* was known as *t'ien-ching* or well of heaven, the axis of the world around which gravitated the various magical planes and from which the occult forces of direction spread.

According to the *Shih-ching* ("Book of Odes" or "Songs"), archaic Chinese interiors (raised, sunken, or half-lowered in the earth) probably had a hole at the top that was connected with the concept of the "well of heaven" or "window of heaven" (*t'ien-ch'uang*) — undoubtedly because of its particular functions as an opening for light and as a conveyer of rain water — and did in fact bear those names. The two elements, light and water, are represented even today on the structural members of some interiors, as for example on the ceiling of the T'ai-ho-tien in Peking (PL. 114), as evidence of an obsolete opening now entirely gone. Similar evidence is presented by the square space between the beams of palace ceilings and in the vaults of Chinese tombs; this space has been called a "well with aquatic plants" (*ch'ao-ching*) because represented there are water plants with roots pointing toward the ceiling and the rest seemingly hanging down into the interior. In other instances, in the palaces and temples of the Ch'ing dynasty (1644–1912), there is represented in the square spaces between beams a coiled dragon which, as an aquatic animal that calls forth hurricanes and rain, symbolizes the well of heaven.

The transition from the hypothetical *Ming-t'ang*, with its sacred central space, to the classic type of dwelling with interior courtyard, or "well of heaven," was undoubtedly brief. Merely enlarging the primitive interior and adding partitions to it was enough to create a dwelling that embodied the scheme of *Ming-t'ang*.

The formal and structural changes which the Chinese interior underwent with the passing of successive dynasties were purely superficial, since the basic principles governing closed space remained the same. Only furnishings and decorations changed, characterizing rooms of different periods according to varying philosophic and religious ideas. The interior of a Chinese house, evolving as the result of many modifications, is a space subdivided into a certain number of independent architectural units, each with a specific function: some rooms are set aside for public life — for receptions, business, and the like — and others devoted solely to the private needs of the immediate family. When circumstances permit, the whole complex is oriented to the south in keeping with ancient geomantic principles. A positive value is accorded interior space in rooms in the public part of the house, that is, in the *ta-t'ing* or main room, in the *shu-chai* or *shu-fang* or library, and even in the *t'ang-wu*, the room of the ancestors. The interior of the *ta-t'ing* is a regular space in which the four piers that support the roof function as standards by which to measure spatial relations in the placement of furnishings and wall scrolls. The back wall, the ideal artistic center of the room, is also important, for in fact it is there that, above a table (*t'iao-chi*) before which another, smaller table is placed (the *pa-hsien-cho* or table of Eight Immortals), a large scroll painting of considerable artistic value (the *t'ang-hua* or hall picture) is hung, lending atmosphere to the interior. In many parts of China the place where the *t'ang-hua* is put assumes a religious significance almost like a family altar, since the little tables of the ancestors (*p'ai-wei*) are set there. Because of its plastered walls and abundant furnishings, the Chinese interior does not appear to have the structural lightness of the Japanese. For example, in the *ta-t'ing* are usually found seats of carved and finely worked black wood set between a series of small tea tables placed against the left wall, numerous scroll paintings (*p'ing-fu*) hung side by side on the other walls, and a carpet covering the floor of beaten earth. The larger *ta-t'ing* are subdivided into seven or more parts by *lo-ti-chao*, a type of wooden partition characterized by intricate openwork. The *lo-ti-chao* link the four piers to the plastered walls, creating graceful arches and connecting the two front piers with the two behind.

The interior described above — also related in form to the *shu-chai* and the *t'ang-wu*, and in structure to other Chinese rooms — is obviously the result of a continual modification of the primitive dwelling. At the beginning of the Christian Era and up to the Eastern Han dynasty (25–221), walls played a secondary role in marking out the part designed for official use, since the structure of the rooms was dependent solely on the foundation, the piers, and the roof, the functional division of space being left to mobile rather than to fixed partitions. Such houses contained a principal room or *chung-t'ang*, the direct predecessor of the *ta-t'ing*, flanked on the right by the "west room" or *hsi-t'ang*, and on the left by the "east room" or *tung-t'ang*. The furnishing of these interiors must have been rather simple and of minimum height, since the occupants were constrained to sit on the floor on reed mats or skin rugs. The interiors of this period reflected the Confucian principles of simplicity and restraint, but after the introduction of Buddhism in the Han period, rooms assimilated influences from the sumptuous interiors of temples, such as painted walls and ceilings. During the period of the Three Kingdoms (220–77) and of the Sui dynasty (581–618) such painted surfaces achieved particular elegance, especially in palaces.

During the T'ang dynasty (618–906) there developed an emphasis on the decoration of beams and piers, mobile screens continuing meanwhile to be the most important element of interior decoration, together with the light allowed to enter from the exterior through the trellised framework. During the Northern Sung dynasty (960–1127) interiors had more ample wall space, which was given over to exhibition of scroll paintings, and movable screens ceased to be used as partitions, their dividing function being taken over instead by walls of plastered brick. For the first time in the history of Chinese interior decoration, rooms were furnished with seats and tables of normal height. With the rise of the Ch'an school of Buddhism during the Southern Sung dynasty (1127–1279), substantial changes occurred in the decoration of interiors based on the principle that simple, natural beauty is superior to splendor. Interiors thus lost their magnificence, and a simplicity in furnishing was introduced that had a somewhat monastic quality; walls were freed of their innumerable scroll paintings, and openwork arches and carving on beams and piers were discontinued. During the Ming dynasty (1368–1644) the trend toward revival of classical elements in Chinese culture brought to interiors an austere beauty based solely on form rather than on openwork and carving. High-arched exterior openings reappeared. Beams and piers were hewn of solid trunks of wood, devoid of all decoration, and walls became the predominant structural element in domestic architecture. The simple beauty of the architecture of this period is reflected also in the furniture, the carving of which is reminiscent of the decorative elements in Chou and Han bronzes.

Interiors of the modern period, lacking the creative force necessary for further development, sum up in their standard type the numerous formal and structural transformations of the primitive dwelling.

c. Japan. The spatial conception of a Japanese interior — whether a private or a public building, a Buddhist or a Shintoist temple — has not changed substantially from the first centuries of the Christian Era to the present day. Indeed, reproduced on the *haniwa* of the 5th century are houses of an already established type of form and structure that — except for the changes in interior decoration, which was always rather scant — has been transmitted intact to present-day dwellings. The Japanese do not consider living space as isolated from natural surroundings but as an expression and continuation of these surroundings. The thin wooden walls do not, in fact, lose contact with the exterior, and the movability of the fusuma (opaque sliding doors) and shōji (translucent sliding doors) allows for creation of spatial volumes of variable form (PLS. 115, 322–25). It is precisely from this ability to control space that the esthetic principles of Japanese interior design arise.

In contrast to Western and to Chinese interiors, which are composed of separate architectural units, the Japanese interior seems, at first glance, to be a single room without spatial divisions. The absence of fixed dividing elements and the simplicity of a structure free of superfluous decorative elements that might destroy the lightness of the building's lines results in continuity of the natural setting, with which, moreover, the Japanese always feels himself to be in harmony. The Japanese interior is among the simplest that exist; it is devoid of furnishings and of architectural elements common to Western rooms, yet possesses a natural airiness that covers the bareness of the walls and of the space by means of the fragile paper shoji of the veranda (*engawa*) which surrounds the building on three sides.

The post-and-lintel combination is the sole important structural and functional element of the interior, and the Japanese avoid covering it, obtaining thereby a clear intersection of horizontal and vertical lines at right angles. In many cases walls and sliding doors, left in a light color, help to simplify the appearance of the rectilinear structure. In addition, the rectangular mats (*tatami*) that cover the floors in every type of Japanese interior intensify the characteristics of the design; they also suggest a continuation of the closed interior space toward the exterior in a perspective diminution of lines, enhancing the simple harmony of the supports and confirming the continuity of outside and inside. The post-and-lintel principle is also dominant in furnishings and in the structure of the shoji. In the latter this rectilinear element accents interior space and eliminates monotony, for as the soft sunlight filters through the paper screen covering the wooden framework, the light thus created softens the rigidity of the defining walls and projects a view of the exterior into the enclosed space.

An interior conceived in this manner invites modification of its rectilinear design, and for that purpose there was introduced in the Muromachi (Ashikaga) period (see JAPANESE ART) an asymmetrical structure initially called an *oshiita* and later a *toko-no-ma*. This structure generally takes up about half the width of a wall, being set into a depth of about 24 in. The other half of the wall is occupied by two or more shelves, *chigaidana*, on which art objects are exhibited. In the architectural style peculiar to the houses of the samurai, or *shoin-zukuri*, the *toko-no-ma* was accompanied by a window space set at right angles to the back wall, a feature of the Kuroshoin, or Black Suite, of the Nishi Honganji in Kyoto. The *toko-no-ma* is a decisive factor in establishing the atmosphere of an interior and very often reflects the personality of the owner of the house. In it are exhibited very valuable scroll paintings (*kakemono* or *kakejiku*), decorative pieces, and flowers, all arranged according to the principles of a special art, *ikebana*. In harmony with the changing seasons or according to particular personal feelings, the *kakemono*, hung in the *toko-no-ma*, are meant to re-create the outside atmosphere or to express profound sentiments.

The architecture of traditional Japanese interiors is based solely on wood, and walls do not represent a closed structural unit. The free space of the room, outlined by posts and beams, can either be left open or framed by the sliding doors called fusuma. The *shōheki-ga*, or pictures on walls — a genre of painting that first appeared during the Heian period (784–1185) and attained its height during the Momoyama period (1573–1614) — were executed on or applied to these doors. Since the fusuma occupy most of the interior wall space, the *shōheki-ga* contribute notably to the atmosphere of the room, and in fact the subject matter of these paintings, which includes landscapes, birds, and flowers, enlivens and overcomes the limits set to the interior space.

The Japanese concept of the equivalence of interior and exterior space is best expressed in the interiors of houses used for the tea ceremony, *chashitsu*, since every structural and formal element in these interiors finds justification in that concept. Such a setting is meant to produce a feeling of the greatest possible closeness to nature; for that reason materials almost in their natural state are used — as, for example, stripped tree trunks, stalks of bamboo, and reeds (*tokusa*) — and the walls are covered with earth in order to exhibit the characteristics of natural soil. The *chashitsu* is the best architectural example of Japanese artistic sensibility. Its simplicity is the result of an

intense study of natural elements arranged to form a beautiful interior that celebrates the beauties of nature. The tea house influenced Japanese domestic architecture, bringing about the appearance of interiors in the *sukiya* style, whose formal and structural elements embrace two tendencies of the Japanese esthetic: the love for all that is at once delicate and strong, and respect for nature.

<div align="right">Antonio PRIORI</div>

Modern interiors. Modern architecture rejects every distinction in principle between interior and exterior space and instead seeks continuity, free articulation, and variable spatial definition through structure, correspondence of size to function, color, and furniture. The gradual liberation from traditional schemes of space formation, accompanied by the gradual supersedure of traditional types, began about the middle of the 19th century with the reevaluation of the structural character of Gothic architecture and with the use of new materials and techniques permitting a freer relationship between supporting elements and empty space. This process of liberation has continued under the influence of new concepts of life and social function, of new techniques of contruction, and of new esthetic values for architecture.

An important element in the transformation of the idea of space in architecture is the radical change in the image of the city (see TOWN PLANNING). The open plan of a city that is functionally organized and continually expanding necessarily eliminates the great palaces and their interior architectural elaboration (such as courts of honor, grand staircases, and splendid ballrooms) and requires a more minute and uniform division of space according to the more modest functions and needs of the middle and lower classes. While the modern social and economic structure, together with the growing expansion of the city caused by industrial development, reduce the space available to the individual family unit close to the so-called "biological minimum," modern architects attempt to reconcile economic needs with the requirements of health and average well-being by fixing the size and area, and at times even the form, of individual rooms in relation to the possibilities for ventilation and insulation. Correspondingly, the home gradually loses all part in the community's productive life, which is increasingly centered in large industrial areas. Social activities that previously revolved about the family, requiring rooms suitable both in size and kind, now take place collectively in places specifically designed for the purpose. Interiors in homes, now for the most part standardized, consist generally of spatial units nearly uniform in size and shape. The architectural arrangement of these units is generally limited to changes in the shape and extent of the sources of light (which tends to be increasingly abundant) and to the coloring and wallpapering of the walls; these variations can render the limits set by the walls less prominent and less oppressive.

Keeping these consequences within the limits of proportion, and hence of practical human use, has been the creative and theoretical contribution of artists and architects of the 19th and 20th centuries. In Europe Morris, Mackintosh, Van de Velde, and Gropius (qq.v.) fought for the creation of dwellings and industrial plants which would be more responsive to human needs and aspirations. The research and achievements of the Bauhaus, and the contributions of Le Corbusier, Mies van der Rohe (qq.v.), Stam, and others, found unanimous support, as manifested especially in the housing exhibitions of the Deutscher Werkbund in Paris and in Berlin, and in the Weissenhof quarter of Stuttgart (1927). At such exhibitions the best European architects expressed their conceptions of the interior in bare, stereometric rooms, in which arrangement, household equiment, and furniture indicated a strong awareness of present-day needs. For problems dealing with the basic living space of domestic dwellings, the model house by Mies van der Rohe exhibited in Berlin in 1931 and his Tugendhat house of 1930 in Brno, with its marvelous interior (X, PL. 57), may be considered the perfect examples and a summation of modern spatial concepts.

In the United States, because of the different organization and needs of American society and the lesser urgency of housing problems, development in domestic architecture took place primarily in suburban dwellings, in contrast to Europe, where experiments were being made primarily with the urban dwelling. Irving Gill and the Greene brothers in California and Wright (q.v.) in the Middle West achieved notable results, especially in their development of relationships between the interior and the natural setting and in the articulation of space. Wright's splendid series of "Prairie" houses testifies both to a mastery of space and to a freedom from the kinds of preconceived schemes which, in part, benefited European thought from 1910 on. Following the 1929 crash, Neutra, Breuer (qq. v.), Schindler, and Wurster created middle-class dwellings of great architectural merit, and Wright approached the problem of middle-class housing with his series of "Usonian" houses, in which a masterly use of materials — stone, brick, wood, and small cement blocks — and spatial control give the interiors an inviting, hospitable atmosphere.

The uniformity of spatial distribution in domestic architecture is compensated for by diversity in interiors designed for collective use. Indeed, the problem of interior space gains most importance in industrial architecture, in great managerial centers, and in schools, museums, and places for sport and entertainment. In industrial architecture interior spaces are determined in their size and shape by functional necessities. Most of the units of industrial machinery — conductors, pipes, ovens, vats, and assembly lines — assume crucial importance even in regard to form, by specifying the size and shape of the interior in relation to a specific function. From the physical as well as the psychological point of view, the sanitary conditions in which work is done are an essential consideration, especially in the more modern industries. This consideration affects not only the conditions of ventilation and lighting but also the size and shape, articulation, and color of the interiors. In other types of buildings having a specific function, the form and division of rooms takes into account not only living conditions but also the requirements of internal traffic (such as in offices and in hospitals), of working speed, and of control. In some buildings, especially in primary schools, the tendency in modern architecture is to seek, besides practicality and the best hygienic conditions, a direct and visual relation between interior and exterior by attempting to eliminate the sense of confinement of a closed space through the use of large openings overlooking areas of greenery. There is a tendency also to focus attention on the functional and psychological problems arising from the teaching program and to give greater consideration to such matters as corridors, colors, and the form of furnishings. Examples of such schools are those designed by Perkins and Wills located in Winnetka (with the Saarinens) and Scarsdale, Illinois, and the school in Suresnes built by Beaudouin and Lods, Jacobsen's school in Denmark, and several built by Neutra. In buildings dedicated to sport, such as stadiums and race tracks, any distinction between inside and outside space is excluded from the start, since these are generally open buildings. Yet spatial continuity is evident to a great extent as well in the auxiliary buildings connected with sports that take place entirely in the open, such as golf and, sometimes, polo.

A special problem in planning is presented by museum interiors. In regard to both form and color, the planning of space in museums is governed by the need to obtain the best conditions of visibility and the most fluid conditions of circulation for visitors. There are many examples of successfully designed museums. The Museum of Modern Art in New York, by Edward Stone with Philip Goodwin, is one of the first examples of a cultural institution designed to fulfill several functions (X, PL. 218). Louis Kahn's art gallery for Yale University has a severe interior notable for its movable exhibition panels, for its imaginative lighting, and for its use of reinforced concrete exposed in a fully equipped ceiling (concealing ducts for utilities) of reticular design (X, PL. 220). Wright in his Guggenheim Museum (X, PL. 217) went beyond the mere function of exhibition space for paintings and sculpture and created a place for contemplation where the interior is conceived as one great island of mystical experience in the city's exhausting turmoil. Franco Albini's Museum of the Cathedral Treasury, Genoa, contrasts the preciousness of gold-

smith's work and of wrought silver, the delicate substance of textiles, and the lightness of crystal with the severity of the cylinders of stone that form the boundaries of the surrounding spaces. Finally, the installations and exhibitions set up in historic buildings by Carlo Scarpa attest to the exceptional sensibility of a cultivated and aware artist.

Another essential element in the elimination of the distinction between interior and exterior space is modern architectural technique. The use of metal and of reinforced concrete, both of which perform their carrying function without the help of large masses of masonry, has practically done away with the necessity of walls as elements of support. Now free of all carrying function, walls act as mere dividing screens which, being independent of the static structure, may be distributed according to the economic, practical, and, in some cases, esthetic requirements of the interior space. Separation of interior and exterior is thus generally assigned to large areas of glass that not only secure for the interior the greatest amount of light (regulated by means of curtains of varied thickness and color) but also create the possibility of almost total visual communication between open and closed spaces. For example, the view from an upper story of a skyscraper of the buildings and streets of New York, with their heavy and orderly traffic, is an essential part of the architecture of that structure, just as the view through the windows of Wright's Kaufmann house of woods and a waterfall (I, PL. 91) constitutes an essential element in the architecture of the interior of that building. The fact, too, that these views may represent psychological stimuli to activity or to repose is but confirmation of their esthetic character, since the entire modern concept of art, especially in the field of town planning and architecture, is founded on the direct psychological impact of form and color.

The structural possibilities of modern architecture, besides favoring the predominance of voids over solids, permit a free articulation of plan. The "walled box" as a fixed boundary between interior and exterior is therefore eliminated, and the supporting structural elements, previously set along the periphery or at the principal axes of the room, are now found in the interior. The free or open plan — that is, one independent of structural limits and modeled according to the requirements of family or social life — has given rise to a whole set of new ways to divide and qualify space, with respect to elevation as well as to ground plan. The interior space of modern architecture, especially in suburban and country residences, is in fact characterized not only by direct communication between closed and open spaces, but also by a diversity in the levels of floors and ceilings, by the use of stairs and balconies as plastic forms within the interior, and by the use of furniture as part of the architectural setting. Examples of such interiors are those designed in 1910 and 1912 by Adolf Loos for houses in Vienna, the house of the writer Tristan Tzara built in Paris in 1926, the Kuhner house built near Vienna in 1930, and the Moller house built in Vienna in 1928. Another example is the sequence of circulation and reading rooms in the Municipal Library at Viipuri designed by Alvar Aalto, in which emphasis upon the diversity of levels is accentuated by the great central staircase and the problem of lighting has been brilliantly solved by a series of skylights and portholes in the ceiling. Aalto reuses this principle in the main room of the Old-Age Pension Building in Helsinki, in the entrance hall to the auditorium of the Teacher's University at Jyväskylä, Finland, and in the students' dining room in Baker House at Massachusetts Institute of Technology. As in Mies van der Rohe's Tugendhat house, in Neutra's house in the Colorado Desert, and in Wright's Usonian houses, mobile walls, made primarily of light, luxurious materials, screens, and hangings, cease to be complementary, accessory elements, and become essential agents in the definition and characterization of space. The abundant light created by the free communication between closed and open space also eliminates a traditional distinction between exterior and interior forms, wherein the former are modeled more sharply because they are exposed to the sunlight, while the latter are modeled more delicately, since they are exposed to a weaker, or even artificial, light. In modern interiors one encounters

unfinished materials such as exposed stone and brick, or wood still in the form of a tree trunk — as in Wright's Kaufmann house at Falling Water, Pennsylvania; in his Lewis house, Libertyville, Illinois; in interiors by Breuer, Wurster, Harris, and Drake; and in the Municipal Hall in Säynätsalo by Aalto. The colors on walls, previously painted in neutral or tempered tones, now often tend to be bright and vividly contrasting, thus approximating the chromatic effects introduced by modern painting, as evident in the experiments and achievements of the Stijl group, such as Van Doesburg's room decorations at the Aubette dance hall in Strasbourg, Rietveld's Schroeder house in Utrecht, and several buildings by Oud (q.v.).

Floors and ceilings also take on particular importance from the esthetic viewpoint, especially in connection with the definition of interior space as a "volume of light." Floors, functioning in this respect as walls formerly did, generally assume the value of a plane of color, at times through the use of plastic materials and facing. Ceilings normally function as surfaces which reflect both natural and artificial light, sometimes by means of the plastic modeling of the surface. The possibilities offered by modern technology in respect to heating and air conditioning are also factors in the shaping of interior space in modern architecture. To meet the need for maximum plant utilization, modern technology has furnished architecture with still another element determining the arrangement of interiors — the equipped ceiling. It has for some time been standard practice in office buildings, in research laboratories, in meeting halls, and, in some cases, in museums to collect within the ceiling structure itself (often a metal trellis) the pipes for air conditioning, electrical wiring, light panels, and acoustical material. A similar functional approach in the construction of exterior walls — of which Gropius's Bauhaus (VII, PL. 81) and Fagus factory (V, PL. 103) and Le Corbusier's monastery of La Tourette are prototypes — and the light, temporary nature of modern movable partitions used as interior walls help to demonstrate that in these characteristically 20th-century interiors the gravitational function belongs chiefly to the floor. This is also helped by diffused and uniform lighting and by acoustical conditions which nearly destroy the stereometric quality of the enclosure. Evidence of this can be found in the General Motors Technical Center at Warren, Michigan, designed by Eero Saarinen and his associates, Sven Markelius's ceiling for the Economic and Social Council Chamber of the U.N., and Louis Kahn's magnificent ceiling of reinforced concrete for the rooms in the Yale University Art Gallery.

Despite the fact that the need for decoration (in this instance understood solely as the plastic and chromatic variations of exterior and interior surfaces) has been reconsidered by such modern masters as Wright (PL. 116) and Breuer, the problem of the decoration or ornamentation of interiors has been determined from the very beginning in modern architecture by the principle of strict functionalism and the consequent elimination of all applied ornament as nonartistic. Clearly, modern architecture, which defines space through structure, severely limits the intervention of other fine arts, especially when they are closely linked to architecture, as are mural painting and sculpture. To be more precise, the functions of spatial determination once exercised by mural painting and sculpture are now normally carried out directly by the architect through the plastic and chromatic manipulation of structural elements. The same may be said of furniture in so far as it is part of the architecture of the interior space. Whereas some pieces of furniture are adopted as architectural elements and even occasionally integrated into the structure as fixed parts, other pieces are clearly separated from the architectural scheme and have full functional and formal autonomy. Both the mass production of furniture and the search for freedom from formal and proportional relationships to architecture have furthered this autonomy. A typical instance is provided by modern tubular and plastic furniture (see FURNITURE) which, because of its lightness and movability, functions merely as an object in the architectural space of the interior. Design experiments at the Bauhaus and the work of Charles Eames for Herman Miller, Inc., (PL. 51; I, PL. 135) have contributed to this trend.

The most recent experiments with large, concrete, freely modeled surfaces have been directed toward the ever more radical elimination of the distinction between exterior and interior space. The goal of such experiments is, in fact, the reduction of architecture to one great covering surface, beneath which the division of interior spaces and their articulation proceeds absolutely free of all structural demands and is modeled solely according to practical and esthetic qualifications. Konrad Wachsmann and R. Buckminster Fuller are conducting experiments based on the repetition of a single standard metal part with special auxiliary nodal devices in order to solve the problem of the covering of great areas with structures of minimal weight. Fuller's geodesic domes (PL. 62), conceived as partially or wholly transparent envelopes, are intimately connected with problems of interior space and foretell developments of unforeseeable consequence. It is interesting to note the use to which these domes have already been put in Fuller's projects for his Skybreak Dwellings and cotton mill.

Giulio Carlo ARGAN

The preceding section includes contributions by Giuseppe Zammerini.

BIBLIOG. *General:* See bibliogs. for ARCHITECTURE; FURNITURE; HOUSE-HOLD OBJECTS; INDUSTRIAL DESIGN. See also: G. C. Argan, A proposito di spazio interno, Metron, XXVIII, 1948, pp. 20-21; R. Kelly, Lighting as an Integral Part of Architecture, College Art J., XII, 1952, pp. 24-30; S. Whiton, Elements of Interior Design and Decoration, 4th ed., Philadelphia, 1960.

Ethnic cultures: V. Mindeleff, A Study in Pueblo Architecture (ARSI, VIII), Washington, D. C., 1891; W. C. Farabee, The Central Arawaks (Univ. Pa. Anthr. Pub., IX), Philadelphia, 1918; L. Frobenius, Kulturgeschichte Afrikas, Frankfurt am Main, 1933; K. Birket-Smith, The Eskimos (Eng. trans., W. E. Calvert), London, 1936; M. Griaule, Dieu d'eau, Paris, 1948; M. Griaule, L'image du monde au Soudan, JSA, XIX, 1949, pp. 81-88; C. D. Forde, Habitat, Economy and Society, London, New York, 1950; J. E. S. Thompson, The Rise and Fall of Maya Civilization, Norman, Okla., 1954; W. J. Phillips, Carved Maori Houses of Western and Northern Areas of New Zealand, Wellington, 1955; J. Soustelle, La vie quotidienne des Aztèques à la veille de la Conquête espagnole, Paris, 1955.

The European West: C. Percier and P. F. L. Fontaine, Recueil de décorations intérieures, 3 vols., Paris, 1801-27; E. E. Viollet-le-Duc, Dictionnaire raisonné du mobilier français de l'époque carlovingienne à la Renaissance, 6 vols., Paris, 1858-75; H. Havard, Dictionnaire de l'ameublement et de la décoration depuis le XIIIᵉ siècle jusqu'à nos jours, 4 vols., Paris, 1887-90; A. Schmidt, Preussische Königschlösser, n.p., 1900; W. Bode, Die italienischen Hausmöbel der Renaissance, Berlin, 1902 (Eng. trans., M. E. Herrick, New York, 1921); E. Guerinet, Intérieurs d'appartements, châteaux, etc., Paris, 1904; G. P. Bankart, The Art of the Plasterer, London, 1908; A. Schiaparelli, La casa fiorentina, I, Florence, 1908; J. Ebersolt, Le grand palais de Constantinople et le livre des cérémonies, Paris, 1910; J. Guérin, La chinoiserie en Europe au XVIIIᵉ siècle, Paris, 1911; Fontainebleau: Les appartements de Napoléon I et de Marie-Antoinette, Paris, 1912; W. M. Odom, History of Italian Furniture, 2 vols., Garden City, N.Y., 1918-19; A. Stratton, The English Interior, London, 1920; H. A. Tipping, English Homes, 9 vols., London, 1921-37; O. von Falke and H. Schmitz, Deutsche Möbel des Mittelalters und der Renaissance, 3 vols., Stuttgart, 1923-24; P. Macquoid and R. Edwards, Dictionary of English Furniture from the Middle Ages to the Late Georgian Period, 3 vols., London, 1924-27 (2d ed., 3 vols., London, 1954); G. K. Lukomskii, Mobilier et décoration des anciens palais impériaux russes, Paris, 1928; T. Garner and A. Stratton, The Domestic Architecture of England during the Tudor Period, 2d ed., 2 vols., New York, London, 1929; G. Janneau, Les beaux meubles français anciens, 5 vols., Paris, 1929; A. and M. S. Byne, Spanish Interiors and Furniture, 2d ed., 2 vols., New York, 1930; G. Adriani, Die Klosterbibliotheken des Spätbarock in Österreich und Süddeutschland, Graz, 1935; R. H. Kettell, ed., Early American Rooms, Portland, Me., 1936; S. F. Kimball, Creation of the Rococo, Philadelphia, 1943; W. A. E. van der Pluym, Het Nederlandsche binnenhuis en zijn meubels, 3 vols., Amsterdam, 1943-51; E. Rettelbusch, Stilhandbuch: Ornamentik, Möbel, Innenausbau von den ältesten Zeiten bis zum Biedermeier, 4th ed., Stuttgart, 1946; M. R. Rogers, American Interior Design, New York, 1947; A. Taullard, El mueble colonial Sudamericano, Buenos Aires, 1947; R. Dutton, The English Interior: 1500-1900, New York, 1948; J. Plath, The Decorative Arts of Sweden, New York, 1948; A. Berendsen, Het nederlandse interieur, Utrecht, 1950; E. O. Christensen, The Index of American Design, New York, 1950; L. T. Davies and H. J. Lloyd-Johnes, Welsh Furniture: An Introduction, Cardiff, 1950; P. Drobecq, La cheminée dans l'habitation, Paris, 1950; M. Jourdain, English Interior Decoration 1500 to 1830, London, 1950; P. Kelemen, Baroque and Rococo in Latin America, New York, 1952; C. Koch, Grosser Malerhandbuch, 9th ed. by K. Würth, Giessen, 1952; A. Pedrini, Il mobilio, gli ambienti e le decorazioni nei secoli XVII e XVIII in Piemonte, Turin, 1953; R. Dutton, The Victorian Home, London, 1954; E. Redslob, Barock und Rokoko in den Schlössern von Berlin und Potsdam, Berlin, 1954; Styles de France, Paris, 1954; H. Kohlhausen, Geschichte des deutschen Kunsthandwerks, Munich, 1955; J. Gloag, Georgian Grace: A Social History of Design from 1660 to 1830, London, 1956; G. Mazzotti, Palladian and Other Venetian Villas, Rome, 1958; La casa italiana nei secoli (exhibi-tion cat.), Florence, 1959; G. Masson, Italian Villas and Palaces, London, 1959.

Iran, India, Islam: P. Coste, Les monuments modernes de la Perse, Paris, 1867; F. Sarre, Denkmäler persischer Baukunst, 3 vols., Berlin, 1901-10; E. Diez, Isfahan, ZfbK, N. S., XXVI, 1915, pp. 90-104, 113-28; U. Tarchi, L'architettura e l'arte musulmana in Egitto e nella Palestina, Turin, 1922; E. Herzfeld, Die Ausgrabungen von Samarra, I: Der Wandschmuck der Bauten und seine Ornamente, Berlin, 1923; O. Reuther, Indische Paläste und Wohnhäuser, Berlin, 1925; O. Reuther, Die Qa'a, Jhb. asiatischer K., II, 1925, pp. 205-16; J. Rosintal, Pendentifs, trompes et stalactites dans l'architecture orientale, Paris, 1928; A. Godard, Isfahān, Athār-é Irān, II, 1937, pp. 6-176; B. Y. Berry, The Development of the Bracket Support in Turkish Domestic Architecture in Istanbul, Ars Islamica, V, 1938, pp. 272-82; H. Zaloscer, Survivance et migration, Mél. islamiques, Inst. fr. d'archéol. o. de Caire, I, 1954, pp. 81-93; H. T. Bossert, Decorative Art of Asia and Egypt, New York, 1956; M. S. Dimand, A Handbook of Muhammadan Art, 3d ed., New York, 1958; B. Ünsal, Turkish Islamic Architecture in Seljuk and Ottoman Times, London, 1959.

China: Kijima Katsumi, Shina Jūtaku-shi (History of Chinese Dwellings), Dairen, 1932; Chi Ch'êng, To-t'ien-kung (Stealing the Work from Heaven), Peking, 1933 (repr.); G. Ecke, Sechs Schaubilder Pekinger Inneräume des 18. Jahrhunderts, B. Catholic Univ. of Peking, IX, 1934, pp. 155-69; Ch'en Chih, Tsao-yüan-hsüeh-kai-lun (Thoughts on the Construction of Gardens), Shanghai, 1935; R. Kelling, Das chinesische Wohnhaus, Tokyo, 1935; Itō Chūta, Shina kenchiku sōshoku (Architectural Decoration in China), 5 vols., Tokyo, 1941; A. I. T. Chang, The Existence of Intangible Content in Architectonic Form Based upon the Practicality of Laotzu's Philosophy, Princeton, 1956; R. A. Stein, Architecture et pensée religieuse en Extrême-Orient, Arts asiatiques, IV, 1957, pp. 163-86.

Japan: R. A. Cram, Impressions of Japanese Architecture and the Allied Arts, New York, London, 1905; Satō Tasuku, Nihon kenchiku-shi (History of Japanese Architecture), Tokyo, 1926; Fujii Kōji, Nihon no jūtaku (Japanese Dwelling Houses), Tokyo, 1928; B. Taut, Houses and People of Japan, Tokyo, 1937; N. F. Carver, Form and Space of Japanese Architecture, Tokyo, 1955; A. Drexler, The Architecture of Japan, New York, 1955; T. Yoshida, The Japanese House and Garden (Eng. trans., M. G. Sims), New York, 1955; H. Kitao, Details of Suyika-House, Tokyo, 1956.

Modern interiors: Arts and Crafts Exhibition Society, London, 1903 (preface by W. Morris); H. Van de Velde, Essays, Leipzig, 1910; J. Badovici, Intérieurs français, Paris, 1925; Le Corbusier, L'art décoratif d'aujourd'hui, Paris, 1925 (2d ed., Paris, 1959, ed.- V. Fréal); W. Gropius and L. Moholy-Nagy, ed., Bauhausbücher, 14 vols., Munich, 1925-30; Deutscher Werkbund, Innenräume (exhibition cat.), Stuttgart, 1928; Deutscher Werkbund: Section allemande, Exposition de la Société des artistes décorateurs (exhibition cat.), Paris, Berlin, 1930; P. T. Frankl, Form and Re-Form, New York, 1930; A. Loos, Trotzdem, Innsbruck, 1931; Cataloghi della Triennale, Milan, 1933 ff.; R. Aloi, L'arredamento moderno, Milan, 1934 ff.; J. Gloag, Design in Modern Life, London, 1934 (bibliog.); R. McGrath and A. C. Frost, Glass in Architecture and Decoration, 2 vols., London, 1937; P. T. Frankl, Space for Living, New York, 1928; E. Genauer, Modern Interiors Today and Tomorrow, New York, 1939; E. Kaufmann, Modern Rooms of the Last 50 Years, New York, 1947; B. van der Heyden, Stijl in huis, Amsterdam, 1947; Victoria and Albert Museum, The Great Exhibition of 1851, London, 1950; H. Bayer, W. Gropius and I. Gropius, Bauhaus 1919-1928, 2d ed., Boston, 1952; De Stijl, 1917-1928 (exhibition cat.), Museum of Modern Art, New York, 1952; G. Nelson, Living Spaces, New York, 1952; E. Kaufmann, What Is Modern Interior Design?, New York, 1953; R. W. Kennedy, The House and the Art of Its Design, New York, 1953; R. Neutra, Survival through Design, New York, 1954; G. Nelson, Problems of Design, New York, 1957; R. Aloi, Architetture per lo spettacolo, Milan, 1958; R. Aloi, Esposizioni, Milan, 1960. See also: Art Index, New York, 1929 ff.; B. Karpel, The Idea of Design, New Furniture, III, 1955, pp. 153-73 (bibliog.); American Institute of Interior Designers, Interior Design and Decoration: A Bibliography, New York, 1961.

Illustrations: PLS. 91-118.

IRAN. Iran (Kishvar-i-shāhinshāhī-i-Īrān), or Persia, is an independent Asian country governed by a hereditary constitutional monarchy. The population comprises several ethnic strains, including Iranian (Persian Tajik, Kurds, and Baluchi), Turkish (Azerbaijani and Turkomans), and Arab, all under Persian political and cultural domination. Covering an area of 636,293 sq. miles, Iran is part of the Iranian plateau, bordered by the U.S.S.R., Turkey, Iraq, Pakistan, and Afghanistan.

SUMMARY. Iran and Iranian civilizations: names and subdivisions (col. 212). Historical, cultural, and artistic periods (col. 214). Sites and monuments (col. 219): *Azerbaijan; Kurdistan; Luristan; Khuzistan; Fars and Laristan; Kerman, Baluchistan, and Seistan; Khorasan; Caspian regions; Teheran region; Isfahan region.*

IRAN AND IRANIAN CIVILIZATIONS: NAMES AND SUBDIVISIONS. Only some of the pre-Islamic and Islamic sites important to Iranian history

are located within the present boundaries of Iran. Such areas of great archaeological and artistic interest as a large part of Seistan and the Afghan and central Asian parts of Khorasan (see AFGHANISTAN; ASIA, CENTRAL) lie outside the borders of the modern country. Those areas within Iran are, however, among the most characteristic from the archaeological point of view, as they comprise almost all the important sites of Islamic Iran; the most significant centers of pre-Islamic civilizations (those of the Elamites, Urarteans, Medians, and Achaemenids) as well as numerous prominent monuments from the Sassanian period (see SASSANIAN ART) are located in the western regions. On the other hand, only faint traces remain in Iran from the Seleucid period (see IRANIAN PRE-SASSANIAN ART CULTURES), and the centers of Transoxiana and Mesopotamia are as important as Iranian sites for a study of the Parthian period. Persia was one of the most lively and active areas of Islamic civilization, especially after A.D. 1000. When the Sassanian homeland of Fars was abandoned, Isfahan frequently served as the capital — in the Buyid (Buwayhid; 10th cent.) and Seljuk (see SELJUK ART) periods. After the Mongol invasions Tabriz, and Sulṭāniya (see ILKHAN ART) became capitals, then Herat, in the Timurid period (see TIMURID ART), and, under the Safavids (see SAFAVID ART), Isfahan. This city remained the capital until the early 18th century, when, after a brief flowering of the new Fars center Shiraz, Teheran, the present capital, replaced it. Besides Herat (in Afghanistan) the major centers of Iranian Islamic civilizations outside the present boundaries of the country are the central Asian Samarkand, Bukhara, and Merv.

The name Iran (Īrān) comes from the Middle Persian (Pahlavi) Ērān (Iranian nation) as opposed to Anērān (foreigners, barbarians). The Sassanian monarchs indicated the universality of their dominion by calling themselves kings of Ērān and Anērān. The Pahlavi form Ērān derives in turn from the ancient Iranian *airyana* (equivalent to later Aveśtan). The term comes from Airya (peoples of Iranian stock in contrast to Turanians) in the Achaemenian inscriptions (cf. Avestan Airyanem vaējō, legendary homeland of the Iranian people). The ethnic significance of the term is explained by the change from *Aryan*, noble, good, of the primitive Indo-European community, to *Aryan*, the nobility, the ruling population of the Indo-Iranian community. The form Īrānshahr (Iranian region) was used by medieval Arab historians and geographers, and the term Īrān (the Iranian ethnic and cultural unity) was popularized by the poetry of Firdausī (10th cent.). But the common use of Īrān (Iranian country) and Īrānī (Iranian) began only in the 19th century, the time of the formation of an Iranian national consciousness in the modern sense. In Europe, the use of Iran is extremely recent and has had difficulty replacing the traditional Western term Persia, which comes from the Greco-Latin Persae. This term was applied to the Iranian ethnic group in power during the Achaemenian period and derived from the Iranian geographic region of Persis (Pārs; Ar., Fāris; Mod. Per., Fārs), homeland of the Parsua tribe mentioned in the Assyrian inscriptions. However, if the Arabic Fāris indicated only the region of Persis, Fārisī, Fārsī (Pārsī) as early as the ancient period meant a language used throughout the entire plateau, which became, after the 9th century, the language written by most Iranian groups. The Arabic Furs, on the other hand, designates Iranians of the pre-Islamic — or heathen — population, while the Arabic term al-ʿajam means a non-Arab, foreign, or barbarian nation and, by inference, Iranian. The term Tajik has many meanings. In ancient times it meant Arab, having derived from Ṭaiy, an Arab tribe neighboring on the Iranian populations; today Tāzī is still the word for the Arabic language. Later the term meant Iranian in opposition to Turk; this usage now prevails, particularly in contrasting Iranians to Turkoman or Uzbek tribes in central Asia and Afghanistan, where Tajik, an eastern Persian dialect, is spoken by Iranian and non-Iranian groups. However, Tajik there is also used in opposition to Pashtu, also an Iranian group, and sometimes in opposition to western Iranian; thus Tajik means "eastern Iranian speaking the Persian language."

The administrative organization of the country has undergone important and repeated changes since its revision in 1938 based on modern standards. The February, 1960, reform abandoned the practice of numbering divisions and divided the country into the following 17 historical regions (*ustān*), listed below with their capitals: Central (Markazi), Teheran; Gilan, Resht; Mazanderan, Sari; Gurgan (Asterabad), Gurgan; Khorasan (Khurasan), Mashhad; Baluchistan and Seistan (Sistan), Iranshahr and Zabul; Kerman (Kirman), Kerman; Fars, Shiraz; Khuzistan, Ahvaz; Luristan, Khurramabad; Kermanshahan (Kirmanshahan), Kermanshah; Hamadan, Hamadan; Kurdistan, Sanandaj; Western Azerbaijan (Ādharbāījān-i-Gharbī), Rizaiyeh; Eastern Azerbaijan (Ādharbāījān-i-Sharqī), Tabriz; Arak (Araq), Araq; Isfahan, Isfahan.

The topographical inventory (col. 219) groups the most important sites in alphabetical order by regions, here reduced to 10 for greater conformity with historical and geographic divisions as well as with the modern political and commercial organization.

HISTORICAL, CULTURAL, AND ARTISTIC PERIODS. The prehistoric period is characterized by a variety of pottery styles (see ASIATIC PROTOHISTORY; IRANIAN PRE-SASSANIAN ART CULTURES) that bear witness to the interweaving of different cultures, sharply contrasting with the stylistic uniformity of neighboring Mesopotamia (q.v.), with which useful comparisons can be drawn in order to establish a relative chronology. Studies completed thus far permit individuation of the cultures of each prehistoric period according to the name of the locality where the principal finds have been made. Traces of the Paleolithic, Mesolithic, preceramic, and ceramic Neolithic are to be found especially in the north, in Ghār-i-Kamarband and Ghār-i-Hūtū in Gurgan and in Tamtama in Azerbaijan (all caves), and in the south at Tang-i-

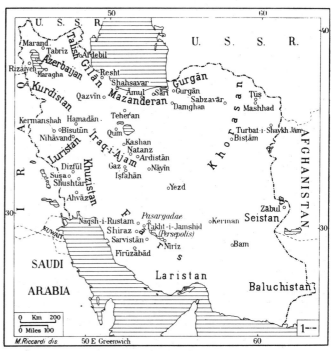

Iran, chief sites of archaeological and artistic significance. *Key* : (1) Modern national boundaries.

Pabda in Khuzistan. Late ceramic Neolithic is primarily represented by two clearly distinguishable cultures, that of Tepe Sialk I (the first level of the famous excavations of Tepe Sialk near Kashan) and that of Tell-i-Jari B, at a site in Fars. The cultures of the chalcolithic period, extending to the beginning of the 3d millennium, include Tepe Sialk II; Tepe Sialk III; Tepe Hissar I (the first level of the famous excavations near Damghan); Tepe Giyan V, in Luristan; Tepe Musyan; Susa I, in Khuzistan; Tell-i-Mushki; Tell-i-Bakun in Fars; Anau II, on the eastern borders of Iran and now in Soviet territory; Shāh Tepe Buzurg and Tureng Tepe in Gurgan; Tepe Sialk IV; Intermediate Susa; Tell-i-Kaftari. The early Bronze Age is represented by Anau III, Tepe Hissar III, Tepe Giyan IV, Susa II, Tell-i-Qalʿa in Fars, and the culture of the Bampur-Khurab region in Kerman; the middle Bronze Age, by Tepe Giyan III and Tell-i-Shugha in Fars; and the late Bronze, Age, to about 1200 B.C., by Tepe Giyan II and Tell-i-Taymuran A in Fars.

The Iron Age, 1200–800 B.C., is primarily represented by the famous Luristan bronzes which first appeared in the hands of Teheran antique dealers between 1928 and 1930; coming from tombs in the Luristan valleys of Harsin, Khurramabad, and Alishtar, they soon enriched museums and private collections, alongside similar objects of varied provenance. The Luristan bronzes include weapons, horse trappings, pins, votive and ritual objects, and utensils with somewhat naturalistic or stylized decoration; they evidence a relation to Hittite work. They may be attributed to the period 1200–1000 B.C., although some scholars advance the end date to the mid-8th century. The cultures of Tepe Sialk V and VI can be associated with them, as well as the gold and silver objects from Kalar Dasht, Khurvin, Hasanlu, and Zawiyeh (Ziviya), all of which are in northern Iran. (These cultures also are represented at other sites; for the most important sites see under the individual entries.)

Elamite civilization is the first historical culture in Iranian archaeology. It relates so closely to the Mesopotamian that it is often difficult to distinguish its specific features. Developing from the 3d millennium to the 7th century B.C., it was influenced successively by southern

Mesopotamia, the art of Ur, and the art of Assyria and reached its apogee in the 13th-12th century B.C. Although its center was in southwestern Iran, there are traces in other regions as well. With this culture appear for the first time the rock reliefs — 16 in all — of religious and royal subjects, which were to play an important part in the history of Iranian art. The principal Elamite centers are Susa, the capital, with architectural remains, ceramics, sculpture, gold- and silverwork, ivories, and seals; Chuga Zanbīl, with a ziggurat and finds of every sort, as rich as those of Susa; Rishahr, on the coast of the Persian Gulf; Tell-i-Ghazir, with architecture and ceramics; and Tulaspīd, in Fars, with architecture. Rock reliefs have been found at the following sites: Kurangun and Naqsh-i-Rustam in Fars; Shikaft-i-Salman, Qul-i-Fara, and Qalʿa-i-Tul in Khuzistan; Hurin Shaykh Khān and Sar-i-Pul-i-Zuhab in Kurdistan.

Succeeding the civilization of Urartu, which is represented by the inscriptions at Tash Tepe and Siqindil and by the stele at Kīl-i-Shīn, all in Azerbaijan, are the first Aryan civilizations, which, unlike the Elamites, have left remains chiefly in northern Iran. The rock tombs at Fakhraka in Azerbaijan and at Uṭāq-i-Farhād, Sakhna, and Sakavand in Kurdistan probably go back to the Medes. The same architectural motifs are found in Fars: Dā ū Dukhtar, Naqsh-i-Rustam, Persepolis, and Takht-i-Rustam; the south is the region of the most important monuments of the ancient Iranian civilization of the Achaem-enids (550–331 B.C.). Their principal centers are Pasargadae, Persepolis, Abarj, Naqsh-i-Rustam, Jin Jin, and Qaṣr-i-Abū-Naṣr, all in Fars; Badr Nishanda, Masjid-i-Sulaymān, and Susa, in Khu-zistan; Hamadan, in Kurdistan; and Dumaviza, in Luristan. These remains include fortified terraces, temples, fire altars, palaces, and sites containing important sculpture, ceramics, goldwork, and glyptics (sculpture fragments have also been found at Yezd). The 10 rock reliefs at Dukkān-i-Dāūd, Sakavand, Behistun (Bisutun), Naqsh-i-Rustam, and Persepolis almost invariably present the same scene of adoration. The Persepolis of Darius I is by far the most important center of Achaemenian art; here stone replaces the typically Mesopo-tamian brickwork. The esthetic elements of various provinces are synthesized in this imperial art without any appearance of confusion or hybrid effect.

The Hellenistic Seleucid period (331–250 B.C.), is little known in the archaeology of Iran. The few monuments which have survived are only fragments; there are few excavated objects. Architecture is sparsely represented by the temple at Nurabad and by one recently discovered at the foot of the terrace at Persepolis. Both these buildings remain faithful to the older Iranian plan, while the temples of Istakhr, Kangavar, and Khurha exemplify a type of Greek architecture whose canons have been freely interpreted. In sculpture the Hellenistic influence is felt more explicitly; in fact, these works are Hellenistic in the cosmopolitan sense. Examples are found at Dinavar, Nihavand (Nehavend), Persepolis, Shami, Susa, and Tell-i-Zuhak. The scant sources of numismatics and ceramics are the excavations of Persepolis, Susa, and Rayy (Rhages). Only two reliefs are extant, both on the door of the temple at the foot of the terrace at Persepolis.

Parthian art (250 B.C.–A.D. 224) was part of a vast culture complex stretching from Syria to the so-called Greco-Bactrian area (see BAC-TRIAN ART). The artistic revolution effected in this period was des-tined to furnish motifs for the entire Iranian Middle Ages. Fired or unbaked brick was substituted for stone, and the vault, the dome, and the liwan came into use. The liwan, a vaulted chamber com-pletely open on one side, was to remain for centuries the architectural symbol of Iranism. Little remains of the late-antique rigid sculptural decoration. The round cities and their temples have barely survived; the most imposing ruins are those of Kuh-i-Khwaja in Seistan, where examples of sculpture, wall painting, stuccowork, and ceramics also were found. Other architectural centers are Takht-i-Sulaymān in Azer-baijan and Shami in Khuzistan, which is better known for its statues and bronzes. Susa yields examples of every kind of art, while Badr Nishanda has sculpture, as does Hamadan, where the famous stone lion was found. At Damavand (Demavend) and Rayy, near Teheran, were found ceramics, glyptics, and coins; at Qaṣr-i-Abū-Naṣr, glyptics and coins; at Burujird, bronzes like those from Shami; at Nihavand, examples of goldwork; at Narishan, Tepe Bulahya, and Makran, ce-ramics. The nine extant rock reliefs from the Parthian period depict scenes of homage, victory, worship, and horsemanship, and are found at Bisutun (Behistun) and Sar-i-Pul-i-Zuhab in Kurdistan and at Shimbar and Tang-i-Sarvak in Khuzistan. The remains of Parthian art which have been found in Iran are qualitatively as well as quanti-tatively inferior to those revealed by excavations in Mesopotamia, especially at Hatra.

Of all the pre-Islamic historical periods, the Sassanian (see SAS-SANIAN ART), has left the most important remains on the plateau, al-though the chief surviving architectural monument, the palace of the de facto capital Ctesiphon, is outside the political and physical boundaries of Iran, in Mesopotamia. Sassanian architecture is known chiefly from the ruins of palaces, fortresses, fire temples, and chahār ṭāqs

(small, open buildings formed by four piers supporting a dome and used for public cult ceremonies), as well as from numerous bridges and dams, in which Roman methods of construction are to some degree evident. The dome-on-a-square plan is found everywhere, as is the liwan. Brick and stone are used for construction, and decoration is painted or of stucco, occasionally mosaic. Sculpture is almost exclusively represented by rock reliefs, of which 30 are known. They are concentrated in Fars, from the oldest at Firuzabad to the latest at Bishapur, but scattered examples are found elsewhere, at Hang-i-Nauruzi in Khuzistan, at Shapur (anc. Salmas) in Azerbaijan (a relief in very poor condition) and, particularly important, at Ṭāq-i-Bustān in Kurdistan. The famous Ṭāq-i-Bustān hunting scenes of Khusrau II, of the 7th century of our era, represent an advance over the immobility of the nationalistic victory scene of the Sassanian king Shāpur over the Roman emperor Valerian, which was endlessly repeated everywhere, along with investitures, triumphs, and ceremonies. This art, consciously and officially Iranian in content and iconography, emulates Rome in its imperial spirit while showing the attitudes and universality of Sassanian civilization. The eastern, or Sassanian, empire and the western, or Romano-Byzantine, empire appear to be two complementary worlds, still politically distinct but both culturally immersed in that late-antique atmosphere which, in art, represents the end of the classical world and leads directly to the Middle Ages. Sassanian silverwork is of particular interest; most of that in Iran comes from the Caspian regions. Textiles are also important, especially for the extensive influence of their decorative motifs, generally enclosed within central medallions; they come from various regions of Iran. Coins provide invaluable evidence for dating the surviving monuments of Sassanian art by a compar-ison of the characteristic heraldic motifs of the individual kings. There are also glyptic and ceramic finds. Those sites connected with the Sassanians are, for the most part, concentrated in Fars and Khuzistan. All the other important centers are either in western Iran — Shapur and Takht-i-Sulaymān in Azerbaijan; Qaṣr-i-Shīrīn, Haush Quri, Ṭāq-i-Girra, Harsin, and Ṭāq-i-Bustān in Kurdistan — or in central Iran: Kalar Dasht, Shahristanak, Rayy (Rhages), Va-ramin, Takht-i-Rustam, Takht-i-Kaykaʿus, Naysar, Atashkuh, Na-tanz, and Yezd-i-Khast. In eastern Iran Sassanian remains are found at Nishapur and Qalʿa-i-Dukhtar in Khorasan and at Karku in Seistan.

Stylistic and technical continuity exists in all forms of Iranian art and is particularly evident in architecture. It has been suggested that Iranian art reacted to the influence of Islam (q.v.), but this was not the case; Islamic art in a pure state did not exist prior to contact with Iran. Characteristic of Islamic art is its successful and total fusion of the two stylistic complexes mentioned above — the Hellenistic Romano-Byzantine and the Hellenistic Irano-Asiatic. For this reason the "Arab" style of Islamic architecture, represented principally by the portico mosque (Iranian examples include the Tārīkh Khāna at Damghan, 735–86, the Jāmiʿ at Nayin, of ca. 960, and the Jāmiʿ at Damavand, 9th cent., as well as other later structures), is merely its archaic style, in which the influence of the Western world still strongly predominates. On the other hand, the "Iranian" style based on dome and liwan became the classic style par excellence of the Islamic world after the fusion had taken place (examples include the Jāmiʿ at Niriz, with liwan, 951; the domed halls of the mosques at Gulpaygan, Qazvin, Ardistan, and Isfahan and of the Ḥaydariya at Qazvin, 12th cent.). This style was diffused throughout the Islamic world — India, central Asia, Turkey, and Anatolia, and even Mameluke Egypt (see MAMELUKE ART) — especially between the 11th and 15th centuries. Iranian Sassanian models may even have inspired some of the oldest Persian mosques. As a matter of fact, the Masjid-i-Rasūl at Bam in Kerman, 650, the mosques at Kaj near Isfahan, 700 (?), at Tabriz, 8th century, and at Shiraz, 894, can be traced back to the type with an isolated pavilion consisting of either a domed chamber or a liwan; the surviving examples would indicate that a liwan oriented toward Mecca was most characteristic.

The classic Iranian mosque, however, is not of this type but is a later evolution of it. It results from an insertion of the mosque with domed chamber into a complex of a square court with four liwans, probably of the type usual in Iranian secular architecture (at least in Khorasan) before the Mongol invasion. Such a plan with four liwans, one in the center of each side, is a constant in classic Persian architecture, both religious and secular, in madrasahs and caravanserais. The domed chamber of the earlier mosque is now placed behind the principal liwan and becomes the sanctuary of the new large mosque, which fills the space remaining between the liwan and exterior walls with vast halls separated by walls or divided into corridors by columns or piers. This transformation appears to have occurred chiefly in the region of Isfahan in the course of the 12th century; its earliest example is the Masjid-i-Jāmiʿ at Zavara. In Ardistan and Isfahan, as in Natanz, Gulpaygan, and Sava, the court with four liwans was added to the existing sanctuaries.

Khorasan, on the other hand, continued for some time to build mosques with plans differing from the madrasah type: those of Farumad, Gunabad, Zuzan, Nishapur, and Sabzavar have courts with only two liwans. This continued until the 15th century, when an architect from Shiraz built the Mosque of Jauhar Shād in Mashhad. The basic difference between the classic religious architecture of west-central and that of eastern Iran stems from this time. However, both regions continued to build some mosques with isolated pavilions, as at Rizaiyeh, Yezd, and Simnan.

Except for the decoration, mosque, madrasah, and caravanserai maintain the classic pattern almost unaltered throughout the 19th century. Only the dome tends to be transformed from an architectural, spatial element to one which is also decorative and linear, developing from the moderate suggestion of bulbousness of the Mausoleum of Tamerlane (Tīmūr Lenk) at Samarkand to the bulb of the Imāmzāda Shāh Chirāgh of Shiraz, as well as to the unpleasing instances of tortuous virtuosity to be found in some minor and provincial architecture. Architectural decoration employs three chief media: stucco, brick, and kashi (luster tile). The masterpieces of kashi and of the colorful Iranian architecture are the Masjid-i-Kabūd, or Blue Mosque, of Tabriz (15th cent.) and numerous religious buildings in Isfahan, notably the Darb-i-Imām and the Hārūn-i-Vilayat. The minaret is a feature closely connected with the mosque but not limited to it. In the Seljuk period it was often isolated and independent, rising starkly out of the ground (the earliest example is at Kashan), with simple brick decoration, of which the most perfect is at Sin near Isfahan. Later twin minarets are used at either side of the Ilkhan portals, which are decorated with kashi; perhaps a prototype is that of Ardistan.

The other type of building, continuing throughout the Iranian Middle Ages and found in practically every region, is the funerary monument. Its basic form is a dome raised on a base which was no longer only square, as in the Sassanian period (and still found, for example, at Maragha), but took a variety of forms, including the circular, as at Damghan, Lajim, Resget, Rayy, Varamin, Darjazin, and West Radkan; pentagonal, as in the much later Safavid tomb of Bābā Rukn al-Dīn at Isfahan; octagonal, the most common form, as in Shahristan, Turan-i-Pusht, the Gunbad-i-Jabaliya at Kerman, all Seljuk buildings, and the famous tower of East Radkan, 13th century; circular on an octagonal base, as in the Mausoleum of Öljeitü (Uljeitu) at Sultāniya, 14th century, and the funerary tower at Ahangan of the Timurid period; ten-sided, as at Bistam and again at Maragha; twelve-sided, as in the Imāmzāda Hūd of Darjazin; and even rectangular, as at Sarakhs. Funerary towers with conical or pyramidal roofs also appear frequently, especially in the north.

Around the tomb or mausoleum are sometimes formed entire architectural complexes, as in the great centers; the finest Ilkhan example is at Bistam, but those of the Timurid period are perhaps more numerous. The sanctuary of 'Abdullāh Ansārī at Herat is most famous, but there are also similar fine examples in Iranian Khorasan at Tayabad and at Turbat-i-Shaykh Jām; the complex of the Haram at Mashhad has a unique position, while that of Mahan near Kerman is of less architectural interest.

Less important forms of religious architecture are the musallā, a kind of chapel, and the khankah (khānaqāh), a monastery; they too are essentially based on the dome and liwan. The great liwan of the Musallā at Mashhad and the dome of the khankah at Safiabad near Simnan were, until a few years ago, among the most interesting extant structures in Iran. The imāmzāda, or saint's tomb, in Persia, roughly corresponding to the western Islamic marabut, has no special architectural plan of its own.

Of the few important remains of secular architecture from periods preceding the Safavid, many have undergone subsequent restoration. The villa at Bayramabad near Kerman is perhaps the best among these remaining edifices, besides the more famous ones of Isfahan. The villas at Shiraz and at Teheran and the surrounding area are later; the most beautiful example of the Qajar period is the Bāgh-i-Fīn near Kashan. The style of late Persian garden architecture still survives, as in the pavilion on the little island in the middle of the Istakhr-i-Shāh of Tabriz and in numerous examples of rustic architecture, at times very humble, in the villages. Even these, however, can well bear comparison with the official constructions of Rizā Shah's Teheran; always dependent upon European influence, these late buildings are all the more eclectic when based on Achaemenian or, less frequently, Sassanian models.

The various phases of modern European influence must be distinguished. At times the Qajar secular architecture of the 19th and early 20th centuries is blended rather harmoniously with architectural elements of Russian character. The first Qajar phase is the most spontaneous and attractive and the most influenced by Russia, through central Asia rather than the Caucasus, and through the new urban complexes of Tashkent and Samarkand as well. There followed a more conscious phase of westernization, but only very

recently was a more functional style adopted for public buildings, in which an occasional attempt is made to interpret the liwan in a cosmopolitan idiom, as in the mosque of the University of Teheran.

Following the example of Teheran, both large and small cities are in the process of eliminating the mud-built urban agglomerations by opening large avenues, often planted with trees; these intersect or meet in a central square and end in circular plazas (falaka); the squares and plazas rarely have fountains but always are landscaped and occasionally are decorated with a monumental bronze statue of one of the two most recent rulers. Usually paved with asphalt and varying in number according to the importance of the city, the principal streets are lined with shops, mostly of one story only, or open into the bazaars, with domes constructed like those of earlier times, and into little streets. High walls usually conceal the gardens from passers-by. Comparison with such Afghan cities as Herat, which have not undertaken modernization, reveals the social advantages and extent of the esthetic transformation produced by this leveling process, which has made all the large and middle-sized cities of Iran almost identical. The "old" cities predate the others only in so far as they contain structures older by some decades, among which are the significant monuments in the more famous centers.

The cultivated plot, the orchard, and the wood are jealously enclosed even outside the city. The fields are fortified oases in the midst of the steppe and the desert and look ancient even immediately after construction. The towns emerge like islands with their caravanserais, great ovens, and inns, the domes of cisterns with their air towers, and the great dovecots so common in central Iran, occurring as round towers at Isfahan and as fortresses of Assyrian type on rectangular bases toward Tabas in the east and Gulpaygan in the west. Everywhere are scattered the ruins of mud huts; they are never repaired by their poverty-stricken inhabitants, but are simply abandoned when they begin to crumble and rebuilt a few steps away.

The important sites for monuments of pre-Islamic Iran are almost wholly concentrated in western Iran, with the single important exception of Kuh-i-Khwaja. Aside from Tepe Sialk and Tepe Hissar they are, more precisely, in the regions of Kurdistan, Luristan, Khuzistan, and Fars, all of which are relatively poor in Islamic monuments (with the exception of Hamadan, Shiraz, and Niriz). The Islamic period is represented almost exclusively in central Iran and Khorasan; the Caspian regions present only their many famous mausoleums, although they furnish the major finds of gold- and silverwork from the pre-Islamic period.

BIBLIOG. *General topography:* M. Kaihān, Jughrāfyā-i mufassal-i Īrān (Detailed Geography of Iran), 3 vols., Teheran, 1310–11 A.H. (1931–32); A. Razmārā, Jughrāfyā-i nizāmī-i Īrān (Military Geography of Iran), 19 vols., Teheran, 1320–25 A.H. (1941–46); A. Razmārā, Farhang-i Jughrāfyā'ī-i Īrān (Geographical Dictionary of Iran), 10 vols., Teheran, 1328–32 A.H. (1949–54).

Historical geography and topography of monuments: a. General works: A. C. Barbier de Meynard, Dictionnaire géographique, historique et littéraire de la Perse et des contrées adjacentes, Paris, 1861; M. J. de Goeje, Biblioteca Geographorum Arabicorum, 8 vols., Leiden, 1873–1939; P. Schwarz, Iran in Mittelalter, nach den arabischen Geographen, 9 vols., Leipzig, 1896–1936; G. Le Strange, The Lands of the Eastern Caliphate, Cambridge, 1905; A. T. Wilson, A Bibliography of Persia, Oxford, 1930 (Western sources, including accounts of travelers and translations of individual Oriental works); C. A. Storey, Persian Literature: A Bio-bibliographical Survey, II, 2, London, 1936 (similar literature in Persian); Hudūd al-'Ālam, "The regions of the world"; A Persian Geography, 372 A.H. (Eng. trans., V. Minorsky), London, 1937; A. Gabriel, Die Erforschung Persiens: Die Entwicklung der abendländischen Kenntnis der Geographie Persiens, Vienna, 1952 (Western exploration of Iran); Abū-Dulaf Mis'ar ibn Muhallil's Travels in Iran in A.D. 950 (Eng. trans., V. Minorsky), Cairo, 1955. *b. Regional works, including tourist guides, in Persian:* M. J. Khūrmūjī, Āthār-i Ja'fari (History of Ja'far), Teheran, 1276 A.H. (1860: Fars and the adjacent countryside); M. H. Kh. Sanī 'al-Daula, Mir'āt al-buldān-i Nāsirī (The Mirror of the Lands of Nāsir), 4 vols., Teheran, 1294–97 A.H. (1877–80: incomplete general study); M. H. Kh. Sanī 'al-Daula, Matla'al-shams (The Place Where the Sun Rises), 3 vols., Teheran, 1303 A.H. (1885–86: Khurasan); M. T. Hakīm, Ganj-i dānish (Treasury of Wisdom), Teheran, 1305 A.H. (1885: general); M. H. Fasā ī, Fārsnāma-i Nāsirī (The Book of Fars of Nāsir), Teheran, 1313 A.H. (1895–96); Fursat Husainī, Āthār-i 'Ajam (History of 'Ajam), Bombay, 1314 A.H. (1896: Fars); B. Karīmī, Jughrāfyā-i mufassal-i tārikhī-i jarb-i Īrān (Great Historical Geography of Western Iran), Teheran, 1317 A.H. (1938); A. Kasravī, Nāmhā-i shahrhā-i Īrān (Names of Iranian Cities), Teheran, 1323 A.H. (1944); A. Kasravi, Musha' sha'īyān, yā bakhshī az tārīkh-i Khūzistān (Pages of History of Khuzistan), Teheran, 1324 A.H. (1945); A. Bairamānī, Daryā-i Khazar yā daryā-i Māzandarān (The Caspian Sea or Sea of Māzandarān), Teheran, 1326 A.H. (1947); K. A. Dānishjū, Khūzistān va Khūzistānīhā (Khuzistan and Its Inhabitants), Teheran, 1326 A.H. (1947); A. Sha'īyān, Māzandarān: Auzhā'-i jughrāfyā i va tārīkhī (Mazandaran: History and Geography), I, Teheran, 1327 A.H. (1948–49); B. Karīmī, Rāhhā-i bāstānī va pāytakhthā-i qadīmī-i jarb-i Īrān (Roads and Ancient Capitals of Western Iran), Teheran, 1329 A.H. (1950); K. Nīkzād, Jughrāfyā va Tarīkh-i Chahār-Mahall va Bakhtyārī (History and Geography of the Region of Chahār-Mahall and of the Bakhtiari), Isfahan, 1331 A.H. (1952–53).

Archaeology and history of art: SPA; D. N. Wilber, The Architecture of Islamic Iran: The Il-Khānid Period, Princeton, 1955; L. Vanden Berghe, Archéologie de l'Iran ancien, Leiden, 1959. See also the bibliogs. for other articles relating to Iran, and the following periodicals: Gudhārishhā-i bāstānshināsī (Archaeological Accounts, in Persian), 1950 ff.; Āthār-e Īrān (Monuments of Iran, in Fr.), I–IV, 1936–49; Ars Islamica, I–XVI, 1934–51; B. Am. Inst. for Persian (Iranian) art and Archaeol., I–V, 1932–38.

Bibliographies, catalogues, encyclopedias: Besides the work of Wilson and of Storey already cited, see the catalogues of the large collections of Arabic and Persian mss., relevant articles in RE and E. of Islam, and the following: M. Schwab, Bibliographie de la Perse, Paris, 1875; I. Smirnov and K. Inostrantsev, Materialy dlya bibliografii musul'manskoi arkheologii (Materials for the Bibliography of Moslem Archaeology), Zapiski vostochnogo otdeleniya imperatorskogo russkogo arkheologicheskogo obshchestva, XVI, 1904–05, pp. 79–145, 213–46; M. Saba, Bibliographie française de l'Iran, 2d ed., Teheran, 1951; J. D. Pearson, Index Islamicus 1906–55. Cambridge, 1958.

Places and monuments: M. A. Mukhbir, Āthār-i tārīkhī-i Fārs (Monuments of Fars), Yādgār, V, 1937, pp. 9–27; A. Shukrā'ī, Tārīkhcha-i qismatī azbanāhā-i tārīkhī-i kishvar (Notices of Some Historic Buildings of the Country), Isfahan, 1318 A.H. (1939); W. Wegener, Syrien, Iraq, Iran, Leipzig, 1943; I. Dībāj, Rāhnumā-i āthār-i tārīkhī-i Ādharbāyjān-i sharqī (Guide to the Monuments of Eastern Azerbaijan), Tabriz, 1334 A.H. (1955); L. Lockhart, Persian Cities, London, 1960; E. Malle, Iran, Bonn, 1960; D. N. Wilber, Persian Gardens and Garden Pavilions, Rutland, Vt., 1962. For recent developments in architecture and urban planning, see Arch. d'aujourd'hui, 70, 1957, p. 90, 78, 1958, p. 96, 81, 1958, pp. 80–81, 82, 1959, p. 94, 84, 1959, pp. 98–100. See also the bibliogs. for individual regions and places.

SITES AND MONUMENTS. *Azerbaijan.* Ardebil (Ardabil). In the Islamic Middle Ages this city was the regional capital alternating with Maragha. Destroyed by the Mongols in 1220, it regained its importance under the Safavids, whose line originated here at the beginning of the 14th century. In the time of Shah ʿAbbās I (1557–1629) it was still among the most flourishing cities of the empire. The few important monuments which have been preserved include the Masjid-i-Jāmiʿ of the 14th century; the contemporaneous tomb of Sheik Jibrāʾīl (perhaps the father of the founder of the Safavid dynasty), about 4 miles north of the city; and the notable architectural complex of the tombs of Sheik Ṣafī, the earliest eminent ruler, and of Ismāʿīl, the first *shāhinshāh* of the Safavid dynasty. Although the earliest portions of the sanctuary of Sheik Ṣafī belong to the latter half of the 14th century, many alterations were made in the 16th and 17th centuries (PL. 160). The shrine is of greater historic and religious interest than artistic importance; its library was taken to St. Petersburg in the early 19th century.

BIBLIOG. P. E., Opisanie Ardavil'skoi mesheti (Description of the Mosque of Ardabil), Moskovskie vedomosti, 90, 1828; F. Sarre with B. Schulz, Ardabil: Grabmoschee des Scheich Safis, Berlin, 1904; M. Siroux, La Mosquée Djoumeh d'Ardabil, BIFAO, XLIV, 1947, pp. 89–100; I. Dībāj, Rāhnumā-i āthār-i tārīkhī-i Ādharbāijān-i sharqī (Guide to the Monuments of Eastern Azerbaijan), Tabriz, 1334 A.H. (1955), pp. 52–91.

Fakhraka. This site is south of Lake Urmia in the vicinity of Tash Tepe. Notable is a rock-carved tomb of the Median period comprising an open portico with two columns and a three-column funerary chamber containing three burials.

BIBLIOG. E.E. Herzfeld, Iran in the Ancient East, London, 1941, pp. 202–03.

Geoy Tepe (Gök Tepe). A site in the Lake Urmia region, Geoy Tepe has yielded material documenting prehistoric contacts between Iran and Anatolia. The excavations, in which eight levels have been distinguished, have brought to light pottery connected with that of Tepe Giyan I and Tepe Sialk II and III and important sculptural fragments (ca. 1000 B.C.).

BIBLIOG. T. Burton-Browne, Excavations in Azerbaijan, 1948, London, 1951.

Hasanlu. This site is in the region of Sulduz, about 30 miles southwest of Rizaiyeh. It has an important necropolis where ceramics, bronzes, and jewelry connected with Tepe Sialk A and B, Tepe Giyan I, and with such Anatolian sites as Alisar have been recovered. In 1959 a gold bucket was found here.

BIBLIOG. A. Stein, Old Routes of Western Iran, London, 1940, pp. 390–404; A. Hākimī and M. Rad, Sharḥ va Natīja-i kāvishā-i ʿilmī-i Ḥasanlū (Soldūz) (History and Results of the Excavations at Hasanlū-Soldūz), Gudhārishhā-i bāstānshināsī, I, 1950, pp. 87–103; R. H. Dyson, Iran 1956, B. Pa. Univ. Mus., XXI, 1957, pp. 37–39; R. H. Dyson, Iran 1957, B. Pa. Univ. Mus., XXII, 1958, pp. 25–32; E. Porada, The Hasanlu Bowl, Expedition, I, 3, 1959, pp. 19–22.

Khiav. About 105 miles northeast of Tabriz, this site has a tomb tower known as Sultan Ḥaydar's, which is cylindrical outside and dodecagonal inside (ca. 1330).

BIBLIOG. D. N. Wilber, The Architecture of Islamic Iran: The Il-Khānid Period, Princeton, 1955, pp. 175–76.

Maragha. This important city about 80 miles south of Tabriz flourished in the Ilkhan (Mongol) period. It is particularly famous for its characteristic tomb towers with crypt and chapel underneath, which date from A.D. 1147–1328: Gunbad-i-Surkh, of rectangular plan (ca. 1147); Gunbad-i-Kabūd (said to be the tomb of Hūlāgū's mother), polygonal in plan (ca. 1197); Gunbad-i-Ghaffāriya, of rectangular plan (ca. 1328); the Joi (Göj) Burj, with cylindrical exterior, now in ruins (ca. 1330). The ruins of Hūlāgū's astronomical observatory (ca. 1258) are also important.

BIBLIOG. J. von Hammer-Purgstall, Geschichte der Ilchane, II, Darmstadt, 1843, pp. 98–184; V. Minorskii, Poezdka v Maragu (Voyage to Maragha), Izvestiya shtaba kavkazkogo voennogo okruga, XX, 1907, pp. 34–56; A. Godard, Les monuments de Maragha, Paris, 1934; A. Godard, Notes complémentaires sur les tombeaux de Maragha, Āthār-e Īrān, I, 1936, pp. 125–60; I. Dībāj, Rāhnumā-i āthār-i tārīkhī-i Ādharbāijān-i sharqī (Guide to the Monuments of Eastern Azerbaijan), Tabriz, 1334 A.H. (1955), pp. 35–44.

Marand. This city is about 45 miles northwest of Tabriz and contains a Masjid-i-Jāmiʿ of rectangular plan, with a sanctuary which may have Seljuk and Ilkhan decorations (mihrab, ca. 1330). About 8 miles to the north is an important Ilkhan caravanserai (ca. 1330–1335).

BIBLIOG. D. N. Wilber, The Architecture of Islamic Iran: The Il-Khānid Period, Princeton, 1955, pp. 172–73, 176–77; M. Siroux, La Mosquée Djumeh de Marand, Arts Asiatiques, III, 1957, pp. 89–97.

Rizaiyeh (Riẓā'iya). This important city is near the west shore of Lake Urmia. Within both the city and its environs lives an important Chaldean minority group; the city and neighboring villages thus contain numerous Christian churches (Catholic and a few Nestorian), although these are modern and of minor architectural interest. There are two notable Islamic monuments, a Seljuk mausoleum known as the Si Gunbad, and the Masjid-i-Jāmiʿ, with a Seljuk domed sanctuary similar in structure to the mosque at Qazvin, and its contemporary mihrab over which was built another in 1277, apparently the earliest extant Ilkhan mihrab.

BIBLIOG. H. Kiepert, Zur Topographie der Umgegenden von Urmi in Persien, Z. der Gesellschaft für die Erdkunden, VII, 1872, pp. 538–45; M. Bittner, Der Kundengau Uschnuje und die Stadt Urumije, Reiseschilderungen eines Persers, SbWien, CXXXIII, 3, 1895; J. C. Wilson, The Masdjid-i jamie of Rizaiya, B. Am. Inst. of Iranian Art and Archaeol., V, 1937, pp. 38–42.

Sujas. A site in the region of Sulṭāniya, Sujas contains a Masjid-i-Jāmiʿ with a Seljuk domed sanctuary of the Qazvin type, built about 1100, and a stucco mihrab of 1290.

BIBLIOG. D. N. Wilber, The Architecture of Islamic Iran: The Il-Khānid Period, Princeton, 1955, p. 118.

Sulṭāniya. Now a modest village, in the Ilkhan period it was the capital. It contains the very famous tomb-mosque of Öljeitü (Uljeitu; VII, PL. 400), built between 1307 and 1313, originally intended to receive the relics of the Shiite Imams. It is among the masterpieces of Ilkhan architecture, comprising an octagonal core with interesting structural variations and eight minarets; it is richly decorated. Also in the city is the octagonal tomb of Chelebi Oghlu; nearby are remnants of the arches and liwan of a khankah (ca. 1330–33).

BIBLIOG. M. Dieulafoy, Mausolée de Chah Koda-Bende, œuvre du XIII siècle, Rev. générale de l'arch. et des travaux publics, X, 1883, pp. 98–103, 145–51, 194–98, 242–43; D. N. Wilber, The Architecture of Islamic Iran: The Il-Khānid Period, Princeton, 1955, pp. 139–41, 173.

Tabriz. The second city of Iran, it was a flourishing capital in the Ilkhan period (especially under Ghāzān, 1295–1304) and in the first Turkoman period (15th cent.). It was also the capital of the first Safavids, until Shah Ṭahmāsp I moved the court to Qazvin. Today Tabriz is a very lively cultural and political center, in some respects rivaling Teheran. Unfortunately earthquakes have spared only a few of its medieval monuments. Although the most famous monument, the Masjid-i-Kabūd (Blue Mosque) erected under Jahān Shah in 1465–66, is badly ruined, its great portal, the lower section of the prayer hall, and a few piers and arches from the courtyard have been preserved with careful restoration. The building is as important for the uniqueness of the plan and the architectural proportions as for what is probably the most perfect surviving example of *kashi* decoration in all Iran. The Masjid-i-Jāmiʿ, of historical interest, has been completely altered. The remains of the Masjid-i-ʿAlī Shah are impressive for their unusually large dimensions; the

building was later transformed into a citadel (Arg) and is so called today (1310–20). About 2 miles west from the center of the city are almost unrecognizable traces of the complex at Ghāzāniya, and a short distance to the east are ruins connected with the construction of Rabʿ-i-Rashīdī (ca. 1300). In the modern rebuilding of the city of Tabriz there are certain interesting examples of secular architecture. The city has the best example in Iran of a public city park, the Bāgh-i-Gulistan, with pavilions influenced by eastern European models.

Bibliog. I. N. Berezin, Puteshestvija po severnoi Persii (Travels in Northern Persia), Kazan, 1852, pp. 55–96; V. Tiesenhausen, Melkie zametki i izvestiya o mecheti Alishaha v Tebrize (Brief Observations and Notes on the Mosque of ʿAlīshāh at Tabriz), Zapiski vostochnogo otdeleniya imperatorskogo russkogo arkheologischeskogo obshchestva, I, 1886, pp. 115–18; V. Minorsky, E. of Islam, s.v. Tabrīz, IV, 1928, pp. 583–93; M. Bahrami, Recherches sur les carreaux de revêtement lustré dans la céramique persane du XIII et du XV siècle, Paris, 1937; A. Sayli, Gazan Han rasathanesi (The Observatory of Ghāzān Khān), Belleten, X, 1946, pp. 625–40; I. Dībāj, Rāhnumā-i āthār-i tārīkhī-i Ādharbāījān-i sharqī (Guide to the Monuments of Eastern Azerbaijan), Tabriz, 1334 A.H. (1955); D. N. Wilber, The Architecture of Islamic Iran: The Il-Khānid Period, Princeton, 1955, pp. 124–26, 129–31, 146–49.

Takht-i-Sulaymān. This site about 45 miles southwest of Miyana is the ancient Parthian Phraaspa, from which remain numerous ruins of various pre-Islamic periods, all situated around a crater lake. The city walls are about 4,000 ft. in circumference, about 15 ft. thick, and some 45 ft. high and have two doors and 27 towers; inside are a large fire temple and various palaces. Among other very recent finds is a well-preserved fortress. Within the city are also the ruins of a palace of Seljuk origin which was rebuilt in the Ilkhan period (1265–81).

Bibliog. M. Crane and D. N. Wilber, Preliminary Report on Takht-i Sulayman, 2–3, B. Am. Inst. of Iranian Art and Archaeol., V, 1937, pp. 71–109; D. N. Wilber, The Parthian Structures at Takhti Sulayman, Antiquity, XII, 1938, pp. 389–410; H. H. von der Osten, H. Henning, and R. Naumann, Takht-i Suleiman, Berlin, 1961.

Kurdistan. Behistun (Bisutun). A site some 25 miles east of Kermanshah, it is most famous for the well-known Achaemenian relief, carved about 195 ft. up on a rock wall, which shows Darius I triumphing over Gaumata and adoring Ahura Mazda (Ormazd); it bears the very famous trilingual inscription — Old Persian, Neo-Babylonian, and Neo-Elamite — celebrating the family and the glory of the ruler. Part of the Neo-Elamite inscription was erased in ancient times in order to make room for the figure of Skunkha the Saka. Two Parthian reliefs with two Greek inscriptions are found closer to the valley. The first, a homage to Mithridates (123–88 B.C.), is the earliest known from this period, though it was mutilated by the addition of a Modern Persian inscription in the 18th century; the other represents the triumph of Gotarzes II (A.D. 38–51). In the same area are a block with a figure bearing incense before a fire altar and two decorated capitals (today removed) of the Ṭāq-i-Bustān type. Nearby is the Hunter's Cave (so named by Carleton S. Coon), of prehistoric and protohistoric interest.

Bibliog. H. C. Rawlinson, The Persian Cuneiform Inscription at Behistun, JRAS, X, 1847; A. V. W. Jackson, The Great Behistun Rock, JAOS, XXIV, 1903, pp. 77–95; L. W. King and R. C. Thompson, The Sculptures and Inscriptions of Darius the Great on the Rock of Behistūn in Persia, London, 1907; F. W. König, Relief und Inschrift des Königs Dareios I am Felsen von Bagistan, Leiden, 1938; G. Cameron, The Old Persian Texts of the Bisutun Inscriptions, J. of Cuneiform S., V, 1951, pp. 47–54; C. S. Coon, Cave Excavations in Iran, Philadelphia, 1951, pp. 20–31, 37–41, 44–52, 69–76, 78–89, 93–95; W. C. Benedict and E. von Voigtlander, Darius Bisutun Inscription, Babylonian Version: Lines 1–19, J. of Cuneiform S., X, 1956, pp. 1–10.

Darjazin. About 3 miles east of Razan (east of Hamadan) is Darjazin, with the Imāmzāda Hūd and the Imāmzāda Azhar, both of the Ilkhan period.

Bibliog. D. N. Wilber, The Architecture of Islamic Iran: The Il-Khānid Period, Princeton, 1955, p. 189.

Dukkān-i-Dāūd. Located about 2 miles southeast of Sar-i-Pul-i-Zuhab, it has a rock-carved tomb with a rectangular portal, at the sides of which are two bases and two column capitals, and behind which is the funerary chamber. Below the tomb is a relief called the Kīl-i-Dāūd (stele of David) with a religious representation from the Median period (7th–6th cent. B.C.). Another unfinished tomb of the same type, the Uṭāq-i-Farhād, is nearby.

Bibliog. H. C. Rawlinson, March from Zohab to Khuzistan, J. Royal Geog. Soc., IX, 1840, pp. 38–39; L. Vanden Berghe, Archéologie de l'Iran ancien, Leiden, 1959, p. 103.

Hamadan. Capital of the region of the same name, this is the ancient Ecbatana, capital of the Medes. Because the modern city,

one of the most important in Iran, was built over the ancient, the latter has been very little excavated. Finds have been due mainly to chance, but have yielded Achaemenian gold jewelry, such as the treasure in the Vidal Collection, New York, a fragment of Achaemenian sculpture, and two bronze heads of the 13th–12th century B.C. Southeast of the city is a great stone lion called the Sang-i-Shīr, much ruined and perhaps from the Parthian period. The building called the Gunbad-i-ʿAlaviyān is a mausoleum of either the Seljuk or the Ilkhan period; its dome has fallen, but its decoration is important. The so-called "tomb of Esther," of the 7th century A.H. (13th cent. of our era), is an important local Jewish shrine and contains a wooden casket of the 8th or 9th century A.H. (14th or 15th cent. of our era). The Burj-i-Qurbān, a very much restored twelve-sided tower, and the structure termed the Buqʿa-i-Hidhr, ornamented with elegant Kufic inscriptions, are also important monuments. The Mausoleum of Avicenna (Ibn-Sīnā), constructed in 1952, is an example of the "new architecture" but derives its inspiration from the Gunbad-i-Qābūs; it has an important library. A star-shaped city plan centers at the Maidan-i-Pahlavi, where the most important buildings are located. Of recent construction are the American Hospital and the Dānishgāh-i-Ibn-Sīnā (Avicenna University).

Bibliog. H. C. Rawlinson, Memoir on the Site of the Atropatenian Ecbatana, J. Royal Geog. Soc., X, 1841, pp. 65–158; A. F. Sthal, Gorod Hamadan i ego okresnosti (The City of Hamadān and Its Environs), B. russkogo imperatorskogo geog. obshchestva, III, 1916, pp. 395–402; H. L. Rabino di Borgomale, Hamadan, Rev. du monde musulman, XLIII, 1921, pp. 221–28; E. E. Herzfeld, Die Gunbadh-i Alawiyyan und die Baukunst der Ilchane in Iran, in A Vol. of O. S. Presented to E. G. Browne, Cambridge, 1922, pp. 186–99; M. T. Mustafawī, Hagmatana, n.p., 1332 A.H. (1953); D. N. Wilber, The Architecture of Islamic Iran: The Il-Khānid Period, Princeton, 1955 (reviewed by M. B. Smith, JAOS, LXXVI, 1956, pp. 243–47).

Kangavar. This site is about 55 miles west of Hamadan. Within the walls of certain buildings are set Doric capitals and Corinthian abaci — the remains of columns from a Seleucid temple of Anahita (ca. 200 B.C.).

Bibliog. M. Dieulafoy, L'art antique de la Perse, V, Paris, 1889, pp. 8–11.

Kermanshah. Capital of the region of Kermanshahan, it is known especially for the Sassanian complex of Ṭāq-i-Bustān in the immediate vicinity. No noteworthy Islamic monuments remain.

Bibliog. H. L. Rabino di Borgomale, Kermanchah, Rev. du monde musulman, XXXVIII, 1920, pp. 1–40.

Qaṣr-i-Shīrīn. This site lies about 15 miles from the Iraqi border on the main Kermanshah–Baghdad road. It contains a Sassanian fire temple called the Chahār Qāpū, a large building of square plan with four doors, as well as a ruined palace called the ʿImārat-i-Khusrau, with a dome and liwan; the complex belongs to the period of Khusrau II (590–628).

Bibliog. G. L. Bell, Palace and Mosque at Ukhaiḍir, London, 1914.

Sakhna. A site on the road between Kermanshah and Kangavar, Sakhna has a rock-carved tomb, perhaps of the Median period, said to be that of Farhād and Shīrīn. Its entrance is flanked by two columns and surmounted by the symbol of Ahura Mazda. The interior includes a vestibule with two niches and a passage leading into a lower chamber, perhaps intended for the burial of a more important person.

Bibliog. W. Inz, Zur iranischen Altertumskunde: Ein wieder aufgefundenes medisches Felsgrab, ZMG, XCIII, 1939, pp. 363–64.

Sar-i-Pul-i-Zuhab. This site lies about 20 miles southeast of Qaṣr-i-Shīrīn. On the rock face are four reliefs, the most important of which belongs to the Elamite period and dates from the late 3d millennium (3d dynasty of Ur); it is divided into two scenes and bears an Akkadian inscription. Two other reliefs are similar but more modest; the fourth, of the Parthian period, also bears an inscription.

Bibliog. E. E. Herzfeld, Am Tor von Asien, Berlin, 1920, pp. 3–5, 53.

Ṭāq-i-Bustān. About 3 miles northeast of Kermanshah, this site contains the most interesting examples of Sassanian sculpture: a relief depicting the investiture of Ardashīr II (379–83); those of the "little" cave or liwan of Shāpur III (383–88), representing this ruler and Shāpur II and having inscriptions; and those of the "large" cave or liwan of Fīrūz II (457–83) or Khusrau II (590–628). The entrance of this last monument bears a tree-of-life relief with acanthus leaves and two winged victories with triumphal crowns; in the middle is a crescent moon. The interior end wall has two scenes; a royal investiture above and Khusrau II on horseback below. The side walls bear hunting scenes. Outside the cave are found a torso of Khusrau II and two decorated capitals.

BIBLIOG. K. Erdmann, Das Datum des Taqi Bustan, Ars Islamica, IV, 1937, pp. 79–97; H. G. Farmer, The Instruments of Music on the Taqi Bustan Bas-Reliefs, JRAS, 1938, pp. 297–412; E. E. Herzfeld, Khusrau Parwiz und der Taqi Bustan, Archaeol. Mitt. aus Iran, IX, 1938, pp. 91–158; K. Erdmann, Die Kapitelle am Taqi Bustan, Z. der d. Orientgesellschaft, LXXX, 1943, pp. 1–42; M. T. Mustafawī, Ṭāq-i Bustān va Bīsutūn (Ṭāq-i Bustān and Bīsutūn), Teheran, 1325 A.H. (1947); F. Wachsmuth, Zur Datierung des Taqi Bustan und der Pariser Silberschale, ZMG, CI, 1949, pp. 212–24.

Zawiyeh (Ziviya). At this site, about 25 miles east of Saqqiz, was found a very famous treasure of gold, silver, and ivory objects, the dating of which is still the subject of controversy; attributions vary from the 9th to the 7th century B.C. Also much discussed is whether the objects belong to one or several groups. See PLS. 124, 125; II, PL. 4; VI, PLS. 248, 249.

BIBLIOG. R. Ghirshman, Notes iraniennes, IV: Le trésor de Sakkiz, les origines de l'art mède et les bronzes du Luristan, AAs, XIII, 1950, pp. 181–206; A. Godard, Le trésor de Ziwiyè (Kurdistan), Haarlem, 1950; Rāhnumā-i Ziwīya (Guide to Ziwīya), n.p., 1950; A. Godard, À propos du trésor de Ziwiye, AAs, XIV, 1951, pp. 240–45; M. Falkner, Der Schatz von Ziwiye, Arch. für Orientforschung, XVI, 1952, pp. 129–32; M. Rād, Iṭṭilā'ātī dar bāra-i chandīn mahall-i tārīkhī dar magrib-i Īrān (Notes on Several Historic Places in Western Iran), Gudhārishhā-i bāstānshināsī, III, 1956, pp. 307–16.

Luristan. This region is especially rich in archaeological remains of the pre-Islamic period. The Masjid-i-Jāmi' of Burujird, which dates from the Seljuk period, is the only Islamic monument worthy of mention. The plateau of Alishtar, the valleys of Badavar, Hulaylan, and Kuh-i-Dasht, the plain of Mahi Dasht, the Rumishgan and Saymarra valleys, and the plain of Asadabad have been explored and have everywhere yielded pottery of the Tepe Giyan type (see CERAMICS; ASIATIC PROTOHISTORY; IRANIAN PRE-SASSANIAN ART CULTURES). There are numerous Sassanian ruins: Dār-i-Shahr, Harsin, Qal'a-i-Hazār Dār, Sirvan, and, in particular, remains of bridges (Pul-i-Āb'Burda, Pul-i-Dukhtar, Pul-i-Khusrau, and Pul-i-Safala).

Nihavand (Nehavend). An important site for pottery in an archaeologically rich zone, this city probably occupies the site of the ancient Laodicea. A Parthian treasure, a Seleucid stele of Antiochus III (223–187 B.C.), and bronze statuettes have been found.

BIBLIOG. E. E. Herzfeld, The Hoard of the Kāren Pahlavs, BM, LII, 1928, pp. 21–27; L. Robert, Inscription hellénistique de Néhavend (Iran), Hellenica, VII, 1949, pp. 5–26.

Surkh-i-Dum. This hill rises in the plain of Kuh-i-Dasht. In an Assyrian sanctuary (883–612 B.C.) have been found various objects, including many decorated pins of the Luristan bronze type, but belonging to a sedentary rather than a nomadic population.

BIBLIOG. R. Dussaud, Anciens bronzes du Luristan et cultes iraniens, Syria, XXVI, 1949, pp. 196–229.

Tepe Giyan. Located about 5 miles southwest of Nihavand in the valley of Khava, Tepe Giyan is an independent ceramic center of great importance. Five levels of separate cultures have been distinguished, from Tepe Giyan V, of which the finds represent a link between Tepe Sialk III and the ceramic centers of southern Iran, to Tepe Giyan I, with three distinct levels connected with the Mesopotamian centers and with Tepe Sialk Necropolis A and B. (See II, PL. 9.) About 5 miles to the south, the 19 tombs of Tepe Jamshidi have furnished further important archaeological material closely related to that of Tepe Giyan.

BIBLIOG. G. Contenau and R. Ghirshman, Fouilles de Tépé-Giyan près de Néhavend, 1931–1932, Paris, 1935.

Khuzistan. **Badr-Nishanda.** This site is about 10 miles northeast of Masjid-i-Sulaymān. Here are ruins of an artificial terrace and remnants of columns which supported a liwan. A Parthian head was found in this locality.

BIBLIOG. A. Godard, Badr Neshandè, Āthār-e Īrān, IV, 1949, pp. 153–62.

Chuga Zanbil. At this site, about 30 miles southeast of Susa, there arose in the mid-13th century B.C. the Elamite city of Dur-Untash (destroyed in 640 by Ashurbanipal). It was enclosed by double walls, which had in their midst a ziggurat of five stories with a cult sanctuary built on the top (original ht., ca. 175 ft.). Three stories of the ziggurat remain, with a present height of about 80 ft. In the sacred area three temples have been excavated; in one of them important finds of arms and various stone objects, marbles, and bronzes have been made. Recently a tablet furnishing important information about the construction of the ziggurat was found.

BIBLIOG. R. De Mecquenem and G. Dossin, La "Marre" de Nabu, Rev. d'assyriologie, XXXV, 1938, pp. 129–35; R. Ghirshman, Campagne de fouilles de la Mission française en Susiane, RA, XLII, 1953, pp. 1–9; M. Rutten, Les documents épigraphiques de Tschoga Zembil, Mém. de la délégation en Perse, XXXII, 1953, p. 88; R. Ghirshman, Travaux de la Mission archéologique française de Susiane, Ars Orientalis, I, 1954, pp. 173–74; R. Ghirshman, Troisième campagne de fouilles à Tchoga-Zanbil, près de Suse, Arts asiatiques, I, 1954, pp. 83–95; R. Ghirshman, La Ziggourat de Tchoga-Zanbil, CRAI, 1954, pp. 233–38, 1955, pp. 112, 322–27; R. Ghirshman, La Ziggourat de Tchoga-Zanbil, près de Suse, RA, XLIV, 1954, pp. 1–5; R. Ghirshman, Nouveaux travaux à la Ziggourat de Tchoga-Zanbil, près de Suse, RA, XLVI, 1955, pp. 63–67; R. Ghirshman, The Ziggurat of Choga-Zanbil, Archaeology, VIII, 1955, pp. 260–63.

Dizful. This city is about 90 miles north of Ahvaz. The bridge or Pul-i-Shāpur, constructed after A.D. 260 with the labor of Roman prisoners, is about 1,310 ft. in length and has 22 arches. It was later rebuilt on Sassanian piers.

BIBLIOG. M. Dieulafoy, L'art antique de la Perse, V: Monuments parthes et sasanides, Paris, 1889, pp. 105–09.

Jundi Shapur. Situated near Shahabad, about 5 miles south of Dizful, this is the ruin of a Sassanian city encampment for Roman prisoners; it was built on the Roman rectangular plan.

BIBLIOG. L. Vanden Berghe, Archéologie de l'Iran ancien, Leiden, 1959, p. 66.

Ivan-i-Karkha. This site is in the region of Shushtar on the Karkha River. The ancient Sassanian city-fortress founded by Shāpur II as a powerful walled fortification preserves remains of the imperial palace: two corridors about 100 ft. long, a large hall, and a pavilion with a triple liwan and walls which once bore frescoes.

BIBLIOG. R. Ghirshman, Cinq campagnes de fouilles à Suse, 1946–51, Paris, 1952, pp. 10–12.

Iza (anc. Malamir). Located about 95 miles northeast of Ahvaz in a plain rich with rock reliefs, the city lay on the ancient Susa-Malamir–Isfahan caravan route (now abandoned), along which are various monuments. Near Iza a ceramic group of the type of Tepe Musyan and Tell-i-Bakun was discovered. Cuneiform tablets of the 2d millennium B.C. with Akkadian texts also have been found. The principal reliefs are in Qal'a-i-Tul at nearby Qul-i-Fara, the most interesting archaeological site in the area; there are five Neo-Elamite reliefs: an offering from King Hauni, of the time of Shutruk Nakhunte II (717–699 B.C.), with an inscription, as well as four others, less well preserved, with scenes of adoration, procession, and sacrifice. Other important reliefs in the area are to be found at Shikaft-i-Salman (four religious scenes), at Shahsavar (bas-relief consisting of two scenes), and at Hang-i-Nauruzi (a relief of the Sassanian period).

BIBLIOG. A. Layard, A Description of the Province of Khuzistan, J. Royal Geog. Soc., XVI, 1846, pp. 1–105; G. Jéquier, Description du site de Malamir, Mém. de la délégation en Perse, III, 1901, pp. 133–43.

Masjid-i-Sulaymān. Located about 30 miles southeast of Shushtar, this site has remains of various man-made terraces built against the mountain and all accessible by staircases; the main stairs lead to a platform with the remains of a triple liwan. There is a fire temple, or fortified terrace with a castle; if it is the latter, a prototype of the buildings at Pasargadae and Persepolis can be recognized.

BIBLIOG. J. M. Unvala, Ancient Sites in Susiana, Rev. d'assyriologie, XXV, 1928, pp. 83–88; A. Godard, Les monuments du feu, Āthār-e Īrān, III, 1938, pp. 7–80 at 49; M. Siroux, Masdjid-é Sulaimān, Āthār-e Īrān, III, 1938, pp. 157–60; K. Erdmann, Das iranische Feuerheiligtum, Leipzig, 1941, pp. 27–29; R. Ghirshman, Masdjid-i Solaiman: Résidence des premiers Achéménides, Syria, XXVII, 1950, pp. 205–20.

Shami. Shami lies about 30 miles north of Iza. It has the foundations of a temple, remains of walls, and tombs of the Parthian period. Here were found the famous statues and bronze and marble objects (3d–1st cent. B.C.; PL. 141).

BIBLIOG. A. Godard, Les statues parthes de Shamī, Āthār-e Īrān, II, 1937, pp. 285–305; C. Picard, Courrier de l'art antique, GBA, XXI, 1939, pp. 201–34 at 229; H. Seyrig, La grande statue parthe de Shami et la sculpture palmyrienne, Syria, XX, 1939, pp. 177–82; A. Stein, Bronze Statue from Khuzistan, Iran, Antiquity, XIII, 1939, pp. 234–36; G. Contenau, Statues élamites de l'époque parthe, in L'âme de l'Iran (ed. R. Grousset et al.), Paris, 1954, pp. 49–66.

Shushtar. This site is about 80 miles north of Ahvaz. It has three Sassanian bridges on the Karun which also function as dams: the very famous Bridge of Shushtar, about 1,800 ft. long, of which 28 arches remain on one side and seven on the other, the Band-i-Gurgar, and the Band-i-Miyān, several times restored. The Islamic period is represented by the Imāmzāda 'Abd-Allāh of the Ilkhan period, which contains two rooms with domes, dating from 1231

and perhaps 1270 respectively. The Masjid-i-Jāmiʿ also is of interest, with its prayer hall formed of aisles delimited by imposing piers.

BIBLIOG. ʿAbdallāh ʿal-Shūshtarī, Tadhkira-i Shūshtar (The Book of Shushtar), 2 vols., Calcutta, 1914–24.

Susa (mod. Shush). The ancient Susa is perhaps the most interesting archaeological center of all Iran for the pre-Islamic period, especially for Elamite and Achaemenian times. The ruins are distributed over four hills: the acropolis (ht., ca. 100 ft.), which was the Elamite city and which also contains the Arab, Sassanian, Parthian, Seleucid, Achaemenian, Neo-Elamite, and proto-Elamite levels; the "Tell of the Apadana," an Achaemenian site near the remains of the Palace of Darius I; the "Tell of the Royal City," containing the residential quarters of the court and officials; the "Tell of the Artisan City." Susa represents the point of contact of the Mesopotamian and the Iranian cultures. Among the most noteworthy results of excavation has been the finding of the ceramic style named Susa I (PL. 119; III, PL. 121; VI, PL. 88), characterized by a light ground with dark decorations comprising geometric, floral, and animal motifs, in levels V and IV of the acropolis. Level III reveals undecorated pottery of the Mesopotamian Uruk type and is related to Level IV of Tepe Sialk. From the upper level of Level III and from Level II come proto-Elamite tablets and the pottery named Susa II (3000–2200 B.C.), both polychrome and monochrome (II, PL. 2). In the same area were found many Mesopotamian objects obviously taken to Susa as trophies (e.g., stele with the Code of Hammurabi; I, PL. 512), and Elamite statues, statuettes, and reliefs. The Palace of Darius had a frieze and a large capital, now in the Louvre (PL. 127); traces of a colonnade from the palace remain. At the same location is the fire temple of Artaxerxes II (404–359 B.C.), and there have also been found trilingual documents of Darius I as well as Seleucid and Parthian limestone sculptures. In the "Royal City" were excavated five levels: two Islamic levels with interesting proto-Islamic pottery; one intermediate level; the Sassanian level, which includes pottery, the remains of an interesting building with frescoes, and a Christian object; a Parthian level in which have been found a relief with an inscription of Artabanus V, a bath decorated with mosaics, and a collection of ceramics. The "Artisan City" has three Islamic levels with remains revealing the plan of a mosque of Arab type which is certainly among the oldest in Iran. There are also a Parthian Seleucid necropolis (300–200 B.C.) with two kinds of tombs, a village of the 7th century B.C. with an interesting building, and a level with Elamite and Neo-Babylonian tablets. The pottery of the lower levels is related to that of Necropolis B of Tepe Sialk, while that of the upper levels is Achaemenian. In the Islamic village is the so-called "tomb of Daniel" with a beehive dome.

BIBLIOG. J. Dieulafoy, A Suse: Journal des fouilles 1884–86, Paris, 1888; J. Dieulafoy, L'Acropole de Suse d'après les fouilles exécutées en 1884–86, Paris, 1893; Mém. de la délégation en Perse, 36 vols., Paris, 1900–54; M. Pézard and E. Pottier, Les antiquités de la Susiane, Paris, 1913; M. Pillet, Les palais de Darius Ier à Suse, Paris, 1914; R. de Mecquenem, Contribution à l'étude du palais achéménide de Suse, Mém. de la délégation en Perse, XXX, 1947, pp. 1–119; R. Ghirshman, Une mosquée de Suse du début de l'Hégire, B. des ét. o., XII, 1948, pp. 77–79; H. W. and T. G. Eliot, Excavations in Mesopotamia and Western Iran: Sites of 4000–500 B.C., Cambridge, Mass., 1950; L. Vanden Berghe, Archéologie de l'Iran ancien, Leiden, 1959, pp. 71–83.

Tell-i-Ghazir. This site lies northwest of Ram Hurmuz. It consists of five hills, into three of which preliminary explorations have been made. Beneath a first Islamic level the principal mound contains the ruins of an Elamite fortress (2d millennium B.C.); there follows a proto-Elamite level with tablets and pottery. Another has tombs of the 1st millennium, and the third bears traces from the 2d millennium B.C.

BIBLIOG. A. Perkins, Archaeological News: The Near East, AJA, LIII, 1949, p. 54.

Tang-i-Sarvak. This valley is about 30 miles north of Bihbihan. It has four groups of reliefs from the late Parthian period, as well as inscriptions.

BIBLIOG. F. Altheim and R. Stiehl, Die Inschriften von Tangi Sarwak, Asien und Rom: Neue Urkunden aus Sassanidischer Frühzeit, Tübingen, 1952, pp. 30–34; W. B. Henning, The Monuments and Inscriptions of Tang-i Sarwak, Asia Major, N.S., II, 1952, pp. 151–78.

Tepe Musyan. This important independent pottery center is about 95 miles northwest of Susa. Most of the pottery found here is older than that of Susa I and may belong to three successive phases. Its yellow or green body has dark decorations of geometric motifs related to certain Mesopotamian forms, as well as zoomorphic motifs; the stylization is typical.

BIBLIOG. J. E. Gautier and G. Lampre, Fouilles de Moussian, Mém. de la délégation en Perse, VIII, 1905, pp. 59–148; L. Vanden Berghe, Les ateliers de la céramique peinte chalcolithique en Iran de sud-est, RA, XXXIX, 1952, pp. 1–21.

Fars and Laristan. Abarj. This site about 30 miles northwest of Persepolis contains remains of three Achaemenian complexes — two dams and a terrace.

BIBLIOG. K. Bergner, Bericht über unbekannte achaemenidische Ruinen in der Ebene von Persepolis, Archaeol. Mitt. aus Iran, VIII, 1936, pp. 1–4.

Bishapur. This site is in the vicinity of Kazarun. It was an important Sassanian center with outstanding architectural remains. Especially notable are the great underground fire temple with a rectangular central hall, corridors, and a staircase; the ruins of Palace A of Shāpur I, with a wedge-shaped central hall that contains niches adorned with painted stucco, a court with mosaics, of which some fragments remain (X, PL. 177), and great triple liwans connected with the palace and decorated with stucco and mosaics; Palace B, or the "Stone Palace," with sculptured decoration; a votive monument with two columns with Corinthian capitals and an inscription of A.D. 266. The valley to the north of the ruins contains six Sassanian bas-reliefs, three of which are dedicated to the victory of Shāpur I over Valerian (VII, PL. 254), with various scenes added at different times; the others date from the periods of Bahrām I (273–76), Bahrām II (276–93), and Shāpur II (309–79). On the rock overlooking the valley are the ruins of a fortress with three towers. About 5 miles from the reliefs is a cave whose walls had been smoothed in preparation for more reliefs; from beneath its entrance a monumental statue of Shāpur I (ht., ca. 25 ft.) has been raised.

BIBLIOG. D. T. Rice, The City of Shapur, Ars Islamica, II, 1935, pp. 174–88; G. Salles and R. Ghirshman, Châpour: Rapport préliminaire de la première campagne de fouilles (automne 1935–printemps 1936), RAA, X, 1936, pp. 117–22; R. Ghirshman, Les fouilles de Châpour, Iran, RAA, XII, 1938, pp. 12–19; G. Salles, Nouveaux documents sur les fouilles de Châpour, RAA, XIII, 1942, pp. 93–100; R. Ghirshman, Shapur: Royal City, Asia, XLV, 1945, pp. 492–96; R. Ghirshman, À propos des bas-reliefs rupestres sasanides, AAs, XIII, 1950, pp. 86–98; R. Ghirshman, Bîchâpour II: Les mosaïques sasanides, Paris, 1956.

Darab. This village is about 175 miles east of Shiraz. It is the ancient Darabjird, an important Sassanian city with double circular walls whose layout is still visible. The Masjid-i-Sang is a cruciform hall carved out of the rock; although it has a mihrab, it was perhaps not originally meant to be a place of Moslem worship.

BIBLIOG. A. Stein, An Archaeological Tour in Ancient Persia, Iraq, III, 1936, pp. 194–99.

Da u Dukhtar. This site is in the Kuh-i-Unari. A double-chambered tomb, which may have served as a royal tomb (ca. 640–560 B.C.), is cut into the rock face at a height of about 655 ft.; its façade is flanked by two proto-Ionic semicolumns.

BIBLIOG. A. Stein, Old Routes of Western Iran, London, 1940, pp. 45–47.

Firuzabad. This was an important Sassanian center. The city, founded by Ardashīr I (ca. 226–41) and named Gur, has a circular plan. At the center of the surrounding double walls are the remains of a tower with a spiral staircase; nearby is a Chahār Ṭāq. Outside the city is the Atashgāh, actually the palace of Ardashīr I, with a great liwan, a square, domed hall, and two similar side halls. On a rock face by the Tang-i-Ab River is the fortress and residence of Ardashīr, today called the Qalʿa-i-Dukhtar, with a domed hall. Next to the rock is a bridge with a Pahlavi inscription. On the other shore of the Tang-i-Ab, about a mile apart, are two Sassanian reliefs depicting the investiture of Ardashīr I and the victory of Ardashīr I over Artabanus V, represented as a duel between two knights. The latter relief, about 65 ft. long, is the earliest and largest known from the Sassanian period. On the same shore of the river, stairs are cut into the rock.

BIBLIOG. R. Byron, Note on the Qalʿa-i Dukhtar at Firuzabad, B. Am. Inst. for Persian Art and Archaeol., III, 1934, pp. 3–6; R. Ghirshman, Firuzabad, BIFAO, XLVI, 1947, pp. 1–28; W. B. Henning, The Inscription of Firuzabad, Asia Major, N.S., IV, 1954, pp. 98–102.

Jin Jin. This site is about 5 miles west of Fahlian on the Susa–Persepolis road. Here are remains of an Achaemenian pavilion with three column bases decorated with lotus blossoms.

BIBLIOG. R. Ghirshman, La tour de Nurabad, Syria, XXIV, 1944, pp. 175–93.

Kharg (Kharj). This island is in the Persian Gulf north of Bushihr. The Imāmzāda Mīr Muḥammad has a dome spire of the

Iraqi type (latter half of 14th cent.). The most interesting remains, however, are those of some sixty tombs cut into the rock, some with crosses and Syrian inscriptions; they have façades with niches and pilasters, vestibules with loculi for the dead, and principal burials. In one of these tombs is a relief with a semirecumbent figure of the Palmyra type.

BIBLIOG. E. E. Herzfeld, Damascus, Studies in Architecture, I: Imām-zāde Mīr Muhammad, Ars Islamica, IX, 1942, pp. 30–31; R. Ghirshman, L'île de Kharg (Ikaros) dans le Golf Persique, RA, L, 1959, pp. 77–79.

Ij (mod. Irij). This village is about 10 miles south of Niriz. Here is a "mosque" carved in the rock, with a hall covered by an elliptical vault; it was constructed before 1332–33, the date given in its inscription.

BIBLIOG. D. N. Wilber, The Architecture of Islamic Iran: The Il-Khānid Period, Princeton, 1955, p. 180.

Istakhr. Istakhr lies on the Persepolis–Pasargadae road about 3 miles north of Persepolis. The ruins, today called the Takht-i-Ṭāʿūs, are the ancient religious center of Fars, where the Sassanian kings were crowned. It remained an important urban center in the first years after the Islamic conquest until the flowering of Shiraz. The ruins consist of some Achaemenian or Seleucid sanctuary columns and piers later utilized in the construction of a mosque; the capitals are Corinthian. Sassanian coins and ceramics were found in the vicinity.

BIBLIOG. M. Streck, E. of Islam, s.v. Iṣṭakhr, II, 1921, pp. 556–60.

Kariyan. At this site south of Jahrum (Laristan) are the ruins of one of the three major ancient fire temples of Iran, the Athur Farnbag.

BIBLIOG. L. Vanden Berghe, Archéologie de l'Iran ancien, Leiden, 1959, p. 19.

Kuh-i-Rahmat. This is the mountain at the foot of which lies Persepolis. The two rock-carved tombs, with cruciform façades, of Artaxerxes II (404–359 B.C.; PL. 133) and Artaxerxes III (359–338 B.C.) overlook Persepolis. They house, respectively, two and three burials; their reliefs depict the kings worshiping Ahura Mazda. On the same mountain, facing Maqsudabad, are two Pahlavi inscriptions. Ossuaries are also found.

BIBLIOG. E. E. Herzfeld, Rapport sur l'état actuel des ruines de Per-sépolis et propositions pour leur conservation, Archaeol. Mitt. aus Iran, I, 1929, pp. 17–38; L. Vanden Berghe, Monuments récemment découverts en Iran méridional, Bib. O., X, 1953, pp. 5–8.

Naqsh-i-Bahrām. At this site northeast of Bishapur is a Sassanian relief of Bahrām II (A.D. 276–93); a contemporaneous one is in nearby Guyum.

BIBLIOG. L. Vanden Berghe, Archéologie de l'ancien Iran, Leiden, 1959, p. 56.

Naqsh-i-Rustam. This site is near Persepolis at the foot of the Kuh-i-Ḥusayn. Here are the four Achaemenian rock-carved tombs (PL. 136; IV, PL. 457) of Darius I (521–485 B.C.), Xerxes I (485–465 B.C.), Artaxerxes I (465–424 B.C.), and Darius II (424–405 B.C.); a door is flanked by four columns with ram-protoma capitals and is surmounted by bas-reliefs representing the king's throne supported by the conquered nations. At the foot of the tombs are eight Sassanian reliefs: the investiture of Ardashīr I (224–41); the investiture of Bahrām II (276–93), carved over an Elamite relief of which traces remain; another of Bahrām II; Shāpur II (309–79); Ormizd II (302–09); the victory of Shāpur I (241–72) over Valerian; Bahrām II again; the investiture of Narsah (293–302). To the left of the complex, in the open, are twin fire altars of the Sassanian period. In front of the complex is the Kaʿba-i-Zardusht, with a staircase and blind windows, of uncertain function (perhaps a funerary monument or a fire sanctuary; PL. 137); it bears a Greco-Pahlavi inscription of Shāpur I. Trial excavations have brought Sassanian and Islamic objects to light. The Sassanian reliefs of Naqsh-i-Rajab are not far away.

BIBLIOG. M. Dieulafoy, L'art antique de la Perse, I, Paris, 1884, pp. 1–71; F. Sarre and E. E. Herzfeld, Iranische Felsreliefs, Berlin, 1910, pp. 3–91; R. Byron, An Early Rock Carving at Naqshi Rustam, B. Am. Inst. for Persian Art and Archaeol., IV, 1935, p. 39; E. F. Schmidt, The Treasury of Persepolis and Other Discoveries, Chicago, 1939, p. 105; K. Erdmann, Die Altare von Naqshi Rustam, Mitt. der d. Orientgesellschaft, LXXXI, 1949, pp. 6–15; W. B. Henning, Pahlavi Inscriptions (Corpus inscriptionum iranicarum, III), II: Private Inscriptions of the Classical Period, 2, London, 1957, pls. 25–48.

Niriz. The Masjid-i-Jāmiʿ, a mosque with a single liwan, is found at this site; despite reconstruction and many additions, the earliest

sections date from the mid-10th century. The liwan, with niches on the sides, is the earliest extant example of a liwan of the Iranian mosque type that goes back to a pre-Seljuk period; in the Seljuk period this type became current in Iran and replaced the Arab type.

BIBLIOG. A. Godard, Le Masdjid-é Djumè de Niriz, Āthār-e Īrān, I, 1936, pp. 163–72.

Nurabad. This site lies about 25 miles north of Bishapur, on the road to Fahlian. About 5 miles to the west is the square tower called Mīl-i-Azdahā, similar in construction to that of Kaʿba-i-Zardusht and to the Zindān-i-Sulaymān of Pasargadae. In the vicinity is a fire temple of the Seleucid or Parthian period.

BIBLIOG. R. Ghirshman, La tour de Nurabad, Syria, XXIV, 1944, pp. 175–93.

Pasargadae. This was the Achaemenian capital, founded by Cyrus II between 559 and 550 B.C. It was the residence of his successor Cambyses II (529–521 B.C.). Here is the famous tomb of Cyrus, known as the Mashhad-i-Madar-i-Sulaymān (PL. 126). It is a rectangular, house-shaped block with a double pitched roof on a high podium of six steps. Around it lie an Islamic cemetery and the remains of a mosque constructed with Achaemenian material in the 13th century. The Pasargadae complex also includes the Apadana (Audience Hall) of Cyrus, with a large rectangular central hall with two rows of columns (one column still stands); here were found fragments of reliefs. Another palace, nearer the Pulvar River, also has a rectangular central hall and portico, as well as a bas-relief with a winged genius (PL. 127). The royal residence has a large hall and vestibule and a trilingual inscription. The structure called the Zindān-i-Sulaymān was probably a fire temple rather than a funerary tower; fragments of its four walls remain. The site also includes the ruins of a fortified terrace and two fire altars with steps.

BIBLIOG. E. E. Herzfeld, Pasargadae: Untersuchungen zur persischen Archäologie, Berlin, 1908; E. E. Herzfeld, Bericht über die Ausgrabungen von Pasargadae, Archaeol. Mitt. aus Iran, I, 1929, pp. 4–16; ʿA. Sāmī, Pāsārgād, Shiraz, 1330 A.H. (1951); ʿA. Sāmī, Gudhārish-i Khākbardārīhā-i, Pāsārgād dar nīma-i duvvum-i sāl-i 1328 va bahār-i 1329 (Reports on Excavations at Pasargade in the second half of 1949 and in the spring of 1950), Gudhārishhā-i bāstānshināsī, I, 1950; ʿA. Sāmī, Pāsārgād yā qadīmtarīn pāytakh-i Kishvar-i Shāhinshāhī-i Īrān (Pasargade: The Oldest Capital of the Iranian Empire), Shiraz, 1330 A.H. (1951); A. Gabriel, Die Erforschung Persiens: Die Entwicklung der abendländischen Kenntnis der Geographie Persiens, Vienna, 1952; D. Zakataly, L'authentique tombeau de Cirus, Teheran, 1954.

Persepolis (Parsa, now Takht-i-Jamshid). This famous complex was the Achaemenid imperial residence, which Darius I founded about 518 B.C. Along with Ṭāq-i-Bustān, Sarvistan, Firuzabad, and Kuh-i-Khwaja, it is one of the rare sites of pre-Islamic Iran of interest for more than purely archaeological reasons. Mention will be made only of the principal buildings on the Terrace built by Darius I on a spur of the Kuh-i-Rahmat (PL. 131). The Terrace, about 1,475 ft. wide by 985 ft., and about 25 to 60 ft. high, was surrounded by a fortified wall, on the south side of which is a cuneiform inscription. At the northwestern corner of the complex (see FIG. 229) is a monumental stairway of 106 steps, about 23 ft. wide, leading to the Gatehouse of Xerxes, a square hall with four columns, two of which still stand, and three doorways about 36 ft. in height to the west, east, and south. Four bulls flank the west doorway; two winged, human-headed bulls the east doorway. The east doorway opens onto an avenue which leads to the propylaea of the Throne Hall of Xerxes or "Hundred Column Hall." The south doorway of the gatehouse opens onto a court with a pool, from which one gains access to the Apadana of Darius and Xerxes, the imperial Audience Hall (PL. 131; I, PL. 404). This building is a great square hall, about 250 ft. on a side, with 36 columns (only 3 are still standing), flanked by porticoes which are also provided with columns (10 remain) to the north, west, and east, and with two stairways to the north and east, decorated with the famous reliefs depicting the homage paid to the ruler by the peoples of his empire. At the southeast corner of the Apadana is the Tripylon, or Council Hall, which has an entrance stairway adorned with reliefs (PL. 132), three great decorated doorways (PL. 135), and a square hall with four columns; to the west of the Tripylon is a poorly preserved section known as the "problematic structure"; further west is the Tachara, or Palace, of Darius, which has a hall with decorated doorways, a portico, and a number of small rooms. South of these three units is the Hadish, or Palace, of Xerxes, similar in plan to the preceding building, with a balcony overlooking the plain. A stairway leads to the "Harem" — composed of various apartments of hypostyle construction with decorated doorways and a vestibule — which, together with the rectangular Treasury, with various hypostyle halls, and a bas-relief showing the homage paid to Darius (PL. 133), occupies the entire southern side of the Terrace. The northeast corner of the

terrace is devoted chiefly to the previously mentioned Throne Hall of Xerxes, or "Hundred Column Hall" (which suffered greatly in Alexander's fire), with its propylaea, court, vestibule, and rich decoration (PL. 134); only the bases of the columns remain. East of the court is a hypostyle hall with portico, and south of the hall are various rooms and magazines. Outside the terrace, to the south, is the unfinished tomb of Darius III (336–331 B.C.). Very little remains of the city at the foot of the royal residence; to the northwest there is a window with bas-relief and, nearby, column bases, perhaps the remains of a Seleucid

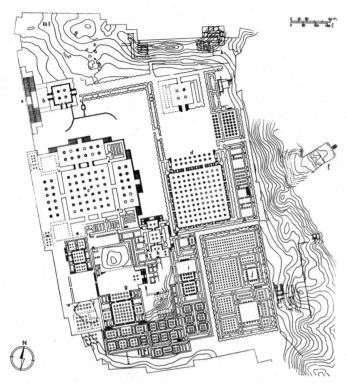

Plan of Persepolis: (*a*) the great entrance stairway; (*b*) Gatehouse of Xerxes; (*c*) Apadana, or Audience Hall, of Darius and Xerxes; (*d*) Throne Hall of Xerxes, or "Hundred Column Hall"; (*e*) Tachara, or Palace, of Darius; (*f*) palace, probably rebuilt by Artaxerxes III; (*g*) Hadish, or Palace, of Xerxes; (*h*) Tripylon, or Council Hall; (*i*) restored area of the "Harem"; (*j*) Treasury; (*k*) section of northern fortifications; (*l*) royal tomb, probably of Artaxerxes II.

temple; to the northeast is a decorated portal, and to the south, column bases, a pool, and the remains of a palace with hall, vestibule, and trilingual inscription of Xerxes I. (See also above, Kuh-i-Rahmat.)

BIBLIOG. F. Stolze and F. C. Andreas, Persepolis, Berlin, 1882; E. E. Herzfeld, Rapport sur l'état actuel des ruines de Persepolis et propositions pour leur conservation, Archaeol. Mitt. aus Iran, I, 1929, pp. 17–38; E. F. Schmidt, The Treasury of Persepolis and Other Discoveries (O. Inst. Comm., XXI), Chicago, 1939; Ḥ. Baṣīrī, Rāhnumā-i Takht-i Jamsīd (Guide to Persepolis), Teheran, 1325 A.H. (1946); A. Godard, Persepolis, CRAI, 1946, pp. 260–70; G. G. Cameron, Persepolis Treasury Tablets, Chicago, 1948; A. Godard, Persepolis: Le Tatchara, Syria, XXVIII, 1951, pp. 62–69; A. Godard, Les travaux de Persepolis, Archaeologia Orientalis in Memoriam E. E. Herzfeld, New York, 1951, pp. 119–28; M. T. Mustafawī, Sarkh-i Ajmal-i Takht-i Jamsīd (Synthetic Exposition of the Monuments of Persepolis), Teheran, 1330 A.H. (1951); E. F. Schmidt, Persepolis, 2 vols., Chicago, 1951–57; A. Gabriel, Die Erforschung Persiens: Die Entwicklung der abendländischen Kenntnis der Geographie Persiens, Vienna, 1952; ʿA. Sāmī, Āthār-i tārīkhī-i julga-i Marvdasht (Monuments of the Plain of Marv Dasht), n.p., 1331 A.H. (1953); ʿA. Sāmī, Persepolis (Takhti Djamshid), Shiraz, 1955; Persepolis Considered as a Ritual City, Proceedings of the 22d Cong. of Orientalists, Istanbul, Leyden, 1957, pp. 58–66; A. U. Pope, Persepolis as a Ritual City, Archaeology, X, 1957, pp. 123–30.

Qaṣr-i-Abū-Naṣr. This site is located about 5 miles southeast of Shiraz. Here are the remains of an isolated Achaemenian portico which probably was brought from Persepolis, as well as ruins of a Sassanian fortress with traces of an earlier Parthian occupation. Bronze objects, pottery, and seals also were found.

BIBLIOG. W. Hauser and J. M. Upton, The Persian Expedition at Kasri Abu Nasr, BMMA, XXVIII, 1933, sup., pp. 39–44, XXIX, 1934, sup., pp. 3–22; M. S. Dimand, An Achaemenide Alabaster Relief, BMMA, XXIX, 1934, pp. 118–19; C. K. Wilkinson, Notes on the Sasanian Seals Found at Kasri Abu Nasr, BMMA, XXXI, 1936 pp. 176–82.

Sarvistan. This village is about 55 miles east of Shiraz. Here are the ruins of the Imāmzāda Shaykh Yūsuf Sarvistānī. There remain massive piers and arches dating from the late 13th century as well as slightly later additions and tombs. About 5 miles from the village is the well-preserved Sassanian palace of Bahrām V (420–40), consisting of a liwan, a square, domed hall, a courtyard, and various domed rooms surrounding the hall.

BIBLIOG. M. Dieulafoy, L'art antique de la Perse, IV, Paris, 1885, pp. 1–29, 67, 71; D. N. Wilber, The Architecture of Islamic Iran: The Il-Khānid Period, Princeton, 1955, p. 117.

Shiraz. This is the most important city of Fars and one of the most famous Persian cities. The home of Ḥāfiẓ and Saʿdī and a place of literary pilgrimage, it does not possess much of artistic interest except its famous gardens. The city suffered greatly from the Afghan invasion in the third decade of the 18th century, and its most important buildings date from after this period. Many were built under the Zand chief Karīm Khan, who made Shiraz his capital in the mid-18th century. Of the early period there remains the Masjid-i-Jāmiʿ, built in 875 by the Saffarid ʿAmr ibn-Layth. It is one of the most ancient mosques in Iran, but later restoration has made the original elements nearly unrecognizable. In the courtyard of the mosque is the library, or Khodāy Khāna, of Abū-Isḥāq (1351). It, too, is very much restored; it is constructed on a square plan with bastions at the four corners and a covered, columned circumambulatory passage around the exterior. The Masjid-i-Nau is originally of the 12th century but has been rebuilt. The so-called "tomb of Abash Khatun" is of the 14th century, while the Madrasah-i-Khān and the Mausoleum of Bībī Dukhtarān date from the Safavid period. From Karīm Khan's time are the citadel, the bazaar, the bath, the cisterns, the "Gate of the Koran" (recently rebuilt), the mausoleums of Ḥāfiẓ and Saʿdī (also rebuilt), the pavilion in the Bāgh-i-Naẓar (now housing the small Museum of Fars, founded in 1938), and, above all, the Masjid-i-Vakīl, with a richly decorated prayer hall with aisles. The Imāmzāda Shāh Chirāgh has religious but no architectural significance. The main beauty of Shiraz lies in the villas in the city and surroundings. These are among the best examples of Persian secular architecture of the period just before Europeanization, although presently the pride of the inhabitants is the modern hospital, the construction of which marked a high point in the renovation of the city. Although it does not differ greatly from the typical modern Iranian city based on a grid formed by great avenues, in general appearance Shiraz is among the most harmonious cities in the country. The Khiyābān-i-Zand, the main boulevard of the city, is pleasantly lined with various kinds of trees and is the widest major street in any Iranian city.

BIBLIOG. A. Zarkub Shīrāzī, Shīrāz Nama (Book of Shiraz), Teheran, 1350 A.H. (1931–32); Sālnāma-i maʿārif-i Fārs 1315 (Handbook of the Sciences of Fars for 1315), Shiraz, 1937, p. 116; A. Bihruzi, Shahr- Shīrāz ya Khāl-i ruḥ-i haft kishvar (The City of Shiraz or the New Face of Seven Lands), Shiraz, 1334 A.H. (1955–56); B. Karīmī, Rāhnumā-i āthār-i tārīkhī-i Shīrāz (Guide to the Monuments of Shiraz), Shiraz, 1337 A.H. (1958); ʿA. Sāmī, Shīrāz shahr-i Sa dī va Ḥāfiẓ, shahr-i gul u bulbul (Shiraz: City of Saʿdi and Hafiz, of the Nightingale and the Rose), Shiraz, 1337 A.H. (1959); A. J. Arberry, Shiraz: Persian City of Saints and Poets, Norman, Okla., 1960; A. Hatami, Shiraz, Teheran, 1961.

Sih-Talu. This site lies northwest of Fahlian on the Shiraz–Ahvaz road. The Elamite rock reliefs of Kurangun (late 3d millennium) are almost inaccessible; they show scenes of adoration and procession.

BIBLIOG. E. E. Herzfeld, Archaeological History of Iran, London, 1935, pp. 4–5; N. C. Debevoise, The Rock Reliefs of Ancient Iran, JNES, I, 1942, pp. 78–80.

Tell-i-Bakun. This site lies in the plain of Marv Dasht and comprises two hills, known as A and B, southwest of the terrace of Persepolis. In more than twenty tepes (mounds) were found neolithic pottery and other ceramics in a style characteristic of the region of Fars. This style is contemporaneous with that of Susa I (first half of 4th millennium).

BIBLIOG. A. Langsdorff and D. E. McCown, Tall-i Bakun A: Season of 1932, Chicago, 1942.

Tell-i-Shugha. At this site in the area between Pasargadae and Persepolis were found ceramics of a type exclusive to this region, characterized by a red body and dark decoration of animal and plant motifs in a somewhat naturalistic style.

BIBLIOG. L. Vanden Berghe, Archéologie de l'Iran ancien, Leiden, 1959, pp. 42–44.

Tang-i-Chak Chak. At this site in the region between Rustaq and Furg (Laristan) are two Sassanian fire temples in an excellent state of preservation.

BIBLIOG. L. Vanden Berghe, Archéologie de l'Iran ancien, Leiden, 1959, p. 20.

Tulaspid. This site is located about 5 miles west of Fahlian. Some Elamite ruins (1550–1000 B.C.) are preserved here.

BIBLIOG. E. E. Herzfeld, Reisebericht, ZMG, LXXX, 1926, pp. 225–84.

Kerman, Baluchistan, and Seistan. This region includes such archaeological sites as Bampur, Damin, Dih-i-Urazi, Khurab, Maula, Pir-i-Kunār, Shahr Daraz, and Tell-i-Iblis. These have yielded painted and incised ceramics which prove that relations existed between such centers as Susa, Tepe Musyan, and Tell-i-Bakun and the cultures of Pakistani Baluchistan. On these, see A. Stein. *Archaeological Reconnaissances in Northwest India and Southeast Iran*, London, 1937; on the neolithic sites — Katukan, Machi, Qal'at-i-Gird, Ramrud, and Shahr-i-Sukhta — F. H. Andrews, "Painted Neolithic Pottery in Sistan, Discovered by Sir Aurel Stein," *BM*, XLVIII, 1925, pp. 304–08; for the interesting bronzes found at Khinaman, see C. Greenwell, "Notes on a Collection of Bronze Weapons, Implements and Vessels found at Khinaman," *JRAS*, XXXVIII, 1907, pp. 196–200. From Jiruft come objects of the Parthian period; there are Sassanian remains at Karku and at Ram Shahristan, the ancient capital of Seistan; see E. E. Herzfeld, "Reisebericht," *ZMG*, V, LXXX, 1926 ff., and in general, A. I. Millar, *Ocherk Seistana: karavannye puti; Otchot o Komandirovke v Kerman (Essay on Sistan: Caravan Routes; Report on a Mission to Kirman), Sbornik Materialov pro Aziyu*, LXXVII, 1904; G. P. Tate, *Seistan: A Memoir on the History, Topography, Ruins and People of the Country (Parts 1–4)*, Calcutta, 1910–12.

Bam. This town is about 120 miles east of Kerman. It is known for its old mosques and especially for its citadel. Of the mosques — the Masjid-i-Rasūl, one of the most important in Iran, and the Masjid-i-Arg — there remain only a few traces. The citadel is the most complete and best-preserved example of a Persian fortified city in existence. It is built entirely of unbaked brick and occupies an area of about 2 sq. miles northeast of the modern city. Imposing bastions with a single monumental gate surround it; within it are still a few well-preserved buildings. The antiquity of its origins is certain, but its uninterrupted use as a fortress over so many centuries made restorations frequent and repeated. Because Persian military architecture changed little, the repairs are not obvious; therefore it is still impossible to give it a precise date.

BIBLIOG. B. Pārīzī, Rāhnumā-i āthār-i tārīkhī-i Kirmān (Guide to the Monuments of Kirmān), Teheran, 1335 A.H. (1956), pp. 26–43.

Chahbar. This is a small port on the Persian Gulf (Makran). Here are the ruins of a Portuguese colonial fortress of the 16th century. Traces of the Portuguese occupation are more evident in this lesser site than at Rishahr (Fars) or at the principal Portuguese center, Hurmuz.

BIBLIOG. S. Mockler, On Ruins in Makran, JRAS, IX, 1877, pp. 121–34; T. H. Holdich, Notes on Ancient and Medieval Makran, Geog. J., VII, 1896, pp. 387–405; P. Schwarz, Hurmuz, ZMG, LXVIII, 1914, pp. 531–43.

Kerman (Kirman). This important city is the capital of the region of the same name. Although of importance throughout much of Persian history, it has been in decline since the coming of the Qajar dynasty (see QAJAR SCHOOL). Among noteworthy monuments are the Qal'a-i-Dukhtar, an ancient citadel on the hill dominating the city; the Gunbad-i-Jabaliya, a domed central-plan building with an octagonal exterior, of uncertain date (perhaps 13th cent.); the Masjid-i-Malik of Seljuk origin, ruined through rebuilding and neglect; the Seljuk Mausoleum of Khwāja Atabek; the Masjid-i-Jāmi', a typical mosque with four liwans, decorated with kashi, and bearing an inscription with the date 1349; the Masjid-i-Pā-Minār (1390); the complex (in ruins but with interesting decorative elements) of the square, caravanserai, and bath of Ganj 'Alī Khan, a governor of the Safavid period, who was also responsible for the very beautiful garden in Bayramabad; the Madrasah of Ibrāhīm Khan, a theological center of the dissident Shiite sect (19th cent.). The vaults of the bazaar preserve some examples of early painted decoration. The *gunbad* and the Masjid-i-Jāmi' have been studied most thoroughly.

BIBLIOG. W. Tomaschek, Allg. E. der Wissenschaften und Künste, s.v. Kirman, 2d ser., XXVI, 1884, pp. 292–96; C. Le Strange, The Cities of Kirman in the Time of Hamd Allah Mustafawī and Marco Polo, JRAS, 1901, pp. 281–90; B. Pārīzī, Rāhnumā-i āthār-i tārīkhī-i Kirmān (Guide to the Monuments of Kirmān), Teheran, 1335 A.H. (1956).

Kuh-i-Kwaja. On this solitary mountain rising as an island in Lake Hamun is one of the most interesting complexes of ruins of ancient Iran. At first thought to be a Buddhist temple, it now is known to have been the residence of a Parthian governor. Two phases of construction can be distinguished inside. A monumental fire temple hall adjoins the palace. Stuccoes and frescoes were found, and although the latter have now almost disappeared, they are of great interest.

BIBLIOG. A. Stein, A Third Journey of Exploration in Central Asia, Geog. J., XLVIII, 1916, pp. 193–229; A. Stein, Innermost Asia, II, Oxford, 1928, pp. 909–25; E. E. Herzfeld, Sakastan, Archaeol. Mitt. aus Iran, IV, 1932, pp. 1–116; F. H. Andrews, Catalogue of Wall Paintings from Ancient Shrines in Central Asia and Sīstān, Delhi, 1933; H. Ṣamadī, Sīstān az anzar-i bāstānshināsī (Sistan in the Light of Archaeology), Gudhārishhā-i bāstānshināsī, III, 1955–56, pp. 147–68.

Mahan. This site located about 25 miles east of Kerman is famous for the monumental complex of the sanctuary of Nūr ad-Dīn Ni'mat Allāh, of the Timurid period. This was restored several times, particularly during the 18th century; thus it now includes Qajar minarets; adjoining it are a museum and library. In its present condition it is not of very great architectural significance, but it is the most important religious center in southeastern Iran.

BIBLIOG. B. Pārīzī, Rāhnumā-i āthār-i tārīkhī-i Kirmān (Guide to the Monuments of Kirmān), Teheran, 1335 A.H. (1956), pp. 74–95.

Qal'a-i-Sang. This site, about 5 miles from Sirjan, is on the site of the ancient city of this name. The remains include a fortress destroyed by Tīmūr Lenk (Tamerlane), traces of walls and of a citadel, Roman baths, and inscriptions of 1019 and 1387.

BIBLIOG. G. Le Strange, The Cities of Kirman in the Time of Hamd Allad Mustafawī and Marco Polo. JRAS, 1901, pp. 281–90.

Khorasan (Khurasan). Ahangan. This site is located about 10 miles north of Mashhad. Here is a domed funerary tower, perhaps from the Timurid period, with an octagonal interior and a circular exterior decorated with semi-columns.

BIBLIOG. A. Godard, Khorasan: Le mīl-é Ahangan, Āthār-e Īrān, IV, 1949, pp. 137–42.

Bistam. This village, located about 5 miles north of Shahrud on the Gurgan road, possesses some of the most beautiful architecture of Iran in the sanctuary of the famous mystic Bāyazīd Bisṭāmī. The structure was begun immediately after the death of the saint (late 9th cent.). It includes traces of pre-Seljuk buildings, a Seljuk minaret, and remains of a Seljuk mosque, all dating from 1120. Ilkhan elements predominate, however, comprising the mosque proper with stucco decorations and a mihrab dated 1299, the portal with stucco stalactites, the entrance corridor with a frieze containing the name of Öljeitü (Uljeitu), dated 1313, and the liwan on the court decorated, like the portal, with faïence. The Masjid-i-Jāmi', with a prayer hall on the eastern side of the court separated by arches, has the typical stucco decoration and a mihrab of the early 14th century. An Ilkhan tomb tower of the Varamin type stands near the Masjid-i-Jāmi' (ca. 1300).

BIBLIOG. O. Benderev, Astarabad-Bastamskii raion Persii (The Astarābād-Bisṭām Region of Persia), Tashkent, 1904; De Qasr-i Shīrīn à Meshhad et Tus, Teheran, 1934, pp. 42–43; I. Yaghmānī, Bisṭām va Bāyazīd-i Bisṭāmī (Bisṭām and Bāyazīd Bisṭāmī), Teheran, 1317 A.H. (1938); D. N. Wilber, The Architecture of Islamic Iran: The Il-Khānid Period, Princeton, 1955, pp. 127–28.

Damghan. This town about 280 miles east of Teheran is known for having the oldest existing mosque in Iran (8th cent.). It is of the Arab type, and its prayer hall has aisles divided by massive columns (Tārīkh Khāna). In the vicinity is a minaret of the Seljuk period (1026–30). The Masjid-i-Jāmi', which has been restored, has a Seljuk minaret (1106–07). The two Seljuk circular tomb towers of Pir-i-'Alamdar and Chihīl Dukhtarān date, respectively, from 1026–27 and 1054–55. Nearby is the portal of a mosque, perhaps of 1315. The Imāmzāda Ja'far, of Seljuk origin with additions from the 15th century, contains decorative elements taken from another building in the vicinity.

BIBLIOG. A. Godard, Le Tari Khane de Damghan, GBA, XII, 1934, pp. 225–35; I. Yaghmānī, Jughrāfyā-i Tārīkhī-i Dāmghān (Historical Geography of Dāmghān), Teheran, 1326 A.H. (1947).

Farumad. This village is about 5 miles from the Shahrud–Sabzavar road, northeast of 'Abbasabad. Ruins of the Masjid-i-Jāmi', with two liwans, are found here; the building is perhaps of Seljuk origin (13th cent.) but it was completed in the Ilkhan period (ca. 1320).

BIBLIOG. A. Godard, Khorasan: Les mosquées de Forūmad et de Zawzan, Āthār-e Īrān, IV, 1949, pp. 83–112.

Kharjird. This site is in the neighborhood of Khaf. The Niẓāmiya, a ruined madrasah of the Seljuk period (latter half of 11th cent.), probably had a square court with four liwans; it is the earliest extant

example of a building form destined to have great success in Iranian architecture. The madrasah of the Timurid period (1444) was probably built by the same architect as that at Tayabad.

BIBLIOG. A. Godard, Khorasan: La Niẓāmīyyè de Khargird, Āthār-e Īrān, IV, 1949, pp. 68–83.

Kal-i-Jangal. At this site southwest of Birjand were found graffiti showing a man with a lion and the profile of a bearded figure; they may date from the beginning of the Sassanian period, in spite of the inscriptions in Arsacid Pahlavi.

BIBLIOG. J. Rizhā'i and S. Kiyā, Gudhārish-i nivishtahā va paikarhā-i Kāl-i Jangal (Report on the Inscriptions and Symbols of Kāl-i Jangal), Irankuda, XIV, 1320 A.H. (1941–42).

Khusraujird. This site lies about 5 miles west of Sabzavar on the road to Shahrud. Here is a Seljuk minaret of 1111–12.

BIBLIOG. A. Godard, Khorasan, Āthār-e Īrān, IV, 1949, pp. 1–150 at 61.

Mashhad (Meshed). This is the capital of Khorasan and the most important Shiite religious center of Iran. Like Teheran, it developed at the expense of an earlier and more famous neighboring center, the present village of Sanabad near Tus, which in 809 received the tomb of the Abbasside Caliph Hārūn al-Rashīd and in 818 that of the eighth of the twelve Shiite Imams, 'Alī al-Riẓā. He had died suddenly accompanying his adoptive father, the Abbasside caliph al-Ma'mūn, on a visit to the place of Hārūn's death. Thus the suburb of Tus became a goal of Shiite pilgrimage and was given the name "Mashhad" or "Burial Place of a Martyr." (The word is first documented in the late 10th cent.) In 1389 Mashhad gave sanctuary to the survivors of the sack of Tus by Tīmūr Lenk (Tamerlane), thereby replacing the destroyed city. The period of greatest splendor of the new capital was that of the Timurid Shah Rukh, to whom the most interesting monument in the sanctuary is due. 'Abbās I did much to beautify the city and to heighten its importance as a national shrine. Nādir Shah made Mashhad his favorite residence; the Qajars also contributed new buildings. Within the sanctuary area (Ḥaram, Bast) is the shrine itself, located in the center of the city and still strictly forbidden to unbelievers. The sanctuary is made up of separate complexes of shrines, madrasahs, a bazaar, and inns which are now hotels. Centered in the enclosure is the tomb of the Imam; it bears two inscriptions dating from 1118 and 1215, although the earliest forms apparent today are those of the 14th century. The Golden Dome, restored in 1675 by Sulaymān I, goes back to the period of 'Abbās I (1607), as does the nearby domed tomb of Allāhvardī Khan, to the northeast, the most notable among all the buildings, both isolated and adjoined, in the vicinity of the Imam's tomb. The "old court" (Ṣaḥn-i-Kuhna), to the north of the Imam's tomb, has an earlier southern section dating from the latter half of the 15th century but completely restored by Nādir Shah, and a northern section which is the work of Shah 'Abbās I. To the same ruler are also due two of the four towers with liwans — the clock tower and the Naqqāra Khāna (Music Gallery) used, according to an ancient tradition, to celebrate the sunrise and sunset. The northern entrance was constructed uder Shah 'Abbās II and is flanked by a minaret of Ṭahmāsp I. The famous Golden Gate on the south, along with its minarets, is of Nādir Shah, as is the octagonal central fountain called the Saqqakhāna-i-Nādirī. The Dār al-Ḥuffāẓ and the Dār al-Siyāda, both of the first half of the 15th century, were built in the period of Shah Rukh between the "old court" and the mausoleum; they are among the most notable buildings of the complex. To the east of the Imam's tomb is the "new court" (Ṣaḥn-i-Nau), begun in imitation of the old by Fatḥ 'Alī Shah in 1818 and completed by Nāṣir al-Dīn in 1855; on this side are also two buildings between the mausoleum and the Golden Gate. To the south of the tomb is the very famous Mosque of Jauhar Shād, wife of Shah Rukh; it was completed in 1418 and has four liwans, a great dome, and kashi decoration. In the center of this so-called Masjid-i-Pīr-i-Zan is an open area surrounded by a balustrade. Among the numerous minor sanctuaries is the Qadam-i-Mubārak, where a footprint of the Imam is venerated. Among the madrasahs worthy of note are the Madrasah-i-Dudar and the Madrasah-i-Parīzād, both of the first half of the 15th century. The library of the shrine was begun by Shah Rukh. The museum, installed (1945) within the sacred area, has an outstanding collection of ceramics, rugs, and illuminated manuscripts. Outside the sacred area the principal monuments are the Masjid-i-Shāh (1451), the Madrasah-i-Mīrzā Ja'far (1650) — the most interesting of the city's many madrasahs (included within it is the contemporary madrasah of Khairāt Khan as well as nine from the time of Sulaymān I and three from the Qajar period) — and from the Safavid period the Mausoleum of Khwāja Rabī', north of the city, with rich kashi decoration and, east of the city, the muṣalla with a great liwan.

BIBLIOG. J. B. Fraser, Narrative of a Journey into Khorasan in the Years 1821–1822, London, 1825, pp. 343–548; N. V. Khanykov, Meched: La ville sainte et son territoire, Le tour du monde, II, 1861, pp. 269–88; M. H. Ṣani' al-Daula, Matla' al-shams (The Place Where the Sun Rises), II, Teheran, 1303 A.H. (1885–86); G. K. Minkevich, Poezdka v Meshed i Ashqabad (Journey to Mashhad and Ashqabād), n.p., 1896; P. Sykes, The Glory of the Shī'a- World, London, 1910, pp. 227–69; P. Sykes, Historical Notes on Khurasan, JRAS, 1910, pp. 1113–54; H. S. Massy, An Englishman in the Shrine of Imam Reza at Mashad, 19th Century and After, LXXIII, 1913, pp. 990–1007; M. M. al 'Alawī, Tārīkh Tūs wa al Mashhad al Riḍawī (History of Ṭūs and Mashhad), Bagdad, 1927; D. M. Donaldson, Significant Mihrabs in the Haram by Mashad, Ars Islamica, II, 1935, pp. 118–27; Shorter E. of Islam, s.v. Mashhad, Leiden, 1953, pp. 354–59; H. Samadi, The Museum of Meshed, Teheran, 1955.

Nishapur. This important city was founded by Shāpur I (241–72). It was one of the principal centers of Khorasan in the Islamic Middle Ages, when it developed its own ceramic style. Here was built one of the most famous mosques of early Persian Islam, of which, however, nothing remains. The present Masjid-i-Jāmi' of 1493–94 has two liwans. The greatest interest presented by the area of Nishapur is archaeological: stuccoes and ceramics were found here. The mausoleums of the poets 'Aṭṭar and Omar Khayyam, in the immediate vicinity of the city, are not of great interest; more notable is the shrine of Qadamgāh of the Safavid period, not far from the city on the Mashhad road.

BIBLIOG. J. M. Upton and others, The Persian Expedition: Excavations at Nishapur, BMMA, XXXI, 1936, pp. 176–82, XXXII, 1937, pp. 1–38, XXXIII, 1938, pp. 1–23, XXXVII, 1942, pp. 82–119.

Qal'at-i-Nādirī. Here is the so-called "Treasure House" of Nādir Shah, a tomb tower of the type of East Radkan and Kishmar, but larger.

BIBLIOG. A. C. Yate, Kalat-i Nadiri, J. Royal Central Asiatic Soc., XI, 1924, pp. 156–68.

East Radkan. This site is in the vicinity of the Mashhad–Quchan road. Here is a tomb tower, said to be the Mīl-i-Rādkān, from the late 13th century. It is perhaps the oldest of this kind of building having an exterior decoration of semicolumns (of which there are 36). The exterior of the tower is twelve-sided, the interior octagonal, and the roof domed.

BIBLIOG. E. Diez, Churasanische Baudenkmäler, Berlin, 1918, pp. 43–46, 107–09.

Rubat Sharaf. This site lies between Mashhad and Sarakhs, about 25 miles south of the latter, on the old Nishapur–Merv road. Here is a complex of the Seljuk period, perhaps completed in 1114–15, comprising a caravanserai, a fortress, and a palace with two courts with four liwans each.

BIBLIOG. A. Godard, Khorasan: Rubat-Sharaf, Āthār-e Īrān, IV, 1949, pp. 7–68.

Sangbast. This village is about 20 miles south of Mashhad. It has a tomb with a dome on an octagonal base from the Ghaznevid period (see GHAZNEVID ART), probably built by the governor of Tus, Arslān Jādhib (first half of 11th cent.). Here also are a minaret and the ruins of a caravanserai.

BIBLIOG. A. Godard, Khorasan, Āthār-e Īrān, IV, 1949, pp. 1–150 at 10, 14; A. Godard, Voûtes iraniennes, Āthār-e Īrān, IV, 1949, pp. 187–368 at 264, 295.

Sarakhs. This site lies at the border of Soviet Turkmenistan. Here is the tomb of Sheik Muḥammad ibn-Luqmān (1356) with a double dome and a liwan portal.

BIBLIOG. E. Diez, Churasanische Baudenkmäler, Berlin, 1918, pp. 62–66.

Tepe Hissar. This very famous archaeological center is in the immediate vicinity of Damghan. Three prehistoric levels have been excavated: Ia, b, c; IIa, b; and IIIa, b, c, all rich in clay vessels and bronze objects. Traces of the Parthian capital Hecatompylos were sought here in vain. (On this see A. D. Mordtmann, "Hekatompylos," *Sitzungberichte der bayerischen Akademie der Wissenschaften zu München*, Historisch-philologische Klasse, I, IV, 1869, pp. 497–536.) However, there were found remains of a Sassanian palace and fire temple (of Kavādh I, 488–531) with outstanding stuccowork.

BIBLIOG. E. F. Schmidt, Excavations at Tepe Hissar, Damghan, Philadelphia, 1937; S. Piggott, Dating the Hissar Sequence: The Indian Evidence, Antiquity, XVII, 1943, pp. 169–82; D. H. Gordon, The Chronology of the Third Cultural Period at Tepe Hissar, Iraq, XIII, 1951, pp. 40–61.

Tayabad. This site lies on the Mashhad–Herat road at the Afghan border. The Masjid-i-Maulānā, one of the most interesting buildings of the period of Shah Rukh (1405–47), was erected in 1444 in honor

of some unknown person. It has splendid marble and kashi decorations and a great domed hall with a liwan, flanked by vaulted rooms also with liwans. The mosque is closely related stylistically to the monument of Turbat-i-Shaykh Jām and to the Mausoleum of 'Abdullāh Anṣārī at Herat in nearby Afghan Khorasan.

BIBLIOG. M. T. Mustafawi, Le Masdjid-é Mawlānā de Tāiyābād, Āthār-e Īrān, III, 1938, pp. 179–99.

Turbat-i Shaykh Jām. At this site on the Mashhad–Herat road is the tomb complex of Shaykh Jām. The earlier parts are Ilkhan (ca. 1330), but the building of the other portions continued over a long period; the portal bears the date 1456; new work was added by Shah 'Abbās I. The over-all aspect is primarily Timurid, and the building generally is related to the Masjid-i-Maulānā of Tayabad.

BIBLIOG. E. Diez, Churasanische Baudenkmäler, Berlin, 1918, pp. 78–82.

Tus. This famous ancient city of Khorasan, destroyed by Tīmūr Lenk in 1389, is today merely a humble village. Its position was taken over by Mashhad. There are remains of a Seljuk bridge, and here also is the Hārūniya, an early-14th-century mausoleum of unknown purpose with a square exterior, octagonal interior, and a great dome.

BIBLIOG. E. Diez, Churasanische Baudenkmäler, Berlin, 1918, pp. 55–62.

Caspian regions. Amul. This is among the most important centers of Mazanderan. Its ancient Masjid-i-Jāmi' has been largely rebuilt in recent times. It has a group of ancient tomb towers, among the most famous of which are the tomb of Shams-i-Ṭabarsī, with a pyramidal roof on an octagonal base, the tomb of Nāṣir al-Ḥaqq, of cubic shape with a pyramidal roof, and the Gunbad-i-Sih Tan. Mazanderan is rich in medieval tomb towers. Other characteristic tomb towers are found at Babul and Babul-Sar.

BIBLIOG. H. L. Rabino di Borgomale, Māzandarān and Astarābād, London, 1928, pp. 33–40.

Bihshahr. Here is the villa of Safiabad, a restored structure of Safavid origin, which is at present a royal residence. At the same site is the Imāmzāda 'Abdullāh.

BIBLIOG. J. C. Hantzsche, Palaste Schah Abbas I, Mazanderan, ZMG, XV, 1862, pp. 669–80, XVIII, 1864, pp. 669–79, XX, 1866, p. 186; H. L. Rabino di Borgomale, Māzandarān and Astarābād, London, 1928, pp. 63–64.

Ghār-i-Hūtū. This cave has yielded prehistoric finds and is among the most important because it furnishes information on life in Mazanderan during the Iron, Bronze, chalcolithic, and Neolithic ages. Similar caves are the Ghār-i-Kamarband and the Ghār-i-'Alī Tepe, near Bihshahr.

BIBLIOG. C. S. Coon, Cave Excavations in Iran, Philadelphia, 1951, pp. 20–31, 37–41, 44–52, 69–76, 78–89, 93–95.

Gunbad-i-Qābūs. This is in ancient Gurgan; today it is an important center of the region. It has the most imposing tomb tower in Iran, called the Gunbad-i-Qābūs (1006–07).

BIBLIOG. E. Diez, Churasanische Baudenkmäler, I, Berlin, 1918, pp. 39–43, 100–06; H. L. Rabino di Borgomale, Māzandarān and Astarābād, London, 1928, pp. 87–88.

Gurgan. Capital of Gurgan, this is the ancient Asterabad (or Astarabad). The famous golden treasure of Asterabad found here includes some objects from the late 3d millennium, relating to Tepe Hissar Level III. About 18 miles to the north are the remains of the structure called the Ṣadd-i-Iskandar, an ancient wall erected against nomad attacks. The Islamic buildings are of little interest.

BIBLIOG. M. I. Rostovtsev, The Sumerian Treasure of Asterabad, JEA, VI, 1920, pp. 4–27; H. L. Rabino di Borgomale, Māzandarān and Astarābād, London, 1928, pp. 73–74; G. Contenau, Le trésor d'Asterabad et les fouilles de Tépé Hissar, Rev. d'assyriologie, XXXI, 1934, pp. 77–80.

Kalar Dasht. This site is in Mazanderan, west of the Karaj-Chalus road. Here was found an important Sassanian metal and silk treasure which includes decorated silver-gilt cups, silver bottles, and silks with scenes of lion hunts. A group of tombs of 1000–800 B.C. contains precious objects and ceramics relating to Tepe Sialk B. (See I, PL. 437; II, PL. 4; VI, PL. 249.)

BIBLIOG. M. Bahrami, L'Exposition d'art iranien à Paris, AAs, XI, 1948, pp. 13–23; H. Samadī, Ganjīna-i Kalār Dasht (The Treasure of Kalar Dasht), Gudhārishhā-i bāstānshināsī, III, 1956, pp. 115–16.

Lajim. This village is in the Zirab region (Savad Kuh). Its structure called the Imāmzāda 'Abdullāh is a circular tomb tower of 1022–23. In Resget, in the same zone, is a similar tower which is probably contemporaneous.

BIBLIOG. A. Godard, Les tours de Ladjim et de Resget, Āthār-e Īrān, I, 1936, pp. 109–21.

Sari. In this important city and capital of Mazanderan Sassanian silver was discovered, including bowls, forks, and a plate. The interesting tomb towers called the Imāmzāda Yaḥyā, the Imāmzāda Zayn al-'Ābidīn, and the Imāmzāda 'Abbās have been preserved.

BIBLIOG. H. L. Rabino di Borgomale, Māzandarān and Astarābād, London, 1928, pp. 51–56; R. Ghirshman, Notes iraniennes, VI: Une coupe sasanide à scène de chasse, AAs, XVIII, 1955, pp. 5–19; A. Ḥakīmī, Bushqāb-i nuqra-i munḥaṣir bifard-i sāsānī makshūfa dar ḥavālī-i Sārī (A Sassanian Silver Platter: Unique Discovery near Sārī), Gudhārishhā-i bāstānshināsī, III, 1956, pp. 329–64.

Talish. This is a mountainous zone near the Caspian shore of Azerbaijan. Here have been discovered many tombs containing objects which range in date from 2100 to 1000 B.C. and which relate to objects from Luristan and Asia Minor.

BIBLIOG. J. De Morgan, Recherches au Talyche persan, Mém. de la délégation en Perse, VIII, 1905, pp. 251–341; B. Nikitine, Notice sur la province persane de Talech, Rev. du monde musulman, I, 1922, pp. 121–38; J. De Morgan, La préhistoire orientale, Mém. de la délégation en Perse, III, 1927, pp. 185–226; C. F. A. Schaeffer, Stratigraphie comparée et chronologie de l'Asie occidentale, London, 1948, pp. 404–43.

Tureng Tepe. This important prehistoric center is about 10 miles east of Gurgan. Three levels of a necropolis have been excavated, revealing objects which are related to finds from Tepe Hissar III. Excavations at Shāh Tepe Buzurg have yielded similar pottery.

BIBLIOG. F. R. Wulsin, Excavations at Tureng Tepe, near Asterabad, B. Am. Inst. for Persian Art and Archaeol., II, 1 bis, 1932, sup., pp. 2–12.

Teheran region. Alamut. Here are the remains of the famous Ismailite fortress of the Assassins, situated on a rocky crag two days' journey northeast from Qazvin.

BIBLIOG. C. Huart, La forteresse d'Alamut, Mém. de la Soc. linguistique, XV, 1907, pp. 130–32.

Ardistan. This village on the road between Kashan and Nayin contains one of the most interesting Seljuk monuments in Iran, the Masjid-i-Jāmi'. The earliest phase of its construction predates the spread of the four-liwan mosque type but seems to be later than the two-domed type of the Isfahan Masjid-i-Jāmi'. The mosque was erected on the site of an earlier Arab type of mosque, of which traces still remain. The domed sanctuary was the first section to be erected; later (1158–60) the building was transformed into a mosque with four liwans and the decoration of the sanctuary was renewed. A madrasah was added, and in the first half of the 15th century the north liwan was reconstructed. The south liwan is still the most beautiful example of Islamic architecture in Iran. Near the Masjid-i-Imām Ḥasan is the remaining minaret from the portal of a Seljuk madrasah that has now disappeared; this is perhaps the earliest extant example of a portal flanked by two minarets.

BIBLIOG. A. Godard, Ardistan et Zawaré, Āthār-e Īrān, I, 1936, pp. 285–309.

Chandar. This site is located in the region of Teheran on the road to Khurvin. Here was discovered a necropolis with ceramics and bronzes related to those of Luristan.

BIBLIOG. L. Vanden Berghe, Archéologie de l'Iran ancien, Leiden, 1959, p. 124.

Chashma-i-'Alī Tepe. At this site, which lies between Teheran and Rayy, excavations have revealed several levels — Seljuk, Sassanian, and Parthian (a temple with ceramics and coins). Here also are prehistoric remains including ceramics of the types of Tepe Sialk I, II, and III.

BIBLIOG. R. De Mecquenem, Notes sur la céramique peinte archaïque en Perse, Mém. de la délégation en Perse, XX, 1928, pp. 115–21; E. F. Schmidt, The Persian Expedition at Rayy, B. Pa. Univ. Mus., V, 1935, pp. 41–49.

Damavand (Demavend). This site is about 35 miles northeast of Teheran. Objects of the Parthian period were found in a necropolis in the vicinity. The Masjid-i-Jāmi' is one of the later examples (11th cent.) of the Arab type of portico mosque, surviving in a period in which the Iranian type of mosque, the domed sanctuary, already predominated. Damavand has some examples of ancient tomb towers, the most notable of which is the one called the Imāmzāda 'Abdullāh (ca. 1300).

BIBLIOG. M. B. Smith, Le Masdjid-i Djuma de Demawend, Ars Islamica, II, 1935, pp. 153–73; D. N. Wilber, The Architecture of Islamic Iran: The Il-Khānid Period, Princeton, 1955, pp. 131–32.

Gulpaygan. This important city is west of Qum. The original Masjid-i-Jāmiʿ, built between 1105 and 1118, includes the domed sanctuary; it is the second earliest remaining example of the Iranian type of mosque, the earliest being that at Niriz. There are many Qajar additions. The Imāmzāda Hifdātān of the Safavid period has a certain interest. Here also is a Seljuk minaret.

BIBLIOG. A. Godard, Les anciennes mosquées de l'Iran, Āthār-e Īrān, I, 1936, pp. 183–210 at 193; A. Godard, Voûtes iraniennes: Les coupoles, Āthār-e Īrān, IV, 1949, pp. 259–325 at 292.

Kashan. The general appearance of this important city is one of the most characteristic in Iran. Its name is connected with the typically Iranian architectural decoration, ceramic inlay or kashi. Few of the early monuments remain. The Masjid-i-Jāmiʿ of the 11th–12th century has been extensively rebuilt; from the Seljuk period there is only one minaret, but it is one of the earliest in Iran (1073–74), in age second only to that of Sava. Another minaret stands isolated. The Masjid-i-Maidan in its present form is of the Timurid period. It contained a noteworthy mihrab of 1226, which has been removed to the Staatliche Museen, Berlin. During the Safavid period the court often resided at Kashan. The Imāmzāda Habīb ibn-Mūsā, probably Ilkhan in date, contains the tomb of Shah ʿAbbās I (d. 1629). ʿAbbās II built the dam on the Quhrud. The Bāgh-i-Fīn in the city environs, slightly beyond Tepe Sialk, was built by ʿAbbās I, who erected a palace in it; whatever remains is due to Fath ʿAli Shah. It contains the best extant examples of wall paintings from a period in which the secular architecture was certainly superior to the religious. The latter is represented in Kashan by such famous buildings as the Madrasah-i-Shāh, which, however, have little intrinsic architectural interest.

BIBLIOG. Abd-al Rahim Kāshānī, Mirʾāt-i Kāshān (The Mirror of Kāshān), Ms. 272, Lib. of the Majlis, Teheran, 1871; B. W. Stainton, A Masterpiece from Old Persia, Int. Studio, LXXVII, 1935, pp. 132–36; A. Godard, The Tomb of Shah ʿAbbas, B. Am. Inst. for Persian Art and Archaeol., IV, 1936, pp. 216–17; Y. A. Godard, Pièces datées de céramique de Kāshān à décor lustré, Āthār-e Īrān, II, 1937, pp. 309–37; F. Sarre and E. Kühnel, Zwei persische Gebetnischen aus lustrierten Fliesen, Berliner Mus., XLIX, 1958, pp. 126–31.

Khurha. This site lies southeast of Qum, on the Araq–Kashan road. The two columns with Ionic capitals which are preserved here are the most notable Seleucid remains in all Iran.

BIBLIOG. E. E. Herzfeld, Am Tor von Asien, Berlin, 1920, p. 32.

Khurvin. This important prehistoric center is about 50 miles northeast of Teheran. The necropolis, which dates from the late 12th century, has yielded unpainted pottery and bronzes; the objects are related to those from Tepe Sialk A and B, Tepe Giyan Ib and c, and Hasanlu. It is one of the earliest necropolises, going back to the first settlement of Iranian populations on the plain.

BIBLIOG. L. Vanden Berghe, Khurwin (Iran): Nécropole des premières tribus iraniennes (Pub. Inst. h. et archéol. néerlandais de Stamboul, VII), Leiden, 1959.

Naysar. This village lies on the Dalijan–Kashan road. One of the most interesting and well-preserved Sassanian fire temples is found here.

BIBLIOG. A. P. Hardy, Le monument de Neisar, Āthār-e Īrān, III, 1938, pp. 163–66.

Natanz. This city is near Kashan. From the pre-Islamic period are the remains of a Sassanian fire temple. The city is especially important for a very famous Ilkhan complex (1304–25) comprising a mosque with four liwans and a domed octagonal sanctuary, the tomb of Sheik ʿAbdu 's-Samad al-Isfahānī, a khankah portal, and a minaret. All are richly decorated with glazed and unglazed ceramics and brick. The Masjid-i-Kūcha-i-Mīr has a Seljuk mihrab. Natanz possesses a few interesting mausoleums and some important examples of Qajar secular architecture, which are, however, poorly preserved. The decline of the city is relatively recent.

BIBLIOG. A. Houtum-Schindler, Reisen in südlichen Persien, Z. die Gesellschaft für Erdkunde zu Berlin, XVI, 1881, pp. 308–09; A. Godard, Natanz, Āthār-e Īrān, I, 1936, pp. 75–102; E. E. Herzfeld, Damascus, Studies in Architecture, I: The Shrine of Sheikh ʿAbd al-Samad, Ars Islamica, IX, 1942, pp. 37–40; E. Schroeder, M. Godard's Review of the Architectural Section of SPA, Ars Islamica, IX, 1942, pp. 211–17.

Qazvin. This important city of central Iran replaced Tabriz as the capital of Safavid Persia under the dynasty's second ruler Tahmāsp I (1524–76). Considerably less splendid than in former times, Qazvin preserves two ancient monuments which are among the most outstanding in the history of Persian architecture. One is the Masjid-i-Jāmiʿ, a work of several generations, the history of which is easily reconstructed. The domed sanctuary was built in 1113 in the vicinity of an earlier madrasah and chapel above the foundations of a pre-Islamic monument; the liwan which leads into the Seljuk sanctuary belongs to the period of ʿAbbās II; the rest is also Safavid. The domed Haydariya is also Seljuk and of the same type as the Masjid-i-Jāmiʿ and the Gulpaygan sanctuaries. The tomb of Hamd-Allāh Mustaufī, perhaps an Ilkhan prototype (ca. 1340) of the mausoleum with conical roof, has been very much restored. From its existence as a capital the city preserves only the ʿĀli Qāpū, a dignified Safavid building. The Masjid-i-Shāh and the Shāhzāda Husayn sanctuary are examples of early 19th-century architecture.

BIBLIOG. M. C. Barbier de Meynard, Description historique de la ville de Kazvin, extraite du Tarikhè Guzideh de Hamd Alla Mustàfi Kazvini, JA, X, 1857, pp. 257–308; A. Godard, Les anciennes mosquées de l'Iran, Āthār-e Īrān, I, 1936, pp. 183–210 at 196; A. Hannibal, Qazwin: Capitale oubliée, Teheran, 1956; M. ʿA. Gubīz, Mīnū-dar ya Bāb al-janna-i Qazvīn (Qazvīn: Gate of Paradise), Teheran, 1337 A.H. (1958).

Qum. This important city is noted primarily for the Fātima bint-Mūsā shrine, in Iran second in religious importance only to Mashhad, and for its present service as seat of the highest hierarchy of the Imams, the supreme Shiite authority not only for Iran but for the entire Islamic world. Since the city was conquered in the 8th century by the tribe of the Ashʿarī Arabs, it has been an active center of the Shiite faith. The sister of the Imam ʿAli al-Rizā (he is buried at Mashhad) died at Qum in 816, but the first mention of the shrine built over her tomb occurs five centuries later in Hamd-Allāh Mustaufī; still later the pilgrimage to the tomb became important. The fact that the city was a Shiite center from early times, in contrast to other principal Persian cities (in 965 there was a religious conflict with Sunnite Isfahan), doubtless contributed to an earlier and more important development of the Fātima shrine than that of the numerous shrines erected over the tombs of the various members of the family of ʿAli which are scattered throughout Iran. For this reason the traditional influx of the faithful left in the vicinity many mausoleums of early periods. Today the general appearance of the sanctuary of Fātima is that given it by the rather unfortunate restorations of Fath ʿAli Shah in the early 19th century. Those tombs north of the city are the more modern; the earlier are to the south, the west, and especially to the east (near the Kashan Gate). The Ilkhan period is best represented; the tombs are mostly octagonal with domes and polyhedral roofs (often conical) and furnish examples from the entire 14th century. The earliest date, 1268–69, is found on a fragment in the museum which was opened in 1936 in a building of the sanctuary; this collection is especially rich in interesting ceramics. There are many restorations. The most important tombs are the three near the Kashan Gate, which were dedicated to unknown persons and are commonly known as those of Saʿīd, Asadī, and Masʿūd. The city also contains the remains of the Masjid-i-Imām Hasan, a restored Ilkhan madrasah of ancient origin, flanked by minarets (ca. 1325), as well as various modern buildings.

BIBLIOG. Hasan ibn Hasan Qummī, Tārīkh-i Qumm (History of Qum), Teheran, 1312 A.H. (1934); F. Bazl, Preliminary Report of the Tombs of the Saints at Qumm, B. Am. Inst. for Persian Art and Archaeol., IV, 1935, pp. 36–38; Rāhnumā-i Qumm (Guide to Qum), Teheran, 1317 A.H. (1938); M. Siroux, Le Kalè Dukhtar de Kumm, Āthār-e Īrān, III, 1938, pp. 113–20.

Rayy (Rhages). The ancient center of Rhagian Media is today merely a poor suburb of what was once its own suburb, Teheran. In its vicinity are the most highly venerated shrine of the capital, that of Shah ʿAbd-al-ʿAzim, of minor architectural interest, and the recently constructed mausoleum of Riza Shāh Pahlavi, the founder of the present Iranian dynasty. The tower said to be Tughril Beg's tomb (1130–40) still stands. Excavations have revealed the foundations of the Abbasside mosque built according to the Arab plan, as well as a madrasah with four liwans, from the Seljuk period, with interesting stucco decoration. Rayy was an important ceramic center in medieval times. Destroyed by the Mongols in 1220, its position later was inherited by Teheran.

BIBLIOG. A. V. W. Jackson, Harpers' Dictionary of Classic Literature, s.v. Rhagae, New York, 1897, pp. 1369–70; A. V W. Jackson, A Historical Sketch of Ragha, Spiegel Memorial Vol., Bombay, 1908, pp. 237–45; A. Nöldeke, Zur Kenntnis der Keramik von Raqqa, Rhages und Sultanabad, O. Arch., I, 1910, pp. 16–17; C. Vignier and R. Fry, The New Excavations at Rhages, BM, XXV, 1914, pp. 211–18.

Sava. This town lies southwest of Teheran in a region rich in prehistoric sites, including Qalʿa-i-Dasht, where ceramics of the Hittite type (see HITTITE ART) were found. The Masjid-i-Jāmiʿ of the Seljuk period, an Iranian mosque type with domed sanctuary, has one of the oldest Persian minarets (1110–11). The Imāmzāda Sayyid Ishāq is much restored but preserves a faïence decoration dated 1277–78. Sava was also an important pottery center of Islamic Iran.

BIBLIOG. G. Le Strange, The Geographical Part of the Nuzhat al-Qulub, London, 1919, p. 68; E. E. Herzfeld, Die Gunbadh-i Alawiyyan und die Baukunst der Ilchane in Iran, A Vol. of O. S. Presented to E. G. Browne, Cambridge, 1922, pp. 186–99; E. F. Schmidt, Flights Over Ancient Cities of Iran, Chicago, 1940, pp. 27–28.

Shahristanak. At this site in the Elburz Mountains is a Sassanian structure called the Qal'a-i-Dukhtar.

BIBLIOG. M. Siroux, Le Kalè Dukhtar de Shahrestānek, Āthār-e Irān, III, 1938, pp. 123–32.

Takht-i-Kayka'us. At this site about 5 miles west of Takht-i-Rustam are a rock terrace dedicated to a fire cult and the remains of a building.

BIBLIOG. M. Siroux, Takhte Rustam et Takhte Kai-kā'ūs, Āthār-e Irān, III, 1938, pp. 93–110.

Takht-i-Rustam. This site is about 30 miles south of Teheran. Here are two terraces for fire worship and a small, domed building.

BIBLIOG. M. Siroux, Takhte Rustam et Takhte Kai-kā'ūs, Āthār-e Irān, III, 1938, pp. 93–110.

Tepe Sialk. This very important prehistoric center is in the immediate vicinity of Kashan, about 3 miles southwest of the city. It comprises two hills which have yielded — along with Tepe Giyan — the most important stratigraphic material for prehistoric Iran. The north hill has two levels, the earliest of which is Sialk I, dating from the end of the Neolithic age, with five sublevels; the ceramics can be divided into four groups, and there are also stone, copper, and carved bone objects. Sialk II follows and has yielded ceramics with plant and, more often, animal motifs. At that point the population transferred to the south hill, about 2,625 ft. to the south; Sialk III shows a striking advance in architecture and ceramics, and comprises seven sublevels. The pottery from the latter part of the period assumes new shapes, has low-relief decoration, and is vitrified; representations of the human figure show a development from realism to stylization. Sialk IV is separated from III by a layer of ashes; within its tombs are jewels and alabaster vases. The pottery is no longer painted but monochrome. Proto-Elamite tablets also have been discovered; Sialk IV was influenced by southwest Iran. After Sialk III, during the 3d and 2d millenniums, the site seems to have been uninhabited. A new population occupied the necropolis about 490 ft. from the hill, which is called Sialk V or Necropolis A. It contains gray pottery, occasionally painted, jewelry, and bronze and iron objects from the late Bronze Age. About 820 ft. from the south hill is the second necropolis, Sialk VI or Necropolis B, which has yielded abundant funerary objects and greatly varied ceramics. This is the necropolis of the conquerors who fortified the south hill, and its culture is the same as that of Susa, Persepolis, Luristan, Geoy Tepe, Tepe Giyan Ic, Hasanlu, and Khurvin.

BIBLIOG. R. Ghirshman, Rapport préliminaire sur les fouilles de Tepe Sialk (Kashan), Syria, XVI, 1935, pp. 229–46; R. Ghirshman, Fouilles de Sialk, près de Kashan, 1933, 1934, 1937, 2 vols., Paris, 1938–39.

Teheran (Tihrān). The capital of Iran is about 3,935 ft. above sea level on the southern slopes of the Elburz Mountains some 35 miles southwest of Mount Damavand. Although its geographical position is not central, it has developed from a small village in the vicinity of Rayy, the major center of Rhagian Media, into the metropolis of Iran, with a population of about a million and a half; this occurred too recently, however, for the city to be of great topographic or artistic importance. The region is of considerable interest for pre-Islamic archaeology, although it has not yet been explored thoroughly. In the immediate vicinity are such centers as Rayy, Varamin, and Damavand, which are important for the history of Islamic art. The first certain mention of Teheran goes back to 1116; the first brief description is in Yāqūt's geography (early 13th cent.), but this does not preclude more remote origins of the early village, and, indeed, this can be indirectly confirmed. Teheran slowly began to develop from the time Rayy was razed by the Mongols in 1220. In the mid-14th century it was a fair-sized town. In the early 15th it was visited by González de Clavijo, who found there a building intended for the royal visits. In the Safavid period Shah Ṭahmāsp added a bazaar and surrounded it with walls and towers, which still appear in a plan from the mid-19th century; on the site of the later citadel, which still stands, Shah 'Abbās I built a palace. In 1618 Pietro della Valle found Teheran to be larger though less populous than Kashan. Shah Ḥusayn, the last of the Safavids, resided there in 1720 just before the Afghan invasion; two old city gates appear to have been built by the Afghans. Teheran also participated in the political events of the period of Nādir Shah, but, above all, it attracted the attention of the Zand chief Karīm Khan, who, in 1760, built a palace there and considered making it the capital, which it later became in 1785–86 under the Qajar dynasty. These rulers

chose the city because of its closeness to Gurgan, their hereditary lands, rather than for practical political reasons. (It has been thought that their purpose was to defend the northern borders of the empire.) The modern Qajar city has developed steadily from south to north, that is, from the plains to the mountains. In 1796 it was a square tract slightly over 2 sq. miles and somewhat sparsely populated; Aqā Muḥammad built there the palace of the citadel. In 1808–09 the perimeter was 4–5 miles and the city had walls and a moat. In 1811 there were 6 gates, 30 mosques and schools, and 300 baths. In 1817 there were said to be 8 gates with great towers, although even in 1838 foreign travelers received the general impression that

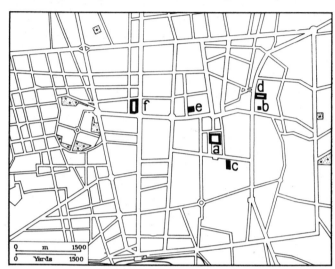

Plan of central Teheran. Chief monuments: (a) Gulistan Palace; (b) Sipāh-sālār Mosque; (c) Masjid-i-Shāh; (d) Majlis (Parliament); (e) Archaeological Museum; (f) Imperial Palace.

Teheran was the poorest of the large Persian cities. Two plans — those of Berezin (1842) and Krzizh (1857) — give an idea of the urban activity in the capital in this early phase of its development. The area of the city was slightly over 3 sq. miles, about one-tenth of which was occupied by the great parallelogram of the citadel. The royal palace had four courts and numerous buildings. The only public square was the Maidan-i-Shāh south of the citadel. Between 1869 and 1874 the second stage of development began, under Nāṣir al-Dīn; the walls and moat were eliminated and Teheran expanded in all directions, assuming the form of an octagon surrounded by new fortifications of the French type with 12 gates. At the same time the new squares of the Tūp Khāna and the Maidan-i-Mashq were built. The countryside to the north was used to form two parallel arteries, Lālazār and 'Alā' al-Daula, running north from the Tūp Khāna and accommodating the foreign embassies. This residential area gradually became the new center of the city, and the citadel zone in the south remained only the commercial center, with its bazaar, which is very large but not sufficiently so as to rival that of Isfahan. A third stage of development coincided with the reign of Riżā Shāh Pahlavi (1925–41). New highways were constructed, as well as many buildings of minor architectural interest, often inspired by pre-Islamic — Achaemenian and Sassanian — styles. As the city was modernized, the Qajar legacy became less evident. Modern Teheran has become the urban model (a rather monotonous one) for the renewal and regeneration of all the other large cities in the country, with its major parallel and perpendicular streets forming a grid. Its growth was interrupted by World War II but afterward was vigorously resumed. Neoclassical (neo-Iranian) forms were abandoned, and buildings were inspired by modern Western architecture; the city extended north toward the suburb of Shamiran. The most recent public constructions are the airport of Mihrabad, the east–west boulevards in the northern zone, the university complex designed by the French architect A. Godard, the Majlis or House of Parliament (1958–59; architects, M. Foroughi and H. Ghiai), the casino (1959–60; architect, H. Ghiai), the banking and commerce center (National Bank of Agriculture, 1958; architects, Foroughi, Sadeghe, and Zafar), a large cinema (Radio City, 1958; architect, H. Ghiai), hotels, residential areas, sports facilities, and the great station of the Trans-Iranian Railroad. Religious architecture in Teheran is represented almost exclusively by the Masjid-i-Shāh, begun in 1809 and completed about 1840, and by the mosque of the Sipāhsālār (1878–90). The secular architecture is very interesting. The Qajar style, which is not without European inspiration and motifs,

has left in the city and its environs various architectural works, the smaller examples of which are perhaps finer than the large royal Gulistan palace (early 19th cent.), which now houses a museum founded in 1894, and the Shams al-'Imāra (1875). In the environs, the palaces of 'Ishratabad, Sa'dabad, Niyavaran, Sahib-i-Qirani, Qaṣr-i-Qājār, and Daushan Tepe are notable. The Teheran Archaeological Museum (founded in 1936) contains important collections from every art period in the country's history.

BIBLIOG. G. A. Olivier, Voyage, V, Paris, 1807, pp. 87–94; J. Chardin, Voyages en Perse (new ed. by L. Langlès), VIII, Paris, 1811, pp. 162–70; J. Morier, A Journey Through Persia (1808–1809), London, 1812, pp. 185–97; J. Morier, A Second Journey (1810–1816), London, 1818, pp. 169–99; A. Dupré, Voyage, II, Paris, 1819, pp. 186–94; R. K. Porter, Travels, I, London, 1821, pp. 306–65; W. Ouseley, Travels in Various Countries of the East, III, London, 1823, pp. 115–200; J. Malcolm, Sketches of Persia, II, London, 1827, pp. 103–52; W. Price, Journal of the British Embassy to Persia, London, 1832, pp. 28–39; F. F. Korf, Vospominaniya o Persii (Memoirs of Persia), St. Petersburg, 1838, pp. 197–216; K. Ritter, Erdkunde, VIII, Berlin, 1838, pp. 604–12; A. Saltykoff, Voyage en Perse, Paris, 1851, pp. 85–115; I. N. Berezin, Putechestvie po Vostoku (Travels in the East), II, Kazan, 1852, pp. 143–77 (plan); X. Hommaire de Hell, Voyage, II, Paris, 1856, pp. 115–213; G. Hirsch, Téhéran, Paris, 1862; E. B. Eastwick, Journal, I, London, 1864, pp. 217–45; E. Forgues, Téhéran et la Perse en 1863, Rev. de deux mondes, LI, 1864, pp. 280–313; H. Brugsch, Reise der Königlichen Preussischen Gesandschaft, I, Leipzig, 1865, pp. 207–34; G. Spasskii, Nineshnii Tegeran i ego okrestnosti (Teheran of Today and Its Environs), Izvestiya russkogo geog. obshchestva, II, 1866, p. 146; A. Wambery, Meine Wanderungen in Persien, Pest, 1868, pp. 106–23; A. M. Mousney, A Journey, London, 1872, pp. 127–47; E. Polak, Topographische Bemerkungen zur Karte der Umgebung und zu der Plane von Teheran, Mitt. der K. K. geog. Gesellschaft, XX, 1877–78, pp. 218–25 (plan of Krzhiz); M. H. Kh. Ṣanī 'al-Daula, Mir'āt al-buldān-i Nāṣiri (The Mirror of the Lands of Nāṣir), I, Teheran, 1294 A.H. (1877), pp. 508–94; E. Stack, Six Months in Persia, II, London, 1882, pp. 151–69; E. Orsolle, Le Caucase et la Perse, Paris, 1885, pp. 210–94; J. Basset, Persia, London, 1886, pp. 102–19; S. G. W. Benjamin, Persia and the Persians, London, 1887, pp. 56–109; G. N. Curzon, Persia and the Persian Question, I, London, 1892, pp. 300–53; E. G. Browne, A Year Amongst the Persians, London, 1893, pp. 82–98; S. G. Wilson, Persian Life and Customs, London, 1896, pp. 140–55; J. B. D. Feuvrier, Trois ans à la cour de Perse, Paris, 1900, pp. 126–219; A. F. Stahl, Teheran und Umgegend, Petermanns Mitt., XLVI, 1900, pp. 49–54 (plan); H. R. D'Allemagne, Du Khorasan au pays de Backhtiaris: Trois mois de voyage en Perse, III, Paris, 1911, pp. 215–68 (plan of Arg); W. Barthold, E. of Islam, s.v. Teheran, IV, 1929, pp. 713–19; S. Abdalian, La région de Téhéran, Teheran, 1943; Rāhnumā-i muvaqqat-i mūza-i Īrān-i bāstān (Provisional Guide to the Museum of Ancient Iran), Teheran, 1325 A.H. (1946–47); Rāhnumā-i Tihrān (Guide to Teheran), Teheran, 1328 A.H. (1949–50, with detailed plans); E. Pakraran, Vieux Téhéran, Teheran, 1951. See also the plans of A. al-Rasūlkhān (1848, 1851) and of 'Abd al Razzāq-khān Bujā'irī (1910).

Varamin (Veramin). This town is in the vicinity of Teheran. On the plain are the remains of a Sassanian structure with ceramics and stuccowork. The impressive Ilkhan Masjid-i-Jāmi' (1322–26), once with four liwans, is in the residential area. The domed sanctuary with its liwan, the portal on the opposite side of the court, and portions of other structures remain in an excellent state of preservation; the decorations are of interest. Notable too are the Imāmzāda Yaḥyā, a tomb chamber of the latter half of the 13th century, which is finely decorated and surrounded by modern buildings; the tomb said to be that of 'Alā ad-Dīn (1289), with fine examples of faïence and brick decoration; the portal of the Masjid ash-Sharīf (1307); and the Imāmzāda Shāh Ḥusayn (ca. 1330).

BIBLIOG. A. Zelenoi, Kal'a-yi-gabr, Veramin, Izvestiya kavkazkogo otdeleniya imperatorskogo russkogo geog. obshchestva, IX, 1886, pp. 92–93; G. Pézard and G. Bondoux, Reconnaissance de Véramin, Mém. de la Délégation en Perse, XII, 1911, pp. 58–62; V. Minorskii, The Mosque of Varamin, Apollo, XIII, 1931, pp. 155–58; V. A. Kratchkowskaya, Notices sur les inscriptions de la Mosquée Djouma-a à Véramine, Rev. des ét. islamiques, V, 1931, pp. 25–58; M. B. Smith and E. E. Herzfeld, Imām Zāde Karrār at Buzun: A Dated Seldjūk Ruin, Archaeol. Mitt. aus Iran, VII, 1935, pp. 65–81; V. A. Kratchkovskaya, Fragments du Mihrab de Varamin, Ars Islamica, II, 1935, pp. 134–35.

Zavara. This village is about 7 miles northeast of Ardistan. The Masjid-i-Jāmi' is the earliest known example of a mosque with four liwans (1135–36). In structure it is similar to the Masjid-i-Jāmi' of Ardistan. There are excellent examples of stucco decoration. Also of interest is the Seljuk Masjid-i-Pā Minār, with a minaret (1068–69) and decorative elements, some of which are Ilkhan.

BIBLIOG. A. Godard, Ardistan et Zaware, Āthār-e Īrān, I, 1936, pp. 285–309.

Isfahan region. Abarqūh. This site is about 85 miles southwest of Yazd. Among its monuments are the Gunbad-i-'Alī, an octagonal tomb tower from the Seljuk period (1056–57); the tomb of al-Ḥasan ibn-Kay Khusrau (ca. 1318–20), adjacent to the remains of a structure of 1415–16; the portal of the Masjid-i-Niẓāmiya, with

two truncated minarets (ca. 1325); the Gunbad-i-Sayyidūn (ca. 1330); the Gunbad-i-Sayyidūn Gul-i-Surkhī (ca. 1330); the Masjid-i-Jāmi', with four liwans, perhaps earlier but primarily Ilkhan in its present state (VII, PL. 400; date of the mihrab, 1337–38); and the tomb of Pīr Ḥamza Sabzpūsh, rebuilt but retaining its early mihrab.

BIBLIOG. A. Godard, Abarkūh, Āthār-e Īrān, I, 1936, pp. 47–72; D. N. Wilber, The Architecture of Islamic Iran: The Il-Khānid Period, Princeton, 1955 (reviewed by M. B. Smith, JAOS, LXXVI, 1956, pp. 243–47).

Ashtarjan. This village is in the area of Falavarjan, about 5 miles north of Isfahan. The Ilkhan Masjid-i-Jāmi' (1315–16) has a domed sanctuary, a liwan, a court, and a portal with two minarets; it is richly decorated. The Imāmzāda Rabī'a Khātūn contains a mihrab of 1308.

BIBLIOG. M. B. and K. Smith, Islamic Monuments of Iran, Asia, XXXIX, 1939, pp. 213–16; Guide du Musée archéologique de Téhéran, Teheran, 1948, p. 54.

Buzan. This village is about 2 miles east of Isfahan. The complex, whose art historical interpretation is controversial, includes a mosque and a domed sanctuary. The Imāmzāda Karrār is Seljuk; some of the elements may be Ilkhan.

BIBLIOG. M. B. Smith and E. E. Herzfeld, Imām Zāde Karrār at Buzun: A Dated Seldjūk Ruin, Archaeol. Mitt. aus Iran, VII, 1935, pp. 65–81.

Dashti. This village is about 5 miles southwest of Isfahan. Here are an Ilkhan mosque, with a domed sanctuary and a monumental portal (ca. 1325), and a minaret.

BIBLIOG. M. B. Smith, The Manars of Isfahan, Āthār-e Īrān, I, 1936, pp. 313–58 at 357; D. N. Wilber, The Architecture of Islamic Iran: The Il-Khānid Period, Princeton, 1955, pp. 162–64.

Garladan. This village is about 5 miles west of Isfahan. The tomb of 'Amr 'Abdullāh, with an Ilkhan liwan (ca. 1315), is flanked by the famous pair of "shaking" minarets, one of the tourist attractions of the Isfahan area. About a mile away on a hill are the ruins known as the Atashgāh of Isfahan; their origins are Sassanian, but the present remains are mostly Islamic.

BIBLIOG. S. Hidāyat, Iṣfahān niṣf-i jahān (Isfahan: Center of the World), Teheran, 1310 A.H. (1932), pp. 43–44; A. Godard, Isfahān: L'Āteshkāh, Āthār-e Īrān, II, 1937, pp. 164–65; N. H. Sādipī, Iṣfahān, Teheran, 1315 A.H. (1937), pp. 162–64.

Gaz. This village is in the vicinity of Isfahan. The Masjid-i-Buzurg, with four liwans, is a monument in which elements of various periods are overlaid. The earliest parts, including the minaret (ca. 1080), are from the Seljuk period. The western liwan is Ilkhan (ca. 1315). Some buildings have been recently reconstructed.

BIBLIOG. R. K. Porter, Travels in Georgia, Persia, Armenia, I, London, 1821, p. 400; A. Godard, Masdjid-é Djum'a d'Iṣfahān, Āthār-e Īrān, III, 1938, pp. 315–26; D. N. Wilber, The Architecture of Islamic Iran, The Il-Khānid Period, Princeton, 1955, pp. 150–51.

Isfahan (Gabae, Aspadana, Sipahan). This is the great artistic center of Islamic Iran, at a height of about 4,920 ft. in the fertile oasis of the 'Iraq-i-'Ajam (the largest oasis on the eastern slopes of the Zagros Mountains) on the northern shore of the Zayinda River. It has been inhabited since earliest times and has played an important part throughout history, especially after the Arab conquest (640–44). A few column capitals from the Sassanian period have been found. The city flourished in the Buyid period (932–1055), when it was the capital, in the Seljuk period (see SELJUK ART), when it was a royal residence until Sultan Sanjar (1117–57) made Merv the capital, and in the Safavid period (see SAFAVID ART), when it was the splendid and populous residence (500,000–600,000 inhabitants) of Shah 'Abbās I (1587–1629). In spite of periods of decline —the city suffered especially from the blows of Tīmūr Lenk (1388) and from the Afghan siege and conquest (1722) — Isfahan still contains important examples from nearly every phase of Iranian architecture of the Islamic period, thus confirming the tradition that it was relatively free of earthquakes. During the Middle Ages there were two civic centers: the earliest, Gayy or Sharistan, about a mile east of the present center, and Yahudiya, the Isfahan of today. The traditional quarters of the city, some of which retain early village names (Karrān, Kūshk, Jaubara, Dardasht), are usually divided into two groups, Ni'matkhāna and Ḥaydarīkhāna, which refer to factions in the Safavid period. In the first there are 14 quarters: Khājū, Baghkārān, Ravāsigān, Shaykh Yūsuf, Pā Qal'a, Karrān, Aḥmadābād, Maidan-i-Mīr Gulbahar, Maidan-i-Kuhna, Jaubara, Gaud-i-Maqṣūd Beg, Chanār-i-Sūkhta, Sayyid Aḥmadiyān, and Shāhshāhān; in the second, 11: Dardasht, Jamala-Galla, Nīm-Āvurd, Masjid-i-Ḥakīm, Bāgh-i-Humāyūn, Bidābād, Darwāza-i-Nau, Shish, Maḥalla-i-Nau, Chahār Sūq, and Shamsābād. The following list of monuments is not in accord with

the historic topography but follows their location in the modern urban sections and their relationship to major architectural complexes.

The Chahār Bāgh is the principal street of the city and, running perpendicular to the river, divides Isfahan into eastern and western halves. It is a great, tree-lined boulevard built by Shah 'Abbās I (1598) at the edge of his city to connect his palace with the outlying gardens. It no longer serves as a park; modern buildings flank most of it, but on the eastern side still stand the palace of Hasht Bihisht, from the Safavid period (ca. 1669) but radically restored by Fath 'Alī Shah and, north of that, the notable and large madrasah

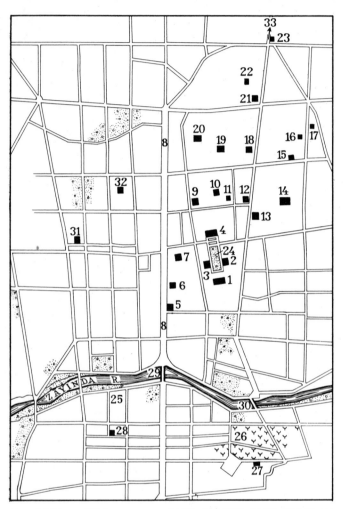

Plan of Isfahan. Chief monuments: (1) Masjid-i-Shāh; (2) Masjid-i-Shaykh Lutfullāh; (3) 'Alī Qāpū palace; (4) entrance to the bazaar (Qaysariya); (5) Chahār Bāgh madrasah (Mādar-i-Shāh); (6) palace of Hasht Bihisht; (7) Chihīl Sutūn ("Hall of Forty Columns"); (8) Chahār Bāgh; (9) Mosque of Hakīm; (10) monument of Hārūn-i-Vilāyat; (11) Mosque of 'Alī with minaret; (12) Imāmzāda Ja'far; (13) Imāmzāda Ismā'īl; (14) Mosque of Sha'yā; (15) Dār al-Ziyāfa minarets; (16) Chihīl Dukhtarān minaret; (17) Sāribān minaret; (18) Masjid-i-Jāmi'; (19) Dardasht minarets; (20) Darb-i-Imām; (21) tomb of Bābā Qāsim; (22) Imāmiya madrasah; (23) Tūqchi minaret; (24) Maidan-i-Shāh; (25) Julfa; (26) cemetery of Takht-i-Pulad; (27) Mausoleum of Bābā Rukn al-Dīn; (28) Cathedral of the Saviour; (29) bridge of Allāhvardī Khan; (30) bridge of Khājū; (31) Mausoleum of Sitt Fātima; (32) Masjid-i-Sayyid; (33) Khiyābān-i-Hātif.

of the Chahār Bāgh, or the Mādar-i-Shāh. This famous building was constructed by Shah Sultan Husayn in 1706–14; it has a court with four liwans, a domed sanctuary, minarets, and rich kashi decoration. East of the Chahār Bāgh is the main area of the city's monuments. It is divided into two sections — to the north the ancient center, to the south the Safavid section — by the Khiyābān-i-Sipah, which runs eastward from the Chahār Bāgh and passes on the north side of the Maidan-i-Shāh, and by its continuation, the Khiyābān-i-Hāfiz. The Maidan-i-Shāh is the heart of the Safavid section, while the Maidan-i-Kuhna, which contains the Masjid-i-Jāmi' ("Friday Mosque"), is the heart of the ancient zone. This early section is in turn divided into eastern and western parts by the Khiyābān-i-Hātif, which parallels the Chahār Bāgh.

The south monumental zone contains monuments along the Khiyābān-i-Sipah, between the Chahār Bāgh and the Maidan-i-Shāh. A large garden crossed by a tributary of the Zayinda River is perhaps a remnant of the famed park of Naqsh-i-qahān. It contains the well-known Hall of Forty Columns (Chihīl Sutūn), built by 'Abbās I (date uncertain) but restored, if not actually rebuilt, by his successors during the 17th century; it comprises a portico with 18 wooden columns, a large liwan, and a central hall with small side rooms. The decoration, which includes painted walls and mirrored ones, is especially notable for the frescoes from the period of Shah 'Abbās I, which recently have been very poorly restored. The four central columns of the portico rest upon four lions, which may be earlier in date. The interior houses a small museum and the regional office of the Department of Antiquities. At each of the four sides of the garden pool is a marble group brought here from the former palace of Chahār Bāgh. Also in the garden are some kashi from the tomb of Pīr-i-Bakrān at Linjan, a portal from the ruined mosque of the city of Qutbiya (1543), and a portal from the shrine called the Darb-i-Kūshk, of the Āq Qoyūnlū period (1496–97), with some kashi which are remnants of destroyed buildings. South of the Chihīl Sutūn are Qajar structures (with traces of a Safavid tower) which now are used by the regional government. Further east is the Tālār Taymūrī, built by Tīmūr Lenk but restored and presently used as an officers' club, and nearby the Tālār Ashraf of 'Abbās II (1642–67), presently serving as the offices of the Department of Education of Isfahan. The Maidan-i-Shāh is the most famous Persian square (ca. 1,680 × 520 ft.), used as a polo field until 'Abbās I reorganized it in 1611–12 by constructing architecturally unified buildings on the four sides of the rectangle, placing the emphasis on the monuments at the center of each side. On the east side is the Masjid-i-Shaykh Lutfullāh, contemporaneous with the Chahār Bāgh (1602–04), which consists of a domed sanctuary, a corridor, and a portal and is famous for its proportions and for its kashis. On the south side is the Masjid-i-Shāh, built between 1612 and 1630, which has since been restored repeatedly. It comprises a great portal flanked by two minarets, a corridor, and a great court into which the four liwans open; the main liwan at the southwest has two minarets and leads into the domed sanctuary, at the sides of which are secondary halls. The construction technique was often poor, and the fragile decorations, mostly painted faïence, make this the lightest and airiest, if perhaps the least solid, example of Persian architecture. The palace of 'Alī Qāpū on the west dates from the Timurid period; it was restored by Shah Ismā'īl and served as the residence of 'Abbās I, whose successors restored it repeatedly. It comprises several stories and a terrace with wooden columns, like the Chihīl Sutūn, and is enriched by pictorial and stucco decoration. On the north side is the Qaysariya (1619–20), the imperial bazaar, which has a great portal leading into it and a two-storied, domed court with kashi and pictorial remains. Beyond is the enormous bazaar of the city. The principal monuments east of the Maidan-i-Shāh are the Mosque of Sārūtaqī (1643–44), in the vicinity of which was once a famous Safavid palace, the Imāmzāda Ahmad of the Safavid period but bearing a Seljuk inscription of A.H. 563 (A.D. 1168), the Safavid mosque of Sheik 'Alī Khan and, farthest east, the Imāmzāda Zayd. The last is a mediocre Safavid edifice, but the inside contains a very interesting and unusual painting of scenes of Islamic sacred history.

The north monumental zone includes the groups of monuments between the Maidan-i-Shāh and the Maidan-i-Kuhna. East of the Khiyābān-i-Hāfiz is an intricate complex of the Imāmzāda Ismā'īl, the Mosque of Sha'yā and its adjoining madrasah; it includes a Seljuk minaret, but its present aspect is mostly Safavid. Farther on is the so-called "Tomb of Nizām al-Mulk." West are the Mullā 'Abdullāh Madrasah of 'Abbās I, the Mosque of Maqsūd Beg (1601–02), a very important example of Safavid architecture; the Imāmzāda Ja'far (ca. 1320), an octagonal tomb tower from the Mongol period; the Safavid Mosque of 'Alī, adjoining but not connected with a Seljuk minaret from the second quarter of the 12th century; the monument of Hārūn-i-Vilāyat, of the period of Shah Ismā'īl (1513), with splendid kashi; the great Mosque of Hakīm ('Abbās II; 1656–57); the reconstruction of an old Buyid mosque, interesting remains of which have recently been discovered and restored in the northwest portal, making it the earliest remaining example of Islamic architecture in Isfahan; the Masjid-i-Surkhī (1605–06), another important work of 'Abbās I. The Maidan-i-Kuhna is of Seljuk origin; also in the zone are the Safavid madrasah of the Kāsagarān, and the Masjid-i-Jāmi', the most complex, rich, and typical extant monument of Eastern Islamic architecture; it was constructed on the site of an earlier Abbasside mosque of a period prior to the 10th century. It is presently in the form of a mosque with four liwans opening onto a central court surrounded on all sides by a continuous wall of buildings of various periods. The oldest section consists of the great domed hall immediately south of the southern liwan and of another, smaller, domed hall, the Gunbad-i-Khākī, at the opposite end north of the northern liwan but not immediately adjoining it because it was once separated from the mosque. Both

domes were built between 1072 and 1092, in the Seljuk period. The four liwans and the many-aisled corridor which surrounds the court on all four sides and connects the liwans were erected later, after the fire of 1121–22 but still within the Seljuk period. The great mihrab on the western side of the surrounding corridor dates from 1310; it was built by the Mongol Öljeitü (Uljeitu). Also Mongol but of uncertain date is the stucco decoration of this corridor. Of 1366–67 (Muẓaffarid period) are the madrasah between the eastern side of the Seljuk corridor and the eastern exterior wall of the mosque; various additions in the same eastern section; the aisled hall which connects the northern liwan with the Gunbad-i-Khākī; and, probably, the hall which interrupts the Seljuk corridor on the western side, now enclosing the mihrab of Öljeitü. The winter prayer hall (*shabistān*) between the western side of the Seljuk corridor and the western outer wall dates from 1447–48 (Timurid period). The two halls at the southwest corner are Safavid; one has a nave with columns (1584) and the other, west of the Gunbad-i-Khākī, is the funerary chapel of Muḥammad Bāqir Majlisī (1681). In modern times the architectural complex has been subject to restoration and additions. The kashi decoration of the interior of the southern liwan and of the liwan façades is from the Āq Qoyūnlū period (1475–76), while most of the other kashi is Safavid. In the section of the Masjid-i-Jāmiʿ, to the west, are the two Ilkhan minarets of Dardasht, flanking the portal of a destroyed building next to a domed structure, the work of Bakht-i-ʿĀqā, perhaps in 1158–59. Here also is the Darb-i-Imām, a building of Qara Qoyūnlū origin with many later changes and additions; it preserves in the portal of Jahān Shah (1453) the most perfect remaining example (along with the remains of the Masjid-i-Kabūd of Tabrīz) of kashi seen in Persian architecture. East of the Khiyābān-i-Hātif are the two Mongol minarets of the Dār al-Ziyāfa (1325–50), the Seljuk minaret of Chihil Dukhtarān (1107–08), and that of Sāribān, perhaps the most beautiful in the city (mid-11th–12th cent.). A monumental group north of the Maidan-i-Kuhna consists of two works from the Muẓaffarid period, the tomb of the theologian Bābā Qāsim (1340–41), especially noteworthy, and its adjoining Imāmiya madrasah (mid-14th cent.). Further west are the Buqʿa-i-Shāhshāhān, of Timurid origin, the Safavid Shaʿfiya Madrasah, in a very poor state of preservation, the so-called "Tomb of Bū ʿAlī," and the truncated minaret called "the Guldasta." (The last two are both of Seljuk origin.) At the north edge of the city is the minaret of Ṭūqchi, of the Ilkhan period (1330–50), the last remnant of an old mosque.

The quarters west of the Chahār Bāgh contain some interesting monuments. (The following list begins with the southernmost building.) These include the madrasah of Shamsābād (1713–14); the Lunbān Mosque, Seljuk in origin but Safavid in its present aspect (1669–70); the Mausoleum of Sitt Fāṭima, with nearby Safavid tombs; the Masjid-i-Sayyid (1840); the Mosque and Ḥammām of ʿAlīqulī Āqā (1710–11); and the Sardarb-i-Shaykh ʿAlī Masʿūd, the portal of a khankah no longer standing (1489–90), with splendid Aq Qoyūnlū kashis.

Spanning the Zayinda River are five bridges, here listed from west to east. Least interesting is the bridge of Marnān. The bridge of Allāhvardī Khan lies at the south end of the Chahār Bāgh and is contemporaneous with it. The bridge (and aqueduct) of Chūbī was built by ʿAbbās I in 1611–12. On the ruins of an Āq Qoyūnlū bridge ʿAbbās II built the bridge of Khājū in 1643–44. The bridge of Shahristān is of Sassanian origin and has Safavid restorations.

Of the surburbs south of the Zayinda River, the westernmost one is Julfa, built by Shah ʿAbbās I expressly for the Armenians who emigrated there in about 1603. It had 24 Gregorian shrines, of which 13 remain. Among these the principal ones all date from the first half of the 17th century: the Cathedral of the Saviour, the Church of Bethlehem, and the Church of St. Mary. Their architecture is Persian rather than Armenian, and in the cathedral paintings Italian influences mix with Iranian traditions. Beyond Julfa are the ruins of the late Safavid palace of Farahabad, a non-Islamic cemetery called the "Armenian cemetery," the Hazār Jarīb garden of ʿAbbās I, and the Takht-i-Pulad, an Islamic cemetery with a surprising complex of tombs and mausoleums of various periods. Of particular note is the Mausoleum of Bābā Rukn al-Dīn, built by ʿAbbās I (1629–30); it is pentagonal with a liwan portal, a conical roof, and a central room with large niches and kashi decoration in a poor state of preservation. It is an outstanding monument of Safavid architecture.

BIBLIOG. P. Bedik, Cehil Sutun, seu explicatio utriusque celeberrimi, ac pretiosissimi theatri quadraginta columnarum in Perside Orientis, Vienna, 1678; Père Sodo, Extrait d'une lettre sur les principales sectes qui devisent les peuples du Levant, Lettres édifiantes, XXX, Paris, 1773, pp. 175–204; A. C. Barbier de Meynard, Dictionnaire géographique, historique et littéraire de la Perse, Paris, 1861; M. Dieulafoy, Notice sur la construction des ponts en Perse: Ponts sur le Zendè-Roud, Ann. des ponts et chaussées, LIII, 2, 1883, pp. 23–48; M. Mahdī al-Iṣfahānī, Niṣf-i jahān fi ta rīf-i Iṣfahān (The Center of the Earth or Description of Isfahan), 1885–86 (Browne Coll. Mss., Cat., I, 3 [9], pp. 121–22); A. Houtum-Schindler, Eastern Persian

Irak, London, 1896; E. G. Browne, Account of a Rare Manuscript History of Isfahan, JRAS, 1901, pp. 411–46, 661–704; W. P. Schulz and W. Baumgartner, Isfahan: Die persische Kunstmetropole, D. geog. Rundschau, XIII, 1901, pp. 433–36; Ispahan: L'ancienne capitale des Shahs de Perse, À travers le monde, N.S., II, 1905, pp. 393–96; G. Le Strange, The Lands of the Eastern Caliphate, Cambridge, 1905; E. Aubin, À Ispahan, Rev. du monde musulman, III, 1907, pp. 221–43; M. van Berchem, Une inscription du sultan mongol Uldjaitu, Mél. Hartwig Derenburg, Paris, 1909, pp. 367–78; E. Diez, Isfahan, ZfBK, N.S., XXVI, 1915, pp. 90–104, 113–28; C. Huart, E. of Islam, s.v. Isfahan, II, 1921, pp. 528–30; A. Jināb, Al-Iṣfahān, Isfahan, 1303 A.H. (1924); B. Carson, Isfahan of To-day, The Fortnightly Rev., CXXVI, 1926, pp. 824–27; J. Daridan and S. Stelling-Michaud, Le peinture séfévide d'Isfahan: Le palais d'Isfahan, Āthār-e Īrān, 1930; L. Bellan, Chah Abbas I: Sa vie, son histoire, Paris, 1932; S. Hidāyat, Iṣfahān, niṣf-i jahān (Isfahan: Center of the World), Teheran, 1310 A.H. (1932); E. Beaudouin, Isfahan sous les grands Chahs, Urbanisme, II, 1933, pp. 1–48; Al-Mafarrukhi, Risāla maḥāsin Iṣfahān (The Beauties of Isfahan), Teheran, 1312 A.H. (1933; originally written in Arabic, 1030); A. Gabriel, Le Masdjid-i Djumʿa d'Isfahan, Ars Islamica, II, 1935, pp. 7–44; A. Godard, Histoire du Masdjid-e Djumʿa d'Isfahan, Āthār-e Īrān, I, 1936, pp. 213–82, III, 1938, pp. 315–26, IV, 1949, p. 363; Y. A. Godard, Notes épigraphiques sur les minarets d'Isfahan, Āthār-e Īrān, I, 1936, pp. 361–65; M. B. Smith, The Manars of Isfahan, Āthār-e Īrān, I, 1936, pp. 313–58; A. Godard, Isfahan, Āthār-e Īrān, II, 1937, pp. 7–176; Y. A. Godard, L'imamzada Zaid d'Isfahan: Un édifice décoré de peintures religieuses musulmanes, Āthār-e Īrān, II, 1937, pp. 341–48; N. Ḥ. Sadiqui, Iṣfahān, Teheran, 1316 A.H. (1937); SPA, II, III, passim; M. Crane, A 14th Century Mihrab from Isfahan, Ars Islamica, VII, 1940, pp. 96–100; D. M. Sabha, A Short Guide to Isfahan, Isfahan, 1944; A. Godard, Le tombeau de Bābā Kāsem et la Madrasa Imāmī, Āthār-e Īrān, IV, 1949, pp. 165–83; M. Siroux, La mosquée Shaʿya et l'Imamzadeh Ismaél à Isfahan, Mél. islamologiques de l'Inst. fr. d'arch. o. du Caire, Cairo, 1954, pp. 1–51; D. N. Wilber, The Architecture of Islamic Iran: The Il-Khānid Period, Princeton, 1955, pp. 141, 161–62, 167–71, 182–87; K. Nikzad, Tārīkhcha-i abnīya-i Iṣfahān (Brief History of the Buildings of Isfahan), 2d ed. Teheran, 1956; L. Honarfar, Historical Monuments of Isfahan, Teheran, 1958; A. Hatami, Welcome to Isfahan, Teheran, 1959.

Kaj. This village is about 10 miles southeast of Isfahan. Its Ilkhan Masjid-i-Jāmiʿ, with a domed sanctuary (ca. 1325), possibly was erected adjacent to remains of one of the earliest Persian mosques.

BIBLIOG. E. Schroeder, Preliminary Note on Work in Persia and Afghanistan, B. Am. Inst. for Persian Art and Archaeol., IV, 1936, pp. 130–35; E. Schroeder, M. Godard's Review of the Architectural Section of SPA, Ars Islamica, IX, 1942, pp. 211–17.

Kuhpaya. This site is on the Isfahan–Nayin road about 40 miles east of Isfahan. The Masjid-i-Miyān-i-Dih is perhaps earlier than its stucco mihrab and its mimbar, which is decorated with kashi and dated 1335.

BIBLIOG. D. N. Wilber, The Architecture of Islamic Iran: The Il-Khānid Period, Princeton, 1955, p. 181.

Linjan. A monument known as the Pīr-i-Bakrān is among the most characteristic of the Ilkhan period, especially for its stucco decoration. It includes a domed sanctuary and a liwan which was transformed into a tomb by Sheik Pīr-i-Bakrān (d. 1303). Its dates range from 1299 to 1312.

BIBLIOG. A. Godard, Isfahan: Le tombeau de Pir Bakrān, Āthār-e Īrān, II, 1937, pp. 29–35; M. Bahrami, Some Examples of Il-Khanid Art, B. Am. Inst. for Iranian Art and Archaeol., V, 1938, pp. 257–60.

Nayin. This city is about 85 miles east of Isfahan. It is famous for the structure called the Ḥusaynīya (13th cent.) and even more for its 10th-century Masjid-i-Jāmiʿ, one of the earliest extant monuments of Iranian Islam. It is an Arab type of mosque, with a columned prayer hall which is richly decorated in a style comparable to that of the roughly contemporary Abbasside buildings of Samarra and the Mosque of Ibn-Ṭūlūn in Cairo; the technique of execution differs, however. The portal and minaret are later in date. The Masjid-i-Bābā ʿAbd-Allāh is Ilkhan (1300–36).

BIBLIOG. H. Viollet and S. Flury, Un monument des premiers siècles de l'Hégire, Syria, II, 1921, pp. 226–34, 305–16; S. Flury, La mosquée de Nayin, Syria, IX, 1930, pp. 43–58; M. B. Smith, The Wood Mimbar in the Masjid-i Djami, Nain, Ars Islamica, V, 1938, pp. 21–28.

Sin. This village is about 15 miles north of Isfahan. A Seljuk minaret of 1132 preserves the earliest dated faïence architectural decoration of Iranian Islam. Here also is an Ilkhan caravanserai (1330–31).

BIBLIOG. M. B. Smith, The Manars of Isfahan: Sin, Āthār-e Īrān, I, 1936, pp. 327–31; A. Godard, Isfahan, Āthār-e Īrān, II, 1937, pp. 1–176 at 170; M. B. Smith and C. C. Miles, Two Dated Seljuk Monuments at Sin (Isfahan), Ars Islamica, VI, 1939, pp. 1–15.

Yezd (Yazd). This well-known city of central Iran is about 195 miles southeast of Isfahan. Along with Kashan, it is perhaps the Persian city which has best preserved its ancient appearance, charac-

terized by numerous domes and towers used to ventilate the houses during the warm season, according to the system in use in central Iran. The bazaar presents a picturesque appearance, with its characteristic 19th-century structures. Yezd and its environs contain most of the Zoroastrian remains in Iran, including a number of fire temples and towers of silence. The principal monuments today are mainly Ilkhan, but the Seljuk and Timurid periods are also well represented. The region has not yet been explored thoroughly; an Achaemenian bas-relief was found by chance near the city. The immense Masjid-i-Jāmiʿ, built between 1324 and 1365, comprises a great portal with a liwan flanked by two minarets, a court with liwans, and a sanctuary with two domes and two lateral prayer halls. Most of the decoration is from the late 14th and 15th centuries. To the east are the remains of a pre-Seljuk mosque. The remaining domed funerary chamber of the Vaqt ū Sāʿat Mosque, in the vicinity, was part of a complex erected by the Sayyid Rukn al-Dīn in 1325. Other noteworthy buildings include the Imāmzāda of the Duvāzdah Imām (1037), with elegant architectural elements and the remains of frescoes; the Shah ʿAbd-al-Qāsim Mosque with a mihrab dated in the 11th–12th century; the Ḥusaynī Haft, of the post-Seljuk era; the Shamsiya madrasah (ca. 1365), with rich decoration; the Buqʿa-i-Shāh Kemālī (1390), in ruins; and the Mosque of Mīr Chaqmaq (1437), with an interesting portal and mihrab. The remains of the walls are among the most notable in Iran, after those of the little city of Bam.

BIBLIOG. M. M. Bafqī, Jāmi i Mufīdī (The Collection of Mufīd), 1671-79, in C. Rieu, Catalogue of the Persian Manuscripts of the British Museum, III, London, 1883, p. 1039a; R. Ghirshman, Les fouilles en Perse, GBA, LXXXVI, 1934, pp. 1–2; A. H. Ayātī, Tārīkh-i Yazd (History of Yezd), Yezd, 1317 A.H. (1938); M. Siroux, La Masjid-e Djumʿa de Yezd, BIFAO, XLIV, 1947, pp. 119–76.

Yezd-i-Khast (Yazd-i-Khast). This site is about 85 miles south of Ishafan. A Sassanian fire temple has been incorporated into the Masjid-i-Jāmiʿ.

BIBLIOG. M. B. Smith, Three Monuments at Yazd-i Khwast, Ars Islamica, VII, 1904, pp. 104–06; M. Siroux, La Mosquée Djumʿa de Yezd-i-Khast, BIFAO, XLIV, 1947, pp. 101–18.

Ziar. This village is about 20 miles southeast of Isfahan. A Seljuk minaret, the only remaining example of the Isfahan type in three sections, dates from the 13th century.

BIBLIOG. M. B. Smith, The Manars of Isfahan: Ziār, Āthār-e Irān, I, 1936, pp. 341–46.

Gianroberto SCARCIA

Illustrations: 4 figs. in text.

IRANIAN PRE-SASSANIAN ART CULTURES. The treatment of the artistic development of pre-Islamic Iran in two articles — the present, dealing with the pre-Sassanian periods (protohistoric, Achaemenid, Parthian), and a subsequent one on Sassanian art (q.v.) — has the practical advantage of conforming to a certain tradition among scholars. Indubitably Sassanian culture offers peculiar aspects that justify separate consideration, for not only did it represent a lively reaction against Parthian culture, which with regard to Iranian art constitutes a problem apart (see PARTHIAN ART), but it had immense irradiation (see ASIA, CENTRAL) and a significant influence on the formation of Islamic art itself (see ISLAM). Yet it is indisputable that the art of the Iranian world, from its earliest manifestations, exhibited constant and unmistakable characteristics, in spite of a multiplicity of trends and currents and an abundance of foreign contributions (Mesopotamian, Greco-Roman, etc.). The art of "Outer Iran," so called — that is, of the peoples of Iranian extraction who lived in a nomad state or stayed beyond the confines of Iran proper — presents special problems. On the one hand, this art is derivative, colored by the artistic traditions with which these peoples came into contact; on the other, it grafts itself onto these same traditions with markedly individual stylistic and typological elements. It is briefly touched on here and treated more fully elsewhere (see GRECO-BOSPORAN AND SCYTHIAN ART; INDO-IRANIAN ART; KHWARIZM; KUSHAN ART; STEPPE CULTURES).

SUMMARY. Prehistory and protohistory (col. 248): *The oldest cultures; The 3d millennium B.C.; The 2d millennium B.C.; The arrival of the Iranians; The early 1st millennium B.C.; The Cimmerians and Scythians in Iran.* The art of the Cimmerians and the Medes (col. 254):

The Luristan bronzes; Median art. The treasure of Zawiyeh and Scythian art (col. 260). Achaemenid art (col. 267): *Civil architecture; Funerary monuments; Religious structures; Sculpture and minor arts; Value and significance of Achaemenid art.* Parthian art (col. 279).

PREHISTORY AND PROTOHISTORY. *The oldest cultures.* From the Paleolithic era to the Neolithic, which has left traces of a rudimentary culture, the inhabitants of the Iranian Plateau lived on the mountains encircling it, for the central depression, now a desert, and the valleys were filled with water. As the valleys drained, men gradually descended from their mountain cave dwellings. By the middle of the 5th millennium B.C. there existed a series of settlements disposed along a crescent whose points faced eastward and whose outline followed what at that time was probably still an inland sea.

Tepe Sialk, near Kashan, about 150 miles south of Teheran, was the first site to reveal the art of the Neolithic period, before man was acquainted with the use of metal (see ASIATIC PROTOHISTORY). At a time when he had only coarse potter's tools and fashioned crude black pottery of a kind also discovered in his previous mountain home, he made his first essays in vase painting. On large bowls of irregular shape he would draw horizontal and vertical lines imitating basketwork; thus, painted pottery had its origin in the imitation of the modest materials of daily use. Although the valuable finds at Tepe Sialk do not permit the assertion that the Plateau was the birthplace of prehistoric painted pottery, such a hypothesis cannot be excluded. More important than pottery during this period was bone carving. A human figure serving as the handle of a flint, to which it was fastened with bitumen (Louvre; see Ghirshman, 1954, pl. 1), shows the tendency to use naturalistic details in representing human beings and seems to indicate that man had already long practiced this art, certainly at the time when he was still living in the mountains.

In the next phase of Iranian culture, during the first centuries of the 4th millennium, the potter achieved more vigorously realistic decorations. Slowly improving his tools, he succeeded in shaping goblets, red in color, on which he drew series of birds, boars, and ibexes in simple black line. The gracefully bounding animals point to a keen sense of observation and to that vision of living things nature offers to the hunting man.

During the following phase — that embracing almost the entire 4th millennium and one of the most appealing in prehistoric Iranian art — the forms of vessels became more complicated, more elaborate. The unstable goblet evolved into the footed cup. The cup developed into the chalice, whose borders were enlivened with rows of birds or panthers, while the body was covered with geometric patterns. The potter continued to reproduce the ibex, which remained a favorite subject of Iranian artists for thousands of years.

In time man learned to make use of copper, the first metal known to him; he was entering the chalcolithic ("cuprolithic") stage, when some of his tools and weapons were already of copper, but stone was still in general use — as it was to remain for a long time. The potter mastered the wheel, which enabled him to achieve graceful and well-balanced forms. A regular kiln, in which he could adjust the temperature of the fire, allowed him the luxury of varying the colors of his vessels, in which gray now appeared as well as red, brown, and buff.

The entire Plateau was dedicated to the art of vase painting. Despite unity of conception, there was great variety in realization; every little center of production introduced its personal note. Naturalism little by little shades into stylization, or rather a tendency to simplify, to give prominence to one characteristic, and to synthesize. On a chalice from Tepe Hissar, near Damghan in northeastern Iran (Teheran, Archaeol. Mus.; see Ghirshman, 1954, fig. 12), the panther is reduced to a triangle. On one of the fine goblets of Susa I (i.e., of the earliest period represented at Susa, a site in the plain skirting the Plateau on the southwest) two triangles joined at the points form the body of an ibex, while a large volute describes the horns; the waders circling the mouth of the vase resemble musical notes — their necks, like the horns of the ibex, are

an expression of the synthesizing tendency (PL. 119). To return to the Plateau itself, a prehistoric site on a hill near Persepolis reveals that the potter arrived at nearly complete abstraction of the animal's body, giving prominence to the horns with broad, powerful strokes of the brush (see Ghirshman, 1954, fig. 11).

The 3d millennium B.C. The cultural unity of Iranian painted pottery, which had endured for over a millennium, was disrupted at the beginning of the 3d millennium under the impact of external forces whose origins it is not always easy to uncover. Susa, surely under the influence of Mesopotamian civilization, abandoned painted decoration; this was the epoch when man realized one of his most wonderful inventions, that of writing. The new current spread beyond the plain of Susiana, penetrating to the center of the Plateau, where manifestations of it have been recognized at Tepe Sialk IV, not only in the common pottery but also in fine jewelry and tablets with proto-Elamite writing; these tablets, well represented at Susa, are the only ones that have been found on the Plateau.

The art of northeastern Iran, too, underwent profound changes, likewise provoked by external currents, among which certain ethnic movements should perhaps be included. Painted pottery, which had flourished in the 4th millennium, was gradually replaced by a new type of production hitherto unknown on the Plateau: a black lustrous ware (II, PL. 1), whose forms, at first imitations of previously familiar ones, later became more varied; the type persisted throughout the 3d millennium and apparently thereafter. During this phase of northeastern Iranian art, which probably affected the whole vast plain lying along the southeastern shore of the Caspian Sea, there was great activity in metalwork, including the making of jewelry. The origin of the new trend remains obscure, and, although it gained hold in a region regarded as one of the gateways of the Plateau for invaders from the east — that is, from central Asia — in certain of its manifestations links with western civilizations, especially Mesopotamia, are detected.

The western portion of the Plateau seems to have escaped influences hostile to the art of painted pottery, and such pottery continued to be produced at Tepe Giyan and elsewhere. The jar became common. Its decoration, confined almost entirely to the shoulder, followed two parallel tendencies: sometimes it consisted of a bird or a quadruped on a clear field, sometimes of a synthesist design, such as the bird comb frequent at Tepe Giyan IV (see Ghirshman, 1954, fig. 24). At Susa, where painted decoration seems to have disappeared for several centuries, it appeared once more with the pottery of Style II, and it was later even associated with polychromy and a neorealistic style. In Elam, of which Susa was the capital, ordinary pottery soon came into its own; it was to continue in use without interruption during the long span until the final collapse of this kingdom in the 7th century B.C.

True, in the last centuries before Elam's fall, potters produced a distinguished enameled ware, often polychrome, but they never again resorted to painting. In this domain the divorce between the Elamite plain of Susiana and the Plateau was complete; the art of the sculptor and the founder, which in Elam reached the level of true masterpieces (PL. 121), seems to have brought about a deflection of taste to artistic outlets other than vase painting.

The 2d millennium B.C. Such was not the case on the Plateau, where — from what we know of its western portion, at least — man seems not to have reached the level of urban organization, and painted pottery remained in favor. To be sure, the forms of vessels changed. At Tepe Giyan III rather soberly decorated tripods made their appearance. In the next phase (Tepe Giyan II), which may be placed in the middle of the 2d millennium, the potter made small craters adorned with metopes filled with birds and suns, as well as jugs and goblets of very light, whitish clay, furnished with a button base and ornamented with lines encircling the body. The second type, known as ''Khabur ware,'' radiated far westward, passing through northern Mesopotamia, and seems to mark an expansion originating

from the Plateau. An inverse current manifested itself shortly before the end of the millennium with the "caliciforms" of Tepe Giyan I, whose silhouette and decoration derive from the pottery of the Hurrians, a people neighboring the Plateau on the north and northwest. Finally, a black pottery of different aspect, well dated in Transcaucasia about 1000 B.C., appeared in the central and western portions of the Plateau (Tepe Sialk V and Tepe Giyan I); its decoration consists of incisions with a knife or incrustations with a white material. It may be representative of other ethnic movements.

The arrival of the Iranians. The exact date when the Indo-European Aryans, or Iranians, arrived on the Plateau to which they gave their name has not yet been determined. Their settlement must have occurred not in consequence of an invasion but as the result of a slow penetration that may have extended over centuries. The first mention of the Medes and Persians, the foremost of the Iranian peoples, in the annals of the Assyrian kings does not go back further than the second half of the 9th century B.C. That life ceased on certain prehistoric hills before the end of the 2d millennium is very significant. It is believed that the beginnings of nomadism in Iran must be assigned to this period.

The route followed by the newcomers to reach the Plateau is not easily established. That across the Caucasus seems probable but does not exclude the plain east of the Caspian Sea, where Soviet archaeologists have brought to light the remains of a civilization similar to that of Necropolis B at Tepe Sialk. Finally, hypotheses have been advanced favoring a third route east of the Aral Sea. It is possible that the Iranians followed two of these routes, or even all three.

Be that as it may, as early as the 10th century B.C. profound changes made themselves felt in the way of life of these Aryans. The dwellings of chiefs rose on hills crowned with a fortified terrace, around which nestled the lower town. The dead were no longer buried under the houses, the practice of the previous inhabitants of the Plateau; "cities of the dead" were created at some distance from the towns. It is at Tepe Sialk that the most ancient installations of the Iranians are found — remains of the dwelling of the chief on top of an artificial mound as well as numerous tombs that may be dated to the late 9th century or even the early 8th century B.C.

Necropolis B at Tepe Sialk, with its megalithic tombs, presents the picture of an already matured society with differentiated classes. To judge from the numerous pieces of harness and weapons, the class holding power was composed of warrior horsemen. The rich had jewels made of silver, the poor, of bronze or iron. Iron was used to forge only the weapons of the rich, and bronze and copper remained widely employed.

The very abundant pottery of Necropolis B offers the most comprehensive view of this archaic phase of Iranian art. The most representative type, a long-spouted pitcher (PL. 120; II, PL. 3), to which the potter sought to give the shape of a bird, was intended to hold a liquid leaving a sediment, which settled into a crawlike pocket at the base of the spout. To increase the resemblance to a bird, the artist drew around the spout and pocket a series of triangles suggesting a collar of feathers or a pair of wings. The significance of birds in the funeral ritual of the Iranians is not known, but it seems clear that vessels of this type could serve only for libations at burials. Very often they bear a sculptural decoration, always subordinated to a specific end. This decoration might be the head of a horse surmounting the mouth of a vessel as if to guard the liquid or, as it looks elsewhere, to watch over the outflow (PL. 120). The animal is a kind of guardian of the contents, as was to be the man whose figure in relief was to decorate the body of another bird-vessel. This formula is worth noting, for it can be recognized as a trait peculiar to the products of potters and metalworkers at other sites on the Plateau and even beyond its borders. Already, too, as in the archaic Greek world, the horse, or the winged horse, made its appearance, as a symbol of the dead man or of death itself carrying him off.

The decorative conventions were firmly established. In obedience to them animals were painted on the lower portion

of the body, near the bottom, so that they could be seen better when the vessel was inclined to release its contents. It is again a horse that is found on a pitcher of a different type, with an upright, flattened, fan-shaped spout and a pocket painted with a human figure, usually female. Man in action is known on only two shards and one whole vessel. On one of the shards he is shown borne by a winged horse — a subject belonging to the cycle of symbolic funerary paintings. May not this winged horse be the earliest representation of the figure later known as Pegasus? On the other shard two men, face to face, with helmets and sheathed swords seem to fight without weapons in their hands. The subject is a war dance, the pyrrhic, which was part of the funerary practices of the Greeks and which the vase painting of Tepe Sialk shows to have existed among the Iranians at a period previous to its appearance in Greek art.

The only whole vessel known that represents a man in action is in Lucerne (PL. 120). On a level below the base of the handle a man is painted on one side, a lion on the other. The man is armed with a spear and a shield, widely used in lion hunting; from his belt hangs a short sword, whose sheath, very broad where the hilt would be, suggests that the weapon is an *akinakes*, or Scythian sword, which was also used by the Medes. The lion faces the hunter on the other side of the handle. Its body is silhouetted, but its eye, lips, nostril, and ear were left light, which heightens the expression of ferocity of this animal. What was intended was a hunting scene. On the one hand, there is the man, fully equipped for a hunting exploit; on the other, the animal, about to attack the man and strike him with his terrible paw. But the artist did not dare or did not know how to give the scene its real meaning of a combat between man and beast. The representation is thus unreal, frozen. The painting seems to have achieved no other end than decoration of the vessel. But if the scene corresponded to some reality, what did it refer to? A funerary vessel for libations at the burial of a hunter-warrior might well bear a representation of the exploits that illumined his life. If this were such a representation, we should have before us the first example of that funerary art which the Iranians produced throughout antiquity, sometimes as sculpture in stone, sometimes as mural painting.

In addition to pottery, Tepe Sialk has yielded weapons and tools made of metal; jewelry (in which gold was apparently not employed), including torques, bracelets, earrings, and braid ornaments; and cylinder seals, on which the subjects of the vase painters appear (see GEMS AND GLYPTICS). Sculptural representation of human beings is almost nonexistent.

The art of Tepe Sialk is an integral part of the new civilization that introduced a fresh spirit into city planning and traditions previously unknown. It reveals new conceptions as foreign to the country's past as they are instructive for the future of Iranian art, for in the art of Tepe Sialk the embryo of what was to become the art of the Persians and the Medes, as well as the "luggage" that must have accompanied the Iranian tribes to the Plateau may be recognized; it is an art permeated with a decorative sense foreshadowing the role of animals in its future manifestations, an art that from the first played no small part in suggesting to the potter the form, the plastic ornament, and the painted decoration of his principal realizations.

Nothing, in the author's view, links the work of the potter of Tepe Sialk with that of his predecessors — neither the consistency nor the firing of the paste, nor the very characteristic color of the glaze. The decoration was no longer distributed around the neck and body but was concentrated around the spout and disposed on a wide free space on the body; even at its most expressive, it might appear on the lower portion of the body, brushing the baseline.

New rhythmic laws seem to have been introduced, but their origin is yet to be ascertained; they do not appear always to follow Oriental principles. What distinguishes the Oriental conception of decoration, whether on a vase or, later, on a carpet, is the continuous, uninterrupted motif; Western taste, on the other hand, demanded a well-defined picture, delimited within a given space and having an intrinsic value. Not for the painter of Tepe Sialk those well-aligned rows of animals following one another to infinity; his animals dispose of large

spaces, and we can only guess whether or not he meant to group them.

In this freedom of expression new touches inspired by textiles were introduced, and if the "textile ornament" reduces the verisimilitude of a scene and emphasizes the unreal character of the figures, by the same token it proclaims the freshness of an art free of the ponderousness, the barrenness, the marks of regression that were to mar the potter's product in the following century in the art of Luristan. At Tepe Sialk we witness the creative phase of an art capable of realizations not devoid of force, elegance, and even ingenuity. Undeniably the painter was animated by that spirit of clarity and measure, rhythm and symmetry, that is found also in the great achievements of Iranian imperial art, in the palaces of Persepolis and the Apadana of Susa. The pottery of Tepe Sialk is only a departure but one rich in promise.

The dawning civilization of Iran was not to disavow for some time the most ancient version of its funerary vase, naturalistically inspired but endowed with a meaning that eludes us. The vessel with an elongated spout apparently remained in use on the Plateau until the Achaemenid period.

The early 1st millennium B.C. Little is known as yet about the diffusion of the painted pottery of the protohistoric Iranians. It is certain, however, that this art continued to flourish on Iranian soil at least until the end of the 7th century B.C., for examples of it have been found in four regions, as much as several hundred miles distant from one another — Azerbaijan, Susiana, Luristan, and Kurdistan. The last two regions will be dealt with in the sections on the Luristan bronzes and the treasure of Zawiyeh (Ziviya).

From the vicinity of Maku in Azerbaijan comes a receptacle in the shape of a horse (Teheran, Archaeol. Mus.; see Vanden Berghe, 1959, pl. 150b), whose harness includes headstall and reins and whose neck bears an ownership mark, a *tamga* in the form of a lily. Its back is covered with a richly decorated and fringed saddlecloth, which was to become classic under the Achaemenids. Each half of the cloth, painted in black and red on a buff ground, represents a hunting scene in which an ibex and a panther run on a field of flowers; some birds are aligned along the border. All the animals are outlined in black, a technique that was to survive for centuries, even in the monumental Iranian murals. Their running style, with forelegs thrown forward almost parallel to the ground, is neither a flying gallop nor the Assyrian "rearing," with the body projected forward rather than up; it seems to have been employed by the artists of Urartu and is not unknown in Achaemenid art or, earlier, in archaic Greek art. The introduction of vegetation, an impulse toward representing landscape, marks an advance over the art of Tepe Sialk, but the flowers have nothing to do with reality; theirs is a conventional art. The saddlecloth must have been a copy of a piece of incrusted leather or of a piece of felt. About 1946–49 some saddlecloths were discovered in the barrows of Pazyryk (Pazirik) in southern Siberia; these are more recent by several centuries than the horse of Maku, which may be attributed to the 8th century B.C. and probably was a ritual vessel used during funeral ceremonies and then probably placed in the tomb.

From the Persian village established at Susa about the beginning of the 7th century B.C. comes a similar receptacle in the shape of a horse (II, PL. 3). Its harness resembles that of the horse of Maku; a *tamga* in the form of a lily marks its neck also. Its saddlecloth is likewise adorned with animals: boars in the flying gallop and birds.

In spite of the distance of several hundred miles that separates the sites of their discovery, the two receptacles are nearly identical. True, the artist of Susa, with his technique of silhouetted animals, has a simpler approach, but he is more concerned with rendering details. Thus, to the Maku painter's abstract landscape he opposes one in a calligraphic style. The idea of giving the vessel the shape of a quadruped may have come from the north, from neighboring countries such as Cappadocia, where the rhyton enjoyed an enduring popularity. On the other hand, presenting the quadruped in the form of

a horse seems to be an Iranian idea, one congenial to a people of warrior horsemen who with this auxiliary progressively extended their conquest of a new country. In the arts of Europe and of those regions of western Asia into which the Indo-Europeans had penetrated from the end of the 2d millennium or the beginning of the 1st, the horse was associated in a variety of ways with solar symbols. In this connection there is a notable frequency, on Greek pottery of the Geometric style, of the horse and of the circle surrounded by dots — motifs that recur on the breast and neck of the Susian horse. Acknowledging the religious and symbolic value of representations of the horse, one may accept the vessel in its image as a funerary object, if only because this animal appears on several vases brought to light in Necropolis B at Tepe Sialk.

The preference for monochrome pottery in Iran during the first centuries of the 1st millennium is a question not of dates but of localities. Communities have been discovered, belonging to the same stage of material culture as Tepe Sialk, that in the 9th and 8th centuries made only black, gray-black, and red pottery — this last, by the way, also common in the tombs of Necropolis B at Tepe Sialk. The Plateau has always shown local divergences in artistic expression. An example from the beginning of the 1st millennium is the necropolis of Khurvin, a little village of the southern spurs of the Elburz Mountains, west of Teheran.

All the pottery of Khurvin is monochrome — black, grayish-black, and, less frequently, red. As at Tepe Sialk, first place belongs to the long-spouted vessel, whose form, as the painted decoration has shown us, imitates the body of a bird. It is said that a receptacle without its ornament is "blind and dumb." Unfamiliar with painted decoration, the potter of Khurvin centered attention and interest on plastic decoration. His vessel "sees" with the inordinately large eyes of the protoma surmounting the spout; and it "speaks," the long spout heralding the ritual act that would cause the sacred liquid to flow through.

The conduct of funeral rites seems to have been the same at Khurvin as at Tepe Sialk, an impression confirmed by the similarities between the funerary furnishings in the two cemeteries. The forms of vessels generally do not differ in the two places, but at Khurvin additional forms are found; for example, the tripod, known on the Plateau at least since the 2d millennium. It may be assumed that in this little community of central Media the absorption of the native population by the conquerors was still under way and that the attachment to ancient forms is a mark of the force of traditions. Metalworking was considerably more advanced than at Tepe Sialk: swords are stronger and longer; jewels, of which several have been found in gold, bear representations of animals and even of human heads. In sculpture the bronzesmith revealed qualities previously unknown. He cast a helmeted warrior who wears a cuirass in the form of a wide baldric and whose oversized raised hands with palms turned outward convey an attitude of prayer (Teheran, Maliki Coll.; see Vanden Berghe, 1959, pl. 156b–c). Similar statuettes have been found among the bronzes of Luristan. The gesture of veneration with uplifted hands was to live for thousands of years in the art of different peoples.

The practice of similar funeral rites and the use, consequently, of pottery of the same kind has been ascertained during this period — datable to the 9th–8th century — on the site of Hasanlu, on the southwestern shore of Lake Urmia. There it was black ware which predominated in the production of vessels similar to those already described, provided with a long spout, whose tapering open gutter was often surmounted by a protoma or even an animal modeled in the round, which "watched" the liquid flow out. This novelty, like the frequent use of tripods, may reflect currents from the north, from that land of Urartu (q.v.) around Lake Van where bronzesmiths produced similar objects. There the bosses of bronze caldrons were adorned with likenesses of animals and human beings, whose function, once again, was to watch over the liquid. Closely related is a red clay vessel from Hasanlu, on which a human being, next to two birds, supervises the outflow of the liquid, expressing the same idea as the similar terra-cotta pitchers of Luristan. The art of the bronzesmith attained a rather high level: he fa-

shioned tripods for caldrons and cast animals in the round; the arms from his workshops are in no way inferior to those we know from Khurvin or to the ones Luristan was to produce. That the horse played its part in the life of the community is proved by the pieces of harness that have been found.

The three sites of Tepe Sialk, Khurvin, and Hasanlu, in the character of their art and funerary traditions, in the forms of their pottery and the appearance of their jewelry, evoke for us the pre-Median civilization of Iran during the first three centuries of the 1st millennium.

The Cimmerians and Scythians in Iran. In the second half of the 8th century B.C. and perhaps even before the end of the preceding century, new invasions by peoples who came from southern Russia, after crossing the Caucasus, profoundly affected the course of history in western Asia and Iran in particular. These peoples were the Cimmerians and Scythians mentioned by the historians of antiquity, according to whom (Herodotus, I, 6, 15, 103; IV, 11 ff.; Strabo, III, ii, 12; XI, ii, 5; XIII, iv, 8) the first, nomad horsemen and breeders of Iranian origin, made numerous raids into Asia Minor, probably beginning as early as the first half of the 8th century. It is not known exactly when the Cimmerians divided into two groups, of which the second penetrated into Iran and settled in the mountains of Luristan, a region that perfectly suited their way of life as nomads and herdsmen.

The invasion of the Scythians took place a little after that of the Cimmerians. They, too, were nomad horsemen of Iranian origin. The discoveries in Iran since the 1930s make it possible to recognize the traces of these invasions and gain a conception of the art of these two peoples so closely connected with the history of Media. Both seem to have left their imprint on the arts of the Median people, whom they helped in their conquest of independence, and contributed to the fall of the Assyrian empire and the disappearance of the kingdom of Urartu.

THE ART OF THE CIMMERIANS AND THE MEDES. *The Luristan bronzes.* The bronzes of Luristan, which made their appearance on the Teheran markets about 1930 and shortly afterward in Europe and America, come from cemeteries in the central part of the Zagros Mountains in western Iran (PLS. 122, 123; I, PL. 437; II, PLS. 5, 6; IX, PL. 497). If the bearers of the civilization that produced the Luristan bronzes were nomads, it is possible that they built dwellings not in the hills, which had been inhabited for thousands of years, but in the plains. They buried their dead in megalithic tombs, outside their living centers, as was done at Tepe Sialk. They had their own religious centers, of which one, at Surkh-i-Dum, has been explored scientifically. The material brought to light there suggests the permanence of the places of worship; in antiquity these continued to be maintained in the same location in spite of profound ethnic and religious changes undergone by the population. It is believed that the new inhabitants of Luristan were Cimmerians, probably related to the Medes, or at least Iranians like them. The identification of a temple that was not part of an agglomeration of dwellings permits the hypothesis that these nomads practiced a kind of amphictyony; in other words, that they formed a community of people who gathered at a religious center, as their descendants, the Lurs, nomads like their ancestors, are doing to this day at Islamic centers of pilgrimage. The Medes seem to have established the same traditions. Their capital, the present Hamadan, before it became a royal city after the formation of their state, was called Hagmatana (the Ecbatana of the Greeks), meaning "place of reunion."

All the peculiarities of the dawning Iranian culture sketched in the preceding section — a culture that may be described as proto-Median — find yet more vigorous expression in the art of Luristan. The existence of cemeteries outside dwelling centers, the megalithic tombs, the abundance of pieces of harness (substitutes for the horse that accompanies death), the use of an identical funerary ware, in pottery or bronze — such are the links between the culture of the Luristan bronzes and

those previously mentioned. A marked progress in metalwork, the improvement in weapons, the wealth of art themes — encompassing, besides real and composite animals, the first treatment of myths and legends connected with the primitive religion of the Iranians — tend to classify the culture of Luristan as more recent than that of Tepe Sialk and to date it in the 8th–7th century B.C., a span that might have to be extended at least to the 6th century B.C.

The potters of Luristan, in contrast to those of Khurvin and Hasanlu, applied painted decoration to the type of vessel with a spout open along its whole length and an animal head surmounting the place where the liquid flowed out. The decoration was confined to checkerboards, crosses, and wavy lines, patterns also known to the painters of Tepe Sialk. Animals no longer found a place in the ornamentation of pottery and passed into the domain of metalcraft. They appear as handles on typical jugs of the Tepe Sialk family, serving as guardians or overseers of the liquid.

One vessel in particular, a bronze jug in the Louvre (see Ghirshman, 1954, pl. 9), deserves our attention, for it opens new horizons on the whole civilization of Luristan, on the attribution of that civilization to a specific people, and on its foreign connections. The first peculiarity of the jug is the handle straddling its mouth, as on a basket. More important is the applied relief in the shape of a bearded personage with arms crossed on his chest and two outspread wings; it is attached to the body of the vessel with the help of rivets. A remarkable product of the workshops of Luristan, known for many years, the vase has never attracted the notice of students of applied ornaments on the caldrons of Urartian origin, discovered mainly in Etruscan tombs and likewise bearing bearded and winged personages. The conception of decoration is the same, as is the role these composite beings were called on to play. Of great significance for Iranian art is that a vessel of the same type (Louvre; unpublished) with a similar applied relief was uncovered in the course of French excavations at Ecbatana (mod. Hamadan), the ancient capital of the Medes. These two objects, not to mention other similar ones from the two regions, point to the identity of the art of the Medes and that of Luristan.

The artist of Luristan did not neglect the bronze rhyton, which in his hands took the form of a lion's head with menacing jaw. The eyes are incrusted, and the mane and the folds of the chaps are brought out in repoussé and worked over with a burin. The open jaws served a practical purpose, for, grasped by the upper jaw, the receptacle could be held like a goblet.

Among the bronzes taken from the tombs of Luristan, bits far outnumber other votive objects. Were all the men of Luristan, then, horsemen or charioteers? Possibly, but not necessarily, for the great majority of the bits were found under the heads of skeletons and bear no trace of use. To place a bit under the head of the deceased was to create the illusion that he would make his last journey by means of this substitute for his terrestrial mount. That is the reason why horses, alone or mounted, or yoked as for a chariot — in other words, the man, the chariot, and the team — are the predominant themes on these bits from Luristan, which must be votive objects.

Several dozen varieties of bits displaying the horse can be enumerated. The animal may be very realistic, with a collar and bell; it may consist only of a protoma behind a sphinx whose paws are crushing an animal stretched out on the ground. The artist's imagination spurred him toward ever more exuberant realizations and new schemes of decoration. He came to adorn an animal with parts of other animals, a formula dear to Scythian art. Thus the head of a monster springs from the tip of the wing of a sphinx; elsewhere a long-necked monster grows out of the rear of a sphinx, astride which sits a personage who is fighting the monster.

What may be termed a veritable explosion in the art of the the bronzesmith was an isolated phenomenon in the history of the plastic arts in western Asia. This art was unique in its role as carrier of the diverse themes created in this part of the Asiatic continent. It offers new subjects charged with new meanings linked to the religious beliefs, the mythology, and even the epic treasures of a new people apparently devoid of

ethnic bonds with its predecessors in the area. The upsurge of Iranian art on the Plateau makes itself felt in full force in the works of the Luristan bronzesmith.

Weapons were deposited in the tombs in large number. The swords, of iron, bronze, or iron and bronze, are richly decorated; the human face flanks the pommel, and little lions protect the guard. Daggers, maces, whetstone handles, axes, all reflect the prodigal fancy of artists whose main preoccupation must have been to create something new every time — an effort to some extent imposed on them by their cire-perdue technique, which obliged them to destroy every mold.

Among the axes, few could have served the warrior as arms. Their great number makes it difficult to regard them as ceremonial weapons; these, moreover, to judge from Achaemenid monuments, were real weapons. By their form and composition the majority of the pieces — which include true works of art — may be considered symbolic weapons, intended to accompany the dead and serve them in the hereafter. A lion or lion's head apparently became the decoration par excellence of axes. To have the blade issue from the open jaws of a lion was to endow the weapon with the strength of the most powerful of beasts. Numerous indeed are the weapons in which a lion's head spits forth the blade; a lion cub is sometimes stretched along the back of the blade, and the spikes of the socket (see PL. 122) may end in human heads with caps, which are the "miters" worn by the Medes.

However, it is not the form of the weapons that reveals the art of the bronzesmiths of Luristan. All, or almost all, types of axes had long been known in western Asia, some since the 3d millennium; others, particularly those with the blade issuing from an animal's jaws, were used especially in the second half of the 2d millennium. The basic forms persisted with little change, but the bronzesmiths were able to adapt them to a new world full of symbols — perhaps symbols of power, perhaps religious, above all funerary. The study of the Luristan bronzes confirms the striking unity of the traditions behind them and makes it clear that this rich ensemble was dedicated to those who had ceased to live.

Besides weapons, the tombs of Luristan have yielded numerous articles of wear and adornment. In the costume of a people of horsemen the belt played an important role, and a great variety of buckles have been found. The belts consisted of thin plaques of gold or bronze sewn on leather bands and generally decorated in repoussé. Bracelets with ends fashioned into animals or heads of birds perpetuated a tradition already ancient among the peoples of western Asia. There are a certain number of bandeaux to tie the hair, in bronze as well as gold, whose decoration, like that of the belts, may represent the exploits of the owner. Torques, fibulas, and pins have been discovered in considerable quantity. In the employment of torques, also found in the tombs of Tepe Sialk and Khurvin, the new population of the Plateau shows its connections with Nordic peoples. Of the pins, several hundreds of which are dispersed among various collections, some could not have been used for adornment, but, as in Greece, must have had a votive purpose. A pin in the Foroughi Collection in Teheran, with a head consisting of two ibex protomas on which climbs an animal, has a shaft of such length that it prohibits ordinary use.

In works in the round the Luristan founder proved himself a talented animal sculptor, producing, for example, a fine ibex (see Ghirshman, 1954, pl. 4a), a subject found throughout Iranian art. He was less successful, however, when he attempted the human figure. A little bronze statue of a divinity in the Archaeological Museum of Teheran is the only example of its kind from Luristan (see Ghirshman, 1954, pl. 6b). It is flat, being nearly 15 in. high and but slightly over half an inch thick. The eyes, a point of attraction for mountain artists, drew all the sculptor's attention. He took pleasure, too, in dwelling on certain details, especially — as a worthy member of a community of warriors — on the armament: the dagger, which has the length, rather, of a sword, the quiver fastened with two thongs. Very likely the god held bow and arrows in his hands. The inscription, in Akkadian, seems to be of the Neo-Babylonian epoch.

Even less successful are the "orants," manifold tabletlike statuettes, very abundant in Luristan, which permit the surmise that all the dead were accompanied by their doubles, on whom it was incumbent to represent them before the judging divinity. The posture of the statuettes is one of adoration or supplication, most often with arms raised and hands turned frontward (II, PL. 5). It is the gesture of the warrior of Khurvin; the traditions of a Median village and those of Luristan seem to have been the same. The cap with a triple fold of one "orant" recalls the Median headdress.

The most common among the idols of Luristan is a group consisting of three parts, often found separated: (1) the central subject, a tube-shaped personage struggling with two animals between whose hindquarters the lower portion of his body disappears (PL. 122; II, PL. 6); (2) a bell-shaped stand provided with a tube; (3) a pin running through the personage and securing him to the stand. Rare is the personage with a single head. A given idol may have as many as four heads superposed, all stopping at the chin and, whatever the number of heads, invariably double-faced, like Janus. The classic piece consists of a bust with arms stretched out to strangle two monsters with wide-open jaws. Each head forms a triangle extended by two large projecting ears and halved by a prominent nose that cuts the face like a saber blade; the button eyes are emphasized by a circular ridge — the Luristan bronzesmith's usual treatment of eyes. The personage wears a necklace, which sometimes takes the form of a pectoral. At the waist he has a wide belt, with which his body stops, to be replaced below by the rumps and legs of the monsters he fights. From either side of his body projects the head of a cock.

To multiply the effigy of the god was, in the same proportion, to multiply his power and extend his protection over the faithful. The more heads he had, and especially the more eyes, the more clearly manifest were his superhuman attributes, and the more useful could he be to his adherents and the more redoubtable to his enemies. Thus the polycephaly of the idol, each of whose heads, moreover, has two faces, stresses the power of the divinity, as do the enormous eyes and jutting ears. It has been suggested (R. Ghirshman, *Bîchâpour, II: Les Mosaïques sassanides*, Paris, 1956, pp. 125-26) that the multiple-headed idol, which seems to have been among the furnishings of nearly all the tombs opened in Luristan, represents the god Sraosha, one of the most ancient and most important divinities of archaic Mazdean Iran. The cock was one of the attributes of Sraosha, who combated monsters, the enemies of the great god Ahura Mazda (Ormazd) — monsters pictured with terrifying jaws, in which it would be difficult to recognize any particular species of animal. Sraosha was also the great dispenser of justice, before whom everyone was obliged to appear after death; and it was to prove the piety of the defunct and draw on him the divine benevolence at the time of the last judgment that the likeness of the god was placed near him in his last home.

There is no hint of the shamanism that some have thought to detect in the Luristan bronzes. Probably they represent the most ancient images of Iranian devotion, dating from the period when, it seems, the Yashts — the most archaic parts of the sacred book of the Iranians, the Avesta — were formed orally. This identification offers a clearer explanation of the funerary furnishings so abundantly distributed by the living as a last offering to the departed, furnishings that must have been, if not all, at least in large part, closely connected with the funerary symbolism.

The statuettes were symbols that explained to the faithful the nature of the god, his role in the lives of men and after their death, his exploits, his victories, even his accouterment. Art was in the service of religious imagery and in a single piece brought together a multitude of facets characterizing a divine being. Here seems to lie the reason for the astonishing association of so many diverse elements juxtaposed or intertwined, for a composition contrary to nature, for the fantastic evocation of a deity with multiple heads on a cylindrical half-body merging with the rumps and paws of monsters.

Of the greatest interest for the history of archaic Iranian religion is a silver plaque in the Cincinnati Art Museum (PL. 123). The middle is occupied by Zurvan or Eternity, a primitive androgynous deity, shown with two heads, both fullface: that of a man with a long beard and, beneath, that of a woman. A god of the firmament, he has a birdlike body and long wings with three rows of feathers; the trapezoidal tail has six rows of feathers. According to tradition, Zurvan sacrificed for a thousand years to have a son, Ahura Mazda, and had begun to doubt the utility of his sacrifices when the twins Ormazd and Ahriman were born. The first became "the Lord, the Wise" (Ahura Mazda), because Zurvan had sacrificed; the second, the spirit of evil, because he had doubted. On the plaque the twins flank the head of Zurvan.

Zurvan, who expected the birth of Ormazd, had promised the universe to the first-born. Now, Ahriman, having learned of this promise, left his father's bosom first, before his brother. But the father recognized Ormazd, luminous and sweet-smelling, and, giving him the barsom, said to him: "I have sacrificed for you until now; henceforth you will sacrifice for me." The plaque pictures the transfer of the barsom, a bundle of twigs, which in the hands of the artist became a palm leaf — a form taken by the barsom in other works from Luristan, too. Three groups of figures carry barsoms. The youngest, seated on the ground, on the left, support with their hands the barsoms carried by the adult figures advancing toward the left-hand twin, who seizes a stalk. The right-hand twin, making the same gesture, receives a barsom brought to him by a procession of old men. The artist's intention of representing three groups of different ages is clear. According to literary sources, Zurvan was a tetraform being who bore the three additional epithets Ashogar, Frashogar, and Zarogar — names referring to the three phases of terrestrial life. It is plain that in all the figures carrying barsoms the same god Zurvan must be recognized.

As Zurvan was the god of destiny, to whom supplicants could address their petitions, and since, in addition, he controlled the road leading to the Bridge of Chinvat, where the souls of the dead were judged, it is easy to understand why pictures of him as well as of Sraosha were placed in the tombs near the dead, who had to present themselves before the Bridge, that their fate might be decided. The plaque is of great value in confirming that the cult of Zurvan must be considered one of the most ancient in the Iranian religion and that it dates from a period earlier than the teachings of Zoroaster, the great reformer of the Mazdean religion. It would also seem to confirm the hypothesis that this cult was propagated especially in the western portions of Iran and was an old Median religion.

Among the bronze objects that appeared on the markets of Teheran were remains of shields, parts of quivers, and a large number of pins with disk-shaped heads, on which a variety of subjects are treated in repoussé. All the objects are supposed to have come from a sanctuary discovered by peasants and later excavated scientifically under the direction of E. F. Schmidt. Nothing about these objects has reference to, or connects them with, the horse. Very likely they are votive offerings by those seeking the benevolent aid of a deity in the realization of their wishes (see DEVOTIONAL OBJECTS AND IMAGES).

Most of the disks on the pins display a human head in fullface at the center and, like the heads of the idols in which we have proposed to identify the god Sraosha, stops at the chin (PL. 123). The image has been interpreted with some plausibility as that of a divinity. On some disks it is possible to recognize Zurvan and the theme of the birth of the twins — the same subject, but less fully developed, as on the plaque described above. Other disks, depicting a woman in labor, can be interpreted as a prayer addressed to the divinity of procreation (the goddess Ashi, the sister of Sraosha?). On one disk the central face is surrounded by lions, of which the two upper ones share a single head (Paris, Coll. David-Weill; see Ghirshman, 1954, pl. 8b) — the earliest known Iranian version of a motif that was to live in the arts for centuries and have a remarkable propagation among Western medieval artists.

There is in the art of Luristan a note so personal as to suggest that an intrusion must have occurred in the evolution of an art generally believed to be that of one and the same people. Beside scenes that had been, and were to remain, more or less

classic themes in the life of a people for whom warfare and hunting provided a richly suggestive and valued framework, we encounter others — unreal, fleeting, tangled — with a spirit that pierces this calm universe and introduces a breath of anxiety. We sense man preoccupied with an unknown world surrounding him and influencing him at every moment of his earthly existence and destined to play a preeminent role in his afterlife.

The whole rich iconography of the Luristan bronzes — this world of composite beings and their conflicts — reflects beliefs in which we discover both funerary symbolism and traces of the mythology of a people, or rather of tribes, who came laden with their baggage of religion and traditions. Those who left cemeteries with tombs overflowing with bronzes were Aryans. And if we cannot specify as yet to what degree they were Cimmerians or Medes, such a determination does not seem out of reach for science, unless the symbiosis of these peoples was so profound that they can only be considered together — given their common Iranian origin and the quasi identity of their language, traditions, and beliefs.

The art of Luristan is an explosion, a sudden flowering of means of expression and of technical command, in which we cannot detect any long evolutionary process. It betrays no coherent stylistic development marked by a series of creative stages. To be sure, the impulse might have come from the exterior; much is to be said for this explanation, but by itself it is insufficient. It was necessary for a whole people to attain a certain phase in its existence before it could freely pass to so broad a manifestation as that offered by an aggregate of several thousand bronzes of Luristan. This art is unacquainted with the glorification of heroism, but neither does it know brutality; it has nothing of the pathetic but delights in the monstrous and in a refined stylization, material rather than cerebral, in which the call of the ancient Asiatic civilizations is to be felt. It belongs to the period when religious consciousness was closely linked to the awakening of national consciousness, which led the Iranians of the 8th–7th century B.C. to the constitution of a first kingdom, that of the Medes.

The annals of the Assyrian kings of the 8th century, and especially of the 7th, make it possible to establish, with a certain degree of likelihood, the presence of the Cimmerians in Luristan. They disclose that the Cimmerians supported the Medes in their struggle for independence against the Assyrians, but that some among them served as mercenaries in the Assyrian army; these must have taken part in the struggle of King Sennacherib against Babylonia and Elam and participated, in 689 B.C., in the pillage and destruction of Babylon and of a part of the Elamite kingdom. Now, among the objects found in the tombs of Luristan, some twenty are known today — weapons and vases — that bear cuneiform inscriptions with the names of Babylonian and Elamite kings and high dignitaries, most of which date from the last centuries of the 2d millennium. The presence of these objects is the main reason why several scholars moved back the date of the Luristan bronzes to the 2d millennium. However, these objects were not presents given by princes or lords of the plain to the mountaineers in their service. It is more likely that they were deposited as offerings in the Babylonian or Elamite temples and fell into the hands of the Cimmerians during the pillage. It has not been noticed that none of the inscriptions of these bronzes mentions an Assyrian name. The mercenaries treasured them, for an inscribed object is endowed with a magic power and may possess apotropaic virtues for him who owns and preserves it. It is a *maktūb*, a piece of writing, which to this day in the East has lost none of its value.

How are we to explain the flowering of the art of the Iranian bronzesmiths in the 8th–7th century B.C.? No civilization, except perhaps that of the Etruscans, has furnished such a profusion of metal objects, such a great variety of forms, a comparable wealth of subjects treated with such diversity of expression, all testifying to the exceptional gifts of invention of the artists. This center of metalwork arose in a region where nothing appears to have prepared for it or allowed it to be foreseen, in a country which seems not previously to have had, and which was not to have later on, a role of any importance in the political, economic, or artistic life of the Plateau.

One explanation is that in metalwork western Iran was associated with Urartu, in which association it played the role of brilliant second or, according to another opinion, of worthy successor; it is also possible that the two were rivals in their dealings with the Western world. The art of the Urartian civilization is beginning to become better known through the researches of Soviet scholars. Deeply rooted in what the Hurrian world, close kin to Urartu, had achieved on a base of ancient western Asian arts, it had sufficient vitality to inspire the Iranians, who had come to a territory in which artistic traditions were for all practical purposes exhausted or inexistent.

In the same period in the West the Greek Geometric civilization continued to function as a barrier between Mycenaean and archaic culture; nothing comparable is known on the Plateau. Its personality asserted itself from the moment when the Iranians, taking possession of the region, were engulfed in that province of metalworkers which extended from the borders of Elam perhaps to the shores of the Black Sea, amalgamating a large variety of ethnic elements. The Iranians — nomads, horsemen and breeders, mercenaries enriched in the service of the Assyrians, or transporters of goods — had only to choose among artisans, of whom those of what are today Kurdistan and Azerbaijan were so sought after by the Assyrian conqueror that he displaced them in large numbers for his own needs. To these artisans was to fall the task of training the national artists, among whom, if Darius is to be believed, the Medes acquired the reputation we know.

Median art. We are acquainted with Median architecture only through a few rock tombs, which give some idea of a dwelling of the period. Two of these tombs, that in Dukkān-i-Dāūd, near Sar-i-Pul-i-Zuhab, and that near the village of Sakhna, are on the road from Baghdad to Hamadan by way of Kermanshah. Their façades, with a door protected by a projecting roof supported on columns, copy contemporary dwellings. This architecture became traditional in the country.

Of Median art only some funerary reliefs are known. These, however, have considerable importance for an understanding of Achaemenid art, for the chief elements that were to enter into the composition of the sculptured scenes on the tombs of Darius and his successors had appeared on the princely Median tombs.

Until now but one attempt has been made to attribute a known object to Median art: the gold sheath of an *akinakes*, or short Scythian sword, which is part of the "treasure of the Oxus" (Dalton, 1926, pp. 9–11, pl. 9). A more intensive study of this treasure might lead to very important results for our knowledge of pre-Achaemenid Iranian art. It includes several dozen small thin gold plaques with representations, in repoussé or engraved, of figures, some of which hold the barsom, as on certain bronzes of Luristan, and others vases or flowers. These must have been offerings deposited by the faithful in a temple, whence the treasure presumably came. A similar practice apparently prevailed in Luristan, where such plaques, in gold or bronze, depicting praying figures engraved with a burin, have also been found (Teheran, Foroughi Coll.; unpublished). The most securely identified Median objects come from Hamadan, where the French expedition of Fossey and Virolleaud brought to light two bronze vases, in every way like those of Luristan, as well as a dozen small bronze animals, also similar to those of Luristan. That one of these long-spouted vases, already mentioned above, is Median is corroborated by a bas-relief of the stairs leading to the Apadana of Persepolis. While dating is controversial, one may with due caution attribute to Median art of the 8th–7th century B.C. a group of gold and terra-cotta (II, PL. 4) objects uncovered at Kalar Dasht in the central portion of the Elburz Mountains. One piece, a gold cup in the Archaeological Museum of Teheran (VI, PL. 249), offers many similarities to the works of the artists of Luristan. It has a convex bottom and an upper and a lower border in a braid pattern, which frame a suite of three lions with bodies in repoussé and heads in high relief.

THE TREASURE OF ZAWIYEH AND SCYTHIAN ART. The 7th century B.C., one of the most important and least known periods

in the history of Iran and its art, has been strikingly illuminated by the fortuitous discovery in 1947 of the treasure (or hoard) of Zawiyeh, whose significance far surpasses all that has been said about it (PLS. 124, 125; VI, PLS. 248, 249). For if the quantity of objects in precious metals and ivory immediately awakened the interest of those who first concerned themselves with it, the historical value of this treasure and the character of its essentially composite art place it among the most astonishing discoveries made in Iran in a half century.

Situated on the border of Azerbaijan and Kurdistan, Zawiyeh near Sakkiz (Saqqiz), is found in that region which in the 8th–7th century was the kingdom of Mannai and which after 650 B.C. was occupied by the Scythians, whose kingdom it seems to have become and whom it served as a base at the time of their dominion over the Medes and of their raids across all western Asia. The treasure of Zawiyeh reflects the peculiarly embroiled political and artistic situation in this part of Iran — one attributable to several factors: the influences and the greed of two great neighboring rival powers, Assyria (see MESOPOTAMIA) and Urartu (q.v.); the national aspirations of the Medes, who had just established their kingdom; the invasions of those peoples of Iranian origin, the Cimmerians and the Scythians (see STEPPES CULTURES), and the latter's seizure of the country; their alliances, now with this people, now with that; finally, the role that could be played by the autochthonous populations, renowned and sought after as artists and artisans.

The major part of the treasure is in the Archaeological Museum of Teheran. Its composition — it consists of a very large number of objects of unequal value — and the presence of fragments of a bronze sarcophagus demonstrate that it comes not from a cache for the shelter of spoils but from the tomb of a powerful Scythian king, buried according to the practices required by Scythian tradition, which, as described with an abundance of detail by Herodotus (IV, 71–72), entailed human sacrifice and the immolation of horses.

To the king let us assign the gold pectorals and torques, as well as the gold sheath for a sword that has disappeared, the gold cuirass, the gold and silver vases, and the furnishings ornamented with sculptured or inlaid ivory. But other objects, such as the numerous gold necklaces, could have belonged only to women; the same is true for the numerous gold earrings and rings and the bracelets whose very dimensions point to a feminine wrist. The treasure includes 44 pins, all of the same shape, but of varying sizes; 4 are of gold, 21 of silver, and 19 of bronze. They would not all have belonged to the one king; the diversity of metals employed would seem to reflect differences in social status among the occupants of the tomb. The fibulas, of which we know 42 — 4 of gold, 38 of silver, nearly all of the same type, without spring — also seem to be an index of rank. So were several hundred small gold objects, bracteates, varying in form and workmanship, some made of very thin gold leaf embedded in a wooden (?) matrix, others ornamented with milling, admirable in execution. They must have been fastened on a variety of garments worn by persons of high rank.

The weapons of gold and silver can be attributed to the king, but the 7 long iron spearheads suggest that the guards were sacrificed. The gold vessels are a royal ware, but the pottery, exceptional in paste and finish, was deposited in the tomb to accompany not the prince but the sacrificed servants; such pottery was always of small scale.

Did the tomb contain horses? It seems more than probable, in view of the presenze of 11 little bronze bells, all of the same workmanship, and a considerable number of gold, silver, bronze, and iron harness pieces. Nor can the hypothesis that a chariot was placed near the deceased be rejected, for broad bronze plaques, decorated with a burin and perforated with holes to accommodate rivets to fasten them, may have been part of the facing of a vehicle, the pole of which ended in a bronze horse's head.

The most important piece is a crescent-shaped gold pectoral meant to be worn around the neck suspended by a chain(?; see Godard, 1950, figs. 15–18, 20–24, 33). It is divided into two registers separated by a torsade and bordered with a frieze of pine cones linked by arcs. Each register has a sacred tree in the middle, toward which converge two processions of composite or real beings, identical on right and left — among them bulls, men-bulls with arms raised in the pose of atlantes, lion-griffins, winged mouflons wearing aprons, sphinxes. The narrow ends of the registers terminate in representations of a feline of very peculiar character, typical of a large number of Scythian objects known from southern Russia, and of a crouching hare, an animal likewise prized by Scythian artists.

Unknown in Assyria and Babylonia, the pectoral is widespread in the civilization of Urartu, and there is no lack of objects, discovered in the territory of this kingdom or its capital, depicting personages wearing this ornament. The half-moon form seems not to have been the only one the Urartians gave the pectoral, for on other works of the same provenance rectangular ones may be seen.

There is every reason to believe that the Scythian prince who was buried at Zawiyeh imitated the Urartian practice. It may also be assumed that the composite beings on the pectoral — originally intended to protect a man's chest — have an apotropaic function. (Whether rectangular or crescent-shaped, the piece in itself as well as in its decoration had this magic value.) The Scythian animals decorating the four extremities also seem to be apotropaic. Thus an object of foreign origin is found introduced into Scythian usage and marked by elements of Scythian animal decoration. The example is not an isolated one; a bronze pectoral has also been discovered at Hasanlu in a Scythian tomb with sacrificed horses.

The hypothesis that the pectoral was a piece of plunder must be rejected; and there is little chance, in spite of the minor character of the Scythian element, that it was a gift from one of the powerful neighbors, who might have had it made for the Scythian prince. It must, then, have been ordered by the prince. The difficulty lies in recognizing the nationality of the artist who executed the jewel. Its themes, to be sure, are as well known in the arts of Assyria as in those of Urartu. But the treatment denotes a hand that, even while reproducing known images, handles them in an unaccustomed fashion. Witness the diversity in the human·faces and their non-Oriental cast, which is noticeable in the sphinxes with their pointed noses and in the androcephalous bulls, which, instead of pointed animal ears, have ears forming a double volute. The position of the animals flanking the sacred tree is unexpected, as is the placement of the two genii on the rectangular plaque (very likely from the same workshop), each of whom besprinkles the scorpion tail of a winged lion spitting fire, instead of besprinkling the tree to fecundate it (PL. 124). All this would be surprising in an artist familiar with the iconography of western Asia, and it seems to point to the work of a foreign artist originating in the West, Ionia for example.

What remains certain, however, is that the artist who executed the great pectoral (and the rectangular plaque) strove to satisfy the taste of his Scythian client in composing the decoration by introducing a typically Scythian subject, though he gave it but a modest place at the extremities of the two registers. Here he did exactly what Greek artists were to do on the borders of the Black Sea for their Scythian clientele. For the remainder, he was content to reproduce figures of the imaginary world offered him by the iconography of Oriental art of the 9th–7th century B.C. — an art he came to know by "units" while remaining ignorant of the underlying religious or symbolic values.

The two magnificent bracelets that probably adorned the prince's wrists are composed of five superposed open rings, of which the central one has a sharp edge and the exterior ones broaden out in back to accommodate two pairs of crouching lion cubs (PL. 125). At each end is a lion's head modeled in the round. The treatment of the cubs' heads is close to that of the terminal ones. The ridge that delimits the top of the forehead and encircles the two protuberances serving as ears would indicate a Urartian workshop or one influenced by Urartu.

It is probable that a workshop serving the Scythian prince and treating subjects of Scythian iconography produced a gold band on which two felines appear front to front and the borders

are decorated with birds' heads, "all beak," whose eyes were filled with polychrome enamel (see Godard, 1950, fig. 29). That the workshops existed on the spot and catered to Scythian taste is proved by a fragment of very delicate pottery, of exquisite finish, painted purplish red. The Scythian feline of the great pectoral and the gold band is found again as an applied relief on a vessel (see Ghirshman, 1954, pl. 10a). The same animal, probably produced by the same workshop, was cast in solid gold on opposite sides of the chape (Ghirshman, 1954, pl. 10c) of a scabbard, itself entirely covered with saigas' heads viewed from above (Godard, 1950, fig. 44) — another subject of Scythian iconography.

The same Scythian animals that are found in gold — the feline, the hare, the head ("all beak") of the bird of prey — appear incrusted on a silver plate, decorating it with several concentric circles (PL. 124). In this piece, too, we seek to identify the artists who produced the objects described above. Let us recall, however, that the disposition of animals in concentric circles might have been copied from certain Urartian objects, the royal shields for example.

One of the pieces most representative of the "Asiatic" style in Scythian art is a gold belt with perforated edges that probably fastened onto a wide leather band (PL. 125). The decoration consists of series of loops joined by lions' heads to form a lattice, whose spaces are filled with alternate rows of stags and ibexes that probably faced each other in the middle of the belt. The lions' heads are treated exactly like those of the lion cubs on the bracelet, a treatment in which Urartian elements may be recognized. The lattice pattern, too, is known from Urartian objects. But the crouching stags are handled here according to the purest traditions of Scythian art of the 6th century B.C., as it is known to us from objects discovered in the most ancient Scythian tombs in southern Russia (VI, PL. 463). The head is stretched forward; the muzzle has a double slope with a ridge along the middle; the ear, cradled in the hollow of the neck, is pointed, as are the superposed hoofs. The shoulder is indicated by an oval bulge, a technique employed by artists of western Asia, and the neck, the body, and the well-developed antlers lying along the back present a double slope with a central longitudinal ridge. The same treatment of surfaces is observable in the ibexes with pricked-up ears. Horns, neck, body, and feet consist of planes meeting in sharp edges. To the Scythian repertory so far identified must be added the stag, preeminently a Scythian animal.

The belt was an attribute of power for that son of Herakles, the Scythian, and, like the cuirass, had a defensive purpose. Endowed with magic properties, it was a part of both masculine and feminine attire. Although no belt so wide as that of Zawiyeh seems to have been found in the Scythian tombs of southern Russia, such belts are known among the bronzes of Luristan and Urartian finds.

From what appears to have been an impressive group of vases in precious metals deposited in the princely tomb, there remain only a few fragments; from these one may attempt to determine, at least in part, what these rich offerings represented. The most important piece, both artistically and as a funerary object, must have been a gold caldron that has disappeared, except for the decoration consisting of two lions, also of gold. From similarities with the protomas of two griffins and two lions on a bronze caldron, probably of Urartian origin, found in the Etruscan Barberini tomb (X, PL. 402; in the Museo di Villa Giulia in Rome) — and from the character, the tension that the artist managed to impart to these beasts, from their very posture, with front members projected forward — it can be deduced that the four animals of Zawiyeh were part of a like caldron, probably melted down by the peasants who discovered the tomb. The ferocious appearance of the lion and the menacing beak of the griffin (PL. 125), as well as the forepaws of these beasts, express the idea of protecting the object on which they were fastened and whose contents they were supposed to guard or defend. The same tradition may be observed in the plastic decoration of proto-Median and Median vases.

The treatment of the griffin has nothing Assyrian about it. On Iranian soil its iconography exists in the bronzes of Luristan, among which it even appears with a three-part crest. The bird's head with a "visor," a peculiarity that might have been thought a Scythian creation, is also encountered in Luristan. If the protomas do not show any bond with Assyrian art, neither do they seem to come from the workshops that produced the objects marked by elements of Scythian art. More likely they are of Urartian workmanship — this for three reasons: (1) the griffin's eye, which was certainly incrusted, is treated exactly like that of the bull in the Urartian relief of Adelyevas, rightly believed to have been inspired by a metal object (H. T. Bossert, *Altanatolien*, Berlin, 1942, no. 1192 and p. 91); (2) in Asia only the winged bronze griffins of Toprak Kale (Urartu) and the ivory man-griffin of the same site are furnished with a double braid forming a spiral; (3) it is also in Urartian art that we find the "visor" covering the griffin's beak.

Surely there was at least one chariot in the tomb. The bronze horse's head rising on a long forward-curving neck, which must have decorated the tip of a chariot pole, should remove all doubt on this subject. The use of such an ornament is attested by representations on Assyrian monuments; to judge from the famous mosaic in Naples (Mus. Naz.), a panther was affixed to the pole of Darius III's chariot at the Battle of Issus. The bronze head from Zawiyeh is the first object of its kind found on western Asian soil. Heavy and massive, it was cast in two sections, the head and the neck. The eyes are indicated by a lozenge-shaped frame in relief, cut in the middle by a line, also in relief; the same technique is used for the nostrils; the modeled ears are heart-shaped like those of the previously described Scythian feline. The work appears Urartian in the manner of handling the eye, which is similar to the technique of the founder who cast the bull on the Urartian bronze caldron found in the Heraion of Argos.

A rich selection of objects in carved and engraved ivory accompanied the Scythian prince into his tomb. At least four different techniques, perhaps reflecting different provenances, are distinguishable. The most important group and the one that, judging from workmanship and dimensions, seems to have been the most sumptuous, constituted the ornamentation of a large object (a throne or a ceremonial bed?), probably of Assyrian origin. The plaques of this group depict scenes of hunting, by chariot, on horseback, and on foot (see Godard, 1950, figs. 83–86). A very peculiar technique of massive incrustation on small ivory plaques marks a few rare surviving pieces. This taste recalls what is known from the arts of Urartu, where so many composite animals and even personages in bronze received incrustations. With some reason, perhaps, an attempt will be made to attribute to a local school the work on a piece of furniture (?) made of ivory. The scene depicted imitates the one Esarhaddon had executed for his palace of Nimrud after the treaty concluded with the Median chief Ramateia. It consists of a series of outlined personages, decorated with simple incisions, who advance toward a chief, of larger dimensions. Finally, a very thick plaque from a casket (?) would seem to be of foreign inspiration but very rudimentary local execution (see Godard, 1950, fig. 91). The representation appears to commemorate an agreement or treaty concluded between two princes. Behind the one on the left a courtier holds a parasol, as was the rule at the Assyrian court; the one on the right is followed by his squire, who holds bow and arrows, the symbols of power par excellence among Iranian peoples. On the left a man sacrifices a bull as a thank offering.

The art of the funerary furnishings in the princely Scythian tomb of Zawiyeh — certain aspects of which are elusive — offers a lesson that can hardly be elucidated in all its complexity. Despite the discovery of new texts that illuminate some notable historical facts, our knowledge of the period bears chiefly on the roles of the great powers, Assyria and Babylonia, less on that of Urartu, little on that of the Medo-Scythians. Now, it was these last who apparently played the preponderant part in the collapse of Assyria and Urartu, as the Persians were to do, less than a century later, in the fall of Babylon.

The funerary furnishings of Zawiyeh, and particularly the pottery, demonstrate that just as the Scythians and Cimmerians drew on Median civilization, so this civilization drew on the culture

of the Scythians and Cimmerians. Certain later monuments, such as the bas-reliefs of Persepolis, induced as keen a mind as Herzfeld's to defend the thesis of mutual dependence, one that now seems confirmed. The diversity of artistic currents crossing in this group of objects reflects the tumultuous role of the Scythians in western Asia in the 8th century B.C. It presages what Iranian art was to become under the Achaemenids, and it doubtless sheds light on the character of Median art.

The appearance of the Scythians west of the Volga took place, according to Soviet archaeologists, about 1000–900 B.C. Their movement did not stop after they had reached the plains north of the Caucasus; their traces have been recognized in the Caucasus and Transcaucasia as early as the 8th century and perhaps even before. There, under pressure from the kingdom of Urartu, they seem to have formed a confederation that, reinforced by a new wave from southern Russia, in the 7th century invaded the regions south of Transcaucasia. From that period onward their career is partly known, thanks to the ancient historians and Assyrian sources. They were at first allied with the Medes, at the time of the great revolt of this people against the Assyrians. Then they changed sides and, maneuvering in the orbit of Assyrian power, established themselves south of Lake Urmia, in what is now Kurdistan, where they created their kingdom. Thence they extended their dominion over the Medes and undertook ravaging forays into various parts of western Asia. The fall of Assyria (612 B.C.) and the rise of Median power marked their withdrawal, and if some of the repelled Scythians remained confined in Transcaucasia, the majority must have crossed the Caucasus once more and extended their hegemony over southern Russia during the first decades of the 6th century.

The Scythians, then, passed through four phases, associated with the following regions: (1) those north of the Caucasus; (2) Transcaucasia; (3) Kurdistan; and, finally, (4) the Kuban region, north of the Caucasus, on the lower Dnieper.

The best-known Scythian art was that of the last phase. The tumulus tombs of Kelermes and of Kostromskaya Stanitsa in the Kuban, and the Litoy kurgan on the Dnieper are the most ancient tombs but probably do not date back further than 580–570. Scythian animal art of this period has a well-established iconography; it features the stag, the feline whose paws, ears, and eyes are shown by means of circles, the head of a bird of prey, the curled-up feline. The source of this art seems to be a religious one, impregnated with totemism and animist ideas. The technique of representation has the tendency to decompose the animal's body into a set of planes joined at an angle — a survival from objects carved in wood, bone, or horn.

Side by side with these specifically Scythian designs, often on the very same object, there appear images deriving from the iconography of the arts of western Asia, for example, animals in a heraldic pose or hybrid creatures. The execution often reveals the hand of Greek artists working for a Scythian clientele. It has been proposed to attribute to the first and most ancient known phase of Scythian art some objects found near Kerch, on which can be recognized the head of the bird of prey and the feline, sculptured in bone; these figures of Scythian iconography would presuppose a long evolution.

The sojourn of the Scythians in Transcaucasia is known mainly through tombs containing human and equine sacrifices. The Soviet excavations of Karmir Blur, a Urartian fortress north of the Araks River, have revealed numerous remains of Scythian objects, arms and harness, and archaeologists have been able to observe the role of Urartu in the formation of Scythian culture and art.

The tomb of Zawiyeh offers a picture of Scythian art in its third or "Asiatic" phase. The bronze sarcophagus seems to be Babylonian or Assyrian; the use of the pectoral comes from Urartu; certain jewels, such as the rings with four-petaled flowers, are close to those of the Artemisions of Ephesus and Delphi — which suggests that the jewelers who executed them were acquainted with Greek products. The link between Scythian art and that of Luristan has yet to be thoroughly studied, but the connections between them cannot be denied. The same workmanship has been recognized in the horse's heads produced by the two cultures; in the stag of Kostromskaya and that of

Luristan, with its antlers resting on its back and its superposed pointed hoofs. The bits of Luristan show the so-called "zoomorphic juncture" dear to Scythian art, where the body of an animal represented whole is charged with parts of another animal, especially heads. Did not the small animals that form the bodies of large animals in Luristan serve, later on, as a point of departure for the creations of Scythian art? The iconography of Zawiyeh is enriched by such a composition as two lions with a single head, which appears on certain objects from Luristan. The iron dagger of Zawiyeh with a guard flanked by two little

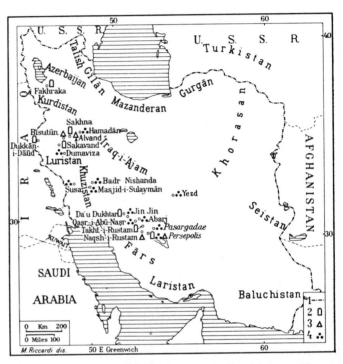

Distribution of the most important pre-Achaemenid and Achaemenid monuments in Iran. *Key*: (1) Modern national borders; (2) rock tombs of the Medes(?) and the Achaemenids; (3) Achaemenid rock reliefs and inscriptions; (4) remains of Achaemenid edifices and architectural complexes.

lions is but a replica of the iron sword of Luristan. The Zawiyeh pottery in its forms and decorations illustrates the eclectic character of this phase of Scythian art; with the long-spouted pitcher it carries on the Median traditions of Tepe Sialk, Khurvin, Hasanlu, and Luristan.

Scythian art remained, and was to remain, profoundly attached to its subjects — the stag, the feline, the bird's head — which were perhaps the patrimony of all peoples who, like the Scythians during their beginnings, wandered over the vast stretches of Eurasia. And when the Scythians arrived on the soil of western Asia, they enriched their art with what the Irano-Urartian idiom had to offer them. The art of Urartu and that of Luristan appear as the most important components of Scythian art, and also as the most profoundly pervasive — more so, it seems, than Assyrian art, whose products swell the funerary array at Zawiyeh.

The encounter of Scythian art with that of western Asia occurred on western Asian soil; through Urartu and Luristan Scythian art also inherited the artistic traditions of the ancient Asiatic civilizations, those of Mesopotamia, Syria, and Asia Minor. On this soil archaic Scythian art, which in the beginning knew only very modest materials such as bone, wood, and horn, was able to select precious metals; for the Scythians acquired prodigious wealth by pillage and conquests that pushed them as far as the frontiers of Egypt. The taste for luxury and polychromy, once acquired, survived even after their return to the plains of southern Russia. But their art remained an applied art, an art of nomads.

Scythian art had a further role. Conditions were favorable for the creation of a close union between Scythian art and that

of the Medes and Cimmerians — Iranians, like the Scythians, and like them inclined to a theriomorphic conception of the world. Thus, one may conclude, did artistic expression of the Plateau acquire unity, a unity that was to survive in Achaememid art, with which the Scythian, enriched by Greek art in the Pontus, was not to break its bonds.

ACHAEMENID ART. *Civil architecture.* The Persians, whose presence to the south and southwest of Lake Urmia is mentioned by the Assyrian annals of 834 B.C., must have continued to move toward the southeast and by the 8th century must have been settled in the valleys of the Zagros that border Susiana on the east. When, about 640 B.C., the victorious army of Ashurbanipal reached the area of the modern city of Shushtar, on the Karun, the king of Parsumash, Cyrus I (Kurush), son of Teispes and grandson of Achaemenes (the founder of the dynasty), presented himself before the Assyrian general and gave him his eldest son as a hostage.

In all probability the Persian prince came from his capital, situated 25 miles east of Shushtar and today known under the name of Masjid-i-Sulaymān, or "Mosque of Solomon." There, backed by the mountainside, is an imposing artificial terrace enclosed by a wall forming alternate projections and recesses and built of rough-hewn, sometimes gigantic blocks, laid without mortar, which recall cyclopean stonework. The wall constituted an enormous caisson for the filling of loose blocks.

Ten stone staircases led to the terrace. The principal one attains a width of 80 ft. and numbers 25 steps, each barely 6 in. in height. Around the terrace emerge the ruins of a group of dwellings. With its triple liwan (*īvān*) the terrace was the fortified residence of a prince; at its foot lay a village, or even a town, inhabited by his subjects. Prehistoric Iran did not know cyclopean stonework; Elamite architecture did not know the use of stone. The terrace of Tepe Sialk may be recognized as the inception of a terrace supporting the abode of a chief. A similar terrace probably rose at Ecbatana, the capital of the Medes.

The technique of construction at Masjid-i-Sulaymān came from afar, very likely from Transcaucasia, which in the first centuries of the 1st millennium had numerous fortified towns employing cyclopean stonework — the prevailing technique in Urartian military architecture. The people who erected this terrace in a barren valley of southwestern Iran could have arrived at their mode of construction only after a sojourn in the neighboring regions of Urartu; and the fact that they gave

their new country the name of Parsumash identifies them as Persians.

A Persian community also settled in Susa in the late 8th or early 7th century. The architecture of this village indicates a transition between the nomadic and the sedentary life of the people. Its art is marked by a great modesty, but it includes painted pottery, abandoned by the Elamite people of Susa for centuries. Some of the pieces, among them a horse-shaped receptacle (II, PL. 3), belong to the family of works due to the proto-Median potters of the Plateau, of Tepe Sialk in particular; and this speaks for the presence of Iranians among the inhabitants of the village.

The terrace of Masjid-i-Sulaymān could even have been built by Achaemenes (ca. 700–675); in all likelihood it existed under his son Teispes (ca. 675–640), who extended his possessions over Parsa, or at least over part of the future province of Persis. At his death Teispes divided his kingdom, probably still in vassalage to Elam, between his two sons. Cyrus I (ca. 640–600) inherited Parsumash, apparently with Masjid-i-Sulaymān as capital, while his brother Ariaramnes (ca. 640–615), representing the younger branch of the dynasty, became king of Parsa. Cyrus I was succeeded by Cambyses I (ca. 600–559) who must have brought about the unification of the kingdom by dethroning Arsames (ca. 615–?), son of Ariaramnes, father of Hystaspes and grandfather of Darius the Great. Cyrus the Great, son of Cambyses I, on his accession, became king of united Parsumash and Parsa but had to recognize the suzerainty of Media.

Was the transfer of the Persian capital from Masjid-i-Sulaymān to Pasargadae, near the Pulvar River, effected by Cyrus the Great or earlier by his father? The second hypothesis seems more credible. The unification of the kingdom might have suggested to its ruler, Cambyses I, that he establish himself in a far richer region than Masjid-i-Sulaymān and one more central in relation to the Persian tribes that swarmed over southwestern Iran and the area south of the great central desert, in the direction of Kerman. Two other arguments may be brought forward in support of the second hypothesis. (1) There is a royal tomb, Da u Dukhtar, hewn out of the rock on the road that must have connected Masjid-i-Sulaymān with Pasargadae. In its conception and façade it occupies a position between the royal Median rock tombs mentioned earlier and those created by Darius the Great at Naqsh-i-Rustam; its attribution to Cambyses I seems plausible. (2) This hypothesis makes it easier to understand the difference in the architecture of Pasar-

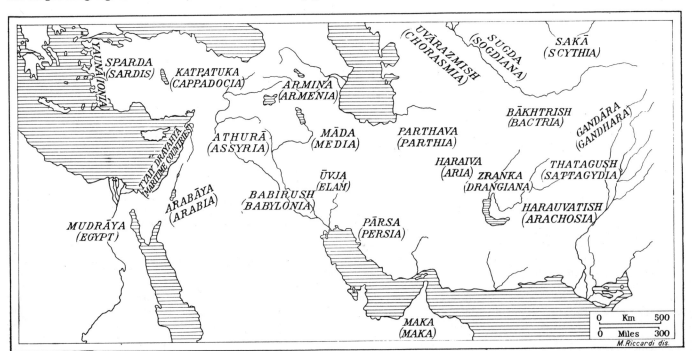

The Achaemenid empire under Darius the Great (521–486 B.C.) and the provinces according to the inscription of Bisutun

gadae itself between the treatment of the stone in the terrace, known as Takht-i-Madar-i-Sulaymān ("Throne of the Mother of Solomon"), on the one hand, and that in the "imperial" buildings erected by Cyrus the Great in the plain, on the other.

Built against an advanced spur, this terrace was conceived according to the same general plan as that of Masjid-i-Sulaymān. The posterior portion of both terraces consisted of a flattened rock prolonged by an artificial structure composed of a mass of rubble, which at Pasargadae was held in by a wall carefully constructed of roughly dressed blocks forming bosses and grooves. This technique of cutting the blocks was new in Iran. It was known in imperial Hittite architecture but disappeared after the fall of the empire, not to be seen again in Asia Minor until the advent of the Phrygians; it was widely developed by the Urartians, whom the Persians very likely imitated. The surface of the terrace has yet to be methodically and scientifically explored; buildings of unbaked brick and wood constituting the prince's residence must have stood there, while the dwellings of the city spread below, west of the mountain. Stone palaces, adorned with sculptures subordinated to the architecture, were not erected until after the victory of Cyrus the Great over Astyages, the last Median king, in 550 B.C., when the Achaemenid became master of the Medo-Persian kingdom. From the fortified dwelling of a vassal prince, Pasargadae became the capital of an empire.

Pasargadae, whose ancient name seems to have been Parsa-gada, signifying "Camp of the Persians," fully justifies that appellation by its plan. Its complex covered almost 1½ miles in length and included palaces, a temple, and the tomb of the "king of kings" (PL. 126), on a surface covered with vegetation and irrigated by canals (FIG. 270). It was the capital of an empire whose sovereign people, changing from a nomadic to a sedentary life, conceived the royal city as a camp materialized in stone. The quarter where the palaces stood, which was enclosed by a wall, had a monumental entrance that formed a hall with two rows of four columns and large doorways flanked by enormous winged bulls. Of the narrower doorways a single jamb is preserved. It is adorned with a bas-relief representing a four-winged genius in a long garment of Elamite type, whose head is surmounted by a complicated headdress of Egyptian origin (PL. 127). In the early 19th century an inscription over the figure could still be deciphered: "I, Cyrus, king, the Achae-menid [have done this]."

About 220 yd. from the monumental entrance stood the Audience Hall, its smooth white columns placed on square bases of black stone, whose capitals, also of black stone, were in the form of protomas of bulls, lions, horned lions, and horses. The door frames still preserve remains of bas-reliefs representing genii, men-fish, and men-bulls.

Some 270 yd. north of the Audience Hall rose another palace, whose roof was also supported by white columns on black stone bases. This bichromy survives likewise in the black and white slabs of the back wall of a portico and the pavement. The central hall, flanked by two porticoes, had two large doors framed by bas-reliefs showing the king followed by a parasol bearer. Here for the first time on an Iranian sculpture appear garments with folds, in contrast to the straight-falling robe of the four-winged genius, executed according to the traditions of ancient Oriental art, which did not endow cloth with the slightest movement or life. True, the royal robes of Pasargadae are somewhat stiffer than those of Persepolis; the relief is too abrupt; the widely spaced folds have a calculated rigidity. But Achaem-enid art here marks a first step in the exploration of a means of expression that was to be developed by the artists of Persepolis.

The palace must have been intended for receptions, or for the banquets that would have followed audiences, rather than for residence, as has been suggested, and, thus, Pasargadae pre-figures the triple articulation of edifices of the time of Darius the Great on the terrace of Persepolis, with the monumental gateway, the Apadana, and the palace reserved for banquets.

The plan of the palace was to remain unique in Achaemenid architecture and was not to be reproduced at either Susa or Persepolis. It recalls the vast tents in which the great lords of Iran, less than a third of a century earlier, received their guests. Open on the two long sides, they offered shelter, de-pending on the hour of the day, under one or the other of the two awnings facing in opposite directions.

At the southern end of the site, nearly a mile from the reception hall, is the Tomb of Cyrus (PL. 126). The monument is made of a fine white limestone. The funerary chamber, which recalls a Nordic dwelling, has a low opening and a roof with

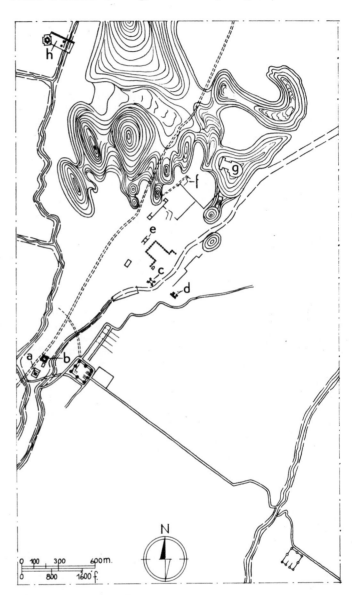

Pasargadae, archaeological plan: (a) Tomb of Cyrus; (b) Islamic construction; (c) Audience Hall of Cyrus (Herzfeld's Palace S); (d) monumental entrance (Herzfeld's Palace R); (e) reception hall of Cyrus (Herzfeld's Palace P); (f) fire temple; (g) terrace (Takht-i-Madar-i-Sulaymān); (h) two stepped fire altars (from Vanden Berghe, 1959).

a double slope. It is placed on a stereobate consisting of six steps of different heights. The whole structure with its seven "stories" might have been inspired by a ziggurat.

Even after the transfer of the capital under Darius, Pasar-gadae was never abandoned and remained a religious capital, where the new kings were crowned. An image of the national culture, the city was a vast manifestation of a Persian art the beginnings of which are obscure but which here reveals a char-acter of its own. The terrace, the plans of the palaces, the tomb of the great monarch, the sensitivity to the play of color evinced in the alternation of black and white stones — all these consti-tute original, if perhaps not entirely independent, achievements, to which Median art was doubtless no stranger. However com-posite, this art knew how to dominate, recast, transpose, and bal-

ance Assyrian, Babylonian, and Egyptian elements, to fashion a new art, striking especially in its architectonic character.

The architects of Persepolis were to learn a great deal from Cyrus' accomplishments at Pasargadae — from the disposition of the principal buildings and the use of the column, whether of stone or of wood embellished with lively colors; from the use of the orthostat; and from the advance in the representation of the human figure with the introduction of drapery folds. It is tempting to believe that the art of Persepolis was born in the valley of the Pulvar. Concentrated on a more restricted surface than at Pasargadae and confined, according to an old tradition, to a terrace, this art comprised what had already been infused by the Iranian spirit and was spread by Cyrus over a large area.

For an empire such as that of Darius, which spread from Egypt to the Indus and from the Danube to the Jaxartes, a capital in a little valley of the Plateau was not sufficiently central. The king decided to establish his political, diplomatic, and administrative capital at Susa. The Elamite city, severely tried by Ashurbanipal's pillaging army about 640 B.C., was at that time situated less than 60 miles from the Persian Gulf, from which two maritime routes led to India and Egypt. Three land routes connected the city with Babylon, Ecbatana, and Persepolis.

A citadel was erected on the Elamite acropolis; north of it, the royal palace, and south of that, the city itself. These three sections were surrounded by a powerful wall and a moat, into which was diverted the small river Chahur. The palace with its Audience Hall, the Apadana, rose on a terrace, as at Masjid-i-Sulaymān or, in the beginning, at Pasargadae. In a region where stone was lacking, it was on a terrace of thick walls of unbaked brick, serving as caissons, between which enormous quantities of gravel were poured, that Darius erected his residence. The palace followed the plan of Babylonian edifices, adopted in hot countries, with three large interior courts, around which were disposed reception and living rooms. To the north, touching the palace, was the Apadana, in which we recognize the architectural principle already elaborated at Pasargadae, with, at Susa, the central hall surrounded by three porticoes. The roof was supported by 72 columns about 65 ft. high, surmounted by capitals with two protomas of bulls. Like the Audience Hall at Pasargadae, the Apadana was put under the protection of benevolent genii — winged lion-griffins, winged bulls, heads of horned lions with stylized manes — all in glazed brick. To these traditional themes Darius added his royal guard (PL. 127; IV, PL. 21), the Immortals who had been with him in Egypt at the time of Cambyses II's conquest of that country and who, in all likelihood, helped him subsequently to reconquer his throne.

An inscription of Artaxerxes II proclaims that the palace of Susa burned under his grandfather Artaxerxes I and that it was he himself who rebuilt it. Darius' palace, then, remained uninhabitable for several decades. Now, a capital of the importance of Susa could not be left without a royal residence, and, as a matter of fact, a "miniature" palace was erected at the southern edge of the city, under Artaxerxes I and Darius II, in which a small hypostyle hall replacing the Apadana adjoined a reception hall that led to the living quarters. All the fragments of stone bas-reliefs found at Susa come from this little palace. Its decorative program was not new — lion-griffins, winged lions, the Immortals, servants bringing fish for a banquet. But the sculptor's art was no longer the same as in the reliefs of Persepolis; it became more delicate, more humanized. Can it be that a breath from Athens touched the vast plain of Susiana, inspiring the sculptor to impart a vigorous realism to the menacing lion, greater verisimilitude to the more abundant drapery folds and a more graceful movement to the gesture of the servant who bears the cup with a duck's head? With regard to the presumed changelessness of Achaemenid art in the two centuries of its existence, these few mutilated fragments bring valuable testimony, suggesting that after Pasargadae and Persepolis Achaemenid sculpture passed through a third stage.

Without abandoning Pasargadae, Darius built Persepolis, a new capital about 40 miles southwest of it (PL. 131). Once

more the architects of the Great King, maintaining the tradition, constructed a mighty terrace with enormous, admirably polished polygonal blocks. As at Pasargadae and Masjid-i-Sulaymān, they propped it against a mountain, a projecting portion of which was leveled and art???cially elongated. On this terrace they erected the finest buildings Asia had known until that period.

This capital was not like the ones that preceded it; it was neither a diplomatic nor an administrative center. A statesman of genius, Darius conceived it as a symbol of imperial unity. Every year, on New Year's Day, the beginning of spring, he inaugurated magnificent ceremonies around the terrace to consecrate the unity of the state. Under the aegis of the great god Ahura Mazda, and in the presence of the Great King, the master peoples, Persians and Medes, witnessed the procession of all the nations composing the immense empire as they deposited gifts and offerings at the foot of the throne in token of fidelity and loyalty.

The building of Persepolis followed the plan preestablished by Darius; what was accomplished after him was not due to the initiative of a Xerxes or an Artaxerxes I. The plan and the decoration of the buildings were anticipated, calculated, and studied by Darius; his successors, who had their names engraved on the monuments, were no more than executors of Darius' directives. Herein lies the basic reason for the quasi immobility imputed to official Achaemenid art. This art was supposed to capture the spectator by its symbolism and convey a sense of grandeur; artistic values were relegated to second place. The artistic program of the Great King was Persian, and what scholars seek to attribute to Greek inspiration — if indeed it existed — are factors of minor importance. The example of Xerxes, who imported works of art from Athens, was imitated on a larger scale by the Romans, who were enamored of the works of Greek artists. Iran remained indifferent to Greek beauty and taste. The kings who succeeded Xerxes still imported Hellenic statues — witness the fine *Penelope* of Parian marble found in the Treasury of Persepolis (Teheran, Archaeol. Mus.; see Ghirshman, 1954, pl. 22a); but their official art bears no trace of that esthetic preoccupation manifested by the Romans. It is probable that the intrinsic value of an object — a granite cup of Ashurbanipal, vases of precious metals — stirred greater interest than its artistic value. Here the Persians display the same propensities as the Scythians, their close relatives. Their sort of enjoyment is very different from that of the Romans.

All the edifices of the terrace of Persepolis were built, arranged, and adorned with reliefs in accordance with the role each was called on to play in the great ceremonies of New Year's Day. An attempt to reconstruct this feast in its relation to each of the palaces follows.

The Apadana, similar in plan and dimensions to those of the Apadana of Susa, was reserved for the audiences the Great King gave the Persian and Median lords (PL. 131). The two monumental staircases that led to it from the esplanade were decorated in bas-reliefs representing, among other subjects, the delegations of the 23 nations bringing gifts to the sovereign. The Susians offered weapons and lions; the Armenians, metal vases and horses; the Babylonians, cups, embroidered cloths, and buffaloes; the Lydians, metalworkers of renown, their products and horses; etc. All the reliefs were painted. It is certain that not everyone went up on the terrace. The decoration told the king's guests what spectacle they would see; it was aimed at the onlookers surrounding the king, who from the top of the terrace followed the procession that unrolled at their feet, in the plain. The narrative value of this sculpture completed its decorative value.

Once the procession was over, the king, surrounded by Persians and Medes, moved to the Tripylon (Council Hall), a small building with three entrances. Those of the north and south show the king followed by a parasol bearer and a fly-whisk bearer. On the north stairway can be seen long rows of his guests from Media and Persia (PL. 132). The little south staircase, decorated with servants bearing dishes, indicates that the whole company moved on to the banquet that must

have been held in the little palace building that lies south of the Apadana.

The feast terminated, the king and his retinue came back to the Tripylon, passing through its eastern door, whose reliefs show Darius seated on his throne, borne by 28 subject nations (PL. 135). A similar decoration adorns the south doors of the Throne Hall ("Hundred Column Hall") — a circumstance that permits us to deduce the direction next taken by the procession. In this hall the king, seated on a throne, received the representatives of all the delegations, who deposited at his feet the most precious gifts. In fact, the decoration of the north doors, through which these men passed, shows the king and, before him, what we may interpret as an usher of ambassadors (PL. 134).

The Apadana, begun under Darius, was not finished until Xerxes' reign, and the Throne Hall, until that of Artaxerxes I, more than half a century later. Now, two bas-reliefs of Darius, nearly identical to those of the north doors of the Throne Hall (cf. PLS. 133 and 134), have been brought to light in the central portion of what the American expedition that explored Persepolis denominated the "Treasury," a complex of three buildings, very different in plan. That reliefs with audience scenes, of very large dimensions, should have been placed in a treasury surprised the excavators. Their emplacement before the entrance of a hall with 99 painted wooden columns suggests that in Darius' time this hall was the provisional throne room, used until the actual one could be completed. It may be supposed that under Darius the procession in the plain passed the south face of the terrace — a hypothesis supported by the fact that Darius' inscriptions are likewise carved on the south face.

The column (FIG. 274) is the most original architectural element at Persepolis. At Susa it was crowned by bulls alone. At Persepolis the royal architects created four different types of capitals: bulls and, in addition, horned lions, human-headed bulls, which also existed in the palace of Ecbatana (PL. 128), and griffins. Each variety must have been an allusion to the interrelationship among the buildings, in the same way as the reliefs were.

The elements of Persian architecture should not be regarded, however, as exclusively Iranian realizations. On the contrary, it is clear that the use of glazed bricks continued Elamite and Babylonian traditions; that the molding used around doors and recesses, the gorge, came from Egypt, to which country the origin of the hypostyle hall is sometimes attributed, too; and that the idea of fluting was taken from Ionia. The Iranian terrace and its stonework (at Masjid-i-Sulaymān, Pasargadae, and Persepolis) came from Urartu; and unless the plans of the palaces at Persepolis are enlarged versions of the dwellings of northern Iran, they, too, are probably of Urartian origin.

Always highly responsive and receptive to ideas from abroad, Iranian art in this period more than in any other is remarkable for its felicitous employment of forms of foreign origin. The harmony and unity of what may be called the Achaemenid architectural style testify to the success with which its constituent elements are controlled and subordinated. In the adaptation of foreign elements Parthian artists achieved far less satisfying results than their predecessors.

To be sure, Achaemenid monumental art cannot escape the criticism that it remained nearly invariable in technique, that it did not explore plastic expression, that it did not rise to the creation of a third dimension, that it was unable to wean itself from the law of isocephaly, that it did not progress beyond the stage of presentation strictly in profile, that it did not form groups in any other way than by spacing the members. One must conclude that, following its initial conception, Persian art, which reigned alone in the palaces of the terrace, had to preserve this archaism, this frozen severity of expression, as the only elements considered worthy of being maintained by tradition.

Funerary monuments. Darius, returning to the ancient traditions, had his tomb excavated in the steep cliff of Naqsh-i-Rustam, 3 ³/₄ miles from Persepolis (PL. 136; FIG. 275). Three of his successors built tombs next to his, while later Achaemenid

kings were buried in the mountain behind the terrace of Persepolis. The tombs of Naqsh-i-Rustam, all built on the same model, are 74 ft. high. The central portion of the façade, with its four engaged columns, imitates the façade of a palace. In the upper portion, on a throne supported by 28 nations, is the king before an altar, over which is a bust of Ahura Mazda in a winged disk. Just as the central portion recalls the Median

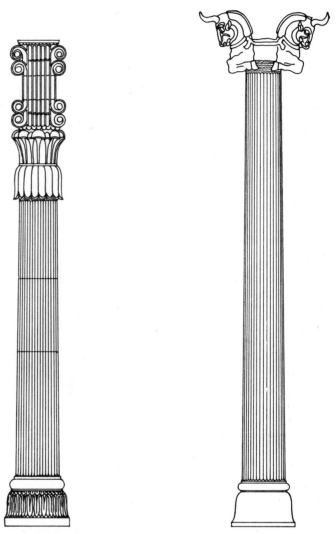

Persepolis, two types of column (*from Ghirshman, 1954*).

rock tombs, the scene on the upper portion recalls the relief that surmounts the Medo-Scythian tomb of Kizkapan (Qyzqapan) in Iraqi Kurdistan.

Religious structures. No religious edifices stood on the terraces of Susa or Persepolis. At Susa a fire temple, or *ayādanā*, was brought to light 2 ¹/₂ miles from the town. At Naqsh-i-Rustam, opposite the royal tombs, there was a religious center with a temple in the form of a square tower (PL. 137), today called Ka'ba-i-Zardusht, very similar to one in ruins at Pasargadae. The remains of Elamite bas-reliefs sculptured on the rocks of Naqsh-i-Rustam seem to indicate a place worshiped before the time of the Persians.

The Mazdean temple appears to have been intended exclusively to preserve the eternal fire, to which only priests had access. The ceremonies must have unfolded before the faithful in the open air, around exterior altars whose fires were lit at the one maintained in the temple. The tower of Naqsh-i-Rustam was probably one of the temples for the preservation of the sacred fire. Built of fine blocks of white limestone, the edifice has on three sides three rows of blind windows made of black stones. On the fourth side a staircase leads to a door that

opens into a single room on a level with the first windows. It is thought that the temple sheltered a statue of Anahita when under Artaxerxes II the cult of this goddess as well as that of the god Mithras had taken on some importance. Before this king the images of gods played no part in the religion of the Achaemenids, and the representation of Ahura Mazda in a winged disk on the bas-relief of Persepolis or on the tombs,

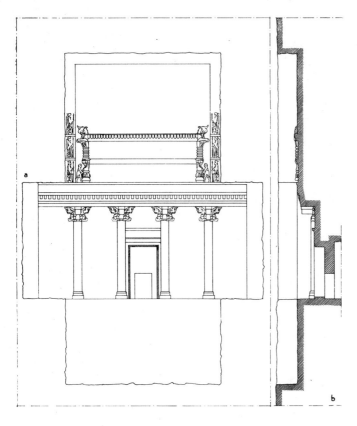

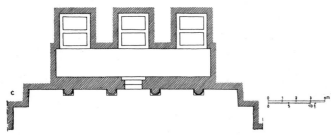

Naqsh-i-Rustam, Achaemenid royal tomb: (*a*) Façade; (*b*) cross section of façade; (*c*) ground plan (*adapted from World History of Architecture. Moscow, 1948, in Russian*).

always over the king, served only to exalt the deeds accomplished by him under the protection and by the grace of the mighty god.

Sculpture and minor arts. The encounter of Persian and Greek art and the resulting amalgamation are illuminated by some monuments uncovered in the western possessions of the Achaemenid empire — works commissioned by Persian notables such as dynasts, satraps, or governors and executed by "Hellenized" Persians or local artists. One of the most important of these monuments was in a village near the presumed site of Dascylium (Daskyleion), capital of the old satrapy of Phrygia; fragments of it were found embedded in houses. One fragment of a bas-relief shows three women following one another on muleback. Nothing in the relief is Greek, neither the folds of the garments nor the eyes of the women or animals, which are presented frontally. This row of figures does not differ from those known at Susa and Persepolis. The same

observation holds for another fragment representing a procession of horsemen. A third fragment shows another kind of subject: two sacrificers before a door with a heap of branches beside it, on which are placed two heads of animals. The treatment of this scene indicates a different hand, in spite of peculiarities that make it recognizable as Achaemenid — the headdresses, the clothes, the sacerdotal objects, the attitude of the priests, all of which point to a subject studied to the last detail. What is unfamiliar is the formula of expression. The eyes of the personages are in profile; their garments cinched by belts fall in folds; other folds can be seen at the bend of the elbow; an attempt to realize the third dimension makes itself felt in the volume of the barsoms.

Of Achaemenid human subjects modeled in the round we know only the fragments of the statue of Darius found in the palace of Susa and two little stone heads, of which one (Louvre) comes from Memphis in Egypt and the other (Brussels, Stoclet Coll.) perhaps also from the workshops of Egypt. One would look in vain for evidence that the artist wished to introduce a note of realism into the portrait. The head of a prince and that of an androcephalous bull obey the same laws; we see the same globular eyes overarched by long sinuous eyebrows, the same small mouth with thin lips, the same drooping mustache with curled ends, the same heavy head of hair with small curls reaching to the shoulders. The ideal type of youthful beauty is conveyed by a small head of lapis-lazuli paste — that of a royal prince, to judge from the crenelated crown — found at Persepolis and quite likely executed there (PL. 129).

The realism of Achaemenid art manifests its power in the representation of animals (PLS. 130, 138–40), as can be seen, too, in the reliefs of the Persepolitan Apadana, where the execution of the many different species reveals an effort to approximate nature. Carved in stone or founded in bronze, the animals — lion, argali, dog — served as guardians of entrances or, more often, as supports of vases, in which they were grouped by threes, their union a revival of the old traditions of tripods with legs ending in a hoof or a lion's paw. The Achaemenid artist was a worthy descendant of the animal sculptor of Luristan.

The archives of the Achaemenid empire were preserved at Ecbatana: so the Bible (Ezra 6:2) gives us to understand, and the excavations of Susa and Persepolis confirm it. All the royal treasures seized by Alexander the Great in the capitals were likewise stored, under the guardianship of Parmenio, at Ecbatana. It was there, or rather in the modern city of Hamadan, that a treasure was found in the 1930s, the most important pieces of which are divided between the Archaeological Museum of Teheran and the Metropolitan Museum in New York. As is also true for the treasure of Zawiyeh, what is known of it seems but a feeble reflection of what must actually have been brought to light.

Two solid-gold rhytons, one in New York, the other in Teheran (see Vanden Berghe, 1959, pl. 136d), in the shape of protomas of winged lions, constitute the principal pieces. Rhytons, so highly prized in later periods, were already in fashion among the Medo-Scythians; they are known in pottery, plain or polychrome, and there is reason to believe that they also existed in precious metals for the use of the Medes, whose traditions the Achaemenids inherited. To the ever more inventive creators of animal forms, who were not without naturalistic tendencies, these traditions provided a full repertory of Iranian works of the Achaemenid period, one which Parthian artists and those of outer Iran were to draw on in their turn.

One of the most heavily ornamented pieces is the gold bowl of Xerxes engraved with an inscription in three languages (Teheran, Archaeol. Mus.; see Vanden Berghe, 1959, pl. 136c). Its embossed decoration, like that of the rhytons, is typical for vessels of its kind. A corolla of petals forms the lower portion; a band of tassel shapes, each framed by a sort of bolster, fills the central portion, whose upper edge, just below the plain vertical rim, shows a row of drops. In a gold bowl bearing the name of Darius (II?; New York, Met. Mus.), on the other hand, the decoration is of great simplicity. The bottom of each bowl is decorated with a rosette, which motif links them

with Assyrian designs of the 8th–7th century, though the central knob is no longer in relief.

An Achaemenid gold plate, unique of its kind, is adorned in the center with a flying eagle (PL. 140). The delicately chased head and body, as well as the feet, are in profile; the wings and tail are presented frontally, following a tradition that goes back to the period of the Luristan bronzes and even left its mark on the painted vases of Tepe Sialk (Necropolis B). The border framing the central subject is embossed with downward-pointed "winged" hazelnut shapes alternating with upward-pointed almond shapes.

Two solid-gold swords were also part of the treasure. According to Herodotus, the Achaemenids carried such weapons during great ceremonies. The one in Teheran has a blade with a double ridge on the flat of it, a pommel consisting of two lions' heads (PL. 140), and a guard adorned with the heads of two ibexes. This decoration resurrects motifs of the Luristan bronzesmiths and, pointing up the kinship, directs our attention once more to the art of the Medes as the great precursor of Achaemenid art.

An important group of gold bracteates, of the same provenance, is divided between the Archaeological Museum of Teheran and the Oriental Institute of the University of Chicago. Some pieces with walking lions, whose muscles, sides, and flanks are partitioned for enamel filling, illustrate the old Iranian taste for polychromy; others show lions in respoussé within a ring; still others, only the heads of animals. Remarkable for its force of expression is a winged lion, within a circular stringlike frame, standing with one paw thrown forward and head turned backward, displaying menacing jaws.

Darius' robe on the bas-relief of his palace at Persepolis bears the engraved image of such lions, which in all probability were painted. The Achaemenids were not the first to introduce bracteates, as a decoration sewn on garments, in Iran. The fashion existed for centuries; and on objects dating as far back as those of Zawiyeh, animals are found alongside geometric motifs. Mesopotamia had been acquainted with such ornamentation of garments since the 2d millennium, particularly as applied to the robes of divinities and royal ceremonial robes, but until the Neo-Babylonian period the motifs of the bracteates were geometric. Two mutilated Babylonian cylinders from the Treasury of Persepolis, probably brought there as trophies, show bracteates in the form of birds and quadrupeds sewn on the dress of a divinity — perhaps Marduk (Schmidt, 1957, pp. 60–61, pl. 26, 2 and 3). The civilization of Luristan has not revealed such habits of luxury as those attested by the Scythian tomb of Zawiyeh, some objects of which mirror a fashion that also prevailed in Urartu on the garments of the divinities of the temple at Musasir. As to the decorative formulas employed in the bracteates, the animals presented partially or in heraldic ensembles in the art of Luristan offered a sufficiently rich iconographic repertory for Medo-Scythian and Achaemenid artists to draw on.

To the variety of languages of the peoples that constituted the empire corresponded a like variety of scripts. Babylonian, Elamite, and Old Persian were written in cuneiform characters on clay tablets, which were signed, barring some exceptions, by rolling engraved cylinders on them. The most frequent silhouette on the cylinders is that of the king with a long robe and a crenelated crown. The cylinders were not his, however, with the exception of those bearing his name; his image served as an emblem of the Achaemenid state. One cylinder, in chalcedony (Teheran, Foroughi Coll.), represents the sovereign standing on a lion and holding a bow and three arrows — an emblem of supreme power that we have previously encountered on an ivory from Zawiyeh.

Value and significance of Achaemenid art. The works of art discussed here were almost all conceived and realized for the use of the Great King, of princes, and of those of the great dignitaries who copied the example of their sovereign.

Many scholars, while acknowledging the unprecedented splendor of Achaemenid art, have criticized it for being a composite art that drew all, or nearly all, from forerunners or con-

temporaries; for being rootless; for passing to maturity without a period of evolution. Nevertheless, we have reached a stage in our knowledge of Iranian arts where a reassessment is called for. There need be no attempt to deny what is all too evident: that Achaemenid art, in obedience to the law that ruled the arts in every country, adopted the Mediterranean column or the hypostyle hall of Egyptian inspiration, the Urartian façade or the Babylonian palace and its decoration, or the Elamite rock-cut

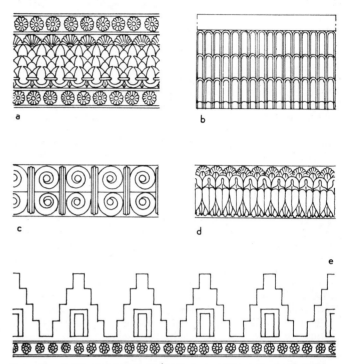

Decorative motifs of Achaemenid architecture at Persepolis: (*a, d, e*) From the stairway of the Apadana; (*b*) from the "Hundred Column Hall"; (*c*) from the base of a column.

bas-relief with a multitude of personages. If the period of greatest Persian power corresponds to the interpretation given above, Iranian art could not have begun before the Achaemenids.

The present state of our knowledge permits us to recognize that Achaemenid art is but a logical continuation of what preceded it for more than four centuries on Iranian soil. The uncertain attribution of certain phases of Iranian art (Luristan bronzes, tomb of Zawiyeh) complicates the understanding of the sequence of events. The frequent references to the past in the preceding discussion were specifically meant to demonstrate that Achaemenid art is not a kind of phoenix but, on the contrary, it is deeply rooted in the epochs when the first Iranians took possession of the Plateau, and that the riches of their art accumulated century after century to constitute, at last, the splendid realization of Iranian art in its maturity.

Admittedly, in our knowledge of this evolution, one element, and one of capital importance, is missing. Median art almost completely eludes us; we guess at it rather than know it. And yet, though of short duration, it was certainly a powerful factor in the formation of Achaemenid art, its successor.

Cyrus's palaces did not spring up out of nothingness, and the rock tombs of the Median princes, with their columns, capitals, and reliefs, seem to lead us to the palaces of Ecbatana, still unknown. Achaemenid cuneiform writing existed before Cyrus; his bas-reliefs at Pasargadae, with their plastic rendering of the body, are closer to those of a Medo-Scythian tomb (Kiskapan) than to the Assyrian relief. Thus, much evidence can be gathered that Achaemenid art in attaining its greatness did not feed only on what foreign peoples had to offer. Quite on the contrary, it represents a plateau after a continuous ascent of Iranian art in the broadest sense that can be attributed to that term, for allied to the Medes and Persians were the Cimmerians and Scythians, each making their own contribution,

to bequeath to the Achaemenids the sum of a long sequence of creations.

That this was so is demonstrated by the very character of Achaemenid art, in essence deeply attached to the formula of ornament, of decoration. In the repetition of subjects on bas-reliefs, without concern for the resulting monotony, in the constant application of the same motif — the lion, for example, found here on a baldachin over the royal throne, there on the robe of a prince, elsewhere adorning a weapon or a jewel — Achaemenid artists go straight back to the applied arts practiced by their predecessors of Tepe Sialk, Luristan, and Zawiyeh. To deny their predilection for animal art is to take away their ancestors. The vision of Persian art can be understood under two aspects. On the one hand, it found expression in urban development and the monumental realizations to which the West contributed its part; on the other, it looked toward the nomad world from which the Persians derived their origins and whose animal art, of a vitality worthy of the traditions, was integrated even into architecture. The dissemination of Achaemenid art was to be similarly twofold. The sedentary peoples were not to reject ideas from this art in the realm of sculpture (particularly on capitals); nor was its expressiveness as animal art to remain without appeal for the world of the great Eurasian spaces.

PARTHIAN ART. The empire of the Achaemenids did not collapse solely because its adversary was Alexander the Great. The weakness of the princes, the intrigues of the harem, the revolts of the satraps were so many factors contributing to a downfall that surprised the Persians themselves first of all. Alexander's conquest opened wide the door to Western penetration and marks a breach in Iranian art, which for seven centuries of its existence had undergone a constant evolution. A stream of men, ideas, and forms invaded Iranian territories, and it seemed as if the conqueror's dream of fusing the two worlds must be realized

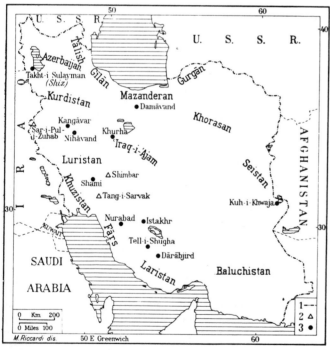

Distribution of the most important Parthian and Seleucid monuments in Iran. *Key:* (1) Modern national borders; (2) rock reliefs; (3) Seleucid and Parthian centers.

there. Yet the empire of which he laid the foundations was not to survive him. Seleucus, who inherited a major portion of the Achaemenid empire and who of Alexander's successors was the least unsympathetic to his ideas, founded a dynasty in which Iranian blood mingled in equal parts with Macedonian. Everything seemed to favor the process of Hellenization in the country.

The reality, however, appears to have been very different. From the late 3d century B.C. onward, the Iranians, thanks to their vitality, were able to influence the conquerors in their turn.

It is known that in eastern Iran Alexander sought to reach the limits of the "sedentary world" and that he established a defensive cordon against the nomad Iranians on the Jaxartes, the present Syr Darya. Less than a century after his death the cordon began to yield before a new onslaught, that of the nomad horsemen, strong in their formation and armament, who were being cast back from the Eurasian pasture lands stretching over areas as vast as continents.

Toward the mid-3d century B.C. three waves of peoples who, it is thought, shared the same point of departure, apparently coming from the same confederation of Iranian tribes known to Herodotus under the name of Massagetae, and who pursued a nomadic existence in the immense area extending from the Caspian to Chinese Turkistan, advanced to the most easterly points ever reached by the Greco-Macedonian world. On the western flank the Sarmatians moved toward the rich Greek cities strung along the northern shore of the Black Sea. On the eastern flank the formation of the kingdom of the Hsiung-nu set into motion the Yüeh-chih, who, allied to the Sakas, put an end to the Greco-Bactrian kingdom in the 2d century B.C., to create at the beginning of our era a powerful empire that incorporated territories from eastern Iran to the valley of the Ganges and from Russian Turkistan to the Indian Ocean. In the center, coming from the plains to the north of the mountains of Khurasan (Khorasan), there advanced one of the tribes of the Dahae, the Parni, who under the leadership of the Arsacid dynasty tried about 250 B.C. to seize the Hyrcano-Parthian satrapy situated southeast of the Caspian; from there began the conquest of Iran, which they were to wrest from the Seleucids in the course of a century of struggle.

Two factors seem to have played a part in these upheavals: on the one hand, the thrust of the peoples, Iranians as well as Turko-Mongols, behind these nomads in motion; on the other, the growing weakness of the Seleucids and Greco-Bactrians, incapable of presenting a united front to the menace and exhausting themselves in internal conflicts. Never subsequently was the Iranian world to know so broad an expansion of the peoples related to it. They spread from the Black Sea with the Sarmatians, to the mouth of the Indus with the Sakas, from the Euphrates with the Parthians, to eastern India with the Kushans. All starting out from the same center, these Iranians were able, despite the diversity of peoples and of countries, of climates and of landscapes, to create in this vast expanse, as in a gigantic province, a composite civilization. The Parthian element played a preponderant role in it.

Nomads, successors of the Achaemenids, and contemporaries of the Greeks and Romans: such was to be the triptych whose parts were to form the constituent elements of the culture, and particularly of the art, of this period of Iranian history.

The reconquest of Iran by the Parthians took long. Starting out about 250 B.C., they did not reach the Euphrates, where the political boundary was to be stabilized for eight centuries to come, until about 140 B.C. Two centuries had elapsed since the fall of the Achaemenids, and more than a century passed before the nomads, under Mithradates II (ca. 123–87 B.C.), became the true masters of the country. Hence Parthian art, properly speaking, cannot be dated from 250 B.C.; a division into two periods is called for, though the demarcation, based on political events, is artificial: (1) the period preceding the 1st century B.C. and (2) the one beginning with the accession of Mithradates II, which was to find its continuation under the Sassanians.

Achaemenid traditions did not disappear after the conquest of Iran and the constitution of the Seleucid monarchy. The little temple with bas-reliefs (see Herzfeld, 1941, pl. 86) built about 300 B.C. by a local dynast at the foot of the terrace of Persepolis is the best proof of that. The Greeks and Macedonians transplanted by the thousands onto Iranian soil had brought with them a taste for arts very different from those of Iran, and they turned to artists who like themselves had left their homeland to seek their fortune in the rich Orient. Their taste

is reflected in the bronze statuettes of the Hellenistic temple of Nihavand (Nihawand; Ghirshman, 1954, pl. 28). For the Parthian princes and nobles who had come from the solitudes of central Asia such works had a sure appeal. Many Hellenistic art works of the 2d century B.C. have been found in Nysa (Nisa), their most ancient capital. They even had Western artists work for them; witness the royal female head discovered at Susa, bearing a signature in Greek (Teheran, Archaeol. Mus.; Ghirshman, 1954, pl. 33b). For the Hellenized Iranians the local artists subjected to Western currents produced works that were neither Greek nor Iranian. In this hybrid art adaptation and form prevailed over spirit.

Thus, probably, was Greco-Iranian art born after the Macedonian conquest. There was likewise a traditionalist current, the little we know of which indicates a considerable regression. Thus there was not one art but several arts reflecting the upheavals suffered by the country and including, besides Hellenistic art, Greco-Iranian and Iranian art proper.

The hybrid aspect of Greco-Iranian art is particularly noticeable in architectural undertakings in which the two arts are amalgamated in the same way as in the works of the Persian artists in Asia Minor who in the Achaemenid era carved intaglios of Greek inspiration on seal stones. At Khurha, for example, is a temple on the Greek plan, with columns of Achaemenid module surmounted by capitals, probably of local origin, in a poor Ionic style — a kind of compromise between the volute capital of the Median tombs and reminiscences of Greek composition; each column rests on a base of Achaemenid type but has a torus bulging over a double plinth (FIG. 282). The artist, attracted by Greek architectonic elements, introduced them in his building without understanding their role or significance. The foreign element was not integrated; it remained a kind of veneer.

The first capital of the Parthians, Nysa was erected on the western border of the desert of Kara Kum, near the modern city of Ashkhabad. On a hill a Soviet expedition cleared a fortified royal palace of the 3d–2d century B.C. Its decoration on terracotta tiles reveals traces of strong Western influence mingled with Iranian subjects: crescents, rosettes, a quiver with arrows and a bow, which are regarded as the emblem of the Parthian warrior horseman, a club, the head of a lion — the guardian animal. Fragments of acanthus leaves of Western inspiration were found next to merlons of pure Achaemenid style. There was a central hall built on a triple-aisle plan, whose walls contained niches with statues of "deified ancestors." South of this complex rose another building, with a central courtyard surrounded by four liwans, where the expedition brought to light several Hellenistic sculptures of the 2d century B.C. and some forty ivory rhytons decorated with Iranian subjects or Western mythological scenes.

Can we interpret these as works of Greco-Bactrian art from the independent Greek kingdom that rose toward 250 B.C., with Balkh as its capital? Can it be that the Greco-Iranian symbiosis produced an original art which might reflect a more strongly cemented political union?

In the architecture of Nysa the nascent Parthian art reveals the complexity of its make-up. Iranian elements were influenced by Western currents, to which was joined an element peculiar to the Parthians from the steppes. The square courtyard with four liwans is probably the oldest example of the architecture that the Parthians introduced as far as Ashur (Assur). The liwan — the use of which became general in their architecture and spread far westward — has been interpreted as an extension of the nomad's tent with an opening on one side. The large triple-aisled hall seems to prefigure the division of Parthian palaces into three liwans. Vaults became the most frequent covering.

The liberation of Iran from foreign dominion brought the Parthians to the borders of the Euphrates. Opposite the Greek city of Seleucia on the Tigris they built their capital on a circular plan. This layout was not haphazard, for the nomads, on their excursions to distant steppes, erected their camps in a circle. They gave the same form to the city of Merv (Mary), and circular cities sprang up all along the route of their advance westward; among them were the great center of Shiz (mod. Takht-i-Sulaymān), the cities of Darabjird and Firuzabad in Fars, and the city of Hatra in northern Mesopotamia. The circular plan evokes another aspect of the life of this period: its insecurity.

Assyro-Babylonian taste in architecture did not demand external decoration of buildings. Under the Achaemenids polychrome glazed bricks and bas-reliefs, inspired by the idea of the orthostat, marked a slight progress in such decoration. Under the Parthians something new was created, specifically the fa-

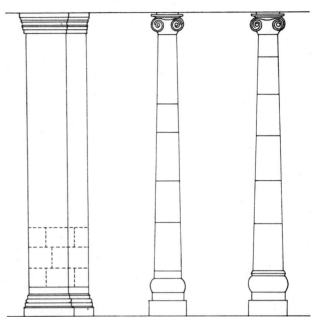

Columns of the temple at Khurha (*from Ghirshman, 1954*).

çade. Successful, however, as the Parthian architect was in grasping the principle of the façade, he failed in its decoration, because he attempted to introduce Western elements. The Doric or Corinthian capital, the Ionic volute transformed into a spiral, are to such a degree barbarized that once more the Iranian artist betrays his incapacity or aversion for an assimilation, producing instead an assemblage. This holds true especially for Ashur in the 1st century of our era and for the stucco decoration of its façade, the only example known to us.

Iran was unfamiliar with stucco decoration before the Parthians, among whom it was in vogue for interior decoration together with mural painting. Murals are well represented in the Parthian palace on the island of Kuh-i-Khwaja, in the middle of Lake Hamun, on the Afghan border (see Herzfeld, 1941, pls. 101–04). The painting, in which color is filled in between heavy contour lines, gives the effect of a "colored drawing." Distributed over small panels, it shows palmettes, of Eastern origin, enriched by Western acanthus leaves; winged Erotes astride animals, whose frozen movements betray the Oriental touch; an Oriental portrait with the head in profile, the body fullface. The Western current in these murals of the 1st century of our era is not easy to explain. Is it attributable to the influence of Greco-Bactrian art, as Herzfeld thought, or to a new wave of Greco-Roman influence, which also seems to have marked the art of Hatra and spread far eastward, leaving its imprint on the Greco-Buddhist art of Gandhara (q.v.)?

More Iranian and Parthian is the mural of the Mithraeum at Dura-Europos, on the Euphrates, representing Mithras hunting a variety of animals (Rostovtzeff, 1938, pl. 18). Dressed as an Iranian, with a short embroidered tunic and ornamented trousers, tight at the ankles, he looks like a Parthian or a nobleman of Palmyra; he is armed with the composite Iranian bow and, his foot pointed downward, rides a horse harnessed in the Iranian manner, with round phalerae. His head and torso are fullface, but his horse is in profile. The flying gallop, the favorite pose for animals on the "Greco-Persian" intaglios, was *de ri-*

gueur. Everything here is Iranian, even the few isolated plants that are supposed to create the impression of a landscape. In spite of the idea of a race that the beasts and the god who pursues them are meant to convey, the action remains suspended.

Frontality, which accentuates the ritual aspects of sacrifice scenes, was dear to the Parthian artist, who cultivated it as a traditionalist — continuing the traditions not of Achaemenid art but of the art from Luristan, which was perhaps also practiced on the confines of Iran. It is exemplified in certain mural paintings at Dura-Europos, as well as in a block with bas-reliefs at Bisutun (mod. Behistun). One side of this block shows a Parthian prince sacrificing before an altar (Ghirshman, 1954, pl. 35a); the two adjoining sides, two winged genii. The personage faces strictly front; the artist lovingly executed the details of dress; the relief is flat. The gesture fixed in stone is the same as that seen in the mural of Conon at Dura-Europos.

From the Hellenistic temple at Shami, in the mountains of southwestern Iran, comes an over-life-size statue in bronze of a Parthian lord (PL. 141). He wears the simple costume of a Parthian horseman, composed of a jacket crossing over the chest, short pants, over which long leather leggings are attached in back at the belt. The head, too small in relation to the body, was not executed in the same place; the treatment and the metal of the head are different from those of the body, which may have been cast on the spot. There is no apparent effort to stress particularities of the body or the costume, a tendency that seems to have manifested itself in Parthian art after the late 1st century B.C. The eyes are not exaggeratedly wide open, as they are in other Parthian works to accentuate the frontal pose. The opposition between the law of frontality and freedom, between form and power, does not create any conflict. The low forehead and thin mouth are not an expression of spirituality or great sensitiveness. Probably not a portrait, the statue is impressive in its static power and would seem related to the art of the earlier phase. The date is difficult to determine. If the temple at Shami was destroyed by Mithradates I, the statue might be of the 2d century B.C.

The Seleucid and Parthian levels at Susa have revealed the existence of a hybrid society in which Iranians and Semites lived side by side with Greeks and Macedonians. In the same district houses built according to the local plan, with a central courtyard, stood next to villas in which the courtyard had a peristyle, the gabled roof was covered with tiles and embellished with terra-cotta acroteriums, and the rooms were decorated with murals. Statuettes representing Herakles, whose cult was widespread in the Parthian kingdom, appeared side by side with representations of divinities (?) whose ethnic type and costumes are of an Oriental cast. Examples of the "grotesque" Alexandrian style were found not far from works in which the two arts were united, as in that emblema (PL. 142) where a goddess of Hellenistic aspect, squeezing her breast over a cup, is enclosed in a framed and pedimented medallion.

As circumstances would have it, after the conquest of Alexander two peoples, Greeks and Iranians, lived together in the same city, in the same quarter, where mixed marriages became commonplace. Two profoundly different conceptions of life and beauty thus came to confront each other. On the one hand, all interest focused on the modeling, the plasticity of the body, its life; on the other, there was nothing but dryness and severity, a linear vision, rigidness, frontality. Greco-Iranian art was the logical product of the encounter.

The reconquest of the country by the Parthians brought a slow return to Iranian traditionalism, which took on the forms of a Neo-Iranian art. Its technique is marked by the disappearance of plastic form; its repertory characterizes it: scenes of combat, hunting, banqueting, or else of investiture or sacrifice. This return to traditionalism was beset by a poverty of workmanship that burdened Parthian art until the end and was inherited by early Sassanian art (q.v.). But the Greek element was not banished; it contributed especially to architecture. However, everything Hellenic was to such an extent barbarized — the metamorphosis was so profound — that it is difficult to identify and trace the origin of a capital or the composition of a façade. The Parthian artist did not imitate; he subordinated.

His art was not the first to cultivate frontality. The potter and coroplast of Tepe Sialk practiced it; and the bronzesmith of Luristan, whose works consisted chiefly of funerary furnishings, adopted it on a large scale, thus seeming to create an atmosphere in which the faithful could establish a more direct contact with the divinity by looking it full in the face. The art of outer Iran, from southern Russia to India, was not to neglect this principle either.

Even while linked by many a bond to the iconography of the "Greco-Persian" intaglios, Parthian art remained faithful to its repertory and was diffused far beyond the frontiers of Iran, among peoples who, whether they were Iranians, Turks, or Mongols, had in common a life on horseback and continual contact with animals. Combats between men, between men and animals, or between animals furnished the favorite artistic subjects to the peoples of Asia and southern Russia during the centuries that preceded and followed the birth of the Christian Era. Parthian art, though not everywhere the sole animating force, remained a dominant one, responsible in large part for the creation of a far-spread idiom among the societies with which the Parthians were linked by their atavism and their traditions. On a strictly Iranian plane they appear as the successors of the Achaemenids, respectful of traditions and concerned with national policy.

The importance of the Parthian period in its successful renewal of the Iranian national spirit is beginning to be recognized; no longer can one believe in a sudden Sassanian renaissance. The Parthians were able to ensure continuity and establish a link between Achaemenids and Sassanians (see also PARTHIAN ART).

BIBLIOG. *General*: M. Dieulafoy, L'Art antique de la Perse, 5 vols., Paris, 1884–89; F. Sarre, Die Kunst des alten Persien, Berlin, 1922; G. Contenau, Manuel d'archéologie orientale, 4 vols., Paris, 1927–47; E. E. Herzfeld, Archaeological History of Iran, London, 1935; G. G. Cameron, History of Early Iran, Chicago, 1936; A. U. Pope and P. Ackerman, eds., A Survey of Persian Art from Prehistoric Times to the Present, 6 vols., London, New York, 1938–39, index, 1958; E. E. Herzfeld, Iran in the Ancient East, London, 1941; E. Diez, Iranische Kunst, Vienna, 1944; G. Contenau, Arts et styles de l'Asie antérieure, Paris, 1948; G. Goossens, L'Art de l'Asie antérieure dans l'antiquité, Brussels, 1948; C. F. A. Schaeffer, Stratigraphie comparée et chronologie de l'Asie occidentale (IIIᵉ et IIᵉ millénaires), London, 1948; C. Huart and L. Delaporte, L'Iran antique: Elam et Perse et la civilisation iranienne, Paris, 1952; H. Frankfort, The Art and Architecture of the Ancient Orient, Harmondsworth, 1954; R. Ghirshman, Iran from the Earliest Times to the Islamic Conquest, Harmondsworth, 1954; H. H. von der Osten, Die Welt der Perser, 2d ed., Stuttgart, 1956; L. Vanden Berghe, Archéologie de l'Irān ancien, Leiden, 1959 (bibliog.); S. Lloyd, The Art of the Ancient Near East, London, 1961; Sept mille ans d'art en Iran, Paris, 1961 (exhibition cat.).

Prehistory and protohistory: J. de Morgan, Céramique archaïque, Mém. de la Délégation en Perse, I, Paris, 1900, pp. 183–90; J. E. Gautier and G. Lampre, Fouilles de Moussian, Mém. de la Délégation en Perse, VIII, Paris, 1905, pp. 59–148; E. Pottier, Etude historique et chronologique sur les vases peints de l'Acropole de Suse, Mém. de la Délégation en Perse, XIII, Paris, 1912, pp. 27–103; R. de Mecquenem, Fouilles de Suse (campagnes 1923–1924), Revue d'Assyriologie et d'Archéologie Orientale, XXI, 1924, pp. 105–18; R. de Mecquenem, Notes sur la céramique peinte archaïque en Perse, Mém. de la Mission archéologique de Perse, XX, Paris, 1928, pp. 99–132; E. E. Herzfeld, Steinzeitlicher Hügel bei Persepolis, Iranische Denkmäler, I, 1–2, Berlin, 1932; F. R. Wulsin, Excavations at Tureng Tepe near Asterābād, Sup. to the B. of the Am. Inst. for Persian Art and Archaeol., II, 1 bis, 1932; E. E. Herzfeld, Niphauanda, Iranische Denkmäler, I, 3–4, Berlin, 1933; G. Contenau and R. Ghirshman, Fouilles de Tépé-Giyan près de Néhavend, 1931 et 1932, Paris, 1935; R. Ghirshman, Notes sur les peuples et l'art de l'Iran préhistorique, RAA, X, 1936, pp. 23–36; A. Stein, An Archaeological Tour in the Ancient Persis, Iraq, III, 1936, pp. 111–225; R. de Mecquenem, Vases susiens à personnages, Revue d'Assyriologie et d'Archéologie Orientale, XXXIV, 1937, pp. 149–53; E. F. Schmidt, Excavations at Tepe Hissar, Damghan, Philadelphia, 1937; A. Stein, Archaeological Reconnaissances in North-Western India and South-Eastern Īrān, London, 1937; R. Ghirshman, Fouilles de Sialk près de Kashan, 1933, 1934, 1937, 2 vols., Paris, 1938–39; A. Stein, Old Routes of Western Iran, London, 1940; A. Langsdorff and D. E. McCown, Tall-i-Bakun: A Season of 1932, Chicago, 1942; D. E. McCown, The Comparative Stratigraphy of Early Iran, Chicago, 1942; T. J. Arne, Excavations at Shah Tepe, Iran, Stockholm, 1945; T. Burton-Brown, Excavations in Azarbaijan, London, 1948; C. S. Coon, Cave Explorations in Iran, 1949, Philadelphia, 1951; L. Vanden Berghe, Les Ateliers de la céramique peinte chalcolithique en Iran Sud-Ouest, RA, XXXIX, 1952, pp. 1–21; L. Vanden Berghe, Iran: De Stand van de archaeologische onderzoekingen in Iran, Jaarbericht Ex Oriente Lux, XIII, Leiden, 1953–54, pp. 347–93; P. A. Clement, Three Ewers from Siyalk in Persia, Los Angeles County Mus., B. of Art Division, VI, 1954, pp. 16–24; L. Le Breton, The Early Period at Susa: Mesopotamian Relations, Iraq, XIX, 2, 1957, pp. 79–124; R. H. Dyson, Jr., Hasanlu and Early Iran, Archaeology, XIII, 1960, pp. 118–20.

Luristan bronzes: R. Dussaud, Haches à douille du type asiatique, Syria, XI, 1930, pp. 245–71; A. Godard, Les Bronzes du Luristan, Ars Asiatica, XVII, 1931; A. U. Pope, Luristan Bronzes in the Boston Museum of Fine Arts, CahArt, 1931, pp. 27–34; M. Rostovtzeff, Some Remarks on the Luristan Bronzes, Ipek, VII, 1931, pp. 45–56; R. Dussaud, Passe-guides du Louristan, Syria, XIII, 1932, pp. 227–29; A. Moortgat, Bronzegerät aus Luristan, Berlin, 1932; G. Contenau, Les Bronzes du Luristan, Genava, XI, 1933, pp. 43–48; R. Dussaud, Ceinture en bronze du Louriston avec scène de chasse, Syria, XV, 1934, pp. 187–99; L. Legrain, Luristan Bronzes in the University Museum, Philadelphia, 1934; F. Hančar, Kaukasus-Luristan, ESA, IX, 1935, pp. 47–112; A. Godard, Bronzes du Luristan, Athār-é Īrān, III, 1938, pp. 233–63; S. Langdon, Some Inscriptions on the Bronzes of Luristān, SPA, I, pp. 279–85; St. Przeworski, Luristān Bronzes in the Collection of Mr. Frank Savery, Archaeologia, LXXXVIII, 1940, pp. 229–69; H. Potratz, Die luristanischen Pferdegebisse, Praehistorische Zeitschrift, XXXII–XXXIII, 1941–42, pp. 169–234; C. J. Gadd, Luristan Bronzes from the Collection of Frank Savery, Transactions of the Oriental Ceramic Society, XIX, 1942–43, pp. 33–36; H. Potratz, Scheibenkopfnadeln aus Luristan, AfO, XV, 1945–51, pp. 38–51; J. Harmatta, Le Problème cimmérien, AErt, series III, VII–IX, 1946–48, pp. 79–132; R. Dussaud, Anciens bronzes du Louristan et cultes iraniens, Syria, XXVI, 1949, pp. 196–229; F. Hančar, The Eurasian Animal Style and the Altai Complex, AAs, XV, 1952, pp. 171–94; W. D. Van Wijngaarden, De Loeristanbronzen in het Rijksmuseum van Oudheden, Supplement op de nieuwe reeks XXXV van de Oudheidkundige Mededelingen van het Rijksmuseum van Oudheden, Leiden, 1954; I. M. D'yakonov, Istoriya Midii (History of Media), Moscow, Leningrad, 1956; F. K. Naumann, Untersuchung eines eisernen luristanischen Kurzschwertes, Archiv für das Eisenhüttenwesen, XXVIII, 9, 1957, pp. 575–81; B. Goldman, Some Aspects of the Animal Deity: Luristan, Tibet, and Italy, Ars Orientalis, IV, 1961, pp. 171–86.

Zawiyeh and the art of the Scythians: I. Tolstoy and N. Kondakov, Russkiya drevnosti v pamyatnikakh iskusstva (Russian antiquities in art monuments), II, St. Petersburg, 1889; S. Reinach, Antiquités du Bosphore cimmérien (1854), rééditées avec un commentaire nouveau et un index général des comptes rendus, Paris, 1892; E. H. Minns, Scythians and Greeks, Cambridge, England, 1913; M. Rostovtzeff, Iranians and Greeks in South Russia, Oxford, 1922; O. M. Dalton, The Treasure of the Oxus with Other Examples of Early Oriental Metal-work, 2d ed., London, 1926; G. Borovka, Scythian Art, New York, London, 1928; W. Ginters, Das Schwert der Skythen und Sarmaten in Südrussland, Vorgeschichtliche Forschungen herausgegeben von E. Ebert, II, 1, Berlin, 1928; M. Rostovtzeff, Le Centre de l'Asie, la Russie, la Chine, et le style animalier, Skythika, I, Seminarium Kondakovianum, Prague, 1929, pp. 31–48; K. Schefold, Der skythische Tierstil in Südrussland, ESA, XII, 1938, pp. 3–78; E. H. Minns, The Art of the Northern Nomads, London, 1942; A. L. Oppenheimer, The Golden Garments of the Gods, JNES, VIII, 3, 1949, pp. 172–93; R. Ghirshman, Notes iraniennes, IV: Le Trésor de Saqqez, les origines de l'art mède et les bronzes du Luristan, AAs, XIII, 3, 1950, pp. 181–206; A. Godard, Le Trésor de Zawiyè (Kurdistan), Haarlem, 1950; F. Hančar, Die Skythen als Forschungsproblem, Reinecke Festschrift, Mainz, 1950, pp. 67–83; A. A. Yesser, Nekotorye pamyatniki VIII–VII v.v. do n.e. na severnom Kavkaze (Some monuments of the 8th–7th century B.C. in the northern Caucasus), Voprosy skifo-sarmatskoy arkheologii (Questions of Scytho-Sarmatian archaeology), Moscow, 1952, pp. 112–31; C. K. Wilkinson, Some New Contacts with Nimrud and Assyria, BMMA, 1952, pp. 233–40; M. Falkner, Der Schatz von Ziwije, AfO, XVI, 1952–53, pp. 129–32; R. D. Barnett and N. Gökçe, The Find of Urartian Bronzes at Altin Tepe near Erzincan, Anatolian Studies, III, 1953, pp. 121–29; S. I. Rudenko, Kul'tura naseleniya Gornogo Altaya v skifskoye vremya (Culture of the population of the Altai Mountains in the Scythian period), Moscow, Leningrad, 1953; R. D. Barnett, The Excavations at the British Museum at Toprak Kale near Van: Addenda, Iraq, XVI, 1, 1954, pp. 3–22; T. Sulimirski, Scythian Antiquities in Western Asia, AAs, XVII, 1954, pp. 282–318; M. Maksimova, Serebryanoe zerkalo iz Kelermesa (Silver mirror from Kelermes), SA, XXI, 1954, pp. 281–305; U. Jantzen, Griechische Greifenkessel, Berlin, 1955; C. K. Wilkinson, Assyrian and Persian Art, BMMA, 1955, pp. 213–24; R. D. Barnett, The Treasure of Ziwiye, Iraq, XVII, 2, 1956, pp. 111–16; R. D. Barnett, Ancient Oriental Influences on Archaic Greece, The Aegean and the Near East Studies presented to Hetty Goldman, New York, 1956, pp. 212–38; R. D. Barnett, A Catalogue of the Nimrud Ivories with Other Examples of Ancient Near Eastern Ivories, London, 1957; T. Talbot Rice, The Scythians, London, 1957; V. V. Petrovskiy, Vanskoe tsarstvo (Kingdom of Van), Moscow, 1959.

Achaemenid art: F. Stolze and F. C. Andreas, Persepolis, 2 vols., Berlin, 1882; J. de Morgan, Découverte d'une sépulture achéménide à Suse, Mém. de la Délégation en Perse, VIII, Paris, 1905, pp. 29–58; A. Moortgat, Hellas und die Kunst der Achaemeniden, Mitt. der Alt-orientalischen Gesellschaft, II, 1, 1926; M. E. Maximowa, Griechisch-persische Kleinkunst in Kleinasien nach den Perserkriegen, AAnz, III–IV, 1928, pp. 647–78; E. Benveniste, The Persian Religion According to the Chief Greek Texts, Paris, 1929; E. E. Herzfeld, Bericht über die Ausgrabungen von Pasargadae, 1928, Archaeologische Mitt. aus Iran, I, Berlin, 1929–30, pp. 4–16; E. E. Herzfeld, Ariyaramna, König der Könige, Archaeologische Mitt. aus Iran, II, Berlin, 1930, pp. 113–27; F. W. König, Der Burgbau zu Susa nach den Bauberichten des Königs Dareios I, Mitt. der vorderasiatisch-ägyptischen Gesellschaft, XXXV, 1, Berlin, 1930; F. W. König, Älteste Geschichte der Meder und Perser, Der Alte Orient, XXXIII, 3–4, 1934; F. W. König, Relief und Inschrift des Königs Dareios I am Felsen von Bagistan, Leiden, 1938; H. Frankfort, Cylinder Seals: A Documentary Essay on the Art and Religion of the Ancient Near East, London, 1939; H. Frankfort, Achaemenian Sculpture, AJA, L, 1, 1946, pp. 6–14; G. M. A. Richter, Greeks in Persia, AJA, L, 1, 1946, pp. 15–30; S. Wikander, Feuerpriester in Kleinasien und Iran, Lund, 1946; G. G. Cameron, Persepolis Treasury Tablets, The Univ. of Chicago Oriental Inst. Pubs., LXV, Chicago, 1948; A. T. Olmstead, History of the Persian Empire (Achaemenid Period), Chicago, 1948; G. Goossens, Artistes et artisans étrangers en Perse sous les Achéménides, La Nouvelle Clio, I, 1–2, 1949, pp. 32–44; G. M. A. Richter, The Late "Achaemenian" or "Graeco-Persian" Gems, Hesperia, Sup. VIII, Commemorative Studies in Honor of Theodore Leslie Shear, 1949, pp. 291–98; K. Erdmann, Griechische und achaemenidische Plastik, Forsch. und Fortschritte, XXVI, 11–12, 1950, pp. 150–53; H. Frankfort, A Persian Goldsmith's Trial Piece, JNES, IX, 2, 1950, pp. 111–12; R. Ghirshman, Masjid-i-Solaiman, résidence des premiers Achéménides, Syria, XXVII, 3–4, 1950, pp. 205–20; A. W. Lawrence, The Acropolis and Persepolis, JHS, LXXI, 1951, pp. 110–19; A. Roes, The Achaemenid Robe, Bibliotheca Orientalis, VIII, 1951, pp. 137–41; G. M. A. Richter, Greek Subjects on "Graeco-Persian" Seal Stones, Archaeologica Orientalia in Memoriam Ernst Herzfeld, 1952, pp. 189–94; A. Roes, Achaemenid Influence upon Egyptian and Nomad Art, AAs, XV, 1–2, 1952, pp. 17–30; H. Seyrig, Cachets achéménides, Archaeologica Orientalia in Memoriam Ernst Herzfeld, 1952, pp. 195–202; E. F. Schmidt, Persepolis, I: Structures, Reliefs, Inscriptions, Chicago, 1953; H. Frankfort, The Art and Architecture of the Ancient Orient, Harmondsworth, 1954; R. Ghirshman, Village perse-achéménide, Mém. de la Mission archéologique en Iran, XXXVI, Mission de Susiane, Paris, 1954; P. Amandry, Vaisselle d'argent à l'époque achéménide, Athēna, 1956, pp. 11–19; C. Picard, De l'incendie de l'Artemision d'Ephèse au sac des palais de Persépolis, Académie des Inscriptions et Belles-Lettres, Comptes rendus des séances de l'année 1956, Jan–Mar., 1956, pp. 81–99; R. D. Barnett, Persepolis, Iraq, XIX, 1, 1957, pp. 55–77; H. J. Kantor, Achaemenid Jewelry in the Oriental Institute, JNES, XVI, 1, 1957, pp. 1–23; H. J. Kantor, Gold Work and Ornaments from Iran, The Cincinnati Art Mus. B., V, 2, 1957, pp. 9–20; E. F. Schmidt, Persepolis, II: Contents of the Treasury and Other Discoveries, Chicago, 1957; P. Amandry, Orfèvrerie achéménide, Antike Kunst, I, 1, 1958, pp. 9–23; D. G. Shepherd, An Achaemenid Sculpture in Lapis Lazuli, Cleveland, Mus. B., XLVIII, Feb., 1961, pp. 18–25.

Parthian art: M. Rostovtzeff, L'Art gréco-iranien, RAA, VII, 1931–32, pp. 202–22; W. Andrae and H. Lenzen, Die Partherstadt Assur, Leipzig, 1933; N. C. Debevoise, Parthian Pottery from Seleucia on the Tigris, Ann Arbor, 1934; M. Rostovtzeff, Dura-Europos and the Problem of Parthian Art, Yale Classical Studies, V, 1935, pp. 157–304; C. Hopkins, Aspects of Parthian Art in the Light of Discoveries from Dura-Europos, Berytus, III, 1936, pp. 1–30; C. Hopkins, The Murals with Banquet and Hunting Scenes, The Excavations at Dura-Europos, Preliminary Report of Sixth Season of Work, New Haven, 1936, pp. 146–67; A. Godard, Les Statues parthes de Shami, Athār-é Īrān, II, 1937, pp. 285–305; H. Seyrig, Armes et costumes iraniens de Palmyre, Syria, XVIII, 1937, pp. 4–31; R. Ettinghausen, Parthian and Sāsānian Pottery, SPA, I, pp. 646–80; O. Reuther, Parthian Architecture: A History, SPA, I, pp. 411–44; M. Rostovtzeff, Dura-Europos and Its Art, Oxford, 1938; R. Ghirshman, La Tour de Nourabad: Etude sur les temples iraniens anciens, Syria, XXIV, 3–4, 1944–45, pp. 175–93; H. Seyrig, La Grande statue parthe de Shami et la sculpture palmyrénienne, in Antiquités syriennes, III, Paris, 1946, pp. 9–15; A. Salmony, Sarmatian Gold Collected by Peter the Great, GBA, XXI, 1947, pp. 5–14, 321–26, XXXII, 1948, pp. 5–10, 63–64; G. A. Pugachenkova, Arkhitekturnye pamyatniki Nisy (Architectural monuments of Nysa), Trudy Yuzhno-Turkmenistanskoy arkheologicheskoy kompleksnoy ekspeditsii (Transactions of the joint archaeological expedition in southern Turkmenistan), I, Ashkhabad, 1949, pp. 201–59; M. E. Masson, Novye dannye po drevney istorii Merva (New data on the ancient history of Merv), Vestnik Drevney Istorii (Annals of ancient history), 1951, IV, pp. 89–101; F. Altheim, Niedergang der alten Welt: Eine Untersuchung der Ursachen, Frankfort on the Main, 1952; J. Charbonneaux, Antigone la Borgne et Démétrius Poliorcète sont-ils figurés sur le sarcophage d'Alexandre? RArts, IV, 1952, pp. 219–23; W. B. Henning, The Monuments and Inscriptions of Tang-i Sarvak, Asia Major, N.S., II, 2, 1952, pp. 151–78; F. Altheim, Alexander und Asien, Geschichte eines geistigen Erbes, Tübingen, 1953; H. Ingholt, Parthian Sculptures from Hatra, Mem. of the Connecticut, Acad. of Arts and Sciences, XII, 1954; M. E. Masson and G. A. Pugachenkova, Ottiski parfyanskikh pechatey iz Nisy (Impressions of the Parthian seals of Nysa), Vestnik Drevney Istorii (Annals of ancient history), 1954, IV, pp. 159–69; H. Lenzen, Architektur der Partherzeit in Mesopotamien und ihre Brückenstellung zwischen der Architektur des Westens und des Ostens, Festschrift für Carl Weickert, Berlin, 1955, pp. 121–36; M. E. Masson and G. A. Pugachenkova, Parfyanskie ritony iz Nisy (Parthian rhytons of Nysa), Yuzhno-Turkmenistanskaya kompleksnaya ekspeditsiya (Expedition in southern Turkmenistan), Moscow, 1956, 120 pls.; M. E. Masson and G. A. Pugachenkova, Mramornye statui parfyanskogo vremeni iz staroy Nisy (Marble statues of the Parthian period from ancient Nysa), Yezhegodnik Instituta Istorii Iskysstv Akademii Nauk S.S.S.R. (Yearbook of the Art History Institute of the Academy of Sciences of the U.S.S.R.), VII, Moscow, 1957, pp. 460–89; G. Widengren, Quelques rapports entre Juifs et Iraniens à l'époque des Parthes, Vetus Testamentum, Sup. IV, 1957, pp. 197–240; M. E. Masson and G. A. Pugachenkova, Parfyanskie ritony iz Nisy (Parthian rhytons of Nysa), Trudy Yuzhno-Turkmenistanskoy arkheologicheskoy kompleksnoy ekspeditsii (Transactions of the joint archaeological expedition in southern Turkmenistan), IV, Ashkhabad, 1959; R. Ghirshman, Parthians and Sassanians, London, 1962.

Roman GHIRSHMAN

Illustrations: PLS. 119–142; 8 figs. in text.

IRAQ. Established in 1920 under British mandate and in 1932 as an independent state, Iraq is bounded on the west by Syria and Jordan, on the north by Turkey along a demarcation line that skirts the lower foothills of the mountains in

Kurdistan, and on the east by Iran along the Zagros Mountains; on the southwest it fronts on the Persian Gulf; to the south it borders on Kuwait and Saudi Arabia. Modern Iraq covers virtually the same area as ancient Mesopotamia (lying outside it are the western portions, now part of Syria and Turkey, and a small strip belonging to Iran); it therefore contains a large share of the archaeological remains and monuments of the great Mesopotamian civilizations (see MESOPOTAMIA) and the classical, Iranian, and Islamic cultures that developed successively within its confines.

SUMMARY. Cultural and artistic epochs (col. 287). Art centers and monuments (col. 292): *Southern Iraq; Central Iraq; Northern Iraq.*

CULTURAL AND ARTISTIC EPOCHS. The presence of Paleolithic hunters in Iraq is evidenced by a series of caverns in the mountainous region between Kirkuk and Sulaymāniya. The settlement of Jarmo reveals the transition, in the Neolithic period, to an agricultural civilization; the presence of the bones of domestic animals attests the beginning of domestication, while crude clay figurines cast light on religious practices. With the 4th millennium, the transition of the Mesopotamian culture to the chalcolithic and the further developments of the latter are marked by different types of pottery; from the pottery of Hassuna, Samarra, and Tell Halaf are derived the names of the chalcolithic cultures of northern Iraq, which are strands in a broader cultural nexus extending from Iran to Syria. In the period immediately following that of Ḥājj Muḥammad and in the middle and late chalcolithic, marked by the cultural phases designated as al-'Ubaid I and II, the practice of irrigation developed on the flood plain of southern Iraq; in this same period the first cities were founded by inhabitants whose origin is uncertain but who were probably pre-Sumerian, since many city names are non-Sumerian (see MESOPOTAMIA).

The Sumerian city-states, with their typical organization centering politically and economically upon municipal temples, were the protagonists of the great development characterizing Mesopotamian protohistory. With the epoch of Uruk VI–IV, about 3000 B.C. (according to the "short" chronology of W. F. Albright and F. Cornelius), there appeared the first written documents, which become increasingly abundant and intelligible in the succeeding period of Jamdat Naṣr (ca. 2800–2700 B.C.). The Jamdat Naṣr period, while marking the continuation of the artistic and cultural high point of the age of Uruk IV, is characterized by the diffusion, albeit partial, of the Sumerian cultural heritage into the adjacent territories of the Near East, from Iran to Syria, from Anatolia to Egypt, which in this particular period received vital stimuli from Mesopotamia in the fields of writing and art. In Iraq, on the other hand, the cultural area and centers of art production extended northward in the succeeding period (ca. 2600 B.C.), named after Mesilim, a king of Kish, whose inscribed macehead has been found. This period marked the beginning of the great artistic heyday of the cities of Diyala (Eshnunna, Khafaje, Tell Agrab), which American excavations have admirably revealed.

Sumerian art can be said to have reached full maturity during the succeeding historical and cultural period (ca. 2500–2350 B.C.), which takes its name from the 1st dynasty of Ur and which marks a point of equilibrium among Sumerian city-states broken only at the close of the conquests of Lugalzaggisi of Umma and thereafter by the advent of the Semitic king Sargon. At that time there extended from the south to the north of the region, and also in territory that was geographically Mesopotamian though now Syrian — such as Mari, for instance — a rich full-blown art production, centered chiefly in Ur, Lagash, Khafaje, Tell Agrab, and Ashur, as well as in Mari (see SYRIA; SYRO-PALESTINIAN ART); the highest achievements of this art are to be found in temple architecture, sculpture, and glyptic art.

The rise to power of Sargon and of the Semitic dynasty of Akkad (ca. 2350–2150 B.C.), which unified the region under their rule, marked a strengthening of the Semitic element in the ethnic make-up of ancient Mesopotamia; in regard to art, while no clear-cut distinction can be made and the new period represents a further development rather than an interruption of the artistic tradition, a limited degree of innovation along naturalistic lines can be detected in Sumerian art, together with greater concern with representation of secular events — as depicted in commemorative war steles, for example. However, the development of Mesopotamian culture under the dynasty of Akkad came to an abrupt halt with the invasion by tribes from the neighboring Iranian mountains, the barbarian Guti, under whom artistic creation ceased. It resumed after the expulsion of the Guti, when the Sumerian city-states were briefly revived (ca. 2050–1950 B.C.). The promoters of this Sumerian renaissance may be said to have been the rulers of the 3d dynasty of Ur, after whom this period is

named; this revival reached its artistic peak in the city of Lagash, where its ruler, Gudea, left the richest set of statues of a sovereign in all ancient Mesopotamia.

About 2000 B.C. a new phase of history opens with the advent of the so-called "Amorites," western Semites who spread over the entire area of the Fertile Crescent and founded a series of city-states; in Mesopotamia there arose Isin, Larsa, Ashur, Mari, and, finally, Babylon, which under the lawgiver Hammurabi (ca. 1728–1686 B.C.) united the entire territory into a kingdom that was to last until 1530 B.C. From then on Semitic hegemony was undisputed. Artistically, the most important production radiated from Mari, while the surviving examples from Babylon are quite limited: by and large, however, it can be said that the creative power of Sumerian art was not matched by a comparable ability among the Semitic peoples, who confined themselves to elaborating further the art forms of previous centuries.

As early as the Amoritic age, the ethnic balance of the region was disturbed by the advent of new tribes: the "mountain people," Indo-Europeans, largely of the ruling class. These peoples — Hittites, Hurrians, and Kassites — imposed their rule in Anatolia, where they created outstanding art forms (see HITTITE ART); in Mesopotamia, where they also established their political rule (the Hurrians in the north, the Kassites in the south), they left marks of their attacks, together with elements of indigenous development.

Meanwhile, in the north, the Middle Assyrian empire was established, reaching the peak of its power about 1100 B.C. with Tiglath-pileser I; after a brief period of crisis, it resumed its expansion in the first half of the succeeding millennium, managing to unify under its sway first Babylonia and then Egypt (671 B.C.). However temporary this latter conquest, it was a significant indication of the great expansive power of the new empire, a power matched by remarkable cultural and artistic vigor, which is particularly evident in the great palaces of the rulers and in their mural reliefs. A clear-cut historical, and what might be called "lay," tradition emerges from these reliefs — very different from the typically ritualistic tradition of southern Mesopotamia.

The abrupt fall of Nineveh, and with it the Assyrian Empire, brought about by the Babylonians and Medes (612 B.C.), placed Babylon in the spotlight of Mesopotamian history for the last time: in the brief period of the Neo-Babylonian or Chaldean dynasty, which extended its rule over a wide radius, the art of the capital city reached its peak in the imposing buildings and the celebrated decorations of walls and streets in glazed brick. This art, though little removed in time from that of the Assyrian palaces, differs profoundly from it, as is shown by the diversity of architectural structures and the absence of orthostats in relief. Thus, the area north of Mesopotamia was perhaps dominated by Sumerian tradition, the region south of it possibly affected by Semitic penetration or by the infiltration of various foreign elements (see ASIA, WEST).

With the conquest of Cyrus in 539 B.C., the territory of modern Iraq, cradle of the Sumero-Akkadian and Babylonian-Assyrian civilizations, lost its independence and became a province of other empires (even artistically, to a great extent): of the Persian empire, first of all (538–331 B.C.); next (312–140 B.C.), after Alexander's conquest, of the kingdom of the Seleucids (see HELLENISTIC ART); later (140 B.C.–A.D. 226), of the Arsacids, with a brief period of Roman domination (see ROMAN ART OF THE EASTERN EMPIRE); and subsequently (A.D. 226–637), of the Sassanids (see SASSANIAN ART).

Iraq was Arabized and Islamized within a few decades after the death of Mohammed. The battle of Qadisiya (Kadisiya; A.D. 637) put an end to Persian rule there, and the establishment of the two Arab metropolises of Kufa and Basra quickly turned the country into a hotbed of Arabism. The caliph 'Alī ibn-abī-Ṭālib made Kufa his capital for a short time, but in general, during the Ommiad period, the Iraqi area remained a marginal region in comparison with the splendid development of Syria and the gravitation of Islamic power toward the Mediterranean. Despite its proximity, the Iranian world, with its great wealth of cultural traditions, was unable to leave any individual impress on these regions, even though there was no lack of Sassanian elements surviving in Ommiad art. In the century following the Ommiad caliphate of Syria, Iraq was the headquarters of the Shiite opposition, which culminated in the revolt of al-Mukhtār but was held in check by the vigor of the great Ommiad governor or viceroy, al-Ḥājjāj. When the Ommiad caliphate was defeated and supplanted by the Abbassides in the mid-8th century, the conquerors, arriving victorious in Iraq at the head of the troops of Khorasan, made Iraq their residence. There, in 762, al-Manṣūr founded Baghdad, destined soon to become the great metropolis of the entire Islamic East and to remain for centuries the seat of the caliphate and the capital of the Moslem civilization (see ABBASSIDE ART; ISLAM). Founded with Baghdad, which was built on a circular plan, was Raqqa (or Rakka; now in Syria), built on a horseshoe-shaped plan; Raqqa was to become, somewhat later,

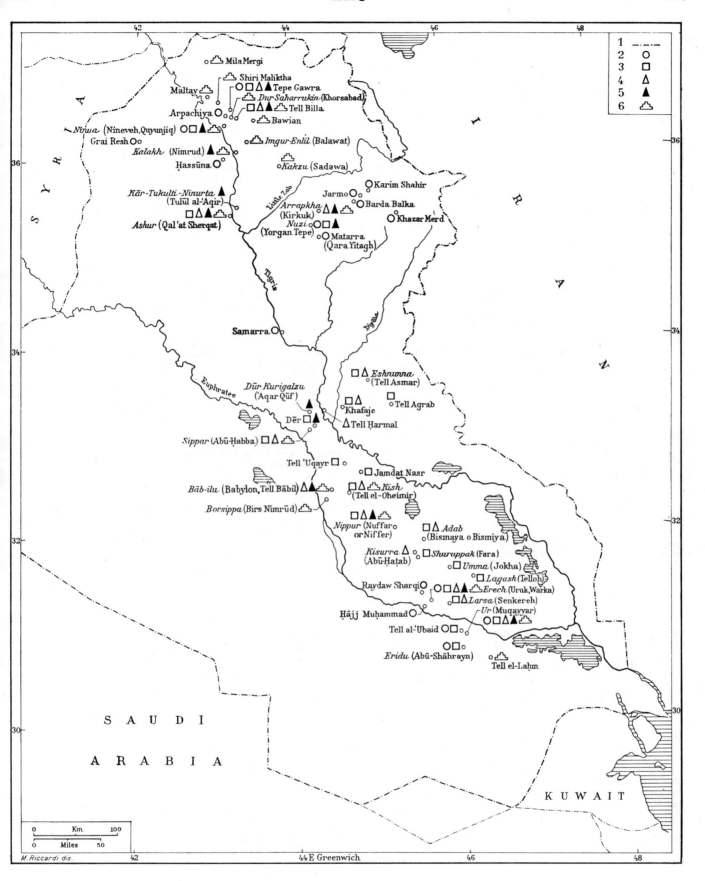

Iraq, archaeological sites and art centers of the ancient Mesopotamian civilizations up to the Persian conquest. *Key:* (1) Modern national bound-aries; (2) late neolithic and chalcolithic settlements; (3) Sumero-Akkadian epoch; (4) period of Isin-Larsa, Old Babylonian and early Assyrian (first half of 2d millennium B.C.); (5) period of the domination of the Kassites, Hurrians, and Mitannians, and Middle Assyrian period (second half of 2d millennium B.C.); (6) Neo-Assyrian and Neo-Babylonian periods (first half of 1st millennium B.C.).

one of the major centers of Islamic art. Samarra especially, with its Great Mosque topped by a high spiral tower, reveals not only the Iranian influence which became dominant through the Abbassides — called the Moslem Sassanians — but also, through its ceramics, shows evidence of the contacts maintained with the Far East, that is, with T'ang China. The first three centuries of the Abbasside caliphate (8th–11th cent.) represent the golden age of Iraq, but even though the political power of the caliphs was enfeebled through

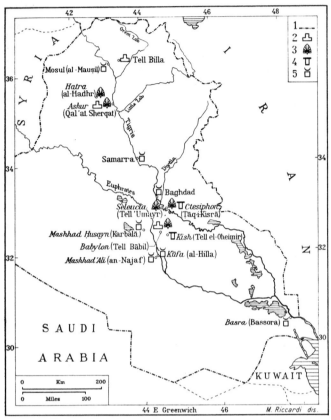

Iraq, archaeological sites and art centers from the Persian conquest to modern times. *Key:* (1) Modern national boundaries; (2) Achaemenian period; (3) Greek and Parthian period; (4) Sassanian period; (5) Islamic period.

the disintegration of the empire and the defeat at the hands of non-Arab elements such as Persians and Turks, Iraq retained a position of cultural primacy. The crisis grew more acute after the year 1000, when the caliphs became mere instruments of alien dynasties — first the Buyids, then the Seljuks — and were ultimately overthrown in the mid-13th century during the second Mongol invasion led by Hūlāgū (Baghdad being captured in 1258). Iraq then underwent a long and profound decline, during which the monuments of the Abbasside period, among others, were almost entirely lost. In the Seljuk period, the entire Iraqi territory again entered upon a period of artistic rebirth under the auspices of the Turkish dynasties (see SELJUK ART). The works created during this period reveal the magnitude of the formal contributions that enriched their art, which was still dominated by Turko-Iranian ingeniousness in blending traditional elements from Iran with others of Central Iranian origin.

After having been a province of the Mongol empire of the Ilkhans, Iraq experienced the rule of petty local dynasties and at the end of the 14th century was overrun and sacked by Tamerlane; however, this did not completely interrupt its art production. Baghdad, for instance, is still considered to have been the greatest center for miniatures illustrating the Koran. In 1509 Iraq was taken over by Persia under the Safavids but was quickly contested by the Ottomans in lengthy wars, which ended only in 1638 with the definitive conquest of the country by Sultan Murād IV. The Ottoman domination, which marked the lowest point of Iraq's history, persisted until the country became a theater of operations during World War I. Among the scant vestiges of architecture of the Ottoman period, Iraq can take pride in the remarkable ruins of Turkish fortifications at Baghdad, Mosul, and Samarra, a modern city still encircled by fortifications from the 19th century; the Adamiya and Ḥaydar Khāna mosques in Baghdad and the Nabī Shith Mosque in Mosul; the al-Mustansiriya Madrasah in Baghdad and those of Basra and Mosul;

and the monumental city gates of Baghdad. In 1921, the English, who had occupied it and placed it under a mandate, made a kingdom of it under the Hashemite dynasty of Fayṣal, son of King Ḥusayn ibn-'Alī of the Hejaz (al-Hijaz).

The independence of the new Iraqi state — at first purely nominal, since it was subject to British control — was gradually realized in the period between the two world wars. In 1932 the mandate was replaced by a military treaty of alliance with Great Britain. At the end of World War II, the military occupation came to an end. In July, 1958, a revolution put an end to the Hashemite monarchy; Iraq has since then been a republic.

Recent architectural accomplishments of interest, among which may be numbered many public works as well as a great many private buildings, are concentrated in the capital. Outstanding examples of present-day city planning and solutions of architectural problems are the health resort of Ṣalāḥ al-Dīn (with its Hotel Pirman, swimming pools, and sports facilities) and the technical installations of the Iraq Petroleum Company at Basra and Kirkuk, where residential quarters, administrative offices, and technological and scientific institutes have been built.

BIBLIOG. *a. History*: P. W. Ireland, 'Iraq, London, 1937; C. Brockelmann, History of the Islamic Peoples (Eng. trans., J. Carmichael and M. Perlmann), New York, 1947; M. V. Seton-Williams, Britain and the Arab States, London, 1948. *b. Archaeology*: V. Christian, Altertumskunde des Zweistromlandes, 2 vols., Leipzig, 1940; A. Parrot, Archéologie mésopotamienne, 2 vols., Paris,1 946–53; S. A. Pallis, The Antiquity of Iraq, Copenhagen, 1956; H. Frankfort, The Art and Architecture of the Ancient Orient, 2d ed., Harmondsworth, 1958; R. J. Braidwood and B. Howe, Prehistoric Investigations in Iraqi Kurdistan, Chicago, 1960; M. A. Beek, Atlas of Mesopotamia, New York, 1962; L. Dillemann, Haute Mésopotamie orientale et pays adjacents, Beirut, 1962; E. Strommenger and M. Hirmer, Fünf Jahrtausende Kunst in Mesopotamien, Munich, 1962. See also bibliog. for MESOPOTAMIA. *c. Islamic and modern period*: W. Wegener, Syrien, Iraq, Iran, Leipzig, 1943; Moyen Orient (Les guides bleus), Paris, 1955; S. M. Longrigg and F. Stoakes, Iraq, London, 1958; K. A. C. Creswell, A Bibliography of the Architecture, Arts and Crafts of Islam, Cairo, 1961, cols. 195–210, 518.

ART CENTERS AND MONUMENTS. The survey of art centers will proceed from south to north and from east to west. Baghdad will be considered first.

Baghdad. Of all the metropolises of ancient Islam, Baghdad has preserved the fewest vestiges of its past greatness. The only surviving monuments of any importance from the Abbasside period are the al-Mustanṣiriya Madrasah, founded in 1233, reduced in the Ottoman period to a customshouse, and now restored and freed of encumbering structures, and the Palace of the Abbassides, now a

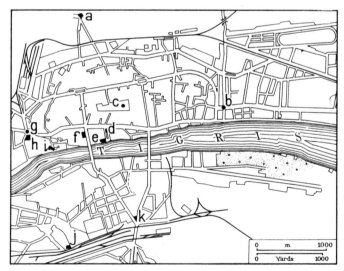

Baghdad, plan of the central district. Principal monuments: (a) Bāb el-Wasṭāni; (b) Bāb el-Khargi; (c) minaret of the Sūq al-Ghazl; (d) Islamic (Arab) Museum; (e) al-Mustanṣiriya Madrasah; (f) Iraq Museum; (g) Bāb el-Mu'aẓẓam; (h) former King Faisal II Hall; (i) Abbasside Palace Museum; (j) tomb of Zubayda; (k) Assyrian Gate.

museum (both, I, PL. 6); there are also part of the city walls, with a few gates (the most important, the Talisman Gate, was destroyed during World War II), the Sūq al-Ghazl quarter (also dating from the 13th cent.), and a few ancient sections of the Mīrjāniya and Khāṣṣekī mosques. Outside the city proper are the tomb of Zubayda,

which is an octagonal structure topped by a pyramidal tower with stalactites, and the sanctuary of Khadimain (al-Kāẓimayn; I, PL. 12). Systematic excavations on the western bank of the Tigris, where the medieval city stood, may produce outstanding results in regard to topography and monuments.

The modern city stands on the eastern bank of the Tigris, extending for about 12 miles. Destroyed by Tamerlane in 1400, Baghdad was a bone of contention between the Turks and Persians for two centuries; it was sacked by Sultan Murād in 1638 and fell to the Ottoman Turks, which hastened its decline. In 1869, the Turkish governor ordered the razing of virtually all the fortifications except the gates. In 1932, when Iraq gained independence, Baghdad became the capital and official residence of the ruling dynasty. Pursuant to the 1938–39 master plan for the city's development, great arteries were constructed, such as Ghazi and Mansur streets, and modern public squares were opened up in the compact mass of the *sūqs* which still characterize the urban center on the eastern bank. A model residential quarter, Karada, was recently constructed southeast of the city. Of special interest among the oldest and best-preserved buildings are the Islamic (Arab) Museum, formerly a seraglio from the 14th century; the Adamiya Mosque (rebuilt, 18th cent.), after which the entire quarter extending northward is named; and the surviving monumental gates of the vanished city walls (Bāb el-Wastāni, Bāb el-Muʿaẓẓam and Bāb el-Khargi). Dating from the 19th century are the great Ḥaydar Khāna Mosque, the al-Mustanṣiriya Madrasah (early 13th cent., but drastically remodeled in 1823; I, PL. 6), the Citadel built by the Turkish governor Midhat Pasha (1869–72), and the seat of the important Iraq Museum. Among the prominent 20th-century monuments, but still embodying the local tradition, are the Assyrian Gate (which was to serve as the monumental entrance of the Iraq Museum); the Central Station, with its great blue dome; and villas, residences, and office buildings — such as the central office of the Armenian community, built in 1954 — mostly designed by the local architect R. K. Chandirli (b. 1926), who blends tradition and the exigencies of contemporary international trends.

Ground was broken in 1962 for the new University of Baghdad, designed by The Architects Collaborative International Limited, under the direction of Walter Gropius, Robert S. MacMillan, and Louis A. MacMillen. Envisioned as a "university city," the project comprises academic and library buildings, administrative headquarters, living quarters for faculty and students, sports facilities, a mosque, and a service block.

BIBLIOG. G. Le Strange, Baghdad during the Abbasid Caliphate, Oxford, 1900 (repr. 1924); Frank Lloyd Wright Designs for Baghdad, Arch. Forum, CI, 1958, pp. 89–101; A. A. Duri, E. of Islam, s.v. Baghdād, I, 2d ed., Leiden, London, 1959, pp. 894–908; The University of Baghdad, Casabella, No. 242, Aug., 1960.

Southern Iraq. Basra (Bassora). Chief city of southern Iraq. Occupied by the Turks in 1668, besieged in 1768 by the Persians who held it for a year, it subsequently fell into the hands of a local Arab chieftain and was retaken by the Turks in 1787. Occupied by the English troops in 1914, the city shared the vicissitudes of the nation. The British influence on the city dates back to 1643, when the English founded a thriving trade center there. Present-day metropolitan Basra consists of three communities: Maʿqil, the coastal quarter, with a very modern port and an airport; ʿAshar, the residential and administrative quarter; and Basra, the old city, where no significant architectural monuments remain. Among the most modern buildings in the environs are those of the Iraq Petroleum Company.

Tell el-Lahm. Site where the explorations of R. Campbell Thompson and the later ones of F. Safar have brought to light a number of bricks bearing the names of the Babylonian kings Bur-Sin and Nabonidus, some tombs from the Neo-Babylonian period, and the ruins of two structures whose function is not known.

BIBLIOG. R. Campbell Thompson, The British Museum Excavations at Abu Shahrain in Mesopotamia in 1918, Archaeologia, LXX, 1920, pp. 101–44 at 141; F. Safar, Soundings at Tell al-Lahm, Sumer, V, 1949, pp. 154–72.

Eridu ('Ιρίδωτις, mod. Abū-Shāhrayn). The remains of the early chalcolithic sanctuary of Enki (Ea) have been discovered in levels XIX–XV. These levels are characterized by the so-called "Eridu" or "Ḥājj Muḥammad" pottery, which corresponds to the northern pottery of Tell Halaf, developed somewhat later. The middle chalcolithic period is documented in levels XIV–VIII by Temples XI, IX, and VIII; connected with these levels is the pottery of al-ʿUbaid. Temple VII is from the late chalcolithic period; a slant-eyed male figure and a small clay ship model also come from this period. From the early Uruk period there are several religious and secular structures; from the Mesilim period, two palaces of plano-convex bricks and an alabaster statuette of a male figure. The ziggurat was built by King Ur-Nammu at the time of the 3d

dynasty of Ur; the two basalt lions placed alongside the portal have been considered contemporaneous but were probably imported.

BIBLIOG. S. Lloyd and F. Safar, Eridu, Sumer, III, 1947, pp. 84–111, IV, 1948, pp. 115–27; E. Douglas van Buren, Excavations at Eridu, Orientalia, XVII, 1948, pp. 115–19; A. Shukri, The Lion of Eridu, Sumer, IV, 1948, pp. 81–85; E. Douglas van Buren, Discoveries at Eridu, Orientalia, XVIII, 1949, pp. 123–24, pls. 3–9; F. Safar, Eridu: A Preliminary Report on the 3d Season's Investigations, Sumer, VI, 1950, pp. 27–38.

Ur (mod. Muqayyar or Muqaiyir). The remains of middle chalcolithic houses with terra-cotta figurines and pottery of early al-ʿUbaid

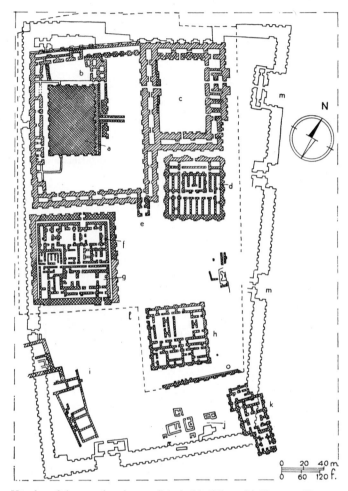

Ur, plan of the sacred enclosure. Principal buildings: (*a*) Ziggurat; (*b*) sanctuary of Nannar; (*c*) court of Nannar; (*d*) E-nun-makh; (*e*) E-dub-lal-makh; (*f*) Gig-par-ku; (*g*) temple of Ningal; (*h*) palace or temple of E-khur-sag; (*i*) temple of Nimintabba; (*j*) royal tombs of the 1st dynasty; (*k*) tombs of Shulgi and Bur-Sin; (*l*) walls from period of Ur III; (*m*) Neo-Babylonian and Persian walls.

type were discovered in the earliest levels; similar finds have been made from the late chalcolithic period. Dating from the Jamdat Naṣr period, as evidenced by the characteristic painted pottery, are a number of stone vases with relief decoration and some cylinder and stamp seals. The level of the Jamdat Naṣr-Mesilim transitional period has yielded other seals and steatite vases with relief decoration. Few cylinder seals from the Mesilim period were found in the royal cemetery, which has, however, yielded extremely rich findings in the style of the 1st dynasty of Ur: harps and lyres (I, PL. 505; X, PL. 226); the so-called "Standard" of Ur (PL. 77; IX, PL. 471); gaming boards (VI, PL. 5); vases of bronze, silver, and gold; the golden helmet of Mes-kalam-dug (VI, PL. 243); weapons; precious ornaments (I, PL. 509); and cylinder seals. Contemporaneous with these royal tombs is the sanctuary of Nannar, which underlies in part the latest ziggurat from the 3d dynasty. Also dating from this period are a number of statuettes, including one of Entemena of Lagash, and the characteristic votive slabs bearing scenes in relief. From the later tombs of the royal cemetery (age of Akkad) come utensils, weapons, ornaments, pottery and seals; contemporaneous with these are a small head of a priestess (Louvre), and a relief of Enkheduanna, daughter of Sargon. During the period of the 3d

dynasty of Ur, the city was extended by a series of religious structures (FIG. 294): new royal tombs were added to the old ones, and to the north of these were erected the palace or temple of E-khur-sag, the Gig-par-ku of the priestesses, the storehouse of the treasury E-nun-makh, and the great ziggurat (I, FIG. 867; III, PL. 485). The sanctuary of Nannar was restored by Ur-Nammu and his successors. Outstanding among the sculptures of this period are statues in the round, a stele of Ur-Nammu, and some seal impressions. In the early Babylonian period, Rim-Sin rebuilt in the port the temple of Enki, which had been constructed just previously. Under the Kassites, many restorations were made by King Kurigalzu I: the sanctuary of Nannar, the ziggurat, the Gig-par-ku, and the adjacent structures of the E-dub-lal-makh and the temple of Ningal. Nebuchadnezzar made further restorations to the ziggurat, and rebuilt the temenos of the sanctuary of Nannar. The temple of Nebuchadnezzar, the temple in the port, and the palace of Nabonidus, all of which were built in the Neo-Babylonian period, still remain standing.

BIBLIOG. H. R. Hall and C. L. Woolley, Ur Excavations, I: Al-'Ubaid, Oxford, 1927; C. J. Gadd et al., Ur Excavations: Texts, 5 vols., London, 1928–53; C. L. Woolley, Ur Excavations, II: The Royal Cemetery, London, 1934; L. Legrain, Ur Excavations, III: Archaic Seal-Impressions, London, Philadelphia, 1936; C. L. Woolley, Ur Excavations, V: The Ziggurat and Its Surroundings, London, Philadelphia, 1939; L. Legrain, Ur Excavations, X: Seal Cylinders, London, Philadelphia, 1951; C. L. Woolley, Ur Excavations, IV: The Early Periods, London, Philadelphia, 1956; M. E. L. Mallowan and D. J. Wiseman, ed., Ur in Retrospect: In Memory of Sir C. Leonard Woolley (Iraq, XXII), London, 1960.

al-'Ubaid. Middle- and late-chalcolithic settlement, from which came the painted pottery named after this site; of the two types, al-'Ubaid I and II, that have been found here, the latter is late chalcolithic, as is the cemetery also. The temple, an outstanding monument, stands on a high terrace; its oldest parts date from the Mesilim period, and the later sections erected on an oval platform date from the time of the 1st dynasty of Ur. Among the most important discoveries from the latter period are a seated statue of the official Kurlil (IX, PL. 474), a large copper relief of the god Imdugud shown hovering above two stags, various animal figures in copper (IX, PL. 475), and a frieze of advancing animals and of milking scenes.

BIBLIOG. H. R. Hall and C. L. Woolley, Ur Excavations, I: Al-'Ubaid, Oxford, 1927; P. Delougaz, A Short Investigation of the Temple at Al-'Ubaid, Iraq, V, 1938, pp. 1–11.

Diqdiqqe. Found here was a cemetery dating from about the end of the 3d or the beginning of the 2d millennium B.C. The badly ruined tombs have yielded terra cottas and cylinder seals from the 3d dynasty of Ur and from the Isin-Larsa period.

BIBLIOG. C. L. Woolley, Excavations at Ur of the Chaldees, AntJ, III, 1923, pp. 311–33 at 332, V, 1925, pp. 1–20 at 18, pls. 7–8; V. Christian, Altertumskunde des Zweistromlandes, Leipzig, 1940, p. 83.

Larsa (mod. Senkereh). Found here were a small four-sided stele, with reliefs, dating from the Jamdat Naṣr-Mesilim transitional period; a vase with incised designs and a number of seals, from the time of the 3d dynasty of Ur; and, from the Old Babylonian period, the palace of Nūr-Adad, two commendable bronze works depicting a kneeling worshiper and a group of three rearing stags, and miscellaneous seals.

BIBLIOG. A. Parrot, Les fouilles de Tello et de Senkereh-Larsa, Rev. d'assyriologie, XXX, 1933, pp. 169–82; A. Parrot, Kudurru archaïque provenant de Sankereh, AfO, XII, 1937–39, pp. 319–24; A. Parrot, Glyptique mésopotamienne, Paris, 1955.

Ḥājj Muḥammad. Site on the Euphrates, not far from Khidr, where excavations in 1936–37 brought to light early chalcolithic painted pottery of a period later than the so-called "Ḥājj Muḥammad" or "Eridu" pottery of Tell Halaf.

BIBLIOG. A. Nöldeke et al., Vorläufiger Bericht über die von der Notgemeinschaft der deutschen Wissenschaft in Uruk-Warka unternommen Ausgrabungen, IX, 1938, pp. 37–38, pls. 36–40, X, 1939, p. 4, XI, 1940, pp. 26–28, pls. 20 c–d (AbhPreussAk, 1937, 11, 1939, 2, 1940, 3); C. Ziegler, Die Keramik von der Qal'a des Ḥaġġi Moḥammed, Berlin, 1953.

Erech (Uruk, mod. Warka). The earliest finds, dating from the middle chalcolithic period, are terra cottas and pottery from levels XVIII–XIV, discovered after deep soundings were made in the "limestone temple." Attributed to the periods immediately following — the late al-'Ubaid and Uruk — are levels XII–VIII, which have yielded specimens of pottery from the last phase of al-'Ubaid and Uruk and some seal impressions; the oldest stamp seal in southern Mesopotamia was found in level XII. From the protohistoric period, designated by levels VI–IV of the sacred precinct of E-anna as a common cultural phase, are a number of religious structures: Temple

A, the "limestone temple," the hall of columns, and the court of mosaic half columns (X, PL. 172), all from level V–IVb; and temples C and D from level IVa. Also from level IVa come numerous seal impressions and the earliest written documents. The temple on a high terrace of level III of E-anna in the three subsequent phases attested by the corresponding levels, and level B (the "White Temple"; I, FIG. 859; IX, PL. 463) of the ziggurat of Anu date from the Jamdat Naṣr epoch. There was also during this period a remarkable development of sculpture in high relief, low relief, and in the round, utilizing clay, stone, metal, and a combination of various materials; outstanding examples are the head of a woman (IX, PL. 464), the Lion-Hunt Stele, and a large alabaster vase (IX, PL. 466), all now in the Iraq Museum in Baghdad. Levels II–I of E-anna range from the end of the Jamdat Naṣr period to the Mesilim era, with discoveries of seals

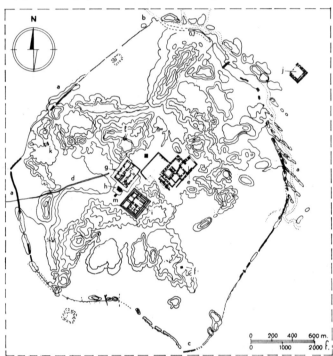

Erech (Uruk), plan. Principal monuments: (a) Remains of walls; (b) north gate; (c) Gate of Ur; (d) street; (e) E-anna; (f) temple from Parthian period; (g) sanctuary with temple of Anu and Antum (Bīt Rēsh); (h) ziggurat with the "White Temple"; (i) sanctuary of Ishtar and Nannar (Irigal); (j) sanctuary of the festivals of Anu and Ishtar (Bīt Akītu); (k) ruins of the palace of Sin-Gashid; (l) houses of the protodynastic period; (m) Mithraeum of the Roman period.

and steatite vases in relief; dating from the Mesilim period are the city walls in plano-convex brick. Sublevels 4–1 of level I, which go back to the age of the 1st dynasty of Ur, yielded the upper portion of a male figure in stone, bearing the name of Lugalkisalsi. The ziggurat is largely the work of Ur-Nammu and his son Shulgi (Dungi), kings of the 3d dynasty of Ur; from this period date a head of a male statuette, jewels of the priestesses Dabbatum and Abbabashti, and figures from the foundation of the temple tower. There are few vestiges of the palace of Sin-Gashid, of the Old Babylonian period. Among the remains from the Kassite age are the temple dedicated to Inanna by King Karaindash, with the original frieze of deities on the façade (VII, PL. 356); a few terra cottas; and a votive stele erected by Nazimaruttash. The temple of Ningizzida and the group of religious structures known as the "southern building" are from the Neo-Babylonian period; a stele, perhaps of King Mardukapaliddina II, is contemporaneous.

BIBLIOG. J. Jordan and C. Preusser, Uruk-Warka, Leipzig, 1928; A. Nöldeke et al., Vorläufiger Bericht über die von der Notgemeinschaft der deutschen Wissenschaft in Uruk-Warka unternommen Ausgrabungen, I ff., 1929 ff. (AbhPreussAk); A. Falkenstein, Archaische Texte aus Uruk, Leipzig, 1936; E. Heinrich, Kleinfunde aus den archaischen Tempelschichten in Uruk, Leipzig, 1936; A. Falkenstein, Topographie von Uruk, Leipzig, 1941; H. Lenzen, Die Entwicklung zer Zikurrat von ihren Anfängen bis zur Zeit der III. Dynastie von Ur, Leipzig, 1942.

Raydaw Sharqi. A late chalcolithic settlement, about 3 miles west of Uruk, which has yielded pottery of the late-al-'Ubaid type. Also uncovered were the ruins of a large inhabited quarter from the same period.

BIBLIOG. A. Nöldeke and others, Vorläufiger Bericht über die von der Notgemeinschaft der deutschen Wissenschaft in Uruk-Warka unternommen Ausgrabungen, IX, 1938 (AbhPreussAk, 1937, 11), pp. 33-37, pls. 19, 35.

Badtibira. Mentioned in texts as the seat of a "pre-Flood" dynasty. Entemena, ruler of Lagash, is said to have built a temple to Dumuzi and Inanna here. V. E. Crawford has convincingly identified the site with Tell Madineh.

BIBLIOG. V. E. Crawford, The Location of Bad-Tibira, Iraq, XXII, 1960, pp. 197-99.

Urukug (mod. el-Hibba). Perhaps part of Lagash. Uncovered here was a sacred building from the time of the 1st dynasty of Ur — a type of elevated temple, erected on an oval terrace, like those in Khafaje and in al-'Ubaid.

BIBLIOG. R. Koldewey, Die altbabylonischen Gräber in Surghul und El Hibba, ZfAssyr, II, 1887, pp. 403-30; R. Koldewey, Die Tempel von Babylon und Borsippa, Leipzig, 1911, p. 61; W. Andrae, Das Gotteshaus und die Urformen des Baues im alten Orient, Berlin, 1930, p. 4, fig. 2; P. Delougaz, The Temple Oval at Khafājah (Univ. of Chicago, O. Inst. Pub., LIII), Chicago, 1940, pp. 143-44.

Telloh (anc. Lagash). Seals from the epoch of Jamdat Naṣr are the earliest objects discovered here. A figure with plumed headdress from the Jamdat Naṣr-Mesilim transitional period, is of special interest for its graphic detail (IX, PL. 467). A ritual spearhead of a king of Kish and a famous votive mace date from the Mesilim period (IX, PL. 470). In the style of the 1st dynasty of Ur are important monuments of the *ensi* (governors) of the city; various statuettes (IX, PL. 474); plaques of Ur-Nina (I, PL. 502), Eannatum, and Dudu (IX, PL. 475); the famous Stele of the Vultures of Eannatum (I, PL. 506); the silver vase of Entemena (I, PL. 504); nails from a foundation; and seals. From the Akkadian period come fragments of a triumphal stele, perhaps King Rimush's (VII, PL. 252), of excellent workmanship, and an inscribed votive tablet of Naram-Sin, as well as seals. Lastly, a group of interesting objects is associated with the name of Gudea; these include cylinders bearing inscriptions concerning the ritual of the temple consecration; a number of statues, both seated and standing, of the princes of the city (I, PL. 511; VII, PL. 356; IX, PL. 472); many stele fragments; stone votive tablets; and libation vases (IX, PL. 481). Also deserving mention are a headless statue (IX, PL. 479) and an extremely expressive bust of Ur-Ningirsu, son of Gudea. The supposed hypogeum of Gudea's successors, from the beginning of the 3d dynasty of Ur, today is believed to be a complex of aqueducts.

BIBLIOG. E. de Sarzec, Découvertes en Chaldée, 2 vols., Paris, 1884-1911; G. Cros, Nouvelles fouilles de Tello, 3 vols., Paris, 1910-14; A. Parrot, Fouilles de Tello, Rev. d'assyriologie, XXIX, 1932, pp. 45-57; A. Parrot, Les fouilles de Tello et de Senkereh-Larsa, Rev. d'assyriologie, XXX, 1933, pp. 169-82; H. de Genouillac, Fouilles de Telloh, 2 vols., Paris, 1934-36; A. Parrot, Tello: Vingt campagnes de fouilles (1877-1933), Paris, 1948; A. Parrot, Glyptique mésopotamienne, Paris, 1954; T. Jacobsen, La géographie et les voies de communication du pays de Sumer, Rev. d'assyriologie, LII, 1958, pp. 127-29.

Umma (mod. Jokha). A large number of interesting sculptures were found here, including an alabaster male statuette from the Mesilim epoch, the upper portion of a female figure from the 3d dynasty of Ur, and a votive slab of Sharatiqubisin from the same period.

BIBLIOG. G. Contenau, Musée du Louvre: Les antiquités orientales, I, Sumer, Babylonie, Elam, Paris, 1927, pl. 10; H. Frankfort, Sculpture of the 3d Millennium B.C. from the Diyala Region (Univ. of Chicago, O. Inst. Pub., XLIV), Chicago, 1939, pl. 115 E.

Fara (anc. Shuruppak). The earliest discoveries consist of items from the Jamdat Naṣr period: stone vases in relief, painted pottery, cylinder and stamp seals, and a vase stand. From the Jamdat Naṣr-Mesilim transitional period there are a few typical seal impressions with the so-called "false writing"; there are also numerous seals and impressions from the Mesilim epoch, with rather complex arrangements of motifs and a bold abstraction of the human figure (IX, PL. 496). A number of votive steles in relief date from the time of King Mesilim. Several important seal impressions of Imdugud-Sukurru from the Mesilim-Ur I transitional period have given their name to this period.

BIBLIOG. E. Heinrich and W. Andrae, Fara: Ergebnisse der Ausgrabungen der Deutschen Orient-Gesellschaft in Fara und Abu Hatab 1902-1903, Berlin, 1931, pp. 8-136.

Abū-Ḥaṭab (anc. Kisurra). Site east of Kish, where German excavations have brought to light cylinder seals and terra cottas from the early Babylonian period.

BIBLIOG. E. Heinrich and W. Andrea, Fara: Ergebnisse der Ausgrabungen der Deutschen Orient-Gesellschaft in Fara und Abu Hatab 1902-1903, Berlin, 1931, pp. 137-53.

Bismaya or Bismiya (anc. Adab). Dating from the Jamdat Naṣr-Mesilim transitional period are fragments of steatite vases carved in relief. From the period of the 1st dynasty of Ur there are many tombs, a statuette of Lugaldalu, and a seated, headless limestone figure. The city is assumed to have been especially flourishing at the time of the Akkadian dynasty, as shown by the numerous discoveries from that period: a palace, the temple of Ishtar restored by Naram-Sin, private residential quarters, and a cemetery, as well as cylinder seals and two pieces of great interest — a golden tablet with an inscription of Naram-Sin and a very fine male head of alabaster (Chicago, University, Oriental Inst.). As evidence of the building activity of the rulers of the 3d dynasty of Ur, bricks bearing the name of Shulgi were found in the ziggurat. Also noteworthy is a statue of a seated goddess from this same period.

BIBLIOG. R. F. Harper, Report from Bismya, Am. J. of Semitic Lang., XX, 1903-04, pp. 207-08, 260-68; E. J. Banks, Bismya, or the Lost City of Adab, New York, 1912; G. Furlani, EAA, s.v. Adab, I, 1958, p. 62.

an-Najaf (anc. Mashhad 'Alī). Like Karbala, this site is one of the most important Shiite shrines in Iraq. The shrine was built over the presumed tomb of 'Alī ibn-abī-Ṭālib (I, PL. 12), in the vicinity of ancient Kufa (about 60 miles southwest of Baghdad). The site, held in extreme veneration by devout Shiites, has undergone destruction and alteration over the centuries, and so the present monuments are the result of many restorations and additions. The dome of the shrine, gilded in the 18th century, is its most outstanding feature. Like the shrine at Karbala, this monument has been insufficiently studied, because of the difficulty of access for non-Shiites.

Kufa. Unlike its twin, Basra (where, however, nothing remains of the ancient era), this Arab metropolis of Iraq has completely disappeared, even to its name, having been replaced by the smaller city of al-Hilla. In recent times, soundings and preliminary excavations have been undertaken here which have produced encouraging results and deserve to be continued.

BIBLIOG. D. T. Rice, The Oxford Excavations at Hira, 1931, Antiquity, VI, 1932, pp. 276-91.

Nippur (mod. Nuffar or Niffer). Sacred structures, including a temple of Inanna from level IX, have been identified as dating from the Mesilim period; other contemporaneous levels have yielded an interesting statuette and votive slabs in relief. Belonging to the period of the 1st dynasty of Ur are a temple of Inanna from level VIII, various sculptures in the round, and votive slabs in relief. The name of the Akkadian ruler Naram-Sin appears on bricks in the city walls and in the ziggurat of Enlil. Stone vases with inscriptions of Rimush, Manishtusu, and Naram-Sin have been discovered. The most noteworthy discoveries from the age of the Sumerian renaissance are: terra cottas; statuettes, from the foundation, of human figures terminating in the shape of a nail; a diorite fragment of a man carrying a lamb; a head of Gudea; a male torso; and a seated clay statuette. Ur-Nammu also left traces of his building activities at Nippur, in the ziggurat and the temple of Inanna. Dating from the successive early Babylonian, Kassite, and Chaldean periods are the continuous restorations and enlargements of the temple of Inanna, as well as some terra cottas and seal impressions. Of paramount importance is the abundant epigraphic material found at Nippur.

BIBLIOG. H. V. Hilprecht, The Babylonian Expedition of the University of Pennsylvania, Series A: Cuneiform Texts, 14 vols., Philadelphia, 1893-1914; H. V. Hilprecht, Die Ausgrabungen der Universität von Pennsylvania im Bel-Tempel zu Nippur, Leipzig, 1903; C. S. Fisher, Babylonian Expedition of the University of Pennsylvania: Excavations at Nippur, Philadelphia, 1905; L. Legrain, Sumerian Sculptures, Univ. of Pa. Mus. J., XVIII, 1927, pp. 217-47; L. Legrain, Terra-cottas from Nippur, Philadelphia, 1930; T. Fish, The Sumerian City Nippur in the Period of the 3d Dynasty of Ur, Iraq, V, 1938, pp. 157-79; D. E. McCown, Excavations at Nippur, ILN, CCXX, 1952, pp. 1084-87; R. C. Haines, The Temple of Inanna Uncovered during Further Excavations at Nippur, ILN, CCXXIX, 1956, pp. 266-69; R. C. Haines, Further Excavations at the Temple of Inanna, ILN, CCXXXIII, 1958, pp. 386-89; V. E. Crawford, Nippur, The Holy City, Archaeol., XII, 1959, pp. 74-83.

Birs Nimrud (anc. Borsippa; Barsippa). Still in evidence are the ruins of two important Neo-Babylonian structures, the ziggurat and the E-zida, a temple of Nabu with a vast court and three main cellae. The ruins of the wall that enclosed the consecrated area have also been found.

BIBLIOG. R. Koldewey, Die Tempel von Babylon und Borsippa, Leipzig, 1911; G. Furlani, EAA, s.v. Barsippa, I, 1958, p. 981; T. Baqir, Babylon and Borsippa, Baghdad, 1959.

Tell el-Oheimir ånd Tell Ingharra (anc. Kish). A small stone relief, with a scene of a ritual taking place before a temple, and a few cylinder seals date from the period of Jamdat Naṣr. The palace, built of plano-convex brick, dates from the Mesilim period; it yielded a mosaic frieze, a figured pedestal in copper, and cylinder seals and seal impressions. A headless alabaster statue and a female head date from the period of the 1st dynasty of Ur. Structure Z on Tell Ingharra and a number of private dwellings belong to the Akkadian epoch; discoveries from this period include male alabaster heads and a fragment of a votive tablet. West of Tell el-Oheimir, the houses and schools for scribes are contemporaneous with the 1st dynasty of Babylonia. On Mound Z stood the ziggurat of Zababa, mainly the work of the kings of the Neo-Babylonian period; these rulers also built, in its final form, the temple on Mound D. Excavations on Mound H of Ingharra have brought to light the Sassanian quarter, with three large groups of buildings, and reliefs, busts, coins, and pottery.

BIBLIOG. S. Langdon et al., Excavations at Kish, 4 vols., Paris, 1924–34; H. de Genouillac, Premières recherches archéologiques à Kich, 2 vols., Paris, 1924–25; E. Mackay, Report on the Excavations of the "A" Cemetery at Kish, Mesopotamia, 2 vols., Chicago, 1925–29; S. Langdon, New Light on Early Persian Art, ILN, CLXXVIII, 1931, p. 261; S. Langdon, Persian Art Discoveries at Kish, ILN, CLXXVIII, 1931, p. 369; S. Langdon, A Christian "Nave" at Kish? The Discovery of a 2d Neo-Persian Palace, ILN, CLXXVIII, 1931, p. 697; S. Langdon, "Palace Three": The Bath of the Sasanian Kings at Kish, ILN, CLXXX, 1932, p. 273.

Babylon (Ka-dingir-ra, Bāb-ilu, Βαβυλών, mod. Tell Bābil). The earliest object found at Babylon is the statue of Puzur-Ishtar (IX, PL. 485) from the "museum" where Nebuchadnezzar collected objects from various epochs. From the age of Hammurabi and his dynasty, when Babylon was the capital of the empire, only the ruins of civil buildings and terra cottas have come to light in the modern district of Merkes; there, too, houses from the Kassite age, a number of tombs, a few cylinder seals, and the kudurru (boundary stone) of King Marduknadinakhe have been found. But the monuments that made Babylon a great city were built (or rebuilt) in the Neo-Babylonian period. The most important urban structures stood west of the Euphrates, close to its banks at that time. An outer wall, consisting of two juxtaposed walls, built by Nebuchadnezzar, started north of that king's palace and descended southeasterly, then turned sharply toward the southwest, extending for about 11 miles. At some distance inside, there was another wall — added to by several kings — also consisting of two juxtaposed walls (Imgur-Enlil and Nimid-Enlil) that extended for about 5 miles. There were several gates in the latter wall, the most important, to the north, being the Ishtar Gate (IX, PL. 494). It was decorated by Nebuchadnezzar with enameled blue brick, on which were arranged rows of reliefs of dragons, bulls, and sacred animals, in alternation; present calcula-

tions are that there were 30 rows of such reliefs. Through the Ishtar Gate passed the great processional way which, skirting the sacred precinct, led to the temple of Marduk. The temple was flanked, for a length of about 1000 ft., by walls roughly 25 ft. thick, which were also decorated with glazed blue brick bearing figures of lions. Like the reliefs on the Ishtar Gate, the decoration was surrounded by rows of white rosettes. However it may have been arranged originally, the processional way, in its final form, which was the work of Nebuchadnezzar, ascended beyond the temple. West of the Ishtar Gate, still outside the walls, stood the northern fortress and the main fortress, which was converted into a museum, according to documents found there from many different periods. On the same side, but inside the walls, was the important complex of the southern fortress, largely the work of Nabopolassar and Nebuchadnezzar. The building (about 1,050 × 625 ft.) consisted of five sections, each containing a central courtyard surrounded by halls and rooms. In the northeast corner, on high terraces supported by vaults, were the famous "hanging gardens" planted by Nebuchadnezzar, which contributed so much to the city's fame in antiquity. Opposite the southern fortress, on the other side of the processional road, stood the temple of Ninmakh, built by Ashurbanipal and restored by Nebuchadnezzar; to the south, on the same side, lay the great rectangular sacred precinct. To the eastern side of it, two large structures, used for stores and warehouses, flanked the main gate; to the south, other buildings housed the priests. Within the rectangle, westward, rose the vast and famous ziggurat called E-temen-an-ki, with a square base of about 300 ft. on each side, on which stood seven successive stories of decreasing size. A triple stairway gave access to the upper floors. In the southern part of the sacred precinct was the temple of Marduk, measuring about 260 × 280 ft. at the base, joined directly to another building (the "eastern building") which was even larger (about 295 × 380 ft.). The E-sagila had a central court, with surrounding chapels; of these, the principal one was that dedicated to Marduk, containing the statues of the god and his consort Sarpanitum. Southeast of the E-sagila stood two more temples: one called Temple Z by Koldewey, and the E-patutila, built by Nabopolassar in honor of Ninurta and restored by Nebuchadnezzar. The private quarters of the city were in the district now known as Merkes. The ruins of many dwellings were found there; these were of the usual type with central courtyard and with the characteristic saw-tooth façades. Many thousands of objects were found in the houses and tombs of this quarter.

BIBLIOG. R. Koldewey, Die Tempel von Babylon und Borsippa, Leipzig, 1911; R. Koldewey, Das Ischtar-Tor in Babylon, Leipzig, 1918; O. Reuther, Die Innenstadt von Babylon (Merkes), Leipzig, 1926; F. Wetzel, Die Stadtmauern von Babylon, Leipzig, 1930; R. Koldewey and F. Wetzel, Die Königsburgen von Babylon, 2 vols., Leipzig, 1931–32; F. Wetzel and F. H. Weissbach, Das Haupttheiligtum des Marduk in Babylon, Esagila und Etemenanki, Leipzig, 1938; A. Moortgat, Vorderasiatische Rollsiegel: Ein Beitrag zur Geschichte der Steinschneidekunst, Berlin, 1940, nos. 600, 610, 616, 685–88, 706, 708, 720, 724–28, 731, 735–36, 740, 744, 755; F. Wetzel, E. Schmidt, and A. Mallwitz, Das Babylon der Spätzeit, Berlin, 1957; G. Furlani, EAA, s.v. Babilonia, I, 1958, pp. 954–56.

Karbala (anc. Mashhad Ḥusayn). Large and very important shrine of the Shiite sect, built on the site of the supposed tomb of al-Ḥusayn (Husain), son of ʿAlī ibn-abī-Ṭālib; al-Ḥusayn, died in 680 in Karbala. Like an-Najaf, Karbala has undergone drastic alterations and additions. The Sanctuary of al-Ḥusayn is a building with a central dome (I, PL. 5), a double minaret at the entrance, and extremely rich ceramic decoration on the façade. A third minaret (al-ʿAbd) rises on the eastern flank of the court which is enclosed by the sanctuary.

BIBLIOG. A. Nöldeke, Das Heiligtum al-Husains zu Kerbelā, Berlin, 1909; A. Honigmann, E. of Islam, s.v. Meshhed Ḥusain, III, Leiden, London, 1932, pp. 477–79.

Jamdat Naṣr (Jemdet Naṣr). The excavations conducted here revealed a hitherto unknown phase of Mesopotamian protohistory. A structure made of Riemchen brick dates from the period named after this site. Pottery with painted geometric patterns — or, in a few cases, with animal designs (IX, PL. 416) — stamp seals, and, especially, typical cylinder seals, decorated with rows of animals, are some of the characteristic discoveries of this time and region.

BIBLIOG. S. Langdon, Pictographic Inscriptions from Jemdet Nasr (Oxford Ed. of Cuneiform Texts, VII), Oxford, 1928; E. Mackay, Report on Excavations at Jemdet Nasr, Iraq, Chicago, 1931; H. Field and R. A. Martin, Painted Pottery from Jemdet Nasr, Iraq, AJA, XXXIX, 1935, pp. 310–20, pls. XXX–XXXVIII.

Tell ʿUqayr. The ruins of middle chalcolithic dwellings were discovered near this settlement, which is located about 40 miles

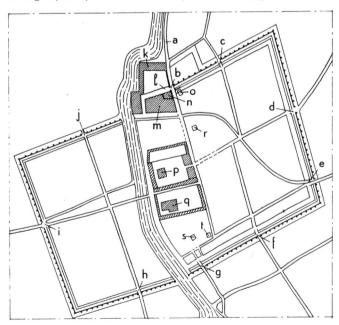

Babylon, plan. (a) Processional way; (b) Ishtar Gate; (c) Sin Gate; (d) Marduk Gate; (e) Zababa Gate; (f) Enlil Gate; (g) Urash Gate; (h) Shamash Gate; (i) Adad Gate; (j) Lugalgirra Gate; (k) northern fortress; (l) main fortress; (m) southern fortress; (n) "hanging gardens"; (o) temple of Ninmakh; (p) E-temen-an-ki; (q) temple of Marduk (E-sagila); (r) temple of Ishtar; (s) Temple Z; (t) temple of Ninurta.

south of Baghdad. Of extreme interest are the fragments of paintings, with geometric and figural motifs, that once adorned the so-called "Painted Temple" in the level corresponding to the Jamdat Naṣr period. The sanctuary stood on an oval terrace.

BIBLIOG. S. Lloyd and F. Safar, Tell Uqair, JNES, II, 1943, pp. 132–58, pls. 1–31.

Central Iraq. Seleucia (Σελεύχεια, Tell 'Umayr). Site whose identification with the Sumerian Akshak is uncertain and which is made up of four levels of a late period, ranging from the Seleucid to the Parthian eras. Here pottery, figurines, and coins have been found, and public buildings (palaces, temples, and theaters) as well as private homes have been uncovered. The only Sumerian vestiges are two royal inscriptions from the 3d millennium.

BIBLIOG. L. Waterman, Preliminary Report upon the Excavations at Tell Umar, Iraq, Ann Arbor, 1931; L. Waterman, Second Preliminary Report upon the Excavations at Tell Umar, Ann Arbor, 1933.

Ctesiphon (Κτησιφῶν, mod. Ṭāq-i-Kisrā). Capital of the Sassanian kingdom; today a field of ruins dominated by the remains of the immense arch of the palace of Shāpur I. Of the great complex of buildings, there remains only a part of the façade and of the south wing. During the excavations stuccoes from the rich decoration were found, as well as pottery and coins of the Sassanian period.

BIBLIOG. O. Reuther, Die Ausgrabungen der deutschen Ktesiphon-Expedition im Winter 1928–1929, Berlin, 1930; E. Weidner, Ausgrabungen: Ktesiphon, AfO, V, 1928–29, p. 188, VIII, 1932–33, pp. 331–32; E. Kühnel, Die Ausgrabungen der zweiten Ktesiphon-Expedition, 1931–1932, Berlin, 1933; E. Kühnel, EAA, s.v. Ctesifonte, II, 1959, pp. 964–66.

Abū-Ḥabba (anc. Sippar). A great many fragments of stone vases and statues inscribed with the names of Rimush and Manish-tusu have been found here, but so far the excavations have not turned up any vestiges of the Akkadian age. Sippar is known from texts as the original site of the magnificent victory stele of Naram-Sin (I, PL. 507), which was later carried to Susa as war booty and rediscovered there. Dating from the early Babylonian period are several houses with schools for scribes and some excellent terra cottas. Dating from the Neo-Babylonian period is the noteworthy *kudurru* of Nebuchadnezzar I (Br. Mus.), and dating from the mid-9th century B.C., a tablet with stone reliefs of Nabupaliddina (IX, PL. 495). The ziggurat and connecting temple were built by Nabonidus.

BIBLIOG. V. Scheil, Une saison de fouilles à Sippar (Mém. pub. par les membres de l'Inst. fr. d'archéol. o. du Caire, I), Cairo, 1902; L. W. King, Babylonian Boundary-stones and Memorial Tablets in the British Museum, I, London, 1912, pp. 29–36, II, London, 1912, pls. 83–91; W. Andrae and J. Jordan, Abu-Habbah – Sippar, Iraq, I, 1934, pp. 51–59.

Akkad. Site known from texts as the capital of the Akkadian kingdom. Up to the present it has not been identified definitely, although S. Langdon in the 1920s identified the city with the ruins of Der, a few miles north of Sippar and southwest of Baghdad. The most recent investigations at Der were made by T. Baqir in 1941, when doubt was once more cast on this identification, especially since early Babylonian material was found in the area. The assumption is that in the immediate vicinity of Sippar, a city dedicated to the god Shamash, there was another city of Sippar, dedicated to Ishtar-Anunitum, which was separated from Sippar only by a canal and had been built over the site where Akkad had stood earlier. This hypothesis has not yet been verified by any discovery. In any case, it is certain that in Nabonidus' time the two cities were not identical. It is known from texts only that Sargon of Akkad transferred his residence to Akkad, enlarged it, and made it into a port, so that ships bearing goods from the Persian Gulf could enter the Euphrates directly and sail up the river to the pier. Hence Akkad must have been located in antiquity on the banks of the Euphrates, or perhaps it may have been linked to the river by a canal. Besides this, it is also known that the famous torso of a diorite statue of Manishtusu was captured as war booty by the Elamites and later moved from Akkad to Susa.

BIBLIOG. S. Langdon, Excavations at Kish, I: 1923–1924, Paris, 1924, p. 7, n. 1; Reallexikon der Assyriologie, s.v. Akkad, I, Berlin, Leipzig, 1928, p. 62; T. Baqir and M. A. Mustafa, Iraq Government Soundings at Dēr, Sumer, I, 1945, pp. 37–54; E. Weidner, Das Reich Sargons von Akkad, AfO, XVI, 1952–53, pp. 1–24.

Der. Two tells, separated by a valley, cover the ruins, which have yielded potsherds from the Kassite period. Still visible today are the ruins of the ancient city walls, which S. Langdon sought to identify in 1924 as Akkad, capital of Sargon's empire. Only one gate in the walls, on the southwestern flank, has been positively identified.

BIBLIOG. S. Langdon, Excavations at Kish, I: 1923–1924, Paris, 1924, pp. 7–8; T. Baqir and M. A. Mustafa, Iraq Government Soundings at Dēr, Sumer, I, 1945, pp. 37–54; A. Parrot, Archéologie mésopotamienne, I: Les étapes, Paris, 1946, pp. 328–29.

Ishchali. Site about 3 miles southeast of Khafaje, where excavations by the Oriental Institute of the University of Chicago have brought to light buildings from the Isin-Larsa period, a temple of Ishtar-Kititum, a temple of Shamash, and private houses. Of interest are a number of terra cottas, cylinder seals, a male head, and bronze figurines, all material from the early 2d millennium B.C., found in the later levels of the temples mentioned above.

BIBLIOG. H. Frankfort, Progress of the Work of the Oriental Institute in Iraq, 1934–1935: Excavations at Ishchali and Khorsabad, O. Inst. Comm., XX, 1936, pp. 74–100; H. Frankfort, More Sculpture from the Diyala Region (Univ. of Chicago, O. Inst. Pub., LX), Chicago, 1943, pp. 20–21, pls. 73 no. 333, 74, 77–81; H. Frankfort, Stratified Cylinder Seals from the Diyala Region (Univ. of Chicago, O. Inst. Pub., LXXII), Chicago, 1955, pls. 86–89.

Khafaje. The oldest structure is the so-called "Temple of Sin" on Mound A, levels I–IV of which date from the time of Jamdat Naṣr. Also from the same period are a female statuette, animal-shaped libation goblets of clay, stone vases, pedestals with relief ornamentation, cylinder seals, and specimens of painted pottery. In the Jamdat Naṣr-Mesilim transitional period, the Temple of Sin was enlarged (levels VI–VII), while the "small temple" and temple of Nintu were erected in five successive stages, corresponding to an equal number of strata. Of particular interest is a steatite vase with relief decoration; pottery called "scarlet ware" and two seals in "brocade style" are characteristic discoveries. During the Mesilim period additions were made to the Temple of Sin (levels VIII–IX), to the temple of Nintu (levels V–VI), and to the "small temple" (levels VI–VIII), and the "oval temple" — so called from the shape of the temenos — was built; subsequent enlargements of this important complex and the level of the "small temple" date from the period of transition to the 1st dynasty of Ur. The third phase of the "oval temple" and a small, single-celled shrine date from the period of the 1st dynasty of Ur. Cylinder seals of the periods ranging from the Mesilim to the Akkad epochs were found, as well as excellent stone and bronze figurines in an attitude of prayer, and votive slabs in relief. Of later date — from the old Babylonian period — are the ruins of a small city appearing on mounds B and C, as well as a great many terra cottas (IX, PL. 485).

BIBLIOG. H. Frankfort, Sculpture of the Third Millennium from Tell Asmar and Khafajeh (Univ. of Chicago, O. Inst. Pub., XLIV), Chicago, 1939, pls. 28–41, 45–61, 64–69, 71–92, 98–105, 107–114; P. Delougaz, The Temple Oval at Khafaje (Univ. of Chicago, O. Inst. Pub., LIII), Chicago, 1940, p. 112, fig. 103, pls. 3–5, 7, 11; P. Delougaz and S. Lloyd, Pre-Sargonid Temples in the Diyala Region (Univ. of Chicago, O. Inst. Pub., LVIII), Chicago, 1942, pp. 18, 29–30, 37, 69, 104, figs. 14, 25, 33, 63, 98, pls. 2–12, 15–17; H. Frankfort, More Sculpture from the Diyala Region (Univ. of Chicago, O. Inst. Pub., LX), Chicago, 1943, pls. 1–27, 46–51, 54; P. Delougaz, Pottery from the Diyala Region (Univ. of Chicago, O. Inst. Pub., LXIII), Chicago, 1952, pp. 60–72, pls. 1–10, 13–16; H. Frankfort, Stratified Cylinder Seals from the Diyala Region (Univ. of Chicago, O. Inst. Pub., LXXII), Chicago, 1955, pls. 72–85.

Tell Agrab. The Shara temple found here was frequently rebuilt; its earliest level, not yet excavated, dates from the Jamdat Naṣr period. The level most remarkable — both for the size which the sanctuary attained at that time and for the objects discovered there — is that of the Mesilim epoch, a period from which the city walls also date. Later construction in the temple area dates from the period of the 1st dynasty of Ur. The earliest objects discovered here are stone vases decorated with figures in high relief and cylinder seals from the Jamdat Naṣr period. In levels of the Jamdat Naṣr-Mesilim transitional period, steatite vases with reliefs, cylinder seals, and so-called "scarlet ware" were found. During the Mesilim period and in the time of the 1st dynasty of Ur, great advances were made in sculpture in the round and in relief; some valuable specimens are a small female head of a delicate, smooth appearance, a bronze draft cart, bronze vases on a base formed by the figures of two men embracing, statuettes of praying figures, and cylinder seals.

BIBLIOG. P. Delougaz and S. Lloyd, Pre-Sargonid Temples in the Diyala Region (Univ. of Chicago, O. Inst. Pub., LVIII), Chicago, 1942; H. Frankfort, More Sculpture from the Diyala Region (Univ. of Chicago, O. Inst. Pub., LX), Chicago, 1943; P. Delougaz, Pottery from the Diyala Region (Univ. of Chicago, O. Inst. Pub., LXIII), Chicago, 1952, pls. 51–58, 65–137; H. Frankfort, Stratified Cylinder Seals from the Diyala Region (Univ. of Chicago, O. Inst. Pub., LXXII), Chicago, 1955, pls. 72–85.

'Aqar Quf (anc. Dur Kurigalzu). Capital of the Kassite state, where discoveries were made of the ruins of the E-gi-rim ziggurat and of a complex of three temples to the east of the ancient capital. A mound of clay bricks — ruins of buildings also dating from the Kassite period — is located on Mound A. The Palace A complex, on Tell Abiad, is also important; its arrangement of courtyards differs from the usual Mesopotamian style. Fragments of a colossal statue of Kurigalzu, a number of fine clay figurines including a male head, and vestiges of wall paintings were found here, as well as specimens of Nuzi pottery.

BIBLIOG. T. Baqir, Iraq Government Excavations at 'Aqar Qūf, Iraq, VI, 1944, Sup., pp. 1–15, VII, 1945, Sup., pp. 1–15, VIII, 1946, pp. 73–93; G. Furlani, EAA, s.v. 'Aqar Quf, I, 1958, pp. 509–10; T. Baqir, 'Aqar Quf, Baghdad, 1959.

Tell Harmal (anc. Shaduppum?). A hill about 6 miles east of Baghdad. Excavations begun here in 1945 have turned up two double temples dating from the early 2d millennium B.C., the larger one dedicated to Nisaba and Khani. Life-size terra-cotta lions come from the sanctuary of Nisaba.

BIBLIOG. T. Baqir, Tell Harmal: A Preliminary Report, Sumer, II, 1946, pp. 22–30, pls. 1–3; B. A. van Proosdij, Van Stedeling tot tentbewoner, Jaarbericht Ex Oriente Lux, X, 1945–48, pp. 537–60 at 538, pls. 29–30; T. Baqir, Tell Harmal, Baghdad, 1959.

Tell el-Dhiba'i. Recent excavations have exposed a temple of the old Babylonian period in level V, corresponding to the level of Tell Harmal. Terra cottas of this same period have also been found.

BIBLIOG. M. A. Mustafa, Soundings at Tell al Dhiba'i, Sumer, V, 1949, pp. 173–97.

Tell Asmar (anc. Eshnunna). A very important archaeological site in the Diyala region, where an American expedition under the direction of H. Frankfort has brought to light two interesting groups of buildings. The earlier comprises the temple of the god Abu. The first religious structure of this group dates back to the Jamdat Naṣr period and has a single cella; subsequently a number of alterations were made that correspond to levels I–IV of the Jamdat Naṣr-Mesilim transitional period, until, in the Mesilim period, the sanctuary acquired the characteristic rectangular form. At the time of the transition to the 1st dynasty of Ur, the temple was reconstructed and, finally, in the Akkadian period, the structure was entirely rebuilt. The other monumental center consisted mainly of a royal palace built by Ilushuilia, ensi of Eshnunna, who also built the adjacent temple dedicated to Shu-Sin (Gimil-Sin), deified king of the 3d dynasty of Ur. After the epoch of the 3d dynasty of Ur, the palace underwent slight alterations at the hands of Nurahum and Bilalama, contemporaneous princes of the dynasties of Isin and Larsa. During the Old Babylonian period, under the ensi Ibiq-Adad II, the "southern building" — whose function is uncertain — and the "northern building" — thought to be an audience chamber — were built. A great many seals have been found, along with specimens of the characteristic "scarlet ware," votive slabs, statuettes — some from the "square temple" of Abu dating from the Mesilim period (I, PL. 501) — and a number of fine terra cottas (IX, PL. 485).

BIBLIOG. H. Frankfort, Sculpture of the Third Millennium from Tell Asmar and Khafajeh (Univ. of Chicago, O. Inst. Pub., XLIV), Chicago, 1939, pls. 1–27, 62–63, 93, 97, 106, 110, 112; H. Frankfort, S. Lloyd, and T. Jacobsen, The Gimilsin Temple and the Palace of the Rulers at Tell Asmar (Univ. of Chicago, O. Inst. Pub., XLIII), Chicago, 1940; P. Delougaz and S. Lloyd, Pre-Sargonid Temples in the Diyala Region (Univ. of Chicago, O. Inst. Pub., LVIII), Chicago, 1942, pp. 156–205, pls. 19–23; P. Delougaz, Pottery from the Diyala Region (Univ. of Chicago, O. Inst. Pub., LIII), Chicago, 1952, pls. 3, 44–46, 52, 63–64, 66–68, 80, 89, 91–92, 96–98, 100–102; H. Frankfort, Stratified Cylinder Seals from the Diyala Region (Univ. of Chicago, O. Inst. Pub., LXXII), Chicago, 1955, pls. 42–71.

Northern Iraq. Samarra. Discoveries have been made here, from the early chalcolithic period in one level, of painted pottery decorated with realistic and geometric motifs in a circular rhythm. This pottery, found together with alabaster vases and stone utensils, is important evidence of the succession of cultures in the Mesopotamian valley. The imposing ruins of the Abbasside "Versailles" on the Tigris (residence of the caliphs from 838 to 889) have been excavated and studied in several expeditions led by E. Herzfeld. Preeminent among the structures from the Moslem period is the Great Mosque of al-Mutawakkil (built 846–52), once capable of containing over 100,000 of the faithful; the flat roof rested upon octagonal masonry piers with engaged marble columns. Outside the enclosing wall stands the lofty minaret of "al-Malawiya" (the spiral; I, PL. 11), a tower with an external spiral ramp, of local Mesopotamian inspiration, which in turn inspired Tulunid architecture in Egypt. A less important mosque is that of Abū-Dulaf. The most important ruins

of secular buildings are those of the caliph's palace (Jausaq al-Khāqānī) and of the Balkuwāra palace (PL. 151), patterned after the Lakhmid palace in Hira, as well as the Qaṣr al-'Ashiq ("Lovers' Castle") on the western bank of the river. Near these monumental buildings are many private houses, decorated with niches, paintings, and stucco ornament (I, PL. 4). The pottery found here is abundant and important (I, PL. 8).

BIBLIOG. E. Herzfeld, Die Ausgrabungen von Samarra, V: Die vorgeschichtlichen Töpfereien von Samarra, Berlin, 1930; E. Herzfeld, Geschichte der Stadt Samarra, Hamburg, 1948.

Matarra (Mattara) or Qara Yitagh. Prehistoric village that shows evidence of the passage from the Neolithic to the chalcolithic age in northern Mesopotamia. Ruins of houses with fragments of Hassuna pottery, clay figurines, utensils of bone and stone, and ornaments of shell and stone were discovered here.

BIBLIOG. R. J. Braidwood, Matarrah, JNES, XI, 1952, pp. 1–75.

Yorgan Tepe (anc. Nuzi). The earliest levels contain pottery of al-'Ubaid type and stamp seals from the Jamdat Naṣr period. The city first attained prominence in the Akkadian period; temples G and F and a number of houses remain from that era. Dating from the Hurrian period are Temple A, which has yielded many small ritualistic objects, and the palace of the viceroy or governor of the city, a contemporary of King Shaushattar. The palace has a large central court, halls, offices, and warehouses. Specimens of Hurrian pottery — painted in white, black, and red — as well as cylinder seals and fragments of wall paintings have been found.

BIBLIOG. R. F. S. Starr, Nuzi: Report on the Excavations at Yorgan Tepe near Kirkuk, Iras, 1927–1931, 2 vols., Cambridge, Mass., 1937–39.

Ashur (Assur; mod. Qal'at Sherqat). This great Assyrian city was circled by a ring of walls built in the 2d millennium and a later enclosure built by Shalmaneser III. Of the 13 gates mentioned in written sources, 7 have been identified. At the northeast end was the temple of the god Ashur, of which, besides the few ruins of the temple of Ilushuma, two phases of construction have been identified. The earlier building — erected by Shamshi-Adad I, a contemporary of Hammurabi — consisted of two courts preceding the antecella and the cella itself; this building was later restored, after a fire, by the rulers of the late 2d millennium and subsequently

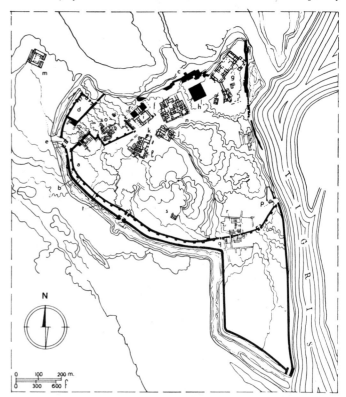

Ashur, plan. Principal monuments: (a) Inner walls; (b) outer walls and moat; (c) Mushlālu Bastion; (d) outer bastion; (e) Gurgurru Gate; (f) Shamash Gate; (g) temple of Ashur; (h) ziggurat of Enlil and Ashur; (i) temple of Anu and Adad; (j) temple of Sin and Shamash; (k) temple of Ishtar; (l) temple of Ishtar and Nabu; (m) Bīt Akītu; (n) palace from the age of Akkad; (o) palace of Tukulti-Ninurta; (p) palace of Prince Ashurilumuballitsu, son of Sennacherib; (q) stele; (r) palace from the Parthian period; (s) private house of early Assyrian period; (t) tombs.

by Sennacherib, who added a court at the southeast corner. Southwest of the temple of Ashur was the ziggurat of Enlil, from the early 2d millennium, later dedicated to Ashur. Farther southwest was the double temple of Anu and Adad, of interest for its originality of design, with two ziggurats and two cellae, preceded by a single vast courtyard; it was erected by Ashurreshishi I and Tiglathpileser I, and restored and made smaller by Shalmaneser III. Another double temple was that of Sin and Shamash, consisting of a central courtyard and two cellae in axial opposition, each with an antecella preceding it; the sanctuary, built by Ashurnirari I, was restored and altered by several rulers, the last being Sennacherib, who erected the southeastern courtyard, opening up two new antecellae and displacing the axis of the group of structures. Levels H and G of the temple of Ishtar provide evidence of the ritualistic environment of the transitional period from the 1st dynasty of Ur up to the time of Akkad, from which votive reliefs (IX, PL. 487), cylinder seals (IX, PL. 496), and fragments of stone vases decorated in relief have been discovered; this sanctuary was rebuilt several times, the last time by Shalmaneser III. Another famous temple of Ishtar is the one built under Sinsharishkun, with two courtyards and three cellae, one of which was dedicated to the god Nabu. Outside the city walls, on the western flank, Sennacherib built the sanctuary of the Bīt Akītu. In the city, the ruins of three palaces have been found: one dates back to the epoch of Akkad but was remodeled later; another was built by Tukulti-Ninurta I; and the third was built by Sennacherib for his son Ashurilumuballitsu. Outstanding among the discoveries here are a torso of a statue in diorite, a spearhead of Manishtusu, and a macehead of Rimush from the Akkad dynasty; a male statue in stone, a bronze female figure, a votive slab of Zariqum, and a large number of seal impressions from the period of the 3d dynasty of Ur (IX; PL. 496); and a ritualistic relief and specimens of Nuzi pottery from the middle of the 2d millennium. In the succeeding period, corresponding to the apogee of the Medean and Neo-Assyrian empire, the main discoveries, in addition to a large number of cylinder seals, are steles, some ivories, an altar of Tukulti-Ninurta I (VII, PL. 405) and a basalt statue of Shalmaneser III (Br. Mus.), and the sarcophagi of a number of Neo-Assyrian rulers discovered in the ancient palace. During the Parthian period the ziggurat of Ashur-Enlil constituted the heart of the fortress, at the foot of which stood two large structures. Also dating from the Parthian period is a palace among a group of buildings that was located near the southern gate.

BIBLIOG. W. Andrae, Der Anu-Adad-Tempel in Assur, Leipzig, 1909; W. Andrae, Die Festungswerke von Assur, Leipzig, 1913; W. Andrae, Die Stelenreihen in Assur, Leipzig, 1913; W. Andrae, Die archaischen Ischtartempel in Assur, Leipzig, 1922; W. Andrae, Farbige Keramik aus Assur, Berlin, 1923; W. Andrae, Kultrelief aus dem Brunnen des Assur Tempels in Assur, Leipzig, 1931; W. Andrae and H. Lenzen, Die Partherstadt Assur, Leipzig, 1933; W. Andrae, Die jüngeren Ischtar-Tempel in Assur, Leipzig, 1935; W. Andrae, Das wiedererstandene Assur, Leipzig, 1938; A. Moortgat, Vorderasiatische Rollsiegel, Berlin, 1940, nos. 76–77, 98, 162, 189, 195, 203, 221, 242, 248, 296, 309, 376, 396, 467, 486, 504–08, 512–13, 516; A. Haller, Die Gräber und Grüfte von Assur, Berlin, 1954; C. Preusser, Die Wohnhäuser in Assur, Berlin, 1954; A. Haller, Die Heiligtümer des Gottes Assur und der Sin-Šamaš-Tempel in Assur, Berlin, 1955; C. Preusser, Die Paläste in Assur, Berlin, 1955; G. Furlani, EAA, s.v. Assur, I, 1958, pp. 747–48.

Tulul al-'Aqir (Kar-Tukulti-Ninurta). In this city, founded in the 13th century B.C. by the Assyrian ruler Tukulti-Ninurta I, was discovered an important cult center dedicated to the god Ashur. It consisted of a ziggurat and a lower temple backed against it on the eastern flank. An interesting wall painting with ornamental motifs comes from the royal palace.

BIBLIOG. W. Andrae, Farbige Keramik aus Assur, Berlin, 1923, pp. 7–11, pls. 1–4; W. Andrae, Das wiedererstandene Assur, Leipzig, 1938, pp. 92, 122, figs. 42–52, pl. 49b.

Hatra ("Ατρα or "Ατραι, Hatrae, al-Hadhr). A thriving city in the 2d century. The ruins of its powerful fortification walls, built of stone and strengthened by towers and bastions, are still visible. The walls were encircled by a deep moat. The official quarters, set off by a rectangular enclosure with the main entrance gate on the eastern flank, included in the western sector the palaces of the governors and a temple dedicated to Mithras. The ruins of private homes, with small altars for the domestic hearth and fragments of sculpture, have been found south of the main group of buildings (IV, PL. 171).

BIBLIOG. W. Andrae, Hatra, 2 vols., Leipzig, 1908–12; J. B. Ward Perkins, EAA, s.v. Hatra, III, 1960, pp. 1116–22.

Kirkuk (anc. Arrapkha). Hurrian seals and seal impressions from the middle of the 2d millennium B.C. have been found here.

BIBLIOG. G. Contenau, Les tablettes de Kerkouk et les origines de la civilisation assyrienne, Babyloniaca, IX, 1926, pp. 69–151, 157–212; G. Castellino, EAA, s.v. Arrapkha, I, 1958, p. 672.

Barda Balka. Site about 35 miles east of Kirkuk, where the earliest traces of the middle Paleolithic culture in Mesopotamia were discovered. Crude axes, stone chips used as weapons, stone utensils, and megalithic steles were found here.

BIBLIOG. Naji al Asil, News and Correspondence: Barda Balka, Sumer, V, 1949, pp. 205–06; R. J. Braidwood, Excavations in Iraqi Kurdistan, Sumer, VII, 1951, pp. 99–104; R. J. Braidwood, From Cave to Village in Prehistoric Iraq, BAmSOR, CXXIV, 1951, pp. 12–18; H. E. Wright and B. Howe, Soundings at Barda Balka, Sumer, VII, 1951, pp. 107–18.

Jarmo (Qal'at Jarmo). Prehistoric settlement, located about 30 miles east of Kirkuk. Five levels from the late Mesolithic period have been discovered here. In levels XV–VI stone vases, but no pottery, have been found, plus a variety of utensils in obsidian, stone, and bone, as well as cult images, fertility symbols made of unfired clay, and bones of domestic animals. Levels V–I, however, have yielded clay vases with red glaze, in addition to cult images and utensils. Houses with foundations partly of stone have also been found.

BIBLIOG. L. S. Braidwood, The Jarmo Flint and Obsidian Industry, Sumer, VII, 1951, pp. 105–06; R. J. Braidwood, Excavations in Iraqi Kurdistan, Sumer, VII, 1951, pp. 99–104; R. J. Braidwood, The Near East and the Foundations for Civilization, Eugene, Ore., 1953, pp. 26–31, figs. 14, 17, 19–22; R. J. Braidwood, The Iraq-Jarmo Project of the Oriental Institute of the University of Chicago, Sumer, X, 1954, pp. 120–38; R. J. Braidwood and B. Howe, Prehistoric Investigations in Iraqi Kurdistan, Chicago, 1960.

Karim Shahir. A settlement, dating from the dawn of the middle Mesolithic age, located about 1 mile west of Jarmo. Discoveries made here include stone utensils, beads, ornaments, rings, bone needles, clay figures, and bones of domestic animals.

BIBLIOG. R. J. Braidwood, From Cave to Village in Prehistoric Iraq, BAmSOR, CXXIV, 1951, pp. 12–18, figs. 1, 3, 4; R. J. Braidwood, Excavations in Iraqi Kurdistan, Sumer, VII, 1951, pp. 99–104; R. J. Braidwood, The Near East and the Foundations for Civilization, Eugene, Ore., 1953, p. 26, figs. 13, 16.

Hassuna. Site whose invaluable continuity of documentation for the late prehistoric epoch has cast light on the earliest chalcolithic period. The earliest level, Ia, is preceramic. In levels Ib–II, fragments of the archaic pottery named after Hassuna were found. Succeeding one another in the upper levels, although with interruptions, are the typical Hassuna, then Samarra, then Tell Halaf pottery, and, finally, pottery of the northern variety of al-'Ubaid type.

BIBLIOG. S. Lloyd and F. Safar, Tell Hassuna, JNES, IV, 1945, pp. 255–89.

Sadawa (anc. Kakzu, Qaṣr Shamamok). On this site, the Italian archaeological mission of 1933 headed by G. Furlani brought to light the ruins of a fortification wall from the time of Sennacherib, other unidentified ruins from the Assyrian epoch, and a Parthian cemetery containing interesting sarcophagi with ceramic decoration.

BIBLIOG. G. Furlani, Ausgrabungen: Kakzu, AfO, IX, 1933–34, pp. 74–75; G. Furlani, Gli scavi italiani in Assiria, Giornale della Soc. asiatica it., II, 1934, pp. 265–76; G. Furlani, Sarcofaghi partici di Kakzu, Iraq, I, 1934, pp. 90–94; G. Garbini, EAA, s.v. Kakzu IV, 1961, p. 290.

Nimrud (anc. Kalakh). From the 2d millennium B.C. there are only cylinder seals and impressions and a building from the time of Shalmaneser I (13th cent. B.C.). Ashurnasirpal II engaged in intensive construction activities in the early 9th century B.C., as attested by a ziggurat on the northern summit of the tell of Nimrud; a double temple of Bel and Ninurta with the splay of the door adorned with animal figures; a stele of Ashurnasirpal II (Br. Mus.); two temples of Ishtar, patroness of the country, from one of which came the well-known statue of Ashurnasirpal II (Br. Mus.); the northwestern palace, with two courtyards, figures of animals in the splay of the doorway, and orthostats with reliefs (genii with a sacred tree, hunting and battle scenes; I, PL. 515). The temple of Nabu, too, in the southwestern area, was begun by this king. In the latter half of the 9th century B.C., Shalmaneser III probably saw to the maintenance and completion of the structures his father had had built; animals decorating the splay of the doorway, bearing his inscription, prove the beginning of work on the central palace, near which was also discovered his Black Obelisk (IX, PL. 488; X, PL. 144). Dating from the time of Adadnirari III (early 8th cent. B.C.) are statues of deities in the temple of Nabu and the so-called "upper chambers." In the latter half of the 8th century, Tiglathpileser III had construction work done on the central palace. Its orthostats in relief were incorporated early in the 7th century B.C. into the southwestern palace of his grandson Esarhaddon. The restoration by Ashuretililani — one of the last Assyrian rulers of the late 7th century — of the temple of Nabu and the surrounding area, the so-

called "southeastern palace," shows that Nimrud continued to be used as a capital. Southeast of the outer city walls of Kalakh, near the present double hill of Tulul el-'Azar, Shalmaneser III erected Fort Shalmaneser in the late 9th century. This was a series of structures apparently used as a barracks and storehouse for arms, wine, and war booty up to the time of Kalakh's destruction in 612 B.C. The most significant discoveries made here are fragments of wall paintings and objects of ivory (PL. 237; I, PL. 526).

BIBLIOG. A. H. Layard, Nineveh and Its Remains, 2 vols., London, 1849; A. H. Layard, The Monuments of Nineveh, 2 vols., London, 1849–53; E. A. W. Budge, Assyrian Sculptures in the British Museum, I, London, 1914; C. J. Gadd, The Stones of Assyria, London, 1936; M. E. L. Mallowan, The Excavations at Nimrud (Kalhu), Iraq, XII, 1950, pp. 147–82, XIII, 1951, pp. 1–20, XIV, 1952, pp. 1–23, XV, 1953, pp. 1–42, XVI, 1954, pp. 59–163, XVIII, 1956, pp. 1–21, XIX, 1957, pp. 1–25, XX, 1958, pp. 101–08, XXI, 1959, pp. 93–157; R. D. Barnett, A Catalogue of the Nimrud Ivories in the British Museum, London, 1957; D. Oates, The Excavations at Nimrud (Kalhu), Iraq XXIII, 1961, pp. 1–14.

Grai Resh. Vestiges of the late chalcolithic period were discovered here, attesting the dissemination in northern Mesopotamia of the al-'Ubaid culture. Examples of pottery from the age of Uruk and ruins of a house from this same period have also been discovered.

BIBLIOG. S. Lloyd, Iraq Government Soundings at Sinjar, Iraq, VII, 1940, pp. 13–21.

Balawat (anc. Imgur-Enlil). The renowned chased bronze revetment that once adorned the doors of the temple of the Assyrian kings Ashurnasirpal II and Shalmaneser III was found here. It is made up of long bronze sheets, ca. 11 in. high, with reliefs depicting such deeds of Shalmaneser III as the campaign in Phoenicia, the conquest of upper Syria, and the expedition to the source of the Tigris (IX, PL. 490).

BIBLIOG. E. Unger, Zum Bronzetor von Balawat, Leipzig, 1913; L. W. King, Bronze-Reliefs from the Gates of Shalmaneser, London, 1915; M. E. L. Mallowan, 25 Years of Mesopotamian Discovery, London, 1956, pp. 79–80; E. Weidner, Ausgrabungen: Balawāt, AfO, XVIII, 1957, p. 180; G. Furlani, EAA, s.v. Balawāt, I, 1958, p. 964; R. D. Barnett, Assyrian Palace Reliefs and Their Influence on the Sculptures of Babylonia and Persia, London, 1960, pls. 137–73.

Mosul (al-Mausil). The richest city of all Iraq in Moslem monuments. Of the earliest congregational mosque, from the Ommiad period, there remain the minaret and library, now transformed into the sanctuary of Sheik al-Shatt. Better preserved are the great Mosque of Nūr al-Dīn (12th cent. of the Christian Era) with a mihrab richly decorated with arabesques and inscriptions, in the center of the city, and a minaret of the Jāmi' al-Kabir with decorative bands of brick (I, PL. 6). On the site of the third major mosque, that of Mujāhid, there now stands the sanctuary of Khidr Ilyās. Many other sanctuaries, among them those of Nabī Jirjis and nearby Nabī Yūnus, are the result of adaptations and transformations during the Islamic period of earlier Christian buildings. Also worthy of note are the Mausoleum of Imam Yahyā (A.D. 1240), with brick ornamentation and plinths of arabesqued alabaster; the Mausoleum of 'Aun al-Dīn, which is cubical, with pyramidal ornamentation like that of the tomb of Zubayda in Baghdad; and the Mausoleum of Panjāh 'Alī. Of special interest also are the ruins of the Sultan's palace (Qara Saray), from the 13th century, with stucco decoration in ornamental and figural calligraphic motifs.

In the modern period Mosul has become a mercantile city, stretching along the right bank of the Tigris. Pillaged and destroyed in 1400 by the Mongols of Tamerlane, it declined under the Ottoman Empire. It was occupied by English troops in 1918 and became part of the British mandate until Iraq's independence in 1932. Among the monumental ruins are part of the city walls (destroyed by the artillery of Nādir Shah in 1743), and the Ottoman Fortress of Bash Tabia (partially collapsed as a result of landslides). More recent are the Mosque of Nabī Shith, in Turkish style, the Dominican convent, the Latin Church, the Archaeological Museum, and the Palace of Justice.

BIBLIOG. G. Le Strange, The Lands of the Eastern Caliphate, Cambridge, 1905; J. M. Fiey, Mossoul chrétienne, Beirut, 1959.

Nineveh (Ninua, Νινευή, Tell Nabī Yūnus, mod. Quyunjiq or Kuyunjik). The site has yielded a type of incised gray monochrome pottery, followed in the stratigraphy by shards of Samarra and Tell Halaf pottery from the early chalcolithic era. The periods of al-'Ubaid and Uruk are likewise documented by the remains of their characteristic pottery. The beautiful pottery of Nineveh from level V is of the Jamdat Nasr-Mesilim transitional period, as are also the cylinder seals from level IV. A splendid bronze head, perhaps of Naram-Sin or Sargon (I, PL. 508), dates from the time of the Akkad

dynasty. Among the discoveries ascribed to the Middle Assyrian period are a mutilated statue of a woman bearing an inscription of Ashurbelkala (IX, PL. 487), and a badly damaged obelisk, perhaps of the same ruler. The monuments of the Neo-Assyrian period are poorly preserved because of the violent conflagration of 612 B.C. and the rudimentary excavation methods of the first archaeologists. The northern palace has been identified as the residence of Ashurbanipal, while the southwestern one, which has yielded fragments of wall paintings, was built by Sennacherib. Reliefs of hunting scenes and animal life in the British Museum come from Ashurbanipal's palace (IX, PL. 493), and many cuneiform tablets come from its celebrated library. At the center of the sacred hill are the scant remains of the temples of Ishtar and Nabu, as well as the palace of Ashurnasirpal II. On the nearby tell of Nabī Yūnus are the ruins of a palace of Esarhaddon.

BIBLIOG. A. H. Layard, Nineveh and Its Remains, 2 vols., London, 1849; A. H. Layard, The Monuments of Nineveh, 2 vols., London, 1849–53; R. Campbell Thompson and R. W. Hutchinson, A Century of Exploration at Nineveh, London, 1929; R. Campbell Thompson and R. W. Hutchinson, The Excavations on the Temple of Nabū at Nineveh, Archaeologia, LXXIX, 1929, pp. 103–48; R. Campbell Thompson and R. W. Hutchinson, The Site of the Palace of Ashurnasirpal at Nineveh, Ann. of Archaeol. and Anthr., XVIII, 1931, pp. 79–112; R. Campbell Thompson and R. W. Hamilton, The British Museum Excavations on the Temple of Ishtar at Nineveh, Ann. of Archaeol. and Anthr., XIX, 1932, pp. 55–116; R. Campbell Thompson and M. E. L. Mallowan, The British Museum Excavations at Nineveh, Ann. of Archaeol. and Anthr., XX, 1933, pp. 71–177; R. Campbell Thompson, The Buildings on Quyunjiq, the Larger Mound of Nineveh, Iraq, I, 1934, pp. 95–104; M. E. L. Mallowan, The Bronze Head of the Akkadian Period from Nineveh, Iraq, III, 1936, pp. 104–10; B. Meissner and D. Opitz, Studien zum Bīt Hilāni im Nordpalast Assurbanaplis zu Ninive, Berlin, 1940; Naji al Asil, Editorial Notes: The Assyrian Palace at Nebi Unis, Sumer, X, 1954, pp. 110–11.

Arpachiya. The tholos structures and the Samarra and Tell Halaf pottery found in the deepest levels of this site are evidences of the early chalcolithic period; these levels also yielded amulets, terra-cotta female statuettes, and stamp seals. Pottery of al-'Ubaid I type, from the middle chalcolithic period, was also found here.

BIBLIOG. M. E. L. Mallowan and J. C. Rose, Excavations at Tell Arpachiyah, Iraq, II, 1935, pp. 1–178.

Bawian (Bavian). Near this village, located in the Gomel valley about 35 miles northeast of Mosul, a few reliefs of Sennacherib, with figures of gods and images of the ruler, still remain, although they are badly deteriorated.

BIBLIOG. W. Bachmann, Felsreliefs in Assyrien: Bawian, Maltai und Gündük, Leipzig, 1927, pp. 1–22.

Tell Billa. A site documented as having been inhabited from the Jamdat Nasr to the Persian periods. Painted pottery, with geometric decoration, from the Jamdat Nasr period, pottery of the Nuzi type from the 2d millennium, and seals have been found. There are also vestiges of private houses from this period as well as religious structures from the Assyrian period.

BIBLIOG. E. A. Speiser and C. Bache, University of Pennsylvania Museum-Baghdad School Expedition at Billah, BAmSOR, XL, 1930, pp. 11–14; E. A. Speiser, The Excavation at Tell Billah, BAmSOR, XLI, 1931, pp. 19–24, XLII, 1931, pp. 12–13, XLIV, 1931, pp. 2–5, XLV, 1932, pp. 32–33, XLVI, 1932, pp. 1–9, XLIX, 1933, pp. 12–14, L, 1933, pp. 3–7, LI, 1933, pp. 20–22, LX, 1935, p. 17; E. A. Speiser, The Pottery of Tell Billa, Univ. of Pa. Mus. J., XXIII, 1932, pp. 249–308; C. Bache, The First Assyrian Level at Tell Billa, Univ. of Pa. Mus. J., XXIV, 1935, pp. 33–48.

Tepe Shenshi. Site about two-thirds of a mile south of Khorsabad. Excavations made here by an American expedition have brought to light the ruins of a settlement from the middle of the 3d millennium.

BIBLIOG. H. Frankfort, Iraq Excavations of the Oriental Institute, 1932–1933: 3d Preliminary Report of the Iraq Expedition (O. Inst. Comm., XVII), Chicago, 1934, pp. 89–91.

Khorsabad (anc. Dur Sharrukin). This is the capital which Sargon II of Assyria built for himself and which was dedicated shortly before his death in 705 B.C.; it was later abandoned by his successors. The area of the city was encircled by a wall with two gates on each side, except on the northwest, where the ruler's palace (I, FIG. 870) stood on a raised terrace with three entries opening onto a vast inner court, flanked by offices and service quarters. The king's apartments were farther to the northwest, grouped about a small courtyard, to the right of which was the great throne room. On the left flank of the residential group stood the characteristic ziggurat, in separate stories, perhaps with a continuous ramp. In

addition to the apartments of high officials, other noteworthy structures are the temple of Nabu, south of the palace, and the temple of the Sibitti. On the southwest flank is another palace, perhaps that of the crown prince, with a colonnaded portico which links one of the courtyards with the terrace. The stone reliefs, many of them now in the Louvre, that adorned the residence of Sargon II are especially remarkable (I, PL. 514; IX, PLS. 488–490; X. PL. 134).

BIBLIOG. P. E. Botta and E. Flandin, Monuments de Ninive, 5 vols., Paris, 1849–50; V. Place, Ninive et l'Assyrie, 3 vols., Paris, 1867–70; G. Loud, Khorsabad (Univ. of Chicago, O. Inst. Pub., XXXVIII, XL), 2 vols., Chicago, 1936–38; F. Safar, The Temple of Sibitti at Khorsabad, Sumer, XIII, 1957, pp. 219–21.

Tepe Gawra. Site near Mosul explored from 1931 to 1938 by an American expedition headed by E. A. Speiser. Although no written documents were found, the excavations produced considerable evidence of continuous occupancy of the site from the Neolithic age to the middle of the 2d millennium B.C. The early chalcolithic period is represented by Tell Halaf pottery found in two areas outside the tepe; in one case six levels of it were found. On Tepe Gawra itself, the oldest level, XX, dating from the middle chalcolithic period, is characterized by al-'Ubaid pottery, which predominates in the succeeding levels up to level XII. The architecture of the al-'Ubaid period is documented in levels XIX–XVIII by irregular rectangular structures and in level XVII by tholoi; some of these structures may have been temples. Stamp seals, seal impressions, and terracotta figurines were also found. The al-'Ubaid period II culminates in level XIII with a temple which has walls with recesses and deep niches, and which doubtless formed part of a larger sanctuary; this layer also contained pottery, stamp seals, and terra-cotta figurines. Levels XIa–X have yielded pottery of the Uruk type, stamp seals, animal figurines, and tholos structures, including a large tholos with several rooms in level XIa. Level IX, which has the same type of pottery and a temple with three aisles, is definitely contemporaneous with the period of Uruk VI–IV. Similar temples found in level VIII were evidently long in use. Level VII has yielded stamp and cylinder seals, several of which are from the Jamdat Naṣr-Mesilim transitional period, and level VI has principally yielded cylinder seals from the age of Akkad. Levels V and IV contain buildings on stone foundations; one of these characteristic structures is unmistakably a temple. The last three levels date from the 2d millennium and have furnished typical Nuzi pottery.

BIBLIOG. E. A. Speiser and A. J. Tobler, Excavations at Tepe Gawra, 2 vols., Philadelphia, 1935–50.

Jerwan. Investigations conducted here by T. Jacobsen and S. Lloyd have revealed as the work of Sennacherib a stone aqueduct over 900 ft. long and 70 ft. wide and about 30 ft. high.

BIBLIOG. T. Jacobsen and S. Lloyd, Sennacherib's Aqueduct at Jerwan (Univ. of Chicago, O. Inst. Pub., XXIV), Chicago, 1935.

Baradost. Site where specimens of Hassuna, al-'Ubaid, and Uruk pottery have been found.

BIBLIOG. F. Safar, Pottery from Caves of Baradost, Sumer, VI, 1950, pp. 118–23; R. S. Solecki, Notes on a Brief Archaeological Reconnaissance of Cave Sites in the Rowanduz District of Iraq, Sumer, VIII, 1952, pp. 37–48.

Shiri Maliktha (Shiro Melektha). Preserved here is a rock relief depicting an Assyrian sovereign in prayer before divine symbols.

BIBLIOG. A. Shukri, Rock Sculptures in the Mountains of North Iraq (in Ar.), Sumer, X, 1954, pp. 86–93, pl. 7; O. Krückmann, Felsreliefs im nördlichen Iraq, AfO, XVII, 1956, p. 426.

Maltay. On the rocky surface of a mountain near this site there are rock reliefs from the time of Sennacherib representing the king paying homage to a number of gods shown in procession. One of the reliefs has been removed and is now in a museum in Baghdad.

BIBLIOG. W. Bachmann, Felsreliefs in Assyrien: Bawian, Maltai und Gündük, Leipzig, 1927, pp. 23–27.

Mila Mergi (Millet Mirji). A rock relief, depicting a Neo-Assyrian sovereign and bearing an inscription, has been preserved here.

BIBLIOG. A. Shukri, Rock Sculptures in the Mountains of North Iraq (in Ar.), Sumer, X, 1954, pp. 86–93; O. Krückmann, Felsreliefs im nördlichen Iraq, AfO, XVII, 1956, p. 426.

Anton MOORTGAT

The information on Islamic art centers was prepared by Francesco Gabrieli.

Illustrations: 7 figs. in text.

IRELAND. This island nation, lying to the west of Great Britain, was known to the Greeks as "Ierne" and to the Romans as "Hibernia" or "Scotia," while its own Celtic-speaking inhabitants have called it "Éire" (mod. Irish) or "Ériu" (early Irish). Although its geographical position on the edge of European civilization has favored conservatism and a certain originality, its cultural and artistic development has also been affected by links with the neighboring larger island (see GREAT BRITAIN). Numerous contacts with the neolithic peoples and the culture of Atlantic Europe existed even in the 3d and 2d millenniums B.C. In the 1st millennium B.C. the land was occupied by Celtic-speaking peoples. Since Ireland, unlike Britain, was not brought within the Roman Empire, Celtic culture persisted into medieval times. Missionaries from Gaul and Britain evangelized the island in the 5th century, bringing the knowledge and use of letters and the rudiments of Roman and Christian civilization. There followed a great flowering of monastic culture and an expansion of Irish Christianity; missionaries went to Scotland, Anglo-Saxon England, Gaul, Switzerland, Germany, Austria, and northern Italy in the 6th to 8th centuries. In the following centuries Ireland suffered much from the attacks of vikings, who came chiefly from western Norway. The Norse harbor settlements became the first cities and towns in the country. In 1169 Ireland was invaded by the Anglo-Normans in an effort to bring it under the English crown; by the end of the 16th century most of the country had been subdued after centuries of warfare, and there was a consequent diffusion of English culture and artistic principles. By this date the struggle between the Irish and English had become largely a religious one, since Ireland had remained predominantly Catholic. The struggle persisted until 1920–21, when the island was partitioned. Six counties (Northern Ireland) have remained under English rule, and the other twenty-six (Éire) have achieved independence, first within the British Commonwealth, and subsequently as an independent republic. (See also ANGLO-SAXON AND IRISH ART.)

SUMMARY. Cultural and artistic periods (col. 310): *Prehistory and protohistory. Celtic Christianity and the vikings: a. Manuscript illumination; b. Sculpture; c. Metalwork; d. Architecture. The Romanesque period. The late Middle Ages. From the Renaissance to modern times.* Art centers (col. 321).

CULTURAL AND ARTISTIC PERIODS. *Prehistory and protohistory.* The neolithic colonists of Ireland left an impressive series of megalithic tombs, of which about two thousand are still to be seen. The tombs are of three major classes, known as "court cairns," "passage graves," and "wedge-shaped galleries." The earliest group, the court cairns, includes many fine specimens. A roofed gallery of massive stones, divided into segments and entered from an open court, is characteristic of this group. The whole tomb is set in a long mound of stones — some of the mounds exceed 150 ft. in length. Court cairns are found chiefly in the northern half of Ireland; two of the finest examples are in County Sligo at Deerpark (or Magheraghanrush) and at Creevykeel.

The passage graves, grouped in cemeteries sited on hilltops, are the most important class for the history of Irish prehistoric art. They date from late Neolithic and possibly early Bronze Age times (ca. 2.000 B.C.). Of Mediterranean type, they consist of a chamber and an entrance passage constructed of great blocks of stone, the whole covered by a round mound. Irish tombs of this class, although closely related to similar tombs in the Breton peninsula, have some distinctive features, principally the frequent use of a cruciform plan in the chamber. Often the surfaces of the stones are dressed with a hammer, and in some of the cemeteries the stones are covered with a profusion of ornament; various abstract or geometric motifs (spirals, chevrons, lozenges, concentric circles, meanders, and other linear patterns) are pecked into the surface, probably with stone mauls. The general effect is often dramatic and striking, since the patterns may appear on the stone curb which retains the mound, on the orthostats of the passage and chamber, and on lintels and roof stones. With the exception of the spiral, which is characteristically Irish, the motifs are comparable to those carved on Breton passage graves and to those found on schist idols and other objects in Spanish passage graves. The larger tombs particularly achieve very impressive architectural effects, especially where the linteled passage is long and the corbel-domed roof of the chamber remains. The principal centers are Carrowmore (Co. Sligo), where there is a cemetery without ornament; Loughcrew (Co. Meath); and

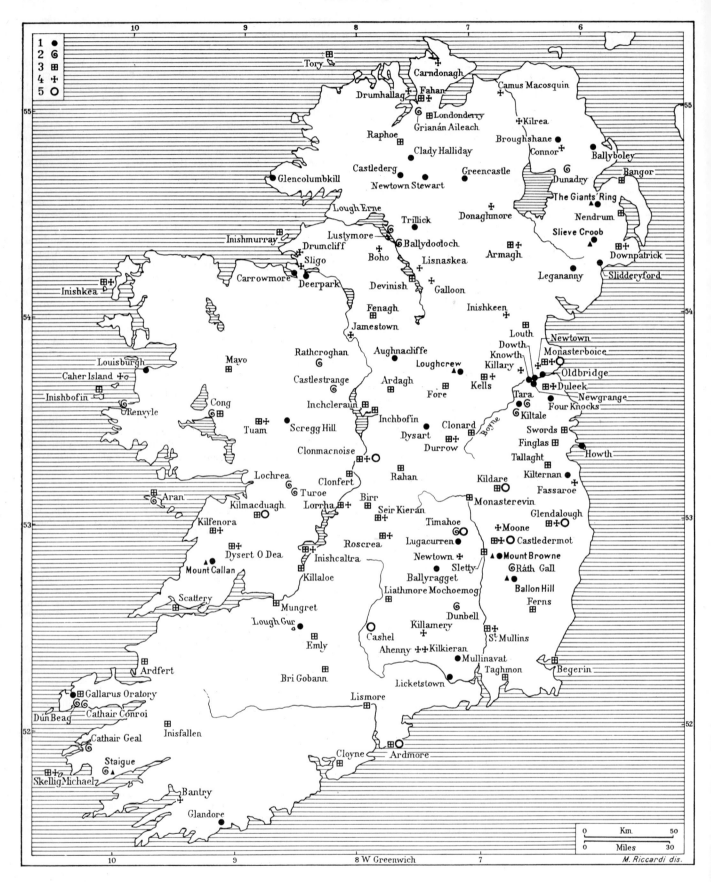

Ireland, principal sites and towns from the Neolithic period to the 12th cent. (modern national boundaries not shown). *Key*: (1) Archaeological sites and monuments of the Neolithic and Bronze ages; (2) archaeological sites and monuments of the Iron Age. Medieval monuments of the 7th–12th cent.: (3) Monasteries; (4) monumental stones and crosses; (5) round towers.

the Boyne Valley east of Slane (Co. Meath). The huge and richly ornamented tomb at Newgrange in the Boyne group is one of the most splendid megalithic tombs in western Europe. Some fine specimens of megalithic art may be seen also at Fourknocks (Co. Dublin), an excavated tomb which is an outlying example of the Boyne group. The wedge-shaped galleries, which date from the beginning of the Bronze Age, are the latest group; they are much smaller, and their interest is chiefly archaeological.

Ireland became an important metalworking center at the beginning of the Bronze Age, exporting metal objects to Britain and northern Europe. The so-called "lunulae," exported to France and the Baltic areas at this time, are the earliest examples of objects of display in Irish gold. They are crescent-shaped objects in sheet gold intended to be worn on the neck or breast. The moon-shaped panel has incised patterns of chevrons and lozenges, usually distributed with restraint in a balanced composition of ornament. The chief collection of these and other examples in bronze and gold of the abstract and decorative arts of the early Bronze Age belongs to the Royal Irish Academy and is housed in the National Museum of Ireland (Dublin).

This same collection also includes many magnificent specimens of the goldsmith's art from later Bronze Age times. Torques and circlets made of twisted ribbons or bars of gold, and large enough to be worn around the neck, or even in some cases around the waist, range in date from early Bronze Age to early Iron Age times. So-called "sun disks" of sheet gold, with incised ornamental patterns, were made both in early and late Bronze Age times, but with different patterns. Gold earrings, pins, rings, and bracelets occur in such numbers as to show that prehistoric Ireland, like Mycenae (which, indeed, provides parallels for some of the objects), was "rich in gold." The most distinctive group of objects is that of the gold gorgets, massive collars, more or less in crescent form like the lunulae, but ornamented with repoussé moldings that are alternately plain and decorated. At the terminals are large disk-shaped plates with ornaments of concentric circles, conical bosses, and the like. All these come from a limited area in southwestern Ireland.

In Ireland a version of the La Tène style appears in the early Iron Age and persists through the Roman period. Among its earliest manifestations are carved stone monuments, presumably of ritual or religious significance; one or two survive in the west, the most perfect at Turoe (Co. Galway) and at Castlestrange (Co. Roscommon). Both are large, rounded, omphaloslike stones carved on the curved surface with flowing curvilinear designs that — on the Turoe stone at least — seem to be related to the Continental Waldalgesheim style, although the carvings cannot be precisely paralleled in stone monuments outside Ireland. There are also some barbaric human representations in stone, which seem to be of Iron Age date; these are found chiefly in the north, notably on Lustymore Island in Lough Erne (Co. Fermanagh) and in a group near Armagh.

The art of the Iron Age, however, is chiefly represented by fine metalwork. The objects of display and luxury which survive from this period, although not numerous, are of high quality; they possess special importance for the history of Irish art, since the origins of the later Christian art styles can be traced in part to them. The principal collections of Irish art of this period are those of the National Museum in Dublin, the Belfast Museum and Art Gallery, the Cork Public Museum, and the British Museum in London. There is some goldwork — notably the collar from Broighter (Co. Derry) — but bronze is the predominant medium of this age. The objects include engraved scabbards, cups and bowls, trumpets, fibulas, horse trappings, and a series of large bronze disks or dishes of unknown purpose with repoussé ornament. Included in one small group of these bronzes are two sets of horns (perhaps from horned helmets) and a convex bronze disk, all masterpieces of bronze-working technique. These have a fine relief ornament composed of elegant and balanced patterns of spirals, with trumpet-shaped and ornithomorphic terminals, produced by graving and channeling the surface of the bronze. The "trumpet pattern," which also appears in cast and repoussé work, is one of the basic motifs of the art of early historic times.

Celtic Christianity and the vikings. Ireland made its most original contributions to art during the period from the coming of the first Christian mission until the height of the viking wars (5th–10th cent.); particular distinction was achieved in the fields of manuscript illumination, stone carving, and metalwork. Owing to the establishment of an Irish kingdom in western Scotland, to the expansion of Irish Christianity from the 6th century onward, and to the carrying-off by the vikings of much booty from Ireland to their homeland, some of the centers important for the study of Early Christian Irish art are outside Ireland.

a. Manuscript illumination. The use of writing in Ireland became established in the 5th century simultaneously with Christianity. The barbarian invasions of the Roman Empire at the same period caused the young Irish Church, for a time, to develop more or less in isolation; its monastic culture blended Roman and Celtic traditions with those Germanic traditions which were acquired to some extent through contacts with Britain and the Continent. Irish monks, copying sacred texts, developed a distinctive and beautiful script in the Celtic half-uncial, the earliest example of which may be seen in the Cathach of St. Columba (I, PL. 284), a fragmentary manuscript of the Psalms. This manuscript, dating from the end of the 6th century, is in the library of the Royal Irish Academy in Dublin. Here can be seen the very beginnings of Irish manuscript ornament, characterized by the initial letters, which are enlarged and embellished with simple designs in vermilion, and by the subsequent letters, which diminish in size as they lead from the initial into the main text. From the surviving manuscripts, this tendency can be traced through the 7th and 8th centuries until an initial (especially the Chi-Rho monogram of Christ) may fill a whole page (I, FIG. 452; PL. 281). It was also in the 7th century that the custom began of devoting a whole page to ornament ("carpet pages"), to an illustration, or to the representation of the symbol of an Evangelist (I, PLS. 282, 283).

The most important center for the study of Irish illumination is the library of Trinity College, Dublin; other important centers are the Cathedral Library at Durham in northern England, the British Museum, the Stiftsbibliothek at Saint-Gallen in Switzerland, and the Biblioteca Ambrosiana in Milan. Single manuscripts can be seen in many other libraries.

Durham Cathedral Library houses a fragment, only a few pages (Ms. A.II.10), of the earliest-known fully illuminated Gospel book of this group (I, PL. 284). Its date is early in the 7th century, and its chief interest is the first appearance of a motif that was to become a standard feature of Irish ornament, ribbon interlace — in this case a plait of broad bands with its contours picked out in a contrasting color. Another fragmentary Gospel book of the early 8th century (Ms. A.II.17) shows the developed repertory of Irish (or Hiberno-Saxon) ornament. It contains a somewhat faded page devoted to a representation of the Crucifixion, as well as some enlarged initials with skillfully designed ornament of trumpet patterns and animal interlace. The British Museum contains the Lindisfarne Gospels (Cotton Nero D.IV; I, PLS. 280, 282), a sumptuously ornamented manuscript written toward the close of the 7th century by an Anglo-Saxon in the Irish foundation of Lindisfarne. The library at Saint-Gallen, another Irish foundation, also contains fragments of a number of manuscripts (I, PL. 282) written and illuminated in the Irish style. Some of the surviving manuscripts from the Irish monastery of Bobbio, which were housed in the Biblioteca Ambrosiana in Milan, suffered damage or destruction in a fire at the beginning of the 20th century, but material of interest still remains (I, PL. 283).

Among the treasures of Trinity College Library is the Book of Durrow [Ms. 57 (A.IV.5); I, PLS. 283, 284; I, FIGS. 449, 451]; named from the monastery in County Offaly where it originated, it is a Gospel book written shortly after the middle of the 7th century. It is the earliest work to show the full repertory of motifs in the Irish "vernacular style" of the early Christian centuries. Its carpet pages are of particular interest: Celtic motifs (spirals and trumpet patterns), Anglo-Saxon motifs (ribbon animals), and Mediterranean motifs (ribbon interlacing) are present in various combinations, which are not blended together but are kept in separate panels. A page is devoted to the symbol of each Evangelist, and on these, as on the abstract ornament, the influence of metalworking designs is perceptible; one of the carpet pages in particular is like a full revival of the richness and elegance of the best La Tène art. The great treasure of Trinity Library, however, is the Book of Kells [Ms. 58 (A.I.6)], named from the monastery in County Meath. This Gospel book of the beginning of the 9th century is a large manuscript, profusely ornamented on every page. Painted with hard, clear colors glowing with the richness of enamels, it is an incomparable and mysterious work. Its art is so deeply devoted to perfection in miniature that, although the general appearance is most impressive, the microscopic fullness of detail seems designed, not to please the eye of the beholder, incapable of comprehending it, but rather to please the mind of the artist, or God. There are elaborate carpet pages, pages devoted to the symbols of the Four Evangelists, full-page illustrations of the text (I, PL. 283), enlarged and elaborated initials, and many interlinear drawings and ornaments. The Chi-Rho monogram (I, PL. 281), which receives a page to itself, is a fantastic compendium of abstract motifs of early Irish art: spirals and trumpet patterns whirling within spirals and trumpet patterns; minute interlacings and frets; faces, animals, and figures of angels tucked into corners of the design. The Book of Kells is one of the most remarkable monuments of western Christian art. Other less elaborate manuscripts, including the Book of Dimma and the Book of Armagh, are also housed in Trinity Library.

b. Sculpture. The chief surviving monuments of early Irish monasticism are not the churches (small structures usually of wood,

which have long since vanished) but the carved stone crosses. This peculiarly Insular development is also found in Britain. The distinctive Irish form is a ringed cross, its arms projecting beyond the open ring and its shaft standing on a pyramidal or subconical base. The surfaces of both cross and base were usually carved with ornament or representations in relief.

The earliest group of Irish high crosses, which dates from the late 7th century, is on the Inishowen peninsula (Co. Donegal). The most important monuments of the group are at Carndonagh, where there is a slablike cross (without a ring) carved with interlace and other patterns, as well as with some human figures, in a style close to that of the Book of Durrow.

At several small monastic sites in the southern midlands there are more monumental crosses of an important 8th-century group. The best centers are Ahenny (Co. Tipperary) and Kilkieran (Co. Kilkenny), places which are only two miles apart. The crosses here are of architectural scale and proportions. The characteristic form has a large open ring set in a rather low position on a shaft that tapers gradually toward the top. Some of the massive bases have carvings of figured scenes depicting hunting parties, animals and birds, a funeral, or ecclesiastics holding pastoral staves. In the Ahenny-Kilkieran group the h∷ad, shaft, and ring are characteristically carved in a bold and extremely effective relief; patterns which are derived directly from metalwork are employed, and despite their drastic change of scale, they remain surprisingly successful in translation. There are bold ornamented bosses as well as panels of trumpet spirals, interlace, and fret patterns. Since the monuments are carved in a hard sandstone, the relief is still bold and clear in spite of centuries of exposure. A somewhat later group, of the 9th century, which is located in the valley of the River Barrow, shows the development in figure carving. Castledermot and Moone, which are a few miles apart in County Kildare, are the chief centers. The Barrow Valley crosses, which are carved in a somewhat coarse-grained granite (an intractable medium for the purpose), possess a distinctive style of their own. The ringed head is a characteristic feature of this group. On its broader faces the shaft of the cross normally has series of panels of figure sculpture which depict Biblical scenes. The commonest subjects in the group are Daniel in the Lions' Den, the Sacrifice of Abraham, the Three Children in the Fiery Furnace, the Miracle of the Loaves and Fishes, and the Crucifixion. Panels depicting the Twelve Apostles also recur. The taller of the two crosses at Moone is the most impressive of the group; it possesses an unusually tall, tapering base on which the figure carving is (atypically) concentrated. The simplification and stylization of the figures, which are carved in a low relief on two planes, produce a curious effect. The panel of the Twelve Apostles in particular is remarkable: the heads are simple ovoids with circular eyes, and the bodies are perfect squares below which out-turned feet protrude; the whole panel produces an appearance of abstract geometry rather than of human life. The shaft of this cross is occupied by panels depicting animals (largely fabulous) from the bestiaries, together with some panels of ornament.

Many of the 8th- and 9th-century crosses seem to be experiments directed toward a successful blending of the various elements of the design. The satisfactory solution, achieved about the beginning of the 10th century, is represented by examples at a number of monastic sites in the midlands; those of particular importance are at Kells (Co. Meath), Clonmacnoise (Co. Offaly), and Monasterboice (Co. Louth). At Kells there are remains of five crosses: the Cross of Patrick and Columba (named from a Latin inscription on its base), from the beginning of the 9th century, has a shaft that is still largely devoted to ornament but bears the beginnings of figure carving; the west cross, a fragment consisting of about half the shaft, is of the fully developed, early 10th-century type; the base of another cross, probably of the 9th century; the east cross, probably of the late 10th century, on which the sculptor's preliminary methods may be studied, because the carving is unfinished; and the market cross, which is typical of the midlands, early 10th-century group. Clonmacnoise is probably the most important center of early Irish stone carving; in addition to the crosses, there are a number of grave slabs. The south cross here, a handsome monument, is of the 9th-century transitional type, which is characterized by some figure carving on the shaft. The west cross, or Cross of the Scriptures (early 10th cent.), has the fully developed scheme, displaying a ringed head with the Crucifixion depicted on its west side and the Last Judgment on its east side; the shaft below is divided into rectangular panels with figured scenes and the base is carved with friezes showing mounted warriors, chariots, birds, and animals. There are also parts of the shafts of other 9th-century crosses and of a 12th-century cross. Minor but very accomplished manifestations of the stonecarver's art are about five hundred inscribed gravestones of the Early Christian period at Clonmacnoise. Some are whole and some fragmentary. Most of the inscriptions are in Irish, with a few in Latin, and the script is in the style of the manuscripts. Many of the slabs also display ornamental or cruciform

patterns in a graphic low relief which, again, is most closely paralleled in the manuscripts. In the west midlands — at Gallen (Co. Offaly), Durrow (Co. Offaly), and on Inishcaltra, an island in Lough Derg (Co. Clare) — there are other important groups of these early grave slabs. The slabs are often elegant and distinguished works of design. Monasterboice (Co. Louth) has the two finest high crosses, which date from that period during the 10th century when the form reached its peak of development. The more perfect of the two is the Cross of Muiredach, named for the abbot who had it carved. This monumentally tall sculptured cross dominates the graveyard. The sandstone head, shaft, and base are carved in high relief in a strict scheme of iconography and ornament. On the east face of the head is the most elaborate depiction of the Last Judgment in the whole series. Christ appears in the Osiris attitude of majesty, with crossed scepter and cross. On His right are the saved, led by a group playing musical instruments, and on His left are the damned, being driven away by a demon bearing a trident. Below is shown the weighing of souls. On the west face of the head is depicted the Crucifixion: Christ on the Cross, with two angels supporting His head, and the lance- and sponge-bearers. Each of the main faces of the shaft below these carvings is divided into three panels with figured scenes, including the fall of man and the murder of Abel. The weathered carvings of the base are the usual hunting scenes and the like. The west cross at Monasterboice, nearly 20 ft. high, has similar panels, more numerous but more severely weathered. There is a third cross carved with only a Crucifixion and a roundel of spirals on the two faces of the head.

Later crosses, which usually occur singly at various sites in the northern parts of Ireland, show a slow decline until a new and typically Romanesque form of cross appeared in the 12th century.

c. Metalwork. The great center for the study of Early Christian Irish metalworking is the National Museum of Ireland, which houses the rich collection of the Royal Irish Academy as well as other specimens. There are also important collections in the British Museum and in the National Museum of Antiquities of Scotland in Edinburgh. Many examples of the precious metalwork carried off by the vikings have been recovered from their graves in western Norway and may be seen in the museums of Oslo, Stavanger, Trondheim, and Copenhagen. The series begins with secular objects dating approximately from the introduction of Christianity into Ireland. Pins, brooches, and dress fasteners at first show Roman influences in their form but rapidly become assimilated to Irish taste and techniques. The commonest early form of brooch was penannular, its expanded terminals ornamented in enamel or millefiori glass. Various simpler forms of pins were also produced, often with cast bronze heads showing patterns in reserve bronze and red champlevé enamel. From about the beginning of the 7th century small reliquaries were being made for the monastic churches. These small caskets, usually of yew sheathed with tinned or silvered bronze, are ornamented with punched or engraved work and with medallions of enamels or of interlaced patterns in gilt relief casting. There are a few of these simple but beautiful objects in the National Museum in Dublin; but as a result of the depredations of the Scandinavian raiders, many of the most interesting examples or fragments are to be seen in the viking grave material in Norway. There are also two fine examples in Edinburgh. Toward the end of the 7th century great elaboration and skill characterized the Irish metalworking, partly as a result of new techniques such as polychrome enameling, gold filigree working, low-relief casting in imitation of chip-carving technique, and the manufacture of elaborate glass studs with silver inlays. The three chief triumphs of this phase of style may be seen in the National Museum. These are the Tara Brooch (from Bettystown, Co. Meath; I, PL. 289), the Ardagh Chalice (I, PL. 285), and the Moylough belt-shrine (IV, PL. 407). These marvels of metalworking art and skill, particularly the brooch and chalice, in the perfection of their fine work rival the minute intricacies of the manuscript painters. The chalice, a heavy two-handled vessel of silver alloyed with bronze, is a major work of art, restrained in the disposition of its ornament but extraordinarily rich in detail in its ornamental panels and mountings, both in the number and elaboration of the techniques employed and in the masterly handling of the motifs (interlacings, animal patterns, frets, and spiral patterns).

This period (ca. A.D. 700) marks a peak in the development of Irish metalworking. A further peak appears in the early 12th century with a different style, though one employing basically the same kinds of motifs. A more or less continuous stream of objects spans the centuries between, including several groups of large elaborate brooches, a large group of crosier, or staff, shrines, and a large group of book shrines. The most splendid among the 12th-century works is the processional Cross of Cong, a great bronze reliquary made to house a relic of the True Cross. This is in cast bronze with openwork panels of animal interlace, settings of glass and enamel, and panels of filigree; a great, ornamented animal's head, cast in the round,

grips the foot of the shaft. This and most of the other major works may be seen in the National Museum in Dublin.

d. Architecture. Early Irish buildings, including the earliest churches, were of wood, and none has survived. Stone buildings seem gradually to have become more common in the 10th–12th centuries. Because of the cenobitic nature of Irish monasticism, the churches were small and simple; when serving a large community, they were multiplied in number rather than increased in size. For centuries ornament was concentrated on the high crosses rather than on the churches. The chief interest of these little buildings is that, unlike most early churches elsewhere, they were not at first influenced by Roman traditions of building. A fine example of the simplest type of stone oratory, corbel-built virtually without mortar and rather similar in shape to an upturned boat, still stands at Gallerus (Co. Kerry). The most remarkable site is an intact Irish monastery, probably of the 7th century, which stands high on Skellig Michael (Scelig Mhichil), a rock in the Atlantic Ocean 10 miles from Cahirciveen (Co. Kerry). Six small, beehive-shaped huts (the cells of the monks) share a long narrow enclosure with two oratories, some roughly shaped crosses, and a small graveyard with simple slabs. A similar site, also in the Atlantic but less perfectly preserved, is on the island of Inishmurray in Sligo Bay. The succeeding type of mortar-built church was generally a simple, small, wooden-roofed structure. Single-celled and built of massive masonry, they have projections (antae) of the side walls at the gable ends and a trabeated west doorway, the jambs of which are inclined inward toward the top. Sometimes a cross is carved or incised on the lintel, or a simple architrave may frame the doorway. More rarely the church has a steep stone roof built on the corbel principle; often the roof is supported by a propping arch inside, which also provides a croft, or roof chamber. An example of this type of roof may be seen at Kells in a building which probably dates from the beginning of the 9th century. The best center for examples of early stone churches, however, is Glendalough (Co. Wicklow), where, among others there are ruins of the principal early monasteries. St. Kevin's Church here is a very fine example of the stone-roofed type. At Killaloe (Co. Clare) may be seen two stone-roofed churches as well as other monastic stonework.

The first works of a truly architectural character in the monasteries — and a most distinctive feature of the Irish landscape — are the round towers, which served as bell towers and places of refuge for the monks. These tall, slender, tapering buildings have conical stone roofs, doorways high above the ground, and a single window for each floor, with four, six, or eight windows at the top, or bell loft. The floors were of wood, approached by ladders, and the bell rung from the top was a small hand bell. These elegant buildings range in date from the late 9th to the late 12th century; they probably owe their original inspiration to Italian belfries. Fine examples may be seen at Clonmacnoise, Glendalough, Cashel (Co. Tipperary), Ardmore (Co. Waterford), and Kilmacduagh (Co. Galway).

The Romanesque period. Elaborate ornament was first applied to Irish churches in the early 12th century, but while the early Irish monastic system persisted, the churches themselves remained structurally simple and small. On the Rock of Cashel, an ancient royal seat in County Tipperary, Cormac MacCarthy (Mac Carthaigh), King of Munster, built a church (1127–34) which is known as "Cormac's Chapel." A conscious effort to introduce the Romanesque style to Ireland, this church remains one of the most interesting in the country. The building, which consists of a rectangular nave and a small square chancel with square towers at the junction of the two, is quite small but elaborately constructed and ornamented. There is a great north porch, gabled and carved with chevrons, animal heads, and other features; both the inner and the outer doorways of the porch are recessed in orders. There is also a south doorway with carved ornament and a third ornamented doorway leading from the interior of the church into the north tower. The chancel arch is elaborately carved in four orders and has a ring of human masks around its outer arch. Blind arcading ornaments both the interior and exterior of the walls, and there is a corbel table of grotesque animal heads. The church has stone roofs with crofts over both nave and chancel; over the nave the roof is supported on a barrel vault, over the chancel on a rib vault. Traces of frescoes remain on the walls and vault of the chancel. Cashel has two other 12th-century monuments: a sarcophagus and a high cross of the distinctive late type without a ring; carved on one side of the cross is a large figure of Christ crucified, and on the other side is a large figure of a bishop. The sarcophagus, with a relief carving of animal ornament in the late Irish version of the Scandinavian Urnes animal style, is very similar in detail and probably near in date to the Cross of Cong.

At Cashel the imported Romanesque style was assimilated into the Irish sculptural tradition, losing its architectural character to become simply a medium of decoration on the doorways, chancel arches, and windows of churches, which remained small in scale and simple in design and structure. The Norman Romanesque chevron, eagerly adapted and elaborated, combines with animal interlace and other native motifs and with human and animal heads in a blended Hiberno-Romanesque ornament. Bases recede to no more than the thickness of the column above. Capitals are reduced to square blocks carved in low relief, which could be treated as a running frieze from order to order. Architectural features are generally suppressed in favor of surface ornament. Remarkably vivid and graphic effects could sometimes be produced by this fine web of ornament in sandstone. There is extremely interesting Irish Romanesque work at Clonmacnoise, the site of several ornamented churches, notably the Nun's Church, which is some distance from the main monastery.

Other centers of interest for the study of Irish Romanesque architecture are Glendalough (Co. Wicklow), Killaloe (Co. Clare), Ardfert (Co. Kerry), Rahan (Co. Offaly), and Kilmore (Co. Cavan). The late Romanesque church at Tuam (Co. Galway) displays extreme elaboration of ornament on its chancel arch and three-light east window, the latter a feature unique in Irish Romanesque. In the same town there are also remains of two mid-12th-century high crosses, elaborately carved in relief with animal ornament. A further conjunction of late cross and Romanesque doorway (ca. 1150) may be seen at Dysert O Dea (Co. Clare). Not far away in the same county is a remarkable group of 11th- and 12th-century high crosses with rich animal ornament and carvings of the Crucifixion and of bishops and abbots. Probably the most characteristically Irish Romanesque works are the doorways at Killeshin (Co. Leix) and Clonfert (Co. Galway), which are crowned with steep-sided pediments and treated with great elaboration of surface ornament. At Killeshin the fine, linear ornament is carved in the lowest relief; at Clonfert, where the doorway recedes in seven orders, the profusion of carving in bold relief gives an effect at once barbaric and splendid and masterly.

The late Middle Ages. The Anglo-Norman invasion makes a sharp break in the tradition of Irish art, although it was not the sole cause of the break. The monastic system was already disintegrating as the result of reform movements within the Church, and ancient Celtic traditions were being overshadowed by Continental fashions. For the next few centuries only architecture and sculpture left remains (mostly ruins) worthy of study, and these no longer have so distinctively Irish a flavor.

The buildings of the Cistercians, the first of the Continental religious orders to be firmly established in Ireland, are of some interest. The most important was their first foundation, Mellifont (Co. Louth), founded by representatives from Clairvaux in 1142 and completed in 1157. This abbey was destroyed by fire in the 13th century, rebuilt, almost totally destroyed again after the Reformation, and later almost completely buried by a landslide. The site was excavated for the Office of Public Works in 1945–55, and the foundations of two successive abbeys can now be studied. The remains show a typical Cistercian plan, with some Irish features in those carvings which remain. Extremely beautiful carving in the Irish Transitional style remains in the elegant arcaded octagonal lavabo which was added to the cloister garth about 1200. Part of the simple but beautiful cloister arcade, the arches of which spring from paired columns, was found in collapse and has been reerected in position. The other principal Cistercian sites — Baltinglass (Co. Wicklow), Boyle (Co. Roscommon), Kilcooly and Holycross (Co. Tipperary), and Jerpoint Abbey (Co. Kilkenny) — are all impressive ruins, with the carving in particular showing a blend of Irish with French or English traditions. Most have 15th-century cloister arcades of an Irish type with twin columns connected by a web of stone; most also have at the crossing a distinctively Cistercian squat square tower, added in the 15th century when the abbeys were fortified. At Boyle, as at such fine non-Cistercian houses in the west as that of the Canons Regular (Augustinian Canons) at Cong (Co. Mayo), are fine specimens of Irish Transitional work of the early 13th century, characterized by delicate foliage carving, sometimes with human or animal figures, and showing western French influence. At Kilcooly and Holycross there are numerous examples of 15th- and 16th-century sculpture, chiefly altars or altar tombs, which are treated with Gothic arcades occupied by figures of the Twelve Apostles and other saints, rather squat in proportion but lively in delineation. A fine collection of similar carvings may be seen in the 13th-century cathedral on the Rock of Cashel.

In the 13th century the Anglo-Normans built cathedral churches in the Early English style; however, in comparison with English work, these were small in scale. The most notable examples are at Cashel, Kilkenny, Kildare, and Ferns. Stone, and perhaps complete carvings, were imported from Britain for some of these. Perhaps more interesting is the somewhat later work in the east and southeast (the areas most intensely settled by the invaders), which has a more

local character; the parish churches of New Ross (Co. Wexford) and Gowran and Callan (Co. Kilkenny), where there is much Hiberno-Norman work of the 13th–15th centuries, are noteworthy, as is the fine series of life-size figure sculpture (ca. 1300) in the graveyard of the modern Church of Ireland Cathedral at Cashel. It is in military architecture, however, that the invaders first left their mark on the Irish countryside, again in a simple extension to Ireland of an English or Welsh style, though a local type of castle, characterized by a great

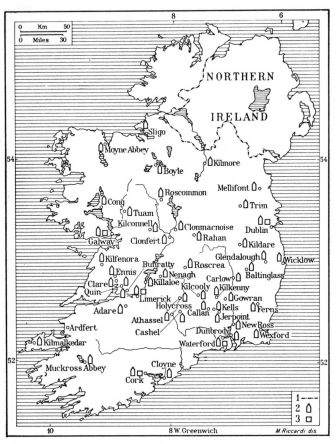

Ireland, principal cities and towns with medieval and modern monuments. *Key*: (1) Modern national boundaries; (2) monuments of the 12th–15th cent.; (3) monuments of the 16th–19th cent.

square keep with round corner turrets (exemplified by the ruined castle of Carlow) was developed by the late 13th century.

In general the chief centers for Hiberno-Norman architecture and sculpture are Trim (Co. Meath), with ruins of a great and magnificent castle (ca. 1200), a cathedral priory church, walls, gates, abbey ruins, and medieval effigy tombs; Kilkenny, with a cathedral, castle, and ruined abbeys and friaries; Cashel, where the rock rising dramatically from the north Munster plain is crowned with ruins, below which lie the remains of Benedictine and Dominican abbeys; and the great fortified houses of the Canons Regular at Athassel (Co. Tipperary) and Kells (Co. Kilkenny).

In those parts of the country which retained native Irish traditions, the most interesting works of architecture are the Franciscan friaries and the late medieval, lightly fortified tower houses. The friaries are small and intimate in scale, the two-storied domestic buildings compactly grouped around a small cloister and against a narrow church, from which there characteristically rises a slender tapering square bell tower. This grouping makes a charming composition, whether seen from a distance or from the arches of the small cloister. An extremely well-preserved example may be seen at Quin (Co. Clare), and there are other excellent examples at Adare (Co. Limerick), Moyne and Ross Errilly (Co. Galway), Kilconnell (Co. Galway), and Ennis (Co. Clare). The tower house of the 15th and 16th centuries was usually a square stone tower with stepped battlements, mural staircases, one or two floors on stone vaults and the others of wood, and a small walled bawn attached. The tower houses are very numerous, and good examples survive at Dungory, near Kinvarra (Co. Galway), and at Castledoe (Co. Donegal). At Bunratty, near Shannon Airport (Co. Clare), a late tower house has been fully restored, furnished in period, and fitted out as a museum.

From the Renaissance to modern times. The Renaissance, which came late to Ireland, first appears in the form of interior ornament, fireplaces, and other minor features in the English Tudor styles. Little of this survives, for the 16th and 17th centuries were periods of merciless warfare. Only one Elizabethan manor house, Ormonde Castle at Carrick-on-Suir (Co. Tipperary), survives in any worthy state of preservation. It is a long two-storied stone building with a hall just 100 ft. in length, which still contains extensive remains of 16th-century stuccowork (portrait medallions, armorial bearings, and allegorical figures) as well as carved fireplaces. Early-17th-century houses are more numerous but are mostly undistinguished or in ruins.

The full effects of the Renaissance were not felt until the late 17th century, when James, Duke of Ormonde, began to replan Dublin as a worthy capital city. This was a period of noble domestic and public architecture, even though painting and sculpture achieved no great distinction. Such minor arts as stuccoworking, bookbinding, and glass cutting flourished, particularly during the second half of the 18th century.

The chief center for the arts of this period is undoubtedly Dublin, scene of the work of the architects Edward L. Pearce (Bank of Ireland), Sir William Robinson (Kilmainham Hospital), Thomas Burgh (Trinity College Library), and, particularly, Richard Cassels (Tyrone House, Clanwilliam House, Powerscourt House, and Leinster House, now the meeting place for Dáil Éireann, the Irish Parliament).

Outside Dublin, similar work was done on a smaller scale in the principal towns. Many of the smaller towns have excellent courthouses or market-houses dating from the 18th or early 19th century; the courthouse at Carlow and the market-house in the village of Dunlavin (Co. Wicklow) are good examples. Great country houses were also built; some of the finest — such as Carton and Castletown (Co. Kildare) and Russborough (Co. Wicklow) — are by Cassels.

The later 19th century was a period of decline in Irish architecture. Two noteworthy buildings in Dublin, however, are the museum building of Trinity College (1853–57) and the Kildare Street Club (shortly after 1860), both by Sir Thomas Deane and Benjamin Woodward. On the whole, later work is undistinguished, and Ireland has little to show in the way of original modern architecture (although the terminal building at Dublin Airport and the Dublin bus terminal building by Michael Scott are worthy designs).

Shortly before and after 1800 James Malton, who made excellent etchings of Dublin, and George Petrie were distinguished engravers in the minor field of topographical illustration. Until recent times painting and sculpture, however, have played very minor roles in Irish art. Irish painting has tended to have a rather literary character, which can be traced through the works of Sir William Orpen, Horace Hone, Daniel O'Neill, John Butler Yeats, and Jack Butler Yeats. Since World War II, original work of a different character has been produced by a growing number of painters and sculptors, among whom should be mentioned Pat Scott, Hilary Heron, Oisin Kelly, and Ian Stuart.

BIBLIOG. *Prehistory and protohistory*: G. Coffey, New Grange (Brugh na Boinne) and Other Incised Tumuli in Ireland, Dublin, 1912; E. C. R. Armstrong, Catalogue of Irish Gold Ornaments in the Collection of the Royal Irish Academy, Dublin, 1920; R. A. S. Macalister, Ireland in Pre-Celtic Times, Dublin, London, 1921; R. A. S. Macalister, The Archaeology of Ireland, London, New York, 1928; S. P. O' Ríordáin, Antiquities of the Irish Countryside, 3d ed., London, 1953; P. J. Hartnett, Excavation of a Passage Grave at Fourknocks, Co. Meath, Royal Irish Acad. Proc., LVIII (sec. C), 1957, pp. 197–277; R. de Valéra, The Court Cairns of Ireland, Royal Irish Acad. Proc., LX (sec. C), 1959, pp. 9–140. *Celtic Christianity and the Vikings*: M. Stokes, Early Christian Art in Ireland, London, 1887; E. H. Zimmermann, Vorkarolingische Miniature, 5 vols., Berlin, 1916; H. S. Crawford, Handbook of Carved Ornament from Irish Monuments of the Early Christian Period, Dublin, 1926; A. K. Porter, The Crosses and Culture of Ireland, New Haven, 1931; A. Mahr and J. Raftery, ed., Christian Art in Ancient Ireland, 2 vols., Dublin, 1932–41; F. Henry, La sculpture irlandaise pendant les douze premiers siècles de l'ère chrétienne, 2 vols., Paris, 1933; G. L. Micheli, L'enluminure du haut moyen âge et les influences irlandaises, Brussels, 1939; F. Henry, Irish Art in the Early Christian Period, London, 1940; H. Shetelig and others, Viking Antiquities in Great Britain and Ireland, 6 vols., Oslo, 1940–54; N. Åberg, The Occident and the Orient in the Art of the 7th Century, 3 vols., Stockholm, 1943–47; E. H. L. Sexton, A Descriptive and Bibliographical List of Irish Figure Sculptures of the Early Christian Period, Portland, Me., 1946; F. Masai, Essai sur les origines de la miniature dite irlandaise, Brussels, 1947; C. Nordenfalk, Before the Book of Durrow, ActaA, XVIII, 1947, pp. 141–74; E. H. Alton and P. Meyer, ed., Evangeliorum quattuor Codex Cenannis (Book of Kells, facsimile ed.), 3 vols., Bern, 1950–51; J. Duft and P. Meyer, Die irischen Miniaturen der Stiftsbibliothek St. Gallen, Bern, 1953; Evangeliorum quattuor Codex Lindisfarnensis (Lindisfarne Gospels, facsimile ed.), 2 vols., Olten, Lausanne, 1956–60; M. and L. De Paor, Early Christian Ireland, London, New York, 1958; Evangeliorum quattuor Codex Durmachensis (Book of Durrow, facsimile ed.), 2 vols., Olten, Lausanne, Freiburg im Breisgau, 1960. *The Middle*

Ages: A. C. Champneys, Irish Ecclesiastical Architecture, London, 1910; H. G. Leask, Irish Castles and Castellated Houses, Dundalk, 1941; H. G. Leask, Irish Churches and Monastic Buildings, 3 vols., Dundalk, 1955-60. *From the Renaissance to modern times*: Georgian Society, Records of 18th Century Domestic Architecture and Decoration in Dublin, 5 vols., Dublin, 1909-13; H. A. Wheeler and M. J. Craig, The Dublin City Churches of the Church of Ireland, Dublin, 1948; M. J. Craig, Dublin, 1660-1860, Dublin, London, 1952; J. Summerson, Architecture in Britain 1530-1830, London, 1953 (3d. ed., Harmondsworth, 1958).

ART CENTERS. Dublin (Baile Átha Cliath). Founded by the Norse in the 9th century, Dublin gradually became the center of English rule in Ireland after the Anglo-Norman invasion in 1169. When Ireland had an independent Parliament for a few years at the close of the 18th century, its seat was in Dublin. Few traces of the small medieval city remain; it was swept away in the replanning of Dublin as a worthy capital, which began at the end of the 17th century and continued into the early 19th. After the Act of Union (1800), which ended the existence of the Irish Parliament, Dublin suffered a slow decline from which it has revived only at the end of the 19th century and during the 20th. Its central areas still owe their character to the great period of building in the 18th century and, perhaps, especially to the activities of an enlightened body known as the Wide Street Commissioners, established in 1757, who controlled the planning of streets, parks, and squares.

Among the churches, the oldest foundation is Christ Church Cathedral, a monastic cathedral originally founded by the Norse and built anew by the Anglo-Normans in 1172. It was extensively rebuilt in the 19th century, but parts of the 12th-century work, purely English in style, have survived. St. Patrick's Cathedral, a secular cathedral built outside the walls (ca. 1225), was also extensively rebuilt in the 19th century. The ruined chancel of St. Audoen's, a Norman parish church, dates to about 1455. The parish church of St. Michan's includes a surviving medieval tower and crypt. St. Catherine's (1760-69) on Thomas Street, by John Smyth, has a ponderous classical design. St. George's (1802-13), influenced by St. Martin-in-the-Fields, London, is the work of Francis Johnston, also the architect of the Chapel Royal in Dublin Castle. Other churches of interest include St. Stephen's (1824-25) by John Bowden; St. Audoen's (1841-46) by Patrick Byrne, a Roman Catholic church in classic revival style; SS. Augustine and John the Baptist (1860) by Edward Welby Pugin and G. C. Ashlin, in French Gothic; and Catholic University Church (1855-56) by John H. Pollen, a miniature Byzantine basilica.

Public buildings of importance include the Kilmainham Hospital (1680-86) by Sir William Robinson, a handsome classical building around a courtyard, influenced by the Invalides (Paris), and Marsh's Library (1703) by the same architect. Steevens' Hospital and Trinity College Library (1712-32) are the work of Thomas Burgh; the roof of the latter was raised and a barrel vault added by Benjamin Woodward (1857). The Parliament House (1729; now Bank of Ireland) is mainly the work of Edward L. Pearce, with a portico by James Gandon and other additions by Francis Johnston. The main front of Trinity College (1752-60), a magnificent if severe façade on a grand scale, is the work of Henry Keene and John Sanderson. The Rotunda Maternity Hospital (1750) by Cassels, the Royal Exchange (1769-79; now the City Hall) by Thomas Cooley, and the Blue-Coat School (1773-83) by Thomas Ivory are other 18th-century examples. The work of Gandon includes the Custom House (1781-91), on the quay of the River Liffey, the Four Courts (1786-96), and the King's Inns (1795-1817). The General Post Office (1815) by Johnston; the Nelson Pillar (1808), a great Doric column surmounted by a statue, by William Wilkins; and the museum building at Trinity College (1853-57) by Deane and Woodward are also noteworthy. Collinstown Airport (1937-41) by Desmond Fitzgerald and Busaras (1949-52; the central bus station) by Michael Scott also deserve mention.

Some domestic buildings of interest are Clanwilliam House (1739), with its magnificent stuccowork on the interiors, and Leinster House (1745-48), now occupied by the National Parliament, both by Cassels. Powerscourt House (18th cent.) and two houses by Sir William Chambers — Charlemont House (1762) and the Casino at Marino (1765-71) — are significant works.

Among the museums, the National Gallery of Ireland possesses Italian primitives and representative collections of the Spanish, Dutch, and English schools of painting, while the Municipal Gallery of Modern Art contains a collection intended to represent modern art. The Irish Antiquities division of the National Museum of Ireland houses many masterpieces of prehistoric and Early Christian metalwork, while many fine examples of Irish craftsmanship in furniture, silver, and other media of more recent times are collected in the Art and Industrial division. Some of the greatest Irish illuminated manuscripts, including the Book of Kells and the Book of Durrow, are preserved in Trinity College Library. The Chester Beatty Library contains a superb collection of Oriental manuscripts.

BIBLIOG. J. Malton, A Picturesque and Descriptive View of the City of Dublin, London, 1792-99; N. Burton, History of the Royal Hospital, Kilmainham, Dublin, 1843; Georgian Society, Records of 18th Century Domestic Architecture and Decoration in Dublin, 5 vols., Dublin, 1909-13; C. P. Curran, Nos. 85 and 86 St. Stephen's Green, Dublin, 1939; C. P. Curran, Dublin Plaster Work, J. Royal Soc. Ant. of Ireland, LXX, 1940, pp. 1-56; C. P. Curran, The Rotunda Hospital: Its Architects and Craftsmen, 2d ed., Dublin, 1945; S. Sitwell, British Architects and Craftsmen, London, 1945, pp. 142-45; E. Butler, The Georgian Squares of Dublin, Country Life, C, 1946, pp. 756-59, 810-12; J. Betjeman, Francis Johnston: Irish Architect, in The Pavilion (ed. M. Evans), London, 1947, pp. 21-38; H. A. Wheeler and M. J. Craig, The Dublin City Churches of the Church of Ireland, Dublin, 1948; C. P. Curran, Cooley, Gandon and the Four Courts, J. Royal Soc. Ant. of Ireland, LXXIX, 1949, pp. 20-25; J. H. Harvey, Dublin, London, New York, 1949; M. J. Craig, Dublin, 1660-1860, Dublin, London, 1952.

Cashel (Caiseal). The Celtic kings of Munster had their fortified royal seat at this site, on a rock which rises from the plains of County Tipperary. The Rock was granted to the Church in 1101, and a market town developed around it in medieval times. Cashel is a good center for the study of Irish medieval architecture and carving.

The earliest building on the Rock is the Round Tower, an 11th-century bell tower, which is a perfectly preserved example of this distinctively Irish type of structure. Cormac's Chapel (1127-34), built by Cormac MacCarthy (Mac Carthaigh), is a stone-roofed two-storied Romanesque church (one story is within the roof) with a barrel-vaulted nave and a rib-vaulted chancel. There are two square towers, three carved doorways, and a richly ornamented chancel arch; traces of mural painting remain. This remarkable building is unique in Ireland. There are also ruins of a cruciform cathedral church (ca. 1250) in Early English style, with repair and reconstruction work, including the main doorway, of the early 15th century; a castle was inserted in the nave in the early 16th century. In the Cathedral are many specimens of medieval Irish carving on altars and tombs. The Dominican Friary was founded in 1243 by Archbishop David MacKelly in the town below the Rock. Hore Abbey, a late 13th-century Cistercian structure, was founded by Archbishop David MacCarroll on the plain below the Rock. In the grounds of the 18th-century Church of Ireland Cathedral there are fine medieval tomb effigies. The Deanery, in the town, is a very handsome early-18th-century house.

BIBLIOG. H. G. Leask, St. Patrick's Rock, Cashel, Co. Tipperary (Official Guide to the National Monuments), Dublin, 1935; H. G. Leask, Irish Churches and Monastic Buildings, 3 vols., Dundalk, 1955-60, passim.

Clonmacnoise (Cluain Mac Nois). One of the greatest of the early Irish monasteries, founded in the early 6th century by St. Ciarán, stood here on the bank of the Shannon in County Offaly. There are extensive ruins and other remains. A fine Irish round tower,

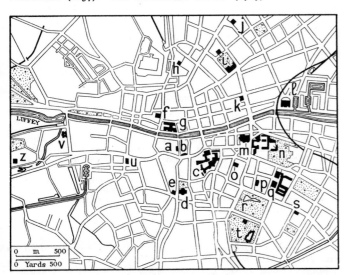

Dublin, central section. Principal monuments: (*a*) St. Audoen's Church; (*b*) Christ Church Cathedral; (*c*) Castle; (*d*) St. Patrick's Cathedral; (*e*) Marsh's Library; (*f*) St. Michan's Church; (*g*) Four Courts; (*h*) King's Inns; (*i*) Rotunda and Municipal Gallery (Charlemont House); (*j*) St. George's Church; (*k*) General Post Office; (*l*) Custom House; (*m*) Parliament House (now Bank of Ireland); (*n*) Trinity College; (*o*) Powerscourt House; (*p*) Mansion House; (*q*) Leinster House, National Museum of Ireland, National Gallery of Ireland, and National Library of Ireland; (*r*) St. Stephen's Green; (*s*) Ely House; (*t*) University College; (*u*) St. Catherine's Church; (*v*) Steevens' Hospital; (*z*) Kilmainham Hospital.

"O'Rourke's Tower," was completed in 1123. Temple Finghin is a ruined Romanesque building (ca. 1160) with a carved chancel arch and a round tower attached to the chancel. The Cathedral, in ruins, was built in the 10th century and reconstructed in the late 12th and 15th centuries; it has an elaborately carved 15th-century north doorway. The Nuns' Church, now in ruins, lies some distance from the main group of buildings. Its carved doorway and chancel arch are perfect specimens of the developed Irish Romanesque style (ca. 1170). The Cross of the Scriptures (early 10th cent.), carved with scenes from the Scriptures and with panels of ornament, is one of the best surviving examples of the Irish high cross, that remarkable type of sculptural monument characteristic of the early Celtic Church. There are several other carved churches and crosses. The most important monument at Clonmacnoise is the magnificent collection of about 500 fragments or complete specimens of inscribed and often ornamented grave slabs of the 7th–11th century. Most of the inscriptions are in Irish in Celtic half-uncial lettering; the ornament, usually lightly incised, is often elegantly designed and composed.

BIBLIOG. R. A. S. Macalister, The Memorial Slabs of Clonmacnoise, Dublin, 1909; F. Henry, La Sculpture irlandaise pendant les douze premiers siècles de l'ère chrétienne, 2 vols., Paris, 1933; R. A. S. Macalister, Corpus Inscriptionum Insularum Celticarum, II, Dublin, 1949; H. G. Leask, Irish Churches and Monastic Buildings, I, Dundalk, 1955.

Cork (Corcaigh). The third largest city in Ireland and the second city in the Republic, Cork was founded by the Norse in the 9th century and later developed as a port and trading center. The small Cork Public Museum has some antiquities of interest, and there is a collection of paintings in the Crawford Municipal School of Art.

Limerick (Luimneach). The third city of the Republic, Limerick was founded by the Norse in the 9th century and later developed as a port. It was also a strategic center which endured several sieges. King John's Castle (early 13th cent.) is the remains of a fine specimen of military architecture. St. Mary's Cathedral, which was founded in 1194 but has seen much rebuilding, contains remains of interesting late Irish Romanesque work, as well as some fine 15th-century carved misericords in black oak. A small museum and art gallery is attached to the Library.

Monasterboice (Mainistir Bhuithe). This site of an early monastery in County Louth contains the remains of two ruined churches, a round tower, a monastic sundial, and three carved crosses. The Cross of Muiredach here is the finest surviving example of the Irish high cross. Dating from the early 10th century, it is carved in sandstone, with elaborate compositions of figures depicting the Crucifixion and the Last Judgment on the head of the cross, other scriptural scenes on the main faces of the shaft, panels of intricate ornament, and scenes showing animals and human beings on the base. The west cross, which is taller but less perfectly preserved, is very similar to the Cross of Muiredach in its general composition. The simpler east cross has carvings of the Crucifixion, without attendant figures, and a roundel filled with spiral ornament appearing only on the head.

BIBLIOG. F. Henry, La sculpture irlandaise pendant les douze premiers siècles de l'ère chrétienne, 2 vols., Paris, 1933; R. A. S. Macalister, Monasterboice, Dundalk, 1946; M. and L. de Paor, Early Christian Ireland, London, New York, 1958; L. de Paor, Monasterboice, Archaeol. J., CXVIII, 1961.

Newgrange. The principal tumulus of the great passage-grave cemetery of the valley of the River Boyne (Co. Meath) is at Newgrange. A great cairn of stones covers a megalithic corbel-roofed chamber almost 20 ft. high, which is approached by a passage more than 60 ft. long. The plan of the chamber is cruciform. The orthostats of the passage and chamber, as well as some of the roofing stones and the stones of the curb surrounding the cairn, are richly ornamented with carvings of spirals, concentric circles, lozenges, chevrons, and many other abstract patterns in the style distinctive to passage-grave art in Ireland and Brittany and closely related to the art style found on objects in Spanish and Portuguese tombs.

BIBLIOG. G. Coffey, New Grange (Brugh na Boinne) and Other Incised Tumuli in Ireland, Dublin, 1912; R. A. S. Macalister, New Grange (Official National Monuments Guide), Dublin, 1929.

Tara. This village (Co. Meath) is famous for its hill, for many centuries, according to tradition, a royal residence and gathering place for the people. Six terraces appear on the hill. The principal terrace is the Fort or Enclosure of the Kings (Ráth na Ríogh), on which are found Cormac's House (Teach Cormac), named for a king who lived in the middle of the 3d century B.C., the Royal Seat (Forradh), and the Mound of the Hostages (Dumha na nGiall). This last monument was attributed to Cormac MacArt, who brought

hostages to Tara; in fact, it predates the Royal Enclosure, and tombs of the middle Bronze Age have been discovered there. North of the Royal Enclosure is the Enclosure of the Synods (Ráth na Seanad), where, it is said, St. Patrick held a synod. This terrace consists of three concentric banks with three ditches. Farther to the north appears the Banquet Hall (Teach Miodhchuarta), in which is recognized the great house with twelve or fourteen doors described in literary sources. Other terraces (Claoin-Fhearta north, Claoin-

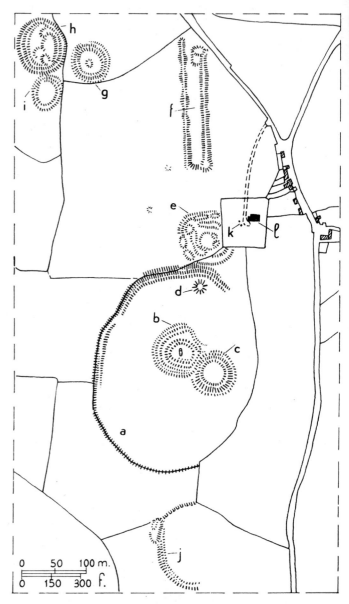

Tara hill, plan. Individual remains and monuments with the traditional names: (a) Fort or Enclosure of the Kings (Ráth na Ríogh); (b) Cormac's House (Teach Cormac); (c) Royal Seat (Forradh); (d) Mound of the Hostages (Dumha na nGiall); (e) Fort or Enclosure of the Synods (Ráth na Seanad); (f) Banquet Hall (Teach Miodhchuarta); (g) Grainne's Fort (Ráth Ghráinne); (h) north sloping trenches (Claoin-Fhearta north); (i) south sloping trenches (Claoin-Fhearta south); (j) King Loiguire's Fort (Ráth Laoghaire); (k) stone fragments; (l) church.

Fhearta south, and Ráth Ghráinne), surrounded by a bank and ditch, were probably tombs, but it is supposed that they were also treated as houses. South of the Enclosure of the Kings is King Loiguire's Fort (Ráth Laoghaire), which takes its name from the king of St. Patrick's period. Also on the hill are other smaller tombs, and it is possible to find some traces of what may be ancient roads.

BIBLIOG. R. A. S. Macalister, Tara: A Pagan Sanctuary of Ancient Ireland, London, 1931; S. P. Ó Ríordáin, Tara, 3d ed., Dundalk, 1960 (bibliog.).

Liam DE PAOR

Illustrations: 4 figs. in text.

ISLAM. Islam may be regarded both as the religion founded by Mohammed and as a way of life which has shown itself capable of absorbing and reconciling peoples of the most diverse origins. The cultural unity fostered by Islam necessarily embraces the sphere of artistic creation. Drawing heavily on the creative forces of conquered countries, Islamic art in time produced from these various sources a new whole whose origins are no longer immediately evident. Islamic art received contributions from the ancient traditions of the Near East (see ARABIAN PRE-ISLAMIC ART; ASIA, WEST), from Iran (see IRANIAN PRE-SASSANIAN ART CULTURES; SASSANIAN ART), from the Hellenistic and Roman worlds (see HELLENISTIC ART; ROMAN ART OF THE EASTERN EMPIRE), from Byzantine civilization (see BYZANTINE ART), from central Asia and Indian traditions (see ASIA, CENTRAL; INDIAN ART; INDO-IRANIAN ART), and finally from the regional and folk trends that emerged in various parts of the Islamic empire. Islamic art may first be distinguished shortly after the age of the Arab conquests, the second half of the 1st century of the Hegira. (The inception of this phase may be conveniently fixed at A.D. 661, the date of the transfer of the Ommiad caliphate to Damascus in formerly Byzantine Syria.) Despite periods of decline and stagnation, the continuity of Islamic art has been preserved up to the present.

This article deals with the common aspects and features of Islamic art in its main lines of development. The several dynastic and historical periods, local developments, and marginal episodes of cultural exchange with other artistic traditions are treated in the following articles: ABBASSIDE ART; FATIMID ART; GHAZNEVID ART; ILKHAN ART; INDO-MOSLEM SCHOOLS; MAMELUKE ART; MOGHUL SCHOOL; MOORISH STYLE; MOZARABIC ART; OMMIAD SCHOOLS; ORIENTAL MODERN MOVEMENTS; SAFAVID ART; SAHARAN-BERBER CULTURES; SAMANID ART; SELJUK ART; TIMURID ART; TULUNID ART; TURFAN.

SUMMARY. Introduction (col. 325). Political background (col. 326). Sociological factors (col. 328). Art and religion (col. 332). City planning (col. 333). Religious architecture (col. 336). Secular architecture (col. 342). Architecture and decoration (col. 347). Ornament (col. 350). Organization of labor (col. 354). Handicrafts (col. 356).

INTRODUCTION. Research in the field of Islamic art is a relatively recent endeavor which has undergone varied phases. The romantic fascination with the Orient of the first half of the 19th century was followed only gradually by a more sober and realistic effort toward tracing the historical development of Islamic art. The effort had to be entirely centered upon the evidence revealed by the monuments themselves, insofar as they have been preserved, and upon extant handicrafts. Comprehensive historical accounts by ancient authors, such as those preserved for the arts of China and classical antiquity, are entirely lacking in Islam, and there are no writings dealing with the esthetic and philosophical implications of Moslem art. Oriental historians and geographers occasionally mention a few details concerning individual architectural enterprises, which assume special importance in those instances where the monuments described are no longer preserved, but such descriptions are seldom reliable. Fantastic accounts and poetic effusions concerning magnificent palaces are plentiful, but they are obviously of limited value for objective investigation. Similarly the occasional praise of the level of craftsmanship attained in this or that city is not a reliable basis for general conclusions.

Authors of European training are further handicapped by inadequate background in Oriental religions, history, and languages. This lack is especially evident when these writers approach their task with the bias of a humanistic or a Christian point of view. Few achieve enough comprehension of the nature and basic concepts of Islamic art to allow them to interpret its real meaning.

Many gaps in the knowledge of Islamic monuments have been filled by evidence accumulated from field expeditions and excavations, especially since the beginning of the 20th century. Through thorough investigation, whole groups of monuments have been uncovered and technical procedures clarified. The relationship between Moslem and Western developments has also been elucidated to a large extent, and reliable surveys have considerably broadened the understanding of Islamic art. Although Arab, Persian, and Turkish scholars also began in the first half of the 20th century to be concerned with the history of art in their respective lands, they followed the patterns established by their European colleagues. A deeper understanding of the basic values of Islamic art has thus far failed to emerge, while the progressive adoption of Western ways in the Orient offers little hope for future progress along these lines.

POLITICAL BACKGROUND. Mohammed and his first disciples led a very simple life in Medina and were not driven by the ambition to build monumental and luxurious structures as a manifestation of their continually growing power. Only with the transfer of the caliphate to Damascus by the first of the Ommiads in A.D. 661 (see OMMIAD SCHOOLS) did the need to rival the existing pagan temples and Christian churches of the capital city assume prime importance. It soon became clear that the head of the faithful could not be content with the modest expenditures of a patriarchal Bedouin sheik if he wished to equal in splendor his fellow rulers, especially the Byzantine emperor. The necessity arose for a regular court to perform its own imposing ceremonials in appropriate surroundings.

Thus, toward the end of the 7th century a vigorous architectural and decorative art production based in part on Byzantine, Sassanian (see SASSANIAN ART), and Coptic (see COPTIC ART) influences, yet with its own original aims, began in earnest under the Ommiads. This activity was most clearly exemplified in the elaboration of a mosque plan, which was immediately taken up in all lands ruled by Islam at that time, including Syria and Palestine, Iraq, Iran, Egypt, and northern Africa. The first Islamic style received the stamp of the ruling dynasty, and the subsequent evolution of Islamic art remained traditionally bound up with political developments.

In the year 750 an important change took place through the forcible assumption of power by the Abbassides, with the transfer of the center of rule to Iraq (see ABBASSIDE ART). The immediate consequence was the cleavage of Islamic unity through secession of the Moslem territory of Andalus (Spain), where, in 755, the only surviving member of the Ommiad house established a capital in Cordova (Córdoba; see MOORISH STYLE). The artistic significance of this event was reflected in the survival of an Ommiad element in the Islamic West (Maghrib) until the 11th century, while in the eastern parts of the Islamic empire, ruled by the Abbassides from their new capital of Baghdad, an entirely new style, influenced by Persian and Turkish art, was elaborated. After the beginning of the 10th century, the propagation of this style met with resistance in the resurgent power of the Iranian princes [Samanids, Ziyarids, Buyids (Buwayhids), etc.], who challenged the weakening central authority wielded by the Abbassides. In the literature and art of Persia, this resistance to Arab culture was translated into a revival of the great national past, partly focused on a new interest in the Sassanian tradition. These developments received an added impulse in the spread of the Shiite movement, a formidable new adversary to Abbasside orthodoxy.

In North Africa, the Shiite movement was encouraged in the 10th century by the Fatimid rulers, who in 970 transferred their capital from Mahdia in Tunisia to the newly founded city of Cairo and ousted the Abbassides from Egypt, Syria, and Sicily. Cairo became at this time the leading cultural center of the Islamic world, and its artistic influence was felt even in the lands of Western Christendom (see FATIMID ART). In the Maghrib proper, Fatimid rule in the last years of the 11th century was ended by the Morocco-based reform movement of the orthodox Almoravide Berbers and their followers the Almohades. Under the Almoravides and the Almohades, who ruled Spain as well as Morocco, the florid and overcomplicated manner of Ommiad art gave way to the more sober Moorish style, which is best exemplified by the royal capitals of Marrakech and Seville.

In the East, a new political pattern was created by the rapid conquest of Near Eastern lands by the Seljuk Turks,

who originated in Turkistan, took Anatolia from the Byzantines, divested the caliphs of Baghdad of all their territories, and established regional dynasties all over the East. The foundation of a Christian state by the Crusaders in the Holy Land did the Seljuks only slight injury. The Seljuks brought with them to Iran the Sunnite orthodoxy, the faith to which they had been converted, and their own artistic preferences; but although they sought religious converts, they seem to have been tolerant of the artistic inclinations of the Persian architects and craftsmen they employed (see SELJUK ART).

The year 1250 was a turning point for the Islamic world in a number of ways. At this time, Spain was reconquered by the Christian states of the West, leaving only the isolated kingdom of Granada in Moslem hands. Here and in the North African cities of Fez, Tlemcen, and Tunis, Moorish art reached its highest peak. In Egypt and Syria, after a brief Sunnite reaction under the Ayyubids, political power passed into the hands of the Mamelukes, who were able to impose a clear and distinctive artistic policy for two and a half centuries (see MAMELUKE ART). In Asia, the Mongolian invasions brought on not only a complete change in the political situation but also added Chinese influence to the stream of Turkistan, Persian, and Mesopotamian art (see MONGOLIAN ART). In India this wave was broken by the resistance of the sultans of Delhi. The Persian-Mongolian trend enjoyed new life through the conquests of the great Tamerlane (Tīmūr Lenk), who transformed his capital in Samarkand into a great art center. Under his successors, architecture and painting came into full flower (see TIMURID ART).

About the year 1500, the medieval period of Islamic art came to an end. After the fall of Granada (1492), Moorish art, bereft of creative ideas, was confined to Morocco. Furthermore, the Islamic countries around the Mediterranean were overpowered by the Ottoman Turks, who followed their conquest of Constantinople (1453) with a determined push west-

ward. The Ottomans, who had occupied Egypt, Syria, and Arabia, were able to subjugate Tunisia and Algeria as well, and they saw to it that the new artistic trends they had developed in Anatolia and Constantinople spread throughout Islam (see OTTOMAN SCHOOLS).

A national renaissance took place in Persia under the Safavid dynasty, centered first in Tabriz and later in Isfahan. Its effects were felt in all areas of artistic life. The production of textiles, which was brought to an unparalleled level of refinement, as well as great undertakings in landscape and garden architecture, evoked the admiration of all Europe. Under the descendants of Tamerlane, who in the 16th century founded the Moghul empire in India, an attractive synthesis of Persian and Indian elements was gradually transformed into an original Indo-Islamic style (see MOGHUL SCHOOL).

By the 18th century, the history of Islamic art was terminated even in the countries which had witnessed its last flowering. Handicrafts were unoriginal and derivative, produced mechanically merely to meet the need for bazaar merchandise, while in architecture, the success of the westernized style initiated in Turkey gradually made Islamic architecture subservient to European developments.

SOCIOLOGICAL FACTORS. More than any other religion, Islam was able to absorb the ethnic and national differences of its adherents and to create a fairly unified culture out of varying customs and traditions. This unifying factor was instrumental in integrating local styles into an artistic development of uncommon homogeneity. The Koran played an essential role in this development, not only as a source of divine revelation for Mohammedans but also as a guide in legal, social, and cultural matters. Since the Koran could be taught only in the original Arabic, the language and script of the Arabs as well as their customs and traditions were transmitted throughout the Islamic world. Considering the fundamental ethnic and

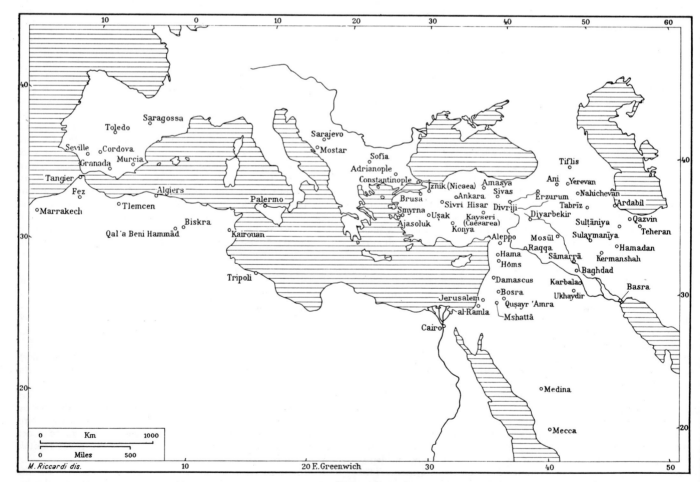

Chief centers of Islamic art in the Mediterranean basin and in the Near East.

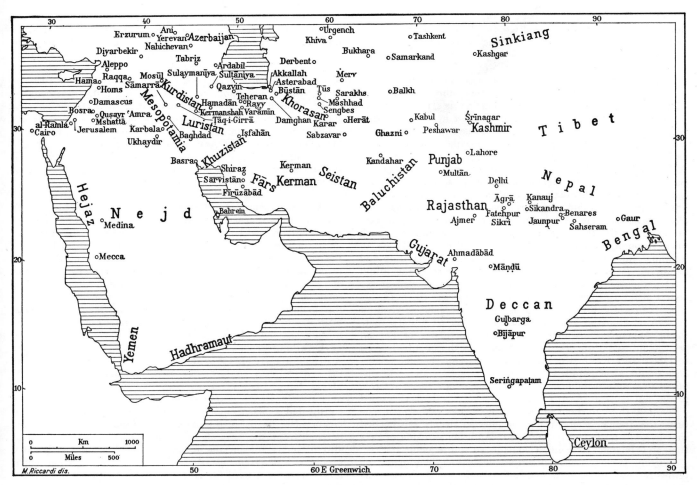

Chief centers of Islamic art in the Near East, India, and neighboring regions.

historical factors that separate Persians, Turks, Indians, and Berbers from Arabs, the revolutionizing power of the Koran is extraordinarily impressive. As a result, there were no individual national styles within Persia, Turkey, Arabia, or India as distinct currents in medieval Islamic art. Not until the dawn of the modern age (roughly speaking, from the 16th cent.) did Islamic art assume a national character in Iran, India, and Turkey. The important stylistic trends of the Middle Ages were linked primarily to dynasties. The direction of Islamic art was determined by political structures which cut across geographical and sociological boundaries. Nevertheless, the local traditions of individual societies contributed to the total development of Islamic art, sometimes in the form of a rebellious reaction. In this connection it is important to evaluate the contribution of the Arabs themselves to Moslem culture, above and beyond language and script. It is true that Arab art developed a specific identity and creative force only in the wake of Arab conquest, but the art that was then produced in Arabia owed as much to the specifically Arabic sensitivity as to the new, universal religion. A strongly marked sense of rhythm pervades not only the poetry of the Arabs, which was diffused through all social strata, but also their music. This sense of rhythm is a basic element of their art, without which it can scarcely be understood. Their interest in astronomy, nurtured in the course of endless wars and wanderings, led the Arabs to mathematical speculation, while the monotony of the desert stimulated them to flights of fantasy. A romantic yearning for endless vistas motivated the Ommiads, once they had become permanently settled, to build castles not in their cities but in the desert; and Ommiad ornament is noted for surfaces filled with endlessly repeated and elaborated decorative patterns, an esthetic that finds parallels in both poetry and music.

In Syria and in Iraq, the ground for the acceptance of new ideas had been prepared by the settling of the Ghassanids and Lakhmids, peoples related to the Arabs who had been earlier driven from the Arabian peninsula. They had been converted to Christianity, but their acceptance of the Monophysite creed placed them in opposition to the Byzantine empire. The caliphs willingly placed these adherents of Nestorianism in the highest administrative posts of government; they were locally influential people with a deep understanding of past tradition and considerable sympathy for early Islamic arts. Thus, despite religious antagonisms, Arabic customs and manners won general acceptance.

Of all the territories conquered by Islam, Spain adopted Islamic culture most swiftly and in the profoundest sense. The art of the Visigoths, the previous conquerors of the Iberian Peninsula, had not penetrated the native culture to a significant degree before the Moslem invasion (see MOZARABIC ART). The horseshoe arch, overladen with geometric decorative motifs, was not regarded as foreign to Arab taste and was immediately taken over by the invader and further developed. The effect of Islam in Spain was so strong that even the Christian population soon lost all marks of cultural and racial difference except their religion. Thus, in Spain, Arabic tradition blossomed into a regional culture of considerable importance, with new developments in both literature and art.

The situation was different in the Maghrib (in northwestern Africa), where, despite the cultural and political bonds with Spain that were maintained throughout the Middle Ages, the tenacious indigenous customs of the Berbers withstood Arabic pressure for a long time, retaining certain unique traits until the present day. Only gradually won over to the centralized orthodoxy, the Berbers retained many of their beliefs, such as their cult of saints, as well as peculiar magical practices. In the mountainous regions of northern Africa, the Berber element continues to dominate folk art, although this element should not be construed as entirely hostile to Islamic style.

The style dominant in Egypt at the time of the Arab conquest, a mixture of ancient and Coptic elements, was perfectly suited to the demands of the Islamic ruling caste. In spite of religious antagonism, even objects produced for a Christian clientele were marked with the stamp of Islamic taste. A complete assimilation of various cultural strains may be said to have taken place, even though a certain number of age-old traditions, stemming in part from pharaonic times, were retained.

The new movement met its severest test in Iran. Contact with a proud people of high artistic achievement and ancient culture made a deep impression on the conquering Moslems and exposed them to the danger of submersion. When the Abbassides made Baghdad — near the former capital of the Sassanian rulers — the capital of the empire, the court ceremonial took on a distinctly Persian coloration. Administrative officials as well as individual caliphs, whose underlings more often than not were of Persian descent, readily adopted local fashions. In the realm of art this process of assimilation took place through the adoption of Iranian vaulting techniques in building and a similar incorporation of Sassanian painting and handicraft methods. The tolerance of the court of the caliph toward the old Persian heritage, a policy also followed at the courts of the relatively independent local princely rulers (Tahirids, Samanids, Buyids, etc.), led to a conscious revival of Iranian traditions in literature and art and helped to perpetuate them. Wherever possible, the cultural inheritance of Persian art was infused with new life, and customs thoroughly foreign to Islam were retained or were newly introduced. The adherence of the local population to the Shiite sect, which was opposed to rigidly orthodox observance, played an important role in the resistance to Arab ideas. By the time orthodoxy gained a foothold, through the conquest of the Seljuks in the 11th century, the Iranian element had become so deeply entrenched that it could no longer be uprooted. An original fusion of Persian and Islamic elements characterized subsequent art.

Scytho-Turkish ornament, an art of abstract, inanimate patternwork, was introduced into the Islamic world as early as the 9th century by the Turkish palace guards at the court of the caliphs. This art, exemplified by the stucco decoration at Samarra (PL. 151; I, PL. 4), exerted a strong influence on the court, even though it stood in contrast to the native Iranian current. The subsequent invasion of the Seljuk Turks brought to Persia a nomadic culture whose main artistic products were textiles and tentlike, domed, brick mausoleums. Undoubtedly, the most important artistic benefit the Islamic world gained through contact with the Turks was the knotted-carpet technique. It is not certain how long the nomadic tribes of eastern Turkistan, the inventors of this type of weave, had practiced their discovery before it was taken up by others, but the Seljuks adopted it at their court as early as the 11th century and encouraged its production by the great workshops. Thus the knotted carpet won acceptance in the Caucasus, in Persia, and especially in Anatolia (see TAPESTRY AND CARPETS). The Seljuks also introduced to Islam the heraldic motifs (see EMBLEMS AND INSIGNIA) that had originated in their feudal customs, while their highly developed garden art helped to stimulate in their successors, the Ottomans, a penchant for naturalistic floral decorative designs.

The development of Islamic art in India presents somewhat more complicated problems. The chief sponsors of this art were Persians and Turks, but a large majority of Indian Moslems had strong ethnic ties to those of their Indian neighbors with polytheistic creeds. This region of Islamic culture was dominated by a synthesis of Turkish and Persian styles, but the Hindu element was never completely overshadowed. The columned halls of the Jains (see JAINISM), examples of Hindu religious architecture whose relatively restrained decoration made them inoffensive to the Moslems, were used as mosques by the Persian conquerors at least until the 12th century. Islamic architecture in India was strongly influenced by Hindu attitudes toward the disposition of space. Although differences between court and folk art are most clearly revealed in craft techniques, painting, which had a decidedly Hindu character, shows this contrast in a very decisive manner.

In China, the influence of Islamic culture, which was introduced as early as the end of the 8th century, proved to be less decisive than in other countries, since converts to Islam, numerous as they were, remained Chinese through and through, adhering only superficially to the new faith. Their places of worship were entirely adapted to local taste, with curved roofs and Oriental decoration, and they differed little from conventional Chinese temples or yamen structures. Realizing that the Koran stands quite apart from the body of Chinese literary production, calligraphers evolved for Koran manuscripts a flamelike stylization of Arabic cursive writing, which gained a certain appreciation in the eastern Asian world. Nevertheless, the dynamism of Islam could not overcome the resistance of an ancient and well-established culture.

ART AND RELIGION. The ties that bound the Moslem to his faith shaped his entire existence, and the world as he saw it bore little resemblance to the world of the Christian. Although he admired the beauty of creation and its endless formal variety, the conception of the harmony of the universe as developed in classical antiquity remained foreign to him. His perception of the ephemeral character of all reality led him to regard its pictorial representation as an act of futility. Characteristic of this belief is the Moslem representation of Satan, who weeps over the beauty of the world because he cannot capture its fleeting shadow.

Unwilling to fix immutably the fleeting image, Moslem art was bound to renounce realistic genres. Consequently, painting and sculpture could not be used to create faithful portraits, lifelike representations of historical events, or accurate records of a ruler's deeds. Attempts at realistic depiction would have constituted a blasphemous affront to the divine prerogative of creation (see IMAGES AND ICONOCLASM). Other religious concepts derived from the severely monotheistic orientation of Islam also played a role in the realm of art. The risk of idolatry served as a deterrent against any form of representation which might have been used for cult purposes. Neither Mohammed, nor his ancestors, nor any holy personage could be depicted in his natural and worldly appearance, and the use of such pictorial aids to propagate the faith was unthinkable.

The oft-mentioned prohibition of pictorial imagery in the Islamic world should not be attributed to the Koran or to other pronouncements of a dogmatic nature. Rather, this prohibition was grounded in the very definition of the role of the arts within Islamic society. The iconoclastic controversy, which engulfed the Christian world in a lengthy religious struggle not resolved until the mid-9th century, undoubtedly played an important role in the formation of Islamic attitudes. Before the 8th century the imitation of human forms had met with little resistance in the Islamic world. In 721, however, iconoclasm was officially decreed by Caliph Yazīd II and became an important element in the propaganda that the caliphs directed toward dissident Christian factions.

At the same time, specific injunctions against the imitation of human and animal forms, together with instructions to the artist to confine himself to plant and abstract motifs, were culled from the collections of the sayings of the Prophet (Hadith), assembled by later writers. These sayings include: "Angels do not enter a house which contains a dog or an image"; "On Resurrection Day God will consider image-makers as the men most deserving of punishment"; "Those who make pictures will be punished on Resurrection Day; it will be said to them: Give life to what you have created."

Puritanic exegesis of such passages resulted in a strict prohibition of all figural representation, whereas the more tolerant interpretation held such strictures to proscribe only the setting-up of cult images. Adhering to the orthodox Sunna (tradition), the majority of the Moslem faithful followed spiritual leaders who were often sternly opposed to anthropomorphic imagery. The preponderance of this attitude undoubtedly accounts for the pronounced lacunae in the chronology of figural representations in Spain, the Maghrib, and Arabia proper, though not in Turkey and India, where adherence to the Sunna was less uncompromising. The followers of the Shiite sect were condi-

tioned by dogmatic tenets other than the Hadith accepted by the orthodox. These rigidly binding tenets, which were less severely opposed to figural art, were influential chiefly among the Persians, among some Iraqi Arabs, eventually among the Fatimids of Egypt, under whose rule an efflorescence of the figural arts took place, and ultimately among the Mongols.

It was by no means inevitable that the new faith should have developed a pronounced iconoclastic attitude. Aside from the limiting condition that painting and monumental sculpture eschew realism, the creative fantasy and imagination of the artist were allowed considerable scope. The less attention the artist had to pay to natural forms, the freer he was in his art. Artists continued to study human and animal forms, but since they were unable to use them except as dry, insignificant elaborations of inanimate main motifs, they preferred to limit themselves to geometric and plant ornament. Discussions took place among the partisans of the more tolerant tendencies within the faith over the acceptability of representation "without shadows," or of an entirely flat appearance. Certain authorities suggested that figural representations should be shown without heads, or pierced with holes, as were the figures used in puppet shows. Within religious sanctuaries, only indistinct hints of human or animal forms were tolerated, but in bathing establishments, paintings of hunting or of love scenes for the entertainment of patrons seldom aroused objection.

A characteristic treatment of figural motifs in Islamic art was to repeat them progressively within established ornamental bands. The sensitive artist did not treat the square or circle as a unified surface within which a single major element must dominate; rather, figural motifs were more likely to be disposed around the periphery of the form or within bands repeated several times over the two-dimensional surface. The individual motif thus lost its independence through a seemingly endless repetition and no longer served as a form of visual attraction. The esthetic intention of this art is not conveyed by individual details but only in the grouping of the entire decorative field in which the details are submerged.

These principles were not questioned by the artists, nor were the relatively narrow confines of this art ever challenged. The leading artistic personalities appear always to have been aware of the norms enforced by tradition and the spiritual message of the Koran.

The contrast between the religious and the secular spheres of art, so sharply etched in the West, is of only minor importance in Islamic art. It is true that specific architectural forms were developed for buildings associated with the religious cult. Decorative principles, however, remained much the same for profane as for sacred structures. In contrast to Christian practice, liturgical vessels and furniture were not used in Moslem services. The movable objects encountered in the mosque, such as the rugs on the floors, the hanging lamps, the pitchers and water containers for ablutions, and the vases for flowers, were identical to those used in private houses. These objects were not essential, and even a copy of the Koran was not always on hand, since the recitation of the services was carried on from memory. Pious donations of luxurious manuscripts of the Koran were occasionally made, and these might be kept in finely wrought containers (V, PL. 458; IX, PL. 275), or upon stands executed for this purpose (PL. 155; X, PL. 119).

CITY PLANNING. When the Arabs settled in newly conquered cities, they carried out few changes in the established architectural arrangements. Perhaps old buildings were torn down, but the general arrangement of the city remained the same. New settlements, where nomadic warriors had to be transformed into city dwellers, were generally little more than primitive encampments fortified with mud walls, studded with towers, which sheltered the tents of the inhabitants.

The first settlements of a specifically urban character to arise in Iraq after the Islamic conquest were Basra and Kufa. Both were founded about 638 and soon emerged as important centers of culture. Basra, erected on an elevated semicircular site near the Tigris, was divided into separate areas according to garrison units. It was connected by two shipping channels to the river and soon developed into a center of trade. The city was entirely destroyed and reconstructed several times, so that the original disposition can no longer be discerned.

Kufa was constructed as a garrison city on the edge of the desert not far from Hira, the capital of the Lakhmids. The fortified palace of these Arabs, who had been Christian converts prior to the coming of Islam, became the model for some of the desert castles of the Ommiads. The Great Mosque

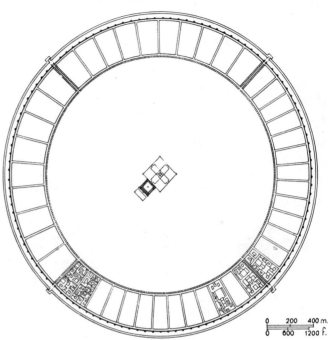

Baghdad, plan of al-Manṣūr's round city (*after F. Sarre and E. E. Herzfeld, 1911–20*).

of Kufa was erected partly with materials looted from Hira. The relationship of the rulers of Hira with the Sassanians was especially close, and pronounced Iranian influences are evident in their domain. 'Alī ibn-abī-Ṭālib, the fourth caliph and the son-in-law of Mohammed, resided in Kufa and was murdered there in 661. The Shiite schism was a direct consequence of this murder, since the followers of 'Alī had recognized him as the sole legitimate heir of Mohammed.

The Abbassides, after seizing the caliphate, established a new capital, Baghdad, near Ctesiphon, the old stronghold of the Sassanians. The plan of Baghdad, designed for Caliph al-Manṣūr, was circular in form. Such a design was not new in the East since the Hittite city of Zincirli, the Parthian city of Hatra, and originally Ctesiphon as well were based upon circular plans, but the builders of Baghdad consciously elaborated a thoroughly new type of plan, which they carried out consistently in execution (FIG. 334). Geodetic and astrological considerations were of fundamental importance for the choice of building site and the time of construction. The ground plan was eventually outlined on the site with ashes, and between 762 and 766 the city was built; sun-dried bricks and spoils from Ctesiphon were used in construction.

The new circular city was enclosed within massive walls with round towers and a thinner outer wall. We are well informed about the appearance of the city through the comprehensive description provided by the geographer Ya'qūb at the end of the 9th century. Four narrow, brick-vaulted passages, which led from the gates to the inner circle, were connected to one another by two streets following the outer and inner circumferences of the city respectively. These passages divided the city into four parts, each of which was further pierced by eight to twelve radial streets. Between these were individual passages with gates, linking stores, workshops, houses, schools, and mosques. The inner circle within the city, framed by arcades, was an open space in which the palace of the caliphs

and the main mosque stood. The original plan of Baghdad, however, was considerably altered in subsequent reconstructions, and al-Manṣūr's design has long since disappeared. The same caliph also experimented, in 772, with a horseshoe city plan at a site on the Euphrates near the old city of Raqqa. The mud walls, fortified by towers, are still visible.

Two days' journey north of Baghdad stood the city of Samarra, the capital of the Abbassides from 838 to 889 and one of the most impressive urban centers ever constructed

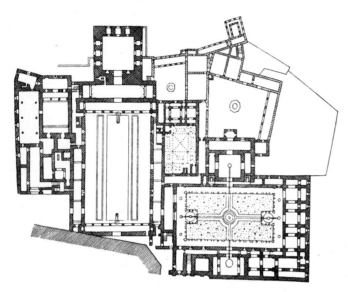

Granada, plan of the Alhambra.

by man. Samarra was thoroughly explored by German excavators between 1910 and 1914. Originally only a garrison settlement for the Turkish militia with the palace of the caliphs located in the center, Samarra was rapidly enlarged through the construction of new residential sections and ultimately came to occupy an area some 20¹/₂ miles in length and a little more than a mile in width along the Tigris. Everything connected with the court was concentrated here, and a large part of the population of Baghdad migrated to the newer city. Owing to this somewhat haphazard growth, the huge but short-lived settlement does not reveal a systematic plan.

Medīna az-Zahra, founded near Cordova (Córdoba) in 936 by 'Abd-er-Raḥmān III, is next in the chronological sequence of important city building projects undertaken by the Moslems (X, PL. 163). Built on an elevated site, this new capital gradually attracted traders and handicraft workers, and became an independent urban center in its own right. The excavations being carried out under Spanish auspices are not far enough advanced, however, to give a clear impression of the over-all plan of the city with its interesting arrangement of palace, mosque, and bazaars. The city was destroyed in 1010, and thus its lifetime was much longer than that of Samarra.

We are somewhat better informed concerning the capital of Cairo (al-Qahira), constructed in the immediate vicinity of the older city of Fostat by the Fatimid al-Mu'izz after the conquest of Egypt at the end of the 10th century. Cairo occupied an area of about 920 sq. yd. and was surrounded originally by a wall of mud brick. Between 1087 and 1093, Syrian architects built a more massive fortification wall based on Byzantine models. The new wall, composed of ashlar blocks, was reinforced by square towers and had four majestic entrance portals, three of which are still preserved (V, PLS. 245, 247). Within this enclosure, which was divided by a wide street running north and south, troops, court personnel, and officials of the administration were housed. Barracks, mosques, and living quarters were grouped around two palaces located opposite each other within a complex of government buildings that have since disappeared. Following the destruction of Fostat and the end of the Fatimid dynasty (1171), the original

urban complex lost its purpose and was swallowed up in the growing city of Cairo.

Little is known of the cities constructed by the Seljuks. New foundations were on the whole avoided, since the sultans and their atabegs preferred to establish themselves in preexisting cities. It can no longer be determined whether the building of the wall of Konya in Anatolia in 1221, with 108 towers, also involved the large-scale replanning of the city as a whole. The Mongols, on the other hand, laid out wide boulevards in their city with great care and probably instituted other fundamental changes in city planning as well. None of their projects, however, has survived as it was executed. Through the sources it is known that Vizier Rashīd al-Dīn erected a whole university complex with individual colleges, a library, housing, shops, and other facilities outside Tabriz.

Tamerlane drew construction workers and artisans from all the lands he conquered to Samarkand, in order to make the seat of his capital ever more splendid. It is not known whether the appearance of the city was originally much different from that of today. The main center was the relatively small Rigistan, a square faced by three great madrasah constructions that dominated the town with their elevated portals and gave a special character to the largely preserved burial street of the city.

In the 13th century, the kings of Granada in Spain built a capital upon a hill overlooking the metropolis, the Alhambra (Ar., al-Ḥamrā'), which in the course of the 14th century came to include a fortified palace complex (PL. 149; X, PLS. 166–168, 171) with gardens, a burial ground, and various other elements, among them a mosque and streets with shops. The entire complex was surrounded by its own wall (FIG. 335).

Following the conquest of Constantinople, the victorious Osmanlis (Ottoman Turks) proceeded gradually to build a residential palace. Various elements were grouped without a defined arrangement, and the over-all ground plan gives the impression of having emerged more or less by chance.

Impressive city plans always bear the imprint of strong personalities. This was indeed the case for the city of Isfahan in Persia, built in the 16th century by Shah 'Abbās I as his imperial capital. The town was dominated by an imposing square surrounded by a continuous row of two-storied liwan arcades pierced in the center of each side by a high entrance portal. One of these led to the palace complex, which was located within a huge park and was methodically arranged as a group of graceful pavilions of varying design. From there, extending as far as the Hazār Jarīb garden, almost 2 miles to the south, was the Chahār Bāgh with its palatial apartments, kiosks, and fountains. A canal flowed through the entire length of the complex, which was framed by rows of plane trees and closed off at both ends by pavilions; other streets ran parallel to this impressive promenade. Great bridges spanned the river and gave to the city an outstanding and original character. Later additions conformed to the system established at the outset, and even today the silhouette of the city forms an impressive panorama.

In India, the emperor Akbar founded the city of Fatehpur Sikri in 1569 on the outskirts of Agra and resided there until 1583. The city was surrounded on three sides by a wall about 3 miles in length, while the fourth side was closed by an artificial lake. A number of palaces were built, each designed as part of a general plan (X, PL. 113). Other buildings, including mosques, bazaars, and service quarters, were never used again and thus have survived in a relatively good state.

RELIGIOUS ARCHITECTURE. Of all Islamic religious architecture, two buildings stand out because of their extraordinary importance to the Islamic world and because they demanded a special ritual: the Kaaba in Mecca and the Dome of the Rock in Jerusalem (PL. 146; X, PLS. 182, 377, 385). The first of these was originally only a modest enclosure sheltering the Black Stone which had been treasured by the Arabs in preIslamic times, but when it became the perennial goal of thousands of pilgrims from the entire world, the enclosure was hung round with a splendid curtain that was replaced every year, and it was gradually surrounded by numerous structures

erected to meet the practical necessities of an important center of worship. Artistically more important, the Dome of the Rock in Jerusalem was erected in 691 by Caliph 'Abd-al-Malik over the holy rock which Jews regarded as the foundation stone and axis of the world and Moslems as the spot of the Prophet's mystic ascent into heaven. The building is octagonal, with a double inner colonnade supporting a wooden dome mounted on an elevated drum. The use of the central plan, undoubtedly inspired by the desire to create a pilgrimage center to rival Mecca, politically apostate at the time, was also partly influenced by the centralized Christian churches of Jerusalem. Neither the Kaaba nor the Dome of the Rock conforms to the plan of the typical mosque.

Mosques were constructed as assembly halls for the faithful (PLS. 146, 161, 163, 170; FIGS. 337, 338, 341). They served primarily for the recitation of prayers in common, a practice which from the very beginning of Islam was of great importance, even though the faithful were permitted to fulfill this religious obligation in the home, workshop, or outdoors. The obligatory Friday sermon (khutbah) was delivered in the larger mosques, and certainly in the leading mosque, of every city. Moreover, mosques were used for religious instruction, for certain memorial services, as hostels for traveling scholars, as places of asylum for the persecuted, and sometimes for teaching. In certain areas, above all in villages, they served as community houses, affording shelter and cooking facilities for

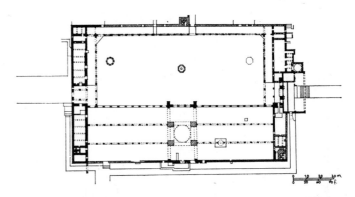

Damascus, plan of the Great Mosque.

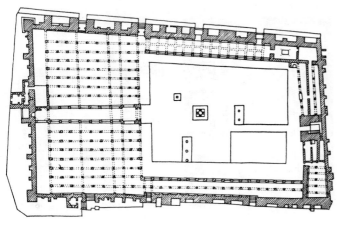

Kairouan, plan of the Great Mosque.

traveling pilgrims. If a mosque had been endowed as a memorial to a deceased person, his tomb was established on the premises.

The plan of the mosque was based on the so-called *muṣallā*, a simple walled precinct used for prayers in pre-Islamic times. Its orientation (*qibla*) was changed and directed toward Mecca by Mohammed, a feature that became canonically binding in all Islamic places of worship, although it was not always exactly followed. In many cases, Christian basilicas were transformed into mosques simply through a change in orientation. In some instances, this was accomplished by constructing a *qibla* wall through the room.

The first large mosques had a skeleton of palm stems and clay and were faced with palm leaves and clay, but it soon became necessary to build more elaborate structures to provide larger numbers of the faithful with protection from the sun, as well as from enemy attack. For this purpose, the outer walls were strengthened and reinforced with towers and crenelation. This type of fortresslike mosque remained in use even after the triumph of Islam rendered the defensive function of the mosque obsolete.

The ground plan of the early mosque already showed the basic characteristics of the more solidly built and widely distributed courtyard mosques. These were distinguished by a large square or rectangular courtyard (*ṣaḥn*), oriented toward Mecca and closed off by means of a more or less elaborate prayer room (*ḥaram*). The flat roof, constructed with beams and planks, rested on round or horseshoe arches, which were

in turn supported by columns disposed in regular rows either parallel or perpendicular to the *qibla* wall. Columns and capitals were taken from ancient buildings, often without much discrimination. Variety in the height of the shafts was compensated for by adjusting the height of the bases or by inserting additional moldings under the capitals. The courtyard, in the center of which stood a fountain for ablution, was usually surrounded by an arcade and sometimes by several rows of arcades.

The *qibla* wall of the prayer hall was at an early date provided with a niche (mihrab), probably modeled on the Christian apse but without the liturgical significance of the latter. This niche did not protrude on the exterior of the building; it was of secondary importance and served only to mark the direction to which the prayers of the faithful were to be addressed. The first mihrab was installed in the memorial mosque built in Medina in honor of Mohammed in 694 by Caliph 'Abd-al-Malik. The significance of the niche, which could be of stone, marble, wood, stucco, or ceramic material, was emphasized by decorative effects and by its position as the culmination point of the hall (PLS. 18, 88, 147, 148; VII, PL. 403; IX, PL. 272).

The required furnishings of the Friday mosques were a raised podium, from which the Imam (the leader in prayer, considered also to be commander of the faithful) could address the congregation, and an imposing lectern (mimbar), the latter undoubtedly based on the ambo of Christian churches (IX, PL. 272). The mimbar usually stood to the right of the prayer niche; it was generally made of wood and hence portable, although sometimes it was constructed of stone or marble. The mimbar was later adopted in mosques which were not intended for the Friday sermon. In addition to the mimbar and the mihrab, a number of mosques were outfitted with a loggia for

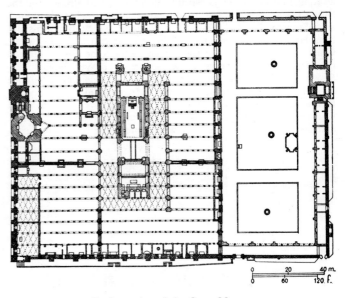

Cordova, plan of the Great Mosque.

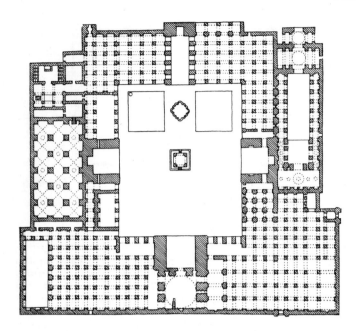

Isfahan, plan of the Masjid-i-Jāmi'.

the nobility (*maqṣūra*), separated from the space of the congregation by a wooden screen. At a later date, the larger houses of worship were provided with a raised platform (*dikka*) to make the officiant visible to the congregation (V, PL. 458).

When the caliphate was transferred to Baghdad, in the vicinity of Ctesiphon (the previous capital of the Sassanian rulers), some local architectural practices, such as the use of fired brick and the employment of a somewhat depressed pointed arch, were taken over by the Moslems. Less frequent use was made of looted columns, since round or rectangular brick piers became the rule. Stucco encrustation was used for decoration and Islamic builders adopted their own variation of the chalice capital. In Persia, where the courtyard type of mosque is also found, contact with Zoroastrian fire temples led to the development of the so-called "kiosk" type, which was composed of a domed space preceded by an anteroom known as the liwan. The liwan mosque, adopted by the Seljuks in Persia in the 11th century, was an outgrowth of this earlier form, although it was also influenced by an Iranian development, the so-called "madrasah" plan.

The madrasahs (FIGS. 339, 340) were developed in Persia as religious schools of jurisprudence intended to strengthen the Sunnite sect in its opposition to the Shiites. Their buildings are characterized by a cruciform plan in which the arms are four large liwans leading onto the central court. The liwans, which were connected to each other by one- or several-storied dormitories, could serve as audience or prayer halls. The first such madrasahs are believed to have come into existence as early as the year 1000 in Ghazni. In especially large establishments of this type [in Isfahan, Baghdad (I, PL. 6), and Cairo (IX, PL. 270)] the liwans, with their adjoining residential complexes, were divided between the four orthodox rites

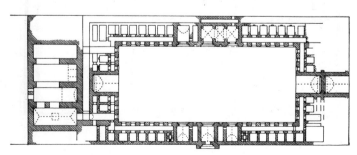

Baghdad, plan of al-Mustanṣiriya Madrasah.

(Malikite, Hanafite, Hanbalite, and Shafiite). In smaller institutions this profusion of liwans was unnecessary, and they were provided with only one or two. The madrasahs of Persia and Iraq were adopted more or less unchanged in Syria, Egypt, and Anatolia. In the Maghrib, they were completely altered to fit traditional Moorish architectural thinking.

In Persia, almost all large mosques erected at this time were based on the madrasah plan. The main liwan was enlarged into a prayer hall and eventually was emphasized through the addition of a dome. Such an addition was bound to create difficulties, and the dome in some cases overshadows the entire structure. In Anatolia, a simpler arrangement — a domed hall preceded by a narthex — prevailed until the 15th century. Only after the conquest of Constantinople in 1453 were steps taken toward grandiose solutions, in the style of St. Sophia, calling for a central dome surrounded by half domes and smaller cupolas. This development reached its high point in the 16th century in the work of Sinān (q.v.; PL. 161; X, PLS. 444-447), chief architect of Sulaymān the Magnificent.

An indispensable feature of the mosque today is the minaret, which was introduced under the Ommiads, less for practical than for formal reasons (PLS. 150, 162, 164; FIG. 343). The minaret was not a prescribed element of the cult edifice, as the call to prayer could be made from a high roof or from the city wall just as easily. In certain regions of Arabia, neither simple village mosques nor larger structures were provided with

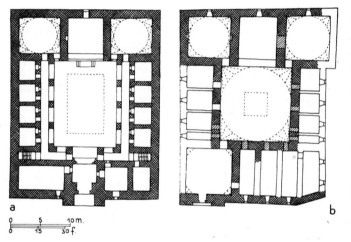

Konya, madrasah plans. (*a*) Sırçalı; (*b*) Büyük Karatay.

such towers. It is unlikely that the towers of Syrian churches played a role in the introduction of the minaret. The derivation of the term, which was first applied to the signal or light towers (Ar., *manāra*) frequently found in the East, in the interior as well as along the coast, suggests the general type within which antecedents are to be sought. The most famous of these towers, the Pharos of Alexandria, known to all travelers on the sea, was the model for a large number of minarets, especially in Egypt. The base of each of these structures was square, with an intermediate octagonal element topped finally by a cylindrical shaft.

The earliest minarets were generally placed at the front of the courtyard, on the axis of the mihrab, but they were sometimes built in a corner of the courtyard or entirely outside the mosque. Access to the upper parts of the tower was by means of an inner staircase or ramp. A 9th-century mosque in Samarra, which has an outer spiral stairway, is an exception to this rule (I, PL. 11). In the West, the minaret was always square in plan and tapered toward the top. In Iran, on the other hand, a cylindrical form of minaret was in common use. In the Seljuk period, when the minarets were joined to the front of the liwan, for reasons of symmetry two were built, although only one was actually used for the prayer call. The Persian variant was taken up in Turkey, where it evolved into a slender, needlelike projection interrupted by parapet galleries.

Monastic establishments were also found in the Islamic world. The oldest and most important of these were the ribats, fortresslike structures housing militant orders who propagated the faith through holy war and needed protection against

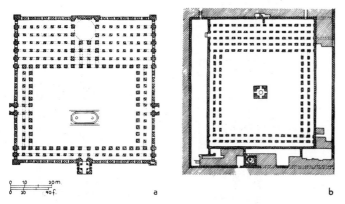

Cairo, mosque plans. (*a*) al-Ẓāhir Baybars; (*b*) Ibn-Ṭūlūn.

enemy attack. The ribats served as military encampments at strategic points and as guard posts against invasion. Each had powerful walls, cells for living quarters, special areas for storing weapons and provisions, a prayer room, and a watchtower. They were especially numerous in Transoxiana but were also to be found along the coasts of Palestine and North Africa. Examples have been preserved in Monastir (late 8th cent.) and in Susa (821), both in Tunisia (see AFRICA, NORTH).

The inhabitants of such institutions were volunteers who withdrew to the ribat for shorter or longer periods under ascetic discipline, engaging in pious recitation and guard duty. The Almoravides, who conquered North Africa and Spain in the 11th century, originated from such ribats in the Sahara and along the Senegal, while the Moroccan capital, Rabat, derives its name from a similar fortress. A change occurred in Persia in the 12th century through the institution of the khankahs (*khānaqāh*s), monasteries of the Sufis, a sect animated by mystical piety and without military aims. Khankahs, often of considerable size, were also built in Egypt during the Mameluke period (see MAMELUKE ART), sometimes in association with mosques, schools, or funerary sites. The *zawiya*s which developed in North Africa were, by contrast, of modest size and without architectural distinction. These foundations were composed of ascetics either led by a sheik or congregated around the grave of a worthy personage.

Mausoleums erected over the graves of holy persons were provided with a mihrab and *qibla* and were often endowed by the deceased with a mosque or madrasah, thus becoming objects of popular worship. Their design, however, hardly

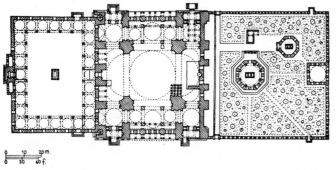

Istanbul, plan of the Mosque of Sultan Sulaymān.

differed from funerary monuments of a purely secular character, and they can scarcely be discussed as a separate category.

There are no large funerary monuments from early Islamic times, since explicit pronouncements of the Prophet prescribed

simple burial. This injunction was generally adhered to in the Islamic world, and the place of burial was marked only by a stele at the head and foot of the grave. Moslem rulers do not seem to have been inclined to commemorate their earthly pilgrimages with imposing monuments.

Turkish potentates, it appears, were the first within ruling circles to abandon traditional restraint, constructing for themselves funerary towers of polygonal or circular plan, with conical terminations and a strongly marked surface grooving, making them reminiscent of the corded conical tents of Central Asian nomads. Such structures were built in eastern Persia from pre-Seljuk times until the 13th century, with some variety in scale and design. Impressive domed mausoleums developed concurrently with these funerary towers and emerged into the foreground at that time. This form was adopted by the Mongols and can be seen in an outstanding example erected for Sultan Öljeitü (Uljeitu; VII, PL. 400). Another type of monument is exemplified by the famous mausoleum constructed for Tamerlane in Samarkand in the funeral precinct reserved for his family.

In Egypt, only a few important mausoleums are preserved from the period of the Fatimids. Under the Mamelukes, however, this type of monument underwent a rapid evolution, and many ruins are still partially visible in the largely preserved necropolis on the outskirts of Cairo (PL. 162). Domed mausoleums were here often connected with mosques, monasteries, schools, and fountains (IX, PLS. 270, 271). The combined funeral monument and madrasah of Sultan Ḥasan (IX, PL. 270), located within the capital proper, has a number of unique architectural features and a complex of cells intended as student residences. Another outstanding mausoleum is that of Sultan Qalā'ūn, with a dome resting on horseshoe arches carried by piers and columns. The Osmanlis contributed a number of additional variations to this basic type.

Under the Safavids (ca. 1502–1736) a large, richly decorated sepulchral mosque was begun in the 16th century in Ardebil, Persia, over the grave of the founder of the dynasty. It was greatly favored as a pilgrimage site and must be counted as one of the most significant examples of sacred architecture of the period. In India, an original type of fortified funerary monument was developed in the 14th century. Under the Moghul emperors, mausoleums were constructed along less formidable lines, as pillared pavilions with arcades of pointed arches, deep niches, and small kiosks, the whole usually set in the midst of a body of water or in a park (PLS. 166, 169; VII, PL. 498; X, PL. 111). The most famous example of this type, the Tāj Mahal near Agra (VII, PL. 498), is situated at the end of a large, landscaped area. It is covered with light-colored marble, surrounded by smaller structures in red sandstone, and framed by rectangular towers in an outstandingly harmonious arrangement.

In Western Turkistan the early walled precinct (*muṣalla*), from which the concept of the mosque sprang, was once more taken up under the Mongols and elaborated into a monumental form.

An important institution for the care and preservation of Islamic religious buildings was the *waqf*, consisting primarily of pious donations of property such as lands, industrial goods, baths, and shops. These donations were operated commercially in order to raise funds for the upkeep of mosques, madrasahs, hospitals, fountains, bridges, and other public buildings and in order to maintain a relief fund for emergencies. This institution was maintained over a number of centuries, and inscriptions recording the names of benefactors were sometimes placed within buildings favored by a donation.

SECULAR ARCHITECTURE. The Prophet, for his own living arrangements, had contented himself with a large yard enclosed by a mud wall, provided on one side with a gallery (*zulla*) covered with palms to shelter his guests from the sun. A number of small rooms were constructed on another side of the wall for his wives. The residences of the first caliphs were in all likelihood not much more elaborate.

It was only with the transfer of the caliphate to Damascus under the Ommiads that more expansive residences were con-

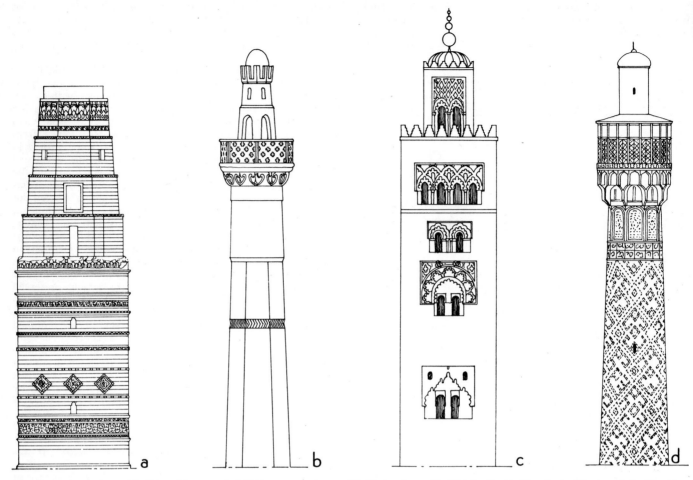

Elevations of minarets. (*a*) Cairo, Mosque of al-Ḥākim, west minaret; (*b*) Nayin, Iran, Masjid-i-Jāmiʻ; (*c*) Marrakech, Mosque of the Kutubiya; (*d*) Isfahan, Chahār Bāgh Mosque.

structed for the ruling class, although nothing specific is known concerning the seat of government in the capital. The majority of the Ommiad rulers were in any case ill at ease in the unaccustomed surroundings of the crowded city, preferring to construct their villas or palaces in the desert of Transjordan or Syria. The ruins of a number of such structures have been preserved. Some of them appear to have been modeled on the Roman forts along the limes, consisting of a wall reinforced by towers, with a single entrance leading into a large courtyard surrounded by reception rooms and living quarters often two stories high. These structures served either as hunting and bathing lodges (*bādiya*) or as permanent residences similar to the fortified palaces of the Lakhmids at Hira. The best-known of the latter type is the palace at Mshattā, which already shows the tripartite division that later became canonical, consisting of a complex of guardhouses, storerooms, and prayer hall; a court of honor and basilican hall with a triconch throne room; and the private apartments of the caliph (FIG. 345).

The next step in the development is exemplified in the palaces of Samarra, which was constructed as a capital for the Abbassides in 835. Through excavations, not only the palace of the caliphs but also a number of other castles and many private houses have been brought to light or traced in ground plan. In the best-preserved palace, Balkuwāra, the tripartite division was again carried out (PL. 151; FIG. 346). In Baghdad proper, nothing has been preserved, but it is known that the palace of al-Manṣūr was closely connected with the main mosque. The palace of the caliph likewise adjoined the main mosque in Fostat, the predecessor of Cairo, and in Cordova, where a few massive remains of the wall of the Alcázar are still visible.

The palaces of the Fatimids are known only through inconclusive descriptions in literary sources. In Mahdia there existed a "castle with golden windows," in Cairo an eastern palace with nine portals and a façade 1,125 ft. in length, as well as a smaller western palace with two wings qradling an open square. On the other hand, excavations have brought to light a number of structures in the capital of the Hammadids, who ruled certain cities in Algeria. The site of Qalʻa Beni Hammād in western Algeria has yielded remains of a "sea palace" (al-Bahr) with a huge pool and a large throne room, as well as a "lighthouse palace" (al-Manār), with an imposing domed hall. In Sicily, there are two relatively well–preserved pavilions from the Norman period, the Cuba (1180) and the Zisa, both in Palermo.

At the end of the 10th century, after the collapse of the caliphate, a large castle was built in Baghdad by the sultan of the Buyids; it is known only through a description, which mentions an inner courtyard surrounded by porticoes with domes, a large audience hall, a small judicial hall, and a park extending to the Tigris. This palace was probably used also by the Seljuks, but as little remains of it as of the other residences of this dynasty and its atabegs in other capitals. Later, the royal encampments of the Mongols undoubtedly were more or less strongly tinged with East Asian influences; at the same time the rigid hierarchical order prevailing among the Mongols was maintained. No precise information is available, and accounts of Tamerlane's palace in Samarkand given by European travelers do not permit drawing of definite conclusions.

Aside from a few remains in Seville, secular architecture in Moorish Spain is represented chiefly by the Alhambra, which is relatively well preserved. The division of the complex into three distinct parts, each constructed around a courtyard, is still clearly visible. The first part (*mashwar*), with guardrooms, a hall for public receptions, rooms for the judiciary, and a small oratory, is followed by the official area (divan),

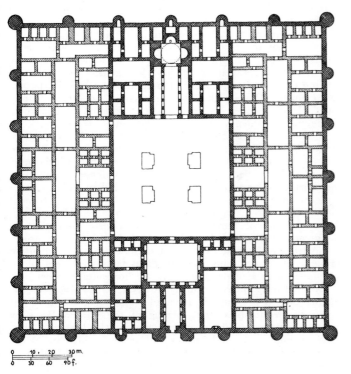

Mshattā, plan of the castle.

with offices for the court officials arranged around a court of honor dominated by a large water basin and connected with a majestic audience hall built into a great tower. The third section of the complex (*harīm*) is built around a large fountain borne by lions and comprises the private quarters of the sultan, with various rooms and halls, with baths, inner gardens, apartments for the princes, and a small prayer room. Connected to this section was the royal funeral precinct (*raudha*) and a passage, no longer recognizable, leading to the mosque. The same disposition, allowing for differences imposed by characteristics of the specific site, was followed in Moroccan and Tunisian palaces, as well as in the Alcázar of Seville (PL. 113; X, PL. 168), which was constructed by Moorish architects in the 14th century for King Pedro el Cruel of Castile.

The palaces of Persia have disappeared almost without trace as have those constructed by the Safavids in Tabriz and Qazvin. By contrast, the complex in Isfahan is still largely preserved. Characteristically, it is a loose arrangement of impressive pavilions and kiosks of varying sizes, rather than one large, unified structure. The palace contains water basins, canals, and lanes framed by rows of trees laid out within a carefully planned park. The palatial precinct was accessible from a large square through a high gate in the middle of one side of the square. Among the pavilions, the slender proportion of the supports in the so-called "Hall of Forty Columns" is reminiscent of similar wooden kiosks which existed in Turkistan.

The Topkapı Saray Palace in Istanbul, which served as the residence of the sultans until the 19th century, was constructed on the site of the Old Acropolis of Byzantium, surrounded on three sides by the sea. The disposition of this structure does not follow a uniform plan; the parts were apparently constructed at different times according to necessity and on the basis of different designs. The oldest and most interesting of these parts, built after 1472, is the well-preserved Chīnīlī Kōshk, with a central dome, liwans laid out according to a cruciform plan, columned anterooms, and a several-storied rear façade. By and large, in the construction of additions to existing palaces Moslem rulers proceeded without much respect for older structures, often razing entire blocks of such constructions or building new parts totally out of character with older parts. The palaces of the Moghul period in India, parts of which are still well preserved, were very large and coherently

planned and were regularly situated on a height overlooking the town, as in Gwalior, Delhi, Lahore, Amber, and Agra (PL. 165). In their execution, they show a happy blend of Persian and Hindu elements.

The private houses of city dwellers varied according to region and climate as well as established traditions. In Iraq, the basement level, equipped with an air shaft for cooling, was used as a guest room (*serdab*). A T-shaped hall composed of small rooms in the corners and a colonnade leading to the courtyard (*tarma*) was used as a reception room. Such rooms can be found in 9th-century Samarra, and in Syria took the form of the widely distributed *qāʿa*. In this arrangement, three liwans, also laid out in the form of a "T," are disposed around a somewhat recessed central space, which was normally equipped with a fountain. This plan was known also in Egypt (IX, PLS. 272, 274) and Turkey.

Another type of private house, which was developed in Turkey and popularized abroad after the Turkish conquest, was a wooden construction with a projecting upper floor and latticed bays. In North Africa and Spain, house construction adhered basically to the Hellenistic tradition of flat roofs with terraces and colonnaded arcades framing inner yards. In Persia, by contrast, vaulting was in common use. Within certain regions, such as Khorasan, the houses of entire villages were roofed with small domes, evidently as a means of protection against both the heat of summer and the winter snows. Indian residential architecture of the Islamic period was greatly influenced by the Hindu tradition.

Among the most important types of public buildings in the Islamic world were the often enormous guest houses or caravansaries (khan or han; in the West, fonduk; PL. 161; I, PL. 13) constructed along the main routes. In the Seljuk period, these were constructed at every isolated relay station and were often fortified outposts for the protection of travelers. The Mongols, Safavids, and Osmanlis also erected imposing struc-

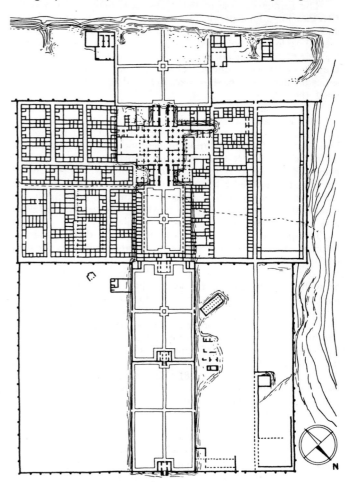

Samarra, plan of the Balkuwāra palace.

tures of this type. In Iran, their disposition had much in common with the plan of the madrasah, consisting of liwan halls laid out in a cruciform pattern and usually separated by two-storied passages, of which the lower ones were used as stables and warehouses and the upper to shelter guests. About sixty such caravan relay outposts from the 13th and 14th centuries have survived in Anatolia. These were all vaulted and usually consisted of a number of halls, with a small, often domed, inner courtyard and sometimes a special oratory.

In the cities, stores and warehouses were constructed according to the same architectural principles and were mostly concentrated in the bazaar quarter (sūq), which constituted a distinct section closed off at night. The bazaar quarter itself was composed of a number of square halls, each of which was covered by a small dome or by a simple protective awning. Remains of such architectural complexes from the Middle Ages are rare, although parts of one are still preserved in Tunis. The 17th-century bazaars of Isfahan and Kashan are architectonically and in plan among the most carefully worked out and impressive. A number of other bazaar complexes in the Orient have been more or less modernized over the centuries.

Hospitals (māristāns) frequently were established as pious private foundations. The most famous of these was the institution constructed by 'Aḍud ad-Daula in Baghdad in the year 979. It had various clinics and stood until the 13th century. The hospital built by Sultan Qalā'ūn in 1284–85 adjoining his mosque could still be appreciated in its original design during the 16th century.

A number of bathing establishments (hammam) in Andalusia go back to the 10th century. These were conceived on a small scale, but still following the over-all design of the Roman thermae, with an apodyterium, tepidarium, and caldarium. The form was further developed by the Turks, as shown by the large baths of the 14th–16th century in Kaplica near Brusa (now Bursa), which are still in existence today.

The bridge designs of the Arabs also follow Roman tradition and for a long period of time they were content to restore and consolidate antique constructions. A truly new and monumental style only appeared during the rule of Shah 'Abbās I (early 17th cent.), who included in his comprehensive plan for the city of Isfahan a number of two-storied bridges with a bold series of niches and pavilions at each end and along the span itself (PL. 160).

ARCHITECTURE AND DECORATION. Despite its originality and rich variety, Islamic architecture for the most part manifested little concern for the solution of genuine structural problems. This lack of interest in such problems may be explained primarily by the preference in the Islamic world for spatial entities of a decidedly horizontal or ground-hugging character. Bold thrusts upward into space and attempts to exploit the possibilities of verticality were nowhere seriously undertaken, and only isolated experiments can be cited.

The prayer room of the early mosque, with its forest of columns, was of limited size and together with an arcaded courtyard formed one distinct entity. Enlargements were carried out through construction of additional bays in the length or width, depending on the availability and character of the land, and without apparent concern for preserving the original axis of the structure. In exceptional cases the courtyard also might be shortened. In order to alleviate the oppressive feeling within these low buildings, the arches supporting the roof were elevated by means of impost blocks. In Cordova, a solution was found in the erection of a second story of arches mounted on consoles (PL. 148). The horizontal tendency thus was slightly modified, as it was also by the introduction of the pointed arch and brick construction in the 9th century; the flat ceiling was retained and the implications of the pointed arch, so fully realized in cathedrals of the West, were not exploited in the Islamic world.

Even where flat roofing was precluded by climatic conditions, single, all-enclosing gabled roofs were avoided and each nave bay was separately spanned. Similarly, monumental portals were avoided in favor of numerous small doors opening onto the courtyard and in the sides of the structure in a regular rhythm, thus increasing interior illumination.

The courtyards within Persian liwan mosques, based on the design of the madrasah, were dominated by large portal niches, one on each of the four sides. These were linked by two stories of consecutive niches, rhythmically arranged and bearing ceramic decoration, thus becoming a primarily decorative element. Despite the rich variety of design which characterizes Islamic dome construction, it is difficult to speak of a pronounced tendency toward monumental vertical effects. Domed mausoleums, funerary towers, and turbehs are characterized by massive and clearly defined forms and produce an impression of earth-bound stability rather than of dynamic elevation. The effect of the bold, pointed dome surmounting the early-14th-century structure of the Ilkhan ruler Öljeitü (Uljeitu) in Sulṭāniya is mitigated by the lower story's rows of niches interrupted by piers supporting towers (VII, PL. 400). An impression of horizontality is also clearly discernible in the great mosques of India. The effect of unity is here largely dissipated by the vast expanse of masonry, by the repetition of the onion-shaped domes, and by the isolation of the entrances. Monumentality is expressed solely by horizontal expansion.

An entirely different effect, however, is achieved in the mighty domed mosques of Istanbul. The construction of the dome on pendentives, the opening of the wall surfaces by rows of windows, and the grooving of the load-bearing piers yield an impression of lightness and airiness which belies the complicated problem of statics resolved in such buildings. Efforts such as these, which can be traced to the inspiration of St. Sophia, went even further in scope, yet real attempts to develop the central mass as an element of towering height were avoided. Moslem architects were more concerned with the decoration of the exterior by rows of small domes and with the creation of contrasts between the slim minarets and the massive volume of the main central dome.

Tower construction was characterized by considerable restraint, and the silhouette of the typical old Islamic city was little affected by such vertical structures. In the West, where towers were apt to be massive rather than tall, they remained a subordinate element in the cityscape. In Cairo, despite numerous types of variants introduced by the Mamelukes, the construction of a large tower to dominate the entire city was never attempted. In Iran, towers had a purely decorative effect, since they were of limited height and were usually built in pairs to flank liwans. Even the tall, needlelike minarets of the mosques of the Osmanlis did not extend substantially beyond the height of the dome.

The canon of horizontality was especially apparent in residential buildings and palaces. Enlargement of existing premises was effected by means of outward expansion, never upward. Large courtyards with water basins played an important role, and buildings were sometimes erected with symmetrically disposed terraces and parks, which were always laid out as flat surfaces. It can be shown that where little space was available, as in Fostat, tall buildings were erected. Such was also the case in certain settlements in Arabia for reasons of a traditional character. These examples, however, are the exceptions that prove the rule.

Concern with structural problems in Islamic architecture is much less evident than interest in decorative effects. The tectonic function of each architectural element was carefully considered, and height, width, and mass were accurately calculated according to a specific canon of proportion; the structural purpose of single elements was deemphasized by a loosening and breaking up of forms and by ornamentation. Round masonry piers were inscribed with deep grooves or decorated with stucco or faïence incrustation, and the weight-bearing function of columns was seemingly denied by the use of impossibly slender columns grouped in clusters. In a number of instances, as, for example, in the Alhambra, the illusion of perspective was created within a relatively shallow space by a coulisselike graduation of passageways.

The encroachment of the decoration upon the structure can be followed with special clarity in the development of the

form of the arch. As early as the 10th century in Cordova, the horseshoe arch began evolving toward the trefoil and zigzag arch (PL. 148; X, PL. 163). The pointed arch was also given a zigzag contour, and Spanish architects of the 11th century in Saragossa made use of stucco, which could be easily modeled to cover the surfaces of arches with a profusion of inorganic ornamental details. A more sober tendency followed, but the contour of the arch was still occasionally given a saw-tooth form. In Granada, a steplike arch of a purely decorative character ultimately developed.

An important aspect of architectural decoration in Islamic art was the use of honeycomb or "stalactite" work. In this technique, developed before the pendentive, the transition between the dome and the square or many-sided supporting structure was made by means of small corner niches. These were eventually decorated with a network of small cells hiding the surface of the transition area under a variegated pattern.

The precise geographical origin of this decorative system, called *muqarna* work, has as yet not been established, although in the 12th century it was in use from Morocco to Turkistan. It was used not only in domes but in all types of vaulting, including portals and prayer niches, as well as in friezes carved in very high relief. In certain buildings it was carried out with great refinement. Stalactite capitals made their appearance in the Alhambra, while the star-shaped vaults of some rooms in the *ḥarīm* complex, covered with minute cellwork, carry this motif to its ultimate point of development (PL. 149). In the 16th-century private Audience Hall (Dīwān-i Khās) of the Indian emperor Akbar in Fatehpur Sikri, the *muqarna* work had a distinctly static character. A central pillar, which branches out into a richly decorated stalactite capital, bears the throne platform; from this platform radiate four diagonally placed "bridges" which lead to a surrounding gallery. The *muqarna* technique was not limited solely to stone or wood but was also carried out in brick and faïence.

Ornamental and figural reliefs in stucco, in all likelihood originally painted, were employed in the decoration of certain desert castles, following Sassanian tradition. Glass and stone mosaic work (see MOSAICS), which was used in floor or wall decoration, was, on the other hand, produced almost exclusively by Byzantine craftsmen (PL. 145). Wall paintings of the 9th century, inspired by Byzantine or Sassanian art, with certain Chinese influences, have been found in Samarra; later examples are less frequent. Strongly coloristic effects were especially favored from the 13th to the 15th century, as is indicated by the popularity of faïence mosaic (see CERAMICS). In Spain, this technique, which was chiefly confined to decoration of the lower parts of the walls, made use of patterns of great variety, composed solely of geometric forms. In Iran, a wider range of color and more complicated curvilinear forms were employed. This art was practiced with great skill by the Persians and later, under Persian influence, by masters from Anatolia and Turkistan.

Under the Timurids and the Safavids, the use of ceramic mosaics in architectural decoration reached an unprecedented level of perfection. Graceful arabesques, colorful floral forms, imitation medallions and cartouches, and friezes of ornate and exquisite inscriptions were combined into tapestrylike patterns of glowing color (see CALLIGRAPHY AND EPIGRAPHY), with a predominance of cobalt blue. Motifs found in such work were undoubtedly transmitted largely through manuscript illumination but were used also with uncommon virtuosity in pottery decoration. Flat surfaces as well as curved vaults, liwans, domes, and even minarets were often covered with an uninterrupted mantle of faïence mosaic, completely hiding the masonry of both exterior and interior. The observer is blinded by the enormous richness of such decoration and is no longer aware of the underlying structure.

In Turkistan during the 15th century, and in Persia from the end of the 16th, the slow and difficult technique of mosaic work was replaced by a simpler method using mainly square tiles. The drawing style and range of color were retained, so that the change from the earlier and more complicated technique is not always immediately apparent. In the 17th century, certain pavilions within the palace complex of Isfahan were decorated with figural compositions consisting of small individually designed tiles covering the surfaces of entire walls.

The same system was used by the Turks, who employed huge quantities of faïence tiles made in Íznik (anc. Nicaea) in decorating the palaces and mosques of Istanbul and eventually of the whole Ottoman empire. Entire wall surfaces were covered with this type of ceramic decoration, using standard arabesque and curved band motifs, and especially floral patterns, which became, together with a particular shade of red, almost a trademark of the Ottoman period (III, PL. 144). Egypt and Syria imported the technique of ceramic incrustation only at a late date; in the Mameluke period, intarsia work in marble was the favored method of architectural decoration, used with especially successful results in the ornamentation of prayer niches in the mosques.

An important characteristic of Oriental interior decoration was the virtual absence of large furniture. The principal aim was to give the wall surface a pleasing appearance. Under the Abbassides, as can still be seen in a number of houses in Samarra, the surface of the wall above an uninterrupted stucco dado was broken up into niches of varying shapes used for the storage of small objects and books. In later times, such niches were given a distinctly playful effect by carving into them replicas of bottles, vases, containers, and other household objects. Eventually it became customary in Persia, as well as in India, to cover the wall with purely decorative niches. At times these were even illusionistically extended onto the ceiling by means of painting. Such a procedure is typical of an esthetic whose aim it was to avoid an empty, smooth surface at all costs. A 17th-century storeroom with niches designed to hold Chinese porcelain is still preserved in the Porcelain Room in Ardebil (PL. 160).

In Egypt, walls were covered with wood paneling into which were cut small niches alternating with doors opening onto closets with shelves. In Syria and Turkey, walls were later designed with closetlike niches, coffered doors, decorative paneling, and an overhanging frieze of stalactite work. A taste for the rich effect of ornamental and figural designs executed in lacquer painting, probably derived from Persia, is also characteristic (PL. 421). On the whole, Spanish and North African practice favored ornamental stucco incrustation above a ceramic dado. In general, then, sharply defined, closed spaces and avoidance of empty surfaces were the rule in Moslem houses.

Since the custom of sitting on the ground prevailed everywhere, the decoration of floors assumed considerable importance. In the West, flagstone was used, while stone mosaic with geometric patterns predominated in Syria and Egypt. Knotted rugs were preferred in Persia and Turkey (PL. 158). The patterns most frequently found have either an over-all repetition of the same motif or one central element surrounded by an over-all background design, as in the Persian "medallion" type. There were either richly coffered, flat ceilings, or round or polygonal domes, with drums pierced for greater illumination, supported by corner consoles of stucco or wood.

ORNAMENT. Islamic art, like other artistic movements, can be understood only in relation to its past. The artistic heritage of the Arabic people was modest, and would not have been sufficient to permit the development of a distinctive decorative style. The Islamic style evolved principally from the artistic resources of older cultures that Islam stimulated to new efflorescence, in which Byzantine, Sassanian, and Coptic decorative practices were adapted to new requirements. The original connotation of these styles and the fact that they had been practiced by peoples regarded as infidels and foreigners were of little concern to the Moslem conquerors. Instead, attention was chiefly devoted to transforming them into an abstract language capable of rhythmical repetition and suitable to the Islamic preference for completely filled surfaces. Artisans had to adapt their style to the taste of their new patrons. The following generation became thoroughly accustomed to the demands of the new clientele, and its ties to the art of the past gradually weakened.

A new and important element which exerted a powerful influence on decorative forms was the Arabic script. It lent itself easily to the formation of ever-new variations. The angular and massive character of Kufic script, as well as the round and readily changeable forms of Naskhi writing, were used both in the elaboration of monumental epigraphy (III, PL. 7) and in the decoration of small household objects (I, PL. 4). The texts used in the decorative scheme of religious as well as secular buildings were for the most part taken from the Koran. In addition, words of acclamation and praise for the ruling prince and wishes for a blissful hereafter for the architect or the owner can also be found, often accompanied by dates. Secular poetry appears with relative infrequence in decorative inscriptions which, even in Persia and Turkey, were normally composed in Arabic (see CALLIGRAPHY AND EPIGRAPHY).

The execution of calligraphic flourishes called for considerable feats of artistry, and in this domain Islamic artisans were unsurpassed. At the height of their art, large surfaces were covered with pious inscriptions written out in a geometricized Kufic script, which was fully legible. Such a playful use of calligraphic forms was especially popular in Persia, where it was used also in book illumination.

Geometric ornament of a very simple character had already been used in the folk art of the Arabs, and certain motifs can be traced back to pre-Islamic times, as shown by extant examples of ceramic ware and textiles. The zigzag band with inserted roundels which dominates the façade of the palace at Mshattā is surely of Arabic origin (X, PL. 381). The Arabs possessed a talent for mathematics, and their experimentation with the line and circle stimulated their imaginations and led them to create ever-varying designs based purely on abstract principles.

Checkerboard and zigzag patterns, as well as the swastika and the meander, were among the most frequently used design motifs. Patterns created through interlacing bands in star and polygonal configurations were also widely employed at an early date. Such patterns, found even on the earliest preserved bookcovers, were used to best advantage in cofferwork of the Seljuk and Mameluke periods. Other combinations of basic geometric forms were also repeatedly used (PL. 147; V, PL. 251; VII, PL. 402). Interestingly, these forms were given by the artisans such highly descriptive names as sun, almond, lemon, rose, drum, and bottle. Knotted configurations, especially in an isolated context, may have had symbolic connotations that retained a superstitious significance among the people. Five-pointed stars called "Solomon's seal" and the popular swastika motif were, in all likelihood, prized solely for their ornamental value. Medallions and rosettes were common, as were crenelation, astragal motifs, and pearl bands.

The vine tendril was the dominant element among plant motifs, occurring in wave, spiral, and loop variations. In its earliest manifestations, as at Mshattā, this motif appeared in combination with vine leaves and grapes, although the rendering can be readily differentiated from late-antique carvings of the same subject because of the denser quality of the Islamic work. In later examples, stylization was carried to the point of almost total abstaction, so that plant forms lost their natural character: for example, grapes appeared as pyramids of drops.

The adaptation of the vine tendril to the form of the arabesque was a decisive phase in its evolution. Earlier writers had applied the term "arabesque" to a wide variety of Islamic decorative motifs, but Alois Riegl has rightly restricted its scope to the forked-leaf vine tendril (Gabelblattranke) and its various derivations. Although the late-antique wavy tendril must be mentioned as a prototype, the development of the arabesque took place in early Islamic times, and it may therefore be designated a specifically Arabic contribution to Islamic decoration, even though it was subsequently adopted in all other Moslem countries.

The arbitrarily stylized plant forms of the arabesque were particularly adaptable, and hundreds of variants of the basic pattern have been traced. The leaf might appear in a compact and somewhat circumscribed form or be given a more elaborate treatment. Either smooth or rough, veined or pierced, pointed, rounded, or rolled, it was never shown in isolation but always

as an organic part of the plant form. The stem was wavy, spiral, or interlaced, penetrating through the leaves, and branching, always in a continual pattern. The doubling of the leaves made possible the constitution of palmette or chalicelike forms which contributed an effective rhythmical articulation to the total design. The arabesque lent itself admirably to every conceivable artistic endeavor. It was used in friezes, borders, as an over-all motif on large surfaces, and especially as a background in panels with decorative inscriptions. Enjoying its greatest popularity in western Islam, the arabesque was introduced into European art toward the end of the 15th century, finding its way into the 16th-century pattern books of Francesco Pellegrino, Peter Flötner, Hans Holbein, and others.

The form of the acanthus, especially in the sculptured capitals made in Spain and Iraq during the 9th and 10th centuries, was adapted to Islamic style. The leaves were pierced and individual stems were treated as isolated elements, with little of the organic character of the motif remaining beyond the basic leaf shapes. Numerous variations of the palmette, such as the chalice-shaped palmette, the full-blossom palmette, and the split palmette were also introduced. The most significant of these variations was the lotus palmette, which originated in eastern Asia and was especially favored in Persia and in Mameluke Egypt. The rosette motif, known in the ancient Orient, also enjoyed widespread favor. In its Islamic form it had no symbolic connotation and was usually so stylized that it can not be traced to any precise botanical type. The treatment of plant forms in a relatively naturalistic style was first introduced on a large scale under the Ottomans, whose ceramic ware and textile designs show tulips, carnations, hyacinths, and roses, as well as vines and artichokes, often in arbitrarily combined and stylized forms which are, nevertheless, clearly differentiated.

The motif of the cornucopia was radically transformed at an early date, and while it undoubtedly derived from antique decoration, its original meaning disappeared entirely in the process of conversion to Islamic art. The characteristically antique festoon is replaced in Islamic art by a regular succession of arabesques and other plant motifs. The wreath appears early in Islamic art, although the specific identity of the plant forms cannot always be determined with certainty. The majority of examples appear to show laurel leaves.

The tendency in Islamic art to adopt symbolic geometric and plant forms of other cultures and to transform them into purely decorative motifs has already been mentioned. The same tendency is evident in the adaptation of the so-called "cloud band," which was taken from the art of eastern Asia. It was brought westward in the course of the Mongol invasions in the form of ball-shaped clouds and in Persia was transformed into an abstract pattern. Having undergone a number of formal changes, the motif was widely used in the arts of Persia, India, and Turkey.

The motif of the isolated animal, treated as an element dominating an entire composition, occurs exclusively in Iranian art and represents a reversion to an earlier Sassanian practice. The use of this motif may be traced in Iranian ceramic ware through the 14th century. Among the various animal forms frequently encountered in Islamic decorative art, the following may be cited: processions of four-footed animals of various types forming a continuous frieze across the surface of a vessel, as were already known in ancient Near Eastern art; birds fluttering, running, or flying, presented in series, frequently fused in border designs; fish in large numbers within a vessel or arranged in rows as a border; animal combats, such as attacks by lions, tigers, panthers, and eagles upon stags, hares, and gazelles; hunting scenes of various types, showing animals pursued by hunters or beaters, mounted or on foot; signs of the zodiac.

Lions, tigers, panthers, lynxes, and wolves were the most frequently represented beasts of prey; others included elephants (I, PL. 7), camels, horses, donkeys, wild asses, bulls, deer, rams, goats, gazelles, and hares. Among the birds, eagles, falcons, pelicans, peacocks in various positions, ducks, doves, swallows, and quail were favored. Various kinds of snakes

were also shown. Such fantastic animals as the griffin (V, PL. 254) and the dragon, in part retaining their peculiar East Asian design, the female sphinx, Pegasus, and the hippocampus, all derived partly from antiquity and partly from Sassanian art, were also employed for decorative purposes. The two-headed eagle and other heraldic combinations of confronted animals such as birds, lions, panthers, or gazelles were particularly favored. They could be shown either facing each other or turning away with heads averted.

The theme of animal combat was of ancient Iranian origin and had retained its symbolic connotation in Sassanian art. In Islamic art, however, it was used for purely decorative purposes and accordingly was not restricted to the conventional scene of the bull attacked by the lion, or the gazelle attacked by the eagle, but included other arbitrary combinations as well. The signs of the zodiac had a cosmic and astrological significance, especially when combined with representations of the constellations, as was often the case in metalwork. Such designs were also used in a purely decorative way, as in ceramic ware. Their fixed number of 12 influenced the design of twelve-sided vessels such as bowls and basins and of twelve-branched chandeliers. Cosmic symbolism connected with the number of the planets may also have been influential in the design of six-sided surfaces, in the center of which was represented the sun.

Animals were often represented with considerable liveliness and a suggestion of natural movement, but they were always stylized in accordance with an overriding decorative purpose. At times a point of near-abstraction was reached, and heads, masks, or protomas were combined with foliate tendrils to create a type of grotesque that was for a time one of the most characteristic manifestations of Islamic art.

When the human figure appears in Islamic decoration, it is never a portrait of a specific individual, and the small scenes that appear on many decorative friezes and medallions were never meant to have significance as historical episodes. A popular theme was that of the enthroned ruler, often with a raised cup, flanked by attendants and sometimes in the company of musicians with various instruments, acrobats, and dancers. Hunting scenes showing the ruler mounted on a horse, a falcon on his wrist, enjoyed great popularity, as did scenes of battle, of tournaments, and of polo games. Despite their obvious relationship to court life, such representations appear entirely divorced from reality, even when dedicatory inscriptions show that they were intended as gifts for a specific prince.

The number and variety of iconographic themes treated in manuscript illumination were considerably greater. Illumination constitutes a separate chapter in Islamic art (PLS. 143, 167; see MINIATURES AND ILLUMINATION), though compositions derived from such art — the meeting of Khusrau and Shīrīn, Majnūn in the desert (I, PL. 14), Bahrām V at the hunt, and similar episodes from popular epics — sometimes entered the repertory of the handicraft worker, especially in Persia.

In representations of the human figure, it is interesting to note that contemporary costumes were shown, regardless of the nature of the subject (PLS. 153, 154; I, PL. 9). Movement of the body was often rendered expressively, but there was little interest in characterization of the face. Figures were generally superimposed upon a background decorated with vine tendrils or branches, and a circular nimbus often set the heads off from the background, though no religious connotation was intended. The figure frequently was highly decorated so that it might hold its own against the almost overpowering arabesque background. Among the representations of supernatural beings, genii, shown as winged angels, were very common. Demonic figures such as the *diw* were represented as rather bizarre, though not always evil, human creatures and were generally restricted to miniature painting. Planets were usually represented by half-length personifications with their characteristic attributes.

Representations of Christian subjects were by no means rare, especially in metalwork. They reveal nothing about the faith of the artist, indicating merely that the object on which they were shown was intended for a Christian congregation or household. Moslem craftsmen might execute such scenes according to a foreign model.

ORGANIZATION OF LABOR. In the construction of cities and of individual buildings, religious or secular, rapid completion was the most important consideration. Rulers laid great stress upon the execution of their plans in the shortest possible time, and they spared neither money, nor materials, nor labor in achieving this end. The painstaking travail of entire generations in the building of a single structure was unknown to Islam, and a new construction was sometimes begun where only enlargement of an existing building was necessary.

The Ommiad caliphs, who were almost entirely dependent on foreign labor for their building activity, relied upon a system by which they were able to avail themselves of construction workers and materials from every part of their domain and thus to carry out their plans in a relatively short time. Provincial governors obviously found it difficult to deny their obligations to the caliph; in certain cases, however, they attempted to avoid conscription of workers by giving increasingly higher cash payments to the caliph. Workers recruited for such service occupied a position on the social scale somewhat higher than that of slaves, but they were permitted little freedom. Sources indicate that in the course of constructing castles in the desert many laborers died of thirst or starvation and that rebellion occasionally broke out.

The participation of a labor force recruited from many countries did not create (as has been erroneously assumed) discrepancies of style in the finished construction. The work was always directed by an architect in a position to impose his ideas and established plan. Even when the task of decorating a newly erected structure fell upon a heterogeneous group of artisans composed, for example, of Syrian sculptors, Greek mosaic craftsmen, stuccoworkers from Iraq, and Coptic wood carvers, individual notions of style had to be set aside in favor of a common purpose.

The system of procurement of laborers used under the Ommiads was still in force under the Abbassides. It is known that for construction of the city of Baghdad, al-Manṣūr conscripted 100,000 workers and designated a commission of astrologers, jurists, and architects, whose names have been preserved. However, because of the use of brick vault construction based on the long-standing Mesopotamian and Iranian tradition, it was necessary to rely largely on local workers. With increasing emphasis on handwork the older system of recruiting gradually lost its purpose, although it continued to be used from time to time. In the 14th century, conscription was employed by Tamerlane to hasten completion of his palace in Samarkand.

It is known that the entire available labor force employed in the production of such objects as pottery and glassware was brought from various places and relocated in Baghdad and Samarra in order to satisfy the needs of a growing population. Although it cannot be conclusively determined whether the Abbassides set up workshops exclusively to meet the demands of the court, it is certain that textile ateliers worked solely to fill the needs of the caliphs. These extended far beyond the personal uses of the ruler, his immediate family, and the personnel of the court, since a custom which long continued to prevail consisted in rewarding outstanding deeds or achievements by means of the khilat, through which the person to be honored was invested by the ruler with special garments. For this purpose, it was necessary to have on hand a large stock of such garments to be distributed at festive receptions or to be presented to foreign courts.

Under the Abbassides, workshops known as *ṭirāz* existed, particularly in Egypt, specializing in the weaving of various types of linen fabric. Some of these, the *ṭirāz-al-khās*, were specifically designated as private workshops in the service of the caliphs, while others, known as the *ṭirāz-al-'āmma*, were supervised by an administrator appointed by the state. After the occupation of the Nile country by the Fatimids, importation of Egyptian stuffs ceased and court ateliers were installed in Baghdad proper and elsewhere. Side by side with the production for the court, other weavers were also active in special areas of Baghdad.

Until well into the 9th century, the artisan class as a whole, and not merely those members who were not of the faith

(Jews, Christians, Zoroastrians), occupied a very low social position. An important change in this condition can be attributed to the influence of the Karmathians, a Shiite sect with socialistic tendencies, who were extremely active under the Abbassides. One of the aims of the Karmathians was to ameliorate the lot of the artisans. They created a comprehensive organizational system involving various grades of artisan labor, which resulted in the formation of individual corporations with the hierarchical subdivisions of apprentice, journeyman, and master, as well as the establishment of initiation rites and examinations. The artisans thus were gradually accepted as true citizens. In Egypt, Syria, and North Africa the Fatimids rigidly effected a similar organization of the artisan class into separate corporations, and this system was ultimately adopted in the entire Islamic world. The various industries were also assigned separate places in the bazaars, and specialized activities could be found grouped along the same street or complex of streets, as is still the case in many cities of the Orient.

The *muhtasib*, the head of the market and trade police (*hisba*), played an important role in the regulation of artistic and handicraft production throughout the Middle Ages. Usually a trained jurist, he had his own staff of officials, the size of which varied with that of the community under his jurisdiction. His judicial authority was limited, compared to that of the *qāḍī*, but he was one of the most important officials of the state. He was responsible for the supervision of all activities in the bazaar, including the prevention of fraud in handling food and art materials. Detailed regulations dealt with these and other problems, and the head of each corporation was responsible for their application within his own membership. A number of treatises concerning the administration of the *hisba*, dating as early as the 10th century, have been preserved and published in part.

The maintenance of high standards of workmanship and prohibition of the use of cheap or inadequate raw materials were of great importance for artistic production. In addition, the *muhtasib* enforced the rules limiting use of figural motifs and intervened where the artist seemed to go too far; above all, he guarded against all religious allusions, tendencies toward obscenity, and similar infractions. One instance called for intervention against the manufacture of dolls, which had to be sufficiently naturalistic to be capable of arousing the maternal instinct of little girls without violating the traditional norms directed against excessive naturalism. Scruples of a similar nature motivated the requirement that shadow puppets used in theatrical performances be pierced with many holes, to stress their unreality.

It is known that palace workshops were founded by various rulers for the production of books, rugs, and other objects; the famous glass-enameling workers of Aleppo, for example (PL. 157; VI, PL. 227; see GLASS), were moved to Samarkand by Tamerlane for the purpose of securing a monopoly on their craft. In these surroundings, however, their art deteriorated rapidly. As a rule, artisanry was left undisturbed and was even protected during political unrest or military conflict. The Mongols, for example, despite the wholesale plundering and massacre accompanying their campaigns, deliberately spared the artisan class.

Islamic handicraft workers were active in large numbers in the Christian West. After the reconquest of Spain, Moorish artists were retained by their new Christian masters and even were employed by religious congregations. They were able to adapt themselves to their new tasks, elaborating the important stylistic current known as Mudejar, without, however, abandoning their own religion and artistic traditions. The situation was similar in Sicily under the Normans, who even brought painters and craftsmen to their island from Cairo.

Whether the unmistakable influence of Islamic art upon the Romanesque sculpture of southern Italy may be attributed to the presence of Eastern sculptors and ivory carvers is not yet clear. On the other hand, the existence of an entire workshop of Islamic metalworkers in Venice during the 15th and 16th centuries has been documented. A variety of work in bronze with silver inlay was produced by them for Venetian consumption, notably, lamps, vases, containers, plates, and keys. Indeed, the distinction between *lavoro all'azzimina* and *lavoro alla damaschina* suggests the existence of two workshops, one Persian (*'ajami*), the other Syrian. A number of individual masters are known through signatures. It has been shown that in Palestine, under the rule of the Frankish Crusaders, a large atelier of Western glassworkers was active, producing enamel work inspired by Syrian products from Aleppo. Venetian enameled and gold glass of the 15th century was also influenced by this Syrian art.

HANDICRAFTS. It is notable that alongside handicraft production there never developed in the Islamic world an independent trend in the monumental arts of painting and sculpture. Creative energy was entirely absorbed by the challenge to produce ever-greater refinement and to create new techniques in the service of the handicrafts. The intensive training of the craftsman and the inheritance of skills through many generations of workers made possible the achievement and maintenance of a high level of quality.

It was considered important that the form of an object be expressive of its function. This aim is seen particularly in certain three-dimensional objects, such as clasps, handles, knobs, and ink stands, which, despite their highly ornate quality, clearly show the function they were intended to perform.

The patronage of the rulers was a decisive element in the prospering of handicrafts, which were expected to supply not only the immediate needs of the court, but also the demand for articles sent to foreign courts and markets to win friends for the caliph and to establish outlets for his merchandise. Important personages in the domain and affluent businessmen were eager to obtain the favor of the ruler by taking an active role in encouraging the sale of local products. The efforts of the artist were stimulated by the personal interest of the patron. The traffic of goods in the bazaars during the Middle Ages, unlike today, consisted less in the sale of ready-made articles than in direct commissions given by prospective buyers.

The master craftsman received detailed instructions from his patron concerning both the form and the choice of material, as well as iconographical and epigraphical considerations. If the object was destined for the ruler, inscriptions recording praise and wishes of good fortune had to appear, while a pious donation to a mosque might be inscribed with a verse from the Koran. Certain Persian faïences carry a personal note in the form of improvised verses addressed to the lady who was the intended recipient of the article.

Production was limited to a degree through restrictions against certain articles of luxury and against the use of figural motifs in religious objects. The most important of these regulations forbade the manufacture of articles in solid gold or silver. Despite these injunctions, ruling princes appear seldom to have been without some objects and even entire services made of the forbidden materials, and ladies were unwilling to do entirely without gold jewelry. In certain Islamic areas only Jewish and Christian artisans were allowed to use these precious metals, and the production of luxury goods was therefore regarded as less objectionable in spite of the injunctions.

Even for those who were eager to maintain an appearance of piety and legality, there existed acceptable ways of eluding these laws by means of various technical refinements. An article might, for example, be made of a nonprecious material, such as bronze, copper, or iron, and be thinly coated with gold or silver, giving it a particularly interesting effect (PLS. 156, 159). This technique, which developed early in Turkistan and in eastern Persia, was brought to its highest perfection in the Mosul school during the 12th and 13th centuries, from which the process spread to Persia, Syria, Egypt, Anatolia, and Venice.

A second means of compensating for the injunction against the use of precious metal was the lusterware technique applied to ceramics (q.v.; V, PL. 253; IX, PL. 275; X, PL. 170). This technique was related to certain procedures known in late antiquity, which were used to impart an almost metallic shimmer to black-glazed ware by means of special additional glazing. The lusterware technique came into its own, however, in

Islamic ceramic production. Perhaps as early as the end of the 8th century, plates and bowls decorated with relief ornament in a manner similar to chased goldwork were coated with glaze which upon firing gave the entire object a shimmer resembling gold or mother-of-pearl. There were subsequently introduced refinements of the basic technique which involved painting the varnish decoration with a brush on a white glazed surface, which was then lightly fired again, giving a pronounced metallic effect. A more or less golden tint was achieved with undertones of yellow, brown, green, red, or purple, and during the earlier period with subtle variations of these colors side by side. There is reason to believe that lusterware was manufactured in Baghdad beginning about the year 800 and that the technique stood in direct competition with the highly prized porcelain from China. Finds from Samarra show that by the mid-9th century this technique was no longer restricted to vessels but was applied to the manufacture of tiles used for architectural decoration. The new invention attracted immediate attention and spread to the entire Islamic world in a relatively short time. Before the end of the 9th century it had been eagerly adopted by the Fatimids in Egypt, and by the end of the 12th, lusterware was being produced in Persia, where Rayy (Rhages; III, PL. 141) and Kashan were the leading centers of this art. It was also manufactured in Spain (X, PLS. 169, 170), where the most outstanding examples were produced in Malaga during the 14th century. After the Christian reconquest, lusterware continued to be made in Valencia, and in the 15th century it was produced with remarkable success in the Italian cities of Deruta and Gubbio.

One of the interesting aspects of Islamic production was the sustained effort of Persian potters to discover the secret of Chinese porcelain (I, PL. 9). In this they were not successful, but their attempts led to the creation of an exceptionally hard and sometimes translucent pierced ware which closely resembled the much prized East Asian ware.

Along with the application of the luster technique to ceramic products, glassware using the same technique was produced in early Islamic times, especially in the period of the Fatimids, raising the possibility that the technique had been first used on glass. The application of gold and colored enamel to glass vessels in order to give them a more precious appearance became a common practice and was perfected by Islamic craftsmen, especially in Syria, into an important branch of the decorative arts. It was used in drinking vessels such as flasks, cups, and bowls, as well as in the countless hanging lamps of the mosque donated by Mameluke emirs. The most important center of this craft was Aleppo in the 13th and 14th centuries.

Another prohibition was directed against the manufacture of silken garments, and especially those worn by men. In the early Islamic period, this traditional injunction was carefully observed; garments were made only of linen, wool, or cotton and often consisted of a very delicate weave, with silken borders either sewn or woven in. Lengthy discussions took place, and regulations were issued concerning the permissible width of such silk strips, which gradually became ampler and more luxurious (V, PL. 243). Even toward the end of the 12th century Şalāh ad-Dīn made a special point of wearing only woolen or linen attire. But in Iran, the silk industry begun by the Sassanians was reinforced by every ruling dynasty and never was discontinued. The injunction against luxurious garments was ultimately forgotten, and silk weaves of unparalleled refinement were produced in every province of the Islamic world (I, PL. 7; V, PL. 244; X, PL. 450).

As a matter of historical record, it would seem that neither injunctions against excessive luxury nor prohibitions against the use of certain motifs exerted a negative influence upon handicraft production. On the contrary, these restraints appear to have motivated the artists to do the best possible work within the prescribed limitations. This was more true in the use made of the technical possibilities offered by materials than in the development of new forms. In many instances, the basic forms of given articles were retained from antiquity with only minor alterations made for functional reasons.

The influence of one branch of handicraft upon another can be demonstrated in a number of instances. The imitation of gold objects in ceramic ware has already been cited. There are also faïence vessels which undoubtedly owe their shape to older metalwork. The figural polychrome ornamentation of *mīnā'ī* ceramics from Rayy is an adaptation of elements found in Persian book illumination, which had reached a peak of development in the 12th and 13th centuries. In the 16th and 17th centuries, the schools of painting in Tabriz and Isfahan exerted an influence on local silk and carpet production. This adaptation of motifs drawn from book illumination to the requirements of carpet design was not, however, to lead to altogether satisfying results.

Knotted carpets (PL. 158) occupied a special place among handicrafts, manufacture being carried out by wandering nomads rather than in established workshops of the city. In Turkistan, until the present day, as well as in Persia and Anatolia, knotted work is produced by nomadic groups who have managed to retain many of the stylistic qualities of older work because of their peculiar way of life (see TAPESTRY AND CARPETS).

The high esteem bestowed on Islamic handicraft products can perhaps be gauged by the large number of works of Islamic origin preserved as treasures in Western churches. It can hardly be doubted that without these works it would be almost impossible to form a clear idea of certain techniques which were prevalent in Moslem art. Among the most highly valued objects of Islamic workmanship were the pitchers, flasks, cups, and chess pieces of rock crystal, which were carved in Iraq and Egypt in the 10th–12th century. Polished, golden, and enameled glassware was imported to Europe from the Islamic East before European production began (see GLASS). Ivory caskets and pyxides, either carved or painted, originally intended for the safekeeping of jewelry or spices, were used as reliquaries in the West. These and such objects as oliphants, combs, and chess pieces constitute the sole evidence for Islamic ivory carving from the 9th to the 12th century (PLS. 242, 244; V, PL. 251), for virtually no ivory objects of this period from the Orient proper have been found (see IVORY AND BONE CARVING). Our knowledge of Islamic silk production would likewise be meager in the absence of silks found in Western churches, cloisters, and burial caches.

It was consistent with Islamic attitudes that handicraft objects should have been created by anonymous artists. Signatures are seldom to be found, although large groups of objects, such as incrusted Mosul bronzes of the 13th century (PL. 159) and certain Mameluke ceramics of the 14th are signed for special reasons. In a few instances, a patron may have requested the signature of the artist.

BIBLIOG. For a complete bibliog. of Islamic art to 1960 see: K. A. C. Creswell, A Bibliography of the Architecture, Arts and Crafts of Islam, Cairo, 1961. See also: W. Behrnauer, Mémoire sur les institutions de police, JA, XV, 1860, pp. 461–508, XVI, 1860, pp. 114–90, 347–92, XVII, 1861, pp. 5–76; J. Karabacek, Das angebliche Bilderverbot des Islam, Kunst und Gewerbe, X, 1876, pp. 281–83, 289–91, 297–99, 307–08, 315–17, 332–33; J. Karabacek, Die Bedeutung der arabischen Schrift für Kunst und Gewerbe des Orients, Kunst und Gewerbe, XI, 1877, pp. 225–28, 233–35, 241–43, 249–51, 257–59; A. Riegl, Stilfragen, Berlin, 1893; E. Mercier, Le code du hobous ou ouakf, Constantine, 1899; F. Sarre, Denkmäler persischer Baukunst, 2 vols., Berlin. 1901–10; H. Saladin, Manuel d'art musulman: L'architecture, Paris, 1907; H. Thiersch, Pharos, Antike, Islam und Occident, Leipzig Berlin, 1909; O. Reuther, Das Wohnhaus in Baghdad und anderen Städten des Irak, Berlin, 1910; F. Sarre and E. Herzfeld, Archäologische Reise im Euphrat- und Tigrisgebiet, 4 vols., Berlin, 1911–20; S. Flury, Die Ornamentik der Hakim- und Azhar-Moschee, Heidelberg, 1912; G. Califano, Il regime dei beni Auqâf nella storia e nel diritto dell'Islam, Tripoli, 1913; O. von Falke, Kunstgeschichte der Seidenwerberei, 2 vols., Berlin, 1913; R. Borrmann, Vom Städtebau im islamischen Osten, Berlin, 1914; G. T. Rivoira, Architettura musulmana, Milan, 1914 (Eng. trans., G. Rushforth, London, New York, 1918); E. Diez, Die Kunst der islamischen Völker, Berlin-Neubabelsberg, 1915; A. Enani Beurteilung der Bilderfrage im Islam nach der Ansicht eines Muslim, Berlin, 1918; S. Flury, Islamische Schriftbänder, Basel, 1920; K. Müller, Die Karawanserai im vorderen Orient, Berlin, 1920; H. Glück, Probleme des Wölbungsbaues, I: Die Bäden Konstantinopels und ihre Stellung in der Baugeschichte des Morgen- und Abendlandes, Vienna, 1921; E. Herzfeld, Der Wandschmuck der Bauten von Samarra und seine Ornamentik, Berlin, 1923; M. S. Briggs, Muhammadan Architecture in Egypt and Palestine, Oxford, 1924; R. Mielck, Zur Geschichte der Kanzel im Islam, Der Islam, XIII, 1924, pp. 109–12; A. J. Wensinck, Ka'ba, E. of Islam. II Leiden, London, 1924, pp. 584–92; H. Glück and E. Diez, Die Kunst des Islam, Berlin, 1925; E. Kühnel, Islamische Kleinkunst, Berlin, 1925; G. Marçais, Note sur les ribâts en

Berbérie, Mél. René Basset, II, Paris, 1925, pp. 395–430; A. Cotta, Le régime du wakf en Égypte, Paris, 1926; G. Marçais, Manuel d'art musulman, 2 vols., Paris, 1926–27; K. Klinghardt, Türkische Bäder, Stuttgart, 1927; G. Migeon, Manuel d'art musulman: Arts plastiques et industriels, 2d ed., 2 vols., Paris, 1927; E. Kühnel, Islamische Kunst, in Handbuch der Kg. (ed. A. Springer), VI, Leipzig, 1929, pp. 371–548, 708–14; C. J. Lamm, Mittelalterliche Gläser und Steinschnittarbeiten aus dem nahen Osten, 2 vols., Berlin, 1929–30; E. Pauty, Contribution à l'étude des stalactites, BIFAO, XXIX, 1929, pp. 129–53; U. Monneret de Villard, La necropoli musulmana di Aswan, Cairo, 1930; A. U. Pope, An Introduction to Persian Art since the 7th Century, London, 1930; E. Diez, Minbar, E. of Islam, III, Leiden, London, 1931, pp. 499–500; A. Gabriel, Monuments turcs d'Anatolie, 2 vols., Paris, 1931–34; T. W. Haig, Miḥrāb, E. of Islam, III, Leiden, London, 1931, pp. 485–90: L. Hautecoeur, De la trompe aux "mukarnas," GBA, VI, 1931, pp. 26–51; K. A. C. Creswell, Early Muslim Architecture, 2 vols., Oxford, 1932–40; A. J. Wensinck, Muṣallā, E. of Islam, III, Leiden, London, 1933, p. 746; E. Lévi-Provençal, Zāwiya, E. of Islam, IV, Leiden, London, 1934, p. 1220; H. Ritter, J. Ruska, F. Sarre, and R. Winderlich, Orientalische Steinbücher und persische Fayencetechnik, Istanbul, 1935; A. Godard, Les anciennes mosquées de l'Īrān, Athār-è-Īrān, I, 1936, pp. 187–210; G. Marçais, Ribāṭ, E. of Islam, III, Leiden, London, 1936, pp. 1150–53; E. Diez, Kubba, E. of Islam, Sup., Leiden, London, 1937, pp. 127–34; E. Diez, Muḳarnas, E. of Islam, Sup., Leiden, London, 1937, pp. 153–54; M. S. Dimand, Studies in Islamic Ornament, I: Some Aspects of Omaiyad and Early Abbasid Ornament, Ars Islamica, IV, 1937, pp. 293–337; C. J. Lamm, Cotton in Mediaeval Textiles of the Near East, Paris, 1937; R. L. Hobson, The Ceramic Art in Islamic Times: Techniques, SPA, II, 1938, pp. 1697–1702; E. Diez, Manāra, Handwörterbuch des Islam, Leiden, 1941, pp. 413–18; L. Massignon, Karmaten, Handwörterbuch des Islam, Leiden, 1941, pp. 269–75; J. Pedersen, Mādrasa, Handwörterbuch des Islam, Leiden, 1941, pp. 382–93; E. Kühnel, Islamische Schriftkunst, Berlin, Leipzig, 1942; G. Marçais, La Berbérie musulmane et l'Orient au moyen âge, Paris, 1946; A. Lane, Early Islamic Pottery: Mesopotamia, Egypt and Persia, London, 1947; D. Barret, Islamic Metalwork in the British Museum, London, 1949; E. Kühnel, Die Arabeske, Wiesbaden, 1949; E. Kühnel, Die Moschee, Berlin, 1949; M. Gómez Moreno, El arte español hasta los Almohades, Arte Mozárabe (Ars Hispaniae, III), Madrid, 1951; E. Kühnel, Kunst und Volkstum im Islam, in Die Welt des Islam, I, 1951, pp. 247–82; B. Farès, Essai sur l'esprit de la décoration islamique, Cairo, 1952; R. B. Serjeant, A Zaidī Manual of Ḥisbah of the 3d Century, Rome, 1953; M. Aga-Oglu, Remarks on the Character of Islamic Art, AB, XXXVI, 1954, pp. 175–202; G. Marçais, L'architecture musulmane d'occident, Paris, 1955; F. Taeschner, Ein Beitrag zur Frage des islamischen Verbotes der Abbildung lebender Wesen, Die Welt des Islam, IV, 1955, pp. 47–50; E. Kühnel, Cairene Rugs and Others Technically Related, Washington, 1957; A. Lane, Later Islamic Pottery: Persia, Syria, Egypt, Turkey, London, 1957; K. A. C. Creswell, A Short Account of Early Muslim Architecture, Harmondsworth, 1958; M. S. Dimand, A Handbook of Muhammadan Art, 3d ed., New York, 1958; J. Beckwith, Caskets from Cordoba, London, 1960; K. Erdmann, Der orientalische Knüpfteppich: Versuch einer Darstellung seiner Geschichte, 2d ed., Tübingen, 1960 (Eng. trans., C. G. Ellis, Oriental Carpets: An Essay on Their History, New York, 1960); K. Erdmann, Die anatolische Karavansaray des 13. Jahrhunderts, Berlin, 1961; R. Ettinghausen, Arab Painting, Geneva, 1962; L. Trümpelmann, Mschatta: Ein Beitrag zur Bestimmung des Kunstkreises, zur Datierung und zum Stil der Ornamentik, Tübingen, 1962.

Ernst KÜHNEL

Illustrations: PLS. 143–170; 15 figs. in text.

ISRAEL. The state of Israel, established in 1948, comprises an irregularly shaped territory of almost 8,000 sq. mi. Its boundaries correspond only in part to those of historical Palestine, some of the territory of the Holy Land forming part of the bordering countries: Lebanon on the north, Syria on the northeast, Egypt on the southwest, and, especially, Jordan on the east and southeast. Thus the information in the present article bears a close relation to the historical, monumental, and topographical data contained in the articles on these countries, Jordan (q.v.), in particular.

FROM PREHISTORIC TO MODERN TIMES: AN OUTLINE. The monuments and artifacts in this area extend from the Lower Paleolithic period onward. The earliest human remains, dating back half a million years — Palestine man (*Palaeoanthropus palestinensis*) — were discovered in 1960 in the Jordan Valley near the kibbutz Afiqim, south of the Sea of Galilee. In the Mesolithic period (8th–6th millennium B.C.) appeared organized settlements, some in caves and others in round or curvilinear houses; there are the beginnings of magic and cults. In the Neolithic period (6th–5th millennium B.C.), pottery entered on the scene, along with hoe cultivation and irrigation

and fertility cults. Metalwork in bronze, figural art of a high order, and the beginnings of true agriculture followed in the Chalcolithic age (4000–3000 B.C.). Organized urban communities with fortifications and storehouses made their appearance in the early Bronze Age (3000–2000 B.C.). With the beginning of the historical period the influence of the great empires of Egypt and Mesopotamia was felt. The country was occupied by Western Semites (Canaanites). The middle Bronze Age (2000–1550 B.C.) represents the apogee of the Canaanites under the sovereignty — until the Hyksos invasion — of the Egyptian Middle Kingdom; this was the age of the Hebrew Patriarchs. In the late Bronze Age (1550–1200 B.C.) Aegean influences asserted themselves, and Egyptian domination, continuing through the 18th and 19th dynasties, was dominant for the last time.

With the Israelite invasion from the east and the Philistine landings on the west, the Canaanites were gradually crushed. In the early Iron Age, or Iron Age I (the age of the Judges and the United Monarchy; 1200–930 B.C.), the Israelites struggled with the Philistines and finally, under David's leadership, defeated them. David's successor, Solomon, made international trade possible for the country by opening up the Red Sea route through the establishment of his seaport Ezion-geber, near Elath (Eilat), at the same time exploiting the copper mines of the Araba; he gave impetus to a development of the visual arts that had great scope, albeit infused with influences from neighboring countries (see JEWISH ART; PHOENICIAN-PUNIC ART; SYRO-PALESTINIAN ART). In Iron Age II (930–586 B.C.) the internal divisions of the Israelite nation led to the split of the United Monarchy into the kingdoms of Israel in the north and Judah in the south; the former ultimately succumbed to the Assyrians and the latter to the Babylonians. The Persians, rising swiftly to power, allowed the Judean exiles to return to their own country. After two centuries of Persian rule (536–332 B.C.), Palestine fell — with the destruction of the Persian Empire by Alexander the Great — first into the hands of the Ptolemaic kings of Egypt (until 198 B.C.), and then of the Seleucid kings of Syria (until 63 B.C.). Under Seleucid rule the process of Hellenization (which had important artistic consequences) advanced rapidly in western Asia, and the effort to Hellenize the Judeans was pressed far beyond the point envisaged even by the Judean Hellenizers, culminating in the occupation of Jerusalem by Antiochus, the desecration of the Temple, and the outright suppression of Judaism. The Hasmoneans, leaders of the rebellion engendered by this attack, after gradually obtaining independence (141 B.C.) extended their power over the entire country; the fall of the Hasmonean dynasty was followed by the establishment of Roman rule (63 B.C.–A.D. 324) by Pompey. The Jews revolted against Rome twice (A.D. 67–73, 132–35) but in the end lost both Jerusalem and the Temple. Both Christianity and normative Judaism had their origins in this period, which was also rich in artistic influences (see IMAGES AND ICONOCLASM). From the Roman period the country passed peacefully into the Byzantine (324–640), during which it was gradually Christianized and numerous churches and monasteries were built. The Arab conquest and domination (640–1099) halted this development, replacing the prevailing Western culture with an Oriental one. The Crusaders (1099–1291) dotted the country with Romanesque churches and castles but were unable to make their rule permanent.

The next rulers of Palestine, the Mamelukes, from whose reign Moslem monuments date, yielded in 1516 to the Ottoman Turks. After a short initial period of building activity under Sulaymān the Magnificent, continuous warfare between the Turks and the local Arab chiefs led to the abandonment and rapid decline of Palestine, briefly interrupted by Napoleon's occupation of the country in 1799. The sultan Maḥmūd II, who took the throne in Constantinople in 1808, was in continual conflict with his pashas over the control of Syria, Palestine, and Egypt, and in 1831 the Turks were expelled by an Egyptian army under Ibrāhīm Pasha; with the aid of an Anglo-French-Russian fleet they recovered possession of Palestine in 1840. The alignment of the Turks against the Allies in World War I led to occupation of Palestine by an English army (1918); by the terms of the peace treaty the British acquired the territory of Palestine as a mandate of the League of Nations (1922). The growth of Jewish settlements, beginning in the early 1900s, aroused the opposition of the Arabs: in 1947 the issue was placed before the United Nations. Termination of the British mandate (1948) and a plan for partition did not serve to avert Arab-Jewish hostilities (1948–49). The actual boundaries of Israel represent the armistice lines laid down in the agreements concluded by the newly declared state with the neighboring countries, February–July 1949.

A considerable number of monuments remain from the Ottoman period, especially in Jerusalem, Safed, Acre (or Akko), and Jaffa. In the 18th century there was an increased diffusion of Europeanized architecture, largely due to the activity of Roman Catholic orders established in the country; churches, monasteries, convents, hospitals, and sanctuaries were built. Jewish immigration began in the second

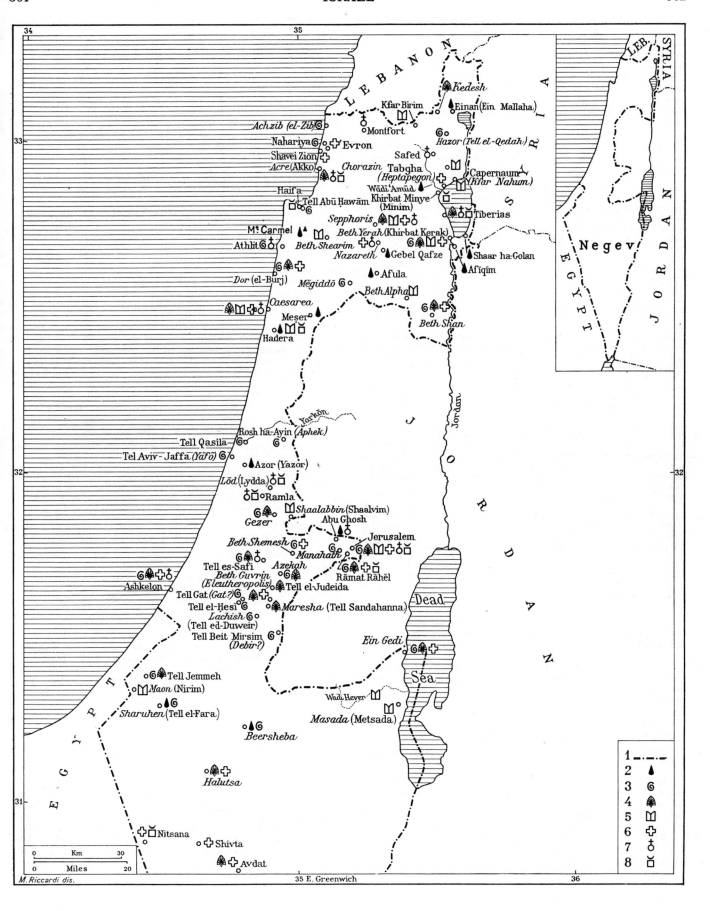

Israel, chief centers of archaeological and artistic interest. *Key:* (1) National boundaries (inset shows full extent). Remains and monuments: (2) pre-historic; (3) Bronze Age and Iron Age; (4) Greco-Roman; (5) Judean; (6) Byzantine; (7) Crusader; (8) Islamic.

half of the 19th century, a series of agricultural colonies constituting the first centers. As the tempo of immigration increased in the early years of the 20th century, these colonies multiplied, new towns were created, and the erection of various works of public utility, hospitals, schools, and administrative buildings, was accomplished. The establishment of the state of Israel favored further development of the country: housing projects, residential quarters, and important monuments were created in accordance with modern town-planning criteria in Haifa, Tel Aviv, Jerusalem, and a number of other cities and towns.

BIBLIOG. *a. History*: E. Schürer, A History of the Jewish People in the Time of Jesus Christ, Eng. trans., 2 vols., Edinburgh, 1924; J. Parkes, A History of Palestine from 135 A.D. to Modern Times, New York, 1949; F. M. Abel, Histoire de la Palestine, depuis la conquête d'Alexandre jusqu'à l'invasion arabe, 2 vols., Paris, 1952; H. M. Orlinsky, Ancient Israel, Ithaca, N. Y., 1954; G. Ricciotti, History of Israel, trans. C. Della Penta and R. T. A. Murphy, 2 vols., Milwaukee, 1955; M. Noth, Geschichte Israels, 3d ed., Göttingen, 1956; J. Bright, A History of Israel, London, 1960; R. de Vaux, Ancient Israel: Its Life and Institutions, trans. J. McHugh, New York, 1961; S. Zeitlin, The Rise and Fall of the Judaean State, I, Philadelphia, 1962. *b. Geography*: F. M. Abel, Géographie de la Palestine, 2 vols., Paris, 1933–38; D. Baly, The Geography of the Bible, New York, 1957; M. Du Buit, Géographie de la Terre Sainte, Paris, 1958. *c. Atlases*: L. H. Grollenberg, Atlas of the Bible, London, 1956; G. E. Wright and F. V. Filson, The Westminster Historical Atlas to the Bible, rev. ed., Philadelphia, 1956; H. M. Z. Meyer, ed., Israel: Pocket Atlas and Handbook, Jerusalem, 1961. *d. Guidebooks*: E.-J. Finbert, ed., Israel (Hachette World Guides), Paris, 1956; Z. Vilnay, The Guide to Israel, rev. ed., Cleveland and New York, 1960; E. and M. Talmi, New Israel Guide, Tel Aviv, 1961; J. Comay, Everyone's Guide to Israel, New York, 1962. *e. Art and archaeology*: A.-G. Barrois, Manuel d'archéologie biblique, 2 vols., Paris, 1939–53; C. A. Mayer, J. Pinkerfeld, J. W. Hirschberg, and J. L. Maimon, Some Principal Muslim Religious Buildings in Israel, Jerusalem, 1950; M. Avi-Yonah, Historical Geography of Erez Israel, 2d ed., Jerusalem, 1951; M. Avi-Yonah, S. Yeivin, and M. Stekelis, The Antiquities of Israel, I, Tel Aviv, 1955; A. Jirku, Die Ausgrabungen in Palästina und Syrien, Halle, 1956; G. E. Wright, Biblical Archaeology, Philadelphia, 1957; J. B. Pritchard, Archaeology and the Old Testament, Princeton, 1958; W. F. Albright, The Archaeology of Palestine, 4th ed., Harmondsworth, 1960; K. Kenyon, Archaeology in the Holy Land, London, New York, 1960; M. Schapiro and M. Avi-Yonah, Israel: Ancient Mosaics, Greenwich, Conn., 1960; M. Avi-Yonah, Oriental Art in Roman Palestine, Rome, 1961; C. Roth, ed., Jewish Art, New York, 1961; E. Anati, Palestine before the Hebrews, New York, 1963. Excavation Reports: see yearly notices in Q. of the Department of Antiquities of Palestine, 1932–50; M. Cassuto-Salzmann, Selected Bibliography: Publications on Archaeological Excavations and Surveys in Israel 1948–1958, 'Atiqot, II, 1959, pp. 165–83; S. Yeivin, A Decade of Archaeology in Israel (1948–1958), Istanbul, 1960. See also bibliog. for JEWISH ART. *f. Modern trends*: S. Barkai and J. Posener, Architecture en Palestine, L'arch. d'aujourd'hui, VIII, 9, Sept. 1937, pp. 2–34; H. Gamzu, Painting and Sculpture in Israel, Tel Aviv, 1951; Architecture in Palestine, The Architect and Building News, CCVI, 1954, pp. 780–91; S. Gilread-Gromet, Israel Scrapbook, Architectural Rev., CXVII, Feb. 1955, pp. 121–28; Bauen in Israel, Werk, XLV, April, 1958, pp. 113–34; M. Zarhy, Constructions récentes en Israël, L'arch. d'aujourd'hui, XXIX, 77, 1958/59, pp. 62–99; Planen und Bauen in Israel, Baumeister, LIX, Jan. 1962 (whole issue).

TOPOGRAPHICAL DIVISIONS, WITH PRINCIPAL CITIES AND SITES. The following account proceeds in general from north to south; the individual sites are taken up in a west-to-east order.

Upper Galilee. The region of Galilee, usually divided into Upper and Lower, is here taken to include the great valley, or plain, of Esdraelon. In the mountainous terrain of Upper Galilee little remains from pre-Roman times; a study has shown that the region was densely wooded in the Canaanite period and that it was infiltrated and settled toward the end of the period by Israelite tribes. Traces of the primitive houses and pottery of these tribes remain.

BIBLIOG. Y. Aharoni, The Settlement of the Israelite Tribes in Upper Galilee, Jerusalem, 1957 (in Hebrew).

Kedesh (Kedesh Naphtali; Qedesh). A site important in Egyptian and Biblical tradition, Kedesh exhibits remains of a temple of the 3d century of the current era, and exploratory soundings of the tell have revealed five strata, going back to the early Bronze Age.

BIBLIOG. Y. Aharoni, Israel Exploration J., III, 4, 1953, p. 263.

Kfar Birim. This site presents the best-preserved of the considerable number of Jewish synagogues in the area, which for the most part belong to the 3d–4th century of our era. These synagogues are characterized by basilican plans combined with architectural details — capitals, columns, lintels, and reliefs — related to those of Syrian architecture of the Roman period and with Orientalizing elements derived from Jewish art of the time of the Second Temple or even earlier. The façade of the Kfar Birim Synagogue is preserved up to the second story (PL. 334).

BIBLIOG. H. Kohl and C. Watzinger, Antike Synagogen in Galilaea, Leipzig, 1916, pp. 89–102.

Montfort. The Crusader castle of Montfort, which originally belonged to the Mandelée family, was ceded in 1229 to Hermann of Salza, grand master of the Teutonic Knights; it became the headquarters of the order and housed the archives and treasury. In 1271 Montfort capitulated to the Mameluke sultan al-Ẓāhir Baybars, and it has since remained a ruin (partly excavated by Met. Mus., 1926). The surviving features include a court of entry, a vaulted square tower, a chapel and lodgings for the knights, and at the east end, separated from the castle and the adjoining mountain by a deep fosse, the base of a square keep.

BIBLIOG. B. Dean, The Exploration of a Crusader's Fortress (Montfort) in Palestine, BMMA, 1927, XXII, no. 9, pt. II, pp. 5–46.

Safed. The castle, built in 1140 by Falk of Anjou, was strengthened by the Templars in 1230, the cost of the operation being defrayed with money provided by Benedict, bishop of Marseilles. Falling to al-Ẓāhir Baybars in 1266, the castle became one of the strongholds of Saracen power. Still visible are remains of the Crusader walls, towers, and cisterns. In the course of the 16th century, Jewish refugees from Spain and Portugal settled in Safed, and it became a center of scholarship and the seat of the Cabalist movement. It was here that the first printing press in the Near East was established (1577). Occupied by Napoleon in 1799, Safed became a Janizary headquarters and the seat of the governor, remaining so until 1837, when an earthquake leveled the city. A slow recovery took place during the second half of the 19th century. Of architectural interest, although simply built, are the synagogues of the Cabalists (16th–17th cent.). Relatively well preserved is the old fortified citadel of the 17th century. Buildings erected in modern times include the schools of the Alliance Israélite Universelle, a sanatorium, and hotels. An artists' colony has grown up in the rambling houses on the southwestern slope, and one old Arab building in this artists' quarter has been adapted to house a Museum of the Printing Arts.

BIBLIOG. S. Klein, Beiträge zur Geographie und Geschichte Galiläas, Leipzig, 1909, p. 58.

Chorazin (Korazim). From the synagogue that once stood here there remain some notable reliefs depicting mythological personages (Hercules, Medusa), centaurs in combat with lions, and scenes of rural life (the vintage).

BIBLIOG. H. Kohl and C. Watzinger, Antike Synagogen in Galilaea, Leipzig, 1916, pp. 41–58.

Lower Galilee. The less mountainous and more fertile portion of Galilee was also much more open to foreign influences: Lower Galilee, which in the Israelite period contained a nucleus of foreign population (hence the name Galil ha-Goyim, lit., "ring or circuit of Gentiles"), became a stronghold of Judaism in the time of the Second Temple and afterwards. It has remained a mixed area of various nationalities.

Sepphoris. Appearing first in the Hasmonean period, Sepphoris was a city that flourished in the Herodian period. As Diocaesarea it became one of the leading cities of Roman Galilee, while remaining purely Jewish; for a time it was the seat of the Sanhedrin. Even in Byzantine times Sepphoris retained its character as a focus of Judaism. Remains include a Roman theater, Byzantine mosaics, a long aqueduct, and a Crusader fortress, in the construction of which Roman sarcophagi were used.

BIBLIOG. L. Waterman et al., Preliminary Report of the U. of Michigan Excavations at Sepphoris, Palestine, in 1931, Ann Arbor, Mich., 1937.

Tiberias. Founded by Herod Antipas (A.D. 18–26) and named in honor of the emperor Tiberius, the city of Tiberias became the seat of the Sanhedrin and a center of rabbinic learning in the 2d century. Little of note remains from the Roman period; the Byzantine period is represented by the 6th-century mosaics from the thermae. The old town is dominated by the dark ruins of the Crusader citadel and of the old city wall, contrasting with the white buildings of the new city, which, following the lead of the suburb Kiryat Shemuel, extends up the hillside. A municipal museum contains a collection of antiquities found in the area.

BIBLIOG. M. Avi-Yonah, Israel Exploration J., I, 1950–51, pp. 160–69; M. Schwabe, B. of the Israel Exploration Soc., XVIII, 3–4, 1954, pp. 157–63; S. Yeivin, RBib. LXIII, 1956, pp. 97–98; Z. Vilnay, The Guide to Israel, Jerusalem, 1958, pp. 431–39; M. Buchman, Tiberias and Its Hot Springs, Tiberias, 1959; M. Schapiro and M. Avi-Yonah, Israel: Ancient Mosaics, Greenwich, Conn., 1960, pls. XXI–XXIII.

Nazareth. The Church of the Annunciation, under construction in 1960, is the fourth structure to be erected on this important site in the life of Mary. Of the original Constantinian church, only a few mosaics and granite columns were found. From its successor, the triapsidal Crusader cathedral, there survive five capitals with fine Romanesque carving (12th cent.); these are preserved in the little Franciscan museum. In the 17th century the local Arab authorities permitted the Franciscans to build a chapel on the presumed site of Mary's house, adjacent to the by then ruined Church of the Annunciation. Later, in 1730, the chapel was included in the construction of the third Church of the Annunciation, which followed a plan perpendicular to the Crusader church. Remodeled in 1877, the third church was pulled down in 1935 to make way for the present church, the plan of which follows the lines of the medieval structure of Crusader times.

BIBLIOG. P. Viaud, Nazareth et ses deux églises, Paris, 1910; C. Kopp, J. of the Palestine Exploration Soc., XVIII, 1938, pp. 187–228, XIX, 1939, pp. 82–119, 253–85, XX, 1940, pp. 29–42, XXI, 1941, pp. 148–64; B. Bagatti, Christian News from Israel, VI, 1955, pp. 28–31; B. Bagatti, Studium Biblicum Franciscanum Liber Annus, V, 1955, pp. 5–44.

Beth Shearim. Considerable archaeological interest attaches to this site on the southwest border of Lower Galilee. For a time the townlet served as the seat of the Sanhedrin (2d cent.); the burial here of the famous patriarch Judah I led to the establishment of a Jewish cemetery, serving places as far away as Palmyra. The cemetery continued in use up to the middle of the 4th century. Excavations within the town have brought to light a synagogue of the transitional type and a basilica which probably housed judicial proceedings. The most interesting finds to date, however, are the 26 catacombs carved out of the slope of the hill on which the town stood, which have yielded mainly inscriptions (80 per cent in Greek) and rudimentary decorations (PL. 333). The catacombs are predominantly of the type consisting of a single rock-cut corridor with lateral burial halls, containing *arcosolia* or loculi, branching off at various levels. Different in type are Catacomb 11, adjoining a masonry mausoleum with sculptured decoration; Catacomb 14, with an arched masonry façade, probably the original burial cave of the patriarchs; and Catacomb 20, a huge cave containing over 200 sarcophagi, some decorated with reliefs of animals (in one case, decorated with a human face), and remains of marble coffins ornamented with mythological scenes.

BIBLIOG. N. Avigad, Israel Exploration J., IV, 1954, pp. 88–107, V, 1955, pp. 205–39, VII, 1957, pp. 73–92, 239–55, VIII, 1958, pp. 276–77; N. Avigad, Archaeology, VIII (1955), pp. 236–44, X (1957), pp. 266–69; B. Mazar, Beth She'arim, I, Jerusalem, 1957; M. Avi-Yonah, EAA, s. v Bet She'arim.

Afula. Finds at this site in the plain of Esdraelon belong to the upper chalcolithic period, specifically to a subculture peculiar to the northern part of the country — the Esdraelon culture; it is characterized by pottery with a burnished-gray slip. In addition to this gray-burnished ware, remains of buildings with mud-brick walls and floors of black beaten earth were found.

BIBLIOG. E. L. Sukenik, J. of the Palestine O. Soc., XXI, 1948, pp. 1–78; M. Dothan, 'Atiqot, I, 1955, pp. 19–70.

The Jordan Valley. Enclosed as it is by cliffs and mountains, and in its lower portion far below sea level, the Jordan Valley has a climate that is tropical and generally insalubrious; nevertheless it has been densely settled through most of the historical epoch because of its fertile soil and abundance of water.

Einan (Ein Mallaha). Human remains belonging to the Mesolithic period have been found here. The remains of houses attest to the beginning of settlement; tombs in the form of circular pits with plastered and painted parapets, used for the burial of rulers, indicate the importance attached to orderly interment as a concomitant of magic or religious belief.

BIBLIOG. J. Perrot, Antiquity and Survival, II, 1957, pp. 91–110; J. Perrot, Israel Exploration J., X, 1960, pp. 14–22; E. Anati, Palestine before the Hebrews, New York, 1963, pp. 146–50, 172–75.

Hazor (Tell el-Qedah). In the middle Bronze Age, Hazor developed into a great city, almost 200 acres in extent; it continued to flourish into the late Bronze Age. The Canaanite city had underground burials in tunnels, a glacis with gates, and three sanctuaries, to one of which was attached a craftsmen's quarter (for potters, etc.). One temple, anticipating the plan of Solomon's Temple, was made up of a vestibule, a hall, and a holy of holies; the orthostat reliefs depicting a crouching lion, the sculptured altars, and the figures of the gods (both here and in another temple) attest to strong northern, in particular Hittite, influence. The Israelite town of Hazor, for-

tified by Solomon, was limited to the tell at the southwest corner of the site. Solomon erected a casemate wall and gate; Ahab added a citadel and various public buildings. An Israelite high place was among the structures brought to light here.

BIBLIOG. James A. de Rothschild Expedition at Hazor, Hazor, 2 vols., Jerusalem, 1958–60 (to be continued).

Capernaum (Kfar Nahum). The synagogue, of the late 2d-century of our era, represents the purest version of the early type: basilican, with a transverse row of columns in addition to the two longitudinal rows, and an adjoining colonnaded courtyard. The relief frieze, showing a mixture of religious and magic (e.g., fertility) symbols, is especially notable (PL. 334).

BIBLIOG. G. Orfali, Capharnaüm, Paris, 1922.

Tabgha (Heptapegon). The Church of the Multiplication of Loaves and Fishes, an early Byzantine basilica with transept, was adorned in the 5th century by a great master of mosaic with two pavement panels showing the fauna and flora of the Sea of Galilee. The style, clearly influenced by Nilotic landscapes, reveals a characteristic Byzantine blending of naturalistic treatment with the typical separation of images.

BIBLIOG. A. M. Schneider, Die Brotvermehrungskirche von et-tâbġa, Paderborn, 1934; M. Schapiro and M. Avi-Yonah, Israel: Ancient Mosaics, Greenwich, Conn., 1960, pls. I–III.

Khirbat Minye (Minim). The early Arab period is represented here by an Islamic palace of the Ommiad period (7th–8th cent.), a square about 250 ft. on a side, with angle towers. An ornamental gate gives access to a spacious court, with a ramp leading to the upper story. Several rooms and a mosque paved with geometric mosaics have been cleared in the excavation to date.

BIBLIOG. A. M. Schneider, Ann. archéologiques de Syrie, II, 1952, pp. 23–45; J. Perrot, O. Grabar, et al., Israel Exploration J., X, 1960, pp. 226–43; M. Schapiro and M. Avi-Yonah, Israel: Ancient Mosaics, Greenwich, Conn., 1960, pl. XXXII.

Beth Yerah (Khirbat Kerak). This site is most notable for its early Bronze Age buildings, including a large Π-shaped stone structure with places for nine silos. This communal granary could only have been erected by some well-established authority able to command forced labor. The early Bronze Age settlement was encircled by a thick wall of mud brick. Other finds at Beth Yerah include Hellenistic-Roman houses and a reused wall with brick superstructure, a rectangular Roman fortress into which a basilical synagogue was built at a later time, a church dated A.D. 529, and thermae that remained in use up to the Arab period.

BIBLIOG. B. Mazar et al., Israel Exploration J., II, 1952, pp. 165–73, 218–29; P. Bar-Adon, Israel Exploration J., III, 1953, p. 132, IV, 1954, pp. 128–29, V, 1955, p. 273; M. Avi-Yonah, EAA, s.v. Bet Yerah; P. Delougaz and R. C. Haines, A Byzantine Church at Khirbet Al-Karak, Chicago, 1960.

Shaar ha-Golan. Near this settlement is a site where archaeologists have been able to discern the transition in neolithic cultural development from the food-collecting to the hoe-agriculture stage. With this step was associated a fertility cult, attested by figurines and pebbles incised to resemble figurines. Pottery decorated with incised bands in a herringbone pattern also makes its appearance. Finds are displayed in a local museum.

BIBLIOG. M. Stekelis, Israel Exploration J., I, 1951, pp. 1–19; M. Stekelis, B. of the Israel Exploration Soc., XVIII, 3–4, 1954, pp. 185–89.

Beth Alpha. The ancient synagogue that was erected here in the early 6th century had a strictly basilican plan, with the apse oriented toward Jerusalem. The surviving mosaic pavement, executed in a rustic but vigorous style, depicts a Biblical scene of the Sacrifice of Abraham (PL. 337) and several symbolic motifs, including the signs of the zodiac and the seven-branched candlestick.

BIBLIOG. E. L. Sukenik, The Ancient Synagogue of Beth Alpha, Jerusalem, 1932; M. Schapiro and M. Avi-Yonah, Israel: Ancient Mosaics, Greenwich, Conn., 1960, pls. VI–XIV, p. 14.

Beth Shan (Beth Shean, Beisan, Scythopolis). The chief remains yielded by this site are four Canaanite temples of the late Bronze Age, which reveal a fusion of Canaanite, Egyptian, and Philistine elements. The occupation of this strategic city by Egyptian troops for three centuries, beginning under Thutmosis III (ca. 1469–1436 B.C.), left its mark on the plans and the decoration of these sanctuaries as well as their contents, which included a stele of Mekal (the local

Baal), steles of Seti I and Ramses II, a locally produced statue of Ramses III, and anthropomorphous sarcophagi apparently made for Philistine mercenaries in the Egyptian service. A fortress (*migdol*), a governor's residence, and a monumental silo represent the secular side of life in the Bronze Age city. In Hellenistic times the city (Scythopolis) expanded into the plain surrounding the tell, attaining its greatest prosperity in the Byzantine period. Among the finds of the post-Biblical periods should be mentioned a Hellenistic-Roman temple, a bust of Alexander, several decorated sarcophagi, a large Roman theater, a round Byzantine church, and a monastery dating from the

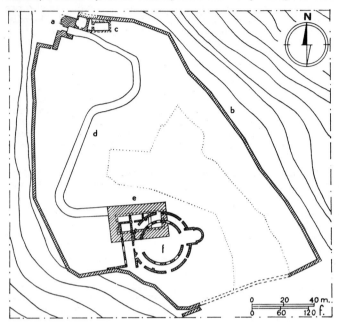

Beth Shan, plan of the citadel: (*a*) Gateway; (*b*) walls of the citadel; (*c*) reservoir; (*d*) road; (*e*) Hellenistic temple; (*f*) central-plan church (*from A. Rowe, 1940, pl. II*).

end of the 6th century; surviving mosaics that decorated the monastery depict the various agricultural labors of the months of the year, vintage scenes, and scenes of everyday village life. There is a local archaeological museum.

BIBLIOG. A. Rowe, The Topography and History of Beth-shan, Philadelphia, 1930; G. M. Fitzgerald, Beth Shan Excavations, 1921–23: The Arab and Byzantine Levels, Philadelphia, 1931; G. M. Fitzgerald, A Sixth Century Monastery at Beth-Shan, Philadelphia, 1939; A. Rowe, The Four Canaanite Temples of Beth-shan, I, The Temples and Cult Objects, Philadelphia, 1940; N. Zori, B. of the Israel Exploration Soc., XVIII, 1–2, 1954, pp. 78–90, XIX, 1–2, 1955, pp. 89–98; N. Tzori, PEQ, XL, 1958, pp. 44–51; M. Avi-Yonah, EAA, s.v. Beisan; M. Schapiro and M. Avi-Yonah, Israel: Ancient Mosaics, Greenwich, Conn., 1960, pls. XVII–XX.

The Phoenician coast. The narrow coastal plain extending from Acre northward belonged to Phoenicia in ancient times and is strongly marked with the impress of its culture.

Achzib (el-Zib). In the cemetery, which belongs to the Iron Age, the rock-cut tombs were in some cases closed with masonry dressed in the characteristic Phoenician manner of the 8th century B.C., exemplified also at Samaria. The funerary equipment is especially rich; it includes pottery vessels, masks, and figurines (of pregnant women, musicians, breadmakers) and models of boats.

Nahariya. A sanctuary and high place of the early to middle Bronze Age discovered in this seaside city were probably dedicated to Asherat-Yam (a manifestation of Astarte). Finds include figurines of the goddess in silver and bronze and offering vessels consisting of clusters of seven little cups.

BIBLIOG. I. Ben-Dor, Q. of the Department of Antiquities in Palestine, XIV, 1950, pp. 1–41; M. Dothan, Israel Exploration J., VI, 1956, pp. 14–25.

Evron. A Byzantine church here has a remarkable mosaic pavement dated by inscription (A.D. 415) and showing lavish use of the symbol of the cross. The Byzantine church at nearby Shavei Zion boasts a comparable 5th-century mosaic pavement.

BIBLIOG. M. Stekelis, 'Alon, II, 1950, pp. 29–30; M. Avi-Yonah, P. Kahane, and Y. Landau, 'Alon, V–VI, 1957, pp. 34–35; M. Schapiro and M. Avi-Yonah, Israel: Ancient Mosaics, Greenwich, Conn., 1960, pl. IV.

Acre, or Akko (Accho, Ptolemais, Saint-Jean-d'Acre). Near the modern city are the remains of a Hellenistic temple and of early Roman tombs with terra-sigillata pottery. From Crusader times there remain the crypt of St. John and a tower overlooking the Bay of Acre. After its capture and destruction by the Mameluke sultan in 1291, the city was abandoned, and it was not resettled until the Turks took possession in the 16th century. Acre acquired new importance in the 18th century as the seat of the emir Dāhir el-'Omar and his successor Aḥmad el-Jazzar, who rebuilt the fortifications. Occupied by Ibrāhīm Pasha of Egypt in 1832, the city reverted to the Turks in 1841, after which it underwent modest development through the establishment of defensive works and an increase in maritime traffic. Among the surviving monuments of the Turkish period are the double circuit of walls (late 18th cent.), in a good state of preservation; the mosque of Aḥmad el-Jazzar (1781), with spacious rectangular court surrounded by porticoes and galleries incorporating marble and granite columns taken from the ruins of ancient Ashkelon, Caesarea, Sidon, and elsewhere; the mausoleums of the pashas Aḥmad el-Jazzar and Sulaymān; the pasha's baths, Ḥammām el-Pāshā, erected in Arabic style by Aḥmad el-Jazzar about 1800, which houses the Akko Municipal Museum; the Jāmiʿ el-Raml ("Sand Mosque"); the Turkish arsenal (*jabakhāna*); and the great "white" market, Sūk el-Abiad. Other monuments that recall the Turkish period are the defense works of the old citadel, the guard towers, the Franciscan monastery and church (first half of 18th cent.), and the Turkish caravansary, Khān el-'Umdān, with a commemorative tower erected in 1906.

BIBLIOG. N. Makhouly and C. N. Johns, Guide to Acre, Jerusalem, 1946; R. Amiran, 'Alon, III, 1951, p. 37.

Mount Carmel and the plain of Sharon. The ridge of Mount Carmel with the adjacent coast down to the Yarkon River has in historic times been an area both of conflict and of give-and-take between the native cultures of the mountains and invading elements from overseas. But long ages before, the Carmel range, with its easily accessible caves, was a habitat of prehistoric man. The excavations of the caves of the Wadi Maghara, Abu Usba, Kabbara, and the Oren Valley have revealed a prehistoric culture extending from the Lower Paleolithic to the Neolithic era. In the Upper Paleolithic the region was inhabited by a race with mixed Neanderthaloid and *Homo sapiens* traits: Mesolithic burials were found with skeletons in a contracted position, an ornament of shells round the skull. Isolated finds include sculptures of animals and human beings, flint sickles, bone fishing hooks, and necklaces made up of teeth. In the chalcolithic period settlement appears to have shifted to the coast.

BIBLIOG. D. A. E. Garrod et al., The Stone Age of Mount Carmel, 2 vols., Oxford, 1937–39; M. Stekelis and G. Haas, Israel Exploration J., II, 1952, pp. 13–47; I. Wreschner, 'Alon, V–VI, 1957, pp. 49–56.

Haifa (Sycaminum?). The past history of the most important and modern port of Israel has left no monuments earlier than the Turkish period, though the site probably represents Sycaminum, a fishing village that goes back to late classical times and passed through the hands of the Crusaders, Ṣalāh ad-Dīn, St-Louis, and al-Ẓāhir Baybars before its occupation and fortification by the emir Dāhir el-'Omar in 1760.

The second largest of Israel's cities, Haifa extends up the slopes of Mount Carmel in three main sections. In the lower town, flanking the docks and the harbor, are the railroad tracks, shops and workshops, offices, warehouses, and plants; outstanding structures are a towering grain silo and a large government hospital. The Haifa Maritime Museum is in this part of the city. On the heights above this section is the part of the city known as Hadar ha-Carmel. In this residential-commercial district are the town hall, which also houses an art gallery and archaeological museum, the Great Synagogue, and the municipal theater. Fronting the municipal building, and overlooking the harbor, is a memorial garden, with a monument in honor of those who fell in the battle of Haifa (1948); this is on the site of the old Turkish fort that defended the town. An unusual monument of Haifa is the gold-domed Bahai shrine, set in an extensive Persian garden; opposite it is the International Bahai Archives building, modeled on the Parthenon. In Hadar ha-Carmel too is the old campus of the Israel Institute of Technology, or Technion, as it is better known, its central (the original) building of hewn stone in Moorish and Byzantine style.

In the section of Haifa on the summit of Mount Carmel, a spot of legendary beauty, modern suburbs of the city incorporate villas, public parks, and hotels. There is a Museum of Japanese Art. On the western promontory of the mountain, overlooking the sea is a Carmelite monastery whose history goes back to the 13th century; at the foot of the cape is the traditional cavern of Elijah, a shrine sacred to Jews, Moslems, and Christians. Opposite the monastery is the old Stella Maris lighthouse, which is still in use.

The environs of Haifa also take in the new campus of the Technion, Israel's primary institute for the training of engineers, architects, and scientists. The basic plan for these 300 acres on the eastern flank of Mount Carmel, designated as Technion City, was laid out by A. Klein. Of the complex of buildings that comprise the new campus, some thirty are in full use. They vary in style but all are in the modern tradition and are constructed of locally produced building materials. Representative are the Winston Churchill Auditorium (1958; A. Sharon and B. Idelson, architects), the Albert Einstein Institute of Physics (1958; N. Zalkind), the Fishbach Electrical Engineering Building (1957; A. Klein); the Samuel Fryer Aeronautical Engineering Building (1953; Y. Ratner), and the Hydraulics Center (1958; A. Mansfeld and M. Weinraub). Contemporary architectural trends are also exemplified in Haifa by the Youth Center, Beth ha-Rofe (House of Physicians), the Rothschild Hospital, the Kiryat Hayim commemorative monument (1950; M. Weinraub and A. Mansfeld), and the Center for the Reeducation of the Blind (M. Weinraub and A. Mansfeld).

BIBLIOG. L'arch. d'aujourd'hui, XXIX, 77, 1958/1959, p. 90; P. Abeles, Institute of International Education, News B., XXXV, 4, 1959, pp. 9–16; Z. Vilnay, The Guide to Israel, Cleveland and New York, 1960; J. Comay, Everyone's Guide to Israel, New York, 1962.

Tell Abu Hawam. This small site at the foot of Mount Carmel was occupied from the late Bronze Age to the Persian period except for an interruption caused by the invasion of Sheshonk I (ca. 926 B.C.). Five strata have been uncovered, and finds include a temple, magazines, and a cemetery with Mycenaean pottery. A hoard of Tyrian coins was also brought to light.

BIBLIOG. R. W. Hamilton, Q. of the Department of Antiquities in Palestine, IV, 1935, pp. 1–69; B. Maisler, BAmSOR, CXXIV, 1951, pp. 21–25; E. Anati, 'Atiqot, II, 1959, pp. 89–102; N. Avnimelech, 'Atiquot, II, 1959, pp. 103–05.

Athlit. The beginnings of habitation at Athlit go back at least as far as the Iron Age. Phoenician settlers cremated their dead here. In the Persian period the site was occupied by Greek mercenaries and their native (or Egyptian) wives. The finds in the deep pit tombs include Attic pottery and Greek seals and weapons as well as Egyptian jewelry and amulets. The main ruins belong, however, to the Crusader period: a magnificent Templar castle with a double wall (an outer wall with a fosse and an inner with two high towers), an octagonal church, and vaulted halls and magazines. Adjacent to the castle was a *faubourg* with its own church, fort, and stables.

BIBLIOG. C. N. Johns, Q. of the Department of Antiquities in Palestine, II, 1933, pp. 41–104, III, 1934, pp. 137–64, IV, 1935, pp. 122–37, V, 1936, pp. 31–60, VI, 1938, pp. 121–52.

Dor (el-Burj). Tentative explorations have established the existence here of a city of the Bronze and Iron ages; remains of later periods include a Hellenistic temple and jetty, a Roman theater, and a Byzantine church.

BIBLIOG. J. Garstang, B. of the Br. School of Archaeol. in Jerusalem, 4, 1924, pp. 35–45, 6, 1924, pp. 65–73; J. Leibovitch, 'Alon, III, 1951, pp. 38–39, V–VI, 1957, p. 35.

Megiddo. The great Bronze and Iron Age site of the region, Megiddo is strategically located where the Valley of Iron (Wadi Ara) — which passed the Via Maris — opens into the plain of Esdraelon. Settlement dates from the chalcolithic age, but the main development began with the creation of the city-state in the early Bronze Age and continued into middle and late Bronze. The earlier strata include a Canaanite temple and high place; the late Bronze Age is represented by finds of ivory carvings and jewelry. In the Israelite period Solomon equipped the city with a casemate wall, gates, and stables; in the time of Ahab new stables were built. The Megiddo water system, which connected the city with a spring outside the city walls by means of a 300-ft. tunnel, belongs to the late Bronze Age. The Megiddo Museum is at the entrance to the site.

BIBLIOG. G. Schumacher and C. Watzinger, Tell el Mutesellim, 2 vols., Leipzig, 1908–29; H. G. May and R. M. Engberg, The Material Remains of the Megiddo Cult, Chicago, 1935; P. L. O. Guy and R. M. Engberg, Megiddo Tombs, Chicago, 1938; R. S. Lamon, G. M. Shipton, G. Loud, ed al., Megiddo, 2 vols., Chicago, 1939–48.

Caesarea (Caesarea Palaestina). Founded by Herod on the site of an earlier anchorage called Strato's Tower, Caesarea was the capital of Palestine for 600 years. Archaeological remains include a Roman and a Byzantine wall, a synagogue, two aqueducts, a hippodrome, a theater, an amphitheater, remnants of an open-air enclosure decorated by the Byzantines with Roman statues, and an extramural church with a mosaic pavement whose decorative motifs

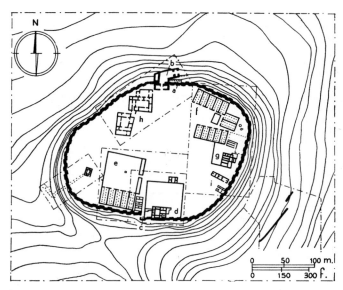

Megiddo, archaeological plan showing levels V (1060–1000 B.C.), IV (1000–800 B.C.), and III (780–650 B.C.): (a) Fortification wall (levels IV–III); (b) north gateway (level III); (c) south gateway; (d) palace (level IV B); (e) south stables (level IV); (f) north stables (level IV); (g) residence (of the chief of the north sector of the city?; level IV); (h) structure surrounding open courts (level III); (i) sacred area of pre-Israelite times (level IV) (*from R. S. Lamon and G. M. Shipton, Megiddo, I, Chicago, 1939, fig. 3*).

include animals and birds. Exploration of the site is still in its early stages. A small museum in the nearby kibbutz of Sedot Yam exhibits finds made at Caesarea.

BIBLIOG. S. Yeivin, Archaeology, VIII, 1955, pp. 122–29; M. Avi-Yonah, EAA, s.v. Caesarea; A. Frova et al., Caesarea marittima, Milan, 1959; M. Avi-Yonah, B. of the L. M. Rabinowitz Fund, III, 1960, pp. 44–48; M. Schapiro and M. Avi-Yonah, Israel: Ancient Mosaics, Greenwich, Conn., 1960, pls. XXIX–XXXI.

Meser. Through the excavations at this site in the Wadi Ara it is known that cisterns (for storing water) were dug with bronze adzes as early as the chalcolithic era.

BIBLIOG. M. Dothan, Israel Exploration J., VII, 1957, pp. 217–28.

Hadera. An important agricultural and communications center, Hadera has yielded, in the course of exploration, a number of pottery ossuaries shaped like miniature houses. There is a fine synagogue, and remains of an Arab caravansary have been found.

BIBLIOG. E. L. Sukenik, J. of the Palestine O. Soc., XVII, 1937, pp. 15–30.

The Philistine coastal plain. The area extending from the Yarkon River to the Sinai desert and from the sea to the Judean foothills is a broad, fertile plain dominated by a few great cities. It served as the Egyptian base of operations into Asia in the 2d millennium B.C.

Tell Qasila. Located on the Yarkon River, Tell Qasila was apparently a Philistine (late Bronze Age) foundation. The city was conquered by David and remained an important trading and administrative center of the Israelite monarchy until it was destroyed by Tiglathpileser III, in 732 B.C.; it revived in the Persian period. The finds that the site has yielded include a casemate wall, smelting ovens, and ostraca certifying the movement of oil and gold to and from the royal storehouses; some of the finds are exhibited in a building adjacent to the site of excavation.

BIBLIOG. B. Maisler, Israel Exploration J., I, 1950–51, pp. 61–76, 125–40, 194–218; Y. Kaplan, Israel Exploration J., VII, 1957, p. 265, VIII, 1958, p. 135.

Rosh ha-Ayin (Aphek, Antipatris). The early Bronze Age town was protected by a brick wall about 8 ft. thick. Rectangular pit graves found here are of a type unusual for the region; recesses in the stone-lined long sides of the tomb wall apparently served to hold remains of earlier burials. A Mameluke castle crowns the tell.

BIBLIOG. J. Ory and J. H. Iliffe, Q. of the Department of Antiquities in Palestine, V, 1936, pp. 111–26, VI, 1937, pp. 99–120; Y. Kaplan, Israel Exploration J., VIII, 1958, pp. 149–60.

Tel Aviv-Jaffa (Jappho, Joppa, Yafo). The merging into a single municipality of one of the world's oldest ports, the ancient Jaffa, and the relatively young metropolis of Tel Aviv, north of it, occurred in 1954. The sparsely documented annals of Jaffa, beginning in the 16th century B.C. (it is mentioned on a pylon of Thutmosis III at Karnak), traverse a Phoenician phase (under Egyptian sovereignty) and a Philistine phase and record its establishment as a Jewish town under the Maccabees and its Roman, Byzantine, and Crusader periods. Excavation of the ancient city mound has to date yielded chiefly survivals from the middle and the late Bronze ages, notably a late Bronze Age brick wall and monumental gate, and inscriptions of Ramses II (1290–1223 B.C.).

Originally a suburb adjacent to Jaffa, Tel Aviv (lit., "Hill of Spring") was founded in 1909 by a group of Jewish immigrants to Palestine who were resident in the port city. A continuing influx

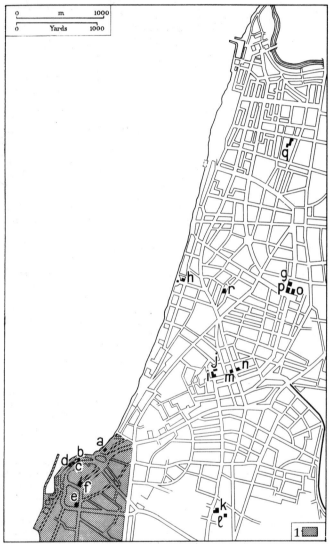

Tel Aviv-Jaffa. Key: (1) Jaffa area. Chief monuments: (a) Maḥmūdiya Mosque; (b) Casa Nova hospice; (c) Church of St. Peter; (d) Franciscan Monastery of St. Peter; (e) Tabitha Mission School, Church of Scotland; (f) French hospital; (g) Tel Aviv Museum, Helena Rubinstein Pavilion; (h) opera house; (i) Achad Haam House; (j) Tel Aviv Museum, Dizengoff House; (k, l) University of Tel Aviv; (m) Great Synagogue; (n) Great Sephardic Synagogue; (o) Mann Auditorium; (p) Habima Theater; (q) Assutah Hospital; (r) Bialik House.

stimulated the development of the new urban nucleus; it quickly recovered from the damage incurred in the course of World War II and the Arab-Jewish conflict of 1948 and took its place as Israel's first city, having absorbed the old town of Jaffa, in large part destroyed in the Arab-Jewish fighting. Among Jaffa's remaining monuments should be mentioned the earliest mosque (1730), which is close to the Franciscan Monastery of St. Peter and to the ancient lighthouse, and the Maḥmūdiya Mosque, with its fine fountain (1810); these stand on the ruins of the old fortified citadel. Jaffa's Museum of Archaeology exhibits antiquities found in the Tel Aviv and Jaffa area.

The city of Tel Aviv, built on sand dunes, is entirely European in planning and execution, the original plan being the work of the Scottish town planner Sir Patrick Geddes. Characterized by cubic buildings and ample gardens, the city has an industrial zone and model residential areas. Important buildings include the Great Synagogue (Israel's largest), the Great Sephardic Synagogue, the Assutah Hospital (1935; J. Neufeld), and the municipal buildings. Representative of contemporary international trends in architecture are the Histadrut building (1953; D. Karmi); the Lessin Cultural Center (A. Sharon and B. Idelson, architects), the Mann Auditorium (1953–57; Z. and J. Rechter and D. Karmi), the Beilinson Hospital (1958, A. Sharon and B. Idelson), the Sheraton Tel-Aviv Hotel (1955; W. J. Wittkower), the Dan Hotel (1955–56; H. Fenchel).

Tel Aviv has been from its beginning a center of culture and of art. The first Hebrew-language college, the Herzliya, was founded there in 1909. Three repertory companies have their permanent base in theaters in Tel Aviv — the Habima, the Ohel, and the Kameri (Chamber). Mograbi Hall and a new amphitheater in the exhibition grounds provide other settings for the performing arts. The Israel National Opera appears in an opera house near the sea. The Tel Aviv Museum came into existence in 1930; the permanent collections are in Dizengoff House (1936; C. Rubin), while temporary exhibitions are held in the Helena Rubinstein Pavilion (1953; D. Karmi and J. Rechter), which also contains a comprehensive art library. This museum owns an impressive collection of old and modern masters, and has built up an extensive collection of works by Israeli artists. Other museums in the city, in addition to the museum in Jaffa, include the Museum Haaretz — of which the Glass Pavilion (W J. Wittkower and E. W. Baumann, architects) is one of 14 planned to form eventually a museum of the civilizations of the eastern Mediterranean region — and the Historical Museum of Tel Aviv.

BIBLIOG. L'arch. d'aujourd'hui, VIII, 9, 1937, p. 26; J. Bowman, B.S.J. Isserlin, and A. Rowe, Proc. of the Leeds Philosophical Soc., IV, 1955, pp. 231–50; Y. Kaplan, Israel Exploration J., VI, 1956, pp. 259–60; L'arch. d'aujourd'hui, XXIX, 77, 1958/59, pp. 62–69.

Azor (Yazur). The earliest settlements of which there is evidence in this general region are the chalcolithic sites here; the tomb caves yielded a great quantity of house-shaped ossuaries, as well as some in the form of a human face.

BIBLIOG. M. Dothan, Israel Exploration J., VIII, 1958, pp. 722–74; J. Perrot, Israel Exploration J., IX, 1959, pp. 266–67.

Lod or Lydda (Diospolis, Ludd). The Church of St. George, like the mosque next to it, stands on Crusader foundations. It incorporates remnants of the medieval structure, which had in turn been erected on the ruins of a Byzantine church built, according to tradition, over the shrine of St. George; a 6th-century inscription on a pillar in the mosque remains from the Byzantine church. North of the city is a noteworthy Islamic monument of the 13th century, a stone bridge built by the Mameluke sultan al-Ẓāhir Baybars. Since Biblical times an important crossroads, Lod is Israel's international airport.

BIBLIOG. C. Enlart, Les monuments des croisés dans le royaume de Jérusalem . . ., 4 vols., Paris, 1925–28, s.v. Lydda; Y. Kaplan, 'Alon, V–VI, 1957, p. 39.

Ramla. The Great Mosque that stands in the center of Ramla was originally a Crusaders' church of the 12th century. From the 8th century there remain Uneiziya cisterns with pointed arches. The square tower that dominates the town dates from 1318; it was once the minaret (and is all that remains) of a large mosque.

BIBLIOG. C. Enlart, Les monuments des croisés dans le royaume de Jérusalem . . ., 4 vols., Paris, 1925–28, s.v. Ramleh; J. Kaplan, 'Atiqot, II, 1959, pp. 106–15.

Ashkelon (Ascalon). The oldest settlement here must date back at least as far as the early Bronze Age, but the accumulation of later remains on this site is so great that the excavators have reached no further than the late Bronze level, with its sub-Mycenaean pottery. The chief remains that have been brought to light are a 3d-century bouleterion with relief sculptures (Nike, Atlas, Isis) and an adjacent portico. Other finds include a Roman painted tomb and a Byzantine-Crusader wall.

BIBLIOG. J. Garstang and W. J. Pythian-Adams, Palestine Exploration Fund Q. Statement, XLIII, 1921, pp. 12–16, 73–75, 163–69, XLIV, 1922, pp. 60–84, 112–19, XLVI, 1924, pp. 24–35; J. Ory, Q. of the Department of Antiquities in Palestine, VIII, 1939, pp. 38–44; J. Perrot, Israel Exploration J., V, 1955, pp. 270–71; M. Avi-Yonah, EAA, s.v. Ascalon; J. Praver, Erets Yisrael, V, 1958, pp. 224–37.

Tell Jemmeh (Tell Gamma). The earliest excavated strata at this site belong to the middle Bronze Age. In the late Bronze Age

the city was occupied for a long time by Egyptian troops (18th and 19th dynasties), and in the Iron Age it apparently served as a base both for the Assyrians and for the Persians in their operations against Egypt; numerous foundries and silos, as well as limestone altars with incised designs, belong to these periods. In the Persian period the town served as a transit station for Greek trade with the Nabateans, hence the finding of a relatively great quantity of Attic shards.

BIBLIOG. W. M. F. Petrie, Gerar, London, 1928; B. Maisler, PEQ, LXXXIV, 1952, pp. 48–51.

Maon (Nirim). A mosaic pavement from an ancient synagogue was found here. This late-6th-century work, showing a mixture of animal and symbolic decoration, is in the Archaeological Museum in Jerusalem.

BIBLIOG. Israel Exploration J., VII, 1957, p. 265; M. Avi-Yonah et al., B. of the L. M. Rabinowitz Fund, III, 1960, pp. 6–40; M. Schapiro and M. Avi-Yonah, Israel: Ancient Mosaics, Greenwich, Conn., 1960, pls. XXIV–XVII and p. 22.

Sharuhen (Tell el-Fara). Contemporary with the chalcolithic sites at Azor are a series of settlements along the valley passing Sharuhen. The tell itself was apparently settled at the end of the early Bronze Age; its principal remains include fortifications attributed to the Hyksos and houses of the Tell el-'Amarna type from an Egyptian colony. Initially the Iron Age brought destruction, but the site was reoccupied either by the Israelites or by the Philistines, and it remained settled through Iron Age I and II. Among the tombs found here were some with anthropomorphous sarcophagi resembling those of Beth Shan. Perhaps the earliest fortified gateway found to date in the Palestinian area is one discovered at this site.

BIBLIOG. W. M. F. Petrie, Beth Pelet, I, London, 1930; E. Macdonald et al., Beth Pelet, II, London, 1932.

The Shephala. The name (lit., "lowlands") denoting this area, which includes the Judean foothills, represents the point of view of the Israelites who inhabited the mountains. The Shephala was in all periods the scene of strife between the people of the mountains and those of the plain, and its passes are guarded by an imposing number of tells. Archaeological investigation to date indicates that these ancient city mounds were first inhabited by chalcolithic cave dwellers, whose occupation of them marked the beginning of Canaanite urbanism in the early Bronze Age. These cities reached their highest point in the late Bronze Age and maintained their position in the Iron Age, declining for the most part in the Hellenistic and Roman periods.

Gezer. The northernmost of the cities of the Shephala, Gezer was first inhabited by chalcolithic cave dwellers, who were able to erect a rough wall on top of the mound; it began to exist as a city in the early Bronze Age. The caves were converted into burial places and a high place with steles was established. In the middle Bronze Age an inner wall was added to the city fortifications and a tunnel was dug to reach a spring at the foot of the mound. The late Bronze period was one of great prosperity for the city, with evidence of a marked increase in Egyptian and Aegean influences. Magazines were now provided in abundance, and a new wall was built. When Solomon took possession of Gezer, a casemate wall was built, with a fortified gate following the plan of those at Hazor and Megiddo. The famous Gezer calendar, a limestone tablet bearing a list of agricultural activities arranged by months, belongs to the Israelite age. Contracts in cuneiform remaining from the Assyrian and Neo-Babylonian periods show that the city continued to exist after 586 B.C. In the Hellenistic period Gezer was a stronghold of the Seleucids until its capture by Simon the Hasmonean, who made it the site of a palace and a fortress. Inscriptions from this time mark the Sabbath boundary of the city (i.e., the walking distance permitted).

BIBLIOG. R. A. S. Macalister, The Excavation of Gezer, 3 vols., London, 1912; A. Rowe, PEQ, LXVII, 1935, pp. 19–33.

Shaalabbin (Shaalvim). Among the remains of the ancient Samaritan synagogue discovered here is an interesting mosaic which is in a class by itself, no others of its kind having yet been found.

BIBLIOG. E. L. Sukenik, B. of the L. M. Rabinowitz Fund, I, 1949, pp. 25–30.

Beth Shemesh. Apparently founded in the early Bronze Age, Beth Shemesh was devastated in the middle Bronze Age and was refortified in the Hyksos period; in addition to these fortifications, a Hyksos necropolis has been found here. After the Hyksos period Beth Shemesh came under the domination of the Egyptian New Kingdom, reaching its zenith under the 19th dynasty (the finds include an 18th-dynasty marriage scarab of Amenhotep III and Queen Tiy). The city continued to exist, with Israelites and Philistines contesting for domination, well into Iron Age I; at some point during this phase it suffered destruction at the hands of the Israelites. In Byzantine times a large monastery was established on the ruins.

BIBLIOG. D. MacKenzie, Palestine Exploration Fund Ann., I, 1911, pp. 41–94, II, 1912–13, pp. 1–39; E. Grant, Beth Shemesh, Haverford, Pa., 1929; E. Grant, Ain Shems Excavations, 5 vols., Haverford, Pa., 1931–39; M. Avi-Yonah, EAA, s.v. Bet Shemesh.

Tell es-Safi. A town existed on this site from the early Bronze Age through Iron Age II, as well as in the Hellenistic period. The archaeological remains from these times suffered by the erection here of the Crusader castle of Blanchegarde in 1140.

BIBLIOG. F. J. Bliss and R. A. S. Macalister, Excavations in Palestine, 1898–1900, London, 1902.

Azekah (Tell Zakhariya). This site developed in the middle and late Bronze Age, and the Israelites fortified it with a citadel; a Hellenistic level was also found in the upper part of the mound.

BIBLIOG. F. J. Bliss and R. A. S. Macalister, Excavations in Palestine, 1898–1900, London, 1902.

Tell el-Judeida (Maresheth Gath). An early Roman villa has been discovered here.

BIBLIOG. F. J. Bliss and R. A. S. Macalister, Excavations in Palestine, 1898–1900, London, 1902.

Beth Guvrin (Eleutheropolis, Beit Jibrin). After the Israelite city of Maresha was destroyed, in 40 B.C., a new town rose on an adjacent site and took its place. This town, which later acquired the name of Eleutheropolis, has yielded a series of fine Byzantine mosaics.

BIBLIOG. L. H. Vincent and F. M. Abel, RBib, XXXI, 1922, pp. 259–81, XXXIII, 1924, pp. 583–604; M. Avi-Yonah, EAA, s.v. Bet Gubrin; M. Schapiro and M. Avi-Yonah, Israel: Ancient Mosaics, Greenwich, Conn., 1960, pls. XV, XVI.

Maresha (Marisa, Tell Sandahanna). The Hellenistic town of Marisa was inhabited chiefly by Sidonians; their painted tombs show the characteristic combination of religious symbols with representations taken from natural history and mythology. The city itself was built on a Hippodamian plan and was provided with many caravansaries; caves and silos attest to its industrial and agricultural activity, while a multitude of Rhodian jar handles give evidence of widespread trade relations. Incantation texts and magical figurines show that Hellenistic enlightenment had to contend with a strong inclination to magic.

BIBLIOG. J. F. Bliss and R. A. S. Macalister, Excavations in Palestine, 1898–1900, London, 1902; J. P. Peters and H. Tiersch, Painted Tombs in the Necropolis of Marissa, London, 1905.

Lachish (Tell ed-Duweir). First settled by chalcolithic cave dwellers, the site acquired a wall and glacis in the middle Bronze Age. In the late Bronze Age a small temple was built in the fosse of the city. About 1230 B.C., destruction visited the city, and this disaster supplies an important clue to the dating of the Israelite invasion. In the Iron Age a new city rampart was constructed, with a double line of walls and a ramp leading up to the gate; this wall is depicted in Assyrian representations of the siege of Lachish by Sennacherib in 701 B.C. The Israelite city was a fully developed trade center, guarded by a fortress; in the Persian period this was replaced by a residence and temple of the sun. In the guardhouse near the gate were found the documents known as the "Lachish letters," ostraca with the correspondence of the city commander in the last days before the Babylonian invasion of 586 B.C.

BIBLIOG. Lachish (The Wellcome Marston Archaeol. Research Expedition to the Near East Pubs., I–IV), 4 vols., London, New York, 1938–58.

Tell el-Hesi (Eglon?). The first Palestinian site whose stratification and pottery have been closely studied, Tell el-Hesi came into existence in the early Bronze Age. In the middle Bronze Age it was fortified with a glacis. The town reached its highest development in the late Bronze Age.

BIBLIOG. W. M. F. Petrie, Tell el Hesy, London, 1891; F. J. Bliss, A Mound of Many Cities, London, New York, 1894.

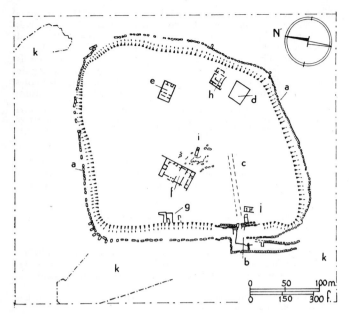

Lachish, archaeological plan. Chief monuments: (*a*) Fortification wall; (*b*) bastions and gateway with access ramp; (*c*) street; (*d*) great cistern; (*e*) sun temple; (*f*) royal palace; (*g*) private house; (*h*) unidentified structure; (*i*) rooms and trenches east of the palace; (*j*) house near the gateway; (*k*) cemeteries outside the walls (*from Lachish, The Wellcome Marston Archaeol. Research Expedition to the Near East Pubs., III, pl. 108*).

Tell Beit Mirsim (Debir?; Kiryat-sepher?). Occupation of this site extends over the period from the early Bronze Age to the 6th century B.C. Fifteen successive strata were discovered in the mound, which had a Hyksos glacis of the middle Bronze Age. A high place with the stele of a serpent goddess and numerous alabaster vessels is also middle Bronze. The late Bronze Age yields little; to it belong magazines of the Cretan type and a letter in cuneiform. A polygonal citadel protected the Israelite city, which was provided with a casemate wall and numerous silos, and there are remains of an active dyeing industry.

BIBLIOG. W. F. Albright, Ann. of the American Schools of Oriental Research, XII, 1932, pp. 1–165, XIII, 1933, pp. 55–127, XVII, 1938, pp. 1–96, XXI–XXII, 1943, pp. 1–230.

Jerusalem and environs. The corridor leading up to the Holy City, established by Israel in the war of 1948–49 and retained by the terms of the armistice agreements, includes most of new Jerusalem; the greater part of the Old City remains within Jordanian boundaries. The Jerusalem Corridor is a segment of the Judean hills, which rise between the coastal plain and the Jordan Valley.

Abu Ghosh (Kiryat Yearim). At this site, doubtless the most interesting, prehistorically, in the Jerusalem Corridor, finds of the Neolithic period — both pottery and the remains of a square building — indicate Syrian influences penetrating Palestine at this early stage; at the other end of the historical scale is the 12th-century Crusaders' church built on the remains of a Roman structure, perhaps a reservoir.

BIBLIOG. R. de Vaux and A. M. Steve, Fouilles à Qaryet el-'Enab, Paris, 1950; J. Perrot, Syria, XXIX, 1952, pp. 119–45.

Jerusalem (Urusalim, Hierosolyma, Aelia Capitolina). Archaeological evidence going back to the early Paleolithic era and documents going back to Akkadian cuneiform and Egyptian hieroglyphic inscriptions begin the long story of the continuous life of Jerusalem as an inhabited city — one of the longest in the world. The Scriptures and the ancient histories carry the account of the royal city of David and of Solomon — the site of Solomon's Temple and the capital of the kingdom of Judah — down through its Roman, Byzantine, Persian, and Moslem periods, through the Crusaders' Latin kingdom, whose capital it was, to the dawn of modern times, when the Holy City was in the hands of the Turks. Whatever traces remain from these early eras are chiefly in old Jerusalem, within the borders of Jordan (q.v.). Of the Old City, Israel has retained only Mount Zion, with the so-called "Tomb of David," which was perhaps originally a late Roman synagogue (the Cenacle, or Hall of the Last Supper, above the tomb is a 14th-century Gothic structure). Also visible on Mount Zion are remains of the Hasmonean First Wall

of historic Jerusalem. Other archaeological monuments within Israeli borders are various rock-cut tombs in the city and its vicinity. Among these is the cave that was the burial place of Herod's family, with a rolling stone to close the entrance and its interior faced with stone slabs. In the upper Valley of the Kidron is the cave containing the tombs of the Sanhedrin ("Tombs of the Judges"), the entrance to which has a fine pediment filled with floral decoration in relief. A rock-cut tomb of the Hasmonean period discovered in 1956 in Rehavia is embellished with wall decorations that include graffiti representing seven-branched candlesticks and drawings representing a maritime battle. At Givat Ram, west of the city, remains of a brick factory of the Roman Legio Decima Fretensis were found, and, near them, of a mid-5th-century church and hospice for the aged built by the empress Eudocia. In the upper reaches of the Hinnom Valley two Iron Age tombs have been discovered. The Israel Department of Antiquities maintains an Archaeological Museum in Jerusalem displaying a collection of finds from sites all over the country.

In the final period of Turkish rule Jerusalem expanded outside the 16th-century walls of the Old City; residential quarters grew up and institutions were founded to accommodate communities and pilgrims from all over the world. Under the Mandate this new Jerusalem expanded still further, adding, within the town, modern buildings to accommodate government and business and, in outlying sections, residential suburbs and parks. It was during this time that the ruling was put into effect that all buildings in Jerusalem be constructed of or faced with the fine limestone in which the site abounds. Among the structures that should be mentioned are the municipal building, the law courts, the Jewish Agency building (1930; Y. Ratner), the original Bezalel National Museum (1906; new buildings are under construction), the Y.M.C.A. (1928), with its tower overlooking the entire city, and the King David Hotel.

A city with more religious associations than any other in the world, Jerusalem has a great number of religious structures. An impressive example is the Hechal Schlomo, the seat of the Chief Rabbinate. The largest and most imposing of the many synagogues is the Yeshurun Synagogue (1934–35; E. Stolzer, M. Robin, R. Friedman). In contemporary style are the synagogue on the campus of the Hebrew University (H. Rau, architect) and the synagogue of the Hebrew University-Hadassah Medical Centre (1962, J. Neufeld, architect); the latter has 12 stained-glass windows, representing symbolically the 12 tribes of Israel, created for it by Marc Chagall (1959–61). In 1963 the Hebrew Union College Biblical and Archaeological School (H. Rau, architect) was completed. Among the noteworthy Christian edifices are Notre-Dame-de-France Monastery, the Pontifical Biblical Institute (1927), Ratisbonne Monastery (1874), Terra Sancta Monastery, the French Lazarist Monastery, the Convent of the Poor Clares (1914), St. Vincent de Paul Convent, St-Rosaire Convent, and the Church and Monastery of the Dormition (1900–10; restored) on Mount Zion, all Roman Catholic; the Monastery of the Cross, the Monastery of St. Simeon, and the Monastery of the Evil Counsel, all Greek Orthodox; the Russian Cathedral and the Church of St. John, both Russian Orthodox; the Abyssinian Monastery and Church, of the Coptic rite; and the Scottish Church of St. Andrew and the Swedish Theological Institute. The Italian and the French hospitals should also be mentioned.

Since the establishment of the State, Jerusalem, as the capital, has been the scene of accelerated building activity. In addition to industrial centers, hotels, apartment blocks, and schools, such projects as the rebuilt Convention Center and the Beth Ha'am (House of the People) are part of this development. Many important monuments are in progress. A group of government buildings, including the new quarters for the Knesset, is partially completed on the Kirya (Capitol) to the west of the city; on another hilltop will stand the Israel National Museum of Art and Archaeology, in gardens designed by Isamu Noguchi. Just west of these locations is the complex of buildings comprising the Hebrew University, whose campus occupies 236 acres. The University buildings are a notable example of the felicitous use of the local limestone; its rich tone is ingeniously set off by the contrasting shades of stones and marbles quarried in other parts of Israel. Among the units completed in the first four years of construction (1954–58) are the administration building and auditorium (D. and R. Karmi, Z. Melzer, architects), the physics and botany laboratory (D. A. Brutzkus), the physical and inorganic chemistry compound (A. Sharon and B. Idelson), the school of economics and social sciences (A. Yaski and S. Powsner), the Institute for Jewish Studies (M. Weinraub and A. Mansfeld), the faculty of letters building (A. Yaski and S. Powsner), the school of archaeology (Z. and J. Rechter, M. Zarhy), the library (A. Alexandroni, Z. Armoni, H. Havron, M. and S. Nadler, S. Powsner, A. Yaski), the youth hostel (A. Sharon and B. Idelson), the stadium (J. Klarwein), and an open-air theater seating 3,000 (S. Mestechkin). The Hebrew Language Academy (1959; L. Attias and A. Kashtan) is housed in

another of the campus buildings. The Medical School of the University will form part of the Hebrew University-Hadassah Medical Center, an impressive modern complex of buildings (J. Neufeld, architect) on the nearby hilltop overlooking Ein Karem; the synagogue of the Center contains the Chagall windows mentioned above. All but two of the main buildings of this, the largest medical complex in the Middle East, have been completed and are in use.

Two of the most striking monuments of the new Jerusalem are the Tomb of Theodor Herzl (J. Klarwein, architect), crowning the terraced War Memorial Cemetery on Mount Herzl, and on the same ridge, on Har ha-Zikaron (Hill of Remembrance), a memorial to the six million victims of the Nazi regime, erected by the Yad Vashem and including a building to house its offices, archives, and library, a memorial shrine, and an exhibition hall (1961; A. El-Hanani, B. Idelson, and A. Sharon), a museum (in progress), and a synagogue (in progress)—all standing on an immense open concrete platform, the Memorial Square.

BIBLIOG. L. A. Mayer and M. Avi-Yonah, A Concise Bibliography of Excavations in Palestine, Q. of the Department of Antiquities in Palestine, I, 1932, pp. 86–94, 139–49, 163–99; M. Avi-Yonah, B. of the Palestine Exploration Soc., XV, 1–2, 1949, pp. 19–24; R. Amiran, B. of the Israel Exploration Soc., XX, 3–4, 1956, pp. 173–79; M. Dothan and L. Y. Rahmani, Israel Exploration J., VI, 1956, p. 127; L'arch. d'aujourd'hui, XXIX, 77, 1958/59, pp. 62–99; H. M. Z. Meyer, Portrait of Jerusalem: Contemporary Views of the Holy City, London, Jerusalem, 1958; Progressive Architecture, XLII, 2, 1961, pp. 122–31; J. Leymarie, The Jerusalem Windows, New York, 1962.

Manahath. At this site near Jerusalem several tumuli have been cleared: heaps of stones up to 20 ft. high and 110 ft. in diameter, surrounded by a low retaining wall. Beneath the tumuli have been found traces of cult installations. The purpose of these constructions, which date from the 7th century B.C., is debated; some hold that they were tombs (although no actual burials were found in them), while others incline to the view that they were high places and were deliberately obliterated by Josiah, king of Judah.

BIBLIOG. R. Amiran, Israel Exploration J., VIII, 1958, pp. 205–27.

Ramat Rahel. Another archaeological site of major importance in the vicinity of Jerusalem is near the kibbutz of Ramat Rahel. Remains include a Byzantine monastery and church (perhaps the famous Church of the Kathisma), a settlement from the time of the Second Temple, and a Judean royal fortress founded in the 8th century B.C., with a casemate wall and a residence in which proto-Aeolic capitals were an architectural feature. The site continued to be inhabited into the Persian period; it has yielded numerous stamped jar handles, some marked *lammelekh* ("belonging to the king") and bearing the name of a city (four cities are represented); other jar handles are stamped with the name of the province (Yehud, or Judea) and in some cases also with the name of the governor.

BIBLIOG. Y. Aharoni, Israel Exploration J., VI, 1956, pp. 102–11, 137–55; Rome, Univ., Missione archeol. nel vicino oriente, Il colle di Rachele (Ramat Rachele), Rome, 1960; A. Ciasca, R. degli studi orientali, XXXVI, 1961, pp. 13–17; P. Testini, The "Kathisma" Church and Monastery, Excavations at Ramat Rahel, Seasons 1959 and 1960, Rome, 1962.

The Negev. The southern part of Israel, south of a line extending rom Gaza via Beersheba to Ein Gedi on the Dead Sea, is a dry area, at present cultivable only in its northern section. The southern part of the Negev is desert except for a few watering places, where forts were built in Nabatean and Roman times. The intensive exploration of this region with a view toward settlement has led to many discoveries that have radically altered concepts of the history and morphology of the remains.

BIBLIOG. F. Frank and A. Alt, Z. der D. Palästina Vereins, LVII, 1934, pp. 191–280, LVIII, 1935, pp. 1–78; N. Glueck, Rivers in the Desert: A History of the Negev, Philadelphia, 1959.

Wadi Hever. The caves here were the last refuge of the defeated remnants of Bar Kokhba's army; they have yielded letters and documents, booty taken from the Romans, and many household utensils, weapons, and articles of clothing; even remains of food have been found.

BIBLIOG. Y. Aharoni, Israel Exploration J., IV, 1954, pp. 126–27, V, 1955, pp. 272–73.

Masada (el-Sebbe, Metsada). The fortress, on a rocky eminence west of the Dead Sea, was founded in the Hasmonean period; it was extended and embellished by Herod, who provided it with huge cisterns (fed by two aqueducts), a storehouse, an arsenal, barracks, and two palaces, one of which was daringly built, in three levels, on the northern extremity of the rock. The earliest mosaics found in Israel were discovered here. The last stronghold of the Zealots, Masada was taken by the Roman army A.D. 73 after a long siege, evidences of which can still be clearly discerned.

BIBLIOG. M. Avi-Yonah et al., Masada, Survey and Excavations, 1955–56, Jerusalem, 1957.

Beersheba. The earliest settlements in the area belong to a subdivision of the chalcolithic culture. At first the inhabitants lived in artificial caves dug in the soft loess of the area; only in the last phase of their settlement did they build houses. They practiced agriculture and animal husbandry, as is evidenced by their silos and the bones found in the houses. Most of the utensils were either pottery or finely polished stone vessels, though in this culture the technique of metal casting was known and was practiced extensively, copper ore being mined at several sites, including the Araba Valley. The artistic production, mainly small ivory statuettes of men, women, and animals, was on a very high level. The Negev Museum in Beersheba exhibits finds from regional excavations.

BIBLIOG. J. Perrot, Israel Exploration J., V, 1955, pp. 17–40, 73–84, 167–89; M. Dothan, 'Atiqot, II, 1959, pp. 1–42.

Halutsa (Elusa, Khalasa). In ancient times the principal city of the Negev, Halutsa was founded by the Nabateans, and it prospered under the Byzantine Empire. The despoiled ruins that remain have yielded mainly inscriptions.

BIBLIOG. C. Woolley and T. E. Lawrence, The Wilderness of Zin, London, 1936.

Nitsana (Nessana). A late Roman and Byzantine center of some importance, this city continued in existence after the Arab conquest. Finds of papyri made in the ruins throw valuable light on the administration and economics of the Byzantine and early Islamic periods; among them were literary works in Greek and Latin.

BIBLIOG. Colt Archaeol. Expedition, 1936–1937, Excavations at Nessana, II–III, Princeton, 1950–58.

Shivta (Subeita). This agricultural city was founded in the 1st century B.C. and continued into the Byzantine period. It had three churches, several hundred houses, grouped round a public pool, and a square that served as a commercial center.

BIBLIOG. C. Woolley and T. E. Lawrence, The Wilderness of Zin, London, 1936.

Avdat (Eboda). Built round a temple with the remains of the deified king Obodas, Avdat, whose beginnings go back to the 3d century B.C., flourished as a Nabatean settlement until A.D. 106, when the Nabatean kingdom was annexed by Rome. That it was a center of trade and industry is apparent from the remains that came to light through the discovery of a pottery kiln, surrounded by extensive dumps. The city revived under Roman rule in the second half of the 3d century of the current era; the Roman finds include remains of a camp. In the Byzantine period two churches and a fortress were erected on the summit of the town hill; in the slope of the hill a number of dwelling caves have been excavated. The distinctive Nabatean art is a blend of Hellenistic and Eastern influences; it is represented by a find of small bronzes, as well as by a mass of painted pottery.

BIBLIOG. A. Negev, Israel Exploration J., IX, 1959, pp. 274–75.

Michael AVI-YONAH

Material on modern monuments was contributed by Francesco NEGRI ARNOLDI.

Illustrations: 5 figs. in text.

ITALIAN ART. A basic phenomenon in Italian art from the middle of the 13th to the end of the 15th century was the development of distinct schools dominated by the personalities of great innovators or by the individual characteristics of various centers. This regional individuality resulted from the political division of the country into small states, each of which had its own particular history (albeit within the larger framework of a common cultural heritage). This independence is reflected in the precocious appearance of "local" art-historical literature devoted to the individual schools. (In fact, the various characteristics of these schools had been distinguished in 17th-century historical writings.) But because of more active cultural exchange among the various centers, local differences began to

diminish in the 16th century. From that time on, the schools were determined less by local cultural life than by the stylistic tendencies of the dominant artistic personalities, who created currents of taste that no longer represented single geographical centers but were sometimes international in scope (e.g., the schools of Caravaggio, Bernini, and the Carraccis).

The aim of this article is not to trace the development of Italian art through the works of the great masters but, on the contrary, to characterize individual schools and their particular histories. See also ROMANESQUE ART; GOTHIC ART; RENAISSANCE; MANNERISM; BAROQUE ART; ROCOCO; NEOCLASSIC STYLES.

SUMMARY. Lombard art from the Romanesque period to the Renaissance (col. 379). The Pisan school and its sphere of influence (col. 386). Florentine art from the Romanesque period to the Renaissance (col. 388). The Sienese school (col. 394). Central and southern Italian art to the 15th century (col. 398): *Southern Italy; Umbria; the Marches; the Abruzzi.* Art in Rome and Latium to the pontificate of Julius II (col. 412). The Emilian school from the Romanesque period to the 16th century (col. 416). Venetian art from the Romanesque period to the 16th century (col. 424). Roman art from the pontificate of Julius II to the end of the 18th century (col. 434). The Tuscan school from the mannerist period on (col. 444). The Emilian school in the 17th and 18th centuries (col. 448). Neapolitan and Sicilian art from the 16th century on (col. 453). The Venetian school in the 17th and 18th centuries (col. 458). Regional schools of northern Italy (col. 463): *Lombardy from the mannerist period to the end of the 18th century; Piedmont; Liguria.* The 19th century (col. 472).

LOMBARD ART FROM THE ROMANESQUE PERIOD TO THE RENAISSANCE. Although the influence of Byzantine art affected several parts of Italy, that courtly and cosmopolitan style was uncongenial in its nature to the tendencies of the Middle Ages that were to culminate in Romanesque art (see BYZANTINE ART; CAROLINGIAN PERIOD; EUROPE, BARBARIAN; OTTONIAN PERIOD; PRE-ROMANESQUE ART; ROMANESQUE ART). It was not until the Romanesque phase, after the year 1000, that individual developments characterized the several regions — forerunners of modern nation-states. This occurred despite extensive cultural inter-

change with Byzantium. Paradoxically, this interchange acted more as a catalyst of the various regional Romanesque styles than as a unifying element.

Lombardy supplied the strongest impetus in the creation of the Italian Romanesque. As early as the 9th century Lombard religious edifices exhibited elements that were to distinguish Lombard construction — loggias applied to the exteriors of apses, piers supporting vaulted roofs, and crypts surmounted by elevated choirs. In the 12th century, following the construction of S. Ambrogio in Milan (10th–11th cent.), this building style was used in the churches of S. Michele in Pavia, S. Abbondio and S. Fedele in Como, and S. Maria Maggiore in Bergamo. Lombard forms spread to Modena, where in 1099 Lanfranco began the Cathedral, another fundamental monument of Lombard architecture, which inspired the cathedrals of Parma (PL. 171), Piacenza, Cremona, and Ferrara, and the Church of S. Zeno in Verona. In the field of secular architecture the type of town hall featuring an open gallery on the ground floor became widespread; thus, the *broletti*, or Courts of Justice in Milan, Pavia, Monza, and Brescia, the Palazzo dell'Arengo in Rimini (PL. 187), and the Palazzo della Ragione at Bergamo.

Lombard sculpture of this period was closely bound to the general development of European Romanesque style because of the activity of Wiligelmo da Modena and Benedetto Antelami (qq.v.). In the first half of the 12th century the sculptural style of Wiligelmo da Modena (influenced by the art of Aquitaine and Burgundy) spread from Modena to Cremona, Nonantola, Ferrara, Verona (Nicolaus, q.v.), and even into Apulia. In the late 12th and early 13th centuries, the style of the school of Antelami (influenced by Provençal art) was carried by the Campionesi (q.v.) throughout the Po Valley (Milan, Piacenza, Modena, Parma, Ferrara, Venice) into Tuscany (Lucca, Pisa, Pistoia), and even to Sicily. In the 14th century the influence of Giovanni Pisano appeared in Milan through the activity of his pupil Giovanni di Balduccio (VI, PL. 367), who introduced the Gothic idiom to the circle of the Campionesi. Lombard works of this period are characterized by a style that combines late Gothic taste with a Renaissance exuberance of ornament.

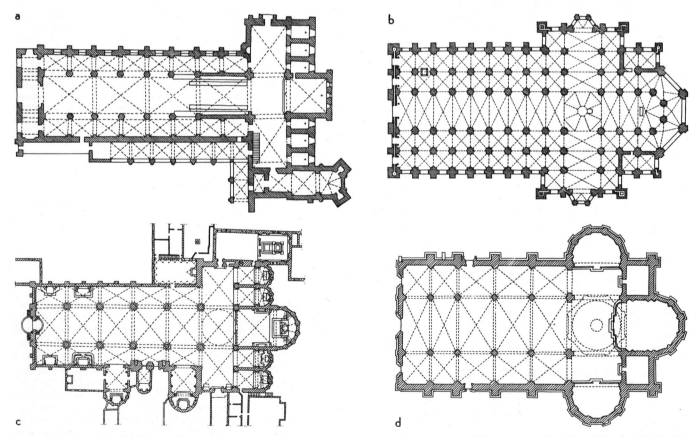

Churches founded in the Middle Ages in Lombardy and the Veneto, plans. (*a*) Chiaravalle, near Milan, Abbey church; (*b*) Milan, Cathedral; (*c*) Venice, SS. Giovanni e Paolo; (*d*) Como, Cathedral.

The Cathedral of Milan (FIG. 379; VI, PL. 337), the Certosa of Pavia, and the cathedrals of Monza and Como (PL. 187) — all of which benefited from the patronage of Gian Galeazzo Visconti — reflect a continuity of taste, even while style was changing. French, Italian, and German architects succeeded one another in the workshop of the Cathedral of Milan, founded in 1386, and it is to these men that the Cathedral owes its pronounced late Gothic stamp, which was also reflected in the Cathedral's sculpture (e.g., Giovanni di Fernach's decoration over the South Sacristy door, PL. 187). The work of these foreign architects influenced such local artists as Giovannino de' Grassi, Matteo de' Raverti, and Jacopino da Tradate. The bizarre imagination of the Tuscan architect and theorist Filarete (q.v.) easily assimilated Gothicizing elements (Milan, the Ospedale Maggiore and the façade of the Castello Sforzesco). Michelozzo (q.v.) successfully introduced the style of Brunelleschi in Milan, but his portal to the Medici bank (now in the Castello Sforzesco) was executed by local craftsmen in accordance with the traditional taste for excessive decoration. His Portinari Chapel in S. Eustorgio, however, is a masterpiece of the new style of architecture and decoration. The works of Giovanni Antonio Amadeo, architect and sculptor of the Cappella Colleoni in Bergamo (ca. 1475) and the Certosa of Pavia (PL. 195), are fine examples of Lombard taste for a picturesque type of decoration that maintained late Gothic traditions in classicistic guise. Guiniforte and Pietro Solari (both active at the Certosa of Pavia), Giovanni Battaggio (Church of the Incoronata, Lodi), Dolcebuono, and Agostino dei Fonduti are the other principal representatives of this tendency; they were somewhat aware of the monumentality of Bramante's work. The Renaissance movement gained full acceptance after Bramante's arrival in Lombardy. In fact Cristoforo Solari (dome of the Church of S. Maria della Passione, Milan) and Bartolommeo Suardi, called "Bramantino" (Trivulzio burial chapel, S. Nazaro Maggiore, Milan 1518), took as their starting point the works of Bramante.

In addition to Giovanni Antonio Amadeo — whose Paduan Renaissance preparation found beautiful expression in the tomb for Medea Colleoni in Bergamo — it was chiefly the Mantegazzas (Certosa of Pavia, PL. 195) and the Rodaris (Cathedral of Como), who in fine sculptures exhibited the lingering Lombard attachment to the Gothic style. More flexible in their feeling for classic plasticity were Benedetto Briosco (also active in Pavia), Cristoforo Caradosso (a renowned goldsmith), and the previously mentioned Agostino dei Fonduti (who provided terra-cotta decoration for Bramante's sacristy of S. Maria presso S. Satiro in Milan). Agostino Busti, called "Bambaja," continued the traditional Lombard taste in decoration into the 16th century.

In painting, after the execution of the early medieval fresco cycle at Castelseprio by an itinerant Byzantine master (II, PL. 445), fresco cycles at Galliano (ca. 1007) and in S. Pietro al Monte in Civate (12th century) reveal the confluence in Lombard art of Byzantine and transalpine styles. Some scholars attribute the severe modeling of the 13th-century frescoes of the Baptistery of Parma to Lombard and Po Valley sources. The 14th-century frescoes in the fortress at Angera are among the earliest examples of secular painting. The contemporaneous frescoes of the apse of the Church of S. Abbondio in Como still bore the imprint of local style. The influence of Giotto, who had been called to Milan by Azzone Visconti, made itself felt in the mid-14th century in the crossing-tower frescoes of the Abbey Church of Viboldone (1349), attributed to the Florentine Giusto de' Menabuoi. Other frescoes of later date in the same abbey evidence an acquaintance with the art of Giovanni da Milano (active previously in Florence), and these, together with frescoes in Solaro, the Oratory of Mocchirolo, in Brianza (IV, PL. 203), and Lentate, express that intimate and secular mode of poetic feeling that was characteristic of northern Italian painting, a mode that was in accord with the naturalism and painterly softness of the International Gothic style. Lombardy made important contributions to International Gothic through the illuminated manuscripts, which, under the name of "ouvraige de Lombardie," were widely diffused throughout Europe, and through the work of such Lombard artists as Giovannino de' Grassi (III, PL. 9; VI, PL. 371), Michelino da Besozzo

(PL. 188), Belbello da Pavia (VI, 386), the Zavattaris in Monza, and Bonifacio and Benedetto Bembo in Cremona. The presence of Gentile da Fabriano and Jacopo Bellini in Brescia, of Pisanello in the Castello of Pavia, and of Masolino in the Collegiate Church and Baptistery of Castiglione Olona (IX, PLS. 375, 376) mark three important chapters in the history of Lombard art within the sphere of the International Gothic style.

Vincenzo Foppa (q.v.) of Brescia, the first Lombard Renaissance painter, emerged from the circle of the Bembos. Foppa's

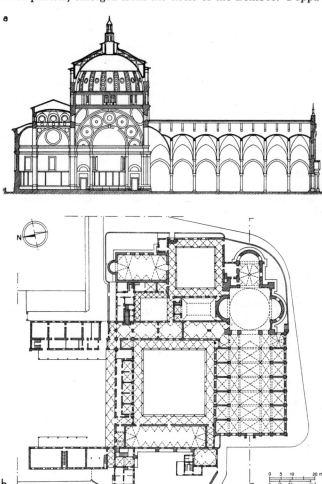

Milan, S. Maria delle Grazie, 1465–90. (a) Longitudinal section; (b) plan of church and adjoining buildings (*from R. Accademia d'Italia, I monumenti italiani, Rome, 1934*).

influence, together with Paduan influences and an almost naïve love of color, is evident in the works of Bernardino Jacobi Butinone (e.g., the altarpiece in Treviglio, painted in collaboration with Bernardino Zenale, ca. 1485) and Il Bergognone (Ambrogio da Fossano; PL. 196). The soft, luminous plasticity characteristic of Lombard painting was predestined to converge with the style of Leonardo da Vinci (q.v.). A good number of artists formed a group about Leonardo and assumed the uniform character of a school. Andrea Solari, though of Venetian background, was allied to this group (*The Virgin with the Green Cushion*, PL. 211), whose chief representatives were Ambrogio de Predis (wings of *Virgin of the Rocks*, London, Nat. Gall.) and Giovanni Antonio Boltraffio (PL. 196). Less important members of this group were Francesco Melzi, Giovanni Pedrini, called "Giampietrino," Marco d'Oggiono, and Cesare da Sesto (later active in southern Italy). Bernardino Luini was more an artist of the 15th century. A painter of the sweet and intimate, he is well represented by the frescoes from the Villa della Pelucca in Monza and by the *Madonna of the Rose Garden* (Milan, Brera). Both Luini and Vincenzo Civerchio (known as Fanone) oscillated between the manner of Foppa and that of Leonardo.

The painting of Bartolomeo Suardi (known as Bramantino, q.v.), reflects the monumentality of Bramante's art. Bramantino's dramatically energetic mode of representation stems from the school of Ferrara (*Nativity*, PL. 196; *Crucifixion*, Milan, Brera). Gaudenzio Ferrari, an artist of great originality, developed an unconventional and dramatic style that gave rise to ambitious decorative complexes (Church of S. Gaudenzio, Varallo; the Church of S. Cristoforo, Vercelli; the dome of the Sanctuary of the Madonna dei Miracoli, Saronno).

Moreover, in the 16th century, important local schools were formed in such towns as Brescia, Bergamo, and Cremona. Bergamo, whose school was dominated by Palma Vecchio, remained closely linked to Venice. The school of Brescia, although it had its origin in the revolutionary art of Giorgione, was bound to the luminous naturalism of Lombard painting of the tradition of Foppa and Leonardo. This is especially evident in the work of G. G. Savoldo (PL. 216; *St. Matthew*, Met. Mus.). Savoldo's night scenes, with their cold, crystalline lights, influenced Il Romanino (Girolamo Romani; PL. 216), a painter who worked in a rather Venetian style, and provided Alessandro Bonvicino (called Moretto da Brescia; PL. 216) with those low-keyed silvery tones that characterize the poetic realism of his altarpieces (*Nativity*, Brescia, Pin. Civ. Tosio Martinengo) and numerous portraits. Portraits were also a specialty of the more crudely incisive Giambattista Moroni (q.v.) of Bergamo, who was a pupil of Moretto.

The major artists of Cremona at this time were Boccaccio Boccaccino and the Campis (VI, PL. 69; IX, PL. 302); Lodi's chief artists were the Piazzas.

BIBLIOG. F. M. Tassi, Vite de' pittori scultori e architetti bergamaschi, 2 vols., Bergamo, 1793; G. Campori, Gli artisti italiani e stranieri negli Stati Estensi, Modena, 1855; G. L. Calvi, Notizie sulla vita e le opere dei principali architetti, scultori e pittori che fiorirono in Milano durante il governo dei Visconti e degli Sforza, 3 vols., Milan, 1859-69; P. Locatelli, Illustri bergamaschi, 3 vols., Bergamo, 1867-79; M. Caffi, Di alcuni maestri di arte nel secolo XV in Milano poco noti o male indicati, Arch. storico lombardo, V, 1878, pp. 82-106; A. Bertolotti, Artisti lombardi a Roma nei secoli XV, XVI e XVIII, 2 vols., Milan, 1881; C. Magenta, I Visconti e gli Sforza nel Castello di Pavia, 2 vols., Milan, 1883; A. Venturi, Relazioni artistiche tra le corti di Milano e Ferrara nel secolo XV, Arch. storico lombardo, XII, 1885, pp. 224-80; A. G. Meyer, Lombardische Denkmäler des XIV. Jahrhunderts, Stuttgart, 1893; F. Malaguzzi Valeri, Pittori lombardi del Quattrocento, Milan, 1902; F. Malaguzzi Valeri, Artisti lombardi a Roma nel Rinascimento, RepfKw, XXV, 1902, pp. 49-64; W. Suida, Neue Studien zur Geschichte der lombardischen Malerei des XV Jahrhunderts, RepfKw, XXV, 1902, pp. 331-47; F. Malaguzzi Valeri, Maestri minori lombardi, Rass. d'Arte, V, 1905, pp. 88-92, VII, 1907, pp. 161-70; P. Toesca, La pittura e la miniatura nella Lombardia, Milan, 1912; F. Malaguzzi Valeri, La corte di Ludovico il Moro, 4 vols., Milan, 1913-23; H. Lehmann, Lombardische Plastik im letzten Drittel des XV. Jahrhunderts, Berlin, 1928; S. Vigezzi, La scultura lombarda del Cinquecento, Milan, 1929; F. Wittgens, Gli affreschi della Badia degli Umiliati in Viboldone, Milan, 1933; S. Vigezzi, La scultura di Milano, 2 vols., Milan, 1934; G. de' Francovich, La corrente comasca nella scultura romanica europea, RIASA, V, 1936, pp. 267-305, VII, 1937, pp. 47-129; A. van Schendel, Le dessin en Lombardie jusqu'à la fin du XVe siècle, Brussels, 1938; L. Bellone, La scultura del '300 a Milano, RArte, XXII, 1941, pp. 178-201; G. Panazza, L'arte medievale nel territorio bresciano, Bergamo, 1942; C. Baroni, Scultura gotica lombarda, Milan, 1944; G. Panazza and C. Boselli, La pittura in Brescia dal Duecento all'Ottocento (exhibition cat.), Brescia, 1946; P. Mezzanotte and G. C. Bascapè, Milano nell'arte e nella storia, Milan, 1948; C. L. Ragghianti, Studi sulla pittura lombarda del Quattrocento, CrArte, VIII, 1949, pp. 31-59, 288-300; C. Baroni and G. Dell'Acqua, Tesori d'arte in Lombardia, Milan, 1952; C. Baroni and S. Samek-Ludovici, La pittura lombarda del Quattrocento, Messina, Florence, 1952; Storia di Milano, Milan, 1953 ff.; M. L. Gengaro, Aggiunte per la storia della pittura lombarda del secolo XV, BArte, XXXIX, 1954, pp. 296-303; Arte lombarda, Milan, 1955 ff.; G. A. Dell'Acqua, Affreschi inediti del Medioevo lombardo, BArte, XL, 1955, pp. 289-97; A. Bombelli, I pittori cremaschi dal 1400 a oggi, Milan, 1957; R. Longhi, Aspetti dell'antica arte lombarda, Paragone, IX, 101, 1958, pp. 3-25; S. Matalon and F. Mazzini, Affreschi del Trecento e Quattrocento in Lombardia, Milan, 1958; Arte lombarda dai Visconti agli Sforza, Milan, 1959; F. Mazzini, Contributi alla pittura lombarda tardo-gotica, Studies in the History of Art (W. Suida Festschrift), London, 1959, pp. 86-89; A. Ottino della Chiesa, Pittura medievale lombarda, Bergamo, 1959; W. Suida, Pitture lombarde del Rinascimento, RArte, XXXII, 1959, pp. 151-73; B. Caizzi, Milano dell'età spagnola, Rome, 1960; M. Magni, Architettura romanica comasca, Milan, 1960.

ARTISTS. *Giovanni Antonio Amadeo*: b. Pavia, 1437; d. Milan, 1522; architect and sculptor (F. Malaguzzi Valeri, G. A. Amadeo, scultore e architetto lombardo, Bergamo, 1904; G. A. Dell'Acqua, Problemi di scultura lombarda: Mantegazza e Amadeo, Proporzioni, II, 1948-49, pp. 89-108, III, 1950, pp. 123-40). *Giovanni Battaggio*:

Lodi, doc. ca. 1466-99, architect (U. Middeldorf, Ein Jugendwerk des Amadeo, Kg. S. für H. Kaufmann, Berlin, 1956, pp. 136-42). *Belbello da Pavia*: doc. ca. 1434-62, miniaturist (S. Samek-Ludovici, Belbello da Pavia, BArte, XXXVIII, 1953, pp. 211-24; S. Samek-Ludovici, Miniature di Belbello da Pavia dalla Bibbia Vaticana e dal Messale Gonzaga di Mantova, Milan, 1954). *Benedetto* and *Bonifacio Bembo*: doc. ca. 1420-89, painters of Cremona (F. Zeri, Due santi di Bonifacio Bembo, Paragone, III, 17, 1951, p. 32; M. Salmi, Nota su Bonifacio Bembo, Comm, IV, 1953, pp. 7-15; R. Longhi, Una cornice per Bonifacio Bembo, Paragone, VIII, 87, 1957, pp. 3-13). *Il Bergognone (Ambrogio da Fossano)*: ca. 1455 - after 1522, painter (N. Apra, Ambrogio da Fossano detto il Bergognone, Milan, 1945; F. Mazzini, Ambrogio da Fossano detto il Bergognone, Brescia, 1948; F. Mazzini, Aggiunte al Bergognone, Paragone, VIII, 87, 1957, pp. 59-62). *Boccaccio Boccaccino*: Cremona, 1467-1524, painter (A. Puerari, Boccaccino, Milan, 1957; M. Calvesi, Nuovi affreschi ferraresi dell'Oratorio della Concezione, BArte, XLIII, 1958, pp. 309-28). *Giovanni Antonio Boltraffio*: Milan, 1467-1516, painter (A. De Hevesy, Boltraffio, Pantheon, XVIII, 1936, pp. 323-29). *Benedetto Briosco*: active 1483-1506, architect and sculptor (A. F. Albuzzi, Memorie per servire alla storie de' pittori scultori e architetti milanesi (II), L'Arte, N.S., XIX, 1956, pp. 75-124 passim; W. R. Valentiner, A Relief by Benedetto Briosco, B. N. C. Mus. of Art, II, 1958, pp. 17-18). *Agostino Busti*, called *Bambaja*: Milan, 1483-1548, sculptor (G. Nicodemi, Agostino Busti detto il Bambaja, Milan, 1945). *Bernardino Jacobi Butinone*: b. Treviglio, ca. 1445; d. Milan, after 1507, painter (F. Zeri, Two Contributions to Italian Quattrocento Painting, BM, XCVII, 1955, pp. 74-77). *Campi*: family of Cremona painters, including *Galeazzo*, 1477-1536; *Giulio*, ca. 1502-72; *Antonio*, d. 1591; *Bernardino*, 1522-90/95; *Vincenzo*, 1536-91 (A. Perotti, I pittori Campi da Cremona, Milan, ca. 1932; M. Monteverdi, Due false inscrizioni per un preteso ritratto di Galeazzo Campi, Arte lombarda, III, 1, 1958, pp. 93-98; S. Zamboni, Per Giulio Campi, Arte antica e moderna, III, 1960, pp. 170-73). *Vincenzo Civerchio*, known as *Fanone*: Crema, ca. 1470-1544, painter (G. R. Ansaldi, Un nuovo Civerchio, L'Arte, XXXIX, 1936, pp. 183-84; M. L. Ferrari, Lo pseudo Civerchio e Bernardo Zenale, Paragone, XI, 127, 1960, pp. 34-69). *Cesare da Sesto*: b. 1477; d. Milan, 1523; painter (G. Nicodemi, L'opera e l'arte di Cesare da Sesto, Milan, 1932; S. Meller, Leonardo-nachzeichnungen von Cesare da Sesto, Phoebus, II, 1948-49, pp. 12-14). *Agostino dei Fonduti* (*de Fondutis*): Crema, doc. ca. 1450-1522, modeler and architect (W. Arslan, I Mantegazza, Il De Fondutis, L'Amadeo, Storia di Milano, VII, Milan, 1956, pp. 703-24; M. Bandiroli, Scheda per Agostino Fonduto scultore, Arte lombarda, III, 1, 1958, pp. 29-44). *Ambrogio de Predis*: Milan, 1455-ca. 1522, painter and miniaturist (W. Suida, Giovanni Ambrogio De Predis, Arte lombarda, IV, 1959, pp. 67-73). *Cristoforo de Predis*: d. 1486, miniaturist (L. Beltrami, Il libro d'Ore borromeo alla biblioteca Ambrosiana miniato da Cristoforo de Predis, Milan, 1896; G. Biscaro, Intorno a Cristoforo Preda, miniatore milanese del secolo XV, Arch. storico lombardo, 4th ser., XIII, 1910, pp. 223-26). *Gaudenzio Ferrari*: b. Valduggia, ca. 1470; d. Milan, 1546, painter (L. Grassi, Gaudenzio Ferrari e i suoi disegni, L'Arte, N.S., IV, 1941, pp. 182-205; Mostra di Gaudenzio Ferrari, Vercelli, Mus. Borgogna (exhibition cat.), Milan, 1956; F. Mazzini, "Maniera" di Gaudenzio Ferrari a Saronno, Arte lombarda, II, 1956, pp. 77-88; A. M. Brizio, Tre dipinti di Gaudenzio Ferrari, Studies in the History of Art: Misc. W. Suida, London, 1959, pp. 226-30). *Filarete* (q.v.). *Gerolamo da Cremona*: 15th-century miniaturist and painter (M. Salmi, Gerolamo da Cremona miniatore e pittore, BArte, N.S., II, 1922-23, pp. 385-404, 461-78; G. Fogolari, Le più antiche pitture di Gerolamo da Cremona, Dedalo, V, 1924-25, pp. 67-85; F. Zeri, Una pala d'altare di Gerolamo da Cremona, BArte, XXXV, 1950, pp. 35-42). *Giovanni di Balduccio*: 14th-century sculptor (A. G. Meyer, Lombardische Denkmäler des XIV. Jahrhunderts, Stuttgart, 1893; E. Carli, Sculture pisane di Giovanni di Balduccio, Emporium, XCVII, 1943, pp. 143-54; W. R. Valentiner, Notes on Giovanni Balducci and Trecento Sculpture in Northern Italy, AQ, X, 1947, pp. 40-61; E. Tolaini, La prima attività di Giovanni di Balduccio, CrArte, N.S., V, 1958, pp. 188-202 (bibliog.). *Giovanni da Milano*: Florence, doc. 1346-96, painter in the Vatican (A. Marabottini, Giovanni da Milano, Florence, 1950; A. Bartarelli, La lunetta della Chiesa di S. Niccolò, Arch. storico pratese, XXXI, 1955, p. 53; A. A. Baratti, La regale abbazia di S. Albino di Mortara e gli affreschi firmati, L'Arte, N.S., XXV, 1960, pp. 7-15). *Bernardino Luini*: b. ca. 1480/90; d. Milan, 1532, painter (A. Ottino della Chiesa, Mostra del Luini, exhibition cat., Como, 1953; A. Ottino della Chiesa, Bernardino Luini, Milan, 1960; S. Stefani, La giovinezza del Luini in uno sconosciuto affresco del 1507, Comm, XII, 1961, pp. 108-19). *Antonio* (d. 1495) and *Cristoforo* (d. 1482) *Mantegazza*: Milanese sculptors and goldsmiths (P. Parente and F. Tonetti, Arte e storia, XXXVII, 1918, pp. 195-200, 213 ff.; G. A. Dell'Acqua, Problemi di scultura lombarda: Mantegazza e Amadeo, Proporzioni, II, 1948-49, pp. 89-108, III, 1950,

pp. 123–40; E. Arslan, Sui Mantegazza, BArte, XXXV, 1950, pp. 27–34; W. Arslan, I Mantegazza, Il De Fondutis, L'Amadeo, Storia di Milano, VII, 1956, pp. 703–24). *Marco d'Oggiono*: Oggiono, ca. 1475–ca. 1530, painter (W. Suida, Leonardo da Vinci und seine Schule in Mailand: Marco d'Oggiono, Mnh. für Kw., XIII, 1920, pp. 265–72; W. G. Constable, Marco d'Oggiono: Head of a Girl, Old Master Drawings, II, 1927–28, pp. 20–21). *Altobello Meloni*: active 1497–1517, painter (L. Grassi, Ingegno di Altobello Meloni, Proporzioni, III, 1950, pp. 143–63; F. Bologna, Altobello Melone, BM, XCVII, 1957, pp. 240–50; M. Gregori, Altobello and Francesco Bembo, Paragone, VIII, 93, 1957, pp. 16–40; M. L. Ferrari, Antologia di artisti: Un recupero per Altobello, Paragone, IX, 97, 1958, pp. 48–53). *Michelino da Besozzo*: ca. 1388–1450, painter; in Venice, 1410; in Milan, 1418–25 (P. Durrieu, Michelino da Besozzo et les relations entre l'art italien et l'art français à l'époque du règne de Charles VI, Paris, 1911; F. Mazzini, Un affresco inedito e il primo tempo di Michelino da Besozzo, Arte lombarda, I, 1955, pp. 40–50; R. Schilling, Ein Gebetbuch des Michelino da Besozzo, MJhb, VIII, 1957, pp. 65–80). *Moretto da Brescia* (q.v.). *Giambattista Moroni* (q.v.). *Piazza*: family of painters from Lodi, including *Martino* (d. 1527) and *Callisto* (1500–61) (E. Ferrari, Albertino e Martino Piazza di Lodi, L'Arte, XX, 1917, pp. 140–58; A. M. Romanini, Note sui fratelli Albertino e Martino Piazza di Lodi, BArte, XXXV, 1950, pp. 123–30; P. Rotondi, Contributo ad Albertino Piazza, Arte lombarda, V, 1960, pp. 69–74). *Matteo de' Raverti*: Milanese sculptor, doc. 1389–1434 (G. Mariacher, Matteo Raverti nell'arte veneziana del primo Quattrocento, RArte, XXI, 1939, pp. 23–40; G. Mariacher, Aggiunta a Matteo Raverti, RArte, XXII, 1940, pp. 101–07; *Rodari*: family of sculptors active in Lombardy, including *Giovanni, Tommaso,* and *Giacomo* (M. Caffi, I fratelli Rodari, Arte e storia, VIII, 1889, p. 174; F. Malaguzzi Valeri, Note sulla scultura lombarda nel Rinascimento, Rass. d'arte, V, 1905, pp. 169–73; P. Bondioli, Tommaso Rodari a Busto Arsizio, Riv. archeol. della prov. e antica diocesi di Como, XCVI, 1929, pp. 185–92). *Girolamo Romani (Il Romanino)*: Brescia, ca. 1484–ca. 1566, painter (G. Nicodemi, Girolamo Romanino, Brescia, 1925; R. Longhi, Di un libro sul Romanino, L'Arte, XXIX, 1926, pp. 144–50; M. Gregori, Altobello, il Romanino e il Cinquecento cremonese, Paragone, VI, 69, 1955, pp. 3–28). *Giovanni Girolamo Savoldo*: Brescia, ca. 1480–1550, painter (G. Gamba, Pittori bresciani del Rinascimento: Gian Girolamo Savoldo, Emporium, LXXXIX, 1939, pp. 373–88; G. Nicco Fasola, Lineamenti del Savoldo, L'Arte, N.S., II, 1940, pp. 51–81; C. Gilbert, Milan and Savoldo, AB, XXVII, 1945, pp. 124–38; L. Coletti, Giunte a Gian Gerolamo Savoldo, Acropoli, I, 1960–61, pp. 39–53). *Andrea Solari*: Milan, ca. 1460–ca. 1520, painter (K. Badt, Andrea Solario, Leipzig, 1914; K. T. Parker, Andrea Solario: Head of the Virgin, Old Master Drawings, X, 1935, pp. 44–45). *Cristoforo Solari*: Milan, ca. 1460–1527, sculptor and architect (W. R. Valentiner, A Madonna by Cristoforo Solari, B. Detroit Inst. of Arts, XXI, 1941–42, pp. 18–20). *Zavattari*: family

of painters, active in Lombardy 1404–79 (P. D'Ancona, Antichi pittori lombardi, Dedalo, IV, 1923–24, pp. 361–80; R. Longhi, Per un polittico lombardo di Castel Sant'Angelo, Paragone, VIII, 87, 1957, pp. 45–47).

THE PISAN SCHOOL AND ITS SPHERE OF INFLUENCE. During the period when Pisa ranked high among the leading seafaring republics of the Italian peninsula, a distinctive Pisan school of art, whose activity encompassed the Romanesque and the early Gothic period, also flourished. Architecture was one of the most important manifestations of the Italian Romanesque, and Pisa's example was widely and strongly influential not only in such Tuscan centers as Lucca and Pistoia but also in Sardinia, Corsica, and Apulia. The Cathedral of Pisa (FIG. 385) is a fundamental monument of the Italian Romanesque. Begun by Busketus (Buscheto) in 1063 and consecrated while still incomplete in 1118, it has a Latin-cross plan with five aisles and an elliptical dome. Lombard elements (exterior galleries, galleries over the aisles), Islamic elements (the high impost blocks of the arches), and Armenian elements (the blind arcades with lozenge decoration) are all fused in a classic whole in which the aisle colonnades recall Early Christian basilicas. The façade, which features the use of arcaded galleries, was added later by Rainaldo. The Baptistery (begun by Diotisalvi in 1153) and the Campanile (the work of Bonannus, 1173) also have arcaded galleries, a feature that remained typical of Pisan architecture until the 14th century.

The influence of Lombard Romanesque art was felt early in Pisan sculpture. Guglielmo's pulpit for the Cathedral of Pisa (PL. 181) evidences this influence mingled with elements derived from Roman sarcophagi. Similar cases are the modest works of Gruamons (Pistoia) and Biduinus (Lucca). Pisa had another great sculptor, one capable of dramatizing expressionistically certain Byzantine elements; this was Bonannus, mentioned above, the creator of the city's Campanile. He also executed the bronze doors of the Cathedral. The principal door (1179) was destroyed by fire in the 16th century; the one that remains, the Porta di S. Ranieri (IX, PL. 508), is considered later in date than Bonannus' door at Monreale (III, PL. 12).

In Lucca the architecture of the oldest churches (S. Alessandro, S. Frediano) registers in forms of great clarity the early and direct influence of Lombard work. It was this influence that dictated the more emphatic plasticity with which Lucca interpreted Pisan forms [e.g., the façade of the Cathedral (S. Mar-

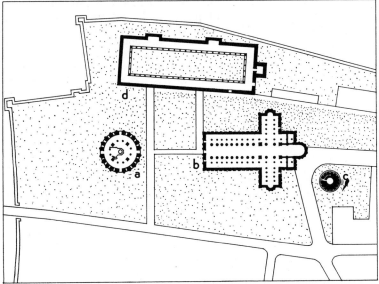

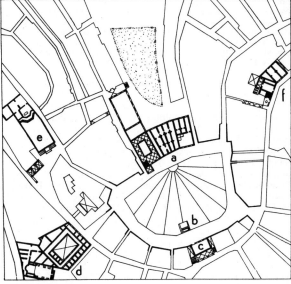

Major architectural complexes in Pisa and Siena, plans. *Left*: Pisa, Piazza del Duomo: (*a*) Baptistery; (*b*) Cathedral; (*c*) Campanile ("Leaning Tower"); (*d*) Camposanto. *Right*: Siena, Piazza del Campo and vicinity: (*a*) Palazzo Pubblico (*b*) Fonte Gaia; (*c*) Loggia della Mercanzia; (*d*) S. Vigilio and part of the University of Siena; (*e*) S. Martino and the Logge del Papa; (*f*) Palazzo Chigi-Saracini (*from G. Rohault de Fleury, La Toscane au moyen-âge, Paris, 1874*).

tino), by Guidetto, 1204; PL. 178]. The decoration of the Cathedral demonstrates the continuity of Lombard influence, both in the sculpture (ca. 1240) by Guido Bigarelli da Como (who also worked in Pisa and Pistoia; PL. 82; III, PL. 19) and in the scenes from the lives of SS. Regulus and Martin by a sculptor of the school of Antelami (PL. 181). In the first half of the 13th century in Lucca even painting was in the hands of a Lombard family, the Berlinghieri.

Pistoia added coloristic emphasis to the Pisan style of architecture in the use of thick bands of bichromatic revetment, to the detriment of the rhythmic clarity of the arcades (S. Giovanni Fuorcivitas, PL. 178). In Arezzo, Lombard and Pisan elements mingled in the Pieve di S. Maria (PL. 182; I, PL. 388).

In the second half of the 13th century Pisa emerged as the focal point of Italian sculpture, because of the work of Nicola Pisano and his son Giovanni (qq.v.) and the sculptor-architects who were trained by them. Giovanni made Siena another important center of his influence. Arnolfo di Cambio (q.v.), Guglielmo, and Lapo were active in Bologna and Rome. Arnolfo's name, however, is primarily associated with Florence. Andrea da Pontedera (q.v.), also called Andrea Pisano, is another Pisan artist known especially for his contribution to Florentine art. The influence of the refined Gothicism of Nino Pisano, Andrea's son, was felt as far away as Venice and Sicily, while Giovanni di Balduccio (VI, PL. 367) carried Pisan influence to Milan.

Pisa was of less importance in painting. Its painted crosses, including those of Giunta Pisano (active 1229–54), are full of Byzantine elements (PL. 179). The Master of S. Martino, perhaps to be identified with Ranieri di Ugolino, a member of the Tedice family, ranks alongside Cimabue and Duccio di Buoninsegna (qq.v.) with his Virgin and Child and stories of the Virgin (PL. 181). In the succeeding century, Pisan painting strongly felt Sienese (Simone Martini) and Florentine influences (Andrea Orcagna). Bolognese influence is also evident in the decoration of the Camposanto, for example, in the *Triumph of Death* (IV, PL. 468; VI, PL. 379), attributed to Francesco Traini (PL. 183).

BIBLIOG. A. Da Morrona, Pisa illustrata nelle arti del disegno, 2d ed., 3 vols., Leghorn, 1812; H. Thode, Studien zur Geschichte der italienischen Kunst im XIV. Jahrhundert: Der Meister von "Triumphe des Todes" in Pisa, RepfKw, XI, 1888, pp. 13–20; A. Schmarsow, S. Martin von Lucca und die Anfänge der toskanischen Skulptur im Mittelalter, Breslau, 1890; I. B. Supino, Il Camposanto di Pisa, Florence, 1896; L. Tanfani Centofani, Notizie di artisti tratte dai documenti pisani, Pisa, 1897; I. B. Supino, Arte pisana, Florence, 1903; I. B. Supino, Pittori pisani del secolo XIV, L'Arte, XXVI, 1923, pp. 33–43, 72–85; W. R. Valentiner, Observations on Sienese and Pisan Trecento Sculpture, AB, IX, 1926–27, pp. 177–220; W. Arslan, Su alcune croci pisane, RArte, XVIII, 1936, pp. 217–44; L. Lasareff, New Light on the Problem of the Pisan School, BM, LXVIII, 1936, pp. 61–73; Mostra della scultura pisana (exhibition cat.), Pisa, 1946; G. Nicco Fasola, Mostra della scultura pisana, ArtiFig, II, 1946, pp. 239–43; R. Longhi, Giudizio sul Trecento, Proporzioni, II, 1948, pp. 5–54; G. Vigni, Pittura del Due- e Trecento nel Museo di Palermo, Palermo, 1950; E. Carli, Pittura medioevale pisana, Milan, 1958; M. Bucci and L. Bertolini, Camposanto monumentale di Pisa: Sinopie e affreschi, Pisa, 1960; E. Carli, Pittura pisana del Trecento, 2 vols., Milan, 1960–61.

ARTISTS. *Biduinus*: fl. 1150–1200, sculptor and architect (I. B. Supino, Arte pisana, Florence, 1903, pp. 51–54; M. Salmi, La scultura romanica in Toscana, Florence, 1928). *Bonannus of Pisa*: 12th-century architect and sculptor (V. Martinelli, Bonanno Pisano scultore, Belle Arti, I, 1946–48, pp. 272–97; A. Boeckler, Die Bronzentüren des Bonannus von Pisa und des Barisanus von Trani, Berlin, 1953). *Busketus (Buscheto)*: 11th-century architect (S. Monini, Buschetto pisano, Pisa, 1896; I. B. Supino, Arte pisana, Florence, 1903, pp. 20–22). *Giunta Pisano*: d. 1255/67, painter (P. Bacci, "Juncta Pisanus Pictor": Note e documenti editi e inediti, BArte, N.S., II, 1922–23, pp. 145–61; C. Brandi, Il Crocifisso di Giunta Pisano in S. Domenico a Bologna, L'Arte, XXXIX, 1936, pp. 71–91; C. Verani, Giunta Pisano ha soggiornato a Roma?, L'Arte, N.S., XXIII, 1958, pp. 241–42). *Guglielmo*: 13th-century architect and sculptor (P. Cellini, Di Fra' Guglielmo e di Arnolfo, BArte, XL, 1955, pp. 215–28; B. Bruni, Il domenicano Fra' Guglielmo da Pisa, Florence, 1957). *Ranieri di Ugolino* (perhaps the *Master of S. Martino*): 13th-century painter (L. Cuppini, Ranieri di Ugolino, Comm, III, 1952, pp. 7–13). *Francesco Traini*: doc. ca. 1321–63, painter (F. Bonaini, Memorie inedite intorno alla vita e ai dipinti di Francesco Traini, Pisa, 1846; M. Meiss, The Problem of Francesco Traini, AB, XV, 1933, pp. 97–173; R. Oertel, Francesco Traini: Der Triumf des Todes im Campo

Santo zu Pisa, Berlin, 1948; G. Paccagnini, Il problema documentario di Francesco Traini, CrArte, VIII, 1949, pp. 191–201; M. Meiss, A "Madonna" by Francesco Traini, GBA, LVI, 1960, pp. 49–56).

FLORENTINE ART FROM THE ROMANESQUE PERIOD TO THE RENAISSANCE. A sense of clarity and balance in structure and decoration characterizes the Florentine Romanesque, and the over-all impression is one of classic measure. Consonant with this impression is the fact that, while most authorities date the octagonal Baptistery of Florence (I, PL. 302) to the 11th century, others attribute it to the 5th century. The inlay decoration of white and green marble is a typical feature (e.g., the Baptistery, PL. 182; S. Miniato al Monte, the façade of the Badia in Fiesole, III, PL. 388; and of the Collegiate Church in Empoli), one that persisted even in the city's Gothic Cathedral (S. Maria del Fiore; X, PL. 295). The 11th-century Church of SS. Apostoli served the architects of the Renaissance as a model (PL. 182).

The architecture of the Gothic period also exhibits sensitively calculated proportions, and the tension, strength, and clarity of its constructions attests to the logical continuity of the development of Florentine architecture from the 11th century to the Renaissance. Works begun toward the end of the 13th century include the Church of S. Maria Novella, a Dominican church (begun ca. 1278 and completed ca. 1360), by Jacopo Talenti. (The façade was added by Leon Battista Alberti; I, PL. 53). Other Florentine structures begun at that time include Sta Trinita (Vallombrosan church, attributed by some to Nicola Pisano), Sta Croce (Franciscan church, begun 1252, and attributed to Arnolfo di Cambio; renewed at various times from 1295 on), the Cathedral (S. Maria del Fiore, started in 1296 after a plan by Arnolfo), the Palazzo del Podestà, or Bargello (PL. 184), and the Palazzo Vecchio, or Palazzo della Signoria (I, PL. 396; VI, PL. 339). Succeeding one another as chief architects of the Cathedral were Giotto, Andrea da Pontedera, and Francesco Talenti (the latter after 1351). Talenti's son, Simone, worked with Benci di Cione Dami on the Loggia della Signoria (1376–81) and on Orsanmichele, where Neri de Fioravante (who also did work in the Palazzo del Podestà) had previously worked.

In sculpture Florence turned, after Arnolfo's death, to Pisa and Siena for its artists. Andrea da Pontedera (q.v.) dominated Florentine sculpture for almost twenty years. With Andrea's art as their basis, Giovanni and Pacio da Firenze worked (beginning in 1343) in Naples on the richly ornate tomb of Robert of Anjou in S. Chiara. Alberto Arnoldi, probably of Lombard origin, carved with archaic sculptural vigor. The lunette over the door to the Bigallo (1361) and the reliefs representing the sacraments on the Campanile of the Cathedral are attributed to him. The ornate and noble sculpture of Andrea Orcagna (q.v.) initiated a third phase in the history of 14th-century Florentine sculpture. The most important monuments of this third phase are two works of the goldsmith's art. One, the scenes from the Old Testament on the Altar of St. James in the Cathedral of Pistoia, is the work of two followers of Orcagna, Francesco di Niccolò and Leonardo di Ser Giovanni; the other is the altar done for the Baptistery of Florence (now in the Museo dell'Opera del Duomo), the work of the afore-mentioned Leonardo among others. The end of the century was marked by the decoration of the Cathedral — in particular, the Porta della Mandorla (begun in 1391), which marks a link between pre-Renaissance and Renaissance art. Among the various masters who worked on the Porta were Giovanni d'Ambrogio da Firenze, Jacopo di Piero Guidi, and Niccolò di Piero Lamberti (who, with his son Piero, later went to Venice); Donatello and Nanni di Banco also participated in the work (PL. 184).

The formation of the Florentine school of painters during the 13th century centered around the mosaic decoration of the Baptistery (III, PLS. 12, 490; IV, PL. 177; X, PL. 188). All the early important personalities were involved; the Magdalen Master (Florence, Accademia), Coppo di Marcovaldo (Madonnas in Orvieto, PL. 183, and in Siena, 1261), and Cimabue (q.v.). Through the activity of Giotto (q.v.) and his followers, the hegemony of Florence in 14th-century Italian painting was assured. Some of Giotto's many collaborators and pupils have

remained anonymous, such as the Master of S. Cecilia (PL. 183; three scenes from the life of St. Francis, in Assisi), the Painter of the Franciscan Vows, and the Master of the Chapel of the Magdalen (last two, active in the Lower Church of S. Francesco in Assisi). The modest Pacino di Buonaguida is known for a polyptych of about 1315 (Florence, Accademia). Other followers of Giotto who have been identified with more or less

certainty are Maso di Banco (q.v.) and Maestro Stefano (VI, PL. 347). The latter's delicate chiaroscuro fusion of light and color was far ahead of its time. The work of Stefano's son, Giottino (VI, PL. 348), is related to northern Italy. Giovanni da Milano brought to Florence the naturalistic pathos of his native Lombardy (IV, PL. 269; VI, PLS. 62, 362). Sienese influences, which had affected the art of Bernardo Daddi (q.v.),

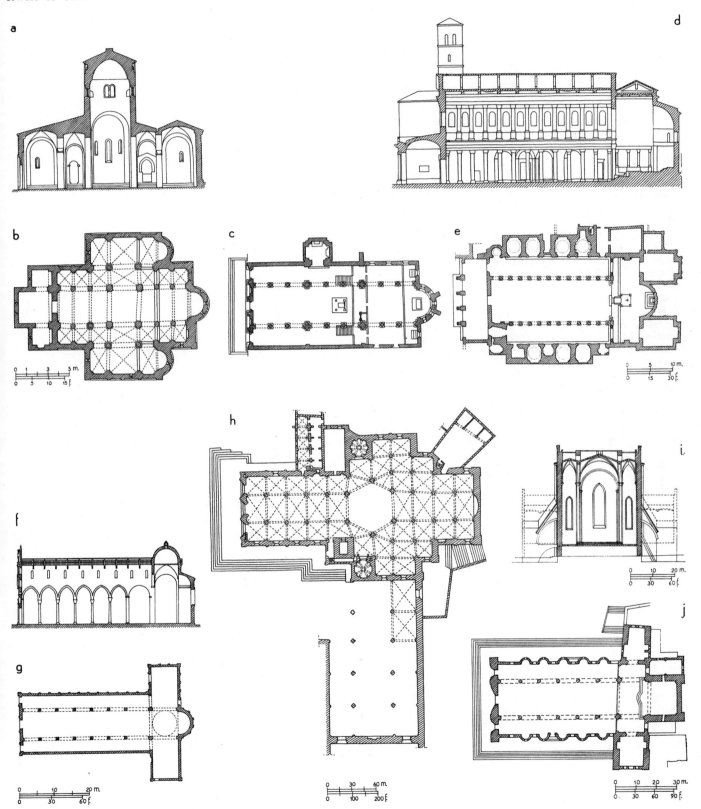

Medieval churches of central Italy. (a, b) S. Maria di Portonovo, near Ancona, 1034–48, transverse section and plan; (c) Florence, S. Miniato al Monte, 11th cent., plan; (d, e) Rome, S. Maria in Trastevere, ca. 1140, longitudinal section and plan; (f, g) Pisa, S. Paolo a Ripa d'Arno, longitudinal section and plan; (h) Siena, Cathedral, 13th–14th cent., plan showing abandoned project of the New Cathedral; (i, j) Orvieto, Cathedral, 1290–1330, transverse section and plan.

mingled with other elements in Florentine painting of the time. A long-time follower of Giotto, Taddeo Gaddi was also attracted by the Sienese manner of narrative description (PL. 183). Shortly after the middle of the 14th century, Florentine art fell under the spell of Andrea Orcagna (q.v.), who, in a sense, resumed the monumentality of Maso. Yet Andrea's brother, Nardo di Cione, was apparently attracted by the refined subtleties of color and modeling that are characteristic of Stefano (the Strozzi Chapel in S. Maria Novella). Giusto de' Menabuoi, who was active in Padua, worked in a vein allied to the style of northern Italy. In the work of Andrea da Firenze (Andrea di Bonajuto, or Andrea Bonaiuti) Sienese influence resulted in a kind of calligraphic art (II, PL. 364; III, PL. 314). Spinello Aretino, on the other hand, was a narrative artist whose breadth and ease are apparent in his many frescoes in S. Miniato al Monte, in the Camposanto in Pisa, and in the Palazzo Pubblico in Siena (VII, PL. 272). The illustrative art of Agnolo Gaddi reflected, at this early date, the International Gothic style (e.g., frescoes in the choir of Sta Croce, VI, PL. 380; and in Prato Cathedral). Gherardo Starnina probably worked with Gaddi in Sta Croce and was also active in Spain. The ascetic art of Lorenzo Monaco (q.v.) marked the end of 14th-century painting in Florence, while the gentle worldliness of the art of Masolino (q.v.) carried the spirit of the International Gothic style, scarcely affected by the spirit of the new era, well into the 15th century.

The spirit of 15th-century Florentine civilization, described by Vasari and succeeding historians as a "rebirth" or "renaissance" (q.v.), showed the most extraordinary vitality and capacity for expansion. Brunelleschi (q.v.) and, immediately after him, Alberti (q.v.), established the principal foundations of the new architecture. The former architect was more Tuscan in background and expression, the latter more Roman and universal. A follower of Brunelleschi was Cosimo de' Medici's architect, Michelozzo (q.v.; e.g., the Monastery of S. Marco; the Palazzo Medici-Riccardi; the Medici villas of Careggi and Cafaggiolo; the Church of S. Agostino in Montepulciano, PL. 191). Michelozzo is important for his part in the creation of the typical *palazzo* of rich Florentines of the Renaissance, a building type that still marks an essential part of the city's appearance. Bernardo Rossellino (q.v.), a follower of Alberti, is chiefly known for the buildings he constructed in the Piazza di Pio II in Pienza for Pope Pius II. The Palazzo Venezia in Rome has been attributed to Rossellino. Also influenced by Alberti was the architect and sculptor Agostino di Duccio, whose works in Perugia are noteworthy examples of architecture richly adorned with sculpture (the façade of the Oratory of S. Bernardino, PL. 191; and the Porta di S. Pietro). Originally a woodcarver, the architect Giuliano da Maiano worked in Arezzo, Siena (Palazzo Spannocchi, 1473), Faenza (Cathedral), and Naples, as well as in Florence. Together with his brother Benedetto and Simone del Pollaiuolo (known as Il Cronaca), Giuliano da Maiano established the direction of civic architecture in the period after Michelozzo, bringing it to the threshold of the 16th century. Benedetto was the architect of the Palazzo Strozzi (1490) in Florence and of the loggia of S. Maria delle Grazie in Arezzo (PL. 191); Il Cronaca completed the Palazzo Strozzi and was the architect of the Church of S. Salvatore al Monte (PL. 191; FIG. 392), the Palazzo Horne and the Palazzo Guadagni in Florence. The history of 15th-century Florentine architecture closes with the work of Giuliano and Antonio da Sangallo the Elder (q.v.). The former summed up in subtle elegance the achievements of the past, while the latter, through the influence of Bramante and Raphael, participated in the vital currents of the new art of the 16th century.

Several Florentine sculptors of the so-called "transitional phase" were influential in the Veneto. Among them were Niccolò di Piero Lamberti and his son Piero, and Nanni di Bartolo, known as Il Rosso. (See below, *Venetian art from the Romanesque period to the 16th century.*) Contemporaneously in Florence Nanni di Banco conceived his figures, at least potentially, as ancient Romans, though he continued to drape them in the Gothic manner (e.g., *The Four Crowned Saints*, III, PL. 391). By this time, however, Florentine sculpture was dominated by Lorenzo Ghiberti and Donatello (qq.v.), whose

strong personalities affected in various ways almost all the artists of Florence throughout the century. Many of the artists already mentioned as architects also worked as sculptors (PL. 192). Michelozzo collaborated with Donatello (1423-33) in tombs for the antipope John XXIII (III, PL. 13) and Cardinal Brancacci (Naples, S. Angelo a Nilo). Bernardo Rossellino happily united the arts of architecture and sculpture in his tomb for Leonardo Bruni (1444-51, Florence, Sta Croce), the monument that established the characteristic form of the Renaissance tomb for the entire 15th century. It was used as a model by Desiderio da Settignano (q.v.) in his tomb for Carlo Marsuppini (Florence,

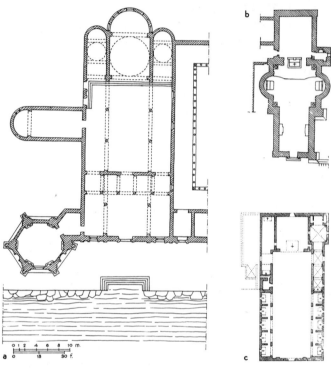

Churches, second half of 15th cent., plans. (*a*) Island of San Michele (near Venice), S. Michele; (*b*) Urbino, S. Bernardino degli Zoccolanti; (*c*) Florence, S. Salvatore al Monte.

Sta Croce) and by Antonio Rossellino in his tomb for the Cardinal of Portugal (Florence, S. Miniato al Monte). In the hands of these artists the pictorial values introduced into sculpture by Donatello took on exquisite refinement, both in *stiacciato* reliefs and in free-standing works. Examples of this refinement are Desiderio's reliefs of the Madonna and Child and his portrait busts of women (Turin, Gall. Sabauda; Florence, Mus. Naz.; Berlin, Staat. Mus.), as well as several reliefs by Antonio Rossellino representing the Madonna and Child, the Infant St. John, and St. Sebastian (Empoli, Gall. della Collegiata), and works in the Piccolomini Chapel of the Church of Monte Oliveto (S. Anna dei Lombardi) in Naples. Mino da Fiesole (q.v.), also active in Rome, worked the lyric vein of Desiderio, sometimes in a mannered, academic fashion (PL. 192). Agostino di Duccio, on the other hand, by accentuating the linear aspect of the *stiacciato* relief technique, attained an imaginative elegance (the decoration of the Tempio Malatestiano in Rimini and of the Oratory of S. Bernardino in Perugia, PL. 191). Together with Antonio Rossellino, Benedetto da Maiano represented a trend toward extreme naturalism in Florentine portraiture, as, for example, in his busts of Pietro Mellini (1474, Florence, Mus. Naz.) and Filippo Strozzi (Louvre). In his pulpit for Sta Croce (Florence, 1472-75), in the shrine of S. Savino (Faenza, Cathedral), and in his altar relief of the Annunciation (1489, Naples, Church of Monte Oliveto) Benedetto showed himself a decorator of great skill. The noble and serenely idealistic art of Luca Della Robbia (q.v.), which was rooted in the tradition of Ghiberti, declined in the work of Luca's followers, through excessive emphasis on naturalistic elements.

ITALIAN ART

But the influence of Donatello was operative in the second half of the 15th century in the well-conceived and original sculpture of Antonio Pollaiuolo and Verrocchio (qq.v.).

Florentine painting of the 15th century embodied the very concept of the Renaissance (q.v.). The name of Masaccio (q.v.) signalizes the decisive turning point of this period. Yet the new style was affirmed in a whole series of original personalities — Fra Angelico, Paolo Uccello, Filippo Lippi, Domenico Veneziano, and Andrea del Castagno (qq.v.), whose works extended in time over the first half of the 15th century and beyond. In the subtly poetic art of Pesellino (Francesco di Stefano), the tradition formed by the above-mentioned artists was adapted to narrative and genre representation (PL. 193). Deriving principally from Lippi and Angelico, Pesellino was a fine painter of small figures on predellas and *cassoni* (Uffizi; London, Nat. Gall.; Boston, Isabella Stewart Gardner Mus.). Similarly Benozzo Gozzoli (q.v.) based his style upon that of Fra Angelico, with whom he had collaborated in Florence, Orvieto, and Rome. Gozzoli imbued his narrative scenes, which were conceived in a late Gothic spirit, with a special kind of circumstantial realism (e.g., work in Montefalco, S. Francesco, 1452; Florence, Palazzo Medici-Riccardi, PL. 193; San Gimignano, S. Agostino, 1465; Pisa, Camposanto, 1468–84). The subtler, more restless spirit of Alesso Baldovinetti (q.v.) was sensitive to a particular kind of dynamic linearism (PL. 194; Florence, the courtyard of SS. Annunziata, S. Miniato al Monte, and Sta Trinita; Louvre). This dynamic linearism was to become a basic element in the work of Florentine painters of the second half of the century, especially in that of Pollaiuolo, Verrocchio, and Botticelli (qq.v.), who influenced other artists active in this period. The influence of these masters was often supplemented by interest in Flemish painting, which enjoyed great prestige in Italy. Domenico Ghirlandajo (q.v.), the head of a successful workshop, occupied a position of special importance as a narrative artist. Cosimo Rosselli at times attained a pleasing descriptiveness that compensated for his poverty of imagination (Rome, three frescoes in the Sistine Chapel, 1482; Florence, S. Ambrogio, ca. 1485). Jacopo del Sellaio, a *cassoni* painter, was a pleasing decorator and pictorial narrator. Of more elevated poetic temperament were Filippino Lippi and especially Piero di Cosimo (qq.v.). Piero, sensitive to the many influences prevalent in his time, was a fascinating and original interpreter of myth and allegory (New York, Met. Mus.; London, Nat. Gall., PL. 211; Cambridge, Mass., Fogg Art Mus.; Uffizi, PL. 194). Incisive and poetic in his figure pieces (St. Mary Magdalene, Rome, Gall. Naz.), Piero di Cosimo also excelled as a portrait painter (of Simonetta Vespucci, Chantilly, Mus. Condé; Francesco Giamberti and Giuliano da Sangallo, Amsterdam, Rijksmuseum). The problematical Raffaellino del Garbo was closely related to Filippino Lippi. Lorenzo di Credi, who seems to have been allied most closely to Andrea del Verrocchio, crystalized that master's vibrant chiaroscuro in craftsmanship of an almost porcelain finish. Lorenzo was also influenced by Perugino (Uffizi, PL. 194; Pistoia, Mus. Civ. and Baptistery).

BIBLIOG. G. Vasari, Le vite, 3 vols., Florence, 1550; R. Borghini, Il Riposo, Florence, 1584; F. Baldinucci, Notizie dei professori del disegno, 6 vols., Florence, 1681–1728; M. Reymond, La sculpture florentine, Florence, 1900; W. Bode, Florentiner Bildhauer der Renaissance, Berlin, 1902 (Eng. trans., J. Haynes, Florentine Sculptors of the Renaissance, London, New York, 1908); B. Berenson, The Drawings of the Florentine Painters, 2 vols., London, New York, 1903; W. Suida, Florentinische Maler um die Mittel des XIV. Jahrhunderts, Strasbourg, 1905; B. Berenson, The Florentine Painters of the Renaissance, 3d ed., New York, London, 1909; M. Salmi, Arte romanica fiorentina, L'Arte, XVII, 1914, pp. 265–80, 369–78; J. Alazard, Le portrait florentin de Botticelli à Bronzino, Paris, 1924; R. Offner, Studies in Florentine Painting: The Fourteenth Century, New York, 1927; P. Toesca, La pittura fiorentina del Trecento, Verona, 1929 (Eng. trans., Florentine Painting of the Trecento, Florence, New York, 1929); M. Salmi, I Mosaici del "Bel San Giovanni" e la pittura del secolo XII a Firenze, Dedalo, XI, 1930–31, pp. 534–70; R. Offner, A Critical and Historical Corpus of Florentine Painting, New York, 1931 ff.; G. Sinibaldi and G. Brunetti, Pittura italiana del Duecento e Trecento (exhibition cat.), Florence, 1937; Mostra del Cinquecento toscano in Palazzo Strozzi (exhibition cat.), Florence, 1940; F. Gebelin, Scultori fiorentini del Quattrocento, Novara, 1941; M. Salmi, Civiltà fiorentina del primo Rinascimento, Florence, 1943; K. Clark, Florentine Paintings: 15th Century, London, 1945; F. Antal, Florentine Painting and Its Social Background, London, 1948; R. G. Mather, Documents Mostly New Relating to Florentine Painters

and Sculptors of the 15th Century, AB, XXX, 1948, pp. 20–65; G. Galassi, La scultura fiorentina del Quattrocento, Milan, 1949; L. Ragghianti Collobi, Lorenzo il Magnifico e le Arti (exhibition cat.), Florence, 1949; L. Grassi, Origine e aspetti del Rinascimento nella scultura fiorentina del Quattrocento, Rome, 1951; M. Meiss, Painting in Florence and Siena after the Black Death, Princeton, 1951; C. L. Ragghianti, Pittura del Dugento a Firenze, Florence, 1955; Mostra del Pontormo e del primo manierismo fiorentino (exhibition cat.), Florence, 1956; C. Brandi, I cinque anni cruciali per la pittura fiorentina del '400, S. in onore di M. Marangoni, Pisa, 1957, pp. 167–75; G. Francastel, Le style de Florence (Le Quattrocento), Paris, 1958; A. Chastel, Art et humanisme à Florence au temps de Laurent le Magnifique, Paris, 1959.

ARTISTS. See individual articles for *Agostino di Duccio. Baldovinetti, Benedetto da Maiano, Bertoldo di Giovanni, Credi, Daddi, Desiderio da Settignano, Gaddi, Gozzoli, Lippi, Michelozzo, Mino da Fiesole, Piero di Cosimo, Rossellino, Sangallo*.

OTHERS. *Andrea da Firenze* (*Andrea di Bonajuto*, or *Andrea Bonaiuti*): 14th-century painter (C. Papini, L'autore degli affreschi del Capitolo di Santa Maria Novella in Firenze, Arte e storia, XXXVI, 1917, pp. 33–41, 65–69, 97–100). *Alberto Arnoldi*: 14th-century Florentine architect and sculptor (W. R. Valentiner, A Marble Statuette by Alberto Arnoldi, Art in America, XVI, 1928, pp. 264–70). *Benci di Cione Dami*: Florence, d. 1388, architect (K. Frey, Die Loggia dei Lanzi, Berlin, 1885; P. Franceschini, L'Oratorio di San Michele in Orto in Firenze, Florence, 1892). *Coppo di Marcovaldo*: b. Florence, ca. 1225; painter [G. Coor-Achenbach, A Visual Basis for the Documents Relating to Coppo di Marcovaldo and His Son Salerno, AB, XXVIII, 1946, pp. 233–47; G. Coor-Achenbach, Coppo di Marcovaldo: His Art in Relation to the Art of His Time, Marsyas, V, 1947–49, pp. 1–22; P. G. Giustini, Una Madonna di Coppo di Marcovaldo a S. Maria Maggiore in Firenze (1250–60), L'Arte, N.S., XXIV, 1959, pp. 277–86]. *Niccolò di Pietro Gerini*: doc. 1370–1415, painter (R. Offner, Niccolò di Pietro Gerini, Art in America, IX, 1921, pp. 148–55, 233–40). *Giovanni d'Ambrogio da Firenze*: active 1384–1418, sculptor (G. Brunetti, Giovanni d'Ambrogio, RArte, XIV, 1932, pp. 1–22). *Giuliano da Maiano*: b. 1432; d. Naples, 1490; architect and decorator [G. Ceci, Nuovi documenti su Giuliano da Maiano ed altri artisti, Arch. storico per le prov. napoletane, XXIX, 1904, pp. 784–92; E. Schottmüller, Sammlung der Bildwerke der christlichen Epoche: Arbeiten von Giuliano der Maiano, Amtliche Berichte (Berlin Mus.), XXXIX, 1917–18, pp. 79–90; L. Cèndali, Giuliano e Benedetto da Maiano, Sancasciano, 1926]. *Jacopo del Sellaio*: Florence, 1441–93, painter (H. Mackowski, Jacopo del Sellaio, JhbPreussKSamml, XX, 1899, pp. 192–202, 271–84; H. P. Horne, Jacopo del Sellaio, BM, XIII, 1908, pp. 210–13; B. Biagiarelli, Jacopo del Sellaio e i trionfi del Museo Bandini a Fiesole, RArte, XIII, 1931, pp. 400–06). *Niccolò di Piero Lamberti*: 1370–1456, sculptor and architect (M. Salmi, La vita di Niccolò di Piero, scultore e architetto aretino, Arezzo, 1910; U. Procacci, Niccolò di Pietro Lamberti, detto il Pela di Firenze e Niccolò di Luca Spinelli d'Arezzo, Il Vasari, I, 1928, pp. 300–16; L. Planiscig, Die Bildhauer Venedigs in der ersten Hälfte des Quattrocento, JhbKhSammlWien, N.S., IV, 1930, pp. 47–120). *Piero di Niccolò di Piero Lamberti*: b. Florence, 1393; d. Venice (?), 1434; sculptor (G. Fiocco, I Lamberti a Venezia, Dedalo, VIII, 1927–28, pp. 287–314, 343–76, 432–57; L. Planiscig, Die Bildhauer Venedigs in der ersten Hälfte des Quattrocento, JhbKhSammlWien, N.S., IV, 1930, pp. 47–120). *Master of S. Cecilia*: Florentine painter of the second half of the 12th century (O. Sirén, A Great Contemporary of Giotto, BM, XXXV, 1919, pp. 229–36, XXXVI, 1920, pp. 4–11; A. Parronchi, Attività del "Maestro di Santa Cecilia," RArte, XXI, 1939, pp. 193–228; A. Smart, The St. Cecilia Master and His School at Assisi, BM, CII, 1960, pp. 405–13, 431–37). *Nanni di Banco*: ca. 1384–1421, Florentine sculptor (L. Planiscig, Nanni di Banco, Florence, 1946; P. Vaccarino, Nanni, Florence, 1950; N. Carboneri, Nanni di Banco e la critica, RArte, XXVII, 1951–52, pp. 231–35). *Pesellino* (*Francesco di Stefano*): Florence, 1422–57, painter (W. Weisbach, Francesco Pesellino und die Romantik der Renaissance, Berlin, 1901; P. Toesca, Francesco Pesellino miniatore, Dedalo, XII, 1932, pp. 85–91; G. Gronau, In margine a Francesco Pesellino, RArte, XX, 1938, pp. 123–46; R. G. Mather, Documents Mostly New Relating to the Florentine Painters and Sculptors of the 15th Century, AB, XXX, 1948, pp. 20–65). *Cosimo Rosselli*: Florence, 1439–1507, painter (R. Musatti, Catalogo giovanile di Cosimo Rosselli, RArte, XXVI, 1950, pp. 103–30; C. Gugliemi, An Unknown Panel by Cosimo Rosselli, BM, XCVII, 1955, p. 221). *Spinello Aretino* (*Spinello di Luca Spinelli*): 1346–1410, painter (G. Gombosi, Spinello Aretino, Budapest, 1926; G. Degli Azzi, Documenti su Spinello Aretino, Il Vasari, III, 1930–31, pp. 216–21; R. Longhi, Il più bel frammento dagli affreschi del Carmine di Spinello Aretino, Paragone, XI, 131, 1960, pp. 33–35).

THE SIENESE SCHOOL. The predominantly Lombard character of Romanesque architecture in the region of Siena is revealed

by the oldest remaining parts of the Cathedral of Siena and, even more, by the simple, rustic parish churches of the surrounding countryside. During the Gothic period, building in Siena was generally characterized by a less organic, less rational sense of structure than in Florence. In particular, Sienese architecture was marked by more attenuated forms that achieved a linear, somewhat ornate delimitation of space. The workshops of the Cathedral, in which Giovanni Pisano was the dominant personality, provided the training ground for a long line of Sienese sculptor-architects, up to Giovanni di Cecco, who in 1377 created the crowning portion of the Cathedral façade. The Gothic aspect of the city, in which secular architecture occupies an important part (with its characteristic Sienese arch, consisting of a segmental arch surmounted by an ogival one), had already been established in large part prior to the terrible plague of 1348. Among Siena's Gothic structures are the city's monumental fountains, the city gates, the public and private *palazzi*, the Franciscan, Dominican, Carmelite, Servite, and Augustinian churches, and the magnificent, but incomplete, New Cathedral. It was for the building of the New Cathedral that Lando di Pietro was summoned back to Siena from Naples in 1339. Upon Lando's death, a year later, construction was entrusted to Giovanni di Agostino (PL. 184). Perhaps the greatest masterpiece of Sienese Gothic architecture, however, is the façade of Orvieto Cathedral (VI, PL. 333), of which the Sienese Lorenzo Maitani (q.v.) was master of works from 1310 to 1330.

Solid plastic masses and broad linear rhythms characterize the art of Tino di Camaino (q.v.; VI, PL. 365), the most monumental of Sienese sculptors, who worked in Pisa, Florence, and Naples, as well as in his native city. Gano da Siena (Galgano di Giovanni) carved the solemn portrait of Ranieri del Porrina (Casole d'Elsa), and Goro di Gregorio (VI, PL. 365) executed small bas-reliefs, soft and evanescent, for the Arca di S. Cerbone (Massa Marittima, Cathedral, 1324) and the tomb of Guidotto De Tabiatis (Messina, Cathedral, 1333). Less fine but vigorously descriptive are the small narrative scenes carved by Agostino di Giovanni and Agnolo di Ventura as part of the tomb of Bishop Tarlati in Arezzo Cathedral (1330). Because of their refined handling of linear elements and incisively pictorial qualities, a series of reliefs on the exterior piers of Orvieto Cathedral have been attributed to Lorenzo Maitani or Ramo di Paganello (IX, PL. 265). The first Sienese painter of the 13th century known to us by name is Guido da Siena (*Madonna and Child Enthroned*, PL. 185). Yet there are anonymous works of even finer quality (e.g., the altarpieces of St. John and St. Peter, Siena, Pin.). But it was Duccio di Buoninsegna (q.v.) who initiated the brilliant course of Sienese Gothic painting, which was influential throughout Europe, from Spain to Bohemia, especially through the activity of Simone Martini (q.v.). Through the work of Ambrogio and Pietro Lorenzetti (q.v.), the sumptuous color of Sienese painting and its characteristically poetic mode of narration even influenced Florentine art. Among the more immediate followers of Duccio were Segna di Bonaventura and Ugolino da Siena (di Neri or Nerio; PL. 185). Lippo Memmi (PL. 185) and the more important Barna da Siena (VI, PL. 379; frescoes in San Gimignano, Collegiate Church) were both active within Simone's circle, while Lippo Vanni and Niccolò di Ser Sozzo Tegliacci (chiefly known as an illuminator) were more closely related to the Lorenzettis. The goldsmith's art was also of great importance in this period. Both Lando di Pietro, an architect and sculptor, and Ugolino di Vieri (q.v.; VI, PL. 382) were famous goldsmiths.

In comparison with this vital first period, the second half of the 14th century was a time of narrow provincialism for Sienese art. A decorative painter such as Bartolo di Fredi, for example, squandered the wealth of his artistic inheritance pleasantly enough without, however, creating anything new. Through the activity of such minor masters as the productive Luca di Tommè, Sienese painting vegetated, exerting influence only on such lesser centers as Pisa and southern Italy. With the work of Paolo di Giovanni Fei (PL. 98), minor artists continued their activity into the 15th century. Meanwhile painters of a substantially higher category appeared. One was

Stefano di Giovanni, known as Sassetta (q.v.), a master who vacillated between the spirit of the International Gothic style and the spirit of the Renaissance, yet was entirely at one poetically with the former style (small narrative scenes from the altarpiece for the Arte della Lana, Siena, Pin., and elsewhere; the altarpiece of Our Lady of the Snows, Florence, Contini Bonacossi Coll.; an altarpiece for Sansepolcro, panels of which are in Settignano, Berenson Foundation, London, Nat. Gall., and elsewhere). Another such master was Giovanni di Paolo (q.v.), an artist totally immersed in his own introverted fantasies, which gave his work its characteristic strong lyrical accent and a kind of dramatic asceticism (VI, PL. 381; Siena, Pin.). The saccharine creations of Sano di Pietro (Ansano di Pietro di Mencio) represented a vulgarization of the poetry of Sassetta. Domenico di Bartolo (PL. 202), instead, accepted the discoveries of the Renaissance, and in his Madonna of 1433 (Siena, Pin.) he came close to Filippo Lippi. Lorenzo di Pietro, known as Il Vecchietta, also assimilated the lessons of Florentine art, though his style always remained predominantly Sienese (*Assumption*, 1461, Pienza, Cathedral). As a sculptor, Il Vecchietta was strongly influenced by Donatello (PL. 202; ciborium, Siena, Cathedral). He thus made a decisive break with the lingering tradition of Jacopo Della Quercia (q.v.), which had inspired the serenely harmonious art of Francesco da Valdambrino as well as the crudely classicizing manner of Antonio Federighi (di Federigo) dei Tolomei. Two pupils of Il Vecchietta were Neroccio di Bartolomeo di Benedetto de' Landi, a painter whose art provides a quintessential example of traditional Sienese sensitivity in a new, 15th-century manner (Madonnas, Siena, Pin.), and Francesco di Giorgio (q.v., PL. 202), a painter and sculptor in contact with contemporary Florentine art and, at the same time, a civil and military architect (works in Urbino, Palazzo Ducale; Church of the Madonna del Calcinaio, near Cortona; San Leo, fortress; Sassocorvaro, fortress, FIG. 396). Another pupil of Il Vecchietta was the sculptor

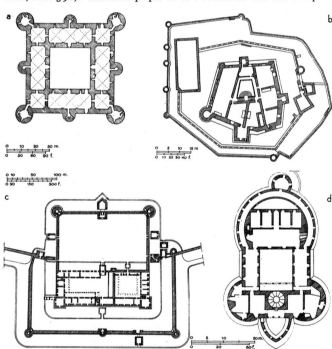

Castles, plans. (*a*) Catania, Castello Ursino, begun 1237; (*b*) Fénis, Castle, begun 1330; (*c*) Milan, Castello Sforzesco, rebuilt 1450 (plan after L. Beltrami); (*d*) Sassocorvaro, Castle, begun second half of 15th cent.

Giacomo Cozzarelli, who worked in terra cotta. Matteo di Giovanni (PL. 202), whose eclecticism amalgamated Sienese and Florentine influences as well as elements deriving from the work of northern European illuminators, represents the last valid compromise made by Sienese painting with the art of the Renaissance. For at this time the Umbrians Perugino and Pinturicchio were summoned to Siena. Another newcomer was

Giovanni Antonio de' Bazzi from Vercelli, known as Sodoma (q.v.). His basically Lombard and Piedmontese preparation filtered through the work of Leonardo and Raphael (Sodoma's frescoes in the Abbey of Monte Oliveto Maggiore, outside Siena; and in Rome, Farnesina) and exerted a strong influence upon Sienese painting from 1501 on. A noble product of this encounter of influences was the art of Domenico Beccafumi (PL. 86; IX, PL. 295).

BIBLIOG. I. Ugurgieri Azzolini, Le Pompe Senesi, Pistoia, 1649; G. Della Valle, Lettere senesi sopra le belle arti, 3 vols., Rome, 1782–86; E. Romagnoli, Biografie degli artisti senesi, Ms. in Bib. di Siena, ca. 1830; G. Milanesi, Documenti per la storia dell'arte senese, 3 vols., Siena, 1854–56; S. Borghesi and L. Banchi, Nuovi documenti per la storia dell'arte senese, Siena, 1898; C. Ricci, Il Palazzo Pubblico e la mostra d'antica arte senese, Bergamo, 1904; Mostra di arte antica senese (exhibition cat.), Siena, 1904; L. Coletti, Arte senese, Treviso, 1906; E. Jacobsen, Sienesische Meister des Trecento in der Gemäldegalerie zu Siena, Strasbourg, 1907; P. Schubring, Die Plastik Sienas im Quattrocento, Berlin, 1907; E. Jacobsen, Das Quattrocento in Siena, Strasbourg, 1908; B. Berenson, A Sienese Painter of the Franciscan Legend, London, 1909; E. Jacobsen, Sodoma und das Cinquecento in Siena, Strasbourg, 1910; B. Berenson, Essays in the Study of Sienese Painting, New York, 1918; W. R. Valentiner, Observations on Sienese and Pisan Trecento Sculpture, AB, IX, 1926–27, pp. 177–220; E. Cecchi, Trecentisti senesi, Rome, 1928; C. H. Weigelt, Die Sienesische Malerei des XIV. Jahrhunderts, Florence, 1930 (Eng. trans., Sienese Painting of the Trecento, New York, 1930); C. Brandi, La regia Pinacoteca di Siena, Rome, 1933; W. Cohn-Goerke, Scultori senesi del Trecento, RArte, XX, 1938, pp. 244–89; P. Bacci, L'elenco delle pitture, sculture e architetture di Siena compilato nel 1625–26 da Mons. Fabio Chigi, B. senese di storia patria, N.S., X, 1939, pp. 197–213, 297–337; E. Carli, Sculture del Duomo di Siena, Turin, 1941; P. Bacci, Fonti e commenti per la storia dell'arte senese, Siena, 1944; Mostra d'arte senese (exhibition cat.), Siena, 1946; J. Pope-Hennessy, Sienese Quattrocento Painting, London, 1947; C. Brandi, Quattrocentisti senesi, Milan, 1949; Mostra di scultura senese (exhibition cat.), Siena, 1949; V. del Vecchi, L'architettura gotica civile senese, B. senese di storia patria, LVI, 1949, pp. 3–52; R. Buscaroli, La scultura senese del Trecento e Jacopo della Quercia, Bologna, 1951; E. Carli, Scultura lignea senese, Milan, 1951; E. Sandberg-Vavalà, Sienese Studies: The Development of the School of Painting of Siena, Florence, 1953; E. Carli, Dipinti senesi del contado e della Maremma, Milan, 1955; E. Carli, La pittura senese, Milan, 1955; G. Mancini, Considerazioni sulla pittura (ca. 1620, ed. A. Marucchi), 2 vols., Rome, 1956–57; E. Carli, Les primitifs siennois, Paris, 1957; T. Burckhardt, Siena: Stadt der Jungfrau, Olten, 1958 (Eng. trans., M. Brown, Siena: The City of the Virgin, London, New York, 1960); N. Rubinstein, Political Ideas in Sienese Art: The Frescoes by Ambrogio Lorenzetti and Taddeo di Bartolo in the Palazzo Pubblico, Warburg, XXI, 1958, pp. 179–207; E. Carli, Musei senesi, Novara, 1961.

ARTISTS: See individual articles for *Barna da Siena, Giovanni di Paolo, Sassetta, Sodoma, Tino di Camaino.*

OTHERS. *Agostino di Giovanni*: doc. ca. 1269–1350, sculptor (W. R. Valentiner, Studies in Italian Gothic Plastic Art, II: Agostino di Giovanni and Agnolo di Ventura, Art in America, XIII, 1924–25, pp. 3–18; W. R. Valentiner, Observations on Sienese and Pisan Trecento Sculpture, AB, IX, 1926–27, pp. 177–220). *Bartolo di Fredi*: Siena, ca. 1330–1410, painter (C. Brandi, Reintegrazione di Bartolo di Fredi, B. senese di storia patria, II, 1931, pp. 206–10; S. L. Faison, Barna and Bartolo di Fredi, AB, XIV, 1932, pp. 285–315; E. Carli, La data degli affreschi di Bartolo di Fredi a San Gimignano, Critica d'arte, VIII, 1949, pp. 75–76). *Domenico Beccafumi*: b. Montaperti, ca. 1486; d. Siena, 1551; painter, engraver, and sculptor (M. Gibellino-Krascenimicowa, Il Beccafumi, Siena, 1933; G. Vigni, L'arte di Domenico Beccafumi, B. senese di storia patria, VII, 1936, pp. 215–44; D. Samminiatelli, The Sketches of Domenico Beccafumi, BM, XCVII, 1955, pp. 35–40; D. Samminiatelli, The Beginnings of Domenico Beccafumi, BM, XCIX, 1957, pp. 401–10). *Giacomo Cozzarelli*: Siena, 1453–1515, architect and sculptor (P. Bacci, Il pittore, scultore e architetto Iacopo Cozzarelli e la sua permanenza in Urbino con Francesco di Giorgio Martino dal 1478 al 1488, B. senese di storia patria, III, 1932, pp. 97–112; L. Bersano, L'arte di Giacomo Cozzarelli, B. senese di storia patria, LXIV, 1957, pp. 109–42). *Domenico di Bartolo*: Siena, 1400–45, painter (M. L. Gengaro, A proposito di Domenico di Bartolo, L'Arte, XXXIX, 1936, pp. 104–22). *Francesco da Valdambrino*: 15th–16th century, sculptor (P. Bacci, Francesco di Valdambrino: Emulo del Ghiberti e collaboratore di Jacopo della Quercia, Siena, 1936; C. L. Ragghianti, Su Francesco di Valdambrino, CrArte, III, 1938, pp. 136–33). *Francesco di Giorgio* (q.v.). *Gano da Siena (Galgano di Giovanni)*: 14th-century sculptor (A. Venturi, La scultura senese nel Trecento, L'Arte, VII, 1904, pp. 209–22; E. Carli, Lo scultore Gano da Siena, Emporium, XCV, 1942, pp. 231–47). *Giovanni di Agostino*: b. 1310, architect and sculptor (W. Cohn-Goerke, Giovanni d'Agostino, BM, LXXV, 1939, pp. 180–94; E. Carli, Sculture inedite di Giovanni d'Agostino, BArte, XXXIII, 1948, pp. 129–42). *Goro di Gregorio*: 14th-century sculptor

(E. Carli, Goro di Gregorio, Milano, 1946). *Guido da Siena*: 13th-century painter (E. Sandberg-Vavalà, The Madonnas of Guido da Siena, BM, LXIV, 1934, pp. 254–71; R. Offner, Guido da Siena and A.D. 1221, GBA, XXXVII, 1950, pp. 61–90; G. Coor-Achenbach, Notes on Two Unknown Early Italian Panel Paintings, GBA, XLII, 1953, pp. 247–58). *Neroccio di Bartolomeo Landi*: Siena, 1447–1500, painter and sculptor (L. Dami, Neroccio di Bartolomeo Landi, Rass. d'arte, XIII, 1913, pp. 137–43, 160–70; E. Carli, Vecchietta e Neroccio a Siena e in "Quel di Lucca," CrArte, N.S., I, 1954, pp. 336–54; G. Coor, Neroccio di Landi, Princeton, 1961). *Luca di Tommè*: 1330 (?)–89, painter (P. Bacci, Una tavola inedita e sconosciuta di Luca di Tommè con alcuni ignorati documenti della sua vita, La Balzana, I, 1927, pp. 51–62; F. Zeri, Sul problema di Niccolò Tegliacci e Luca di Tomè, Paragone, IX, 105, 1958, pp. 3–16). *Rutilio di Lorenzo Manetti*: Siena, 1571–1639, painter (C. Brandi, Rutilio Manetti, Siena, 1931; H. Voss, L'opera giovanile di Rutilio Manetti, Vita artistica, III, 1932, pp. 57–68). *Matteo da Siena (Matteo di Giovanni di Bartolo)*: b. Sansepolcro, ca. 1435; d. Siena, ca. 1495; painter (G. F. Hartlaub, Matteo da Siena und seine Zeit, Strasbourg, 1910; B. Berenson, Essays in the Study of Sienese Painting, New York, 1918, pp. 81–94; M. L. Gengaro, Matteo di Giovanni, La Diana, IX, 1934, pp. 149–85; J. Pope-Hennessy, A Crucifixion by Matteo di Giovanni, BM, CII, 1960, pp. 63–67). *Lippo Memmi*: doc. 1317–46, painter (L. Ozzola, Lippo Memmi collaboratore del padre Memmo e di Simone Martini, Rass. d'arte, N.S., VIII, 1921, pp. 117–21; H. S. Francis, A Sienese "Madonna and Child" by Lippo Memmi, Cleve. Mus. B., XL, 1953, pp. 59–61). *Paolo di Giovanni Fei*: doc. 1372–1410 (C. Brandi, Francesco di Vannuccio e Paolo di Giovanni Fei, B. senese di storia patria, IV, 1933, pp. 25–42). *Ventura Salimbeni*: Siena, 1567–1613, painter (P. A. Riedl, Zum Oeuvre des Ventura Salimbeni, Mitt. der Kunsthist. Inst. in Florenz, IX, 1959–60, pp. 221–48; G. Scavizzi, Su Ventura Salimbene, Comm, X, 1959, pp. 115–36). *Sano di Pietro (Ansano di Pietro di Mencio)*: 1406–81, painter (E. Gaillard, Un peintre siennois au XV siècle: Sano di Pietro, Chambery, 1923; J. Trübner, Die stilistische Entwicklung der Tafelbilder des Sano di Pietro, Strasbourg, 1925). *Segna di Bonaventura*: doc. 1298–1331, painter (G. De Nicola, Una copia di Segna di Tura della Maestà di Duccio, L'Arte, XV, 1912, pp. 21–32; F. Zeri, Un polittico di Segna di Bonaventura, Paragone, IX, 103, 1958, pp. 63–66). *Taddeo di Bartolo*: ca. 1362–1422, painter (L. Dami, Taddeo di Bartolo a Volterra, BArte, N.S., IV, 1924–25, pp. 70–76; N. Rubinstein, Political Ideas in Sienese Art: The Frescoes by Ambrogio Lorenzetti and Taddeo di Bartolo in the Palazzo Pubblico, Warburg, XXI, 1958, pp. 179–207; P. Rotondi, Nicolò da Voltri, Taddeo di Bartolo nella chiesa di San Colombano a Genova, Genoa, 1960). *Niccolò di Ser Sozzo Tegliacci*: d. 1363, painter (C. Brandi, Niccolò di Ser Sozzo Tegliacci, L'Arte, XXXV, 1932, pp. 223–36; F. Zeri, Sul problema di Niccolò Tegliacci e Luca di Tomè, Paragone, IX, 105, 1958, pp. 3–16). *Francesco Vanni*: 1563–1610, painter (G. Bianchi Bandinelli, La vita del pittore Francesco Vanni, B. senese di storia patria, N.S., I, 1942, pp. 69–92; G. Bianchi Bandinelli, Catalogo delle opere del pittore Francesco Vanni, B. senese di storia patria, N.S., II, 1943, pp. 139–55; P. A. Riedl, Zu Francesco Vanni und Ventura Salimbeni, Mitt. der Kunsthist. Inst. in Florenz, IX, 1959–60, pp. 60–70). *Lippo Vanni*: doc. 1344–75, painter (B. Berenson, Un antiphonaire avec miniatures par Lippo Vanni, GBA, IX, 1924, pp. 257–85; M. Meiss, Nuovi problemi e vecchi dipinti, RArte, XXX, 1955, pp. 107–45). *Il Vecchietta (Lorenzo di Pietro)*: b. Castiglione d'Orcia, ca. 1412; d. Siena, 1480; painter, sculptor, and architect (G. Vigni, Lorenzo di Pietro detto il Vecchietta, Florence, 1937; E. Carli, Vecchietta e Neroccio a Siena in "Quel di Lucca," CrArte, N.S., I, 1954, pp. 336–54; C. L. Ragghianti, Vecchietta scultore, CrArte, N.S., I, 1954, pp. 330–35).

CENTRAL AND SOUTHERN ITALIAN ART TO THE 15TH CENTURY: *Southern Italy*. The dominant elements of the Romanesque art of southern Italy were Byzantine, Arabic, and Norman. In Apulia, however, Lombard and occasional Pisan forms exerted a certain influence. Examples of more traditional Byzantine architecture (with a plan in the form of a Greek cross inscribed within a square) have survived in Calabria (Rossano; Stilo, FIG. 399) and Apulia (Otranto; Trani, PL. 172; Canosa di Puglia). The remains of S. Maria della Roccella in Catanzaro Marina (11th cent.) as well as other Calabrian churches attest to the encounter of Sicilian elements with strong Byzantine influence transmitted by Basilian monks.

In Campania, a typical church related to that of Monte Cassino (where Byzantine artists worked) is the Church of Sant'Angelo in Formis (11th cent.). The frescoes of this church (II, PL. 285), together with the illuminated manuscripts produced by Benedictine artists in the scriptoria of Monte Cassino, con-

stitute the chief examples of this region's Romanesque painting. The Arab architectural taste is seen especially in decoration (Amalfi, Chiostro del Paradiso; Caserta Vecchia, Cathedral, 1153; Ravello, Palazzo Rufolo).

In sculpture, such work as the ivory altarpiece of the Cathedral of Salerno (12th cent.) reflects a classical feeling that

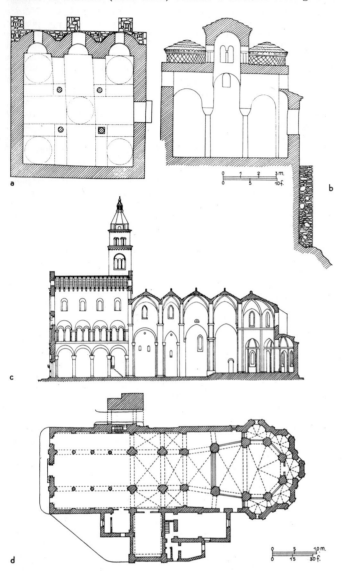

Medieval churches of southern Italy. (*a, b*) Stilo, La Cattolica, 10th cent., plan and transverse section; (*c, d*) Barletta, Cathedral, 12th–15th cent., longitudinal section and plan (*from L'Architettura, XXXIV, 1958*).

is of Byzantine origin. Yet the pulpits of this same Cathedral (late 12th cent.), though they are classical in structure, are richly decorated with marble inlay and mosaic of mixed Sicilian and Arabic inspiration. The bronze door of the Cathedral of Benevento (first half of the 13th cent.) testifies to western Romanesque influence. The Campanian classical tradition enjoyed a revival in the reign of Frederick II (see ANTIQUE REVIVAL). There are productions of this revival both in Campania (works in Capua, Mus. Prov. Campano) and in Apulia (Castel del Monte). Nicola d'Apulia, later known as Nicola Pisano (q.v.), was probably a product of this milieu. The pulpit of the Cathedral of Ravello (1272) by Niccolò di Bartolommeo da Foggia belongs to this classicizing trend.

In Apulia Byzantine influence (e.g., domes of the Cathedral of Canosa di Puglia, late 11th cent.) and Norman influence (e.g., towers of S. Nicola in Bari, 11th–12th cent., and the high roof slopes combined with Lombard forms, especially in the Terra di Bari region (Bari; Bitonto; Trani, 12th cent.; Ruvo di Puglia, 13th cent.; PL. 172), and with Pisan forms in the Ca-

pitanata region (Troia, 11th–12th cent.; Siponto; Monte Sant'Angelo). Although Byzantine and Islamic elements are to be found in sculpture of this period (the bronze door of the Cathedral of Troia, 1119; doors by Barisanus of Trani in Trani, IX, PL. 508, Ravello, 1179, and Monreale), it is chiefly the influence of Lombard and northern European work that is reflected in contemporaneous sculptural decoration of church doors and furnishings.

In Sicily, the three sources of stylistic influence were assimilated with particularly coherent and original results. The Arabic element is evident in the prevalence of the pointed arch, small elevated domes, and exterior decoration featuring interlaced arches. The Norman element, that is to say, the Latin monastic factor, is apparent in the elevation of buildings and in the use of large façade towers, and the mosaic decoration of interiors achieves a typically Byzantine magnificence (PL. 426; II, PLS. 286, 456, 457; see MOSAICS). Many religious and secular structures arose in Sicily during this period (ca. 1060– ca. 1200). The most noteworthy are in Palermo, Cefalù (PL. 173), and Monreale (PL. 426; FIG. 401). Cathedrals, churches, palaces, and castles (e.g., Palermo, the Zisa and the Cuba) strongly reflect Islamic influence.

The era of Gothic architecture in southern Italy began with the great building activity of Frederick II and continued throughout the period of Swabian domination. In Sicily, the Cistercians, who had left incomplete a large basilica in Murgo near Lentini (ca. 1225), were employed by Frederick II in the building of Castel Maniace in Syracuse. This castle, like the Castello Ursino in Catania (FIG. 396) and Castel del Monte in Apulia, is one of the chief examples of the kind of architecture built under that ruler. In connection with all this building, important work was carried on in the field of sculpture. The Sicilian Vespers (when Sicily severed itself from the mainland domination of the Angevins) all but marked the end of the development of Gothic architecture in Sicily. Subsequent activity was limited to a phenomenon of purely local importance — "Chiaramontane" architecture (named for the Palazzo Chiaramonte, Palermo, 1307).

Building activity in Naples, on the other hand, greatly increased at this time. The Angevin court probably employed French architects (the choir of S. Lorenzo Maggiore, the Church of S. Eligio), which would explain the connections with French Gothic architecture and, during the reign of Robert of Anjou, Provençal architecture that are evident in many Neapolitan churches. Yet local craftsmen endowed the architecture with a special flavor (e.g., S. Chiara, S. Maria Donnaregina, S. Domenico Maggiore, the Cathedral, and S. Pietro a Maiella, all of which were built in the first three decades of the 14th century). This period was also marked by great activity in painting and sculpture. Pietro Cavallini, Simone Martini, and Giotto (qq.v.) worked in Naples, and their production and that of their assistants played a decisive role in the development of local painting and manuscript illumination. A notable example of their influence is the fresco cycle in the Church of S. Maria Incoronata. These frescoes may be the work of Roberto d'Oderisio (second half of 14th cent.), a painter with whom Giovanni di Pietro da Napoli (active later at Pisa) was at first associated. The Sienese sculptor Tino da Camaino (q.v.) played a role of prime importance in the artistic life of Naples from 1324 to 1337. Briefly followed in this role by Lando di Pietro, Tino spread knowledge of Tuscan sculpture throughout southern Italy. They were followed in Naples by Giovanni and Pacio da Firenze (the tomb of Robert of Anjou in S. Chiara, 1343).

The disposition to welcome foreign works and artists continued through the second half of the century (e.g., the Florentine painter Niccolò di Tommaso and the Sienese Andrea Vanni). This tendency grew stronger in the 15th century, when, owing in part to the political vicissitudes of the city, Naples embraced the influences of Flemish painting (the Van Eycks and Rogier van der Weyden), Catalan (Jacomart Bacó), and French (Fouquet). Thus was established the artistic milieu to which Antonello da Messina (q.v.) was to be drawn during the period of his apprenticeship with the Neapolitan Colantonio. After the Lombard painter Leonardo Molinari da Besozzo, who went to

Naples in 1442 (frescoes in S. Giovanni a Carbonara), there was a new influx of northern painters toward the end of the century. Bramantino and Antonio Solario went to Naples, as did Cristoforo Scacco of Verona, and they added their influence to that of Antoniazzo Romano. The Renaissance style penetrated Naples only sporadically. Indeed, local activity in architecture and sculpture was dominated by stonecutters from Latium, the best known being Antonio Baboccio da Piperno. The work of these Latian craftsmen, with its Gallicizing archaisms, provided a natural transition to the Catalan Flamboyant Gothic of the 15th century. (Guillermo Sagrera worked on the Castel Nuovo toward the middle of the century.) The first Renais-

developed in Palermo, where Tuscan elements of lesser importance (from Pisa and Siena) were also operative. Thus was forged in Sicily a modest link in that chain of mutual influence among the Mediterranean cities which, in Spain, had among its exponents Gherardo Starnina and the Master of the Bambino Vispo. Spanish influence also took on some Provençal coloring (as in Naples). A manifestation of this complex interaction of influences is the fresco of the Triumph of Death in Palermo (Gall. Naz. della Sicilia). Catalan-Provençal and Adriatic idioms combined in the art of Tommaso de Vigilia and the Piazza Armerina Master (Crucifix, Piazza Armerina, Cathedral), who may be one and the same person. Similar influences affected

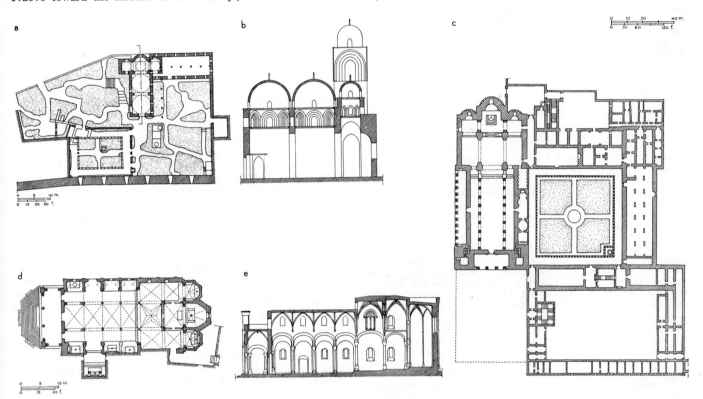

Sicilian religious architecture. (a, b) Palermo, S. Giovanni degli Eremiti, founded 1132, plan of church and cloister, and longitudinal section of church; (c) Monreale, Cathedral and monastery, founded 1174, plan; (d, e) Palermo, S. Maria della Catena, end of 15th cent., plan and longitudinal section.

sance undertaking in Naples was the triumphal arch of Alfonso of Aragon in the Castel Nuovo. The Palazzo Cuomo is another of the very few surviving Renaissance structures in Naples. Active in Naples toward the end of the century were Giuliano da Maiano (the Porta Capuana; the villa at Poggioreale, destroyed) and the Veronese Fra Giovanni Giocondo.

Renaissance sculpture had made an early but almost unnoticed appearance in Naples in the Brancacci Tomb, on which both Donatello and Michelozzo worked (IV, PL. 245). Later came the sculptors of the triumphal arch of Alfonso of Aragon — Francesco Laurana (see RENAISSANCE), Domenico Gaggini, and other artists, both Roman and Lombard. Finally Antonio Rossellino, Benedetto da Maiano, and Guido Mazzoni worked in the Church of Monte Oliveto (S. Anna dei Lombardi).

The local flavor of 14th-century architecture in Sicily was preserved in 15th-century architecture, which was in close contact with Catalan Gothic. Even at the end of the 15th century, elements of Spanish derivation persisted, forming an integral part, for example, of the complex artistic personality of Matteo Carnevale (Matteo de Carnilivari; Palermo, Palazzo Aiutamicristo and Palazzo Abbatelli). Renaissance style first appeared in the portals in the Cathedral of Palermo decorated by Domenico Gaggini, who went to Palermo in 1463. Francesco Laurana worked in Sicily after 1467 and brought the Renaissance style in sculpture to the island. In painting of the first decades of the 15th century, notable in Syracuse was Valencian influence, which tended to assimilate Adriatic elements. Similar trends

Riccardo Quartararo, who also worked in Naples. In eastern Sicily the most notable painter was Marco di Costanzo (paintings in Syracuse, Cathedral). After Antonello da Messina the school of Messina was continued by his relatives Jacopo (Jacobello) d'Antonello and Antonello de Saliba, who were rather modest artists. Antonio Giuffrè (called "Antonello de lu Re") and Salvo di Antonio represented the school on the threshold of the 16th century.

BIBLIOG. J. P. Hackert, Memorie dei pittori messinesi, Naples, 1792; G. Grosso-Cacopardo, Memorie dei pittori messinesi e degli esteri che in Messina fiorirono dal secolo XII al secolo XIX, Messina, 1821; C. Diehl, L'art byzantin dans l'Italie méridionale, Paris, 1894; G. Di Marzo, La pittura in Palermo nel Rinascimento, Palermo, 1899; E. Bertaux, L'art dans l'Italie méridionale, Paris, 1904; C. Villani, Scrittori ed artisti pugliesi, Trani, 1904; C. Waern, Mediaeval Sicily, London, 1910; M. Wackernagel, Die Plastik des XI. und XII. Jahrhunderts in Apulien, Leipzig, 1911; F. Nicolini, L'arte napoletana del Rinascimento, Naples, 1925; C. Ricci, Architettura e scultura del medio evo nell'Italia meridionale, Stuttgart, 1928; W. F. Volbach, Sculture medioevali della Campania, RendPontAcc, XII, 1936, pp. 81–104; G. Ceci, Bibliografia per la storia delle arti figurative nell'Italia meridionale, 2 vols., Naples, 1937; C. Valente, Aspetti dell'arte medievale nella Lucania, Atti V Cong. naz. S. romani, III, 1942, pp. 131–46; W. F. Volbach, Oriental Influences in the Animal Sculpture of Campania, AB, XXIV, 1942, pp. 172–80; O. Morisani, Pitture del Trecento a Napoli, Naples, 1947; S. Ortolani, Inediti meridionali del '200, BArte, XXXIII, 1948, pp. 295–319; G. Carandente, Dipinti quattrocenteschi in Calabria, BArte, XXXIV, 1949, pp. 68–70; C. D. Sheppard, A Chronology of Romanesque Sculpture in Campania, AB, XXXII, 1950, pp. 319–26; G. Vigni and G. Carandente, Antonello da Messina e la pittura del Quattrocento in Sicilia (exhibition cat.), Messina, 1953; S. Bottari, La cultura figurativa in Sicilia, Messina, 1954; S. Bottari, La pittura del Quattrocento in Sicilia,

Messina, Florence, 1954; M. Brion, L'art en Sicilie, Paris, 1955; R. Causa, Pittura napoletana dal XV al XIX secolo, Bergamo, 1957; F. Susinno, Le vita de' pittori messinesi (ed. V. Martinelli), Florence, 1960.

ARTISTS. *Antonello de Saliba*: Messina, 1466/67–1535, painter (E. Brunelli, Antonello de Saliba, L'Arte, VII, 1904, pp. 271–85; G. Vigni and G. Carandente, I restauri compiuti dall'Istituto Centrale del Restauro per la Mostra di Antonello da Messina e del Quattrocento siciliano, B. Ist. Centrale del Restauro, 14–15, 1953, pp. 67–168, esp. 155). *Barisanus of Trani*: late-12th-century sculptor (A. Boeckler, Die Bronzetüren des Bonanus von Pisa und des Barisanus von Trani, Berlin, 1953). *Matteo Carnevale (Matteo de Carnilivari)*: 15th-century Sicilian architect (F. Meli, Matteo Carnelivari e l'architettura del Quattro e Cinquecento in Palermo, Rome, 1958). *Colantonio*: ca. 1352–1442, Neapolitan painter (A. Maresca, Osservazioni sulla vita di Colantonio del Fiore, Naples, 1883; C. Aru, Colantonio, ovvero il "Maestro della Annunciazione di Aix," Dedalo, XI, 1930–31, pp. 1121–41; C. Grigioni, Il primo documento d'archivio su Colantonio, pittore napoletano, Arti Fig, III, 1947, pp. 137–39). *Marco di Costanzo*: 1468–1500, Syracusan painter (S. Bottari, Un pittore siciliano del Quattrocento: Marco Costanzo, BArte, XXXVI, 1951, pp. 124–29; G. Vigni and G. Carandente, I restauri compiuti dall'Istituto Centrale del Restauro per la Mostra di Antonello da Messina e del Quattrocento siciliano, B. Ist. Centrale del Restauro, 14–15, 1953, pp. 67–168, esp. 127). *Domenico Gaggini*: d. 1492, sculptor (G. Di Marzo, I Gagini in Sicilia e la scultura in Sicilia nei secoli XV e XVI, 2 vols., Palermo, 1880–83; E. Mauceri, L'opera di Domenico Gagini in Sicilia, L'Arte, VI, 1903, pp. 147–58; W. R. Valentiner, The Early Development of Domenico Gagini, BM, LXXVI, 1940, pp. 76–87; M. Accascina, Aggiunte a Domenico Gagini, BArte, XLIV, 1959, pp. 19–29). *Antonio Giuffrè* (called *Antonello de lu Re*): Messina, late-15th-century painter (E. Brunelli, Antonio Giuffrè, Rass. d'arte, VII, 1907, pp. 109–10; G. Vigni and G. Carandente, I restauri compiuti dall'Istituto Centrale del Restauro per la Mostra di Antonello da Messina e del Quattrocento siciliano, B. Ist. Centrale del Restauro, 14–15, 1953, pp. 67–168, esp. 144). *Niccolò di Bartolommeo da Foggia*: 13th-century sculptor (S. Bottari, Intorno a Nicola di Bartolomeo da Foggia, Comm, VI, 1955, pp. 159–63). *Riccardo Quartararo*: doc. 1485–1501, Sicilian painter (L. Serra, Su Riccardo Quartararo, Rass. d'arte, IX, 1909, pp. 203–05; S. Bottari, Da Tuccio di Gioffredo a Riccardo Quartararo, Arte antica e moderna, II, 1959, pp. 170–72). *Roberto d'Oderisio (Roberto Oderisi)*: Neapolitan painter of the second half of the 14th century (B. Berenson, A Panel by Roberto Oderisi, Art in America, XI, 1923, pp. 69–76; V. Lasareff, A New Panel by Roberto Oderisi, BM, LI, 1927, pp. 128–29; O. Morisani, An Altar Panel by Roberto d'Odorisio, AQ, XX, 1957, pp. 156–62). *Salvo di Antonio*: Messina, doc. 1493–1526, painter (G. Vigni and G. Carandente, I restauri compiuti dall'Istituto Centrale del Restauro per la Mostra di Antonello da Messina e del Quattrocento siciliano, B. Ist. Centrale del Restauro, 14–15, 1953, pp. 67–168, esp. 163). *Cristoforo Scacco*: b. Verona, active in southern Italy ca. 1500, painter (A. De Santis, Della patria

di Cristoforo Scacco, ArtiFig, II, 1946, pp. 226–30; R. Causa, Due tavole inedite ed una precisazione cronologica di Cristoforo Scacco, Paragone, III, 25, 1952, pp. 40–43). *Tommaso de Vigilia*: doc. 1460–93, painter [G. Vigni and G. Carandente, I restauri compiuti dall'Istituto Centrale del Restauro per la Mostra di Antonello da Messina e del Quattrocento siciliano, B. Ist. Centrale del Restauro, 14–15, 1953, pp. 67–168, esp. 159; S. Bottari, Taccuino meridionale, I: Resti di un polittico di Tommaso de Vigilia (?), Arte antica e moderna, III, 1960, pp. 159–60].

Umbria. During the Romanesque period Lombard craftsmen were active in Umbria. At work chiefly on the basilicas, they were subject to Latian influences and drew inspiration from surviving classical monuments in Umbria. A typical aspect of their activity was compartmental treatment of façades (Assisi, Cathedral, built by Giovanni da Gubbio, 1140, 13th-cent. façade; Spoleto, S. Pietro, PL. 176). Spoleto, Assisi, and Bevagna are rich in buildings of the Romanesque period. There are also important examples of the Romanesque in Ferentillo, Perugia, Narni, Todi, and Foligno. At the beginning of the Gothic period Assisi assumed a leading position in architecture with the construction of the Church of S. Francesco (PL. 186; FIG. 403). Begun in 1228, this basilica became the splendid model for the single-aisled churches of the predicant orders. Moreover, at the end of the century it was host to a peerless school of Italian painting. Umbrian churches modeled after S. Francesco include S. Chiara in Assisi, S. Francesco in Gualdo Tadino, and S. Francesco al Prato in Perugia. Other churches, however (Perugia, S. Domenico and the Cathedral; Todi, S. Fortunato), derived from France the scheme of three aisles of equal or nearly equal height. Of special distinction is the civil architecture of the time, which retained something of the Romanesque in its rude severity and in the blocklike mass of the *palazzi*, such as those in Todi, Perugia, Orvieto (PL. 186), Gubbio, and Città di Castello. The architect in the case of the last two cities was Angelo da Orvieto. A later architect of genius was Gattapone (Matteo di Giovannello di Maffeo), who worked extensively in Umbria (Assisi; Spoleto, the fortress; 1362–70; Perugia, S. Giuliana, cloister).

In sculpture, after the work of Nicola and Giovanni Pisano in Perugia and of Arnolfo in Orvieto, Umbrian sculpture came under the influence of Siena, particularly through the work of Lorenzo Maitani (q.v.) on the façade of Orvieto Cathedral. Symptomatic of this change is the fact that Angelo and Francesco di Pietro d'Assisi, who executed, among other works, the tomb of St. Margaret of Cortona for the Church of S. Margherita, Cortona, were altogether Sienese in style.

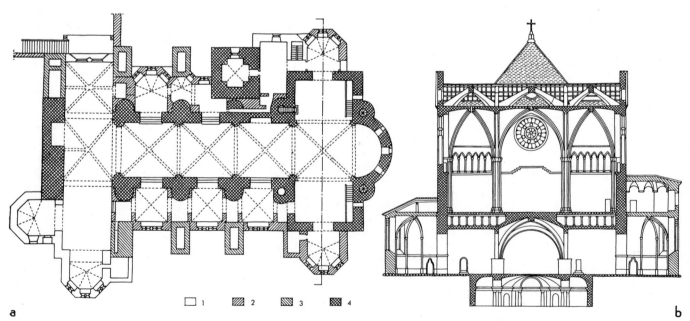

a □ 1 ▨ 2 ▨ 3 ▨ 4 b

Assisi, S. Francesco. (*a*) Lower Church, plan. *Key*: Constructions of (1) 1228–39; (2) 1280–1300, (3) 1300–50; (4) 1350–1400. (*b*) Upper Church, Lower Church, and crypt, transverse section (*from B. Kleinschmidt, San Francesco in Assisi, Berlin, 1915*).

Umbrian painting of the 12th century is represented by frescoes in the Abbey of S. Pietro in Valle, near Ferentillo, and in the Church of S. Maria Infraportas in Foligno, as well as by Alberto Sotio's Crucifix of 1187 (PL. 177). To Sotio are also attributed the frescoes in the Church of SS. Giovanni e Paolo in Spoleto. Local initiative of the 13th century is exemplified by frescoes signed by a certain Bonamico (1225, Perugia, S. Prospero). Later, the influence of Giunta Pisano appeared, as in the St. Francis Master (Assisi, S. Maria degli Angeli), and continued to have some effect up to the execution of the frescoes in S. Francesco, which then established Assisi as a painting center. However the work in Assisi had slight effect on the course of 14th-century Umbrian painting, which was chiefly influenced by Sienese art, although occasional influences from Florence and the Marches made themselves felt. Meo di Guido da Siena was active for a long time in Perugia, and subsequently the style of the Lorenzettis was especially influential in Gubbio (frescoes by Guido di Palmerucci). Under the leadership of Ugolino di Prete Ilario (frescoes in Orvieto Cathedral: Chapel of the Holy Corporal, 1357-64, and choir, 1370-80) there was established in Orvieto a group of masters who worked in a Sienese style. One of this company was Pietro di Puccio, who later worked in the Camposanto in Pisa. Ottaviano Nelli of Gubbio was an exponent of the late Gothic trend in Umbria. Although he possessed a style akin to that prevalent in the Marches, he was vitally affected also by Bolognese miniature painting (PL. 186; frescoes, Foligno, Palazzo Trinci, 1424; frescoes, Urbino, Oratorio di Sta Croce, 1428-32). Bartolomeo di Tommaso da Foligno, who worked in the Marches as well as in Umbria, is another artist whose forceful style was of late Gothic derivation (Foligno, S. Salvatore, triptych of 1437; Foligno, Pin. Com., fresco, 1449). About 1425 Gentile da Fabriano (q.v.) worked in Orvieto, and Masolino was in Todi in 1432. Innovations appeared with Domenico di Bartolo and Domenico Veneziano in Perugia (1438) and with such works as the polyptych (1437) in Perugia (Gall. Naz. dell'Umbria) by Angelico (q.v.; who was in Orvieto in 1447); works by Gozzoli in Montefalco (1450-52), Narni, and Foligno; a polyptych by Piero della Francesca (ca. 1460, Perugia, Gall. Naz. dell'Umbria); and frescoes by Lippi in Spoleto (1467-69). The Umbrian school of the 15th century, with its two principal branches in Foligno and Perugia, was founded on the work of these artists. Proximity to Montefalco placed the artists of Foligno in particular contact with the art of Benozzo Gozzoli. Such was the case of Pierantonio Mezzastris and Niccolò Alunno (Niccolò di Liberatore di Giacomo di Mariano). The latter also worked in the Marches, and there he became acquainted with the works of the Vivarinis and of Crivelli and derived from them a very personal firmness of style and an intense, naturalistic expressiveness (polyptych, 1483, Nocera Umbra, Pin.; polyptych, 1492, Foligno, S. Nicolo). Matteo da Gualdo was also allied to the Foligno group. Among the Perugians the influence of Florentine art was more varied in effect. Benedetto Bonfigli subtly assimilated the lessons of Domenico di Bartolo, Filippo Lippi, and Benozzo Gozzoli (PL. 203; processional banners, e.g., Perugia, Chapel of the Confraternità della SS. Concezione, 1461). Bartolomeo Caporali was a collaborator of Bonfigli. Fiorenzo di Lorenzo (PL. 203) absorbed various influences. Although Perugino (q.v.) was, in a certain sense, the very symbol of Umbrian painting, he rose above this provincial environment by virtue of the high level of his art. One of Perugino's many pupils, among whom even Raphael (q.v.) is to be numbered, was Bernardino Betti, known as Pinturicchio (q.v.). Translating, as it were, his master's poetry into prose, Pinturicchio gradually turned to narrative illustration and to a decorative evocation of a miniaturist's color (Rome, S. Maria in Aracoeli, Chapel of St. Bernardino; the Borgia Apartments in the Vatican, 1492-94; Spello, S. Maria Maggiore, Baglioni Chapel, 1501; Siena, Cathedral and Piccolomini Library, 1503-08). Giovanni di Pietro, known as Lo Spagna, and Eusebio da San Giorgio both helped to spread the influence of the art of Perugino and Raphael. Pastura (Antonio Massari da Viterbo) followed Perugino and Pinturicchio.

Renaissance architecture and sculpture made intermittent appearances in Umbria — in the work of Agostino di Duccio (Perugia, Oratory of S. Bernardino, façade, 1457-61; Porta S. Pietro, 1475) and in that of a follower of Verrocchio, Francesco di Simone Ferrucci (Perugia, S. Maria di Monteluce, tabernacle, 1483; Ancarano, S. Maria Vecchia, a marble Madonna). The plan of Francesco di Giorgio's Church of the Madonna del Calcinaio, near Cortona, influenced that of the Church of the Madonna dei Miracoli in Castel Rigone (1494). Perugia has a Renaissance building in its Palazzo del Capitano del Popolo (1472), and the Cathedral in Città di Castello was renovated under the inspiration of works of Il Cronaca and Sangallo. But it was not until the 16th century that native Umbrian architects came into their own. Such architects were Ippolito Scalza of Orvieto, who was also a sculptor, the Perugians Valentino Martelli and Vincenzo Danti, who was also a sculptor (IX, PL. 307), and the architect and painter Adone Doni (Dono dei Doni) of Assisi. The last three artists all entered into Michelangelo's sphere of influence, discarding any traces of membership in an Umbrian school. Likewise lacking any specific Umbrian character were the Perugian Galeazzo Alessi, who worked in Genoa and Milan, and Ascanio Vittozzi of Orvieto, who worked in Piedmont.

BIBLIOG. L. Pascoli, Vite de' pittori, scultori ed architetti perugini, Rome, 1732; A. Mariotti, Lettere pittoriche perugine, Perugia, 1788; B. Orsini, Memorie de' pittori perugini del secolo XVIII, Perugia, 1806; A. Rossi, I pittori di Foligno nel secolo d'oro delle arti italiane, Perugia, 1872; L. Manzoni, Documenti estratti dall'Arch. Distrettuale Notarile di Perugia: Pittori perugini e umbri, Perugia, 1897; U. Gnoli, L'arte umbra alla Mostra di Perugia, Bergamo, 1908; W. Rothes, Anfänge und Entwicklungsgänge der Alt-Umbrischen Malerschulen, insbesondere ihre Beziehungen zur frühsienesischen Kunst, Strasbourg, 1908; W. Bombe, Geschichte der Peruginische Malerei, Berlin, 1912; E. Jacobsen, Umbrische Malerei der XIV., XV., und XVI. Jahrhundert, Strasbourg, 1914; G. Urbini, Arte umbra, Todi, 1916; O. Fischel, Die Zeichnungen der Umbrer, Berlin, 1917; E. Giovagnoli, Le origini della pittura umbra, Città di Castello, 1922; U. Gnoli, Pittori e miniatori nell'Umbria, Spoleto, 1925; G. de' Francovich, Un gruppo di sculture in legno umbro-marchigiane, BArte, N.S., VIII, 1928-29, pp. 481-512; G. de' Francovich, Una scuola d'intagliatori tedesco-tirolesi e le Madonne umbre in legno, BArte, XXIX, 1935, pp. 207-28; U. Tarchi, L'arte nell'Umbria e nella Sabina, III-V, Milan, 1938-55; C. Gamba, Pittura umbra del Rinascimento, Novara, 1949; I. Ceroni, Periplo dell'arte romanica nell'Umbria, Rome, 1950; L. Grassi, Pittura umbra del Quattrocento, Rome, 1952; H. Keller, Umbrien, Vienna, 1959 (Eng. trans., M. Heron, New York, 1961).

ARTISTS. Domenico di Paride Alfani: Perugia, b. ca. 1480, painter (A. Briganti, Alcuni documenti su Domenico Alfani, Rass. d'arte umbra, I, 1909-10, pp. 27-31; W. Bombe, Domenico Alfani: Regesten und Urkunden, JhbPreussKSamml, XXXVII, 1916, sup., pp. 1-21; M. Salmi, Un'opera ignota di Domenico Alfani, Rass. d'arte umbra, III, 1921, pp. 84-89). Bartolomeo di Tommaso da Foligno: active 1425-55, painter (M. Faloci-Pugliani, Bartolomeo di Tommaso: Pittore umbro del XV secolo, Rass. d'arte umbra, III, 1921, pp. 65-80; F. Zeri, Bartolomeo di Tommaso da Foligno, BArte, XLVI, 1961, pp. 41-64). Benedetto Bonfigli: Perugia, ca. 1420-96, painter (W. Bombe, Benedetto Bonfigli: Eine kunsthistorische Studie, Berlin, 1904; W. Bombe, Die Tafelbilder, Gonfaloni und Fresken des Benedetto Bonfigli, RepfKw, XXXII, 1909, pp. 97-114, 231-46; A. Venturi, Pitture inedite del Bonfigli e del Caporali, L'Arte, XXX, 1927, pp. 86-88). Bartolomeo Caporali: active in Perugia, 1442-1509, painter (M. Salmi, Bartolomeo Caporali a Firenze, RArte, XV, 1933, pp. 253-72). Vincenzo Danti: Perugia, 1530-76, sculptor, goldsmith, painter, architect, theoretician, and poet (H. Keutner, The Palazzo Pitti "Venus" and Other Works by Vincenzo Danti, BM, C, 1958, pp. 427-31). Eusebio da San Giorgio: active in Perugia, b. 1465-70, d. after 1539, painter (G. Urbini, Eusebio di San Giorgio, Augusta Perusia, I, 1906, pp. 33-40, 49-57, 63-69; W. Bombe, Eusebio da San Giorgio, RepfKw, XXXIX, 1916, pp. 30-51). Fiorenzo di Lorenzo: Perugia, ca. 1445-1525, painter (J. C. Graham, The Problem of Fiorenzo di Lorenzo, Perugia, 1903; S. Weber, Fiorenzo di Lorenzo, Strasbourg, 1904; E. Jacobsen, Fiorenzo di Lorenzo, GBA, XI, 1914, pp. 189-208, 309-26). Gattapone (Matteo di Giovannello di Maffeo): 14th-century architect (A. Muñoz, Matteo Gattaponi da Gubbio e il chiostro di S. Giuliana in Perugia, BArte, N.S., II, 1922-23, pp. 295-300; O. Guerrieri, Angelo da Orvieto, Matteo di Giovannello Gattapone e i palazzi pubblici di Gubbio e di Città di Castello, Perugia, 1959). Matteo da Gualdo: d. 1503, painter (A. Rossi, Prospetto cronologico della vita e delle opere di Matteo da Gualdo, Giorn. di erudizione artistica, I, 1872, pp. 107-14; U. Gnoli, Matteo da Gualdo: Opere sconosciute e opere non sue, Vita d'arte, III, 1909, pp. 151-57; G. Cristofani, Matteo di Pietro da Gualdo, L'Arte, XVI, 1913, pp. 50-57). Ottaviano Nelli: painter, b. Gubbio,

active first half of 15th century, painter (L. Bonfatti, Memorie storiche di Ottaviano Nelli, Gubbio, 1843; U. Gnoli, Affreschi del Nelli in Fano, Rass. d'arte umbra, II, 1911, pp. 10–15; F. Santi, Un capolavoro giovanile di Ottaviano Nelli, Arte antica e moderna, III, 1960, pp. 373–84). *Niccolò Alunno* (*Niccolò di Liberatore di Giacomo di Mariano*): Foligno, ca. 1430–1502, painter (R. Ergas, Niccolò di Liberatore gennant Alunno, Munich, 1912; U. Gnoli, Opere inedite e opere smarrite di Niccolò da Foligno, BArte, VI, 1912, pp. 249–62). *Guido di Palmerucci*: b. Gubbio, 1280; d. after 1345; painter (R. van Marle, Guido Palmerucci e la sua scuola a Gubbio, Rass. d'arte umbra, III, 1921, pp. 7–13; M. Salmi, Un polittico di Guido Palmerucci, Belvedere, IV, 1923, pp. 38–42; R. van Marle, Nuove opere di Guido Palmerucci, La Diana, VI, 1931, pp. 267–69). *Pinturicchio* (q.v.). *Giovanni di Pietro*, called *Lo Spagna*: b. ca. 1450; d. Spoleto, 1528; painter (Catalogo della mostra delle opere di Giovanni di Pietro detto lo Spagna nel IV centenario della morte, Spoleto, 1928). *Ugolino di Prete Ilario*: Orvieto, 14th–15th-century painter and mosaicist (R. van Marle, La scuola pittorica orvietana del '300, BArte, N.S., III, 1923–24, pp. 305–35).

The Marches. The Romanesque architecture of the Marches represents an encounter of Byzantine traditions (e.g., the form of the Greek cross inscribed in a square, the plan of such churches as S. Claudio al Chienti, near Macerata, and Sta Croce in Sassoferrato) and Adriatic and Lombard influences (S. Maria di Portonovo, 11th cent., near Ancona; Ancona Cathedral, 11th–13th cent.; Baptistery of Ascoli Piceno, 12th cent.). The miniature arches of the façade of S. Maria della Piazza in Ancona (PL. 176) are a Pisan motif that seems to have come to the Marches from Dalmatia. The geometrical compartmentation of the façade of SS. Vincenzo e Anastasio in Ascoli Piceno is an Umbrian feature. Elements of Umbrian derivation were more numerous in the Gothic period (Camerino, S. Venanzio; Ascoli Piceno, S. Francesco), when Venetian influence also made itself felt. The Venetian contribution became more important in the early years of the 15th century, inspiring such monuments as the portal of the Church of S. Domenico in Pesaro, executed in the manner of the Dalle Masegne, and that of the Church of S. Nicola in Tolentino by the Florentine-Venetian Il Rosso (q.v.). These portals, together with the works of Giorgio da Sebenico in Ancona [Loggia dei Mercanti, ca. 1455, and portals for the churches of S. Francesco delle Scale (S. Maria Maggiore) and of S. Agostino], are among the few examples we have of the sculpture of this region.

Painting in the Marches soon manifested distinctive local characteristics, although it was contained within the framework of derivation from the great art of Tuscany. The school of the Marches may be said to begin with the work of the Master of Campodonico (near Fabriano), an artist influenced by Giotto and by Sienese painting; the Master of Campodonico painted the frescoes in the Abbey of S. Biagio in Caprile (1345). This anonymous master seems to have provided the starting point for Allegretto Nuzi of Fabriano, who visited Florence about the year 1346. Allegretto produced a provincial variant of the colorful Giottesque manner of Bernardo Daddi that was craftsmanly but heavy in its handling of decorative elements (PL. 186). Allegretto Nuzi found a follower in Francescuccio Ghissi. From this modest milieu emerged Gentile da Fabriano (q.v.), whose career constitutes an important chapter in the history of late Gothic painting. The brothers Lorenzo and Jacopo Salimbeni of Sanseverino, attractive representatives of late Gothic painting in the Marches, worked together on the frescoes in the Church of S. Giovanni Battista in Urbino (VI, PL. 383) and on those (preserved in fragmentary state) in the Old Cathedral at Sanseverino. Their art reflects northern Italian influences, probably transmitted through illuminated manuscripts. Gentile da Fabriano exerted a strong influence on Arcangelo di Cola da Camerino, who was also in contact with Florence (1420–21). Contacts with Tuscany, with the art of Siena, and with the art of Piero della Francesca are evident in the work of Giovanni Boccati da Camerino (Madonnas, Perugia, Gall. Naz. dell'Umbria; polyptych, 1468, Belforte del Chienti, S. Eustachio). The contemporary Girolamo di Giovanni da Camerino (polyptych, Monte San Martino, 1473; triptych, Milan, Brera, PL. 203) strongly felt the influence of the Vivarinis and Carlo Crivelli. In fact, Crivelli had settled in the Marches in 1468, and Pietro

Alemanno, who came to the Marches from Austria, became a loyal follower of that artist (works in Ascoli Piceno, Pin. Civ.). Lorenzo d'Alessandro da Severino is another painter for whom the influence of Crivelli proved essential. Another basic influence upon Lorenzo was that of Niccolò Alunno (triptych, Corridonia, SS. Pietro, Paolo e Donato, 1481; frescoes, Sarnano, S. Maria di Piazza, 1483). Painting in Fabriano in the second half of the 15th century is represented by Antonio da Fabriano I (Crucifix, Matelica, Mus. Piersanti, 1452; triptych and standard, Genga, parish church), whose work was influenced by Piero della Francesca and Flemish painting. A second representative of this school is Francesco di Gentile, whose work is marked by nostalgic reminiscences of late Gothic style and the influence of Crivelli and of Antonio da Fabriano I (works Matelica, Mus. Piersanti; Perugia, Gall. Naz. dell'Umbria; Rome, Vat. Mus.).

Urbino, the seat of the Montefeltro family, was an extraordinary center of Renaissance culture, one of the most brilliant and characteristic of 15th-century cities. Urbino was the meeting point of such personalities as Luciano Laurana, Francesco di Giorgio, Piero della Francesca, and Bramante (qq.v.), and from Urbino came, almost as the natural product of such an environment, Raphael, the greatest painter of the Marches. At a lower level, the art of the second half of the 15th century manifested itself in Urbino in the work of Giovanni Santi (Raphael's father), Evangelista di Pian di Meleto, and the painter and architect Girolamo Genga. Urbino was represented in the 16th century by Federico Barocci (q.v.), an artist of originality who studied Raphael, Correggio, and the Venetians and elaborated an elegant style (IV, PL. 429; IX, PL. 303).

A vital center of artistic activity during the 15th–16th centuries was Loreto. Many artists worked on the Sanctuary of the Holy House from 1468 on, including such architects as Giuliano da Maiano, Giuliano da Sangallo, Baccio Pontelli, Bramante, and Andrea Sansovino; the painters Luca Signorelli and Melozzo da Forlì; and the sculptors Andrea Sansovino and Baccio Bandinelli.

After the 16th century there was no school of the Marches in any strict sense of the term. Artists from the Marches, among them Simone Cantarini da Pesaro, Carlo Maratti, Sassoferrato (G. B. Salvi; PL. 219) and Mario de' Fiori (Mario Nuzzi), were assimilated in the great current of Bolognese and Roman 17th-century painting. The neoclassic Giuseppe Piermarini became Milan's chief architect. Regional characteristics survived only in the minor arts.

BIBLIOG. G. Cantalamessa Carboni, Memorie intorno i letterati e gli artisti di Ascoli nel Piceno, Ascoli, 1830; A. Ricci, Memorie storiche delle arti e degli artisti della Marca di Ancona. 2 vols., Macerata, 1834; C. Ferretti, Memorie storiche dei pittori anconitani dal XV al XIX secolo, Ancona, 1884; G. Castellani, Saggio di bibliografia per la storia delle arti a Fano, Rass. bibliog. dell'arte it., III, 1900, pp. 53–67; G. Pauri I Lombardi-Solari e la scuola recanatese di scultura, Milan, 1915; L. Venturi, Opere di scultura nelle Marche, L'Arte, XIX, 1916, pp. 25–50; Rass. marchigiana, 12 vols., Pesaro, 1922–34; R. Sassi, Documenti di pittori fabrianesi, Rass. marchigiana, II, 1923–24, pp. 473–88, III, 1924–25, pp. 45–56, 87–96, 180–89; L. Serra, L'arte nelle Marche, 2 vols., Rome, 1929–34; B. Molajoli, Alcune sculture in legno umbro-marchigiane, Atti Dep. storia patria delle Marche, 4th ser., VIII–IX, 1931–32, pp. 103–08; A. Colasanti, Die Malerei des XV. Jahrhunderts in dem italienischen Marchen, Florence, 1932; G. Pallotta, Note sull'arte marchigiana del medio evo, Rome, 1933; G. Gronau, Documenti artistici urbinati, Florence, 1935.

ARTISTS. *Antonio da Fabriano I*: Fabriano, second half of 15th century, painter (B. Molajoli, Ignorati affreschi di Antonio da Fabriano, L'Arte, XXX, 1927, pp. 267–70; L. Serra, Antonio da Fabriano, BArte, XXVI, 1932–33, pp. 359–78). *Arcangelo di Cola da Camerino*: 15th-century painter (A. Venturi, Di Arcangelo di Cola da Camerino, L'Arte, XIII, 1910, pp. 377–81; R. Longhi, Arcangelo di Cola: Un pannello con la "Sepoltura di Cristo," Paragone, I, 3, 1950, pp. 49–50; F. Zeri, Arcangelo di Cola da Camerino, Paragone, I, 7, 1950, pp. 33–38). *Barocci* (q.v.). *Giovanni Boccati da Camerino*: b. Camerino, ca. 1420, painter (B. Feliciangeli, Sulla vita di Giovanni Boccati da Camerino, San Severino, 1906; B. Feliciangeli, Ancora una tavola di Giovanni Boccati da Camerino, Atti Dep. storia patria delle Marche, IX, 1913, pp. 1–7). *Evangelista di Pian di Meleto*: b. Pian di Meleto (Urbino), 1458; d. Urbino, 1549; painter (E. Scatassa, Evangelista di Mastro Andrea di Piandimeleto, pittore, Rass. bibliog. dell'arte it., VI, 1903, pp. 110–21; A. Venturi, Il primo maestro di Rafaello, L'Arte, XIV, 1911, pp. 139–46; L. von Schlegel, Evangelista da Pian di Meleto, Rass. d'arte, N.S., I, 1914, pp. 182–88).

Francesco di Gentile: Fabriano, late-15th-century painter (L. Serra, Francesco di Gentile da Fabriano, Rass. marchigiana, XI, 1933, pp. 73–109). *Girolamo Genga*: ca. 1476–1551, painter (C. Grigioni, Per la tavola di Girolamo Genga già nella chiesa di S. Agostino in Cesena, Rass. bibliog. dell'arte it., XII, 1909, pp. 56–61; M. Salmi, Intorno a Genga, Rass. marchigiana, VI, 1927–28, pp. 229–36). *Francescuccio Ghissi*: doc. 1359(?)–95, painter (A. Colasanti, Note sull'antica pittura fabrianese: Allegretto Nuzi e Francescuccio di Cecco Ghissi, L'Arte, IX, 1906, pp. 263–77). *Girolamo di Giovanni da Camerino*: doc. ca. 1450–73, painter (B. Berenson, Gerolamo di

an inclination toward French taste (PL. 176). Characteristic of the architecture of the Abruzzi are the preferences for timber roofing and for the church façade surmounted by a horizontal crowning element. These predilections survived until the 16th century, from the 13th-century Cathedral of Atri and the Church of S. Maria di Collemaggio in Aquila (decorated with polychrome inlay) to the façade by Cola dall'Amatrice (Nicola di Filotesio) for S. Bernardino in Aquila (1527).

The art of the Abbey of Monte Cassino inspired the painting

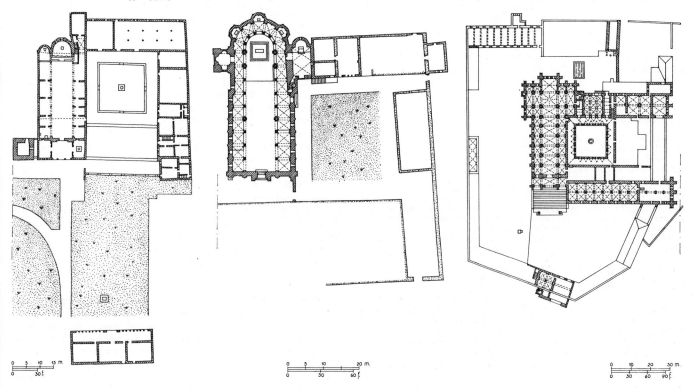

Medieval abbeys, plans. *Left*: Pomposa, Emilia, 8th–12th cent. *(from Architettura, XIV, 1956)*. *Center*: S. Antimo, Tuscany, 9th and 11th cent. *(from Siena Monumentale, Siena, 1911–12)*. *Right*: Casamari, Lazio, consecrated 1217 *(from L. Fraccaro de Longhi, Chiese Cistercensi, Milan, 1958)*.

Giovanni da Camerino, Rass. d'arte, VII, 1907, pp. 127–35; B. Feliciangeli, Sulle opere di Girolamo di Giovanni da Camerino, Camerino, 1910; L. Serra, Girolamo di Giovanni da Camerino, Rass. marchigiana, VIII, 1929–30, pp. 246–68). *Lorenzo d'Alessandro da Severino*: doc. ca. 1468–1503, painter (A. Colasanti, Affreschi inediti di Lorenzo d'Alessandro da Sanseverino, Rass. d'arte, N.S., IV, 1917, pp. 81–92; L. Serra, Due opere inedite di Lorenzo d'Alessandro, Rass. marchigiana, IX, 1930–31, pp. 131–40). *Allegretto Nuzi*: doc. 1346–73, painter (F. Zeri, Note su quadri italiani all'estero, BArte, XXXIV, 1949, pp. 21–30; A. Marabottini Marabotti, Allegretto Nuzi, RArte, XXVII, 1951–52, pp. 23–55). *Pietro Alemanno*: active in the Marches 1475–98, painter (P. Zampetti, Considerazioni su Pietro Alemanno, Arte Veneta, V, 1951, pp. 101–10). *Salimbeni: Lorenzo*, b. ca. 1374; d. before 1420; *Jacopo*, living 1427, painters (P. Rotondi, Studi e ricerche intorno a Lorenzo e Jacopo Salimbeni, Pietro da Montepulciano e Giacomo da Recanati, Fabriano, 1936; P. Zampetti, Gli affreschi di Lorenzo e Jacopo Salimbeni nell'Oratorio di San Giovanni di Urbino, Urbino, 1956; A. Gherardini, Lorenzo e Jacopo Salimbeni da Sanseverino, L'Arte, N.S., XXIII, 1958, pp. 3–11, 121–42). *Giovanni Santi*: Urbino, 1430/40–94, painter (A. Schmarsow, Giovanni Santi der Vater Raphaels, Berlin, 1887; L. Serra, Giovanni Santi, Rass. marchigiana, XII, 1934, pp. 258–74).

The Abruzzi. Although the Abruzzi region was exposed to diverse influences, it retained the conservative attitude characteristic of mountainous localities. During the Romanesque period, the monasteries assimilated artistic trends of various origins. The effects may be seen in such churches as S. Liberatore della Maiella (a ruin; second half of 11th cent.), S. Giovanni in Venere, and the Basilica Valvense (or Basilica of S. Pelino), near Pentima (1104–24). Lombard, Apulian, and Campanian influences are evident in these churches. The early Gothic features of the Abbey church of S. Clemente a Casauria reveal

of the 12th and 13th centuries in the Abruzzi region. Examples include frescoes in S. Pellegrino in Bominaco, 1263, and in S. Maria delle Grotte (or ad Cryptas) near Fossa, 1283. The 14th-century frescoes in the Cathedral of Atri reveal some awareness of northern Gothic art, as does contemporary miniature painting in the Abruzzi, which was influenced by Neapolitan and French work. Tuscan influences, especially Sienese, were also important in the Abruzzi (e.g., S. Maria Arabona, the frescoes of 1373). Fifteenth-century painting in the Abruzzi found its chief representative in the naïve but imaginative Andrea Delitio, whose art stood midway between the Gothic style and the narrative style of Benozzo Gozzoli. Among Andrea's works is a fresco of St. Christopher in Guardiagrele, in the Church of S. Maria Maggiore, 1473; there are frescoes attributed to him in the Cathedral of Atri. The influence of two artists who worked in Ascoli Piceno was felt in the Abruzzi. They were Cola dall'Amatrice and Pietro Alemanno (see above, *The Marches*).

The art of sculpture flourished in the Abruzzi as early as the Romanesque period, as witness the many carved pulpits in local churches. There are also signs of Near Eastern influence in these pulpits. In the 14th century the influence of Tuscan and Neapolitan sculpture reached the Abruzzi (e.g., sepulcher in S. Maria della Strada, near Matrice), and in the first decades of the 15th century the sculpture of the Abruzzi reflected a northern and flamboyant Gothic style introduced by Gualtiero d'Alemagna (tomb, Caldora Chapel, Sto Spirito, Sulmona, 1412; Camponeschi tomb, S. Biagio, Aquila, 1432, attributed). The contemporary Nicola Gallucci da Guardiagrele, an elegant goldsmith and sculptor (crosses and ostensoria, VI, PL. 265; Francavilla Alta, S. Franco, 1413; Atessa, S. Leucio, 1418; Lanciano,

S. Maria Maggiore, 1422), came into contact with the art of Florence, that of Ghiberti in particular (silver altar in the Cathedral of Teramo, 1433–38). Later, a certain Andrea di Jacopo, said to be from Aquila and termed a "disciple of Donatello," worked on the triumphal arch of Alfonso of Aragon in Naples. To this Andrea is attributed the altar of the Church of the Madonna del Soccorso in Aquila. Another important sculptor was Silvestro da Sulmona (Silvestro di Giacomo di Paolo da Sulmona). The noble style of his work in Aquila took inspiration from Florentine sculpture of the second half of the 15th century, from Antonio Rossellino in particular (Agnifili tomb, Cathedral, 1476–80; wood sculpture of St. Sebastian, Mus. Naz. d'Arte Abruzzese; tomb of Maria Pereira, S. Bernardino, 1488; terra-cotta Madonna, S. Bernardino, ca. 1495). Documents indicate that Silvestro was also a painter and architect.

After the 15th century, specifically regional characteristics survived only in such minor arts as pottery, wrought iron, and lacemaking.

Bibliog. V. Bindi, Artisti abruzzesi: Pittori, scultori, architetti, Naples, 1883; V. Balzano, L'arte abruzzese, Bergamo, 1910; G. Poggi, Arte medievale negli Abruzzi, Milan, 1914; C. Gradara Pesca, Bibliografia artistica dell'Abruzzo, Rome, 1927; M. Chini, Documenti relativi ai pittori che operarono in Aquila fra il 1450 e il 1550 circa, B. Dep. abruzzese di storia patria, 3d ser., XVIII, 1927, pp. 13–138; V. Mariani, Sculture lignee in Abruzzo, Bergamo, 1930; M. Gabrielli, Scultura lignea abruzzese, Rass. marchigiana, XI, 1933, pp. 114–23; G. S. Savorini, Monumenti della miniatura negli Abruzzi, Casalbordino, 1933; I. Gavino, Sommario della storia della scultura in Abruzzo, Atti Conv. storico abruzzese-molisano, I, Casalbordino, 1934, pp. 353–72; E. Carli, Per la scultura lignea del Trecento in Abruzzo, Le Arti, III, 1940–41, pp. 435–42; E. Carli, Per la pittura del Quattrocento in Abruzzo, RIASA, IX, 1942, pp. 164–211; O. Lehmann-Brockhaus, Die Kanzeln der Abruzzen im 12. und 14. Jahrhundert, Jhb. der Bib. Hertziana, VI, 1942–44, pp. 257–428; Catalogo della mostra dell'oreficeria abruzzese, Chieti, 1950.

Artists. Andrea dall'Aquila: active 1456–96, sculptor and painter (W. R. Valentiner, Andrea dell'Aquila: Painter and Sculptor, AB, XIX, 1937, pp. 503–36; W. R. Valentiner, Andrea dell'Aquila in Urbino, AQ, I, 1938, pp. 274–88). Cola dall'Amatrice (Nicola di Filotesio): b. Amatrice, 1489; d. Ascoli Piceno (?), ca. 1547; painter (A. Massimi, Cola dell'Amatrice, Amatrice, 1939; G. Fabiani, Cola dell'Amatrice secondo i documenti ascolani, Ascoli Piceno, 1952). Andrea Delitio: Guardiagrele, painter (F. Bologna, Andrea Delitio, Paragone, I, 5, 1950, pp. 44–50). Gualtiero (Valtero) d'Alemagna: German sculptor active in the Abruzzi, early 15th century (L. Serra, Aquila monumentale, Aquila, 1912). Nicola Gallucci da Guardiagrele: Guardiagrele, 1395(?)–1462(?), goldsmith and painter [F. Ferrari, Nicola Gallucci da Guardiagrele, Chieti, 1903; S. J. A. Churchill, Nicola da Guardiagrele: Orafo abruzzese, Arte e storia, XXXVII, 1918, pp. 132–41, XXXVIII, 1919, pp. 68–73; E. Carli, Nicola da Guardiagrele e il Ghiberti: Primi ragguagli sulla scultura guardiese, L'Arte, N.S., X, 1939, pp. 144–64, 222–38; A. Lipinsky, Das silberne Antependium des Nicola da Guardiagrele im Dom zu Teramo (1433/47), Das Münster, XI, 1958, pp. 233–50]. Silvestro (di Giacomo di Paolo) da Sulmona (also known as Silvestro Aquilano): b. Sulmona; d. Aquila, 1504; sculptor, painter, architect (M. Chini, Silvestro Aquilano e l'arte in Aquila nella II metà del secolo XV, Aquila, 1954).

ART IN ROME AND LATIUM TO THE PONTIFICATE OF JULIUS II. During the Middle Ages, the principal element in the continuity of what can be called a Roman tradition in art was the inspiration that artists drew from Early Christian models, which were equally influential in the 7th–8th century (S. Maria in Cosmedin, FIG. 411, I, PL. 394; S. Giorgio in Velabro) and in the 12th (S. Clemente, PL. 176, III, PL. 477; S. Maria in Trastevere, FIG. 389). From the time of the "palimpsest" frescoes in S. Maria Antiqua, that is, from the 8th century, there were two stylistic currents in painting — one of Byzantine inspiration, the other deriving from the freer tradition of late Roman art intermixed with Syrian influences. In the 9th century, in the fervor of the renewed construction of basilicas (S. Maria in Domnica and S. Prassede being among the principal objects of that activity), Byzantine influence manifested itself in mosaics and in the consequent renunciation of plastic effects in favor of the luministic effects of the mosaic tesserae. But in this same period, mural painting exhibited great feeling (inspired by Benedictine acquaintance with Carolingian manuscript illumination) for energetic line and dynamic figure representation (Assumption in the lower church of S. Clemente). This artistic current developed throughout the 10th century and, having assimilated the subtleties of Byzantine line, produced such 11th-century works as the frescoes in the Castel Sant'Elia (near Civita Castellana) and a panel in the Vatican (by the same artists),

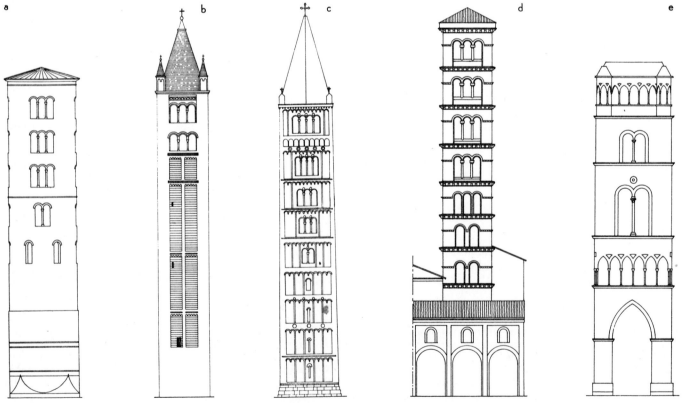

Campaniles, elevations. (a) Ravenna, S. Apollinare in Classe, 9th cent.; (b) Verona, S. Zeno Maggiore, first half of 11th cent.; (c) Pomposa, Emilia, Abbey, second half of 11th cent.; (d) Rome, S. Maria in Cosmedin, 12th cent.; (e) Caserta Vecchia, Cathedral, 12th cent.

the scenes from the lives of SS. Alexis and Clement in the lower church of S. Clemente (1095–1106), and a triptych in the Cathedral of Tivoli. As for mosaics, the apse decoration of S. Clemente (X, PL. 194) and of S. Maria in Trastevere (PL. 177) marked a renewal of Early Christian solemnity of style, which paralleled a similar development in architecture.

While 12th-century Roman architecture was marked by a classical revival, other Lombard influences also penetrated Rome. Square campaniles were characteristic structures of the period; each story was decorated with double-arched apertures, and the

of S. Maria Novella in Florence). Even the work of Arnolfo di Cambio (q.v.) had little following in Rome, save in the modest work at the end of the 13th century of Giovanni and Deodato di Cosma, who represent the decline of the Cosmati marbleworkers. Almost no works of art were produced during the 14th century, and even after the return of the papacy, schism and disputes over the reestablishment of papal power precluded all thought of artistic activity until after 1420.

The Renaissance came early to Rome. In fact, at the very time when Gentile da Fabriano (1427) and Pisanello (1431), represent-

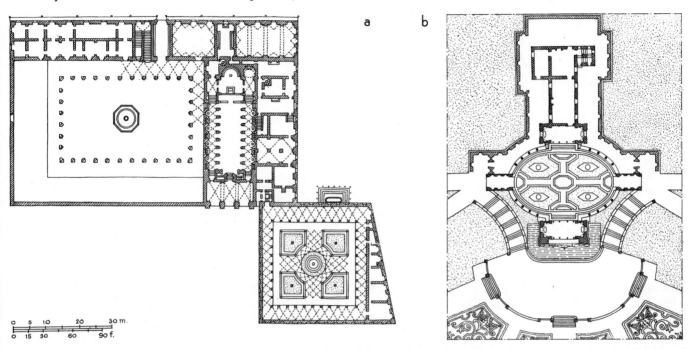

a b

Rome, structures of 15th and 16th cent. (a) Palazzo Venezia, S. Marco and Palazzetto (before dismantling and reconstruction of 1911); (b) Casino of Pius IV, in Vatican Gardens.

basically Lombard manner of construction was softened by the colorful decoration of marble and of majolica plates set into the brick. Similarly typical of this period were cloisters that featured arcades, usually having small painted columns. The marbleworkers who decorated the cloisters, pavements, pulpits, episcopal thrones, and paschal candlesticks of the period are known collectively as the Cosmati (q.v.).

The classicizing movement in Roman painting, rooted in Early Christian and Byzantine art, came to a climax with the artists of the second half of the 13th century. The most important of these was Pietro Cavallini (q.v.). There was in this art an exchange of influences between Florence and Rome. Cimabue, Arnolfo, and Giotto were in Rome for a period after 1272. Roman masters, on the other hand, were active in the Upper Church of S. Francesco in Assisi. Among these artists was Jacopo Torriti, the creator of the apse mosaics of St. John Lateran (1291) and of S. Maria Maggiore (PL. 177) in Rome. Filippo Rusuti, who created mosaics for the façade of S. Maria Maggiore, was a modest follower of Torriti and Cavallini. The effects of the encounter of Roman and Florentine art can also be seen in a triptych (the central panel of which depicts the Saviour) in the Church of S. Andrea, Anagni; in the frescoes of S. Maria in Vescovio, Stimigliano; and in the frescoes of the Sacro Speco, Subiaco (where Conxolus also worked). From Viterbo, where Sienese influence was dominant, came Matteo di Giovanetti, who worked in Avignon (1343–66) with Simone Martini (q.v.) and in that artist's style. Matteo's work substantially represents Latium's contribution to Gothic art.

The removal of the papal seat to Avignon (1309–77) brought artistic activity in Rome to a halt. Consequently Rome has few examples of Gothic architecture (the mere vestige of the Franciscan reconstruction of S. Maria in Aracoeli, and S. Maria sopra Minerva, ca. 1280, modeled after the Dominican Church

atives of the older trends, were summoned to paint in St. John Lateran (the works are lost), Masaccio and Masolino (qq.v.) also went to Rome. Leon Battista Alberti had served as papal abbreviator to Pope Eugenius IV, and perhaps it was Alberti who recommended Bernardo Rossellino to the Humanist pope Nicholas V when the latter first turned his attention to the problem of a new St. Peter's. Fra Angelico and Benozzo Gozzoli (qq.v.) both worked in the Vatican from 1448 to 1450, and after them, in 1459, Piero della Francesca (q.v.; whose Vatican works are lost). It is not certain what works Alberti and Rossellino did execute, but among the possibilities is the Palazzo Venezia (FIG. 413), built after 1455 for Pope Paul II. The tempo of building activity quickened in the second half of the century, especially under Sixtus IV. Important in this activity was the Florentine Baccio Pontelli, who, with another Florentine, Meo del Caprino, was one of the principal creators of the Renaissance style of Roman architecture, examples of which are S. Maria del Popolo (PL. 205), S. Agostino (FIG. 415), S. Pietro in Montorio, the Ponte Sisto, and the Ospedale di Sto Spirito. In the meantime Melozzo da Forlì was working in Rome and, between 1481 and 1483, Domenico Ghirlandajo, Botticelli, Cosimo Rosselli, Piero di Cosimo, Luca Signorelli, Perugino, and Pinturicchio were summoned to decorate the walls of the Sistine Chapel. Pinturicchio executed many other works in Rome in the course of the following decade. Mantegna (1488) and Filippino Lippi (1489–93) also spent some time in Rome. The results for local painting of all these arrivals and departures many be summed up in two names, that of Lorenzo da Viterbo and that of Antoniazzo Romano. The art of Lorenzo da Viterbo represents a mixture of the styles of Benozzo Gozzoli and Piero della Francesca (PL. 204). In the course of his long career, Antoniazzo Romano (whose initial preparation was similar to that of Lorenzo) felt successively

the influences of Melozzo, Ghirlandajo, and even Raphael. In Rome there are works of Antoniazzo in the Pantheon, in the Church of S. Maria sopra Minerva, and in the Vatican Museums (PL. 204). The Church of S. Giovanni Evangelista in Tivoli contains frescoes attributed to Antoniazzo.

Roman sculpture of the early 15th century is modestly represented by the work of Paolo Romano. But the Renaissance

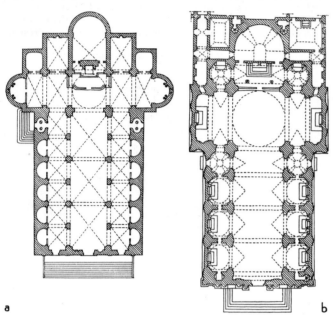

a b

Rome. (a) S. Agostino, second half of 15th cent., plan; (b) S. Andrea della Valle, 16th–17th cent., plan.

sculpture in Rome, represented by an abundant production of tombs and altars, was chiefly the work of Tuscan and Lombard masters. Donatello was in Rome in 1432–33, and Filarete executed his bronze doors for St. Peter's in 1433–45. At this time Isaia da Pisa, whose dry classicizing style was influenced by Michelozzo, settled in the city (PL. 205). Mino da Fiesole first went to Rome in 1463 and returned there after 1470. During his second stay, which lasted about ten years, he did some work in collaboration with Lombard sculptors, of whom the most important was Andrea Bregno. Against this background of mingled Tuscan and Lombard influences, there developed among the lesser men active in the production of funerary monuments a style sufficiently homogeneous to characterize a genuine school. Among these artists were Mino (Dino) del Reame (Regno), who also worked in Naples, and Giovanni Dalmata (Rome, 1460–80; later in Venice and Ancona). Gian Cristoforo Romano, the son of Isaia da Pisa, was a product of this artistic environment, but he soon left Rome to work in Ferrara, Pavia, and Mantua (1498–1505). Also in Rome were two other Lombards of classicizing tendency, Luigi di Giampietro Capponi, who was probably a pupil of Bregno, and the goldsmith and bronzeworker Cristoforo Foppa, known as Caradosso. A substantially higher level of creativity, however, was represented by the works in Rome of Antonio Pollaiuolo (q.v.; tombs of Sixtus IV and Innocent VIII).

At the end of the 15th century Castel Sant'Angelo was fortified (1492–95) by Antonio da Sangallo the Elder, and the Palazzo della Cancelleria was erected. The latter work has been variously attributed, and some credit part of the work to Bramante. It was under the aegis of Bramante, Raphael, and Michelangelo, all employed by Pope Julius II, that the transition from 15th- to 16th-century art occurred, the transition from the Florentine phase of the Renaissance to the Roman and European.

BIBLIOG. A. Ferri, L'architettura in Roma nei secoli XV e XVI, Rome, 1867; E. Müntz, L'art à la cour des papes pendant le XVe et le XVIe siècle, 3 vols., Paris, 1878–82; E. Steinmann, Rom in der Renaissance, Leipzig, 1899; E. Bertaux, Rome de l'ère des catacombes à l'avènement de Jules II,

2 vols., Paris, 1905; L. Filippini, La scultura del Trecento a Roma, Turin, 1908; A. Bertini-Calosso, Le origini della pittura del Quattrocento attorno a Roma, Rome, 1920; R. van Marle, La peinture romaine au moyen âge, Strasbourg, 1921; R. V. Monti, Lineamenti dell'arte medievale in Roma, Rome, 1933; P. Pecchiai, Roma nel Rinascimento, Bologna, 1940; A. Riccoboni, Roma nell'arte: La scultura nell'evo moderno dal Quattrocento ad oggi, Rome, 1942; F. Hermanin, L'arte in Roma dal secolo VIII al XIV, Bologna, 1945; L. Bruhns, Die Kunst der Stadt Rom: Ihre Geschichte von den frühesten Anfängen bis in die Zeit der Romantik, 2 vols., Vienna, 1951; C. Cecchelli, La vita di Roma nel Medioevo, 2 vols., Rome, 1951–60; I. Faldi and L. Mortari, La pittura viterbese dal XIV al XVI secolo (exhibition cat.), Viterbo, 1954; E. Battisti, I comaschi a Roma nel primo rinascimento, Arte e artisti lombardi (ed. E. Arslan), I, Como, 1959, pp. 3–61.

ARTISTS. *Antoniazzo Romano*: late-15th-century painter (A. Gottschewski, Die Fresken des Antoniazzo Romano im Sterbezimmer der heiligen Catarina von Siena zu S. Maria sopra Minerva in Rom, Strasbourg, 1904; O. Okkonen, Note su Antoniazzo Romano e sulla scuola pittorica romana nel '400, L'Arte, XIII, 1910, pp. 51–53; A. Sacchetti-Sassetti, Antoniazzo Marcantonio e Giulio Aquili a Rieti, L'Arte, XIX, 1916, pp. 88–98; R. Longhi, In favore di Antoniazzo Romano, Vita artistica, II, 1927, pp. 226–33; C. Lorenzetti, Nuove documentazioni di forme pittoriche melozziane e antoniazzesche a Napoli, BArte, XXXI, 1937, pp. 180–92). *Antonio (Massari) da Viterbo*, known as *Pastura*: 15th-century painter (E. Steinmann, Antonio da Viterbo, Munich, 1901; U. Gnoli, A Painting of Antonio da Viterbo, Art in America, IX, 1921, p. 24). *Andrea Bregno (Andrea da Milano)*: d. Rome, 1503; Lombard architect and sculptor (E. Lavagnino, Andrea Bregno e la sua bottega, L'Arte, XXVII, 1924, pp. 247–63; H. Egger, Beiträge zur Andrea Bregno Forschung, Festschrift für Julius Schlosser zum 60. Geburtstage, Vienna, 1927, pp. 122–36; A. Paolucci, Monumenti sepolcrali della seconda metà del Quattrocento in Roma, Roma, X, 1932, pp. 525–42). *Luigi di Giampietro Capponi*: active in Rome 1485–96, sculptor (U. Gnoli, Luigi Capponi da Milano: Scultore, Arch. storica dell'arte, VI, 1893, pp. 85–101; F. Negri-Arnoldi, Luigi di Pietro Capponi da Milano, Arte lombarda, VI, 1961, pp. 195–201). *Caradosso (Cristoforo Foppa)*: Mondonico, ca. 1452–ca. 1526, goldsmith and sculptor (A. Venturi, Le primizie del Caradosso a Roma, L'Arte, VI, 1903, pp. 1–6; E. Malaguzzi Valeri, Note sulla scultura lombarda del Rinascimento, Rass. d'arte, V, 1905, pp. 169–73; P. Bondioni, Per la biografia di Caradosso Foppa, Arch. storico lombardo, 8th ser., I, 1948–49, pp. 241–42). *Gian Cristoforo Romano*: 15th–16th-century sculptor and goldsmith (P. Giordani, Studii sulla scultura romana del Rinascimento: Gian Cristoforo Romano a Roma, L'Arte, X, 1907, pp. 197–208). *Giovanni Dalmata (Giovanni da Traù, or Johannes Duknowich de Tragusia)*: b. Trogir, Yugoslavia, ca. 1440; d. Rome, ca. 1509; sculptor (L. Donati, L'attività in Roma di Giovanni Dalmata da Traù, Arch. storico della Dalmazia, X, 1931, pp. 523–34, XI, 1931, pp. 55–66; K. Prijatelj, Profilo di Giovanni Dalmata, Arte antica e moderna, II, 1959, pp. 283–97; J. Balogh, Ioannes Duknovich de Tragurio, Acta historiae artium, VII, 1960, pp. 51–78). *Isaia da Pisa*: active in Rome ca. 1450, sculptor (F. Burger, Isaia da Pisas plastische Werke in Rom, JhbPreussKSamml, XXVII, 1906, pp. 228–44; L. Ciaccio, Scultura romana del Rinascimento, L'Arte, IX, 1906, pp. 165–84, 345–56, 433–41; A. Paolucci, Monumenti sepolcrali della seconda metà del Quattrocento in Roma, Roma, X, 1932, pp. 525–42). *Lorenzo da Viterbo*: mid-15th-century painter active ca. 1479 (C. Ricci, Lorenzo da Viterbo, Arch. storico dell'arte, I, 1888, pp. 26–34, 60–67; C. Ricci, Santi e Artisti, 2d ed., Bologna, 1910, pp. 67–97; A. Podestà, La ricostruzione degli affreschi di Lorenzo da Viterbo, Emporium, CVII, 1948, pp. 68–70; F. Zeri, Un pala d'altare di Lorenzo da Viterbo, BArte, XXXVIII, 1953, pp. 38–44). *Matteo di Giovanetti da Viterbo*: mid-14th-century painter (C. Volpe, Un'opera di Matteo Giovannetti, Paragone, X, 119, 1959, pp. 63–66). *Paolo Romano (Paolo Taccone)*: active ca. 1451–77, sculptor (V. Leonardi, Paolo di Mariano Marmoraro, L'Arte, III, 1900, pp. 86–106, 259–74; Venturi, VI, 1908, pp. 1110–20). *Baccio Pontelli*: b. Florence, 1450; d. Rome, 1495; architect (P. Giordani, Baccio Pontelli a Roma, L'Arte, XI, 1908, pp. 96–112; E. Lavagnino, L'architetto di Sisto IV, L'Arte, XXVII, 1924, pp. 4–13).

THE EMILIAN SCHOOL FROM THE ROMANESQUE PERIOD TO THE 16TH CENTURY. Romanesque art in Emilia was influenced by that of Lombardy. The Cathedral of Modena (begun in 1099 by Lanfranco, who was probably from Como), which served as a model for the Abbey Church of Nonantola and the Cathedral of Ferrara (PL. 171), evidences this influence, as do religious edifices in Piacenza, Cremona, and Parma, cities that were also important because of the activity of Wiligelmo da Modena, Benedetto Antelami (qq.v.), and their schools.

In the Gothic period many non-Emilian architects and sculptors, including Nicola Pisano, Lapo, Arnolfo di Cambio,

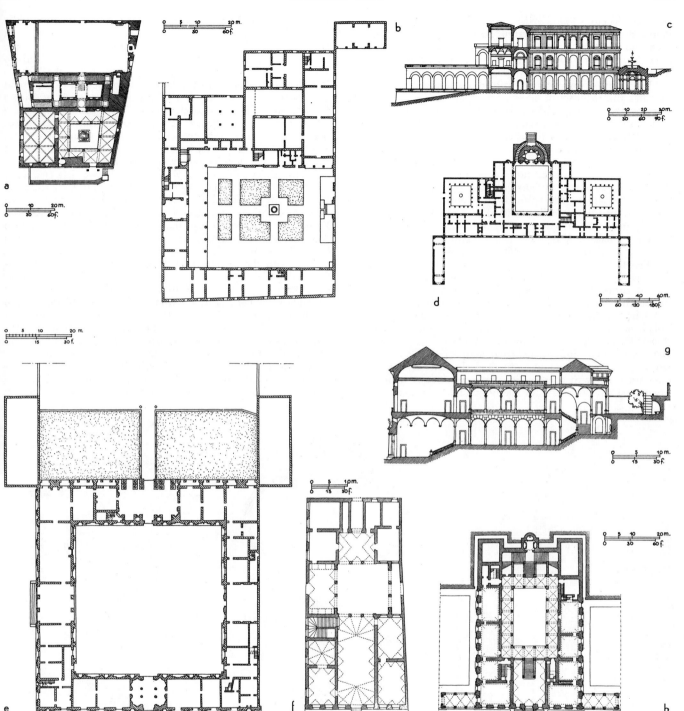

Secular buildings, 14th–16th cent., in northern and central Italy. (*a*) Florence, Palazzo della Signoria (Palazzo Vecchio), 1298–1314, plan; (*b*) Ferrara, Palazzo dei Diamanti (architect: B. Rossetti), plan; (*c, d*) Florence, Palazzo Pitti, begun 1458, transverse section and plan; (*e*) Mantua, Palazzo del Te, 1524–35 (architect: G. Romano), plan; (*f*) Verona, Palazzo Pompei, 1536 (architect: M. Sanmicheli), plan; (*g, h*) Genoa, Palazzo Comunale, 1564 (architect: R. Lurago), transverse section and plan.

and Guglielmo, were summoned to Bologna to work on the tomb of St. Dominic in the Church of S. Domenico (1264–67). In the 14th century the Dalle Masegne went to Bologna. (Pier Paolo dalle Masegne worked on an altar in the Church of S. Francesco there, 1388–92). Later, Jacopo Della Quercia went to Bologna to decorate the façade of S. Petronio (1435–38). Dominican and Franciscan churches were the principal productions of Gothic architecture in Emilia. The French features of the choir, ambulatory, and radial chapels of the 13th-century Church of S. Francesco in Bologna are noteworthy. Later, however, central Italian influence predominated, as evidenced by Antonio di Vincenzo's work for the Church of S. Petronio (1390), which was inspired by Florentine Gothic art. Venetian

elements added soft touches of color to the loggia of the Palazzo della Mercanzia, and Gattapone (Matteo di Giovannello di Maffeo) was called from Gubbio to Bologna to work on the Collegio di Spagna. The Gothic tradition was continued in the work of the Bolognese architect Fioravante di Ridolfo Fioravanti, who designed part of the Palazzo del Comune (1425–28).

The schools of Rimini and Bologna provided several original developments in Emilian painting of the 14th century. From an originally Giottesque tradition and Sienese influences, the painters of Rimini created a style of great refinement (fragile architectural backgrounds, elongated figures, and delicate touches of color and ornament), which penetrated as far as the Marches

and the Veneto. These artists, prominent among whom were Pietro da Rimini and Giovanni Baronzio (PL. 180), painted such important fresco cycles as those in Pomposa (in the abbey refectory), Rimini (S. Agostino), Ravenna (S. Chiara), and Tolentino (the Chapel of St. Nicholas, S. Nicola da Tolentino).

Traditions of international culture centering in the university and the manuscript scriptorium that served it fostered a painting style that combined the Gothic sense of fantasy with acute observation of nature and human affairs. Vitale da Bologna (q.v.; VI, PL. 352) was the special master of this style in the first half of the 14th century. The problematical Dalmasio headed a movement receptive to Florentine culture in the second half of the 14th century. Contemporaneously, Jacopino de' Bavosi, who was initially inspired by the art of Rimini, opened the way to the spirited, folk-rooted expressionism of Bolognese painting, which persisted into the 15th century (especially in the art of Giovanni da Modena; VI, PL. 383). Bolognese art had some repercussions in Tuscany (where Barnaba da Modena worked; PL. 188). The art of Bologna also influenced the Veneto and, by the naturalism of the art of Tommaso da Modena (q.v.; VI, PL. 361), the entire Po Valley.

Fifteenth-century Emilian architecture turned to Tuscan models (the work of Alberti in Ferrara and Rimini; the Biblioteca Malatestiana in Cesena by Matteo Nuti, 1452; the Casa Isolani in Bologna by Pagno di Lapo Portigiani, a follower of Donatello, ca. 1455; the Cathedral of Faenza by Giuliano da Maiano, ca. 1476–86). In Bologna, however, Emilian architecture acquired a remarkably individual character by combining a certain majesty in construction with picturesque handling of ornamental brickwork and the use of ground-floor arcades (e. g.,

Palazzo Fava). Between 1470 and 1490 were constructed the two most important examples of Renaissance architecture in Bologna, the Palazzo del Podestà (whose reconstruction some attribute to a design of Aristotele di Fioravante di Ridolfo Fioravanti, who was later active in Moscow) and the Palazzo Bevilacqua. Elements in the latter (the rusticated exterior and the courtyard) recall aspects of the severest work of Biagio Rossetti of Ferrara, the architect and town planner of Ercole d'Este (Ferrara, the Palace of Ludovico il Moro; the Palazzo dei Diamanti: FIG. 417; the churches of S. Francesco, 1494, and of S. Maria in Vado, begun 1495). In Parma, a high point of 15th-century architecture was marked by Bernardino Zaccagni the Elder's Church of S. Giovanni Evangelista (PL. 200), which bears some similarity to the Cathedral of Faenza by Giuliano da Maiano. The Church of the Madonna della Steccata (1521–39; FIG. 419) by Zaccagni and his son Giovan Francesco, however, reveals the influence of Bramante. Alessio Tramello of Piacenza reflected a similar influence in the Church of the Madonna di Campagna (1522–28) and was probably in contact with the architectural circles of Rome, which also influenced the Bolognese palace architecture of this period (Palazzo Fantuzzi, 1517–32). The Palazzo Albergati is attributed to Baldassarre Peruzzi (q.v.), who worked in Carpi for the Pio family (from 1514). One of Peruzzi's Bolognese pupils, Sebastiano Serlio, marked the way for the development of 16th-century taste; his influence is apparent in the Palazzo dei Banchi by Vignola. Local 16th-century architects included Andrea da Formigine (Andrea di Pietro Marchesi) and Antonio di Bernardino Morandi, known as Terribilia (the cloister of S. Giovanni in Monte, 1545–48, now a prison; the Palazzo Marconi;

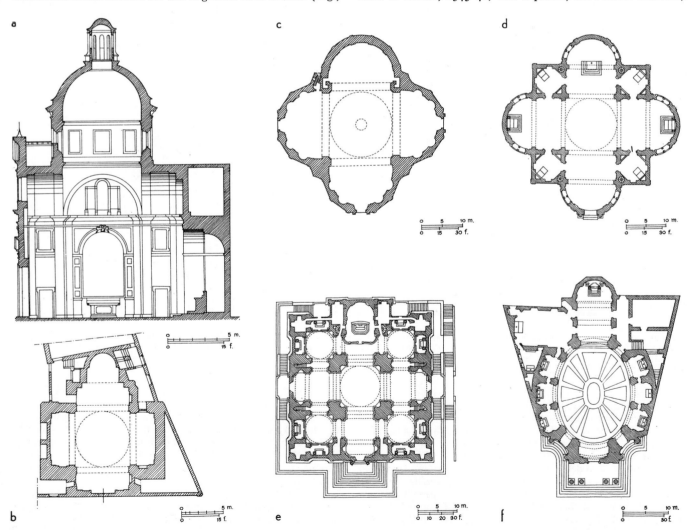

Central-plan churches, 16th and 17th cent. (*a, b*) Rome, S. Eligio degli Orefici, designed by Raphael, transverse section and plan; (*c*) Todi, S. Maria della Consolazione, plan; (*d*) Parma, Madonna della Steccata, constructed by the Zaccagnis, plan; (*e*) Genoa, S. Maria Assunta di Carignano, designed by G. Alessi, plan; (*f*) Rome, S. Maria di Montesanto (designed by C. Rainaldi), plan.

the Archiginnasio, 1562–63). Emilian architecture was also influenced by Pellegrino Tibaldi, who worked in Bologna, and Palladio, to whom are attributed the designs for the façade and courtyard of the Palazzo di Giustizia.

In sculpture, after Jacopo Della Quercia's heroic Humanist work for S. Petronio in Bologna, the impact of the Renaissance was felt in Ferrara in the work of the Florentine Niccolò Baroncelli (the horse of the monument to Nicholas III and the bronze figures of the Crucifixion, Ferrara, Cathedral, 1451) and the Paduan Domenico di Paris (statues in the Cathedral, 1466); the sculpture of both was a Paduan interpretation of Donatello. Agostino di Duccio worked as a young man in Modena in 1442; he worked for some years in Rimini (1447–54) and returned to Bologna in 1463. Francesco di Simone Ferrucci, who also worked in Forlì and Rimini, brought the Florentine type of tomb to S. Domenico in Bologna (Tartagni tomb, 1477). The Cathedral of Faenza houses the beautiful shrine of St. Terentianus (of undetermined attribution) and the shrine of St. Savinus by Benedetto da Maiano (1474–76). Thus, Florence provided the principal external influence on Emilian Renaissance sculpture, but its effects on local sculptors were limited until the appearance of Niccolò da Bari, known as Niccolò dell'Arca (after his work on the arca, or tabernacle, of S. Domenico in Bologna, 1469–73). Combining Tuscan and, later, Ferrarese influences with an essentially Franco-Burgundian cultural background, he produced a style of passionately intense expression that fitted easily into the Emilian tradition (e.g., a terra-cotta Pietà in S. Maria della Vita, Bologna). Based on Niccolò's art was that of Guido Mazzoni of Modena, who was noted for his life-size groups in polychrome terra cotta, scattered throughout Emilia and beyond (PL. 200). A somewhat vague Roman influence, with occasional Venetian elements, was manifested in the work of Alfonso Lombardi of Ferrara, who continued the Emilian terra-cotta tradition (*Death of the Virgin*, 1522, Bologna, Oratorio di S. Maria della Vita), and in that of Antonio Begarelli of Modena, who was partially influenced by Lombardi (many works in Modena). The effects of Florentine mannerism were seen in Bologna in Niccolò Tribolo's work on the side doors for S. Petronio, about 1530, and in Giambologna's reelaboration of classical motifs (*Neptune*, 1563; IX, PL. 308).

Ferrara was the center of the most vital and influential artistic developments in Emilian art of the 15th century. The Este court encouraged art by offering hospitality, in the period 1430–50, to such important painters as Pisanello, Jacopo Bellini, Piero della Francesca, Mantegna, and Rogier van der Weyden (qq.v.). Paduan culture influenced Bono da Ferrara and Ansuino da Forlì, who worked with Mantegna in the Church of the Eremitani in Padua, and filtered into the dramatic temperament of Cosmè Tura (q.v.), who was originally associated with the followers of Squarcione, as was Marco Zoppo of Bologna (PL. 197). The gloomy metallic splendor of Tura's paintings, expressions of intense visionary torment, was softened in the work of Francesco del Cossa (q.v.) into a crystalline limpidity that recalls Piero della Francesca. Cossa's art was followed by the sharp and elegant stylizations of Ercole de' Roberti (q.v.). The work of the Ferrarese artists Tura and Cossa dominated the Bolognese scene after 1470. Lorenzo Costa (PL. 201), initially one of their followers, was later influenced by Umbrian art and the uniform placidity of the style of Francesco Francia of Bologna (PL. 201); he worked primarily in Bologna. With these painters, another wandering Bolognese, Amico Aspertini, and the Modenese Francesco de' Bianchi-Ferrari, Emilian painting entered the 16th century.

Melozzo da Forlì achieved a solid synthesis of the lessons of Piero and Mantegna in Humanism and perspective. A contemporary of the three great Ferrarese, he worked chiefly in Rome, but also in Urbino, Loreto, Ancona, and Forlì. Melozzo's assistant, Marco Palmezzano, was influenced by Venetian culture. In Ravenna, Nicolò Rondinello and Lattanzio da Rimini followed Giovanni Bellini, while Bernardino and Francesco di Bosio Zaganelli worked in a belated 15th-century style.

The school of Ferrara retained its vitality in the 16th century through the work of Ortolano (Giovanni Battista Benvenuti) and Garofalo (Benvenuto Tisi; PL. 217), who were influenced by Venetian, Roman, and Cremonese art. Dosso Dossi (q.v.) was of greater importance, however. Combining the Ferrarese tradition with those of Venice and Brescia, his imagination, akin to that of the poet Ariosto, produced an art of magic and exorcisms, which he rendered in sumptuous color (PL. 212).

In the 17th century Parma dominated Emilian painting, as had Bologna in the 14th century and Ferrara in the 15th. In Parma flourished the luminous art of Correggio (q.v.), who figured among the great artists of the Renaissance and exerted a notable influence on later artists. Michelangelo Anselmi of Siena was noteworthy among Correggio's numerous followers. Parmigianino (q.v.), however, because of his originality and mannerist vigor, cannot accurately be numbered among the followers of Correggio, though he was fascinated by the latter's art and drew from it elements which he incorporated into the intellectual and somewhat anguished elegance of his own particular vision. Parmigianino expressed his vision with keen sensitivity in portraits and engravings (IV, PL. 428; X, PL. 388). The work of Girolamo Mazzola-Bedoli (IX, PL. 301) showed qualities of both Parmigianino and Correggio.

These two painters of Parma also influenced art in Bologna, freshening the stagnant environment created by mediocre painters such as Bagnacavallo (Bartolomeo Ramenghi). Parmigianino and Correggio revitalized the mannerist style, which absorbed contemporary Roman influences through Giulio Romano. Mannerism was subsequently taken to Fontainbleau by the Bolognese Francesco Primaticcio (1532) and later (1552) by his Modenese follower Niccolò dell'Abate (PL. 217; IV, PL. 415; IX, PLS. 299, 301). After Niccolò's departure, Pellegrino Tibaldi brought to Bologna the Michelangelesque style, displayed in his frescoes in the Archiginnasio and the Accademia delle Scienze (IX, PL. 298). Lelio Orsi, an imaginative mannerist painter of note, active in Reggio Emilia, depicted subtle artifices with dramatic luminosity (IX, PL. 301). His pupil Raffaello Motta (Raffaellino da Reggio) worked primarily in Rome.

SCHOOL OF BOLOGNA. *a. Bibliog.* I. B. Supino, La scultura in Bologna nel secolo XV, Arch. storico dell'arte, III, 1890, pp. 281–95; F. Malaguzzi Valeri, Documenti per la storia dell'arte in Bologna, Arch. storico dell'arte, N.S., I, 1895, pp. 124–26; F. Malaguzzi Valeri, L'architettura a Bologna nel Rinascimento, Rocca San Casciano, 1899; F. Malaguzzi Valeri, Contributo alla storia della scultura a Bologna nel Quattrocento, RepfKw, XXII, 1899, pp. 279–99; R. Baldani, La pittura a Bologna nel secolo XIV, Bologna, 1908; R. Longhi, La mostra del Trecento a Bologna, Paragone, I, 5, 1950, pp. 5–44; R. Longhi, ed., Mostra di pittura bolognese del secolo XIV (exhibition cat.), Bologna, 1950; R. Bernheimer, Gothic Survival and Revival in Bologna, AB, XLVI, 1954, pp. 263–84.

b. Artists. Dalmasio: d. 1410, painter (C. Ricci, Una pittura di Lippo Dalmasio, Arte e storia, III, 1884, pp. 212–13; E. Mauceri, Lippo Dalmasio, Il Comune di Bologna, XX, 2, 1933, pp. 5–10). *Jacopino de' Bavosi*: late-14th-century painter, also active in Pavia 1365–83 (L. Frati, Jacopino de' Bavosi: Pittore bolognese del secolo XIV, L'Arte, XVII, 1914, pp. 393–95; W. Arslan, Jacopo de' Bavosi e Jacopo Avanzi, Il Comune di Bologna, XVIII, 1, 1931, pp. 3–14). *Simone dei Crocefissi*: active 1355–99, painter (E. Sandberg-Vavalà, Vitale delle Madonne e Simone dei Crocifissi, RArte, XII, 1929, pp. 449–80, XIII, 1930, pp. 1–36; I. Patrizi, Nota su Simone dei Crocifissi, CrArte, N.S., II, 1955, pp. 249–57). *Vitale da Bologna* (q.v.).

SCHOOL OF FERRARA. *a. Bibliog.* G. Baruffaldi, Le vite de' pittori e scultori ferraresi, 2 vols., Ferrara, 1844–46; G. Campori, I pittori degli estensi nel secoldo XV, Atti Dep. storia patria, prov. modenesi e parmensi, 3d ser., III, 2, 1886, pp. 525–85; G. Gruyer, L'art ferrarais à l'époque des princes d'Este, 2 vols., Paris, 1897; H. J. Hermann, Zur Geschichte der Miniaturmalerei am Hofe der Este und Ferrara, JhbKSammlWien, XXI, 1900, pp. 117–272; G. Zippol, Artisti alla corte degli Estensi nel '400, L'Arte, V, 1902, pp. 405–06; A. Venturi, Maestri ferraresi del Rinascimento, L'Arte, XI, 1908, pp. 419–32; E. Gardner, The Painters of the School of Ferrara, London, New York, 1911; Mostra della pittura ferrarese del Rinascimento (exhibition cat.), Ferrara, 1933; B. Nicolson, The Painters of Ferrara, London, 1950; R. Longhi, Officina ferrarese, rev. ed., Florence, 1956; M. Salmi, Arte e cultura artistica nella pittura del primo Rinascimento a Ferrara, Rinascimento, IX, 1958, pp. 123–29; M. Salmi, Echi della pittura nella miniatura ferrarese del Rinascimento, Comm, IX, 1958, pp. 88–98.

b. Artists. Lorenzo Costa: d. Mantua, 1535, painter (A. Venturi, Lorenzo Costa, Arch. storico dell'arte, I, 1888, pp. 241–56; H. Bodmer, Lorenzo Costa, Pantheon, XXV, 1940, pp. 141–45; M. Calvesi, Nuovi affreschi ferraresi dell'Oratorio della Concezione, II, BArte, XLIII, 1958, pp. 309–28). *Dossi* (q.v.). *Garofalo (Benvenuto Tisi)*: Ferrara, 1481–1559, painter (A. Neppi, Il Garofalo, Milan, 1959). *Ludovico Mazzolino*: Ferrara, ca. 1480–ca. 1530, painter (G. Baruffaldi, Vite, I, Ferrara, 1844, pp. 126–31; A. Venturi, Ludovico Mazzolino, Arch. storico dell'arte, III, 1890, pp. 445–59). *Ortolano (Giovanni Battista Benvenuti)*: Ferrara, 1488–1525(?), painter (W. R. Valentiner, Three Ferrarese Paintings, B. Detroit Inst. of Arts, XII, 1930–31, pp. 65–70; G. Frabetti, L'Ortolano nella critica fino al tardo '800, Atti Seminario int. di Storia dell'arte, Pisa, 1954, pp. 180–86). *Biagio Rossetti*: d. Ferrara, 1516; architect (B. Zevi, Biagio Rossetti, architetto ferrarese: Il primo moderno europeo, Turin, 1960). *Marco Zoppo*: b. Cento, 1433; d. Venice, 1478; painter (I. B. Supino, Nuovi documenti su Marco Zoppo, pittore, L'Archiginnasio, XX, 1925, pp. 128–32; G. Fiocco, Un libro di disegni di Marco Zoppo, Misc. Supino, Florence, 1933, pp. 337–51; J. Kühnel-Kunze, Zum Werk des Marco de Rugeri gen. Lo Zoppo, ZfKw, I, 1947, pp. 98–104).

SCHOOL OF MODENA. *a. Bibliog.* T. Lancillotto, Catalogo di modenesi illustri, Modena, 1543 (new ed. reviewed by A. Venturi, L'Arte, XXV, 1922, pp. 27–33); L. Vedriani, Raccolta de' pittori, scultori, e architetti modenesi più celebri, Modena, 1662; G. Tiraboschi, Notizie di pittori, scultori, incisori ed architetti nati negli Stati del Serenissimo Duca di Mantova, Modena, 1786; G. Campori, Delle opere di pittori modenesi che si conservano nella Galleria degli Uffizi in Firenze, Florence, 1845; A. Venturi, La pittura modenese nel secolo XV, Arch. storico dell'arte, III, 1890, pp. 379–96; G. Forghieri, La pittura a Modena dal XIV al XVIII secolo, Modena, 1953.

b. Artists. Barnaba da Modena: late-14th-century painter (C. Ricci, Barnaba da Modena, BM, XXIV, 1913–14, pp. 65–69; R. Longhi, Una "Santa Caterina" di Barnaba da Modena, Paragone, XI, 131, 1960, pp. 31–33). *Guido Mazzoni*: d. 1518, sculptor (A. Pettorelli, Guido Mazzoni da Modena, Turin, 1925; C. Gnudi, L'arte di Guido Mazzoni: Problemi e proposte, Atti e Mem. Dep. prov. modenesi, IV, 1952, pp. 98–111). *Tommaso da Modena* (q.v.).

SCHOOL OF RIMINI. *a. Bibliog.* G. B. Costa, Notizie dei pittori riminesi: Lettere al Co. F. Algarotti, Rimini, 1762; C. Yriarte, Les arts à la cour Malatesta au XV^e siècle, GBA, XIX, 1879, pp. 19–47, 122–46, 444–75; C. Grigioni, Per la storia della scultura in Rimini nel secolo XV, Rass. bibliog. dell'arte it., XVII, 1914, pp. 44–46; M. Salmi, La scuola di Rimini, RIASA, III, 1931–32, pp. 226–67, IV, 1932–33, pp. 145–201; C. Brandi, Sulle pitture del trecento riminese, CrArte, I, 1935–36, pp. 229–37; M. C. Ferrari, Contributo allo studio della miniatura riminese, BArte, XXXI, 1938, pp. 447–61; M. Salmi, Ancora della pittura riminese, RArte, XX, 1938, pp. 93–94; A. Medea, L'iconografia della scuola di Rimini, RArte, XXII, 1940, pp. 1–50; S. Bottari, I grandi cicli di affreschi riminesi, Arte antica e moderna, I, 1958, pp. 130–45.

b. Artists. Giovanni Baronzio: active ca. 1345, painter [L. Romiti, L'opera di Giovanni Baronzio nella Romagna e nelle Marche, L'Arte, XXXI, 1928, pp. 215–29; C. Brandi, Giovanni da Rimini e Giovanni Baronzio, CrArte, II, 1937, pp. 193–99; P. Toesca, Schedula per Giovanni Baronzio da Rimini, Essays in Honor of Georg Swarzenski (ed. O. Goetz), Chicago, 1952, pp. 66–69]. *Francesco da Rimini*: active ca. 1350, painter (M. Salmi, Francesco da Rimini, BArte, XXVI, 1932–33, pp. 249–62; L. Pasquini, Un'attribuzione a Francesco da Rimini, Melozzo da Forlì, III, 1938, pp. 151–52). *Lattanzio da Rimini*: doc. 1495–1527, painter (B. Berenson, Giovanni Martini and Lattanzio da Rimini, in Venetian Painting in America: The 15th Century, New York, 1916, pp. 227–31; G. Fiocco, Piccoli maestri: Lattanzio da Rimini, BArte, N.S., II, 1922–23, pp. 363–70). *Pietro da Rimini*: early-14th-century painter (A. Moschetti, Giuliano e Pietro da Rimini a Padova, B. Mus. Civico di Padova, XXIV, 1931, pp. 201–07).

SCHOOL OF THE ROMAGNA. *a. Bibliog.* G. V. Marchetti, Vitae illustrium forlivensium, Forlì, 1726; M. Oretti, Pitture nella città di Forlì descritte dal Cav. Carlo Cignani…, Forlì, 1757; C. Ricci, Per la storia della pittura forlivese, L'Arte, XIV, 1911, pp. 18–92; L. Coletti, Sull'origine e sulla diffusione della scuola pittorica romagnola nel Trecento, Dedalo, XI, 1930–31, pp. 197–217, 291–312; Catalogo della mostra di Melozzo e del Quattrocento romagnolo (exhibition cat.), Forlì, 1938.

b. Artists. Marco Palmezzano: Forlì, ca. 1455–1539, painter (C. Grigioni, Marco Palmezzano pittore forlivese nella vita, nelle opere, nell'arte, Faenza, 1956; E. Golfieri, In margine al V centenario della

nascita di Marco Palmezzano, Arte veneta, XI, 1957, pp. 246–47; Mostra delle opere di Marco Palmezzano in Romagna: Forlì, 1957, exhibition cat., Faenza, 1957). *Francesco di Bosio Zaganelli*: Cotignola, ca. 1470–ca. 1509, painter (W. Suida, Francesco Zaganelli von Cotignola und die deutsche Kunst, ZfbK, LXI, 1930–31, pp. 248–51).

OTHER EMILIAN ARTISTS. *Niccolò dell'Abate*: b. Modena, 1512; d. Fontainebleau, 1571, painter (H. Bodmer, L'attività di Niccolò dell'Abbate a Bologna, Il Comune di Bologna, XXI, 1934, 9, pp. 37–54, 12, pp. 31–49; W. Arslan, Osservazioni su Niccolò dell'Abbate, Paris Bordone, Forabosco, Le Arti, I, 1938–39, pp. 76–81; S. Beguin, L'école de Fontainebleau: Le manierisme à la cour de France, Paris, 1960, pp. 57–68). *Niccolò dell'Arca (Niccolò da Bari)*: late-15th-century sculptor (C. Gnudi, Niccolò dell'Arca, Turin, 1942; P. Toesca, On Niccolò dell'Arca, AQ, XIX, 1956, pp. 271–77). *Raffaello Motta (Raffaellino da Reggio)*: d. Rome, 1578; painter (F. Malaguzzi Valeri, Notizie di artisti reggiani: 1300–1600, Reggio Emilia, 1892; I. Faldi, Contributi a Raffaellino da Reggio, BArte, XXXVI, 1951, pp. 324–33). *Pellegrino Tibaldi*: b. Bologna, 1527; d. Milan, 1596; painter, sculptor, architect (G. Briganti, Il manierismo e Pellegrino Tibaldi, Rome, 1945; F. Bologna, Inediti di Pellegrino Tibaldi, Paragone, VII, 73, 1956, pp. 26–30; A. Peroni, Contributi a Pellegrino architetto: La ricostruzione di S. Maria a Puria e il S. Fedele di Milano, Arte lombarda, III, 2, 1958, pp. 84–97; P. Rotondi, Ipotesi sui rapporti Cambiaso-Tibaldi, BArte, XLIII, 1958, pp. 164–70). *Bernardino Zaccagni the Elder*: 15th–16th-century architect (M. Salmi, Bernardino Zaccagni e l'architettura del Rinascimento a Parma, BArte, XII, 1918, pp. 85–109).

VENETIAN ART FROM THE ROMANESQUE PERIOD TO THE 16TH CENTURY. The geographical isolation of Venice and its maritime contacts with the Adriatic and the eastern Mediterranean fostered Venice's attachment to Ravennate and Byzantine styles and the coloristic, rather than modeled, treatment of architecture. While such Romanesque centers of the Venetian mainland as Verona reflected Lombard and Emilian architecture, S. Marco in Venice (11th cent.), the Cathedral in Murano, and S. Fosca in Torcello (PL. 174; FIG. 424) were uniquely Byzantine and eastern. A predilection for the airy spaciousness of porticoes and loggias, stilted arches, picturesque façade tracery, and chromatic decoration with marble and mosaics were continuing and characteristic elements of Venetian architecture.

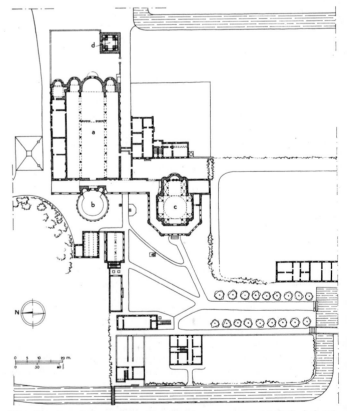

Torcello, plan of the nucleus of medieval monuments. (*a*) Cathedral, 7th, 9th, and 11th cent.; (*b*) Baptistery, 7th cent.; (*c*) S. Fosca, 11th cent.; (*d*) Campanile, 9th cent. (*from B. Schulz, Torcello, Berlin, 1927*).

The 13th century marked the beginning of Venice's expansion into broader political and cultural relations with the rest of Italy and western Europe. But this was reflected before 1200, in the mosaics of S. Marco and the Cathedral of Torcello, and more clearly in the first half of the 13th century, in the expressionistic mosaics of the Passion of Christ and the Romanesque naturalistic scenes from Genesis. In the latest of these mosaics, a return to Byzantine feeling coincided with formal characteristics that became integral parts of the Gothic style. There was a comparable development in 13th-cen-

(polyptych in S. Giacomo Maggiore), where he was later followed by Lorenzo Veneziano (1368) and Jacobello di Bonomo, who painted the polyptych in the Palazzo Comunale in Santarcangelo di Romagna (1385). These painters were the vanguard of the 14th-century extension of Venetian art along the Adriatic coast as far as Apulia. In the 14th-15th centuries, influences from northern Europe, another periodic "constant" in the artistic culture of the Venetian republic, were evident in the work of such Venetian artists as Niccolò di Pietro and Zanino di Pietro.

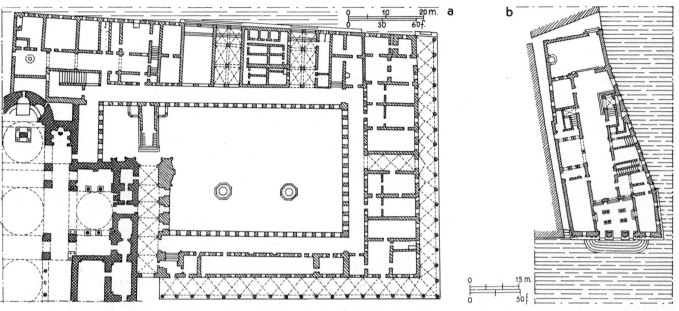

Venice. (a) Doges' Palace, plan of ground floor, 14th-15th cent.; (b) Palazzo Grimani (now Court of Appeals), plan of ground floor, begun 1556 (designed by Sanmicheli).

tury Venetian sculpture (the main portal of S. Marco), in which elements deriving from Antelami were accompanied by classicizing Byzantine rhythms.

In the Gothic Church of S. Antonio in Padua (PL. 174) the northern European type of ambulatory with radiating chapels was combined with Venetian domes of eastern type. Wall surfaces of churches in Verona (S. Fermo Maggiore) and Treviso (S. Nicolò) were treated pictorially, an interpretation of the new Venetian style. The greatest monuments of this style in the 14th century were the Dominican Church of SS. Giovanni e Paolo (FIG. 379) and the Franciscan Church of S. Maria Gloriosa dei Frari in Venice. They are marked by clarity and solemnity in their expansive treatment of space. In secular architecture, the taste for administrative buildings with an arcade on the ground floor, a taste congenial to Venice, was given a chromatic interpretation in the extremely original Doges' Palace (FIG. 425; VI, PL. 340).

The isolationist and conservative tendencies of Venice were distinctly evident in its painting. Despite Giotto's activity in Padua, 14th-century Venetian painting did not participate in the Giottesque renewal and, at most, was only indirectly affected by it. Until past mid-century the aristocratic "Grecism" of Paolo Veneziano (VI, PL. 346) remained the most noble expression of Venetian painting (Dormition of the Virgin, Vicenza, Mus. Civ., 1333; cover of the Pala d'Oro, Venice, S. Marco, ca. 1345). Nevertheless, echoes of two styles eventually penetrated Venice — that of Emilia, and that of Tuscany. The Emilian current was centered in Treviso, and the Tuscan, based in Padua, was later augmented by the current stemming from Verona.

There was a reciprocal exchange of influences. In addition to masters from Rimini, artists who went north from Emilia were Vitale (who worked at the Cathedral in Udine and probably in the Dominican church in Bolzano), Tommaso da Modena (to Treviso), and Barnaba da Modena and Giovanni da Bologna (to Venice). Meanwhile Paolo Veneziano went south to Bologna

The artistic exchange between Padua and Venice was due principally to Guariento (PL. 188) and Nicoletto Semitecolo. The former was called from Padua to Venice to fresco the "Paradiso" in the Doges' Palace (1365–67). The latter went from Venice to Padua, where he painted the scenes from the life of St. Sebastian (Cathedral, 1367). Somewhat later, the work in Padua of the Florentine Giusto de' Menabuoi represented an infusion of Giottesque and Lombard influences, work characterized by a slow, grave monumentality (Baptistery, 1376). His counterpart may be considered Antonio Veneziano, who went to work in Tuscany (Pisa, Camposanto). Po Valley–Venetian art of the late 14th century is seen at its best in the creations of the Veronese Altichiero (q.v.), who worked in Padua; local Veronese painting was represented by Turone (polyptych, Mus. di Castelvecchio) and other minor artists.

The development of Venetian sculpture proceeded pari passu with that of Venetian civilization. Both responded slowly to the moods of the surrounding world and turned from the values of traditional archaism to late Gothic qualities. The end of the 14th century saw the appearance of Pier Paolo dalle Masegne's refined, ornately graceful style (altar in S. Francesco in Bologna, 1388–92) and the ruder force of his brother Jacobello (VI, PL. 368).

Through the middle of the 15th century, the Venetian area, within the framework of the extensive artistic complex of the Po Valley and Lombardy, participated in the International Gothic style, with particularly notable results in Veronese painting and Venetian stonework. Verona, in fact, was one of the foremost centers of late Gothic painting, because of the work of Pisanello (q.v.) and the Veronese master Stefano da Zevio (I, PL. 380; IV, PL. 269; VI, PL. 372). Stefano interpreted northern motifs in an Italianized idiom which approached the style of Gentile da Fabriano (q.v.). In Venice, Gentile (followed there by Pisanello about 1417) incorporated the most vital features of 14th-century Po Valley painting (Tommaso da Modena and Altichiero) with the new International style and exer-

cised a determining influence on this area of Venetian painting, which included Jacobello del Fiore (scenes from the life of St. Lucy, Fermo, Pin.) and Michele Giambono (painting of St. Chrysogonus, Venice, S. Trovaso).

Contemporaneously, the artists in stone, who generally were masters both in sculpture and architecture as complementary elements in a single decorative enterprise, created the "flowery" style typical of Venice's taste for pictorial values. Fine examples of this style are the decoration of the Doges' Palace (begun at the beginning of the 15th century and continued well into the 16th), the crowning of the façade of S. Marco, and the Ca' d'Oro (VI, PL. 338). The collaboration of Lombard, Tuscan, and Venetian artists (which often consisted of family workshops) led to the achievement of this total "Venetian quality." Matteo Raverti from Milan worked on S. Marco and the Ca' d'Oro (begun in 1421); the Florentines Nicolò di Piero Lamberti and Piero di Nicolò di Piero Lamberti, on the crowning of S. Marco; and the Venetians Giovanni and Bartolomeo Bono, on the Doges' Palace, the Porta della Carta (1438), and the Ca' d'Oro. The Brenzoni monument (1427) in Verona (S. Fermo) was executed by another Florentine, Nanni di Bartolo, known as Il Rosso (q.v.), to whom is also attributed the handsome capital with the depiction of the Judgment of Solomon in the Doges' Palace. (Others attribute this capital to Pietro Lombardo.) Giorgio da Sebenico, a follower of the Bonos, introduced this style to Ancona.

Venetian art in the second half of the 15th century thrived for two decades on the legacy of the first, through the work of the Lombard Antonio Bregno, once a collaborator of the Bonos (the Foscari Arch in the Doges' Palace; the Foscari monument in S. Maria Gloriosa dei Frari, 1457, done with his brother Paolo). Later emerged the latent contrast between the substantially "modern" attitude of such original talents as the Veronese Antonio Rizzo and the Bergamask Mauro Coducci, on the one hand, and, on the other, the more narrowly decorative attitude that was adopted by Pietro Lombardo and his sons Antonio and Tullio. The latter view evoked the description "Lombardesque" as applied to the precious and traditionalist, though superficially Renaissance, style of such buildings as the Palazzo Dario (PL. 198) and the Church of S. Maria dei Miracoli (1489). Such works as the Foscari Arch in the Doges' Palace and the side of the court with the Scala dei Giganti united these artists — from Bregno to Rizzo (the Arch), from Rizzo to Pietro Lombardo (the Scala; PL. 198) — in a stylistic continuity. Rizzo (the tomb of Doge Nicolò Tron; PL. 198) and Bregno received their artistic initiation in Lombardy at the Certosa of Pavia; Rizzo, who was also sensitive to the plastic rigor of pure Renaissance forms, executed the extremely beautiful statues of Adam and Eve in the Foscari Arch. In contrast, Pietro Lombardo sought an analytical and decorative finesse (Malipiero and Mocenigo monuments, ca. 1480, in SS. Giovanni e Paolo), as did his son Tullio in the overly renowned statue of Guidarello Guidarelli (1525, Ravenna, Acc.).

Donatello's (q.v.) activity in Padua contributed to the creation of a particular style in sculpture, elements of which have been credited to Andrea Mantegna (q.v.). Agostino dei Fonduti, later active in Milan, was trained in this sculptural style. Donatello's influence is evident in the pictorial qualities of Niccolò Pizzolo's work (e.g., the terra-cotta altar, Padua, Church of the Eremitani) and in that of Bartolomeo Bellano, who interpreted Donatello's sense of drama with a noble, expressionistic freedom (Padua, reliefs in S. Antonio; Roccabonella monument in S. Francesco, 1498). In the 16th century, Andrea Briosco, known as Riccio, expressed the naturalistic vein of the Paduan ambient in his small mythological bronzes inspired by antiquity.

Mauro Coducci's architecture was unique. It authentically affirmed the Venetian version of the sculptural and spatial concepts of the Tuscan Renaissance and assimilated derivations from Michelozzo and Alberti (S. Michele all'Isola, begun 1469, PL. 198; FIG. 392; S. Maria Formosa, begun 1492; S. Giovanni Crisostomo; the Corner Spinelli and Vendramin Calergi palaces, both ca. 1500, where the traditional loggia ambulatories were

replaced by twin-arched windows). The traditional, conservative "picturesque" style survived in the 16th-century work in the court of the Doges' Palace and, later, in the Procuratie Vecchie (1514) and the Scuola di S. Rocco (begun in 1517) by Bartolomeo Bono the Younger. A fugitive from the sack of Rome in 1527, the Florentine Jacopo Sansovino, gave the needed impetus to the development of 16th-century Venetian architecture and became the dominant figure there, as both architect and sculptor. His light and serene classicism was innately disposed to merge with the pictorial qualities of the Venetian tradition, to which he imparted an organic clarity and consistency full of movement and elegance (S. Francesco della Vigna; Palazzo Corner, now Ca' Grande, 1537; Libreria Vecchia di S. Marco, begun 1536; the small loggia of the campanile; the sculpture of the Madonna and the reliefs for the loggetta, 1540-45; the statues of the Evangelists inside S. Marco; the bronze gate of the sacristy, PL. 214).

Sansovino's pictorial luminism was adapted to such mannerist sculpture as the reliefs of Tiziano Minio for the baptismal font in S. Marco. Danese Cattaneo from Carrara was a noteworthy portraitist, as was Alessandro Vittoria of Trent, whose pictorial eloquence in the second half of the 16th century prefigured baroque dynamism.

In architecture, the "Romanism" of Sansovino was combined with other Roman influences. That of Peruzzi is especially evident in the work of Gian Maria Falconetto of Verona (the Loggia Cornaro, Padua; the Villa dei Vescovi, Luvigliano). The Veronese Michele Sanmicheli (q.v.), who worked with Antonio da Sangallo the Younger in Rome, later followed Serlio's mannerist pictorialism, expressing an original spirit of elegant and measured solemnity (Verona, Palazzo Bevilacqua; Venice, Palazzo Grimani, FIG. 425; military fortifications in Verona and elsewhere). The great Andrea Palladio (q.v.) and his academic disciple Vincenzo Scamozzi (Vicenza, Palazzo Trissino, 1577; Venice, the Procuratie Nuove, PL. 214; Sabbioneta, the Theater, 1589) worked in Vicenza.

The 15th century saw the beginning of the exceptional development of Venetian painting that made Venice, along with Florence and Rome, one of the great centers of European painting. The International Gothic of Gentile da Fabriano and Pisanello was enriched by a curiosity toward nature and its depiction in the art of Jacopo Bellini and Antonio Vivarini (qq.v.), the heads of their respective family workshops in Venice and Murano. Paolo Uccello (q.v.) worked in Venice for five years (1425-30), but his early productions exerted little influence at that time. Andrea del Castagno (q.v.) was in Venice in 1442, and his work influenced later Venetian artists.

The city that was most open to Renaissance influence was Padua. Its tradition of cultural interchange with Tuscany, so notable in the 14th century, was revitalized in the 15th century by the Florentine exile Palla Strozzi and the work in Padua of Filippo Lippi, Paolo Uccello, and Donatello (qq.v.). The curious Francesco Squarcione was important as a teacher and impresario of young talent (PL. 197). The young Andrea Mantegna was an apprentice in Squarcione's workshop before becoming the great and solemn innovator of Po Valley and Venetian painting. Squarcione's imprint was evident in the agitated sharp figures of Marco Zoppo and Giorgio Schiavone and, to a lesser degree, in the work of Tura of Ferrara and the Venetian Carlo Crivelli (q.v.). Crivelli brought from Padua and Murano to the Marches (where he worked after 1467) the piercing Neo-Gothic perfection of his almost carved and enameled surfaces.

Mantegna's "form" was influential throughout the Veneto (as well as in Lombardy and Emilia) and became the basic theme for a succession of variations. In the school of Murano, it was combined with the taste for almost sculptural design and vitreous color that derived from Andrea del Castagno. This development can be seen in the work of Bartolomeo Vivarini, the brother of Antonio (PL. 197). Influenced by Piero della Francesca's (q.v.) achievements in the treatment of space and color and by the work of Antonello da Messina, Giovanni Bellini (qq.v.) also adapted Mantegna's form. Thus, Mantegna's influence on Venetian painting was assimilated by Giovanni Bellini, who influenced other artists. This particular combina-

tion affected the Muranese and Veronese schools as well as the undistinguished Paduan painter Jacopo da Montagnana. In contrast, Antonello's influence followed its own particular course (affecting Alvise Vivarini and his colleagues), only partially uniting with that of Bellini in a complex knot of relationships and results. Paralleling Antonello's influence was that of the "narrative" vein of Venetian painting originated by Gentile Bellini (q.v.) and carried to great lyric heights by Carpaccio (q.v.).

Fifteenth-century painting in the Veneto presents several aspects. In Padua the trend following Mantegna was vulgarized by Bernardo Parentino (Parenzano). In Venice the style of Bellini was further developed in the work of Francesco Bissolo and other minor painters, although it was colored intermittently by the styles of Vivarini and Giorgione, evident in the work of Vincenzo Catena and the Bergamask Andrea Previtali. Such other artists as Lazzaro di Jacopo Bastiani and Giovanni Mansueti (PL. 199) collaborated in the large canvases of Giovanni Bellini. The formalist disciples of Antonello, however, constituted the most important segment of 15th-century Venetian painting. Their limpid manner of rendering figures was in opposition to the atmospheric tonalism of Giorgione and Giovanni Bellini. In addition to Alvise Vivarini (the son of Antonio), considered the initiator of this tendency after Antonello, the group included such talented painters as Cima da Conegliano (q.v.; PL. 199), the less renowned Marco Basaiti (PL. 199), and the Vicentines Bartolomeo Montagna and Giovanni Buonconsiglio, known as Marescalco. In Verona the local school, including Francesco Benaglio, Domenico (VII, PL. 275) and Francesco Morone (influenced by Bellini), Francesco Bonsignori, Girolamo dai Libri, and Liberale da Verona (Liberale di Jacopo dalla Brava), remained faithful to the tradition of Mantegna. The Carnia region also had a school of local artists, working in a Paduan-Muranese style. The most important of these painters was Gian Francesco da Tolmezzo (Giovanni Francesco dal Zotto), who painted frescoes and polyptychs in churches in Friuli.

While Bellini and Carpaccio were still at the height of their activity, Giorgione was blending color and light into a unified atmospheric vision. "Tonal" color became, in the first decade of the 16th century, the typical expressive means of Venetian painting, which in its naturalist inclination (man immersed in nature considered as a poetic element of landscape) is quite distinct from the Tuscan and Roman concentration on form (the human figure considered as a monument that dominates space). Despite their opposite natures, these two viewpoints met in a series of reciprocal influences. The Florentine Fra Bartolommeo (q.v.) worked in Venice in 1508, while one of Giorgione's collaborators, Sebastiano del Piombo, went to Rome, where after 1511 he acquired a style of stately monumentality. The complex artistic style of Giovanni Antonio da Pordenone (IX, PL. 302) derived originally from the school in the Friuli of Gian Francesco da Tolmezzo and Pellegrino da San Daniele. Later Pordenone studied the Roman style and accentuated its dynamism by contrasts of color and light, achieving results which anticipated future artistic developments. Apart from the Roman elements, Venetian painting of the beginning of the 16th century displayed a taste for Flemish and German art, which was nurtured especially by prints from northern Europe. Moreover, Dürer himself (q.v.) lived for a time in Venice, where in 1506 he painted an altar screen for the Church of S. Bartolomeo (IV, PL. 296). Northern taste was also evident in the work of such minor artists as Bartolomeo Veneto, Marco Marziale, Benedetto Diana, and, especially, Jacopo de' Barbari, and it became an element of the art of the great "irregular" of Venetian art, Lorenzo Lotto (q.v.), and the Brescian painters.

In the meantime Titian's (q.v.) art triumphed in Venice. Derived from Giorgione's intimate naturalism, though dramatically extrovert and heroic, Titian's art was the expression of a temperament overflowing with vitality. Several artists continued rather strictly to follow the style of Giorgione; among them were the Campagnolas (in particular, Giulio, a fine engraver), Domenico Mancini, and the Veronese Francesco Torbido known as Il Moro (later responsive to Roman influences). But the combined style of Titian and Giorgione extended its influence throughout the Veneto, which included Bergamo, where Palma Vecchio (q.v.), famous for his paintings of the Madonna and saints, Bernardino Licinio, and Giovanni de' Busi, known as Cariani (VI, PL. 67), worked. This influence penetrated Brescia as well, though Brescian art showed greater independence of artistic idiom, albeit related to Lombard taste.

In the middle of the 16th century a second, decidedly mannerist wave of "Romanism" reached Venice. One of the artists principally responsible for this was Giulio Romano, who had recently worked in Mantua. Before 1530 Il Rosso, followed by Francesco Salviati (VII, PL. 268; IX, PL. 309) and Giovanni da Udine in 1539, carried this trend to Venice itself. Giorgio Vasari worked in Venice in 1541, while Titian was summoned to Rome in 1545 by Paul III. And minor Venetian artists, such as Giovanni Battista Franco (IX, PL. 300), were assimilated among the followers of Michelangelo in Rome. Mannerist elements appeared in the mature work of some painters who initially had been followers of Titian or Palma, among whom were Paris Bordone of Treviso and Bonifazio Veronese (Bonifazio di Pitati; PL. 213). Parmigianino's mannerism also influenced Venetian painting and inspired Andrea Meldolla, known as Lo Schiavone, who dissolved Parmigianino's style in fluid, chromatic, and luminous vibrations. Mannerism was formally resumed by Tintoretto in the chiaroscuro key and by Jacopo Bassano (qq.v.) in a chromatic key. In his mannerist use of form Paolo Veronese (q.v.) was related to Tintoretto and Bassano. But, in contrast to Tintoretto's abstract luminism and Bassano's profound, earthy chromaticism, Veronese affirmed his own limpid, solar vision, thus culminating 16th-century Venetian painting on a classic note, parallel to Palladio's architectural development.

The schools of these masters acquired a family character through the extensive activity of their relatives (in addition, of course, to their other followers); thus Titian with Francesco, Cesare, and Marco Vecellio; Tintoretto with his children, Domenico and Marietta; Bassano with his sons Francesco, Leandro, and Girolamo; Veronese with his son Carlo Caliari and other relatives. In Verona, the local school, which had passed from Mantegna's to Giorgione's influence, assimilated Roman elements in the art of Giovanni Francesco Caroto and Torbido, and assumed the imprint of the decorative quality of the art of Paolo Veronese (as exemplified in the villas of the Veneto) in the work of such minor artists as Giambattista Zelotti (PL. 214) and Giovanni Antonio Fasolo from Vicenza. Although Palma Giovane (PL. 214) sometimes worked with distinction, Venice entered into the decadence of a mannered local eclecticism that was continued in the 17th century by the dull academic production of Alessandro Varotari, known as Padovanino. From the currents of influence of Tintoretto and the Bassanos, however, emerged two original painting phenomena — the work of Jacopo Mariscalchi of Feltro and the vastly more ambitious and important work of Domenico Theotocopuli, known as El Greco (q.v.).

BIBLIOG. C. Ridolfi, Le meraviglie dell'arte, ovvero degli illustri pittori veneziani dello Stato, 2 vols., Venice, 1648; M. Boschini, La carta del navegar pittoresco, Venice, 1660; M. Boschini, Le ricche minere della pittura veneziana, Venice, 1674; M. Boschini, I gioielli pittoreschi, virtuoso ornamento della Città di Vicenza, Vicenza, 1676; B. Dal Pozzo, Le vite dei pittori, scultori e architetti veronesi, Verona, 1718; G. B. Verci, Notizie intorno alla vita e alle opere di pittori, scultori e intagliatori della città di Bassano, Venice, 1775; T. Temanza, Vite dei più eccellenti architetti e scultori veneziani che fiorirono nel secolo XVI, Venice, 1778; F. Bartoli, Pitture, sculture e architetture della città di Rovigo, Venice, 1793; P. Brandolese, Del genio dei lendinaresi per la pittura e di alcune pregevoli pitture di Lendinara, Padua, 1795; D. Federici, Memorie trevigiane sulle opere del disegno dal 1100 al 1800, 2 vols., Venice, 1803; B. Gamba, De' bassanesi illustri, Bassano, 1807; S. Ticozzi, Storia dei letterati ed artisti del Dipartimento del Piave, Belluno, 1813; G. A. Moschini, Dell'origine e delle vicende della pittura in Padova, Padua, 1826; P. Selvatico, Sull'architettura e la scultura in Venezia dal Medioevo ai nostri giorni, Venice, 1847; N. Pietrucci, Biografie degli artisti padovani, Padua, 1858; P. Paoletti, L'architettura e le sculture del Rinascimento a Venezia, 4 vols. in 2, Venice, 1893–97; B. Berenson, Venetian Painters of the Renaissance, New York, 1894; J. von Schlosser, Ein veronisches Bilderbuch und die höfische Kunst des XIV. Jahrhunderts, JhbKhSammlWien, XVI, 1895, pp. 144–230; L. Venturi, Le origini della pittura veneziana, Venice, 1907; L. Testi, La storia della pittura veneziana, 2 vols., Bergamo, 1909-15; L. Planiscig, Venezianische Bildhauer der Renaissance, Vienna, 1921; E. Sandberg-Vavalà,

La pittura veronese del Trecento e del primo Quattrocento, Verona, 1926; L. Coletti, Studi della pittura del Trecento a Padova, RIASA, XII, 1930, pp. 323–80, XIII, 1931, pp. 303–63; S. Bettini, La pittura di icone cretese-veneziana e i madonneri, Padua, 1933; S. Bettini, La pittura friulana del Rinascimento e Giovanni Antonio da Pordenone, Le Arti, I, 1938–39, pp. 464–80; L. Coletti, La crisi manieristica della pittura veneziana, Convivium, II, 1941, pp. 109–26; G. de' Francovich, Contributi alla scultura romanica veronese, RIASA, IX, 1942, pp. 103–48; E. Arslan, La pittura e la scultura veronese dal secolo VIII al secolo XIII, Milan, 1943; H. Tietze and E. Tietze-Conrat, Drawings of the Venetian Painters in the 15th and 16th Centuries, New York, 1943; R. Pallucchini, La pittura veneziana del '500, Novara, 1944; R. Pallucchini, Cinque secoli di pittura veneta (exhibition cat.), Venice, 1945; R. Longhi, Viatico per cinque secoli di pittura veneziana, Florence, 1946; A. Avena, Capolavori della pittura veronese (exhibition cat.), Verona, 1947; R. Pallucchini, Exposition "Trésor de l'art vénitien" (exhibition cat.), Lausanne, 1947; R. Gallo, Contributo alla storia della scultura veneziana, Arch. veneto, XLIV–XLV, 1949, pp. 1–40; P. Zampetti, Pittura veneta nelle Marche (exhibition cat.), Bergamo, 1950; F. Bologna, Contributi alla storia della pittura veneziana del Trecento, Arte veneta, V, 1951, pp. 21–31, VI, 1952, pp. 77–81; L. Coletti, Pittura veneta del Quattrocento, Novara, 1953; F. M. Godfrey, Early Venetian Painters, London, 1954; F. Valcanover, Mostra di pitture del Settecento bellunese (exhibition cat.), Venice, 1954; G. Nicco Fasola, Il manierismo e l'arte veneziana del Cinquecento, Atti XVIII Cong. int. Storia dell'Arte, Venice, 1955, pp. 291–93; Venezia e l'Europa, Atti XVIII Cong. int. Storia dell'Arte, Venice, 1955; G. Marchetti and G. Nicoletti, La scultura lignea nel Friuli, Milan, 1956; V. Querini, Contributi allo studio della pittura medievale nel Friuli occidentale, Il Noncello, 6, 1956, pp. 39–119, 10, 1958, pp. 3–58; T. Pignatti, Pittura veneziana del Cinquecento, Bergamo, 1957; G. Delogu, Pittura veneziana dal XIV al XVIII secolo, Bergamo, 1958; L. Magagnato, Da Altichiero a Pisanello (exhibition cat.), Venice, 1958; C. Basso, Le XVᵉ siècle vénitien, Novara, 1959; T. Pignatti, Pitture veneziane del Quattrocento, Bergamo, 1959; L. Cocchetti Pratesi, Contributi alla scultura veneziana del Duecento, Comm, XI, 1960, pp. 3–21, 202–19, XII, 1961, pp. 12–30.

ARTISTS: See individual articles for *Cima da Conegliano, Palma Vecchio, Scamozzi, Sebastiano del Piombo, Sansovino, Vivarini.*

OTHERS. *Antonio Veneziano*: 14th-century painter (R. Offner, Five More Panels by Antonio Veneziano, Art in Am., XI, 1923, pp. 217–28; M. Salmi, Antonio Veneziano, BArte, N.S., VIII, 1928–29, pp. 433–52; W. Cohn, Neue Beiträge zu Antonio Veneziano, Berliner Mus., N.S., VII, 1957, pp. 52–53). *Bartolomeo Veneto*: doc. 1502–30, painter (A. Venturi, Bartolomeo Veneto, L'Arte, II, 1899, pp. 432–62; R. Marini, Bartolomeo Veneto e un eminente inedito, Venice, 1951). *Marco Basaiti*: b. Venice, 1480; d. ca. 1530; painter (B. Berenson, Venetian Painting in America: The 15th Century, New York, 1916, pp. 231–43; B. Degenhart, Dürer oder Basaiti? Zu einer Handzeichnung der Uffizien, Mitt. der Kunsthist. Inst. in Florenz, V, 1940, pp. 423–28). *Lazzaro Bastiani*: late-15th-century painter (G. Fiocco, A proposito dei pittori Bastiani e del Carpaccio, Riv. di Venezia, XII, 1933, pp. 31–40; L. Collobi, Lazzaro Bastiani, CrArte, IV, 1939, pp. 33–53). *Bartolomeo Bellano*: ca. 1434–96/97, sculptor (A. Scrinzi, Bartolomeo Bellano, L'Arte, XXIX, 1926, pp. 248–60; S. Bettini, Bartolomeo Bellano "ineptus artifex"?, RArte, XIII, 1931, pp. 45–108; J. Pope-Hennessy, Two Paduan Bronzes, BM, XCVI, 1954, pp. 9–13). *Francesco Benaglio*: doc. 1432–82, Veronese painter (E. Sandberg-Vavalà, Francesco Benaglio, Art in Am., XXI, 1933, pp. 48–65; R. Brenzoni, Sulla datazione dell'ancona di Francesco Benaglio nella chiesa di S. Bernardino di Verona, BArte, XLIII, 1958, pp. 68–69). *Bonifazio Veronese (Bonifazio di Pitati)*: b. Verona, 1487; d. Venice, 1553; painter (D. Westphal, Bonifazio Veronese, Munich, 1931; E. Arslan, Bonifacio Veronese, Florence, 1932). *Giovanni* and *Bartolomeo Bono*: 15th-century sculptors and architects, (G. Fogolari, Gli scultori toscani a Venezia nel Quattrocento e Bartolomeo Bon, veneziano, L'Arte, N.S., I, 1930, pp. 427–66; G. Fogolari, Ancora di Bartolomeo Bon, scultore veneziano, L'Arte, N.S., III, 1932, pp. 27–45). *Bonsignori*: a family of Veronese painters active during the 15th–16th centuries (R. Brenzoni, Sull'origine della famiglia di Francesco Bonsignori, L'Arte, N.S., XXIII, 1958, pp. 295–99). *Paris Bordone*: b. Treviso, 1500; d. Venice, 1571; painter (L. Bailo and G. Biscaro, Della vita e delle opere di Paris Bordone, Treviso, 1900; M. Muraro, Un ciclo di affreschi di Paris Bordone, Arte veneta, IX, 1955, pp. 80–85). *Giovanni Buonconsiglio*, known as *Marescalco*: 15th–16th-century painter (A. Foratti, Di alcuni quadri inediti di Giovanni Buonconsiglio, BArte, XII, 1918, pp. 70–80; A. Martini, Spigolature venete: Bartolomeo Montagna e Giovanni Buonconsiglio, Arte veneta, XI, 1957, pp. 60–61). *Caliari*: a family of Veronese painters active during the 15th–16th centuries, including *Carlo* (G. Gamulin, Contributi al Cinquecento, Arte veneta, XIII–XIV, 1959–60, pp. 88–95). *Campagnola*: a family of artists active during the 15th–16th centuries, including *Domenico* (G. Fiocco, La pittura bresciana del Cinquecento a Padova, BArte, N.S., VI, 1926–27, pp. 305–23; T. E. Mommsen, Petrarch and the Decoration of the Sala Virorum Illustrium in Padua, AB, XXXIV, 1952, pp. 95–116), *Girolamo* (S. de Kunert, Due codici miniati da

Girolamo Campagnola?, RArte, XII, 1930, pp. 57–80), and *Giulio* (K. F. Suter, Giulio Campagnola als Maler, ZfbK, LX, 1926–27, pp. 132–41; U. Middeldorf, Eine Zeichnung von Giulio Campagnola?, Festschrift Martin Wackernagel, Cologne, 1958, pp. 141–52). *Cariani (Giovanni de' Busi)*: Venice, 1485–1547 (A. Foratti, L'arte di Giovanni Cariani, L'Arte, XIII, 1910, pp. 177–90; L. Gallina, Giovanni Cariani: Materiale per uno studio, Bergamo, 1954). *Caroto*: a family of Veronese painters, including *Giovanni Francesco*, 1480–1555 (L. Simeoni, Nuovi documenti sul Caroto, L'Arte, VII, 1904, pp. 64–67; B. Baron, Giovanni Caroto, BM, XVIII, 1910–11, pp. 41–44, 176–83; A. Avena, Giovan Francesco Caroto e Battista Zelotti alla corte di Mantova, L'Arte, XV, 1912, pp. 205–08). *Vincenzo Catena*: Venice, 1470–1531, painter (G. Robertson, Vincenzo Catena, Edinburgh, 1954). *Danese Cattaneo*: b. Colonnata, 1509; d. Padua, 1573; sculptor (G. Campori, Danese Cattaneo, Il Buonarroti, VI, 1871, pp. 149–62; E. Delmar, "The Nuptials of Peleus and Thetis" by Danese Cattaneo, GBA, XXVII, 1945, pp. 347–56). *Mauro Coducci*: b. Lenna, 1440; d. Venice, 1504; architect (L. Angelini, Le opere in Venezia di Mauro Coducci, Milan, 1945). *Benedetto Diana*: late-15th-century Venetian painter (G. Ludwig, Archivalische Beiträge zur Geschichte der venezianischen Malerei: Benedetto Diana, JhbPreussKSamml, XXVI, 1905, sup., pp. 56–61; G. Mariacher, Il restauro del Cristo in Pietà attribuito a Benedetto Diana, B. Mus. Civ. Veneziani, 1958, 1, pp. 25–33). *Marcello Fogolino*: doc. 1480–1518, painter (P. Zampetti, Affreschi inediti di Marcello Fogolino, Arte veneta, I, 1947, pp. 217–22; P. Zampetti, Precisazioni sull'attività trentina di Marcello Fogolino, BArte, XXXIV, 1949, pp. 218–24). *Francesco dei Franceschi*: doc. 1443–68, painter (E. Arslan, Intorno a Giambono e a Francesco dei Franceschi, Emporium, LIV, 1948, pp. 285–89). *Michele Giambono*: doc. ca. 1420–62, painter (E. Sandberg-Vavalà, Michele Giambono and Francesco dei Franceschi, BM, LI, 1927, pp. 215–21; V. Moschini, Nuovi aspetti di opere famose, BArte, XXXIV, 1949, pp. 162–70). *Gian Francesco da Tolmezzo*: see *Tolmezzini*. *Giorgio da Sebenico*: d. 1475, architect and sculptor (D. Frey, Der Dom von Sebenico und sein Baumeister Giorgio Orsini, Jhb. der Zentralkomm., VII, 1913, pp. 1–169; G. Praga, Documenti su Giorgio di Sébenico, architetto e scultore del secolo XV, Arch. storico della Dalmazia, XII, 1932, pp. 523–31; R. Petrovitch, Questi Schiavoni, III: Giovanni Duknovich and Giorgio da Sebenico, GBA, XXXII, 1947, pp. 143–50; C. Bima, Giorgio da Sebenico, la sua cattedrale e l'attività in Dalmazia e in Italia, Milan, 1954). *Girolamo dai Libri*: Verona, 1474–1555, painter and miniaturist (A. Forti, Francesco Morone e Girolamo dai Libri, Madonna Verona, XIV, 1920, pp. 57–172; R. Wittkower, Studien zur Geschichte der Malerei in Verona, III: Der Schüler des Domenico Morone, Jhb. für Kw., 1927, pp. 185–222; G. Fiocco, Una miniatura di Girolamo dai Libri, Arte veneta, VII, 1953, p. 163). *Guariento*: doc. 1338–70, Paduan painter (L. Coletti, Studi nella pittura del Trecento a Padova, I: Guariento e Semitecolo, RArte, XII, 1930, pp. 323–80; R. Longhi, Guariento: Un'opera difficile, Paragone, VIII, 91, 1957, pp. 37–40; F. D'Arcais, Un'altra cappella dipinta dal Guariento agli Eremitani di Padova, Arte veneta, XIII–XIV, 1959–60, pp. 189–91). *Jacopo de' Barbari*: b. Venice (?), ca. 1440; d. Malines, 1516; painter and engraver (L. Servolini, Jacopo de' Barbari, Padua, 1944; C. Gilbert, Ancora di Jacopo de' Barbari, Comm, VIII, 1957, pp. 155–56). *Jacobello del Fiore*: d. Venice, 1439, painter (G. Fiocco, Segnalazioni venete nel Museo di Kieff, Arte veneta, XII, 1958, pp. 31–37). *Liberale da Verona (Liberale di Jacopo dalla Brava)*: 1445–ca. 1526, painter and miniaturist [R. Brenzoni, Documenti inediti e tavole sconosciute (o quasi) di M. Liberale da Verona, L'Arte, N.S., XIX, 1954, pp. 9–19; R. Longhi, Un apice espressionistico di Liberale da Verona, Paragone, VI, 65, 1955, pp. 3–7; C. del Bravo, Liberale a Siena, Paragone, X, 129, 1960, pp. 16–38]. *Bernardino Licinio*: ca. 1489–1565, Venice, painter (A. Martini, Spigolature venete: Licinio e Tiziano, Arte veneta, XI, 1957, pp. 62–64; C. Boselli, Un Licinio nel Duomo di Lonato, Arte veneta, XII, 1958, pp. 195–96). *Lombardo*: a family of Lombard sculptors and architects active during the 15th–16th centuries (L. Planiscig, Pietro, Tullio und Antonio Lombardo, JhbKhSammlWien, N.S., XI, 1937, pp. 87–115; G. Mariacher, Tullio Lombardo Studies, BM, XCVI, 1954, pp. 366–74; G. Mariacher, Pietro Lombardo a Venezia, Arte veneta, IX, 1955, pp. 36–52). *Lorenzo Veneziano*: painter, doc. 1356–79 (M. Caffi, Lorenzo da Venezia ed altri pittori veneti antichi, Arte e storia, V, 1886, pp. 201–03; R. Longhi, Calepino veneziano, II: Il trittico di Lorenzo Veneziano per l'Ufficio della Seta (1371), Arte veneta, I, 1947, pp. 80–85). *Marco Marziale*: late-15th-century Venetian painter (B. Geiger, Marco Marziale und der sogenannte nordische Einfluss in seinen Bildern, JhbPreussKSamml, XXXIII, 1912, pp. 1–22, 122–48; A. Bertini, Un dipinto poco noto di Marco Marziale, Arte veneta, XI, 1957, pp. 200–02). *Jacobello* and *Pier Paolo dalle Masegne*: Venetian sculptors, doc. 1383–1409 (C. Gnudi, Jacobello e Pietro Paolo da Venezia, CrArte, II, 1937, pp. 26–38; C. Gnudi, Nuovi appunti sui fratelli dalle Masegne, Proporzioni, III, 1950, pp. 48–55).

Andrea Meldolla, called *Lo Schiavone*: b. Sebenico, 1522; d. Venice, 1563; painter and engraver (V. Moschini, Capolavori di Andrea Schiavone, Emporium, XCVII, 1943, pp. 237–42; G. Fiocco, Nuovi aspetti dell'arte di Andrea Schiavone, Arte veneta, IV, 1950, pp. 33–42; S. Rosenberg, A Sheet of Studies by Andrea Schiavone, Essays in Honor of Georg Swarzenski (ed. O. Goetz), Chicago, 1952, pp. 165–69). *Bartolomeo Montagna*: b. Orinovi, ca. 1450; d. Vicenza, 1523; painter (A. Foratti, Bartolomeo Montagna, Padua, 1908; E. Zocca, Appunti su Bartolomeo Montagna, L'Arte, N.S., VIII, 1937, pp. 183–91; A. Martini, Spigolature venete: Bartolomeo Montagna e Giovanni Buonconsiglio, Arte veneta, XI, 1957, pp. 60–61). *Paolo Moranda*, called *Cavazzola*: Verona, 1486–1522, painter (G. Gamba, Paolo Moranda detto il Cavazzola, Rass. d'arte, V, 1905, pp. 33–40; F. J. Dubiez, Paolo Moranda en Jan van Scorel, Oud Holland, LXV, 1950, pp. 71–72). *Morone*: a family of Veronese painters, including *Domenico*, 1442–1517, and *Francesco*, ca. 1471–1529 (A. Forti, Francesco Morone e Girolamo dai Libri, Madonna Verona, XIV, 1920, pp. 57–172; R. Brenzoni, Domenico Morone vita e opere, Florence, 1956). *Palma Giovane*: Venice, 1544–1628, painter [K. Prijatelj, Le opere del Palma il Giovane e dei manieristi veneziani in Dalmazia, Atti XVIII Cong. int. Storia dell'Arte, Venice, 1955, pp. 294–96; A. Ghidiglia Quintavalle, Jacopo Palma il Giovane nel Modenese e nel Reggiano, Arte veneta, XI, 1957, pp. 129–42; A. Forlani, Mostra dei disegni di Jacopo Palma il Giovane (exhibition cat.), Florence, 1958]. *Palma Vecchio* (q.v.). *Paolo Veneziano*: doc. 1333–62, painter (E. Sandberg-Vavalà, Maestro Paolo Veneziano, BM, LVII, 1930, pp. 160–83; V. Lasareff, Maestro Paolo e la pittura veneziana del suo tempo, Arte veneta, VIII, 1954, pp. 77–89; R. Pallucchini, Nota per Paolo Veneziano, Scritti di Storia dell'arte in onore di Lionello Venturi, I, Rome, 1956, pp. 121–37). *Pordenone, Giovanni Antonio da*: b. Pordenone, ca. 1484; d. Ferrara, 1539; painter [B. Molajoli, Mostra del Pordenone e della pittura friulana del Rinascimento (exhibition cat.), Udine, 1939; S. Bettini, La pittura friulana del Rinascimento e Giovanni Antonio da Pordenone, Le Arti, I, 1939, pp. 464–80; A. Morassi, L'arte del Pordenone, Mem. storiche forogiuliensi, XLII, 1956–57, pp. 123–38; G. Fiocco, Luca Cambiaso, Gerolamo da Treviso e Pordenone, S. in onore di Matteo Marangoni, Florence, 1957, pp. 213–19]. *Andrea Riccio* (*Andrea Briosco*): b. Trent, 1470; d, Padua, 1532; architect and sculptor (L. Planiscig, Andrea Riccio. Vienna, 1927; T. Pignatti, Gli inizi di Andrea Riccio, Arte veneta, VII, 1953, pp. 25–38). *Antonio Rizzo*: doc. 1465–83, Veronese sculptor (G. Mariacher, Profilo di Antonio Rizzo, Arte veneta, II, 1948, pp. 67–84; G. Mariacher, Aggiunte ad Antonio Rizzo, Arte veneta, IV, 1950, pp. 105–07; E. Arslan, Œuvres de jeunesse d'Antonio Rizzo, GBA, LXII, 1953, pp. 105–14). *Santacroce, Girolamo da*: d. 1556, painter (G. Fiocco, I pittori da Santacroce, L'Arte, XIX, 1916, pp. 179–206). *Nicoletto Semitecolo*: doc. 1353–70, Venetian painter (S. Bettini, Contributo al Semitecolo, RArte, II, 1930, pp. 163–74; E. Sandberg-Vavalà, Semitecolo and Guariento, Art in Am., XXII, 1933, pp. 3–15). *Stefano da Zevio* (or *da Verona*): Verona, ca. 1374–1438, painter (R. Brenzoni, Stefano da Verona ed i suoi freschi firmati, Verona, 1923; E. Arslan, Un affresco di Stefano da Verona, Le Arti, V, 1942–43, pp. 203–06; G. Fiocco, Disegni di Stefano da Verona, Proporzioni, III, 1950, pp. 56–64. *Tolmezzini*: a school of 15th-century painters, including *Gian Francesco da Tolmezzo* (*Giovanni Francesco dal Zotto*), (L. Venturi, Due opere di Gian Francesco da Tolmezzo, L'Arte, XII, 1909, pp. 211–15; R. Marini, La Scuola di Tolmezzo, Padua, 1942; R. Marini, Arte veneta e arte nordica in Gianfrancesco da Tolmezzo, Emporium, CXXII, 1955, pp. 157–68; F. R. Valcanover, Contributo a Gianfrancesco da Tolmezzo, Arte veneta, IX, 1955, pp. 29–35). *Francesco di Marco India Torbido*, called *Il Moro*: Verona, ca. 1482–1562, painter (D. Viana, Francesco Torbido detto il Moro: Pittore veronese, Verona, 1933). *Turone*: Veronese painter, active ca. 1360 (E. Sandberg-Vavalà, Turone miniatore, Dedalo, X, 1929–30, pp. 15–44; F. Zeri, Una "Annunciazione" di Turone, Paragone, VIII, 89, 1957, pp. 48–52; E. Arslan, Una tavola di Altichiero e un affresco di Turone, Comm, XI, 1960, pp. 103–06). *Alessandro Varotari*, called *Padovanino*: b. Padua, 1588; d. Venice, 1648; painter (V. Moschini, Alcuni dipinti nei depositi demaniali di Venezia, Riv. di Venezia, XII, 1933, pp. 231–44; C. Semenzato, Un Padovanino ed un Celesti in Puglia, Arte veneta, XI, 1957, pp. 213–15; K. Prijatelj, Le opere di Padovanino in Dalmazia, Arte veneta, XIII–XIV, 1959–60, pp. 204–06). *Vecellio*: family of painters from Pieve di Cadore, active in Venice during the 16th century (Catalogo della mostra dei Vecellio a Belluno, Belluno, 1951). *Alessandro Vittoria*: b. Trent, 1524; d. Venice, 1608; sculptor (W. R. Valentiner, Alessandro Vittoria and Michelangelo, AQ, V, 1942, pp. 149–57; G. Zorzi, Alessandro Vittoria a Vicenza e lo scultore Lorenzo Rubini, Arte veneta, V, 1951, pp. 141–57; K. Prijatelj, Alessandro Vittoria e la Dalmazia, Arte veneta, XII, 1958, pp. 205–07). *Giambattista Zelotti*: b. Verona, 1526; d. Mantua, 1578; painter (A. Venturi, Giambattista Zelotti, L'Arte, XXXII, 1929, pp. 49–67; E. Arslan, Nota su Veronese e Zelotti, Belle Arti,

I, 1946–48, pp. 227–45; G. Gamulin, Contributi al Cinquecento, Arte veneta, XIII–XIV, 1959–60, pp. 88–95).

ROMAN ART FROM THE PONTIFICATE OF JULIUS II TO THE END OF THE 18TH CENTURY. The creative splendor resulting from the immense artistic activity that centered around the papal court had its beginning in the art of Bramante, Raphael, and Michelangelo (qq.v.) and made of Rome a capital of European art for more than two centuries. Rome's power of attraction and diffusion in the field of art became steadily stronger and more evident. A true picture of Roman art in this period requires not only a disregard of merely local and regional considerations but often demands a viewpoint that goes beyond Italy to include, for example, French and Flemish artists.

Together with Bramante and Raphael (the two great artists of the early 16th century), Baldassarre Peruzzi and Antonio da Sangallo the Younger (qq.v.) were leaders in the Roman school of architecture. The architectural activities of Michelangelo in Rome followed the death of Sangallo (1546) and were contemporaneous with the first works of Vignola (q.v.). The architect of the Church of the Gesù (begun 1568), Vignola belonged to the second phase of 16th-century Roman art, which was concerned with the political and spiritual objectives and the expression of the ideals of the Counter Reformation. Related to the work of Michelangelo and Vignola was that of the Lombard Giacomo della Porta (Rome; façade of S. Luigi dei Francesi; Madonna dei Monti; S. Atanasio; Palazzo della Sapienza, 1579; Frascati, Villa Aldobrandini, 1598–1602). Della Porta also collaborated in the execution of works designed by Michelangelo and Vignola (dome of St. Peter's, façade of the Church of the Gesù, IX, PL. 312) and set his stamp on Roman architectural taste in the late 16th century. One of his contemporaries, Domenico Fontana, another Lombard and the architect of Sixtus V, was the principal creator of the city plan of Rome, which is essentially the plan of the modern city and features streets connecting the large basilicas and obelisks and fountains forming the directrixes of vistas. Fontana was also the architect of the Cappella Sistina (or, del SS. Sacramento) in S. Maria Maggiore and the papal palaces of the Quirinal and the Lateran. From these main currents emerged the baroque conception of church and palace structures, which long retained its influence on the development of architecture. The development of villas and gardens was also important for baroque style (see LANDSCAPE ARCHITECTURE). In the Villa Giulia, Rome, the Villa d'Este, Tivoli (PL. 432; IX, PL. 313), and the Casino of Pius IV, in the Vatican Gardens (PL. 429; FIG. 413), ideas drawn from Bramante, Raphael, Peruzzi, and the writings of Sebastiano Serlio were developed in refined mannerist forms. Because of their fusion of architecture and nature, landscape and scenography, these villas and gardens also anticipated succeeding architectural developments.

Roman architecture in the late 16th century was completely dominated by Lombard artists; Martino Longhi the Elder, his son Onorio, and his grandson Martino the Younger (who lived in the 17th century) formed a virtual dynasty of Lombard architects (PL. 207; S. Girolamo degli Schiavoni, 1587; Palazzo Borghese). Martino the Elder was a follower of Giacomo della Porta, while Flaminio Ponzio was inspired by Fontana (façade of Palazzo Sciarra-Colonna; Cappella Paolina in S. Maria Maggiore, 1605–11). Ottaviano Mascherino (PL. 207) established the prototype of the two-story façade in his Church of Sto Spirito and was as notable an architect as he was insignificant a painter. In the work of the Lombard Carlo Maderno (q.v.; II, PLS. 132, 137) and Girolamo Rainaldi, a Roman follower of the Lombard architects, this late mannerism or early baroque became truly 17th-century work.

Roman sculpture at the beginning of the 16th century was dominated by Tuscan masters, even without considering the supreme figure of Michelangelo, whose influence was widespread for decades. Andrea (Contucci) Sansovino (q.v.) brought to Rome his decorative classicism, a style unaffected by the emotion of the school of Michelangelo (IV, PL. 455; work in S. Agostino); Andrea's pupil Jacopo (Tatti) Sansovino showed a taste for pictorial handling of sculpture (work in S. Agostino;

PL. 206), which he was to develop further in Venice, where he settled after the sack of Rome (1527). Of the many other Tuscans who worked in Rome, the most important were Lorenzetto (Lorenzo di Ludovico di Guglielmo Lotti), Raffaello (Sinibaldi) da Montelupo, Baccio Bandinelli (tombs of Leo X and Clement VII in S. Maria sopra Minerva), Vincenzo di Raffaello (de') Rossi (Cesi Chapel in S. Maria della Pace), Ammanati (q.v.; Del Monte tombs, 1553, S. Pietro in Montorio), and Taddeo Landini (PL. 206). The Lombard sculptor Guglielmo della Porta (PL. 208) was a follower of Michelangelo. Numerous minor Lombard sculptors, including Nicolas Cordier, a Frenchman from Lorraine, Giovanni Antonio Paracca, known as Valsolda, and Pietro Bernini (PL. 208), the father of Gian Lorenzo, often worked with architects on the sculptural decoration of tombs (e.g., those in the Aldobrandini Chapel, S. Maria sopra Minerva, by Giacomo della Porta), and chapels (e.g., S. Maria Maggiore, Cappella Sistina, by Domenico Fontana, and Cappella Paolina, by Flaminio Ponzio). Other sculptors involved in these enterprises were Stefano Maderno, the sculptor of the famous statue of St. Cecilia in the Church of S. Cecilia in Trastevere, and Camillo Mariani of Vicenza (II, PL. 164). The work of these men and, even more, that of Francesco Mochi, a pupil and collaborator of Mariani, are substantially baroque, although in Mochi's work the dramatic and poetic influence of Tuscan mannerism is also apparent.

Raphael and Michelangelo dominated Roman painting in the 16th century, and their influence permeated the mannerism of their followers. Sebastiano del Piombo, Peruzzi, and Sodoma (qq.v.) came under Raphael's influence, collaborating with him in the decoration of the Farnesina (PL. 101; III, PL. 392; X, PL. 250). It should be noted, however, that Sebastiano was influenced by Venetian colorists and that this aspect of his work had an effect on Raphael himself. Among the direct followers of Raphael, Giulio Romano (q.v.) attempted a synthesis of the style of his master and that of Michelangelo, as demonstrated by his panels (PL. 208) and by his frescoes for the Sala di Costantino in the Vatican, where he was assisted by Giovan Francesco Penni (called "Il Fattore"). But only later, in the Palazzo del Te in Mantua (IX, PL. 298), was Giulio to reveal fully his bold imaginative capacity. Other followers of Raphael, such as Giovanni da Udine (PL. 206), the Florentine Perino del Vaga, and Polidoro da Caravaggio (IX, PL. 311), exploited the possibilities of a decorative style based on classical models, using stuccoes and grotesques with insets of frescoed scenes derived from Raphael himself. These three painters carried their art to Venice, Liguria, and southern Italy. Among the followers of Michelangelo, aside from such minor artists as the Venetians Marcello Venusti and Giovanni Battista Franco (IX, PL. 300), the most significant painters working in Rome were the Florentines Francesco Salviati and Jacopino del Conte (Jacopo Conte). Salviati's frescoes in S. Marcello, in the chapel of the Palazzo della Cancelleria (ca. 1550), and in the Palazzo Farnese (VII, PL. 268; IX, PL. 294), together with those in the Oratory of S. Giovanni Decollato, where he worked with Jacopino (IX, PL. 309), are among the most important mannerist works in Rome. Daniele da Volterra (Daniele Ricciarelli) painted friezes in the Palazzo Farnese, but his most important work is the *Deposition* in the Trinità dei Monti, executed with other frescoes in 1541–46. Vasari, aided by his Florentine pupils, frescoed the *Salone dei 100 giorni* in the Palazzo della Cancelleria. Toward the middle of the 16th century, the young Pellegrino Tibaldi also worked in Rome (S. Marcello; Castel S. Angelo), and Pirro Ligorio executed frescoes in S. Giovanni Decollato. Girolamo Siciolante and Scipione Pulzone (IX, PL. 297), both good portraitists, were exponents of a painting style of a chaste simplicity that was particularly inspired by precepts of the Counter Reformation. Likewise reflecting the hagiographic and didactic theories of the Counter Reformation is the cycle of frescoes (1582, in S. Stefano Rotondo) comprising a martyrology, by Niccolò Circignani, known as Niccolò Pomarancio, and others. During the mannerist period, the subject matter of works was considered more important than the quality of artists, a fact that benefited many mediocre painters from every part of Italy. Taddeo Zuccari from the Marches was the chief representative of official art among such painters as Girolamo Muziano, Giovanni Battista Ricci, Cesare Nebbia (Nebula), Andrea Lilio (Andrea d'Ancona), and Baldassare Croce (also known as Il Baldassarino). Taddeo, an erudite and skillful illustrator, was succeeded after 1566 by his brother Federico in the painting of frescoes for the Palazzo Farnese in Caprarola (IX, PL. 310) and in the Trinità dei Monti in Rome. The decoration of the Oratory of S. Lucia del Gonfalone brought together various artists of this period, including Federico Zuccari, who worked throughout Italy and abroad (England and Spain) and followed Michelangelo in the decoration of the

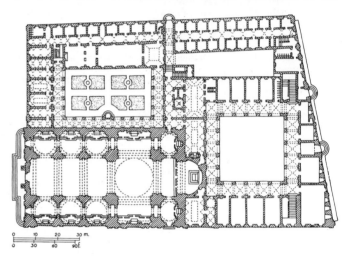

Rome, Collegio Romano and S. Ignazio, plan (*from P. Letarouilly, Edifices de Rome moderne, Paris, 1860*).

Pauline Chapel in the Vatican (1580–84). Federico, who was a theorist as well as a painter, also served as president of the Accademia di S. Luca. In the work of the Cavalier d'Arpino (G. Cesari), Federico Zuccari's less creative successor, Rome's eclectic late mannerism survived well into the 17th century (IX, PL. 303). However, the forces that were to open new paths for painting had already appeared. In 1597, Michelangelo Merisi, called "Caravaggio" (q.v.), was in Rome creating such works as the paintings for S. Luigi dei Francesi, and the Carraccis (q.v.) were decorating the gallery of the Palazzo Farnese. Moreover, the influx of foreign artists to Rome, a factor that was to be so important for 17th-century Roman art, had already begun. Thus, certain foreign artists came to be considered as part of the Roman mannerist movement. Such artists included the architect Jan van Santen, who was known as Giovanni Vasanzio (Casino Borghese; Frascati, Villa Mondragone) and the Flemish painter Paul Brill (frescoes in the Vatican), who was important for the subsequent development of landscape painting.

The severity of late 16th-century architecture was absorbed in the opening of space that the exuberant imagination of Gian Lorenzo Bernini (q.v.) established as the foundation of baroque expression. His art, however, encountered the resistance of such traditionalists as Algardi and Girolamo Rainaldi and the opposition of his only real spiritual antagonist, Francesco Borromini (q.v.), whose anticipation of the rococo outstripped the 17th century. In the baroque period, there was a group of architects, for the most part local artists, who outwardly complied with the new tendencies of expression but still manifested an attachment to late 16th-century styles. Among these architects were Rainaldi and the more original Giovan Battista Soria, author of the façades of S. Maria della Vittoria (II, PL. 137), S. Gregorio Magno (1633), and S. Carlo ai Catinari (1623). Others were Martino Longhi the Younger, who finished the work begun by his father, Onorio, in S. Carlo al Corso (1619–27) and designed the façade of SS. Vincenzo ed Anastasio; Vincenzo della Greca, who worked on the Palazzo Chigi and constructed the façade of SS. Domenico e Sisto; and, somewhat later, Antonio del Grande (Palazzo di Spagna; part

of the Palazzo Doria) and Giovanni Antonio de' Rossi (S. Pantaleo; Cappella del Monte di Pietà; Altieri and Misciatelli palaces). Pietro da Cortona (q.v.) was the third principal architect of the Roman baroque. Although somewhat related to Bernini, Pietro won distinction by an original sense of movement in his handling of architectural mass and chiaroscuro. Next in importance to Pietro da Cortona was Carlo Rainaldi, distinguished for the pictorial dynamism of his Church of S. Maria in Campitelli (I, PL. 405), for the scenographic setting of S. Maria di Montesanto (FIG. 419) and S. Maria dei Miracoli at the head of the three streets issuing from the Piazza del Popolo (II, PL. 134), and for the rear façade of S. Maria Maggiore (1673; II, PL. 132). Antonio Gherardi (called "Reatino"),

façade of the Palazzo Doria Pamphili on the Corso (ca. 1734), by Gabriele Valvassori, is most typical of the century, although contemporaries considered it capricious and daring. Another outstanding example of the Roman rococo, executed in 1735 and attributed to Giuseppe Sardi is the façade of the Church of S. Maddalena (II, PL. 138). At the same time, however, the Florentine Alessandro Galilei virtually revived 16th-century style in Rome with the façade for S. Giovanni dei Fiorentini (1734) and with the solemn, distantly Palladian quality of the façade of St. John Lateran (1733–36). Nicola Salvi returned instead to the style of Bernini for the Fontana di Trevi (1732–44, completed in 1762 with the sculptures of P. Bracci and others; II, PL. 137). The Palazzo della Consulta (FIG. 437; II, PLS.

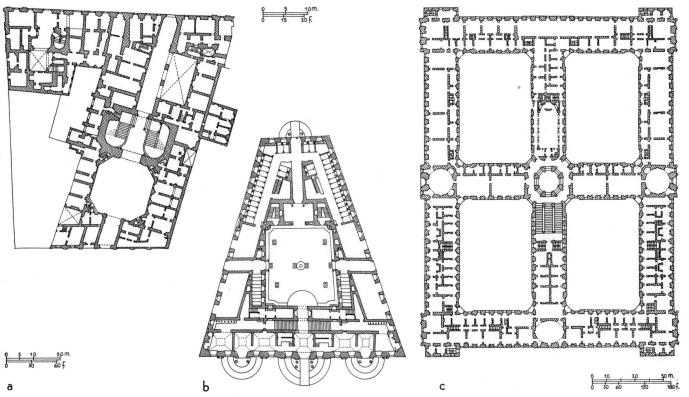

Secular buildings, 18th cent., Rome and Campania, plans. (a) Naples, Palazzo Serra di Cassano (architect: F. Sanfelice); (b) Rome, Palazzo della Consulta (architect: F. Fuga); (c) Caserta, Royal Palace (architect: L. Vanvitelli).

who was particularly influenced by the painting of Pietro da Cortona, achieved original scenographic effects in the Chapel of St. Cecilia in S. Carlo ai Catinari (ca. 1686) and the Avila Chapel in S. Maria in Trastevere (1690). Carlo Fontana, instead, was initially linked with Bernini, whose work on the Palazzo di Montecitorio he completed. Fontana's other works include the façade of S. Marcello (1683; PL. 223), the Cybo Chapel in S. Maria del Popolo (1685) and, at the end of his career, the reconstruction of SS. Apostoli (1702–14). Fontana's sensitivity to the inspiration of Borromini in the handling of moldings and profiles was particularly advanced and marked a genuine introduction to the 18th century.

Although the Roman rococo was rather moderate, it integrated and developed the schemes projected by the imagination of Borromini, possibilities which the 17th century, dominated by the art of Bernini, had generally neglected. At this time Rome was embellished with new squares and monuments that completed its baroque appearance. Alessandro Specchi, a pupil of Fontana (Porto di Ripetta, begun 1703, now destroyed; Palazzo De Carolis, 1722–27, now Banco di Roma) and Francesco de Sanctis (with Specchi: Spanish Steps of Trinità dei Monti, 1723–25) inaugurated the development of civic construction in the 18th century. A smaller masterpiece was Filippo Raguzzini's layout of Piazza S. Ignazio with the three elegant small palaces (1727–28) that close the square. The

138, 139), the Palazzo Corsini (1732–36), the Church of S. Maria della Morte, and the façade of S. Maria Maggiore (1743; PL. 223), by the Florentine Ferdinando Fuga, have an 18th-century *brio* and elegance. Borrominian elements, ordered with a certain emphasis on the monumental, prevail in the façade of Sta Croce in Gerusalemme (1743), by Domenico Gregorini and Pietro Passalacqua (II, PL. 138). Two artists whose styles were inspired by the classical-Renaissance tradition were Luigi Vanvitelli (who worked on the renovation of S. Maria degli Angeli) and Carlo Marchionni (Villa Albani, 1760; PL. 442; Sacristy of St. Peter's; 1776–84). Piranesi, the architect of S. Maria del Priorato (ca. 1765; X, PL. 267) occupied a unique position. In architecture, as well as in engravings, he tried to evoke the classical past, freely adapting its elements and arranging them with severe and picturesque elegance.

Baroque sculpture was dominated by Bernini (q.v.) and his open forms. The Bolognese artist Alessandro Algardi (q.v.; II, PLS. 164, 168), unlike Bernini, emphasized closed academic forms and was extremely intent on the true and "picturesque" (in Annibale Carracci's sense of the word). Nevertheless, Algardi showed traces of Bernini's influence, as did to a greater degree the Fleming François Duquesnoy (also known as Francesco Fiammingo; II, PL. 168), whose less vivid personality produced works halfway between the style of Bernini and that of the classicizing tradition. The chief followers of Bernini and

Algardi were the Lombards Ercole Ferrata (II, PL. 167) and Antonio Raggi. Ferrata developed the precision and correctness of Algardi in a Berninian key; Raggi transmuted the exuberance of Bernini into an elegance that anticipated the 18th century. Tombs, chapels, narrative reliefs used as altarpieces, large decorative statues, and portraits were the chief objects of baroque sculpture. Among the sculptors active in Rome, many of whom worked with Bernini or Algardi or were pupils of Ferrata, were Andrea Bolgi, Giuliano Finelli, Francesco Baratta (all from Carrara), Melchiorre Caffà (II, PLS. 165), Francesco Aprile, Cosimo Fancelli (who was also a collaborator of Pietro da Cortona), Filippo Carcani, Domenico Guidi, Lorenzo Ottone, Bernardino Cametti (Cometti), and Giuseppe Mazzuoli (Mazzuola) the Elder. The last-named artists were at work in Rome at the beginning of the 18th century, as were the Frenchmen Pierre Legros, Pierre Etienne Monnot (X, PL. 150), and Jean-Baptiste Théodon, who had long careers in Rome and in whose work the late baroque acquired accents of 18th-century classicism. But the work of the Lombard sculptor Camillo Rusconi (PL. 223) summed up the qualities of the 17th century with the greatest vitality and provided the point of departure for the best sculptors of the 18th century. (For the artists mentioned above, see BAROQUE ART.) The grace and measured elegance of the Florentine Filippo della Valle, one of Rusconi's students, well represented the classicizing tendencies of the 18th century. The Roman Pietro Bracci (PL. 223), who probably studied with Rusconi, was the chief exponent of the style of Bernini in the 18th century. Bracci's style was rich in movement, pictorial sensitivity, and rococo scenic elegance. The Basilica of St. John Lateran contains examples by most of the artists mentioned, from Lorenzo Ottone on. Also worthy of mention for his activity in Rome is another French sculptor of Flemish origin, René-Michel (known as Michel-Ange) Slodtz. A pupil of Slodtz was the extremely refined and somewhat precious Jean Antoine Houdon (q.v.).

Rome maintained an official link with French artists through the French Academy (established in Rome in 1666 under the auspices of Louis XIV). Flemings and Dutchmen (see FLEMISH AND DUTCH ART) were also attracted to Rome — a fact about which much was written at the time (by such men as Giulio Mancini, Giovanni Baglione, Giovanni Pietro Bellori, and Giuseppe Passeri).

The ferment created at the end of the 16th century by Caravaggio and the Carraccis (qq.v.) was channeled into the two currents that characterized 17th-century painting. The Caravaggesque tendency was most important in the first two decades of the 17th century. At the same time, a classical tendency derived from the Carraccis came into vogue in Bologna. The latter tendency culminated in the courtly and cluttered decoration of the baroque period, while the taste for naturalism found expression in genre painting, after having given a vital impetus to Italian and European painting in general. Followers of Caravaggio included the Mantuan Bartolomeo Manfredi (II, PL. 179); the Roman Orazio Borgianni (II, PL. 180), who took something of El Greco's Spanish style and adroitly combined it with that of the Bassanos; the Venetian Carlo Saraceni (II, PL. 183), with his luminous color, who had some contact with Adam Elsheimer; and the Tuscan Orazio Gentileschi (q.v.; II, PL. 181), who retained the limpidity and elegance of form of his mannerist education and exercised an influence on the art of northern Europe during his sojourns in Paris and London. Roman influences also reached northern Europe through such foreigners as the Frenchmen Valentin, Georges de La Tour, and Jean Le Clerc and the Dutchmen Hendrik Terbrugghen, Gerard van Honthorst, and Dirk van Baburen (see BAROQUE ART; FRENCH ART; FLEMISH AND DUTCH ART), who had come into contact with the work of Caravaggio in Rome. Caravaggio also influenced painters of more modest gifts and less distinctive styles, such as Antiveduto Grammatica and Giovanni Pietro Baglione, the teacher of Tommaso (Mao) Salini, one of the first to paint still lifes in a Caravaggesque style. The painting of the Bamboccianti (q.v.) was also associated with Caravaggio.

An area of Roman art that can only be termed a neutral zone was that represented by the long activity of the Cavalier

d'Arpino, a few other mannerists, and such semi-mannerists as Cristofano Roncalli, called "Il Cavaliere delle Pomarance (Pomarancio)," and Antonio Circignani.

Of Bolognese artists after the Carraccis, Rome knew the rigor and balance of Domenichino (q.v.), the idealistic elegance of the greatly admired Guido Reni (q.v.), and the Arcadian mythology of Francesco Albani (PLS. 218, 219). Later additions to this group were Sassoferrato (G. B. Salvi; PL. 219) from the Marches and the Calabrian Francesco Cozza, who adhered to the classicizing formalism of Domenichino. It was precisely this trend of classicizing formalism that showed the greatest divergence from the realistic orientation of Caravaggio, although during his stay in Rome Guercino's early "Neo-Venetian style" (II, PL. 197) almost gave the impression that the two currents were converging. Giovanni Lanfranco's early style was based on the pictorialism of Lodovico Carracci. Lanfranco also showed a deep sensitivity to color and light, which was combined with derivations from Correggio's work and became an element in the grand decorative style of the baroque, in which foreshortening, dynamic masses, and aerial perspective were dominant features. From about 1630 Pietro da Cortona (q.v.) was the greatest exponent of this style, in which virtually all the monumental frescoes of the baroque age were created. Pietro da Cortona was more influential than Lanfranco, who nevertheless had some influence on such followers of Pietro as Simon Vonet and Mattia Preti. Among the numerous followers of Pietro da Cortona were Ciro Ferri and Giovanni Francesco Romanelli (PL. 220).

In opposition to this trend was the work of a Roman follower of Albani, Andrea Sacchi, whose works include a handsome altarpiece in the Vatican Museums (Vision of St. Romuald; PL. 220) and the ceiling of a room in the Palazzo Barberini. In the latter work, the search for monumental simplicity in a classically balanced composition shows a conscious attempt to avoid the numerous figures and the dynamic foreshortenings of Pietro da Cortona's work. Yet Sacchi and Pietro, despite this opposition of styles, were related by their interest in the color tones of the Venetians, so that some scholars are inclined to speak of a "Neo-Venetian" phase in the Roman painting of this period. Nicolas Poussin (q.v.) was living in Rome at this time, while the Lombard Pier Francesco Mola returned to Rome from Venice with a rich and colorful palette. Pietro Testa, known as Il Lucchesino, was guided by the examples of Pietro da Cortona and Poussin. This so-called "Neo-Venetianism" was particularly evident in the picturesque and almost preromantic treatment of landscape. Salvator Rosa (q.v.), who was related to Mola and Testa in some respects, settled in Rome about 1650; Rosa had grown up in Naples and spent some time at the court of the Grand Duke of Tuscany.

Landscape painting had a distinctive and important development in Rome. The genre was initiated by the Fleming Paul Brill, and his concepts contributed to the formation of Annibale Carracci's "ideal" or "heroic" landscape. The German Adam Elsheimer brought a Caravaggesque luminism to landscape painting. Agostino Tassi followed the lead of Brill and Carracci and transmitted their ideas to the young Claude Lorrain (q.v.), who worked in Rome until his death in 1682. Claude's luminous visions, transmitted by the English landscape painters, were influential until the time of the impressionists. Poussin gave a humanistic intensity and a comfortable warmth to the heroic landscape; Gaspard Dughet (G. Poussin), his brother-in-law, who was born and lived in Rome, imbued the heroic landscape with a romantic passion that was evident even in his choice of subjects.

In the second half of the 17th century, the antithesis between Pietro da Cortona and Andrea Sacchi continued to influence the evolution of the two stylistic tendencies. The one tendency brought baroque decoration on the grand scale to its ultimate consequences in the work of two artists from Lucca, Giovanni Coli and Filippo Gherardi (frescoes in the Palazzo Colonna), and in that of Giovanni Battista Gaulli, known as Bacciccio or Bacciccia (II, PL. 171; III, PL. 303), and Andrea Pozzo, a Jesuit from Trent (II, PL. 172). The other tendency continued to adhere to the theories of classicism. This tendency was repre-

sented by Carlo Maratti (or Maratta) of the Marches, a pupil of Sacchi who was hailed by Bellori as a new Raphael (II, PL. 204). Through the work of his numerous followers, who were active even in the 18th century, the balance and harmonious correctness of Maratti's art found its logical conclusion in the neoclassic movement.

One of the most faithful followers of Maratti was the Roman Giuseppe Chiari. Of this older generation, the principal artists were the Florentine Benedetto Luti (who turned from the tradition of Pietro da Cortona to the puristic ideal of the tradition centered around Maratti) and Francesco Trevisani (called "Romano") of Istria, who represented a new source of Venetianism in Roman painting. His style was not classicistic but adhered, rather, to the occasionally affected decorative taste of the rococo. At the same time, Rome received contributions from the Neapolitan school, which was based in the art of Luca Giordano, once a collaborator of Pietro da Cortona. Neapolitan influence was brought to Rome by Francesco Solimena (PL. 227) in 1701, and Sebastian Conca worked in Rome from 1706 to 1750 (PL. 220). Of greater importance was the intermittent, though artistically more vital, contribution of Corrado Giaquinto (PL. 227). The dominant trend in painting, however, was the more academic style of such painters as Placido Costanzi, Marco Benefial, and Pompeo Girolamo Batoni (III, PL. 307). The Roman Benefial had an almost veristic, bourgeois spirit; Batoni, of Lucca, showed considerable assurance in handling his decorative, courtly creations and cultivated classical talents, one factor which contributed to his fame as a portraitist. In direct contrast to the work of Batoni were the caricatures of Pier Leone Ghezzi (III, PL. 422), whose position in the art of the time was relatively isolated. The French classicism of Pierre Subleyras, who settled in Rome in 1728, was characterized by breadth of conception and clarity of vision. The decorative vein, on the other hand, was exploited by the virtuoso Roman fresco painter Gregorio Guglielmi, who also worked in Germany, Austria, and Russia, where in 1769 he entered the service of Catherine II.

The same two tendencies were evident in landscape painting. The Fleming Jan Frans van Bloemen and the Roman Andrea Locatelli continued the tradition of the ideal landscape, following in the line of descent from Dughet and Lorrain, while Gaspar van Wittel, known as Vanvitelli, was the first in Italy to produce views of city life based on Dutch models. Giovanni Paolo Pannini (PL. 228) adapted the scenographic ability acquired in the circle of the Galli Bibiena family to an extremely animated rendition of real and imaginary ruins. His art greatly influenced Claude Joseph Vernet and the picturesque and preromantic style of Hubert Robert. Robert was also acquainted with the engravings of Piranesi (q.v.), who transformed archaeological motifs into vivid poetic reality.

Anton Raphael Mengs' work in Rome (e.g., *Parnassus*, 1761, Villa Albani) marked a melancholy return to 16th-century idealism and, thus, in a sense, to the puristic Sacchi-Maratti tradition, as well as a decided inclination to the coolness of neoclassicism. Such able painters as Ludwig Stern, Domenico Corvi, and Giuseppe Cades could not alter the trend of the times, to which a decisive contribution was also made by Jacques Louis David and Canova (qq.v.). The lively personalities of Felice Giani and Vincenzo Camuccini (VII, PL. 268) could not prevent the incipient decline of Rome's artistic position. In the Napoleonic period Paris supplanted Rome as the artistic center of Europe.

BIBLIOG. D. Fontana, Della trasposizione dell'obelisco vaticano e delle fabbriche di N. S. Papa Sisto V, Rome, 1590, Naples, 1604; G. Mancini, Viaggio per Roma (before 1630), in Considerazioni sulla pittura (ed. A. Marucchi and L. Salerno), I, Rome, 1956, pp. 265–88; G. Celio, Delli nomi dell'artefici delle pitture che sono in alcune chiese, facciate, e palazzi di Roma, Naples, 1638; G. Baglione, Le vite di pittori, scultori, ed architetti, Rome, 1642; F. Titi, Studio di pittura, scultura, ed architettura delle chiese di Roma, Rome, 1674; N. Pio, Vite de' pittori, Rome, 1714 (ms.); L. Pascoli, Vite dei pittori, scultori e architetti moderni, 2 vols., Rome, 1730–36; F. Milizia, Vite dei più celebri architetti..., Rome, 1768 (Eng. trans., E. Cresy, 2 vols., London, 1826); G. B. Passeri, Vite de' pittori, scultori ed architetti che hanno lavorato in Roma morti dal 1641 al 1673, Rome, 1772; E. Müntz, Les artes à la cour des papes pendant le XVᵉ et XVIᵉ siècles, 3 vols., Paris, 1878–82; A. Bertolotti, Artisti lombardi a

Roma, 2 vols., Milan, 1881; A. Bertolotti, Artisti veneti a Roma, Venice, 1884; E. Steinmann, Rom in der Renaissance, Leipzig, 1899; G. Magni, Il barocco a Roma nell'architettura e nella scultura decorativa, 3 vols., Turin, 1911–13; J. A. F. Orbaan, Documenti sul barocco a Roma, 2 vols., Rome, 1920; H. Voss, Die Malerei der Spätrenaissance in Rom und in Florenz, 2 vols., Berlin, 1920; H. Voss, Die Malerei des Barock in Rom, Berlin, 1925; A. Muñoz, Roma barocca, 2d ed., Rome, 1928; O. Pollak, Die Kunsttätigkeit unter Urban VIII, I, Vienna, 1928; Istituto di Studi Romani, Mostra di Roma secentesca (exhibition cat.), Rome, 1930; E. K. Waterhouse, Baroque Painting in Rome, London, 1937; T. H. Fokker, Roman Baroque Art: The History of a Style, 2 vols., London, 1938; L. Bruhns, Das Motiv der ewigen Anbetung in der römischen Grabplastik des 16., 17. und 18. Jahrhunderts, Röm. Jhb. für Kg., IV, 1940, pp. 253–432; U. Donati, Artisti ticinesi a Roma, Bellinzona, 1942; A. Riccoboni, Roma nell'arte: La scultura nell'evo moderno, dal Quattrocento ad oggi, Rome, 1942; A. De Rinaldis, L'arte in Roma dal Seicento al Novecento, Bologna, 1948; L. Bruhns, Die Kunst der Stadt Rom: Ihre Geschichte von den frühesten Anfängen bis in die Zeit der Romantik, 2 vols., Vienna, 1951 (bibliog.); V. Mariani, L'arte in Roma, Genoa, 1954; Il Settecento a Roma (exhibition cat.), Rome, 1959; C. Pericoli Ridolfini, Le case romane con facciate graffite e dipinte (exhibition cat.), Rome, 1960.

ARTISTS: See individual articles for *Fontana, Maderno, Pira esi, della Porta, Rainaldi, Romano.*

OTHERS. a. *Painters. Giovanni Baglione*: Rome, 1571–1644 ,C. Guglielmi, Intorno all'opera pittorica di Giovanni Baglione, BArte, XXXIX, 1954, pp. 311–26). *Pompeo Girolamo Batoni*: b. Lucca, 1708; d. Rome, 1787 (E. Emmerling, Pompeo Batoni, Darmstadt, 1932; L. Cochetti, Pompeo Batoni ed il neoclassicismo a Roma, Comm, III, 1952, pp. 274–81; R. Chyurlia, Pompeo Batoni o del classicismo settecentesco, Emporium, CXVII, 1953, pp. 56–67). *Marco Benefial*: Rome, 1684–1764 (M. E. Paponi, Appunti su Marco Benefial a Città di Castello, Paragone, IX, 97, 1958, pp. 59–63). *Orazio Borgianni*: d. Rome, 1616 (R. Longhi, Orazio Borgianni, L'Arte, XVII, 1914, pp. 7–23). *Cavalier d'Arpino (Giuseppe Cesari)*: Rome, 1568–1640 (A. Quadrini, Il Cavalier d'Arpino, Isola Liri, 1940; J. Hess, Caravaggio, D'Arpino und Guido Reni, Z. für Kw., X, 1956, pp. 57–72). *Ciro Ferri*: Rome, 1634–89 (B. Canestro Chiovenda, Ciro Ferri, Giovan Battista Gaulli e la cupola della chiesa di S. Agnese in Piazza Navona, Comm, X, 1959, pp. 16–23). *Gaulli* (see *Liguria*, below). *Felice Giani*: b. San Sebastiano di Monferrato (near Genoa), ca. 1760; d. Rome, 1823 (I. Faldi, Opere romane di Felice Giani, BArte, XXXVII, 1952, pp. 234–46). *Giovanni da Udine*: b. Udine, ca. 1487; d. Rome, 1564 (R. Averini, Giovanni da Udine, inventore di grottesche e stucchi, S. romani, V, 1957, pp. 29–38; R. U. Montini and R. Averini, Palazzo Baldassini e l'arte di Giovanni da Udine, Rome, 1957). *Gregorio Guglielmi*: b. Rome, 1714; d. St. Petersburg, 1773 (A. Griseri, Gregorio Guglielmi a Torino, Paragone, VI, 69, 1955, pp. 29–38). *Pirro Ligorio*: b. Naples, ca. 1500; d. Ferrara, 1583 (ThB, s.v.; D. R. Coffin, Pirro Ligorio and Decoration of the Late 16th Century at Ferrara, AB, XXXVII, 1955, pp. 167–85). *Andrea Lilio (Andrea d'Ancona)*: b. Ancona, ca. 1555; d. Ascoli Piceno, 1610 (G. Scavizzi, Note sull'attività romana del Lilio e del Salimbeni, BArte, XLIV, 1959, pp. 33–40). *Andrea Locatelli*: d. Rome, ca. 1741 (EI, s.v.). *Benedetto Luti*: b. Florence, 1666; d. Rome, 1724 (V. Moschini, Benedetto Luti, L'Arte, XXVI, 1923, pp. 89–114). *Bartolomeo Manfredi*: b. Ostiano (near Mantua), ca. 1580; d. Rome, ca. 1620 (K. Bauch, Aus Caravaggios Umkreis, Mitt. des Kunsthist. Inst. in Florenz, VII, 1953–56, pp. 227–38). *Carlo Maratti (Maratta)*: 1625–1713 (A. Mezzetti, Contributi a Carlo Maratti, RIASA, N.S., IV, 1955, pp. 253–354). *Pier Francesco Mola*: b. Coldrerio, 1612; d. Rome, 1666 (W. Arslan, Opere romane di Pier Francesco Mola, BArte, N.S., VIII, 1928–29, pp. 55–80; V. Martinelli, Nuovi ritratti di Guidubaldo Abbatini e di Pierfrancesco Mola, Comm, IX, 1958, pp. 99–109). *Girolamo Muziano*: b. Brescia, 1528; d. Rome, 1592 (U. da Como, Gerolamo Muziano note e documenti, Bergamo, 1930; U. Procacci, Una vita inedita di Girolamo Muziano, Arte veneta, VIII, 1954, pp. 242–64). *Giovanni Paolo Pannini (Panini)*: b. Piacenza, 1691; d. Rome, 1765 (L. Ozzola, G. P. Pannini, Turin, 1921). *Giovan Francesco Penni, called Il Fattore*: Florence 1488(?)–1528(?), (ThB, s.v.). *Luca Penni, called Romanus*: b. Florence; d. Paris, 1556 (L. Golson, Luca Penni, a Pupil of Raphael, at the Court of Fontainebleau, GBA, XCIX, 1957, pp. 17–36). *Perino del Vaga (Pietro Buonaccorsi)*: b. Florence, ca. 1501; d. Rome, 1547 (A. E. Popham, On Some Works by Perino del Vaga, BM, LXXXVI, 1945, pp. 56–66; G. Frabetti, Sulle tracce di Perin del Vaga, Emporium, CXXVII, 1958, pp. 195–204). *Pomarancio* (see the *Tuscan school*, below). *Scipione Pulzone*: b. Gaeta, before 1550; d. Rome, 1598 (F. Zeri, Pittura e controriforma: L'arte senza tempo di Scipione da Gaeta, Turin, 1957). *Giovanni Francesco Romanelli*: Viterbo, ca. 1610–62 (C. Galassi-Paluzzi, Roma, II, 1924, pp. 84–89; J. Hess, Affreschi di Gianfrancesco Romanelli nel Palazzo del Vaticano, Ill. Vaticana, VI, 1935, pp. 241–45). *Andrea Sacchi*: Rome(?), 1599–1661 (H. Posse, Der römische Maler Andrea Sacchi, Leipzig, 1925; C. Refice, Andrea Sacchi disegnatore, Comm, I, 1950, pp. 214–

18). *Tommaso (Mao) Salini*: Rome, ca. 1575-1625 (L. Salerno, Di Tommaso Salini, un ignorato caravaggesco, Comm, III, 1952, pp. 28-31). *Girolamo Siciolante*: b. Sermoneta, 1521; d. Rome, ca. 1580 (F. Zeri, Intorno a Girolamo Siciolante, BArte, XXXVI, 1951, pp. 139-49). *Agostino Tassi*: Rome, ca. 1580-1644 (J. Hess, A. Tassi: Der Lehrer des Claude Lorrain, Munich, 1935; E. Schaar, Zu den Landschafts Gemälden Agostino Tassi, Mitt. des Kunsthist. Inst. in Florenz, IX, 1960, pp. 136-40). *Pietro Testa*, called *Il Lucchesino*: b. Lucca, 1611(?); d. Rome, 1650 (A. Petrucci, Originalità del Lucchesino, BArte, XXIX, 1935-36, pp. 409-19; A. Marabottini, Novità sul Lucchesino, Comm, V, 1954, pp. 116-35). *Francesco Trevisani*, called *Romano*: b. Capodistria, 1656; d. Rome, 1746 (A. Griseri, Un orologio dipinto dal Trevisani, B. Mus. comunale di Roma, VII, 1960, pp. 17-21). *Zuccari: Taddeo*, b. San Angelo in Vado, 1529; d. Rome, 1566; *Federico*, b. San Angelo in Vado, ca. 1540; d. Ancona, 1609 (W. Friedländer, The Academician and the Bohemian: Zuccari and Caravaggio, GBA, XXXIII, 1948, pp. 27-36; D. Helkamp, Ancora su Federico Zuccari, BArte, XLIII, 1958, pp. 45-50; A. Terzaghi, La nascita del Barocco e l'esperienza europea di Federico Zuccari, Actes du XIXᵉ Cong. int. d'h. de l'Art, Paris, 1958, pp. 285-97).

b. Sculptors. Baccio da Montelupo (Bartolomeo Sinibaldi): Montelupo, 1469-1535 (F. Filippini, Baccio da Montelupo in Bologna, Dedalo, VIII, 1927-28, pp. 527-42). *Andrea Bolgi*: b. Carrara, 1605; d. Naples, 1656 (V. Martinelli, Contributi alla scultura del '600: Andrea Bolgi a Roma e Napoli, Comm, X, 1959, pp. 137-58). *Pietro Bracci*: Rome, 1700-73 (K. von Domarus, Pietro Bracci, Strasbourg, 1915; C. Gradara, Pietro Bracci, 1700-1773, Milan, 1920; F. Hermanin, Due busti di Pietro Bracci, Dedalo, X, 1929-30, pp. 251-62). *Melchiorre Caffà (or Cafà)*: b. Malta, ca. 1630; d. Rome (?), after 1669 (E. Sammut, Melchiorre Cafà Maltese: Sculptor of the Baroque, Malta, 1957). *Ercole Ferrata*: b. Pellio Inferiore, 1610; d. Rome, 1686 (V. Golzio, Pittori e scultori nella chiesa di S. Agnese a Piazza Navona in Roma, Arch. d'Italia, 2d Ser., I, 1933-34, pp. 302-10; V. Golzio, Lo "studio" di Ercole Ferrata, Arch. d'Italia, 2d Ser., II, 1935, pp. 64-74; I. Faldi, Ercole Ferrata: Un bozzetto della pala di Sant'Emerenziana, Paragone, VII, 87, 1957, pp. 69-72; M. V. Brugnoli, Due bozzetti del '600: Ercole Ferrata e Pierre Etienne Monnot, BArte, XLV, 1960, pp. 339-45). *Giuliano Finelli*: b. Carrara, ca. 1601; d. Rome, 1657 (U. Prota-Giurleo, Notizie napoletane sugli scultori carraresi Vitale e Giuliano Finelli, Arch. d'Italia, 2d Ser., XXIV, 1957, pp. 157-63; A. Nava Cellini, Un tracciato per l'attività ritrattistica di Giuliano Finelli, Paragone, XI, 131, 1960, pp. 9-30). *Domenico Guidi*: b. Torano (near Carrara), 1625; d. Rome, 1701 (A. Nava Cellini, Per Alessandro Algardi e Domenico Guidi, Paragone, XI, 121, 1960, pp. 61-68). *Stefano Maderno*: b. Bissone (?), ca. 1576; d. Rome, 1636 (A. Donati, Stefano Maderno scultore, 1576-1636, Bellinzona, 1945). *Camillo Mariani*: b. Vicenza, 1556; d. Rome, 1611 (G. Fiocco, Camillo Mariani, Le Art, III, 1940-41, pp. 74-86; V. Martinelli, Le prime sculture di Camillo Mariani a Roma, Venezia e l'Europa: Atti XVIII Cong. int. storia arte, Venice, 1955, pp. 309-11). *Giuseppe Mazzuoli (Mazzuola)*: b. Siena, 1644; d. Rome, 1725 (F. Pansecchi, Contributi a Giuseppe Mazzuoli, Comm, X, 1959, pp. 33-43). *Francesco Mochi*: b. Montevarchi, 1580; d. Rome, 1654 (P. della Pergola, L'attività di Francesco Mochi a Roma, BArte, XXVII, 1933-34, pp. 103-10; V. Martinelli, Francesco Mochi a Roma, Comm, II, 1951, pp. 224-35; V. Martinelli, Francesco Mochi a Piacenza, Comm, III, 1952, pp. 35-50). *Carlo Monaldi*: Rome, 1690-1760 (R. Chyurlia, Di alcune tendenze della scultura settecentesca a Roma e Carlo Monaldi, Comm, I, 1950, pp. 222-28). *Antonio Raggi*: b. Vicomorcote (near Como), 1624; d. Rome, 1686 (U. Donati, Contributi alla storiografia artistica ticinese, J, Bellinzona, 1939). *Camillo Rusconi*: b. Milan, 1658; d. Rome, 1728 [S. Samek-Ludovici, Le "Vite" di Francesco Saverio Baldinucci (II), Arch. d'Italia, 2d Ser., XVII, 1950, pp. 209-22; V. Martinelli, Due modelli di Camillo Rusconi ritrovati, Comm, IV, 1953, pp. 231-41; M. I. Webb, A Rusconi Relief of "Leda and the Swan," BM, XCVIII, 1956, p. 207]. *Cristoforo Stati*: b. Bracciano, 1556; d. Rome, 1619 (V. Martinelli, Cristoforo Stati e il gruppo di "Venere e Adone," BArte, XLII, 1957, pp. 233-42).

c. Architects. Ferdinando Fuga: b. Florence, 1699; d. Rome, 1781 (G. Matthiae, Ferdinando Fuga e la sua opera romana, Rome, 1952; R. Pane, Ferdinando Fuga, Naples, 1956). *Alessandro Galilei*: b. Florence, 1691; d. Rome, 1736 [I. Toesca, Alessandro Galilei in Inghilterra, Eng. Misc., III, 1952, pp. 189-205; P. Sanpaolesi, L'oratorio del Vivaio a Scarperia, Atti VIII Conv. naz. Storia Arch. (1953), Caserta, 1956, pp. 193-98]. *Antonio Gherardi*, called *Reatino*: b. Rieti, 1644; d. Rome, 1702 (A. Mezzetti, La pittura di Antonio Gherardi, BArte, XXXIII, 1948, pp. 157-79). *Pirro Ligorio*: (see *Painters*, above). *Ottaviano Mascherino (Mascarino)*: b. Bologna, 1524; d. Rome, 1606 (V. Golzio, Note su Ottaviano Mascherino architetto in Roma, Dedalo, X, 1929-30, pp. 164-94). *Flaminio Ponzio (Ponzi)*: b. Milan, 1560 (?); d. Rome, 1613 (L. Crema, Flaminio Ponzio: Architetto milanese in Roma, Atti IV Conv. naz. Storia Arch., Milan, 1939, pp. 281-308). *Girolamo Rainaldi*: Rome, 1570-1655 (A. Corbara, Girolamo Rainaldi, il Borromini e l'Algardi per una chiesa faentina, CrArte, V, 1940, pp. 141-42; R. Battaglia, La pianta dell'Acqua Felice di Girolamo Rainaldi, Rome, 1943). *Filippo Raguzzini (Rauzzini, Rausini)*: b. Benevento; d. Rome, 1771 (M. Rotili, F. Raguzzini e il rococò romano, Rome, 1951). *Nicola Salvi*: Rome, 1697-1751 (A. Schiavo, La fontana di Trevi e le altre opere del Salvi, Rome, 1956). *Giuseppe Sardi*: b. San Angelo in Vado, ca. 1680; d. Rome, 1753 (V. Golzio, La chiesa di Santa Maria Maddalena a Roma, Dedalo, XII, 1932, pp. 55-81). *Alessandro Specchi*: Rome, 1668-1729 (T. Ashby and S. Welsh, Alessandro Specchi, Town Planning Rev., XIII, 1927, pp. 237-48). *Gabriele Valvassori*: Rome, 1683-1761 (M. Loret, L'architetto del Palazzo Doria Pamphilj, Ill. Vaticana, IV, 1933, pp. 303-04; A. Rava, Gabriele Valvassori: Architetto romano, Capitolium, X, 1934, pp. 385-98).

THE TUSCAN SCHOOL FROM THE MANNERIST PERIOD ON. Leonardo, Michelangelo, and Raphael (qq.v.) gave to the art of Tuscany and central Italy the all-embracing idealism that characterized the 16th century, allowing Florence and Rome to become complementary centers. Tuscan artists, who were gravitating toward the mannerist style (see MANNERISM), carried the influence of 16th-century Florentine art throughout Italy and abroad, and were instrumental in widening Europe's artistic horizons.

The older Florentine painters of the 16th century (the generation born about 1475), usually schooled in the methods of Ghirlandajo and Piero di Cosimo (qq.v.), were most strongly influenced by Leonardo and Raphael, who dominated the culture of the time. The artists of the time also felt the influence of Umbrian, German, and Flemish art. The Dominican Fra Bartolommeo (q.v.; PL. 209) sought to achieve effects of monumentality in his handling of color masses that emerge from chiaroscuro backgrounds and contributed to the development of 16th-century ideals of painting. A more pictorially vibrant vision animated the work of Andrea del Sarto (q.v.), who also worked in France. Despite the fact that Andrea's handling of pictorial form was always controlled by a classicist moderation, his style formed the point of departure for the two principal Florentine mannerists, Pontormo and Il Rosso (qq.v.).

This phase of painting closely paralleled the idealized character of the sculpture of Andrea Sansovino (q.v.), who returned to Florence after a decade in Portugal. The pictorial qualities of Leonardo's style influenced both painters and sculptors, including Andrea Sansovino (and, more particularly, his pupil Jacopo Sansovino), Baccio da Montelupo, and, most notably, Giovan Francesco Rustici (bronze statue of John the Baptist, Florence, Baptistery, 1506-11), who later worked in France. Andrea Ferrucci and Benedetto da Rovezzano (Benedetto di Bartolomeo de' Grazini) maintained more traditional positions; both artists worked outside Italy as well, the former in Hungary, the latter in England and France.

Many minor artists, especially painters, belonged to this phase of 16th-century Tuscan art. Among them were Mariotto Albertinelli (collaborator of Fra Bartolommeo), Franciabigio (collaborator of Andrea del Sarto), Giuliano di Piero di Simone, Bugiardini, Francesco Granacci, Ridolfo Ghirlandajo, and such younger artists as Giovannantonio di Francesco Sogliani, Domenico Puligo, and Francesco Ubertini (Francesco d'Ubertino Verdi), known as Bachiacca.

In the third decade of the 16th century, other artists challenged the vitality of 16th-century classicism, departing from its theory of proportions and dissolving its formal language. Michelangelo's influence, abetted by the innovations of the younger artists of this period and a new taste for northern art, exerted the major force in this transformation. Among the leaders of the anticlassical trend was Pontormo, an artist of extraordinary imagination (IV, PL. 201; IX, PL. 289). Il Rosso compressed intense color into almost sculptured forms (IX, PLS. 290, 291), and the sensitive Sienese painter Domenico Beccafumi undertook similar experiments (PL. 86; IX, PL. 295). Bronzino (q.v.), court painter of Florence, cultivated closed, compact forms and was especially successful in portraits (IX, PL. 296).

The creative phase of mannerism was followed by an academic one, which, although it maintained a superficial fidelity

to the principles of Michelangelo, was characterized by literary and rhetorical subject matter and by virtuosity of design and iridescent color. The final period of Il Rosso in France (1530–40) was essentially academic. Academicism was more evident in the work of Francesco Salviati, Giorgio Vasari, Daniele da Volterra (Daniele Ricciarelli), and Jacopino (Jacopo) del Conte, all of whom worked in Rome, as well as in Tuscany; Salviati, the liveliest of the group, also worked in Venice. Typical of this period was the decoration of various halls in the Palazzo Vecchio (including the *Studiolo* of Francesco I de' Medici; PLS. 102, 103). Vasari's numerous pupils assisted him in the execution of this work; among them were Battista (Giovanni Battista) Naldini, Tommaso d'Antonio Manzuoli (Maso da San Friano), Jacopo Zucchi, and two artists distinguished for their fresh ease of painting, Girolamo Macchietti (Girolamo del Crocefissaio), and Mirabello di Antonio Cavalori (Mirabello da Salincorno). An exotic note was contributed to the decoration by Jan van der Straet, known as Stradano, who went to Florence from Bruges.

With the loss of its skilled, formal elegance, Tuscan painting sank into tedium, notwithstanding the influence of Venetian painting, which was transmitted by the Veronese immigrant Giacomo Ligozzi and such Tuscan artists as Passignano (Domenico Cresti), who spent time in Venice. The tradition of decorative fresco painters was continued by Alessandro Allori, his son Cristofano, and Bernardino Poccetti (Barbatelli); they were followed by Santi di Tito (PL. 209), Lodovico Cigoli (Cardi), Passignano, the Circignanis, and Cristofano Roncalli, called "Il Cavaliere delle Pomarance (Pomarancio)," all of whom also worked in Rome and formed an easily recognizable current. Of notable originality in decorative fresco painting were Andrea Boscoli, who also worked extensively in the Marches, and Jacopo Chimenti. Another tendency, which derived from Federico Barocci (q.v.), appeared in Siena in the paintings of Francesco Vanni, Ventura Salimbeni, Alessandro di Agostino Casolani (called "Alessandro della Torre"), and Pietro Sorri.

In the early 16th century Tuscan architects, including the two Sangallos and Baldassarre Peruzzi, as well as Michelangelo, were attracted chiefly to Rome. The numerous Sangallo family formed the so-called "Sangallo party." Jacopo Sansovino spread the Roman taste to Venice. The influence of Michelangelo was absorbed in a decorative style of rational elegance in the architecture of Giorgio Vasari (q.v.; IX, PL. 312), Giovan Antonio Dosio (Florence, Palazzo Giacomini, now Larderel), and Bartolommeo Ammanati (q.v.), who was also a sculptor and worked with Sansovino in Venice. The style of Michelangelo was adapted with theatrical and fanciful inventions by Bernardo Buontalenti (q.v.; PLS. 430, 431; Florence, Casino di S. Marco, now Corte d'Appello, 1574; Signa, Villa di Artimino). Characteristic of this period in Florence was an interest in gardens and fountains, in which Niccolò Tribolo specialized, as well as a predilection for ephemeral decorations for public holidays, weddings, triumphal processions, and funerals.

In sculpture, mannerism was expressed in two trends. On the one hand, it found expression in the decorative exuberance of Tribolo (fountains for the Medici villas of Castello, PL. 431, and La Petraia; project for the Boboli Gardens, 1550) and Giovanni Angelo Montorsoli, who worked in Messina (fountains of Orion, 1550, and of Neptune, 1557), both former assistants of Michelangelo. On the other hand, mannerism developed into the refined elegance of certain works of Bandinelli (*Bacchus*, Pitti, 1547), Cellini (q.v.; *Narcissus*, Florence, Mus. Naz., 1548), and Giambologna (q.v.; *Mercury*, Bologna, Mus. Civ., 1564; Venus Fountain, Florence, Boboli Gardens, 1573). This manifestation of a subtle and intellectual classicism, combining virtuosity and sensuousness while avoiding the negative effects of Michelangelo's tortured monumentality, formed the most valid poetic element in the work of these sculptors. Cellini's long stay in France (1540–45) and Giambologna's northern European training established another link between Italian and European mannerism, with the school of Fontainebleau in particular. The art of Giambologna was influential in Germany and the Low Countries; in Italy it was successfully followed by the art of the Frenchman Pietro Francavilla (who worked

on the bronze doors of the Cathedral of Pisa), the Florentine Taddeo Landini (Rome, statues of the Fontana delle Tartarughe, PL. 206), and Giovanni Battista Caccini, and in the 17th century by Pietro Tacca from Carrara, who also worked in Spain (Madrid, equestrian monument to Philip IV; Leghorn, statues of the Four Moors in the monument to Ferdinand I; IX, PL. 308).

Others instrumental in the diffusion of mannerism were Leone Leoni (of Tuscan family, though born and active in Lombardy), who traveled extensively as the official artist of Charles V, and Leoni's son Pompeo, who worked chiefly in Spain. The Tuscan Stoldo Lorenzi did work in Milan, while Michelangelo Naccherino and Pietro Bernini, father of Gian Lorenzo, went to Naples. Francesco Camilliani (PL. 225), Andrea Calamech, and Montorsoli traveled to Sicily, as did the painter Filippo di Benedetto Paladini (Paladino), who popularized the facile elegances of Florentine mannerism, the last important movement of a Tuscan school.

In the following two centuries, some Tuscan artists overcame their regional limitations, preserving little more of Tuscany than their origins. The sculptor Francesco Mochi (II, PL. 164; X, PL. 149) and the painter Orazio Gentileschi (q.v.; a follower of Caravaggio) were such artists. In their work, the clearness and elegance derived from their mannerist training was still evident. Other Tuscans were Pietro da Cortona (q.v.), a pupil of Cigoli, Sebastiano Mazzoni, who settled in Venice, and in the 18th century, Alessandro Galilei, who formed his style in England, and Ferdinando Fuga, a pupil of Foggini, all of whom worked outside Tuscany. Among other Tuscan artists who worked abroad were Count Bartolomeo Carlo Rastrelli and his son Bartolomeo Francesco, two Florentine architects who settled in Russia.

Local work in Tuscany, marked by a certain constitutional reluctance to accept the criteria of the baroque, became much less important. In architecture, Matteo Nigetti, a pupil of Buontalenti, retained a linear clarity (PL. 210; Florence, S. Gaetano, begun in 1604), and Gherardo Silvani maintained an acute sense of balance and measure (Florence, reconstruction of S. Gaetano, 1633–48, and of Corsini palaces). The only architect who accepted the baroque (in the field of sculpture as well) was Giovanni Battista Foggini, an artist who followed Roman models (II, PL. 169; Florence, Feroni Chapel, SS. Annunziata). The complex of buildings most characteristic of the 18th century, albeit timid in style, was the Monastery of the Filippini (S. Firenze, PL. 210), on which Ferdinando Ruggieri, and Zanobi del Rosso worked.

The attempt to revive the mannerist tradition in painting, following Emilian and Venetian models (Cigoli, Passignano, Cristofano Allori), met with small success. The diligent Matteo Rosselli fathered a populous though undistinguished school, from which the majority of 17th-century Florentine painters descended. The influence of the Fleming Justus Sustermans, a portraitist for the court of the Medici, also contributed to the unimpressive mannerist revival. His pupils included Jacopo Vignali, the affected Carlo (Carlino) Dolci, Lorenzo Lippi, who was influenced by Tirolese and Bavarian art, and Francesco Furini (PL. 209), known for his hazy and ambiguous female nudes. The more gifted Giovanni da San Giovanni, who also began as a student of Sustermans, later came to know the works of the Carraccis and Lanfranco in Rome and created a style of luminous color (Pitti, Sala degli Argenti, 1634) that had an important influence on 18th-century painting as well. Baldassarre Franceschini, called "Il Volterrano," who acquired his dexterity from Giovanni, later became a follower of Pietro da Cortona (dome of SS. Annunziata, 1680–83). By the time Pietro da Cortona returned to Florence to renovate the Palazzo Pitti and fresco its rooms (1637–47), he had become a Roman master whose international style was almost unrelated to that of the Florentine painters. His influence, together with that of Luca Giordano (dome of the Corsini Chapel, S. Maria del Carmine; frescoes in the Palazzo Medici-Riccardi, 1682–83) and Sebastiano Ricci (Palazzo Marucelli, later Fenzi, 1706), swept away what little remained of Renaissance tradition. In the 18th century Tuscan painters adopted the rococo style and were subject to Roman, Bolognese, and Venetian influences (Giovanni Camillo

Sagrestani, Pietro Dandini, Anton Domenico Gabbiani, Alessandro Gherardini, and Sebastiano Galeotti). A notable representative of this style was Giovanni Domenico Ferretti.

BIBLIOG. G. Campori, Memorie biografiche degli scultori, architetti e pittori nativi di Carrara, Modena, 1873; C. G. Cavallucci, Notizie storiche intorno alla R. Accademia delle arti e del disegno a Firenze, Florence, 1873; G. Milanesi, Sulla storia dell'arte toscana, Siena, 1873; K. von Stegmann and H. von Geymüller, Die Architektur der Renaissance in Toscana, 11 vols., Munich, 1885–1908; B. Berenson, The Florentine Painters of the Renaissance, New York, London, 1896; L. Tanfani Centofani, Notizie d'artisti tratte da documenti pisani, Pisa, 1898; B. Berenson, The Drawings of the Florentine Painters, 2 vols., New York, London, 1903 (rev. ed., 3 vols., Chicago, 1938); P. Bacci, Documenti toscani per la storia dell'arte, 2 vols., Florence, 1910–13; W. Bode, Florentiner Bildhauer der Renaissance, 2d ed., Berlin, 1910; A. Della Vita, Documenti sui pittori aretini dei secoli XV–XVI, RArte, IX, 1916–18, pp. 142–59; F. Ingersoll Smouse, La sculpture florentine à la fin du XVIIe siècle, GBA, V, 1920, pp. 220–32; H. Voss, Die Malerei der Spätrenaissance in Rom und Florenz, 2 vols., Berlin, 1920; Mostra della pittura italiana del Seicento e del Settecento (exhibition cat.), Florence, 1922; J. Alazard, Le portrait florentin de Botticelli au Bronzino, Paris, 1924; P. Baratti, Architettura barocca e neoclassica a Livorno, Liburni Civitas, I, 1928, pp. 221–31; M. Neusser, Die Antikenergänzungen der florentiner Manieristen, Wiener Jhb. für Kg., VI, 1929, pp. 7–42; W. and E. Paatz, Die Kirchen von Florenz, 6 vols., Frankfurt, 1940–54; G. Poggi, Mostra del Cinquecento toscano in Palazzo Strozzi (exhibition cat.), Florence, 1940; L. Becherucci, Manieristi toscani, Bergamo, 1944; A. Chastel, Florentine Drawings, 14th–17th Centuries, New York, 1950; M. Marangoni, Settecentisti fiorentini, in Arte Barocca, Florence, 1953, pp. 203–42 (previously pub. in RArte, VIII, 1912, pp. 61–102); G. Sinibaldi and others, Mostra dei disegni dei primi manieristi italiani (exhibition cat.), Florence, 1954; F. Chabod and others, Il Cinquecento, Florence, 1955; L. Berti and L. Marcucci, Mostra del Pontormo e del primo manierismo fiorentino (exhibition cat.), Florence, 1956; M. Praz and others, Il Sei-Settecento, Florence, 1956; M. Salmi, Pietro da Cortona (exhibition cat.), Cortona, 1956; D. Heikamp, Rapporti fra accademici e artisti nella Firenze del '500, Il Vasari, XV, 1957, pp. 139–63; G. Nudi, Storia urbanistica di Livorno dalle origini al secolo XVI, Venice, 1959; Mostra dei disegni dei Grandi Maestri (exhibition cat.), Florence, 1960; K. Lankheit, Florentinische Barockplastik, Muinch, 1962.

ARTISTS: See individual articles for *Ammanati, Bronzino, Buontalenti, Cellini, Gentileschi, Giambologna, Pontormo, Rosso.*

OTHERS. *Mariotto Albertinelli*: Florence, 1474–1515, painter (H. Bodmer, Opere giovanili e tarde di Mariotto Albertinelli, Dedalo, IX, 1928–29, pp. 299–320; J. Balogh, Albertus pictor Florentinus, Ann. Ist. ungherese di storia dell'arte di Firenze, I, 1947, pp. 74–80). *Cristofano Allori*: Florence, 1577–1621, painter (H. Koritzer, Cristofano Allori, Leipzig, 1928). *Bachiacca (Francesco Ubertini, Francesco d'Ubertino Verdi)*: Florence, 1494–1557, painter (A. McComb, Francesco d'Ubertino detto il Bacchiacca, AB, VIII, 1926, pp. 141–67; L. Marcucci, Contributo al Bachiacca, BArte, XLIII, 1958, pp. 26–39). *Baccio Bandinelli*: Florence, 1493–1560, sculptor (U. Middeldorf, A Group of Drawings by Baccio Bandinelli, Print Coll. Q., XXIV, 1937, pp. 290–304; W. R. Valentiner, Bandinelli: Rival of Michelangelo, AQ, XVIII, 1955, pp. 241–62). *Giovanni Biliverti*: b. 1576; d. Florence, 1644; painter (G. J. Hoogewerff, Appunti sulle opere di Giovanni Bilivert, Comm, IX, 1960, pp. 139–56). *Andrea Boscoli*: Florence, 1550–1606, painter [A. Forlani, Mostra di disegni di Andrea Boscoli (exhibition cat.), Florence, 1959; M. Rivosecchi, I disegni di Andrea Boscoli, Capitolium, XXXIV, 11, 1959, pp. 12–14]. *Jacopo Chimenti (known as Jacopo da Empoli)*: b. Empoli, ca. 1554; d. Florence, 1640; painter (S. de Vries, Jacopo Chimenti da Empoli, RArte, XV, 1933, pp. 329–98; S. Bottari, Due "nature morte" dell'Empoli, Arte antica e moderna, III, 1960, pp. 75–76). *Ludovico Cigoli (L. Cardi, known as Il Cigoli)*: b. Castelvecchio, 1559; d. Rome, 1613; painter and essayist [M. Bucci, Cigoli e suo ambiente (exhibition cat.), San Miniato, 1959; L. Berti, Disegni del Cigoli, Pantheon, XVIII, 1960, pp. 127–34]. *Antonio Circignani*, known as *Antonio Pomarancio*: b. Pomarancio, 1570; d. Rome, ca. 1630; painter (L. Salerno, L'opera di Antonio Pomarancio, Comm, III, 1952, pp. 128–34). *Niccolò Circignani*, known as *Niccolò Pomarancio*: Pomarancio, 1517–96, painter (W. Stechow, Niccolò Circignani, called Il Pomarancio, Old Master Drawings, X, 1935, pp. 13–14). *Pietro Dandini*: Florence, 1646–1712, painter (M. Marangoni, La pittura fiorentina nel Settecento, RArte, VIII, 1912, pp. 61–102). *Daniele da Volterra (Daniele Ricciarelli)*: b. Volterra, 1509; d. Rome, 1566; painter and architect (M. L. Mez, Daniele da Volterra, pittore, BArte, XXVII, 1934, pp. 459–74; F. Baumgart, Contributi a Michelangelo, BArte, XXVIII, 1935, pp. 344–56; S. H. Levie, Daniele da Volterra e Tiziano, Arte veneta, VII, 1953, pp. 168–70). *Carlo (Carlino) Dolci*: Florence, 1616–86, painter (G. Heinz, Carlo Dolci: Studien zur religiösen Malerei im 17. Jahrhundert, JhbKhSammlWien, LVI, 1960, pp. 197–234). *Alessandro (di Vincenzio) Fei*: Florence, 1543–92, painter (J. Rusconi, Le "Studio" de François de Médicis au Palazzo Vecchio, Les Arts, X, 110, 1911, pp. 1–7). *Giovanni Battista Foggini*: Flor-

ence, 1652–1725, architect and sculptor (K. Lankheit, Die Corsini-Kapelle in der Carmine-Kirche zu Florenz und ihre Reliefs, Mitt. des Kunsthist. Inst. in Florenz, VIII, 1957–58, pp. 35–60; K. Lankheit, Il giornale di Foggini, RArte, XXXIV, 1959, pp. 55–108). *Franciabigio (Francesco di Cristofano)*: Florence, 1482–1525, painter (O. Giglioli, Note su Franciabigio e Jacopo Del Conte, RArte, XVIII, 1936, pp. 191–94; G. and C. Thiem, Ein Studienblatt des Franciabigio, Panthèon, XVIII, 1960, pp. 192–95). *Francesco Furini*: Florence, ca. 1600–46, painter (E. Berti Toesca, Francesco Furini, Rome, 1950). *Anton Domenico Gabbiani*: Florence, 1652–1726, painter (A. Bartarelli, Domenico Gabbiani, RArte, XXVII, 1951–52, pp. 107–30). *Giovanni da San Giovanni*: b. San Giovanni Valdarno, 1592; d. Florence, 1636; painter (O. H. Giglioli, Giovanni da San Giovanni, Florence, 1949; G. Briganti, Appunti di Giovanni da San Giovanni, Paragone, I, 7, 1950, pp. 52–56; F. Zeri, Giovanni da San Giovanni: La Notte, Paragone, III, 31, 1952, pp. 42–47; G. Briganti, La "Burla del Piovano Arlotto" di Giovanni da San Giovanni, Paragone, IV, 39, 1953, pp. 46–49). *Francesco Granacci*: Florence, 1477–1543, painter (G. Fiocco, La data di nascita di Francesco Granacci e un'ipotesi michelangiolesca, RArte, XII, 1930, pp. 193–220, XIII, 1931, pp. 109–31; L. Berti, Francesco Granacci, BArte, XXXVII, 1952, pp. 258–59). *Jacopino (Jacopo) del Conte*: b. Florence, 1510; d. Rome, 1598; painter (F. Zeri, Salviati e Jacopino del Conte, Proporzioni, II, 1948, pp. 180–83; G. Urbani, Schede di restauro, B. Ist. centrale del Restauro, 3–4, 1950, pp. 103–04). *Battista (Giovanni Battista) Naldini*: b. Fiesole, 1537; d. Florence, 1591; painter (H. Voss, Über einige Pietà-darstellungen des Battista Naldini, Berl. Mus., XLIV, 1923, pp. 15–19; U. Baldini, Un disegno di Naldini per il Salone dei Cinquecento in Palazzo Vecchio a Firenze, RArte, XXVIII, 1953, pp. 157–60). *Matteo Nigetti*: Florence, 1560–1649, architect (L. Berti, Matteo Nigetti, RArte, XXVI, 1950, pp. 157–84, XXVII, 1951–52, pp. 93–106). *Passignano (Domenico Cresti)*: b. Passignano, ca. 1560; d. Florence, 1636; painter (H. Schwarz, Two Drawings Attributed to Domenico Passignano, AQ, XVI, 1953, pp. 337–40; A. Martini, Un singolare dipinto del Passignano, Paragone, X, 109, 1959, pp. 55–58). *Pierino da Vinci*: b. Vinci, ca. 1530; d. Pisa, 1553; sculptor (U. Middeldorf, Notes on Italian Bronzes, I: Drawings and a Tripod by Pierino da Vinci, BM, LXXIII, 1938, pp. 204–09; J. Wilde, An Illustration of the Ugolino Episode by Pierino da Vinci, Warburg, XIV, 1951, pp. 125–27). *Cristofano Roncalli*, known as *Il Cavaliere delle Pomarance (Pomarancio)*: b. Pomarancio, 1552; d. Rome, 1626; painter (F. Dal Monte, I disegni del Pomarancio per gli affreschi distrutti della Cupola di Loreto, Rass. marchigiana, VIII, 1929–30, pp. 41–56; I. Toesca, Pomarancio a Palazzo Crescenzi, Paragone, VIII, 91, 1957, pp. 41–45). *Matteo Rosselli*: b. Florence, 1578; d. 1650; painter (L. H. Fischer, Die Cena von Matteo Rosselli im Kloster S. Francesco in Lesina, ZfbK, XIX, 1907–08, p. 223; E. Bassi, Disegni dell'Accademia di Venezia, RArte, XXI, 1939, pp. 175–86). *Giovan Francesco Rustici*: b. Florence, 1474; d. Tours, 1554; painter and sculptor (C. Loeser, Gianfrancesco Rustici, BM, LII, 1928, pp. 260–72; U. Middeldorf, New Attributions to Giovan Francesco Rustici, BM, LXVI, 1935, pp. 71–81; W. R. Valentiner, Rustici in France, S. in the H. of Art Dedicated to W. E. Suida, London, 1959, pp. 205–17). *Francesco Salviati (Francesco de' Rossi, or Cecco di Salviati)*: b. Florence, 1510; d. Rome, 1563; painter (H. Voss, Kompositionen des Francesco Salviati in der italienischen Graphik des XVI. Jahrhunderts, Die Graphischen Künste, XXXV, 1912, Sup., pp. 30–37, 60–70; F. Antal, Around Salviati, BM, XCIII, 1951, pp. 122–25; L. Mortari, Alcuni inediti di Francesco Salviati, S. in the H. of Art Dedicated to W. E. Suida, London, 1959, pp. 247–52). *Santi di Tito*: b. Sansepolcro, 1536; d. Florence, 1603; architect and painter (G. Arnolds, Santi di Tito: Pittore di S. Sepolcro, Arezzo, 1934; R. Chiarelli, Contributi a Santi di Tito architetto, RArte, XXI, 1939, pp. 126–55; L. Berti, Santi di Tito, BArte, XXXVII, 1952, pp. 353–54). *Gherardo Silvani*: Florence, 1579–1675, architect and sculptor (R. Linnenkamp, Una inedita vita di Gherardo Silvani, RArte, XXXIII, 1958, pp. 73–114). *Pietro Tacca*: b. Carrara, 1577; d. Florence, 1640; sculptor (E. Lewy, Pietro Tacca: Ein Beitrag zur florentiner Skulptur, Cologne, 1928; A. M. Crinò, Documenti relativi a Pietro da Cortona, Ciro Ferri, Pietro Tacca, Pier Maria Baldi, Il Guercino e Federigo Zuccaro, RArte, XXXIV, 1959, pp. 151–57). *Niccolò Tribolo*: Florence, 1500–50, sculptor (B. H. Wiles, Tribolo in His Michelangelesque Vein, AB, XIV, 1932–33, pp. 59–70; J. Holderbaum, Notes on Tribolo, BM, XCIX, 1957, pp. 336–43, 369–72). *Jacopo Zucchi*: b. Florence, ca. 1541; d. Rome, ca. 1589; painter (A. Calcagno, Jacopo Zucchi e la sua opera a Roma, Il Vasari, V, 1932, pp. 39–56, 119–68).

THE EMILIAN SCHOOL IN THE 17TH AND 18TH CENTURIES. The development of baroque architecture in Emilia was relatively unimportant, except in the field of theatrical architecture and scenography, in which Bologna made a contribution to the

formation of European rococo. The principal Bolognese structures of the baroque period were the work of the Lombard Giovanni Ambrogio Magenta (plan for the Cathedral, reconstruction begun 1605; S. Paolo, 1611) and Bartolomeo Provaglia (Palazzo Davia-Bargellini, 1638; Porta Galliera, 1661). Padre Giovanni Battista Bergonzoni gave a Borrominian cast to the Church of S. Maria della Vita (ca. 1687–90), while in the 18th century Carlo Francesco Dotti reconstructed the sanctuary of the Madonna di S. Luca, near Bologna, in a scenographic manner. The work of Alfonso Torreggiani was balanced and elegant (Oratory of S. Filippo Neri; Palazzo Montanari). In Parma, the Palazzo della Pilotta and its adjoining gardens were constructed in the 17th century according to the designs of the 16th-century Tuscan Giovanni di Tommaso Boscoli (known as Nanni da Montepulciano and as Giovanni della Fontana), and Giovanni Battista Aleotti built the Teatro Farnese in a Palladian style.

Equally modest was the development of sculpture in this period; the leading Bolognese sculptor, Alessandro Algardi (q.v.), went to Rome to work (II, PLS. 164, 168). In Rome, his classicistic and balanced sense of measure represented the chief opposition to Bernini's boldly imaginative sculpture. It was Camillo Mazza (a pupil of Algardi) who, with his son Giuseppe (who also worked in Venice), brought the Emilian tradition of terra-cotta work back into respect. This work in terra cotta was continued by Filippo Scandellari (Scandellarra) with his crèche figures.

Emilia's role in painting at this time was quite significant. Bolognese painting of the time was an important aspect of European baroque art. Bartolomeo Passarotti (IX, PL. 297) enlivened his mannerist style with a genuine sense of reality, similar to that of the Lombard Campis; and the Carraccis (q.v.), schooled in the methods of Passarotti, combined their early apprenticeship in naturalism with the study of Correggio and the great Venetian tradition. Annibale Carracci and his pupils Domenichino (q.v.), Francesco Albani (PL. 219), and Giovanni Lanfranco all worked in Rome and developed a style so distinct from the realism of Caravaggio that even in Rome their school was called "Bolognese." Guido Reni (q.v.), along with others, transferred his allegiance from the Fleming Denys Calvaert to the school of the Carraccis. Reni's compositional structure, his concern with ideal perfection, and his expression of emotions opened the way for the classicism that Poussin and Maratti were to develop in the course of the 17th century. In his late works Reni achieved a dematerialized style, composed of luminous transparencies, veiled impasto, and pastel tonalities that anticipated the art of Luca Giordano and the 18th century. The art of Domenichino was even more classicistically oriented (PL. 218); his clear renderings of figures have an almost Raphaelite sense of grace and design. Only the Parmesan Lanfranco stood apart from classicism in seeking to develop the scenographic and baroque possibilities (breaks in the sky, foreshortening, dynamic masses) already implicit in the style of his compatriot Correggio.

Two painters of this period who may be classified as "petits maîtres" were noted for their primary interest in pictorial values. They were Scarsellino and Mastelletta. Scarsellino (I. Scarsella) of Ferrara adapted the style of Veronese and Bassano to the simple, intimate poetry of his small compositions (PL. 217). Mastelletta (Giovanni Andrea Donducci) of Bologna created scenes and landscapes with a rapidity of brush stroke that endowed the imaginative elegance of mannerism with a particular vivacity and charm.

The luministic and anticlassic branch of Emilian painting derived from the art of Lodovico Carracci, though some contact with the work of Caravaggio is also evident. Its leading advocates were Lionello Spada; Bartolomeo Schedoni (II, PL. 197), an original exponent of forms stylized by lighting effects; Giacomo Cavedone, whose sturdy naturalism was rich in Venetian influences (PL. 219); and Guercino (q.v.), whose airy luminism and warm, Venetian palette resulted in an atmospheric pictorialism that had extensive influence (II, PL. 197). The early luminism of Guercino (PL. 218), which paralleled that of Caravaggio, later froze into a classicizing and conventional academicism that was inspired by Guercino's desire to surpass his rival Guido Reni.

Reni, Domenichino, and Albani, who worked in their native Bologna as well as elsewhere, were the masters of the classical branch of Emilian art, which was in opposition to the trend that derived from Lodovico Carracci. Reni's followers included the Fleming Michele (di Giovanni) Desubleo (called "Michele Fiammingo"), Francesco Gessi, Giovanni Andrea Sirani and his daughter Elisabetta, and Simone Cantarini da Pesaro, who was also a skillful engraver. Carlo Cignani interpreted the classicism of these masters with 18th-century grace, and Guido Canlassi (known as Cagnacci), who emigrated to Vienna about 1660, combined the influence of Reni with that of Venice.

The Italian perspectivists (q.v.) known as *quadraturisti* developed the illusionistic possibilities inherent in the decorative perspective of late Roman mannerism [Cherubino (Zaccaria Matteo) Alberti]. This special category of perspectivists included Girolamo Curti, known as Dentone, Angelo Michele Colonna, Agostino Mitelli (I, PL. 409), the several generations of the Galli family (known as Bibiena after their native Tuscan village), architects and scenographers who worked throughout Italy and Europe until the end of the 18th century. The Galli Bibienas' great significance derived from their diffusion of a taste for perspectivism and scenography, which marked one of the highest achievements of the period in which baroque decoration merged with the rococo. An important example of the taste for perspectivism and scenography is the dome of S. Ignazio in Rome, by Fra Andrea Pozzo (q.v.; II, PL. 172). Other artists who worked in this style were Vittorio Maria Bigari and Stefano Orlandi, who collaborated (as figure painter and perspectivist respectively) in the decoration of 18th-century villas and palaces in Milan, Verona, and Turin.

Aside from this specialized current, the two main trends of 17th-century Bolognese painting influenced 18th-century painting in that city. The tendency bound to classicistic canons, specifically those deriving from Reni, included such artists as Giovan Gioseffo dal Sole, Marco Antonio Franceschini, Donato (Donatino) Creti, Ercole Graziani the Younger, and Francesco Monti (called "Il Brescianino delle Battaglie"). The other tendency, pictorially more vital, derived from the tradition begun by Lodovico Carracci and included among its exponents Lorenzo Pasinelli, Gian Antonio Burrini, and Giuseppe Maria Crespi. Crespi studied the work of Lodovico and Guercino and, instinctively inclined toward the simple human poetry of observed reality, created a style worthy of Chardin or of 17th-century Dutch painting (PL. 221; III, PL. 313). The Gandolfi brothers, Ubaldo and Gaetano, painted in a decorative style inspired by Tiepolo; they attempted a free-ranging dynamism of structure that was not without a certain superficiality.

BIBLIOG. A. Masini, Bologna perlustrata, Bologna, 1650 (3d ed. 1666); L. Vedriani, Raccolta di pittori, scultori ed architetti modenesi più celebri, Modena, 1662; L. Scaramuccia, La finezza dei pennelli italiani, Pavia, 1674; C. C. Malvasia, Felsina pittrice, 2 vols., Bologna, 1678; P. A. Orlandi, Abecedario pittorico, Bologna, 1704; G. B. Costa, Notizie di pittori riminesi, Lucca, 1766; L. Crespi, Vite dei pittori bolognesi non descritte nella "Felsina pittrice," Rome, 1769; C. Cittadella, Catalogo storico dei pittori e scultori ferraresi, delle opere loro . . ., 4 vols., Ferrara, 1782–83; G. Tiraboschi, Notizie de' pittori, scultori, incisori ed architetti nati negli stati del S.S. Duca di Modena, Modena, 1786; G. Giordani, Notizie delle donne pittrici di Bologna, Bologna, 1832; A. Bolognini-Amorini, Le vite dei pittori ed artefici bolognesi, 2 vols., Bologna, 1841–43; G. Baruffaldi, Vite de' pittori e scultori ferraresi (1679–1722), 2 vols., Ferrara, 1844–46; G. Campori, Gli artisti italiani e stranieri negli stati estensi, Modena, 1855; G. Bosi, Manuale pittorico felsineo, ovvero repertorio dei pittori bolognesi, Bologna, 1859; G. Bosi, Manuale di notizie degli scultori di Bologna e loro scuola, Bologna, 1860; G. Martinetti Cardoni, Vite brevi degli artefici defunti, che fecero per Ravenna opere esposte al pubblico, Ravenna, 1873; G. Gozzadini, Note e studi sull'architettura civile in Bologna dal secolo XIII al XVI, Bologna, 1877; L. Ambiveri, Gli artisti piacentini, Piacenza, 1879; C. Cimati, Artisti pontremolesi dal secolo XV al XIX, Parma, 1899; F. Malaguzzi Valeri, L'architettura a Bologna nel Rinascimento, Rocca San Casciano, 1899; C. Ricci, Memorie dei pittori, scultori ed incisori ravennati raccolte dal cav. Camillo Spreti, Ravenna, 1902; S. Bernicoli, Arte e artisti in Ravenna, Felix Ravenna, 1911–12, pp. 89–98, 137–49, 194–207, 217–43, 305–17; E. Scarabelli-Zunti, Memorie e Documenti di belle arti parmigiane, I, Parma, 1911; C. Grigioni, Per la storia della pittura in Cesena nel primo quarto del XVI secolo, Rass. bibliog. dell'arte it., XVI, 1913, pp. 3–4; G. Rouchès, La peinture bolonaise à la fin du XVIe siècle (1575–1619); Les Carraches, Paris, 1913; T. Gerevich, Questioni sull'arte barocca e sulla pittura bolognese, Atti X Cong. int. Storia Arte, Rome, 1923, pp. 385–97;

H. Voss, Die Malerei des Barock in Rom, Berlin, 1924; A. Foratti, Aspetti dell'architettura bolognese dalla seconda metà del secolo XVI alla fine del Seicento, Il Comune di Bologna, XVIII, 12, 1931, pp. 15–24; R. Longhi, Momenti della pittura bolognese, L'Archiginnasio, XXX, 1931, pp. 111–46; G. Zucchini and R. Longhi, Mostra del Settecento bolognese (exhibition cat.), Bologna, 1935; L. Bianchi, La mostra del Settecento bolognese, Rome, 1936; R. Buscaroli, La storiografia artistica bolognese dal Lamo all'Orlandi, L'Archiginnasio, XXXI, 1936, pp. 193–224; H. Bodmer, Studien über die bologneser Malerei der XVIII. Jahrhunderts, Mitt. des Kunsthist. Inst. in Florenz, V, 1937, pp. 76–91; H. Bodmer, Correggio und die Malerei der Emilia, Vienna, 1942; A. Ghidiglia Quintavalle, Mostra parmense di dipinti noti ed ignoti dal XIV al XVIII secolo, Parma, 1946; D. Mahon, Studies in Seicento Art and Theory, London, 1947; G. Zucchini, Paesaggio e rovine nella pittura bolognese del Settecento, Bologna, 1947; G. Forghieri, La pittura a Modena dal XIV al XVIII secolo, Modena, 1953; Mostra dell'Incisione bolognese del secolo XVIII (exhibition cat.), Florence, 1953; O. Kurz, Bolognese Drawings of the 17th and 18th Centuries at Windsor Castle, London, 1955; G. C. Cavalli and others, Mostra dei Carracci (exhibition cat.), Bologna, 1956; F. Arcangeli, Mostra dei Maestri del Seicento emiliano (exhibition cat.), Bologna, 1959; A. Emiliani, Mostra dei disegni del Seicento emiliano nella Pinacoteca di Brera (exhibition cat.), Milan, 1959; S. Zangheri, Bibliografia scientifica della Romagna, Faenza, 1959.

ARTISTS: See individual articles for *Algardi, Domenichino, Guercino, Reni.*

OTHERS. *Francesco Albani*: Bologna, 1578–1660, painter (A. Boschetto, Per la conoscenza di Francesco Albani, Proporzioni, II, 1948, pp. 109–46; M. V. Brugnoli, Gli affreschi dell'Albani e del Domenichino nel Palazzo di Bassano di Sutri, BArte, XLII, 1957, pp. 266–77). *Giovanni Battista Aleotti*: b. Argenta, ca. 1546; d. Ferrara, 1636; architect (F. Zeri, Per Giovanni Battista Aleotti, Proporzioni, II, 1948, pp. 176–77). *Sisto Badalocchi*: b. Parma, 1581; d. Ordogno, 1647; painter (L. Salerno, Per Sisto Badalocchi e la cronologia del Lanfranco, Comm, IX, 1958, pp. 44–64, 216–18). *Bibiena*: see *Galli* below. *Vittorio Maria Bigari*: Bologna, 1692–1776, painter (G. Ravaglia, Le pitture di Vittorio Maria Bigari nel palazzo di Giustizia di Bologna, Bologna, 1925; E. Mauceri, Vittorio Bigari nella pittura italiana del Settecento, L'Archiginnasio, XXXVII, 1942, pp. 56–58). *Carlo Bononi*: Ferrara, 1569–1632, painter (R. Longhi, Officina Ferrarese, Rome, 1934, pp. 152–53; C. Volpe, Per il primo tempo di Carlo Bononi, Arte antica e moderna, II, 1959, pp. 79–81). *Gian Antonio Burrini*: Bologna, 1656–1727, painter (E. Riccomini, Giovanni Antonio Burrini, Arte antica e moderna, I, 1958, pp. 219–27). *Guido Canlassi*, known as *Cagnacci*: b. S. Arcangelo di Romagna, 1601; d. Vienna, 1681; painter [F. Arcangeli and others, Mostra della pittura del '600 a Rimini (exhibition cat.), Rimini, 1952; C. Gnudi, Una fantasia interrotta: I "Quadroni" del Cagnacci, CrArte, N.S., I, 1954, pp. 33–48; G. Heinz, Der Anteil der italienischen Barockmalerei an der Hofkunst zur Zeit Kaiser Ferdinand III. und Kaiser Leopold I., Wiener Jhb. für Kg., LIV, 1958, pp. 173–96]. *Simone Cantarini da Pesaro*: Pesaro, 1612–48, painter (A. Petrucci, Il Pesarese acquafortista, BArte, XXXI, 1938, pp. 41–54; F. Arcangeli, Simone Cantarini: Due dipinti, Paragone, I, 7, 1950, pp. 38–42; A. Emiliani, Simone Cantarini: Opera grafica, Arte antica e moderna, II, 1959, pp. 438–56). *Domenico Maria Canuti*: Bologna, 1620–84, painter (E. Feinblatt, The Roman Work of Domenico Maria Canuti, AQ, XV, 1952, pp. 45–64; C. Volpe, Antefatti bolognesi ed inizi di Giuseppe Maria Crespi, Paragone, VIII, 91, 1957, pp. 25–37). *Giacomo Cavedone (Cavedoni)*: b. Sassuolo, 1577; d. Bologna, 1660; painter (H. Bodmer, Die Zeichnungen des Cavedoni, Die Graphische Künste, N.S., V, 1940, pp. 11–21; R. Roli, Per un "incamminato": Giacomo Cavedoni, Paragone, VII, 77, 1956, pp. 34–50). *Bartolomeo Cesi*: Bologna, 1556–1629, painter (A. Graziani, Bartolomeo Cesi, CrArte, IV, 1939, pp. 54–95). *Carlo Cignani*: b. Bologna, 1628; d. Forlì, 1719; painter (S. Vitelli Buscaroli, Il pittore Carlo Cignani, Bologna, 1953). *Angelo Michele Colonna*: b. Rovenna (Como), 1600; d. Bologna, 1687; painter (S. De Vita Battaglia, Note su Angelo Michele Colonna, L'Arte, XXXI, 1928, pp. 13–28; E. Feinblatt, A Drawing by Angelo Michele Colonna, AQ, XVII, 1954, pp. 290–94; E. Feinblatt, Six Ceilings by Colonna at Zola Predosa, AQ, XXI, 1958, pp. 265–75). *Giuseppe Maria Crespi*: Bologna, 1665–1747, painter [H. Voss, Giuseppe Maria Crespi, Rome, 1921; F. Arcangeli and C. Gnudi, Mostra di Giuseppe Maria Crespi (exhibition cat.), Bologna, 1948; C. Volpe, Antefatti bolognesi ed inizi di Giuseppe Maria Crespi, Paragone, VIII, 91, 1957, pp. 25–37]. *Donato (Donatino) Creti*: b. Cremona, 1671; d. Bologna, 1749; painter (E. Arslan, Altri due dipinti per il McSwiny, Comm, VI, 1955, pp. 189–92; R. Roli, Donato Creti, Arte antica e moderna, II, 1959, pp. 328–41). *Girolamo Curti*, called *Dentone*: Bologna, ca. 1570–1632, painter [C. Moschini, Le vite di Girolamo Curti detto il Dentone, Giorn. di Belle Arti, II, 1833, pp. 391–92; V. Alce, Cronologia delle opere d'arte della Cappella di San Domenico in Bologna dal 1597 al 1619 (II), Arte antica e moderna, I, 1958, pp. 394–406]. *Carlo Francesco Dotti*: Bologna, 1670–1759, architect (A. Foratti,

Carlo Francesco Dotti, L'Arte, XVI, 1913, pp. 401–18). *Pietro Faccini*: Bologna, 1562(?)–1602, painter (M. Marangoni, Pietro Faccini, L'Arte, XIII, 1910, pp. 461–66; M. Marangoni, EI, s.v., XIV, 1932, pp. 708–09). *Luca Ferrari (Luca da Reggio)*: Reggio Emilia, 1605–61, painter [G. Grasselli, Luca da Reggio, Reggio Democratica, Sept. 14, 1949; M. Degani, Mostra di Luca da Reggio (exhibition cat.), Reggio Emilia, 1954]. *Marco Antonio Franceschini*: Bologna, 1648–1729, painter (D. C. Miller, L'opera di Marcantonio Franceschini nel Duomo di Piacenza, BArte, XLI, 1956, pp. 318–25; D. C. Miller, Franceschini and the Palazzo Podestà, Genoa, BM, XCIX, 1957, pp. 231–34; D. C. Miller, An Early Series of Decorations by Franceschini in the Palazzo Monti, Bologna, BM, CII, 1960, pp. 32–35; D. C. Miller, A Ceiling Decoration by Franceschini-Haffner, BM, CIII, 1961, p. 469). *Galli Bibiena*: family of Bolognese architects, 17th–18th centuries: *Ferdinando*, 1657–1743 [C. Ricci, I Bibiena: Architetti teatrali, Milan, 1915; V. Mariani, Mostra dei disegni dei Bibiena (exhibition cat.), Florence, 1940; G. Prota-Giurleo, Partenope, I, 1960, pp. 175–90]. *Giuseppe Gambarini*: Bologna, 1680–1725, painter (G. Fiocco, Pitture del '700 italiano in Portogallo, Rome, 1940; D. C. Miller, Per Giuseppe Gambarini, Arte antica e moderna, I, 1958, pp. 390–93). *Gandolfi*: family of painters and stuccoworkers, including *Gaetano*, b. San Matteo della Decima (near Bologna), 1734; d. Ravenna, 1802; and *Ubaldo*, b. San Matteo della Decima (near Bologna) 1728; d. Ravenna, 1781 (L. Bianchi, I Gandolfi, Rome, 1936). *Francesco Gessi*: Bologna, 1588–1649, painter [A. Emiliani, Un viaggio sconosciuto di Gianfrancesco Gessi, Arte antica e moderna, I, 1958, pp. 53–57; R. Roli, Gianfrancesco Gessi: Reniano in libertà (1588–1649), Arte antica e moderna, I, 1958, pp. 40–52]. *Antonio Gionima*: b. Venice, 1697; d. Bologna, 1732; painter (R. Roli, Per Antonio Gionima, Arte antica e moderna, III, 1960, pp. 300–07). *Giovan Gioseffo dal Sole*: Bologna, 1654–1719, painter (E. Mauceri, Giovan Gioseffo dal Sole, Il Comune di Bologna, XIX, 6, 1932, pp. 35–40; G. Lippi Bruni, Gian Gioseffo dal Sole, Arte antica e moderna, II, 1959, pp. 109–14). *Ercole Graziani the Younger*: Bologna, 1688–1765, painter (G. Zucchini, Di un quadro attribuito a Ercole Graziano, Bologna, XXII, 3-4, 1936, pp. 9–10). *Giovanni Lanfranco*: b. Parma, 1582; d. Rome, 1647; painter (L. Salerno, The Early Work of Giovanni Lanfranco, BM, XCIV, 1952, pp. 188–96; L. Salerno, Per Sisto Badalocchi e la cronologia del Lanfranco, Comm, IX, 1958, pp. 44–64, 216–18; I. Toesca, Note sul Lanfranco nella Cappella Buongiovanni in Sant'Agostino di Roma, BArte, XLIV, 1959, pp. 337–46). *Carlo Lodi*: Bologna, 1701–65, painter (F. Malaguzzi Valeri, Palazzi e ville bolognesi: La Villa Barbieri già Pepoli a S. Lazzaro, Cron. d'arte, V, 1928, pp. 109–22). *Lucio Massari*: Bologna, 1569–1633, painter (C. Volpe, Lucio Massari, Paragone, VI, 71, 1955, pp. 3–18; F. Arcangeli, "Una gloriosa gara," Arte antica e moderna, I, 1958, pp. 236–54). *Mastelletta (Giovanni Andrea Donducci)*: Bologna, 1575–1655, painter [M. Marangoni, Il Mastelletta, L'Arte, XV, 1912, pp. 174–82; V. Alce, Cronologia delle opere d'arte della Cappella di San Domenico in Bologna dal 1597 al 1619 (II), Arte antica e moderna, I, 1958, pp. 394–406]. *Lodovico Mattioli*: b. Crevalcore, 1662; d. Bologna, 1747, engraver (G. Atti, Vita di Lodovico Mattioli da Crevalcore, incisore del secolo XVIII, Bologna, 1836). *Camillo* and *Giuseppe Mazza*: *Camillo*, Bologna, 1602–72, and his son *Giuseppe*, Bologna, 1653–1741, sculptors and stuccoworkers (A. Sorbelli, Il rinvenimento di una Madonna in terracotta del Mazza, Il Comune di Bologna, XXI, 8, 1934, pp. 46–48; A. Arfelli, Lettere inedite dello scultore C. M. Mazza e dei suoi corrispondenti, L'Archiginnasio, XXIX, 1934, pp. 416–34; A. Alisi, Per l'identificazione di uno scultore, L'Archiginnasio, XXXVI, 1941, pp. 232–35). *Agostino* and *Giuseppe Maria Mitelli*: *Agostino*, b. Bologna, 1609; d. Madrid, 1660; *Giuseppe Maria*, Bologna, 1634–1718, decorators, architects, and painters (R. Buscaroli, Agostino e Giuseppe Maria Mitelli, Bologna, 1931; A. Arfelli, Per la bibliografia di Agostino e Giuseppe Maria Mitelli, Arte antica e moderna, I, 1958, pp. 295–301). *Francesco Monti*, called *Il Brescianino delle Battaglie*: Bologna, 1685–1768, painter (L. Frati, Lettere autobiografiche di pittori al P. Pellegrino Antonio Orlandi, RArte, V, 1907, pp. 63–76). *Stefano Orlandi*: Bologna, 1661–1760, painter (E. Mauceri, Disegni di quadraturisti bolognesi, Il Comune di Bologna, XXI, 11, 1934, pp. 57–65). *Lorenzo Pasinelli*: Bologna, 1629–1700, painter (C. Baroncini, Lorenzo Pasinelli, Arte antica e moderna, I, 1958, pp. 180–90; D. C. Miller, Notes on Lorenzo Pasinelli, BM, CI, 1959, pp. 106–09; C. Volpe, Un'altra "Maddalena" di Lorenzo Pasinelli, Arte antica e moderna, II, 1959, pp. 436–37). *Bartolomeo Passarotti*: Bologna, 1529–92, painter (E. Bodmer, Bartolomeo Passarotti, Il Comune di Bologna, XXI, 1934, pp. 9–22). *Scarsellino (Ippolito Scarsella)*: Ferrara(?), 1551–1620, painter (M. A. Novelli, Lo Scarsellino, Bologna, 1955; M. A. Novelli, Qualche aggiunta allo Scarsellino, Paragone, X, 117, 1959, pp. 46–50; C. Volpe, Per il primo tempo di Carlo Bononi, Arte antica e moderna, II, 1959, pp. 79–81). *Bartolomeo Schedoni (Schidone)*: b. Modena, ca. 1570; d. Parma, 1615; painter (A. Ghidiglia Quintavalle, Un dipinto giovanile di Bartolomeo Schedoni,

Aurea Parma, XXXV, 1951, pp. 28–30; J. Bean, A propos de Bartolomeo Schedoni, Aurea Parma, XLI, 1957, pp. 111–14). *Elisabetta Sirani*: Bologna, 1638–65, daughter of *Giovanni Andrea Sirani*, Bologna, 1610–70, both painters (M. Minghetti, Elisabetta Sirani, Bologna, 1877; A. Manaresi, Elisabetta Sirani, 1897; E. F. Edwards, Elisabetta Sirani, Art in Am., XVII, 1928–29, pp. 242–46; E. Mauceri, La Madonna della Rosaria di Elisabetta Sirani, Il Comune di Bologna, XX, 9, 1933, pp. 21–22). *Lionello Spada*: b. Bologna, 1576; d. Parma, 1622; painter [M. Marangoni, Un affresco dimenticato di Lionello Spada, BArte, V, 1911, pp. 152–53; J. Hess, Modelle e modelli del Caravaggio, Comm, V, 1954, pp. 271–89; V. Alce, Cronologia delle opere d'arte della Cappella di San Domenico in Bologna dal 1597 al 1619 (II), Arte antica e moderna, I, 1958, pp. 394–406]. *Alessandro Tiarini*: Bologna, 1577–1668, painter (F. Malaguzzi Valeri, Alessandro Tiarini, Cron. d'arte, I, 1924, pp. 133–54; T. Fiori, La prima attività bolognese di Alessandro Tiarini, Comm, VIII, 1957, pp. 105–12).

NEAPOLITAN AND SICILIAN ART FROM THE 16TH CENTURY ON.
The many northern Italian artists working in the south in the early 16th century...

[body text continues]

in 1607, and the Spanish artist Ribera (q.v.) was there from about 1616. Guido Reni (q.v.) arrived in 1622, Artemisia Gentileschi (q.v.) worked in Naples from 1636, and both Domenichino (q.v.) and Giovanni Lanfranco worked there for several years. Caravaggio and the Bolognese decorative styles often influenced the same artists. Thus, the extremely talented Giovanni Battista Caracciolo (PL. 224), who was initially a follower of Caravaggio (e.g., *The Liberation of St. Peter*; II, PL. 183), adopted a style of Bolognese derivation after 1620. Ribera's early artistic preparation was in the style of the Caraccis, but after his contact in Naples with the style of Caravaggio, the Spaniard developed a solidly realistic style. Although Artemisia Gentileschi was a follower of Caravaggio, she maintained an elegance of form and color in her painting that was to influence the work of such local artists as Massimo Stanzione and Bernardo Cavallino (PL. 224). Artemisia Gentileschi's influence was complemented by the residual influence of 16th-century Neapolitan formalism and reflections of Flemish art (Van Dyck rather than Rubens). The work of Andrea Vaccaro and Francesco (Pacecco) De Rosa reflected similar influences. The Neapolitan influence of Ribera — which was particularly important for the work of Francesco and Cesare Fracanzano in Apulia — was sometimes complemented by accents of Velázquez (who had been in Naples in 1630–31) or Grechetto (Giovanni Benedetto Castiglione), who had been in Naples in 1635.

Although the sources of Neapolitan realistic painting were as diverse in temper as Caravaggio and Ribera, they were combined with ease in portrayals of daily life, a genre represented in Rome by the Dutchman Pieter van Laer and Michelangelo Cerquozzi (see BAMBOCCIANTI). The Bergamask-Roman Viviano Codazzi, a perspectivist closely related to the Bamboccianti, worked in Naples in 1634–48, painting views of monuments adorned with figures. The Neapolitan Aniello Falcone painted similar subjects, as did his pupil Domenico Gargiulo (Micco Spadaro). Falcone acquired particular renown as a painter of battles, a genre popularized in Rome by Jacques Courtois (Il Borgognone). The Neapolitan Salvator Rosa (q.v.), too, was famous as a painter of battle scenes. Although he left his native city as a young man to work in Florence and Rome, he remained Neapolitan in spirit and style, even though his development was away from genre painting toward the *peintre-philosophe* ideal represented by Poussin. Still life enjoyed particular success in Naples in the work of Giovanni Battista Ruoppoli (Ruopolo) and Giuseppe Recco, both of whom assimilated a typically baroque exuberance of composition and color with the influence of Caravaggesque luminism.

Decorative painting in the grand style was revitalized by two artists, Mattia Preti (II, PL. 203) and Luca Giordano. Mattia Preti's early training was in the style of Caravaggio, but study of Lanfranco, Guercino, and the 16th-century Venetians resulted in a style rich in dramatic vigor; Luca Giordano's luministic paintings opened the way for 18th-century art in Italy and Spain (PL. 224; II, PLS. 204, 205; V, PL. 226).

Francesco Solimena, whose art straddled the 17th and 18th centuries, inherited the grand manner of Lanfranco, Pietro da Cortona (q.v.), Preti, and Giordano and created a decorative style that influenced Neapolitan painting throughout the 18th century (PL. 227). Influenced in varying degrees by Solimena were Francesco de Mura, Corrado Giaquinto, and Sebastiano Conca. Conca moved early to Rome. Giaquinto, an extremely sensitive painter, worked in Rome for many years, in Turin (where he collaborated with De Mura on the Royal Palace), and in Madrid (1753–62), where he influenced the artistic development of Francisco Goya. It was because of Giordano and Giaquinto that Neapolitan painting achieved European importance at this time. In the 18th century Gaspare Traversi (whose work was often confused with that of the less distinguished and academic Giuseppe Bonito) continued the realistic portrayal of scenes of daily life. An ironic observer of contemporary mores, Traversi worked in Rome and Emilia.

The mannerism of Filippo Paladino long survived in Sicilian painting, but in Palermo Pietro Novelli, influenced by Ribera and Van Dyck (who was in Palermo in 1624), came into prominence. Caravaggio was in Sicily (1608–09), but his influence was little felt outside of Messina. There was a foreign exponent of the Caravaggesque style in Sicily in the Fleming Matthias Stomer, who worked in the manner of Gerrit van Honthorst. In the 18th century many Sicilian decorative painters drew inspiration from Roman and Neapolitan painting. Among these artists were the Fleming Willem (Guglielmo) Borremans and the more vigorous and original Palermitan Vito d'Anna.

BIBLIOG. *Naples, Campania, and Apulia*: B. De Dominici, Vite dei pittori scultori ed architetti napolitani, 3 vols., Naples, 1742–43; F. Gagliardi, Della scuola pittorica napoletana: Sua origine e suoi confronti, Naples, 1888; L. Salazar, Documenti inediti intorno ad artisti napoletani del secolo XVII, Napoli nobilissima, IV, 1895, pp. 185–87, V, 1896, pp. 123–25, VI, 1897, pp. 129–32, VII, 1898, pp. 90–93; B. Croce, Scritti della storia dell'arte napoletana anteriori al De Dominici, Napoli nobilissima, VII, 1898, pp. 17–20; C. Tutini (ed. B. Croce), De' pittori, scultori, architetti, miniatori e ricamatori nazionali e regnicoli napolitani (1667), Napoli nobilissima, VII, 1898, pp. 121–24; G. Ceci, Per la biografia degli artisti del XVI e XVII secolo, Napoli nobilissima, XIII, 1904, pp. 45–47, 57–61, XV, 1906, pp. 116–18, 133–40, 158–59, 162–67; L. Serra, La pittura napoletana del Rinascimento, L'Arte, VIII, 1905, pp. 340–54; O. Giannone, Storia dell'arte napoletana (rev. ed. by G. Ceci), Naples, 1909; A. Muñoz, Studi sulla scultura napoletana del Rinascimento, BArte, III, 1909, pp. 55–73, 83–101; W. Rolfs, Geschichte der Malerei Neapels, Leipzig, 1910; L. Hautecœur, Les arts à Naples au XVIIIᵉ siècle, GBA, V, 1911, pp. 395–411, VI, 1911, pp. 156–71; A. De Rinaldis, Note sulla pittura napoletana del '600, Naples, 1912; L. Serra, Note sullo svolgimento dell'architettura barocca a Napoli, Napoli nobilissima, N.S., II, 1921, pp. 35–39, 68–71, 88–90, III, 1922, pp. 1–7; P. N. Signorelli, Gli artisti della seconda metà del XVIII secolo, Napoli nobilissima, N.S., II, 1921, pp. 10–16, 77–79, 90–93, 148–52, III, 1922, pp. 26–31, 117–19; G. Ceci, Le fonti della storia dell'arte nelle Puglie, Atti X Cong. int. Storia Arte, Rome, 1923, pp. 54–56; A. Filangieri di Candida, Per le fonti di storia dell'arte a Napoli e nella province meridionali, Atti X Cong. int. Storia Arte, Rome, 1923, pp. 542–44; S. Sitwell, Southern Baroque Art, London, 1924; E. Tormo y Monzò, España y el arte napolitano, Madrid, 1924; A. De Rinaldis, La pittura del Seicento nell'Italia meridionale, Verona, 1929; N. Catanuto, Contributi alla pittura napoletana del Rinascimento, influsso ispano-fiammingo, Reggio Calabria, 1934; G. Ceci, Bibliografia per la storia delle arti figurative nell'Italia meridionale, 2 vols., Naples, 1937; G. Ceci, Notizie e documenti su artisti napoletani, Arch. d'Italia, N.S., III–IV, 1937, pp. 233–42; G. Chierici, Architettura religiosa a Napoli nei secoli XVII e XVIII, Palladio, I, 1937, pp. 17–26, 99–108; R. Pane, Architettura del Rinascimento in Napoli, Naples, 1937; S. Ortolani, La pittura napoletana dal Sei all'Ottocento, Emporium, LXXXVII, 1938, pp. 173–92; S. Ortolani and others, Mostra della pittura napoletana dei secoli XVII–XVIII–XIX (exhibition cat.), Naples, 1938; J. Pope-Hennessy, Neapolitan Painting, 1600–1900, BM, XLI, 1938, pp. 225–79; R. Pane, L'architettura dell'età barocca in Napoli, Naples, 1939; A. Schiavo, L'architettura barocca in Campania, Palladio, III, 1939, pp. 279–85; O. Giannone, Giunte sulle vite de' pittori napoletani (rev. ed. by O. Morisani), Naples, 1941; O. Morisani, Saggi sulla scultura napoletana del Cinquecento, Naples, 1941; E. Arslan, Sul '600 napoletano, Le Arti, V, 1942–43, pp. 257–60; R. Causa, Mostra dei Bozzetti napoletani del '600 e del '700 (exhibition cat.), Naples, 1950; W. G. Constable, Carlo Bonavia and Some Painters of Vedute in Naples, Essays in Honor of Georg Swarzenski, Chicago, 1952, 1952, pp. 198–204; U. Prota-Giurleo, Pittura napoletana del Seicento, Naples, 1953; R. Causa, Mostra della Madonna nella pittura del '600 a Napoli (exhibition cat.), Naples, 1954; A. Maiuri, Mostra del Ritratto storico napoletano (exhibition cat.), Naples, 1954; G. Simoncini, Osservazioni sull'arte del tardo Settecento in provincia di Bari, Q. Ist. di Storia dell'Arch., 18, 1956, pp. 1–7; R. Causa, Pittura napoletana dal XV al XIX secolo, Bergamo, 1957; N. di Carpegna, Mostra dei pittori napoletana del Seicento e del Settecento, Rome, 1958; O. Morisani, Letteratura artistica a Napoli tra il Quattrocento e il Seicento, Naples, 1958; F. Bologna, Roviale spagnolo e la pittura napoletana del Cinquecento, Naples, 1959; M. Calvesi, Influenze Napoletane e siciliane sull'architettura nel Salento, Atti IX Conv. naz. Storia Arch., Bari, 1959, pp. 177–87; A. Calza Bini, Relazione generale sul tema "Il Barocco Salentino," Atti IX Conv. naz. Storia Arch., Bari, 1959, pp. 158–63; M. Manieri Elia, Il Barocco Salentino nel suo quadro storico: Gabriele Riccardi e Francesco Antonio Zimbalo, Atti IX Conv. naz. Storia Arch., Bari, 1959, pp. 189–202; U. Prota-Giurleo, Note inedite su alcuni pittori napoletani del Settecento, Partenope, II, 1961, pp. 43–45.

Sicily. a. General works: G. Di Marzo, Delle belle arti in Sicilia, 4 vols., Palermo, 1858–64; A. Bertolotti, Alcuni artisti siciliani a Roma nei secoli XVI e XVII, Palermo, 1879; P. M. Rocca, Documenti relativi a tre ignoti pittori siciliani del secolo XVI–XVII, Palermo, 1896; P. M. Rocca, Documenti relativi a 6 pittori siciliani dei secoli XVII e XVIII, Arch. storico siciliano, XXXII, 1903, pp. 271–86; E. Mauceri, Artisti siciliani ignoti o dimenticati del secolo XVII, Arte e Storia, XXX, 1911, pp. 372–74; N. Scalia, Antonello da Messina e la pittura in Sicilia, Milan, 1914; E. Mauceri, Pittori siciliani del XVIII secolo, Rass. d'arte, N.S., III, 1916, pp. 130–34; E. Mauceri, Caratteri dell'arte siciliana del Rinascimento, Rass. d'arte, N.S., VI, 1919, pp. 210–22; F. Meli, Arte e artisti di Sicilia, Palermo, 1929; F. Meli, L'arte in Sicilia dal secolo XII al XIX, Palermo, 1929; E. Calandra, Breve storia dell'architettura in Sicilia, Bari, 1938; E. Maganuco, L'architettura plateresca e del tardo '500 in Sicilia, Catania, 1939; I. Lo Monaco, Pittori e scultori siciliani dal Seicento al primo Ottocento, Palermo, 1940; V. Ziino, Contributi allo studio dell'architettura del Settecento in Sicilia, Palermo, 1950; L. Epifanio, Schemi compositivi dell'architettura sacra palermitana del Seicento e del Settecento, Palermo, 1952; S. Bottari, La cul-

tura figurativa in Sicilia, Messina, 1954; S. Caronia Roberti, L'architettura del Barocco in Sicilia, Atti VII Conv. naz. Storia Arch., Palermo, 1956, pp. 173–98; S. Bottari, Contributo alla conoscenza dell'architettura del Settecento in Sicilia, Palladio, N.S., VIII, 1958, pp. 69–77; F. Minissi, Aspetti dell'architettura religiosa del Settecento in Sicilia, Rome, 1958; M. Sanchez-Requeira, Antonello Gagini y la escultura siciliana de las siglas XV y XVI, Goya, XLII, 1961, pp. 396–401. *b. Palermo:* G. Di Marzo, La pittura in Palermo nel Rinascimento, Palermo, 1899; C. Matranga, Scultura e pittura a Palermo dal secolo XII al XIX, Palermo, 1911; S. Caronia Roberti, Il Barocco in Palermo, Palermo, 1935; F. Meli, Degli architetti del Senato di Palermo nei secoli XVII e XVIII, Arch. storico per la Sicilia, IV–V, 1938–39, pp. 305–470; F. Meli, M. Carnelivari e l'architettura del '400 e del '500 in Palermo, Rome, 1958; M. Accascina, Sculptores habitatores Panormi, RIASA, XVII, 1959, pp. 269–313. *c. Messina:* J. P. Hackert, Memorie dei pittori messinesi, Naples, 1792 (reprint ed. S. Bottari, Messina, 1932); G. Grosso-Cacopardo, Memorie dei pittori messinesi e degli esteri che in Messina fiorirono dal secolo XII al secolo XIX, Messina, 1821; G. Lafarina, Ricerche intorno alle Belle Arti e agli artisti fioriti in varie epoche in Messina, Messina, 1835; L. Ozzola, Appunti sull'arte barocca a Messina, Vita d'arte, III, 1909, pp. 93–102; F. Susinno, Le vite de' pittori messinesi (ca. 1724, ed. V. Martinelli), Florence, 1960.

ARTISTS. *Giacomo Amato:* Palermo, 1643–1732, architect (L. Biagi, Giacomo Amato e la sua posizione nell'architettura palermitana, L'Arte, N.S., X, 1939, pp. 29–40). *Carlo Bonavia (Bonaria):* Neapolitan painter, active 1754–56 (W. G. Constable, Carlo Bonavia, AQ, XXII, 1959, pp. 19–44; T. J. McCormick, Notes on Some Further Attributions to Bonavia, AQ, XXIII, 1960, pp. 371–74). *Giuseppe Bonito:* b. Castellammare di Stabia, 1707; d. Naples, 1789; painter (G. Cosenza, Giuseppe Bonito, Napoli nobilissima, XI, 1902, pp. 81–87, 103–09, 122–27, 154–58, XII, 1903, pp. 12–14; R. Mesuret, Musée de Rodez: Le portrait de Charles IV par Giuseppe Bonito, RArts, VI, 1956, pp. 116–17). *Giovanni Battista (Battistello) Caracciolo:* Naples, ca. 1570–1637, painter (R. Longhi, "Battistello," L'Arte, XVIII, 1915, pp. 58–75, 120–37; H. Voss, Neues zum Schaffen des Giovanni Battista Caracciolo, JhbPreussKSamml, XLVIII, 1927, pp. 131–38; R. Causa, Aggiunte a Battistello, Paragone, I, 9, 1950, pp. 42–45; F. Bologna, Altre aggiunte a Battista Caracciolo, Paragone, XI, 129, 1960, pp. 45–51). *Bernardo Cavallino:* Naples, 1622–54, painter (A. De Rinaldis, Bernardo Cavallino, Rome, 1921; W. R. Juynboll, Bernardo Cavallino, B. Mus. Boymans-van Beuningen, XI, 1960, pp. 83–91). *Sebastiano Conca:* b. Gaeta, 1680; d. Naples, 1764; painter (C. Gilbert, Italian Paintings at St. Meinrad Archabbey, GBA, LII, 1958, pp. 355–68; V. Martinelli, Sebastiano Conca in Umbria, Spoletium, V, 1958–59, pp. 27–35). *Giovanni Andrea Coppola:* ca. 1597–ca. 1659, Neapolitan painter (V. Lisci, Il pittore Giovanni Andrea Coppola e la fisiologia moderna, Rinascenza Salentina, IX, 1941, pp. 187–90). *Francesco Cozza:* Stilo Calabro, 1605–82, painter (L. Cunsolo, Francesco Cozza: Acquafortista, Arch. storico per la Calabria e la Lucania, IX, 1939, pp. 169–99; L. Mortari, Aggiunte all'opera di Francesco Cozza, Paragone, VII, 73, 1956, pp. 17–21). *Monsù Desiderio (Francesco de Nomé):* Neapolitan painter of the middle of the 17th century (L. Reau, L'énigme de "Monsù Desiderio," GBA, XIII, 1935, pp. 242–51; A. Scharf, Francesco Desiderio, BM, XCII, 1950, pp. 18–22; R. Causa, Francesco Nomé, detto Monsù Desiderio, Paragone, VII, 75, 1956, pp. 30–46). *Aniello Falcone:* 1600–50, Neapolitan painter (F. Saxl, The Battle Scene without a Hero: Aniello Falcone and His Patrons, Warburg, III, 1939, pp. 70–87; M. S. Soria, Some Paintings by Aniello Falcone, AQ, XVII, 1954, pp. 3–15). *Cosimo Fanzago (Fansago):* b. Clausone, 1591; d. Naples, 1678; architect and sculptor (P. Fogaccia, Cosimo Fanzago, Bergamo, 1945; A. Nava Cellini, Un documento romano per Cosimo Fanzago, Paragone, IX, 105, 1959, pp. 17–24). *Paolo Domenico Finoglia:* Naples, 1590–1645, painter (M. d'Orsi, Paolo Finaglio, pittore napoletano, Japigia, IX, 1938, pp. 55–66, 176–86, 337–79). *Fracanzano (Fracanzani):* family of Veronese painters, of whom the most important was *Francesco:* b. Monopoli, 1612; d. Naples, 1657 (F. S. Vista, Cesare e Francesco Fracanzano, Rass. pugliese, XIX, 1902, pp. 337–43; L. Salazar, Salvator Rosa ed i Fracanzani, Napoli nobilissima, XII, 1903, pp. 119–23; F. S. Vista, Cesare Fracanzano, Rass. pugliese, XXIII, 1907, pp. 160–69). *Domenico Gargiulo, called Micco Spadaro:* Naples, 1612–75, painter (G. Ceci, Domenico Gargiulo detto Micco Spadaro, Naples, 1902; R. Causa, Domenico Gargiulo, Naples, 1947). *Corrado Giaquinto:* b. Molfetta, 1703; d. Naples, ca. 1765; painter (M. d'Orsi, Corrado Giaquinto, Rome, 1958; M. Volpi, Corrado Giaquinto e alcuni aspetti della cultura figurativa del '700 in Italia, BArte, XLIII, 1958, pp. 263–82; M. Volpi, Traccia per Giaquinto in Spagna, BArte, XLIII, 1958, pp. 329–40). *Luca Giordano:* Naples, 1632–1705, painter [E. Petraccone, Luca Giordano, Naples, 1919; A. De Rinaldis, Luca Giordano, Florence, 1922; R. Longhi, Due "mitologie" di Luca Giordano, Paragone, III, 35, 1952, pp. 41–43; A. Griseri, I bozzetti di Luca Giordano per l'escalera dell'Escorial, Paragone, VII, 81, 1956, pp. 33–39; Y. Bottineau, À propos du séjour espagnol de Luca Giordano (1692–1702), GBA, LVI, 1960, pp. 249–60]. *Francesco Guarini (Gua-*

rino): Solofra, 1611–54, painter (L. Landolfi, De' dipinti e della vita di Francesco Guarini da Solofra, Naples, 1852). *Francesco de Mura:* Naples, 1696–1782, painter (E. Carli, Segnalazioni di pittura napoletana, L'Arte, N.S., IX, 1938, pp. 255–79; C. Gilbert, Italian Paintings at St. Meinrad Archabbey, GBA, LII, 1958, pp. 355–68). *Pietro Novelli:* b. Monreale, 1603; d. Palermo, 1647; painter (G. di Stefano, Pietro Novelli il Monrealese, Palermo, 1940; R. Salvini, La mostra di Pietro Novelli a Monreale, Le Arti, II, 1939–40, pp. 116–17). *Giacomo del Pò:* b. Rome, 1652; d. Naples, 1726; painter and architect (G. Ceci, Notizie e documenti su artisti napoletani, V: Nascita e morte di Giacomo del Pò, Arch. d'Italia, 2d Ser., IV, 1937, pp. 237–38; M. Picone, Per la conoscenza del pittore Giacomo del Pò, BArte, XLII, 1957, pp. 163–72, 309–16). *Mattia Preti:* b. Taverna, 1613; d. Malta, 1699; painter (A. Venturi, Mattia Preti, Rome, 1925; A. Frangipane, La pittura e il dramma di Mattia Preti, Brutium, XXXVI, 7–8, 1957, pp. 2–11; C. Refice Taschetta, Contributo alla conoscenza di Mattia Preti, Brindisi, 1959). *Giovanni Battista Quagliata:* Messina, 1603–73, painter (E. Mauceri, Giovan Battista Quagliata, BArte, N.S., I, 1921–22, pp. 381–85). *Giuseppe Recco:* Naples, 1634–95, painter (F. Zeri, Giuseppe Recco: Una natura morta giovanile, Paragone, III, 33, 1952, pp. 37–38; N. di Carpegna, I Recco: Note e contributi, BArte, XLVI, 1961, pp. 123–32). *Francesco (Pacecco) de Rosa:* Naples, ca. 1600–54, painter (A. Pigler, Pacecco de Rosa müvészetéhez, AErt, XLV, 1931, pp. 148 ff.). *Salvator Rosa* (q.v.). *Giovanni Battista Ruoppoli (Ruopolo):* Naples, 1620–85, painter [M. Marangoni, Valori mai noti e trascurati della pittura italiana del Seicento (alcuni pittori di "Natura morta"), RArte, X, 1917, pp. 1–31]. *Giuseppe Sanmartino (Sammartino):* Naples, 1720–93, sculptor (G. Alparone, Note sul Cristo velato nella Cappella Sansevero a Napoli, BArte, XLII, 1957, pp. 179–85; G. Alparone, Un bozzetto del Corradini ed una statua dispersa del Sanmartino, BArte, XLV, 1960, pp. 287–88). *Giacomo Serpotta:* Palermo, 1656–1732, sculptor (F. Meli, Giacomo Serpotta, Palermo, 1934; N. Basile, Serpottiana, Palermo, 1935; P. Fazio, Giacomo Serpotta, Palermo, 1956). *Francesco Solimena:* b. Canale di Serino, 1657; d. Naples, 1747; painter (F. Bologna, Francesco Solimena, Naples, 1958). *Massimo Stanzione:* b. Orta d'Atella, 1585; d. Naples, 1656; painter (C.T. Dalbono, Massimo Stanzione e i suoi tempi e la sua scuola, Naples, 1871; H. Voss, Charakterköpfe des Secento, I: Massimo Stanzione, Mnh. für Kw., I, 1908, pp. 266–74; H. Schwanenberg, Leben und Werk des Massimo Stanzione, Bonn, 1937; U. Baldini and L. Berti, Note brevi su inediti toscani, BArte, XXXVIII, 1953, pp. 277–83). *Gaspare Traversi:* Naples, d. 1769, painter. (R. Longhi, Di Gaspare Traversi, Vita artistica, II, 1927, pp. 145–67; R. Longhi, Traversi: Un'opera e nuove notizie, Paragone, I, 1, 1950, pp. 44–45; A. Ghidiglia Quintavalle, Inediti di Gaspare Traversi, Paragone, VII, 81, 1956, pp. 39–45). *Giovanni Battista Vaccarini:* b. Palermo, 1702; d. Milazzo, 1768; architect (F. Fichera, Giovan Battista Vaccarini e l'architettura del Settecento in Sicilia, 2 vols., Rome, 1934; A. Giuliana-Alajmo, Giovan Battista Vaccarini e le sconosciute vicende della sua vita, Palermo, 1950). *Andrea Vaccaro:* Naples, 1598–1670, painter (M. Commodo Izzo, Andrea Vaccaro, Naples, 1951). *Domenico Antonio Vaccaro:* Naples, 1681–1750, sculptor (N. F. Faraglia, Notizie di alcuni artisti che lavorarono nella chiesa di S. Martino sopra Napoli, Arch. storico per le prov. napoletane, XVII, 1892, pp. 657–78; R. Mormone, D. A. Vaccaro architetto, Napoli nobilissima, I, 1961, pp. 135–50; R. Mormone, Scultura di D. A. Vaccaro in San Paolo Maggiore, Napoli nobilissima, I, 1961, pp. 43–51). *Luigi Vanvitelli:* b. Naples, 1700; d. Caserta, 1773; architect [G. Chierici, La Reggia di Caserta, Rome, 1937; F. Fichera, Luigi Vanvitelli, Rome, 1937; G. R. Ansaldi and others, Vanvitelliana, Atti VIII Conv. naz. Storia Arch. (1953), Caserta, 1956, pp. 31–155; A. Ghidiglia Quintavalle, Luigi Vanvitelli e il Barocco, Florence, n.d.]. *Giovanni Vermexio (Vermescio):* architect in Syracuse, active during the first half of the 17th century (G. Agnello, L'opera di Giovanni Vermexio nel Palazzo del Senato a Siracusa, Arch. d'Italia, 2d Ser., XI–XVI, 1949, pp. 46–81; G. Agnello, I Vermexio: Architetti ispano-siculi del secolo XVII, Florence, 1959). *Francesco Zimbalo:* late-17th-century architect, Puglia (M. Manieri Elia, Il Barocco Salentino nel suo quadro storico: Gabriele Riccardi e Francesco Antonio Zimbalo, Atti IX Conv. naz. Storia Arch., Palermo, 1959, pp. 189–202).

THE VENETIAN SCHOOL IN THE 17TH AND 18TH CENTURIES. The glorious art of 16th-century Venice exercised a determining influence on baroque style, although Venice itself stagnated in this later period. Venetian art was a point of departure for some of the supreme representatives of the baroque, from the Carraccis to Rubens, and influenced the development of painting in Bologna, Rome, Naples, and Europe in general. Venetian architecture anticipated neoclassicism in the English Palladian movement; Venice supplied essential precedents for modern painting from Turner through impressionism.

For two centuries, the influence of Sansovino and Palladio was of prime importance for Venetian architects, the most important of whom was Baldassarre Longhena (q.v.), a student of Scamozzi. Longhena's Church of S. Maria della Salute (1631–81; II, PL. 141) was a masterpiece of scenographic grandeur, new to Venice in terms of ground plan and volume but firmly bound to the pictorial and atmospheric values of the Venetian artistic tradition. This is also true of Ca' Rezzonico (PL. 226; II, PL. 220) and Palazzo Pesaro. Longhena also designed the Church of the Scalzi (S. Maria di Nazareth), to which a façade was added in 1689 by Giuseppe Sardi of Ticino, who had earlier built the façade of S. Maria Zobenigo (1678–83). These façades and that of S. Moisè (by Alessandro Tremignon, 1668) illustrate the tendency of the period toward excessive ornamentation, which detracted from the architectural values of the buildings. In Verona there was a strict continuation of the style of Sanmichele in the work of his nephew and pupil Domenico Curtoni (Palazzo della Gran Guardia, begun 1610).

Early 18th-century Venice began to temper the baroque with classicistic motifs from the Palladian tradition, evidenced in the work of Andrea Tirali of Ticino (Church of S. Vitale) and Domenico Rossi (façade of S. Stae, ca. 1709; reconstruction of the Church of the Gesuiti, or S. Maria Assunta, 1715–29; Palazzo Corner della Regina, begun 1724). The structures of Antonio Gaspari (Caspari), such as S. Maria della Fava (1705), contain Borrominian schemata and motifs handled with a light touch. Giorgio Massari, who completed Gaspari's work in S. Maria della Fava, also designed the airy Church of the Gesuati (1725–36) and the restrained almost neoclassic Palazzo Grassi (now Stucky, ca. 1750). Clearly neoclassical was the work of Tommaso Temanza (Church of the Maddalena), Giovanni Antonio Selva (the theater La Fenice, 1792), who brought neo-Palladian forms back to Venice from England, and Calderari, who was especially active in the Vicenza area. The Bergamask Giacomo Quarenghi, who worked in St. Petersburg after 1779, also formed his style in Venice.

Venetian sculpture of the 17th century was dominated by the work of the Fleming Josse de Corte, a theatrical and virtuosic artist who went from Rome to Venice (altar figures for S. Maria della Salute, ca. 1670). Other masters, including such foreigners as the German Melchior Barthel, created ever heavier sculptural and architectural decorations, and only toward the end of the century did the pictorial sensitivity of Francesco Cabianca and Orazio Marinali revitalize Venetian sculpture. The leading wood sculptor about the end of the 17th and early 18th century was Andrea Brustolon of Belluno. The work of his pupil Giovanni Marchiori was lively, though marked by a rather academic grace. The elegant virtuosity of Antonio Corradini, who also worked in Naples, was admired in Germany, Vienna, and Prague. But the most representative 18th-century sculptor in Venice was Johann Maria (Giammaria) Morlaiter (Morleitner), whose work, especially the clay models (Venice, Mus. Correr; sculpture in the Gesuati), is marked by a lively spontaneity, elegance, and a pictorial vision parallel to that of contemporaneous painting. The young Canova was influenced by Morlaiter's style before turning to neoclassic ideals.

The return from Rome of the Caravaggesque painter Carlo Saraceni (II, PL. 183) might have revived Venetian painting if that painter had not died so soon (1620) after his arrival in Venice. The task of regeneration devolved upon non-Venetian artists, such as Johann Liss (Lys), a German who had studied in Holland. Liss went to Venice from Rome in 1622; the Roman Domenico Fetti went to Venice from Mantua in 1622; and Bernardo Strozzi of Genoa arrived in 1630. These artists, influenced by Caravaggio and Rubens, painted in rich\color and tended to translate sacred and mythological subjects into scenes of contemporary life or genre.

This new spirit was particularly evident in Francesco Maffei's rich bold touch and visionary exuberance and in the Florentine Sebastiano Mazzoni's free and luminous brush stroke, which prefigured 18th-century painting. Traditionalism, based on the style of Padovanino (Alessandro Varotari), was represented in 18th-century Venetian painting by Girolamo Forabosco and Giulio Carpioni, who was influenced by the clas-

sicistic trend as well. (The imitations of 16th-century style by Pietro Muttoni, known as Pietro della Vecchia, constitute a special case.)

The Franco-Fleming Nicolas Regnier (known in Italy as Niccolò Renieri) moved to Venice in 1626; his original Caravaggesque style was gradually modified by academic forms of Bolognese origin. The Lombard-Roman Pier Francesco Mola, who worked for a time in Venice, was also influenced by the Emilians. The influence of Pietro da Cortona appeared in Venice in the work of the Tuscans Giovanni Coli and Filippo Gherardi and the Paduan Pietro Liberi (an artist of affected sweetness who was active in Vienna and Germany), and most notably in that of the Roman Francesco Ruschi (Rusca) and the Genoese Giovanni Battista Langetti (Langhetti). In the typical chiaroscuro of Venetian art of the second half of the 17th century, the work of these men expressed a taste for violent naturalism. This tendency encountered the Neapolitan style, which was brought to Venice by Luca Giordano (three paintings in S. Maria della Salute) and affected such painters as Antonio Carneo, Antonio Zanchi, the German Johann Carl Loth, and later Antonio Molinari (Mulinari), the teacher of Piazzetta. Fumiani's large, architectural perspective paintings owed much to his Bolognese training; the flowing decorative effect of the paintings of Antonio Balestra, who continued to work in the first decades of the 18th century, also derived from the Bolognese school and from Maratta. The luminous ease of color of Andrea Celesti, who also worked in Austria, was an important forerunner of 18th-century painting. The famous portraitist Sebastiano Bombelli of Udine worked in Vienna and Munich.

The fact that many Venetian painters were called to work abroad corroborates Venice's new importance in 18th-century European art. Sebastiano Ricci (in Vienna, 1701–03; London, Paris, 1712–17) was the first of the new Venetian painters to work in a style that harmonized perfectly with the European rococo (PL. 227). His work marked a passage from an emphasis on chiaroscuro to one on color, a transformation complemented by the rediscovery of Paolo Veronese's handling of light. The international importance of Venetian art was enhanced by Giovanni Antonio Pellegrini, whose work was characterized by delicate color and broad, sparkling brush strokes. Pellegrini worked in England (1708–13), Germany, Holland, Paris (1720), Würzburg, Prague, Dresden, Vienna (1724–25), and Mannheim. Jacopo Amigoni, a Neapolitan born in Venice, carried his gallant, worldly style, suffused with Arcadianism and academicism, to Bavaria (Nymphenburg and Schleissheim; from 1711), England, Paris (1736–39), and Madrid (1747–52). Giovanni Battista Crosato, who worked in Turin (1730–36, 1740–42) as well as in Venice, contributed to the international diffusion of Venetian painting, as did Rosalba Carriera, who created portraits in pastels, a technique that was greatly admired in France.

Giovanni Battista Piazzetta (q.v.; PL. 222) is noteworthy among the painters of this generation who worked nearer to Venice. He started out in the style of the 17th-century Venetian "tenebrosi," acquired concrete dramatic force in Bologna under the direction of Crespi and the study of Guercino, and brightened his palette under the influence of Domenico Fetti and Liss. The style of Giovan Battista Tiepolo (q.v.), the foremost representative of courtly decorative painting, derived from Piazzetta, Ricci, Paolo Veronese, and the expressionism of Federico Bencovich (who was active in Vienna, 1716, and Wurzburg, 1733, and contributed to establishing the Venetian stamp of the Germanic rococo).

The style of such artists as Giovanni Battista Pittoni (PL. 227), a clever and elegant exponent of the international rococo style, Nicola (Giannicola) Grassi of Friuli, and Gaspare Diziani of Belluno was variously determined by the work of Ricci, Piazzetta, and Tiepolo. The last two were also followed by numerous minor artists. Francesco Capella (Daggiù), Domenico Maggiotto (Majotto), Giulia (Lisalba) Lama, and Giuseppe Angeli were among the disciples of Piazzetta; those of Tiepolo included Fabio Canal, Francesco Zugno, Jacopo Guarana, and the talented Francesco Fontebasso, who was initially influenced by Ricci and worked in St. Petersburg in 1760–61. Antonio Zuc-

chi, a modestly talented pupil of Fontebasso and Amigoni, worked in England (1770–82), where he married Angelica Kauffmann. Pietro Antonio Rotari of Verona, was court painter and portraitist in Vienna, Dresden, and St. Petersburg, where he died in 1762. The Veronese tradition survived in the school of Balestra and in the work of the Cignaroli family, of whom the most important was Gianbettino. Giovanni Antonio Guardi (q.v.), a contemporary of Tiepolo, adopted the clear, airy manner of Ricci and Pellegrini. Giovanni Antonio's younger brother and collaborator, Francesco Guardi, was a stronger artistic personality.

Pietro Longhi's (q.v.) scenes of contemporary life and the portraits of his son Alessandro were distinctly different from the decorative or "historic" art of the time. Giovanni Domenico Tiepolo, after departing from the style of his father, portrayed contemporary conditions with a lively and bitter spirit.

"Views" (vedute) or "landscapes" constituted another area of 18th-century Venetian painting, even though it was an imported genre, derived from Roman, Neapolitan, and Genoese art. Luca Carlevaris of Udine, following the models of Van Wittel, introduced the "view" to Venice. Canaletto (q.v.) brought the "view" to its highest expression and also interpreted English landscape with extraordinary intensity. Michele Marieschi, who was for a while a scene designer in Germany, successfully painted "composed" landscapes. In contrast, Bernardo Bellotto (q.v.), a nephew and pupil of Canaletto, created a style of concentrated reality and dense imagery. The disembodied vision of Francesco Guardi transfigured the elements of the landscape into pure imaginative values of light and atmosphere. The genre of landscape painting had been initiated in Venice by Marco Ricci, who studied with his uncle Sebastiano (whom he followed to London, Holland, and Paris) and was influenced by the art of Pannini, Rosa, and Magnasco. The preromantic force of Ricci's work was transformed into Arcadian insubstantiality by the Tuscan Francesco Zuccarelli, who went to Venice from Rome and then traveled through England, France, Holland, and Germany. The two diverse tendencies converged in the landscapes of Giuseppe Zais of Belluno.

The assimilation of Venetian painting to neoclassic style in the first decades of the 19th century devolved upon Johann Baptist II Lampi (Lamp) of Trent, a courtly portraitist who studied in Verona and Austria, worked in Poland (1788) and Russia (1791), and finally settled in Vienna.

BIBLIOG. C. Ridolfi, Le meraviglie dell'arte, 2 vols., Venice, 1648 (new ed. V. Hadeln, 2 vols., Berlin, 1914–24); M. Boschini, La carta del navegar pittoresco, Venice, 1660; M. Boschini, Le ricche miniere della pittura veneziana, Venice, 1674; A. M. Zanetti, Varie pitture a fresco de' principali maestri veneziani, Venice, 1760; A. Longhi, Compendii delle vite de' pittori veneziani, istorici più rinomati, Venice, 1762; A. M. Zanetti, Della pittura veneziana e delle opere pubbliche de' veneziani maestri, Venice, 1771; N. Melchiori, Vite di dieci pittori veronesi inedite, Venice, 1845; N. Pietrucci, Biografia degli artisti padovani, Padua, 1858; J. Crowe and G. B. Cavalcaselle, A History of Painting in North Italy, 2 vols., London, 1871; V. Joppi, Nuovo contributo alla storia dell'arte nel Friuli e alla vita dei pittori e intagliatori friulani, 4 vols., Venice, 1887–94; D. Zanandreis, Le vite dei pittori, scultori e architetti veronesi, Verona, 1891; B. Berenson, Venetian Painters of the Renaissance, New York, London, 1894; A. Vecellio, I pittori feltrini, Feltre, 1898; G. Lorenzetti, Venezia e il suo estuario, Venice, 1926; H. Voss, Studien zur venezianischen Vedutenmalerei des XVIII. Jahrhunderts, RepfKw, XLVII, 1926, pp. 1–45; G. Damerini, I pittori veneziani del '700, Bologna, 1928; G. Fiocco, La pittura veneziana alla Mostra del Settecento, Venice, 1929; G. Fiocco, La pittura veneziana del Seicento e del Settecento, Verona, 1929; G. Delogu, Pittori veneti minori del Settecento, Venice, 1930; V. Moschini, La pittura italiana del Settecento, Florence, 1931; E. Arslan, Studi sulla pittura del primo Settecento veneziano, CrArte, I, 1935–36, pp. 184–97, 238–50; L. Coletti, La crisi manieristica della pittura veneziana, Convivium, II, 1941, pp. 109–26; R. Pallucchini, Mostra degli incisori veneti del Settecento (exhibition cat.), Venice, 1941; G. Lorenzetti, La pittura italiana del Settecento, Novara, 1942; H. Tietze and E. Tietze-Conrat, The Drawings of the Venetian Painters, New York, 1944; R. Pallucchini, Pittura veneziana del Cinquecento, 2 vols., Novara, 1944; R. Pallucchini, Cinque secoli di pittura veneta, Venice, 1945; E. Arslan, Il concetto di "luminismo" e la pittura veneta barocca, Milan, 1946; R. Longhi, Viatico per cinque secoli di pittura veneziana, Florence, 1946; O. Benesch, Venetian Drawings of the 18th Century in America, New York, 1947; W. G. Constable, Venetian Paintings, London, 1949; K. Scheffler, Venezianische Malerei, Berlin, 1949; M. Pittaluga, Acquafortisti veneziani del Settecento, Florence, 1950; F. Valcanover, Mostra del Settecento Bellunese (exhibition cat.), Venice, 1954; K. Dobrowski and others, Bernardo Bellotto (exhibition cat.), Venice, 1955; D. Gioseffi, Pittura veneziana del Settecento, Bergamo, 1956; D. Donzelli, I pittori veneti

del Settecento, Florence, 1957; T. Pignatti, Pittura veneziana del Cinquecento, Bergamo, 1957; G. Delogu, Pittura veneziana dal secolo XIV al XVIII, Bergamo, 1959; M. Levey, Painting in 18th Century Venice, London, 1959; A. Morassi, Mostra dei disegni veneti del Settecento (exhibition cat.), Venice, 1959; M. Muraro, Pittura veneta del Settecento, Milan, 1959; P. Zampetti and others, Mostra della pittura del Seicento a Venezia (exhibition cat.), Venice, 1959; R. Pallucchini, Storia della pittura veneziana, I: La pittura veneziana del Settecento, Venice, 1960.

ARTISTS: See individual articles for Bellotto, Fetti, Longhena, Piazzetta.

OTHERS. Jacopo Amigoni: b. Venice, 1675; d. Madrid, 1752; painter (H. Voss, Jacopo Amigoni und die Anfänge der Malerei des Rokoko in Venedig, JhbPreussKSamml, XXXIX, 1918, pp. 145–70; G. M. Pilo, Studiando l'Amigoni, Arte veneta, XII, 1958, pp. 158–68; A. Griseri, L'ultimo tempo dell'Amigoni e il Nogari, Paragone, XI, 123, 1960, pp. 21–26; G. M. Pilo, Ricci, Pellegrini, Amigoni: Nuovi appunti su un rapporto vicendevole, Arte antica e moderna, III, 1960, pp. 174–89). Marcantonio Bassetti: Verona, 1588–1630, painter (F. Zeri, Due opere di Marcantonio Bassetti, Paragone, VI, 63, 1955, pp. 38–40; R. Longhi, Presenze alla Sala Regia, Paragone, X, 117, 1959, pp. 29–38). Giuseppe Bazzani: b. Reggio Emilia, ca. 1690; d. Mantua, 1769; painter [N. Ivanoff, Mostra del Bazzani (exhibition cat.), Mantua, 1950; N. Ivanoff, Bazzani, Mantua, 1950; L. Ozzòla, Giuseppe Bazzani, Comm, II, 1951, pp. 43–46]. Federico Bencovich (called Ferghetto and Dalmatino): b. Dalmatia, 1687; d. Gorizia, 1756; painter (R. Pallucchini, Federico Bencovich, RArte, XIV, 1932, pp. 302–20; R. Pallucchini, Profilo di Federico Bencovich, CrArte, I, 1935–36, pp. 205–20, III, 1938, pp. 114–15). Antonio Bonazza: Padua, 1690–1763, sculptor (C. Semenzato, Antonio Bonazza, Venice, 1957; C. Gould, A Note on F. A. Bustelli and Antonio Bonazza, BM, CIII, 1961, p. 185). Girolamo Campagna: b. Verona, ca. 1550; d. Venice, ca. 1626; architect and sculptor (G. Liberali, Originali inediti di Paolo Veronese, Jacopo Palma, Antonio Fumiani, Girolamo Campagna, Antonio Zucchi e altri minori nella chiesa di S. Teonisto a Treviso, RArte, XXII, 1940, pp. 254–71). Luca Carlevaris: b. Udine, 1665; d. Venice, 1731; painter (F. Mauroner, Luca Carlevarijs, Padua, 1945; F. J. B. Watson, Un nuovo libro di disegni del Carlevaris, Arte veneta, IV, 1950, pp. 131–34; F. Valcanover, Per Luca Carlevaris, Arte veneta, VI, 1952, pp. 193–94). Antonio Carneo: b. Concordia, 1637; d. Porto Gruaro, 1692; painter (B. Geiger, Antonio Carneo, Udine, 1940). Giulio Carpioni: b. Venice, 1611; d. Verona, 1674; painter (M. Muraro, Giulio Carpioni, Acropoli, I, 1960–61, pp. 67–78). Rosalba Carriera: Venice, 1675–1757, painter (V. Malamani, Rosalba Carriera, 2d ed., Bergamo, 1910; J. Wilhelm, Le portrait de Watteau par Rosalba Carriera, GBA, LXII, 1953, pp. 235–46). Andrea Celesti: Venetian painter, active 1637–ca. 1712 (A. M. Mucchi, Il pittore Andrea Celesti, Milan, 1954). Giovanni Battista Crosato: Venice, ca. 1697–1756, painter (G. Fiocco, Giambattista Crosato: Pittore di casa Savoia, Venice, 1941; N. Ivanoff, Un ignoto ciclo pittorico di Giovanni Battista Crosati, Arte veneta, V, 1951, pp. 170–71; A. Griseri, Il "rococo" a Torino e Giovan Battista Crosati, Paragone, XII, 135, 1961, pp. 42–61). Gaspare Diziani: b. Belluno, 1689; d. Venice, 1767; painter (R. Pallucchini, Nota per Gaspare Diziani, Arte veneta, II, 1948, pp. 135–38; G. Mariacher, Recenti restauri a Cà Rezzonico: Dipinti di Gaspare ed Antonio Diziani, Arte veneta, V, 1951, pp. 173–76). Girolamo Forabosco (Ferabosco, Ferrabosco): Padua, 1604/05–79, painter (G. Fiocco, Girolamo Forabosco ritrattista, Belvedere, IX, 1926, pp. 24–28; H. Voss, Zum Werk des Girolamo Forabosco, Belvedere, IX, 1926, pp. 179–85; E. Arslan, Opere del Forabosco e del Migliori, Riv. di Venezia, XIII, 1934, pp. 93–98). Giovanni Battista Langetti (Langhetti): b. Genoa, 1625; d. Venice, 1676; painter (G. Fiocco, Giambattista Langetti e il naturalismo a Venezia, Dedalo, III, 1922, pp. 275–88; R. Pallucchini, Le ultime opere di Giambattista Langetti, BArte, XXVIII, 1934, pp. 251–57; N. Ivanoff, Intorno al Langetti, BArte, XXXVIII, 1953, pp. 320–22). Gregorio Lazzarini (Lazarini): b. Venice, 1655; d. Villa Bona, 1730; painter (G. M. Pilo, Lazzarini e Tiepolo, Arte veneta, XI, 1957, pp. 215–19; G. M. Pilo, Fortuna critica di Gregorio Lazzarini, CrArte, N.S., V, 1958, pp. 233–42; G. M. Pilo, Opere di Gregorio Lazzarini al Museo Correr, B. Mus. civici veneziani, II, 1958, pp. 15–25). Pietro Liberi: b. Padua, 1614; d. Venice, 1687; painter (S. de Kunert, Notizie e documenti su Pietro Liberi, RArte, XIII, 1931, pp. 539–75; N. Ivanoff, Gli affreschi del Liberi e del Celesti nella Villa Rinaldi Barbini di Asolo, Arte veneta, III, 1949, pp. 11–14; E. Herzog, Zwei philostratische Bildthemen der venezianischen Malerei, Mitt. der Kunsthist. Inst. in Florenz, VIII, 1957–58, pp. 112–23). Francesco Maffei: b. Vicenza, 1620; d. Padua, 1660; painter [N. Ivanoff, Mostra di Francesco Maffei (exhibition cat.), Vicenza, 1956; R. Pallucchini, Inediti della pittura veneziana del Seicento, Arte antica e moderna, II, 1959, pp. 97–102]. Domenico (Fedeli) Maggiotto (Majotto): Venice, 1713–94, painter (R. Pallucchini, Domenico Fedeli detto il Maggiotto, Riv. di Venezia,

XI, 1932, pp. 485–95). *Giovanni Marchiori*: b. Caviola d'Agordo, 1696; d. Treviso, 1778; sculptor (E. Arslan, L'attività veneziana e trevigiana del Marchiori, BArte, N.S., VI, 1926–27, pp. 117–31; E. Arslan, Di Giovanni Marchiori, scultore veneziano del Settecento, Cron. d'Arte, III, 1926, pp. 301–08; L. Menegazzi, Disegni di Giovanni Marchiori, Arte veneta, XIII–XIV, 1959–60, pp. 147–54). *Michele Marieschi*: Venice, ca. 1694–1743, painter and engraver (G. Fogolari, Michele Marieschi: Pittore prospettico veneziano, BArte, III, 1909, pp. 241–51; M. Pittaluga, Le acqueforti di Michele Marieschi, L'Arte, N.S., IX, 1938, pp. 209–37; F. Mauroner, Michele Marieschi, Print Coll. Q., XXVII, 1940, pp. 178–215). *Orazio Marinali*: b. Bassano, 1643; d. Vicenza, 1720; sculptor (C. Tua, Orazio Marinali e i suoi fratelli, RArte, XVII, 1935, pp. 281–322; A. M. Semenzato Paris, Per un catalogo degli scultori Marinali, CrArte, N.S., III, 1956, pp. 589–91; C. Semenzato, Quattro figure agresti di Orazio Marinali, Arte veneta, XIII–XIV, 1959–60, pp. 213–15). *Giorgio Massari*: Venice, 1686–1766, architect (V. Moschini, Giorgio Massari, architetto veneto, Dedalo, XII, 1932, pp. 198–229; C. Semenzato, Problemi di architettura veneta: Giorgio Massari, Arte veneta, XI, 1957, pp. 152–61). *Sebastiano Mazzoni*: b. Florence, ca. 1611; d. 1683 or 1685; painter (C. Gnudi, Sebastiano Mazzoni e le origini del Crespi, Bologna, XXII, 1935, pp. 18–36; C. Gnudi, Giunte al Mazzoni, CrArte, I, 1935–36, pp. 181–83; F. Valcanover, Aggiunte al Sebastiano Mazzoni, Arte veneta, XII, 1958, pp. 209–12; N. Ivanoff, Sebastiano Mazzoni, Saggi e mem. di storia dell'arte, II, 1958–59, pp. 209–80). *Johann Maria (Giammaria) Morlaiter (Morleitner)*: b. Villabassa (Niederdorf), Pusteria, 1699; d. Venice, 1781; sculptor (G. Lorenzetti, D'un gruppo di bozzetti di Gian Maria Morlaiter, Dedalo, XI, 1930–31, pp. 988–1012; E. Arslan, G. B. Tiepolo e G. M. Morlaiter ai Gesuati, Riv. di Venezia, XI, 1932, pp. 19–26). *Pietro Muttoni (Pietro della Vecchia)*: Venice, 1605–78, painter (G. Fiocco, Nuovi aspetti di Pietro Vecchia, Arte veneta, IV, 1950, pp. 150–51; L. Fröhlich-Blum, Su Pietro Vecchia, Paragone, III, 31, 1952, pp. 34–39; C. Semenzato, Pietro Vecchia a Carpenedo, Arte veneta, XIII–XIV, 1959–60, pp. 209–11). *Giovanni Antonio Pellegrini*: Venice, 1675–1741, painter [A. Bettagno, Mostra di Giovanni Pellegrini (exhibition cat.), Venice, 1959; R. Pallucchini, Novità ed appunti per Giovanni Pellegrini, Pantheon, XVIII, 1960, pp. 182–91]. *Giovanni Battista Pittoni*: Venice, 1687–1767, painter (L. Goggiola Pittoni, Giovan Battista Pittoni, Florence, 1922; R. Pallucchini, Disegni di Giovan Battista Pittoni, Padua, 1945; E. Arslan, Breve note su Pittoni, BArte, XXXVI, 1951, pp. 27–30; I. Fenyö, Zur Kunst Giovan Battista Pittonis, Acta historiae artium, I, 1953–54, pp. 279–300). *Marco Ricci*: b. Belluno, 1676; d. Venice, 1729; painter [N. Ivanoff, Questioni riccesche, Emporium, CVII, 1948, pp. 3–7; N. Ivanoff, Un appunto su Marco Ricci, Emporium, CXII, 1950, pp. 274–75; F. Valcanover, Mostra del Settecento bellunese (exhibition cat.), Venice, 1954; R. Pallucchini, Studi ricceschi (II): Contributo a Marco, Arte veneta, IX, 1955, pp. 171–98; R. Pallucchini, Giunte a Sebastiano ed a Marco Ricci, Arte veneta, X, 1956, pp. 149–62]. *Sebastiano Ricci*: b. Belluno, 1659; d. Venice, 1734; painter [I. von Derschau, Sebastiano Ricci, Heidelberg, 1922; R. Pallucchini, Studi ricceschi (I): Contributo al Sebastiano, Arte veneta, VI, 1952, pp. 63–84; A. Ghidiglia Quintavalle, Premesse giovanili di Sebastiano Ricci, RIASA, V–VI, 1956–57, pp. 395–415; see also Marco Ricci above]. *Carlo Saraceni*: Venice, ca. 1585–1620, painter (A. Porcella, Carlo Saraceni, Venice, 1929; R. Longhi, Ultimi studi sul Caravaggio e la sua cerchia, Proporzioni, I, 1943, pp. 5–63; R. Longhi, Presenze alla Sala Regia, Paragone, X, 117, 1959, pp. 29–38; V. Martinelli, Le date della nascità e dell'arrivo a Roma di Carlo Saraceni, pittore veneziano, S. romani, VII, 1959, pp. 679–84). *Alessandro Turchi, called Orbetto*: b. Verona, ca. 1578; d. Rome, ca. 1650; painter (G. Corso, La Maddalena dell'Orbetto, Madonna Verona, XIV, 1920, pp. 33–43; R. Longhi, Una Sant'Agnese del Turchi, Paragone, VI, 61, 1955, pp. 53–54). *Antonio Zanchi*: b. Este, 1631; d. Venice, 1722; painter [A. Riccoboni, Antonio Zanchi, pittore veneto (1631–1722) nel secondo centenario della morte, Rass. d'arte, N.S., IV, 1922, pp. 109–19; G. Ewald, Eine unbekannte Entwurfszeichnung für das Hochaltarbild der Theatinerkirche in München, Das Münster, XIII, 1960, pp. 260–63]. *Francesco Zuccarelli*: b. Pitigliano, 1702; d. Florence, 1788; painter (G. Rosa, Zuccarelli, Milan, 1945; R. Bassi-Rathgeb, Un album inedito di Francesco Zuccarelli, Bergamo, 1949; A. Morassi, Documenti, pitture e disegni inediti dello Zuccarelli, Emporium, CXXXI, 1960, pp. 7–22).

REGIONAL SCHOOLS OF NORTHERN ITALY. *Lombardy from the mannerist period to the end of the 18th century.* The Duchy of Milan, which came under Spanish domination in 1535, was formally united in 1555 to the Spain of Philip II, as were other Italian dominions. Lombard art of this period, particularly that of Milan, was characterized by the didactic moralism

typical of the Counter Reformation and comparable to contemporaneous Spanish manifestations. Perhaps more important for this tendency than the mere political situation was the influence exercised on the arts, and culture in general, by Cardinal Federigo Borromeo.

Lombard mannerism was epitomized by the painter and theoretician Giovanni Paolo Lomazzo and his pupil Ambrogio Giovanni Figino. In sculpture the influence of Michelangelo was transmitted through the composite style of Leone Leoni. Leoni, whose father was Tuscan, was both a sculptor and medalist (PL. 215). The influence of Michelangelo was also brought to Lombardy by the Tuscan Stoldo Lorenzi and particularly influenced Annibale Fontana. Other Lombards, such as the Della Portas and Fontanas, went elsewhere to practice their sculpture, especially to Rome.

Mannerist architecture in Milan owed much to Galeazzo Alessi of Perugia, who went to Milan from Genoa to design the Palazzo Marino and the Church of S. Maria presso S. Celso (PL. 215), and to Pellegrino Tibaldi, author of the Church of S. Fedele and of work for the Palazzo Arcivescovile. Vicenzo Seregni (Palazzo dei Giureconsulti, 1564) and Martino Bassi, who continued the tradition of Alessi and Tibaldi, were also noteworthy. The local tradition of rich, plastic decoration influenced the development of architecture and was characteristically manifested in the stuccowork of many churches.

The evolution of the baroque from mannerism in Lombardy was effected easily because of the severity of the architecture of the first half of the 17th century. This early 17th-century architecture included the work of Fabio Mangone, Federigo Borromeo's architect (Collegio Elvetico, now Palazzo del Senato, begun in 1608), and the less severe work of Francesco Maria Ricchino, who built the Church of S. Giuseppe (1607–30) and the Palazzo di Brera (II, PL. 145). The courtyard of the Palazzo di Brera also demonstrated the continued affinity between the architecture of Milan and Genoa, both much affected by the work of Alessi.

The rococo spirit smoothly followed on baroque simplicity, and was especially evident in certain palaces in Milan, Brescia, and Cremona, the many beautiful villas on the lakes, and in Brianza and the region north of Brescia. Finally, the 18th century produced the clear simplicity of neoclassicism, primarily through the work of Giuseppe Piermarini of Foligno, who arrived in Milan in 1769.

In a typical manifestation of the Lombard baroque, sculpture and painting were combined in the scenographic realism of the decoration of the chapels leading up to the Sacro Monte in Varese (1604–80), where, among others, Dionigi Bussola and Giuseppe Rusnati created sculptural decorations and Nuvolone and Morazzone painted. Even in the baroque period, the workshops of the Cathedral of Milan remained the centers of Lombard sculpture. Lombard painting of the 17th century was initiated by the Bolognese Procaccini family, of whom Giulio Cesare, younger brother of Camillo, was the most significant artist. Giulio Cesare Procaccini was notable for the hedonistic quality of his conceptions, derived from his study of Correggio and Parmigianino (PL. 215; II, PL. 198). This Emilian influence merged with the traditional luminism of Lombard art and influences transmitted by Genoa (Rubens, and later, Van Dyck) to create the particular qualities of a somewhat academic art, which was hedonistic beneath its veil of piety and sometimes psychologically realistic in its taste for martyrdoms (of St. Francis, by Morazzone, Milan, Mus. del Castello Sforzesco) and unusual effects (Herodias, by Francesco del Cairo, Vicenza, Mus. Civ.). Giovanni Battista Crespi (called "Cerano") nobly expressed his dramatic and decorative sense through the use of warm color with broad contrasts in composition and light. Elements of Gaudenzio Ferrari's art survived in the decorative exuberance of Morazzone (Pier Francesco Mazzucchelli), whose tortured effects of light influenced Magnasco. In portraiture, Carlo Francesco Nuvolone of Cremona achieved an academic pleasantness with a softly eclectic style. Conversely, Daniele Crespi was interesting for a severe realism that approximated Spanish style, recalling Velázquez and Zurbarán. The portraits of the Bergamask Carlo Ceresa, Crespi's pupil, were in-

tensely objective, as were the still lifes of the Bergamask Evaristo Baschenis, whose visual clarity was worthy of a Dutch master.

Attention to reality was a traditional quality of painting in Bergamo from the time of Moroni to the 18th century. The person portrayed was rendered with concrete immediacy, as seen in the work of Fra Galgario (Vittore Ghislandi), a pupil of Sebastiano Bombelli in Venice. Even more severe was the humble "truth" of the poor people depicted by Giacomo Ceruti of Brescia.

The environment of Milan, where he worked for many years, contributed many elements to the art of the Genoese Alessandro Magnasco (q.v.). His lashing brush strokes flashed over the surfaces of his visionary conceptions, depicting certain aspects of the life of his time in a manner between the caustic and the semitragic and rendering landscapes with high pictorial intensity. Magnasco's art was partly based on the prints of Callot (friars, gypsies, maskers, vagabonds, feasts). In Mantua, the 17th-century examples of Rubens and Fetti contributed to the mannerist elegance of Giuseppe Bazzani, whose nervous brush stroke produced luminous effects that recalled the Venetians.

BIBLIOG. A. Bertolotti, Artisti lombardi a Roma nei secoli XV, XVI e XVII, 2 vols., Milan, 1881; L. Malvezzi, Le glorie dell'arte lombarda in pittura, scultura ed architettura dal 1590 al 1850, Milan, 1882; R. Longhi, Cose bresciane del Cinquecento, L'Arte, XX, 1917, pp. 99–144; G. Nicodemi, Pittori lombardi, Rome, 1922; S. Vigezzi, La scultura lombarda nel Cinquecento, Milan, 1929; S. Vigezzi, La scultura lombarda nell'età barocca, Milan, 1930; H. Hoffmann, Die Entwicklung der Architektur Mailands von 1550–1650, Wien Jhb. f. Kg., IX, 1934, pp. 63–100; E. Calabi, La pittura di Brescia nel Seicento e Settecento (exhibition cat.), Brescia, 1935; F. Lechi and G. Panazza, La pittura bresciana del Rinascimento, Bergamo, 1939; C. Baroni, L'architettura lombarda da Bramante al Richini, Milan, 1941; C. Baroni, Problemi della scultura manieristica lombarda, Le Arti, V, 1942–43, pp. 180–90; R. Longhi, Dal Moroni al Ceruti, Paragone, IV, 41, 1953, pp. 18–36; R. Longhi, R. Cipriani and G. Testori, I pittori della realtà in Lombardia (exhibition cat.), Milan, 1953; F. Mazzini, Mostra di Fra Galgario e del Settecento in Bergamo (exhibition cat.), Milan, 1955; R. Ciardi, Seicento lombardo, CrArte, N.S., VII, 1960, pp. 212–16.

ARTISTS. Galeazzo Alessi: Perugia, 1500–72, architect (R. Gerla, La grande sala detta dell'Alessi in Palazzo Marino, Milano, 1954; E. De Negri, Galeazzo Alessi: Architetto a Genova, Genoa, 1957). Giuseppe Arcimboldi (Arcimboldo): Milan, ca. 1530–93, painter (B. Geiger, I dipinti ghiribizzosi di Giuseppe Arcimboldi, pittore illusionista del Cinquecento, Florence, 1954; F. C. Legrand and F. Sluys, Arcimboldo et les arcimboldesques, Paris, 1955; S. Alfons, Giuseppe Arcimboldo, Malmö, 1957). Evaristo Baschenis: Bergamo, 1617–77, painter (M. Biancale, Evaristo Baschenis bergamasco: Dipintore degli antichi liuti italiani, L'Arte, XV, 1912, pp. 321–24; L. Angelini, I Baschenis, 2d ed., Bergamo, 1946). Lorenzo Binaghi (Binago): Milan, 1556–1629, architect (O. Premoli, Appunti su Lorenzo Binaghi architetto, Arch. storico lombardo, XLIII, 1916, pp. 831–46). Faustino Bocchi: Brescia, 1659–1742, painter (P. Bautier, Faustino Bocchi, peintre de nains, Rev. belge d'archéol. et d'h. de l'art, XXVIII, 1959, pp. 205–23). Vincenzo Bonomini: Bergamo, 1757–1839, painter (R. Bassi-Rathgeb, Vincenzo Bonomini decoratore e pittore macabro del '700, Bergamo, 1942, and ed., Venice, 1957). Francesco del Cairo: b. 1598(?); d. Milan, 1674; painter (S. Matalon, Francesco del Cairo, RArte, XII, 1930, pp. 497–532; G. Testori, Su Francesco del Cairo, Paragone, III, 27, 1952, pp. 24–43). Calegari (Callegari, Caligari): Alessandro, 18th century, and Antonio, Brescia, 1698–1777, sculptors (G. Nicodemi, I Calegari: Scultori bresciani del Settecento, Brescia, 1924). Carlo Ceresa: b. 1609 (?); d. Bergamo, 1679; painter (G. Testori, Carlo Ceresa ritrattista, Paragone, IV, 39, 1953, pp. 17–28). Giacomo Ceruti: doc. 1720–50, painter [A. Morandotti, Cinque pittori del Settecento: Ghislandi, Crespi, Magnasco, Bazzani, Ceruti (exhibition cat.), Venice, 1943; G. Testori, Il Ghislandi, il Ceruti e il Veneti, Paragone, V, 57, 1954, pp. 16–33; R. Longhi, Due ritratti del Ceruti, Paragone, XI, 125, 1960, pp. 37–41]. Daniele Crespi: b. Busto Arsizio, 1600; d. Milan, 1630; painter (L. Belotti, Daniele Crespi, Busto Arsizio, 1930; G. Nicodemi, Daniele Crespi, Busto Arsizio, 1930; G. Gamulin, Un'opera sconosciuta di Daniele Crespi, Arte lombarda, VI, 1961, pp. 41–42). Giovanni Battista Crespi, called Cerano: b. Cerano, ca. 1575; d. Milan, 1633; painter and sculptor (N. Pevsner, Die Gemälde des Giovan Battista Crespi genannt Cerano, JhbPreussKSamml, XLVI, 1925, pp. 259–85; G. A. Dell'Acqua, Per il Cerano, L'Arte, N.S., XIII, 1942, pp. 159–79, XIV, 1943, pp. 14–38; G. Testori, Inediti del Cerano giovine, Paragone, VI, 67, 1955, pp. 13–21). Ambrogio Giovanni Figino: Milan, 1584–1608, painter (R. Longhi, Ambrogio Figini e due citazioni del Caravaggio, Paragone, V, 55, 1954, pp. 36–38; A. E. Popham, On a Book of

Drawings by Ambrogio Figino, Bib. d'humanisme et Renaissance, XX, 1958, pp. 266–76). Annibale Fontana: Milan, 1540–87, sculptor (W. Suida, Leonardo und sein Kreis, Munich, 1929; E. Kris, Materialen zur Biographie des Annibale Fontana und zur Kunsttopographie der Kirche S. Maria presso S. Celso in Mailand, Mitt. der Kunsthist. Inst. in Florenz, III, 1930, pp. 201–53). Fra Galgario (Vittore Ghislandi): Bergamo, 1655–1743, painter [G. Testori, Il Ghislandi, il Ceruti e il Veneti, Paragone, V, 57, 1954, pp. 16–33; F. Mazzini, Fra' Galgario e del '700 in Bergamo (exhibition cat.), Bergamo, 1955]. Leone Leoni: b. Arezzo, 1509; d. Milan, 1590; goldsmith and sculptor (E. Plon, Leone Leoni, sculpteur de Charles-Quint et Pompeo Leoni, sculpteur de Philippe II, Paris, 1887; L. Planiscig, Bronzi minori di Leone Leoni, Dedalo, VII, 1926–27, pp. 544–67; A. Del Vita, Benvenuto Cellini e Leone Leoni, Il Vasari, XVI, 1958, pp. 21–30). Ottavio Leoni: 1578–1630, painter (F. H. Thomas, Ottavio Leoni: A Forgotten Portraitist, Print Coll. Q., VI, 1916, pp. 323–73; A. Petrucci, Una galleria romana di ritratti, Capitolium, XXVI, 1951, pp. 112–18). Pier Francesco Mazzucchelli, called Morazzone: b. Morazzone, ca. 1571; d. Piacenza, 1626; painter (G. Nicodemi, Pier Francesco Mazzucchelli detto il Morazzone, Varese, 1927; R. Ciardi, Documenti e commenti sul Morazzone, CrArte, N.S., VI, 1959, pp. 80–89, 145–65; M. Rosci, Contributi al Morazzone, BArte, XLIV, 1959, pp. 151–57). Carlo Francesco Nuvolone: b. Cremona, 1608; d. Milan, ca. 1661; painter (G. Gamulin, Contributi a due pittori cremonesi, Comm, IX, 1958, pp. 171–74). Procaccini: a family of painters, including Ercole, b. Bologna, 1515; d. Milan, 1595; Camillo, b. Bologna, 1551; d. Milan, 1629; and Giulio Cesare, b. Bologna, 1570; d. Milan, 1625 (N. Ivanoff, Disegni dei Procaccini, CrArte, N.S., V, 1958, pp. 223–32; A. Arfelli, Per la cronologia dei Procaccini, Arte antica e moderna, II, 1959, pp. 457–61). Francesco Maria Ricchino: Milan, 1584–1658, architect (P. Mezzanotte, Apparati architettonici del Richino per nozze auguste, Rass. d'arte, XV, 1915, pp. 224–28; M. L. Gengaro, Dal Pellegrino al Richino: Costruzioni lombarde a pianta centrale, BArte, XXX, 1936, pp. 202–06; E. Cattaneo, Il San Giuseppe del Richini, Milan, 1957). Vincenzo Seregni: Milan, ca. 1504–94, architect (C. Baroni, Gli edifici di Vincenzo Seregni nella Piazza dei Mercanti a Milano, Milan, 1934; C. Baroni, Intorno a tre disegni milanesi per sculture cinquecentesche, RArte, XX, 1938, pp. 392–410). Todeschini (Giacomo Francesco Cipper): 18th-century painter (W. Arslan, Del Todeschini e di qualche pittore affine, L'Arte, N.S., IV, 1933, pp. 255–73; M. Mojzer, Giacomo Francesco Cipper, Acta historiae artium, IV, 1956, pp. 77–98).

Piedmont. The art of Piedmont acquired distinctive characteristics only during the baroque period. Until then, the artistic needs of this small border state were limited and were sufficiently satisfied by imported works and by local elaborations of Lombard and French influences. Thus Romanesque architecture in Piedmont, which was based on Lombard style, absorbed Burgundian and Provençal elements, as in the 12th-century Abbey of S. Maria in Vezzolano and the Abbey of Cavagnola. The work of Antelami in S. Andrea in Vercelli at the beginning of the 13th century confirmed these cultural sources (I, PL. 297; VI, PL. 332). Piedmont almost completely missed the stylistic phase of the Renaissance. (The Cathedral of Turin, 1491–98, by Meo del Caprino of Settignano, is an exception.) This absence of one of the most significant developments of Italian art gave a nonclassic, northern character to Piedmontese art, which evolved directly from the Gothic to the baroque. Particularly interesting creations include the famous castles of the feudal period; the frescoes in the Castello della Manta (VI, PL. 64) and those executed by Jacquerio in the Abbey of S. Antonio in Ranverso were manifestations of the elegant style of 15th-century International Gothic.

As Lombard and French influences were important for Romanesque architecture in Piedmont, so in painting they affected two early 16th-century Piedmontese artists, Giovanni Martino Spanzotti and his pupil Defendente Ferrari. These men reflected the Renaissance, but only indirectly, by way of the work of the Lombard Foppa. Spanzotti and Ferrari were also clearly in contact with French art, and their work was undoubtedly more coherent than that produced by Macrino d'Alba's (Gian Giacomo de Alladio) eclectic derivations from the art of central Italy. Sodoma (q.v.) and Gaudenzio Ferrari left Vercelli to participate in the broader movements of Italian painting, while Gerolamo Giovenone, who continued to paint after the middle of the 16th century, remained a provincial artist. But from the province of Vercelli came the most important

Piedmontese painter of the period from the end of the 16th to the beginning of the 17th century, Tanzio da Varallo (Antonio d'Enrico Tanzio). His early artistic training was in the tradition of Lombard mannerism, but he was influenced by the style of Caravaggio after a trip to Rome about 1615 (frescoes in Novara, S. Gaudenzio).

In the second half of the 16th century, under Emmanuel Philibert (who oriented Piedmontese politics toward Italy), and later under Charles Emmanuel I (duke from 1580 to 1630), Piedmont experienced a notable artistic revival, which was responsible for the urban development of the city of Turin. The first concern was military, and in 1564 Francesco Conte Paciotti (Pacciotto) of Urbino was called to construct the citadel

(including stuccoworkers and wood carvers), whose styles were extensively influenced by France. The sculpture of the period was of mediocre quality. Among the representative painters were the Venetian Giovanni Battista Crosato (who created decorations for the Royal Palace, the Villa della Regina, Stupinigi, and the Consolata), Claudio Francesco Beaumont of Turin (the vault of the Galleria dell'Armeria, Royal Palace, 1744), and the Frenchman Charles André van Loo (frescoes at Stupinigi), a pupil of his brother Jean Baptiste, who worked in the Castello di Rivoli. Numerous Romans, Neapolitans, Genoese, and Venetians were also commissioned to decorate the new churches and palaces in Piedmont. The Venetian group was especially important and included, besides Crosato, two or

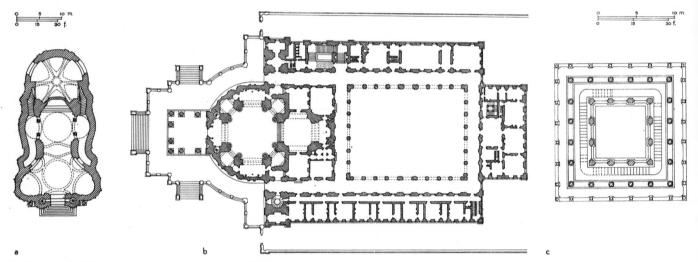

Piedmontese buildings, 18th–19th cent., plans. (a) Agliè, S. Marta (architect: C. Michela); (b) Superga, Basilica (architect: F. Juvara); (c) Turin, Mole Antonelliana (architect: A. Antonelli).

of Turin. By 1577, however, the Church of the SS. Martiri had been begun, after a design of Pellegrino Tibaldi. The most active architects in Piedmont at this time were Ascanio Vittozzi of Orvieto, ·Carlo di Castellamonte, and Amedeo di Castellamonte. Ascanio Vittozzi opened new streets and designed squares (e.g., Piazza Castello, 1584), churches (e.g., Corpus Domini, 1609), and villas (e.g., Villa della Regina and its park). Carlo di Castellamonte provided plans for the beautiful Piazza S. Carlo, which was constructed in 1640, just after the artist's death. His son, Amedeo di Castellamonte, continued his work with the uniform sobriety and correctness evident in the structure of the Royal Palace (begun in 1646), the Via Po, the Ospedale of S. Giovanni, and the hunting lodge of Venaria Reale. Minor architects of the time included Maurizio Valperga and Francesco Lanfranchi, whose work was overshadowed by the vast production of Guarino Guarini (q.v.), who worked in Turin from 1668.

In 1714, Victor Amadeus II made Filippo Juvara (q.v.) of Messina first architect of his court (FIG. 467). Juvara's style, marked by a refined elegance of modeling and pictorial spatial effects, raised the quality of Turin's architecture to the level of the leading 18th-century European courts. The façade of the Palazzo Madama (PL. 226) and the royal hunting lodge of Stupinigi (I, PLS. 389, 407; II, PL. 141) are particularly noteworthy. After Juvara, the two leading 18th-century architects in Piedmont were Benedetto Alfieri and Bernardo Antonio Vittone. Alfieri's style was halfway between that of Guarini and that of Juvara (Alessandria, Palazzo Ghilini, 1730; Turin, Royal Palace, decoration; Carignano, S. Giovanni Battista, 1757–71); Vittone sought complex rococo effects in the tradition of Borromini and Guarini (Bra, S. Maria degli Angeli, 1742; Turin, S. Maria di Piazza, 1751). Such minor architects as Gian Giacomo Planteri, Carlo Filippo Aliberti, and Dellala (Count Francesco Valeriano Dellala di Bernasco) designed churches, palaces, and villas that contributed a particular Piedmontese stamp to the local architecture of this period. This architecture also derived characteristics from painters and other artists

three members of the Cignaroli family and Francesco Trevisani (called "Romano"). Trevisani had been Beaumont's master in Rome. This union of Venetian art with the brilliant superficial art of Van Loo established 18th-century painting in Piedmont as one of the expressions of the European rococo.

BIBLIOG. G. Vernazza di Freney, Notizie patrie spettanti all'arte del disegno, Turin, 1792; G. A. De Giorgi, Notizie sui celebri pittori e su altri artisti alessandrini, Alessandria, 1836; A. Angelucci, Arte e artisti in Piemonte, Turin, 1878; G. Colombo, Documenti e notizie intorno agli artisti vercellesi, Vercelli, 1883; E. Bertea, Ricerche sulle pitture e sui pittori del pinerolese dal XIV secolo alla prima metà del XVI, Pinerolo, 1897; S. Weber, Die Begründer der Piemonteser Malerschule in XV. und zu Beginn des XVI. Jahrhunderts, Strasbourg, 1911; A. Baudi di Vesme, Per le fonti della storia dell'arte piemontese, Atti X Cong. int. Storia Arte, Rome, 1923, pp. 501–06; A. E. Brinckmann, Theatrum novum Pedemontii, Düsseldorf, 1931; A. Baudi di Vesme, L'arte negli stati sabaudi (Atti Soc. piemontese di archeol. e belle arti, XIV), Turin, 1932; A. E. Brinckmann, Von Guarino Guarini bis Balthasar Neumann, Berlin, 1932; L. Rosso, La pittura e la scultura del '700 a Torino, Turin, 1934; N. Gabrielli, Monumenti della pittura nella provincia di Alessandria dal secolo X alla fine del XV, Alessandria, 1935; E. Olivero, Miscellanea di architettura piemontese del Settecento, Turin, 1937; A. M. Brizio, La pittura in Piemonte dall'età romanica al Cinquecento, Turin, 1942; V. Viale, La pittura in Piemonte nel Settecento, Torino, XXII, 6, 1942, pp. 3–22; N. Gabrielli, Pitture romaniche in Piemonte, Turin, 1944; M. Passanti, Architettura in Piemonte, Turin, 1945; L. Mallé, La pittura piemontese tra '400 e '500, B. Soc. piemontese di archeol. e belle arti, VI–VII, 1952–53, pp. 76–131; L. Benevolo, L'architettura della Valsesia superiore durante l'età barocca, Palladio, N.S., III, 1953, pp. 7–20, 81–90, 165–74; A. M. Brizio, L'architettura barocca in Piemonte, Turin, 1953; G. Testori, Mostra del manierismo piemontese e lombardo del Seicento (exhibition cat.), Turin, Ivrea, 1955; Atti X Conv. naz. Storia Arch., Turin, 1959; N. Gabrielli, Rappresentazioni sacre e profane nel Castello di Issogne e la pittura nella Val d'Aosta alla fine del '400, Turin, 1959; A. Griseri, L'autunno del Manierismo..., Paragone, XII, 141, 1961, pp. 19–36; A. Griseri, Il "Rococò" a Torino e Giovan Battista Crosato, Paragone, XII, 135, 1961, pp. 42–65.

ARTISTS. Benedetto Alfieri: b. Rome, 1700; d. Turin, 1767; architect (L. Mina, Del Palazzo Reale in Alessandria e del suo architetto, Alessandria, 1914; G. Chevalley, Un avvocato architetto, il conte Benedetto Alfieri, Turin, 1916; M. Rosci, Benedetto Alfieri e l'architettura del '700 in Piemonte, Palladio, N.S., III, 1953, pp. 91–100). Claudio Francesco Beaumont: Turin, 1694–1766, painter (M. Zucchi, Della vita e delle opere di Claudio Francesco Beaumont,

Turin, 1921; M. Viale-Ferrero, Claudio Beaumont and the Turin Tapestry Factory, Connoisseur, CXLIV, 1959, pp. 145–51). *Guglielmo Caccia*, called *Moncalvo*: 1588–1625, painter (F. Picco, Un pittore piemontese del secolo XVI, Rass. d'arte, IV, 1904, pp. 169–74; V. Moceogatta, Un disegno del Moncalvo, Arte antica e moderna, II, 1959, pp. 325–27). *Di Castellamonte*: *Carlo*, Turin, ca. 1560–1640, and *Amedeo*, d. 1683, civil and military architects and city planners (C. Boggio, Gli Architetti Carlo e Amedeo di Castellamonte e lo sviluppo edilizio di Torino nel secolo XVII, Turin, 1896; L. Collobi Ragghianti, Carlo di Castellamonte: Primo ingegnere del Duca di Savoia, B. storico bibliog. subalpino, XXXIX, 1937, pp. 232–63). *Defendente Ferrari* (*de Ferrari*, *Deferrari*): doc. 1511–35, painter (A. M. Brizio, Defendente Ferrari da Chivasso, L'Arte, XXVII, 1924, pp. 211–46; V. Viale, Schedule su Defendente Ferrari, S. ... of Art Dedicated to W. E. Suida, London, 1959, pp. 231–35). *Juvara* (q.v.). *Macrino d'Alba* (*Gian Giacomo de Alladio*): Alba, ca. 1470–1528, painter (E. Milano, Macrino d'Alba ed il suo ambiente, Arte e storia, XXIX, 1910, pp. 353–66; G. O. Della Piana, Macrino d'Alba, Turin, 1935). *Giovanni Martino Spanzotti*: b. Casale, ca. 1450; d. Chiavasso, ca. 1528; painter (A. Baudi di Vesme, Nuove informazioni intorno al pittore Martino Spanzotti, Turin, 1918; G. Testori, G. M. Spanzotti, Ivrea, 1958). *Tanzio da Varallo* (*Antonio d'Enrico Tanzio*): Alagna, 1574–ca. 1655, painter [G. Testori, Mostra di Tanzio di Varallo (exhibition cat.), Turin, 1959; M. Rosci, Tanzio da Varallo at Turin, BM, CII, 1960, pp. 31–32]. *Bernardo Antonio Vittone*: Turin, 1705–70, architect (E. Olivero, Le opere di B. A. Vittone, Turin, 1920; C. Ceschi, Progetti del Guarini e del Vittone per la Chiesa di San Gaetano a Nizza, Palladio, V, 1941, pp. 171–77; A. E. Brinckmann, Tre astri nel cielo del Piemonte: Guarini, Vittone, Juvara, Atti X Conv. naz. Storia Arch., Turin, 1959, pp. 345–47; V. Golzio, L'architetto B. A. Vittone urbanista, Atti X Conv. naz. Storia Arch., Turin, 1959, pp. 101–12). *Ascanio Vittozzi*: b. Orvieto, 1539; d. Turin, 1615; architect and military engineer (C. Brayda, Vitozzo Vitozzi, ingegnere militare e alcuni disegni di Torino antica, Torino, XVIII, 2, 1939, pp. 15–19; E. Olivero, Un pensiero architettonico di Ascanio Vittozzi, Torino, XVIII, 7, 1939, pp. 29–36).

Liguria. The artistic development of Lombardy, Piedmont, and Liguria was connected by common elements, reciprocity of influence, and exchanges of artists. Liguria's cultural range was broader than that of Piedmont, as evidenced in Liguria's Romanesque architecture, which joined Tuscan and Byzantine elements to Lombard and French qualities (Noli, S. Paragorio; San Fruttuoso, Monastery of S. Fruttuoso di Capodimonte; Genoa, S. Donato and S. Maria di Castello). Gothic features began to appear early in Liguria, but Gothic structures retained some traditional Romanesque elements, including dichromatic ornamentation. These characteristics and French influences (13th–14th cent.) marked the conception of Genoa Cathedral (S. Lorenzo) and appeared in secular structures (Genoa, Palazzo di S. Giorgio; the Doria houses in Piazza S. Matteo) even into the 15th century. This late Gothic style represented the taste of the entire region, which, like Piedmont, did not really experience the Renaissance (despite the fact that Alberti was born in Genoa). Even in the Genoese work of the Lombards Domenico Gaggini and his nephew Elia, architecture and sculpture were combined to achieve a decorative effect that properly belonged to the so-called "flamboyant" style (Genoa, Cathedral, Chapel of S. Giovanni Battista, ca. 1456), although some Tuscan elements did appear in their work.

In the 13th–14th century many Tuscan painters did work for Genoa, from Manfredino d'Alberto (Manfredino da Pistoia) to Taddeo di Bartolo. Barnaba da Modena worked extensively in Liguria in the period 1360–80; the Byzantine Gothicism he brought to Genoa was accompanied by the delicacies of Po Valley chiaroscuro, which were revived in the 15th century in the art of Vincenzo Foppa (q.v.). Foppa worked in Genoa and Savona, where he collaborated with Ludovico Brea on the polyptych (1489–90) of the Church of S. Maria di Castello. Brea was the outstanding painter of a group that created the first local style of painting in Nice. Franco-Flemish tradition was strong in this school, which was related to the art of Catalonia and Sicily by certain characteristics found throughout the Mediterranean area. The work of Carlo di Giovanni Braccesco (known as Carlo da Milano), who worked in Liguria (Imperia, Genoa), also displayed elements derived from Flemish art and the work of Foppa.

The 16th century marked the beginning of Genoa's artistic efflorescence. Mannerism came to Genoa in the work of Giovanni Angelo Montorsoli (Palazzo Doria Pamphili), Perino del Vaga, Beccafumi, and Giambologna (q.v.; bronze figures and reliefs for the Grimaldi Chapel, ca. 1579–85, now in the University of Genoa). But it was chiefly Galeazzo Alessi (active in Genoa ca. 1548–60) who brought to Genoa the developments of the Roman 16th century (subtly animated with elements drawn from Sebastiano Serlio) and thereby established the basis for the picturesque, scenographic luminism of contemporaneous Genoese architecture (S. Maria Assunta di Carignano, 1552; FIG. 419; Villa Cambiaso and Villa Pallavicino delle Peschiere; the former Palazzo Cambiaso, now Banco di Napoli; Palazzo Parodi). The intensive building activity of this period, which saw the opening of the noble Via Nuova (or Via Maggiore, later called Via Garibaldi), produced the famous Genoese palaces with airy loggias and staircases. Two Lombard architects who followed the lead of Alessi in these activities were Giambattista Castello, who was also a painter (Palazzo Carrega-Cataldi, begun 1558; Palazzo Podestà; Palazzo Doria, 1564), and Rocco Lurago (Palazzo Comunale, II, PL. 144; FIG. 417). Another Lombard, Baccio Bartolommeo del Bianco, was the principal architect of Genoa in the 17th century (Via Balbi; Durazzo-Pallavicini and Balbi-Senarega palaces, and Palazzo dell'Università, 1615–38); he created clear scenographic impressions, which harmoniously blended his structures with their surroundings. The Genoese tradition was continued in the 18th century by Gregorio Petondi, architect for the Palazzo Balbi (1780; PL. 226).

Sculpture, which was of little importance up to the middle of the 17th century, acquired a certain significance in the work of Pierre Puget of Marseilles, who worked in Genoa from 1661 to 1667 (sculptures in S. Maria Assunta di Carignano, II, PL. 170; statue of the Virgin of the Immaculate Conception, Oratory of S. Filippo Neri), and in that of the Genoese Filippo Parodi, who also worked in Venice and Padua. Parodi assimilated the influence of Bernini and Algardi in a style of pictorial theatricality that had psychological overtones. Parodi's son Domenico and the brothers Bernardo and Francesco Schiaffino (*Rape of Prosperine*, Genoa, Royal Palace) handled sculpture with decorative ease and were also admired abroad.

But Ligurian art found its highest expression in the exuberance of its baroque painting. The greatest Genoese painter of the 16th century was Luca Cambiaso (IX, PL. 302), a pupil of his father Giovanni and of Giovanni Battista Castello. Luca, a mannerist of rich imagination, was an originator of the local tradition of mural decoration. Even after the time of Beccafumi, Sienese art continued to influence that of Genoa. The visits of Rubens and Van Dyck were of fundamental importance to 17th-century Genoese painting. From these painters the local artists derived their fine intense color, evident, for example, in the work of Andrea Ansaldo and in that of Bernardo Strozzi (II, PL. 202), who emigrated to Venice in 1630. The work of Gioacchino Assereto, a pupil of Ansaldo, occasionally approached the tones of French art or of Neapolitan work after Caravaggio. The tendency to treat pictorial subjects as realistic or "genre" scenes achieved fine results in the work of Giovanni Benedetto Castiglione, known as Grechetto. An excellent engraver and an admirer of Rembrandt, Grechetto was influenced by Flemish and Venetian art. As a painter of animals, Castiglione was preceded by Sinibaldo Scorza and followed by Anton Maria Vassallo. Giovanni Andrea de' Ferrari and Domenico Fiasella, students of the late mannerist Bernardo Castello, still interpreted their "historical" subjects in a realistic manner, although their work evidenced a somewhat superficial and academic eclecticism. The portraitist Giovanni Bernardo Carbone was strongly influenced by Van Dyck.

There was another trend in Genoese painting, that of the great decorators who frescoed the vaults of churches and palace salons and galleries. Taddeo Carlone's sons, Giovanni Andrea and Giovanni Battista, continued the tradition of Cambiaso and Giovanni Battista Castello. But the most vital representatives of this Genoese decorative painting were Valerio Castello (son of Bernardo), Domenico Piola, and Gregorio de' Ferrari.

Castello was receptive to the hedonism of Correggio, Giulio Cesare Procaccini, Rubens, and Van Dyck; Piola's numerous works were characterized by a joyful brilliance; and De' Ferrari continued these pleasant qualities into the 18th century (II, PL. 201). Giovanni Battista Gaulli (known as Bacciccio or Baciccia) went to Rome in 1657, at the age of eighteen. The masterpiece of his daring imagination was the ceiling fresco of the Church of the Gesù in Rome (II, PL. 171). Mulinaretto (Giovanni Maria dalle Piane), who was in contact with Gaulli during a period of study in Rome, was an elegant portraitist in the ornate tradition of contemporary French and English artists. Mulinaretto later became court painter in Naples (1730–41). Quite different was the painting of Magnasco (q.v.), whose extended stay in Milan as a young man produced an art that was more Milanese than Genoese in character.

BIBLIOG. R. Soprani, Le vite dei pittori, scultori e architetti genovesi, e dei forestieri che in Genova operarono, 2d ed., 2 vols., Genoa, 1768; F. Alizeri, Notizie dei professori del disegno in Liguria dalla fondazione dell'accademia, 3 vols., Genoa, 1864–66; F. Alizeri, Notizie dei professori del disegno in Liguria dalle origini al secolo XVI, 6 vols., Genoa, 1870–80; M. Staglieno, Appunti e documenti sopra diversi artefici poco o nulla conosciuti che operarono in Genova al secolo XV, Genoa, 1870; F. Ingersoll Smouse, La sculpture à Gènes au XVIIᵉ siècle, GBA, XII, 1914–16, pp. 11–24; O. Grosso, Decoratori genovesi, Rome, 1921; M. Labò, Contributi alla storia dell'arte genovese, Genoa, 1926; G. Delogu, Pittori minori liguri, lombardi, e piemontesi del Seicento e del Settecento, Venice, 1931; P. Barbieri, Genova romanica, Genoa, 1938; O. Grosso and others, Mostra di pittori genovesi del Seicento e del Settecento (exhibition cat.), Milan, 1938; V. Straneo, L'arte in Liguria nelle sue vicende storiche, Turin, 1939; A. Morassi, Mostra di pittura antica in Liguria (exhibition cat.), Genoa, 1946; A. Morassi, Mostra della pittura del Seicento e Settecento in Liguria (exhibition cat.), Milan, 1947; P. Rotondi, Mostra della Madonna nell'arte in Liguria (exhibition cat.), Genoa, 1952; C. Ceschi, Architettura romanica genovese, Milan, 1954; A. Griseri, Appunti genovesi, S. in the H. of Art Dedicated to W. E. Suida, London, 1959, pp. 312–24.

ARTISTS. *Andrea Ansaldo*: b. Voltri, 1584; d. Genoa, 1638; painter (E. Hoffmann, Verlorene Dürerzeichnungen und einige italienische Zeichnungen..., Jhb. Mus. der bild. K. in Budapest, X, 1940, pp. 17–23). *Gioacchino Assereto*: Genoa, 1600–49, painter (R. Longhi, L'Assereto, Dedalo, VII, 1926–27, pp. 355–77; R. Longhi, E ancora dell'Assereto, Pinacoteca, I, 1928–29, pp. 221–25; L. Grassi, Deposizione inedita dell'Assereto, Paragone, III, 11, 1952, pp. 40–42; G. F. Castelnovi, Intorno all'Assereto, Emporium, CXX, 1954, pp. 17–35). *Carlo di Giovanni Braccesco* (called *Carlo da Milano*): doc. 1451–1501, painter (R. Longhi, Carlo Braccesco, Milan, 1942; F. Zeri, Two Contributions to Lombard Quattrocento Painting, BM, XCVII, 1955, pp. 74–77). *Ludovico Brea*: Nice, ca. 1450–1523, painter (L. H. Labande, Les Brea: Peintres niçois des XVᵉ et XVIᵉ siècles en Provence et en Ligurie, Nice, 1937; L. H. Labande, Louis Brea, GBA, XVIII, 1937, pp. 73–92, 143–60). *Luca Cambiaso*: b. Moneglia (Genoa), 1527; d. Madrid, 1585; painter (B. and W. Suida, Luca Cambiaso, Milan, 1958; L. Collobi Ragghianti, Il magistrale Luca Cambiaso, CrArte, N.S., VI, 1959, pp. 166–84). *Giovanni Bernardo Carbone*: Albaro (Genoa), 1614–83, painter (O. Grosso, Giovanni Bernardo Carbone, Dedalo, VIII, 1927–28, pp. 109–34). *Carlone*: family of painters of Lombard origin, active in Genoa from the 2d half of the 15th century, of whom the best known are *Giovanni Battista*, b. Genoa, 1592; d. Turin, 1677; and *Giovanni Andrea*, Genoa, 1639–97 (M. Marangoni, I Carlone, Florence, 1925). *Bernardo Castello*: b. Albaro (Genoa), 1552; d. Genoa, 1629; painter (M. V. Brugnoli, Il soggiorno a Roma di Bernardo Castello e le sue pitture nel palazzo di Bassano di Sutri, BArte, XLII, 1957, pp. 255–65). *Valerio Castello*: Genoa, 1625–59, painter (M. Labò, Valerio Castello, Emporium, XCVI, 1942, pp. 369–78; B. Riccio, Contributo a Valerio Castello, Comm, VIII, 1957, pp. 39–46). *Giovanni Benedetto Castiglione*, called *Grechetto*: b. Genoa, 1610(?); d. Mantua, 1665; painter (G. Delogu, Giovanni Benedetto Castiglione detto il Grechetto, Bologna, 1928; A. Blunt, A Poussin-Castiglione Problem, Warburg, III, 1939–40, pp. 142–47; A. Blunt, The Drawings of Giovanni Benedetto Castiglione and Stefano della Bella... at Windsor Castle, London, 1954). *Giovanni Andrea de' Ferrari*: 1598–1669, painter (P. Rotondi, Contributo a Giovanni Andrea de' Ferrari, BArte, XXXVI, 1951, pp. 280–83; E. Falletti, Inediti giovanili di Giovanni Andrea de' Ferrari e proposte per una cronologia, Comm, VII, 1956, pp. 158–69; A. M. Goffredo, Per la conoscenza di Giovanni Andrea de' Ferrari, Comm, VII, 1956, pp. 147–57). *Gregorio de' Ferrari*: b. Porto Maurizio, 1644; d. Genoa, 1726; painter (J. De Masi, La vita e le opere di Gregorio de' Ferrari, Genoa, 1945; A. Griseri, Per un profilo di Gregorio de' Ferrari, Paragone, VI, 67, 1955, pp. 22–46). *Domenico Fiasella*: b. Sarzana, 1589; d. Genoa, 1669; painter (W. Suida, Ein Bild des Domenico Fiasella in Wien,

Belvedere, II, 1922, pp. 78–80). *Giovanni Battista Gaulli*, called *Bacciccio* (*Baciccia*): b. Genoa, 1639; d. Rome, 1709; painter (M. V. Brugnoli, Disegni del Bacciccio, ArtiFig, I, 1945, pp. 49–54; M. V. Brugnoli, Contributi a Giovan Battista Gaulli, BArte, XXXIV, 1949, pp. 225–39; R. Enggass, Gaulli's Late Style, 1685–1709, AQ, XX, 1957, pp. 2–16). *Filippo Parodi*: Genoa, 1630–1702, sculptor (P. Rotondi, Filippo Parodi maestro dell'intaglio, BArte, XLIV, 1959, pp. 46–56; P. Rotondi, La prima attività di Filippo Parodi, Arte antica e moderna, II, 1959, pp. 63–73). *Domenico Piola*: Genoa, 1627–1703, painter (G. V. Castelnovi, I dipinti dell'Oratorio di S. Giacomo della Marina a Genova, Genoa, 1953; J. Bean, Un groupe di dessins génois, RArts, VIII, 1958, pp. 267–72). *Sinibaldo Scorza*: b. Voltaggio, 1589; d. Genoa, 1631; painter (K. T. Parker, Sinibaldo Scorza, Old Master Drawings, I, 1926–27, pp. 51–54). *Semino*: family of 16th-century Genoese painters, including *Andrea*, ca. 1525–ca. 1595 and *Ottavio*, ca. 1520–1604 (L. Ragghianti Collobi, Andrea Semino disegnatore, CrArte, N.S., I, 1954, pp. 133–43). *Bernardo Strozzi*: b. Genoa, 1581; d. Venice, 1664; painter (A. M. Matteucci, L'attività veneziana di Bernardo Strozzi, Arte veneta, IX, 1955, pp. 138–54; L. Mortari, Su Bernardo Strozzi, BArte, XL, 1955, pp. 311–33; I. Fenyö, Contributo ai rapporti artistici tra Palma Giovane e Bernardino Strozzi, Acta historiae artium, V, 1958, pp. 143–55). *Anton Maria Vassallo*: 17th-century painter (O. Grosso, Anton Maria Vassallo e la pittura d'animali nei primi del '600 a Genova, Dedalo, III, 1922–23, pp. 502–22; G. Delogu, Pitture italiane del '600 e del '700 a Vienna, L'Arte, N.S., VIII, 1937, pp. 222–41).

THE NINETEENTH CENTURY. The neoclassic period (see NEOCLASSIC STYLES) was followed by a general decline in the figural arts. Italian art assumed a marginal, almost isolated position, in relation to European art in general. However, distinct stylistic and regional groups continued to exist.

In Rome, after Valadier, architecture underwent a puristic phase in the work of Luigi Poletti, followed by a period of eclecticism in the structures of Gaetano Koch (1849–1910), Pio Piacentini (1846–1928), Guglielmo Calderini (1840–1916), Giuseppe Sacconi (1853–1905; X, PL. 157) and others. The work of these architects is interesting and constituted the first adaptation of the ancient city to its role as capital of Italy. In painting, the Roman neoclassicism of Felice Giani (Gianni), Vincenzo Camuccini, and Bartolomeo Pinelli was followed by the purism of such artists as Pietro Tenerani and Tommaso Minardi. The sculptors active in Rome felt the influences of tradition, purism, and the new realistic trends.

In Tuscany, the verism of the sculptors Lorenzo Bartolini, Giovanni Dupré, and Adriano Cecioni constituted a definite regional school of sculpture. In painting, Tuscany was the home of the Macchiaioli (q.v.), who produced the most vital expression of 19th-century painting in Italy.

In Naples the anti-academic reaction was characterized by the sculpture of Vincenzo Gemito and, in painting, by the so-called "school of Posillipo," dominated by Giacinto Gigante. Later masters of the Neapolitan school were Filippo Palizzi, Domenico Morelli, Gioacchino Toma, Antonio Mancini, and Giuseppe De Nittis (the last-named in contact with the Macchiaioli and the impressionists).

Lombard art was also distinguished by some particular characteristics. The architects Giuseppe Mengoni and Giuseppe Sommaruga worked in Milan, and Alessandro Antonelli worked in Turin, but their architecture, unlike the other arts, did not assume a distinctly regional flavor. There was, instead, a parallel between the development of regional sculpture and painting in this period. Thus, the pictorial inclination of the sculpture of Vincenzo Vela and Giuseppe Grandi culminated in the impressionistic creations of Medardo Rosso. In painting, after the work of the romantic Francesco Hayez, there was a second period of romanticism (represented by the work of Domenico and Gerolamo Induno, Giovanni Carnevali, called Piccio, and Federico Faruffini), which terminated in a style influenced by the mid-19th century literary movement known as the *scapigliatura lombarda*. The chief exponents of this style in painting were Tranquillo Cremona and Daniele Ranzoni. The last phase of 19th-century Lombard art was represented by the divisionist painting style of Gaetano Previati and Giovanni Segantini, which marked the extreme development of the *scapigliatura* and was similar to the development of the French pointillists.

In Turin, the dominant personality was that of the painter Antonio Fontanesi. In Venice, the leading artists were Giacomo Favretto, Guglielmo Ciardi, and Pietro Fragiacomo. Other isolated personalities of 19th-century Italian art were Francesco Paolo Michetti from the Abruzzi and Armando Spadini.

The first real break with tradition occurred in the work of Antonio Sant'Elia (I, PL. 408) and the futurists (see CUBISM AND FUTURISM), and Italy again began to participate more intimately in the broad development of European art (see EUROPEAN MODERN MOVEMENTS).

ARTISTS. *Andrea Appiani*: Milan, 1754–1817, painter (G. Bergamaschi, Le opere di Andrea Appiani pittore, Milan, 1849). *Lorenzo Bartolini*: b. Savignano, 1777; d. Florence, 1850; sculptor (M. Tinti, Lorenzo Bartolini, 2 vols., Rome, 1936). *Michele Cammarano*: Naples, 1835–1920, painter (M. Biancale, Michele Cammarano, Milan, 1936). *Vincenzo Camuccini*: Rome, 1771–1844, painter (P. E. Visconti, Notizie intorno alla vita del Barone Vincenzo Camuccini pittore, Rome, 1845). *Luigi Canina*: b. Casale Monferrato, 1795; d. Florence, 1856; architect (G. Bendinelli, Luigi Canina: Le opere e i tempi, Alessandria, 1953). *Giovanni Carnevali*, called *Piccio*: b. Montenegrino Luino, 1804; d. Caltaro sul Po, 1873; painter [C. Caversazzi, Giovanni Carnevali detto il Piccio, 3d ed., Bergamo, 1946; M. Valsecchi, Giovanni Carnevali (exhibition cat.), Varese, 1952]. *Bernardo Celentano*: b. Naples, 1835; d. Rome, 1863; painter (M. Biancale, Bernardo Celentano, Rome, 1936). *Tranquillo Cremona*: Pavia, 1837–78, painter (A. Neppi, Tranquillo Cremona, Rome, 1931; G. Nicodemi, Tranquillo Cremona, Milan, 1933). *Giuseppe De Nittis*: b. Barletta, 1846; d. Saint-Germain-en-Laye, 1884; painter (E. Piceni, Giuseppe De Nittis, Rome, 1932). *Giovanni Duprè*: b. Siena, 1817; d. Florence, 1882; sculptor (G. Rosadi and others, Giovanni Duprè, Milan, 1917). *Federico Faruffini*: b. Sesto San Giovanni, 1831; d. Perugia, 1869; painter and engraver (P. M. Bardi, Federico Faruffini, Milan, 1934). *Giacomo Favretto*: Venice, 1849–87, painter (D. Valeri, Giacomo Favretto, Venice, 1950). *Antonio Fontanesi*: b. Reggio Emilia, 1818; d. Turin, 1882; painter and engraver (C. Carrà, Fontanesi, Rome, 1924; M. Bernardi, Antonio Fontanesi, Milan, 1933; G. Briganti, Catalogo della retrospettiva di Antonio Fontanesi, Reggio Emilia, 1949). *Vincenzo Gemito*: Naples, 1852–1929, sculptor (O. Morisani, Vita di Gemito, Naples, 1936; E. Somarè and A. Schettini, Gemito, Milan, 1946; P. Bellonzi and R. Frattarolo, Appunti sull'arte di Gemito, Rome, 1952). *Giacinto Gigante*: Naples, 1806–76, painter (S. Ortolani, Giacinto Gigante, Bergamo, 1930; M. Limoncelli, Giacinto Gigante, Naples, 1934; S. Ortolani, La scuola di Posillipo, Bergamo, 1934; R. Causa, Acquarelli di Giacinto Gigante, Naples, 1955; A. Schettini, Giacinto Gigante, Naples, 1956). *Emilio Gola*: Milan, 1851–1923, painter (P. M. Bardi, Emilio Gola, Bergamo, 1930; R. Taccani and G. Nicodemi, Mostra celebrativa di Emilio Gola, Milan, 1956). *Francesco Hayez*: b. Venice, 1791; d. Milan, 1882; painter (F. Hayez, Le mie memorie, Milan, 1890; G. Nicodemi, Dipinti di Francesco Hayez, Milan, 1934). *Induno*: Domenico, Milan, 1815–78, and *Gerolamo*, Milan, 1827–90, painters (G. Nicodemi, Domenico e Girolamo Induno, Milan, 1945). *Antonio Mancini*: Rome, 1852–1930, painter (V. Guzzi, Antonio Mancini, Rome, 1943; F. Bellonzi and C. Lorenzetti, Antonio Mancini, Rome, 1953; A. Schettini, Antonio Mancini, Naples, 1953). *Giuseppe Mengoni*: b. Fontanelice (Bologna), 1829; d. Milan, 1877; architect (G. Ricci, La vita e le opere dell'architetto Giuseppe Mengoni, Bologna, 1930). *Francesco Paolo Michetti*: b. Tocco Casauria (Chieti), 1851; d. Francavilla a Mare, 1929; painter (T. Sillani, Francesco Paolo Michetti, Milan, 1932). *Tommaso Minardi*: b. Faenza, 1787; d. Rome, 1871; painter (I. Faldi, Il Purismo e Tommaso Minardi, Comm, I, 1950, pp. 238–46). *Domenico Morelli*: Naples, 1826–1901, painter (A. Conti, Domenico Morelli, Naples, 1927; V. Spinazzola, Domenico Morelli, Rome, Milan, 1927). *Filippo Palizzi*: b. Vasto, 1818; d. Naples, 1899; painter (A. Mezzetti, Contributi alla pittura italiana dell'800, BArte, XL, 1955, pp. 244–58, 334–45). *Bartolomeo Pinelli*: Rome, 1781–1835, painter and sculptor (V. Mariani, Bartolomeo Pinelli, Rome, 1948). *Gaetano Previati*: b. Ferrara, 1852; d. Lavagna, 1920; painter (V. Pica, Gaetano Previati, Bergamo, 1912; N. Barbantini, Gaetano Previati, Milan, 1919; V. Costantini, Gaetano Previati, Bergamo, 1931). *Daniele Ranzoni*: Intra, 1843–89, painter (C. Carrà, Ranzoni, Rome, 1924; R. Giolli, Ranzoni, Milan, 1926; M. Sarfatti, Daniele Ranzoni, Rome, 1935). *Medardo Rosso*: b. Turin, 1858; d. Milan, 1928; sculptor (A. Soffici, Medardo Rosso, Florence, 1929; G. Papini, Medardo Rosso, Milan, 1940; M. Borghi, Medardo Rosso, Milan, 1950). *Giovanni Segantini*: b. Arco, 1858; d. Engadine, 1899, painter [F. Servaes, Giovanni Segantini: Sein Leben und sein Werk, Leipzig, 1920; E. Somarè, Segantini, Bergamo, 1937; N. Barbantini, Giovanni Segantini, Venice, 1945; E. Diem, Giovanni Segantini, Kunst, XLVII, 1949, pp. 120–203; Kunstmuseum St. Gallen, Giovanni Segantini (exhibition cat.), Saint-Gallen, 1956]. *Ar-*

mando Spadini: b. Poggio a Caiano, 1883; d. Rome, 1925; painter (A. Soffici, Armando Spadini, Rome, 1925; A. Venturi and E. Cecchi, Armando Spadini, Milan, 1927; O. Vergani and L. Borghese, Spadini nella vita e nelle opere, Milan, 1946). *Pietro Tenerani*: b. Torano (Carrara), 1798; d. Rome, 1869; sculptor (O. Raggi, Della vita e delle opere di Pietro Tenerani del suo tempo e della sua scuola, Florence, 1880). *Gioacchino Toma*: b. Galatina, 1836; d. Naples, 1893; painter [M. Biancale, Gioacchino Toma, Rome, 1933; A. De Rinaldis, Gioacchino Toma, Milan, 1934; L. Salerno and E. Lavagnino, Mostra di Gioacchino Toma (exhibition cat.), Rome, 1954; R. Causa, Gioacchino Toma, BArte, XL, 1955, pp. 39–52]. *Giuseppe Valadier*: Rome, 1762–1839, architect (I. Ciampi, Vita di Giuseppe Valadier, Rome, 1870; G. Matthiae, Piazza del Popolo attraverso i documenti del primo Ottocento, Rome, 1946). *Vincenzo Vela*: Ligornetto, 1820–91, sculptor (M. Calderini, Vincenzo Vela scultore, Turin, 1920). *Federico Zandomeneghi*: Venice, 1841 – Paris, 1917, painter (E. Piceni, Federico Zandomeneghi, Milan, 1933; E. Piceni, Zandomeneghi, Milan, 1952).

SOURCES AND GENERAL BIBLIOG. *a. Sources*. G. Vasari, Le vite de' più eccellenti pittori, scultori e architetti, 3 vols., Florence, 1568 (ed. Milanesi, 8 vols., Florence, 1878–82); G. Mancini, Considerazioni sulla pittura, ca. 1620 (ed. A. Marucchi and L. Salerno, 2 vols., Rome, 1956–57); G. Baglione, Le vite de' pittori, scultori e architetti dal pontificato di Gregorio XIII, dal 1572, fino ai tempi di papa Urbano VIII nel 1642, Rome, 1642 (facsimile ed., Rome, 1935); G. P. Bellori, Le vite de' pittori, scultori ed architetti moderni, Rome, 1672 (facsimile ed., Rome, 1931); F. Baldinucci, Notizie de' professori del disegno, 6 vols., Florence, 1681–1728; L. Pascoli, Vite de' pittori, scultori ed architetti moderni, 2 vols., Rome, 1730–36 (facsimile ed., Rome, 1933); G. B. Passeri, Vite de' pittori, scultori ed architetti che hanno lavorato in Roma morti dal 1641 al 1673, Rome, 1772; M. G. Bottari and S. Ticozzi, Raccolta di lettere sulla pittura, scultura ed architettura scritte da' più celebri personaggi dei secoli XV, XVI e XVII, 8 vols., Milan, 1822–25; G. Gaye, Carteggio inedito d'artisti dei secoli XV, XVI, XVII, con documenti pure inediti, 3 vols., Florence, 1839–40.

b. General bibliog. L. Lanzi, Storia pittorica d'Italia, 3 vols., Bassano, 1795–96 (3d ed., 6 vols., Bassano, 1809); L. Cicognara, Storia della scultura dal suo risorgimento fino al secolo di Canova, 7 vols., Prato, 1823–25; G. B. L. Seroux d'Agincourt, Histoire de l'art par ses monumens, 6 vols., Paris, 1823; G. Rosini, Storia della pittura italiana, 11 vols., Pisa, 1839–55; J. Burckhardt, Der Cicerone, Basel, 1855 (rev. ed., H. Wölfflin, 2 vols., Stuttgart, 1933); A. Springer, Handbuch der Kunstgeschichte, Stuttgart, 1855 (rev. ed., 5 vols., Leipzig, 1921–25); A. Ricci, Storia dell'architettura in Italia dal secolo XIV al secolo XVIII, 3 vols., Modena, 1857–59; J. A. Crowe and G. B. Cavalcaselle, A New History of Painting in Italy, 3 vols., London, 1864–66; G. Schnaase, Geschichte der bildenden Künste, 2d ed., 8 vols. in 7, Düsseldorf, 1866–79; E. Müntz, Histoire de l'art pendant la Renaissance, 3 vols., Paris, 1889–95; R. Cattaneo, L'architecture en Italie du VIᵉ au XIᵉ siècle, Venice, 1890; Venturi; Michel; F. Burger and A. E. Brinckmann, Handbuch der Kunstwissenschaft, 27 vols., Berlin-Neubabelsberg, 1912–30; P. Toesca, Storia dell'arte italiana, I: Medioevo, Turin, 1913–26; P. Schubring, Die italienische Plastik des Quattrocento, Berlin-Neubabelsberg, 1919; H. Voss, Die Malerei der Spätrenaissance in Rom und Florenz, 2 vols., Berlin, 1920; W. von Bode, Die italienische Plastik, 6th ed., Berlin, Leipzig, 1922; F. Knapp, Italienische Plastik vom 15. bis 18. Jahrhundert, Munich, 1923; C. Ricci, L'architettura del Cinquecento in Italia, Turin, 1923; Van Marle; U. Ojetti, L. Dami and N. Tarchiani, La pittura italiana del Seicento e del Settecento nella Mostra a Palazzo Pitti, Milan, 1924; G. Vitzthum and F. Volbach, Die Malerei und Plastik des Mittelalters in Italien, Wildpark-Potsdam, 1924; W. Weisbach, Die Kunst des Barock in Italien, Frankreich, Deutschland und Spanien, Berlin, 1924; E. Cecchi, Pittura italiana dell' 800, Rome, 1926; Toesca, Md; N. Pevsner, Die italienische Malerei vom Ende der Renaissance bis zum ausgehenden Rokoko, Wildpark-Potsdam, 1928; C. Ricci, La pittura del Cinquecento nell'alta Italia, Verona, 1928; A. Schmarsow, Italienische Kunst im Zeitalter Dantes, 2 vols., Augsburg, 1928; E. Somarè, Storia dei pittori italiani dell'Ottocento, 2 vols., Milan, 1928; A. De Rinaldis, La pittura del Seicento nell'Italia meridionale, Florence, 1929; U. Ojetti, La pittura italiana dell'Ottocento, Milan, Rome, 1929; L. Réau, Histoire universelle des arts des temps primitifs jusqu'à nos jours, 4 vols., Paris, 1930–36; G. Delogu, Pittori minori liguri, lombardi, piemontesi del Seicento e del Settecento, Venice, 1931; B. Berenson, Italian Pictures of the Renaissance: A List of the Principal Artists and Their Works with an Index of Places, Oxford, 1932; U. Ojetti, Il Settecento italiano, 2 vols., Milan, 1932; S. Vigezzi, La scultura italiana dell'Ottocento, Milan, 1932; F. Baumgart, Italienische Kunst: Plastik, Zeichnung, Malerei, Berlin, Zürich, 1936; E. Lavagnino and others, Storia dell'arte italiana (Collana dell'Utet), Turin, 1936 ff.; M. Pittaluga, Arte italiana, 3 vols., Florence, 1937–38; N. Tarchiani, L'architettura italiana dell'Ottocento, Florence, 1938; A. M. Brizio, Ottocento e Novecento, Turin, 1939; S. Bottari, Storia dell'arte italiana, 2 vols., Milan, 1943; U. Nebbia, La pittura italiana del Seicento, Novara, 1946; H. Focillon, Art d'occident, 2d ed., Paris, 1947; E. B. Garrison, Italian Romanesque Panel Painting: An Illustrated Index, Florence, 1949; V. Golzio, Seicento e Settecento, Turin, 1950; Toesca, Tr; R. Salvini, Lineamenti di storia dell'arte, 3 vols., Florence, 1952–59; G. Bazin, Histoire de l'art de la préhistoire à nos jours, Paris, 1953; P. D'Ancona, F. Wittgens, and M. L. Gengaro, Storia dell'arte italiana, 3 vols., Milan, Florence, 1953; M. Salmi, Arte italiana, 2 vols., Florence, 1953; E. Carli and G. A. Dell'Acqua, Profilo dell'arte italiana, 2 vols., Bergamo, 1954–55; S. Bottari, Storia dell'arte italiana, 3 vols., Milan, Messina, 1955–57; A. Chastel, L'art italien, 2 vols., Paris, 1956; G. Mazzariol and T. Pignatti, Storia dell'arte italiana, 3 vols.,

Milan, 1957–58; R. Wittkower, Art and Architecture in Italy, 1600–1750, Harmondsworth, 1958; C. Maltese, Storia dell'arte in Italia (1785–1943), Turin, 1960.

Giorgio VIGNI

The bibliog. was prepared by Filippa Maria ALIBERTI, Guglielmo CAPOGROSSI and Francesco NEGRI ARNOLDI.

Illustrations: PLS. 171–228; 20 figs. in text.

ITALO-ROMAN FOLK ART. The arts of ancient Rome and of the Roman world during the periods of the late Republic and the Empire had no uniform characteristics or line of development. In some respects they were clearly influenced by Hellenistic forms and ideals (see HELLENISTIC ART; HELLENISTIC-ROMAN ART), notably in the taste for ornament and in the sphere of official art, although the latter presented new and specifically Roman requirements in architecture, in great commemorative reliefs, in portraiture, etc. (see ROMAN IMPERIAL ART). But there were also deeply rooted local traditions in the Italic and Etruscan world (including Rome itself in the early centuries of its history; see ETRUSCO-ITALIC ART) and in the Greek colonial world of southern Italy and Sicily (see GREEK ART, WESTERN), traditions that met and merged in the art culture produced by the unification of Italy under Rome during the late republican period. These traditions survived to some extent during the Empire, with certain unmistakable features, in minor works or in those produced privately or by the less important centers, even while the major trends of Imperial art were being established. Such works often have a decidedly folk character, as in a certain type of funerary relief, in house paintings and shop signs, and in random graffiti, which are of special interest because at times they are apparently reflected in sophisticated art and because of their relationship with provincial and Early Christian art (see CATACOMBS).

The production of folk art obviously must have arisen from local traditions, since Hellenism was an acquired culture and thus at first belonged to the intellectual world. Literature and the visual arts, though both notably influenced by Hellenism, took different paths of development. Literature of this period was produced by original personalities of high ability and vigor (for example, Plautus in the drama and Ennius in history), while art had no such masters until centuries later. There was no parallel in the visual arts for the folk humor and frankness of Plautus and his capacity for interpreting Hellenistic themes and turning them to his own purposes. In literature, the nature of the Latin language, unified in structure and vocabulary and closely related to the organization of Roman life, tended to standardize the means of expression. Art, having no such common idiom, developed later, expressing two different tendencies: one, an intellectual adoption of the wealth of Hellenistic forms, and the other a fluent narrative quality, a simple expressive immediacy — in other words, folk art. During the early period when the literary expression of the Roman spirit was taking form (ca. mid-3d cent. B.C.), there was no Roman art; instead, the imported Hellenistic art coexisted with the various local Italic currents, each with its own history and meaning. Roman civilization was to function as the catalyst, effecting the spread and assimilation of the Hellenistic influence.

For the sake of clarity the following discussion of Italo-Roman folk art is organized by areas. The subject does not lend itself to a judgment of esthetic values, but at the same time the undistinguished level of many of the products cannot always be attributed to artistic immaturity and lack of skill. The terms "impressionism" and "expressionism" are to be understood in the relative sense suggested by R. Bianchi Bandinelli and do not imply intention on the part of the artists.

One of the regions richest in Italo-Roman folk art is Campania, in the south, where the full development of local expression coincides approximately with the Romanization of the area, though there are iconographical similarities to Etruscan work. For example, the mother goddesses (IV, PL. 207) that were so frequent in Capua as to become stereotyped must be related to the similar and older figures from Chiusi (V, PL. 43), but the Capuan examples reveal no effort at formal discipline; the aim appears to be simple representation, which at times verges on expressionism. The Hellenistic contribution to local art appears in numerous pseudo-*naiskos* funerary steles with one or more full figures or busts (PL. 229). Comparison of the stele of Sabictius (which closely follows Hellenistic models in the placement of the figures) with that of Publilius (with its three crowded figures breaking through the border) indicates a transition from strict conformity toward the emergence of local characteristics, though the draperies of female figures continued to imitate Hellenistic forms.

The terra-cotta sculpture of Campania, which ranges from small religious images to statues of large dimensions and represents some rather ambitious subjects, shows greater freedom and a more clearly local manner. Cales (mod. Calvi Risorta), for example, produced *palliati* (cloaked figures) that repeat classic forms, but without understanding of organic structure; draperies are simplified to a few broad folds unrelated to the figure beneath, so that the clothed figure appears merely as a play of surfaces and serves as a support for the head. Some attempt to idealize the features is evident, and the locks of hair are rendered for effects of mass and color. The best of the Calene group is a bust that shows an original interpretation of a fine-arts theme. Similar treatment of borrowed themes may be seen in fragments of large terra-cotta steles, bearing images of veiled women or warriors or portraits of the deceased with the attributes of Hercules. Closer to Hellenistic models are the two great cult statues, *Jupiter* and *Juno*, from Pompeii, now in Naples (Mus. Naz.). The *Jupiter* shows a clearer understanding of figure construction. The *Juno* reflects the Eastern (Asiatic) Hellenistic motif of the female figure wearing a light tunic over a heavy robe, but the proportions are altered. In contrast to these, the *Victimarius* (sacrificing priest), also from Pompeii, is completely naturalistic, though in a manner quite different from the Hellenistic baroque influence seen in the *Victimarius* found in Rome, now in the Museo Nuovo dei Conservatori. The large Campanian terra cottas have various baroque characteristics (e.g., the attempt at effects and at expressiveness), but these are different from Hellenistic baroque, even though certain types are imitated (the *Jupiter* and *Juno* mentioned above, and the Pompeian statuette of a seated old man of the Hellenistic philosopher type). Frequently the small terra cottas show folk traits — for example, lack of interest in structural logic and coherence, purely superficial representation, and an occasional caricatural gesture such as may be found in later Pompeian bronzes (the naked old woman and the traveling vendor with his tray, examples that are quite consistent with the Hellenistic taste for the abnormal and the typification of physical deformity).

Pompeian painting gives further evidence of the objective realism of Campanian artists. The classic and Hellenistic designs widely adopted by the Campanian decorators seem to have had almost no influence on the manner of execution. The representations are sketchy, quick and spare in technique, and show little regard for problems of composition or color harmony. Immediacy of representation is the primary concern; caricature appears rarely and then usually in traditional iconography such as that of the well-known parody of the Judgment of Solomon (Naples, Mus. Naz.; VII, PL. 191) and in the gryllos, *The Flight of Aeneas*, in the same museum.

The subject matter of this local painting is broad, including religious images, genre scenes, narrative episodes, and portraits, sometimes in combination. The stately image of Venus, patron goddess of Pompeii, in an elephant-drawn quadriga (an Oriental motif) is painted on the wall of the fuller's shop of M. Vecilius Verecundus in Pompeii above a shop sign showing the work of the establishment (PL. 233; VI, PL. 61). A scene of similar character is that of the bakery (PL. 234), the work of a gifted craftsman who carefully depicted the details of the stall and the display of loaves. Not unlike the Venus in style are numerous lararium paintings, such as that from the House of the Centenary (Naples, Mus. Naz.), showing Bacchus enveloped in a bunch of grapes and a view of Vesuvius. Elimina-

tion of perspective is frequent in the lararium panels, and the ancient religious symbol of a serpent (agathodaemon) almost always appears coiling among the bushes. In these small domestic sacella the religious iconography and other elements of sophisticated art are set aside in the development of local characterists. Representations of sacred ceremonies, particularly of the Oriental cults, often show the folk point of view. The procession painted in House IX, 7, 1 in Pompeii is an interesting example; the bearers have set down the litter with the statue of Cybele, which is surrounded by worshipers in one of those crowd scenes typical of folk art. Here, as in the Herculaneum mosaic of a school, lively portrait details single out individual gestures and personalities from the anonymous group. More fluent in execution, but also narrative in character, is the fresco, now in Naples (Mus. Naz.), of a procession of carpenters, showing a ceremony in the humble surroundings of an artisans' guild. The inn of House VI, 14, 36 of Pompeii has scenes with dice-throwers and other customers who "speak" through the inscriptions set beside them in a series of amusing episodes from everyday life.

Some influence of sophisticated origins does appear, however, as in the Pompeian genre mosaics attributed to Dioskourides of Samos (VII, PL. 166). From this type of subject only a short step is required for the representation of a historical incident of serious consequences, the wall painting of the brawl between Pompeians and Nucerines in the amphitheater of Pompeii (PL. 231). The pseudoperspective of the amphitheater and its surroundings (city walls, palaestra, trees, sheds, and vendor booths) gives a compositional unity to the small scattered groups of miniature figures.

In contrast to this scene, with its attempt at bird's-eye perspective and its episodic and sequential arrangement, are realistic representations with a more unified construction certainly modified by sophisticated art. In such paintings as realistic banquet scenes (as in a house in Pompeii V, 2), with careful iconographical details and keen observation of humorous episodes, and the fresco of the student whipped in the presence of his classmates, the emphasis is on simple representation of an event, and there is no attempt at depth or perspective. A neutral background eliminates spatial values, and prolepsis often serves in place of perspective (S. Ferri). Furthermore, the inorganic construction of the figures indicates that they were painted without a cartoon and that the painter was left to his own improvisational devices. What is most interesting in these genre scenes, in addition to the immediacy of the events depicted, is the individuality of the characters, realistically distinguished as portrait sketches.

True portraits appear in the Pompeian fresco long thought to be of a baker and his wife (VII, PL. 204), with its insistence on individual physical details such as the sparse beard and moustache of the man and the artificially curled locks of the woman. The dignity implied by the inclusion of a scroll and a tablet and writing stylus does not disguise the fact that the couple portrayed are probably persons of modest status.

Along with this strain of analytical realism in Campanian painting, another manner was adapted to folk themes, making use of a rather impressionistic spot technique (macchia). This technique may be seen in the well-known painting The Worship of Isis from Herculaneum and in paintings from the Villa of Julia Felix in Pompeii, including a group of horses and riders, a vignette of a pack mule, and a view of an open-air market before a colonnade (all, Naples, Mus. Naz.). These reveal an awareness of style and a search for expressive means beyond simple representation of incidents and episodes; paintings of sacred landscapes and imaginary views of villas and gates combine Hellenistic influences with later developments of much greater range. Nevertheless, the local current of analytical realism also enters into copies of famous paintings, giving them a folk quality. Examples are found in a Pompeian rendering of Achilles at Skyros and in a Pompeian fresco version of Theseus, slayer of the Minotaur, showing the hero surrounded by youths (both, Naples, Mus. Naz.). A painting from Isernia (anc. Aesernia), also now in Naples, popularizes the funerary theme of Hermes Psychopompos with the idiom of folk painting.

The political-economic unification of Italy under Roman domination contributed greatly to a mutual assimilation among the various culture components of the Italic world. This process operated in two ways: the founding of Roman colonies (4th–2d cent. B.C.) gradually enlarged the area of Roman-Latin population, while Italic elements flowed into Rome in great numbers. The Romanization of central and southern Italy in this manner is demonstrated in some of the sculpture. A series of busts, chiefly intended as portraits, from the Tarentine area indicates Roman colonization. Their structure and character are foreign to the tradition of Magna Graecia and comparable, rather, to works from the central-southern area of the Tyrrhenian shores, from Tarquinia to Palestrina to Campania. [In this connection, Herbig (1942) has pointed out the magical value attributed to the head, which is conjectured to have given rise to portraiture.] The imagines common to Etruria, Latium, and Campania (which continued in Campania even amidst an environment of sophisticated art, as in the lararium of the House of Menander in Pompeii) are often unrealistic in proportions and, instead of belonging to figures, are directly attached to geometric supports; those in Taranto resemble the upper part of a herm. The attempt to represent individual traits, to define a personality by an exact reproduction of the facial features, partly parallels and partly follows the production of these family cult images (perhaps with the intervening step of the funerary mask). However, little effort at portraiture is shown in certain clay heads from Latium, and others from Bologna and Piedmont, which represent the deceased person with a crown (PL. 230). These heads are related to other examples from southern Etruria and have in common a tendency toward expressionism that, in spite of the diversity of the versions, identifies a particular method adopted in Etruria and Campania to represent form. The Etruscan examples reveal a greater artistic awareness and capacity for authentic details, while the Campanian works are casual and vacuous. The geographical range of these heads is demonstrated by the fact that a bust from Ancona, although not particularly early (after 50 B.C.), shares the same traits as those from Etruria and, even more clearly, those from Campania.

The Romanization of northern Italy followed the pattern of the central-southern unification. Colonists for the Po Valley were drawn in great numbers from the central and southern districts, though other peoples settled there independently of the Roman governmental program. These movements took place just before and during the period of political unrest in the east, when Italy was opened to Asian and Greek Hellenistic influence, both directly and, as in earlier times, by way of the cities of Magna Graecia.

The effect of these events in the sphere of art was not only to flood Rome, and eventually other centers, with classic and Hellenistic original works, copies, and academic reinterpretations, and to attract great numbers of artists and craftsmen to the city, but also to extend the Greek influence into even the most modest local workshops. Rome itself had had no previous artistic distinction and in ancient times had relied on the Etruscans for the more important artistic undertakings, a responsibility later entrusted to Italiotes, Greeks, or Hellenized natives. Republican Rome appears to have been indifferent to art, an attitude which, even with the full assimilation of Hellenism, was expressed from time to time in conservative writing. Two art forms excepted from this indifference were the imagines of the domestic cult and triumphal paintings. The latter were viewed as informational pictorial reports of battles and other important topics and may have contained landscape or cartographic elements along with the figures. Among the few remains of such paintings are the fragments of a fresco from the Esquiline hill, with the meeting of Quintus Fabius and Marcus Fannius (VII, PL. 260). While its immediacy of representation and lack of stylistic pretense suggest folk art, it cannot easily be so classified, since practically none is known to have been produced in Rome. However, this statement must be balanced against the fact that little archaeological material remains from the early and middle republican period in Rome and its immediate surroundings. Later, in the first century B.C., when

figural art increased and aroused the interest of a broad public, the focus was almost exclusively on funerary portraiture.

Portraits on the tomb slabs of the Roman cemeteries are strongly realistic, though some clearly show a stylistic adaptation to one or another of the Hellenistic influences which tended to soften the objectivity of the literal portrait. Further dependence of funerary portraiture on sophisticated forms is often shown in the borrowing of Hellenistic iconographical schema or drapery rhythms, particularly in female figures. The formation of the Roman portrait head was perhaps influenced more by Campanian "realism" than by the contemporary art of Etruria, which was more prone to interpretation than to simple analytical rendering of facial features. By comparison, Campanian art is closer to folk art in feeling, in that it tended to create the type-sketch and shows little effort at delineation of individual personality even by detailed observation of the features. Actually, the physiognomical portrait, with its serious approach, expresses a concept of personality that is characteristic of the Roman mentality; it cannot, thus, be explained simply as an adoption of folk-art elements into sophisticated art. However, in contemporary literature the transformation of nonliterate folk forms (the *atellana*, the *fescennino*, the *satura*) into sophisticated forms can be clearly demonstrated. The original dialects were replaced by the Latin language; so that the transformation obviously took place in the sphere of Roman culture. These folk literary forms came from about the same areas as the art forms discussed above, but there is not sufficient contemporary evidence to prove that the figural arts underwent a similar development, even though the literary parallel might suggest this.

During the middle and especially the late Republic, the central Italian cultural area produced a great deal of figural art, well defined as to subject matter, with reliefs of ceremonial and public spectacles, such as the *ludi gladiatorii*, predominating. The descriptive character of these reliefs can be related both to Samnite painting and to Etruscan reliefs with processions of magistrates. Outstanding examples of this local art are two reliefs from Preturo, now in the museum of Aquila, one a gladiatorial combat and the other a funeral scene (PL. 229). In the latter the scattering of the procession in superimposed registers and the pseudoperspective view indicate that the artist could have had no more than a superficial knowledge of sophisticated sculpture and painting.

The gladiatorial reliefs, too, are often characterized by pseudoperspective and prolepsis. The theme occurs in Pompeii (tomb of M. Umbricius Scaurus, with stucco reliefs), but representations of the kind are particularly frequent in middle and southern Apennine Italy, where the dimensions of the reliefs are occasionally very large. While the gladiatorial spectacle may have been originally an Etruscan custom (Athenaeus, *The Deipnosophists*, iv, 153 f) and is first represented in Etruscan art, the subject was widely popular. This is amply documented by the relief from Preturo and by those from the tomb of C. Lusius Storax in Chieti (anc. Teate), now in the local archaeological museum. The figures, though occasionally revealing classical or Hellenistic influences, are generally marked by a direct observation of nature and are executed according to a few rather uniform schemes. They would seem to be the antecedents of the many clay and bronze statuettes of gladiators, of decidedly folk-art character, that were widespread throughout Roman Italy and beyond, and of the gladiator reliefs on lamps, terra sigillata, and other objects, all more or less homologous over a long period. The aspects of particular interest in the gladiator type are the pose and the equipment denoting his specialities. In time, however, the minute descriptiveness evolved into a representation so summary as to be sketchy and expressionistic. The gladiatorial reliefs belong to a particular period in the artistic development of central and southern Italy and are rarely found north of the Apennines. An exception is a rather well-known slab of the republican period from the eastern necropolis of Bologna.

In the funerary sculpture of central Italy the same episodic and descriptive character appears, but portraiture occasionally followed the Roman physiognomical type, though with varying degrees of proficiency. These tendencies are evident with particular immediacy on a stele from Isernia depicting a conversation between a traveler and his host; the dialogue is indicated in the inscription and gives color and comic cadence to the scene. This relief presents an interesting parallel to the Campanian paintings of tavern scenes, and the presence of such a subject and the use of dialogue on a funerary stele are particularly indicative of the narrative trend.

In the region north of the Po, as well as in Venetia, the representation of realistic themes and sketches from daily life appears chiefly on clay lamps, a folk product for folk use, though the figural repertory was for the most part abandoned in local imitations of Arretine ware. The lamp decorations vary greatly in subject matter, including many hunting and arena scenes, and are at times crudely pornographic. Themes of genre type are also documented in the north by small carvings in amber, comparable to similar earlier products of southern Italy. Examples of such carvings have been found northwest of the Po, notably at Aquileia; the anecdotal character of these pieces often takes a grotesque form. Aside from these objects, however, the arts of the north present the problem of the relationship between folk art (q.v.) and provincialism (see PROVINCIAL STYLES), and since in many respects the north of Italy was culturally a province, subject to a considerable time lag in its development, the question of the origin of peripheral art styles is also involved. The survival of the local pre-Roman civilizations in this region was limited in its effect on art, providing subject matter rather than determining form. A few elements from the Celtic past were retained, such as the bodiless heads, *têtes coupées* (III, PL. 111), placed in classicizing decorative contexts, and representations of the devouring funerary monster, a fairly common element of funerary iconography in the Po Valley. Of the Venetic past, whose direct connection with early Roman elements is documented in Este, no traces remain in the developments of local Roman art. On the whole the artistic crafts of the north, particularly the funerary sculpture, had their origin in the mainstream of sophisticated arts; both in the portrait type and in the use of classicizing or Hellenizing motifs and rhythms, they constitute a popularization of fine-arts forms, rather than a continuation of folk strains. Venetia, in particular, was open to Hellenizing influences and diffused them to the interior of the Po Valley.

In the funerary portraiture of the north a detailed realism was generally favored, even after this was no longer fashionable elsewhere, but the idealized portraits of the Augustan, Julio-Claudian, and Flavian periods also frequently served as models. As a result, realistic representation of the features often gave way to indefinite, rather than idealized, traits, and the identification and characterization of the individual personality were left to the inscription.

In Venetia a severe, dry linear style became general, and only rarely did there appear such scenes of daily life and activities as the relief of the situla maker in Este (anc. Ateste) and the more cursive one of the fruit vendor in Verona. In Verona, Brescello (anc. Brixellum), and the lower Po region figures shown wearing the *lorica* or the *lacerna* occasionally show iconographic influences from beyond the Alps. In Emilia and Lombardy there was no such homogeneous style as that of Venetia, but the characteristics of portraiture were approximately the same. Genre scenes such as that on the stele of the *faber navalis* (shipwright) Longidienus in Ravenna (PL. 229) and that of the goldbeater and the swineherd in Bologna (Mus. Civico) are isolated examples. In Piedmont (western Po Valley and inner Liguria), however, genre scenes are common; recurrent themes include the flocks and herds of domestic animals and the wine carts so characteristic of the area. Also, in Piedmont strongly local tendencies are revealed in the accentuated provincialism of works such as the silver bust of Lucius Verus from Bosco Marengo (Turin, Mus. di Antichità), the *Jupiter* of Aosta (Mus. Archeologico), and small bronzes such as the *cucullatus* of Aosta (PL. 230), which is more caricatural than realistic. A unique work of this local craftsmanship is a large statue of a female divinity, probably Minerva, in Bergamo (Mus. Archeologico). It is an eclectic patchwork of disparate

elements, not assimilated to one cultural tradition but superficially recorded in a summary way, and not comparable to any recognized type. Northern Etruria, in comparison with the rather well-defined artistic facies of central and southern Italy, shows a dissipation of its earlier tradition and a waning of expressive capacity. The precepts of the 2d-1st centuries B.C. were no longer effective, and the funerary production of the Etruscan area became fairly uniform and lacking in character.

Except for the few areas and products mentioned above, northern craftsmanship does not in general display the lively inventiveness nor the detailed anecdotal observation found in the south and is impoverished in such forms of expression as the small clay sculptures. The figural types of the north are, for the most part, related to transalpine provincialism, that is, to a fusion of elements derived from the more sophisticated arts and adapted to local styles. On the whole, the folk-art trends of Italic origin tended to die out during the Imperial age, giving way to popularized versions of fine-arts themes, with a decline of interest in everyday life and an orientation toward elaborate acquired forms illustrating mythology and history.

The relationship between the art of the north and that of the southern and central regions, as well as the existence of a considerable, though indirect, Hellenistic influence, is apparent in all these movements. The connections are evident in the most widespread forms of the funerary marker: the cusped cippus and the architectural stele, which are comparable in development to the Campanian steles. In the steles of the Po Valley, for example, the Hellenistic pseudoarchitectural tradition merged with the Roman one of multifigured slabs, giving rise to the typical monument of the area, the great stele with a series of busts. The surviving Celtic elements are more difficult to identify, but the devouring monsters mentioned above and the decorative and iconlike heads in the garland altars of Venetia may be recognized as relics of Celtic iconography.

Much of the funerary art, because of the preponderance of small markers over great monuments, remained on the folk level, distinct from the eclectic and academic imitations of the fine arts. At times folk art also encompassed both religious themes from the sophisticated tradition (as in the previously cited goddess of Bergamo and the *Jupiter* of Aosta) and Imperial iconography (bust from Bosco Marengo) in a phase coexisting with the "provincial" component in Imperial art from Trajan's Column on. Moreover, although its characteristics have not yet been clearly defined, a local artistic activity also existed in seemingly out-of-the way areas, such as the territory of the Segusii (Susa), where, in 12 B.C., an official monument was carved by local stonecutters who did not limit themselves to copying the models sent from Rome (PL. 230). The isocephalism of the sacrificial animals in a part of the Susa frieze suggests an artistic tradition rather than a chance arrangement. Unfortunately, the antecedents, the connecting links, that would explain the origin of such figural forms are lacking. Even so, in spite of their apparent awkwardness, these forms cannot be ascribed solely to lack of skill; in a stele marked "Rinnius" in Turin, for example, with the theme of the wine cart, the design is clearly intentional.

Of the arts of northern Italy, those of Venetia, Lombardy, and Emilia certainly stand out as the most sophisticated, the most refined and elaborated, while those of the western Po Valley present many similarities to the figural forms of the neighboring transalpine provincial areas. A comparison of the products of these two broad cultural regions reveals that provincial art and folk art are not identical — or at least that they may produce differing forms and results. For example, the severe linearism of Roman steles in Venetia is quite unlike the pleasing decorative line of the northern examples of "Orientalizing" style. Similarly, though the Celtic background emerges more in the subject matter than in the form, direct borrowing, if not actual importation, occurs in Liguria; for example, the so-called "Tarasca" (Fr., Tarasque), or "Cerberus," in Genoa (Mus. Civico di Archeologia Ligure). All northern Italian funerary art, as well as that of central Italy and of Rome itself, has a folk-art quality consistent with the social classes for whom the extant monuments were produced.

Italo-Roman folk art, especially funerary art, was at its apex during the 1st century B.C. and the 1st century of the Christian Era. Thereafter no substantial innovations occurred, and craftsmanship stagnated. It was in painting and mosaics that the earlier elements continued in effect throughout the Imperial period. The pavement mosaics of the Piazzale delle Corporazioni in Ostia Antica (PL. 232), with scenes relating to the various agencies that surrounded the square, offer a range of such elements. The scenes are sketchy and lack the effective immediacy and the clear narrative quality of the genre scenes of 1st-century Campania. They are emblematic fixed elements that serve to identify the individual offices rather than to advertise their activities. Ostia also has preserved a quantity of small works illustrating daily life and activity. Together with Pompeii, Ostia offers the broadest coverage of examples of this kind: a greengrocer counting on his fingers behind the counter, with a lavish display of wares made clearly visible by the pseudoperspective; shoemakers at work; a poultry seller; and a midwife depicted with crude realism — these are among the most cogent documents of this functional folk art. Also included in this category are the paintings in the House of the Painted Vaults, an advertising display of food in the Thermopolium (a bar where hot drinks were served), and reliefs of a butcher, a milkman, and a knife grinder. All these folk works at Ostia, however, lack the vivacity of their Campanian antecedents. Instead of being characterized as individuals, the figures tend to be typed, the action being of more interest than the subject. The style in such reliefs as those of the poultry seller, the butcher, and the tavern on the port, is very close to that of the sarcophagi of the late 2d century and the 3d, works, that is, which are not on the craft level but belong to the fine arts.

The question thus arises whether these works are to be considered an adoption of the expressive forms of fine art by folk artists, or the acquisition and interpretation of folk motifs by the fine arts. G. Rodenwaldt (1935) was one of the first to maintain that the folk component had a significant influence on the stylistic revolution that began in the Antonine period (see ROMAN IMPERIAL ART), though this influence cannot have been due exclusively to elements from the Italic cultures. A more accurate explanation may be the existence of a wide circulation of folk elements, quite complex and still insufficiently analyzed. The developments of Style III that were carried over into wall ornamentation of the 2d and 3d centuries can be described only as folk art. Isolated figures, which are allusive rather than descriptive, are sketched in the oblong areas formed by the threadlike partitions of the uniformly white field of the wall. The motifs are even more cursive in the late-2d-century House of Diana in Ostia, in a contemporary house on the Palatine, in sacella, in shops such as the tavern at the foot of the Capitoline hill (A.D. 240), in tombs, columbaria, and Christian and Jewish catacombs. This decorative art can be considered folk art more because of its diffusion than for its inspiration, since it is almost always indirectly derived from sophisticated art and is more symbolic in spirit than narrative or episodic. In this way folk forms entered into the formation of the art of the late-antique period (q.v.).

In brief, the discussion of Italo-Roman folk art may be summarized as follows: the folk trends of Roman Italy do not form a unified whole, but vary greatly according to their local antecedents (Campania), to the degree of importation of outside elements (central and eastern Po Valley), or to the assimilation of elements traceable only theoretically by parallels with transalpine art (western Po Valley). The provincial character of northern art is thus clearly different from that of central and southern Italy, where elements of continuity can be distinguished.

In all these areas the art of the folk is essentially representational, with caricatural overtones in the south, functional and utilitarian elsewhere. The caricatural vein is far removed from the humor of the ancient *phlyax* vases and the Tarentine figures. At times, as in the wall paintings of great men in the Baths of the Seven Sages at Ostia (G. Calza, *Die Antike*, XV, 1939, p. 99), the satire exists not in the representation but in a literary context, in this case the juxtaposition of inscriptions prescribing for the bodily functions. In general, the effort at realistic inter-

pretation precluded the distortion inherent in caricature, and in any case, the Roman spirit was closer to the crudity of sarcasm than to the finesse of irony.

There is no particular medium peculiar to Italo-Roman folk art; rather, folk themes occur in all the fine arts and crafts media. The folk character of the works relates more to their purpose than to their source of inspiration. Practically speaking, religious *imagerie* is always derived from the fine arts.

These developments should be judged with caution; their influence on the art forms of the provinces cannot yet be precisely defined, and the possibility of concurrent art movements should not be ignored.

BIBLIOG. G. Rodenwaldt, Römisches in der antiken Kunst, AAnz, 1923–24, cols. 365–71; Pfuhl, II, pp. 884–92; L. Curtius, Die Wandmalerei Pompejis, Leipzig, 1929, pp. 370–76; G. E. Rizzo, La pittura ellenistico-romana, Milan, 1929, pp. 88–90; S. Ferri, Stadi, nodi e sviluppi della critica intorno alla questione dell'arte romana, Rome, 1933; G. von Kaschnitz-Weinberg, Bemerkungen zur Struktur der altitalischen Plastik, SEtr, VII, 1933, pp. 135–95; F. Wirth, Römische Wandmalerei vom Untergang Pompejis bis aus Ende des dritten Jahrhunderts, Berlin, 1934; G. Rodenwaldt, Über den Stilwandel in der antoninischen Kunst, AbhPreussAk, 1935, 3; R. Bianchi Bandinelli, EI, s.v. Roma: Arti figurative, XXIX, 1936, pp. 729–45; M. Pallottino, Arte figurativa e ornamentale, Rome, 1940; C. Carducci, Il substrato ligure nelle sculture romane del Piemonte e della Liguria, Riv. Ingauna e Intemelia, VII, 1941, pp. 67–95; O. Vessberg, Studien zur Kunstgeschichte der römischen Republik, Lund, Leipzig, 1941, pp. 169–80; R. Herbig, Die italische Würzel der römischen Bildniskunst, in Das neue Bild der Antike, II, Berlin, 1942, pp. 85–99; G. Lo Duca, L'art romain primitif, Paris, 1944; R. Bianchi Bandinelli, Storicità dell'arte classica, 2d ed., Florence, 1950, pp. 79–92, 117–33, 137–53, 157–205, 231–324; A. Maiuri, Roman Painting (Eng. trans., S. Gilbert), Geneva, 1953, pp. 139–48; M. Borda, La pittura romana, Milan, 1958, pp. 187–297; G. A. Mansuelli, Il ritratto romano nell'Italia settentrionale, RM, LXV, 1958, pp. 67–99.

Guido A. MANSUELLI

Illustrations: PLS. 229–234.

ITALY. The territory of Italy constitutes a well-defined geographic and ethnic unit. Bounded on the north by the Alps, the Italian peninsula and islands extend into the Mediterranean toward the African coast. Because of its position, the territory has served as a bridge to continental Europe and has been a constant participant in world history. Under the Roman Empire Italy was the center of Western civilization for several centuries. With Rome as the seat of the papacy and the center of Western Christianity, the learning of classical civilization was collected and preserved in Italy during the Middle Ages. And, as the cradle of the Renaissance, Italy exercised a preeminent influence on the intellectual and artistic development of modern Europe. While Italy's open coastline has fostered the assimilation of external influences, often decisive for the cultural experiences of the Italian area, its mountainous terrain has favored the development and survival of distinct regional customs. This diversity, however, did not prevent the advancement of cultural unity. Even in antiquity there was a sense of unity, which increasingly asserted itself in culture and language through the Middle Ages and into modern times. This development culminated in the 19th century with the attainment of Italian political independence and unity. (The Kingdom of Italy was established in 1861; Italy became a republic in 1946.) The art of Italy parallels its history in that it has frequently been of universal importance (as in the diffusion and repeated revivals of classicism) and sought after and revered by other cultures. From the end of the Middle Ages, Italian art (q.v.) has gradually acquired common characteristics that transcend local schools and make it a well-defined and significant entity within the larger confines of European art.

SUMMARY. Historic and artistic periods (col. 484): *Antiquity: a. Prehistory and protohistory; b. Pre-Roman Italy; c. Roman Italy. The Middle Ages: a. Early Middle Ages; b. Romanesque period; c. Gothic period. Modern period; a. The Renaissance; b. Baroque; c. Neoclassicism; d. 19th and 20th centuries. Art centers. Historical geography of Italy* (col. 511). *Rome, including Vatican City* (col. 512). *Piedmont and the Aosta Valley* (col. 531). *Lombardy* (col. 541). *Trentino-Alto Adige* (col. 561). *Veneto* (col. 565). *Friuli-Venezia Giulia* (col. 587). *Liguria* (col. 592). *Emilia and Romagna, including the Republic of San Marino* (col. 598). *Tuscany* (col. 615). *Umbria* (col. 646). *Marches* (col. 660). *Latium* (col. 669). *Abruzzi and Molise* (col. 686). *Campania* (col. 693). *Apulia* (col. 712). *Lucania* (col. 721). *Calabria* (col. 725). *Sardinia* (col. 731). *Sicily* (col. 736).

HISTORIC AND ARTISTIC PERIODS. *Antiquity. a. Prehistory and protohistory.* Remains of Upper Paleolithic art are less profuse in Italy than in western Europe (see FRANCE; SPAIN), but numerous rock engravings have been discovered in Apulia (Grotta Romanelli), Calabria (in a cave near Papasidero), the Egadi (Aegadian) Islands (Levanzo), and Sicily (on Mount Pellegrino, particularly in the Addaura cave). The Addaura cave contains not only representations of animals but also lively compositions with human figures. Some of these carvings may date from the early Mesolithic period, but remains of genuinely schematic mesolithic carvings are rare (e.g., at Sezze Romano). The earliest sculptures are the naturalistic "steatopygous Venuses"; particularly important ones were found at the Balzi Rossi in Liguria, Savignano on the Panaro River, and Chiozza di Scandiano near Reggio Emilia. The last two are certainly postpaleolithic and perhaps from a relatively late period. (See XI, PLS. 244, 257, 283–285, 287, 293, 294.)

The succession of cultures in Italy from the Neolithic through the Iron Age has been reconstructed (though with not a few gaps and uncertainties), chiefly on the basis of stratigraphic excavations carried out by L. Bernabò Brea in the Arene Candide cave (Liguria) and in the Lipari Islands (see MEDITERRANEAN PROTOHISTORY). The beginning of the Neolithic period dates at least from the 5th millennium B.C. Broadly speaking, the following periods in Italian prehistory may be distinguished: (a) Early Neolithic — diffusion of stamped pottery. (b) Middle Neolithic — painted and incised pottery in southern and central Italy. Danubian influences (e.g., square-mouthed vases) in the north. (c) Late Neolithic — monochrome polished pottery (Diana and Lagozza styles). (d) Early metal ages, including the Aëneolithic period (corresponding to the chalcolithic), and the early Bronze Age (from the late 3d to the first half of the 2d millennium B.C.) with varying agricultural societies — Early and Middle Helladic influences in southern Italy; diffusion of bell beakers from western Europe. In Sicily the important cultures included those of Serraferlicchio, San Cono – Piano Notaro, Conca d'Oro, and Castelluccio; in Sardinia, Anghelu Ruju; and in continental Italy, Cellino San Marco, Gaudo, Rinaldone, Remedello, and the so-called "proto-Apennine cultures." (e) The height of the Bronze Age (15th–13th centuries B.C.) — influences from Late Mycenaean civilization (see CRETAN-MYCENAEAN ART), in Sicily (Thapsos), the Lipari Islands (Milazzese promontory), and in Apulia (Scoglio del Tonno), and the Apennine cultures. (f) Late Bronze Age and the transition to the Iron Age — a well-defined sequence of cultures in Sicily (Pantalica Nord with Mycenaean reminiscences, Cassibile-Dessueri, and Pantalica Sud; otherwise defined as Pantalica I, II, and III); the Lipari Islands (Ausonian I and II). The peninsula saw a vast diffusion of the sub-Apennine culture, the appearance of cremation tombs of the proto-Villanovan type, and, in the Po plain, terramara settlements.

Ceramics (q.v.) constitutes the most significant aspect of early art production; in its diverse techniques it attained a high degree of excellence, particularly in the Neolithic period. The Serra d'Alto pottery, diffused throughout southern Italy, is especially noteworthy for its fine clay, elegant geometric designs (particularly the spiral meanders), and variety of plastic ornamentation on the handles and spouts (IX, PL. 429). Sculpture is limited to modest examples of terra-cotta or stone statuettes, less interesting stylistically than the pottery. The Sardinian limestone idols, however, are an exception; these schematic female statuettes recall the idols of the Aegean Sea (Cyclades, Crete). Similar figures, painted, have been found in a cave in Levanzo in the Egadi Islands.

As early as the Neolithic period hut villages protected by trenches or walls appeared; the huts were round, ovoid, or rectangular, and sometimes had dry stonework foundations. Palafitte dwellings were typical of northern Italy and particularly of the Alpine lakes; they developed most extensively during the Bronze Age. Toward the end of the Bronze Age, villages on pilings protected by embankments (the already mentioned terramare) flourished in the Italian plain. Architecture assumed a durable and monumental aspect only in the south and in the islands. Sardinia, like Corsica (see FRANCE), participated in the diffusion of western European megalithic architecture (see EUROPEAN PROTOHISTORY), as evidenced by its dolmens and menhirs. The megalithic corridor tomb developed in the late 2d millennium into the characteristic "giant's tomb" with exedra façade and central stele. Apulia boasts a few isolated dolmens and menhirs, which date no earlier than from the Bronze Age. On the other hand, the nuraghi of Sardinia are linked not to western Europe but to the Mediterranean tradition — Cyprus (q.v.), the Aegean (see GREECE), Malta (q.v.), and the Balearic Islands (see SPAIN, and more generally, MEDITERRANEAN, ANCIENT WESTERN; MEDITERRANEAN PROTOHISTORY).

These complexes consist of truncated-cone towers and rings of large, hewn or irregular blocks of stone, and false vaults or domes. Thousands of these monumental nuraghi still survive, testifying to a highly advanced Bronze Age civilization (second half of 2d–early 1st millennium B.C.) on the island (XI, PLS. 401, 402). Similar round structures, of much coarser workmanship, are extant in Apulia and the island of Pantelleria.

As far as we know, the figural arts from the Bronze Age until the beginning of the Iron Age were modest and without a continuing tradition, and there was a remarkable diversity in style from one region to another. In the Alpine zone, schematic rock carvings of real subjects and symbolic images have been found near cult places that continued to be frequented even during the historic period, as in the Valcamonica and in the Valley of Marvels at Mont-Bégo near Tenda (Tende, France). Steles carved in the shape of human figures, the so-called "stele-menhirs" survive in Lunigiana, Alto Adige, Apulia, and Sardinia (as well as Corsica). The production of small terracotta figurines, sometimes added to vases as ornaments, continued sporadically. Small cast bronze figures used as vase ornaments or votive figures began to appear; about the beginning of the 1st millennium B.C., the nuraghic culture of Sardinia particularly excelled in this art. The art of hammered cast bronze, directly connected to central European and Danubian production centers, had its most significant development in continental Italy, particularly in the Iron Age. Until the Iron Age the decoration of ceramics, bone objects, metal ornaments, and utensils remained faithful to geometric systems. (These objects are of small esthetic interest; painted pottery with geometric ornament largely disappeared in the Bronze Age.) There were stylistic differences according to period and place. The Apennine settlements, especially Ariano Irpino, Filottrano in the Marches, and Belverde on Mount Cetona, produced impasto vases, sometimes engraved or inlaid, decorated with painted meanders, spirals, and checkerboard patterns.

b. Pre-Roman Italy. The Iron Age cultures (from the 9th century B.C.) exhibited close connections with the preceding prehistoric cultures. The social structure remained based on village groups. Since production depended on the needs of the family and the small community, it was limited to household goods and objects of personal use. But certain innovations did appear at this time: the establishment of cremation rites using cinerary urns (especially in north-central Italy), progress in bronze working, and the use of iron in weapons and tools. A geometric decorative system of rectilinear motifs was adopted; it was parallel to and partly inspired by contemporaneous Greek Geometric (see GEOMETRIC STYLE). The Greek colonization of Italy, which began in the 8th century, soon exerted a determining influence on the development of Italian Iron Age civilization, enriching it with Eastern and Greek elements (see ORIENTALIZING STYLE). By the 7th–6th century, a large part of the Italian peninsula, especially the south and the Tyrrhenian area, had entered the sphere of a superior urban civilization of archaic Greek inspiration.

The Iron Age is particularly characterized by the formation of well-defined regional areas, which by their geographical distribution correspond in large part to the ethnic groups of ancient Italy as recorded in literary sources. These groups have also been documented by the discovery of epigraphs in the various languages and dialects. In Sicily the Siculi held the east-central part of the island (Finocchito culture) and the Sicani the western part. The area of southern Italy from Calabria to Campania, characterized by heavy Greek infiltration, was inhabited by the Itali, Siculi, Morgetes, Oenotrii, and Ausones, all of whom buried their dead in pit graves. The Daunian, Peucetian, and Messapian peoples occupied Apulia and made up the Apulo-Salentine cultures; they produced typical Geometric-style pottery and practiced inhumation in pit and box graves. The cultures of the south-central Adriatic side of the peninsula, corresponding in large part to the area of the Umbro-Sabellian dialect, used burial rites; particularly interesting finds have been made in the Marches (notably in the Picenum area). Cremation rites were practiced by the early Latins, who occupied Latium. The Villanovan culture was centered in Etruria, with other sites in Romagna and Picenum (Fermo) and a similar group in southern Italy in the Salerno region (Pontecagnano near Salerno and Sala Consilina inland); this culture too practiced cremation, and is known for its typical biconical ossuary. The Atestine culture (from Ateste, now Este), which flourished in the Veneto and practiced cremation rites, is certainly to be identified with the Veneti of Roman tradition. The Golaseccan culture, situated in the upper and middle Po plain, the Alpine lake district, and Liguria, practiced both cremation and inhumation rites and is to be attributed in large part to the Liguri.

The primitive structure of some of these cultural groups remained unaltered by the passage of time and the diffusion of Greek and Etruscan influences. For example, the Apulo-Salentine peoples, while adopting the Greek city type and certain forms of Greek artistic

production, remained faithful to their custom of burying the dead in caskets in their towns (as at Gioia del Colle) and to the tradition of geometric pottery decoration until the end of the Hellenistic age. Likewise, forms of Iron Age culture long survived in central Italy and among the Veneti and Ligurians of northern Italy. The arrival of Celts in northern and central Italy during the 5th and 4th centuries B.C. brought no substantial cultural changes, although traces of Celtic art and culture are to be noted here and there in the Po plain and especially in Picenum (see CELTIC ART). The primitive Villanovan and Latian cultures were, however, early transformed into the urban civilization of Etruria and Latium. (For detailed ethnographic and historical description of pre-Roman Italy see ETRUSCO-ITALIC ART and V, FIG. 103.) From the artistic point of view, the zone occupied by Greek colonies — Sicily and that part of southern Italy known as "Magna Graecia" — was most important. The principal art centers in Sicily, from north to south, were Himera, Zankle (mod. Messina), Naxos, Katana (mod. Catania), Leontinoi (mod. Lentini), Megara Hyblaia, Syracuse, Camarina, Gela, Akragas (mod. Agrigento), and Selinous (mod. Selinunte); in Magna Graecia, from east to west, Taras (mod. Taranto), Metapontion (mod. Metaponto), Siris, Sybaris, Kroton (mod. Crotone), Caulonia, Lokroi hoi Epizephyrioi (mod. Locri), Rhegion (mod. Reggio Calabria), Medma, Hipponion, Pyxous (mod. Policastro), Velia (or Elea), Poseidonia (Paestum), Naples, Pithekoussai (mod. Ischia), and Cumae. From the 8th to the 3d century B.C. these Greek centers produced work in no way inferior to that of the motherland in philosophy, literature, science, art, architecture, and social and economic organization. Local geographic conditions, however, gave this work certain distinctively Italian aspects (see GREEK ART, WESTERN). Imposing remains of temples, especially Doric, survive, some almost totally intact (e.g., at Paestum, Agrigento, and Selinunte); also extant are ruins of theaters (e.g., Syracuse), sepulchral monuments, and other buildings. From the late 6th century on, the plan of many cities consisted of a regular design based on the perpendicular crossing of main avenues (πλατεῖαι) and smaller streets (στενωποί) rhythmically interspaced, creating elongated rectangular blocks of uniform size (with, as a rule, a short side of one *actus*, about 115 ft., in length). This grid type of city plan, which the ancients attributed to Hippodamos (q.v.) of Miletos, is best documented in Italy. There are notable remains of city fortifications in Syracuse and Selinunte. Architectural sculpture was also important (temple metopes from the Heraion at the mouth of the Sele and Selinunte, among others, are extant), and painted and occasionally modeled terra cottas were developed for decorative ends. Terra-cotta votive figures were produced throughout the area. In addition to imported ceramics (Geometric, Corinthian, Laconian, East Greek, Attic, etc.) there were local styles, which, from the 5th century on, increased in importance and originality in the wake of widespread imitation of Attic pottery (proto-Italiote, Apulian, Lucanian, Campanian, and Siceliote). The art of coinage, especially at Syracuse, reached a high level.

Some few remains testify to the architectural and artistic activity of the Phoenician and Carthaginian colonies. In western Sicily fortifications have been discovered at Mozia (anc. Motye) and tombs at Capo Boeo (anc. Lilybaion); in Sardinia ruins of sacred buildings and tombs survive in Cagliari, Sulci, and Tharros. Valuable examples of Orientalizing goldsmith work, masks, and multicolored glass-paste jewelry have been found in the necropolis of Tharros (see PHOENICIAN-PUNIC ART).

Apart from Greek Italy, the civilization that first demonstrated a clear political and cultural structure and unity was that of the Etruscans. It evolved after the middle of the 8th century from the Iron Age Villanovan culture, within the area bounded by the Tiber and Arno rivers and the Tyrrhenian Sea. Cinerary urns were replaced by chamber tombs, and new art forms of Orientalizing inspiration were introduced. This culture comprised autonomous urban centers, chiefly coastal, that were linked by language and religion. During the 6th century the Etruscans expanded southward into Latium and Campania (where they founded Capua) and northward into Emilia (founding Marzabotto, Felsina, etc.). This expansion was arrested by the Greeks at the battles of Ariccia (end of 6th cent.) and of Cumae (474 B.C.). In the 4th century grave losses were inflicted by the Gauls to the north and east, and in the following century even more decisive losses were sustained at the hands of the Romans. But the complete assimilation of the Etruscan culture by the Roman did not take place until the 1st century B.C., with the municipia and veterans' colonies established by Sulla and later by the Triumvirates.

Etruscan cities were usually built on hilltops with fortifying walls of ashlar (as at Caere, mod. Cerveteri; and Veii, mod. Veio) or polygonal masonry (Rusellae, mod. Roselle; and Cortona), according to the area. The arch was developed as a monumental form from the 4th century on. Very little is known of Etruscan city planning: a regular division has been suggested, on the basis of analogy with the division of the sky by orthogonals (for divinatory purposes), but

this thesis is not confirmed by study of the few remains (e.g., at Vetulonia and Veio); the plans of Marzabotto and Capua must reflect Greek plans, since even the measurements correspond closely. The temple is typical of the architecture of the period because of its traditionalism; it long preserved the wooden structure and clay decoration, the ritual orientation of the structure (generally to the south), the tripartite plan of three equal cellae or a large central cella with two smaller flanking ones (this was, however, more rigid in Vitruvius' theory than in reality), and the architectural concentration on the frontal view.

Less is known about the Etruscan house. The ancients' belief that the atrium is Etruscan in origin seems to find support in the internal arrangement of some tombs and certain cinerary urns in the form of houses. Sepulchral architecture, however, is well documented. Contemporaneous with the cremation shaft grave, the pit grave developed in the Villanovan area; the latter evolved into the chambered tomb, which from its oldest known example, the 7th-century B.C. Regolini-Galassi tomb at Cerveteri, continued into the 3d century without ever totally eliminating cremation rites. During the Orientalizing period, the burial chamber was partly dug from the earth and partly covered by an ogival vaulting. Later the chamber was entirely dug from the earth. In some areas, especially Cerveteri, the tomb was surmounted by an artificial mound. Usually the chamber walls were painted, as at Tarquinia, Veio, Vulci, and Chiusi (anc. Clusium), but at Cerveteri architectural decoration prevailed. A type of external architectural decoration was employed in the necropolises carved into the rock hillsides at Norchia, Castel d'Asso, Sovana, and other places.

Etruscan art and culture, mixed with that of the Greeks, exercised a major influence on the neighboring regions of Umbria and Latium as well as on Campania.

c. Roman Italy. From their beginnings the culture and art of Rome and Latium played an important part in the history of early Italy. Rome seems to have had a notable development during the archaic period, under the Etruscan monarchy of the Tarquins. Some noteworthy monumental remains have been preserved from this period. A period of decline followed, and only after the destruction of the neighboring Etruscan city of Veii (396 B.C.) and the invasions of the Gauls (390 or 387 B.C.) did Rome regain a prominent position in Latium and begin its expansion throughout the peninsula. Roman legions moved to the south and after a very hard struggle defeated the Samnites and their allies — Gauls, Etruscans, and Umbrians — in the Battle of Sentinum (295 B.C.). The Roman menace to the Greek cities of Italy provoked the intervention of Pyrrhos, but the long war ended in victory for the Romans at Beneventum in 275 B.C. By the middle of the 3d century B.C., through conquest or pacts of alliance, Rome had gained control of the entire Italian peninsula from Pisa and Rimini to the Strait of Messina. By passing from the peninsula into Sicily, Rome provoked the struggle with Carthage: the First Punic War (264–241 B.C.) resulted in the acquisition of Sicily, which became Rome's first province, and shortly thereafter of Sardinia (238 B.C.). There followed the invasion of the Po plain and the fight against the Gauls. The Second Punic War (218–201 B.C.) sorely tried the unity of the federation of Italian cities, but its outcome made Rome a world power. The recapture of those parts of the Po Valley lost in the Second Punic War and the defeat of the Ligurians completed the Roman conquest of Italy; then began the conquest of the Mediterranean and of Europe.

The granting of Roman citizenship to the Italian peoples at the beginning of the 1st century B.C. accelerated the Romanization of Italy. The civil wars brought grave destruction to many of the Italian cities which participated in the fight, but under Sulla and later under the Triumvirates many were reconstructed and given new fortifying walls. In 42 B.C. the borders of Italy were extended from the Magra and Rubicon Rivers of Sulla's time to the Var River (Lat., Varus) to the west and to the Arsia in Istria to the east; in the Alps the boundary passed through Mount Viso, the Great and Little Saint Bernard and Saint Gotthard passes, the Splügen Pass, the upper valleys of the Adige River, the Isarco River, and the Carnic Alps. For administrative purposes Augustus divided Italy into regions (see below, *Historical geography of Italy*). The islands and parts of the Alpine chain continued or were organized as provinces. Under Augustus not only Rome but many other Italian cities saw the creation of monumental structures. Notable building activity continued in the following centuries in spite of the fact that with the development of the Roman Empire the economic and political importance of Italy gradually diminished: under Caracalla the provinces were made equal to it, under Diocletian it was made one of the twelve dioceses, and thereby lost its position as the center of the Empire. The barbarian invasions which devastated Italy many times, especially in the 5th century, caused widespread destruction and led to the depopulation of many cities. But the fall of the Roman world did not destroy urban life; it continued through the Middle Ages, and, in fact, the Roman plans of many cities were preserved. Late-antique art also continued to flourish, though turning to Christian themes, and some remarkable monuments were produced in architecture, sculpture, painting, and mosaics.

The contribution of Rome to the civilization of Italy was from the beginning a dynamic one, continually developing and altered by interaction with elements in the Italian culture. In religion new divinities and cults were introduced from Etruria, Magna Graecia, and the Italic cultures and were in turn disseminated by the Romans; for example, the Capitolium (with the worship of the triad of Jupiter, Juno, and Minerva), which was the supreme expression of Roman religion and was introduced in all the colonies almost as if to sanctify Roman rule, was probably Etruscan in origin. A major Roman contribution to city planning was the creation of a centralized rectangular plan, traversed by two perpendicular main avenues (the *cardo* and *decumanus*) with the forum usually at the center; the intersecting secondary streets formed almost square blocks which were often two *acti* long. The oldest example of this type of plan is Ostia (mid-4th cent. B.C.); later examples are Minturnae (Minturno) and Pyrgi (Santa Severa); a variant inspired probably by the castrum plan places one of the axes off center, as in Turin and Aosta. Also widely adopted was a modified Hippodamian plan in which the central axes do not predominate, the blocks are long and narrow, and the perimeter is irregular [Norba, Alba Fucense (mod. Albe), and Cosa (mod. Ansedonia)]. During the early centuries the cities founded by Rome reflected the exigencies of military life, and expressions of monumentality were limited to walls and temples. In later centuries of the republic there was more extensive urban development. In the 2d century a monumental architecture was developed, especially in Latium, which, while drawing on Hellenistic precedent, brought new spatial values and an extraordinary scenographic sense to architecture, thanks in part to the perfection of vaulting and the use of concrete. A typical example is the Sanctuary of Fortuna Primigenia at Praeneste (mod. Palestrina; VII, PL. 199).

The administrative structure of the cities reflected that of Rome and brought about the creation of relatively uniform types of public buildings (the *curia* for the assembly of the *decuriones*, the *comitium* for the elected representatives, and the basilica for judicial functions). The cities were no less attentive than Rome in their concern for the roads, public services, and the aqueducts and cisterns vital to the water supply. They constructed strong walls with monumental portals which, during the 4th and 3d centuries B.C. and perhaps in the civil wars, were intended to serve for defense purposes; but afterward the monumental portals seem to have acquired the function of consecrating the city (e.g., in the Augustan era). In some places civil and cultural developments were in advance of those in Rome: theaters and amphitheaters were being built in Campania perhaps as early as the 1st century B.C., and thermal establishments appeared in the provinces before they did in Rome. It was Rome, nevertheless, that was responsible for disseminating these developments to the minor isolated centers. The atrium house developed from Etrusco-Italic and Hellenistic elements, but with the rapid growth of cities there was born a new type of housing — the insula or apartment house — which was particularly adapted to such overpopulated centers as Ostia. Various types of tomb architecture developed: quadrangular monuments, pavilions, exedrae, and columns, all Hellenistic in origin; pyramids; circular mausoleums inspired by Etruscan tumuli; and chambered tombs and columbaria.

During the 2d and 1st centuries B.C. closer contacts with the Greek world had a decisive influence on art: Greek works were imported; as a result Greek artists were employed in Italy, and Neo-Attic schools were formed (see HELLENISTIC-ROMAN ART; NEO-ATTIC STYLES). Beginning in the 2d century B.C., Greek influence can be clearly seen in religious and decorative sculpture, paintings, and mosaics (especially in Campania), decorative terra-cotta plaques, silverwork, and relief ceramics (e.g., the Arretine workshops). In architecture, however, a new disposition for spatial effects gave prominence to the arch and the vault — both Italic elements. Local traditions found expression in votive and funerary portraits, tomb reliefs, and paintings of popular, secular subjects (see ITALO-ROMAN FOLK ART).

During the Imperial period architecture exhibited both classicizing (traditional preference for straight surfaces and right angles) and more strictly Roman tendencies (curvilinear plan, functionalism, spacious interiors). In the other cities the ties with Rome became increasingly obvious, not only in the monuments erected by the emperors but also in the buildings constructed on local initiative. The classicizing tendency is especially evident in the Augustan and Antonine periods and in certain types of structures, particularly the temple. The imaginative use of space began under Nero and continued until the end of the Empire. Especially original solutions were achieved under Hadrian, and baroque tendencies developed

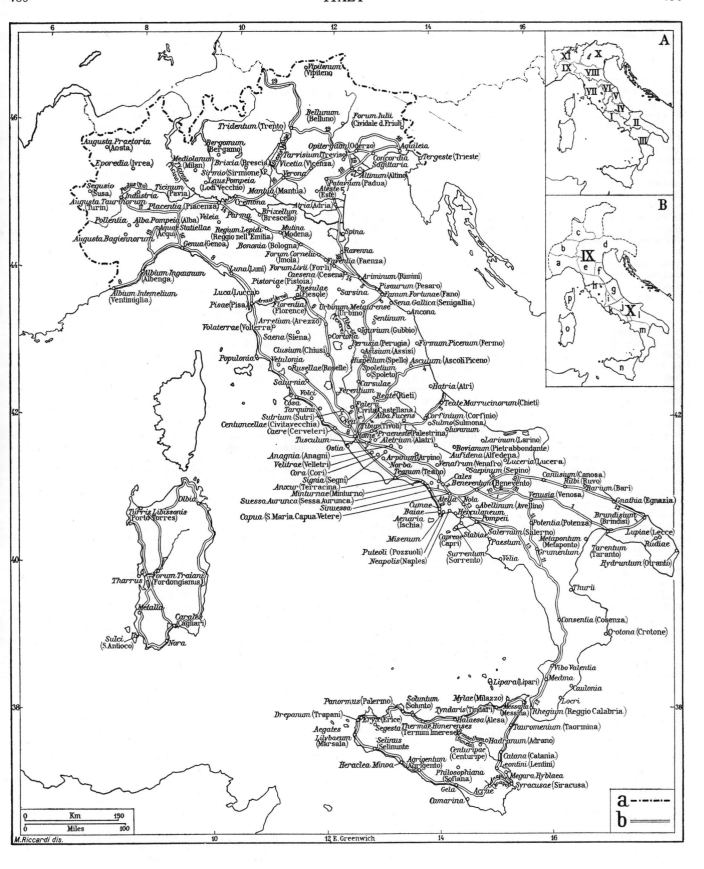

Chief Roman centers in Italy, with the ancient roads. Key: (a) Modern national boundaries; (b) principal Roman roads: (1) Appia; (2) Latina; (3) Claudia Valeria; (4) Salaria; (5) Flaminia; (6) Cassia; (7) Clodia; (8) Aurelia; (9) Domitiana; (10) Aurelia; (11) Herculia; (12) Trajana; (13) Popilia; (14) Aemilia Lepidi; (15) Aemilia Scauri; (16) Postumia; (17) Fulvia; (18) Popilia; (19) Claudia Nova. Inset A: Italy in the Augustan era, with regional divisions; (I) Latium et Campania; (II) Apulia et Calabria; (III) Lucania et Bruttium; (IV) Samnium; (V) Picenum; (VI) Umbria; (VII) Etruria; (VIII) Aemilia; (IX) Liguria; (X) Venetia et Histria; (XI) Transpadana. Inset B: Italy in the age of Diocletian, with regional divisions and the boundaries of the two dioceses (to the north: IX, Italia Annonaria; to the south: X, Italia Suburbicaria). Provinces: (a) Alpes Cottiae; (b) Liguria; (c) Raetia; (d) Venetia et Histria; (e) Aemilia; (f) Flaminia et Picenum; (g) Picenum Suburbicarium; (h) Tuscia et Umbria; (i) Valeria; (j) Samnium; (k) Campania; (l) Apulia et Calabria; (m) Lucania et Bruttium; (n) Sicily; (o) Sardinia; (p) Corsica.

under the Flavians and Severi. Functionalism found its best expression in private buildings (e.g., insulae) and commercial premises.

In freestanding sculpture, particularly in statues of divinities, Greek forms remained dominant. But historical reliefs attained a high level of originality (from the time of Augustus, and particularly under Domitian, Trajan, and Marcus Aurelius) in their vibrant representations of real events and in their experiments with spatial illusionism. An interest in profound personal characterization resulted in a remarkable development of portraiture (see ROMAN IMPERIAL ART).

Throughout Roman art there is an evident contrast between the classicizing tendency of official art (which in some periods was accentuated in coldly academic forms or a refined eclecticism) and the tendency which continued the pictorial and expressionist characteristics of Italic art. The latter tendency was that of popular art and certain isolated centers, but it gradually began to shape the course of official art, reaching an apex toward the end of the 2d century (e.g., Column of Marcus Aurelius) and passing into late-antique art in the 3d century. The late-antique style gathered together and summarized in new and universal forms the artistic experiences of the Romanized world, absorbing Eastern and provincial traditions (see LATE-ANTIQUE AND EARLY CHRISTIAN ART). From the late 3d to the early 5th century marks the last great phase of ancient monumental development in Italian cities — in Rome, above all. Some of the most spectacular surviving Roman structures, both civil and religious, are from this late period.

<div style="text-align:right">Ferdinando CASTAGNOLI</div>

The Middle Ages: a. Early Middle Ages. With the spread of Christianity the classic modes of expression did not disappear but instead were readily adapted in the selection of themes and symbols to the needs of the new religion, especially in funerary painting (see CATACOMBS) and in sculpture. After the Edict of Milan (A.D. 313), which assured freedom to Christians, the first monumental sacred buildings were built in new forms suited to Christian liturgy and practices. Thus the first sacred basilicas and baptisteries were built, often on the sites of older classical buildings and incorporating Roman remains. The cities retained the Roman city plan, but the center tended to be displaced from the forum to the site of the most important religious edifice: in Rome, for example, the center moved from the Forum to St. John Lateran. Funerary monuments continued to be constructed outside the city walls; cemetery shrines and mausoleums followed late-antique forms (e.g., S. Costanza, Rome) and cemetery basilicas took the form of churches (e.g., Old St. Peter's, S. Paolo fuori le Mura, Rome). Churches were often built on sites of private halls which had been previously adapted for Christian use (halls of Theodore at Aquileia). The central plan, though widespread in the east, was used in Italy mainly for baptisteries (St. John Lateran, Rome; Novara; Albenga; S. Giovanni in Fonte, Naples); for churches the basilican plan was preferred, except for rare cases such as S. Stefano Rotondo in Rome and S. Angelo in Perugia. The interiors of these buildings were adorned with wall mosaics originally exhibiting either a lively decorative character (S. Costanza, Rome) or a solemn classical monumentality (S. Pudenziana and SS. Cosma e Damiano, Rome), but always tending more toward abstract forms influenced by eastern motifs (triumphal arch of S. Maria Maggiore, Rome) and sometimes achieving a refined aniconic symbolism (Baptistery of Albenga, church at Casarenello). Many churches boasted fine polychrome mosaic pavements (halls of Theodore at Aquileia).

The transfer of the western capital of the Empire from Rome to Ravenna in 402 brought about a building surge in Ravenna, the impetus of which lasted until the mid-6th century. These new structures (Mausoleum of Galla Placidia; the churches of S. Vitale, S. Apollinare Nuovo, and S. Apollinare in Classe; the baptisteries of the Orthodox and of the Arians) were in a local interpretation of Byzantine style (see BYZANTINE ART) and were characterized by a pictorial and luministic unity of architecture and mosaic decoration which even influenced later monuments, especially along the north coast of the Adriatic. The presence of barbarian tribes in Italy (Ostrogoths and Lombards, 6th–9th cent.) left its mark in gold- and silverwork (see EUROPE, BARBARIAN), but for the most part the barbarians fell under the influence of late classical tradition (Mausoleum of Theodoric at Ravenna) due mainly to the conversion work of the Church and assimilation with the local peoples (see PRE-ROMANESQUE ART). Urban centers fell into decay and began to be depopulated, so much so that architecture entered a period of stagnation. A few Lombard centers (Castelseprio) and monastic churches of the period (S. Salvatore, Brescia; the Tempietto, Cividale) testify to the impoverishment of building techniques. Sculpture developed a certain coarseness, revealed in the ornamental interlace motifs and intense decorativism that give a completely different tone even to those elements derived from classical art (Altar of Ratchis, Cividale).

The Carolingian renaissance (9th cent.) significantly changed the situation, as indicated by the wealth of valuable Carolingian art which remains. Rather than being all-encompassing, the revival tended to express itself in isolated phenomena, as, for instance, the widespread use of crypts as reliquary chapels and the rare creation of double-choired basilicas (Farfa) and simple hall churches in the Alpine zone (Malles). Goldsmith work was of major importance, and Milan seems to have been a center of activity in that art: the famous "iron crown" of Monza (VI, PL. 260) was probably made there, as was the golden altar of S. Ambrogio (III, PL. 63; see CAROLINGIAN PERIOD). The structure of small north Italian centers began to be determined in this period: the church and its piazza was the center around which the towns were built; monastic foundations were built in isolated places. These monastic centers (often mentioned in medieval literature) were composed of a church, living quarters for the monks, a few chapels, and a hospice or guest rooms for pilgrims and were important centers of culture and land reclamation. Famous monasteries in southern Italy were those at Monte Cassino, San Vincenzo al Volturno, and Cava dei Tirreni; in central Italy, Ferentillo; and in northern Italy, Pomposa, San Giorgio (near Sant'Ambrogio di Valpolicella), and Sesto al Reghena. During the same period eastern asceticism spread in those parts of the south that had ties with Byzantium, as evidenced by the numerous cave-chapels, many with frescoes of a later date. The gap between northern and southern Italy is marked both geographically and, in a certain sense, figuratively by Rome; there in the 8th and 9th centuries architecture turned to Early Christian models for inspiration (e.g., Chapel of S. Zenone in S. Prassede; S. Maria in Domnica). In the 10th century the economic system of the peninsula, strongly based on agriculture (in part because of the Arabs' domination of the Mediterranean), continued to contribute to the depopulation of urban centers. This situation was intensified in the development of feudalism, which was responsible for the first fortified castles, which were strategically located and sometimes as isolated as monasteries. It was rare, however, that Italian monastic centers and castles fostered the foundation of towns around them, as was often the case in the northern countries. But in the 10th and 11th centuries, under the Ottonians and Salians (see OTTONIAN PERIOD; PRE-ROMANESQUE ART), there was a reaction in Italy against the feudal system; this reaction was encouraged by a revival of commercial activities. There was a consequent resumption of city life, characterized by a desire for freedom and economic independence (on the model of maritime republics). As a result, a genuine architectural revival in civil and religious building took place in the 11th century.

b. Romanesque period. During this period (see ROMANESQUE ART) almost all Italian cities seem to have built or rebuilt their main churches; usually the episcopal palace was built next to the principal church and often shared a piazza with the *palazzo comunale*, or town hall. Cities began to expand and develop haphazardly: narrow twisted streets — leading past porticoed houses, never more than two stories high, with ground floors given over to shops — flowed from the main piazza into the minor ones, where chapels or small churches were usually located. Feuds between cities prompted the construction of fortified city walls with towers and gates, sometimes built upon the ruins of the ancient Roman wall or restored from the pre-Romanesque defensive system. The uneven configuration of the terrain fostered the construction of a citadel at the center of the city in some areas (mainly Umbria, Tuscany, and Latium); later, in the period of the seigniories, the citadel became the seat of the lord. Private feuds between families were responsible for the development of the tower-house — a structure uniquely suited for defense; these buildings came to dominate the sky line of many medieval Italian cities (e.g., Bologna, Pisa, Volterra, San Gimignano, and Viterbo).

Contemporaneous with the political and economic revival was a religious awakening, effected particularly through the work of the Dominican and Franciscan orders. Monasteries were enlarged and renovated, hospices were increased, and new foundations arose, which, except those of the contemplative orders, were not erected in isolated areas but on the edges of cities; often later extensions of the city walls would bring the monasteries within the orbits of the cities. Thus, church campaniles stood alongside tower-houses and gave a particular aspect which many Italian cities still retain.

The first intensive period of building activity was centered in Lombardy, where the workshops of the lake district, which had been active in preceding centuries (e.g., the *magistri comacini*), organized themselves into genuine guilds (e.g., the *magistri antelami*; see INSTITUTES AND ASSOCIATIONS). They worked in numerous cities where there first arose sacred buildings (S. Ambrogio in Milan, 11th cent., is considered the fundamental example) and then, with the development of the communes, the communal palace. These masters, who were both builders and stone cutters, worked outside Lombardy as well, in Emilia, along the Adriatic coast, and even in southern Italy, where in the 11th century they were commissioned, among others,

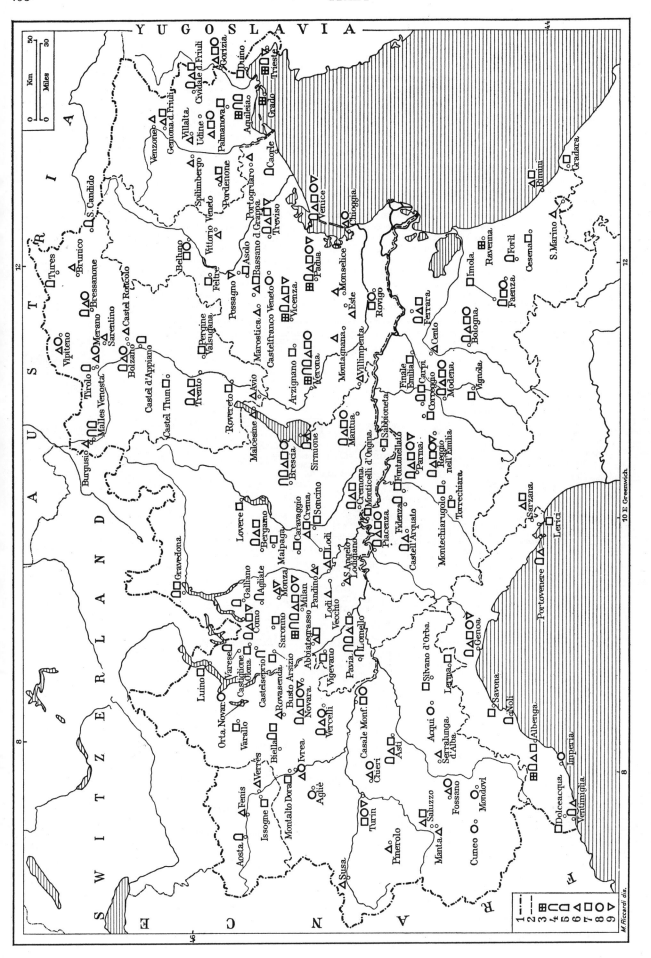

Italy, medieval and modern centers of art-historical interest in Piedmont, Lombardy, Veneto, Emilia, and Liguria. *Key:* (1) Modern national boundaries; (2) regional boundaries. Structures: (3) Early Christian; (4) pre-Romanesque; (5) Romanesque; (6) Gothic; (7) Renaissance; (8) baroque; (9) neoclassic and modern.

M. Riccardi dis.

by Abbot Desiderius of Monte Cassino. The style of the new buildings was characterized by a massiveness and volumetric quality partly resulting from an extensive use of the groin vault; the distinguishing features of the architecture included the characteristic three apses (the main one at the center and one at the head of each of the side aisles) and blind loggias decorating both the façade and the apse exteriors and sometimes enlivened with zoomorphic ornament with reminiscences of barbarian art.

The autonomous Italian communes, following the example of the maritime republics, also sought to express their artistic individuality. Thus the character of Romanesque art varied according to region. In the Veneto the plastic forms of Lombardy were softened (e.g., Verona, S. Zeno). In Venice connections with the east resulted in a unique expression of forms (S. Marco). In Florence the persistence of the classical tradition stimulated a system of architectural decoration consisting of polychrome marble arranged in strictly ordered geometric patterns (S. Miniato al Monte; the Baptistery). While sharing the chromatic taste of Tuscany, Pisa felt eastern and Lombard influences and developed a decorative system involving the regular multiplication of façade loggias (Cathedral; Baptistery, campanile). This motif was taken up at Lucca but with a distinctive character (Cathedral, S. Frediano). In Latium the Cosmati (q.v.) revived the late-antique art of *opus sectile*, decorating doorframes, pavements, ambos, Paschal candlesticks, and cloister columns in a lively manner (e.g., St. John Lateran, S. Paolo fuori le Mura, both in Rome); the portico of the Cathedral of Civita Castellana contains

some of the most remarkable work of the Cosmati. Also in central Italy the first city government buildings were built flanking the religious structures; these civic structures were built in solid masonry and had narrow windows or superimposed loggias (Palazzo della Ragione, Pomposa; Palazzo del Popolo, Orvieto; Palazzo del Comune and Palazzo del Podestà, Massa Marittima; Palazzo del Popolo, Todi).

In southern Italy there was a mixture of numerous influences: Byzantine, Islamic, Lombard, and Norman. The Norman influence was especially prevalent in Apulia and Sicily, where Norman churches (Bari, Palermo, Monreale, Cefalù) are characterized by closely knit masonry work and façade or corner towers. The red domes of Moorish masonry distinguished Sicilian buildings, while Campanian churches were adorned with splendid pulpits, decorated with vibrantly colored mosaic, ornamental sculpture, and intricate marble inlays in geometric designs. In the 13th century Frederick II fostered a revival of classical motifs in southern Italy and Sicily (see ANTIQUE REVIVAL). His building program was particularly intense in civil architecture. In almost every city castles were constructed, some with clear French influences (e.g., Gioia del Colle). Frederick's architectural masterpiece was Castel del Monte, designed as a hunting lodge, which has elements that herald Gothic style. Benedictine monasteries continued to be built in isolated areas; the foremost of them was Monte Cassino, rebuilt by Abbot Desiderius. It served as a model for several other foundations (S. Angelo in Formis), and the Byzantine artists summoned by Desiderius to decorate his church brought a revitalizing spirit to painting (S. Angelo in Formis;

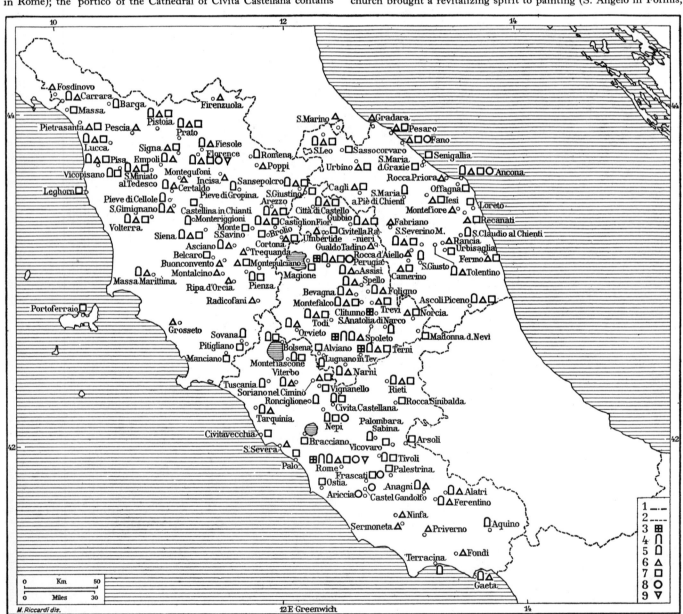

Italy, medieval and modern centers of art-historical interest in Tuscany, Umbria, the Marches, and Latium. *Key:* (1) Boundaries of the Republic of San Marino; (2) regional boundaries. Structures: (3) Early Christian; (4) pre-Romanesque; (5) Romanesque; (6) Gothic; (7) Renaissance; (8) baroque; (9) neoclassic and modern.

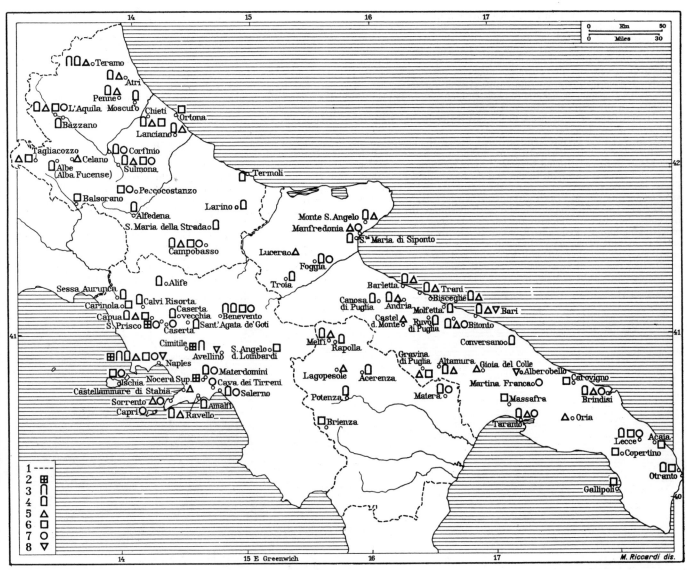

Italy, medieval and modern centers of art-historical interest in Abruzzi and Molise, Lucania, Apulia, and Campania. *Key*: (1) Regional boundaries. Structures: (2) Early Christian; (3) pre-Romanesque; (4) Romanesque; (5) Gothic; (6) Renaissance; (7) baroque; (8) neoclassic and modern.

II, PL. 285), miniatures (Exultet Rolls of Monte Cassino, Salerno, etc.), and mosaics throughout southern Italy and Sicily (Cefalù, Palermo, Monreale). The polychrome Basilian country churches in Sicily, in Calabria, and in Lucania reflected Byzantine influence. Thus the various regions of Italy continued to develop their own characteristics, adapting in different and original ways the forms of Romanesque taste.

c. Gothic period. Gothic architecture was introduced into Italy by the Cistercian order and first appeared in single structures: the abbeys of Fossanova and Casamari in Latium; San Marino al Cimino in Umbria; San Galgano in Tuscany; Chiaravalle di Fiastra and Chiaravalle (S. Maria di Castagnola) in the Marches; Chiaravalle della Colomba in Emilia; and Chiaravalle near Milan (see GOTHIC ART). The earliest manifestations were simple and severe, in accordance with the austerity of St. Bernard of Clairvaux. The Franciscan and Dominican mendicant orders readily adopted Gothic forms for their churches. These were modest structures, usually of brick, the soaring quality of the vaults being checked by an emphasis on the horizontal procession of arches and piers along the nave and aisles (S. Maria Gloriosa dei Frari and SS. Giovanni e Paolo in Venice; S. Anastasia and S. Fermo in Verona; S. Francesco in Bologna; Sta Croce and S. Maria Novella in Florence) or along the single nave (S. Domenico in Siena, Church of the Eremitani in Padua). Southern Italy only rarely adopted elements of the new style, but in north-central Italy, alongside the churches of the predicant orders, there developed a sacred architecture modeled after that of French cathedrals. Their elegance and pomp was rendered in the new architecture with a sobriety that was completely Latin. The cathedrals of Florence, Orvieto, and Siena are the masterworks of this develop-

ment. Even the most conservative Lombard workshops adopted the new style, albeit retaining Romanesque elements; but the most outstanding Gothic monument of Lombardy is Milan Cathedral, which, in part because of the collaboration of foreign architects, conforms to French and German models. In many Italian cities monuments begun in the Romanesque period were continued and completed in the Gothic period, consequently blending the styles of the two periods (baptisteries of Pisa and Parma, Cathedral of Ferrara, Cathedral of Trent). The architecture of some regions is marked by the presence of elements derived from dissimilar traditions: for example, the presence of the domes in S. Antonio in Padua reveals a lively and flourishing contact with the Byzantine world, and the exterior of the Cathedral of Palermo is clearly linked to Spanish Gothic.

Urban construction especially flourished during the Gothic period. The most beautiful communal palaces in Italy were built then (Perugia, Gubbio, Viterbo, Siena, Florence); they were generally three stories high with rhythmically placed lancet windows and often flanked by high towers. In northern Italy the plan developed during the Romanesque period was retained for these government buildings: open ground-floor loggias and large windows in the second floor (Piacenza; Palazzo Ducale in Venice). The battlements crowning the structures were holdovers from fortress architecture. The revival of commerce brought about the construction of loggias which were actually markets (e.g., the loggia of the Palazzo della Mercanzia, Bologna; loggia, Narni); the main square was usually adorned with a monumental fountain (Perugia, Siena); roadside tabernacles were constructed in quantity. Sepulchral monuments, in the traditional Gothic form of elevated tombs covered by carved canopies, achieved extremely high levels of quality, particularly in Bologna and Verona (e.g., the Tombs of the Scaligeri, I, PL. 380; III, PL. 21).

With the transition from communal government to rule by lords (14th cent.), castles of the old feudal type were again required; fortified palaces, surrounded by walls and defensive structures, were sometimes built in the heart of the city, for example, the Castelvecchio in Verona and the original nucleus of the Castello del Buonconsiglio in Trent. Castles guarding mountain passes were erected in isolated spots in Trentino, Alto Adige (Castel Tirolo, or Schloss Tirol; Castel Roncolo, or Schloss Runkelstein), and Piedmont (Castle at Fénis). In the south the Angevins continued the work of Frederick II, fortifying as bridgeheads to the east the castles the Emperor had built (e.g., at Lucera).

About this time private construction reflected the emergence of a wealthy *bourgeoisie*. Particularly in northern and central Italy, there began to be constructed larger and more comfortable dwellings of two and three stories with single- and double-mullioned windows. These residences were built along the main streets, which were widened in this period. Such a residence is the Palazzo Davanzati in Florence. One of the most refined of such dwellings, the Ca' d'Oro in Venice, foreshadows the taste though not the style of Renaissance bourgeois buildings. Venice itself found the Gothic style particularly suited to its unique character. In northern Italy 14th- and 15th-century houses were enlivened with balconies and external stairs and usually included small inner courtyards with central wells. This was not the case in southern Italy, however, where except for some late Angevin structures with Spanish Flamboyant Gothic influences (Carinola), private dwellings continued to be modest buildings falling short of art. Nevertheless, the southern Italian towns owe their present appearance fundamentally to the medieval period, and they are dominated even today by the monumental churches around which are gathered even the humblest private dwellings. In central and northern Italy the more prosperous economy of the 14th century determined the fundamental structure of cities and towns; thus, imposing public buildings were erected along with the churches, and notable private dwellings were built, many of some originality.

Modern period. a. The Renaissance. The first tentative approach to Italian national unity was embodied in the ambitions of Gian Galeazzo Visconti, duke of Milan. Most of the powerful families of the time were avid patrons of the arts: the House of Aragon in Naples welcomed Tuscan artists; the Gonzaga family of Mantua were Mantegna's patrons; the Montefeltro family brought to Urbino Luciano Laurana and Tuscan, Flemish, and Spanish artists; and the Este family of Ferrara patronized Biagio Rossetti, who developed the first systematic urban plan. The court of the Medici in Florence was full of artists, writers, and politicians. The love of learning spread rapidly, and the private dwelling evolved into the Renaissance gentleman's palace, a model for the rest of Europe, which was just beginning to emerge from the Middle Ages. The bonds with an-

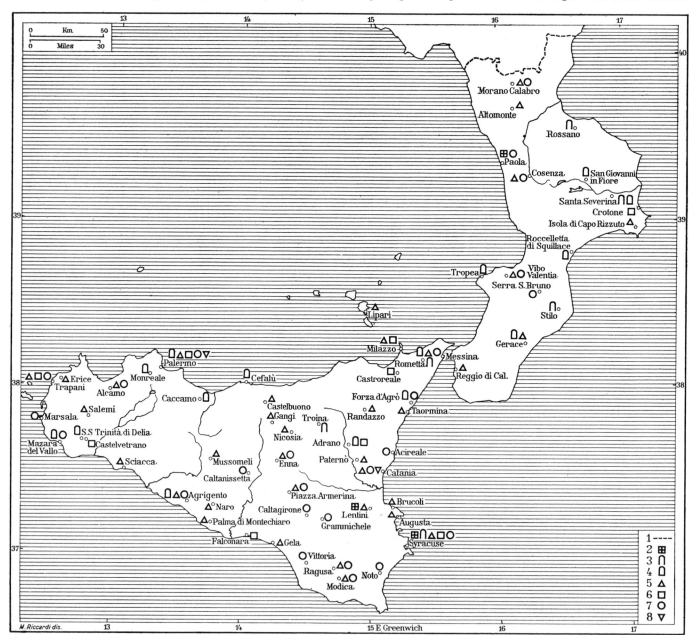

Italy, medieval and modern centers of art-historical interest in Calabria and Sicily. Key: (1) Regional boundaries. Structures: (2) Early Christian; (3) pre-Romanesque; (4) Romanesque; (5) Gothic; (6) Renaissance; (7) baroque; (8) neoclassic and modern.

tiquity were strengthened in the Renaissance (q.v.) in the desire to revive in new forms the grandeur of Rome; Humanism paralleled this sentiment with its love for ancient objects and writings. Florence was the chief seat of this new culture, which was also fostered by the papal courts of Julius II, Leo X, Clement VII, and Paul III, who commissioned such artists as Raphael, Bramante, and Michelangelo.

In the 16th century Piedmont, Lombardy, the Venetian Republic, the Papal States, and the Kingdom of Naples and Sicily continued

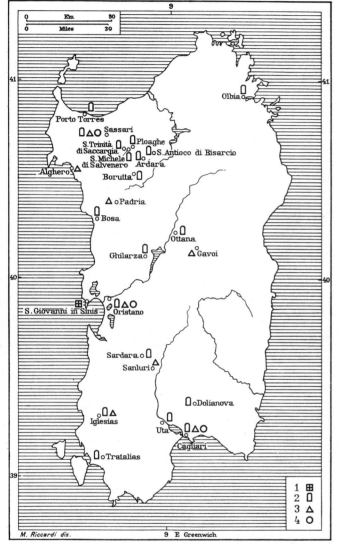

Italy, medieval and modern centers of art-historical interest in Sardinia.
Key: Structures: (1) Early Christian; (2) Romanesque; (3) Gothic; (4) baroque.

their independent political existences. The larger European countries, such as Spain and France, had consolidated themselves as nations and began to vaunt their respective hereditary rights to certain Italian states. The foreign conquests in Italy were begun at the end of the 15th century by Charles VIII of France, continued by his successors, opposed by Emperor Charles V, and concluded in 1559 with the peace of Cateau-Cambrésis, which confirmed Spanish dominion in Italy from Milan to the Kingdom of Sicily. Venice remained independent, having since the 10th century extended its own dominion over the Venetian mainland and into part of Lombardy and having survived the invasion of 1509 of Emperor Maximilian and the League of Cambrai.

The first center of the Renaissance was, as mentioned above, Florence. In architecture two currents began to take shape there in the early 15th century: that of the lively linear impulse of Brunelleschi (q.v.) and that of the Humanist Leon Battista Alberti (q.v.). The two artistic traditions came together in the work of the Sangallo (q.v.) family of Tuscany, who achieved a new grandeur in architecture by the use of smoothly finished massive façades accented with windows (Villa of Poggio a Caiano, PL. 428; I, PL. 305; Palazzo Farnese

in Rome). From Michelozzo in Florence and Laurana in Urbino they borrowed new systems of proportions, which they applied to palace courtyards. They elaborated the Greek-cross plan for churches; S. Maria delle Carceri, in Prato, S. Biagio, in Montepulciano, and S. Maria della Consolazione, in Todi, paved the way for Bramante's plan for St. Peter's in Rome. Bramante (q.v.), after his early experience in the Marches and Milan (at the Sforza court, where his contact with Leonardo da Vinci had far-reaching results on his career), became the leading exponent of the new classicism. In his design for the Cortile del Belvedere in the Vatican, Bramante placed three orders one above the other in the manner of Roman Imperial façades, and his plan for St. Peter's consisted of a Greek-cross plan inscribed in a square and surmounted by a large central dome with four smaller domes at the corners of the arms, a scheme ultimately deriving from Byzantine sources. The pilasters and paired columns on huge bases, designed by Bramante and Raphael, were used in the Palazzo Corner (called "Ca' Grande") of Sansovino in Venice and became distinctive elements of Venetian baroque religious architecture.

Michelangelo (q.v.), departing from the Tuscan dichromatic tradition, introduced a new tension in Florentine architecture. His work in architecture and city planning culminated in the perspective arrangement of the Capitol in Rome. The development of new forms in Rome was of particular importance for Venice and Mantua. After the sack of Rome in 1527, it was in Venice that Sansovino applied his talents to the Biblioteca Marciana and the Loggetta di S. Marco. The work of Giulio Romano (q.v.), painter and architect at the Gonzaga court in Mantua, and of Michele Sanmicheli (q.v.) in Verona and Venice balance the classical tendency and the creation of original new forms. Giulio Romano, in his Palazzo del Te in Mantua (PL. 428), reflects the influence of the Villa Madama in Roma; Sanmicheli, a military architect and city planner, exhibits a classicizing tendency in the Palazzo Canossa, Palazzo Pompei, and the Pellegrini Chapel (S. Bernardino), all in Verona, while in the Palazzo Grimani (now Court of Appeals) in Venice and the Palazzo Bevilacqua in Verona he displays a taste for chiaroscuro effects. Palladio (q.v.) followed in the Humanist tradition of Alberti. In Palladio's architecture in Vicenza and Venice and through his *Quattro libri dell'architettura*, he transmitted this tradition, distilled directly from Roman Imperial sources and Renaissance developments, to later generations of Europeans and Americans. His villas, which in their isolation and independence easily assimilated classical as well as functional elements, were the forerunners of modern dwellings. He achieved new chiaroscuro effects by placing a deep porch before the façade of the villa, thus introducing a new and entirely personal development. The villas were frescoed with subjects from classical myths and heroic poems. In Vicenza the dynamism of the Basilica, the airy loggias of Palazzo Chiericati, the soaring quality of the arcades in the courtyard of Palazzo Thiene (now the Banca Popolare), the functional and classical interpretation of the Teatro Olimpico, and the development of thermal plans created a new atmosphere.

In the 16th century villa architecture also flourished in Lombardy (La Simonetta, outside Milan); Galeazzo Alessi built several villas and palaces in Liguria, mainly in Genoa, often embellished with light arched loggias and external frescoes. Renaissance villas adorned Naples, Florence and Tuscany (Villa di Artimino by Buontalenti), and Latium (Palazzo Farnese at Caprarola by Vignola; Villa Lante at Bagnaia, PL. 433); surrounded by green parks and gardens with statues and flowing fountains, these villas were the settings for the lives of 16th-century lords.

The late Renaissance was marked by the adaptation of earlier developments to large buildings that, because of their functional purposes and requirements, became less works of art than exemplifications of a highly sophisticated taste. In urban design the Procuratie Nuove in Venice (PL. 214) with which Scamozzi completed Piazza S. Marco (I, PL. 402), and the Uffizi in Florence (IX, PL. 312) by Vasari were noteworthy achievements. Among the functional structures produced in the 15th century were the hospitals, with an altar and a ciborium at the crossing (e.g., Sto Spirito, Rome; the former Ospedale Maggiore, Milan). The old hotel Scudo di Francia in Vicenza was built in the 16th century and the first Monte di Pietà (designed for Feltre) was erected in Belluno. In northern Italy in the late 15th and early 16th centuries many important irrigation plans (some the work of Leonardo and Fra Giovanni Giocondo) were carried out. Notable urban designs include that of Pienza, commissioned by Pope Pius II, and the work of Biagio Rossetti in Ferrara. Important, too, was the urban design of Vigevano — linking castle, tower, and piazza — which incorporated innovations at the end of the 15th century. In Rome Pope Sixtus V (1585–90) opened the great avenue from the hill where the SS. Trinità dei Monti is located to S. Maria Maggiore and the Lateran. In the 17th century in Turin the Savoy dukes laid out over the Roman grid plan a frame of streets and piazzas, based on French models, creating a coherent and unified city plan. Each Italian state had its sumptuous seats: that of the

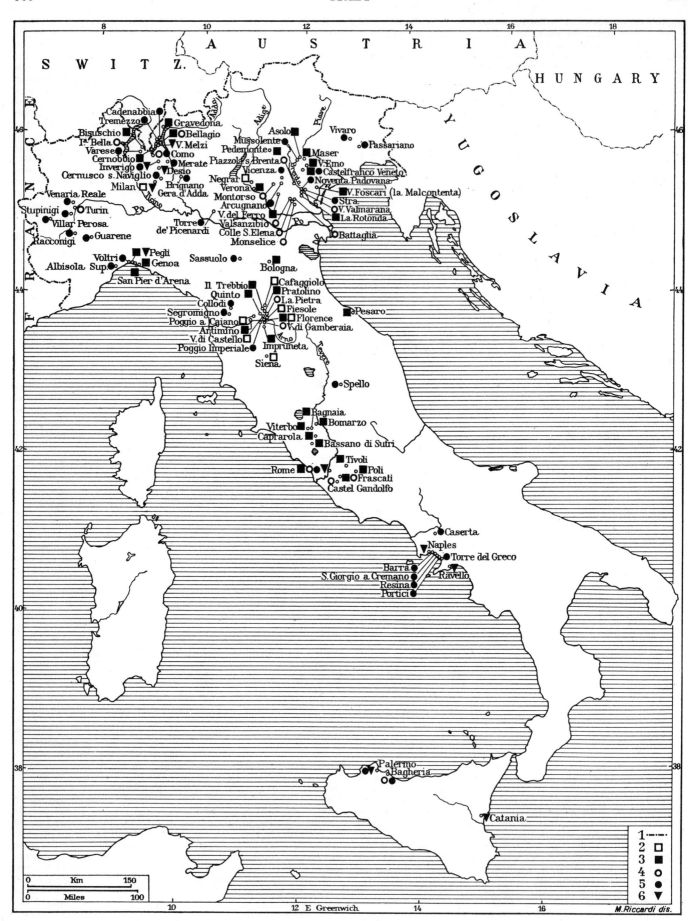

Italy, principal villas. *Key*: (1) Modern national boundaries; (2) 15th-century villas; (3) 16th-century villas; (4) 17th-century villas; (5) 18th-century villas; (6) 19th-century villas.

Doges in Venice (14th–15th cent.); the Visconti family in Milan, Pavia, and Vigevano; the Sforza in Milan; the Este in Ferrara; the Malatesta in Rimini; the Montefeltro in Urbino and Gubbio; the Medici in Florence; the House of Aragon, the Spanish Viceroys, and the Bourbons in Naples, Palermo, and Caserta; the House of Savoy in Turin, Moncalieri, Racconigi, Stupinigi, and Venaria Reale.

The idea of bastioned fortifications — in masonry and terreplein construction, providing less of a target for artillery bombardment — seems to have been Francesco di Giorgio's. They were constructed by Giuliano da Sangallo (Nettuno), Antonio da Sangallo the Elder (Civita Castellana), and Baccio Pontelli (castle at Ostia). Castel S. Angelo in Rome was transformed into a fortress in the 15th–16th century; it had served as a model for the Venetian fortress at Monfalcone (15th cent.). Important because of its polygonal form is the fortress of Palmanova (16th cent.). Circular keeps continued to be built, in part over Venetian structures, until the 19th century, under the Austrian rulers of northern Italy. Fortified churches were common: Monte Cassino and Bobbio (both early medieval), the Sanctuary of SS. Vittore e Corona (near Belluno), Sesto al Reghena (near Udine), and Loreto. Cities were reopened, and fortifications were built along the territorial borders: for example, the towers built by the Venetians (beginning in the 15th century) to guard the border valleys from the Austrians. In Naples, the Castel Nuovo was embellished with the triumphal arch of Alfonso of Aragon (III, PL. 390); elsewhere fortified structures were transformed into castle-palaces, as those of the Este family in Ferrara, the Montefeltro in Urbino, and the Medici and Strozzi palaces in Florence. Those outside towns became castle-villas, as the Careggi and Cafaggiolo villas near Florence and the immense Cataio near Padua. In the 16th century crenelated towers were built in those sensitive areas most exposed to the Saracens — along the Amalfi coast and the shores of Latium and Liguria.

b. Baroque. In the 16th century Rome answered the challenge of Protestantism with the Counter Reformation, and throughout the 17th and 18th centuries continued with unabating energy its campaign for unity of dogma and presentation and against innovation in government, philosophy, and science; the reforms and policies formulated at the Council of Trent were disseminated throughout Europe and America. Having become the center of a powerful court, Rome took full advantage of the new baroque style (see BAROQUE ART) in the works of such men as Bernini, Borromini, Pietro da Cortona, and Rainaldi (qq.v.), artists whose vibrant sculptural sensitivity had its roots in classical tradition.

During the period after the Treaty of Cateau-Cambrésis (1559), Lombardy, the Kingdom of Naples, and some smaller states were subject to Spanish influence. The victory at Saint-Quentin brought prestige to the duchy of Savoy, which subsequently entered the sphere of French influence. Turin was then considered the first modern city in Italy. It experienced an architectural efflorescence beginning in the 17th century, which was noteworthy especially for the functionalism of its apartment buildings and for the design of its squares and streets (Piazza San Carlo, designed on the model of an ancient Roman forum, Piazza Castello, and the present Via Po), all conceived in unified architectural forms, dominated by the masterpieces of Guarino Guarini and Filippo Juvara (qq.v.).

With the Treaty of Aix-la-Chapelle in 1748 an official division of the country between Spain (Naples and Sicily) and Austria (Lombardy, Tuscany, Parma, Piacenza) was agreed upon. At first Austrian rule was well received because of the enlightened attitude and many reforms of Maria Theresa, particularly in Milan, which had declined under the Spanish domination, and because of the summoning of many Italian writers and artists to the Austrian court. The baroque style of Bernini and, more especially, Borromini spread through England, Poland, Russia, and the Americas. Venice, victorious over the Turks at Lepanto (1571) and successful in the reoccupation of its territories in the Peloponnesus (1685–1715), revealed a keen taste for art and continued to dominate the scene with Baldassarre Longhena, G. B. Piazzetta, the Tiepolos, Canaletto, the Guardis, and the Longhis (qq.v.). Meanwhile, the rococo was imported from France and, with its pastel colors and *rocaille* stucco, was readily adopted in Venice.

The development of the baroque was heralded by Michelangelo, who, with the Biblioteca Laurenziana (Florence), the statue of Moses (Rome, S. Pietro in Vincoli), and the dome of St. Peter's, created a new vision of plastic space articulated and set in motion by alternating volumes and voids. Parallel to the Counter Reformation the new style monumentally affirmed the renovated life and authority of the Church. In the 17th century Bernini continued the monumental affirmation of the Counter Reformation with his elliptical St. Peter's Square (I, PL. 403), whose powerful Doric columns and dynamic portico were almost concrete expressions of the expanding power of the Roman Catholic Church. The conception of Borromini's Roman

façades and interiors presupposed an inner vitality of matter. After Michelangelo's ingenious design for S. Maria degli Angeli, laid out within the tepidarium of the Baths of Diocletian, the spatial possibilities of thermal architecture began to be explored in Rome, first in Vignola's interior of the Church of the Gesù and later, in a lighter idiom, in the aisles of S. Ignazio. The lively but soothing structure of S. Maria in Campitelli, by Rainaldi (I, PL. 405), and the vigorous chiaroscuro effect of the façade of S. Maria in Via Lata (XI, PL. 172), by Pietro da Cortona, exemplify the full Roman baroque, which subsequently showed signs of decline in the mannered repetition of fixed schemata. There was a revival in the 18th century, inspired by a taste for perspective effects, that produced the Spanish Steps of the Trinità dei Monti, the Fontana di Trevi, by Nicola Salvi (1762), display architecture in general, theater and festival displays, and the neo-Palladian façade with which Alessandro Galilei completed St. John Lateran.

In Naples the spatial designs of Domenico Fontana attained a remarkable fusion of solemnity and ease in the Royal Palace. Luigi Vanvitelli employed a more varied system of forms in his design for the Royal Palace in Caserta, imbuing it with a light grandeur beautifully complemented by the magnificent perspective of the park, embellished with statues, grottoes, and waterfalls (I, PL. 389). Inspired by Roman models, baroque architecture spread through southern Italy and Sicily: for example, the Quattro Canti (Piazza Vigliena) in Palermo and church façades in Naples, Palermo, Catania, and Syracuse. There were original interpretations in the 18th century in Noto and Palma di Montechiaro, and Spanish influence can be discerned in religious and secular edifices in Lecce.

In Turin the baroque was advanced through the works of Guarino Guarini (q.v.), who seems to have been influenced by Borromini and Spanish and Neo-Gothic structural principles in his design for the Palazzo Carignano (VII, PLS. 104, 105), the dome of S. Lorenzo (I, PL. 383), and the Chapel of the Sta Sindone in the Cathedral (I, PL. 421; II, PL. 143; VII, FIG. 196). Juvara in the Basilica of Superga (II, PL. 140) reelaborated with new chiaroscuro effects the Palladian arrangement of a porch with gigantic order preceding the façade; he was also influenced by French models and prepared the way with the Turin Palazzo Madama for the baroque experiments in Madrid. During this period the castles of the Savoy family near Turin, Venaria Reale and Racconigi (VII, PL. 106), were built — either in a severe classicizing or baroque-rococo style — reaching a culmination in the hunting lodge of Stupinigi (I, PL. 389; II, PL. 141), which in its decoration and furnishings reveals French influence.

Venetian baroque, especially the work of Longhena, was influenced by Sansovino in the monumentality of palace structures, but the play of light and shadow on the rusticated ashlar and the vertical thrust of engaged columns represent a different treatment of problems of light. S. Maria della Salute marked a new departure in Venetian baroque with a structure of rich plastic intensity, emphasized by the large volutes under the dome (II, PL. 141). After Palladio's horseshoe-shaped Teatro Olimpico in Vicenza, the first of its kind in modern Europe, theaters with box seating began to appear — the theaters of the Galli Bibienas in Bologna and Pavia, the mid-18th-century Teatro alla Scala in Milan, by Giuseppe Piermarini, and the late-18th-century Teatro Fenice in Venice, by G. A. Selva. The splendor of 16th-century Venetian villas and the even more elaborate 17th-century arrangements of parks with pavilions, tall trees, labyrinths, and lawns attracted the attention of Le Nôtre, who went to Italy in 1679 to study them. Le Nôtre so thoroughly assimilated what he saw that garden architecture returned to Italy as a French fashion. Baroque villa and garden architecture was popular not only in Venice but also in Milan, Turin, Florence, Rome, Frascati, and Caserta — all offering remarkable examples of the fusion of man's work with that of nature. Garden architecture had had further developments elsewhere. Gardens were decorated with figures of monsters, dwarfs (Vicenza, Bagheria near Palermo), and, turning again to artificial and natural landscaping, with artificial grottoes, ruins, and hidden water jets (Valsanzibio, near Padua).

c. Neoclassicism. Neoclassicism in Italy received a decisive stimulus from Winckelmann, who was in Rome from 1755, and from the excavations and discoveries sponsored by the Bourbons of Naples in Herculaneum (1737) and Pompeii (1748), which revived interest in antiquity and collecting. This classical trend spread to foreign countries (particularly to England, through Lord Burlington, who brought back Palladio's designs from Maser) before being widely adopted in Italy, in the work of Alessandro Galilei in Rome and Selva in Venice. The latter imported the "corridor" plan of the middle-class residence from England and thus influenced functional architecture for many years to come. In the mid-18th century, Giuseppe Piermarini's Teatro alla Scala and Palazzo Belgioioso in Milan and Leopold Pollack's Villa Reale marked a return to classical modes, but it was a sterile classicism compared with the inventiveness of the contem-

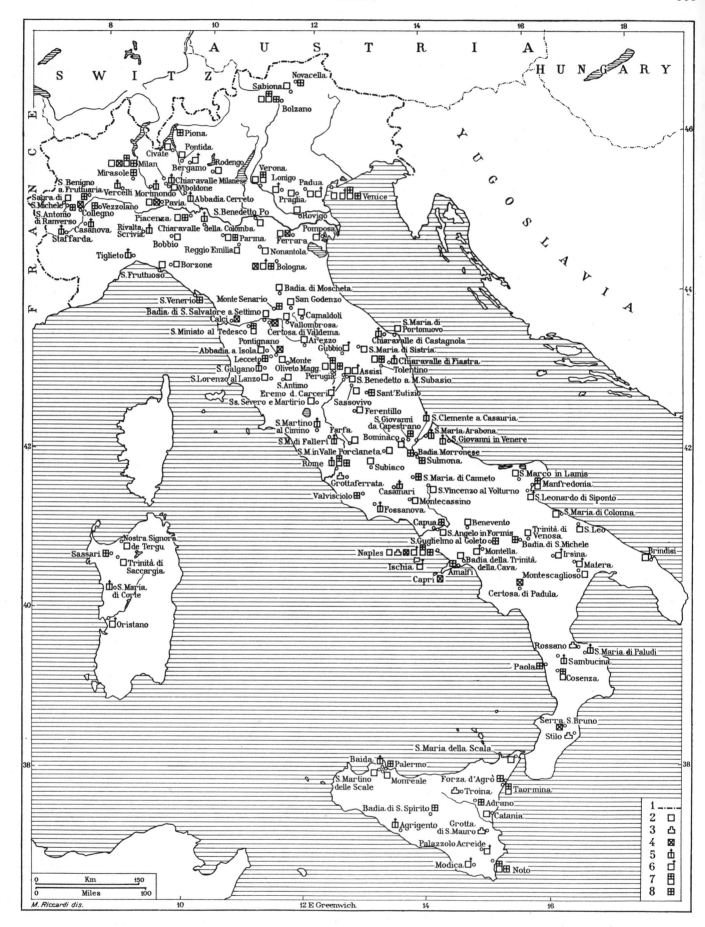

Italy, principal abbeys and monastic edifices. *Key*: (1) Modern national boundaries; (2) Benedictine; (3) Basilian; (4) Carthusian; (5) Cistercian; (6) Franciscan; (7) Dominican; (8) other orders.

poraneous work at Caserta. Neoclassicism began in Venice with the designs of Giorgio Massari, whose Palazzo Grassi (now Stucky) and Church of the Gesuati are based on Palladian schemes. Ottavio Bertotti-Scamozzi, who produced an important new edition of Palladio, also turned to neoclassicism. The classicizing style was used in the Napoleonic period not only for the Emperor's monuments (Arch of Peace, Milan) but also for functional works [the Arena (Studio Civico) of Milan, by Luigi Canonica; Pasquale Poccianti's Cisternone (reservoir) in Leghorn]. Giuseppe Japelli deserves mention for the subtle Neo-Hellenic and Neo-Gothic detailing of the Caffè Pedrocchi in Padua (X, PL. 292). The lively urban developments of Giuseppe Valadier (Piazza del Popolo and the Pincio, Rome) and the spatial ones of Antolini (Foro Buonaparte, Milan), concluded this phase.

Neoclassic art in its essential values seemed to have reached its end with the Venetian and Roman work of Antonio Canova (q.v.), but the style continued to be widely accepted and encouraged in Italy even in the romantic period, when northern influences predominated. An interesting, albeit somewhat severe, return to classical forms was marked by Peter von Nobile's interior for S. Antonio Nuovo (1825) in Trieste, derived from that artist's study of Roman thermal buildings (see NEOCLASSIC STYLES).

d. 19th and 20th centuries. The unification of Italy was effected in 1861 and constituted the political affirmation of the cultural and artistic unity that had existed from the Middle Ages and the Renaissance. The Italian state was completed in 1870 with the annexation of Rome. During the 19th and early 20th centuries older styles were revived in Rome: Luca Carimini's romantic neomedieval and Neo-Renaissance styles, the romantic revival of Giuseppe Sacconi in the monument to Victor Emmanuel II (X, PL. 157) and Guglielmo Calderini's neobaroque Palazzo di Giustizia. At the same time Italy saw the widespread diffusion of Art Nouveau (q.v.), whose most influential Italian exponents were Ruggero Berlam (Trieste, Synagogue), Ernesto Basile (Rome, new façade of Palazzo Montecitorio; palaces and villas in Palermo and Catania), Sullam and Giuseppe Torres in Venice, Raimondo D'Aronco in Turin, and Giuseppe Sommaruga in Milan.

More strictly functional designs (railroad stations, ports, airports, mountain and seaside resorts, industrial centers, hospitals, expositions, and highways) were developed in the 19th and 20th centuries in a variety of styles that seemed to reflect the emergence of new elements in society. During the period between the two world wars Italy only gradually began to partake of the more progressive international architecture. Since World War II extraordinary building activity has changed the appearance of cities and countryside to a degree beyond the control of city planners, dramatically exposing the particular problems of modern urban development (see EUROPEAN MODERN MOVEMENTS).

<div align="right">Fausto FRANCO</div>

BIBLIOG. *Antiquity: a. Bibliographies, encyclopedias, journals:* NSc, 1876 ff.; AAnz, 1889 ff.; MALinc, 1890 ff.; G. F. Gamurrini, Bibliografia dell'Italia antica, I, Arezzo, 1905; A. Mau, E. von Merklin, and F. Matz, Katalog der Bibliothek des K. Deutschen archäologischen Instituts in Rom, 4 vols., Rome, Berlin, Leipzig, 1913–32; JdI (bibliog.); FA, 1946 ff.; RE. *b. General works:* P. Clüver (Cluverius), Italia antiqua, 2 vols., Leiden, 1624; H. Nissen, Italische Landeskunde, 2 vols. in 3, Berlin, 1883–1902; G. de Sanctis, Storia dei Romani, 4 vols., Turin, 1907–23; E. Pais, Italia antica, 2 vols., Bologna, 1922; L. Homo, L'Italie primitive et les débuts de l'imperialisme de Rome, Paris, 1925 (2d ed., 1953); Forma Italiae (Unione Accad. Naz.), 1926 ff.; Edizione archeologia della Carta d'Italia al 100,000, Florence, 1927 ff.; A. Della Seta, Italia antica, 2d ed., Bergamo, 1928; A. Della Seta, I monumenti dell'antichità classica, ed., 2 vols., Milan, Genoa, 1929; P. Ducati, L'Italia antica, Milan, 1936; L. Pareti, Storia di Roma, 6 vols., Turin, 1952–61; P. MacKendrick, The Mute Stones Speak, New York, 1960. *c. Prehistory and protohistory:* BPI, 1875 ff.; W. Helbig, Die Italiker in der Poebene, Leipzig, 1879; O. Montelius, La civilisation primitive en Italie, 5 vols., Stockholm, 1895–1910; G. A. Colini, Il sepolcreto de Remedello Sotto nel bresciano ed il periodo eneolitico in Italia, BPI, XXIV, 1898, pp. 1–47, 88–110, 206–60, 280–95, XXV, 1899, pp. 1–27, 218–95, XXVI, 1900, pp. 57–101, 202–67, XXVIII, 1902, pp. 5–43, 66–103; L. Pigorini, Le più antiche civiltà dell'Italia, BPI, XXIX, 1903, pp. 189–211; T. E. Peet, The Stone and Bronze Ages in Italy, Oxford, 1909; F. von Duhn, Italische Gräberkunde, 2 vols., Heidelberg, 1924–39; M. Mayer, Molfetta und Matera: Zur Prähistorie Süd-Italiens und Siziliens, Leipzig, 1924; RLV (particularly the articles Italien und Sizilien); G. Sergi, Le prime e le più antiche civiltà, Turin, 1926; D. Randall MacIver, The Iron Age in Italy, Oxford, 1927; D. Randall MacIver, Italy before the Romans, Oxford, 1928; R. Vaufrey, Le paléolithique italien, Paris, 1928; H. M. R. Leopold, La sede originaria dei Terramaricoli, BPI, XLIX, 1929, pp. 19–34; U. Rellini, Le origini della civiltà italica, Rome, 1929; N. Åberg, Bronzezeitliche und früheisenzeitliche Chronologie, 2 vols., Stockholm, 1930–32; H. M. R. Leopold, Le sale del Museo preistorico Luigi Pigorini contenenti oggetti delle palafitte e terramare della Valle Padana, BPI, L–LI, 1930–31, pp. 148–78; H. M. R. Leopold, L'età del bronzo nell'Italia centrale e meridionale, BPI, LII, 1932, pp. 22–40; U. Rellini, Le stazioni enee delle Marche di fase superiore e la civiltà italiana, MALinc, XXXIV, 1932, pp. 130–279; U. Rellini, L'uomo fossile della Maiella e i primi mediterranei, Casalbordo,

1932; U. Rellini, La civiltà enea in Italia, BPI, LIII, 1933, pp. 63–96, LIV, 1934, pp. 65–94; U. Rellini, La più antica ceramica dipinta in Italia, Rome, 1934; F. Messerschmidt, Bronzezeit und frühe Eisenzeit in Italien, Berlin, Leipzig, 1935; A. C. Blanc, Nuovi giacimenti paleolitici del Lazio e della Toscana, SEtr, XI, 1937, pp. 273–304; U. Rellini, La stirpe di Neanderthal nel Lazio, BPI, N.S., I, 1937, pp. 5–56; G. Säflund, Le terremare delle provincie di Modena, Reggio Emilia, Parma, Piacenza, Uppsala, 1939; G. von Merhart, Donauländische Beziehungen der früheisenzeitlichen Kulturen Mittelitaliens, BJ, CXLVII, 1942, pp. 1–90; J. Sundwall, Die älteren italischen Fibeln, Berlin, 1943; P. Laviosa Zambotti, Origine e diffusione della civiltà, Milan, 1947; H. Krahe, Die Indogermanisierung Griechenlands und Italiens, Heidelberg, 1949; V. Gordon Childe, Prehistoric Migrations in Europe, Oslo, Cambridge, Mass., 1950; G. Devoto, Gli antichi italici, 2d ed., Florence, 1951; G. Patroni, La preistoria, 2d ed., Milan, 1951; V. Pisani, Le lingue dell'Italia antica oltre il latino, Turin, 1953; P. Laviosa Zambotti, Il Mediterraneo, l'Europa e l'Italia durante la preistoria, Turin, 1954; M. Pallottino, Le origine storiche dei popoli italici, Rel. X Cong. int. di sc. storiche, II, Florence, 1955, pp. 1–60; P. Leonardi, Il paleolitico dell'Italia padana, Atti del I Convegno interregionale padano di paletnologia, Milan, 1956; W. Taylour, Mycenean Pottery in Italy, Cambridge, 1958; R. Peroni, Per una definizione dell'aspetto culturale "subappenninico" come fase cronologica a se stante, MemLinc, 8th ser., IX, 1959, pp. 1–253; S. Puglisi, La civiltà appenninica, Florence, 1959; M. O. Acanfora, Pittura dell'età preistorica, Milan, 1960; P. Graziosi, Palaeolithic Art, New York, 1960. *d. Pre-Roman and Roman Italy:* J. Beloch, Der italische Bund unter Roms Hegemonie, Leipzig, 1880; R. Koldewey and O. Puchstein, Die griechischen Tempel in Unteritalien und Sizilien, 2 vols., Berlin, 1899; K. Miler, Itineraria Romana, Stuttgart, 1916; G. Giannelli, Culti e miti della Magna Grecia, Florence, 1924; D. Randall MacIver, Villanovans and Early Etruscans, Oxford, 1924; E. Ciaceri, Storia della Magna Grecia, 3 vols., Milan, 1927–32; P. Ducati, Etruria antica, 2 vols., Turin, 1927; SEtr, 1927 ff.; F. Schachermeyr, Etruskische Frühgeschichte, Berlin, Leipzig, 1929; Å. Åkerström, Studien über die etruskischen Gräber, Lund, 1934; W. Hoffmann, Rom und die griechische Welt im 4. Jahrhundert, Leipzig, 1934; J. Whatmough, The Foundations of Roman Italy, London, 1937; A. Andrén, Architectural Terracottas from Etrusco-Italic Temples, Lund, 1940; J. Bérard, Bibliographie topographique des principales cités grecques de l'Italie méridionale et de la Sicilie dans l'antiquité, Paris, 1941; A. Afzelius, Die römische Eroberung Italiens (Acta Jutlandica, XIV, 3), Copenhagen, 1942; Å. Åkerström, Der geometrischen Stil in Italien, Lund, 1943; J. D. Beazley, Etruscan Vase-Painting, Oxford, 1947; M. E. Blake, Ancient Roman Construction in Italy from the Prehistoric Period to Augustus, Washington, 1947; M. Pallottino, L'origine degli Etruschi, Rome, 1947; R. Thomsen, The Italic Regions (Classica et medievalia, IV), Copenhagen, 1947; T. S. Dunbabin, The Western Greeks, Oxford, 1948; F. Sartori, Problemi di storia costituzionale italiota, Rome, 1953; M. Pallottino, Art of the Etruscans, New York, 1955; M. Pallottino, The Etruscans, Harmondsworth, 1955; M. Pallottino, Mostra dell'arte e della civiltà etrusca (exhibition cat.), Milan, 1955; F. Castagnoli, Ippodamo di Mileto e l'urbanistica a pianta ortogonale, Rome, 1956; J. Bérard, La colonisation grecque de l'Italie méridionale et de la Sicilie dans l'antiquité, 2d ed., Paris, 1957; G. Lugli, La tecnica edilizia romana, 2 vols., Rome, 1957; M. E. Blake, Roman Construction in Italy from Tiberius through the Flavians, Washington, 1959; L. Crema, L'architettura romana, Turin, 1959; F. Sartori, La Magna Grecia e Roma, Arch. storico Calabria e Lucania, XXVIII, 1959, pp. 137–91; A. Maiuri, Arte e civiltà nell'Italia antica, Milan, 1960. See also the bibliogs. for: ETRUSCO-ITALIC ART; HELLENISTIC-ROMAN ART; ITALO-ROMAN FOLK ART; LATE-ANTIQUE AND EARLY CHRISTIAN ART; ROMAN IMPERIAL ART.

Medieval and modern Italy: a. General works: C. K. J. Bunsen, Die Basiliken des christlichen Roms, Munich, 1843–44; L. Canina, Ricerche sull'architettura più propria dei tempi cristiani, I, Rome, 1846; C. von Stegmann and H. von Geymüller, Die Architektur der Renaissance in Toscana, 11 vols., Munich, 1855–1908; C. Boito, Architettura del Medioevo in Italia, Milan, 1880; P. Laspeyres, Die Kirchen der Renaissance in Mittelitalien, Berlin, Stuttgart, 1882; J. C. Raschdorff and A. Haupt, Palastarchitektur von Oberitalien und Toskana vom XIII. bis zum XVIII. Jahrhundert, 6 vols., Berlin, 1886–1922 (rev. ed., 3 vols., London, 1931); R. Cattaneo, L'architettura in Italia dal secolo VI al Mille circa, Venice, 1888 (Eng. trans., I. Curtis-Cholmeley, London, 1896); C. Enlart, Les premiers monuments gothiques d'Italie, B. monumental, LVII, 1891–92, pp. 160–190; A. Choisy, Histoire de l'architecture, 2 vols., Paris, 1899; A. Conti, Monumenti nell'Italia meridionale, Rome, 1902; L. Pozzi, Le parte artistiche di bronzo degli edifizi monumentali religiosi e civili d'Italia dall'epoca romana fino ai nostri giorni, Bergamo, 1903; A. Frova, Chiese gotiche cadorine, Milan, 1908; G. T. Rivoira, Le origini della architettura lombarda e delle sue principali derivazioni nei paesi d'oltre Alpi, 2d ed., Milan, 1908; B. Ebhardt, Die Burgen Italiens, 6 vols., Berlin, 1909–24; F. Benoît, L'architecture, 2 vols., Paris, 1911–12; T. F. Bumpus, The Cathedrals of Central Italy, London, 1911; Catalogo delle cose d'arte e di antichità d'Italia, Rome, 1911 ff.; E. D'Auvergne, Famous Castles and Palaces of Italy, London, 1911; M. De Benedetti, Palazzi e ville reali d'Italia, 2 vols., Florence, 1911–13; G. T. Rivoira, Architettura musulmana, Milan, 1914; H. Willich and P. Zucker, Die Baukunst der Renaissance in Italien, 2 vols., Wildpark-Potsdam, 1914–29; A. Colasanti, Volte e soffitti italiani, Milan, 1915; W. W. Collins, Cathedral Cities of Italy, New York, London, 1917; P. Toesca, Affreschi decorativi in Italia fino al secolo XIX, Milan, 1917; J. Baum, Baukunst und dekorative Plastik der Frührenaissance, Stuttgart, 1920; M. De Benedetti, I palazzi che abitarono i Re, Rass. d'arte, VII, 1920, pp. 187–95; A. Haseloff, Die Bauten der Hohenstaufen in Unteritalien, Leipzig, 1920; U. Ojetti, I palazzi e le ville che non sono più dei Re, Milan, 1921; C. Ricci, L'architettura del Cinquecento in Italia, Turin, 1923; L. Dami, Il giardino italiano, Milan, 1924; G. Ferrari, L'architettura rusticana nell'arte italiana dalle capanne alle chiese medievali, Milan, 1925; N. Tarchiani, Italia medievale, Bologna, 1925; T. F. Bumpus, The Cathedrals and Churches

of Italy, New York, London, 1926; A. Colasanti, Le fontane d'Italia, Milan, 1926; I. C. Gavini, Storia dell'architettura in Abruzzo, 2 vols., Milan, Rome, 1927–28; F. Sapori, Gallerie, Musei, Scavi, Biblioteche in Italia, Rome, 1927; Inventario degli oggetti d'arte d'Italia, 9 vols., Rome, 1931–38; I monumenti italiani (Rilievi raccolti dalla R. Accademia d'Italia), Rome, 1934–35 ff.; C. Shearer, The Renaissance of Architecture in South Italy, Cambridge, 1935; Ricerche sulle dimore rurali in Italia, Bologna, Florence, 1938 ff.; A. Pica, Architettura moderna in Italia, Milan, 1941; P. Verzone, L'architettura religiosa dell'alto medioevo nell'Italia settentrionale, Milan, 1942; C. Cecchelli, La decorazione paleocristiana e dell'alto Medio Evo nelle chiese d'Italia (Roma esclusa), Atti del IV Cong. int. archeol. cristiane, Vatican City, 1948, II (S. di antichità cristiana, XIX, 1948), pp. 127–212; L. Marchetti and C. Bevilacqua, Basiliche e Cattedrali d'Italia, Novara, 1950; L. Réau, Basiliques et sanctuaires d'Italie, Paris, 1950; F. Rodolico, Le pietre delle città d'Italia, Florence, 1953; L. Magagnato, Teatri italiani del Cinquecento, Venice, 1954; U. Nebbia, Castelli d'Italia, Novara, 1955; U. Nebbia, Cattedrali d'Italia, Novara, 1955; E. Dupré Theseider, Aspetti della città medievale italiana, Bologna, 1956; G. Chierici, Il palazzo italiano dal secolo XI al secolo XIX, Milan, 1957; R. Contigiani, Chiese antiche e chiese nuove nell'Italia meridionale, Quaderni di Chiesa e Quartiere, I, 1957, pp. 34 ff.; A. Boëthius, Urbanism in Italy, Acta Cong. Madvigiani, IV, 1958, pp. 87–102; H. Decker, Italia romanica, Vienna, 1958 (Eng. trans., J. Cleugh, Romanesque Art in Italy, New York, 1959); L. Fraccaro de Longhi, L'architettura delle chiese cistercensi italiane, Milan, 1958; J. W. Franklin, The Cathedrals of Italy, London, 1958; G. Masson, Italian Villas and Palaces, London, 1959; R. Alci, Ville in Italia, Milan, 1960; C. Fiorani, Giardini d'Italia, Rome, 1960; M. S. Briggs, Architecture in Italy, London, 1961. b. Guides: G. Barri, Viaggio pittoresco, in cui si notano tutte le Pitture dei più celebri Pittori che si conservano in qualsivoglia città d'Italia, Venice, 1671 (Eng. trans., W. Lodge, London, 1679); C. N. Cochin, Voyage d'Italie ou Recueil de notes sur les ouvrages d'architecture, de peinture et de sculpture que l'on voit dans les principales villes d'Italie, 3 vols., Paris, 1758; F. Bartoli, Notizie delle pitture, sculture ed architetture che ornano le principali città d'Italia, 2 vols., Venice, 1776; J. Burckhardt, Der Cicerone, Basel, 1855 (Eng. trans., A. H. Clough, rev. ed., London, New York, 1908); C. Jacini, Il viaggio del Po: Traccia storico-estetica per la visita ai monumenti ed ai luoghi della Valle Padana, 7 vols., Milan, 1937–58; L. Schudt, Italienreisen im 17. und 18. Jahrhundert, Vienna, 1959. c. Collections, atlases, reviews: Le cento città d'Italia illustrate, Milan, 1887 ff.; Le vie d'Italia, Milan, 1895 ff.; Italia artistica, Bergamo, 1906 ff.; Touring Club Italiano, Attraverso l'Italia, Milan, 1930 ff.; M. Baratta, P. Fraccaro, and L. Visintin, Atlante storico, 4th ed., Novara, 1938; Musei e Gallerie d'Italia, Rome, 1956 ff.; L'Italia, Rome, 1957 ff.

ART CENTERS. *Historical geography of Italy.* Since Roman times the name "Italy" has been used to designate that part of the European continent that forms a peninsula to the south of the Alps (with some variations of boundary). The name was first applied by the Greeks to the extreme southern end of that peninsula, which was inhabited by the Itali. Later the term was extended to all of the southern portion of the peninsula, which came to be known as "Magna Graecia" when the Greeks colonized the area. Thus the ethnic term "Italiote," inhabitant of Italy, came to be applied to the Greek colonists on the coasts of Italy, while the ethnic term "Italici" was applied to the indigenous population of the region. Between the 4th and 1st centuries B.C. the name "Italy" was extended to the entire peninsula south of the Tuscan-Emilian Apennines; the area to the north comprised provinces of Rome. In the time of Julius Caesar the term "Italy" was applied to the peninsula as far as the Alps. Consequently Roman citizenship was extended to the inhabitants of northern Italy, which was included in the province of Cisalpine Gaul. Only with Diocletian's administrative reform did Sicily, Sardinia, Corsica, and the western Alpine territories come to be considered part of Italy. Previously they had been administered as provinces and considered extra-Italian territories. This geographical (and ethnic) concept of Italy as consisting of this entire area survived throughout the Middle Ages and modern times, notwithstanding the fact that the tradition of the Kingdom of Italy created by Charlemagne was essentially that of northern Italy.

The subdivisions of ancient Italy derived from the geographical and physical configuration of the country and, in part, from ethnic and historical factors. The evolution of the various regions was concluded by the Roman unification of the country and its division into eleven regions under Augustus (regions that correspond, for the most part, to the names of the ancient local inhabitants, see ETRUSCO-ITALIC ART): I. Latium et Campania (corresponding to the southern part of modern Latium and Campania); II. Apulia et Calabria (mod. Apulia); III. Lucania et Bruttium (mod. Lucania and Calabria); IV. Samnium (part of Umbria, the Abruzzi, and Molise); V. Picenum (southern part of the Marches); VI. Umbria (Umbria, and northern part of the Marches); VII. Etruria (Tuscany and northern Latium); VIII. Aemilia (Emilia); IX. Liguria (Liguria and southern Piedmont); X. Venetia et Histria (Veneto, almost all of Istria, and eastern Lombardy); XI. Transpadana (northern Piedmont, the Aosta Valley, and western Lombardy).

After Diocletian's reform, some slight variations were effected, with the organization of Italy in dioceses and provinces. Etruria was joined to Umbria under the name of Tuscia or Tuscia Suburbicaria.

Picenum was divided into Picenum Suburbicarium (to the south) and Flaminia et Picenum (to the north). Transpadana was divided up between Liguria and Venetia. Sicily, Sardinia, Corsica, the Cottian Alps, and Raetia (as far as the Danube) were also included in Italy. The province of Venetia et Histria was extended to the east. For some time, Italy was divided into two dioceses: Suburbicaria (the south) and Annonaria (the north).

On the whole, the ancient division of Italy survived until the end of the Roman Empire and has, with some variations, been revived in modern times, according to historico-cultural and ethnic-linguistic traditions and political administration. The principal modification was effected by the formation of the Lombard states and their contradistinction from Byzantine Italy. The Germanic invasions established the name and concept of Lombardy. The period of Byzantine domination is responsible for the character of Romagna (eastern Emilia, with its center at Ravenna) and Pentapoli (later the March of Ancona, now the Marches).

For several centuries Italy was generally divided into three large areas: the northern and central territories (which had once formed part of the Roman-Germanic empire); the papal region in the center of the peninsula (with the addition of Romagna); and the Kingdom of Naples (later the Kingdom of the Two Sicilies) to the south. Within these larger divisions, the older historical regions did not disappear but reemerged after the political unification of Italy in the 19th century.

Rome, including Vatican City. The discussion of the monuments of Rome, which for obvious reasons has been removed from its regional context (see below, *Latium*) and placed before the other Italian cities, is presented in a general topographical preface followed by a detailed description of each period. Following this is a description of Vatican City, which, although geographically a part of Rome, has preserved since the Middle Ages a certain individuality and has been since 1929 an independent territory under the sovereign rule of the pope.

a. General topographical character. Rome is situated in the lower valley of the Tiber, on both sides of the river and on the surrounding hills. The city's size, wealth of monuments, and singularly varied urban aspect reflect its complex history.

The ancient city, originally enclosed within the circuit of the Aurelian walls, reflects most intensely the succession and superimposition of the various phases of Rome's history. Within the region of the ancient city on the east bank of the Tiber, the following areas may be distinguished: (1) to the south is the area embracing the Palatine, Aventine, and Caelian hills and the urban zone around the Via Appia; (2) northwest of these is the flat area of the ancient Campus Martius, now distinguished by a dense conglomeration of historic monuments and structures and an urban aspect determined in the period from the Renaissance through the 19th century; (3) to the northeast are the Quirinal, Viminal, and Esquiline hills, with late 19th-century structures for the most part and some isolated historic monuments. On the west bank of the Tiber, the Trastevere area extends to the south. Part of Trastevere was included within the ancient Roman walls, and under Urban VIII it was fortified along the crest of the Janiculum hill. To the north is the area called "the Leonine City," which was fortified by Leo IV and Paul III and includes Vatican City. Since the 19th century Rome has spread in various directions: to the northwest (Prati), to the north and northeast (the Flaminio, Pinciano, Salario, and Nomentano residential areas, with the villas Borghese, Albani, and Torlonia, large suburban villas of the 18th and 19th centuries), and to the east and south (the residential and industrial districts of Tiburtino, Prenestino, Tuscolano, Appio, Ostiense, and Portuense). More recently, urban districts have been built at Monte Mario, Monte Sacro (across the Aniene), and in the E.U.R. area (Esposizione Universale di Roma) and along the road leading to Rome. Within the administrative area of Rome is Ostia, which because of its particular historical importance will be considered separately (see below, *Latium*).

During the Imperial period, ancient Rome was divided into 14 districts, including the district of Trastevere. The nucleus of the modern city has been divided into 22 *rioni* (or "wards," from the word meaning "region"): the traditional *rioni*, established before the 19th-century expansion of the city are: Monti, Trevi, Colonna, Campo Marzio (the ancient Campus Martius), Ponte, Parione, Regola, S. Eustachio, Pigna, Campitelli, S. Angelo, Ripa, Trastevere, and Borgo. Around these wards are 18 others, generally named for the ancient consular roads. Finally, there are the surrounding suburbs, villages, and rural areas.

b. The ancient period. Concerning the foundation of Rome, ancient authors have handed down various legends and dates, but the founding date 754 B.C. or 753 B.C. seems to have become traditional by

the end of the republican period. Apart from sporadic earlier remains, archaeologists have discovered the existence of settlements and burial areas as early as the 9th–8th century B.C., particularly on the Palatine and in the valley of the Roman Forum. It is likely that the Palatine represents the original nucleus of the city (that which the ancients called *Roma Quadrata*), but it is also possible that the city evolved from the fusion of early villages built on this and other hills, such

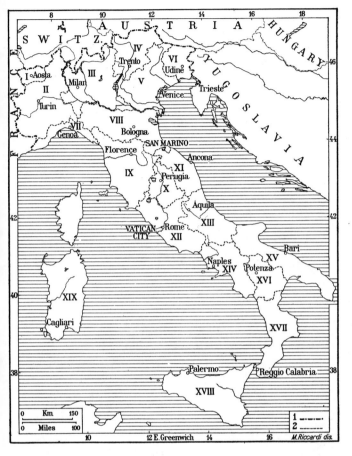

Italy, the regions and their capitals. *Key*: (1) Modern national boundaries; (2) regional boundaries. The regions: (I) Aosta Valley; (II) Piedmont; (III) Lombardy; (IV) Trentino-Alto Adige; (V) Veneto; (VI) Friuli-Venezia Giulia; (VII) Liguria; (VIII) Emilia and Romagna; (IX) Tuscany; (X) Umbria; (XI) the Marches; (XII) Latium; (XIII) Abruzzi and Molise; (XIV) Campania; (XV) Apulia; (XVI) Lucania; (XVII) Calabria; (XVIII) Sicily; (XIX) Sardinia.

as the Quirinal and the Esquiline. A particularly advanced stage of urban development was achieved in the 6th century B.C. under the Etruscan dynasty of the Tarquins (the city of the *Quattuor Regiones*). Notable urban and building projects were carried out, including the draining of the valleys, construction of the Forum, and perhaps some fortification. Several temples were constructed, as proved by the discovery of terra-cotta architectural fragments in various parts of the city. Among the temples were that of Jupiter Capitolinus on the Capitoline (509 B.C.), those of Fortuna and the Mater Matuta in the Forum Boarium, and that of Diana on the Aventine. Other temples were built in the early years of the republic: the temples of Saturn, in the Forum (501–493); Ceres, Liber and Libera, on the Aventine (493); and Castor and Pollux, in the Forum (484). In 456 B.C. the Aventine was assigned to the plebs and retained that character until the early centuries of the Empire.

An invasion of the Gauls in 390 B.C. (or 387 B.C.) seems to have inflicted serious damages on the city, but it was hastily rebuilt. The wall traditionally called the "Servian Wall" was begun in 378 B.C. in *opus quadratum* and encompassed the Capitoline, the Quirinal, a large part of the Esquiline, the Caelian, the Aventine, and the Palatine hills. The perimeter of the wall was about 6½ miles. New temples were constructed: to Mars, on the Via Appia (388); Concordia in the Forum (367); Apollo (431 or 353); Juno Moneta on the Capitoline (344); Bellona, in the Campus Martius (soon after 298); Jupiter Victor (295), Victory (294), and Jupiter Stator (294), all on the Palatine; and Aesculapius, on the island in the Tiber; and others. After the middle of the 4th century, urban construction increased. Rostra

were constructed for the assemblies at the Comitium and in the Forum (which ceased to serve as a market place and retained only its political character); the Circus Maximus was begun (339), and the first aqueduct, the Aqua Appia, was built under the auspices of the censor Appius Claudius (310). The earliest stone temple in Rome, the so-called "Temple C" in Largo Argentina, dates from the late 4th century. Temple A in Largo Argentina was built in the middle of the 3d century.

The Second Punic War, contact with the Hellenistic world, and Rome's role as a Mediterranean power stimulated new urban and monumental developments; porticoes resembling those of Hellenistic cities, warehouses (e.g. Emporium and Portico of Aemilia, 193), and masonry bridges were constructed (e.g. the Aemilian Bridge, 179). Temple construction began to be influenced by Greek architecture: the two temples of the Forum Holitorium are peripteral; the Temple of Jupiter Stator (after 146) near the Circus Flaminius is peripteral *sine postico*; the Temple of Hercules Victor (perhaps early 2d century) in the Forum Boarium, that of Hercules Musarum (after 187) near the Circus Flaminius, and Temple B in Largo Argentina (which is almost surely the Temple of Fortuna consecrated in 101 by Lutatius Catulus) are pseudoperipteral circular temples. New architectural forms were created, such as the triumphal and honorary arch (the first ones by Stertinius; 196), and the basilica, the first being the Basilica Porcia (184), built by Cato the Elder, and the Basilica Aemilia (179).

The invention of *opus incertum*, which made possible the construction of daring vaults, gave a new impetus to the development of architecture. Sulla constructed the Forum and the Comitium, and during his consulship Lutatius Catulus built the Tabularium (record office) on the Capitoline. The Tabularium served as a kind of scenographic backdrop to the Forum, thus assuming an important role in the urban physiognomy of the area.

With Pompey and Caesar urban development became a political program, and monuments were often erected in carefully planned and regulated urban redevelopment projects. Pompey selected the Campus Martius, an area destined for extensive monumental development, for the construction of an important complex of structures, the Hecatonstylon, with porticoes, a theater (the first of stone masonry in Rome), and the Temple of Venus Victrix. Next to the old Forum, Caesar built a new one, with the Temple of Venus Genetrix.

Augustus effected a great architectural revival. Besides important structures in the Roman Forum, he built a new forum with the Temple of Mars Ultor. Augustus erected a large temple to Apollo on the Palatine near his house, which some authorities identify as the so-called "House of Livia." The Gardens of Maecenas and the Market of Livia were built on the newly reclaimed Esquiline. In the area of the Campus Martius were erected the Pantheon (I, PL. 401), the Septa, the Basilica of Neptune, the Baths of Agrippa, the Amphitheater of Statilius Taurus, the Portico of Philippus, the Theater of Balbus, the Ara Pacis (III, PLS. 385, 488; VII, PL. 211), and the Mausoleum of Augustus; the Theater of Marcellus (I, PL. 394) was completed, and the Temple of Apollo Sosianus and the Portico of Metellus (renamed the "Portico of Octavia") were restored. Particular care was given to the aqueducts, either newly constructed (Aqua Vergine, Aqua Julia) or restored. In comparison with the work of Augustus, that of Tiberius was rather modest: the Temple of Divus Augustus, the Domus Tiberiana (Tiberius' palace) on the Palatine, and the Castra Praetoria. The Claudian and Anio Novus (begun by Caligula) aqueducts were built under Claudius, and the Aventine hill was included within the pomerium. In the first phase of Nero's reign, the Macellum Magnum on the Caelian hill, the Baths of Nero in the Campus Martius, and the Domus Transitoria were constructed. Later, Nero's reign saw two decisive events in the urban development of Rome: the great fire of A.D. 64, which spared only four regions of the city, and the imposition of a city plan prescribing rectilinear housing districts, straight broad streets, and porticoes in front of houses; the plan was not carried out, however, until the time of the Flavians. An extraordinary undertaking was the immense Domus Aurea (Golden House of Nero; VII, PL. 215), which with its park extended over Mt. Oppius, the Caelian, and the Palatine. Vespasian built the Flavian Amphitheater (the Colosseum, inaugurated by Titus in A.D. 80) on the site of a lake that had been part of the gardens of the Domus Aurea. He enlarged the pomerium of Rome, built the Forum Pacis and reconstructed the Capitol (destroyed in A.D. 69). During the reign of Titus there was a great fire (A.D. 80), which destroyed many structures in the Campus Martius and again destroyed the Capitol. Domitian rebuilt the Capitol and in the Campus Martius erected the Divorum, a stadium, and an odeum; he also began a new forum (later dedicated by Nerva) and redesigned the Palatine, which was almost entirely occupied by the imperial palace. Trajan, whose architect was Apollodoros of Damascus (q.v.), left two great works: the Baths of Trajan on the Esquiline and Trajan's Forum. Building activity under Hadrian was intense.

Among his most important works of reconstruction was that of the Pantheon; new constructions included the Temple of Venus and Roma (designed by Hadrian himself) and Hadrian's Mausoleum (now Castel S. Angelo). In the Roman Forum, Antoninus Pius built the Temple of Antoninus and Faustina and in the Campus Martius the Temple of Divus Hadrian, not far from which were erected the Column of Antoninus Pius and the Column of Marcus Aurelius. The serious damages resulting from the fire of A.D. 191 were repaired by Septimius Severus, who also enlarged the imperial palace and built the Septizonium. Near the beginning of the Appian Way Caracalla built a new thermal complex, the Baths of Caracalla (I, PL. 384).

Architectural activity diminished in the 3d century. Aurelian built a large temple to the sun in the Campus Martius and, against the new dangers of invasion, a massive city wall 10 miles long. Diocletian reconstructed the Curia and the other buildings that had been burned under Carinus in 283 and built the Baths of Diocletian.

Maxentius rebuilt the Temple of Venus and Roma and began the Basilica of Maxentius (Basilica of Constantine). Constantine was also responsible for the Baths of Constantine on the Quirinal and the Arch of Constantine, not to mention several Christian basilicas. The buildings of Constantine were the last important works of antiquity in Rome, for the difficult political situation of the city and the transfer of the capital of the Empire put an end to building activity. The chief concern was the maintenance of existing structures. The invasions of 410 and 455 were hard blows (notwithstanding the restorations of Honorius and Theodoric) and, together with the depopulation of the city, led to the continuous deterioration of ancient structures, many of which survived, at least in part, only when they were transformed into churches, sacred buildings, or fortresses.

c. From the Middle Ages to the 16th century. With the transfer of the capital of the Empire from Rome to Byzantium (330), building

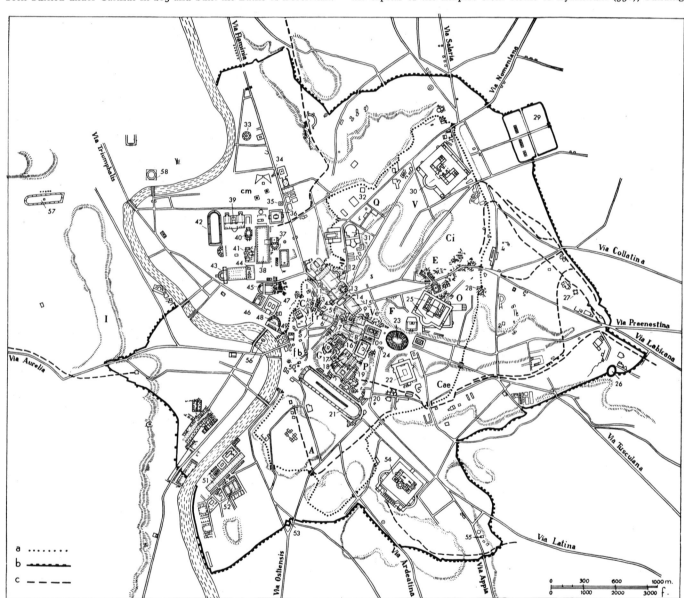

Rome, plan of the ancient city. *Key*: (*a*) Servian walls; (*b*) Aurelian walls; (*c*) aqueducts. Hills and principal sites of historical and topographic interest: (*P*) Palatine; (*G*) Germalus; (*Ve*) Velian; (*C*) Capitoline; (*Q*) Quirinal; (*V*) Viminal; (*E*) Esquiline; (*Ci*) Cispian; (*O*) Oppian; (*F*) Fagutal; (*Cae*) Caelian; (*A*) Aventine; (*I*) Janiculum; (*fr*) Forum Romanum; (*fb*) Forum Boarium; (*cm*) Campus Martius; (*s*) Subura. Principal monuments; (1) Arx Capitolina; (2) Temple of Jupiter Capitolinus; (3) Tabularium; (4) Curia; (5) Basilica Aemilia; (6) Basilica Julia; (7) Temple of Vesta and Atrium of the Vestals; (8) Arch of Titus; (9) Basilica of Maxentius; (10) Temple of Venus and Roma; (11) Forum of Caesar with Temple of Venus Genetrix; (12) Trajan's Forum with the Basilica Ulpia; (13) Forum of Augustus with Temple of Mars Ultor; (14) Forum of Nerva with Temple of Minerva; (15) Forum Pacis; (16) Domus Tiberiana; (17) Temple of Palatine Apollo; (18) Domus Flavia; (19) Hippodrome and Domus Augustana; (20) Septizonium; (21) Circus Maximus; (22) Temple of Divus Claudius; (23) Flavian Amphitheater (Colosseum); (24) Arch of Constantine; (25) Baths of Trajan and the area of the Domus Aurea (Golden House of Nero); (26) Castrensian Amphitheater; (27) Nymphaeum of the Horti Liciniani (so-called "Temple of Minerva Medica"); (28) Auditorium of Maecenas; (29) Castra Praetoria; (30) Baths of Diocletian; (31) Baths of Constantine; (32) Capitolium Vetus; (33) Mausoleum of Augustus; (34) Ara Pacis Augustae; (35) Column of Marcus Aurelius; (36) Temple of Divus Hadrian; (37) Temple of Isis; (38) Septa Julia; (39) Baths of Nero; (40) Pantheon; (41) Baths of Agrippa; (42) Stadium of Domitian; (43) Theater and Portico of Pompey; (44) sacred area of the Largo Argentina; (45) Theater and Crypt of Balbus; (46) area of the Circus Flaminius; (47) Portico of Octavia; (48) Theater of Marcellus; (49) edifices of the Forum Holitorium; (50) Ara Maxima of Hercules; (51) Emporium and Portico of Aemilia; (52) Horrea Galbana; (53) Pyramid of Gaius Cestius; (54) Baths of Caracalla; (55) Tomb of the Scipios; (56) Temple of Aesculapius on the island in the Tiber; (57) Circus of Nero; (58) Hadrian's Mausoleum (*prepared by F. Castagnoli*).

activity in Rome diminished, especially in regard to civil structures, while the closing of the temples and the proscription of pagan cults marked the beginning of the slow decay of the most important monuments of classical antiquity. At the same time the earliest forms of Christian monumental architecture evolved. The Basilica of St. John Lateran (311–14) became the new center of Rome. The baptistery and the episcopal palace were built alongside St. John Lateran. The episcopal palace (destroyed in the 14th century) was the seat of the bishops of Rome until the Avignon exile. In the 4th century, the imposing basilicas of St. Peter's and S. Paolo fuori le Mura, similar in structure to St. John Lateran, were erected outside the Aurelian walls. The various districts of the city, while preserving the character of the Roman period, were enriched with churches (e.g., S. Maria Maggiore, S. Sabina, S. Clemente; PL. 176; III, PL. 477), some of which were adapted from earlier structures (e.g., Sta Croce in Gerusalemme, SS. Cosma e Damiano). Besides the longitudinal plan, which was used for churches of this type, the central plan was employed for funerary monuments and baptisteries and only later for churches (e.g., S. Stefano Rotondo).

Many of the monuments of the 4th and 5th centuries have undergone radical transformations and remodelings through the centuries. Of the three Constantinian basilicas with atrium, nave and four side aisles, and transept, St. John Lateran was completely remodeled in the 17th century (see below); Old St. Peter's (326) was demolished in the 16th century, but remains of the original structure exist below the present church. S. Paolo fuori le Mura (314) burned in 1823 but was reconstructed according to the original plan. There are remains of 5th-century mosaics in the triumphal arch; the apse mosaics are of the Venetian school (13th century); there is an Easter candlestick by Niccolò d'Angelo and Pietro Vassalletto (III, PL. 477) and a ciborium by Arnolfo di Cambio (1285; I, PL. 462). The 4th century saw the construction of several churches: S. Lorenzo, rebuilt in 578 (see below); S. Balbina, adapted from the house of the consul L. Fabius Cilo (restored 1930); S. Pudenziana, totally altered in its structure but preserving the original 5th-century apse mosaic (restored; III, PL. 305); and S. Marco. The major central-plan structure of the 4th century is the Mausoleum of S. Costanza with an annular vault decorated with mosaics, paired columns supporting the dome, and 5th-century mosaics in the ambulatory apses. Notwithstanding the Visigothic (410) and Vandal (455) devastations, church construction continued: S. Maria Maggiore, completely rebuilt (432–40) on the site of the preceding Constantinian edifice, preserves the original structure of nave and two side aisles without a transept, the contemporaneous nave and triumphal-arch mosaics, and 13th-century apse and mosaics by Torriti (X, PL. 188); façade mosaics by Filippo Rusuti (13th century; for remodelings, 16th–18th cent., see below). SS. Cosma e Damiano (527), rebuilt from the Bibliotheca Pacis, retains the original apse mosaic (III, PL. 305; X, PL. 178). The Baptistery of St. John Lateran is an octagonal structure preceded by an apsed pronaos with 5th-century mosaics; two orders of columns, one above the other, support the ambulatory roof and drum of the dome; chapels (461–68) dedicated to John the Baptist and John the Evangelist as well as the 7th-century Oratory of S. Venanzio, with original mosaics, surround the octagon. S. Sabina (5th. cent.; restored in 1936–38) consists of nave and two side aisles with ancient columns and Corinthian capitals supporting semicircular arches; the church has preserved the original wooden door with carved panels and the mosaic decoration of the inner façade, while the *schola cantorum* has been reconstructed with marble panels of the 7th–11th century; the apse contains 16th-century frescoes by the Zuccaris (who also frescoed the Chapel of S. Giacinto). The Cappella d'Elci was added in the 17th century, and the adjacent monastery is of the 13th century. A central plan was used for S. Stefano Rotondo (4th–6th cent., IX, PL. 39), which has a double circular ambulatory of ancient columns supporting architraves (16th-cent. frescoes by N. Circignani and A. Tempesti). S. Maria Antiqua was built in part of a structure of Domitian on the Palatine (II, PL. 445).

Rome so declined (partly because of malaria and plague) that building activity was reduced to sporadic undertakings. The steps Theodoric had taken to preserve the ancient monuments proved futile, for the Byzantine-Ostrogothic wars devastated the city and put an end to the last vestiges of ancient Roman civil organization. The Church took the place of the Empire, and new constructions were sponsored by the popes. S. Agnese, dating from the 7th century (restored many times), was built with narthex, galleries, capitals with impost blocks, and apse mosaics showing Byzantine influence. S. Giorgio in Velabro, perhaps 7th century, is preceded by a portico and has a nave with two side aisles, ancient columns, a ciborium by the Cosmati, and apse frescoes attributed to P. Cavallini (restored). S. Maria in Cosmedin was enlarged in the 8th century with apses at the heads of the aisles (perhaps the first such design in Rome), a crypt (III, PL. 49), a mosaic, iconostasis, ciborium (III, PL. 479), *schola cantorum*, and Cosmati pavement. The Con-

stantinian Basilica of S. Lorenzo fuori le Mura (330) and the Church of the Vergine (8th cent.) were joined to make a single structure, to which was added in the 12th century the campanile and in 1220 the portico of the Vassallettos (13th-cent. frescoes); the episcopal furnishings and Cosmati episcopal throne (III, PL. 483) are of the 12th–13th century, and the adjacent cloister is of the 12th century. In 705–07 Pope John VII restored and decorated with frescoes S. Maria Antiqua; in 757–67 Pope Paul I also embellished the church. The frescoes represent the most interesting examples of early medieval painting in Rome (II, PL. 445).

With the restoration of the Empire and the crowning of Charlemagne (800) Rome partly regained its position as capital. There was some increase in building activity, limited for the most part to the restoration of ancient monuments. Paschal I, besides donating valuable treasures to many churches, was responsible for several important restorations, including that of S. Prassede (822), with 9th-century mosaics in the apse (X, PL. 182). The Chapel of S. Zenone (817–24) is completely covered with Byzantinizing mosaics. The Santini tomb is by G. L. Bernini, the Alano tomb by A. Bregno; there are frescoes by G. Cesari (IX, PL. 303) and Federico Zuccari. S. Maria in Domnica (remodeled in 15th cent., restored in 19th cent.; Renaissance portico attributed to Peruzzi) preserves the original apse mosaics. S. Cecilia in Trastevere (817–24; restored several times) has its original plan of nave and two aisles, an apse mosaic, a ciborium by Arnolfo di Cambio (I, PL. 461), the Forteguerri monument by Mino da Fiesole, and a sculpture of St. Cecilia by S. Maderno. In the convent are frescoes by Cavallini (III, PLS. 107, 109); the cloister is Romanesque. Between 822 and 844 Pope Gregory VII reconstructed S. Marco; transformed through the centuries, it has preserved a 9th-century apse mosaic. There are works of Palma Giovane and C. Maratti, the Pesaro tomb by A. Canova, and a statue of St. Mark the Evangelist by Melozzo da Forlì. In the sacristy is a tabernacle by Mino da Fiesole; a porch and loggia were added to the façade in the 15th century. Pope Gregory VII also restored SS. Nereo e Achilleo, but a major redecoration completed in 1597 (including frescoes by N. Circignani) changed all but the plan of nave and two side aisles and the triumphal arch mosaic. S. Teodoro, also restored by Gregory VII, was rebuilt in the 18th century with a semicircular atrium by C. Fontana; the church contains the original apse mosaic (perhaps 8th–9th cent.; restored) and works of Bacciccio and F. Zuccari.

With the Saracen raids in the middle of the 9th century, conditions in the city again became difficult. By way of defense, Pope Leo IV erected the fortifying wall (848–52) around the Vatican. The political disorder that followed the end of the Carolingian dynasty, the first contests among the German rulers for the possession of the imperial crown, and the subsequent controversy over investiture made the 10th century a period of enormous decline for Rome, which was to be devastated in 1084 by the Normans. Only toward the end of the 11th century did relative peace and internal reorganization permit the repair of religious buildings and the construction of new ones. The Romanesque style did not achieve in Rome the success it enjoyed in other Italian cities, and Rome maintained the Early Christian tradition of basilican construction. After the Norman destruction, Pope Paschal II rebuilt the Church of the SS. Quattro Coronati (1111; restored, 1914), with a fortifying wall. The broad apse (frescoed by Giovanni da San Giovanni, 1630) survives from the original structure; the cloister is 13th-century, as is the separate structure of the Chapel of S. Silvestro with its contemporaneous frescoes of the Roman school. S. Clemente (PL. 176) was rebuilt on the ruins of the 4th-century basilica (which had been remodeled in the 7th–9th cent.). The earlier structure was later adapted as a lower church (containing 9th–12th-cent. frescoes). The building recalls 4th-century churches in its design of atrium preceded by a small porch and portal; preserved within are an apse mosaic imitating that in the pronaos of the Lateran Baptistery, a 12th-century *schola cantorum* with some 6th-century elements (III, PL. 477), the 15th-century Chapel of S. Caterina with frescoes by Masolino (IX, PL. 378), the Roverella monument by A. Bregno and Giovanni Dalmata, and works by S. Conca, F. Trevisani, B. Luti, P. L. Ghezzi, and G. Chiari. In 1113 S. Crisogono was erected (on a 5th-cent. foundation; remodeled in the 17th cent.) with nave and two side aisles, separated by columns supporting architraves, and a Cosmati pavement; the campanile is contemporaneous, and the Cappella del Sacramento was designed by Bernini. S. Maria in Trastevere (12th cent.) has 12th–13th-century mosaics on the façade, mosaics on the arch and vault of the apse (ca. 1140; PL. 177), and a mosaic band by P. Cavallini (III, PLS. 105, 106, 110); the nave and two side aisles are separated by ancient columns. SS. Giovanni e Paolo, built on the remains of the saints' house (of which survive some rooms with mural decorations), has its original atrium, portal, and campanile. The apse frescoes are by N. Circignani (late 17th cent.). The interior, with nave and two aisles, was completely rebuilt in the 18th century.

During the 12th and 13th centuries the Cosmati (q.v.) were active in Rome. They were responsible for much of the liturgical furnishings of medieval Roman churches (e.g., S. Cesareo, III, PL. 482; S. Balbina; S. Saba). They were likewise responsible for the construction of the cloisters of St. John Lateran (13th cent.) and S. Paolo fuori le Mura (III, PL. 480) and the portico of S. Lorenzo fuori le Mura. In S. Maria in Aracoeli (nave and two aisles; rebuilt in 1250; remodeled several times) are fine examples of their work in the two pulpits, the pavement, two tombs in the choir, and the tomb of Cardinal Acquasparta (with frescoes by P. Cavallini).

Campaniles were characteristic Romanesque structures in Rome. Their design was derived from Lombard architecture, but the Roman examples were enlivened with polychrome ceramic panels and inlaid marble. Such campaniles include those of S. Maria Maggiore (which

was reconstructed in the 14th cent.), SS. Giovanni e Paolo, Sta Croce in Gerusalemme, S. Francesca Romana, S. Lorenzo fuori le Mura, S. Marco, S. Maria in Cosmedin, S. Giorgio in Velabro, and S. Silvestro in Capite. Important civil edifices of the period include the Milizie, Conti, Colonna, Millina, Grillo, and Capocci towers; the Casa di Cola di Rienzo (or dei Crescenzi), the Palazzetto degli Anguillara (restored), and the Casa dei Mattei; and the monasteries of SS. Quattro Coronati, S. Clemente, and S. Paolo fuori le Mura.

In the 14th century, when the popes were in Avignon, there was little new construction in Rome. A part of the Church of S. Maria in Aracoeli, with its impressive stairway, belongs to this period. Within the church is the Bufalini Chapel by Pinturicchio and the tomb slab of G. Crivelli by Donatello. The Gothic Church of S. Maria sopra Minerva has a nave and two aisles (completed 15th cent.).

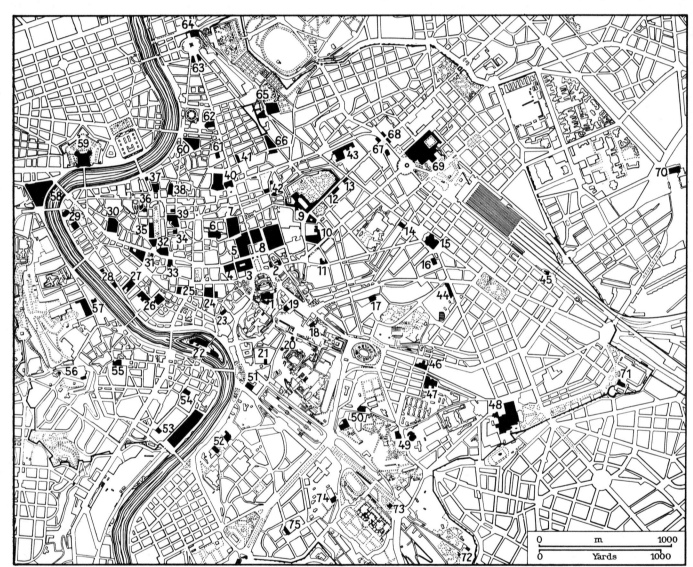

Rome, plan of the center with principal monuments. (1) Piazza del Campidoglio, Capitoline Museums, and S. Maria in Aracoeli; (2) S. Maria di Loreto and SS. Nome di Maria; (3) Palazzo Venezia and S. Marco; (4) the Gesù; (5) Palazzo Doria Pamphili and S. Maria in Via Lata; (6) S. Maria sopra Minerva; (7) Collegio Romano and S. Ignazio; (8) Piazza SS. Apostoli and Odescalchi, Salviati, and Colonna palaces; (9) Quirinal and Consulta palaces; (10) Palazzo Pallavicini-Rospigliosi; (11) Villa Aldobrandini; (12) S. Andrea al Quirinale; (13) S. Carlo alle Quattro Fontane; (14) S. Pudenziana; (15) S. Maria Maggiore; (16) S. Prassede; (17) S. Pietro in Vincoli; (18) SS. Cosma e Damiano; (19) SS. Luca e Martina; (20) S. Maria Antiqua and S. Teodoro; (21) S. Giorgio in Velabro; (22) S. Bartolomeo and Hospital of S. Giovanni di Dio; (23) S. Maria in Campitelli; (24) Palazzo Mattei and S. Caterina dei Funari; (25) S. Carlo ai Catinari; (26) Palazzo Spada and Monte di Pietà; (27) Palazzo Farnese; (28) Palazzo Falconieri and S. Eligio degli Orefici; (29) S. Giovanni dei Fiorentini and Palazzo Sacchetti; (30) S. Maria in Vallicella and the Oratorio dei Filippini; (31) Palazzo della Cancelleria, S. Lorenzo in Damaso, and Museo Barracco; (32) Palazzo Braschi (Museo di Roma) and Palazzo Massimo alle Colonne; (33) S. Andrea della Valle; (34) S. Ivo alla Sapienza; (35) Piazza Navona, Palazzo Pamphili and S. Agnese in Agone; (36) S. Maria della Pace and S. Maria dell'Anima; (37) Palazzo Altemps and Museo Napoleonico; (38) S. Agostino; (39) S. Luigi dei Francesi and Palazzo Madama; (40) Montecitorio and Chigi palaces; (41) S. Silvestro in Capite; (42) Trevi Fountain, SS. Vincenzo e Anastasio, and Palazzo Carpegna; (43) Palazzo Barberini (Galleria Nazionale); (44) Palazzo Brancaccio (Museo Nazionale d'Arte Orientale); (45) S. Bibiana; (46) S. Clemente; (47) SS. Quattro Coronati; (48) St. John Lateran and Baptistery; (49) S. Stefano Rotondo and S. Maria in Domnica; (50) SS. Giovanni e Paolo and S. Gregorio Magno; (51) S. Maria in Cosmedin; (52) S. Sabina and SS. Bonifacio e Alessio; (53) S. Francesco a Ripa and the Istituto Romano di S. Michele; (54) S. Cecilia in Trastevere; (55) S. Maria in Trastevere; (56) S. Pietro in Montorio and fountain of the Acqua Paola; (57) Farnesina and Palazzo Corsini; (58) Church and Hospital of Sto Spirito; (59) Castel S. Angelo; (60) Palazzo Borghese; (61) S. Lorenzo in Lucina; (62) S. Carlo al Corso; (63) S. Maria dei Miracoli and S. Maria di Montesanto; (64) S. Maria del Popolo; (65) Piazza di Spagna, Spanish Steps, and Church of the Trinità dei Monti; (56) Palazzo di Propaganda Fide and S. Andrea delle Fratte; (67) S. Susanna and S. Bernardo; (68) S. Maria della Vittoria and fountain of the Acqua Felice; (69) S. Maria degli Angeli and Museo Nazionale Romano; (70) S. Lorenzo fuori le Mura; (71) Sta Croce in Gerusalemme; (72) S. Giovanni a Porta Latina and S. Giovanni in Oleo; (73) SS. Nereo e Achilleo; (74) S. Balbina; (75) S. Saba.

Within the church (restored 19th cent.) is the Cappella dell'Annunziata by C. Maderno, with a panel by Antoniazzo Romano; the Carafa Chapel, with frescoes by Filippino Lippi; an adjacent room, decorated by Raffaellino del Garbo; works by M. Venusti; the statue of Christ carrying the Cross by Michelangelo; the Tornabuoni tomb by Mino da Fiesole; sculptures by C. Mariani, E. Ferrata, Raffaelle da Montelupo, N. Cordier; the Chapel of S. Domenico, after designs by C. Marchionni; and the Raggi monument by Bernini.

In the 15th century Rome's medieval aspect was not substantially modified. Most building activity was concerned with the restoration and repair of monuments, although some new structures were erected. The Palazzo Venezia, begun in 1452, is medieval in character, while the unfinished inner portico is fully Renaissance, in fact Albertian, in style. The small adjacent palace, erected in the same period, was dismantled in 1911 and rebuilt farther back to make room for the monument to Victor Emmanuel II. Under Pope Sixtus IV there was an initial effort to solve problems of city planning (e.g., confluence at Ponte S. Angelo of the roads delimiting the so-called "Curial City"; construction of Ponte Sisto connecting the wards of Regola and Trastevere). Among the churches that were built or reconstructed in this period is S. Maria del Popolo, a medieval structure rebuilt toward the end of the 15th century (PL. 205); basilican interior with nave and two aisles, altered by Bernini, and with sculptures by A. Bregno, frescoes by Pinturicchio (Della Rovere Chapel, 1485–89); apse and choir by Bramante (II, PL. 344), funerary monuments by A. Sansovino (IV, PL. 455), A. Bregno, Mino da Fiesole; stained glass by G. de Marcillat; Cerasi Chapel, with paintings by A. Carracci and Caravaggio (Conversion of St. Paul; III, PL. 34; Martyrdom of St. Peter); Chigi Chapel, designed by Raphael (mosaics after his cartoons; X, PL. 192), with statues by Lorenzetto and Bernini (I, PL. 381), altarpiece by Sebastiano del Piombo; Cybo Chapel by C. Fontana with altar painting by C. Maratti. S. Agostino (attributed to B. Pontelli or J. da Pietrasanta) has a nave and two aisles. There is a Madonna del Parto by J. Sansovino, a fresco of Isaiah by Raphael, and a Madonna dei Pellegrini by Caravaggio. The main altar is by Bernini, and there are works by Guercino and Lanfranco. Of the 15th-century structure of S. Giovanni Battista dei Genovesi only the cloister survives, attributed to B. Pontelli. S. Pietro in Montorio, with nave and side chapels, contains works by Sebastiano del Piombo, G. Vasari, N. Circignani, Daniele da Volterra, D. van Baburen, and Bernini and pupils. S. Maria della Pace (see below) has been renovated several times. S. Pietro in Vincoli was refurbished by Meo del Caprina, with façade preceded by a portico (as in the Church of SS. Apostoli; see below; interior (altered in 18th cent.), with nave and two aisles; the broad nave is adorned with columns taken from earlier buildings; tomb of Julius II, designed by Michelangelo, with the Moses. Secular structures include the Palazzo della Cancelleria (ca. 1485), perhaps by A. Bregno. To Bramante are ascribed the courtyard and the adjacent Church of S. Lorenzo in Damaso. The Palazzo del Governo Vecchio, the Palazzo dei Penitenzieri (1481), and the courtyards of the Cesi and Cesarini-Sforza palaces also date from this period, as do the Casa del Burcardo and the Hospital of Sto Spirito, with façade attributed to Rossellino (restored), flanking sections by B. Pontelli (much altered), and portal by A. Bregno.

d. The modern period. In the early 16th century, with the building of the new St. Peter's (see below, *Vatican City*), papal patronage, and the presence of several great artists, including Bramante (q.v.), the new Renaissance appearance of Rome gradually emerged. Julius II opened new streets (e.g., Via Giulia, Via della Lungaretta) flanked by palaces of the nobility. Bramante, who directed the work at St. Peter's, also built the Tempietto in the courtyard of S. Pietro in Montorio (I, PL. 305) and the courtyard of S. Maria della Pace; he began the Vatican buildings (Cortile di S. Damaso and design for the Belvedere; II, PLS. 345, 346) and the Palazzo dei Tribunali (never completed) in Via Giulia. Other structures built on Via Giulia at this time include the Palazzo Sacchetti (room frescoed by F. Salviati), Palazzo Falconieri (loggia toward the Tiber added in the 17th cent. by Borromini), the rear portion of Palazzo Farnese (loggia by G. della Porta), built by A. da Sangallo the Younger and completed by Michelangelo (gallery frescoed by Annibale Carracci and assistants; I, PL. 381; II, PL. 194; III, PL. 86).

S. Giovanni dei Fiorentini is by J. Sansovino, A. da Sangallo the Younger, and G. della Porta, with façade by A. Galilei (1734) and apse after designs by Michelangelo. S. Eligio degli Orefici, by Raphael, is of rectangular plan and has been much altered. S. Maria di Loreto is by A. da Sangallo the Younger, 1507–15, and G. del Duca, 1582. Sto Spirito in Sassia (A. da Sangallo the Younger, 1540) has a façade by O. Mascherino. S. Giuseppe dei Falegnami (G. della Porta, 1538) was built on the ruins of the Mamertine Prison. Between Via Giulia and the present Corso Vittorio Emanuele arose the Piccola Farnesina (now the Museo Barracco), attributed to A. da Sangallo the Younger. The Palazzo Spada (1540) was decorated by

G. Mazzoni, who may also have been the architect (courtyard; IX, PL. 311, and perspective gallery by Borromini). The Palazzo Vidoni (formerly Caffarelli) has a 19th-century façade; the rear portion is after Raphael's design. The Palazzo Massimo alle Colonne has a curved façade (B. Peruzzi; XI, PL. 121). The Palazzo Altemps was begun by B. Peruzzi and completed by M. Longhi the Elder. The Palazzo Alberini was designed by G. Romano. The Palazzo Salviati on Via della Lungara is by Nanni di Baccio Bigio.

In addition to his work on the new construction of St. Peter's, Michelangelo (q.v.) undertook urban planning schemes, including the arrangement of the Piazza del Campidoglio. Michelangelo also built the Porta Pia (partly rebuilt in the 19th cent.) and adapted part of the Baths of Diocletian as the Basilica of S. Maria degli Angeli (1563–66; altered by Vanvitelli). In the area of Via Flaminia and on the opposite side of the Tiber arose the first of the Roman villas. The Farnesina was built for Agostino Chigi (1508–11, by B. Peruzzi; XI, PLS. 119, 120; gallery with frescoes by G. Romano and Giovanni da Udine after cartoons by Raphael, who painted the famous *Galatea*; III, PL. 392; X, PL. 250; Salone delle Prospettive by B. Peruzzi; XI, PL. 118; *Marriage of Alexander and Roxana* by Sodoma; fresco by Sebastiano del Piombo). The Villa Madama was built after designs by Raphael (continued by A. da Sangallo the Younger, unfinished; stuccoes by Giovanni da Udine and frescoes by Giulio Romano; PL. 206). Also of this period is the Villa of Julius III, or Villa Giulia (1551–53; by B. Ammanati and Vignola, court redone by Vasari), together with a country house built by Vignola for the pope, and S. Andrea in Via Flaminia (I, PL. 305), by the same architect. The Palazzina of Pius IV (IX, PL. 313) and the Casino of Pius IV (see below, *Vatican City*) are by P. Ligorio (1558). The Villa Medici on the Pincio is by A. Lippi (IX, PL. 312). Among Renaissance structures are the Ruspoli, Caetani, and Firenze palaces and the Collegio Romano, all by B. Ammanati; Palazzo della Sapienza (now Archivio di Stato; G. della Porta); Palazzo Sciarra (F. Ponzio); Palazzo del Quirinale (PL. 207; F. Ponzio, O. Mascherino, D. Fontana, altered by Bernini; the long wing by F. Fuga); Palazzo Chigi (G. della Porta; completed by C. Maderno and F. della Greca; *salone* by R. Stern); Palazzo Borghese (PL. 207; M. Longhi the Elder; nymphaeum by C. Rainaldi).

Religious structures: S. Giovanni Decollato (frescoes and oil paintings by N. Circignani, F. Salviati, J. del Conte, G. Vasari). The Gesù (1568, by Vignola) was the archetype of countless churches built during the Counter Reformation; single aisle with side chapels; dome over the crossing of the arms of the Latin-cross plan (frescoed ceiling by Bacciccio; altar of St. Ignatius by A. Pozzo). S. Maria in Vallicella, or Chiesa Nuova, was built after a design by M. Longhi the Elder (with façade by F. Rughesi; nave and side aisles; frescoes by P. da Cortona and works of Rubens, C. Ferri, C. Rainaldi, Cosimo Fancelli, and G. Muziano). S. Luigi dei Francesi has a façade by G. della Porta (1589; Contarelli Chapel decorated by G. Cesari, with paintings by Caravaggio; frescoes by Domenichino). S. Caterina dei Funari has a façade by G. Guidetti (1564) and work by Annibale Carracci, F. Zuccari, G. Muziano, and S. Pulzone. S. Paolo alle Tre Fontane was built in the 5th century, rebuilt in the Gothic period, and remodeled by G. della Porta. S. Maria dell'Orto may have been built after a design by G. Romano (façade variously attributed: Vignola, M. Longhi the Younger). S. Nicola in Carcere was built by G. della Porta on an earlier structure. Numerous fountains were erected at this time, including the Fontana delle Tartarughe (PL. 206) and the fountain in Piazza Campitelli.

At the end of the 16th century, Sixtus V resumed the work of urban planning. Domenico Fontana created a vast plan for streets to connect the basilicas and principal monuments visited by religious pilgrims, with an eye to emphasizing perspective views of the monuments (streets joining St. John Lateran, S. Maria Maggiore, and Trinità dei Monti). The ideal center of this scheme was the Basilica of S. Maria Maggiore. Squares were adorned with obelisks and fountains (e.g., the squares in front of St. Peter's and St. John Lateran; X, PL. 151). The first monumental fountains at the ends of aqueducts appeared (e.g., Acqua Felice, D. Fontana, 1585–87). Churches took on monumental proportions, and palaces repeated Renaissance forms, which were amplified in an early baroque manner (e.g., Lateran Palace, by D. Fontana; Monte di Pietà, etc.). Churches erected in this period were S. Susanna (1603; C. Maderno), with frescoes by B. Croce; S. Maria della Vittoria (1605; C. Maderno), with façade by G. B. Soria [Cornaro Chapel with Bernini's *Ecstasy of St. Theresa* (II, PL. 273), and Guercino's *Trinity*]; S. Sebastiano, by F. Ponzio and G. Vasanzio (J. van Santen); S. Gregorio Magno (G. B. Soria), and the nearby chapels of S. Andrea, S. Silvia, and S. Barbara, with frescoes by Domenichino, G. Reni, and A. Viviani. S. Andrea della Valle was begun by P. P. Olivieri (1591) and completed by C. Maderno (1650), with façade by C. Rainaldi (1663). The interior has a Latin-cross plan, dome frescoes by G. Lanfranco, pendentives and conch of the apse by Domenichino, apse by M.

Preti; works of A. Raggi. S. Maria dei Miracoli and S. Maria di Montesanto, in Piazza del Popolo, both circular with dome and columned pronaos, are by C. Rainaldi. S. Maria in Campitelli (C. Rainaldi; I, PL. 405) has works of L. Giordano, Bacciccio, and S. Conca. Bernini (see below, *Vatican City*), was responsible for the colonnade of St. Peter's Square (I, PL. 403); S. Bibiana, reconstruction of an Early Christian building (1625; within, statue of St. Bibiana by Bernini; II, PL. 272; frescoes by P. da Cortona); S. Andrea al Quirinale, of elliptical plan; the layout of Piazza Navona with the Fountain of the Four Rivers and the Fontana del Moro (I, PL. 402); the planning of the internal façade of the Porta del Popolo (1655; the outer façade had been rebuilt earlier by Vignola). Borromini (q.v.) created the façade of S. Agnese in Agone (II, PL. 306; central-plan interior begun by Rainaldi; sculptures by E. Ferrata, D. Guidi, A. Raggi, M. Caffà; frescoes by Bacciccio and C. Ferri); S. Carlo (Carlino) alle Quattro Fontane (1640), with an elliptical plan (I, PL. 420; II, PLS. 303–05, 308); S. Ivo alla Sapienza (1660), on a star plan with dome and spiral lantern (I, PL. 420; II, PLS. 301, 302, 312); S. Andrea delle Fratte (1656; crossing tower and campanile; single aisle, several times altered, with statues by Bernini; façade by G. Valadier); the Oratorio dei Filippini (1637–62; II, PL. 307); S. Giovanni in Oleo; the Palazzo di Propaganda Fide (II, PLS. 308, 311); S. Maria dei Sette Dolori (II, PL. 309); and S. Maria delle Fornaci. Borromini also did the interior remodeling of St. John Lateran (II, PLS. 309, 310), with nave and four aisles, piers along the nave enclosing the columns of the earlier church, and niches with statues [apse mosaic, 19th-century restoration of the original by J. Torriti; monument of Cardinal Annibaldi by Arnolfo di Cambio; fragment of Giotto's fresco of Boniface VIII; Corsini Chapel by A. Galilei, who also built the façade (1736)]. Also noteworthy was the activity of Pietro da Cortona (q.v.): S. Maria in Via Lata (1660), with remains of an earlier building and 8th-century frescoes; SS. Luca e Martina (1640; I, PL. 419), erected on the site of the 8th-century Church of S. Martina; the baroque façade of the 15th-century S. Maria della Pace, with columned, semicircular pronaos (I, PLS. 381, 419), and octagonal interior surmounted by a dome and preceded by a nave [frescoes by Raphael (Sibyls) and B. Peruzzi (Ponzetti Chapel; XI, PL. 119); paintings by O. Gentileschi, B. Peruzzi, F. Albani; works of C. Fancelli; main altar by C. Maderno, with sculptures by S. Maderno]. Other 17th-century buildings: S. Carlo al Corso (dome attributed to P. da Cortona; modified project of O. and M. Longhi the Younger). SS. Vincenzo e Anastasio (1630; M. Longhi the Younger). S. Ignazio, a Jesuit church, with façade by A. Algardi; interior design by O. Grassi, with ceiling frescoes by A. Pozzo (*Triumph of St. Ignatius*; II, PL. 172), who also created the immense canvas simulating a dome and designed the altars of the transept. S. Marcello, with façade by C. Fontana (PL. 223) and reliefs by A. Raggi; single-aisle interior designed by J. Sansovino; with frescoes by Perino del Vaga and assistants. S. Francesca Romana (S. Maria Nova), with façade by C. Lombardi (1615), built on an earlier building of which there remains the apse mosaic (12th cent.) and the campanile. S. Isidoro, by C. Bizzaccheri (1620), with works by C. Maratti, A. Sacchi, and others. Church of Gesù e Maria by C. Maderno, with single aisle covered by a barrel vault, the Bolognetti sepulchral monuments by F. Aprile, F. Cavallini, M. Maille (Maglia); façade by G. Rainaldi. S. Francesco a Ripa, with façade by M. de' Rossi; Altieri Chapel with statue of the Blessed Lodovica Albertoni by G. L. Bernini (II, PL. 279). S. Maria in Via (first built in 10th cent., several times rebuilt); plan by G. della Porta; façade by M. Longhi the Elder and C. Rainaldi (1595–1670). S. Martino ai Monti, retaining the original basilican structure; rebuilt after designs probably by Pietro da Cortona, façade of 1676, frescoes by G. Dughet (G. Poussin). S. Carlo ai Catinari, by R. Rosati (1611), façade by G. B. Soria; Greek-cross plan interior, altered in the 19th century. S. Caterina da Siena, with façade by G. B. Soria (1630). SS. Domenico e Sisto, by Vincenzo della Greca.

Secular architecture exhibited decorative and scenographic effects; squares were adorned with fountains and obelisks. In addition to the fountains in Piazza Navona, Bernini (q.v.) was responsible for the Triton Fountain (Piazza Barberini) and the two Fountains of the Bees (Vatican; Piazza Barberini). Also of this period is the monumental fountain of the Acqua Paola by F. Ponzio (PL. 207) and that of Ponte Sisto. Numerous palaces were built: Palazzo Barberini (II, PL. 134), begun by C. Maderno in 1625 with the collaboration of Borromini and completed by Bernini, with later additions. Palazzo Pamphili in Piazza Navona (G. Rainaldi, 1650, with frescoes by P. da Cortona). Palazzo di Montecitorio (II, PLS. 269, 271), on designs by Bernini, completed by C. Fontana, now the seat of the Chamber of Deputies. Palazzo Misciattelli, by G. A. dei Rossi (1660). Palazzo Carpegna, built in the 16th century but enlarged in the 17th century, now the seat of the Accademia di S. Luca. Palazzo Verospi (C. Rainaldi, considerably altered, with a frescoed loggia by F. Albani). Palazzo Altieri (G. A. dei Rossi; frescoes by C. Ma-

ratti). • Palazzo Salviati on the Corso (C. Rainaldi, 1662). Palazzo Pallavicini-Rospigliosi, by G. Vasanzio (J. van Santen; 1603), enlarged by C. Maderno; Casino with fresco of Aurora by G. Reni (PL. 218). Villa Borghese (PL. 445), with Casino by Vasanzio. Villa Ludovisi (Casino dell'Aurora frescoed by Guercino; II, PL. 197). Villa Doria Pamphili (Casino by A. Algardi, after 1650).

In the 18th century, the baroque scenographic style persisted until the establishment of neoclassicism. The Spanish Steps of the Trinità dei Monti (A. Specchi, F. De Sanctis, 1725), with the layout of Piazza di Spagna (Palazzo di Spagna, A. Specchi). Trevi Fountain (II, PL. 137; N. Salvi; reworking of an earlier project by Bernini). Architectural setting of Piazza S. Ignazio, by Raguzzini (the architect of the Hospital and Church of S. Gallicano). Layout of the Porta di Ripetta (destroyed). Monumental undertakings of the 18th century included the façade of S. Maria Maggiore (F. Fuga, 1743) and of St. John Lateran (A. Galilei, 1736). Façade of Sta Croce in Gerusalemme (II, PL. 138; D. Gregorini), with baroque interior by P. Passalacqua; apse fresco attributed to Antoniazzo Romano; works of C. Giaquinto, C. Maratti, Quinones tomb by J. Sansovino. SS. Apostoli, with 15th-century portico (upper part modified by C. Fontana in 1702), façade by G. Valadier (1827); nave and two aisles, baroque interior with ceiling fresco by Bacciccio, monument to Clement XIV by Canova. S. Maria dell'Orazione e Morte, with façade by F. Fuga, works of G. Lanfranco, C. Ferri, P. L. Ghezzi. SS. Nome di Maria (A. Deriset; 1738). S. Maria in Monticelli (M. Sassi; 1715). S. Maria in Aquiro, with façade completed by P. Camporese the Elder (1744–45), interior by Francesco da Volterra (1590; restored), works of C. Mariani, C. Saraceni, S. van Honthorst. Church of S. Maddalena, with façade by G. Sardi (1735), interior several times altered, by C. Fontana, G. A. de' Rossi, C. Quadri; Latin-cross plan with elliptical nave; works by S. Conca, Bacciccio, P. Bracci. S. Filippo Neri (F. Raguzzini). S. Maria della Quercia (F. Raguzzini). SS. Trinità dei Pellegrini (F. De Sanctis, 1723). SS. Marcellino e Pietro (reconstructed by G. Theodoli, 1725). SS. Celso e Giuliano (reconstructed by C. de Dominicis, 1736). SS. Trinità degli Spagnoli, by M. Rodrigues dos Santos and G. Sardi (1741), elliptical interior with frescoes by C. Giaquinto. Palaces: Palazzo della Consulta (F. Fuga, 1737; II, PLS. 138, 139). Palazzo Corsini (F. Fuga; completed after 1751). Palazzo Cenci-Bolognetti (F. Fuga). Palazzo Doria Pamphili; façade on the Corso by G. Valvassori (1734), façade in Via del Plebiscito by P. Amelli (1744), façade in Piazza del Collegio Romano by A. Del Grande (1652–71). Palazzo Simonetti (A. Specchi, 1727). Palazzo Rondanini (now the Banca dell'Agricoltura). Villa Albani (C. Marchionni, PL. 442, 445; X, PL. 211). Late 18th-century palaces include Palazzo Braschi (PL. 226), Palazzo della Stamperia, and the Spinola, Lovatelli, Del Drago, Corsetti, and Colonna palaces (PL. 105).

The revived interest in antiquity, the excavation of the Roman Forum, and the activities of Winckelmann, Mengs, and Piranesi (S. Maria del Priorato, X, PL. 267) created a new taste for spatial clarity. The architect G. Valadier represents this tendency. He was responsible for the new arrangement of Piazza del Popolo (1816–20; II, PL. 134) and of the adjacent Pincio, where he built the Casino Valadier; embankments on the Tiber; the restoration of the Arch of Titus; the façade of S. Pantaleo; S. Rocco. The interior organization of the Casino and Villa Borghese, with the Temples of Diana and Aesculapius, was supervised by A. Asprucci (X, PL. 209). In this period Via Nazionale was opened, the Milvian bridge restored, and the Column of the Immaculate Conception erected (L. Poletti, 1856). Palazzo Wedekind (P. Camporese, 1838), with Ionic pronaos (columns from Veio, anc. Veii). Twin palaces of Piazza del Popolo (G. Valadier). Teatro Argentina (P. Camporese).

In the second half of the 19th century (particularly after 1870, when Rome became the capital of Italy) several unfortunate restorations were undertaken (e.g., S. Paolo fuori le Mura), and new structures were built in the "Umbertino" style (so called for King Humbert I). Rome suffered the loss of whole neighborhoods (e.g., the Aracoeli area), which were destroyed to make room for monuments, squares, and official buildings in the new style (e.g., Piazza dell'Esedra, with buildings by G. Koch, 1885, and the Naiad Fountain, by M. Rutelli, 1901). The embankments of the Tiber were given their final forms. Monument to Victor Emmanuel II (X, PL. 157; by G. Sacconi, with sculpture by A. Zannelli and E. Chiaradia). Palazzo di Giustizia (G. Calderini). Ministero delle Finanze (R. Canevari, 1871); Ministero dell'Agricoltura e Foreste (O. Cavagnari), Ministero della Pubblica Istruzione (C. Bazzani), Ministero di Lavori Pubblici (P. Passerini), Ministero degli Interni (M. Manfredi), Ministero di Grazia e Giustizia (P. Piacentini). Cassa di Risparmio (A. Cipolla), Banca d'Italia (G. Koch). Palazzo delle Esposizioni (P. Piacentini). Galleria Nazionale d'Arte Moderna in Valle Giulia (C. Bazzani). Palazzo Margherita (G. Koch; now U. S. Embassy). Opera House, rebuilt by M. Piacentini, who completed the reconstruction in 1960. In the period between the two world wars new residential sections

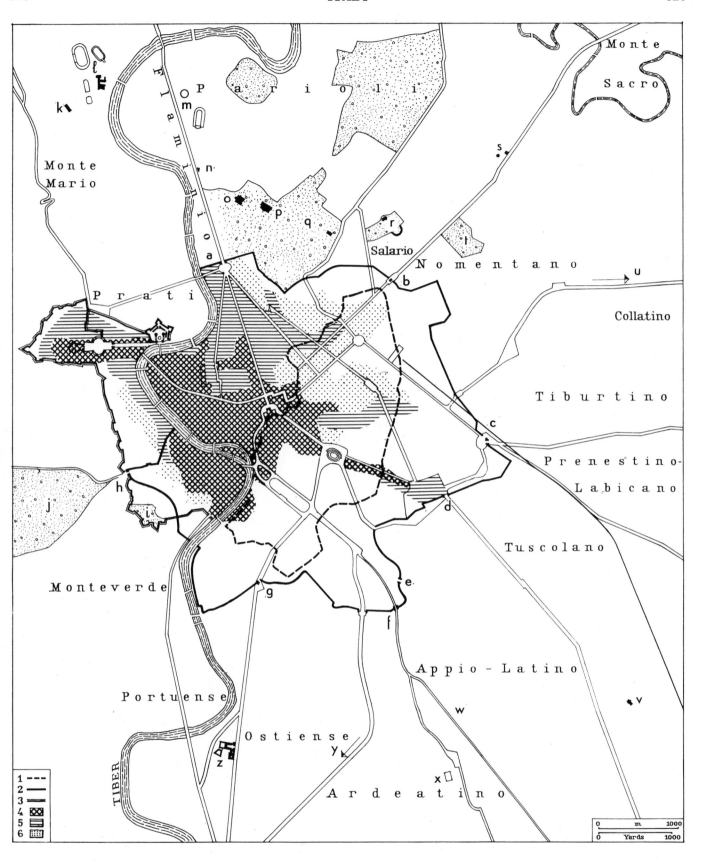

Rome, with walls, urban expansion, and principal monuments outside the center. *Key*: (1) Course of the Servian walls; (2) course of the Aurelian walls; (3) 16th-century walls. Expansion of the city: (4) 12th century; (5) end of 16th century; (6) 1870. Principal monuments: (*a*) Porta del Popolo; (*b*) Porta Pia; (*c*) Porta Maggiore; (*d*) Porta S. Giovanni; (*e*) Porta Latina; (*f*) Porta S. Sebastiano; (*g*) Porta S. Paolo; (*h*) Porta S. Pancrazio; (*i*) Villa Sciarra; (*j*) Villa Doria Pamphili; (*k*) Villa Madama; (*l*) Foro Italico; (*m*) Stadio Flaminio and Palazzetto dello Sport; (*n*) S. Andrea; (*o*) Villa Giulia; (*p*) Galleria Nazionale d'Arte Moderna; (*q*) Villa Borghese; (*r*) Villa Albani; (*s*) S. Agnese fuori le Mura and S. Costanza; (*t*) Villa Torlonia; (*u*) to Tivoli; (*v*) S. Stefano; (*w*) Via Appia Antica (the Appian Way); (*x*) memorial park of the Fosse Ardeatine; (*y*) to the E.U.R. area; (*z*) S. Paolo fuori le Mura.

and public structures were erected. The arrangement of the Stazione Termini and surrounding area (F. Mazzoni) was completed in 1952 by E. Montuori, A. Vitellozzi, and others; the striking façade of the station was decorated by A. Tot. Other outstanding 20th-century structures include the Stadio Flaminio (A. and P. L. Nervi) and the Palazzetto dello Sport (P. L. Nervi and A. Vitellozzi; V, PL. 117).

Museums and galleries: Museo Pigorini. Museo di Villa Giulia (Etruscan finds). Museo Nazionale Romano (collection of Greek and Roman sculpture and painting). Museo Barracco (Etruscan, Egyptian, Roman, Greek, and Assyrian sculpture). Capitoline Museum (and Palazzo dei Conservatori; ancient sculpture collections; painting gallery, with works of 15th–17th cent.). Museo della Civiltà Romana (documentary material, models, plans). Galleria Nazionale (in the Barberini and Corsini palaces; Italian and foreign paintings of 14th–18th cent.). Galleria Borghese (works by Bernini, Caravaggio, Titian; ancient sculpture). Galleria Nazionale d'Arte Moderna (large collection of modern art). Galleria Spada (17th-cent. paintings; Roman remains). Museo di Palazzo Venezia (13th–17th cent. paintings; enamels, ceramics, arms and armor, tapestries, small bronzes, 13th–18th cent. Italian sculpture). Museo Nazionale di Castel S. Angelo (including armory and painting gallery). Accademia di S. Luca (Italian and Flemish 16th–17th cent. painting; 17th–19th-cent. sculpture of the Roman school). Galleria Comunale d'Arte Moderna (in Palazzo Braschi; 19th- and 20th-cent. Roman artists). Museo di Roma (in Palazzo Braschi; documents and works related to the topography, history, and life of Rome from the Middle Ages to the present). Museo Nazionale d'Arte Orientale (Iranian, Chinese, Indian, Tibetan, Nepalese, and Siamese art). Calcografia Nazionale (print collection, 17th–20th cent.). Gabinetto Nazionale delle Stampe. Museo Numismatico della Zecca. Collezioni dell'Istituto Italiano di Numismatica. Museo Nazionale delle Arti e Tradizioni Popolari (Italian folk art and crafts). Galleria Colonna (15th–18th-cent. paintings). Galleria Doria Pamphili (14th–18th-cent. paintings; Roman sculpture; bronzes and marbles by Algardi and Bernini). Galleria Pallavicini (15th–18th-cent. paintings). Museo Torlonia (Greek originals, Roman copies, Roman portraits, Etruscan finds). Museo Africano (ethnological collections).

e. Vatican City. Surrounded by a bastioned wall, except for the section bounded by Bernini's colonnade, Vatican City comprises two main areas: one occupied by gardens, the other by St. Peter's Basilica and the palaces. In Roman Imperial times the site was occupied by the Circus of Nero and gardens. From the time of Nero, the area north of the Circus (including the present site of St. Peter's) was a cemetery, which has been partly excavated. Tradition has it that St. Peter is buried there. Constantine the Great erected the first Basilica of St. Peter's (324–49), thereby concealing the tombs, which were for the most part pagan. Old St. Peter's was a five-aisled basilica preceded by a large atrium. The basilica was partially reconstructed in 1452 by Pope Nicholas V, after a design by Bernardo Rossellino (Latin-cross with dome over the crossing). In the early 16th century, under Julius II, the western end was demolished by Bramante (q.v.), who was commissioned to build the new basilica. New St. Peter's was begun in 1506, with a Greek-cross plan and a dome modeled after that of the Pantheon. With the death of the pope (1513) and the architect (1514), construction was interrupted at the piers of the crossing. The work was resumed later and successively modified by some of the greatest artists of the age. Bramante was succeeded by Raphael (q.v.), who, together with Fra Giovanni Giocondo and Giuliano da Sangallo, proposed a Latin-cross plan (1516). Baldassarre Peruzzi proposed a return to the Greek-cross plan (1520; IV, PL. 189), A. da Sangallo the Younger favored a Latin-cross plan, and Michelangelo reproposed the Greek-cross plan surmounted by a central dome, articulated with ribs and fenestrated. Michelangelo's work (IV, PL. 193; IX, PL. 541) was continued after his death by Vignola and Pirro Ligorio. The dome was completed by G. della Porta and D. Fontana, who altered Michelangelo's plan. C. Maderno, who was entrusted with the completion of the basilica, returned to the Latin-cross idea, but he did not alter the parts already completed. Maderno built the façade (1607–14), articulated by six gigantic columns surmounted by an attic supporting statues of Christ and the apostles (II, PL. 269). Bernini (q.v.) was responsible for the plan of the square in front of St. Peter's (I, PL. 403). He added two projecting lateral wings to the church. From the lateral wings he extended elliptical colonnades (1657–63) of four rows of Doric columns and piers, surmounted by statues. The colonnades enclose the square, in the center of which is the monolithic obelisk of red granite, the ancient *meta* of the Circus of Nero. The obelisk is flanked by two fountains (one by C. Maderno, the other erected under Clement XI). The portico which was to have closed the ellipse of the colonnades was never executed. Access to the Apostolic palaces is obtained by the Scala Regia, designed by Bernini (II, PL. 270). Five doors give access to the church: the main door, a work of Filarete, has six

sculptured panels and was designed for the old basilica; one of the side doors is by G. Manzù (1962). In the vestibule, facing the main door is Giotto's (q.v.) *Navicella*. The interior has three aisles, divided by grooved piers with Corinthian pilasters, and a broad transept and lateral chapels. Four pentagonal piers, constructed by Bramante and consolidated by Michelangelo, support the four arches on which the dome rests. The piers were embellished by Bernini with four niches, in which there are statues of saints (Bernini; II, PL. 275; A. Bolgi, F. Mochi, and F. Duquesnoy; II, PL. 168). Beneath the dome, which is decorated with mosaics after cartoons of the Cavalier d'Arpino (X, PL. 192), is the *confessio* (after designs by C. Maderno), where Canova's kneeling statue of Pius VI is placed. Above the *confessio* is the bronze baldacchino of Bernini, supported by four twisted columns and surmounted by a diadem-shaped element (II, PL. 267; IV, PL. 400). At the back of the apse is the Cathedra Petri, by Bernini (II, PLS. 135, 275, 280). Among the papal funerary monuments, the following are of particular importance: Innocent VIII (A. Pollaiuolo); Paul III (Guglielmo della Porta; PL. 208; IX, PL. 365); Urban VIII (II, PL. 275) and Alexander VII (both by Bernini; II, PL. 167); Leo XI (A. Algardi); Clement XIII (A. Canova); and Pius VII (Thorvaldsen). Other works include the bronze statue of St. Peter, sometimes considered a work of the 4th or 5th century but perhaps of the 13th (Arnolfo di Cambio?), and Michelangelo's *Pietà* (IX, PL. 526). The sacristy, by C. Marchionni, was begun in 1776 and consists of a great octagonal hall and several other rooms, including the Cappella dei Beneficiati, with a marble tabernacle by Donatello (1432). The Chapel of the Sacrament (Cappella del Sacramento) has an altar and a bronze ciborium by Bernini (IX, PL. 169), a screen by Borromini (II, PL. 219), and the *Trinity* by Pietro da Cortona. In the Vatican Grottoes are preserved fragments of the Early Christian church, mosaics (X, PL. 99), sarcophagi, and medieval inscriptions; noteworthy are the sarcophagus of Junius Bassus (I, PL. 301; II, PL. 282) and the tombs of Boniface VIII (Arnolfo di Cambio) and Sixtus IV (A. Pollaiuolo). Beneath the Grottoes is the Roman cemetery and the tomb assumed to be that of St. Peter.

From the basilica to the walls of the Porta Angelica extend the

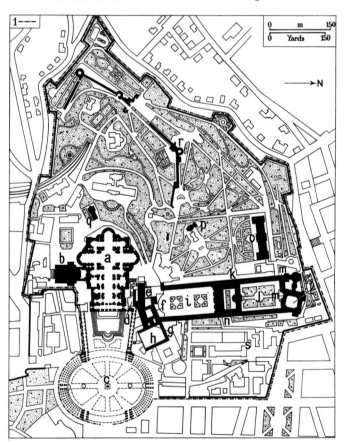

Vatican City. *Key*: (1) Territorial boundary. Monuments and museums: (*a*) St. Peter's; (*b*) Sacristy; (*c*) Piazza S. Pietro and Bernini's colonnade; (*d*) Scala Regia; (*e*) Sistine Chapel; (*f*) Borgia Apartment and the Stanze of Raphael; (*g*) Logge of Raphael; (*h*) Cortile di S. Damaso; (*i*) Cortile del Belvedere; (*j*) Cortile della Pigna; (*k*) Library and Galleria delle Carte Geografiche; (*l*) Museo Pio-Clementino and the Octagonal Courtyard; (*m*) Museo Gregoriano and Museo Gregoriano Egizio; (*n*) Museo Chiaramonti and Galleria Lapidaria; (*o*) Pinacoteca; (*p*) Casino of Pius IV; (*q*) S. Stefano; (*r*) remains of walls of Leo IV; (*s*) Roman cemetery.

complex of buildings begun by Nicholas V (1455), enlarged and restored by later popes. The Scala Regia gives access to the Aula delle Benedizioni (Maderno) and to the Sala Regia (designed by A. da Sangallo the Younger and frescoed by various artists; IX, PL. 294). The Pauline Chapel contains frescoes by Michelangelo (IX, PLS. 534, 537). In the Sistine Chapel are frescoes by Perugino, S. Botticelli, Piero di Cosimo, Cosimo Rosselli, L. Signorelli, D. Ghirlandajo, Pinturicchio, and Bartolommeo della Gatta (1482); on the rear wall, the *Last Judgment* by Michelangelo (IX, PLS. 533, 536); on the ceiling, scenes by Michelangelo of the Creation, sibyls, and prophets (III, PL. 312; IX, PLS. 528, 535, 538); Cosmati pavement. Frescoed by Raphael are the Stanza della Segnatura (I, PL. 307; III, PL. 209; IV, PL. 230), Stanza d'Eliodoro, Stanza dell'Incendio (executed in large part by G. Romano and G. F. Penni), and Stanza di Costantino (completed after the death of Raphael by G. Romano and G. F. Penni). Adjacent to the Sistine Chapel are the Chapel of Nicholas V with frescoes by Angelico (I, PL. 270) and the loggias begun by Bramante and continued by Raphael, who supervised the decoration. The Borgia Apartment is almost entirely frescoed by Pinturicchio. The exedra of the Belvedere (II, PL. 346), by Bramante, was modified by P. Ligorio. The only work of Bramante surviving intact is a spiral ramp in a tower of the Belvedere (II, PL. 345). In the Vatican Gardens are the Rotunda and the Casino of Pius IV (PL. 429). Vatican Museums (for the most part in the palaces): Pinacoteca (including collection of Italian primitives, Leonardo, Raphael, Caravaggio, Poussin); Museo Pio-Clementino (X, PLS. 210, 212) and Museo Chiaramonti, with ancient sculpture and inscriptions; Museo Gregoriano Etrusco and Museo Gregoriano Egizio; Library (important codices); Museo Sacro (frescoes of the Augustan Age).

Some extraterritorial buildings were ceded to the Papal State in the Concordat of 1929. Among the more important structures in Rome are the Lateran Palace (including the museums), the basilicas of S. Paolo and S. Maria Maggiore, and the Palazzo della Cancelleria. In Castel Gandolfo are the Palazzo Pontificio and the Villa Barberini.

SOURCES: C. Hülsen, Nomenclator topographicus, app. to H. Kiepert and C. Hülsen, Formae urbis antiquae, 2d ed., Berlin, 1912; R. Valentini and G. Zucchetti, Codice topografico della città di Roma, 4 vols., Rome, 1940–53; G. Lugli, Fontes ad topographiam veteris urbis Romae pertinentes, 4 vols., Rome, 1952 ff.; G. Carettoni, A. M. Colini, L. Cozza, and G. Gatti, La pianta marmorea di Roma antica, Rome, 1960.

BIBLIOG. *Antiquity: a. Manuals*: H. Jordan and C. Hülsen, Topographie der Stadt Rom im Altertum, 2 vols. in 3, Berlin, 1871–1907; O. Gilbert, Geschichte und Topographie der Stadt Rom im Altertum, 3 vols., Berlin, 1883–90; R. Lanciani, The Ruins and Excavations of Ancient Rome, London, 1897; R. Lanciani, Storia degli scavi di Roma . . . , 4 vols., Rome, 1902–12; S. B. Platner and T. Ashby, A Topographical Dictionary of Ancient Rome, London, 1929; G. Lugli, I monumenti antichi di Roma e suburbio, 4 vols., Rome, 1930–40; G. Lugli, Roma antica: Il centro monumentale, Rome, 1946; H. Bloch, I bolli laterizi e la storia edilizia romana, Rome, 1947; L. Homo, Rome impériale et l'urbanisme dans l'antiquité, Paris, 1951; F. Castagnoli, Roma antica, in Topografia urbanistica di Roma, Bologna, 1958, pp. 1–186 (bibliog.); E. Nash, Pictorial Dictionary of Ancient Rome, 2 vols., New York, 1961–62. *b. Maps*: R. Lanciani, Forma urbis Romae, Milan, 1893–1901 (1:1000 scale); G. Lugli and I. Gismondi, Forma urbis Romae imperatorum aetate, Novara, 1949. *c. Origins*: G. Pizna, Monumenti primitivi di Roma e di Lazio antico, MALinc, XV, 1905, cols. 5–844; S. M. Puglisi and others, Gli abitatori primitivi del Palatino attraverso le testimonianze archeologiche e le nuove indagini stratigrafiche sul Germalo, MALinc, XLI, 1951, cols. 1–146; E. Gjerstad, Early Rome, 3 vols., Lund, 1953–60; H. Müller-Karpe, Vom Anfangs Roms, Heidelberg, 1959; R. Bloch, The Origins of Rome, London, New York, 1960. *d. The pomerium and Augustan regions*: M. Labrousse, Le "pomerium" de la Rome impériale, Mél, LIV, 1937, pp. 165–99; A. von Gerkan, Grenzen und Grösse der vierzehn Regionen Roms, BJ, CIL, 1949, pp. 5–65. *e. Walls, aqueducts, and the Tiber*: I. A. Richmond, The City Walls of Imperial Rome, Oxford, 1930; G. Säflund, Le mura di Roma repubblicana (Acta Inst. Rom. Regni Sueciae, I), Lund, 1932; E. B. van Deman, The Buildings of the Roman Aqueducts, Washington, 1934; T. Ashby, The Aqueducts of Ancient Rome, Oxford, 1935; J. Le Gall, Le Tibre fleuve de Rome dans l'antiquité, Paris, 1953. *f. Studies of regions and monuments*: A. Merlin, L'Aventin dans l'antiquité (Bib. École Fr., XCVII), Paris, 1906; E. De Ruggiero, Il Foro Romano, Rome, 1913; F. E. Brown, The Regia, MAARome, XII, 1935, pp. 67–88; G. E. Rizzo, Le pitture della "casa dei Grifi," Rome, 1936; G. E. Rizzo, Le pitture della "casa di Livia," Rome, 1936; D. E. L. Haynes and P. E. D. Hirst, Porta Argentariorum, London, 1939; H. P. L'Orange and A. von Gerkan, Der spätantike Bildschmuck des Kostantinbogens, Berlin, 1939; A. M. Colini, Il tempio di Apollo, BCom, LXVIII, 1940, pp. 9–40; A. M. Colini, Aedes Veiovis inter arcem et Capitolium, BCom, LXX, 1942, pp. 5–56; A. M. Colini, Stadium Domitiani, Rome, 1943; P. Grimal, Les jardins romains (Bib. École Fr., CLV), Paris, 1943; A. M. Colini, Storia e topografia del Celio nell'antichità (MPontAcc, 3d ser., VII), Vatican City, 1944; M. Pallottino, L'arco degli Argentari, Rome, 1946; F. Castagnoli, Il Campo Marzio nell'antichità, MemLinc, 8th ser., I, 1946–48, pp. 91–193; G. Lugli, I monumenti minori del Foro Romano, Rome, 1947; G. Caraffa, Il tempio detto di Vesta nel Foro Boario, Rome, 1948; G. Moretti, Ara Pacis Augustae, 2 vols., Rome, 1948; E. Brödner, Untersuchungen an den Caracalla-thermen, Berlin, 1951; G. Lugli, Il tempio di Apollo Aziaco e il gruppo augusteo sul Palatino, Atti Acc. Naz. di S. Luca, N.S., I, 1951–52, p. 26 ff.; A. Calza

Bini, Il teatro di Marcello, B. Centro. S. storie arch., VII, 1953, pp. 1–44; C. Caprino and others, La Colonna di Marco Aurelio, Rome, 1955. *g. Catacombs*: see CATACOMBS, bibliog.

Medieval and modern Rome: Mirabilia urbis Romae (13th cent.), ed. G. Parthey, Berlin, 1869 (Eng. trans., F. M. Nichols, London, Rome, 1889); Fra Mariano da Firenze, Itinerarium urbis Romae, ca. 1518 (ed. E. Bulletti, Rome, 1931); F. Albertini, Mirabilia Romae, Lyon, 1520; M. Mercati, Degli obelischi di Roma, Rome, 1589; P. Totti, Ritratto di Roma moderna, Rome, 1645; G. B. Falda, Nuovo teatro delle fabbriche di Roma, 4 vols., Rome, 1669; G. B. Falda, Li giardini di Roma, Rome, 1670; F. Titi, Studio di pittura . . . di Roma, Rome, 1674; G. B. Falda, Fontane di Roma, Rome, 1675; G. D. Francini, Descrizione di Roma, Rome, 1677; J. von Sandrart, Des alten und neuen Roms grosser Schau-Platz, Nürnberg, 1685; Roma sacra antica e moderna figurata e divisa in tre parti, Rome, 1687; Descrizione di Roma moderna, Rome, 1697; D. De Rossi, Studio di architettura civile, 3 vols., Rome, 1701–21; F. Dasseine, Beschryving van oud en nieuw Rome, Amsterdam, 1704; Roma ampliata e rinnovata o sia Nuova Descrizione dell'antica e moderna città di Roma, Rome, 1750; F. Titi, Descrizione delle pitture, sculure e architetture . . . in Roma, Rome, 1763; N. Roisecco, Roma antica e moderna, Rome, 1765; R. Venuti, Accurata e succinta descrizione di Roma moderna, 2 vols., Rome, 1767; M. Vasi, Itinerario istruttivo di Roma, Rome, 1774; P. Rossini, Il Mercurio errante delle grandezze di Roma tanto antiche che moderne, 10th ed., 2 vols., Rome, 1776; M. Prunetti, L'osservatore delle Belle Arti in Roma, Rome, 1808–11; A. Nibby, Itinerario istruttivo di Roma e delle sue vicinanze, 2 vols., Rome, 1824; C. J. Bunsen and others, Beschreibung der Stadt Rom, Stuttgart, Tübingen, 1829; G. Melchiorri, Guida metodica di Roma e suoi contorni, Rome, 1834; A. Nibby, Roma nell'anno 1838, Rome, 1838; P. Le Tarouilly, Les édifices de Rome moderne, 3 vols., Paris, 1840–50; F. Tosi, ed., Raccolta di monumenti sacri e sepolcrali, Rome, 1842; C. J. Bunsen, Die Basiliken des christlichen Rom, 2 vols., Munich, 1842–43; E. Pistolesi, Descrizione di Roma e suoi contorni, Rome, 1846; A. Nibby, Analisi storico-topografica antiquaria dei dintorni di Roma, 3 vols., Rome, 1849; C. Zimmermann, Rom und seine Umgebung, Leipzig, 1862; J. R. Rahn, Über den Ursprung des christlichen Central und Kuppelbaues, Leipzig, 1866; F. Schultz, Profanbauten des Mittelalters in Rom und Umgebung, ZfbK, IV, 1869, pp. 50–54, 285–87; I. Guidi, La descrizione di Roma nei geografi arabi, Arch. Soc. romana storia patria, I, 1877, pp. 173–218; R. Lanciani, Sulle vicende edilizie di Roma, Rome, 1878; G. B. De Rossi, Le piante iconografiche e prospettiche di Roma anteriori al XVI secolo, Rome, 1879; P. Adinolfi, Roma nell'età di mezzo, 2 vols., Rome, 1881; A. J. C. Hare, Walks in Rome, 11th ed., 2 vols., London, 1883; E. Müntz, Les antiquités de la ville de Rome aux XIVe, XVe et XVIe siècles, Paris, 1886; L. Duchesne, Note sur la topographie de Rome au moyen âge, Mél, VI, 1886, pp. 25–37, VII, 1887, pp. 217–43, 387–413, IX, 1889, pp. 346–62, X, 1890, pp. 126–49, 225–50, XXII, 1902, pp. 3–22, 385–428, XXXIV, 1914, pp. 307–56, XXV, 1915, pp. 3–13; M. Armellini, Le chiese di Roma dal secolo IV al XIX, 2d ed., Rome, 1891; G. Schiaparelli, Alcuni documenti dei "Magistri aedificiorum Urbis" (sec. XIII e XIV), Arch. Soc. romana storia patria, XXV, 1902, pp. 5–60; E. Steinmann, Rom in der Renaissance, 2d ed., Leipzig, 1902; G. Lafenestre and E. Richtenberg, La peinture en Europe: Rome, Les musées, les palais, les collections particulières, Paris, 1905; F. Ehrle, Le piante maggiori di Roma dei secoli XVI–XVII, Rome, Vatican City, 1908; A. L. Frothingham, The Monuments of Christian Rome from Constantine to the Renaissance, New York, 1908; K. Escher, Barock und Klassizismus, Leipzig, 1910; J. A. Orbaan, Sixtine Rome, London, 1910; A. Calza Roma moderna: La trasformazione edilizia, Milan, 1911; G. Magni, Il Barocco a Roma nell'architettura e nella scultura decorativa, 3 vols., Turin, 1911–13; D. Angeli, Roma, 2 vols., Bergamo, 1912–14; A. Colasanti, Case e palazzi barocchi di Roma, Milan, 1912; H. Bergner, Rom in Mittelalter, Leipzig, 1913; H. Bergner, Das barocke Rom, Leipzig, 1914; T. Ashby, A Topographical Study of Rome in 1581, London, 1916; M. Guidi, Le fontane barocche di Roma, Zürich, 1917; J. P. Kirsch, Die römischen Titelkirchen im Altertum, Paderborn, 1918; A. Muñoz, Roma al tempo di Dante, Milan, 1921; B. Blasi, Vie, piazze, ville di Roma nel loro valore storico e topografico, Rome, 1923; P. Fedele, Aspetti di Roma nel Trecento, Roma, I, 1923, pp. 107–22; D. Frey, Beiträge zur Geschichte der römischen Barockarchitektur, Vienna, 1924; O. Kaemmel, Rom und die Campagna, Leipzig, 1925; W. Gaunt, Rome: Past and Present, London, 1926; C. Hülsen, Note di topografia romana antica e medievale, 2 vols., Rome, 1926–27; A. Tani, Le acque e le fontane di Roma, Turin, 1926; A. Serafini, Torri campanarie di Roma e del Lazio nel medioevo, Rome, 1927; P. Spezi, Bibliografia metodico-analitica delle chiese di Roma, Rome, 1928; G. Giovannoni, Le vicende edilizie di Roma, Architettura, IX, 1929–30, pp. 49–60; A. Muñoz, Roma barocca, Milan, 1929; D. Angeli, Le chiese di Roma, Rome, 1930; L. Schudt, Le Guide di Roma: Materialen zu einer Geschichte der römischen Topographie, Vienna, 1930; C. Cecchelli, Edicole stradali, Capitolium, VII, 1931, pp. 437–67; A. Bianchi, Il centro di Roma, la sistemazione del Foro Italico e le nuove vie del Mare e dei Monti, Architettura, XII, 1933, pp. 137–56; A. Proia and P. Romano, Roma nel Cinquecento, 3 vols., Rome, 1933–36; C. Hülsen, Saggio di bibliografia ragionata delle piante di Roma dal 1557 al 1748, Florence, 1935; Ministero della Pubblica Istruzione, Elenco degli edifici monumentali: Roma, 8 vols., Rome, 1935–38; B. M. Apollonj Ghetti, Il quartiere del Rinascimento in Roma, Rome, 1937; A. Bianchi, Le vicende urbanistiche della Roma napoleonica, L'Urbe, II, 1937, pp. 18–29; R. Krautheimer, Corpus basilicarum christianarum Romae, Vatican City, 1937 ff. (Eng. and Ital. eds.); T. H. Fokker, Roman Baroque Art, London, 1938; C. Cecchelli, Aspetti di Roma medievale, L'Urbe, IV, 1939, 4, pp. 3–23, 8, pp. 1–16; U. Gnoli, Topografia e toponomastica di Roma medievale e moderna, Rome, 1939; P. Spezi, Le chiese di Roma nei XX secoli di Cristianesimo: Topografia, toponomastica, Bibliografia, Rome, 1940; M. Armellini, Le chiese di Roma dal secolo IV al XIX, Rome, 1941 (new ed. by C. Cecchelli); R. Battaglia, L'Aventino nella rinascita e nel barocco, Rome, 1942; P. Tomei, L'architettura a Roma nel '400, Rome, 1942; A. Muñoz,

Studi sull'architettura barocca in Roma, L'Urbe, VIII, 9–10, 1943, pp. 3–16; P. Pecchiai, Acquedotti e fontane di Roma nel Cinquecento, Rome, 1944; L. Callari, Le fontane di Roma, Rome, 1945; F. Hermanin, L'arte in Roma dal secolo VIII al XIV, Bologna, 1945; M. Zocca, Sistemazioni urbanistiche minori del Settecento in Roma, Capitolium, XX, 1945, pp. 22–30; Istituto di studi romani, ed., Le chiese di Roma, 91 vols., Rome, 1946–61; J. Babelon, L'art au siècle de Léon X, Lausanne, 1947; G. Marchetti Longhi, L'Aventino nel Medioevo, Rome, 1947; E. Amadei, I ponti di Roma, Rome, 1948; F. W. Deichmann, Frühchristliche Kirchen in Rom, Basel, 1948; A. De Rinaldis, L'arte in Roma dal Seicento al Novecento, Bologna, 1948; F. Fasolo, Le chiese di Roma nel '700, Rome, 1949; P. Magri, La pianta dei Parioli: Sistemazione urbanistica, Capitolium, XXV, 1950, pp. 247–52; L. von Matt, Die Kunst in Rom, Zürich, 1950; L. Bruhns, Die Kunst der Stadt Rom, Vienna, 1951; B. Bello, Le strade di Roma, Rome, 1952; M. Piacentini and F. Guido, Le vicende edilizie di Roma dal 1870 ad oggi, Rome, 1952; F. Sapori, Architettura in Roma, 1901–1950, Rome, 1953; P. Zucker, Space and Movement in High Baroque City Planning, J. Soc. Arch. Historians, XIV, 1955, pp. 8–13; C. Elling, Rom: Arkitekturens liv fra Bernini til Thorwaldsen, Copenhagen, 1956; G. Ferrari, Early Roman Monasteries, Vatican City, 1957; C. D'Onofrio, Le fontane di Roma, Rome, 1957; T. Magnuson, Studies in Roman Quattrocento Architecture, Stockholm, 1958; A. Milani, Le sinagoghe del vecchio ghetto di Roma, S. romani, VI, 1958, pp. 138–59; A. La Padula, Roma 1809–1814: Contributo alla storia dell'urbanistica, Rome, 1958; C. Galassi Paluzzi, Chiese romane, 2 vols., Rome, 1959–61; E. Lavagnino, G. R. Ansaldi, and L. Salerno, Altari barocchi in Roma, Rome, 1959; R. Vieilliard, Recherches sur les origines de la Rome chrétienne, Rome, 1959; Il Settecento a Roma (exhibition cat.), Rome, 1959 (bibliog.); E. Mâle, The Early Churches of Rome, London, Chicago, 1960; V. Mariani, Roma barocca, Genoa, 1960; V. Mariani, Roma medievale, Genoa, 1960; R. Melis, L'E. U. R. nella Roma d'oggi, Capitolium, XXXV, 2, 1960, pp. 19–23; L. Piccinato, Problemi urbanistici di Roma, Milan, 1960.

Vatican City: C. Cecchelli, Il Vaticano, Milan, Rome, 1927; B. M. Apollonj Ghetti and others, Esplorazioni sotto la Confessione di San Pietro in Vaticano, Vatican City, 1951; L. Gessi, La città del Vaticano, Rome, 1954; J. Toynbee and J. Ward Perkins, The Shrine of St. Peter, London, 1956; R. U. Montini, Le tombe dei papi, Rome, 1957; M. Guarducci, I graffiti sotto la Confessione di San Pietro in Vaticano, Vatican City, 1959; M. Guarducci, La tomba di San Pietro, Rome, 1959; C. Pichon, Le Vatican, Paris, 1960; A. Schiavo, San Pietro in Vaticano, Rome, 1960.

Piedmont and the Aosta Valley. The western part of the Po Valley (with the adjacent area of the Alps) was first inhabited by Ligurian peoples and, later, also by Celts. The region formed a border area between Italy and Gaul and subsequently between Italy and France. (Aosta now constitutes an autonomous region, within the Italian republic, and is distinct from Piedmont.) The area preserves imposing monumental remains of the Roman Imperial period. In the Middle Ages various feudal lords dominated the area until the Duchy of Savoy was established. Many modern towns have medieval origins. Romanesque and Gothic art flourished in the cities, abbeys, and castles; the castles are a particular characteristic of Aosta. Since the Renaissance, art in Piedmont has been rather close to that of Lombardy. The patronage of the house of Savoy favored a particular development of architecture during the baroque period, especially in Turin. The area has also witnessed important 19th- and 20th-century artistic developments.

BIBLIOG. C. M. Audiberto, Regiae Villae poetice descriptae, Turin, 1711; L. Aubert, La Vallée d'Aoste, Paris, 1861; C. Promis, Le antichità di Aosta, Turin, 1862; C. Promis, Gli ingegneri militari che operarono e scrissero in Piemonte dal 1300 al 1650: notizie, Turin, 1871; J. B. De Tillier, Historique de la Vallée d'Aoste, Aosta, 1880; A. Manno and V. Promis, Bibliografia storica degli stati della monarchia di Savoia, 10 vols., Turin, 1884–1934; T. Tibaldi, Storia della valle d'Aosta, 4 vols., Turin, 1900–09; P. L. Bruzzone, L'arte nel Monferrato, Alessandria, 1907; C. Errera, L'Ossola, Bergamo, 1908; C. Bobbio, Le chiese del Canavese, Ivrea, 1910; G. Lobetti-Bodoni, Castelli e monumenti del Saluzzese, Saluzzo, 1911; A. Chevalley, Gli architetti, l'architettura e la decorazione delle ville piemontesi del XVIII secolo, Turin, 1912; E. Pais, La romanizzazione della Val d'Aosta, RendLinc, 5th ser., XXV, 1916, pp. 3–27; A. Baudi di Vesme, Per le fonti della storia dell'arte piemontese, Rome, 1922; P. Barocelli, La strada e le costruzioni romane dell'Alpis Graia, Mem. Acc. Sc. di Torino, 2d ser., LXVI, 5, 1924; P. Barocelli, Sepolcreti novaresi della prima età del ferro, BPI, XLVI, 1926, pp. 175–94; XLVII, 1927, pp. 64–92; A. Baudi di Vesme, L'arte alla corte di Emanuele Filiberto e di Carlo Emanuele I, Atti Soc. piemontese Archeol. e Belle Arti, XI, 1928, pp. 93–254; G. Brocherel, Castelli valdostani, Aosta, 1930; C. Bricarelli, L'influenza di Roma nell'architettura barocca in Piemonte, Rome, 1931; A. E. Brinckmann, Theatrum novum Pedemontii, Düsseldorf, 1931; G. C. Argan, Per una storia dell'architettura piemontese, L'Arte, XXXVI, 1933, pp. 391–97; P. Barocelli, Il Piemonte dalla capanna neolitica ai monumenti di Augusto, Turin, 1933; P. Barocelli, Ricerche e studi sui monumenti romani della Val d'Aosta (Aosta, VI, sup.), Ivrea, 1934; M. Bernardi, Arte piemontese, Turin, 1937; C. Nigra, Torri, castelli e case-forti del Piemonte dal 1000 al secolo XVI, Novara, 1937; M. Bernardi, Spirito e forme dell'arte piemontese dal Trecento al Settecento, Padua, 1938; C. de Bray and G. Ricci, Urbanistica e architettura minore nel Medioevo in Piemonte, Torino, XVIII, 5, 1938, pp. 7–15; M. Bernardi, Castelli Piemontesi, Turin, 1939; C. de Danilowicz, Una carta topografica dell'arte rustica in Piemonte, Lares, XI, 1940, pp. 18–22; C. Carducci, Notiziario delle scoperte e ritrovamenti archeologici del Piemonte, B. Soc. Piemontese Archeol. e Belle Arti, VI–VII, 1952–53, pp. 11–32; A. M. Brizio, L'architettura barocca in Piemonte, Turin, 1953; I. Beretta, La romanizzazione della Val d'Aosta, Varese, Milan, 1954; R. Bossaglia, Per un profilo del gotico piemontese, Palladio, N.S., IV, 1954, pp. 27–43, 185–88; R. Berton, Les châteaux du Val d'Aoste, 2d ed., Turin, 1956; G. F. Lo Porto, Documenti di vita preromana in Piemonte, RSLig, XXII, 1956, pp. 199–210; L. Benevolo, Le chiese barocche valsesiane, Q. Ist. Storia dell'Arch., 22–24, 1957, pp. 1–67; C. Albiaggi, Caratteri dell'architettura del Settecento in Valsesia, Atti X Conv. naz. Storia Arch., Rome, 1959, pp. 445–50; C. Carducci, L'architettura in Piemonte nell'antichità, Atti X Conv. naz. Storia Arch., Rome, 1959, pp. 151–86; S. Castelli, Quattro chiese benedettine del XII secolo in Monferrato, Atti X Conv. naz. Storia Arch., Rome, 1959, pp. 309–30; A. Cavallari Murat, Considerazioni sull'urbanistica in Piemonte dall'antichità all'Ottocento, Atti X Conv. naz. Storia Arch., Rome, 1959, pp. 39–61; L. Crema, L'architettura medievale in Piemonte, Atti X Conv. naz. Storia Arch., Rome, 1959, pp. 235–65; S. Finocchi, Problemi di topografia e urbanistica in Piemonte, Atti X Conv. naz. Storia Arch., Rome, 1959, pp. 113–26; L. Manino, Di taluni problemi relativi alle fortificazioni delle città romane del Piemonte, Atti X Conv. naz. Storia Arch., Rome, 1959, pp. 199–213; C. Perogalli, Contributo alla documentazione sui battisteri medievali lombardi e piemontesi, Atti X Conv. naz. Storia Arch., Rome, 1959, pp. 268–75; A. Terzaghi, Origini e sviluppo della cupola ad arconi intrecciati nell'architettura barocca del Piemonte, Atti X Conv. naz. Storia Arch., Rome, 1959, pp. 369–79; L. De Stefano and L. Vergano, Chiese romaniche nella provincia di Asti, Asti, 1960; D. Gribaudi, Piemonte e Val d'Aosta, Turin, 1960; C. Carducci, Monumenti e sculture di età romana nel Piemonte, Atti VII Cong. int. Archeol. classica, II, Rome, 1961, pp. 461–74.

a. Piedmont. Acqui (Lat., Aquae Statiellae or Aquae Statiellorum). On the left bank of the Bormida River, Acqui takes its name from thermal springs that were already in use during the Roman period. Inhabited by the Statielli, a Ligurian tribe of Celtic origin, it was a Roman municipium of considerable importance for its position at the intersection of the Via Aemilia Scauri, of which a part has been found, and the road to Augusta Taurinorum (mod. Turin). Ruins of the thermal establishment, mosaics near the warm spring, tombs, and remains of an aqueduct survive. In the Middle Ages Acqui became the capital of Upper Montferrat and passed to the house of Savoy in 1708. The Cathedral (1067), originally in the Lombard-Romanesque style, has been remodeled, the three semicircular apses (repeated in the crypt), transept, campanile (completed in 13th cent.), 17th-century atrium, and 15th-century façade portal (1405) are preserved intact. The old Cathedral, S. Pietro, was built in the 11th century on the site of a 5th-century Christian cemetery. Other structures of note include a cloister (14th cent.) with gallery; the Palazzo Vescovile (1460); and La Bollente, an octagonal aedicula under which gushes warm water and sulphurous vapors (1870; G. Ceruti).

BIBLIOG. V. Scatti, Acqui: monumenti antichi, Arte e storia, XI, 1892, pp. 12–13; P. Barocelli, Stazione neolitica di Acqui, BPI, XLV, 1925, pp. 148–49; V. Mesturino, La basilica latina di S. Pietro, Turin, 1933; EAA, s.v. Acqui.

Alba (Lat., Alba Pompeia). Located in an area of notable interest for the prehistory of the province of Cuneo, Alba became a Roman municipium in the 1st century B.C., taking its name from G. Pompeius Strabo. There are remains of the ancient city walls and gate and a late-antique building with a mosaic near S. Giuseppe. An episcopal seat from the 4th century, the town was devastated by Saracens in the 9th century and torn by internal and external strife during the late Middle Ages. In 1631 it passed to the house of Savoy. The center of the city, of almost circular plan, preserves numerous medieval towers (e.g., the four-storied Torre Astesiano). The influence of Lombard architecture is prevalent. The Cathedral, of Latin-cross type, has a nave and two aisles covered by ogival vaults and terminates in a presbytery over a crypt; it was remodeled in 1456 and restored in the 19th century. S. Domenico, a basilican church divided by pilasters and with a polygonal apse, is of Lombard inspiration. The Loggia dei Mercanti, with a pointed-arch portico; S. Giovanni Battista, with works by Macrino d'Alba and Barnaba da Modena; and the Church of the Maddalena, the floor plan of which is an ellipse inscribed in a rectangle (B. A. Vittone, 1749) are noteworthy. The Museo Archeologico "Federico Eusebio" houses prehistoric and Roman collections.

BIBLIOG. A. Piccarolo, La cattedrale antica d'Alba, Alba, 1893; F. Eusebio, Le mura romane di Alba Pompeia, Palermo, 1906; F. Boella, La Cattedrale di Alba, Alba, 1933; N. Lamboglia, Alba Pompeia e il Museo Storico-archeologico "Federico Eusebio," Bordighera, 1949; A. Stella, La cultura ecclesiastica in Alba dalle origini all'età napoleonica, B. Soc. storici, archeol. ed artistici nella provincia di Cuneo, XXVII, 1950, pp. 10–19; A. Stella, Nuove chiese della diocesi di Alba, Arte Cristiana, XLII, 1954, pp. 135–43; G. Pozzetti, La Cattedrale di San Lorenzo in Alba, Alba, 1955; EAA, s.v. Alba.

Asti (Lat., Hasta, Asta). A Roman municipium, an episcopal seat in the Middle Ages, destroyed in 1091, Asti developed again as a

commune, only to be devastated once more by Frederick Barbarossa in the 12th century. It passed to the house of Savoy in 1575. The medieval nucleus of the city, the so-called "enclosure of the nobles," was elliptical in plan and situated on the slope of the hill; it included a masonry wall, towers, and gates, built partly on Roman foundations. Asti expanded to the south and west to include the "enclosure of the villagers." A large number of medieval towers survive, including the Torre di S. Secondo (or Torre di S. Caterina), built on Roman foundations; the Troyana, Roero di Cortanze, Ponte di Lombriasco, S. Bernardino, or Comentina, and Guttari towers; and the octagonal Tower of the Three Kings, the only extant remains of the fortified royal palace. A number of Romanesque and Gothic houses have in part been preserved: Casa Bosia (12th–13th cent.); Palazzo Catena (11th cent.). Religious structures include the crypt of S. Anastasio (before 792) and the crypt of S. Secondo (before 10th cent.). The Baptistery of S. Pietro (called the "Rotonda") is a remarkable Romanesque octagonal edifice with a 12th-century dome. The Collegiate Church of S. Secondo (12th–15th cent.), in Lombard style, has a remodeled apse and an unfinished campanile. The Cathedral (1324–54), was built on the site of an 11th-century Lombard church; the apsidal part was lengthened by B. A. Vittone in 1764–69; it has a Gothic portico on the south side and a Romanesque campanile, reconstructed in 1266; in the interior are baroque frescoes. The Museo Archeologico is in the former Church of S. Pietro in Consavia, and the Pinacoteca in a 17th-century palace.

BIBLIOG. N. Gabbiani, Le torri, le case-forti e i palazzi nobili medievali in Asti, Pinerolo, 1906; A. Bevilacqua Lazise, L'architettura prelombarda in Asti, Asti, 1932; L. Vergano, Storia di Asti, II: Dalle origini alla organizzazione del Comune, Riv. di storia, arte, archeol. per le provincie di Alessandria e Asti, LIX, 1950, pp. 1–136; L. De Stefano and L. Vergano, Chiese romaniche nella provincia di Asti, Asti, 1960.

Biella. This city is first mentioned in a document of A.D. 826 with the name of Bugello. There is a Roman cemetery of the 2d century. The upper city (Biella Piazzo) was founded in 1160; until then the city lay only in the plain (Biella Piano), where the oldest monuments and the modern quarter are situated. Biella passed to the house of Savoy in 1379. A noteworthy Romanesque monument is the Baptistery, built of Roman remains, on a central plan with four apses and an octagonal dome (9th–10th cent.); in the interior are remains of frescoes. The adjacent Romanesque campanile belonged to the Church of S. Stefano (now destroyed). The Gothic Cathedral of the 14th century was remodeled in the 18th and 19th centuries. The Renaissance Church of S. Sebastiano has a façade rebuilt in the 19th century. Baroque churches include Sta Trinità (1626) and S. Filippo (18th cent.). S. Cassiano is neoclassic. In the upper city are the Romanesque Chapel of S. Giacomo, some 15th-century houses, Palazzo della Cisterna (16th cent.), Palazzo Gromo di Ternengo (16th cent.), with porch and loggias ornamented with terra cotta, and Palazzo Ferrero Lamarmora. The Museo Civico has Roman, Egyptian, and modern art.

BIBLIOG. A. Roccavilla, L'arte nel Biellese, Biella, 1905; G. Marangoni, Vercelli, il Biellese e la Valsesia, Bergamo, 1931; A. Rosazza, Note sul "Battistero di Biella," Biella, 1936; Il Battistero di Biella, Palladio, II, 1938, pp. 63–67; C. Carducci, La necropoli romana di Biella, B. Soc. piemontese Archeol. e Belle Arti, IV–V, 1950–51, pp. 23–39; C. Carducci, Romanità di Biella, Riv. biellese, IV, 1950, pp. 27–29; D. De Bernardi Ferrero, L'architettura romanica nella diocesi di Biella, Turin, 1959; C. Perogalli, Contributo alla documentazione sui battisteri medievali lombardi e piemontesi, Atti X Conv. naz. Storia Arch., Rome, 1959, pp. 268–75.

Casale Monferrato. Mentioned for the first time in 1039 and destroyed in 1215 by the inhabitants of Alessandria and Vercelli, the town was restored and passed under the rule of various princes, until it became the capital of Montferrat in 1514. In 1681 its defenses were dismantled, and in 1703 it finally passed to the house of Savoy. Medieval remains are scanty. The 11th-century city tower was reconstructed in the 16th century and restored in 1921. The Cathedral was remodeled after the damages of 1215 and restored in the 19th century, with some few remains of the original Lombard-style construction. A few 15th-century palaces of late Gothic character are extant (notably, Casa Tornielli). S. Domenico (1469; restored in 19th–20th cent.) has a portal of 1505 by a follower of G. A. Amedeo. Baroque monuments include S. Paolo (1586; L. Birago), with rococo fittings, the work of Moncalvo (Guglielmo Caccia) and F. da Castello; S. Filippo, built by P. F. Guala (ca. 1667), on a Greek-cross plan with dome; S. Stefano (redone by Guala on site of 11th-cent. church). The Palazzo Municipale (1778) is rich in sculpture and frescoes. The Palazzo Gozzani di Treville was built in 1730 after a design by Giovanni Battista Scapitta (façade later). The Ospedale di Carità is by B. A. Vittone (1740).

BIBLIOG. P. D'Ancona, Due preziosi cimelii miniati nel Duomo di Casale Monferrato, L'Arte, XIX, 1916, pp. 85–87; N. Gabrielli, L'arte a Casale Monferrato dall'XI al XVIII secolo, Turin, 1935.

Chieri (Lat., Carrium, Carreum Potentia). This town was perhaps originally inhabited by the ancient Ligurians. A Roman military colony, Potentia, was established there in the 2d century B.C. In the Middle Ages it was subject to the bishops of Turin; Bishop Landolfo walled the town in the 11th century. Frederick Barbarossa destroyed it in the 12th century, but the town was soon rebuilt. It passed to the house of Savoy in 1418. The predominance of Lombard architecture is evident in the medieval structures. The 11th-century Cathedral was reconstructed in Lombard style in the early 15th century, altered in the 17th century, and restored in the 19th century. Nevertheless, it retains much of its original structure. The façade has a very high gable over the center portal. There are a nave and two aisles, with intercommunicating side chapels. (The Chapel of the Madonna delle Grazie was built by B. A. Vittone in 1757–59.) The 13th-century baptistery, of octagonal floor-plan, is Lombard Romanesque in the lower part and Gothic in the upper. The campanile is of the 14th century. Of the original Gothic construction of S. Giorgio (14th cent.) the polygonal apse and the internal form of nave and two aisles with ogival vault survive. S. Domenico (14th cent.) has a contemporaneous pinnacled campanile. The campanile of S. Antonio dates from the 13th century. Many houses have Romanesque and Gothic windows. S. Bernardino, designed by B. A. Vittone (1740–44), S. Antonio Abate, designed by F. Juvara (ca. 1764), and S. Filippo, with façade by G. Guarini and interior by F. Juvara are representative 18th-century churches.

In the environs is the Abbey of S. Maria di Vezzolano, completed in 1189 with superimposed loggias of Pisan derivation on the façade; the interior is formed of nave and two aisles, of which one serves as a side of the adjacent cloister; also preserved is a large pulpit carved in the French style and showing early Gothic features.

BIBLIOG. C. T. A. Bosio, Memorie storico-religiose e di belle arti del Duomo e delle altre chiese di Chieri, Turin, 1878; A. Motta, L'abbazia monumentale di Santa Maria di Vezzolano, Turin, 1912; B. Valimberti, Il Duomo di Chieri, Chieri, 1928; E. Olivero, L'architettura gotica del Duomo di Chieri, Turin, 1939; A. Bosio, A. Ferrato, and E. Olivero, La cripta del Duomo di Chieri e le tombe dei Balbo, Chieri, 1958; G. Lange, Le mura di Chieri, Atti X Conv. naz. Storia Arch., Rome, 1959, pp. 127–150; S. Caselle, La cappella dei Gallieri, Turin, 1960.

Ivrea (Lat., Eporedia). Situated at the beginning of the Aosta Valley, on the left bank of the Dora River, the city was a Roman military colony (from 100 B.C.), built on an earlier Gallic site. The regular castrum plan survives, along with part of the encircling Roman wall, the forum, and ruins of a theater and amphitheater. During the Middle Ages, Ivrea was a Lombard duchy and subsequently a marquisate; in 1313 it passed to the Savoy family, who built the castle (1358) on a square plan; there are round towers at the corners. The Early Christian Cathedral was rebuilt in the 11th century and remodeled in the 17th; in 1850 a neoclassic façade was added. The only parts of the old Romanesque structure preserved are the dome, the two Lombard-type campaniles, and the crypt. In the Cathedral are canvases by Defendente Ferrari and the 12th-century ivory reliquary of Varmondo d'Ivrea. Other Romanesque remains include a tower in the Vescovado and the campaniles of S. Domenico and the destroyed S. Stefano. S. Bernardino (15th cent.; deconsecrated) contains frescoes by G. M. Spanzotti (beginning of 16th cent.). S. Nicola da Tolentino (1605), a baroque church, has canvases by D. Ferrari. The Palazzo del Seminario was built by F. Juvara. S. Gaudenzio may have been designed by B. A. Vittone. The Olivetti industrial center, with its complex of factories and living and study centers, is a noteworthy example of contemporary design. The Museo Archeologico and the Museo "Garda" are in the Palazzo Comunale.

At nearby Pavone Canavese is a castle (10th–14th cent.) that once belonged to the bishops of Ivrea.

BIBLIOG. F. Carandini, Vecchia Ivrea, 2d ed., Ivrea, 1927; P. Barocelli, Carta Archeologica d'Italia, f. 42, Ivrea; C. Carducci, Scavi e scoperte: Eporedia, FA, IX, 1956, no. 4678; P. Fraccaro; La colonia romana di Eporedia (Ivrea) e la sua centuriazione, Opuscola, III, Pavia, 1957, pp. 93–121; P. Barocelli, Nuovi titoli sepolcrali di Ivrea, AC, X, 1958, pp. 25–31; S. Finocchi, Problemi di topografia e urbanistica romana in Piemonte, Atti X Conv. naz. Storia Arch., Rome, 1959, pp. 113–26; EAA, s.v. Ivrea.

Mondovì. Founded in 1198 by the inhabitants of the village of Vico, Mondovì developed on the plain (Mondovì Breo) and on the neighboring hill (Mondovì Piazza). Ruled by various lords, it passed in 1418 to the house of Savoy. Its oldest remains include 14th–15th-century houses, towers, and churches. Particularly noteworthy is Mondovì Carassone, just outside the town proper, with the Church of S. Giovanni in Lupazzano and the Chapel of the Madonna delle Vigne. Baroque monuments are numerous and include the Church of the Gesù, by G. Boetto and others (with frescoes by A. Pozzo), S. Filippo, the Cathedral, and the Seminario (all by F. Gallo). Gallo

also completed the nearby Sanctuary of Vicoforte, which had been begun by A. Vittozzi in 1596.

BIBLIOG. L. Lobera, Delle antichità della terra, castello e chiese di Vico e dell'origine della città di Mondovì, Mondovì, 1791; L. Berra, L'Assunta del Santuario della Madonna di Mondovì a Vico, Arte Cristiana, XXXVIII, 1951, pp. 14–15.

Novara (Lat., Novaria). Situated in a plain, the city follows its ancient urban plan. Originally a Ligurian-Celtic center, it later became a Roman municipium. During the Middle Ages it was the seat of bishop-rulers and then a free city; after being ruled for a time by the Viscontis of Milan, Novara came under Savoy rule in 1734. Remains of the original Cathedral are preserved in the presbytery of the present Cathedral. The oldest parts of the Baptistery (octagonal in plan with corbel tables and three niches decorating each face of the exterior) date from the 4th–6th centuries; it was almost entirely rebuilt in the Romanesque period (11th cent.) and has undergone later remodelings. The Church of Ognissanti was built about 1045, but the original structure is almost entirely hidden by 18th-century alterations. The Broletto comprises three medieval buildings: the Palazzo del Comune (1205–08) with portico, external staircase, and a great hall on the first floor, all typical of the period; the 15th-century Palazzo del Podestà; and the 13th-century Palazzetto dei Paratici, with a Gothic portico and terra-cotta decorations on the window apertures of the first floor. Notable among the Gothic civil edifices is the Casa della Porta (15th cent.). Late Renaissance architecture in Novara includes S. Gaudenzio (begun 1577), by P. Tibaldi, with works by G. Ferrari, Tanzio da Varallo, and others; the campanile is by B. Alfieri and the dome by A. Antonelli (19th cent.). Baroque monuments include S. Marco (1607–14), by A. Mazzenta, with frescoes by Moncalvo and canvases by D. Crespi; the Church of the Rosario (or S. Pietro), with works by G. C. Procaccini and Fiammenghino (Giovanni Mauro della Rovere); and S. Eufemia, rococo in taste, especially the interior. The architecture of the 19th century is represented by the Palazzo del Mercato (1817–39), the Teatro Coccia (1886; G. Oliverio), and the buildings of A. Antonelli (e.g., Cathedral, 1863–65, built on the site of an 11th-century structure). The Corso Vittorio Emanuele, which is flanked by porticoes, has a neoclassic air. The Museo del Broletto contains archaeological finds and a collection of 15th–18th-century paintings. The Galleria Giannoni houses modern art. There is also an ethnographical museum.

BIBLIOG. A. Rusconi, Il castello di Novara, Novara, 1877; A. Massata, I primordi dell'arte novarese, Rass. d'arte, VI, 1906, pp. 170–81; R. Giolli, Appunti d'arte novarese, Rass. d'arte, VIII, 1909, pp. 67–69; F. A. Bianchini, Le cose rimarchevoli della città di Novara, Novara, 1928; A. Viglio, L'antico palazzo del Comune di Novara, Novara, 1928; G. Rocco, Le architetture di Pellegrino Pellegrini a Novara, B. storico per la provincia di Novara, XXV, 1931, pp. 437–67; P. Verzone, Il Duomo, la Canonica e il Battistero di Novara, B. storico per la provincia di Novara, XXVIII, 1934, pp. 115–245; C. Nigra, Cenno sulla evoluzione della casa nelle prealpi novaresi e lombarde, Novara, 1935; P. Verzone, L'architettura romanica nel novarese, 2 vols., Novara, 1935–36; A. Daverio, La cupola di S. Gaudenzio, Novara, 1941; F. Cognasso and others, Novara e il suo territorio, Novara, 1952; P. Verdier, L'origine structurale et liturgique des transepts de nef des cathédrales de Novare et de Pave (Atti II Conv. int. di S. alto medioevo), Turin, 1953, pp. 354–61; R. Fumagalli, Apporti al Museo Civico di Novara in seguito a ritrovamenti archeologici 1952–1953, B. storico per la provincia di Novara, XLIV, 1953, pp. 216–22.

Saluzzo (Lat., Saluciae). Mentioned for the first time in a document of 1028, Saluzzo was the seat of a rich and flourishing marquisate until the 16th century. The end of the 15th century was a period of particular brilliance and building activity. Numerous towers and houses with Gothic remains are preserved. Of "La Castiglia," the 13th-century castle of the marquises of Saluzzo (rebuilt in the 19th century), there survives a fortified tower of the medieval structure. The 15th-century Casa Cavassa (Cavazza) has a marble portal attributed to Matteo Sanmicheli. The 15th-century Casa di Davide has Gothic windows decorated with terra cotta. The Gothic apse of S. Giovanni (13th cent.; enlarged in 1472) was originally intended as a funeral chapel and is known as the Cappella di Sto Sepolcro. The tomb of Ludovico II is attributed to B. Briosco. There is a cloister, a chapter house (containing the tomb of G. Cavassa, by M. Sanmicheli, 1528), and a campanile with single-mullioned windows. The late Gothic Cathedral (begun 1492) has an apse, ambulatory, and baroque campanile. S. Agostino (1500) is Lombard Gothic. The Fontana della Drancia has a 15th-century basin. The Ospedale and Palazzo Municipale (1726) were designed by F. Gallo. The Casa Cavassa houses the local museum.

Near Saluzzo is the Cistercian Abbey of Staffarda (12th cent.; restored), whose church has a Romanesque façade. The campanile is of Lombard type. The cloister (13th–14th cent.) has paired columns, and the chapter house is Gothic.

BIBLIOG. E. Milano, Monumenti artistici in Saluzzo e nel suo territorio, Arte e storia, XXXI, 1912, pp. 77–85; G. Vacchetta, La chiesa di San Giovanni di Saluzzo, Turin, 1931. For Staffarda: D. Lanza and C. Bertea, L'Abbazia di Staffarda, Turin, 1929; F. Savio, La abbazia di Staffarda, Turin, 1932.

Susa (Lat., Segusium). Situated at the junction of the Susa and Mont Cenis valleys, Susa was successively a Segusian oppidum, the residence of King Cottius, a Roman vicus, and, during the Augustan period, the capital of the province of the Cottian Alps. It preserves important ancient monuments, including parts of the late 3d-century wall and of the amphitheater, as well as the Arch of Augustus (12 B.C.), with a sculptural frieze commemorating the pact of friendship between Rome and the Alpine populace (PL. 230). The town was destroyed by Constantine as punishment for siding with Maxentius, but rose again in the Middle Ages. Except for the castle and the churches, it was again burned to the ground by Frederick Barbarossa in 1168. Save for short periods of French domination, it belonged to the house of Savoy from 1047. Outside the old city walls is the Borgo dei Nobili (12th–13th cent.), founded by Savoy families and containing many houses of medieval origin. The remains of the Church of S. Maria Maggiore are Romanesque and include two campaniles. The Church of S. Francesco and the Casa De Bartolomeis are Gothic. The Cathedral, founded shortly after 1000, was reconstructed in the Gothic style and successively altered; it is rich in 14th-century works. Only the campanile survives of the original design. The Museo Civico has archaeological material.

Some distance from the town, in an isolated position on Monte Pirchiriano, is the Sagra di S. Michele, a fortified medieval monastery. The church has a nave, two side aisles, three semicircular apses (the center one with a large window and Romanesque sculptured reliefs showing French influence), and a crypt begun in the 12th century (on the remains of an 11th-century predecessor) and finished in the 13th century; the decoration of the Portal of the Zodiac includes some of the earliest sculpture of Master Nicolaus (q.v.).

BIBLIOG. E. Ferrero, L'Arc d'Auguste à Suse, Turin, 1901; F. Savio, Il Monastero di S. Giusto di Susa, Rome, 1907; P. Barocelli, Appunti di topografia segusina, BMImp, VII, 1936, pp. 3–22; C. Carducci, Le mura di Susa, Atti V Cong. naz. S. Romani, II, 1940, pp. 72–76; C. Capello, Scoperta di rocce cappelliformi nell'agro Segusino, B. Soc. piemontese archeol. e belle arti, III, 1949, pp. 27–37; B. M. Felletti Maj, Il fregio commemorativo dell'Arco di Susa, RendPontAcc, XXXIII, 1960–61, pp. 129–53. For the Sagra di S. Michele: G. Avogadro di Valdengo, Storia dell'abbazia di S. Michele della Chiusa, Novara, 1897; G. Gaddo, La Sacra di S. Michele in Val di Susa, Domodossola, 1958; R. Salvini, Un inedito di scultura romanica piacentina, Arte antica e moderna, II, 1959, pp. 407–19.

Turin (Lat., Augusta Taurinorum; It., Torino). The city is set in the plain of the Po, except for a modern part which extends onto higher ground. It was founded in 29–28 B.C. as a Roman military colony (Augusta Taurinorum) in the territory of the Ligurian Taurini at the point where the road from Monginevro joined the road to Milan. The modern city plan follows the original Roman castrum plan of blocks approximately 230 ft. long. Parts of the Roman wall still stand, including the Porta Palatina; next to the gate is the Roman theater with a post-scaenam portico. The city was the capital of a Lombard duchy, then of a French marquisate; it became a free city and in the 13th century passed to the house of Savoy. Until the reign of Emmanuel Philibert (1553–80), the city remained largely within the limits of the Roman walls. Little noteworthy architecture of that early period remains.

Surviving Romanesque monuments are the Campanile of the Consolata (11th cent.) and a part of the Palazzo Madama. (Remains of the substructure of a Roman gate can be seen inside the palace.) Gothic structures include the Church of S. Domenico (1300–44; subsequently restored, with a simple façade divided by three projecting pilasters topped by pinnacles, and some houses (in the Via Conte Verde and Via T. Tasso) whose lancet windows are decorated with terra cotta.

The Cathedral, one of the few Renaissance buildings in Turin, was begun in 1490 by Meo del Caprino, who probably also designed the façade; the interior contains work by D. Ferrari, B. Caravoglia, and P. Le Gros; behind the raised presbytery is the Chapel of the Sta Sindone (II, PL. 143), designed by G. Guarini (q.v.). Emmanuel Philibert began the real architectural embellishment of the city. Architects from central Italy (e.g., F. Paciotti, P. Tibaldi) went to Turin. The Palazzo S. Giovanni, which preceded the present Royal Palace, was built. The city was encircled with a powerful defensive system (the keep of the citadel survives; 1564–68), and many churches were built. Among the churches are S. Dalmazzo, S. Agostino, SS. Martiri, and S. Tommaso (1585; remodeled in 19th cent.). Ascanio Vitozzi redesigned the Piazza Castello (1584) and the connecting Via Nuova (now Via Roma), maintaining the checkerboard pattern of the ancient city, built the Church of SS. Trinità (1590–1606;

partly redone by Juvara, who decorated the interior), the Church of Corpus Domini (1609–71; restored in the 18th cent. with decorations by B. Alfieri), and the Church of Sto Spirito (1610), a Greek-cross structure restored in the 19th century. Vitozzi also built the church on the Monte dei Cappuccini (1585) and the Villa della Regina (1616; enlarged by A. di Castellamonte; façade rebuilt in the 18th cent. by P. A. Massazza di Valdondona).

Intensive building activity under Charles Emmanuel I and II saw the completion of the rectangular Piazza S. Carlo by Carlo di Castellamonte, construction of S. Cristina (1639; façade by F. Juvara, 1714), and the rebuilding (1633–38) of the Castello del Valentino. Several baroque churches were constructed in the center of the city, including S. Teresa (1642–74; with chapel and side altar by F. Juvara; works by S. Conca and C. Giaquinto); the two main streets (now Via Verdi and Via Po) leading from the Piazza Castello were opened. Via Po is flanked by palaces with porticoes, after the plan of Amedeo di Castellamonte, who in 1646 had begun the Royal Palace (gardens

after a design by the French architect Andre Le Nôtre) and completed the Ospedale Maggiore (Ospedale di S. Giovanni). Francesco Lanfranchi built the Palazzo di Città and the churches of S. Rocco (1667), SS. Maurizio e Lazzaro (1679; façade, dome, and interior decoration, 19th cent.), and the Visitazione (1661). The palaces of the same period include the Palazzo Barolo (with a double-ramped staircase), the Palazzo Paesana di Saluzzo (ca. 1720; by G. Planteri with a richly decorated courtyard and interior) and the Palazzo dell'Accademia Filarmonica.

Much of the credit for the great surge in building during the second half of the 17th century must go to the two architects Guarino Guarini and Filippo Juvara (qq.v.). Guarini's major works are: the completion of the Church of S. Lorenzo (II, PLS. 142, 143; VII, PL. 103), the previously mentioned Chapel of the Sta Sindone, the Palazzo Carignano (VII, PLS. 104, 105), the Collegio dei Nobili (now the Accademia delle Scienze; 1679), and the Church of S. Filippo Neri (reconstructed by Juvara; neoclassic façade of 1835, aisleless

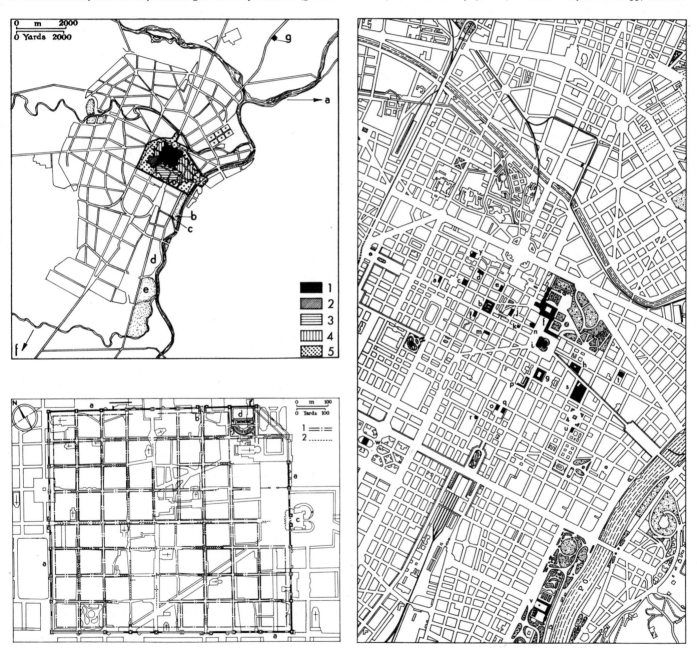

Turin. *Left, above*: Urban expansion from Roman times to the present. *Key*: (1) From Roman times to the 15th century; (2) later expansion within the 16th-century fortifications; (3) within the 17th-century fortifications; (4) within the 17th–18th-century walls; (5) to 1848. Monuments outside the city; (*a*) to Superga; (*b*) Borgo and medieval castle; (*c*) Palazzo per la Moda e le Esposizioni; (*d*) Museo dell'Automobile; (*e*) "Italia 61" area; (*f*) to Stupinigi; (*g*) Abbey of Stura. *Below*: Plan of the Roman city. *Key*: (1) Course of the ancient roads; (2) sewers. (*a*) Walls with towers; (*b*) Porta Palatina; (*c*) Porta Praetoria; (*d*) theater. *Right*: Principal medieval and modern monuments: (*a*) Church of the Carmine; (*b*) Palazzo di Città; (*c*) Palazzo Barolo; (*d*) S. Agostino; (*e*) S. Domenico; (*f*) Royal Palace and Cathedral; (*g*) Palazzo Carignano; (*h*) Palazzo dell'Università; (*i*) Palazzo Madama; (*j*) Church of Corpus Domini; (*k*) SS. Trinità; (*l*) SS. Martiri; (*m*) S. Francesco d'Assisi; (*n*) S. Lorenzo; (*o*) S. Carlo; (*p*) Palazzo dell'Accademia delle Scienze (Galleria Sabauda, Museo Egizio, and Museo Civico d'Arte Antica); (*q*) S. Cristina; (*r*) Church of the Visitazione; (*s*) Galleria dell'Accademia Albertina di Belle Arti; (*t*) Mole Antonelliana; (*u*) Sta Croce; (*v*) Castello del Valentino; (*w*) Galleria Civica d'Arte Moderna; (*x*) Citadel and Museo Nazionale d'Artiglieria; (*y*) Santuario della Consolata.

interior flanked by elliptical side chapels and works by F. Solimena, F. Trevisani, Guercino, G. B. Tiepolo, C. Maratti). Juvara, the other great baroque architect in Turin, is especially noteworthy for his attempts to integrate his buildings within the entire urban complex. He designed whole new areas of the city (e.g., the Quartieri Militari), worked on the façade of the Palazzo Madama (PL. 226), the façade of the Palazzo Ferrero d'Ormea, the Palazzo della Corte d'Appello (completed by B. Alfieri and I. Michela), Palazzo Martini di Cigala, Palazzo della Valle di Panaro, and the churches of Sta Croce and the Carmine. Juvara influenced B. Alfieri and B. A. Vittone. Alfieri completed the Piazza Castello by erecting the Teatro Regio, designed the Piazza del Palazzo di Città, and built the Palazzo Chiablese. Vittone was responsible for S. Chiara (1745) and S. Maria di Piazza (1751; 19th-cent. façade).

Later works were carried out by the French during the Napoleonic occupation: the Ponte Vittorio Emanuele I was built to connect the vast porticoed Piazza Vittorio Veneto with Piazza Gran Madre di Dio, where F. Bonsignori's Church of the Gran Madre di Dio (1818–31), modeled after the Pantheon, is situated. The 1860s and 70s saw the laying out of Piazza Statuto, the construction of the Stazione Centrale, by A. Mazzucchetti and C. Ceppi (1866–68; later modified), the creation of the new areas of the Crocetta (1859), the Corso Vinzaglio (1872), and the Piazza d'Armi (1880). During the 19th and early 20th centuries the principal piazzas were adorned with many commemorative monuments, including the monument to Emmanuel Philibert by C. Marocchetti in Piazza S. Carlo (X, PL. 149). Among the modern works have been the reorganization of stretches of the Via Roma (1931–37; M. Piacentini and others) and the building of the Galleria S. Federico by E. Corte. In the same period came the first successes of rational architecture: the Fiat-Lingotto factory (ca. 1919; by Mattè Trucco), the stadium with the adjacent athletic center (1933; Bianchini, Fagnoni, Ortensi), the Fiat-Mirafiori factory (1939; Bonadè, Bottino), and the Palazzo E.I.A.R. (1939; later remodeled). Among the more important contemporary works are the Salone dell'Auto and the Palazzo del Lavoro, both by P. L. Nervi; the Nuovo Auditorio, by A. Morbelli; the Lancia office building, by N. Rosani; and the Galleria d'Arte Moderna (1959), by C. Bassi and G. Boschetti.

Museums include the Museo Civico di Arte Antica (in the Palazzo Madama) and the Galleria dell'Accademia Albertina; in the Palazzo delle Scienze: Galleria Sabauda, Museo Egizio, and the Museo di Antichità, the latter with archaeological material from prehistoric through late Roman times.

In the environs of Turin: the Basilica of Superga by F. Juvara (1715–31; II, PL. 140). The hunting lodge, or castle, of Stupinigi (I, PLS. 389, 407; II, PL. 141), also by Juvara, is in a park with contemporaneous tenant houses; the plan is in the form of a St. Andrew's cross whose arms extend toward the southwest to form a great octagonal piazza; the interior (on which B. Alfieri collaborated) has frescoes and canvases by V. A. Cignaroli, G. B. Crosato, Giuseppe and Domenico Valeriani, and C. A. van Loo. The castle of Venaria Reale was originally designed by Amedeo di Castellammonte and restored by Juvara and Alfieri; the hunting lodge of Venaria Reale was built by Juvara; the parish church was reconstructed by B. Alfieri. At Carignano: 14th- and 15th-century houses (Via Monte di Pietà, Via Vittorio Veneto, and Via Bastioni), some with portals and terra-cotta decoration; 17th-century churches of S. Giuseppe and Sto Spirito; Ospizio di Carità (1749), designed by B. A. Vittone.

BIBLIOG. C. Promis, Storia dell'antica Torino, Turin, 1869; A. Frizzi, Borgo e Castello medioevali in Torino, Turin, 1894; P. Toesca, Torino, Bergamo, 1911; A. Midana, Il Duomo di Torino, Italia sacra, I, 1928, pp. 301–429; A. Telluccini, Il Palazzo Madama, Turin, 1928; G. Bendinelli, Torino romana, Turin, 1929; M. R. Bianchi, La chiesa di S. Domenico, Italia sacra, II, 1931–34, pp. 1009–83; I. S., La chiesa di S. Francesco, Italia sacra, II, 1931–34, pp. 1213–83; E. Olivero, L'architettura in Torino durante la prima metà dell'Ottocento, Turin, 1935; C. Brayda, Antichi quartieri del centro di Torino, Turin, 1937; G. Rodolfo, L'architettura barocca in Carignano, Atti Soc. piemontese di Archeol. e Belle Arti, XVI, 1937, pp. 130–86; M. Balzanelli, La città di Torino e le sue antiche fortificazioni, Torino, XVIII, 12, 1938, p. 41; C. Merlini, Torino medievale e cinquecentesca, Torino, XVIII, 6, 1938, pp. 11–15; C. Brayda, Vitozzo Vitozzi: ingegnere militare e alcuni disegni di Torino antica, Torino, XIX, 2, 1939, pp. 15–19; E. Olivero, Architettura religiosa preromanica e romanica nella archidiocesi di Torino, Turin, 1941; R. Carità, Il giardino reale di Torino, BArte, XXXIX, 1954, pp. 148–65; S. Solero, Il Duomo di Torino, Pinerolo, 1956; M. Bernardi, Torino e i suoi dintorni, Rome, 1957; E. Battisti, Note sul significato della Cappella della Santa Sindone, Atti X Conv. naz. Storia Arch., Rome, 1959, pp. 358–68; N. Carboneri, Il Duomo di Torino dal 1694 al 1729, Atti X Conv. naz. Storia Arch., Rome, 1959, pp. 381–96; F. Cognasso, Storia di Torino, Milan, 1959; M. Passanti, Le trasformazioni barocche entro l'area della Torino antica, Atti X Conv. naz. Storia Arch., Rome, 1959, pp. 69–100; R. Moro and others, La Chiesa di San Giovanni in Carignano, L'Architettura, VI, 1960–61, pp. 194–201. For Superga: G. Stefani, Superga, Turin, 1850. For Stupinigi: A. Telluccini, Le decorazioni della Reale Palazzina di Stupinigi, Turin, 1924; C. Mulin, Stupinigi, Torino, XVIII, 8, 1938, pp. 19–26; M. Bernardi, La palazzina di caccia di Stupinigi, Turin, 1958.

Varallo. Mentioned in a document of 1028, Varallo was a feudal domain of the Biandrate and then a commune. S. Maria delle Grazie (15th cent.) has a fresco cycle by G. Ferrari (1513). S. Gaudenzio (13th cent.), rebuilt in 1710, has a polyptych by G. Ferrari. On a hill overlooking the town is the Sanctuary of Sacro Monte, comprising 45 chapels built between 1490/91 and 1765, rich in frescoes [especially noteworthy, those by G. Ferrari, P. F. Mazzuchelli (Morazzone), and Tanzio da Varallo] and sculpture. The 17th-century Church of the Assunta, with a 19th-century façade, is included in the complex. A short distance away is the Chapel of the Madonna di Loreto (15th cent.), with frescoes by A. Zanetti, G. Ferrari, A. Solari, T. Cavalazzi, and B. Luini. The Museo Civico Pietro Calderini contains archaeological material.

BIBLIOG. A. Durio, Il Santuario di Varallo, B. storico per la provincia di Novara, XXIV, 1930, pp. 82–94, 279–91, 453–98, XXXVII, 1943, pp. 75–100; N. Gabrielli, Affreschi di Nicolò da Varallo in Valsesia? Scritti di storia dell'arte in onore di L. Venturi, I, Rome, 1956, pp. 255–70; L. Benevolo, Le chiese barocche valsesiane, Q. Ist. Storia Arch., 22–24, 1957, pp. 1–67; M. Bernardi, Il Sacro Monte di Varallo, Turin, 1960.

Vercelli (Lat., Vercellae). Originally a Roman municipium, Vercelli was successively an episcopal seat, a Lombard duchy, and a French county. While a commune, the town was surrounded by walls. Vercelli passed to the house of Savoy in 1761. The 13th century was a particularly prosperous period for the town. The Church of S. Bernardo (1164) is Romanesque in the front, but the apse is modern. S. Giuliano is Romanesque, with nave and two aisles and contemporaneous campanile (remodeled interior). The Romanesque Church of S. Paolo (1262), with nave and two side aisles, was altered in the 18th century but preserves the original façade and campanile; the interior was partially redone in the baroque period. The Ospedale Maggiore and the Castle are 13th-century structures. S. Andrea (VI, PL. 332; restored in the 19th cent. and in 1927) represents the transitional period between Romanesque and Gothic; it is the work of Lombard masters who apparently were sensitive to French influences. The façade, flanked by two campaniles, has a lunette attributed to B. Antelami (I, PL. 297). The adjacent abbey is of the Cistercian type and has a cloister with Romanesque columns and 16th-century vaults. The Casa Alciati and the octagonal Torre dei Tizzoni are 15th-century structures. The former Casa Centoriis has a Renaissance courtyard (1496). The Church of S. Cristoforo (1526), another Renaissance building, preserves a fresco cycle and the Madonna del Melarancio, a large canvas, both by G. Ferrari. The original Cathedral was built on the site of Roman and Early Christian buildings but reconstructed by P. Tibaldi in 1572 and rebuilt in part in the 18th century, with an atrium by B. Alfieri; an annex houses the Biblioteca Capitolare, which contains many illuminated manuscripts; there is a 12th-century campanile. Baroque monuments include the Seminary, the Palazzo Avogadro Della Motta (18th cent.), Palazzo Langosco (1707; with a beautiful portal), and Palazzo del Governo. The Church of S. Chiara is by B. A. Vittone. S. Lorenzo was built toward the end of the 18th century. The Museo Camillo Leone occupies the Casa degli Alciati and the Palazzo Langosco. The Museo Borgogna contains paintings of the 14th–19th centuries. The Cathedral Treasury contains liturgical furnishings of the 8th–12th centuries and Gothic and Renaissance goldsmith work.

BIBLIOG. G. Marangoni, Vercelli, il Biellese e la Valsesia, Bergamo, 1931; P. Verzone, L'architettura romanica nel vercellese, Vercelli, 1934; A. M. Brizio, Il tesoro della cattedrale di Vercelli, L'Arte, XXXVIII, 1935, pp. 48–65; A. M. Brizio, Vercelli, Rome, 1935; P. Verzone, Il restauro della casa Alciati, Vercelli, 1935; P. Verzone, Sant'Andrea di Vercelli e l'arte emiliana, Turin, 1936; P. Verzone, L'abbazia di S. Andrea, Vercelli, 1939; M. Bernardi, Ventiquattro capolavori di Vercelli, Milan, 1955; RE, s.v. Vercellae; F. Cenisio, I castelli del vercellese, Vercelli, 1957; V. Viale, Il progetto di Filippo Juvara per la Chiesa di Vercelli, Atti X Conv. naz. Storia Arch., Rome, 1959, pp. 427–34.

b. Aosta Valley. Aosta (Lat., Augusta Praetoria). The Roman colony was founded by Augustus in 25 B.C. in the territory of the Ligurian Salassi, at the juncture of the roads to the Little Saint Bernard and Great Saint Bernard passes. Aosta preserves the rectangular Roman castrum plan of blocks 230 × 260 ft., as well as large parts of the surrounding wall, two Roman gates, the Roman bridge over the Buthier River, the monumental Arch of Augustus, the Roman theater, the forum, a temple, and the amphitheater. Various lords dominated the city during the early Middle Ages; in the 11th century Aosta passed to the house of Savoy. The Cathedral (11th–12th cent.; crypt preserved), totally rebuilt in the 15th and 16th centuries, has a nave covered by rib vaults, two barrel-vaulted side aisles, and an ambulatory; in the choir are a 12th-century mosaic pavement and

sculptured choir stalls by Jean Vion of Samoëns and Giovanni di Chetro. The Cathedral Treasury contains a 15th-century reliquary and an ivory diptych depicting the Emperor Honorius (406). The lower part of one of the two campaniles dates from the 11th century. The neoclassic façade dates from 1848. Adjacent to the church is the cloister (1460). The Early Christian Church of S. Orso was rebuilt in the 15th century. The cloister, also rebuilt in the 15th cen-

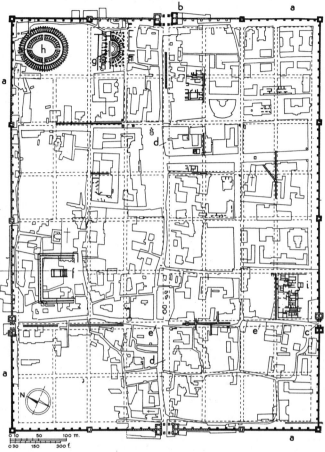

Aosta, plan of the Roman city, with the course of the ancient streets indicated in broken lines. (*a*) Walls and lookout towers; (*b*) Porta Praetoria; (*c*) Porta Principalis Dextra; (*d*) *decumanus maximus*; (*e*) *cardo maximus*; (*f*) area of the forum with cryptoporticus and temple; (*g*) theater; (*h*) amphitheater; (*i*) residences.

tury, has columns and historiated capitals from the original structure (before 1133). The four-storied campanile was erected in the 12th–13th century. The 15th-century priory consists of three separate structures, each with a porch facing the church. Other medieval remains include numerous towers and the campanile of S. Benigno. Among the 17th- and 18th-century buildings are S. Stefano, Sta Croce, and the Palazzo Vescovile. Particularly noteworthy is the early 16th-century Palazzo Roncas. Museums include the Museo Archeologico, the Cathedral Treasury, and the Treasury of S. Orso.

BIBLIOG. F. de Lasteyrie, La Cathédrale d'Aoste, Paris, 1854; C. Promis, Le antichità di Aosta, Turin, 1862; P. Toesca, Aosta, Rome, 1911; P. Barocelli, Carta archeol. d'Italia, f. 28, Aosta, Florence, 1928; M. Aldrovandi, Aosta: Le sue valli e i suoi castelli, Turin, 1930; P. Barocelli, Augusta Praetoria, Rome, 1949; C. Carducci, Aosta: Tombe e costruzioni romane, NSc, 8th ser., IV, 1950, pp. 183–88; R. Berton, I capitelli del chiostro di Sant'Orso, Novara, 1956; EAA, s.v. Aosta; S. Finocchi, Scavi e scoperte nel territorio di Aosta, Cisalpina, I, 1959, pp. 103–15; N. Gabrielli, Rappresentazioni sacre e profane nel castello d'Issogne e la pittura nella valle d'Aosta alla fine del '400, Turin, 1959; F. Lugli, Osservazioni sulla topografia di Aosta antica, Atti X Conv. naz. Storia Arch., Rome, 1959, pp. 187–97; M. Salmi, La decorazione rinascimentale del Duomo d'Aosta, Atti X Conv. naz. Storia Arch., Rome, 1959, pp. 333–42; S. Finocchi, Le origini dell'impianto urbanistico di Aosta, Atti VII Cong. int. Archeol. Classica, II, Rome, 1961, pp. 375–80.

Lombardy (It., Lombardia). Occupying the central Po Valley and the adjacent Alpine foothills, Lombardy preserves modest remains of lake villages and of the Golaseccan and Celtic cultures. Important Roman cities were established in the region, including Mediolanum (mod. Milan), which was the residence of the Roman

emperors in the 4th century. But only after the Lombard conquest did the province become the center of original and intense artistic activity; it excelled in gold- and silverwork, sculpture, and above all, architecture, culminating in the work of the *magistri comacini* and in the Lombard Romanesque style. Later, fine monuments were created in the Gothic and Renaissance styles. During the Renaissance, a school of painting flourished in Lombardy, and Leonardo da Vinci and Bramante were active in a prosperous period of Milan's history. The subsequent history of Lombardy under Spanish and Austrian rule offers no remarkable artistic developments except for Milanese neoclassicism.

BIBLIOG. F. de Dartein, Études sur l'architecture lombarde, 2 vols., Paris, 1865–92; L. Malvezzi, Le glorie dell'arte lombarda in pittura, scultura, architettura dal 1590 al 1850, Milan, 1882; R. Cattaneo, L'architettura in Italia dal secolo V al Mille circa, Venice, 1888; A. G. Meyer, Lombardische Denkmäler des 14. Jahrhunderts, Stuttgart, 1893; A. G. Meyer, Oberitalienische Frührenaissance: Bauten und Bildwerke der Lombardei, 2 vols., Berlin, 1897–1900; G. T. Rivora, Le origini dell'architettura lombarda, 2d ed., Milan, 1908; A. Haupt, Palastarchitektur von Oberitalien und Toscana, V, Berlin, 1911–13; U. Monneret de Villard, I dati storici relativi ai mosaici pavimentali cristiani di Lombardia, Arch. storico lombardo, XLIII, 1916, pp. 341–92; F. Reggiori, Tre chiese lombarde o prelombarde, Architettura, IV, 1924–25, pp. 433–57; C. Terrasse, L'architecture lombarde de la Renaissance (1450–1525), Paris, Brussels, 1926; G. Baserga, Osservazioni sopra la prima età del ferro nel comasco, Riv. archeol. dell'antica provincia e diocesi di Como, XCIV–XCV, 1928, pp. 6–19; R. Krautheimer, Lombardische Hallenkirchen in XII. Jahrhundert, Jhb. für Kw., 1928, pp. 176–91; P. Verzone, Nuove ricerche sull'origine della basilica lombarda a volte, Cron. d'arte, V, 1928, pp. 267–84; W. Boeck, Oberitalien und Toskana in der Kunst der Renaissance, Bonn, Leipzig, 1930; G. Muzio, Alcuni architetti d'oggi in Lombardia, Dedalo, XI, 1930–31, pp. 1082–1119; F. Reggiori, Dieci battisteri lombardi minori dal secolo V al secolo XII, Rome, 1935; M. L. Gengaro, Dal Pellegrini al Richino, BArte, XXX, 1936, pp. 202–06; A. Calderini and others, Lombardia romana, 2 vols., Milan, 1938–39; L. Laviosa Zambotti, Le civiltà palafitticole lombarde e la civiltà di Golasecca, Como, 1939; F. Reggiori, Ville e giardini di Lombardia, Emporium, XLV, 1939, pp. 27–40; C. Baroni, Documenti per la storia dell'architettura a Milano nel Rinascimento e nel Barocco, Florence, 1940; R. Dadi, Antiche piazze di città lombarde, Atti IV Conv. naz. Storia Arch., Milan, 1940, pp. 17–24; M. L. Gengaro, Dal Bramante al Richino, Le Arti, III, 1940–41, pp. 443–48; P. Verzone, Origine della volta lombarda a muratura, Atti IV Conv. naz. Storia Arch., Milan, 1940, pp. 53–64; C. Baroni, L'architettura lombarda da Bramante al Richini, Milan, 1941; A. Calderini, Lombardia preistorica e protostorica, Rome, 1945; U. Ewins, The Early Colonisation of Cisalpine Gaul, BSR, XX, 1952, pp. 54–71; E. Arslan, Les églises lombardes du VI^e au X^e siècle, CRAI, 1954, pp. 65–70; F. Leoni, Il Cesariano e l'architettura del Rinascimento in Lombardia, Arte lombarda, I, 1955, pp. 90–97; C. Saibene, La casa rurale nella pianura e nella collina lombarda, Florence, 1955; O. Cornaggia Castiglioni, La Lagozetta di Besnate e gli insediamenti "palustri" della civiltà di Polada, S. in onore di A. Calderini e R. Paribeni, III, Milan, 1956, pp. 35–58; A. Frova, Bronzi antichi di Lombardia, S. in onore di A. Calderini e R. Paribeni, III, Milan, 1956, pp. 235–48; M. Bertolone and C. Storti, Recenti ricerche del Centro di Studi preistorici ed archeologici di Varese, RScPr, XII, 1957, pp. 125–32; Arte lombarda dai Visconti agli Sforza (exhibition cat.), Milan, 1958; L. Grassi, L'abbazia di Mirasole e l'architettura lombarda degli Umiliati, Arte lombarda, III, 2, 1958, pp. 15–47; M. A. Romanini, Le chiese a sala nell'architettura "gotica" lombarda, Arte lombarda, III, 2, 1958, pp. 48–64; E. Süss, Le incisioni rupestri della Valcamonica, Milan, 1958; E. Arslan, Architetti e scultori del Quattrocento (Arte e artisti dei laghi lombardi, I), Como, 1959; O. Cornaggia Castiglioni, Il ripostiglio di Manerbio e il problema delle monetazioni pagane con iscrizioni in alfabeto leponzio, Cisalpina, I, 1959, p. 149 ff.; A. Frova, Le suppellettili bronzee romane in Lombardia, Cisalpina, I, 1959, p. 309 ff.; M. Mirabella Roberti, Cinque anni di lavori per le antichità in Lombardia, Cisalpina, I, 1959, pp. 72–86; Mostra storica dei giardini di Lombardia (exhibition cat.), Milan, 1959; A. Ottino della Chiesa, L'età neoclassica in Lombardia (exhibition cat.), Milan, 1959; C. Perogalli, Contributi alla documentazione sui Battisteri medievali lombardi, Atti X Conv. naz. Storia Arch., Rome, 1959, pp. 268–75; F. Rittatore, Problemi dell'età del bronzo in Val Padana, Cisalpina, I, 1959, p. 219 ff.; R. Ciardi, Seicento lombardo, CrArte, VII, 1960, pp. 212–15; E. Guldan, Die Tätigkeit der Maestri Comacini in Italien und Europa, Arte lombarda, VI, 1, 1960, pp. 27–46; L. Grassi and P. Portalupi, Scuola e "maniera" nell'architettura lombarda del Cinquecento, Q. Ist. Storia Arch., 31–48, 1961, pp. 225–42.

Abbiategrasso. The town was established in the Middle Ages and flourished under the Visconti and Sforza families. The castle, which had existed as early as the year 1000, was partially destroyed by Frederick Barbarossa in 1167. It was rebuilt by Gian Galeazzo Visconti in 1382; altered subsequently, it preserves remains of its tower and 14th-century windows. S. Maria Nuova was begun in 1375, and the interior was remodeled by F. Croce in 1740; a porch in the form of a large arch was added to the façade by Donato Bramante in 1497; a 15th-century atrium decorated with terra cotta and sculpture stands before the church. The neoclassic Pia Casa degli Incurabili was designed by L. Pollak and G. Balzaretti (1784).

BIBLIOG. N. Bertoglio Pisani, L'oratorio di Donato Del Conte e la chiesa di Vegano-Certosino, Arte e storia, XXXI, 1912, pp. 105–11; P. Mez-

zanotte, I graffiti sforzeschi recentemente scoperti a S. Maria Nova di Abbiategrasso, Atti IV Conv. naz. Storia Arch., Milan, 1940, pp. 105-14.

Bergamo (Lat., Bergomum). The city was originally a Gallic settlement, then a Roman municipium, and an episcopal seat from the second half of the 4th century. Situated at the mouth of the Brembana and the Seriana valleys, Bergamo consists of two parts — the older, upper city, still enclosed by the Venetian walls (1561–88); and the modern, lower city, much larger than the upper city and completely remodeled by M. Piacentini (1919–29). In the upper

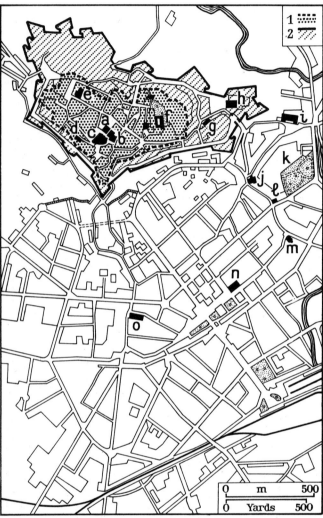

Bergamo, plan of the upper and lower cities, with later expansions. *Key*: (1) Original urban nucleus within the medieval walls; (2) expansion of the city within the Venetian walls of the 15th–16th century. Principal monuments. Upper city: (*a*) Palazzo Vecchio (Palazzo della Ragione); (*b*) Cathedral; (*c*) Baptistery, S. Maria Maggiore, and Colleoni Chapel; (*d*) S. Grata inter Vites; (*e*) Church of the Carmine; (*f*) the Rocca; (*g*) S. Michele al Pozzo Bianco; (*h*) former Church of S. Agostino. Lower city: (*i*) Palazzo dell'Accademia Carrara; (*j*) S. Alessandro della Croce; (*k*) public park; (*l*) S. Bernardino in Pignolo (*m*) Sto Spirito; (*n*) S. Bartolomeo; (*o*) S. Alessandro in Colonna.

city traces of the Roman wall and street layout, as well as the site of the forum, have been identified. Remains of an elaborate thermal structure, an aqueduct, a large reservoir, and a few tombs have been discovered.

As a Lombard duchy and a Frankish county during the Middle Ages, the city led a tempestuous existence. From 1428 to 1797 it belonged to Venice. The Cathedral was rebuilt by Antonio Filarete in 1459, renovated in 1689 by C. Fontana, and is richly decorated within (paintings by G. Moroni, S. Ricci, and G. B. Tiepolo). In the Piazza Vecchia is S. Maria Maggiore (1137), the most remarkable Romanesque monument of the city. Lacking a façade and hidden in part by other edifices built against it, the church preserves at the end of the left transept a notable porch by Giovanni da Campione, with an equestrian statue of St. Alexander (1353; III, PL. 21). At the end of the right transept is a porch with depictions of the Labors of the Months, also by a Campionese master (see CAMPIONESI). The interior was remodeled in the baroque period and crowned with an

octagonal dome by F. M. Ricchino (1615); it contains choir stalls with intarsia work after designs by L. Lotto and the tomb of Guglielmo Longhi, attributed to Ugo da Campione (III, PL. 19). In front of the Cathedral is the octagonal Baptistery (1340; Giovanni da Campione), formerly in S. Maria Maggiore, poorly restored in 1898; within are carved panels, by an anonymous Lombard master, which were perhaps part of the baptismal basin. The Colleoni Chapel, which abuts on S. Maria Maggiore, has a polychrome façade of the early Lombard Renaissance (G. A. Amadeo, 1470–76); within the chapel (remodeled in the 18th cent.) are the tombs of Bartolommeo Colleoni and his daughter Medea. Between Piazza del Duomo and Piazza Vecchia is the Palazzo della Ragione (existing as early as 1199), which in spite of several restorations has retained its original appearance. Opposite is the Palazzo Nuovo, begun by A. Vannone (ca. 1593) and continued on a Palladian design of V. Scamozzi (1611); the façade was completed in the 20th century. Also in the upper city are the Church of the Carmine (with an early 16th-century cloister), rebuilt in 1730 by G. B. Caniana; S. Andrea, documented as early as 785 but reconstructed 1840–47; the former Church of S. Agostino, with a 15th-century façade; and various Renaissance secular structures (e.g., Casa dei Rivola, Casa Passetti, Casa dell'Arciprete, and Casa Grumelli).

The lower city also preserves several noteworthy churches and buildings: S. Bernardino al Pignolo, late Gothic (restored), with painting by L. Lotto; S. Bartolomeo, reconstructed in the 17th century (painting by Lotto); Sto Spirito, rebuilt in 1521 [altar frontal by Lotto, polyptych by Il Bergognone (Ambrogio da Fossano)]; S. Alessandro della Croce (17th cent.); and the Palazzo dell'Accademia Carrara, neoclassic, by Galizioli (enlarged by Simone Elia). To the renovations of Piacentini (1919–29) belong the Piazza Vittorio Veneto and Piazza Dante. F. Rota's Tempio Votivo, a war memorial, was consecrated in 1952. Museums include the Galleria dell'Accademia Carrara, which contains work from the Venetian, Lombard, and Tuscan schools of the 15th and 16th centuries, and the Museo Archeologico.

BIBLIOG. P. Pesenti, Bergamo, Bergamo, 1927; Inventario degli oggetti d'arte d'Italia, I, Prov. di Bergamo, Rome, 1931; L. Angelini, Caratteri e schemi dell'architettura rustica bergamasca, Bergamo, 1932; A. Morassi, Gli affreschi del Lotto in S. Michele del Pozzo Bianco a Bergamo, BArte, XXVI, 1932–33, pp. 160–72; I. Negrisoli, Bergamo romana, Bergamo, 1937; L. Angelini, Le architetture a loggia della città e provincia di Bergamo, Atti 3StArch, pp. 175–84; L. Angelini, Scoperte e restauri di edifici medioevali in Bergamo alta, Palladio, V, 1940, pp. 35–43; R. Cessi, Bergamo medievale, Atti Ist. veneto di Scienze, Lettere e Arti, CI, 1941–42, pp. 383–92; S. Locatelli Milesi, Bergamo vecchia e nuova, Bergamo, 1945; L. Angelini, Il volto di Bergamo nei secoli, Bergamo, 1951; P. Pesenti, La basilica di Santa Maria Maggiore in Bergamo, Bergamo, 1953; N. Zucchelli, Capolavori d'arte in Bergamo, Bergamo, 1954; A. Ottino Della Chiesa, Accademia Carrara, Bergamo, 1955; P. Pesenti, La Cappella Colleoni nel gruppo monumentale di Bergamo alta, Bergamo, 1955; L. Angelini, Arte minore bergamasca, Bergamo, 1956; L. Angelini, Architettura settecentesca a Bergamo, Atti X Conv. naz. Storia Arch., Rome, 1959, pp. 159–64; EAA, s.v. Bergamo; F. Speranza, Il complesso monumentale di Sant'Agostino a Bergamo, Bergamo, 1959; O. Venanzio, Costruzioni romaniche a sistema centrale nel bergamasco, Arte lombarda, IV, 1, 1959, pp. 29–35.

Brescia (Lat., Brixia). An important Cenomanian settlement, Brescia came under Roman domination in 225 B.C. and became a colony in 27 B.C.. In the 6th century it was a Lombard duchy and during the 12th century a free commune; then it was ruled successively by the Torriani, Scaliger (Della Scala), and Visconti families; and in the 15th century it was annexed to the Venetian Republic. The grid plan of the Roman streets and the site of the forum have been identified. The principal Roman ruin is the Capitolium, dedicated A.D. 72–73 but built on the site of a republican predecessor. The ruins of the forum, curia, and theater are especially noteworthy. Of less importance are the remains of an aqueduct, bridge, and thermal building.

From the period of Lombard domination, some remains survive of the Church of S. Salvatore (8th cent.), under which an older church has been excavated (1957). Remains from the communal period are more extensive and better preserved. The Rotonda, or Old Cathedral (PL. 171), preserves the crypt of S. Filastrio (11th cent. or possibly earlier) and a 15th-century presbytery. The Cathedral was built on the site of S. Maria Maggiore (6th–7th cent.), of which some mosaic pavement fragments remain. The Broletto (12th–17th cent.), restored to its original form, has mullioned windows, decorated with sculpture, facing on an interior courtyard. The palace is dominated by the Torre del Popolo (begun in 11th cent.). S. Maria in Solario is a 12th-century oratory consisting of a polygonal upper structure on a square lower structure and crowned by a dome. The façade of S. Francesco is of the 13th century.

In the Piazza della Loggia are two Renaissance structures, Venetian in spirit: the Monte di Pietà (or Monte Vecchio, 1484; A. Zur-

lengo); and the Palazzo Comunale (or Loggia), begun by T. Fromenton(e) (1492) and worked on by J. Sansovino (1554), G. Alessi, A. Palladio, and G. A. Rusconi (1562). P. M. Bagnadore built the Palazzo del Monte Nuovo (1597) and probably also the palace with the Torre dell'Orologio. The Church of S. Giovanni Evangelista (15th cent.) preserves several panels by Moretto da Brescia. The Church of the Madonna del Carmine was begun in 1429. The Church of S. Maria dei Miracoli (1488–1581) was bombed in 1945, but the original façade, decorated with reliefs, survives. The Romanesque Church of S. Pietro in Oliveto was rebuilt in 1510. S. Giuseppe was built in 1521–78. The Church of the Madonna delle Grazie was built by L. Barcella (1522). The New Cathedral, built by G. B. Lantana (1604), Renaissance, has a Greek-cross plan; the dome is by L. Cagnola (1825); preserved inside are the shrine of SS. Apollonius of Brescia and Filaster (1510), of Venetian influence, and paintings by Romanino. Numerous palaces were erected during the Renaissance, including several by L. Beretta: Cigala, Maggi di Gradella, Martinengo da Barco (beginning of 16th cent., rebuilt in 1680). The Castle, in its present state, dates from the 16th–17th century.

During the baroque period were built the Palazzo Martinengo Cesaresco (1663; now the Questura), the Church of the Carità (1640), and the Church of SS. Faustino e Giovita (S. Carra, after 1622; frescoes by G. D. Tiepolo). Structures of the 18th century include S. Zeno (1745); SS. Nazaro e Celso (18th-cent. façade), which has a polyptych by Titian (depicting the Resurrection, Annunciation, and saints) and a Coronation of the Virgin by Moretto da Brescia; S. Maria Calchera, with paintings by Moretto da Brescia and Romanino; and S. Eufemia (1776), with a 15th-century crypt. The Fé, Bruni-Conter, and Gambara palaces are by A. Marchetti. S. Maria della Pace (G. Massari), the Palazzo Pancera Zoppola, the cemetery (1815; R. Vantini), and S. Alessandro (façade, 1894; an Annunciation by J. Bellini, ca. 1444) are neoclassic. The Piazza della Vittoria (M. Piacentini, 1932) is the center of the modern city. The new Ospedale Civile was begun in 1938, after a design by A. Bordoni. Museums include the Museo Romano, Museo Cristiano, and the Pinacoteca Civica Tosio Martinengo.

BIBLIOG. A. Ugolotti, Brescia, Bergamo, 1909; P. Guerrini, Elenco delle opere d'arte della diocesi e della provincia di Brescia, Brixia Sacra, XI, 1920, pp. 10–17, XII, 1921, pp. 9–17, 106–12, 128–33, XIII, 1922, pp. 77–82, 173–76; C. Marchetti, Le fontane di Brescia, Architettura, VI, 1925–26, pp. 97–117; R. Pacini, La sistemazione del centro di Brescia dell'architetto M. Piacentini, Architettura, XI, 1933, pp. 649–73; A. Guaga, Le cerchie murali di Brescia nel medioevo, Brescia, 1936; G. Panazza, L'arte medievale nel territorio bresciano, Bergamo, 1942; G. Panazza, Arte medievale e moderna: I danni prodotti dalla guerra al patrimonio artistico bresciano, Arti figurative, II, 1946, pp. 98–101; P. Guerrini, Le chiese longobarde di Brescia, Atti I Cong. int. Studi Longobardi, Spoleto, 1951, pp. 341–48; C. Boselli, L'architetto comunale di Brescia nel secolo XVI, Atti V Conv. naz. Storia Arch. (1948), Florence, 1957, pp. 353–65; EAA, s.v. Brescia; Miscellanea Studi bresciani sull'alto Medioevo, Brescia, 1959; O. Guarnieri, L'edificio romano scoperto sotto S. Salvatore di Brescia, Arte lombarda, V, 2, 1960, pp. 149–60; L. Imbriani, Passeggiate bresciane: la città, i laghi, le valli, Turin, 1960; M. Mirabella Roberti, Il Campidoglio repubblicano di Brescia, Atti VII Cong. int. archeol. classica, II, Rome, 1960, p. 347 ff.; G. Panazza, Di alcuni affreschi medievali a Brescia, Comm, II, 1960, pp. 179–201; G. Panazza, Le scoperte in S. Salvatore a Brescia, Arte lombarda, V, I, 1960, pp. 13–21; A. Peroni, La decorazione a stucco di S. Salvatore a Brescia, Arte lombarda, V, 2, pp. 187–220; E. Schmid, Verona - Brescia, Frauenfeld, 1961; G. Panazza and A. Peroni, La chiesa di San Salvatore in Brescia (Atti VIII Cong. di s. sull'arte dell'alto Medioevo, II), Milan, 1962.

Castiglione Olona. Possibly of Roman origin, the town owes its present appearance to the numerous buildings erected between 1420 and 1440 under the patronage of Cardinal Branda Castiglioni. The Chiesa di Villa (1432–35) shows the influence of Brunelleschi; flanking the portal are colossal statues of St. Anthony and St. Christopher, probably by Jacopino da Tradate. The Collegiate Church (1421) preserves the life of the Virgin by Masolino (q.v.), the life of St. Stephen, perhaps by Il Vecchietta, and the life of St. Lawrence, possibly by Paolo Schiavo, as well as the tomb of Cardinal Branda Castiglioni by a Campionese master. The Baptistery has a cycle of frescoes of the life of John the Baptist by Masolino (IX, PLS. 375, 376). There is a landscape frescoed by Masolino in the Casa Castiglioni.

BIBLIOG. M. Salmi, La chiesa di Villa a Castiglione Olona e le origini del Rinascimento in Lombardia, Misc. E. Verga, Milan, 1931, pp. 271–83; A. Barili, Castiglione Olona e Masolino da Panicale, Milan, 1938; G. Mariacher, Sculture di Castiglione Olona, L'Arte, XLV, 2, 1942, pp. 59–70, LI, 18, 1948–51, pp. 20–39; P. Toesca, Masolino a Castiglione Olona, Milan, 1944; A. Morassi, Die Fresken des Masolino im Baptisterium von Castiglione Olona, Pantheon, XIX, 1947, pp. 72–80; T. Foffano, La costruzione di Castiglione Olona in un opuscolo inedito di F. Pizolpasso, Padua, 1960.

Castelseprio (Lat., Sibrium). Originally a settlement of the Insubres, then a Lombard castrum, Castelseprio is now in ruins. There are remains of the encircling wall with square towers, of the castle (destroyed in 1287), S. Giovanni Evangelista, the 6th-century Baptistery, and S. Paolo (11th cent.). A short distance from the site of the castrum is the most noteworthy monument, the Church of S. Maria Foris Portas (7th–8th cent.). It is built on a trilobed rectangular plan, preceded by a large narthex. Preserved within is an important fresco cycle depicting the Infancy of Christ, attributed by some authorities to the 7th–8th century and by others to the 9th; the frescoes are virtually the sole surviving example of pre-Ottonian fresco painting in Lombardy and are in all probability by an itinerant eastern master (II, PL. 445).

BIBLIOG. F. Reggiori, Dieci battisteri lombardi minori, Rome, 1935; G. P. Bognetti, G. Chierici, and A. De Capitani D'Arzago, Santa Maria di Castelseprio, Milan, 1948; P. Toesca, Gli affreschi di Castelseprio, L'Arte, LI, 1948–51, pp. 12–19; K. Weitzmann, The Fresco Cycle of Santa Maria d Castelseprio, Princeton, 1951; R. C. Morey, Castelseprio and the Byzantine Renaissance, AB, XXXIV, 1952, pp. 174–201; L. Crema, I pavimenti di Santa Maria di Castelseprio, Arte del primo millennio (Atti II Conv. int. di S. alto medioevo), Turin, 1953, pp. 194–98; A. Grabar, Les fresques de Castelseprio et l'Occident, Frühmittelalterliche Kunst in den Alpenländer (Akten 3. int. Kong. für frühmittelalterliche Kunst), Olten, Lausanne, 1954, pp. 85–93; G. de' Francovich, Problemi della pittura e della scultura preromanica, I problemi comuni dell'Europa post-carolingia, Settimane di studio del Centro it. S. Alto Med., III, Spoleto, 1955, pp. 355–519; M. Schapiro, Notes on Castelseprio, AB, XXXIX, 1957, pp. 292–99; G. P. Bognetti, Castelseprio, Venice, 1960; F. Bologna, Castelseprio: Sopravvivenza della classicità nell'Italia longobarda, Civiltà nell'arte, Bologna, 1961, pp. 84–89; M. Mirabella Roberti, Una basilica adriatica a Castelseprio, Beiträge zu Kg. und Archäol. des Frühmittelalters (Akten 8. int. Kong. für frühmittelalterforschung, 1958), Graz, Cologne, 1962, pp. 74–87.

Civate (formerly Clivate). The town developed around the Benedictine monastery said to have been founded in the 8th century by Desiderius, the last king of the Lombards. Of the monastery, only the small Church of S. Pietro al Monte and the Chapel of S. Benedetto survive. S. Pietro al Monte was almost completely rebuilt toward the end of the 11th century, when a second apse intended as an imperial loggia and reminiscent of Carolingian *Westwerke* was added. The church has a single aisle and a crypt. Corbel tables supported by pilasters form the external decoration; inside are a notable ciborium decorated with 11th-century stuccowork and an important cycle of frescoes (11th–12th cent.). The Chapel of S. Benedetto has a single cross vault and a square, triapsidal presbytery; the altar is decorated with paintings contemporary with those in S. Pietro. Within the Casa del Cieco (formerly the Monastery of S. Calogero) is the Church of S. Calogero, completely rebuilt, in which were discovered a series of frescoes of Old Testament scenes that are related to those in S. Pietro and may date from the beginning of the 12th century.

BIBLIOG. P. Toesca, Monumenti dell'antica abbazia di S. Pietro al Monte di Civate, Florence, 1943; E. Ruggiero, I pittori della chiesa di S. Pietro al Monte di Civate, Lecco, 1953; G. de' Francovich, Problemi della pittura e della scultura preromanica, I problemi comuni dell'Europa post-carolingia, Settimane di studio del Centro it. S. Alto Med., II, Spoleto, 1955, pp. 355–519; G. Bognetti and C. Mancora, L'abbazia benedettina di Civate, Civate, 1957; L'Abbazia benedettina di S. Pietro in Monte a Civate, L'Architettura, V, 1959–60, pp. 849–53.

Como (Lat., Comum, Novum Comum). The city lies at the southwestern extremity of Lake Como. First settled by Gallic tribes, it later became a Roman colony and a municipium. In the late Empire it was a naval base of considerable importance because of its proximity to Mediolanum (Milan). The Byzantine general Narses fortified the city in the 6th century. In the Middle Ages it became part of the Lombard duchy of Milan, then a Frankish fief, and in the 12th century a free commune. Torn by the conflict between the Guelphs and the Ghibellines, it finally passed to the Viscontis of Milan.

Roman monuments include remains of a late wall, probably built on a republican predecessor; the Porta Praetoria, rebuilt during the late Empire (perhaps 3d cent.); remains of a thermal establishment; and a fine late Roman house. Columns perhaps of the 3d century support the porch of S. Cecilia. No medieval monument dating before the 11th century survives. Romanesque monuments, however, are numerous, though often mutilated or rebuilt. Ruins of the 11th-century Palazzo Vescovile were discovered in 1939. The 11th-century Church of S. Abbondio is almost intact. The church has a nave and four side aisles, an internal narthex, twin campaniles (one rebuilt in the 19th cent.), and 14th-century frescoes in the apse. S. Fedele (12th cent.) represents a novel fusion of the basilican and central plans. Noteworthy are the apse with internal and external loggias and the sculpture of the adjacent portal. Of the 12th-century structure of S. Giacomo, the transept, dome, and a portal survive. A five-storied medieval gate tower (the Torre di Porta Vittoria; 1192) stands near the Roman gate. The Broletto (1215) is early Gothic.

It was partly demolished to make way for the Cathedral, which was begun by Lorenzo degli Spazi (1396) and continued by Pietro da Breggia (1426). The late Gothic façade (PL. 187) was designed by Florio da Bontà; the façade sculpture is by the Rodari family (late 15th cent.); the right transept is by F. M. Ricchino (1627–33) and the left by C. Buzzi (1653–69). The apse is by Tommaso Rodari (1513) and the dome by F. Juvara. The church contains sculpture by T. Rodari and paintings by G. de' Ferrari, B. Luini, and Morazzone. The Church of the Annunziata (or Santuario del Crocefisso; 1564–74) has a neoclassic façade and chapels decorated by C. Carlone (1726) and Morazzone. S. Giorgio is baroque (1644; built over a previous church), with frescoes by G. P. Recchi (1686). The neoclassic Villa Olmo (1782) is by S. Cantone, and the Cimitero Maggiore was erected after a design by L. Tatti. Modern structures include the Tempio Voltiano (1927) by F. Frigerio, A. Sant'Elia's monument to the war dead, and the Casa del Fascio by G. Terragni (V, PL. 112). The Museo Civico is in the Palazzo Giovio and contains archaeological finds.

Near Como are the Romanesque Church of S. Carpoforo (11th–12th cent.) and the Villa d'Este, Cernobbio (16th cent.); the Villa Carlotta (1747), between Cadenabbia and Tremezzo, has sculpture by A. Canova and B. Thorvaldsen.

BIBLIOG. Riv. archeol. della provincia e antica diocesi di Como, 1872 ff.; D. Santo Monti, La Cattedrale di Como, Como, 1897; D. Santo Monti, Storia ed arte nella provincia e antica diocesi di Como, Como, 1902; U. Monneret de Villard, L'isola comacina: Ricerche storiche e archeologiche, Riv. archeol. della provincia e antica diocesi di Como, LXXVI–LXXVIII, 1914, pp. 1–243; D. Santo Monti, Como, Florence, 1922; U. Monneret de Villard, I monumenti del Lago di Como, Italia Monumentale, Florence, 1933, pp. 4–27; A. Pica, Il piano regolatore di Como, Architettura, XIII, 1934, pp. 741–52; F. Reggiori, Dieci battisteri lombardi minori, Rome, 1935; A. Giussani, I restauri della basilica di S. Abbondio in Como, Arte cristiana, XXV, 1937, pp. 30–41; R. Gazzola, La Cattedrale di Como, Rome, 1939; G. U. Arata, Il Lago di Como, Novara, 1946; F. Frigerio, Il Duomo di Como e il Broletto, Como, 1950; F. Tolotti, Tre basiliche cristiane dedicate agli apostoli in alta Italia, Misc. G. Belvederi, Vatican City, 1954, pp. 369–85; P. G. Giusti, Como e le ville del Lario, Como, 1957; EAA, s.v. Como; G. F. Miglia, ed., Larius, Milan, 1959; M. Magni, Architettura romanica Comasca, Como, 1960; P. O. Rave, Das Museo Giovio zu Como, Misc. Bibliothecae Hertzianae, Vienna, Munich, 1961, pp. 275–84. For Cernobbio: N. Podenzani, Villa d'Este, Milan, 1949.

Crema. Perhaps of Celtic origin, Crema was a fief in the 11th century and then a free commune. Destroyed by Frederick Barbarossa in 1160, the city was rebuilt in 1185. It belonged to the Venetian Republic from 1449 to 1797. The Lombard Gothic Cathedral was built in the 13th–14th century and preserves an old Romanesque portal (perhaps from the structure destroyed by Barbarossa); the interior was remodeled in the 17th–18th century. The central Piazza del Duomo is surrounded by 16th-century porticoed buildings. The baroque Palazzo Terni De Gregori was built in 1698 by G. Cozzi. The Church of SS. Trinità is the work of A. Nono (1739).

Outside Crema is the Church of S. Maria della Croce, a structure of Bramantesque character by G. Battagio (1493; completed by A. Montanaro). A short distance from Crema is the Church of S. Maria di Bressanoro, rebuilt in the 15th century in a mixture of Gothic and Renaissance styles.

BIBLIOG. G. Verga, Studi sul Duomo di Crema, Cremona, III, 1931, pp. 85–93, 154–63; G. Verga, I monumenti architettonici di Crema e dintorni, Crema, 1939; G. Sacchi, La Serenissima e i progetti di fortificazione della città di Crema, Atti Ist. veneto di Sc., Lettere e Arti, CII, 1942–43, pp. 299–300; Il Duomo di Crema alla luce dei nuovi restauri, Cremona, 1955; G. Verga, La ricostruzione del portale meridionale del Duomo di Crema, Palladio, N.S., VI, 1956, pp. 181–88; G. Verga, Il campanile del Duomo di Crema, Arte lombarda, IV, 1, 1959, pp. 36–51, 2, pp. 228–44.

Cremona. A Roman colony was established in 218 B.C. and became a municipium in 90 B.C.; a stronghold of the supporters of Vitellius in A.D. 69, Cremona was destroyed and then rebuilt by Vespasian. The modern city retains the rectilinear Roman plan; some tombs and several mosaics have been discovered. Cremona became a free commune in the 11th century and in 1334 passed to the Viscontis. The most notable medieval buildings are grouped around Piazza del Comune. The Church of S. Michele (rebuilt in the 12th cent.) has a simple but elegant façade and remains of 14th-century frescoes. The Cathedral was rebuilt in the 12th century on a basilican plan. The subsequent addition of the transept transformed the plan to a Latin cross. There are sculptures of the school of Wiligelmo da Modena and statues attributed to Gano da Siena (14th cent.). In the interior are frescoes by B. Boccaccino, Altobello Meloni, Il Romanino, Pordenone (IX, PL. 302), and Antonio and Bernardino Campi. Next to the Cathedral is the Torrazzo, a campanile which has become the symbol of the city; it was begun in 1250 and topped by a pinnacle in 1284, making it the highest campanile in Italy (ca.

365 ft. high). The loggia at its base dates from 1515. The octagonal Romanesque Baptistery was remodeled in the 15th century. In the same square are situated the Palazzo del Comune (1206–46; since remodeled) and the Loggia dei Militi (1292). The Palazzo del Popolo is of the 13th century. Two notable Gothic churches are S. Agostino (14th cent.), which preserves a painting by Perugino in its 16th-century interior, and S. Luca, remodeled in the 15th century. The Renaissance Portico della Bertazzola was begun by L. Trotti in 1499 and contains the tomb of Folchino Schizzi by Bonino da Campione. Sixteenth-century architecture is represented by S. Margherita (1547; built and frescoed by G. Campi), S. Pietro al Po (1563), the Palazzo Fodri, and the Palazzo Affaitati Magio. The Palazzo Stanga (1768) and Palazzo Tinti are rococo. The Palazzo Barbò is neoclassic. The Museo "Ala Ponzone" in Palazzo Affaitati Magio contains Cremonese paintings and an archaeological collection.

Near Cremona are the Church of S. Sigismondo, frescoed by 16th-century painters from Cremona, and the Church of S. Vincenzo, 17th century, which preserves a 12th-century apse from the original building.

BIBLIOG. E. Signori, Cremona nei suoi monumenti del medioevo, Milan, 1899; M. Monteverdi, Il Duomo di Cremona, il Battistero e il Torrazzo, Milan, 1911; T. Krautheimer-Hess, Die figurale Plastik der Ostlombardei von 1100 bis 1178, Marburger Jhb. für Kw., IV, 1928, pp. 231–307; E. Signori, Cremona, Bergamo, 1928; C. Bonetti, L'età del Battistero, della Cattedrale e del Torrazzo, Cremona, I, 1929, pp. 217–23; A. Malesani, L'abbazia di S. Sigismondo, Cremona, 1942; G. Pontiroli, La scoperta di mosaici romani nel sottosuolo dell'ex Chiesa di S. Giovanni Nuovo, B. storico cremonese, XVIII, 1952–53, pp. 244–50; M. Monteverdi, La chiesa di Sant'Agostino in Cremona, Cremona, 1953; C. Podestà Albertini, Municipium Cremona, Cremona, 1954; S. Degani, Note sul prospetto del Duomo di Cremona, Palladio, N.S., V, 1955, pp. 109–23; A. Puerari, Cremona, Milan, 1955; M. Levi, Vecchia Cremona, Cremona, 1956; A. Frova, I mosaici romani di Cremona, BArte, 4th Ser., XLII, 1957, pp. 325–34; EAA, s.v. Cremona.

Galliano. This was the site of a Roman vicus whose inhabitants probably were called "Braecorii Gallianates." The Basilica of S. Vincenzo, founded perhaps as early as the 5th century but reconstructed in 1007 by Aribertus of Intimiano, is located here; the exterior is simple and the interior consists of nave and one side aisle with a raised presbytery, perhaps later, and a crypt. The remarkable frescoes that decorate the nave, apse, and crypt represent a rare example of early 11th-century Lombard painting and show strong ties to Ottonian art. The Baptistery of S. Giovanni, perhaps mid-10th century, is square in plan with four hemicycles and an interior upper gallery, access to which is obtained through the west narthex; there is a circular font for baptism by immersion.

BIBLIOG. RE, s.v. Braecorii; F. Reggiori, Dieci battisteri lombardi minori, Rome, 1935; J. Baum, Bemerkungen zu Galliano, Basel, Civate, Med. S. in Memory of A. Kingsley Porter, I, Cambridge, 1939, pp. 165–79; P. Clerici, La cripta e il presbiterio della basilica di Galliano, Arte cristiana, XXXI, 1943, p. 55; G. de' Francovich, Problemi della pittura e della scultura preromanica, I problemi comuni dell'Europa post-carolingia, Settimane di Studio del Centro it. S. Alto Med., II, Spoleto, 1955, pp. 355–519; A. Pica, Galliano, Cantù, 1956; A. Annoni, La basilica di Galliano, Atti V Conv. naz. Storia Arch. (1948), Florence, 1957, pp. 239–49.

Gravedona. Situated on Lake Como, Gravedona became important in the 12th century, the period in which S. Maria del Tiglio was built. The church is Lombard Romanesque, with Burgundian influence, and was built on the site of an Early Christian baptistery; the simple interior (restored) has a single aisle and three apses. Beneath the floor are remains of the original basin for baptism by immersion. In the central apse is a wooden Romanesque crucifix. S. Vincenzo, an Early Christian church completely remodeled in the 17th–18th century, preserves part of the original crypt. SS. Gusmeo e Matteo, a 13th-century church (later remodeled), has frescoes by G. M. and G. B. Fiammenghino (1606). S. Maria delle Grazie (1467) has a Renaissance façade. The Palazzo Gallio was designed by P. Tibaldi (1586).

BIBLIOG. G. Rocco, Il palazzo delle quattro torri di Pellegrini a Gravedona, Como, 1929; U. Monneret de Villard, I monumenti del Lago di Como, Florence, 1932; M. Zecchinelli, Le tre pievi: Gravedona, Dongo, Lorico, con appendice sull'Abbazia di Piona, Milan, 1951.

Lodi. Frederick Barbarossa founded Lodi in 1158 after the destruction by the Milanese of its nearby predecessor, Laus Pompeia (now Lodi Vecchio). Lodi flourished during the late Middle Ages and the Renaissance. The Cathedral is a Romanesque structure (completed 1163) but has been extensively rebuilt; it has the original sculptured façade portal, preceded by a later porch with column-bearing lions taken from the Cathedral of Laus Pompeia. The unfinished campanile dates from the 16th century. S. Francesco (13th–14th cent.) has a brick façade, with a vestibule, a rose window, and

lancet windows; within are frescoes of the 14th–15th century. S. Agnese is a Lombard Gothic hall church. Ruins of the Broletto (1284) survive. The Church of the Incoronata (G. Battagio, 1488–89; G. G. Dolcebuono, 1494) has an octagonal interior with niches and windowed loggias and is covered by a segmented dome; within are 16th-century reliefs, four panels of the Life of the Virgin by Il Bergognone, and painted decoration by Callisto, Cesare, and Scipione Piazza (PL. 195). The Ospedale Maggiore, begun in 1459 and enlarged by P. Tibaldi (1571), has a small court decorated with terra cotta (1473) and a façade by G. Piermarini (1792). The Palazzo Veresi (formerly Mozzanica) is perhaps by Battagio. The Palazzo Barni is baroque, as is the Palazzo del Vescovo (1730; G. A. Veneroni). The Museo Civico contains archaeological material, a ceramic collection, and a painting gallery with works of local artists.

A few miles from Lodi is Lodi Vecchio (Lat., Laus Pompeia). The town was founded by the Boii, a Celtic tribe, and later became a Roman municipium. Destroyed in 1151, it grew up again as a village. The layout of the ancient Roman streets can still be seen, as well as part of the wall and perhaps the forum.

In the countryside is the Basilica of S. Bassiano, an Early Christian church rebuilt in the 10th and 14th centuries. The Gothic façade is divided into three parts by engaged columns; the interior consists of nave and two side aisles separated by piers and preserves 14th-century frescoes.

Across the Adda River from Lodi is Abbadia Cerreto. A Benedictine abbey existed there as early as 1084; it later subscribed to the Cistercian reform. Surviving is the Cistercian Church of S. Pietro (second half of 12th cent.; restored). An octagonal tower rises above the crossing (first half of the 14th cent.), and composite piers divide the nave from the two side aisles of the Romanesque structure. Ruins of the monastic buildings also survive.

BIBLIOG. G. Agnelli, Lodi e territorio nel Settecento, Arch. storico lombardo, 3d Ser., VIII, 1897, pp. 265–341; G. Agnelli, Lodi e il suo territorio nella storia, nella geografia e nell'arte, Lodi, 1917; A. Foratti, L'Incoronata di Lodi e il suo problema costruttivo, L'Arte, XX, 1917, pp. 219–39; A. Terzaghi, L'Incoronata di Lodi, Palladio, N.S., III, 1953, pp. 145–52; A. Caretta, Laus Pompeia (Lodi Vecchio) e il suo territorio, Milan, 1954; L. Cremascoli and A. Novasconi, L'Incoronata di Lodi, Milan, 1956; A. Frova, A proposito degli scavi di Lodivecchio, Arch. storico lombardo, 8th Ser., VIII, 1958, pp. 271–73; A. Degani, Lodi: Cattedrale di S. Maria Assunta — Chiesa di S. Cristoforo, Arte lombarda, IV, 1, 1959, pp. 149–49; A. Degani, L'organismo romanico del Duomo di Lodi, Arte lombarda, IV, 2, 1959, pp. 202–27; A. Carretta and A. Degani, In margine ai restauri della Cattedrale di Lodi, Arte lombarda. V, 1, 1960, pp. 22–26; EAA, s.v. Lodivecchio. For Abbadia Cerreto: L. Fraccaro de Longhi, L'architettura delle chiese cistercensi italiane, Milan, 1958, pp. 83–95.

Lomello (Lat., Laumellum). Originally a Celtic settlement, it became a Roman vicus. Later it was a Lombard center and retains walls from that period. The Baptistery of S. Giovanni ad Fontes dates from the 5th century; it was rebuilt in its upper parts in the 8th century and restored in 1940. It has alternating rectangular and horseshoe-shaped niches and an octagonal dome. Within are remains of a hexagonal baptismal basin. The 10th-century Church of S. Maria Maggiore was built by Bruningus on the site of a church contemporary with the Baptistery. The Castle has been rebuilt many times (1157, 1381, after 1407) and preserves two rooms with 16th-century frescoes.

BIBLIOG. RE, s.v. Laumellum; F. Reggiori, Dieci battisteri lombardi minori, Rome, 1935; G. Nigra, La basilica di S. Maria Maggiore di Lomello, Novara, 1936; G. Chierici, Il Battistero di Lomello, AttiPontAcc, XVII, 1940–41, pp. 127–37; A. K. Porter, S. Maria Maggiore di Lomello, Pavia, 1940; G. Chierici, La chiesa di S. Maria Maggiore di Lomello, Palladio, N.S., I, 1951, pp. 67–69.

Lovere. The city is situated at the northern end of Lake Iseo and preserves gold- and silverwork from a necropolis of the Gallic and Roman periods. The Church of S. Maria in Valvendra was built by Lombard masters (1473–83), but the interior was remodeled during the baroque period (1647 and 1751). The Galleria dell'Accademia Tadini (19th cent.; S. Salimbeni) has a noteworthy collection of paintings and porcelain.

About nine miles from Lovere is Clusone. The Oratorio dei Disciplini (1450) has a frescoed façade (*Triumph of Death* and *Dance of Death*, 1485); within are frescoes of the Life of Christ (1471). The Church of S. Maria Assunta (17th cent.) has a portico at one side and preserves 17th-century sculpture and carving by A. Fantoni, as well as paintings of the Venetian school.

BIBLIOG. A. Sina, La parrocchia di Lovere, Brixia Sacra. XIII, 1922, pp. 133–51; A. Sina, Le chiese e le cappelle di Lovere, Brixia Sacra, XV, 1924, pp. 97–116, XVI, 1925, pp. 1–11, 17–27; L. Gallina, L'Accademia Tadini in Lovere, Bergamo, 1957; EAA, s.v. Lovere. For Clusone: A. Giudici, Il Trionfo della morte e la danza macabra, Clusone, 1906; L. Olmo, Memorie storiche di Clusone e della valle seriana superiore, Bergamo, 1906.

Luino. Situated on the east bank of Lake Maggiore at the mouth of the Tresa River. The Church of the Madonna del Carmine (15th cent.) preserves a porch, sculptured portal, terra-cotta Madonna and Child in the lunette, and frescoed chapel (1540; school of G. Ferrari). The Oratory of S. Pietro was rebuilt in the 17th and 18th centuries and has a Romanesque campanile. The Church of S. Giuseppe dates from the 18th century, as does the Palazzo del Municipio (F. Soave).

BIBLIOG. M. Sanvito, Luino nella storia e nell'arte, Varese, 1931.

Mantua (It., Mantova). Situated in a bend of the Mincio River, the city is surrounded on three sides by water. Mantua may have been founded by the Etruscans, who probably occupied it until a very late date, and it also seems to have been a center of the Cenomani. In Roman times part of the territory was portioned out to military veterans. The neighboring Roman village of Andes is famous as the birthplace of Vergil. Mantua flourished during the Middle Ages, first as a free commune (12th–13th cent.) and from 1273 under the Bonacolsi family. The Gonzagas ruled from 1328 to 1707 and gave the city its present appearance. (In the 16th century Giulio Romano undertook a complete urban renovation.) The Romanesque Rotonda di S. Lorenzo (late 11th cent.; restored) has a hemispherical dome without a drum. S. Maria di Gradaro (13th cent.) is a monastic church of Romanesque-Gothic transitional style. The 13th-century battlemented palaces and towers of Piazza Sordello give it a medieval character (Acerbi houses, Palazzo Bonacolsi with a tower of 1303, Torre della Gabbia). The Broletto, a civil edifice of the communal period (1227–73), also has battlements and a high corner tower; on the façade (remodeled in the 15th cent.) is a statue of Vergil (13th cent.). The Palazzo della Ragione dates from 1250. S. Francesco (restored 1952), a Gothic modification of an earlier, Romanesque oratory, has a brick façade and an impressive portal; within are 13th–14th-century frescoes. The Palazzo Ducale consists of a group of buildings erected and transformed between 1290 and 1707. The Castello di S. Giorgio is a part of this complex. The nucleus of the Palazzo Ducale is formed of two palaces built by the Bonacolsi family (13th–14th cent.): the Palazzo del Capitano and the Magna Domus. The former preserves remains of 14th-century decoration. The Magna Domus was gradually expanded from the 14th through the 18th century. In the 14th century, Bartolino da Novara worked on the Castello di S. Giorgio (1380), followed, in the 15th century, by L. Fancelli, who may have constructed the courtyard of the Castello and the apartments of Eleonora de' Medici. In the 16th century, A. M. Viani built the Galleria Nuova and the Appartamento Ducale. Giulio Romano worked on the Appartamento Estivale and the Cortile della Cavallerizza (the latter completed by G. B. Bertani). P. Pozzo redesigned the Appartamento degli Arazzi in the 18th century. The interiors are richly decorated with stuccoes, frescoes, and wood carving; the stuccowork in the Stanza di Apollo is attributed to F. Primaticcio, who may also have painted the frescoes in the Sala di Manto. The *studiolo* of Isabella d'Este has a carved ceiling designed by the Mola brothers. There are numerous frescoes by Giulio Romano and his pupils, and Mantegna (q.v.) frescoed the Camera degli Sposi (IX, PLS. 328, 329).

Luca Fancelli built S. Sebastiano (1460; restored; I, PL. 56), after a design L. B. Alberti (q.v.). S. Andrea (1472–94) was also built by Fancelli, after a design by Alberti (1470; I, PLS. 57, 58). The choir and transept are the work of A. M. Viani (ca. 1500), and the dome was designed by F. Juvara. The campanile is Gothic (1413). Giulio Romano built the Palazzo del Te (PL. 428) and also frescoed the Sala di Psiche; several artists worked on the decoration of the palace, including Primaticcio (stucco frieze in the Sala degli Stucchi), Polidoro da Caravaggio (Saletta dei Grotteschi), Giovanni da Udine (Saletta della Cupola Ottagona), and Rinaldo Mantovano (Sala dei Giganti; IX, PL. 298). The medieval Cathedral was remodeled in 1545 but retains a Romanesque campanile and some Gothic work. There are 14th-century frescoes and, in the apse and choir, frescoes by D. Fetti. Bertani designed the Church of S. Barbara (1562–65). Surviving 15th-century palaces include the house of Mantegna, perhaps designed by the artist himself; the Università dei Mercanti, with remains of frescoes by Pordenone on the façade; and the Palazzo Andreasi. Surviving 16th-century structures include the house of Giulio Romano, designed by the artist (1544), and the Palazzo Guerrieri, rebuilt in the 16th century but retaining the medieval Torre della Gabbia. The Palazzo Canossa dates from the 17th century. The Palazzo dell'Accademia Virgiliana has a neoclassic façade by G. Piermarini (1773). Inside is the Teatro Scientifico by A. Galli Bibiena (PL. 106). The Teatro Sociale by L. Canonica is a 19th-century design. The Galleria e Museo di Palazzo Ducale contains a picture gallery with tapestries made from Raphael cartoons, and canvases by Rubens, D. Fetti (II, PL. 202), and others; Greek and Roman sculpture; medieval and 13th–18th century sculpture; Egyptian art.

BIBLIOG. N. Giannantoni, Il Palazzo Ducale di Mantova, Rome, 1929; G. and A. Pacchioni, Mantova, Bergamo, 1930; A. Levi, Sculture greche e romane nel Palazzo Ducale di Mantova, Rome, 1931; A. Spinazzola Levi, Monumenti inediti di Mantova in rapporto con l'arte di Giulio Romano, AttiPontAcc, 3d Ser., XXI, 1945–46, pp. 213–39; C. Battaglia, La Rotonda di San Lorenzo in Mantova, Mantua, 1955; U. Tibaldi, La divina armonia di Sant'Andrea, Verona, 1955; U. Tibaldi, Mantova di ieri e di oggi, Mantua, 1956; G. Paccagnini, Il palazzo del Te, Milan, 1957; Mantova: La storia, I (G. Coniglio), Mantua, 1958, Le arti, I (G. Paccagnini), II (E. Marani and C. Perina), Mantua, 1960–61; EAA, s.v. Mantova.

Milan (Lat., Mediolanum). Although Milan is a markedly modern city, it preserves important artistic monuments from several periods. Founded by the Insubrians in the early 4th century B.C., it became subject to Rome in 196 B.C. Milan was a municipium and then a colony, under Hadrian; it achieved great importance toward the end of the 3d century as the capital of the Roman Empire. Remains of the Roman period include 16 Corinthian columns (perhaps from a temple) that were assembled as the front colonnade of the atrium which stood before the Church of S. Lorenzo, and the great 24-sided tower of the city wall of Maxentius. There are also remains of a theater (Augustan age), a thermal establishment (Via Brisa, perhaps Constantinian), one of the towers of the carceres of the circus, a tower of the Porta Ticinese, stretches of the wall around the circus and of an octagonal wall built around S. Vittore al Corpo, where an octagonal mausoleum once stood. Ruins of the Augustan city wall and of Maximian's additions to it, the amphitheater, a porticoed street (perhaps 2d cent.), another thermal building (perhaps the Baths of Hercules), and less important civil and religious buildings have been discovered. The sites of the forum, mint, and imperial palace are also known.

Several Early Christian basilicas are extant. Those built before S. Ambrogio (end of 4th cent.) are S. Tecla (only foundations remain), S. Giovanni in Conca (parts), and the Chapel of S. Vittore in Ciel d'Oro (later incorporated within S. Ambrogio). In the time of St. Ambrose, several basilicas were erected: Martyrum (S. Ambrogio), Apostolorum (S. Nazaro Maggiore), Salvatoris (S. Dionigi), and Virginum (S. Simpliciano). The central-plan Church of S. Lorenzo Maggiore may not have been built until the early 5th century. Some Early Christian monuments have been destroyed (e.g., S. Tecla); others have been much changed through the centuries, although their original structures have been identified (e.g., S. Ambrogio, S. Nazaro Maggiore, S. Lorenzo Maggiore, S. Simpliciano). These buildings represent the architectural development of late antiquity and the Early Christian period. S. Lorenzo, which was rebuilt in 1573 by M. Bassi, preserves the original quatrefoil plan. The three annexed chapels of S. Ippolito, S. Sisto, and S. Aquilino radiate from the central core. S. Aquilino preserves important mosaics (4th–5th cent.). The mosaics in S. Vittore in Ciel d'Oro (in S. Ambrogio) are later and reveal Byzantine influence.

Milan was destroyed by the Goths in the 6th century but was rebuilt in the pre-Romanesque period, when the building activity of the Lombard craftsmen known as the magistri comacini began. The apse of S. Ambrogio was built in the 8th century, and those of S. Vincenzo in Prato and S. Eustorgio date from the 9th century. Early Romanesque structures include the Chapel of the Pietà (S. Maria presso S. Satiro) and the churches of S. Babila (I, PL. 394) and S. Celso; all have been remodeled but preserve Romanesque elements. A high point of medieval architecture was marked by the reconstruction of S. Ambrogio, a basilica of imposing size with an atrium; the use of cross vaults with flat ribs supported by cruciform piers was a development of far-reaching importance (I, PL. 384). Also of the 9th century is the golden altar of S. Ambrogio (III, PL. 63). In 1162 Frederick Barbarossa devastated the city, but it was rebuilt (this time as a free commune) with a new fortifying wall. Churches rebuilt at this time include S. Eufemia, S. Calimero, and S. Eustorgio, all of which followed the building principles of S. Ambrogio. In the early 13th century the Palazzo della Ragione (or Broletto Nuovo) was built. It preserves a façade relief of the podesta Oldrado da Tresseno; the work of a local master, this equestrian sculpture reveals the influence of Benedetto Antelami.

Building activity continued under the rule of the Viscontis, when Gothic style had its effects on local work, but Milanese masters were reluctant to abandon completely their traditions in favor of the new style. This is particularly evident in the Gothic Loggia degli Osii, which is adorned with Campionese sculptures that are rather heavy and ponderous in their modeling (III, PL. 21). The work of the Pisan sculptor and architect Giovanni di Balduccio brought fresh influences to Milan (e.g., tomb of St. Peter Martyr, in S. Eustorgio; VI, PL. 367). The Gothic monument par excellence in Milan is the Cathedral (begun 1386), which was built on the site of the former Church of S. Maria Maggiore and became the central focus of the city; it is related to northern Gothic through the influence of successive French and German masters among the directors of the work.

It reveals a taste for excessive ornament (evident also in Lombard Renaissance architecture), on the exterior, which is adorned with a great number of pinnacles (VI, PL. 337), and in the interior, particularly in the richly decorated capitals conceived by Giovannino de' Grassi. The polygonal apse is extremely graceful, but the façade is somewhat inconsistent, having been completed only in the 19th century. Among the treasures within are the Aribertus Cross, the Trivulzio Candelabrum, and Campionese sculptures of apostles (III, PL. 18).

The reign of the Sforza family, particularly that of Ludovico (Il Moro; 1451–1508), was a fruitful period for Milan's architecture. The Castello Sforzesco, a huge brick structure with a square plan and towers at the corners, was begun by Giovanni da Milano (1450) and successively worked on by Filarete and Bartolomeo Gadio. The structure was almost complete when Francesco Sforza died (1466); and was completed and decorated under Galeazzo Maria and Lodovico. The tower at the main gate was built by Filarete; destroyed in 1521, it was reconstructed by Beltrami at the end of the 19th century. The Ponticella of Lodovico, a small complex of loggia and private apartments over the moat, is attributed to Bramante. The Renaissance Portico of the Elephant and the Loggia of Galeazzo Maria (B. Ferrini) are in the ducal court; the portico in the Cortile della Rocchetta is by B. Ferrini (east side attributed to Bramante). The Sala delle Asse has frescoes designed and possibly painted by Leonardo da Vinci (q.v.). The chapel was frescoed by Bonifacio Bembo. The Sala del Tesoro has a fresco by Bramantino. The Ospedale Maggiore (Albergo de' Poveri), a Renaissance building with Gothic elements, was restored after World War II. Filarete began the structure in 1456 with the south wing; F. M. Ricchino, G. B. Pessina, F. Mangone, and Cerano were responsible for the central part with the great courtyard and the church (1625–49), and F. Castelli built the neoclassic north wing (1798–1804). The Portinari Chapel in S. Eustorgio, by Filarete and Ferrini, represents a fusion of Lombard elements with the style of Michelozzo. It is frescoed with scenes from the life of St. Peter by V. Foppa (V, PL. 358). S. Maria presso S. Satiro (1483; Bramante; façade by G. Vandoni, 1871) consists of a nave and two aisles covered with a barrel vault and a hemispherical dome; the simulated apse consists of three niches and a coffered vault, all in illusionistic perspective in stucco (II, PLS. 338–40, 344). The octagonal sacristy (or baptistery) has polychrome terra-cotta decoration by Agostino dei Fonduti. S. Maria delle Grazie was partly built by G. Solari (façade, nave and two aisles with Gothic arches and cross vaults, 1466–90) and partly by Bramante (II, PLS. 341, 342; trefoil choir with dome and external loggias begun in 1492; cloister and Old Sacristy). The Church was restored in 1934–37 and again in 1947; Solari's large cloister was completely destroyed in 1943. There are frescoes of Dominican saints by B. Butinone (1482?), scenes from the life of Christ by G. Ferrari (ca. 1540), and the famous Last Supper by Leonardo da Vinci (IX, PL. 125). The Church also preserves a Crucifixion by Donato da Montorfano (1495). S. Pietro in Gessate was built in 1460, perhaps by Solari, and contains frescoes by Il Bergognone, B. Zenale, B. Butinone, and A. Campi. S. Bernardino alle Monache was built about 1428. S. Maria della Pace (1466–97; G. Solari) preserves frescoes by Tanzio da Varallo. S. Maria del Carmine (1446–49) was remodeled in the 19th century (façade, 1880). S. Maria Incoronata consists of two churches side by side (1451 and 1460) in the style of the Solari family. S. Maria della Passione was built by G. Battagio (1482–85) and transformed in the 16th century, with a dome by Cristoforo Solari (1530) and a baroque façade. G. G. Dolcebuono, Cristoforo Solari, and G. A. Amadeo began S. Maria presso S. Celso in 1493–97; it was completed in the 16th century by C. Cesariano, C. Lombardo, V. Seregni, and G. Alessi. The Portico della Canonica (1492–99) of S. Ambrogio is by Bramante, as are the two cloisters (now courtyards of the Università Cattolica del Sacro Cuore), which were part of a larger project by the architect (II, PL. 345). The Cascina Pozzobonelli is a triapsidal oratory (1498) with a polygonal cupola. The Trivulzio Chapel is by Bramantino (1512) and serves as the vestibule of S. Nazaro Maggiore. The chapel contains the tomb of Gian Giacomo Trivulzio by F. Briosco. The Chapel of S. Maria alla Fontana (under the church of the same name) was begun in 1507; formerly attributed to Leonardo, it is now believed to be the work of anonymous followers of Bramante.

Fifteenth-century secular architecture includes the Casa Fontana (now Silvestri), the Bicocca degli Arcimboldi, Casa Atellani (now Conti), the Casa del Panigarola, the Bramantesque portal and courtyard of the Palazzo Castani, and the courtyard of the Casa dei Grifi. The Casa dei Borromei was severely damaged in World War II. It has been restored and preserves frescoes, in the International Gothic style, depicting aristocrats at play (VI, PL. 6).

In the 16th century G. Alessi built the Palazzo Marino, Palazzo Municipale (1553–58, restored), the Church of SS. Paolo e Barnaba (1560), and the façade of S. Maria presso S. Celso (1565). Pellegrino Tibaldi worked on the Palazzo Arcivescovile, where he built the

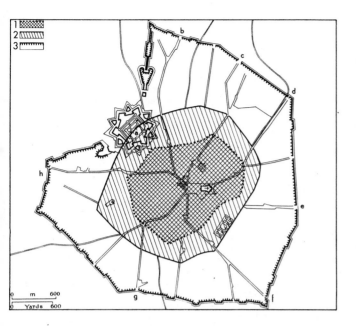

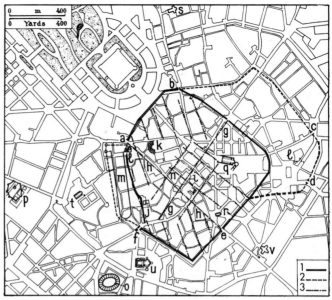

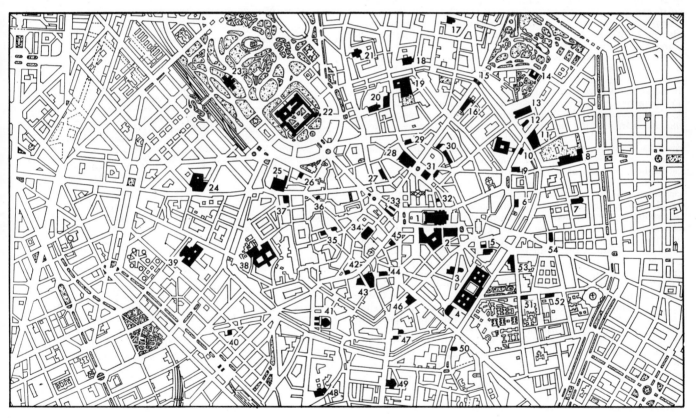

Milan. *Above, left*: Urban expansion to the 16th century. *Key*: (1) Area of the Roman city within the walls of Maximian; (2) expansion within the 14th-century walls of Azzone Visconti; (3) expansion within the bastions of Ferrante Gonzaga. (*a*) Castello Sforzesco. Principal gates: (*b*) Comacina; (*c*) Nuova; (*d*) Orientale; (*e*) Tosa; (*f*) Romana; (*g*) Ticinese; (*h*) Vercellina. *Right*: Plan of the city in Roman and Early Christian periods. *Key*: (1) Walls of the Augustan age; (2) extension of the walls in the time of Maximian; (3) course of Roman streets. (*a*) Porta Vercellina; (*b*) Porta Comacina; (*c*) Porta Argentea; (*d*) Porta Herculea (?); (*e*) Porta Romana; (*f*) Porta Ticinensis; (*g*) *decumanus maximus*; (*h*) *cardo maximus*; (*i*) forum; (*j*) area of the Palatium; (*k*) theater; (*l*) baths; (*m*) circus; (*n*) area of the mint; (*o*) amphitheater; (*p*) wall and octagonal mausoleum; (*q*) Basilica Nova (S. Tecla); (*r*) S. Giovanni in Conca; (*s*) Basilica Virginum (S. Simpliciano); (*t*) Basilica Martyrum (S. Ambrogio); (*u*) Basilica Palatina (S. Lorenzo Maggiore); (*v*) Basilica Apostolorum (S. Nazaro Maggiore); (*w*) presumed area of the Basilica Portiana. *Below*: Principal medieval and modern monuments. (1) Cathedral; (2) Palazzo Arcivescovile, Royal Palace, and S. Gottardo; (3) Palazzo Greppi and S. Antonio Abate; (4) former Ospedale Maggiore and S. Nazaro Maggiore; (5) S. Stefano Maggiore and S. Bernardino alle Ossa; (6) Palazzo Durini; (7) S. Maria della Passione; (8) Palazzo Isimbardi; (9) S. Babila; (10) Casa Fontana-Silvestri and Seminario Vescovile; (11) Palazzo Serbelloni; (12) S. Pietro Celestino; (13) Palazzo del Senato; (14) Galleria d'Arte Moderna; (15) Arches of Porta Nuova; (16) Palazzo Gallarati Scotti; (17) S. Angelo; (18) S. Marco; (19) Palazzo di Brera; (20) S. Maria del Carmine and Palazzo Cusani; (21) S. Simpliciano; (22) Castello Sforzesco; (23) Palazzo dell'Arte; (24) S. Maria delle Grazie; (25) Palazzo Litta; (26) Palazzo dal Verme; (27) Palazzo Clerici; (28) Teatro alla Scala; (29) S. Giuseppe; (30) Museo Poldi-Pezzoli and Palazzo Belgioioso; (31) Palazzo Marino and S. Fedele; (32) S. Raffaele; (33) Piazza Mercanti; (34) Palazzo dell'Ambrosiana and S. Sepolcro; (35) S. Maria Podone and Casa dei Borromei; (36) S. Maria alla Porta; (37) Monastero Maggiore and Museo Archeologico; (38) S. Ambrogio; (39) S. Vittore al Corpo and Museo della Scienza e della Tecnica Leonardo da Vinci; (40) S. Vincenzo in Prato; (41) S. Lorenzo; (42) S. Giorgio al Palazzo; (43) Casa Piatti and Palazzo Trivulzio; (44) S. Alessandro in Zebedia; (45) S. Maria presso S. Satiro; (46) Palazzo Annoni (now Cicogna); (47) S. Eufemia and S. Paolo; (48) S. Eustorgio; (49) S. Celso and S. Maria presso S. Celso; (50) S. Calimero; (51) SS. Paolo e Barnaba; (52) S. Maria della Pace; (53) Palazzo Sormani-Andreani; (54) S. Pietro in Gessate.

chapel and the portal and courtyard of the presbytery (1572–1604). Tibaldi also designed the churches of S. Fedele (begun 1569, completed by M. Bassi and F. M. Ricchino), S. Carlo al Lazzaretto, and S. Sebastiano (1577; remodeled by M. Bassi, F. Mangone, and G. Meda). The Casa degli Omenoni ("the house of the big men") by L. Leoni (1573) has eight large telamones by A. Abbondio, from which the building derives its name. V. Seregni built the Palazzo dei Giureconsulti (1562) and designed the interior of the Certosa di Milano a Garegnano, which preserves a fresco cycle by Daniele Crespi (1629). The Church of S. Maurizio al Monastero Maggiore (1503–81) was decorated within by B. Luini, S. Peterzano, A. Campi, and G. P. Lomazzo. The architecture and decoration of S. Angelo (1552–84) are late mannerist in style.

Fabio Mangone and Francesco Maria Ricchino were the two principal architects of the baroque period. Mangone built the Palazzo del Senato (designed as the Collegio Elvetico), altered S. Sebastiano (1617), remodeled S. Maria Podone (1625), and completed the Seminario Maggiore (1608; begun by A. Trezzi before 1602). Ricchino was responsible for the Scurolo di S. Carlo in the crypt of the Cathedral (1606), the incurving façade of the Palazzo del Senato (1627), the Church of S. Giuseppe (1607–30), the Palazzo Annoni (now Cicogna; 1631), Palazzo Durini (1644–45), and Palazzo Litta (1648; staircase by C. G. Merli, 1690; façade by B. Bolli, 1752–63; PL. 226), the facing and courtyard of the Palazzo di Brera (1651; II, PL. 145), the Church of S. Maria alla Porta (1650), and the entrance portal (1644) of the Seminario Vescovile. Girolamo Quadrio built the campanile (begun by C. Buzzi) of S. Stefano Maggiore, the Arese Chapel in S. Vittore al Corpo, the Chapel of the Madonna del Carmine (1616–76) in S. Maria del Carmine, and the Church of S. Nicolao (1659). S. Alessandro in Zebedia (1602–60) was constructed on a plan by L. Binaghi (Binago) under the successive guidance of Ricchino, G. Quadrio, and V. Castelli.

Important rococo works were created during the period of Austrian domination (18th cent.), particularly in civil architecture: S. Maria della Sanità (1708; C. Pietrasanta), S. Francesco di Paola (1728; M. Bianchi), the Palazzo Cusani (1719) and the Palazzo Trivulzio (1707–13), both by C. Ruggeri, and the Palazzo Sormani-Andreani (1736; F. Croce; restored). G. B. Tiepolo painted an immense fresco, depicting the chariot of the sun, in the Palazzo Clerici; he also painted frescoes in the Palazzo Dugnani (allegorical subjects and scenes of the lives of Scipio and Massinissa; VII, PL. 269). Under Napoleon, Milan received its first regulated urban plans (1801–07). Thus was established the basis of the modern city, which spread beyond the old walls and became one of the most representative centers of neoclassicism. G. Piermarini built the Palazzo Belgioioso (1777; frescoes by M. Knoller), the Palazzo Greppi in Via S. Antonio (1776; interior decoration by G. Albertolli and Knoller), the public gardens (1782; enlarged in the 19th cent.), the façade of the Royal Palace (1770–78), and the Teatro alla Scala (1776–78). B. Alfieri designed the inner façade of Palazzo Sormani-Andreani (1756). The Villa Reale was built by L. Pollack (1790–96); the Palazzo Serbelloni is by S. Cantone (1794; X, PL. 267). Of the projected Foro Buonaparte near the Castello Sforzesco, only the Arco della Pace (1807–38) by L. Cagnola and the Arena (1805–07) by L. Canonica were erected. The Gothic revival resulted in the completion of the façade of the Cathedral (1805–13) by C. Amati, who also built S. Carlo (1832–47). The eclecticism of the second half of the 19th century is represented by the Cimitero Monumentale (1866; C. Maciachini); there are monuments by Medardo Rosso, Vincenzo Vela, Giuseppe Grandi, Adolph Wildt, and others. The most representative personality of this period is G. Mengoni, who built the Galleria Vittorio Emanuele II (1865–77) and redesigned the Piazza del Duomo. The Palazzo Castiglioni was built in 1903 by G. Sommaruga in Art Nouveau style. The Stazione Centrale, designed by U. Stacchini, was erected in 1906–31.

Since the end of the 19th century Milan has undergone a series of noteworthy urban expansions: 1884–89, 1912, 1934, 1953. Noteworthy among building and reconstruction projects carried out after World War II are new apartment houses in Via Italia and Via Corridoni (L. Moretti); the Mangiagalli quarter (F. Albini and I. Gardella); the new business district (known as the Centro Direzionale), with the Palazzo Lane Rossi (1953; Chiolini and Brandolini) and the Palazzo S.I.R.T.I. (1954; G. Valtolina and others); the T.8 District, an experimental complex of structures by Italian and foreign architects, built on the occasion of the 8th Triennale of Milan (from which it derives its name; 1947) under the general direction of the architect P. Bottoni. Skyscrapers have also begun to appear, including the Centro Svizzero (1953; A. Meili) in Piazza Cavour; the Grattacielo di Milano (1955; the Soncini brothers, L. Mattioni, and P. Portaluppi) in Piazza della Repubblica; the skyscraper designed by Baciocchi (1938); the Pirelli building (G. Ponti and G. Valtolina); and the Vespa building (1955) by L. Vietti.

Milan is especially noteworthy for its excellent museums. The Pinacoteca di Brera has a fine collection of 15th–18th-century Lombard and Venetian art. The Museo Poldi Pezzoli has Lombard, Tuscan, and Venetian painting, of the 15th–18th century, as well as a collection of arms, archaeological material, and furnishings. The Museo del Castello Sforzesco was redesigned in the 20th century by the architects Belgioioso, Peressutti, and Rogers and is a noteworthy example of a modern museum designed within an old building. The sculpture collection includes late Roman, Byzantine, Gothic, and Renaissance works; the museum also contains furniture and paintings. The Pinacoteca Ambrosiana has a famous collection of drawings; the paintings are chiefly of the Lombard and Venetian schools. Other museums include the Museo Sacro di S. Ambrogio, the Museo del Duomo, and the Galleria d'Arte Moderna. The Museo Teatrale alla Scala has a collection of archaeological material, as does the Museo Archeologico.

Near Milan are two important abbeys: Chiaravalle and Viboldone. The former, founded by Cistercians in 1135, preserves its brick church (VI, PL. 331), a structure combining Lombard and Cistercian-Gothic elements. A very tall polygonal tower (14th cent.) surmounts the church. Within, the nave is divided from the two side aisles by short cylindrical pillars. The Abbey of Viboldone was begun by the Humiliati in the 12th century; construction continued throughout the 13th century, and the structure was completed in the 14th. Consequently the church has both Romanesque and Gothic structural elements. The brick Lombard façade is tripartite, divided by engaged columns; over the portal is a marble lunette sculptured by an anonymous artist. The spired campanile is of the 13th century, and inside the church is a cycle of Giottesque frescoes (PL. 188).

BIBLIOG. M. Caffi, L'antica badia di S. Celso a Milano, Arch. storico lombardo, 2d Ser., V, 1888, pp. 350–71; C. Boito, Il Duomo di Milano, Milan, 1889; U. Nebbia, Le sculture del Duomo di Milano, Milan, 1910; C. Romussi, Milano nei suoi monumenti, 2 vols., Milan, 1912–13; F. Savio, L'Ospedale di S. Barnaba a Milano, Arch. storico lombardo, XLII, 1915, pp. 168–76; U. Monneret de Villard, L'antica basilica a S. Tecla, Arch. storico lombardo, XLIV, 1917, pp. 1–24; A. Colombo, Le mura di Milano comunale e la pretesa cerchia di Azzone Visconti, Arch. storico lombardo, L, 1923, pp. 227–334; M. Salmi, Il tesoro del Duomo di Milano, Dedalo, V, 1924–25, pp. 267–88, 358–82; P. Pecchiai, L'Ospedale Maggiore di Milano, Milan, 1927; O. Lissoni, M. Fara and C. Pellini, Reminiscenze di storia e d'arte in Italia: I portali, Milan, 1928; A. Novelli, La basilica di Sant'Eustorgio, Milan, 1928; C. Ponzoni, Le chiese di Milano, Milan, 1930; C. Baroni, San Simpliciano, Milan, 1934; G. Bisiach Oddorno, La basilica di S. Nazaro Maggiore in Milano, Milan, 1935; V. Adami, Le strade di Milano al principio del secolo XIX, Arch. storico lombardo, N.S., II, 1937, pp. 230–41; M. C. Mengazzi, La chiesa di S. Marco nella storia e nell'arte, Milan, 1937; A. Pica, Il gruppo monumentale di S. Maria delle Grazie in Milano, Rome, 1937; C. L. Bardeaux, Catalogo delle guide di Milano, Arch. storico lombardo, N.S., III, 1938, pp. 111–36, IV, 1939, pp. 424–28, V, 1940, pp. 205–14, VII, 1942, pp. 130–39, VIII, 1943, pp. 113–17; G. Nicodemi, Il Duomo di Milano, Turin, 1938; A. Pica and P. Portaluppi, Le Grazie, Rome, 1938; G. Chierici, Di alcuni risultati intorno alla basilica di S. Lorenzo e alle basiliche paoliniane di Cimitile, RACr, XVI, 1939, pp. 51–72; Z. Kluckhan, Gestalt und Geschichte der Ambrosiuskirche in Mailand, Mitt. des Florentiner Inst., VI, 1940–41, pp. 73–97; F. Reggiori, La basilica ambrosiana, Milan, 1941; R. Calzini, Il palazzo di Giustizia di Milano, Architettura, XXII, 1942, pp. 1–72; G. Chierici, La chiesa di San Satiro, Milan, 1942; G. Bascapè, I palazzi della vecchia Milano, Milan, 1945; F. Reggiori, La Basilica di Sant'Ambrogio a Milano, Florence, 1945; F. Reggiori, Milano 1800–1943: Itinerario urbanistico edilizio, Milan, 1947; P. Mezzanotte and G. Bascapè, Milano nell'arte e nella storia, Milan, 1948; J. C. Ackermann, Gothic Theory of Architecture at the Cathedral of Milan, AB, XXXI, 1949, pp. 86–111; R. Aloi, Nuove architetture a Milano, Milan, 1949; A. Calderini, G. Chierici and C. Cecchelli, La basilica di San Lorenzo Maggiore in Milano, Milan, 1951; A. Calderini and R. Paribeni, Milano, Rome, 1951; A. Belloni, Milano com'era un tempo, Milan, 1952; G. Ceriani, La basilica di S. Babila, Milan, 1952; A. De Capitani d'Arzago, La "Chiesa Maggiore" di Milano, S. Tecla, Milan, 1952; P. Mezzanotte and G. Bascapè, Milano: Il Duomo, Milan, 1952; E. Tea, Architettura e decorazioni nelle chiese di Milano, Milan, 1952; Storia di Milano, Milan, 1953 ff.; E. Villa, La basilica Apostolorum sulla via romana a Milano, Arte del primo millennio (Atti II Conv. int. S. Alto Medioevo), Turin, 1953, pp. 77–90; E. Arslan, Brevi considerazioni sulla basilica di San Simpliciano, Rend. Ist. lombardo, LXXXVII, 1954, pp. 8–12; G. Chierici, La basilica di S. Lorenzo a Milano, Palladio, N.S., IV, 1954, pp. 171–74; L. Crema, Recenti scoperte nella chiesa di S. Giovanni in Conca, Frühmittelalterliche Kunst in den Alpenländern (Akten 3. int. Kong. für frühmittelalterliche Kunst), Olten, Lausanne, 1954, pp. 76–82; F. Wittgens, Glorie d'arte di Milano e della sua diocesi dal II all'XI secolo, Milan, 1955; G. Grossi, Vecchia Milano, Milan, 1956; G. Nicodemi, Milano spagnola, Milan, 1956; E. Schmid, Mailand, Frauenfeld, 1956; E. Villa, Basilica Apostolorum: Valutazione di alcuni organismi architettonici minori del primo Millennio, S. in onore di A. Calderini e R. Paribeni, III, Milan, 1956, pp. 709–30; P. Arrigoni, G. Belloni, and C. Rosa, Il Castello Sforzesco, Milan, 1957; G. Verga, Le absidi di S. Maria delle Grazie in Milano, Atti V Conv. naz. Storia Arch. (1948), Florence, 1957, pp. 335–37; E. Arslan, Nuovi ritrovamenti di S. Simpliciano, BArte, 4th Ser., XLIII, 1958, pp. 199–212; L. Grassi, La Cà Granda, Milan, 1958; M. Cagiano de Azevedo, Admiranda Palatia: I palazzi imperiali e le residenze tetrarchiche, B. centro di S. per la storia dell'arch., XIV, 1959, pp. 3–15; M. Ramperti, Vecchia Milano, Milan, 1959; R. Taccani, Milano di oggi e le città lombarde attraverso l'arte, Milan, 1959; A. Paredi, S. Ambrogio e la sua età, Milan, 1960; E. Arslan, Milano e Ravenna: Due

monumenti dell'architettura paleocristiana, Felix Ravenna, 3d Ser., LXXXIV, 1961, pp. 5–35; E. Arslan, Ultime novità a San Simpliciano, Arte lombarda, VI, 1961, pp. 149–64. For Chiaravalle: R. Bagnoli, L'Abbazia di Chiaravalle milanese, Milan, 1935. For Viboldone: P. Gazzola, L'Abbazia degli Umiliati in Viboldone, L'Arte, XLIV, 1941, pp. 147–58; L. Castelfranchi Vegas, L'Abbazia di Viboldone, Milan, 1959.

Monza (Lat., Modicia). An Insubrian settlement and then a Roman site, it became the residence of veterans returned from Mogontiacum (mod. Mainz). Monza became an important center under the Lombards (6th cent.); it was a free commune for a short period and came under the domination of the Viscontis in 1324. Bronze Age remains have been found, as well as several Roman tombs. The Cathedral was erected in the late 6th century but was entirely rebuilt in Gothic style in the 13th–14th century. The campanile is by P. Tibaldi (1592–1606); the bichrome marble façade, which shows Tuscan influence, is by Matteo da Campione (1390–96). The interior (remodeled in the 17th and 18th cent.) contains Campionese sculpture in the organ gallery; the main altar in marble and bronze is by A. Appiani (1798); there is a gilded silver repoussé altar frontal by Borgino dal Pozzo (1350–57). The Chapel of Queen Theodolinda is frescoed with scenes from the life of the queen by the Zavattari family (1444); the same chapel preserves the famous "iron crown" (VI, PL. 260). The Cathedral Treasury contains valuable relics of the 5th–9th centuries (IX, PL. 163). The Arengario (or Palazzo del Comune, 1293) was built in imitation of the Palazzo della Ragione in Milan and has an external loggia, where decrees were read to the populace. S. Maria in Strada was erected by Ambrogio da Milano (1357; remodeled). S. Maria delle Grazie is a late Gothic structure (1473; remodeled). The Villa Reale, a typical example of a neoclassic country house (1777–80; G. Piermarini) is a complex of buildings (including a rotunda in the park and the Cappella Espiatoria) with neoclassic decoration by G. Albertolli, A. Sanquirico, G. Traballesi, and A. Appiani; the park is by L. Canonica and Giacomo Tazzini (1806). The Villa Reale houses the Pinacoteca Civica and the Museo Storico.

North of Monza is Agliate, whose Church of S. Pietro dates from the 10th–11th century (restored in late 19th cent.). It is a timber-roofed structure with nave and two aisles divided by ancient columns with octagonal capitals. There are remains of 12th-century frescoes. The adjacent polygonal baptistery is contemporaneous with the basilica and has remains of frescoes and of the baptismal basin.

BIBLIOG. U. Nebbia, La Brianza, Bergamo, 1912; RE, s.v. Modicia; F. Reggiori, Dieci battisteri lombardi minori, Rome, 1935; La Basilica e il Tesoro di S. Giovanni Battista in Monza, Monza, 1956; C. Marcora, Fonti per la storia della Pieve di Monza, Milan, 1959. For Agliate: P. Corbella, Memorie di Agliate e della sua antichissima basilica, Milan, 1895; E. Della Valle, Agliate: Basilica e Battistero, Seregno, 1958.

Pavia (Lat., Ticinum). The city was probably founded by the Ligurians or by an Insubrian tribe. In the beginning of the 2d century B.C. it was annexed by the Romans; it became an important center when the Via Aemilia was extended beyond the Po River. The Roman street plan is well preserved, and the first city wall has been identified (perhaps dating to the 1st century B.C. but strengthened and enlarged in the late Empire), along with the gates, one of which, probably Augustan, stood near the Palace of Theodoric. In the Middle Ages Pavia was the capital of the Lombard kings (6th–8th cent.), a commune (12th–13th cent.), and, from 1359, part of the Duchy of Milan. Medieval Pavia saw much building activity, but the Roman city plan with rectilinear intersections was respected. Many medieval towers survive, all made of brick, a material that has come to be a distinctive characteristic of the city's architecture.

Of the numerous Lombard monasteries which existed there, some traces of the original Lombard structure of the Church of S. Felice remain; the others were almost entirely rebuilt during the great architectural activity of the Romanesque period. The rebuilding of S. Michele was begun in 1117, and the church was consecrated in 1155; the sandstone façade is decorated with horizontal bands of low reliefs of fantastic figures. The interior has a Latin-cross plan with galleries, compound piers and richly carved capitals, and a vaulted ceiling. There is an octagonal crossing dome, a raised choir, and a crypt. There is a silver repoussé crucifix of the 12th century in one of the chapels. S. Pietro in Ciel d'Oro was reconstructed in the 12th century (restored by A. Savoldi, 1875–99) and follows the style of S. Michele in its façade. The façade of S. Pietro in Ciel d'Oro is richer in effects of color because brick and sandstone are used together with decorative majolica tiles. Above the main altar is the tomb of St. Augustine (1360), one of the finest examples of local Gothic sculpture, showing the influence of the Tuscan Giovanni di Balduccio. S. Teodoro (13th cent.; restored 1904–06) is a brick structure and preserves important frescoes of the 13th–14th century. S. Maria in Betlemme is also a 13th-century structure. Other Romanesque monuments include the Broletto, a 12th-century edifice with

13th-century additions and a loggia of 1563 (restored 1927); the Torre Civica (to which P. Tibaldi added the bell chamber, 1683); the remains of S. Stefano (13th cent.); and the former Palazzo Belcredi (remodeled in 14th and 15th cent.).

The Gothic period produced fewer buildings. S. Francesco (1230–98) is in the Romanesque-Gothic transitional style, and S. Maria del Carmine was begun in 1390. Particularly noteworthy is the Castello Visconteo, an impressive square structure with four towers (two destroyed) and a large courtyard. The Cathedral (1488), a notable product of the Lombard Renaissance, was designed by C. de' Rocchi, G. A. Amadeo, and G. G. Dolcebuono; Bramante designed the interior (not completed until 1884), with high nave and two side aisles and the large dome (II, PL. 343). The polygonal-plan sacristy in the crypt with an umbrella vault was also designed by Bramante (II, PL. 344). The façade was completed only in 1898. S. Maria di Canepanova by G. A. Amadeo is a central-plan church and has frescoes and canvases by C. Moncalvo and G. C. and C. Procaccini. Other Renaissance buildings include the Palazzo Bottigella (now the Convitto Gandini), with a courtyard by G. A. Amadeo; the Palazzo Cavagna, with elegant brick decoration; and the tower of the palace of Cristoforo Bottigella. The Palazzo Vescovile is a late Renaissance structure (1560–91). The Collegio Borromeo (1564; P. Tibaldi) is an example of Lombard mannerist architecture; it was partly remodeled in the 18th century by G. Veneroni. S. Maria delle Grazie (G. B. Tassinari, 1609) is a baroque structure, and the Palazzo Municipale (formerly Palazzo Mezzabarba, by Veneroni, 1728–30) is rococo. The old parts of the university date from the 15th century but underwent major changes in the 18th (G. Piermarini) and 19th centuries (L. Pollack).

The Museo del Castello, in the Castello Visconteo, contains medieval sculpture and archaeological material. The Pinacoteca Malaspina has a collection of paintings. The Museo della Certosa, in the Palazzo Ducale, has documents relative to the Certosa and a collection of Renaissance paintings and sculpture.

On the road to Milan is the Certosa of Pavia, the famous Carthusian monastery founded in 1396 by Gian Galeazzo Visconti. The church, designed by Giovanni and Guiniforte Solari, is preceded by a large courtyard, access to which is gained through a vestibule decorated with 16th-century frescoes; on the south side of the courtyard is the baroque Foresteria (pilgrim's hospice; F. M. Ricchino). The façade of the church was begun by Giovanni Solari (1473) and decorated by Antonio and Cristoforo Mantegazza, G. A. Amadeo (1473–99), and C. Lombardo (16th cent.). The façade is adorned with polychrome marble and sculptures (PL. 195). The façade portal may have been designed by Gian Cristoforo Romano and is decorated with reliefs by B. Briosco. The interior has both Gothic and Renaissance elements and consists of a nave and two aisles separated by piers and flanked by cross-vaulted chapels containing many works of art, flanking the presbytery are the lavabo and the old sacristy, with a large ivory triptych of scenes from the life of the Virgin and depictions of saints by Baldassare degli Embriachi (1400–09; PL. 245). The small cloister has a portal signed by G. A. Amadeo (1466). The large cloister has terra-cotta decoration.

Not far from Pavia, in San Lanfranco, is the Church of S. Salvatore. It was built in the 7th century, enlarged in the 10th with a Benedictine monastery annexed, and rebuilt in the 15th–16th in Renaissance style with some Gothic elements.

BIBLIOG. A. Annoni, Le chiese di Pavia, Florence, 1925; R. Krautheimer, Lombardische Hallenkirchen in XII. Jahrhundert (S. Pietro in Ciel d'Oro, S. Michele), Jhb. für Kw., 1928, pp. 176–91; G. Nocca, Topografia di Ticinum all'epoca romana, Atti III Cong. naz. S. romani, I, Bologna, 1934, pp. 415–22; R. Krautheimer, Die Doppel Kathedrale in Pavia, London, 1936; A. Morassi, La Certosa di Pavia, Rome, 1938; F. Rittatore, Pavia, Carta archeol., 59, Florence 1939; N. Degrassi, Rinvenimento di un tesoretto: Le orificerie tardo-romane di Pavia, NSc, 7th Ser., II, 1941, pp. 303–10; G. Chierici, La Certosa di Pavia, Rome, 1942; G. Panazza, La chiesa di S. Agata al Monte, Proporzioni, III, 1950, pp. 16–29; E. Faccioli, L'arte della chiesa dei SS. Primo e Feliciano, Parma, 1953; E. Stenico, Relazione definitiva sui trovamenti archeologici nell'alveo del Ticino a Pavia, B. Soc. pavese Storia patria, V, 1953, pp. 37–80; E. Arslan, Note sulla scultura romanica pavese, BArte, 4th Ser., XL, 1955, pp. 103–18; C. E. Aschieri, ed., Pavia e la sua provincia, Pavia, 1955; F. Gianoni, Basilica di San Teodoro in Pavia, Pavia, 1956; C. Panazza, Campanili romanici di Pavia, Arte lombarda, II, 1956, pp. 18–27; P. Vaccari, Pavia nell'alto Medioevo e nell'età comunale, Pavia, 1956; A. Boerchio, Pavia e la Certosa, Pavia, 1957; G. Panazza, La chiesa dei SS. Gervasio e Protasio, Atti V Conv. naz. Storia Arch. (1948), Florence, 1957, pp. 221–38; E. Schmid, Pavia und Umgebung, Frauenfeld, 1958; R. Bossaglia, Torri civili del medioevo pavese, Arte lombarda, IV, 2, 1959, pp. 198–201; G. Chierici, La Certosa di Pavia, BArte, 4th Ser., XLIV, 1959, pp. 268–72; F. Fagnani, Il tracciato delle mura romane di Ticinum, B. Soc. pavese Storia patria, XI, 1959, p. 3 ff.; G. Franchi, Ancora alla ricerca di Pavia che fu, Pavia, 1959; C. Salette, La fabbrica quattrocentesca dell'Ospedale di S. Matteo in Pavia, Arte lombarda, V, 1960, pp. 48–55; F. Fagnani, La piazza grande di Pavia, B. Soc. pavese Storia patria, XIII, 1961, p. 71 ff.

Sabbioneta. In 1446 Sabbioneta was taken over by a minor branch of the Gonzaga family. By order of Vespasiano Gonzaga, Sabbioneta was rebuilt in the 16th century on a rectilinear plan. The same prince commissioned the fortifying wall, built by G. Cataneo of Novara, and oversaw the construction of numerous buildings, many of which are still standing and represent a unified complex

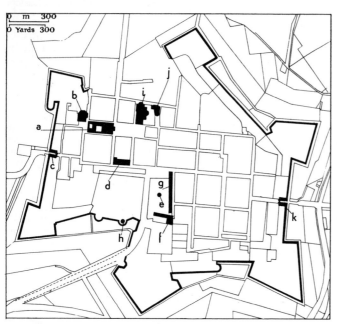

Sabbioneta, plan. Principal monuments: (a) Palazzo Ducale; (b) Church of the Incoronata; (c) Porta della Vittoria; (d) Teatro Olimpico; (e) Column of Pallas; (f) Palazzo del Giardino; (g) Galleria degli Antichi; (h) ruins of the Gonzaga castle; (i) S. Maria Assunta; (j) S. Rocco; (k) Porta Imperiale.

of 16th-century architecture. The Palazzo Ducale (1560) may have been designed by Vespasiano Gonzaga himself. The Palazzo del Giardino (1580–84) is decorated with frescoes, stuccowork, and grotesques by B. Campi, Giulio Romano, A. Cavalli, and Fornarotto of Mantua. Next to the Palazzo del Giardino is the Galleria degli Antichi (1584), frescoed by the Pesentis. The parish church (S. Maria Assunta; 1581) is by P. M. Pesenti; the 18th-century Chapel of the Sacred Heart has a dome by F. Galli Bibiena. The Church of the Incoronata (1586) contains the tomb of Vespasiano Gonzaga, by G. B. della Porta, and a bronze statue of the prince by L. Leoni (1588). The Teatro Olimpico (1589; V. Scamozzi) is built on a rectangular plan with semicircular stepped seats and loggia; there are frescoes of the school of Paolo Veronese.

Bibliog. G. F. Marini, Sabbioneta: piccola Atene, Casalmaggiore, 1914; T. Buzzi, Il palazzo ducale di Sabbioneta, Dedalo, IX, 1928–29, pp. 221–52, X, 1929–30, pp. 272–301; A. Puerari, Sabbioneta, Milan, 1955; G. Sena Chiesa, Guida da Sabbioneta, Milan, 1957.

Saronno. The town is famous as the site of the Sanctuary of the Madonna dei Miracoli. The sanctuary was begun in 1498, perhaps by G. A. Amadeo, with a square plan and a polygonal dome. The church was added later. The façade, by P. Tibaldi (1596–1612), has a double order of paired columns. The interior was designed by V. Dell'Orto and has baroque decorations. The campanile is by P. Della Porta (1516). Fresco decoration includes a concert of angels by Gaudenzio Ferrari (1536). There are also frescoes by B. Luini (1524–25).

Bibliog. F. Malaguzzi Valeri, Gli affreschi della Cupola di Saronno, Rass. d'arte, IV, 1904, pp. 69–73; G. Moretti, Il Santuario di Saronno, Rass. d'arte, IV, 1904, pp. 73–75; P. M. Sevesi, Il Santuario di Saronno, Milan, 1926.

Sirmione (Lat., Sirmio). The town is situated on a peninsula at the southern end of Lake Garda. At the extreme end of the peninsula are remains of a Roman villa improperly called the "Grotte di Catullo." It has been dated to the 1st century of the Christian Era, although some remains may date to the 1st century B.C. Sirmione also enjoyed a certain importance under the Lombards and the Franks. Ansa, the wife of Desiderius (king of the Lombards, 756–74), founded a monastery, of which some ruins are extant. The 11th-century Church of S. Pietro in Mavino was enlarged in the 14th century and preserves 12th–16th-century frescoes superimposed

one upon another. In the 13th century, control of the city passed to the Scaliger family, who fortified it with a surrounding wall and built the Rocca Scaligera (1259), a high keep entirely surrounded by water. The Scaligers also fortified Porto Vecchio with a battlemented wall. The Antiquarium delle Grotte di Catullo contains material from the Roman villa.

Bibliog. L. Costanza Fattori, Chiesa di S. Pietro in Mavino, Arte lombarda, III, 2, 1958, p. 130; G. A. Mansuelli, Le ville del mondo romano, Milan, 1958, p. 81; M. Mirabella Roberti, Sirmione: Les grottes de Catulle, Trieste, 1959; L. Costanza Fattori, Cappella di S. Anna, Arte lombarda, V, 2, 1960, pp. 259–61.

Sondrio. There is no documentation of the existence of Sondrio before A.D. 1000. From 1336 until the beginning of the 16th century, it belonged to the Duchy of Milan; then it belonged to the Grigioni family until 1797, when it was included in the Cisalpine Republic. Sondrio boasts several noteworthy palaces, including the Renaissance Palazzo Pretorio, the Palazzo Sassi de Lavizzari (16th cent.), the Palazzo Sertoli (18th cent.), which has frescoes attributed to G. Coduri, the Palazzo Carbonera with a spiral staircase and ironwork balconies, and the 20th-century Palazzo del Governo, by G. Muzio, with paintings by G. F. Usellini. The most distinguished monument is the collegiate church (SS. Gervagio e Protasio), designed by G. P. Ligari (18th cent.), with a façade by G. Sertoli (1838); in the interior are paintings by P. Ligari (1738) and 18th-century carved wooden choir stalls. The Teatro Sociale is by L. Canonica (1820). The Palazzo Quadrio-Tua houses the Museo Valtellinese, which has a collection of works of local artists.

Bibliog. Inventario degli oggetti d'antichità e d'arte d'Italia, IX, Provincia di Sondrio, Rome, 1938; Piccola guida turistica della Provincia di Sondrio, Varese, n.d.

Varese. Near the site of modern Varese were prehistoric lake-village settlements. During the Middle Ages Varese was a fortified site. For the most part, Varese is a modern center. The Baptistery dates from the late 12th or early 13th century and was built over an earlier hexagonal baptistry (8th–9th cent.); in the interior is an octagonal baptismal basin (late 13th cent.) and 14th-century frescoes. S. Vittore was rebuilt (1580–1615) after a design by P. Tibaldi and has a neoclassic façade by L. Pollack (1795); there are paintings by F. del Cairo, Morazzone, and Cerano. The baroque campanile (1617–1774) was designed by G. Bernascone. The Palazzo Ducale was built between 1766 and 1772 and has preserved its Italian-style gardens. The Villa Mirabello (18th cent.) contains the Musei Civici, with prehistoric and archaeological collections.

Near Varese is the Sanctuary of S. Maria del Monte, founded in the 7th century, enlarged in 1472 (perhaps by B. Gadio), and renovated in the 16th and 17th centuries. Parts of the crypt date from before the 11th century, and there are 14th-century frescoes. On the way to the sanctuary are chapels with polychromed terracotta sculptures, depicting the Stations of the Cross, and paintings by Morazzone, Nuvolone, and others. Annexed to the Sanctuary is the Museo Baroffio with a collection of altar cloths, gold- and silverwork, and other material.

Bibliog. M. Salmi, La chiesa di Villa a Castiglione Olona e le origini del Rinascimento in Lombardia, Misc. di S. lombardi in onore di E. Verga, Milan, 1931, pp. 271–83; C. Del Frate, Santa Maria del Monte sopra Varese, Chiavari, 1934; C. Baroni, Milano e le Cappelle del sacro Monte di Varese, Arch. storico lombardo, N.S., VIII, 1936, pp. 187–93; M. Bertolone, Varese: Le sue castellanze e i suoi rioni, Milan, 1952; F. Reggiori, Il Battistero di Varese e la sua rinascita, Milan, 1952; C. Maviglia, Il microbulino di Varese, Sibrium, I, 1953–54, pp. 1–5.

Vigevano. During the Roman era Vigevano was a fortified trade center. Under the rule of the Viscontis and the Sforzas (14th–15th cent.), Vigevano enjoyed its most flourishing period. S. Francesco (1378; Bartolino da Novara) and S. Pietro Martire (1363; remodeled in 1445 and restored in 1919) are Gothic monuments. The 10th-century castle was transformed in the 14th century and was rebuilt by Lodovico Sforza ("Il Moro") with the collaboration of Bramante (1491–94); it has preserved the walled keep with four battlemented towers, an open loggia which may have been an aviary for falcons, the stables, and external painted decorations and the Palazzo delle Dame. The Piazza Ducale may have been designed by Leonardo (1493–94); it is a vast rectangle from which radiate the seven principal avenues of the city and is surrounded on three sides by uniform porticoed palaces. On the fourth side of the square is the Cathedral. The square is dominated by the Torre del Castello (planned by Bramante). The Cathedral, which existed as early as the 10th century, was rebuilt in the 14th by Bartolino da Novara, in the 16th by Antonio da Lonate, and completed in 1612; the concave baroque façade (1680) is by the Spaniard J. Caramuel de Lobkowitz, and

the dome was built in 1708. Inside the Cathedral are several 16th-century paintings. Giacomo Moraglia was responsible for the two Saporiti palaces (1828–1857). The Civico Museo Archeologico has a collection of Roman and prehistoric antiquities as well as paintings by local artists.

BIBLIOG. G. Barucci, Il Castello di Vigevano nella storia e nell'arte, Turin, 1909; C. Dell'Acqua, Vigevano nella storia, nell'arte e nell'industria, Vigevano, 1939.

Trentino-Alto Adige (*Venezia Tridentina*). A mountainous border region surrounding the valley of the Adige River. In ancient times it was populated by the Raetians, an Alpine people. There are modest traces of prehistoric inhabitants that indicate Celtic influence from the north and paleo-Venetic influence from the south. In the Julio-Claudian period the region was Romanized, most of it forming a part of Italy, the rest going to the extra-Italian provinces of Raetia and Noricum. With the barbarian invasions (especially of the Bawarii, or Baiuwarii, in the Isarco and Pusterthal valleys) the northern territories began to gravitate culturally and linguistically toward the Germanic world (Tirol). In the 11th century the ecclesiastical principalities of Trent and Bressanone began to dominate the area. Later the region became an integral part of the Austrian empire, with which it remained until 1918. At present the region has an autonomous administrative status. The medieval artistic tradition, a provincial Gothic in particular, persisted for a long time in the north; the Trentino, on the other hand, was considerably influenced by the Renaissance, especially under the prince-bishops Bernardo Clesio and Cristoforo Madruzzo. Later Italian and Austrian influences both played their parts. The German- and Ladin-speaking people of the valleys have a strong tradition of folk art.

BIBLIOG. A. Roschmann, Tyrolis pictoria et statuaria, Innsbruck, Bib. Dipauliana (Ms. 1031, I, Ms. 1032, II), 1742; P. Orsi, Monumenti cristiani del Trentino anteriori al Mille, Arch. storico per Trieste, l'Istria e il Trentino, I, 1881–82, pp. 101–05; K. Atz, Kunstgeschichte von Tirol und Vorarlberg, Bolzano, 1885; G. B. Trener, Notizie per la storia dell'arte nel Trentino, Trent, 1902; F. Largaiolli, Bibliografia del Trentino (1475–1903), 2d ed., Trent, 1904; Scritti di Storia dell'arte per il XV centenario della morte di S. Vigilio, Trent, 1905; L. Marchetti, La storia dell'arte trentina in una memoria di L. O. in Alto Adige, Trent, 1912; L. Oberziner, Le fonti edite e inedite della storia dell'arte nel Trentino, Arch. trentino, XXVIII, 1913, pp. 74–80; J. Weingartner, Die Kunstdenkmäler Südtirols, Vienna, 1923; G. B. Ceas, Due castelli della Val Pusteria, Architettura, V, 1925–26, pp. 433–48; A. Morassi, Affreschi romani del Castel Appiano, BArte, N.S., VI, 1926–27, pp. 433–58; S. Weber, Per la storia dell'arte nel Trentino, S. trentini, VII, 1927, pp. 118–44; U. Tomazzoni, La romanizzazione della Val d'Adige, Trent, 1930; G. B. Emert, Monumenti e opere d'arte nella Venezia Tridentina, Trent, 1931; P. Laviosa Zambotti, L'età del bronzo e la prima età del ferro nell'Alto Adige, SEtr, VII, 1933, pp. 393–411; P. Laviosa Zambotti, La seconda età del ferro nella Venezia Tridentina, SEtr, VIII, 1934, pp. 375–96; A. Morassi, Storia della pittura nel Trentino sino al secolo XVI, Rome, 1934; S. Weber, Le chiese della Val di Non nella storia e nell'arte, 3 vols., Trent, 1937–38; G. B. Emert, Fonti manoscritte inedite per la storia dell'arte nel Trentino, Florence, 1939; W. Arslan, Il museo dell'Alto Adige a Bolzano, Rome, 1942; N. Rasmo, Arte medievale nell'alto Adige, Bolzano, 1949; L. Dal Rè and U. Tomazzoni, Storia del Trentino, I, Rovereto, 1951; M. Caminiti, Guida dei Castelli dell'Alto Adige, Bolzano, 1955; M. Caminiti, Castelli dell'Alto Adige, Novara, 1956; W. and E. Frodl, Kunst in Südtirol, Munich, 1960.

a. Trentino. Anaunia (Val di Non). Northwest of Trent, this region is divided into the upper and lower Valle di Non by the Noce River. The seat of a Celtic-Raetian tribal community (remains have come to light in excavations near Sanzeno) which gravitated within the orbit of Tridentum. It was finally Romanized by Claudius (A.D. 46; according to the inscription of the *tavola clesiana*, Mus. Naz., Trent) to whom is attributed the foundation of towns in the region, as in the adjacent Val Venosta. The region was converted to Christianity in the 4th century (remains of an Early Christian cemetery under the chapel of the parish church of Sanzeno).

From 1027 to 1802 Anaunia was the fief of the prince-bishops of Trent. The area is rich in medieval castles, which were often built on the ruins of Roman towers. Among the notable castles are Castel Cles, dominated by two rectangular towers (the third was destroyed in the 19th cent.), enlarged and altered in the 16th century by Bernardo Clesio. The façade, the ground-floor loggia in the courtyard, and the frescoing (school of Il Romanino) of several rooms date from this time. Castel Thun, or Tono, rebuilt after 1569, has bastioned walls, an interior court with loggias, and a Chapel of Giorgio with frescoes by the school of Bressanone; Castel Bragher, or Brughiero, has a charming 17th-century court; the Chapel of S. Celestino was frescoed in 1461 by Jacopo Sunter (school of Bressanone). The Renaissance Castel Valer is built around an octagonal tower. There are three courtyards, a loggia decorated with coats of arms, and a Chapel of S. Valerio with frescoes by the Baschenis family (1495). The Renaissance Castel Nanno is a rectangular structure with a small central tower surrounded by low walls with four low corner towers.

Religious structures of the region include the Sanctuary of S. Romedio, which comprises five chapels built one over the other. The oldest chapel, which has a portal dating from 1000, was built in part from material from older structures. There are frescoes variously dated from the 10th to the 13th century. There are numerous churches in the region that were erected by Lombard artisans. Most of these structures are single-aisled with pyramidal-peaked campaniles (e.g., Cles, parish church, by A. Medaglia, 16th cent.). The Baschenis family painted frescoes for a number of these churches, and there are polychromed wood altars in a provincial baroque style.

BIBLIOG. F. Detlefsen, Das Pomerium Roms und die Grenzen Italiens, Hermes, XXI, 1886, pp. 497–562; H. Schmölzer, J. Sunter's Malereien in der Schloss-Capelle zu Brughiero, Mitt. K. K. Zentral-Kommission, N.S., XV, 1889, pp. 147–52; S. Weber, Le chiese della Val di Non nella storia e nell'arte, 3 vols, Trent, 1937–38; L. Franch, La Valle di Non, Trent, 1953; A. Degrassi, Nuovi documenti epigrafici del Trentino e Alto Adige, Vjesnik za arheologiju i historiju dalmatinsku, LVI–LIX, 1954–57 (Mél. Abramic, I), pp. 139–44; O. Montenovesi, Il Santuario di S. Romedio nella Valle di Non, Archivi d'Italia e rassegna internazionale degli archivi, XXVII, 1960, pp. 163–83.

Rovereto. Perhaps of Roman origin, the city lies at the foot of the castle built by G. di Castelbarco in the 14th century. The castle was enlarged by the Venetians, who added three circular towers, and transformed by the Austrians into a garrison. It has since been restored. Parts of the 14th-century walls remain. The Palazzo del Municipio, enlarged in the 15th century, has remains of façade frescoes attributed to Fogolino. The Palazzo della Cassa di Risparmio, which dates from the 15th century (rebuilt in its original form in 1906), shows Venetian influence. The Church of S. Marco (1462), which was rebuilt in the 17th century, restored in the 19th, has a baroque interior. The Church of S. Maria del Carmine, which dates from the 14th century, was rebuilt in the baroque period. The Museo Civico is in the Palazzo Iacob.

BIBLIOG. G. Tartarotti, Memorie antiche di Rovereto e dei luoghi circonvicini, Venice, 1754; G. Chini, Il Castello di Rovereto, Rovereto, 1928; U. Tomazzoni and G. Tiella, Rovereto, Rovereto, 1954; C. Conci and L. Tamanini, Guida del Museo Civico di Rovereto, Rovereto, 1958.

Trent (Lat., Tridentum). A pre-Roman Raetian settlement, in which traces of Celtic influence have been found, Trent was Romanized in the course of the 1st century B.C. and became a municipium and an honorary colony in the Antonine period. Laid out on a regular plan around the Capitolium (Doss Trento), it was later extended along the left bank of the Adige. An amphitheater of the Julio-Claudian period, sculpture of the 2d and 3d centuries, and 3d-century walls remain. Ruins of an Early Christian church are preserved on the Doss Trento. Invaded by the Goths, Lombards, and Franks, Trent became an episcopal fief in 1027. The city reached its peak of splendor in the 16th century. The medieval city followed the general plan of the old Roman city with its *cardo* and *decumanus*. The oldest monuments date from the Romanesque period. The Cathedral was founded in the 6th century (remains are incorporated in the Castelletto; see below), altered in the 9th century, rebuilt and consecrated in 1145, renovated in the 13th–14th century by Adamo d'Arogno and the Campionesi, and completed in the 16th century. The dome was rebuilt in the 19th century. The Cathedral is in Lombard style; an exterior gallery runs above the apse and along the left side and the façade. A single rose window (Egidio da Campione) adorns the façade, which is flanked by two campaniles (the right one unfinished). On the left side is a porch rebuilt in the 16th century (containing sculpture influenced by Antelami) and the so-called "Madonna degli Annegati" (12th cent.). The porch of the apse contains sculpture by Campionese masters. The interior is a Latin cross covered by rib vaults supported on compound piers. The triapsidal presbytery over the crypt (now filled in; probably of the 12th-cent. structure) was rebuilt in the 18th century; the two side apses contain Campionese sculpture by the school of Adamo d'Arogno; frescoes by Monte da Bologna (14th cent.); numerous tomb slabs; the Cappella del Crocifisso (17th cent.) in the left aisle with canvases by J. C. Loth. S. Lorenzo, dating from the second half of the 12th century, was restored after World War II; it has a basilican plan with composite piers and an octagonal dome. The Palazzo Pretorio (13th cent., restored after World War II) has an older part, the so-called "Castelletto," incorporated within the structure of the Cathedral. The Castello del Buonconsiglio, built on Roman foundations and surrounded by circular bastions of the 16th century, stands within and against the medieval city walls. Towers include the Torre Grande (or Torre di Augusto), the Torresello di Mezzo, the Torre dell'Aquila (with a cycle of International Gothic style frescoes), the Torre Vanga, and the Torre Verde. The castle

consists of three structures: the Castelvecchio, dating from the middle of the 13th century, altered and enlarged in the 15th century with a Venetian Gothic loggia; the Magno Palazzo, erected by Bernardo Clesio (1528–36); and a 17th-century structure, the "Giunta Albertiana," linking the two earlier structures. The decoration of the Magno Palazzo is the work of M. Fogolino, Il Romanino, the two Dossis, A. Falconetto, the Carotos, and others. S. Maria Maggiore (A. Medaglia, 1520) is a Lombard Renaissance structure; the façade was rebuilt in the 20th century, but the campanile is Romanesque. Within the church are canvases by Moroni and Cignaroli and a notable *cantoria* (singing gallery) by V. Grandi (1534). The city's numerous Renaissance palaces reveal Lombard or Venetian influences. Such palaces include the Palazzo Tabarelli, Palazzo del Municipio (formerly Tono), Palazzo Geremia, Palazzo Del Monte (the last two with façade frescoes), and outside the city, the Palazzo delle Albere. The Palazzo Galasso is a baroque structure built for the Fuggers. Also baroque is the Church of S. Francesco Saverio (1701), built after plans by A. Pozzo. The monument to Dante (1896) is by C. Zocchi. Modern undertakings include the arrangement of Piazza Italia and the building of the post office, the station, and the monument to Cesare Battisti on the Doss Trento. The Museo Nazionale is in the Castello del Buonconsiglio. The Museo Diocesano Tridentino is in the Palazzo Pretorio. Outside Trent is Civezzano, where there was a Lombard cemetery. The parish church is Renaissance and has paintings by the Bassanos.

BIBLIOG. G. Tura, Le chiese dedicate a S. Apollinare nella diocesi di Trento, Felix Ravenna, XVI, 1914, pp. 679–82; G. Fogolari, Trento, Bergamo, 1916; C. Cecchelli, Reliquie trentine dell'età barbarica, Trent, 1929; F. Wittgens, Un ciclo di affreschi di caccia lombardi del Quattrocento, Dedalo, XIII, 1932–33, pp. 65–83; G. Giuseppe, Il Castello del Buonconsiglio e il Museo Nazionale di Trento, Rome, 1934; F. Filippini, Gli affreschi di Monte da Bologna nel Duomo di Trento, Atti Deputazione di Storia patria per le provincie di Emilia e Romagna, V, 1939–40, pp. 189–203; G. de Carli, La Cattedrale di Trento, Trent, 1941; G. Roberti, Trento, Ed. archeologica della carta d'Italia, fol. 21, Florence, 1952; G. B. Emert, Monumenti di Trento, Trent, 1954; M. Sandonà, Il Castello del Buonconsiglio a Trento, Trent, 1954; F. Bertoldi, Vecchia Trento, Trent, 1957; C. Pacher, La Cattedrale di Trento, Trent, 1957; C. Pacher, Guida di Trento, Trent, 1957; N. Rasmo, Gli affreschi di Torre Aquila, Rovereto, 1962.

b. Alto Adige (Ger., *Tiroler Etschland*). Bolzano (Ger., *Bozen*). Mentioned for the first time (as Bauzanum) by Paulus Diaconus, Bolzano formed part of the episcopal principality of Trent beginning in the 11th century and was joined to the Tirol in the 16th century. The oldest part of the city is that around the small Romanesque Church of S. Giovanni in Villa (12th cent; frescoes of the 14th–15th cent.), but the greatest building activity was that of the Gothic period, when Bolzano became a major mercantile center. Houses with loggias and balconies, and, outside the city, numerous castles were built. The Cathedral (13th cent.) was rebuilt in the course of the 14th and 15th centuries (restored after World War II). Its form, that of a hall church (*Hallenkirche*), evidences influence from beyond the Alps. The campanile and roof of polychrome tiles are notable. The Dominican Church (deconsecrated), of Italian influence, dates from the end of the 13th century but was altered in the 15th and 17th centuries. The adjacent 14th-century chapel is decorated with contemporaneous frescoes of the Bolognese school. The Franciscan Church, also of Italian influence, was built in the 13th century and rebuilt in the 14th; it has a 14th-century cloister. The baroque Palazzo Mercantile was built about the beginning of the 18th century. In more recent times the city has expanded across the Talvera River and merged with the suburb of Gries, which developed around the Benedictine monastery (with a 15th-century cloister and medieval tower). The Church of S. Agostino (18th cent.) and the Gothic parish church, which preserves a polychromed wooden altarpiece by Michael Pacher, are located in Gries. The Museo Civico is the local museum.

In the environs of Bolzano: Castel Flavon (Ger., *Haselburg*), originally of the 13th century, remodeled in the 16th, with 16th-century Lombard frescoes. Castel Firmiano (Ger., *Schloss Sigmundskron*) was rebuilt in the Romanesque period (Torre Bianca and the Chapel of S. Stefano, with frescoes) and enlarged in 1473. Castel Roncolo (Ger., *Schloss Runkelstein*, 1237); the Sala da Bagno and the Sala del Torneo are decorated with secular frescoes of the late Gothic period (and frescoes of Tristan and Isolde). Castel Sarentino (Ger., *Schloss Rafenstein*) dates from the 16th century.

BIBLIOG. P. Rossi de Paoli, Gli edifici della nuova Piazza della Vittoria a Bolzano, Architettura, XVIII, 1939, pp. 105–10; R. Salvini, Un ciclo di affreschi trecenteschi a Bolzano, RIASA, VIII, 1941, pp. 228–55; N. Rasmo, Arte medievale nell'Alto Adige (exhibition cat.), Bolzano, 1949; M. Martinelli and L. Merci, Guida di Bolzano e dintorni, Bolzano, 1953; N. Rasmo, Il chiostro monumentale di San Domenico a Bolzano, Bolzano, 1953; J. Weingartner, Bozner Burgen, Innsbruck, Vienna, Munich, 1953; N. Rasmo, La basilica paleocristiana di Bolzano, Cultura atesina, XI, 1957, pp. 7–20; N. Rasmo, Il Museo Civico di Bolzano, Bolzano, 1957.

Bressanone (Ger., *Brixen*). In 993 the episcopal seat was transferred to Bressanone from nearby Sabiona. In 1027 the bishops were invested with the temporal dominion of Bressanone, which they retained until 1803, when the territory passed to Austria. The center of the town contains a number of monuments grouped around the Cathedral. The Baptistery is the oldest of the monuments, with frescoes of the 13th–14th century (restored). The adjacent cloister is of Romanesque origin but was rebuilt at the end of the 14th century. The cloister contains a late Gothic fresco cycle (14th–16th cent.), executed by local artists, of subjects drawn from the *Biblia pauperum*. The Cathedral was built on Romanesque foundations (13th cent.) but altered in the 18th century. The façade is flanked by two towers; the interior, on a Latin-cross plan, contains altarpieces by G. Cignaroli and C. and M. Unterberger. There are frescoes by P. Troger. The Church of S. Michele, connected to the Cathedral by the Old Cemetery, has carved medieval tomb slabs. The church was rebuilt in the 15th century with a Gothic campanile. Inside are canvases by F. Unterberger and M. T. Polak. The Palazzo dei Principi Vescovi was begun in the 13th century and enlarged and rebuilt many times, with an inner court flanked on two sides by three tiers of loggias decorated with statues (1559). Characteristic streets are those flanked by houses with porticoes and balconies. Notable among these is Casa Pfaundler, which fuses northern European elements with Italian Renaissance forms. The Museo Diocesano houses the Cathedral treasury, a collection of medieval wooden sculpture, and canvases by local artists.

In the environs: the Monastery of Novacella, built in 1142 with a hospice, enlarged at different periods, fortified in the 15th century against the Turks. Among the oldest structures are the Chapel of S. Michele (12th cent.) with a circular ground plan, transformed into a fortress in the 16th century; the campanile (12th–13th cent.); the cloister, rebuilt at the end of the 14th century, with frescoes of the same period; the Chapel of S. Vittore, Romanesque, with frescoes from the beginning of the 14th century; the monastery church, originally Romanesque, rebuilt in Bavarian baroque form in the 17th century; the library, with a collection of illuminated manuscripts by local schools of the 14th–16th centuries. On a steep rock is the Monastery of Sabiona, an episcopal seat under the patriarch of Aquileia in the 6th–10th centuries; it was destroyed in the 16th century and rebuilt in the 17th. It preserves in part its ancient walls.

BIBLIOG. H. Dollmayr, Paul Troger's Fresken im Dom zu Brixen, Mitt. K. K. Zentral-Kommission, N.S., XVII, 1890, pp. 93–96, 174–77; H. Semper, Neuaufgedeckte Fresken in der Johannes Kapelle am Kreuzgang des Brixener Doms, Mitt. K. K. Zentral-Kommission, 3d Ser., III, 1905, pp. 194–208; A. Sparber, Abriss der Geschichte des Chorherrenstiftes Neustift, Bressanone, 1920; M. M. Dell'Antonio, Gli affreschi romanici della chiesa di Nostra Signora in Bressanone, Riv. d'arte, XII, 1930, pp. 311–21; S. Bstieler, Der Brixener Dom: Seine Entstehung und Ausstattung, Bressanone, n.d.

Brunico (Ger., *Bruneck*). Brunico is the principal town of Pusterthal (Val Pusteria). The main street is flanked by old houses that are crowned with crenellated gables. The castle was begun in the middle of the 13th century.

Nearby is the village of San Lorenzo di Sebato (Ger., *Sankt Lorenzen*), which preserves remains of ancient Sebatum (Roman villa and sculpture of the 2d cent.). The parish church has a wood sculpture of the Madonna and Child by Michael Pacher.

BIBLIOG. A. Ilg. Aus Brunnecken, Mitt. K. K. Zentral-Kommission, N.S., VIII, 1882, pp. cxxvi–cxxx.

Malles Venosta (Ger., *Mals*). The Church of S. Benedetto is a single-aisle Carolingian edifice with the entrance on the side. The campanile dates from the 12th century. Within the church are remains of 9th-century stucco decoration (columns and capitals) and frescoes (Christ Blessing, St. Gregory the Great, and St. Stephen in three apsidioles cut into the wall); other figural compositions in registers on the walls and between the windows, with scenes from the lives of SS. Benedict, Paul, and Stephen.

BIBLIOG. J. Garber, Die karolingische St. Benediktskirche in Mals, Innsbruck, 1915; J. Schmidt, Malles, Bressanone, 1942.

Merano (Ger., *Meran*). Founded by the Venostes, it was occupied in 17 B.C. by Drusus, who founded the Castrum Maiense. In medieval documents it appears with the names "Meirania" and "Forum Meranum." It was a vassal city of the prince of Trent. There are remains of the medieval city walls and towers (e.g., Torre della Polvere). The Cathedral (14th–15th cent.) has three aisles of equal height (hall church) and an elegant campanile, the city's most important monument. The octagonal Gothic Baptistery has a crypt. The Church of S. Barbara (1423) and the former hospital church

(a hall church with a carved double portal and star vaults) are late Gothic structures. The Castello Principesco, with its entrance court, chapel (frequently restored), and tower, dates from 1480. The city has numerous 16th-century houses. Castello S. Zeno, not far from the Torre della Polvere, is a Romanesque structure of the beginning of the 12th century; it was devastated in the 14th century. The surviving chapel portal is adorned with 13th-century carving. The Museo Civico has works by local artists.

In the environs: Castel Tirolo (Ger., Schloss Tirol), built in the 12th century by the Counts of Venosta (from 1141 onward known as the Counts of Tirol; restored). The portals of the atrium and of the two-storied Romanesque chapel preserve 12th-century carvings.

BIBLIOG. B. Weber, Meran und seine Umgebungen, Innsbruck, 1845; Gotter, Das Schloss Tyrol, Mitt. K. K. Zentral-Kommission, XIII, 1868, pp. xxxviii–xliv; K. Atz, Meran: Sculpturen und Malereien in der Burg Tyrol, RepfKw, XV, 1892, pp. 391–94; K. Atz, Die Pfarrkirche von Meran, Mitt. K. K. Zentral-Kommission, N.S., XXVII, 1900, pp. 68–70; G. Gerola, La stufa del castelletto di Merano, Dedalo, XI, 1930–31, pp. 88–101; W. Knapp, Burgen um Meran, Z. des d. Vereins für Kw., IV, 1937, pp. 131–43; K. Moeser, Zur Baugeschichte der drei Meraner Gotteshäuser aus der Zeit der Gotik, Beiträge zur Kunstgeschichte Tirols, 1955, pp. 119–30; C. Caminada, Die Skulpturen im Schloss Tirol, ikonographisch und volkskundlich gedeutet, ZfSAKg, XVII, 1956, pp. 140–56; E. Prieth, Beiträge zur Geschichte der Stadt Meran im 16. Jahrhundert, Merano, 1957.

Naturno (Ger., Naturns). Noteworthy is the Church of S. Procolo, an 8th-century structure with a single aisle; the campanile is incorporated into the 11th-century rectangular presbytery. Frescoes of about 1400 decorate the exterior. Within are remains of frescoes that may have been inspired by Irish miniatures (St. Paul, figures of angels; 8th–9th cent.).

BIBLIOG. G. Gerola, Gli affreschi di Naturno, Dedalo, VI, 1925–26, pp. 415–40; A. Kleeberg, Die Wandgemälde in der St. Prokulus-Kirche zu Naturns, Bolzano, 1958; E. Schaffran, Die vorromanischen Wandmalereien in der St. Prokuluskirche zu Naturns, Innsbruck, 1958; E. Theil, St. Prokulus bei Naturns, Merano, 1959.

San Candido (Ger., Innichen). Notable is the Collegiate Church of SS. Candido e Corbiniano, founded in the 8th century by Tassilo II, duke of Bavaria, and rebuilt in Romanesque form in the 13th century (frequently restored). Within the church is a polychrome wooden crucifix of the early 13th century. The Church of S. Michele dates from 1760.

BIBLIOG. G. Tinkhauser, Die romanische Stiftkirche zu Innichen in Tirol, Mitt. K. K. Zentral-Kommission, III, 1858, pp. 225–39; L. Weidemayr, Die Hofmark Innichen, 2 vols., Innichen, 1908–10.

Vipiteno (Ger., Sterzing, Lat., Vipitenum). A Roman way-station in the province of Raetia, the town preserves inscriptions and sculpture of the 2d and 3d centuries. There was a Mithraic sanctuary in the 3d century. In the Middle Ages, Vipiteno was a commercial and mining center. It reached its maximum development in the 15th and 16th centuries, when it was several times the seat of the provincial diet. A late Gothic style of architecture based on northern types is predominant, as is evidenced in the crenelated houses with balconies, façade frescoes, and coats of arms in hammered iron. The Palazzo Comunale (16th cent.) has two battlemented polygonal projections which run along the top of the façade. The triapsidal parish church dates from the 15th–16th century. The Church of the Spirito Santo, with nave and two side aisles, has 15th-century frescoes by local masters. The Ospedale Civico dell'Ordine Teutonico (founded in 1241) was rebuilt in the 16th century. The Museo Civico is in the Palazzo Comunale. The Museo Multscher contains works by Hans Multscher.

BIBLIOG. O. R. Dietich, Die Bauten Sterzings, Sterzing, 1914; A. V. Wais, Vipiteno e dintorni, Vipiteno, 1940.

Veneto. The modern Veneto comprises the central and historically most important part of the area once inhabited by the ancient Venetii, which was included in the Roman Venetia and later reunified under the hegemony of Venice. The paleo-Venetic culture, whose principal archaeological center is Este and which felt only limited Greek influences (Adria), is known for decorated bronzes and, in particular, for the so-called "art of the situlae," which was also widespread in the Alpine valleys and in Slovenia. Rome and Byzantium left their mark on the region's monuments. From the early Middle Ages onward, the essential fact for the Veneto was the birth and development of Venice on the islands of the lagoon. Venice became one of the great centers of Italian art, for its fusion of eastern and central European traditions in the Romanesque and Gothic periods, for its vital Humanist tendency in the 15th century, and for the development in the 15th, 16th, and 18th centuries of a school of painting and architecture that profoundly influenced European culture.

BIBLIOG. R. Cattaneo, L'architettura in Italia dal secolo VI al Mille circa, Venice, 1888; A. Haupt, Palastarchitektur von Ober-Italien und Toscana von XIII. bis zum XVIII. Jahrhundert, III-IV, Berlin, 1903–08; A. Michieli, Venezia Euganea, Turin, 1927; G. Fasolo, Le ville del vicentino, Vicenza, 1929; G. Zucchini, Nuove costruzioni rurali in Italia (Emilia, Romagna, Veneto), Rome, 1929; B. Brunelli and A. Callegari, Ville del Brenta e degli Euganei, Milan, 1931; A. Callegari, Guida dei Colli Euganei, Padua 1931; B. Bresciani, Terre e castelli delle basse veronesi, Bergamo, 1933; F. Forlati, L'architettura nell'alto Adriatico prima del 1000, Atti3StArch, pp. 163–70; P. Verzone, Architettura religiosa del Medioevo nell'Italia settentrionale, Milan, 1942; G. Fiocco, Da Ravenna ad Aquileia: Contributi alla storia dei campanili cilindrici, S. aquileiesi in onore di G. Brusin, Aquileia, 1953, pp. 373–83; F. Forlati, La basilica dell'alto Medioevo nella regione veneta, Arte del primo millennio (Atti II Conv. int. di S. alto Medioevo), Turin, 1953, pp. 39–56; P. Verzone, Le chiese cimiteriali cristiane a struttura molteplice nell'Italia settentrionale, Arte del primo millennio (Atti II Conv. int. di S. alto Medioevo), Turin, 1953, pp. 28–41; G. Mazzotti, Le ville venete, Treviso, 1954; M. Muraro, Les Villas de la Vénétie, Venice, 1954; R. Battaglia, Riti, culti e divinità delle genti paleovenete, B. Mus. Civico di Padova, XLIV, 1955, pp. 1–50; G. Mazzotti, Ville venete, Rome, 1957; P. L. Zovatto, Architettura paleocristiana della Venezia in epigrafi commemorative, Pordenone, 1958; L. Candida, La casa rurale nella pianura e nella collina veneta, Florence, 1959; G. Fogolari, Panorama della protostoria del Veneto e i suoi problemi, Cisalpina, I, 1959, pp. 185–96; V. M. Coronelli and G. Costa, Ville del Brenta, Milan, 1960; Mostra dell'arte delle situle dal Po al Danubio (exhibition cat.), Florence, 1961. For further general and particular bibliog., see also: Storia di Venezia, Venice, 1957 ff.; Cisalpina, I, 1959, passim and pp. 408–17. *Periodicals:* Ateneo veneto: Rivista, 1812 ff.; Atti dell'Istituto veneto di Scienze, Lettere e Arti, 1840 ff.; Archivio veneto, 1871 ff.; Le Tre Venezie, 1926–44; Arte veneta, 1947 ff.; La Biennale di Venezia, 1950 ff.

Adria (Lat., Atria, Hatria). Situated on the Adriatic, to which it gave its name, Adria is divided into three parts by the Canal Bianco (linking the Adige and Po rivers with the Adriatic). A Veneto-Etruscan port, it received, as early as the archaic period, many importations of Attic ceramics. Later, in the 5th century B.C., it seems to have declined because of the competition of Spina. A new efflorescence in the 4th–3d century B.C. is attested by finds of Campanian, "upper Adriatic," and Gallic vases. From the Roman period are remains of a theater and cemetery, the latter including rudimentarily anthropomorphic steles. In the Middle Ages Adria was subject to various rulers. Destroyed in 1482, it was rebuilt and united with Venice. Of Adria's most important buildings, almost all have been rebuilt or altered in recent times. The New Cathedral (G. Baccari, 19th cent.; with a campanile of 1688) incorporates the Old Cathedral with remains of the old baptismal font, crypt, and Byzantine-style frescoes (8th cent.). The Church of S. Maria Assunta della Tomba (restored in 1718) has an octagonal baptismal basin of the 8th century and 15th-century terra cottas. The Teatro Comunale, by G. B. Scarpari, is a 20th-century structure. The Museo Civico contains Greek and Italic vases, objects of the minor arts, and sculpture.

BIBLIOG. C. Cessi, Filistina, Ateneo Veneto: Rivista, XXI, 1898, 2, pp. 129–53; A. Cappellini, Adria antica e moderna, Adria, 1936; A. de Bon, Il Polesine nell'antico impero, Padua, 1946; B. Forlati Tamaro, Iscrizioni inedite di Adria, Epigraphica, XVIII, 1956, pp. 50–76; EAA, s.v. Adria; G. B. Pellegrini and G. Fogolari, Iscrizioni etrusche e venetiche di Adria, SEtr, XXVI, 1958, pp. 103–52.

Altino (Lat., Altinum). A Roman municipium and, in imperial times, an important transportation center (Via Aemilia, Via Annia, Via Claudia, Via Altinate, port). Its ruins were used in the construction of Venice, hence few traces remain. An interesting type of funerary monument is found here. The Antiquarium contains architectural and decorative fragments.

BIBLIOG. J. Marcello, La via Annia alle porte di Altino, Venice, 1956; Ist. veneto di Scienze, Lettere e Arti, Atti del Convegno per il retroterra veneziano, Venice, 1956, passim; EAA, s.v. Altino.

Asolo (Lat., Acelum). A polygonal fortress dating from the late Roman Empire stands on a hill above the town. From a Venetic settlement, Asolo became a Roman municipium; ruins of a theater and baths survive. After being dominated by several ruling houses, it was united with Venice. The city is distinguished for its porticoed houses, some of them frescoed. There are remains of the walls, of the clock tower, and the Castello della Regina (Caterina Cornaro, 1489–1509). The Palazzo del Comune (15th cent.) has façade frescoes by A. Contarini (1560). The Palazzo del Municipio dates from the 17th century. In the Cathedral (rebuilt in the 17th cent., completed in the 19th) are canvases by Lorenzo Lotto (1506), L. Bastiani, and Jacopo Bassano. The Museo Civico is in the Loggia del Capitano (archaeological finds, works of Antonio Canova; 17th-century paintings).

In the environs: Church of S. Angelo, with frescoes attributed to Paolo Uccello. Ca' Pasini (17th cent.). Villa Contarini (now Villa del Collegio Armeno di Venezia; 16th cent.), with façade frescoed

by Lattanzio Gambara. Villa Falier (18th cent.); oratory by G. Massari, statues by G. Bernardi and A. Canova.

At Altivole: The Barco della Regina Cornaro, a 15th-century villa with fragments of exterior frescoes. At Maser: Villa Barbaro by A. Palladio (PLS. 434, 435; XI, PL. 33), with frescoes by P. Veronese (PL. 102), statues and stuccoes by A. Vittoria.

BIBLIOG. M. Sernagiotto, Memoria della antichissima città di Asolo, Turin, 1869; P. Scomazzetto, Asolo, NSc, 1876, pp. 81, 178, 1877, pp. 235–40, 1880, p. 43, 1881, p. 205, 1882, pp. 289–90, 1883, pp. 118–23; V. L. Palladini, Asolo e il suo territorio, Asolo, 1892 (2d ed., Bologna, 1919); P. Fraccaro, Intorno ai confini ed alla centuriazione degli agri di Putavium e di Acelum, S. Ciaceri, Naples, 1940, pp. 100–23; E. Bernardi, Guida di Asolo, Asolo, 1942; EAA, s.v. Asolo; P. Ojetti, Palladio, Veronese e Vittoria a Maser, Milan, 1960.

Bassano del Grappa. First documented in the 10th century, a free commune in the 13th, Bassano was united with Venice in 1402. Of the medieval walls there are remains of masonry, towers, and gates (1389–92). Within the walls of the Castello degli Ezzelini is the 15th-century Cathedral. Inside are canvases by the Bassanos. S. Francesco (13th cent.) has a 14th-century vestibule and adjoining chapel. S. Giovanni Battista (oval), and SS. Trinità were rebuilt by G. Miazzi in the 18th century. S. Luigi is decorated with 18th-century stuccoes. Typical of the civil architecture are the small palaces, frequently adorned with porticoes (15th–17th cent.) and decorated on the outside with frescoes: Palazzo Pretorio (14th–15th cent.); the house of Lazzaro Bonamico; and the Michieli houses. The Villa Rezzonico (now Gasparini) may have been designed by B. Longhena. The Ponte Coperto (the covered wooden bridge on the Brenta) is documented as early as 1209 but has been destroyed and rebuilt many times. The Museo Civico has local ceramics, drawings by A. Canova, etchings and popular prints by J. A. Remondini; the painting gallery has works by the Bassanos and Venetian painters.

In the environs: Marostica, a town built on a square plan and surrounded by towers and medieval walls. Just outside Marostica is the Castello Superiore (14th cent.). The Palazzo Municipale (or Castello Inferiore, 15th cent.) is in the Piazza del Castello, which is surrounded by porticoes. S. Antonio Abate has a 13th-century tower and an altarpiece by J. and F. Bassano. Possagno is dominated by the Tempio di Canova, designed by Canova in 1819 on the plan of the Pantheon and completed in 1830. Within are works by Luca Giordano, Moretto da Brescia, Palma Giovane, and A. Canova. The house of Canova and the adjacent Gipsoteca house clay and wax models by the artist and plaster casts of nearly all his work.

BIBLIOG. D. Vittorelli, Viaggio e guida di Bassano, Bassano, 1833; A. Roberti, Il Forestiero a Bàssano: Guida di Bassano, Bassano, 1880; L. Cicognara, Del tempio eretto in Possagno da A. Canova, Giorn. di Belle Arti, I, 1883, pp. 286–301; O. Brentari, Guida di Bassano e Sette Comuni, Bassano, 1886; G. Chiuppani, Le piante storiche della città di Bassano, B. Mus. Civica di Bassano, I, 1904, pp. 55–64; G. Gerola, Bassano, Bergamo, 1910; G. Vaccari, Bassano e dintorni, Bassano, 1910; E. di Montemalo (P. M. Tua), Piccola guida di Bassano, Bassano, 1929; F. Forlati, Il ponte vecchio di Bassano, BArte, XXXIV, 1949, pp. 177–81. For Marostica: F. Spagnolo, ed., Memorie storiche di Marostica e del suo territorio, Vicenza, 1868; F. and G. Spagnolo, Marostica e i Comuni del suo territorio, 2 vols., Vicenza, 1906–08; A. Lorenzoni, Marostica, Milan, n.d.

Belluno (Lat., Bellunum). Archaeological finds date back to the paleo-Venetic period (5th–4th cent. B.C.). Roman influence is evident in the checkerboard plan of the town. Medieval remains include the Torre Civica (12th cent.), Porta Rugo (12th cent.; restored in 1622), and Porta Doiona (13th cent., rebuilt in 1553). There are remains of the Gothic structure in the Church of S. Pietro (1326, rebuilt in 1750), which preserves two wooden altarpieces by A. Brustolon and canvases by S. Ricci and Lo Schiavone. S. Stefano (1486) is a late Gothic building. The Cathedral was designed by T. Lombardo (beginning of the 16th cent., partially rebuilt in the 19th cent.); with unfinished façade and 16th-century portals. Inside are paintings by Lo Schiavone, C. Vecellio, J. Bassano, and Palma Giovane; the campanile is by F. Juvara. The Baptistery, or S. Maria delle Grazie, dates from the 16th century (restored). Among Renaissance civil edifices are Casa Miari (15th cent.); Palazzo della Banca Cattolica (formerly Doglioni); Palazzo dei Rettori (1491), with porticoed façade and a double row of bifurcated windows; Casa Alpago (15th cent.); Palazzo Persico Piloni; Monte di Pietà (1501); Palazzo Piloni, with frescoes by C. Vecellio. The Ospedale Civile was formerly a seminary (A. Tremignon, 18th cent.). The Teatro Sociale is a neoclassic structure by G. Segusini (1835). The Museo Civico has pre-Roman and Roman antiquities, works of Venetian painters, and a collection of coins and seals.

BIBLIOG. G. Alvisi, Belluno e la sua provincia, Milan, 1858; M. Guggenheim, Il Palazzo dei rettori di Belluno, Venice, 1894; A. Buzzati, Bibl. bellunese, Venice, 1910; A. Bevilacqua Lazise, Frammenti di architettura ravennate nel bellunese, Arte e storia, XXX, 1911, pp. 3–12; G. Ravazzini, Il palazzo dei Rettori a Belluno, Arte e storia, XXX, 1911, pp. 69–81; P.N., Palazzo Persico detto "Reviviscar," Palladio, I, 1937, p. 75; N. Degrassi, Un sarcofago romano di Belluno, BMImp, XI, 1940, pp. 17–34; F. Forlati, Palazzetto "Reviviscar," Palladio, V, 1941, pp. 778–81; G. B. Pellegrini, Contributo allo studio della romanizzazione della provincia di Belluno, Padua, 1949; EAA, s.v. Belluno.

Castelfranco Veneto. Of medieval origin, Castelfranco originally developed around the castle (1199), a square structure with five towers and brick walls and portals, and surrounded by a moat. The town, now expanded, boasts squares with small porticoed palaces, some of them frescoed. The Cathedral (F. M. Preti, 1723–45) has a panel by Giorgione; in the sacristy are frescoes by Veronese (from the Villa Soranza). S. Giacomo is the work of G. Massari. The Teatro Accademico is by F. M. Preti. The Museo Civico contains archaeological material and paintings by local artists.

In the environs: Villa Comer (now Bolasco; V. Scamozzi, 1607; rebuilt in the 19th cent.); Ca' Tiepolo (now Chiminelli; 16th cent.) with frescoes of the school of Veronese; the "Barchessa" of the Villa Soranza (Sanmichele); remains of the Villa Priuli di S. Felice (Scamozzi); Villa Dolfin (now Carlon; 17th–18th cent.; 18th-cent. stuccoes); Ca' Moro (now Pasinato; 16th cent.; frescoes of the school of Veronese); and the Villa Corner-Chiminelli.

In Fanzolo di Vedelago is Palladio's Villa Emo (ca. 1550), with frescoes by G. B. Zelotti and in part by Veronese.

BIBLIOG. C. Agnoletti, Treviso e le sue pievi, Treviso, 1897; E. Sbrissa, Castelfranco Veneto e il suo distretto, Treviso, 1905; G. Morozzi, Architetture e dipinti che ritornano in luce, BArte, XXXVI, 1951, pp. 179–83; G. Bordignon Favero, Palazzo e parco Revedin, Treviso, 1958; G. Bordignon Favero, La villa Soranza di M. Sanmicheli a Castelfranco, Treviso, 1958; G. Bordignon Favero, Il Teatro Accademico di F. M. Preti in Castelfranco, Arte veneta, XIII–XIV, 1959–60, pp. 174–81; G. Mariacher, La villa Corner-Chiminelli di Castelfranco Veneto, Acropoli, I, 1960–61, pp. 173–85.

Chioggia. Originally a Roman mansio, Chioggia became a genuine city by the 9th century. Its destiny was bound to that of Venice. S. Domenico (13th cent.; remodeled) has works by A. Vicentino, V. Carpaccio, and L. Bassano. S. Martino is Gothic (1392). S. Andrea is baroque (1743). S. Giacomo was rebuilt by D. Pelli in the 18th century. The Cathedral, originally a Romanesque structure, was rebuilt by B. Longhena (1633–74). The campanile dates from the 13th century. The "Granaio" is a Gothic structure (1322; restored).

The area along the banks of the Brenta is particularly notable for its villas: Villa Foscari ("La Malcontenta," A. Palladio; XI, PL. 32); Villa Mocenigo, with frescoes by G. D. Tiepolo; Villa Lazara Pisani ("La Barbariga"; 17th cent.; enlarged in the 18th cent.), with 18th-century stuccoes and furnishings; and Villa Pisani (Villa Nazionale), in Stra, planned by G. Frigimelica, executed by F. M. Preti (1736–56), with decorations by G. B. Tiepolo. The Palazzo Ferretti, in Dolo, is the work of V. Scamozzi.

BIBLIOG. A. Savorin, Cenni topografico-storici della città di Chioggia, Chioggia, 1830; C. Bullo, Degli oggetti d'arte più rimarchevoli esistenti in Chioggia, Rovigo, 1872; V. Bellenco, Il territorio di Chioggia, Chioggia, 1893; I. Tiozzo, Chioggia nella storia, nell'arte, nei commerci, Chioggia, 1926; L. Pagani and C. Galimberti, Chioggia e il suo territorio, Venice, 1929; I. Tiozzo, La Cattedrale di Chioggia: Notizie storiche, Chioggia, 1929; V. M. Coronelli and G. Costa, Ville del Brenta, Milan, 1960.

Cittadella. A fortified town built in 1220 by the Paduans as a defense against Treviso, Cittadella was successively under the domination of Ezzelino da Romano, the Scaligers, and the Viscontis, and finally became part of the territory of Venice. Elliptical in plan, Cittadella is cut by two intersecting streets and fortified by a wall with 32 rectangular towers, a patrol walk, galleries, moats, and four triple portals with pointed arches. The Torre di Malta was erected in 1251. The neoclassical parish church (1775) contains a canvas by J. Bassano.

BIBLIOG. Il Castello di Cittadella: Cenni storici, Padua, 1899.

Concordia Sagittaria (Lat., Julia Concordia). This village is situated on the site of a Roman settlement, perhaps founded in 42 B.C., on the Via Annia. A flourishing trade center in the early Empire, it later became a center for the manufacture of arms. The course of the Roman wall and the probable location of the forum and the theater have been identified. An Early Christian burial area (4th–5th cent.), a cella trichora, and remains of a cemetery basilica have been excavated. The Romanesque baptistery (13th cent., restored) is built on a Greek-cross plan with three apses. The Cathedral, a Gothic-Renaissance structure, has a Romanesque campanile. Interesting sarcophagi of the Sidamara type and numerous other fragments are in the Museo Concordiese in Portogruaro (see below).

Caorle was probably the port of ancient Concordia. Destroyed many times by the barbarians, Caorle was an episcopal seat until the 19th century. The Romanesque Cathedral (1048) has a cylindrical campanile of Ravenna type (end of the 11th cent.).

BIBLIOG. E. Degani, Il Battistero di Concordia-Sagittaria, Arte e storia, XIII, 1893, pp. 84–86; G. Grandis, Cenni storici su Portogruaro e Concordia, Portogruaro, 1926; P. L. Zovatto, Una notevole area sepolcrale scoperta a Concordia, Mem. storico forogiuliesi, XXXIX, 1943–51, pp. 102–05; P. L. Zovatto, Il Battistero di Concordia, Arte veneta, I, 1947, pp. 171–82, 243–46; P. L. Zovatto, Il sarcofago simbolico di Faustiniana e Julia Concordia, Felix Ravenna, LIV, 1950, pp. 38–42; G. Brusin, Il sepolcreto paleocristiano di Concordia Sagittaria, BArte, XXXVI, 1951, pp. 168–74; P. L. Zovatto, La basilica apostolorum nel nuovo complesso cimiteriale paleocristiano di Julia Concordia, Il Noncello, 9, 1957, pp. 27–44; B. Forlati Tamaro, Gli edifici paleocristiani di Julia Concordia, Atti Ist. veneto di Sc., Lettere e Arti, CXVII, 1958–59, pp. 143–52; P. L. Zovatto, Scavi di Concordia e recenti studi, Mem. storico forogiuliesi, XLIII, 1958–59, pp. 233–39; G. Brusin and P. L. Zovatto, Monumenti romani e cristiani di Julia Concordia, Il Noncello, 12–13, 1959, pp. 5–218; EAA, s.v. Concordia Sagittaria; G. Facchini, Julia Concordia, Udine, 1959; B. Forlati Tamaro, Il sepolcro paleocristiano di Concordia Sagittaria, CahA, XI, 1960, pp. 251–55. For Caorle: F. Ughelli, Italia sacra..., V, Venice, 1720, cols. 1046–48; G. Filiasi, Memorie storiche de' Veneti primi e secondi, III, Venice, 1796, pp. 342–53, V, 1797, p. 6, 306, VI, 1797, pp. 64–66; P. Scarpia Bonazza, La basilica di Caorle, Atti II Cong. int. S. alto Medioevo, Spoleto, 1953, pp. 279–89.

Conegliano. The town grew up around the Castle (10th cent.?; now in ruins), of which survive the bell tower and the Torre Mozza. Characteristic are the arcaded streets with frescoed houses. The Cathedral (1352) has a 14th–15th-century façade. The restored interior has works by L. Toeput and Cima da Conegliano; the adjacent Sala dei Battuti (14th cent.) has frescoes of the schools of Lombardy and the Veneto (15th–16th cent.). S. Rocco (1630–40) has a 20th-century façade. S. Martino dates from the 17th–18th century. The Palazzo Montalban Vecchio is attributed to Longhena; the Palazzo Montalban Nuovo was built by A. Zorzi in the 18th century. The Teatro dell'Accademia is neoclassic (1869; A. Scala). The Museo Civico del Castello has a collection of local paintings.

In the environs: Villa Paccagnella (17th cent.); Villa Giustinian (1665); and Villa Mondini (17th cent.).

BIBLIOG. V. Bottean, Ricerche storiche intorno alla chiesa dei SS. Rocco e Domenico a Conegliano, Conegliano, 1901; A. Vital, Il castello di Conegliano, Conegliano, 1905; A. Vital, Piccola guida storico-artistica di Conegliano, Treviso, 1906; A. Vital, Vecchi palazzi coneglianesi, Cron. d'arte, I, 1924, pp. 127–32; A. Sant, Cenni storici del Duomo di Conegliano, Turin, 1941; A. Vital, Le vicende storiche di Conegliano dalle origini al 1420, Archivio veneto, XXXVI–XXXVII, 1945, pp. 5–136.

Este (Lat., Ateste). Este was the center of the paleo-Venetic culture. Its necropolises, sanctuaries, and certain areas of the town have yielded abundant remains of its early artistic production, especially of vases and decorated bronzes. Remains of two bridges, an aqueduct, and some houses with mosaics date from Roman times. Rebuilt in the Middle Ages, Este became the domain of the Este family in 1050 and later was joined to Venice. The town is dominated by the castle (1339), which was built on the site of an 11th-century fortress. Este has developed on a rectangular plan, with its center in the Piazza Maggiore. The Romanesque Church of S. Martino has a campanile dating from 1293. The Cathedral, a medieval structure rebuilt (1690–1708) by A. Gaspari, has an elliptical plan. Inside is a painting by G. B. Tiepolo and a marble composition by A. Corradini (1725). The upper portion of the campanile was erected in the 18th century on an 8th-century base. The Church of the Beata Vergine delle Consolazioni (Church of the Zoccoli; 1505) has a single aisle, with later additions; there is a Madonna and Child by Cima da Conegliano. The Church of the Beata Vergine della Salute (17th cent.) has an octagonal plan; there are two octagonal campaniles flanking the apse. S. Maria delle Grazie (mid-15th cent.) was rebuilt in the 18th century. The Torre di Porta Vecchia was reconstructed in 1690. The Arch of S. Francesco was built in the 16th century. The former Church of S. Michele has a façade by V. Scamozzi. The Villa Cornaro (now Benvenuti) has a 19th-century park by G. Japelli. The Villa Contarini, known as the Vigna Contarena, was built in the 17th century. The Palazzo del Municipio is an 18th-century edifice. The Palazzo del Principe was designed by V. Scamozzi. The Palazzo Mocenigo dates from the end of the 16th century. The Museo Nazionale Atesino is in the castle of Umbertino de Carrara.

In the environs: Arquà Petrarca, with the 14th-century house of Petrarch. The marble sarcophagus of the poet was erected in 1380; the bronze bust, by P. P. Valdezocco, was added in 1547. Monselice: The castle (Ca' Marcello) was founded in the 13th century, enlarged by Ezzelino da Romano, by the Carraresi and by the Marcellos; it was restored in 1935–39. There is a collection of paintings, sculpture,

and medieval and Renaissance household objects. The old Cathedral (S. Giustina) was built in 1256. S. Giacomo is Romanesque-Gothic, with restored interior. Other noteworthy structures include the Sanctuary of the Sette Chiese (V. Scamozzi, with paintings by Palma Giovane); Villa Duodo, now Balbi-Valier (V. Scamozzi and A. Tirali); Torre Civica (1244; upper part, 16th cent.); Loggia del Monte di Pietà (16th cent.); Villa Nani-Mocenigo (16th–17th cent.); and the ruins of the fortress of Frederick II. Valsanzibio di Galzignano: Villa Barbarigo, now Pizzoni Ardemagni, with Italian-style garden and fountains (17th cent.).

BIBLIOG. Bibl. Atesina, Bologna, 1881; M. Sartori Boratto, Guida di Este, Venice, 1907; G. Fogolari, Il Museo Nazionale Atestino in Este, Rome, 1957; G. Bermond Montanari, Monumenti funerari atestini, RIASA, N.S., VIII, 1959, pp. 111–45; C. Gallan, Guida d'Este, Este, 1959; EAA, s.v. Este. For Arquà Petrarca: A. Callegari, Arquà e il Petrarca, Padua, 1952; P. Chevallier, Una visita a Arquà Petrarca, Padua, n.d. For Monselice: A. Callegari, La rocca di Monselice, Dedalo, IV, 1923–24, pp. 155–72; A. Callegari, Guida dei Colli Euganei, Padua, 1931; N. Barbantini, Il Castello di Monselice, Venice, 1940; A. Mazzaroli, Monselice, Padua, 1940.

Feltre (Lat., Feltria). A Roman center, probably a municipium, which succeeded what may have been a Raetian community on the Via Opitergium-Tridentum. In the Middle Ages, Feltre was a free commune and later came under various rulers. In 1420 it passed to Venice. The old walled city has a number of 16th-century buildings, many with projecting roofs and with frescoes or graffiti. Almost all the city gates are Renaissance (e.g., Porta Pusterla, Porta Castaldi). The Cathedral (16th cent.) has a Gothic apse, a 9th-century crypt, and a campanile of 1392 (partially rebuilt in the 17th century). The Baptistery (15th–16th cent.) has works by L. Bassano. The Church of Ognissanti (altered) has a Transfiguration by Morto da Feltre. S. Maria degli Angeli was erected in 1492, and the Church of S. Rocco in 1599. The design of the former Palazzo Comunale is attributed to Palladio. The Museo Civico, in Palazzo Villabruna (Venetian Gothic), has an archaeological section, a picture gallery, and a collection of medals, bronzes, and ceramics. The Galleria d'Arte Moderna "Carlo Rizzarda," in Palazzo Cumano (16th cent.), has a collection of wrought iron and 19th–20th-century paintings.

In the environs: Sanctuary of SS. Vittore e Corona (1096–1101) in Byzantine style, with 15th-century frescoes. Lentiai: S. Maria Assunta (15th cent.), with coffered ceiling and paintings by C. Vecellio and Palma Vecchio. Soranzen: Villa Bovio (17th cent.); Villa Martini e Moro (17th–18th cent.); Villa Mauro (18th cent.). Mel: Parish church with works by C. Vecellio and Lo Schiavone.

BIBLIOG. D. A. Zanghellini, Del Fondaco del Comune di Feltre, Bassano, 1865; A. Cambruzzi and A. Vecellio, Storia di Feltre, ed. G. B. Zanettini, 5 vols., Feltre, 1873–84; M. Salmi, Miscellanea preromanica: Il Campanile di Ognissanti a Feltre, Atti I Cong. int. S. Longobardi, Spoleto, 1951, pp. 473–75; A. Dal Zotto, Introduzione alla storia antica di Feltre, Padua, 1955; EAA, s.v. Feltre. For Lentiai: O. Monti, Lentiai e le sue opere d'arte, Arte e storia, II, 1883, pp. 138–40.

Lonigo. The earliest documentation dates from 997. After having been subject to various rulers, Lonigo passed to Venice in 1404. There are ruins of a medieval castle and tower near the Cathedral (Neo-Romanesque, 19th cent.). The medieval Church of SS. Quirico e Giulitta (much restored) has a 16th-century campanile. The Palazzo Pisani (1557), now the Palazzo Comunale, is attributed to M. Sanmicheli. The Rocca Pisani (1578) was built by V. Scamozzi on the site of an earlier castle. The Villa Giovanelli (19th cent., G. Balzaretti) encloses a Benedictine cloister (rebuilt and restored, 19th cent.).

In the environs: the Franciscan hermitage of S. Daniele (1243), with a much restored 15th-century church and a Gothic cloister. Sanctuary of the Madonna dei Miracoli (façade in Lombard style; 1488–1501). Villa Costozza (at Villa del Ferro), in the style of Sanmicheli (16th cent.).

BIBLIOG. A. Melani, Lonigo e il suo Duomo, Arte e storia, III, 1884, pp. 75–76; G. Lorenzoni, Ancora del Santuario di S. Maria dei Miracoli di Lonigo, B. Centro int. S. Arch. A. Palladio, II, 1960, pp. 93–96.

Montagnana. A Roman vicus and subsequently a medieval Lombard center, Montagnana passed to Venice in 1405. The old town is within the rectangular complex of well-preserved turreted walls built by Ezzelino and the Carraresi (12th–14th cent.). The walls have four gates and are surrounded by moats. The Cathedral (1431–1502) was built on the site of 11th-century structures (a few traces remain); a portal is attributed to J. Sansovino. The single-aisled interior (restored) has a Transfiguration by Veronese. The Church of S. Francesco was erected in the 14th century and altered in the 15th and 17th centuries. The Church of S. Benedetto dates from the 17th–18th century. The Palazzo Foratti (attributed to A. Lamberti; 15th cent.) has Venetian Renaissance features. The Palazzo del Municipio was

built on a plan by Sanmicheli (remodeled in the 17th–18th cent.). The Villa Pisani, now Placco (16th cent.), has a central part designed by Palladio (ca. 1565).

BIBLIOG. G. Giacomelli, Per la integrità delle mura di Montagnana, Padua, 1911; A. Foratti, Le mura di Montagnana, Arte e storia, XXXII, 1913, pp. 102–10; G. Antonio, Montagnana: Mura e Castelli, Montagnana, 1955; S. Carazzolo, Ricognizioni castellologiche, Montagnana, 1955; G. Cenzato, Antica beatitudine sorvegliata da ventiquattro torri, Montagnana, 1955; D. Valeri, Montagnana vista da tre scrittori, Montagnana, 1955.

Oderzo (Lat., Opitergium). Originally a paleo-Venetic settlement, it later became a Roman center, probably a municipium. In the Middle Ages it was devastated several times. The single-aisled Cathedral was built in the 10th century, rebuilt in the 14th, and altered in succeeding centuries. There are small palaces of various periods, all characteristically Venetian in aspect. Some of them have frescoed façades (15th–16th cent.). The Museo Civico contains archaeological finds, including mosaics.

BIBLIOG. F. Forlati, Restauri di architettura minore nel Veneto (Oderzo, Palazzo Pretorio), Architettura, VI, 1926–27, pp. 49–66; A. Vital, Traccie di romanità nel territorio di Conegliano, Arch. veneto, 5th Ser., IX, 1931, pp. 1–58; P. L. Zovatto, Scene di caccia e di uccellagione nei mosaici opitergini, Il Noncello, 7, 1956, pp. 3–22; P. L. Zovatto, Mosaici opitergini con scene all'aria aperta, CrArte, XX, 1957, pp. 97–107; E. Bellis, Cenni storici sul Duomo di Oderzo, Treviso, 1958; B. Forlati Tamaro, Guida del Museo Civico di Oderzo, Milan, 1958.

Padua (Lat., Patavium; It., Padova). Of paleo-Venetic origin (necropolis), it became a Roman colony in 89 B.C. and a municipium in 49 B.C. From the 4th century onward it was an episcopal seat. Destroyed in 602, it flourished once again during the period of the city-states and was annexed by Venice in 1406. The Roman city was laid out on the *cardo* and *decumanus* and contained within the rectangular area formed by the river channels. (The modern city has followed the same plan.) There are traces of a river harbor and bridges that spanned the Medoacus (Bacchiglione), ruins of an amphitheater and forum, and numerous tombs. From the Early Christian period dates the Chapel of the Madonna in the Church of S. Giustina (5th–6th cent.). In the Romanesque period the city was enclosed with new walls, and S. Sofia (end of 9th–12th cent.) and S. Giustina were rebuilt. Building activity of the 13th century is attested by the Palazzo della Ragione (1215–19), to which was added in 1306 another story, the exterior loggias, and the roof (rebuilt in the 18th cent.); the Palazzo del Podestà (now Palazzo Municipale, rebuilt in the 16th cent. with a façade of 1930); the Palazzo della Cancelleria; and the Palazzo degli Anziani (1285; restored). These formed the civic center of the city. The religious center comprised the Cathedral (rebuilt in the 16th-century), the Baptistery (1171, rebuilt in 1260; fresco cycle and polyptych by Giusto de' Menabuoi), the Palazzo Vescovile (1309, altered many times), and the Biblioteca Capitolare. Erected at some distance from the center were the principal monastic buildings of the city. S. Antonio ("Il Santo") a Franciscan church (begun 1231) of Latin-cross plan, roofed with domes, represents a fusion of Romanesque forms with Gothic and Byzantine elements; later additions to the church are the Chapel of the Blessed Luca Belludi (or Cappella dei Conti, 1382), with frescoes by Giusto de' Menabuoi, the Chapel of Gattamelata (or Cappella del Sacramento, 15th cent.), the baroque Cappella delle Reliquie (or "Cappellone"; 1689), the Chapel of S. Felice (or S. Jacopo) by A. de Sanctis (1372–78), with frescoes by Altichiero and Avanzo (I, PL. 68), the Cappella dell'Arca del Santo (16th cent.), with low reliefs of scenes from the life of St. Anthony and sculptures by A. and T. Lombardo, Sansovino, D. Cattaneo, M. Mosca, and others; in the presbytery, enclosed by an altar rail with sculptures by T. Aspetti (1593) and bronze gates by C. Mazza (1661), is the main altar, the arbitrary reconstruction by C. Boito (1895) of the dismantled original altar of Donatello (1446–50; IV, PLS. 248–251); numerous sculptures and tombs. Adjacent is the monastery (passage with frescoes by G. de' Menabuoi), with the Chiostro del Capitolo (1240) and the Chiostro del Noviziato (Romanesque portal surmounted by a Renaissance loggia); there are remains of the Chiostro del Paradiso (1229) and the Chiostro del Generale (1434). The Oratory of S. Giorgio has frescoes by Altichiero and Avanzo (I, PLS. 69, 70, 72, 73). The Scuola di S. Antonio (1430; raised higher in the 16th cent.) has frescoes by Titian and others. Among the Romanesque-Gothic buildings is the Church of the Eremitani (1276–1306), single-aisled with transept and a timber roof with a trilobate arch. (The east end of the church was destroyed in World War II along with the frescoes in the Ovetari Chapel; it has been rebuilt.) Other structures of the period include S. Maria del Carmine (1212; altered many times) and the adjacent Scuola del Carmine (14th cent.), with 16th-century frescoes. On the site of the ruins of the Roman arena is the Scrovegni Chapel (beginning of the 14th cent.), single-aisled, barrel-vaulted,

with frescoes by Giotto (II, PL. 287; III, PLS. 211, 392; VI, PLS. 199–203); on the altar is a Madonna and Child by Giovanni Pisano (VI, PL. 211); behind the altar is the tomb of Enrico degli Scrovegni by A. de Sanctis. S. Maria dei Servi (late 14th cent.) has a 16th-century arcade. The earliest Renaissance structures in Padua appeared sporadically during the 15th century. New chapels were added to the more important churches, and many church interiors were remodeled. In the Piazza del Santo is Donatello's monument to Erasmo da Narni (IV, PL. 249). In 1493 work was begun on the new building for the university (founded in 1222), with façade (altered) and courtyard by Andrea Moroni (16th cent.), the Teatro Anatomico, the first such anatomical theater in Europe (1544), and the Aula Magna, decorated with coats of arms (enlarged in 1938). Other civil buildings of the period include the Loggia della Gran Guardia (or del Consiglio) with columned portico (A. Maggi, 1496; B. Rossetti, 1523). The Monte di Pietà, erected in the Middle Ages, was rebuilt by G. M. Falconetto (1530) and enlarged in the 17th century by V. Dotto. In the 16th century, the city walls were again enlarged and reinforced with bastions (e.g., Bastione della Gatta). Also rebuilt was the Church of S. Giustina, attributed to Andrea da Valle and A. Moroni (1518–87), after plans by A. Briosco. Built on a three-aisled, Latin-cross plan, with barrel vault, the interior decoration constitutes an important ensemble of Venetian paintings of the 16th–18th centuries. In the Coro Vecchio (1462) are 15th-century funerary monuments. In the Benedictine monastery is the so-called "Chiostro Dipinto" (15th cent.), with remains of the original frescoes of the life of St. Benedict, by Bernardo Parentino and Girolamo del Santo. The Cathedral (S. Maria Assunta, by Andrea da Valle, mid-16th cent.) has a three-aisled Latin-cross plan. Inside is the sarcophagus of Cardinal Pileo da Prata, attributed to the Dalle Masegnes (14th cent.); panels of St. Sebastian, the Trinity, the Madonna dell'Umiltà, and the Epiphany by Nicoletto Semitecolo (1367); and paintings by G. D. Tiepolo, F. and G. Bassano, D. Campagnola, Paris Bordone, and others. The Treasury has fine medieval objects. S. Gaetano, by V. Scamozzi, is a single-aisled structure. The Palazzo Pesaro, formerly Priuli, is also by V. Scamozzi (ca. 1590). The Casa degli Specchi, by A. Maggi, dates from the 16th century. The Palazzo dei Monti Vecchi (now the Banca Popolare) was erected in 1590. The Palazzo Mantova-Benavides, now Protti, dates from the 17th–18th century. There are few baroque monuments, including the Valaresso Arch (1632) in Piazza del Duomo and the Palazzo Selvatico by G. Frigimelica. Structures of the 18th century are the Palazzo Papafava (1763), with a neoclassic interior, and the Teatro Verdi (1748), which was remodeled by G. Japelli (1847), who also designed the Caffè Pedrocchi and Il Pedrocchino (X, PL. 292). Twentieth-century architecture includes the Liviano, part of the University, with frescoes by M. Campigli and a sculpture, *Titus Livius*, by Arturo Martini. The Museo Civico has a collection of antiquities, a painting gallery (15th–19th cent.), and a collection of small sculptures. The Museo Bottaccin is annexed to the Museo Civico. The Museo Antoniano contains works from the Church and Monastery of S. Antonio.

There are numerous villas in the environs, including Villa Spessa (15th cent.), in Carmignano di Brenta; Villa dei Vescovi, in Luvigliano di Torreglia, begun by B. Bon and continued by G. M. Falconetto; "Il Cataio," a battlemented castle (1570–72) with a large park, frescoes by G. B. Zelotti (1571); Villa Emo Capodilista (16th–17th cent.), in Battaglia Terme, with frescoes by Luca Ferrari (1650) and others. In Noventa Padovana are Villa Cappello (16th cent.), Villa Giustiniani (now De Chantal; 17th cent.), and Villa Giovanelli (now De Benedetti, 18th cent.). In Piazzola sul Brenta is Villa Camerini (formerly Contarini degli Scrigni), a Palladian structure with baroque additions.

BIBLIOG. G. Moschini, Guida per la città di Padova, Venice, 1817; A. Faggiani, Topografia della città e dintorni, Padua, 1837; B. Gonzati, La basilica di S. Antonio, 2 vols., Padua, 1852–54; P. Selvatico, Guida di Padova e contorni, Padua, 1869; F. Sartori, Guida storica delle chiese ed oratori della città e diocesi di Padova, Padua, 1884; F. Pizzi, Bibliografia per servire alla storia della Basilica e Monastero di S. Giustina in Padova, Padua, 1903; A. Moschetti, Padova, Bergamo, 1912; P. Camerini, Piazzola, Milan, 1925; A. Scrinzi, La scoperta di un tempietto bizantino del VI secolo: L'oratorio di S. Prosdocimo annesso alla chiesa di S. Giustina, L'Arte, XXIX, 1926, pp. 75–84; A. Venturi, Edifici di un umanista a Padova (Palazzo Giustiniano), L'Arte, N.S., I, 1930, pp. 265–75; E. Arslan, Appunti sulla chiesa di S. Sofia, Padua, 1931; M. Tonzig, La basilica romanico-gotica di Santa Giustina in Padova (B. Mus. Civico di Padova, V, 1929), Padua, 1932; W. Arslan, Inventario degli oggetti d'arte d'Italia, VII, Provincia di Padova, Rome, 1936; S. Bettini, Padova e l'arte cristiana d'Oriente, Atti Ist. veneto di Sc., Lettere e Arti, XCVI, 1936–37, 2, pp. 203–97; C. L. Ragghianti, Casa Vitaliani, CrArte, II, 1937, pp. 236–50; G. Fabris, Una guida di Padova del primo trecento, Padova, XII, 1, 1939; C. Gasparotto, Il palazzo pubblico di Patavium, B. Mus. Civico di Padova, XXXI–XLIII, 1942–54, pp. 35–44; E. Rigoni, Il Chiostro del Capitolo di S. Giustina in Padova, B. Mus. Civico di Padova, XXXI–XLIII, 1942–54, pp. 137–44; F. Forlati and M. L. Gengaro, La chiesa degli Eremitani a Padova, Padua, 1945; C. Gasparotto, Padova Romana, Padua, 1951; L. Micheletto, L'oratorio paleocristiano di "Opilione" annesso alla basilica di S. Giustina, Pal-

ladio, N.S., IV, 1954, pp. 179–84; A. Moschetti, La cappella degli Scrovegni e la Chiesa degli Eremitani a Padova, Milan, 1954; G. Nicco-Fasola, L'antico portale di Santa Giustina a Padova, Arte veneta, VIII, 1954, pp. 49–60; A. Barzan, Padova cristiana dalle origini all'anno 800, Padua, 1955; V. Gamboso, La Basilica del Santo, Padua, 1955; C. Gasparotto, S. Maria del Carmine, Padua, 1955; S. Bazzarin, Stele romane con ritratti dal territorio padovano, B. Mus. Civico di Padova, XLV, 1956, pp. 3–64; F. Franco, Santa Sofia, Forsch. zur Kg. und christlichen Archäol., III, 1957, pp. 210–20; L. Gaudenzo, Padova attraverso i secoli, Padua, 1958; P. L. Zovatto, La pergula paleocristiana del Sacello di S. Prosdocimo, RACr, XXXIV, 1958, pp. 137–67; P. Orati and C. Gasparotto, Il Carmine: L'opera di ricostruzione dal 1946 al 1960, Padua, 1960; Padova: Guida ai monumenti e alle opere d'arte, Venice, 1961 (bibliog.); C. L. Ragghianti, Problemi padovani, Battistero, Cappella Belludi, CrArte, VIII, 1961, pp. 1–15.

Pieve di Cadore. The origins of the chief town of Cadore go back to Roman times. The town was particularly prosperous in the 14th, 15th, and 16th centuries and long enjoyed the protection of Venice. The Palazzo della Magnifica Comunità Cadorina (1525) was built over a 15th-century building. The parish church (19th cent.) has paintings by Titian and C. Vecellio. The house reputed to have been Titian's, a typical local construction, has been transformed into a museum. The Quadreria di Guglielmo Talamini and the Museo dell'Arte Paleoveneta are in the Palazzo della Magnifica Comunità Cadorina.

In the vicinity is Lagole di Calalzo, where an ancient sanctuary with paleo-Venetic bronzes was discovered. Rizzíos is a typical regional village with wooden constructions.

BIBLIOG. A. Ronzon, Il Cadore descritto e illustrato, Venice, 1877; N. Mocenigo, Del castello di Cadore, Venice, 1884; L. Toffoli, Opere d'arte a Vigo del Cadore, Arte e storia, XIII, 1894, p. 94; O. Brentari, Guida del Cadore e Valle di Zoldo, Turin, 1902; A. Frova, Chiese gotiche cadorine, Rass. d'arte, VII, 1907, pp. 10–14, 23–26, VIII, 1908, pp. 54–59; A. Lorenzoni, Cadore, Bergamo, 1907; P. Weingartner, Der Stand der Kunstdenkmäler in Ampezzo und Buckenstein, Mitt. K. K. Zentral-Kommission Wien, 3d Ser., II, 1918, pp. 86–88; G. B. Pellegrini, Importanza degli scavi di Lagole nel quadro della preistoria italiana, Feltre, 1951; M. Lejeune, Les dédicaces du Sanctuaire de Lagole, REL, XXXII, 1954, pp. 120–38; G.B. Pellegrini, Noterelle venetiche, SEtr, XXIII, 1954, pp. 275–88.

Portogruaro. A fortified commune in the Middle Ages, Portogruaro was subject to the Venetian Republic after 1420. The city extends along two parallel streets, flanked by 15th- and 16th-century buildings, some of them frescoed, with arcades supported by low piers and with high pointed arches. Three medieval gates and remains of moats survive. The Palazzo Comunale has a brick façade with an ornamented gable (14th–16th cent.; enlarged and restored in the 19th cent.). The Palazzo dal Moro and the Palazzo Fabris are by G. Bergamasco. The Cathedral (17th cent.) has a Romanesque campanile. The Romanesque baptistery is built on a Greek-cross plan and is triapsidal; the atrium (restored) is from the early 12th century. The Museo Concordiese has a collection of objects excavated in Concordia Sagittaria.

BIBLIOG. A. Grandis, Cenni storici su Portogruaro e Concordia, Portogruaro, 1926; R. Cessi, "Nova Aquileia," Atti Ist. veneto di Sc., Lettere e Arti, LXXXVII, 1929, pp. 543–94; P. L. Zovatto, Il Battistero di Concordia, Arte veneta, I, 1947, pp. 171–82, 243–50; P. L. Zovatto, L'architettura civile gotica e rinascimentale a Portogruaro, Atti Ist. veneto di Sc., Lettere e Arti, CVII, 1948–49, pp. 215–36; P. L. Zovatto, Concordia e l'antica struttura urbana di Portogruaro, Il Noncello, 12–13, 1959, pp. 193–215.

Praglia. The Benedictine monastery of Praglia was founded in 1080. The Church of the Assunta (1490–1548) is by T. Lombardo; built on a Latin-cross plan, the church has a nave and two side aisles and has barrel vaults. The campanile is Romanesque (1292–1300). The monastery comprises four cloisters, the Chiostro Doppio di Levante (1460), with ogival portico and loggia, the Chiostro Pensile, begun in 1495, the Chiostro Botanico (15th cent.), with trilobed double-lancet windows and terra cottas, and the Chiostro Rustico, with a terra-cotta frieze.

BIBLIOG. A. Dobrilovich, Badia monumentale di Praglia, Padua, 1923; A. Roberti, La Badia di Praglia, Padua, 1933.

Rovigo (Lat., Rhodigium; Rodigo). First documented in the 9th century, Rovigo remained under the rule of the house of Este until its union with Venice (1482). Rovigo is pentagonal in plan and encircled by walls. The Porta S. Bortolo was erected in 1482–86. The Cathedral was founded in the 10th century, rebuilt in the 15th century and again in the 17th, after plans by G. Frigimelica (1696); the dome was added in 1790 (G. Sabadini). The single-aisled interior is in the form of a Latin cross. The Church of S. Francesco (begun in the 14th cent.; campanile of 15th cent.; remodeled in 19th cent.; façade of 20th cent.), is built on a Latin-cross plan. The Church

of the Beata Vergine del Soccorso, called "La Rotonda" (1594), is by F. Zamberlan, a pupil of Palladio; the church is octagonal in plan and surrounded by a trabeated portico; the campanile is by B. Longhena (1655). S. Bartolomeo has a baroque façade and campanile attributed to Fra Giovanni da Verona; the interior has rich stucco decorations. In the adjoining Convento degli Olivetani is a Renaissance cloister and a wellhead attributed to J. Sansovino. The Palazzo Roverella was designed by an architect from Ferrara (begun in early 15th cent.). The Palazzo Roncale (1555), with rusticated portico, is by M. Sanmicheli. The Palazzo del Municipio was built in the 16th century and remodeled in 1765. The Palazzo Angeli (now the Questura) was erected in 1780 by F. Schiavi. The Seminario Vescovile is an 18th-century construction (D. Cerato). The Palazzo dell'Accademia dei Concordi, by S. Baseggio the Younger (1814), houses the Museo del Risorgimento and a painting gallery. The Museo del Seminario Vescovile has an archaeological collection, Venetian paintings of the 16th–18th centuries, sculpture, miniatures, etc.

Near Rovigo is Badia Polesine, where there are remains of the Abbey of Vangadizza, founded in the 10th century and remodeled in the 15th. In Fratta Polesine is the Villa Badoer (now Cagnoni), designed by Palladio, and the Villa Bragadin (16th cent.).

BIBLIOG. A. E. Baruffaldi, La fine dell'Abbazia della Vangadizza, Padua, 1906; Elenco degli edifici monumentali, XXII, Rovigo, Rome, 1915; M. T. Dazzi, Rovigo nel '700, Cron. d'Arte, II, 1925, pp. 68–76; G. Cardellini, La chiesa della Beata Vergine del Soccorso in Rovigo, Italia Sacra, I, 1928, pp. 533–66; A. Cappellini, Rovigo nella storia e nell'arte, Rovigo, 1934.

Thiene. A Roman settlement, a fortified center in the Middle Ages, and later a free commune (12th cent.), Thiene finally came under the hegemony of the Venetian Republic. The town, with its elegant Renaissance structures with multiple-lighted mullioned windows and arcades, developed around the Palazzo Porto Colleoni (now Thiene; after 1450). (The palace is also known as the Castello di S. Maria.) The Church of Vincenzo was erected in 1330 and frescoed in the 14th–15th century. The Cathedral (1669; enlarged) was built over an earlier structure.

Near Thiene is Lugo di Vicenza, the site of Villa Godi (now Valmarana) and the Villa Piovene Porto Godi, both by Palladio. In Villaverla is the Palazzo Verlato (now Dalla Negra Dianin), by V. Scamozzi (1576; enlarged in 17th cent.), and the Palazzo Ghellini (now Dall'Olmo), by A. Pizzocaro (17th cent.).

BIBLIOG. S. Rumor, Il Castello di S. Maria di Thiene..., Vicenza, 1887.

Treviso (Lat., Tarvisium). A Roman municipium built on the site of an earlier Veneto-Gallic settlement, Treviso became a free commune in the Middle Ages and later adhered to the Venetian Republic. From the communal period (11th–12th cent.) are the Baptistery, the crypt of the Cathedral, the ruins of S. Vito, and the Loggia dei Cavalieri (1195), with two layers of frescoes. The modern center of Treviso (Piazza dei Signori) coincides with the medieval one and is the site of municipal buildings, including the Palazzo dei Trecento (13th cent.; enlarged in the 16th, and later restored) and the Palazzo Pretorio (rebuilt), both crenelated. The Torre del Comune surmounts the Palazzo del Podestà (now Palazzo del Governo). Romanesque and Gothic structures include S. Caterina dei Servi di Maria, with a single aisle (14th–15th-cent. frescoes); S. Francesco (much restored), on a Latin-cross plan, with a single aisle and five apsidal chapels; and S. Nicolò, on a Latin-cross plan, with nave and two aisles. In S. Nicolò are frescoes by Tommaso da Modena and the monument to Agostino Onigo (early 16th cent.), with decoration by L. Lotto. The adjacent Seminario Vescovile (13th–14th and 16th cent.) has frescoes by Tommaso da Modena (1352) in the Sala del Capitolo dei Domenicani. The 14th-century Church of S. Lucia, with nave and two side aisles, has contemporaneous frescoes. S. Maria Maggiore (called "Madonna Grande"; 1474), a late Gothic structure of Venetian type, was rebuilt on the site of an earlier structure. The Cathedral, a Romanesque structure (ruins uncovered by bombardments), was rebuilt in the 15th–16th century (apsidal section) on designs by P. Lombardo and his sons (15th–16th cent.); all but the apse was remodeled by G. Riccati (18th cent.). The Cathedral has frescoes by Pordenone and assistants (1520), an Annunciation by Titian, and reredos by P. Bordone. The Romanesque baptistery (11th–12th cent.) was extensively remodeled. Inside the building of the Monte di Pietà is the Cappella dei Rettori (16th cent.), decorated with gilded leather (17th cent.) and Biblical scenes by L. Toeput. The Church of S. Gaetano (1504) is the work of Jacopo da Como, and S. Maria Maddalena (1576) is a Renaissance structure. The Church of S. Vito was founded in the 12th century and rebuilt in 1568. The façade decorations of several Renaissance structures have been traditionally attributed to such artists as Titian, P. Bordone, and Pordenone. Baroque buildings are few, but noteworthy structures are S. Agnese in SS. Quaranta, of Palladian type (1613),

and the rococo S. Agostino (1750–58), by F. Vecelli. The Museo Civico Luigi Bailo has collections of prehistoric objects, classic and medieval marble sculptures and reliefs, and paintings from the Middle Ages to the 18th century. The Museo della Casa Trevigiana houses works of the minor arts.

BIBLIOG. A. Marchesan, Treviso medievale, Treviso, 1923; L. Coletti, Treviso, Bergamo, 1926; L. Coletti, Catalogo delle cose d'arte e d'antichità d'Italia, Treviso, Rome, 1935; A. Lazzari, La chiesa di S. Maria Maddalena, Treviso, 1939; L. Coletti, Storiografia artistica trevigiana, Arch. veneto, 5th Ser., XLVI–XLVII, 1950, pp. 190–205; F. Forlati, Il Palazzo dei Trecento di Treviso, Venice, 1952; M. Botter, Ornati a fresco di case trevigiane, Treviso, 1955; C. Chimenton, Chiesa di Sant'Agnese, Vedelago, 1955; L. Berti and C. Boccazzi, Scoperte paletnologiche e archeologiche nella provincia di Treviso, Florence, 1956.

Venice (It., Venezia). Venice was founded in the lagoons between the mouths of the Piave and Brenta by fugitives from the barbarian invasions inland. The city comprises more than 100 islands linked by bridges. In the 9th century the center was the Civitas Rivoalti (comprising the modern zone of the Rialto, S. Marco, and the Arsenale). Dependent on Byzantium, Venice declared its sovereignty in the 11th century as a marine republic. The city became an active center of cultural exchange between East and West and extended its sway to the surrounding mainland.

Venice is divided in two by the Grand Canal and irregularly linked by quays, narrow streets, and small squares, laid out parallel to the canals or intersecting one another in a closely woven network.

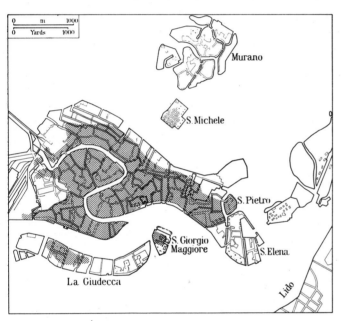

Venice and environs. Shaded area indicates extent of the city in the 12th century.

Of the earliest structures (9th cent.), known from written sources, few traces remain (crypt, remains of foundations, and marble carvings in S. Marco). Building activity was intense during the Romanesque and Gothic periods, which gave a particular stamp to the city. The civil monuments of the time, characterized by successive ranks of galleries (e.g., Palazzo Loredan dell'Ambasciatore), often reveal Near Eastern influences, and their decoration consists largely of spoils taken from the eastern Mediterranean (e.g., patens, low reliefs, faience bowls). Other Eastern works include the four bronze horses of S. Marco (Greek work of the 4th–3d cent. B.C.); the group of the Tetrarchs (4th cent. of the Christian Era), and the two pilasters with rinceaux in front of the Baptistery door. In 1073, the new Church of S. Marco was erected on the site of the earlier basilica. S. Marco, which has a central plan and is topped by domes, blends Romanesque and Byzantine elements in its structure; the crowning reveals late Gothic influences. Decorated with Byzantine and local sculpture, and with the narthex and interior completely covered by mosaics (12th–14th cent.; several times restored), S. Marco is a unique Italian Romanesque creation. The interior has a nave and two aisles, galleries (reduced to catwalks after the fire in 1145), and a chancel built over the crypt (that of the preceding building). The choir screen is surmounted by statues of the Madonna and the apostles, by the Dalle Masegnes (14th cent.; VI, PL. 368). The church is

adorned with works from various centuries, including the bronze doors (11th–16th cent.), the ciborium of the high altar, with two Early Christian and two Romanesque columns (according to some experts, the entire ciborium is Romanesque), the Pala d'Oro (IV, PL. 405), Renaissance sculptures, and 15th–16th-century mosaics by Tuscan and Venetian artists. The Campanile was rebuilt in 1903–12, an exact copy of the earlier structure, which collapsed. Dating from the Gothic period is the reconstruction of the Doges' Palace (VI, PL. 340; original building from the 9th cent.), connected with S. Marco by the Porta della Carta (B. Bon; 1438–42). Work on the Doges' Palace continued well into the 15th century: the east façade (1483) was designed by A. Rizzo, who was also responsible for the Scala dei Giganti (PL. 198) and courtyard. The interior of the palace was decorated by some of the major Venetian artists, particularly during the Renaissance. The Avogaria contains work by D. and J. Tintoretto. The Scala d'Oro was probably created under the direction of J. Sansovino and Scarpagnino (Antonio di Pietro Abbondi), with stuccoes by A. Vittoria. The Atrio Quadrato and the Sala delle Quattro Porte were decorated by J. Tintoretto, G. B. Tiepolo, and others. The Anticollegio and the Sala del Collegio were built after designs by Palladio (1575) and decorated by A. Vittoria, Veronese, J. Bassano, and J. Tintoretto. The Sala del Senato (or Sala dei Pregadi) has works by J. Tintoretto. The Sala del Consiglio dei Dieci (preceded by a room containing works by H. Bosch, II, PL. 320) has works by Veronese, as does the Sala della Bussola. The Saletta dei Tre Inquisitori di Stato has a ceiling frescoed by J. Tintoretto. The Sala dell'Armamento (or Sala del Guariento) preserves fragments of frescoes by Guariento. The Sala del Maggior Consiglio was decorated by Tintoretto (Paradise and other works), P. Veronese, F. da Ponte, Palma Giovane, L. Bassano, and D. Tintoretto.

A great many churches were built in the Gothic period. SS. Giovanni e Paolo (1246–1430; façade remodeled in the 15th cent.) has a nave and two side aisles, a groin vault, and polygonal apse, illuminated by two rows of mullioned windows; the church contains Gothic and Renaissance tombs. There are frescoes and canvases by Venetian artists from the Renaissance to the 18th century. S. Maria Gloriosa dei Frari (1338–1443) is similar in plan to SS. Giovanni e Paolo and has been adorned through the centuries with paintings and sculpture. The campanile dates from 1396. S. Maria del Carmelo (14th cent.) was extensively remodeled in the 16th and 17th centuries; the façade has a curved tympanum (16th cent.). S. Polo seems to have been founded in the 9th century; it was remodeled several times during the Gothic period and in the 19th century; it has a nave and two side aisles, all with apses, and a carinate ceiling. S. Stefano, built in the 14th century and remodeled in the 15th, has a nave and side aisles, polygonal apse, carinate ceiling, and chancel (1488). The cloister is attributed to Scarpagnino. S. Giovanni in Bragora, perhaps first built in the 8th century, was rebuilt in 1475 and restored in 1728. The Gothic interior has a nave and two side aisles and a carinate ceiling. The Church of the Madonna dell'Orto was erected in the 14th century and remodeled in the 15th and 16th centuries; the decorated brick façade is crowned with statues by the Dalle Masegne brothers. The former Church and Abbey of S. Gregorio (9th cent.; rebuilt in 15th) has a cloister dating from 1342. The former Church of the Carità, originally a Gothic structure, was rebuilt by B. Bon (1441–52); part of the courtyard by Palladio survives. Among the outstanding examples of civil architecture which continued Gothic forms even during the 15th century are the Ca' d'Oro, Ca' Foscari, and the Pisani, Contarini (1421), Priuli, Contarini-Fasan (called the "Casa di Desdemona"; 1475), Da Mula (now Morosini), Loredan, Giustinian, Brandolin, Erizzo alla Maddalena, and Minotto palaces.

More akin to Renaissance models, yet maintaining the characteristic Venetian predilection for tracery surfaces, are the palaces (15th and early 16th cent.) with large semicircular arches, often adorned with marble revetment, clipei, and polychrome decoration. Among these structures are the Lombardesque Dario (1487) and Grimani palaces; Palazzo dei Dieci Savi (1521) and the Fabbriche Vecchie di Rialto by Scarpagnino (1522); Palazzo dei Camerlenghi (G. Bergamasco, 1522–28); Palazzo Trevisan (formerly Cappello), by B. Bon and G. Bergamasco; Palazzo Zorzi a S. Severo, by M. Coducci; the unfinished Ca' del Duca; Palazzo Contarini delle Figure; Palazzo Corner-Spinelli and Palazzo Vendramin Calergi (formerly Loredan), with spacious, two-lighted, round-arched windows, and a double order of fluted columns, both palaces attributed to M. Coducci; and the Fondaco dei Tedeschi, whose courtyard has superimposed galleries. The walled and towered Arsenale was enlarged several times from the 11th to the 16th century. Within the walls are structures by Sanmicheli (1544–47) and A. da Ponte (1579); the outer gateway is by Gambello (1460) and is adorned with sculptured lions from Athens and Delos. The Fort of S. Andrea (1543) on the island of the Vignole, opposite the Lido, is by Sanmicheli. Renaissance, too, are the structures in the Piazzetta and Piazza S. Marco: the Loggetta di S. Marco,

with relief decoration and four bronze statues by J. Sansovino; the Libreria Vecchia di S. Marco, begun by Sansovino and continued by V. Scamozzi; the Palazzo della Zecca (1536), also by Sansovino, with a massive rusticated front. The Torre dell'Orologio (clock tower) in Piazza S. Marco is by M. Coducci (1496–99); the famous bronze Moors that sound the hours are 15th-century works. The Procuratie Vecchie, by B. Bon (1514) and G. Bergamasco, was modeled after a Byzantine structure and has two superimposed orders of galleries and decorative battlements. The Procuratie Nuove, begun

(1444–65) and began the façade, which was completed by M. Coducci (1480–1500). The interior comprises a nave and two side aisles, with semicircular arches, groin vaults, and polygonal apse. The church is adorned with works by Giovanni Bellini (II, PL. 266), Tintoretto, and Palma Giovane. The Chapel of S. Tarasio has frescoes by A. del Castagno (I, PLS. 234, 235) and polyptychs by A. Vivarini and Giovanni de Alamagna (1443). The interior of S. Maria Formosa, founded in the Middle Ages, was completely rebuilt by M. Coducci (1492), with nave and two side aisles, transept, and

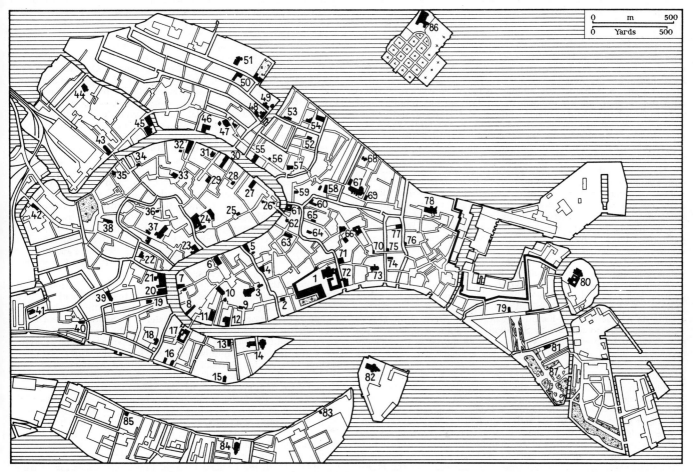

Venice, central area. Principal monuments: (1) S. Marco, Doges' Palace, the Procuratie, and Libreria Vecchia; (2) S. Moisè; (3) S. Fantin and Teatro La Fenice; (4) Palazzo Contarini del Bovolo; (5) S. Luca and Palazzo Grimani; (6) Palazzo Corner-Spinelli; (7) Palazzo Grassi-Stucky and S. Samuele; (8) Palazzo Giustinian; (9) S. Maria Zobenigo; (10) S. Stefano and S. Maurizio; (11) Palazzo Pisani; (12) Palazzo Corner (Ca' Grande); (13) Palazzo Dario; (14) S. Maria della Salute and S. Gregorio; (15) Church of the Spirito Santo; (16) S. Maria del Rosario (the Gesuati) and Church of the Visitazione; (17) Galleria dell'Accademia; (18) S. Trovaso; (19) S. Barnaba; (20) Ca' Rezzonico; (21) Ca' Foscari; (22) S. Pantalon; (23) Palazzo Pisani-Moretta; (24) Palazzo Soranzo, Palazzo Corner-Mocenigo, and S. Polo; (25) Aponal; (26) S. Giacomo di Rialto and S. Giovanni Elemonsinario; (27) Palazzo Querini; (28) S. Cassiano; (29) Palazzo Viaro Zane and S. Maria Mater Domini; (30) Ca' Pesaro (Galleria Internazionale d'Arte Moderna); (31) S. Stae; (32) Fondaco dei Turchi and S. Giovanni Decollato; (33) S. Giacomo dall'Orio; (34) S. Simeone Grande; (35) S. Simeone Piccolo; (36) S. Giovanni Evangelista; (37) S. Maria Gloriosa (the Frari), S. Rocco, and the Scuola Grande di S. Rocco; (38) S. Niccolò da Tolentino; (39) S. Maria del Carmelo; (40) S. Sebastiano; (41) S. Niccolò dei Mendicoli; (42) S. Andrea della Zirada; (43) S. Maria di Nazareth (the Scalzi); (44) S. Giobbe; (45) S. Geremia and Palazzo Labia; (46) Palazzo Vendramin Calergi; (47) S. Fosca, Palazzo Correr, and Church of the Maddalena; (48) Scuola Nuova di S. Maria Valverde della Misericordia and Palazzo Lezze; (49) S. Maria Valverde and Scuola Vecchia della Misericordia; (50) Palazzo Mastelli; (51) Palazzo Contarini Dal Zaffo and Church of the Madonna dell'Orto; (52) Palazzo Contarini-Seriman; (53) S. Caterina; (54) S. Maria Assunta (the Gesuiti) and the Oratory of the Crociferi; (55) Ca' d'Oro; (56) S. Sofia; (57) SS. Apostoli; (58) Palazzo Sanudo and S. Maria dei Miracoli; (59) S. Giovanni Crisostomo; (60) Palazzo Bragadin Carabba; (61) Fondaco dei Tedeschi and the Rialto bridge; (62) S. Bartolomeo; (63) S. Salvatore; (64) S. Maria della Fava; (65) S. Lio; (66) S. Maria Formosa, Palazzo Querini-Stampalia, and Palazzo Grimani; (67) SS. Giovanni e Paolo and Scuola Grande di S. Marco; (68) S. Lazzaro dei Mendicanti; (69) S. Maria dei Derelitti (the Ospedaletto); (70) Palazzo Priuli; (71) Palazzo Trevisan; (72) the Bridge of Sighs and prison; (73) S. Zaccaria; (74) S. Giorgio dei Greci; (75) Palazzo Zorzi; (76) Scuola di S. Giorgio degli Schiavoni; (77) S. Lorenzo; (78) S. Francesco della Vigna; (79) S. Francesco di Paola; (80) S. Pietro di Castello and the former Palazzo Patriarcale; (81) S. Giuseppe di Castello; (82) S. Giorgio Maggiore; (83) S. Maria della Presentazione (the "Zitelle"); (84) Church of the Redentore; (85) S. Eufemia; (86) S. Michele; (87) Biennale Internazionale d'Arte.

by V. Scamozzi (1584) and completed by B. Longhena (1640), has a colonnade with piers and half-columns supporting two rows of windows. The Fabbrica Nuova (1810) is by G. Soli. Noteworthy Renaissance religious edifices of the 15th and 16th centuries include S. Michele on the island of San Michele, by M. Coducci (1469–78); the façade has a curved tripartite crowning, and the interior comprises a nave and two side aisles. The adjacent Emiliani Chapel (ca. 1530), by G. Bergamasco, is a hexagonal domed structure. S. Zaccaria was founded in the 10th century. Of the earliest structure, a three-aisled crypt remains. The campanile dates from the 13th century. A. Gambello worked on the reconstruction of the church

lateral chapels; the façade was completed in the early 17th century. There are polyptychs by Palma Vecchio and B. Vivarini and works by L. Bassano and Padovanino. S. Giovanni Crisostomo (1497–1504), by M. Coducci, has a Greek-cross plan, with barrel vaults and central dome on piers; there are works by Giovanni Bellini, Sebastiano del Piombo, and T. Lombardo. S. Maria dei Miracoli (S. Maria Nuova; 1481–89), by P. Lombardo, is faced inside and outside with polychrome marble; the interior comprises a barrel-vaulted nave, with a coffered ceiling, and sculptural decoration by the Lombardos. S. Giobbe was built after 1450; it was begun in Gothic style by A. Gambello and continued in Renaissance style by P. Lombardo

and assistants. Consecrated in 1493, the church has a single aisle, groin-vaulted, and contains works by P. Bordone, B. Vivarini, Giovanni de Alamagna, P. Lombardo, Bregno, and G. B. Piazzetta. SS. Apostoli was first erected in the Middle Ages and rebuilt in the 16th century. S. Giorgio Maggiore was completely rebuilt by Palladio and subsequently finished by V. Scamozzi. The façade has four colossal columns and a triangular tympanum. The interior has a nave and two side aisles and a domed transept and chancel. There are works by J. Tintoretto, J. Bassano, S. Ricci, and Palma Giovane. The adjoining monastery (now the headquarters of the Fondazione Giorgio Cini) was founded in the Middle Ages and enlarged and rebuilt over the centuries. The campanile dates from 1791. The Church of the Redentore, by Palladio, has a single aisle with a wide transept, intercommunicating lateral chapels, and hemispherical dome. The church has works by P. Veronese, F. Bissolo, F. Bassano, Palma Giovane, C. Saraceni, L. Bastiani, and Alvise Vivarini. Influenced by Palladio was S. Maria della Presentazione (1582), a polygonal-plan church. S. Lorenzo was remodeled by S. Sorella (1592–1617) on a square plan but left unfinished. S. Trovaso was rebuilt about 1590 in Palladian style; it contains works of M. Giambono and J. Tintoretto. S. Pietro di Castello was erected by F. Smeraldi (1596) and G. Grapiglia (1619), after designs by Palladio; the high altar and the Vendramin Chapel are by B. Longhena, and the campanile is by M. Coducci (1482–88).

Noteworthy, too, is S. Sebastiano (1544–48), by Scarpagnino, with a single aisle; there are paintings and frescoed friezes by P. Veronese. S. Maria Mater Domini is attributed to Sansovino; the interior comprises a nave and two side aisles and contains works by V. Catena, Tintoretto, Bissolo, Bonifacio de' Pitati, and L. Bregno. The medieval Church of S. Salvatore was rebuilt in the 16th century (completed by J. Sansovino); the façade was completed in the 18th century after a design attributed to G. Sardi. The interior comprises a nave and two side aisles. There are works by Titian, Sansovino, Palma Giovane, A. Vittoria, and P. Bordone. S. Giuliano was remodeled about 1555 by J. Sansovino and A. Vittoria; the square interior has a carved wooden ceiling. There are works by Palma Giovane, L. Corona, A. Vittoria, Veronese, B. Boccaccino, and Girolamo da Santacroce. S. Fantin was begun by Scarpagnino (1507–49); the chancel and apse are by Sansovino. S. Francesco della Vigna was designed by Sansovino (1534); the façade portal is by Palladio (1568–72). The Latin-cross structure has a single aisle, and there are paintings by Antonio Vivarini, Palma Giovane, Giovanni Bellini, and P. Veronese, as well as monochrome frescoes by G. B. Tiepolo. In the 15th and 16th centuries, the *scuole di devozione* (seats of the confraternities) were important art centers. Such was the Scuola Grande di S. Marco (now the Ospedale Civile), designed by P. Lombardo and G. Buora (1488–90) and completed by M. Coducci. The façade is decorated with illusionistic architectural perspectives and sculpture by T. Lombardo and B. Bon; in front of the Scuola is Verrocchio's equestrian monument to B. Colleoni. The Scuola di S. Giorgio degli Schiavoni dates from the 16th century; the façade was designed by Giovanni de Zan (1551); within there are canvases by Carpaccio. The Scuola Vecchia della Misericordia (15th cent.) is Gothic. The Scuola Nuova di S. Maria Valverde della Misericordia was begun by Sansovino (1532); the façade was left unfinished. The Scuola di S. Giovanni Evangelista was enlarged in the 15th century. The Scuola preserves paintings by D. Tintoretto, S. Peranda, D. Tiepolo, and J. Marieschi. The Scuola Grande di S. Rocco, by B. Bon, S. Lombardo, and Scarpagnino (1517–1550), is decorated with 56 canvases by Tintoretto.

Among the religious edifices built or partially rebuilt in the 17th and 18th centuries is S. Rocco, built in the 15th century by B. Bon and rebuilt by Scalfarotto (1725); the façade by B. Maccarucci is adorned with statues by G. M. Morlaiter; within the church are canvases by J. Tintoretto, F. Solimena, and S. Ricci. S. Niccolò da Tolentino was designed by V. Scamozzi (1591–1602); the pronaos was added by A. Tirali (18th cent.). The church preserves works by Palma Giovane, S. Peranda, L. Giordano, and Padovanino. S. Maria della Salute, by B. Longhena (1631–81), has an octagonal plan, with a wide chancel at one side, hemispheric dome, and a smaller dome over the chancel. The monumental façade stands at the head of a broad flight of steps leading up from the water. There are works by Titian, L. Giordano, Palma Giovane, Sassoferrato, and J. Tintoretto. The Seminario Patriarcale is by Longhena (1670). The "Dogana da Mar" (marine customs house), by G. Benoni (ca. 1667), is surmounted by bronze sculptures. The Church of the Angelo Raffaele, rebuilt by F. Contino (1618), has scenes from the story of Tobias (VII, PL. 98), attributed to G. A. or F. Guardi. The Church of the Gesuati (S. Maria del Rosario), by G. Massari (1726–43), is elliptical in plan, and there are frescoes by G. B. Tiepolo and works by G. B. Piazzetta, G. M. Morlaiter, and Tintoretto. S. Stae (façade, 1709), by D. Rossi and G. Grassi (interior, 1658), contains works by G. B. Tiepolo, G. B. Pittoni, G. B. Piazzetta, A. Balestra, and

others. The Scuola di S. Gerolamo (or Scuola di S. Fantin), by A. Contino (1592–1600), has works by A. Vittoria, P. Veronese, Tintoretto, and ceiling canvases by Palma Giovane. The Church of the Ospedaletto (S. Maria dei Derelitti), by B. Longhena (1674), is decorated with early works of G. B. Tiepolo. Typical examples of Venetian baroque, particularly rich in their external ornamentation, are S. Moisè, by A. Tremignon (1668), decorated by A. Merengo; S. Maria Zobenigo (S. Maria del Giglio), by G. Sardi (1680–83); S. Bartolomeo, a medieval church rebuilt in 1723; S. Maria di Nazareth (the Scalzi), by B. Longhena (1670–80); the Church of the Jesuits (S. Maria Assunta), with façade by G. B. Fattoretto (18th cent.); S. Simeone Piccolo, built by Scalfarotto (1718–38); S. Maria della Pietà (or Church of the Visitazione; 1760), by G. Massari; and S. Vitale, with façade by A. Tirali (1700).

Among the most important civil structures of the 16th, 17th, and 18th centuries are the Palazzo Corner, called "Ca' Grande" (now the Palazzo del Governo), with two orders of paired columns on a high rusticated base, and the Palazzo Manin, by J. Sansovino; the Palazzo Grimani and the Palazzo Corner-Mocenigo, by Sanmicheli; the Lombardesque Palazzo Malipiero-Trevisan (early 16th cent.); the Palazzo Priuli (1580), by B. Monopola; the Palazzo Loredan, by Scarpagnino (1536); the Palazzo Pisani (16th–18th cent.) in Campo Pisano; and the prison, by G. A. Rusconi (1560) and Antonio da Ponte (1589), completed in 1614 by the Continos. Other edifices include the Palazzo Giustinian-Lolin (1623), by B. Longhena, the Palazzo Moro-Lin (now Pascolato), by S. Mazzoni, the Ca' Matteotti (formerly Palazzo Michiel dalle Colonne; 17th cent.), the Palazzo Contarini (formerly Corner), the Lombardesque Palazzo Grassi-Stucky, by G. Massari (18th cent.), the Palazzo Balbi, by A. Vittoria (1590), the Palazzo Papadopoli (formerly Coccina-Tiepolo; second half of 16th cent.), the Palazzo Contarini degli Scrigni (1609), by V. Scamozzi, the Palazzo Rezzonico (1660) and the Palazzo Pesaro (1710), both designed by Longhena, and the Palazzo Corner della Regina (now Monte di Pietà; 1724).

Among the buildings erected in the neoclassic period are the Teatro La Fenice, by A. Selva (1790–92); the Church of the Maddalena, on a circular plan, by T. Temanza (18th cent.); and the façade of the former Palazzo Patriarcale, by L. Santi (19th cent.). The romanticism of the 19th century fostered the creation of areas of green in front of the small palaces on the Grand Canal, as well as the construction of a number of Neo-Gothic structures. Museums include the Museo Archeologico; the Museo Marciano, adjoining S. Marco; the Treasury of S. Marco; the Mostra Permanente dei Cimeli della Biblioteca Marciana; the Museo Correr (19th-cent. Venetian painting); the Galleria Querini Stampalia (Venetian works of the 15th–18th cent.); the Pinacoteca Manfrediniana e Raccolte del Seminario Patriarcale (fragments, sculptures, and inscriptions from former churches and convents; 15th–16th-cent. Venetian works); the Gallerie dell'Accademia (collection of Venetian paintings, from the primitives to the 18th century, as well as Tuscan and Lombard works); the Ca' d'Oro (with the Galleria Giorgio Franchetti, collection of paintings, tapestries, and medals of the 15th and 16th cent.); the Ca' Rezzonico (18th-cent. paintings, furniture, objets d'art, ceramics, etc.); the Museo Storico Navale; the Museo Orientale, in Ca' Pesaro; the Museo della Congregazione dei Padri Armeni Mechitaristi di Venezia, on the island of San Lazzaro degli Armeni (with a small collection of Egyptian art, Roman objects, and Armenian miniatures and coins); and the Galleria Internazionale d'Arte Moderna.

Torcello, one of the earliest inhabited islands in the Venetian estuary, has a group of monumental edifices surrounding its piazza. The Church of S. Fosca (11th cent.), octagonal in plan, has an external colonnade on five faces and a pentagonal apse between two semicircular apsidioles with two rows of blind arches; the interior has a Greek-cross plan, with timber roof. The Cathedral was erected in the 7th century, remodeled in the 9th, rebuilt in 1008, and subsequently altered. The façade is brick, and the interior has a basilican plan, with columns of Greek marble and Corinthian capitals. There are mosaics from the 9th and 12th centuries, and the campanile dates from the 11th century. The Palazzo dell'Archivio and the Palazzo del Consiglio date from the 14th century. In Burano is the Church of S. Martino, which has a Crucifixion by G. B. Tiepolo. On the island of San Francesco del Deserto is a small church and a 14th-century cloister. Murano was a flourishing center in the 11th century and enjoyed its greatest prosperity in the 16th century. An ancient center of the art of glass-making, it is still very active. The Church of S. Pietro Martire (14th cent.), which has been rebuilt several times, contains works by G. Bellini, Tintoretto, and Veronese. The Church of SS. Maria e Donato was rebuilt in the 12th century with an octagonal apse and a double order of columns. The Latin-cross interior has 12th-century mosaic paving and a 13th-century mosaic in the apse. The campanile dates from the 13th century. S. Maria degli Angeli (1529) is a Lombardesque structure. The Palazzo Da Mula (15th cent.) is Gothic. The Museo Vetrario has a

fine collection of glass from the 15th century to the present. The Palazzo del Podestà and the Church of the Assumption in Malamocco are 15th-century structures.

BIBLIOG. F. Sansovino, Venezia città nobilissima, Venice, 1581; G. Moschini, Guida per la città di Venezia, 2d ed., Venice, 1815; P. Selvatico, Sulla architettura e sulla scultura a Venezia, Venice, 1847; F. Ongania, La Basilica di San Marco, 2d ed., Venice, 1888; J. Ruskin, The Stones of Venice, 4th ed., London, 1888; P. Paoletti, L'architettura e la scultura del Rinascimento a Venezia, Venice, 1893; P. Molmenti, Venice, Bergamo, 1907; P. L. Rambaldi, La Chiesa dei SS. Giovanni e Paolo, Venice, 1913; P. Molmenti, La storia di Venezia nella vita privata dalle origini alla caduta della Repubblica, 2 vols., Bergamo, 1922–25; G. Fogolari, I Frari e i SS. Giovanni e Paolo, Milan, 1935; F. Forlati, Il Fondaco dei Tedeschi, Palladio, IV, 1940, pp. 275–86; E. Trincanato, Venezia minore, Milan, 1948; G. Fogolari, Il Palazzo Ducale, Milan, 1949; G. Mariacher, Il Palazzo Ducale, Florence, 1950; G. Mariacher and T. Pignatti, La basilica di S. Marco, Florence, 1950; F. Forlati, Il primo S. Marco, Arte veneta, V, 1951, pp. 73–76; G. Perocco, Guida alla scuola di S. Giorgio degli Schiavoni, Venice, 1952; M. Murano, Nuova guida di Venezia, Florence, 1953; G. Lorenzetti, Venezia e il suo estuario, 2d ed., Rome, 1955; G. Damerini, L'isola e il Cenobio di San Giorgio Maggiore, Venice, 1956; T. Pignatti, Piazza S. Marco, Novara, 1956; A. Sartori, S. Maria Gloriosa dei Frari, 2d ed., Padua, 1956; F. Forlati, L'architettura di S. Marco a Venezia e suoi restauri, Atti Acc. naz. S. Luca, N.S., III, 1957–58, pp. 97–104; A. Krönig, Venezia, Bonn, 1957; M. Luxoro, Palazzo Vendramin Calergi, Florence, 1957; A. Caccin, La chiesa dei SS. Giovanni e Paolo, Bologna, 1959; S. Muratori, Studi per una operante storia urbana di Venezia, Palladio, N.S., IX, 1959, pp. 99–209; E. Bassi and E. Trincanato, Il Palazzo Ducale nella storia e nell'arte di Venezia, Milan, 1960; J. Morris, Venice, London, 1960. For Torcello: B. Schulz, Die Kirchenbauten auf der Insel Torcello, Berlin, 1927; G. Lorenzetti, Torcello, Venice, 1939; G. Perocco, L'isola di Torcello, Venice, 1956.

Verona. As early as the Bronze Age, Verona was the site of lake dwellings. From the 7th century B.C., it was a center of Atestine culture. The Cenomani seem to have begun to enter the region in the 4th century B.C. Relations with Rome were well established as early as the 2d century B.C. (construction of the Via Postumia) and consolidated about 89 B.C., when Verona became a Roman colony. Dating from the end of the Roman Republic are the walls, rebuilt in 265 by Gallienus, while the Porta dei Borsari and the Porta dei Leoni date from the Flavian period. Other Roman remains include the so-called "Arena," a theater, the Arco dei Gavi, and a Roman bridge. The seat of various monarchies (Ostrogoths, Lombards, and Franks), Verona was devastated by the Magyars in the 10th century. Rebuilding began in the 11th century, when Verona was an independent commune. In the 14th century it became a seigniory of the Scaliger family. In 1405 it came under the rule of Venice and shared the fate of that republic.

The medieval city largely followed the outlines of the Roman city. The various phases of growth are attested by successive enlargements of the walls: in the 6th century (walls of Theodoric, of which no trace remains), in the 11th (walls of the period of the commune), in the 14th (walls of the Scaligers, remarkably well preserved). In the 16th century the medieval walls were restored and fortified by Sanmicheli and in the 19th century by the Austrians. Many of the churches date from the Early Christian period, but nearly all were remodeled in the Romanesque period and are characterized by conical-topped campaniles and wall facings of thin courses of stone and brick. Vestiges of the various building phases from the Early Christian to the Romanesque are combined in the Church of S. Stefano, which dates from the 5th century. The Church of SS. Tosca e Teuteria (5th cent.) has a Greek-cross plan. The 5th-century structure was a pagan shrine; it was consecrated in the 8th century and remodeled in the 12th.

Noteworthy Romanesque edifices include the group of buildings centering upon the Cathedral, which incorporates remains from various periods. Excavations in the cloister (1123) uncovered fragments of mosaic pavements and sculpture from an Early Christian basilica. The columns and capitals of the atrium linking the Cathedral to the Baptistery probably survive from the 8th-century Cathedral, which was rebuilt in 1139–87. The Cathedral was enlarged in the 15th–16th centuries with Gothic and Renaissance elements. Of the Romanesque structure, there remain the lower portions of the outer walls, the apses and the bay of the chancel, and nearly all of the tripartite façade with blind galleries, and the Lombard porch by Master Nicolaus (q.v.). The right flank preserves part of the Romanesque cornice decorated with hunting subjects and a porch with sculptured capitals. The circular apse is also Romanesque, and the campanile (completed by Sanmicheli in the 16th cent.) has a 12th-century base. The Gothic interior of the Cathedral comprises a nave and two side aisles. Along the side aisles are Renaissance chapels, some of which are framed by sham architecture by Falconetto. The Cathedral preserves several Renaissance paintings. The Baptistery (S. Giovanni in Fonte), rebuilt in 1123, has a nave with two side aisles and

three apses. The sculptured baptismal font dates from about 1200 and reflects Byzantine influence. The Church of S. Elena (9th cent.) was rebuilt and reconsecrated in 1140. The Vescovado, behind the Cathedral, preserves vestiges of the Romanesque structure (portico; tower of Bishop Ognibene, 1162). There are Renaissance frescoes inside the Vescovado. The most distinctive Romanesque church in the city is S. Zeno Maggiore. It was erected in the 5th century and rebuilt in the 9th century by the architect Pacificus. Its present form dates from 1120–38. The upper part of the church was completed in the 12th–13th centuries; the apse was rebuilt in 1385–98; and the restoration dates from 1870. The tripartite façade, with pilaster strips, is broken horizontally by a gallery with mullioned windows. The portal with porch has column-bearing lions. The portal, by Nicolaus, is flanked by two bands of sculpture by Guillelmus (ca. 1135). The campanile dates from 1045–1178, and the battlemented tower, the sole vestige of the old Benedictine abbey, dates from the 13th–14th centuries. The interior of S. Zeno has a Latin-cross plan. The aisles are separated by alternating piers and columns with remarkable Romanesque capitals. The large statue of St. Zeno dates from the 13th century. There are numerous frescoes from the 12th–15th centuries and a triptych by Mantegna. The spacious crypt is surrounded by carved colonnades with 12th-century capitals. The octagonal baptistery dates from the 12th century. Other Romanesque churches include S. Lorenzo (early 12th cent.; restored) and S. Giovanni in Valle (9th cent.; reconsecrated in 1194; restored). S. Giovanni in Valle has frescoes from the 12th–13th centuries. In the 9th-century crypt is the 4th-century sarcophagus of SS. Simon and Jude. There are remains of the Romanesque cloister (12th cent.); the campanile dates from the 16th century. In the center of the medieval town is the Piazza delle Erbe (I, PL. 402), with remodeled houses standing on Gothic and Romanesque foundations. Also in the square is the Fontana di Madonna Verona. The statue that gives the fountain its name is Roman. In the Piazza dei Signori is the Palazzo del Comune (begun in 1193), with a single row of triple-lighted mullioned windows. The Palace is topped by the Torre dei Lamberti (1172; completed in 15th cent.). The Palazzo del Governo (formerly Reggia degli Scaligeri, late 13th cent.; restored in 1930) has a ground-floor gallery, Guelph battlements, and an interior court. The triumphal door is by Sanmicheli. The Palazzo dei Tribunali (formerly the Palazzo del Capitano) is a late-14th-century structure. Additions and alterations were made in the 15th–17th centuries. The small Romanesque Church of S. Maria Antica was founded in the 7th century, rebuilt in the 11th.

The Gothic style became established late in the 13th century, with the churches of the Dominicans and Franciscans. The Dominican Church of S. Anastasia (1291–1323) has a Latin-cross plan and chapels flanking the apse. The church preserves remarkable late-Gothic frescoes (by Altichiero, Pisanello, Turone, and Stefano da Zevio). S. Fermo Maggiore comprises an upper and a lower church, both dating from the 12th century. The upper church was rebuilt in the 13th century and has a single nave with carinate ceiling and five apses. It preserves 14th-century frescoes, a Crucifixion by Altichiero, an Annunciation by Pisanello, and the Brenzoni monument by Nanni di Bartolo. S. Eufemia (end of 13th–15th cent.) is a single-aisled church. A notable Gothic civil structure is the Castelvecchio (1354–75), which consists of two structures encircled by a moat with drawbridges. From the late Gothic period are the Scaliger tombs in the Piazzaletto delle Arche (I, PL. 380; III, PL. 21).

The work of Fra Giocondo, to whom the Loggia del Consiglio is ascribed (1475–92), marked the beginning of the Renaissance in Verona. At the end of the 15th century, Lombard masters became prominent. Michele Sanmicheli (q.v.) was responsible for several 16th-century structures, including the Porta Nuova, Porta Palio, the Palazzo Guastaverza (now Malfatti), the Palazzo Pompei, the Palazzo Canossa, the Palazzo Bevilacqua, the portal of the Palazzo dei Tribunali (formerly Palazzo del Capitano), the Pellegrini Chapel in S. Bernardino, and the decoration of the lower façade of S. Maria in Organo. Renaissance in style is the Church of S. Giorgio Maggiore (S. Giorgio in Braida; 1477–1536), which has a hemispherical dome on an arcuated drum and an altar by Sanmicheli. Noteworthy buildings with painted façades are the Mazzanti houses (dating from the time of the Scaligers), with frescoes by N. Giolfino, G. F. Caroto, and A. Cavalli, and the Gran Guardia (begun 1610). The baroque style had a moderate vogue in Verona (Palazzo Maffei, 1668, in Piazza delle Erbe). Dating from the 18th century is the Italian-style garden of the Palazzo Giusti. Museums include the Museo Archeologico al Teatro Romano, the Museo Maffeiano, the Museo di Castelvecchio (14th–18th-cent. works), the Galleria d'Arte Moderna, and the Biblioteca Capitolare (with 5th-cent. codices).

Near Verona is Bardolino, the site of the late medieval Church of S. Zeno (cruciform) and a castle built by the Scaligers. The town of San Giorgio has a Romanesque parish church, which preserves an 8th-century Lombard ciborium and remains of a small Romanesque

cloister. In San Bonifacio is the Church of S. Abbondio, a Romanesque structure with 15th-century frescoes. In Santa Sofia di Pedemonte is Palladio's Villa Boccoli (formerly Villa Sarego).

BIBLIOG. T. Sarayna, De origine et amplitudine civitatis Veronae, Verona, 1540; S. Maffei, Verona illustrata, 4 vols., Verona, 1731–32; G. Biancolini, Notizie storiche delle chiese di Verona, 6 vols., Verona, 1749–62; P. Valesi, Varie fabbriche antiche e moderne della città di Verona, Verona, 1753; G. B. Da Persico, Descrizione di Verona e della sua provincia, 2 vols., Verona, 1820–21; L. Marinelli, I Castelli di Verona, Venice, 1902; C. Cipolla, La chiesetta di S. Abbondio presso S. Bonifacio, Arte e Storia, XXIV, 1905, pp. 168–69; G. Biadego, Verona, Bergamo, 1909; L. Simeoni, Guida della città, 3d ed., Verona, 1909 (rev. and amplified by N. Zanoni, Verona, 1953); C. Cipolla, S. Anastasia, L'Arte, XVII, 1914, pp. 91–106, 181–97, 395–414, XVIII, 1915, pp. 157–71, 296–304, 459–67, XIX, 1916,

pp. 115–24, 234–40; A. Da Lisca, Le fortificazioni di Verona dai tempi romani al 1866, Verona, 1918; L. Simeoni, Verona, Rome, 1929; P. Marconi, Verona romana, Bergamo, 1936; E. Arslan, L'architettura romanica veronese, Verona, 1939; Collana "Le Guide," Verona, 1952 ff. (small volumes concerning individual monuments of Verona and environs); F. Dal Forno, Il teatro romano di Verona, Verona, 1954; T. Lenotti, L'arena di Verona, Verona, 1954; A. Zarpellon, Verona e l'agro veronese in età romana, Verona, 1954; F. de' Maffei, Le arche scaligere, Verona, 1955; P. L. Zovatto, La chiesa altomedievale di S. Zeno di Bardolino, Palladio, N.S., V, 1955, pp. 1–6; R. Brenzoni, La loggia del Consiglio veronese nel suo quadro documentario, Atti Ist. veneto Sc., Lettere e Arti, CXVI, 1957–58, pp. 265–307; B. Forlati, La basilica paleocristiana di Verona e le nuove scoperte, RendPontAcc, XXX, 1957–59, pp. 117–27; B. Forlati Tamaro, La casa romana nel Veneto e una nuova scoperta a Verona, AC, X, 1958, pp. 116–20; P. Gazzola, La Pergula della Cattedrale di Verona, BArte, XLV, 1960, pp. 97–110; Istituto per gli studi storici veronesi, Verona e il suo territorio, Verona, 1960; P.L.

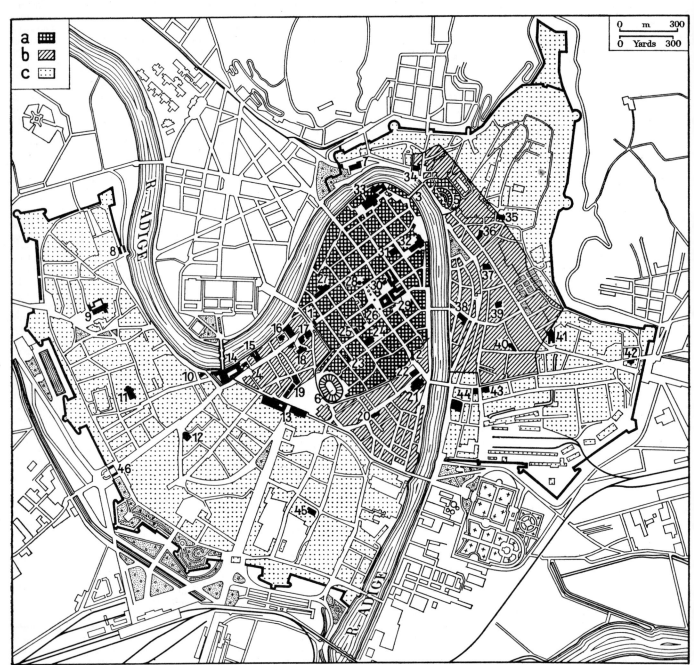

Verona, plan. *Key*: (*a*) Area of the Roman city; (*b*) area of the medieval city, to the beginning of the 13th century; (*c*) area within the walls of Cangrande I (1323–25), later bastioned. Roman monuments; (1) Porta dei Borsari; (2) Porta dei Leoni; (3) Ponte Pietra; (4) Arco dei Gavi, reconstructed and moved; (5) theater; (6) amphitheater (the Arena). Medieval and modern monuments: (7) Porta S. Giorgio and Church of S. Giorgio Maggiore; (8) Porta Catena; (9) S. Zeno Maggiore; (10) S. Zeno in Oratorio; (11) S. Bernardino; (12) S. Teresa degli Scalzi; (13) Museo Maffeiano and Palazzo della Gran Guardia; (14) Castelvecchio and Ponte Scaligero; (15) Palazzo Canossa; (16) S. Lorenzo and Palazzo Pozzani; (17) Bevilacqua, Scannagatti, and Carnesali palaces; (18) SS. Apostoli; (19) Vaccari, Barbaro, and Malfatti palaces; (20) S. Pietro Incarnario; (21) S. Fermo Maggiore; (22) Palazzo Murari Dalla Corte-Bra; (23) Palazzo dei Diamanti; (24) S. Maria della Scala; (25) Casa da Lisca; (26) Casa dei Mercanti, in Piazza delle Erbe; (27) S. Eufemia; (28) Palazzo Maffei and Gardello Tower; (29) Palazzo del Comune, Palazzo dei Tribunali, and Scaliger tombs; (30) Palazzo del Governo (Reggia degli Scaligeri); (31) Palazzo Forti (Galleria d'Arte Moderna); (32) S. Anastasia; (33) Cathedral, S. Giovanni in Fonte (Baptistery), and Vescovado; (34) S. Stefano; (35) S. Giovanni in Valle; (36) S. Chiara; (37) S. Maria in Organo; (38) S. Tommaso Cantuariense; (39) Palazzo del Seminario; (40) S. Maria del Paradiso; (41) SS. Nazaro e Celso; (42) S. Toscana; (43) S. Paolo; (44) Casa Camozzini and Palazzo Pompei; (45) SS. Trinità; (46) Porta Palio.

Zovatto, Il sacello paleocristiano delle SS. Tosca e Teuteria a Verona, Felix Ravenna, XXXI, 1960, pp. 133–41; E. Schmid, Verona-Brescia, Frauenfeld, 1961.

Vicenza (Lat., *Vicetia*). A Paleo-Venetic settlement and later a Roman municipium, Vicenza was devastated by the barbarians and was the scene of continual strife in the Middle Ages. The city flourished again under Venetian rule (from 1405) and achieved its greatest magnificence in the 16th century, when the monumental physiognomy of the city was established by Palladio. Vicenza's modern appearance dates from that time. The plan of the modern city, in

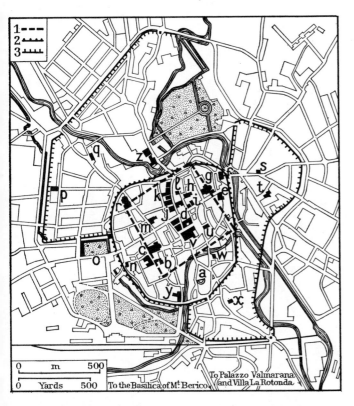

Vicenza, plan. *Key:* (1) Probable extent of the Roman city; (2) course of the first communal walls; (3) course of the extended city walls of the 15th century. Principal monuments: (*a*) Roman theater of Berga; (*b*) Oratory of the Cathedral and Palazzetto Proti, with Roman cryptoporticus below; (*c*) Cathedral and Palazzo Vescovile; (*d*) Palazzo del Comune, Loggia del Capitano, and Monte di Pietà; (*e*) Palazzo Chiericati (Museo Civico); (*f*) Teatro Olimpico; (*g*) Sta Corona and Palladio's house; (*h*) S. Stefano; (*i*) S. Gaetano and Palazzo Da Schio; (*j*) Thiene and Porto-Barbaran palaces; (*k*) Casa Poloni and Biego, Colleoni, and Porto-Breganze palaces; (*l*) Casa Longhi; (*m*) Palazzo Valmarana; (*n*) Palazzo Breganze; (*o*) Salvi Garden, Loggia Valmarana, and Loggia del Longhena; (*p*) S. Rocco; (*q*) S. Maria del Carmine; (*r*) S. Lorenzo; (*s*) Palazzo Regaù; (*t*) S. Pietro in Piano; (*u*) S. Maria dei Servi; (*v*) the Basilica, or Palazzo della Ragione, and Torre di Piazza; (*w*) S. Nicola da Tolentino; (*x*) S. Chiara; (*y*) Palazzo Trissino del Velo d'Oro; (*z*) Piovene and Vaccari palaces.

which the outlines of the ancient city are discernible, extends along a main axis (Corso Palladio) and is centered on the Piazza dei Signori. Remains of the Roman period include the ruins of a theater, cryptoporticus, bridge, and aqueduct. The Via Postumia passed through the Roman city and served as its *decumanus maximus*. Surviving from the Early Christian period is the square-plan Chapel of S. Maria Mater Domini (4th–5th cent.) adjoining the 10th-century Church of S. Felice, which was originally founded in the 5th century. Vestiges of a basilica having a nave and four side aisles with mosaic pavement have been found under the Cathedral. The tradition of the "hundred towers" of Vicenza goes back to the 11th–13th century. Towers surviving from this period include the Torre di Piazza and the Torre del Girone (called "Torre del Tormento"). There are few Romanesque remains because of the virtual destruction of Vicenza by Frederick II of Austria in 1236. The Scaligers extended the city's fortifications. In the 13th–14th century a great many Romanesque and Gothic churches were built. The Dominican Church of Sta Corona (1260), with nave and two side aisles, has a crypt and chancel by Lorenzo da Bologna (1482). The Franciscan Church of S. Lorenzo (1280–1344) has a façade with blind arches and boasts a carved marble

portal by Andriolo de Sanctis. The Church of S. Maria dei Servi, with nave and two side aisles, was erected in 1407 and enlarged in 1490. A structure marking the transition from the Gothic to the Renaissance is the Cathedral, which was begun in the 14th century and completed in the 16th. The façade is attributed to Domenico Veneziano (1467). Flamboyant Gothic buildings include the Palazzo Regaù, the Casa Longhi, and the Casa Pigafetta (1481). The Palazzo Da Schio is a Gothic-Renaissance structure (early 15th cent.; partially rebuilt). Venetian Gothic palaces include the Palazzo Colleoni-Porto (14th cent.). The Palazzo Thiene was designed by Lorenzo da Bologna (1489); the unfinished courtyard and the façade are the work of Palladio. The fine loggia in the Palazzo Vescovile (1494–95) is attributed to Bernardino di Martino da Milano, who probably worked after a plan by A. Rizzo. The Church of S. Rocco is a 15th-century edifice, but the façade dates from 1530. The Church of S. Pietro in Piano was reconstructed in the 15th century. The nearby Oratory of S. Pietro (or Oratorio dei Boccalotti) also dates from the 15th century. The late-15th-century Palazzo Negri has two crenelated towers. The two Arnaldi houses are also 15th-century structures. The Palazzo della Ragione (or "Basilica"), in the Piazza dei Signori, was rebuilt by Palladio (XI, PL. 29). The original structure had been erected in the 13th century and subsequently remodeled. Among Palladio's other works in Vicenza are the Palazzo Trissino dal Velo d'Oro (attributed), the Palazzo Chiericati, the Palazzo Porto-Barbaran, and the Palazzo Valmarana, as well as the Loggia del Capitanio. (See XI, PLS. 30, 35.) The Teatro Olimpico (IX, PL. 312; XI, PL. 36), with its permanent perspective scenery, was begun by Palladio and completed by Scamozzi. The Palazzo Bonin, which is attributed to Scamozzi, is Palladian in style. Scamozzi's original creations include the Palazzo della Prefettura (formerly Palazzo Godi) and the Palazzo del Comune (formerly Palazzo Trissino; completed by A. Pizzocaro). Also in the Palladian tradition are the Palazzo Migliorini and the Casa Bortolan (16th cent.). Baroque architecture in Vicenza is represented by the works of C. Borella, who was responsible for the Palazzo Montanari (now the Palazzo della Banca Cattolica del Veneto; ca. 1680–90), the Palazzo Piovene (1676–80), and the central-plan Church of Ara Coeli (1675–80). In the 18th century, G. Massari built the Palazzo Vecchia (Romanelli, 1748), and F. Muttoni designed the new façade of the Monte di Pietà (1704). Muttoni was also responsible for the Palazzo Repeta (now Banca d'Italia; 1701–11). A more resolute return to Palladian classicism is represented by the Cordellina (1776) and the Zileri Dal Verme (1782) palaces, by O. Calderari, and the Pagello (1780) and Folco palaces (1770), by O. Bertotti-Scamozzi. Neoclassic traits are evident in the façade of the Palazzo Vescovile (1819), by G. Verda, the Palazzo Franco (1830), by A. Piovene, and the cemetery, by B. Malacarne and G. Verda. The Museo Civico (in the Palazzo Chiericati) has an archaeological collection with prehistoric materials; there is also a painting gallery. The Biblioteca Comunale Bertolina has a collection of rare codices and incunabula.

Near Vicenza is the villa by Palladio called "La Rotonda" (XI, PL. 31). A central-plan structure, it has four porches with Ionic columns and pediments. Not far from "La Rotonda" is the 18th-century Villa Valmarana, which contains frescoes by G. B. Tiepolo and his son Giovanni Domenico. The Church of Monte Berico (1688–1703), by C. Borella, also near Vicenza, has a Greek-cross plan and is surmounted by a dome. In the refectory is the *Feast of Gregory* by Paolo Veronese.

BIBLIOG. S. Rumor, Bibliografia storica della città e provincia di Vicenza, Vicenza, 1916; D. Bartolan and S. Rumor, Guida di Vicenza, Vicenza, 1919; G. Zorzi, Contributo alla storia dell'arte vicentina nel secolo XV e XVI, Venice, 1925; G. Fasolo, Le ville del vicentino, Vicenza, 1929; F. Franco, La scuola architettonica di Vicenza dal secolo XV al XVIII, Rome, 1934; A. De Bon, La romanità del territorio vicentino, Bassano, 1938; F. Franco, L'"interpolazione" del Filarete trattatista fra gli artefici del rinascimento architettonico a Venezia, Atti IV Conv. naz. Storia Arch., Milan, 1942, pp. 171–82; A. Sartori, La chiesa di S. Lorenzo, Vicenza, 1953; W. Arslan, Vicenza, I: Le chiese, Rome, 1956; F. Barbieri, R. Cevese, and L. Magagnato, Guida di Vicenza, Vicenza, 1956; B. Faldati, F. Forlati, and F. Barbieri, Il Duomo di Vicenza, Vicenza, 1956; R. Cevese, Ville vicentine, Milan, 1957; G. Lorenzon, Il complesso monumentale della basilica dei Martiri Felice e Fortunato a Vicenza, Atti V Conv. naz. Storia Arch. (1948), Florence, 1957, pp. 211–19; G. P. Bognetti, B. Forlàti, and C. Lorenzon, Vicenza nell'alto medioevo, Venice, 1959.

Vittorio Veneto. Created by the union of Serravalle and Ceneda (1866), Vittorio Veneto was named in honor of Victor Emmanuel II, the first king of Italy. Part of the medieval fortifications of Serravalle survive. There are porticoed Gothic buildings as well as interesting Renaissance structures. The Palazzo Comunale di Serravalle, or Loggia Serravallese (15th cent.), preserves a Romanesque tower and portico. The Church of S. Lorenzo (with 14th-cent. frescoes) is incorporated in the Ospedale Civile (14th cent.). S. Giovanni Battista has a Romanesque Gothic façade (1267) and a portal dating from 1483. The parish

church of Bigonzo (S. Andrea) was rebuilt early in the 14th century. S. Giustina (rebuilt in the late 16th cent.) houses the tomb (1336–40) of Rizzardo VI da Camino. The Cathedral of Serravalle was rebuilt in 1775; in the interior is a Madonna and Child with Saints by Titian. The Museo del Cenedese is in the Loggia Serravallese.

The Church of S. Maria di Meschio preserves an Annunciation by A. Previtali. The Cathedral of Ceneda, built in 1740–73, has retained its Romanesque campanile, which was built as a defense tower for the Castle of S. Martino. The former Palazzo Comunale, or Loggia Cenedese, was erected in 1537–38. The Castle of S. Martino, now the Sede Vescovile, was rebuilt in the 15th century. The Sanctuary of S. Augusta has a small Gothic portico.

The Abbey at Follina, southwest of Vittorio Veneto, was founded in the 12th century.

BIBLIOG. L. Mason, Guida di Vittorio Veneto e suo distretto, Vittorio Veneto, 1889; I. Bernardi, Il chiostro di Follina, Arte e Storia, XII, 1893, pp. 90–91; F. Troyer, Vittorio Veneto, Milan, 1893; F. Forlati, Restauri di architettura minore nel Veneto (Follina), Architettura, VI, 1926–27, pp. 49–66; G. B. Cervellini, Il monumento caminese di Serravalle, BArte, IX, 1929–30, pp. 456–77.

Friuli-Venezia Giulia. Much of the history of this region is that of the entire Venetian area (see above, *Veneto*). The development of the culture of the *castellieri*, a kind of stone enceinte, was an early historic phenomenon peculiar to the mountainous territories of the Carni and Histri. The city of Aquileia was an influential center of civilization from the time of its foundation, in the 2d century B.C., until the Middle Ages, when the influence of Venice dominated the region. Most of Istria is now part of Yugoslavia (q.v.).

BIBLIOG. F. di Maniago, Storia delle belli arti friulane, 2d ed., Venice, 1823; G. B. Cavalcaselle and U. Valentinis, Elenco dei monumenti per il Friuli, 1876 (ms. in Udine, Bib. Civ.); G. Occioni Bonaffons, Bibliografia storica friulana dal 1861 al 1882, 2 vols., Udine, 1884–87; V. Joppi, Nuovo contributo alla storia dell'arte del Friuli, 4 vols., Venice, 1887–92; R. Cattaneo, L'architettura in Italia dal secolo VI al Mille circa, Venice, 1888; V. Joppi, Contributo terzo alla storia dell'arte nel Friuli e alla vita dei pittori ed intagliatori friulani, Venice, 1892; B. Benussi, La regione Giulia, Parenzo, 1903; C. Marchesetti, I castellieri di Trieste e della Regione Giulia, Trieste, 1903; A. Tamaro, La Vénetie Julienne et la Dalmatie, I, Rome, 1918; A. Morassi, Chiese gotiche in Val d'Isonzo, Architettura, II, 1922–23, pp. 177–89; C. Ermacora, Il Friuli, Vicenza, 1935; P. Sticotti, L'orma di Roma nella Venezia Giulia, Bergamo, 1938; C. Cecchelli, Monumenti del Friuli, Milan, Rome, 1943; B. and F. Forlati, L'arte della Venezia Giulia, La Venezia Giulia terra d'Italia, Venice, 1946; C. F. Bozzi, Il Friuli: Luoghi e cose notevoli, Udine, 1951; A. Degrassi, Il confine nord-orientale dell'Italia romana (Diss. Bernenses, I, 6), Bern, 1954.

Aquileia. The Latin colony of Aquileia was founded in 181 B.C. and enlarged in 169 B.C. Later it became a municipium and an important center of trade and industry. Aquileia is laid out with streets intersecting at right angles. The Roman port installations along the Natissa River canal have been brought to light, as have the vestiges of the republican and imperial walls, the forum, houses with mosaic pavements, suburban villas (with statues and mosaics), a thermal establishment, an amphitheater, and tombs.

Devastated by the barbarian invasions in the 5th century, Aquileia rose again as the seat of a patriarchy. It reached its zenith in the 11th century, when the canal linking it with the sea was reopened, the Cathedral rebuilt, the patriarchal palace and campanile erected, the walls restored, and a large number of monasteries founded in the immediate vicinity. There was some building activity in the 14th century, but subsequently malaria, the Austrian occupation (1509), and the abolition of the patriarchate (1751) marked the decline of Aquileia. The sole witness to Aquileia's former splendor is the Cathedral, with its massive campanile, rebuilt under the auspices of the patriarch Poppo (1019–42). In the 4th century two religious chambers were erected. The northern chamber was converted into a basilica and, in the second half of the 4th century, replaced by a larger structure with a baptistery. This structure was destroyed by the Huns in the 5th century, and only the splendid mosaic pavement (near the present campanile) remains; the southern chamber (*cathecumeneum* and *consignatorium*) was also converted into a church, but it was replaced by a basilica with baptistery, which, having collapsed in the 10th century, was rebuilt and completed by Poppo (1031). The present Romanesque building is preceded by a fragmentary portico (9th cent.; built of material from earlier structures) and has a basilican plan with elevated choir. The pointed arches and carinate ceiling date from the restoration following an earthquake in 1348. Dating from the 11th century are the apse frescoes and the circular Holy Sepulcher, of simple ashlar masonry, with an attic on small columns and a conical roof. The Cripta degli Scavi may date from the 5th-century church. A portico and the so-called "Church of the Pagans" (frescoed rectangular room, 13th cent.) link the Cathedral with the Baptistery (in ruins), which was

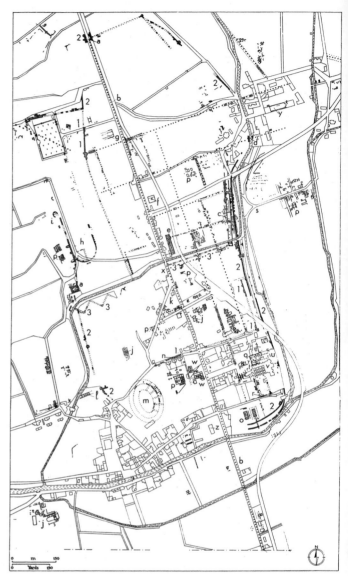

Aquileia, plan of the Roman and medieval city (laid out over the modern plan). Dotted lines indicate the probable layout of the old streets. (1) Walls of the republican period; (2) walls of the imperial period; (3) medieval walls. Roman monuments: (*a*) Gates; (*b*) Via Julia Augusta; (*c*) layout of the port, with docks and warehouses; (*d*) bridge; (*e*) forum; (*f*) reservoir of the aqueduct; (*g*) basilica; (*h*) circus; (*i*) "Temple of Jupiter"; (*j*) thermal structures; (*k*) mausoleum, reconstructed and moved; (*l*) burial area; (*m*) amphitheater; (*n*) porticoed street; (*o*) late-imperial markets; (*p*) houses; (*q*) remains of a Roman house (late republican or early imperial) and of a *domus ecclesiae* (3d–4th century), found under the post-Theodoran church; (*r*) presumed imperial Palatium; (*s*) area of a mithraeum. Early Christian and medieval monuments: (*t*) churches of the time of Patriarch Theodorus; (*u*) later churches; (*v*) Cathedral; (*w*) Early Christian oratories; (*x*) medieval gates; (*y*) monastery; (*z*) Museo Archeologico.

built on Roman foundations. The Oratory of S. Antonio dates from the baroque period (1697). The Museo Archeologico contains classic, Early Christian, and Romanesque material.

BIBLIOG. K. Lankoronski, Der Dom von Aquileia, Vienna, 1906; A. Morassi, Il restauro dell'abside della Basilica di Aquileia, BArte, III, 1923–24, pp. 75–94; P. Toesca, Gli affreschi del Duomo di Aquileia, Dedalo, VI, 1925–26, pp. 32–57; A. Calderini, Aquileia romana, Milan, 1930; G. Brusin, Gli scavi di Aquileia, Udine, 1934; G. Brusin, Nuovi monumenti sepolcrali di Aquileia, Venice, 1941; S. Stucchi, Le basiliche paleocristiane di Aquileia, RACr, XXIII, 1947–48, pp. 169–207; V. Scrinari, I capitelli romani di Aquileia, Padua, 1952; M. Mirabella Roberti, Considerazioni sulle aule teodoriane di Aquileia, S. aquileiesi in onore di G. Brusin, Aquileia, 1953, pp. 209–44; G. Brusin, Guida di Aquileia, 4th ed., Padua, 1956; P. L. Zovatto, Le aule paleocristiane della basilica di Aquileia, Mem. storiche forogiuliesi, XLII, 1956–57, pp. 177–86; G. Brusin and P. L. Zovatto, Monumenti paleocristiani di Aquileia e di Grado, Udine, 1957; H. Kähler, Die spätantiken Bauten unter dem Dom von Aquileia, Saarbrücken, 1957; G. Brusin, La più antica "Domus Ecclesiae" di Aquileia e i suoi annessi, Mem. storico forogiuliesi, XLIII, 1958–59, pp. 33–60; G. C. Menis, La basilica

paleocristiana nelle diocesi settentrionali della metropoli di Aquileia, Vatican City, 1958; EAA, s.v. Aquileia; P. Testini, Aquileia e Grado, RACr, XXXIV, 1958, pp. 169–81; L. Magnani, Gli affreschi della basilica di Aquileia, Turin, 1960.

Cividale del Friuli (Lat., Forum Julii). In antiquity the site marked a point of encounter between Venetic and Celtic peoples. Forum Julii was so named in honor of Julius Caesar; it became a municipium either in 49 B.C. or in the Augustan age. A hypogeum of the Celtic period had been discovered. Traces remain of a wall of the Roman republican period and of a later wall, possibly of the 2d century of our era. A forum was found beneath the modern Piazza del Duomo, with traces of a single-aisled basilica. Houses with mosaic pavements (1st–2d cent. of our era), baths, and villas in the nearby countryside also survive. An episcopal seat from the 5th century, Forum Julii acquired considerable importance under the Lombards. It was destroyed by the Avars in 620 but was reestablished as Civitas Forumiuliana. In the 8th century its name was changed to Civitas Austriae, and the town became the seat of the patriarch of Aquileia, who exercised temporal jurisdiction there until 1031. In the 16th century the town declined. A necropolis dating from the barbarian period yielded rich finds (e.g., fibulas and plaques). Remains from the 8th century include the Altar of Ratchis (VII, PL. 373) and the octagonal aedicular baptistery (both in the Cathedral). The Tempietto (or Oratory of S. Maria in Valle), a rectangular hall covered by barrel vaults and terminating in a triapsidal presbytery, also dates from the 8th century. The oratory is decorated with fine stuccoes, variously dated between the 8th and 11th centuries, and wall frescoes of the 11th century; the wooden choir stalls date from the 14th century. The other medieval churches have, for the most part, been remodeled. The Cathedral was begun in 1453 and completed in mid-16th century by Pietro Lombardo; the façade is adorned with three ogival portals. The nave is covered with a barrel vault. The Cathedral has a silver altar frontal from the 12th century and a 13th-century wooden crucifix, as well as works by Palma Giovane and M. Ponzone. The Church of S. Maria dei Battuti has a Renaissance presbytery and a triptych by Pellegrino da San Daniele. The Museo Archeologico Nazionale contains barbarian and medieval gold- and silverwork and illuminated manuscripts, as well as archaeological finds.

BIBLIOG. F. di Maniago, Guida di Udine e Cividale, Udine, 1825; G. Fogolari, Cividale del Friuli, Bergamo, 1906; A. Santangelo, Catalogo delle cose d'arte e d'antichità d'Italia: Cividale, Rome, 1936; G. Fuchs, La suppellettile rinvenuta nelle tombe di S. Giovanni a Cividale, Mem. storiche forogiuliesi, XXXIX, 1943–51, pp. 1–13; S. Stucchi, Forum Iulii, Rome, 1951; L. Coletti, Il tempietto di Cividale, Rome, 1952; E. Dyggve, Il Tempietto di Cividale, Atti II Cong. int. S. Alto Medioevo, Spoleto, 1952, pp. 75–79; H. P. L'Orange, L'originaria decorazione del Tempietto di Cividale, Atti II Cong. int. S. Alto Medioevo, Spoleto, 1952, pp. 94–113; H. Torp, Note sugli affreschi più antichi dell'Oratorio di S. Maria in Valle a Cividale, Atti II Cong. int. S. Alto Medioevo, Spoleto, 1952, pp. 81–93; C. Mutinelli, Il Duomo, Udine, 1956; G. Marioni and C. Mutinelli, Guida storico-artistica di Cividale, Udine, 1958; B. Civiletti, Ricerche nuove del tempietto di Cividale, Arte veneta, XIII–XIV, 1959–60, pp. 260–62; EAA, s.v. Cividale; C. Mutinelli, Eccezionali ritrovamenti longobardi a Cividale, Arte veneta, XIII–XIV, 1959–60, pp. 258–60; H. Torp, Il problema della decorazione originaria del Tempietto longobardo, Udine, 1959.

Gemona. Mentioned by Paulus Diaconus under the name of Castrum Glemonae, it was a dependency of the patriarchate of Aquileia and enjoyed its greatest prosperity in the 13th century. Gemona is dominated by the ruins of the ancient castle (of which two towers survive). The Cathedral (13th–14th cent.) was designed by Giovanni Griglio of Gemona. The façade (restored in the 19th cent.) has an arcade with statues and three rose windows; the Gothic interior comprises a nave and two side aisles. S. Giovanni preserves Romanesque vestiges; the coffered ceiling is the work of P. Amalteo (1533). The Palazzo del Comune has Lombard Renaissance features (1505). The Church of S. Maria delle Grazie preserves a Madonna by Cima da Conegliano (1494) and a Holy Family by G. F. da Tolmezzo (1510). There is a collection of paintings in the Palazzo del Comune.

BIBLIOG. G. Bragato, Da Gemona a Venzone, Bergamo, 1913; I. Giuliani, Il Convento e la chiesa di S. Maria delle Grazie in Gemona, Venice, 1942; G. Marchetti, Gemona e il suo mandamento, Udine, 1958.

Gorizia. First mentioned in 1001, Gorizia was the fief of the counts of Gorizia until 1420, when it passed to Austria. The town lies at the foot of the castle built by the counts of Gorizia, which was enlarged by the Venetians in the 16th century. Among the edifices inside the walls is the Palazzina dei Conti (12th cent.). The Cathedral was built in the 14th century, damaged during World War I, and rebuilt in 1927. There are remains of the medieval structure in the apse. The Cathedral Treasury contains objects from the Basilica of Aquileia. The Church of S. Ignazio (1680–1725, restored) is a baroque structure. Gorizia contains many houses and palaces showing Venetian influence. The 18th-century fountain with Neptune and naiads was designed by Nicolò Pacassi. Museums include the Museo Storico Provinciale (minor arts, archaeological collection) and the Galleria d'Arte.

BIBLIOG. A. Morassi, Chiese gotiche in Val d'Isonzo, Architettura, II, 1922–23, pp. 177–89; A. Morassi, Gorizia nella storia dell'arte, Gorizia, 1925; A. Morassi, Architettura di Gorizia e le sue vicende storiche, Mem. storiche forogiuliesi, XXXVIII, 1942, pp. 61–78; R. M. Cossar, Storia dell'arte e dell'artigianato di Gorizia, Pordenone, 1948; M. Mirabella Roberti, Catalogo della Mostra delle opere d'arte e del tesoro dell'archidiocesi di Gorizia, Gorizia, 1951; C. Bozzi, Il Castello di Gorizia, 2d ed., Gorizia, 1960.

Grado. On a small island between the lagoon and the sea, Grado developed as a port closely linked with Aquileia by means of the Natisone. In the imperial age Grado was a resort for the wealthy of Aquileia. On the nearby island of Gorgo, the ruins of a country villa with mosaics have come to light. Grado enjoyed a period of great prosperity in the 6th century, when the schism in the patriarchate of Aquileia began, and Grado, too, had a patriarch. Grado's decline began in the 11th century. In the 20th century Grado has become a bathing resort, with broad, regularly laid out streets, but it still retains virtually intact the ancient medieval center. Grado's Early Christian buildings are particularly noteworthy. S. Maria delle Grazie, built in the 5th century and rebuilt toward the end of the 6th century, preserves part of the 5th-century mosaic pavement. The Cathedral, basilican in form, was built in the 6th century, over an earlier structure. (Remains of the Church of S. Eufemia lie under the present floor.) The Cathedral was remodeled in later centuries and recently restored. In addition to the mosaic pavement and contemporaneous choir enclosure, the Cathedral has a 14th-century ambo built of Roman and late medieval remains. The ambo has a Gothic-Moorish cupola. The Cathedral also preserves a silver reredos from the 14th century. The Cathedral has a fine treasury. The octagonal Baptistery (mid-5th cent.; restored) has spacious round-headed windows and vestiges of contemporaneous mosaic pavement. The small altar has a hexagonal front. Between the Baptistery and Cathedral are remains of a *cella trichora* with reconstructed outer walls, now used as a lapidarium.

BIBLIOG. G. Caprin, Lagune di Grado, Trieste, 1890; P. Bellini, Gli affreschi di S. Pietro a Grado, Rass. d'arte, III, 1903, pp. 70–74; P. L. Zovatto, La Basilica di S. Maria di Grado, Mem. storiche forogiuliesi, XXXIX, 1943–51, pp. 14–33; P. L. Zovatto, Il Battistero di Grado, RACr, XXIII, 1947–48, pp. 231–51; P. L. Zovatto, La Basilica di Sant'Eufemia di Grado, Palladio, II, 1952, pp. 112–25; G. Brusin, Aquileia e Grado, 4th ed., Padua, 1956; M. Mirabella Roberti, Grado: Piccola guida, Trieste, 1956; G. Brusin and P. L. Zovatto, Monumenti paleocristiani di Aquileia e di Grado, Udine, 1957; F. Franco, La basilica di Grado, Atti V Conv. naz. Storia Arch., Florence, 1957, pp. 597–612; P. Testini, Aquileia e Grado, RACr, XXXIV, 1958, pp. 169–81; P. L. Zovatto, Grado nella storia e nei monumenti, Gorizia, 1959; EAA, s.v. Grado.

Pordenone (Lat., Portus Naonis). An Austrian possession from 1029 to 1508 (when it passed to Venice), Pordenone is characterized by Gothic and Renaissance houses, with arcades and exterior frescoes. The Palazzo Comunale (1291; enlarged in the 20th century) has a Renaissance tower built after designs by P. Amalteo (1542). The 15th-century Cathedral was built on the site of an earlier structure. The unfinished 19th-century façade has a Renaissance portal. The Cathedral preserves frescoes and canvases by Pordenone. The Cathedral Treasury has some fine reliquaries of the 13th–16th centuries. The Romanesque Church of the Trinità has a brick dome and an octagonal campanile (16th cent.). The Campanile of S. Giorgio is shaped like a Doric column (early 19th cent.). The local art gallery is in the Palazzo Comunale.

BIBLIOG. V. Candiani, Pordenone, Pordenone, 1902; A. Benedetti, Breve storia di Pordenone, Pordenone, 1956; V. Muzzatti, Guida di Pordenone, 3d ed., Pordenone, 1956.

Spilimbergo. This town was formerly the seat of the Counts of Spilimbergo, who built the castle (14th–15th cent.). The castle comprises a group of extensively remodeled structures, one of which is Gothic, with frescoes, and the others Renaissance. The Cathedral (begun 1284) is in Romanesque-Gothic style and has a Romanesque crypt. The portal on the left flank is Romanesque and has sculptured decoration by Zenone da Campione (1376). Within the Cathedral are canvases by Pordenone and wooden choir stalls by Marco Gozzi of Vicenza.

BIBLIOG. D. Tovebia, Il Duomo di Spilimbergo, Spilimbergo, 1931; L. Coletti, Il "maestro" dei Padiglioni, Misc. Supino, Florence, 1933, pp. 211–28; T. Linzi, Il Duomo di Spilimbergo, Udine, 1952.

Trieste (Lat., Tergeste). The chief city of Venezia Giulia, Trieste is on the eastern shore of the Adriatic, at the foot of the Carso. Trieste was the site of a prehistoric *castelliere* settlement, later a trade center, and then an Augustan colony. The city was particularly prosperous in the Flavio-Trajanic period. There are traces of the Roman walls (perhaps Augustan), vestiges of a gate (probably late-Augustan), a temple (perhaps the Capitolium) dating from the Claudian period, a theater and the forum area with double-apsed basilica from the Trajanic period, remains of the Roman port, and traces of the network of the city streets of the western slopes of the hill of S. Giusto. After being subject to various barbarian lords, Trieste became a free commune. Fought over by Venice and Austria, it sought unceasingly to maintain its independence. The old town, with its narrow winding streets, extends along the foot and up the hill of S. Giusto, where a rectangular Early Christian basilica of Istrian type was erected in the 5th century; there are remains of the original mosaic pavement. The present Cathedral developed from two flanked churches: the Church of the Assunta (11th cent.) and that of S. Giusto, both having a nave and two aisles. The result of the fusion of the two structures was a church with a nave and four side aisles, subsequently altered. The Cathedral ends in a deep apse (remodeled in 1933) flanked by two smaller apses (the one at the left with 13th-century mosaics of the Venetian school). The fortified campanile (enlarged in 1337) incorporates a Roman structure. S. Silvestro (11th cent.) is rectangular in plan and has a small campanile to one side. The Castle of S. Giusto was built in the late 14th century and enlarged by the Venetians in the 16th century. The modest specimens of Renaissance structures in Trieste include the 16th-century Palazzo Marenzi. The chief port of the Austro-Hungarian empire, Trieste was enriched in the 18th century with civil structures characterized by splendid portals, arcades, and arches on the roofs. Building activity continued during the 19th century with a series of neoclassic edifices, among them S. Nicolò dei Greci (1786–1819), the Palazzo Carciotti (1800), and the Teatro Verdi (1801), all by G. N. Pertsch. The Borsa Vecchia (Old Exchange) was by A. Mollari (1806). The Church of S. Antonio da Padova (or S. Antonio Nuovo) was built in 1849 by P. Nobile. The Lloyd Triestino building, by E. von Ferstel, dates from 1880–85. The Neo-Gothic Evangelical Church (1875) and Palazzo Diana are also 19th-century structures. Of interest are the Serbo-Illyric Church of S. Spiridione (C. Maciachini; 1868), the Synagogue (1910), and the Scala dei Giganti (Giants' Staircase) by R. and A. Berlam, and the Faro della Vittoria (Victory Lighthouse; 1927) by A. Berlam. The University was designed by R. Fagnoni and U. Nordio (1947). Museums include the Museo Civico di Storia e d'Arte, the Orto Lapidario, the Galleria d'Arte Antica, the Museo Civico del Castello di S. Giusto, the Museo Sartorio, the Museo Revoltella-Galleria d'Arte Moderna, and the Museo Morpurgo. Just outside Trieste is the Castello di Miramare (C. Junker, 1856–60) with its park.

Bibliog. G. Caprin, Il trecento a Trieste, Trieste, 1897; G. Caprin, Trieste, Bergamo, 1906; C. Curiel, Trieste settecentesca, Naples, 1922; A. Weiss, Cattedrale di S. Giusto: I mosaici, Trieste, 1925; G. Gaertner, La basilica di S. Giusto, Trieste, 1928; F. Forlati, La chiesa di S. Silvestro, BArte, XXIV, 1929–30, pp. 49–58; P. Sticotti, Il Castello di Miramare, Rome, 1930; A. Tamaro, Storia di Trieste, Rome, 1934; U. Piazzo, Architettura neoclassica a Trieste, Rome, 1935; P. Frausin, Gli affreschi di Muggia Vecchia, Ann. triestini, XVII, 1946–47, pp. 229–47; V. Scrinari, Tergeste, Rome, 1951; M. Walcher-Casotti, S. Maria Maggiore di Trieste, Trieste, 1956; M. Mirabella Roberti, Il sacello di S. Giusto a Trieste, Forsch. zur Kg. und christlichen Archeol., III, 1957, pp. 193–209; S. Libutti, Il Castello di Miramare, Trieste, 1961; R. Marini, Andrea Pozzo e Santa Maria Maggiore a Trieste, Emporium, CXXXIII, 1961, pp. 199–208.

Udine. The capital of Friuli developed around the local castle, mentioned in 983 but surely of earlier origin. Fief of the patriarch of Aquileia, who chose it as his seat in the 13th century, Udine was a theater of conflict for more than two centuries, until it fell under the dominion of Venice (1420). Udine has a Venetian aspect, with typical arcaded houses that have mullioned windows. S. Maria di Castello was remodeled in the 13th century; the Romanesque interior has a nave and two side aisles and three apses (fresco from 1200). The 16th-century façade shows Lombard influence. The Church of S. Francesco is a restored 13th-century structure. The Cathedral (13th–14th cent.) was remodeled in baroque style (18th cent.) Of the 13th-century structure (overlying an older building) it retains the middle portal and that of the campanile (overlying the former octagon of the baptistery). The crossing and chancel are by D. Rossi, and there are frescoes by L. Dorigny. The Cathedral preserves the tomb of the Blessed Bertrando, with sculptures (1345); an altarpiece and frescoes by G. B. Tiepolo; and an organ, with paintings by Pordenone and Amalteo. The Piazza Vittorio Emanuele II (formerly Piazza Contarena) with its pointed-arch loggia, after designs by Niccolò Lionelli (1456), is extremely harmonious. The Loggia of S. Giovanni, by Bernardino da Morcote, has a clock tower after designs by Giovanni da Udine (1527). The small Church of S. Giovanni is also by Bernardino da

Morcote. The Bollani Arch is ascribed to Palladio. S. Giacomo, built in the 14th century, has Renaissance and baroque additions. The castle (restored) was rebuilt by G. Fontana (1517) over the ruins of the patriarchal castle. The hall of the Friuli Parliament in the castle was decorated by G. B. Grassi and S. Secante (16th cent.) and G. B. de Rubeis (18th cent.). S. Cristoforo has a portal by Bernardino da Bissone (1518). The baroque Church of the Zitelle (1610) has works of Maffeo da Verona, M. Vecellio, and S. Peranda. The Palazzo della Frattina dates from the 16th century. The Palazzo Antonini, now the Bank of Italy, was built after designs by Palladio but left unfinished. The Monte di Pietà was built in 1690. The Palazzo della Provincia (late 17th cent.) has frescoes by G. Quaglia (1698). The Manin Chapel has sculptures by Torretti (18th cent.). The Palazzo Arcivescovile has frescoes by G. B. Tiepolo, stuccoes by G. Mengozzi-Colonna, and a hall decorated with grotesques by Giovanni da Udine. The Oratorio della Purità has frescoes by G. B. Tiepolo; the monochrome murals are by Giovanni Domenico Tiepolo (1759). The remodeling of the Church of the Madonna delle Grazie (original structure dating from the 15th cent.) dates from the 19th century. The Church of the Redentore (18th cent.) has a neoclassic façade (1838). S. Pietro Martire, rebuilt in the 19th century, preserves Romanesque vestiges. The Palazzo Kechler was designed by G. Japelli (1833). The Palazzo degli Uffici Municipali was begun in 1911 after designs by Raimondo d'Aronco di Udine. The Museo Civico e Galleria d'Arte Antica e Moderna is housed in the castle.

Bibliog. F. di Maniago, Guida di Udine e Cividale, Udine, 1825; D. Mantovani, Il Castello di Colloredo, Rome, 1894; A. Battistella, Udine nel secolo XVI, Mem. storiche forogiuliesi, XVII, 1921, pp. 83–102, XVIII, 1922, pp. 149–92, XIX, 1923, pp. 1–35; G. Valentinis, Udine, Udine, 1921; A. Foratti, La Loggia del Comune di Udine, BArte, N.S., III, 1923–24, pp. 291–304; G. Valentinis, La chiesa di S. Maria del Castello, Mem. storiche forogiuliesi, XXVI, 1930, pp. 17–25; A. Battistella, Il castello di Udine, Udine, 1932; C. Ermacora, S. Francesco di Udine, Udine, 1955; C. Ballerio, Architettura minore di Udine, Atti V Conv. naz. Storia Arch., Florence, 1957, pp. 387–94; G. Biasutti, Storia e guida del Palazzo Arcivescovile di Udine, Udine, 1958.

Liguria. The coastal caves of the Riviera di Ponente were extensively inhabited in prehistoric times and have preserved remains of paleolithic and neolithic civilization and art. The territory of the ancient Liguri, for whom the region is named, formerly extended north of the Apennines to the Po; limited traces remain (e.g., anthropomorphic steles from the region of Luni). In antiquity and in the Middle Ages, Liguria was open to maritime contacts and at the same time linked to Tuscany and to Provence. Elements of Provençal Gothic were assimilated by the local Romanesque style, which was essentially Lombard. Since the Renaissance, there has been no lack of local contributions to architectural and painting styles. The narrowness of the territory, in a land of coasts dropping steeply down to the sea, has strongly influenced the layout of the cities and the form of the civil buildings, which tend to be taller and narrower, with open arcades. Also characteristic are the minor architectural works, such as villas and inns.

Bibliog. C. G. Ratti, Descrizione delle pitture, sculture e architetture ... delle due Riviere, Genoa, 1780; A. Bertolotti, Viaggio nella Liguria Marittima, Turin, 1834; Descrizione di Genova e del Genovesato, Genoa, 1846; D. E. Maineri, Liguria occidentale, 1877–1893, Rome, 1894; W. Hörstel, Die Riviera, Bielfeld, Leipzig, 1902; L. De Villeneuve and others, Les grottes de Grimaldi, 2 vols., 1906–12; G. Bres, L'arte nell'estrema Liguria occidentale, Nice, 1914; G. Dellepiane, Alpi e Appennini liguri, Genoa, 1914; Ministero Pubblica Istruzione, Elenco degli edifici monumentali, VI: Provincia di Genova, 2 vols., Rome, 1924; C. Brunetti, Castelli liguri, Genoa, 1932; N. Lamboglia, Liguria romana, I, Alassio, 1939; N. Lamboglia and others, La Liguria antica, Milan, 1941; P. Verzone, L'arte preromanica in Liguria e i rilievi decorativi dei secoli barbari, Turin, 1945; L. Bernabò Brea, Gli scavi della caverna delle Arene Candide, 2 vols., Bordighera, 1946–56; L. Bernabò Brea, Le Caverne del Finale, Bordighera, 1947; C. Ceschi, I monumenti della Liguria e la guerra, 1940–1945, Genoa, 1949; V. Straneo, L'arte in Liguria e le sue vicende storiche, Turin, 1949; C. Ceschi, Architettura romanica genovese, Milan, 1954; K. Jud, Von Genua bis Pisa, Zürich, Stuttgart, 1959; C. Merlo, Liguria, Turin, 1960.

Albenga (Lat., Albingaunum). The chief center of the Liguri Ingauni, the town was conquered by the Romans in 181 b.c. and later became a municipium; the original urban plan of regularly laid blocks is still discernible. Ancient remains include a small amphitheater, an aqueduct, and a funerary monument (the so-called "Pilone") from the 2d century of the Christian Era. A Byzantine city until the 7th century, Albenga remained an episcopal see until the 12th century, when it became an independent commune. It passed under the domination of Genoa in the 13th century. Towers and dwellings survive from the medieval city. Dating from the early 5th century is the Baptistery (now part of the Civico Museo Ingauno). In one of the eight niches is a nonfigural mosaic from the 5th–6th century. There are

remains of an immersion pool, transennas, and openwork windows from the 8th century. The Cathedral, several times restored, retains 11th- and 13th-century elements. The portal and interior are baroque, and the dome has been restored. The bishop's palace, remodeled, has a 12th-century corner tower. The Palazzo del Comune (13th cent.; remodeled in 1387–91) has a ground-floor arcade (1421) and a late-13th-century tower. The 13th-century Torre and Casa Cazzulini are characteristic red-brick structures with stone bases. The Palazzo Del Carretto di Balestrino is a typical aristocratic Ligurian dwelling of the 16th century. Museums include the Civico Museo Ingauno and the Museo Navale Romano.

BIBLIOG. N. Lamboglia, Topografia storica dell'Ingaunia nell'antichità, Collana storico-archeol. della Liguria occidentale, II, 5, 1933; G. de Angelis d'Ossat, I battisteri di Albenga e di Ventimiglia, B. Deputazione Storia Patria per la Liguria, Sez. Ingauna e Intemelia, II, 1936, pp. 207–50; D. N., Albenga: Restauro di monumenti, Palladio, I, 1937, p. 43; N. Lamboglia, Liguria romana, I, Alassio, 1939, pp. 119–64; N. Lamboglia, Note sulla cattedrale di Albenga, Riv. ingauna e intemelia, IV, 1949, pp. 1–8; N. Lamboglia, Albenga romana e medievale (Itinerari liguri, I), Borgo San Dalmazzo, 1957; EAA, s.v. Albenga.

Genoa (Lat., Genua; It., Genova). Capital of the Genuates in pre-Roman times, Genoa was an important trade center by the 5th century B.C. The city was rebuilt by the Romans in 203 B.C. after the Carthaginian devastation of 205 B.C. There are remains of the earliest settlement on the slopes of the Castello hill, as well as a pre-Roman cemetery dating from the 5th–3d century B.C. The Roman excavation area has the structure peculiar to the castrum. Many Roman sculptures and sarcophagi survive, several of which are incorporated in the walls of churches. During the early Middle Ages, under the successive domination of the Byzantines, Lombards, and Franks, the territory of Genoa proably did not extend beyond the limits of the Roman oppidum. Only in the 10th century, apparently, was the city surrounded by new walls. Reliable evidence of the town's expansion in the 12th century are the walls dating from 1155, which enclose the various regions that overlook the sea and are arranged roughly in the form of an amphitheater. A third set of walls was added in 1546 and another in 1630, with monumental defense works, parts of which are still standing. Chiefly because of modern industrial expansion and the intensive activity of the port, the city has also annexed the suburban districts to the east.

The medieval city and its numerous monuments are virtually enclosed within the 12th-century walls, of which the Porta Soprana and Porta dei Vacca survive. Notable medieval edifices that have preserved their original structures include several churches. Traces of construction erected prior to the 11th century survive in few structures, and almost all of these were remodeled in the 12th century; several have undergone successive alteration. Among these churches are SS. Cosma e Damiano, S. Maria di Castello, S. Stefano, S. Maria delle Grazie, S. Maria delle Vigne, and S. Donato. Of the Benedictine Convent of S. Andrea, only the cloister survives (early 12th cent.; rebuilt). The most flourishing period in Genoese building extended from the 12th to the 13th century, when the attainment of full independence and economic prosperity allowed the leading families to undertake the construction of religious and private buildings. In 1118, the rebuilt Cathedral (S. Lorenzo) was consecrated. The rebuilding was begun in the 11th century, and construction continued through several centuries. The façade (restored in 1934) shows Pisan influence in the narrow bands of black and white marble. Of French derivation are the portals with their sharp-pointed arches, deep splay, and sculptural decoration. (The upper portion of the façade, less homogeneous, is from different epochs.) The dome was built after designs by G. Alessi. Off the side aisles are chapels added over the centuries, including the Chapel of S. Giovanni Battista, by Domenico and Elia Gaggini, with sculpture by M. Civitali and A. Sansovino. Dating from 1138 is the Church of S. Luca, which was rebuilt in 1626. S. Maria del Prato (1172) was remodeled in the 15th century and later. The Church of S. Matteo was founded in 1125, and the black-and-white striped façade dates from 1278. Particularly noteworthy is the adjacent 14th-century cloister, attributed to a certain "Magister Marcus Venetus," whose name appears on a sculptured capital. In the 13th–14th century, a number of churches were built for the monastic orders, including the Church of S. Agostino (1260), which now houses the Museo Civico d'Architettura e Scultura Ligure. Of the original Church of S. Francesco (1324–87), only the portal with tympanum has been preserved in subsequent remodeling (15th and 17th cent.). The Palazzo del Comune was begun in 1291, and the Torre del Popolo was added in 1307. The remains of the Palazzo del Comune are incorporated in the Ducal Palace. A number of aristocratic residences of the period survive, including the Lamba Doria houses (13th cent.; restored in 1951), the Torre degli Spinola (13th cent.), remains of the Palazzo Fieschi Maruffi, and the Palazzo S. Giorgio (1260; extensively remodeled and enlarged in the 16th century

and restored in the 19th). Gothic traits persisted in 15th-century architecture, which continued the tradition of white-and-black striped façades with multipaned mullioned windows. Toward the middle of the century, frequent restorations and remodelings were carried out in the medieval districts; galleries and arcades were closed, façades were plastered and frescoed, and Renaissance portals decorated with the likeness of St. George were erected. Noteworthy in this connection are the house of Andrea Doria (1486) and the Palazzo Spinola in the Vico della Scienza. In the 16th century it became a popular practice to fresco building façades. The latter half of the century saw extensive undertakings in city planning. In 1550 the Via Nuova (mod. Via Garibaldi) was opened. The street is lined with monumental palaces, largely after plans by Alessi or later architects inspired by him. These palaces are generally severe on the exterior, but scenographic effects were attempted in the construction of the courtyards, and the interiors are adorned with rich stucco and fresco decoration. Among the more important buildings in the Via Garibaldi are the Cambiaso (1565), Gambaro (1565), Parodi (1567), Carrega Cataldi (1558), Doria (formerly Spinola; 1563), Podestà (1583), Cattaneo Adorno, and Serra palaces, as well as the Palazzo Municipale (Palazzo Doria Tursi; 1564). Also in Via Garibaldi are the Palazzo Rosso ("Red Palace"; 1672–77) and the Palazzo Bianco ("White Palace"; 1565). Both palaces now house painting galleries. Other 16th-century edifices include the Palazzo della Meridiana and the Palazzo Belimbau (formerly Negrotto-Cambiaso). Examples of 16th-century religious architecture, also largely influenced by Alessi, include S. Maria Assunta di Carignano (begun, 1552), S. Siro (rebuilt, 1613), S. Maria Maddalena, S. Bartolomeo degli Armeni (rebuilt, 1595), and S. Nicola da Tolentino (1597). An important part of 16th-century building activity in Genoa was the construction of suburban villas, usually two-storied structures with loggias and towers. The villa gardens were adorned with grottoes, triumphal arches, small lakes, and statues. The Cambiaso (1548), Pallavicino delle Peschiere (1560), and Scassi (formerly Imperiale; 1560) villas are by Alessi. Other villas of the period, many of which were modeled after Alessi's villas, include the Villa Bombrini and the Villa Imperiale (formerly Cattaneo, ca. 1520), as well as the Villa Doria and the Villa Rostan in suburban Pegli. Among the rather severe 17th-century buildings in Via Balbi (which was opened early in the century) are the Palazzo Balbi Senarega, the Palazzo Durazzo Pallavicini, and the Palazzo dell'Università (1634–36), all designed by B. Bianco. The Royal Palace was built about the middle of the 17th century, after designs by P. F. Cantone and A. Falcone, and restored in the 19th century. The Church of S. Carlo also dates from the first half of the 17th century. Building activity was less intense in the second half of the 17th century and throughout most of the 18th century. Dating from this period are the Albergo dei Poveri (1655) and the churches of the SS. Annunziata, S. Maria della Consolazione (1681–1706), S. Filippo Neri (1712; several times enlarged), and S. Torpete (1733).

During the 19th century, the city was transformed by the neoclassic work of C. Barabino, who in 1825 opened the Via Carlo Felice (now Via XXV Aprile), erected the Carlo Felice Theater (now Teatro Comunale dell'Opera; 1828) and Palazzo dell'Accademia Ligustica di Belle Arti (1831), laid out the Giardino dell'Acquasola, and planned the Via Assarotti, on which, in the late 19th century, was built the Neo-Renaissance Church of the Immacolata. Late-19th and early-20th-century developments include the creation of Via XX Settembre (1892), the erection of the Ponte Monumentale (1895), which crosses over the street, and the construction of several palaces, including the Palazzo Pastorino, by G. Coppedè. Around 1930, M. Piacentini supervised the arrangement of the Piazza della Vittoria, with its Arco ai Caduti (a monument to the war dead). Other modern architectural undertakings include the Ansaldo housing project (architect: R. Morozzo della Rocca; 1959–60).

Museums include the Galleria di Palazzo Bianco, the Galleria di Palazzo Rosso, the Museo Civico dei Monumenti Genovesi (in the former Church of S. Agostino), the Museo d'Arte Orientale "Edoardo Chiossone," the Galleria del Palazzo Reale, the Museo Civico di Archeologia Ligure (in the Villa Durazzo Pallavicini, Pegli), the Galleria Nazionale di Palazzo Spinola, the Museo dell'Accademia Ligustica di Belle Arti, the Raccolte di Palazzo Tursi (in the Palazzo del Comune), and the Galleria Civica di Arte Moderna.

BIBLIOG. P. P. Rubens, Palazzi moderni di Genova, Antwerp, 1652, repr. Novara, 1955; I. Friedländer, Notizien über einige Kunstwerke in Sizilien und Italien (Genua: S. Donato), D. Kunstblatt, II, 1851, p. 421; P. de Luchi, La chiesa di Sant'Agostino, San Pier d'Arena, 1893; G. Poggi, Genova preromana, romana e medievale, Genoa, 1914; M. Labò, Studi di architettura genovese, L'Arte, XXIV, 1921, pp. 139–51, XXV, 1922, pp. 69–75, XXVIII, 1925, pp. 271–80, XXIX, 1926, pp. 52–55; C. Enlart, Il portale della cattedrale di S. Lorenzo a Genova, Atti X Cong. int. Storia dell'Arte, Rome, 1922, pp. 135–38; Ministero Pubblica Istruzione, Elenco degli edifici monumentali, VI: Provincia di Genova, 2 vols., Rome, 1924; O. Grosso, Genoa, Bergamo, 1926; G. A. Bono and M. Labò, Le chiese di

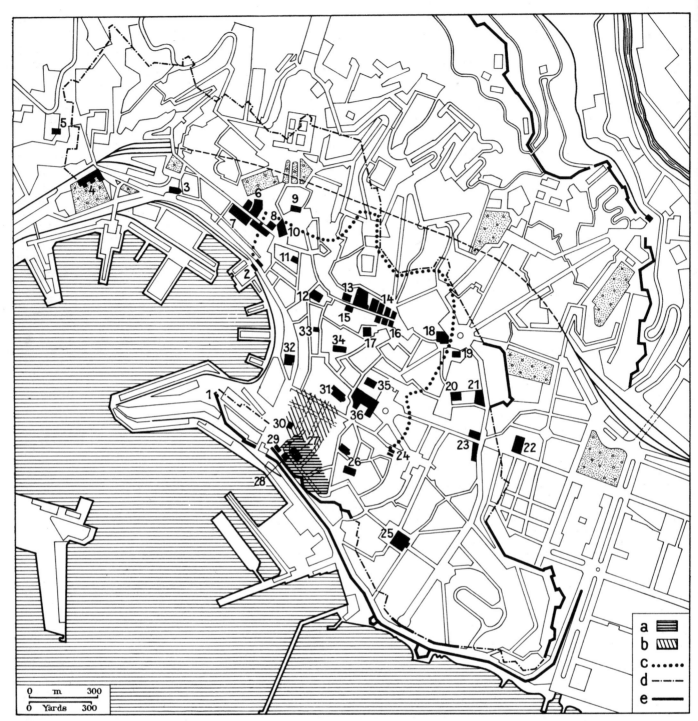

Genoa, plan. *Key*: (*a*) Presumed pre-Roman area; (*b*) presumed Roman area; (*c*) course of the walls of 1155; (*d*) course of the walls of 1546; (*e*) surviving sections of the walls of 1546 and 1630. Principal monuments: (1) Porta del Molo (or Siberia); (2) Porta dei Vacca; (3) S. Giovanni di Prè; (4) Palazzo Doria Pamphili; (5) S. Rocco; (6) S. Carlo and Palazzo dell'Università; (7) Royal Palace and Raggio and Balbi Senarega palaces; (8) Palazzo Durazzo Pallavicini; (9) Church of the Carmine; (10) SS. Annunziata; (11) S. Filippo Neri; (12) S. Siro; (13) Palazzo Bianco and Palazzo Municipale (Doria Tursi); (14) Podestà, Spinola, Parodi, and Cambiaso palaces; (15) Palazzo Rosso; (16) Doria, Cataldi, and Gambaro palaces; (17) S. Maria Maddalena; (18) Palazzo del Governo; (19) S. Marta; (20) Palazzo di Pammatone; (21) S. Caterina; (22) S. Maria della Consolazione; (23) S. Stefano; (24) Porta Soprana; (25) S. Maria Assunta di Carignano; (26) S. Agostino and S. Donato; (27) S. Maria di Castello; (28) S. Giacomo della Marina; (29) S. Maria delle Grazie; (30) SS. Cosma e Damiano; (31) Cathedral; (32) Palazzo S. Giorgio; (33) S. Luca; (34) S. Maria delle Vigne; (35) S. Matteo; (36) Ducal Palace.

Genova illustrate: Nostra Signora dei Servi, Genoa, 1927; M. Labò, Le ville genovesi, Emporium, XLIV, 1938, pp. 131–44; N. Lamboglia, Liguria romana, I, Alassio, 1939, pp. 193–242; L. Bernabò Brea, CVA, Italia, fol. 19, Rome, 1942; O. Grosso, Genova e la Riviera ligure, Rome, 1951; C. Ceschi, Restauro di edifici danneggiati dalla guerra: Liguria-Genova, BArte, XXXVIII, 1953, pp. 75–90; O. Grosso and C. Pezzagno, Il Palazzo del Comune di Genova, Milan, 1953; E. Bach, La cité de Gênes au XIIe siècle, Copenhagen, 1955; O. Grosso, Dimore genovesi, Milan, 1956; C. Ceschi, La chiesa di Santa Maria del Prato, Atti V Conv. naz. Storia Arch., Florence, 1957, pp. 271–79; M. Labò, Galeazzo Alessi a Genova, Atti V Conv. naz. Storia Arch., Florence, 1957, pp. 367–77; A. Dillon, Il Restauro del Campanile di S. Maria delle Vigne, Palladio, N.S., VIII, 1958, pp. 86–88; C. O. Guglielmino, Volto di Genova perduta, Genoa, 1958; P. Rotondi,

Il Palazzo di Antonio Doria a Genova, Genoa, 1958; A. Campostano and B. Pesce, La Cattedrale di Genova, Genoa, 1959; L. Frassati, Genova come era, 1870–1915, Lausanne, 1960; EAA, s.v. Genova; E. Cozzani, Genova, 2d ed., Turin, 1961; C. Marcenaro, Una fonte barocca per l'architettura organica: Il Palazzo Rosso di Genova, Paragone, XII, 139, 1961, pp. 24–49.

Luni (Lat., Luna). A Roman colony was founded on the site in 177 B.C., and Luni was particularly important in the imperial age because of its port and the nearby marble quarries. With the abandonment of the quarries in the 4th century of our era Luni entered a period of decline. The raids of the Lombards and Normans in the 9th century and the silting up of the port completed Luni's ruin. The regular

plan of the streets is still discernible. Parts of the walls remain, as do portions of the streets, baths, a theater inside the walls, and a well-preserved amphitheater from the age of the Antonines. Other finds include pediment reliefs (Florence, Mus. Arch.) dating from the 2d century B.C. There are ruins of parts of the Romanesque Cathedral of S. Maria (three apses and the campanile). Near the Cathedral is the Antiquarium Lunense.

BIBLIOG. L. Banti, Luni, Florence, 1947; R. U. Inglieri, L'Antiquarium lunense, BArte, XXXVIII, 1953, pp. 346–47; R. U. Inglieri, Un rilievo votivo di Diana e il culto della dea a Luni, XXXIX, 1954, pp. 166–68; G. Caputo, Nuova testa fittile del tempio di Luna, SEtr, XXIV, 1955–56, pp. 221–26; EAA, s.v. Luni.

Noli. Founded in Roman times, Noli developed during the Byzantine period and enjoyed its greatest importance in the 13th and 14th centuries, when it was a free commune and the seat of a diocese. The surviving walls, with towers and gates (13th cent.), surround typical medieval houses and palaces. Noteworthy is the Romanesque Church of S. Paragorio (11th cent.; restored in 19th cent.). The nave is covered by a ceiling with exposed beams, while the two side aisles are vaulted. The church has a monumental wooden crucifix of uncertain date (13th cent.?) and a 13th-century episcopal throne. The Cathedral was erected in the 13th century and remodeled in the 17th. The Torre del Comune also dates from the 13th century.

Near Noli are the ruins of the 12th-century Castello Ursino.

BIBLIOG. B. Lamboglia, La città di Noli, Savona, 1885; F. Noverasco, Noli e il suo S. Paragorio, Per l'arte sacra, II, 1925, pp. 11–14.

Portovenere. The town was built by the Genoese between 1113 and 1161 at the foot of Castrum Vetus and fortified against the Pisans. The only surviving vestige of Castrum Vetus is the Church of S. Pietro, which was erected in the 6th century and enlarged in Gothic style in the second half of the 13th century (restored in 1935). The original structure has a rectangular plan and semicircular apse (remnants of marble floor). The façade of the church is decorated with black and white marble bands. In Portovenere is S. Lorenzo (1131), several times remodeled and restored (1938), with treasury. The castle (Castrum Superior) dates from 1113 but was rebuilt in the 16th century.

On the island of Palmaria are ruins of the Abbey of S. Venerio (mid-11th cent.). The interlaced arches of the cloister reveal Arabo-Siculan influence.

BIBLIOG. P. F. Ferro, La chiesa di San Pietro Apostolo in Portovenere, La Spezia, 1930; U. Formentini, Monumenti di Porto Venere, La Spezia, 1940; G. Imbrighi, Porto Venere, La Spezia, 1955; G. Devoto, Porto Venere, Turin, 1958.

Sarzana. First documented in 963, Sarzana was a fief of the bishops of Luni until the early 14th century. In the 16th century it passed to the Republic of Genoa. The Romanesque Church of S. Andrea has been remodeled several times but preserves some traces of the original construction. The Cathedral was begun in 1204 and completed in 1474. The Gothic Church of S. Francesco, extensively remodeled, contains a tomb by Giovanni di Balduccio. The Fortress of Sarzanello, with its keep and round corner towers, is just outside the town.

BIBLIOG. F. Podestà, Arte antica nel Duomo di Sarzana, Genoa, 1904; F. Podestà, L'arte in Sarzana, Florence, 1915; L. Berghini, Arte a Sarzana dal XII al XVIII secolo (exhibition cat.), Sarzana, 1961.

Savona (Lat., Savo). This city of the Liguri was mentioned during the Second Punic War. A bridge from the Roman period survives. Savona enjoyed its greatest prosperity in the Middle Ages under the D'Aleramo family. The original construction of the port and the Torre del Brandale, a massive structure in compact masonry, date from the 12th century. Dating from the 13th century is the Palazzo degli Anziani. The Renaissance Palazzo Della Rovere was built after designs by Giuliano da Sangallo. The Oratory of S. Maria di Castello was reconstructed in the 17th century and restored in the 19th. The Cathedral was built in 1589–1603 and has a 19th-century marble façade by G. Calderini. The Pinacoteca Civica is in the Palazzo Pozzobelli.

A few miles from Savona is the Sanctuary of Nostra Signora di Misericordia (16th cent.), the work of Lombard architects. Nearby is the Museo del Santuario di Nostra Signora di Misericordia.

At Vado Ligure are remains of the ancient Vada Sabatia (founded 2d-1st cent. B.C.).

BIBLIOG. A. Bertolotto, Il Duomo di Savona, Savona, 1881; E. Bensa, Savona nella storia e nell'arte, Genoa, 1928; C. Calcaprina, Concorso per il Piano Regolatore di Savona, Architettura, XVII, 1938, pp. 503–10; P. Poggi, Città di Savona, Savona, 1938; N. Lamboglia, Vado romana, Bordighera, 1940; P. Rotondi, Il Palazzo di Lamba Doria a Savona, Savona, 1958; P. Rotondi, L'arte nel Santuario di Nostra Signora della Misericordia a Savona, Savona, 1959.

Ventimiglia (Lat., Albintimilium). Of pre-Roman origin, this was the home of the Liguri Intemeli and later a Roman municipium. It was devastated during the struggles between Otho and Vitellius. The ruins of the ancient city, east of the modern town, include walls, a well-preserved theater, and thermal installations. During the early Middle Ages, Ventimiglia was repeatedly devastated by the barbarians. A free commune in the 12th century, it was later partitioned between the Republic of Genoa and the Count of Provence. The Cathedral dates from the 11th century but has additions from the 12th century (apses, dome) and the 13th (façade portal). The contemporaneous Baptistery may have been built over an earlier structure. The Baptistery, which is octagonal, preserves an immersion pool from 1100. S. Michele was built in the 10th century and subsequently reconstructed. The crypt has Roman columns. In the 12th century, when Ventimiglia enjoyed its greatest prosperity, it was girdled with walls, parts of which still exist. The Museo Archeologico Girolamo Rossi contains archaeological material from Albintimilium.

At Grimaldi (near the French border), in the district known as the Balzi Rossi, are caves and rock shelters preserving prehistoric material from the Paleolithic to the Mesolithic period. The earliest deposits (among the most important in Europe) have been found in three caves — the Grotta del Principe, the Barma Grande, and the Caverna dei Fanciulli. (In the last-named cave were found bodies, with Negroid features, interred in a crouching position.) In the upper strata of the deposits in the Barma Grande, and apparently, in the Grotta del Principe, were found a number of statuettes known as the Grimaldi "Venuses."

BIBLIOG. P. Baroncelli, Albintimilium, MALinc, XXIX, 1923, cols. 5–150; D. F. Anfossi, La Cattedrale di Ventimiglia, Per l'Arte sacra, I, 1924, pp. 125–26; G. de Angelis d'Ossat, I battisteri di Albenga e di Ventimiglia, B. Deputazione Storia Patria per la Liguria, Sez. Ingauna e Intemelia, II, 1936, pp. 207–50; N. Lamboglia, Il teatro romano e gli scavi di Ventimiglia, Bordighera, 1949; N. Lamboglia, La stratigrafia del teatro di Albintimilium e la datazione dei monumenti romani, RSLig, XVI, 1950, pp. 171–99. For the Balzi Rossi: P. Graziosi, I Balzi Rossi, 2d ed., Bordighera, 1951; P. Graziosi, Paleolithic Art, New York, 1960.

Emilia and Romagna, including the Republic of San Marino. (a) Emilia and Romagna. Although the name of Emilia (from the Via Aemilia, which traversed the region lengthwise at the foot of the Apennines and along which the principal cities were located) is applied officially to the entire region, actually the eastern portion retains the medieval name of Romagna (Romania). Always a corridor for movements of people, an integral part of the Po plain, fronting on the Adriatic, linked with Tuscany by numerous passes, it has witnessed a wide range of important historic, cultural, and artistic developments. Besides the prehistoric traces, including such art works as the "Venuses" of Savignano and Chiozza, there are remains of the Apennine bronze culture, the Villanovan iron culture, and Etruscan centers with strong Greek influence (through the port of Spina in particular). The imperial Roman civilization everywhere left impressive monuments (e.g., Rimini) along with works showing local characteristics (mosaics, tomb sculptures). At the end of the antique period and the beginning of the Middle Ages Ravenna produced its splendid works of architecture, mosaics, and sculpture, blending Roman Christian tradition and Byzantine influences. Emilia later became one of the major centers in the development of Italian Romanesque, in direct touch with Lombardy; equally important were the developments in Gothic art there. In the 15th century Ferrara, under the Este family, was a center of Humanistic culture and an example of modern urban development; it had an important school of painting. In the 16th and 17th centuries Bologna and the other Emilian cities provided original interpretations of Renaissance and baroque styles, playing a decisive role i n the development of Italian art.

BIBLIOG. G. Cesari, Castelli del Modenese, Modena, 1906; A. Frova, Archeologia ed arte nei dintorni di Salsomaggiore, Milan, 1907; G. Gotelli, I principali castelli della provincia di Reggio Emilia, Parma, 1909; C. Ricci, Emilia e Romagna, Bergamo, 1911; A. Haupt, Palastarchitektur von Ober-Italien und Toscana von XIII. bis zum XVII. Jahrhundert, V, Berlin, 1911–13; F. Lupis, L'arte popolare della Romagna, Rass. d'arte ant. e mod., VIII, 1921, pp. 59–69; G. Zucchini, Nuove costruzioni rurali in Italia (Emilia, Romagna, Veneto), Rome, 1929; L. Marinelli, Le antiche fortezze di Romagna, Imola, 1937; Emilia romana, 2 vols., Florence, 1941–44; G. A. Mansuelli, La rete stradale e i cippi miliari della regione ottava, Atti Deputazione Storia Patria per la Romagna, VII, 1941–42, pp. 33–69; G. A. Mansuelli, Demografia e paleografia emiliana, Atti Deputazione Storia Patria per la Romagna, IX, 1943–45, pp. 1–89; P. E. Arias, Scoperte archeologiche nel biennio 1949–50 in Emilia e Romagna, Atti Deputazione Storia Patria per la Romagna, N.S., II, 1950–51, pp. 219–27; L. Gambi, La casa rurale nella Romagna, Florence, 1950; A. Ghidiglia Quintavalle, I Castelli del Parmense, Parma, 1950; B. Nice, La casa rurale nell'Appennino, Florence, 1953; M. Ortolani, La casa rurale nella pianura emiliana, Florence, 1953; M. Pellegri, I castelli, le chiese e i paesi del Comune di Langhirano nella storia e nell'arte, Parma, 1954; Donato di San Giovanni in Persiceto, I conventi dei frati minori cappuccini della provincia di Bologna, Budrio, 1956; G. A. Mansuelli, M. Cal-

vesi and A. Quintavalle, Musei di Emilia, Parma, 1959; G. A. Mansuelli and R. Scarani, L'Emilia prima dei Romani, Milan, 1961; Mostra dell'Etruria padana e della città di Spina (exhibition cat.), 2d ed., Bologna, 1961.

Bobbio. On the left bank of the Trebbia, the town developed around the monastery founded in 612 by St. Columbanus. Episcopal see from 1014 on, Bobbio passed in the 15th century into the hands of the Dal Verme family (vassals of the Viscontis), who in 1440 built the castle in a dominant position (vestiges of the walls and a keep). Of the old monastery, the church, S. Colombano, has remains of plutei, capitals, and inscriptions (collected in the crypt) but was remodeled and reconstructed from the 15th to 17th century. The façade, preceded by a portico, incorporates Romanesque elements; the interior is by B. Lanzano (1526), the choir stalls by Domenico da Piacenza (1488); the campanile is 11th-century. The Cathedral, originally Romanesque, was remodeled in the 15th and 17th centuries. The Museo della Basilica di S. Colombano has an ivory pyxis from the 4th century of the Christian Era.

BIBLIOG. D. Bertacchi, Monografia di Bobbio, Pinerolo, 1859; C. Cipolla, Notizie e documenti sulla storia artistica della Basilica di S. Colombano nell'età della Rinascenza, L'Arte, VII, 1904, pp. 241–55; A. Rava, La chiesa di S. Colombano in Bobbio, Palladio, V, 1941, pp. 74–77.

Bologna (Etruscan, Felsina; Lat., Bononia). The city stands at the foot of a spur of the Apennines, between the Reno and Sávena rivers. On the heights of the Osservanza and on the plain there are evidences of occupation from the Bronze Age, succeeded by a settlement dating from the Iron Age, with necropolises to the east and west that have yielded abundant and characteristic material from the Villanovan culture (9th–6th cent. B.C.). The subsequent "Certosa" phase (6th–4th cent. B.C.) left the definitive urban outlines of Etruscan Felsina (between the hills and the former beds of the Ravone and Aposa rivers); from this phase come carved commemorative steles, bronzes, Greek vases, etc. Extremely rare traces remain of the occupation by the Gallic Boii, who gave the city its second name. The Roman colony was founded in 191 B.C. The Roman street plan, intersecting at right angles, is still quite recognizable in the medieval and modern street plan at the center of the city; the Via Emilia was the *decumanus maximus*. Still in use is the aqueduct of the Augustan age.

Bologna experienced a new growth in the 11th century as a result of the establishment of the commune and the foundation of the University. It radiated outward from the gates of the original girdle walls along the Via Emilia until it spread as far as the line of the 13th-century walls, now destroyed. It attained special magnificence in the 13th and 14th centuries; after being ruled by various nobles, it passed to the Church. Except for a few 19th-century buildings (Via dell'Indipendenza, Via Rizzoli), the modern city lies beyond the walls, with marked development of new quarters.

A great many monuments of medieval Bologna survive. Of its formerly abundant towers, only a few still stand, among them being the famous and characteristic Garisenda and Asinelli towers (1109). The dwellings are usually of two stories above the ground floor, the second of which has two- or three-lighted mullioned windows projecting over corbels or an arcade. Exceptions are the palace of King Enzo (1246; restored) and the Pepoli houses (14th cent.), without arcades and with crenelated crown. The most notable Romanesque group in the city, called S. Stefano, consists of four churches, a cloister, several courtyards and chapels, and the campanile of the Chiesa del Crocifisso. The complex includes the remains of Early Christian buildings in the octagonal Chiesa del Calvario (or Sto Sepolcro; rebuilt, 12th cent.) and SS. Vitale e Agricola (basilican, with nave, two side aisles, and three apses, rebuilt in the 11th cent.). Dating from the 13th century is the Chiesa della Trinità, with two transverse aisles and a cruciform chapel rebuilt (1927) over the foundations of the 11th–12th century; worthy of note is the 11th-century Romanesque cloister, with 12th-century gallery; the courtyard of Pilate has 12th-century cruciform piers on two sides, and at the center an 8th-century marble pool. These buildings are in the Lombard style that must also have characterized the Cathedral (Metropolitana), dedicated to St. Peter (restored, 16th–17th cent.), of which the ruins of the Lion Door (1220–23) and the tower remain. In the 13th century the Dominicans and Franciscans introduced the Gothic style, drawing their inspiration from Cistercian structures and applying it to Romanesque elements. S. Francesco (13th cent.), which has a nave and two side aisles, buttresses, outer flying buttresses sustaining the ribbed vaults, and an apse with ambulatory and radial chapels, has remained virtually intact (VI, PL. 332); on the high altar is a marble altarpiece by Pier Paolo and Jacobello dalle Masegne (1388–92); also noteworthy is the tomb of Pope Alexander V, by Nicolò Lamberti and Sperandio Mantovano (1424–82). S. Domenico (begun in 1221, incorporating the anterior portion of S. Nicolò delle Vigne), was remodeled in the 18th century; the façade, freed from its later superstructure, remains.

The baroque interior retains a *Crucifixion* by Giunta Pisano (12th cent.); the marble tomb of St. Dominic (1267), attributed to Nicola Pisano and workshop (X, PL. 326), with a marble coping by Niccolò da Bari (1469–73; also called Niccolò dell'Arca) and Michelangelo (1495); a reredos by Filippino Lippi; the inlaid wooden choir, 16th century; and the Tartagni tomb by·Francesco di Simone Ferrucci (1477). Frescoes in the adjoining chapels include works by Guido Reni and Lodovico Carracci. S. Giacomo Maggiore, begun in 1267,

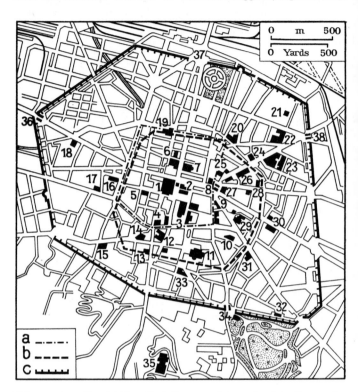

Bologna, plan. *Key:* (*a*) Hypothetical course of the walls of the Roman city; (*b*) presumed boundary in the 10th century; (*c*) remains and course of the walls, 14th–19th century. Principal monuments: (1) Palazzo Comunale and the Neptune fountain; (2) Palazzo del Podestà and palace of King Enzo; (3) S. Petronio, Museo Civico, and Archiginnasio: (4) Oratory of the Spirito Santo and S. Giovanni Battista dei Celestini; (5) S. Salvatore; (6) Fava palaces and Church of the Madonna di Galliera; (7) the Metropolitana (S. Pietro); (8) Casa dei Drappieri and the Garisenda and Asinelli towers; (9) Loggia della Mercanzia and Palazzo Pepoli; (10) S. Giovanni in Monte; (11) S. Domenico; (12) S. Procolo and Palazzo Bevilacqua; (13) Corpus Domini; (14) Collegio di Spagna; (15) Palazzo Albergati; (16) S. Francesco; (17) S. Isaia; (18) S. Maria della Carità; (19) Palazzo Montanari; (20) Palazzo Bentivoglio; (21) Palazzina della Viola; (22) Pinacoteca Nazionale; (23) University; (24) Teatro Comunale; (25) Malvasia and Salem palaces; (26) S. Giacomo Maggiore and Palazzo Malvezzi De' Medici; (27) S. Bartolomeo; (28) SS. Vitale e Agricola and Palazzo Fantuzzi; (29) S. Stefano and Casa Isolani; (30) S. Maria dei Servi and Palazzo Davia Bargellini; (31) Palazzo Sanguinetti (formerly Vizani); (32) Madonna del Baraccano; (33) Palazzo di Giustizia (court of justice); (34) Porta Castiglione and S. Maria della Misericordia; (35) former monastery of S. Michele in Bosco; (36) Porta S. Felice; (37) Porta Galliera; (38) Porta S. Donato.

has been many times remodeled but retains many Romanesque and Gothic elements. The single-aisled interior with lateral chapels preserves works by Lorenzo Costa (IV, PL. 468) and Francesco Francia (PL. 201). S. Maria dei Servi, begun in 1346, was continued during the 14th century and subsequently remodeled and completed in the 15th and 16th centuries. It is preceded by an atrium of the late 15th century and has a basilican interior with a nave and two side aisles, alternating octagonal piers and columns that sustain pointed arches, and an apsidal peribolos with three radial chapels. A marble altar by Giovanni Angelo da Montorsoli, the Gothic inlaid wooden choir, the *Madonna* by Cimabue, and works by Pellegrino Tibaldi, Guido Reni, and Francesco Albani· (PL. 219) are to be seen in the interior. S. Martino (founded, 1217; remodeled several times) has a 19th-century façade, a nave and two side aisles, and pointed arches and vaults. S. Petronio (begun, 1390 by Antonio di Vincenzo; continued throughout the 16th cent. and left unfinished) has a 15th-century façade (also incomplete) with three portals, the center one with bas-reliefs and sculpture by Jacopo Della Quercia (IV, PLS. 152, 153). The Gothic interior (VI, PL. 332) has a spacious chancel and apse. It contains out-

standing works by Jacopo Sansovino, Parmigianino (XI, PL. 46), Lorenzo Costa, and Giovanni da Modena (VI, PL. 383).

Civil construction, both public and private, developed tremendously; worthy of note is the type of house in brick with terra-cotta decoration, stone arcades, and wooden beams, including the Reggiani Grassi, Pepoli, and Rubini houses, and the Uguzzoni, Azzoguidi, and Galluzzi towers. There are numerous tower-houses, and the Palazzo del Podestà (13th cent.; rebuilt 15th cent. after designs by Aristotile Fieravanti), surmounted by the crenelated Torre dell'Arengo (13th cent.). The Palazzo Comunale (13th cent.) incorporates several buildings, including the house of Accursio, an Gothic-influenced flank by Fieravanti (1425–28), a portal by Galeazzo Alessi and Pellegrino Tibaldi (ca. 1555), and courtyards of the 15th–17th centuries. (The entire group has been restored.) Other buildings of interest are the Palazzo dei Notai (14th–15th cent.); the Collegio di Spagna, by Matteo Gattapone (1365); and the Loggia della Mercanzia (begun, 1383), attributed to Antonio di Vincenzo (extensively restored).

In the Renaissance period a great many buildings were erected by the Bentivoglios (1463–1506). *Churches*: Corpus Domini (1478–80) had a façade decorated in terra cotta and 17th-century interior by Marco Antonio Franceschini (heavily damaged in 1943). S. Giovanni in Monte, rebuilt and enlarged in 1440, overlies a Romanesque structure; the façade is by Domenico Berardi (1474) with lunette decorated by Niccolò da Bari (ca. 1480); in the interior are a circular window with stained glass after designs by Francesco del Cossa, works of Lorenzo Costa, and inlaid wooden choir by Paolo Sacca (1527), and a fine 14th-century *Crucifixion*. The Church of the Madonna del Baraccano (15th cent.; remodeled later; 18th-cent. dome) has a notable *Madonna* in fresco by Francesco del Cossa (1472). S. Michele in Bosco (1494–1510), church of a former monastery, perhaps after designs by Biagio Rossetti, has a door by Giacomo Andrea da Ferrara and Bernardino da Milano (1522); the interior, with nave and spacious choir, is noteworthy for the tomb of Armaciotto de' Ramazzotti (1526) by Alfonso Lombardi; in the refectory and library are frescoes by Cristoforo Gherardi, Stefano Veltroni, Domenico Maria Canuti, and Enrico Haffner; the Carracci cloister is so called from the poorly preserved cycles of frescoes by Lodovico and pupils. The Church of the Madonna di Galliera (rebuilt, 1479) has a fine façade of 1486 and a baroque interior by Giuseppe Antonio Torri. *Secular architecture*: Attributed to Andrea da Formigine are the former Fantuzzi palace (1532) and the Palazzo Calzoni (1529). Other palaces include three formerly belonging to the Favas, one of which is 14th-century, one 15th-century, and one 16th-century, the last with frescoes by the Carraccis and Albani and friezes by Niccolò dell'Abate; the Pallavicini-Fibbia (1497); the Tanari (16th cent.); the Palazzina della Viola, with frescoes by Amico Aspertini and Prospero Fontana; the Bevilacqua (begun, 1474), rusticated, with galleried courtyard; the Bentivoglio (1550–60); the Casa Isolani (formerly Bolognini, 1451–55); the Malvezzi-De' Medici (1560) and the Sanguinetti (formerly Vizani; 1549–62) both by Bartolomeo Triachini; and the Salem (formerly Magnani; 1577–87) by Domenico Tibaldi, with frescoes by the Carraccis (III, PL. 80). The Casa dei Drappieri (1486–96) was remodeled in the baroque period. Of the 16th century is the Neptune fountain, after designs by Tomaso Laureti, with a bronze statue by Giambologna (1566). The Palazzo dei Banchi dates from 1412 but was remodeled by Vignola (1565–68). The Palazzo di Giustizia (formerly Ruini) is partly attributed to Palladio. The University building incorporates three older palaces, the central one of which was formerly the Palazzo Poggi, by P. Tibaldi (1549), which contains frescoes by Niccolò dell'Abate (PL. 217) and Tibaldi (IX, PL. 298).

In the baroque period, in addition to new building, much remodeling of existing buildings was done (e.g., S. Giacomo Maggiore and the Metropolitana). S. Bartolomeo (1653–84) has works by Francesco Albani and Guido Reni. S. Salvatore was rebuilt (1623) by Giovanni Ambrogio Magenta and Tomaso Martelli; it contains works of Vitale da Bologna, Girolamo da Treviso, Giacomo Cavedoni, Garofolo, and others. S. Maria della Vita, on an elliptical plan by G. B. Bergonzoni (1687–90), has an 18th-century dome; the interior has a terra-cotta *Pietà* by Niccolò da Bari; adjoining the church is an oratory by Floriano Ambrosini (1617). S. Maria della Carità, by Pietro Fiorini (1583), has been restored since World War II. The Oratory of S. Maria dei Guarini, by Giuseppe Tubertini, dates from 1788. Outside the city is the Sanctuary of the Madonna di S. Luca (1723–57), by Carlo Francesco Dotti; the plan is elliptical and the forms almost neoclassical; within are works of Donato Creti, Guido Reni, and Guercino, and a 12th-century *Madonna*. S. Paolo (1611), by Magenta, with façade by Ercole Fichi (1636), has works by Lodovico Carracci, Guercino, and Alessandro Algardi.

Among the baroque secular structures are the Archiginnasio (1562–63; by Francesco Terribilia), which houses the public library; the Palazzo Bolognini-Amorini (1525–1902); the Palazzo Davia Bargellini (1638–58; by Bartolomeo Provaglia); the Palazzo Montanari

(1752; by Alfonso Torreggiani); and the Teatro Comunale, by Antonio Bibiena (1756), several times remodeled. The Palazzo Hercolani and the Villa Aldini are neoclassic. *Museums*: Pinacoteca Nazionale; Museo Civico, with archaeological material from the Villanovan and Etruscan periods, Roman lapidary work, and medieval and modern sections; Collezioni Comunali d'Arte (in the Palazzo Comunale); Museo d'Arte Industriale and Galleria Davia Bargellini (in the palace of the same name), with crafts, miniatures, and paintings; Galleria d'Arte Moderna (in the Villa delle Rose); Museo di S. Petronio; Museo di S. Stefano; and the museum of S. Domenico.

BIBLIOG. G. Zanti, Origine delle porte, strade, borghi, ecc., della città di Bologna, Bologna, 1635; G. C. Malvasia, Pitture, sculture ed architetture della città di Bologna, Bologna, 1706; E. Corty, Le chiese parrocchiali della diocesi di Bologna, 4 vols., Bologna, 1844–51; G. Gozzadini, Delle croci monumentali ch'erano nelle vie di Bologna nel secolo XIII, Bologna, 1863; G. Gozzadini, Studi archeologico-topografici sulla città di Bologna, Atti Deputazione Storia Patria per la Romagna, VII, 1868, pp. 3–104; G. Gozzadini, Delle torri gentilizie di Bologna, Bologna, 1875; G. Gozzadini, Note per studi dell'architettura civile in Bologna del secolo XIII, Modena, 1877; P. Lamo, Graticola di Bologna, Bologna, 1884; E. Brizio, Relazione sugli scavi eseguiti a Marzabotto presso Bologna, MALinc, I, 1889, cols. 249–426; G. B. Comelli, Della pianta di Bologna dipinta nel Vaticano e di altre piante e vedute, Atti Deputazione Storia Patria per la Romagna, 3d ser., XIII, 1895, pp. 153–219; F. Malaguzzi Valeri, L'architettura a Bologna nel Rinascimento, Rocca San Casciano, 1899; L. Weber, Bologna, Leipzig, 1902; L. Weber, San Petronio zu Bologna, Leipzig, 1904; E. Calzini, L'architettura bentivolesca a Bologna e il Palazzo del Podestà, Bologna, 1909; P. Ducati, Le pietre funerarie felsinee, MALinc, XX, 1910, cols. 361–728; A. Grenier, Bologna villanovienne et étrusque VIII–IV siècles avant notre ère, Paris, 1912; A. Gatti, La Basilica Petroniana, Bologna, 1913; G. B. Comelli, Piante e vedute della città di Bologna, Bologna, 1914; I. B. Supino, La basilica di S. Petronio, Bologna, 1914; F. von Duhn, Bologna preetrusca ed etrusca, Bologna, 1915; G. del Vecchio, Per le torri di Bologna, Milan, 1917; G. Zucchini, La ricostruzione di Bologna turrita, L'Archiginnasio, XIII, 1918, pp. 64–67; V. Gabelli, Architettura romanica bolognese, Bologna, 1924; I. B. Supino, La chiesa di S. Maria dei Bulgari, Bologna, 1926; Le chiese di Bologna illustrate, Bologna, 1927; A. Finelli, Bologna nel Mille, Bologna, 1927; T. Alfonsi, La basilica di S. Domenico, Italia sacra, I, 1928, pp. 145–220; I. P. Ducati and A. Sabelli, Storia di Bologna, 2 vols., Bologna, 1928–30; A. Foratti, Aspetti dell'architettura bolognese dalla seconda metà del secolo XVI alla fine del '600, Il Comune di Bologna, XVIII, 1931, pp. 15–24; G. Zucchini, Edifici di Bologna, 2 vols., Rome, 1931–54; I. B. Supino, L'architettura sacra in Bologna nei secoli XIII e XIV, Bologna, 1932 (bibliog.); S. Della Rovere, Architettura razionale bolognese, Il Comune di Bologna, XX, 1933, pp. 53–56; I. B. Supino, L'arte nelle chiese di Bologna del secolo XV–XVI, Bologna, 1938 (bibliog.); G. Zucchini, Chiese e ville bolognesi in un libro di disegni dell'Archiginnasio (1578), L'Archiginnasio, XXXIV, 1939, pp. 71–80; G. Zucchini, Palazzi, case e osterie di Bologna in un manoscritto del 1771, L'Archiginnasio, XXXVI, 1941, pp. 226–32; G. Zucchini, Disegni inediti per S. Petronio di Bologna, Palladio, VI, 1942, pp. 153–66; P. Ducati, Nuove stele funerarie felsinee, MALinc, XXXIX, 1943, cols. 373–446; G. Zucchini, S. Michele in Bosco di Bologna, L'Archiginnasio, XXXVIII, 1943–48, pp. 18–70; E. Andreoli, Bologna nell'antichità, MPontAcc, VI, 1947, pp. 143–82; A. Raule, Architettura bolognesi, Bologna, 1952; A. Barbacci, La basilica di San Francesco in Bologna e le sue secolari vicende, BArte, XXXVIII, 1953, pp. 69–75; G. Zucchini, Guida della Basilica di San Petronio, Bologna, 1953; G. A. Mansuelli, Etruria padana: Nuove scoperte nelle necropoli bolognesi, SEtr, XXIII, 1954, pp. 357–82; A. Raule, Le chiese di S. Stefano, Bologna, 1955; A. Raule, S. Giacomo Maggiore a Bologna, Bologna, 1955; N. Beseghi, Palazzi di Bologna, Bologna, 1956; G. Fabbri, Le fortificazioni del Medioevo a Bologna, Bologna, 1956; N. Beseghi, Castelli e ville di Bologna, Bologna, 1957; N. Beseghi, Introduzione alle chiese di Bologna, 2d ed., Bologna, 1957; G. A. Mansuelli, La terza Bologna, SEtr., XXV, 1957, pp. 13–30; A. Roversi, Bologna, Bologna, 1957; A. Raule, La chiesa metropolitana di San Pietro, Bologna, 1958; B. Trebbi, L'artigianato nelle chiese di Bologna, Bologna, 1958; P. E. Arias, EAA, s.v. Bologna, II, 1959, pp. 125–28; F. Bizzarri, Torri, palazzi, porte di Bologna, Bologna, 1959; G. A. Mansuelli, Bologna, Riv. mensile del Comune, 1959, p. 6; L. Laurenzi and G. Montanari Bermond, CVA, Italia, fols. 5, 7, 12, 27; R. Renzi, Nuovissima guida ai monumenti di Bologna, Bologna, 1960; G. C. Susini, Il lapidario greco e romano di Bologna, Bologna, 1960; G. Tibalducci, Bologna, Turin, 1960.

Carpi. Recorded as early as the Lombard period, Carpi was a seigniory of the Pio family from 1327 to 1525, of the Este family up to 1859. Of the Lombard period is the parish church of the Sagra (consecration), rebuilt in the 12th century. In 1515 the church was shortened and the Romanesque portal was restored to the façade. A 12th-century marble pulpit and 13th-century frescoes are in the interior. The campanile is 13th-century. On the site of an older fortress (11th cent.) stands the Pio castle (14th–16th cent.), which has a long façade with niches, clock tower, keep (1456), and small circular tower (aviary) of 1480. Within are a Renaissance courtyard (restored) and a tower of 1320; the various rooms are handsomely decorated, the Sala dei Mori having frescoes by Giovanni Del Sega. The Cathedral, begun in 1514 by Baldassare Peruzzi, has a baroque façade (1667) with a portal of 1771. The Museo Civico "Giulio Ferrari," is in the castle.

BIBLIOG. A. Sammarini, Il Duomo di Carpi, Modena, 1894; D. Tirelli, Guida storico-artistica di Carpi, Carpi, 1900; A. Venturi, Sculture romani-

che nella Sagra di Carpi, L'Arte, VII, 1904, pp. 286–97; P. Foresti, La Cappella Pio nel Castello Comunale di Carpi, BArte, VI, 1912, pp. 303–22.

Castell'Arquato. Known since the 6th century, it was subject to the bishops of Piacenza from the 8th to 13th century and subsequently ruled by various nobles. The aspect of the town is predominantly medieval. The Rocca (fortress; 1343) has battlemented towers and a very lofty keep. The Palazzo Pretorio (1293) has a pentagonal tower of the early 14th century and colonnade and outside stairway of the 15th. The Palazzo del Duca (13th–14th cent.; rebuilt in the 15th) faces a fountain of 1292 (restored). The Collegiata (collegiate church) of the 12th century overlies an earlier structure; its façade is decorated with pilaster strips and unsupported small arches, and the basilican interior preserves an 8th-century baptismal font and 14th-, 15th-, and 18th-century frescoes. The Museo della Collegiata houses metalwork, Byzantine textiles, remains of 12th-century sculpture, and paintings.

Bibliog. C. Capezzuoli, Accanto alla Rocca di Castell'Arquato, Cron. d'arte, V, 1928, pp. 3–16; L. Dodi, Il torrione di Castellarquato, Palladio, VI, 1942, pp. 188–91; A. Ambrogio, Castell'Arquato, Piacenza, 1955.

Cesena (Lat., Caesena). On the right bank of the Savio, this was a prehistoric and Roman center. Fine polychrome mosaic pavements from the 3d century have been found here, as have also two large silver plates, one of which has incised figural decoration (III, PL. 387), preserved in the Biblioteca Malatestiana. Devastated by the barbarians, Cesena attained importance in the Byzantine period. Burned in the 10th century, it revived and flourished under the rule of the Malatestas (14th–15th cent.). The oldest part of the city, girdled by walls, is overlooked by the Rocca Malatestiana (fortress), of the late 14th century, enlarged by Matteo Nuti (1466) and Cristiano and Francesco Baldini da Ferrara, with bastions, towers, and curtain wall showing Venetian Gothic influence. The Cathedral (late 14th cent., completed in the 15th and subsequently enlarged) preserves late Gothic elements in the flanks and apse; the façade is of Venetian Renaissance type; the interior has a nave and two side aisles with ogive arches, a chapel with vault frescoed by Corrado Giaquinto (1750), and works of Lorenzo Bregno and Giovanni da Traù. The Biblioteca Malatestiana by Nuti (1452) houses an extensive collection of codices and incunabula. In the center of the Piazza del Popolo is a fountain by F. Masini (1583). S. Agostino (18th cent.) preserves an Annunciation by Girolamo Genga. In neoclassic style is the Osservanza (1791), by Leandro Marconi. The Raccolte Comunali are annexed to the Biblioteca Malatestiana.

Bibliog. L. Marinelli, La Rocca Malatestiana di Cesena, Reggio Emilia, 1907; C. Grigioni, Un secolo di operosità artistica nella Chiesa di Santa Maria del Monte presso Cesena, Rass. bibliog., XIV, 1911, pp. 66–73, XVI, 1913, pp. 152–56, XVII, 1914, pp. 15–22, 53–56, 86–89; P. E. Arias, Il piatto argenteo di Cesena, ASAtene, N.S., VIII–X, 1946–48, pp. 309–44; G. A. Mansuelli, Caesena, Forum Popili, Forum Livi, Rome, 1948; A. Solari, Sulla topografia di Caesena, RendLinc, 8th ser., X, 1950, pp. 366–70; G. A. Mansuelli, EAA, s.v. Cesena, II, 1959, pp. 125–28.

Correggio. Roman village, Lombard fief, and earldom as early as 1452, it retains the appearance it acquired under the rule of the da Correggio family (late 12th cent.–1630): nearly square in plan, with broad streets on which face buildings with arcaded façades. The Palazzo dei Principi, begun about 1500, is a brick structure, with simple façade, windows with semicircular arches, marble portals, and colonnaded Renaissance courtyard. S. Quirino, begun in 1513, is attributed to Vignola. S. Francesco (15th cent.; later remodeled) is in Gothic style; the interior has a nave and two side aisles, with alternating piers and columns, and contains a St. Bernardino attributed to Mattia Preti. The Museo Civico in the Palazzo dei Principi has works by Mantegna and Aspertini.

Bibliog. E. Bertolini, Le opere artistiche del Principato di Correggio, Reggio Emilia, 1930; R. Finzi, L'urbanistica della città di Correggio, Correggio, 1959.

Faenza (Lat., Faventia). Known especially since the 12th century for its ceramics (faïence), it was probably first an Etruscan town, then Roman; it was a free commune in the 12th and 13th centuries; in 1313, it became a fief of the Manfredi family and finally, in 1510, a church domain. It is laid out on a grid plan and is predominantly Renaissance in character. Little remains of the medieval monuments largely rebuilt or remodeled, such as the Romanesque Church of the Commenda (S. Maria Maddalena), with frescoes by Girolamo Pennacchi (1533); S. Bartolomeo (1209); and S. Agostino, which incorporates 14th-century remnants. The principal monuments face on the adjoining squares, Piazza del Popolo and Piazza della Libertà. The Cathedral (façade incomplete) was designed by Giuliano da Maiano (1474); the interior, with a nave and two side aisles divided by rhythmically

spaced alternating piers and columns, was completed by Lapo di Pagno Portigiani the Younger and subsequently remodeled. Notable works within include the shrine of St. Savinus (1476) by Benedetto da Maiano; the shrine of St. Terentianus (15th cent.); and frescoes by Ferraù Fenzoni. The Palazzo del Podestà retains medieval fragments from the 12th and 13th centuries. The Palazzo del Municipio (13th cent., remodeled) contains 18th-century frescoes; adjoining it is the "big arch" of the Molinella, decorated with grotesques by Marco Marchetti (1566). Near the Cathedral is a monumental fountain (1619–21), after designs by D. Castelli, and in the Piazza del Popolo a clock tower, rebuilt after World War II. In the 19th century the loggias characterizing a number of piazzas were restored or reconstructed. Also noteworthy are S. Maria Vecchia (1665), rebuilt over the original 8th-century church, with 10th-century campanile; SS. Ippolito e Lorenzo (1773); S. Domenico, by Francesco Tadolini (1759), with wooden choir stalls by Fra Domenico Paganelli (17th cent.); S. Francesco (rebuilt, 1752), by Giovanni Battista Campidori; the Palazzo Ferniani (16th–18th cent.); Palazzo Laderchi, with 18th-century pictorial decoration. Museums: Pinacoteca e Museo Civico, with paintings by the Emilian school from the 14th to the 17th century, and sculpture (Donatello, Benedetto da Maiano, Todin); Museo Internazionale delle Ceramiche.

[Bibliog. C. Grigioni, Il Duomo di Faenza, L'Arte, XXVI, 1923, pp. 161–74; G. Ballardini, Il "Palatium Communis" e il "Palatium Populi," BArte, N.S., VI, 1926–27, pp. 189–92; A. Medri, Faenza romana, Bologna, 1943; G. C. Susini, Profilo di storia romana della Romagna: La cronologia dei centri romani e la fondazione di Faenza, S. romagnoli, VIII, 1957, pp. 1–45; A. Archi, Guida di Faenza, Faenza, 1958; EAA, s.v. Faenza.

Ferrara. Built on the lower Po plain on the bank of the former Po di Volano, its origin is uncertain. Of the imperial Roman age a pagus on the left bank of the Volano is recorded. Fortified by the exarch of Ravenna in the 6th century and subsequently a Lombard and Frankish possession, it became an independent commune in the 11th century. Ferrara experienced a long period of cultural and economic primacy, when, in the 15th and 16th centuries, under the rule of the Este family, it became an important Humanistic center and was encircled with bastioned walls culminating in the Castle. At the flank of the medieval city there developed at that time a spacious quarter laid out according to a regular master plan evolved by Biagio Rossetti. In 1598, with its annexation to the Papal State, its decline set in.

Very few medieval monuments remain. A few traces of preRomanesque construction may be seen in the former Church of S. Romano, with small 12th-century Romanesque cloister. The Cathedral, begun about 1135 by Lombard artisans, retains intact the original structure of the flanks, with gallery of arches, which also runs along the façade, on which was superimposed, late in the 13th century, the present Gothic façade, with three rows of galleries (PL. 171); the earlier Lombard porch and portals (sculptures by Nicolaus) from the 12th century remain (X, PL. 327). In the Gothic loggia surmounting the porch is a Madonna ascribed to Cristoforo da Firenze (1427); in the tympanum, the Last Judgment (13th–14th cent.), with strong French influences. Added to the right flank in the 15th century were a second gallery and the Loggia dei Merciai (Drapers' Arcade). The interior, reduced from five to three aisles (15th–18th cent.), retains a fresco by Bastianino (1583) in the conch of the apse and canvases by Garofalo and Francia. The Palazzo Comunale (1243; rebuilt in 1924) has a courtyard with a grand staircase by Pietro Benvenuti (1481). The castle of the Este family, square, with corner towers and ringed by a moat, was built by Bartolino da Novara (1385); it incorporates a 13th-century tower. The structure was enlarged by Girolamo da Carpi (1544); in the interior is the outstanding Salone dei Giuochi (Gaming Room), with works of the 15th-century Ferrarese school and the Lombardesque Chapel of Renée of France.

In the Renaissance a growing preciousness appeared in private construction, with the modernization of houses and the construction of new ones with cornices, arched windows, and corner piers. Especially noteworthy are the Este palaces, particularly that of Schifanoia (begun, 1385; enlarged many times), with a marble doorway ascribed to Francesco del Cossa; in the interior, the Sala dei Mesi, with frescoes by Cossa and others (II, PL. 25; IV, PLS. 1–3, 5). The Palazzo Pareschi (formerly Estense) has a 15th-century arcaded courtyard with monumental stairway of the 18th century. The Palazzo dei Diamanti was begun by Sigismondo d'Este about 1492 (completed about 1565), with exterior decoration of marble pyramidal bosses, corner frieze with candelabra, and corner loggetta. The Palazzina di Marfisa (1559; restored) has an imposing marble doorway and a 16th-century loggia called "Teatro di Morfisa." Also worthy of mention is the incomplete palace of Ludovico il Moro (1503), attributed to Biagio Rossetti, with an arcaded courtyard on two sides and a frescoed hall attributed to Garofalo; as well as the following palaces and houses:

the former Rondinelli and Bevilacqua palaces, the Prosperi-Sacrati and Roverella (1508; rich terra-cotta decoration) palaces, the Casa Cini and Casa Romei (15th cent.), and the Strozzi and Bentivoglio palaces.

A revival of religious architecture also took place in this period. S. Benedetto (1496–1554) has been rebuilt since World War II. S. Cristoforo (begun, 1498), attributed to Rossetti, has a single aisle with lateral chapels and works of Bastianino, Laureti, etc. Adjoining it is the Certosa (1461), today a cemetery. S. Francesco (1494–1530),

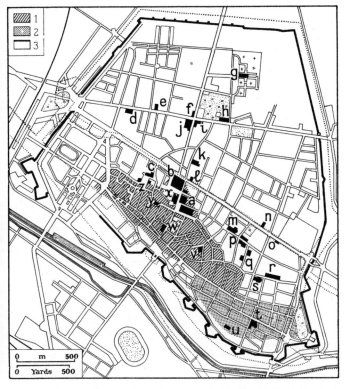

Ferrara, plan. *Key*: (1) Medieval area; (2) area developed by Duke Borso d'Este (1451); (3) area within the walls, 1592, including area developed by Duke Ercole I. Principal monuments: (*a*) Cathedral, Arcivescovado, and Palazzo del Seminario; (*b*) Castle; (*c*) S. Domenico; (*d*) S. Benedetto; (*e*) S. Maurelio; (*f*) Palazzo Prosperi-Sacrati; (*g*) S. Cristoforo (or Church of the Certosa); (*h*) Palazzo Massari; (*i*) Palazzo di Bagno; (*j*) Palazzo dei Diamanti; (*k*) Church of the Gesù; (*l*) S. Carlo; (*m*) S. Francesco; (*n*) Capuchin church; (*o*) Palazzina di Marfisa; (*p*) Palazzo Pareschi and Casa Romei; (*q*) S. Girolamo and Corpus Domini; (*r*) Palazzo Schifanoia; (*s*) S. Maria in Vado; (*t*) Palazzo di Ludovico il Moro; (*u*) Monastery of S. Antonio in Polesine; (*v*) Palazzo dell'Università; (*w*) S. Paolo; (*x*) Palazzo Comunale; (*y*) S. Stefano; (*z*) Bentivoglio and Strozzi palaces.

built by Rossetti over an earlier building, has a nave and two side aisles with terra-cotta decoration and frescoes by Garofalo. S. Maria in Vado (1495–1518), with nave and two side aisles, rebuilt after designs by Rossetti and later restored, has frescoes by Lodovico Mazzolino and Carlo Bononi. S. Paolo (1575), designed by Alberto Schiatti, has a severe façade; the interior, with nave and two side aisles, contains frescoes and canvases by Scarsellino and others. The Church of the Gesù (1570), by Schiatti and Giovanni Tristani, contains works by Giuseppe Maria Crespi and the *Deposition*, a terra-cotta group by Guido Mazzoni.

Among the most eminent 17th- and 18th-century structures are the unfinished S. Maria dei Teatini (17th cent.) by Luca Danesi, with frescoes by Clemente Maiola and an altarpiece by Guercino; S. Domenico (1726) by Vincenzo Santini, with a campanile of the early 13th century, terra-cotta façade, and single aisled interior containing works of Scarsellino and 17th- and 18th-century sculpture and paintings; S. Carlo, on an elliptical plan (1623) by Giovanni Battista Aleotti; and the Palazzo del Monte di Pietà (1761). *Museums*: Museo Archeologico Nazionale (in Palazzo di Ludovico il Moro), with excavated material from Spina, important for 5th-century Attic pottery; Pinacoteca Nazionale and Museo Lapidario (in Palazzo dei Diamanti); Museo dell'Opera del Duomo, with 13th-century reliefs from the Cathedral and organ doors painted by Cosmè Tura; Museo di Schifanoia, with miniatures, medals, etc.; Casa Romei, detached frescoes.

BIBLIOG. G. A. Scalabrini, Memorie istoriche delle chiese di Ferrara, Ferrara, 1773; Indice manuale delle cose più rimarcabili in pittura, scultura e architettura della città e borghi di Ferrara, Ferrara, 1844; L. Cittadella, Documenti e illustrazioni per la storia artistica ferrarese, Ferrara, 1868; L. Cittadella, Il Castello di Ferrara, Ferrara, 1875; P. Bottoni, La chiesa di S. Romano, Arte e Storia, VIII, 1889, p. 99; G. Gruyer, La Cathédrale de Ferrare, Rev. de l'art chrétien, 4th ser., II, 1891, pp. 384–404; G. Agnelli, Ferrara e Pomposa, Bergamo, 1902; G. Agnelli, Ferrara: Porte di chiese, di palazzi, di case, Bergamo, 1909; A. Haupt, Palastarchitektur von Ober-Italien und Toscana, V, Berlin, 1911–13; F. Bogatti, L'origine della città di Ferrara, 2d ed., Città del Castello, 1913, A. Giglioli, Riv. di Ferrara, II, 1934, pp. 58–68; A. Sautto, Il Duomo di Ferrara dal 1135 al 1935, Ferrara, 1934; S. Aurigemma, Il Museo di Spina, Ferrara, 1935; G. Giovannoni, La cattedrale di Ferrara nella evoluzione dell'architettura romanica in Italia, Riv. di Ferrara, III, 1935, pp. 411–18; G. Medri, Il Palazzo estense di Schifanoia, Riv. di Ferrara, III, 1935, pp. 323–28; La Cattedrale di Ferrara, Verona, 1937 (bibliog.); G. Righini, La chiesa di S. Giovanni Battista a Ferrara, Ferrara, 1938; G. Bargellesi, Palazzo Schifanoia, Bergamo, 1945; G. Bovini, Sculture paleocristiane e alto-medievali conservate a Ferrara, Felix Ravenna, 3d ser., XIV, 1954, pp. 22–36; G. Righini, Come si è formata la città di Ferrara, Ferrara, 1954; P. E. Arias and N. Alfieri, Il Museo Archeologico di Ferrara, Ferrara, 1955; S. Aurigemma and M. Alfieri, Il Museo Nazionale Archeologico di Spina in Ferrara, Rome, 1957, pp. 141–56, 309–28; R. Jannucci, Storia di Ferrara, Ferrara, 1958; G. M. Zanotti, La basilica di S. Francesco, Genoa, 1958; EAA, s.v. Ferrara.

Fidenza (Lat., Fidentia). Of Roman origin, it won administrative autonomy in the 1st cent. B.C., declined in the 3d century of the Christian Era, then revived in the 9th under the name of Borgo San Donnino. In the Middle Ages it was a commune, then passed under the control of various nobles. In 1927 it again took its ancient name.

It is built around a central square on which stands the Palazzo Comunale, a Lombard structure of the late 13th century. The most outstanding monument is the Romanesque Cathedral (1207), carried forward in Gothic style (vaults, apse) in the late 12th century; the façade (I, PL. 297), unfinished, is flanked by two towers and has three Lombard porches with columns supported by animal figures and rich splayed portals decorated with reliefs by different hands, all in the tradition of Benedetto Antelami (q.v.); attributed to Antelami himself are the statues of the prophets flanking the main doorway (I, PL. 295); the basilican interior has a nave and two side aisles, with galleries and a 12th-century crypt with the urn of St. Donnino, perhaps by Pietro da Rho.

BIBLIOG. A. Pettorello, S. Antonio, Rass. d'arte, VI, 1906, pp. 22–30; G. de' Francovich, Benedetto Antelami, Florence, 1952; N. Denti, Guida di Fidenza, Fidenza, 1959; EAA, s.v. Fidenza.

Forlì (Lat., Forum Livi). Settlements from the Bronze and Iron ages have been unearthed in the environs. Occupied in the 2d century B.C. by a Gallic people, it was later a Roman town, the remains of which include baths and pottery workshops and epigraphic, architectural, and mosaic relics. In the Middle Ages it flourished as a free commune and in the Renaissance under the rule of the Ordelaffi family. It centers around a square, on which the principal monuments face. S. Mercuriale, with its campanile, dates to the 12th century but has been remodeled at various times. The portal is decorated with reliefs by disciples of Antelami. The interior, basilican in plan, was lengthened in the 16th century; the nave and side aisles are divided by columns and piers. The mosaic pavement is 14th-century, the crypt from 1176. Works in the interior include the tomb of Barbara Manfredi (ca. 1470) by Francesco di Simone Ferrucci; panels and frescoes by Marco Palmezzano, Bernardino Poccetti, Passignano, Carlo Cignani, and others; and inlaid wooden choir stalls (1535). The Palazzo del Municipio (rebuilt, 1359), with Renaissance arcade and various alterations of 1459 preserves frescoes by Bibiena and Francesco Menzocchi. The Palazzo del Podestà (1459–60) is extensively restored and rebuilt. S. Filippo is of the 17th century; and S. Maria dei Servi, the octagonal S. Antonio Abate, the Church of the Carmine, and the Church of the Trinity are all of the 18th century. In 1841 Giulio Zambianchi almost entirely rebuilt the 12th-century Cathedral (Sta Croce), already altered in the 15th century; in the neoclassic interior, with nave and two aisles, is a baptismal font by Tomaso Fiamberti and *The Assumption* by Carlo Cignani. The Rocca di Ravaldino (fortress of the late 14th cent.) has been several times enlarged, destroyed, and rebuilt. The Pinacoteca Comunale, the Museo Etnografico Romagnolo, and the Museo Archeologico are all housed in the same building.

BIBLIOG. G. Gerola, La facciata di S. Mercuriale, Felix Ravenna, XVII, 1915, pp. 814–19; G. Tura, La facciata di S. Mercuriale, Felix Ravenna, XXIX, 1919, pp. 38–42; E. Casadei, La città di Forlì e i suoi dintorni, Forlì, 1928; A. Arfelli, La Pinacoteca e i Musei Comunali di Forlì, Rome, 1936; G. Giovannoni, Chiostro di S. Mercuriale, Palladio, VI, 1942, pp. 38–39; P. Reggiani, Contributo allo studio di Forlì romana, Emilia romana, II, Florence, 1944, pp. 317–62; G. A. Mansuelli, Caesena, Forum Popili, Forum Livi, Rome, 1948; M. Mazzotti, Scavi a S. Mercuriale di Forlì, Felix Ravenna, 3d ser., 11, 1953, pp. 54–57; EAA, s.v. Forlì.

Imola (Lat., Forum Cornelii). The Roman city, which was named for Lucius Cornelius Sulla (82 B.C.), developed on a presumably Etruscan site; the modern city dates from the Middle Ages (mentioned by Paulus Diaconus). It was at first a dependency of the exarch and later of the bishop of Ravenna. Subsequently it was ruled by a number of lords; in 1504 it passed to the Church. The town plan of the 1st century, aligned in accordance with the *cardo* and *decumanus* (Via Flaminia), accounts even today for the city's urban appearance, with its rectangular plan based on a regular rectilinear street system. From the 1st and 2d centuries there remain an amphitheater and some mosaics. The medieval buildings were extensively remodeled by Cosimo Morelli in the 18th century. The Cathedral (S. Cassiano), basilican, with dome (12th–13th cent.) and campanile (1473–85), was completely rebuilt in 1781; the façade is 19th-century. S. Maria in Regola, rebuilt, retains the cylindrical campanile from 1181. S. Domenico (14th cent.) has incorporated in the 18th-century reconstruction the Gothic portal and polygonal apse; within, *Martyrdom of St. Ursula*, by Lodovico Carracci. The Palazzo Comunale, known since the 12th century, has some Romanesque and Gothic remnants but was remodeled in 1758. The Rocca (14th cent.), with fortifications dating from 1473, later enlarged and then partially dismantled, has a square plan with cylindrical corner towers. *Museums*: Museo Archeologico; Raccolta d'Arte Comunale.

Bibliog. L. Orsini, Imola e la valle del Salterno, Bergamo, 1907; M. Baratta, La pianta d'Imola di Leonardo da Vinci, B. Soc. geog. it., 4th ser., XII, 1911, pp. 945–67; Il nuovo centro di Imola (Arch. G. B. Milani), Architettura, XII, 1933, pp. 299–303; L. Laurenzi and G. Cencetti, eds., Storia di Imola, I, Rome, 1957; G. A. Mansuelli and G. C. Susini, Imola nell'antichità, Rome, 1957; D. Lanzoni, Imola, Imola, 1960; EAA, s.v. Imola.

Modena (Lat., Mutina). Inhabited since protohistoric and Etruscan times, it became first a Roman colony (183 B.C.), then a municipium with regular plan on the Via Aemilia. Its decline began in the 4th century; it revived in the 9th, developing around the small basilica of S. Giminiano (on the site of the present Cathedral), and was girdled with walls. It became a free commune in the 12th century; from 1336 on it was a domain of the Este family. Divided in two by the Via Emilia, it is circled by broad, tree-shaded streets (replacing the pentagonal walls), beyond which extends the modern city.

The Cathedral, begun by Lanfranco in 1099, overlying earlier buildings of the 4th century, was completed in the 13th century. The tripartite façade has sculpture by Wiligelmo da Modena (q.v.) and the Campionesi (q.v.), an arcaded covered gallery that is carried around the flanks, and center portal with porch and gallery. On the right flank are the Porta dei Principi (restored), with sculptures by the school of Wiligelmo, and the Porta Regia (13th cent.) of the Campionesi; on the left, the Porta della Pescheria (X, PL. 253) by a disciple of Wiligelmo. The campanile ("Ghirlandina") is contemporaneous, with spire from 1261–1319 (I, PL. 395). The interior has a nave and two side aisles (with 15th-cent. vaults) and three apses, without a transept. The *pontile* is decorated with carving by Anselmo da Campione and assistants (III, PLS. 17, 18); the choir stalls are by Cristoforo and Lorenzo da Lendinara (1465). The only monastic church retaining its ancient structure is S. Francesco (Gothic, 1244; restored 1828–29 with simple brick façade, nave and two side aisles, and three polygonal apses; within is a *Deposition* (terra cotta) by Antonio Begarelli.

In the Renaissance, the Church of S. Pietro was rebuilt with typical terra-cotta decoration on the façade, campanile with spandrels, and interior with nave and four side aisles (works of F. Bianchi Ferrari, Romanino, Antonio Begarelli, Dosso Dossi, and Giacomo Cavedoni). S. Biagio was rebuilt in 1661 after designs of Cristoforo Malagola (Galaverna), with single apsidal nave and dome; within are frescoes by Mattia Preti and others. S. Agostino (14th cent.; rebuilt in the 17th) has interior stucco decoration and a *Deposition* by Antonio Begarelli. The Chiesa del Paradiso (S. Filippo Neri; 1596) was designed by Giovanni Guerra, with ellipsoidal nave, transept, and dome on paired columns. S. Giorgio was begun in 1647 after designs by Gaspare Vigarani, with façade and high altar by Antonio Lurago (17th cent.). The Jesuit church, S. Bartolomeo (1607), with façade of 1727, contains frescoes by Andrea Pozzo and assistants. S. Giovanni Battista (restored, 1799), on a Greek-cross plan, preserves a terra-cotta *Lamentation* by Guido Mazzoni (1476; PL. 200).

Secular architecture of note includes the Palazzo Ducale (1634, designed by Bartolomeo Avanzini), with a salon frescoed by M. A. Franceschini and the Salottino d'Oro by Michele Salvadori; the Palazzo Comunale, medieval but almost entirely rebuilt in the 17th and 18th centuries; the Ghisellini and Ferrari-Moreni Renaissance palaces; and the Palazzo dei Musei (former Almshouse) from 1753, remodeled later. *Museums*: Galleria, Museo e Medagliere Estense (in the Palazzo dei Musei), with works by El Greco, Velázquez, Giovanni di Paolo, Bernini, Correggio, Tura, and Niccolò dell'Abate, and medals by Pisanello and Matteo de' Pasti; Biblioteca Estense, with the Bible of Borso d'Este (15th cent.); Museo Lapidario del Duomo (detached metopes); Museo Lapidario; Museo Civico.

Bibliog. L. Forni and G. Campori, Modena a tre epoche, Modena, 1844; G. Soli, Atti Deputazione Storia Patria per l'Emilia e la Romagna, Prov. modenesi e parmensi, 3d–4th ser., XXIV–XXII, 1906–31 (churches of Modena and its environs); A. Haupt, Palastarchitektur von Ober-Italien und Toscana, I, Berlin, 1911–13; G. Bertoni, La Cattedrale modenese preesistente all'attuale, Modena, 1913; Elenco degli edifici monumentali, Provincia di Modena, Rome, 1920; P. Frankl, Der Dom in Modena, Jhb. für Kw., IV, 1927, pp. 39–54; M. Corradi Cervi, Mutina, Deputazione Storia Patria per l'Emilia e la Romagna, Sezione di Modena, S. e doc., I, 1937, pp. 137–64; E. P. Vicini, Del secondo Castello degli Estensi a Modena, Atti Deputazione Storia Patria per l'Emilia e la Romagna, Sezione di Modena, II, 1938, pp. 87–97; L. Lanegg, Il Palazzo Ducale di Modena, RIASA, IX, 1942, pp. 212–52; G. de' Francovich, Benedetto Antelami, Florence, 1952; A. Barbacci, Il restauro del Duomo di Modena danneggiato dalla guerra, BArte, XXXVII, 1933, pp. 273–76; F. Richeldi, Il restauro della Abbazia di Nonantola, Atti Deputazione Storia Patria per l'Emilia e la Romagna, Antiche provincie modenesi, 8th ser., V, 1953, pp. 222–26; G. Moreali, Nonantola, Rocca San Casciano, 1956; A. Ghidiglia Quintavalle, La Galleria estense di Modena, Genoa, 1959.

Parma. Situated on the Via Emilia and the Parma River, Parma became a Roman colony in 183 B.C. From the 4th century onward it declined, but a perceptible revival of building activity was manifest in the 12th and 13th centuries and later, in the 19th century, during the period of the grand duchy of Marie Louise of Austria, who was responsible for most of the urban transformation of the city and its predominantly modern aspect, with broad streets and squares. The medieval city centered upon the Romanesque Cathedral, begun before 1046, largely destroyed by the 1117 earthquake, and subsequently rebuilt, with Gothic chapels inserted on the left flank (14th cent.) and campanile (1284; PL. 171). The façade has a covered gallery and porch (in the archivolt, *Assumption of Mary*); the interior has a nave with two side aisles, women's galleries, transept, and choir over a crypt. Notable works within are a carved altar of red Veronese marble, from the preceding structure; *Deposition* (I, PL. 292) and episcopal throne by Benedetto Antelami (q.v.); frescoes from the 15th to 18th century, and, in the dome, frescoes by Correggio (III, PL. 471). The Baptistery (1196–1307), attributed to Antelami, save for the Gothic crowning, is octagonal, with three doors and five rows of loggias (one blind) and sculptures by Antelami (I, PLS. 292–295, 297). The polygonal interior has a ribbed dome (I, PL. 414), decoration by Antelami and assistants, and 13th-century frescoes showing Byzantine influence. The only remnants of the Romanesque structure of Sta Croce (1210) are the apse, the oblong windows, the portal, and the plan of the interior. Also built in the communal period but heavily restored are the Palazzo del Capitano del Popolo (ca. 1230), the Palazzo dei Notai (1287), and the Vescovado (mid-13th cent.). Specimens of Gothic are S. Francesco del Prato (1260–1462); the former Church of the Carmine (1313–1494); and Sto Sepolcro (1252), extensively remodeled, particularly in 1460.

The city's development with regard to its monuments was remarkable during the 16th, 17th, and 18th centuries, when it was the capital of the duchy of the Farnese family. S. Giovanni Evangelista (1510), by B. Zaccagni the Elder, with façade by Simone Moschino of Orvieto (1607), has a basilican Renaissance interior with nave and two side aisles separated by piers (PL. 200). The spandrels and dome (III, PL. 470) and the left transept were frescoed by Correggio. In the left aisle are frescoes by Parmigianino. The Madonna della Steccata (begun, 1521) was designed by Bernardino and Giovanni Francesco Zaccagni on a Greek-cross plan, with semicircular apses on either side and corner chapels visible on the outside. The dome has external decoration by Mauro Oddi (late 17th cent.). The interior contains works by Parmigianino. The Camera del Correggio, the chamber of the abbess of the former Convent of S. Paolo (also called Camera di S. Paolo), is one of the masterpieces of Correggio, with a vault divided into 16 segments over lunettes with mythical figures (III, PL. 465). The SS. Annunziata (begun, 1566) has an elliptical plan by Giovanni Battista Fornovo and dome by Girolamo Rainaldi (1632). S. Alessandro, built (1507) by B. Zaccagni the Elder over an earlier structure, was rebuilt by Giovanni Battista Magnani (1622–24); the interior has a nave with lateral chapels and frescoes by Angelo Michele Colonna and Alessandro Tiarini. The Oratory of S. Lucia, rebuilt over a 13th-century church, has a façade by Mauro Oddi (1691) and altarpiece by Sebastiano Ricci (1730). The Oratory of the Capuchins, by Giovanni Francesco Testa (1561–69), was later remodeled; within are frescoes by Giovanni Maria Conti and Pier Antonio Bernabei and the *Dead Christ* by Ricci. S. Maria del Quartiere, by G. B. Magnani and G. B. Aleotti (1604; remodeled in the 18th cent.), is hexagonal in plan; frescoes in the dome are by Bernabei (1626–29). S. Antonio Abate was begun in 1712 after designs by Ferdinando Galli (Bibiena), with nave and frescoed double vault. S. Pietro Apostolo

rebuilt (1761) by Ennemondo Petitot, has a single aisle and stucco and fresco decoration by Antonio Ferraboschi and Giovanni Antonio Vezzani. The ancient Church of S. Ulderico, remodeled (1740), has a façade by Gaetano Ghidetti (1762), a single aisle, and frescoes by Antonio Bresciani (1762). *Secular architecture*: The Palazzo della Pilotta (begun, 16th cent.), after designs by Giovanni Boscoli, was continued in the 17th century by Giovanni Domenico Campanini, Pier Francesco Battistelli, and G. B. Magnani. The Farnese Theater (1618), by G. B. Aleotti, is annexed to it. The Palazzo Ducale, in a park, was begun in 1564 by G. B. Boscoli and remodeled by Petitot in 1767; frescoes in the interior are by Cignani and Tiarini. The Palazzo del Municipio (1627), by G. B. Magnani, retains vestiges of the 13th-century palace. The Teatro Regio by Nicola Bettoli (1829) is neoclassic. The INA Building by F. Albini (V, PL. 117) is notable among the modern buildings. *Museums*: Museo Nazionale di Antichità e Galleria Nazionale (works of Correggio, Parmigianino, Venetian painters) in the Palazzo della Pilotta; Pinacoteca Stuard; Museo Etnografico Cinese (Oriental Collection).

BIBLIOG. G. Garofani, Parma città d'oro, Parma, 1722; L. Testi, Parma, Bergamo, 1905; G. Melli, La piazza maggiore di Parma nel Medioevo, Aurea Parma, I, 3–4, 1912, pp. 25–37; L. Testi, Il Palazzo Vescovile di Parma, Aurea Parma, IV, 1920, pp. 325–35; L. Testi, S. Maria della Steccata, Florence, 1922; G. Mariotti, Le mura e le porte di Parma nel Medioevo e nel Rinascimento, Parma, I, 1933, pp. 7–13, 61–68, 203–16; L. Testi, La Cattedrale di Parma, Bergamo, 1934; G. Marussy, Una vecchia pianta di Parma romana, Crisopoli, III, 1935, p. 276; G. De Angelis d'Ossat, Cronologia costruttiva del Battistero di Parma, Palladio, IV, 1939, pp. 145–52; G. de' Francovich, Benedetto Antelami, Florence, 1952; I. Mannocci, L'oratorio di S. Colombano in Parma, Aurea Parma, XXXVII, 1953, pp. 169–76; A. Scotti, Cose viste e Parma nel 1612, Aurea Parma, XXXIX, 1955, pp. 33–36; G. Monaco, I mosaici della Piazza del Duomo e la primitiva chiesa parmense, Aurea Parma, XLI, 1957, pp. 149–59; A. Ghidiglia Quintavalle, L'Oratorio della Concezione a Parma, Parma, 1958; A. Terzaghi, Parma barocca, Aurea Parma, XLIII, 1959, pp. 153–64; F. Razzetti, Parma medievale nelle tarzie di Cristoforo da Lendinara, Aurea Parma, XLIV, 1960, pp. 41–44; P. Toesca, Il Battistero di Parma, Milan, 1960.

Piacenza (Lat., Placentia). At the terminus of the Via Emilia, on the right bank of the Po, this was a Roman colony (218 B.C.) and later a municipium. Important in the early Middle Ages as a trade center, it attained communal autonomy in the 11th century and later was a fief of various nobles. In the center of the modern city, the ancient Roman castrum is discernible in the right-angled pattern of the streets. The medieval city developed eastward, giving rise to the present elliptical plan. It was encircled with fortified walls in the 16th century and had a castle (destroyed). The Austrians converted it into a fortress in the 19th century (walls and bastions now in ruins).

The original cathedral, S. Antonino (4th cent.), fallen into ruins in the 9th century, was rebuilt in the 11th on an eastward-facing Greek-cross plan and was subsequently (13th cent.) redesigned as an inverted Latin cross with different orientation; it is noteworthy for the atrium, called "the Paradiso" (restored), by Pietro Vago (1350). The present Cathedral (1122–1233) is a domed basilica in Lombard Romanesque style with a number of Gothic features; its portal has sculpture by the school of Wiligelmo da Modena and Nicolaus (qq.v.); frescoes in the interior date from the 14th to 17th century (L. Carracci, C. Procaccini, P. F. Morazzone, Guercino); and the carved wooden chancel is by Giangiacomo da Genova (1471). S. Savino, recorded as early as the 10th century, retains 12th-century construction (restored) the 12th-century mosaics in the pavement of the transept and the crypt, and a noteworthy wooden Crucifix from the 12th century. Other medieval churches include S. Brigida (12th cent.; remodeled), S. Ilario (now housing the city archives), founded about 1120; and S. Francesco, which dates from the Gothic period (begun, 1278), with apse, ambulatory, and radial chapels. Lombard influences are apparent in the Church of S. Giovanni in Canale (founded, 1220; remodeled). The Palazzo del Comune (begun, 1281) develops the forms of the courthouses of the northern Italian cities (VI, PL. 339). It was enlarged and remodeled in later centuries. S. Sisto (1511), by Alessio Tramello, with façade reconstructed in 1755, has a nave and two side aisles with granite columns and is preceded by a barrel-vaulted narthex; in the interior are works of Guercino, Procaccini, Palma Giovane, and L. Bassano. Sto Sepolcro (1513–33) was designed by Tramello. The Madonna di Campagna (1522–28), also by Tramello, is built on a Greek-cross plan, with octagonal dome and lantern and corner chapels; the chancel was lengthened in the 18th century. Frescoes in the dome are by Pordenone and Soiaro. S. Vincenzo (1595), with nave and two side aisles, is surmounted by an octagonal dome; fresco decoration is by Andrea Galluzzi and Giovanni Battista Draghi. *Secular architecture*: The Palazzo Landi (15th cent.; now the Courthouse) has an elegant lateral marble door and terra-cotta decoration in the courtyard. The Palazzo Farnese (1558–93) was built after designs by Francesco Paciotti, under the supervision of Vignola,

but remained unfinished. Modern buildings of note include the housing unit by the architect L. Vaccaro, and the Rossi Cement Laboratory by L. Magistretti. *Museums*: Museo Civico; Galleria del Collegio Alberoni; Galleria d'Arte Moderna Ricco Oddi (19th-century Italian artists); Museo di S. Antonino.

BIBLIOG. L. Scarabelli, Guida ai monumenti storici ed artistici della città di Piacenza, Lodi, 1841; S. Fermi, Le chiese medievali di Piacenza, Milan, 1912; P. A. Corna, Castelli e rocche del Piacentino, Piacenza, 1913; G. Nicodemi, S. Sisto di Piacenza, Rass. d'arte ant. e mod., III, 1916, pp. 12–24; G. V. Arata, S. Antonino, Rass. d'arte ant. e mod., VI, 1919, pp. 37–68; P. Roi, La chiesa e il convento di S. Sepolcro, BArte, N.S., III, 1923–24, pp. 356–79; E. Nasalli Rocca, Il "castrum" medievale, B. storico piacentino, XXIII, 1928, pp. 145–56; E. Nasalli Rocca, Dell'ubicazione e della struttura architettonica dei Castelli del Piacentino, B. storico piacentino, XXIV, 1929, pp. 97–107; E. Nasalli Rocca and M. Corrado Cervi, Placentia, Arch. storico provincia parmense, 3d ser., III, 1938, pp. 45–83; P. Gazzola, Piacenza nella storia dell'architettura del Cinquecento, B. storico piacentino, XXXV, 1940, pp. 17–26; F. Buonasera, Un'antica pianta della città di Piacenza, B. storico piacentino, XLV, 1950, pp. 18–21; R. Hanslik, RE, s.v. Placentia, XL, 1950, cols. 1897–1910; A. M. Romanini, Contributo alla conoscenza del romanico piacentino, Palladio, N.S., I, 1951, pp. 78–93; G. Dosi, Come vide il Campi i monumenti piacentini, B. storico piacentino, XLIX, 1954, pp. 132–36; G. Dosi, Il Sant'Agostino del Pordenone, B. storico piacentino, XLIX, 1954, pp. 23–26; G. Dosi, Ripristini e restauri a chiese piacentine, B. storico piacentino, XLIX, 1954, pp. 82–83; A. M. Romanini, Die Kathedrale von Piacenza, ZfKg, XVII, 1954, pp. 129–62; G. Dosi, Malefatte architettoniche nella Piacenza del secolo XIX, B. storico piacentino, L, 1955, pp. 124–28; E. Nasalli Rocca, Panorami di Piacenza, Piacenza, 1955; A. M. Romanini, La Cattedrale di Piacenza dal XII al XIII secolo, B. storico piacentino, LI, 1956, pp. 1–45; E. Nasalli Rocca, Un regolamento edilizio del Cinquecento, Palladio, N.S., VII, 1957, pp. 179–80; F. Arisi, Il museo civico di Piacenza, Piacenza, 1960; G. Fiocco, S. Maria di Campagna, Bologna, 1960.

Pomposa. This small town was named after the abbey, founded in 523, which was a thriving cultural center throughout the Middle Ages and seat of a priory with civil jurisdiction. Because of the unhealthful climate the abbey declined in the 13th century. The monastic complex consists of the church, with campanile, and living quarters arranged along two sides of an open courtyard (formerly the cloister). The church (S. Maria) was built between 751 and 874. It is basilican in form, influenced by Ravenna models, with median apse that is circular inside and polygonal outside. The last two bays and the triple-arched portico, with decoration of terra cotta and majolica, and the transenna were added about the beginning of the 11th century. The interior, which has a nave and two side aisles, is decorated with 14th-century frescoes. The campanile (by Deusdedit; 1036) has courses of red and yellow brick with nine rows of cornices, slender string-courses, and conical spire. The monastic rooms — chapter hall (with Giottesque frescoes from the 14th cent.), refectory (with frescoes attributed to Pietro da Rimini, 14th cent.), and dormitory on the second floor — reveal the 12th-century construction. The Palazzo della Ragione, where the abbott dispensed justice, stands apart. Dating from the 11th century (restored), it has a gallery of Venetian type over a flat portico.

BIBLIOG. M. Salmi, L'Abbazia di Pomposa, Rome, 1936 (bibliog.); G. Zanini, L Abbazia di Pomposa, L'Architettura, II, 1956–57, pp. 594–99.

Ravenna. Built as early as the pre-Roman period on pilings in the islands of the lagoon in the Po delta, it was separated from the mainland by broad swampy areas slowly silted up over the ages; the city is now on a plain about 7 miles from the sea. It was inhabited, according to tradition, by Etruscans and Umbrians; it became a Roman municipium, with a rectangular perimeter and grid plan, still discernible today. Augustus built the military port of Classis there. Dating from the Augustan age are the relief bearing the likenesses of the members of the Julio-Claudian family and a considerable number of polyconic steles, several bearing portraits of soldiers from the fleet of Classis. In 402 Honorius moved the imperial headquarters there and made it a bulwark against the barbarians. The city continued to expand, first to the north and then to the east. Enriched with monuments by Galla Placidia and by the barbarian kings Odoacer and Theodoric, it reached its zenith when it became the seat of the Exarchate in 544, in the service of Byzantium. Its decline set in in the 8th century with the obstruction of the port and canals. Reclamation works, particularly the dredging of the canals, are today giving new life to the city.

As early as the beginning of the 5th century the Basilica Ursiana (Church of the Anastasis) was built, backing against the walls; it was completely remodeled in the 18th century (see below, Cathedral); there remain a few fragments of 12th-century sculpture and the mosaics from the apse. Within the limits of the Caesarean city, Galla Placidia had the Church of S. Giovanni Evangelista built; it retains the basilican plan and columns with capitals on impost blocks, but little remains of its ancient decoration (X, PL. 190). In the region of

the Domus Augusta is Sta Croce (mutilated and despoiled). There are several commemorative shrines: that of St. Vitalis is within S. Vitale, and that of St. Lawrence in the so-called "Mausoleum of Galla Placidia" (early 5th cent.). The latter building, adjoining Sta Croce, is perfectly preserved. It is in the form of a Latin cross, with walls sheathed in brick adorned with vertical moldings and blind arches (II, PL. 425) and, in the interior (IV, PL. 458), very remarkable mosaics of local workmanship in which elements of the late-antique period mingle with those of incipient Byzantine art (X, PL. 179). Dating from a few years later (mid-5th cent.) is the octagonal Baptistery (of Neon,

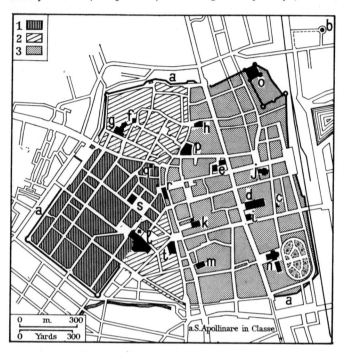

Ravenna, plan. Key: (1) Area of the Roman municipium; (2) 5th-century expansion; (3) barbarian and Byzantine addition. Principal monuments: (a) Walls; (b) Mausoleum of Theodoric; (c) ruins of the Palace of Theodoric; (d) S. Apollinare Nuovo; (e) Baptistery of the Arians and Church of the Spirito Santo; (f) "Mausoleum of Galla Placidia"; (g) S. Vitale and Museo Nazionale; (h) S. Giovanni Battista; (i) Palazzo dei Calchi (or degli Esarchi); (j) S. Giovanni Evangelista; (k) S. Francesco and the tomb of Dante; (l) Cathedral, Baptistery, and Arcivescovado; (m) S. Agata Maggiore; (n) S. Maria in Porto and Loggia del Giardino; (o) Rocca di Brancaleone; (p) Palazzo Spreti; (q) S. Domenico; (r) Palazzo Comunale; (s) Palazzo Rasponi dalle Teste; (t) Accademia di Belle Arti.

or the Orthodox), with alternating niches, and dome decorated in stucco and mosaic. In the vicinity is the Arcivescovado (bishop's palace; completely remodeled), with internal chapel (5th–6th cent.), in the form of a Greek cross, preceded by a vestibule and terminating in a semicircular apse (fresco of the *Christus militans*, and mosaics). Under Theodoric (6th cent.) the Arians juxtaposed their own monuments with the Catholic ones. Among these are the former Church of S. Teodoro (now the Church of the Spirito Santo, rebuilt in the 16th cent.), which still has 6th-century columns, capitals, and ambo; and the octagonal Baptistery of the Arians with mosaic in the dome. Within the limits of the Caesarean city, Theodoric built his own palace and S. Apollinare Nuovo (probably the pontifical church), basilican, with nave and two side aisles, adorned with mosaics in three registers. The upper band represents scenes from the life of Christ; the center, prophets and saints; and the lower band was completed by the *Procession of the Virgins and Martyrs* (III, PL. 301) in the mid-6th century. The city of Theodoric ended to the eastward in the field of the Coriandro, where the so-called "Cuirass of Theodoric" was found. There stands the tomb of the Ostrogothic king (IV, PL. 457), decagonal on the outside but in the form of a Greek cross on the interior, with great limestone conchs and monolithic dome. Under the reign of Amalasunta work was begun on the construction of S. Vitale (II, PL. 430), which was consecrated by Maximian (547 or 548). Octagonal in plan, the church is preceded by an apsidal narthex and triangular connecting vestibules, with triforia terminating in two staircase towers. Within (I, PLS. 384, 411), the center room opens into exedrae which lead into an ambulatory on the ground floor and a gallery on the upper level; the center room is surmounted by a dome. The main apse is flanked by two apsidioles, the *prothesis* and *diaconicon* (II, FIG. 775). The mosaics depicting the Court of Theodora and Justinian (II, PLS. 440,

446; IV, PL. 18) are by Byzantine masters, the others by local artists; the capitals with impost blocks are noteworthy. Building activity continued with the erection of S. Apollinare in Classe (consecrated in 549; II, PL. 430), with atrium (now gone), exonarthex flanked by towers (restored), and basilican interior (II, PL. 431) with contemporaneous mosaics (X, PL. 181) and sarcophagi from different periods. After the 6th century only enlargements (crypts) and restorations are noted. In the 9th and 10th centuries, cylindrical campaniles were erected, with varying numbers of rows of windows (e.g., S. Apollinare Nuovo, S. Apollinare in Classe). In the Romanesque and Gothic periods there was a resumption of construction by the religious orders. S. Maria in Porto Fuori was built by the Portuensi (1096; rebuilt after the 1944 bombardment), and the now deconsecrated S. Chiara (13th cent.) by the Franciscans.

From the 16th century onward construction was chiefly devoted to the alteration and restoration of earlier buildings such as the Palazzo Comunale (with portico) and the adjacent Palazzetto Veneto (1462). The Rocca di Brancaleone, a Venetian fortress (1457), was partially dismantled in the 17th–18th century. The Loggia del Giardino (1508) is in Lombard style. S. Agata Maggiore (rebuilt about 1600 over a 5th-cent. building) has a Renaissance façade and a basilican interior with nave and two side aisles; within are an ambo (8th cent.) and a wooden choir (1545) by Alessandro Bigni. The cylindrical campanile is of 1560. S. Maria in Porto (begun, 1553) has an 18th-century façade by Camillo Morigia, interior with nave and two side aisles, a Byzantine marble relief of the "Greek Madonna," wooden choir (1593), and canvases by Scarsellino and Palma Giovane. S. Giovanni Battista, by Pietro Grossi, is 17th-century; it overlies a 5th-century building, of which parts of the apse remain, and has a cylindrical campanile. S. Domenico (1269) was remodeled in the 14th century and rebuilt in 1699–1703 after designs by Giovanni Battista Contini. S. Maria Maggiore, rebuilt in 1671 over an earlier 6th-century building, has retained the original columns with capitals and portal. Dating from the 18th century are the Rasponi dalle Teste and Spreti palaces. The Cathedral, rebuilt in 1743 over the Basilica Ursiana by Giovanni Francesco Buonamici, has a dome by G. Pistocchi and a cylindrical campanile of the 9th–10th century; the interior, with nave and two side aisles, preserves a 6th-century ambo and the sarcophagi of St. Rainaldo Concoreggio and St. Barbaziano. The Chapel of the Sacrament, by Carlo Maderno, has frescoes by Guido Reni and assistants (1620). The tomb of Dante, by Pietro Lombardo (1483), lies within a small temple designed by Morigia (1780). *Museums*: Museo Nazionale; Museo Arcivescovile (with the so-called "throne of Maximian," 6th cent.); Pinacoteca dell'Accademia di Belle Arti.

BIBLIOG. C. Ricci, Ravenna, Bergamo, 1902; H. Duetscke, Ravennatische Studien, Leipzig, 1909; Ministero Pubblica Istruzione, Elenco degli edifici monumentali: Ravenna, Rome, 1916; C. Diehl, Ravenne, 3d ed., Paris, 1928; G. Galassi, Roma o Bisanzio, Rome, 1929; G. Gerola, I monumenti di Ravenna bizantina, Milan, 1930; M. Baratta, Topografia antica di Ravenna e del suo territorio, Felix Ravenna, N.S., II, 1931, pp. 33–37; A. Torre, Il porto di Ravenna, Felix Ravenna, N.S., IV, 1934, pp. 186–206; H. Kähler, Die Porta Aurea in Ravenna, RM, L, 1935, pp. 172–224; G. Gerola, L'orientazione delle chiese in Ravenna antica, RIASA, V, 1936, pp. 242–66; E. Dyggve, Ravennatum Palatium Sacrum, Copenhagen, 1941; O. G. Simson, Sacred Fortress, Chicago, 1948; G. A. Mansuelli, La situazione geografica e storica di Ravenna nell'antichità, S. Romagnoli, I, 1950, pp. 257–63; F. W. Deichmann, Gründung und Datierung von S. Vitale zu Ravenna, Arte del primo millennio (Atti II Conv. int. S. Alto Medioevo), Turin, 1953, pp. 111–17; C. O. Nordström, Ravennastudien, Stockholm, 1953; A. Benini, Architettura e scultura rinascimentale a Ravenna, Ravenna, 1954; M. Mazzotti, La basilica di Sant'Apollinare in Classe, Vatican City, 1954; P. Verzone, Le absidi poligonali del IV e del V secolo, Frühmittelalterliche Kunst in den Alpenländer (Akten II. Int. Kong. für Frühmittelalterforschung), Olten, Lausanne, 1954, pp. 35–40; G. Bovini, Le origini di Ravenna e lo sviluppo della città in età romana, Felix Ravenna, 3d ser., 19, 1956, pp. 38–60, 21, 1956, pp. 27–68; M. Mazzotti, L'attività edilizia di Massimiano di Pola, Felix Ravenna, 3d ser., 20, 1956, pp. 5–30; G. Bovini, Ravenna i suoi mosaici e i suoi monumenti, Florence, 1957; M. Mazzotti, Cripte ravennati, Felix Ravenna, 3d ser., 23, 1957, pp. 28–63; G. Bovini, Principale bibliografia su Ravenna romana, paleocristiana e paleobizantina, Ravenna, 1958; F. W. Deichmann, Frühchristliche Bauten und Mosaiken von Ravenna, Baden-Baden, 1958; G. de' Francovich, Studi sulla scultura ravennate, Felix Ravenna, 3d ser., 26–27, 1958, pp. 5–171; F. X. Barthl and J. Boehringer, Ravenna (introd. by F. W. Deichmann), 2 vols., Baden-Baden, 1959; G. Bovini, Il Mausoleo di Teodorico, Ravenna, 1959; C. Casalone, Ricerche sul Battistero della Cattedrale di Ravenna, RIASA, N.S., VIII, 1959, pp. 202–68; K. Wessel, San Vitale in Ravenna: ein Bau Theodorichs der Grossen? Zu alten und neuen Thesen, ZfKg, XXII, 1959, pp. 201–51; N. Duval, Palais de Théodoric, Mél., LXXII, 1960, pp. 337–71; R. Farioli, Ravenna paleocristiana scomparsa, Felix Ravenna, 3d ser., 31, 1960, pp. 5–96, 32, 1961, pp. 5–88; E. Arslam, Milano e Ravenna: Due monumenti dell'architettura paleocristiana, Felix Ravenna, 3d ser., 33, 1961, pp. 5–35; G. Bovini, Sant'Apollinare, Milan, 1961; Studi storici topografi ed archeologici sul "Portus Augusti" di Ravenna e sul territorio, Faenza classicano, 1961; G. De Angelis d'Ossat, Studi ravennati: Problemi di architettura paleocristiana, Ravenna, 1962.

Reggio Emilia (Lat., Forum Lepidi, Regium Lepidi). In a district that was densely populated during the prehistoric period, the Roman town was built in the 2d century B.C. on the Via Aemilia. Monumental cemeteries remain from the republican and Augustan periods; mosaic pavements, from the 2d cent. In the Middle Ages Reggio became a free commune, subsequently passing under the sway of various rulers, the last ones being the Este family. Renaissance and baroque edifices characterize the city in a still-medieval urban setting. The Cathedral (9th cent.; rebuilt in the 13th and at various times thereafter) has retained elements of the Romanesque façade in the partial revetment by Prospero Spani (1544); it is dominated by an octagonal tower with copper Madonna by Bartolomeo Spani (1552). The interior, rebuilt in the 17th century, has a nave and two side aisles with piers and barrel vaults, elevated chancel over the crypt with three semicircular apses, tombs of Valerio Malaguzzi and Bishop Arlotti by B. Spani; tomb of Bishop Rangone; tombs of Girolamo Fossa and Cherubino Sforzani; and ciborium by P. Spani. The Baptistery (S. Giovanni Battista), incorporated into the façade of the bishop's palace, assumed its present form in the late 15th century. The Torre del Comune (del Bordello) is of the same period. The Madonna della Ghiara (begun, 1597, by Alessandro Balbi) has a dome by Francesco Pacchioni (1619); the interior, in the form of a Greek cross, is rich in frescoes. S. Giovanni Evangelista, a single-aisled church, has a Deposition in terra cotta by Guido Mazzoni. The Benedictine church, SS. Pietro e Prospero, rebuilt (1586–89) by Giulio della Torre, has a dome by Paolo Messori (1629) and façade by Pietro Armani (1782); there are modern frescoes (1930) by Anselmo Govi in the single-aisled interior. The cloisters of the former monastery are by Prospero and Francesco Pacchioni and B. Spani (16th cent.). S. Prospero (10th cent.; rebuilt in 1514–27) has an 18th-century façade (1748–53) by Giovanni Battista Cattani; within, nave and two side aisles with frescoes; the octagonal campanile, incomplete, is by Cristoforo Ricci (1551). S. Agostino was rebuilt in the 15th century by Antonio Casotti (apse and campanile still extant) and subsequently in 1651–66 by Gaspare Vigarani. S. Gerolamo, also by Vigarani (1646), consists of three superimposed churches, one of which is circular. S. Giorgio (1638) was enlarged in 1743 by Alfonso Torregiani, who added the dome and transept; the interior has frescoes by Bibiena. Secular architecture: The Palazzo Comunale (1414) was rebuilt in the 18th century. The Casa Ruini and the little palace called "Boiardi" are elegant private dwellings of the 16th century. Neoclassic buildings of the 19th century include the Palazzo Corbelli by Pietro Marchelli and the Municipal Theater (C. Costa). In the 20th century, the Palazzo del Capitano del Popolo was rebuilt in Gothic style. Notable recent buildings are the INA apartments, the Chamber of Commerce and Mercantile Exchange, and the Chiesa della Vecchia by the architect Manfredini (1959). Museums: Musei Civici (with notable paleolithic collection including the "Venus" of Chiozza); Galleria Anna e Luigi Parmeggiani (Flemish paintings, El Greco).

BIBLIOG. O. Siliprandi, Tempio della B. Vergine della Ghiara, Reggio Emilia, 1924; R. Andreotti, Due centri romani dell'Emilia occidentale: Regium Lepidi e Fidentia, Historia, III, 1929, pp. 464–60; O. Siliprandi, Tempio dei Santi Pietro e Prospero, Reggio Emilia, 1930; A. Solari, Brixellum, Athenaeum, N.S., IX, 1931, pp. 420–25; A. Fulloni, Reggio Emilia, Bergamo, 1934; O. Siliprandi, Scavi archeologici, Reggio Emilia, 1936; G. Piccinini, Piante e vedute di Reggio nell'Emilia, Deputazione Storia Patria per l'Emilia e la Romagna, Sezione di Modena, S. e doc., II, 1938, pp. 155–76, 209–22; M. Corradi Cervi, Municipium Forum Lepidi Reggi, Emilia romana, I, Florence, 1941, pp. 41–71.

Rimini (Lat., Ariminum). A port on the Adriatic, the town was probably Etruscan, Umbrian, and later Gallic; it became a colony of the Romans in 268 B.C. Remaining from the Roman period are the Arch of Augustus (27 B.C.), serving as a monumental gate to the city at the outlet to the Via Flaminia; the Bridge of Tiberius; the amphitheater, perhaps from the first imperial period; and the walls. The regular urban plan is discernible. A commune in the medieval period, it reached its zenith under the rule of the Malatestas (15th cent.). The Palazzo dell'Arengo (1204, remodeled) has a portico below, with pointed arches, and above a row of multiple-arched windows (PL. 187); in the interior is a large salon with frescoes (14th cent.). The Palazzo del Podestà (ca. 1334) has been extensively remodeled. S. Agostino (1247), with single aisle, was rebuilt in the 18th century and decorated with stucco by Bibiena and frescoes by Vittorio Bigari; it preserves frescoes of the 14th-century Rimini school. The tall campanile is Gothic.

Particular importance attaches to the building activities during the Renaissance. The Castello Sigismondo (Malatesta), completed in 1446, is now a ruin. Refacing and remodeling of the Gothic Church of S. Francesco (renamed Tempio Malatestiano) was begun by Leon Battista Alberti (q.v.); Matteo de' Pasti supervised the execution of the Albertian project and the refinishing of the interior. The façade (I, PL. 52) is divided into three sections by fluted semi-

columns, between which are three semicircular blind arches. The upper part, with broken triangular tympanum, is incomplete. The flanks, broken at regular intervals by imposing semicircular arches separated by piers, house the tombs of a number of Humanists. The interior, which has a nave flanked by chapels, retains the Gothic plan, the structure of which is enriched by Renaissance sculptural decoration created by Agostino di Duccio (q.v.) and his assistants (III, PL. 302). Noteworthy in the interior are the tombs of Sigismondo Malatesta and Isotta degli Atti (IV, PL. 400); the Arca degli Antenati e dei Discendenti (1454; A. di Duccio); the Chapel of the Reliquaries, with fresco by Piero della Francesca (1451); the Chapel of the Liberal Arts, with allegories by Agostino di Duccio; and a Crucifix attributed to Giotto (VII, PL. 377).

In 1551–78, on the site of the Benedictine Abbey (9th cent.), S. Giuliano was rebuilt with a single aisle; within are the Martyrdom of St. Giuliano by Veronese and a polyptych by Bittino da Faenza (1409). In the baroque period the Palazzo Comunale was built (1687) by Francesco Garampi. S. Maria dei Servi (ca. 1357) was rebuilt in 1779 by Gaetano Stegani; it has a single aisle and stucco decoration by Antonio Trentanove. Giovanni Francesco Buonamici designed the clock tower (1759; now rebuilt). Museums: Museo Civico; Pinacoteca Comunale; Museo Missionario Francescano.

BIBLIOG. T. Temanza, Della antichità di Rimino, II, Venice, 1741; L. Tonini, Rimini avanti il principio dell'era volgare, Rimini, 1848; L. Tonini, Rimini, dal principio dell'era volgare all'anno MCC, Rimini, 1856; C. Ricci, Il Tempio Malatestiano, Milan, 1925; A. Pica, La chiesa di S. Francesco, Italia sacra, I, 1928, pp. 621–806; G. A. Mansuelli, Ariminum, Rome, 1941; G. A. Mansuelli, Additamenta ariminensia, S. riminesi in onore di G. Lucchesi, Faenza, 1952, pp. 113–28; C. Brandi, Il Tempio Malatestiano, Turin, 1956; N. Matteini, Rimini, Rocca San Casciano, 1956; N. Matteini, Rimini e suoi dintorni, Bologna, 1956; G. A. Mansuelli, La posizione storica dell'arco di Augusto, Atti V Conv. naz. Storia Arch. (1948), Florence, 1957, pp. 167–71; M. Salmi, La facciata del Tempio Malatestiano, Comm, XI, 1960, pp. 244–47; G. Soergel, Die Proportionslehre Albertis und ihre Anwendung an der Fassade von S. Francesco in Rimini, Kchr., XIII, 1960, pp. 348–51.

Spina. An ancient city, ascribed by tradition to the Pelasgi, built probably toward the end of the 6th century at the mouth of a now silted-up branch of the Po, Spina became the greatest Etruscan port of call of the Po area and of northern Italy on the Adriatic, with intensive traffic with Greece. It began to decline because of its increasing separation from the sea and the Gallic invasion (4th cent.). In the Roman period it had shrunk to a small village. Two vast cemeteries have been discovered and excavated in the Trebba and Pega "valleys," now reclaimed, to the west. Finds include Attic vases (XI, PL. 188), largely from the 5th century B.C., Etruscan bronzes, and metalwork (Ferrara, Mus. Arch.). By means of aerial photography and a number of soundings, the town has been definitely located, standing on pilings in the midst of canals.

BIBLIOG. S. Aurigemma, Il R. Museo di Spina, Ferrara, 1935; M. G. Vallet, Athènes et l'Adriatique, Mél, LXII, 1950, pp. 33–52; P. E. Arias and N. Alfieri, Il museo archeologico di Ferrara, Ferrara, 1957; N. Alfieri, P. E. Arias, and M. Hirmer, Spina, Florence, 1958; Spina e l'Etruria padana, SEtr, XXVII, 1959, Sup; Mostra dell'Etruria padana e della città di Spina (exhibition cat.), 2d ed., 2 vols., Bologna, 1961.

Velleia (Lat., Veleia). In the midst of the Apennines, south of Piacenza, it was built over a pre-Roman town of the Liguri Veleiates; it became a Roman colonia in 89 B.C., then a municipium in 49. Landslides caused the town to be abandoned after the downfall of the empire. It was built on terraces, necessitated by the nature of the terrain. Discoveries include the forum and basilica, adorned with statues of members of the Julio-Claudian family (now in Parma, Mus. Naz. di Antichità), a small amphitheater, houses, three public buildings, and the baths. Velleia is the source of the bronze Tabula Alimentaria of Trajan, a basic document on the agricultural economy of the district. The Antiquarium containing bronzes, coins, architectural fragments, and casts of the sculptures which are now in Parma.

BIBLIOG. G. Monaco, Velleia, La Spezia, 1936; S. Aurigemma, Velleia, Rome, 1940; G. Monaco, Museo di Parma e scavi di Velleia, Parma, 1948; G. Monaco, Velleia romana, Piacenza, 1954; Studi Veleiati, Atti e mem. del I Conv. di S. storici e archeol., Piacenza, 1954.

(b) Republic of San Marino. This is the oldest surviving town-republic in Europe, having developed about a religious community founded by St. Marinus (4th cent.) on Mount Titanus, on the border between the Marches and Romagna. The city of San Marino is predominantly medieval in appearance, with remarkable ruins of three concentric rings of walls from the 13th–16th centuries, surmounted by three towers (La Rocca, La Cesta, and Il Montale). The Rocca (Geraita) is surrounded by two rows of walls; the original medieval construction (probably 11th cent.) underwent remodeling in the 15th–17th centuries. La Cesta is a 15th-century pentagonal tower encircled

by walls. Il Montale (13th cent.) was rebuilt in the 18th and 19th centuries and restored in 1935. The principal buildings are much restored. S. Francesco dates from 1361; the façade was transformed by 17th-century additions (1631; portico) and heightening during the 19th century; the original structure of the single-aisled interior is completely concealed by an 18th-century superstructure. There remain frescoes from the 14th-century school of Rimini. S. Pietro (16th cent.) was completely remodeled in the 19th century. The Basilica of S. Marino (1836; by Antonio Serra) is neoclassic; the interior is basilican, with nave and two side aisles, containing sculptures by Tadolini and others. The campanile is of the 14th century. Palaces of nóte are the Valloni (15th cent., with 17th-cent. wing) and the Neo-Gothic Palazzo del Governo (1894) by Francesco Azzurri. The Palazzo Valloni houses a museum with archaeological and numismatic collection, antique ceramics, and paintings, particularly from the 17th century.

BIBLIOG. C. Ricci, La pittura a S. Marino, Rass. d'arte, I, 1901, pp. 129–32; C. Ricci, La Repubblica di San Marino, Bergamo, 1903; G. Zani, Le fortificazioni del Monte Titano, Naples, 1933; M. V. Brugnoli and E. Zocca, Guida di San Marino, Rome, 1953.

Tuscany (It., Toscana). The preeminent position of Tuscany in the development of Italian civilization and its great wealth of monuments and works of art are largely the legacy of the Middle Ages and the Renaissance. Even in antiquity, however, it was the center of the Etruscan civilization, and the modern region corresponds mainly to that of the Etruscans, or Tusci, from whom the name Tuscany derives. (For southern Etruria, see *Latium*.) From these people there remains an architectural, monumental, and artistic heritage of the first importance. Many of the cities founded by them have led an uninterrupted existence to the present time. Other great cities, such as Florence and Siena, were founded by the Romans, whose domination began in the 4th century B.C. But in the 11th century many of the cities became independent communes, initiating the most flourishing period of Tuscan history. Romanesque architecture, drawing its inspiration from traditional classical forms, spread from the focal centers of Florence and Pisa; to this were added later Gothic forms. Sculpture received an impetus through the Pisan school, and medieval painting reached a high point during the 13th and 14th centuries in Florence and Siena. From the 15th century onward, Florence, as the center of activity of the great masters of the Renaissance, assumed a leading role in the world of art throughout the whole of Italy and Europe. So strong was the imprint of the Renaissance in Tuscany that baroque forms are relatively scarce. On the other hand, later developments such as neoclassicism, 19th-century painting, and modern architecture have had important results in Tuscany.

BIBLIOG. F. Fontani, Viaggio pittorico della Toscana, Florence, 1801; E. Repetti, Dizionario geografico-storico della Toscana, 6 vols., Florence, 1833–46; C. Stegmann and H. von Geymüller, Die Architektur der Renaissance in Toscana, 11 vols., Munich, 1855–1908; G. E. Saltini, Le arti belle in Toscana da mezzo il secolo XVIII ai di nostri, Florence, 1862; G. Milanesi, Sulla storia dell'arte toscana, Siena, 1873; G. Rohault de Fleury, La Toscana au moyen-âge, 2 vols., Paris, 1874; G. Dennis, The Cities and Cemeteries of Etruria, 3d ed., London, 1883; J. C. Raschdorff and A. Haupt, Palastarchitektur von Ober-Italien und Toscana vom XIII. bis zum XVIII. Jahrhundert, 6 vols., Berlin, 1886–1922 (rev. ed., 3 vols., London, 1931); E. Müntz, Florence et la Toscana, Paris, 1897; V. Marmottan, Les arts en Toscane sous Napoléon, Paris, 1901; K. Biebrach, Die Holzgedeckten Franziskaner- und Dominikanerkirchen in Umbrien und Toskana, Berlin, 1908; C. Kreplin, Die Anfänge der Gotik in Toskana, Leipzig, 1909; P. Bacci, Documenti toscani per la storia dell'arte, 2 vols., Florence, 1910–12; B. Patzak, Palast und Villa in Toskana, 2 vols. (Die Renaissance und Barockvilla in Italien, II), Leipzig, 1912–13; A. Solari, Topografia storica dell'Etruria, 3 vols., Pisa, 1918–20; H. D. Eberlein, Villas of Florence and Tuscany, Philadelphia, 1922; SEtr, 1927 ff., *passim*; H. Bodmer, Die skulpierten romanischen Kanzeln in der Toskana, Belvedere, XII, 61–62, 1928, pp. 3–17; M. Salmi, L'architettura romanica in Toscana, Milan, Rome, 1928; M. Tinti, L'architettura delle case coloniche in Toscana, Florence, 1934; W. Paatz, Werden und Wesen der Trecento Architektur in Toskana, Burg am M., 1937; R. Biasutti, La casa rurale nella Toscana, Bologna, 1938; G. Franceschini, Chiese a coppie in territori arimannici dell'alta valle del Tevere, Atti I Cong. int. S. Longobardi, Spoleto, 1951, pp. 323–29; M. Fondi, La casa rurale nella Lunigiana, Florence, 1952; W. Braunfels, Mittelalterliche Stadtbaukunst in der Toskana, Berlin, 1953; O. Demus, Der toskanische Inkrustationstil und Venedig, Alte und neue Kunst, III, 1954, pp. 1–7; M. Salmi, Chiese romaniche nella campagna toscana, Milan, 1958; L. Banti, Die Welt der Etrusker, Stuttgart, 1960; M. Santangelo, Musei e monumenti etruschi, Novara, 1960; M. Salmi, Chiese romaniche della Toscana, Milan, 1961.

Arezzo (Lat., Arretium). Etruscan city, allied with Rome in the late 4th century, later a municipium, and, under the empire, a colonia. Of the Etruscan-Roman period there remain sectors of the walls, terra-cotta revetments from a 5th-century Etruscan temple, and traces of a number of potteries which produced the famous

Arretine pottery during the 1st century B.C. and the 1st century of our era. Among the most important discoveries made in the city (in the 16th century) are the Etruscan Chimera (V, PL. 40) and a bronze statue of Minerva (now, Mus. Arch., Florence). The plan and appearance of the city are predominantly medieval; the oldest section, surrounded by walls, was modified at various times during the Renaissance. A modern quarter has been developed on the level ground to the southwest.

The most intensive period of building began in the mid-13th century. One of the most important Tuscan Romanesque churches, the Pieve di S. Maria (I, PL. 388), dates mainly from this period, although it was altered many times later. The façade, erected in the early 13th century, shows Pisan influences in its tiers of blind arches and horizontal coping. The sculptured portals of Lombard influence date from 1216–21. The interior has a nave and two aisles, with an open-trussed timbered ceiling, divided by columns supporting pointed arches. The presbytery is raised above the crypt. The high altar has a polyptych by Pietro Lorenzetti (IX, PL. 191). The massive rectangular campanile was completed in 1330. The most important group of secular Romanesque buildings, on the Piazza Grande, includes the Palazzo Pretorio (14th cent., restored in 1933), the Torre della Bigazza (1351), and the Palazzo del Comune (1333). The city contains many Gothic buildings. S. Domenico (1275) has a sculptured portal and, in the interior, 14th- and 15th-century frescoes by Arretine and Sienese artists and a Crucifix by Cimabue (III, PL. 320). The Cathedral was begun in the late 13th century in a transitional Romanesque-Gothic style, but construction went on in the 14th and 16th centuries and was completed in the present century. The interior has a long nave with two lateral aisles divided by Gothic arches on cruciform piers and ends in a polygonal apse with wide, double-arched windows. The stained-glass windows are mostly by Guglielmo de Marcillat (1518–20). Among the important monuments in the Cathedral are the tomb of Bishop Guido Tarlati by Agostino di Giovanni and Agnolo di Ventura of Siena (1330), the frescoes of the Sienese school in the Tarlati Chapel, the fresco *Mary Magdalene* by Piero della Francesca, and terra cottas by Andrea della Robbia in the Chapel of the Madonna del Conforto. S. Francesco, begun in 1322 in a Franciscan Gothic style, has a nave decorated with frescoes of the 14th and 15th centuries; in the Guasconi Chapel are frescoes by Spinello Aretino (III, PL. 311), and in the choir is the great fresco cycle *The Legend of the True Cross* by Piero della Francesca (XI, PL. 159). The Palazzo della Fraternità dei Laici, originally begun as a Gothic structure (1375–77), was enlarged in the 15th century on Renaissance lines by Bernardo Rossellino, who also began the sculpture on the façade (completed by Giuliano and Algozzo da Settignano, 1460). The Palazzo della Dogana, begun in 1445 by Donato di Leonardo Bruni, has been restored since 1945. The Church of the SS. Annunziata was begun in 1491 from designs by Bartolomeo della Gatta and completed in 1517 by Antonio da Sangallo the Elder. The interior, with three aisles divided by piers, has stained-glass windows by Guglielmo de Marcillat (1509) and works by Pietro da Cortona, Giorgio Vasari, Matteo Rosselli, and Spinello Aretino. S. Maria delle Grazie (PL. 191) has a nave with a groin-vaulted ceiling; the portico (late 15th century) is by Benedetto da Maiano.

Other structures of interest include the Palazzo delle Logge (1573–81) designed by Vasari; the church of the Badia (SS. Flora and Lucilla; 13th cent.), enlarged by Vasari, with works by Vasari and Benedetto da Maiano; S. Maria in Gradi, rebuilt by Bartolommeo Ammanati in 1592, incorporating the crypt of the old church (10th or 11th cent.); the Fortress of the Medici, designed by Giuliano and Antonio da Sangallo (16th cent.); and the Fontana Pubblica (16th cent.). A number of medieval churches have been rebuilt in modern times, including S. Michele (originally 13th cent.), S. Agnese (retaining part of the 11th-cent. façade), and S. Lorenzo. The Via di Borgunto, is a good example of a 16th-century city street. *Museums*: Pinacoteca and Museo dell'Arte Medioevale e Moderno, with works by medieval, Renaissance, and modern Tuscan artists; Museo Archeologico Mecenate (in the former Monastery of S. Bernardo), Etruscan and Roman art, and Arretine pottery; and the house of Giorgio Vasari (decorated by the artist), with the Vasari Archive and works by Tuscan mannerists. Monte San Savino, 14 miles southeast of Arezzo, is the birthplace of Andrea Sansovino. It has a number of buildings designed by the artist, and other Renaissance structures, including the Loggia del Mercato, designed jointly by Sansovino and Antonio da Sangallo the Elder.

BIBLIOG. A. Fischer, Monte San Savino, ZfbK, XIV, 1879, pp. 149–52; G. Franciosi, Arezzo, Bergamo, 1909; M. Falciati, Arezzo: La sua storia e i suoi monumenti, Florence, 1910; G. Arata, Il Duomo d'Arezzo, Rass. d'arte ant. e mod., XIV, 1914, pp. 265–77; M. Salmi, L'architettura romanica nel territorio aretino, Rass. d'arte ant. e mod., XV, 1915, pp. 30–42, 63–72, 134–44, 156–64; M. Salmi, La Cattedrale di Arezzo, L'Arte, XVIII, 1915, pp. 373–91; E. Pernier, Arezzo: Ricerche per la scoperta delle antiche mura urbane laterizie nei terreni di "Fonte Pozzolo" e "Catona," NSc,

1920, pp. 167–215; C. Lazzeri et al., Arezzo etrusca, SEtr, I, 1927, pp. 99–127; C. Lazzeri, Resti dell'antica cerchia urbana di Arezzo, SEtr, VI, 1932, pp. 533–42; D. Viviani-Fiorini, La "Badia" di Arezzo e Giorgio Vasari, Il Vasari, XII, 1941, pp. 74–83; D. Viviani-Fiorini, La costruzione delle Logge Vasariane di Arezzo, Il Vasari, XII, 1941, pp. 109–17, XIII, 1942, pp. 39–46; G. Maetzke, Terrecotte architettoniche etrusche scoperte ad Arezzo, BArte, XXXIV, 1949, pp. 251–53; M. Salmi, San Domenico e San Francesco di Arezzo, Rome, 1951; G. Caputo, Arezzo, FA, IX, 1954, 4379, X, 1955, 165, 4296, XI, 1956, 2632; G. Maetzke, Tomba con urnetta iscritta trovata in Arezzo, SEtr, XXIII, 1954, pp. 353–56; A. Stenico, Matrici a placca per applicazioni di vasi aretini del Museo Civico di Arezzo, AC, VI, 1954, pp. 43–77, 315–16; L. Berti, La casa del Vasari, Florence, 1955; A. Stenico, Il vaso pseudocorneliano con le monete e l'opere di C. Cispius, AC, VII, 1955, pp. 66–74; A. Del Vita, Guida di Arezzo, Arezzo, 1956; G. Maetzke, EAA, s.v. Arezzo, I, 1958, pp. 617–18; F. Coradini, La chiesa monumentale della SS. Annunziata in Arezzo, RArte, XXXV, 1960, pp. 107–42; M. Salmi and U. Lumini, La chiesa inferiore di S. Francesco d'Arezzo, Rome, 1960.

Asciano. The site was inhabited in ancient times, as attested by an Etruscan underground burial place with urns and vases. The town has a medieval appearance and is surrounded by 14th-century walls. It was under Sienese domination from 1285 to 1554. The Collegiata (S. Agata) is a Romanesque church (11th cent.; interior restored). S. Agostino, originally Romanesque, was rebuilt in Gothic style. S. Francesco (14th cent.) is Romanesque-Gothic; the interior was remodeled in the 17th century. *Museums*: Museo di Arte Sacra, in the former church of the Compagnia della Sta Croce, with paintings of the 15th-century Sienese school; Museo Etrusco. *Environs*: Abbey of Monte Oliveto Maggiore, founded 1313, has a church built in 1400–17 but remodeled several times. Its interior was remodeled in 1772. The 15th-century Great Cloister is decorated with frescoes, the *Life of St. Benedict*, by Luca Signorelli (1497–1501) and Giovanni Antonio Bazzi (Sodoma; 1505–08). Buonconvento, founded in the 13th century, is surrounded by 14th-century walls and retains its medieval layout. The parish church, remodeled in the 18th century, contains the *Madonna and Child with Saints* by Matteo di Giovanni; adjoining is a museum with paintings of the Sienese school.

BIBLIOG. G. Carocci, Il restauro della Collegiata di Asciano, Arte e storia, IV, 1885, pp. 161–63; G. Clausse, Les origines bénédictines: Subiaco, Mont-Cassin, Monte Oliveto, Paris, 1899; A. Liberati, Buonconvento, B. senese storia patria, N.S., IV, 1933, pp. 164–81; E. Carli, Il nuovo museo d'arte sacra di Asciano Senese, BArte, XXXVII, 1952, pp. 83–85; R. M. Capra, Monte Oliveto Maggiore, Seregno, 1954; E. Carli, L'abbazia di Monte Oliveto, Milan, 1961.

Certaldo. This town of the feudal period, surrounded by walls, developed around the castle of the Alberti, counts of Vernio. The old part, on a hill, retains its original medieval aspect, with fountains in the Sienese style, towers, and brick houses. The Church of SS. Michele e Jacopo (13th cent., restored) has a nave ending in a semicircular apse with a trussed ceiling. It adjoins a small 14th-century cloister. S. Tommaso (deconsecrated) is probably of the 13th century and retains a Romanesque-Gothic façade. The Palazzo del Vicariato (or Pretorio) was rebuilt in the 15th century, when the Loggia was added (restored, 1893). The Chapel of the Madonna della Tosse (formerly Tabernacolo dei Giustiziati) contains frescoes by Benozzo Gozzoli and Giusto d'Andrea (1466). The Casa di Boccaccio, said to have been the residence of the writer, is a reconstruction of the original. The Porta del Sole was remodeled in 1570.

BIBLIOG. N. Cioni, Il palazzo vicariale di Certaldo, Misc. storica della Valdelsa, X, 1902, pp. 75–97; A. Arrighi, La chiesa dei SS. Michele e Jacopo di Certaldo..., Orvieto, 1913; G. Luschi, La decadenza del palazzo vicariale di Certaldo, Misc. storica della Valdelsa, XLI, 1933, pp. 13–30; I. Malenotti, Notizie istoriche riguardanti il castello di Certaldo, Certaldo, 1956.

Chiusi (Etruscan, Clevsin, Chamars; Lat., Clusium). One of the great Etruscan cities, dominating the Valdichiana, its most flourishing period was between the 7th and 5th centuries B.C. In the 4th century B.C. it became an ally of Rome and later a municipium. It was later a Lombard duchy, then passed under the successive dominations of Orvieto, Perugia, Siena, and finally Florence (1556). There are still traces of the ancient walls and a reservoir, and the city plan is Roman. The Etruscan necropolises were mostly situated on the hills surrounding the city (Poggio Renzo, Poggio Gaiella) and as far as the lake of Chiusi. Many of them are of monumental proportions, such as the so-called "Labyrinth of Porsenna" on the Gaiella hill. The Tomba della Scimmia, on Poggio Renzo (5th cent. B.C.), has several rooms, of which two are decorated with paintings. The Tomba della Pellegrina (3d–2d cent. B.C.) still retains its sarcophagi and cinerary urns. The Tomba del Granduca (3d–2d cent. B.C.) has a barrel-vaulted chamber lined with travertine slabs. The material recovered from these tombs is typical of the local artistic production. It includes canopic anthropomorphic cinerary jars, bucchero vases with decorations in relief, urns and sepulchral pillars

with archaic carving, cinerary urns with statues and groups, painted pottery of the 4th and 3d centuries B.C., and even a considerable quantity of imported Attic pottery. There are also a few Early Christian catacombs (S. Mustiola and S. Caterina). The medieval buildings and monuments are few, and most of them have been remodeled in later times. The Cathedral, of Early Christian origin, was rebuilt in the 12th century and clumsily restored in the late 19th. The façade is neoclassic; the interior, of basilican plan, has ancient columns of different designs (probably from Roman buildings). It contains paintings by Bernardino Fungai and Benvenuto di Giovanni. In the sacristy is a collection of codices from the Abbey of Monte Oliveto Maggiore illuminated by Sano di Pietro, Liberale da Verona, Girolamo Bembo, and other 15th-century artists. The freestanding campanile (12th cent.) was altered in the 16th and 17th centuries. S. Francesco (13th cent.) has a portal and part of the façade of the Romanesque period. S. Maria della Morte (13th cent.) has been restored and partly rebuilt. There are also remains of a fortress from the late 12th century. The Museo Archeologico Nazionale contains an important collection of Etruscan art.

BIBLIOG. F. Liverani, Le catacombe e antichità cristiane di Chiusi, Siena, 1872; F. Liverani, Il ducato e le antichità longobarde e italiche d Chiusi, Siena, 1875; F. Bargagli-Petrucci, Montepulciano, Chiusi e la Val di Chiana senese, Bergamo, 1907; L. Serra, S. Vittore di Chiusi, Rass. marchigiana, I, 1922–23, pp. 126–36; R. Bianchi Bandinelli, Clusium, MALinc, XXX, 1925, cols. 210–578; D. Levi, Chiusi: La tomba della pellegrina, NSc, 1931, pp. 475–505; D. Levi, I canòpi di Chiusi, CrArte, I, 1935, pp. 18–26, 82–89; E. Paribeni, I rilievi chiusini arcaici, SEtr, XII, 1938, pp. 57–139, XIII, 1939, pp. 179–202; R. Bianchi Bandinelli, Monumenta pittura antica in Italia, I, I, Rome, 1939; G. Maetzke, Museografia e restauri di monumenti: Chiusi, SEtr, XX, 1948, p. 230; G. Maetzke, Restauri nel Museo di Chiusi, BArte, XXXV, 1950, pp. 331–35; J. Thimme, Chiusinische Aschenkisten und Sarkophage der hellenistischen Zeit, SEtr, XXIII, 1954, pp. 25–147; A. W. van Buren, Some Observations on the Tomb of Lars Porsena near Clusium, Anthemon, Florence, 1955, pp. 85–92; G. Maetzke, Per un Corpus dei bronzetti etruschi: La collezione del Museo Archeologico Nazionale di Chiusi, SEtr, XXV, 1957, pp. 489–523; M. Pallottino, EAA, s.v. Chiusi, II, 1959, pp. 559–62.

Cortona (Etruscan, Curtun; Lat., Cortona). Situated on a mountain spur overlooking the Valdichiana, Cortona was an important Etruscan city. It became an ally of Rome in the 4th century B.C. and later was a municipium. In the 13th century it became an independent commune, later subject to Arezzo and Siena; in 1411 it was sold to Florence. Of the Etruscan period there are several sections of the city walls, built of large stone blocks, without towers (5th cent. B.C.). Of the necropolises outside the city there remain the mounds (called *Meloni*) of Camucia and Il Sodo, and a circular monument of disputed date known as the "Tomb of Pythagoras." Among the important Etruscan finds are a great bronze sculptured lamp with figures of satyrs and sirens.

There are few Romanesque buildings. Parts of the old parish church (11th cent.) are incorporated into the Cathedral, rebuilt in the 15th and 16th centuries and enlarged in the 18th century. The portals are by Giuliano da Sangallo and Cristofanello Sensi. The interior has a nave and two aisles. The altar is by Francesco Mazzuoli, the canopy by Ciuccio di Nuccio (1491), and the apse contains a *Madonna and Saints* by Cigoli. The campanile dates from 1566. The Palazzo Comunale, already existing in the early 13th century, was remodeled in 1275 and enlarged in the 16th century. It still retains some of the original structure. The Palazzo del Popolo (13th cent.) was remodeled and enlarged in the 16th century. The Palazzo Pretorio (also 13th cent.) was rebuilt in late Renaissance style by Filippo Berettini (1608). One side is part of the original structure. S. Francesco (begun 1245) was remodeled in the 17th century. The interior contains works by Cigoli, an *Annunciation* by Pietro da Cortona, and a *Crucifixion* by Luca Signorelli. S. Domenico (late 14th–early 15th cent.) has a simple façade with Gothic elements; the interior has a nave ending in three rectangular apses. It contains works by Signorelli, Lorenzo di Niccolò Gerini (1402), and Bartolomeo della Gatta.

During the Renaissance, two churches were built outside the city. The Madonna del Calcinaio (1485–1513) was built from designs by Francesco di Giorgio Martini. It is a Latin cross with an octagonal dome. S. Maria Nuova (1550–54), designed by Cristofanello Sensi, is square, with a hemispherical dome. The square Medici Fortress (Grifalco), designed by Francesco Laparelli (1549), overlies the ruins of Etruscan walls and a 14th-century fortress.

Modern structures include the Sanctuary of St. Margaret of Cortona (begun 1856) in neo-Romanesque style, containing the tomb of St. Margaret by Angelo and Francesco di Pietro (1362). Nearby is the *Via Crucis*, in mosaic from designs by Gino Severini. *Museums*: The Accademia Etrusca, with the Museo dell'Accademia Etrusca, containing Etruscan and Egyptian antiquities; Diocesan Museum, annexed to the former Church of the Gesù, with works by Pietro Lorenzetti, Fra Angelico, Sassetta, and Signorelli.

BIBLIOG. G. Mancini, Cortona nel Medioevo, Florence, 1897; G. Mancini, Cortona, Montecchio Vesponi e Castiglione Fiorentino, Bergamo, 1909; A. Neppi Modona, Cortona etrusca e romana, Florence, 1925; A. Pica, S. Maria del Calcinaio, Per l'arte sacra, III, 1926, pp. 126–33; G. Maetzke, Contributi per la carta archeologica: Cortona, SEtr, XXI, 1950–51, pp. 297–99; G. Maetzke, Tazza di fabbrica chiusina nel Museo di Cortona, SEtr, XXI, 1950–51, pp. 49–53, 193–94; A. Bernardini, Cortona, Cortona, 1951; U. Lumini, Chiesa di S. Maria Nuova a Cortona, Palladio, N.S., I, 1951, pp. 130–34; A. Minto, La "Tanella Angòri" di Cortona, Palladio N.S., I, 1951, pp. 60–66; G. Maetzke, Tomba etrusca a camera in località "Il Passaggio," SEtr, XXIII, 1954, pp. 349–52; M. Demus-Quatenber, Zur Konstruktionsweise der "Tomba di Pitagora" bei Cortona, Palladio, N.S., VII, 1957, pp. 49–53, 193–94; M. Pallottino, EAA, s.v. Cortona, II, 1959, pp. 868–69.

Cosa (Lat., Ansedonia). Situated on a hill overlooking the sea, south of Orbetello, Cosa was founded as a Roman colonia and port in 273 B.C., possibly as a harbor for Vulci. Now in ruins, it retains traces of girdle walls, of polygonal stone blocks, fortified with 18 towers, and the orthogonal plan of the city. The forum was at the center, with a triple-arch propylaeum, a basilica, and an aerarium. The *capitolium* was at the summit of the acropolis, separated from the rest of the city by an inner wall, which also enclosed two temples (early 2d cent. B.C.).

On the island of Giglio (Lat., Igilium), inhabited from the Iron Age on, are the remains of a Roman villa of the Domitii Ahenobarbi, built in the 1st century B.C. and enlarged in the 1st century of our era. Remains of another Roman villa, probably contemporary with the villa at Giglio and belonging to the same family, are on the island of Giannutri.

BIBLIOG. F. E. Brown, Cosa: Exploration in Etruria, Archaeology, II, 1949, pp. 2–10; F. E. Brown, Cosa I: History and Topography, MAARome, XX, 1951, pp. 1–113; M. Lopes Pegna, La vera origine di "Cosa vulcente," SEtr, XXII, 1952–53, pp. 411–20; M. Santangelo, L'Antiquarium di Orbetello, Rome, 1954; F. Castagnoli, La centuriazione di Cosa, MAARome, XXIV, 1956, pp. 147–65; L. Richardson, Jr., Cosa and Rome: Comitium and Curia, Archaeology, X, 1957, pp. 49–55; D. M. Taylor, Cosa: Blackglaze Pottery, MAARome, XXV, 1957, pp. 65–193; A. von Gerkan, Zur Datierung der Kolonie Cosa, Scritti in onore di G. Libertini, Florence, 1958, pp. 149–56; F. E. Brown, EAA, s.v. Cosa, II, 1959, pp. 869–70; F. E. Brown and E. H. Richardson, Cosa II: The Temples of the Arx, MAARome, XXVI, 1960; G. Maetzke, EAA, s.v. Giannutri, Giglio, III, 1960, pp. 871–72, 895.

Elba (Gr., Aethalia; Lat., Ilva). The largest island of the Tuscan archipelago, it was occupied by the Etruscans of Populonia, then in the 5th century, B.C., by the Syracusan Greeks, and thereafter by the Romans, who founded a number of colonies. In the early Middle Ages it belonged to the duchy of Tuscany, was conquered by the Saracens, and then belonged in turn to Pisa, Lucca, Genoa, Spain, and France. The capital city is Portoferraio, already existing in the 4th century B.C. and called by the Romans Fabricia. In its present form it dates from the reign of Cosimo I, who acquired it in 1548 and laid out a new town from plans by Giovanni Battista Bellucci. Fortifications were built, of which the forts of Falcone and Stella, on the high ground, still exist in a fairly good state of preservation. The maritime fort of Linguella is now half destroyed. Buildings of interest include the Church of the Misericordia (1566) and the Casa dei Mulini, originally formed by two mills, enlarged and decorated in neoclassic style as a residence by Napoleon I (1814). The Pinacoteca Comunale Foresiana (in the former Villa Demidoff) contains paintings and historical objects (mostly Napoleonic) of the 17th, 18th, and 19th centuries. In the vicinity are the Villa San Martino, Napoleon I's summer residence, remodeled several times in neoclassic style, now the Napoleonic Museum; the Volterraio, a ruined Pisan fortress; and the ruins of the Church of S. Stefano, of the 12th–13th century. Among the other towns on the island are Porto Azzurro (formerly Porto Longone), with a 17th-century Spanish fortress; Marciana Marina, with a tower known as "Torre Medicea"; and Marciana, with a ruined castle of the Appiani.

The other islands of the archipelago are Gorgona (with a Pisan fortress of the 13th century, now restored), Capraia (with the 15th-century fortress of San Giorgio), and Montecristo (with ruins of a fortress and an abbey).

BIBLIOG. F. Gregorovius, Die Insel Elba, Leipzig, 1883; E. Giannitrapani, Elba, Rome, 1940; G. Monaco, Elba: Villa romana, FA, XIII, 1958, 4133.

Empoli. The city grew up around the parish church of S. Andrea after 1119. It came under Florentine rule in 1182 and was the scene of many important events of Florentine history in the 13th and 14th centuries. Sacked twice in the 16th century, it has lost much of its medieval character. The most important medieval church is the Romanesque Collegiata (S. Andrea), built in 1093, possibly on the site of a 5th-century church. The façade has a geometric pattern in white and green marble (upper part, 18th cent.). The interior

of the church (remodeled in the 18th century; restored after World War II) had a baptismal font of the school of Donatello (now in the Galleria). S. Stefano (14th cent.; remodeled several times) has a fresco by Masolino in the lunette above the sacristy door. The Church of the Madonna del Pozzo dates from 1621. The Galleria della Collegiata contains works by Lorenzo Monaco, Filippino Lippi, Masolino, Francesco Botticini, Mino da Fiesole, Antonio Rossellino, Pontormo, and other Tuscan artists.

BIBLIOG. L. Lazzeri, Storia d'Empoli, Empoli, 1873; G. Bucchi, Guida d'Empoli illustrata, Florence, 1906; O. A. Giglioli, Empoli artistica, Florence, 1906; I. B. Supino, Gli albori dell'arte fiorentina (Empoli, S. Andrea), Florence, 1906; A. Morelli, Guida ... di Empoli, Bologna, 1959.

Fiesole (Lat., Faesulae). On the summit of a hill, north of Florence, it was an Etruscan acropolis which dominated the small Etruscan settlements in the middle Arno valley, known for their production of carved funerary steles in the archaic period. In the 4th and 3d centuries B.C. it became a city. Destroyed in the Social War, it was repopulated by Sulla in 80 B.C. In the early Middle Ages, under the Lombards and Carolingian Franks it was ruled by bishops and was a flourishing city, but gradually it came under Florentine domination and was destroyed as a political power by Florence in 1125. Of the Etruscan period are the walls (pseudo-isodomic) which enclosed an Italic temple *ad alae*, the remains of which belong to the 6th, 5th, and 1st centuries B.C. The Roman theater has a *cavea* of the 1st century B.C. Of the Sullan city is a bath with an aqueduct and traces of a forum and of the *capitolium*. The Cathedral is Romanesque, enlarged in the 13th and 14th centuries and restored in 1883. It has a tripartite nave divided by columns with ancient capitals. The presbytery is raised above a crypt. The high altar has a triptych by Bicci di Lorenzo, and the Salutati Chapel contains frescoes by Cosimo Rosselli and sculptures by Mino da Fiesole. The campanile was built in 1213. The Palazzo Pretorio (now Comunale) is of the 14th century but has been altered several times. S. Francesco, also of the 14th century, but remodeled at various periods, has a unitary nave. The oratory of S. Maria Primerana, with a single aisle, has decorations of the 14th, 15th, and 16th centuries, rather radically restored. The Oratory of Sto Sepolcro contains 14th-century frescoes. S. Alessandro was built in the Early Christian period over an Etruscan, later Roman, temple. It was remodeled in the 11th century, and rebuilt in the 16th, 18th, and 19th centuries. The Seminary was built in the 17th century. The adjoining Palazzo Vescovile, originally of the 11th century, was rebuilt at the same time. *Museums:* Museo Fiesolano, with antiquities excavated in the Fiesole district; Museo Bandini, with paintings by 14th- and 15th-century Tuscan artists.

On the road between Florence and Fiesole is the Church and Monastery of S. Domenico, founded in 1406 and later enlarged. The portico on the façade and the campanile were designed by Matteo Nigetti in the 17th century. The interior of the church contains works by Lorenzo di Credi. In the chapter house of the monastery there is a fresco of the *Crucifixion* by Fra Angelico. Near S. Domenico is the Badia Fiesolana with a façade of inlaid marble in two colors (III, PL. 388). The design is geometric, similar to the design of S. Miniato in Florence. The church was remodeled and then rebuilt in the manner of Brunelleschi, on the plan of a Latin cross, in 1459–66. The frescoes in the refectory are by Giovanni da San Giovanni.

The neighborhood of Fiesole contains many villas, among which are Villa Salviati, originally a 14th-century castle, transformed into a Renaissance villa by Giuliano da Sangallo; Villa Medici (Belcanto), designed by Michelozzo in 1458–61; and Villa Rondinelli Vitelli (16th cent.). Also near Fiesole is the Convent of S. Maria Maddalena (15th cent.) with frescoes by Fra Bartolomeo.

BIBLIOG. C. de Fabriczy, La badia di Fiesole, Arte e storia, X, 1891, pp. 17–23; L. Ferretti, La chiesa e il convento di San Domenico di Fiesole, Florence, 1901; E. Galli, Fiesole, Milan, 1914; D. Brunori, L'Eremo di S. Gerolamo di Fiesole, Fiesole, 1920; E. Galli, Gli scavi governativi del Tempio etrusco-romano di Fiesole, NSc, 1925, pp. 28–36; V. Viti, La Badia Fiesolana, Florence, 1926; F. Magi, Carta archeologica d'Italia, Fiesole, Florence, 1929; A. Minto, Sistemazione della zona archeologica fra il teatro ed il tempio, NSc, 6th ser., VI, 1930, pp. 496–513; A. Rusconi, Fiesole, Bergamo, 1931; O. H. Giglioli, Catalogo delle cose d'arte e di antichità d'Italia: Fiesole, Rome, 1933; A. Minto, I teatri romani di Firenze e di Fiesole, Dioniso, VI, 1937, pp. 1–7; M. Lombardi, Faesulae, Rome, 1941; G. Maetzke, Fiesole: Un nuovo tratto di mura etrusche nella villa S. Girolamo, SEtr, XX, 1948, pp. 225–26; G. Maetzke, Scoperta di antichi avanzi nella chiesa di S. Maria Primerana, NSc, 8th ser., II, 1948, pp. 58–60; A. De Agostino, Fiesole, Rome, 1949; G. Caputo, Fiesole: Scoperta di un tempio, FA, IX, 1954, 2852; G. Caputo, Sistemazioni e scavo del santuario, FA, X, 1955, 2533; G. Maetzke, Il nuovo tempio tuscanico di Fiesole, SEtr, XXIV, 1955–56, pp. 227–53; A. De Agostino, Scavi e Museo di Fiesole, Rome, 1959; G. Caputo and G. Maetzke, Presentazione del rilievo di Fiesole antica, SEtr, XXVII, 1959, pp. 41–63; H. L. Heydenreich, Die Cappella Rucellai und die Badia fiesolana, Kchr., XIII, 1960, pp. 352–54; G. Maetzke, EAA, s.v. Fiesole, III, 1960, pp. 660–61.

Florence (It., Firenze; Lat., Florentia). Florence was founded in the Roman period on a previously inhabited site on the Arno River. In the 3d and 2d centuries B.C. Florentia was a municipium, later becoming a colonia. Under the empire it was an important city, the seat of the Corrector Italiae (3d cent.). In the Middle Ages it grew in size and importance, especially after the establishment of the commune in 1115, reaching its apogee under the *Signoria* of the Medici in the 15th century, when it was one of the leading economic and artistic centers of Europe.

The central part of the city still retains traces of the rectangular Roman plan, with a central forum (Piazza della Repubblica), and remains of the *capitolium* (2d–1st cent. B.C., restored under the empire). There are a few traces (mostly out of view) of baths, a theater,

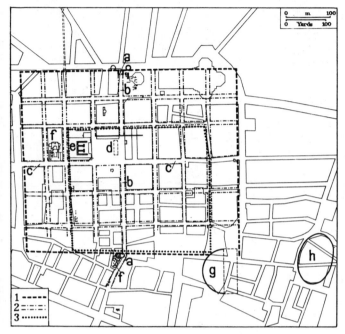

Florence, plan of the ancient city. *Key:* (1) Walls of the Roman period; (2) course of the Roman streets; (3) walls of the Byzantine period. Principal monuments: (*a*) gates; (*b*) *cardo maximus*; (*c*) *decumanus maximus*; (*d*) forum; (*e*) *capitolium*; (*f*) baths; (*g*) theater; (*h*) amphitheater.

and an amphitheater. The fusion of the compact layout of the medieval city with the more spacious Renaissance elements is perfect, and it is only since 1860, and especially since World War II (which wrought much irreparable damage), that this organic unity of the city has been compromised.

The perimeter of the earliest medieval walls (late 7th cent.) followed (with a few variants) that of the Roman walls. It formed a rectangle which enclosed the area between the Arno River and the present Piazza del Duomo, Via Tornabuoni, and Via del Proconsolo. The walls of 1172 enclosed a larger rectangle, following the river between the Carraia (1220) and Rubaconte (Ponte alle Grazie, 1237) bridges, and included an area across the Arno as far as Sto Spirito and the Pitti Palace. A third wall, built in the 13th and 14th centuries still partly exists on the south bank of the Arno. On the north it followed the circle of the modern boulevards (Circonvallazione) laid out in 1865–71, as part of the city plan of Giuseppe Poggi (who also laid out the Viale dei Colli).

There are practically no vestiges of Early Christian or early medieval buildings: they were demolished or rebuilt in the course of later enlargements of the city. The oldest important monuments date from the early period of the commune. The Baptistery (consecrated 1059; I, PL. 302) is octagonal, and the outer walls are faced with white and green marble in geometric patterns. The small tribune (*scarsella*; X, PL. 188) and the upper story are 13th-century additions. The bronze doors are by Andrea da Pontedera (Pisano; I, PLS. 228–230) and Lorenzo Ghiberti (II, PL. 290; VI, PLS. 169–174, 177). The interior of the dome and of the *scarsella* are decorated with mosaics of strong Byzantine and Roman influences (III, PLS. 12, 490). The tomb of the antipope John XXIII (III, PL. 13) is by Donatello and Michelozzo (1422–27). Also by Donatello (a late work) is the statue of St. Mary Magdalene (III, PL. 211). The façade of S. Miniato al Monte (11th–13th cent.) is also faced with white, black, and green marble in geometric designs. The lower part is a five-arched blind portico, with a 13th-century mosaic. The interior is

basilican in form, with a trussed ceiling and a raised presbytery over an 11th-century crypt. The inlaid marble floor of the nave, the *schola cantorum*, the liturgical objects, and the pulpit (PL. 182) date from 1207. The sacristy is decorated with frescoes by Spinello Aretino and others. The Renaissance shrine of the Crucifix at the end of the nave is by Michelozzo. The Chapel of the Cardinal of Portugal (1461–66) was designed by Antonio Manetti and is decorated with works by Antonio Pollaiuolo, Alessio Baldovinetti, and Luca della Robbia; the cardinal's tomb is by Antonio Rossellino. In the cloister are remains of frescoes by Paolo Uccello. SS. Apostoli (11th cent., rebuilt 15th cent.) is in basilican form, with a nave and two side aisles divided by arches on green marble columns with capitals in classic style (PL. 182). It contains works by Giovanni della Robbia, Pomarancio, and Bartolommeo Ammanati. S. Pietro Scheraggio (consecrated 1068) is now incorporated in the Palazzo degli Uffizi. It was built over an older 9th-century church, but now lacks the nave and has been altered a number of times. Other Romanesque churches retaining some original elements are S. Jacopo so-pr'Arno and S. Salvatore al Vescovo.

The first Gothic elements were introduced into Florence from across the Alps in the 13th century. They are seen in the Church of S. Maria Novella, begun about 1278 and completed about 1360, on the site of a 10th-century oratory enlarged in the 11th and 12th centuries. The façade (I, PL. 53) was designed by Leon Battista Alberti (completed 1470). The interior (VI, PL. 334) is a Latin cross, with a rectilinear apse flanked by rectangular chapels. The Gothic vaulted ceiling is supported by composite piers and arches. It contains works by Giotto, Spinello Aretino and his pupils, Nardo di Cione, Andrea di Cione (Orcagna), and Masaccio. The choir is decorated with a cycle of frescoes by Domenico Ghirlandajo and his assistants; the Strozzi Chapel has frescoes by Filippino Lippi (IX, PLS. 147, 148). The sculptures are by Lorenzo Ghiberti (1423), Filippo Brunelleschi, Bernardo Rossellino, and Giambologna. Adjoining the church is the Dominican monastery. The Chiostro Verde (second half of the 14th century) is decorated with frescoes by Paolo Uccello (XI, PLS. 37, 38, 41). The chapter house, also known as the Spanish Chapel (Cappellone degli Spagnoli), was designed by Jacopo Talenti after 1350, with frescoes by Andrea da Firenze (II, PL. 364; III, PL. 314). Sta Croce was begun in the late 13th century, replacing a small church founded in 1228. The design is attributed to Arnolfo di Cambio. The façade was built in 1853–63. The interior (I, PL. 463) has a tripartite nave, divided by octagonal piers with pointed arches, and a transept. The ceiling is trussed. The polygonal apse has 10 lateral chapels (5 on each side) decorated with frescoes by Giotto (Bardi and Peruzzi chapels; VI, PLS. 206–208), Taddeo Gaddi (Baroncelli Chapel; PL. 183; VI, PL. 380), Agnolo Gaddi (Castellani Chapel and choir; VI, PL. 380), Giovanni da Milano (Rinuccini Chapel; VI, PL. 62), Bernardo Daddi (Pulci and Berardi Chapel; IV, PL. 106), and Maso di Banco (Bardi di Vernio Chapel; IX, PLS. 369–371). The church contains important Renaissance sculptures, including the *Annunciation* by Donatello (ca. 1435), the pulpit by Benedetto da Maiano (1472–76), the monument to Leonardo Bruni by Bernardo Rossellino, and the monument to Carlo Marsupini by Desiderio da Settignano. In 1434 Michelozzo built the Chapel of the Novitiate adjoining the sacristy, adorned with reliefs by the school of Donatello and a reredos by Andrea della Robbia. In the course of later centuries the church was enriched with works by Santi di Tito, Bronzino, Vasari, and Canova. Sta Trinita, begun in 1258, possibly by Nicola Pisano (on the site of an 11th-century church, of which vestiges are visible in the crypt), was enlarged in the 14th century. The façade is by Bernardo Buontalenti (1593–94). The nave is tripartite, with Gothic arches and a cross-vaulted ceiling. There are lateral chapels on the right and left aisles and at the head of the transept. The church contains a cycle of frescoes and a panel painting by Lorenzo Monaco. The Sassetti Chapel is decorated with frescoes by Domenico Ghirlandajo and assistants (VI, PLS. 180, 182, 183). There are also works by Giuliano da Sangallo, Neri di Bicci, Desiderio da Settignano, Benedetto da Maiano, and Luca della Robbia. The Church of the Badia (founded 978) was rebuilt in the 13th century and remodeled in the 17th. Of the 13th-century structure, partly attributed to Arnolfo di Cambio, there are some remains; the hexagonal cusped campanile is of the 14th century. In the interior (remodeled 17th cent.) are traces of 14th-century frescoes, sculptures by Mino da Fiesole (PL. 192), and paintings by Filippino Lippi (IX, PL. 149), Giorgio Vasari, and others. The adjoining Chiostro degli Aranci (15th cent.) is possibly attributable to Benedetto da Maiano.

The Cathedral (S. Maria del Fiore) was begun in 1296, from plans by Arnolfo di Cambio (I, FIG. 762). The nave is tripartite, with piers and Gothic arches, and a trefoil apse by Francesco Talenti. In 1357 Talenti enlarged the original plan. The building was completed in 1461, when Brunelleschi's dome (1418–34; II, PL. 365) was crowned with the lantern. The original façade, modified by Talenti,

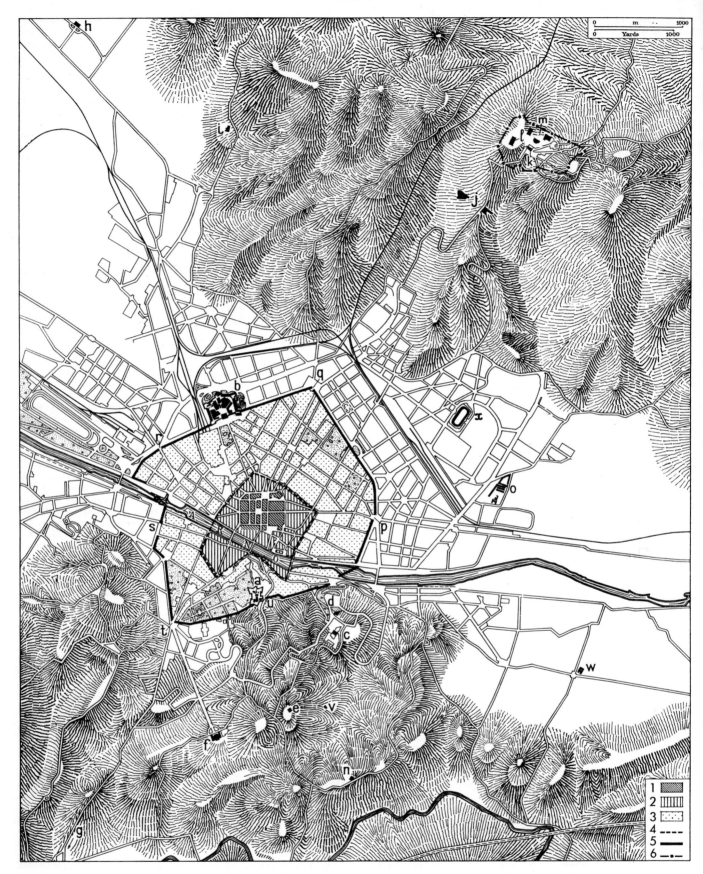

Florence and environs, with principal monuments in the immediate vicinity. *Key*: (1) Area of the Roman city; (2) expansion to the beginning of the 13th century; (3) expansion from the 13th century to 1860. Medieval and modern walls: (4) 13th-century walls; (5) 14th-century walls; (6) course and remains of Etruscan walls of Fiesole. Principal monuments: (*a*) Forte di S. Giorgio (Belvedere); (*b*) Fortezza da Basso; (*c*) S. Miniato; (*d*) S. Salvatore al Monte; (*e*) Torre del Gallo; (*f*) Villa di Poggio Imperiale; (*g*) Certosa of Galluzzo; (*h*) Medici Villa at Castello; (*i*) Medici villa at Careggi; (*j*) S. Domenico and the Badia Fiesolana; (*k*) Fiesole Cathedral; (*l*) S. Francesco (in Fiesole); (*m*) archaeological zone of Fiesole; (*n*) S. Margherita a Montici; (*o*) Ospedale S. Salvi; (*p*) Porta alla Croce; (*q*) Porta S. Gallo; (*r*) Porta al Prato; (*s*) Porta S. Frediano; (*t*) Porta Romana; (*u*) Porta S. Giorgio; (*v*) Villa di Gamberaia; (*w*) San Pietro a Ripoli, parish church; (*x*) stadium.

was demolished in 1588; the present façade (19th cent.) was built by Emilio de Fabris (X, PL. 295). The exterior is faced with polychrome marble in geometric patterns on traditional Florentine Romanesque lines. The lateral portals are decorated with sculptures (e.g., PL. 184; I, PL. 306). The interior has stained-glass windows designed by Paolo Uccello, Andrea del Castagno, Lorenzo Ghiberti, and Donatello. It contains works by Bernardo Daddi, Tino di Camaino, Paolo Uccello, Andrea del Castagno, Lorenzo Ghiberti (VI, PL. 176), and Michelangelo (IX, PL. 526). Giorgio Vasari and Federico Zuccari decorated the interior of the dome. The two sacristies open from each side of the tribune. The Old Sacristy (of the Canons) has a portal with a lunette by Luca della Robbia, who also designed the two angel candelabra in the interior. The New Sacristy (of the Mass) has a portal with a lunette and a bronze door by Luca della Robbia (IV, 158, 159). The inlaid cupboards were carved by Antonio Manetti and Giuliano da Maiano, from designs by Alessio Baldovinetti and Maso Finiguerra (PL. 83). The freestanding campanile was designed and begun by Giotto in 1334, continued by Andrea da Pontedera and Francesco Talenti (completed ca. 1359). It is a rectangular tower, without spire or cusp, in five stages, marked by stringcourses. There are two orders of double-arched windows and one order of triple-arched windows above (by Talenti). The facing of polychrome marble is similar to that of the Cathedral. The lower course is decorated with a series of hexagonal reliefs by Andrea da Pontedera (I, PLS. 231, 232), Nanni di Bartolo, and Luca della Robbia (IV, 160). Above these are a series of niches with copies of statues of prophets and sibyls by Andrea da Pontedera, Donatello, and Nanni di Bartolo (originals now in Mus. dell'Opera del Duomo; I, PL. 233; IV, PL. 243).

S. Maria Maggiore, in existence before the 11th century, was rebuilt in the 13th century. The façade was remodeled by Buontalenti in the 16th century. The interior is decorated with 13th- and 14th-century frescoes. S. Ambrogio (possibly built on the site of a 6th-century church) has been altered and restored several times. It contains works by Alesso Baldovinetti, Cosimo Rosselli, and Mino da Fiesole. Orsanmichele (S. Michele in Orto) was originally a loggia for the grain market, built by Arnolfo di Cambio in 1290. It was rebuilt after a fire in 1337, and in 1380 it was transformed into a church, and an upper floor to be used as a granary was added. The interior is divided into two aisles with hemispherical vaulting and contains a marble tabernacle by Andrea di Cione (Orcagna; X, PL. 392). On the exterior are a number of shrines with sculptures of the patron saints of the various guilds (Arti) of the city by Lorenzo Ghiberti (VI, PL. 175), Nanni di Banco (III, PL. 391), Donatello, and Verrocchio.

There are remains of a number of 13th-century tower houses in the medieval quarter which surrounds the Palazzo del Podestà (the Bargello; PL. 184), now the Museo Nazionale. This three-storied building with a high crenelated tower was begun in 1254. It is built around a central porticoed courtyard, with an open staircase leading to a porch and a loggia on the second story. The chapel of the Podestà is decorated with 14th-century frescoes of the school of Giotto. The construction of the Palazzo Vecchio (dei Priori, or della Signoria; I, PL. 396; VI, PL. 339) began in 1298 from plans probably by Arnolfo di Cambio. It has three stories surmounted by a crenelated gallery and a tower 308 ft. high. On the south side of the Piazza della Signoria is the Loggia della Signoria (Loggia dei Lanzi) built by Benci di Cione and Simone Talenti (ca. 1376–80). It consists of three wide arcades, with round arches decorated with lobed enameled plaques designed by Agnolo Gaddi. The Tribunale della Mercanzia (14th cent.; restored, 19th cent.) is on the east side of the square. In 1308 the guild of wool merchants built their own palace (Arte della Lana) near the Piazza della Signoria (restored, 1905). Also of the early 14th century (enlarged, 15th cent.) is the Palazzo dei Capitani di Parte Guelfa. Of the second half of the 14th century are the Loggia del Bigallo and the Loggia of the Accademia, formerly the Hospital of S. Matteo. Good examples of 14th-century patrician domestic architecture are the Palazzo Davanzati (PL. 100), a three-story brick building (loggia on top story, 15th cent.), which has retained the interior arrangement of rooms, and the Palazzo Spini-Ferroni, also of three stories (restored, 19th cent. and now in its original form). The so-called "Houses of the Alighieri," of the same period, have been restored and remodeled almost beyond recognition. Of the 14th-century walls, several gates still stand, including the Porta S. Giorgio, Porta S. Niccolò (both built in 1324), Porta Romana (1326), and the Porta S. Frediano (1332), which is now isolated. The Ponte Vecchio, with three spans, and small shops on each side, was rebuilt in 1345.

During the period of the rule of the Medici, in the 15th and 16th centuries, the city increased in size, population, and wealth, and many important secular and religious monuments were erected. Brunelleschi's (q.v.) solutions of architectural and urban problems based on his study of classic Roman architecture heralded the great

Humanistic era of the Renaissance. His most famous work is the dome of the Cathedral (II, PL. 365; FIG. 655). His Barbadori (Capponi) Chapel in the Church of S. Felicita (1418) was somewhat mutilated by remodeling in 1736. The Ospedale degli Innocenti, designed by Brunelleschi (constructed 1421–44), has a porticoed façade (II, PL. 366) with semicircular arches outlined in gray sandstone and decorated with enameled terra-cotta medallions by Andrea della Robbia. This façade served as a model for the others around the Piazza della SS. Annunziata. Brunelleschi also enlarged the Palazzo di Parte Guelfa in 1420. About 1429 he designed the Pazzi Chapel (II, PLS. 367, 368) of Sta Croce, on a rectangular plan, with a hemispherical dome above the tribune (II, FIG. 662); the frieze on the outer architrave of the pronaos is by Desiderio da Settignano; the interior is decorated with glazed terra cottas by Luca della Robbia and Brunelleschi and stained-glass windows designed by Alesso Baldovinetti. Brunelleschi began the Rotunda of S. Maria degli Angeli (II, FIG. 659) about 1434, but it remained unfinished. S. Lorenzo, on the site of two earlier churches, was rebuilt on plans by Brunelleschi (1418; II, FIG. 654) in 1422–46 (with later additions). The interior (II, PLS. 369, 370) contains works by Filippo Lippi, Desiderio da Settignano, Donatello and pupils, Il Rosso, and Bronzino. Brunelleschi at the same time designed the Old Sacristy of S. Lorenzo on a square plan surmounted by a dome (II, PL. 368), completed in 1428. It is decorated with stuccoes, bronze doors, and terra cottas by Donatello and contains the tombs of Giovanni and Piero de' Medici by Andrea Verrocchio. The New Sacristy was begun in 1520 by Michelangelo, who designed and carved the tombs of Giuliano and Lorenzo de' Medici. Beyond the cloister is the Biblioteca Laurenziana, also by Michelangelo, entered through a vestibule with a wide stairway (1524). Sto Spirito, begun by Brunelleschi in 1444 (II, PLS. 370, 371), completed much later by Antonio Manetti, is a basilica with a tripartite nave and lateral semicircular chapels (one designed by Andrea Sansovino) on a higher level. It contains works by Bernardo Rossellino, Filippino Lippi, and Cosimo Rosselli. The sacristy, reached by a rectangular vestibule with a barrel-vaulted ceiling by Simone del Pollaiuolo (Il Cronaca), was designed by Giuliano da Sangallo (1489–92). The Palazzo Pitti (II, PL. 372) was designed by Brunelleschi and later enlarged by Ammanati, who built the courtyard. Built of rusticated ashlar, it was the first of a series of palaces of the rich and noble families. Among these are the Palazzo Rucellai (I, PL. 55), built by Bernardo Rossellino (1446–51) from plans by Leon Battista Alberti; the Palazzo Medici-Riccardi (1444–60), by Michelozzo, with frescos by Benozzo Gozzoli in the chapel; the Palazzo Gondi (begun 1490), by Giuliano da Sangallo; and the Palazzo Panciatichi Ximenes, by Giuliano and Antonio da Sangallo (ca. 1499, later remodeled). Brunelleschi received the commission to design the Palazzo Pazzi (later Quaratesi; II, PL. 373), which was actually built by Giuliano da Maiano in 1462–72. The Palazzo Strozzi is by Benedetto da Maiano, with a cornice by Il Cronaca.

In the Palazzo Vecchio work was resumed during the Renaissance period. The courtyard, remodeled by Michelozzo, with a fountain by Verrocchio, was further decorated in the 16th century. The Salone dei Cinquecento was designed by Il Cronaca and adorned with frescoes by Giorgio Vasari and assistants. The studiolo of Francesco I (PL. 103), designed by Vasari and V. Borghini, was decorated with stuccoes, paintings, and statues by mannerist artists. The Sala dei Duecento, the Sala dell'Udienza, and the Sala dei Gigli were designed by Benedetto and Giuliano da Maiano. Also of the 15th century are the shrine of the Holy Sepulcher in the Rucellai Chapel (I, PL. 50) and the tribune of the SS. Annunziata by Leon Battista Alberti (I, PL. 58). Founded in the 13th century, SS. Annunziata was rebuilt by Michelozzo (1444–81) and later altered several times. The portico, in the manner of Brunelleschi, leads into a cloister decorated with frescoes by Alesso Baldovinetti, Cosimo Rosselli, Andrea del Sarto, Pontormo, and Rosso Fiorentino. The interior is baroque (remodeled, 1857), with a carved wooden ceiling designed by Volterrano. The shrine of the Annunciation (15th cent.) was designed by Michelozzo. The church also contains works by Andrea del Castagno (I, PLS. 236, 237), Bernardo Rossellino, Veit Stoss, and others. The adjoining Great Cloister (Chiostro dei Morti), designed by Michelozzo and built by Pagno Portigiani, contains the Madonna del Sacco by Andrea del Sarto (I, PL. 255). The Dominican monastery and Church of S. Marco, founded in the 13th century, were enlarged and rebuilt by Michelozzo in the 15th century. The church, remodeled by Giambologna (16th cent.) and later altered, has a baroque façade. The sacristy and cloister were built by Michelozzo. The monastery has frescoes by Fra Angelico (I, PLS. 266, 272), who also decorated the chapter house. The small refectory contains a Last Supper by Domenico Ghirlandajo. S. Felice, a 13th-century church, remodeled in the 14th and 15th centuries, has a façade by Michelozzo and frescoes in the interior by Giovanni da San Giovanni. S. Maria Maddalena dei Pazzi, founded

in the 13th century, was rebuilt by Giuliano da Sangallo in 1480–92 and remodeled in the 17th century; in the chapterhouse of the adjoining convent is a fresco *Crucifixion* by Perugino. S. Salvatore al Monte (PL. 191) was built by Il Cronaca in 1475, but subsequently remodeled. The Cenacolo di S. Apollonia has fresco decorations by Andrea del Castagno and is now the Castagno museum, with frescoes by the artist from other locations (I, PLS. 238, 240–245). The Bran-

cacci Chapel of S. Maria del Carmine contains frescoes by Masolino (IX, PL. 374), Masaccio (IX, PLS. 347–350), and Filippino Lippi.

In the 16th century, while architecture continued to develop the 15th-century forms, Michelangelo was active in devising new forms, not only in the complex of structures of S. Lorenzo but also in the plan for the fortress of S. Miniato (1530–33), later transformed by Francesco da Sangallo. Other 16th-century fortresses are the For-

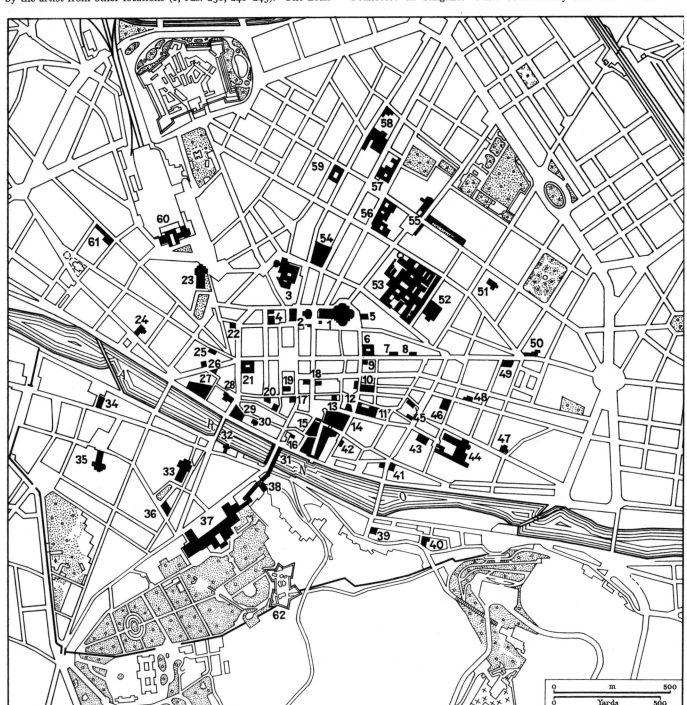

Florence, plan of the center. Principal monuments: (1) Cathedral and campanile; (2) Baptistery, Palazzo Arcivescovile, and Loggia del Bigallo; (3) S. Lorenzo, the Medici tombs, and the Biblioteca Laurenziana; (4) S. Maria Maggiore and Palazzo Orlandini; (5) Museo dell'Opera del Duomo; (6) Palazzo Nonfinito; (7) Palazzo Altoviti; (8) Palazzo Albizi; (9) Palazzo Pazzi; (10) Palazzo del Podestà (Museo Nazionale del Bargello) and Badia Fiorentina; (11) S. Firenze; (12) Palazzo Gondi; (13) Palazzo Uguccioni; (14) Palazzo Vecchio (della Signoria); (15) Palazzo degli Uffizi and Loggia della Signoria; (16) S. Stefano al Ponte; (17) Logge del Mercato Nuovo; (18) Orsanmichele and S. Carlo dei Lombardi; (19) Palazzo dell'Arte della Lana; (20) Palazzo Davanzati and Palazzo dei Capitani di Parte Guelfa; (21) Palazzo Strozzi; (22) Palazzo Antinori; (23) S. Maria Novella; (24) Ognissanti; (25) Rucellai Chapel; (26) Palazzo Rucellai; (27) Palazzo Corsini; (28) Sta Trinita; (29) Palazzo Spini-Ferroni; (30) SS. Apostoli; (31) Ponte Vecchio; (32) S. Jacopo sopr'Arno, near the Ponte Sta Trinita; (33) Sto Spirito; (34) S. Frediano; (35) Church of the Carmine; (36) Palazzo Guadagni; (37) Palazzo Pitti and Boboli Gardens; (38) S. Felice; (39) Museo Bardini; (40) S. Nicolò sopr'Arno; (41) Fondazione Horne and Palazzo Bardi; (42) Loggia del Grano; (43) Casa dell'Antella; (44) Sta Croce, Museo dell'Opera, and Pazzi Chapel; (45) S. Simone and Palazzo Serristori; (46) Palazzo Pepi; (47) S. Giuseppe; (48) Casa Buonarroti; (49) Loggia del Pesce; (50) S. Ambrogio; (51) S. Maria Maddalena dei Pazzi; (52) Teatro della Pergola; (53) Arcispedale di S. Maria Nuova, Church of S. Egidio, and Rotunda of S. Maria degli Angeli; (54) Palazzo Medici-Riccardi; (55) Piazza della SS. Annunziata, portico of the Ospedale degli Innocenti, and Palazzo della Crocetta (Museo Archeologico); (56) Galleria dell'Accademia di Belle Arti; (57) Church and Monastery of S. Marco (Museo di S. Marco); (58) Casino Mediceo, Cloister of the Scalzo, Church of S. Giovannino dei Cavalieri, and Palazzo Pandolfini; (59) Cenacolo di S. Apollonia; (60) central station; (61) Palazzo Ginori-Venturi; (62) Forte di S. Giorgio (Belvedere) and remains of the 14th-century walls.

tezza da Basso, by Antonio da Sangallo the Younger (ca. 1535), and the Forte di S. Giorgio (Belvedere), built between 1590 and 1595 by Giovanni de' Medici and Bernardo Buontalenti. Private palaces and public buildings of the period include the Palazzo Pandolfini, designed by Raphael (ca. 1520); Palazzo degli Uffizi (1560–85), begun by Giorgio Vasari and completed by Alfonso Parigi and Buontalenti; and the Logge del Mercato Nuovo, by Giovanni Battista del Tasso (1551). Ammanati enlarged the Palazzo Pitti, adding the inner wings around the courtyard (1570). He also built the Bridge of Sta Trinita (1569, rebuilt after its destruction in 1944 with the original material), the fountain in the Piazza della Signoria (PL. 210), the Vitali and Mondragone palaces, and the façade of the Church of S. Giovanni Evangelista. Bernardo Buontalenti remodeled the House of Bianca Cappello (1570–74) and parts of the Palazzo Nonfinito (1593). The Casa Buonarroti, with late mannerist decorations, is also of this period. The streets which have retained the character of the Renaissance city are the Via Maggio, Via Tornabuoni, Borgo Santi Apostoli, the streets between Borgo Albizi and Via Ghibellina, Borgo Sta Croce and Via de' Ginori. Also of the Renaissance are the gardens of Villa di Castello, laid out by Tribolo, and the Boboli Gardens, begun by Tribolo in 1550 and continued by Ammanati and Buontalenti (PLS. 429–431).

Florence contains few baroque or 18th-century buildings, and many of them are older edifices remodeled. The most prominent Florentine baroque architect was Matteo Nigetti, who built the Oratory of S. Francesco dei Vanchetoni (1603), the Chapel of the Princes in S. Lorenzo (begun in 1604), the Church of SS. Filippo e Giacomo, and the façade of the Ognissanti (1637). The interior of this last, with a single aisle (14th cent.; rebuilt, 17th cent.), is decorated with frescoes by Taddeo Gaddi, Botticelli (II, PL. 328), the Ghirlandajos, and Giovanni da San Giovanni. In the adjoining cloister by Michelozzo are frescoes by Giovanni da San Giovanni, and in the refectory is Ghirlandajo's *Last Supper*. Nigetti rebuilt S. Gaetano (1604–48) as a Latin cross over a previous 11th-century church. Pier Francesco Silvani designed the Palazzo Corsini (1648–56) and part of the Convento dei Filippini, now S. Firenze, which consists of a palace and two churches (PL. 210). The Via Cavour and Via Sto Spirito contain a number of private palaces of the 17th and 18th centuries. The most noteworthy example of baroque decoration is the Niccolini Chapel in Sta Croce, designed by Giovanni Antonio Dosio, with an oval dome decorated with frescoes by Volterrano, who also painted the dome of the SS. Annunziata. Baroque frescoes in the Palazzo Pitti are by F. Furini, Giovanni da San Giovanni, Pietro da Cortona, and Ciro Ferri. The frescoes in the gallery of the Palazzo Medici-Riccardi (PL. 224) and the dome of the Corsini Chapel in S. Maria del Carmine (1682–83) are by Luca Giordano. In neoclassic style are the Arch of Triumph (late 18th cent.), the Palazzo Borghese, the lobby of the Teatro della Pergola by Gaetano Baccani, 1826), and the Villa di Poggio Imperiale, designed by Gaspare Maria Paoletti and Pasquale Poccianti.

In the 19th and early 20th centuries the façades of the Cathedral and Sta Croce were remodeled in Neo-Gothic style and the castle of Vincigliata and the Torre del Gallo were adapted in Neo-Romanesque. Notable structures of the 20th century include the stadium by Pier Luigi Nervi (1932), the central station (1935) by G. Michelucci and others, the Vespucci bridge (1955–57) by R. Morandi, E. and G. Gori, and E. Nelli, and the Cassa di Risparmio (1957–58) by G. Michelucci.

Museums and Galleries: Uffizi Gallery (paintings) and Gabinetto dei Disegni e Stampe (drawings and prints), in the Palazzo degli Uffizi; Galleria Palatina, Museo degli Argenti, and Galleria di Arte Moderna, in the Palazzo Pitti; Museo dell'Opera del Duomo (with many of the original sculptures from the Campanile and the Cathedral); Museo di S. Marco, in the monastery of S. Marco (with works of Fra Angelico); Galleria dell'Accademia (Florentine paintings and sculptures by Michelangelo); Museo Archeologico (Egyptian, Greek, Roman, and Etruscan art); Museo Nazionale, in the Bargello (Tuscan sculpture, 14th–17th cent., and minor arts); Museo dell'Opera di Sta Croce; Fondazione Horne (paintings, drawings, decorative arts, and furniture); Belvedere fortress (exhibition of detached frescoes); Casa Buonarroti (works by Michelangelo); Galleria dell'Ospedale degli Innocenti; Museo Preistorico and Museo Storico e Topografico, in the former convent of the Oblates; Palazzo Vecchio (the Loeser Collection of Tuscan painting and sculpture); Galleria Corsini; Galleria Ferroni; Museo Mediceo, in the Palazzo Medici-Riccardi; Museo del Bigallo; museum of the Opificio delle Pietre Dure (workshop of semiprecious stones); Museo Bardini (paintings, sculpture, and minor arts); Fondazione Salvatore Romano, in the refectory of Sto Spirito; Museo Stibbert (paintings, minor arts, armor and weapons); Museo dell'Antica Casa Fiorentina, in the Palazzo Davanzati; Biblioteca Laurenziana (permanent exhibition of codexes, illuminated missals and choir books, incunabula); Museo Nazionale dell'Artigianato (applied and folk art); Museo Duprè.

Environs: Badia di S. Salvatore a Settimo, with its church (SS. Salvatore e Lorenzo), existed in the 10th century, was rebuilt in the 13th by the Cistercian Order, and was later remodeled. The church has a nave and two side aisles, a trussed wooden ceiling, and a rose window. The apses are Renaissance. There are noteworthy remains of the Cistercian monastery, including the chapter house. The Certosa of Galluzzo (founded 14th cent.) includes the church, remodeled in succeeding centuries, containing works by 14th–18th-century Florentine artists. The monastery contains frescoes by Bronzino and Pontormo. The priest's house at Sant'Angelo a Vico l'Abate contains the *Madonna Enthroned* by Ambrogio Lorenzetti (1319). The parish church, San Pietro a Ripoli, has existed since the 8th century but has been completely rebuilt. The Church of S. Maria at Impruneta has two chapels decorated by Luca della Robbia. In the surrounding countryside are many Renaissance villas and older houses transformed by Renaissance architects; among them are the Medici villa at Careggi, originally a battlemented castle, enlarged and turned into a country villa by Michelozzo (ca. 1443), later decorated by Pontormo and Bronzino; Poggio a Caiano, rebuilt by Giuliano da Sangallo, restored and enlarged (16th cent.), with frescoes by Andrea del Sarto, Pontormo, and Alessandro Allori; the Villa Demidoff at Pratolino, rebuilt by Buontalenti (1569–81); Villa di Gamberaia; Il Riposo (Villa Signorini), with works by Giambologna; the Medici villa at Castello (remodeled 15th and 16th cent.), with gardens laid out by Tribolo and decorated with statues by him, Ammanati, and Giambologna; I Tatti, at Settignano, with the Berenson Collection (now property of Harvard University).

BIBLIOG. F. Bocchi, Le bellezze della città di Firenze, Florence, 1591; F. L. del Migliore, Firenze città nobilissima, Florence, 1684; J. Carlieri, Ristretto delle cose più notabili della città di Firenze, Florence, 1692; G. Richa, Notizie istoriche delle chiese fiorentine, 10 vols., Florence, 1754–62; L'antiquario fiorentino, Florence, 1765; L. Biadi, Notizie storiche sulle antiche fabbriche di Firenze, Florence, 1824; F. Fantozzi, Pianta geometrica della città di Firenze, Florence, 1843; S. Mattei, Ragionamento intorno all'antica chiesa del Carmine...., Florence, 1869; E. Mazzanti, Raccolta delle migliori fabbriche di Firenze, Florence, 1876; C. Guasti, Santa Maria del Fiore, Florence, 1887; E. Mazzanti, Studi storici sul centro di Firenze, Florence, 1889; J. Ruskin, Mornings in Florence, New York, 1889; L. A. Milani, Reliquie di Firenze antica, MALinc, VI, 1895, cols. 1–72; G. Poggi, Or San Michele, Florence, 1895; G. Carocci, Firenze scomparsa, Florence, 1897; G. Carocci, Il centro di Firenze, Florence, 1900; H. Brockhaus, Forschungen über Florentiner Kunstwerke, Leipzig, 1902; A. Cocchi, Le chiese di Firenze, Florence, 1903; I. Ross, Florentine Palaces, London, 1905; W. Limburger, Die Gebäude von Florenz, Leipzig, 1910; F. Rupp, Inkrustationstil der romanischen Baukunst zu Florenz, Strasbourg, 1912; L. C. Rosenberg, The Davanzati Palace, New York, 1922; H. Beenken, Die Florentiner Inkrustationsarchitektur des XI. Jahrhunderts, ZfbK, LX, 1926–27, pp. 221–30, 245–55; N. Cherici, Guida storico-artistica del R. Spedale di S. Maria degli Innocenti di Firenze, Florence, 1926; E. W. Anthony, Early Florentine Architecture and Decoration, Cambridge, 1927; A. Lensi, Firenze medievale, Atti Soc. Colombaria, XXIX, 1928–29, pp. 187–203; O. Masino, Firenze attraverso i secoli, Bologna, 1929; K. H. Busse, Der Pitti Palast: Seine Erbauung 1458–60 und seine Darstellung in den ältesten Stadtansichten von Florenz (1469), JhbPreussKSamml, LI, 1930, pp. 110–32; L. H. Heydenreich, Die Tribuna der SS. Annunziata in Florenz, Mitt. des Kh. Inst. in Florenz, III, 1930, pp. 268–85; N. Tarchiani, Palazzo Medici Riccardi, Florence, 1930; C. Botto, L'edificazione della chiesa di Santo Spirito in Firenze, Riv. d'arte, XIII, 1931, pp. 477–511, XIV, 1932, pp. 23–53; Q. Fannucci, La basilica di S. Miniato al Monte, Italia sacra, II, 1931–34, pp. 1137–1207; Il concorso per la Stazione di Firenze, Architettura, XII, 1933, pp. 713–19; L. Ernst, Manierische Florentiner Baukunst, Potsdam, 1934; G. Sinibaldi, Il Palazzo Vecchio di Firenze, Rome, 1934; W. Paatz, Die gotische Kirche S. Trinita in Florenz, Misc. Goldschmidt, Berlin, 1935, pp. 113–18; V. Crispolti, Santa Maria del Fiore alla luce dei documenti, Florence, 1937; W. Horn, Das Florentiner Baptisterium, Mitt. des Kh. Inst. in Florenz, V, 1937–40, pp. 99–151; W. Lotz, Michelozzos Umbau der SS. Annunziata in Florenz, V, 1937–40, pp. 402–22; W. Braunfels, Santa Maria Novella, Florence, 1938; M. Wackernagel, Der Lebensraum des Künstlers in der florentinischen Renaissance, Leipzig, 1938; W. Paatz, Die Hauptströmungen in der Florentiner Baukunst der frühen und höhen Mittelalters, Mitt. des Kh. Inst. in Florenz, VI, 1940–41, pp. 33–72; G. Maetzke, Florentia, Rome, 1941; P. Sanpaolesi, La cupola di Santa Maria del Fiore, Rome, 1941; P. Moschella, Le case a "sporti" in Firenze, Palladio, VI, 1942, pp. 167–73; A. Rusconi, I Tabernacoli delle vie fiorentine, Emporium, XCV, 1942, pp. 67–74, 158–66; W. Horn, Romanesque Churches in Florence, AB, XXV, 1943, pp. 112–31; P. Rosconi, Il Campanile di Giotto, Bergamo, 1943; R. Baldacchini, Il Ponte Vecchio, Florence, 1947; G. Maetzke, Osservazioni sulle recenti ricerche nel sottosuolo di Firenze, Atti e mem. Acc. La Colombaria, N.S., II, 1947–50, pp. 185–90; F. Castagnoli, La centuriazione di Florentia, L'Universo, XXVIII, 1948, pp. 361–68; C. L. Ragghianti, Ponte a Santa Trinita, Florence, 1948; A. Fortuna, La basilica di S. Lorenzo e le Cappelle Medicee, Florence, 1949; R. Baldaccini, Santa Trinita nel periodo romanico, Riv. d'arte, XXVI, 1950, pp. 23–72; R. Baldaccini, S. Trinita nel periodo gotico, Riv. d'arte, XXVII, 1951–52, pp. 57–91; M. Salmi, Il palazzo della parte Guelfa, Rinascimento, II, 1951, pp. 3–11; P. Sanpaolesi, I quartieri del Ponte Vecchio e di Ponte a S. Trinita, Palladio, N.S., I, 1951, p. 49; E. Dori and P. Guicciardini, Le antiche Case e il Palazzo dei Guicciardini in Firenze, Florence, 1952; L. D. Ettlinger, A 13th Century View of Florence, BM, XCIV, 1952, pp. 160–67; W. and E. Paatz, Die Kirchen von Florenz, 5 vols., Frankfurt

am Main, 1952; M. Salmi, Del ponte a Santa Trinita e di altri ancora, Comm, III, 1952, pp. 87–92; G. Morozzi, Restauri nell'ex Convento di S. Marco a Firenze, BArte, XL, 1955, pp. 350–54; E. Pucci, Tutta Firenze: nella storia, nella pittura, nella scultura, Florence, 1955; R. Sciamannini, La basilica di Santa Croce, Florence, 1955; S. Orlandi, Santa Maria Novella e i suoi chiostri monumentali, Florence, 1956; N. Bemporad, Il forte Belvedere e il suo restauro, BArte, XLII, 1957, pp. 122–34; E. Casalini, La Basilica Santuario della SS. Annunziata, Florence, 1957; P. Bargellini, Aspetti minori di Firenze, Florence, 1958; L. Berti, Palazzo Davanzati, Florence, 1958; E. Micheletti, Chiese di Firenze, Novara, 1959; E. Sandberg-Vavalà, Studies in the Florentine Churches, Florence, 1959; U. Schlegel, La Cappella Barbadori e l'architettura fiorentina del primo Rinascimento, Riv. d'arte, XXXII, 1959, pp. 77–106; A. Arnaud, Il palazzo del Podestà, Florence, 1960; G. Caputo, Tomba etrusca "La Montagnola," Florence, 1960; M. Hürlimann, Florenz, Zürich, 1960; G. Pampaloni, Il palazzo Portinari, Florence, 1960; M. Wundram, Albizzo di Pietro: Studien zur Bauplastik von Or San Michele in Florenz, Festschrift Schrade, Stuttgart, 1960, pp. 161–76; L. H. Heydenreich, Über den Palazzo Guadagni in Florenz, Misc. Hanfstaengl, Munich, 1961, pp. 43–51; G. Kiesow, Zur Baugeschichte des Florentiner Domes, Mitt. des Kh. Inst. in Florenz, X, 1961, pp. 1–22; H. Saalman, The Church of Santa Trinita in Florence, Marsyas, X, 1961, p. 71 (diss. summary); Pianta della città di Firenze rilevata esattamente nel 1783, n.p., n.d. Environs: A. Lensi, Ville fiorentine medievali, Dedalo, XI, 1930–31, pp. 1319–34; A. Rusconi, Le ville medicee di Boboli, Castello, Petraia e Poggio a Caiano, Rome, 1938; G. Fanfani, Voci e volti delle ville fiorentine, Florence, 1939; G. C. Lensi-Orlandi-Cardini, Le ville di Firenze, 2 vols., Florence, 1954–55; C. Calzolai, La storia della Badia a Settimo, Florence, 1958; F. Rossi, La Cripta dell'Impruneta, Palladio, N.S., VIII, 1958, pp. 88–94; G. Maetzke, G. A. Mansuelli, G. Caputo, and T. Coco, EAA, s.v. Firenze, III, 1960, pp. 696–701.

Grosseto. The town grew up around a 9th-century castle, after the destruction of the ancient town of Roselle by the Saracens in 935. Its most remarkable features are the city walls, on a hexagonal plan with six powerful bastions (1574–90), following the circuit of the 12th-century walls built by the Aldobrandeschi and incorporating the Rocca, a Sienese fortress (ca. 1330). In the 19th century the bastions and ramparts were turned into avenues with trees and public gardens. The Cathedral, originally Romanesque (12th and 13th cent.), was rebuilt (1294–1302) by Sozzo di Rustichino of Siena in Gothic form and has been restored a number of times. The façade was rebuilt in Neo-Romanesque style (1840–45). S. Francesco (13th cent.) is in Franciscan Gothic style. The Palazzo Comunale (1870) is in neoclassic style. The Palazzo della Provincia, in Neo-Gothic style, is of the 20th century. Museums: Museo Diocesano d'Arte Sacra (paintings and religious art by Sienese artists); Museo Archeologico (Etruscan and Roman antiquities).

Approximately 2½ miles north-east of Grosseto are the remains of the Etruscan city of Roselle (Rusellae), which became subject to Rome in 294 B.C., and was a civitas foederata until the 1st century B.C. In the Middle Ages it was the see of a bishop, from the 5th century until 1138. The ancient walls, of polygonal masonry are still standing. Part of the zone of the forum, an amphitheater (1st cent. B.C.) and a necropolis, with graves from the 8th century B.C. to the Roman period have been discovered.

Bibliog. L. A. Milano, Rusellae, NSc, 1887, pp. 134–37; A. Ademollo, I monumenti medievali e moderni della provincia di Grosseto, Grosseto, 1894; A. Pasqui, Tomba arcaica sul limite meridionale della necropoli rusellana, NSc, 1907, pp. 315–19; A. Pasqui, Saggi di scavo sul monte della Moscona presso il sito dell'antica Rusellae, NSc, 1908, pp. 170–71; G. Vigni, L'architettura del Duomo di Grosseto, Riv. d'arte, N.S., XX, 1938, pp. 49–59; F. Fedi, L'abbazia di S. Maria dell'Alberese presso Grosseto, Naples, 1942; G. Caputo, Stele etrusca arcaica, FA, XI, 1956, 2418; U. Baldini, Architettura preromanica e romanica nel territorio grossetano, Atti V Conv. naz. Storia Arch. (1948), Florence, 1957, pp. 251–55; C. Laviosa, Rusellae, SEtr, XXVII, 1959, pp. 3–41, XXVIII, 1960, pp. 289–337, XXIX, 1961, pp. 31–45; R. Naumann and F. Hiller, Rusellae, RM, LXVI, 1959, pp. 1–30.

Leghorn (It., Livorno). A modern port city, Leghorn probably first developed as a fortified spot. In the 12th century there was a castle on the site, belonging at various times to Pisa, Genoa, the Angevins, Florence, and Lucca. In 1421 it was ceded by Genoa to Florence. The Medici strengthened the fortifications and built an arsenal in the 16th century. Cosimo I connected the port with Pisa by a canal and built the customs house and a fortress at Antignano. Bernardo Buontalenti directed the enlargement of the harbor in 1571. Ferdinand I raised Leghorn to the rank of a city in 1605, declared it a free port, and promoted the construction of the Cathedral. The canal quarters of Venezia Nuova and S. Marco were laid out by Ferdinand II. Because of the numerous destructions and the continual growth of the city, few monuments have survived, and its appearance is almost entirely modern. The Fortezza Vecchia was built (1521–30) by Antonio da Sangallo the Younger and the Fortezza Nuova, designed by Giovanni de' Medici, Bernardo Buontalenti, and Vincenzo Bonanni, was begun in 1590. The two were once united by a curtain wall. Many of the 17th-century buildings have been destroyed or rebuilt, among them, the Church of the SS. An-

nunziata, by Alessandro Pieroni (1601); the Consolazione, also by Pieroni (1599), containing works by Matteo Rosselli and Volterrano; and the Cathedral, designed by Buontalenti and completed by Pieroni. The monument to Ferdinand I (erected 1607; also known as the "Quattro Mori") incorporates figures by Giovanni Bandini (1595) and Pietro Tacca (added 1624). S. Ferdinando (Chiesa della Crocetta) was built in 1707–14, from designs by Giovanni Battista Foggini. The Cisternino (formerly a filtering plant, now a concert and exhibition hall) and the Cisternone, a reservoir, were built (1829–42) by Pasquale Poccianti. The neoclassic Palazzo De Larderel was built in 1832 and enlarged by Ferdinando Manganini in 1850. The Piazza della Repubblica ("del Voltone") contains two gigantic statues of Ferdinand III and Leopold II. The Città Ospedale was built in 1931, from plans by Ghino Venturi. The Accademia Navale (1881) was designed by Angelo Badaloni. The Museo Civico Giovanni Fattori (in the Villa Fabbricotti) contains prehistoric, Etruscan, and Roman material, and paintings by Giovanni Fattori and others.

Bibliog. N. Magri, Stato antico e moderno, ovvero origine di Livorno dalla sua fondazione fino all'anno 1646, 3 vols., Florence, 1767–72; P. Vigo, Livorno, Bergamo, 1915; P. Baratti, L'architettura barocca e neoclassica a Livorno, Liburni Civitas, I, 1928, pp. 179–88; L. Servolini, L'arte nel Santuario di Montenero, Liburni Civitas, VII, 1934, pp. 30–53; G. Nudi, Storia urbanistica di Livorno, Venice, 1960.

Lucca (Lat., Luca). A Latin colony, founded in 180 B.C. in the Garfagnana. The Roman city was almost a perfect rectangle, with the streets laid out on a checkerboard pattern. There are remains of an amphitheater. The prosperity of the Middle Ages from the 11th to the 13th century left an imprint on the city which has remained more or less unaltered. The Pisan Romanesque was interpreted by the Luccan architects with a greater emphasis on the decorative element. A good example is the Cathedral (S. Martino), begun in 1060. The plan is a Latin cross. The façade has three orders of small arcades above a portico; the upper part, by Guidetto da Como (1204), has inlaid decorations of white and black marble. The campanile was completed in the 13th century (PL. 178). The three portals are decorated with reliefs by Lombard artists and a lunette by Nicola Pisano (X, PL. 326). The interior, remodeled in Gothic style in the 14th and 15th centuries, contains the original sculpture of St. Martin and the beggar (copy on the façade; PL. 181); the Tempietto del Volto Santo (1482–84) with a Crucifix (IV, PL. 210) mentioned by Dante (Inferno XXI, 48); the tomb of Ilaria del Carretto, by Jacopo della Quercia (IV, PL. 148); and works by Fra Bartolommeo, Giambologna, Domenico Ghirlandajo, Matteo Civitali, and Cosimo Rosselli. S. Frediano (1112–47) has a façade divided into three sections by pilaster strips, with a small loggia and architrave over the central section, and a mosaic of the Ascension in Italo-Byzantine style. The interior is a basilica with a tripartite nave and ancient columns. It contains a 12th-century

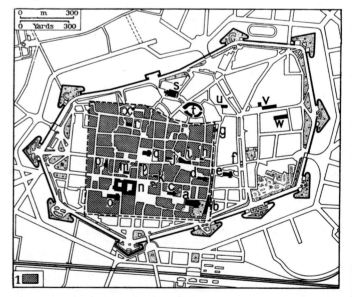

Lucca, plan, with expansion within and without the 16th-century walls. Key: (1) Area of the Roman city. Principal monuments: (a) Cathedral; (b) Palazzo dell'Arcivescovado and the Oratory of S. Maria della Rosa; (c) S. Giovanni; (d) S. Maria dei Servi; (e) S. Maria Forisportam; (f) Porta dei SS. Gervasio e Protasio; (g) SS. Simone e Giuda; (h) S. Giulia; (u) Palazzo Bernardini; (j) S. Cristoforo; (k) S. Giusto; (l) Palazzo Pretorio; (m) S. Alessandro; (n) Palazzo della Prefettura; (o) S. Romano; (p) S. Paolino; (q) S. Michele in Foro; (r) S. Maria Corteorlandini; (s) S. Frediano; (t) Roman amphitheater; (u) S. Pietro Somaldi; (v) S. Francesco; (w) Museo Nazionale di Villa Guinigi; (x) area of the Roman theater.

baptismal basin (reassembled, 1950), a baptismal font by Matteo Civitali (1489), a carved altar, tombs of the Trenta family by Jacopo della Quercia (IV, PL. 151), sculptures by Andrea della Robbia, and frescoes by Amico Aspertini. S. Michele in Foro (1143) was enlarged a number of times. It is in the form of a Latin cross. The 13th-century façade (restored, 19th cent.) has a series of blind arches surmounted by four orders of small loggias. The interior contains a *Crucifixion* by a 13th-century Luccan painter, a *Madonna and Child* by Andrea della Robbia, and *SS. Jerome, Sebastian, Rocco, and Helena* by Filippino Lippi. S. Giusto (12th cent.) is in a simple version of the local Pisan Romanesque style. S. Alessandro (12th cent.) has a sober white-and-gray striped marble façade; the marble decorations of the apse are of the 13th century. S. Maria Forisportam (13th cent.) is designed on strictly Pisan Romanesque lines; in the interior are a baptismal font made from an Early Christian sarcophagus, and paintings by Guercino. S. Pietro Somaldi (12th cent.) has a 13th-century two-color façade. The Chiesa del Salvatore (12th cent., remodeled in Gothic style) has sculpture by Biduinus (12th cent.). The Gothic style, noted above in the remodeling of certain churches, is found in few buildings, which are inferior in quality and wealth of decoration to their Romanesque predecessors. Among them are the Oratory of S. Maria della Rosa (1309, later enlarged); S. Romano (rebuilt, 1280; enlarged, 1373 and 17th cent.) with the tomb of St. Romanus by Matteo Civitali and a *Circumcision* by Rutilio Manetti; S. Maria dei Servi (14th cent., remodeled several times), with marble tabernacles by Nicolao Civitali and paintings by Matteo Rosselli; S. Francesco (founded, 1228; repeatedly rebuilt), with a Gothic portal on the façade and works by Deodato Orlandi, Il Passignano (Domenico Crespi), and Federico Zuccari; the former Oratory of S. Franceschetto (1309); S. Andrea (13th cent.); and S. Anastasio (12th–14th cent.). There are several noteworthy houses of this period, such as the Guinigi houses, with great archivolts enclosing triple and quadruple arched windows. On the Via Fillungo and Via Santa Croce there are several 13th- and 14th-century houses. Other Gothic structures include the Loggia dei Guinigi and the Villa of Paolo Guinigi.

In the Renaissance period the Palazzo Pretorio was begun (1492); the design is attributed to Matteo Civitali, but it was continued by his son Nicolao and enlarged in 1588 by Vincenzo Civitali. The 16th-century Palazzo Bernardini and Palazzo Cenami are both attributed to Nicolao Civitali. S. Paolino, begun in 1522 by Baccio da Montelupo and completed in 1539 by Bastiano Bertolani, has a high Renaissance façade with three orders of pilasters, single aisle, and transept with lateral chapels. The Church of SS. Trinità (1589) contains the *Madonna della Tosse* by Matteo Civitali. The Palazzo Bernardi (now Micheletti) was designed by Bartolommeo Ammanati (1556), as was also the Palazzo della Signoria (now della Prefettura; begun 1578), which was finished in 1728 by Francesco Pini on plans after Filippo Juvara and Ammanati. The Palazzo Buonvisi (Bottini), also known as Palazzo del Giardino, was built in 1566. The city walls, built between 1504 and 1645, with diamond-shaped bulwarks and a platform, have been turned into a promenade planted with trees. *Museums*: Pinacoteca Nazionale di Palazzo Ducale; Museo Nazionale di Villa Guinigi.

BIBLIOG. T. Trenta, Guida del forestiere per la città e contado di Lucca, Lucca, 1829; A. Solari, Sulla storia di Lucca nell'antichità, S. storici, XIV, 1905, pp. 279–95; A. Solari, Il territorio lunese-pisano, Pisa, 1910; A. Behne, Der Inkrustationstil zu Lucca, Z. für Geschichte der Archäol., VII, 1914–19, pp. 14–26; A. Solari, Lucca centro itinerario nell'antichità, B. storico lucchese, I, 1929, pp. 25–30; P. Guidi, Di alcuni maestri lombardi a Lucca nel secolo XIII, Florence, 1930; E. Lazzareschi, Lucca, Bergamo, 1931; G. G. Lunardi, S. Frediano e la sua basilica in Lucca, Pescia, 1931; A. L. Pettorelli, Il palazzo Buonvisi in Lucca detto anche del "Giardino," Crisopoli, II, 1934, pp. 481–98; E. Luporini, Nota introduttiva all'architettura romanica lucchese, Belle Arti, I, 1946–48, pp. 321–24; F. Castagnoli, La centuriazione di Lucca, SEtr, XX, 1948, pp. 285–90; I. Belli, La chiesa romanica di S. Frediano in Lucca, Lucca, 1950; I. Belli, Guida di Lucca, Lucca, 1953; S. Burger, L'architettura romanica in Lucchesia e i suoi rapporti con Pisa, Atti Seminario int. di storia dell'arte, Pisa, 1953, pp. 121–28; I. Belli, Le mura di Lucca, Lucca, 1954; L. Nardi and L. Molteni, Le case torri lucchesi, Florence, 1957; I. Belli, La diocesi di Lucca, Spoleto, 1959; G. Leva, Lucca e la sua provincia, Lucca, 1959; I. Belli Barsali, Problemi sulla tarda architettura di Bartolomeo Ammannati: il Palazzo Pubblico di Lucca, Palladio, N.S., X, 1960, pp. 50–68; D. Corsi, Statuti urbanistici medievali di Lucca, Venice, 1960; P. Pierotti, Ricerca dei valori originali nell'edilizia civile medievale in Lucca, CrArte, N.S., VII, 1960, pp. 183–98; O. Cresti Manco, EAA, s.v. Lucca, IV, 1961, p. 705.

Massa and Carrara. These two neighboring cities form a single administrative unit as a provincial capital. Massa, in the foothills of the Apuan Alps, was in existence at least in 882. Its growth was contemporary with the decline of the ancient city of Luni (now a ruin). The first fortified nucleus (Massa Vecchia) was built (11th cent.) by the Obertenghi family; in 1442 the Malaspinas built a castle surrounded by walls. The lower town, Massa Nuova, dates from 1557 and is dominated by the Palazzo Cybo-Malaspina (begun 16th cent., enlarged by Gian Francesco Bergamini in 1665, completed by Alessandro Bergamini, who designed the façade, in 1701). The Cathedral, founded in the 15th century, was later remodeled in neoclassic style; the façade is modern.

Carrara has been famous for its marble quarries from ancient times. Mentioned in a document of 963, it was disputed territory during the Middle Ages until it came into possession of Giacomo Malaspina of Massa, in 1473, after which its history parallels that of Massa. The Cathedral (11th–14th cent.) is of Pisan Romanesque type with Gothic elements. The Palazzo Cybo-Malaspina, attached to the 13th-century fortress, was built in the 16th century but has been radically restored. It houses the Accademia di Belle Arti. Also of the 16th century is the Church of the Carmine. S. Francesco and S. Maria delle Grazie are of the baroque period, and the Chiesa del Suffragio, of the early 19th century.

Nearby is the town of Pietrasanta, medieval in plan, with buildings concentrated around the main square. The Cathedral (founded, 1330; restored, 17th and 19th cent.) has a rose window and a tripartite façade with 14th-century sculptured portals. The Baptistery, of 1608, was restored in the 18th century. S. Agostino, of the 14th century, has three blind arches, above which is a Gothic loggia (1431).

BIBLIOG. L. Mussi, Le chiese di Massa lunense nei documenti della Curia vescovile di Luni - Sarzana dal 1500 al 1700, Riv. d'arte, VIII, 1912, pp. 19–23; L. Mussi, Il Castello di Massa in Lunigiana, Vita d'arte, XI, 1913, pp. 206–08; M. Salmi, Il Duomo di Carrara, L'Arte, XXIX, 1927, pp. 124–35; L. Gravina, Città e marina di Pietrasanta, Livorno, 1931.

Massa Marittima. Known to have belonged to the Etruscans and later to the Romans, its history is linked with that of Populonia (see below). It was destroyed by the Saracens in 935, but in the later Middle Ages it became prosperous. It declined after the 16th century on account of malaria, but in the 19th century reclamation brought a return of prosperity. It is divided into a lower (older) city and an upper (newer) city and is surrounded by walls, partially destroyed in 1337, rebuilt and enlarged at a later date. The layout of the streets is irregular, except in the newer quarters. The Cathedral (13th–14th cent.) was originally Romanesque with Pisan influences; the later parts have Gothic elements, especially in the presbytery and apse; the campanile has been rebuilt. The interior has three aisles, with richly carved capitals, and contains a baptismal font carved by Giroldo da Lugano (1267), the tomb of St. Cerbonius, by Goro di Gregorio di Siena (1324), and an altarpiece *Madonna delle Grazie* (derived from Duccio's *Maestà*). The upper city contains a number of Romanesque secular buildings, including the house of the Biserno family (13th cent., with Renaissance additions), with a crenelated tower; the Palazzo Comunale (central part by Stefano di Meo and Gualtiero di Sozzo, 14th cent.) with its tower (Bargello) built in the 13th century; and the Torre del Candeliere (or Orologio), part of a fortress built in 1228, adjoining the 14th-century Porta alle Silici. The Sienese fortress, built after the conquest of the city in 1337, was later partly demolished and rebuilt. S. Agostino, built 1299–1312, is Gothic, with a monumental portal and a rose window on the façade and a polygonal apse. S. Francesco (13th cent.), Romanesque Gothic, retains the original polygonal apse but is much damaged. The Museo Civico, in the Palazzo Comunale, contains the *Maestà* by Ambrogio Lorenzetti.

BIBLIOG. L. Petrocci and E. Lombardi, Guida storico-artistica di Massa Marittima, Massa Marittima, 1957; P. Bocci, EAA, s.v. Massa Marittima, IV, 1961, pp. 918–19.

Montalcino. Situated on a hill between the valleys of the Ombrone and the Asso, the site was inhabited in Etruscan and Roman times. In 814 it was donated to the Abbey of S. Antimo but later became an independent commune. The Palazzo Comunale, with a high tower, was built in the 13th and 14th centuries under the commune in Florentine style. The Loggia (14th–15th cent.) is nearby. The Rocca, a Sienese fortress built in 1361 during the war between Siena and Florence, incorporates walls of the 13th century and has bastions added in the 16th century. S. Egidio was built by the Sienese in 1325 on the site of an older church. S. Francesco is of the 13th century (remodeled, 18th cent.). The Cathedral, originally Romanesque, was rebuilt in neoclassic style (1818–32). *Museums*: Museo Civico, with Sienese art, local archaeological material, and ceramics; Museo Diocesano di Arte Sacra.

A few miles south is the Abbey of S. Antimo, founded in the early 9th century as a Benedictine congregation. The church (1118) is Romanesque of French influence, with nave and side aisles, an ambulatory, radiating chapels in the apse, and gallery. The crypt is part of the original 9th-century building. The campanile, of Lombard type, is of the 13th century.

BIBLIOG. F. Bargagli-Petrucci, Pienza, Montalcino e la Val d'Orcia, Bergamo, 1911; A. Canestrelli, L'abbazia di Sant'Antimo presso Montalcino, Vita d'arte, VIII, 1911, pp. 212–16.

Montepulciano. The site was probably inhabited by the Etruscans. It was mentioned as Mons Politianus in a document of 715. It was nearly always subject either to Florence or Siena, being independent only between 1208 and 1260. In appearance the city is mostly of the Renaissance. Surviving medieval buildings were originally Gothic but are mostly remodeled. S. Agnese (built, 1311; remodeled in the 17th cent.; façade, 1926) preserves a 14th-century portal and frescoes of the Sienese school. S. Maria dei Servi (14th cent.) has a Gothic façade with a cusped portal; the baroque interior, decorated with frescoes, was designed by Pier Andrea Pozzo. The Casa del Poliziano, the Palazzo Comunale (with double battlemented tower), and the Palazzo del Capitano del Popolo (now della Pretura), are all of the 14th century but partly remodeled. The Palazzo Neri-Orselli Bombagli is in Sienese Gothic style (restored). The Renaissance buildings and monuments show Florentine influences. S. Agostino, in transitional Gothic-Renaissance style, has a late Gothic façade completed and decorated by Michelozzo (PL. 191); the single-aisled interior, remodeled in the 18th century, contains works by Pollaiuolo, Lorenzo di Credi, and Giovanni di Paolo. The Cathedral (1592–1630) was designed by Ippolito Scalza; in the interior are parts of the dismantled tomb monument of Bartolomeo Aragazzi, by Michelozzo (III, PL. 391), and a triptych of the *Assumption* by Taddeo di Bartolo. A number of palaces are attributed to Vignola, including the Avignonesi, Tarugi (formerly Nobili), and Grugni (formerly Gagnoni). The Palazzo Contucci (fomerly Del Monte) was designed by Antonio da Sangallo the Elder in 1519 but was completed by Baldassare Peruzzi; frescoes in the interior are by Pier Andrea Pozzo. Peruzzi also designed the Palazzo Ricci. The Palazzo Cervini, designed by Antonio da Sangallo the Elder, was never completed. Also attributed to Antonio da Sangallo the Elder is the Cocconi palace. The Logge del Mercato, with a triple arcade supported by piers, are attributed to Ippolito Scalza. Of the baroque period is the Gesù (begun 17th cent.), on a circular plan, by Giovanni Battista Arrigoni, remodeled by Pozzo, and completed (1733) by Sebastiano Cipriani. Pozzo also designed the oval Church of S. Bernardo. S. Lucia has a baroque façade by Flaminio del Turco (1653); the interior (restored) contains the *Madonna della Misericordia* by Luca Signorelli. The Museo Civico, in the Palazzo Comunale, contains 14th–17th-century Tuscan paintings and minor arts.

Beyond the Porta al Prato is the Church of the Madonna di S. Biagio, the masterpiece of Antonio da Sangallo the Elder (1518–45), in the form of a Greek cross with a dome over the crossing and a projecting semicircular apse. To the left of the church is the Canonica, designed by Sangallo the Elder (1595), with two orders of loggias. Also outside the city is the Church of S. Maria delle Grazie, designed by Ippolito Scalza.

BIBLIOG. F. Bargagli-Petrucci, Montepulciano, Chiusi e la Val d'Elsa, Bergamo, 1907; G. B. Mannucci, L'impronta artistica di Montepulciano, Arte e storia, XXXIII, 1914, pp. 97–103; G. Giovannoni, Il Duomo di Montepulciano, Palladio, I, 1937, pp. 180–82; R. Bonelli, L'architetto e le vicende costruttive del Duomo di Montepulciano, Palladio, III, 1939, pp. 91–92; R. Bonelli, Ippolito Scalza e il Duomo di Montepulciano, B. senese storia patria, N.S., X, 1939, pp. 1–10; A. Schiavo, La Madonna di S. Biagio a Montepulciano, B. Centro S. storia arch., VI, 1952, pp. 33–50; G. Secchi Tarugi, Guida di Montepulciano, Milan, 1959.

Orbetello. On a narrow strip of land projecting into the Orbetello lagoon, it was a flourishing Etruscan city between the 8th and 4th centuries B.C. Under Rome it declined, its place being taken by Cosa. In the Middle Ages it belonged successively to the Abbey of Tre Fontane, the Aldobrandeschi and Orsini families and, from 1414 to 1555, to Siena. From 1555 to 1708 it was the capital of the Spanish presidio, which included Porto Ercole, Porto Santo Stefano, the Monte Argentario peninsula, Talamone, and Porto Longone (on Elba). In 1736 it became a part of the Kingdom of Naples, and in 1815 it was annexed by the grand duchy of Tuscany. Of the Etruscan period are parts of the polygonal walls, with double piling (3d cent. B.C.). There are traces of a Roman temple of the republican period. The Cathedral (founded 1376) was enlarged in the 17th century; it retains the original Gothic façade. There are remains of the Spanish fortifications of 1557–1620. The Antiquarium Comunale contains Etruscan, Greek, and Roman antiquities found in the neighborhood.

BIBLIOG. G. Pellegrini, Tegoli e mattoni sigillati trovati nella villa romana del Castellare presso Giglio Marina, NSc, 1901, pp. 5–7; T. Campanile, Rinvenimenti archeologici in località "Le Tombe" e "Santa Francesca," NSc, 1919, pp. 261–75; P. Raveggi, Le rovine romane del "Castellare" e del "Bagno del Saraceno," NSc, 1919, pp. 275–79; P. Raveggi, Orbetello antica e moderna, Grosseto, 1933; F. E. Brown, Cosa I: History and Topography, MAARome, XX, 1951, pp. 5–113 at 7; M. Santangelo, L'Antiquarium di Orbetello, Rome, 1954.

Pescia. In the Valdinievole, between Pistoia and Lucca, this was an independent commune from the 12th century until it came under Florentine rule in 1329. The Palazzo Vicario (now the Municipio) dates from the 13th century. S. Francesco's (late 13th cent.; façade remodeled, 1505 and 1632) interior (restored) is notable for the Cardini Chapel attributed to Andrea Cavalcanti (Il Buggiano), a pupil of Brunelleschi; for a panel portraying St. Francis by Bonaventura Berlinghieri (1235); and for works by Neri di Bicci and Niccolò di Pietro Gerini. S. Antonio (1361) is decorated with frescoes by Bicci di Lorenzo and contains a 13th-century *Deposition* in wood. The Oratory of the Madonna a Piè di Piazza (SS. Pietro e Paolo), built in 1447, is attributed to Il Buggiano. The Cathedral, rebuilt in 1693 by Antonio Ferri, incorporates some Romanesque fragments from the earlier church. The campanile was built in 1306. The Museo Civico and the Biblioteca Comunale, with an important collection of incunabula and manuscripts, are in the Palazzo Galeotti.

Approximately 5 miles west of Pescia is Collodi with the Villa Garzoni, situated in an Italian garden laid out by Ottaviano Diodati (18th cent.). In the town is a monument to Pinocchio by Emilio Greco (1954).

BIBLIOG. L. Crespi, Descrizione delle sculture, pitture et architetture della città e sobborghi di Pescia, Bologna, 1772; M. Ansaldi, Chiesa e conventi di S. Francesco di Pescia, Pescia, 1911; E. Nucci, La chiesa cattedrale di Pescia, Pescia, 1938; E. Nucci, La chiesa plebana della SS. Annunziata, Pescia, 1938.

Pienza. The town is named after Pope Pius II (Aeneas Silvius Piccolomini), who sponsored its construction on the site of the medieval village of Corsignano and commissioned Bernardo Rossellino to plan it. Begun in 1459, it has retained the Renaissance unity of style, centered around a square of monumental character (I, PL. 390). The Cathedral (1459–62; III, PL. 388) was designed by Rossellino, on the *Hallenkirche* plan, with a nave and two lateral aisles terminating in a circular ambulatory. The church contains works by Sano di Pietro, Lorenzo di Pietro (Il Vecchietta), and Matteo di Giovanni. The Palazzo Piccolomini, which derives from Alberti's Palazzo Rucellai in Florence, is also by Rossellino, to whom the Palazzo Comunale is attributed as well. The former Palazzo Borgia (now Vescovile) was remodeled from a Gothic structure, probably by Il Vecchietta. Also of the 15th century are the Palazzo Ammannati (now Newton) and the Palazzo Simonelli (formerly Gonzaga). A few of the buildings of the older town of Corsignano still exist. S. Francesco (13th cent., restored) has a single aisle with a trussed ceiling. The old parish church, outside the city, is Romanesque of the 11th and 12th centuries, with small unsupported arches crowning the façade. The Museo Diocesano di Arte Sacra has a collection of material from the Cathedral and other churches.

BIBLIOG. F. Bargagli-Petrucci, Pienza, Montalcino e la Val d'Orcia, Bergamo, 1911; G. B. Mannucci, Pienza, Montepulciano, 1915; G. B. Mannucci, La pieve romanica di Corsignano, Milan, 1930; A. Barbacci, Ruderi di una chiesa romanica rinvenuti sotto il Duomo di Pienza, BArte, XXVI, 1932–33, pp. 352–58; A. Barbacci, Il Duomo di Pienza e i suoi restauri, Siena, 1934; L. H. Heydenreich, Pius II als Bauer von Pienza, ZfKg, VI, 1937, pp. 105–46; A. Schiavo, Monumenti di Pienza, Milan, 1942; P. Torriti, Pienza e i suoi dintorni, Genoa, 1956.

Pisa (Lat., Pisae). Originally, a port, Pisa now is situated on both banks of the Arno, about 6 miles from the estuary. It may have been a Greek Phocian colony (founded, 7th–6th cent. B.C.) on Ligurian territory or a Ligurian city conquered by the Etruscans in the 5th century B.C. Under the Romans it was an important naval base, and its maritime activity continued in the early Middle Ages. As a free commune and a maritime republic (11th–14th cent.), Pisa flourished, and the major architectural monuments and city plan of the present are of those centuries, though heavily damaged in World War II. Of the Roman period there are remains of baths (the so-called "*Bagno di Nerone*"), of the 2d century, and traces of the forum and of an amphitheater.

Pisan Romanesque architecture, seen at its finest in the Piazza dei Miracoli (Piazza del Duomo), is expressed in forms of great originality which had an influence far beyond the borders of Tuscany (see *Apulia, Sardinia*). The Cathedral, begun in 1063 by Busketus, was enlarged (1150–60) by Rainaldo, who lengthened the nave and erected the façade with an order of arches on the ground level and four orders of loggias above. The lateral walls have a series of blind arches. The bronze doors of the Porta di S. Ranieri (IX, PL. 508) are by Bonannus of Pisa. The interior is a Latin cross, with a nave and four aisles and a semicircular apse. The arms of the transept also have semicircular apses. The conch of the central apse is decorated with 13th-century mosaics completed by Cimabue (III, PL. 327). The dome above the crossing rests on an ellipsoid drum above pointed arches of Islamic type. The pulpit is by Giovanni Pisano (VI, PLS. 213, 214; X, PL. 248). The church also contains canvases by Domenico Beccafumi and a series of paintings by Tuscan and mannerist painters of the

16th and 17th centuries (among them, Andrea del Sarto; I, PL. 252). The freestanding Campanile (the famous "Leaning Tower") was begun in 1174 by Bonannus and completed in 1372. It is cylindrical, and the decoration repeats that of the façade of the Cathedral, with open loggias above an order of high blind arches on the ground level. The Baptistery, begun in 1153 by Diotisalvi, is circular in plan, faced with blind arcades, and surmounted by a dome. The crowning and decorations are Gothic. The cusps of the loggia of the second level are decorated with half figures by Nicola and Giovanni Pisano and assistants (some are copies). The interior has a gallery supported by eight pillars and four piers, creating a circular ambulatory. The octagonal baptismal font is by Guido Bigarelli da Como (VIII, PL. 82). The hexagonal pulpit, by Nicola Pisano (I, PL. 303; X, PL. 321) is supported by seven columns. The Piazza dei Miracoli is completed by the Camposanto. Designed by Giovanni di Simone in 1278, the plan is a rectangular enclosure, with an outer marble wall decorated with blind arches, and the inner space surrounded by a porticoed gallery. It contains sculptures of various periods and a cycle of 14th- and 15th-century frescoes, among them, *The Triumph of Death* (IV, PL. 466; VI, PL. 379) and works by Antonio Veneziano, Spinello Aretino, Benozzo Gozzoli, and Taddeo Gaddi, all badly damaged in 1944 and heavily restored. S. Paolo a Ripa d'Arno (PL. 178), built over a 9th-century church, was reconsecrated in 1148. The façade has arches of various types, some of Oriental derivation and some with twisted columns. Directly behind the church is the octagonal Chapel of S. Agata (12th cent.), which shows Lombard influences. Most of the other Romanesque churches have been restored or remodeled, including S. Pierino (1072–1119), with a vast crypt; S. Frediano (11th–12th cent.; restored, 16th–17th cent.); S. Matteo (11th–13th cent.; remodeled, 17th cent.); S. Jacopo in Orticaia, with 12th-century exterior (interior remodeled, 17th cent.); S. Cecilia (1103), with a simple Romanesque façade decorated with majolica plaques; and S. Andrea Forisportam (12th cent.; remodeled, 1840).

The earliest Gothic influences appeared in the second half of the 13th century. The Dominican Church of S. Caterina, built between 1251 and 1300, has a traditional Pisan façade (1330), but the arches of the two upper orders of arcades are Gothic. The interior contains works by Nino Pisano (VI, PL. 366), Francesco Traini, Fra Bartolommeo, Santi di Tito, and others. The campanile of the Benedictine Church of S. Nicola (mid-13th cent.) is cylindrical in the lower part, octagonal above, and surmounted by a loggia. The church was completely remodeled at a later period. S. Francesco was founded in 1211 but rebuilt in its present form in the 14th century; the façade was completed in 1603. It contains frescoes by Taddeo Gaddi (1342), Niccolò di Pietro Gerini (1392), and Taddeo di Bartolo (1397). S. Maria della Spina (VI, PL. 337) was originally a small oratory on the banks of the Arno; it was enlarged in 1323, and in 1871 it was dismantled and reassembled, on a higher level, on the Lungarno. The façade and right side are decorated in an elaborated Gothic style, with statues by pupils of Giovanni and Nino Pisano. Of the late 14th century, but all remodeled to a greater or lesser extent, are S. Domenico, with frescoes by Benozzo Gozzoli; S. Maria del Carmine, rebuilt in 1612; S. Giorgio ai Tedeschi, with a 14th-century Rhenish wooden crucifix; S. Ranierino, with frescoes by Spinello Aretino and a *Crucifixion* in Byzantine style by Giunta Pisano; S. Martino; and S. Antonio.

Medieval secular architecture is represented by a number of house towers and a few palaces, including the Palazzo Medici (now the Prefettura), recently restored; the Palazzo Gambacorti (now Palazzo Comunale), with a 17th-century lateral façade; and the Scorzi and Agostini palaces. There are few important buildings or monuments of the 15th century: The Fortress (restored) was originally a Pisan arsenal (12th cent.?) and was rebuilt by the Florentines in 1405; the Ospizio dei Trovatelli (Foundling Hospital) is in Florentine style. The Piazza dei Cavalieri, laid out in the 16th century by Giorgio Vasari, is dominated by the Palazzo dei Cavalieri, rebuilt by Vasari in 1562. Adjoining it is the Church of S. Stefano dei Cavalieri (also by Vasari, 1565–69); the interior, with a single aisle, has a 17th-century carved wooden ceiling and contains the so-called "S. Rossore" (a reliquary figure) by Donatello, a *Nativity* by Bronzino, and works by late mannerist Florentine artists. The Palazzo dell'Orologio (now Gherardesca), the Palazzo del Collegio Puteano, and the Palazzo del Consiglio dell'Ordine dei Cavalieri di S. Stefano complete the square. Other late 16th- and 17th-century buildings include the Palazzo Upezzinghi (also known as *alla Giornata*), by Cosimo Pugliani (1594); the Palazzo Reale, by Baccio Bandinelli (1559); the episcopal palace; and the Palazzo Simoneschi. The Logge di Banchi, an arcade built in 1603–05 as a textile market, are attributed to Buontalenti. The Museo Nazionale contains an important collection of Tuscan painting and sculpture from the 12th to the 15th century, including works by Giovanni Pisano, Simone Martini, Donatello, Jacopo della Quercia, Verrocchio, Fra Angelico, and Masaccio.

Outside the city, between Pisa and the sea, is the Romanesque Church of S. Pietro a Grado (mid-11th cent.), built over a 6th–7th-century church, at the point where, in Roman times, the Arno flowed into the Pisan bay. It has no façade, but the exterior is decorated with pilaster strips, unsupported arches, and glazed terra-cotta medallions. It has a triple apse at the eastern end and a single apse at the western end. The interior is divided into a nave and two aisles by ancient columns and preserves 13th-century frescoes.

BIBLIOG. G. M. Rohault de Fleury, Les monuments de Pise au moyen âge, 2 vols., Paris, 1866; I. B. Supino, Pisa, Bergamo, 1905; F. Buonamici, Sulla origine di Pisa, Pisa, 1910; A. Manghi, La Certosa di Pisa, Pisa, 1911; A. von Berger, Architettura sacra del Medioevo in Pisa, Siena, 1912; R. Papini, Catalogo delle cose d'arte e di antichità d'Italia: Pisa, Rome, 1912; I. B. Supino, La costruzione del Duomo di Pisa, Bologna, 1914; Ministero Pubblica Istruzione, Elenco degli edifici monumentali, XXXIII: Provincia di Pisa, Rome, 1921; A. Neppi Modona, Carta archeologica d'Italia, Florence, 1932; M. Salmi, Il palazzo e la piazza dei Cavalieri, Bologna, 1932; A. Bartolini, L'architettura civile del medioevo in Pisa, Pisa, 1937; E. Carli and P. E. Arias, Il Camposanto di Pisa, Rome, 1937; C. L. Ragghianti, Architettura lucchese e architettura pisana, CrArte, VIII, 1949, pp. 168–72; P. Sanpaolesi, La piazza dei Miracoli: il Duomo, il Battistero, il Campanile, il Camposanto di Pisa, Florence, 1949; A. Neppi Modona, Pisae (Forma Italiae), Rome, 1953; G. C. Nuti, La chiesa di S. Paolo a ripa d'Arno e i suoi recenti ritrovamenti, Palladio, N.S., III, 1953, pp. 177–84; L. Pera, L'architettura minore del periodo romanico in Pisa, Rome, 1954; G. Nannicini Canale, Pianta di Pisa al tempo del gentiluomo, CrArte, N.S., III, 1956, pp. 526–34; P. Sanpaolesi, Il campanile di Pisa, Pisa, 1956; P. Sanpaolesi, La facciata della Cattedrale di Pisa, RIASA, N.S., V–VI, 1956–57, pp. 248–394; A. Del Bufalo, Architettura religiosa minore pisana, Rome, 1957; A. Del Bufalo, La chiesa di S. Francesco, Rome, 1957; A. Boscolo, L'abbazia di San Vittore, Marsiglia, Pisa e la Sardegna, Padua, 1958; D. Herlihy, Pisa in the Early Renaissance: A Study of Urban Growth, New Haven, 1958; P. Sanpaolesi, Il restauro delle strutture della Cupola della Cattedrale di Pisa, BArte, XLIV, 1959, pp. 199–230; M. Bucci and L. Bertolini, Camposanto monumentale di Pisa, Pisa, 1960; S. Burger, Osservazioni sulla storia della costruzione del Duomo di Pisa, CrArte, N.S., VIII, 1961, 43, pp. 28–44, 44, pp. 20–35.

Pistoia (Lat., Pistoriae). Of Roman origin (3d or 2d century B.C.), Pistoia became an episcopal see in the 5th century and under the Lombards was an imperial city. In 1115 it became an independent commune. Periods of prosperity alternated with wars against Lucca and Florence, until in 1530 Pistoia became subject to the latter. In World War II it suffered heavy damage. From the Roman period the city still retains traces of the rectangular plan, growing up around a central square within the bastions. The local Romanesque architecture is derived from Pisan models, with an added emphasis on delicacy of pattern and on the use of color. The Cathedral, founded in the 5th century, has retained Romanesque elements in the façade and in the interior (partly remodeled, 17th cent.). It contains the silver altar frontal of St. James (VI, PL. 388), the monument of Cardinal Forteguerri, in part by Verrocchio, and the *Madonna and Child Enthroned with Saints*, begun by Verrocchio and completed by Lorenzo di Credi (1485). In the sacristy (Museo della Cattedrale) there are a storied cross by Coppo di Marcovaldo and his son, and a rich treasury. Several churches have retained their original Romanesque structure intact. S. Bartolomeo in Pantano (1159) has a façade with five arches and central portal, with sculptured architrave attributed to Gruamonte (1167). The interior is divided into three very narrow aisles and contains a pulpit by Guido Bigarelli da Como (III, PL. 19). S. Andrea (12th cent.) is of similar design; the sculptures above the central portal are by Gruamonte and Adeodatus (1166); the pulpit in the interior is by Giovanni Pisano (III, PL. 312; VI, PL. 212). S. Giovanni Fuorcivitas, built between the 12th and 14th centuries, has an unfinished façade; its lateral walls are decorated with white and green marble stripes and blind arches enclosing geometric designs (PL. 178). The architrave of the lateral portal is by Gruamonte (1162). In the interior, which has a single aisle and a raised presbytery, are a pulpit by Fra Guglielmo (1270), a holy-water stoup by Giovanni Pisano, and a polyptych by Taddeo Gaddi (1355).

Gothic elements are seen in the Baptistery, finished by Cellino di Nese (1359) from designs by Andrea Pisano. It is octagonal, with wall facings of white and green marble, showing Florentine influence. S. Domenico, probably designed by Fra Sisto and Fra Ristoro in the late 13th century, enlarged in 1380, is Gothic, with a rectangular apse. The interior has a wide nave with a trussed ceiling and Gothic vaulting in the transept; it preserves 14th-century frescoes, the tomb of Filippo Lazzari by Bernardo and Antonio Rossellino (1462–68), and a *Madonna and Child* by Fra Bartolommeo. S. Francesco, begun in 1294 (façade 1717), is Latin cross in plan, with a single aisle and a trussed ceiling. The apse is flanked by the five groin-vaulted chapels of the transept. The walls are decorated with 14th- and 15th-century frescoes by the school of Giotto and Sienese artists.

Secular buildings of the period include the Palazzo del Comune (begun 1294; enlarged several times), with a portico and two orders of double- and triple-arched windows above; the Palazzo Pretorio (1367; with a wing added, 1844–46); the Palazzo Panciatichi (1313–22); and the Palagetto (late 13th cent.), with ancient shops.

Renaissance buildings show a strong Florentine influence. S. Maria delle Grazie was designed by Michelozzo in 1452–69 and was restored in 1896. S. Giovanni Battista, built by Ventura Vitoni (1487–1516), has been reconstructed since World War II. The form is a rectangle with a hemispherical dome on squinches over a rectangular drum. The façade was never completed. The Church of the Madonna dell'Umiltà by Vitoni (begun 1509) has an unfinished façade with an 18th-century portal. The interior is an octagon, with dome and lantern added by Vasari after 1561. The vestibule has barrel vaulting and a small dome on squinches at the center. The Ospedale del Ceppo (founded, 14th cent.) has a portico in the style of Brunelleschi added in 1514. The enameled terra-cotta frieze is by Giovanni della Robbia and assistants (III, PL. 313). The Church of the Spirito Santo is baroque (consecrated, 1647), with an altar in the style of Bernini, a frontal by Pietro da Cortona, and works by Giovanni da San Giovanni. The Borsa Merci (V, PL. 117) was designed by G. Michelucci (1950). *Museums*: Museo Civico, in the Palazzo Comunale, with works by Tuscan artists; Museo della Cattedrale, in the sacristy of the Cathedral.

BIBLIOG. G. Beani, La cattedrale pistoiese, Pistoia, 1903; O. H. Giglioli, Pistoia nelle sue opere d'arte, Florence, 1904; G. Pellegrini, Scavi archeologici in piazza del Duomo, NSc, 1904, pp. 241–70; P. Bacci, La chiesa di S. Giovanni "Forcivitas," BArte, I, 1907, pp. 23–30; I. Gonfiantini, Pistoia artistica, Pistoia, 1927; L. Chiappelli, Della topografia antica di Pistoia, B. storico pistoiese, XXXII, 1930, pp. 170–93, XXXIII, 1931, pp. 19–36, 80–85; M. P. Puccinelli, Lo sviluppo topografico di Pistoia, B. storico pistoiese, XLIX, 1947, pp. 3–31; A. Chiti, Il santuario della Madonna dell'Umiltà in Pistoia, Pistoia, 1952; Q. Santoli, Il Palazzo del Podestà, B. storico pistoiese, LVI, 1954, pp. 41–84; A. Chiti, Pistoia, Pistoia, 1956; S. Ferrali, Fasti e nefasti d'un monumento: Appunto di storia della Cattedrale di Pistoia, Pistoia, 1956.

Populonia (Etruscan, Fufluna, Pupluna). On a promontory north of Piombino, it was inhabited in the 9th century B.C. (Villanovan civilization) and from the 7th century B.C. was an important Etruscan port and industrial center. In the 3d century B.C. it became a Roman foundry center and in 90 B.C. a municipium. It declined during the Middle Ages. There are remains of the Etruscan walls. At Porto Baratti, on the shore below the site of the ancient city, there is a vast necroplis with tombs of Villanovan and Orientalizing Etruscan types, Etruscan tumuli (7th–6th cent. B.C.) with underground chambers and false vaulting, and aedicula tombs of the 5th and 4th centuries. Tomb furnishings included bronzes, gold jewelry, and pottery, both Etruscan and Greek. On the heights is a medieval fortress with towers. The Museo Etrusco contains artifacts of the Villanovan, Etruscan, and Roman periods from the necroplis and others sites in the vicinity.

BIBLIOG. A. Minto, Populonia, Florence, 1922; A. Minto, Le ultime scoperte archeologiche di Populonia (1927–1931), MALinc, XXXIV, 1932, cols. 289–420; A. Minto, Populonia, Florence, 1943; A. de Agostino, Tomba etrusca a camera scoperta nella zona "Podere S. Cerbone," NSc, 8th ser., VII, 1953, pp. 7–9; A. Minto, L'antica industria mineraria in Etruria ed il porto di Populonia, SEtr, XXIII, 1954, pp. 291–319; A. de Agostino, Nuovi contributi all'archeologia di Populonia, SEtr, XXIV, 1955, pp. 255–68; G. Caputo, Populonia: Scoperte nella necropoli, FA, X, 1955, 2602, XI, 1956, 2801.

Prato. The earliest historical record of the town is dated 998. In the 12th century Prato became an independent commune and in 1351 it came under Florentine domination. Its prosperity, from the 13th century onwards, was based on its wool weaving industry, which flourished in the 14th century with the mercantile expansion of Francesco di Marco Datini. The Romanesque Cathedral was founded in the 9th century, but rebuilding was begun in 1211 by Guidetto da Como, who decorated the façade with blind arches (now covered by the 15th-century façade of white and green marble but still visible from the inside). The portal has a lunette by Andrea della Robbia (1489). On the right corner of the façade is a pulpit by Donatello and Michelozzo (1434–38). The five-story campanile (1340–56) has five orders of double- and triple-arched windows. In the interior, the nave is separated from the aisles by dark-green marble columns. The church was enlarged in the 14th century with the addition of the crossing and transept (with Gothic arches and vaulting) and the five chapels of the presbytery. The frescoes in the choir are by Filippo Lippi (IX, PL. 145). The Cathedral also contains works by Antonio Rossellino, Mino da Fiesole, Benedetto and Giuliano da Maiano, Giovanni Pisano, Agnolo Gaddi, and Andrea di Giusto. S. Fabiano, formerly an abbey church, is also Romanesque but has been radically remodeled and restored. S. Francesco (late 13th cent.; remodeled several times) has a 15th-century façade and a single aisle with a trussed ceiling; inside is the tomb of Gimignano Inghirami, attributed to Bernardo and (possibly) Antonio Rossellino. The adjoining cloister is of the 15th century. The chapter house is decorated with frescoes by Niccolò di Pietro Gerini (ca. 1395). S. Domenico (1283–1322) has an unfinished façade with a marble portal; the interior was remodeled in baroque style. S. Bartolomeo, of the late 14th century,

was rebuilt after World War II. S. Niccolò, built in 1322, has a baroque interior.

There are a number of interesting secular buildings. The Castello dell'Imperatore (ca. 1237–45), a castle of a type rare in Tuscany, was built for Frederick II, on the perimeter of the old city walls. Square in plan, it has rectangular towers on the corners and a pentagonal tower in the center of each side. The Palazzo Pretorio was built partly in the 12th century and enlarged in the 14th; the small tower was added in the 16th century. The Palazzo Datini (13th cent.), bequeathed to the poor at the owner's death, has external painted decorations and interior frescoes by Niccolò di Pietro Gerini. It houses extensive commercial archives and cloth samples.

One of the masterpieces of Giuliano da Sangallo, S. Maria delle Carceri, was built between 1484 and 1495 in the form of a Greek cross. The unfinished exterior is faced with colored marble. The structure of the interior is outlined in *pietra serena* and is decorated with friezes and medallions of enameled terra cotta by Andrea della Robbia. S. Vincenzo (1733) is an example of the local baroque style. *Museums*: Galleria Comunale, in the Palazzo Pretorio, with paintings of the Florentine school, 14th–17th century; Museo dell'Opera del Duomo.

BIBLIOG. G. Guasti, Della Cattedrale di Prato, Prato, 1844; O. H. Giglioli, Prato, Florence, 1902; E. Corradini, Prato e i suoi dintorni, Bergamo, 1912; G. Poggi, La Cappella del Sacro Cingolo nel Duomo di Prato e gli affreschi di Agnolo Gaddi, Riv. d'arte, XIV, 1932, pp. 355–76; R. Nuti, Topografia di Prato nel Medioevo, Arch. storico pratese, XII, 1934, pp. 172–81, XIII, 1935, pp. 33–37, 76–84, 131–43, XIV, 1936, pp. 112–17, XXVII, 1951, pp. 45–68, XXIX, 1953, pp. 25–48; G. Agnello, Il Castello svevo di Prato, RIASA, N.S., III, 1954, pp. 147–227; S. Bardazzi, Struttura della città medioevale, Arch. storico pratese, XXX, 1954, pp. 21–28; M. Lopes Pegna, Prato romana, Arch. storico pratese, XXX, 1954, pp. 3–20; S. Bardazzi, Il Castello dell'Imperatore, Arch. storico pratese, XXXI, 1955, pp. 26–35; G. Marchini, Prato, Florence, 1956; G. Marchini, Il Duomo di Prato, Rome, 1957; N. Bemporad, Il restauro del palazzo Datini a Prato, Prato, 1958.

San Gimignano. The site was inhabited in ancient times. The present town was a free commune in the 12th century but was frequently at war with Florence, under whose rule it came in 1354. Enclosed within walls it has retained its medieval appearance. Its most salient characteristic is the large number of towers and the narrow twisting streets. The most noteworthy monuments are Romanesque. S. Pietro (11th cent.) has frescoes by Barna da Siena and other 14th-

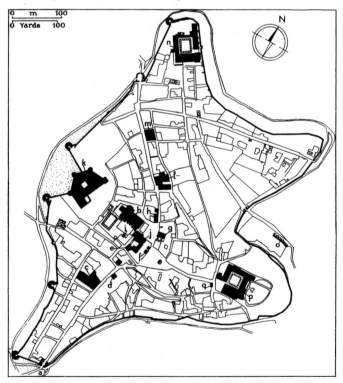

San Gimignano, plan of the city within the 13th-century walls. Principal monuments: (*a*) Porta S. Giovanni; (*b*) Collegiata (Cathedral); (*c*) Palazzo Pratellesi; (*d*) Cugnanesi tower; (*e*) Palazzo Becci and tower; (*f*) Ardinghelli tower; (*g*) Palazzo del Podestà; (*h*) Salvucci tower; (*i*) Palazzo della Prepositura; (*j*) Palazzo del Popolo; (*k*) fortress; (*l*) Pesciolini tower-house; (*m*) Palazzo Tinacci; (*n*) S. Agostino; (*o*) fountains; (*p*) penitentiary (formerly Monastery of S. Domenico); (*q*) S. Lorenzo in Ponte (*from G. Rohault de Fleury, La Toscane au Moyen-âge, Paris, 1874*).

century Sienese artists. The Collegiata (Cathedral) was consecrated in 1148; originally basilican, it was remodeled in the form of a Latin cross by Giuliano da Maiano in 1458 and several times thereafter; the façade (1239) has also been remodeled a number of times. The walls and ceiling are frescoed with various cycles, including scenes from the life of Christ by Barna da Siena (1381?), Old Testament scenes by Bartolo di Fredi (ca. 1356), *The Last Judgment* by Taddeo di Bartolo (III, PL. 417), and *The Martyrdom of St. Sebastian* by Benozzo Gozzoli (1465). The church also contains works by Matteo Rosselli, Piero Pollaiuolo, and Jacopo della Quercia. The Chapel of S. Fina, added by Giuliano da Maiano in 1468, contains an altar frontal by Benedetto da Maiano and frescoes of scenes from the life of St. Fina by Domenico Ghirlandajo (VI, PL. 179). The ciborium in the presbytery is also by Benedetto da Maiano. S. Jacopo (founded 13th cent.) has a Romanesque façade, but the interior was remodeled in Gothic style. S. Lorenzo in Ponte (1240, restored) has a Romanesque portal and 15th-century frescoes. Gothic influences are seen in the three apses of S. Agostino (1280–98); the interior contains works by Bartolo di Fredi, Benozzo Gozzoli, Benedetto da Maiano, and Piero Pollaiuolo (XI, PL. 183).

Some of the most interesting architecture is secular. The Palazzo del Podestà (1239; enlarged, 1337) has a tower known as "la Rognosa." The twin towers (13th cent.) of the rival Guelph and Ghibelline families Ardinghelli and Salvucci rise in the center of the town. The Palazzo del Popolo (now Comunale), built in 1288 and enlarged in 1323, is attached to the Torre Grossa (1298); in the council chamber (Sala di Dante) is a fresco copy by Lippo Memmi of Simone Martini's *Maestà*. The Casa-torre Pesciolini (late 13th cent.) is a tower-house of Florentine type. The Via S. Matteo is flanked by some of the best-preserved medieval houses and ends at the Porta S. Matteo (1262), one of the five gates of the city. Palaces of the 14th century include the Tortoli and the Pratellesi. *Museums*: The Pinacoteca in the Palazzo del Popolo, with Sienese and Florentine paintings of the 13th–15th centuries; Museo d'Arte Sacra.

BIBLIOG. N. Baldoria, Monumenti artistici in San Gimignano, Arch. storico dell'arte, III, 1890, pp. 35–68; R. Pantini, San Gimignano, Bergamo, 1908; C. Falci de' Franzisi, San Gimignano, Florence, 1950; J. C. Moreaux, San Gimignano, Rev. des arts, III, 1953, pp. 13–15; M. Mazzoni, San Gimignano, Siena, 1954; Y. Bruard, S. Gimignano et ses enceintes, Mél, LXVII, 1955, pp. 259–77.

S. Quirico d'Orcia (formerly San Quirico in Osenna). Seat of an imperial vicar in the Middle Ages, it came under Sienese rule in 1265. The most noteworthy monument is the Church of the Collegiata (Pieve), known to have existed in the 8th century and rebuilt in Romanesque style in the 12th and 13th centuries (restored after World War II). The Romanesque portal (late 12th cent.) of Lombard type is incorporated into a façade of early Gothic influence. On the right wall is another portal, attributed to Giovanni Pisano (late 13th cent.). A third portal opens into the right side of the crossing. The interior (restored) is a Latin cross and preserves a triptych by Sano di Pietro and wooden choir stalls by Antonio Barili (1482–1502). The little Church of S. Maria (12th cent.) is Romanesque of Lombard influence. It was probably built with the help of master masons from the Abbey of S. Antimo. The Palazzo Chigi, of the 17th century, was damaged in 1944. The Orti Leonini is a large landscaped park, designed by Diomede Leoni, partly enclosed by the walls of the town.

BIBLIOG. A. Canestrelli, La pieve di S. Quirico, Siena, 1906; A. Liberati, San Quirico d'Orcia, B. senese di storia patria, N.S., VII, 1936, pp. 64–68.

Sansepolcro. The town grew up around the original oratory founded in the 10th century by two pilgrims who returned from the Holy Land bearing relics from the Holy Sepulcher. In the 11th century it belonged to the Benedictines and then to the Camaldolites. Later it was an independent commune. In the 15th century it belonged to the Church, which sold it to Florence in 1515. In spite of its recent growth, the appearance of the town is medieval. The Cathedral, formerly a Camaldolite abbey, was originally Romanesque (1012–49) but has been repeatedly remodeled. The stone façade, with three portals and a rose window, is part of the original Romanesque structure. S. Francesco (1258) has a Gothic portal and rose window; the interior, with a single aisle, was remodeled and enlarged in 1764. The high altar (1304) is Gothic; the inlaid wooden choir stalls are of the late 15th century. The cloister has a Gothic portal opening into the chapter house. S. Antonio (1345) is Gothic; over the portal is a lunette with a relief dated 1366. The Church of S. Maria dei Servi, completely rebuilt in 1884, contains works by Matteo di Giovanni (1487). Secular buildings of note include the Palazzo Comunale (13th–14th cent., remodeled); the Fortress (14th cent.), rebuilt by Alberto Alberti after 1561; the Palazzo Pretorio (14th cent.), rebuilt in 1840, decorated with glazed terra cottas from the Della Robbia workshop; and numerous truncated towers, including the Torre di Berta. There

are many private houses and towers of the Renaissance period, among them the Palazzo Cherici, with frescoes and graffiti on the façade by Cherubino Alberti (1587); the house where Piero della Francesca is said to have been born (15th cent.); and the Palazzo delle Laudi, begun in 1591 by Alberto di Giovanni Alberti and completed by Antonio Cantagallina in 1609. S. Agostino, rebuilt in 1771, retains a 16th-century portal and the Romanesque campanile. S. Lorenzo (16th cent.) contains the *Deposition* by Il Rosso. S. Maria delle Grazie (1518) has a porch on the left side and a carved wooden ceiling by Alberto di Giovanni Alberti. The Pinacoteca Comunale, in the Palazzo Comunale, contains paintings of the Tuscan Renaissance, among which are the *Madonna of Mercy* (XI, PL. 157) and *The Resurrection* by Piero della Francesca.

BIBLIOG. O. H. Giglioli, Sansepolcro, Florence, 1921; I. Ricci, Borgo Sansepolcro, Sansepolcro, 1932; I. Ricci, L'Abbazia Camaldolese e la cattedrale di Sansepolcro, Sansepolcro, 1942; V. Carini, Breve guida storico-artistica della Cattedrale di S. Sepolcro, Sansepolcro, 1943.

Siena (Lat., Saena). Siena is situated on three hills in a zone inhabited by the Etruscans, but it arose as a city in the Roman republican period. The Middle Ages witnessed a struggle for power between the people and the nobility, and between Guelphs and Ghibellines (Siena was traditionally a Ghibelline city, as the rival of Guelph Florence), but the prosperity of the city grew as her merchants and bankers extended their sphere of activity all over Europe. In 1530 the city was occupied by the troops of Charles V, and in 1559 it became part of the Medici grand duchy under Cosimo I. Siena has retained its medieval aspect and plan, with buildings mainly of the 14th and 15th centuries.

The city is almost entirely surrounded by walls. There are 14th-century gates fortified with barbicans and battlements, of a design peculiar to Sienese military architecture. There are numerous public fountains (late 13th cent.), generally rectangular, with a vaulted covering opened by two or three Gothic arches. Siena has relatively little Romanesque architecture; examples include the apses of S. Andrea and S. Cristoforo (12th cent.), the portal of SS. Quirico e Giulitta, the campanile of S. Giorgio, and the façade of S. Maria in Betlem (Pisan, 13th cent.). The Cathedral was begun in Romanesque style in the 12th century, but the upper part of the façade was completed only in 1376 and the apse in 1382. The facing of the exterior (and of the Romanesque campanile built in 1313) is of white and black marble horizontal stripes. The façade, of white and colored marble, is Romanesque and Gothic, with three gables. The lower part was designed by Giovanni Pisano (1284–99). On the right side of the façade are the beginnings of structures intended to enlarge the Cathedral but abandoned in 1355. The interior is a Latin cross divided by compound piers and arches into a nave and two lateral aisles, with a dome above the crossing. The apse is very deep and has a stained-glass window designed by Duccio di Buoninsegna (1288). The interior repeats the pattern of black and white horizontal marble stripes of the exterior. The Piccolomini Library (1497), opening from the left aisle, was designed by Lorenzo di Mariano Fucci (Il Marrina) and is decorated with frescoes by Pinturicchio. It contains choir books with illuminations by Liberale da Verona, Girolamo da Cremona, Sano di Pietro, and others. The baroque Chigi Chapel (Cappella della Madonna del Voto), added in 1661, contains sculptures by Gian Lorenzo Bernini, Antonio Raggi, and Ercole Ferrata. The Chapel of S. Giovanni Battista (1482), by Giovanni di Stefano, has a portal by Il Marrina and frescoes by Pinturicchio. The inlaid marble floor (1369–1547) of the Cathedral is divided into 56 figured sections with Biblical scenes by Matteo di Giovanni, Neroccio, Pinturicchio, and Domenico Beccafumi (PL. 86), and others. The pulpit is by Nicola Pisano (VI, PL. 364; X, PLS. 322, 323). The tomb of Cardinal Petroni was carved by Tino di Camaino (1317–18). The high altar, by Baldassare Peruzzi (1532), is surmounted by a bronze baldachin by Lorenzo di Pietro (Il Vecchietta) and flanked by candelabra in the form of angels by Giovanni di Stefano (1482) and Francesco di Giorgio Martini (1497–99). The Baptistery, under the apse of the Cathedral, has a white marble Gothic façade (1382); the baptismal font has sculptured panels by Jacopo della Quercia (IV, PL. 149), Donatello, Lorenzo Ghiberti, Giovanni di Turino, and Turino di Sano.

There are many Gothic churches. S. Domenico, of Cistercian type (begun, 1226; remodeled and enlarged, 14th and 15th cent.), is T-shaped in plan, with an open trussed ceiling over the nave. It contains works by Sano di Pietro, Giovanni di Paolo, Francesco di Giorgio Martini, Matteo di Giovanni, Benvenuto di Giovanni, Ventura Salimbeni, Rutilio Manetti, and Mattia Preti. The Chapel of S. Caterina is decorated with frescoes by Sodoma (1526). S. Maria dei Servi (13th cent.; enlarged, 14th and 15th cent.) has two rose windows on the façade. The interior, in the form of a Latin cross, was remodeled on Renaissance lines, possibly by Peruzzi. Works in the church include the *Madonna del Bordone* by Coppo di Marcovaldo

(1261) and others by Segna di Bonaventura, Rutilio Manetti, Taddeo di Bartolo, Matteo di Giovanni, Bernardino Fungai, Lippo Memmi (PL. 185), Giovanni di Paolo, and Pietro Lorenzetti. S. Francesco (begun 1326) was completed in 1475 from a design attributed to Francesco di Giorgio Martini. It has been altered and restored several times. The interior consists of a single aisle and contains frescoes by Pietro and Ambrogio Lorenzetti (IX, PLS. 191, 197). S. Agostino (1258) has a Gothic apse of the 14th century; the interior was remod-

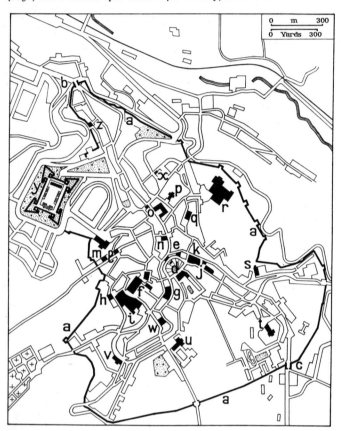

Siena, plan of the city, within and outside the walls. Principal monuments: (a) City walls; (b) Porta Camollia; (c) Porta Romana; (d) Piazza del Campo, Fonte Gaia, and Palazzo Pubblico; (e) Loggia della Mercanzia and Palazzo Sansedoni; (f) Palazzo del Magnifico, Cathedral, and Museo dell'Opera del Duomo; (g) Palazzo Chigi-Saracini; (h) S. Sebastiano; (i) Hospital of S. Maria della Scala and Palazzo del Capitano di Giustizia; (j) Logge del Papa and Church of S. Martino; (k) Palazzo Piccolomini; (l) Fonte Branda; (m) S. Domenico; (n) Palazzo Tolomei; (o) Palazzo Salimbeni and S. Maria delle Nevi; (p) S. Donato; (q) S. Maria di Provenzano; (r) S. Francesco, Seminary, and Oratory of S. Bernardino; (s) Sto Spirito; (t) S. Maria dei Servi; (u) S. Agostino; (v) Palazzo Pollini-Neri and S. Maria del Carmine; (w) Pinacoteca Nazionale (Palazzo Buonsignori); (x) Fonte Nuova; (y) former Forte di S. Barbera (16th cent.); (z) Church of Fontegiusta.

eled in 1775 by Luigi Vanvitelli. It contains works by Perugino, Matteo di Giovanni, Sodoma, and Simone Martini.

The most important medieval secular buildings are those facing the great shell-shaped Piazza del Campo (I, PL. 390). The Palazzo Pubblico (VI, PL. 339), begun at the end of the 13th century, was enlarged in the 14th century with the addition of the prisons (1327), the Council Chamber (1330–42), and the Torre del Mangia (1338–48). The brick tower, 387 ft. high, by Minuccio and Francesco di Rinaldo, is surmounted by turrets built by Agostino di Giovanni from a design attributed to Lippo Memmi. In the various chambers and halls are frescoes by Ambrogio Lorenzetti (IX, PLS. 194–196), Sano di Pietro, Sodoma, Andrea di Bartolo, Domenico di Bartolo, Il Vecchietta, Taddeo di Bartolo, Spinello Aretino and Parri Spinelli (VII, PL. 272), and Simone Martini (IX, PL. 332). The Cappella di Piazza was begun in 1352 by Domenico di Agostino but was altered and demolished several times before it was completed in 1376 by Giovanni di Cecco. Antonio Federighi added the Renaissance arches and coping (1463–68). The Palazzo Sansedoni (1216, enlarged in 1339), with a curved façade, has a rhomboid tower. Also facing the square is the rear façade of the Loggia della Mercanzia, remodeled in 1763 by Ferdinando Fuga. In the center of the piazza is the Fonte Gaia, a fountain designed by Jacopo della Quercia (1409–19). The reliefs are copies of the originals, now in the Palazzo Pubblico (IV, PLS, 149, 150). Other noteworthy Gothic buildings are the Castel-

lamare, the Forteguerri tower-house, the Palazzo Tolomei (13th cent.), the Palazzo del Capitano di Giustizia (13th–14th cent.), Palazzo Buonsignori (early 15th cent.), Palazzo Chigi-Saracini (14th cent., enlarged in 1787), the Palazzo Salimbeni (14th cent., restored in 1879), and the Palazzo di Giustizia.

The city has a number of Renaissance buildings, including S. Maria delle Nevi (1471); S. Caterina in Fontebranda (1474); and the Church of Fontegiusta (1482–84), on a square plan, with a tripartite nave and frescoes by Baldassare Peruzzi (XI, PL. 119) and others. S. Maria del Carmine, originally a 14th-century church, was rebuilt in 1517, probably by Peruzzi. Of the 15th century are the Oratory of S. Bernardino, with frescoes by Beccafumi, Sodoma, and Girolamo del Pacchia; S. Maria degli Angeli; and Sto Spirito (1498), with a portal (1519) attributed to Peruzzi, dome by Giacomo Cozzarelli, and frescoes by Beccafumi, Sodoma, and others. S. Maria di Provenzano was built in 1594 by Flaminio del Turco; the interior is baroque. S. Martino (1537) has a façade by Giovanni Fontana (1613); in the interior are works by Guido Reni, Guercino, and Beccafumi.

Secular palaces of the period include the Piccolomini (delle Papesse), by Bernardo Rossellino (1460–95), the Spannocchi, begun in 1470 by Giuliano da Maiano; the Bichi Ruspoli (1520); the Piccolomini-Adami (formerly Chigi), with rooms frescoed by Bernart van Orley; the Bindi-Sergardi; the Palazzo del Governo, designed by Bernardo Buontalenti; the Palazzo del Magnifico (1508); the Tantucci (1548), by Bartolomeo Neroni (Il Riccio); and the Pollini (now Neri), by Baldassare Peruzzi. *Museums*: Museo dell'Opera del Duomo, with sculptures by Giovanni Pisano, the *Maestà* by Duccio di Buoninsegna, works by the Lorenzettis, and objects formerly in the Cathedral; Pinacoteca Nazionale (in the Palazzo Buonsignori), with works by Sienese painters of the 12th to 16th century; Museo Archeologico, with Villanovan, Etruscan, Greek, and Roman material; Archivio di Stato, in the Palazzo Piccolomini, collection of painted *Tavolette di Biccherne*, wooden covers for the semiannual fiscal accounts of the city; Museo del Seminario Arcivescovile; and the museum of the Società di Esecutori di Pie Disposizioni, Sienese religious art.

BIBLIOG. L. M. Richter, Siena, Berlin, 1901; A. Canestrelli, L'architettura medievale a Siena e nel suo antico territorio, Siena, 1904; A. Canestrelli, Di alcuni avanzi di edifici romanici a Siena, B. senese di storia patria, XV, 1908, pp. 181–92; G. Carotti, Il Duomo di Siena, Milan, 1910; A. Rusconi, Siena, Bergamo, 1910; V. Lusini, Il Duomo di Siena, Siena, 1911; L. Dami, Siena e le sue opere d'arte, Florence, 1915; G. Chierici, La maison siennoise du moyen-âge, Actes Cong. int. d'H. de l'art, II, 1, Paris, 1921, pp. 149–57; E. Cianetti, Il Campo di Siena e il Palazzo Pubblico, Florence, 1921; V. Lusini, Note storiche sulla topografia di Siena nel secolo XIII, B. senese di storia patria, XXVIII, 1921, pp. 239–41; G. Chierici, Architetti ed architettura del '700 a Siena, Architettura, II, 1922–23, pp. 129–48; R. Bianchi Bandinelli, Carta archeologica d'Italia, Florence, 1927; L. Sbaragli, Il palazzo del Comune, Siena, 1932; G. Becatti, Alcune scoperte archeologiche nell'anno 1933 nella provincia di Siena, B. senese di storia patria, N.S., IV, 1933, pp. 419–22; H. Keller, Die Bauplastik der Sienezer Dom, Jhb. der Bib. Hertziana, I, 1937, pp. 139–221; P. Bacci, L'elenco delle pitture, sculture e architetture di Siena, compilato nel 1625–26 da Mons. Fabrizio Chigi, B. senese di storia patria, N.S., X, 1939, pp. 197–213, 297–337; A. Liberati, Chiese, monasteri, oratori e ospedali senesi, B. senese di storia patria, X, 1939, pp. 157–67, 261–68, 341–47; P. Cellini, La facciata "semplice" del Duomo di Siena, Proporzioni, I, 1948, pp. 55–61; A. Masseron, Sienne, Paris, 1955; R. Niccoli, Alcune osservazioni circa lo studio dell'urbanistica medievale di Siena, Atti VII Conv. naz. Storia Arch., Palermo, 1956, pp. 377–83; A. Susini and S. Chierichetti, Siena, Siena, 1956; A. Liberati, Chiesa e conventi di San Francesco, B. senese di storia patria, LXV, 1958, pp. 142–50; G. Mandel, Siena, Zürich, 1959; A. Tailetti, Guida artistica illustrata di Siena e provincia, Siena, 1959; A. Tailetti, Gli oratorii delle contrade di Siena, Siena, 1962.

Sovana (Etruscan, Suana). An abandoned village near Sorano (where there is a fortress of the Orsini family), Sovana has remains of the Etruscan walls and of an urban temple of the 3d or 2d century B.C. Outside the village is an important Etruscan necropolis hewn from the rock, with tombs of various types: some on a square column base, some with portico and a tympanum, others in the form of a temple or a shrine (Tomba Ildebranda, Grotta Pola). The town is medieval in character, with a few notable houses and a Romanesque Cathedral (12th–13th cent.); the Church of S. Maria (12th cent.); and the ruined Rocca Aldobrandesca, a fortress.

Pitigliano, on the summit of a volcanic ridge nearby, was also an Etruscan city (unidentified, but possibly Catetia). Of the Etruscan period are traces of the town (late period), fragments of the walls, and a large necropolis, with tombs of the 7th–5th century B.C. The medieval part of the town has remained almost intact. It is dominated by the large Orsini palace (14th–16th cent.). Also of interest are S. Maria (1506) and the Cathedral (16th cent.), with a baroque façade.

There are a number of Etruscan sites in the neighborhood, including Statonia and Saturnia.

BIBLIOG. G. C. Conestabile, Degli scavi eseguiti nel territorio di Sovana nel marzo e aprile 1859, B. Scavi Soc. Colombaria (ASI, 2d ser., XI, 2),

1860, pp. 30–48; A. Ademollo, La cattedrale di Sovana, Arte e storia, IX, 1890, pp. 137–40; G. Carocci, Una città moribonda: Sovana o Soana, Arte e storia, X, 1891, pp. 89–93; G. Pellegrini, Necropoli e pago etrusco di Poggio Besco, NSc, 1896, pp. 263–83; G. Pellegrini, Risultato degli scavi del 1896–97 a Poggio Buco, NSc, 1898, pp. 429–50; G. Pellegrini, Nuove scoperte nella necropoli, NSc, 1903, pp. 217–25; G. Chierici, Chiesa di S. Maria a Sovana: Rocca di Sovana, BArte, 2d ser., IV, 1924–25, pp. 191–92; A. Minto, Saturnia etrusca e romana, MALinc, XXX, 1925, cols. 586–708; R. Bianchi Bandinelli, Sovana, Florence, 1929; E. Scamuzzi, Tomba a camera scoperta in località detta "Valle Rodeta," NSc, 7th ser., I, 1940, pp. 19–29; G. Matteucig, Poggio Buco: The Necropolis of Statonia, Berkeley, 1951; G. Caputo, Restauro delle mura di Saturnia, FA, IX, 1954, 371; E. Bandini, Sovana, Florence, 1955; G. Maetzke: Pitigliano: Tomba etrusca, NSc, 8th ser., IX, 1955, pp. 41–45; P. Portoghesi, Nota sulla Villa Orsini di Pitigliano, Q. Ist. Storia Arch., 7–9, 1955, pp. 74–76.

Vetulonia [Etruscan, Vatl(u)na]. A prosperous Etruscan city in the archaic period, it declined in the 5th century B.C., flourished again in the Hellenistic and Roman period, and was destroyed at an unknown date. The walls of the acropolis (6th–4th cent. B.C.) and remains of houses and shops of the later period (3d–1st cent. B.C.) are still visible. The necropolis contains Villanovan, Orientalizing, and archaic tombs. Some bronzes found here show influences of the Sardinian nuraghe culture (8th–6th cent. B.C.). The largest tomb is the Tumulo della Pietrera. Sculptures and grave furnishings from this and other tombs are now in the Museo Archeologico in Florence. Some Etruscan and Greco-Roman artifacts are in the local Museo Archeologico.

BIBLIOG. I. Falchi, Vetulonia, Florence, 1891; D. Lev i, Carta archeologica di Vetulonia, SEtr, V, 1931, pp. 13–40; D. Massaro, Le ambre di Vetulonia, SEtr, XVII, 1943, pp. 31–46; G. Renzetti, Vetulonia: Carta archeologica della città, SEtr, XXI, 1950–51, pp. 291–96; G. Caputo, Restauro della tomba della Pietrera, FA, IX, 1954, 374; E. Vetter, Zu der Kriegerstele von Vetulonia, SEtr, XXIV, 1955, pp. 301–10.

Volterra (Etruscan, Velathri; Lat., Volaterrae). Situated on the summit of the uplands between the valleys of the Era and the Cecina rivers, this was a powerful Etruscan city. In the 3d century B.C. it became a Roman municipium. In the Middle Ages it was ruled by bishops, but in the 12th century it became an independent commune; in 1472 it was conquered by the Florentines. Etruscan girdle walls, of a local stone called *panchina*, are well preserved; they were extended in the 4th and 3d centuries B.C. To this period belong the Porta dell'Arco (V, PL. 48), of which the piers and the protomas are Etruscan. There are also remains of Etruscan sacred buildings in the Pian di Castello, the ancient acropolis, and the Roman theater (1st cent. B.C.–1st cent. of our era), beyond the Porta Fiorentina.

The present aspect of Volterra is medieval. Around the central square, Piazza dei Priori, are the Palazzo Pretorio (13th cent.; altered and enlarged several times), with a loggia and double-arched windows and the attached Torre del Podestà; Palazzo dei Priori (1208–54), with a crenelated tower; and the bishop's palace (remodeled 1472). The Romanesque Cathedral (12th cent.; rebuilt, 13th and 14th cent.) has a tripartite nave with a 15th-century coffered wooden ceiling. It contains a 12th-century marble pulpit (restored 17th cent.), a *Deposition* of carved and painted wood of the 13th century, and carved wood choir stalls (1404). The canopy of the altar and several other sculptures are by Mino da Fiesole; there are frescoes in the presbytery and nave by Cristoforo Roncalli (Il Pomarancio). The Baptistery (13th cent.) is octagonal, with a white and green marble façade; the interior, with a single aisle, was remodeled in 1826. There are several medieval houses and towers, including the tower-house of the Buomparenti family (13th cent.), the three Cafferecci towers (14th cent.), and the houses of the Alegretti, Baldinotti, and Miranceli families. The Church of S. Francesco has been almost entirely rebuilt; the nave has a trussed wooden ceiling, and in the Gothic Chapel of Sta Croce di Giorno (1315) are frescoes by Cenni di Francesco di Ser Cenni (1410).

S. Antonio Abate and S. Pietro in Selci are of the 15th century. S. Pietro was altered in 1507 and has a baroque façade. The Fortress was begun in 1343, rebuilt and enlarged in the 15th and 16th centuries. Of the 16th century are the Palazzo Solaini, attributed to Antonio da Sangallo the Elder; the Palazzo Maffei (1527); and the Palazzo Viti, attributed to Bartolommeo Ammanati. Ammanati is also credited with the façade of the Badia, a Romanesque church which was rebuilt at various times and finally collapsed in 1895, although the façade and the Renaissance cloister have survived. The Church of SS. Giusto e Clemente is baroque, on a Latin-cross plan with a single aisle; it is decorated with frescoes by Volterrano (1631) and works by Il Pomarancio. *Museums*: Museo Guarnacci, with Etruscan antiquities from local excavations; Pinacoteca Comunale, with paintings by Florentine, Sienese, and Volterran artists, 14th–17th century; Museo Diocesano di Arte Sacra.

BIBLIOG. G. Amidei, Delle fortificazioni volterrane, 2 vols., Volterra, 1864; G. Ghirardini, La necropoli primitiva di Volterra, MALinc, VIII, 1898, cols. 101–216; C. Ricci, Volterra, Bergamo, 1905; A. Barbacci, Il Battistero di Volterra, La Balzana, I, 1927, pp. 121–29; O. H. Giglioli,

La cappella Inghirami nella cattedrale di Volterra, Riv. d'Arte, XII, 1930, pp. 429–54; E. Fiumi, Le necropoli etrusche di Volterra, Lucca, 1933; L. O. Cappelli, La cattedrale e il battistero di Volterra attraverso i secoli, Volterra, 1937; E. Fiumi, Appunti di toponomastica volterrana, SEtr, XVIII, 1944–45, pp. 371–82; E. Fiumi, Per la cronaca dei ritrovamenti archeologici nel Volterrano, SEtr, XIX, 1946–47, pp. 349–55; G. Viegi, Le fibule dell'antico fondo del Museo "Guarnacci" di Volterra, SEtr, XXIII, 1954, pp. 417–33; A. de Agostino, Il teatro romano: Studio architettonico e ricostruzione, NSc, 8th. ser., IX, 1955, pp. 150–81; E. Fiumi, Scavi nell'area del teatro romano degli anni 1950–1953, NSc, 8th ser., IX, 1955, pp. 114–50; E. Fiumi, Gli scavi della necropoli del Portone degli anni 1873–74, SEtr, XXV, 1957, pp. 367–415; E. Fiumi, Materiali volterrani nel Museo Archeologico di Firenze, SEtr, XXV, 1957, pp. 463–87; E. Fiumi, Scoperta di due tombe etrusche e di una tomba romana in località Poggio alle Croci (Volterra), SEtr, XXVII, 1959, pp. 251–60.

Umbria. In ancient times this region was inhabited, east of the Tiber, by the Umbri and, west of it, by the Etruscans, who left significant monumental evidence of their civilization around Perugia and Orvieto. Under. the Romans a number of settlements grew up along the Via Flaminia, the main Roman artery through central Italy. Many architectural remains of these once flourishing ancient centers are perceptible amid the predominantly Romanesque and Gothic lineaments of towns and cities that became independent communes during the Middle Ages.

Early Umbrian paintings and stone and wood sculpture reveal Romanesque and Byzantine influences; subsequently, Tuscan influence became more decided — especially in the work of the great artists at the Franciscan sanctuary of Assisi and in Orvieto — and reached its height during the Renaissance, in the works of Perugino, Raphael, and other artists of the Umbrian school. Throughout every period the applied arts and local handicrafts — such as textiles, embroidery, metalworking, and ceramics — have been important.

BIBLIOG. M. Guardabassi, Indice-guida dei monumenti pagani e cristiani riguardanti l'istoria e l'arte esistenti nella provincia dell'Umbria, Perugia, 1872; D. Gaspari, Fortezze marchigiane e umbre del secolo XV, Foligno, 1886; U. Gnoli, L'arte romanica nell'Umbria, Augusta Perusia, I, 1906, pp. 22–27, 41–43; G. Sordini, Notizie dei monumenti dell'Umbria, Spoleto, 1907; L. Tiberi, Il Trasimeno (L'abbazia di Magione, Castel di Zocco, Isola Polvese), Augusta Perusia, II, 1907, pp. 177–85; L. Fiocca, Preliminari: Il Medioevo nell'arte umbra, Vita d'arte, XII, 1913, pp. 133–52; T. Ashby and L. Fell, The Via Flaminia, JRS, XI, 1921, pp. 125–90; U. Tarchi, Studi e progetti della scuola di architettura umbra, Milan, 1923; R. Riccardi, Ricerche sull'insediamento romano nell'Umbria, Rome, 1931; U. Tarchi, L'arte nell'Umbria e nella Sabina, 5 vols., Milan, 1937–42; I. Ceroni, Periplo dell'arte romanica nell'Umbria, Rome, 1950; L. Salvatorelli, ed., L'Umbria nella storia, nella letteratura, nell'arte, Bologna, 1954; U. Tarchi, L'arte del Rinascimento nell'Umbria e nella Sabina, Milan, 1954; F. Bonasera, La casa rurale nell'Umbria, Florence, 1955; M. C. Fabbri, I palazzi comunali umbri, Milan, 1957; C. Martelli, L'abbaziale di S. Felice di Giano e un gruppo di chiese romaniche intorno a Spoleto, Palladio, N.S., VII, 1957, pp. 74–91; C. Pietrangeli, Osservazioni sulle mura delle città umbre, Atti V Conv. naz. Storia Arch. (1948), Florence, 1957, pp. 459–66; F. Santi, Appunti sull'architettura rustica in Umbria, Atti V Conv. naz. Storia Arch. (1948), Florence, 1957, pp. 543–50. *Reviews*: Augusta Perusia, 1906 ff.; Rass. d'arte umbra, 1909–10 ff.; Spoletium, 1954 ff.

Amelia (Lat., Ameria). Located on the watershed between the Tiber and Nera rivers, Amelia was a city of the Umbri; later it became a Roman municipium. From ancient times there remain massive polygonal walls (restored several times), on which the medieval walls were raised.

The Church of S. Francesco (1287; interior remodeled 1767) has a Gothic portal and contains the tomb of Geraldini by Agostino di Duccio. The Cathedral — a Romanesque structure, remodeled in 1640, in which the original twelve-sided campanile was retained — contains paintings by Niccolò Pomarancio (Circignani), monuments of two members of the Farrattini family by Ippolito Scalza (1534), and sculpture of the school of Agostino di Duccio. The Church of S. Pancrazio was built in the 14th century, but its interior was remodeled in 1747. Dating from the Renaissance period are Palazzo Ferrattini, attributed to Antonio da Sangallo the Younger; Palazzo Petrignani, with frescoes by artists of the school of Zuccari; and on the outskirts of the city, Rocca di Albino (1455–1511; present-day Doria Pamphili), a square castle with corner towers and a central courtyard. The Palazzo Comunale, which houses an archaeological collection in its entrance hall, is also noteworthy.

In the neighboring village of Lugnano in Teverina is the Romanesque church of S. Maria Assunta (12th cent., remodeled 15th cent.), which has a façade with a portico of the 13th century and, in the interior, an altar, ciborium, iconostasis, and *schola cantorum* of the 13th century — poorly restored — and a triptych by Niccolò Alunno.

BIBLIOG. G. Mancini, Ritrovamenti di antichità in località Montepiglio, NSc, 1920, pp. 15–20; U. Gnoli, Pittori in Amelia, Rass. d'arte umbra, III, 1921, pp. 49–52; A. Di Tommaso, Guida di Amelia, Terni, 1931; P. Grassini, Appunti sulla chiesa collegiata di Lugnano in Teverina, B. Ist. storico artistico orvietano, 1950, pp. 6–14; U. Ciotti, Amelia: Restauri

e scoperte, FA, X, 1955, 2471; G. Matthiae, La suppellettile presbiteriale della Chiese di Lugnano in Teverina, Atti V Conv. naz. Storia Arch. (1948), Florence, 1957, pp. 501–03; EAA, s.v.

Assisi (Lat., Assisium). Situated on the northwest slope of Mt. Subasio, this was a town of the Umbri, later a Roman municipium. Dating from the Roman period are remains of the walls and, on one side of the forum, the so-called "Temple of Minerva" (probably 1st cent. B.C.), with a hexastyle Corinthian pronaos, which was converted into the Church of S. Maria sopra Minerva in the 16th century, then remodeled by G. Giorgetti in the 17th century and renamed S. Filippo Neri. Remains of the forum, with a tribunal and

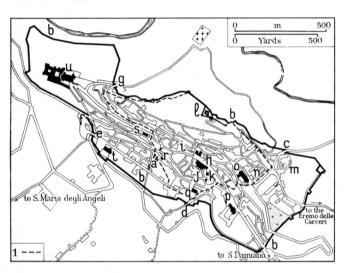

Assisi, plan. *Key:* (1) Boundary of the Roman city. Principal monuments: (*a*) Roman gate; (*b*) medieval walls; (*c*) Porta Perlici; (*d*) Porta Moiano; (*e*) Porta S. Pietro; (*f*) Porta S. Francesco; (*g*) Porta S. Giacomo; (*h*) Piazza del Comune, over remains of the Roman forum; (*i*) Palazzo del Capitano, Torre del Popolo, and the so-called "Temple of Minerva"; (*j*) Palazzo Comunale (Pinacoteca); (*k*) Chiesa Nuova and Oratory of S. Francesco Piccolino; (*l*) Rocca Maggiore; (*m*) area of the Roman amphitheater; (*n*) area of the Roman theater; (*o*) Cathedral (S. Rufino); (*p*) S. Chiara; (*q*) S. Maria Maggiore, over a Roman house; (*r*) Oratory of S. Francescuccio; (*s*) Monte Frumentario; (*t*) S. Pietro; (*u*) Basilica and Monastery of S. Francesco.

a shrine to Castor and Pollux, are visible below the piazza. Under the episcopal palace is a house with frescoes. There are also remains of a theater and of an amphitheater.

In Lombard times the city belonged to the Duchy of Spoleto, but after the 11th century it became a prosperous free commune. During the 12th and 13th centuries the city was encircled with walls (which still exist) and fortified. Of the eight gates along the walls, the best preserved is the 12th-century Porta S. Pietro. The larger of the two medieval fortresses, the Rocca Maggiore, was demolished in the 12th century and rebuilt in the 14th. The city expanded as narrow, winding streets and small piazzas were added, and it still retains its medieval appearance. Between the 11th and 13th centuries the Cathedral (S. Rufino) was built, in Lombard Romanesque style, on the site of a 9th-century church, the crypt of which remains; the interior, remodeled in 1571 by Galeazzo Alessi, has wooden choir stalls by Giovanni di Pier Giacomo of San Severino. S. Maria Maggiore, the former Cathedral, was rebuilt in the 12th century by Giovanni da Gubbio, also in Romanesque style, over a Roman structure probably dating from the 4th century. The interior of this church bears traces of 14th- and 15th-century frescoes. The Museo Capitolare contains two 15th-century triptychs, one by Niccolò Alunno, another by Matteo da Gualdo. Also Romanesque are the small churches of S. Giacomo ("de muro rupto"), with a cross-vaulted ceiling; S. Giorgio, incorporated into the Convent of S. Chiara; and S. Maria delle Rose.

The most famous structure in the city, S. Francesco, with its monastery, belongs to the Gothic period. Begun in 1228 and consecrated in 1253, the edifice consists of two superimposed churches, supported by massive retaining walls. The Upper Church (I, PL. 386) is single-aisled, with a transept and a polygonal apse; the Lower Church is built on a similar plan, but with side chapels, a narthex, and a crypt. The façade (PL. 186), on the level of the Upper Church, is divided into three horizontal areas and has a double rose window encircled with Cosmati ornamentation. Some of the most noted artists of the 13th and 14th centuries contributed their talents to the frescoes of S. Francesco: Cimabue (1277) was responsible for

the transept and the vault of the apse — both in poor condition — in the Upper Church (III, PLS. 324–326), as well as the Madonna, angels, and St. Francis in the Lower Church (III, PL. 328); artists of the Roman school illustrated stories from the Old and New Testaments in the Upper Church; Giotto (q.v., for problematical dating of his work here) added scenes from the life of St. Francis in the Upper Church (VI, PLS. 196–198); pupils of Giotto, the so-called "Master of the Assisi Vault" outstanding among them, painted the majority of the frescoes in the Lower Church; Pietro Lorenzetti and his pupils embellished (ca. 1325–30) the left wing of the transept of the Lower Church (VI, PL. 62; IX, PLS. 188, 189); Simone Martini decorated the Chapel of St. Martin (1322–26) and executed some of the frescoes in the transept of the Lower Church (IX, PL. 333). Attached to S. Francesco is the friary, Sacro Convento, with a chapter house (13th cent.), a refectory (18th cent.), the portico known as "Calce" (1300), and cloisters (the large cloister, built in 1476, probably designed by Antonio da Como), as well as the treasury.

The Church of S. Pietro, a Romanesque structure rebuilt during the Gothic period, has a basilican plan that retains some of the original Romanesque character; its three aisles are divided by piers and its presbytery is surmounted by a cantilevered cupola. Within are 14th-century tombs (along the walls) and a triptych by Matteo da Gualdo. The Church of S. Chiara, consecrated in 1265, has a rose window over a portal in transitional style, and its walls are faced with bands of white and red marble, the left wall supported by flying buttresses. Its interior is decorated with frescoes by followers of Giotto and a panel (13th cent.) by the Master of S. Chiara, depicting scenes from the life of St. Clare, as well as with a 13th-century crucifix, perhaps also by the same artist.

Secular buildings of the 13th and 14th centuries include houses on the Via di Porta Perlici, whose gate dates from the 12th century, and the following edifices, built on the site of the Roman forum: Palazzo del Capitano del Popolo, with a battlemented tower (1212–1305); Palazzo Comunale (or dei Priori; 1337), which now contains the Pinacoteca Comunale of works predominantly by Umbrian artists; and not far from it, Palazzo dei Consoli (1225) and the portico of Monte Frumentario (1267).

Dating from the Renaissance period are the arcade of Piazza di S. Francesco (1476); the Oratory of S. Bernardino, with fine reliefs by the brothers Girolamo, Bartolomeo, and Francesco Zampa of Assisi (1488); the Bindangoli palace designed by Giulio Danti; the reconstructed Oratory of the Pilgrims (rebuilt 1431), which has frescoes by Matteo da Gualdo, and Casa dei Maestri Comacini (rebuilt 15th cent.) — both originally 13th-century structures; and from the latter half of the 16th century, Fonte Marcella and Fonte Oliviera. Other buildings of interest are the Chiesa Nuova (begun 1615), built in the form of a Greek cross with one central dome and domes on each of the four arms, which has decorations by Cesare Sermei; the 17th-century Bernabei, Giacobetti, and Vallemani palaces, all by Giacomo Giorgetti; and the Museo Civico, noteworthy for its archaeological collection.

Just outside the city walls stands the Church of S. Maria degli Angeli, which was designed by Galeazzo Alessi, Giacomo Giorgetti, and Girolamo Martelli (begun 1569; completed 1679); having been partly destroyed by an earthquake in 1832, it was rebuilt by Luigi Poletti in 1836–40. Its Neo-Renaissance façade was designed by Cesare Bazzani in 1928. The interior is based on a basilican plan, with three aisles, transept, and a dome that dates from the original building. Incorporated into this structure are the Porziuncola, a simple 12th-century oratory with decorations of various periods and styles; the Oratory of S. Bonaventura and the Cappella del Roseto, both with frescoes by Tiberio d'Assisi (1506, 1518); and the Cappella del Transito, with frescoes by Giovanni di Pietro (Lo Spagna) on the interior (ca. 1515) and by Domenico Bruschi on the exterior (1886), and containing a terra-cotta statue of St. Francis by Andrea della Robbia. Against one of the church walls is the Fonte delle 26 Cannelle (1610). Adjoining the church are the Conventino di S. Bernardino da Feltre, which contains a *Last Supper* by Niccolò Pomarancio, and the old convent begun in the time of St. Francis, as well as the Museo della Basilica di S. Maria degli Angeli, with a panel by the St. Francis Master, a *Crucifixion* by Giunta di Bonagiunta, and other paintings by Sano di Pietro and Niccolò Alunno.

On the outskirts of the city, to the southeast, is the early-13th-century church of S. Damiano (containing 15th- and 16th-century works); adjacent are the convent and cloister, as well as the Oratory of S. Chiara (14th-cent. frescoes). East of the city, on Mt. Subasio, stands the Eremo delle Carceri (15th cent.).

BIBLIOG. A. Brizi, Mura pelasgiche in Assisi, Atti Acc. Properziana, II, 1901–09, pp. 269–74; A. Brizi, Tracce umbro-romane in Assisi, Atti Acc. Properziana, II, 1901–09, pp. 405–34; A. Brizi, Di una importante iscrizione recentemente scoperta in Assisi, Atti Acc. Properziana, II, 1901–09, pp. 318–22; A. Venturi, La basilica di Assisi, Rome, 1908; B. Kleinschmidt, Die Basilika S. Francesco in Assisi, Berlin, 1915; I. B. Supino, La basilica

di S. Francesco di Assisi, Bologna, 1924; E. Stefani and P. Romanelli, Scoperta di antichi resti della città romana, NSc, 1935, pp. 19–28; E. Zocca, Catalogo delle cose d'arte e d'antichità d'Italia: Assisi, Rome, 1936; U. Tarchi, Rilievi e ricostruzioni di monumenti romani nell'Umbria, BMImp, XII, 1941, pp. 35–46; M. Bizzarri, Contributo all'aggiornamento della carta archeologica del municipio romano di Assisi, B. Deputazione Storia Patria per l'Umbria, XLIV, 1947, pp. 39–44; A. Pantoni, S. Benedetto al Subasio, Benedictina, II, 1948, pp. 47–74; E. Zocca, Assisi e dintorni, Rome, 1954; G. Bovini, Assisi, Milan, 1957; I. Chierichetti, Assisi, Milan, 1957; G. Cristofani, S. Benedetto al Subasio, Atti V Conv. naz. Storia Arch. (1948), Florence, 1957, pp. 481–82; G. Cristofani, Le vicende di un grande monumento nell'ultimo sessantennio, Atti V Conv. naz. Storia Arch. (1948), Florence, 1957, pp. 639–42; D. Formaggio, Basiliche di Assisi, Novara, 1958; C. Pietrangeli and U. Ciotti; EAA, s.v. Assisi, I, 1958, p. 741.

Bevagna (Lat., Mevania). Bevagna was a prosperous municipium on the Via Flaminia in Roman times. In the 13th century the walls that still stand were built over the remains of the ancient walls, which were made of small stone blocks and bricks. Remains of a pseudoperipteral temple, a theater (1st cent. of our era), and thermae with a fine mosaic of marine animals (2d cent.) are to be found near the original site of the ancient forum. The most important medieval monuments (restored) are located on the main piazza, which on the whole retains its medieval appearance. The Church of S. Silvestro (1195), a Romanesque structure designed by Binello and Rodolfo da Bevagna, has an unfinished façade with a carved portal; its interior is basilican, divided by columns, and the presbytery is built over a crypt. The Church of S. Michele (12th–13th cent.; interior recently restored), also by Binello and Rodolfo, exhibits a carved portal with Cosmati decoration, a massive campanile, and a crypt. Other churches worth noting are S. Francesco, with a 13th-century façade and an interior dating from 1756; S. Margherita, built in 1271 and remodeled in 1640; and S. Filippo, a 17th-century edifice. The Palazzo dei Consoli (1270) is a Gothic structure, with a portico on the lower floor, a wide outside staircase, and two rows of twin-arched windows. In the Palazzo Comunale is the Pinacoteca Comunale. Bevagna also has an Antiquarium housing a Roman collection.

BIBLIOG. G. Urbini, Spello, Bevagna, Montefalco, Bergamo, 1913; G. Urbini, Guida artistica di Bevagna, Spoleto, 1926; C. Pietrangeli, Mevania-Bevagna, Rome, 1953; G. Martelli, L'Abbazia di S. Felice di Giano e un gruppo di chiese romaniche intorno a Spoleto (S. Silvestro e S. Michele Arcangelo), Palladio, N.S., VII, 1957, pp. 74–91; C. Pietrangeli, EAA, s.v. Bevagna, II, 1959, p. 77; C. Pietrangeli, Guida di Bevagna, Spoleto, 1959.

Città di Castello (Lat., Tifernum, Tiberinum). This ancient town of the Umbri later became a Roman municipium. Dating from the Roman period are remains of edifices decorated with mosaics, including ruins of what was probably thermae in the Rignaldello district. Pliny the Younger owned large estates in this region, as well as the villa "In Tuscis," vestiges of which remain on Colle Plinio. The town was destroyed by Totila in the 6th century, but it rose again as Castrum Felicitatis. Its present name dates from the 10th century. During the Middle Ages it was initially an independent commune; later it became subject to other cities and then to the Church, and from the mid-15th century it was dominated by the Vitelli family.

The Palazzo del Governo (or del Podestà) dates from the 14th century and is attributed to Angelo da Orvieto; one of the wings is Gothic, but the façade of the building is baroque (1686). The Palazzo Comunale, by Angelo da Orvieto, is a Gothic structure in rustic ashlar masonry, with a wide twin-arched portal. S. Domenico, a late Gothic church rebuilt in 1424, is single-aisled and is decorated with frescoes of the 14th and 15th centuries; adjoining it is a cloister. To the Renaissance period belong the Church of S. Maria Maggiore (considerably remodeled), which has 15th-century frescoes; S. Maria delle Grazie; Palazzo Bruni-Bufalini; and two other palaces — Palazzo Vitelli alla Cannoniera, built by Antonio da Sangallo the Younger (with sgraffito designs by Vasari on its façade), and Palazzo Vitelli at the Porta Sant'Egidio (1540), possibly built from designs by Vasari and richly decorated with frescoes by Prospero Fontana and others. The Pinacoteca Comunale (Palazzo Vitelli alla Cannoniera) contains paintings by Umbrian and Tuscan artists.

The Cathedral, originally a Romanesque building, was enlarged in 1356 and remodeled between 1466 and 1529. Of the original Romanesque structure only the cylindrical companile remains; a lateral portal from the 14th-century Gothic addition has been preserved. The baroque façade was begun in 1632 by Francesco Lazzari but left unfinished. The single-aisled interior is Tuscan Renaissance in style and has an 18th-century wooden ceiling. Attached to the Cathedral is the Museo Capitolare, which contains religious objects, including a 12th-century gilded silver altar frontal with reliefs.

Other noteworthy buildings include the Church of S. Francesco, rebuilt in the early 18th century, incorporating the apse and a portal

from the original Gothic church of 1273 and containing the Renaissance Vitelli Chapel by Vasari; Castello Bufalini (built in 1492; altered by Vasari), located nearby at San Giustino, with a collection of 15th-, 16th-, and 17th-century paintings; and the Sanctuary at Canoscio, built by Emilio de Fabris in 1855–78, where an important collection of Early Christian objects was found.

BIBLIOG. H. Winnefeld, Tusci und Laurentinum des jüngeren Plinius, JdI, VI, 1891, pp. 201–17; G. Magherini-Graziani, L'arte a Città di Castello, Città di Castello, 1897; G. Magherini-Graziani, Il Rinascimento a Città di Castello, Spoleto, 1902; E. Giovagnoli, Città di Castello, Città di Castello, 1921; D. Diringer, Città di Castello, Ed. archeol. della carta d'Italia, Florence, 1930; V. Corbucci, Il Palazzo di A. Vitelli e la Pinacoteca Comunale di Città di Castello, Città di Castello, 1931; O. Guerrieri, Città di Castello, Todi, Bergamo, 1939; G. Giorgi, Città di Castello: Chiesa di Santa Maria Maggiore, Palladio, VI, 1942, pp. 117–19; G. Giorgi, La Chiesa di S. Maria Maggiore in Città di Castello e i suoi restauri, Atti V Conv. naz. Storia Arch. (1948), Florence, 1957, pp. 635–38; C. Pietrangeli, EAA, s.v. Città di Castello, II, 1959, p. 699; C. Rosini, Città di Castello, Città di Castello, 1962.

Foligno (Lat., Fulginiae; med., Fulginium). Situated in the center of a wide plain at the junction of the Topino and Clitunno valleys, this city of the Umbri was conquered by the Romans in about 295 B.C., and thereafter became a municipium. The regular layout of the Roman city is still clearly visible; the principal streets of the modern city correspond to the ancient decumanus and cardo maximus. Vestiges of the Roman period also include four bridges, remains of an arch, and ruins of a villa called "Palazzo di Decio".

In the Middle Ages Foligno was a free commune, but possession then passed to the Church in the 13th century, a time of renewed building activity in the city. Among the palaces constructed during the medieval period are Palazzo del Podestà (1190), which was remodeled in the 16th century and restored extensively in the present century; Palazzo della Canonica, a 14th-century Gothic structure, later almost entirely rebuilt; Palazzo Trinci, a 14th-century edifice with a neoclassic façade and 15th-century additions, which contains a loggia (with frescoes attributed to Lorenzo Salimbeni of Sanseverino), a chapel with frescoes by Ottaviano di Martino Nelli (1424), and the Pinacoteca Comunale; and the Palazzetto by Gentile da Foligno (14th cent.).

Many churches were also built during this period, among them: S. Maria Infraportas, Romanesque in form (basilican in plan, with three aisles divided by piers) but actually originating in an earlier period, with frescoes of the 12th and 16th centuries by Pierantonio Mezzastris, Ugolino di Gisberto, and others; S. Caterina, of which only the façade (1251) remains; S. Giacomo, with a chapter house and 15th-century cloister; S. Claudio, built about 1240 (interior reconstructed); and S. Salvatore, a 14th-century structure of white and red masonry (interior remodeled).

The Cathedral, begun in 1133, had its principal façade restored during the present century; the secondary façade, by Rodolfo and Binello da Bevagna, has a fine Romanesque portal (1201). The interior, with nave and transept, was rebuilt in the 16th century (only the Chapel of the Sacrament, designed by Antonio da Sangallo the Younger, remains from this period) and further remodeled by Giuseppe Piermarini (1771) in neoclassic style.

Renaissance architecture survives in the following buildings: Church of the Nunziatella (1494), with paintings by Perugino; Church of S. Nicolò (begun 14th cent., remodeled 16th cent.), with works by Niccolò Alunno and apse decorations by Sebastiano Conca; Palazzo Comunale (which acquired a neoclassic façade by Ireneo Aleandri in the baroque period), with a 15th-century battlemented tower; Palazzo Deli, designed in the 16th century by Baccio d'Agnolo Baglioni; and also dating from the 16th century, the Pesci-Feltri, Cybo, and Orfini palaces, and the old hospital (1517), converted into a school.

Dating from the baroque period are the Ubaldi, Mancia-Salvini, and Barnabò palaces.

In the vicinity of Foligno are other structures worth noting: the Church of S. Giovanni Profiamma (early 13th cent.), with a three-aisled basilican interior, raised presbytery, and an Early Christian crypt (possibly 6th cent.); the Romanesque-Gothic church of the Madonna della Fiammenga; the Abbey of Sassovivo, with a cloister (1229) and the original crypt (11th–12th cent.); the Church of S. Maria in Campis (14th–15th cent.; partly destroyed by an earthquake in the 19th cent. and rebuilt), decorated with frescoes by Umbrian painters, chiefly Pierantonio Mezzastris and Niccolò Alunno; in the village of Sant'Eraclio, the Trinci Castle (15th cent.), of which the outside walls and two towers remain.

BIBLIOG. M. Faloci-Pulignani, Foligno, Bergamo, 1907; M. Faloci-Pulignani, Il Duomo di Foligno, Foligno, 1908; M. Faloci-Pulignani, Guida di Foligno e dintorni, Foligno, 1909; O. von Gerstfeld, Umbrien: Foligno, Leipzig, 1912; M. Faloci-Pulignani, Un chiostro romano nell'Abbazia di Sassovivo in Umbria, L'Illustrazione Vaticana, IV, 1933, p. 388; G. Domi-

nici, Questioni sulle antichità di Foligno, Verona, 1935; M. Faloci-Pulignani, L'antico Palazzo del Podestà in Foligno, Foligno, 1937; A. Messini, Documenti per la storia di palazzo Trinci a Foligno, RArte, XXIV, 1942, pp. 74–98; M. Salmi, Rapporti nella pittura tardogotica tra Ferrara e Foligno, Commentarii, I, 1950, pp. 211–13; EAA, s.v.

Gubbio (Lat., Iguvium; med., Eugubium). City of the Umbri; seven bronze tablets with ritual texts in the ancient Umbrian language are preserved in the Palazzo dei Consoli. It became a municipium under the Romans. From the Roman period there are ruins of a large theater (ca. mid-1st cent.) and remains of thermae and of a mausoleum known as the tomb of Genzio or of Pompino Grecino.

The city has retained its medieval appearance; the main streets, with houses in ashlar masonry, run parallel to each other at different levels. The Cathedral — a 13th-century single-aisled structure with a very wide nave, a large portal, a rose window, and 13th-century sculpture on its façade (remodeled 16th cent.) — contains paintings by 16th-century artists of Umbria and the Marches as well as a rich treasury. Other 13th-century churches include: S. Pietro (greatly restored); S. Agostino (with a modern façade), the nave and presbytery of which were decorated by Ottaviano di Martino and his pupils; S. Francesco (built by Fra Bevignate of Perugia, 1259–92), with three polygonal apses, the left apse frescoed by Nelli or one of his followers; and S. Giovanni Battista, a single-aisled church with a square apse that has been restored in modern times. S. Secondo, originally also a 13th-century edifice, retained only the polygonal apse of the original structure when the church was rebuilt in the 15th century. Noteworthy among the secular buildings of the 13th century are Palazzo del Capitolo and Palazzo del Bargello.

Fourteenth-century structures include the Palazzo Pretorio, designed by Gattapone (Matteo di Giovannello di Maffeo), and the Palazzo dei Consoli, surmounted by battlements and a small tower, designed by Gattapone and Angelo da Orvieto (housing the Museo e Pinacoteca Comunali, an archaeological collection and a gallery of paintings by artists of the Umbrian school). The Church of S. Domenico, which contains 15th-century frescoes, dates from the 14th century, but its interior has been remodeled. The Church of S. Maria Nuova has a simple ogival portal, an arcaded side wall, and interior frescoes by Nelli and others (PL. 186). Dating from the 15th century are the Palazzo Ducale (with a porticoed interior court in Renaissance style), probably designed by Luciano Laurana, in imitation of the palace at Urbino; Palazzo della Porta, which has a fine Renaissance portal; and Palazzo Beni. The Church of S. Ubaldo is also a 15th-century structure, with a nave and four aisles, but much of it has been rebuilt. Later noteworthy constructions include the 18th-century Church of the Madonna del Prato, built in the form of a Greek cross, and the neoclassic Palazzo Ranghiaschi-Brancaleoni.

Bibliog. R. Schulze, Gubbio und seine mittelalterliche Bauten, Berlin, 1915; M. Salmi, Le chiese gotiche a Gubbio, L'Arte, XXV, 1922, pp. 220–21; A. Colasanti, Gubbio, Bergamo, 1925; L. Fenini Baldini, Gubbio, Florence, 1926; E. Giovagnoli, Gubbio nella storia e nell'arte, Città di Castello, 1932; P. Moschella, Il teatro di Gubbio, Dioniso, VII, 1939–40, pp. 3–16; G. Devoto, Tabulae Iguvinae, Rome, 1940; Gubbio: Chiesa di S. Francesco, Arti figurative, I, 1945, p. 89; EAA, s.v.

Montefalco (med., Corcurione). Destroyed in 1249, the town was rebuilt in the 14th century, and later came into possession of the Church. Medieval in appearance, with turreted walls and gates of the 14th and 15th centuries, Montefalco stands on a hill overlooking the plain of Foligno. Ruins remain of the Church of S. Bartolomeo (11th–12th cent.), which belonged to the older, Romanesque town. S. Agostino (begun 1275; enlarged 1327), a single-aisled church with a polygonal apse, is decorated with frescoes by Umbrian and Sienese painters of the 14th, 15th, and 16th centuries. The Porta di S. Bartolomeo, a gate with towers, was built by Emperor Frederick II in 1244. The Palazzo Comunale, begun in 1270 but later remodeled, has a 15th-century portico. S. Francesco, an early-14th-century church converted into a museum (Pinacoteca Comunale), has a Renaissance portal and a 16th-century wooden door; it is decorated with 15th- and 16th-century frescoes, including scenes from the life of St. Francis by Benozzo Gozzoli (1452), and works by Francesco Melanzio, Pierantonio Mezzastris, and Perugino. S. Illuminata (16th cent.), a single-aisled church with lateral niches, is decorated with frescoes by artists of the local school such as Melanzio (early 16th cent.). The Oratorio di S. Maria di Piazza (or del Popolo) also contains frescoes by Melanzio (1490). The Scorzoni, Pambuffetti, and Senili palaces belong to the 15th century, while the Palazzo Camilli dates from the 16th century. Adjacent to the Church of S. Chiara, a medieval structure greatly remodeled in the 17th century, is the Cappella di Sta Croce, the walls of which are covered with frescoes by Umbrian painters (1333). S. Maria Maddalena is another remodeled (18th cent.) medieval church, with 15th- and 16th-century frescoes by artists from Foligno and Gubbio. On the

outskirts of Montefalco is the Church of S. Fortunato (5th cent.; rebuilt 15th cent.), which has a colonnaded 14th-century portico decorated with frescoes by Benozzo Gozzoli (1450) and Tiberio d'Assisi, as well as a chapel frescoed by Tiberio (1512).

Bibliog. O. Scalvanti, Di alcuni monumenti nell'Umbria, nelle Marche e in provincia di Teramo, Rass. d'arte, IV, 1904, pp. 17–23; L. Fiocca, Gli affreschi trecentisti nella cappella della chiesa di S. Chiara in Montefalco, Rass. d'arte, IX, 1909, pp. 164–67; G. Urbini, Spello, Bevagna, Montefalco, Bergamo, 1913; M. Mattioli, Montefalco, Spoleto, 1953; A. Morghen, Tradizione religiosa e Rinascimento nel ciclo degli affreschi francescani di Montefalco, Atti V. Cong. int. S. sul Rinascimento, Florence, 1956, pp. 149–56.

Narni (Umbrian, Nequinum; Lat., Narnia). This city was founded as a colonia by the Romans in 299 B.C. on the site of the Umbrian Nequinum, which they had destroyed during a long siege. A station on the Via Flaminia, it was strategically important during a civil war in A.D. 69 and in the wars against the Goths. From the Roman period there remain two gates on the Via Flaminia, as well as an arch and two pylons of a triple-arched viaduct (1st cent.).

Narni acquired its present appearance during the Middle Ages, when it was a flourishing and prosperous city. (Its prosperity declined after the city was sacked in 1527 by the imperial troops of Charles V.) The city, which was encircled by a wall with towers during the medieval period, is dominated by a citadel (Rocca) at its southeastern end; rectangular in plan, with towers at the corners, the Rocca was built in 1370 and modified in the 15th century. Attached to the Cathedral is a rare example of Early Christian art, the shrine of SS. Giovenale e Cassio (6th cent.), which has a façade decorated with sculpture and 9th-century mosaics. The Cathedral itself (12th cent.) is a Romanesque structure, basilican in plan, with its main portal decorated with sculpture; in the 15th century, a porch was added and the interior altered by the addition, on the right, of a third aisle. Within are notable examples of 15th- and 16th-century art, including a wooden statue of St. Anthony Abbot by Il Vecchietta (Lorenzo di Pietro). S. Maria in Pensole (1175), a Romanesque church with sculptured portals, has a porch with surbased arches and contains a crypt (possibly 9th cent.). The Church of S. Domenico (12th cent.) was also built in Romanesque style, but only the carved portal and campanile of the original remain. S. Francesco (14th cent.), a Gothic church with nave and two aisles, and a polygonal apse, contains traces of 15th- and 16th-century frescoes. The Church of S. Agostino (15th cent.) is a Renaissance structure, with frescoes by Lorenzo di Cristoforo Torresani (16th cent.).

Many of the medieval towerlike houses still stand. The Piazza Priora, completely medieval in appearance, is the site of Palazzo del Podestà (Comunale), a combination of three 13th-century buildings (altered 16th cent.); the Loggia dei Priori (mid-14th cent.); and a fountain with a polygonal basin (1301), a design like that of the Fontana Maggiore in Perugia. The Pinacoteca Comunale is located in the Palazzo Comunale.

Bibliog. G. Eroli, Descrizione delle chiese di Narni, Narni, 1898; R. Robusti, Guida della città di Narni e dintorni, Rome, 1924; G. Castelfranco, Chiese protoromantiche nei dintorni di Narni, BArte, N.S., XXV, 1931–33, pp. 214–22, 262–72; G. Collosi, Il Palazzo dei Priori e il Palazzo del Podestà nel comune di Narni, Narni, 1940; G. Collosi, Le porte di Narni romana e medioevale, Narni, 1941; C. Pietrangeli, Narni colonia e municipio romano, Roma, XIX, 1941, p. 1 ff.; M. Salmi, Un problema storico-artistico medievale (a proposito di un mosaico nel Duomo di Narni), BArte, XLIII, 1958, pp. 213–31.

Norcia (Lat., Nursia). Situated at the edge of a plain (Piana di Santa Scolastica) in the heart of the Umbrian Apennines, this Sabine city was conquered by the Romans in 290 B.C. Traces of this later phase of its history remain in the many Roman ruins incorporated in the foundations of later edifices. In the Middle Ages Norcia became a prosperous commune, and afterward the seat of a prefecture of the Papal States. The city walls were built in the 14th century, and the notable buildings of the city also date from that period.

S. Benedetto, a Gothic church (rebuilt late 14th cent.) with a richly ornamented façade and a remodeled interior, stands over the ruins of a Roman structure (probably a public building, late 1st or early 2d cent.), traces of which are visible in the crypt. The Church of S. Agostino is also a 14th-century Gothic structure; however, its interior was remodeled in the 17th century. There are Gothic elements in the churches of S. Francesco and S. Giovanni, as well as in the Cathedral (16th cent.), which incorporates the Gothic portal and the campanile of the Church of S. Maria Argentea (destroyed early 14th cent.). The Church of S. Filippo dates from the 18th century. The Palazzo Comunale, remodeled and enlarged many times, has a 13th-century porch, an early-18th-century tower, and a loggia dating from the 19th century; the building presently holds the Raccolta Comunale (paintings, sculpture, codices, goldwork). The Edi-

cola, or Tempietto (1354), an unusual design by Vanni Tuzi, is a small square building with semicircular arcading along two sides. The Castellina of Giacomo da Vignola, a rectangular fortress with corner bastions, was built (1554–63) over an ancient temple.

On the outskirts of the city stands a Renaissance church, Madonna delle Nevi (1565–71), with an octagonal exterior and a Greek-cross interior, frescoed by Camillo and Fabio Angelucci (1576–84). In nearby Valle Castoriana, a religious retreat in the Middle Ages, is the Abbey of S. Eutizio, with a Romanesque church (1190) by Maestro Pietro; within are significant works of Renaissance art.

BIBLIOG. V. Paris, Guida di Norcia, Spoleto, 1906; G. Sordini, La più antica chiesa e la cripta di S. Benedetto da Norcia, B. diocesani di Norcia, III, 1913; G. Sordini, Resti di un antico, sconosciuto edificio esistente a Norcia, Perugia, 1913; G. Carocci, La Badia di S. Eutizio presso Norcia, Arte e storia, XXXIII, 1914, pp. 9–46; P. Tremoli, Nuove epigrafi di Norcia, Epigraphica, X, 1948, pp. 69–73; P. Pirri, La scuola miniaturistica di S. Eutizio in Valcastoriana presso Norcia nei secoli X–XII, Scriptorium, III, 1949, pp. 3–10; U. Ciotti, Saggi di scavo nella cripta di S. Benedetto, FA, X, 1955, 4385; G. Valli, Le chiese a due navate nella regione di Norcia e comuni limitrofi, Atti V Conv. naz. Storia Arch. (1948), Florence, 1957, pp. 539–42; P. Pirri, L'abbazia di Sant'Eutizio e le chiese dipendenti, Rome, 1960.

Orvieto (anc. Salpinum, Volsinii Veteres?). The name "Urbs Vetus," derived from the "Ourbibentos" of Procopius of Caesarea (6th cent.), dates only from the early Middle Ages. Thereafter, as "Urbiventus," it was mentioned by Paulus Diaconus and in documents of Pope Gregory the Great. Because of its impregnable position atop an almost perpendicular cliff of volcanic tuff, the ancient city was never walled; the only access was from the west, at Porta Maggiore. Its Capitolium may perhaps lie under the present Palazzo del Popolo. The Tempio Augurale (or del Belvedere; probably 5th cent. B.C.), a minor temple with three cellae, lay outside the city proper. Traces of two other temples and many architectural terra cottas have come to light. Of great interest are the Etruscan necropolises with chamber tombs, at the base of the cliff at Crocifisso del Tufa and Cannicella.

The medieval city, built over the ancient site, did not achieve full development until the 12th century. The Church of S. Andrea, a Romanesque structure (11th–12th cent.; restored 16th and 20th cent.) that incorporates remains of a 6th-century church on Roman foundations, has a portico on the left flank and a massive dodecagonal campanile (12th cent., restored). S. Giovenale (11th–12th cent.) has a simple high altar dated 1170 and is adorned with 13th- and 14th-century frescoes. Toward the end of the 13th century, Gothic elements were introduced and initially blended with the prevailing Romanesque style: for example, in the imposing Palazzo del Popolo (PL. 186), which has triple-arched windows on the second story — reached by a broad exterior stairway — and a massive arcade, now partly walled up, on the ground level. The Palazzo dei Papi (or Soliano; 1297–1304) also has triple-arched windows and an outside staircase.

The Cathedral, one of the masterpieces of Italian Gothic architecture, was begun in 1290, probably by Fra Bevignate of Perugia; from about 1305 to 1330 its construction was carried on under Lorenzo Maitani, designer (?) of the façade (VI, PL. 333; IX, PL. 265) and much of the sculptural decoration (IX, PLS. 267–269). The side walls and the apse are faced with uniform white and black horizontal bands, an austere pattern that recurs on the walls within and on the piers. The deep presbytery has a stained-glass window (1325–34) and is decorated with frescoes by Ugolino di Prete Ilario, Pinturicchio, and Pastura (Antonio Massari da Viterbo). The arms of the transept end in two chapels: on the right, the Cappella Nuova (Madonna of S. Brizio), with vault frescoes by Fra Angelico and Benozzo Gozzoli (1447) and the celebrated fresco cycle of Luca Signorelli (IV, PL. 179; VII, PL. 380); on the left, the Chapel of the Corporal, containing a reliquary by Ugolino di Vieri (VI, PL. 382), a Madonna of Mercy attributed to Lippo Vanni (III, PL. 309), and frescoes by Ugolino di Prete Ilario and his pupils (1357–64). On the wall of the left aisle is a fresco of the Madonna by Gentile da Fabriano (1425). The Church of S. Domenico (13th cent.) has been greatly damaged, altered, and restored over the centuries; a Gothic portal transferred from another church was added in modern times. Within are the tombs by Arnolfo di Cambio (13th cent.; I, PLS. 456, 457) and Ippolito Scalza (late 16th cent.). The Petrucci Chapel was designed by Michele Sanmicheli. The Church of S. Francesco combines a Gothic façade with a baroque interior. S. Lorenzo in Arari (13th cent.) contains 14th-century frescoes and a 12th-century ciborium.

During the Renaissance many medieval buildings were enlarged and renovated, among them the Palazzo Comunale (16th-century façade by Scalza), and work on the Cathedral was intensified, under Simone Mosca, Scalza, and Sanmicheli. New buildings were erected, including Palazzo Crispo (later Marsciano), designed by Antonio da Sangallo the Younger, and many of the houses on Via Cavour. Dat-

ing from the Renaissance are the 15th-century Palazzo Mancini (Ficarelli) and Palazzo Filippeschi (Petrangeli), as well as the following 16th-century palaces: Urbani (Petrucci; by Sanmicheli), Clementini (by Scalza), Gualterio (presently Banco di Roma; design by Mosca and portal by Scalza), Buzi and Saracinelli (Baiocchini; also by Scalza), Ceccantoni, and Caravajal-Simoncelli. The Oratory of S. Giovanni Decollato also dates from the 16th century. The Pozzo della Rocca (or di S. Patrizio; 1527–37), a peculiar example of engineering by Antonio da Sangallo the Younger, consists of a cylindrical shaft about 20 ft. deep pierced by 72 windows, with a double spiral staircase.

Two examples of the baroque are the Church of the Gesù, which has rich stucco decoration, and S. Bernardino, a convent church that has a façade decorated with volutes and a richly ornamented oval interior. The Church of S. Maria dei Servi, built in Gothic style in 1259 but remodeled in a neoclassic manner by Virginio Vespignani in the 19th century, contains a Madonna and Child by Coppo di Marcovaldo (PL. 183). Also noteworthy is the Teatro Civico Mancinelli, designed by Giovanni Santini and Vespignani and decorated by Cesare Fracassini (19th cent.). Museums: Museo Faina (Palazzo Faina), with an important collection of Greek vases; Museo dell'Opera del Duomo (Palazzo dei Papi), emphasizing Italian painting and sculpture in its galleries. The archaeological section is housed in the 17th-century Palazzo dell'Opera nearby.

On the outskirts is the Abbey (Badia) of SS. Severo e Martirio, which includes a 12th-century church and a dodecagonal campanile. There are Etruscan painted tombs in the vicinity: at Poggio dei Settecamini (or del Roccolo), the Golini tomb and the "Tomba delle Due Bighe," the frescoes of which have been removed to the Museo Archeologico in Florence; and near Castel Rubello, the still frescoed Tomb of the Hescanas.

BIBLIOG. L. Fumi, Il palazzo del popolo di Orvieto, Foligno, 1889; L. Fumi, Il Duomo di Orvieto, Rome, 1896; L. Fiocca, Chiesa e abbazia dei Santi Severo e Martirio, BArte, IX, 1915, pp. 119–44; L. Fumi, Orvieto, Bergamo, 1919; L. Pernier and E. Stefani, Tempio etrusco presso il Pozzo della Rocca, NSc, 1925, pp. 133–61; G. Becatti, Carta archeologica d'Italia, Orvieto, Florence, 1934; S. Puglisi, Studi e ricerche su Orvieto etrusca, Catania, 1934; A. L. Calò, Una fabbrica orvietana di vasi etruschi nella tecnica a figure nere, SEtr, X, 1936, pp. 429–39; M. Tordi, Orvieto, Rome, 1950; L. Borelli Vlad, Il distacco delle tombe Golini I e II di Orvieto, B. Ist. centrale del Restauro, V–VI, 1951, pp. 21–50; R. Bonelli, Il Duomo di Orvieto e l'architettura del '200–300, Città di Castello, 1952; G. Riccioni, Guida di Orvieto, Orvieto, 1955; R. Bonelli, Bevignate: Architetto o amministratore?, CrArte, V, 28, 1958, pp. 329–32; P. Cellini, Appunti orvietani, III: Fra' Bevignate e le origini del Duomo di Orvieto, Paragone, IX, 90, 1958, pp. 3–16; J. White, The Reliefs on the Façade of the Duomo at Orvieto, Warburg, XXII, 1959, pp. 254–302; M. Bizzarri, La Necropoli di Crocifisso del Tufo in Orvieto, SEtr, XXX, 1962, pp. 1–154, 16 pls.

Perugia (Lat., Perusia). One of the most important of the federated Etruscan cities, it is rich in artistic evidence of that period; however, its remote origins are probably Umbrian. An ally of Rome and later a municipium (after A.D. 90), it maintained its importance throughout the Empire and in the Middle Ages. In 1540 it passed to the Papal States, and thereafter declined. The ancient walls, surrounding the oldest quarter, follow an irregular course over the high ground (FIG. 655) and are of irregular opus quadratum. Although their Etruscan origin has been established, the date remains problematical (probably 4th–2d cent.). Six of the ancient gates still stand, including the so-called "Arch of Augustus" (erroneously named from the inscription "Augusta Perusia Colonia Vibia"). The arch is decorated with a Doric frieze and is flanked by two massive towers, one topped by a 16th-century loggia. The upper part of the Porta Marzia (V, PL. 48), another gate of Etruscan origin, surmounted by a blind loggia with sculptured figures (possibly Jupiter and the Dioscuri), was incorporated into the 16th-century Rocca Paolina. Etruscan and Roman necropolises are found in the surrounding country. A tomb type that seems characteristic of the Perugia region consists of a single chamber holding Hellenistic figured urns in travertine or terra cotta. Among the notable Etruscan monuments are three underground tombs: Villa Sperandio, where a sarcophagus with reliefs of an archaic Chiusi type was recovered; S. Manno, with a barrel-vaulted ceiling; and that of the Volumnii, carved into the rock in imitation of a house with rooms, reliefs, and urns (IV, PL. 454).

The appearance of the city is medieval. In the 14th century the walls were extended to enclose the S. Pietro and S. Angelo quarters. At the northern edge of the city is the Early Christian Church of S. Angelo (late 5th or early 6th cent., restored), circular in plan, with a circular ambulatory and 16 ancient Roman columns supporting the central drum. The Gothic portal dates from the 14th century, and the external buttresses from the 17th. The Church of S. Prospero, a small 10th-century structure with later additions, contains an 8th-century ciborium. S. Pietro (ca. 1000) has retained, almost intact, its original basilican structure, with aisles separated by two rows of 18 ancient columns with Ionic capitals. The decora-

tion of the interior, including the coffered ceiling of the central aisle, is of the 15th and 16th centuries. The paintings are by Antonio Vasilacchi (Aliense), Bonifacio Veronese, Sassoferrato, Guercino, and Vasari, among others. The carved and inlaid wooden choir stalls and the wardrobes in the sacristy are 16th-century works; the sacristy also contains small paintings on wood by Perugino. The hexagonal campanile dates from the 15th century, the portico from the 17th.

Perugia has many Romanesque churches, most of which have been remodeled or altered at a later date: S. Ercolano, S. Francesco

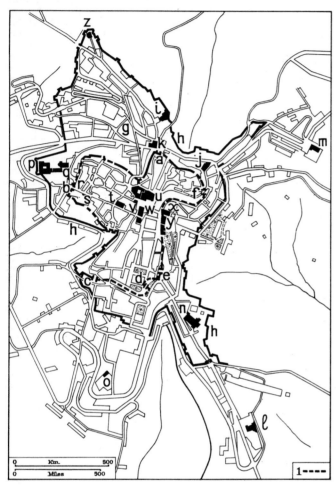

Perugia, plan. *Key*: (1) Boundary of the ancient and early medieval city, with the course and remains of the Etruscan walls. Principal monuments: (*a*) So-called "Arch of Augustus"; (*b*) Porta S. Luca; (*c*) Porta della Mandorla; (*d*) remains of Rocca Paolina and Porta Marzia; (*e*) Porta S. Ercolano and Church of S. Ercolano; (*f*) Porta Sole; (*g*) area of the Roman baths; (*h*) walls, 13th–16th century; (*i*) S. Agostino; (*j*) S. Maria Nuova; (*k*) Palazzo Gallenga Stuart; (*l*) S. Pietro; (*m*) Church and Convent of S. Maria di Monteluce; (*n*) S. Domenico; (*o*) S. Giuliana; (*p*) Accademia di Belle Arti; (*q*) Churches of S. Francesco al Prato and S. Bernardino; (*r*) Church of the Madonna della Luce; (*s*) Sciri tower; (*t*) S. Filippo Neri; (*u*) Cathedral, Palazzo del Seminario, and Fontana Maggiore; (*v*) archiepiscopal palace; (*w*) Palazzo Comunale (or dei Priori) and Collegio del Cambio; (*x*) Church of the Gesù; (*y*) Palazzo del Capitano del Popolo and Palazzo dell'Università Vecchia; (*z*) S. Angelo.

al Prato, S. Maria Nuova (baroque interior; 17th-century campanile rebuilt from designs by Galeazzo Alessi), S. Agostino (18th-century interior; choir stalls and lectern of inlaid wood by Baccio d'Agnolo, 1502–32). S. Bevignate (late 13th cent.) marks the combination of early monastic Gothic influences with Romanesque elements. Gothic features are also seen in the following 13th-century churches: S. Giuliana, with 13th- and 14th-century frescoes, as well as remains of a 13th-century cloister and one of the 14th century in the former convent; S. Maria di Monteluce, remodeled in the 14th and 15th centuries, with a *Crucifixion* (ca. 1490; detached fresco) by Fiorenzo di Lorenzo; S. Maria della Valle; SS. Stefano e Valentino; S. Agata (remodeled), with a 15th-century polyptych of Lello da Velletri. The Cathedral (S. Lorenzo; 1345–1490) is a late Gothic *Hallenkirche*, with an exterior in rough masonry, for the marble facing was never completed. The façade is preceded by a wide flight of steps, atop which is the bronze statue of Pope Julius III by Vincenzo Danti

(1555); the Renaissance portal is by Alessi (1568). The interior contains carved wooden choir stalls by Giuliano da Maiano and Domenico del Tasso (1486–91) and bas-reliefs by Agostino di Duccio and assistants. The Chapel of S. Bernardino contains a *Descent from the Cross* by Federico Barocci (1569); works of Cesare Nebbia (late 16th cent.) are in the Cappella del Sacramento. The lunette above the Altar of the Gonfalon is by Giannicola di Paolo, to whom the *Madonna delle Grazie* in the nave is attributed as well.

Secular architecture (12th–15th cent.): The Sciri house and the adjacent tower are probably of the 12th century. The Gothic Palazzo Comunale (or dei Priori; 1293–1443) has a large fan-shaped stairway leading to a portal surmounted by a griffin and a Guelph lion in bronze, the two symbols of the city. On the side facing Corso Vannucci is a richly ornamented portal, with a round arch and lunette sculpture (ca. 1340). There are two bands of triple-arched windows, and the whole is surmounted by a battlemented cornice. The Hall of the Notaries (formerly the council chamber), a huge arched room on the second floor, is decorated with frescoes of the school of Cavallini (1297); on the same floor is the Cappella dei Priori, with frescoes by Benedetto Bonfigli (1454–96). The Fontana Maggiore (X, PLS. 324, 325), in the square between the Palazzo Comunale and the Cathedral, is by Nicola and Giovanni Pisano (late 13th cent., restored). It consists of two concentric polygonal basins, on two levels, and is surmounted by a circular bronze bowl with three nymphs supporting a wreath. Among the many residences and towers of this period are the Baglioni houses, once incorporated in the Rocca Paolina but since freed from the ruins of the fortress.

Monuments of the early Renaissance period include Porta S. Pietro (begun 1447), with major work by Agostino di Duccio (1475, unfinished); the battlemented Porta S. Angelo (14th cent., restored); several large palaces; the loggias of Braccio Fortebraccio (1423), by the Bolognese Fioravante di Rodolfo Fioravanti, and of Baldo degli Ubaldi (15th cent.); Palazzo dell'Università Vecchia (1453–83); Palazzo del Capitano del Popolo (1472–81), with decorations probably by Lombard masters; and the former Dominican monastery. Of the same period, but still Gothic in form, are the remaining portal and mullioned windows of the Collegio dei Notari (1446) and the Sala del Collegio della Mercanzia (first half of 15th cent.), with its splendid late Gothic ornamentation. The Collegio del Cambio (1452–57) is Renaissance in form; some of its halls were frescoed by Perugino and his pupils (1496–1500; XI, PLS. 114, 116). It also contains fine carved and inlaid woodwork by Domenico del Tasso (1492) and Antonio da Mercatello (1508). The Oratory of S. Bernardino (1457–61), a work of Agostino di Duccio, has a polychrome façade elaborately decorated with sculpture in niches and reliefs (PL. 191). High Renaissance architecture of the 16th century is represented in the Church of the Gesú (partly rebuilt in the present century), with frescoes by Andrea Carlone and a carved ceiling; S. Maria del Popolo, by Galeazzo Alessi; the small churches of S. Angelo della Pace (by Alessi), Madonna della Luce, Maestà delle Volte (by V. Martelli, with frescoes by Niccolò Pomarancio); and the loggia of the left tower of the Arch of Augustus. The Rocca Paolina (largely destroyed in the revolution of 1848) was built by Antonio da Sangallo the Younger for Pope Paul III in 1540. The archiepiscopal palace retains parts of a 14th-century building and the earlier Palazzo del Podestà in its façade and side wall. The Church of S. Domenico, originally 14th-century Gothic, was rebuilt by Carlo Maderno in 1632; it is three-aisled and has altar decorations by Agostino di Duccio and Gothic stained-glass windows.

Baroque buildings of the 17th and 18th centuries that are prominent include: S. Filippo Neri, with frescoes by Andrea Carlone and Francesco Appiani; Church of S. Teresa (or degli Scalzi); Palazzo Gallenga Stuart, by P. Carattoli (the present-day Università per Stranieri); Palazzo Donini, also by Carattoli; the Convent and Church of the Olivetani, the seat of the modern university, designed by L. Vanvitelli; S. Severo, with paintings by Raphael and Perugino; and Teatro Morlacchi. Of 19th-century origin are Palazzo del Governo (by A. Arienti); Teatro del Pavone, decorated by Benvenuti; Palazzo della Banca d'Italia, in Neo-Renaissance style, by G. Rossi; Palazzo Cesaroni, by G. Calderini; and the monument to Victor Emmanuel II, by G. Tadolini.

Museums: Galleria Nazionale dell'Umbria (Palazzo dei Priori), containing important collections of painting and sculpture; Museo dell'Opera del Duomo (Palazzo dei Canonici), with religious objects and paintings; Musei Civici (former Convento di S. Domenico); in the Palazzone locality, Museo dell'Ipogeo dei Volumni (Etruscan tomb art); Istituto d'Arte e Accademia di Belle Arti.

BIBLIOG. A. Bellucci, La pianta eusebia di Perugia nel 1602, Augusta Perusia, I, 1906, pp. 125–28; A. Bellucci, L'antico rilievo topografico del territorio perugino misurato e disegnato dal padre Ignazio Danti, Augusta Perusia, II, 1907, pp. 89–92, 118–26; R. Gigliarelli, Perugia antica e Perugia moderna, Perugia, 1908; G. Körte, Das Volumniergrab bei Perugia, Berlin, 1909; W. Bombe, L'acquedotto e la fontana di Perugia, Arte e storia,

XXIX, 1910, pp. 228-33; W. Bombe, Perugia, Leipzig, 1914; M. S. Mazzara, La chiesa di S. Angelo a Perugia e l'arte medievale cristiana, Arte e storia, XXXIV, 1915, pp. 128-40; A. Lupatelli, Il Cambio di Perugia, Perugia, 1923; V. Amidei, La chiesa di S. Francesco al Prato in Perugia, Città di Castello, 1925; R. A. Gallenga Stuart, Perugia, Bergamo, 1929; E. Ricci, La chiesa di S. Pietro e i pittori del Duecento in Perugia, Perugia, 1929; P. S. Riis, The Etruscan City Gates in Perugia, ActaA. V, 1934-35, pp. 65-98; V. Campelli, La cinta murata di Perugia, RIASA, V, 1935, pp. 7-36; L. Banti, Contributo alla storia ed alla topografia del territorio perugino, SEtr, X, 1936, pp. 97-127; U. Calzoni, Il Museo Preistorico dell'Italia centrale in Perugia, Rome, 1940; F. Messerschmidt and A. von Gerkan, Das Grab der Volumnier bei Perugia, RM, LVII, 1942, pp. 122-35; A. M. Pierotti, Contributi per la carta archeologica di Perugia: Scoperta nella cinta etrusca alla Cupa, SEtr, XIX, 1946-47, pp. 313-14; E. Bevilacqua, Perugia: Ricerche di geografia urbana, Mem. di geog. antropica, IV, 1949, pp. 15-23; A. M. Pierotti and M. Calzoni, Ricerche su Perugia etrusca: La civiltà e la necropoli urbana, SEtr, XXI, 1950-51, pp. 275-89; P. Cellini, Della Fontana Maggiore di Perugia, Paragone, II, 15, 1951, pp. 17-22; G. Nicco Fasola, La fontana di Perugia, Rome, 1951; A. Paoletti, Ipogeo dei Volumni, Perugia, 1953; A. Paoletti, Ricerche di materiale archeologico nelle chiese umbre (S. Ercolano, S. Maria degli Angeli, Porziuncola), Perugia, 1953; O. Guerrieri, La basilica di S. Pietro in Perugia, Perugia, 1954; O. Guerrieri, La chiesa di S. Agostino a Perugia e le sue vicende architettoniche, Atti V Conv. naz. Storia Arch. (1948), Florence, 1957, pp. 557-63; M. Montanari, Considerazioni sulla primitiva chiesa di S. Pietro in Perugia, Atti V Conv. naz. Storia Arch. (1948), Florence, 1957, pp. 495-99; A. Pantoni, Chiese perugine dipendenti da monasteri, Benedictina, XI, 1957, pp. 177-218; O. Guerrieri, La Rocca Paolina di Perugia, 2d ed., Perugia, 1958; P. Cellini, Giochi d'acqua a Perugia: Fra' Bevignate e la fontanina di Arnolfo, Paragone, XI, 127, 1960, pp. 3-34; F. Santi, La Galleria Nazionale dell'Umbria, Rome, 1960.

Spello (Lat., Hispellum). Perhaps of Umbrian origin, in 41 B.C. it became a Roman colonia of some importance. The walls, probably from the Augustan period, had a number of gates, of which the Porta Venere (with three supporting arches and two towers) and the Porta Consolare are best preserved. There are also portions of a large amphitheater and of a theater. The principal monuments, nearly all medieval, are on the main street, which runs the full breadth of the town, with narrow and twisting streets branching off, many of them spanned by arches. S. Maria Maggiore (12th-13th cent., altered greatly in the 17th cent.) contains frescoes by Pinturicchio in the Baglioni Chapel. S. Lorenzo was built in the 12th century, but the façade was remodeled in 1540; the neoclassic Cappella del Sacramento within was built by Neri di Foligno, after a design by Giuseppe Piermarini (1793). In the Church of S. Andrea (13th cent.) is a large altar frontal, Madonna and Child with Saints, by Pinturicchio and Eusebio da San Giorgio (1508). The Villa Fidelia (or Costanzi) is a suburban neoclassic residence of the 18th century. The museum of S. Maria Maggiore is in the Cappella del Sepolcro.

BIBLIOG. G. Urbini, Due affreschi del Perugino a Spello, Arte e storia, XIII, 1894, pp. 37-38; G. Urbini, Opere d'Arte di Spello, Arte e storia, XIII, 1894, pp. 75-76, 126-27, XIV, 1895, pp. 50-53, 138-41; G. Urbini, Le opere d'arte di Spello, Arch. storico dell'arte, N.S., II, 1896, pp. 367-96, III, 1897, pp. 16-53 (bibliog.); G. Urbini, Spello, Bevagna, Montefalco, Bergamo, 1913; D. Viviani, Porta Venere e torri di Properzio, BArte, IX, 1915, pp. 301-04; I. A. Richmond, Augustan Gates at Torino and Spello, BSR, XII, 1932, pp. 52-62; G. Cecchini, Spello, Foligno, 1958.

Spoleto (Lat., Spoletium). An Umbrian settlement that became a Latin colonia in 241 B.C., Spoletium was destroyed by Sulla in the 1st century B.C., but grew again in size and wealth under Augustus and during the late Empire. Destroyed by Totila in the 6th century, it was rebuilt by Narses in 552. In 571 Spoleto became the seat of a powerful Lombard duchy, and in 776 it came under Frankish rule. In the late 12th century it became part of the Papal States.
The Umbrian walls of polygonal masonry, possibly raised in the 5th century B.C., were restored in Roman times. The ancient acropolis was on the hill of Sant'Elia. There are numerous Roman remains, and the Roman network of streets is still in evidence. In the forum (the modern Piazza del Mercato) are the Arch of Drusus and Germanicus (1st cent.), a 1st-century temple with tetrastyle pronaos (Church of S. Ansano), and scant remains of the capitolium. There are a theater (reign of Augustus) and an amphitheater (2d cent.).
The present-day city retains its medieval aspect, dominated by the Rocca, a fortress erected in the early 14th century and enlarged in the 15th. S. Salvatore (late 4th-6th cent., several times restored), a basilica beyond the walls, is three-aisled and triapsidal and has a façade with three portals and three windows, decorated with sculpture in a classical manner that reveals probable Oriental influence (I, PL. 416). The above-mentioned S. Ansano, a small church built over the ruins of a Roman temple in the 11th and 12th centuries, retains a crypt (possibly 7th cent.), with frescoes in a Byzantine manner from a later period. S. Eufemia (probably 10th cent., restored), basilican in plan, has alternating columns and piers inside, three apses, and galleries. Churches of the Romanesque period are well represented. SS. Giovanni e Paolo, an 11th-century con-

struction, contains frescoes of the 12th and 13th centuries. S. Paolo Intervineas is also decorated with frescoes of that date. S. Gregorio Maggiore was begun in the late 11th century but has been rebuilt in the present century. Its massive campanile is Romanesque, its portico Renaissance. The interior has a raised presbytery over a crypt divided into five aisles, with frescoes of the 12th to 15th century. S. Pietro (PL. 176), outside the city walls, is a 13th-century structure probably raised over the ruins of a 5th-century church. The façade, decorated with 12th-century reliefs, is from the original; the interior was remodeled in the 18th century. The most important of the Romanesque buildings is the Cathedral. In spite of additions (15th-cent. portico) and the remodeling of the interior in the 17th century, it has retained the massive lines of the original structure. The façade, divided horizontally into three bands, has a large rose window framed with sculpture on the second level and mosaics (1207) in a Byzantine manner above. In the interior are a painted crucifix by Alberto Sotio (PL. 177), a cycle of frescoes in the apse (scenes from the life of the Virgin) by Filippo Lippi (1467-69; IX, PL. 146), frescoes by Pinturicchio, and paintings by Pinturicchio and Annibale Carracci. The earliest Gothic architecture is found in S. Domenico (13th cent.) and, outside the city, in the Ponte delle Torri (second half of 14th cent.), probably designed by Matteo Gattapone. Of S. Nicolò (1304), which was destroyed by fire, only the original polygonal apse has survived. The Palazzo Comunale was built in the 13th century, but only the tower of the original remains; the rest was rebuilt in the late 18th century. The Palazzo Cecili-Pompili and the Torre dell'Olio are medieval (12th-14th cent.).
Significant Renaissance architecture includes the Casa dell'Opera del Duomo (1419); Tempietto della Manna d'Oro (1527), in the style of Bramante and with works by Sebastiano Conca; Church of the Madonna di Loreto (1572), with decorations by Giovanni Baglione; and Palazzo Arroni (15th-16th cent.), with graffiti probably executed from designs by Lo Spagna. From the 17th century are S. Filippo (ca. 1650), with works by Conca; the Ancaiani and Mauri palaces; and the great fountain in the Piazza del Mercato. The Teatro Nuovo, by Ireneo Aleandri, and the Teatro Caio Melisso, originally a baroque edifice (rebuilt ca. 1875-80; restored 1958), exemplify 19th-century architecture of the city. Museums: Pinacoteca Civica (Palazzo Comunale); Museo Civico (Palazzo della Signoria), containing the Lex Spoletina of the 3d century B.C.; Galleria Comunale di Arte Moderna (Palazzo Collicola).
Near Sant'Anatolia di Narco is the Romanesque Church of S. Felice (late 12th cent.), its façade ornamented with a rose window and sculpture. Farther south, near the source of the Clitunno, is Fonti del Clitunno, with a small temple dedicated in antiquity to the personification of the river and a 5th-century Christian shrine (perhaps 8th-cent.), containing the oldest frescoes in Umbria (7th-8th cent.).

BIBLIOG. G. Angelin i Rota, Spoleto e il suo territorio, Spoleto, 1920; G. Bandini, Spoleto, Bergamo, 1922; O. Guerrieri, Spoleto, Florence, 1928; F. C. Gavini, Restauri del medioevo: Il tempietto di Clitunno e la chiesa del Salvatore di Spoleto, BArte, XXVII, 1933, pp. 1-6; C. Pietrangeli, Spoletium, Rome, 1939; G. Becatti, CVA, Italia, XVI, Rome, 1940; E. Galli, Clitunnus, SEtr, XV, 1941, pp. 9-26; F. W. Deichmann, Die Entstehung von Salvatorkirche und Clitumnustempel bei Spoleto, RM, LVIII, 1943, pp. 107-48; M. Salmi, La decorazione della Basilica di San Salvatore a Spoleto, ASAtene, XXIV-XXVI, 1946-48, pp. 346-70; A. Rambaldi, Nuove epigrafi romane a Spoleto, BCom, LXXIII, 1949-50, app., pp. 49-60; P. Laureti, I monumenti longobardi a Spoleto, Atti I Cong. S. longobardi, Spoleto, 1951, pp. 363-68; M. Salmi, La Basilica di San Salvatore di Spoleto, Florence, 1951; A. Vignali, Chiese e basiliche dedicate al Salvatore in Italia sotto i Longobardi, Atti I Cong. S. longobardi, Spoleto, 1951, pp. 505-16; M. Salmi, Sant'Eufemia di Spoleto, Spoletium, I, 2, 1954, pp. 3-11; J. Sydow, Spoleto vista da viaggiatori tedeschi dal XIX secolo, Spoletium, I, 2, 1954, pp. 23-27; G. Martelli, L'abbazia di S. Felice di Giano e un gruppo di chiese romaniche intorno a Spoleto, Palladio, N.S., VII, 1957, pp. 74-91; J. Sydow, Sul problema di Sant'Eufemia, Spoletium, IV, 1, 1957, pp. 9-11; R. de Luca, Il "Nobile Teatro" ora "Caio Melisso" e la sua recente sistemazione, Spoletium, V, 1958, pp. 5-26; C. Pietrangeli, EAA, s.v. Clitunno, II, 1959, p. 723; B. Toscano, Spoletium, VI, 1959, pp. 20-33; U. Ciotti, Spoletium, VII, 1960, pp. 9-26; S. Monelli, Alta Spoleto, Rome, 1960.

Terni (Lat., Interamna Nahars). Situated on a plain in the Nera Valley, Terni was inhabited in the Iron Age (nearby necropolises), later was a town of the Umbri, and then became a Roman municipium. The regular layout of the Roman city is clearly distinguishable. There are remains of the Roman walls, an amphitheater (A.D. 32), and a theater. Under the Church of S. Salvatore are vestiges of Roman structures, and on the outskirts of the city is an Early Christian cemetery. The town was destroyed by Christian of Mainz in 1174 but was rebuilt and repeatedly changed hands between the Church and the Empire. The city was badly damaged during World War II, and subsequent reconstruction has given it a predominantly modern appearance, in spite of many ancient and medieval monuments.
The Church of S. Salvatore dates from an Early Christian con-

struction of the 5th century, incorporating a Roman temple. Its circular presbytery and 12th-century nave contain traces of frescoes of the 13th and 14th centuries. The Cathedral (rebuilt 1653) was originally Romanesque, and from that period the central portal of the façade and the crypt have survived. Gothic churches include S. Francesco (1265, enlarged and several times restored), with the Paradisi Chapel, containing 15th-century frescoes possibly by Bartolomeo di Tommaso; S. Pietro (14th cent., restored); and S. Lorenzo (13th cent., enlarged 17th cent.). Secular architecture of the 14th and 15th centuries is represented by the Palazzo Mazzancolli and the tower and houses named for the Castelli family. Dating from the Renaissance are the Pierfelici, Spada (by Antonio da Sangallo the Younger), Gazzoli (late 16th cent.), Morelli, Mastrozzi-Magroni, and Bianchini-Riccardi palaces, as well as the courtyard of the Palazzo Alberici. The Palazzo Fabrizi is a 17th-century residence. The Teatro Comunale was designed by L. Poletti in the 19th century. The fountains in Piazza del Duomo (by C. Vigni) and Piazza Tacito, by M. Ridolfi and L. Fagiolo (1936; with mosaics by C. Cagli), and the Palazzo della Prefettura of C. Baggiano (1936) are noteworthy modern constructions. The Museo e Pinacoteca Civica is in the Palazzo Carrara.

In the neighboring countryside, near Ferentillo, is the Abbey of S. Pietro in Valle, founded in the 8th century. The three apses, the transept, and part of the marble ornamentation belong to the original structure; the cloister and the upper part of the campanile date from the 12th century. The frescoes in the church are of the Roman school (12th cent.).

BIBLIOG. A. Lupatelli, La Chiesa di S. Francesco e gli affreschi del XIV secolo nella cappella Paradisi, Terni, 1892; L. Lanzi, Terni, Bergamo, 1910; E. Rossi Passavanti, Interamna Nahars, Rome, 1932; A. Ghidiglia-Quintavalle, Il Medioevo nella Badia di S. Pietro a Ferentillo, Naples, 1933; E. Fuselli, Il concorso nazionale per il piano regolatore di Terni, Architettura, XIII, 1934, pp. 107–17; I. Ciauro, Bibliografia della città di Terni e del suo territorio, Terni, 1938; R. Teofoli, Terni e la sua provincia, Rome, 1941; P. Grassini, Delimitazione dell'antica Terni secondo scoperte archeologiche, B. Deputazione Storia Patria per l'Umbria, XLIV, 1947, pp. 34–38; P. Grassini, Le sottostrutture romane alla luce dei recenti scavi della chiesa di S. Salvatore in Terni, Atti V Cong. naz. Storia Arch. (1948), Florence, 1957, pp. 475–80.

Todi (Lat., Tuder). Town probably of Umbrian origin, but subject to strong Etruscan influence. After 90 B.C. it became a Roman municipium, and during the reign of Augustus a military colonia was established. In the Middle Ages it was a prosperous commune, reaching its peak size in the 13th century. From the Umbrian-Etruscan period are the earliest city walls (partly rebuilt, 1st cent.); and within the city, remains of Etrusco-Italic temples have come to light. The so-called "Mars of Todi" (V, PL. 44) was found in one of these. The Roman period is evidenced by the Mercato Vecchio and vestiges of a theater and amphitheater.

The medieval city was built on the site of the Roman city, but in the 13th century it expanded markedly, and a third course of walls, with towers, was built; this still delimits the city. At the highest point is the Rocca, a ruined fortress. In the center of the city is Piazza del Popolo, until the 16th century entered by four gates. Fronting on it are the Cathedral, begun in the 12th century on Romanesque lines but completed with Gothic additions; Palazzo del Popolo, begun in 1213; and Palazzo del Capitano and Palazzo dei Priori, both late-13th-century edifices, the latter of which was altered in the 16th century. The Church of S. Fortunato (begun 1292) is a three-aisled Gothic hall church; it is preceded by a long flight of steps. The uncompleted façade was undertaken in the 15th century. Within is a *Madonna and Child with Two Angels* by Masolino. S. Ilario, with frescoes by Lo Spagna, and S. Maria in Camuccia are 13th-century churches. S. Maria delle Grazie, built in the mid-15th century, was later remodeled and dedicated to S. Filippo Neri. S. Maria della Consolazione (PL. 206), begun in 1508 and completed in 1607, is a Greek cross with a high dome on a drum in the style of Bramante, designed and built by Cola da Caprarola, Rocco da Vicenza, Ambrogio da Milano, Valentino Martelli, and Ippolito Scalza. The Chiesa del Crocifisso (late 16th cent.), also a Greek cross in plan, was designed by G. D. Bianchi and built by Scalza. The Palazzo Atti was built in 1552. The Palazzo del Seminario has a portal and a courtyard designed by Giacomo da Vignola (16th cent.). The Teatro Comunale was designed by Carlo Gatteschi in the 19th century. *Museums*: Museo e Pinacoteca Civica (Palazzo del Popolo); Museo del Duomo.

BIBLIOG. A. Alinari, Avanzi di una antica chiesa in Todi, RACr, XIV, 1937, pp. 361–66; G. Becatti, Forma Italiae, Regio VI: Tuder-Carsulae, Rome, 1938; O. Guerrieri, Città di Castello, Todi, Bergamo, 1939; A. Tenneroni, La Cattedrale, il tempio di San Fortunato e gli avanzi dell'epoca romana comunemente denominati tempio di Marte, Todi, 1939; G. Becatti, CVA, Italia, XVI, Rome, 1940; G. de Angelis d'Ossat, Sul tempio della Consolazione, BArte, XLI, 1956, pp. 207–13.

Trevi (Lat., Trebiae). The Roman municipium was located below the site of the present town; the transfer of the inhabitants to higher ground occurred during the late Roman Empire. Latin inscriptions and vestiges of Roman edifices have been found at the ancient site. Nearly all the medieval buildings have been remodeled, including the churches of S. Emiliano (12th cent.) and S. Francesco (13th cent.). S. Martino (14th cent.), a Minorite church outside the town, contains frescoes by Lo Spagna and Tiberio d'Assisi. S. Maria di Pietrarossa (14th cent.) is built of salvaged Roman material and has paintings of the Umbrian school of the 15th and 16th centuries. The Palazzo Comunale (14th cent.) retains the portico on the ground floor and the tower of the original construction. The Church of the Madonna delle Lacrime (1487), by Antonio Marchisi, has a portal and sculpture by Gianpietro da Venezia (1495). The single-aisled interior contains works by Lo Spagna and Perugino. The Palazzo della Porta has frescoes by the Zuccaris (16th cent.). The Pinacoteca Comunale is in the Palazzo Comunale.

BIBLIOG. L. Fiocca, Preliminari: Il medioevo nell'arte umbra, Vita d'arte, XII, 1913, pp. 133–52; T. Valenti, La chiesa monumentale della Madonna delle lacrime a Trevi, Rome, 1928; A. Bonaca, La Piazza di Trevi: Il patrimonio artistico del Comune di Trevi, Foligno, Rome, Milan, 1942; G. Urbani, Schede di restauro, B. Ist. Centrale del Restauro, XVII–XVIII, 1954, pp. 41–83 at 58; A. Bonaca, Trevi nella natura, nella storia, nell'arte, Terni, n.d.

The Marches (It., Marche). This region, corresponding for the most part to ancien Picenum, contains fairly extensive evidence of Bronze Age cultures (ceramics) and of the Piceni (an Italic people) and Cisalpine Gallic (Celtic) tribes, who produced excellent bronze artifacts, jewels (especially amber), fibulae, pottery, and weapons. There are also traces of Greek influence. Roman and Early Christian remains are few. In the early Middle Ages close ties with the exarchate of Ravenna (the Pentapolis) and with the Church favored the maintenance of long-standing Byzantine traditions. Close relations also existed with Venice, and in the later Middle Ages the art of the region was characterized by Lombard and Venetian influences, as well as provincial elements from the Abruzzi. In the Renaissance, Tuscan influence was strong, especially at the court of Urbino.

BIBLIOG. A. Ricci, Memorie storiche delle arti e degli artisti nella Marca di Ancona, Macerata, 1834; A. Amatori, Le abbazie e i monasteri piceni, Camerino, 1870; D. Gaspari, Fortezze marchigiane e una umbra del secolo XV, Foligno, 1886; E. Brizio, La necropoli di Novilara, MALinc, V, 1895, cols. 85–438; A. Colasanti, Per la storia dell'arte nelle Marche, L'Arte, X, 1907, pp. 409–22; G. Colini, Necropoli del Pianello presso Genga (Ancona) e l'origine della civiltà del ferro in Italia, BPI, XXXIX, 1913, pp. 19–68, XL, 1914–15, pp. 121–63, XLI, 1916, pp. 48–70; L. Venturi, Attraverso le Marche, L'Arte, XVIII, 1915, pp. 1–28, 172–208; L. Venturi, Opere di scultura nelle Marche, L'Arte, XIX, 1916, pp. 25–50; L. Serra, Riflessi bizantini nell'architettura romanica delle Marche, Arch. e arti decorative, V, 1925–26, pp. 291–304; L. Serra, L'arte nelle Marche, Rass. Marchigiana, IV, 1925–26, pp. 347–80, 441–82, V, 1926–27, pp. 1–28, 51–81, 159–84, 209–32, 249–73, 395–418, 435–64, 475–96, VI, 1927–28, pp. 1–28, 41–58, 81–112, 125–54, 165–92, 237–58, 269–93, 309–43; V. Dumitrescu, L'età del ferro nel Piceno, Bucharest, 1929; L. Serra, L'arte nelle Marche, 2 vols., Pesaro, Rome, 1929–34; G. Bonarelli Modena, I giardini all'italiana nelle Marche, Rass. marchigiana, IX, 1930–31, pp. 163–83; P. Franciosi, Rocche e castelli del Montefeltro, Rass. marchigiana, IX, 1930–31, pp. 141–52, 184–99, 263–68; A. Colasanti, La pittura del XV secolo nelle Marche, Florence, 1932; B. Molajoli, Alcune sculture in legno umbro-marchigiane, Fabriano, 1932; P. Marconi, La cultura orientalizzante nel Piceno, MALinc, XXXV, 1933, cols. 265–454; G. Pallotta, Note sull'arte marchigiana del Medioevo, Rome, 1933; L. Serra, L'architettura del Rinascimento nelle Marche, Rass. marchigiana, XII, 1934, pp. 55–82; G. Speranza, Il Piceno dalle origini alla fine di ogni sua autonomia sotto Augusto, Ancona, 1934; G. de' Francovich, A Romanesque School of Wood-Carvers in Central Italy, AB, XIX, 1937, pp. 5–57; A. Luchetti, La casa e l'architettura rustica nelle Marche, Lares, XII, 1941, pp. 23–27; F. Laureati, Storia ed arte in terra di Montecosaro, Macerata, 1942; A. Mori, La casa rurale nelle Marche settentrionali, Florence, 1946; Mostra della Pittura veneta nelle Marche (exhibition cat.), Ancona, ed., 1950; Soprintendenza alle antichità, monumenti e gallerie delle Marche, ed., Collana di studi archeologici e artistici marchigiani, Urbino, 1952 ff.; L. Brigidi and A. Poclà, La casa rurale nelle Marche centrali e meridionali, Florence, 1953; I Piceni e la civiltà etrusco-italica: Atti II Conv. S. Etrusco-Piceni, SEtr, XXVI, 1959, sup.

Ancona ('Αγχών; Lat., Ancona). The town is mainly modern in appearance; nevertheless, despite great devastation both in earlier times and during World War II, there remain noteworthy monuments and other vestiges of the early Villanovan and Picenian cultures. In the 4th century B.C. Ancona was a colony of Syracuse and after the Social War became a Roman municipium. In the early years of the 2d century Trajan built a new port on the site. From the 10th to the 12th century, the city was a prosperous maritime republic.

From the Greek period there are traces of an acropolis and of a temple of Aphrodite, located under the Cathedral. The most notable Roman monuments are the Arch of Trajan (built by Apollo-

dorus of Damascus), an amphitheater (erected in the reign of Augustus and rebuilt under Hadrian), and sections of wall in *opus quadratum*. From Early Christian and pre-Romanesque times, Ancona has the most important remains in the region. These include a Roman sarcophagus, a 7th-century ambo (now in S. Maria della Misericordia), and a 7th-century mosaic pavement below S. Maria della Piazza. The Cathedral (S. Ciriaco) dates from the 11th–13th century, though built over an older basilica (S. Lorenzo, 4th–6th cent.). The portal, of white and red marble, is recessed under a cusped Gothic vestibule. The plan is a Greek cross, with a polygonal dome on a drum showing Byzantine influence blended with early Gothic elements. The interior has a nave and side aisles, continued into the apsidal arms of the transept. Venetian influence is seen in the carinated ceiling (14th–15th cent.), and there are two 12th-century screens with inlaid reliefs. S. Maria della Piazza, built in the 12th century over an older church, has a façade (PL. 176) derived from the Cathedral of Zara. The interior contains a *Madonna and Saints* by Lorenzo Lotto. Also of the Romanesque period are the portal of S. Anna and the façades of S. Pietro and of the Palazzo del Senato (remodeled at a later date, but restored 1952). Of the 14th and 15th centuries, in Gothic or late Gothic forms, are S. Maria della Misericordia (1399) and the Palazzo Farina. The Loggia dei Mercanti (X, PL. 440), the portal of S. Francesco delle Scale, and the portal of the former Church of S. Agostino (1460) were designed by Giorgio da Sebenico (Orsini). The Palazzo del Governo (degli Anziani; remodeled a number of times) was probably in part designed by Francesco di Giorgio Martini, with a courtyard built in 1493; an entrance portico by Pietro Amoroso (1470) is in Renaissance style. The Palazzo Giovanelli Benincasa, also Renaissance, has a façade by Giorgio da Sebenico (1446–48). The Church of the Sacrament was built in 1538, but its interior was remodeled in the 18th century. The Palazzo Ferretti (1540) is attributed to Pellegrino Tibaldi; the balcony was added by Luigi Vanvitelli (18th cent.). The interior contains frescoes by Tibaldi and the Zuccaris. Also attributed to Tibaldi is the Fontana del Calamo (1560).

In the 18th century many structures were designed in the neoclassic style of Vanvitelli; these include the Porta Pia (1787–89) and the Arco Clementino (Vanvitelli; 1738). The Lazzaretto (1733), also built by Vanvitelli, is in the form of a pentagon isolated by a ring of canals connected with the main basin of the old harbor. S. Domenico (1763–88), designed by Carlo Marchionni, contains a *Crucifixion* by Titian. The façade of the Gesù was designed by Vanvitelli (1743). The interior holds works by Sebastiano Conca and Orazio Gentileschi. Of the buildings erected since 1945, the most interesting is the complex of pavilions for the Fiera della Pesca. *Museums*: Museo Nazionale delle Marche (Palazzo Ferretti), with prehistoric and archaeological material; Pinacoteca "Francesco Podesti" (Palazzo degli Anziani); Museo Diocesano.

BIBLIOG. A. Ricci, Memorie storiche delle arti e degli artisti della Marca di Ancona, Macerata, 1834; C. Ferretti, Memorie storico-critiche di pittori anconitani dal XV al XIX secolo, Ancona, 1883; P. Enrico, Memoria storico-critica sulla Cattedrale di Ancona, Ancona, 1893; C. Posti, Il Duomo di Ancona, 2 vols., Iesi, 1911–12; L. Luzio, Elenco degli edifici monumentale e delle opere d'arte immobili della provincia di Ancona, Rass. marchigiana, II, 1923–24, pp. 125–32, 344–52; A. K. Porter, Il portale romanico della Cattedrale di Ancona, Dedalo, VI, 1925–26, pp. 69–79; E. Costantini, L'antico palazzo del Podestà, Rass. marchigiana, VII, 1928–29, pp. 54–56; S. Luzi, Monumenti cristiani del V–VI secolo scoperti in Ancona sotto la Chiesa di S. Maria della Piazza, Rass. marchigiana, VII, 1928–29, pp. 113–65; L. Serra, Restauri e scoperte in S. Maria della Piazza di Ancona, BArte, N.S., IX, 1929–30, pp. 97–121; M. Natalucci, Antichità cristiane di Ancona, Ancona, 1934; Inventario degli oggetti d'arte d'Italia, VIII: Provincie di Ancona e Ascoli Piceno, Rome, 1936; T. Cecon, Cattedrale di S. Ciriaco in Ancona, Ancona, 1937; N. Alfieri, Topografia storica di Ancona antica, Atti Deputazione Storia Patria per le Marche, 5th ser., II, 1938, pp. 151–235; L. Zampetti, Il portale del Duomo di Ancona, Ancona, 1940; M. Moretti, Ancona, Rome, 1945; D. Lollini, L'abitato preistorico e protostorico di Ancona, BPI, N.S., X, 1956, pp. 237–62; S. Stucchi, Il coronamento dell'arco romano nel porto di Ancona, RendNapoli, XXXII, 1957, pp. 149–64; G. Annibaldi, EAA, s.v. Ancona, II, 1958, pp. 354–55; G. Annibaldi, La riapertura del Museo Nazionale delle Marche, BArte, XLIII, 1958, pp. 184–86; G. Marchini, La Pinacoteca "Francesco Podesti" di Ancona, Musei e gallerie d'Italia, III, 2, 1958, pp. 14–17; M. Natalucci, Visita al Duomo di San Ciriaco e breve itinerario della città di Ancona, Città di Castello, 1958; M. Natalucci, Ancona attraverso i secoli, Città di Castello, 1960; M. Marinelli, L'architettura romanica in Ancona, Ancona, 1961.

Ascoli Piceno (Lat., Asculum). At the confluence of the Tronto and Castellano rivers, the site has been inhabited since the Iron Age. Under the Romans it became a colonia in 286 B.C.; in the Middle Ages it was a free commune and thereafter passed into the possession of the Church (1502). Of the Roman period are the late republican Porta "Gemina," with a double archway over the Via Salaria; the bridge over the Tronto, a temple, and a theater are Augustan constructions. The city walls were rebuilt in the Middle Ages. Many Romanesque buildings remain from the period of the commune (1185–

1242). Influences from Umbria and the Abruzzi are evident in the façades of many churches, including SS. Vincenzo e Anastasio (12th–14th cent.); S. Tomaso (13th cent.), with frescoes of the 14th century; S. Venanzio; S. Angelo Magno (1292), with works by Cola dell'Amatrice; S. Vittore (12th–13th cent.), with frescoes of the 14th and 15th centuries; and S. Pietro in Castello (13th–14th cent.). The octagonal Baptistery (12th cent.) is in Lombard Romanesque style. The exterior terminates in a series of blind arches, and the interior has a spherical vault. Romanesque secular architecture is represented in numerous houses, towers, and portals of the medieval quarters. Noteworthy among these are the Torre Ercolani (12th cent.) and the Casa Longobarda, of ashlar masonry (probably 12th cent.).

Gothic buildings are numerous. S. Francesco, begun in the second half of the 13th century and based on a design after the Cathedral of Siena, was not completed until the 16th century. Its most striking feature is the posterior, comprising seven apses (three on the nave and two on each arm of the transept). The interior has a nave and side aisles, separated by Gothic arches on octagonal piers, and two triforia. S. Pietro Martire (1332) has a 17th-century façade by Giuseppe Giosafatti. S. Agostino, built between 1317 and 1485, contains paintings by Francescuccio Ghissi, Cola dell'Amatrice, and Bacciccio. S. Giacomo dates from the 13th–15th century. The Malatesta fortress was built in 1348 and was enlarged by Antonio da Sangallo the Younger in the 16th century. The Ponte Maggiore dates from 1373.

The Renaissance witnessed a great burst of building activity in Ascoli, and many houses and palaces from this period are found in various quarters. The Piazza del Popolo is surrounded by 16th-century arcades, the Loggia dei Mercanti (early 16th cent., begun by Bernardino da Carona), and the Palazzo del Popolo. Originally a 13th-century building, the tower of which still stands, the palace was rebuilt during the Renaissance, with a portal by Cola dell'Amatrice and a courtyard with a double loggia. The Piazzetta di S. Pietro Martire is also Renaissance, as are many houses on the Corso Mazzini, including Palazzo Malaspina, with an unusual 16th-century loggia attributed to Cola dell'Amatrice. Some of the most important buildings in the city face the Piazza Arringo: the episcopal palace (16th cent.), as well as Palazzo Comunale and Palazzo dell'Arringo, 12th- and 13th-century structures joined in 1683 with a baroque façade by Giuseppe Giosafatti. On the same square is the Cathedral, originally of the 13th century or possibly even older, rebuilt in 1482. The façade, attributed to Cola dell'Amatrice, was begun in 1532 but remained unfinished. The interior (remodeled) has a nave and side aisles and octagonal piers; the presbytery is over a crypt. Within the Cathedral are a polyptych by Carlo Crivelli (1475) and a number of precious sacred furnishings. The Casa Bonaparte (1507) is probably the work of Lombard builders. The Pia fortress, on Colle dell'Annunziata, was reconstructed by Pius IV in 1564. Among the more notable buildings of later periods are the Palazzo del Seminario (1603, F. Morelli); the Church of the Carmine (1651), with a façade by C. Rainaldi; the Chiesa dell'Angelo Custode (1679), also with a façade by Rainaldi; the Palazzo della Cassa di Risparmio, by Cesare Bazzani; and the Teatro Ventidio Basso (1841–46) by Ireneo Aleandri. *Museums*: Museo Civico; Pinacoteca Civica (Palazzo Comunale).

BIBLIOG. B. Orsini, Descrizione delle pitture, sculture, architetture ed altre cose rare della insigne città di Ascoli nella Marca, Perugia, 1790; G. Cantalamessa Carboni, Memorie intorno i letterati e gli artisti della città di Ascoli nel Piceno, Ascoli, 1830; E. Luzi, Gli antichi monasteri benedettini di Ascoli Piceno, Fermo, 1877; E. Luzi, Cenno storico della Cattedrale Basilica di Ascoli Piceno, Florence, 1894; C. Mariotti, I maestri lombardi in Ascoli Piceno, Rass. bibliog. dell'arte it., III, 1900, pp. 211–17; C. Grigioni, Per la storia della pittura in Ascoli Piceno nella seconda metà del secolo XV, Rass. bibliog. dell'arte it., XI, 1908, pp. 1–5; C. Mariotti, Ascoli Piceno, Bergamo, 1913; E. Cesari, La chiesa dei Santi Vincenzo e Anastasio in Ascoli Piceno, Empoli, 1919; C. Mariotti, Il monastero e la chiesa di S. Angelo in Ascoli Piceno, Ascoli Piceno, 1920; G. Moretti, L'antico Ponte di Cecco e l'annessa fortezza in Ascoli Piceno, BArte, IV, 1924, pp. 43–48; G. Poli, Ascoli vecchia e nuova, Ascoli, 1934; Inventario degli oggetti d'arte d'Italia, VIII: Province di Ancona e Ascoli Piceno, Rome, 1936; Ministero dell'Educazione Nazionale, Elenco degli edifici monumentali, XLII: Ascoli Piceno, Rome, 1936; C. L. Agostini, Asculum, Ascoli Piceno, 1947; G. Fabiani, Ascoli nel Quattrocento, 2 vols., Ascoli, 1950–51; C. Cardarelli and E. Ercolani, La civica pinacoteca di Ascoli Piceno, Ascoli, 1954; G. Poli, Ascoli, Ascoli, 1954; L. Leporini, Ascoli Piceno, Ascoli, 1955; L. Benevolo, Ascoli Piceno, Milan, 1957; EAA, s.v.; G. Fabiani, Ascoli nel Cinquecento, 2 vols., Ascoli, 1957–59.

Cagli (Lat., ad Cale, Callium). Umbrian site which yielded a rich cache of bronze artifacts. Almost totally destroyed during a civil war in 1287, it was rebuilt on a regular checkerboard plan in 1289. It retains this 13th-century plan and, in part, the appearance of a small medieval borough. The churches of S. Francesco (1234–40) and S. Domenico are Romanesque with some Gothic elements. S. Angelo (14th cent.) is Gothic. The Cathedral, begun in 1424, has a portal by Antonio di Cristoforo da Fossombrone; the portico

on the left side belonged to the original structure. The Palazzo Co-
munale, dating from the 14th century, was remodeled by Francesco
di Giorgio Martini, who also designed the Rocca, a fortress of which
only the tower still stands. The town has many baroque buildings.

BIBLIOG. E. Calzini, Una visita ai monumenti di Cagli, Nuova riv.
misena, II, 1889, pp. 245–53; M. Morgana, Il Palazzo Comunale di Cagli
e sue vicende, Rass. marchigiana, V, 1926–27, pp. 82–88; L. Serra, Le
rocche di Mondani e di Cagli, Misc. Supino, Florence, 1933, pp. 435–55;
L. Serra, L'architettura del Rinascimento nelle Marche, Rass. marchigiana,
XII, 1934, pp. 55–82; V. Faraoni, Memoria di antichi monasteri nella Dio-
cesi di Cagli, Studia Picena, XI, 1935, pp. 59–79; EAA, s.v.

Chiaravalle di Castagnola. The modern village grew up from
the 16th century around the Abbey of Chiaravalle (S. Maria in Casta-
gnola), probably founded in the 12th century. The abbey church
is one of the oldest examples of Cistercian Gothic architecture in
Italy. The cloister and monastery date from the 16th century.

BIBLIOG. G. Dehio, Zwei Zisterzienserkirchen: Ein Beitrag zur Ge-
schichte der Anfänge des gotischen Stils, JhbPreussKSamml, XII, 1891,
pp. 91–103; A. H. Frothingham, Introduction f Gothic Architecture into
Italy by the French Cistercian Monks, III: Chiaravalle di Castagnola, AJA,
VII, 1891, pp. 283–88; L. Serra, L'arte nelle Marche, I, Pesaro, 1929,
pp. 181–86; R. Pacini, Abbazia cistercense di Chiaravalle, Ancona, 1947;
H. Hahn, Die frühe Kirchenbaukunst der Zisterzienser, Berlin, 1957, pp 166–
69; L. Fraccaro de Longhi, L'architettura delle chiese cistercensi italiane,
Milano, 1958, pp. 217–31.

Chiaravalle di Fiastra. This abbey, one of the earliest Cistercian
buildings in Italy, was founded at the end of the 12th century and
completed in the 13th century (restored). The church plan is a Latin
cross, with an interior narthex, nave and side aisles, and a rectangular
apse flanked by four chapels and lit by a rose window. The adjacent
cloister is of the 14th–15th century.

BIBLIOG. L. Serra, L'arte nelle Marche, I, Pesaro, 1929, pp. 186–88;
G. Pallotta, Note sull'arte marchigiana del Medio Evo: Santa Maria di
Chiaravalle di Fiastra, Rome, 1937; F. Caraceni, L'abbazia di Santa Maria
di Fiastra o di Chienti, Urbania, 1951; H. Hahn, Die frühe Kirchenbaukunst
der Zisterzienser, Berlin, 1957, pp. 156–62; L. Fraccaro de Longhi, L'archi-
tettura delle chiese cistercensi italiane, Milan, 1958.

Fabriano. An extensive necropolis of the Piceni is evidence of
an Iron Age settlement on this site. The present city arose from the
union of two neighboring castles within a single wall in the 13th
century. The center of the town has a monumental fountain (1351),
the battlemented Palazzo del Podestà (1255, restored), Palazzo
Comunale (17th-cent. façade), the clock tower, the episcopal pal-
ace (16th–18th cent.), and the Loggia of S. Francesco (completed
late 17th cent.). There are a number of Gothic churches, remodeled
to a greater or lesser extent. S. Nicolò (13th cent.), remodeled in
the 14th and again in the 17th century, contains works by Guercino,
Giacinto Brandi, and others. S. Lucia retains the left wall, apse, and
campanile of the Gothic structure (14th–15th cent.); the single-
aisled interior (18th cent.) contains works by Francescuccio Ghissi
and Orazio Gentileschi, as well as frescoes by Allegretto Nuzi and his
school. The Cathedral has a 14th-century polygonal apse in its original
form and is decorated with frescoes by Nuzi. SS. Biagio e Romualdo
dates from the 13th century (remodeled 1748), while the adjoining
cloister is of the 16th century. S. Agostino retains only the 13th-
century portal; its interior dates from the 18th century. The Hospital
of S. Maria del Buon Gesù, built in 1456, is in a transitional Gothic-
Renaissance style. S. Benedetto (begun 1290; rebuilt 16th and 18th
cent.) has a baroque interior containing works by Gentileschi, Brandi,
and Francesco Vanni. The Oratorio del Gonfalone was built in 1610–
36, and its gilt wooden ceiling completed in 1643. *Museums*: Pina-
coteca Civica and Museo degli Arazzi, both in the bishop's palace.

BIBLIOG. A. Anselmi, Ignoti artisti fiorentini del trecento a Fabriano,
RArte, V, 1907, pp. 167–69; L. Nicoletti, Fabriano nelle sue opere d'arte,
Fabriano, 1921; R. Sassi, Chiese artistiche fabrianesi, Rass. marchigiana,
I, 1922–23, pp. 285–98; R. Sassi, Documenti di pittore fabrianesi, Rass.
marchigiana, II, 1923–24, pp. 473–88, III, 1924–25, pp. 45–56, 87–96; V.
Benigni, Compendioso ragguaglio delle cose più notabili di Fabriano, Fa-
briano, 1924, pp. 473–81; R. Sassi, Pittori fabrianesi del periodo barocco,
Rass. marchigiana, III, 1924–25, pp. 180–89; R. Sassi, L' "Hospitale cal-
colariorum terre Fabrianini," Rass. marchigiana, IV, 1925–26, pp. 21–28;
R. Sassi, Arte e storia fra le rovine di un antico tempio francescano, Rass.
marchigiana, V, 1926–27, pp. 331–51, 419–29; R. Sassi, Chiarimenti su le
origini della Cattedrale di Fabriano, Rass. marchigiana, VI, 1927–28, pp. 113–
19; R. Sassi, Chiese artistiche di Fabriano, Rass. marchigiana, VII, 1928–29,
pp. 13–19, 45–51, 90–114, 333–42, X, 1931–32, pp. 121–32, 143–66; L.
Serra, Architettura militare del Rinascimento nelle Marche, Rass. marchi-
giana, XI, 1933, pp. 437–55; B. Molajoli, Guida artistica di Fabriano, Fa-
briano, 1936; N. Alfieri, EAA, s.v. Fabriano, III, 1960, p. 566.

Fano (Lat., Fanum Fortunae). At the point where the Via Fla-
minia reaches the Adriatic coast, the settlement grew up about a

temple of Fortune, of which no trace remains. Under Augustus
Fanum became a colonia. Destroyed by the Goths in the 5th century,
it was rebuilt by Belisarius in the 6th century and became the seat
of the Maritime Pentapolis. The Roman street plan can still be dis-
cerned. Of the Augustan Era are sections of the walls and the Arch
of Augustus (also the gate of the Roman city), with three vaults.
Remains of a basilica may mark that built and described by Vitruvius
(1st cent. B.C.). The Cathedral was raised over an older structure
in the 12th century but was later remodeled. The Nolfi Chapel is
decorated with frescoes of scenes from the life of the Virgin by Do-
menichino. S. Agostino, built in 1200 over remains of a Roman con-
struction, has been remodeled and restored; it preserves works by
Guercino (III, PL. 311) and others. The Palazzo della Ragione is
dated 1299, with the tower rebuilt by Luigi Vanvitelli (18th cent.).
S. Domenico (1300) contains frescoes by artists from Rimini and
Umbria.

Under the rule of the Malatestas (mid-14th to mid-15th cent.)
the city underwent remarkable development. The Malatesta palace
was built in 1413–21 and enlarged in the 16th century. The Rocca
Malatestiana (fortress), designed by Matteo Nuti, was completed in
1452. The Gothic Church of S. Francesco contains two monumental
tombs of the Malatestas in the portico. One is late Gothic (ca. 1400),
designed by a follower of Pier Paolo Dalle Masegne; the other is of
the Renaissance, in the manner of Alberti. The Logge di S. Michele
were built in the 15th century. Between the Malatesta palace and Pa-
lazzo della Ragione is an arch in the manner of Bramante (1491). S.
Maria Nuova (rebuilt 1500) contains a *Madonna and Child with Saints*
and an *Annunciation* by Perugino and a *Visitation* by Giovanni Santi.
S. Michele has a façade of 1504, with portal by Bernardino di Pietro
da Carona (1511–13). S. Paterniano (ca. 1550) may have been built
from designs by Jacopo Sansovino; the cloister is also of the 16th
century. The Madonna dei Piattelletti has a portal dated 1480. S.
Pietro in Valle is baroque; begun in 1610–13, it was not completed
until 1696. Within is an *Annunciation* by Guido Reni. The Museo Ma-
latestiano is in the Malatesta palace.

BIBLIOG. L. Masetti, La chiesa e la porta di S. Michele a Fano, Fano,
1878; G. Castellani, Le arti minori a Fano nel secolo XVI, Rass. bibliog.
dell'arte it., II, 1899, pp. 206–09; G. Castellani, Saggio di bibliografia per
la storia delle arti a Fano, Rass. bibliog. dell'arte it., III, 1900, pp. 53–67;
L. Asioli, La chiesa di S. Domenico a Fano, Fano, 1910; G. Castellani,
Notizie di artisti fanesi o che lavorarono a Fano nel secolo XV, Rass. bibliog.
dell'arte it., XIII, 1910, pp. 123–32; C. Selvelli, Fanum Fortunae, 3d ed.,
Fano, 1924; C. Giuseppe, La chiesa di S. Michele a Fano e gli artisti che
vi lavorarono, Studia Picena, III, 1927, pp. 147–82; C. Selvelli, La facciata
di S. Michele a Fano, Cron. d'arte, V, 1928, pp. 191–99; C. Selvelli, Fano
e Senigallia, Bergamo, 1931; P. Bargelli, Il convento, la chiesa di S. Ago-
stino e gli affreschi trecenteschi, S. Picena, X, 1934, pp. 203–12; C. Sel-
velli, La facciata del Duomo di Fano, S. Picena, XIII, 1938, pp. 43–53;
C. Selvelli, Un episodio di storia urbanistica (le Mura della Mandria), S. Pi-
cena, XV, 1940, pp. 63–75; F. Pellati, La basilica del Fano e la formazione
del trattato di Vitruvio, RendPontAcc, XXIII–XXIV, 1947–48, pp. 153–74;
F. Bonasera, Fano: Studio di geografia urbana, Fano, 1951; L. Asioli, La
Basilica cattedrale di Fano, Fano, 1954; EAA, s.v.

Fermo (Lat., Firmum Picenum). Originally a settlement of
the Piceni, Firmum became a Roman colony in 264 B.C. and later
a municipium. In the Middle Ages the town was the seat of a mar-
quisate. Destroyed in 1176 by Frederick Barbarossa, it was rebuilt
on a radial plan. There are remains of pre-Roman, republican, and
Augustan city walls. Also Roman are portions of a large filtering res-
ervoir, a theater built during the reign of Claudius (1st cent.), and
vestiges of harbor works at Castellum Firmanorum. The oldest
Christian relic is a 4th-century sarcophagus in the Cathedral crypt.
From the Romanesque period, only the Church of S. Zenone (1171),
with a figured portal (1186), and the crude portal in the apse of S.
Pietro (1261) remain. The Cathedral, Romanesque and in part Gothic,
was founded in 1227 on the site of an Early Christian basilica (rem-
nants of 5th-century mosaic pavement near the presbytery) and of
a subsequent 10th-century edifice, probably destroyed in 1176. The
façade, the base of the campanile, and part of the right wall have
survived from the 13th-century structure, designed by Giorgio di
Como. The interior (remodeled by Cosimo Morelli, 1789) has a
tabernacle by Girolamo and Ludovico Lombardo (1571).

There are several noteworthy churches of the Gothic period,
for the most part remodeled: S. Domenico (begun 1233); S. Francesco
(1240) with façade rebuilt in the 18th century, but with the original
13th-century portal and 15th-century froescoes within; and S. Filippo,
its 17th-century interior holding a *Nativity* of Peter Paul Rubens and
a *Pentecost* by Giovanni Lanfranco. The Palazzo Fogliani and the
Monte di Pietà (with late Gothic portal) are of the 15th century, and
the Palazzo Azzolino of the 16th. The Church of the Pietà was de-
signed by Pellegrino Tibaldi (16th cent.). The Palazzo Vitali Rosati
also dates from the 16th century. The Piazza del Popolo is flanked
by the Palazzo Comunale (rebuilt 1446), with a portico (mid-16th cent.)

surmounted by a statue of Sixtus V (1590), and the Palazzo degli Studi. *Museums*: Museo Archeologico; Pinacoteca Comunale.

BIBLIOG. G. B. Carducci, Sulle antiche romane mura di Fermo, Fermo, 1876; G. Napoletani, Fermo nel Piceno, Rome, 1907; F. Maranesi, Guida artistica della città di Fermo, Milan, 1923; P. Rotondi, Scoperte nella Chiesa di S. Agostino a Fermo, BArte, XXXII, 1938, pp. 454–64; G. Breccia, Rinvenimenti archeologici sotto la Chiesa Metropolitana, Palladio, III, 1939, pp. 85–86; F. Maranesi, La Cattedrale di Fermo, Fermo, 1940; EAA, s.v.

Iesi (Lat., Aesis). Possibly a settlement of the Umbri, Aesis became a Roman colonia in 247 B.C. and a commune in the 11th century. In the 13th–15th century Iesi was subject to various overlords until it passed to the Papal States. The city plan is somewhat complex, having two separate nuclei. The lower sector, on the southeast, is modern; above is the older part, set within 14th-century walls that have retained, almost intact, their medieval defenses. S. Marco (13th cent.) is Gothic, its interior decorated with frescoes by artists from Rimini. The Palazzo della Signoria (1486–98), designed by Francesco di Giorgio Martini, houses a library, museums, and painting gallery (works by Lorenzo Lotto and local artists). Its spacious courtyard, with porticoes and loggias, was designed by Andrea Sansovino; the tower was rebuilt in the 17th century. The Cathedral was built in 1732–41 over an older Gothic church, and its façade was added in the late 19th century. S. Giovanni Battista is 17th-century.

BIBLIOG. A. Anselmi, La nuova facciata del Duomo di Jesi, Nuova riv. misena, II, 1889, p. 194; C. Annibaldi, Guida della città di Jesi, Jesi, 1902; U. Pierpaoli, Del tempio di S. Marco in Jesi, Rass. bibliog. dell'arte it., VI, 1903, pp. 56–61; L. Serra, Catalogo della pinacoteca civica di Jesi, Rass. marchigiana, II, 1923–24, pp. 502–10; L. Marinelli, Le mura di Jesi, Cron. d'arte, IV, 1927, pp. 1–11; EAA, s.v.

Loreto. The town grew up in the 13th century around the Holy House (legendary home of the Virgin miraculously transported to Loreto) and was raised to the rank of city in 1586 by Pope Sixtus V. The girdle walls were built by C. Resse early in the 16th century, after plans by Antonio da Sangallo and Andrea Sansovino, and enlarged with bulwarks in the 17th century. The Sanctuary of the Holy House was begun in 1468 in a transitional Gothic-Renaissance style, under the direction of the Venetian architect Marino di Marco Cedino; it was continued, after 1476, along Renaissance lines by Giuliano da Maiano. Thereafter it was enlarged and work was carried on by Baccio Pontelli, who built the apse, and by Giuliano da Sangallo (1498–1500), who designed the dome. The original project was then modified by Bramante (1509–11), Andrea Sansovino (1513–26), and Antonio da Sangallo the Younger (1531–35). The façade, completed in 1587, has three portals with bronze doors in relief. The campanile was built by Luigi Vanvitelli in 1750–54. The interior of the sanctuary is Gothic, with nave and side aisles and three apses, triapsidal transepts, and cross-vaulted ceilings. The monochrome frescoes of Luca Signorelli in the nave were later repainted. In the Sacristy of S. Marco are frescoes by Melozzo da Forlì (PL. 204) and Marco Palmezzano. The Sacristy of S. Giovanni contains other notable frescoes by Signorelli. The baptismal font is by Tiburzio Vergelli and pupils (1600–07). The Holy House itself, directly below the dome, is faced with architectural elements and reliefs executed under the direction of Gian Cristoforo Romano, Andrea Sansovino, and Raniero Nerucci, with other sculpture by Baccio Bandinelli, Raffaello da Montelupo, Andrea Sansovino (*Annunciation, Nativity, Adoration of the Sheperds*), Niccolò Tribolo, and Francesco da Sangallo. On two sides of the piazza fronting the sanctuary is the Palazzo Apostolico, with two ranges of arcades, begun by Bramante, continued by Antonio da Sangallo the Younger, Andrea Sansovino, Raniero Nerucci, and Giovanni Boccalini, and completed in the 18th century by Vanvitelli. Inside is a museum devoted to the Holy House. The statue of Sixtus V in the square is by Antonio Calcagni and Vergelli, the fountain (early 17th cent.) by Carlo Maderno and Giovanni Fontana. Other monuments of the city include the Fontana dei Galli, with bronzework by Tarquinio and Pier Paolo Jacometti (17th cent.), and the Porta Romana by Pompeo Floriani.

BIBLIOG. P. Gianuizzi, Documenti inediti sulla Basilica Lauretana, Arch. storico dell'arte, I, 1888, pp. 273–76, 321–27, 364–69, 415–24, 451–53; A. Colasanti, Loreto, Bergamo, 1910; P. Bonaventura, Guida di Loreto, Loreto, 1929; L. Serra, Architettura militare del Rinascimento nelle Marche, Rass. marchigiana, XI, 1933, pp. 437–55; L. Serra, Sopravvivenze gotiche nell'architettura del Quattrocento: La Basilica di Loreto, Rass. marchigiana, XI, 1933, pp. 405–24; P. Rotondi, Sculture e bozzetti lauretani, Urbino, 1941; P. Scarpa, Guida storico-artistica di Loreto, Rome, 1956.

Macerata. Despite its over-all modern appearance, Macerata is rich in monuments of various periods and styles. The city, founded in 1138 by the fusion of the ancient borough of Poggio San Giuliano with the Castle of Macerata, has in turn belonged to the Church and various overlords. From the Middle Ages, there remain parts of the 14th-century walls; the Church of S. Maria della Porta, a late Romanesque structure, with a portal dated about 1340 and a lower church of the 11th century; and the battlemented Porta Montana (14th cent.). To the Renaissance belong the Loggia dei Mercanti, possibly designed by Cassiano da Fabriano; the Palazzo del Governo, built in the 16th century, incorporating parts of a 14th-century structure; the Torre Maggiore of Galasso Alghisi, erected in 1558; and S. Maria delle Vergini, in the form of a domed Greek cross, also by Alghisi (1550). Among the 16th-century palaces are Palazzo Ferri, Palazzo Aurista, and Palazzo Mignardi, of diamond-shaped ashlar masonry and with a portal attributed to Rocco da Vicenza. The 18th century, until the occupation by the French in 1807, witnessed a very active building period in the city. The Cathedral was built in 1771–90 by Cosimo Morelli, who retained the campanile from the preceding 15th-century church. Morelli also built the Church of S. Giorgio (1792). S. Giovanni (1721) is by Rosato Rosati. The Palazzo Santafiora was built in 1773. The Teatro Lauro Rossi was built from plans (1767) by Francesco Galli Bibiena, with modifications by Morelli. The interior remodeling of the 15th-century Church of the Madonna della Misericordia was the work of Luigi Vanvitelli (1742). The Sferisterio (1821–29), a playing field with a neoclassic peristyle and wide stairs, is by Ireneo Aleandri. The Pinacoteca e Museo Civico contains paintings of the 14th to the 19th century.

In the vicinity of Macerata are the ruins of the Roman colonia of Helvia Ricina Pertinax (destroyed by Visigoths, 5th–6th cent.), including a theater of the 1st century and a column of the Severan period (2d–3d cent.). The Romanesque Church of S. Claudio al Chienti shows Byzantine influence. Probably a 12th-century structure (restored), it consists of two superimposed churches, interconnected by spiral staircases within two cylindrical towers on the façade. Both plans are rectangular and triapsidal, with two lateral apses. Similar in plan is S. Vittore delle Chiuse (11th cent.), near Genga; however, it is on one level and has a single tower (also with spiral staircase). The Church of the Annunziata (or S. Maria) at Piè di Chienti consists of two superimposed churches with nave and side aisles and apses with radiating chapels.

BIBLIOG. A. Gentiloni-Silveri, Elenco degli edifici monumentali: Provincia di Macerata, Rass. marchigiana, I, 1922–23, pp. 315–24; Ministero della Pubblica Istruzione, Elenco degli edifici monumentali, XLI: Provincia di Macerata, Rome, 1923; L. Serra, Elenco degli oggetti d'arte mobili della provincia di Macerata, Rass. marchigiana, III, 1924–25, pp. 114–22; A. Ricci, Aggiunte al catalogo degli oggetti d'arte di Macerata, Rass. marchigiana, VIII, 1929–30, pp. 129–30; C. Astolfi, Le complicate vicende di costruzione dello Sferisterio di Macerata, Rass. marchigiana, XI, 1933, pp. 50–58; L. Serra, Architettura militare del Rinascimento nelle Marche, Rass. marchigiana, XI, 1933, pp. 437–55; L. Serra, L'architettura del Rinascimento nelle Marche, Rass. marchigiana, XII, 1934, pp. 55–82; N. Alfieri, Ricina, Atti Deputazione Storia Patria per le Marche, 5th ser., I, 1936, pp. 21–38; R. U. Inglieri, Il teatro romano di Helvia Ricina, Dioniso, VII, 1939, pp. 104–09; A. Cordoni, Macerata e Provincia, Macerata, 1950; G. Annibaldi, Helvia Ricina: Villa Potenza near Macerata, FA, VI, 1951, 4624; F. Caraceni, L'abbazia di Santa Maria di Fiastra o di Chienti, Urbania, 1951.

Pesaro (Lat., Pisaurum). A coastal city settled by the Piceni and then by the Cisalpine Gauls, in 184 B.C. Pesaro became a Roman colonia, a status renewed under Augustus. Destroyed by the Goths, it was rebuilt by Belisarius in the 6th century and became one of the cities of the Maritime Pentapolis. Although the city was badly damaged during World War II, many Gothic and Renaissance buildings (13th–16th cent.) have survived. Of the Roman period the regular layout of the ancient city is discernible, and parts of the bridge that carried the Via Flaminia over the Foglia River still stand. The Cathedral, probably built over the remains of a Roman temple, has a late-13th-century Gothic façade. Under the present floor are parts of a mosaic pavement of the 5th or 6th century. S. Agostino (14th cent.) has a Gothic portal (1413) and a baroque interior. S. Francesco (1356–78) has a Gothic portal and contains 15th-century frescoes and tombs of the 14th century. S. Domenico retains a Gothic Venetian portal (1395), incorporated in the side wall of the Palazzo della Posta. During the Renaissance new walls were erected (15th–16th cent.). The Palazzo Ducale, built in the second half of the 15th century, was destroyed by fire and rebuilt by Girolamo and Bartolomeo Genga in the 16th century. The Rocca Costanza, built from plans by Luciano Laurana in 1474–83, is an excellent example of Renaissance military architecture in the Marches. The Castello Imperiale (1469–72; 1530), designed by Girolamo Genga, is set within a large park on San Bartolo hill. The interior was decorated by Perin del Vaga, Girolamo Genga, Dosso Dossi, F. Menzocchi of Forlì, and others. A number of small Renaissance palaces of brick show Venetian influence (Leonardi and Vaccai palaces). The Palazzo Mosca-Mazzolani (18th cent.) was designed by Giovanni Andrea Lazzarini. The painting gallery of the Museo Civico contains an altarpiece of the *Coronation of the Virgin* (ca. 1475–80) by Giovanni Bellini. The ceramics collection includes majolica ware from Pesaro, Gubbio, Faenza,

and Urbino. The Museo Archeologico Oliveri holds Greek, Etruscan, and Roman artifacts.

In the vicinity of Pesaro is the necropolis of Novilara, which has yielded steles, fibulae, pottery, and weapons of the Iron Age civilization of the Piceni. Sassocorvaro, a citadel founded in the 10th century, has 15th-century fortifications.

BIBLIOG. B. Patzak, Die Renaissance- und Barockvilla in Italien, III: Die Villa Imperiale in Pesaro, Leipzig, 1908; G. Vaccai, Pesaro: Pagine di storia e di topografia, Pesaro, 1909; G. Vaccai, Pesaro, Bergamo, 1909; L. Serra, Elenco degli edifici monumentali della provincia di Pesaro-Urbino, Rass. marchigiana, III, 1924–25, pp. 230–42; L. Serra, Architettura militare del Rinascimento nelle Marche, Rass. marchigiana, XI, 1933, pp. 437–55, XII, 1934, pp. 1–23; F. Bonasera, L'architettura rustica nell'agro pesarese, Lares, XIII, 1942, pp. 167–73; G. Annibaldi, Pesaro: Scavi nella città, FA, VIII, 1953, 3692; R. Sabatini, L'arte nella Chiesa di S. Agostino a Pesaro, Bologna, 1954; G. C. Polidori, Orazio Fontana e le sue maioliche nei musei civici di Pesaro, BArte, XLIV, 1959, pp. 141–50.

San Severino Marche (Lat., Septempeda). Settled by the Piceni (Iron Age necropolis in nearby Pitino), Septempeda became a Roman colonia and municipium in the 3d and 2d centuries B.C. When the town was destroyed by Totila in 545, the inhabitants took refuge on Montenero, a height where they built a citadel. The present city has two nuclei — this ancient Castello and the Borgo. From the Roman period, little survives except the regular layout of the streets. The Castello sector retains a 14th-century tower and the Old Cathedral, with a façade and campanile of the 14th century and remains of a fresco cycle by the Salimbeni brothers, depicting the Life of St. John the Evangelist. The Borgo, established in the Middle Ages, contains the Romanesque Church of S. Lorenzo in Doliolo (8th or 9th cent., remodeled 11th cent.), with nave and side aisles, a presbytery raised above a crypt decorated with frescoes by the Salimbenis and a campanile built in the 14th century. The New Cathedral (S. Agostino), begun in the mid-10th century and enlarged in the 14th century (also remodeled 17th–18th cent.), contains a *Madonna with Angels and Donor* by Pinturicchio. Also in the Borgo district are some small Renaissance palaces and town houses (Palazzo Gentili, Casa Scuderoni, Casa Servanzi, Casa Vannucci). The Palazzo Comunale (1764), by Clemente Orlandi, houses the Pinacoteca.

BIBLIOG. V. Aleandri, L'oreficeria in Sanseverino Marche nel Medioevo, Arte e storia, XII, 1893, p. 90; V. Aleandri, La torre e il Castello di San Severino Marche, Arte e storia, XIII, 1894, pp. 42–43; V. Aleandri, Il Duomo antico di San Severino Marche, San Severino, 1905; L. Serra, Catalogo della Pinacoteca Civica di Sanseverino, Rass. marchigiana, I, 1922–23, pp. 459–69; G. Bonarelli Modena, I giardini all'italiana nelle Marche, Rass. marchigiana, IX, 1930–31, pp. 163–83; L. Serra, La scuola pittorica sanseverinate, Rass. marchigiana, XI, 1933, pp. 141–72; L. Serra, L'architettura del Rinascimento nelle Marche, Rass. marchigiana, XII, 1934, pp. 55–82.

Senigallia (Lat., Sena Gallica). A Gallic settlement of the Senones, this reached a peak of prosperity from the mid-4th century to the beginning of the 3d century B.C. (burial ground at Montefortino di Arcevia). In 289 B.C. it became a Roman colonia. Destroyed by Alaric in the 5th century, it rose again and was one of the cities of the Maritime Pentapolis. A short stretch of the earliest city wall still exists. The Palazzo Comunale is of the 16th century (restored). The Rocca, a fortress built in 1480–92 by Baccio Pontelli, has a square plan and cylindrical towers at the four corners. The palace of the Duke of Urbino, also attributed to Pontelli, was remodeled in the 18th century. The Church of S. Rocco contains a *Madonna of the Rosary* by Federico Barocci (ca. 1590). S. Martino contains works by Guercino and Palma the Younger. Sta Croce (begun 1576, remodeled early 17th cent.) contains an *Entombment* by Barocci (ca. 1580). The Cathedral was rebuilt in 1790, and its façade dates from the 19th century. On the outskirts of the town is the Church of S. Maria delle Grazie (1491), in Renaissance style, perhaps by Pontelli.

BIBLIOG. M. Zaggarini, Senigallia nella storia e nell'arte, Senigallia, 1927; C. Selvelli, Fano e Senigallia, Bergamo, 1931; N. Zaggarini, Senigallia e il suo circondario, Senigallia, 1937; M. Ortolani and N. Alfieri, Sena Gallica, RendLinc, 8th ser., VIII, 1953, pp. 152–90; A. Baviera, Senigallia und seine Umgebung, Senigallia, 1958.

Tolentino (Lat., Tolentinum). An important settlement of the Piceni in the 6th and 5th centuries B.C. (metalwork), Tolentinum became a Roman municipium in the 1st century B.C. In the early Middle Ages the town grew up around a Benedictine abbey (on the site of the present Cathedral). In the 11th century it was an independent commune, and then came under the rule of the Varano and Sforza families until it became subject to the Church in 1445. The oldest church is the Romanesque Carità (11th cent.). An interesting, though stylistically heterogeneous church, the Basilica of S. Nicola was built in the 13th century but was remodeled several times. The façade is baroque (1628–1767), with a transitional Gothic-Renaissance portal by Nanni di Bartolo (1432–35). The single-aisled interior has a 17th-century ceiling. The Gothic Chapel of S. Nicola is decorated with 14th-century frescoes of the school of Rimini. Adjoining the church are the cloister (13th–14th cent.) of the Augustinian monastery and a ceramics museum. The Cathedral is of early medieval origin (8th–9th cent.), but it was rebuilt in the 13th century and entirely remodeled in the 19th. Noteworthy among the modern buildings is the hydrothermal plant at the Santa Lucia springs. The Museo Civico contains mainly Picenian archeological material from the vicinity.

BIBLIOG. M. Rivosecchi, La Basilica di Tolentino, Florence, 1927; L. Serra, Lineamenti dell'architettura romanica nelle Marche, Rass. marchigiana, VII, 1928–29, pp. 1–12; L. Serra, La pittura del Rinascimento nelle Marche: Relazioni con la scuola veneziana, Rass. marchigiana, X, 1932, pp. 67–86; L. Serra, Architettura militare del Rinascimento nelle Marche, Rass. marchigiana, XI, 1933, pp. 437–55; M. Azzi-Vitelleschi, La Basilica di San Nicola in Tolentino, Turin, 1934; F. Maranesi, Il Cappellone di San Nicola a Tolentino, Fermo, 1940; Il Santuario di S. Nicola di Tolentino, Tolentino, 1954; F. Ciommei, Tolentino artistica, Tolentino, 1957.

Urbino (Lat., Urbinum Metaurense). The foundations of Iron Age huts uncovered in the vicinity furnish evidence of the early origins of this city, later a Roman municipium. The layout of the modern city, spread out over two hills, is almost entirely that of the Renaissance. The majority of its monuments are connected with the Montefeltro family, who ruled the city from 1213 to 1508 and made of it a brilliant artistic center. There are a number of Gothic churches of monastic foundation: S. Domenico (prior to 1365; interior remodeled 1727–32, by Luigi Vanvitelli) has a simple brick façade with double gable and a 15th-century portal with a lunette terra cotta by Luca della Robbia; S. Francesco (second half of 14th cent.) retains the original portico on its façade, but the interior was remodeled by Vanvitelli in 1740; S. Giovanni Battista (late 14th cent.) has retained its original design intact, its nave with carinated wooden ceiling, and frescoes by the Salimbeni brothers (VI, PL. 383).

The Palazzo Ducale (IX, PL. 98), the most notable building in the city, was built over the remains of an ancient fortress. Designed by Luciano Laurana and begun about 1470, the huge complex was completed in 1563, with the addition of the top floor by Girolamo Genga; restorations were carried out in 1756, 1874, and 1912–19. The plan is on the whole rectangular, with an interior courtyard having an arcade at ground level and a band of windows between pilasters above (IX, PLS. 99, 100). On the west façade facing out over a steep slope are two cylindrical towers with four orders of single-arched loggias superimposed between them (known as the "façade of the torricini"; IX, PLS. 96, 97). The palace interiors were decorated by some eminent Renaissance artists, among whom were Justus of Ghent (panels in the *studiolo* of Federico da Montefeltro) and Pedro Berruguete. The intimate, illusionistic space of this ducal chamber is the work of Bramante (PLS. 80, 100; IX, PL. 97). Several of the larger rooms contain sculpture and fireplaces by Domenico Rosselli (late 15th cent.). Some of the rooms are paneled with wood inlay designed by Francesco di Giorgio Martini (reception room and study), Baccio Pontelli, and Botticelli (study). The perspective plan of the Cappella del Perdono (II, PL. 337) is attributed to Bramante.

The Passionei, Palma, Luminati, and Semproni palaces — all of the same period as the ducal palace — were designed in imitation of Luciano Laurana. The Church of S. Bernardino degli Zoccolanti (I, PL. 397), in Renaissance style (1472) and attributed variously to Bramante or to Francesco di Giorgio Martini, contains the baroque tombs (1620) of Federigo and Guidobaldo, dukes of Montefeltro. The Cathedral was founded in the mid-15th century, and its Palladian façade was completed about 1800, from designs by Camillo Morigia. The dome is by Muzio Oddi (1604); the interior was remodeled in neoclassic style by Giuseppe Valadier in the 19th century and contains works by Federico Barocci, Carlo Maratta, Carlo Cignani, and Giovanni Bandini. The Galleria Nazionale delle Marche (Palazzo Ducale) has an important collection of works of various periods, particularly the Renaissance. The Casa di Raffaello, the birthplace of the artist, is maintained as a public shrine. Sections of the city walls, built in 1507, have also survived.

BIBLIOG. G. Ciccolini, Urbino, NSc, 1877, pp. 255–57, 1878, pp. 362–64; G. Lipparini, Urbino, Bergamo, 1906; U. Rellini, Fondi di capanna dell'età del ferro, presso Urbino, BPI, XXXIII, 1907, pp. 23–37; L. Venturi, Studii sul Palazzo Ducale di Urbino, L'Arte, XVII, 1914, pp. 415–73; L. Venturi, Opere di sculture nelle Marche, L'Arte, XIX, 1916, pp. 25–50; A. Venturi, L'ambiente artistico urbinate nella seconda metà del Quattrocento, L'Arte, XX, 1917, pp. 259–93, XXI, 1918, pp. 26–43; L. Serra, Elenco degli edifici monumentali della provincia di Pesaro-Urbino, Rass. marchigiana, III, 1924–25, pp. 230–42; L. Serra, Catalogo delle cose d'arte e d'antichità: Urbino, Rome, 1932; G. Gronau, Documenti artistici urbinati,

Florence, 1936; G. Giovannoni, S. Bernardino di Urbino, Belle Arti, I, 1946–48, pp. 121–22; Studi artistici urbinati, Urbino, 1949 ff.; P. Rotondi, Il Palazzo Ducale di Urbino, 2 vols., Urbino, 1950–51; P. Zampetti, Il Palazzo Ducale di Urbino e la Galleria Nazionale delle Marche, Rome, 1951; Una piazza italiana del Quattrocento: Piazza della Pròspettiva di Urbino, Q. Ist. Storia Arch., 2, 1953, p. 8; B. Ligi, Le chiese monumentali in Urbino, Urbino, 1956; P. Rotondi, Fasi costruttive del Palazzo Ducale di Urbino, Atti V Conv. naz. Storia Arch. (1948), Florence, 1957, pp. 295–99; G. Marchini, Il palazzo Ducale di Urbino, Rinascimento, IX, 1958, pp. 43–78; A. Pigrucci Valentini, Guida turistica di Urbino, Faenza, 1958; L. Moranti, Bibliografia urbinate, Florence, 1959; G. Marchini, Aggiunte al Palazzo Ducale di Urbino, BArte, XLV, 1960, pp. 73–80.

Latium (It., Lazio). Although divided in antiquity by the Tiber River into Latium to the south and Etruria to the north, the territory of the present region presents relatively homogeneous physical and historical characteristics, even as far back as prehistoric times. The culture of the southern Etruscan cities in the archaic period, of which significant monumental remains surivive (e.g., rock sepulchers, painted tombs, city walls, and art objects of every kind), represents the nucleus of the earliest and most intensive development of Etruria in general. This culture had immediate parallels and reflections in Rome, temporarily part of the Etruscan orbit, and also in Faliscan and Latin cities. The rise of Rome, starting in the 4th century B.C., marked the beginning of the progressive concentration in this city of innovating impulses, continually renewed Greek influences, and the most intense building and artistic activities. At the same time there was also some notable development of other cities and sanctuaries in Latium, especially during the republican period. Roman influence was spread by way of the former consular roads, and the architectural and artistic history of Latium became identical in great part with that of Rome (see above, *Rome*). Nevertheless, in the Middle Ages, Latium exhibited vitality and originality in its pre-Romanesque and Romanesque churches, in the work of the Cosmati, and in the Cistercian abbeys. Since the Renaissance, the most important developments in the region (excluding Rome) have involved villa and military architecture. In southern Latium, the influence of the Neapolitan baroque was widespread.

BIBLIOG. G. A. Guattani, Monumenti sabini, 3 vols., Rome, 1827–30; A. Nibby, Itinerario della campagna romana, Rome, 1838; W. Gsell, The Topography of Rome and Its Vicinity, 2d ed., London, 1846; A. Nibby, Analisi storico-topografica della carta dei dintorni di Roma, 3 vols., Rome, 1849; A. Guglielmetti, Storia delle fortificazioni sulla spiaggia romana, Rome, 1880; G. Marocco, Monumenti dello Stato Pontificio e relazione topografica di ogni paese, 7 vols., Rome, 1883–86; R. Fonteanive, Sui monumenti ed altre costruzioni poligonie nella provincia romana, Rome, 1887; E. Abbate, Guida della provincia di Roma, Rome, 1894; G. B. Giovenale, I monumenti preromani del Lazio (DissPontAcc, 2d ser., VII), Rome, 1900; T. Ashby, Classical Topography of the Roman Campagna, BSR, I, 1902, pp. 125–281, III, 1906, pp. 1–212, IV, 1907, pp. 1–159, V, 1910, pp. 213–432; G. Pinza, Monumenti primitivi di Roma e del Lazio, MALinc, XV, 1905, cols. 5–844; R. Delbrück, Hellenistische Bauten in Latium, 2 vols., Strasbourg, 1907–12; F. Tomassetti, La campagna romana, 4 vols., Rome, 1910–26; A. Muñoz, Monumenti d'architettura gotica nel Lazio, Vita d'arte, VIII, 1911, pp. 75–103; A. Muñoz, Monumenti d'arte della provincia romana, BArte, VII, 1913, pp. 251–71, 291–305; B. Sante, I Monti del Cimino, Bergamo, 1914; A. Muñoz, I monumenti del Lazio e degli Abruzzi danneggiati dal terremoto, BArte, IX, 1915, pp. 61–112; A. Solari, Topografia storica dell'Etruria, 3 vols., Pisa, 1915–20; U. Rellini, Cavernette e ripari preistorici nell'agro Falisco, MALinc, XXVI, 1920, cols. 5–180; S. Kambo, I Castelli romani, Bergamo, 1923; F. Tomassetti, Note di topografia medievale della campagna romana, Arch. Soc. romana Storia patria, XLVI, 1923, pp. 245–70; U. Antonielli, Appunti di paletnologia laziale, BPI, XLIV, 1924, pp. 154–92; P. Molajoni, Caratteristiche dell'arte costruttiva romana: le torri striate del Lazio, Ill. vaticana, VII, 1936, pp. 807–09; N. Cuen, La casa medievale nel Viterbese, Ephemeris Dacoromana, VIII, 1938, pp. 1–104; G. Galassi-Paluzzi, L'urbanistica dei Castelli romani, Rome, 1938; U. Rellini, Il Lazio nella preistoria d'Italia, Rome, 1941; M. Zocca, Aspetti dell'urbanistica medievale nel Lazio, Palladio, VI, 1942, pp. 1–15; E. Battisti, Monumenti romanici del viterbese: Le cripte al sud dei Cimini, Palladio, N.S., III, 1953, pp. 67–80 (bibliog.); A. M. Radmilli, Esplorazioni paletnologiche nel territorio di Tivoli, Atti e mem. Soc. tiburtina di storia e d'arte, XXVI, 1953, pp. 157–74; A. W. Van Buren, A Bibliographical Guide to Latium and Southern Etruria, 5th ed., Rome, 1953; A. C. Blanc, Giacimento ad industria del Paleolitico inferiore (Abbevilliano superiore ed Acheuleano) e fauna fossile ad Elephas a Torre in Pietro presso Roma, Riv. di antropologia, XLI, 1954, pp. 345–53; J. B. Ward Perkins, Notes on Southern Etruria and the Ager Veientanus, BSR, XXIII, 1955, pp. 44–72; B. Andreae, Archäologische Funde und Grabungen im Bereich der Soprintendenzen von Rom 1949–1956/57, AAnz, 1957, cols. 110–358; S. M. Puglisi, I dolmen con muri a secco di Pian Sultano, BPI, LXV, 1956, pp. 157–74; M. W. Frederiksen and J. B. Ward Perkins, The Ancient Road Systems of the Central and Northern Ager Faliscus, BSR, XXV, 1957, pp. 67–204; R. Prete and M. Fondi, La casa rurale nel Lazio settentrionale e nell'agro romano, Florence, 1957; J. B. Ward Perkins, Etruscan and Roman Roads in Southern Etruria, JRS, XLVII, 1957, pp. 139–43; M. Apollonj Ghetti, L'architettura della Tuscia, Rome, 1959; L. Banti, Die Welt der Etrusker, Stuttgart, 1960; M. Santangelo, Musei e monumenti etruschi, Novara, 1960. *Periodicals*: SEtr, 1927 ff., passim.

Alatri (Lat., Alatrium, Aletrium). This city of the Hernici came into the orbit of Rome in the 4th century and later became a municipium. Surviving is the complete circuit of walls, in polygonal work, around the city and acropolis, with gates of the late 4th century B.C., assimilated in medieval constructions in the destroyed sections. In the lower city are remains of an aqueduct. Devastated in the 6th century of our era by Totila, the city was rebuilt with the name of Civitanova. It became the seat of a bishopric in 547, underwent various dominations, and passed in 1389 to the Church. The modern city retains its medieval character. The Romanesque-Gothic Church of S. Maria Maggiore has a rose window on its façade and a campanile with twin-arched windows. The church preserves a painted wooden sculpture of the Virgin and Child (the "Madonna di Costantinopoli"; early 13th cent.). S. Stefano has been remodeled, but it preserves the original portal (1275). S. Silvestro contains Renaissance frescoes. S. Francesco is a late-13th-century structure with a Gothic rose window and portal; the interior has been redone. The Cathedral and the episcopal palace are on the acropolis. The most important complex of secular architecture is the tower-house of Cardinal Gottifredo and the adjoining Gothic Palazzo Casagrandi. Noteworthy, too, are the Palazzo del Collegio Conti Gentili and the Museo Civico.

BIBLIOG. A. Cozza, Di un antico tempio scoperto presso Alatri, RM, VI, 1891, pp. 349–59; G. Pierleoni, Le antichità di Alatri, Alatri, 1916; G. Marchetti-Longhi, Pervetusta Fumonis Arx, Arch. Soc. romana Storia patria, XLVII, 1924, pp. 189–320; A. W. Van Buren, L'iscrizione di Lucio Betilieno Varo ad Alatri, RendPontAcc, IX, 1933, pp. 137–44; G. Zander, Il palazzo del cardinale Gottifredo, Palladio, N.S., I, 1951, pp. 109–12; L. G. Longhi, Il cardinale Gottifredo ... e il suo palazzo, Arch. Soc. romana Storia patria, LXXV, 1952, pp. 17–49; EAA, s.v.

Anagni (Lat., Anagnia). This city of the Hernici was conquered by Rome in 306 B.C. Surviving are walls in ashlar (perhaps 3d–2d cent. B.C.) and remains of baths and of a Mithraeum. An ellipsoidal area on the plain has been tentatively identified with the Circus Maritimus Anagninus mentioned in Livy (IX, 42, 12). Anagni became a diocese in 487 and was of great importance in the Middle Ages, especially because of historical events connected with the pontificate of Boniface VIII. The city has largely preserved its medieval appearance (e.g., Via Dante, Via Tufoli, Piazza delle Carceri, part of the Corso). The 13th-century Palace of Boniface VIII is a ruin. The Palazzo Comunale (13th cent.; extensively restored) has two façades, a loggia passageway, round arches, a 15th-century upper loggia, and windows with intersecting arches that recall Moorish style. The Barnekow house, with external staircase, dates from the 13th–14th century. The Cathedral (S. Maria, 1074–1104), a Romanesque structure, was remodeled in the 13th century. The façade has three portals and three single-arched windows, and there are three apses in Lombard style. On a portico with two arches and a balcony is a niche with a statue of Boniface VIII (1295). The interior has three aisles, with piers alternating with cylindrical pillars, and a Cosmati pavement (ca. 1226; Cosma di Jacopo). The choir enclosure is closed off by plutei and has a Romanesque mosaic floor and ciborium. The paschal candlestick and the bishop's throne (1263) are the work of one of the Vassallettos (see COSMATI). The Caetani Chapel, with the Caetani tomb, preserves a Madonna and Child of the Roman school (1325). The crypt (said to be that of St. Magnus) has three aisles and three apses, a pavement (after 1231) by Cosma and his sons, and important 13th-century frescoes. The rectangular Romanesque campanile was remodeled in the 19th century. The Cathedral treasury adjoins the Cathedral. In the Church of the Cappuccini are remains of 13th-century frescoes.

BIBLIOG. P. Zappasodi, Anagni attraverso i secoli, Veroli, 1908; S. Sibilia, La Cattedrale di Anagni, Orvieto, 1914; G. Marchetti Longhi, Il Palazzo di Bonifacio VIII, Arch. Soc. romana Storia patria, XLIII, 1920, pp. 379–410; G. Matthiae, Fasi costruttive nella Cattedrale di Anagni, Palladio, VI, 1942, pp. 41–48; G. Zander, Fasi edilizie e organismo del Palazzo di Bonifacio VIII in Anagni, Palladio, N.S., I, 1951, pp. 112–19; M. Cagiano de Azevedo, Circus Maritimus Anagninus, S. in onore di A. Calderini e R. Paribeni, III, Milan, 1956, pp. 329–34; EAA, s.v.

Aquino (Lat., Aquinum). This was successively a Volscian city, a federated Roman city, a municipium, and a colony. Ancient walls survive, perhaps from the 3d century B.C. and from the Augustan age. Other remains include the Capitol, a theater, a structure that may have been part of a thermal complex, an amphitheater, an aqueduct, and a triumphal arch. These monuments all date from the Augustan Era or slightly later. Destroyed by Totila and then by the Lombards, Aquino was rebuilt about the 8th century in the vicinity of the old city. The fief of the counts of Aquino, the city passed in 1796 to the Kingdom of the Two Sicilies. On the ruins of the Temple of Hercules Liberator, the Church of S. Maria della Libera was erected in 1125. The church was modeled after the Basilica of Montecassino.

BIBLIOG. M. Cagiano de Azevedo, La chiesa di S. Maria della Libera in Aquino, RIASA, VIII, 1941, pp. 189-99; M. Cagiano de Azevedo, Aquinum, Rome, 1949; G. Cressedi, EAA, s.v. Aquino, I, 1958, p. 522.

Bolsena (Etruscan, Velsna; Lat., Volsinii). Situated on Lake Bolsena, the medieval city developed on the slope of a hill. In more recent times Bolsena has spread into the plain toward the lake. The Etruscan city was destroyed by Rome in 265 B.C. and later reconstructed. Of the Roman city there remain traces of private buildings, baths, and an amphitheater. A sanctuary, perhaps that of Nortia, also survives. In 1468 Bolsena passed to the Church. The Church of S. Cristina, with three aisles and apses, was constructed in the 11th century over Christian catacombs. The façade was redone in the 15th century. Within the church a sculptured Romanesque portal gives access to the Chapel of the Miracolo and the adjoining Grotto of S. Cristina (part of the catacombs), which preserves a 9th-century ciborium and a painted terra cotta of St. Christina of Bolsena by G. della Robbia. In the Chapel of the Rosario and the apse of the right aisle, there are 15th-century frescoes of the Sienese school. The castle dates from the 12th-13th century; rectangular in design, it has towers at the corners. The Palazzo Cozza-Spada has frescoes of the school of the Zuccaris. The Antiquarium Comunale is in the Palazzo Comunale.

In nearby Gradoli is a Farnese palace, a 16th-century structure attributed by some to Vignola. In Capodimonte is a 13th-century square castle, within the grounds of which is an octagonal palace of the Farnese family, variously attributed to A. da Sangallo the Younger or to Vignola. In Marta is a Renaissance palace of the Farnese family. On the island of Bisentina is another Farnese palace and the Church of SS. Giacomo e Cristoforo, begun by A. da Sangallo the Younger and finished by Vignola. Also on the island are five 15th-century chapels, two of which preserve frescoes by the school of Benozzo Gozzoli.

BIBLIOG. H. Stevenson, Das Coemeterium der Hl. Christina zu Bolsena, RQ, II, 1888, pp. 327-53; A. Sacco, La Rocca di Bolsena, Rome, 1892; E. Gabrici, Scavi nel sacellum della dea Nortia sul Pozzarello, MALinc, XVI, 1906, cols. 169-239; P. Romanelli, Villa romana: Statuetta virile in bronzo, NSc, 1929, pp. 244-56; R. Bloch, Volsinies étrusque: Essai historique et topographique, Mél, LIX, 1947, pp. 9-39; R. Bloch, Volsinies étrusque et romaine, Mél, LXII, 1950, pp. 53-123; R. Bloch, Découverte d'une nouvelle nécropole étrusque auprès de Bolsena, Mél, LXV, 1953, pp. 39-61; R. Bloch, Découverte d'un habitat étrusque archaïque sur le territoire volsinien, Mél, LXVII, 1955, pp. 49-70; R. Bloch, Découverte d'un nécropole villanovienne près de Bolsena, CRAI, 1955, pp. 420-30; M. J. Vermaseren, De Franse opgravingen te Bolsena, Hermeneus, XXIX, 1957, pp. 38-43; L. Banti, EAA, s.v. Bolsena, II, 1959, pp. 131-32.

Caere (Etruscan, Chaire; It., Cerveteri). This Etruscan city, which was particularly important in the 7th-6th century B.C., was conquered by Rome in the 4th century B.C. The area of the ancient city, inside of which is the modest medieval and modern town of Cerveteri, preserves traces of ancient walls (5th-4th cent. B.C.). Various Etruscan temple areas with terra-cotta decorations have been discovered, as well as a Roman theater with imperial statues. In the Regolini-Galassi tomb (7th cent. B.C.) were found rich Orientalizing furnishings (V, PLS. 25, 429; X, PLS. 404, 408). Northwest of the city, on the Banditaccia hill, there is a monumental Etruscan necropolis with numerous tumuli (excavated and restored), hypogeum tombs (including the Tomb of the Reliefs, PL. 95), and sepulchral roads. The material discovered dates from the 7th-3d century B.C. There is another necropolis with monumental tombs on Mt. Abatone.

Pyrgi, the port of ancient Caere was near the modern Santa Severa. Remains of an Etruscan sanctuary survive, as well as polygonal walls of the 3d-2d century B.C. and a medieval castle.

BIBLIOG. R. Mengarelli, Nuove esplorazioni nella necropoli di Caere, NSc, 1915, pp. 347-86; R. Mengarelli, Caere e le recente scoperte, SEtr, I, 1927, pp. 145-72; R. Mengarelli, Il luogo e i materiali del tempio di "Hpa a Caere, SEtr, X, 1936, pp. 67-86; L. Pareti, La Tomba Regolini-Galassi, Vatican City, 1947; M. Pallottino, Necropoli della Banditaccia: Scavo eseguito a cura dell'Istituto di Archeologia dell'Università di Roma, NSc, 8th ser., IX, 1955, pp. 46-113; B. Pace and others, Caere (MALinc, XLII), Rome, 1955; F. Castagnoli and L. Cozza, Appunti sulla topografia di Pyrgi, BSR, XXV, 1957, pp. 16-21; M. Moretti, Lastre dipinte inedite da Caere, AC, IX, 1957, pp. 18-25; M. Pallottino, La necropoli di Cerveteri, 4th ed., Rome, 1957; M. Pallottino, Scavi nel santuario etrusco di Pyrgi, AC, IX, 1957, pp. 206-22; F. Sanguinetti, La chiesa di S. Maria Maggiore in Cerveteri, Palladio, N.S., VII, 1957, pp. 190-92; G. Colonna, A. Ciasca, and G. Foti, Scavi e ricerche nel sito dell'antica Pyrgi (1957-58), NSc, 8th ser., XIII, 1959, pp. 153-263; Q. F. Maule and H. W. Smith, Votive Religion at Caere . . . , Berkeley, Calif., 1959; EAA, s.v.

Casamari. The Abbey of Casamari (I, PL. 416), in an isolated site near Veroli, was founded in 1005. It adopted the Benedictine rule in 1036 and passed in 1151 to the Cistercians, who began reconstruction in 1204. The abbey declined in the 18th century and was sacked by the French in 1799. The church (consecrated in 1217) is Cistercian Gothic in style and modeled after that of Fossanova.

BIBLIOG. G. Pallavicini, La Badia Cistercense di Casamari, Rome, 1906; P. Rotondi, Osservazioni storiche e stilistiche sulla Badia di Casamari, Rome, 1933; H. Hahn, Die frühe Kirchenbaukunst des Zisterzienser, Berlin, 1957, passim; L. Fraccaro de Longhi, L'architettura delle chiese cistercensi italiane, Milan, 1958, pp. 241-48.

Cassino (Lat., Casinum). Of Volscian origin, the city was conquered by the Samnites and, in 312 B.C., by the Romans. The ancient city, on the slopes of Montecassino, was joined to the acropolis (where the abbey now stands) by polygonal walls, of which there are some remains. The most important monuments date from the 1st century of our era: an amphitheater, a theater, baths, and the central-plan tomb known as the tomb of Ummidia Quadratilla, which was transformed into the Chapel of the Crocefisso. Cassino was destroyed in the 6th century by the Lombards. At first only the area around the forum continued to be inhabited. In the 9th century the inhabitants moved to the nearby area of San Germano (renamed Cassino in 1871). The city, totally destroyed in World War II and subsequently rebuilt, preserves traces of the foundations of the 8th-century Church of S. Maria delle Cinque Torri.

On top of the mountain, St. Benedict founded the Abbey of Montecassino in 529. It was reconstructed by Abbot Desiderius in the 11th century. Razed to the ground by an earthquake in 1349, it was again rebuilt. Completely destroyed in 1944, it has been reconstructed in its prewar aspect. The basilica was rebuilt after the design (1649) of C. Fanzago.

BIBLIOG. L. Paterna Berdizzi, Rocca Ianula nell'arte e nella storia, Naples, 1912; A. Rusconi, Montecassino, Bergamo, 1929; G. Carettoni, Casinum, Rome, 1940; E. Scaccia Scarafoni, La chiesa cassinense detta S. Maria delle Cinque Torri, RACr, XXII, 1946, pp. 138-89; G. Giovannoni, L'Abbazia di Montecassino, Florence, 1947; G. Carettoni, Le fortificazioni medievali di Cassino, Palladio, N.S., II, 1952, pp. 135-41; A. Pantoni, La basilica di Gisulfo e tracce di onomastica longobarda a Montecassino, Atti I Cong. int. S. longobardi, Spoleto, 1952, pp. 433-42; A. Pantoni, Su di un cimitero alto medioevale a Montecassino e sul sepolcro di Paolo Diacono, Atti II Cong. int. S. alto Medioevo, Spoleto, 1953, pp. 257-64; A. Bertini Calosso, Come si ricostruisce la chiesa abbaziale di Montecassino, Atti VII Cong. naz. Storia Arch., Palermo, 1956, pp. 33-40; EAA, s.v.

Civita Castellana (Lat., Falerii Veteres). This Faliscan city became an ally of Rome in 357 B.C., but rebelled in 293 and 241. The city was destroyed and its inhabitants transferred to nearby Falerii Novi. Sections of the ancient city and acropolis walls survive. There are also remains of temples and sanctuaries. In the 8th or 9th century, the inhabitants of Falerii Novi returned to the site of Falerii Veteres, then known as La Civita. The city assumed its present name, Civita Castellana, because of its dominion over nearby castles. It was successively the property of the pope and a fief of the Sevellis and of the Borgias. The 12th-century Cathedral is preceded by a portico designed by Jacopo di Lorenzo and his son (I, PL. 302). Jacopo di Lorenzo also did the right portal of the façade (III, PL. 478; see COSMATI). The interior was redone in the 18th century. The pentagonal fortress dates from 1494-1500 and has an octagonal keep, which was added by Antonio da Sangallo the Elder. Parts of the rectangular courtyard are Renaissance. Inside there are frescoes by the Zuccaris and Pier Matteo di Amelia.

Falerii Novi preserves large city walls with arched gates, from the Roman period. There are also remains of an amphitheater and traces of a theater. Dating from the medieval period are the ruins of S. Maria di Falleri (11th-12th cent.), with three aisles, a large transept in Cistercian style, and five apses crowned by small arches.

BIBLIOG. F. Barnabei and others, Degli scavi di antichità nel territorio falisco, MALinc, IV, 1894, cols. 5-94; A. Muñoz, Alcune sculture della cattedrale di Civitacastellana, BArte, V, 1911, pp. 121-34; A. Valle, La chiesa di S. Maria di Falleri, Rass. d'arte ant. e mod., II, 1, 1915, pp. 199-208; P. Molajoli, S. Maria di Faleri, Per l'arte sacra, XIV, 3-4, 1937, p. 15 ff.; B. Götze, Das Rundgrab in Falerii, Stuttgart, 1939; A. Andrén, Architectural Terracottas from Etrusco-Italic Temples, Lund, 1940, pp. 80-148; E. Stefani, Tempio di Giunone Curite: Nuove ricerche ed ulteriori osservazioni, NSc, 8th ser., I, 1947, pp. 69-74; M. Santangelo, Una terracotta di Falerii e lo Zeus di Fidia, BArte, XXXIII, 1948, pp. 1-16; E. Stefani, Avanzi di antiche costruzioni scoperte in vocabolo "Sassi caduti," NSc, 8th ser., II, 1948, pp. 102-09; F. Sanguinetti, La fortezza di Civita Castellana, Palladio, N.S., IX, 1959, pp. 84-92; EAA, s.v. Falerii.

Civitavecchia (Lat., Centumcellae). This commercial city was erected around Trajan's port. There are remains of the Taurine Baths. Near Civitavecchia, Bronze and Iron Age habitations and an Etruscan necropolis have been excavated. Dominated by the Byzantines and then by the Saracens, who drove away the inhabitants, the city was rebuilt in A.D. 880 with the name of Civitavecchia. The city enjoyed particular prosperity under papal dominion (from mid-15th cent.), when the port was reconstructed for the papal fleet.

The city is essentially modern in appearance with broad streets. The Forte Michelangelo has a rectangular ground plan with cylindrical towers at the corners. The design was Bramante's (1508), and construction was begun under the direction of Bramante himself. Building continued under the successive supervision of Antonio da Sangallo the Younger, Giuliano Leno, and Michelangelo. It was Michelangelo who added the upper part of the octagonal keep. Also noteworthy are a fountain by L. Vanvitelli and the arsenal by Bernini. The Museo Civico has a fine archaeological collection.

BIBLIOG. S. Bastianelli, Monumenti etruschi del Museo di Civitavecchia, SEtr, XIV, 1940, pp. 359–66; R. Mengarelli, Civitavecchia, NSc, 7th ser., II, 1941, pp. 344–69; S. Bastianelli, Nuove esplorazioni eseguite nelle Terme Taurine, NSc, 7th ser., III, 1942, pp. 235–52; R. Mengarelli, Necropoli etrusca detta della "Torre Valdaliga" ovvero della "Cava della Scaglia," NSc, 7th ser., III, 1942, pp. 10–42; S. Bastianelli, Centumcellae, Rome, 1954; S. Bastianelli and P. Cordelli, Tombe dell'VIII secolo a. C. scoperte presso la città, NSc, 8th ser., XII, 1958, pp. 50–55; O. Toti, La città medioevale di Centocelle, Allumiere, 1958.

Cori (Lat., Cora). As early as the 5th century B.C., this was a Latin outpost in Volscian territory. It became a Roman municipium before 211 B.C. Having been destroyed several times, it passed in the 15th century to the Church. Divided into Cori a Monte and Cori a Valle, it occupies the summit and slopes of a hill, with narrow streets closed in by 15th- and 17th-century stone houses. There are polygonal walls with towers. Ancient remains include a Doric temple, perhaps that of Hercules (ca. 100 B.C.; VII, PL. 201), two Corinthian columns of the so-called "Temple of Castor and Pollux," and a bridge from the republican period. The Collegiate Church (S. Maria della Pietà) preserves a 12th-century paschal candlestick with a sculptured base. The Church of S. Oliva comprises two churches of different epochs joined longitudinally by large arches in their common wall. The older building has the structure of a crypt. The other, begun in 1477 and finished in 1677, has 16th-century frescoes on the vault and in the apse. The cloister has a portico on all four sides; a loggia above runs around three sides. The Monte di Pietà dates from the 16th century, and the Santuario del Soccorso from 1626.

BIBLIOG. G. Giovannoni, Il chiostro di S. Oliva, L'Arte, IX, 1906, pp. 108–16; A. von Gerkan, Die Krümmungen im Gebälk des dorischen Temples in Cori, RM, XL, 1925, pp. 167–80; A. Accrocca, Cori, Rome, 1933; G. Lugli, EAA, s.v. Cori, II, 1959, p. 836.

Ferentino (Lat., Ferentinum). This Hernican city was conquered by the Volsci and then by the Romans. Roman city walls survive, with gates and towers restored in the Middle Ages. The acropolis, in the form it took in the time of Sulla (inscriptions by the censors Hirtius and Lollius), consists of a flattened space sustained by powerful sustaining walls (squared masses of limestone and rectangular blocks of travertine). The episcopal palace is located on a jutting portion of the acropolis. Beneath the episcopal palace is the substructure of a large construction that may have been a temple. There are meager remains of a theater of the period of Trajan and Hadrian. Outside the Porta Casamari the testament of Aulus Quintilius (who lived in the time of Trajan) is carved on a rock. From the Middle Ages Ferentino was almost always the property of the Church. The city is predominantly medieval in appearance. Located on the ancient acropolis is the Romanesque Cathedral, with three aisles and three semicircular apses and a beamed ceiling. The pavement (1116) and paschal candlestick are Cosmati work, and there is a 13th-century ciborium by Drudo (Drudus) de Trivio. The campanile has twin-arched and triple-arched windows. The Palazzo Comunale preserves remains of the original 12th-century structure. The Palazzo dei Cavalieri Gaudenti is medieval. The Church of S. Maria Maggiore is a Cistercian Gothic structure. The façade has three portals and a rose window, and a polygonal dome tops the crossing. The Church of S. Francesco has a Romanesque-Gothic façade. The Church of S. Agata dates from 1750. The Collezione del Comune contains archaeological finds and medieval reliefs.

BIBLIOG. T. Ashby, Ferentinum, RM, XXIV, 1909, pp. 1–58; A. Bartoli, Ferentino: Teatro, NSc, 1928, pp. 356–65; A. Boëthius and N. Carlgren, Die spätrepublikanischen Warenhäuser in Ferentino und Tivoli, ActaA, III, 1932, pp. 181–208; A. Bartoli, L'acropoli di Ferentino, BArte, XXXIV, 1949, pp. 293–306; A. Bartoli, Una seduta del Senato di Ferentino, RendPontAcc, XXV–XXVI, 1949–51, pp. 88–93; A. Bartoli, Ferentinvm: Ferentinvm novvm, Ferentinvm maivs, RendPontAcc, XXV–XXVI, 1949–51, pp. 153–56; G. Gullini, I monumenti dell'Acropoli di Ferentino, AC, VI, 1954, pp. 185–216; L. Benevolo and F. Fasolo, L'Acropoli di Ferentino, Q. Ist. Storia Arch., 10, 1955, pp. 8–11; EAA, s.v.

Ferento (Lat., Ferentium). There are remains of a Roman city in an area that had already been inhabited in Etruscan times. These include baths and a theater partly executed in brick (1st century of our era). In the area are Etruscan and Roman hypogea and remains of the Church of S. Bonifacio (9th–10th cent.).

BIBLIOG. A. Gargana, Ferento, Viterbo, 1935; A. Gargana, Il teatro di Ferento, Viterbo, 1937; A. Rossi Danielli, Ferento, Viterbo, 1959; G. Maetzke, EAA, s.v. Ferento, III, 1960, pp. 623–24.

Fondi (Lat., Fundi). Once a city of the Volsci, Fundi later became Roman. The ancient rectangular plan of the city has been preserved. There are remains of the ancient walls and of villas and tombs. The city was destroyed by the Saracens in the 9th century and later passed to the Church. In the 13th century it came under the dominion of Naples and was successively a fief of various families. It enjoyed its greatest prosperity under the Caetani family but declined in the 16th century. Among the medieval monuments is the Church of S. Pietro, constructed in the 4th–5th century over a pagan temple and reconstructed in the 12th, 13th, and 14th centuries. The façade portal is flanked by column-bearing lions and has a sculptured architrave. The interior has been considerably restored. There are remains of the 4th-century mosaic pavement, an ambo by the Roman Giovanni di Nicola (1286), a triptych by Antoniazzo Romano, and the tomb of Cristoforo Caetani (15th cent.). The campanile dates from the middle of the 13th century. S. Domenico (reconstructed in 1466) has a Renaissance portal. The campanile dates from 1278. The Renaissance Church of S. Maria Assunta (1490–1508) has a travertine façade. The Palazzo del Principe has a large cylindrical tower (15th. cent.) on a square base. The Castle proper, which is rectangular, has cylindrical crenelated towers at the corners. The Antiquarium is in the cloister of the former Monastery of S. Francesco (14th cent.).

BIBLIOG. B. Amante and R. Bianchi, Memorie ... di Fondi in Campania, Rome, 1903; G. Rizza, Pitture e mosaici nelle basiliche paoliniane di Nola e di Fondi, Siculorum Gymnasium, I, 1948, pp. 311–21; D. Faccenna, Fossa con materiale fittile votivo, FA, VIII, 1953, 2179; S. Aurigemma, A. Bianchini and A. De Santis, Circeo, Terracina, Fondi, Rome, 1957; G. Cressedi, EAA, s.v. Fondi, III, 1960, pp. 719–20.

Fossanova. The Abbey of Fossanova was founded by the Benedictines in the 9th century and passed to the Cistercians in the 12th century. The Cistercians rebuilt the monastic complex and erected the Gothic church. The buildings are arranged, according to the traditional monastic scheme, around a quadrangular cloister. The cloister is Romanesque on three sides; the fourth side, rebuilt 1280–1300, is Gothic. The church, which was consecrated in 1208, is the first Italian structure in the Cistercian Gothic style. The simple façade (VI, PL. 331) has a portal by the Cosmati and a rose window. There are remains of an atrium that once stood in front of the church. The sides of the church are buttressed, and the transept and apse are rectangular. The lantern is octagonal. The unadorned interior has three aisles with piers and engaged columns. There are smooth groin vaults and acute transversal arches (VI, PL. 331). The apse is flanked by chapels (two on each side) facing the transept. To the north of the cloister is the chapter room with Romanesque walls and Gothic vaults (mid-13th cent.).

BIBLIOG. A. Serafini, L'Abbazia di Fossanova e le origini dell'architettura nel Lazio, Rome, 1924; H. Hahn, Die frühe Kirchenbaukunst des Zisterzienser, Berlin, 1957, pp. 174–79; L. Fraccaro de Longhi, L'architettura delle chiese cistercensi italiane, Milan, 1958, pp. 235–41.

Frascati. The city developed on the site of an immense Roman villa of the Imperial period. When nearby Tusculum was destroyed in A.D. 1191, the refugees settled in Frascati. Little remains of the medieval city because of extensive later rebuilding. The city was badly damaged in World War II and has been reconstructed. The Church of S. Maria in Vivario (popularly known as S. Rocco) was reconstructed with a basilican plan at the end of the 15th century. The Romanesque campanile was erected in 1305. Remains of the former fortress (now the bishop's residence) include the keep and corner towers. The Church of the Cappuccini (S. Francesco) has a simple façade (1575) and a single aisle. The façade of the Church of the Gesù may have been erected after a design by Pietro da Cortona. The interior has frescoes by A. Pozzo and assistants. In the adjacent seminary are frescoes by Pozzo and T. Kuntz. The Cathedral (S. Pietro) was designed by C. Rainaldi and P. De Rocchi, with a façade by G. Fontana and two campaniles of later date. The Villa Aldobrandini (or Belvedere; G. della Porta, C. Maderno, C. Fontana) has decorations by the Zuccaris, the Cavalier d'Arpino, and the school of Domenichino. The park is adorned with artificial grottoes, statues, terraces, and ingenious fountains. The Villa Grazioli was built toward the end of the 16th century. Noteworthy, too, are the Villa Muti and the Villa Lancellotti. The 16th-century Villa Torlonia boasts decorative waterworks designed by C. Maderno. The Villa Falconieri (1545–48) was enlarged by Borromini. The Villa Mondragone was built in 1573–75. The Museo Tuscolano contains local archaeological materials.

Near Frascati are the ruins of Tusculum, a powerful Latin city that enjoyed particular prosperity in the Roman Imperial period as a resort. Remains survive of the acropolis, forum, cistern, theater, amphitheater, and the so-called "Villa of Cicero."

BIBLIOG. G. B. Lugari, L'origine di Frascati e la distruzione di Tuscolo, Rome, 1891; R. Lanciani, La riedificazione di Frascati per opera di Paolo III, Arch. Soc. romana Storia patria, XVI, 1893, pp. 517–22; S. Kambo, Il Tuscolo e Frascati, Bergamo, 1929; M. Borda, Origini di Tuscolo, L'Urbe, XVI, 1, 1953, pp. 3–11; M. Borda, Tuscolo e la sua nuova strada, Capitolium, XXVIII, 1953, pp. 170–79; M. Borda, Il Museo Tuscolano, Capitolium, XXIX, 1954, pp. 157–60; G. Lugli, Per i colli tuscolani alla ricerca della Villa di Cicerone, Capitolium, XXV, 1955, pp. 365–72; K. L. Frank, Die Barockvillen in Frascati, Munich, Berlin, 1956; M. Borda, Tuscolo, Rome, 1958; G. Toffanello, Frascati, Civitas Tuscolani, Frascati, 1958.

Gaeta (Lat., Caieta). A port and resort town as early as Roman times, Gaeta preserves remains of villas and of two mausoleums (ca. 20 B.C.), that of L. Munatius Plancus (the so-called "Tower of Orlando") and that of L. Sempronius Atratinus. The city was the scene of complex political events in the Middle Ages and a military stronghold. The medieval center, much damaged in World War II, is crowded around the base of the castle, which was built in the 8th century and subsequently enlarged and restored (13th–16th cent.). The upper castle is Aragonese, and the lower is an Angevin structure surrounded by bastioned walls. The Cathedral (consecrated 1106) preserves the original campanile but is otherwise an 18th-century renovation. The Museo del Duomo has a fine collection of sculpture and paintings, including three 11th-century exultet parchments. S. Giovanni a Mare (12th cent.) represents a compromise between the Byzantine central plan and the basilican plan. Inside there are remains of what may have been the original fresco decoration as well as 15th-century work. S. Lucia is a 16th-century enlargement of an older church, of which are preserved transepts and remains of the 13th-century mosaic pavement. The Church of the Trinità stands on a rocky spur. Noteworthy is the adjacent monastery (11th century; reconstructed) and the Chapel of the Crocefisso (1434). The Church of the Annunziata dates from 1321 but was remodeled in 1621. Of the early structure, a Gothic portal survives. The palace known as the Palazzo Ladislao dates from the 15th century.

Near Gaeta is Formia, which preserves some Roman ruins, including regular polygonal walls, a piscina, an amphitheater, an aqueduct, a cistern, the so-called "Villa of Cicero," and remains of other villas. The so-called "Tomb of Cicero" also survives. The Antiquarium in Formia has an archaeological collection and medieval coins.

BIBLIOG. P. Fantasia, Sui monumenti medievali di Gaeta, Naples, 1919; G. Zander, Case del Rinascimento a Gaeta, Q. Ist. Storia Arch., 2, 1953, pp. 17–18; S. Aurigemma and A. De Santis, Gaeta, Formia, Minturno, Rome, 1955; R. Fellmann, Das Grab des Lucius Munatius Plancus bei Gaeta, Basel, 1957; G. Iacopi, Restauro del Mausoleo di Munazio Planco a Gaeta, FA, XII, 1957, 324; A. De Santis, Nella Gaeta del Settecento, Archivi, XXV, 1958, pp. 309–34; R. A. Staccioli, Il restauro del Mausoleo di L. M. Planco, Capitolium, XXXIII, 9, 1958, pp. 17–19; EAA, s.v.

Grottaferrata. This city in the Alban Hills developed around the Abbey of Grottaferrata, which was founded in 1004 by Basilian monks on the remains of a Roman villa. The abbey was fortified in the 15th century by Giuliano da Sangallo the Elder and B. Pontelli. The 11th-century Church of S. Maria was extensively remodeled in the 18th century and restored at the beginning of the 20th. Preceded by a portico and flanked by a 12th-century campanile, the church preserves a marble portal with carved door (11th–12th cent.), a contemporaneous mosaic, and a sculptured baptismal font (10th–11th cent.?) in the narthex. The basilican-plan interior preserves a triumphal arch with a 13th-century mosaic as well as Byzantinizing frescoes. The Chapel of St. Nilus was frescoed by Domenichino (1610). The Museo della Badia contains ancient and medieval sculpture as well as tapestries and sacred vestments.

BIBLIOG. S. Kambo, I castelli romani, Grottaferrata e il Monte Cavo, Bergamo, 1923; F. Tomassetti, La campagna romana, IV, Rome, 1926, pp. 280–332 (bibliog.); P. Guidi, Il ripristino della Badia di Grottaferrata, Ill. vaticana, II, 10, 1931, pp. 19–25; M. De Vita, I resti romani sotto la Badia di Grottaferrata, BCom, LXXI, 1943–45, app., pp. 45–51; G. Zander, La chiesa medievale della Badia di Grottaferrata e la sua trasformazione del 1754, Palladio, N.S., III, 1953, pp. 120–31; M. Borda, Monumenti paleocristiani del territorio tuscolano, Misc. Belvederi, Vatican City, 1954, pp. 209–44; E. Amadei, Storia e vicende della Badia greca di Grottaferrata, Capitolium, XXXII, 8, 1957, pp. 14–17.

Minturno (Lat., Minturnae). This city of the Ausones became a Roman colony in 296 B.C. There are remains of polygonal walls and ashlar walls, the forum (crossed by the Appian Way) with portico, temples, theater, traces of the amphitheater, baths, and an aqueduct. Minturno was devastated by the Lombards toward the

end of the 6th century, and the inhabitants retreated to the hill where the present city, medieval in appearance, is located. The Church of S. Pietro was erected in the middle of the 12th century, enlarged and remodeled in the 17th, and restored in the 20th century. The campanile has Romanesque twin-arched windows. The three-aisled church has Gothic arches. The church preserves works by Pellegrino (Peregrino) da Sessa, including the pulpit (1260), the paschal candlestick, and schola cantorum. Some sections of the Castello (Palazzo Baronale) date from the 14th and 15th centuries.

BIBLIOG. H. C. Butler, The Roman Aqueducts as Monuments of Architecture, AJA, V, 1901, pp. 175–99; G. Abatino, La cattedrale di Minturno, Napoli nobilissima, XII, 1903, pp. 56–59; J. Johnson, Excavations at Minturnae, 2 vols., Philadelphia, 1933–35; A. K. Lake, Campana Supellex (The Pottery Deposit at Minturnae), B. Assoc. int. S. Mediterranei, V, 1934–35, pp. 97–136; A. Adriani, Catalogo delle sculture trovate negli anni 1931–1933, NSc, 1938, pp. 159–226; P. Mingazzini, Il santuario della dea Marica alle foci del Garigliano, MALinc, XXXVII, 1938, cols. 693–984; C. Cecchelli, La torre di Pandolfo Capodiferro al Garigliano, Arch. Soc. romana Storia patria, LXXIV, 1951, pp. 1–26; S. Aurigemma and A. De Sanctis, Gaeta, Formia, Minturno, Rome, 1955.

Montefiascone. The origin of Montefiascone is uncertain, although it probably existed in antiquity. The city was devastated during the barbarian invasions. Montefiascone became a free commune in the 12th century and long remained independent. The Cathedral (M. Sanmicheli, 1519, and C. Fontana) has a façade designed by P. Gazola (1840–43) with a portal flanked by two campaniles. The octagonal interior is surmounted by an octagonal dome. S. Flaviano consists of two superimposed churches. The façade has three arches below and a small loggia above. The lower church (11th cent., restored in 14th cent.) has three aisles (with piers and fine capitals) and three apses arranged almost in a semicircle. The upper church was built later and follows the division into three aisles, but, since the central section has no floor and is connected directly with the lower church, the upper church practically forms a gallery for the lower. The churches preserve interesting frescoes, dating, for the most part, from the 14th century.

BIBLIOG. E. Lavagnino, Osservazioni sulla pianta del San Flaviano, Misc. Supino, Florence, 1933, pp. 41–47; P. Cao, La chiesa lombarda di San Flaviano a Montefiascone, Viterbo, 1938; P. Verdier, Remarques sur le plan de San Flaviano, Mél, LVII, 1940, pp. 167–72; G. de Angelis, Sull'origine e le vicende della città e chiesa di Montefiascone, Montefiascone, 1941; E. Battisti, Monumenti romanici del Viterbese: Il S. Flaviano di Montefiascone, RArte, XXVIII, 1953, pp. 99–113; A. Grenier, Rapport sur l'École française de Rome et ses travaux pendant l'année 1955–1956, CRAI, 1956, pp. 323–33; G. T. Ricca and N. Antonelli, S. Flaviano e S. Maria di Montedoro in Montefiascone, Rome, 1958; O. Fasolo, Contributo ad A. e G. B. da Sangallo: La Rocca di Montefiascone, Q. Ist. Storia Arch., 31–48, 1961, pp. 159–68.

Nepi (Etruscan, Nepet; Lat., Nepete). An Etruscan city and later a Roman colony, Nepi was destroyed by the Lombards. Subsequently it was rebuilt and passed to the Church. The Cathedral, an Early Christian structure, was destroyed and reconstructed many times. It preserves the Romanesque portico with three arches and a crypt. The interior has five aisles and contains a panel by Giulio Romano and the sarcophagus of St. Romanus, attributed to Bernini. S. Biagio preserves a Romanesque portal and an oratory with a Romanesque façade. In the apse are frescoes of various periods. The Palazzo Comunale was begun by Vignola and completed in the baroque period. The square in front of the palace has a fountain designed by Bernini.

Near Nepi is Castel Sant'Elia. The Basilica of Castel Sant'Elia, founded in the 6th century and reconstructed in the 11th, has a façade with three portals. The three-aisled interior has columns taken from ancient structures. In the apse and transept are frescoes signed by Roman artists of the 11th–12th century (the brothers Giovanni and Stefano, and Nicolò, nephew of Giovanni) and an 11th-century pulpit. Nearby is the Church of the Madonna ad Rupes.

BIBLIOG. G. B. Ranghiarci-Brancaleoni, Memorie sull'origine, nome, ecc., di Nepi, Todi, 1845; R. Serra, Il santuario di S. Maria ad Rupes, Rome, 1899; C. M. Kaufmann, Sant'Elia, Hamm i.V., 1900; G. Giovannoni, S. Tolomeo di Nepi, Architettura, VII, 1927–28, pp. 241–50; G. J. Hoogewerff, Gli affreschi nella chiesa di Sant'Elia presso Nepi, Dedalo, VIII, 1927–28, pp. 331–43; U. Ciotti, Rilievo romano e plutei medievali ritrovati a Castel Sant'Elia, BArte, XXXV, 1950, pp. 1–8; L. Mortari, Il Museo di arredi sacri a Castel S. Elia, BArte, XLI, 1956, pp. 275–77; Y. Batard, Les fresques de Castel Sant'Elia et le "Jugement dernier" de la Pinacothèque Vaticane, Cah. de civ. méd., I, 1958, pp. 171–78.

Ostia. The city was built at the former mouth of one branch of the Tiber River. (The Latin ostium means "river mouth.") The city became a Roman colony about 335 B.C. By the 3d century B.C.

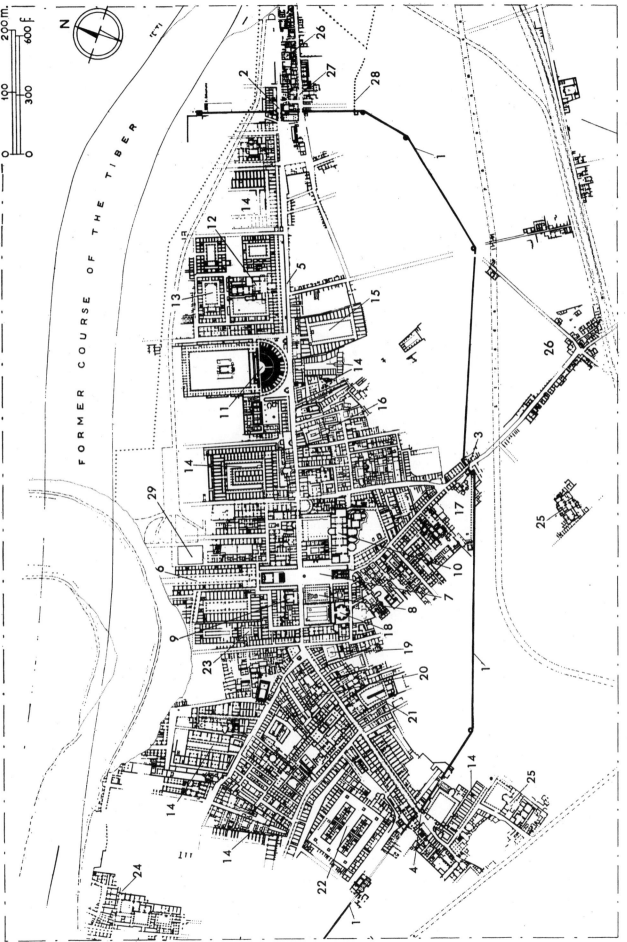

Ostia Antica, plan. (1) Walls; (2) Porta Romana; (3) Porta Laurentina; (4) Porta Marina; (5) *decumanus maximus*; (6) *cardo maximus*; (7) forum, to the north of which, the Capitol, and to the south, the Temple of Roma and Augustus; (8) basilica; (9) curia; (10) baths of the forum; (11) theater, facing toward the Piazzale delle Corporazioni, with the "Temple of Ceres"; (12) Baths of Neptune; (13) guard barracks; (14) horrea; (15) Horrea of Hortensius; (16) the seat of the Augustali; (17) campus of the Magna Mater; (18) round temple, perhaps an Augusteum; (19) *macellum*; (20) Christian basilica; (21) Trajan's Schola; (22) area of garden houses; (23) Horrea Epagathiana et Epaphroditiana; (24) so-called "Imperial Palace"; (25) baths; (26) burial ground; (27) Via dei Sepolcri; (28) aqueduct; (29) museum.

it was already an important port and subsequently became the base of the Roman fleet. The excavations of Ostia Antica constitute one of the most important archaeological complexes in Italy, especially for the constructions of the Imperial period. Of the oldest, rectangular-plan nucleus, there remain traces of the walls and of the forum. The walls erected by Sulla mark the city limits as they were in the 3d–2d century B.C., slightly less extensive than in the Imperial period. The principal monuments include the Capitol (2d cent. B.C.), a theater (Augustan age), the forum built under Tiberius, and the Temple of Roma and Augustus. The curia and basilica date from the time of Trajan, the Baths of Neptune and guard barracks from the time of Hadrian. The Piazzale delle Corporazioni, where the merchants had their *scholae*, was constructed under Septimius Severus. Other monuments include horrea, Mithraea, the campus of the Magna Mater, and a synagogue. Especially interesting are remains of private constructions, with apartment houses of several stories and in blocks (*insulae*). The city survived in Christian times, and there are remains of a basilica. It was then abandoned because of the silting-up of the port and the threat of the Saracens. Immense quantities of mosaics, sculpture, and other objects have been excavated (VIII, PLS. 96, 232; IX, PL. 251; X, PL. 176). In the medieval area are two works of B. Pontelli, the small Church of S. Aurea and the castle. The Museo Ostiense contains archaeological finds.

Near the mouth of the right branch of the Tiber stood the city of Porto (Lat., Portus), with the port of Claudius. There are remains of moles, the lighthouse, boats, and warehouses. The hexagonal Portus Traiani (now Lake Traiano) was dug in Trajan's time, after the silting-up of the port of Claudius. The Roman necropolis of Isola Sacra comprises more than 100 tombs (2d–4th cent.).

BIBLIOG. G. Lugli and G. Filibeck, Il porto di Roma imperiale, Rome, 1935; P. Verdier, La rocca d'Ostie dans l'architecture du Quattrocento, Mél, LVI, 1939, pp. 280–331; G. Calza, La necropoli del porto di Roma, Rome, 1940; G. Calza, Ancora sulla basilica cristiana di Ostia, AttiPontAcc, XVIII, 1941–42, pp. 135–48; R. Calza, Museo Ostiense, Roma, 1947; G. Calza, Nuove testimonianze del Cristianesimo a Ostia, AttiPontAcc, XXV–XXVI, 1949–51, pp. 123–38; G. Despy, La rocca di Ostia: Problema di date e di forme architettoniche, BArte, XXXVI, 1951, pp. 277–78; G. Calza and others, Scavi di Ostia, 4 vols., Rome, 1953–62; G. Calza and G. Becatti, Ostia, 4th ed., Rome, 1957; H. Schaal, Ostia, Bremen, 1957; R. Calza and E. Nash, Ostia, Florence, 1959; R. Meiggs, Roman Ostia, Oxford, 1960; V. Scrinari, Strutture portuali relative al "porto di Claudio" messo in luce durante i lavori dell'Aeroporto Intercontinentale di Fiumicino (Roma), Rass. dei Lavori Pubblici, VII, 1960, pp. 173–90.

Palestrina (Lat., Praeneste). The city was already flourishing in the 8th–7th century B.C. Remains of this period include the Orientalizing Bernardini and Barberini tombs, whose furnishings are now in the Museo di Villa Giulia, Rome (X, PLS. 402, 408, 409). The city was an ally and then an enemy of Rome until it became a *civitas foederata* and, in 90 B.C., a municipium. Sacked by Sulla, it again became a municipium under Tiberius. The height on which the village of Castel San Pietro Romano now stands was the acropolis of Praeneste. The center of Palestrina is occupied by the Sanctuary of Fortuna Primigenia (VII, PLS. 198, 199, FIG. 399; see HELLENISTIC-ROMAN ART), of which there are two sections. The lower complex (behind the Cathedral) includes a hall of basilican type (the so-called "Sacred Area") flanked by two structures (almost certainly nymphaea); the so-called "Antro delle Sorti," with a polychrome mosaic pavement representing an ocean landscape; and the apsed room where the celebrated mosaic of the Nile was found (VII, PL. 197). The upper complex extends over five levels, the upper part of which is incorporated in the Palazzo Barberini. The entire architectural complex of the sanctuary seems to date from the same period, that of Sulla, but some consider the lower part more recent. Because of its organic structure and its scenographic sense, the sanctuary is the most important monument of Roman republican architecture. After the time of Sulla, the city expanded toward the south. Nearby are remains of villas of the Imperial age. The medieval city was built on the ruins of the sanctuary. Occupied by the Lombards, it later became a fief of the Counts of Tuscolo. The city was destroyed in 1298 by Pope Boniface, who erected another city (Civitas Papalis) to the south, on the site of the modern Church of the Madonna dell'Aquila. The city was reconstructed under the auspices of the Colonna family, to whom it remained subject until the 17th century. The Cathedral (S. Agapito) was initially the result of the transformation of an ancient temple. In the 12th century the campanile was built, side aisles were added, and the nave was lengthened. The Cathedral has been remodeled and restored at various times. The present structure preserves the original campanile and the upper part of the original façade. The Palazzo Baronale (now Palazzo Barberini) was constructed in the 11th century on the remains of the upper part of the sanctuary. The palace was rebuilt in 1493 by the Colonnas and in the 17th century by the Barberinis. The Barberini family also erected the Church of S. Rosalia (1656–60),

which contains four tombs of that family. The Palestrina Museo Archeologico Nazionale is in the Palazzo Barberini.

BIBLIOG. D. Vaglieri, Preneste e il suo Tempio della Fortuna, BCom, XXXVII, 1909, pp. 213–74; O. Marucchi, Guida archeologica della città di Palestrina, 3d ed., Rome, 1932; G. Gullini and F. Fasolo, Il santuario della Fortuna Primigenia a Palestrina, Rome, 1953 (rev. by H. Kähler, Gnomon, XXX, 1958, pp. 366–83); G. Gullini, Ancora sul Santuario della Fortuna Primigenia a Palestrina, AC, VI, 1954, pp. 133–46; G. Lugli, Il santuario della Fortuna Primigenia in Preneste e la sua datazione, Rend-Linc, IX, 1954, pp. 51–87; P. Mingazzini, Note di topografia prenestina: L'ubicazione dell'antro delle sorti, AC, VI, 1954, pp. 295–301; A. Degrassi, L'epigrafia e il santuario prenestino della Fortuna Primigenia, AC, VII, 1955, pp. 302–04; G. Lugli, Nota sul Santuario della Fortuna prenestina, AC, VII, 1955, pp. 305–11; F. Fasolo, Il palazzo Colonna-Barberini di Palestrina e alcune note sul suo restauro, BArte, XLI, 1956, pp. 73–81; G. Gullini, Guida del Santuario della Fortuna Primigenia a Palestrina, Rome, 1956; G. Gullini, I mosaici di Palestrina, Rome, 1956; G. Quattrocchi, Il Museo Archeologico Prenestino, Rome, 1956; H. Kähler, Das Fortunaheiligtum von Palestrina-Praeneste, Ann. Univ. Saraviensis, VII, 1958, pp. 189–240; G. Iacopi, Il Santuario della Fortuna Primigenia e il Museo Archeologico prenestino, Rome, 1959.

Rieti (Lat., Reate). Once the capital of the Sabines, Reate later became a Roman municipium. It was a Guelph commune and a residence of popes in the Middle Ages. Noteworthy sections of the 13th-century walls survive. The cathedral was begun in 1109 on the site of the 5th-century Basilica of S. Maria is the crypt of the modern Cathedral. The crypt has three aisles divided by 16 ancient columns. The upper church was built in the 14th century and transformed in 1639. It preserves the Romanesque façade, before which stands a Renaissance portico (1458). The interior is built in the form of a Latin cross with three aisles. The campanile is medieval. The Palazzo Vescovile dates from 1283 but was remodeled later. The Loggia Papale was built in 1288 and restored in the 20th century. The Arco del Vescovo (Bishop's Arch) was built in 1298. The former Church of S. Domenico (13th cent.) preserves frescoes of the 14th, 15th, 16th, and 17th centuries. Adjacent is the former Oratory of S. Pietro Martire, frescoed by L. and B. Torresani (1552–54). S. Agostino preserves a fine Romanesque portal (early 13th cent.). The campanile is also Romanesque. S. Francesco (1245) has a Romanesque portal. The interior of the church is built on a Latin-cross plan. The adjacent Oratory of S. Bernardino has 16th-century stuccoes by Tobia Cicchino (known as Tobias Aquilanus; 1578). S. Pietro Apostolo (1153) has a Romanesque portal and a 15th-century carved wooden door. The Chiavelloni, Colelli, and Vecchiarelli palaces, the Casa Zapparelli, and the Palazzo Vincentini (now Palazzo del Governo) are interesting examples of civil architecture. The Palazzo Comunale (14th cent.) has a baroque façade by F. Brioni (1748). The remains of the 14th-century Palazzo del Podestà are incorporated in the Palazzo del Seminario. *Museum:* Museo Civico.

BIBLIOG. P. Angelotti, Descrizione della città di Rieti, Rome, 1635; A. Bellucci, Notizie di architetti lombardi a Rieti nel secolo XV (1439–1458), Rass. d'arte, III, 1903, pp. 66–68; F. Palmeggiani, L'antichissimo palazzo vescovile di Rieti, Rome, 1925; F. Palmeggiani, La cattedrale basilica di Rieti con cenni storici sulle altre chiese della città, Rome, 1926; F. Palmeggiani, Santuari francescani di Rieti, Rieti, 1926; A. Sacchetti Sassetti, Guida illustrata di Rieti, Rieti, 1930; A. Sacchetti Sassetti, Il Palazzo Vicentini di Rieti e il suo architetto, Rieti, 1955.

Sermoneta. This town of medieval appearance (mentioned for the first time in 1222) is still partly surrounded by the original walls. The Castello Caetani was erected at the end of the 13th century by the Caetanis, feudatories of the town from 1297. Contemporaneous is the Cistercian Gothic Cathedral, which has been extensively remodeled. The campanile has five stories of twin-arched windows. The Cathedral preserves a *Madonna* by Benozzo Gozzoli and 16th-century frescoes. S. Giuseppe has frescoes by G. Sicciolante.

Near Sermoneta is the Abbey of Valvisciolo with a 13th-century church (SS. Pietro e Stefano). It has a simple façade decorated with a rose window. Remains of the abbey include the chapter room and a cloister (restored).

BIBLIOG. M. Raymondi, La Badia di Valvisciolo, Velletri, 1905; M. Raymondi, L'abate e la Badia di Valvisciolo, Arte e storia, XXXI, 1912, pp. 241–48; R. Fraccaro de Longhi, L'architettura delle chiese cistercensi italiane, Milan, 1958, pp. 269–75.

Subiaco (Lat., Sublaqueum). The town grew up around a villa built for Nero, of which imposing ruins remain. In the 6th century, St. Benedict organized there what was to become the Benedictine Order. Twelve monasteries were erected, eleven of which were destroyed in 601 by the Lombards. The only one remaining is that of S. Scolastica, which has been remodeled and enlarged through the centuries. It comprises a church and three adjoining cloisters,

dominated by a Romanesque campanile (1053). Of the three cloisters, the first (1580) was completely rebuilt after World War II; the second (1052) was reconstructed in Gothic style in the 13th century; the third is the original work of Cosma and his sons Luca and Jacopo (1227–43; see COSMATI). The Church of S. Scolastica, consecrated in 981, was renovated in Cistercian style in the 13th century and transformed in neoclassic style by G. Quarenghi in 1769. The construction of the Sacro Speco, or Monastery of S. Benedetto, was begun in the 13th century. The complex comprises two superimposed churches and several chapels supported on a series of nine arches. Three corridors, frescoed in the 14th and 15th centuries, lead into the upper church, which is composed of several irregularly shaped rooms with groin vaults, almost completely covered with 14th- and 15th-century frescoes. The lower church was carved out of the rock, without any real organic plan. It preserves frescoed scenes from the life of St. Benedict painted by Conxolus (13th cent.). In the Grotto of S. Benedetto (transformed into a chapel) is a marble statue of St. Benedict by A. Raggi. The Chapel of S. Gregorio preserves a fresco of St. Francis (1228) painted a few years after his supposed visit to Subiaco. The Scala Santa and the adjacent chapel are decorated with 14th-century frescoes of the school of Siena. On the opposite side of the town, near a medieval bridge, is S. Francesco (1327), a single-aisled church with a Romanesque campanile. The churches of S. Pietro and S. Giovanni Battista have Romanesque campaniles. S. Andrea, built on a Latin-cross plan, has three aisles and a neoclassic façade (1795).

BIBLIOG. R. Lanciani, Subiaco, NSc, 1883, pp. 19–20; L. Allodi, Subiaco, NSc, 1884, pp. 425–27; P. Egidi and others, I monasteri di Subiaco, Rome, 1904; P. Pistone, Guida storico-artistica dei monasteri sublacensi, Subiaco, 1925; G. D., Subiaco: Convento del Sacro Speco, Palladio, III, 1939, pp. 87–88; W. Krönig, Deutsche spätgotik Architektur in Farfa und Subiaco, 25. Jahre Kaiser Wilhelm Gesellschaft, III, 1937, pp. 57–67; M. Accascina, Note sul campanile di S. Scolastica di Subiaco, Atti V Conv. naz. Storia Arch. (1948), Florence, 1957, pp. 257–64.

Sutri (Etruscan, Suthri; Lat., Sutrium). This Etruscan city came under the domination of Rome in the 4th century B.C. Remains include an amphitheater dug out of tuff (1st cent. B.C.) and an Etruscan tomb (later converted into the Church of the Madonna del Parto). This was the first city to be donated to the Christian Church; Liutprand, king of the Lombards, gave Sutri to Pope Gregory II. The three-aisled Cathedral has been completely remodeled. Of the original Romanesque construction are remains of the mosaic pavement, the three-aisled crypt of the presbytery, the campanile, and remains of 13th-century frescoes. Noteworthy civil structures are the Palazzo Comunale and the Palazzo Episcopale, the latter with Gothic windows. In nearby Bassano di Sutri is the Palazzo Odescalchi, which preserves frescoes by Domenichino and the school of the Zuccaris. The garden was designed by Vignola.

BIBLIOG. G. Bazzichelli and others, Sutri, NSc, 1877, pp. 150–51, 1878, pp. 159–60, 1882, pp. 111, 265; G. F. Gammurini, Scoperte avvenute dei restauri nella cattedrale, NSc, 1891, pp. 26–28; R. Paribeni, Scoperta di una statuina di bronzo, NSc, 1912, pp. 373–77; G. Bendinelli, Bacinella di bronzo barbarica, scoperta in località "Condotti," NSc, 1920, pp. 121–22; A. Vogliano, Iscrizioni greche, NSc, 1925, pp. 373–74; U. Antonielli, L'età enea in Etruria, SEtr, I, 1927, pp. 1–60 at 57; P. C. Sestieri, La chiesa di Santa Maria del Parto presso Sutri e la diffusione della religione di Mitra nell'Etruria meridionale, BMImp, V, 1934, pp. 33–36; P. C. Sestieri, L'anfiteatro di Sutri, Palladio, III, 1939, pp. 241–48; G. Foti, Saggio di scavo in contrada "Solfatara," NSc, 8th ser., IV, 1950, pp. 53–59; R. Bartoccini, Sutri: Tombe etrusche, FA, VI, 1951, 2605; P. Portoghesi and others, I Palazzi Giustiniani a Bassano di Sutri e a Roma, BArte, XLII, 1957, pp. 222–308; G. Duncan, Sutri, BSR, XXVI, 1958, pp. 63–134; J. B. Ward Perkins, The Problem of Etruscan Origins, Harvard S. in Classical Philology, LXIV, 1959, pp. 1–26.

Tarquinia (Etruscan, Tarchuna; Lat., Tarquinii). One of the greatest cities of Etruria, it was finally conquered by Rome in the 3d century B.C. and federated. It became a municipium in 90 B.C. and was still prosperous in the Imperial period. Remains include walls of the 5th–4th century B.C., the so-called "Ara della Regina," the podium of a large temple (capitals and fragments of a terra-cotta pediment with winged horses), and Roman baths. The Etruscan necropolis of Tarquinia, its tombs painted with funerary scenes and scenes of everyday life, provides the most important surviving examples of Etruscan painting of the 6th–1st century B.C. About 50 painted tombs are preserved, most of which can be visited (I, PLS. 363, 364; IV, PL. 263; V, PLS. 32, 41, 42, 46; VI, PLS. 55, 56; IX, PL. 2; X, PL. 480). Some of the wall paintings have been detached and are in the Museo Nazionale Tarquiniese (I, PLS. 368, 374). Among other objects of artistic interest found in the tombs, particularly noteworthy are the Hellenistic stone sarcophagi adorned with portraits and reliefs. Tarquinia was destroyed in the Middle Ages, and a new city, Corneto, was built nearby. Corneto, which took the name of Tarquinia in the 20th century, is a picturesque town with some notable monuments. Surrounded by walls built in the 9th–10th century (several times restored), Tarquinia is predominantly medieval in appearance and has many towers. One of the oldest churches is that of S. Maria di Castello (1121–1208), which incorporates Lombard forms with Cosmati decoration. The façade has three portals, the central one by Pietro di Ranuccio (1143); the twin-arched window above it is by Nicola di Ranuccio (III, PL. 478). The Romanesque Church of S. Giacomo Apostolo has a single aisle. Arabic-Byzantine influences are evident in the cupola. S. Martino and S. Salvatore are also Romanesque. The following churches were built in the period of transition from Romanesque to Gothic (13th cent.): S. Pancrazio, with a rose window on the façade and three semicircular apses (one redone); the Annunziata, in the shape of a Tau cross; S. Francesco, in the shape of a Latin cross, with Romanesque piers and a raised transept with Gothic arches; and S. Giovanni Battista (remodeled), with three apses. The Palazzo Vitelleschi, built in the first half of the 15th century, incorporates earlier Gothic structures. The palace now houses the Museo Nazionale Tarquiniese.

BIBLIOG. E. La Valle, Corneto e i suoi monumenti, Tarquinia, 1909; A. K. Porter, La chiesa dell'Annunziata di Corneto, Arte e storia, XXXII, 1913, pp. 260–65; A. K. Porter, S. Giacomo di Corneto, Arte e storia, XXXII, 1913, pp. 165–71; A. K. Porter, S. Giovanni Gerosolimitano di Corneto-Tarquinia, Arte e storia, XXXII, 1913, pp. 325–30; A. K. Porter, San Pancrazio di Corneto, Arte e storia, XXXII, 1913, pp. 9–17; A. K. Porter, S. Francesco di Corneto-Tarquinia, Arte e storia, XXXIII, 1914, pp. 5–12; R. Krautheimer, Lombardische Hallenkirchen in XII. Jahrhundert (S. Maria di Castello), Jhb. für Kw., 1928, pp. 176–91; P. Ducati, La pittura delle tombe delle Leonesse e dei vasi dipinti (MPA, I, 1), Rome, 1937; M. Pallottino, Tarquinia, MALinc, XXXVI, 1937, cols. 1–615; B. M. Apollonj, La chiesa di S. Giacomo a Tarquinia, Palladio, II, 1938, pp. 171–83; G. Giovannoni, Palazzo Vitelleschi, Palladio, V, 1940, p. 85; L. Marchese, Tombe etrusche e romane in località Monterozzi, ai Primi Archi, NSc, 7th ser., V–VI, 1944–45, pp. 7–23; P. Romanelli, Scavi e ricerche nell'area della città, NSc, 8th ser., II, 1948, pp. 193–270; E. Stefani, Scoperta di due tombe etrusche dipinte, NSc, 8th ser., VIII, 1954, pp. 185–94; L. Banti, Problemi della pittura arcaica etrusca: La tomba dei Tori a Tarquinia, SEtr, XXIV, 1955–56, pp. 143–81; G. Becatti and F. Magi, Le pitture delle tombe degli Auguri e del Pulcinella (MPA, I, 3–4), Rome, 1955; G. Jacopi, CVA, Italia, fasc. 25–26, Rome, 1955; R. Bartoccini, C. M. Lerici, and M. Moretti, La tomba delle Olimpiadi, Milan, 1959; R. Pardi, Nuovi rilievi della chiesa di S. Maria di Castello in Tarquinia, Palladio, N.S., IX, 1959, pp. 79–83; P. Romanelli, Tarquinia: La necropoli e il museo, 4th ed., Rome, 1959.

Terracina. The Volscian city of Anxur became the Roman colony of Tarracina in 329 B.C. (remains of polygonal walls). The Via Appia served as the city's decumanus maximus. There are remains of a forum and basilica in the upper city. In the lower city (outside the walls) are other ruins. There are remains of baths, an amphitheater, and, on Mt. S. Angelo, a temple of Jupiter Anxur. The city was a possession of the Church from the Middle Ages to the 19th century. The medieval center of Terracina, on the slope of a hill, has narrow streets and houses with external staircases. The modern part of the city extends from the Appian Way to the sea. The Cathedral was consecrated in 1074, completed in the 13th century, partially redone in the 17th century, and restored in the 20th century. It was built on the site of a temple of Apollo, of which parts are preserved. On the architrave of the portico of the Cathedral is a 12th-century mosaic frieze. The interior has three aisles divided by ancient columns, a Cosmati pavement (III, PL. 483), a Cosmati pulpit (1245) supported by five columns on lions, and a 13th-century paschal candlestick. The 14th-century brick campanile has four stories of blind pointed arches. The Gothic influence of the nearby Abbey of Fossanova is evident in the architecture of other churches. S. Domenico (13th cent.) has a large rose window on its façade. S. Francesco and the Annunziata were severely damaged in World War II. There are several interesting civil structures of the Middle Ages. The Antiquarium has an archaeological collection.

BIBLIOG. L. Borsari, Del tempio di Giove Anxure, scoperto sulla vetta di Monte S. Angelo, NSc, 1894, pp. 96–111; A. Rossi, Terracina e la palude pontina, Bergamo, 1912; G. Lugli, Anxur-Tarracina (Forma Italiae), Rome, 1926; C. C. van Essen, Terracina, Hermeneus, XXV, 1953–54, pp. 129–33; S. Aurigemma, A. Bianchini, and A. De Santis, Circeo, Terracina, Fondi, Rome, 1957; G. Zander, Terracina medievale e moderna attraverso le sue vicende edilizie, Q. Ist. Storia Arch., 31–48, 1961, pp. 315–30.

Tivoli (Lat., Tibur). An ancient city that entered the Roman orbit very early, Tivoli preserves notable monuments of antiquity, especially of the Roman republican period. Remains include the mensa ponderaria near the modern Piazza del Duomo, where the forum was located; a round Corinthian temple, the so-called "Temple of the Sibyl," or "Temple of Vesta" (VII, PL. 201); a rectangular temple (1st cent. B.C.); a market; an amphitheater; baths and a large sanctuary of Hercules Victor. There were many villas in the area (including those of Cassius, Horace, and Maecenas), of which im-

portant remains are still extant. The city also prospered in the Middle Ages. Many of the churches are of medieval origin, datable to the 10th–14th century but subsequently remodeled and rebuilt, especially in the 18th century. They have a basilican ground plan and campaniles decorated with ancient marbles and polychrome plates of ceramic. Many have been restored. The Church of S. Pietro, which was restored to its original form in 1959, has an interesting crypt and remains of Cosmati pavement. The lower Church of S. Biagio dates from the 11th century; the upper church was added in the 14th century. S. Maria Maggiore was probably erected in the Early Christian period. It retains the façade of the Romanesque reconstruction, with Gothic elements (portal and rose window). The Church of S. Silvestro has a single aisle and a crypt. There are frescoes from the 12th–13th century on the triumphal arch and in the apse. The church preserves a wooden relief of St. Valerius (1138). The Cathedral was reconstructed in the 12th century on the site of a Roman structure that had been transformed into a church. The upper part of the façade and the campanile are all that remain of the Romanesque structure; the rest is a later remodeling. The Cathedral preserves a wooden sculpture of the Deposition (an early-13th-century masterpiece) and a silver reliquary enclosing a triptych of the Saviour between Mary and St. John (11th–12th cent.). The Rocca Pia, a Renaissance fortress, was erected in the 15th century. The most important 16th-century structure is the Villa d'Este, with its terraced gardens, ingenious waterworks, and fountains (IX, PL. 313). Pirro Ligorio built the villa (1550) for Cardinal Ippolito d'Este (VIII, PL. 432). The interior was decorated by followers of the Zuccaris and other 16th-century painters.

Near Tivoli is Hadrian's Villa, constructed between 125 and 135 of our era by Emperor Hadrian, who wished to commemorate his travels by recreating the buildings and objects that had most impressed him in Greece and Egypt. The villa, almost a city in its size and inhabited throughout the Imperial period without any important changes, consists of various groups of buildings arranged with a knowing sense of scenography. The structures are laid out on different levels, according to the disposition of the terrain. The various architectural groups are separated by large areas of green and joined by peristyles, porticoes, and cryptoporticuses. Fountains and pools of water, rich architectural decoration, paintings, mosaics, and reliefs added to the sumptuousness of the villa. Aside from the Greek Theater, the Nymphaeum (presumed Temple of Venus), and the so-called "Palaestra," the remaining edifices can be grouped together in this way: the Poikile, the so-called "Philosophers' Hall," the building with three exedrae, and the nymphaeum formerly thought to be a stadium; the Canopus (III, PL. 386) with the Temple of Serapis, preceded by the vestibule and by the Small and Great Baths and flanked by the Praetorium; the Piazza d'Oro, the Doric Atrium, the Great Peristyle, the Court of the Libraries, the *hospitalia* (rooms for guests), the Imperial Triclinium, and the Pavilion of Tempe; the Odeon, the "Academy," the Tower of Roccabruna, the Island Nymphaeum ("Water Theater"), baths with the *heliocaminos*, the Greek and Latin Libraries, and the barracks of the guards. The hundreds of works of art (e.g., statues and mosaics) found in the villa are preserved in the Capitoline and Vatican Museums, in the Torlonia Collection, in the Galleria Borghese (all in Rome), and in the Louvre and in other museums (VII, PL. 205; X, PLS. 174, 265). Recent archaeological finds are in the Antiquarium di Villa Adriana.

BIBLIOG. S. Cabral and F. Del Re, Delle ville e de' più notabili monumenti antichi della città e del territorio di Tivoli, Rome, 1779; R. Del Re, Tivoli e i suoi monumenti antichi e moderni, Rome, 1886; G. Cascoli, Bibliografia di Tivoli, Tivoli, 1923; A. Boëthius and N. Carlgren, Die spätrepublikanischen Warenhäuser in Ferentino und Tivoli, ActaA, III, 1932, pp. 181–208; C. Carducci, Tibur, Rome, 1940; D. Faccenna, Prima notizia intorno al rinvenimento dell'anfiteatro romano, NSc, 8th ser., II, 1948, pp. 278–83; C. Pietrangeli, La villa tiburtina detta di Cassio, RendPontAcc, XXV–XXVI, 1949–51, pp. 157–81; M. De Vita, Il restauro della chiesa di S. Pietro in Tivoli, BArte, XXXVI, 1951, pp. 174–79; D. R. Coffin, The Villa d'Este at Tivoli, Princeton, 1960. *Hadrian's Villa*: F. Piranesi, Pianta delle fabbriche esistenti nella Villa Adriana, Rome, 1781; H. Kähler, Hadrian und seine Villa bei Tivoli, Berlin, 1950; H. Kähler, EAA, s.v. Adriana, villa, I, 1958, pp. 74–83; R. Vighi, Villa Hadriana, Rome, 1958; S. Aurigemma, Villa Adriana, Rome, 1962.

Tuscania. An Etruscan city and later a Roman municipium, Tuscania preserves remains of its ancient walls as well as Etruscan sarcophagi. The city was of particular importance during the Middle Ages. About 1300 the city took the name of Toscanella, but in the 20th century it resumed its ancient name. Examples of medieval civil architecture include numerous squat towers and a few houses with external staircases of the type characteristic of Viterbo, the ruins of the old castle, and the Palazzo del Podestà. Particularly noteworthy are the churches of S. Pietro and S. Maria Maggiore. S. Pietro, flanked by two towers and the ruins of the Palazzo Episcopale, dates

to the 8th century but was enlarged and partially reconstructed in the 11th–12th century (restored in 1959). The façade (12th–13th cent.; restored in 1870) has three portals, a loggia, and a large rose window decorated with sculpture and flanked by two twin-arched windows. The interior has three aisles divided by large arches supported by short columns. There are Byzantinizing frescoes in the apse. The crypt has groin vaults supported by columns. Some of the capitals were taken from earlier constructions. S. Maria Maggiore was built toward the end of the 8th century and almost entirely rebuilt in the 12th. The façade has three richly sculptured portals, a small loggia above the central portal, and a large rose window (PL. 176). The interior has a Latin-cross plan with three aisles divided by columns with Romanesque capitals. The ambo was recomposed in the 12th century with 8th- and 9th-century marble work. In the apse is a 13th-century fresco of the Last Judgment. The rectangular campanile also dates from the 13th century. The Church of the Rosa was built in the 14th century and has been remodeled several times. The façade has three portals and a rose window between two Gothic twin-arched windows. The interior has three aisles and preserves a carved wooden altarpiece with scenes painted by Giulio Pierino d'Amelia (16th cent.). The three-aisled Church of S. Maria del Riposo is a Renaissance structure. This church, too, has a carved wooden altarpiece with panels by Giulio Pierino d'Amelia. The Cathedral was built in the 18th century.

BIBLIOG. S. Campari, Tuscania e i suoi monumenti, 2 vols., Montefiascone, 1856; A. Aureli, Toscanella e i suoi monumenti, Viterbo, 1910; G. Cerasa, Gli acquedotti e le fontane di Tuscania, Viterbo, 1914; G. Bendinelli, Tomba a camera rinvenuta in località "Poggio Calvello": Resti di costruzioni romane presso la chiesa di S. Maria Maggiore, NSc, 1920, pp. 112–17; E. Lavagnino, S. Pietro a Toscanella, L'Arte, XXIV, 1921, pp. 215–23; H. Thümmler, Die Kirche S. Pietro in Tuscania, Jhb. der Bib. Hertziana, II, 1938, pp. 263–88; P. Verdier, La façade-temple de l'église San Pietro de Tuscania, Mél, LVII, 1940, pp. 178–89.

Veio (Lat., Veii). This Etruscan city submitted to Rome, after a severe struggle, at the beginning of the 4th century. Of the Etruscan city there remain sections of the walls in ashlar and traces of sanctuaries, including a small temple of the 6th century B.C. on the acropolis, and especially the Temple of Portonaccio (6th–5th century). From the excavations of this temple come numerous architectural terra cottas of the archaic period (V, PL. 38). Particularly interesting are the acroteria in the form of statues, including the famous Apollo of Veio (I, PL. 359). Many small votive statues in terra cotta have been found (V, PLS. 39, 47). There are archaic necropolises around Veio. Particularly noteworthy is the Campana Tomb, which preserves traces of Orientalizing wall paintings (7th–6th cent. B.C.).

BIBLIOG. R. Lanciani, Scoperte nell'area della città e nella necropoli veientana, NSc, 1889, pp. 10-12, 29–31, 60–65; R. Mengarelli, Nuove indagini nell'area della necropoli veientana, NSc, 1901, pp. 238–46; E. Gabrici, Brevi cenni intorno all'andamento degli scavi che si fanno a Veio . . . , NSc, 1913, pp. 164–69; E. Stefani, Scoperte archeologiche al bivio della Cassia e della Clodia, NSc, 1913, pp. 384–91; G. A. Colini et al., Scavi nell'area della città e della necropoli, NSc, 1919, pp. 3–37; G. Q. Giglioli, Veio: Ritrovamenti sporadici, NSc, 1923, pp. 163–73; R. U. Inglieri, Veio: Scavi nella necropoli, NSc, 1930, pp. 45–73; E. Stefani, Esplorazione del tumulo di Vaccareccia, NSc, 1935, pp. 329–65; R. Vighi, Veio: Scavi nella necropoli, NSc, 1935, pp. 39–68; M. Santangelo, Per la storia di Veio . . . , RendLinc, 8th ser., III, 1948, pp. 454–64; M. Pallottino, Il grande acroterio femminile di Veio, AC, II, 1950, pp. 122–79; M. Santangelo, Veio, santuario "di Apollo," BArte, XXXVII, 1952, pp. 147–72; E. Stefani, Tempio detto dell'Apollo . . . , NSc, 8th ser., VII, 1953, pp. 29–112; C. Ambrosetti, Resti di necropoli etrusca: Iscrizione votiva, NSc, 8th ser., VIII, 1954, pp. 1–5; S. Ferri, La "Iuno Regina" di Veii, SEtr, XXIV, 1955–56, pp. 107–13; G. Baffioni, L'emissario del lago Albano e il destino di Veio, SEtr, XXVII, 1959, pp. 303–10; J. B. Ward Perkins, Excavations Beside the North-west Gate at Veii, 1957–58, BSR, XXVII, 1959, pp. 38–79; J. B. Ward Perkins, Veii: The Historical Topography of the Ancient City, BSR, XXIX, 1961, pp. 1–123.

Velletri (Lat., Velitrae). This very ancient Volscian city (Velester) was finally conquered by Rome in the 4th century. Remains include traces of an amphitheater, temples, a basilica, and large villas of the Imperial period. A commune in the 12th century, Velletri passed to the Church in the 16th century. Severely damaged during World War II, Velletri preserves few monuments. The Cathedral was built over the ruins of a Roman pagan basilica (perhaps in the 4th cent.; much remodeled in the 13th and 14th). It was restored in 1659–62. The Torre del Trivio (1353) has three stories of double twin-arched windows and one of single-arched windows. The Church of S. Maria del Trivio was completely rebuilt (1622) after a design by C. Maderno. The façade is neoclassic (1840). S. Maria del Sangue (1523–79) is an octagonal structure with simple forms in the style of Bramante. The church may have been built after a design by Alessandro da Parma. S. Martino, mentioned in 1065, was reconstructed on a Greek-cross plan in 1772–78. The Palazzo Comunale was begun by

G. della Porta, after a design by Vignola (1573–80). It was completed in the 18th century and was restored in the 20th.

BIBLIOG. A. Remiddi, Il palazzo comunale di Velletri, Frosinone, 1904; A. P. Wagener, Roman Remains in the Town and Territory of Velletri, AJA, XVII, 1913, pp. 399–428; A. Gabrielli, La cattedrale di Velletri nella storia dell'arte, Velletri, 1918; G. Lugli, Studi topografici intorno alle antiche ville suburbane, BCom, LVIII, 1930, pp. 5–28; R. Vighi, Nuove ricerche nella villa veliterna creduta degli Ottavi, BMImp, XII, 1941, pp. 17–33; G. Cressedi, Velitrae, Rome, 1953; G. Zander, Il tempietto di Santa Maria del Sangue, Palladio, N.S., IV, 1954, pp. 85–89.

Viterbo (Lat., Viterbium). A small city in Roman times, Viterbo may once have been Etruscan. There are remains of Roman public works (bridges, aqueducts, and baths). A free commune (11th cent.) and residence of the popes, Viterbo enjoyed great prosperity until the 14th century. The city walls date from this period. The S. Pellegrino quarter survives almost intact, with houses of two or three stories, dominated by towers, and equipped with external staircases (*profferli*). Narrow streets of such houses surround the Piazza S. Pellegrino, where the Palazzo degli Alessandri stands (first half of 13th cent.). Noteworthy are the Casa Poscia (14th cent.), the Palazzo di Donna Olimpia, and the Gatti (13th cent.; restored), Capocci, and De Vico palaces. Examples of Romanesque religious architecture include the remains of the Church of the Morte (formerly S. Tomaso; restored). Other noteworthy 11th-century churches are those of the Gesù (formerly S. Silvestro), S. Giovanni in Zoccoli, S. Sisto, and S. Maria Nuova. The Church of S. Francesco was built in 1236 and remodeled in the 14th–17th century. It was severely damaged in World War II and subsequently restored. The church preserves the tomb of Pope Hadrian V, attributed to Arnolfo di Cambio, and that of Cardinal Marco da Viterbo (IV, PL. 455). The former Church of S. Maria della Verità was built in the 12th century,

a good deal enlarged in the 14th and 15th centuries, and recently restored. The single-aisled, Latin-cross structure now houses the Museo Civico. The 13th-century Church of S. Pietro has a baroque façade (1622). S. Andrea, founded in the 12th century, has a 13th-century crypt of the Cistercian type. The Gothic S. Maria della Salute has an elegant checkerboard façade and a 14th-century portal with low-relief decoration. The Cathedral dates from the 12th century but was considerably remodeled in the 16th and 17th centuries (restored). The campanile was remodeled in Gothic style in the second half of the 14th century. In the Piazza della Cattedrale is the Palazzo Papale (1257–66) with the adjoining Loggia (1267) and the Romanesque house of Valentino della Pagnotta. Typical of the structures of medieval Viterbo are the fountains, generally set on a polygonal or circular basin with a central shaft: Fontana Grande (Bertoldo and Pietro di Giovanni; 1206–79) and those in Piazza della Morte and Piazza di Fontana di Piano. Renaissance buildings include the octagonal Oratory of S. Elisabetta (or S. Maria della Peste; 1494), in the style of Bramante; S. Giovanni Battista (1515), designed by Bernardino di Giovanni; and S. Maria delle Fortezze (1514), designed by Battista di Giuliano da Cortona (restored). Also of this period are the Palazzo Farnese, in late Gothic style, the Palazzo Chigi (15th cent.), and the Palazzo Santoro (1466). Baroque churches include S. Ignazio (1671), the Pace (1667), and the Gonfalone (1665–1726). S. Angelo in Spata, rebuilt in 1746, incorporates Romanesque remains. To the right of the portal is a Roman sarcophagus (known as the tomb of Bella Galiana). The Museo Civico (in the former Church of S. Maria della Verità) has an archaeological collection and a painting gallery (with works by Sebastiano del Piombo).

Outside Viterbo is the Renaissance Church of S. Maria della Quercia (1470–1525), with a rusticated façade. The cloister has two stories; the lower is Gothic, and the upper is Renaissance.

In nearby Bagnaia is the Villa Lante, completed in 1578 after a design attributed to Vignola. The park has an Italian-style garden and numerous fountains (VIII, PL. 433). In Bomarzo is the Palazzo Orsini (1525–83), in part the work of Vignola. The palace consists of two structures joined by terraces and surrounded by a park with sculptures of imaginary creatures (X, PL. 137). In Caprarola is the Villa Farnese; begun by Antonio da Sangallo the Younger, it was completed by Vignola (I, PL. 388; IV, PL. 191). The salons were frescoed by T. and F. Zuccari (IX, PL. 310).

BIBLIOG. C. Pinzi, Gli ospizi medievali e l'Ospedale grande di Viterbo, Viterbo, 1893; R. Mortimer, Santa Maria della Quercia, Florence, 1904; G. Palducci, Il Palazzo Farnese di Caprarola, Rome, 1910; C. Pinzi, Il Palazzo papale di Viterbo, Viterbo, 1910; C. Pinzi, I principali monumenti di Viterbo, 4th ed., Viterbo, 1911; V. Scriattoli, Viterbo nei suoi monumenti, 2 vols., Rome, 1915–20; A. Jacobetti, La chiesa monumentale di S. Francesco d'Assisi, Viterbo, 1935; L. Collobi, Taddeo e Federico Zuccari nel Palazzo Farnese a Caprarola, CrArte, III, 1938, pp. 70–74; Special issue dedicated to the Villa Orsini di Bomarzo, Q. Ist. Storia Arch., 7–9, 1955; A. Gottardi, Viterbo nel Duecento, Viterbo, 1955; M. Rivosecchi, Bomarzo: Il Vignola e le ville della Tuscia, Capitolium, XXX, 1955, pp. 171–78; A. Bruschi, Bagnaia, Q. Ist. Storia Arch., 17, 1956, pp. 1–15; M. Calvesi, Il Sacro Bosco di Bomarzo, Scritti di storia dell'arte in onore di L. Venturi, I, Rome, 1956, pp. 369–402; A. Cantoni, La Villa di Bagnaia, Rome, 1957; E. Quaranta, Incantesimo a Bomarzo, Florence, 1960.

Vulci (Etruscan, Veic-). This powerful Etruscan city was conquered by the Romans in 280 B.C. and later became a municipium. Excavations have revealed walls and gates, the *decumanus*, and a large temple. The civilization and artistic production of Etruscan Vulci can be seen in the objects found in the necropolises (8th–2d cent. B.C.). There are tumulus tombs and chamber tombs (e.g., the François Tomb, with painted walls; IV, PL. 169; V, PL. 52; VII, PL. 260). Nenfro funerary sculpture has been found as well as bronze sculptures and large quantities of imported Greek ceramics (IV, PL. 168; V, PLS. 30, 50, 56, 185, 186; VI, PL. 247; VII, PL. 18; IX, PL. 504; X, PLS. 98, 410). The picturesque Ponte dell'Abbadia is a Roman reconstruction, but the supports of the bridge are Etruscan.

BIBLIOG. S. Gsell, Fouilles de Vulci, Paris, 1891; G. Bendinelli, Relazione sopra una campagna di scavi nel territorio di Vulci 1925–27, SEtr, I, 1927, pp. 129–44; R. Mengarelli, Nuove ricerche archeologiche a Vulci, BArte, N.S., VIII, 1928–29, pp. 368–80; F. Messerschmidt, Nekropolen von Vulci, Berlin, 1930; M. Guarducci, I bronzi di Vulci, SEtr, X, 1936, pp. 15–53; F. Rittatore, Recenti scoperte del periodo eneolitico e dell'età del bronzo nella valle del fiume Fiora, SEtr, XX, 1948, pp. 267–70; A. Hus, Sculpture étrusque archaïque: Le cavalier marin de la Villa Giulia, Mél, LXVII, 1955, pp. 71–126; R. Bartoccini, Vulci: Storia, scavi, rinvenimenti, Atti VII Cong. int. Archeol. classica, Rome, 1960, p. 125 ff.

Abruzzi and Molise. These territories, essentially mountainous areas that are rich in prehistoric remains, were inhabited in ancient times by the so-called Sabellian peoples: Sabines, Equi, Marsi, Peligni, Pretuzi, Marrucini, and to the south the large Samnite groups (whence the ancient name of Samnium). There are numerous remains

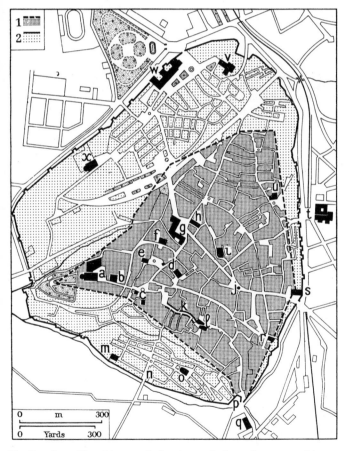

Viterbo, plan. Key: (1) area of the city until the 11th century; (2) area of expansion within the walls, 11th–13th century. Principal monuments: (a) Cathedral (S. Lorenzo), Loggia and Palazzo Papale; (b) Palazzo Farnese; (c) Church and Loggia of the Morte; (d) S. Maria Nuova and Torre del Borgognone; (e) Church of the Gesù; (f) Palazzo Chigi; (g) Palazzo Comunale and Palazzo del Podestà; (h) S. Angelo in Spata; (i) Casa Poscia; (j) Fontana Grande; (k) Via S. Pellegrino and the medieval quarter; (l) Palazzo degli Alessandri and Church of S. Pellegrino; (m) S. Carlo; (n) Porta del Carmine; (o) S. Andrea; (p) Porta S. Pietro; (q) Church of S. Pietro; (r) S. Maria delle Fortezze; (s) S. Sisto; (t) S. Maria della Verità (Museo Civico); (u) S. Giovanni in Zoccoli; (v) S. Francesco; (w) La Rocca; (x) Church of SS. Trinità.

of walls of polygonal masonry, sculpture, and Italic bronzes. A cantonal structure of the inhabited zones and a pastoral economy have always been characteristic of the region; moreover, the Romanization that progressed along the route of the Via Valeria, the Via Claudia Nova, and the Via Caecilia retained significant local features. The Romanesque and Gothic styles of this area also had distinctive accents, a certain provincialism not without rude vigor, especially in the urban churches and the Cistercian abbeys, with their elaborately sculptured ambos. Even today certain traditions of folk art (ceramics, woodworking) have retained an importance consonant with the rustic, self-subsistent character of much of the region.

BIBLIOG. E. W. Schulz, Denkmäler die Kunst des Mittelalters in Unteritalien, Dresden, 1860; C. Minieri Riccio and A. Parascandolo, Bibliografia storico-topografica degli Abruzzi, Naples, 1862; V. Bindi, Monumenti d'arte negli Abruzzi, Naples, 1882; V. Bindi, Monumenti storici ed artistici degli Abruzzi, Naples, 1889; P. Piccirilli, L'Abruzzo monumentale, Rass. abruzzese, III, 1899–1900, pp. 3–30; P. Piccirilli, La Marsica, Trani, 1904; L. Fiocca, L'arte negli Abruzzi: Porte delle chiese marse, L'Arte, XI, 1908, pp. 47–51; V. Balzano, L'arte abruzzese, Bergamo, 1910; G. A. Colini, Scoperte archeologiche nella Valle del Vibrata, Parma, 1910; R. Gardner, The Via Claudia Nova, JRS, III, 1913, pp. 205–32; G. Poggi, Arte medievale negli Abruzzi, Milan, 1914; U. Rellini, L'età della pietra sulla Maiella, BPI, XL, 1914, pp. 30–42, 95–121; Ministero Pubblica Istruzione, Elenco degli edifici monumentali, XLV: Provincia di Teramo, Rome, 1916; A. Muñoz, Monumenti d'Abruzzo, BArte, XI, 1917, pp. 35–48; A. Maurer, Petites villes d'Italie: Abruzzes, Pouilles, Campanie, Paris, 1920; C. Gradara, L'arte in Abruzzo, B. del Bibliofilo, III, 1921, pp. 93–108; Ministero Pubblica Istruzione, Elenco degli edifici monumentali, XLV: Provincia di Chieti, Rome, 1921; C. Gradara, Bibliografia artistica dell'Abruzzo, Rome, 1927; Ministero Pubblica Istruzione, Elenco degli edifici monumentali, XLVI: Provincia di Aquila, Rome, 1927; E. Galli, Monumenti ignorati del Bruzio e della Lucania, BArte, N.S., VII, 1927–28, pp. 385–415; I. C. Gavini, Storia dell'architettura in Abruzzo, 2 vols., Milan, Rome, 1927–28; G. Matthiae, Architettura medievale nel Molise, BArte, XXXI, 1937–38, pp. 93–116; C. de Danilovich, Carta topografica dell'arte rustica dell'Abruzzo e Molise, Lares, XIII, 1942, pp. 324–50; O. Lehmann-Brockhaus, Die Kanzeln der Abruzzen im 12. und 13. Jahrhundert, Jhb. der Bib. Hertziana, VI, 1946, pp. 257–423; D. Priori, Badie e Conventi Benedettini di Abruzzo e Molise, I, Lanciano, 1950; A. M. Radmilli and others, Attività della Sopraintendenza alle Antichità di Chieti e della sezione abruzzese-molisana dell'Istituto Italiano di Paletnologia umana, BPI, N.S., VIII, 5, 1953, pp. 48–83; A. M. Radmilli, Una nuova facies del paleolitico superiore italiano presente in Abruzzo, BPI, N.S., IX, 1954–55, pp. 73–105; Restauri di edifici monumentali dell'Abruzzo e del Molise, Palladio, N.S., V, 1955, pp. 91–94; G. Leopardi and A. M. Radmilli, Esplorazioni paletnologiche in Abruzzo, BPI, N.S., X, 1956, pp. 433–48; V. Cianfarani, Terra italica, Turin, 1959; M. Ortolani, La casa rurale negli Abruzzi e del Molise, Florence, 1961. Periodical: Rass. d'arte degli Abruzzi e del Molise, 1912 ff.

Alba Fucens (It., originally Albe). This city of the Equi was made a colony by the Romans in 303 B.C., and afterward a municipium. The Roman city, orthogonal in plan, extended over a hill with three summits and into a valley crossed by the Via Valeria. Walls of polygonal masonry, in part contemporary with the establishment of the colony, with sections of irregular work from the Sullan period, are extant. Remains include a Tuscan temple in antis, dedicated to Apollo; amphitheater (mid-1st century of our era); theater; cryptoporticus; forum with basilica, market, and baths; shops along the Via dei Pilastri. The town of Albe had become insignificant by the end of the Middle Ages and was destroyed by the earthquake of 1915. Surviving, however, are traces of the façade of the Romanesque church of S. Pietro, with a portal of 1526 and a Cosmatesque ambo, work of the Roman marble artisans identified as Giovanni and Andrea (12th–13th cent.).

BIBLIOG. C. Promis, Le antichità di Alba Fucense negli Equi, Rome, 1836; I. C. Gavini, Studi sull'architettura d'Abruzzo, Rass. d'arte degli Abruzzi e del Molise, IV, 1915, pp. 1–75; I. C. Gavini, Sommario della storia della scultura in Abruzzo, Atti I Conv. storico abruzzese-molisano, I, Casalbordino, 1933, pp. 353–72; E. Carli, Affreschi benedettini del XIII secolo in Abruzzo, Le Arti, I, 1938–39, pp. 442–63; F. de Visscher et al., Scavi di Alba Fucense, NSc, 8th ser., IV, 1950, pp. 248–88; J. Bingen, Elenco descrittivo del materiale rinvenuto nelle campagne di scavo 1949–50, NSc, 8th ser., VI, 1952, pp. 233–52; M. Guarducci, Graffiti nell'antico tempio sul colle di S. Pietro, NSc, 8th ser., VII, 1953, pp. 117–25; F. de Visscher and J. Mertens, Alba Fucense: Notizie sommarie sugli scavi eseguiti nel 1955, NSc, 8th ser., XI, 1957, pp. 163–70; EAA, s.v.; J. Mertens, Le système urbain d'Alba Fucens à l'époque républicaine et la centuration de l' "Ager Albensis," AntC, XXVII, 1958, pp. 363–72.

Alfedena (Lat., Aufidena). City of the Caracenian Samnites, in the valley of the Sangro, the site has a necropolis rich in bronzes, as well as walls of cyclopean dry masonry. Remains of the Roman era are also in evidence. The medieval section retains a few houses, ruins of the castle, and the Church of SS. Pietro e Paolo (13th cent.; four aisles, irregular ground plan) and is separated from the modern part of the town. Museum: Museo Civico Aufidenate.

BIBLIOG. C. Mariani, Aufidena, MALinc, X, 1901, cols. 226–638; G. Carocci, Alfedena: Le sue antichità, il suo Museo, Arte e storia, XXI, 1902,

pp. 25–26; M. Barosso, L'abbazia di S. Vincenzo Martire alle fonti del Volturno, Palladio, N.S., V, 1955, pp. 164–67; EAA, s.v.

Aquila. The settlement was founded in 1254 and laid out according to a regular checkerboard ground plan. Wars and frequent earthquakes have in part modified the original appearance of the town, which nonetheless reveals the stamp of medieval city planning. Many of its monuments have been restored and reconstructed over the centuries. Outside the city walls is S. Maria di Collemaggio (begun 1287), which has remained almost intact; this structure, typical of the late Romanesque of the region, has a rectangular façade of pink and white dressed stones in geometric designs, three rose windows, and three extremely ornate portals. The three-aisled interior (redone 1706) has paintings by C. Ruthart (17th cent.) and holds the tomb of S. Pietro Celestino by Girolamo da Vicenza (1517). Other Romanesque edifices: S. Flaviano (end of 13th cent.); S. Giusta (1257, remodeled inside); S. Maria di Paganica (1308, greatly restored), with impressive sculptured portals; S. Biagio, with the Camponeschi monument by Gualtiero d'Alemagna (1432); S. Silvestro (14th cent.; interior redone 18th cent.; frescoes of 15th cent.), with a portal in red and white dressed stones. Romanesque portals (lunette of right portal perhaps by Silvestro da Sulmona) remain on the Church of S. Marco (inside are important 15th- and 16th-cent. groups in wood), on S. Marciano, and on S. Pietro di Coppito. Gothic elements occur in the Church of S. Maria di Roio (beginning of 14th cent.) and in the former Church of S. Domenico (1309), which retains the lower part of the façade of the original construction. Of Renaissance origin: S. Bernardino (1454–72), atop a high staircase, with a façade by Cola dall'Amatrice (1527), punctuated by paired columns in three superimposed rows (Tuscan, Ionic, Corinthian), with horizontal crowning and three portals decorated with bas-reliefs by the school of Silvestro da Sulmona (baroque interior of 1674 and 1730, with carved wood ceiling by F. Mosca, who also made the organ); Mausoleum of S. Bernardino (1505) and Maria Pereira tomb (1496), both by Silvestro and assistants with terra cottas by Andrea della Robbia and Silvestro and canvases by P. Cesura; Madonna del Soccorso (outside the walls), with a façade of pink and white stone (1496) and a baroque interior covering the previous ogival structure, containing sculpture of the 15th and 16th centuries; Fountain of the Ninety-nine Spouts (early 15th cent.). Renaissance palaces: Dragonetti (15th cent.); Benedetti, with elegant 15th-century twin-arched windows; reconstruction of the Palazzo di Giustizia over a Gothic structure (1573, B. Marchirolo; restored at various times). Castle: square with bastions at the corners,

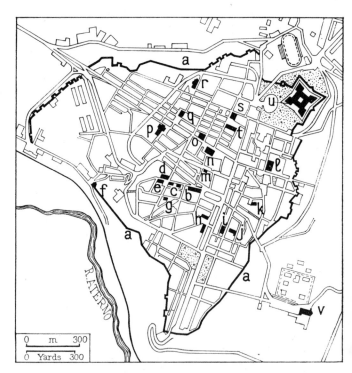

Aquila, plan of the city within and outside the medieval walls. Principal monuments: (a) Walls; (b) Cathedral; (c) Palazzo Rivera and Palazzo de Torres-Dragonetti; (d) Palazzo Persichetti; (e) S. Maria di Roio; (f) Fountain of the Ninety-nine Spouts; (g) S. Marciano; (h) churches of S. Marco and S. Agostino; (i) Palazzo Genti; (j) S. Giusta; (k) S. Flaviano; (l) S. Bernardino; (m) S. Biagio; (n) Palazzo di Giustizia; (o) Palazzo Quinzi; (p) S. Domenico; (q) S. Pietro di Coppito; (r) S. Silvestro; (s) Palazzo Franchi; (t) S. Maria di Paganica; (u) Castle; (v) S. Maria di Collemaggio.

surrounded by a moat (1535, by the Spaniard L. Scriva). Numerous baroque buildings (17th–18th cent.): Oratory of S. Luigi Gonzaga; Church of the Suffragio, with baroque interior, 19th-century dome by G. Valadier (other later decorations by F. Bedeschini and T. Patini); S. Agostino, 18th-century reconstruction by F. Fuga of an earlier Gothic church, much remodeled (elliptic plan topped with an elliptic dome). Baroque palaces: Centi (1766), Franchi (F. Fontana da Accumoli), Manieri, Sardi, Pica Alfieri, Carli, Persichetti (F. Fuga), Rivera, De Torres-Dragonetti, Antonelli. Damaged by earthquake at the beginning of the 18th century, the Cathedral was reconstructed in 1703, thereafter restored at various times. *Museums*: Museo Nazionale d'Abruzzo; Museo Diocesano.

Bibliog. L. Rivera, Le piante e i prospetti della città di Aquila, Aquila, 1905; F. Faraglia, La chiesa primitiva e il monastero di S. Bernardino nell'Aquila, Trani, 1912; G. B. Manieri, Come sorse il tempio di S. Bernardino in Aquila, Arte e storia, XXXI, 1912, pp. 18–20; L. Serra, Aquila monumentale, Aquila, 1912; A. Muñoz, I monumenti del Lazio e degli Abruzzi danneggiati dal terremoto, BArte, IX, 1915, pp. 61–112; Ministero Pubblica Istruzione, Elenco degli edifici monumentali: Provincia di Aquila, Rome, 1927; L. Serra, Aquila, Bergamo, 1929; E. Albino and others, Aquila nella storia e nell'arte, Rome, 1935; Inventario degli oggetti d'arte d'Italia: Provincia di Aquila, Rome, 1939; U. Chierici, Il Castello dell'Aquila, BArte, XXXVI, 1951, pp. 225–39; G. Matthiae, Il Castello dell'Aquila e il Museo Nazionale abruzzese, Rome, 1959.

Atri (Lat., Hatria Picena, Hadria). On a height with a view of the coast, this city of the Picenes was Romanized in the 3d century B.C. (graffiti vases and bronze furnishings of the 7th–5th cent. B.C., remains of Roman temple, architectural terra cottas). In the Middle Ages the site was the domain of the Acquavivas. Characteristic of the local architecture of the Romanesque-Gothic epoch are various churches with rectangular ground plan, no apses, and lunette vaults. The Cathedral (13th–14th cent.) has a rectangular façade with decorated portal and rose window (Rainaldo, 1302), as well as three portals on the right side. Worthy of note is the quadrangular bell tower with a polygonal cuspate crowning, the archetype for the bell towers of the province. The interior (three aisles) displays frescoes by A. Delitio (15th cent.); the crypt below (five aisles, 8th cent.?) is perhaps a Roman swimming pool transformed and has remains of frescoes. Nearby is a 14th-century cloister, along with a rich treasury and archives. S. Agostino (14th cent.) bears a rectangular façade from about 1470, with the portal attributed to Andrea Lombardo; the polygonal apse has decoration in terra cotta. Also extant are remains of S. Nicola di Bari (13th cent.), S. Andrea, and S. Domenico (14th-cent. façade, baroque interior). The Palazzo dei Duchi (14th cent.), erected over Roman pools, has a façade of Renaissance type constructed in the 18th century. There is a museum attached to the Cathedral.

Bibliog. E. Brizio, Scoperta di un tempio romano e della necropoli preromana, NSc, 1901, pp. 181–94; E. Brizio, Costruzioni romane nella città, NSc, 1902, pp. 4–13; L. Canevaghi, Antichi affreschi nel Duomo di Atri, BArte, I, 3, 1907, pp. 14–18; L. Sorricchio, Hatria, Rome, 1911; G. Aurini, il pittore della cattedrale di Atri, Rass. d'arte degli Abruzzi e del Molise, I, 1912, pp. 82–97; I. C. Gavini, Studio sull'architettura d'Abruzzo, Rass. d'arte degli Abruzzi e del Molise, IV, 1915, pp. 1–75; EAA, s.v.

Campobasso. The area retains traces of the pre-Roman city walls and the Norman walls (11th–13th cent.), as well as Romanesque elements in some of its churches (S. Bartolomeo, S. Giorgio). Survivals of Gothic architecture (14th–15th cent.) are found in the Church of S. Leonardo and in the S. Cristina and Mancini portals, the only remnants of the 14th-century walls. Of the reconstruction carried out by Nicolò Monforte after the earthquake of 1546, there remain the castle (1549) and ruins of the double circuit of walls, once united by arches and vaults for support. One or two small towers and the Porta S. Antonio record the defensive apparatus of the Aragonese (16th cent.). The lower city took form in the 17th and 18th centuries, with its late baroque houses and palaces. Nineteenth-century structures include the neoclassic Cathedral (SS. Trinità, 1829, B. Musenga), the Collegio M. Pagano (1800), and public buildings. The Museo Sannitico has archaeological and medieval objects.

In the vicinity is S. Maria della Strada, an early Benedictine abbey with a small church of the 12th century.

Bibliog. E. V. Gasdia, Sancta Maria de Strada, Riv. storica benedettina, XVI, 1925, pp. 29–67, XVII, 1926, pp. 35–55; G. Matthiae, Architettura medievale nel Molise, BArte, XXXI, 1937–38, pp. 93–116; A. Mancini, Castelli molisani, I: Il Castello di Campobasso, Campobasso, 1942.

Carsoli (Lat., Carseoli, Carsioli). Town of the Equi and a station on the Via Valeria, 42 miles from Rome. A Latin colony from 302 to 298 B.C., it then became a municipium. On the site are traces of walls in ashlar work of tuff, the podium of a temple, and remains of various other edifices. A group of votive offerings of the 3d–2d century B.C., with heads in Italic style, is also present. Destroyed by the

Saracens, the town was rebuilt at the present site and became a fief of the Orsini family and then of the Colonnas. Noteworthy as well are the remains of the donjon of the Angevin castle (1293); the Palazzetto Orsini (13th cent.), with ogival twin-arched and Guelph windows; numerous houses of the 15th century; and a parish church of the 16th century.

Bibliog. P. Piccirilli, La Marsica: Appunti di storia e d'arte, Napoli nobilissima, XII, 1903, pp. 148–56; G. J. Pfeiffer and T. Ashby, Carsioli, Sup. Pap. Am. School of Classical Studies in Rome, I, 1905, pp. 108–40; A. Cederna, Carsòli: Scoperta di un deposito votivo del III secolo a. C., NSc, 8th ser., V, 1951, pp. 169–224; A. Cederna, Teste votive di Carsòli, AC, V, 1953, pp. 187–209; EAA, s.v.

Chieti (Lat., Teate Marrucinorum). Overlooking the right bank of the Pescara, this principal city of the Marrucini became a Roman municipium after the Social War. It was crossed by the Via Valeria (Corso Marrucino), which determined its development and its preeminent position among the Marrucinian centers. The high zone (Civitella) retains the ancient octagonal plan. Interesting Roman remains include a theater (second half of 1st cent. of our era); three temples on a high podium; and large cisterns connected with the baths, built in the early Imperial era and later enlarged. Destroyed by the barbarians and reconstructed by the bishop Theodoric I, the city became a Lombard "gastaldia" and then the seat of a Norman count. The Cathedral (11th cent.?) has been reconstructed along medieval lines after earthquake damage (20th cent.); its crypt is decorated with baroque stuccoes (traces of 11th-century masonry can be seen); the bell tower is without cusp (begun 1335, B. di Giacomo; finished 1498, A. da Lodi). Of the early Gothic period are Porta Pescara and the Church of S. Agata, as well as remains of S. Francesco della Scarpa and S. Agostino. Built in full Gothic style during the 14th century were S. Maria della Civitella (ca. 1320) and S. Antonio. The present Church of S. Maria del Tricalle (remodeled in second half of 15th cent.) is a Renaissance building with central ground plan. The towered Palazzo Arcivescovile (1480; remodeled) is decorated with polychrome plates. S. Giovanni and S. Chiara provide examples of the baroque of the area. Northeast of the city has risen the modern industrial and commercial quarter of Chieti-Scalo. The Museo Nazionale di Antichità is the repository for archaeological material of the region (among the most important are the statue of a warrior from Capestrano, the reliefs of L. Storax, and the bronze bed from Amiternum). Other collections are found in the Pinacoteca Municipale and the Museo Diocesano Teatino.

In the vicinity is the Cistercian Gothic Church of S. Maria Arabona (1208). Mutilated in its forward section, the church has three aisles divided by compound piers and a rectangular apse flanked by chapels; the ciborium and paschal candlestick are of the 13th century. Adjacent are the remains of the monastery.

Bibliog. G. De Chiara, Origine e monumenti della città di Chieti, Chieti, 1857; C. De Laurentis, La chiesa cattedrale di Chieti, Chieti, 1899; V. Zecca, La Chiesa di S. Domenico, Rass. d'arte degli Abruzzi e del Molise, III, 1914, pp. 47–57, 65–81, 97–117; V. Zecca, Il tempio di S. Paolo a Chieti, Riv. abruzzese, XXIX, 1914, pp. 394–409; Ministero Pubblica Istruzione, Elenco degli edifici monumentali: Provincia di Chieti, Rome, 1921; R. Staccioli, S. Maria Arabona, Rome, 1932; E. Galli, Il Museo Provinciale di Chieti nel Capitolinum Teatinum, Le Arti, I, 1938–39, pp. 396–401; G. Colosimo, Il serbatoio romano di Chieti, Atti III Conv. naz. Storia Arch., Rome, 1940, pp. 251–62; V. Cianfarani, Chieti, FA, V, 1950, 4362; U. Chierici, Monoppelo: Chiesa di S. Maria Arabona, Palladio, N.S., I, 1951, pp. 127–29; V. Cianfarani, Touta Marouca, Studi in onore di A. Calderini e R. Paribeni, III, Milan, 1956, pp. 311–27; V. Ciangarani, EAA, s.v. Chieti, II, 1959, pp. 550–52; V. Cianfarani, Il Museo Nazionale di antichità degli Abruzzi e del Molise, Chieti, 1959; V. Cianfarani, Urbanistica di alcune città della quarta regione augustea (Chieti, Alba Fucense, Sepino), Atti VII Cong. int. Archeol. classica, Rome, 1961, pp. 295–313.

Isernia (Lat., Aesernia). The town was first a Samnite center, a Latin colony from 263 B.C., and finally a municipium. From Roman times there are remains of polygonal walls, a bridge, and the foundation of an Italic temple under the Cathedral. Subjected to repeated devastation, the area has preserved few medieval monuments: Romanesque portal and bell tower (1015) of the destroyed Church of S. Maria delle Monache, with adjoining convent; the Cathedral, redone in neoclassic style (1837) over the earlier Gothic base. The Museo Civico, in the former convent, houses an archaeological collection.

Bibliog. R. Garrucci, Storia di Isernia, Naples, 1848; F. Castagnoli, BCom, LXXVII, 1959–60, p. 24 ff.; EAA, s.v.

Lanciano (Lat., Anxanum). In the upper valley of the Feltrino, the town comprises an ancient nucleus on a hill, to which a modern quarter has been added on the plain below. The principal city of the Frentani, perhaps the Samnite Frentrum, it then became a Roman municipium. Tombs of the Iron Age have been revealed, as well as

the aqueduct and theater from Roman times. Inside the massive city walls (11th cent., many times renovated) the following monuments are to be found: the former Romanesque Church of S. Biagio (12th cent.), with bell tower of 1340; S. Agostino (1270), a Gothic structure with portico; S. Francesco and S. Lucia (13th cent.), Gothic, the latter with a 14th-century portal; S. Maria Maggiore (1227; remodeled in later centuries), also Gothic, with a fine portal (1317; F. Petrini); Cathedral (S. Maria del Ponte), built in 1389 on the four arches of the Bridge of Diocletian, redone in the 18th century, with unfinished neoclassic façade, portico, terrace, and freestanding campanile (1614).

Not far away is S. Giovanni in Venere, originally of the 8th century, reconstructed in 1165 and remodeled in the 13th century in Cistercian Gothic style (restored after 1945). The church has a portal from about 1230, an apse with arcades bearing Islamic-style polychrome decorations, a raised presbytery, a crypt, and frescoes executed in the 12th century. The adjacent cloister has been restored, but the monastery is in ruins.

BIBLIOG. A. De Nino, Lanciano, NSc, 1884, pp. 452–53; V. Zecca, La basilica di San Giovanni in Venere nella storia e nell'arte, Pescara, 1910; A. Lora, Brevi cenni su alcune chiese monumentali di Lanciano, Rass. bibliog. dell'arte it., XVI, 1913, pp. 121–22; C. Marciani, La chiesa di San Francesco di Lanciano, Lanciano, 1954.

Pescara (Lat., Aternum). Port of the Vestini, Marrucini, and Peligni, Pescara was devastated by the Goths and the Lombards; during the Middle Ages it flourished again, centered about the castle, but was destroyed in 1209 by Otto IV and then reconstructed early in the 15th century by Ladislas I, King of Naples. The scene of struggles between the Angevins and the Aragonese, the area finally became the fief of the De Avalos. No monuments have been preserved from these periods, except for remnants of defensive works erected by Charles V (dismantled in 1867). Since 1927 the two adjoining towns of Pescara and Castellamare Adriatica have been united. Seriously damaged by the bombings of 1943–44, the city has risen again in line with modern architectural planning. Notable are its new industrial and port installations and the stadium, by L. Piccinato. The house of Gabriele d'Annunzio, maintained by the city, holds a collection of objects and photographs relating to the life of the writer.

BIBLIOG. Guida turistica, Pescara, 1959.

San Clemente a Casauria. This abbey, built in the 9th century on a small island in the Pescara River near Torre de' Passeri, is presently situated at a bend in the river. In the 10th century it was sacked by the Saracens and in the 11th by the Normans. Reconstructed in the 12th century, the abbey was again damaged in the 14th century and also in the 20th by earthquakes (restored 1920 and 1934). The church (1176–82; restored after 1945), one of the most successful buildings in the Cistercian transitional style between Romanesque and Gothic, is preceded by a portico composed of three arches and roofed with ribbed vaults. There are three sculptured portals; the central one is closed by a bronze door with figures of abbots and monks (1191). The interior has three aisles divided by piers, a slightly projecting transept, and a semicircular apse and retains its very early pulpit, the paschal candlestick, and ciborium. The altar is formed of an Early Christian sarcophagus; the dome has groin vaults on antique columns. In the crypt is a double apsidal enclosure, with the exterior part dating from the 9th century. Adjoining the church is the Museo Casauriense.

BIBLIOG. P. L. Calore, L'Abbazia di S. Clemente, Arch. storico dell'arte, IV, 1891, pp. 9–36; P. L. Calore, La ricomposizione delle porte di S. Clemente, Arch. storico dell'arte, VII, 1894, pp. 201–17; R. Pantini, S. Clemente, Vita d'arte, I, 1908, pp. 98–108; G. B. Amoroso, San Clemente a Casauria, Teramo, 1916; I. C. Gavini, Il restauro della Badia di San Clemente, BArte, N.S., VI, 1926–27, pp. 97–109; R. Biolchi, Il problema della cripta della chiesa di S. Clemente, BArte, XXV, 1931–32, pp. 315–20.

Sulmona (Lat., Sulmo). A city of the Peligni located at the center of the large Peligna Valley — and the birthplace of Ovid — Sulmona became a municipium after the Social War. A section of polygonal walls, Italic and Roman necropolises, and a theater and amphitheater survive from this epoch. The city was quite important during the Middle Ages, when it was a Lombard "gastaldia" and then successively a Swabian and Angevin possession. The Romanesque Cathedral (S. Panfilo, 9th cent.; restored ca. 1075–1120), many times destroyed by fire, retains a Gothic portal, Romanesque colonnades inside, a triapsidal crypt of the 11th century (with 12th-cent. cathedra), and a baroque interior. From the Church of S. Francesco della Scarpa, a Gothic structure erected in 1290 (ruined by earthquakes), there remain an imposing portal atop a staircase and remnants of a side wall. A large aqueduct (1256) with pointed arches is a relic of the medieval

water system. The Porta Napoli (14th cent.) provides the oldest testimony of the urban renovation of the 14th and 15th centuries. Of the complex of the Annunziata (14th–18th cent.) there remain the palace, constructed in various stages (portals of 1415, 1483, 1522), revealing a fusion of Gothic and Renaissance elements; the church, reconstructed in 1710, perhaps after a design by P. Fontana, over a previous late Gothic building; and the 16th-century bell tower. The 15th-century constructions that survive include the Church of S. Maria della Tomba, its 15th-century façade with a horizontal crowning and ogival portal (remodeled, including the interior); Fontana del Vecchio (1474); Convent of S. Lucia; Convent of S. Chiara, with cloister of 1518; the Palazzi de Sardi (1420), della Sanità (mid-15th cent.), Tabassi (with portal by Pietro da Como, 1449), and Tironi (or de Petris, with later additions). Somewhat later are the Palazzi delle Palle, Colombino, Faciani, and della Banca Agricola. Baroque architecture left its mark on many secular buildings. *Museums*: Museo Civico, in the Palazzo dell'Annunziata (goldwork); Museo della Cattedrale (sacred art).

Outside the city is the old Morronese abbey (Sto Spirito), near the so-called "Ovid's Villa," with an abbey church transformed in the 18th century, and the Oratorio di S. Onofrio (12th cent.), with frescoes by Gentile da Sulmona. On the slopes of Mount Morrone is a large cult complex dedicated to Hercules Curinus.

BIBLIOG. F. and L. de Sanctis, Notizie storiche e topografiche della città di Sulmona, n.p., 1796; P. Piccirilli, Monumenti architettonici sulmonesi, Lanciano, 1891; P. Piccirilli, Sulmona medievale, Rass. abruzzese, I, 1897, pp. 123–36; P. Piccirilli, La Chiesa di S. Francesco, Rass. abruzzese, II, 1898, pp. 33–45; P. Piccirilli, Gli affreschi della Cappella Caldora in Santo Spirito di Sulmona, L'Arte, XV, 1912, pp. 385–95; I. C. Gavini, Studi sull'architettura d'Abruzzo, Rass. d'arte degli Abruzzi e del Molise, IV, 1915, pp. 1–75; I. C. Gavini, La cattedrale valvense e l'attuale restauro, Rass. d'arte ant. e mod., IV, 1917, pp. 169–78; P. Piccirilli, Monumenti abruzzesi: Il palazzo della SS. Annunziata in Sulmona, Rass. d'arte ant. e mod., VI, 1919, pp. 119–37; G. Piccirilli, Sulmona, Sulmona, 1932; B. Andreae, Fundbericht Nord- und Mittelitalien 1949–1959: Sulmona, AAnz, 1959, cols. 236–39.

Tagliacozzo. On a height dominating the valley of the Imele, the town was perhaps founded by the Goths. A fief of the Orsini family (1255–1497) and then of the Colonnas, Tagliacozzo has preserved monuments of both the Gothic and the Renaissance periods: S. Francesco (1233), single aisle, rectangular façade ornamented with a 15th-century portal and rose window, baroque interior; SS. Cosma e Damiano (15th cent.), with portal (1452) by the Lombard Martino da Biasca; S. Maria del Soccorso (end of 15th cent.), with a portico of 1542; Palazzo Ducale (14th–15th cent.), with a Renaissance portal and an architraved loggia on the left side, and Renaissance frescoes attributed to G. d'Atri; Palazzo Argoli-Ruota (15th cent.).

BIBLIOG. L. Fiocca, L'arte negli Abruzzi, L'Arte, XI, 1908, pp. 47–51; T. M. Jackson, Affreschi inediti a Tagliacozzo, L'Arte, XV, 1912, pp. 371–84.

Teramo (Lat., Interamnia Praetuttiorum). City of the Pretuzi, Roman municipium, and then a colony; the site has a necropolis antedating the 5th century B.C. Other remains of its antique history include a theater, an amphitheater, and a group of tombs along the road to Amiternum (1st cent. of our era). After being destroyed several times during the barbarian period, Teramo had a great flowering under the Angevins (12th–14th cent.) but declined again at the end of the 14th century, for from the 15th century onward its fortunes reflected the vicissitudes of the Kingdom of Naples. The old nucleus of the city retains the early ground plan, traces of the walls and of medieval seignorial palaces, the ruins of the Church of S. Maria Interamnensis (6th–8th cent.), and the site of S. Getulio (S. Anna dei Pompetti, 12th cent.), the only remnant of the old cathedral (burned ca. 1155). The present Cathedral, with rectangular crenelated façade, has a Gothic portal decorated with mosaics and reliefs by Deodato di Cosma (1332) and a bell tower from the late 12th or early 13th century. It retains some parts of the original construction (1158). The interior, in part Romanesque and in part Gothic, counts among its furnishings a silver altar frontal by Niccolò da Guardiagrele (1433–48) and a polyptych by Jacobello del Fiore (early 15th cent.). S. Francesco (13th–14th cent.), a Romanesque-Gothic edifice that preserves part of its original structure, was extensively remodeled in the late 16th century. There is a local museum.

BIBLIOG. G. de Petra, Di un ripostiglio di monete di bronzo fuse e battute, NSc, 1896, pp. 65–66; F. Savini, Resti di edifici di età romana ed avanzi della primitiva cattedrale teramana, NSc, 1898, pp. 137–40; F. Savini, S. Maria Aprutiensis, Rome, 1898; F. Savini, Scoperte della necropoli preromana dell'antica Interamnia Praetuttiorum, NSc, 1905, pp. 267–69; F. Savini, Tomba romana scoperta presso il villaggio di Rocciano, NSc, 1905, p. 198; F. Savini, Gli edifici teramani nel Medio Evo, Rome, 1907; F. Savini, Loggia medievale del Palazzo Vescovile di Teramo, Rass. d'arte

degli Abruzzi e del Molise, II, 1913, pp. 91–99; Ministero Pubblica Istru-zione, Elenco degli edifici monumentali: Provincia di Teramo, Rome, 1916; F. Savini, Il restauro di S. Domenico, Teramo, 1931; A. Riccoboni, Restauri del Duomo di Teramo, Ill. vaticana, V, 1934, pp. 33–37; U. Savorini, In-troduzione storico-artistica agli studi del piano regolatore della Città di Te-ramo, Teramo, 1934; E. Galli, Ricognizione preliminare dell'Anfiteatro romano, NSc, 1939, pp. 335–49; G. Giovannoni, Teramo: Teatro romano, Palladio, III, 1939, p. 84; R. Rozzi, Pianaccio: Stazioni eneolitiche, NSc, 8th ser., VII, 1953, pp. 113–16; Teramo: Guida turistica, Pescara, 1959.

Termoli. On a rocky promontory of the Adriatic coast, the town consists of a medieval nucleus with narrow streets and an adjacent zone (Borgo) having a regular pattern of wide streets. The Cathedral (S. Basso) was erected during the 12th century in the Pisan-Apulian variant of Romanesque, over earlier constructions, and was remodeled from the 13th to 15th century. The façade is punctuated with a series of recessed blind arches that continue along the right side, a portal with reliefs, and a 12th-century rose window. The three-aisled inte-rior has been completely redone, and the crypt is a modern construc-tion that incorporates sections from the 6th and 7th centuries and remnants of the old mosaic pavement (10th–11th cent.). In the adjoin-ing bishop's residence, there are fragments of a Romanesque pulpit. The defensive installations of the port, constructed by Frederick II (1247), have been reduced to a large tower and a section of the walls with small cylindrical towers.

Bibliog. F. Laccetti, Termoli e i suoi monumenti, Napoli nobilissima, XIII, 1904, pp. 131–41; G. Matthiae, Architettura medievale nel Molise, BArte, XXXI, 1937–38, pp. 93–116; G. Colonna, Un miliario poco noto della via Claudia Valeria, Epigraphica, XXI, 1959, pp. 51–59.

Campania. The name is derived from the Campani, the in-habitants of ancient Capua. In the Iron Age the region was colonized by the Greeks and Etruscans, and in the 5th century B.C. it was occupied by the Samnites, who were known there as Opici and Osci (Oscans); later it came into Roman possession. The preservation of archaeological evidence of these ancient civilizations is truly unique, since a number of cities (Pompeii, Herculaneum, Stabiae) were buried by the eruption of Vesuvius in A.D. 79. In the Early Christian and Byzantine periods the Campanian cities continued to flourish. A period of great prosperity from the 11th to the 13th century was particularly noteworthy in architecture, in which Romanesque and Arabo-Norman elements were fused with local classical tradi-tions. The establishment of the Angevin kingdom in the 13th cen-tury and of the Aragonese dynasty in the 15th brought an influx of Italian, French, and Spanish Gothic elements. Naples gradually became the center of artistic activity, and it remained the cultural and artistic capital until modern times; it was particularly important during the Renaissance and in the baroque period. In the 15th cen-tury, Flemish and Tuscan influences were strong, and later Spanish and French elements appeared. The art of the 18th and early 19th centuries was linked with the Bourbon court culminating in the construction of the royal palaces of Caserta and Capodimonte.

Bibliog. D. Salazaro, Studi sui monumenti dell'Italia meridionale dal II al XIII secolo, 2 vols., Naples, 1871–81; J. Beloch, Campanien, 2d ed., Breslau, 1890; E. Bertaux, I monumenti medievali della regione del Vulture, Napoli nobilissima, VI, 1897, pp. i–xxiv; P. Carucci, La grotta preistorica di Pertosa, Naples, 1907; E. Bertaux, L'art dans l'Italie méridionale, 2 vols., Paris, 1909; H. Koch, Dachterrakotten aus Campanien, Berlin, 1912; R. Pane, Tipi di architettura rustica in Napoli e nei campi Flegrei, Architet-tura, VII, 1927–28, pp. 529–43; C. Ricci, Architettura e scultura del Me-dioevo nell'Italia meridionale, Stuttgart, 1928; A. Maiuri, Una necropoli arcaica presso Salerno e tracce dell'espansione etrusca nell'agro picentino, SEtr, III, 1929, pp. 91–101; G. Chierici, Contributo allo studio dell'archi-tettura paleocristiana nella Campania, Atti III Cong. int. Archeol. Cristiana, Rome, 1934, pp. 203–16; A. Schiavo, Torri sacre in Campania, Arch. sto-rico per la provincia di Salerno, N.S., III, 1935, pp. 245–47; R. Pane, Architettura rurale campana, Florence, 1936; G. Ceci, Bibliografia per la storia delle arti figurative nell'Italia meridionale. 2 vols., Naples, 1937; A. Schiavo, L'architettura barocca in Campania, Palladio, III, 1939, pp. 279–85; N. Borelli, L'architettura rustica in Campania, Lares, XII, 1941, pp. 293–304; A. Maiuri, Passeggiate campane, 2d ed., Florence, 1950; W. Johan-nowski, Contributi alla topografia della Campania antica, RendNapoli, XXVII, 1952, pp. 83–146; R. U. Montini, Profilo storico dell'arte in Campania, Naples, 1952; M. Rotili, L'arte nel Sannio, Benevento, 1952; S. Bottari, Un quesito sugli elementi lombardi nell'architettura campana e pugliese, Arte lombarda, I, 1955, pp. 9–13; S. Bottari, I rapporti tra l'architettura siciliana e quella campana del Medioevo, Palladio, N.S., V, 1955, pp. 7–28; B. Crova, Le terme romane nella Campania, Atti VIII Conv. naz. Storia Arch., Rome, 1956, pp. 277–88; R. Salinas, Le cupole nell'architettura della Campania, Atti VIII Conv. naz. Storia Arch., Rome, 1956, pp. 289–91; M. Salmi, Problemi dell'architettura di Terra di Lavoro nell'alto Medioevo e nel tempo romanico, Atti VIII Conv. naz. Storia Arch., Rome, 1956, pp. 21–28; A. De Franciscis and R. Pane, Mausolei romani in Campania, Naples, 1957; A. Maiuri, I Campi Flegrei, 3d ed., Rome, 1958; A. Venditti, Architettura neoclassica a Napoli, Naples, 1961; R. Wagner-Rieger, San Lorenzo Maggiore in Neapel und die Süditalienische Architektur . . . , Misc. Bib. Hertzianae, Munich, Vienna, 1961, pp. 131–43.

Amalfi. Of early medieval origin, and under Byzantine rule in the 6th century, it was sacked by the Lombards in the 8th, and in the following two centuries became a powerful maritime republic, maintaining close relations with the East. After it was attacked and defeated by Pisa in 1137, the power of Amalfi declined. Later the city became a fief of various noble families. The Cathedral is of early medieval origin, and excavations have revealed parts of the initial structure. It was rebuilt in 1203 in Romanesque style and, after various other changes, remodeled in baroque forms in 1701–31. Of the Romanesque structure there remains only the campanile (restored); decorated in polychrome, it has four small turrets of Arab derivation. The general plan of the Cathedral is that of the Roman-esque construction: it is divided into a nave and two aisles and has three apses, a raised presbytery, and a crypt. The stairway, porch, and façade are 19th-century reconstructions after the presumed 13th-century design. There are a few remains of Romanesque deco-ration on the façade and some Romanesque sculpture in the portals. The bronze doors of the central portal, decorated with crosses and inlaid figures, were cast in Constantinople before 1066. (The Church of S. Salvatore de Bireto in the neighboring town of Atrani has similar doors, cast in 1087.) Of the 12th- and 13th-century Roman-esque interior furnishings there remain two columns, two candelabra, and two rebuilt ambos decorated with mosaics. The adjoining cloister (Chiostro del Paradiso) has paired columns supporting arches of the Arabic type, ornamented with stucco (1266–68). The Convento dei Cappuccini (converted into a hotel) retains the original cloister with interlacing arches. The remains of the Arsenale della Repubblica comprise a two-aisled structure with an ogival roof supported by 10 piers. The Fontana di S. Andrea (or del Popolo) was built in 1760. The monument to Flavio Gioia by A. Balzico dates from 1926.

Bibliog. L. M. Mansi, Illustrazione dei principali monumenti del ver-sante amalfitano, Rome, 1898; G. B. D'Addosio, Illustrazione e documenti sulle cripte di S. Andrea in Amalfi e S. Matteo in Salerno, Arch. storico province napoletane, XXXIV, 1909, pp. 19–48; G. Castelfranco, L'atrio del Duomo d'Amalfi, BArte, XXVI, 1932–33, pp. 314–21; M. Berza, Amalfi preducale, EphDR, VIII, 1938, pp. 349–444; P. Pirri, Il duomo di Amalfi e il Chiostro del Paradiso, Rome, 1941; A. Schiavo, Monumenti della costa di Amalfi, Milan, 1941; G. Imperatore, Amalfi nella natura, nella storia e nell'arte, Amalfi, 1956.

Baia (Lat., Baiae). As a thermal center Baia enjoyed great pop-ularity in late republican and imperial times. Of particular impor-tance are three large domed halls, the earliest of which dates from the late 1st century B.C. and is known as the "Temple of Mercury." Five bath complexes have been identified and may be assigned to the 1st–4th century. Much sculpture has been discovered here.

Bibliog. A. Maiuri, Terme di Baia, BArte, XXXVI, 1951, pp. 359–64; A. Maiuri, I Campi Flegrei, 3d ed., Rome, 1958; M. Napoli, EAA, s.v. Baia, I, 1958, pp. 960–62 (bibliog.); F. Rakob, Litus beatae Veneris aureum: Untersuchungen am "Venustempel" in Baiae, RM, LXVIII, 1961, pp. 114–49.

Benevento (Lat., Beneventum). This ancient town of the Irpini was originally called Maleventum, or Maluentum (first mentioned 297 B.C.); its name was changed to Beneventum when the Romans made it a colony in 268 B.C. Notable ancient monuments have sur-vived, including a theater of the 1st century of our era and the great triumphal arch of Trajan (IX, PL. 161; X, PL. 154), decorated with reliefs depicting events in the life of the Emperor. There are many figures of deities and animals in Egyptian style (Mus. del Sannio), as well as an obelisk from the time of Domitian, all from a Temple of Isis. In the Middle Ages Benevento prospered markedly under the Lombards. During their hegemony the city was surrounded with walls, from which the Torre della Catena and Porta Arsa remain. Rule of the city was subsequently disputed between the Normans and the Church, until in 1077 the Church gained the ascendancy.

Of S. Ilario di Porta Aurea (7th cent.), only the semicircular apse remains. S. Sofia, a church connected with a Benedictine con-vent, was constructed in the 8th century (restored after an earthquake in 1688). The octagonal interior has retained the original Byzantine plan: pairs of reused columns form a hexagon within the octagon and support a dome on a drum; the vaulted ceiling was rebuilt in the 17th century. The church contains some notable frescoes of the 10th–12th centuries. The adjoining 12th-century cloister has horseshoe arches of Arabic derivation and capitals carved in the manner of Antelami. The Cathedral, founded in the 7th century, originally comprised only the nave; two side aisles were added in the 11th cen-tury and two more in the 12th. Almost completely destroyed in 1943, it was rebuilt (completed 1959) with the original materials. The 13th-century façade has survived intact; it shows Apulian in-fluences, with a blind arcade and loggia above. The jambs and the architrave of the central portal were carved by Master Rogerius. The bronze doors (13th cent.; restored 1693 and later) are decorated with figures and ornaments in a Byzantine style that shows Arabic

influence. The campanile (1279) is decorated with Roman reliefs. The Rocca dei Rettori (Castle; 14th cent.) overlies the Lombard fortress. The Palazzo Municipale was constructed in the 16th century (restored 19th cent.). Eighteenth-century structures include the Church of S. Bartolomeo, the baroque Fontana delle Catene, and the Vanvitelli bridge (an older bridge enlarged and restored by Luigi Vanvitelli). The Church of the Madonna delle Grazie (1839), with hexastyle porch and Greek-cross interior, and the Teatro Vittorio Emanuele II (1851–62) by Pasquale Francesconi are neoclassic in style. The Museo del Sannio (in the convent and cloister adjoining S. Sofia) contains archaeological and medieval material.

BIBLIOG. I. de Vita, Thesaurum antiquitatum beneventarum, 2 vols., Rome, 1754–64; A. Meomartini, Benevento, Bergamo, 1909; R. Pane, Lavori nel teatro romano, NSc, 1924, pp. 516–21; R. Paribeni, Optimus Princeps, II, Messina, 1927, pp. 261–63; G. Mollat, Construction d'une fortresse à Bénévent sous les pontificats de Jean XXII ed de Benôit XII, Mél, LXII, 1950, pp. 149–64; A. Zazo, Il Castello di Benevento, Naples, 1954; L. Cochetti, La decorazione plastica del Chiostro di S. Sofia a Benevento, Comm, VIII, 1957, pp. 17–26; EAA, s.v.; H. Giess, The Sculpture of the Cloister of Santa Sofia in Benevento, AB, XLI, 1959, pp. 249–56; P. Veyne, Une hypothèse sur l'art de Bénévent, Mél, LXXII, 1960, pp. 191–219.

Calvi Risorta (Lat., Cales). Originally a center of the Aurunci, Cales was conquered by the Romans in 332 B.C. and was destroyed by the Saracens in 879. It was famous in the Hellenistic period for its black-glazed terra-cotta vases (Calene ware). Remains from the ancient period include a stretch of the Roman walls, a temple on a podium, an amphitheater, and a theater (1st cent. B.C.). The 9th-century Cathedral (restored 1452) has a Romanesque blind arcade on the façade and three well-preserved Romanesque apses. Inside are an episcopal throne and a mutilated ambo (12th cent.), with sculptured and mosaic decorations; the crypt is supported by reused Roman columns. The 9th-century castle, built on a square plan with cylindrical corner towers, is largely in ruins.

Nearby is the Grotta dei Santi, an artificial cave with a semicircular raised apse and votive frescoes of the 10th and 11th centuries. The Grotta delle Formelle has similar frescoes.

BIBLIOG. A. Pagenstecher, Die Calenische Reliefkeramik (JdI, Ergänzungsheft, VIII), Berlin, 1909; P. Del Prete, L'antica Calvi e la Grotta dei Santi, Piedimonte d'Alife, 1913; A. De Franciscis, EAA, s.v. Cales, II, 1959, p. 273; A. Rocca, EAA, s.v. Caleni, vasi, II, 1959, pp. 271–72; W. Johannowski, Relazione preliminare sugli scavi di Cales, BArte, XLVI, 1961, pp. 258–68.

Capri (Καπρέαι; Lat., Capreae). A mountainous island in the Bay of Naples, Capri has been inhabited since prehistoric times (neolithic pottery found in the Grotta delle Felci). It was colonized by the Greeks (remains of the polygonal walls) and later served as a Roman imperial residence. A villa built by Augustus (enlarged in the time of Tiberius) lies west of Marina Grande; the Villa Iovis was constructed by Tiberius on the eastern promontory; another villa of Tiberius was near the Torre di Damecuta.

The architecture seen at Capri and Anacapri is of a Mediterranean type, incorporating Roman, Byzantine, and Arab elements. The houses are plain, whitewashed structures with arcaded loggias and terraced or convex roofs. The churches, also of this simple type of architecture, include S. Maria del Soccorso, S. Anna (13th cent.), and S. Maria Cetrella (14th cent.). S. Costanzo (ca. 11th cent., enlarged 14th cent.), at Marina Grande, has the form of a Greek cross inscribed within a square, with a small central dome; late Byzantine forms are combined with Arabic elements. Late Gothic influences fused with Byzantine forms appear in the Chapel of S. Michele (on the slopes of Mt. Tiberio) and in two churches of Anacapri, S. Maria di Costantinopoli and S. Cataldo. The Certosa di S. Giacomo (1371–74) presents a local adaptation of Gothic; restored to its original form, it is a single-aisled church with an ogival groined vault and adjoins a small 15th-century cloister and a larger 16th-century one, around which are the monks' cells. Local character also prevailed in the architecture of the baroque period, as seen in the Church of S. Stefano, rebuilt about 1683 by Francesco Antonio Picchiatti, and in S. Salvatore (1685), by Dionisio Lazzari, with the adjoining Convento delle Teresiane (1678). The Church of S. Michele (1719) at Anacapri, by Domenico Antonio Vaccaro, is octagonal. The floor, of glazed tiles, was made by Leonardo Chiaiese (1761) from designs by Francesco Solimena.

BIBLIOG. E. Cerio, L'architettura minima nella contrada delle Sirene, Architettura, II, 1922–23, pp. 156–76; U. Rellini, La grotta delle Felci a Capri, MALinc, XXIX, 1923, cols. 305–406; A. Lipinsky, La chiesa di S. Costanzo a Marina Grande, Per l'arte sacra, VII, 1929, pp. 112–16; L. Serra, La chiesa di S. Costanzo, BArte, XXX, 1936–37, pp. 253–66; I. Friedländer, Capri, Rome, 1938; G. Ruocco, La basilica di San Costanzo, Naples, 1948; G. Buchner, La stratigrafia dei livelli a ceramica e i ciottoli con dipinti schematici antropomorfi della Grotta delle Felci, BPI, N.S.,

IX, 1954–55, pp. 107–35; R. Pane, Capri, Venice, 1954; P. Mingazzini, Le grotte di Matermania e dell'Arsenale a Capri, AC, VII, 1955, pp. 139–63; A. Maiuri, Capri: Storia e monumenti, Rome, 1956; G. Ruocco, Capri e Filippo IV di Spagna, Naples, 1956; A. Maiuri, Capri, Rome, 1957; L. Rochetti, EAA, s.v. Capri, II, 1959, pp. 332–34.

Capua (Lat., Casilinum). The present city was founded in 856 by fugitives from Capua Vetere. In the 9th century it came under Lombard rule, and in the 11th it was conquered by the Normans. It was subsequently besieged and sacked several times, and suffered much damage during World War II. In the early period, access to the city from the Via Appia was provided by the Roman bridge (restored 12th cent., destroyed during World War II, and since rebuilt). It is hogback in form, with five spans, and at the far end are the bases of the towers of a gate, built by Frederick II in the 13th century. Most of the Lombard and Norman churches have been remodeled or rebuilt. The Cathedral, founded in 856 and reconstructed in the 12th century (destroyed in World War II and rebuilt), is entered through a porch supported by 16 ancient columns with Corinthian capitals. Inside is a carved paschal candlestick of the 13th century. The massive campanile is of the 9th century. S. Michele a Corte (9th cent.), S. Giovanni a Corte (10th cent.), and S. Salvatore Maggiore a Corte (10th cent.) have been substantially remodeled, and little remains of the original structures. S. Marcello Maggiore (9th cent.) has a 12th-century carved portal showing Lombard influence. The Palazzo dei Principi Normanni (or Castello delle Pietre), from the Norman period, still has one rectangular crenelated tower. The ogival portal of the Palazzo Fieramosca, reconstructed during the Renaissance, is of the 14th century. Several Gothic portals of the Durazzo type date from the 15th century, including one in the Palazzo Antignano; the Porta Napoli, exhibiting the Tuscan Doric order, is of the same century. Sixteenth-century structures include the Palazzo del Municipio, its façade decorated with carved heads from the Roman theater of ancient Capua; the Church of the Annunciata (late 13th cent., rebuilt 1531–74), with a dome by Domenico Fontana; and the campanile of S. Eligio. The Museo Provinciale Campano, in the 13th-century Palazzo Antignano, contains archaeological material, medieval sculpture, and paintings.

About 3 miles east of Capua is the Church of S. Angelo in Formis, built sometime before the 10th century and reconstructed in 1073 by Desiderius of Montecassino, on the site of a temple of Diana Tifatina (traces of the ancient mosaic pavement). It is basilican in form, modeled after the Abbey Church of Montecassino, and is entered through a frescoed porch (12th–13th cent.). The portal, classical in form, is surmounted by a lunette with frescoes of the 11th century. The interior preserves a cycle of 11th-century frescoes. The massive campanile, detached from the church, is partly built with material from the Roman amphitheater.

BIBLIOG. G. Rucca, Capua Vetere, o sia descrizione di tutti i monumenti di Capua antica, Naples, 1828; A. Lauri, La basilica di Sant'Angelo in Formis e l'arte del secolo XI, Florence, 1912; G. Di Salvatore, Da Capua a Caserta, Bergamo, 1924; P. Toesca, L'architettura della porta di Capua, Mél. Bertaux, Paris, 1924, pp. 292–99; A. Adriani, Sculture in tufo del Museo Campano, Alexandria, Egypt, 1933; G. Chierici, Note sull'architettura della contea longobarda di Capua, BArte, XXVII, 1933–34, pp. 543–54; P. Mingazzini, CVA, Italia, fasc. 11, 23, 29, Rome, 1935–38; C. Shearer, The Renaissance of Architecture in Southern Italy, Cambridge, 1935; G. Chierici, L'architettura nella Longobardia del Sud, Capua: S. Salvatore e S. Michele, Atti I Cong. int. S. longobardi, Spoleto, 1951, pp. 223–26; O. Morisani, La pittura cassinese e gli affreschi di Sant'Angelo in Formis, Atti VIII Cong. int. S. bizantini, II, Rome, 1951, pp. 220–22; S. Bottari, Le sculture di S. Marcello in Capua, Comm, VI, 1955, pp. 235–40; G. de' Francovich, Problemi della pittura e della scultura preromanica, Settimane di studio del Centro it. S. Alto Med., III, Spoleto, 1955, pp. 355–519 at 475; P. Anker and K. Berg, The Narthex of Sant'Angelo in Formis, ActaA, XXIX, 1958, pp. 95–110; J. Wettstein, Sant'Angelo in Formis e la peinture médiévale en Campanie, Geneva, 1960.

Caserta. This modern city, of gridiron plan, developed in the 18th century when the Royal Palace (I, PL. 389) was built for Charles III, Bourbon king of Naples. Luigi Vanvitelli designed the palace and supervised the construction from its inception in 1752. After his death in 1773, his son Carlo altered the design. The structure is rectangular in plan, with the façades divided horizontally into two bands of two stories each. On the upper level the center and end sections, which project from the main body of the façade, are decorated with pilasters and semicolumns of giant order. The interior space is divided into four rectangular courtyards by two wings intersecting at right angles. A monumental staircase (PL. 226) leads to an octagonal vestibule opening onto the royal apartments, with many rooms decorated with stuccowork and frescoes in neoclassic style, and onto a rectangular chapel; the latter has a wide apse, is covered with polychrome marble, and contains works by Giuseppe Bonito, Sebastiano Conca, and Anton Raphael Mengs. The neoclas-

sic theater (1769) is reached through a courtyard. The great park (PL. 441), designed by Vanvitelli, is a monumental complex of picturesque fountains, sculpture, pools, and waterfalls. At the far end is the English garden (1782), designed by the British landscape architect John Andrew Graeffer. Other works by Vanvitelli are the so-called "Castelluccio Reale" (an octagonal miniature fortress; X, PL. 267), the fish pond, and the Caroline aqueduct.

Caserta Vecchia, about 3 miles northeast of Caserta, founded by the Lombards in the 8th century, has retained its medieval character. The Cathedral (12th cent.) is Romanesque, with Apulian and Arabo-Sicilian elements. The exterior (PL. 175) is decorated with interlaced blind arches and polychrome ornaments of glazed terra cotta. The interior, a Latin cross surmounted by a high dome, comprises a nave and two aisles, divided by reused ancient columns; there is a single rectangular apse. The floor of the presbytery had remains of a figured mosaic; the pulpit has mosaic decoration of the 12th century. The 13th-century companile rests on a Gothic archway. The Church of the Annunziata is a small Gothic structure of the 13th century. Of the 9th-century castle, only the keep remains.

Between Caserta and Caserta Vecchia is the Church of S. Pietro ad Montes, built with material from ancient Roman buildings and similar in plan to S. Angelo in Formis (12th-cent. frescoes).

BIBLIOG. Ministero Pubblica Istruzione, Elenco degli edifici monumentali: Provincia di Caserta, Rome, 1917; G. di Salvatore, Da Capua a Caserta, Bergamo, 1924; G. Chierici, La reggia di Caserta, Rome, 1937; A. Schiavo, Progetto di Mario Gioffredo per la Reggia di Caserta, Palladio, N.S., II, 1952, pp. 160–70; F. De Filippis, Caserta e la sua Reggia, Caserta, 1953; A. Schiavo, Il progetto di Luigi Vanvitelli per Caserta e la sua Reggia, Rome, 1953; A. Schiavo, The Royal Palace at Caserta, Caserta, 1953; G. D'Anna, Caserta e il suo borgo medioevale, Caserta, 1954; G. Mongiello, La reggia di Caserta, Caserta, 1954; M. Perrone, Il Castello di Caserta, Bologna, 1954; G. Ansaldi, Luigi Vanvitelli e il neoclassico, Atti VIII Conv. naz. Storia Arch., Rome, 1956, pp. 31–50. Caserta Vecchia: T. Laudando, La Cattedrale di Caserta Vecchia, Caserta, 1927; M. Felici, Caserta Vecchia e l'antica sua cattedrale, Caserta, n.d.

Castellammare di Stabia (Lat., Stabiae). Originally an Oscan settlement, it was destroyed by Sulla during the Social War; later many villas were built, but these were buried by the eruption of Vesuvius in A.D. 79. Of the city proper, only the Temple of the Genius Civitatis and a necropolis (7th–3d cent. B.C.) are known. On the Varano Plateau are remains of country houses and villas of urban type, two of which have elaborate decorations in Pompeian Style IV. The town was abandoned during the barbarian invasions in the 6th century, but in the 9th the Castrum ad Mare de Stabiis was built on the site (hence the modern name). Castello Angioino, of the 9th century, is so called because it was enlarged by Charles I of Anjou (1266). The Grotta di S. Biagio is decorated with votive frescoes by various 11th- and 12th-century artists. On the outskirts of the town is the Villa Quisisana, built by Robert of Anjou in 1310 (converted into a hotel); it served as a royal residence until the end of the Bourbon dynasty. The Cathedral dates from the second half of the 16th century (remodeled 1875–93), and the Church of the Gesù is from 1615. The Cathedral has an Antiquarium.

BIBLIOG. F. Forckheim, Bibliografia di Pompei, Ercolano e Stabia, 3d ed., Naples, 1891; G. Cosenza, Opere d'arte del circondario di Castellammare di Stabia, Napoli nobilissima, X, 1901, pp. 141–43, 152–57; L. D'Orsi, Gli scavi di Stabia, Rome, 1954; O. Elia, Pitture di Stabia, Naples, 1957.

Cava dei Tirreni. A town of very early origin, in 1058 it was donated by Gisulph, Prince of Salerno, to the Abbey of Trinità. In a dominant position nearby is the Abbey of Trinità della Cava, founded by St. Alferio Pappacarbone in 1011. It grew in importance, eventually administering the Cava congregation of 500 abbeys, including the great Benedictine abbey of Monreale. The Trinità complex was rebuilt in the 18th century, but the 13th-century cloister, with Roman and medieval sarcophagi, survives. Other medieval sections are the Gothic chapter house, the Chapel of the Crucifix (with a relief by Tino di Camaino), and an 11th-century burial crypt. The subterranean Chapel of S. Germano is decorated with 14th-century frescoes. The new chapter house (restored 18th cent.) has a noteworthy floor of glazed terra-cotta tiles (1600), and 16th-century carved and inlaid wooden choir stalls. The church, remodeled in the 18th century, retains an ambo and an Easter candlestick with mosaic decoration from the 12th century.

BIBLIOG. L. Mattei Cerasoli, Badia della Santissima Trinità della Cava, Rome, 1937; O. Morisani, Tino a Cava dei Tirreni, CrArte, VIII, 1949, pp. 104–10.

Cimitile. This city occupies the site of an Early Christian coemeterium (remains of frescoed arcosolia and tombs), the burial place of St. Felix, first bishop of the nearby city of Nola. In the 4th century it became one of the most venerated sites in the region, and

from 394 to 410, St. Paulinus of Nola established a monasterium there, with basilicas, chapels, and hospices. It began to decline in 410, when it was sacked by Alaric. Excavations have been conducted, but the exact identification of the various components is difficult, because some of the buildings were erected over older ones. The earliest churches (before 394) are SS. Martiri, S. Calionio (both single-aisled with an apse), S. Tommaso (rebuilt 18th cent.), and S. Stefano (rebuilt 19th cent.). S. Felice (365–84), originally comprising a tripartite nave and an apse, was lengthened by the addition of another apse, at the opposite end of the nave (5th cent.). The most important church constructed by St. Paulinus is the Basilica Nuova, adjoining S. Felice; both churches are almost completely below ground, with the Church of S. Felice in Pineis built over them. The Basilica Nuova contains the sarcophagi of St. Felix the Younger and of St. Paulinus the Younger, vestiges of nonfigural mosaics, frescoes (4th–5th cent.), and sculpture (9th–11th cent.). In the 14th century the trilobate arcaded apse of the basilica was incorporated into the Church of S. Giovanni (remains of 14th-cent. frescoes). Other structures built by St. Paulinus include a fifth church — of which some 14th-century frescoes remain — whose apse was decorated with nonfigural mosaics. The titulus of this church is preserved in a letter of St. Paulinus. The porticoed Cappella dei Martiri (8th cent.) has frescoes of the 10th–12th century within. S. Felice in Pineis is entered through a quadriporticus. Surmounted by a stepped dome, the interior has remains of frescoes and sculpture (9th–14th cent.).

BIBLIOG. A. Ferraro, De cemeterio nolano, Naples, 1644; H. Hozlinger, Die Basilica des Paulinus zu Nola, ZfBK, XX, 1855, pp. 135–41; A. W. Byvanck, De gebouwen aan het graf van Sint Felix bij Nola, Meded. van het Nederlandsch H. Inst. te Rome, IX, 1929, pp. 49–70; G. Chierici, Metodo e risultati degli ultimi studi intorno alle basiliche paleocristiane di Cimitile, AttiPontAcc, XXIX, 1956–57, pp. 139–49; G. Chierici, Cimitile, Palladio, N.S., III, 1953, pp. 175–77, VII, 1957, pp. 69–73; G. Chierici, Cimitile: La necropoli, RACr, XXXIII, 1957, pp. 99–125; A. Weis, Die Verteilung der Bildzykliken des Paulin von Nola in den Kirchen von Cimitile, RQ, LII, 1957, pp. 129–50; G. Chierici, Cimitile, Arch. storico Terra di Lavoro, II, 1959, pp. 159–69; P. Manzi, Il monastero e la chiesa di S. Francesco di Paola in Cimitile, Rome, 1959; L. Voelkl, Archäologische Funde und Forschungen, RQ, LIV, 1959, pp. 94–97; P. Manzi, Carlo Guadagni e le basiliche di Cimitile, Rapallo, 1960; H. Belting, Die Basilica dei SS. Martiri in Cimitile und ihr frühmittelalterlicher Freskenzyklen, Wiesbaden, 1962.

Cumae (Κύμη). A site inhabited in the Iron Age, Cumae was colonized by Greeks from Chalcis and Eretria about the mid-8th century B.C. It served as a center from which Hellenic civilization spread through central Italy, and especially prospered during the archaic period. Here was the seat of the renowned Cumaean sibyl. Conquered by the Samnites about 402 B.C., Cumae nonetheless remained an important town until the Middle Ages.

The ancient center occupied a hilly area between the acropolis and the summit of Mt. Grillo, and here have been found remains of the Greek walls and of the acropolis from the Samnite period. A series of passages connected the forum with the harbor on the west and the town with Lake Averno, site of a Roman military port (Portus Julius). The ruins of the Temple of Apollo lie on a lower terrace of the acropolis; the stylobate is part of the Greek structure, while other remains are from the reconstruction in the time of Augustus. On the summit of the acropolis is the Temple of Jupiter (same dates), transformed into a Christian basilica (5th cent.). Also on the acropolis is the Cave of the Sibyl, with an early Greek dromos and an inner chamber of the Hellenistic-Roman period. In the forum are a portico built of tuff (1st cent. B.C.) and a temple on a podium of Samnite origin, remodeled in the Flavian era. In the lower part of the town two baths have been identified. Beyond the walls, to the south, is an amphitheater of the republican period. The necropolis was used from the Iron Age until the Roman imperial period.

BIBLIOG. E. Gabrici, Cuma: Dalle origini ai principii del secolo VI a. C., MALinc, XXII, 1913, cols. 1–448; A. Maiuri, Nuovi saggi di scavo a Cuma, Campania romana, I, 1938, pp. 9–15; A. Maiuri, I Campi Flegrei, 3d ed., Rome, 1958; W. Johannowski, EAA, s.v. Cuma, II, 1959, pp. 970–73.

Herculaneum. This ancient city was perhaps first settled by the Oscans, then was occupied by the Etruscans, and afterward by the Samnites; later it became a Roman municipium. Situated at the foot of Vesuvius, it was buried by the eruption of A.D. 79. Excavation and restoration began in the 18th century, below the present-day village of Resina. The city is rectangular in plan, with blocks whose length is twice the width. Among the most important monuments is the theater built by Augustus and later emperors, where much sculpture has come to light. Near the forum is a bath of the early Augustan period, with decorations from the time of Claudius or Nero. There is also a large gymnasium. The Samnite House (3d–2d of cent.) particular interest for its impressive atrium.

The House of the Bicentenary is of the Augustan Era. The House of the Stags, dating from the reign of Nero, differs in plan from the other houses: it is built around a courtyard, with a cryptoporticus and porticoes facing the sea. The House with the Mosaic Atrium is similar in plan, with a three-aisled tablinum. The Trellis House, a multifamily dwelling, is worthy of note for its use of wooden laths in the masonry (opus craticium) and for the common court and well that served its residents. Of great interest are the wooden furnishings of the houses (V, PL. 429). The painted wall decorations are mostly of Styles III and IV (PL. 424; VII, PL. 214; X, PL. 173). In the maritime suburb, separated from the city by a wall (1st cent. B.C.), are two slaughterhouses and baths of the Flavian era. On the northwest fringe of the city is the large suburban Villa of the Papyri (1st cent. B.C.), as yet explored only through underground passages; it probably belonged to L. Calpurnius Piso, Caesar's father-in-law. Several pieces of sculpture, as well as papyri from the private library of his philosopher friend Philodemus of Gadara, have been recovered.

BIBLIOG. A. Maiuri, Ercolano, Rome, 1959; EAA, s.v.

Ischia (Πιθηκοῦσσαι; Lat., Pithecusa, Aenaria). A large volcanic island between the Gulf of Gaeta and the Bay of Naples, inhabited since the Bronze Age. Pithekousai was perhaps the earliest West Greek colony, established about the first half of the 8th century B.C. by Chalcidian and Eretrian colonists; it was situated on the slope of Mt. Vico, in the northwestern part of the island, where a necropolis with Geometric and Orientalizing pottery has been found. In the 5th century it belonged to Neapolis, and in 82 B.C. was destroyed by Sulla. The eruption of Mt. Epomeo in the early 14th century obliged the islanders to take refuge on the rocky islet of the Castello d'Ischia. Here, enclosed by fortifications, are the Angevin castle (quadrilateral in plan) and the 14th-century Cathedral, with a Gothic crypt decorated with 14th-century frescoes. The Immacolata, an 18th-century church, has an adjoining Clarist convent. There are remains of the Church of S. Pietro (16th cent.). The causeway connecting the islet with the town of Ischia Ponte was built by the Aragonese in 1438. The modern quarter surrounds the ancient harbor. At Porto d'Ischia are S. Maria di Portosalvo (neoclassic) and S. Pietro a Pontaniello, as well as the Museo dell'Isola d'Ischia.

BIBLIOG. E. S. Mariotti, Il Castello d'Italia, Portici, 1915; G. Cipriani, Motivi di architettura ischiana, Architettura, VI, 1926–27, pp. 481–94; G. Algranati, Ischia, Bergamo, 1930; G. Buchner and A. Rittmann, Origine e passato dell'isola d'Ischia, Naples, 1948; L. Benevolo and F. Scanzani, Itinerari per Ischia: Il tempietto esagono di Castel S. Pietro, Q. Ist. Storia Arch., 4, 1953, pp. 14–15; G. Buchner, Figürlich bemalte spätgeometrische Vasen aus Pithekussai und Kyme, RM, LX–LXI, 1953–54, pp. 37–55; G. Buchner and C. F. Russo, La coppa di Nestore e un'iscrizione metrica da Pittecusa dell'VIII secolo a. C., RendLinc, 8th ser., X, 1955, pp. 215–34; G. G. Cervera, Guida dell'Isola d'Ischia, Naples, 1959; EAA, s.v.

Naples (Νεάπολις; Lat., Neapolis; It., Napoli). The city is mainly modern in appearance, with picturesque quarters of steep, narrow streets divided by avenues and long rectilinear thoroughfares. Much of the central and harbor areas was rebuilt after damage by bombing in World War II.

Settled by Greek colonists (Cumaean or Rhodian) about the mid-6th century, Parthenope (later called Palaiopolis) was situated on the Pizzofalcone hill (necropolis of 7th–6th cent.; section of 6th-cent. walls). At the end of the 6th century B.C., after the destruction of Parthenope, the colonists founded Neapolis about a mile to the northeast. This part of the city retains the (5th-century Greek) regular urban grid plan (FIG. 700; VII, PL. 235), with elongated blocks formed by three broad avenues (plateiai) and as many as twenty-one narrow streets (stenopoi). Vestiges of the 5th-century walls (reinforced 4th cent. B.C.) are worthy of note. The remains of the supposed Temple of the Dioscuri (zone of the agora), of a theater, and of the odeum, as well as a large building (probably the aerarium) near S. Lorenzo Maggiore, are all of the 1st century of our era. The necropolis was used from the 5th century until the Roman period. In the 1st century B.C. the Palaiopolis area was occupied by a villa of Lucullus. On Cape Posillipo, at the western end of the bay, are the remains of Villa Pausilypon (of Vedius Pollionus) and part of the Serino aqueduct, built by Augustus (rebuilt 2d cent.; popularly known as "Ponti Rossi").

The earliest Christian monument is the Catacomb of S. Gennaro (2d cent.), with frescoes of various periods. The Catacomb of S. Gaudioso (5th cent.) contains frescoes of the 5th and 6th centuries. (See FIG. 703 for location of monuments.) The oldest church is S. Restituta (4th cent.), rebuilt during the Angevin period, when it was incorporated into the Cathedral, and redecorated in the 18th century (ceiling by Luca Giordano). It originally comprised a nave and four side aisles, divided by reused ancient columns and capitals, with a circular apse bounded by five square chapels. Other

churches of the period had arcaded apses: S. Giorgio Maggiore (late 4th–early 5th cent.; remodeled 17th cent. by Cosimo Fanzago) has retained its original apse of this design. S. Gennaro extra Moenia (or dei Poveri; 5th cent.), comprising a nave and two aisles and a horseshoe-shaped apse, has remains of 5th- and 6th-century frescoes. S. Giovanni Maggiore (rebuilt 17th cent.) has retained part of the original 6th-century basilican structure. An important Early Christian building is the Baptistery of S. Giovanni in Fonte (5th cent.), on a square plan, surmounted by an octagonal dome on squinches of Eastern inspiration. Most of the mosaics are of Byzantine derivation,

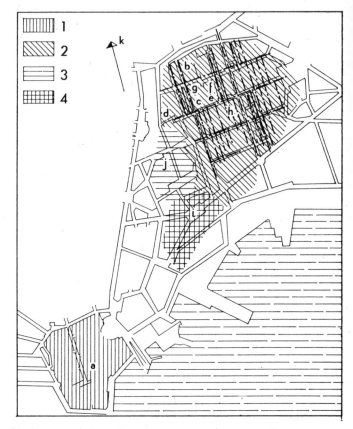

Naples, plan of the ancient city with layout of streets. Key: (1) Area of the Greek Parthenope (Palaiopolis), ca. 680–530 B.C.; (2) area of the Greco-Roman city (Neapolis), from the 5th century B.C.; (3) expansion of the urban area in the age of Valentinian III (A.D. 440); (4) expansion of the urban area in the age of Narses (A.D. 556). Greek period: (a) Acropolis of Palaiopolis (mod. Pizzofalcone hill); (b) acropolis of Neapolis; (c) agora; (d) course of walls, 4th cent. B.C. Roman period: (e) Presumed Temple of the Dioscuri; (f) theater; (g) odeum; (h) probable aerarium; (i) baths; (j) edifice, perhaps thermal; (k) to the catacombs of S. Gennaro and S. Gaudioso.

but some are in a traditional Hellenistic-Campanian style. The only examples of Romanesque architecture are the campanile of S. Maria Maggiore (11th cent.), the Castel dell'Ovo, and the Castello Capuano (both 12th cent., later altered).

When Naples became capital of the Angevin kingdom in 1266, French architects, summoned by the court, brought with them a Provençal type of Gothic. S. Lorenzo Maggiore (begun 1267; remodeled in the 18th century and thereafter restored) has a high apse, with an ambulatory and radiating chapels. It contains the tomb of Catherine of Austria (1323), by Tino di Camaino. S. Maria del Carmine (1283–1300) is similar in type (remodeled 18th cent.). S. Domenico Maggiore (1298–1324; rebuilt several times) has a Latin-cross interior, with a nave and two aisles and lateral chapels. Gothic architectural elements are still to be seen in the Spinelli Chapel. In the church are the tombs of John and Philip of Anjou, by Tino, works by Giordano, a Flagellation by Caravaggio (1607), an Annunciation by Titian, frescoes of the school of Giotto, and many other works. The Cathedral (1294–1323; rebuilt and remodeled several times) has a Neo-Gothic façade (19th–20th cent.) incorporating the three Gothic portals of Antonio Baboccio da Piperno (1407). The interior is basilican in form, with nave and two aisles flanked by lateral chapels. The baroque chapel of S. Gennaro (begun 1608) is decorated with works by Fanzago, Giuliano Finelli (II, PL. 168), Giovanni Lanfranco, Domenichino, and Jusepe de Ribera. The Minutolo Chapel contains frescoes (14th–15th cent.) and a polyptych

by Paolo di Giovanni Fei. S. Eligio (13th cent.) has a French Gothic portal (restored). S. Chiara (1310–28) had a baroque interior; damaged in World War II, however, it has been restored according to the 14th-century scheme. The façade has a rose window; the porch is Gothic. The interior comprises a nave flanked by chapels with funerary monuments and reliefs (14th cent.) by Tino and by Giovanni and Pace da Firenze. The adjoining Minorite cloister has a range of pointed arches over rounded ones. The Clarist cloister (14th cent.) was later (18th cent.) elaborately decorated with genre

Italian artists, among them probably Francesco Laurana. Inside the castle is the 14th-century Church of S. Barbara (Palatine Chapel), which has a Renaissance portal and contains a *Madonna* by the same Laurana as well as 14th-century frescoes. The Hall of the Barons, a square chamber designed by Sagrera (1443–53; remodeled and restored), is covered with an eight-part ribbed vault.

Also of the Renaissance is the Porta Capuana, built in 1484 by Giuliano da Maiano; it stands between two towers of the Aragonese walls. Numerous palaces were built by the nobility during this

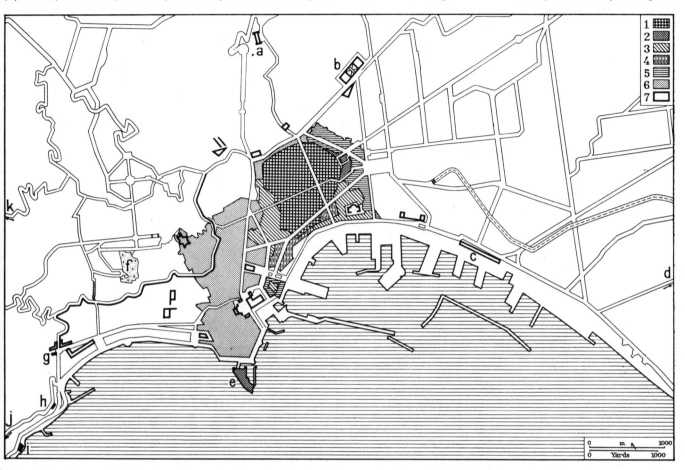

Naples and environs, with indications of expansion from the Greek period to modern times. *Key*: (1) Greco-Roman period, until 5th century of our era; (2) Norman period; (3) Angevin period; (4) period of the Durazzo line; (5) Aragonese period; (6) Spanish period; (7) structures of the Bourbon period. (*a*) Capodimonte; (*b*) Albergo dei Poveri; (*c*) Granili; (*d*) to Barra; (*e*) Castel dell'Ovo; (*f*) Villa Floridiana; (*g*) S. Maria di Piedigrotta; (*h*) S. Maria del Parto; (*i*) Palazzo di Donn'Anna; (*j*) to Posillipo; (*k*) to the Campi Flegrei (Phlegrean Fields).

scenes, landscapes, and ornamental elements in majolica. S. Maria Donnaregina (ca. 1320) contains the tomb of Queen Mary of Hungary by Tino (1326). The choir of the nuns is decorated with frescoes by Cavallini and pupils (III, PL. 108). The frescoes in the apartment of the abbess are by Solimena; those in the chapel are by Preti. S. Maria Incoronata (1352) has a Gothic apse and an arcaded porch with ogival arches; the frescoes are of the 14th and 15th centuries. S. Giovanni a Carbonara (1343; later rebuilt and thereafter restored) is a single-aisled church, approached by a flight of steps (18th cent.). Within is a monument to King Ladislaus (d. 1414), designed by Andrea da Firenze, with frescoes by Leonardo Molinari da Besozzo. The Cappella Caracciolo del Sole contains the tomb of Ser Gianni Caracciolo and frescoes by Perrinetto di Matteo and Besozzo (15th cent.); the floor is of glazed terra cotta (15th cent.).

Two buildings dominate the city: Castel S. Elmo (1329), on the summit of the Vomero hill, rebuilt on a star-shaped plan (16th cent.), and slightly below, the Certosa di S. Martino, built in the 14th century and remodeled in the baroque period. Gothic elements persisted through the 15th century, along with early Renaissance forms introduced by Tuscan artists. This "Durazzo" Gothic, introduced during the Angevin reign of the Durazzo line, is a form of Catalan Gothic brought to Naples by the court architect Guillermo Sagrera. The Castel Nuovo, built by Charles I (1279–82) and reconstructed in the 15th century, marks the transition from late Gothic to Renaissance. Trapezoidal in plan, with crenelated cylindrical towers at the corners, it is entered through the triumphal arch of Alfonso of Aragon (ca. 1454–67; III, PL. 390), the work of various Italian and non-

period. While some retain Catalan elements (ogival arches of the Durazzo type), others derive from 15th-century Tuscan models, with severe façades of rusticated ashlar and sometimes with inner porticoed courtyards. These include the Penne (1406), Cuomo (1464–90), Santangelo (late 15th cent.), Marigliano (1513), Carafa di S. Severino, Filomarino (rebuilt 1512), with a baroque portal, and Gravina (1513–49). Tuscan influence is evident in religious architecture, particularly in the monastic complex of S. Anna dei Lombardi, which includes the Church of Monte Oliveto (ca. 1410–15; remodeled after damage in World War II). Entered through a porch with a Catalan Gothic arch, the church comprises a nave with lateral chapels; the Mastrogiudice Chapel contains an *Annunciation* and other decorative reliefs by Benedetto da Maiano (1489). The Oratorio del Sto Sepolcro is decorated with frescoes by Francesco Ruviale (Il Polidorino) and contains the terra-cotta *Pietà* by Guido Mazzoni (1492), a striking group of eight freestanding figures, as well as the tomb of A. Fiodo by Francesco da Sangallo (Il Margotta). The Tolosa Chapel is by G. da Maiano. The Piccolomini Chapel, which may have been designed by the same artist, contains a *Nativity* and other reliefs (ca. 1475), along with the tomb of Mary of Aragon, all by Antonio Rossellino. Other noteworthy Renaissance ecclesiastical structures are the Pontano Chapel (1492) and S. Caterina a Formello (1519–93). The Gesù Nuovo (1584–1601; afterward enlarged and remodeled) incorporates the façade of the Palazzo Sanseverino (1470), executed in diamond-shaped ashlar of southern Italian type. The interior, an interesting example of Neapolitan baroque, comprises a tripartite nave and a transept faced with polychrome inlaid marble; there are

frescoes and other works by Solimena, Belisario Corenzio, Lanfranco, Stanzione, Giordano, Ribera, and Aniello Falcone.

The use of Renaissance classic forms persisted through the late 16th and early 17th centuries, with greater emphasis on the decorative element; this is seen in the Church of S. Gregorio Armeno, reconstructed by Giambattista Cavagna (late 16th cent.). The additions to the Certosa di S. Martino were built by Giovan Antonio

Dosio, with the collaboration of Giovanni Giacomo Conforto (1580–1623), and were continued by Fanzago (until 1643). Within the monastery are works by Simon Vouet, Corenzio, Giuseppe Cesari ("Cavalier d'Arpino"), Caracciolo, and Stanzione (PL. 224). The floor and the marble decorations of the chapels in the church are by Fanzago (PL. 87). The church also contains frescoes and paintings by Lanfranco, Stanzione, Ribera, Andrea Vaccaro, Carlo Maratti

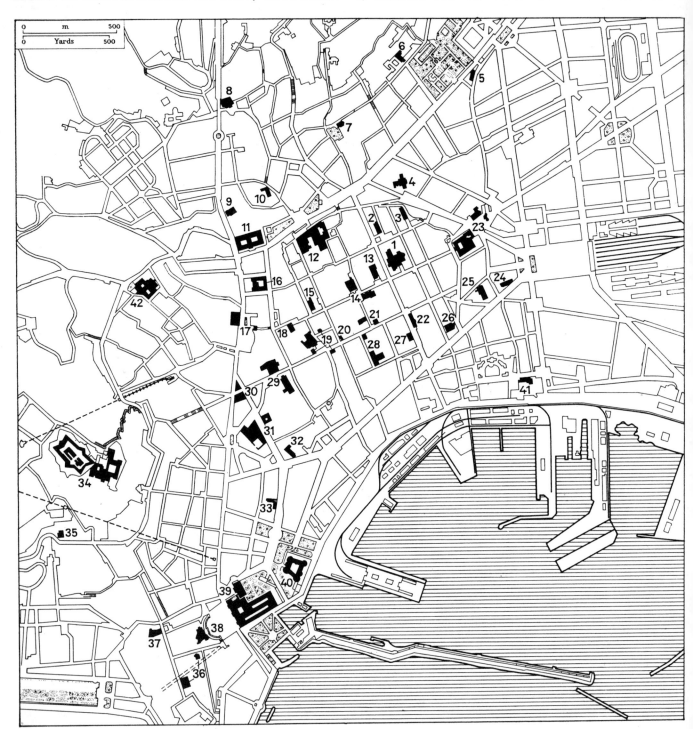

Naples, plan of the center. Principal monuments: (1) Cathedral and archiepiscopal palace; (2) S. Maria Donnaregina; (3) SS. Apostoli; (4) S. Giovanni a Carbonara; (5) S. Antonio Abate; (6) S. Maria degli Angioli alle Croci; (7) S. Maria dei Miracoli; (8) S. Maria della Sanità; (9) S. Teresa degli Scalzi; (10) S. Maria della Stella; (11) Museo Nazionale; (12) S. Maria delle Grazie and Hospital of the Incurables; (13) Church of the Gerolomini (S. Filippo Neri); (14) S. Paolo Maggiore and S. Lorenzo Maggiore; (15) S. Maria Maggiore; (16) Accademia di Belle Arti; (17) Palazzo Bagnara and Porta Alba; (18) S. Pietro a Maiella; (19) Palazzo Del Balzo, S. Domenico Maggiore, S. Maria della Pietà del Sangro, and S. Angelo a Nilo; (20) Palazzo Santangelo; (21) S. Gregorio Armeno and Palazzo Marigliano; (22) S. Giorgio Maggiore; (23) Castel Capuano, S. Caterina a Formello, and Porta Capuana; (24) S. Pietro ad Aram; (25) Church of the Annunziata; (26) S. Agostino della Zecca; (27) Palazzo Cuomo (Museo Civico Gaetano Filangieri; (28) SS. Severino e Sosio and Palazzo del Monte di Pietà; (29) Church of S. Chiara and the Gesù Nuovo; (30) D'Angri and Maddaloni palaces; (31) Church and Cloister of S. Anna dei Lombardi and Palazzo Gravina; (32) S. Maria la Nova; (33) S. Maria Incoronata and S. Giorgio dei Genovesi; (34) Castel S. Elmo and Museo Nazionale di S. Martino (Certosa); (35) S. Maria Apparente; (36) Palazzo Serra di Cassano and S. Maria Egiziaca a Pizzofalcone; (37) S. Maria degli Angeli; (38) S. Francesco di Paola; (39) Palazzo Reale and Teatro San Carlo; (40) Castel Nuovo; (41) S. Maria del Carmine; (42) Church and Hospital of Gesù e Maria.

(II, PL. 204), and Solimena. In the sacristy are works by Luca Cambiaso and Cesari; the Great Cloister (PL. 225) is by Fanzago and Dosio. The Church of S. Maria della Stella was designed by Carlo Fontana. The Church of S. Filippo Neri (I Gerolomini) was begun by Dosio in 1592 and completed in 1619; the façade was reconstructed by Ferdinando Fuga (18th cent.). There are frescoes by Giordano (1684) and paintings by Corenzio, Bernardo Cavallino, Guido Reni, and Solimena. The gallery adjacent to the church contains an important collection of paintings. The Palazzo del Monte di Pietà, built by Cavagna (1597–1605), has an adjoining chapel decorated by Pietro Bernini, Michelangelo Naccherino, and Corenzio. The Palazzo Reale, by Domenico Fontana (1600–02), is a large structure with three superimposed orders. It was altered in the 18th and 19th centuries.

The Neapolitan baroque, which characterizes a large part of the city, has a greater exuberance of decorative detail than the Roman baroque from which it derived, especially in those churches with high domes sometimes covered with glazed terra-cotta tiles (e.g., the churches designed by Giuseppe Nuvolo). The interiors are richly decorated with stuccowork, frescoes, and polychrome marble inlay and generally follow a plan derived from the designs of Giacomo da Vignola, with a nave and lateral chapels. The Church of SS. Apostoli, by Francesco Grimaldi (1626–33), contains frescoes and paintings by Lanfranco and Giordano, as well as the Filomarino altar of Borromini (X, PL. 192). S. Maria di Constantinopoli, designed by Nuvolo, has fresco decorations by Corenzio. The leading decorator and architect of the Neapolitan baroque was the Lombard Cosimo Fanzago. His works include S. Ferdinando (1628–60), S. Maria degli Angioli alle Croci (1638), S. Giorgio Maggiore (1640), S. Domenico Soriano, with a tripartite nave (begun 1648), and the façade of S. Maria della Sapienza. He also designed several churches on the Greek-cross plan: S. Giuseppe a Pontecorvo (1660); the Ascensione a Chiaia (1622–45); S. Teresa a Chiaia (1650–62), approached by a double circular staircase, and containing works by Fanzago and Giordano; S. Maria Egiziaca a Pizzofalcone, with a convex façade (1651); and S. Maria Maggiore (or La Pietrasanta; 1653–67), with works by Giuseppe Bonito. Of the same period is S. Maria della Sanità (1602), by Nuvolo, who incorporated into it the 5th-century Chapel of S. Gaudioso (below the presbytery); the church contains works by Giordano and Francesco (Pacecco) De Rosa. Many churches are elliptical in plan, for example, S. Maria Egiziaca, by Dionisio Lazzari (1684). Fewer are basilican, with tripartite nave and lateral chapels; these include S. Maria degli Angeli and S. Paolo Maggiore (ca. 1585–1603), both by Grimaldi, the latter with two Corinthian columns from the Temple of the Dioscuri incorporated into the façade.

The architecture of the late 17th and first half of the 18th century continued baroque forms and decoration. Campaniles and obelisks were added to the churches and the baroque piazzas of the city. The Guglia di S. Gennaro (a freestanding decorated pinnacle) was designed by Fanzago (1637–60); the obelisk of S. Domenico is by Francesco Antonio Picchiatti and Domenico Antonio Vaccaro (1658 and 1737, respectively), and the spire of the Immacolata (1747–51) is by Giuseppe Genuino and Giuseppe Di Fiore. S. Nicola alla Carità is by Onofrio Antonio Gisolfi and Fanzago, with the façade and frescoed ceiling (1701) by Solimena. One great exponent of 18th-century Neapolitan baroque was Domenico Antonio Vaccaro, who designed the Concezione a Montecalvario, a central-plan church, and decorated the interior as well. His works also include the Church of S. Michele (1730), the Palazzo Spinelli di Tarsia (unfinished), and the Cloister of S. Chiara, decorated with majolica. Ferdinando Sanfelice created a more theatrical style in both his secular and religious architecture. He remodeled Palazzo Pignatelli (1718), designed the portal of Palazzo Filomarino and the façade of S. Lorenzo Maggiore, and built the Church of the Nunziatella.

The Bourbon dynasty (1735–1860) brought about a period of expansion in Naples, with a particular increase in secular architecture. Among the buildings of this period are the Albergo dei Poveri (poorhouse), begun in 1751 by Fuga (completed much later), and the Palazzo di Capodimonte, begun in 1738 by Giovan Antonio Medrano (completed 19th cent.). The most important architect of the second half of the 18th century was Luigi Vanvitelli, who built the Palazzo Calabritto (1756) and rebuilt the Church of the Annunziata (1760), with a unitary nave flanked by Corinthian columns and surmounted by a dome. He also built the Foro Carolino (Piazza Dante), with a columned hemicycle in the Tuscan Doric order (1763). The Church of the Trinità (1796) exhibits a complex plan comprising two octagons joined by a rectangle; the Oratorio della Scala Santa (1772–73), on the other hand, has a more rigorously geometric plan.

The architecture of the early 19th century is neoclassic. The plan of S. Francesco di Paola (1817–46; I, PL. 305), by Pietro Bianchi, was derived from the Roman Pantheon. The Teatro San Carlo, built by Medrano in 1737 but later damaged by fire, was rebuilt in 1816 by Antonio Niccolini; the Villa Floridiana (1817–19) was de-

signed by the same architect. In the late 19th century many public buildings were erected in the "Floreale" style. An example is the Galleria Umberto I, designed by Emanuele Rocco (1887–90) in imitation of the Galleria in Milan. About the same time many wide streets and avenues were laid out, including Corso Umberto I, or Rettifilo (1888–94). In the urban development of the 20th century, new quarters have been built on regular grid plans (e.g., the Vomero, Carità, and Mergellina quarters).

Museums and Galleries: Museo Nazionale (Farnese Coll., antiquities from Campania); Museo e Gallerie Nazionali di Capodimonte (paintings, sculpture, decorative arts); Museo Civico Gaetano Filangieri (Palazzo Cuomo; paintings, ceramics, minor arts); Museo Nazionale di S. Martino (Certosa; paintings, drawings, sculpture, minor arts); Museo Duca di Martina alla Floridiana (porcelain, ceramics, paintings); Galleria dell'Accademia di Belle Arti (paintings, sculpture); Museo Principe Diego Aragona Pignatelli Cortes (porcelain); Raccolta d'Arte Pagliara (paintings, drawings, ceramics).

BIBLIOG. B. di Falco, Descrittione dei luoghi antiqui di Napoli, Naples, 1580; C. Caracciolo, Napoli sacra, Naples, 1623; N. Carletti, Topografia universale della città di Napoli, Naples, 1776; L. Catalani, Le chiese di Napoli, 2 vols., Naples, 1845–53; C. N. Sasso, Storia dei monumenti di Napoli, 2 vols., Naples, 1856–58; S. d'Alce, Storia delle chiese di Napoli, 5 vols., Naples, 1861; B. Capasso, Pianta della città di Napoli del secolo XI, Arch. storico province napoletane, XVI, 1891, pp. 832–62, XVII, 1892, pp. 422–84, 679–726, 851–81, XVIII, 1893, pp. 104–25, 316–63; M. Schipa, Una pianta topografica di Napoli del 1566, Napoli nobilissima, IV, 1895, pp. 161–66; W. Rolfs, Neapel, 2 vols., Leipzig, 1905; V. Spinazzola, L'arte e il Seicento in Napoli alla Certosa di S. Martino, Naples, 1905; A. Sorrentino, La basilica di Santa Restituta, BArte, III, 1909, pp. 217–33; V. Spinazzola, Di Napoli antica e della sua topografia, BArte, IV, 1910, pp. 125–43; A. de Rinaldis, Santa Chiara, Naples, 1920; L. Serra, Note sullo svolgimento dell'architettura barocca a Napoli, Napoli nobilissima, N.S., III, 1922, pp. 1–7; A. Filangieri, La chiesa e il Monastero di S. Giovanni a Carbonara, Arch. storico province napoletane, N.S., IX, 1923, pp. 1–35; G. Chierici, Le chiese angioine di Napoli, Naples, 1933; G. Chierici, Il restauro della chiesa di S. Maria di Donnaregina, Naples, 1934; H. Achelis, Die Katakomben von Neapel, Leipzig, 1936; G. Chierici, Architettura religiosa a Napoli nei secoli XVII e XVIII, Palladio, I, 1937, pp. 17–26, 99–108; R. Pane, Architettura del rinascimento a Napoli, Naples, 1937; R. Pane, Architettura dell'età barocca in Napoli, Naples, 1939; G. Rosi, Il restauro del Castelnuovo a Napoli, Le Arti, IV, 1941–42, pp. 284-87; P. Amodio, Ricerche e studi sui monumenti gotici napoletani, Naples, 1944; E. Gabrici, Contributo archeologico alla topografia di Napoli della Campagna, MALinc, XLI, 1951, cols. 553–674; P. Colletta, Storia del Reame di Napoli, new ed., 3 vols., Naples, 1953–57; R. Pane, Il Chiostro di Santa Chiara, Naples, 1954; V. Dattilo, Castel dell'Ovo, Naples, 1956; F. De Filippis, Castelcapuano, Naples, 1956; R. U. Montini, La chiesa del Gesù, Naples, 1956; R. Pane, Il monastero napoletano di S. Gregorio Armeno, Naples, 1957; G. Rosi, La cinta bastionata del Castelnuovo di Napoli, Atti V Conv. naz. Storia Arch. (1948), Florence, 1957, pp. 317–26; D. Maggiore, Chiese storiche ed artistiche della città di Napoli, Naples, 1958; B. Molajoli, Notizie su Capodimonte, Naples, 1958; M. Napoli, Napoli greco-romana, Naples, 1959; M. Picone, La Cappella Sansevero, Naples, 1959; F. Strazzullo, Saggi storici sul Duomo di Napoli, Naples, 1959; A. Bellucci, Nuove osservazioni sulla topografia del cimitero paleocristiano di S. Gennaro extra moenia, Partenope, I, 1960, pp. 167–73; G. Russo and C. Cocchia, Napoli: Contributi allo studio della città, 3 vols., Naples, 1960–61; G. Del Guercio, Il restauro della chiesa di S. Maria dell'Incoronata, Partenope, II, 1961, pp. 29–41; Hirpinus, S. Lorenzo Maggiore a Napoli: Ritrovamenti paleocristiani e alto medievali, Napoli nobilissima, 3d ser., I, 1961, pp. 13–21; B. Molajoli, Il Museo di Capodimonte, Naples, 1961; R. Mormone, Notizie sull'urbanistica napoletana del Settecento, Napoli nobilissima, 3d ser., I, 1961, pp. 199–200; R. Wagner-Rieger, S. Lorenzo Maggiore in Neapel. Misc. Bibliothecae Hertzianae, Munich, Vienna, 1961, pp. 131–43.

Nocera Superiore. This town of ancient origin is situated on the north side of the pass between the valley of the Sarno and the Gulf of Salerno, on the Via Popilia. In the 5th century B.C. it prospered under the Samnites, but was conquered by the Romans in 307. The orthogonal plan is still recognizable; there are remains of sections of the walls (2d–1st cent.), an amphitheater, and the ruins of a cryptoporticus. S. Maria Maggiore was built as a baptistery (5th cent.?); although it was partly remodeled and later restored, the basic structure has not been altered. A circular building, with a dome supported by columns, it contains a basin for baptism by immersion. Outside the town a number of ancient tombs have been found, the oldest of which date from the 6th century. Near Nocera is the Sanctuary of Materdomini, built between 1168 and 1172 (remodeled 1771–96; restored 1947).

BIBLIOG. M. De Santi, Studio storico sul santuario di S. Maria Materdomini, Naples, 1905; M. Stettler, Das Baptisterium zu Nocera Superiore, RACr, XVII, 1940, pp. 83–142; M. and A. Fresa, Primo contributo alla topografia di Nuceria Alfaterna, RendNapoli, XXXIII, 1958, pp. 177–202.

Nola. This city was first Ausonian and later Etruscan. It was conquered by the Samnites in the latter half of the 5th century, and in 313 B.C. it became an ally of Rome. Destroyed by Alaric in 410, it was rebuilt as a Christian city. Under the Angevins it was a county;

later it belonged to the Orsinis, and in 1528 it became a royal city. Nola is known for the numerous Greek vases, both imported and locally manufactured, that have been found there. Also of the ancient period are remains of the Samnite walls, of houses, and of a Roman amphitheater, as well as an important necropolis with painted chamber tombs. The Church of the Misericordia (or S. Biagio; 14th cent.) has a Romanesque façade and campanile and a Gothic apse. The palace built for the Orsini family (1461) was partially of material salvaged from the Roman amphitheater. The Palazzo Covoni (16th cent.) is in Renaissance style and also incorporates Roman fragments. The churches of the Annunciata and the Immacolata are baroque. The seminary of the episcopate (1749) is by Luigi Vanvitelli, as are the Duke of Aosta Barracks. The neoclassic Cathedral was designed by Nicola Breglia (1878-1909), to replace the, 14th-century Cathedral destroyed by fire. The crypt, built over the ruins of a Temple of Jupiter, contains fragments of 8th- and 9th-century sculpture.

BIBLIOG. F. Wickoff, Das Apsismosaik in der Basilica des H. Felix zu Nola: Versuch einer Restauration, RQ, III, 1889, pp. 153-76; G. Patroni, Nola: Scoperte di antichità avvenute negli ultimi anni, NSc, 1900, pp. 100-12; M. Della Corte, Nola: Sopraluogo di ricognizione, NSc, 1928, pp. 377-78; G. Rizza, Pitture e mosaici nelle basiliche paoliniane di Nola e di Fondi, Siculorum Gymnasium, I, 1948, pp. 311-21; G. Rossi, Il campanile della Cattedrale di Nola, BArte, XXXIV, 1949, pp. 10-20; F. Castagnoli, Tracce di centuriazioni nei territori di Nocera, Pompei, Nola, Alife, Aquino, Spello, RendLinc, 8th ser., IX, 1954, pp. 373-78; M. Zampino, La chiesa vecchia di S. Chiara in Nola, Atti V Conv. naz. Storia Arch. (1948), Florence, 1957, pp. 437-50.

Paestum (Ποσειδωνία). Situated about a half mile from the present coast line of the Gulf of Salerno, the site was inhabited in the Neolithic age (necropolis near Contrada Gaudo, ca. 2400-1900). In the late 7th or early 6th century Achaean Greeks founded the colony of Poseidonia. An important center of commerce with the Etruscans, it was conquered by the Lucani in the early 4th century and by the Romans in 273 B.C.

The city has a roughly trapezoidal plan, which is divided by three east-west *plateiai* and numerous north-south *stenopoi*, creating long rectangular blocks (120 × 1,000 ft.). The sanctuaries and the forum are at the center (VII, PL. 53). Substantial sections of the walls are well preserved, the oldest probably dating from the 6th century B.C. They have both round and square towers, four principal gates, and numerous posterns. The two largest temples, the so-called "Basilica" and the Temple of Hera Argiva (called "Temple of Neptune"), are enclosed in a common temenos, south of the forum. The "Basilica" (I, PL. 333), the earliest temple preserved at Paestum (mid-6th cent. B.C.), has 9 Doric columns on each end and 18 on either side. From the portico, a pronaos *in antis* (the 2 piers, like the 3 columns, with entasis) leads to the cella, divided longitudinally by a row of 7 columns. The so-called "Temple of Neptune" (or Poseidon; ca. 450 B.C.) is the largest of the Paestum temples. Architecturally similar to the Temple of Zeus at Olympia, it is a peripteral hexastylos with 14 columns along the sides. Small shrines and treasuries of various periods, as well as altars, surrounded these temples. North of the forum are an underground shrine dedicated to an unidentified goddess (6th cent. B.C.) and the Athenaion, or "Temple of Ceres" (late 6th cent. B.C.), a peripteral hexastylos with 13 columns along the sides. The peristyle is Doric, but the columns of the pronaos are Ionic. The Athenaion was also surrounded by smaller buildings and votive shrines. North of the forum is an Italic temple, begun in 273 as the *capitolium*, then abandoned, and resumed about 80 B.C. Near the eastern flank are the remains of a circular cavea, probably used for public assemblies of the Roman colonia. Other structures around the forum include the presumed senate house (*curia*), an amphitheater, and tabernae. Later excavations have brought to light several houses built around an atrium (some from the republican period), a large gymnasium, and several baths. The necropolis contains painted tombs (IV, PL. 397; VII, PL. 72), and there are funerary *naskoi* on platforms that date from a later period. The Museo Archeologico holds finds from Paestum and the Sele Heraion.

About 5 miles north of Paestum, at the mouth of the Sele River, is a Heraion (late 6th cent. B.C.), from which the foundations of the peristasis have been preserved. There are also remains of a treasury and a megaron, somewhat earlier in date. Most of the figured metopes from the temple and the treasury have been recovered; some of these had been reused in structures of the 4th century B.C.

BIBLIOG. A. D. Trendall, Paestan Pottery, London, 1936; F. Krauss and R. Herbig, Der Korinthisch-dorische Tempel am Forum zu Paestum, Berlin, 1939; F. Krauss, Paestum, Berlin, 1941; P. Zancani Montuoro and U. Zanotti Bianco, Heraion alla foce del Sele, 2 vols., Rome, 1951-54; P. C. Sestieri, Paestum, Rome, 1953; P. C. Sestieri, Il museo di Paestum, Rome, 1955; P. C. Sestieri, Il Sacello — Heroon Posidoniate, BArte, XL, 1955, pp. 54-64; B. Neutsch, Archäologische Grabungen und Funde im Bereich

der unteritalischen Soprintendenzen von Tarent, Reggio di Calabria und Salerno (1949-1955): Paestum, AAnz, 1956, cols. 373-444; B. Neutsch, Τὰς νύμφας ἐμὶ ἱαρόν: Zum unteritalischen Heiligtum von Paestum, Abh. der Heidelberger Akad. der Wissenschaften, Philosophisch-historische Klasse, 1957, 2.

Pompeii. Situated north of the mouth of the Sarno, this city, though probably of indigenous origin, was early dominated by the Etruscans and Greeks. In the 5th century it was conquered by the Samnites, and in 80 B.C. it became a Roman colonia. Severe damage was caused by the earthquake in A.D. 62, and the eruption of Vesuvius in 79 buried the city beneath a thick layer of volcanic ash and pumice. The continuing excavations began as early as 1748.

The oldest nucleus, which appears to have been inhabited from about the 6th century B.C., includes the southwestern sector of the city and the area of the forum (FIG. 708). To this period belong the Temple of Apollo, near the forum, and the oldest parts of a Doric peripteros dedicated to Hercules (later to Athena also), set within the so-called "Triangular Forum." The enlarged city of the 5th century B.C. follows the Hippodamian plan, with *plateiai* and *stenopoi* marking out elongated, mostly orthogonal blocks. Many blocks in the eastern sector were only partially occupied, suggesting that urban areas were laid out according to a regular plan, in preparation for future development. The first stage in the construction of the city walls dates from the pre-Samnite epoch, while three further stages are from Samnite times. In the last of these phases, a few years before the Samnite Wars (late 4th-early 3d cent.), the towers were built, with ramps to accommodate military equipment. The gates, of the Samnite and Roman periods, are deeply set back between

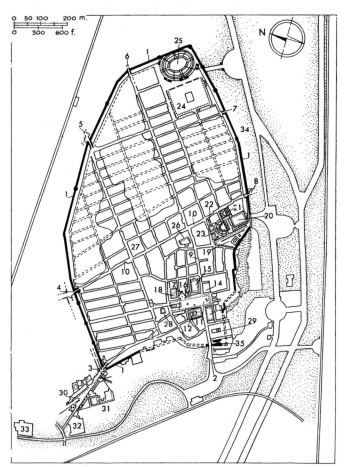

Pompeii, schematic plan of the ancient city. (1) Walls; (2) Porta Marina; (3) Porta Ercolano; (4) Porta Vesuvio; (5) Porta di Nola; (6) Porta di Sarno; (7) Porta Nuceria; (8) Porta di Stabia; (9) *decumanus maximus* (Via dell'Abbondanza); (10) *cardo maximus* (Via di Stabia); (11) forum, north of which is the Temple of Jupiter; to the south, the *curia*, between the office of the aediles and that of the duumvirs; (12) Temple of Apollo; (13) so-called "Basilica"; (14) comitium; (15) building of Eumachia; (16) Temple of Vespasian; (17) lararium; (18) *macellum*; (19) Triangular Forum, with Doric temple; (20) large theater and the Ludo Gladiatorio; (21) odeum; (22) Temple of Jupiter Meilichius (Zeus Meilichios); (23) Temple of Isis; (24) palaestra; (25) amphitheater; (26) Stabian Baths; (27) central baths; (28) Baths of the Forum; (29) Temple of Venus; (30) Via dei Sepolcri; (31) Villa of Cicero; (32) Villa of Diomedes; (33) Villa of the Mysteries; (34) necropolis; (35) antiquarium (*from A. Maiuri, Pompei, Rome, 1959*).

lateral bastions. The forum is of the Samnite period and comprises shops, a large three-aisled basilica, the Temple of Apollo (with a quadriporticus), the platform of the Temple of Jupiter, and the oldest market (*macellum*). Of the same period is the Triangular Forum, which may have served as the citadel; it includes a long Doric portico and a sacred well with a monopteral covering, along with the aforementioned older Doric temple. Adjacent are the palaestra and a large open theater. The original structure of the Stabian baths is also Samnite, with reconstruction during the time of the Roman colonia and later. The upper part of the *capitolium*, the Temple of Venus Pompeiana, the odeum, the amphitheater, and the Baths of the Forum (PL. 96) all date from the early years of the colonia. Somewhat later in date are the *curia*, the Temple of Isis, the great palaestra, the Temple of Fortuna Augusta, the aqueduct and the so-called "Castellum Aquae" for channeling the water, the mercantile building of Eumachia (given by this priestess to the *fullones*, a clothmakers' guild), and several commemorative arches in the zone of the forum. The Temple of Vespasian, a large part of the portico of the forum, the vast and luxurious central baths, and a number of partly finished reconstructions (e.g., the *macellum*) were undertaken after the earthquake of A.D. 62.

Pompeii preserves Italic domestic architecture and wall decoration in the period from the 4th century B.C. through the first century of the Empire. The House of Sallust, with well-preserved stucco decorations in Style I, is a fine example of a Samnite house. The austere House of the Surgeon is a characteristic structure of the so-called "limestone period" (4th–3d cent.) and derives from the oldest known type of Italic house. The larger houses, with at least one peristyle and often with two atria, date from the 2d century B.C.; among these are the House of the Faun (VII, PLS. 154, 200), the House of the Labyrinth, and the House of Pansa. Also from the 2d century are some isolated examples of houses with a Corinthian atrium, such as the House of Edipius Rufus, which had a paved platform before the entrance. The standard type of patrician mansion is seen fully developed in the House of the Silver Wedding (of Samnite origin, with further construction under Augustus and later) and in the House of Menander (1st cent. B.C.). The houses of the Neronian era, which foreshadow the Ostia type, are represented by the House of the Golden Cupids, with a raised stagelike area at one end of its peristyle. Elaborate garden architecture is a feature of many of the larger residences (PL. 425). Some of the suburban villas have portions dating back to the Samnite period; these include the Villa of Diomedes and the Villa of the Mysteries. The latter residence is of particular interest not only for the organic quality of its architecture but also for the excellent decorations in Style II, with wall paintings of Dionysian subjects (IV, PL. 168; VII, PL. 203; IX, PL. 246). The Roman funerary monuments in the city are remarkable for the variety of types (with exedra, aedicula, altar, etc.).

Near Pompeii are many Roman country houses, notably at Boscoreale and Scafati. There is an Antiquarium at the excavation site of Pompeii.

BIBLIOG. A. Mau, Pompeji in Leben und Kunst, Leipzig, 1900; E. Pernice and others, Die Hellenistische Kunst in Pompeji, 7 vols., Berlin, Leipzig, 1912–41; A. Maiuri, La casa del Menandro, Rome, 1932; A. Maiuri, L'ultima fase edilizia di Pompei, Rome, 1942; A. Maiuri, La villa dei Misteri, Rome, 1947; Pompeiana (Misc.), Naples, 1950; V. Spinazzola, Pompei alla luce degli scavi nuovi di Via dell'Abbondanza, Rome, 1953; A. Maiuri, Pompei, Rome, 1959.

Pozzuoli (Δικαιάρχεια; Lat., Puteoli). Situated west of Naples, on the Bay of Pozzuoli, the town was founded by Greek exiles from Samos (ca. 529–520 B.C.), and for a time was probably a dependency of Cumae. During the war against Hannibal it was a Roman stronghold, and in 194 B.C. a maritime colonia was established. It became the chief port for Rome and remained an important commercial center until the last years of the Empire. A Christian community existed even before the arrival of St. Paul in A.D. 61. After the barbarian invasions the site was abandoned. Views of Roman Puteoli are found in paintings of the 1st and 2d centuries (IX, PL. 5) and on some glass bottles of the 4th century. The acropolis stood on an isolated hill near the sea, where remains of Greek-Samnite walls and of the Temple of Augustus can still be seen. The ancient city lay north and west of this point, but the coastal portion has gradually become submerged. On the higher terrain there remain two amphitheaters, of the republican and Flavian periods, two reservoirs (one, the vast Piscina Cardito), a porticoed square, two large bath complexes (2d cent.), and vestiges of warehouses, the stadium, and several villas. In the lower city are the ruins of the emporium and of the large market (the so-called "Temple of Serapis"), partially submerged. The harbor basin was protected by the "Opus Pilarum," a quay composed of arches resting on buttresses. Along the roads to Capua and Naples there are columbaria of the 1st and 2d centuries. The Cathedral (S. Procolo), built in the 11th century on the site of a Temple of Augustus, incorporated salvaged Corinthian columns (reconstructed 17th cent.).

BIBLIOG. C. Dubois, Pouzzoles antique, Paris, 1907; A. Maiuri, L'anfiteatro flavio Puteolano, Naples, 1955; A. Maiuri, I Campi Flegrei, 3d ed., Rome, 1958.

Ravello. The town prospered in the 11th and 12th centuries, when Ravello maintained close commercial relations with Sicily and absorbed from it the Arabo-Norman style of architecture evident in many buildings. The Palazzo Rufolo (begun 11th cent.; PL. 175) has interlacing arches that fulfill a structural as well as a decorative function. S. Maria Immacolata (or a Gradillo), a small three-aisled church, dates from the 12th century. S. Giovanni del Toro (founded 975, consecrated 1276) has a 12th-century pulpit (restored), richly decorated with mosaics and majolica. The Annunziata, S. Agostino, and S. Martino are all similar in design: surmounted by a dome with two-color decoration, they have basilican interiors with aisles divided by stilted arches and covered by groined vaults. Siculo-Arabic influence is seen in the campaniles of these churches. The contemporaneous Cathedral (S. Pantaleone; 1086) was executed in a pure Romanesque style (remodeled 1786). Originally it was preceded by a portico; the façade (restored 1932) has bronze doors designed by Barisanus of Trani (1179). The interior furnishings have been reconstructed partly from the original materials. These include an ambo (1130) and a carved pulpit, by Niccolò di Bartolommeo da Foggia (1272); both have mosaic ornamentation similar to that of the episcopal throne (reassembled in part from material take from the pulpit). Two antique columns comprise the paschal candlestick. The campanile, with two orders of double-arched windows, dates from the 13th century. The Casa di Tolla, the present-day Municipio, was built in the 11th century. The Gothic church of S. Francesco retains part of the original transept and a small Romanesque cloister.

BIBLIOG. L. Mansi, Ravella sacra-monumentale, Ravello, 1887; L. Benevolo, La chiesa e l'oratorio della SS. Annunziata, Q. Ist. Storia Arch., 12, 1955, pp. 9–16; L. Benevolo, I mosaici medievali di Ravello, Q. Ist. Storia Arch., 19, 1957, pp. 1–16.

Salerno (Lat., Salernum). A site inhabited in the Iron Age (Villanovan culture in a necropolis at Pontecagnano), it was probably colonized by the Etruscans, perhaps as the town of Marcina (necropolis at Fratte di Salerno, 6th–3d cent.). Salernum became a Roman colonia in 194 B.C. In 646 it was conquered by the Lombards, and in 1077 by the Normans under Robert Guiscard. From the early Middle Ages until 1812 it was the seat of a renowned school of medicine.

The city consists of a medieval quarter, with narrow, irregular streets coursing the side of a steep hill crowned by a castle, and a modern sector paralleling the water front, with a rectilinear disposition of broad streets. From the Lombard period are the additions to the Castle of Arechi, founded by the Romans, later enlarged and remodeled under the Normans; the remains of the Porta Rateprandi; the Arch of Arechi, the only extant portion of the 8th-century palace of the Lombard prince Arechi; the Church of S. Pietro a Corte, built as the chapel of the palace; and the Church of the Crocifisso, remodeled in the 18th century but once more restored to its original form within (13th-century fresco in the crypt). The earliest building remaining from the Norman period is the Cathedral, built in 1079–84 and remodeled in the 18th century by Arcangelo Guglielmelli. Restoration has revealed some of the original Romanesque structure. The present façade (built in 1722) retains the bronze doors cast in Constantinople (1099), which are framed with Romanesque jambs and a Roman marble architrave. Remodeled in the 18th century, the interior preserves some mosaics in a Byzantine manner (11th–13th cent.); in the nave there are two restored 12th-century ambos (PL. 82), with mosaic decoration showing Sicilian influence. The iconostasis (reassembled) and the paschal candlestick are also decorated with mosaics (11th cent.). The balustrade enclosing the altar is of the 12th century and has mosaic decoration. In the central apse are remains of the marble throne of Pope Gregory VII (Hildebrand), who is buried under the left apse. The floors of the presbytery and transept are of marble mosaic, similar to those executed for Abbot Desiderius at Montecassino. There are many funerary monuments, among them that of Margaret of Durazzo, wife of Charles III, by Antonio Baboccio da Piperno (15th cent.). The crypt was remodeled in the 17th century by Domenico Fontana and decorated by Pietro Bernini and Belisario Corenzio (restored 1954). The walls are faced with polychrome marble. Also of the 12th century are the small campanile of S. Andrea and the episcopal palace, with Romanesque portico and a two-aisled Gothic hall (salvaged columns from the Roman temple of Pomona). There exist some 13th-century parts of the Norman aqueduct and remains of the Palazzo Fruscione.

Of the baroque period are the churches of S. Giorgio (1674), Monte dei Morti, and S. Salvatore; the Addolorata; the Annunciata, with a campanile by Luigi Vanvitelli; the Palazzo Bottigliari; and the Palazzo d'Avossa. *Museums*: Museo Provinciale; Museo del Duomo.

BIBLIOG. M. De Angelis, La reggia salernitana del Longobardo Arechi, Arch. storico per la provincia di Salerno, N.S., II, 1934, pp. 7–18; M. De Angelis, Il Duomo di Salerno, Salerno, 1936; G. Chierici, Il Duomo di Salerno e la chiesa di Monte Cassino, Rass. storica salernitana, I, 1937, pp. 96–109; A. Schiavo, Montecassino e Salerno, Rome, 1939; A. Schiavo, L'abbazia salernitana di S. Benedetto, Atti IV Conv. naz. Storia Arch., Milan, 1942, pp. 217–28; G. Rosi, L'atrio della Cattedrale di Salerno, BArte, XXXIII, 1948, pp. 225–38; G. Rosi, La reggia normanna di Salerno, BArte, XXXV, 1950, pp. 18–27; P. C. Sestieri, Salerno: Scoperte archeologiche in località Fratte, NSc, 8th ser., VI, 1952, pp. 86–164; A. Schiavo, Il campanile del Duomo di Salerno, B. Centro S. Storia Arch., IX, 1955, pp. 3–32; A. Pontoni, La basilica di Montecassino e quella di Salerno ai tempi di San Gregorio VII, Benedictina, X, 1956, pp. 23–47.

Santa Maria Capua Vetere (Lat., Capua). Site of old Capua. Originally inhabited by the Oscans, an indigenous Italic people, it may perhaps be identified with Volturnum (Vulturnum). Later the chief Etruscan city of Campania, in the second half of the 5th century B.C. it was conquered by the Samnites. Thereafter it became one of the major Roman cities in southern Italy. After its destruction by the Saracens about 840, the population took refuge in Casilinum (mod. Capua). The Roman centuriation of the *ager campanus* (early 2d cent. B.C.) can be seen in the modern road network and property divisions; the Hippodamian grid of the Roman city is visible in parts of the modern city.

From a sanctuary in the Fondo Patturelli have come figures of mothers with children in swaddling clothes, carved from volcanic tuff (6th–1st cent.; V, PL. 352), as well as architectural fragments and terra cottas. Some of these are among the best examples of Italic art (PL. 229; V, PL. 38). There are also a number of tombs, the earliest dating from the 7th century B.C.; some have funerary chambers with painted decoration (4th cent. B.C.). Of the Roman period are a 1st-century theater and an amphitheater built in the reign of Hadrian (2d cent.). An underground Mithraeum with wall paintings dates from the early 2d century. The brick triumphal arch spanning the Via Appia was probably built in honor of Hadrian; it was originally tripartite, but only the south arch and three piers have survived. There is a cryptoporticus, once probably part of a large bath. Along the Via Appia are two noteworthy Roman tombs of the 1st and 2d centuries. The present-day church of S. Maria delle Grazie incorporates the minor apse of the basilican Church of SS. Stefano e Agata (4th cent.), which contains a 13th-century fresco. The Cathedral was founded in 432 (enlarged 787 and 1666; remodeled 18th cent. and 1884); most of the interior columns were taken from Roman monuments. The Antiquarium has archaeological material.

BIBLIOG. A. Minto, Santa Maria di Capua Vetere: Scoperta di una cripta mitriaca, NSc, 1924, pp. 353–75; G. Pesce, I rilievi dell'anfiteatro Campano, Rome, 1941; J. Heurgon, Recherches sur l'histoire, la religion et la civilisation de Capoue préromaine des origines à la deuxième guerre punique, Paris, 1942 (bibliog.); G. Olivieri, La chiesa e il Convento di S. Maria delle Grazie in S. Maria Capua Vetere, Portici, 1942; A. De Franciscis, S. Maria Capua Vetere: Resti di abitazioni, NSc, 8th ser., X, 1956, pp. 65–79; A. De Franciscis, Templum Dianae Tifatinae, Caserta, 1956; A. De Franciscis, EAA, s.v. Capua, II, 1959, pp. 335–36; M. W. Frederiksen, Republican Capua: A Social and Economic Study, BSR, XXVII, 1959, pp. 80–130.

Sessa Aurunca (Lat., Suessa). Founded by the Aurunci, in 313 B.C. Suessa became a colonia with the Latin right. During the time of the Social War it became a municipium (90 B.C.), but under Augustus it was again a colonia. In the Middle Ages it belonged to the Church; in the 13th century Clement IV ceded it to Charles I of Anjou, as part of the Kingdom of Naples. There are remains of the Hellenistic walls (restored 1st cent. B.C.), of a theater, of an amphitheater, and of a cryptoporticus; outside the town are remnants of a brick bridge from the Roman era. Of the early Middle Ages are the city walls, incorporating the Porta Cappuccini (flanked by small cylindrical towers), as well as a small Early Christian church. The castle, partly in ruins, has a high rectangular tower.

The Cathedral was begun in 1103; salvaged Roman materials were used in the construction. It is preceded by a 13th-century porch, which has three arches decorated with reliefs. The three portals of the façade are also decorated with sculpture, some of which is Roman. The interior is basilican, with nave and two aisles. Remodeled in the baroque period, it retains some of the original furnishings, including the altar, the paschal candlestick (PL. 175), the pulpit (X, PL. 439), and the parapet of the organ loft, all with marble mosaic ornamentation and sculpture by Taddeo and Pellegrino (13th cent.). Also from the original structure are the columns and the mosaic pavement with geometric designs. Except for the stairs, the

crypt is in the original state. Many houses have 15th-century portals of the Durazzo type. The Palazzo Ducale was built in Renaissance style (much restored) over the ruins of a Roman structure, perhaps a Temple of Hercules. Many of the campaniles and domes in the town are faced with yellow and green majolica.

BIBLIOG. L. Pepe, La Cattedrale di Sessa Aurunca, Napoli nobilissima, VII, 1898, pp. 55–61; G. Chierici, Note sull'architettura della contea longobarda di Capua, BArte, XXVII, 1933–34, pp. 543–54; L. Cochetti Pratesi, Rilievi nella Cattedrale di Sessa Aurunca e lo sviluppo dei marmorari "neocampani" nel XIII secolo, Comm, IX, 1958, pp. 75–87.

Sorrento (Lat., Surrentum). Possibly a town of Greek origin, it was later under Samnite and then Roman rule, and in the late republican period it became a municipium. Distributed over its regular grid plan are a few remains of the Samnite walls and of Roman edifices; on the outskirts of the town, there are tombs dating from the 6th century B.C. to the Roman period. An ancient sanctuary dedicated to the sirens is known to have existed, as well as a Roman sanctuary of Athena (Minerva), at Punta Campanella. There are also vestiges of Roman seaside villas.

A number of 11th-century works show Byzantine influence: the campanile of the Cathedral, with Corinthian and Byzantine capitals; the windows in the Palazzo Veniero; and the side portal of the Church of S. Antonino, which has moldings with geometric patterns in white stone alternated with black lava. The Gothic style is represented only by the cloister of S. Francesco d'Assisi (14th cent.), with interlaced arches of Arabic type, the Palazzo Correale (early 15th cent.), the Casa Ferola, and houses on the Vico Grazie. The Sedile Dominova (15th cent.), a square loggia with rounded arches, is surmounted by a 17th-century dome faced with glazed terra-cotta tiles. The Cathedral was remodeled in the 15th century, and the Neo-Romanesque façade was added in 1924. A few sections of the 16th-century walls survive. The Museo Correale di Terranova has archaeological exhibits and paintings.

BIBLIOG. M. T. Tozzi, Sculture medievali dell'antico Duomo di Sorrento, Rome, 1931; P. Mingazzini and F. Pfister, Surrentum (Forma Italiae), Florence, 1946; R. Pane, Sorrento e la costa, Naples, 1955; A. Grelle, Frammenti medievali nella Cattedrale di Sorrento, Naples, 1961.

Apulia (It., Puglia, or Puglie). This region was the most advanced area of the Italian mainland in prehistoric times. Particular evidence of the region's development is provided by its production of painted and incised ceramics and prehistoric monumental remains, including dolmens, menhirs, and the rock tumuli known locally as *specchia*. The region was subsequently subject to the influence of Cretan-Mycenaean culture. In historical times the Greeks founded the colony of Taras (mod. Taranto), which was to become one of the most important cities of Magna Graecia. Nevertheless the population of Apulia chiefly comprised the indigenous Iapygians, or Apulians, subdivided into Daunians in the north, Peucetians in the central area, and Messapians in the south. These Greek-influenced Apulians lived in large fortified cities, and Geometric pottery was a characteristic artistic production. By the 4th century B.C. there were important centers of the production of Greek-style ceramics (e.g., the Apulian and Gnathia vases). Under the Romans, Brundisium (mod. Brindisi), at the eastern terminus of the Via Appia, became the chief Italian port to the eastern Mediterranean. The period of Byzantine domination (to which belong the rock-hewn grottoes, known as lauras, of the Basilian monks) was marked by continual strife between the Lombards and Byzantines. With the Normans, the Crusades, and the Hohenstaufen monarchy, Apulia again attained a certain historical and cultural eminence, attested by the castles and large Romanesque cathedrals that were built. The most significant artistic manifestation after the Middle Ages was the baroque art created in Lecce, an art characterized by a great abundance of decorative elements, influenced in part by Spain. Noteworthy too is the folk architecture represented by the trulli of Alberobello and other Apulian towns.

BIBLIOG. H. Swinburne, Travels in the Two Sicilies, London, 1777; J. L. A. Huillard-Bréholles, Recherches sur les monuments de l'histoire des Normands et de la maison de Souabe dans l'Italie méridionale, Paris, 1844; J. L. A. Huillard-Bréholles, Historia diplomatica Friderici II, Paris, 1852; H. W. Schultz, Denkmäler der Kunst des Mittelalters in Unteritalien, Dresden, 1860; D. Salazzaro, Studi sui monumenti dell'Italia meridionale, Naples, 1871; F. Lenormant, L'art du moyen âge dans la Pouille, GBA, XXII, 1880, pp. 193–210; P. Gregorovius, Nelle Puglie, Florence, 1882; F. Lenormant, Les terres cuites de Tarente, GBA, XXV, 1882, pp. 201–24; S. Simone, La Puglia medievale, Arte e storia, II, 1883, pp. 332–34, 341–42, 350–51, 357, 381–82, 390–91, 396, 405, III, 1884, pp. 37–38, 46–47, 61–63, 140–42, 149–51, 159, 165–67, 174, 198–99, 206–07, 222–23; K. Frey, Ursprung und Entwicklung schwäbischer Kunst in Unteritalien, D. Rundschau, LXVIII, 1891, pp. 271–97; C. Diehl, L'art byzantin dans l'Italie méridionale, Paris, 1894; C. Mazza, Le basiliche palatine pugliesi, Bari, 1894; E. Bertaux, Les arts de l'Orient musulman dans l'Italie méri-

dionale, Mél. XV, 1895, pp. 419–53; E. Bertaux, Per i monumenti meridio-
nali, Napoli nobilissima, VI, 1897, pp. 15–16; C. de Giorgis, Geografia della
provincia di Lecce, Lecce, 1897; N. de Rossi, Codice diplomatico barese,
Bari, 1899; F. Carabellese, Della storia dell'arte in Puglia fino al secolo XIII:
La terra di Bari, Trani, 1900; M. Avena, Monumenti dell'Italia meridionale,
Rome, 1902; E. Bertaux, L'art dans l'Italie méridionale, Paris, 1904; A.
Haseloff, Die Kaiserinnengräber in Andria: Ein Beitrag zur Apulischen Kunst-
geschichte unter Friedrich II, Rome, 1905; F. Carabellese, Il restauro an-
gioino dei Castelli di Puglia, L'Arte, XI, 1908, pp. 197–208, 367–72; M.
Wackernagel, Die Apulische Skulptur und die Mitte des XI. Jahrhunderts,
Halle, 1909; A. Mosso, La necropoli neolitica di Molfetta, MALinc, XX,
1910, cols. 237–356; G. Ceci, Saggio di una bibliografia, Bari, 1911; M.
Wackernagel, Die Plastik des XI. und XII. Jahrhunderts in Apulien, Leipzig,
1911; M. Gervasio, I dolmen e l'età del bronzo nelle Puglie, Bari, 1913;
A. Jatta, Puglia preistorica, Bari, 1914; M. Mayer, Apulien: Vor und währ-
end der Hellenisierung, Leipzig, 1914; E. Sthamer, Die Bauten der Ho-
henstaufen in Unteritalien, Leipzig, 1914; A. Vinaccia, I monumenti medie-
vali in terra di Bari, 4 vols., Bari, 1915; G. Ceci and A. Simioni, Bollettino
bibliografico di storia del Mezzogiorno, Naples, 1916; M. Salmi, Appunti per
la storia della pittura in Puglia, L'Arte, XXII, 1919, pp. 149–92; A. Haseloff,
Die Bauten der Hohenstaufen in Unteritalien, Leipzig, 1920; Architettura
e scultura medievale nelle Puglie, Turin, 1922; L. Preiss, Apulien, Stutt-
gart, 1922; A. K. Porter, Romanesque Sculpture of the Pilgrimage Roads,
Boston, 1923; G. Angelillis, Le porte di bronzo bizantine, Arezzo, 1924;
J. Gay, Jusqu'où s'étend, à l'époque normande, la zone hellénisée de l'Ita-
lie méridionale, Mél. Bertaux, Paris, 1924, pp. 110–28; M. Mayer, Molfetta
und Matera, Leipzig, 1924; G. Bacile di Castiglione, Castelli pugliesi, Rome,
1927; G. A. Blanc, Grotta Romanelli, Arch. per l'antropologia e l'etnologia,
LVIII. 1928, pp. 365–411; U. Rellini et al., Rapporto preliminare sulle ri-
cerche paleo-etnologiche condotte sul promontorio del Gargano, BPI,
L–LI, 1930–31, pp. 43–133; R. Krautheimer, S. Nicola in Bari und die
apulische Architektur des 12. Jahrhunderts, Wiener Jhb. für Kg., IX, 1934,
pp. 5–42; S. Jonescu, Le chiese pugliesi a tre cupole, EphDR, VI, 1935,
pp. 50–128; G. Gabrieli, Inventario topografico e bibliografico delle cripte
eremitiche basiliane di Puglia, Rome, 1936; Q. Quagliati, La Puglia preisto-
rica, Trani, 1936; G. Ceci, Bibliografia per la storia delle arti figurative nel-
l'Italia meridionale, 2 vols., Naples, 1937; A. Medea, Affreschi nelle cappelle
rupestri pugliesi, Per l'arte sacra, XIV, 1937; A. Medea. Gli affreschi delle
cripte eremitiche pugliesi, Rome, 1939; C. Bertacchi, Nella Puglia pietrosa:
I monumenti megalitici e la sopravvivenza della casa primeva in provincia
di Bari, Japigia, N.S., XI, 1940, pp. 5–26; P. M. Favia, Architettura minore
di Puglia, Rome, 1947; S. Puglisi, Le culture dei capannicoli sul promontorio
Gargano, MemLinc, 8th ser., II, 1948, pp. 1–57; M. Bernardini, Panorama
archeologico dell'estremo Salento, Trani, 1955; S. Palumbo, Inventario
dei dolmen di terra d'Otranto, RScPr, XI, 1956, pp. 84–108; S. Palumbo,
Salento megalitico, S. salentini, I, 1956, pp. 58–73; G. Simoncini, Osserva-
zioni sull'architettura del tardo '700 in provincia di Bari, Q. Ist. Storia
Arch., 18, 1956, pp. 1–7; Atti II Cong. storico pugliese, Terra d'Otranto,
1957; D. Mustilli, Le città della Mesapia ricordate da Strabone, Atti XVII
Cong. geografico it., III, Bari, 1957, pp. 568–76; M. Calvesi, Influenze na-
poletane e siciliane nell'architettura barocca del Salento, Atti IX Conv.
naz. Storia Arch., Rome, 1959, pp. 177–87; G. Chierici, Il trullo, Atti IX
Conv. naz. Storia Arch., Rome, 1959, pp. 203–07; M. Manieri Elia, Il ba-
rocco salentino nel suo quadro storico, Atti IX Conv. naz. Storia Arch.,
Rome, 1959, pp. 189–202; A. Petrignani, Gli architetti militari in Puglia,
Atti IX Conv. naz. Storia Arch., Rome, 1959, pp. 127–48; F. Schettini,
I castelli angioini-aragonesi in Puglia, Atti IX Conv. naz. Storia Arch.,
Rome, 1959, pp. 117–25; G. Simoncini, Chiese pugliesi a cupola in asse,
Atti IX Conv. naz. Storia arch., Rome, 1959, pp. 67–80; C. A. Willemsen
and D. Odental, Puglia, Bari, 1959; C. Brandi, Pellegrino di Puglia, Bari,
1960; A. Petrucci, Le cattedrali di Puglia, Rome, 1960; G. Simoncini, Ar-
chitettura contadina di Puglia, Genoa, 1960; H. Hahn, Hohenstaufenbur-
gen in Süditalien, Ingelheim am Rhein, 1961.

Alberobello. This town is noted for the curious form of its
houses, known as trulli (from the Greek word τροΰλλος, "cupola").
The cylindrical base of the trullo is whitewashed on the outside.
The base is topped by a steep conical roof formed of concentric
rings of grey stones. The original design is a one-story structure.
Only the so-called "Trullo Sovrano," in Piazza Sacramento, has two
stories and is almost 50 feet tall. The trulli probably derive from
the circular dwellings of protohistoric Mediterranean cultures. This
folk architecture has influenced local modern architecture (e.g., the
Church of S. Antonio). Trulli are very common residences in the
area (V, PLS. 337, 354).

BIBLIOG. G. Notarnicola, I trulli di Alberobello, Rome, 1940; G. Chie-
rici, Il trullo, Atti IX Conv. naz. Storia Arch., Rome, 1959, pp. 203–07;
M. Castellano, La valle dei trulli, Bari, 1960.

Altamura. Remains of megalithic walls have been found in Al-
tamura, but the present city was founded by Frederick II in the
first half of the 13th century. The Cathedral, one of the palatine
basilicas of Apulia, was begun in Romanesque style in 1232, rebuilt
after the earthquake of 1316, and remodeled in 1534. The façade
is flanked by two 16th-century towers with baroque spires (added
in 1729) and has a richly ornamented Romanesque portal and a 14th-
century rose window. The Gothic Church of S. Nicolò dei Greci
preserves interesting low reliefs of Biblical subjects on the portal.

BIBLIOG. P. Viti, Indagini sulle antichità di Altamura, Trani, 1888;
O. Serena, La chiesa di Altamura: La serie dei suoi prelati e le sue iscrizioni,

Rass. pugliese, XIX, 1902, pp. 322–37; N. Ciccimarra, La Cattedrale di
Altamura nella storia e nell'arte, Altamura, 1941; F. M. Panzetti, Cripte
ed eremi medievali di Altamura, Japigia, N.S., XII, 1941, pp. 77–111; G.
Masi, Altamura farnesina, Bari, 1959.

Andria. The site has been inhabited since prehistoric times, as
attested by tombs. The city was founded by the Normans and for-
tified with walls. Particularly important under Hohenstaufen rule,
it finally became the duchy of the Carafas (16th–18th cent.). The
Cathedral, originally Romanesque but completely remodeled, pre-
serves the original campanile (1118; upper part, 13th–14th cent.)
and the 9th–10th-century crypt. The churches of S. Agostino and
S. Francesco are baroque. The sacristy of S. Domenico contains
a bust (1472) of Francesco II del Balzo, duke of Andria, attributed
to Francesco Laurana. In the cloister adjacent to the Church of
S. Maria Vetere are three small paintings (of SS. Clare, Augustine,
and Bernardino) by Antonio Vivarini. The 15th-century Church of
S. Maria di Porta Santa has a Renaissance portal. The Palazzo Ducale
was remodeled in the late 16th century and again in the 19th century.
The Porta S. Andrea was rebuilt in baroque form in 1593. Outside
the town are Sta Croce, a 9th-century Basilian laura with late Byzan-
tine frescoes, and S. Maria dei Miracoli, a 16th-century basilica built
over a Basilian crypt.

Near Andria is Castel del Monte, begun before 1240 by Emperor
Frederick II as a hunting castle. It is octagonal and has octagonal
towers at the corners. The castle has eight trapezoidal rooms (one
to each side of the octagon) on each floor, with vaulted ceilings and
Gothic capitals.

BIBLIOG. Franco da Catania, Di Santa Maria de' Miracoli d'Andria.
Naples, 1606; F. Gregorovius, Castel del Monte, Leipzig, 1880; E. Mevia
Castel del Monte presso Andria, Trani, 1895; E. Bertaux, Castel del Monte
et les architectes français de l'empereur Frédéric II, Paris, 1897; E. Bernich,
Andria e le sue reminiscenze sveve, Andria, 1904; A. Quacquarelli, Appunti
storici su Castel del Monte, Bari, 1929; B. Molajoli, Guida di Castel del
Monte, Fabriano, 1934; G. Chierici, Castel del Monte, Rome, 1934; P.
Cafaro, Le tombe delle imperatrici sveve in Andria, Bari, 1938; C. Ceschi,
Gli ultimi restauri a Castel del Monte, Japigia, N.S., IX, 1938, pp. 3–22;
C. A. Willemsen, Castel del Monte: Die Krone Apuliens, Wiesbaden, 1955;
P. Cafaro, Castel del Monte, Andria, 1957; B. Molajoli, Castel del Monte,
Naples, 1958.

Bari (Lat., Barium). The chief city of Apulia, Bari has an
old quarter known as Bari Vecchia, with picturesque and irregular
narrow streets. The newer part began to develop in the early 19th
century. Bari may have been a Peucetian city in its own right or,
at the least, the port of the neighboring city of Caeliae (mod. Ceglie
del Campo). Under the Roman Empire, Bari was a municipium.
In the Middle Ages the city was important chiefly for its relations
with the eastern Mediterranean. It was alternately dominated by the
Byzantine Empire, the Lombards, and the Normans. It was one of
the embarkation ports for the Crusades, and the city prospered under
the Hohenstaufen dynasty.

The Church of S. Nicola, one of the palatine basilicas of Apulia,
was begun in the late 11th century and consecrated in 1197 (XII,
PL. 223). It is the prototype of Apulian Romanesque church architec-
ture. It was built within the precincts of the castle of the Byzantine
catapan. The façade, flanked by unfinished squat towers, is simple
but well proportioned. The façade of the transept has two orders
of double-arched windows and a round window. The portals and
windows are decorated with sculptures of classical and Byzantine
derivation. The interior, with three aisles, is reinforced by transversal
arches added in the 15th century. The presbytery (built over a crypt)
runs directly into the transept, which is as tall as the nave. The
altar has a 12th-century ciborium. In the central apse, which has
a 12th-century mosaic floor, is the monument to Bona Sforza (16th
cent.). Below this monument is the marble episcopal throne (12th
cent.). In the right apse is a panel of the Madonna with four saints
by Bartolomeo Vivarini (1476). The ceiling of the central aisle and
presbytery is of the 17th century. The Cathedral was built in 1170–78
on the ruins of the Byzantine cathedral that had been destroyed by
William of Sicily. Although similar in plan to S. Nicola, the Ca-
thedral was remodeled a number of times and restored to its original
design in 1954–55. All that remains of earlier remodeling are the
three baroque façade portals. The interior preserves the columns
and the screens from the Byzantine building. The episcopal throne
and the pulpit were reassembled from the original fragments in 1934
(restored in 1954). The Cathedral also preserves some noteworthy
sculpture. The elegant baroque decoration of the crypt has been
retained. Off the left aisle of the Cathedral is the so-called "Trulla,"
a cylindrical structure (1618–1740) that serves as the sacristy. The
Romanesque Church of S. Gregorio (completed in 1089) preserves
its original façade. The interior has three aisles and three apses
without transept. Tall impost blocks rest on columns of different
forms and provenances. The main nucleus of the castle was built

by Frederick II (1233–40) on earlier Norman fortifications. The jutting bulwarks with towers were added in the 16th century. The Renaissance Church of S. Agostino (also known as S. Anna) incorporates in the façade fragments of the earlier Romanesque Church of S. Pelagia. The Renaissance Palazzo Tanzi was built in the 15th century. Baroque churches include S. Teresa dei Maschi, S. Michele (the crypt of which was the Romanesque Church of S. Felice), and S. Chiara. The modern part of the city is laid out on a rectangular plan of regular square blocks with neoclassic and modern edifices. *Museums*: Museo Archeologico (in the Ateneo); Pinacoteca Provinciale (in the Palazzo della Provincia); Gipsoteca (in the castle).

BIBLIOG. D. Bartolini, Sull'antica basilica di S. Nicola di Bari nella Puglia, Rome, 1882; S. Simone, Gli edifizi medievali di Bari, Arte e storia, III, 1884, pp. 229–30, 252–54, 260–62, 269–70, 277–78, 284–86, 294–95, 309–11, 316–18, 333–35, 351, 357–58, 374, 397–98, IV, 1885, pp. 6–7; F. Nitti di Vito, Le costruzioni edilizie di Bari nei secoli X–XII, Bari, 1901; F. Carabellese, Bari, Bergamo, 1909; A. Vinaccia, I monumenti medievali in terra di Bari, Bari, 1915; A. K. Porter, Bari, Modena, and St. Gilles, BM, XLIII, 1923, pp. 58–67; A. K. Porter, Compostela, Bari and Romanesque Architecture, Art S., I, 1923, pp. 7–21; R. Krautheimer, San Nicola in Bari und die apulische Architektur des XII. Jahrhunderts, Wiener Jhb. für Kg., IX, 1934, pp. 5–42; F. Schettini, Restauri nel Castello di Bari, Japigia, N.S., IX, 1938, pp. 151–63; F. Nitti di Vito, La Basilica di San Nicola di Bari, Bari, 1939; F. Schettini, La chiesa di S. Gregorio di Bari, Palladio, V, 1941, pp. 252–69; F. Schettini, Mostra documentaria sulla ricostruzione della suppellettile marmorea della Cattedrale di Bari, Bari, 1955; EAA, s.v. Bari, I, 1958, p. 980.

Barletta (Lat., Barduli). The site was inhabited in the 3d century B.C. It became important under the Normans, who built the walls and the rectangular castle. The castle was rebuilt by the Hohenstaufens and enlarged under the Angevins, in 1282–91. The four lance-shaped bulwarks on the corners were added in 1532–97. The oldest part of the Cathedral, one of the palatine basilicas of Apulia, was begun about 1140 and consecrated in 1267. The three-aisled Apulian Romanesque Cathedral originally had three apses, but in the 14th century it was lengthened and a polygonal apse with five radiating chapels was built. The original façade has been preserved, but with the addition of the 16th-century central portal and Gothic spires. Within the Cathedral are a 13th-century pulpit and episcopal throne and a Romanesque ciborium. Sto Sepolcro, originally built in Romanesque style, was remodeled in Burgundian-Gothic style in the late 13th century. The baroque façade preserves the Gothic right portal. The base of the campanile is incorporated in the left side of the façade. The dome was reconstructed in the 18th century. The interior has a nave and two aisles divided by cruciform piers. The church has a fine treasury. Outside Sto Sepolcro is the statue known as the Colossus of Barletta (IX, PL. 60), an imperial work of disputed date. Probably brought from Constantinople in the 13th century, the statue is almost 15 feet tall. S. Giacomo and S. Agostino (both, 13th–14th cent.) retain little of the original structures. The 14th-century Palazzo Bonelli is the best-preserved Gothic palace in the city. S. Andrea, built in the 12th century but enlarged and remodeled in 1528, retains only a few fragments of the original Romanesque structure. Baroque structures include the palace of the Monte di Pietà and adjoining church (formerly Church of the Gesuiti); Palazzo della Marra; the Banco di Napoli (formerly Palazzo Gentile di Lesina); the Church of the Purgatorio (18th cent.); and S. Ruggero, built in the 13th century but entirely remodeled in 1732. *Museum*: Museo e Pinacoteca Comunale.

BIBLIOG. G. Leccia, Descrizione della città di Barletta. . . , Bari, 1842; M. Salmi, Il tesoro della chiesa del Santo Sepolcro a Barletta, Dedalo, IV, 1923–24, pp. 87–98; S. Santeramo, Guida di Barletta, Bagnoregio, 1926; O. Pedico, La chiesa del Santo Sepolcro di Barletta e i suoi campanili, Barletta, 1949; EAA, s.v. Barletta, Colosso di, I, 1958, pp. 980–81.

Bisceglie. Founded in the Middle Ages, Bisceglie was fortified with walls and towers by the Normans. The medieval and modern parts of the city are distinctly separate. The principal monuments are of the Romanesque period: the single-aisled Church of S. Margherita (1197), with three tombs of the Falcone family (13th cent.); and S. Adoeno (1074), the interior of which has been completely remodeled. The Cathedral (1073–1295) has sculptured portals. The three-aisled interior was remodeled in baroque style. The crypt is Romanesque. Three rectangular towers remain of the Norman castle, built in the 11th century. The Palazzo Mazzalorsa is Renaissance in style. Outside the city is the Romanesque Church of S. Maria di Giano (11th cent.), with medieval frescoes. In the environs of Bisceglie are noteworthy megalithic remains from the Bronze Age, including dolmens and menhirs (IV, PL. 456).

BIBLIOG. A. Perotti, Il coro della Cattedrale di Bisceglie, Napoli nobilissima, N.S., I, 1920, pp. 97–100; M. Berucci, Studi sulla Cattedrale di Bisceglie, Palladio, N.S., VII, 1957, pp. 127–33.

Bitonto (Lat., Butuntum). This city of the Apulians was colonized by Greeks and later became a Roman municipium. Sacked by the Byzantine catapan in 975, it was rebuilt in the 11th century. The medieval nucleus is incorporated in the modern city. The Cathedral (1175–1200, restored) was modeled after the Church of S. Nicola in Bari. The decoration is lighter than that of the prototype. The portals and the rose window are delicately ornamented, as are the single-arched window in the apse and the six-arched lateral windows. The basilican interior is in pure Romanesque style. The Cathedral preserves a sculptured ambo (1229), with the inscription *Nicolaus sacerdos et protomagister*, a Romanesque baptismal font, and a pulpit assembled (1240) from fragments of the original high altar. The Abbey of S. Leo was erected in the 9th century by the Benedictines, remodeled several times, and restored in the 20th century. The abbey church preserves the 13th-century rectangular apse, which is decorated with 14th-century frescoes that combine Byzantine techniques and iconography with Romanesque forms. The Church of S. Francesco d'Assisi preserves only the façade of the structure built in 1286. S. Matteo has been restored to its 13th-century form. S. Francesco di Paola (1625; rebuilt, early 18th cent.) and S. Gaetano (1609) are baroque. The 15th-century Palazzo Sylos Labini has a Catalan-Gothic portal and a porticoed courtyard and loggia with Renaissance low reliefs. The Palazzo Sylos Calò has late-16th-century decorations. The Palazzetto Regna and the Palazzo Sylos Sersale have baroque portals. The two Gentile palaces (one now the Municipio) were designed by Luigi Castellucci (19th cent.). The Obelisco Carolino, designed in 1734 by G. A. Medrano, was completed in 1859.

BIBLIOG. E. Bernich, L'architettura nelle Puglie, Il monastero di S. Leo a Bitonto, Trani, 1894; C. Ceschi, Rass. di Arch., July, 1934, p. 313 ff.; G. Mongiello, La Cattedrale di Bitonto, Caserta, 1952; G. Mongiello, La torre di Bitonto a porta Baresana, Palladio, N.S., IV, 1954, pp. 137–41; P. Amendolagine, Motivi ornamentali nella Cattedrale di Bitonto, Bitonto, 1954; V. Acquafredda, Bitonto attraverso i secoli, Bitonto, I, 1957, II, 1958.

Brindisi (Gr., Brentesion; Lat., Brundisium). This Adriatic city was occupied by the Romans in 266 B.C. and became a Roman colony in 246 B.C. After the Social War it became a municipium. Connected to Rome by the Via Appia (2d cent. B.C.) and by the Via Traiana (under Trajan), Brindisi was a busy commercial center. There are remains of the forum, baths, and a temple, as well as one of the two tall Roman columns that marked the end of the Via Appia. The column (perhaps dating from the 3d century of our era) has a composite capital with sculptured decoration. Dominated successively by the Goths, Lombards, and Byzantines, Brindisi was destroyed in the 9th century by Emperor Louis II. The city sprang up again at the time of the Crusades, as a port for the East. The city's development was considerably incremented under Frederick II. Later the city passed to the Angevins and the Aragonese, who did much to develop the city's fortifications. The Aragonese built the port channel for defense against the Turks.

In the old city there are a number of Romanesque buildings, but most of them were altered or restored in later centuries as a result of damage from the frequent earthquakes. Of the 12th-century Cathedral, only portions of the apse with a mosaic floor remain. The present structure dates from the 18th century. The well-preserved Church of S. Giovanni al Sepolcro was erected by the Knights Templar in the 11th century and later became the church of the Knights of the Holy Sepulcher. This curious building is circular in plan but one fourth of the circumference is closed off by a straight wall. The interior preserves a circular colonnade of eight columns and traces of 14th-century frescoes. S. Benedetto dates from 1080 but was remodeled in the 16th century and later. The campanile is Romanesque, as is the cloister of the former monastery. The Romanesque Church of S. Lucia (or SS. Trinità) has been remodeled, but the 11th-century crypt preserves Byzantinizing frescoes (12th cent.) and others of the 13th–14th century. The Church of the Cristo (1230) has alternate bands of white and gray stone on the façade. The single-nave church preserves a 13th-century painted wood sculpture of the Madonna Enthroned and a crucifix. The Church of S. Paolo was built in the 14th century but subsequently rebuilt. The façade is baroque. The most important secular structure of the Middle Ages is the castle built by Frederick II (1227). Its plan is rectangular, and there are towers on the corners. The castle was reinforced in 1481 with a barbican and four cylindrical towers. In 1550 it was further enlarged by Charles V. Other secular structures include remains of the Angevin mint, the Porta Mesagne, and the Palazzetto Balsamo (14th cent.). Of the baroque period are S. Teresa (1670) and the Palazzo Granafei-Nervegna. The Palazzo del Seminario (1720–44) houses the Biblioteca Arcivescovile "De Leo," with a number of incunabula and rare manuscripts. The Museo Provinciale "Francesco Ribezzo" contains local antiquities.

Outside the city is the Church of S. Maria del Casale (early

14th cent.). The façade is decorated with bands of stone of two colors. The single-aisled church preserves 14th-century frescoes.

Bibliog. G. Nervagna, Brindisi: S. Giovanni al Sepolcro e la raccolta di oggetti antichi, Arte e storia, XI, 1892, pp. 126–27; P. Camassa, Santa Maria del Casale di Brindisi, Brindisi, 1916; T. Krautheimer-Hess, Due sculture in legno del XIII secolo in Brindisi, L'Arte, XXXVI, 1933, pp. 18–29; P. Camassa, La romanità di Brindisi, Brindisi, 1934; N. Vacca, Brindisi ignorata, Trani, 1945; G. Marzano, Recenti scavi in piazza del Duomo a Brindisi, Bari, 1954; L. C. Cesanelli, Della chiesa millenaria della Santissima Trinità in Brindisi, Verona, 1957; EAA, s.v.

Canosa di Puglia (Κανύσιον; Lat., Canusium). This Apulian city fell to Rome in 318 B.C. After the Social War it became a municipium. It was a colony under Antoninus Pius, when it enjoyed the favors of Herodes Atticus. The ancient city was famous for its ceramics (q.v.). Destroyed by the Lombards and then by the Saracens, the city was rebuilt in the 10th century. Little remains of the Apulian city, but hypogea of the 4th–3d century B.C. have been found. They comprised several rooms carved out of the natural tuff and decorated with painted stucco. Of the Roman period are remains of an aqueduct (probably built in the time of Herodes Atticus), baths, a temple, and an arch. Along the Via Traiana are a number of Roman tombs. The Cathedral was begun in the late 11th century and subsequently remodeled several times. The three-aisled interior has a Latin-cross plan. Of the original structure are the last two bays, the transept, and the central apse, surmounted by five small domes supported by ancient columns. Preserved are the cathedra by Romualdus (PL. 172) and the 11th-century pulpit (reassembled) by Acceptus. The crypt was remodeled in the 16th century. Outside the church is the tomb chapel of Bohemund I, prince of Antioch (d. 1111), a cubic structure surmounted by an ovoid dome resting on an octagonal drum. The walls are covered with marble slabs. The bronze doors are decorated with silver damascene in Byzantine style and Arab-style relief disks. The door is the work of Rogerius of Melfi. There are vestiges of a medieval castle. *Museum*: Museo Civico.

Bibliog. M. Wackernagel, La bottega dell'"Archidiaconus Acceptus" scultore pugliese dell'XI secolo, BArte, II, 1908, pp. 143–50; N. Jacobone, Canusium, Lecce, 1929; R. Bartoccini, La tomba degli ori di Canosa, Japigia, N.S., VI, 1935, pp. 225–62; F. Bertocchi, Ritrovamento di un ipogeo ellenistico, NSc, 8th ser., XII, 1958, pp. 192–96; EAA, s.v.; B. M. Scarfì, Restauro della teca di specchio di Canosa, BArte, XLIV, 1959, pp. 166–70.

Casaranello. Of the old town, which ceased to exist in the 15th century, all that survives is the three-aisled church (S. Maria della Croce), with barrel vaults and 12th–13th-century frescoes. The church incorporates the transept and dome of an earlier church, which are adorned with fine aniconic mosaics of the 5th century. These are the only Early Christian-Byzantine mosaics in Apulia.

Bibliog. A. Haseloff, I musaici di Casaranello, BArte, II, 1907; R. Bartoccini, Casaranello e i suoi mosaici, Felix Ravenna, N.S., IV, 1934, pp. 157–85.

Egnazia (Gr., Gnathia). Originally an Apulian city, Gnathia later became a Roman municipium. There are remains of walls (4th cent. B.C.), as well as of the agora and harbor constructions. Excavations of the necropolis have yielded large quantities of vases, including 4th-century B.C. Gnathia ware. Hypogeum tombs with wall paintings have also been excavated. Some of the few surviving wall paintings are now in the Museo Nazionale in Naples. There are also remains of the Roman city, including tabernae, the foundations of an arch, a forum with a Hellenistic portico, and a basilica.

Bibliog. C. Drago, EAA, s.v. Gnathia, III, 1960, pp. 967–71 (bibliog.).

Foggia. First mentioned in the 11th century, Foggia was an imperial residence under Frederick II. It has few medieval remains. The Romanesque Cathedral (founded ca. 1170), whose structure was influenced by Pisan architecture, was largely rebuilt in baroque style. Of the original structure are the lower part of the façade, a number of ornamental sculptures, and the large crypt, with 13th-century capitals. Of the palace of Frederick II (begun, 1223), only a portal arch by Bartolomeo da Foggia survives. The Palazzo De Rosa is Renaissance. The Church of Calvario (1693–1740) is baroque. The Villa Comunale, a large public garden, was laid out by Luigi Oberty in 1820. The Musei Civici contains an archaeological collection and a painting gallery.

Bibliog. C. Capuano, La cattedrale di Foggia in rapporto alle origini della città, Rass. pugliese, XXV, 1910, pp. 416–21; R. Gaggese, Foggia e la Capitanata, Bergamo, 1910; M. Biccari and M. Locco, Guida di Foggia e della provincia, Bari, 1957.

Lecce (Lat., Lupiae). Originally a Messapian city, Lupiae became a Roman municipium. It reached the peak of its development under the Antonines, when the Roman amphitheater and theater were built. Sacked by Totila in the 6th century of our era, it later came under Byzantine domination. In 1040 it fell to the Normans, becoming the chief city of the Salento. Under the Angevins and Aragonese it followed the destiny of the rest of the region. The Church of SS. Nicolò e Cataldo is the only surviving Norman monument. Founded in 1180, the original structure has survived almost unaltered, in spite of the baroque remodeling of the façade (1716), which, however, retained the 12th-century sculptured portal and rose window. The interior, which has three aisles (and a transept in the center) with pointed barrel vaulting, shows the influence of Burgundian architecture. The baroque decorations are mostly of the 17th century. Of the 15th century is the round Torre del Parco (1419). The castle (1539–48), built by G. G. dell'Acaia on a trapezoid plan, has lance-shaped bastions jutting out at the corners. S. Sebastiano (1520) has an elegant portal, as does the former Church of S. Marco (1543). S. Francesco di Paola (or S. Maria degli Angeli; 1524) is attributed to Baldassare Peruzzi; the portal is attributed to G. Riccardi. The Arch of Triumph (Porta Napoli; 1548), designed by G. G. dell'Acaia, bears the coat of arms of Emperor Charles V. Other 16th-century structures include the Palazzo del Seggio (1592), which has two large arches below and a small loggia above, and the Palazzo Adorno (1572), with baroque decorations in the courtyard.

The city is chiefly characterized by its baroque architecture, which is sober in its structural lines but sumptuous and exuberant in its ornamentation. Sta Croce, of the 14th century, was rebuilt between 1549 and 1695 by Francesco Antonio Zimbalo, Gabriele Riccardi, and Cesare Penna. The original Romanesque structure was retained in part, but the exterior and interior decoration of the three-aisled church is baroque (II, PL. 146). S. Chiara (1694; G. Cino) has a convex façade with a horizontal coping. S. Teresa (1620–27) has an unfinished façade. S. Irene (1591–1639), attributed to Michele Coluzio, is a sober building in late-Renaissance style; the interior is baroque. The Church of the Rosario, or S. Domenico (1691–1728; G. Zimbalo), is built in the form of a Greek cross inscribed in an octagon. The façade is particularly ornate, as are the richly ornamented altars. S. Matteo (reconstructed, 1667–1700) has a façade modeled after that of Borromini's Church of S. Carlo alle Quattro Fontane in Rome. The classicizing Church of S. Maria delle Grazie (1606) was designed by Michele Coluzio. S. Antonio was built in 1586 and remodeled in the 18th century. S. Angelo (1663) and the Church of the Alcanterine (1724) are also baroque structures. The Church of the Gesù (or Buon Consiglio) was built in 1575–79 and remodeled in 1745. The Church of the Carmine was rebuilt by G. Cino in 1711–17. The Piazza del Duomo presents a harmonious ensemble of baroque edifices, including the Cathedral (rebuilt, 1659–70), the campanile by Giuseppe Zimbalo, and the episcopal palace (rebuilt, 1632). Adjacent is the Seminario (1694–1709; G. Cino), with a triple-arched window above the main portal. The courtyard has a richly decorated well in the center. There are many baroque secular buildings in Lecce, including the Municipio (formerly Palazzo Carafa, 1764–71), Palazzo Rollo, Palazzo Giromini, and the Palazzo della Prefettura (formerly a monastery, 1659–95). The Column of S. Oronzo was erected in 1666 by Giuseppe Zimbalo. The Museo Provinciale "Sigismondo Castromediano" (in the Palazzo della Prefettura) contains a large collection of Messapian and Roman antiquities. Just outside Melendugno, near Lecce, are dolmens.

Bibliog. G. Gigli, Il Tallone d'Italia, Lecce e dintorni, Bergamo, 1911; P. Romanelli and M. Bernardini, Il Museo Castromediano, Rome, 1932; R. Bartoccini, Il teatro romano di Lecce, Syracuse, 1935; M. Bernardini, I ritrovamenti archeologici di Lecce, Lecce, 1941; G. Paladini, Guida storica ed artistica della città di Lecce, Lecce, 1952; M. Calvesi, La chiesa del convento dei Celestini, Comm, V, 1954, pp. 316–29; G. Paladini, La chiesa cattedrale di Lecce e la sua cripta, Lecce, 1956; T. Delle Noci, Lecce: Ateneo del Barocco, Galatina, 1957; M. Bernardini, Lupiae, S. salentini, V–VI, 1958, pp. 5–68, VII, 1959, pp. 5–87; M. Bernardini, Lupiae, Lecce, 1959; G. Bresciani Alvarez, Accostamenti e proposte per un'impostazione critica dell'architettura leccese, Atti IX Conv. naz. Storia Arch., Rome, 1959, pp. 155–76; H. Korte, Troia, Trani, Lecce, Oldenburg, 1959; M. Manieri Elia, Il barocco salentino nel suo quadro storico, Atti IX Conv. naz. Storia Arch., Rome, 1959, pp. 189–202.

Lucera (Lat., Luceria). This ancient Daunian city produced some noteworthy votive and architectural terra cottas (VII, PL. 78). It was an ally of Rome during the Second Samnite War. In 314 B.C. it became a colony, and after the Social War it became a municipium. Under Augustus it gained importance. Roman remains include the amphitheater (1st cent.). The city flourished under the Hohenstaufens and under the first Angevin rulers. The fortress of Frederick II, built in 1233, was transformed by Charles I of Anjou, who girdled it with towered walls. It is pentagonal in plan and stands on the crest of a hill outside the town proper. The Gothic

Cathedral (1300–11) is one of the best-preserved Angevin churches in southern Italy. The church preserves a cenotaph with a statue of an Angevin knight (14th cent.), a 16th-century pulpit, and frescoes by Belisario Corenzio. S. Francesco, another Angevin structure, has baroque altars. Eighteenth-century buildings are the episcopal palace, the Palazzo Lombardi, and the Church of the Carmine. The Museo Civico "Giuseppe Fiorelli" preserves local antiquities.

BIBLIOG. A. Colasanti, Storia dell'antica Lucera, Lucera, 1894; P. Rivoira, Lucera, sotto la dominazione angioina, Rass. pugliese, XVIII, 1901, pp. 179–88, 201–15; F. Branca, L'antica Lucera, Naples, 1909; G. B. Giluni, Lucera, Lucera, 1934; R. Bartoccini, Anfiteatro e gladiatori in Lucera, Bari, 1936; S. Folliero, Lucera, Milan, Rome, 1952; F. Schettini, Sul restauro dell'anfiteatro di Lucera, Palladio, N.S., V, 1955, pp. 159–63; M. Pallottino, Ancora dell'anfiteatro di Lucera, AC, IX, 1957, pp. 116–18.

Manduria. One of the principal Messapian cities, Manduria was conquered by Hannibal. Destroyed by Totila in A.D. 547 and by the Saracens in A.D. 977, it was rebuilt in the 11th century with the name of Casalnuovo. It resumed its old name, Manduria, in 1789. Of the three circles of megalithic walls, several sections are well preserved. The inner wall is probably of the 5th century B.C., the middle wall of the 4th, and the outer probably of the late 3d century B.C. Beyond the walls are a number of necropolises, which have yielded local pottery with Geometric decoration and Gnathia ware. The Cathedral, originally Romanesque, was remodeled in the Renaissance. The campanile is Romanesque.

BIBLIOG. N. Degrassi, Manduria, FA, XII, 1957, 2836; M. D. Marin, Manduria, Ann. della Facoltà di Lettere e Filosofia dell'Università di Bari, IV, 1958, pp. 53–78; N. Degrassi, Le recenti scoperte archeologiche della provincia di Taranto, La ricerca archeologica nell'Italia meridionale, Naples, 1960, p. 119 ff.

Manfredonia. The city was founded by King Manfred in 1256 near the site of ancient Sipontum. The castle was begun by Manfred and completed under Charles I of Anjou. It consists of a rectangular fortress with four towers (three cylindrical and one rectangular) and is enclosed by rectangular walls with three cylindrical towers built in the 15th century and a pentagonal bulwark added in the 16th century. Many of the medieval buildings, including the Cathedral (rebuilt, 1680), were destroyed by the Turks in 1620. Only the Church of S. Domenico was spared. It incorporates the earlier Chapel of the Maddalena, built by Charles II. The Gothic interior of the church is decorated with late-14th-century frescoes. Next to the church is the former Dominican Monastery of S. Domenico, a 17th-century building that now houses public offices. The Palazzo di S. Chiara also dates from the 17th century. Outside Manfredonia are the remains of the city of Sipontum. The Romanesque Church of S. Maria di Siponto, the former Cathedral, is built on a square plan. The dome and external decoration show Pisan influence. The portal is adorned with Apulian Romanesque sculptures. Adjacent to the church are the remains of an Early Christian basilica, with a mosaic pavement. The Church of S. Leonardo di Siponto was erected in the 11th–12th century and restored in 1950. The exterior decoration incorporates Pisan elements. The interior has three vaulted aisles, three apses, and two small octagonal domes.

Near Manfredonia, at the Masseria Coppa Nevigata, an aëneolithic village has been excavated. At Fontanarossa, another settlement and an Apulian necropolis have been excavated.

BIBLIOG. A. Mosso, Stazione preistorica di Coppa Nevigata presso Manfredonia, MALinc, XIX, 1910, cols. 305–86; S. M. Puglisi, Industria microlitica nei livelli a ceramica impressa di Coppa Nevigata, RScPr, X, 1955, pp. 19–37; S. Mastrobuoni and N. De Feudis, Manfredonia, Siponto, S. Leonardo, Foggia, 1957.

Monte Sant'Angelo. The town developed around the Sanctuary of S. Michele Arcangelo, which was founded, according to legend, at the end of the 5th century, after the miraculous appearance of St. Michael. The sanctuary (which was built around the Grotto of the Archangel), is irregular in shape, with chapels of various periods. It preserves many precious relics and treasures, including bronze doors made in Constantinople in 1076. The interior of the church has a rib-vaulted nave (1273) and contains a pulpit by Acceptus (1041) and a marble episcopal throne (11th cent.). At the end of the nave is the baroque Chapel of the Sacrament (rebuilt, 1690). The church has two atria (the outer one built in 1865) connected by a staircase. The octagonal campanile dates from the 13th century. The Tomba di Rotari, a 12th-century rectangular building with a semicircular dome resting on an octagonal drum, may once have been a baptistery. Adjacent are the remains of the Church of S. Pietro (reconstructed, 12th cent.). S. Maria Maggiore was reconstructed in the early 12th century and again rebuilt in 1170. The façade portal was created in 1198. The church preserves frescoes in Byzantine style (12th–13th cent.). The castle, begun under the Hohenstaufens,

preserves an 11th-century pentagonal tower and two 15th-century cylindrical towers.

BIBLIOG. M. Wackernagel, La bottega dell'"Archidiaconus Acceptus" scultore pugliese dell'XI secolo, BArte, II, 1908, pp. 143–50; G. Tancredi, Montesantangelo monumentale, Monte Sant'Angelo, 1932; G. Tancredi, La porta di bronzo della Reale Basilica Palatina di S. Michele in Monte Sant'Angelo, Torremaggiore, 1938; G. Tancredi, La tomba di Rotari, Monte Sant'Angelo, 1941; G. Angelillis, Il campanile della Basilica di S. Michele in Monte S. Angelo, Arch. storico pugliese, II, 1949, pp. 248–63; C. Angelillis, Guida breve di Monte Sant'Angelo, Monte Sant'Angelo, 1953; A. Petrucci, Relazione del restauro iniziato nella basilica di S. Michele in Monte Santangelo, Napoli nobilissima, N.S., I, 1961, pp. 75–77.

Otranto (Lat., Hydruntum). An ancient city, perhaps founded by Tarentine Greeks, Otranto and its port were particularly important in the 11th and 12th centuries of our era. The small town's most important monument is the Cathedral (1080–88; restored). The façade has a Gothic rose window (late 15th cent.) and an ornate baroque portal (1764). The left side of the church has a Renaissance portal by Niccolò Ferrando. The interior is basilican, with three aisles divided by columns. The church preserves a remarkable mosaic floor by a priest named Pantaleone (1165–66; X, PL. 190). Below the presbytery is a crypt (consecrated, 1088) with five aisles and three semicircular apses. The small Byzantine Church of S. Pietro (10th–11th cent.) has three semicircular apses and a cylindrical dome. There are numerous frescoes of various periods. The castle was built by Ferdinand of Aragon in 1485–98. It is rectangular and has cylindrical towers on the corners. Near Otranto are the ruins of the 12th-century Church of S. Nicola di Casole, the only remaining portion of a large Basilian hermitage destroyed by the Turks in 1480.

BIBLIOG. C. Diehl, Le monastère de St.-Nicolas de Casole près d'Otranto, Mél, VI, 1886, pp. 173–88; C. Diehl, Notes sur quelques monuments byzantins de l'Italie méridionale, Mél, XII, 1892, pp. 379–405; G. Bacile di Castiglione, Le mura e il Castello di Otranto, Napoli nobilissima, XIV, 1905, pp. 1–4, 20–25; P. Palumbo, Castelli in terra d'Otranto, Lecce, 1906; G. Gigli, Il Tallone d'Italia: Gallipoli, Otranto e dintorni, Bergamo, 1911; Weiss, RE, s.v. Hydruntum, XVII, 1914, col. 87; T. Horia, Eglises cruciformes dans l'Italie méridionale: S. Piero d'Otranto, EphDR, V, 1932, pp. 22–134; A. Antonacci, Otranto, Galatina, 1955.

Ruvo di Puglia ('Ρύψ; Lat., Rubi). This important Peucetian city became a Roman municipium and a station on the Via Traiana. It is known for its large production of Italiote ceramics. Excavations have yielded rich finds, including tomb paintings (III, PL. 299; V, PL. 45) and fine bronzes (I, PLS. 350, 439). Tradition has it that the city was destroyed by the Goths in A.D. 463. The city was rebuilt in the Norman period. The Cathedral (12th–13th cent.) has an elegant façade with relieving arches on half columns framing the three portals. The central portal is elaborately carved (PL. 172). Above the central portal is a double-arched window, and the façade is topped by a fine rose window. Running around the exterior of the church is a series of small arches supported by corbels with sculptured heads. This motif is repeated in the interior of the church. The Museo Jatta has a fine collection of ancient ceramics.

BIBLIOG. E. Bernich, La Cattedrale e i monumenti di Ruvo, Bari, 1901; F. Jatta, Sintesi storica della città di Ruvo, Ruvo, 1930; R. Rieger, Siena und Ruvo: Ein Beitrag zur Baugeschichte der beiden Dome, Festschrift J. A. Weissenhofer, Vienna, 1954, pp. 97–111; P. Testini, Note sul Duomo di Ruvo, Palladio, N.S., IV, 1954, pp. 6–18; M. Tessari, La Cattedrale di Ruvo di Puglia, L'Architettura, II, 1956–57, pp. 278–83.

Taranto (Τάρας; Lat., Tarentum). From early times an important port, according to tradition the city was founded (on a site that had been inhabited in prehistoric times) at the end of the 8th century B.C. by Spartan colonists. The city was long at war with the Messapians and Iapygians and later fought various cities of Magna Graecia. The city's most prosperous period was the 4th century B.C., under the rule of Archytas of Tarentum. It sided with Pyrrhus in the war against Rome. It became a colony in 125 B.C. and a municipium after the Social War. There are remains of a temple (early 6th cent. B.C.), vestiges of a wall (second half of 5th cent. B.C.), an amphitheater, Roman baths, and sanctuaries. Attic and Italiote ceramics have been recovered from necropolises, hypogea (some painted), and isolated tombs (VII, PLS. 56, 74).

The modern city comprises the Old City, the New City, and the Borgo. The Old City, with irregular narrow streets, is situated on an island formed by two canals. The New City and the industrial Borgo are joined to the Old City by bridges. The basilican Cathedral, founded in 1071, was much remodeled. It has been restored to its original appearance, except for the baroque façade. On the lateral walls some of the Romanesque decoration has been uncovered. The interior, with three aisles separated by two rows of ancient columns, preserves parts of the 11th-century mosaic

floor. The crypt preserves remains of Byzantine-style frescoes (12th cent.). The baroque Chapel of S. Cataldo (17th–18th cent.) is richly decorated with inlaid marbles and stuccoes. S. Domenico Maggiore (rebuilt, 1302; later remodeled) preserves the original Gothic façade above the baroque double staircase. The castle, built by Ferdinand of Aragon (1481–92) over older fortifications and enlarged in 1577, has four large cylindrical towers and bastions. In the New City, with its broad streets and squares, are the Municipio (D. Conversano, 1886), the Banca d'Italia (C. Bazzani), and the Palazzo degli Uffici (G. Galeone, 1896). On the sea front (Lungomare) are the Post Office (C. Bazzani) and the Palazzo del Governo (A. Brasini). The Museo Nazionale houses the most important collections of Apulian antiquities, including prehistoric material (mainly vases), Greek and Italiote ceramics, terra cottas, sculpture, and gold- and silverwork.

Bibliog. T. Gregorovius, Tarent, Leipzig, 1880; L. Viola, Taranto, NSc, 1881, pp. 383–444; Q. Quagliati, Relazione degli scavi archeologici che si eseguirono nel 1899 in un abitato terramaricolo, allo Scoglio del Tonno, presso la città, NSc, 1900, pp. 411–64; Q. Quagliati, Tombe neolitiche in Taranto e nel suo territorio, BPI, XXXII, 1906, pp. 17–49; G. Blandamura, Il Duomo di Taranto, Taranto, 1923; G. Blandamura, Chiesa e monastero di S. Michele, Taranto, 1934; C. Ceschi, Opere militari e civili del Rinascimento in Puglia: Una torre e una cappella del castello di Taranto, Bari, 1936; P. Wuilleumier, Tarente: Des origines à la conquête romaine, Paris, 1939; G. Importuno, Gli albori del Borgo, Rinascenza salentina, IX, 1941, pp. 1–26; G. Antonucci, Il mosaico pavimentale del Duomo di Taranto e le tradizioni calabrosicule, Arch. storico per la Calabria e la Lucania, XII, 1942, pp. 121–32; L. Bernabò Brea, I rilievi tarantini in pietra tenera, RIASA, N.S., I, 1952, pp. 5–241; C. Drago, Lo scavo di Torre Castelluccia, BPI, N.S., VIII, 5, 1953, pp. 165–91.

Trani (Lat., Turenum, or Tarenum). Although the city may have been founded in the 3d or 4th century of our era, it became important only after the destruction of Canosa di Puglia in the 9th century. Few Roman remains have been found. The Cathedral (restored) was begun in 1096 on the site of the Church of S. Maria della Scala, or Episcopio, which is known to have existed as early as the 7th century. The Cathedral was erected in several phases, the most intensive being the period 1159–86. The Cathedral was completed in the 13th century. The plan is traditional Apulian Romanesque. The façade has a steep gable. The central portal is richly carved, and the double doors, by Barisanus of Trani (1175–79; IX, PL. 508), are of wood covered with bronze. On the right side of the façade is the campanile, about 190 ft. high (PL. 172). The lower part was built in the 13th century, the upper part in the 14th century. The interior of the Cathedral is divided into three aisles by two rows of paired columns (the only example in Apulia). In the presbytery are sections of a Byzantine floor mosaic (11th cent.). The Crypt of S. Nicola has a ceiling supported by 28 columns (I, PL. 400). The Romanesque Church of Ognissanti (12th cent.) is preceded by a double portico. The central portal is sculptured with elaborate fantastic motifs. S. Francesco (1176–84; restored, 1897) is a three-aisled church. S. Andrea is a small basilica of Byzantine type (11th cent.). The plan of the church is that of a Greek cross inscribed within a rectangle. S. Giacomo was originally Romanesque. The façade preserves three orders of corbels sculptured with human and animal figures. The castle was begun under Frederick II, in 1233. It was completed in 1249 and remodeled in the 15th and 16th centuries. The late-Gothic Palazzo Caccetta (1458) has a fine portal and Gothic windows.

Bibliog. F. Sarlo, Il Duomo di Trani, Trani, 1897; L. Maffucini, La città di Trani, Trani, 1951; B. Piracci, Guida del Duomo di Trani, Trani, 1957; H. Korte, Troia, Trani, Lecce, Oldenburg, 1959.

Troia. The city was built on the site of the Apulian Aecae. Under Septimius Severus, it became a colony and a station on the Via Traiana. The present city began its history as a Byzantine fortress founded in A.D. 1019 on the ruins of the Roman city. The architecture of the Romanesque Cathedral, founded in 1093 and completed in the 13th century, incorporates Byzantine and Islamic elements with Pisan influences. The elegant façade, with a rose window, has bronze doors by Oderisius of Benevento (1119). On the right wall is another bronze door by Oderisius (1127). The basilican-plan church preserves a carved marble pulpit (1169). S. Basilio (11th cent.) is also a Romanesque church.

Bibliog. C. Hülsen, RE, s.v. Aecae, I, 1894, col. 443; A. Tredanari, Troia e la sua storica cattedrale, Troia, 1935; M. Cagiano de Azevedo, Restauri a porte di bronzo (Trani, Troia, Montecassino), B. Ist. centrale del restauro, IX–X, 1952, pp. 23–40; H. Korte, Troia, Trani, Lecce, Oldenburg, 1959.

Lucania (or Basilicata). This predominantly mountainous region has two short stretches of coastline on the Ionian and Tyrrhenian seas. There is considerable evidence of prehistoric and protohistoric cultures and artistic activity, especially in the area around Matera. (These cultures form part of the Apulian complex.) In the 8th century B.C. several Greek colonies were established on the Ionian coast (Metapontion, Siris), and many of the indigenous fortified settlements of the interior were subjected to Hellenic influences. In the 6th century B.C. the region was invaded by the Lucani, an Italic people (whence the name Lucania). The name Basilicata is of Byzantine origin. Despite its relative isolation, the region flourished under the Norman and Hohenstaufen dynasties, the majority of important monuments dating from the 11th to the 13th century.

Bibliog. H. W. Schulz, Denkmäler der Kunst des Mittelalters in Unteritalien, 4 vols., Dresden, 1860; D. Salazaro, Studi sui monumenti dell'Italia meridionale dal IV al XIII secolo, 2 vols., Naples, 1871–77; F. Lenormant, À travers l'Apulie et la Lucanie, Paris, 1883; G. Racioppi, Storia dei popoli della Lucania e della Calabria, Rome, 1889; C. Diehl, L'art byzantin dans l'Italie méridionale, Paris, 1894; E. Bertaux, I monumenti medievali della regione del Vulture, Napoli nobilissima, VI, 1897; pp. i-xxiv; V. di Cicco, L'arte nella Lucania, Arte e storia, XVI, 1897, pp. 108–10, 118–19; G. B. Guarini, Chiesette medievali della Basilicata, Napoli nobilissima, X, 1901, pp. 93–96; A. Avena, Monumenti dell'Italia meridionale, Rome, 1902; E. Bertaux, L'art dans l'Italie méridionale, Paris, 1904; L. Fiocca, L'architettura romanica nell'Italia meridionale, Riv. abruzzese di sc., lettere e arti, XIX, 1904, pp. 368–72; G. De Lorenzo, Venosa e la regione del Vulture, Bergamo, 1906; W. Arslan, Relazione di una missione artistica in Basilicata, Campagne della Soc. Magna Grecia (1926–27), Rome, 1928, pp. 81–90; C. Valente, Guida artistica della Basilicata, Potenza, 1932; E. Galli, Danni e restauri ai monumenti della zona del Vulture, BArte, XXVI, 1932–33, pp. 321–41; C. Shearer, The Renaissance of Architecture in South Italy, Cambridge, 1935; G. Ceci, Bibliografia delle arti figurative nell'Italia meridionale, 2 vols., Naples, 1937; C. Valente, L'architettura rustica nella Lucania, Lares, XI, 1940, pp. 424–34; L. Franciosa, La casa rurale nella Lucania, Florence, 1942; E. Magaldi, Lucania romana, I, Rome, 1948; B. Cappelli, Le chiese rupestri del Materano, Arch. storico per la Calabria e la Lucania, XXVI, 1957, pp. 223–89; U. Kahrstedt, Ager publicus und Selbstverwaltung in Lukanien und Bruttium, Historia, VIII, 1959, pp. 174–206; L. Ranieri, Basilicata, Turin, 1951. Periodicals: Brutium, 1923 ff.; Arch. storico per la Calabria e la Lucania, 1931 ff.

Acerenza (Lat., Aceruntia, Acerentia, Acheruntia, Acherontia). Believed to have been an Oscan settlement, conquered by the Romans in 318 B.C., this was a colonia not later than the end of the Republic. It was the center of long political struggles after the 5th century. In the 9th century it came under Byzantine and in the 11th century under Norman rule, declining in importance in modern times. The Cathedral, one of the most noteworthy medieval monuments of the region, is of the 12th century (the foundations may be older). The façade, remodeled in 1524, retains the central portal in Apulian Romanesque style. The interior is a Latin cross, with an ambulatory behind the presbytery and chapels in the apses showing French influence. Of the 11th or 12th century are the churches of SS. Annunziata and of S. Laviero (with arcades and dome). The Palazzo Saluzzi is of the 18th century.

Bibliog. C. Hülsen, RE, s.v. Aceruntia, I, 1894, col. 155; R. Delbrück, Ein Porträt Friedrich's II von Hohenstaufen, ZfBK, XIV, 1903, p. 17; J. R. Dieterich, Das Porträt Kaiser Friedrich's II, ZfBK, XIV, 1903, p. 246; C. Muscio, Acerenza, Naples, 1957.

Grumentum. The site of an ancient city of the Lucanians near modern Grumento Nova. Destroyed by the Romans during the Social War, it later became a municipium and then a colonia. It was again destroyed by the Saracens in the 10th or 11th century. There are remains of 1st-century B.C. walls, a theater of the period of Augustus or Tiberius, an amphitheater, thermae, an aqueduct, and funerary monuments. The "Bronze of Siris," a fine cuirass (Br. Mus.) was found here in 1820.

Bibliog. E. Magaldi, Grumento, Arch. storico per la Calabria e la Lucania, III, 1933, pp. 325–59; C. Valente, Zona archeologica di Grumentum, NSc, 7th ser., II, 1941, p. 251; P. C. Sestieri, Scavo del teatro romano, FA, VIII, 1953, 3648; G. Bermond Montanari, Rilievo da Grumentum con scena di sacrificio, AC, X, 1958, pp. 37–40; EAA, s.v. Grumento.

Irsina (formerly Montepeloso). Perhaps the ancient Vertinae (Οὐερτῖνοι), which declined and was superseded by Irsum, on Mount Irsi, 5½ miles east, where Hellenistic-Roman objects have come to light. It was a bulwark of the Byzantine defense against the Normans, who conquered it in the 11th century. Destroyed by Roger II in 1133, it was rebuilt in the 13th century. The Cathedral (13th cent., on foundations of the 10th) was remodeled in 1777. The façade is somber; the interior, in the form of a Latin cross, has three aisles, a dome above the crossing, and a crypt. The only remaining part of the original structure is the campanile, with pointed double-arched windows. The former monastery of S. Francesco (now the town hall) incorporates the remains of a Norman castle remodeled by Frederick II in 1228 and enlarged after 1531. The adjoining church, S. Francesco, was rebuilt after 1531 (façade remodeled 1717, incorporating

two 13th-cent. columns). The crypt, originally an oratory built in 1110 (remodeled, 1228), within a quadrangular tower of the castle, has 14th-century frescoes by a Neapolitan artist. Noteworthy also are S. Andrea (1566), the Church of the Purgatorio (1638), and the episcopal palace (1638). The Museo Ianora contains prehistoric artifacts, Italiote vases, coins and medals.

In the vicinity are the Grotta di S. Lucia, a Basilian chapel with traces of frescoes; and, on Mount Irsi, remains of the Hellenistic city, the Church of S. Maria d'Irsi (11th cent.; many times remodeled), and ruins of a castle.

BIBLIOG. M. Ianora, Memorie storiche, critiche e diplomatiche della città di Montepeloso oggi Irsina, Matera, 1901; P. Geraci, Nella cripta trecentesca di Irsina, Brutium, VI, 11, 1927; E. Galli, Monumenti ignorati del Bruzio e della Lucania, BArte, N.S., VII, 1927–28, pp. 385–415; M. Nugent, Affreschi del Trecento nella cripta di S. Francesco ad Irsina, Bergamo, 1933.

Lagopesole. This village is noted for a castle begun by Frederick II in 1242 and completed by Charles I of Anjou in 1278. The plan is rectangular, with rectangular towers on the corners and a massive keep of rough ashlar.

BIBLIOG. G. Fortunato, Il Castello di Lagopesole, Trani, 1902; T. Claps, Il castello di Lagopesole e una singolare leggenda su Federico Barbarossa, Arch. storico per la Calabria e la Lucania, III, 1933, pp. 461–71.

Matera (Lat., Mateola?). In an area inhabited since the Paleolithic period, the modern city is of obscure origin. It is known to have been destroyed five times before the 11th century. In 1064 it came under Norman rule, later passing to the Aragonese, forming part of Apulia. It was the capital of Basilicata from 1663 to 1806. The salient characteristics of the modern city are the two gullies (Sassi) with dwellings hewn out of the rock, one above the other, the only masonry construction often being the façade. The streets on the higher level are narrow and twisting; many houses have baroque galleries and balconies resting on elaborately carved corbels. The city is dominated by the unfinished castle, with three cylindrical towers and bastions (late 15th cent., incorporating sections of an older Norman castle). The Cathedral (1268–70) is in Apulian Romanesque style. The façade, in three sections (the central one very high, surmounted by a tympanum), is decorated with small blind arcades, a rose window, and a series of blind corbeled arches. It is articulated by pilaster strips, which are also found on the lateral walls. The interior (remodeled, 1627 and 1776) is baroque but retains the original columns; it preserves a carved stone reredos by Altobello Persio da Matera (1539), a polychrome stone Nativity by Altobello and Sannazaro d'Alessano (1534), and carved wooden choir stalls by Giovanni Tantino (1453). Within a courtyard entered through the Cathedral is the little Church of S. Maria di Costantinopoli (13th cent.). Other 13th-century churches include S. Giovanni Battista (restored), with Apulian, Burgundian, and Oriental elements; S. Domenico, retaining part of the original façade and a Romanesque portal; and S. Pietro Barisano, partly carved out of the rock (17th-cent. façade and Gothic campanile). The city contains a number of baroque churches, among them the Carmelo (1608–10), with five arches and a rose window on the façade; S. Pietro Caveoso (1656; remodeled, 1752); S. Francesco d'Assisi (1670), built over the 11th-century Church of SS. Pietro e Paolo (vestiges of frescoes); SS. Lucia e Agata (18th cent.), with a set-back baroque façade; the Church of the Purgatorio (1747); and S. Agostino (1750), with a façade in the style of Borromini. Secular buildings of note include the Palazzo del Liceo Duni and Convitto Nazionale, in the former Seminary (1668–72); the Palazzo di Giustizia, a former convent, with an 18th-century façade; the Palazzo Bronzini Padula (1779); the Palazzo Giudicepietri, incorporating the southern corner of the old Norman castle, decorated with courses of diamond-pointed ashlar; and the Municipio, with a monumental portal (1779). The modern urban renewal plan, drawn up by Luigi Piccinato in 1954, includes the clearance of the slum zones of the Sassi and the building of new quarters. The Museo Nazionale Domenico Ridola, in the former monastery of S. Chiara (1698), houses local archaeological finds.

The neighborhood of Matera is rich in prehistoric sites, especially of the Neolithic period. Among these are the fortified villages of Murgia Timone, Murgecchia, Tirlecchia, and Serra d'Alto, which have yielded painted pottery. Other sites, such as Timmari (a village with a necropolis), Croccia Cognato, and Garaguso are typical villages of Bronze and Iron Age cultures, which lasted well into the classical age. Also in the environs are many rock-cut underground churches of the Byzantine period (some decorated with frescoes), including S. Maria de Idris, above another church of the 8th century; S. Barbara; Cappuccino Vecchio; Cristo alla Gravinella (17th-cent. façade); S. Maria della Valle (or Balea, Vaglia), with a Romanesque façade. Spirito Santo (known also as La Palomba), built between two rocks, has a Romanesque façade with a rose window.

BIBLIOG. P. F. Volpe, Memorie storiche profane e religiose su la città di Matera, Naples, 1817; G. de Cosimo, I monumenti di Matera, Arte e storia, IX, 1890, pp. 169–70; T. Bazzi, Matera, Emporium, XIII, 1901, pp. 140–48; Q. Quagliati and D. Ridola, Necropoli arcaica ad incinerazione presso Timmari nel Materano, MALinc, XVI, 1906, cols. 1–166; D. Ridola, Le origini di Matera, Rome, 1906; G. Gattini, La Cattedrale di Matera, Arte e storia, XXX, 1911, pp. 16–17; D. Ridola, Le grandi trincee preistoriche di Matera: La ceramica e la civiltà di quel tempo, BPI, XLIV, 1924, pp. 97–122, XLV, 1925, pp. 85–98, XLVI, 1926, pp. 134–74; U. Rellini, Nuove osservazioni sulla età eneolitica ed enea nel territorio di Matera, Atti e Mem. Soc. Magna Grecia, 1929, pp. 129–47; E. Mele, La torre metellana, Brutium, XII, 2, 1933; F. Bracco, Rinvenimenti di età varia in località Ospedale Vecchio, NSc, 1935, pp. 107–25; E. Bracco, Rinvenimento di un sepolcro di età greca nel Sasso Caveoso, NSc, 1936, pp. 84–88; M. de Vita, La chiesa di S. Giovanni Battista a Matera, BArte, XXXIII, 1948, pp. 320–29; E. Bracco, Necropoli dei bassi tempi, NSc, 8th ser., IV, 1950, pp. 140–67; B. Cappelli, Chiese rupestri del Materano, Calabria nobilissima, X, 1956, pp. 45–59; M. Sestieri Bertarelli, Il tempietto e la stipe votiva di Garaguso, Atti e Mem. Soc. Magna Grecia, N.S., II, 1958, pp. 67–78; F. Biancofiore, Lucania preclassica: La cultura di Serra d'Alto e le sue relazioni con le civiltà protostoriche eurasiatiche, Arch. storico per la Calabria e la Lucania, XXIX, 1960, pp. 47–57.

Melfi. The town is built of lava on a secondary crater of Mount Vulture, an extinct volcano. It is of Italic origin. Of minor importance in Roman times, it flourished in the Middle Ages under Byzantine, then Norman rule. It was sacked by the emperor Frederick I in 1167 but became a favorite residence of Frederick II. Devastated in 1528 by the French army of Lautrec, it never recovered its former prosperity. There are few medieval remains. The Cathedral (founded 1153) has been remodeled numerous times. The campanile (1153) retains its original form, save for the modern octagonal upper story and pinnacle. It has two orders of Romanesque double-arched windows decorated with geometric designs and two griffins (emblem of the Norman kings) in contrasting colored lava. There are medieval portals in the churches of S. Andrea (12th cent.), S. Maria la Nuova (13th cent.), and S. Lucia (14th cent.), and in a baronial palace (13th cent.). The Castle, of Norman origin, rebuilt by Charles I (1278–81), remodeled in the 16th century, and restored after 1851, is on a quadrangular plan with seven towers and is surrounded by a moat. The Porta Venosina (13th cent.), with a Gothic arch, stands between two towers and walls of the Spanish viceroyal period. In the courtyard of the Vescovado is the Rapolla sarcophagus, Roman, of the reign of Marcus Aurelius (2d cent.). The Antiquarium (in the Municipio) has archaeological objects and Hellenistic vases.

In the vicinity are a number of underground churches, some with remains of frescoes — S. Lucia (1192); Madonna delle Spinelle; and S. Margherita (13th cent., restored). S. Maria del Monte (12th cent.) is a small Benedictine church with a single aisle, cross-vaulted ceiling, and campanile.

BIBLIOG. G. Guarini, Curiosità d'arte medioevale nel Melfese, Napoli nobilissima, IX, 1900, pp. 132–36, 152–58; G. Guarini, Un resto della cattedrale normanna di Melfi, Melfi, 1900; G. Lenzi, Il Castello di Melfi e la sua costruzione, Amatrice, 1935; P. Lojacono, Restauro in zone sismiche: Il campanile del Duomo di Melfi, Palermo, 1936; E. Galli, La chiesa rupestre di S. Margherita, Arte e restauro, XVII, 1940, pp. 13–22; P. C. Sestieri, Melfi: Scavi e scoperte, FA, XIII, 1958, 2342; A. Lipinsky, Melfi medioevale e i suoi fonditori in bronzo, Brutium, XXXVIII, 1, 1959, pp. 5–7.

Metaponto (Gr., Μεταποντιον; Lat., Metapontum). A Greek colony was founded in the first half of the 8th century B.C. The town came under the domination of Taras in the 3d century B.C. It was probably abandoned in the late Imperial period and finally destroyed by the Arabs in the Middle Ages. Aerial photography has revealed the perimeter of the walls (parts of which can be seen on the ground), as well as the layout of the city, on a checkerboard pattern. Still extant are the foundations and portions of the walls of the Temple of Apollo (early 5th cent. B.C.) and necropolises of the 6th and 5th centuries B.C. with tombs covered with slabs and of the Hellenistic period with graves roofed with tiles. About 1 mile north of the city are the remains of a Doric temple of the late 6th century, known as "Tavole Palatine" (VII, PL. 54).

BIBLIOG. M. Lacava, Topografia e storia di Metaponto, Naples, 1891; E. Galli, Metaponto: Esplorazioni archeologiche e sistemazione dell'area del tempio delle tavole Palatine, Campagna della Soc. Magna Grecia (1926–1927), Rome, 1928, pp. 63–79; P. C. Sestieri, Metaponto: Campagna di scavi, NSc, 7th ser., I, 1940, pp. 51–122; P. C. Sestieri, Note sull'arte del Metaponto, Le Arti, III, 1940–41, pp. 92–99; C. Drago, Metaponto: Rinvenimenti preistorici, BPI, N.S., VIII, 5, 1953, p. 116; C. M. Craay, Epis de Métaponte, Schw. Münzblätter, VII, 1957, pp. 73–77; M. Guarducci, Inscrizione arcaica della regione di Siri, Atti e Mem. Soc. Magna Grecia, N.S., II, 1958, pp. 51–61; F. Castagnoli, La pianta di Metaponto: Ancora sull'urbanistica ippodamea, RendLinc, 8th ser., XIV, 1959, pp. 49–55; G. Schmiedt and R. Chevallier, Caulonia e Metaponto: Applicazioni della fotografia aerea in ricerche di topografia antica nella Magna Grecia, Florence, 1959; P. C. Sestieri, EAA, s.v. Metaponto, IV, 1961, pp. 1095–97.

Potenza (Lat., Potentia). Probably of Lucanian or Picenian origin, the settlement became a Roman municipium in the 2d century B.C. The ancient city was situated on the left bank of the Basento; the move to the present site on a high ridge took place in the Middle Ages. The present city consists of the medieval part, extending along the ridge and divided by the Via Pretoria, where the principal edifices rise, and modern quarters with wide streets and residential and agricultural suburbs at each end. The Church of S. Michele Arcangelo (11th–12th cent.) retains the medieval exterior. The interior has been remodeled several times. The Cathedral (built 1197-1200; rebuilt, 1783–99 by Antonio Magri) has both the rose window on the façade and the apse of the original 12th-century structure. S. Francesco (1274) has a 15th-century carved wooden door with Gothic decorations and two 14th-century portals. The single-aisled interior has a Gothic apse and contains a Renaissance marble tomb and a 13th-century Madonna. The Museo Provinciale Lucano houses archaeological, medieval, contemporary, and folk collections.

BIBLIOG. E. Viggiano, Memorie della città di Potenza, Naples, 1805; N. Alfieri, I fasti consulares di Potentia (Regio V), Athenaeum, XXVI, 1948, pp. 110–34; C. Valente, Potenza: Scultura, armi greche e vasi italioti del museo archeologico, NSc, 8th ser., III, 1949, pp. 106–13; M. Marini, Le origini di Potenzia Antica, Orbis: B. int. Doc. linguistique, V, 1956, pp. 91–106; M. Sestieri Bertarelli, Il Museo Archeologico Provinciale di Potenza, Rome, 1957; F. Ranaldi, Ricerche archeologiche nella provincia di Potenza, 1956–1959, Potenza, 1960.

Rapolla (anc. Strapellum?). In the 10th century, St. Vitalis founded a Basilian monastery in the locality. The town (probably fortified with a castle) was conquered by the Normans in 1042. In was devastated twice during the 12th century but each time was rebuilt. In 1851 and 1930 it suffered damage by earthquakes. The Church of S. Lucia, of Norman origin, shows definite Byzantine influences; the interior has three aisles with two crossings, each surmounted by an elliptical cupola, and a semicircular apse. The Cathedral, rebuilt in the 13th century in Cistercian Gothic style, was restored after the earthquake of 1930. The surviving Romanesque portal is by Melchiorre da Montalbano (1253). The quadrangular campanile dates from 1209. There are many houses and Basilian grottoes hewn from the volcanic tuff, both in the town and the surroundings. The Church of the Crocifisso is carved from the rock and contains 14th-century frescoes.

BIBLIOG. F. Chiaromonte, Cenno storico sulla chiesa vescovile di Rapolla, Naples, 1848; E. Bertaux, L'art dans l'Italie méridionale, II, Paris, 1904, pp. 784–86.

Venosa (Lat., Venusia). In 291 B.C. a Roman colonia was established. Situated between the territories of the Samnites, Lucani, and Bruttii, it was an important Roman stronghold in the later Samnite wars. The Arabs sacked the town in the 9th and 10th centuries. It came under Norman rule in 1041, was destroyed in 1133, but rose again. It has suffered frequent damage by earthquake. Of the Roman period remain an amphitheater; the so-called "House of Horace," a circular building, perhaps originally baths; and Jewish catacombs (2d–5th cent.) with inscriptions. The most important medieval monument is the Abbey (Abbazia della Trinità), founded in the 11th century by Benedictines under Count Drogo. It comprises the abbatial building (restored) and two churches joined longitudinally, the second unfinished. The older church (completed, 1098; restored several times) retains portions of a late 13th-century portal. The basilican interior has vestiges of frescoes. The second church (12th cent.) is attached to the eastern end of the older one. The plan, which shows influences of French Cistercian architecture, is a Latin cross, with three aisles and a deep presbytery, behind which is an ambulatory with three radiating apses. The Cathedral (1470–1502) has been much disfigured. The façade has a marble portal by Cola da Conza (1512). The three aisles of the interior are divided by pilasters supporting Gothic arches. S. Biagio and S. Maria della Scala are both of the 15th century. The Castle (1470) is quadrangular, with cylindrical towers at the corners. The walls and towers of the town also date from the 15th century. Local prehistoric material is exhibited in the Collezione Preistorica Briscese.

BIBLIOG. G. Crudo, La SS. Trinità di Venosa, Trani, 1899; G. De Lorenzo, Venosa e la regione del Vulture, Bergamo, 1906; A. Bordenache, La cappella romanica della foresteria nell'Abbazia di Venosa, BArte, XXVII, 1933, pp. 178–84; N. Jacobone, La patria di Orazio, Venusia: Centro stradale dell'Apulia e della Lucania, Japigia, N.S., VI, 1935, pp. 307–32; G. Pesce, Scavo dell'anfiteatro e restauro della cosidetta "Casa di Orazio," NSc, 1936, pp. 450–61; A. Bordenache, La SS. Trinità di Venosa, EphDR, VII, 1937, pp. 1–76; H. J. Leon, The Jews of Venusia, AJA, LVII, 1953, p. 109; E. Lauridia, Guida di Venosa, Bari, 1959.

Calabria. Because of its location Calabria has been since prehistoric times (paleolithic rock drawings near Papasidero) a bridge to

Sicily. Here lived the Siculi; the Italii, who gave the name to a part of the region and later to the whole of Italy; and the Bruttii (Brettii), whence Bruttium, the name by which the region was known in antiquity. In the area were numerous Greek colonies, which participated actively in the development of the civilization and art of Magna Graecia, especially in the 6th and 5th centuries B.C. After the collapse of the Roman Empire in the West, Calabria once more witnessed a limited cultural flowering in the early Middle Ages under Byzantine rule, a revival linked with the spread of Basilian monasticism, and later under the Normans. Byzantine influence was decisive in the development of the regional architecture between the 9th and 12th centuries. During the baroque period Naples was influential.

BIBLIOG. E. Jordan, Monuments byzantins de Calabre, Mél, IX, 1889, pp. 321–36; C. Diehl, Notes sur quelques monuments byzantins de Calabre, Mél, X, 1890, pp. 284–302; G. Minasi, Le chiese della Calabria dal V al X secolo, Naples, 1896; T. Kutschmann, Meisterwerke saracenisch-normannischer Kunst in Sizilien und Unteritalien, Berlin, 1900; E. Bertaux, L'art dans l'Italie méridionale, Paris, 1904; P. Orsi, Gli scavi di Calabria, NSc, 1908–15, sup.; F. von Duhn, Cenni sull'arte reggino-locrese, Rome, 1913; A. Frangipane, Artisti calabresi del secolo XIX, Bergamo, 1913; C. Sinopoli, S. Pagano, and A. Frangipane, La Calabria, Catanzaro, 1924; A. Frangipane, L'arte in Calabria, Messina, 1925; E. Galli, Attività della Soprintendenza per il Bruzio, Lucania (1925), Rome, 1926; A. Frangipane and C. Valente, La Calabria, Bergamo, 1929; P. Orsi, Le chiese basiliane della Calabria, Florence, 1929; T. Horia, Les églises à cinq coupoles en Calabre, EphDR, IV, 1930, pp. 149–80; C. Diehl, Chiese bizantine e normanne in Calabria, Arch. storico per la Calabria e la Lucania, I, 1931, pp. 141–50; P. Orsi, Bibliografia della Calabria-Lucania e della Magna Grecia, Arch. storico per la Calabria e la Lucania, II, 1932, pp. 103–18; M. Boretti, Appunti da documenti inediti su monasteri e chiese cistercensi della Calabria, Arch. storico per la Calabria e la Lucania, VI, 1936, pp. 337–46; B. Cappelli, Un gruppo di chiese medievali della Calabria settentrionale, Arch. storico per la Calabria e la Lucania, VI, 1936, pp. 41–62; H. M. Schwarz, Die Baukunst Kalabriens und Siziliens im Zeitalter der Normannen, Jhb. der Bib. Hertziana, VII, 1946, pp. 1–113; A. Frangipane, Maestranze di Calabria, Brutium, XXX, 1951, 1-2, pp. 6–8, 3-4, pp. 5–7; G. Pugliese Carratelli, La Calabria nell'antichità: Visioni e problemi della ricerca moderna, Arch. storico per la Calabria e la Lucania, XXIV, 1955, pp. 273–81; U. Zanotti Bianco, Le ricerche archeologiche in Calabria durante l'ultimo cinquantennio, Arch. storico per la Calabria e la Lucania, XXIV, 1955, pp. 257–72; G. Martelli, Chiese monastiche calabresi del secolo XV, Palladio, N.S., VI, 1956, pp. 41–53; G. Martelli, Influssi campani nell'architettura del secolo XII in Calabria, Atti VIII Conv. naz. Storia Arch., Rome, 1956, pp. 293–300; A. Frangipane, Calabria ignota, Messina, 1957. *Periodicals:* Brutium, 1923 ff.; Arch. storico per la Calabria e la Lucania, 1931 ff.

Catanzaro. City of Byzantine origin. Among the important churches are S. Domenico (late 16th cent.), with an oratory decorated with 17th-century stucco and inlay; the Immacolata (rebuilt 1765), with baroque façade; the Church of the Monte dei Morti, with a very ornate 18th-century portal; Church of the Osservanza, a small edifice containing a marble *Madonna della Ginestra* by Antonello Gaggini (1508) and works by Giovanni da Reggio (1650). Two noteworthy buildings in the neoclassic style are the Cathedral (rebuilt 19th cent.) and the Teatro Comunale (1818). The Museo Provinciale contains archaeological finds and paintings by artists of southern Italy.

Near Catanzaro Marina are the ruins of the Roccelletta (S. Maria) of the Bishop of Squillace, a Norman basilica of the 11th century.

BIBLIOG. G. Foderaro, La Basilica della Roccelletta, Arte e storia, IX, 1890, pp. 97–101; E. Caviglia, La Roccella del Vescovo di Squillace, Rass. d'arte, III, 1903, pp. 51–57; G. Abatino, La Roccelletta presso la Marina di Catanzaro nella letteratura d'arte, Naples, 1908; Inventario degli oggetti d'arte, Calabria: Province di Catanzaro, Cosenza, Reggio Calabria, Rome, 1933; Ministero Pubblica Istruzione, Elenco degli edifici monumentali, LVIII–LX: Catanzaro, Cosenza, Reggio Calabria, Rome, 1938; G. Mazzocca, Teatro Comunale, Palladio, II, 1938, p. 101.

Caulonia (Καυλωνία). Perhaps established as a colony of the Achaian settlement Kroton (7th cent. B.C.), on the promontory Punta Stilo, Caulonia was a member of the Italiote league and subsequently was largely destroyed by Dionysius the Elder of Syracuse in 389 B.C. Some sectors survived this conquest and destruction, and much of the city was rebuilt at the end of the 4th century B.C. Remains include walls with towers, Hellenistic houses, and Christian tombs.

BIBLIOG. P. Orsi, Caulonia, MALinc, XXIII, 1915, cols. 685–948, XXIX, 1924, cols. 409–90; A. De Franciscis, Scavi e scoperte nel territorio dell'antica Caulonia, FA, X, 1955, 1831; EAA, s.v.

Cosenza (Lat., Consentia, Cosentia Bruttiorum). Cosenza was the most important town of the Bruttii. A river divides the city into two parts — the older quarter on the steep slope of Colle Pancrazio, and the modern on the level valley floor to the north, laid out on a regular checkerboard plan. In 204 B.C. the city fell to Rome. In the Middle Ages the city grew in size and importance, and political events, especially during the Angevin period, forged links to Naples. The foundation of its Academy in the 16th century made

Cosenza an important intellectual center. The castle on the summit of Colle Pancrazio was built by the Normans, and then was enlarged and fortified by the Emperor Frederick II, who added the polygonal tower and the splay windows (with later alterations). The Church of S. Francesco d'Assisi (early 13th cent.) retains the portal, a chapel, and an adjoining cloister from the original Gothic construction. The old quarter (15th cent.), between S. Francesco and the Crati, has vestiges of a Roman wall and is characterized by architectural elements of Neapolitan and Catalan derivation, especially in the portals with surbased arches. The Cathedral, built in Cistercian Gothic style (1185–1222), was remodeled in the 18th century, and a pseudo-Gothic façade was added in 1831. Of the original construction it retains three Gothic portals and the large central rose window (restored). The interior has three aisles, divided by piers supporting semicircular arches, and three apses. Within is the tomb of Isabella of Aragon (d. 1271), the work of a French sculptor. S. Domenico (1449) was remodeled in the 18th century with a baroque dome but retains the original façade, with a Gothic porch and rose window. Part of the apse is also from the original structure. The former convent adjoining the Cathedral has a 15th-century cloister. S. Maria di Costantinopoli (deconsecrated), rebuilt in the 17th century, contains several paintings by Willem Borremans. In the Church of the Cappuccinelle is an *Immaculate Conception* by P. Negrone (1558). The treasury of the archdiocese contains a Byzantine reliquary in the form of a cross (II, PL. 485), and the Museo Civico has a varied collection.

BIBLIOG. N. Arnone, Il Duomo di Cosenza, Siena, 1893; E. Galli, Per la Sibaritide: Studio topografico e storico con la pianta archeologica di Cosenza, Acireale, 1907; P. Orsi, Cosenza: Rilievo sepolcrale, NSc, 1912, sup., pp. 64–66; M. Boretti, La Cattedrale di Cosenza, Cosenza, 1933; Inventario degli oggetti d'arte d'Italia, Calabria: Province di Catanzaro, Cosenza e Reggio Calabria, Rome, 1933; E. Galli, Cosenza secentesca, Rome, 1934; E. Galli and M. Scornajenchi, Necropoli ellenistica di contrada "Moio," NSc, 1935. pp. 182–90; Ministero Pubblica Istruzione, Elenco degli edifici monumentali, LVIII–LX: Catanzaro, Cosenza, Reggio Calabria, Rome, 1938; M. Boretti, Il Castello di Cosenza, Cosenza, 1940; G. Martelli, Conclusioni sulla iconografia absidale originaria della cattedrale cosentina, Calabria nobilissima, IV, 1950, pp. 67–73; S. Bottari, Il monumento della Regina Isabella nella Cattedrale di Cosenza, Arte antica e moderna, I, 1958, pp. 339–44; M. Boretti, Guida breve di Cosenza, Cosenza, 1960.

Crotone (Κρότων; Lat., Crotona). This was originally a Greek colony, founded about 710 B.C. by Achaians and Corinthians. It was a famous seat of learning, renowned especially for medicine and philosophy — Pythagoras lived and taught there for 20 years. Its fine harbor made it wealthy, particularly after the destruction of Sybaris in 510 B.C. In the 3d century B.C. the city became Roman, and in 194 B.C. a colonia was established. In wars between the Goths and the Byzantine Empire in the 5th and 6th centuries, Crotone was an important Byzantine fortress. In the 16th century it was heavily fortified by the Spanish viceroy Pedro de Toledo. From the Greek period, only traces of the walls, port installations, and a few houses remain. A necropolis of the 3d and 4th centuries is testimony to the Roman dominion. The Cathedral is of the 16th century, with a 19th-century chapel containing the *Madonna di Capocolonna*, a Byzantine painting on wood. The castle, with massive fortifications, was built on the site of the Greek acropolis in 1541 and incorporated much ancient material; it has two cylindrical towers, barbicans, and vestiges of a moat. The Palazzo Barracco dates from the 18th century. The Museo Civico in the castle contains prehistoric and antique material, coins, and inscriptions.

On Capo Colonna (anc. Lacinium Promontorium), to the south, are the remains of the great Italiote sanctuary of Hera Lacinia. These consist of a single standing column and part of the stylobate of a Doric temple (late 6th or early 5th cent. B.C.), from which important fictile revetments have been recovered.

BIBLIOG. F. von Duhn, Antichità greche di Crotone, del Lacinio e di alcuni altri siti del Brezio, NSc, 1897, pp. 343–60; P. Orsi, Prima campagna di scavi al santuario di Hera Lacinia, NSc, 1911, sup., pp. 77–124; A. W. Byvanck, Aus Bruttium, RM, XXIX, 1914, pp. 143–67; R. Lucente, Crotone: Scoperte archeologiche varie nel territorio dell'antica città, NSc, 1932, pp. 364–77; P. Larizza, Crotone nella Magna Grecia, Reggio Calabria, 1934; G. Jacopi, Capo Cimmiti: Iscrizione greca, NSc, 8th ser., VI, 1952, pp. 167–76; G. Jacopi, Un askos di bronzo configurato da Crotone, AC, V, 1953, pp. 10–22; A. De Franciscis, Scavi del Santuario di Hera Lacinia, FA, X, 1955, 1854; P. C. Sestieri, EAA, s.v. Crotone, III, 1960, p. 964.

Gerace. Gerace was founded in the 7th century by refugees from Locri. It was a flourishing Norman town. The Cathedral (mid-11th cent.) was remodeled in 1222 and restored thereafter. It is the largest church in Calabria, in the form of a Latin cross with an elaborate transept; its three aisles are separated by reused columns (perhaps from the temples of Locri), interspersed with piers. There are three apses and a vast crypt with a ceiling supported by columns also taken from Locri. Other notable churches are S. Giovan-

nello, a small Norman church with a semicircular apse; S. Francesco (1252), in Cistercian Gothic style, very much remodeled with remains of the cloister; and S. Anna and S. Caterina, both containing baroque works of art. Atop a rocky eminence is the castle (frequently rebuilt) with 15th-century bastions.

BIBLIOG. A. Frangipane, La cattedrale di Gerace, Arte e storia, XLI, 1922, pp. 10–17; A. Appedisano, Le Catacombe della Cattedrale di Gerace, 2 vols., Polistena, 1940–42; R. Dattola Morello, Cattedrale di Gerace, Brutium, XXXIII, 1954, pp. 7–8; G. Martelli, La Cattedrale di Gerace, Palladio, N.S., VI, 1956, pp. 117–26.

Locri (Λόκροι Ἐπιζεφύριοι). Magna Graecian colony founded in the 7th century B.C. (according to Eusebius, 673 B.C.). Famous for its written code of laws, associated with Zaleucus, Lokroi was the ally of Syracuse against the Italiote league in 424 B.C. and against Athens in 415–413 B.C. In the late 3d century B.C. it was garrisoned by the Romans, and under the Empire the city declined, becoming little more than a village. It was destroyed by the Arabs in the 7th century, and the surviving inhabitants took refuge at Gerace. Scant remains of the circuit of Greek walls are visible. To the north is an archaic necropolis, with pre-Greek graves that contained Greek Geometric vases antedating the colonization. Excavations have revealed portions of four temples. The Ionic temple (5th cent. B.C.) in the Marasà sector, believed to be built above an archaic one of the 7th century B.C., yielded a marble acroterial group representing the Dioscuri (Naples, Mus. Naz.). A Doric temple (late 6th cent. B.C.) near Casa Marafioti was the source of a fictile acroterium, depicting a youth riding a horse supported by a sphinx. Locri was the site of a celebrated sanctuary of Persephone, and many terra-cotta pinaces have been found in the vicinity (V, PL. 429; VII, PL. 75). Other excavations have disclosed a Greek theater and residential quarters. A great ancient center of bronzeworking, Locri has furnished many examples of this craft (VII, PLS. 73, 79), especially mirrors and vases. The Museo Civico holds archaeological material from the ancient city and vicinity.

BIBLIOG. Q. Quagliati, Civiltà preelenica del territorio di Lokri Epizephyrii, BPI, XXXVI, 1910, pp. 38–61; S. Ferri, Il gruppo acroteriale di Marasa (Loccri) BArte, N.S., VII, 1927–28, pp. 159–80; P. E. Arias, Locri: Scavi archeologici in contrada Caruso-Polisà, NSc, 7th ser., VII, 1946, pp. 138–61; P. E. Arias, Locri: Scavi di case antiche, NSc, 8th ser., I, 1947, pp. 165–71; P. Zancani Montuoro, Note sui soggetti e sulla tecnica delle tabelle di Locri, Atti e Mem. Soc. Magna Grecia, N.S., I, 1954. pp. 71–106; D. Mustilli, La rinascita di Locri, Ecclesia, XV, 1956, pp. 43–45; A. De Franciscis, Un frammento di Arula da Locri, Atti e Mem. Soc. Magna Grecia, N.S., II, 1958, pp. 37–49; A. De Franciscis, Scavi e scoperte, FA, XIII, 1958, 2327; A. De Franciscis, Locri antica, Naples, 1959.

Medma (Μέδμα, Μέσμα). Founded by colonists from Lokroi in the 6th century B.C., Medma was located on a hill that is the site of modern Rosarno, on the left bank of the Mesima River. It may have been destroyed during the war against Hannibal (ca. 210 B.C.). The site is noteworthy for the excellence of its votive terra cottas from a sanctuary of Persephone and Kore, especially busts of the tutelary goddesses and equestrian figures, as well as for models of buildings, important sources for the study of archaic architecture.

BIBLIOG. P. Orsi, Rosarno (Medma): Esplorazione di un grande deposito di terrecotte ieratiche, NSc, 1913, sup., pp. 55–144; V. Russo, Sul luogo di Medma, Arch. storico per la Sicilia orientale, XXI–XXII, 1926, pp. 395–451; P. Orsi, Medma-Nicotera: Ricerche topografiche, Campagne della Soc. Magna Grecia (1926–27), Rome, 1928, pp. 31–61; P. E. Arias, Rosarno: Scavi della necropoli in contrada Nodio Carrozzo, NSc, 7th ser., VII, 1946, pp. 133–38; A. d'Arrigo, Ricerche geofisiche sul litorale tirrenico della Calabria e sull'antico porto di Medma in Magna Grecia, Geofisica pura e applicata, XI, 1948, pp. 101–21 (rev. in BCH, LXXIV, 1950, p. 280); S. Ferri, Il "tempietto" di Medma e l'origine del triglifo, Rend Linc, 8th ser., III, 1948, pp. 402–13; R. Demangel, Retour offensif des théories vitruviennes sur la frise dorique, BCH, LXXIII, 1949, pp. 476–82.

Morano Calabro (anc. Summuranum). Morano Calabro is built on a hill dominated by the ruins of a Norman castle. The Church of S. Bernardino (1452, remodeled 17th cent.) has an ogival portal, a single-aisled interior with a wood-beamed ceiling of Venetian type, and a polyptych by Bartolomeo Vivarini (1477). The Collegiata della Maddalena, one of the finest examples of Calabrian baroque architecture, contains a *Madonna and Child* by Antonello Gaggini (1505). The Church of S. Pietro contains sculpture by Pietro Bernini.

BIBLIOG. B. Cappelli, I conventi francescani in Morano Calabro, Castrovillari, 1926; B. Cappelli, Un gruppo di chiese medievali della Calabria settentrionale, Arch. storico per la Calabria e la Lucania, V, 1935, pp. 41–62; G. Martelli, Uno sguardo all'architettura calabra, Brutium, XXX, 1951, pp. 2–3.

Reggio di Calabria ('Ρήγιον; Lat., Rhegium). Founded in the 8th century B.C. by Chalcidian and Messenian Greeks, the city was de-

stroyed in 387/386 B.C. by the Syracusans and was rebuilt by Dionysius II a few years later. In the 3d century B.C. Rhegion was an ally of Rome; it then became a municipium during the Social War, but retained its Greek character. From the Greek city, portions of the walls and temple areas still exist. The remains of a sanctuary near the Vicolo Griso Laboccetta are particularly significant because they have yielded numerous terra-cotta architectural fragments and archaic votive material. There are traces of a Hellenistic odeum, and from the Roman period date parts of several thermae and houses. In modern times the black-figured ceramics of the 6th century B.C. known as "Chalcidian" ware have been attributed to potters from Greek Rhegion.

The present-day city has a completely modern aspect because of reconstruction after the earthquake of 1908 and the bombardments of 1943. The plan is regular, with long rectilinear streets paralleling the sea front, and earthquake-proof houses are a common feature. In the Church of the Ottimati four columns and some pavements are all that remain of the Norman construction. The castle has a section of walls of the Aragonese period (15th cent.) and towers. The Cathedral is of modern origin, having been reconstructed in an ornate Romanesque style. The large chapel of the SS. Sacramento has retained its 17th- and 18th-century polychrome decoration. The Neo-Romanesque Church of S. Agostino contains a reredos by S. Conca. The Palazzo Municipale was designed by E. Basile; the Palazzo della Prefettura (del Governo), by G. Zani; the Palazzo della Provincia, by C. Autore; the Palazzo di Giustizia, by P. Farinelli; and S. Giorgio della Vittoria, by C. Autore. The Museo Nazionale (M. Piacentini) contains prehistoric material and archaeological and artistic documentation from all the Greek centers of ancient Calabria. Of particular importance are terra cottas (VII, PL. 62) and vases from Reggio, fictile pinaces and bronzes from Locri, terra cottas from Medma, and the Apollo Alaeus of Ciro. The Museum also has medieval and modern sections (works by Antonello da Messina).

BIBLIOG. N. Putorti, Terrecotte inedite del Museo civico di Reggio-Calabria, Neapolis, I, 1913–14, pp. 247–55; N. Putorti, Mosaici di Reggio-Calabria, Catanzaro, 1917; P. Orsi, Scoperte negli anni dal 1911 al 1921, NSc, 1922, pp. 151–86; Inventario degli oggetti d'arte d'Italia, Calabria: Province di Catanzaro, Cosenza, Reggio Calabria, Rome, 1933; Ministero Pubblica Istruzione, Elenco degli edifici monumentali, LVIII–LX: Catanzaro, Cosenza, Reggio Calabria, Rome, 1938; B. D. Meritt, The Athenian Alliances with Rhegium and Leontinoi, Classical Q., XL, 1946, pp. 85–91; G. Procopio, Rhegium: Scoperte nell'area urbana, FA, IX, 1954, 4999; A. Frangipane, Arte, monumenti e ricordi della vecchia Reggio, Brutium, XXXIV, 1955, pp. 11–12; A. De Franciscis, Il Museo Nazionale in Reggio Calabria, Rome, 1958; G. Vallet, Rhégion et Zancle, Paris, 1958.

Rossano (Lat., Roscianum). Traces of the Roman period exist in the Sant'Antonio sector. In the Byzantine period Rossano was the most important city in Calabria. The following churches date from this period: S. Panaghia, with remains of frescoes; S. Nicola al Vallone; and S. Maria del Piliere. In the southeast quarter of the town is the Church of S. Marco, the oldest part of which (11th cent.) is similar to the Cattolica at Stilo — square, with five small cupolas on drums, and three apses. Portions of contemporaneous frescoes have survived in the interior. The Cathedral (Assunta), restored in baroque form, has a façade by F. Salvatori that was completed in 1914; a few traces of the original Gothic structure can be seen. The interior contains a fresco of the Madonna Achiropita dating from the 11th or 12th century. S. Bernardino, built in the mid-15th century, was afterward remodeled in baroque style. The Museo Arcivescovile holds a manuscript collection that includes the celebrated Codex purpureus rossanensis (X, PL. 67), containing the Gospels of St. Matthew and St. Mark illustrated with miniatures on purple parchment, probably a Syrian work of the 6th century.

Approximately 3 miles from Rossano is the Norman Church of S. Maria del Patir (12th cent.), basilican in form and triapsidal. The interior has a 12th-century mosaic floor bearing animal designs.

BIBLIOG. P. Orsi, Chiese niliane, II: Il patirion di Rossano, BArte, N.S., II, 1922–23, pp. 529–62; T. Horia, Les églises à cinq coupoles en Calabre: S. Marco de Rosano et la Cattolica di Stilo, EphDR, IV, 1930, pp. 149–80; E. Galli, Un restauro monumentale: La chiesetta bizantina di S. Marco, Arte Sacra, II, 1932, pp. 69–73; M. T. Mandalari, La chiesetta di Santa Panaghia, Per l'arte sacra, XIV, 5–6, 1937, pp. 12–17; F. Russo, Il codice purpureo di Rossano, Calabria nobilissima, II, 1948, pp. 174–77, III, 1949, pp. 190–97, 247–56; M. H. Laurent, Charles II d'Anjou et l'Abbaye du Patir, S. bizantini e neoellenici, IX, 1957, pp. 259–63.

Santa Severina. Situated on a hill at the site of the Greco-Roman city of Siberene (Σιβερηνή), the town of Santa Severina was subject to both Byzantine and Norman rule. The castle dates from the latter period but was enlarged at later times. Among the notable Byzantine monuments is the baptistery (8th–9th cent.) attached to the Cathedral; a circular building, it is surmounted by a ribbed dome supported on eight columns (restored). The Cathedral (S. Anastasia) was built in the late 13th century but later was extensively remodeled. The Church of S. Filomena (11th–12th cent.) combines Byzantine elements such as the dome, prothesis, and diaconicon with portals of Norman decorative type. It is built over a lower church known as S. Maria del Pozzo. In the "Grecia" quarter (so called because of the Albanian inhabitants who emigrated there in the 15th century) are remains of two small churches: S. Pietro and S. Nicola, with vestiges of frescoes.

BIBLIOG. Philipp, RE, s.v. Siberene, 2d ser., IV, 1923, col. 2070; P. Lojacono, Sul restauro del Battistero di S. Severina, BArte, XXVIII, 1934–35, pp. 174–85; B. Cappelli, Rossano bizantina minore, Arch. storico per la Calabria e la Lucania, XXIV, 1955, pp. 31–53.

Stilo. Founded in the 7th century, it was the center of a number of Basilian hermitages and monasteries. The earthquake of 1783 destroyed the town almost completely. The most important local monument is the Cattolica (restored); a small 10th-century church of Eastern derivation, it has the form of a free cross and is triapsidal, with five small cupolas and traces of contemporaneous frescoes in Byzantine style. The 14th-century Cathedral retains only the portal, with a pointed arch, from the original structure.

Near Stilo stands the Basilian Church of S. Giovanni Vecchio; basilican in form, it is preceded by an atrium. The interior contains frescoes in a Byzantine manner. Grottoes once used as hermitages are found in the cliffs of Mount Consolino, on the summit of which lie the ruins of a late medieval castle.

BIBLIOG. G. Abatino, L'architettura bizantina in Calabria: La Cattolica di Stilo, Napoli nobilissima, XII, 1903, pp. 18–21; T. Horia, Les églises à cinq coupoles en Calabre: S. Marco de Rosano et la Cattolica di Stilo, EphDR, IV, 1930, pp. 149–80; D. de La Cueva, L. Durin, and I. Raffin, La Cattolica di Stilo, L'Architettura, V, 1959–60, pp. 194–99; M. H. Schwarz, Zur Stilsynthese und Datierung einer ältesten griechischen Mönchskirchen Calabriens: S. Giovanni Vecchio bei Stilo, Misc. Bib. Hertzianae, Vienna, Munich, 1961, pp. 77–89.

Sybaris (Σύβαρις). An Achaian Greek colony near the Ionian coast, ancient Sybaris (near modern Sibari) was situated between the Crati and Cosile rivers. Achaian Sybaris flourished in a providential manner, especially after the destruction of Siris. In 510 B.C. the city was destroyed by Kroton, and the inhabitants fled to Laos, Skidros, and Poseidonia (Paestum). Intervention by Poseidonia seems to have made possible the temporary resettlement of a few Sybarites who had remained nearby, but this short-lived community was also destroyed by Kroton. About 445 B.C. the city rose once more as an Athenian colony, taking the name of Thourioi (Θούριοι). The surviving Sybarites founded a new Sybaris on the Traente River (anc. Trais), in the vicinity of modern Castiglione di Paludi, from which walls of the 4th century B.C., a theater, and a necropolis have come to light. Vestiges of a wall (perhaps fortifications) and a hydraulic installation on the banks of the Crati have been attributed to the Athenian-sponsored Thourioi. The submerged site of the first Sybaris has lately been identified at the mouth of the Crati River.

BIBLIOG. F. S. Cavallari, Sibari, NSc, 1879, pp. 245–53; U. Kahrstedt, Die Lage von Sybaris, Nachr. Gesellschaft der Wissenschaften zu Göttingen, Philologisch-historische Klasse, 1931, pp. 279–87 (rev. by U. Zanotti Bianco, Arch. storico per la Calabria e la Lucania, II, 1932, pp. 283–91); J. S. Callaway, Sybaris, Baltimore, 1950; P. Zancani Montuoro, Sibari, Poseidonia e lo Heraion, Arch. storico per la Calabria e la Lucania, XIX, 1950, pp. 65–84; G. Procopio, Esplorazioni nell'area dell'antica città, FA, IX, 1954, 2016; L. Breglia, Le monete delle quattro Sibari, Ann. Ist. it. numismatica, II, 1955, pp. 9–26; A. d'Arrigo, Premessa geofisica alla ricerca di Sibari, Naples, 1959; E. Aletti, Sibari-Turio-Copia, Rome, 1960.

Tropea. Founded in ancient times, this city on the Tyrrhenian coast became the seat of a bishop sometime in the 4th or 5th century and subsequently flourished under Angevin and Aragonese domination. The 11th-century Cathedral holds Early Christian remains. The exterior decoration along the sides and that of the apses show Sicilian-Norman influence. Rebuilt in the 16th century, the Cathedral was restored according to the original design in 1928. In the episcopal palace are displayed remains of the 13th and 14th centuries, as well as a chapel, with 15th-century frescoes. On a rock near the shore is the small Church of S. Maria dell'Isola, with Gothic remains. The Church of the Annunziata represents the type of church built by the Minorites in the second half of the 15th century, but it has been remodeled. The Church of S. Francesco d'Assisi (rebuilt 1661) incorporates a 14th-century Gothic chapel, formerly an oratory, decorated with frescoes. The Palazzo Toraldo contains a collection of Christian inscriptions of the 4th and 5th cnturies; and the Antiquarium houses other local finds.

BIBLIOG. E. Galli, La cattedrale normanna di Tropea restituita al suo pristino aspetto, Rome, 1932; A. Galluzzi, La Cattedrale di Tropea, Turin, 1933; P. Toraldo, Un ipogeo cristiano ritenuto distrutto nel cimitero di Tropea, RACr, XII, 1935, pp. 329–37; P. Toraldo, Una basilichetta ceme-

teriale in Tropea, RACr, XIII, 1936, pp. 155–60; A. Ferrua, Note su Tropea paleocristiana, Arch. storico per la Calabria e la Lucania, XXIII, 1955, pp. 9–29.

Vibo Valentia ('Ιππώνιον). Hipponion was founded as a colony of Italiote Lokroi, on the site of an older Siculan settlement from which a necropolis has been discovered. Destroyed by Dionysius the Elder in 388 B.C., the city was later rebuilt but was captured by the Bruttii in 356 B.C. In 192 B.C. it became a Roman colonia, and afterward a municipium. There are important remains of the Greek walls, of a Doric peripteral temple *in antis* (late 6th–early 5th cent.), and of three other temples in the area. In Byzantine times a trenched camp was built on the site. The city was destroyed by the Arabs and was rebuilt by Frederick II in 1235 as Monteleone, the name by which it was known until 1928, when the old Roman name was reassumed. The castle, of Norman origin, was enlarged by the Hohenstaufens and the Angevins. The Renaissance Church of S. Michele (1519) has a façade and side walls with fluted pilasters on the exterior and a bell tower built in 1671. The façade of the Collegiata di S. Leone Luca, or Leoluca (1680–1723), is set between two 19th-century towers. The interior, in the form of a single-aisled Latin cross, contains statues by Antonello Gaggini (1524). The 18th-century Church of the Rosario incorporates a Gothic chapel of the Angevin period (late 13th cent.).

BIBLIOG. C. F. Crispo, Di Hipponio e della Brettia nel secolo V a. C., Atti e Mem. Soc. Magna Grecia, 1928, pp. 55–109; G. Säflund, The Dating of Ancient Fortifications in Southern Italy and Greece, Acta Inst. Romani Regni Sueciae, II, 1935, pp. 87–119; Cronaca dei ritrovamenti e dei restauri, Vibo Valentia: Chiesa di S. Maria degli Angeli, Le Arti, V, 1943, p. 272; G. Procopio, Il medagliere della collezione Capialbi a Vibo Valentia (Catanzaro), Ann. Ist. it. numismatica, II, 1955, pp. 172–81.

Sardinia (It., Sardegna). The protohistoric period differs both ethnologically and culturally from that of continental Italy. The island contains a number of monumental remains of the period (IX, PLS. 401, 402), and certain ancient customs and geographical names survive today. The earliest culture was aëneolithic, characterized by rock-cut tombs, pottery, and schematic statuettes. The succeeding Bronze Age culture, the nuraghe civilization, lasted from the mid-2d to the mid-1st millennium B.C. It takes its name from the peculiar structures in the form of a truncated cone that are found all over the island. This period also produced a considerable quantity of bronze statuettes (IX, PLS. 403, 404). In the 8th century B.C. the island was partially colonized by Phoenicians and Carthaginians. There are many Punic remains. In 283 B.C. Sardinia became subject to Rome and remained Roman until the 5th century, when it was conquered by the Vandals. In 534 it was conquered by the Eastern Roman Empire. Between the 11th and 14th centuries Pisa and Genoa disputed control of the island, and this period is marked by a considerable amount of Pisan Romanesque architecture. In the 14th century Sardinia was awarded to Aragon. Much Catalan Gothic architecture goes back to the 14th–16th centuries, especially in churches and castles. The 17th and 18th centuries were stagnant artistically. Because of the remoteness of the island and the innate conservatism of the people, many purely local cultural elements have been retained from ancient times, especially in folk-art forms (textiles, costumes, jewelry, wood carving and inlay, basketry), which still survive (III, PL. 164; V, PLS. 341, 342, 344; VI, PL. 277; VII, PL. 311).

BIBLIOG. G. Pinza, Monumenti primitivi della Sardegna, MALinc, XI, 1901, cols. 5–280; D. Scano, Notizie di arte sarda, BArte, I, 1907, pp. 3–16; D. Scano, Storia dell'arte in Sardegna, Cagliari, 1907; W. Biehl, Kunstgeschichtliche Streifzüge durch Sardinien, ZfbK, N.S., XXIV, 1912, pp. 17–24, 26–32; G. U. Arata, Arte rustica sarda, Dedalo, I, 1920–21, pp. 698–722, 777–802, II, 1921–22, pp. 130–46; E. Pais, Storia della Sardegna e della Corsica durante il dominio romano, Rome, 1923; D. Scano, Chiese medievali di Sardegna, Cagliari, 1929; A. Taramelli, I nuraghi e i loro abitatori, Rome, 1930; R. Branca, Artisti sardi, Genoa, 1931; R. Ciasca, Bibliografia sarda, 5 vols., Rome, 1931–35; R. Branca, Arte in Sardegna, Milan, 1933; R. Carta Raspi, Castelli medievali di Sardegna, Cagliari, 1933; F. Liperi, L'architettura gotica in Sardegna e la cattedrale di Alghero, Sassari, 1934; G. U. Arata and G. Biasi, Arte sarda, Milan, 1935; I. Pelizzaro, La chiesa di San Nicola di Silanos e l'architettura romanica in Sardegna, Padua, 1936; A. Vicario, Uno sguardo all'architettura sarda sul principio del secolo XVII, BArte, XXX, 1936–37, pp. 178–87; G. Lilliu, Per la topografia di Biora (Serri-Nuoro), S. sardi, VII, 1947, pp. 29–104; G. Delogu, Architetture cistercensi della Sardegna, S. sardi, VIII, 1948, pp. 99–131; M. Pallottino, La Sardegna nuragica, Rome, 1950; O. Balducci, La casa rurale in Sardegna, Florence, 1952; G. Sotgiu, Culti e divinità nella Sardegna romana attraverso le iscrizioni, S. sardi, XII–XIII, 1, 1952–54, pp. 575–88; G. Delogu, L'architettura del Medioevo in Sardegna, Rome, 1953; P. Meloni, I miliari sardi e le strade romane in Sardegna, Epigraphica, XV, 1953, pp. 20–50; V. Mossa, Architettura religiosa minore in Sardegna, Sassari, 1953; M. Muraro, Monumenti medievali di Sardegna, Florence, 1953; C. Zervos, Civilisation de la Sardaigne du début de l'énéolithique

à la fin de la période nouragique, Paris, 1954; G. Lilliu, Nuovi templi a pozzo della Sardegna nuragica, S. sardi, XIV–XV, 1, 1955–57, pp. 197–282; G. Lilliu, Il nuraghe di Barúmini e la stratigrafia nuragica, Sassari, 1955; G. Lilliu, Scultura della Sardegna nuragica, Cagliari, 1956; G. Lilliu, Religione della Sardegna prenuragica, BPI, N.S., XI, 1957, pp. 7–96; V. Mossa, Architettura domestica in Sardegna, Cagliari, 1957; A. Boscolo, L'Abbazia di San Vittore, Pisa e la Sardegna, Padua, 1958; R. Salinas, Architetti piemontesi in Sardegna, Atti X Conv. naz. Storia Arch., Rome, 1959, pp. 235–44; G. Pesce, La Sardegna punica, Cagliari, 1961.

Alghero. Believed to have been founded in the early 12th century, the town was held by the Dorias of Genoa for about 150 years and was their chief stronghold. In 1354 it became a Catalan colony. Part of the 12th- and 13th-century Genoese fortifications, restored and enlarged by the Spanish, is still extant. There are sections of the city walls, with numerous towers, such as the 16th-century Torre dello Sperone. S. Francesco was built in the 14th century, enlarged in the 15th, and remodeled in the 18th. In the interior the choir retains the Gothic vaulted ceiling (restored). The Cathedral is preceded by a neoclassic pronaos. The richly decorated portal, the campanile, and the apse, with lateral chapels and a vaulted ceiling, are in Catalan Gothic 16th-century style. The Casa Doria (16th cent.) has a Renaissance portal and Catalan Gothic windows.

Six and a half miles north of Alghero is the aëneolithic Ánghelu Rúiu necropolis, with rock-cut tombs that have yielded important grave furnishings.

BIBLIOG. S. Rattu, Bastioni e torri di Alghero, Turin, 1951; D. Levi, La necropoli di Anghelu Ruju e la civiltà eneolitica della Sardegna, S. sardi X–XI, 1952, pp. 5–51.

Barúmini. In the Marmilla region, southeast of Oristano, this zone has about twenty nuraghi; the most important complex is that of Su Nuraxi, comprising a nuraghe and an adjoining nuraghic village (IX, PL. 401). The nuraghe consists of a central structure with a round tower, surrounded by four smaller towers connected

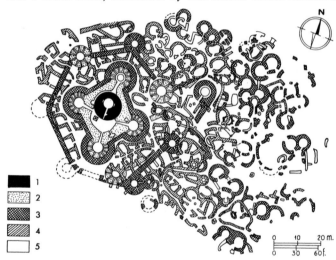

Barúmini, plan of the nuraghe and nuraghic village. *Key:* (1) structures of the archaic nuraghic period; (2) structures of nuraghic period Lower I; (3) structures of nuraghic period Upper I; (4) structures of nuraghic period II; (5) structures of the Punic-Roman period.

by walls enclosing a courtyard in which other fortifications are located. The construction is of several phases, from approximately the 12th to the second half of the 8th century B.C. The village also shows a range of building periods. Of interest are the circular huts of the 8th century B.C., laid out around an open circular area, with a larger communal hut.

BIBLIOG. G. Lilliu, Il nuraghe di Barúmini e la stratigrafia nuragica, S. sardi, XII–XIII, 1, 1952–54, pp. 90–469; G. Lilliu, Il nuraghe di Barúmini e la stratigrafia nuragica, Sassari, 1955; EAA, s.v.

Bíthia (or Bítia). Near modern Chia, on the south coast, this was a city of Punic origin on a site of the nuraghe civilization, as evidenced by remains of a nuraghic village on the Punic acropolis. Some Punic structures were used again later by the Romans, who decorated them with paintings and stuccoes. In a Punic sanctuary was a statue of the god Bes and a depository of votive objects (terracotta figures, vases, Punic and Roman coins). On the beach is a necropolis with Punic and Roman tombs.

BIBLIOG. G. Pesce, EAA, s.v. Bithia, II, 1959, p. 107; G. Pesce, Sardegna punica, Cagliari, 1961, pp. 108–10.

Cagliari (Lat., Carales, or Karales). Capital of Sardinia, the town is situated on a gulf on the south coast. Founded by Phoenicians, it became the leading Carthaginian city in Sardinia, then a prosperous Roman port. It was sacked by the Vandals in the 5th century and declined during the Byzantine period. In the 13th century the city came under the rule of the Pisans, who fortified it. In 1327 it passed to Aragon. After 1720, under the house of Savoy, it was the capital of the Kingdom of Sardinia. During World War II it was heavily damaged. In spite of its antiquity, the city now has a predominantly modern appearance. Of the Punic period are the remains of a sanctuary and two rock-cut necropolises. Remains from the Roman period include the baths (called "Casa di Tigellio"), with a mosaic floor; the tomb popularly called "Grotta delle Vipere"; and an elliptical amphitheater partly carved out of the rock. A necropolis (2d–5th cent.) excavated in 1950 contains both pagan and Christian tombs. The only Early Christian Church to have escaped destruction by the Vandals is SS. Cosma e Damiano (formerly S. Saturnino), which has been restored after bomb damage to the eastern bay in 1943. The original 5th-century building of massive ashlar masonry was rectangular, with a hemispheric dome resting on piers. The barrel-vaulted eastern bay, in Provençal style, was added between 1082 and 1119. Another bay on the western end is now an atrium, the vault having collapsed. Of the 13th-century Pisan fortifications, two battlemented limestone towers (Torre S. Pancrazio, 1305, and Torre dell'Elefante, 1307, both by Giovanni Capula) and a gate (Porta dei Leoni) remain. Rectangular in shape, the towers are open on the inner sides with wooden platforms connected by stairs. The Aragonese added other bastions, and the Bastione di St-Remy dates from the Savoyard period. Most of the fortifications were dismantled in the 19th century, and the modern city was built on the site of the bastions and ditches. The older part of the city, Castello, is situated on the hill of that name, where the few remaining old fortifications still stand. The Cathedral (S. Maria) was begun in the 13th century in Tuscan Romanesque style but was remodeled in baroque form in the 17th century. Fragments of the original façade were incorporated in a reconstruction of 1933, and the arms of the transepts retain some of the original structure. The three-aisled interior, in the form of a Latin cross, contains two pulpits fashioned from the dismantled great pulpit of Master Guglielmo (PL. 181) brought from the Cathedral of Pisa; a lectern attributed to Guido da Como (14th cent.); and the tomb of Martin of Aragon, King of Sicily (d. 1409). In the Museo Capitolare is a triptych by G. David (Triptych of Clement VII). The campanile is of the 13th century (restored). Of S. Domenico (founded, 1254; remodeled under the Aragonese; bombed, 1943) there remain only the lower courses of the walls and the Cappella del Rosario (1580), a Catalan Gothic construction with Renaissance influences. S. Francesco di Stampace (late 16th cent.) was destroyed by fire in 1872, and only a portion of the cloister remains. The bastions of the Aragonese castle have been transformed into a terrace with a large double-ramped stairway. A good example of Catalan Gothic architecture is the Purissima, a 16th-century church with a single aisle, lateral chapels with Gothic arches, and vaulted ceiling. In baroque style are S. Michele, with stuccoes by G. Altomonte; S. Anna (1785–1817), in Piedmontese baroque style; the "Cappellone del Sto Sepolcro"; the University (by G. Balgrano, 1765); the Tridentine seminary (18th cent.); and the Prefettura (18th cent.). The 18th-century glacis of the fortifications of the castle and harbor was turned into a public promenade in 1839. The neoclassic building of the Galleria Comunale d'Arte was designed by C. Boyl in 1828. It houses ethnographic and Oriental collections and paintings by Sardinian artists. The Museo Archeologico contains Sardinian archaeological material.

BIBLIOG. G. Cossu, Della città di Cagliari, Cagliari, 1780; E. Brunelli, Appunti sulla storia dell'arte in Sardegna: Gli amboni del duomo di Cagliari, L'Arte, IV, 1901, pp. 59–67; A. Taramelli, Il nuraghe Lugherras presso Paulilatino, MALinc, XX, 1910, cols. 153–234; F. Giarrizzo, Una chiesa del VI secolo a Cagliari, Emporium, XLV, 1917, pp. 415–19; F. Giarrizzo, La Chiesetta di S. Giovanni di Assemini, BArte, XIII, 1919, pp. 117–32; Ministero Pubblica Istruzione, Elenco degli edifici monumentali: Provincia di Cagliari, Rome, 1922; F. Giarrizzo, La chiesa di Santa Maria di Castello di Cagliari, Per l'arte sacra, N.S., V, 1928, pp. 17–33; A. Lancellotti, Le decorazioni pittoriche del Duomo di Cagliari, Ill. vaticana, IV, 1933, pp. 731–32; A. Taramelli, Chiesa di S. Saturnino poi dei SS. Cosma e Damiano, BArte, XXVIII, 1934–35, pp. 164–73; S. Rattu, La chiesa di San Saturnino di Cagliari, Cagliari, 1935; A. Vicario, Il restauro della cattedrale di Cagliari, BArte, XXIX, 1935–36, pp. 457–70; S. Rattu, Bastioni e torri di Cagliari, Turin, 1939; D. Levi, The Amphitheatre in Cagliari, AJA, XLVI, 1942, pp. 1–9; P. Mingazzini, Resti di santuario punico e di altri ruderi a monte di Piazza del Carmine, NSc, 8th ser., III, 1949, pp. 213–74; P. Mingazzini, Sul tipo architettonico del tempio punico di Cagliari, S. sardi, X–XI, 1952, pp. 161–64; R. Fagnoni, Continuità e architettura del San Domenico cagliaritano, Atti Acc. naz. di San Luca, N.S., III, 1957–58, pp. 109–25; B. Virdis, San Michele di Stampace in Cagliari, Palladio, N.S., VII, 1957, pp. 137–42; E. Mandolesi, Le torri di Cagliari, Rome, 1958; G. Pesce, EAA, s.v. Cagliari, II, 1959, pp. 255–56; L. Piloni, Cagliari nelle sue stampe, Cagliari, 1959.

Cornus. At this site of a Punic colony on the west coast, there are remains from the nuraghe civilization, Punic graves, and Roman vestiges. On the acropolis, on the Corchina hill, late Roman remains have been found.

BIBLIOG. A. Taramelli, Ricerche ed esplorazioni nell'antica Cornus, NSc, 1918, pp. 285–331; G. Pesce, EAA, s.v. Cornus, II, 1959, pp. 860–61; G. Pesce, Sardegna punica, Cagliari, 1961, pp. 46–47.

Fordongianus (Lat., Forum Trajani). There are notable Roman remains, including a bridge and baths dedicated to the nymphs. Within the town there is a late 16th-century house with a portal and windows in Catalan Gothic style, with ogival arches. The parish church has part of the old structure in a similar style. In the vicinity is S. Lussurio (Lussurgiu; 1100–20, restored), a Romanesque church with French influences, on the site of ancient catacombs. The south wall was built in 1250. The façade is Catalan Gothic of the 15th century.

BIBLIOG. A. Vicario, Uno sguardo all'architettura sarda sul principio del secolo XVII, BArte, XXX, 1936–37, pp. 178–87.

Iglesias. This small town grew up in the Middle Ages in the center of a mining region. In the 14th century the Pisan government fortified the town. Sections of the walls with battlemented towers and the castle of Salvaterra remain. S. Salvatore retains some traces of the original 10th- and 11th-century structure. The Cathedral (1285–88) has a transitional Romanesque-Gothic façade. The interior, with a single aisle, was remodeled in Catalan Gothic style. The Church of S. Chiara (1284–88) retains vestiges of earlier Franciscan Romanesque-Gothic structures, with traces of Islamic influence. S. Francesco, similar in style, was remodeled on Catalan Gothic lines in the 16th century. Nostra Signora di Valverde (Cappuccini), built in 1280–1300, has been restored. It retains the original façade in Pisan-Aragonese style.

BIBLIOG. F. Sanfilippo, La cattedrale di Iglesias, Arte e storia, XXI, 1902, pp. 122–23; R. Branca, La predella di Valverde, Iglesias, 1936.

Nora. An ancient city, its importance in the Punic period is attested by the remains of a sanctuary to Phoenician deities, dwellings, aqueducts, traces of fortifications, a necropolis where inhumation took place, and another where cremation was practiced. From a subsequent Roman city there remain a forum, a temple, vestiges of an amphitheater, a theater, and two baths.

BIBLIOG. G. Patroni, Nora: Colonia fenicia in Sardegna, MALinc, XIV, 1904, cols. 109–268; G. Pesce, Nora: Guida agli scavi, Bologna, 1957.

Olbia (Terranova Pausania until 1939). The name of this port would indicate that it may have been a Greek colony. Of the subsequent Punic city there remain traces of a temple and a necropolis. Olbia existed in Roman times but was destroyed, probably by the Vandals, in the 5th century. Rebuilt and renamed Phausania (or Pausania) in Byzantine times, in the 11th century it became an important commune under the Pisans, who renamed it Terranova. In the 14th century it passed to Aragon. The Church of S. Simplicio, in Pisan Romanesque style, is probably attributable to Tuscan builders who were influenced by the Lombard Romanesque. It was completed between 1100 and 1120 but was remodeled later. The interior contains traces of 14th-century frescoes. In the vicinity are nuraghic remains, in which were found the characteristic bronzes (IX, PL. 404) and other objects.

BIBLIOG. D. Levi, Le necropoli puniche di Olbia, S. sardi, IX, 1950, pp. 5–120; D. Panedda, Olbia nel periodo punico e romano (Forma Italiae, Sardinia), Rome, 1952; D. Panedda, L'agro di Olbia nel periodo preistorico, 1959; G. Pesce, Sardegna punica, Cagliari, 1961, pp. 48–49.

Oristano. Capital of the Giudicato of Arborea (one of the four medieval administrative districts of the island), Oristano was founded (ca. 1070) on a Roman site. In the 11th and 12th centuries it was a flourishing town. The Torre di S. Cristoforo, a survival of the 13th-century walls, is closed on three sides and open on the fourth, with open galleries, like those at Cagliari. The Cathedral was almost entirely rebuilt in 1773, but the apse and the lower part of the campanile date from 1288. The interior contains fragments of the 11th-century ambo and an *Annunciation* by Nino Pisano. Next to the sacristy is the so-called "Archivietto," built in a retardative Gothic-Renaissance style in 1626. S. Francesco was rebuilt in neoclassic style in 1838 by G. Cima but retains parts of the Franciscan Gothic façade, with Islamic elements, of 1250–80. In the Church and Convent of S. Chiara (14th cent.) there are remains of the original construction. The Antiquarium Arborense contains local art and artifacts.

In the environs: S. Salvatore is built over a subterranean Roman sanctuary and contains Roman wall paintings of the 4th century. Adjoining are the ruins of Tharros (see below). S. Giovanni in Sinis is of the 5th century, Byzantine in style, with a dome resting on piers. The interior (enlarged 11th cent.) has three aisles and a barrel-vaulted ceiling. S. Giusta (12th cent; PL. 178) has a Lombard façade and three-aisled interior, with reused ancient columns. The presbytery is raised above a large crypt, and the side aisles have ceilings vaulted with pointed arches. S. Maddalena (14th cent.) is in Romanesque-Gothic style.

Bibliog. D. Scano, Scoperte artistiche in Oristano, L'Arte, VI, 1903, pp. 15–30; C. M. Deville, Il convento francescano di Oristano, Oristano, 1927; P. L. Manconi, Un antico simulacro cristiano: Il "Crocefisso di Nicodemo" ad Oristano, Ill. vaticana, IV, 1933, p. 805; D. Levi, L'ipogeo di San Salvatore di Cabras, Rome, 1949; G. Pesce, Il primo scavo di Tharros (anno 1956), S. sardi, XIV–XV, 1, 1955–57, pp. 307–72; F. Cherchi Paba, Il Duomo di Oristano, Cagliari, 1956; F. Barreca, Scoperte a Capo S. Marco, NSc, 8th, ser., XII, 1958, pp. 409–12.

Porto Torres (Lat., Turris Libisonis). Probably of Punic origin, this became a prosperous port under the Romans. In the early Middle Ages it was abandoned on account of the perennial threat from pirates. In the 11th century the site was resettled and under Pisan rule again became an important center. The oldest remains are Roman, including a bridge with seven arches (1st cent.); a temple of Fortune, with adjoining basilica and tribunal (rebuilt 3d cent.); baths; an aqueduct (1st or 2d cent.); and a necropolis. There are remains of the medieval fortifications. S. Gavino (late 11th–early 12th cent.) was built in Pisan Romanesque style on the site of an ancient necropolis. Later it was enlarged by Lombard builders. The interior has a nave and two side aisles divided by columns with Roman and Early Christian capitals (5th cent.). The crypt contains several Roman sarcophagi.

Bibliog. D. Scano, Notizie di arte sarda, BArte, I, 1907, pp. 3–16; M. Pallottino, Sardegna negli anni 1941–42, S. sardi, VII, 1947, pp. 225–32; G. Lilliu, Notiziario archeologico (1947): Civiltà romana, S. sardi, VIII, 1948, pp. 429–31; P. Meloni, Turris Libisonis romana alla luce delle iscrizioni, Epigraphica, XI, 1949, pp. 88–114.

Sant'Antioco (Lat., Sulcis). On a small island 3 miles from the southwest coast, the site was inhabited in the nuraghe period and was later a Phoenician colony. Under the Romans Sulcis was a municipium. It was destroyed by the Saracens in the early Middle Ages and rebuilt in the 11th century. There are remains of a Punic sanctuary and necropolis. The parish church (11th cent.) is built over a part of the necropolis, turned into a catacomb in the early Christian Era. There is a relatively well-preserved fresco (Early Christian) of the Good Shepherd in one of the chambers.

Bibliog. A. Taramelli, Inscrizione bizantina nell'antica chiesa di Sant'Antioco, NSc, 1906, pp. 135–38; G. Lilliu, Le stele puniche di Sulcis, MALinc, XL, 1941, cols. 293–418; G. Lilliu, Notiziario archeologico (1947): Civiltà punica, S. sardi, VIII, 1948, pp. 421–28; P. Mingazzini, Resti di santuario fenicio in Sulcis, S. sardi, VIII, 1948, pp. 73–80; G. Pesce, Sardegna punica, Cagliari, 1961, pp. 43–44.

Santa Vittoria di Serri. On the basalt plateau, Giara di Serri, near the ruins of the medieval church of S. Vittoria is one of the most important cult centers of the nuraghe civilization. It is surrounded by megalithic fortifications and contains numerous edifices, all prior to the 5th century B.C. Among the most important is the temple built around a well (originally covered by a dome) within an elliptical wall. Another building is a hypaethral temple, on a rectangular plan, of megalithic construction. There was also an enclosure for feasts and markets, containing an inner enclosure associated with the symbol of the double ax, a kitchen, and a building believed to have been a foundry. One of the edifices contained a relief depicting a double amulet (Cagliari, Mus. Arch.). There are traces of dwelling huts, of which one was probably for the guardian of the sanctuary. Bronze statuettes (IX, PL. 403) and pottery have been recovered.

Bibliog. A. Taramelli, Il tempio nuragico... di Santa Vittoria di Serri, Rome, 1914; A. Taramelli and G. Patroni, Il tempio nuragico ed i monumenti primitivi di S. Vittoria di Serri, MALinc, XXIII, 1914, cols. 313–440.

Sassari. Founded in the Middle Ages, the town became the capital of the Giudicato of Torres. Between the 11th and 14th centuries it was contested between Pisa and Genoa, and in the 14th century it voluntarily placed itself under Aragon. Its present appearance is predominantly modern, although the older part retains the medieval plan, with narrow irregular streets. S. Michele di Plaiano retains some of the original structure of 1082. The Romanesque Cathedral (12th–13th cent.; partly remodeled, 15th cent.) retains some of the

earlier structure in the side walls and the lower part of the campanile. The façade (18th cent.) is in Spanish colonial baroque style, and the interior in late-15th-century Catalan Gothic. A number of churches of the 13th century have in common certain characteristics due, perhaps, to Spanish builders, who combined the local Romanesque style with Islamic elements imported from Spain and, later, the Catalan Gothic influences characteristic of Aragonese territories. Among these are S. Donato (1278, remodeled later), S. Pietro di Silki, and S. Maria di Betlem (1250–80). The adjoining Convento di S. Maria di Betlem is in Catalan Gothic style (15th–16th cent.). Secular constructions include the Fonte Rosello (1606), a fountain in late Renaissance style; the Palazzo del Comune (18th cent.); the Palazzo della Provincia and the monument to Victor Emanuel II (both 19th cent.); and the Palazzo di Giustizia (1939). The medieval fortifications were dismantled in 1835, and the modern quarters of the city have spread beyond their ancient perimeter. The Museo Giovanni Antonio Sanna contains collections of archaeological and ethnographic material and a gallery of paintings.

Approximately 11 miles outside the city is perhaps the finest example of Pisan Romanesque architecture in Sardinia, the Abbey Church of SS. Trinità di Saccargia (founded, 1116; enlarged, 1180–1200). It is built of alternating strips of dark trachyte and white limestone. The façade has a small portico (1180–1200) and false galleries above. The single-aisled interior, in the form of a Latin cross, has 13th-century frescoes in the three apses. The campanile (ca. 1180) has two orders of double- and triple-arched windows.

Bibliog. Ministero Pubblica Istruzione, Elenco degli edifici monumentali, Provincia di Sassari, Rome, 1922; M. Saniconi, Piano regolatore di Sassari, Architettura, XV, 1936, pp. 345–48; E. Costa, Sassari, Sassari, 1937; P. Carbonara, Progetto di massima per il piano regolatore di Sassari, Architettura, XIX, 1940, pp. 613–20; V. Mossa, Restauri nella Cattedrale di Sassari, 1951; M. Accascina, Gli affreschi di Santa Trinità di Saccargia, BArte, 4th ser., XXVIII, 1953, pp. 21–30.

Tharros. Ruins of a Phoenician-Punic foundation and a subsequent Roman municipium are found here. There are a large Punic necropolis and two temples; notable finds of jewelry were made here (X, PL. 410; XI, PL. 128). Of the Roman period are a castellum aquae, baths, and a drainage system.

Bibliog. M. Pinna, La penisola del Sinis, S. sardi, IX, 1950, pp. 246–76; G. Pesce, Il primo scavo di Tharros (anno 1956), S. Sardi, XIV–XV, 1, 1955–57, pp. 307–72; F. Barreca, Scoperte a Capo S. Marco, NSc, 8th ser., XII, 1958, pp. 409–12; G. Pesce, Sardegna punica, Cagliari, 1961, pp. 44–46.

Sicily (It., Sicilia). Sicily has partaken of cultural developments in the Mediterranean world from the earliest times. Figural rock art, evidence of Upper Paleolithic — and perhaps even Mesolithic — cultures, has been found in various parts of Sicily (near Palermo, the Egadi Islands). Neolithic, Copper, Bronze, and Iron Age cultures are represented in finds made throughout the island. The Greek colonization, which began in the second half of the 8th century B.C., brought the first notable flowering of culture, and important monuments remain from this period (see GREEK ART, WESTERN). A few traces of Phoenician and Carthaginian civilization are found in the western part of the island, an area that was subject to Carthage. Nor did the cultural significance of Sicily diminish under the sway of republican and imperial Rome, or later in the Byzantine epoch. Of the Arab domination (9th–11th cent.) there is little physical evidence, for almost every trace of this prosperous period has been destroyed or lost; however, documentary evidence is plentiful. In the Norman era (1072–1195) Sicily underwent remarkable architectural and artistic development, representing a distinctive fusion of Byzantine, Arabic, and Romanesque elements.

The Gothic art of Sicily is less ample than that of the mainland in this period. Predominant in the 14th century was the so-called "Chiaramonte style," a Norman Gothic variant characterized by extensive use of the zigzag motif; in the 15th century Catalan Gothic influences were strong. During the Spanish period (16th–17th cent.) late Gothic, Renaissance, and baroque architecture — the latter especially in Palermo, which was largely rebuilt under the Spanish viceroys in the early 17th century — flourished as elsewhere, with a particularly rich heritage of the baroque. Close relations with Italy (above all, Naples) under the Bourbons (1735–1860), as well as the reconstruction of many cities and towns after the catastrophic earthquake of 1693, are evidenced not only in the design of individual churches, palaces, and villas but also in the over-all plans of many cities. Baroque forms continue to be adapted in the minor arts and in folk art.

Bibliog. T. Fazello, De rebus Siculis, Palermo, 1558; P. Clüver, Sicilia antiqua, Leiden, 1619; D. Serradifalco, Antichità della Sicilia esposte e illustrate, 4 vols., Palermo, 1834–42; G. Di Marzo, Delle belle arti in Si-

cilia, 4 vols., Palermo, 1858–62; A. Holm, Geschichte Siziliens im Altertum, 3 vols., Leipzig, 1870–98; R. Kekule, Die Terrakotten von Sizilien, Berlin, 1884; P. Orsi, Nuove scoperte nelle necropoli sicule della provincia di Siracusa, BPI, XVI, 1890, pp. 77–81; P. Orsi, Stazione neolitica di Stentinello, BPI, XVI, 1890, pp. 177–200; E. A. Freeman, The History of Sicily from the Earliest Times, 4 vols., Oxford, 1891–94; P. Orsi, La necropoli sicula di Castelluccio, BPI, XVIII, 1892, pp. 1–34, 67–84; P. Orsi, Il sepolcreto di Tremenzano, BPI, XVIII, 1892, pp. 84–94; P. Orsi, Thapsos, MALinc, VI, 1895, cols. 89–150; R. Koldewey and O. Puchstein, Die griechischen Tempel in Unteritalien und Sizilien, Berlin, 1899; P. Orsi, Pantalica e Cassibile, MALinc, IX, 1899, cols. 33–146; G. F. Hill, Coins of Ancient Sicily, Westminster, 1903; F. Winter, Die Typen der figürlichen Terrakotten, Berlin, 1903; G. A. Colini, La civiltà del bronzo in Italia, II: Sicilia, BPI, XXX, 1904, pp. 155–99, 229–304, XXXI, 1905, pp. 18–70; P. Orsi, Sicilia, NSc, 1904, pp. 367–74; J. Fuehrer and V. Schultze, Die altchristlichen Grabstätten Siziliens, Berlin, 1907; E. Mauceri and S. Agati, Il Cicerone per la Sicilia, Palermo, 1907; V. Fazio Allmayer, Gli Arabi e l'arte in Sicilia, Rass. d'arte, VIII, 1908, pp. 37–39, 76–79; L. Fiocca, L'arte in Sicilia: Alcuni monumenti del medioevo inediti e poco noti, Rass. d'arte, VIII, 1908, pp. 196–98, 207–15; L. Fiocca, L'arte in Sicilia: Finestre e porte medievali, Rass. d'arte, VIII, 1908, pp. 146–50; V. Fazio Allmayer, L'arte in Sicilia, Rass. d'arte, IX, 1909, pp. 65–70; G. V. Arata, L'architettura arabo-normanna e il Rinascimento in Sicilia, Milan, 1914; K. Escher, Die sizilienische Villa beim Übergang von Barock zum Klassizismus, Mnh. für Kw., IX, 1916, pp. 1–12; B. Pace, Arti e artisti della Sicilia antica, MemLinc, 5th ser., XV, 1917, pp. 469–628; E. Mauceri, Caratteri dell'arte siciliana del Rinascimento, Rass. d'arte, XIX, 1919, pp. 210–22; E. D. van Buren, Archaic Fictile Revetments in Sicily and Magna Grecia, London, 1923; A. Meli, Arti e artisti di Sicilia, Palermo, 1926; A. Della Seta, Italia antica, 2d ed., Bergamo, 1927; E. Langlotz, Die frühgriechischen Bildhauerschulen, Berlin, 1927; F. Meli, L'arte in Sicilia, Palermo, 1929; P. Marconi, La scultura e la plastica nella Sicilia antica, Historia, IV, 1930, pp. 645–74; B. Pace, Ceramiche della Sicilia, CVA; D. Randall-MacIver, Greek Cities in Italy and Sicily, Oxford, 1931; G. Samonà, L'influenza medievale per la formazione degli elementi architettonici del secolo XVI nella Sicilia orientale, BArte, XXV, 1931–32, pp. 517–24; P. E. Arias, Il Teatro greco fuori d'Atene, Florence, 1934; F. Fichera, G. B. Vaccarini e l'architettura del Settecento in Sicilia, Rome, 1934; P. Orsi, Romanità ed avanzi romani in Sicilia, Roma, XII, 1934, pp. 346–53; G. Agnello, L'architettura sveva in Sicilia, Rome, 1953; G. Di Stefano, L'architettura gotico-sveva in Sicilia, Palermo, 1935; B. Pace, Arte e civiltà della Sicilia antica, 4 vols., Città di Castello, 1935–39; G. Samonà, Elementi medievali nell'architettura del secolo XVI in provincia di Messina, Naples, 1935; F. Basile, Chiese siciliane del periodo normanno, Rome, 1938; E. Calandra, Breve storia dell'architettura in Sicilia, Bari, 1938; G. Di Stefano, L'architettura religiosa in Sicilia nel secolo XIII, Arch. storico per la Sicilia, IV–V, 1938–39, pp. 39–82; E. Maganuco, Architettura plateresca e del tardo Cinquecento in Sicilia, Catania, 1938; S. Bottari, Chiese basiliane della Sicilia e della Calabria, Messina, 1939; L. Epifanio, L'architettura rustica in Sicilia, Palermo, 1939; E. Maganuco, Problemi di datazione nell'architettura siciliana del medioevo, Catania, 1939; G. A. Garufi, Per la storia dei monasteri di Sicilia nel tempo normanno, Arch. storico per la Sicilia, VI, 1940, pp. 1–96; P. Lojacono, L'architettura bizantina in Calabria e in Sicilia, Atti V Cong. int. S. bizantini, II, Rome, 1940, pp. 183–97; M. Accascina, I borghi di Sicilia, Architettura, XX, 1941, pp. 185–98; E. Calandra, Chiese siciliane del periodo normanno, Palladio, V, 1941, pp. 232–39; P. Orsi, Sicilia bizantina, Rome, 1942; S. Bottari, I mosaici della Sicilia, Catania, 1943; G. E. Rizzo, Monete greche della Sicilia, Rome, 1946; H. M. Schwarz, Die Baukunst Kalabriens und Siziliens im Zeitalter der Normannen, Jhb. der Bib. Hertziana, VII, 1946, pp. 1–113; S. Bottari, L'architettura della Contea, Catania, 1948; J. Dunbabin, The Western Greeks, Oxford, 1948; O. Demus, The Mosaics of Norman Sicily, London, 1949; R. Salvini, Mosaici medievali della Sicilia, Florence, 1949; S. Bottari, Monumenti svevi in Sicilia, Palermo, 1950; P. Mingazzini, Archäologische Grabungen und Funde in Italien: Sicilia, AAnz, 1950–51, cols. 255–68; V. Ziino, Contributi allo studio dell'architettura del Settecento in Sicilia, Palermo, 1950; G. Agnello, L'architettura sveva in Sicilia, Florence, 1951; C. Agnello, L'architettura bizantina in Sicilia, Florence, 1952; G. Agnello, La pittura paleocristiana in Sicilia, Florence, 1952; S. Bottari, Ancora sulle origini dei castelli svevi in Sicilia, Atti Conv. int. S. federiciani, Palermo, 1952; A. Giuliana-Alaimo, Architetti regi in Sicilia, Palermo, 1952; G. Samonà, I castelli di Federico II in Sicilia e nell'Italia Meridionale, Palermo, 1952; L. Bernabò Brea, La Sicilia preistorica y sus relaciones con Oriente y la Peninsula ibérica, Ampurias, XV–XVI, 1953–54, pp. 137–235; Touring Club Italiano, Sicilia, 4th ed., Milan, 1953; S. Bottari, La cultura figurativa in Sicilia, Messina, 1954; B. Neutsch, Archäologische Grabungen und Funde in Sizilien von 1949–1954, AAnz, 1954, cols. 465–706; G. Di Stefano, Monumenti della Sicilia normanna, Palermo, 1955; F. Villard, Sicile grecque, Paris, 1955; F. Basile, Le nuove ricerche sull'architettura del periodo normanno in Sicilia, Atti VII Conv. naz. Storia Arch., Palermo, 1956, pp. 257–66; S. Bottari, Architettura medievale in Sicilia, Atti VII Conv. naz. Storia Arch., Palermo, 1956, pp. 109–54; S. Caronia Roberti, L'architettura del barocco in Sicilia, Atti VII Conv. naz. Storia Arch., Palermo, 1956, pp. 173–98; A. Drago Beltrandi, Castelli di Sicilia, Milan, 1956; G. Lugli, L'architettura in Sicilia nell'età ellenistica e romana, Atti VII Conv. naz. Storia Arch., Palermo, 1956, pp. 89–107; F. Missini, Aspetti dell'architettura religiosa del Settecento in Sicilia, Rome, 1956; H. Rau, Normannische Kunst in Sizilien, Stuttgart, 1956; G. Samonà, L'architettura in Sicilia dal XIII secolo a tutto il Rinascimento, Atti VII Conv. naz. Storia Arch., Palermo, 1956, pp. 155–72; M. Sánchez Regniera, La arquitectura gotica civil del levante de España en Sicilia, Madrid, 1956; J. Bérard, La colonisation grecque de l'Italie méridionale et de la Sicile dans l'antiquité, 2d ed., Paris, 1957; L. Bernabò Brea, Sicily before the Greeks, London, 1957; V. Tusa, I sarcofagi romani in Sicilia, Palermo, 1957; V. Ziino, Schemi di ville settecentesche siciliane, Atti V Conv. naz. Storia Arch. (1948), Florence, 1957, pp. 407–17; L. Bernabò Brea, Musei e monumenti di Sicilia, Novara, 1958; S. Bottari, Contributi alla conoscenza dell'architettura del Settecento in Sicilia, Palladio, N.S., VIII, 1958, pp. 69–77; Kokalos, IV, 1958 (articles devoted to the period of Timoleon in Sicily); G. Agnello, Catacombe inedite di Cava d'Ispica, RACr, XXXV, 1959, pp. 87–101; C. G. Canale, Strutture architettoniche normanne in Sicilia, Palermo, 1959; L. Pareti, La Sicilia antica, Palermo, 1959; G. Agnello, L'architettura civile e religiosa in Sicilia nell'età sveva, Rome, 1961; S. Boscarino, Studi e rilievi di architettura siciliana, Messina, 1961.

Acireale ('Ακίς; Lat., Aquilia). The origins of this town, perhaps on the site of the Greek Akis, are obscure. Remains of a Roman bath and of a temple from the republican period are at nearby Cape Molini, on the coast, and parts of another Roman edifice have been found in the Casalotto sector. Already devastated by an earthquake in 1169, the old town near the sea was permanently abandoned after an attack by the fleet of Robert II (d'Anjou) of Naples in 1326. The survivors built the present town, then called Aci, on a lava terrace overlooking the sea.

Again severely damaged by earthquake in 1693, the town was rebuilt in predominantly baroque style. The centrally located Piazza del Duomo is lined with baroque buildings: Church of SS. Pietro e Paolo (17th cent., restored), with statues of the titular saints on the façade; Palazzo Comunale (1659, much restored), with balconies supported by carved corbels; and the Cathedral (1597–1618), with 19th-century façade in Neo-Gothic style by G. B. F. Basile, incorporating a 17th-century marble portal between two bell towers. The Cathedral interior has frescoes by Pietro Vasta (1737) and Antonio Filocamo (1711). The 17th-century church of S. Sebastiano has an ornate façade (completed 1705), preceded by a balustrade surmounted by 10 statues of Old Testament figures. The dome, chapels, and transept are decorated with frescoes by Vasta. The Church of the Filippini and the Baths of S. Venera are neoclassic structures. The Palazzo Pennisi di Floristella, by Mariano Falcini (19th cent.), contains an important collection of Greco-Siculan coins of the 6th to 4th century B.C. The Pinacoteca dell'Accademia Zelantea contains coins, archaeological material, and paintings.

BIBLIOG. V. Raciti Romeo, Acireale e dintorni, Acireale, 1927; EAA, s.v.

Addaura. This cave on the slopes of Mount Pellegrino, near Palermo, contains a remarkable group of incised rock drawings of human figures and animals, attributed to the Sicilian Upper Paleolithic period (XI, PLS. 284, 285).

BIBLIOG. I. Bovio Marconi, Incisioni rupestri all'Addaura, BPI, N.S., VIII, 1952–53, pp. 5–22; P. Graziosi, Palaeolithic Art, New York, 1960, passim.

Adrano ('Αδρανόν; Lat., Hadranum; It., Adernò, until 1929). This town on the southwestern slopes of Etna, at the site of a Siculan temple dedicated to the indigenous god Adrano, was founded by Dionysius the Elder in 400 B.C. (sections of cyclopean walls with towers). Roman rule, under which the town declined steadily, is marked by portions of a bath and a necropolis on the outskirts. The Norman castle, rectangular in plan, was built by Count Roger in the 11th century. The Assunta (Chiesa Madre), originally a Norman structure, was enlarged and restored in 1640–56 and again in 1811. The former monastery of S. Lucia (1158), which achieved its present-day aspect in the 15th and 16th centuries, has an elliptical interior and a façade flanked by two bell towers. The Museo Petronio Russo conserves local archaeological material.

In the Mendolito district vestiges of a Siculan town have been uncovered and have yielded substantial artifacts, including the bronzes known as the "Mendolito hoard" (8th cent. B.C.; Syracuse, Mus. Archeol.).

BIBLIOG. G. Paternò Castello, Nicosia, Sperlinga, Cerami, Troina, Adernò, Bergamo, 1907; P. Orsi, Insigne ripostiglio di bronzi siculi, NSc, 1909, pp. 387–88; S. Petronio Russo, Illustrazione storico-archeologica di Adernò, 2d ed., Adernò, 1911; P. Orsi, Ghianda fittile scritta: Epigrafi bronzi siculi, NSc, 1912, pp. 414–19; P. Orsi, Deposito di terrecotte ieratiche, NSc, 1915, p. 227 ff.; P. Orsi, Piccoli bronzi e marmi inediti del Museo di Siracusa, Ausonia, VIII, 1915, pp. 44–75; G. Libertini, Comune della valle del Simeto, Riv. del Comune di Catania, V, 1933, pp. 36–46; EAA, s.v.

Agrigento ('Ακράγας; Lat., Agrigentum; It., Girgenti, until 1927). Located about 2 miles inland, on the hilly site of prehistoric settlements, the Greek Akragas was founded in 582–580 B.C. by colonists from Gela. The city grew in size and wealth under Phalaris (570–555) and Theron (488–473), to such a degree that its splendor in the 2d half of the 5th century became proverbial. Destroyed by Carthage in 406 B.C., it was rebuilt by Timoleon in 340 and was conquered by the Romans in 210; under Roman rule it continued to flourish.

The early-5th-century city, below and south of the modern city, was arranged along Hippodamian lines. The circumference of the

walls, which had nine fortified gates and square towers, was 7½ miles; they enclosed the highest points of the modern city, as well as the summit of the easterly Rupe Atenea, perhaps the site of the acropolis. The agora adjoined the Temple of Olympian Zeus (Olympieion). A series of temples and sanctuaries, mostly of the mid-5th century B.C., were built along the eastern and southern sections of the city wall, on the edge of a natural rampart. Among these is the Temple of Demeter, over whose base rises the small Norman church of S. Biagio. Below, outside the walls, is a prehistoric sanctuary carved into the rock around a spring; this site of an indigenous cult, which has yielded considerable votive material, was adapted by the Greeks and later by the Romans. The so-called temples of Hera Lacinia and of Concordia and that of Herakles, along the southern rampart, are all Doric.

The Olympieion, begun after the victory of Himera in 480 B.C., was one of the largest of all Greek temples; some of its gigantic telamons have survived (VII, PL. 57). At the southwest corner of the ancient city is the sanctuary of the chthonian deities, with temples, sacella, and altars (7th–6th cent.), probably over a prehistoric site. The reconstructed fragment (1836) erroneously called the "Temple of Castor and Pollux" is actually a combination of elements from two temples — four Doric columns from one (5th cent.), the corner entablature from a Hellenistic construction. Beyond the western wall, across the Hypsas River, are the ruins of the so-called Temple of Hephaistos (actual dedication uncertain). Also beyond the walls, to the south, stands the Temple of Asklepios (5th cent.), a small structure in antis. Near the Church of S. Nicola excavations have revealed a large Hellenistic-Roman quarter (VII, PL. 236), with shops and dwellings, where excellent mosaics have been recovered. Other Hellenistic works are the small heroön known as the "Oratory of Phalaris" (1st cent. B.C.) and the commonly designated "Tomb of Theron," another funerary monument, probably of the Roman republican period. Along the south walls are Early Christian catacombs.

After the Arab conquest in 827, the city was renamed Gergent (Girgenti) and declined until it occupied only part of the western hill, but under the Normans it became the seat of a rich diocese. To this later medieval period belongs the Romanesque-Gothic church of S. Maria dei Greci, built over a 5th-century Doric temple from which six column bases can yet be seen. The church has a 13th-century Gothic portal. The Cathedral, built largely in the 13th–14th century and altered several times thereafter, has in part been restored to its 14th-century form. The interior has a nave and two side aisles, covered with both wood-beamed and coffered sections, and baroque stuccoes. Adjacent is an unfinished bell tower (15th cent.), which fuses Catalan Gothic with characteristic zigzag Arabo-Norman elements. This sawtooth decoration is also extensively used on the abbey church of Sto Spirito, built in 1290 (interior remodeled 18th cent.), which retains a Gothic portal and rose window on its façade; within are a trompe l'oeil ceiling and stuccoes attributed to Giacomo Serpotta. The cloister has several Gothic portals, the finest of which leads to the chapter house; both refectory and chapter house are roofed with Gothic vaults. The Church of S. Nicola is a single-aisled Cistercian Gothic structure of the 13th century, with remains of a monastery adjacent. The Church of the Purgatorio and the seminary are baroque. *Museums*: Museo Civico Archeologico; Galleria Sinatra (or di Arte Moderna); Antiquarium di Villa Aurea; Museo Diocesano.

BIBLIOG. G. Schubring, Topografia storica di Agrigento, Turin, 1888; S. Rocco, Girgenti, Bergamo, 1903; A. Cremona, Novissima guida storico-artistica di Girgenti e dei suoi monumenti, Agrigento, 1925; E. Gabrici, Scavi e scoperte archeologiche dal 1916 al 1924, NSc, 1925, pp. 420–61; P. Marconi, Agrigento: Studi sulla organizzazione urbana di una città classica, RIASA, II, 1930, pp. 7–61; P. Marconi, Agrigento, Rome, 1933; C. Mercurelli, Scavi e scoperte nelle catacombe siciliane (1941), RACr, XXI, 1944–45, pp. 5–104; A. Giuliana Alaimo, La chiesa di San Nicola dei Cistercensi in Agrigento, Palermo, 1955; P. Griffo, Agrigento, 2d ed., 1955; F. Castagnoli, Ippodamo di Mileto e l'urbanistica a pianta ortogonale, Rome, 1956, pp. 22–25; E. De Miro, Il quartiere ellenistico-romano di Agrigento, RendLinc, 8th ser., XII, 1957, pp. 135–40; EAA, s.v.; G. Schmiedt and P. Griffo, Agrigento antica dalle fotografie aeree e dai recenti scavi, Florence, 1958.

Alcamo. Founded by the Arabs in the 9th century, Alcamo grew in importance under the Aragonese kings, during whose rule it was fortified with battlemented walls. It is dominated by a 14th-century castle, quadrangular in plan, with round and square towers at the corners. The Church of S. Tomaso (15th cent.), with Gothic portal and single-arched Gothic windows, is surmounted by small arches. The Church of S. Nicolò (16th cent.) has a round-arched portal and single-arched windows. From the baroque period are the Church of S. Francesco d'Assisi (ca. 1625); the Badia Nuova (or S. Francesco di Paola), built in 1699 by Giovanni B. Amico; the Badia Grande; and S. Oliva (ca. 1725), also by Amico. The Assunta (or Chiesa Matrice), of 14th-century origin, was entirely rebuilt in 1669.

BIBLIOG. P. M. Rocca, Di alcuni antichi edifici di Alcamo, Palermo, 1905; S. Monticciolo, La chiesa di S. Maria delle Grazie, Alcamo, 1942; V. Regina, Brevi note su Alcamo del '700, Alcamo, 1956.

Caltagirone. The site has been inhabited since prehistoric times (scattered necropolises, both in the city and in the surrounding countryside). In the early 11th century Caltagirone — the name is of Arab derivation — was conquered by the Ligurians, and in 1090 by the Normans. Devastated by the earthquake of 1693, the town gained its present appearance, marked by narrow and irregular squares, ramps, and stairways, in the baroque period. Few existing monuments antedate this disaster: part of the bell tower of the Church of S. Giorgio dei Genovesi (1030; rebuilt 1699), and of the left wall of the Church of S. Giacomo (1090; rebuilt 1694–1708); and the Corte Capitaniale, a single-storied edifice with alternate portals and windows, the work of Antonuzzo and Gian Domenico Gaggini (16th–17th cent.). Baroque 18th-century churches include the Rosario (Carlo Longobardi) and the Salvatore (Natale Bonaiuto). An imposing stairway known as the "Scala" rises from the Piazza Municipio to the Church of S. Maria del Monte (1143; rebuilt 1542 and after 1693). Another noteworthy building is the massive Monte di Pietà (1782), the former Bourbon prison, built by Bonaiuto.

Caltagirone has been famous since the Arab domination for its brilliantly colored majolica (III, PL. 157). The use of majolica for decoration of churches and secular buildings is characteristic. In the Villa, the vast public garden designed by Giovanni Basile (1846–48), is a collection of ceramics. *Museums*: Museo e Pinacoteca Civici Luigi Sturzo (Corte Capitaniale); Museo della Ceramica (Teatrino).

BIBLIOG. F. Perticone, Caltagirone: Sua origine e suoi nomi, Arte e storia, IV, 1885, pp. 94–95, 102–03; M. Ventura, La Cattedrale di Caltagirone, Arte e restauro, XV, 1–2, 1938, pp. 28–30.

Catania (Κατάνη; Lat., Catina or Catana). The site, at the foot of Mount Etna, was inhabited in prehistoric times (early neolithic finds). The city was founded in 729 B.C. by Chalcidian Greeks from Naxos. In 477/476 B.C. it was conquered by Hieron I of Syracuse, who renamed it Etna; when in 461 the original inhabitants drove out the Syracusans, the city resumed its old name. After having been captured by Dionysius the Elder in 403 B.C., and again in 396, the city fell to Rome in 263 B.C. Greek remains include a Chalcidian necropolis, a theater and adjacent odeon, with Roman superstructures, and the acropolis, where many ceramics and terra-cotta figures have been recovered (late 7th–3d cent.). Of the Roman period are parts of the forum, the thermae on the site of the ancient monastery of S. Maria dell'Indirizzo, another bath (now Church of S. Maria della Rotonda), and parts of a large amphitheater.

The Byzantine epoch is recorded by a small basilica (5th–6th cent.) with remains of mosaics and the Cappella del Salvatorello (8th–9th cent.). From the Norman period, only a few portions of the Cathedral (begun 1092) remain. The Castello Ursino, built in 1239–50 (remodeled 16th cent., restored 1924), is square with round towers at the corners. The interior, centered around a court, preserves some rooms of the 13th century. Also of the 13th century is the Romanesque portal of the 18th-century church of Sto Carcere, originally on the Cathedral. The convent of S. Nicolò (begun 1558; 18th cent., remodeled in Spanish baroque style) is built around two porticoed courts. The convent church, built by Francesco Battaglia in the early 18th century, has an uncompleted façade; the interior is a three-aisled Latin cross. The Church of S. Maria di Gesù, rebuilt in 1706, retains the Paternò Chapel and sculpture by Antonello Gaggini from the original construction (15th–16th cent.).

The over-all baroque aspect dates from the reconstruction of the city after the great earthquake of 1693. Architect of this late baroque plan was Giovanni Battista Vaccarini, designer of much of the 18th-century construction, the most important being the rebuilding of the Cathedral (PL. 225). A three-aisled basilica, it followed a design by Girolamo Palazzotto that incorporated remains of the Norman structure. The façade, in the style of Borromini, and the balustraded prospect along the north wall were added by Vaccarini in 1736. The Museo di Castello Ursino has collections of archaeological material and medieval, Renaissance, baroque, and modern art.

BIBLIOG. F. De Roberto, Catania, Bergamo, 1906; F. Fichera, La casa dei Platamone e l'attiguo quartiere di Catania medievale, Catania, 1907; A. Holm, Catania antica, Catania, 1924; F. Fichera, Una città settecentesca, Rome, 1925; G. Libertini, Scavi e scoperte a Catania, Arch. storico Sicilia orientale, XXVIII, 1932, pp. 411–13; G. Agnello, La cosiddetta trichora del Salvatore, RACr, XXIII–XXIV, 1947–48, pp. 147–68; G. Policastro, Catania prima del 1693, Turin, 1952; G. Rizza, Mosaico pavimentale di una basilica cemeteriale paleocristiana di Catania, BArte, XL, 1955, pp. 1–11; G. Libertini, Necropoli romani e avanzi bizantini nella via Dottor Consoli, NSc, 8th ser., X, 1956, pp. 170–89; G. Rizza, Catania: Scavi e scoperte fortuite, FA, XIII, 1958, 4120; EAA, s.v.

ITALY

Cefalù (Κεφαλοίδιον; Lat., Cephaloedium). A pre-Hellenic sanctuary (9th–8th cent.) known as the "Temple of Diana," including a sacred well and some megalithic walls, is situated above the town. In the 5th or 4th century B.C. a new construction of polygonal masonry in classic style was added. The first historical mention of Cefalù came in 396 B.C., when the city signed a treaty with Carthage. It was conquered by Dionysius I and then by Agathokles in 307; the Romans seized it in 254 B.C. The see of a bishop under Byzantine rule, it was subsequently taken from the Arabs in 1036 by Roger I.

The city is dominated by the Cathedral, begun in 1131; the façade (1240), by Giovanni Panettera, has two towers with three orders of single- and double-arched windows (PL. 173). The central section is surmounted by two orders of blind arcades, the lower one with interlacing arches, and is preceded by a triple-arched porch by Ambrogio da Como (1471). The single portal is richly ornamented. The triapsidal interior, with interlacing arches, is a three-aisled Latin cross, with transept and elevated presbytery. The central apse and the adjoining walls are decorated with mosaics (II, PL. 456), which are the work of Byzantine masters, perhaps with local assistants. The adjacent square cloister has paired columns and ogival arches (restored). Also from the Norman period are parts of the so-called "Osterio Magno," residence of Roger II. Museo Mandralisca: paintings, vases, and coins.

Bibliog. R. Salvo di Pietraganzilli, Cefalù: La sua origine ed i suoi monumenti, Palermo, 1888; P. Marconi, Il cosiddetto "Tempio di Diana," NSc, 1929, pp. 273–95; G. Samonà, Monumenti medievali nel retroterra di Cefalù, Naples, 1935; G. Samonà, Il Duomo di Cefalù, Rome, 1940; G. Agnello, La Domus Regia di Ruggero II in Cefalù, Atti Conv. int. S. ruggeriani, Palermo, 1955, pp. 455–63; I. Bovio Marconi, I monumenti megalitici di Cefalù e l'architettura protostorica mediterranea, Atti VII Conv. naz. Storia Arch., Palermo, 1956, pp. 213–22; E. Gabrici, Alla ricerca della Soluto di Tucidide, Kokalos, V, 1959, pp. 1–53; EAA, s.v.

Centuripe (Κεντόριπα; Lat., Centuripae). The site was occupied by a Siculan settlement that remained independent until the mid-4th century B.C., when it came under Syracusan dominion. It flourished under the rule of Hieron II. Numerous necropolises in the vicinity have yielded rich Hellenistic material, in particular the highly regarded terra-cotta figures and the glazed pottery, painted and decorated with reliefs ("Centuripe ware"; III, PL. 138; VII, PL. 78). Portrait heads in marble (including one of Augustus; Syracuse, Mus. Archeol.) have been found in a Roman building of the imperial era; a Roman bath and a Hellenistic house have also come to light. The so-called "Castello di Corradino" is probably the ruin of a mausoleum from imperial times. In the 13th century the town was razed by Charles I of Anjou and was rebuilt in 1548 as the feud of the Moncada family. The Antiquarium is in the Palazzo Comunale.

Bibliog. G. Libertini, Centuripe, Catania, 1926; P. Griffo, Nuova testa di Augusto e altre scoperte di epoca romana fatte a Centuripe (S. siciliani di Archeol. e Storia antica, 3), Agrigento, 1949; G. Libertini, Rinvenimento di una tomba arcaica, NSc, 8th ser., VI, 1952, pp. 332–41; G. Libertini, Nuove indagini sulle costruzione presso il Mulino Barbagallo; Campagna di scavo 1950–51, NSc, 8th ser., VII, 1953, pp. 353–68; B. Neutsch, Archäologische Grabungen und Funde in Sizilien von 1949–1954, Centuripe, AAnz, LXIX, 1954, cols., 481–91; EAA, s.v.

Enna ("Εννα; Lat., Castrum Hennae; It., Castrogiovanni, until 1927). Situated in an almost impregnable position, Henna was a Siculan stronghold (tombs of 8th–6th century at the nearby lake of Pergusa). Though Greek influence was felt as early as the 7th–6th century B.C., the city remained independent until 397, when it fell under the tyranny of Dionysius the Elder of Syracuse, and in 307 B.C. to Agathokles. For a while it was under Carthaginian rule and then passed to Rome in 258 B.C. In ancient times the region was the center of the cult of Demeter, and remains of a sanctuary have been found at the so-called "Rocca di Cerere."

Afterward an important Byzantine fortress, in 859 it fell to the Arabs, who called it Qaṣr Yani (whence the later Italian name) and fortified it. Conquered by the Normans in 1087, the city flourished anew under the Hohenstaufen and Aragonese kings, who were responsible for landmarks such as the octagonal tower of Frederick II (13th cent.) and the Castello di Lombardia, a two-storied octagonal structure that had twenty towers, of which the Torre Pisana is the best preserved of the remaining six. The Cathedral, built in the early 14th century and remodeled in the 16th, retains the transept and the three polygonal apses of the original. The churches of S. Francesco d'Assisi, S. Tommaso, and S. Giovanni all have Gothic bell towers. Part of the 15th-century Palazzo Pollicarini is in the Catalan Gothic style. Of the 16th century are the Church of the Carmine and the portico of S. Tommaso. S. Chiara was built in 1614; S. Benedetto is baroque. Museo Alessi: coins, jewelry, ceramics.

Bibliog. E. L. Falantano, Castrogiovanni, Palermo, 1907; EAA, s.v.

Erice ("Ερυξ; Lat., Eryx; It., Monte San Giuliano, until 1934). Erice was settled by the Elymi. There are significant prehistoric remains in the region, which had a celebrated shrine to the goddess of fecundity, the Roman Venus Ericina, from which but a few fragments have survived. Vestiges of a Punic house exist below the castle, and parts of the city walls are Carthaginian work of the 5th century B.C. Devastated in 260 by the Carthaginians, in 247 B.C. it fell to the Romans, under whom it declined. Marking the Roman period, part of a bath and a well have been discovered.

The town regained prominence in the 12th century, after it was captured by the Normans, who called it Monte San Giuliano and built the castle (12th–13th cent.) on the site of the Temple of Venus Ericina, using salvaged material. They also strengthened the ancient walls. Erice has an over-all medieval aspèct, although most of its churches were remodeled between the 17th and 19th centuries. The Chiesa Matrice (or Assunta; 1314) has a 15th-century Gothic porch; the interior, restored in Neo-Gothic style (1865), contains a *Madonna* attributed to Francesco Laurana. In front of the church stands a massive bell tower, originally built as a watchtower by Frederick II of Aragon in 1312. The Church of S. Giovanni Battista retains a 13th-century portal; within is sculpture by Antonino and Antonello Gaggini. The Museo Antonio Cordici holds archaeological material and a marble Annunciation group also by Antonello Gaggini (1525).

Bibliog. A. Sorrentino, Da Erice a Lilibeo, Bergamo, 1928; G. Cultrera, Il "temenos" di Afrodite Ericina e gli scavi del 1930 e del 1931, NSc, 1935, pp. 294–328; F. Majorana, Su e giù per Erice, Palermo, 1935; E. Caracciolo, Ambienti edilizi nella città sul Monte Erice, Arch. storico siciliano, 3d ser., IV, 1950–51, pp. 187–257; E. Caracciolo, La città sul Monte Erice, Palermo, 1951; I. Bovio Marconi, EAA, s.v. Erice, III, 1960, pp. 413–14.

Gela (Γέλα; Lat., Gela; It., Terranova, until 1927). Gela is one of the most important archaeological sites in Sicily. Greek colonists from Rhodes and Crete, arrived about 688 B.C. Very prosperous by the late 7th and early 6th century B.C., Gela extended its rule toward the north and west; and about 580 B.C. colonists from Gela founded Akragas (Agrigentum). Under the tyrants Hippokrates and Gelon (early 5th cent. B.C.) the city gained large territories in southeastern Sicily. Even after Gelon became tyrant of Syracuse and transferred a large part of the population there, Gela flourished until 405 B.C., when Carthage destroyed it. Refounded in 339–338 by Timoleon, it was occupied by Agathocles (317–311) and completely destroyed by Phintias of Akragas in 282 B.C. The site was very likely abandoned until 1230, when Frederick II founded the fortified town of Terranova.

On the Molino a Vento height was the archaic Greek acropolis, with temples and subsidiary sacred edifices. Part of the stylobate of the oldest temple (6th cent. B.C.), dedicated to Athena, has been excavated and some of the fictile polychrome decorations recovered (mostly Syracuse, Mus. Archeol.). From another Doric temple, built after 480 B.C., only a single column and part of the foundation remain. The base of another temple, with fictile revetments, was recently discovered under the Molino Di Pietro, around which are signs of other small sacred buildings. Beneath the Nuovo Municipio was a temple dedicated to Hera, and smaller sanctuaries lay on the north slope of the hill. The rebuilt Gela of Timoleon extended farther west, as far as Cape Soprano, with a perceptible urban plan of regular orthogonal blocks. Excavations there have revealed a residential quarter of the 4th century B.C., including vestiges of a bath. Also at Cape Soprano is a stretch of the fortified walls that fully enclosed the ancient city for the first time under Timoleon (VII, PL. 55).

From medieval Terranova, which declined in importance and occupied only the western part of the hill, there remain the Porta Marina, with bulwarks of the Spanish period, and the former Church of S. Biagio (1391), with a small apse in Norman style. The Castelluccio, a 14th-century fortress, dominates the valley of the Gela from a ridge a few miles away. The neoclassic Cathedral (mid-18th cent.) has a façade with two superimposed orders of columns; the lower order may include salvaged ancient material. The Museo Nazionale contains archaeological material from Gela and environs.

Bibliog. P. Orsi, Gela: Scavi del 1900–1905, MALinc, XVI, 1906, cols. 5–758; P. Mingazzini, Su una edicola sepolcrale del IV secolo rinvenuto a Monte Saraceno presso Ravanusa (Agrigento), MALinc, XXXVI, 1938, cols., 621–92; L. Bernabò Brea, L'Athenaion di Gela e le sue terrecotte architettoniche, ASAtene, XXVII–XXIX, 1949–51, pp. 7–102; P. Orlandini, Le nuove antefisse sileniche di Gela e il loro contributo alla conoscenza della coroplastica siceliota, AC, VI, 1954, pp. 251–66; D. Adamesteanu, Due problemi topografici del retroterra gelese, RendLinc, 8th ser., X, 1955, pp. 199–210; D. Adamesteanu, Monte Saraceno ed il problema della penetrazione rodio-cretese nella Sicilia meridionale, AC, VIII, 1956, pp. 121–46; D. Adamesteanu and P. Orlandini, Gela: Scavi e scoperte 1951–1956, NSc, 8th ser., X, 1956, pp. 203–401; P. Orlandini, Storia e topografia di Gela dal 405 al 282 a.C. alla luce delle nuove scoperte archeologiche, Kokalos, II, 1956, pp. 158–76; H. Wentker, Die Ktisis von Gela bei Thukydides, RM, LXIII, 1956, pp. 129–39; D. Adamesteanu, Nouvelles fouilles a Géla

et dans l'arrière-pays, RA, 6th ser., XLIX, 1957, pp. 20–46, 147–80; P. Orlandini, Tipologia e cronologia del materiale archeologico di Gela dalla nuova fondazione di Timoleonte all'età di Ierone II, AC, IX, 1957, pp. 4–75, 153–73; D. Adamesteanu, Gela: Scavo di una fattoria-officina, NSc, 8th ser., XII, 1958, pp. 290–334; EAA, s.v.

Lentini (Λεοντῖνοι; Lat., Leontini). In the 9th and 8th centuries B.C. this was the site of an important Siculan town. Rock-cut tombs have yielded great quantities of pottery and figurines, as well as bronzes of the Finocchito type (750–600). In 730–29 B.C. Chalcidian Greeks from Naxos occupied the site. The settlement was devastated by the Syracusans in 424 B.C. and became subject to Dionysius I in 403 B.C. After a period of revival in the second half of the 4th century, in 214 B.C. it was conquered by the Romans and eventually declined.

There are vestiges of Siculan huts, rectangular in plan. Imposing sections of the archaic Greek walls stand to the south of the modern city; these were rebuilt several times (fortified gate with reentrant bastions). The so-called "archaeological zone" also contains traces of various sacred buildings and some necropolises (6th–2d cent.). In the area of the ancient city are found a number of Early Christian and Byzantine sanctuaries. On the Castellaccio hill, are the ruins of a Hohenstaufen fortress.

The modern town, adjoining the ancient on the north, was built after the earthquake of 1693, which destroyed the old city almost completely. The Chiesa Madre (S. Alfio), with three aisles divided by columns, incorporates a Christian hypogeum of the 3d century. It contains an icon (*Madonna Odigitria*; perhaps 9th cent.) and a Byzantine reliquary and parchments. The Church of the Martyrs (or della Fontana) has a holy-water stoup made from the capital of a column carved with images of the months (13th cent.). The local museum holds material from excavations in the region.

BIBLIOG. P. Orsi, Scavi di Leontini-Lentini, Atti Soc. Magna Grecia, 1930, pp. 7–39; P. Griffo, Lentini: Campagna topografia e scavi in località varie, Le Arti, III, 1940–41, pp. 212–13; P. Griffo, Necropoli del secolo V in contrada "Grazie," NSc, 7th ser., II, 1941, pp. 120–29; G. Rizza, Nota di topografia lentinese, Siculorum Gymnasium N.S., II, 1949, pp. 276–84; L. Belfiore, La Basilica di Murgo, Siculorum Gymnasium, N.S., III, 1950, pp. 43–67; G. Rizza, Gli scavi di Leontini e il problema della topografia della città, Siculorum Gymnasium, IV, 1951, pp. 190–98; G. Rizza, Scavi e ricerche nella città di Leontini negli anni 1951–1953, BArte, XXXIX, 1954, pp. 69–73; G. Rizza, Campagne di scavi 1950-1951 e 1951–1952, NSc, 8th ser., IX, 1955, pp. 281–376; G. Agnello, Gli affreschi dei Santuari rupestri della Sicilia, RendPontAcc, XXX–XXXI, 1957–59, pp. 189–204; EAA, s.v.

Lévanzo. On this island of the Egadi group, in the Cave of Cala Genovese (or dei Cervi), important samples of prehistoric art have been discovered (XI, PLS. 283, 287, 293).

BIBLIOG. P. Graziosi, Le pitture e i graffiti preistorici dell'isola di Lévanzo nell'arcipelago delle Egadi; RScPr, V, 1950, pp. 1–43; P. Graziosi, Palaeolithic Art, New York, 1960, passim; EAA, s.v.

Lipari (Λιπάρα; Lat., Lipara). Lipari offers a succession of archaeological evidence from the Neolithic through the Greek epoch. The oldest artifacts, found in the village of Castellaro Vecchio, are the incised and painted pottery of the Stentinello culture. Since the early Bronze Age the Castello of Lipari has been the site of the most important settlements. The inhabitants engaged in extensive Mediterranean trading; hence much Aegean pottery has been found on the island, together with local products. About the 15th century B.C. contacts between the Aeolian Islands and the Mycenaean world seem to have been close, as evidenced in certain round huts of this "Milazzese period" (named after a village discovered in the Milazzese locality on the neighboring island of Panarea). Next came the Ausonian culture (ca. 12th cent. B.C.), related to the Appenine cultures of the mainland. New forms of artifacts, quadrangular buildings, and cremation were introduced in this period (VII, PL. 314; IX, PL. 437). In 580 B.C. a colony of Cnidian Greeks once more established a flourishing civilization, lasting until 252 B.C., when the island was conquered by the Romans. Protohistoric and Greek strata retain the location of an acropolis. Also surviving are a tower from the Greek walls (4th–3d cent.), two Roman burial hypogea, and part of a bath, with mosaic pavement (2d cent.).

Inhabited largely by monks in the early Middle Ages, the island revived once more under the Normans and became the see of a bishop. Sections of the 13th- and 14th-century walls and towers still stand. Sacked by the Turks in 1544, Lipari was afterward rebuilt and repopulated, at which time the existing Spanish citadel was built on the site of the ancient acropolis. The present-day city developed at the foot of the Castello, outside the old walls, in the 18th century. The Cathedral, a Norman construction (1084), was almost entirely rebuilt in 1654 (façade added in 1861). The three-

aisled interior is baroque. The Museo Eoliano, in the episcopal palace, contains material of the various island cultures.

BIBLIOG. G. Libertini, Le isole Eolie nell'antichità greca e romana, Florence, 1921; L. Zagami, Le isole Eolie nella storia e nella leggenda, Messina, 1939; L. Bernabò Brea and M. Cavalier, Civiltà preistoriche delle isole Eolie e del territorio di Milazzo, BPI, LXV, 1956, pp. 7–98; L. Bernabò Brea, Il Castello di Lipari e il Museo Archeologico, Palermo, 1958; L. Bernabò Brea and M. Cavalier, Meligunis-Lipara, I, Palermo, 1960; L. Bernabò Brea, EAA, s.v. Eolie, isole, III, 1960, pp. 349–53.

Marsala (Λιλύβαιον; Lat., Lilybaeum). A Punic stronghold founded on Cape Boeo after the destruction of the Carthaginian Mozia (see below) in 397 B.C., Lilybaeum remained the chief Carthaginian bulwark in Sicily. Occupied by the Romans in 241 B.C., it became in turn an important commercial and military port, a municipium, and then a colonia, ultimately the chief administrative center in western Sicily. From the Roman period are 3d-century thermae with mosaic floors and a necropolis having aediculae painted with funerary banquet scenes (Palermo, Mus. Naz. Archeol.). Under the Arabs, who called it Marsa-Alì, the port flourished, and continued so under the Normans and Aragonese. In the 16th century it declined after Charles V obstructed the harbor against the Barbary pirates.

Dating from the medieval period are remnants of the bastions and a catacomb beneath the Church of S. Maria della Grotta, with Byzantine frescoes of saints (11th–12th cent.). S. Pietro, with a rose window on the façade, and the Church of the Carmine, with an octagonal campanile and triple-arched portico, are 16th-century constructions. The tower of the Convent of S. Pietro has two levels of triple-arched loggias. The present-day Porta Garibaldi is also a 16th-century work. The Cathedral, founded by the Normans (remodeled 18th cent.), has an unfinished baroque façade; the apse and dome, destroyed in 1943, have been restored. The interior furnishings include eight Flemish tapestries of the 16th century. The Church of the Purgatorio (1701) has an ornate baroque façade and interior stuccowork. The 18th-century Palazzo Comunale has a round-arched portico and a central tower and loggia above. The Porta Nuova is another 18th-century monument. The Museo Civico has an archaeological collection.

On the island of S. Pantaleo, north of Marsala, was the Phoenician city of Mozia (Μοτύη; Lat., Motya). Founded in the late 8th century B.C. on the site of a prehistoric settlement, it became an important commercial center and the chief Carthaginian defense against Greek expansion in western Sicily, until it was destroyed (397 B.C.) by the Syracusans under Dionysius I. Excavations have revealed part of the city, including walls with towers and gates, the rectangular Punic port, a sacred precinct, several houses, necropolises and a causeway that joined the isle to the mainland. The Whitaker Museum houses the finds from local excavations.

BIBLIOG. J. I. S. Whitaker, Motya, London, 1921; A. Sorrentino, Da Erice a Lilibeo, Bergamo, 1928; E. Gabrici, Stele sepolcrali di Lilibeo a forma di Heroon, MALinc, XXXIII, 1929, cols., 41–60; P. Cicalone, Marsala attraverso le chiese, i monumenti, le epigrafi, Marsala, 1933; B. S. J. Isserlin, P. J. Parr, and W. Culican, Excavations at Motya, Antiquity, XXX, 1956, pp. 110–13; G. A. Ruggieri, Motya and Lilybaeum, Archaeology, X, 1957, pp. 131–36; B. S. J. Isserlin, W. Culican, W. L. Brown, and A. Tusa Cutroni, Motya, BSR, XXVI, 1958, pp. 1–29; EAA, s.v. Lilibeo.

Mazara del Vallo (Mazaris, Mazare). Initially a Phoenician trading post, Mazaris became a commercial port for Selinous in the 6th and 5th centuries B.C. In 409 B.C. it fell to the Carthaginians, and to the Romans during the Second Punic War. Its good harbor, close to Africa, made it prosperous, even when Selinous was destroyed; and traces of ancient wharves and of Roman constructions have been found. Under the Normans the town was enclosed with a double wall; there are remains of a castle built by Roger I in 1071. The Cathedral (ca. 1075; rebuilt 1690–94) retains some of the original construction in the apse and transept walls. The façade, completed in 1906, has a portal relief of an equestrian Count Roger trampling a Moslem (1584). Within is a marble Transfiguration group by Antonello and Antonino Gaggini (1537), in the presbytery, and a ciborium signed by Antonello Gaggini (1532). The baroque bell tower was built in 1654–58. The Norman church of S. Nicolò Regale (12th cent.) has an inscribed-cross plan and three apses; the exterior walls have recessive blind arches pierced by single-arched windows. On the right wall of S. Caterina (1318; remodeled 17th cent.) is a Gothic portal in the Chiaramonte style from the original structure; the façade is baroque. Inside is a *St. Catherine* by Antonello Gaggini.

Structures belonging to the baroque period are S. Michele (1637) and the Jesuit College (1675–86), with a decorative portal and porticoed court. Also of the 17th century is the Palace of the Knights of Malta. The seminary and the episcopal palace are 18th-century edifices. The Church of S. Veneranda (1714) has an elaborate façade,

with a wrought-iron balcony over the portal. The Museo Civico (Palace of the Knights of Malta) has Roman material and paintings.

A little more than a mile outside the town is the 12th-century Basilian monastery of the Madonna dell'Alto (or S. Maria delle Giummarc); its unusual roof consists of a series of parallel transverse barrel vaults resting on the exterior walls.

BIBLIOG. A. Sorrentino, Da Erice a Lilibeo, Bergamo, 1928; G. B. Quinci, Mazara del Vallo, Rome, 1931; G. Pensabene, La cattedrale normanna di Mazara, Palermo, 1934; V. Scuderi, Contributo alla storia dell'architettura normanna in Val di Mazara, Atti Conv. int. S. ruggeriani, Palermo, 1955, pp. 317-25; V. Tusa, EAA, s.v. Mazara del Vallo, IV, 1961, pp. 939-40.

Megara Hyblaea (Μεγάρα Ὑβλαία). Near the modern town of Augusta a fortified neolithic village, with circular huts, has yielded incised pottery of the Stentinello type (IX, PL. 428). In the Bernardina sector, early Bronze Age pottery of the Castelluccio type has been found in a necropolis. In 728 B.C. Chalcidian Greeks founded a colony that lasted until 482 B.C., when Gelon destroyed it and moved the inhabitants to Syracuse. From the archaic Greek period are the foundations of three temples and subsidiary buildings, near which sculpture (VII, PL. 64) and painted terra-cotta architectural fragments have been found. Traces of the later walls of Agathokles and archaic and Hellenistic necropolises have also been uncovered.

On the Magnisi Peninsula (anc. Thapsos) are many rock-cut tombs with antechambers (ca. 1400–1250 B.C.) that have been the source of quantities of material, both local and imported Mycenaean.

BIBLIOG. P. Orsi, Megara Hyblaea, MALinc, XXVII, 1921, cols., 109–80; F. Villard and G. Vallet, Megara Hyblaea, Mél. LXIII, 1951, pp. 1–52, LXIV, 1952, pp. 7–38, LXV, 1953, pp. 9–38, LXVII, 1955, pp. 7–34, LXX, 1958, pp. 39–59; G. V. Gentili, Tombe arcaiche e reperti sporadici nella proprietà della "Rasion," e tomba arcaica in predio Vinci, NSc, 8th ser., VIII, 1954, pp. 80–113; K. Parlasca, Das Verhältnis der megarischen Becher zum alexandrinischen Kunsthandwerk, JdI, LXX, 1955, pp. 129–54; G. Vallet and F. Villard, Les fouilles de Mégara Hyblea (1949–1959), BArte, XLV, 1960, pp. 263–73; EAA, s.v.

Messina (Ζάγκλη, Μεσσάνα, Μεσσήνη; Lat., Messana). This site on the Strait of Messina was probably inhabited in pre-Greek times. It was colonized by Euboeian Greeks, perhaps about 730 B.C. In 493 B.C. the city was taken over by fugitives from Samos and Miletos, and not long afterward became subject to Anaxilas, tyrant of Rhegion, who changed the name. As Messana, it flourished particularly in the 6th and 5th centuries B.C. Very few antiquities remain, and the present over-all aspect of the city is modern. Heavily damaged in World War II, the city has undergone large-scale reconstruction.

The Cathedral, begun early in the 12th century (consecrated 1197), was almost completely destroyed by earthquake and war in modern times and has been rebuilt in the Norman form. Original elements conserved include the lower part of the façade, with three Gothic portals (the central one by Pietro de Bontade, 1468); a 16th-century portal on the right wall by Polidoro da Caravaggio (once the commemorative arch of Charles V); some of the painted ceiling beams; vestiges of the apse mosaics (14th cent.), in Byzantine style; and the tomb of Archbishop De Tabiatis, by the Sienese Goro di Gregorio (1333). The bell tower, with a remarkable Strasbourg clock (1933), was designed by Francesco Valenti in this century from old prints of the original tower. The Annunziata dei Catalani, a Norman church of the second half of the 12th century rebuilt after the 1908 quake, shows Pisan influence. The Church of S. Francesco d'Assisi is a 20th-century reconstruction of the original Gothic edifice (1254); single-aisled, it is especially notable for its three battlemented polygonal apses. There are remains of the Gothic church of S. Maria Alemanna (early 13th cent.) and of the Cattolica, a church of the Greek rite antedating the Cathedral. The fountains of Orion (1547) and Neptune (1557), by G. Montorsoli, have been restored. The Spanish fortress of S. Salvatore (1546) guards the harbor entrance. The bronze statue of John of Austria (Piazzetta dei Catalani) is by Andrea Calamecca (1572). The Teatro Vittorio Emanuele was designed by Pietro Valente (1852); and the cemetery, surrounding the imposing Famedio, was laid out by Leone Savoia in 1872. Among the buildings erected after 1908 are the University, by Giuseppe Botto, and the Palazzo di Giustizia, by Marcello Piacentini. The Museo Nazionale contains archaeological material, medieval and modern paintings and sculpture, and baroque decorative arts.

About 2 miles west of the city are the picturesque ruins of the early-13th-century Benedictine monastery of S. Maria della Scala (or della Valle), known as the "Badiazza."

BIBLIOG. G. Buonfiglio, Messina città nobilissima descritta in XIII libri, Venice, 1606; L. Ozzola, Appunti sull'arte barocca a Messina, Vita d'arte, III, 1909, pp. 93–102; E. Mauceri, Messina, Florence, 1924; S. Bottari, Il Duomo di Messina, Messina, 1929; F. Valenti, La SS. Annunziata detta dei "Catalani," BArte, XXV, 1931–32, pp. 533–51; E. Mauceri, Messina nella gloria della sua arte, Messina, 1939; G. Agnello, S. Maria della

Valle, Palladio, N.S., III, 1953, pp. 49–66; G. Vallet, Rhégion et Zancle, Paris, 1958; G. Agnello, La chiesa di S. Maria degli Alemanni a Messina, Siculorum Gymnasium, XIII, 1960, pp. 109–16; W. Hager, Guarinis Theatiner Fassade in Messina, H. Schrade zum 60. Geburstag, Stuttgart, 1960, pp. 230–40; F. Basile, La palazzata di Messina, Q. Ist. Storia Arch., 31–48, 1961, pp. 299–306; G. V. Gentili, EAA, s.v. Messina, IV, 1961, pp. 1084–86.

Milazzo (Μυλαί; Lat., Mylae). The promontory of Milazzo was the site of important protohistoric settlements between the 14th and 8th centuries B.C. (necropolises evidencing both inhumation and cremation practices). A colony of Greek Zankle (Messina) was established here in 716 B.C. The ancient city was on the high ground of the cape; the modern city lies below. The highest point is dominated by the castle built by Frederick II in the 13th century (incorporating older structures). It has an ogival doorway, set between two 15th-century towers, and a Gothic portal of the 14th century.

BIBLIOG. G. Agnello, Il castello svevo di Milazzo, RIASA, N.S., IV, 1955, pp. 209–41; L. Bernabò Brea and M. Cavalier, Civiltà preistoriche delle isole Eolie e del territorio di Milazzo, BPI, LXV, 1956, pp. 7–98; L. Bernabò Brea and M. Cavalier, Mylai, Catania, 1959.

Modica (Μότυχα; Lat., Motyce). Set within a hollow and resembling an amphitheater in layout, Modica presents a characteristic ancient city plan; but Greek and Roman evidence is negligible. Although the city was heavily damaged during the earthquake of 1693, it was rebuilt according to the early plan and its present-day appearance typifies the older Sicilian towns. In the chapel of the Casa De Leva is a 14th-century Gothic portal in the Chiaramonte style. The Church of the Carmine (15th cent.) retains a Gothic portal and a rose window on the façade. The Church of S. Maria di Betlem incorporates the late Gothic chapel of the Sacramento (15th–16th cent.). Linking the lower and the upper town is a grandiose stairway leading to the Church of S. Giorgio (18th cent.), probably designed by Vincenzo Sinatra; the imposing façade has an elaborate towerlike central segment of three tiers. The Church of S. Maria del Gesù (late 15th cent.) retains an ornate Catalan Gothic portal; the former convent of the Minori Osservanti, with a small cloister, is adjacent (ca. 1478).

BIBLIOG. E. Mauceri, La contea di Modica nell'arte, L'Arte, XVII, 1914, pp. 120–34; F. L. Belgiorno, Modica e le sue chiese dall'origine del cristianesimo ad oggi, Modica, 1955; L. Bernabò Brea, Sicily before the Greeks, London, 1957.

Monreale. The founding of the surrounding town was coincident with the building of the Cathedral, one of the masterpieces of Norman architecture (1174–89). The edifice is preceded by an 18th-century portico set between the two Norman towers. The upper part of the façade is ornamented with interlacing arches of limestone and lava in Arabic style, a motif that is elaborated on the exterior of the famed triple apse. The west portal has bronze doors with reliefs of Biblical scenes, the work of Bonannus of Pisa (III, PL. 12). The north wall displays another bronze door, by Barisanus of Trani (1179), reached through a portico designed by Gian Domenico and Fazio Gaggini (1547–69). The basilican interior (PL. 173) has three aisles, defined by salvaged ancient columns and capitals supporting pointed Arabic arches, and a square domeless presbytery in Byzantine style. The trussed ceiling, with wooden stalactites in Arabic style over the sanctuary, is a reconstruction (1811). The pavement of granite and porphyry disks, with interlaced marble strips, was part of the original conception (completed 16th cent.). The apse and side walls are covered with 12th- and 13th-century mosaics (II, PLS. 286, 457; X, PL. 193), which are the work of local and Venetian mosaicists influenced by Byzantine masters. The Cathedral contains the sarcophagi of William I and William II (1575). The Chapel of S. Benedetto (1569) was faced with rich marble inlay and stuccoes by Giovan Battista Marino in 1728. Adjoining the Cathedral is the cloister of the Benedictine monastery (12th cent.), surrounded by a portico composed of pointed arches with double archivolts and string molding of Arabic type. The arches are supported by paired columns of varying forms (some plain, others decorated with mosaic) and imaginative figural capitals. In the southeastern corner is a columnar fountain resembling a palm trunk, enclosed by a small inner portico in Arabic style (PL. 426). The treasury holds reliquaries, sacred vestments, and other ritual objects. Fragments of the Norman royal palace are incorporated in the seminary behind the Cathedral.

On the summit of Mount Caputo are the ruins of the Castellaccio, a 12th-century fortified monastery of the Benedictines. The several baroque churches of Monreale include the Chiesa del Monte, with stuccoes of the school of Serpotta.

BIBLIOG. G. L. Lello, Descrizione del real tempio e monasterio di Santa Maria Nuova, Palermo, 1702; D. B. Gravina, Il Duomo di Monreale, Palermo, 1859; V. Di Giovanni, I casali esistenti nel secolo XII nel territorio

della chiesa di Monreale, Palermo, 1892; C. Concetti, Monreale e i suoi dintorni, Palermo, 1912; F. Pottino, Monreale, Milan, 1917; E. Mauceri, Il Duomo e il chiostro di Monreale, Milan, 1929; R. Salvini, I mosaici del Duomo di Monreale, Florence, 1942; C. D. Sheppard, Monreale und Chartres, GBA, XXXV, 1949, pp. 401–14; C. D. Sheppard, A Stylistic Analysis of the Cloisters of Monreale, AB, XXXIV, 1952, pp. 35–41; A. Boeckler, Die Bronzetüren des Bonannus von Pisa and des Barisanus von Trani, Berlin, 1953; S. Bottari, Note sul Duomo di Monreale, Atti Conv. int. S. ruggeriani, Palermo, 1955, pp. 269–75; F. Braun, Palermo und Monreale, Munich, 1960; E. Kitzinger, I mosaici di Monreale, Palermo, 1960.

Morgantina (Μοργαντίνη, Μοργάντιον). The excavations at Serra Orlando, near Aidone, can very likely be identified with the Hellenized Siculan city of Morgantina. The site, which appears to have been inhabited from the Bronze Age, was colonized by Greeks in the early 6th century B.C. and seems to have flourished particularly during the 4th and 3d centuries B.C. There are remnants of the late-4th-century walls, and on the acropolis are vestiges of an indigenous protohistoric village, also marking the earliest Greek settlement, where archaic antefixes have been recovered. The rectangular Hellenistic agora, from the time of Agathokles (4th cent. B.C.), was on two levels, joined by an impressive trapezoidal stairway that probably served for the *ekklesiasterion* as well. A 2d-century Roman commercial center, with porticoed tabernae and macellum, utilized the same site. Behind the agora was a sanctuary of the chthonic deities, Demeter and Kore, the source of many terra-cotta votive objects.

BIBLIOG. P. Orsi, Aidone: Scoperte diverse a Serra Orlando, NSc, 1912, pp. 449–54; E. Sjöqvist and R. Stillwell, Excavations at Serra Orlando: Preliminary Report, AJA, LXI, 1957, pp. 151–59, LXII, 1958, pp. 155–64, LXIII, 1959, pp. 167–73; E. Sjöqvist, Excavations and Discoveries, FA, XII, 1957, 2851; K. Erim, Morgantina, AJA, LXII, 1958, pp. 79–90; R. Stillwell, Excavations 1958, FA, XIII, 1958, 2348; M. T. Piraino, Morgantina e Murgentina nella topografia dell'antica Sicilia Orientale, Kokalos, V, 1959, pp. 174–89.

Nicosia. Possibly occupying the site of the Siculan Herbita (Ἕρβιτα), Nicosia became important in the Middle Ages when populated by colonies of Lombards and Piedmontese under the Norman kings. Spread over the slopes of four rocky hills, with steep narrow streets and stairways, it is dominated by the ruins of a Norman castle. The Church of S. Maria Maggiore, erected in 1267 but rebuilt after the major landslide of 1757, has a baroque portal on its façade. From the original 14th-century structure of the Cathedral (S. Nicola), the façade, with an elaborately carved Gothic portal, and a small rose window have survived. On the left wall is a 15th-century portico with ogival arches. The massive Gothic bell tower (13th–14th cent.) has been restored. Churches dating from the 15th century are S. Michele and S. Benedetto. S. Vincenzo is decorated with frescoes by Willem Borremans (1777).

BIBLIOG. G. Paternò Castello, Nicosia, Sperlinga, Cerami, Troina, Adernò, Bergamo, 1907.

Noto (Νέητον; Lat., Neetum). There are two sites — Noto Antica, abandoned after the earthquake of 1693, and the new Noto built in the 18th century. The ancient town was Siculan (necropolises of the 9th–7th cent. B.C.); it later came under Syracusan domination; thereafter it became subject to Rome. Under the Arabs it was sufficiently important to lend its name to the Val di Noto, one of the three administrative districts of Sicily until 1817. From the medieval period there remain sections of the city walls, a square castle, and a fortified gate (Porta Reale).

The modern city, laid out on a series of terraces coursing the slopes of a hill, constitutes an excellent example of baroque urban planning, with spacious piazzas and stairways punctuating a rectilinear layout. The Cathedral (completed ca. 1770) has three façade portals, is flanked by two bell towers, and is approached by a broad, gentle staircase. The Palazzo Ducezio (1746; the present Municipio), designed by Vincenzo Sinatra, is surrounded with a classicizing portico. The Church of the Jesuit College (mid-18th cent.) is attributed to Rosario Gagliardi; S. Domenico and S. Chiara, with convex façades, are other 18th-century churches assigned to Gagliardi. The convent church of SS. Salvatore (1791–1801), by Antonio Mazza, has a neoclassic façade; the attached monastery dates from 1706. The former Dominican convent houses the communal museum.

In the region, also, are vestiges of a village (18th cent. B.C.), at Castelluccio, which has given its name to an important period of Sicilian protohistory. Here, ovenlike rock-cut tombs have yielded pottery, bronze, and bone burial goods (Syracuse, Mus. Archeol.). The Grotta dei Santi is a Byzantine troglodyte oratory, with traces of frescoes. Near Noto Marina are the remains of the Greek town of Heloros (wall and towers of the 5th century B.C., Hellenistic theater, and hypogeum). A columned structure, called "La Pizzuta," is probably a Hellenistic funerary heroön.

BIBLIOG. A. Salinas, Monumenti inediti di Lentini e di Noto, L'Arte, VI, 1903, pp. 159–64; G. Dunbabin, The Western Greeks, Oxford, 1948; G. Agnello, La Chiesa della Favorita presso Noto, BArte, XXXIV, 1949, pp. 307–10; N. Pisani, Noto barocca, Syracuse, 1950; L. Bernabò Brea, Sicily before the Greeks, London, 1957, passim; J. J. Ide, Noto: The Perfect Baroque City, J. Royal Inst. of Br. Arch., 3d ser., LXVI, 1959, pp. 11–15; F. Popelier, Noto: Ville baroque de Sicilie, GBA, LIX, 1962, pp. 81–92.

Palazzolo Acreide ("Ακραι; Lat., Acrae). In a strategic position on the watershed between the Anapo and Tellaro rivers, atop the Serra Palazzia above the modern town, Syracusan Greeks established Akrai as a colony in 664 B.C. (Siculan necropolis, remnants of Greek walls). The town flourished particularly under Hieron II (3d cent. B.C.; small semicircular theater, bouleuterion). The so-called "Templi Ferali," quarrylike chambers (latomies) carved into the face of the rock, have votive or funerary niches and inscriptions recalling the names and deeds of the dead. The notable complex of funerary carvings known as the "Santoni" mark a sanctuary of the Hellenistic cult of Cybele (Magna Mater).

After having declined under the Romans, the town flourished again in Byzantine times and was destroyed, presumably by the Arabs, in the 9th century. The present town arose in the 12th century, as Placeolum. Partly destroyed by the earthquake of 1693, it was rebuilt in the 18th century; thus its appearance is predominantly baroque. The Palazzo Iudica houses a collection of antiquities.

BIBLIOG. G. Agnello, La Chiesa dell'Annunziata a Palazzolo Acreide, Per l'arte sacra, IV, 4, 1927, pp. 5–11; J. Dunbabin, The Western Greeks, Oxford, 1948, passim; L. Bernabò Brea, Akrai, Catania, 1956; EAA, s.v. Acre.

Palermo (Πάνορμος; Lat., Panormus). A Carthaginian emporium, the city fell to the Romans in 254 B.C. It became a municipium and then a colony (20 B.C.). Excavations have brought to light sections of ancient walls, a vast Punic necropolis, and mosaics. Invaded by the barbarians and later subject to Byzantium (A.D. 535–831), Palermo fell to the Arabs in the 9th century and became the seat of an emir. Under the Arabs the city was particularly prosperous. In 1072 Palermo was conquered by the Normans. It was probably under Emperor Frederick II that Palermo achieved its greatest splendor.

One of the first Norman structures is the Church of S. Giovanni dei Lebbrosi (restored). If, as tradition would have it, the church was founded in 1072, it is the earliest; but scholars generally ascribe it to the early 12th century. S. Giovanni degli Eremiti (ca. 1132) incorporates parts of an Arabic building (probably a mosque). The church has five small red domes in Arabic style (I, PL. 413). The small cloister adjacent is of the 13th century. S. Maria dell'Ammiraglio (1143, restored), known as the "Martorana," has a campanile decorated with Arabic lava inlays. The central dome is supported by four columns and is decorated with Byzantine mosaics (II, PL. 458). The Palazzo Reale was originally an Arab fortress, which the Normans transformed into a fortified castle. Of the Norman building, there remain the 11th-century Torre Pisana and the chamber of Roger II, which is decorated with mosaics of secular subjects (PL. 426). The façade of the palace dates from the 16th–18th century. Incorporated in the palace is the Cappella Palatina (ca. 1130), which has a ceiling with Moorish stalactite vaults arranged in a honeycomb design (1143). The chapel preserves 12th-century Byzantine mosaics, as well as mosaics by local artists (PL. 173; II, PL. 457; IX, PL. 6). The pulpit, decorated with mosaics, and the sculptured paschal candlestick incorporate Byzantine and Moorish elements (PL. 173).

In Norman times an immense park extended southeast of the city. Palaces, kiosks, and fountains were erected there, for the most part by Arab artists in the service of William I and William II of Sicily. The palaces had high towers and usually included a large hall with exedrae and stucco and mosaic decoration. Among the edifices surviving are the Zisa (1154–60), which preserves a noteworthy mosaic frieze; the Cuba (1180); the Palazzo dell'Uscibene, probably of Arabic origin, with an adjacent Norman chapel; the Cuba Soprano, of which some arches survive; and the Cubula, a small kiosk surmounted by a red hemispherical dome. Moorish elements are also evident in the Castello della Favara, of which one wing and the chapel added by Roger II yet stand. The reigns of William I and William II (1154–89) were propitious for church building. S. Cataldo (ca. 1155), a three-aisled chapel, has three small domes. The Church of Sto Spirito (ca. 1178) has interlaced blind arcades on the exterior of the three apses. The north wall and transept are decorated with pointed arches. The Church of the Magione (SS. Trinità; 1150) preserves elements of the 12th-century cloister. The Cathedral (begun ca. 1170) was remodeled in the 14th–16th century and again from 1781, when the interior was redone and the dome by Ferdinando Fuga added. Only the two-aisled crypt and the apse date from the 12th century. The Cathedral preserves the royal tombs of the Normans and Hohenstaufens (12th–13th cent.).

The city declined under the Angevins but prospered again in the 14th century under the Aragonese. The Palazzo Chiaramonte

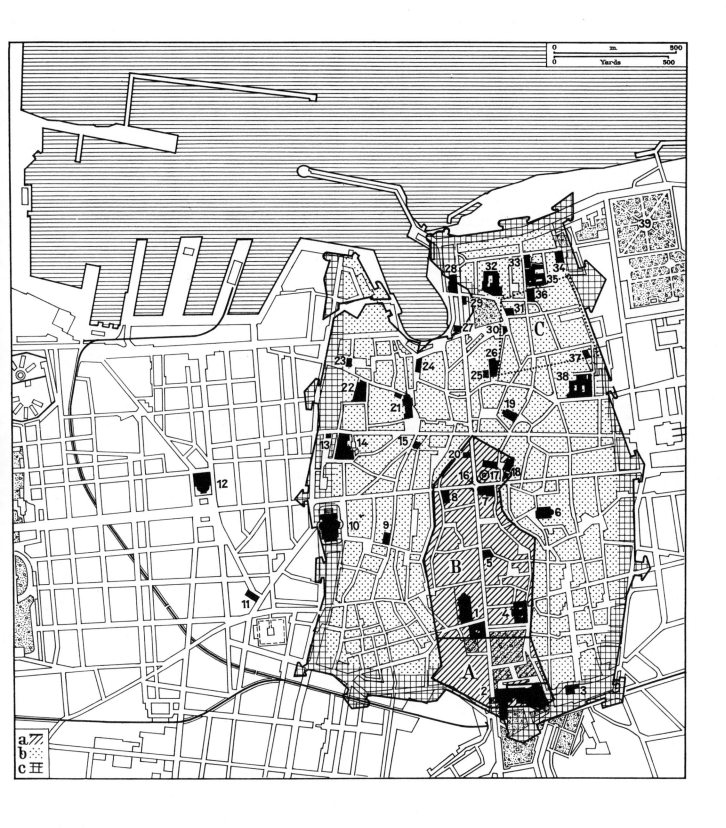

Palermo, plan. *Key:* (*a*) Area of the ancient city: (*A*) *palaia polis*; (*B*) *neapolis*; (*b*) area of the Arabo-Norman city, with citadel (*C*) known as Kalsa; (*c*) later expansion within the 16th-century fortified walls. Principal monuments: (1) Cathedral and Palazzo Arcivescovile; (2) Palazzo Reale and Cappella Palatina; (3) S. Giovanni degli Eremiti; (4) Palazzo Sclafani; (5) S. Salvatore; (6) Church of the Gesù (or Casa Professa); (7) S. Giuseppe dei Teatini; (8) Church of the Crociferi; (9) S. Agostino; (10) Teatro Massimo; (11) S. Francesco di Paola; (12) Politeama Garibaldi and Galleria d'Arte Moderna; (13) Museo Archeologico Nazionale; (14) Church of the Olivella and Oratory of S. Caterina d'Alessandria; (15) Palazzo Pietratagliata; (16) the "Quattro Canti"; (17) Piazza Pretoria and S. Caterina; (18) S. Cataldo and the "Martorana"; (19) S. Anna; (20) S. Matteo; (21) S. Domenico and Oratory of the Rosario; (22) S. Zita; (23) S. Giorgio dei Genovesi; (24) S. Maria La Nuova; (25) Oratory of S. Lorenzo; (26) S. Francesco d'Assisi; (27) S. Maria di Porto Salvo; (28) S. Maria della Catena; (29) S. Giovanni dei Napoletani; (30) S. Maria dei Miracoli; (31) Palazzo S. Cataldo; (32) Palazzo Chiaramonte; (33) Church of the Pietà; (34) S. Teresa; (35) Palazzo Abbatelli; (26) S. Maria degli Angeli; (37) Church of the Magione; (38) Palazzo Aiutamicristo; (39) Villa Giulia.

(known as Lo Steri; 1307) has a splendid painted wooden ceiling, the work of Cecco di Naro, Dareno da Palermo, and Simone da Corleone. Exemplary also is the Palazzo Sclafani (1330). Noteworthy 14th-century churches include S. Agostino (interior remodeled 17th cent.) and S. Francesco d'Assisi, both with Gothic portals and rose windows. The Gothic style in Palermo absorbed Catalan influences in the 15th century. The La Grua-Talamanca Chapel (1429) in the Church of S. Maria di Gesù reflects this development. The work of Matteo Carnevale (Matteo de Carnilivari) marks the transition from the Catalan Gothic to Renaissance style in the architecture of Palermo. He built the Palazzo Aiutamicristo (1490) and the Palazzo Abbatelli (ca. 1495), which are characterized by depressed arches and porticoed inner courtyards. Also attributed to Carnevale is the Church of S. Maria della Catena.

Renaissance buildings of the 16th century retained some traditional elements. Renaissance churches include S. Maria di Porto Salvo, after a design by Antonello Gaggini; the square-plan S. Maria dei Miracoli (1547), attributed to Fazio Gaggini; S. Giorgio dei Genovesi (1579-91); S. Giovanni dei Napoletani (1526-1617); S. Francesco di Paola (1594); and S. Maria degli Angeli (or the Gancia), with the adjacent monastery. The Palazzo Santa Ninfa, the Porta Nuova (1534), the Porta Felice (begun 1582), and the fountain in Piazza Pretoria (PL. 225) are all late Renaissance works. The Norman church of S. Salvatore was remodeled in Renaissance style (1528). In the 16th century new streets were opened, such as Via Maqueda and the present Corso Vittorio Emanuele, which at their intersection form the Piazza Vigliena, whose four corners (the "Quattro Canti") are adorned with statues and fountains (G. Lasso, 1609-20). The baroque architecture of Palermo, both secular and ecclesiastical, is elaborately ornamented (e.g., Palazzo Ugo and Palazzo Villafranca). The interiors of the churches of the period were adorned with marble engravings and inlays. Such churches include S. Caterina (1566-96), the Olivella (1598), the Gesù (or Casa Professa, 1564-1636), S. Giuseppe dei Teatini (1612), S. Matteo (1633), S. Domenico (rebuilt 1636), and the Pietà (1689). The baroque church of S. Teresa (1686-1706) was designed by Giacomo Amato, who may also have been responsible for the Church of the Crociferi (17th-18th cent.). The Church of S. Anna (1606-32) has a fine baroque façade (18th cent.). The 18th-century oratories of the Rosario, S. Zita (1688-1718), and S. Lorenzo (1698-1710) are decorated with stuccoes by Giacomo Serpotta (II, PL. 169). Also 18th-century are the Villa Giulia (or Flora, 1777), the Botanical Gardens (1789), and the Parco della Favorita (1799). Interesting neoclassic architecture of the second half of the 18th century is represented by the work of Venanzio Marvuglia, who built the Oratory of S. Filippo Neri (1769), the Villa Belmonte (1806), and the "Palazzina Cinese" in the Parco della Favorita (V, PL. 200). *Museums*: Museo Nazionale Archeologico (Selinunte finds, prehistoric material, pottery, sculpture, Etruscan objects); Galleria Nazionale della Sicilia (art from the Middle Ages through the 18th century); Museo Diocesano (Palazzo Arcivescovile); Galleria d'Arte Moderna (works by southern Italian artists); Museo Etnografico Giuseppe Pitré (Sicilian folk art); Cathedral treasury.

BIBLIOG. O. Scina, La topografia di Palermo e dei suoi contorni, Palermo, 1818; S. Morso, Descrizione di Palermo antica, Palermo, 1827; A. Springer, Die mittelalterliche Kunst in Palermo, Cologne, 1869; V. Di Giovanni, La topografia antica di Palermo dal secolo X al secolo XV, Palermo, 1884; L. F. Bolaffio, Guida di Palermo, Milan, 1891; M. G. Zimmermann, Palermo, Leipzig, 1905; G. M. Columba, Storia e topografia antica e medievale di Palermo, 2 vols., Palermo, 1910-11; G. B. Siragusa, Sulla topografia medievale palermitana, RendLinc, XXII, 1913, pp. 45-66; L. Biagi, Palermo, Bergamo, 1929; A. Cultrera, Il palazzo degli Emiri di Sicilia in Palermo, BArte, XXV, 1931-32, pp. 198-205; E. Gabrici and E. Levi, Le Storie di Palermo e le sue pitture, Milan, 1932; S. Caronia Roberti, Il Barocco in Palermo, Palermo, 1935; E. Caracciolo, La chiesa e il convento di Badia presso Palermo, Arch. storico per la Sicilia, II-III, 1936-37, pp. 109-46; F. Meli, Degli architetti del senato di Palermo, Arch. storico per la Sicilia, IV-V, 1938-39, pp. 305-407; L. Epifanio, La chiesa di San Giorgio dei Genovesi in Palermo, Palermo, 1939; M. Guiotto, La chiesa di San Filippo nel castello di Favora, Palladio, IV, 1940, pp. 209-22; I. Bovio Marconi, La cultura tipo conca d'oro della Sicilia nord-occidentale, MALinc, XL, 1944, cols. 1-170; M. O. Acanfora, Panormo punica, MemLinc, 8th ser., I, 1947, pp. 195-248; M. Guiotto, Il palazzo ex reale di Palermo, Palermo, 1947; L. Epifanio, Schemi compositivi dell'architettura sacra palermitana del '600 e '700, Palermo, 1950; U. Monneret de Villard, Il soffitto della Cappella Palatina, Rome, 1950; F. Rotolo, La basilica di San Francesco d'Assisi di Palermo, Palermo, 1952; A. Zonca, La Cattedrale di Palermo, Palermo, 1952; I. Bovio Marconi, Interpretazione dell'arte parietale dell'Addaura, BArte, XXXVIII, 1953, pp. 61-68; P. Lojacono, L'organismo costruttivo della Cuba alla luce degli ultimi scavi, Palladio, N.S., III, 1953, pp. 1-6; I. Bovio Marconi, Necropoli punica, FA, IX, 1954, 2940; I. Bovio Marconi, Nuovi graffiti preistorici nelle grotte del M. Pellegrino (Palermo), BPI, LXIV, 1954-55, pp. 57-72; V. Tusa, Rinvenuti di una tomba in Piazza Indipendenza, NSc, 8th ser., VIII, p. 136; W. Krönig, Considerazioni sulla Cappella Palatina di Palermo, Atti Conv. int. S. ruggeriani, Palermo, 1955, pp. 247-68; G. Falzone, Palermo, Palermo, 1956; F. Di Stefano, Sguardo su tre secoli di architettura palermitana, Atti VII Conv. naz. Storia Arch.,

Palermo, 1956, pp. 393-407; S. Di Matteo, Palermo nei secoli, Palermo, 1958; F. Meli, Matteo Carnelivari e l'architettura del '4-500 in Palermo, Rome, 1958; G. Giacomazzi, Il Palazzo che fu dei re, Palermo, 1959; F. Braun, Palermo und Monreale, Munich, 1960; L. Russo, La fontana di piazza Pretoria, Palermo, 1961; G. Spatrisano, Architettura del Cinquecento in Palermo, Palermo, 1961.

Piazza Armerina. This town was founded in the 12th century, after William I destroyed the nearby rebel town of Platia. The Church of S. Giovanni di Rodi (13th cent., restored) has a Gothic portal. The 14th-century castle is a rectangular structure with square corner towers. The Church of the Carmine (15th cent.) retains the original campanile, with Catalan Gothic windows, and a small 16th-century cloister. S. Pietro (restored) was built in the early 17th century. The former church of S. Anna has a curved baroque façade; S. Ignazio (1603) preserves fine stucco decoration. S. Rocco (1613) is baroque, as is the Palazzo Trigona della Floresta, which houses a collection of paintings. The Cathedral (1627), designed on a Latin-cross plan by Orazio Torriani, has a baroque portal with twisted columns (1719). The lower part of the campanile has Catalan Gothic windows (1420). The Museo Civico is in a former convent.

Near Piazza Armerina was the city of Sofiana (anc. Philosophiana), which flourished in Roman and Byzantine times. There are remains of houses and a basilica, as well as other material. A short distance from these ruins is the large Roman villa at Casale, variously ascribed to the late 3d or early 4th century of our era or to the second half of the 4th century. The most notable feature of the villa is its late-antique mosaic pavements, one of the finest extant groups of ancient mosaics (X, PL. 178).

BIBLIOG. G. V. Gentili, Grandiosa villa romana in contrada "Casale", NSc, 8th ser., IV, 1950, pp. 291-335; H. P. L'Orange, E un palazzo di Massimiano Erculeo che gli scavi di Piazza Armerina portano alla luce?, Symbolae Osloensis, XXIX, 1952, pp. 114-28; H. P. L'Orange, Aquileia e Piazza Armerina, S. aquileiesi, Aquileia, 1953, pp. 185-95; B. Pace, I mosaici di Piazza Armerina, Rome, 1955; G. V. Gentili, La villa imperiale di Piazza Armerina, Rome, 1956; P. Lojacono, La chiesa del Priorato a Piazza Armerina, Palladio, N.S., VII, 1957, pp. 133-37; N. Neuerburg, Some Considerations on the Architecture of the Imperial Villa at Piazza Armerina, Marsyas, VIII, 1957-58, pp. 22-29; G. V. Gentili, La villa erculea di Piazza Armerina, Rome, 1959.

Ragusa. The city comprises two zones, Ragusa Superiore (largely modern, on a checkerboard plan) and Ragusa Ibla (narrow irregular streets). The latter area, the old city, was probably the site of the Siculan Hybla Heraea. A Greek necropolis (6th cent. B.C.) has been disclosed in the area. Almost totally destroyed by the earthquake of 1693 and rebuilt in the 18th century, the present appearance is generally baroque. The Cathedral (1706-60) has a wide baroque façade and a tall campanile at one side. The Basilica of S. Giorgio (1738-75) was designed by Rosario Gagliardi. The façade, preceded by an imposing staircase, has three orders of columns; the neoclassic dome was completed by Carmelo Cutrano in 1820. Nineteenth-century structures include the neoclassic church of the Collegio di Maria Addolorata (1801) and the Bridge of the Cappuccini (1820). The Antiquarium houses archaeological material.

BIBLIOG. P. Orsi, Nuove esplorazioni nella necropoli di Hybla Heraea, NSc, 1899, pp. 402-18; L. Bernabò Brea, Catacomba cristiana detta la Grotta della Taddarita (o Tallarica), NSc, 8th ser., I, 1947, p. 255; A. Di Vita, Recenti scoperte archeologiche in provincia di Ragusa, Arch. storico siracusano, II, 1956, pp. 30-44; L. Bernabò Brea, Sicily before the Greeks, London, 1957, passim; A Di Vita, Breve rassegna degli scavi archeologici condotti in provincia di Ragusa nel quadriennio 1955-1959, BArte, XLIV, 1959, pp. 347-63.

Randazzo. The origins of Randazzo are remote; the city enjoyed its greatest prosperity under the Aragonese kings and thereafter declined. Built largely of black lava from Mount Etna, Randazzo preserves its medieval appearance in the narrow winding streets, parts of the city walls, houses with double-arched windows (divided with slim, often twisted columns), and doorways with pointed arches. A square tower of unplastered black lava is all that remains of the Aragonese castle. The Cathedral (S. Maria), built in the 13th century and subsequently remodeled, has three polygonal apses from the original structure and two lateral Catalan Gothic portals of the 15th century. The campanile on the façade dates from 1863. S. Nicolò (rebuilt 1585) retains a 13th-century transept, choir, and polygonal apse. The façade is of the 17th century and the campanile of the 18th. The church preserves a 14th-century baptismal font and sculpture and reliefs by Antonello and Giacomo Gaggini. S. Martino dates from the 13th-14th century but was subsequently remodeled; the façade was built in the 17th century, and the crenelated campanile is a 14th-century structure. The Palazzo Finocchiaro was built in 1509. The museum in the Palazzo Vagliasindi houses artifacts (5th-2d cent. B.C.) from the Greek necropolis at Sant'Anastasia.

BIBLIOG. E. Mauceri, Monumenti di Randazzo, L'Arte, IX, 1906, pp. 185–92; F. De Roberto, Randazzo e la Valle dell'Alcantara, Bergamo, 1909; V. Raciti Romeo, Randazzo: Origine e monumenti, Acireale, 1909; E. Maganuco, Cicli di affreschi medievali a Randazzo e Nunziata di Giarre, Catania, 1939; E. Maganuco, Opere d'arte della Sicilia inedite o malnote, Catania, 1944; G. Di Stefano, Monumenti della Sicilia normanna, Palermo, 1955.

Sant'Angelo Muxaro. This hilly site may be identified with the ancient fortress of Kamikos, which according to legend was built by Daidalos for the Sicanian king Kokalos. A Siculan necropolis, with large dome tombs (tholoi), has been excavated. Some of the goldwork found (evidencing Mycenaean influence) may date from the 2d millennium B.C., while most of the tomb furnishings date from the 8th–6th century B.C. Nearby are ruins of a medieval castle.

BIBLIOG. P. Orsi, La necropoli di S. Angelo Muxaro (Agrigento) e cosa essa ci dice di nuovo nella questione sicula, Atti Acc. di Palermo, XVII, 1932, pp. 271–84; B. Pace, Ori della reggia sicana di Camico, 'Εφημ, 1953–54, pp. 273–88; P. Griffo, Sull'identificazione di Camico con l'odierna S. Angelo Muxaro a nord-ovest di Agrigento, Arch. storico Sicilia orientale, 4th ser., VII, 1954, pp. 58–78; G. Caputo, Il fiume Halykos, via del Sale e centro della Sikania, La parola del passato, XII, 1957, pp. 439–41; G. Caputo, EAA, s.v. Kamikos, IV, 1961, pp. 307–08.

Sciacca. The town, noted for its hot springs, was known as Thermae Selinuntinae in Roman times. The city was given its present name by the Arabs, under whose domination Sciacca became an important city. It was fortified with walls three times, by Roger I, by Frederick II of Aragon, and by the Spanish viceroy De Vega (1550); sections of the last walls survive. The older parts of the town retain a medieval aspect. Romanesque structures include S. Nicolò (12th cent., restored), with a simple façade, blind arcading, and three apses; the Cathedral (12th cent., rebuilt 17th cent.), which preserves the three original semicircular apses and 16th-century sculpture by the Gagginis; and S. Maria delle Giummare (or Valverde; rebuilt 18th cent.), with a crenelated façade between two towers adorned with double-arched windows. A number of churches preserve Gothic portals, including S. Gerlando (14th cent.) and S. Margherita (1342). The latter has a 14th-century Gothic portal on the façade and a lateral portal by Domenico Gaggini (1468). The 14th-century Castello Luna is in ruins. The Steripinto, a 15th-century palace in Siculo-Catalan style, has a façade of rusticated ashlar. The Porta S. Salvatore (16th cent.), the chief gate of Sciacca, is adorned with platneresque carving.

BIBLIOG. G. Frosina Cannella, Di Sciacca e delle sue anticaglie, Il Buonarroti, XIII, 1879, pp. 3–14; I. Scaturro, Storia della città di Sciacca, 2 vols., Naples, 1924–26.

Segesta ('Έγεστα, Αΐγεστα, Σέγεστα). Founded by the Elymi, on Mount Barbaro, Segesta was early Hellenized. During the Punic Wars it sided with the Romans. It was devastated by the Vandals and the Saracens in the Middle Ages. There are remains of fortifications from the 5th century B.C., including towers and gates. The famous temple of Segesta (second half of 5th cent. B.C.) stands alone west of the city. Thirty-six columns and the trabeation survive intact (VII, PL. 54). The Hellenistic theater is notable.

BIBLIOG. E. Mauceri, De Segesta a Selinunte, Bergamo, 1903; P. Marconi, Esplorazione della scena del Teatro, NSc, 1929, pp. 295–318; P. Marconi, Scoperte varie, NSc, 1931, pp. 397–400; A. von Gerkan, Zu den Theatern von Segesten und Tyndaris, Festschrift Andreas Rumpf, Krefeld, 1952, pp. 82–92; A. Giuliano, Fuit apud Segestanos ex aere Dianae simulacrum, AC, V, 1953, pp. 48–54; V. Tusa, Rinvenimento di un frammento di scultura a rilievo, NSc, 8th ser., VIII, 1954, pp. 146–47; V. Tusa, Aspetto storico-archeologico di alcuni centri della Sicilia orientale, Kokalos, III, 1957, pp. 79–93; V. Tusa, La Sicilia Occidentale alla fine del V secolo ed agli inizi del IV secolo a.C., Arch. storico siciliano, 3d ser., IX, 1957–58, pp. 151–59.

Selinunte (Σελινοῦς; Lat., Selinus). Founded in the 7th century B.C. by colonists from Megara Hyblaea, this city represented the westernmost Greek penetration in the direction of the territory of the Carthaginians and the Elymi. The Greek Selinous reached the acme of its power in the 6th–5th century B.C.. In 250 B.C. the Carthaginians destroyed the city. East of the city are three temples (VII, PL. 53): Temple E (dedicated to Hera; first quarter of 5th cent.), Doric peripteral hexastyle; Temple F (end of 6th cent.); and the great Temple G (mid-6th cent.), Doric octostyle, almost 370 feet long. On the acropolis are Temple A and Temple O, both Doric (480 B.C.); Temple C, Doric hexastyle (first half of 6th cent.), once decorated with large polychrome terra cottas; Temple D (6th cent.); and the small Temple B, of the Hellenistic period. Along the principal roads are remains of dwellings of the Hellenistic period. Walls and massive earthworks also survive, including the fortifications of Hermocrates, protected by a moat with a semicircular tower. The

city proper was located to the north of the acropolis. Beyond the Modione River was the Sanctuary of Demeter Malophoros, originally a funerary divinity; remains include a rectangular enclosure and a temple with pronaos, cella, and adyton (preceded by two altars), but without columns. There is another enclosure with the small temple of Zeus Meilichios. Much of the material from Selinous is in the Museo Nazionale Archeologico in Palermo (VII, PLS. 58, 59, 68). Two inhumation necropolises excavated nearby have yielded proto-Corinthian and Corinthian artifacts. A cinerary necropolis, northwest of the sanctuary of Demeter Malophoros, has yielded pottery of the 5th century B.C..

BIBLIOG. E. Mauceri, Da Segesta a Selinunte, Bergamo, 1903; J. Hulot and G. Fougères, Selinunte, Paris, 1910; E. Gabrici, Il monumento della Malophoros a Selinunte, MALinc, XXXII, 1927, cols., 1–419; E. Gabrici, Acropoli di Selinunte: Scavi e topografia, MALinc, XXXIII, 1929, cols. 61–112; E. Gabrici, Per la storia dell'architettura dorica in Sicilia, MALinc, XXXV, 1933–35, cols. 137–250; C. Picard, Sur l'identification des temples de Sélinonte: Plateau de Marinelli (I Pileri), RA, 6th ser., VIII, 1936, pp. 12–45; A. Di Vita, L'elemento punico a Selinunte nel IV e nel III secolo a.C., AC, V, 1953, pp. 39–47; M. Santangelo, Selinunte, Rome, 1953; I. Bovio Marconi, Inconsistenza di una Selinunte romana, Kokalos, III, 1957, pp. 70–78; G. Schmiedt, Applicazioni della fotografia aerea e ricerche estensive di topografia antica in Sicilia, Kokalos, III, 1957, pp. 18–30; I. Bovio Marconi, Scavi a Selinunte, Urbanistica, XXVII, 1958, pp. 76–80.

Solunto (Σολοῦς; Lat., Solus, Soluntum). Although there was a Phoenician settlement in the area in the 8th century B.C., the city whose remains survive was built no earlier than the mid-4th century B.C. The site remained in Carthaginian hands until 254 B.C. Under Roman rule it became a civitas decumana. A portion of the walls remain, in addition to part of the city, disposed over a series of terraces on a regular plan of intersecting streets. The streets are paved with stone blocks and bricks. There are vestiges of an arcaded agora, a small Roman theater with an atrium but without peristyle, and numerous cisterns. The Antiquarium conserves local archaeological material.

BIBLIOG. A. Salinas, Solunto, Palermo, 1884; S. Ferri, Il Problema archeologico di Solunto, Le Arti, IV, 1941–42, pp. 250–58, G. Caputo, Teatro ellenistico in Solunto, Dioniso, XVII, 1954, pp. 183–84; V. Tusa, Aspetti storico-archeologici di alcuni centri della Sicilia occidentale, Kokalos, III, 1957, pp. 79–93, IV, 1958, pp. 151–62; V. Tusa, La Sicilia Occidentale alla fine del V secolo ed agli inizi del IV secolo a.C., Arch. storico siciliano, 3d ser., IX, 1957–58, pp. 151–59; E. Gabrici, Alla ricerca della Solunto di Tucidide, Kokalos, V, 1959, pp. 1–42.

Syracuse (Συρακούσαι; Lat., Siracusae; It., Siracusa). Situated on the island of Ortygia and on the mainland opposite the island, the city was founded in 734 B.C. by Corinthian colonists on the site of an earlier indigenous settlement. It became the most powerful city in the western Greek orbit, particularly after it came under the rule of Gelon in 485 B.C. The city enjoyed periods of immense prosperity and political power under Hieron I (478–466 B.C.), Dionysius the Elder (405–367 B.C.), Agathokles (316–289 B.C.), and Hieron II (ca. 275–215 B.C.). The conquest by the consul Marcus Claudius Marcellus (212 B.C.) marked the beginning of the city's decline. The city had expanded from the island of Ortygia (the site of the earliest settlement) to the mainland, and by the end of the 5th century B.C. the newer quarters of the city (Achradina, Neapolis, Tyche, and Epipolae) had been enclosed within the walls. On Ortygia is the Temple of Athena (Doric peripteral, hexastyle), built by Gelon after 480 B.C. and in the early Middle Ages adapted for a Christian church. The hexastyle Temple of Apollo (or Artemis), on Ortygia, is probably the oldest large Doric temple in Sicily (late 7th or early 6th cent. B.C.). In the Achradina quarter is the so-called "Roman Gymnasium," actually a theater of the 1st century of our era, with a quadriporticus and a small temple. In the Neapolis quarter is the Greek theater, which was built in the 5th century B.C., entirely rebuilt in the 3d century B.C., and again rebuilt by the Romans (VII, PL. 55). Also in the Neapolis quarter are the sanctuary of Apollo Temenites, the altar of Hieron II (almost 650 ft. long), and the penal stone quarries (or latomies). In the Epipolae quarter are the most important remains of the fortifications erected by Dionysius I, including the Euryelos castle with its towered keep and moats.

In the Middle Ages the city was limited to the island of Ortygia. A center of important Christian communities, it was an imperial seat during the Byzantine domination (A.D. 663–68). Notable among the catacombs are those of S. Lucia and S. Giovanni, with the adjacent crypt of S. Marziano (4th cent.). S. Giovanni, the first Cathedral, was rebuilt after the earthquake of 1693. S. Pietro (4th–5th cent.; remodeled 14th cent.) preserves fragments of its Byzantine frescoes. Little remains from the Byzantine, Arabic, and Norman periods. As noted above, in the 7th century the Temple of Athena was transformed into a Christian church, the present Cathedral. The cella of the Greek temple, pierced by arches, comprises the nave. The

baroque façade was built by Andrea Palma in 1728–54 and decorated with sculpture by Ignazio Marabitti (1757). Within are statues by Antonello Gaggini. The 11th-century church of S. Nicolò was built over the remains of a Roman piscina. S. Tommaso (1199) has a Gothic portal. S. Lucia (12th cent.) preserves its original apses, portal, and the lower part of the campanile; the rose window on the façade dates from the 14th century. The rest of the church is the result of 18th-century remodeling. Over the altar is the *Burial of St. Lucy* by Caravaggio (1609). Under the Hohenstaufen and Aragonese dynasties, there was notable building activity. The Castello Maniace (ca. 1239), built on a rectangular plan with cylindrical towers at the four corners, preserves a Gothic portal and a triple-arched window. Several palaces have façades adorned with Catalan Gothic windows; some also have Spanish-style courtyards with porticoes and exterior staircases. Notable among these palaces are the Bellomo (13th cent., restored), Montalto (1397), Lanza (15th cent.); and Gargallo (15th cent.) palaces. The Porta Marina (15th cent.) has a Catalan aedicula above the outer arch. After the major earthquake of 1693, the city was rebuilt with baroque structures, some having balconies with elaborate wrought-iron railings (e.g., the Palazzo Beneventano del Bosco). The Church of the Spirito Santo (1727) was designed by Pompeo Picherali; the huge church of the Collegio is a somewhat earlier structure (1635–87). Modern structures include the Fountain of Artemis by Moschetti and buildings by Francesco Fichera. *Museums*: The Museo Archeologico houses material from all of eastern Sicily; the Museo Nazionale di Palazzo Bellomo contains objects from the Byzantine period through the Renaissance; the Antiquarium di Castello Eurialo preserves artifacts found about the Euryelos Castle.

BIBLIOG. A. Holm and F. S. Cavallari, Topografia archeologica di Siracusa, 2 vols., Palermo, 1883–91; P. Orsi, L'Olympieion di Siracusa (Scavi del 1893 e 1902), MALinc, XIII, 1903, cols. 369–92; E. Mauceri, I Bellomo e la loro casa, BArte, V, 1911, pp. 183–96; Ministero Pubblica Istruzione, Elenco degli edifici monumentali; Provincia di Siracusa, Rome, 1917; G. E. Rizzo, Il teatro greco di Siracusa, Milan, 1923; G. Agnello, Siracusa medievale, Catania, 1927; E. Mauceri, Il castello Eurialo nella storia e nell'arte, Rome, 1928; G. Agnello, La basilica dei santi Giovanni e Marziano in Siracusa, BArte, 2d ser., IX, 1929, pp. 3–24; E. Mauceri, Siracusa e la Valle dell'Anapo, 2d ed., Bergamo, 1930; B. Pace, L'urbanistica di Siracusa antica, Syracuse, 1931; G. Agnello, Siracusa bizantina, Milan, 1932; C. Barreca, Le catacombe di Siracusa, 2d ed., Rome, 1934; G. Agnello, Architettura aragonese-catalana, in Siracusa, Rome, 1942; C. Anti, Il teatro antico di Siracusa, Syracuse, 1948; M. Guarducci, L'iscrizione dell'Apollonion di Siracusa, AC, I, 1949, pp. 4–10; G. Agnello, Architetti e scultori ignorati nella Cappella Torres a Siracusa, Arch. d'Italia, 2d ser., XVIII, 1951, pp. 143–61; G. Cultrera, L'Apollonion-Artemision di Ortigia in Siracusa, MALinc, XLI, 1951, cols., 701–860; G. V. Gentili, Scoperte nelle due nuove arterie stradali, NSc, 8th ser., V, 1951, pp. 261–334; G. Agnello, Il palazzo dei Vescovi a Siracusa, Palladio, N.S., II, 1952, pp. 65–70; G. Cultrera, Il "Temenos" delle "Thesmophoroi" e la cripta di S. Marziano, Atti I Cong. naz. Archeol. cristiana, Rome, 1952, pp. 143–48; M. Minniti, Siracusa: Guida . . . della città e dei suoi dintorni, Syracuse, 1954; S. Agnello, Il restauro del palazzo Bellomo a Siracusa, Palladio, N.S., V, 1955, pp. 167–75; J. Bérard, La colonisation grecque de l'Italie méridionale et de la Sicile dans l'antiquité, 2d ed., Paris, 1957, passim; G. and S. Agnello, Siracusa barocca, Caltanissetta, Rome, 1961.

Taormina (Ταυρομένιον; Lat. Tauromenium). Occupied by the Siculi from the 8th century B.C., the city was conquered by Dionysius the Elder in 392 B.C. In 358 B.C. the Greek city was founded by refugees from nearby Naxos. Under the Romans the city was a *civitas foederata*. For aligning with Pompey, it was reduced to the status of a colonia by Octavian, who drove out the inhabitants and established a military garrison. Remains include sections of the walls; the base of a temple (perhaps dedicated to Apollo), part of which was later occupied by a Roman odeum; the so-called "Naumachia" of the 2d–3d century of our era; a temple that may have been dedicated to Serapis; a large theater probably built in the 3d century B.C. and rebuilt in Roman imperial times; and a Roman cistern known as the "Piscina Mirabilis."

In A.D. 902 the city was destroyed by the Arabs, who rebuilt it under the name of Almoezia. In 1079 it was captured by the Normans. The city began to decline in the 15th century. Of the Byzantine period is the so-called "Saracen necropolis" near the Church of S. Pietro. From the Arab period perhaps is a tower incorporated in the Palazzo Corvaia. To the 13th century belong the walls (with the Torre dell'Orologio and the Porta Capena), the castle, and the Cathedral (much remodeled later). Important structures were built in the period from the end of the 14th century to the middle of the 15th. These edifices are Gothic, with some elements of Spanish origin (e.g., portals with depressed arches). Structures of this period include the Badia Vecchia, the Palazzo dei Duchi di S. Stefano, the Palazzo Ciampoli, and the former church of S. Agostino. Sixteenth-century buildings include the Casa Floresta and the former church of S. Maria del Piliere. In the former monastery of S. Domenico is a 16th-century cloister with a 17th-century well. The baroque Palazzo del Comune (1704) was rebuilt after World War II. The Antiquarium preserves local archaeological finds.

BIBLIOG. E. Mauceri, Taormina, Bergamo, 1907; G. Libertini, Il teatro di Taormina, Dioniso, III, 1930, pp. 111–21; A. Dillon, Interpretazioni di Taormina, Turin, 1948; M. Santangelo, Taormina e dintorni, Rome, 1950; G. Lugli, L'architettura in Sicilia nell'età ellenistica e romana, Atti VII Conv. naz. Storia Arch., Palermo, 1956, pp. 89–107. For Naxos: P. Rizzo, Naxos siceliota, Catania, 1894; J. Dunbabin, The Western Greeks, Oxford, 1948, passim; R. van Compernolle, La fondation de Naxos et les sources littéraires, B. Inst. historique belge de Rome, XXVI, 1950–51, pp. 163–85; G. V. Gentili, Scavi nell'area urbana, FA, IX, 1954, 2163, X, 1955, 2582; J. Bérard, La colonisation grecque de l'Italie méridionale et de la Sicile dans l'antiquité, 2d. ed., Paris, 1957, pp. 75–83.

Tindari (Τυνδαρίς; Lat. Tyndaris). The Greek city, founded by Dionysius the Elder in 396 B.C., passed to the Romans in 234 B.C. and was a colonia in the Augustan age. In the 1st century of our era a large part of the city disappeared into the sea after a landslide. There are remains of prehistoric necropolises, Greco-Roman walls, a Greek theater (3d–2d cent. B.C.) remodeled by the Romans for gladiatorial spectacles, the so-called "Basilica," and tabernae. Tindari was a diocese in the Early Christian period. There are remnants of Byzantine walls and fortifications. The city was destroyed by the Arabs. The Sanctuary of the Madonna, a modern edifice, preserves parts of a 16th-century structure. The Museo Civico, is the repository for material from local sites.

BIBLIOG. G. Parisi, Tyndaris, Messina, 1949; A. von Gerkan, Zu den Theatern von Segesta und Tyndaris, Festschrift Andreas Rumpf, Krefeld, 1952, pp. 82–92; M. A. Mezquiriz, Ceramica ibérica en Tyndaris (Sicilia), AEA, XXVI, 1953, pp. 156–61; F. Barreca, Tindari colonia dionigiana, RendLinc, 8th ser., XII, 1957, pp. 125–34; F. Barreca, Tindari dal 345 al 317 a. C., Kokalos, IV, 1958, pp. 145–50; F. Barreca, Precisazioni circa le mura greche di Tindari, RendLinc, 8th ser., XIV, 1959, pp. 105–13; N. Lamboglia, Una fabbricazione di ceramica megarica a Tindari e una terra sigillata siciliana?, AC, XI, 1959, pp. 87–91.

Trapani (Δρέπανον, Δρέπανα; Lat., Drepanum). Trapani is divided into two sectors: the older, with narrow twisting streets on the end of a peninsula; the modern, with broad streets on a checkerboard plan. An ancient Sicanian village, it became an important city in 260 B.C., when the Carthaginians expelled the population of Eryx and resettled some in Drepanon. It declined under the Romans. The greatest prosperity began under the Aragonese kings, who enlarged and walled the city. In the 14th, 15th, and 16th centuries Catalan Gothic architecture flourished. The Sanctuary of the Annunziata (1315–32; rebuilt 1760) preserves the original façade, with a Gothic portal and a rose window; the baroque campanile was erected in 1650. The sanctuary comprises several chapels. The rectangular Cappella dei Pescatori (Fishermen's Chapel; 15th cent.) has a Gothic arch and an octagonal frescoed dome. The rectangular Cappella dei Marinai (Mariners' Chapel; 16th cent.) has shell-shaped niches around the walls. The rectangular Chapel of the Madonna has a marble arch (decorated with reliefs by Antonello and Giacomo Gaggini; 1531–37), with a bronze gate by Giulio Musarra (1591). On the altar is a *Madonna and Child* attributed to Nino Pisano or his atelier (14th cent.). S. Domenico and S. Agostino, both 14th-century constructions, preserve their original rose windows; the latter church also has a Gothic portal. The 16th-century church of S. Maria del Gesù has a Gothic-Renaissance façade and a Gothic portal; within is a *Madonna of the Angels* in enameled terra cotta, by Andrea della Robbia. The Palazzo della Giudecca, formerly Casa Ciambra (16th cent.), has a tower of rusticated ashlar and Catalan Gothic windows. The Fountain of Saturn was built in the late 16th century. The baroque Cathedral (1635) has a portico (1740) on its façade. The Church of the Collegio has a baroque façade by Natale Masuccio (1636). The Palazzo del Municipio (1696) has a façade adorned with columns and balconies. The Convent of the Annunziata houses the Museo Pepoli, with archaeological material, sculpture, and paintings.

BIBLIOG. G. Polizzi, I monumenti d'antichità ed arte nella provincia di Trapani, Trapani, 1879; C. Trasselli, Sull'arte in Trapani nel '400, Trapani, 1948; G. Monaco, Notizie storiche della Basilica Santuario della Madonna di Trapani, Trapani, 1950; V. Scuderi, Opere d'arte inedite o poco note del Museo Pepoli di Trapani, La Giara, I, 1952, pp. 96–99; C. Trasselli, Notizie sull'arte a Trapani nei secoli XV e XVI, Arch. storico Sicilia orientale, 4th ser., VI, 1953, pp. 41–45; V. Scuderi, Contributo alla storia dell'architettura del Rinascimento in Trapani, Atti VII Conv. naz. Storia Arch., Palermo, 1956, pp. 289–302; E. Caracciolo, Elementi platereschi nell'architettura trapanese del '500, Atti V Conv. naz. Storia Arch. (1948), Florence, 1957, pp. 331–33.

* *

Illustrations: 44 figs. in text.

IVORY AND BONE CARVING. Because of their resistance to the elements and their workability, ivory and bone have been used in all civilizations for furnishings and utensils. But these very qualities have made them equally suitable as media for engraving and small statuettes (see SCULPTURE). The story of these works, the products of a highly specialized class of artisans — and at times presenting the most highly refined aspect of the art of a particular people — can be traced, in a fairly unitary view, across the boundaries of periods and cultures.

SUMMARY. Materials and techniques, with special reference to tribal art (col. 757). Objects of ivory and bone in the ancient world (col. 763). Ivory work in Byzantium and western Europe (col. 768). Ivory in the East (col. 772): *Islam; India; China and Japan.*

MATERIALS AND TECHNIQUES, WITH SPECIAL REFERENCE TO TRIBAL ART. Among the prehistoric remains found in caves in Europe and Asia are numerous objects made of ivory from the tusks of elephants and mammoths and of bone and horn from other animals. As early as Upper Paleolithic times, primitive man was trying his skill in techniques of carving these materials. The simplest examples represent human and animal figures scratched or incised on the surface of a previously scraped fragment of ivory or on a naturally flat piece of reindeer antler, but prehistoric man also knew how to make effective figures in relief and to model figurines in the round, both naturalistic and abstract, representing animals — probably connected in some way with hunting magic — and, more rarely, female figures (PL. 235; I, PL. 436; VII, PLS. 351, 352; see PREHISTORY). A few of the patterns seem to be completely nonobjective.

Figural carving was highly developed in Eastern agricultural societies, especially in Egypt. The two forms of ivory used — hippopotamus and elephant — have definite characteristics that make it fairly easy to distinguish between them. The tusks, or incisor teeth, of the elephant (which are the ivory of commerce) and those of its ancient cousin, the mammoth, have a pattern, easily visible in section or on any cut surface, of thin, curving lines arching outward from the center and intersecting at regular intervals, producing an effect that suggests the engine turning on the case of an old-fashioned gold watch. Also, the tusks of the elephant family, in growing, are built up layer by layer, in thin cones, and when the ivory is very old the component parts tend to separate into these conic sections; this tendency has been observed in the case of the ancient Egyptian carvings in elephant ivory on furniture from the royal tombs at Abydos.

In contrast, hippopotamus ivory does not have the pattern of crossing lines; its inner structure, seen under magnification, is very different. Moreover, it can be identified by certain characteristics which are peculiar to it and are connected with the form of the raw material. Hippopotamus ivory comes from the long, tusklike canines and lower incisors. The canine tooth of the hippopotamus is roughly triangular in section and has a marked curvature, the curve being far more extreme than that of any elephant tusk; this curving form is preserved in numerous ancient Egyptian carvings, notably in the so-called "magic knives"; made of longitudinal sections, these were engraved with figures of animals, real and mythical, for occult purposes. The incisor tooth of the hippopotamus is long and straight, round in section; a considerable portion is hollow, which does not leave much solid ivory for carving. Both canines and incisors are sharply beveled near the point by abrasion from contact with opposing teeth; they never have the rounded, tapering end seen in elephant and other tusks. When hippopotamus ivory is very old, as in objects recovered from ancient Egyptian tombs, it tends to develop longitudinal splits and occasional transverse cracks, so that it comes apart in long chunks or blocks; it does not disintegrate in cones as elephant ivory does.

Probably at first under Egyptian inspiration, the ancient Phoenicians developed an extensive ivory-carving industry, doubtless using ivory from the elephants of Syria and Asia Minor (until these finally became extinct), as well as African ivory imported through Egypt. Also, it would seem that ivory was already coming from India at the time of King Solomon (10th cent. B.C.). The Phoenicians, being a strongly commerce-minded people, worked extensively for export, sending their carved ivories into Palestine and Mesopotamia as well as to parts of the Mediterranean world as far away as Spain. Engrossed in mercantile endeavor, they seem to have had little appreciation of the intrinsic qualities of tone and texture that characterize ivory as a medium, and they painted, gilded, and even encrusted it, with glass, lapis lazuli, and other valued substances, until sometimes little of the original surface could be seen.

Both Phoenician and Cretan influences may have affected the style of the huge chryselephantine statues of the Olympian gods created by Phidias and other Greek masters of the 5th century B.C. In order to obtain ivory pieces of sufficient width for the giant faces the sculptors must have cut cylindrical sections from the central portion of a large elephant tusk; these were presumably sawed part way through, longitudinally, and then softened by soaking — perhaps in vinegar and almond oil — until they could be opened out flat. The pieces of worked ivory and beaten gold were probably fastened onto wooden cores, the ivory parts undoubtedly being further ornamented by staining or painting, just as the stone statues generally were in ancient Greece.

Egyptian, Phoenician, and Greek techniques of ivory carving must have ultimately reached Rome. Early ivories have been found in Etruscan tombs, but it has been suggested that these were probably importations — perhaps of Phoenician workmanship — rather than products of a local industry. Ivory was popular in Rome and was highly valued among the Romans: Pliny the Elder, writing in the 1st century of our era, reported that because of its scarcity, even the bones of elephants, cut into layers, were beginning to be used as a substitute; owing to the demand, an ample supply of ivory was by then "rarely obtained except from India" (*Naturalis historia,* viii, 4).

We also learn from Pliny that in his time the people of northern Europe were using the horns of aurochs for drinking — anticipating the later Norse drinking horns — and that the Romans had a fairly substantial industry devoted to the use of horn, applying it to many articles of luxury, sometimes dyeing it, sometimes painting it, sometimes engraving it (*ibid.,* xi, 45). Undoubtedly in this period antlers were still being carved by the German tribes.

With the coming of Christianity to the Roman world, ivory carvers turned to producing objects of worship, with Antioch and Alexandria as centers; Constantinople, which was founded in 330, soon took the lead in this field. Some of the ivory used in Constantinople was walrus ivory from northern Russia, brought south by viking traders. This kind of ivory was to be the type most used by the ivory carvers of northern and western Europe during the Middle Ages. It is readily differentiated from other types. The tusks, or canine teeth, of the walrus are much larger than hippopotamus tusks, often exceeding 2 ft. in length, and are generally oval in section. A newly taken tusk has a white outer layer, which gradually turns yellow with age and exposure; the fossil tusks that Alaskans call "beach ivory" are often beautifully mottled in shades of violet and brown. This outer layer, not very thick, is plain in section: it does not have the fine intersecting lines of elephant ivory. The inner core of the tusk consists of a secondary deposit of dentine, which fills the original pulp cavity as the tooth grows outward. This core substance, somewhat darker than the outside, looks as though it were composed of many small round crystals. When a thin section of a walrus tusk is examined against the light, the inner core is definitely translucent, in contrast to the outer section, which is opaque.

The Moslem countries of the Near East and North Africa acquired both the ivory-carving technique and walrus tusks from Byzantium long before the conquest of Constantinople by the Turks, and the art reached a high point of development, in Persia particularly. Elephant ivory was a great deal easier to come by, since it could be obtained either from central Africa or from India, but the Moslems valued the walrus ivory much more highly; they prized it especially for sword and

dagger hilts because it was reputed to have magical properties capable of stanching the flow of blood and healing wounds. Similarly, its fancied power to reveal the presence of poison led to its wide use for ornamental spoons. In order to show that the substance they were using was indeed walrus ivory, the carvers would deliberately expose the core, either by carving down to it or by splitting the tusk in half and mounting the two pieces outside to outside so that the inner surface was the one that showed. The latter technique is particularly in evidence in the hilts of the Turkish yataghans.

Through the influence of Islamic culture and through trade with Persia, walrus ivory was brought into northern India, where again it was highly valued for its supposed magical and medical properties. But long before this there had been in India a tradition of working elephant ivory. The quality of this work gradually declined during the Moghul period, but it revived to some extent in the 19th century. Even in the period of decline, however, ivory was carved into plaques for the decoration of walls, doors, and other woodwork. Indian ivory workers usually soften the ivory first by wrapping it in wet cloths for several days; in much of the actual carving the use of the bowdrill, to create fine lacelike effects, is apparent. To avoid waste, they often split a tusk in half and use both pieces. Thus one finds modern figures of elephants, horses, and other animals which are convex on one side and concave on the other.

In modern times much Indian ivory work has been done on the lathe rather than by hand carving, and some of it is artificially colored. Hyderabad is especially noted for its dyed and colored ivories in red and green. Since the tusks of the Indian elephants are smaller and coarser in texture than those of the African ones, there has been extensive importation of tusks from East Africa. In general, the Indian ivory is softer, whiter, and more opaque than the African and shows the characteristic pattern of arching lines less clearly.

In Ceylon, ivory was used even more extensively than it was in India, and the carving of ivory was considered a high art. The Singhalese used ivory from the native elephant, whose tusks are exceedingly small but provide ivory of fine quality and good texture. They made Buddha images, usually painted, and detailed statuettes of rulers and other mortals, always in the form of standing figures, as well as ornamental door plaques and such objects of utility as fancy combs and knife handles. Ivory turning was less esteemed but was highly developed. Horn was employed for sword handles, circular boxes, and combs.

The Burmese ivory carvers in Moulmein developed a distinctive style. Taking whole tusks or sections of tusk from the native elephant, they first carved the outside with intricate patterns of birds, animals, and flowers, following a tradition evolved by the carvers of teak. Then they carved out of the interior one or more figures — generally Buddha images — in such a way as to make them clearly visible through the latticelike openings in the outer tracery of plant and animal forms. The same technique was used in the making of ivory knife hilts and sword scabbards.

In Africa there have been two principal centers of fine native ivory carving — the Ivory Coast region, formerly centering in Benin, and the Congo region. Elephant ivory was of course readily accessible in both these areas, but, particularly along the Congo River, hippopotamus tusks as well were carved. A sensitive feeling for the innate form of the tusks distinguishes the products of both these regions. The carvers often worked whole tusks with carving in low relief, projecting from a surface which, since the depth of the carving was kept uniform, maintained the original roundness and the graceful lengthwise curve of the tusk.

In Benin, during the 19th century and earlier, giant tusks up to 5 ft. long were worked in horizontal bands of geometric designs representing interwoven cords or endless knots; others were even more elaborately decorated with rows of royal figures in full regalia. These huge tusks were originally mounted on fine bronze bases in the form of idealized portrait heads, and set up on the royal altars in the city of Benin. Legend has it that they were anointed with blood, and surviving examples in European and American museums usually have an unpleasantly rough surface said to result from the removal of the crusting caused by such libations. The actual carving is often extremely detailed — the rendering of crowns, necklaces, weapons, and so forth being fairly minute — but it is apt to be rather crude; in some cases the crudeness contributes to an impression of strength. More refined work was often done by the Benin ivory craftsmen on smaller objects such as trinket boxes (PL. 250) and bracelets (see GUINEAN CULTURES).

In the region of Loango, along the lower Congo, entire tusks of small elephants were often decorated with processions of figures in low relief, advancing upward toward the point of the tusk in a gradual spiral; the larger hippopotamus teeth were similarly decorated. Higher up the river and along its tributaries, in the former Belgian Congo, much ivory carving was done (PL. 250), especially by the Mangbetu people. This tribe seems to have used great quantities of ivory, pressing it into service for every possible utilitarian and decorative purpose. Even in the fashioning of a rather plain handle for a knife or a ceremonial cleaver, the great skill of the Mangbetu workers is apparent. Their art is obviously the product of a long tradition; unfortunately it is not possible to study the development of the tradition because, as a consequence of the tribal custom requiring that upon the death of a king his residence and all his property be destroyed, there are no ancient examples. A sign by which many of the Mangbetu ivory carvings can be quickly recognized is the depiction of figures with strangely tall, narrow heads; this reflects the tribal custom of binding infants' heads in order to make them long and pointed, a shape regarded as a mark of beauty. Such heads often form the finials of handles, and they are seen on the ends of tusks made into trumpets.

Turning to Indonesia, we find that Java and Sumatra, particularly, had a high tradition of ivory carving. This found its chief expression in the carving of handles for the traditional dagger, the kris. The most typical of these handles represent old Hindu guardian deities, such as Garuḍa, or rakshasa (Skr., rākṣasa, ogre). Unlike the Balinese images of these beings, which are fairly naturalistic, the Javanese examples are conventionalized almost beyond recognition. This is a reflection of the dominance of Islam, with its abhorrence of the image. The tusks of elephants native to Sumatra supplied some of the ivory for the Indonesian carvings, but far more valued, and hence more often found in the finer knives, is dugong ivory, that is, ivory from the tusks of the sea cow (Halicore dugong). This ivory comes principally from the female sea cow, surprising as this may seem, in view of the general opinion (even in scientific circles) that only the male dugong has tusks and that those of the female are abortive or rudimentary. The female dugong outwardly does not appear to bear tusks, but inside the skull are huge ones, fully twice as long as those of the male, much larger in diameter, and almost entirely solid (whereas the tusk of the male has a deep basal cavity and prominent surface scoring, both of which reduce the amount of usable ivory). This conclusion is based on an examination of dugong skulls, male and female, in the American Museum of Natural History, New York, and a study of Indonesian knives in the Lau Collection in the University Museum, Philadelphia.

The shape of the tusk of the dugong determined the form of the handles of the röntjongs of Sumatra, and this odd form was continued even in the case of hilts made of other materials, such as gold, precious wood, and buffalo horn. Dugong ivory is used throughout this area, as far as the Philippines. The Indonesians also seem to have been pioneers in the use of another out-of-the-ordinary substance — "hornbill ivory." This is a dense, carvable substance found in the solid casque of the helmeted hornbill (Rhinoplax vigil), growing above the upper mandible. Structurally speaking, hornbill ivory is neither ivory nor horn nor bone, yet it has locally been called "ivory" (gading or more precisely angang gading) for many centuries. It is softer than real ivory and very different in coloring. The hornbill "ivory" proper, contained within the casque, is a soft creamy yellow, becoming somewhat reddish at the top and sides, where it comes into contact with a brittle outer sheathing of vivid red.

The latter is more like true horn, and has an amusing resemblance to a huge lacquered toenail. It is the core material that has generally been used for fine carvings; once a highly valued commodity in East Asia, it was carved into unusual and costly ornaments in Java and in China (PL. 248). The outer sheathing, which was even more greatly prized, was sometimes removed and worked separately, especially by the Chinese. On the island of Borneo the whole casque, together with the attached upper mandible of the beak, was often carved into huge earrings for important chieftains. Such earrings are still being made and worn among the Kelabits of Sarawak.

China's long history of ivory carving — perhaps the longest — includes the working of walrus ivory, in addition to elephant tusks and mammoth ivory from Siberia. In northern China, walrus ivory was used at least as early as the T'ang dynasty; it was not regarded as a mere substitute for elephant ivory but was a far more expensive material, since it was popularly supposed to guard against poison. During the Ch'ing dynasty ivory carvers in many cases used only the crystalline core, frequently dyeing it a deep green with verdigris; the dyed form was much in demand for jewelry in the Manchu court. Hippopotamus tusks were commonly worked in Canton, especially the sharply curved canines, which were ideally suited for arched ornaments such as the popular elephant bridges and the elaborate scenic bridges that became a Cantonese specialty.

Another substance that the Chinese used for fine carvings and valued as an antidote to poison was rhinoceros horn. This dark-brown material is not true horn but comes from the concretion of hairlike fibers on the nose of the Asiatic (and African) rhinoceros which is known as its horn. Sometimes entire horns, up to 3 ft. long, were made into ornaments, but usually the horns were cut into sections and carved into ornamental cups. These cups, whose costliness made them available only to the very wealthy, generally show the fine ends of the fibers on the bottom of the inside or on the underside of the base, and their thinner edges, usually translucent, often have a golden glow.

Another of the major ivory-carving cultures, from the point of view of quantity produced, is the Eskimo, especially that of the peoples inhabiting northwestern Siberia and northern Alaska. These Eskimos seem to have inherited the tradition from an earlier people who belonged to the Old Bering Sea culture (V, PLS. 1–4, 8, 9). The Eskimo worked mainly in walrus ivory, to a lesser extent in bone and antler, using these substances for all manner of things, from hunting implements, sled runners, and boat fittings to household implements, personal ornaments, and toys. In a region where the only wood available was occasional drift logs found along the beaches, and where metal was nonexistent, there was no choice but to use these readily accessible animal materials (see ESKIMO CULTURES).

Although made primarily for utility, the Eskimo carvings are often works of art, with shapes dictated by function and with simple decorations consisting sometimes of small embossed figures or nucleated circles (PL. 249), sometimes of engraved pictures. Originally the figures of men and animals or complete hunting scenes engraved on walrus tusks and pieces of bone, sometimes on reindeer antlers, were probably drawn as records of events or for hunting magic. Later such carving was executed primarily as decoration of objects the Eskimos had made, such as tubular boxes for tobacco and snuff, and needlecases. There are also examples of engravings that appear to have been made just for the pleasure of the making.

The Eskimo people of northeastern Canada and Greenland also have for many centuries used walrus ivory for making tools and utensils, but they never seem to have achieved the artistic skill of their cousins in Alaska. In a few centers on the Labrador coast the work has been encouraged by the Grenfell Mission, and there are a few places in Greenland where artists have been trained under Danish guidance in recent years. The work cannot be said to be especially artistic, and it does not seem to be spontaneous, most of the designs having been suggested by Europeans as appropriate for European trade. And even in Alaska the Eskimo is making ornaments for the tourist trade, using power tools to fashion objects in fresh walrus ivory and the beautifully mottled "beach ivory."

The Indians of the northwest coast of North America far surpassed the Eskimo in their fine carvings in walrus tusk, the large bones of deer, and whalebone (PL. 249). Whalebone is easily recognized by its coarse texture; it has in exaggerated form the small pores and surface checking characteristic of animal bones in general. The Indians also made some remarkable horn spoons for ceremonial use, steaming and shaping the huge light-colored horns of the mountain sheep to make the dipper portion and adding exquisitely carved handles made from the much smaller black horns of mountain goats. The totem-pole style of decoration on the handles makes these easy to identify. Many other Indians of North America used large bones (particularly bones from the bison) and the antlers of deer and elk to make all manner of tools and implements.

Other primitive northern peoples, both in Europe and in Asia, made extensive use of reindeer antlers, as well as of walrus and mammoth tusks, for carving. Sometimes, as in the case of the modern ivory work of the Yakut, the Chukchi, and the Koryak tribes of eastern Siberia, the carving was solely a means of artistic expression; more commonly it was a means of decorating useful objects. The Lapps of northeastern Europe have long been noted for their pipes, spoons, knife handles, and sheaths of reindeer antler, decorated with primitive yet effective engravings, often depicting the reindeer itself. The Lapps, the Dolgans (PL. 249) of the Yenisei region in Siberia, and other peoples who domesticated the reindeer had a ready supply of this material from their own herds.

In medieval times and later, European carvers had at their command, brought from the far north, narwhal tusks as well as walrus ivory. However, these long, straight, spiraling tusks, known as "unicorn horns," were so greatly prized in the whole state that they were rarely cut up for carving. Among the exceptions were beakers and reliquaries, which turned to account the hollowness of the tusk, and swords, scepters, and bishops' staves. An elaborate use of narwhal ivory was made in the construction of the Danish coronation chair (ca. 1665) in Rosenborg Castle, Copenhagen.

Among the less valued substances — in addition to bone, which was much used as a substitute for ivory in the making of knife handles, combs, and ornamental panels, often beautifully engraved — was staghorn: from the antlers were made hilts and handles, particularly for rustic hunting swords and domestic carving sets. Ornamental carvings of staghorn are still made in forested regions such as the Austrian Tirol.

The 16th century brought great changes in European ivory work, with the widespread use of the lathe for turning small columns and splinters of ivory to be employed in the decoration of furniture. In the 17th century came an extensive use of ivory for inlays, and there was much demand for thin-sawed ivory panels; these were etched or engraved and set into wood, often in combination with tortoise shell, a type of decoration generally called Boulle work (or buhlwork) after André Charles Boulle, the 17th-century French cabinetmaker who devised this method of inlaying.

In more recent times, with the development of power-driven machinery, European ivory workers have had the advantage of circular power saws, which cut the tusks very quickly and neatly and with minimum wastage of the valuable material, and of strong power lathes for shaping. But perhaps the greatest change came with the introduction by Sir Hubert von Herkomer — better known as painter and academician — of the power drill for fine carving. These tools and the new commercial methods have spread all over the world, replacing the old hand craftsmanship. Wherever this has happened — in Bombay and Colombo, in Hong Kong and the ports of Japan, and even, as has been said, in Alaska — a decline in the artistic quality of the products is all too apparent.

Finally, there is a type of ivory that came into extensive use rather late, though perhaps known in ancient times — the ivory from whales' teeth. The 3d-century Roman writer Solinus mentions the use of teeth of a marine animal in the making of sword hilts in Ireland (*Polyhistor*, xxxv), and this reference could be to the teeth of sperm whales. Ivory from whale and porpoise teeth had probably provided material for

small objects in England and Scandinavia for many centuries, but the greatest use of whales' teeth for carving came during the 19th century. English and American whalemen used to while away their time on the long and tedious voyages by scrimshawing, as it was called — carving and engraving whales' teeth, as well as occasional walrus tusks and, more rarely, a hippopotamus tusk picked up in an African port. Some of these untrained engravers proved to be natural artists of great ability, and much of this scrimshaw work ranks high as folk art. Whale ivory can easily be recognized by the short, stubby shape of the whale teeth, their broadly rounded ends, and their conical base cavities; in section, it can be identified by the thick outer layer of cement and the interior of dentine, both marked with fine concentric lines.

The British and American whalemen also carried sperm whales' teeth and walrus tusks to Hawaii and other South Sea Islands, including Fiji and New Zealand, using them in barter with the native peoples, who carved these materials into necklaces and other ornaments in accordance with their own traditions. In all these places the indigenes had probably been doing some ivory work in whale and porpoise teeth before the Europeans came — this was certainly true in Hawaii — but the scope of the work was vastly extended with the increase in raw material resulting from trade with the whalemen.

Schuyler Van Rensselaer CAMMANN

Clear analogies with ivory and bone carving are offered by the art of wood carving. But since wood is an extremely perishable material, our knowledge of the art of wood carving is limited in the case of many old civilizations. This makes it difficult to follow a particular historical filiation in any thoroughgoing way. Moreover, wood is available in a wide range of dimensions, so that it lends itself to sculpture of large as well as small proportions (see SCULPTURE).

A closer affinity with ivory and bone — both because of the way it is worked and because of the smallness of the objects produced — is presented by amber. The term covers various fossil resins. Amber was much used in preclassical times from the Neolithic period on, especially in the Baltic countries (finds have made been in Danish, Swedish, and English tombs). But it was traded to the Mediterranean region (finds in Egypt, Syria, Mycenae, Italy) and thus came to be extensively worked in Islamic countries and in the Near East.

* *

OBJECTS OF IVORY AND BONE IN THE ANCIENT WORLD. In Egypt a large number of objects of practical and personal use, in both ivory and bone, have been found in the predynastic tombs — among them arrowheads, hooks, fishhooks, bodkins, spoons, pins, combs, bracelets, necklaces. The first crude female figures in ivory appear in the Aëneolithic period, represented by the Badari finds. Ivory combs with handles ending in stylized zoomorphic figures — gazelles, giraffes, ostriches, and waterfowl — are characteristic of the predynastic era. At the end of this period, the handles show these motifs finely incised in three or four registers on both faces. The scenes are well differentiated and begin to acquire greater fluency. New animals make their appearance, depicted with a lively naturalistic feeling: the elephant, the lion, the antelope, the hyena, the wild boar, the snake. Finally, on the handles of ivory knives of late predynastic times, the ornamental passes over into the historical and descriptive with the appearance of human beings in scenes of war and the chase. A typical example is the knife handle from Gebel el Arak in the Louvre (IV, PL. 321), one side of which shows a desert hunting scene, with the hero subduing two lions (a motif of Mesopotamian origin), the other, warriors fighting in single combat, and a naval battle. A number of ivory plaques used as labels for jars of balsamic oil placed in the tombs of kings of the 1st dynasty have incised on them summary depictions — to us not always clear — of notable events.

Ivory was much used as decoration for the funerary furniture of the 1st–3d dynasties (ca. 2850–2600). Ivory supports (in the form of bull's legs) for beds and gaming tables found in the royal cenotaphs of Abydos reveal a particularly refined technique and an attentive observation of anatomy. Playing pieces were often of ivory, too, generally in the form of resting lions, in accordance with a canon that lasted until the end of the Pharaonic period. There are statuettes of sovereigns carved in ivory, but these are exceptional. In an archaic example (1st dynasty) from Abydos in the British Museum the king is dressed in an ample fringed mantle, his hands are crossed on his breast, and he wears the crown of Upper Egypt (IV, PL. 326). A second example, marked by highly individualized features, represents Cheops (Khufu; 4th dynasty) seated on a cube-shaped throne (Cairo, Egyptian Mus.); this, although carved with much refinement, is not far removed in style from similar works in stone. The production of ivory statuettes of nude female figures continued into the Middle Kingdom, a period which also produced ivories bearing finely incised decorations of subjects having magical significance. Four ivory statuettes of dancing pygmies, which were made to move by a system of strings, are felicitous expressions of the grotesque (Cairo, Egyptian Mus., and Met. Mus., New York; PL. 236). The greater part of the ivory and bone objects of the New Kingdom and the Late Period were made for the dressing table and for related uses (PL. 236).

Sergio BOSTICCO

The ivories of the ancient Near East that have come down to us can be divided, chronologically and stylistically, into two main groups: the first, belonging to the latter part of the 2d millennium B.C., reveals a connection with the Mycenaean world; the second, from the early centuries of the succeeding millennium, shows greater homogeneity and can be ascribed, despite the different origins of the various motifs, to a well-defined school, clearly Phoenician.

The ivories of the 2d millennium, the most notable examples of which come from Megiddo, Ugarit, Minet el Beida, Byblos, and Alalakh, faithfully reflect the complex culture (and not only in its artistic aspect) of the eastern Mediterranean on the eve of the invasion of the Peoples of the Sea: Mycenaeans and Phoenicians elaborated on Egyptian models, but reciprocal and overlapping influences are so strong that it is not always possible to establish whether a particular work should be assigned to the one or to the other. A case in point is the magnificent piece found at Minet el Beida depicting the *Potnia Theron*, in which Cretan-Mycenaean influence is apparent in both style and subject (PL. 237). It is also clear that the inspiration of many motifs is Asian — for example, animals in combat and the griffin — or Egyptian — for example, the Sphinx. On the other hand, Hittite influence, chiefly noticeable in a few Syrian works, seems relatively slight. If a large plaque from Megiddo showing a number of divinities, monsters, and men, which has been regarded as unquestionably a Hittite work, is correctly attributed, then it must be admitted that Egyptian influence made its way as far as Anatolia, for this piece has Egyptian motifs. The ivories from Megiddo are particularly important: some of the examples depict rather complicated scenes — triumphs, banquets, chariot battles — rendered in a style that can be described as local, or Syrian, and this in turn makes it possible to speak of a Phoenician contribution to the art of this period, hitherto thought to have been inspired entirely by Mycenae.

The ivories of the 1st millennium (PL. 237; I, PL. 526) differ from those of the preceding period: with the decrease in Mycenaean influence, the Egyptian is felt more strongly, although confined to motifs such as sphinxes confronted by Horus as a boy and variations on the palmette. However, there is no lack — indeed there is a preponderance — of new motifs of Near Eastern origin such as the woman at the window, the lion hunt, musical scenes, and in general female figures. In the study of such ivories a historical fact must be borne in mind: the powerful Assyrian empire, in particular the Assyrian court, had become the best client of the Phoenician artisans, many of whom went to Assyria to work. Ivories originating in Syrian cities (Samaria, Damascus; actually the Damascene examples were found at Arslan Tash, where the Assyrian king Adadnirari III had taken them) are mostly of mediocre quality, while those

originating in Assyrian cities (Khorsabad, Nimrud) are in many cases real masterpieces. Particularly noteworthy are some examples found at Nimrud: A plaque of gilded ivory depicts a youth, seized in the jaws of a leopard, against a background of stylized flowers. In an example found in 1957 a young stag is shown, a motif which had not until then been seen in the art of western Asia. Naturally, not all the Assyrian ivories are on the same artistic plane. Nevertheless they are on the average definitely superior to those found in Syria. That we are dealing here with Phoenician and not native Assyrian artists is clear, for the ivory works of native Assyrian artists do not depart from the cold and stately style of the bas-reliefs of the royal palaces. We can therefore conclude that in this period too the best works — indeed the only great school in the field of ivory work — can be traced to Syria and credited to the Phoenicians.

<div align="right">Giovanni GARBINI</div>

Ivory carving spread from the Near East through the Mediterranean world (see MEDITERRANEAN PROTOHISTORY; CRETAN-MYCENAEAN ART). Crete has bequeathed to us, from prehistoric times on, remarkable ivory objects, among them a cylindrical seal with scorpions on one side and on the other a composition of spirals. From the palace at Knossos comes the statuette known as the *Acrobat* (IV, PL. 64), a figure famous for the agility of his jump, apparently over the bull — a theme also treated in frescoes in the palace. The physical structure is handled with minute care, even to details like the veins; the hair is encrusted with gold. In Palaikastro were found ivory figures of nude boys, magnificently rendered in the tenderness of their age, their gold loincloths tied at the side, evidently with cords, the loops for which can be seen. This combination of ivory and gold is found frequently in antiquity, among all peoples. On the social plane, it answered to the requirements of a wealthy ruling class of taste and refinement; on the esthetic plane, it satisfied the predilection for strongly contrasting monochrome tones.

But more ivories of this age have been found in tombs on the mainland — at Mycenae, Sparta, and Menidi — than in Crete, and for this reason they may more properly be classed as Mycenaean. At the same time it must be noted that it is a question whether these ivories do in fact belong to the Cretan-Mycenaean civilization. They reveal a strong Near Eastern influence and in some cases, for instance, the small helmeted male head from Mycenae (PL. 237), we are doubtless dealing with Syro-Phoenician works (see above). For the most part the ivories are utilitarian objects; typical is a small box with hunting scenes dating from the 12th–11th century B.C. These Mycenaean figured ivories are closely related to objects found on the island of Cyprus, especially at Enkomi (see CYPRIOTE ART, ANCIENT), among them a cup on which is depicted a reclining calf, and a mirror handle showing a man fighting against a winged beast. Indications of Aegean influence are not lacking in ivories of Samaria and Nimrud, such as the superb plaque with a cow suckling a calf, in the Louvre (I, PL. 526). A second group of ivories from Nimrud show, in turn, Cypriote influence. The numerous references in the *Iliad* and, more especially, in the *Odyssey* lend credence to the belief that the use of ivory was widespread in the Homeric age. The house of Menelaos at Sparta, we are told, had walls covered with gold, silver, electrum, bronze, and ivory; of the "gates of dreams" (*Odyssey*, xix, 563), one was of ivory and one of horn — which suggests a Near Eastern environment, a view supported by recent excavations.

The great tradition of Mediterranean ivories was continued in Greece in the archaic period (see ARCHAIC ART; I, PL. 341). In Athens there have come to light many statuettes, one a female figure, from the Geometric period (1000–750 B.C.) which already reveal the essential characteristics of Greek archaic art. Of the utmost importance was the discovery of two tiny sphinxes in a temple near Perachora. Daedalic works of the first quarter of the 6th century B.C., these are executed with extraordinary vigor and at the same time great delicacy. The Greek colonies on the coast of Asia Minor were prolific, and the production was of high quality. The sanctuary of Artemis at Ephesos is the place of origin of two statuettes, one of a female priestess, the other of a chief priest (and eunuch; *Megabyzos*) — Ionic

works of the 8th–7th century B.C. showing Near Eastern influence. In continental Greece many ivories of the same period were found in the ruins of the sanctuary of Artemis Orthia in Sparta, where they had been left as votive offerings; outstanding among them are a group of seated women and a man with long hair, from the 7th century B.C. The sanctuary of Apollo in Delphi is also rich in ivories; the hero subduing a lion (PL. 238) is one example. At this point there intervenes in all Greece a hiatus in the finds extending practically to the Hellenistic period, but to draw conclusions from this would be unwarranted. The Hellenistic ivories begin with a bust of Seilenos found at Sidon, which reveals great skill as well as great sensitivity. A little later in date is a statuette of extraordinarily fine workmanship representing a pygmy (PL. 239). Two statuettes of Athena fighting a giant, found in Paestum and belonging to the 2d century, are works of a certain amount of taste but of a decidedly regional character. A telamon in the Museo Nazionale, Naples, comes from Pompeii. A statuette of an actor from Rieti, in the Petit Palais, Paris, is striking for its polychromy. A fine statuette of Harpocrates from Szombathely in Hungary dates from Roman imperial times but in style is Syro-Hellenistic of the 2d century.

Among the ivory objects famous in ancient times but now lost is the Chest of Kypselos (tyrant of Corinth, 6th cent.), which was of cedar with inlaid decoration of ivory and bone, a technique which is found in the above-mentioned sphinxes of Perachora. It follows from this that even furniture was often inlaid with ivory. Practically speaking, there is no object for either use or ornament in which ivory cannot play a part. Particular interest attaches to chryselephantine work, which is well documented by the discoveries at Olympia and Delphi. However, not a single fragment has come down to us of the famous works of Phidias employing this technique, in the making of which he availed himself of the aid of Kolotes, whom we know to have been his collaborator in the creation of the *Zeus* of Olympia. The other widely renowned work of Phidias (q.v.) was the *Athena Parthenos* on the Acropolis of Athens. And we know that Skopas (q.v.) made an ivory statue, the famous *Hera* of Argos.

The taste for chryselephantine work merits a brief digression. The forerunners of this style were not so much the Cretan boys of Palaikastro as that kind of Assyrian work of which an example remains in the gold relief from Arslan Tash with incrustations of ebony. Ivory in ancient times was generally painted, following the practice that was customary for sculpture. In the great statues of Phidias, however, it is believed — though it must be granted that the sources are silent on this point — that the ivory parts were not painted. It is certain that combining gold and ivory as was done in the age of Phidias expressed a deeply-rooted chromatic sense responsive to pure and vivid color unmodified by chiaroscuro. The same taste is evident in vase painting and hence may be presumed in wall painting, which was innocent of *sfumatura* or any gradation of tones. Of large ivory sculpture there remain only a head and hand in Rome (Vat. Mus.) and a hand in the Cabinet de Médailles, Paris. Literary sources inform us that ivory was used for decorations in the interior of houses and also in decorating ceremonial vessels such, for example, as those which belonged to the Hellenistic king Ptolemy IV Philopator (Athenaeus, v, 541) and to the Syracusan tyrant Hieron II. The leaves of the door of the Temple of Athena in Syracuse were made of ivory, and according to Cicero, Verres had destroyed a very fine head of Medusa entwined with serpents which ornamented this door (*Verrine Orations*, iv, 124).

Etruria was as much subject to foreign influence in the art of ivory carving as in the other arts. Ivories of a more or less Oriental type were frequently imported in the 7th century B.C. (see ORIENTALIZING STYLE); those done locally were in the Syrian style. Of prime importance are ivories of the 6th century such as the decorative furniture and casket panels of Ionic-Etruscan style, the finest of which are perhaps those of Orvieto (PL. 238) and of Tarquinia. The little calf-bearer relief of Ionic style from the neighborhood of Perugia (PL. 238) should also be mentioned.

As was pointed out earlier, ivory was well known and widely used in Rome. It decorated the richest furniture and must have been very expensive at least until the beginning of the

Empire, for Horace speaks of it as a luxury in which he takes pride in not indulging himself. According to Propertius (ii, 31), the Temple of Apollo erected on the Palatine by Augustus had doors of ivory depicting the flight of the Celts from Delphi and the slaughter of the children of Niobe. Bone was also very widely used in Rome, particularly for small objects such as dolls, dice, pyxides, styluses. Finer pieces, such as the portrait bust from the second half of the 2d century of our era in the Vatican Library, were rare; how much the scarcity of finds is a matter of lessening interest in ivory and how much pure chance, it is hard to say. It is not until the 4th century, when there was a great revival of ivory work, that documentation becomes possible. It must be borne in mind, however, that these ivories — whether Christian in character or pagan but inherited by the Church or by monasteries — have been preserved because they were used as ornaments for furnishings or for sacred books. Certain it is that in the 4th century the art of ivory working reached a level comparable to that attained in Greece and in the the great preclassical civilizations of the Mediterranean world.

Gianguido BELLONI

The representative works of the Asiatic prehistoric cultures, for example, the Isakovo (3500–2500 B.C.) and the Serovo (middle of the 3d millennium), are carved in bone, horn, and ivory. Sufficient to remind us of this is the impressive head of a bear from Bratsk, which epitomizes in its realism a sculptural trend that was to find notable echoes in surrounding regions (see ASIATIC PROTOHISTORY).

The prevalence of metals, particularly of bronze, did not preclude production in ivory and bone; even in the period of the apogee of the so-called "art of the steppes," admirable works in these materials exist side by side with the considerably greater metallic output. It is chiefly the Scythian works — products of a culture linking Greek and nomad — that are of interest. The subjects, like those of the works in metal, are inspired by animals and conform to that highly original style which adds to a savage vigor a frequently virtuosic decorative sense. A spoon with bear's-head handle in Moscow, found at Chkalov and datable to the 6th–5th century B.C., a lion's head in fullface, and finally some heads of wild asses coming from the steppes of western Siberia but probably of Scythian inspiration indicate the technical ability and originality of Scythian ivory workers.

It is not beyond the bounds of possibility that accurate knowledge of the developed technique of ivory working reached India from the west — from Greece, Asia Minor, Scythia, and Persia. But this is only a hypothesis. Certainly there were typical local products: proof of this is the object known in Tamil as *kammal*, a small round instrument made in series (with increasing diameters) from the vertebrae of fish and probably designed to enlarge the ear-lobe perforation gradually through successive use. The *kammal* proper of southern India is related to various objects made from the bones of cows, the uses of which remain unknown. The excavations of Arikamedu (Virampatnam) have brought to light a great number of these objects, together with others of lesser importance — some of bone, some of ivory — which make it possible to follow the development of methods of workmanship. J. M. Casal, the discoverer, comments that he was astonished to find both types of objects characteristic of Virampatnam in excavations in the House of the Griffins on the Palatine, Rome, dating from republican times. We have here evidence of commercial exchanges, probably indirect, between southern Indian and Rome going back to the 2d century of our era. The *kammal* is thus important not only as an example of material and technique but also as a historical document attesting to exchanges between India and the classical world in a very early period.

As to Indian production proper, even though the techniques of ivory work were derived from the Asian and the classical West, and notwithstanding the paucity of documentation, there is no doubt that the art attained a high level of excellence. The discovery of an ivory statuette in Pompeii shows that objects of this kind found their way to the West and were valued in the markets of the classical world. The fact that the ivories of Begram, in Afghanistan, worked in a different technique and intended for different purposes, are unquestionably Indian in style (in part resembling those of Mathura, in part those of Amaravati) demonstrates that the Indian schools had, in this specific art form, attained such prestige that their works were well received even in regions themselves in contact with both the classical West and the Far East. A fuller account of the ivories of Begram is included in the section on India (see below).

Mario BUSSAGLI

IVORY WORK IN BYZANTIUM AND WESTERN EUROPE. The production of ivory increased in the West in the period that saw the end of the ancient world (PL. 240). Late-antique art and Byzantine art, with their Christian inspiration, seem to represent, rather than a point of arrival, a point of departure for the medieval world. As in every civilization and period in which the esthetic impulse finds its best expression in the minor arts, in these times ivories tend to assume, both in subject matter and in fineness of technique, the function performed in other periods by painting and full-scale sculpture.

From the 4th to the 6th century there were many centers of ivory production, and the assignment of single works, which must depend on iconographical and stylistic analysis, is still in many cases debated.

At first ivories with secular subjects predominated, but gradually these were replaced by works with religious themes. Among the former, particular importance attaches — because of their certain dating and high artistic quality — to the consular diptychs. These were sent out by the consuls as notification of their new dignity and as inaugural gifts; the outside was decorated with a portrait of the magistrate or sometimes a representation of circus games, and the inside was used for writing. Later the decoration of the outside was a framed medallion. The Roman series extends from the year 406 (Probus; Volbach, no. 1) to the year 530 (Orestes; Volbach, no. 31) and the Constantinopolitan series from the year 506 (Aureobindus; Volbach, nos. 8–14) to the year 540 (Justin; Volbach, no. 33). On some diptychs the figure of an emperor is represented, generally identifiable only with difficulty. Others relate to minor functionaries (Probianus; Volbach, no. 62) or allude to events allying two families (e.g., the Nicomachi and the Symmachi; I, PL. 301; Volbach, no. 55) or depict imperial apotheoses, hunting scenes, mythological episodes, the poet and his muse, and other themes. Besides the usual diptychs there are some with five plaques on each valve intended for the binding of manuscripts (the Barberini ivory in the Louvre; Volbach, no. 48). Cylindrical boxes carved out of the base of the tusk and intended as incense containers were also decorated with mythological scenes. Bone was frequently employed, often with sgraffito, for lesser objects such as combs, medallions, tesserae, handles.

Among ivories with sacred themes there were only a few diptychs (Adam and St. Paul, Florence, Mus. Naz.); these were disposed in several registers, with or without division. More numerous were the quinquepartite ivories used as bindings for codices (Milan, Ravenna, Paris, Echmiadzin). Of the many caskets, some were certainly intended from the beginning as reliquaries; there are some examples preserved intact (Brescia, PL. 240; Pola), others only in part (London). It is not clear whether certain detached reliefs with episodes from the life of Christ (Munich) and with Christ and the Madonna between saints were parts of caskets, bindings, and the like, or were independent devotional objects. Cylindrical pyxides with representations of sacred subjects (Berlin; Trier; Bologna; Florence; London; Pesaro, PL. 240), originally used for incense, then for the Eucharist, were made in considerable number. On the other hand, liturgical pectorals, medallions, and buckles for belts were few. Panels of ivory were widely used in episcopal thrones: a surviving example is the "throne of Maximian" in Ravenna (V, PLS. 340, 432); those once known in Trier and Grado are lost.

Byzantine production of works of art in ivory enjoyed a vigorous revival after the iconoclastic period, especially from the 9th to the 11th century, with emphasis on caskets decorated

with representations of mythological subjects. Some 50 complete examples are extant (Paris, London, Rome, Florence); they are of parallelepiped form with covers either flat or in the shape of a truncated pyramid (I, PL. 303; II, PL. 481). There are a few examples with Christian themes. Certain single leaves of ivory are of an official character (Coronation of Romanus II, Louvre); those of a religious character served as miniature portable altars (the Forty Martyrs ivory, Berlin, Staat. Mus.; Death of Mary, Munich; Last Judgment, London, Vict. and Alb.). There are also triptychs (Louvre, Vat. Mus.), sometimes arched, as in the case of the Virgin in Utrecht. Triptychs with scenes in several registers are less numerous. Still other reliefs, such as that with St. John and other saints enclosed by roundels in the Victoria and Albert Museum, served as book covers. Among the statuettes — a rare type — the Virgin in the Victoria and Albert Museum and the group in the Dumbarton Oaks Collection, Washington, D.C., dating perhaps from the 12th century, should be cited. The principal center of production was Constantinople; there were others, but they are rather difficult to identify with certainty.

When it comes to the rare pieces of Western provenance antedating the Carolingian period, we should take note of the quinquepartite binding of St. Lupicinus in Paris (Bib. Nat.), not forgetting the controversial hypothesis as to its Merovingian origin; of the Irish binding at Stonyhurst College, Lancashire, England, and of the Franks Casket with panels in whalebone in the British Museum (I, PL. 287). Carolingian ivory carvers (see CAROLINGIAN PERIOD) took up again the Early Christian types: diptychs in two or three registers (London, Milan), bindings of the quinquepartite type (London, Vatican), single reliefs for devotional use (Brussels, Paris, Munich, etc.). The centers of production — determined on the basis of stylistic similarity to groups of manuscripts — appear to have been Lorsch for the Ada Group (quinquepartite ivories in London, the Vatican); Reims for the Liuthard Group (Crucifixion in Munich; II, PL. 284); Metz for another important group (Crucifixion in London, diptych in Würzburg). There were other workshops in France and the Rhineland; the workshop of Saint-Gallen appears to have been connected later with these — as does a monk named Tuotilo (cover of Cod. 53, Saint-Gallen, Stiftsbib.).

In the Ottonian period (q.v.), while the French ivory centers declined those of the Moselle and Rhine regions continued to flourish; various workshops, not all of which can be satisfactorily localized (Crucifixion on cover of the Codex Aureus Epternacensis, Nürnberg, Germanisches National-Mus.) exerted an influence that reached the Netherlands and Liège. The workshop of Cologne began to take the lead, and it remained actively in operation throughout the Romanesque period. Other flourishing workshops were those of Reichenau (panels in Munich) and Bamberg (cover of the Würzburg Gospels). Besides bookbindings, liturgical combs, small buckets, liturgical knives, panels with imperial coronations and scenes of devotion, there were produced portable altars such as those of Melk and altarpieces such as that of Henry II for Magdeburg (now dismembered). Italian production (linked with the transalpine ivory centers) was rather slight between the 7th and the 10th century (pax of Duke Orso, Cividale, Mus. Arch. Naz.; binding of Berengar I, Monza, Cathedral Treas.; bucket of Gotifredo, Milan Cathedral). The diptych from Rambona (XI, PL. 326) is attributed to a Roman workshop.

In the Romanesque period other categories of objects in ivory made their appearance, among them tau crosses, crosiers, carved disks to serve as pawns, and other chess pieces (see ROMANESQUE ART). Ivory is also found used in reliquaries of complicated architectural form such as were produced by the school of Cologne (Eltenberg Reliquary in London; VI, PL. 261) and in caskets in the form of churches (Stuttgart). To the ever active German workshops, those of southern France, the Low Countries, and England were now added, and there was considerable use of bone at this time. In Italy there was a short-lived workshop in the north which either was in touch with transalpine workshops or was influenced by monumental sculpture (covers at Nonantola and Modena). But more im-

portant and more independent was the Salernitan workshop to the south, to which the altarpiece of Salerno Cathedral may be attributed. Among other works credited to this atelier are several tesserae from larger works since dismembered; the tesserae formerly part of the episcopal throne in Grado, on the Adriatic coast; the coffer in Farfa, in central Italy; and perhaps the coffer in Bagnoregio, near Orvieto, which is somewhat Arab in 'manner.

In the Gothic period (see GOTHIC ART) the French workshops, especially those in the general region of Paris, became preeminent, and their influence on the others renders classification difficult. Among sacred subjects the single statuette was considerably developed [Virgin from the Ste-Chapelle in the Louvre; Virgin and Child in Villeneuve-lès-Avignon (PL. 243)], as was the group [Annunciation, Deposition (PL. 243), and Coronation in the Louvre]. Triptychs have single figures or groups in high relief in the center, the subjects in the wings being arranged in various registers, often in an architectural frame (PL. 245). Secular works now included looking-glass mounts (PL. 244) and jewel boxes ornamented with depictions of episodes taken from romances, especially the Breton cycle.

In this period the German and English production of ivory carving slackened somewhat as compared with the enormous increase in France. Still more markedly in decline was Italian production: examples are few and of little value, and there is not always agreement about them. An exception is the Madonna and Child of Giovanni Pisano (VI, PL. 211), which reaffirms the relation between ivory and monumental sculpture.

Guglielmo MATTHIAE

In the 15th century, ivory work may be said to have entered a waning phase, although for the first few decades the late Gothic style maintained itself where there was still medieval resistance — as there was in Germany, Flanders, and France — to the new ideas. In Italy the workshop of Baldassare degli Embriachi was, from the late Trecento on, a particularly active center of ivory and bone working (in Florence and then in Venice); among the patrons were the Viscontis of Milan and the Dukes of Burgundy and Berry. In 1431 the sons of Baldassare, Giovanni and Antonio, inherited from their father a supply of both worked and unworked material, and they continued the atelier; besides small objects — caskets (PL. 242), diptychs, triptychs, and portable altars — the Embriachis produced monumental works such as the altarpiece of the Certosa of Pavia (PL. 245). Typical of their style was the fitting of reliefs into wooden frames decorated with certosina (i.e., minute geometric inlays of elephant ivory, bone, hippopotamus ivory, mother-of-pearl, and precious woods), a technique that had been used in the Trecento by the Carthusians. Through the Embriachis this technique found its way into the furniture made by the Lombard-Venetian workshops.

During the Renaissance, coincidentally with the slump in the ivory trade resulting from Turkish seizure of routes of communication to the East, there was a sharp decline in the quality of ivory carving in Italy: it was reduced to the level of artisanship by efforts to achieve effects and techniques of monumental sculpture little suited to the material, and to update it by employing the art of perspective. In the late 15th century some important works were still being produced [Florentine triptych in the Louvre, formerly attributed to Benedetto da Maiano; Mantegnesque reliquary in the Cathedral of Graz, Austria; Triumph of Love (PL. 246)]. In the 16th century the imitation of full-scale sculpture became rather pedestrian: imitations of Michelangelo, especially a then well-known crucifix type, abounded. In addition to small sculptures (sometimes, especially in northern Italy, of considerable excellence), the ivory workers made objects of everyday use carved and engraved with scenes of various sorts (hunting horns and powder horns, rosaries and frames, knife handles, chess pieces; PL. 244). Ivory began to be used again in intarsia, along with mother-of-pearl, for serving trays, display saddles, and furniture. In this field the tradition was to continue into baroque times in the typical Boulle work.

In the 16th century — the Portuguese having found a route to the East round the Cape of Good Hope and having established colonies in Africa and Asia — a new center of export arose, namely Goa, in India. Indian ivory was carved either in Goa or in Portugal and Spain (religious subjects especially were treated: crucifixes, representations of the Good Shepherd, rosaries, etc.).

The ductile quality of ivory fitted in with the baroque tendency toward virtuosity, and this, together with a new influx of the material resulting from the increased Dutch traffic in it, led to a revival of the art of ivory carving, especially in Flanders, Germany, and Austria (PL. 247). Some of the works produced, for example, the small horse in a net by the Sicilian Filippo Planzone (1604–30), in the Museo degli Argenti in Florence, and works in the Chinese taste by Johann Eisenberg (18th cent.) — a sphere pierced with four large holes, within which are smaller concentric spheres — are frankly exercises in ingenuity. But the greater number of ivories imitate monumental sculpture, especially in the 17th century, presenting in miniature not only the traditional crucifixes and Madonnas with saints, but also secular scenes, bacchanals, battles, landscapes in low relief, and groups of several figures in full round. Many ivory carvers treated themes from Roman history and from mythology in the picturesque style of Bernini and Rubens, often following prints from paintings. Among these artists were Gérard van Opstal (ca. 1597–1668), active in Paris, whose works include five bas-reliefs of Bacchic scenes and cupids in the Louvre, and Lucas Faydherbe (1617–97), whose *Dance of the Putti* in the Prado is one of his many decidedly Rubensian works. To the Flemish school belongs Francis van Bossuit (1635–92), who took Bernini as his model. The vitality of the Flemish school is demonstrated by the influence it exercised in Germany. In this period new items were added to the traditional repertory of ivory carvers: beer mugs, vases and centerpieces, frames for looking glasses, plates, furniture decoration, candelabra, scientific instruments, and others.

As we draw nearer to the 18th century and to the rococo taste, which in Germany especially struck a note of fantasy and caprice, ivory came to be used for all kinds of bibelots, from objects intended to be displayed in curio cabinets or behind glass in drawing-room china cupboards to accessories of costume. An extensive production of small portraits either in full round or in the form of medallions (a type known in antiquity) made its appearance, and ivory once more came into use for snuffboxes, handles for fans and cutlery, toilet articles, and the like. Combined with ebony — according to the method initiated by Simon Troger (ca. 1693–1786), who composed small groups (PL. 247) — and with various metals, especially silver, ivory and bone retained in their various applications a generally aristocratic character; indeed production was centered in the various princely courts. In Bavaria, at the court of Maximilian I (1597–1651), Christoph Angermair executed large chests — truly pieces of furniture — made entirely of ivory. In Augsburg, Georg Petel (VI, PL. 144) and Ehregott Bernhard Bendel (1668–1736) were active. Nürnberg saw two centuries of activity by the various members of the Zick family. The microscopically detailed and virtuosic carvings and the reproductions — sometimes macabre — of anatomical forms, all characteristic of the school of Nürnberg, can be skipped over, but mention should be made of such outstanding artists of the school as Leonhard Kern (1585/88–1662), Benedikt Herz (1594–1635), and, most particularly, Balthasar Stockamer (d. ca. 1700), who, employed by Cosimo III de' Medici, executed on the designs of Pietro da Cortona the *Hercules* and the *Hydra* in the Museo Nazionale, Florence. Finally, an admirable portraitist active from 1750 to the beginning of the 19th century was Michael Hammer.

The city of Ulm was known for a school of ivory workers founded in the second half of the 17th century by David Heschler and continued by Johann Michael Maucher (active in Würzburg from 1693 on), by the brothers Michael Knoll (1740–1800) and Wilhelm Benoni Knoll (d. 1764). In Dresden, Melchior Barthel (1627–72) was active, as was that Balthasar Permoser (1651–1732) who as a young man had been in Florence and worked for Cosimo III de' Medici, forming his style after Bernini and

Pietro da Cortona. Members of the Lücke family were active at the Saxon court and in Brunswick.

Ranked among the finest ivory workers are Jacob Dobbermann, who was active in the first half of the 18th century (PL. 247), and Ignaz Elhafen, who was born in Nürnberg in the second half of the 17th century and worked in Italy, in Vienna, and at the court of Düsseldorf, following designs and engravings by Pietro Testa, Pieter Saenredam, Raphael, Charles Lebrun, and Pietro da Cortona. In Austria, Matthias Rauchmiller (1645–86), Johann Caspar Schenck (d. 1674), and Matthias Steinle (1644–1727) were the outstanding masters of the art.

Baroque France, after the decline of the Parisian ateliers in the 15th century, had flourishing workshops in Dieppe and in Normandy. Jean Cavalier, David Le Marchand (1674–1726), particularly esteemed in England, and Jean Mauger (ca. 1640–1719/22) were in vogue in all the princely courts. A noted dynasty of ivory carvers was the Rosset family of Saint-Claude, in the Franche-Comté. Joseph (1706–86), who was the ablest, assisted by his sons Jacques (1741–1826) and Antoine (1749–1818), executed medallions and busts of Voltaire, Montesquieu, Rousseau, and other celebrated persons of the time, reproducing their faces on the snuffboxes and caskets designed in series which were so much in fashion.

In the hierarchy of this art Italy held a place of lesser importance. Mention should be made of Antonio Leoni, who was born in Venice and was active in Düsseldorf 1704–16, and of Giovanni Battista Pozzi (ca. 1670–1752), who numbered among his principal patrons Prince Eugene of Savoy, and in Rome, Cardinal Alessandro Albani, whose collection of busts of ancient philosophers he reproduced in ivory.

In general, as has been said, in Europe the character of works in ivory is aristocratic; this is true even of the realistic efforts of Peter Hencke (d. 1777), who was active in Mainz; he seems to have invested his reliefs of drunken peasants with something of the burlesque and caricaturing spirit of a Brouwer and even to have created — as in the case of the anonymous tinker serving as a perfumeholder, in the Museo degli Argenti in Florence — works which are in effect genre yet belong in the aristocratic drawing-room.

In the 19th century, with neoclassic ideas holding sway for the most part in sculpture and architecture, ivory entered a period of pronounced decline despite the efforts made in several international expositions to improve its fortunes. Up to the middle of the century the ateliers of Saint-Claude remained in operation. In Italy Giuseppe Bonzanigo (1740–1820) was noted as a specialist in microscopically detailed work. In Belgium there was an ephemeral and artificial revival of ivory production following on the exploration of the Congo.

Current ivory and bone carving, whether in handicraft or in industry, has virtually no artistic significance.

Luigi SALERNO

IVORY IN THE EAST. *Islam.* In Islamic lands ivory carving in the round was rare. By far the greater proportion of ivories were executed in either relief or intaglio. There was also much *a jour*, inlay, and incrustation work, in addition to simple engraving and surface cutting. Among the objects produced were caskets, small boxes, and pyxides, hunting horns, chessmen, combs, sword hilts, as well as mimbars, cenotaphs, and door panels. In Christian Egypt, and later in the early Islamic period, bone was skillfully carved by Coptic ivory workers (III, PL. 445). In the Islamic section of the Staatliche Museen, Berlin, and in other collections there are a great number of revetment panels, originally forming part of pieces of furniture of some kind, which belong to the transitional period in the East between the Early Christian and the Islamic period. Some of these at least can be considered as pre-Islamic (i.e., ca. 7th cent.) and as Egypto-Coptic. They show without question a relation to the decorations of the façade of Mshattā — a relation that is made even clearer by the comparison of an example in Berlin with an ivory fragment in the Benaki Museum, Athens (cf. Migeon, 1917, fig. 146): that these two examples belong to the Ommiad art of the 8th century admits of no doubt.

A similarly transitional aspect is presented by some ivory pyxides, closely resembling one another, with slightly bulging bodies and cupola-shaped covers (mostly missing). They are decorated on the outside with relief carving of vine leaves and grapes springing from vases or developing into a clear spiral design; an example in the Victoria and Albert Museum has birds as well. There are other examples in Berlin (Staat. Mus.) and in Paris (coll. of the Marquis de Ganay). To this category of works also belongs a small basin in New York (Met. Mus.). In general there is a tendency to consider these Syrian works of the 6th to the 8th century; a later dating would ascribe them to the general vicinity of the Ommiad dynasty, during which the technique of wood carving had its flowering, about 800.

The Coptic tradition in Egypt was mainly one of using bone and ivory in wood — a type of intarsia work. Many intarsia works of arched shape (panels from cenotaphs; some at first erroneously thought to be bookbindings) are preserved in the museums of Cairo, Berlin, and New York. Their origin can certainly be placed in the 8th and 9th centuries, and their Islamic character is equally certain. It is possible that the technique was also practiced in the Tulunid period (9th–10th cent.), but no examples of this period remain. Nor is there any known example of Abbasside ivory work.

A large ivory pyxis preserved in the Church of St. Gereon, Cologne, takes us into an entirely different area of Islam. An Arabic inscription on the cover states that the pyxis was made in Aden for the emir 'Abd-Allāh ibn-al-Rabī', governor of Yemen from 775 to 780. This established provenance is of particular importance, for it raises the question whether a whole series of other objects which have the same decoration of concentric circles and points also come from southern Arabia. At issue chiefly is a group of chessmen that have always been assigned to the first Islamic period (8th–10th cent.). Because of their close relation to other small objects of bone decorated in the same primitive way and indisputably going back to the Coptic era, an Egyptian origin had been previously postulated for the entire group.

A type of work in the round made at a relatively early date was the chess piece (analogous to the Western bishop) known in the East as the "elephant" (al-fīl); a 9th- or 10th-century example, perhaps from Mesopotamia, is in the Museo Nazionale, Florence. Entirely different is the imposing carving of an elephant in the Bibliothèque Nationale, Paris, which comes from Saint-Denis and is thought to have been a gift from Hārūn al-Rashīd to Charlemagne. It could reasonably be taken for Indian if there were not on the lower part of the base an inscription in Arabic referring to a master named Yūsuf al-Bahīlī, perhaps an Iraqi. This ivory can be placed somewhere in the 10th century, and it may be connected with the Arab conquest of the Indus Valley. A smaller elephant from Saint-Denis, even more markedly Indian, is from about the same period.

The first example of ivory painted in several colors dates from the 10th century: a chest, rather large and flat, in the Museo Arqueológico, Madrid, has a long inscription in Kufic characters with Shiite formulas, which mentions the Fatimid caliph al-Mu'izz and states that it was made at his residence, Sabra al-Manṣūriya, near Kairouan in Tunisia, in other words, before the move of the caliph to Egypt following his conquest of that country; thus it must have been made between 952 and 969. This chest, however, has a rather isolated place in the ivory work of the Islamic world, in which the technique of painting was taken up again only later, and then in Sicily, a region culturally and geographically close to North Africa.

It is interesting to note that the art of ivory carving, the beginnings of which can be traced to the Ommiad period, did not develop in the East proper but rather in Islamic Spain, chiefly in Cordova, the very capital of the descendants of the first dynasty driven out by the Abbassides; it is a warranted conclusion that the ivory workers emigrated from Damascus, where, in the 8th century, the art had had its first efflorescence, to Andalusia, and there worked at the court of the Ommiads. The examples that have survived go back no further than the 10th and 11th centuries, but they are unquestionably products of a high order of craftsmanship that presupposes earlier stages of development.

Fortunately the works are so frequently inscribed (always on the lower rim of the cover) that in many cases we have not only the name of the commissioner of the object but also a definite and indisputable date; in some cases women of the caliph's family are named as purchasers, and a poetic inscription on one pyxis (D752, Hispanic Society of America, New York) declares that it was intended to hold sweet-smelling essences. It is established that the guild of ivory workers was active not only in Cordova but also at the palace of Medina az-Zahra built outside the gates of the city by 'Abd-er-Raḥmān III. On a box in the Instituto de Valencia de Don Juan, Madrid, which is dated 966 and was intended for a princess, Medina az-Zahra is named in the inscription as the place of manufacture; the decoration, rather deeply carved, consists, as in the pieces previously mentioned, almost exclusively of arabesques and foliage. Dated two years earlier, 964, is a splendid pyxis from Zamora (Mus. Arqueológico, Madrid); the decoration shows peacocks and gazelles scattered against a background of foliage of Moorish type.

In this period we encounter for the first time the name of one Ḥalaf, an ivory worker, whose signature appears on a box dated 966 in the Church of Fitero (Navarre) together with the name of Medina az-Zahra as the place of origin. It is his name that appears, too, at the end of the inscription on the imposing pyxis in the Hispanic Society in New York, which extols its own beauty as well as the precious purpose it serves. From a different workshop, but also dated 966, is a small casket in the Musée des Arts Décoratifs in Paris.

Here follows chronologically a splendid series whose place of origin — whether Medina az-Zahra or Cordova itself — is in question. Three pyxides are chiefly concerned: one in the Louvre, dated 968; one of the same period in the Victoria and Albert Museum; and a third, without a lid, again in the Louvre. All three show, in a series of medallions, various figural scenes taken mainly from court life (princes on their thrones, musicians, falconers, elephants, etc.) but also from the late Byzantine and Sassanian worlds (Dioskouroi, birdcatchers, pairs of horsemen beside a tree of life, animals fighting, etc.). Some of these motifs, used in disregard of the Moslem prohibition of the rendering of figures, are a novelty in Islamic art, so that there is a crying need for a more exact history of these works.

A casket in the Cathedral of Pamplona made in 1005 for the minister 'Abd-al-Malik, as is clear from the inscription, marks the end of this brilliant period. It shows the same repertory of motifs as the above-mentioned pieces but so far surpasses them in profusion of figural composition as to rank as the outstanding work of the Cordovan school. Four signatures of ivory carvers can be deciphered in different places, from which it can be concluded that we are dealing here with the cooperative work of a large atelier. Roughly contemporaneous is a pyxis in the Cathedral of Braga (Portugal), a more modest work but elegantly carved with arcades in relief. This too was commissioned by the minister 'Abd-al-Malik, who fell in 1008. As the last example of the series we may mention a casket in the Victoria and Albert Museum.

The decline of the power of the caliphs of Cordova in the first half of the 11th century meant the end of Cordova's ivory industry. The ivory workers found a new field of activity in Cuenca, in Castile, under the protection of the Dhul-Nunid dynasty, which had come into power in Toledo. A casket in Burgos which comes from S. Domingo de Silos bears an inscription stating that it is the work of Muḥammad ibn-Zayān, created in the city of Cuenca in the year 1026. There is an entirely new orientation in that the decoration of animal motifs — somewhat crude as to detail — is very different, being arranged on the surfaces in horizontal bands rather than in medallions, with hunters placed here and there. The cover, on the other hand, with its birds and intricate scrollwork, reminiscent of the Ommiad taste, reflects the tradition of the Cordovan school. A casket from Palencia in the Museo Arqueológico, Madrid, also appears to be close to the Cuenca workshop (PL. 242); its date is 1049.

The caskets and boxes mentioned above, like the pyxides, were probably originally colored with paste and enlivened with

gold backgrounds. They had locks and hinges of gilded silver, often replaced later by coarser ones. Most of these objects came rather early into the Christian West; in princely houses they served as jewel boxes, in churches and monasteries as reliquaries.

That Arab ivory carvers also served Christian clients even before the definitive conquest of the Kingdom of Toledo by the Castilians (1085) is certain. An outstanding example of their work is a processional cross of which part is in the Louvre and part in the Museo Arqueológico, Madrid; the three arms that are preserved come from San Millán de la Cogólla, as do some small strips with very similar decoration in the Madrid museum which once served to adorn a portable altar and which are surely of the 11th century.

While in the latter half of the 11th century the Islamic ivory art of Moorish Spain was gradually dying out, other centers of ivory production with quite different aims were flourishing. It was now principally the hunting horn that was the object of artistic adornment. The legendary ivory horn — named "Olifant" — of Roland may have given rise to the manufacture of these magnificent objects, all of which go back to this prototype and thus have been invariably associated with this paladin of Charlemagne. It is probably true that these *tubae eburneae*, as they are called in medieval sources, were part of the equipment of royal personages. It is curious that there is no trace of their use in the East and that they are found only in the Christian West — the more so since a great number of them give clear evidence of Saracenic workmanship.

Among the ivory horns that have come down to us, about 30 in all, three types can be distinguished. The first is best represented by the so-called "horn of Charlemagne" in the Cathedral of Aachen, which, together with another in the Staatliche Museen, Berlin, stands at the head of the series. In the second type (Berlin, Paris, London, Edinburgh, Stockholm, New York) the entire surface is decorated with animal motifs except for the links to which the pendant is attached, which are in the form of medallions. Of the third group there are characteristic examples in Florence (Mus. Naz.) and in Brunswick; in these the animals are arranged in vertical bands, in circles, or are freely rendered around the rim of the horn.

In both composition and details these ivory horns reflect the Fatimid style as it developed in the 11th and 12th centuries in Egypt and Syria (PL. 244). But certain peculiarities, as well as the occasional occurrence of motifs alien to Islamic art, suggest a contact with the Byzantine and pre-Romanesque art of the West; if we are here dealing with works by Arab artisans, the possibility must be entertained that they were resident in Sicily or southern Italy. The case was also reversed, for example, in Apulia, where Christian sculptors from time to time came under the influence of their Saracen fellow artisans. In this connection should be mentioned a very small number of oliphants bearing the same decoration as the second group mentioned above; these are so mediocre in execution as to have been at times taken for forgeries but have recently been recognized as Romanesque imitations of Islamic models. Contemporarily with the horns here described and clearly in the same workshops were produced caskets, doubtless for jewels, similar in form to, but slightly larger than, the somewhat earlier Spanish ones. Only a few of this type are preserved (Berlin, New York, Mastricht, Leningrad).

At a relatively early date, both boxes and horns were given, after they had served their secular purpose, to churches and monasteries, where they found use as reliquaries and were specially valued because of the costliness of their material. Fatimid elements and strong Saracen influence are also present in liturgical objects for Christian use. In England, it is clear, the oliphant type of horn was particularly widespread, and it seems that ivory drinking horns served as feudal attributes, the inscribed "tenure horn" constituting the official record of the bestowal of a grant of lands.

In this entire group of works in ivory, not one bears an inscription in Arabic, which is further reason for questioning their Islamic origin. It is especially difficult to localize their provenance with any certainty, and we must be content with purely hypothetical attributions. Detailed study of the carving shows that they are close to Egypto-Syrian artistic trends, and this seems to justify the Fatimid thesis. Chiefly it is a matter of ivory (more rarely bone) panels used as covers, rectangular or polygonal in shape, sometimes curvilinear, with arabesques, animals, or human figures carved in high relief, and the background showing; originally these must have been affixed to wooden caskets or strongboxes or to pieces of furniture. An especially fine series is preserved in the Museo Nazionale of Florence (PL. 242); another is in the Staatliche Museen, Berlin. Figures of musicians, dancers, revelers, hunters on foot and on horseback, and peasants are seen against a background of vine trellises; the closest parallels to these are some friezes in Cairo (Mus. of Islamic Art) from the destroyed western palace of the Fatimids, which are very similar in decoration. Thus the ivory panels may go back to the 11th century; according to Maqrīzī, many ivory boxes decorated with such panels were included in the treasure of the Fatimid sovereign al-Mustanṣir (1035–94). Fragments have been brought to light in the ruins of Fostat (Old Cairo), and in no case is it possible to speak of any degree of adaptation, as in the case of oliphants, to Western conceptions.

When it comes to the category of ivories that are not carved in relief but painted and gilded — for the most part jewel boxes, pyxides (known to have served to contain the Host), and combs — the time and place of production are rather easily determined. The material here could be much thinner than in the case of the carved ivories; the painting was done in red, green, and blue with black outlining, and gold was applied either in paint or in leaf. In many cases the decoration has of course been partially or wholly worn off. In addition to medallions with arabesques, a variety of animal motifs, falconers, harp players, and so on, there are subjects that are unquestionably Christian. However, the fairly frequent occurrence of Arabic inscriptions, in Kufic or in cursive script, mostly with wishes for the anonymous owner, proves that we are here dealing with the work of Saracen artisans. Of about 100 works of this type examined by P. B. Cott (1939) and J. Ferrandis Torres (1935–40) the most important are a small box in Berlin (Staat. Mus.), a box with flat cover and single figures in the Cathedral of Würzburg, and a third box, somewhat later in date, in the Cappella Palatina in Palermo.

Following tentative attributions to various Eastern countries, eventually general agreement was reached that most arguments speak for an origin in Sicily in the 12th and the early 13th century, that is, in the Norman and Hohenstaufen periods — which is further corroboration of Arab workmanship. Some late-13th-century pyxides with very shallow carved decoration on the front only (grapevines with birds, hares, etc.) in the museums of Paris, Lyons, and Cairo, which have close connections with the painted ivories in design, may be of Sicilian origin, even though they are no earlier than late-13th-century. That works having ivory intarsia, such as the well-known chest in the Cappella Palatina in Palermo, are Sicilian has been questioned by U. Monneret de Villard (1938), who holds that they stem from Egypt, where the technique had a long tradition. But stylistically they can be fitted neither into the Fatimid nor into the succeeding — the Ayyubid — trend, and further examples in the same technique, in a more evolved phase, found in Spanish cathedrals (León, Tortosa) can hardly have originated elsewhere than in the Spain or Sicily of the 13th century, given their suggestion of Western motifs. One of these caskets bears the signature of a certain Muḥammad ibn-al-Sarrāj. A small group of related panels of excellent workmanship in Ravenna (Mus. Naz.) and Leningrad (The Hermitage) may be considered as *mudéjar* modifications of Moorish carving; decorated with single animals and animals in combat, on a ground of vines, they show Arabo-Gothic influence and probably date from the end of the 13th century.

An important decorative function in association with architecture accrued to ivory carving (though limited to plant motifs and inscriptions) in the period of Cairo's ascendancy under the Mamelukes (see MAMELUKE ART). Whereas at first in decoration of borders of doors and mimbars only wood intarsia was used, now more and more often larger or smaller ivory panels with very delicate arabesques are found, and sometimes

even the whole surface, with dedicatory texts, is carved in the more precious material. Among objects of daily use, boxes with simple, closely carved geometrical decoration and marginal inscriptions were popular — a weak reflection of the once highly developed ivory industry.

This essentially completes the story of medieval Islamic ivory carving. Mention should perhaps be made of the scimitar and dagger handles among the Moorish arms of the 14th and 15th centuries; these — at times very richly adorned — played a greater role in Persia and India in the 16th–17th century but were later often executed in narwhal ivory, which looked much the same but was cheaper than elephant ivory. The powder horns enlivened with figural motifs of all sorts suffered the same substitution. Small objects in ivory, such as inkwells, boxes, and toilet articles, were produced in the Islamic East up to recent times; these pieces, though in many cases very tasteful, are insignificant in the artistic development of ivory carving.

Ernst KÜHNEL

India. The use of ivory and bone in India before the Christian Era is attested by the finds from Taxila in the Punjab (West Pakistan). According to Sir John Marshall several of the objects antedate the 2d century B.C.; a greater number, from the earliest of the successive sites, the Bhir mound, and from Sirkap, the next site chronologically (i.e., the Taxila of Parthian times), belong to the period extending from then to the 1st century of our era. Mostly these are objects of daily use: personal ornaments, articles for the toilet and for domestic use, pieces used in games. But many of the finds seem to have been imported, and according to Marshall the origin of the ivories of Taxila must be sought in Greece and western Asia. This opinion is in accord with A. K. Coomaraswamy's view that the use of ivory had a non-Indian origin.

However, the existence of ateliers of ivory workers in India before the beginning of our era is known from an inscription on the south portal, or torana, of the Great Stupa of Sanchi; according to this, the guild of ivory workers of Vidisa (mod. Bhilsa) executed and donated this, the most ancient torana, which dates according to A. Foucher and Sir John Marshall from the 1st century B.C. The ivory figurine of Indian workmanship found in Pompeii confirms the activity of Indian ivory workers at a date only slightly later.

The figurine from Pompeii has been linked with the female figures depicted on the Great Stupa of Sanchi, and with the torso of a woman from the same site, by P. Stern, who has pointed out definite similarities in headdress and costume. These and other similarities of iconography and attire (the double belt, the heavy headdress, and the great braids of hair, falling in an arc down the back) establish the work as contemporaneous with the three later toranas (north, east, and west) of the Great Stupa — in other words, as belonging to the beginning of the Christian Era. Four mirror handles, of which three are more or less similar, found at Taxila must be from a period hardly more recent. The rather coarse look of the female figures suggests work that is local but inspired by Indian models. A comb also from Taxila has, on the contrary, real artistic merit. It was discovered at Sirkap in the stratum belonging, according to Marshall, to the 1st century of our era, and the style and the motifs seem to establish an Indian origin. This piece with intaglio carving has with reason been regarded by A. Ghosh as closely connected with the ivories from Begram and, in the treatment of the figures, with the sculpture from Mathura and Amaravati.

However valuable, the data concerning ivory carving in ancient India supplied by these works remain fragmentary. Quite a different range is presented by the Begram finds, an important group of objects in ivory and bone discovered in 1937 and in 1939–40 in the course of excavations by J. Hackin, Ria Hackin, and J. Carl. The first lot was discovered in a walled-up room in the royal palace: Begram (anc. Kapisi), was the summer residence of the Kushan dynasty. The 1939–40 excavations brought to light further objects, and here again ivories of Indian origin were found with Hellenistic-Roman glass and bronze

(chiefly from Alexandria), and with fragments of Chinese lacquer. The ivories from Begram are above all close in style to Mathura and go back to the "half century following the advent of Kanishka" — a still disputed date somewhere between the end of the first and the middle of the 2d century of the Christian Era.

Some rare figurines of good size and some motifs in console form have been found, but the bulk of these ivories are bands and rectangular plaques used to decorate furniture (chairs, stools, and perhaps small chests). The frequency of feminine themes — scenes of dressing and of diversion — justify the belief that these objects appertained to a gynaeceum. The photographs, sketches. and notes made in the course of the excavations by J. Carl made it possible for P. Hamelin to reconstruct the general appearance and the decoration of several chair backs and footstools. Their form was already known through their representation in reliefs in the style of Mathura and Amaravati, particularly the curving upper band above the backs supported by console-shaped motifs alternating with decorated plaquettes and finely turned colonnettes. Frequently covered by a strip of mica, the plaquettes were affixed to the wooden structure by copper nails or by ivory pegs. Various techniques were utilized in executing the lively scenes and ornamental motifs decorating these bands and rectangular plaques, all of which reveal great technical ability, even virtuosity (PL. 241).

The scenes represented on some of the plaques relate to an episode identified by A. Foucher as belonging to a Jātaka (story of the previous life of the Buddha). All the remaining scenes appear, on the other hand, to be of purely secular inspiration: graceful female figures are represented in groups of two or three — sometimes accompanied by children or domestic animals — busying themselves at the toilette, or making music, or playing ball, or gathering flowering branches, or enjoying sweets. Sometimes a larger group gathered round a seated personage of importance evokes the brilliant atmosphere of the court scenes depicted at Amaravati. Other plaques show only one or two female figures standing under a torana in one of the undulant poses that are so typically Indian. One of these attitudes — "dancing" and, as it were, "falling" — has been compared by Stern to the same posture occurring in works in the Mathura style.

The decorative motifs coincide in general with the ornamental repertory of works more or less contemporaneous (Sanchi, Amaravati, Mathura especially). Many of these subjects are definitely Indian, or if of foreign origin, are already strongly Indianized. Several motifs are of Western inspiration, particularly a rinceau with tendrils (found by J. Hackin in Roman art of the 1st century of our era, and also to be found in Persia) and a complicated motif that gives rise to the rinceau. The association of human faces and of the heads and protomas of animals recalls a similar association in the carving known by the Greek term *grylloi* and probably of Mediterranean origin.

The excavations of 1937 also brought to light three large female figures carved in very high relief and of unusual dimensions (ca. 20 in. in height). They stand on a *makara* (fantastic marine animal), and thus relate to the decidedly Indian theme of river goddesses — of which they are among the oldest representations. One of them, however, wears a long tuniclike robe of very light material and of foreign type.

In spite of these foreign strains, the ivories of Begram — now in the Kabul Museum (PL. 241) and in the Musée Guimet, Paris — are essentially manifestations of Indian taste and are close to the indigenous styles: to that of Mathura in the first place and then to the style of the Great Stupa of Sanchi and to the style of Amaravati. Seen from another angle, reflecting as they perhaps do the decoration of vanished palaces, they remain the sole witness to the secular art of ancient India.

The references to ivory objects in literature alone testify to the esteem in which this artistic genre was held during the Gupta and post-Gupta periods. With the discovery of an ivory in early Pala style, an interesting find made in 1854–56 in the Province of Sind became even more valued. Northeast of Hyderabad, at a site identified as being that of the old city of Brahmanabad, A. F. Bellasis discovered, in fact, several ivory figures, which appear to have decorated a coffer or a number of coffers. These pieces, of which the largest is about 4½

inches high, are chiefly standing female figures, very *hanchées*; they often hold a lotus in one hand and a scarf in the other, and one is looking at herself in a mirror. According to D. Barrett these ivories, preserved in the British Museum, are near in style and iconography to the art of central India in its westernmost aspects, that is, in Gwalior and Malwa; he notes certain resemblances to the sculptures of the temples of Candravātī (Jhalawar, Malwa), which seem to be 10th-century or slightly earlier. Thus the ivories discovered by A. F. Bellasis may go back to a comparable date.

The later Indian ivories are numerous and better known, testifying to the activity of many workshops in very diverse parts of the country: first of all in the south, in particular Ceylon and Travancore; then in Mysore; and to a lesser degree in north India and Orissa. The museums of Colombo and London own fine collections of pieces from Ceylon, some of which go back to the 15th century. The variety of objects in ivory is very great, ranging from images of the Buddha and a variety of statuettes to handles of all sorts, combs, book covers, and coffers made of ivory plaques held together with metal mountings. There are perfume atomizers so thin that they can be squeezed. Architectural appliqués of ivory are recorded in the *Mahāvaṃsa* (historical chronicle of the island of Ceylon), which, as early as the 12th century mentions a royal park in Ceylon "girdled by pillars with rows of representations in ivory" and a pavilion built of this material. Such ivory appliqués are seen on the posts and the lintels of entrances. In the Ridi Vihara in Ceylon pierced ivory is combined with ebony in door frames. In the same region there are, among the pieces in bas-relief, plaques representing the gate guardians, or *dvārapālas*, placed on either side of monastery doors.

The old techniques reappear: on the one hand, ivories incised or carved in low relief, against a ground either smooth and plain or pierced, and, on the other hand, turned ivories. Examples of ivory incrustation and appliqué are numerous; some still can be seen at the palace of Tanjore. Coomaraswamy (1913) mentions two chairs, of the 17th or 18th century, decorated with ivory plaques enriched with colored lacquer. In this type of work, first the surface of the ivory is engraved and then the lacquer is poured hot into the incised parts; after scraping and polishing, the design appears in color on the ivory ground. The process is still in use in Tanjore, particularly for musical instruments, and also in Mysore and Ceylon. The work done in Travancore is allied to the Singhalese traditions: many of the ancient Indian motifs are retained. The 18th-century objects have a beauty that is still in evidence in more modern examples. Coomaraswamy notes that the Travancore ivories preserved a purity of design, while those of Ceylon and Mysore fell into an obvious decline as a result of the effort to detach the figures from the ground by exaggerating the relief. The works from Mysore had, however, given evidence of true quality in the 18th century (VII, PL. 491), and the region had been a center of work in ivory incrustation; black lacquer also was used.

Northern India too had its centers of production. In Orissa some fine ivory statuettes of the 18th century maintained the tradition of earlier Indian sculpture. The inlaying of ivory in wood — often in sandalwood — was an art especially developed in the Punjab (chairs, small caskets, musical instruments, and even the decoration of doors, as in the Golden Temple at Amritsar). Subtle floral ornament inspired by the Moghul style predominant in northern India from the 17th century on is frequently found: delicate flowered sprigs curve up and down or form harmonious rinceaux. The doors of the palace in the city of Amber and of the Bari Mahal in Udaipur were covered with a veneer of ivory plaques in Moghul style showing hardly any Hindu influence.

Madeleine HALLADE

CHINA AND JAPAN. In the Paleolithic age, man seems already to have been making articles of bone, as can be inferred from the fact that fragments of objects of bone, indented or notched, were found with the skeleton of Peking man at Chou-k'ou-tien. Among the other finds from the site are earrings of bone and other personal ornaments made by piercing holes through the dogteeth of animals of prey — all presumably Middle Paleolithic. Ivory and bone carving emerges into the light of history in the Shang dynasty (ca. 1523–1028 B.C.). By this time fair progress seems to have been made in processing various materials; the art of casting bronze vessels had attained notable refinement. In An-yang, which is thought to have been the center of Shang civilization, pail-shaped vessels of ivory have been excavated. These were made of the thicker part of the elephant tusk, the base of the tusk forming the mouth of the vessel; inserted in the other end was a raised bottom. The surface of these vessels is carved with a row of motifs, each resembling a cicada as viewed from above. In the lower part is carved a design of a monster. These motifs are much the same as those found on the bronze vessels of the period. There have also been found in An-yang and its environs a number of bone receptacles with exquisite *t'ao-t'ieh* designs (III, col. 476) carved on them; among these finds are fragments presumably of vessels for wine and spirits. Ornamental bodkins made of bone and fish-shaped pendants of ivory (ca. 1 in. long) have also been brought to light in the same area. Nor is this all. There have been recovered a quantity of fragments bearing carved characters indicating that records of the time were incised on tortoise shell and animal bone. Among the decorative designs on bronze utensils of the Shang dynasty are some representing the elephant. The Freer Gallery of Art in Washington has a bronze piece of the Shang dynasty made in the shape of an elephant (III, PL. 224). It may be inferred that the nobility of the Shang dynasty had a strong interest in and appreciation of elephants and ivory.

From the Chou through the Han dynasty (ca. 1128 B.C.–221 B.C.) ivory carvings must have been turned out in some quantity, but the ivory works that have come down to us are not abundant. From ancient Chinese sources we learn that in these dynasties ivory was used for seals, and for the staff or baton (*hu*) borne by dignitaries when wearing ceremonial dress and that vehicles were decorated with ivory carvings. We learn too that craft products of ivory and rhinoceros horn were noted local specialties of Ch'ing-chou and Yang-chou, and that during the Han dynasty ivory wares of exquisite workmanship were imported from Rome. Another Chinese source states that in the 4th century an ivory tower was sent to China from India as a present, and it seems likely that all sorts of ivory works of Indian make had found their way to China prior to the Han dynasty. It is also recorded that Chinese ivory workers carved Buddhist images in ivory in the 6th century. With the establishment of the T'ang dynasty in the 7th century, the use of ivory in China grew more and more extensive: it became a favorite material for articles of luxury used by the aristocratic class. Surviving ivory works from the T'ang dynasty are not plentiful, it is true, but, judging from the records, the poetry, and the relics of the time, the art of carving in ivory must have enjoyed considerable development during this dynasty.

It is worthy of note that the China of the T'ang dynasty apparently was considerably influenced by the ivory art of Europe, the Near East, and India, as a result of the vigorous interchange carried on with India, Persia, and Byzantium; it may be that many of their products were brought into China. Numbered among such imports must be the portable shrine adorned with carvings in ivory depicting a Jātaka (Lanchow, Kansu Provincial Mus.); it was presumably made in India in the 8th century.

Works of art of the highest quality were produced for the emperors and high officials of the T'ang dynasty in the government workshops, and it was probably in these shops that the production of superior works in ivory centered. Ivory tusks were evidently imported from Annam and Burma, but elephants were bred in China too, it is said. The various ivory works produced during the T'ang dynasty may be divided roughly into two groups — those entirely of ivory and those in which ivory is combined with other materials. The former include plectrums for string instruments, flutes, rulers, the stones used in the game of *go* (Chinese chess), *hu*, combs, hairpins, jewel boxes, and small folding screens; the latter include boxes, furniture, stationery items, and musical instruments.

The techniques employed are of two kinds. One, featuring skill in relief carving and openwork, presents ivory in its natural color, while the other, in which designs were engraved on the dyed surface of ivory, reveals the true color of the ivory only in the carved parts. The latter method, the technical term for which is *po-lou*, was much in demand for its capacity to produce an effect at once pictorial and ornamental. Another decorative method extensively practiced was inlaying ivory, that is, inserting a veneer of ivory in the surface of an object made of another material. The use of ivory for the *hu*, which was an attribute of the most exalted personages of ancient China, is a measure of the esteem in which this material was held. Rhinoceros horn was also held in high esteem, as is clear from the facts that it was carved into winecups, and that inlays of rhinoceros horn were applied to utensils.

During the Sung dynasty (10th–12th cent.) both ivory and rhinoceros horn were imported from Persia and Arabia. That the techniques of inlaying and carving ivory and rhinoceros horn were handed down from the T'ang dynasty is known from literary sources. Works whose dating is so clear as to establish them as having been handed down from the Sung dynasty are few and far between.

Fukien was famous as a center of ivory carving during the Ming dynasty (14th–17th cent.; PL. 248). Chief among the ivory carvers of the Sung dynasty were Fang Ku-lin, Chu Hsiao-sung, and Chu Lung-ch'uan; the leading artist in rhinoceros horn carving of the same dynasty was Pao T'ien-ch'eng. The ivory works of the Sung dynasty include seal boxes, incense cases, folding fans, and chopsticks, all adorned with carvings — of landscape with several-storied structures, of human figures, and of flowers and birds. These works are not so elaborate in detail as the products of the Ch'ing dynasty (17th–20th cent.; PL. 248), but artistically they have greater merit. A number of Buddhist images and figures of lohan (Buddha's disciples) carved in ivory have come down to us from the Ming dynasty; these are works of art giving evidence of skill raised to a very high level.

During the K'ang-hsi era of the Ch'ing dynasty a number of manufactories were established in Peking for the purpose of supplying the Court, and one of them had a department devoted to ivory carving. Skilled artisans for this workshop were assembled from all parts of the country. Chief among the types of articles produced there — all artistic works of a high order — were the *wan-chên* (hand rest used in writing small characters), *pi-tung* (cylindrical vessel to hold writing brushes), *pei-p'an* (stand for a winecup) *ho-tzŭ* (small vessel with lid), seal boxes, *ju-i* (originally an object held by a Buddhist priest while preaching, later a room ornament), *ch'a-p'ing* (single-leafed screen), *kua-p'ing* (hanging tablet), chairs, and *wei-p'ing* (folding screen). All these were ornamented with carving; the decorative motifs included a Taoist hermit, the *tao-shih* (a supernatural being who figures in Taoism and Buddhism), birds and animals, a several-storied structure, landscape, fruit, flowers, poems. The carvings are sometimes in relief, sometimes in line engraving, sometimes in openwork, and sometimes in the more elaborate technique known as *lou-k'ung* (in which the cutting is done in such a way as to give the effect of a carved object set in a concavity). Still other works are colored with pigment or dyes. Very few of these ivory carvings bear marks showing when they were made. The so-called "medical ivories" belong to a separate category. Small reclining female figures, generally nude or lightly clothed, they were used by Chinese women when consulting a physician to indicate their symptoms without a physical examination.

Among the ivories that European nations imported from Ch'ing China and from the Chinese Republic are fine specimens of *sa-shan* (folding fans) and *tao-ch'iu*. The latter is a series of several detached concentric spheres carved ingeniously within a pierced ivory ball; each sphere is decorated with a different openwork design. Some *tao-ch'iu* have more than 10 inner spheres. These spheres within a sphere are begun by carving a ball out of a piece of ivory. Then several holes are pierced from the exterior toward the center. The knife is then thrust in to carve a central ball about $1/4$ in. in diameter. The outer

spheres are then carved, one after another, till the *tao-ch'iu* is completed. A similar technique is applied to the carving of an ivory ornament of which the nucleus is a carved palace, with chairs, folding screens, human figures, and even tinkling bells and lanterns hanging from the eaves represented inside. The traditions of the dexterous Ch'ing ivory carvers have not been lost; the Chinese ivory industry flourishes in Kwangtung province. With a view to further improvement in quality the Chinese government has required the formation of a cooperative association to handle the production of ivory works of all types, from choice ornaments such as *tao-ch'iu*, down to articles of daily use such as chopsticks and combs.

In Nationalist China (Taiwan) the use of ivory is rare, but carvings in bone and horn are being produced. Buffalo horn is the material commonly used, the chief products being combs, buttons, flower vases, *shui-ti* (tiny vessels for holding water used in preparing India writing ink), smoking pipes, paperweights, paper knives, and dishes.

In the Neolithic age in Japan, that is, the age of the Jōmon earthenware culture (200 B.C. or earlier) various articles of daily use were made of bird and animal bone or horn: bone fishing hooks, harpoons, combs, hairpins, sewing needles, girdle pendants, and so on have been dug out of shell mounds. The decorative designs on these works are akin to those on earthenware of the Jōmon (lit. rope-pattern) type. Carvings in deer horn have also been dug out of shell mounds. Bone and horn thus have a much longer history in Japan than does ivory.

In the history of ivory carving in Japan the two high points are the 8th century and the 18th century. The Asian continent and Japan have of course had close cultural relations from earliest times, and it is therefore quite possible that the technique of ivory carving came to Japan from China even before the 8th century. But it would be difficult to prove this from the extant remains, though many 8th-century ivories survive.

In the Aëneolithic age, following the Neolithic, bronze and jade works evidently began to be made; perhaps personal ornaments made of bone or horn gradually came to be replaced by articles of these new materials. The use of deerhorn was apparently maintained; from ancient tombs of the 5th century there have been excavated specimens of relief sculpture in horn on scabbards, with designs based on crossing straight lines and curves. As for the *magatama*, the comma-shaped ornaments, often of jade, that were the characteristic personal adornment in ancient Japan, there is a body of opinion which holds that their curved form is a conventionalization of the shape of animal teeth or tusks; be that as it may, 4th- and 5th-century *magatama* were chiefly of stone and glass. With the introduction of Buddhism into Japan from the continent in the 6th century, various handicraft techniques were also imported. Such techniques developed in Japan along with the growing practice of adorning Buddhist temples in a style according with the extravagant life led by the aristocracy of the time. In 8th- and 9th-century Japan it became the fashion among the nobility to ape the T'ang culture of China, and it was natural that the ivory art of the T'ang dynasty should be welcomed in Japan. It seems that ivory as a material was imported from China. So strong was the influence of Chinese culture that it is next to impossible to tell which of the ivory works preserved in the Hōryūji (the temple that is the oldest wooden structure in Japan) and the Shōsōin (the Imperial Treasury in Nara) are of Chinese make and which are of Japanese make.

The technique known as *bachiru* or *hane-bori* (*po-lou* in Chinese) was applied to the making of all sorts of ivory objects. This method consisted of engraving a design on an ivory surface, which had been dyed red or green, in such a way that the carved parts would form a design in the white of the ivory. In some cases the carved design was dyed in another color instead of being left white. This technique was frequently applied to articles made entirely of ivory. Among such ivory works that have come down to us are small cylindrical cases decorated with flower and bird designs, plectrums for the *biwa* (a lutelike instrument), with designs of birds and flowers, landscapes, and animals; rulers

with similar designs; and stones used in the game of *go*, with centered motif of a bird holding a flower in its beak.

There are also examples of ivory carving in the round, such as the holder of a bamboo writing brush and the rollers for a scroll preserved in the Shōsōin. This bamboo brush holder is in the shape of a pagoda, a motif apparently thought appropriate for a brush with which Buddhist scripture would be written. As might be expected, the Chinese custom by which an exalted personage held a *hu* when in ceremonial dress was introduced into Japan, where noblemen carried it on ceremonial occasions. The *shaku*, as the Japanese call this flat ceremonial baton, was sometimes made of ivory. As a rule, the ivory *shaku* bore no decorative design, but the patterned grain of the ivory was often used to advantage, just as choice grains are turned to account in woodcraft. Ivory and rhinoceros horn were much used for knife handles, and the ivory parts were usually adorned with carving. It was also the custom to decorate boxes, vessels, and furniture with ivory inlays forming designs of straight lines or curves. Sometimes deerhorn was substituted for ivory. Other uses of ivory are indicated by the frames of the stringed instruments treasured at the Shōsōin, which are decorated with arabesque designs of inlaid ivory, shell, or amber, and by the goban, or Japanese chessboards, which are similarly decorated. It is recorded that incense burners made of ivory were used in this period, and it was customary to adorn the back and chest of a horse with some sort of decoration of ivory or horn; quivers were also so decorated. Rhinoceros horn was another prized material; there is a floral-shaped sake cup carved out of rhinoceros horn in the Shōsōin.

The art of ivory carving evidently fell into desuetude in Japan after the 8th century, for delicate works comparable to those preserved in the Shōsōin ceased to be produced. Even in the 15th and 16th centuries, when things Chinese appealed strongly to the Japanese taste, there was no significant ivory production. Toward the 18th century it became the fashion in Japan to wear an inro (lit. "seal box") at the girdle. Originally intended for holding the seal (*in*), the inro actually was used as a medicine holder. As a concomitant of this custom of wearing a girdle pendant there developed the art of the netsuke, a miniature toggle that did duty to anchor the inro (PL. 248). Ivory netsuke were carved with all sorts of motifs, including human figures, birds, animals, plants, insects, and fish. The use of the netsuke was not restricted to the inro, since the tobacco pouch and pipe case were also worn at the girdle and required fasteners. Pipe cases and inro as well were made of ivory. Various materials besides ivory were used for making netsuke, among them deerhorn, whalebone, boar tusk, rhinoceros horn, metal, wood, earthenware, and shell; but ivory was by far the favorite, for it is more amenable to carving, more durable, and more pleasant to the touch than the others. Peculiar to Japan, this appendage of the girdle pendant — the netsuke — occasioned the development of a uniquely Japanese art of elaborately detailed miniature carving on a microscopic scale. Needless to say, netsuke have always captured the fancy of the curio collector; beyond this, though they can hardly be said to be possessed of noble sculptural beauty, they do have a charm of their own, which may be likened to that of the Chinese *tao-ch'iu*.

Chief among the noted carvers of ivory netsuke who flourished before the 20th century were Kaigyokusai (1813–92), famous for his rabbits and mice; Tomotada (mid-18th cent.?), for his fine oxen; Tomochika I (1800–73), for his human figures and skulls; Mondo (1857–1917), for his carvings of Taoist hermits; Mitsuhiro (1810–75), for his human figures, birds, animals, fish, insects, and plants; Minko (1735–1816), for tours de force such as carvings of human figures and animals with movable eyes; and Rantei (late 18th cent.), whose forte was carving animals, birds, and flowers. Among the carvers of deerhorn netsuke were Kokusai (mid-19th cent.); Tomiharu (1723–1811) and Issai (late 18th cent.) were famous as carvers in boar tusk and whalebone, respectively.

In the latter half of the 19th century, when trade with foreign countries began, ivory carvings — chiefly netsuke and dolls — were produced in large numbers for export. The skill of the Japanese artisans, added to the fact that the differential in wage standards made it economically feasible for them to work at a relatively slow pace, enabled them to turn out carefully elaborated ivory works which met with considerable success.

Taiji MAEDA

BIBLIOG. *General*: E. Molinier, Ivoires (Histoire générale des arts appliqués à l'industrie, I), Paris, 1896; H. Graeven, Antike Schnitzereien aus Elfenbein und Knochen, Hanover, 1903; A. Maskell, Ivories, London, New York, 1905; G. F. Kunz, Ivory and the Elephant in Art, Archaeology and Science, Garden City, N.Y., 1916; O. Pelka, Elfenbein, 2d ed., Berlin, 1923; H. T. Bossert, Geschichte des Kunstgewerbes, I, IV, Tübingen, 1930; G. C. Williamson, The Book of Ivory, London, 1938; E. von Philippowich Elfenbein: Ein Handbuch für Sammler und Liebhaber, Brunswick, 1961 (bibliog.).

Various types of ivory and bone, techniques, trade: B. Laufer, Arabic and Chinese Trade in Walrus and Narwhal Ivory, TP, 2d ser., XIV, 1913, pp. 315–64; B. Laufer, Supplementary Notes on Walrus and Narwhal Ivory, TP, 2d ser., XVII, 1916, pp. 348–89; G. Schönberger, Narwhal-Einhorn, Städel-Jhb., IX, 1935–36, pp. 167–247; J. J. L. Duyvendak, China's Discovery of Africa, London, 1949; S. van R. Cammann, The Story of Hornbill Ivory, Univ. [Pa.] Mus. B., XV, 4, 1950, pp. 19–47; T. K. Penniman, Pictures of Ivory and Other Animal Teeth, Bone and Antler, with a Brief Commentary on Their Use and Identification, Oxford, 1952; S. van R. Cammann, Carvings in Walrus Ivory, Univ. [Pa.] Mus. B., XVIII, 3, 1954, pp. 3–31; R. D. Barnett, Phoenicia and the Ivory Trade, Archaeology, IX, 1956, pp. 87–97.

Museum collections and exhibitions: W. Maskell, A Description of the Ivories Ancient and Mediaeval in the South Kensington Museum, London, 1872; J. O. Westwood, A Descriptive Catalogue of the Fictile Ivories in the South Kensington Museum, London, 1876; E. Molinier, Musée National du Louvre: Catalogue des ivoires, Paris, 1896; O. M. Dalton, Catalogue of the Early Christian Antiquities ... of the British Museum, London, 1901; J. Destrée, Musées Royaux des Arts décoratifs: Catalogue aux ivoires, Brussels, 1902; R. Kanzler, Gli avori dei Musei Profano e Sacro della Biblioteca Vaticana, Rome, 1903; R. Berliner, Die Bildwerke des bayerischen Nationalmuseums, IV: Die Bildwerke in Elfenbein, Knochen ..., Augsburg, 1926; M. H. Longhurst, Catalogue of Carvings in Ivory, Victoria and Albert Museum, 2 vols., London, 1927–29; C. R. Morey, Gli oggetti di avorio e di osso del Museo Sacro Vaticano (Catalogo del Museo Sacro della Biblioteca Apostolica Vaticana, I), Vatican City, 1936; G. Bovini and L. B. Ottolenghi, Catalogo della mostra degli avori dell'alto medio evo, 2d ed., Ravenna, 1956; H. W. Hegemann and K. Degen, Ivoires: Travaux d'artistes et artisans allemands, Geneva, 1960; L. Laurenzi, Lavori in osso e avori dalla preistoria al rococò, 2d ed., Bologna, 1960.

Prehistoric and tribal cultures: W. J. Hoffman, The Graphic Art of the Eskimos, Washington, 1897; A. H. L. Fox-Pitt-Rivers, Antique Works of Art from Benin, London, 1900; H. L. Roth, Great Benin, Halifax, 1903; E. Piette, L'art pendant l'Age du Renne, Paris, 1907; H. Lang, Famous Ivory Treasures of a Negro King, Am. Mus. J., XVIII, 1918, pp. 529–52; A. Leroi-Gourhan, Les bois de renne gravés de Laponie, RAA, XI, 1937, pp. 25–35; R. T. Davis, Native Arts of the Pacific Northwest, Stanford, Calif., London, 1949; A. Salmony, Some Palaeolithic Ivory-Carvings from Mezine: An Essay of Reinterpretation, AAs, XII, 1949, pp. 104–18; R. B. Inverarity, Art of the Northwest Coast Indians, Berkeley, 1950; B. C. Champion, Restauration de statuettes aurignaciennes en ivoire, RA, XXXVIII, 1951, pp. 129–33; V. V. Antropova, Sovremennaya chukotskaya i eskimosskaya reznaya kost' (Contemporary Chukchi and Eskimo Ivory Carving), Sbornik Muzeya antropologii i etnografii, Akademiya nauk SSSR, XV, 1953, pp. 5–96; S. van R. Cammann, Notes on Ivory in Hawaii, JPS, LXIII, 1954, pp. 133–40; E. Carpenter, Ivory Carvings of the Hudson Bay Eskimo, Canadian Art, XV, 1958, pp. 212–15, 244; W. B. Fagg, W. and B. Forman, Afro-Portuguese Ivories, London, 1959; M. Vaughan, An Exceptional Benin Ivory at Brooklyn Museum, Connoisseur, CXLIV, 1959, pp. 67–68.

The ancient Near East: H. Schäfer and W. Andrae, Die Kunst des alten Orients, Berlin, 1925; Hispanic Society of America, Early Engraved Ivories, New York, 1928; R. D. Barnett, The Nimrud Ivories and the Art of the Phoenicians, Iraq, II, 1935, pp. 179–210; J. W. and G. M. Crowfoot, Early Ivories from Samaria, London, 1938; R. D. Barnett, Phoenician and Syrian Ivory Carving, PEQ, LXXI, 1939, pp. 4–19; G. Loud, The Megiddo Ivories (Univ. of Chicago, O. Inst. Pub., LII), Chicago, 1939; E. Bille-De Mot, Ivoires prédynastiques égyptiens, B. Musées royaux d'art et d'histoire (Brussels), 3d ser., XV, 1943, pp. 86–91; G. Steindorff, The Magical Knives of Ancient Egypt, J. Walters Art Gall., IX, 1946, pp. 41–51; J. D. Cooney, Three Ivories of the Late XVIII Dynasty, Brooklyn Mus. B., X, 1, 1948, pp. 1–16; R. Dussaud, L'art phénicien du IIe millénaire, Paris, 1949; E. Porada, Ornament from an Assyrian Throne, Archaeology, VI, 1953, pp. 208–10; C. Decamps de Mertzenfeld, Inventaire commenté des ivoires phéniciens et apparentés, Paris, 1954; H. Frankfort, The Art and Architecture of the Ancient Orient, Harmondsworth, 1954; A. J. B. Wace, Ivory Carvings from Mycenae, Archaeology, VII, 1954, pp. 149–55; H. J. Kantor, Syro-Palestinian Ivories, JNES, XV, 1956, pp. 153–74, 235; C. Picard, L'ivoire archaïque des deux-deésses au Metropolitan Museum, New York, MPiot, XLVIII, 2, 1956, pp. 9–23; R. D. Barnett, A Catalogue of the Nimrud Ivories with Other Examples of Ancient Eastern Ivories, London, 1957; B. Goldman, Achaemenian Chapes, Ars Orientalis, II, 1957, pp. 43–54; J. Perrot, Ancient Ivories from the Negev, Graphis, XIV, 1958, pp. 68–70; A. Blanco Freijeiro, Orientalia: Los marfiles de Carmona, AEA, XXXIII, 1960, pp. 3–25; H. J. Kantor, Ivory Carving in the Mycenaean Period, Archaeology, XIII, 1960, pp. 14–25.

Classical antiquity: H. Blümner, RE, s.v. Elfenbein, X, cols. 2356–66; C. Albizzati, Two Ivory Fragments of the Statue of Athena, JHS, XXXVI, 1916, pp. 373–402; P. Amandry, Rapport préliminaire sur les statues chryséléphantines de Delphes, BCH, LXIII, 1939, pp. 86–119; G.W. Elderkin, An Ivory Ariadne, Art in America, XXX, 1942, pp. 50–53; M. C. Ross, A 4th Century Ivory Statuette in the Walters Art Gallery, Art in America, XXXIV, 1946, pp. 105–08; H. Gallet de Santerre and J. Tréheux, Rapport sur le dépôt égéen et géométrique de l'Artémision à Délos, BCH, LXXI–LXXII, 1947–48, pp. 148–254; R. D. Barnett, Early Greek and Oriental Ivories, JHS, XLVIII, 1948, pp. 1–25; G. Fouet and M. Labrousse, Ivoires romains trouvés à Saint-Loup-de-Comminges, Haute-Garonne, MPiot, XLVI, 1952, pp. 117–29; C. P. Sestieri, Statuine eburnee di Posidonia, BArte, XXXVIII, 1953, pp. 9–13; G. P. Stevens, Remarks upon the Colossal Chryselephantine Statue of Athena in the Parthenon, Hesperia, XXIV, 1955, pp. 240–76; E. Baja-Thomas, ed., Archäologische Fund in Ungarn, Budapest, 1956; Y. Huls, Ivoires d'Etrurie, Brussels, Rome, 1957.

Late antiquity, the Middle Ages, and the European West: G. Stuhlfauth, Die altchristlich Elfenbeinplastik, Freiburg, Leipzig, 1896; C. Scherer, Studien zur Elfenbeinplastik der Barockzeit, Strassburg, 1897; H. Graeven, Früchristliche und mittelalterliche Elfenbeinwerke in photographischer Nachbildung, 2 vols., Rome, 1898–1900; J. von Schlosser, Die Werkstatt der Embriachi in Venedig, JhbKhSammlWien, XX, 1899, pp. 220–87; A. M. Cust, The Ivory Workers of the Middle Ages, London, 1902; C. Scherer, Elfenbeinplastik seit der Renaissance, Leipzig, 1902; O. M. Dalton, Catalogue of the Ivory Carvings of the Christian Era, London, 1909; M. Laurent, Les ivoires prégothiques conservés en Belgique, Paris, Brussels, 1912; A. Goldschmidt, Die Elfenbeinskulpturen, 4 vols., Berlin, 1914–26; E. B. Smith, Early Christian Iconography and A School of Ivory Carvers in Provence, Princeton, 1918; R. Koechlin, Les ivoires gothiques français, 2 vols., Paris, 1924; A. Julius, Jean Cavalier och några andra elfenbenssnidare, Uppsala, 1926; M. H. Longhurst, English Ivories, London, 1926; E. Capps, The Style of the Consular Diptychs, AB, X, 1927, pp. 61–101; R. Delbrück, Die Consulardiptychen und verwandte Denkmäler, Berlin, 1929; A. Goldschmidt and K. Weitzmann, Die byzantinischen Elfenbeinskulpturen des X.–XIII. Jahrhunderts, 2 vols., Berlin, 1930–34; D. D. Egbert, Baroque Ivories in the Museo Cristiano of the Vatican Library, Art Studies, VIII, 2, 1931, pp. 35–45; J. Kollwitz, Die Lipsanothek zu Brescia, Berlin, 1933; C. Cecchelli, La cattedra di Massimiano ed altri avori romano-orientali, 4 vols., Rome, 1936–44; C. R. Morey, Early Christian Ivories of the Eastern Empire, Dumbarton Oaks Pap., I, 1941, pp. 41–60; A. C. Soper, The Brescia Casket: A Problem in Late Antique Perspective, AJA, XLVII, 1943, pp. 278–90; J. de Borchgrave d'Altena, Oeuvres de nos imagiers romans et gothiques: sculpteurs, ivoiriers, orfèvres, fondeurs, Brussels, 1944; D. M. Robb, Capitals of the Panteón de los Reyes, San Isidoro de León, AB, XXVII, 1945, pp. 165–74; G. van Bever, Les "tailleurs d'yvoire" de la Renaissance au XIXᵉ siècle, Brussels, 1946; J. de Borchgrave d'Altena, A propos de l'ivoire de Genoels Elderen et des fonts de Tirlemont, B. Musées royaux d'art et d'histoire (Brussels), 3d ser., XVIII, 1946, pp. 29–49; L. Grodecki, Ivoires français, Paris, 1947 (bibliog.); E. P. de Loos-Dietz, Vroeg-christelijke ivoren: Bijdrage tot de studie der stijlonwikkeling op den overgang van de vierde naar de vifde eeuw, Assen, 1947; D. J. A. Ross, Allegory and Romance on a Mediaeval French Marriage Casket, Warburg, XI, 1948, pp. 112–42; A. Boeckler, Elfenbeinreliefs der ottonischen Renaissance, Phoebus, II, 1949, pp. 145–55; P. Lemerle, Un bois sculpté de l'Annonciation, MPiot, XLVII, 1949, pp. 98–118; K. Weitzmann, Euripides Scenes in Byzantine Art, Hesperia, XVIII, 1949, pp. 159–210; O. Beigbeder, Le château d'amour dans l'ivoirerie et son symbolisme, GBA, XXXVIII, 1951, pp. 65–76; J. Natanson, Gothic Ivories of the 13th and 14th Centuries, London, 1951; K. Weitzmann, A Late Romanesque Ivory Virgin, Princeton Mus. Record, X, 2, pp. 1–6; R. Delbrück, Probleme der Lipsanothek in Brescia, Bonn, 1952; M. Schapiro, Joseph Scenes on the Maximinianus Throne in Ravenna, GBA, XL, 1952, pp. 27–38, 72–76; W. F. Volbach, Elfenbeinarbeiten der Spätantike und des frühen Mittelalters, 2d ed., Mainz, 1952 (bibliog.); J. Natanson, Early Christian Ivories, London, 1953; J. Hunt, Adoration of the Magi: Origin of the Whale Bone Relief in the Victoria and Albert Museum, Connoisseur, CXXXIII, 1954, pp. 156–61; E. Rosenbaum, The Andrews Diptych and Some Related Ivories, AB, XXXVI, 1954, pp. 253–61; W. S. A. Dale, English Ivories, 925–1175, Cambridge, Mass., 1955 (unpubl. diss., Harvard Univ.); J. Beckwith, An Ivory Relief of the Ascension, BM, XCVIII, 1956, pp. 118–22; J. Beckwith, An Ivory Relief of the Deposition, BM, XCVIII, 1956, pp. 228–33; W. S. A. Dale, An English Crozier of the Transitional Period in the Victoria and Albert Museum, AB, XXXVIII, 1956, pp. 137–41; B. Young, Scenes in an Ivory Garden, Met. Mus. B., N.S., XIV, 1956, pp. 252–56; E. Herzog and A. Ress, RDK, s.v. Elfenbein, Elfenbeinplastik, IV, 1957, cols. 1307–62; J. Beckwith, The Andrews Diptych, London, 1958; J. Beckwith, The Werden Casket Reconsidered, AB, XL, 1958, pp. 1–11; R. A. Koch, An Ivory Diptych from the Waning Middle Ages, Princeton Mus. Record, XVII, 2, 1958, pp. 55–64; T. Neumann, Die Elfenbeinpyxis von Xanten und ihr Umkreis, Berlin, 1958; P. Singelenberg, Iconography of the Etschmiadzin Diptych and the Healing of the Blind Man at Siloe, AB, XL, 1958, pp. 105–12; J. Beckwith, Sculptures d'ivoire à Byzance, Oeil, 51, 1959, pp. 18–25; J. Kollwitz, Reallexikon für Antike und Christentum, s.v. Elfenbein, IV, 1959, cols. 1106–41; L. Mortari, Un avorio gotico francese nel Lazio, BArte, XLV, 1960, pp. 313–19; E. von Philippovich, Anatomische Modelle in Elfenbein und andere Materialen, Sudhoff's Archiv für Geschichte der Medizin, XLIV, 1960, pp. 150–78; J. Beckwith, Some Anglo-Saxon Carvings in Ivory, Connoisseur, CXLVI, 1961, pp. 241–46; H. Landais, Département des objects d'art: les donations Mège et Côte au Louvre, Rev. du Louvre, XI, 1961, pp. 108–12, 128–34; E. von Philippowich, Simon Troger und andere Elfenbeinkünstler aus Tirol, Innsbruck, 1961.

Islam: T. P. Ellis, Ivory Carving in the Punjab, JIAI, IX, 1901, pp. 45–52; E. Kühnel, Sizilien und die islamische Elfenbeinmalerei, ZfBK, XXV, 1913–14, pp. 162–70; C. Migeon, Manuel d'art musulman, 2d ed., I, Paris, 1927, pp. 337–69; O. von Falke, Elfenbeinhörner, I: Ägypten und Italien, Panthon, IV, 1929, pp. 511–17; J. Ferrandis Torres, Marfiles arabes de Occidente, 2 vols., Madrid, 1935–40; U. Monneret de Villard, La cassetta incrostata della Cappella Palatina di Palermo, Rome, 1938; P. B. Cott, Siculo-Arabic Ivories, Princeton, 1939; W. Born, Ivory Powder Flasks from the Mughal Period, Ars Islamica, IX, 1942, pp. 93–111; R. Pinder-Wilson, E. of Islam, s.v. 'Adj, I, 1955, pp. 205–09; K. A. C. Creswell, A Bibliography of the Architecture, Arts and Crafts of Islam, Cairo, 1961, cols. 869–86 (bibliog.); E. Kühnel, Die islamischen Elfenbeinskulpturen (in preparation).

India: C. L. Burns, Ivory Carving in the Bombay Presidency, JIAI, IX, 1901, pp. 53–56; A. K. Coomaraswamy, Arts and Crafts of India and Ceylon, London, Edinburgh, 1913; J. Hackin, Recherches archéologiques à Begram, 2 vols., Paris, 1939; A. Maiuri, Statuetta eburnea di arte indiana a Pompei, Le Arti, I, 1939, pp. 111–15; A. K. Coomaraswamy, An Ivory Cabinet from Southern India, AB, XXIII, 1941, pp. 207–12; A. Ghosh, Taxila, Ancient India, IV, 1944–45, pl. XX; J. M. Casal, Fouilles de Virampatnam-Arikamedu, Paris, 1949; M. L. D'Ancona, An Indian Statuette from Pompeii, AAs, XIII, 1950, pp. 166–80; M. Rogers, An Ivory Sārdūla from Begram, AAs, XV, 1952, pp. 5–9; J. Hackin and others, Nouvelles recherches archéologiques à Begram, 2 vols., Paris, 1954; P. Stern and J. Auboyer, in Hackin, 1954; D. Barrett, A Group of Medieval Indian Ivories, O. Art, N.S., I, 1955, pp. 47–49; S. Kramrisch, Early Indian Ivory Carving, Philadelphia Mus. B., LIV, 261, 1959, pp. 55–66. See also bibliog. for INDIAN ART.

Far East: A. Brockhaus, Netsuke, Leipzig, 1909; B. Laufer, Ivory in China, Chicago, 1925; H. Maspero and R. Grousset, Les ivoires religieux et médicaux chinois d'après la collection Lucien Lion, Paris, 1939; B. C. Eastham, Chinese Art Ivory, Tientsin, 1940; W. E. Cox, Chinese Ivory Sculpture, New York, 1946; E. Saccasyn della Santa, Un coutelas siamois de type ancien, B. Musées royaux d'art et d'histoire (Brussels), 3d ser., XVIII, 1946, pp. 77–80; S. E. Lee, Two Early Chinese Ivories: Hāritī and Acrobats, AAs, XVI, 1953, pp. 257–64; A. B. Griswold, Notes on Siamese Art: An 18th Century Ivory Cetiya AAs, XXIII, 1960, pp. 6–9; Y. Okada, Netsuke: A Miniature Art of Japan, 4th ed., Tokyo, 1960; R. Bushell, ed., The Netsuke Handbook of Ueda Reikichi, Rutland, Vt., 1961 (bibliog.); M. Feddersen, Japanese Decorative Art, New York, 1962.

Illustrations: PLS. 235–250.

JAINISM. Jain art in general evolved in the same manner as Indian art, but it is imbued with a very different spirit. Early Jain buildings resemble Buddhist structures, and later ones Hindu archictecture, but they reveal characteristic differences of planning and decoration. Although Jain sculptures and paintings are of the same type as Buddhist and Hindu ones, the iconography and psychological approach are different. Buddhist figural art is characterized by a warm humanity and that of the Hindus by dynamism and sensuality, whereas Jain art is cold and intellectual, the result of the Jain doctrine, of the history of the sect, and of the social position of its members.

SUMMARY. Doctrine (col. 786). History (col. 787). Architecture col. 788). Sculpture (col. 792): *Sculpture before the 4th century; Iconography; Sculpture after the 4th century; Bronzes*. Painting (col. 797). Minor arts (col. 798).

DOCTRINE. The present Jain doctrine was formulated by Vardhāmana (ca. 599–527 or ca. 549–477 B.C.), called Mahāvīra (Great Hero), who was a contemporary of the Buddha. Mahāvīra reformed a religion preached over 200 years earlier by Pārśvanātha, and although he is considered the historic founder of Jainism the Jains themselves regard Mahāvīra as the last in a series of 24 tirthankaras (saviors) or jinas (victors; whence the name Jains, followers, or sons, of the victor). Like early Buddhism, Jainism is an atheistic, rationalistic, ascetic, and anti-Brahmanical doctrine, but with a "scientific" (physical) rather than a psychological emphasis. It interprets the world in terms of soul-monads, several kinds of ether and atoms which can form various compounds. Karma (the effect of action), which Buddhism regarded as a moral force, represents such a "physical" element, attracted by the activity engendered by earlier karma. Thus the circle of life through hells, animal and human existence, and many heavens is kept going from birth to rebirth. But avoiding murder, theft, lies, lewdness, and avarice and by self-discipline, patience, fasting, self-mortification, study, and meditation the influx of further karma can be stopped, and the soul-monad, omniscient and blissful, be freed from the entanglements of matter. As a result of this "physical" interpretation of salvation the Jains have occupied

themselves very much with speculations on the structure of the universe; the number of worlds in the infinity of space; the world axis with Mount Meru in the center of Jambudvīpa (where India is situated); the number and character of the other continents, oceans, heavens and hells, and of their inhabitants; and the number and character of successive world periods in the infinitude of time, oscillating between bad ages in which man has sunk down to the most primitive level and golden ages of a paradisaic life without sorrows and sins. The bad, though not yet the worst, age is believed to have commenced after Mahāvīra's death, with the result that the decline of the true religion has become inevitable, the Jains remaining the last group of "elect ones."

The Jains accept the Hindu gods and goddesses, though under different names, but concede to them only a subordinate role as higher, but not fundamentally different, beings. They also accept the Hindu myths and legends, but give them a rationalistic interpretation. The real objects of veneration are the 24 tirthankaras, the great world teachers. Though the devotees cannot communicate with these blissful monads on the summit of the universe, Isatprāgbhāra, the tirthankaras can strengthen the devotees' faith and reduce their karma. The lay devotees aspire merely to a rebirth in a better world; only the monks and nuns try to achieve salvation, sometimes by starving themselves to death.

By the 3d century B.C. the Jain religion had split up into two sects: the more rigorous Digambaras ("clothed in space," i.e., nude) and the moderate Śvetāmbaras ("clothed in white"). The Digambaras, who once predominated in the south, originally went about completely naked as did Mahāvīra, regard the original scriptures as lost, and differ in many details of ritual, monastic rules, and iconography from the Śvetāmbaras. The Śvetāmbaras, found mainly in the north, at present are more numerous and influential.

HISTORY. The Jains were originally one of the many ascetic sects of eastern India. The order never was strong, nor did its doctrine appeal to the emotional masses. But it found a lay following among the more sober-minded educated classes, especially merchants, bankers, administrators, army officers, and scholars. These gave rich donations, built beautiful temples and monasteries, and wielded considerable influence, even becoming the dominant political power in many states. Another access of strength came from foreign converts, especially Scythian immigrants, as Jainism did not acknowledge the Hindu caste system, which denied to non-Indians an elevated social status. In consequence, Jainism, although losing influence in its home country, gained strength in all frontier areas, first at Mathura, then in Rajasthan, Gujarat, the Deccan, Mysore, and the south (Tondainad, Tamilnad, the Pandya country, and Kerala). There it played a glorious pioneering role; the rise of local art and literature was more or less its work. Because they were in the minority the Jains generally were in a position similar to that of the Jews in Europe and were periodically exposed to cruel pogroms (their martyrs, tradition relates, suffered mass executions by impalement, on the stake, in boiling cauldrons or oil mills, on red-hot copper sheets), for example, in the Tamil south in the 7th century and under several Chola emperors, in Mysore in the 12th century, and in Gujarat during the reign of the Solanki king Ajayapāla (1174–77). Many Jains later embraced the Saiva or Vaishnava faith; a number of Saiva temples and caves and a few Vaishnava ones belonged to the Jains.

The Jains got along rather well with the Moslems. Though fanatic sultans and governors periodically destroyed the Jain temples and idols, others, more tolerant, were prepared to accept these as memorials of great human teachers, though they took exception to the "indecent" naked statues. They granted lucrative contracts (army provisions and equipment or tax collection) to the great Jain bankers and merchants, were prepared to listen to suave Jain scholars, and permitted the restoration of the mutilated sanctuaries. Especially in the late 16th and early 17th centuries the Jains exercised considerable influenced at the court of the Great Moghuls.

This situation affected the character of later Jain art very much because it engendered a spirit of loving conservation. Temples were carefully rebuilt many times more or less on the original pattern, and damaged sculptures were replaced by new ones. Copies of illuminated manuscripts were distributed to distant temples and monasteries, which were provided with underground "bunkers" and secret vaults. Even today the ancient treasures of Jain art are the best protected in India, the most important collections being kept in huge steel safes. For this reason Jain art could preserve the medieval tradition intact despite the cataclysm of the Moslem invasions; furthermore, the late medieval Hindu temple style both in the north and in the Deccan, the architecture of the Gujarat sultanate, and finally early Rajput painting were inspired by it to a considerable degree. But because of the fairly good relations with the Moslems Islamic art infiltrated to some degree.

ARCHITECTURE. Very little early Jain architecture has been preserved, and it does not differ greatly from Buddhist architecture. Stupas were erected over the ashes of the tirthankaras and Sthaviras (their successors as spiritual leaders). One such stupa still stands on Vipulagiri hill near Rajgir. Remnants of another stupa (of the seventh tirthankara Supārśvanātha, according to the *Tīrthakalpa* of Jinaprabhasūri, A.D. 1333), belonging to the late Śuṅga-Kushan period, have been excavated at Kaṅkālī Tīlā, Mathura. Stupas are pictured on the reliefs of some *āyāgapaṭas* (*āryakapaṭras*, votive tablets) found at the same place and at Maholi (3³/₄ mi. southwest). The great Udayagiri inscription of King Khāravela (1st cent. B.C.) of the Meghavāhana dynasty of Kalinga mentions the erection of a huge Jain temple enclosing a hall of beryl decorated with painted walls and ceilings — probably resembling a Buddhist chaitya hall — on the spot of the present Liṅgarāja temple in Bhuvaneshwar (Orissa). The same king and his family laid out a retreat for Jain arhats (hermits) on the Kumari (now Udayagiri and Khandagiri) hills, 6¼ mi. northwest. Some of these caves are single cells, others rock-cut copies of whole houses. Except for Khāravela's inscription, we could not attribute these to the Jains for nothing of the decoration reveals their Jain character: the deities depicted are early Hindu, for example, the sun-god Sūrya and the lotus goddess Gaja-Lakṣmī (Padmā-Śrī); the figural reliefs in the Rānī Gumpha have been interpreted by some as scenes from the life of Pārśvanātha and by others as episodes from the popular stories of Vāsavadattā and of Śakuntalā; and the whole building is even thought to have been a theater. The Barabar and Nagarjuni Caves (south of Patna), of the 3d century B.C., cannot be strictly claimed for the Jains, as the Ājīvika monks, to whom they had been donated, had turned, from followers of Mahāvīra's order, into its most bitter opponents. The only other early Jain cave in northern India is the Sonbhandar at Rajgir (Bihar). Excavated by Muni Vairedeva (probably identical with the Śvetāmbara teacher Vajra, d. A.D. 57), this cave has two chambers containing tirthankara images, and was also used as a habitation for monks (*caityavāsa*). Other early Jain caves, of the Sātavāhana, Kshatrapa, and Vākāṭaka periods (1st–4th cent.), are found in Saurashtra (Talaja) and the northern Deccan, for example, Cāmar Leṇā (a few miles northwest of Nasik), at Bhamer (Khandesh), Bhamchandra (25 mi. northwest of Poona, now Saiva), Dharasinva (with a vast vihara hall, 37 mi. north of Sholapur), Nāgarjuna's Koṭrī and Sītā-kī Nahānī at Paithan (on the western flank of Kanhar hill fort) near Pitalkhora, and Ankai Tankai (also on the flank of a hill fort) near Manmad. Except for having occasional jina (tirthankara) images the caves do not differ from their numerous Buddhist counterparts. The only Jain cave temple of the classic Gupta period is No. 20 at Udayagiri (Bhilsa) with a dedication inscription to the tirthankara Pārśvanātha, dated A.D. 426 under Kumāragupta I. In the south proper there are few Jain monuments although Jainism had been the dominant religion during the Samgam (i.e., originally Jain *sangha* = order) Age, because most of them were destroyed during the fanatic Saiva revival (6th cent. onward). Here and there rock-cut hermitages, sometimes with Brahmi or Pallava Grantha inscriptions, are found, for example, at Tirumparan-

kunram and in Ramanathapuram district. Other monuments, such as those at Kuzhithera (Chitral Koyil) in Kerala and Narthamalai in Pudukkottai, were later turned into Saiva temples.

The later Jain cave temples belong to the 7th–10th century. The earliest probably is the small shrine at the foot of a great cliff at Sittanavasal (Pudukkottai), founded by the Pallava king Mahendravarman I (ca. 600–30) before his conversion to Saivism; it is completely covered with beautiful murals (royal portraits, dancers, pond with lotus gatherers, jumping deer, and ascetics). Not much later are the Jain caves (dedicated to Pārśvanātha) at Aihole and No. 4 at Vatapi (mod. Badami). The last group in the Deccan are the five Jain caves (Nos. 30–34) of Ellora. They were begun in the 9th century, probably under the Rashtrakuta king Amoghavarṣa (814–80), a rather weak but highly cultured ruler, who, in contrast to his fanatically Saiva predecessors, was sympathetic to the peaceful Jain tenets; excavation ceased with the fall of the Rashtrakuta empire in 974, but the caves remained in use until the 13th century. Ellora by that time had been superseded as the capital by Manyakheta (Malkhed-Malkair), but, like most ex-capitals it continued to flourish as an industrial and mercantile center, and was dominated by Jain businessmen. The Choṭa (Little) Kailāsa is, as its name implies, a smaller (only one-storied) imitation of the famous great Śiva temple (No. 16, the Kailāsa) standing in a court carved out of the cliffside. The Indra Sabhā, a real cave but preceded by a court with a freestanding rock-cut chapel, and the Jagannātha Sabhā, a pure rock-cut cave, are two-storied, though the lower stories were never completed. The decoration is like that in the Buddhist and Brahmanical caves, but richer and harder; there are some fine images of Pārśvanātha, Gommaṭeśvara (see below), Indra (Kubera), Kuṣmāṇḍinī-Ambikā, etc. (PL. 251). The last Jain caves of the Deccan are near Chandor (dedicated to Candraprabha, 12th cent.). The latest in India are at Gwalior, by the 8th century (under King Ama, 753–60, son of Yaśovarman) a center of Jainism. The caves are situated along the foot of the cliffs of the hill fort. The oldest ones, of the 6th–8th century, are on the west side, outside the entrance to the Arvahi cliffs; those of the 8th–9th century are above the Lower Fort (Bādalgarh); the majority, executed by order of the Jain ministers of the Tomār rajas, especially of Duṅgar Siṅgh (1425–54) and Kīrti Siṅgh (1454–79), are on the southeast and northwest sides and on both ends of the Arvahi cliffs. All of these caves contain chapels with one or several images and reliefs, and sometimes cells for monks. The early sculptures are of high artistic quality (especially the birth of Mahāvīra and a yaksha couple); the late ones are sometimes grandiose and extremely crude (PL. 256).

Numerous Jain idols, in stone and in bronze, which date from the Kushan period (2d cent.) on, exist. Although a sizable number of early Hindu and Buddhist temples constructed in dressed stone are still standing, not a single Jain temple earlier than the 6th or 7th century has survived. This may be because the Jain communities were concentrated in the big cities, which were destroyed many times and thoroughly, and also because the middle class preferred brick construction as it was cheaper, but there is reason to believe that the temples were deliberately destroyed during periods of persecution, since the number of genuine medieval Jain temples preserved is unnaturally low when compared with those mentioned in inscriptions, the ones existing now having been rebuilt or at least heavily restored in the last centuries. The oldest still surviving Jain temples seem to be a ruin on Vaibhara hill near Rajgir, which encloses an apparently contemporaneous later Gupta Pārśvanātha image, and the Odegal Basti (from *vasati, vasatikā* = temple) at Sravana Belgola, a triple shrine in the flat-roofed early Gupta style (probably 6th–7th cent.).

The not too numerous genuine medieval Jain temples in the south belong to the Digambara sect, who are believed to have originated there with the immigration of Bhadrabāhu early in the 3d century B.C. Their first settlement was lonely Sravana Belgola in western Mysore (PLS. 252, 253). Its temples on and between two bare rock cones are rather well preserved.

On Doddabetta, or Vindhyagiri, hill stands the colossal monolithic statue of Gommateśvara (or Bāhubali, son of the first tirthankara Ṛṣabhanātha, said to have renounced the world after a bitter struggle for empire with his brother Bharateśvara), carved ca. 983 under Cāmundarāya, regent for the Ganga king Rācamalla III; around its fortified enclosure (containing a set of excellent tirthankara images) are the already mentioned Odegal Basti and two small shrines of the Vijayanagar period. On Chikkabetta, or Chandragiri, hill are the majority of temples: the Candraprabha Basti (8th cent.); the important Cāmuṇḍarāya Basti (A.D. 995), erected by Jinadevaṇa, the son of Cāmuṇḍarāya; the Kattale (1118), Śāsana (1117–18), and Eraḍukatte (1118) *bastis*, erected by Gangarāja, the great general of the Hoysala king Viṣṇuvardhana (1100–52); the beautiful Savatigandhavārana Basti (1123), built by Viṣṇuvardhana's queen Śāntale Devī (the famous temple dancer and musician). In the village are the huge Bhaṇḍārī Basti (1159), built by Hulla, the treasurer of King Narasiṁha I (1152–75), and the Akkana Basti (1181), erected by the wife of a minister of Ballāla II (1172–1220). They belong to the finest examples of Hoysala art. The Meguti temple in the fort at Aihole was erected in 634 by Ravikīrti, court poet of the Chalukya king, Pulakeśin II. The temple dedicated to Pārśvanātha at Pattadakal is of the 7th or 8th century. The other temples belong to the 10th–13th century, when the Western Chalukyas, Kadambas, Hoysalas, Yādavas, etc., were struggling for supremacy over the Deccan. Such, for example, are the temples at Aihole south of the town, Halsi, Degamve (Kallagudi Basti, A.D. 1175), Yalavatti, Belgaum (two in the fort, 1205), Anjaneri (near Nasik), Halebid (Pārśvanātha and Śāntinātha *bastis*, 11th cent.), Angadi (11th cent., Mysore), and Lakkundi (1171). Most of them are outside or at the periphery of the town; those that are in or near its center were erected after its reduction to a provincial industrial town.

The only surviving Jain centers of any importance in the Tamil country are Tirumalaipuram (with a 10th-cent. *basti*) and Tiruparuttikunram, a suburb of Kanchi (Conjeevaram), containing the Candraprabha and Vardhamāna (Trikūṭa Basti) temples built by the Chola emperors Rājendra I (ca. 1014–44) and Kulottuṅga I (1070–1120), and added to by Rājarāja III (1216–46), Bukka II (in 1387–88), and Kṛṣṇa Deva Rāya (in 1518). These temples, in provincial late Pallava style, are remarkable for their unique murals, which date from the 16th–18th century, with fragments from the 14th century.

The temples of the Vijayanagar period, apart from those already mentioned at Sravana Belgola and Tiruparuttikunram, belong mainly to two areas: Vijayanagar proper as well as its successor Penukonda and South Kanara (hinterland of Mangalore). The Vijayanagar (mod. Hampi) temples are the Gaṇigitti Jainanātha Caityālaya, erected in 1385 by Irugappa, general of Harihara II (1347–1404) and his brother Bukka II, who had added the mandapa at Tiruparuttikunram; a *basti* on a hill between the Viṭṭhala temple and Acyuta Rāya's temple; and the group of temples on the Hemakuta, near the Pampāpati temple, of a very simple style and with few sculptures, almost the only temples in the Deccan of the 14th and 15th centuries. The South Kanara temples, mainly of the 12th–16th century, are of the Kerala-Malabar coastal style, being constructed completely or partly in wood or imitating wood forms in stone. At Mudbidri there are 16 *bastis*, the largest and most notable being the Hosa Basti (1430). There is a Jain temple at Guruvayankeri. Karkal and Venur (Yenur) have colossal statues of Gommaṭeśvara.

There are also few genuine medieval Jain temples in northern India. The earliest are the Mahāvīra and Saccikā Devī temples at Osian (near Jodhpur, erected by Vatsarāja Pratīhāra, ca. 780–800). The next is the Śāntinātha at Deogarh (near Lalitpur with an inscription of 862 by the Pratīhāra king Bhoja I), very archaic, with a pronounced circumambulation passage and an open mandapa; around this are the remains of about thirty other Jain shrines and numerous detached images (8th–13th cent.). Other Jain temples or ruins stand at Gyaraspur (Mālādevī and Bajra Mātā), Un (Goaleśvara, 11th cent.) and Purana Chanderi in Malwa; at Khajuraho (10th–11th cent.) and Mahoba (12th–13th cent.) in Bundelkhand; Amwa near Ajanta (ca. 11th

cent.); Sirpur (Ṛṣabhanātha, 1412) and Aundha (Nāganātha, 13th cent., now Saiva) in Berar; and Tringalavadi (Ṛṣabhanātha, 1188) near Nasik. The best preserved of all these temples are those at Khajuraho: Pārśvanātha (VII, PL. 472) and Ādinātha, 11th century; here also is the Ghantai, a fine mandapa ruin. The earliest Indo-Islamic mosques, the Quwwat-ul-Islām at Lalkot (Delhi) and the Arhai-dīn-kā-Jhonpṛa at Ajmer, are simply remodeled Jain temples, for the arcaded courts of these temples could easily be transformed as desired.

The center of Jain art was and still is Gujarat and Rajasthan, especially Marwar, Mewar, Jaisalmer, and Bikaner. Here the number of temples is legion, and the wealth of their decoration simply overwhelming. This is the result of the great influence which Jain ministers and generals exercised under the Solanki (or Chaulukya, ca. 961–1244) and Vāghelā dynasties of Gujarat (ca. 1222–98), because Kumārapāla (1143–73), the founder of the younger branch of the Solankis, and then Lavaṇaprasāda and Vīradhavala, the first Vāghelās, had been placed on the throne with the help of the Jains. As the Solanki empire expanded over southern Rajasthan, Jain art spread over that whole area. Most important are Anhilwara (mod. Patan), Dholka, Pawagarh, Taranga Hill, and Mount Abu (Dilwara and Achalgarh; PL. 254) in Gujarat; Satrunjaya near Palitana (PL. 257) and Girnar near Junagarh in Saurashtra; Bhadreshwar (Vasai), Devakota, and Sambhavanatha in Cutch; Hathundi, Jalor, Kekind, Kumbharia, Mandor, Nadlai, Nadol, Pali, Phalodi, and Pindwara in Marwar; and Bijolia, Chitorgarh, and Nagda in Mewar. The principal builders were Vimala Shā (prime minister of the Solanki ruler Bhīma I, 1022–64), who founded the great temple groups of Dilwara, Kumbharia, and Satrunjaya; Kumārapāla, who built at Chitorgarh, Achalgarh, Girnar, Jalor, Taranga Hill, Devakota, etc.; and Vastupāla and Tejapāla [mighty ministers of the last Solanki ruler Bhīma II Bholo (the Simpleton)], who built at Dilwara, Satrunjaya, Girnar, Sambhavanatha, Sanchor, etc. All these rulers and ministers were shrewd enough not to neglect the temples of the Hindu masses, just as tolerant Hindu rulers made, or at least confirmed, donations to Jain sanctuaries. Some of these temples are in ruins; others have been restored, enlarged, and embellished many times, beginning in the 14th century, but especially in the 15th to the early 17th century (ascendency of the Rajput federation from Rana Kumbha to Sangrām; tolerant rule of the Moghul emperors Akbar and Jahāngīr), and again in the 18th and 19th centuries.

Most of these reconstructions and numerous new temple foundations (e.g., the famous Caumukh temple at Ranakpur, 1440) were due to the munificence of the Jain ministers of the various Rajput maharajas, especially the Jain pattidars (holders of trade monopolies). In the 19th century the role of patron was taken over by the big Jain bankers and millowners in Ahmadabad, Bombay, Calcutta, etc. These later temples, often temple cities (for, as in Buddhism, the donation of each temple or image is regarded as a meritorious work contributing to salvation), spread over northern Rajasthan, first during the 13th and 14th centuries (time of worst Moslem invasions) to Jaisalmer, Lodurva, and Rajgir; in the 15th to Bikaner; in the 16th to Amber, Sanganer, Bairat, Sikar, etc.; in the 18th and early 19th centuries to central India (Sonagiri or Sonagarh, near Datia; Mau Ranipur), then Bihar (Rajgir; Mount Parasnath or Sammeta-Sikhara, near Hazaribagh), Berar (Muktagiri, near Ellichpur), and finally to modern Delhi (the Chandni Chauk), Ahmadabad (especially the Hāthī Siṅgh temple), Indore, Calcutta (garden of Badrīdās), and Bombay.

As the Jain cult adjusted itself to the Hindu ritual in many ways, even to the introduction of temple music, very emotional hymns, and dancing girls, so too did the style of the temple, except in minor details. Even the sculptures and murals on the temple walls and ceilings superficially looked very similar, differing only in the details of their iconography. However, because the Jains were an often-disliked minority amid the Hindus and Moslems, because fundamentally all tirthankaras were equally venerated, and because among the Śvetāmbaras the lay congregation had an active share in the cult, certain special features, with a special terminology, developed. Most

Jain temples (basti) stand in the midst of a closed court (bhamti, bhamli) surrounded by a covered arcade, behind which are arranged chapels (khuntā-re-mandir, devakulikā) — often topped by their own shikaras — for all the tirthankaras, and sometimes also for minor deities, and cells for the resident monks (caitya-vāsin). In other cases (e.g., at Ranakpur) large subsidiary shrines (madar) or niches (gokhala) are grouped around the sanctuary (mūlagarbhāro gambhara) with its altar (śaluṅkhā). Detached minor temples have a circumambulation passage (bhrama) around the sanctuary, closed, as the mandapa often is, by a stone screen (pinjrā). In the temples of Gujarat and Rajasthan the hall (sabhāmaṇḍapa, cāvaḍā, cāvaḍī, cauṛī) in front of or around the sanctuary fills most of the court; at Ranakpur it is two to three stories high. In the court or in front of the temple there stands a flagpole (mānastambha), or sometimes a slim tower, such as the one at Chitorgarh (PL. 255), erected by Allata in 895 according to an inscription which is now lost, but in any case dating before 1100. A special type of temple is the caturmukha (caumukh). The center of this temple is occupied by a symbolic world mountain (Meru) around which are grouped four tirthankara images (samavasa-raṇa), with four corresponding sanctuary doors, mandapas, and temple entrances. Variations of samavasaraṇas are Mount Parasnath, on which 20 of the 24 tirthankaras are believed to have died, and Nandīśvaradvīpa, one of the mythical continents of the central world, a kind of earthly paradise.

The north Indian Jains have diligently preserved the medieval temple style up to the present day. However, Islamic influences began to infiltrate in the late 15th century, especially in the ornamentation, and during the Moghul period contemporary Islamic forms — pillars, niches, and domes — were taken over. Many temples of the 18th and early 19th centuries, for example, those at Mau Ranipur, Sonagiri, Muktagiri, and Merta, are built in the late Rajput-Moghul style. Finally, even Victorian European art was adapted, with an emphasis on mirrors, mirror mosaics, chandeliers, and sentimental female statues, as exemplified in the Jain temples of the Badrīdās at Calcutta.

SCULPTURE. Sculpture before the 4th century. Jain tradition, according to the Vasudevahiṇḍī, written before 610, and the Āvaśyakacūrṇi, 733, claims that an image of Mahāvīra (as Jī-vantasvamin, i.e., as prince before his renunciation) had been made while he was alive. This image was first in the possession of King Udayana of Vitabhaya-Patan, then of King Pradyota of Ujjain; later it was installed at Dasapura (Mandasor) and, according to Hemacandra, taken by Kumārapāla and placed in a temple at Anahillapattana. The earliest extant images, which may date from Maurya times (Patna, Mus.), are from Lohanipur; they are amazingly similar to the well-known protohistoric statuette from Harappa. Next come the Pārśvanātha bronze (Bombay, Prince of Wales Mus.) and the bronzes from Chausa (Patna, Mus.); see Bronzes. Jain reliefs first turn up at Mathura (Kaṅkālī Tīlā and Maholi). The earliest ones (1st cent.) are gateway (torana) reliefs from the stupa of Supārśvanātha and votive reliefs (āyāgapaṭas) decorated with a stupa venerated by godlings, or with triratna (nandyāvartana) symbols (of Harappan type) enclosing a tirthankara image (PL. 258). In the Kushan period the Jain iconography began to evolve, although it was still hardly distinguishable from the Buddhist one, and it was in the Gupta period (4th–7th cent.) that it first assumed its characteristic form.

Iconography. The central figures are always the tirthankaras in samadhi, represented either in a rigid standing posture (kāyotsarga) or in yogasana. These images, whose features are completely conventional, are characterized by a jewel (cintāmaṇi) on their chest and a Wheel of the Law (dharmacakra) on their throne. Traits by which the tirthankaras are distinguished are skin color, a tree (dīkṣāvṛkṣa) under which they are sometimes sitting, male and female tutelary deities (yaksha and yakshini; Skr., yakṣa, yakṣinī), and an animal on each side of the throne. These emblems reveal a close relationship to early Buddhist iconography: the Bo tree (bodhidruma), the snake demon Vāsuki, the dharmacakra, and the flanking lions or deer.

The yakshas were often depicted on the railing pillars of Buddhist stupas or, in the form of Pañcika and Hāritī, were venerated as protective deities converted to Buddhism. After the Council of Valabhi in 453 the iconography of the Digambara and Śvetāmbara sects began to bifurcate. In the 8th century a bloody fight took place between the two sects for the possession of the temples on Mount Girnar; King Āma of Gwalior intervened and decided in favor of the Śvetāmbaras. It was then that the tirthankara images began to be represented differently, those of the Digambaras showing the virile member, those of the Śvetāmbaras covered by a loin cloth (in the early images; later, this part of the body was often hidden by folded hands). The iconographic scheme is shown in the table on cols. 795–796 (D = Digambara, S = Śvetāmbara). From the point of view of religious history the yaksha and yakshini figures are the most interesting, because here we find many Hindu deities and some late Buddhist ones still in their original, or at least in a transitional, form before their integration into the later orthodox pantheons.

Most of the tirthankaras and yakshas are represented only in the complete series, either in friezes or in the series of chapels surrounding the temple courts. However, some have been especially venerated, with temples and individual images dedicated to them. In order of importance they are the tirthankaras Pārśvanātha, Mahāvīra, Ādinātha, Śāntinātha, Neminātha, Mallinātha, Candraprabha, and Supārśvanātha; the yakshas Gomukha, Brahmeśvara, and Pārśvayakṣa; and the yakshinis Ambikā, Cakreśvarī, Padmāvatī, and Mānasī. Ambikā (gold) is very popular and is shown as a mother goddess, sitting on a lion, a child on her lap and surrounded by children; Cakreśvarī (red), attended by Garuḍa, holds two disks (cakras); Padmāvatī, with a swan (haṃsa), holds lotuses. The jina whom they attend is then represented on top of their heads, as in Buddhism the Dhyani Buddha is depicted on or in the crown of the bodhisattva.

The Jain pantheon is not limited to these divinities. There are other blessed souls (siddhas), that is, the future tirthankaras, who are already saints; those who have attained enlightenment (arhats); teachers (ācāryas); universal monarchs (chakravartins), and the many categories of deities, such as the Nārāyaṇas or Vāsudevas, Baladevas, Manus, Rudras, Kāmadevas, Vyantara-Devas, Vaimānika-Devas, Vidyā-Devīs, Śāsana Devatās, and Dikpālas or Kṣetrapālas. But only a few of these are depicted in the art of the Jains. The Vidyā-Devīs, who are the goddesses of learning and are a special group of yakshis, are shown as Rohiṇī, Prajñaptī, Vajraśṛṅkhalā, Kuliśāṅkuśā, Cakreśvarī, Naradattā, Kālī, Mahākālī, Gaurī, Gāndhārī, Sarvāstramahājvalā, Mānavī, Vairoṭyā, Acchhuptā, Mānasī, Mahāmānasikā, and Sarasvatī (the Hindu goddess of learning, who in Jain art is the messenger of the tirthankaras = śāsana-devī). Also depicted, mainly in early Jain art, is the ram- or horse-headed yaksha Naigameṣa or Harinegameṣin; according to legend, this yaksha, who originally did harm to children, transferred the embryo of Mahāvīra from the womb of the Brahman lady Devānandā to that of Queen Triśalā and thus became the patron of expectant mothers and of children. There are cycles of reliefs and miniatures which depict the legends of Ṛṣabhanātha (and Gommaṭeśvara), Neminātha (especially the wedding from which he fled at the last moment to become an ascetic), Pārśvanātha, and Mahāvīra.

An important place in Jain iconography is occupied by the samavasaraṇas, halls built by the gods where each tirthankara delivered his first sermon, actually models of a mountain city enclosed by three ramparts; the aṣṭāpadas, the mountain rising in eight terraces on which Rsabhanātha died, identified with Mount Parasnath in Bihar; and the five Merus, the central mountains of the five continents. These all seem to be iconographic substitutes for the stupas when the latter went out of fashion. There are also kalpavṛkṣas or kalpatarus, wish-fulfilling trees of paradise (X, PL. 247), and dīkṣavṛkṣas, initiation trees of the tirthankaras; world diagrams; representations of Nandīśvaradvīpa, the earthly paradise where even slack devotees have a chance of being reborn; jinapaṭas, a kind of Jain mandala, showing the tirthankara enthroned in a temple, surrounded by his samavasaraṇa, yaksha, yakshi, principal apostles, and auspicious symbols; and yantras, called siddhacakras or navadevatās, that is, the "Nine Divinities," consisting of the "Five Supreme Ones" (arhat, siddha, ācārya, and upādhyāya, and sadhu) and the "Four Essentials" (right knowledge, faith, conduct, and penance); and the "Eight Auspicious Symbols" (aṣṭamaṅgala), that is, swastika, śrīvatsa, nandyāvartana, varddhamānaka (powder flask), bhadrāsana (throne), kalaśa (vase), darpaṇa (mirror), and matsya-yugma (pair of fishes).

Sculpture after the 4th century. The characteristic cult image developed in the Gupta period (4th–7th cent.). In the center was the tirthankara, standing, or in yogasana, on a lotus or a lion throne (siṃhāsana), surrounded by a halo (prabhāvalī) that was often combined with the back of a throne; at his feet on both sides the attending yaksha and yakshi; on the pedestal the dharmacakra and other symbols; and finally, the dīkṣāvṛkṣa with adoring deities on each side. By the 6th or 7th century other subjects appeared, such as individual images of yakshas and yakshinis, especially of Ambikā and Sarasvatī, or three tirthankaras were combined into one (tritīrthikamūrti). By the late 8th century the style of Jain sculpture had approached other Indian styles, and temple walls were covered with statues and reliefs of yakshas, yakshis, and many classes of gods and goddesses, the only difference being that the sanctuary and the principal wall niches were reserved for the tirthankaras. In succeeding centuries the goddesses (especially Cakreśvarī, Padmāvatī, and the Vidyā-Devīs) became increasingly important, as did various symbols, yantras, etc., and especially the samavarasaṇa. Jain sculpture is found scattered over the whole of India, from the eastern Punjab (Ketas) to Bengal (Burdwan, Bahulara, Bankura, Mahasthan, etc.), from the Himalaya (Kangra, Baijnath) to the southern tip of India (Kalugumalai, Tiruchchanattamalai, etc.), and in areas where not a single Jain temple has survived (or at least the sparse remnants have not yet been explored).

From about the 11th century the comprehensive relief cycles of the legends of the most famous tirthankaras began to appear, followed by representations of Nandīśvaradvīpa, and then statues of the donors of the temples (from small reliefs with sitting or kneeling figures to life-size statues on elephant back). This growing typological wealth went hand in hand with the progressing exuberance of medieval decoration, when the walls, columns, lintels, doors, and ceilings of every temple were covered with hundreds, and even thousands, of elegant sculptures, at first large in size and later almost diminutive. The ideal type of most of these figures does not differ from the all-Indian one, including the voluptuous bodies of the goddesses, though the overwhelming sexuality of Hindu sculpture is absent.

In the Islamic period the character of Jain sculpture changed. It now definitively became a hieratic tradition. By the 14th century the figures had lost all proportion, in the 15th century they degenerated into lifeless, though still vivid, images, and in the 17th into clumsy and grotesque dolls. During this last phase it was the fashion to give the eyes of the statues corneas of silver, glass, or jewels, which made them protrude like frogs' eyes. This degeneration was to some degree stemmed by the influence of Moghul and Rajput art (see MOGHUL SCHOOL; RAJPUT SCHOOL). This influence is shown in the contemporaneous costumes of the minor deities and secular figures, especially the minor goddesses dressed like dancing girls. In many temples in Rajasthan the Moghul-Rajput style of decorative reliefs superseded the traditional type, often with very happy results. The latter type is also found in the numerous wooden temples of Gujarat and southern Rajasthan (e.g., Anhilwara, Ahmadabad, Baroda, and Dabhoi), inspired by contemporaneous residential architecture; Gujrati and even Marāṭhā costumes are depicted in the reliefs.

Bronzes. Jain bronzes constitute a most important part of the sculpture (PL. 258). These bronzes represent the "good works" of the Jain lower middle class, votives of monks and nuns, artisans, small merchants, etc. In most cases they have an inscription on the back, mentioning the donor and consecrating priest, the date of consecration, and the temple to which they were donated. The donors are often represented on the pedestal as diminutive conventional figures. Many bronzes were house images, and were placed in small cupboard-like

Tirthankara (Jina)	Color	Tree	Emblem	Yaksha	Yakshini
1. Rṣabhanātha or Ādinātha	gold	banyan	bull	Gomukha	Cakreśvarī (D); Aprati-cakrā (S)
2. Ajitanātha	gold	sal	elephant	Mahāyakṣa	Rohiṇī (D); Ajitabalā (S)
3. Śambhavanātha	gold	prayāla	horse	Trimukha	Prajñaptī (D); Duritāriḥ (S)
4. Abhinandana	gold	priyaṅgu	monkey	Yakṣeśvara (D); Yakṣanāyaka (S)	Vajraśṛṅkhalā (D); Kālikā (S)
5. Sumatinātha	gold	sal	wheel, circle, or curlew (krauñcha)	Tamburu	Puruṣadattā (D); Mahākālī (S)
6. Padmaprabha	red	chchhatra	red lotus	Kusuma	Manovegā, Manoguptī (D); Śyāmā, Acyutā (S)
7. Supārśvanātha	green (D); gold (S)	siris	swastika and 5 snake hoods above head	Varanandi (D); Mātaṅga (S)	Kālī (D); Śāntā (S)
8. Candraprabha	white	nāga	crescent moon	Śyāma (D); Vijaya (D, S)	Jvālāmālinī (D); Bhṛkuṭī (S)
9. Puṣpadaṇta or Suvidhinātha	white	sālī	makara (crocodile) or crab	Ajita	Mahākālī or Ajitā (D); Sutārā (S)
10. Śītalanātha	gold	privaṅgu	śrīvṛkṣa (wishing tree) (D); śrīvatsa (S)	Brahmā, Brahmeśvara, or Brahmaśānti	Mānavi (D); Aśokā (S)
11. Śreyāṃsanātha	gold	taṇḍuka	deer, rhinoceros, or Garuḍa	Iśvara (D); Yakṣeṭ (S)	Gaurī (D); Mānavī (S)
12. Vāsupūjya	red	pāṭali	buffalo or bullock	Kumāra	Gāndhārī (D); Candrā, Caṇḍā (S)
13. Vimalanātha	gold	jambo	boar	Ṣanmukha or Kārttikeya	Vajroṭi or Vairoṭyā (D); Viditā (S)
14. Anantanātha	gold	asak	bear (falcon)	Pātāla	Anantamatī (D); Aṅkuśā (S)
15. Dharmanātha	gold	dadhiparṇa	vajradaṇḍa (thunderbolt)	Kinnara	Mānasī (D); Kandarpā (S)
16. Śāntinātha	gold	nandi	deer (tortoise)	Kimpuruṣa (D); Garuḍa (S)	Mahāmānasī (D); Nirvāṇī (S)
17. Kunthunātha	gold	bhilaka	goat	Gandharva	Vijayā or Jayā (D); Balā (S)
18. Aranātha	gold	mango	fish (D); nandyāvarta diagram (S)	Kendra (D); Yakṣeṭ, Yak-ṣendra (S)	Ajitā (D); Dhāraṇī, Dha-nā (S)
19. Mallinātha	gold (D); blue (S)	asak	water pot or jar	Kubera	Aparājitā (D); Vairoṭyā or Dharaṇapriyā (S)
20. Munisuvrata	black	champac	tortoise	Varuṇa	Baḥurūpinī (D); Nara-dattā (S)
21. Naminātha (Nimi or Nimeśsvara)	gold	bakula	blue waterlily	Bhṛkuṭī	Cāmuṇḍā (D); Gāndhārī (S)
22. Neminātha (Ariṣṭa-nemi)	black	vetasa	conch	Sarvāhna (D); Gomedha (S)	Kuṣmāṇḍinī or Dharma-devī (D); Ambikā (S)
23. Pārśvanātha	blue	dhātakī	serpent on seat and 7 snake hoods above head	Dharanendra or Pārśva-yakṣa	Padmāvatī
24. Mahāvīra (Vardha-māna)	gold	sal or teak	lion	Mātaṅga	Siddhāyiṇī or Siddhāyikā

shrines of wood or brass. The shape of the pedestal is similar to other Indian and early Chinese Buddhist bronzes. The yakshas sit on lotuses that swing out from the pedestal. Other bronzes form part of the ritualistic equipment, such as incense burners and statuettes of girls swinging fly whisks (*cāmaradhāriṇī* or chowry bearers) or holding one or several oil lamps (*dīpalakṣmī*) either in their hands or on lotus stalks.

The earliest bronze, a Pārśvanātha figure in Bombay (Prince of Wales Mus.; ca. 1st cent. B.C.), reminds us, by its technique, of the dancing girl figurine from Mohenjo-daro. The Chausa tirthankaras (Patna, Mus.) are of a weird naturalism. A *dharmacakra* from Chausa can stand comparison with the Amaravati reliefs. The apogee of this art was reached during the Gupta period, thanks to a remarkable founding technique in cire-perdue, with which the artisans could master the most complicated forms, modeled very sensitively and inlaid (especially the eyes and ornaments) with gold, silver, and copper. In the subsequent half millennium the composition became richer and richer (*aṣṭatritīrthikamūrti, caturvimśatipaṭa*, i.e., all the 24 jinas, *caturmukha*), the number of subsidiary figures increased, and the throne backs were filled with godlings and goddesses; however, the modeling was conventional and heavy. In 7th-century Marwar and northern Gujarat we find short figures with Mongoloid features (Hun settlers?) and ponies. Between the late 8th and early 10th centuries the "baroque" style reached its zenith. The quality of the bronzes was maintained until the 12th century, when they became crude; the inlaid silver eyes, for example, became mere rectangles. Here also the Rajput folk style exercised a beneficent influence, resulting, in the 16th–18th century, in a renascence that was charming though rather "primitive" (mainly chowry bearers, *dīpalakṣmīs*, etc.), but which ended, in the 19th century, in a philistine naturalism. The most important hoards of Gupta and early medieval Jain bronzes were discovered at Akota (Baroda), Vasantgarh (Pindwara in Marwar), Lilva-Deva (Panch Mahals), and Rajnapur-Khinkhini (Madhya Pradesh). The few known Jain bronzes from south India are no more than iconographic varieties of the dominating Saiva types.

PAINTING. Although murals are mentioned in Khāravela's Udayāgiri inscription (1st cent. B.C.), no vestiges earlier than the 7th century are extant. To the beginning of that century belong the exquisite wall paintings in the small cave temple of Sittanavasal (Pudukkottai); apart from diminutive figures of squatting ascetics in the continuous ceiling ornament (a repair of the 9th cent.) they are purely secular. The fragments of ceiling paintings at Ellora (ca. 900–1100), Tirumalaipuram (10th and 14th cent.), and Tiruparuttikunram (earlier series 14th cent.) depict scenes from the legend of Pārśvanātha, yakshas, yakshis, and venerating godlings. The long series of friezes in the Vardhamāna temple at Tiruparuttikunram depict the legends of Ṛṣabhanātha, Mahāvīra, Neminātha and his cousin Kṛṣṇa, and the Brahman lady Agnilā transformed into the yakshini Ambikā or Dharmadevī. Here are represented a variety of styles; the oldest, of the 16th century, recall the paintings at Lepakshi (see ANDRHA; DRAVIDIAN ART); the latest, of the 19th century, are similar to paintings found at Madura and Travancore. At present the only known illustrated south Indian Jain manuscript is the *Ṣaṭkhaṇḍāgama*, ca. 1113–20, from Mudbidri.

In northern India no Jain paintings before the 11th century have been preserved. But there do exist an uninterrupted series of illustrated manuscripts (until the 13th cent. generally on palm leaves, thereafter on paper) from the time of the Solanki dynasty up to the present day, a number of painted wooden book covers, and a few large pictures on cloth. The majority of these works come from Gujarat, a smaller number from southern Rajasthan, and a few from Jaunpur in Uttar Pradesh, Palam near Delhi, and Mandu in Malwa. These manuscripts were carefully preserved in the bhandars (monastery libraries) of Ahmadabad, Baroda, Anhilwara, Cambay, Chani, etc., and particularly Jaisalmer. Jain manuscripts, especially of the *Kalpasūtra* and *Kālakācāryakathā*, have found their way into some Occidental museums. The *Kalpasūtra* is a handbook of disciplinary rules and is indispensable in every monastery (*upāśraya*); it is illustrated with scenes from the legend of Mahāvīra: his descent from heaven, conception in the womb of the Brahman lady Devānandā, transfer to Queen Triśalā, life as prince, renunciation of the world, terrible self-mortification, and sermon as world teacher in the *samavasaraṇa*. The *Kālakācāryakathā* is a Jain counterpart to the Book of Esther; it relates how the barbarian king Gardabhilla abducted a Jain nun and how her brother Kālakācārya went to the Scythian barbarians (Śakas) and induced them to invade India and to overthrow the tyrant. It is interesting to observe that the Scythian friends of the Jains are always depicted as contemporary Moslems. These two texts were diffused only late in the 13th century, about the time when Gujarat was conquered by the Moslems. The manuscripts of the pre-Moslem centuries deal with different texts, hagiographies, commentaries, etc., such as the *Jñātasūtra, Mahāvīracarita, Subāhukathā, Oghaniryukti, Daśavaikālikalaghuvṛtti, Niśīthacūrṇi*, and *Sāvagapaḍikammanasuttacuṇṇī*. Historical pictures and portraits of this time exist, among which are portraits of King Jayasimha Siddharāja, King Kumārapāla, the great scholar and missionary Hemacandra, and Jinadattasūri; and there is a representation of the disputation in 1126 between Devasūri and the Digambara Kumudacandra who had come from the Carnatic. Beginning in the 15th century there was a revival of original painting, illustrating secular or Hindu texts such as the *Vasantavilāsa, Bālagopālastuti, Devīmāhātmya, Ratirahasya*, and *Kumārasaṃbhava*; though this type of painting had originally been done by the Jains, it seems that they soon gave it up when it was taken over by the Hindus. Jain art and doctrine had become set and orthodox, but now the spell of ossification was broken, new subjects were taken up (e.g., the *Supārśvanāthacarita, Uttarādhyayanasūtra*), and secular subjects, such as dancing girls, were introduced. The late 16th century saw the introduction of a new realism: secular subjects were treated in, for instance, the *vijñaptipatras* (official invitation scrolls addressed to famous *ācāryas*), and ancient legends were put into a contemporaneous setting (e.g., the *Kālakācāryakathā, Sālibhadramahāmunicarita*).

Jain painting during the reign of the Solankis, Vāghelās, and Paramāras (later Ellora murals) followed the general medieval tradition, especially the "School of the Ancient West." Though the typology and formal canon were derived from the classical Gupta tradition, the spirit which animated it had turned into its very opposite. This painting was characterized by vivid but hard outline, a rather crude realism, no modeling, no space, only the slightest indication of scenery and background, and bright, simple colors, especially red or yellow backgrounds. During the early Islamic period this primitive style became completely ossified, and the scenes were reduced to conventionalized ornaments, farther from naturalism than even Byzantine icons. Heads seen from the front are globes; in profile, they resemble birds' heads, with beaklike noses and eyes projecting like daggers. Men have breasts like women; the attendant figures form lateral friezes; the representations of rooms, furniture, etc. are reduced to a top or bottom ornament. But these miniatures do exhibit a great linear beauty, a perfect balance of surfaces, and a simple harmony of bright colors and golden surfaces. When Śakas are depicted, they appear to have been copied from Islamic prototypes of the Abbasside-Seljuk, later of the Timurid (Herat), school. The Rajasthan variety of the style is simpler than that of Gujarat. In the 15th century this style began to disintegrate, the figures were freely handled like shadow-play dolls, new compositions were tried out, and Islamic scenes and ornaments were introduced. An especially ostentatious and ponderous style developed in Jaunpur, a very simple one in Mandu. In the 16th century the style was influenced by the early Rajput, in the 17th century the Rajput style became dominant, and finally European elements infiltrated.

MINOR ARTS. The Jains used the same objects and articles as the other Indians, but in the ornamentation introduced their own iconography: figures of the tirthankaras, the *aṣṭamaṅgala*, benedictions, etc. The articles were painted, executed in lacquer, carved, embroidered, etc.

BIBLIOG. *a. Religion and community*: Jaina Sūtras (Eng. trans., H. Jacobi), 2 vols., Oxford, 1884–95; A. Guérinot, Répertoire d'épigraphie djaina, Paris, 1908; U. D. Barodia, History and Literature of Jainism, Bombay, 1909; M. Stevenson, The Heart of Jainism, Oxford, 1915; P. C. Nahar and K. Ghosh, An Epitome of Jainism, Calcutta, 1917; W. J. Kirfel, Die Kosmographie der Inder, Leipzig, 1920; J. Hertel, On the Literature of the Shvetambaras of Gujarat, Leipzig, 1922; H. von Glasenapp, Der Jainismus: Eine indische Erlösungsreligion, Berlin, 1925; A. Guérinot, La religion djaina, Paris, 1926; Hemachandra, Triṣaṣṭiśalākāpuruṣacarita (Eng, trans., H. M. Johnson), 2 vols., Baroda, 1931–37; A. Sen, Schools and Sects in Jain Literature, Bombay, 1931; C. J. Shah, Jainism in North India 800 B.C.–A.D. 526, Calcutta, 1932; B. A. Saletore, Mediaeval Jainism: With Special Reference to the Vijayanagar Empire, Bombay, 1938; M. B. Jhavery and K. V. Abhyankar, Comparative and Critical Study of Mantraśāstra, Ahmedabad, 1945; G. Hanumantha Rao, Jainism in the Deccan, J. Ind. H., XXVI, 1948, pp. 45–49; U. P. Shah, Yaksha Workship in Early Jaina Literature, J. Baroda O. Inst., III, 1953, pp. 54–71; C. B. Sheth, Jainism in Gujarat; A.D. 1100–1600, Bombay, 1953; B. P. Desai, Jainism in South India, Sholapur, 1959. *b. The arts in general*: J. Burgess, Reports of the First Season's Operations in the Belgâm and Kaladgi Districts, London, 1874; J. Fergusson and J. Burgess, The Cave Temples of India, London, 1880; A. K. Coomaraswamy, Notes on Jaina Art, JIAI, XVI, 1914, pp. 81–98; Puran Chand Nahar, Ragjir Jain Inscription, JBORS, V, 1919, pp. 331–43; R. Narasimhachar, Inscriptions at Śravana Belgola (Ep. Carnatica, II), Bangalore, 1923; R. P. Chandra, Jaina Remains at Ragjir, Archaeol. Survey of India Ann. Rep., 1925–26, pp. 121–27; V. H. Jackson, Notes on the Barabar Hills, JBORS, XII, 1926, pp. 49–52; Muniraj Shri Jayantavijayanji, Ābū, 3 vols., Ujjain, 1933–41; T. N. Ramachandran, Tiruparuttikunram and Its Temples, Madras, 1934; B. C. Law, Sacred Places of the Jains, J. United Provinces, H. Soc., IX, 2, 1936, pp. 100–04; H. D. Sankalia, The Archaeology of Gujarat (Including Kathiawar), Bombay, 1941; Sarabhai M. Nawab, Jaina Tirthas in India and Their Architecture, Ahmedabad, 1944; A. Banerji, Jain Antiquities in Ragjir, Indian H. Q., XXV, 1949, pp. 205–10; K. K. Handiqui, Yaśastilaka and Indian Culture, Sholapur, 1949; A. Banerji, Traces of Jainism in Bengal, J. Uttar Pradesh H. Soc., XXIII, 1950, pp. 164–68; H. Goetz, Art and Architecture of Bikaner State, Oxford, 1950; T. N. Ramachandran, Jain Monuments and Places of First-class Importance, Calcutta, 1950; U. P. Shah, Studies in Jaina Art, Benares, 1955. *c. Architecture*: J. Burgess, Śatruñjaya, London, 1870; J. Burgess, Report on the Antiquities of Kathiâwàd and Kachh, London, 1876; J. Burgess, Report on the Antiquities in the Bidar and Aurangabad Districts, London, 1878; J. Burgess, Report on the Elura Cave Temples and the Brahmanical and Jaina Caves in Western India, London, 1883; G. Bühler, The Barabar and Nagarjuni Hill Cave Inscriptions of Aśoka and Dasaratha, Indian Ant., XX, 1891, pp. 361–65; G. Bühler, The Jaina Inscriptions from Śatruñjaya, Ep. Indica, II, 1894, pp. 34–86; G. Bühler, A Legend of the Jain Stupa at Mathura, Indian Ant., XXVII, 1898, pp. 49–54; V. A. Smith, The Jain Stupa and Other Antiquities at Mathura, Allahabad, 1901; J. Burgess and H. Cousens, The Architectural Antiquities of Northern Gujarat, London, 1903; D. R. Bhandarkar, Chaumukh Remple at Rānpur, Archaeol. Survey of India Ann. Rep., 1907–08, pp. 205–18; D. R. Bhandarkar, Temples, of Osiā, Archaeol. Survey of India Ann. Rep., 1908–09, pp. 100–15; J. Fergusson and J. Burgess, History of Indian and Eastern Architecture, II. London, 1910; Archeol. Dept. of Hyderabad, Ann. Rep., 1914–15 ff.; D. R. Bhandarkar, Some Temples on Mount Abu, Rūpam, 3, 1920, pp. 11–21; H. Cousens, Chalukyan Architecture of the Kanarese Districts, Calcutta, 1926; B. M. Barua, Old Brahmi Inscriptions in the Udayagiri and Khandagiri Caves, Calcutta, 1929; H. Cousens, Mediaeval Temples of the Dakhan, Calcutta, 1931; H. Cousens, Somānatha and Other Mediaeval Temples in Kāṭhiāwād, Calcutta, 1931; M. M. H. Kuraishi, List of Ancient Monuments Protected under Act VII of 1904 in the Province of Bihar and Orissa, Calcutta, 1931; A. H. Longhurst, Hampi Ruins, 3d ed., Delhi, 1933; S. Chandrasekhar, Jainism and Penukonda Jain Temples, J. Andhra H. Research Soc., XVII, 1946–47, pp. 162–70; B. M. Barua, Khāravela as King and Builder, JISOA, XV, 1947, pp. 45–61; H. Goetz, Pāwāgadh-Champaner, J. Gujarat Research Soc., XI, 1949, pp. 51–66; T. N. Ramachandran, The Mañcapuri Cave, Indian H. Q., XXVII, 1951, pp. 103–08; T. N. Ramachandran and Chhotalal Jain, Khandagiri-Udayagiri Caves, Calcutta, 1951; Dilwara Temples, New Delhi, 1952; K. Fischer, Caves and Temples of the Jains, Aliganj, 1956; Krishna Deva, The Temples of Khajurāho in Central India, Ancient India, XV, 1959, pp. 43–65; E. Zannas and J. Auboyer, Khajurāho, The Hague, 1960. *d. Iconography*: J. Burgess, Digambara Jaina Iconography, Indian Ant., XXXII, 1903, pp. 459–64; D. R. Bhandarkar, Jain Iconography, Part 1, Archaeol. Survey of India Ann. Rep. 1905–06, pp. 141–49, Parts 2–3, Indian Ant., XL, 1911, pp. 125–30, 153–61; R. P. Chandra, The Śvetāmbara and the Digambara Images of the Jainas, Archaeol. Survey of India Ann. Rep., 1925–26, pp. 176–82; T. N. Ramachandran, Tiruparuttikunram and Its Temples, Madras, 1934, appendix; H. D. Sankalia, Unsual Form of a Jain Goddess, Jaina Ant., IV, 1938, pp. 85–88; B. Bhattacharyya, Indian Images, II: Jaina Iconography, Lahore, 1939; H. D. Sankalia, Jaina Iconography, New Indian Ant., I, 1939, pp. 497–520; H. D. Sankalia, Jaina Yakshas and Yakshinīs, B. Deccan Coll. Research Inst., I, 1940, pp. 157–68; U. P. Shah, Iconography of the Jain Goddess Ambikā, J. Univ. Bombay, IX, 2, 1940, pp. 147–69; P. K. Gode, Haṃsa-Vāhanā and Mayūra-Vāhanā Sarasvatī, JISOA, IX, 1941, pp. 133–40; U. P. Shah, Iconography of the Jain Goddess Sarasvatī, J. Univ. Bombay, X, 2, 1941, pp. 195–218; U. P. Shah, Iconography of the Sixteen Jaina Mahāvidyās, JISOA, XV, 1947, pp. 114–77; U. P. Shah, Age of the Differentiation of Digambara and Śvetāmbara Images, B. Bombay Mus., I, 1952, pp. 30–40; U. P. Shah, Harinegameṣin, JISOA, XIX, 1952–53, pp. 19–41; A. K. Bhattacharyya, Iconography of Some Minor Deities in Jainism, Indian H. Q., XXIX, 1953, pp. 332–39; U. C. Bhattacharyya, Gomukha Yaksha, J. Uttar Pradesh H. Soc., n.s., V, 2, 1957, pp. 8–9; U. P. Shah, Parents of the Tīrthankaras, B. Bombay Mus., V, 1957, pp. 24–30; U. P. Shah, Brahma-Śānti and Kaparddi Yakshas, J. Baroda Univ.,

VII, 1, 1958, pp. 59–72. *e. Sculpture*: A. Cunningham, Four Reports (Archaeol. Survey of India, Rep., II), Simla, 1871, A. Cunningham, Report of Tours in Bundelkhand and Malwa in 1874–75 and 1876–77 (Archaeol. Survey of India, Rep., X), Calcutta, 1880; G. Bühler, On the Pedestal of an Image of Parśvanātha in the Kangra Bazar, Ep. Indica, I, 1892, p. 120; G. Bühler, Specimens of Jaina Sculptures from Mathura, Ep. Indica, II, 1894, pp. 311–23; A. Rea, Buried Jaina Remains in Dānavulapād, Archaeol. Survey of India Ann. Rep., 1905–06, pp. 120–27; Hirananda Sastri, Some Recently Added Sculptures in the Provincial Museum, Lucknow, Calcutta, 1922; W. S. Hadaway, Notes on Two Jaina Metal Images, Rūpam, 17, 1924, pp. 48–49; M. Govind Pai, Why Are the Bahubali Colossi Called Gommaṭa?, Indian H. Q., IV, 1928, pp. 270–86; B. N. Treasurywalla, Wood Sculpture from Guzerat, Rūpam, 35–36, 1928, pp. 31–34; O C. Gangoly, A Jaina Relief from South Kensington Museum, Rūpam, 37, 1929, pp. 1–2; Anu Ghose, A Jaina Madonna, Roopa-Lekha, I, 1, 1929, pp. 15–18; J. P. Vogel, La sculpture de Mathura, Paris, Brussels, 1930; K. P. Jayaswal, Jain Image of the Maurya Period, JBORS, XXIII, 1937, pp. 130–32; H. D. Sankalia, A Jaina Gaṇeśa in Brass, Jaina Ant., V, 1939, pp. 49–66; A. Banerji-Shastri, Maurya Sculptures from Lohanipur-Patna, JBORS, XXVI, 1940, pp. 120–24; H. D. Sankalia, Story in Stone of the Great Renunciation of Neminātha, Indian H. Q., XVI, 1940, pp. 314–17; S. C. Upadhyaya, A Metal Chaturviṃśati Jina-Paṭṭa in the Prince of Wales Museum, J. Gujarat Research Soc., II, 1940, p. 150 ff.; H. D. Sankalia, Jain Monuments from Deogarh, JISOA, IX, 1941, pp. 97–104; Adris Banerji, Two Jaina Images, JBORS, XXVIII, 1942. p. 43 ff.; V. S. Agrawala, Mathura Āyāgapattas, J. United Provinces H. Soc., XVI, 1, 1943, p. 58 ff.; V. S. Agrawala, Vāsavadatta and Śakuntalā Scenes in the Rāṇīgumphā Cave of Orissa, JISOA, XIV, 1946, pp. 102–09; H. Goetz, The "Pretty Archaic Style" in Old Gujarati Sculpture, J. Gujarat Research Soc., VIII, 1946, p. 113 ff.; M. R. Majumdar, Problematic Image of a Goddess, J. Gujarat Research Soc., VIII, 1946, p. 134 ff.; H. Goetz, The Post-medieval Sculpture of Gujarat, B. Baroda Mus., V, 1947–48, pp. 29–42; H. Goetz, A Monument of Old Gujerātī Wood Sculpture; The Jaina Mandapa in the Baroda Museum, B. Baroda Mus., VI, 1948–49, pp. 1–30; V. S. Agrawala, Catalogue of the Mathura Museum, J. Uttar Pradesh H. Soc., XXIII, 1950, pp. 35–147; U. P. Shah, Sidelights on the Life-time Sandalwood Image of Mahāvīra, J. Baroda O. Inst., I, 1951–52, pp. 358–68; U. P. Shah, A Unique Jaina Image of Jīvantasvāmī, J. Baroda O. Inst., I, 1951–52 pp. 72–79; U. P. Shah, Female Chaurī-bearer from Ankottaka and the School of the Ancient West, B. Bombay Mus., I, 1952, pp. 43–46; U. P. Shah, Seven Bronzes from Lilvā-Devā (Pañch Mahāls), B. Baroda Mus., IX, 1952–53, pp. 43–51; U. P. Shah, An Early Bronze Image of Pārśvanātha, B. Bombay Mus., III, 1953, pp. 63–65; U. P. Shah, Jaina Sculpture from Ladol, B. Bombay Mus., III, 1953, pp. 66–73; R. C. Agrawala, A Unique Image of the Jaina Goddess Saccikā, J. Bombay Branch of the Royal Asiatic Soc., n.s., XXIX, 1954, pp. 63–66; U. P. Shah, Bāhubali: A Unique Bronze in the Museum, B. Bombay Mus., IV, 1954, pp. 32–39; D. C. Sirkar, Two Jain Inscriptions in the Lucknow Museum, Indian H. Q., XXX, 1954, pp. 183–88; Balchandra Jain, Jain Bronzes from Rajnapur Khimkhini, J. Indian Mus., XI, 1955, p. 15, ff.; S. R. Rao, Jain Bronzes from Lilva-Deva, J. Indian Mus., XI, 1955, p. 30 ff.; U. P. Shah, Bronze Hoard from Vasantagaḍh, Lalit Kalā, 1–2 1955-56, pp. 55–65; U. P. Shah, More Images of Jīvantasvāmī, J. Indian Mus., XI, 1955, pp. 49 ff.; R. C. Agrawala, Some Interesting Sculptures of the Jaina Goddess Ambikā from Marwar, Indian H. Q., XXXII, 1956, pp. 434–38; D. Barrett, A Group of Bronzes from the Deccan, Lalit Kalā, 3–4, 1956–57, pp. 39–45; R. C. Agrawala, Some Unpublished Sculptures from Western Rajasthan, J. Gujarat Research Soc., XIX, 1957, pp. 40–44; B. P. Desai, Jainism in Kerala, J. Indian H., XXXV, 1957, pp. 243–46; R. C. Agrawala, An Image of Jīvantasvēmī from Rajasthan, Brahmā Vidyā, XXII, 1958, pp. 32–34; U. P. Shah, Akota Bronzes, Bombay, 1959. *f. Painting*: W. Hüttemann, Miniaturen zum Jinacaritra, BA, II, 1913, pp. 47–77; A. K. Coomaraswamy, Catalogue of the Indian Collections in the Museum of Fine Arts, IV, Boston, 1924; N. C. Mehta, Studies in Indian Painting, Bombay, 1926; Ajit Ghose, The Development of Jaina Painting, AAs, II, 1927, pp. 187–202; W. N. Brown, Early Śvetāmbara Jaina Miniatures, Indian Art and Letters, III, 1929, pp. 16–26; A. K. Coomaraswamy, An Illustrated Śvetāmbāra Jaina Manuscript of A.D. 1260, Eastern Art, II, 1930, pp. 237–40; A. K. Coomaraswamy, Two Western Indian Manuscripts, Boston Mus. B., XXIX, 4, 1931, pp. 6–11; W. N. Brown, The Story of Kālaka, Washington, 1933; P. Nahar, An Illustrated Sālibhadra Ms., JISOA, I, 1933, pp. 63–67; W. N. Brown, A Descriptive and Illustrated Catalogue of Miniature Paintings of the Jaina Kalpa-Sūtra as Executed in the Early Western Indian Style, Washington, 1934; K. P. Jain, Banner of the Jinas and Its Use, Indian Culture, I, 1934–35, pp. 81–88; S. M. Nawab, Jain Chitrakalpadruma (in Gujarati), Ahmedabad, 1936; H. Sastri, Indian Pictorial Art as Developed in Book Illustrations, Baroda, 1936; H. Sastri, The Oldest Known Illustrated Paper Manuscripts, J. Bombay Univ., V, 3, 1936–37, pp. 94–95; W. N. Brown, A Jaina Manuscript from Gujarat Illustrated in Early Western Indian and Persian Styles, Ars Islamica, IV, 1937, pp. 154–72; W. N. Brown, Stylistic Varieties of Early Western Indian Miniature Painting About 1400 A.D., JISOA, V, 1937, pp. 2–12; S. Kramrisch and V. Raghavan, Dakṣiṇa-Citra, JISOA, V, 1937, pp. 218–37, VI, 1938, pp. 195–96; S. Paramasivan, The Mural Paintings in the Cave Temple at Sittanavasal (Harvard Tech. S. VIII, 2), 1938; Cambridge, Mass., 1939; H. Sastri, Scroll Letters of the Jains, Asia, XXXIX, 1939, pp. 630–34; W. N. Brown, Manuscript Illustrations of the Uttarādhyayana Sūtra, New Haven, 1941; S. M. Nawab, Chitrakalpasūtra (in Gujarati), Ahmedabad, 1941; U. P. Shah, Varddhamana Vidyā-Paṭa, JISOA, IX, 1941, pp. 42–51; H. Sastri, Ancient Vijñaptipatras, Baroda, 1942; A. C. Eastman, An Illustrated Jain Manuscript Transitional to the Rajput Style, JAOS, LXIII, 1943, pp. 285–88; A. C. Eastman, Iranian Influences in Svetambara, Jaina Painting in the Early Western Indian Style, JAOS, LXIII, 1943, pp. 93–113; W. N. Brown, A Painting of a Jain Pilgrimage, Art and Thought, London, 1947, pp. 69–72; S. M. Nawab, Masterpieces of Kalpasūtra Painting, Ahmedabad, 1948; V. S. Agrawala, A Jaina Cloth Painting or Chitrapata of Taruna Prabha Sūri, J. Uttar Pra-

desh H. Soc., XXII, 1949, p. 214 ff.; Moti Chandra, Jain Miniature Paintings from Western India, Ahmedabad, 1949; U. P. Shah, Śrīkālikācāryakathā-samgraha, Ahmedabad, 1949; H. Goetz, Decline and Rebirth of Mediaeval Indian Art, Mārg, IV, 2, 1950, pp. 36–48; S. M. Nawab, Sri Jaina Chitrā-valī, Ahmedabad, 1951; Moti Chandra, An Illustrated Manuscript of the Kalpasūtra and Kālakāchāryakathā, B. Bombay Mus., IV, 1954, pp. 40–48; S. M. Nawab, Astanhika-Kalpa-Subodhikā, Ahmedabad, 1954; S. M. Nawab, The Golden Leaves and the Paintings of the Kalpasūtra Manuscripts Newly Discovered from Ahmedabad Gyāna Bhandār, Ahmedabad, 1954; S. M. Nawab, Jain Chitra-Paṭāvalī, Ahmedabad, 1954; S. M. Nawab, Pavitra Kalpa-Sūtra, Ahmedabad, 1954; Muni Sri Punyavijayaji, Jaisālmer-nī Chitrasamṛddhi, Ahmedabad, 1954; Moti Chandra, An Illustrated Ms. of Mahāpurāna in the Collection of Sri Digambar Naya Mandir, Delhi, Lalit Kalā, V, 1959, pp. 68–81; Promod Chandra, Notes on Mandu Kalpasūtra, Mārg, XII, 3, 1959, pp. 51–54; K. Khandalawala and Moti Chandra, A Consideration of an Illustrated Ms., from Maṇḍapadurga (Mandu) Dated 1439 A.D., Lalit Kalā, 6, 1959, pp. 8–29; S. M. Nawab, Jaina Chitrakalpalatā, Ahmedabad, n.d. g. Minor arts: M. R. Majumdar, Specimens of Arts Allied to Painting from Western India, New Indian Ant., I, 1939, pp. 377–82; H. M. Johnson, Jain Patterns, JAOS, LXIV, 1944, p. 32; U. P. Shah, A Brass Incense-Burner from Akota, JISOA, XIX, 1952–53, pp. 6–10; R. N. Mehta, The Historical Evidence for Two Jain Velvets, J. Indian Textile H., II, 1956, p. 53 ff.

Hermann GOETZ

Illustrations: PLS. 251–58.

JAPAN. The name Japan is adapted from the Chinese "Jih-pên kuo" ("Land of the Rising Sun"), which Marco Polo made known to Europe in the form of Zipangu (Eng., Cipango). The official name for Japan is Nippon or Nihon, which seems to have come into use in the 7th century B.C. Japan consists of four main islands, Hokkaido, Honshu, Shikoku, and Kyushu, and numerous small islands, covering a total area of 142,338 square miles. It is divided into eight administrative districts: Hokkaido, Tohoku (or Ou), Kanto, Chubu, Kinki, Chugoku, Shikoku, and Kyushu.

SUMMARY. Population and natural surroundings (col. 801). Periods of art history (col. 802): Pre-Jōmon (prepottery) period; Jōmon period; Yayoi period; Great Burial (or Yamato) period; Asuka period; Nara period; Heian period; Kamakura period; Muromachi period; Momoyama period; Edo period; Meiji-Taisho period; Tendencies of contemporary art. Kinki district (col. 810): Historical outline; Regions and centers of artistic interest: a. Prefecture of Nara; b. Prefecture of Kyoto; c. Prefecture of Osaka; d. Prefecture of Shiga; e. Prefecture of Mie; f. Prefecture of Wakayama; g. Prefecture of Hyogo. Chugoku and Shikoku districts (col. 826): Historical outline; Regions and centers of artistic interest: a. Prefecture of Tottori; b. Prefecture of Shimane; c. Prefecture of Okayama; d. Prefecture of Hiroshima; e. Prefecture of Yamaguchi; f. Prefecture of Kagawa; g. Prefecture of Kochi; h. Prefecture of Ehime. Kyushu district (col. 829): Historical outline; Regions and centers of artistic interest: a. Prefecture of Fukuoka; b. Prefecture of Oita; c. Prefecture of Saga; d. Prefecture of Nagasaki; e. Prefecture of Kumamoto; f. Prefecture of Kagoshima. Chubu district (col. 832): Historical outline; Regions and centers of artistic interest: a. Prefecture of Aichi; b. Prefecture of Shizuoka; c. Prefecture of Gifu; d. Prefecture of Nagano; e. Prefecture of Yamanashi; f. Prefecture of Fukui; g. Prefecture of Ishikawa; h. Prefecture of Toyama; i. Prefecture of Niigata. Kanto district (col. 835): Historical outline; Regions and centers of artistic interest: a. Prefecture of Kanagawa; b. Tokyo metropolitan area; c. Prefecture of Chiba; d. Prefecture of Saitama; e. Prefecture of Tochigi. Tohoku district (col. 840): Historical outline; Regions and centers of artistic interest: a. Prefecture of Fukushima; b. Prefecture of Yamagata; c. Prefecture of Akita; d. Prefecture of Miyagi; e. Prefecture of Iwate; f. Prefecture of Aomori. Hokkaido district (col. 843): Historical outline; Regions and centers of artistic interest.

POPULATION AND NATURAL SURROUNDINGS. The Japanese archipelago is mountainous, with few plains; its coast line is extremely intricate, and its scenery beautiful and rich in variety. The rivers are mostly short and rapid; the longest river, the Shinano, is 230 miles in length.

It has hitherto been held that the aboriginal race of Japan was the Ainu, that later on Mongolians came through Korea into Japan, that there was another invasion of people from the south Pacific, and that these merged to form what is known as the Japanese race. In other words, the people of the Jōmon period belonged to the Pan-Ainu type, and were replaced by races coming from the Asiatic continent (the people who used the Yayoi pottery). The Ainus were driven northward and now survive in part of Hokkaido, while the people from the continent are the ancestors of the present-day Japanese. However, owing to the discovery of skeletons of the people of the Jōmon period in recent excavations, a new theory has been suggested. According to this, the aborigines of Japan were not the Ainus; on the contrary, it was the ancestors of the present-day Japanese who used the Jōmon pottery. The ancestors of the present Ainus occupied only a part of Hokkaido and northeastern Honshu. Their level of living was about the same as that of the Jōmon people, but, in contrast to them, the Ainus did not assimilate the new continental culture, which, represented by the Yayoi pottery, already possessed an advanced knowledge of agriculture (cultivation of rice). The Ainus were thus gradually overpowered by the Japanese, who rapidly absorbed the new culture. If, as it appears, the Japanese race originally migrated from the continent, its original home has still not been ascertained. From the conformation of the skeletons, the indigenous Japanese race shows elements in common with the ethnic type of central to southern China.

Japanese art is closely connected with the climate of the islands, and its constant, fundamental characteristic is a direct communication with natural beauty. The archipelago stretches from the temperate to the subtropical zone and is dominated by high volcanic peaks, which are permanently snow-covered, while the lower mountains and hillsides have lush vegetation. The coast line is deeply indented, and on the small islands that dot the sea around it the reddish hue in the sky contrasts with the rich green of the landscape. Surrounded on all sides by water, the land in wrapped in vapors that change in form according to season and altitude, creating a continual variety of scenic effects.

The climate and the changeable beauty of the landscape have imprinted themselves deeply on all aspects of Japanese art and civilization, not least upon its architecture. Most Japanese buildings are made of wood and harmonize with nature. There are only slight permanent partitions separating the interior from the exterior, such as a row of wood or paper sliding doors. When the doors are opened or removed, the interior of the house is open to the outside world. Even when they are closed, the paintings of landscapes or flowers and birds on the fusuma (sliding doors of wooden framework covered with paper) that separate the rooms suggest natural scenery, as though nature were penetrating in to the houses (see INTERIOR DECORATION AND DESIGN). In obedience to the same principle of communion with nature, gardens too are designed to give an effect of naturalness. The most ancient gardens are miniature reproductions of landscapes. Later, when the development of urban areas diminished the size of gardens, trees and rocks were always arranged so as to suggest a natural landscape; even today, this remains the principal aim of private gardens (see LANDSCAPE ARCHITECTURE).

In sculpture, wood, which is abundant in all the islands, is the material most often used. Except in the Asuka and Nara periods, when Chinese influence was strong, wood sculpture achieved a remarkable development. There are few sculptures in stone, because stone is a material that is rare in Japan.

The influence of nature is most evident in paintings. Painting in the earlier periods, strongly influenced by Buddhist art originating in India and introduced through central Asia and China, contained many continental elements, but the painting in native Japanese style, which developed in the 10th century, showed a close intimacy with nature. Its subjects were largely derived from the changing aspects of nature throughout the 12 months (tsukinami-e, or monthly order painting) and the 4 seasons (shiki-e, or four seasons painting). Buddhist painting also began to have backgrounds of Japanese scenery. Landscapes and flowers and birds thus became the main motifs of Japanese art, as they still are. In delineation and coloring, Japanese painting is characterized by an extremely plein-airist manner in which shading is almost entirely absent. This is true of nearly all types of Japanese painting, and is particularly noticeable in the case of Ukiyo-e (q.v.). Impressionist art in Europe was influenced by this manner.

Furniture, clothes, and other works of decorative arts also derive most of their ornamental motifs from plants.

PERIODS OF ART HISTORY. The history of Japanese art and culture is generally classified into the following periods: pre-Jōmon; Jōmon; Yayoi; Great Burial (or Yamato); Asuka: 552–645; Nara: 645–793; Heian: 794–1185; Kamakura: 1185–1333; Muromachi: 1334–1573; Momoyama: 1573–1615; Edo: 1615–1867; Meiji-Taisho: 1868–1926. The Jōmon to Heian periods are called the ancient period; the Kamakura and Muromachi, the medieval period; the Momoyama and Edo periods, the early modern period; and the Meiji and thereafter, the modern period.

Pre-Jōmon (prepottery) period. Discussions of the history of Japanese culture have hitherto begun with the Jōmon period, although some archaeologists believed in the existence of a previous culture. In 1949, however, a few stone implements were excavated in the stratum of volcanic ash deposited during the diluvial epoch at Iwajuku in Gumma prefecture, situated below the stratum containing Jōmon

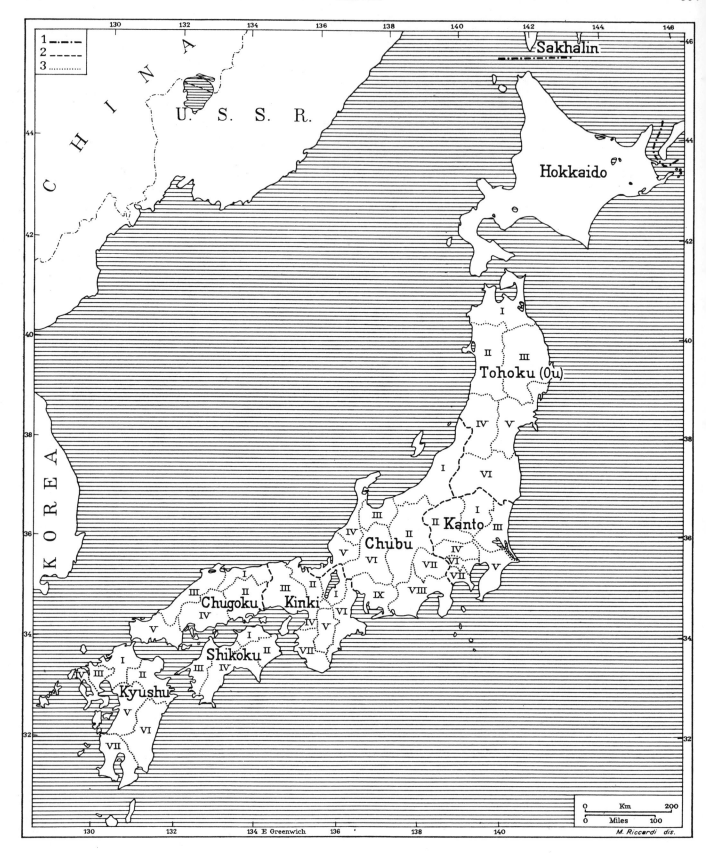

Districts and prefectures. *Key*: (1) Modern political boundaries; (2) district boundaries; (3) prefecture boundaries. Prefectures, of Tohoku (Ou) district: I Aomori, II Akita, III Iwate, IV Yamagata, V Miyagi, VI Fukushima; of Kanto district: I Tochigi, II Gumma, III Ibaraki, IV Saitama, V Chiba, VI Tokyo metropolitan area, VII Kanagawa; of Chubu district: I Niigata, II Nagano, III Toyama, IV Ishikawa, V Fukui, VI Gifu, VII Yamanashi, VIII Shizuoka, IX Aichi; of Kinki district: I Shiga, II Kyoto, III Hyogo, IV Osaka, V Nara, VI Mie, VII Wakayama; of Chugoku district: I Tottori, II Okayama, III Shimane, IV Hiroshima, V Yamaguchi; of Shikoku district: I Kagawa, II Tokushima, III Ehime, IV Kochi; of Kyushu district: I Fukuoka, II Oita, III Saga, IV Nagasaki, V Kumamoto, VI Miyazaki, VII Kagoshima.

pottery pieces; similar stone implements were discovered in 1951 at Moro in Tokyo, and later more specimens were found in Chubu, Tohoku, Hakkaido, and Chugoku districts. This leads to the inevitable conclusion that a prepottery culture existed in all parts of Japan, but it is not yet possible to ascertain its date and duration. The stratum in which these stone implements were found does not contain any pottery fragments, so ceramics were probably unknown. This period is therefore termed the prepottery period.

Jōmon period. Sites of the Jōmon period exist in large numbers, and the manner of life of the times is relatively well known. Recent carbon 14 tests on wood implements from these sites reveal that the period began several thousand years ago (see II, col. 21). Its end is generally placed in the 5th or 4th century B.C., though there is a considerable discrepancy between the eastern and western parts of Japan.

In contrast to the cultures of later periods, which spread from the western part of the island, the Jōmon culture appears to have had its center in eastern Japan. This hypothesis, however, cannot be clearly demonstrated owing to the lack of material relating to western Japan. What has been verified so far leads to the conclusion that the Jōmon culture extended over nearly all of Japan (PLS. 260, 261; II, 16, 17).

Yayoi period. The Yayoi period was from about the 5th or 4th century B.C. to about the middle of the 3d century of our era. During the Jōmon period hunting and fishing were the means of subsistence; in the Yayoi period agriculture was introduced. The new agricultural culture began in northern Kyushu (the area nearest the Asiatic continent and most open to continental influences) and subsequently made its appearance in the Kinki district, the area around Ise Bay, and the Chubu and Tohoku districts. The earthenware associated with the new culture was either shaped by hand or made by coiling (preparing the paste in the shape of rope and coiling it upward to fashion the rough shape) and was finished on the surface with a combing tool. Its body is thinner than the Jōmon type, its forms more regular, and its firing higher (probably at 600°C–800°C). This earthenware is called Yayoi pottery, because the first specimen was unearthed on Yayoi St. in Tokyo (II, PLS. 16, 17; III, PL. 171).

Owing to the necessities of rural life, dwellings of this period were nearly always located in the plains. The houses seem to have been most elaborately built, usually of rectangular or oval ground plan, with rounded corners.

The use of metal and the art of weaving already existed in the early part of this period. Metal objects were either of iron or bronze; notable among the bronze articles are swords, spears, halberds, mirrors, and *dōtaku* (II, PL. 17). The *dōtaku* are bell-shaped objects, the origin and purpose of which are not known; they were perhaps derived from the *pien chung* (flattened bell) of China or similar bronze bells from Korea. The swords, spears, halberds with long, narrow blades, and the mirrors of the early Han period were imported from the continent into northern Kyushu and later imitated in Japan. In time the weapons lost their functional value and were transformed into ritual objects with wide, flat blades. The swords, spears, and other bronze implements are chiefly found in northern Kyushu; the *dōtaku* in the Kinki and neighboring districts.

Great Burial (or Yamato) period. This denotes the period from about the second half of the 3d century to the introduction of Buddhism in the mid-6th century. In this period agricultural life spread to the greater part of the land, and the economic improvement that resulted was the first impulse toward the formation of an embryonic nation. The Yamato clan became powerful in the 3d–4th century in Yamato province, in Kinki district, and gradually engulfed the neighboring and more distant communities and brought the land under a single control. The clan was overlord to all the local powers, and the rulers of the merged clans also began to enjoy a prosperity far above that of the rural population they controlled. The burial mounds, or tumuli, were the tombs of the clan leaders.

Since the culture of this period is represented only by the tumuli and the funeral offerings found in them, the life of the lower class is almost unknown, but probably it was not much different from that in the Yayoi period. The houses of the ruling class were more advanced, consisting of a wooden superstructure covered by a roof; some houses had low floors, and some were built on tall pillars with raised floors. There were three types of roof: the *kirizuma*, or gabled roof; the *shichū*, or hipped roof; and the *irimoya*, a combination of hipped and gabled roof, with the gabled roof placed on top of the hipped roof. Some of the houses seem to have been similar to modern Japanese farmhouses.

During this period there was a remarkable development in iron weapons such as swords, spears, and arrowheads; undoubtedly this was instrumental in establishing the hegemony of the Yamato clan.

In the late 4th century the power of this clan extended as far as southern Korea, and the relations with Korea resulted in remarkable cultural advances in the Yamato plain. Continental influence began to be manifested in local clans as well. The clan leaders, who had previously been little more than officiating priests, now began to have administrative power. In addition to bronze mirrors and beads of various types made of jade, nephrite, and crystal, which were regarded as "divine treasures," gold and silver now began to be used in various decorative arts. A new kind of pottery known as "Sue ware" began to be made at this time; it had been introduced by Chinese and Korean craftsmen. It was made on the potter's wheel and fired in a climbing-passage kiln at about 1000°C.

Another important type of artifact in this period was the *haniwa*, terra-cotta tomb figures or cylinders placed on or around the tumulus (PL. 261). Whether or not the *haniwa* had any connection with the Chinese funerary figures, which were placed inside the burial chamber, is still an open question. Like the prehistoric earthenware, the *haniwa* were made by the coiling method and were of two kinds: one shaped like a barrel or cylinder, which was set around the base of the tumulus to prevent the soil from washing away, and the other modeled in the shape of humans, animals, houses, etc., which was placed on top of the mound. The latter type give important information about the material culture of the times.

Asuka period. Asuka is the name of a district within which the capitals (which changed on the death of each emperor) were located; the Asuka period began with the introduction of Buddhism in 552 and ended with the Taikwa Reforms of 645–46. After King Syongmyong of Paekche in Korea presented Buddhist icons and ritual objects to the Japanese imperial court, there was a serious conflict in Japan between those who accepted Buddhism and those who rejected it. Finally Buddhism triumphed and, under the patronage of the pious prince Shōtoku Taishi (572–621), developed rapidly. In the following centuries the development of Japanese art was closely related to Buddhism, which revolutionized both technically and stylistically all the arts that came in contact with it. The art of this period was inspired by Chinese art of the Six Dynasties period, particularly of the Northern Wei dynasty, introduced through the Korean peninsula.

Nara period. T'ang China in this epoch was extremely powerful and its cultural life was brilliant. Japan repeatedly sent imperial envoys to China, and as a result of its influence the golden age of Buddhist culture began in Japan. The country became more prosperous and powerful and Buddhism, protected by the government, flourished. In the middle part of this period, an imperial edict was issued by the emperor Shōmu (701–56) that a Kokubunji (provincial monastery) and a Kokubunniji (provincial convent) should be built in each province throughout the country. As a result, local districts, which had previously had little access to Buddhist culture, now possessed Buddhist temples and statues. Remains of these temples exist all over Japan except in Iwate prefecture and the northern part of Tohoku district.

The wall paintings in the Kondō (main hall) of the Hōryūji in Nara are monumental works of art of the early part of this period. They contain many Indian elements, proving that Japanese art of the time had an international basis. The Yakushiji, Tōshōdaiji, Shin-Yakushiji, and other temples were built in Nara at this time, and contain numerous fine statues of bronze, clay, wood, and dry lacquer (made of many layers of hemp cloth cemented with lacquer). The most notable monuments of this golden age are the Rushana Butsu (Vairocana) statue and the Shōsōin (treasury), both at the Tōdaiji.

Heian period. This period takes its name from Heian (mod. Kyoto), which in 794 became the new capital. The first 100 years of this period are called the early Heian or the Jōgan period. The influence of T'ang culture still continued in this period, but Buddhism and the Buddhist arts began to assume a different aspect. The Buddhist sects that had flourished in Nara under national protection began to degenerate, while the new esoteric sects, brought back from China by the priests Saichō (also called Dengyō Daishi, 767–822) and Kūkai (Kōbō Daishi, 774–835), won wide favor.

Realizing that the secular life was a bad influence on the Buddhist priests in Nara, the new sects built their monasteries on the mountains, and thus the layouts of the temple buildings became irregular and intricate. From this period are the main hall and the five-storied pagoda of the Muroji, Murō, in Kinki district, which illustrate perfectly the aspect of "mountain Buddhism." The grace and elegance of the painted and sculptured images was replaced by a stern, mysterious aspect. Wood came to be used almost exclusively in Buddhist sculpture, gradually replacing the dry lacquer and clay of the Nara period. It was also in this period that Shintoism (q.v.),

under the influence of Buddhist sculpture, began to produce sculptured icons.

The late Heian period, from 895 to 1185, is also called the Fujiwara period, because the Fujiwara family became very powerful at court. In this period the emperor ceased sending envoys to China, and Japanese art began to assert its native grace, with particular attention to beauty and elegance of expression; many of the traditions of art born in this period are still alive today. The artistic center of the country was Kyoto, but about the 12th century the influence of Fujiwara art began to spread to other regions. The Chūsonji in Iwate prefecture, the Shiramizu Amidadō in Fukushima, and the Fukiji in Oita are examples of the metropolitan culture transplanted to remote localities.

Kamakura period. The Kamakura period was an age of warriors. In the arts the emphasis was turned from dilettantism to simplicity, soundness, and vigor. The first indication of the new spirit appeared in the reconstruction of the Tōdaiji and the Kōfukuji in Nara, which had been burned during the civil wars of the 12th century. Unkei, Kaikei (qq.v.), and other noted sculptors produced some of their finest works for these temples. The Tenjikuyō or "Indian" style, which was in fact a style imported from southern China, was employed in reconstructing the Tōdaiji; it is a powerful, solid, and bold style.

Traditional Buddhism had previously been practiced almost exclusively by the upper classes; in this period many new sects directed to the masses made their appearance. As Buddhism became widely diffused, numerous paintings of Buddhist deities and scroll paintings illustrating stories concerning the origins and histories of temples or describing the deeds of the founders of the sects were produced. Zen, or Meditative, Buddhism was also introduced at this time from China. The new sect found great favor among the warriors because of its simplicity and emphasis on contemplation and self-discipline. The high priests of Zen were portrayed both in painting and sculpture. Previously, real persons had rarely been depicted; what had been called portraits were mostly imaginative, stylized, or symbolic images, but the Zen portraits were real likenesses, executed during the subjects' lifetime or soon after their death. Chinese art of the Sung dynasty was the model for Japanese art not only in architecture but also in sculpture, painting, and the minor arts.

Although the political center was Kamakura, the cultural center was still Kyoto. However, from the earliest part of the period many Zen monasteries were built in Kamakura, and the city, no longer a distant corner of the country, began to develop culturally. In the latter part of the period Kamakura produced certain types of art that were characteristic of the area, and finally it became second only to Kyoto as the artistic center of Japan.

Muromachi period. The animating spirit of this age was Zen Buddhism. While Buddhist art had previously served strictly religious ends, in Zen the emphasis was on human experiences. The black-and-white painting termed *sumi-e* or *suiboku-ga* (India ink painting), which flourished in this period, is an example of the new kind of art and is characterized by austere simplicity.

The personal taste of the Ashikaga shoguns, such as Yoshimitsu (1358–1408) and Yoshimasa (1435–90), also played an important part in matters of art. The Ginkaku (Silver Pavilion) or Jishōji and the Kinkaku (Golden Pavilion) or Rokuonji, erected in the shoguns' villas on the outskirts of Kyoto, illustrate their manner of living; though sumptuous, these buildings are subdued and moderate (*shibui*). Up to this time the art had been concentrated in the Buddhist temples, but now the shoguns' private residences were repositories of art. Under the patronage of the shoguns the *cha-no-yu* (tea ceremony or tea cult) and the Nō play, performed with slow, elegant dances, were developed. The spreading of the rulers' artistic taste to the lower classes eventually paved the way for the arts of the early modern period.

Momoyama period. This age was dominated by the three rulers: Oda Nobunaga (1534–82), Toyotomi Hideyoshi (1536–98), and Tokugawa Ieyasu (1542–1616). The arts boldly manifested the spirit of a new age. The huge castles built at this time, some still standing, are characteristic of the period. The paintings decorating the walls, sliding doors, and screens of the castles and temples were ornate and powerful works. Kanō Eitoku (1543–90), Kanō Sanraku (1559–1635), Kaihō Yūshō (1533–1615), and Hasegawa Tōhaku (1539–1610) were among the master artists in this field. Minor arts, for interior decoration, also reflected the spirit of the age, typified by the bold, unconventional designs in the Kōdaiji style of *maki-e* lacquer. Although florid grandeur prevailed, there also arose at this time the quiet and secluded (*wabi*) type of tea ceremony inspired by Sen-no-Rikyū (1521–91), who emphasized rustic simplicity.

It was in this period that Japan first had contact with Western civilization. The Portugese and the Spanish began to visit Japan, introducing Christianity, and this contact gave rise to a more or less Western style of art known as *namban* (Southern Foreigners, as the Westerners were called, since they came by way of the south Pacific; see NAGASAKI SCHOOL). Kyoto and the neighboring areas still held a central position in the arts but the metropolitan culture spread rapidly throughout the country, as shown by the many castles and other relics of the time that are found in all parts of Japan.

Edo period. From 1615 to 1867 the Tokugawas ruled the country from Edo (mod. Tokyo). They encouraged Confucianism (q.v.), banned Christianity, and isolated Japan from the world. Trade with China was barely maintained, and only the Dutch were permitted at the port of Nagasaki, so that there was little foreign contact.

The development of residential architecture for the lower classes was one of the new achievements in this period, for in this type of architecture there had been little progress since early times, whereas religious, palace, and castle architecture as well as dwellings for the nobility and the warriors had made notable strides. Beside the Kanō school (q.v.), who worked for the feudal government, there arose various new schools of painting, each with its distinctive style. One of these was Ukiyo-e (q.v.), an art by and for the townsmen, dealing with subjects of popular character. Sculpture, closely connected with religion, went into a decline, but the minor arts developed considerably in nearly all parts of Japan because they were in great demand by the people.

Meiji-Taisho period. Toward the end of the Edo period the feudal system declined. Inside the country there was agitation to overthrow the feudal government and restore national rule to the emperor; from outside, the European countries and America demanded that Japan's ports be opened for trade. The entire country suffered from continual social disturbances, until finally the Tokugawa government fell and the imperial court resumed its rule in 1867. The year 1868 marks the beginning of the Meiji period, also called the modern period. The Meiji government adopted a constitutional system, abolished the caste system, discarded the policy of national isolation, and resumed communications with the outside world.

In the past, foreign influence had been almost exclusively Chinese; now European and American influence was predominant, with the result that the arts underwent a radical change. The most important innovation was the abandonment of the hereditary system in the practice of the artistic professions; for the first time artists and craftsmen were allowed to engage in the arts solely on the basis of their personal gifts. Wood had been the principal material in traditional architecture; now, under Western influence, other materials, such as brick and concrete, were utilized. Oil colors began to be used in painting. Statues of marble and alabaster were made, as well as the traditional sculpture in wood. Thus many changes were effected in all branches of the arts. For a while during the Meiji period (1868–1912) the excessive admiration of Western culture led to the neglect of the traditional Japanese arts; however, the artistic heritage of Japan was soon rediscovered. The felicitous merging of East and West constitutes the chief characteristic of modern Japanese arts.

BIBLIOG. *General works and guides on artistic topography*: Sekai Chiri Fūzoku Taikei (World's Ethnology Series), vol. on Japan, Shinkō-sha, 1927–29; S. Taki and K. Kume, Nihon Kobijutsu Annai (Guide to Ancient Japanese Works of Art), Tokyo, 1931; G. B. Sansom, Japan, A Short Cultural History, London, 1931; T. Minamoto, Kobijutsu Kengaku (Visits to Historical Art Collections), Tokyo 1944; Japan Travel Bureau (ed.), Nippon Annai-ki (Guide to Japan), Tokyo, 1949; M. Ishida, Kokuhō to Shiseki (Art Treasures and Historic Sites of Japan), Tokyo, 1953; Sekai Bunka Chiri Taikei (World's Cultural Topography Series), Tokyo, 1954; Society of Friends of Eastern Art (ed.), Art Guide of Nippon, I: Nara, Mie and Wakayama Prefectures, Tokyo, 1954; Nippon Bunka Fudo-ki (Cultural Topography of Japan), Tokyo 1955–56; Shiseki Meishō Tennen Kinembutsu (Historic Sites, Scenic Spots, and Natural History Monuments), Tokyo, 1956–57; Nippon Fudo-ki (Topography of Japan), Tokyo, 1957; Tourist Industry Bureau (ed.), Japan: The Official Guide, 8th ed., Tokyo, 1961.

Takeshi KUNO

Tendencies of contemporary art. The impact of Western civilization on Japan at the beginning of the Meiji period quickly led to the abandonment of traditional arts. However, thanks to Ernest Fenollosa, an American professor, and Okakura Kakuzo (Tenshin), a Japanese critic, who formed a society for the propagation of traditional Japanese art, the balance of critical values was soon restored. Okakura was head of the Nihon-ga (Japanese-style painting) movement, and Nihon-ga, despite many subsequent attempts to modernize it, exists today and persists in a rigid formalism.

Among the more important movements and tendencies in the present century are the Nippon Bijutsuin or Inten, founded by Okakura; the Seiryū-sha (Blue Dragon Group) of Kawabata Ryūshi;

the *d'après nature* school of Takeuchi Seihō (PL. 330); the modernizing movement in Ukiyo-e; and the work of Murakami Kagaku, which combines Nanga traditions with a sort of mystical romanticism. In the 1930's some young Nihon-ga painters formed the Sōzō Bijutsu (Creative Art) group, freer in their imagery and means of expression and influenced by contemporary Western painting. The younger generation, those painting after World War II, are attempting to free themselves from the traditional motifs and forms although using the traditional techniques.

In 1876 the first art school in Japan was established in Tokyo; a course in Western oil painting was given by Antonio Fontanesi (1818–82), an Italian. The Barbizon school and impressionism were introduced by Japanese artists who had studied in Europe. Artists appeared, such as Shigeru Aoki, who combined the European romanticism of the late 19th century with mythical Japanese elements. In 1910 the Shirakaba school, a group of writers and artists, was founded; they introduced the works of Cézanne, Van Gogh, Gauguin, Rodin, and Bourdelle to Japan. In 1914 the Nika-kai was organized in opposition to the academism of the official salon. Prominent among the Western-style painters are Umehara Ryūzaburō (b. 1888), a student of Renoir, whose style is remarkable for its Japanese sense of color and simplification of form; and Yasui Sōtarō (1888–1955), influenced by Pisarro and Cézanne, who developed a sober and very individual graphic style. Fauvism, cubism, futurism, and German expressionism were introduced in Japan after 1920.

In 1930 the Dokuritsu Bijutsu Kyōkai (Independent Art Association) was founded by artists who were influenced by Derain, Vlaminck, and the School of Paris. In 1937 Hasegawa Saburō formed the Jiyū Bijutsuka Kyōkai (Liberal Artists Association), a group interested in abstract art. In 1939 another avant-garde group, the Bijutsu Bunka Kyōkai (Art Culture Association), which promoted surrealism, was founded by Fukuzawa Ichirō. Many organizations were founded and, in time, split into new groups, and often what began as an opposition movement ended as a simple professional association.

All forms of liberalism in the arts were suppressed during World War II, but freedom of expression was restored after the war. What stands out in the postwar years is the marked activity of the artists of the younger generation, to be seen especially in the two annual Independent Exhibitions, held without judges and without prizes, where artists freely exhibit, with only a nominal fee for wall space. The problems of contemporary art in Japan after 1950 are in general parallel to those in Europe and America.

There has been a revival in the art of the woodprint. Since the 1920's, when such artists as Onchi Kōshirō began producing woodprints in a Western style, woodblock print artists have been very active. Their forms and techniques are freer (including copperprints and lithography). This field is considered today one of the outstanding expressions of contemporary art.

Calligraphy, which has always been looked upon as one of the fine arts, is practiced today by many artists, though there is, as always, the inevitable danger of mannerism. In the postwar years there has arisen a vigorous avant-garde movement of young calligraphers who combine the traditional characters with abstract and symbolic forms in a very contemporary way. This movement has a close and significant affinity with tachism.

In sculpture the drastic separation from tradition is evident; whether in wood, stone, or bronze, sculpture was almost always Buddhist, but in the present century it has completely lost its religious motive. As with painting, a distinct but parallel historical development with its Western counterpart is to be found in native sculpture. A few sculptors follow the special ancient technique of wood sculpture, but this art is too conventionally bound to express itself freely. Some sculptors were greatly influenced by Rodin, Maillol, and Bourdelle, but the works they produced were banal and complacently academic. The years after World War II have seen a revival of interest in sculptural art as well as a reappraisal of primitive sculpture. Some sculptors have been inspired by the simplicity of the *haniwa* and the extraordinary vitality of Jōmon figures. Abstract and expressionist tendencies prevail today. Ceramics, long considered one of the decorative arts, is also playing a part in modern sculpture. Also included in the field of sculpture are the *ikebana* or flower arrangements of Teshigahara Sōfu and his followers, who use wire, iron, stone, tree roots, boards, tin, etc., in conjunction with flowers.

Western-style architecture was introduced in the late 19th century by European architects. In 1920 the Japanese Secessionist group (Sutemi Horiguchi and other architects) was formed and after the earthquake of 1923 the group applied their new principles to the work of restoration. The influence of Frank Lloyd Wright (Imperial Hotel, Tokyo), of Antonin Raymond (long resident in Japan), and, since 1930, of Gropius and Le Corbusier has been great. The writings of Bruno Taut, the German architect who fled to Japan in 1933, on Japan's ancient architecture (such as the Great Shrine of Ise

and the Katsura palace) were most influential. Owing to ultranationalist tendencies immediately before World War II, the modern architectural movement was suppressed.

Today architects are once again in a ferment with new ideas and fresh opportunities; functionalism and traditionalism are being applied in new projects with a harmonious unity. Even the typically native traditional wooden structures are becoming modernized and, at the same time, Western-style buildings are making increasing use of the best elements of traditional architecture. Town planning, although it frequently conflicts with the necessity for industrial development, is generally respected in the reconstruction of the city areas devastated in the war.

In minor arts, the traditional craftsmen ignore new forms and work with conventional techniques and designs. The *mingei* (folk art) movement, led by Yanagi Muneyoshi (who had been a member of the Shirakaba school), stresses functional beauty and tries to preserve the best of the folkcrafts. Outstanding among the *mingei* ceramists are Tomimoto Kenkichi and Kawai Kanjiro. Industrial designs for mass production had long been neglected, but in 1952 the Japan Industrial Designers' Association was organized, whose members, together with the graphic designers, are strongly conscious of the need for genuine expression and creativity through the new industrial techniques.

Japan has been passing through a complicated cultural phase, but today she is seeking to evolve a new style that will be open to contemporary Western currents but will not neglect traditional elements. Thus it is hoped that Japanese art, which refuses to be isolated, will play an increasingly important part in the art and culture of the world.

BIBLIOG. T. Hijikata *et al.* (eds.), Sekai Bijutsu Zenshu (Art of the World), vols. 4, 5, Tokyo, 1951; S. Tominaga *et al.* (eds.), Gendai Nihon Bijutsu Zenshu (Contemporary Japanese Painters), 10 vols., Tokyo, 1951; J. Harada, The Lesson of Japanese Architecture, rev. ed., London, 1954; A. Imaizumi *et al.* (eds.), Kindai Bijutsu Zenshu (Modern Japanese Painting and Sculpture), 6 vols., Tokyo, 1954; S. Koike, Nihon no Gendai Kenchiku (Contemporary Architecture in Japan), Tokyo, 1954; S. Horiguchi and Y. Kojiro, Architectural Beauty in Japan, Tokyo, 1955; K. Ishikawa, Western Style Painting in Japan, Tokyo, 1955; S. Takiguchi and T. Uemura, Abstraction and Fantasy, Tokyo, 1955; M. Kawakita, Currents in Japanese Painting, Tokyo, 1955; M. Kawakita, Modern Japanese Painting, Tokyo, 1955; S. Noma, Artistry in Ink, Tokyo, 1955; Annual of Advertising Art in Japan, Tokyo, 1957, 1958, 1959; K. Abe, Meiji Architecture, Japanese Arts and Crafts in the Meiji Era, Tokyo, 1958; H. R. Hitchcock, Architecture Nineteenth and Twentieth Centuries, Harmondsworth, 1958; R. Hamaguchi *et al.* (eds.), Sekai Kenchiku Zenshu (Architecture of the World), 14 vols., vols. 9–14 devoted to modern art, Tokyo, 1959 (only vols. 3, 6, and 14 published); T. Miyauchi *et al.* (eds.), Annual of Japanese Architecture, Tokyo, 1960.

Shuzo TAKIGUCHI

KINKI DISTRICT. *Historical outline.* The Kinki district, situated in the central part of the principal island, consists of seven administrative prefectures: Osaka, Kyoto, Nara, Shiga, Mie, Wakayama, and Hyogo. The district was the first political center of the nation. Arts developed here from very early times, and there remain numerous sites and monuments of various periods. The sites of the Jōmon period are relatively few, while those of the Yayoi period are numerous. The people of the Yayoi period, who depended chiefly on agriculture (rice), appear to have been the first cultivators of the Yamato plain and the plain situated to the east of Osaka Bay. During the Bronze Age, the Kinki district was the center of the culture represented by *dōtaku* (bell-shaped bronzes); in the Kyushu district another type of culture existed, represented by *doken* (bronze swords) and *doboko* (bronze spears). The existence of numerous huge tumuli in this district proves that a powerful clan, supported by riches coming from the valleys in Yamato (Nara) and Kochi (Osaka) provinces, appeared about the 3d century, ruling over the district and subsequently over nearly the whole of Japan. Most of the tumuli were probably built about the 5th century. Bronze mirrors and coins found in burial chambers of the tumuli suggest the existence of communication with China during these times.

The Kinki district maintained its position as the cultural center of the country even after the introduction of Buddhism in the 6th century, as is evident from the records of the times and from the fact that 45 out of the 49 sites of Buddhist temples of this period are found in the Kinki district. The capitals of the country, that is, the cities where the emperors lived, which changed with every reign, were mostly situated in the Asuka area in Nara prefecture, and nearly all the existing specimens of art and architecture from the 7th century are found in this district. In the early 8th century a permanent capital, known as Heijo-kyō (Heijō capital; mod. Nara), was established, and this became the political as well as cultural center.

The capital was transferred to Heian-kyō (Heian capital; mod. Kyoto) at the end of the 8th century. The Kyoto area is rich in

works of art dating from the 8th to the 12th century. In the late 12th century the reins of power passed from the imperial court to the warrior Minamoto Yoritomo. Yoritomo established his military government in Kamakura in the Kanto district, but Kyoto still remained the cultural center of the country. Kyoto again became

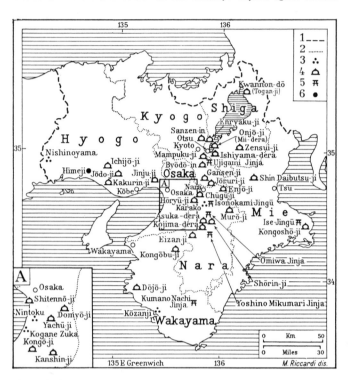

Kinki district. *Key*: (1) District boundaries; (2) prefecture boundaries; (3) archaeological sites and tumuli; (4) Buddhist temples; (5) Shinto shrines; (6) secular buildings of historic interest.

the political center in the 14th century, when the Ashikagas set up their military government in the Muromachi quarter of Kyoto. In the 17th century the Tokugawas established their central feudal government in Edo (mod. Tokyo), which became and remained the administrative center of the country. The center of creative arts, however, remained in Kyoto, and it was only much later that Edo began to have its own distinctive art.

Regions and centers of artistic interest. a. Prefecture of Nara. Nara. The city, capital of Nara prefecture, was founded in 710 by the empress Gemmyō (661–721) and was modeled on the ancient Chinese capital Ch'ang-an. For 18 years it was called Heijō and on the site of Heijō-kyō are remains of palace buildings of the Nara period. Nara was the first permanent capital of Japan and continued as the capital until 784, when the emperor Kwammu transferred the seat of administration to Nagaoka (west of Kyoto). It was the scene of the earliest historic events in the province of Yamato (Kii Peninsula), and it gave its name to a period of art history. The seven great Buddhist temples, the Shintoist monasteries, the magnificent palaces, and other buildings all bear witness to Nara's splendor and importance during many centuries of artistic activity.

Tōdaiji: Headquarters of the Kegon sect. In 740 the emperor Shōmu issued an imperial edict to make a colossal bronze statue of Rushana Butsu (Vairocana); the statue, the Daibutsuden (Great Buddha hall), and other buildings of the Tōdaiji were completed in 752. The Tōdaiji is the largest temple of the Nara period. Most of its original main buildings were destroyed in repeated fires, but many important buildings and works of art of various periods remain. The Nandaimon (great south gate), the front entrance of the temple, was built in 752 and rebuilt in 1199 after being destroyed by a typhoon in 962; it is in the Tenjikuyō or "Indian" style of architecture. The exterior niches of the Nandaimon contain standing wood statues (Kamakura period) of the Niō (Two Deva Kings; PL. 291), the joint work of Unkei and Kaikei (qq.v.). The two-storied Daibutsuden (Edo period) contains a seated bronze statue of Rushana Butsu 53½ ft. high. The knees of the statue and the petals of the lotus pedestal are original, and the rest is a restoration of the Edo period. The lotus petals are engraved with pictures of the "Lotus-flower World" presided over by Rushana Butsu. The octagonal bronze lantern (Nara period) in front of the Daibutsuden is a typical specimen

of 8th-century metalwork. The Hokkedō, or Sangatsudō (Third Month Temple), was founded in 733 by the monk Rōben; it consists of a main hall (Nara period) and a Raidō (chapel; Kamakura period). In the Hokkedō are the following famous statues, all of the Nara period: Fukūkenjaku Kwannon (Amoghapaśa), a standing dry-lacquer statue 12 ft. high, ca. 748; Bonten (Brahmā), Taishakuten (Indra), the Shitennō (Four Deva Kings), and the Niō, all standing dry-lacquer statues; and Nikkō Bosatsu (Sūryaprabhāsa), Gakkō Bosatsu (Candraprabhāsa), Shūkongojin (Vajrapāni), Kichijōten (Mahāśrī), and Benzaiten (Sarasvatī), all standing clay statues. The sutra repository of the Hokkedō is of the Nara period. The Kaisandō (Kamakura period) is dedicated to Rōben, founder of the temple, and contains seated wooden statues of Rōben (Jōgan period; II, PL. 392), the priest Shunjō (Kamakura period), and the Shinto god Hachiman as a Buddhist priest (Kamakura period; PL. 295) by Kaikei. In the Kaidanin are standing clay statues of the Shitennō (Nara period). In the belfry (Kamakura period), east of the Daibutsuden, is a temple bell, 13½ ft. high and 9½ ft. in diameter, cast in 752 and recast in 1239 after being damaged by the typhoon of 989. Other buildings are the Tengaimon (gate) of the Nara period and the Ōyuya (bathhouse for priests) of the Muromachi period. The Tōdaiji owns numerous other treasures, among which are the Birth of the Buddha (Nara period), a bronze statue; 21 wooden Gigaku masks (Nara period), most of which were used at the consecration ceremony of the Rushana Butsu statue; 8 wooden Bugaku masks (Fujiwara and Kamakura periods); standing wooden statues of Jizō Bosatsu (Ksitigarbha) and Miroku (Maitreya) by Kaikei (Kamakura period; PL. 345); and the Kusha Mandara (Kamakura period), a painting in color on silk. The Shōsōin, west of the Daibutsuden, was built in the mid-8th century. With its 40 pillars supporting a high floor and its sides composed of triangular horizontal members, the Shōsōin belongs to the type of construction known as *azekura*. It houses treasures from the Nara period, the nucleus of the collection being ritual implements used at the consecration ceremony, objects for the personal use of Emperor Shōmu, and manuscripts.

Kasuga Shrine: A typical example of the Kasuga type of Shinto architecture, in which the sanctuary has a gabled front with an additional roof on its front over the staircase. The present buildings were built in 1863 but retain the style of the Nara period. The shrine contains many examples of painting, sculpture, and arms and armor, among which are a sword mounting of the *kenukigata* type (Fujiwara period), gold-lacquered with mother-of-pearl inlay, and a suit of armor with red lacing (Kamakura period).

Kōfukuji: Headquarters of the Hossō sect and one of the seven great temples of Nara. The Kōfukuji, the family temple of the Fujiwaras, was originally founded in 669 and transferred in 710 to its present site. At one time there were as many as 175 buildings in the precincts, but all were subsequently destroyed by fire. However, the temple still retains many buildings of later periods and numerous important works of art. The Tōkondō (eastern main hall), first built in 726 by order of Emperor Shōmu and repeatedly burned down, was finally rebuilt in the 15th century; it contains seated wooden statues of Monju (Mañjuśrī) and Yuima (Vimalakīrti), both of the Kamakura period, and a bronze head of Yakushi (Bhaiṣajyaguru) of 685, which shows Chinese influence. The Hokuendō (north octagonal hall) was first built in 721 by order of Empress Gemmyō, and destroyed three times; the present building dates from 1240. It contains a seated wooden statue of Miroku (Kamakura period) by Unkei and standing wooden statues of the priests Muchaku (Asanga) and Seshin (Vasubandhu), both of the Kamakura period, by Unkei and assistants. The three-storied pagoda was built at the wish of Taikemmon-in, consort of Emperor Gotoba, in 1143. The five-storied pagoda, originally erected in 730 at the wish of Empress Kōmyō, was destroyed five times by fire; the present building was completed in 1426. The Nanendō (south octagonal hall) was built in 813 and repeatedly burned, and the present building dates from 1789. It contains the following wooden statues (Kamakura period) by Kōkei, father of Unkei: the Fukūkenjaku Kwannon, a seated statue made in 1188; the Shitennō, standing statues; and the Hossō Rokuso (Six Patriarchs of the Hossō sect), seated statues. Also in the Kōfukuji are the Hachibushū (Eight Guardian Devas; PL. 268) and the Jūdai Deshi (Ten Great Disciples), of which only 6 remain; these 14 standing dry-lacquer statues, made in 734, are representative masterpieces of sculpture of the Nara period. There are also standing statues by Jōkei of the Niō (Kamakura period; VII, PL. 396); standing wooden statues of the lantern bearers Ryūtōki and Tentōki (Kamakura period) by Kōben, son of Unkei; and a color painting on silk of the priest Jion Taishi (Fujiwara period).

Shin-Yakushiji: Founded in 747 by Empress Kōmyō. In the main hall (Nara period) are the Jūni Shinshō (Twelve Heavenly Generals; Nara period), standing clay statues (one is a recent replacement), and a seated wooden statue of Yakushi, a fine specimen of single wood-block sculpture of the late 8th century.

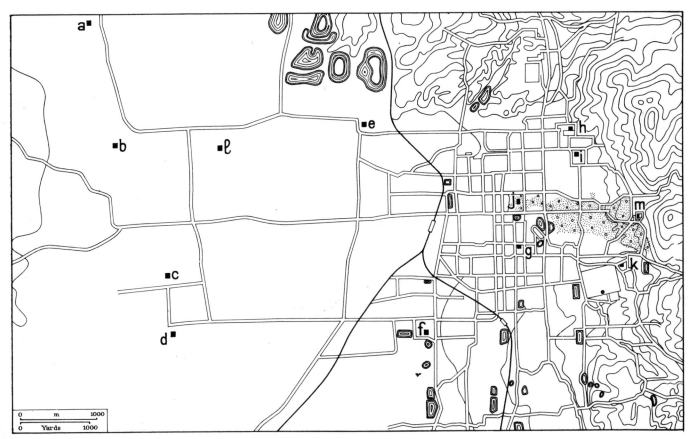

Nara, plan of the city. (a–k) Buddhist temples: (a) Akishinodera, (b) Saidaiji, (c) Tōshōdaiji, (d) Yakushiji, (e) Hokkeiji, (f) Daianji, (g) Gokurakuin, (h) Shōsōin, (i) Tōdaiji, (j) Kōfukuji, (k) Shin Yakushiji; (l) site of Heijō-kyō; (m) Kasuga Jinja.

Zuto: A large mound with stones on which are carved Buddhist images in relief (Nara period).

Cave temple at Jigokudani (Jōgan period).

Gangōji: Formerly called Asukadera, this was originally founded at the village of Asuka and transferred to its present location in the 8th century, when the capital was moved to Nara. Now dilapidated after recurrent fires, it contains a standing wooden statue of Yakushi (Jōgan period).

Gokurakuin: This consists of a main hall (IV, PL. 198) and a Zendō (contemplation hall), both of the Kamakura period.

Hokkeiji: A convent founded in 745 by Empress Kōmyō. The main hall was rebuilt in 1601 and contains a standing wooden statue of Jūichimen Kwannon or Eleven-headed Kwannon (Ekādaśamukha), a masterpiece of so-called "sandalwood sculpture" style of the 9th century. Sandalwood sculpture is made of a hard incense wood, unpainted (except for the eyes and lips) so as to keep the fragrance of the wood alive. Because wood of this kind is rare in Japan, examples of real sandalwood sculpture are few, but its style was sometimes copied. Also in the main hall are a seated wooden statue of Yuima (Jōgan period) and a painting in color on silk of the Amida (Amitābha) Triad (Fujiwara period).

Saidaiji: Founded in 765 by Empress Shōtoku. It contains the Jūniten (Twelve Devas; PLS. 270, 274), paintings in color on silk, the oldest existing esoteric Buddhist paintings (Jōgan period); Shaka (Śākyamuni), a standing wooden statue by the monk Eison (1201–90), a copy of the Shaka statue in the Seiryōji, Kyoto; and a seated wooden statue of the priest Kosho Bosatsu (Kamakura period).

Tōshōdaiji: Founded in 759 by Ganjin (Chinese, Chien Chên), a priest of the T'ang dynasty. This important monument retains some of its original main buildings. The Kondō (Nara period) contains a seated dry-lacquer statue of Rushana Butsu, attributed to T'an Ching and Szŭ T'o, disciples of Chien Chên, a representative work of sculpture of the late Nara period; standing dry-lacquer statues of Senju Kwannon or Thousand-handed Kwannon (Sahāsrabhuja) and Yakushi, both of the Nara period; standing wooden statues of Bonten and Taishakuten, carved by Chun Fa Li, and of the Shitennō, all of the Nara period; and a dry-lacquer statue of Ganjin, a masterpiece of portrait sculpture of the Nara period. The Kōdō (lecture hall), rebuilt in 759 by Chun Fa Li, was originally the assembly hall of the Nara court. In it are a Yakushi (Nara period), a standing wooden statue, and numerous other works of wooden sculpture from

the last part of the Nara period. Treasure repository (Nara period). Sutra repository (Nara period). Raidō (Kamakura period). The Korō (drum tower; Kamakura period) contains the Tōsei E-den, a scroll painting in color on paper (Kamakura period) illustrating stories about Ganjin's trip to Japan.

Yakushiji: This temple was begun in 680 by Emperor Temmu and finished in 698. Originally located at Fujiwara in the Asuka area, it was moved to its present place in 718, following the transfer of the capital to Nara. The temple has excellent specimens of art from the early Nara period. The three-storied east pagoda (Nara period; PL. 283) is the most beautiful pagoda in Japan. The Yakushi Triad (Nara period), kept in the Kondō (which was rebuilt in 1600), is a masterwork of bronze sculpture following the early T'ang style, ascribed by some scholars to ca. 697 and by others to ca. 718. In the Tōindō (east hall; Kamakura period) is a standing bronze statue of Kwannon (Avalokiteśvara), and in the Kōdō is another bronze Yakushi Triad, all of the Nara period; these, together with the Yakushi Triad in the Kondō, are among the most eminent works of bronze sculpture. In the Bussokudō (hall of the Buddha's footprint) is a stone with the Buddha's footprint made in 752, based on a copy of the reproduction of the Buddha's footprint brought from China by the Japanese painter Kibumi-no-Motozane; this reproduction was brought from India to China by the Chinese priest Wang Hsüan-ts'e. The Yakushiji also contains a standing wooden statue of Jūichimen Kwannon (Nara period); seated wooden statues of three Shinto deities (Jōgan period; PL. 271); Kichijōten (PL. 269), a painting in color on hemp cloth which is a typical example of Nara painting following the T'ang style; and Jion Taishi (Fujiwara period), a painting in color on silk.

National Museum: Founded in 1895, it has 13 exhibit rooms and possesses a fine collection of ancient works of art, particularly of the Nara period. Also exhibited are objects on loan from shrines, temples, and private collections, mainly of the Asuka through Heian periods and from Nara prefecture.

Sakurai. Village 12 miles south of Nara. This is an important communications center, for the roads and railways south to the Kii Peninsula pass through it. Near Sakurai are two tumuli of the Great Burial period: the Tennōzan tumulus, a square tumulus ca. 148 ft. east to west, 138 ft. south to north, and 31 ft. high; and the Chausuyama tumulus, squared in front and rounded in the back (keyhole-

shaped), ca. 656 ft. long. The Shōrinji contains a dry-lacquer statue of Jūichimen Kwannon, a representative specimen of sculpture of the 8th century. The Shakuiji, at a site known as Ossaka, possesses a stone relief of the Buddha and two attendants (Nara period).

Yanagimoto. Village near Nara. The Chōgakuji has a two-storied gateway (Fujiwara period) and a wooden Amida Triad dated 1151. Statues of the Kamakura period are characterized by a vivid expression owing in part to the eyes inlaid with crystal; this Amida Triad is notable as one of the earliest examples of the use of inlaid crystal eyes.

Abe. Village south of Nara. In the Monjuin are wooden statues of Monju and attendants (Kamakura period), traditionally attributed to Kaikei.

Kawahigashi. Village south of Nara. At the Karako site (Yayoi period) beautiful earthenware, wood, horn, bone, and stone articles were found, as well as personal ornaments such as lacquered wooden bracelets and combs.

Miwa. Small town 11 miles south of Nara on the railway line to Takada. Close to the town is the Ōmiwa Shrine dedicated to Ōmononushi-no-Mikoto, a Shinto deity; it is said to have been founded in the 1st century B.C. and may be the most ancient temple in Japan. It is situated at the foot of Miwa hill, which is itself an object of worship — an interesting example of nature worship in ancient Japan. The Haiden (hall of worship) dates from the Edo period.

Tambaichi. Small town 6 miles south of Nara on the railway line to Sakurai. To the east is the Isonokami Shrine with a remarkable Haiden and two-storied gateway, both of the Kamakura period. The shrine contains a sword, 29½ in. long, bearing an inscription inlaid in gold with a date that is interpreted to be of the year Tai-ho 4 (A.D. 369) of the Eastern Chin dynasty of China. According to tradition, this sword was presented to Emperor Jimmu by the goddess Amaterasu Ōmikami.

Asuka. Village near Nara. The Buddhist temple of Asukadera (also called Hōkōji and Gangōji) was founded by Soga-no-Umako in 588. Recent excavation of the original site of this temple proves that it had a pagoda, main hall, and lecture hall in a straight south-north row, plus two more main halls to the east and west of the pagoda, a plan suggesting Korean influence. The temple contains a seated bronze statue of Shaka; the image was made in 606 by Tori, but only the head is original.

Harigabessho. Village near Nara. The Kinryūji contains a standing wooden statue of a *bosatsu* (bodhisattva; Nara period).

Takaichi. Near this village is the Ishibutai tumulus (Great Burial period). It is known as Ishibutai (stone stage) because the soil covering the tumulus is gone, exposing the huge rocks that form the ceiling of its burial chamber. Pottery fragments of the so-called "Haji ware" and "Sue ware" found here suggest that the tumulus belongs to the Asuka period.

Unebi. Small town 15½ miles south of Nara. Nearby is the site of the imperial palace of Fujiwara, built in 694 by the empress regnant Jitō. Fujiwara remained the seat of imperial rule until 710. There are remains of some important palace buildings. The Yamato Rekishikan at Unebi contains archaeological material from the Yamato district.

Takatori. In this village is the Kojimadera, which contains the Kojima Mandara (Jōgan period). Painted in gold and silver on purple twill silk, this mandara is an important specimen of esoteric Buddhist art of the 9th century.

Ikaruga. Village southwest of Nara. Nearby is the famous Hōryūji (PL. 282), originally built in 607 by the empress regnant Suiko and her son Shōtoku Taishi in obedience to the will of the deceased emperor Yōmei. It seems that the buildings were destroyed by fire in 670 and were reconstructed soon after that, although another theory says that the temple which was burned was a different temple and that the main buildings still existing date from the first half of the 7th century. They are, in any case, the oldest wooden buildings in the world. The two-storied Kondō is a representative example of 7th-century architecture; the 28 massive pillars have a slight entasis and eaves bracketing in "cloud" form. The Kondō was partly burned down in 1949, and the present building, an exact replica, was completed in 1954. In the Kondō is the bronze Shaka Triad, made in 623 by the famous sculptor Tori. The central figure,

a seated Shaka, is 34 in. high. This triad is the greatest extant piece of Asuka sculpture. Also in the Kondō are a bronze seated Yakushi (Asuka period); wooden statues of the Shitennō (Asuka period); and three wooden canopies, two of the Asuka period and one of the Kamakura period. The five-storied pagoda, built in 607, is the oldest existing pagoda in Japan. On the first floor of the pagoda are clay statues; made in 711, they are fine works of art and give valuable information about the manners and costumes of the time. The Chūmon (middle gate), built in 607, has covered corridors on each side of the two-storied gateway. In the niches of the Chūmon are a pair of Niō with clay heads (Nara period) and wooden bodies (Kamakura period). The cloister is of the Asuka period. The Kōdō (Fujiwara period) contains wooden statues of the Yakushi Triad and the Shitennō, both of the Fujiwara period. The Shōryōin (hall of the sacred spirits; Kamakura period) contains wooden statues of Shōtoku Taishi and of his attendants (Fujiwara period). The refectory and the Kyōzō (sutra repository) are of the Nara period. The Yumedono (Dream Hall; Nara period) is the main hall of the Tōin (East Temple) and the most beautiful octagonal building in Japan (PL. 282). The chief object contained there is the standing wooden statue of the Yumedono Kwannon (PL. 262), a masterpiece of the late 7th century. There is also a dry-lacquer statue of the priest Gyōshin (Nara period), founder of the building (d. 750). The E-dono (picture hall; Kamakura period) contains several sliding screens decorated with pictures which illustrate the life of Shōtoku Taishi. The Dempōdō (preaching hall; Nara period) contains dry-lacquer statues of the Amida Triad (Nara period). The Daihōzōden (treasure hall) is a ferroconcrete building containing treasures of the Hōryūji and consists of two galleries, the southern and northern. In the southern gallery is Lady Tachibana's Miniature Shrine, made of wood, containing a bronze Amida Triad (IX, PL. 514), both representative pieces of decorative art and sculpture of the early 8th century; and the Tamamushi Zushi (Asuka period; PL. 418), so termed because it was decorated, under its openwork metal borders, with wing sheaths of the *tamamushi* beetle (*chrysochroa elegans*). The panels of its pedestal have Jātaka paintings (representing episodes from the life of Shaka), which are the only existing examples of painting from the first half of the 7th century. The southern gallery also contains an example of *shokkō-kin* (gold brocade) of the Asuka period in the style of the Chinese *shu-hung-chin*. In the northern gallery is a standing wooden statue of Kwannon (Asuka period), popularly known as the Kudara Kwannon (PL. 396). This tall, slender figure is numbered among the most beautiful works of Japanese sculpture. Also in the northern gallery are a wooden nine-headed Kwannon (T'ang dynasty); a Buddha with two attendants (Nara period) in copper repoussé; 29 Gigaku and Bugaku masks of the Nara, Fujiwara, and Kamakura periods; and a fan-shaped sutra, painted in color on silk (Fujiwara period).

Chūgūji: This contains a seated wooden Miroku in meditation (Asuka period, PL. 266; II, PL. 396), which is famous for its modest, elegant beauty. The temple calls this statue Nyoirin Kwannon (Cintāmaṇicakra), but this name is erroneous because the worship of Cintāmaṇicakra in Japan did not begin until the 9th century. The embroidery known as the Tenjukoku Mandara (PL. 267) is the oldest existing work of embroidery in Japan (622) and was made by Tachibana-no-Oiratsune, consort of Prince Shōtoku, in memory of the Prince. Only a few fragments of the mandara remain.

Tomisato. Village north of the Hōryūji. The Hōrinji was founded in 622 by Yamashiro-no-Ōe, eldest son of Prince Shōtoku Taishi. It contains a Yakushi, a seated wooden statue, and a Kokūzo (Ākāśagarbha), a standing wooden statue, both of the Asuka period. East of the Hōrinji is the Hōkiji (or Hōkkiji), founded in 638 by the priest Fukuryō. The chief attraction here is the three-storied pagoda which is said to date from 686.

Taima. Village south of the Hōryūji, near which is the Taimaji or Taimadera. Said to have been originally built in Kochi province in 612 by Prince Maroko, son of Emperor Yōmei, and moved here in 673. The Kondō (Kamakura period) contains a seated clay statue of Miroku (Nara period) and the Shitennō (Nara period), the oldest existing dry-lacquer statues in Japan. In the Hondō (main hall; also called the Mandaradō) is the Taima Mandara (Kamakura period), a painting in color on silk, which represents the Buddhist paradise (*gokuraku-jōdo*). This picture is a copy, made in the Kamakura period, of the original mandara painted in 673; fragments of the original are also in the temple, in a very bad state of preservation. The east and west pagodas are both of the Nara period. Situated in the compound of the Taimaji is the Buddhist Oku-no-in.

Kawai. Village near Taima. This is the site of the Samida Takarazuka tumulus (Great Burial period), a keyhole-shaped tumulus ca. 295 ft. long.

Uchi. In this village is the Eizanji. In the octagonal hall (Nara period) are paintings in color on wooden panels.

Yoshino. Small town in the middle of the prefecture of Nara. Near the town is the Mikumari Shrine, built in 1604 by Toyotomi Hideyori. The shrine buildings (Momoyama period) are the sanctuary, hall of worship, hall of offerings, two-storied gateway, and cloister. Inside the sanctuary is a seated wooden statue of the Shinto goddess Tamayorihime-no-Mikoto, a masterpiece of Shinto sculpture of the Kamakura period.

Daianji. Village on the outskirts of Nara. The temple of the same name was founded in 639, but was moved in 710 to its present site. Of the original temple only ruins remain. In the Daianji are preserved standing wooden statues of Senju Kwannon and Fukū-kenjaku Kwannon, both of the Nara period, together with nine other wooden statues from the Nara period.

Oyagyu. Village on the outskirts of Nara. The Enjōji contains a seated wooden statue of Amida (Fujiwara period) and a statue of Dainichi Nyorai (Vairocana Tathāgata; PL. 292), made by Unkei in 1176, in the joined-wood technique, with eyes inlaid with crystal.

Heijō. In this village is located the Akishinodera. It was founded in 780 at the wish of the emperors Kōnin and Kammu but destroyed by fire in 1135, except for the Kōdō. Later the Kōdō was restored and became the Hondō (Kamakura period). Here the representation of Gigeiten, goddess of the arts, is kept; the standing figure is of wood (Kamakura period) with a dry-lacquer head (Nara period). There is also a standing dry-lacquer statue of Bonten (Nara period).

Murō. Village on the Kinki railway line, east of Sakurai. The Murōji is situated deep in the mountains, and is the only complex in which buildings of the 9th century survive. In the Kondō (Jōgan period) are standing wooden statues of Yakushi, Monju, Jūichimen Kwannon, Jizō Bosatsu, and Shaka, all of the Jōgan period. In the five-storied pagoda (Jōgan period, although it is claimed that the pagoda was inherited from a temple on the site founded ca. 790) are wooden statues of Miroku and Shaka, also of the Jōgan period.

b. Prefecture of Kyoto. Kyoto. The capital of Kyoto prefecture was founded in 794 by Emperor Kammu. It was the capital of the country until 1868, when the capital was moved to Edo (mod. Tokyo). The new city, called Heian-kyō (capital of peace and tranquillity), was completed in 805 and, like Nara, it was modeled after the Chinese capital of Ch'ang-an. The history of Kyoto is full of misfortune and disaster. Twice the imperial palace was destroyed, first in 960 and again in 1177. In 1221 the city was seized by the Kamakura Shogunate, and from 1336 on was the scene of many battles. A brief interlude of peace followed, but from 1467 to 1474 Kyoto was again desolated owing to the rivalry between the opposing Yamana and Hosokawa forces. In 1569 it was occupied by Oda Nobunaga, who found the town in a deplorable condition and set about rebuilding the imperial palace; this was completed by Toyotomi Hideyoshi, who also restored the temples and other famous buildings. Kyoto, with its magnificent temples, gardens, and beautiful, stately palaces, is, even today, the spiritual and artistic center of Japan.

Imperial palace: This is located in the imperial park and was originally built by Emperor Kammu in 794; it was often destroyed by fire and the present buildings date only from 1854. However, the buildings are in the same style as the original palace, so they are valuable sources of information about the style of palace architecture of the Heian period. The Shishinden (ceremonial hall; Edo period) is used for important state functions. The Seiryōden ("serene and cool chamber"; Edo period) is decorated with paintings of the Tosa school; this was the hall where the emperor lived.

Shōkokuji: A great monastery of Zen Buddhism built in 1382 by Ashikaga Yoshimitsu. The Hattō (lecture hall; Momoyama period) was rebuilt by Toyotomi Hideyori.

Nishijin: The district near the northwest corner of Kyoto. Since about the 16th century Nishijin has been a center of textile manufacture, famous for products of high quality known as Nishijin fabrics. Silk gauze, silk crepe, "Japanese brocade," "Chinese brocade," gold brocade, Ming-style damask, and satin, as well as European-style lace and velvet, are still made here.

Daihōonji: In the main hall (Kamakura period) are standing wooden statues of the Jūdai Deshi, by Kaikei, and of Shaka, all of the Kamakura period.

Kitano Shrine: A Shinto temple, also called Kitano Tenjin. It is dedicated to Sugawara-no-Michizane (845–903), the greatest scholar of Chinese literature of his time; he was deified under the name of Tenjin. The shrine was founded in 947, but the present buildings were rebuilt in 1607 by Toyotomi Hideyori. Among the temple

treasures are nine scrolls of the Kitano Tenjin Engi by Fujiwara-no-Nobuzane (1176–ca. 1268), an illustrated history of the Kitano Tenjin, painted in color on paper; two scrolls of the Kitano Tenjin Engi by Tosa Yukimitsu (14th cent.), painted in color on paper; and Dragons and Clouds, folding-screen painting by Kaiho Yūshō (1533–1615).

Rokuonji (popularly known as Kinkakuji): This was originally the Kitayama villa of the Saionji family, which Ashikaga Yoshimitsu (1358–1408) bought and enlarged. After Yoshimitsu's death the villa was converted into a Buddhist monastery. The three-storied Kin-kaku (Golden Pavilion), so named because it was originally covered with gold leaf, was built ca. 1394–1427, and was representative

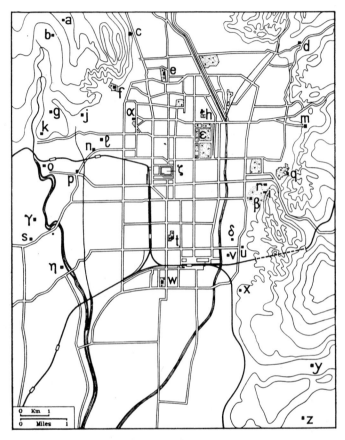

Kyoto, plan of the center of the city. (*a–z*) Buddhist temples: (*a*) Kōzanji, (*b*) Jingoji, (*c*) Kōetsudera, (*d*) Shūgakuin, (*e*) Daitokuji, (*f*) Rokuonji (Kinkakuji), (*g*) Daikakuji, (*h*) Shōkokuji, (*i*) Chionin, (*j*) Ninnaji, (*k*) Seiryōji, (*l*) Myōshinji, (*m*) Jishōji (Ginkakuji), (*n*) Hokongōin, (*o*) Tenryūji, (*p*) Kōryūji, (*q*) Nanzenji, (*r*) Shōrenin, (*s*) Saihōji, (*t*) Nishi Honganji, (*ū*) Chishakuin, (*v*) Rengeōin, (*w*) Kyōōgokokuji, (*x*) Tōfukuji, (*y*) Sambōin, (*z*) Hōkaiji. (α-δ) Shinto shrines: (α) Kitano Jinja, (β) Yasaka Jinja, (ν) Matsunoo Jinja, (δ) Hōkoku Jinja. (ε-η) Secular buildings: (ε) Imperial palace, (ζ) Nijō castle, (η) Katsura palace.

of the architecture of that time; it burned down in 1950 and was reconstructed in 1955. The garden (Muromachi period) is a fine example of landscape gardening of this period.

Kōetsudera: Buddhist temple containing the Taikyōan (Edo period), a tea-ceremony house. It was in this area that Hon-ami Kōetsu (1558–1637) established a village of artists which lasted from the late Momoyama to the early Edo period.

Daitokuji: This is one of the chief temples of Zen Buddhism, and was founded in 1324 by the priest Daitō Kokushi. The buildings in this monastery, although rebuilt in 1479, are typical examples of Karayō, an architectural style of Chinese origin. The Karamon (Chinese-style gate; Momoyama period) was transferred from Toyotomi Hideyoshi's Jurakudai Mansion. The present main buildings, except the Kuri (priests' living quarters; Muromachi period) and the two-storied Sammon (main gate), which was built in 1589 by Sen-no-Rikyū, the famous master of tea ceremonies, were constructed during the Edo period. In the Hōjō (superior's quarters) are 84 paintings by Kanō Tanyū (1602–74) mounted on sliding screens. Other paintings here are a triptych of Kuan-yin (Kwannon), Monkey, and Crane (X, PL. 201) in ink on paper and a diptych of Dragon and Tiger (X, PL. 201) in ink on silk by the Chinese painter Mu-ch'i

(q.v.); Kuan-yin (Sung dynasty), color on silk; and portraits of Daitō Kokushi and Emperor Godaigo, both of the Kamakura period, color on silk. In the enclosure of the Daitokuji are a number of small monasteries in which valuable works of art are preserved. The Shinjuan contains three paintings on sliding doors attributed to Soga Jasoku (d. 1483): two Landscapes and one Flowers and Birds. In the Daisenin are a Landscape attributed to Sōami (d. 1525), painted on sliding doors, and a painting of Flowers and Birds (1509) attributed to Kanō Motonobu (PL. 313). The Jūkōin contains the tomb of Sen-no-Rikyū; a tea-ceremony house (Momoyama period); and a number of Landscapes and Flowers and Birds painted on sliding walls (PL. 318) attributed to Kanō Eitoku (1534–90), which are representative masterworks of panel paintings in the Momoyama period. In the Sōkenin is the painting Rose Mallows in Rain (X, PL. 201) attributed to Mu-ch'i, in ink on paper. The Kōtōin contains a Landscape (Sung dynasty), ink on silk, and Peonies (Yüan dynasty), color on silk. The Gyokurinin has a tea-ceremony house named Minoan (Edo period) and a painting of Shaka in color on silk (Edo period). In the main hall (Momoyama period) of the Ryūkōin are three paintings attributed to Mu-ch'i: Persimmons (X, PL. 201) and Chestnuts, both in ink on paper, and a Landscape, in ink and faint color on silk. The Kohōan has a main hall, a building in shoin style, and seven tearooms in sukiya style, all of the Edo period. The Ōbaiin contains a main hall (Momoyama period) and a Landscape with Figures attributed to Unkoku Tōgan (1547–1618), painted on sliding doors.

Nijō castle: This was built in 1602 to accommodate Tokugawa Ieyasu and his retinue on their visits to Kyoto, and was decorated during the following 20 years; it is a valuable example of the style of the interiors of castles of the Edo period. The Mikuruma-yose, Tosaburai, Ōhiroma, Kuroshoin, and Shiroshoin, all of the Edo period, are examples of the shoin style in the castle. The paintings on the sliding doors and walls are fine works by famous artists of the Edo period (PLS. 114, 322–324). The garden of the ninomaru is of the Edo period.

Nishi Honganji: Headquarters of the Jōdo-Shinshū sect and considered by art critics to be the most beautiful temple in Kyoto. The Hiunkaku (Momoyama period; PL. 115) was transferred from Jurakudai Mansion; it is a three-storied building, decorated by Kanō Tanyū, Kanō Eitoku, and Tokuriki Zensetsu (1591–1680). In the Hiunkaku is kept the Sanjūroku-nin-shū (Fujiwara period; PL. 286), a collection of poems by the "Thirty-six Poetic Immortals," copied by famous calligraphers of the Fujiwara period, in ink with decorative paintings. The Karamon is of the Momoyama period. The audience hall and Shiroshoin (Momoyama period) were transferred from Hideyoshi's castle at Fushimi. The audience hall is decorated with paintings by Kanō Tanyū, Kanō Ryōku, and Maruyama Ōkyo (PLS. 325, 326). In the Shiroshoin are paintings by Kanō Kōi, Kaihoku Yūsetsu, and Kanō Ryōtaku. The two-storied Kuroshoin (Momoyama period) was also brought from the castle at Fushimi; it contains Warblers on Willow in Snow (Yüan dynasty), a painting in color on silk, and the Kumano Kaishi (Kamakura period), poems by Emperor Gotoba and others, in ink on paper.

Kyōōgokokuji (popularly known as Tōji or East Temple): A magnificent monastery built soon after the transfer of the capital to Heian (Kyoto) in 794. In 823 the Emperor donated it to the priest Kūkai, founder of the Shingon sect of esoteric Buddhism, and it became the center of the Shingon sect. The two-storied main hall, built by Toyotomi Hideyori between 1599 and 1606, contains wooden statues of the Godai Myōō (Five Great Kings; Jōgan period), which are representative specimens of esoteric Buddhist sculpture; Bonten and Taishukuten, wooden statues (Jōgan period); and the Shitennō, standing wooden statues (Jōgan period). The five-storied pagoda (Edo period), rebuilt by Iemitsu, the third Tokugawa Shogun, is the highest pagoda in Japan. It contains Bishamonten (Kubera; Jōgan period), a wooden statue in the form known as Tōbatsu Bishamonten, a unique form of the god that originated in Central Asia and was introduced to Japan through China; this is the original of all Tōbatsu Bishamonten statues. Also in the pagoda are seated wooden statues of Fudō Myōō (Acala) and of Monju as a priest, both of the Jōgan period, and the following paintings in color on silk, all of the Fujiwara period: a sansui byōbu (folding screen used in the Shingon initiation service, PL. 277); the Godai Myōō; two sets of the Jūniten, one set attributed to Takuma Shōga; and the Ryōgai (or Kongokai) Mandara. The Kanchiin contains a painting in color on silk of Emmaten (Yama; Fujiwara period) and wooden statues of the Godai Kokūzō (five manifestations of Ākāśagarbha; T'ang dynasty).

Rokuharamitsuji: Founded in 963 by the priest Kūya. It contains wooden statues of Jizō Bosatsu, seated (Kamakura period; PL. 295); Jūichimen Kwannon, standing (Fujiwara period); and the priest Kūya, standing (Kamakura period), by Kōshō.

Chionin: Headquarters of the Jōdo sect, founded in 1211 by Hōnen Shōnin. The two-storied Sammon (Edo period) contains a painting in color on silk of Amida with 25 bosatsu (Kamakura period; PL. 296). The Seishidō contains the Hōnen Shōnin E-den (Kamakura period), 48 scrolls of an illustrated biography of Hōnen; paintings in color on silk of Bishamonten (Kamakura period), Jizō Bosatsu (Fujiwara period), and Tao-li-yüan and Chin-kuo-yüan (Sung dynasty); and Buddha and Two Attendants in copper repoussé (Nara period).

Tōfukuji: Founded in 1236. The two-storied Zendō, the Gekkamon (gateway), the Tosu (lavatory), and the Yokushitsu (bathhouse) are all of the Muromachi period. The last two buildings, where priests seek to purify themselves both physically and spiritually, are very important in a Zen monastery. In the two-storied Sammon (Muromachi period) are paintings in color on paper attributed to Minchō (also called Chōdensu; 1352–1431): a set of Five Hundred Rakan on 50 kakemono and a portrait of Shōitsu Kokushi, the founder of the Tōfukuji.

Hōkoku Shrine: Shinto temple dedicated to Toyotomi Hideyoshi. It was originally built in 1599 by order of Emperor Goyōzei, then rebuilt in 1868. The Karamon is a fine building of the Momoyama period. In the shrine is the Hōkoku Festival by Kanō Naizen Shigesato (1570–1616), a six-part folding screen, painted in color on paper.

Kenninji: Founded by the priest Eisai in 1202. The original buildings, with the exception of the Chūmon, were destroyed by fire and rebuilt about the middle of the 18th century. In the temple are a pair of two-part folding screens of the Wind God and the Thunder God (PL. 314) in color on gold, attributed to Tawaraya Sōtatsu (early 17th cent.).

Shōrenin: The present buildings date from 1895. Here is found a painting in color on silk of Fudō Myōō (Fujiwara period).

Yogenin: In this temple are Pine Trees, painted on sliding doors, and Cypress Trees, painted on wooden doors, attributed to Tawaraya Sōtatsu (early 17th cent.).

Yasaka Shrine (commonly called Gion Shrine): The present buildings date from 1654; the Honden (sanctuary) is noteworthy.

Seisuiji (popularly known as Kiyomizudera). The present structures were erected in 1633 by order of Tokugawa Iemitsu; the main hall is outstanding (PL. 311).

Rengeōin (popularly known as the Sanjūsangendō): This temple was first built in 1132 by order of Emperor Goshirakawa and was rebuilt in 1251, after having been destroyed by fire in 1249. The Hondō (Kamakura period) is long and narrow, as it was designed to house 1,000 statues of Senju Kwannon; it is the longest wooden building in Japan. The seated wooden statue of Senju Kwannon (Kamakura period) is a representative work of Tankei, son of Unkei. Other standing wooden statues include the Nijūhachi-bu-shu, representing the 28 faithful followers of Kwannon (Fujiwara and Kamakura periods), and the Wind God and the Thunder God, both of the Kamakura period.

Chishakuin (or Chijakuin): Headquarters of the Chizan school of the Shingon sect. It was rebuilt by Tokugawa Ieyasu in 1598, and houses 51 paintings of flowers in color on gold paper on sliding doors and walls (PL. 319); these are typical examples of the gorgeous decorative panel paintings of the Momoyama period. There are also three folding screens of Pine Trees and Autumn Grasses in color on gold paper of the same period.

Manshūin (or Manjūin): This temple contains paintings in color on silk of Fudō Myōō (Fujiwara period), widely known as the "Yellow Fudō" because the god's body is painted in that color, and Monkeys (Sung dynasty).

Shūgakuin palace: This was built for Emperor Gomizuno-o (1596–1680) by Tokugawa Hidetada (1579–1623). Its garden, nearly 70 acres in area, is one of the most beautiful in Japan.

Jishōji (popularly known as Ginkakuji): Originally built in 1489 by Ashikaga Yoshimasa. The two-storied Ginkaku (Silver Pavilion) was modeled on the Kinkaku. In the Buddha hall is an image of the Buddha by Jōchō (d. 1057). In the Tōgudō (tea-ceremony hall; Muromachi period) is a tiny tearoom, which is the model for all the later rooms used for the tea ceremony.

Konkaikōmōji: Belongs to the Jōdo sect. Here is a painting in color on silk of Amida Appearing Over the Mountains (Kamakura period).

Nanzenji: A famous temple of the Rinzai sect. It was founded in 1293 but twice destroyed by fire; some buildings erected by Tokugawa Ieyasu remain. The two-storied Sammon was built in 1628. The Hōjō (Momoyama period) was originally the Seiryōden of the imperial palace in Kyoto; the 63 paintings on the sliding doors and walls were done by Kanō Eitoku and other artists of the Kanō school. The smaller suite of apartments attached to the Hōjō was transferred from the Fushimi castle; the painting of Tigers in gold leaf on the sliding screens is attributed to Kanō Tanyū. The temple also contains a Daruma (Dharma; Muromachi period) by Keishoki, painting in ink on paper, and the Hermit Yao Shan Talking to the Poet Li Po

(Southern Sung dynasty; III, PL. 264) by Ma kung-hsien, painting in ink and faint color on silk. The Konchiin has a tea-ceremony house known as Hassoseki (Momoyama period). In the Konchiin are the following paintings: Autumn Landscape and Snow Landscape, in color on silk, attributed to Hui-tsung (1082–1135); Hut in the Valley (known as the Keiin Shōchiku), in ink on paper, attributed to Minchō; Landscape with Pavilion at Lake, by Kanō Motonobu (1476–1559), in ink on paper; and Monkeys and Pine Trees, both of the Momoyama period, painted on sliding doors in ink on paper.

Zenrinji (also known as Eikandō): This was rebuilt during the 15th century. Here there is a painting in color on silk of Amida Appearing Over the Mountains (Kamakura period; PL. 293) and the Yūzūnembutsu Engi (Muromachi period), two scrolls illustrating stories concerning the origin of the Yūzūnembutsu sect of Buddhism.

Shinshō Gokurakuji: This contains a painting in color on paper of Fūgen Bosatsu (Samantabhadra; Kamakura period) and the Shinnyodō Engi (Muromachi period), three scrolls illustrating legends of the origin of the Shinnyodō.

Anrakujuin: This temple contains a seated wooden statue of Amida (Fujiwara period).

Daigoji: A famous temple of the Shingon sect, founded in 874 by the priest Shōbō. The five-storied pagoda, built in 951, is decorated with beautiful paintings on wooden panels dating from the same time as the building. The Yakushidō (Fujiwara period) contains wooden statues of the Yakushi Triad (Fujiwara period) and 39 Buddhist iconographic drawings in ink on paper (Fujiwara and Kamakura periods). In the Kōdaiin is a painting of Monju Crossing the Ocean (Kamakura period; PL. 297) in color on silk. The museum of the temple, the Daigoji Reihōkan, contains paintings, sculptures, historical manuscripts, and sutras.

Sambōin: A celebrated temple of the Shingon sect, founded by the abbot Shōkaku in 1115. The Karamon and the landscape garden, one of the finest in Japan, are of the Momoyama period. In the temple are two pairs of two-fold screens by Tawaraya Sōtatsu (early 17th cent.), one showing Bugaku dancers and the other with painted fans pasted on the screen; a painting of Kishi-bojin (Hāritī; Fujiwara period) in color on silk; and a Fudō Myōō of painted wood by Kaikei (PL. 345).

Hōkaiji: This temple of the Shingon sect is of the 10th century. In the Amidadō (probably 11th cent.) is a seated wooden statue of Amida attributed to Jōchō (d. 1057).

Ryūanji (or Ryōanji): Founded in 1473 by Hosokawa Katsumoto. It is famous for its garden (Muromachi period; PL. 448) with its unique rock-and-sand formation and absence of trees, the work of Soami.

Myōshinji: The temple was built between 1336 and 1338 on the site of the imperial villa of Emperor Hanazono, but the present monastery buildings are of the Edo period. The Myōshinji has three pairs of six-fold screens of the Momoyama period: Kin Ki Sho Ga and Flowers, both by Kaiho Yūshō, and Monkeys (PL. 309), by Hasegawa Tōhaku. No other Buddhist temple has as many dependent temples as the Myōshinji; notable among these are the Taizōin, containing a typical specimen of black-ink painting of the Muromachi period, Catching a Catfish with a Gourd (PL. 305), by Josetsu; the Reiunin, containing 49 Landscapes and Flowers and Birds (PL. 357), by Kanō Motonobu (1476–1559); and the Tenkyūin, with a painting on sliding doors of Birds and Plum Trees, attributed to Kanō Sanraku (1559–1635).

Hokongōin: It contains a seated wooden statue of Amida (Fujiwara period).

Ninnaji: Belongs to the Shingon sect and was founded in 886 by Emperor Kōkō. The Kondō (Momoyama period) contains an Amida Triad (Jōgan period), seated wooden statues. The five-storied pagoda was built in 1637. The Mieidō (portrait chapel; Momoyama period) contains the Kujaku Myōō (Mahāmayūri; Sung dynasty), a painting in color on silk. Other works of art of the Heian and later periods are also kept here.

Kōryūji (better known as Uzumasadera): This belongs to the Shingon sect, and was originally founded in 622 by Hata Kawakatsu to house a statue of the Buddha given to him by Prince Shōtoku Taishi. The lecture hall in its present state dates from 1165 and contains a seated wooden statue of Amida and a standing wooden statue of Jizō Bosatsu, both of the Jōgan period. The main hall of the Keigūin, built in 1251, contains a seated wooden Miroku in meditation (Asuka period), which is a masterpiece of wooden sculpture of the 7th century, and standing wooden statues of the Jūni Shinshō (PL. 272), made by Chōsei, a famous Buddhist sculptor, in 1064.

Kōzanji: Here are kept four famous scrolls in ink on paper of Animal Caricatures (PL. 287; III, PL. 435; IV, PL. 282; X, PL. 255) by Kakuyū [Toba Sōjō (1053–1140)]; a painting of the Butsugen Butsumo (Kamakura period), in color on silk; a painting in color on paper of Myōe Shōnin (Kamakura period); and six scrolls of the Kegon Engi (Kamakura period), in color on paper, illustrating the

history of the Kegon sect. In the past these scrolls were attributed to Fujiwara-no-Nobuzane (13th cent.), but they are in fact the work of members of the community.

Jingoji: Founded in 824 but allowed to fall into ruin for 200 years and rebuilt in the 12th century. The Yakushi, a standing wooden statue, is a representative work of single wood-block sculpture of the late 8th century. The Godai Kokūzō, seated wooden statues, are typical specimens of Buddhist sculpture of the 9th century. The temple also contains a pair of sansui byōbu (Kamakura period), six-fold screens in color on paper; portraits said to be of Minamoto Yoritomo, Fujiwara Mitsuyoshi (PL. 290), and Taira-no-Shigemori, all of the Kamakura period, painted in color on silk, which are among the best portraits of lay persons of the Kamakura period; a Two Worlds Mandara (Jōgan period), in gold and silver on purple silk; and a Shaka (Fujiwara period; PL. 276), in color on silk.

Saihōji (popularly known as Kokedera, Moss Temple): Belongs to the Rinzai sect. The garden was designed by Musō Kokushi (1275–1351) and is a typical example of a "scenery garden," in which famous scenes are reproduced. The ground is completely covered with moss. In the garden is the Shōnantei (Momoyama period), a tea-ceremony house.

Matsunoo Shrine: Dedicated to the Shinto god Ōyamakui-no-Mikoto and his consort. Here are three seated wooden statues (two gods and one goddess; PL. 273) of Shinto deities (Jōgan period), which are among the oldest and finest examples of Shinto sculpture, and a painting in color on silk of I'ūgen Emmyō (Vajrāmoghas-mayasattva; IV, PL. 225) of the Kamakura period.

Seiryōji (commonly called Shakadō): In the main hall is a standing wooden statue of Shaka (Sung dynasty), brought to Japan in 987 by the priest Chōnen; this is the prototype of the Seiryōji type of Shaka that was frequently copied in the Kamakura period. In a recent examination models of viscera were discovered inside this statue.

Tenryūji: Founded in 1339 by Ashikaga Takauji. The present buildings were reconstructed in 1900 after repeated damage by fire. Of particular interest is the garden, designed by Musō Kokushi, who was also the first superior of the temple.

Daikakuji (or Daigakuji): Originally a residence of Emperor Saga, it was turned into a temple in 876 by Emperor Junna. Peonies and Pink Prunus Blossoms, paintings on sliding doors, in color on gold paper, are both of the Momoyama period. The Godai Myōō in wood are by Meien (Myoen; Fujiwara period).

Katsura palace: A beautiful mansion in the sukiya style of architecture with a "scenery garden" (PL. 448). Originally designed and built by Prince Tomohito between 1617 and 1626, it was enlarged by Prince Tomotada ca. 1645. Buildings include the Koshoin, Chūshoin, and Shinshoin (old, middle, and new shoin), and two tea-ceremony houses, the Gepparō and Shōkintei (PL. 115).

Kiyomizu: Center of production of Kiyomizu ware, which is famous for its elegance. Ceramic manufacture began in this area in the mid-15th century, when a potter named Otowaya Kuroemon opened a factory here. With the increasing popularity of the tea ceremony, the region thrived on the manufacture of tea-ceremony articles. In the 17th century the famous potter Nonomura Ninsei originated Kyoto ware, which is still made in enormous quantities.

Kyoto National Museum: Here is housed a vast collection of paintings (PL. 317), sculpture, handicraft arts, calligraphy, historical manuscripts, and archaeological specimens belonging to the museum, as well as objects on loan from shrines, temples, and private collectors.

Yūrinkan Museum: Contains specimens of ancient Oriental art.

Municipal Modern Art Gallery: This gallery displays contemporary arts: Japanese-style and Western-style paintings, decorative works of art, and sculpture. From time to time the museum holds exhibitions of contemporary art.

Ōhara. Village 4 miles north of Kyoto. The Sanzenin was rebuilt in 860 by the priest Jōun. The main hall, known as Ōjōgoku-rakuin (hall of paradise in rebirth), was built in 985 and contains wooden statues of the Amida Triad (Fujiwara period.)

Kurama. Village 6 miles north of Kyoto. The Kuramadera, founded in 770 by the priest Kantei, stands on the peak of Mount Kurama; its present buildings, however, date only from 1872. Here are wooden statues of Shō Kwannon (Āryavalokiteśvara; Kamakura period) by Jōkei, a Sung-style work with intricate drapery, and of Bishamonten (Fujiwara period).

Mukōmachi. Village 4 miles from Kyoto. In the Hōbōdaiin is a seated wooden statue of Gakkō in meditation (Jōgan period), showing the influence of the later T'ang dynasty art of China.

Otokuni. Village near Kyoto. In the Chōhōji is the Resurrection of the Buddha (Fujiwara period; PL. 275), in color on silk, a typical example of graceful Buddhist painting of the late 11th century.

Uji. Small town 3 miles south of Kyoto on the railway line to Nara. Nearby are a number of temples of distinct artistic and historical interest.

Mampukuji: Headquarters of the Ōbaku sect. The temple was founded in 1659 by the priest Ingen. It contains a painting of Lake Hsi-hu by Ike-no-Taiga (1723–76) and five other paintings of the Edo period.

Ujigami Shrine: The Honden (Fujiwara period) is the oldest and most typical example of the *nagare* style of Shinto architecture. The Haiden is of the Kamakura period.

Byōdōin: Originally a villa built ca. 1000 for Fujiwara Michinaga, it was converted into a Buddhist temple in 1052 by Fujiwara Yorimichi, who built the Hōōdō (Phoenix hall; PL. 284) in 1053. The Hōōdō is one of the most beautiful specimens of architecture of the period; it contains a seated statue of Amida (Fujiwara period) attributed to the famous Buddhist artist Jōchō, which is the prototype of the Jōchō style of Buddhist sculpture. While earlier statues used to be carved out of a single block of wood, this is made by the joined-wood technique invented by Jōchō, in which each part of the statue is carved separately and all the parts subsequently joined. Above the Amida is a wooden canopy (Fujiwara period). Admirable also are the figures of worshippers (Fujiwara period; PL. 272), 52 heavenly beings flying on clouds, sculptured in wood and fixed to horizontal supports near the ceiling on the inside of the building.

c. Prefecture of Osaka. Osaka. Capital of Osaka prefecture, its foundation can be dated back to the 4th century, when the emperors Ōjin and Nintoku decided to build their palaces here. The place where Osaka now stands was originally called Naniwa ("rapid waves"), and this name is still used in poetry. In the 16th century, with the reign of Toyotomi Hideyoshi, Osaka became a great commercial city, mainly because of its port, and it continued to grow throughout the era of the Tokugawa Shogunate. Despite its long history, Osaka has few places of artistic or archaeological interest.

The mint building, belonging to the period immediately after 1870, was designed by an Englishman, T. J. Waters, and shows the eclecticism then current in European architecture. Tōgo Murano's Sogō Department Store (1936), Tetsurō Yoshida's Central Post Office (1939), and the Sports Stadium (1955) are outstanding examples of modern architecture. There are three important museums in Osaka: the Municipal Art Museum, with a permanent display of ancient Oriental art (ceramics, lacquer, Buddhist sculpture, paintings, etc.) in the northern part of the building and contemporary works of art in the southern part; the Nihon Kōgeikan, with Japanese handicrafts and contemporary decorative arts; and the Fujita Museum of Art, containing 3,000 specimens of painting, sculpture, calligraphy, and decorative arts, as well as a fine collection of objects connected with the tea ceremony.

Shitennōji: Originally founded in 593 by Prince Shōtoku Taishi, it was repeatedly burned down, rebuilt in 1812, but razed to the ground in World War II. It gives its name to the Shitennōji type of temple plan, used in many temples, consisting of the inner gateway, pagoda, main hall, and lecture hall standing in a straight south-north line. Among the temple treasures are the fan-shaped Saddharmapuṇḍarīka Sūtra (PL. 286), famous for its beautiful paintings in color, and a seated bronze statue of Kwannon in meditation (Asuka period).

Osaka castle: Built in 1583 by Toyotomi Hideyoshi, and destroyed by Tokugawa Ieyasu in 1615. The Tokugawas began reconstructing the castle in 1620 as a base from which to control the western regions of Japan and finished it in 1630, but it was abandoned after the Meiji Restoration (1868).

Sakai. Lying south of Osaka along the coast, this is the second largest city of the prefecture. Nearby is the tumulus of Emperor Nintoku, the largest (1620 ft. long) of the "keyhole-shaped" tumuli; it is believed to date from the 5th century, which would indicate that the imperial court in Yamato was firmly established at the time. The Koganezuka tumulus (Great Burial period) is also a "keyhole-shaped" tumulus 280 ft. long; in and near the wooden coffin in the burial chamber were found various funeral offerings, including a mirror decorated with gods and animals, dated 239.

Kawakami. In this village is the Kanshinji, a monastery of esoteric Buddhism, said to have been founded in 836 by Jitsue, a disciple of Kūkai. In the main hall (Muromachi period; PL. 310) are a seated wooden statue of Nyoirin Kwannon, a representative specimen of esoteric Buddhist sculpture of the first half of the 9th century, and three small bronze Buddhist statues (Asuka period).

Amano. Village south of Osaka. In the main hall (Kamakura period) of the Kongōji are a pair of screens of Landscapes with Sun and Moon (Muromachi period), in color on paper, an early specimen of the type of decorative painting that flourished in the Momoyama and Edo periods.

Takawashi. In the village is Yoshimura House, a fine example of a commoner's dwelling of the Edo period.

Hanyū. Near the village is the Yachūji, containing a seated bronze statue of Miroku in meditation, an important specimen bearing the date of 666.

Domyōji. In the village is the Domyōji, containing a Jūichimen Kwannon (Jōgan period), an excellent specimen of so-called "sandalwood sculpture" that flourished in the late 8th to 9th century. Nearby is the Kōfuku site (Jōmon period), which has yielded pieces of early to middle Jōmon earthenware, Yayoi earthenware, stone implements, etc. Also in this area is the tumulus of Emperor Inkyo (Great Burial period), a huge "keyhole-shaped" tumulus.

Nagano. Small town southeast of Osaka. The Kanshinji Reihōkan contains numerous objects of art of the Asuka and later periods.

d. Prefecture of Shiga. Otsu. Capital of Shiga prefecture, the city is 6 miles east of Kyoto on Lake Biwa. The city, which was the seat of the imperial court in the 2d century and again in the 7th, is chiefly a tourist center, but it also has buildings of artistic worth.

The Shiga Kenritsu Sangyō Bunkakan (Institute of Culture and Industry of Shiga prefecture) contains works of art from temples, shrines, and private collections in the prefecture. Otsu-e is a type of folk painting that has been produced in the Otsu area since the Edo period. It was originated by Iwasa Matabei (1578–1650), a painter of the Tosa school. These souvenirs are interesting for their rough but expert brushwork.

Onjōji (also called Miidera). Founded in 686 in memory of Emperor Kōbun and a center of the Tendai sect. Of the hundreds of buildings that at one time were within the temple precincts only a few remain that are worthy of note. The Ōmon (front gate) and three-storied pagoda are of the Muromachi period. The main hall (Momoyama period) contains a painting in color on silk of Fudō Myōō, popularly known as the "Yellow Fudō" because of the color of the god's body, and seated wooden statues of Shiragi Myōjin and Chisō Daishi, all of the Jōgan period. The *shinden* of the Emmanin is of the Momoyama period. In the Emmanin are Peacocks and Peonies by Maruyama Ōkyo (1733–95), painted in color on silk; Scenes at Sumiyoshi Shrine (Momoyama period), sliding panels in color on gold paper; and Genre Scenes (Momoyama period), four sliding doors in color on gold paper.

Ishiyama. Small town 1½ miles south of Otsu. The Ishiyamadera was founded by the priest Rōben in 749 and rebuilt in the 12th and 16th centuries. Noteworthy are the main hall (Heian period) and the Tahōtō (Kamakura period; PL. 285). The temple houses the Ishiyamadera Engi (Kamakura period), seven scrolls in color on paper, illustrating legends about the origin of the Ishiyamadera.

Iwane. In this village is the Zensuiji, containing a standing bronze statue of the Birth of the Buddha (Nara period) and wooden statues of the Yakushi Triad (Fujiwara period).

Shigaraki. Town 16 miles south of Otsu. Shigaraki pottery is produced here. This ware became famous during the Muromachi period with articles made for the tea ceremony, and Shigaraki ware is still manufactured here.

Sakamoto. Small town 2 miles north of Otsu. Nearby, on Mount Hiei, is the Enryakuji headquarters of the Tendai sect, founded in 788 by the priest Saichō by order of Emperor Kammu. Its buildings, though mostly reconstructed in the Edo period, retain an earlier Chinese style. In the Komponchūdō (original main hall; Edo period) is a standing wooden statue of Senju Kwannon (Jōgan period).

Minami Tominaga. In the village is the Kwannondō (also called the Toganji), containing a standing wooden statue of Jūichimen Kwannon (Jōgan period).

e. Prefecture of Mie. Ise. Small town on the Kii Peninsula on Ise Bay, composed of Uji and Yamada, formerly two separate towns but now a single municipality. Nearby is the Great Shrine of Ise, one of the oldest Shinto shrines. Because the sanctuary is rebuilt every 20 years, the present building is a new one, but it retains the high-floored style of architecture of ancient Japan.

Yokkaichi. Port on the shore of Ise Bay. Banko pottery is produced here. Banko ware was originated about 1736 in the Kuwana area nearby, and was manufactured in Yokkaichi from the Meiji era on. This enameled porcelain is decorated with exotic motifs.

Awa. In the village is the Shin-Daibutsuji, containing a seated wooden statue of the priest Shunjō (Kamakura period).

f. Prefecture of Wakayama. Kōyasan. East of Wakayama, capital of the prefecture, is Kōyasan or Mount Kōya (near the village of Kōya), where there are a number of architectural complexes.

Kongōbuji: Headquarters of the Shingon sect. The temple was founded in 819 by Kūkai, but owing to repeated fires most of the original buildings no longer exist. Except for the Fudōdō and the sutra repository, both of the late Fujiwara period, the present buildings were erected in the early modern period. Most of the treasures of the temple are exhibited in the Reihōkan (treasure house; built in 1921). In the Kongōbuji are found a painting of the Nehan (Parinirvāna, or Death of the Buddha; II, PL. 378), in color on silk, dated 1086, a notable example of the graceful Buddhist work of the period; Shaka and His Host (Jōgan period), carved in relief on the inside of a cylindrical box consisting of three panels of wood, which is said to have been brought from China by Kūkai and is possibly a T'ang work; standing wooden statues of the Hachidai Doji (Eight Messengers of Fudō Myōō; Kamakura period), attributed to Unkei; Kujaku Myōō by Kaikei (PL. 345); and a lacquered sutra box (PL. 288).

Myōōin: Here is kept a famous painting of Fudō Myōō (Jōgan or possibly Kamakura period), in color on silk, popularly known as the "Red Fudō."

Ryūkōin: This contains a painting in color on silk, the Senchū Yūgen Kwannon (Fujiwara period), said to be the image of Kwannon as he appeared over the boat to Kūkai during his voyage from China to Japan.

Junji Hachimankō group of monasteries: Here is kept an Amida Raigō painting (Fujiwara period). The believers in the paradise of Amida, who were numerous in the Heian period, thought that Amida, accompanied by his attending *bosatsu*, would come down from heaven to receive the soul of the faithful at the moment of death. These "coming to welcome" (*raigō*) scenes were frequently represented in painting, and the finest and most famous of this type of painting is the one on Mount Kōya. Also kept here are the Godai Rikiku (Five Awesome Divinities; Heian period), three paintings of the five originals, in color on silk (PL. 274).

Henjōkōin: In the temple are sliding screens of Sages in a Mountain Retreat by Ike-no-Taiga, probably painted ca. 1761 or 1762.

Negoro. Village east of Wakayama, noted for the production of Negoro lacquer ware. This originated in the Negorodera, a monastery founded in 1288 by priests from Mount Kōya; it is one of the representative lacquer wares of Japan.

Yada. Village 37 miles south of Wakayama. Near here is the Dōjoji. The main hall (Muromachi period) contains standing wooden statues of Senju Kwannon, Gakkō, and Nikkō, all of the Jōgan period, and the Dōjoji Engi (Muromachi period), two scrolls, in color on paper, illustrating legends of the origin of the Dōjoji and the moral relating to it.

Nachi. Village in the southernmost part of Kii Peninsula, with the highest waterfall in Japan (PL. 299). The Kumano-Nachi Shrine was founded in the 4th century. From ancient times this shrine was the center of mountain worship, and it flourished especially during the Heian period and later, owing to the spread of *honji-suijaku*, the concept that Buddhist and Shinto deities were identical, one manifesting the other.

Shingu. Town close to Nachi. The treasure hall of the Kumano-Hayatama Shrine contains objects of art produced in the Heian and later periods (PL. 420).

g. Prefecture of Hyogo. Kobe. Capital of Hyogo prefecture. When Kobe was opened to foreign trade in 1868 it was a fishing village. Close to Kobe was the port of Hyogo, a very ancient city. Gradually Kobe increased in importance and in 1889 it was granted a city charter with Hyogo incorporated into it. In recent years Kobe has expanded considerably, absorbing villages and outer suburbs into the urban area. The city is divided into eight wards, and the town plan is extremely complicated because of the irregularity of the street system.

The prevailing style of architecture is Western. Worthy of note are the Town Hall by the architect Nikken Sekku Komu (1955) and the Central Post Office (1956). Kobe has two important museums: the Kobe Municipal Art Museum, containing numerous specimens of *namban* art and decorative arts, and the Hakutsuru Art Museum, containing Chinese bronzes, ceramics, mirrors, silverwork, objects from archaeological sites in Japan, and decorative arts.

Ono. Near this village is the Jōdoji, a monastery founded by the priest Chōgen (d. 1206) on the site of a temple originally founded by the priest Gyoki (668–749). The Jōdodō (Kamakura period) is a specimen of Tenjikuyō, the so-called "Indian" style but actually of southern Chinese origin, introduced by Chōgen. It contains wooden statues of the Amida Triad (Kamakura period).

Shimosato. Village northwest of Kobe. The three-storied pagoda (Muromachi period) of the Ichijōji contains ten paintings in color on silk of Prince Shōtoku and the Forefathers of Tendai Buddhism (Fujiwara period) and two standing bronze statues of Kwannon (Asuka period).

Kakogawa. Small town west of Kobe on the Kobe-Moji railway line. In the Kakurinji is the Taishidō (Fujiwara period), with wooden statues of the Shaka Triad (Fujiwara period); the Jōgyōdō (Fujiwara period); and the main hall (Muromachi period), with a standing bronze statue of Kwannon (Nara period). The temple also functions as a museum, preserving objects of art of the Asuka and later periods.

Himeji. City 34 miles west of Kobe. North of the city is Himeji castle (PL. 311), also called Rojō or Hakurojō. The three-storied tower was built by Toyotomi Hideyoshi in 1580; the five-storied donjon and other buildings were constructed about twenty years later by Ikeda Terumasa. Himeji is the most beautiful Japanese castle still existing. The main donjon is five-storied, and the west, northwest, and east towers are three-storied; all are of the Momoyama period.

Shosha. Village 7½ miles from Himeji, on the slopes of Mount Shosha. On the summit of the mountain stands the Enkyōji, founded in 988 by the priest Shōku, which contains wooden statues of the Shaka Triad (Fujiwara period).

Kamigōri. Region west of Kobe. The Nishinoyama tumulus (Great Burial period) is located here, a round mound ca. 56 ft. from south to north and ca. 10 ft. high.

BIBLIOG. S. Nakano, Kokuhō Sōran (General Catalogue of National Treasures), vol. on Shiga Prefecture, Kyoto, 1937; Besson Kyoto Butsuzō Zusetsu (Illustrated Guide of Buddhist Statues in Kyoto), Kyoto, 1943; M. Kawakatsu, Kyoto Kofun Angya (Guide to the Tumuli of Kyoto), Kyoto, 1947; Wakayama Prefectural Educational Commission (ed.), Bunkazai Shūsei (Catalogue of Cultural Resources), Wakayama, 1954; Nara Prefectural Educational Commission (ed.), Nara-ken Bunkazai Mokuroku (Catalogue of Cultural Resources in Nara Prefecture), Nara, 1955; Mie Prefectural Educational Commission (ed.), Mie-ken Bunkazai Yōran (Outline of Cultural Resources in Mie Prefecture), Mie, 1955; Shiki Branch of Association for Preservation of National Treasures in Nara Prefecture (ed.), Shiki no Kōbunka (Ancient Culture of Shiki Area), Shiki, 1955.

CHUGOKU AND SHIKOKU DISTRICTS. *Historical outline.* Chugoku district, which consists of the five prefectures of Tottori, Shimane, Okayama, Hiroshima, and Yamaguchi, is located at the western end of Honshu. Shikoku district, with the four prefectures of Kagawa, Tokushima, Kochi, and Ehime, is on the opposite side of the Inland Sea, parallel to Chugoku. Because the two districts belong to the same general cultural sphere, they are discussed here together.

Sites of the pre-Jōmon period have recently been discovered in these districts, but details about them have not yet been published. Sites of the Jōmon period are found along the coast of the Inland Sea and in Shimane prefecture on the coast of the Sea of Japan. In the Yayoi period the coastal plains, suitable for farming, were rapidly cultivated; earthenware pieces of this period belong to a type intermediate between the types of northern Kyushu and Kinki district. Bronze culture was introduced to Japan in this period, and archaeological finds in this district, notably bronze mirrors and swords which are believed to have been imported from the continent, prove that the bronze civilization spread from the western to the eastern regions of Japan.

In the Great Burial period, however, the spread of culture tended to move in the opposite direction, the influence of Kinki district being very strong in this area. Tumuli are found scattered in various parts of Chugoku and Shikoku. While the Kibi area abounds in groups of tumuli consisting of large mounds squared in front and rounded in back ("keyhole-shaped"), as in the Yamato area, and small round mounds, in the Izumo area another type of tumulus, squared in front and squared in back, is represented; this indicates that the two areas formed different cultural spheres. Three Buddhist temples of the Asuka period exist in Okayama prefecture, located near Kinki district, and in Ehime prefecture, on the coast of the

Inland Sea, which was an important means of communication in former times. Even in the Nara and Heian periods these places were ready to receive cultural influence from Kinki district, as is attested to by the number and at times the high quality of the early works of art. One of the chief activities of the culture in this area from the ancient to the medieval period was the art of making swords, notably in the Kibi area of Okayama prefecture.

In the medieval period the Ōuchi family, ruling the fief in what is now Yamaguchi prefecture, eager to assimilate the metropolitan

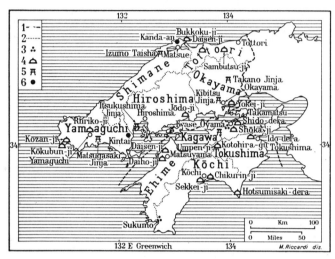

Chugoku (north) and Shikoku (south) districts. *Key:* (1) District boundaries; (2) prefecture boundaries; (3) archaeological sites and tumuli; (4) Buddhist temples; (5) Shinto shrines; (6) secular buildings of historic interest.

culture from Kyoto, invited weavers, printers, and other craftsmen from Ming China to encourage industry in their fief. Some of the masterworks by Sesshū were born as a result of the patronage with which the Ōuchis favored this great *suiboku* painter. In the early modern period the political center moved to the Kanto district, which began to absorb the culture of Kinki district, and Chugoku and Shikoku became, culturally, somewhat backward, as they are to this day.

Regions and centers of artistic interest. a. Prefecture of Tottori. Oyama. In this village, not far from Mount Daisen, stands the Daisenji, founded in 718. All the buildings were destroyed by fire, and only a few structures now remain. In the Amidadō (Muromachi period) are wooden statues of the Amida Triad (Fujiwara period), as well as two Buddhist statues (Asuka period) in bronze whose style attests to the existence at that time of contact with Korea.

b. Prefecture of Shimane. Matsue. Capital of Shimane prefecture, on the edge of Lake Shinji. Here is Matsue castle, built by Horio Yoshiharu between 1596 and 1610, and the Kandaan, an elegant tea-ceremony house with a beautiful sand garden, built by Matsudaira Fumai, lord of Matsue.

Mihonoseki. Village at the southeastern extremity of Shimane Peninsula, northeast of Matsue. Here is found the Sarugahana cave, where late Jōmon earthenware pieces have been discovered, and the Bukkokuji, containing a seated wooden statue of Yakushi and a standing wooden statue of Kwannon, both of the Jōgan period.

Wanibuchi. Village near Izumo. The Gakuenji was founded toward the end of the 6th century. The Kwannon in the temple has an inscription to the effect that it was cast in 692 in Izumo province.

Taisha. Village 4½ miles north of Izumo, near which stands the Great Shrine of Izumo. This locality has been a center of Shinto religion from prehistoric times. The sanctuary, built in the style of ancient residential architecture, is dedicated to Okuninushi-no-Mikoto. The present shrine was rebuilt in 1874. The treasure hall contains paintings, sculpture, decorative arts, manuscripts, archaeological specimens, and objects connected with religious ritual.

c. Prefecture of Okayama. Okayama. Capital of the prefecture and the cultural center of Chugoku district. Near the town is the Korakuen, a landscape garden laid out in 1786 by Ikeda Tsunamasa, lord of Bizen. The Kanakurayama tumulus (Great Burial period) is "keyhole-shaped" and 540 ft. long.

Magane. Village to the west of Okayama. Near here is the Kibitsu Shrine founded by Emperor Nintoku in the 4th century. The shrine is an ancient center of culture in this area and is dedicated to Kibitsuhiko-no-Mikoto, son of Kōrei, the seventh emperor. The sanctuary was rebuilt in 1485. The two-storied hall of worship is of the Muromachi period.

Tsuyama. City 36½ miles north of Okayama. The Takano Shrine contains two wooden statues of the Zuijin, Shinto deities who guard the doors of the shrine, carved in 1162.

d. Prefecture of Hiroshima. Hiroshima. Capital of the prefecture, it was destroyed by the first atomic bomb August 6, 1945. Among recently constructed buildings is the Memorial Peace Center (begun 1951; X, PL. 428) by Kenzō Tange, Takashi Asada, and Sachio Otani.

Itsukushima. A small island in the Inland Sea just off the coast; also called Miyajima. The Itsukushima Shrine is dedicated to the three daughters of the Shinto deity Susano-o-no-Mikoto. The shrine, of ancient origin, whose existence is recorded as far back as 811, was deeply revered by Taira-no-Kiyomori, who became virtual dictator in the 12th century. Restored by the Taira clan, it was burned down twice, reconstructed in 1241, and repaired during the Muromachi and Momoyama periods. The shrine is a unique specimen of architecture, built extending into the sea. Near the five-storied pagoda (Momoyama period) is the treasure hall, containing works of calligraphy and decorative arts of the Fujiwara and later periods. The 33 scrolls of the Heike-no-kyō (or Taira sutras) illustrate the Hoke-kyō (or Lotus Sūtra), and were done between 1164 and 1167 by members of the Taira family and donated to the shrine. Other treasures include a *hiōgi*, or fan made of strips of cypress wood (Fujiwara period), decorated with colorful paintings and said to have been donated by the Taira family; nine wooden Bugaku masks (Fujiwara period); a lacquered box for the Heike-no-kyō with an ivy design in *maki-e* (Momoyama period); and armor with dark blue lacing and with light blue lacing (Fujiwara period).

e. Prefecture of Yamaguchi. Yamaguchi. The capital of Yamaguchi prefecture was founded in the 14th century and came under the domination of the Ōuchi family. Many magnificent temples were built in imitation of those of Kyoto. A type of lacquer ware, known as Ōuchi lacquer, has been produced here since the Edo period.

Rurikoji: The five-storied pagoda is of the Muromachi period.

Hase Kwannondō: Here is kept a standing wooden statue of Jūichimen Kwannon (T'ang dynasty or Jōgan period), carved in the "sandalwood sculpture" style introduced from China.

Joeiji: This temple has a fine garden, said to have been designed by Sesshū (1420–1507), on a piece of land belonging to the Ōuchi family but detached from their main property.

Shimonoseki. City at the most southwesterly point of Honshu, on Shimonoseki Strait, which separates this island from Kyushu. Here is the Kokubunji, containing the Anchin Mandara (Fujiwara period), painted in color on silk, and a seated wooden statue of Fudō Myōō (Jōgan period). The museum at Chōfu contains specimens relating to local cultural history.

Bōfu (or Hōfu). Bōfu, southeast of Yamaguchi on the southern coast of the prefecture, is a single municipality made up of Mitajiri and Miyaichi. The Matsugasaki Shrine (also called the Miyaichi Temmangū) is dedicated to Sugawara-no-Michizane, a Shinto saint. Here is kept the Matsugasaki Tenjin Engi (Kamakura period), six scrolls in color on paper, illustrating the life of Michizane.

Iwakuni. A small town on the border between Yamaguchi and Hiroshima prefectures. It is famous for its bridge, the Kintai-bashi (also known as the Soroban-bashi), built in 1673 and characterized by its unusual arched form. The Iwakuni Chōkōkan, the municipal museum, contains examples of fine arts, minor arts and crafts, and objects illustrating the local history of the region.

Hagi. Town on the northern coast of the prefecture, noted for Hagi ceramics. This pottery was first produced at the beginning of the 17th century by Korean craftsmen and its tea-ceremony utensils are highly valued. Recent products of Hagi ware are generally limited to tableware.

f. Prefecture of Kagawa. Takamatsu. Capital of Kagawa prefecture and formerly the seat of the Matsudaira family. In the government factory of the Takamatsu fief a type of ceramics has been produced since 1694; it was called Takamatsu ware, but after the Meiji period the name was changed to Rihei ware.

Iwase Ōyama group of tumuli: These "keyhole-shaped" mounds (Great Burial period) exemplify the oldest tomb style of the period.

Ritsurin park: This is the site of the former mansion of the Matsudaira family. The area around South pond is said to have been laid out from ca. 1624 to 1628, the rest ca. 1673. In the park is a museum containing local objects of art; exhibitions of contemporary local arts are also held.

Shido. Village 10 miles east of Takamatsu. The Shidodera, a famous temple of the Shingon sect, was founded in the 17th century. It contains standing wooden statues of Jūichimen Kwannon with Two Attendants (Jōgan period).

Kotohira. Small town southwest of Takamatsu. The Kotohiragū (popularly known as Kompira-san) is dedicated to the Shinto god Ōmononushi-no-Mikoto. The treasure hall of the shrine contains specimens of historical painting, calligraphy, weapons, manuscripts, and paintings by Takahashi Yuichi (1828–94). In the shrine are a standing wooden statue of Jūichimen Kwannon (Fujiwara period); a scroll painting illustrating the Nayotake Monogatari (Kamakura period), in color on paper; and paintings on sliding doors of Landscapes, Figures, and Animals by Maruyama Ōkyo (1733–95).

Nio. Near the village is the Kotsutajima shell mound, a kitchen midden from which pieces of stamped earthenware from the early Jōmon period have been excavated.

g. Prefecture of Kochi. Sukumo. Village in the extreme south of the prefecture, southwest of Kochi, the capital of Kochi prefecture. Here is the Sukumo shell mound, a kitchen midden of the Jōmon period.

Godaisan. In the village is the Chikurinji. The main hall (Muromachi period) contains a wooden statue of Mahātejas (Fujiwara period).

Muroto. Village 55 miles southeast of Kochi on the Muroto promotory. At the tip of the promontory is the Hotsumizakidera (also called Tōji), founded by Kūkai. Here is a seated stone statue of Nyoirin Kwannon in meditation (Fujiwara period), a rare and fine example of stone sculpture.

Nagahama. In this village is the Sekkeiji. The temple contains standing wooden statues of Bishamonten and Two Attendants (Kamakura period), representative works of Tankei, son of Unkei. The statue of Kichijōten, one of the attendants, clearly shows the influence of Chinese Sung art. Also in the Sekkeiji are wooden statues of the Yakushi Triad (Kamakura period).

h. Prefecture of Ehime. Matsuyama. Capital of Ehime prefecture and one of the principal cities of Shikoku district. Since about 1818 a cotton fabric with double-woven splashed patterns (*kasuri*), called Iyo *kasuri*, has been produced here.

Daihoji: In the main hall (Kamakura period) are seated wooden statues of Amida and Shaka, both of the Fujiwara period.

Miyaura. Village on Ōmi-shima, an island north of Imabari. The Oyamazumi Shrine was founded in prehistoric times; its treasure hall contains armor, weapons, etc.

BIBLIOG. Research Section of Hiroshima Prefectural Educational Commission (ed.), Hiroshima-ken Kokuhō Sen (Selections from National Treasures in Hiroshima Prefecture), Hiroshima, 1951; Social Education Section of Tottori Prefectural Educational Commission (ed.), Tottori-ken Bunkazai Zuroku (Illustrated Catalogue of Cultural Resources in Tottori Prefecture), Tottori, 1952; Office of Yamaguchi Prefectural Educational Commission (ed.), Yamaguchi-ken Bunkazai Gaiyō (Outline of Cultural Resources in Yamaguchi Prefecture), Yamaguchi, 1952; Office of Kochi Prefectural Educational Commission (ed.), Tosa no Bunkazai (Cultural Resources in Tosa Province), Kochi, 1952; Tokushima Prefectural Educational Commission (ed.), Tokushima-ken no Bunkazai (Cultural Resources in Tokushima Prefecture), Tokushima, 1954.

KYUSHU DISTRICT. *Historical outline.* Kyushu consists of the seven administrative prefectures of Fukuoka, Oita, Saga, Nagasaki, Kumamoto, Miyazaki, and Kagoshima, and of the Ryukyu (Luchu) Islands. The Jōmon culture was diffused in various parts of this district. Toward the end of the Jōmon period the eastward spread of the power of the Chinese Han dynasty and the willingness of the people in Kyushu to accept the new civilization made Kyushu the first district to develop the new Yayoi culture. Northern Kyushu in this period was the leading point of contact with foreign culture and the center of the newly introduced civilization. An interesting illustration of this fact is the gold seal excavated in 1784 at Shikanoshima in Fukuoka prefecture. It is engraved with five characters interpreted to mean "King of Nu State in Wa Country [Japan],

Han dynasty," and is presumed to have been given to the ruler of a community in Kyushu in 57 A.D. by the Chinese emperor Kuang Wu-ti of the Eastern Han dynasty. Owing to the close cultural communication with the continent, the use of metal (bronze and iron) implements here made rapid progress.

The existence of tumuli with huge mounds built over the burial chambers seems to indicate that Kinki exercised a strong influence over Kyushu during the Great Burial period. From then on, cultural supremacy passed from Kyushu to the Yamato area. However,

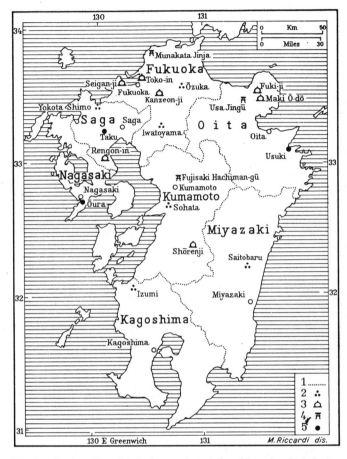

Kyushu district. *Key:* (1) Prefecture boundaries; (2) archaeological sites and tumuli; (3) Buddhist temples; (4) Shinto shrines; (5) secular buildings of historic interest.

Kyushu still retained some of its distinctive cultural characteristics in the Great Burial period, such as the wall paintings in burial chambers. Honshu also has a considerable number of tumuli with wall paintings, but those in Kyushu are far superior in quality as well as quantity.

Kyushu was the first place in Japan to receive Western civilization, and this was one of the most important events in its history. When Portuguese ships began to visit Japan they were enthusiastically welcomed by the feudal clans in this district, who were suffering from a grave economic crisis and were barely able to maintain themselves by trading with China and Korea. European ships, besides offering the possibility of increased trade, brought the first Christian missionaries to Japan. Under the influence of Western art a new type of painting, termed "Western-style" painting, was born at this time, and it gradually spread to Kinki and more easterly regions. In 1587 Toyotomi Hideyoshi banned Christianity, and the succeeding Tokugawa government followed his example. In 1614 the Tokugawas adopted a policy of isolating Japan from other parts of the world, so that Western influence gradually decreased. Later on, trade with the Netherlands alone was permitted at Dejima in the port of Nagasaki, and this became the only door open to Western civilization. The Nagasaki school (q.v.) of realistic painting began here. After the Meiji Restoration in 1868, the policy of national isolation was abandoned and Japanese arts were greatly influenced by the West.

Kyushu district is noted for its ceramics. Sakaida Kakiemon (or Kakiemon I), a great potter who was active in the first half of the 17th century, is credited with introducing the technique of

enameling to porcelain. The manufacture of porcelain has continued to the present day; the area around Arita, in particular, is one of the ceramic centers of Japan (see CERAMICS).

Regions and centers of artistic interest. a. Prefecture of Fukuoka. Fukuoka. The capital of the prefecture was the scene of violent warfare between 1274 and 1281, when Kublai Khan's Mongolian hordes attempted to invade Japan. Takatori pottery, a type of ceramics originated by Korean potters in the early 7th century, is still made in Fukuoka.

Tokoin: This temple contains wooden statues of the Fujiwara period: a standing Yakushi; a seated Yakushi; the Juni Shinshō, standing, of which only nine remain.

Seiganji: Here is kept a miniature pagoda, one of the 84,000 iron models of pagodas made in 955 by the kings of Wu-Yüeh state in China and distributed to temples in China and abroad.

Yame. In this small town is the Iwatoyama tumulus (Great Burial period), a "keyhole-shaped" tumulus 476 ft. long. Stone figures of humans, horses, etc., were found in the soil covering the burial chamber.

Maebaru. Near this village is the Shito dolmen (Yayoi period). The dolmens found here are of the type known as *shisekibo*, tombs surmounted by boulders. They are similar to the burial mounds of Korea and indicate the existence of communications with Korea in the remote past.

Mizuki. In this village is the largest Buddhist monastery in Kyushu, the Kanzeonji, founded in 709. The existing buildings and Buddhist statues are from the Fujiwara and later periods, but some of the objects preserved in the temple, such as the bronze bell and fragments of clay statues, reveal the style of the Nara period. They are standing wooden statues of Fukūkenjaku Kwannon, Batō Kwannon or Horse-headed Kwannon (Hayagrīva), Daikokuten (Mahākāla), and Bishamonten, all of the Fujiwara period, and Bugaka masks (Fujiwara period; PL. 278).

Katsuragawa. Near the village is the Ōzuka tumulus (Great Burial period), famous for the wall paintings in the stone burial chamber.

Nodajima. In this village is the Munakata Shrine, containing a stone stele with the text of the Amida-kyō engraved on it (Sung dynasty), and two pairs of statues of the Koma-inu (lion-dogs guarding the gate), one of stone (Sung dynasty) and one of wood (Kamakura period).

b. Prefecture of Oita. Usuki. City south of Oita, capital of Oita prefecture, in the southern part of Saganoseki Peninsula. About 3 miles from Usuki is Fukuda, where over 50 images of the Buddha (Fujiwara period), the finest and largest in Japan, are carved in relief on the cliffs.

Kunisaki. Village north of Oita on the eastern coast of Kunisaki Peninsula. Near here is the Ankokuji site where archaeological remains of the Yayoi period have been found.

Usa. Village north of Oita on the west coast of Kunisaki Peninsula. The Usa Shrine has been a center of Shinto worship from very ancient times, though the date of its original founding is unknown. The shrine (Edo period) is a typical example of the Hachiman type of Shinto architecture: there are two similar and connected buildings, each with a gabled roof, and the front runs parallel to the ridgepole. The shrine contains five wooden statues of Shinto deities (Fujiwara period).

c. Prefecture of Saga. Karatsu. Port northwest of Saga, capital of Saga prefecture. Karatsu pottery (see CERAMICS) is produced in Karatsu and the surrounding territory. There have been ceramic kilns in this area since the late Kamakura or Muromachi period. They were abolished for a certain period, but after Toyotomi Hideyoshi's expedition to Korea (1592–98) the production of Karatsu ware was resumed under the guidance of Korean potters. Today the chief products are utensils for daily use.

Arita. Village west of Saga, known for Imari ware, which is produced in and around Arita. Enameled porcelain has been made here since the early Edo period (see CERAMICS), and this is still one of the great centers of ceramic manufacture in Japan.

Sebuno. Near this village is the Mitsu site, dating from the Yayoi period.

d. Prefecture of Nagasaki. Nagasaki. Capital of the prefecture, situated on the west coast of Kyushu. Of interest here is the Catholic church Ōura Tenshudō. Christianity was prohibited in Japan after 1587, but after the signing of an agreement in 1858 the authorities allowed Christian churches to be constructed for foreigners living near Japanese ports. The Ōura Tenshudō was built between 1862 and 1864 by two French Jesuits and was the first Western church erected in Japan. Though improved and enlarged in 1874, it retains the form of the Gothic-style architecture of the time. The museum contains a collection of material relating to local history at the time of Japan's opening of communication with foreign countries, in particular with the introduction of Christianity and of trade relations with China and the Netherlands.

Orioze. Village near Nagasaki, where Hirado pottery is produced. Hirado ware, originated by Korean potters in the late 16th century, is characterized by elaborate pieces in celadon and white porcelain. This is still one of the important ceramic centers in Kyushu.

e. Prefecture of Kumamoto. Kumamoto. Capital of the prefecture, on the west coast of Kyushu. The city contains various buildings of historic and artistic interest. Kumamoto castle was built by Katō Kiyomasa, lord of the Kumamoto region, between 1601 and 1608. Only the stone foundations and a few towers and gateways remain. The treasure hall of the Hommyōji contains works of art from the Zentsūji and manuscripts and objects that belonged to Kiyomasa.

Kikusui. In the village is the Funayama tumulus (Great Burial period), a "keyhole-shaped" tumulus ca. 154 ft. long. Swords with silver inlay and other fine works of art have been excavated here.

Kurohiji. In this village is the Shōrenji. The Amidadō (Kamakura period) contains wooden statues of the Amida Triad (Kamakura period).

f. Prefecture of Kagoshima. Kagoshima. Capital of the prefecture, on the west coast of Kagoshima Bay facing Sakurajima Peninsula. The museum contains paintings by Kuroda Kiyoteru (1866–1924), an artist from this area, and other contemporary works of art.

Ōshima. Island in southern Kagoshima. Made here is Ōshima *tsumugi*, a distinctive type of silk fabric with a double-woven splashed (*kasuri*) pattern. This fabric was originated in the early 1700's and is still produced today.

Ijūin. Village a few miles west of Kagoshima, famous for Satsuma pottery (see CERAMICS), which has been produced since the Edo period. Satsuma ware is the collective term for all ceramics produced in Kagoshima prefecture. A speciality of Satsuma ware is porcelain with a brocaded pattern, known as Satsuma *nishikide*.

BIBLIOG. Kanzeonji Taikyō (Complete Catalogue of the Treasures of the Kanzeonji), Tokyo, 1934; Fukuoka-ken Jūyō Bunkazai Kaisetsu (Guide to the Important Cultural Properties in Fukuoka Prefecture), Fukuoka, 1952.

CHUBU DISTRICT. *Historical outline.* Chubu district is divided into nine prefectures: Aichi, Shizuoka, Gifu, Nagano, Yamanashi, Fukui, Ishikawa, Toyama, and Niigata. Situated between the Kinki and Kanto districts, Chubu is characterized by its mixed culture, inspired by both eastern and western Japan. Pre-Jōmon sites are found at Chausuyama in Suwa-guni, at Babadaira and Nobeyama in Minami Saku-gun, and at Nojiriko in Kami Minochi-gun, all in Negano prefecture. Future excavations will no doubt bring forth other centers of this period.

The important vestiges that the Jōmon period has left in this district reveal different characteristics according to the areas where they were found. About the middle of the Jōmon period Chubu, together with Kanto district, appears to have been one of the most thriving areas in Japan. Earthenware pieces include some particularly valuable specimens showing the effects of contact between the Jōmon-type pottery from the east and the Yayoi-type pottery from the west.

The Yayoi period has also left numerous traces. Highly decorative pieces of earthenware with "combed" patterns have been unearthed in the Tōkai area, that is, the region along the Pacific coast. Metal implements such as bronze spears, halberds, and bells (*dōtaku*) have also been found. Chubu is the most northerly region of bronze culture in Japan.

The district has many monuments of the Great Burial period. The tumuli are of various types, from the most primitive kind to the "keyhole-shaped" type, and often as enormous as those in the Yamato area. Ornaments showing strong continental influence have been excavated from some of the tumili.

No Buddhist temple remains datable to the Asuka period have

been discovered in this district, but there are vestiges of several Kokubunji, the provincial temples built in the 8th century by imperial order. The influence from Kinki district was strong in the western part of Chubu; its eastern part was largely influenced by Kanto. In Buddhist sculpture the Yakushi Triad in the Yakushiji, Ishikawa prefecture, and the dry-lacquer statue of Jūichimen Kwannon in the Jimokuji, Aichi prefecture, are examples of the style current in the 7th and 8th centuries in this district; no statues of this type have been found in the regions situated to the east of those mentioned. Specimens of *nata-bori* (roughly finished wood carving retaining chisel marks on the surface), which thrived chiefly in Kanto district, have survived in the eastern part of Chubu; the western limit of their distribution is the line connecting the Tōkannonji and

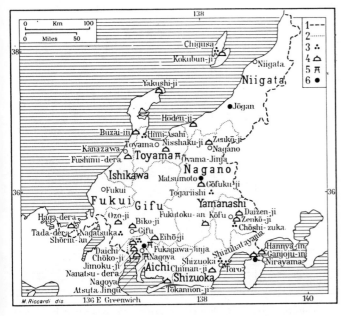

Chubu district. *Key:* (1) District boundaries; (2) prefecture boundaries; (3) archaeological sites and tumuli; (4) Buddhist temples; (5) Shinto shrines; (6) secular buildings of historic interest.

Chōrakuji in Aichi prefecture and the Hodenji in Niigata prefecture. This line may also be considered to divide the eastern and western cultural spheres of Chubu.

The most notable artistic production of the medieval period was the ceramic ware made in Seto and the vicinity. The origin of the ceramic industry in this area dates back to the Fujiwara period, and from then on it has supplied pottery and porcelain of good quality to all parts of Japan. The word *setomono* ("Seto goods") is still used as a general term for ceramics in Japan.

Chubu produced many powerful military lords in the early modern period, including the Tokugawa family, which ruled Japan for 250 years. Nagoya castle is one of the monuments that best illustrate the importance of this district.

Regions and centers of artistic interest. a. Prefecture of Aichi. Nagoya. This city is the capital of Aichi prefecture and is located on Ise Bay. It was founded in the 16th century. Nagoya contains buildings of historic and artistic interest, as well as museums.

Atsuta Shrine: This Shinto shrine was founded in the 2d century. Here are kept the Hoke-kyō (Fujiwara period), a scroll on paper decorated with paintings in color, and 11 wooden Bugaku masks (Fujiwara and Kamakura periods).

Nanatsudera (also called Chōfukuji): This temple was founded in 735 in the village of Nanatsudera and transferred to its present site in 1611. It contains seated wooden statues of Kwannon and Seishi (Mahāsthāmaprāpta), both of the Fujiwara period; these are early examples of the technique of using inlaid pieces of crystal for the eyes.

Nagoya castle: The castle, begun in 1610 and completed in 1612, was built by Tokugawa Ieyasu. It was destroyed in 1945 but was recently reconstructed. The numerous paintings on the sliding doors had been removed before the bombing and were not damaged; they were painted by members of the Kanō school.

Jimokuji. Village near Nagoya. The temple of the same name has a Nandaimon of the Kamakura period. The statue of Jūichimen Kwannon (Nara period; the lower half is a later restoration) is in

dry lacquer; this statue is the most easterly example of dry lacquer in Japan. The Jimokuji also contains two paintings in color on silk: Fudō Myōō (Fujiwara period) and Nehan (Kamakura period).

Ōsato. In this village is the Chōkoji. Here is kept an iron statue of Jizō Bosatsu (Kamakura period). Many Buddhist statues were made of iron during the Kamakura period, chiefly in eastern Japan; this is a typical specimen. Also in the Chōkoji is a portrait of Oda Nobunaga (1583) by Kanō Motohide (PL. 352).

Iwakura. Village near which is the Daichi site (Yayoi period). Earthenware of the Yayoi type inspired by the Jōmon style was discovered here, as well as ruins of dwellings.

Seto. City ca. 13 miles northeast of Nagoya, and one of the most important ceramic centers in Japan (see CERAMICS). Pottery with wood-ash glazing was produced in and around Seto as early as the Fujiwara period. In 1223 Katō Shirōzaemon (commonly called Tōshirō) went to China to study pottery techniques, and on his return he introduced a new type of glazed pottery by adding iron to the glaze; this is known as *amekusuri* ("caramel glaze," that is, dark brown or black iron glaze). The Seto ware of the Momoyama and early Edo periods is outstanding. The Seto Ceramic Ware Exhibition Hall contains numerous antique and modern examples of Seto pottery and porcelain.

Tokonabe. Small town on the Chita Peninsula. Tokonabe pottery has been produced in this vicinity since the Heian period. During the Kamakura period the ware was unglazed and with very simple decoration, but in the Edo period the Tokonabe ceramics reached a high level of technical elaboration. Utensils for everyday use are still made here.

Futagawa. Near this village is the Tōkannonji. The two standing wooden statues of Bishamonten (Fujiwara period) preserved here are the most westerly examples of *nata-bori* sculpture.

b. Prefecture of Shizuoka. Shizuoka. Capital of the prefecture, Shizuoka is situated on the delta of the Abegawa River. There are two important archaeological sites, both ca. 1 mile from the city.

Toro: This is the site of an excavated hamlet of the Yayoi period. The ruins of houses and other buildings are remarkably well preserved. Many articles for daily use and jewelry have been unearthed.

Shizuhatayama tumulus: In the precincts of the Sengen Shrine is this round tumulus from the later part of the Great Burial period.

Ōtsu. In this village is the Chimanji. The temple contains a standing wooden statue of Senju Kwannon and a wooden box with Amida and His Heavenly Host carved in relief, both of the Fujiwara period.

Mishima. This town is the entrance to Izu Peninsula. The museum of Mishima Shrine contains treasures of the Kamakura and later periods (PL. 419).

Nirayama. Village on Izu Peninsula. Nearby is the Ganjojuin, with a seated wooden statue of Amida (Kamakura period).

Izusan. Spa on the east coast of Izu Peninsula 1 mile from Atami. The Hannyain contains a seated wooden statue of the Shinto god Izusan Gongen (Kamakura period).

c. Prefecture of Gifu. Gifu. Capital of the prefecture. The Bikoji contains a dry-lacquer statue of Jūichimen Kwannon (Nara period), originally in a temple in Mie prefecture.

Yokokura. Near this village is the Ozoji. In the temple are kept a seated wooden statue of Yakushi (Kamakura period); a wooden relief, called the Hokke Mandara (Fujiwara period); a seated wooden statue of Rushana Butsu (Kamakura period); and a standing wooden statue of a guardian god of Buddhism, Jinja Taishō (Fujiwara period).

Tajimi. Small town 21 miles south of Gifu. The Eihōji was founded by Soseki (Musō Kokushi) between 1312 and 1317. Buildings include the two-storied Kwannondō (Kamakura period) and the Kaisandō, or founder's hall (PL. 310), built in 1352, a typical example of Karayō architecture. The garden is of the Kamakura period. In the Eihōji is a painting of Senju Kwannon (Sung dynasty), in color on silk.

d. Prefecture of Nagano. Nagano. Capital of the prefecture. The Zenkōji, founded in 664, has a two-storied main hall that was reconstructed in 1726.

Matsumoto. City south of Nagano. In Shiroyama Park are the remains of Matsumoto castle, built by Ishikawa Yasumasa in the late 16th century. This is a valuable example of castle architecture, preserving its original appearance fairly well.

Kataoka. Near this village is the Gōfukuji (or Ushibushidera), containing wooden statues of the Fujiwara period of Jūichimen Kwannon, standing; Fudō Myōō, standing; and Shaka, seated.

e. *Prefecture of Yamanashi.* Kōfu. Capital of Yamanashi prefecture. The Zenkōji contains two groups of the Amida Triad in wood (Fujiwara period), transferred here from the Zenkōji in Nagano.

Katsunuma. Village east of Kōfu. The two-storied main hall (Kamakura period) of the Daizenji contains a Yakushi Triad (Jōgan period).

Chudō. Village near Kōfu. The Chōshizuka tumulus (Great Burial period), a "keyhole-shaped" tumulus 446 ft. long, is located here.

f. *Prefecture of Fukui.* Obama. Town on the coast of Wakasa Bay, southwest of Fukui, capital of Fukui prefecture. The Tadadera in Obama contains wooden statues of Nikkō, Gakkō, and Yakushi (Jōgan period), and the Shōrinan has a seated bronze *bosatsu* in meditation (Nara period). Wakasa lacquer, named for the province in which Obama is located, has been produced since the early 17th century and is characterized by colorful designs.

g. *Prefecture of Ishikawa.* Kanazawa. Capital of Ishikawa prefecture. The Fushimidera contains a seated Amida, a fine and very rare example of bronze sculpture of the 9th century.

Kutani. Village southwest of Kanazawa. Kutani ware, one of the representative enameled porcelain wares of Japan (see CERAMICS), is produced here. Kutani ware originated in the mid-17th century (PL. 303); production was suspended until the 19th century, but the kilns are now active again.

Wajima. Village on the west coast of Noto Peninsula. Wajima lacquer has been produced since the first half of the 19th century; it is characterized by its durable quality as well as by an elaborate decorative technique known as *chinkin*, or hairline engraving filled in with gold leaf.

h. *Prefecture of Toyama.* Ōiwa. In the village is the Nisshakuji, containing five groups of Buddhist images, carved in relief on the cliff, the largest being that of Fudō Myōō, nearly 10 ft. high.

Takaoka. City west of Toyama. The museum contains modern Japanese and Western paintings, sculpture, and handicrafts by local artists.

i. *Prefecture of Niigata.* Itoigawa. Village southwest of Niigata, capital of Niigata prefecture. The Hodenji contains a standing wooden statue of Jūichimen Kwannon (Fujiwara period).

Mano. Village on Sado Island. The Kokubunji contains a seated wooden statue of Yakushi (Jōgan period).

BIBLIOG. Ishikawa Prefectural Government (ed.), Ishikawa-ken Jinja Bukkaku Kobijutsu Gaikan (Outline of Historical Art Objects in Shinto Shrines and Buddhist Temples in Ishikawa Prefecture), Ishikawa, 1938; Shizuoka Prefectural Educational Commission (ed.), Shizuoka-ken no Kokuhō (National Treasures in Shizuoka Prefecture), Shizuoka, 1950; Yamanashi Prefectural Educational Commission (ed.), Yamanashi-ken no Kokuhō (National Treasures in Yamanashi Prefecture), Yamanashi, 1951; Public Relations Bureau of Nagoya Municipality (ed.), Nagoya Shiseki Meishō Kiyō (Outline of Historic Sites and Scenic Spots in Nagoya), Nagoya, 1951; Toyama Prefectural Educational Commission (ed.), Toyama-ken no Jūyō Bunkazai Shiseki Meishō Tennen Kinembutsu Ichiran (List of Important Cultural Properties, Historic Sites, Scenic Spots, and Natural History Reserves in Toyama Prefecture), Toyama, 1952; Fukui Prefectural Government (ed.), Fukui-ken no Gaiyō (Outline of Fukui Prefecture), Fukui, 1952; Niigata Prefectural Educational Commission (ed.), Niigata-ken Bunkazai Zuroku (Illustrated Catalogue of Cultural Resources in Niigata Prefecture), Niigata, 1952; Fukui Prefectural Educational Commission (ed.), Bunkazai Chōsa Hōkoku (Report of Investigations on Cultural Resources), Fukui, 1954; Gifu Prefectural Society of Cultural Resources (ed.), Nōhi no Bunkazai (Cultural Resources in Mino and Hida Provinces, i.e., Gifu Prefecture), Gifu, 1955; Nagano Prefectural Educational Commission (ed.), Nagano-ken Bunkazai Zuroku (Catalogue of Cultural Resources in Nagano Prefecture), vol. on Fine Arts and Handicrafts, Nagano, 1955.

KANTO DISTRICT. *Historical outline.* Kanto district comprises the six prefectures of Kanagawa, Chiba, Saitama, Gumma, Tochigi, and Ibaraki, and the Tokyo Metropolitan Area. Iwajuku in Gumma

prefecture was the first place where a pre-Jōmon site was discovered. Kanto must have been a paradise for the Jōmon-period people, judging by the existence of numerous important sites of the period. During the Yayoi period Kanto had a cultural life that was very different from that of western Japan. The scarcity, if not the nonexistence, of bronze implements, which by this time were widely diffused in all the western regions of the country, is noticeable in Kanto. Earthen-

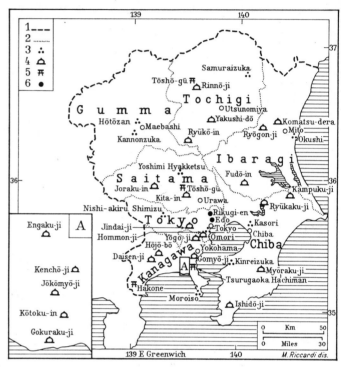

Kanto district. *Key:* (1) District boundaries; (2) prefecture boundaries; (3) archaeological sites and tumuli; (4) Buddhist temples; (5) Shinto shrines; (6) secular buildings of historic interest.

ware of the Yayoi period retains many elements of the Jōmon period. Earthenware intermediate between the Jōmon and Yayoi types occurs, as has been shown, in Chubu district, but it is much more conspicuous in Kanto district. Contact with Kinki district was, perhaps, stronger in Kanto than in Chubu. The number of tumuli here is considerably larger than in other districts. The area around what is now Gumma prefecture was the cultural center of the district during the Great Burial period. In this prefecture there are more than 8,000 tumuli, 370 of which are of the "keyhole-shaped" type.

During the 7th and 8th centuries this district was all but a dependency of the Yamato court. The arts were directly imported from the Yamato area, as is demonstrated by examples still existing, such as the Buddhist statues in the Ryūkakuji at Ajiki, in Chiba prefecture, and the Jindaiji in Tokyo. After the 9th century, however, the inhabitants of Kanto began to develop a more independent character. Their arts were crude but original, as exemplified by *nata-bori* sculpture. The military lord Minamoto Yoritomo triumphed in the civil wars of the 12th century and established his military government at Kamakura. Kanto was thus no longer isolated, although in the early part of the Kamakura period Kyoto still remained the center of artistic life. From the middle of the Kamakura period, under the influence of Chinese Sung art, Kanto seems to have produced original types of art.

Most of the Ukiyo-e artists and many of the "literati" painters lived and worked in Edo, and various other schools of art were also born here. With the Meiji Restoration in 1868 the Tokugawa feudal government relinquished national rule. Emperor Meiji made Edo the capital of Japan and renamed it Tokyo. The constitutional government abolished the policy of national isolation previously adopted by the Tokugawas.

Regions and centers of artistic interest. a. Prefecture of Kanagawa. Yokohama. This city is the capital of Kanagawa prefecture and lies on the west coast of Tokyo Bay. It was here, in 1854, that Commodore Perry landed to deliver a letter from the President of the United States. Yokohama was opened to foreigners in 1859.

In 1923 Yokohama was almost totally destroyed by an earthquake and subsequently rebuilt according to principles of modern

town planning. The center of the city was reserved almost entirely for office quarters, with buildings in the Western style.

Yokohama was again rebuilt after World War II. It is divided into 10 wards. In the past few years architecture has been oriented toward the international style. Notable modern examples are the library and municipal auditorium, built in 1954 and designed by Kunio Maekawa, and the prefectural office by Kenzō Tange (1958).

Gumyōji: This is the oldest Buddhist temple in the city. It contains a standing wooden statue of Jūichimen Kwannon (Fujiwara period). This statue, together with the Yakushi Triad in the Hōjōbō at Takabeya, is one of the oldest examples of nata-bori sculpture.

Shōmyōji: The temple was founded by Kanazawa Akitoki. It contains a seated bronze statue of Aizen Myōō (Rāga; Kamakura period); a standing wooden statue of Shaka (Kamakura period); and portraits of Kanazawa Sanetoki, Kanazawa Akitoki, Kanazawa Sadaaki, and Kanazawa Sadatoki, all of the Kamakura period, in color on silk.

Kanazawa Bunko (library): The library was founded in 1275 by Kanazawa Sanetoki, a member of the Hōjō family of Kamakura; it was then part of the Shōmyōji precincts. The present library was brought together in 1930 and contains Japanese and Chinese books collected by Sanetoki during the Kamakura period, as well as works of art from the Kamakura and Muromachi periods that were preserved in the Shōmyōji.

Kamakura. Famous city on Sagami Bay in the northern part of Miura Peninsula. Kamakura became capital of Japan in 1192, when Minamoto Yoritomo established his government there, and it remained the seat of government until 1333. During this period and in the following one, which lasted from 1335 to 1573 under the Ashikaga Shogunate, the city reached a high degree of prosperity, and a great number of temples and art treasures remain, particularly in the historic part of the city.

Kōtokuin: In the temple precincts is a seated bronze statue of Amida (PL. 301), known also as the Great Buddha of Kamakura. This beautiful work of art was cast in 1252 by Ōno Gorōemon, one of the greatest sculptors of the time and the most celebrated in the region.

Gokurakuji: Founded in 1113 in the village now called Fujisawa, the temple was moved in 1259 to its present site. It contains a statue of Shaka and standing wooden statues of the Jūdai Deshi, all of the Kamakura period.

Tsurugaoka Hachimangū: The shrine was founded in 1063 by Minamoto Yoriyoshi on another spot and moved to its present location in 1191. It is dedicated to Emperor Ōjin. In the shrine is a seated wooden statue of Benzaiten (Kamakura period). The treasure hall contains objects of art of the Kamakura and later periods.

Kamakura Kokuhōkan (Kamakura Art Museum): The museum houses numerous objects of art from the Kamakura and Muromachi periods on loan from shrines, temples, and private collectors in Kamakura and the neighboring areas.

Kakuonji: The temple was founded in 1218 by Hōjō Yoshitoki. It contains a standing wooden statue of Jizō Bosatsu (Kamakura period).

Zuisenji: In the Kaisandō is a seated wooden statue of the priest Soseki (Kamakura period), who founded the temple in 1327.

Jōkōmyōji: The temple contains wooden statues of the Amida Triad (Kamakura period), typical specimens of a new style of Buddhist sculpture that arose in this period under the influence of Chinese Sung art.

Engakuji: This great monastery of Zen Buddhism was built in 1282 by Hōjō Tokimune. The two-storied Shariden (relic hall; PL. 284) is an outstanding example of Karayō architecture. In the Engakuji area are a seated wooden statue of the priest Bukko Kokushi (Kamakura period); a Nehan (Kamakura period), painting in color on silk; paintings of 23 rakan (arhats), traditionally attributed to the Chinese painter Chang Ssŭ-kung; and the rakan Badara (Muromachi period), painting in ink and faint color on paper, attributed to Sōen.

Tōkeiji: The temple was founded in 1284 by the widow of Hōjō Tokimune. It contains a wooden statue of Kwannon (14th cent.), which shows the influence of Chinese art of the late Sung period. The decorative patterns on the robe of this statue are executed in a technique peculiar to this area, the so-called "relief coloring," consisting of a mixture of colors and clay.

Meigetsuin: Contains a seated wooden statue of Uesugi Shigefusa (Kamakura period; PL. 294), a typical piece of secular portrait sculpture.

Kenchōji: This Zen monastery was built in 1253 by Hōjō Tokiyori for the Chinese priest Tai Chaio, known in Japan as Daigaku Zenji. It contains many fine works of art: the Jūroku Rakan (Sixteen Rakan), eight paintings in ink and faint color on silk, attributed to Minchō (also called Chōdensu; 1352–1431); Shaka Triad, painting in color on silk, attributed to the Chinese painter Chang Ssŭ-kung; a portrait of Daigaku Zenji (Muromachi period), in color on silk,

with an inscription by Daigaku Zenji; and a seated wooden statue of Hōjō Tokiyori (Kamakura period). The garden is of the Edo period.

Yokosuka. City south of Kamakura on the east coast of Miura Peninsula. The Tado site and the Natsushima shell mound, both of the Jōmon period, are located here.

Ōyama. Village northwest of Kamakura at the foot of Mount Ōyama. Nearby is the Daisenji, containing Fudō Myōō and Two Messengers (Kamakura period), fine examples of the iron statues frequently made during the Kamakura period, chiefly in Kanto district.

Takabeya. In the village is a small monastery, the Hōjōbō. The statues of the Yakushi Triad are considered to date from the last part of the 11th century, and are numbered among the oldest existing specimens of nata-bori sculpture. Also in the Hōjōbō are seated wooden statues of Amida and Yakushi (Kamakura period).

Moto-Hakone. Village on the eastern shore of Lake Ashi. The Hakone Shrine (popularly called the Hakone Gongen) is located at the foot of Mount Koma. It was founded in 757 by the priest Mangan, and is dedicated to three Shinto deities. The treasure hall of the shrine contains many rare works of art, among which are a seated wooden statue of Mangan (Jōgan period) and the Hakone Gongen Engi, a single scroll illustrating the origin of the shrine.

Miyagino. Village 4 miles north of Moto-Hakone. The Hakone Art Museum contains numerous examples of Oriental painting, sculpture, prints, and handicrafts.

b. Tokyo metropolitan area. Tokyo is the capital of Japan but does not have a very long history. In 1457 Ōta Dōkan built a fortress at Edo, as it was then called. In 1590 Tokugawa Ieyasu raised Edo to the status of capital of the eight provinces of Kanto, and from then on it grew rapidly in size and splendor. In 1787 it was one of the largest cities in the world, with almost a million and a half inhabitants. In 1868 it became the capital of Japan, and the name was changed to Tokyo.

Among the most important buildings constructed after 1868,

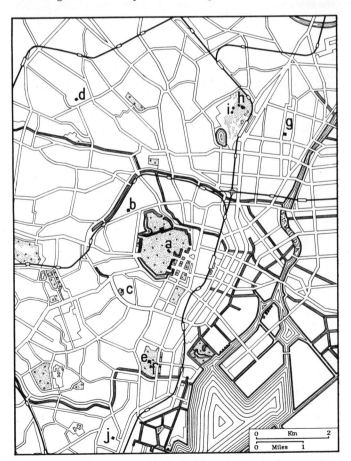

Tokyo, plan of the center of the city. (a) Imperial palace; (b, c, f) Shinto shrines: (b) Yasukuni Jinja, (c) Hie Jinja, (f) Tōshōgū; (d, e, g, j) Buddhist temples: (d) Gokokuji, (e) Zōjōji, (g) Higashi Honganji, (j) Sengakuji; (h) National Museum; (i) Metropolitan Fine Art Gallery.

which reflect the eclecticism current in European architecture at the time together with elements taken from local tradition, are the Historical Museum by C. V. Cappelletti, the Rokumeikan Social Center by J. Conder, and the Law Court by A. Hartung.

The first buildings in reinforced concrete began to appear in Tokyo early in the 20th century, and after the earthquake of 1923 they became increasingly common. In the years before World War II new building methods, based on reducing the volume of walls by the use of reinforced concrete pylons and broad windows, began to be widely practiced. Buildings of great importance in this respect are Tetsurō Yoshida's Central Post Office (1931) and Mamoru Yamada's Communications Hospital (1937).

The attempt to combine the ancient quarter and the modern city has produced, in the most recent buildings, a new approach to the functional method, enriched by the study of different solutions of space problems, yet keeping the ties with traditional local architecture. Examples of recent architecture are the Readers Digest group of buildings, the Shinjō (temple), the Nippon Gekki building, the Metropolitan Office by Kenzō Tange (1956), Masachika Murata's International Trade Center (1959–60), Hirosi Hohe's Hōsei University (1954), and the Japanese Academy of Arts by Soya, Yoshida, and others (1960).

There are many museums and galleries in Tokyo; some of the outstanding ones are cited here. The National Museum consists of 20 rooms devoted to textiles, metalwork, swords, ceramics, lacquer, painting, sculpture, calligraphy, etc., from the prehistoric through the Edo period. The Hyōkeikan has eight rooms that at present display Japanese archaeological specimens. The exhibits (which are changed from 2 to 12 times a year) include the permanent collection as well as pieces lent or deposited temporarily by shrines, temples, and private collectors. Exhibitions take place every spring and autumn. The Metropolitan Fine Art Gallery holds exhibitions of contemporary Japanese arts throughout most of the year. The Kami Negishi Calligraphy Museum contains numerous specimens of calligraphy. Japanese and Chinese painting, sculpture, and handicrafts are exhibited in the Ōkura Shūkokan. The Nezu Art Museum has many examples of Oriental painting, calligraphy, sculpture, metalwork, swords, ceramics, lacquer, tea-ceremony articles, etc. In the Mingeikan (Folk Art Museum) are folk arts and crafts from all parts of Japan. The Bridgestone Gallery shows work by modern Western and Japanese artists. The National Museum of Modern Art contains examples of modern art from Japan, Europe, and America.

Hommonji: This temple is the headquarters of the Nichiren sect, and was founded in 1274 by Ikegami Munenaka, a follower of the priest Nichiren (1222–82). There is a seated wooden statue of Nichiren (Kamakura period) here.

Edo castle: Edo castle was originally built by Ōta Dōkan, military lord of the area, in 1457; later it became the dwelling of Tokugawa Ieyasu, founder of the Edo feudal government. It was improved and enlarged between 1624 and 1644. Since the Meiji Restoration it has been the imperial palace. Although most of the original buildings were lost owing to recurrent fires, the palace is a representative example of castle architecture of the Edo period.

Ōmori shell mound: This mound (Jōmon period) was discovered by Professor E. S. Morse, an American, in 1873. It was the first archaeological excavation made in Japan according to scientific criteria.

Jindaiji: Founded in 733, this temple belongs to the Tendai sect. It contains a bronze statue of Shaka (Nara period), seated in the Western manner.

c. Prefecture of Chiba. Ajiki. In this village is the Ryūkakuji, containing a seated bronze statue of Yakushi. The head is of the Nara period (the oldest piece of sculpture in Kanto); the body was restored during the Edo period.

Sawara. Port on the Tone River. Near here is the Kampukuji, with seated bronze statues of Shaka, Jūichimen Kwannon, Yakushi, and Jizō Bosatsu, all of the Kamakura period.

Chiba. This city is the capital of Chiba prefecture, and is located at the beginning of Bōsō Peninsula. Nearby is the Kasori shell mound (Jōmon period).

Mizusawa. In the village is the Myōrakuji, containing wooden statues (all of the Fujiwara period) of Dainichi Nyorai, seated; Fudō Myōō, standing; and Bishamonten, standing, in the *nata-bori* style.

d. Prefecture of Saitama. Kawagoe. Small town north of Tokyo. The Tōshōgū contains paintings of the "Thirty-six Poetic Immortals" in color on wood boards and framed, attributed to Iwasa Matabei (1578–1650). The Kitain was founded in 830 by Jikaku Daishi; it contains a pair of six-fold screens, on which are painted in color on paper Pictures of Crafts, attributed to Kanō Yoshinobu (1552–1640).

Yoshimi. Village north of Tokyo. Near here is a group of some 250 tombs in the form of caves dug in the side of a hill, known as Yoshimi Hyakketsu (Great Burial period).

e. Prefecture of Tochigi. Utsunomiya. Northwest of Utsunomiya, capital of Tochigi prefecture, is the Ōya-Kwannon temple, said to have been founded by Kūkai (Kōbō Daishi, 774–835). On the walls of the temple, built partly within a cave, are a group of Buddhist images carved in high relief (Fujiwara period).

Mashiko. Village south of Utsunomiya where Mashiko pottery is produced. Mashiko ware, originated about 1848, is simple and crude. The kilns in this vicinity still produce quantities of pottery rich in folkloristic interest.

Azuma. Village north of Utsunomiya. The Ryūkōin contains a wooden statue of Erasmus of Rotterdam, made in Amsterdam in 1598 and placed at the stern of the sailing boat Erasmus. The boat was confiscated in Japan and the statue alone survived.

Nikkō. Small mountain town, northwest of Utsunomiya. Nikkō is famous for its temples and the magnificent mausoleum of Tokugawa Ieyasu (1542–1616), founder of the Tokugawa Shogunate.

Tōshōgū Shrine: Ieyasu was buried at Nikkō in 1617, but it was not until 1634 that his mausoleum was begun; it was completed two years later. The architecture of the main shrine is of a style established in the late Momoyama period, consisting of a Honden, a Haiden located in front of it, and a passageway connecting the two. The Yōmeimon (gate of sunlight), popularly called the Higurashimon (twilight gate), is of the Edo period.

Rinnōji: This temple belongs to the Tendai sect and contains many statues and portraits.

Daiyūin: This is the mausoleum of Tokugawa Iemitsu, third Tokugawa Shogun; here is a standing wooden statue of Senju Kwannon (Fujiwara period).

Southwest of the Tōshōgū Shrine is the treasure hall, which contains antiquities from the shrines and temples in Nikkō.

BIBLIOG. Educational Commission of the Tokyo Metropolitan Area (ed.), Tokyo-tō Bunkazai Ichiran (List of Cultural Properties in Tokyo), Tokyo, 1950; A Concise Handbook of Tokyo, Tokyo, 1950; Saitama Prefectural Educational Commission (ed.), Saitama no Bunkazai (Cultural Resources in Saitama), Saitama, 1951; Tochigi Prefectural Educational Commission (ed.), Tochigi-ken Bunkazai (Cultural Resources in Tochigi Prefecture), Tochigi, 1952; Social Education Section of Kanagawa Prefectural Educational Commission (ed.), Kanagawa-ken Bunkazai Mokuroku (Catalogue of Cultural Resources in Kanagawa Prefecture), Kanagawa, 1952; Chiba Prefectural Educational Commission (ed.), Chiba-ken Bunkazai Yōran (Outline of Cultural Resources in Chiba Prefecture), Chiba, 1953; S. Koike, Nihon no Gendai Kenchiku (Contemporary Architecture of Japan), Tokyo, 1954; J. W. Hall, The Cattle Town and Japan's Modern Urbanization, Far Eastern Q., XV, 1, 1955, pp. 37–56; Gumma Prefectural Educational Commission (ed.), Gumma-ken Bunkazai Mokuroku (Catalogue of Cultural Resources in Gumma Prefecture), Gumma, 1955; Tangen Inamura and Hirokai Toyoshima, Tokyo-tō no Shiseki to Bunkazai (Historic Sites and Cultural Resources in Tokyo), Tokyo, 1955.

TOHOKU DISTRICT. *Historical outline.* Tohoku (or Ou) district, situated at the northern end of Honshu, consists of six prefectures: Fukushima, Yamagata, Akita, Miyagi, Iwate, and Aomori. Recent discoveries have proved that a pre-Jōmon culture existed in this district. Earthenware of the Jōmon type found here is notable for its complicated decoration; the clay figurines, of grotesque appearance, are more numerous and of a superior quality in Tohoku than in other districts. Tools and implements of bone, horn, wood, etc., attest to the high cultural development achieved here in the Jōmon period, which might indicate that the Jōmon culture first appeared in Tohoku and spread later to Kanto and Chubu districts. Notable also among sites of this period are the stone circles at Ōyu in Akita prefecture. Several other sites of similar nature have been discovered in the district; presumably they are relics of the religious customs of the times.

Various sites existing in the district show that the Yayoi culture, which was born and developed in western Japan, reached the southern part of Tohoku not much later than in other districts. During the Great Burial period many tumuli were built, and they are found in all the prefectures except Aomori.

As late as the historic period Tohoku was still inhabited by a primitive tribe called the Ezo. According to a widely accepted theory, the Ezos were not an independent race but a local tribe which remained hostile to the central government. Even in the 7th and 8th centuries the Ezo community in the northern part of Miyagi was frequently in revolt against the Yamato court. Many priests and generals were sent by the court to subjugate the Ezos and to exploit the unclaimed regions. The official culture quickly took root in the

district, as is attested to by the existence of the ruins of a Kokubunji (official provincial temple built in each province by imperial order in the 8th cent.) in Miyagi prefecture.

In the 12th century the Fujiwara clan, a powerful family of the Ezo tribe, who controlled the regions around Iwate prefecture, created a short but brilliant period of prosperity; the Chūsonji, Mōtsuji, and Muryōkoin, famous in the cultural history of the district, were the direct result of the admiration of the Fujiwaras for the court culture. After the Fujiwaras were conquered by Minamoto Yoritomo

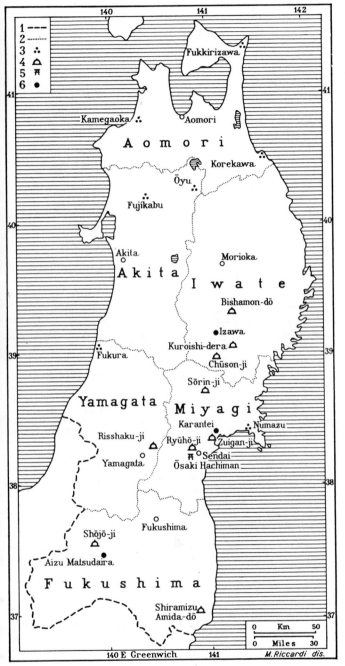

Tohoku district. *Key:* (1) District boundaries; (2) prefecture boundaries; (3) archaeological sites and tumuli; (4) Buddhist temples; (5) Shinto shrines; (6) secular buildings of historic interest.

in the Kamakura period, the central power reached the remotest parts of Tohoku, with the inevitable end of the local culture and the permeation of the civilization of the metropolis.

This situation remained unchanged in the early modern period. It is worth mentioning, however, that a school of Western-style painting, termed the Akita school, made its appearance in the Akita area in the 18th century. The lord of Akita, in the hope of increasing the production of his copper mines, invited Hiraga Gennai (1726-79) from the capital to advise him. Gennai, a man of inventive, progressive mind and with a knowledge of Western techniques, not only

offered his help to the lord but also taught the elements of Western-style painting to the people of the area. The Akita school of painting flourished for a short period of time. Various other industries were encouraged, such as Aizu and Sōma ceramics, produced in Fukushima prefecture, and iron kettles (Nambu *tetsubin*) and lacquer ware (Nambu *nuri*), produced in Nambu province in Iwate prefecture. Although these forms of handicrafts are still active, generally speaking artistic activities have not thrived in Tohoku since the Meiji Restoration.

Regions and centers of artistic interest. a. Prefecture of Fukushima. Uchisato. In this small town is located the Shiramizu. The Amidadō, built in 1160, contains wooden statues of the Amida Triad, flanked by two standing wooden deities, all of the Fujiwara period.

Aizu-Wakamatsu. City southwest of Fukushima, capital of Fukushima prefecture. Aizu lacquer ware has been produced here since 1590, when the industry was founded by Gamo Ujisato, lord of Aizu.

Hongō. Aizu pottery has been made in this village since ca. 1644. At first only pottery was produced, but since ca. 1800 blue-and-white porcelain has been fabricated as well.

Shōjō. In this village stands the Shōjōji. It is not known when the temple was founded, but it probably existed by the 9th century. The dimensions of the main hall (Muromachi period) are very unusual for a building situated in a local district. In the Shōjōji are wooden statues of the Yakushi Triad (Jōgan period), important examples of eastern Japanese art which perpetuate several elements of the style of the Nara period; and standing wooden statues of Jūichimen Kwannon, Jizō Bosatsu, Kwannon, and the Shitennō, all of the Jōgan period.

b. Prefecture of Yamagata. Yamagata. Capital of the prefecture. The Risshakuji (also called the Yamadera) is 9 miles from Yamagata. The temple belongs to the Tendai sect and is said to have been founded in the 9th century by the priest Ennin. It contains the head of a statue of the priest Jikaku Daishi (Jōgan period) in wood.

Sakata. City at the mouth of the Mogami River. The Homma Art Museum contains examples of Oriental arts (manuscripts, ceramics, etc.) and of Western arts (paintings, prints, etc.).

c. Prefecture of Akita. Ōyu. Village in the northern part of the prefecture, near the boundary of Aomori prefecture. The Ōyu site is of the late Jōmon period. The site consists of large circles of stone disposed in groups; the eastern group is 158 ft. in diameter and the western one 148 ft.

d. Prefecture of Miyagi. Sendai. Capital of Miyagi prefecture. Date Masamune (1566-1636) was the daimio of the province in which Sendai is situated, and lived in Sendai castle.

Ōsaki Hachiman Shrine: The shrine was built in 1606. The main building is noted for its architectural beauty and richly decorated interior.

Ryūhoji: This temple contains a statue of Shaka (Kamakura period), which is the most northerly example of the Seiryōji type of Shaka statue.

Saitō Hōon Museum: Here are exhibited objects relating to the natural and cultural history of Tohoku district.

Matsushima. Village 10 miles north of Sendai in Matsushima Bay. There are over 800 small islands in the district of Matsushima.

Zuiganji: The temple was founded in 828 and rebuilt in 1609 by Date Masamune. The buildings, which are considered typical of the Momoyama period, include the Hondō, Onarimon (gate of honor), Nakamon (middle gate), Kuri, and Kairō (corridors).

Kanrantei (wave-viewing house): The Kanrantei, which was given to Date Masamune by Toyotomi Hideyoshi, is said to date from the end of the 16th century. The paintings of Flowering Plants on the sliding doors are attributed to Kanō Sanraku (1559-1635).

e. Prefecture of Iwate. Mizusawa. Small town south of Morioka, capital of Iwate prefecture. In the town are the ruins of Izawa castle, an important citadel built in 802 by Sakanoue-no-Tamuramaro, one of the military generals dispatched from the Yamato court to subdue the Ezo tribe; and the Kuroishidera, containing a seated wooden statue of Yakushi, dated 862.

Hiraizumi. Village south of Mizusawa. The famous Chūsonji (or Chūzonji) is the only reminder of the past glories of Hiraizumi, which the Fujiwara family ruled from ca. 1090 to 1189. The Chūsonji was founded in 1105 by Fujiwara Kiyohira. His successors Motohira and Hidehira enlarged the temple from 1108 on until it had more than 40 buildings, rivaling in size the great religious centers of Kyoto. The only original buildings remaining are the Konjikidō

(golden hall), also called the Hikarudō (glittering hall), and the Kyōzō. The Konjikidō was built in 1124, and was enclosed within a larger building in 1288 to preserve it; its was originally covered with gold leaf, and roofed with wooden blocks in the shape of tiles. The Kyōzō was built in 1108; originally two-storied, the upper story was destroyed by fire in 1216. Among the treasures kept in the temple are six bronze pendants or *keman* (Fujiwara period), symbolizing chaplets of flowers, and a seated wooden statue of Ichiji Kinrin (a manifestation of Dainichi; Fujiwara period), with its original color well preserved. In front of the Konjikidō is the treasure hall, which houses specimens of Buddhist arts of the 12th century. In the precincts of the temple is the Daichōjūin, containing various works of art: the Suvarṇaprabhāsa Sūtra (Fujiwara period), 10 sheets of dark-blue paper with the sacred texts copied in gold ink and the characters arranged in the shape of a pagoda, surrounded by paintings in color illustrating the meaning of the chapters; the Issai-kyō (Tripiṭaka), kept in 266 boxes (Fujiwara period); and an altar, an octagonal platform of lacquered wood with mother-of-pearl inlay (Fujiwara period).

Tsuchizawa. In the village is the Bishamondō, containing two standing wooden statues, one of Bishamonten and another said to be of Kichijōten, both of the Fujiwara period.

Jōhōji. In this village is the Tendaiji, containing standing wooden statues of Shō Kwannon in the *nata-bori* style and Jūichimen Kwannon, both of the Fujiwara period. Jōhōji lacquer is produced here, and consists mainly of cinnabar-lacquered bowls and other vessels.

f. Prefecture of Aomori. Hirosaki. City south of Aomori, capital of the prefecture. Hirosaki was formerly the castle town of the Tsugaru family. Tsugaru lacquer, said to have been originated in 1658 by the lacquerer Ikeda Gembei, is still produced today.

Kizukuri. Village on the Tsugaru Peninsula. The Kamegaoka site (Jōmon period) is 7 miles from Kizukuri. This is a famous archaeological site where numerous specimens of earthenware from the late Jōmon period have been excavated (PL. 261).

BIBLIOG. Chūson-ji to Fujiwara Yodai (The Chūson-ji Temple and the Four Generations of the Fujiwaras), Tokyo, 1950; Office of Fukushima Prefectural Educational Commission (ed.), Fukushima-ken no Shiseki to Meishō (Historic Sites and Scenic Spots in Fukushima Prefecture), Fukushima, 1951; Miyagi Prefectural Educational Commission (ed.), Miyagi-ken no Bunkazai (Cultural Resources in Miyagi Prefecture), Miyagi, 1953; Office of Fukushima Prefectural Educational Commission (ed.), Fukushima-ken Bunkazai Chōsa Hōkokusho (Report of Investigations on Cultural Resources in Fukushima Prefecture), Fukushima, 1955; T. Toyada *et al.*, Tōhoku-shi no Shin Kenkyū (A New Study on the History of Northeastern Japan), Sendai, 1955; Iwate Prefectural Educational Commission (ed.), Iwate-ken no Bunkazai (Cultural Resources in Iwate Prefecture), Iwate, 1956; Yamagata Prefectural Educational Commission (ed.), Yamagata-ken no Bunkazai (Cultural Resources in Miyagi Prefecture), Yamagata, 1957.

HOKKAIDO DISTRICT. *Historical outline.* Hokkaido is located north of Honshu. It is separated from Honshu by Tsugaru Strait, and from Sakhalin (Jap., Karafuto) on the north by Soya Strait. To the northeast lie the Kuril (Jap., Chishima) Islands serving as a bridge to Kamchatka Peninsula.

The recent discovery of paleolithic implements at Tarukishi on the coast of the Sea of Japan proves that the pre-Jōmon culture existed in Hokkaido. Sites of the early Jōmon period have also been discovered, though they are somewhat different in nature from those in Honshu. Some pieces of the mid-Jōmon period resemble Siberian finds; these are unique examples not found in Honshu. The stone circles in Hokkaido, unlike those at Ōyu in Akita prefecture, were probably tombs.

The inhabitants of Hokkaido were first mentioned in the literature in the mid-7th century. They were called the Ezo, as were the people in Tohoku. It is obvious that the Ezos of Hokkaido are the Ainus, the aboriginal people who still live in Hokkaido, but whether the Ezos of Tohoku were also Ainus is still an open question. Regarding the Ainus themselves, some scholars believe them to be a branch of an ancient Siberian tribe belonging to the Caucasian group, whereas others consider them a race of unidentified origin. Other races appear to have inhabited Hokkaido, such as the Moyoris, of whom little is known except that they used the earthenware known as the Okhotsk type (found also in northern Manchuria, Sakhalin, the Kuril Islands, and Kamchatka).

In the mid-8th century the Yamato court sent a government official, the so-called Watarishima Tsugaru-no-tsukasa (Tsugaru Governor of Foreign Relations), to Hokkaido to maintain relations with the inhabitants of the district. After moving the seat of government to Kyoto the imperial court began to lose power, and the policies it had adopted toward the Ezos were not continued. The Fujiwaras, the powerful clan in Tohoku district, then became the instrument

through which the court maintained uninterrupted contact with Hokkaido.

Until the beginning of the modern period the Matsumae clan from Aomori prefecture maintained a fief in Hokkaido and were loyal to the Tokugawa central government. Fukuyama castle was the seat of the Matsumaes. In 1859 the Tokugawa government began the construction of the Goryōkaku, a citadel under the jurisdiction of the Hakodate magistery, where, during the Meiji Restoration, Enomoto Buyō and other vassals of the Tokugawa Shogun

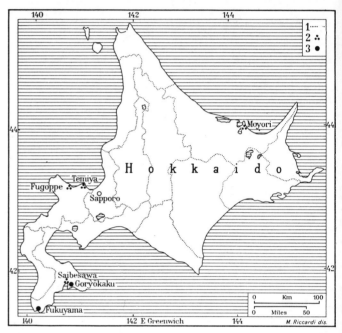

Hokkaido district. *Key*: (1) Prefecture boundaries; (2) archaeological sites and tumuli; (3) secular buildings of historic interest.

attempted a last resistance to the imperial forces. After the fall of the Tokugawa regime, the new constitutional government under imperial rule set up a Commissioner of Colonization to govern Hokkaido and Sakhalin. Sakhalin belonged for a certain period to Russia; after the Sino-Japanese War the southern half of it became Japanese territory. Since World War II Sakhalin as well as the Kuril Islands has come under the control of Russia.

No systematic study has been made of the arts in Hokkaido. The aboriginal inhabitants, centered around the Ainus, continued until recently their primitive way of life with its emphasis on fishing and hunting. Then they began to engage in agriculture, but only of a very primitive kind. Thus, except for earthenware of the Jōmon type and some ancient wall paintings in caves, Hokkaido has few works of art worth special mention.

Regions and centers of artistic interest. Matsumae. Village near Hakodate which is the site of Fukuyama castle (also called Matsumae castle; Edo period).

Hakodate. City on Tsugaru Strait. Here is the site of Goryōkaku, the seat of the Hakodate magistery. It was built between 1859 and 1864, on a pentagonal plan (*goryō*), and was surrounded by stone and earth fortifications. The citadel was built by Takeda Hisaburō, who based his plans on the most advanced fort constructions, obtained from Dutch books of military architecture.

Yoichi. Small town west of Sapporo, the capital of Hokkaido. The Fugoppe cave is located here; it is 16½ ft. deep with an entrance 13 ft. in diameter; on the walls are primitive paintings.

Otaru. Port west of Sapporo. The Temiya cave, 1 mile from the city, contains an inscription in ancient characters.

Abashiri. Small town on the Sea of Okhotsk. The Moyori shell mound is located here. Horn and bone implements, earthenware of the Okhotsk type, and human bones surmounted by vases have been excavated from this site.

BIBLIOG. Japan, The Official Guide, 8th ed., Tokyo, 1961, pp. 605-35.

Takeshi KUNO

Illustrations: 11 figs. in text.

JAPANESE ART. Japan is linked in a number of ways to the continent of Asia; in fact, her full integration with world history was brought about only through contact with the civilizations of China and Korea, which had earlier reached a high level of development (see CHINESE ART; KOREAN ART). For over a thousand years, from the Asuka period, beginning in the 6th century, to the Edo, Japanese art was profoundly influenced by Chinese works; these were successively assimilated and transformed until works of independent Japanese character evolved, only to be immediately abandoned whenever the still-evolving art of China opened up new prospects. This constant exchange, stimulated by a search for independence and adaptation, led to a kind of dialogue between Chinese and Japanese art, and it was a factor of fundamental importance in shaping the character of the latter. Later, the discovery of Japanese art by the West and the influences which this had upon modern European schools, together with a simultaneous aridity in the creative vein of China, replaced the Chinese-Japanese "dialogue" with an equally rich and productive one between Japan and Europe. The fame enjoyed by Japanese art in the West is partly the result of these early exchanges, and it certainly reflects the first profound impression made upon Western artists. Thus there exists a real tradition linking the artistic activity of Japan to that of Europe. However, even today, if certain artistic movements in Japan reflect, modify, or transform the creations of modern art in the West, there remain traditional tendencies which have interest and validity both in Japan and in the art of the world. Much remains to be done in the study and appraisal of the trends and styles flourishing in that distant land of art. The immense wealth of Buddhist art is pregnant with complex symbolism, and some of its meaning still requires clarification, as do many of its iconographic and stylistic elements. Similarly, a full critical reappraisal is needed if we are to understand properly the secular art of Japan, which is hardly ever of the order of mere craftsmanship even when its aims are utilitarian. The interest that Japanese architecture has aroused among modern exponents of architectural theory and practice amply demonstrates its value and importance. The development of Japanese art, accompanied by a strict plan of artistic learning, is both rich and coherent, even though, for the most ancient periods, it lacks a critical literature of its own comparable to that found in China.

According to Japanese archaeologists, the earliest history of the Japanese people in Japan consists of two chronologically distinct periods: the Jōmon, prior to 300 B.C., and the Yayoi, ca. 200 B.C. to ca. A.D. 200. These periods are discussed in the article on JAPAN; see also ASIATIC PROTOHISTORY and CERAMICS. The history of Japanese fine arts may be said to begin with the Yamato period, when the population had begun to advance from the primitive agricultural society of the Yayoi. In this article the salient features of this art are presented, and certain traditional opinions that exist today in Japan are discussed.

SUMMARY. Great Burial or Yamato period (col. 845). Asuka period (col. 846): *Architecture; Sculpture; Painting; Minor arts.* Nara period (col. 849): *Architecture; Sculpture; Painting; Calligraphy; Minor arts.* Heian period (col. 856): *Architecture; Sculpture; Painting; Calligraphy; Minor arts.* Kamakura period (col. 862): *Architecture; Sculpture; Painting; Calligraphy; Minor arts.* Muromachi period (col. 869): *Architecture; Sculpture; Painting; Minor arts.* Momoyama period (col. 874): *Architecture; Sculpture; Painting; Minor arts.* Edo period (col. 880): *Architecture; Sculpture; Painting; Calligraphy; Minor arts.* Meiji-Taisho period (col. 889): *Architecture; Sculpture; Painting: a. Traditional-style painting; b. Western-style painting; Minor arts.* Shōwa period (col. 894): *Architecture; Sculpture; Painting; Minor arts.*

GREAT BURIAL OR YAMATO PERIOD. From the 3d to the 6th century the most influential clan governed the district of Yamato (the modern prefecture of Nara), and this era is called the Yamato period by historians. Archaeologists designate it the Great Burial, or Tumulus, period. At that time the standard of living of even the most powerful families was exceedingly low. Although mythology tells us that the palaces of successive emperors of that age were gigantic in scale, we may conclude

from examining the house-shaped clay images excavated from ancient tombs that even the largest imperial palace would have been a one-storied wooden house, about 18 ft. wide and 12 ft. high, constructed with several pillars, beams, and cross beams, either plastered or boarded and roofed with thatch. Although the present sanctuaries of the Great Shrines of Ise and of Izumo are said to retain the architectural style of the Yamato period, scholars have recently concluded that their style and form are not quite identical despite similarity of architectural plan and principle; according to these scholars, the architectural style of the high-floored Shintoist shrine with no windows was derived from the high-floored granary of the period.

Many burial mounds exist in Japan; the largest is that of Emperor Nintoku, 1620 ft. long and 90 ft. high, built in the 5th century. These tombs were derived from Chinese models, but the Japanese developed a unique ground plan, square in front and rounded in the back. Inside every ancient tomb, large or small, is a sepulchral vault constructed of heaped-up rocks, which is smaller in scale and quite different from the stone edifices found in China. The walls of the vaults have figures of men and horses, as well as geometrical patterns, incised in line and plastered with colored clay; these line drawings show that the art of the period was still at a primitive level. The tombs contained bronze mirrors, bronze harnesses plated with gold and silver, swords (II, PL. 17), ornaments, jewels, pottery, and dyed and lacquered objects. These represent a mixture of styles introduced into Japan from China and then formalized into a traditional Japanese style during this and the preceding Yayoi period.

Around the burial mounds were clay images (*haniwa*), made by members of a clay workers' corporation, which may be described as truly sculptural works, best exemplifying the plastic arts of the period. The *haniwa* were made in two parts, both hollow: the lower part, cylindrical in shape, was placed underground and held the figures firm; the upper part, originally unadorned, later became ornamented with houses, implements in the form of armor and shields, animals (horses, dogs, pigs, fowl), and male and female figurines (PL. 261). The *haniwa* are products of a simple, natural, intuitive artistic technique, and do not seem to have any magical significance. They hold a unique position among the ancient plastic arts of the world and conceivably represent the original esthetic temper of the Japanese race.

ASUKA PERIOD (552–645). *Architecture.* This period, which takes its name from the district of Asuka, is also sometimes called "Suiko," after the famous empress who reigned from 593 to 628. It was the custom at this time to change the seat of the imperial court at the death of each emperor, although the capital always remained within the district of Asuka. Thus the capital did not readily develop a definite style of its own; the imperial palace and the houses of the aristocrats were all viewed as temporary and were small in scale.

The architecture of these secular buildings was no match for the spectacular development of Buddhist temples. Buddhism (q.v.) was introduced into Japan in the middle of the 6th century and began to spread rapidly all over the country. The oldest and largest of the Buddhist temples is Asukadera, which was begun in 588 by the Soga clan, with the actual work undertaken by various architects and artists presented to the imperial court of Yamato by the king of Kudara (Paekche) in Korea (see KOREAN ART). Later a large number of Buddhist temples were built in the Kinki district, particularly in the Yamato area. The architecture of these temples reflects Chinese and Korean styles. By 624 there were 46 temples, 816 priests, and 569 priestesses in Japan.

No Buddhist architecture indisputably of the Asuka period survives, but two temples give some illustration of the style: the main or "golden" hall (Kondō, FIG. 847), five-storied pagoda, middle gate (Chūmon), and corridor of the Hōryūji and the three-storied pagoda of the Hōkiji. The Hōryūji was built about 607, destroyed by fire in 670, and reconstructed a short time later. There has been, however, a dispute among

scholars for the last half century as to whether the temple was really reconstructed or not, the opponents of the reconstruction theory asserting that the written records are misleading and that the present temple is the original one since its architectural style is completely different from that of other buildings of the period preceding the Nara.

For the present, the reconstruction theory is predominant. Every column of the main temple of the Hōryūji has a slight entasis like that in Greek columns, and Chinese prototypes have this characteristic too. The architectural style of the Hōryūji and Hōkiji bears a resemblance to that of Chinese temples during the Six Dynasties period. These facts indicate that the Hōryūji may have been built after the antique style of the Asuka period even if it was reconstructed immediately before the Nara period (PL. 282). The three-storied pagoda

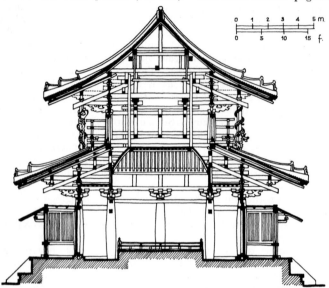

Kondō at the Hōryūji at Nara, section (*after Paine and Soper*).

of the Hōkiji, built in 685, and the Tamamushi Zushi in the Hōryūji (see below, *Painting*) may be regarded as specimens of the antique style.

In the Asuka period the novel, grand, and exotic architecture of the Buddhist temples existed side-by-side with the local and traditional architecture of Shinto shrines (see SHINTOISM). It is commonly presumed that the architectural style of Shinto shrines had been brought to perfection during the Yamato period in the 4th century. The fundamental architectural style of all Shinto shrines is illustrated by the main building of the Inner Shrine at Ise. All the columns are buried underground; two columns at each end of the gable support the ridgepole; the two gables extend crosswise beyond the ridgepole, which has several heavy logs placed across it. This style is called *shimmei-zukuri* and is unlike the Buddhist architecture introduced from the continent. The four architectural styles typical of Shinto shrines are *shimmei-zukuri*; *taisha-zukuri*, named after the main hall of the Great Shrine of Izumo; *sumiyoshi-zukuri*, after the main hall of the Sumiyoshi Shrine; and *kasuga-zukuri* after the Kasuga Shrine in Nara (constructed immediately before the Nara period). The style of the sanctuary and treasury of any Shinto shrine constructed in one of these four styles may be said to be a transformation and development of the architecture of the high-floored granary of the Yayoi period.

Only the Buddhist temples had tiled roofs. Roofing and crest tiles, before being baked, were carved and embellished with figures and patterns, Japanese artisans having been taught this art by Korean and Chinese tilemakers.

Sculpture. In 577 Korean Buddhist artists and architects were presented to the court of Yamato as tribute from the king of Kudura. From then on a large number of artists came from the continent and trained the Japanese in various crafts.

Of the schools of sculpture in the Asuka period, the Tori school was the most famous. Tori was the grandson of Shiba Tattō (or Tatsuto), a Chinese who had become a naturalized Japanese in 522, and the son of Tasuna, who had made Buddhist sculptures for the Sakatadera in 587. Only two of Tori's works remain today: a bronze statue of Shaka (Śākyamuni), made in 606, of which only the head is original, made for the Gangōji and now preserved at the Asukadera in Nara prefecture; and the bronze Shaka Triad (Trinity), made in 623, in the Hōryūji. Other works in the style of the Tori school in the Hōryūji are a bronze statue of Shaka (628), the Yumedono Kwannon (Avalokiteśvara; PL. 262), and about a dozen small statues.

In the style of the Tori school the bodies of the statues are symmetrical and flat; some are unfinished in the back because they are meant to be viewed only from the front. The heads have long faces, eyes shaped like ginkgo nuts, and an archaic smile, although the visage is sternly contemplative. These characteristics show how close the Japanese sculpture of this time was to the gigantic stone sculptures of the Six Dynasties period in the stone caves of Lungmên and Yün-kang in China (see CHINA; CHINESE ART).

In striking contrast to these Tori school sculptures are the wooden statues of Kwannon (PL. 396, commonly called the Kudara Kwannon) in the Hōryūji, of Kokūzō (Ākāśagarbha) and of Yakushi (Bhaiṣajyaguru) in the Hōrinji, of Miroku (Maitreya; PL. 266 and II, PL. 396) in the Chūgūji, and about a dozen bronze statues in the Chūgūji and Kōryūji.

These two separate trends, which may be said to have formed the main streams of sculpture in the Asuka period, gave birth to another school, examples of which are the wooden statues of the Shitennō (Four Deva Kings) in the Hōryūji (PL. 263) and the bronze statue of Miroku in the Yachūji. Upon each of the statues of the Shitennō are engraved the names of four sculptors, one of whom, Yamaguchi-no-Oguchi-no-Atai by name, lived until 650. The statue of Miroku was made in 666. At the end of the Asuka period Japanese sculptors were beginning to express a sense of volume, which indicates that they were emerging from the influence of the Chinese sculpture of the Six Dynasties period.

Many wooden Gigaku masks painted in various colors are preserved in the Shōsōin of the Tōdaiji. Gigaku was originally a musical dancing play of eastern Asia, which came to Japan in 612 through the Middle East and China. During the Asuka and Nara periods the plays were performed outdoors in front of Buddhist temples on feast days. The players wore different masks (q.v.) and costumes according to the kind of dance to be performed. The features and expressions of the masks are exotic and exaggerated. They were copied from Chinese models by Japanese artisans.

Painting. According to an ancient chronicle, in 588 the painter Byakka was invited to Japan from Kudara, and in 610 the priest Donchō came to Japan from Koguryo in Korea and taught the Japanese how to prepare colors and make paper and ink. Buddhist paintings were in great demand because of the number of temples being constructed, so to supply these demands many painters came from the continent; together with their sons and Japanese apprentices, they rapidly spread Chinese and Korean painting styles throughout the country. It is known that in 604 some clans of painters were invited to the imperial court and were exempted from taxes, which shows that the art of painting was very highly esteemed. The hereditary system of professional painters established itself much earlier than that of other artists.

The only example of painting of the first half of the 7th century is that decorating the Tamamushi Zushi, so called because it was once decorated with the iridescent wings of the beetle *tamamushi* (*chrysochroa elegans*). The shrine stands on a square pedestal. On the doors of the shrine are paintings of the Niō (Two Deva Kings), *bosatsu* (bodhisattvas), and pagodas; on the four sides of the pedestal are depicted episodes from the life of Shaka. The boards were first covered with black lacquer, then the images were painted in red, green,

and yellow lacquer. The figures are archaic, simple, and abstract, and show the influence of Chinese painting styles. To indicate the chronological development of a story, the artist depicts the same character three times in some of the pictures (PL. 418). This may be regarded as the precursor of the pictorial method of the scrolls.

Minor arts. The minor arts of the Yamato period had been limited principally to metalwork, such as swords and armor, and the ceramic ware known as Sue. It was during the Asuka period that the minor arts began to develop, stimulated by the demand for decoration in Buddhist temples and at the imperial court. We find at this time elements of the art of lacquer (q.v.), wood, and textiles that became fully developed in the second half of the Nara period. The techniques and styles were introduced into Japan by Chinese and Korean artists.

Objects that may be considered typical of this age include the *ban*, a gilded bronze banner that hung from the ceiling of the Hōryūji; the metalwork of the Tamamushi Zushi; and the crowns adorning the statues of the Yumedono Kwannon (PL. 262) and of the Kudara Kwannon (PL. 396). The *ban* is now in the collection of the Imperial Household, and the other three works of art are preserved in the Hōryūji. The first two are made of thin plates of metal with openwork areas; the crowns of the two Kwannons are of perforated metal, decorated with precious stones. These objects furnish proof that the techniques of gilding, soldering, and alloying were highly developed at this time.

Some textiles have come down to us from this period. In the Yamato era coarse materials such as rough hemp had been used; in the Asuka period thin silk, damask, and brocade were employed into which threads of silk dyed in various colors were skillfully woven. A large embroidered image of the Buddha (known only from literary records) was made in 605. An embroidered screen of 622 in the Chūgūji represents scenes of the Buddhist paradise (PL. 267); only fragments remain. The rough sketches for the embroidery were made by three designers: Yamato-no-Aya-no-Maken, Koma-no-Kasei, and Aya-no-Nukakori.

Wood carvings of this period are preserved in the Hōrūyji (PL. 264).

NARA PERIOD (645–793). *Architecture.* In 645–46, at the beginning of the reign of Emperor Kōtoku, the Taikwa Reforms were introduced. The statutes were modeled on those of China, the traditional clan system was abolished, and the central government and prefectural government offices were systematized and placed under the control of the emperor.

Just as the institutions were copied from those of the Chinese T'ang dynasty, so was the capital, Naniwa (the present Osaka), modeled on the plan of Ch'ang-an and Loyang, both of which had been T'ang capitals (see CHINA). In 694 the capital was transferred to Fujiwara near the present Unebi (in Nara prefecture) and in 710 to Heijō (the present Nara city). After the move to Heijō the conventional custom of changing the capital with each succeeding emperor was abolished. The remains of these capitals have been excavated and investigated by archaeologists, but they do not tell us much about the architecture of the age. The investigations do show that the city limits and the imperial palace of Fujiwara were greater in extent than those of Heijō and Heian (the present Kyoto city).

In 645 an imperial edict was issued to propagate Buddhism. Temples built or begun in the Asuka period were reconstructed or completed, and new temples were started. By 680, according to an ancient chronicle, there were as many as 24 temples in the capital alone. It was during this time that the present Hōryūji was reconstructed (PL. 282). The plan of this temple is that of the Asuka period: within the quadrangle surrounded by corridors are the Kondō and the small pagoda, not on the central axis but to the east and west of it. The Yakushiji was founded in 680 at Fujiwara, and was transferred to Heijō in 718 or 719. In this temple the great south gate (Nandaimon),

Chūmon, Kondō, and lecture hall (Kōdō) stand on the central axis, with the Kondō in the center of the quadrangle; two pagodas were to the east and west of the Kondō, preceding it, but only the east pagoda remains today (PL. 283). Whether the Yakushiji was rebuilt at Heijō exactly as it had been at Fujiwara or according to a different plan is not known; but it is considered that the style of the present three-storied pagoda of the temple is neither that of the Asuka period nor of the later Nara period. The columns of the Kondō in the Hōryūji are round and have a slight entasis; those of the Yakushiji have soft, elegantly curved lines. Each floor of the pagoda has *mokoshi*, or intermediate projections between floors, which give it the appearance of a six-storied pagoda. This derives from the architecture in the early part of T'ang dynasty and is more refined in form and technique than the style of the previous period. Therefore we conclude that the east pagoda of the Yakushiji is the one surviving relic of the time when Fujiwara was the capital.

Heijō capital (or Heijō-kyō) had an area of 2½ miles from east to west and about 3 miles from north to south; the palace had an area of about 1 square mile. In the palace precincts were many large buildings modeled on buildings of the T'ang dynasty. Although the Kōdō of the Tōshōdaiji and the preaching hall (Dempōdō) of the Hōryūji were formerly a part of the palace, from where they were removed and improved, we can see what the secular architecture was like. When Heijō was made the capital, such temples as the Kōfukuji, Gangōji, Yakushiji, and Daianji were brought here from the former capitals of Asuka and Fujiwara. In 742 an imperial edict was issued to erect Kokubunji (provincial monasteries) and Kokubunniji (nunneries) all over the country; the Tōdaiji was the first of all these to be erected in Heijō, followed by the Saidaiji, till the number of the temples in the whole country amounted to several hundred. From the early Nara period it had been national policy to put temples under court (i.e., state) management, and in the latter half of the period this policy was strengthened so much that Buddhism acquired the character of a state religion.

Two schemes can be seen in the plans of the temples of this time: one is that of the Yakushiji (first half of the Nara period) and the other is that of the Kōfukuji and the Tōdaiji. In the second type the court, which is surrounded by corridors uniting the Chūmon and the Kondō, has no building in it and the pagoda stands outside the Chūmon. Beside these, there were many other types of building arrangements, which gave rise to various forms of architecture, such as octagonal halls. Thus the second half of the Nara period became the most fruitful period in the architectural history of Japanese Buddhism.

The principal remains surviving from this period are the two-storied Kyōzō, or building in which the sutras are preserved (710–30), the Tōdaimon or east gate (720–40), and the Yumedono (dream hall, 735–50; PL. 282), all in the Hōryūji; the Hokkedō (or Sangatsudō, founded 733, FIG. 851), Shōsōin or treasure house (750–60), and Tengaimon or gateway (745–60) of the Tōdaiji; the east and west pagodas of the Taimadera (immediately after 756); the Kondō of the Tōshōdaiji (759–80; FIG. 854); the Hakkakudō or octagonal hall of the Eizanji (ca. 763); and the Hondō or main hall of the Shin-Yakushiji. Of all these the most outstanding for size and splendor is the Kondō of the Tōshōdaiji, which measures 96 ft. from east to west and 48 ft. from north to south. Probably the largest wooden building in the world is the Daibutsuden (hall of the Great Buddha) of the Tōdaiji; the present building, which was restored between 1696 and 1708 to two-thirds of its original size, is 188 ft. from east to west, 166 ft. from north to south, and 157 ft. high.

Although the temples were built in imitation of those of T'ang China, they did not use wood and bricks as in Chinese architecture, but only wood. This imposed technical difficulties but at the same time permitted greater liberty in construction, and this may account for the originality and uniqueness of Japanese Buddhist temples.

To every temple there was attached a Shōsōin, seven of

which are extant today, the best being the Shōsōin of the Tōdaiji. These structures resemble large log cabins whose walls are made up of logs which are triangular in cross section and produce a faceted surface outside and a smooth surface inside. This type of construction is called *azekura-zukuri*. It can be traced back to the granary architecture peculiar to Japan from about the 1st century and perfected in the first half of the Nara period.

Roof tiles (*kawara*) play an important role in the structure and beauty of a temple. In true Japanese architecture, the roof was generally thatched with grass, bark, or shingle, but in the Asuka period the *kawara* was introduced into Japan from Korea and *kawara* artisans were invited to teach the Japanese how to make them. In the first half of the Nara period the *kawara* was used in the palace roof, and later Buddhist temples and residences of court lords were tiled. But it was not until the Edo period that the *kawara* came into general use. The tiles vary accoring to the structure of the roof. Some tiles are decorated with flower patterns which differ according

in Lady Tachibana's Miniature Shrine, both in the Daihōzōden of the Hōryūji; the Jūichimen Kwannon or Eleven-headed Kwannon (Ekādaśamukha) at the Kakurinji; and the Shaka images in the Jindaiji and the Kanimanji.

The main features of style common to all these early Nara statues are the treatment of the human form, which is both plastic and sensuous, and realistic in every detail, including the clothing, and the gracious archaic smile on the faces, which nevertheless still express inner feelings.

The stylistic changes that took place between the Asuka and Nara periods reflect similar changes in China; the images of the Asuka period reflect in style as well as in iconography the taste of the Northern Wei dynasty, while the Nara period reflects the mature style of the Sui dynasty and the early T'ang dynasty.

It is the Yakushi Triad in the Yakushiji that may be said to mark the turning point in the evolution of sculpture in the Nara period. The date of the triad is disputed. Some authorities hold that it was completed by 679; others argue

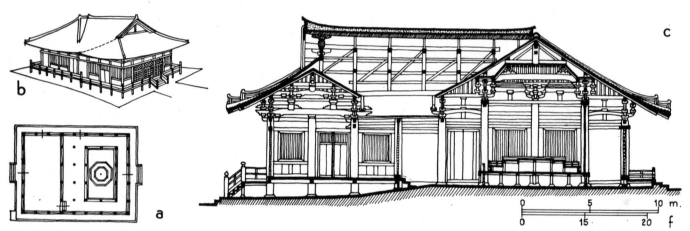

Hokkedō of the Tōdaiji at Nara. (*a*) Ground plan; (*b*) perspective; (*c*) section (*after Paine and Soper*).

to the year they were made, so the date of a building may be ascertained from the tiles.

The fundamental types of Shinto shrines described earlier reached perfection in the Nara period. The houses of the common people, centered round the farms, changed little from the Yamato to the Nara period and were no more than mud huts roofed with grass or shingle.

Sculpture. Temples and images were built at state expense, under the supervision of the Zōbutsu-sho, or bureau of Buddhist sculpture, a government organ established for the purpose. Large Buddha images were carved or cast in great numbers during this period. Over 200 Buddhist statues of Nara date have come down to us, representing a great variety of types as well as materials. Artists of the Asuka period had worked exclusively in bronze and wood; sculptors of the Nara period used these materials and also dry lacquer, clay, and even stone and brick.

The major Buddhist sculptures of certain date produced in the Nara period are the following: the Miroku Bosatsu, at the Yachūji (666); a head of Yakushi, at the Kōfukuji (685); the bronze plaque in high relief, at the Hasedera (686); a group of clay statues, in the five-storied pagoda of the Hōryūji (711; II, PL. 392); the Niō, in the Chūmon of the Hōryūji (711); the Jūdai Deshi (Ten Great Disciples) and the Hachibushū (Eight Guardian Devas, PL. 268), at the Kōfukuji (734); the nine dry-lacquer statues, including the eight-armed Fukukenjaku Kwannon (Amoghapaśa), at the Hokkedō of the Tōdaiji (746–48); the Jūni Shinshō (Twelve Heavenly Generals), at the Shin-Yakushiji (729–66); the Rushana Butsu (Vairocana), at the Tōshōdaiji (757–64); and the statue of the Demon of the Shitennō, at the Saidaiji (765).

Prominent among the images produced in the early Nara period are the Hōzō Bosatsu, and the Amida (Amitābha) Triad

that it was made about 718, when the temple was transferred to Heijō. The head of Yakushi in the Kōfukuji, which was produced in 685, is similar to the Yakushi Triad both in size and style, but the Yakushi Triad is far superior in sense of volume and balance and expresses much more strongly the spiritual ideas of Buddhism. The formality typical of the Asuka or the early Nara works is replaced by a totally new style with a single intellectual ideal. One reasonable explanation of this change or development may be the establishment of the capital at Heijō and the emperor's desire to build up a new empire with a strong political-religious ideology. The best illustrations of this Buddhist ideal are the Tōdaiji and its principal icon, the Rushana Butsu, ordered by the emperor Shomū. This Great Buddha, which is the largest ever made, took over 15 years to construct under the direction of Kuninakano-Muraji-Kimimaro and was completed in 752. Unfortunately, however, it has not survived in its original form; it was burned in 1180, reconstructed in the same year, destroyed again in 1567, and repaired in 1692. The original statue is best preserved in the knees of the Great Buddha and the lotus-flower petals of the pedestal.

The dignity and sublime beauty that are expressed in the Great Buddha of the Tōdaiji are to be found again in the 14 statues preserved in the Hokkedō of the Tōdaiji. These may be divided into two groups from the stylistic and technical point of view. The first one consists of nine images: the Fukūkenjaku Kwannon, the Bonten (Brahmā), the Taishakuten (Indra), the Shitennō, and the Niō. The second group consists of five clay images: the Shukongōjin (Vajrapāni), the Nikkō Bosatsu (Sūryaprabhāsa), the Gakkō Bosatsu (Candraprabhāsa), the Kichijōten (Mahāśrī), and the Benzaiten (Sarasvatī), all of which were produced about 748.

The Jūichimen Kwannon at the Shōrinji belongs stylistically to the first group. The second group had been moved to the

Hokkedō from another place and is of the same style and date as the Shitennō at the Kaidanin of the Tōdaiji and the Jūni Shinshō in the Tōdaiji and the Shin-Yakushiji. Of this group, the images of the Shūkongōjin, the Shitennō, and the Jūni Shinshō all abundantly show passionate emotion and momentary changes of feeling, while those of the Nikkō Bosatsu and Gakkō Bosatsu and of Kichijōten show the deities in calm meditation.

The free expression of emotion marks a great advance toward realism in this sculpture. The same is illustrated by the excellent dry-lacquer portrait sculptures of Gyōshin at the Yumedono in the Hōryūji and of Ganjin at the Tōshōdaiji. Intense facial expression, the muscles of the body, and the folds of garments are naturalistically represented in the Jūdai Deshi and the Hachibushū at the Kōfukuji, produced in 734. These statues reflect the influence of T'ang China.

Toward the end of the Nara period sculpture underwent a further change, as is seen in the statues at the Tōshōdaiji. This temple was built by the Chinese priest Ganjin, who went to Japan in 754. The emperor Shōmu offered him help in the construction of a Ritsu sect temple. In the Kondō of the temple are preserved dry-lacquer statues of Rushana Butsu, Yakushi, and the Senju Kwannon or Thousand-handed Kwannon (Sahāsrabhuja). These are the largest lacquer statues produced in this period and they have domineering facial expressions suited to the massiveness of the figures, executed in a style totally different from that of Buddhist sculptures mentioned above, including those of the Hokkedō. The probable explanation of this unique style is that the images belong to the Ritsu sect, whose commandments are far stricter than those of other sects; in addition, they were presumably carved under the direction of Chinese sculptors who came to Japan with Ganjin. Besides these the Kondō preserves images of the Bonten, the Taishakuten, and the Shitennō. In the Kōdō stand the Fukūkenjaku Kwannon, the Daijizaiten, the Shishiku, and the Amida. Although most of the Buddhist images of the Nara period were of bronze, clay, or dry lacquer, some of the statues in the Tōshōdaiji are made of wood. They are carved out of a single tree trunk. This new technique, believed to have been introduced by the Chinese carvers who accompanied Ganjin to Japan, is called *ippon-bori*. These wooden statues are more rounded than lacquer images of the period and create a more solid impression. The style and technique employed in their production led to the new style of the Buddhist sculpture in the Heian period.

Special mention must be made here of the Gigaku mask (PL. 278), a unique branch of the sculpture of this period. Gigaku reached its zenith in the second half of the Nara period, dwindling to nothing in the middle of the Heian period. Among the extant wooden masks of this type, mostly of the Nara period, are 31 masks in the collection of the imperial family; 164 masks in the Shōsōin of the Tōdaiji which were used in Gigaku performances for the "eye-opening ceremony" that marked the completion of the Great Buddha at the temple; and 33 masks at the Tōdaiji temple itself.

Painting. Although no detailed account can be given of the painting of the Nara period, since no more than ten Nara paintings, either religious or secular, survive today, these works as well as a few references in the literature lead us to believe that painting probably played a role equal to that of sculpture during this period. The painters of the Asuka period had copied with little understanding or criticism the Buddhist paintings produced in China and Korea; the Japanese painters of the Nara period "assimilated" some well-chosen T'ang religious paintings and with this inspiration they enlivened their own works. The establishment of imperial rule and the constriction of the court and capital stimulated the development of such nonreligious paintings as were required for decorating the interiors of palaces and mansions. In this secular field also Japanese artists took the works of T'ang China as their models. The progress achieved in both religious and secular paintings, which enabled Japanese painters to represent in their own work the ideals of Japanese Buddhism and court

life, amply proves that the painting of the Nara period had developed greatly since the Asuka period.

The most important of the Buddhist paintings of Nara date are the 45 famous wall paintings in the Kondō of the Hōryūji. These are usually divided into three groups: the first is made up of 4 larger sections and 8 smaller ones; the second consists of the figures of the Buddha's disciples painted on 13 smaller sections in the upper part of the outer chamber of the temple; the third is made up of 20 smaller sections of the figures of heavenly beings. Unfortunately, the most important of these paintings, the 32 works of the first and third groups, were severely damaged by fire in 1949 and only discolored fragments now remain, which are preserved outside the Kondō. The 12 paintings that constitute the first group are the largest of all and the figures of the Buddhas are life-size. The larger sections represent Amida in his paradise in a triad style (II, PL. 395); in the smaller sections are individual paintings

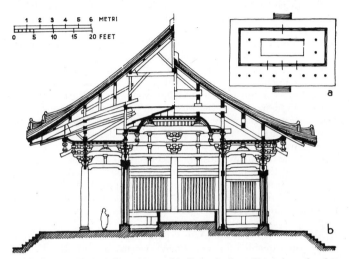

Kondō of the Tōshōdaiji at Nara. (*a*) Ground plan; (*b*) section, showing present roof at left and reconstruction of original roof at right (*after Paine and Soper*).

of *bosatsu*. The names of the Buddhas are still disputed by scholars. Although most Japanese mural paintings are done on panels, these are painted directly on the walls; shading is employed to suggest the roundness of the body and the contours are delineated with a strong line of even thickness. The wall paintings of the Hōryūji are considered to exemplify the advance eastward of an ancient type of painting, because they are closely related to works of the Gupta period (see GUPTA, SCHOOL OF) in India and T'ang China. The murals were painted in 711 and we may reasonably suppose that wall painting of the late Nara period continued to develop after this date. This is proved by the representation of the "Lotus-flower World," executed in 752 on the petals of the lotus throne on which the Great Buddha of the Tōdaiji is seated. This is an engraving on bronze of complicated design and composition, and the design that served as the model must have been of even greater artistic excellence. Also, the image of Kichijōten (PL. 269) in the Yakushiji, with its harmonious coloring, and the figure of a *bosatsu* at the Shōsōin of the Tōdaiji, with its forceful lines, illustrate the height of development reached in the painting of the late Nara period.

A work of special importance is the Kako-Genzai-Inga-kyō, a scroll illustrating the sutra of the Past and Present Incarnations of Shaka, painted in 735; fragments are now owned by the Hōonji, the Jōbon-Rendaiji, and the Tokyo University of Arts. The style of the painting, conservative and close to the Asuka type, suggests that the artist had copied the painting from an older model of Northern Wei times in China. This is the first instance of *emakimono*, or narrative picture scrolls; the text is written beneath the illustration. The scroll is exceptional among the works of this period, and all the fragments are remarkably well preserved.

The emperor, who lived in a magnificent palace, demanded for the decoration of the interiors a great many paintings which would be in harmony with the surroundings. On the walls and on either side of the screens used to partition rooms were painted subjects embodying the Confucian spirit or exalting the power and dignity of the emperor. In the Shōsōin of the Tōdaiji is a screen showing ladies standing under trees; this was originally decorated with birds' feathers. Every piece of furniture, vessel, utensil, or musical instrument that was used in the imperial palace was richly painted, as were the garments worn at court ceremonies. Also preserved in the Shōsōin is a lute (biwa) painted with a mountain landscape. Thus, during the Nara period Japanese painting flourished, and this was largely due to the increased power of the court.

Calligraphy. Japan adopted Chinese characters in the 5th century, but it was not until the 7th century that calligraphy, or *sho*, began to be taken seriously as an art. Because Buddhism in the Asuka and Nara periods became the focus of Japanese culture, the work of copying the sutras, indispensable to the study of Buddhism, was essential. A large number of copying experts, called *shajisei*, were trained. The aristocrats of the Nara period thought that good calligraphy was the highest accomplishment. The most ancient *sho* text extant in Japan is the four-volume Hokekyō Gisho, written by Prince Shotoku Taisha (572–621), in the possession of the imperial family. The oldest extant copy of the sutras bearing the date of its copying (686) is a volume called Kongō Baradanikyō (owned by Ogawa Hiromi, Kyoto). Of the later Nara period there remain the Shinkan Zōshū, a collection of imperial letters written by the emperor Shōmu, the Gakkiron written by the empress Kōmyō, and a number of sutras copied by the *shajisei*. These are all written in the calligraphic styles of the Six Dynasties and Sui dynasty periods.

Minor arts. In the Asuka period the artisans had been under the control of a hereditary system, but in the Taikwa Reforms of 645–46 their freedom of occupation was admitted. The government was able to build up a system by which it could employ excellent artists. Also, between 701 and 703 several governmental departments were established which superintended every kind of industrial art (textiles, forging, iron casting, pottery, lacquering, etc.) and trained and protected expert artisans. This development in the first half of the Nara period produced the brilliant flowering of minor arts that came in the second half.

A few works of the first half of the period remain. Among them are two canopies in the Hōryūji and the copper bell at the Myōshinji in Kyoto. The canopies hang over the Shaka Triad and the Yakushi Triad; they are rectangular in shape and consist of a metal plate of openwork, a net knitted with thread dotted with glass beads and jewels, a piece of material, and a wooden frame; they are beautifully painted in five colors and decorated with small wooden images of heavenly beings and phoenixes. The copper bell is the oldest in Japan, and bears an inscription indicating that it was cast in 698.

Thousands of objects are preserved in the Shōsōin of the Tōdaiji. These were dedicated to Rushana Butsu by the empress Kōmyō in 756, and a catalogue of the objects, called the *Kenmotsuchō*, still exists. Works in lacquer, gold, leather, wood, paper, textile, stone, pottery, glass, and cloisonné are included. There are utensils used by the emperor Shōmu either officially or privately in the court, as well as implements used for the "eye-opening ceremony" of the Great Buddha and for the ceremony of the anniversary of the death of the emperor Shōmu, and those donated to the Great Buddha by noblemen; in short, they are all the everyday necessities of the court and courtiers of the period. Many of the objects were imported from T'ang China; some show Persian influence. Beauty of decoration can be truly appreciated among articles preserved in the Tōdaiji in which gold and silver are used for inlay and gilding. Minor arts of the Nara period are also found in many other temples.

With the establishment of an organized state, complicated rules were instituted concerning ceremonial dress and crowns to be worn by the emperor and government officials; the rules required them to wear garments of different design and color according to their official rank, and this greatly encouraged the art of making and dyeing textiles. For dye, vegetable materials were used, producing 60 to 70 different colors. There were three techniques for making designs by means of color: 1. *rōketsu* or batik technique; 2. *kyōketsu* or block-printing technique; and 3. *kōketsu* or tied-and-dyed technique. The materials used in this period were cotton, hemp, and silk, of which silk was the most valued. According to the way in which it was woven silk fabric was named *ra* (silk gauze), *aya* (damask), *nishiki* (brocade), and *shokusei* (patterned silk). The *nishiki* in particular was rich and intricate, the patterns being woven either in the warp or in the woof. The *shokusei* corresponded to the modern *tsuzure-ori*, and the Taima Mandara at the Taimadera, said to have been made in 763, is a fine example of it, so exquisitely woven that it can hardly be distinguished from a painting. An embroidered Shaka-Seppō-zu (Preaching Shaka) in the Kajuji was imported from T'ang China.

From the early unglazed earthen pottery developed glazed pottery that was shaped by a *rokuro* (potter's wheel); this was mainly ceremonial ware. Dishes and bowls in "three-color ware" (glazed white, green, and yellow) were also made and are now preserved at the Shōsōin of the Tōdaiji. However, the development of ceramics remained far behind other minor arts of the period.

HEIAN PERIOD (794–1185). *Architecture.* In 794 the capital was moved to Heian, the present Kyoto city. The 400 years that followed, until the time when Minamoto Yoritomo seized political power and founded a military government in Kamakura, are called the Heian period. During the first 100 years the emperor ruled the country according to national laws and the reign was not unlike that in the Nara period; this is known as the early Heian or Jōgan period. In the next century the Fujiwara family, filling the office of regent, took the reins of the empire from the emperor and the power and influence of the nobles reached their zenith. During the next 200 years political power was in the hands of retired emperors and the aristocratic society, while powerful local chiefs trained soldiers to stand against the aristocratic power. The era from 894 to 1185, the late Heian period, is often referred to as the Fujiwara period. Each of these three periods has its own characteristics, which are reflected in the arts of the time.

The imperial palace of the new capital was called Daidairi, and was divided into three sections: the Chōdōin, where the emperor administered the affairs of state and where ceremonies were held; the Burakuin, where various ceremonies also took place; and the Dairi, where the emperor and empress lived. In each section there were a number of large buildings intended for different purposes, and each was surrounded by many offices dealing with administrative affairs. Of these the Burakuden and the Daigokuden were the largest buildings. The Daigokuden, or great hall of state, was roofed with green tiles and the woodwork was painted red. It stood on a stone base, and was modeled on the palace buildings of T'ang China. Other buildings were of purely Japanese style, built of plain wood, thatched with the bark of the *hinoki* (cypress) tree and floored with planks. The entire palace, completed in 805, was destroyed by fire for the first time in 960, and burned down 15 times afterwards; the Chōdōin and the Burakuin were not rebuilt in the final reconstruction. Since then, all the court ceremonies have taken place in the Shishinden (ceremonial hall) or the Seiryōden ("serene and cool chamber"), which belong to the Dairi. The present buildings of the Shishinden and the Seiryōden, though reconstructed in 1854, still retain the original plan of the buildings of the Heian period (FIG. 858).

There were also detached palaces, such as the Shinsenen, with a beautiful garden that harmonizes perfectly with the building, the Reiseiin, and the Sujakuin. As the power of the aristocracy became stronger and their daily life attained the same level as that of the court, they perfected the style of their mansions, using the Shinsenen as their model. This style of architecture, perfected by the beginning of the 10th century,

is called *shinden-zukuri*; it was the typical mansion style for nobles from the middle of the Heian period until the Kamakura period. The Byōdōin, now a temple, was first built as a villa for Fujiwara Michinaga and serves as a representative example of *shinden-zukuri*. In contrast to his, the houses of the common people were mere one-story cottages, roofed and floored with boards, the façades measuring 17 ft. at the most.

The style of Shinto architecture was almost finally fixed between the Nara period and the early Heian period, but the Kitano Shrine, erected in 947, and the Itsukushima Shrine, built in 1169, belong to a new style. Many new Shinto buildings were erected and were much influenced by Buddhist architecture in their design, construction, and details; the "colored" style, in particular, began after the Heian period. As it was customary for most of the shrines to be rebuilt after a certain number of years, very few retain their original buildings. The innermost building of the Ujigami Shrine is an example of Shinto architecture of the middle part of the Heian period (latter part of the 11th cent.).

In the Heian period, Buddhism, though it had lost national patronage, still flourished because of the religious fervor of the imperial family and nobles. Thus the repairing of old temples and the building of new ones continued vigorously. Two big temples were erected in Heian resembling the Kōfukuji: the Tōji (east temple) and the Saiji (west temple). In the early Heian period *mikkyō*, or esoteric Buddhism, was introduced in Japan and became more popular than *kengyō*, or traditional Buddhism, and it was *mikkyō* which inspired the temples of the period. *Kengyō* temples were built in cities and towns, *mikkyō* temples on the mountains; this meant that the arrangement of buildings was subject to change according to the natural features of the mountain. *Mikkyō* temples, moreover, developed special buildings, such as the Tahōtō (a type of pagoda), Jōgyōdō, Godaidō, and Gomadō, which are not found in *kengyō* Buddhism. The first *mikkyō* temple was the Enryakuji, on Mt. Hiei, established in 788 by Saichō (or Dengyō Daishi), founder of the Tendai sect; when finished, the monastery was so large that 3,000 priests lived there. Next came the Kongōbuji, on Mt. Kōya, established in 816 by Kūkai (or Kōbō Daishi), founder of the Shingon sect; the Tahōtō here was 151 ft. high, and was the tallest religious edifice in Japan at that time. The Jingoji in Kyoto city, the Kanshinji in Osaka prefecture, and the Murōji in Nara prefecture were all constructed about the same time, but only the pagoda and Kondō of the Murōji are the original structures. The five-storied pagoda, roofed with the bark of the *hinoki* tree, and the Kondō fit gracefully into the mountain background.

In the middle and later parts of this era a vast number of large Buddist temples were built by the imperial family, by the Fujiwaras, and by the nobles; of these the following still exist: the five-storied pagoda of the Daigoji, in Kyoto prefecture (finished 951); the Hōōdō (phoenix hall) of the Byōdōin (1053; PL. 284); the main hall of the Jōruriji, in Kyoto prefecture (1108); and the Konjikidō (golden hall) of the Chūsonji, in Iwate prefecture (1124). The interior of the Hōōdō is decorated with *raden* (inlaid mother-of-pearl) and painted; the roof is surmounted by two copper phoenixes. The Konjikidō was erected by Fujiwara Kiyohira; the interior glitters with gold foil laid over black lacquer in the *maki-e* method. Besides these, there remain some superb buildings in Kyoto: the Amidadō of the Hōkaiji, the Yakushidō of the Daigoji, the Kondō of the Sanzenin, the Kōdō of the Kōryūji, and others. These all illustrate how in the late Heian period the T'ang style of building in Buddhist architecture was superseded by a purely Japanese manner. Moreover, at this time Buddhist temples were constructed to serve as dwelling places as well as places of worship. The interior decoration and the construction in every part of the buildings became delicate and refined, which points to a relation between temple architecture and the *shinden-zukuri* style of residential architecture.

Sculpture. The *ippon-bori* (sculpture from a single tree trunk) method of carving Buddhist images, which had been introduced in the last years of the Nara period, became very common in the early Heian period. Wood was used almost exclusively for statues. The reasons usually ascribed for this use of wood are the abundance and cheapness of this material in Japan; the influence of the Buddhist images of the Tōshōdaiji; and the popularity at this time of sandalwood images imported from China, which led to the style known as *danzō* (a figure carved out of the *dan*, or sandalwood, tree).

The *ippon-bori* style of sculpture gave rise to two distinct styles. The first is called the T'ang style, a fusion of the style of the Tōshōdaiji with the *danzō*. The following statues, all of the early Heian period, are representative of this style: the Yakushi statues in the Jingoji at Kyoto, in the Gangōji at Nara,

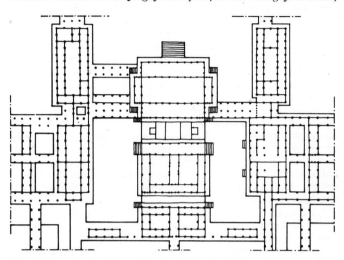

Plan of the central building of the imperial palace at Kyoto (*after Paine and Soper*).

and in the Shin-Yakushiji at Nara; and the Jūichimen Kwannon in the Hokkeji at Nara. These statues have massive bodies with heavy bellies and thighs, and the faces have rather mysterious expressions; they are quite different from the images in the Hokkedō of the Tōdaiji (II, PL. 392). The drapery has the characteristic *hompa* (rolling waves) style, a series of curving, ridgelike folds whose waves are alternately carved — a high one and a low one — the top of the high wave being rounded and that of the low one pointed.

The second style is called *mikkyō* and is represented by the following statues: the Godai Myōō (Five Great Kings), the Shitennō, and five images of *bosatsu* sculptured around 839, all in the Tōji at Kyoto; the Nyoirin Kwannon (Cintāmaṇicakra) in the Kanshinji in Osaka prefecture, also carved around 839; and the Godai Kokūzō in the Jingoji, ca. 854. *Mikkyō* (esoteric Buddhism) was first introduced from T'ang China by Saichō in 805 and Kūkai in 807. It emphasized the salvation of believers by incantations and prayers and therefore gave the sacred images mysterious expressions and attitudes to make their magical efficacy more powerful. The two *mikkyō* sects won the favor of the imperial family and the aristocrats and developed rapidly, becoming the most powerful Buddhist sects. Thus statues in the *mikkyō* style became the main current of Heian sculpture, although the traditional style of the Nara period still survived, as exemplified by the following nine statues: the Shitennō images at the Kōfukuji in Nara (792) and at the Daianji in Nara prefecture (reputed to have been made in 807) and the Amida in the Kōryūji at Kyoto (ca. 792). The Amida and the Shitennō at the Daianji are in the *ippon-bori* style and may be said to retain an early Heian form.

In the later 9th century the two styles — *danzō* and *mikkyō* — merged into one. A perfect example of this is the seated statue of Shaka at the Murōji in Nara prefecture. In the middle of the Heian period the Yakushi images in the Daigoji (ca. 908) and the Hōryūji still retain the massiveness characteristic of the early Heian period. But in the Amida of the Iwafunedera in Kyoto prefecture (946) and the Yakushi of the Kōfukuji (1013) the harmony of figure and proportion has gone, and the expres-

sion on the faces has become almost cheerful — quite different from the images of the early Heian period. This reflects the fact that sculptors now sought to portray softness rather than strength.

The aristocratic spirit was most typically expressed in the image of Amida in the Hōōdō of the Byōdōin, carved by the famous Buddhist sculptor Jōchō in 1053. Besides this change of style there was also a major change in the technique of wood carving. The image of Amida by Jōchō was not sculptured out of a single tree trunk but was made by the joined-wood technique (*yosoki-zukuri*). Each section of a statue — hands, feet, head, and body — was carved separately, and the parts were then put together to make up the whole, which was hollow. There were various advantages to this method: no big tree trunk was needed; the finished image did not weigh much; and statues could be made in a shorter time by a division of labor. The method thus originated by Jōchō was called the Jōchō style, and it superseded all other methods of wood carving and became the standard method by which Japanese Buddha images were made until the Edo period.

In the latter part of the Heian period there was a demand for delicacy rather than elegance in sculpture, and artists began laying stress on beauty of form by means of decoration. At the same time a new movement developed which tried to free itself from this tendency; the Godai Myōō statues by Meien (Myoen), made about 1176 and kept in the Daikakuji in Kyoto, are an example. This style was perfected by Unkei (q.v.) in the Kamakura period.

A special form of sculpture is the Bugaku mask (PL. 278). The Gigaku of earlier times was transformed into Bugaku, a musical drama for the courtiers, and was perfected in the middle of the Heian period. It is still performed in Japan. Examples of Bugaku masks, carved in 1042, are preserved in the Tōdaiji and others, carved in 1160 in the Tamukeyama Shrine at Nara.

Although Buddhism no longer received official protection from the state in the Heian period, it enjoyed the full support of the aristocratic class. With the appearance of a number of new Buddhist sects there was an increased demand for Buddha images.

Consequently the *busshi*, or sculptors of Buddhist images, increased in number, and were much esteemed and favored by the aristocracy. They often attained high positions; Jōchō, for example, was given the rank of *hōgen* (Eye of the Law). In addition, the profession of *busshi* became hereditary and was divided into various schools, which characterize the artistic life of the epoch.

Painting. Just as a purely Japanese school of Buddhist sculpture was established in the middle of the Heian period, so a purely Japanese school of painting, the so-called Yamato-e, originated at about the same time. It was not, however, only Buddhist painting but secular painting as well that developed and enriched the daily life of the aristocracy.

In the early Heian period when *mikkyō* was flourishing, there must have been a remarkable output of esoteric paintings, but only ten examples survive today. *Mikkyō* was characterized by solemn and mysterious ceremonies in the temples and by prayers to the Buddhas for protection from disease and disaster and for deliverance from earthly suffering. Among the paintings that decorated the interiors of the temples were the mandaras (Skr., *maṇḍala*), or magic diagrams of the Buddha world, and pictures of terrifying divinities. These paintings were mainly reproductions of T'ang Buddhist paintings brought home by the Japanese priests who studied in China. The oldest of the surviving mandaras are the Ryōgai or Kongōkai (diamond world) Mandara and the Taizōkai (womb world) Mandara, both produced in 833 or earlier and kept in the Jingoji, Kyoto. There is a Ryōgai Mandara in the Kojimadera and one in the Tōji (899), and a Hokke (or Tendai) Mandara in Boston (Mus. of Fine Arts). The Taishakuten Mandara painted on the wall of the Kondō of the Muroji is of the same date as the Tōji mandara. Other Buddhist paintings of this period are the paintings of the Jūniten (Twelve Devas) in the Saidaiji, Nara, produced in the middle of the 9th century (PLS. 270, 274), and three

paintings of the Godai Rikiku (Five Awesome Divinities) of 900 in the Daienin (one of the Junji Hachiman monasteries; PL. 274). All these works were produced after the fashion of the T'ang dynasty, and show pleasing effects of light and shade. Portrait paintings of famous monks of the esoteric sects were produced in large numbers about this time, as was the custom among Buddhists. Of all the imported portraits, the oldest are those of the Chinese Shingon patriarchs painted by Li Chên in the 8th century. Kūkai brought these to Japan and had the portraits of Lung Mên and Lung Chih painted on these Chinese models in 821; these pictures are still preserved at the Tōji.

Although the monasteries of the esoteric sects were originally located on mountains or in forests, in the middle of the Heian period *mikkyō* became urbanized; its religious rites became part of the annual functions of the court, and the sects themselves were popularized. Thus, though *mikkyō* paintings were still produced in abundance, they lost their intrinsic qualities because of the artists' eagerness to adapt their works to the taste of the nobility, and in the end they differed from Buddhist paintings of other sects only in subject matter. Furthermore, with the growth of the Jōdo sect, the solid, dynamic, and massive portrayals of the first half of this period gave place to flat ornamentation. The Ryōgai Mandara and the wall paintings of the eight Shingon patriarchs in the pagoda of the Daigoji in Kyoto prefecture, painted in 951, still follow the style of the early Heian period, whereas the mural paintings of the Amida Raigō (showing the descent of Amida to welcome the spirit of his believer) in the Hōōdō of the Byōdōin, painted in 1053, are typical specimens of Jōdo sect painting. The murals represent the nine levels of Amida's Western Paradise and decorate the wall behind Amida's image and the three doors of the Hōōdō; they are entirely new in composition and typically Japanese in design, and are close to the style of landscape paintings. The Nehan (*parinirvāṇa*, or Death of the Buddha; dated 1086) in the Kongōbuji (II, PL. 378) also deserves mention.

Prominent among other works of art in this period are the Resurrection of the Buddha (commonly called the "Buddha rising out of the golden coffin") kept in the Chōhōji, Kyoto (PL. 275), and the Amida Raigō in the Daienin (a Junji Hachiman monastery) and in the Hokkeji of Nara. The Daienin painting is an especially large work consisting of three pictures representing Amida, surrounded by a score of Buddhist *bosatsu*, flying across the sky to welcome his believers. Its grand composition and realistic style make this one of the best Buddhist paintings ever produced in Japan.

Buddhist painters were generally called *e-busshi* as distinct from *busshi* or Buddhist sculptors. The *e-busshi* took holy orders and, like the *busshi*, held a high social rank; various schools were founded and became hereditary.

Before the early Heian period most of the nonreligious paintings were imitations of Chinese work of the T'ang dynasty, but the development of *shinden-zukuri* architecture gave rise, in the middle of this period, to an absolutely new school of painting, reflecting the Japanese way of life. This was known as Yamato-e, or Japanese painting, in contrast to Kara-e, or Chinese-style painting. Yamato-e includes paintings executed on screens, often representing landscapes, separating the rooms of *shinden-zukuri* buildings and scroll paintings and paintings in the form of a book. Japanese in subject, thought, and sensibility, these paintings were the first to free themselves completely from Chinese influence. The best expressions of Yamato-e of this period are usually known by the name of *kinu-e* or paintings on silk. Most of them are either *shiki-e* (paintings of the four seasons) or *meishō-e* (landscape paintings). Characteristic of these paintings is the precision with which they are depicted and the *waka* or poems accompanying them. The only large-sized Kara-e of the period that survives today is the *sansui byōbu* or folding screen, executed in the 11th century and preserved in the Tōji, which represents scenes from the life of the great Chinese poet Po Lo Tien (PL. 277). Nothing remains of the larger Yamato-e of this time, but their style and technique can be deduced from the mural paintings in the Hōōdō, the series of paintings called the Shōtoku Taishi E-den, representing scenes from the life of Prince Shōtoku Taishi (originally in the E-dono

or Picture Hall of the Hōryūji but transferred to folding screens, which are preserved in the imperial collection), and the Raigō paintings of the imperial collection.

Among the smaller works the following are outstanding: the Genji Monogatari (Tale of Genji) scroll in Nagoya (Tokugawa Art Mus.), believed to have been painted by Fujiwara-no-Takayoshi in 1119; the 12th-century Shigisan Engi (history of Shigisan), kept in the Chōgosonshiji in Nara prefecture; the late-12th-century Story of Ban Dainagon in the Sakai Collection (PL. 287); the illustrations of the Buddhist scrolls presented in 1141 to the temple of Kunōzan hill and now in the Muto Collection; and the Buddhist scrolls known as Heike-no-kyō, donated by Taira-no-Kiyomori to the Itsukushima Shrine about 1164–67.

These paintings were usually kami-e, or paintings on paper. The Genji Monogatari scroll was painted by a method generally known as tsukuri-e in which a thin ink outline and thick colors were used. The paintings produced by this method were also called onna-e, or feminine pictures, because they were generally symbolic and esthetic, while vigorous pictures which depended almost wholly on line with only a slight addition of color were called otoko-e, or masculine pictures. The Shigisan Engi is an example of the second type. In the middle of the Heian period stories, histories, and biographies were used as subject matter, and the paintings reflect the literary taste of the period. They are called monogatari-e or narrative paintings, and technically belong to the tsukuri-e group. Here there is no connection between the illustration and the text. Even when copying sacred writings the men of this time were more interested in the portrayal of secular life than in the contemplation of religious truths. This tendency is reflected in the set of senmen-kosha-kyō, or fan-shaped sutras, kept in the Shitennōji in Osaka (PL. 286), produced in 1188.

There was a second technique, called sumi-e (or suiboku-ga, India ink drawing); lines of different thicknesses are used and the ink tones are varied. Representative works of the latter group are the Animal Caricatures Scroll (Chōjū-giga; PL. 287; III, PL. 435; IV, PL. 282; X, PL. 255) preserved at the Kōzanji, Kyoto, and believed to have been drawn by Kakuyū (1053–1140, commonly called Toba Sōjō).

As mentioned above, the e-busshi were members of the priesthood; the painters who produced secular paintings were generally laymen, and some were in the employ of the imperial court. In 808 the E-dokoro, or bureau of painters, was put in charge of all matters relating to paintings and painters of the imperial court; this bureau appointed a number of professional painters as e-shi, or official painters. In the latter half of the period the head of the E-dokoro was called the E-dokoro-no-Azukari. This system remained in force until the Meiji Restoration.

Calligraphy. In the early Heian period the calligraphic style of the T'ang dynasty was learned. The emperor Saga (786–842), the priest Kūkai (774–835), and Tachibana-no-Hayanari (d. 842) were called the three great masters of calligraphy. In the middle of the Heian period, a purely Japanese style was created in calligraphy, as it had been in painting. It was Ono Michikaze (Dōfu, 894–966) who paved the way, followed by Fujiwara-no-Sukenari (944–998) and Fujiwara-no-Yukinari (972–1027); these were the three masters of this era. As the writing of ideograms became more Japanese, the running style (sō) was transformed in the early 10th century into hiragana (III, PL. 15). In the later part of the Nara period, some of the Chinese characters had been discarded and the remainder were called katakana. There are, then, two kinds of kana — hiragana (running script) and katakana (side script) — both evolved from Chinese ideographs.

Hiragana is more complicated in form, and thus can be considered an element of calligraphic art. It was generally used by women and in this it may be compared to the relation between Yamato-e and onna-e in painting. In the later part of the Heian period both men and women composed waka (31-syllabled poem) and wrote stories and romances in hiragana combined with Chinese characters. In the following two works the running style has been used: the two-volumed Ko-

kinshū, written in 1120 (in the possession of Mitsui Takahiro, Tokyo), and the Sanjūroku-nin-shū, a collection of poems by 36 poets in 36 volumes, written about 1120 (in the Nishi Honganji, Kyoto; PL. 286).

Minor arts. In the middle part of the Heian period the aristocratic class was firmly established and held great political and economic power. The nobility lived in the greatest style, as manifested by the typical shinden-zukuri architecture. The interiors were as elegant and sumptuous as the exteriors. It may be said that here for the first time a purely Japanese mode of life came into existence.

Of all the crafts that of lacquer made the most spectacular development. This period gave birth to the unique technique of maki-e, in which gold is used to represent pictures on a lacquered background, and also to raden, the inlaid mother-of-pearl technique. The oldest pieces are the hōsōgemon maki-e sasshibako, or book box with a honeysuckle pattern, made in 919, preserved at the Ninnaji in Kyoto (PL. 417), in which, however, the old technique of the Nara period is used; the hōsōgemon maki-e kyōbako, or sutra box with a honeysuckle design, preserved in the Enryakuji, in Kyoto prefecture, made in the 11th century and showing a newer technique; and the sawachidorimon maki-e karabitsu, or big, deep box with a design of plovers flying over a marsh, made in the 12th century, in the Kongōbuji, Wakayama (PL. 288). This box shows a design of purely Japanese character, more complex than the earlier examples, and free instead of being geometrically angular. The surfaces of these boxes have elaborate kebori designs, a fine hairlike incision of decorative carving.

The art of metalwork developed more for the manufacture of butsugu, or articles used for decoration or for ceremonies in the temple (PL. 302), than for objects of daily use, but since the butsugu were usually manufactured according to the requirements of the Buddhist religion there was little change in their shape and form. As they were used daily by the priests, few examples remain.

For the art of shaping, beating and carving methods were applied. The keman, an openwork decoration hanging from the ceiling in front of the Buddha image in the Konjikidō of the Chūsonji, is an example. The metal fittings of the box containing the Heike-no-kyō scrolls are an outstanding example of the application of these two techniques. This sutra case was presented by Taira-no-Kiyomori in 1167 to the Itsukushima Shrine.

The most beautiful metalwork objects are the mirrors. In the Nara period tōkyō, or T'ang-made mirrors, imported from China, were used, but in the Heian period Japanese craftsmen began producing their own. These are known as wakyō, or Japanese mirrors; they are smaller and flatter than the Chinese ones and have lovely decorative designs on their backs.

A distinctively Japanese sense of color appeared in this era and was most remarkably reflected in the coloring of the clothes. In the middle part of the period the sokutai dress was worn by men and the jūnihitoe dress by women. These were made of silk with dyed or woven designs. The priests' robes were made in the same way. Every kind of cloth, but principally silk, was manufactured, and the dyeing and weaving industries developed rapidly. The sense of color in textiles was even stronger than in painting. Unfortunately, no entire pieces of decorated cloth have survived, only a few fragments from the latter part of the period.

In contrast, the ceramic industry showed little development. The traditional pottery made of gray clay, baked, shaped, and simply marked, continued to be produced and was used in Shinto rituals and in everyday life. Green-glazed tiles and vessels for use in the imperial palace were also made.

KAMAKURA PERIOD (1185–1333). *Architecture.* In the feudal Heian period samurai, or military retainers, were appointed to take charge of the many tracts of land, called shōen, owned by the aristocracy. Gradually these warriors acquired more power and fell into two opposing factions, headed by the Taira and Minamoto families. They contended with each other

in the hope of obtaining the right of government till finally in 1185 Minamoto Yoritomo conquered the Taira family and the aristocrats, seized power, and moved the seat of government from Kyoto to Kamakura. In 1192 he founded the Bakufu or Shogunal Government at Kamakura. Thus began the military government of the samurai with the emperor still residing in Kyoto as nominal head of the state; this lasted until 1333, when power was seized by the Ashikagas.

The imperial household and the aristocracy, whose authority and economic powers had so dwindled, were in no position to encourage new art, but were only able to keep up the tradition of the *kuge*, or court, culture that had developed during the Heian period. The vast area of the Daidairi in Kyoto, where the emperor's palace, his living quarters, and many official buildings stood, burned in 1227, and the Dairi, the Shishinden, and the Seiryōden were rebuilt on a smaller scale. The style of building employed there has been handed down to this day, as may be seen in the Kyoto Gosho structure.

The aristocrats, who during the Heian period had lived in *shinden-zukuri* mansions, had become so poor that they could no longer afford to build in that style, which required large tracts of land and a variety of buildings. They were obliged to restrict themselves to the *shinden*, or principal building, and a few adjacent buildings. The samurai simplified still further this already simplified scheme.

With regard to Shinto architecture, it is to be noted that no new form appeared in the Kamakura period. After the late Heian period the Rōmon (two-storied gate) and the Kairō (corridor) of Buddhist architecture were included in Shinto shrines, and in these shrines the Buddhist architectural influence becomes more and more apparent.

Changes and new developments took place in Buddhist architecture. During the hostilities between the Minamotos and the Tairas the Tōdaiji and the Kōfukuji in Nara had been almost completely destroyed; now the emperor, the courtiers, and the samurai all strove together to reestablish what had been the center of Buddhism since the Nara period. The Hokuendō (northern octagonal hall) and three-storied pagoda of the Kōfukuji were reconstructed in the traditional Japanese style of the Heian period. Other important examples of the Japanese style are the Tahōtō of the Ishiyamadera in Shiga prefecture, built in 1193 (PL. 285), and the Hondō of the Rengeōin, Kyoto, built in 1266. The latter is popularly known as the Sanjūsangendo (hall of 33 spaces).

The Tōdaiji, on the other hand, was rebuilt in a new mode hitherto unknown in Buddhist architecture; later this came to be called the Tenjikuyō, or "Indian," style. This was a style of Buddhist architecture of the Sung dynasty of China, which the abbot Chōgen, who was in charge of the reconstruction of the Tōdaiji, had seen on a journey to China in 1168. In collaboration with Ch'ên Ho-ch'ing, an excellent Buddhist image sculptor who came to Japan with him, Chōgen drew plans for the Tōdaiji and under their joint supervision it was erected. The present Nandaimon and the belfry date from this time. The Jōdodō of the Jōdoji in Hyōgo prefecture, erected in 1192, is another representative example of Tenjikuyō. The special features of this style are the use of huge wooden beams and bracketing.

Another new style of architecture was introduced to Japan by Eisai, a priest of the Zen (Chinese, Ch'an) sect who returned from China bringing the style of building employed by the Zen sect during the Southern Sung dynasty; this was afterwards called Karayō or Chinese style. The first Zen temple in Japan was the Kenninji in Kyoto, built by Eisai in 1202, and the perfect example of this style is the Kenchōji in Kamakura (1253). Characteristic of Karayō is its symmetrical plan and light structure; the only extant example of this type is the Shariden (relic hall) of the Engakuji in Kamakura, built about 1279 (PL. 284).

Sculpture. The *busshi* who took charge of making the Buddha images for the reconstructed Kōfukuji and Tōdaiji was Kōkei. He collaborated with his eldest son Unkei (q.v.) and his disciples, Kaikei (q.v.), Jōkei, and many others. Of their extant sculptures, the most ancient (all of 1188) are the statues of Fuku-

kenjaku Kwannon, of the Shitennō, and of the Hossō Rokuso (Six Patriarchs of the Hossō sect), preserved in the Nanendō of the Kōfukuji. Kōkei was born and grew up in the last decade of the Heian period, and his works reflect the style of those years; but the special features of sculpture in the Kamakura period are seen in the works of Unkei, his son. Unkei collaborated with Kaikei in 1203 in modeling the Niō (PL. 291) in the Nandaimon of the Tōdaiji and the statues of Miroku, Muchaku (Asanga), and Seshin (Vasubandhu) in 1208 at the Hokuendō of the Kōfukuji. That Unkei, when young, was influenced by his father and followed the style of the Heian period can be proved by the image of the Dainichi Nyorai (Vairocana Tathāgata; PL. 292) in the Enjōji in Nara, carved in 1176; the above-mentioned works made in his middle years are quite different in style. The Niō are huge statues standing 27 ft. high, with furious expressions and exaggerated movements of the body. If the images of Muchaku and Seshin are compared with the images of the Hossō Rokuso by Kōkei, it will be seen that the realism of Unkei expressed the personalities of the high priests whereas Kōkei's statues are more formal. It was Unkei who first attained the strength and realism peculiar to sculpture and who gave birth to the special features of sculpture in the Kamakura period.

Pieces of crystal were first used for eyes in the Amida Triad (1151) at the Chōgakuji in Nara prefecture, but the technique became widespread in the time of Unkei. It added to the realism of the images. The decorative objects attached to the images of the Buddha were now made of metal, jade, and jewels instead of wood, and this too produced a realistic effect. The portrait of Chōgen, director of the reconstruction of the Tōdaiji (this is thought to be a probable work of Unkei), is typical of the portrait sculpture of the time, perfectly portraying the features of a wise high priest. A similar movement appeared in painting with a technique called *nise-e* (likeness pictures), which attempted to catch the actual character of the men portrayed. A technique with just the same intention as *nise-e* which may be termed portrait sculpture was adopted in the middle of the Kamakura period. Examples are the secular portrait statue of Uesugi Shigefusa at the Meigetsuin, Kamakura (PL. 294), that of Hōjō Tokiyori at the Kenchōji, Kamakura, and others.

The sculptors Jōkei and Kaikei cooperated with Unkei in furthering this realistic style. Jōkei carved the image of Yuima (Vimalakīrti) in the Kōfukuji in 1196, images of Bonten and Taishakuten in 1201, and also Niō statues (VII, PL. 396). Kaikei's representative works are the statues of Miroku (Boston, Mus. of Fine Arts; formerly Kōfukuji), of Kujaku Myōō (Mahāmayūri) in the Kongōbuji in Wakayama prefecture (1200; PL. 345), of Sōgyō Hachiman, or Hachiman in priestly attire, in the Tōdaiji (1201; PL. 295), and of Amida in the Tōdaiji (1208). The realistic style of Kaikei, however, is in striking contrast to that of Unkei: Kaikei's figures are calm and gentle, with graceful features and elegant pose, profusely painted, while Unkei's show dynamic, inner power.

This realism in the sculpture of the Kamakura period may have reflected the spirit of the samurai of the time, but more directly it was influenced by the rising realism in the sculpture of contemporary Sung China. It is generally held that the earnest devotion of Chōgen and Ch'ên Ho-ch'ing to the Chinese style and their own example contributed greatly to furthering the realistic tendency of the art of the time.

Unkei worked on a large number of Buddhist statues for temples throughout Japan; consequently his style spread far and wide and was continued by his eldest son, Tankei (1173–1256), Tankei's five younger brothers Kōun, Kōben, Kōshō, Unga, and Unjō, and many of their disciples. Tankei made the statue of Senju Kwannon in the Rengeōin in Kyoto (1254) and three images of Bishamonten (Kubera) in the Sekkeiji in Kochi prefecture; the Tentōki and Ryūtōki in the Kōfukuji (both 1213), demons (*oni*) holding lanterns in their right hands, are by Kōben; Kōshō carved the statue of Kūya, a famous priest, at the Rokuharamitsuji in Kyoto and an Amida at the Hōryūji (1232). In the latter part of this period sculpture began to decline, but it could still produce an exceptional work: the bronze statue of Amida, popularly known as the Great Buddha of Ka-

makura, in the Kōtokuin, made in 1252, which retains traces of the style of Kakei (PL. 301).

Painting. The *e-busshi*, unlike Unkei or Kakei in sculpture, were much too conservative to start any new style in Buddhist painting of the Kamakura period. Sonchi (active 1207–24), one of the *e-busshi* who worked at the Kōfukuji, produced works that are typical of the classical style; examples are his Shōtoku Taishi Kōsan-zu, a picture representing Prince Shōtoku reading a sutra; and his picture of Tembu painted in 1212 on boards in the *zushi*, or miniature temple (in possession of the Tokyo Bijutsu Daigaku). The picture of Shinto deities painted on a board by Gyōgan in 1295 is also traditional in style.

A new style of painting was born among the Jōdo, Kegon, and *mikkyō* sects, which were widely diffused in the Kyoto district. The Jōdo sect was founded by Hōnen Shōnin at the very beginning of the Kamakura period. An offshoot of this, Jōdo-Shinshū, was founded by Shinran; this sect developed the *raigō-zu*, or a painting showing the descent of the Buddha to welcome the spirit of his believer to the Buddhist paradise.

The first painting of this kind is preserved at the Konbuin in Nara and represents Amida with 25 *bosatsu*. Unlike the pictures of the Heian period, in which the Buddha is welcoming the dead sitting quietly upright and looking straight ahead, the welcoming figures are in a half-standing position and are looking sideways. A special type of Amida Raigō was the Yamagoshi Raigō, in which the Buddha appears over the mountains. In two Yamagoshi Raigō-zu — one in the collection of Ueno Seiichi of Osaka and one in the Konkaikōmyōji in Kyoto — Amida and two *bosatsu*, painted gold, emerge from behind the mountains. Amida has white and red strings in both hands; it was believed the the departing soul, by grasping them, could enter Gokuraku (paradise), led by the hand of the Buddha. In the Yamagoshi Raigō-zu in the Zenrinji (PL. 293) the two *bosatsu* are below Amida and stand on white clouds. These paintings are characteristic of the middle part of the Kamakura period. Coming to the later part of the period, there are two pictures at the Chionin in Kyoto, the Haya Raigō-zu, in which Amida and 25 *bosatsu* rush to fetch the departing soul from his home (PL. 296), and the Kaeri Raigō-zu, which shows Amida departing, back view, having already welcomed the dead soul. The spirit of realism is evident in these descriptive paintings of the Kamakura period with their appeal to the people's hearts.

In contrast to Gokuraku there are, according to the Jōdo sect, six worlds of agony: these include *gakidō*, or the Buddhist hell of starvation; *jigoku*, the true hell; and *chikushōdō*, the tormenting purgatory. Pictures still existing that show these worlds of anguish include the Nika Byakudō-zu at the Konkaikōmyōji in Kyoto; the Jukkai-zu at the Raikōji in Shiga prefecture; and the Jūō-zu in the Nisonin in Kyoto. These are all representative works produced in the middle of the Kamakura period and the type is called *rokudo-ē*, or pictures showing the six worlds of agony (see III. col. 772).

In connection with the reconstruction of the Tōdaiji, the priest who revived the Kegon sect of Buddhism was Myōe Shōnin (Kōben) of the Kōzanji. To this temple came such *e-busshi* as Jōnin and Shunga to study and promulgate the sect. As a matter of course they painted many pictures; their school is called the Kōzanji-ha. The portrait of Myōe in the Kōzanji, painted in 1230, is believed to be by Jōnin. The Kegon Engi (history of the Kegon sect) scroll, also in the Kōzanji, and many other paintings are works of the *e-busshi* of the Kōzanji-ha.

After the middle of the Heian period the Tendai and the Shingon sects of esoteric Buddhism gradually diverged and established two separate doctrines. These sects began to collect and edit Buddhist icons. Examples are the Eigen-shō edited by Eigen in 1139 and the 57 books of Besson Zakki edited by Shinkaku about 1162. Among the collections edited in the Kamakura era which are still extant are the various icons in the Kōzanji edited by Genshō (1146–1206); the 120 books of Kakuzen-shō edited by Kakuzen before 1211; and the 280 books of Asabāshō edited by Shōchō between 1249 and 1274. Two kinds of icons were typical of esoteric Buddhist sects, one of large size, like the pictures in temples, and the other scroll

drawings; both are line drawings in black, called *hakubyō-ga.* This line-drawing technique influenced all the painting of the period.

Icons of the Southern Sung period in China were also collected and their style and technique studied; there is a close relationship between the Buddhist paintings of the Kamakura period and those of Sung China. A typical work of this Chinese style is the Butsugen Butsumo in the Kōzanji, and the artist who first used the technique was Takuma Shōga of the Tōji in Kyoto. The Jūniten *byōbu* which Shōga painted in 1191, preserved at the Tōji, is a masterpiece with vivid coloring and strongly accented lines. The Southern Sung style gradually became fashionable and was indeed the special feature of painting in the Kamakura period. It is seen in many paintings preserved in the Daigoji in Kyoto, a Shingon temple, such as the one depicting Monju (Mañjuśrī) crossing the ocean (PL. 297). The paintings of Kokūzō and of Dainichi Nyorai in the Daigoji gave rise to an ornamental style in Buddhist painting with fresh colors and serene outlines. The icons in the possession of this temple are by Genshō, Shōga, and Shinkai.

At this time two entirely new schools of painting arose: one coming from the Zen sect of Buddhism and the other from the mixture of Shintoism (q.v.) and Buddhism. The Zen sect, introduced to Japan by two great priests, was divided into the Rinzai sect, founded by Eisai (1141–1215), and the Sōtō sect, founded by Dōgen (1200–52); both of these found adherents among the samurai and developed rapidly. The Zen adherents believed that their doctrines should be taught by teachers without the mediation of images; therefore, they rejected them but did use images of high priests and especially portraits of Zen high priests for their purposes. Besides the portraits used in temple ceremonies, many were painted for high priests to present to their disciples as mementos when they attained *satori* (enlightenment). The peculiar technique and form of Zen painting had been established in Sung China and is so individual as to be easily distinguished from that of other sects; it is generally known by the name of *chinzō*. The portrait of Nyozō, which Dōgen brought back from China, now preserved at the Eiheiji, in Fukui prefecture, and the portrait of Mujun Shihan at the Tōfukuji in Kyoto, brought home to Japan by Enji Ben-en (or Shōitsu Kokushi) in 1262, are the oldest *chinzō* introduced from Sung China. Under the influence of these, *chinzō* began to be painted from the Japanese point of view. Representative examples are the portrait of Gotsuan Funei at the Shōdenji in Kyoto; that of Shinchi Kakushin painted by Kakukei in 1315, preserved at the Kōkokuji, near Kainan; and that of Shūhō Myōchō (Daitō Kokushi) also painted by Kakukei in 1334 and preserved at the Daitokuji in Kyoto. Although many portraits were produced as a means of promulgating the religion to the public, only a few of them are of real artistic merit.

Portrait painting, similar in appearance but different in significance from the portraits of high priests, began to be in vogue about this time, and it became popular among believers to have their own pictures drawn in the robes and style of high priests. These were objects of veneration when religious services for the deceased believers took place at their own family temples, and after the latter part of the Heian period they began to be produced in every sect. The portrait of the emperor Goshirakawa painted in the early part of the Kamakura period, now preserved at the Myōhōin in Kyoto, and that of the emperor Hanazono painted by Gōshin in 1338, owned by the Chōfukuji in Kyoto, are excellent examples of this kind. Moreover, when such religious services were held for the dead, the portrait of a powerful believer in layman's attire would be used for worship; typical examples are the portraits of Minamoto Yoritomo and Taira-no-Kiyomori at the Jingoji in Kyoto and of the emperor Gotoba painted in 1221 by Fujiwara-no-Nobuzane in the Minase Shrine in Osaka prefecture. This period was the heyday of portrait painting, reflected in the realistic tendencies of the time.

The new trend in religious painting, the only one to be nurtured by the samurai, was the so-called *suijaku-ga.* One of the characteristics of Shintoism was that is used no pictures for worship. However, after the middle of the Heian period

there arose a theory that Shinto gods are manifestations of the Buddhist deities; this is called *honji-suijaku*. As the Kamakura *buke*, or warriors, adapted the Shinto philosophy for their political theory and ethics, Shintoism became more and more prosperous; shrine authorities decided that pictures would be helpful for the promulgation and understanding of the religion. The pictures that resulted are called Shinto *suijaku* portraits (or *suijaku-ga*). There are two kinds of pictures in this category: one represents the Buddhist image which is said to be the original form of the Shinto deity, called *honji* mandara, and the other shows the complex of the temples depicted in a scenic manner, called *miya* mandara. Many of those paintings survive, though not all are of artistic value. Notable is the one representing the Nachi waterfall (PL. 299), which is thought to be one of the incarnations of the Kumano Shrine in Wakayama prefecture.

The *buke* of the Kamakura period lived a simple life, and had little contact with the arts in general. The court nobles, no longer in a governing position, only maintained the traditional arts of the Heian period, and so the Yamato-e, which had derived from them, and especially such large-scale pictures as those painted on the fusuma and *byōbu* used in their daily life, did not show any special development. None of them survive today except for the *sansui byōbu* which were used in the ceremonial services of the *mikkyō* sects, now preserved at the Jingoji in Kyoto. These continued the tradition of large-scale scenic painting begun in the late Heian period.

Since the court nobles appreciated, as in the preceding age, picture scrolls illustrating literary works, many of these were produced and survive today. Among such scrolls, done in the *tsukuri-e* technique like the Genji Monogatari, are the Nezame Monogatari in the Yamato Bunkakan in Osaka and the Murasaki Shikibu Nikki in the Fujita Museum of Art in Osaka. Among the pictures in the *sumi-e* technique, the representative one is the Makura-no-Sōshi (Pillow Book) in the Asano Collection, Odawara. Noteworthy among the *senki monogatari* (stories of military exploits) are the Heiji Monogatari scrolls in the Tokyo National Museum and the Boston Museum of Fine Arts (VII, PL. 258) and the Mōko Shūrai scroll, painted in 1293, in the possession of the National Commission for the Protection of Cultural Properties. Among the scrolls recording events of court life are the Kōke Retsuzō-zu, also in the possession of the National Commission; the Zuishin Kijō-zu, showing nobles riding horses, painted in 1247 and kept in the Ōkura Shūkokan, Tokyo; and the Tennō Sekkan-zu (owned by the imperial family), portraying the emperor with his *sesshō* (regent) and *kampaku* (chief advisor), painted jointly by Fujiwara-no-Tamenobu and Gōshin, his grandson. These scrolls are of great interest since they portray contemporary people and are assumed to be reasonable likenesses. Portraits done with a few simple strokes and executed on paper on a small scale are termed *nise-e* (likeness pictures); this style was devised in the Kamakura period and was perfected by Fujiwara-no-Nobuzane.

Religious scrolls can be divided into four classes according to subject matter. First come scrolls dealing with religious sutras, such as the Jigoku Sōshi, Gaki Sōshi, and Kegon Gojūgo-shō, in Tokyo (Nat. Mus.; see III, col. 772; IV, col. 815); these were all done in the very early part of the Kamakura period. Second are the scrolls that deal with the origins and virtues of a shrine or temple, for example, the Kitano Tenjin Engi (1219) preserved at the Kitano Shrine in Kyoto prefecture, the Kasuga Gongen Reigenki by Takashina Takakane (1310) in the possession of the imperial family, the Ishiyamadera Engi in the Ishiyamadera in Shiga prefecture, and many other works of this type. The third consists of picture scrolls, the subjects of which are the lives of high priests of Japan and China (PL. 298); the Kegon Engi in the Kōzanji in Kyoto and the Hōnen Shōnin E-den in the Chionin in Kyoto are representative. The last group consists of scrolls recounting tales and stories then in vogue; the representative example is the Kibi-no-Otodo Nyūtō scroll in the Boston Museum of Fine Arts, painted in the early part of the Kamakura period.

Calligraphy. In the Heian period the art of calligraphy had gradually acquired an entirely Japanese style and at the same time kana, a unique device for writing Japanese syllables, was invented. Chinese characters and kana were the two forms used in writing Japanese after the middle of the Heian period, and it was in the latter part that Fujiwara Tadamichi (1097–1164) established and perfected the Japanese style of writing.

The school which kept up this style was called Hōjōjiryū; it prospered greatly in the early Kamakura period and produced such masters of calligraphy as Jakuren, a priest (1141–1202), Fujiwara Ietaka (1158–1237), Fujiwara Sadaie (1162–1241), Gokyōgoku Yoshitsune (1169–1206), Asukai Masatsune (1170–1221), the emperor Gotoba (1180–1239), and others.

Yoshitsune's style is termed the Gogkyōgoku school, and Masatsune's the Asukai school, but these are only branches of Hōjōjiryū. The calligraphy of these masters is preserved in the Kumano Kaishi scroll, but compared with the flowing and expressive style of the Heian era the calligraphy of this later period seems severe and solemn in style.

In the latter part of the Kamakura period Son-en (1298–1356) inaugurated a new style called Shōren-in. Though suggestive of Chinese strictness, this is still only a variation of Hōjōjiryū. When this Japanese style was at its peak Eisai, Shunjō, and other Zen priests went to China, where they learned the strict style of writing used by the Zen sect. This style was adopted and developed by Zen society in Japan.

In the latter part of the period, however, a free style of writing of a Zen priest in the Yüan dynasty was introduced into Japan and used by such calligraphers as Jakushitsu Genkō (1290–1367) and Soseki (Musō Kokushi, 1275–1351), but the most brilliant master of all was Shūhō Myōchō (Daitō Kokushi, 1282–1337). In the Muromachi period the calligraphy of the Zen sect, though flourishing, degenerated into formalism.

Minor arts. Buddhism remained the main source of ispiration and development for minor arts in this period because of the need for decorative arts in the temples. Neither the nobles, who had lost their power and wealth, nor the samurai, who lived simply, demanded the luxurious objects necessary to stimulate artistic activity on a large scale.

The only artists who prospered were the lacquerers (see LACQUER). From the decoration on certain lacquered pieces of the period it can be seen that the "symbolist" tendency of the Heian period was in decline and that the realism of the age of Kamakura was beginning. The use of lacquer and inlay together to enhance the decorative effect had begun in the Nara period, but in this era almost all the *maki-e* was inlaid and inlay was used profusely on objects of wood. The gold lacquer contrasting with the bluish silvery-white of the mother-of-pearl inlay gives a pleasing effect. The black backgrounds, sprinkled with gold dust, are magnificent and differ from the ordinary *maki-e* with a black ground and with only lacquer and inlay. This kind of lacquered ground is called *ikakeji*, later known as *kinji*. A number of saddles of horses, with mother-of-pearl inlay exist (PL. 419); the one called Shigure-no-kura (Shigure's saddle) in the possession of Hosokawa Moritatsu of Tokyo is the most elaborate.

The Kamakura period saw a notable development in the making of swords and armor (see ARMS AND ARMOR). Representative examples of swords are the *tachi* (long sword) in the Itsukushima Shrine and in the Nibutsuhime Shrine. The *maki-e* technique was used in decorating the sheaths of swords, as in the sword called Uesugi-no-tachi, now in the Tokyo National Museum.

Up till the middle of the Heian period two kinds of armor were used, both originating in China; one named *tankō*, made of iron plates fitted together with rivets, and the other named *keikō*, made of oblong iron plates fitted together by straps. In the latter part of the Heian period, when the samurai were becoming powerful, they devised a unique form of armor called *yoroi*, which was strong and flexible and enabled them to fight on horseback. The generals, to display their authority, wore imposing armor, embellished with metal ornaments; examples of this may be seen at the Itsukushima Shrine and at the Ontake Shrine in Tokyo. The metalwork for the swords and armor required a precise technique of workmanship, including *chūkin* (casting), *tankin* (wrought gold), and *chōkin* (chasing).

An example of the high technical and artistic level reached in metalwork is the *sharitō* or reliquary in the Saidaiji in Nara (IV, PL. 211). The *wakyō*, or Japanese bronze mirrors, had first appeared in the late Heian period, and were manufactured in great quantities in the Kamakura period. In addition to the incised design on the back of the mirror, it became the fashion to decorate the face of the mirror with a drawing of the Buddha; this was called a *kyozō*, or mirror image.

In the field of ceramics (q.v.), the demand for *kawara*, or roof tiles, and other pottery objects either for ritual or for practical use was great. Ceramics were made throughout the country, but especially at the following six kilns: Seto and Tokonabe (in Aichi prefecture), Bizen (in Okayama prefecture), Echizen (in Fukui prefecture), Shigaraki (in Shiga prefecture), and Tamba (in Kyoto prefecture); these six kilns are called Nippon Kōrokuyō, or six oldest kilns of Japan. They produced in great quantities various kinds of utensils for everyday use, similar in style to the ceramics of the Heian period.

Katō Shirōzaemon (better known as Tōshiro) had accompanied the Zen priest Dōgen to China in 1223 to study ceramics. On his return (ca. 1229) he settled at Seto and began to make pottery by techniques called *kataoshimon* and *kokumon*, which he had learned in China. His stoneware has a light brown or black glaze. The Seto kiln became the center of pottery manufacture, and *setomono*, meaning Seto ware, is the name by which chinaware is known in Japan to this day.

MUROMACHI PERIOD (1334–1573). *Architecture*. In 1334 Hōjō Takatoki, the supreme commander of the Bakufu of Kamakura, was defeated and killed by his rival Ashikaga Takauji, and so the Bakufu of Kamakura was destroyed. Ashikaga Takauji seized political power and established his Bakufu in Kyoto in 1338. The period during which the Ashikagas ruled is called the Muromachi period, after the name of the street where the seat of government was. Like the preceding period, this was also an age of the samurai, and the power of court nobles dwindled still further so that they were unable to foster new movements in the arts. The samurai no longer lived such an austere life and gradually began to demand fine arts of their own — a characteristic of the Muromachi period.

Since the court and the nobles had lost the reins of government state ceremonies were no longer in their hands and they did not require any new buildings. The imperial palaces and mansions in *shinden-zukuri* became smaller and smaller. The samurai of the Muromachi period copied and improved the simplified *shinden-zukuri* adopted by the warriors of the Kamakura period. None of these houses remains today, except for the Tōgudō (tea-ceremony hall) built by Ashikaga Yoshimasa in 1486 and the Kwannonden, commonly known as the Ginkaku, or Silver Pavilion, built by him in 1489 (both in the temple grounds of the Jishōji in Kyoto). These, however, were villas of the Shogun and not warriors' houses.

The Kinkaku or Golden Pavilion of the Rokuonji (reconstructed after a fire in 1950) was originally a villa built by Ashikaga Yoshimitsu in 1398. The samurai residences of this period had a very large room divided into smaller rooms by fusuma, or papered sliding doors, and *hiki-chigaido*, or doors that can be opened right and left. One of the divided rooms was used for conversation: this was called kaisho (meeting place), and it contained a tokonoma (an alcove for a *kakemono*, or vertical painted scroll), a *tana* (niche with shelves on which to place decorative objects), and a *shoin* (bay window containing a reading desk).

A room in the Tōgudō named the Dōjinsai is the oldest relic of its kind. Since the samurai of this period, like the Kamakura warriors, were followers of the Zen sect, Zen temples were built throughout the country. They followed the Karayō architecture of the Kenninji built in the Kamakura period, but all were destroyed by fire except the Kaisandō of the Eihōji (PL. 310), built in 1352, and the Sammon (main gate) and Zendō (hall of meditation) of the Tōfukuji in Kyoto, built in the middle of this period. Buddhist temples belonging to other sects, though retaining the traditional Japanese style of architecture, began to be influenced by Karayō and to be built in a mixed style.

Examples of this are the Kondōs of the Kanshinji (ca. 1375; PL. 310) and of the Kakurinji in Hyogo prefecture (1398), the Tōkondō (eastern main hall) of the Kōfukuji in Nara (1416), and the five-storied pagoda of the Kōfukuji (1426). As for Shinto architecture, though it retained the style of the Kamakura period, it showed a strong inclination to absorb the form and technique of the Buddhist architectural style.

The characteristic of architecture in the Muromachi period was its abundant use of sculptural ornamentation in the interior as well as the exterior. It was also in this period that gardens became really important (see LANDSCAPE ARCHITECTURE). The garden, which came into fashion together with the *shindenzukuri* residence in the Heian period, had decreased in importance with the decline of this type of mansion. With the rise of the Zen sect the gardens attached to the temples regained their importance and reached perfection in the early part of the Muromachi period. The garden represented symbolically the world outlook and view of nature of the Zen sect; thus its construction was under the direction of the Zen priest.

Sculpture. As has been observed, the Muromachi period witnessed the spread of Buddhism, and especially the Zen and Jōdo sects, which claimed great numbers of believers all over Japan. Thus even more temples were built and Buddhist images carved than in the preceding period, but the belief in the Buddha had become superficial and formal, and sculptural art deteriorated. It may be said that after the Muromachi period sculpture entered a decline.

Among the most representative works may be cited the Shitennō belonging to the Zen and Jōdo sects in the Hōryuji, Nara, the joint work of Kankei, Junkei, and Kōzen (ca. 1355). Sculpture of the *mikkyō* sects includes the Fudo (Acala) Triad at the Hokkedō of the Tōdaiji (ca. 1373), the Fudo Myōō at the Hōryūji, by Shunkei (ca. 1380), and the Gokei Monju by Shunkei (1460). In the Zen sect, as has been said, it was the custom to have images of Zen high priests. The oldest extant portraits are that of Shūhō Myōchō at the Daitokuji in Kyoto, made immediately after his death in 1336, and that of Soseki at the Zuisenji (ca. 1351); these were followed by many images of Zen priests. Generally speaking, Buddhist sculpture is idealistic and only a small number of works in Japan aim at realism. It is this realism that distinguishes the portrait sculpture from all other Buddhist statues.

Masks (q.v.) used in the No and Kyōgen plays first made their appearance during the Muromachi period. In Japan there were two musical plays, Gigaku of the Nara period and Bugaku of the Heian period, in both of which masks were used. There also existed from the Heian period a light drama called Sarugaku, and a rustic dance known as Dengaku was performed by the peasantry in the Kamakura period. These last two were rearranged into the No play and Kyōgen by the famous actor Kanami (1333–84) and his son Zeami (1363–1443). No and Kyōgen developed under the protection of the Ashikagas and the samurai, and today they enjoy great popularity.

The No play aims at expressing the depth of the human spirit, which the mask strives to express symbolically. Characteristic of the No masks is the intensity of feeling expressed. The No mask covers only the face. Although there are several hundred varieties of mask, used according to the kind of story, they are generally classified into five kinds: deity, male, female, madman, and demon. The oldest mask, called Beshimi, carved by Chigusa Saemondayū in 1413, is owned by the Mamehiko Shrine in Nara prefecture. In 1493, Hikakimoto Hichirō carved excellent masks of a young man (*waka-otoko*) and a young woman (*waka-onna*), now preserved at the Katte Shrine in Nara prefecture. Masks of this period are preserved by the masters of the various No schools.

Kyōgen is a comic interlude, performed in the intervals between serious No plays. Since it is the dialogue that is important, masks are rarely used; however, a few do exist. In contrast to the No masks with their serious expressions, the Kyōgen masks are comical.

Painting. Yamato-e, which had prospered under court patronage in the Kamakura period, now declined. However,

the E-dokoro still survived. The painter who was appointed E-dokoro-no-Azukari was usually the most eminent man in his field; at the beginning of the Muromachi period Nakamikado Yukimitsu became E-dokoro-no-Azukari, succeeded by his eldest son, Mitsushige, his second son, Mitsukuni, and between the years 1394 and 1428 by Yukihiro, the eldest son of Mitsushige. The name of Tosa was first adopted by Yukihiro; it is therefore a mistake to say that the family name existed from the Heian period. Members of the Tosa family from Hirokane on were appointed "official artists" by the Ashikaga Bakufu; they were acclaimed by both the court and the warrior class. Thus the Tosa family grew in power and prestige.

Many Yamato-e artists, led by the Tosa family, painted not only for the court and nobles but also for temples and shrines and for the *buke*. Many of these pictures are preserved today and include the following examples of picture scrolls: 3 volumes depicting the fighting of Gosannen-Kassen, drawn by Korehisa in 1327, in possession of the National Commission for the Protection of Cultural Properties; 10 volumes of the Boki Eshi illustrating the life of the priest Kakujō, painted by Fujiwara Takamasa and Fujiwara Takaaki in 1351, in the Nishi Honganji; 12 volumes of an illustrated history of Kōbō Daishi in the Tōji in Kyoto, drawn jointly by Kose Yukitada and five others about 1351; 2 volumes of the Yūzūnembutsu Engi, describing the origin of the Yūzūnembutsu sect, at the Seiryōji in Kyoto, a joint work by members of the Tosa family, Mitsukuni, Yukihide, and Yukihiro, together with three artists Jakusai, Ryūkō, and Eishun; and 3 volumes of the Konda Sōbyō Engi, a history of the patriarchs of the Konda Shrine.

In the middle of the Muromachi period, Tosa Mitsunobu (1434–1525) became the official artist both for the court and the Bakufu, and was granted a large tract of land as a fief; thus the social position of the Tosa family was established. Through his long life, Mitsunobu painted many murals, Buddhist pictures, portraits, and scroll pictures, of which about fifteen survive, including the Jūō-juppuku-zu, representing the Ten Kings of Hell, painted in 1489 and preserved in the Jōfukuji, Kyoto; a portrait of Go-Enyūin (1492) in the Unryūin, Kyoto; and three scrolls of the Kiyomizudera Engi, or history of the Kiyomizu temple, painted in 1517, in the Tokyo National Museum. Of the later part of this period, the following two works may be cited as representative: the three scrolls of the Kuwanomidera Engi, or history of the Kuwanomi temple (Shiga prefecture), drawn by Mitsumochi, the son of Mitsunobu; and the three scrolls of the Shinnyodō Engi, or history of the Shinnyodō (1524), now kept in the Shinsō Gokurakuji in Kyoto, painted by Fujiwara Hisakuni, a Yamato-e artist, though not of the Tosa family.

No large-size works of Yamato-e in this period are extant today, and we can imagine what they were only by viewing the *fusuma-e*, or pictures drawn on the movable room partitions, and *byōbu-e*, or pictures drawn on the folding screens, as painted in picture scrolls. Recently, however, a pair of *byōbu* consisting of six panels, entitled Hamamatsuzu, or the Hamamatsu scenery, in the possession of Satomi Chūzaburō of Kyoto, have been recognized by connoisseurs as works of the mid-Muromachi period. In this series of pictures, the sea and the shore with pine trees are given as much space as possible. The feeling of the seasons and the lyricism which are an essential part of Yamato-e are absent, replaced by a realistic representation of the beauties of nature. This is different from the traditional Yamato-e, and it may be assumed that a new type of Yamato-e came into existence at this time.

No traditional Buddhist art of freshness and excellence was produced at this time. Compared with the paintings of the preceding period, the religious pictures are inferior.

Very different from Yamato-e was Kara-e, or Chinese-style painting, which was developed in this period and may be considered the highest artistic expression of the Muromachi period.

Zen monasteries were great centers of culture at this time. *Chinzō*, or portraits of high priests, continued to be painted. Zen priests were required to be well versed in literature, to draw Chinese-style ink paintings, called *suiboku-ga* or *sumi-e*, and to be connoisseurs of art. Zen priests coming from China and Japanese Zen priests returning from China brought with them pictures of the Sung and Yüan dynasties, which became prized treasures in every temple. According to a record called Butsunichian in a Zen temple in Kamakura, the temple possessed a total of 278 pictures, of which 115 were portraits of Zen priests, 91 represented flowers, birds, and beasts, and 72 were landscapes.

These pictures are divided into three categories: *dōshaku-ga*, paintings representing the moment when *satori* is attained; *sansui-ga*, landscape paintings; and *kachō-ga*, paintings of flowers and birds. They are executed with *sumi* (India ink) and a *fude* (writing brush), generally on paper, and are known as "blackand-white" art. They aim to grasp the object intuitionally, and the result is concise and uncluttered. This was a new kind of painting, quite different from Yamato-e.

Japanese Zen priests and artists lost no time in learning *suiboku-ga*, as this way of painting expressed the spirituality and aims of the Zen sect. At first, only *dōshaku-ga* and simple pictures of orchids, bamboo, trees, and plum trees were drawn. The first Zen priest to paint like this was Mokuan, who lived in the latter part of the Kamakura period and died in China about 1345; his portrait of Kanzan is in the Nagao Art Gallery in Tokyo. About 1350, the beginning of the Muromachi period, such Zen priests as Kaō, Tesshū Tokusai, and Ryōzen became well versed in *suiboku-ga*.

An outstanding example of *chinzō* is the portrait of Soseki, painted by Mutō Shūi in 1349, in the Myōchiin in Kyoto. Zen priests who excelled in drawing were called *gasō*, or priestartists. The most outstanding for talent and versatile ability was Minchō (1352–1431), also known as Chōdensu. Many of his works are preserved in the Tōfukuji in Kyoto.

Zen priests at this time, influenced by Zen priests of the Yüan and Ming dynasties, studied Chinese poetry and were themselves fine poets who could compose in Chinese. Moreover, the Ashikaga Shoguns Yoshimitsu and Yoshimochi, fervent Zen followers, were on the most friendly terms with these Zen priests and met with them frequently to compose poems; thus they had the opportunity of seeing the imported Sung and Yüan pictures. The poetry dealt chiefly with the beauties of scenery, and it became the custom at this time to illustrate the poems. The first *sansui-ga* was done by Josetsu, a Zen priest connected with the Shōkokuji in Kyoto, whose Hyōnen-zu is preserved in the Taizōin in Kyoto; this represents a man trying to catch a catfish with a gourd (PL. 305). It was originally on a small screen used at Yoshimochi's villa, but is now a *kakemono*. On the upper space of the *kakemono* were poems by Gyokuen Bompō, who excelled in painting orchids. The *suiboku-ga* in which poetry and painting occur together is termed a *shigajiku* (hanging picture with poems); it was established in the years between 1394 and 1427 and was much in vogue among the Zen priests and *buke*. Certain powerful Zen priests built themselves private houses in the temple grounds, where they enjoyed the life of literati. They had *suiboku-sansui-ga* drawn on the fusuma or on the byōbu by *gasō*, and this custom soon prevailed among the Shogun and powerful warriors.

A *gasō* named Shūbun of the Shōkokuji, a disciple of Josetsu, visited Korea in 1423, where he was able to study Chinese painting, and so produced an improved *sansui-ga* (PL. 306). In his old age, he left the Shōkokuji and was appointed official artist to the Ashikaga Bakufu. There are many *sansui-ga* attributed to him which cannot be positively substantiated; however, a landscape *byōbu* in the Maeda Tokuiku Foundation in Tokyo may be ascribed to Shūbun. That the Ashikaga family collected Sung and Yüan pictures and loved the *suiboku-ga* may be shown by the fact that the Bakufu employed such artists as Kinami, Senami, and Nōami (Shinnō, 1397–1471) as art advisers. The style of Shūbun was taken up by two *gasō* of the Shōkokuji, Sōtan and Sesshū (1420–1506; q.v.). Sōtan's extant works consist of a *sansui-zu* in possession of Hatakeyama Kazukiyo of Tokyo and 24 panels of *sansui* and *kachō* (birds and flowers), which were executed for the fusuma of the Yōtokuin in Kyoto and are now in possession of the National Commission for the Preservation of Cultural Property. These pictures follow the style of Shūbun faithfully. Sesshū, on the other hand, created an individual style that is quite different from that of Shūbun. Sesshū's most famous work is the long landscape scroll of

1486 (Yamaguchi, Mōri Motomichi Coll.). Other works are the Eka-dampi-zu, showing Eka cutting off his arm at the elbow, painted in the same year, in the Sainenji in Aichi prefecture; two landscapes, one painted in 1495, in the Tokyo National Museum (PL. 307); the Ama-no-hashidate, representing the three great scenic beauties of Japan, painted in his old age, preserved by the National Commission for the Preservation of Cultural Property; and a landscape owned by Ōhara Sōichirō of Okayama prefecture.

The technique of these works is characterized by the use of thick lines and strong contrast of light and shade, expressing a cold attitude to the beauty of nature, quite devoid of lyricism. In that sense the style of Sesshū differs greatly from the *sansui-ga* of the period. Most of the *suiboku-ga* artists modeled their pictures on those imported from China, but Sesshū went to study in China in 1468, returning the next year. Thus he himself saw the actual scenes which were the original inspiration of *suiboku-ga*, and learned the technique at first hand. A picture such as the Ama-no-hashidate shows that, although other *suiboku* artists were painting using Chinese scenery as their models, Sesshū was depicting the actual Japanese landscape in the *suiboku-ga* style. Thus Sesshū deserves to be considered the first painter who executed true Japanese *suiboku-ga*.

In addition to Sōtan and Sesshū, there were other excellent *suiboku* artists such as Geiami (Shingei; 1431–85), who was the son of Nōami, Bunsei, Gakuō Zōkyū, and a secular artist named Kanō Masanobu (1434–1530?), each with a different technique. These artists flourished during Ashikaga Yoshimasa's rule, and his era is often referred to as the Higashiyama period.

Kanō Masanobu, being a layman, was not limited by the ideas of the Zen sect as the *gasō* were, and thus could portray more worldly feelings. He was appointed official artist after Sōtan's death. He introduced a style germane to the mentality and sentiments of the *buke*, which stripped the *suiboku-ga* of its religious and literary Chinese elements and transformed it into a style expressing strength and feeling, easily understandable by the *buke*. Of Masanobu's surviving works (PL. 351), the only one that gives some idea of this style is the painting of Hotei, one of the Seven Gods of Luck, in the possession of Kuriyama Zenshirō, Tokyo.

Masanobu's eldest son, Kanō Motonobu (1476–1559), and second son, Kanō Yukinobu (1513–75), accentuated the worldly character of the style of the Kanō family by adding color to the pictures (PL. 357), as was done in the Yamato-e of the time. At the Daisenin of the Daitokuji in Kyoto are works by Motonobu and Yukinobu of fusuma depicting landscapes and birds and flowers, as well as other large paintings (PL. 313). Motonobu united Kara-e and Yamato-e, creating a new style which is indeed the pictorial style of the Muromachi period.

In the latter part of the Muromachi period, there were such *gasō* as Sōami (Shinsō; 1472–1525), the son of Geiami, Sōami's pupil Kenkō Shōkei, Shūgetsu Tōkan and Jōsui Sōen, who were pupils of Sesshū, and Sesson Shūkei (PL. 308), who painted in the Sesshū style, but their works are inferior to those of their masters.

Another feature of the painting of this period was the diffusion of portrait paintings. The Zen custom of esteeming portraits spread to the general public and almost all the court nobles, samurai, and important people had their portraits painted in priestly or secular attire. The samurai were painted in armor and on horseback to show their authority. Representative works are the portraits of Ashikaga Takauji in the possession of Moriya Kōzō of Kyoto, of Ashikaga Yoshihisa by Kanō Masanobu in the Jizōin in Aichi prefecture, and of Hosokawa Sumimoto painted in 1508 belonging to Hosokawa Moritatsu of Tokyo.

Minor arts. Minor arts, which had been on the wane in the Kamakura period, began to develop again, with the emphasis on objects for use in the daily life of the samurai. The influence of the Sung, Yüan, and Ming dynasties in China is evident in the minor arts.

Of all the applied arts of Japan lacquer is the most exquisite. It was perfected in the Heian period, but during the Muromachi period it made even greater strides; thus these two periods mark the two highest peaks in the history of Japanese lacquer art. Until the Kamakura period the forms and shapes of articles such as *suzuri* (inkstands) and *fubako* (book boxes) were generally quite similar, but after craftsmen had seen Chinese objects they began to vary the shapes of the articles.

Hitherto the techniques generally used were *hira-maki-e* and *raden*, but a technique of relief design was now invented, termed *taka-maki-e* and *shishiai-maki-e*, by which the lacquerers succeeded in expressing a sense of volume. Other decorative techniques were also developed, such as *kirikane*, in which very thin pieces of gold or silver are cut into small square pieces and scattered on the surface of the *maki-e*; *kanagai*, in which very thin pieces of gold or silver are cut to a certain shape and applied to the *maki-e*; *chinkin*, where the design is first drawn on the lacquered ground with a sharp-pointed knife and then gold dust is rubbed in so that the outline comes up gold; and *usugai*, where sea shells are used, as with *raden*, but they are broken up into small fragments before being applied. These last two techniques derive from Chinese art of the Ming dynasty. It was in the middle of the Muromachi period, when Ashikaga Yoshimasa succeeded to the Shogunate, that *maki-e* reached its zenith. Kōami Michinaga (1410–78) and Igarashi Shinsai were in the personal service of Yoshimasa as expert *maki-e* masters and worked exclusively for the Ashikaga family; their descendants kept the position of official *maki-e* masters until the end of the Edo period.

A lacquer technique called *tsuishu* existed in China in which the designs were carved deeply through many layers of red or cinnabar lacquer varnish. The Japanese artists learned this technique and began to make *kōgo*, or vessels for storing incense, in *tsuishu*. From this they then created a technique known as Kamakura *bori*, which is still employed today.

Metalwork also prospered at this time. There was little development in the making of Buddhist vessels and utensils, and the shapes and forms of the preceding era were copied. Remarkable progress, however, was made in the decorative metalwork of swords and other military articles required by the *buke*. The number of artists who made armor and helmets increased after the Kamakura period. Typical of these professional families were the Myōchin, superb artists who produced such decorative articles for swords as tsuba or sword guards, *menuki* or the head of the nail fixing the sword to its handle, and *kozuka* or the small knife attached to the sword sheath. Besides the Myōchin family, Gotō Yūjō (1440–1512) was appointed official sword decorator to Ashikaga Yoshimasa, and his descendants were in the service of the Bakufu until the end of the Edo period. The special feature of metalwork of this period was the exquisiteness of the pictorial and decorative designs, produced by means of such techniques as *sukashi* (openwork), *ukibori* (relief work), and *zōgan* (inlay). In the Kamakura period, *ō-yoroi*, large suits of armor, were manufactured, but later on fighting was conducted not on horseback but on foot and with spears. Therefore, the *ō-yoroi* came to be used only for ceremonies, while lighter, simpler armor, such as the *domaru* and *haramaki*, was used in war. As a consequence, armor lost much of its artistic quality.

Another feature of this period was the vogue for *cha-no-yu*, the tea cult. Iron kettles for boiling water for tea, many of great artistic value, were manufactured in every part of the country; in particular, Ashiyagama kettles made at Ashiya in Fukuoka prefecture and Temmyōgama kettles made at Sano in Ibaraki prefecture were of the very best quality.

Ceramics after the middle of the Muromachi period began to be influenced by the ceramics of China and Korea and also by the vogue for *cha-no-yu*. The ceramic articles used in the tea ceremony and in daily life reached a high level of quality.

Textile arts had already begun to decline in the Kamakura period and in this era the tendency continued. Elegant and rich textiles such as *kinran* (gold brocade), *donsu* (silk damask), and *shuchin* (twills) were imported from China and were highly prized; they were called *meibutsu-gire* or famous materials.

MOMOYAMA PERIOD (1573–1615). *Architecture.* In the latter half of the Muromachi period, a host of daimios or feudal

lords rose in various parts of the country against the central government, the Ashikaga Shogunate. A turbulent age ensued, with the daimios competing for power all over the country, until at last Oda Nobunaga came to power in 1573, having defeated the armies under the command of the Shogun and such daimios as had stood in his way. In 1576, he built a castle at Azuchi in Shiga prefecture and from there directed the affairs of the country. Nobunaga died in 1582 and was succeeded by Toyotomi Hideyoshi, who transferred the government to Osaka, where he built a castle in 1583, and then to Fushimi on top of Momoyama, a hill near Kyoto, where he erected a castle in 1594. Hideyoshi died in 1598, and in 1600 Tokugawa Ieyasu, who had held a high position in Hideyoshi's government, defeated the Shogunate army in the battle of Sekigahara and came to power. He established his Bakufu in Edo (mod. Tokyo) in 1603. The year 1615 saw the fall of Osaka castle and the final ruin of Hideyoshi's house, so that Ieyasu became sole master. For the next 2½ centuries the Tokugawas ruled Japan from Edo. The period from 1573 to 1615 is called the Azuchi-Momoyama period, from the names of the Azuchi and Momoyama castles, or simply the Momoyama period.

In the process of this political disintegration, the greater part of the capital of the time, Kyoto, was reduced to ashes. But the swing of the pendulum brought years of comparative peace, and reconstruction work was begun. Daimios built castles to protect their fiefs against invaders. Thus, the Momoyama period saw architecture and public building in full swing. The introduction of the musket into Japan by Portuguese traders in 1543 revolutionized Japanese warfare and made stronger and more extensive fortresses necessary. The central portion of the moated and stone-walled castle was called the *honmaru* or inner portion, its outer ring the *ninomaru* or secondary fortress, and the outermost ring the *sannomaru* or third fortress; each was surrounded with a high stone wall and deep, broad moat, and had several turrets, magazines, and gateways. The whole structure was protected with thick walls. The largest tower of the *honmaru*, which was usually three- to five-storied, was, so to speak, the conning tower of the castle and was known as the *tenshu-kaku* or keep. Around it stood magnificent dwellings of the lord of the castle. The huge castle with its white walled citadels and turrets was the administrative and military base of the lord and was, at the same time, the symbol of his political power over the inhabitants in his region. The daimios decorated the interior of the castle tower and the dwellings with gorgeous paintings, sculptures, and objects of art to match the grandeur of the exterior, thus stimulating the development of various plastic arts. Kano Eitoku (1543–90) was appointed by Nobunaga to decorate and paint his seven-storied Azuchi castle.

In addition to the Osaka and Fushimi castles, Hideyoshi built the Jurakudai in Kyoto in 1585. Among the castles erected by other daimios that survive today are Matsumoto castle (1594), Kumamoto castle (1601), Nijō castle (1602), Inuyama castle (ca. 1603), Himeji castle (1608), Matsue castle (1611), and Hirosaki castle (1611). The best-preserved castle is Himeji. With its four towers connected by turreted passages, it looked from a distance like a white heron on the wing; for this reason it was commonly called Shirasagijō or the Castle of the Snowy Heron (PL. 311). The contrast between its white walls and black tiles and the arrangement of buildings and enclosures, high and low, large and small, resulted in an architectural beauty unknown in previous Japanese buildings.

Within the castle precincts were a number of imposing structures that were used by the daimios for various purposes, public and private. Some of the extant buildings are the Hiunkaku (flying-cloud pavilion; PL. 115) and the No stage of the Nishi Honganji in Kyoto, which were removed from the Jurakudai; the main gate of the Daitokuji in Kyoto; the *shoin* of the Nishi Honganji (PL. 325), which is said to have been Hideyoshi's audience hall of the Fushimi castle; and the sanctuary of the Tsukubusuma Shrine in Shiga prefecture. This was a new type of *buke-zukuri* architecture, usually known by the name of *shoin-zukuri*, which developed under the patronage of the feudal vassals contemporaneously with the building of

Azuchi castle. Among the surviving Momoyama *shoin-zukuri* buildings are the guest chambers of the Kōjōin in the Onjōji (also called Miidera) and the Kangakuin (both in Otsu) and the Gekkōden (moonlight hall) in the Gokokuji in Tokyo.

Together with this magnificent type of architecture, there arose a new kind of garden, vast, with a large lake containing a number of rocks, which fitted in well with the *buke-zukuri* architecture (PL. 448). The garden of the Sambōin in Kyoto is a typical example. In contrast to the garden of the *shoin-zukuri* architecture, there appeared the *chatei* or teahouse garden, originated by Sen-no-Rikyū (1521–91). It was a tiny and simple garden devoid of artificiality, attached to the teahouse.

Cha-no-yu or the tea ceremony developed into a fine art, and a special form of architecture, that of the *chaseki* or *chashitsu*, arose in connection with it. The *chaseki* was a detached house like a simple primitive hut, in striking contrast to the grand and elegant *shoin-zukuri*. It was in the middle of the Muromachi period (15th cent.) that the habit of taking tea and admiring objects of art culminated in the tea ceremony. In earlier years the *kuge*, the samurai, and the priests held tea gatherings in one of the rooms of their own dwelling houses, which had to measure 4½ mats (about 10 sq. ft.). In the *shoin-zukuri* buildings erected in this period, no detached room or building was provided especially for drinking tea. It was Sen-no-Rikyū who originated a new type of tea ceremony and who devised the *chashitsu*, which consisted of the *sōan* or thatched hut and the *roji* or narrow lane leading to it in the garden. The thatched hut was built of natural materials, and it became smaller in later years, resulting in an effect of quiet taste (*wabi*) and refined simplicity (*sabi*), fit for meditation. The simple elegance of the *chaseki* of the days of Sen-no-Rikyū may still be seen in the Taian of the Myōkian in Kyoto prefecture, the Santei of the Kōdaiji in Kyoto, the Shōnantei of the Saihōji in Kyoto, and the Jōan in Kanagawa prefecture.

Though remarkable development was achieved in the *buke-zukuri* architecture of castles and in the *shoin-zukuri* buildings, little was added in this period to the traditional style of Buddhist architecture. But in the last hundred years of warfare in the Muromachi period many temples had been burned down and reconstruction work was carried on extensively. Prominent from this period are the Sammon of the Daitokuji (1582) and of the Myōshinji (1599), both in Kyoto; the main hall of the Onjōji in Otsu (1601); the main buildings of the Hokkeji in Nara (1601) and of the Shōkokuji in Kyoto (1605); and the Kondō of the Tōji in Kyoto (1606).

The Shinto architecture of the Momoyama period added little to the style of the previous period, but shared the love of gorgeous decoration characteristic of the architecture of this age. The Ōsaki Hachiman Shrine in Sendai is the most notable of this age. At the same time a new type of Shinto architecture began to appear: the sanctuary and main shrine of the Hōkoku Shrine in Osaka (in which the body of Hideyoshi is enshrined) were connected by a stone-floored room; this style is generally known as *gongen-zukuri*. In the Edo period all the shrines erected to the spirit of Tokugawa Ieyasu, as well as many others, were built in this style.

Sculpture. Many instances of the Buddhist sculpture of this period are preserved to this day in various parts of Japan; these include the images of Yakushi and the Juni Shinshō in the main hall and four images of the Buddha in the five-storied pagoda of the Tōji which Kōsei erected in nine years, beginning in 1602. Buddhism itself having been formalized, however, this period ranks lower than the Muromachi period for its Buddhist sculpture. It gradually became the custom to have portrait sculptures of the influential supporters of the temple installed beside the images of the Buddha, and there was a marked increase in the number of such carvings produced. Prominent among the realistic and formal images are those of Toyotomi Hidetsugu (1597) and his mother Nisshū (1601) in the Zenseiji, Kyoto; of Toyotomi Sutemaru (1580) in the Ringein, Kyoto; and of Ashina Moriuji (1580) in the Sōeiji, Fukushima prefecture.

A more characteristic branch of Momoyama sculpture was

No mask carving. Mitsuteru, disciple of the celebrated No mask carver Sanko-bō of the Muromachi period, founded a new school called Echizen-deme, from which branched off the Ono-deme school founded by Yoshimitsu and the Omi-deme school created by Chikanobu. The descendants of these carvers continued to produce No masks.

But the spirit of this age found its expression far more markedly in ornamental sculpture than in the type of sculpture mentioned above. The principal ornamental carvings on Japanese buildings, which came into fashion after the Kamakura period, were *kaerumata* (frog-leg supports), *kibana* (ends of beams), *ramma*, *hame* (decorated panels), and *kōzama* and *hashirahari* (small pillars). The chief reason for this flowering was the increase in castles and palaces, which stimulated the development of ornamental sculpture. The remains of the structures in the Nishi Honganji that were part of the Jurakudai and Fushimi castle mentioned above enable us to visualize the splendor of the original beauty of these sculptures, though they preserve little of their original design. Flowers, trees, birds, and animals carved in relief or openwork contributed to the magnificence and solemnity of the buildings erected in this period of expansion and exuberance.

Painting. The use of bright color in thick pigments, simple subjects, and expressive patterns were the characteristics of Momoyama painters. Kanō Eitoku was asked to decorate Nobunaga's castle at Azuchi in 1576. Later he decorated Osaka castle and the Jurakudai for Hideyoshi. Eitoku's brother Sōshū (1551–1601) and his son Mitsunobu (ca. 1565–1608) embellished Fushimi castle in 1594.

We are told that each story of these castles and palaces was decorated with huge paintings, some of which were on the papered walls, ceilings, and pillars of the buildings, while others were on the fusuma and byōbu. Almost all the walls and ceilings were adorned with mural paintings, the work of numerous pupils, Eitoku directing and assuming complete responsibility for the composition as a whole. Different motifs and different styles of painting were employed in the various stories or rooms: among the subjects chosen were landscapes, flowers and birds, and portraits, some works being done in the richly colored style characteristic of this age and others in the *suiboku* style. The whole surface of the paintings was covered with gold foil, and strong colors were used to harmonize with the lively reflecting surface. This was because the spacious rooms were not very light and the military rulers, being men of coarse fiber, wanted an art which was ostentatious in technique and sensuous in effect. Thus there came into existence a new type of painting with the strongest color effects in the history of Japanese paintings; this is considered to have been founded by Eitoku.

Unfortunately none of those works remains, but we can imagine the splendor of the castle murals and the style of the artists employed in their production from the flowers and birds paintings and landscapes in *suiboku* style (fusuma painting) in the Jūkōin of the Daitokuji, done by Eitoku in his youth (PL. 318); a (Chinese) Lion Screen in the Imperial Household Collection (X, PL. 140) by Eitoku; Flowers and Birds, a fusuma painted by Mitsunobu in 1600 and preserved in the Kangakuin, Otsu; Eagles and Pines, a screen owned by Jurobei Nishimura (Shiga prefecture) done by Kanō Sanraku (1559–1635), pupil and principal helper of Eitoku; and a portrait screen belonging to the Tokyo National Museum. Particularly beautiful and suited to the grandeur of the castles and palaces are the series of paintings kept in the Chishakuin, Kyoto, from which we can also obtain an idea of the style and content of the Momoyama mural paintings. There are 25 fusuma paintings, representing cherry trees (PL. 319), maples, pines, plum trees, flowers, and grasses in rich color against a golden ground, and a two-part folding screen made from a fusuma painting. They are estimated to have been produced early in the Momoyama period; it is not certain by whom they were done nor where they belonged. Of the late Momoyama fusuma paintings the following deserve special mention: Flowers and Grasses (1598) in the Sambōin, Kyoto, and Peony in the Daikakuji, Kyoto, ascribed to Kanō Sanraku. Surviving to this day are the fusuma paintings and *hari-e* (pictures with colored paper or cloth pasted on) of Nagoya castle. The castle itself was destroyed by fire in World War II, but the chief works of art there had been removed elsewhere and escaped injury. The collection consists of fusuma paintings believed to have been done by Kanō Sadanobu and some members of his family in 1614 and paintings by Kanō Tanyū and other artists of his family (ca. 1633). The former are the only remnants of castle paintings of the Momoyama period that survive in the original state, and for that reason they are particularly important. They are rather less magnificent than those preserved in the Chishakuin.

Among the artists whose active period almost exactly spanned this Momoyama age were Kaiho Yūshō (1533–1615), Hasegawa Tōhaku (1539–1610), Unkoku Tōgan (1547–1618), and Soga Chokuan (active 1596–1610). The surviving works of these artists are as follows: fusuma paintings in *suiboku* style of landscapes, portraits, and flowers and birds, in the Kenninji, Kyoto, several screens of flowers and birds in rich color against a golden ground, and portraits in the Myōshinji, Kyoto, all by Yūshō; Pines, a screen in Tokyo (PL. 309), and Monkeys, a screen in *suiboku* style in Kyoto (PL. 309), both by Tōhaku; 44 fusuma paintings in *suiboku* style of landscapes, flowers and birds, and portraits by Tōgan, in the Obaiin of the Daitokuji, Kyoto; and multicolored flowers and birds screens in the Tokyo National Museum and the Hōkiin in Wakayama prefecture, by Chokuan. These four painters equaled Eitoku in genius and individuality. Eitoku and other master artists, including these four, competed with one another for supremacy, until Eitoku conquered, so to speak, the country. The main reason why Eitoku was particularly patronized by Nobunaga and Hideyoshi was that his great-grandfather Masanobu and grandfather Motonobu had been in the employ of the Ashikaga Shogunate and that he successfully originated a new colorful style of painting. His sharp ink lines strengthened the decorative patterns of the *suiboku* style. The splendid colors are characteristic of the Yamato-e (q.v.) school.

The birth of decorative paintings with strong color effects was one of the characteristics of this age, together with genre painting on a large scale and the introduction of Western-type painting. Some artists had started, in the Heian period, to illustrate in their works the life of their own time, but it was only toward the end of the Muromachi period that manners and customs came to be taken up as independent subjects of painting. The first known picture of this school is Maple Viewing at Takao, a screen by Kanō Hideyori, the second son of Motonobu, belonging to the Tokyo National Museum. Some of the extant genre paintings are In and Around Kyoto, a screen by Eitoku, owned by Uesugi Takanori (Yamagata prefecture); Hōkoku Festival, a screen by Kanō Naizen Shigesato (1570–1616), portraying the surging crowds at the festival of the Hōkoku Shrine, done in 1604 and kept in the Hōkoku Shrine, Kyoto; a *hari-e* representing the customs in front of the Hie Shrine, painted between 1573 and 1591 and kept in the Emmanin of the Onjōji, Otsu; and the *hari-e* on the walls of Nagoya castle, showing the manners and customs of Kyoto and Osaka citizens. Certainly the choice of subjects, such as festivals and scenes of domestic life of the *chōnin* (townsfolk), who were of the lowest social order, reflected a change in the structure of Japanese society, that is, the rise of the newly rich merchants. At this time artistic interest was taken in man and his life, and it is from this type of genre painting that Ukiyo-e (q.v.) developed during the Edo period.

Western paintings were introduced in Japan with Christianity. The new religion spread in western Kyushu and central Honshu after the first visit to Japan of St. Francis Xavier in 1549, and late in the Momoyama period about 200 chapels were built and the number of believers swelled to hundreds of thousands. The pictures were religious paintings used by the missionaries in their work and Western paintings illustrating Christian life. At the same time, missionaries trained some Japanese artists in Western-style painting. The religious paintings were done on hemp cloth or copperplates, and those of Western life were chiefly painted on fusuma in Japanese style.

During the persecution of the Christians which began in 1638 the paintings were largely destroyed. Those that survive include a Madonna in the Tokyo National Museum, a portrait of St. Francis Xavier, and a screen of warrior kings on horseback in the Kobe Art Museum. The importation of the religious pictures introduced for the first time in Japanese history the Renaissance type of Western painting with its emphasis on realistic description, but the influence of Western art died out after the prohibition of Christianity without making itself greatly felt in Japanese painting. There arose at the same time an interest in the customs and exotic costumes of the Western visitors, so that Western objects were used in designs of various works of art. This new type of art was generally known as *namban* or the art of the "Southern Barbarians," as Westerners were then commonly called in Japan.

The Tosa family was in decline, as was the Yamato-e that they had practiced. Tosa Mitsumoto, the master of the family, joined the Shogunate army in 1569 as official painter, and was killed in battle. The family, deprived of their master, moved from Kyoto to Sakai, a newly developed town of commerce, accompanied by Mitsumoto's disciple, Mitsuyoshi (1539–1613; VII, PL. 258). The celebrated Tosa line thus died out, and Mitsuyoshi succeeded to the house.

Minor arts. The outstanding characteristics of Momoyama craftsmanship are the lavish use of gold and silver, rich coloring, and clear, strong design. The ornaments found in the Tsukubusuma Shrine and in the Kōdaiji in Kyoto, moved from Fushimi castle, are excellent examples. The interiors of these buildings are richly colored and decorated with *maki-e*. In the Kōdaiji, in particular, there are 14 kinds of lacquerware (16 pieces in all), including chairs and kitchen utensils (see LACQUER). This type of lacquer, which is usually called Kōdaiji *maki-e*, is regarded as the finest example of Momoyama craftsmanship. Numerous other lacquered objects are preserved, among them an 8-legged table with an autumn flower design, a saddle with a reed pattern, designed by Eitoku, an inkstone case by Hon-ami Kōetsu (1558–1637; VII, PL. 336), and a reading stand (VII, PL. 339), all in the Tokyo National Museum; a dagger case with the imperial crest in the Homma Art Museum, Sakata; and a miniature writing desk in the Myōhōin, Kyoto. The most prominent workers in gold lacquer were the sons of Kōami Chosei, who had been in the employ of the Ashikaga Shogunate, namely, Chōan (1569–1610) and Chōgen (1572–1607), both of whom served Hideyoshi.

Architectural decoration and the manufacture of arms stimulated the development of metalwork. In the field of casting the *e-kagami* (hand mirror), which had come into existence toward the end of the previous period, became popular; Ao Ietsugu and Kisetsu Jōami (d. 1618) were famous makers of mirrors. Builders' hardware, temple bells, and dedicatory lanterns were made in great numbers in connection with the reconstruction of temples. The technique of casting must have been on a very high level in view of the fact that the image of the Great Buddha (destroyed by an earthquake in 1595) of the Hōkōji in Kyoto cast by Nagoshi Sanshō was larger in size than the one in Nara. The continued popularity of *cha-no-yu* stimulated the production of teakettles. Nishibayashi Dōjin and Tsuji Yojirō, under the guidance of the tea masters Takeno Jōō and Sen-no-Rikyū respectively, became master teakettle craftsmen in Kyoto; their kettles were usually called Kyō-gama (Kyoto kettles), and Kyoto gradually became the center of teakettle production.

The techniques of chasing and work in wrought gold were highly developed, and exquisite sword ornaments were produced. The three master craftsmen, Jōshin (1512–62), Kōjō (1529–1620), and Tokujō (1550–1631), were members of the Gotō family who had been in the employ of the Ashikaga Shogunate. Among the celebrated sword-guard producers were Kaneie and Umetada Myōju (1558–1631; PL. 302). Kaneie was the first to inlay sword guards with gold and silver.

Japanese pottery, which had not kept pace with the other crafts, expanded rapidly in the Momoyama period. The chief reason for this was the importance of the tea ceremony, which created a demand for articles such as tea caddies, tea bowls,

and pitchers. The potters who had been engaged in the manufacture of household utensils began to produce tea objects and ornamental ceramics under the guidance of tea masters. In the Muromachi period, Japan had depended on China to supply finer glazed ceramics. As a result of the military expedition to Korea undertaken by Hideyoshi, plain and rather crude Korean pottery was imported. The birth of the *wabi* school or "tranquil" tea ceremony influenced the artistic taste of the time, and the Korean type of ware came to be appreciated and used. Native ceramics, formerly excluded from tea gatherings, now came into use at the *cha-no-yu*, and potters at various traditional sites of ceramic manufacture, Seto potters among them, recommended the production of tea bowls. Shino ware and Oribe ware, offshoots of the Seto type, made their first appearance about this time in Gifu prefecture. In Kyoto, Raku Chōjirō improved on the Seto type and began to make raku ware, which his descendants still continue to produce. Ceramics of this school were usually called Kyō-yaki, the raku ware produced by Chōjirō's descendants being called Hon-gama, or original kiln, and those by other families called Waki-gama, or subsidiary kilns. The best-known pieces of raku ware are those made by Hon-ami Kōetsu. Hideyoshi brought back Korean potters, who stayed in and around Arita in Kyushu, where they started to produce ceramics of their own, called Arita-yaki (better known as Imari ware). The Korean influence is particularly seen in the Karatsu ware of Kyushu, and also spread to potteries around Kyoto and Osaka.

The dyeing and weaving industries, which had been on the decline, also began to flourish in these few decades, firstly because the bold decorative sense of the age found expression in gorgeous costumes and secondly because the style of costumes had changed (see COSTUME). By the end of the Muromachi period a two-piece garment had been the general rule, regardless of the sex or class of the wearer. The fashionable garment now among the samurai class, both male and female, was a short-sleeved one-piece kimono called *kosode*. Larger and more picturesque designs were employed to decorate the new-style kimono. The use of richly colored materials and bright designs, which matched the splendor of Momoyama life, appealed to the taste of the public at large. The stuffs that had been imported from Ming China in Ashikaga days, such as brocade, damask silk, satin, and thin silk crepe, were produced at Hakata in Fukuoka prefecture, Sakai in Osaka prefecture, and Nishinjin in Kyoto. These beautiful fabrics were enriched by adding embroidery, *shibori-zome* or dappled dyeing, and *suri-haku* or gold and silver foil glued to the material. The most splendid Momoyama garments, produced by a complicated process of dyeing, are the marvelous Nō costumes. Many of these exquisite and dainty Nō costumes still exist, and show how far the craftsmen of this period had advanced in their skills (IV, PL. 9).

EDO PERIOD (1615–1867). *Architecture.* In the Edo period (sometimes called the Tokugawa period) the nation was remodeled according to Confucian principles (see CONFUCIANISM), and a strictly feudal society developed. The policy of national seclusion prevented the introduction of Western civilization into Japan, and Japanese culture flourished under this protection. The characteristics of the period were the existence of two centers of culture, the old traditional capital of Kyoto and the new seat of feudal government, Edo (in 1868 the name was changed to Tokyo), and the diffusion of national culture throughout the country owing to the efforts and encouragement of the feudal lords.

Tokugawa Ieyasu rebuilt Edo castle in 1606 with a majesty suited to the headquarters of the Tokugawa government. The daimios were forbidden to have more than one castle per fief and were obliged to reduce their castles to a certain size. No additions or repairs were permitted throughout the period, and at the time of the Meiji Restoration what remained was largely in ruins so only fragments of the Edo castles survive today, as is the case with the castles and palaces of the Momoyama period. Of the daimio dwellings built in castles, only the *ninomaru* of the Nijō castle (PLS. 114, 322–324), repaired in 1626, survives in an excellent state of preservation. It follows

the *shoin-zukuri* of the previous period. There are five large buildings of similar design, built one behind the other, with a garden on a scale of unusual grandeur in front. Square pillars are used throughout the palace and the floors of its rooms are covered with *tatami* (mats), the rooms themselves being separated by fusuma. The principal rooms are gorgeously decorated and contain tokonoma, *tana*, and *shoin*. The fusuma and ceilings are adorned with paintings, and there are elaborate colored carvings in the *ramma* or frieze between the pillar and the ceiling.

In various provinces as well as Edo, feudal lords encouraged the capitals of their fiefs to be built with the castle as center. The towns were generally known as *jōka-machi* (castle cities) and were inhabited by *bushi* and *chōnin*, the merchants and craftsmen. The dwellings of the warriors were similar to those of the daimios whom they served, that is, *shoin-zukuri*. The merchants lived in single- or double-storied buildings, part of which they used for the conduct of their business. When Edo was nearly destroyed by a great fire in 1657, the government ordered rigid economy to be practiced and imposed restrictions on the construction of warriors' and ordinary citizens' houses. Few buildings of merit were erected and domestic architecture declined. But after 1703, when the merchant class gained financial control over much of the economic life of the country, wealthy merchants began to build *shoin-zukuri* houses like those of the daimios, so much so that the *shoin-zukuri* became the rule for domestic architecture of the Edo period, though more attention was paid to beautifying the interior than the exterior.

With the continuing cult of the *cha-no-yu* more teahouses of high quality were built. The most prominent of all the Edo architects was Kobori Enshū (1579–1647). The Mittan of the Ryūkōin in Kyoto and Bōsen of the Kohōan of the Daitō-kuji in Kyoto, which are extant today, are believed to have been built on his design. The *chashitsu* style and *shoin* style were fused to form what is generally known as the *sukiya* style, examples of which are furnished by the three *shoin* of the Katsura palace in Kyoto (FIG. 882), the Koshoin, Chūshoin, and Shinshoin (old, middle, and new *shoin*). These domestic buildings in the new style were built as villas, the first two having been erected for Prince Tomohito before 1623 and the third for Prince Tomotada before 1643. The two teahouses in this palace, the Gepparō and Shōkintei (PL. 115), deserve mention, as do the gardens (PL. 448). The Shūgakuin palace, which was completed in 1659, consists of three summer houses and gardens, and has a *sukiya* flavor about it. In contrast to the *shoin* style, these *sukiya* buildings of the daimios and rich merchants were intended as private retreats.

Buddhist temples were not exempt from the government's rigid economic policy and in fact were not permitted to be built on a large scale; only reconstruction of buildings destroyed by fire was permitted. Among the Edo Buddhist temples that remain are the main hall of the Kiyomizudera, Kyoto (1633; PL. 311); the five-storied pagoda of the Tōji, Kyoto (1644), the highest pagoda in Japan; and the Daibutsuden of the Tōdaiji (1709). A unique example of Edo Buddhist architecture is offered by the temples of the Ōbaku sect which was introduced from Ming China by the famous Chinese priest Ingen. The Mampukuji in Kyoto, headquarters of the sect, built in 1659, shows how well the style of Ming China was understood and imitated.

In Shinto architecture as well, the period followed the traditional style of the preceding ages, and this may be seen from most of the Shinto shrines in existence today, which were rebuilt in the Edo period. One exception is the development of the memorial-shrine structure, in *gongen-zukuri* (a three-part complex), the best known of which is the Tōshōgū Mausoleum of Ieyasu at Nikkō, built in 1617 and repaired in 1636. Though unsatisfactory from an architectural point of view, the whole of the shrine is executed with garish splendor and is decorated with the most elaborate ornamental detail.

Sculpture. Buddhist sculpture deteriorated even more in the Edo period than it had in the Momoyama period, while the number and kind of nonreligious carvings produced showed a marked increase.

The main reason for the decline of Buddhist sculpture was that few sculptors felt any strong inspiration to express Buddhist ideas because Buddhism itself had become formalized and petrified by ritualism. Buddhist sculptures were, however, produced in large numbers to meet the demand of temples rebuilt or repaired in this age. These were of three different kinds, and those that are preserved today may be classified accordingly: 1. Images of the Buddha produced by professional carvers in the traditional style. Works include the Shaka Triad in the Sammon of the Chionin, Kyoto, by Kōyū (1619); the Shaka Triad and the 16 disciples of the Buddha in the Sammon of the Nanzenji, Kyoto; the portrait of the emperor Shōmu by Gyōkai (1689) in the Tōdaiji, Nara; and the two images on either side of the Great Buddha by Kenkei (ca. 1726) in the Tōdaiji. 2.

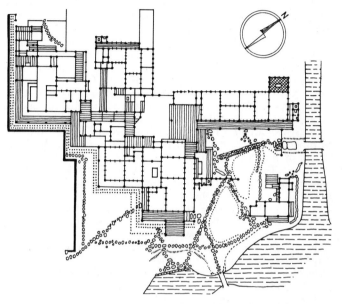

Ground plan of Katsura palace at Kyoto (*after Paine and Soper*).

Some expressions of personal faith in the Buddha by nonprofessional Buddhist priests. Examples include many carvings in the Rakanji, Tokyo, such as the Shaka Triad and the images of the 500 disciples of the Buddha produced by Shōun Genkei (1648–1710) before 1695; and the Godai Myōō by Hōzan Tankai (1629–1716) created in 1701 and installed in the Hōzanji, Nara prefecture. 3. A number of highly exotic sculptures by Wan Tao Sheng, a Chinese *busshi* from Ming China, whose influence, however, did not make itself felt very much. These include the Shaka Triad and the 16 disciples of the Buddha (ca. 1668) in the Mampukuji.

Two types of nonreligious sculpture flourished: No masks and ornamental sculptures such as *okimono*, or small ornaments, dolls, and netsuke. Small figures of men, animals, and plants adorned the study and the drawing room of the homes of the samurai and townspeople. These *okimono* were produced by *busshi* and other craftsmen. Decorative dolls in clay and wood were made in various parts of the country; the most famous were the dolls of Saga, Fushimi, Gosho (Kyoto), and Nara. Netsuke were made of wood, ivory, horn, or metal and were beautifully carved in various designs; they were suspended from the girdle and held in place tobacco pouches, purses, medicine boxes (inro), etc.

Painting. The early part of the Edo period saw no marked change from the preceding age. With the establishment of a feudal society, however, and the remodeling of civil administration on Confucian ideas, new schools of art gradually arose at Edo, the seat of the Tokugawa regime, which were consonant with the interests of the different social classes. The painting of this period may be classified into three main divisions: that of the warrior class, that of the wealthy merchant class and of middle- and lower-class citizens, and that of the men of letters.

When the Tokugawa Shogunate stabilized its position Kanō Tanyū (1602–74; PLS. 353, 354) was given a residence in Edo and served the Shogunate as court painter. Tanyū was a cousin of Kanō Sadanobu (1597–1623), who had been the master of the main Kanō school (q.v.). In 1630 Tanyū's younger brother Naonobu (1607–50; PL. 355) was ordered by the Shogun to move to Edo as court artist; so was Naonobu's younger brother Yasunobu (1613–85), who had been adopted by Sadanobu as heir to the main Kanō family. Thus the Kanō school as a whole moved to Edo with the Tokugawa rulers, except for the pupils of Kanō Sanraku and some others who remained in Kyoto. With this trio — Tanyū, Naonubo, and Yasunobu — the Kanō school split up into three branches which were designated by their places of residence in Edo; the Kajibashi-Kanō, Kobikichō-Kanō, and Nakabashi-Kanō. Later, Minenobu (1662–1708), Naonobu's grandson, created a new branch which was called also by the place of his residence, the Hamachō-Kanō. The process of branching off continued in this extraordinary family until, in the middle of the period, Kanō branch families numbered 19, all serving the Tokugawa Shogunate. The 4 oldest families are usually called *oku-eshi*, and the other 15 families are called *omote-eshi*. There were also hundreds of other painters of the Kanō school, all active in painting and all calling themselves Kanō; they are generally known as Machi-Kanō or nonofficial Kanō school artists. This Kanō school became more influential as time went on and is called the Edo-Kanō school; the Kanō school of Kyoto is called simply Kanō.

It was Tanyū who formalized the type of technique, subject matter, and style that all later generations of the Kanō family followed. Interpreting the Kanō style that his forefathers had founded in the light of Confucianism, he reoriented it to serve the purposes of the regime, thus bringing about a closer relationship between the Shogunate and the Kanō school. Tanyū's style was further refined by Tsunenobu (1636–1713; PL. 355), son of Naonobu, and most of the Kanō artists followed in the steps of Tanyū and Tsunenobu. By the middle of the Edo period the Kanō school began to enjoy a nationwide popularity, and the daimios commissioned works from the Kanō artists of Edo. By this time, however, the Kanō painters had lost their freshness and inspiration. Some of the Kanō school painters rebelled against the academism and formalism of the house and founded independent schools of their own; among these were Kusumi Morikage (ca. 1680), Hanabusa Itchō (1652–1724), who was a pupil of Yasunobu, and Tani Bunchō (1763–1842). Of the Kanō school in Kyoto, Sansetsu (1589–1651), son of Sanraku, and Einō (1634–1700), grandson of Sanraku, were outstanding, but their paintings tended to formalism.

The Tosa family (see TOSA SCHOOL), who enjoyed as long a history as the Kanō family, had been in Sakai in the Momoyama period. In 1634 Mitsunori (1584–1638), son of Mitsuyoshi, went back to Kyoto. It was, however, Mitsuoki (1617–91) who reestablished the school there and was appointed E-dokoro-no-Azukari; thus the relations between the imperial court and the Tosa family, which had long been broken off, were reopened. Mitsuoki adopted the Kanō manner in fashion at that time, thus deviating from the regular Yamato-e. In the period from 1646 to 1710, from Mitsunori on, the Tosa school continued to flourish, but, as in the case with the Kanō school, their works became formalized. The Tokugawa Shogunate ordered Jokei (1599–1670), younger brother of Mitsunori, to come to Edo as official artist in 1662. He took the family name of Sumiyoshi at the command of the emperor. Jokei's son Gukei (1631–1705) and his descendants succeeded to the position; they were more influenced by the Kanō school than the Tosa. There was a distinct revival of the Tosa school in the 19th century under Tanaka Totsugen (1768–1823), Ukita Ikkei (1795–1854), and Reizei Tamechika (1823–64), whose works are interesting as a reaffirmation of the old Yamato-e and are better than those done by any member of the Tosa or the Sumiyoshi family.

It was the Sōtatsu-Kōrin school rather than the Tosa school that revived the tradition of Yamato-e. Tawaraya Sōtatsu, under the guidance of Hon-ami Kōetsu, created a neo-Yamato-e, mixing the decorative trend in arts of the Momoyama period and the classicism of Yamato-e. Of Sōtatsu's life nothing is

known except that in 1630 he copied a picture scroll of the life of the saint Saigyō, owned by Mōri Motomichi of Yamaguchi prefecture. However, more than ten of his paintings survive, among which are a pair of folding screens illustrating the Genji Monogatari in the Seikadō Bunko in Tokyo and a pair of folding screens of the Wind God and the Thunder God (PL. 314), which are his best-known works. Sōsetsu, his younger brother, followed his brother's style. Ogata Kōrin (1658–1716; q.v.) too based his style on that of Sōtatsu. He was a member of a cultured and wealthy merchant family. Kōrin produced works on a variety of themes (PL. 315; IV, PL. 224). Among them are large pictures with richly decorative effects, such as a pair of folding screens in the Nezu Art Museum, Tokyo, depicting irises, and another pair, showing red and white plum trees, in the Atami Museum in Shizuoka prefecture. A small picture of azaleas by Kōrin is owned by Dan Inō of Tokyo. Ogata Kenzan (1663–1743; q.v.), Kōrin's younger brother, and Watanabe Shikō (1683–1755) were among Kōrin's pupils. This Sōtatsu-Kōrin school was revived in Edo by Sakai Hōitsu (1761–1828), but his works are inferior to theirs.

Other schools of painting were current in the Edo period, such as the Nanga or Southern school, the Maruyama-Shijō or Western-style painting school, and Ukiyo-e (q.v.) or popular school. As already noted, Confucianism was the official philosophy of the Tokugawa period, and deep study was devoted to both the philosophical and literary aspects of Chinese philosophy. A host of scholars of the Chinese classics arose and not only the Shogunate but a number of daimios employed official scholars. Among these scholars the Chinese way of living came into fashion; they composed Chinese poems and held calligraphy and painting in high esteem. They also admired the Nanga school of painting, which originated in China in the Ming and early Ch'ing dynasties. In the middle of the Edo period some Japanese professional painters began to produce Nanshū-ga, or pictures in the Southern style, on the models of the Chinese paintings. It was Sakaki Hyakusen (1697–1752) who founded the Japanese Nanga school and Ike-no-Taiga (1723–76) who brought it to perfection. Taiga has left a great many works, large and small, including landscapes and portrait paintings applied to fusuma and to a *byōbu* in the Henjōkōin on Mount Kōya and a landscape screen now in the Tokyo National Museum. Yosa Buson (1716–83) also deserves special mention (PL. 327); his paintings, which are combined with *haiku* (17-syllable poems), are usually called *haiga* or *haiku* pictures. Uragami Gyokudō (1745–1820), also of this school, purified Taiga's style and rendered it more subjective (PL. 329). Other Nanga artists are Kimura Kenkadō (1736–1802), Okada Beisanjin (1744–1818), and Okada Hankō (1782–1846), son of Beisanjin, in Osaka; Tanomura Chikuden (1777–1835) of Takeda in Oita prefecture and his pupil Takahashi Sōhei (1803–34) in Kyushu; Yamamoto Baiitsu (1783–1856) and Nakabayashi Chikudō (1778–1853) in Nagoya; Watanabe Kazan (1793–1841) and his disciple Tsubaki Chinzan (1801–54) in Edo.

In this period, the only outlet for foreign trade was Nagasaki and the port town flourished accordingly. It was at the same time the only inlet of advanced culture from abroad, with the result that painters of the Nanga and Western-style schools as well as scientists went to Nagasaki to study. These painters must have learned much from visiting Chinese artists, such as I Fu-chiu who came to Japan in 1720 and Fei Han-yüan who visited Nagasaki in 1734. Thus, along with the Nanga style, a new style of Ming and early Ch'ing China origin was introduced into Japan through Nagasaki (see NAGASAKI SCHOOL). Birds and flowers were chosen as subjects, and the paintings were both realistic and decorative. Kumashiro Hi (also called Yūhi and Shukukō, 1713–72) studied under Shēn Ch'üan (or Nanp'in), who came to Nagasaki in 1731. Sō Shiseki (1712–86) studied under Sung Tzu-yen (or Sō Shigan), who came to Nagasaki in 1758. Hi and Shiseki mastered the style of this school, and Kurokawa Kigyoku (1732–56) introduced it to Edo. This particular style is called the Nan-p'in school.

Maruyama Ōkyo (1733–95) of Kyoto brought this style to perfection. At first he was severely criticized by the Nanga artists, who laid stress on the literary significance of their art,

and by the Kanō painters, who valued Confucian ideas. Being plain and easy to understand, however, Ōkyo's works gradually came to be appreciated and understood by the merchant class until at last his school, the Maruyama school, became the center of Kyoto artists. Examples include the Hozu Rapids screen owned by Nishimura Sōzaemon of Kyoto, 90 fusuma landscapes and portraits in the Kotohiragū in Kagawa prefecture, and a pair of byōbu in Tokyo (PL. 327). Among Ōkyo's pupils were Komai Genki (1747–97), Hara Zaichū (1750–1837), Nagasawa Rosetsu (1755–99; PL. 329), and Yamaguchi Soken (1759–1818). Matsumura Gekkei (also known as Goshun, 1752–1811) was another of Ōkyo's pupils, but his style is more lyrical than his master's. The school he founded is known as the Shijō school. Gekkei's style was handed down through his younger brother Matsumura Keibun (1779–1843) and Okamoto Toyohiko (1773–1845). The Maruyama and Shijō schools were combined by Shiokawa Bunrin (1807–77) late in the Edo period, and this style was prevalent in much of Japanese art until fairly recently.

The influence of Western pictures that had been introduced to Japan in the Momoyama period died out soon afterward, but Western scientific books continued to enter through Nagasaki; many of these books contained copper-engraved illustrations. The artists studied these books and began to produce copperplate prints and Western-style oil paintings. Though originating in Nagasaki, oil painting was done with success at Edo by Hiraga Gennai (1726–79). Shiba Kōkan (1738–1818) and Aōdō Denzen (1748–1822) were pupils of Gennai, and they painted Japanese subjects in Western style, making use of Japanese paints, and made copperplate prints. Odano Naotake (1749–80) and Satake Shozan (1748–85) also studied under Gennai and spread Western painting in Akita district, while Wakasugi Isohachi (1759–1805) and Kawahara Keiga (ca. 1810) were also prominent in the same school. These painters were attracted by the Western techniques of realistic description and they were interested, at the same time, in the exotic customs and manners of the Dutch. This particular school of Western-style painting, founded by Gennai, is usually called kōmō-ga or red-haired European-style painting, in contrast to namban art. This Western realism influenced Tany Bunchō and Watanabe Kazan in Edo and Maruyama Ōkyo in Kyoto, and from it they derived their naturalism.

It was in the Momoyama period, as has been observed, that the customs and manners of ordinary citizens began to be used as an independent subject of painting. This genre painting attained a still higher degree of popularity in the early part of the Edo period. The most popular subjects were Kabuki players and courtesans. A number of large paintings, including a screen showing manners and customs of the time (generally called the Hikone screen) owned by Naosuke Ii (PL. 321), represent a type of genre painting generally called "early Edo original genre painting." It is sometimes claimed that Iwasa Matabei (1578–1650) was the originator of this school and thus the founder of Ukiyo-e ("painting of the fleeting world"), but this is not correct. Matabei did produce some genre paintings, but he excelled rather in the classical style which he originated by fusing the styles of the Kanō and Tosa schools.

When the ordinary citizens became more influential in society in the middle of the Edo period, theaters and the Yoshiwara or gay quarters flourished as centers of entertainment; later, the warrior class patronized them. Celebrated actors and lovely geisha were depicted by many painters. Great masters of the early part of the period were Hishikawa Moronobu (ca. 1618–ca. 1694), who had moved from Kyoto to Edo, and Miyagawa Chōshun (1682–1752). Moronobu also made woodcuts to illustrate books on plays and the Yoshiwara. About this time Kaigetsudō Doshin produced black-and-white woodcuts of beauties, usually standing. Torii Kiyonobu (or Kiyonobu I, 1664–1729), who had been a sign painter, added the color tan (red) to the Ukiyo-e prints by hand; this particular type of colored print was called tan-e. Okumura Masanobu (1686–1764) added three colors — red, orange, and green — by hand, and he called these three-colored prints beni-e. Ishikawa Toyonobu (1711–85) used blocks to add colors to the black-and-white

prints, adding two colors, red and green, and calling this technique beni-suri-e. The fully developed color print, called nishiki-e or brocade picture, was the creation of Suzuki Harunobu (1725–70; IV, PL. 446). The Harunobu style was carried on by Torii Kiyonaga (1752–1815; IV, PL. 448) and Kitao Shigemasa (1739–1820). The greatest exponent of nishiki-e was Kitagawa Utamaro (1753–1806; q.v.), who is particularly noted for his half-length portraits of women (IV, PL. 446); these are generally called ō-kubi or large-head pictures. It was Tōshūsai Sharaku who founded a new style in the portrayal of Kabuki players. Little is known about his life except that all his prints were made in ten months (from May of 1794 to February of 1795). Sharaku's faces are contorted by the intensity of their expressions and are highly individualized. Utagawa Toyokuni (or Toyokuni I, 1769–1825), who was influenced by Sharaku, also depicted Kabuki actors.

With the death of Utamaro (and Sharaku) the great period of Japanese prints had come to an end, and the nishiki-e production tended to be perfunctory until two great innovators appeared: Katsushika Hokusai (1760–1849; q.v.) and Andō Hiroshige (1797–1858; q.v.). Instead of portraying beauties, actors, or sumo wrestlers, Hokusai devoted himself to landscapes, thus revolutionizing woodprinting. Of his numerous sets of prints, the finest are the Thirty-six Views of Mt. Fuji (II, PL. 30; IV, PL. 447). The other great landscape artist of Ukiyo-e, Hiroshige, excelled his predecessor. Among his works are the Fifty-three Stages on the Tōkaidō Highway (IV, PL. 447) and Scenic Attractions of Yedo (Edo). Ukiyo-e denotes woodprints produced in Edo ranging from Moronobu's black-and-white prints to Hiroshige's nishiki-e, works that vividly reflect the life and feelings of the ordinary people.

Calligraphy. Early in the Edo period, several calligraphers of the Shōren-in school founded a new school of penmanship that was easier to write and therefore more practical. The leading calligraphers of this new style were Hon-ami Kōetsu (1558–1637), Konoe Sanbyakuin (or Konoe Nobutaka, 1565–1614), Shōkadō Shōjō (1584–1639), and Karasumaru Mitsuhiro (1579–1638). The new school, called Oie, spread among the various social classes and lasted into the Meiji period.

The Karayō, or Chinese style, was also in use at this time. The Tokugawa Shogunate supported Confucianism, and Chinese literature, including the scroll poems composed in the Muromachi period, was very popular. Chinese Zen priests, such as Ingen (1592–1673), introduced the calligraphic styles of Ming and early Ch'ing China to Japan. Throughout the Edo period, however, there were few calligraphers of real artistic skill in either the Japanese or the Chinese style, and it may be said that calligraphy did not show great improvement in quality, though it became much more widespread.

Minor arts. New styles and new types of wares were developed in this period and production increased, reflecting the demand by people of various classes. As has already been observed, there were two centers of culture at this time, Edo and Kyoto, and both developed characteristics of their own.

Kōami Nagashige (1599–1651), the son of Chōan, produced lacquered works of high quality; a shelf called Hatsune-no-tana made by him is preserved in the Tokugawa Art Museum in Nagoya. Kome Kyūi (d. 1663), like Nagashige, was employed by the Shogunate in 1626, and Kajikawa Hikobei followed him to Edo as official maki-e artist. The traditional styles of the three schools — Kōami, Koma, and Kajikawa — were continued with great success at Edo by the descendants of these three artists. In Kyoto, where the traditional style of maki-e flourished, Yamamoto Harumasa (1610–82) was the most prominent lacquer artist. Among maki-e craftsmen in provincial towns, Igarashi Dōho, who was in the employ of the lord of Kaga in Ishikawa prefecture, was outstanding. The style founded by Dōho is generally called Kaga maki-e. In the early Edo period the free shape of the works, fresh design, and simple artistry, which were characteristic of Momoyama lacquer, were brought to a higher level by the refined taste and workmanship of the maki-e artists.

In the middle of the Edo period, Japan was politically sta-bilized under the Tokugawa regime. Civil affairs were ably managed, and the various classes participated in the cultural life. At this time some of the wealthy merchants were financially more powerful than the daimios. The love of magnificence of society in general was reflected in the forms and decorative design of lacquer ware (PL. 289), especially in *maki-e* objects where the design was executed to perfection. The masterpieces of the age are a group of landscape *maki-e* pieces in the Ōkura Museum, ascribed, with some certainty, to the official artists of the Shogunate. The collection was produced by order of the fifth Shogun, Tokugawa Tsunayoshi, and is generally called Jōkenin *maki-e*, Jōken being the posthumous Buddhist name of Tsunayoshi. Every known *maki-e* technique was employed in their production, with particular care to the details; the lavish use of gold powder and gold fittings added to the sumptuousness of the design and decoration. One artist stands out who, con-trary to the trend of the times, created works of highly individual quality: Ogata Kōrin (q.v.). He was a versatile painter and, like Hon-ami Kōetsu and Sōtatsu of the Momoyama period, adapted his designs to the production of *maki-e*; he originated a style of design known as Kōrin *moyo* (Kōrin design). Among his works are two inkstone boxes, one called Yatsuhashi in the Tokyo National Museum and the other known as Suminoe in the Seikadō Bunko in Tokyo. In contrast to these works of purely Japanese spirit, Ogawa Haritsu (1663–1747) of Kyoto produced *maki-e* works of Chinese design and technique.

Late in the Edo period the following were among the prom-inent artists: Koma Koryū (ca. 1780), Iizuka Tōyō (ca. 1840), Koma Kansai (ca. 1840), and Hara Yōyūsai (ca. 1840) of Edo; Nishimura Zōhiko (ca. 1780) of Kyoto; and Tamakaji Zōkoku (1805–69) of Takamatsu in Kagawa prefecture. From an artistic point of view, however, the period showed deterioration in the production of *maki-e*; the design became overornate and the techniques formalized. The elaborate *maki-e* works applied to sword sheaths and inro show the trend of the age.

Among the schools that continue their production today are Aizu lacquer at Aizu-Wakamatsu (in Fukushima prefecture), Tsugaru lacquer at Hirosaki (in Aomori prefecture), Wakasa lacquer at Obama (in Fukui prefecture), Wajima lacquer at Wajima (in Ishikawa prefecture), and Shunkei lacquer at No-shiro (in Akita prefecture).

Metalwork also deteriorated into mannerism, emphasis being placed on elaborate detail alone. In this period, as in other periods, mirrors were produced in large quantities and the number of craftsmen engaged in this work reached several hun-dred. The Ao family continued to be the main mirror crafts-men in Kyoto, producing chiefly hand mirrors, which had first been made in the Momoyama period. The Gotō family, who had been patronized by the Ashikaga Shoguns and Toyo-tomi Hideyoshi, lived in Edo and served the Tokugawa Shoguns. The family and their pupils continued to produce metalwork in their traditional style. Yokoya Sōmin (1670–1733), one of the pupils, became dissatisfied with the Gotōs' traditionalism and created a style of his own. His method of chiseling patterns and designs on the metal surface produced effects similar to those of line drawings. Prominent among Kyoto goldsmiths were the Umetada and the Shōami schools, who inlaid sword guards with gold and silver. In the provinces, Nara Toshinaga (1673–1736) with his Nara school was prominent, and Hagi (in Yamaguchi prefecture) recorded the highest sword-guard output in Japan during the Edo period. The continued popu-larity of *cha-no-yu* stimulated the manufacture of tea articles, including iron kettles and garden lanterns. At the beginning of the Edo period, Nagoshi Iemasa and Ōnishi Jōsei (1603–82) moved to Edo, where they began the production of kettles. The heightened standard of living among warriors and ordinary citizens created a demand for ornamental works in metal such as *okimono*, or small ornaments for alcoves, and desk objects.

The most striking development in the crafts of the Edo period was the production of porcelain (see CERAMICS). Korean-style earthenware pottery originated at Arita in the Momoyama period, but it was not until 1616 when a Korean potter, Li San-pei (Jap., Ri Sampei), discovered porcelain clay of fine quality near

the town that Japanese potters began manufacturing *some-tsuke hakuji* or fine porcelain ware with a pure white body decorated in cobalt colors. About 1643, Sakaida Kakiemon (also known as Kakiemon I) originated a technique of producing enameled porcelains with glazed painted designs. The Arita ware made in this way had rich colors, among which red (*aka*) was often predominant, so the Kakiemon style is sometimes called *aka-e*. This ware became extremely popular. The first five masters of the Kakiemon family produced porcelains of very similar de-sign; the sixth master, Shibuemon (ca. 1700), employed much richer designs, which have been handed down to the present day and are still made by the Kakiemon family. Arita ware was exported to China in 1646 and later to European countries through the nearby port of Imari (in Saga prefecture) and for that reason is usually called Imari ware. Kilns both in Japan and Europe were influenced by the style of the Imari ware. Another outstanding type of porcelain made in the Arita dis-trict is the Nabeshima ware; it was made in kilns at Okawachi for the Nabeshima family, lords of Saga province. The Nabe-shima ware has a regularity and perfection of shape and color that is unique.

The method of manufacturing enameled porcelain spread throughout the country. The earliest enameled ware was Ku-tani ware (in Ishikawa prefecture). *Aka-e* porcelain was first produced there about 1650 but the kilns were closed about 1690 and not reopened till 1823. The earlier wares are called *ko*-Kutani, or Old Kutani (PL. 303). The later products are noted for the strength of their designs, often executed in magnificent *kinrande* (gold brocade) style.

The Seto kiln supplied the better part of the nation's demand for ceramics in this period. It was on the advice of Katō Ta-mikichi (1772–1824) that they changed over to the production of enameled porcelain, an art which Katō had learned at Arita.

Among the numerous potters of the age, there were two whose works may be regarded as outstanding: Nonomura Ninsei (1598–1666) and Ogata Kenzan (1663–1743; q.v.). Nin-sei is particularly famous for the shapes of his ceramics and for his use of gold-sprinkling and painting in gold, techniques which he adapted from the gold lacquer designs. He was also influenced by contemporary painting and he often used Yamato-e designs; generally the colors are bright. It was Ninsei who introduced Arita enameled ware into Kyoto, which led to the application of the enameling process to Kyoto ware. Among his finest pieces are a tea pot with wisteria flower pattern (Nagao Art Gall., Tokyo), a tea pot with a mountain temple design (Nezu Art Mus., Tokyo), and a tea pot with a moon and plum tree (Tokyo Nat. Mus.). Kenzan was the disciple of Ninsei and an even finer potter; it was he who applied painted designs to raku ware (III, PL. 171).

About 1750 Kiyomizu Rokubei began to make porcelain in Kyoto, known as Kiyomizu ware, and his descendants still pro-duce this ware. Later, Okuda Eisen (1752–1811) of this school started the production of porcelain in imitation of the enameled wares of Ming and Ch'ing China. Among his pupils were such experts as Aoki Mokubei (1767–1833), Nin-ami Dōhachi (1783–1855), and Eiraku Hozen (1795–1854), Dōhachi's pupil.

Early in the Edo period the *kosode* was worn by the whole nation — courtiers, samurai, and ordinary citizens alike — so the weaving and dyeing industries flourished. In the middle of the period longer sleeves became the fashion in women's *kosode*, as did broader obi (sashes). The people of this period desired gorgeous and elaborate decorative patterns. The Ni-shijin district of Kyoto, which had started production in the Mo-moyama period, was the center of the textile industry, but other mills were developed. As was the case with ceramics, various lords encouraged the weaving industry, and some cities and towns produced textiles of individual style for which they became famous. Many of them have continued manufacturing.

With the growth in size of the textile patterns, printed patterns came to take the place of woven designs because of the stronger effects these produced. Patterns were printed by the *chaya* process, originated by Chaya Sōri (ca. 1640) of Edo, and by the *komon* process, a special way of dyeing small patterns; both of these were employed in manufacturing the ceremonial

garments of the samurai. Later, as ordinary citizens became more and more influential, their love of ostentatious richness in dress created a demand for freer patterns. Miyazaki Yūzen (d. 1711) of Kyoto invented a special process of dyeing, the *yūzen* process, by which he could dye cloths with as much ease as if he were painting pictures on them. The *yūzen* silk fabrics are still a specialty of Kyoto.

MEIJI-TAISHO PERIOD (1868–1926). *Architecture.* The accession of the emperor Meiji to the throne in 1867 was followed immediately by the overthrow of the Tokugawa Shogunate, and this led to a complete change in Japanese government. The warriors who had been in power since the Kamakura period ceased to govern, and the new emperor, who moved his court from Kyoto to Edo (which he renamed Tokyo), reassumed direct control of the country. Edo castle, the former abode of the Tokugawas, was chosen as the new seat of the imperial palace.

Toward the end of the Edo period commercial buildings, dwellings, and churches were built in wood for the Western residents in open ports such as Nagasaki and Yokohama; these followed, outwardly, a Western style, but Western architecture did not exert a great influence on the Japanese architecture of that period. The Meiji government, however, established a positive policy of adopting Western culture, and simultaneously displayed a great interest in town planning and in the construction of government offices in the Western manner. Employment was offered to such European architects as T. J. Waters and Josiah Conder (1852–1920) of England and C. de Boinville of France, who went to Japan between 1868 and 1877. Under their guidance, brick buildings and wooden buildings in a pseudo-Western style with plastered or stone-fronted walls and pantiled roofs were erected in big cities such as Tokyo and Yokohama. Conder was appointed professor of architecture at Kōbu University (the present Department of Technology of Tokyo University), which in 1879 turned out the first graduates to have studied Western design and building practice under the British architect. In the first 20 years of the Meiji period the Western eclectic or semi-European style made itself felt in Japan. The only surviving building of this type is the church of St. Nicholas in Tokyo, which was built on Conder's design in 1891 in a Russo-Saracen style.

Between 1887 and 1919, Japanese architects who had studied Western designs and practices in Europe erected Western-style buildings after their own plans. To celebrate the promulgation of the constitution in 1889, the government decided to build at Hibiya (Tokyo) various government offices, including a building to house the Diet. Three architects — Tsumaki Yoriki, Watanabe Yuzuru, and Kawai Kōzō — together with various construction engineers were sent abroad to study. Graduates of Kōbu University who had studied under Conder, including Tatsuno Kingo (1858–1919), and those who had studied in England and other countries joined the project. Western-style architecture constructed during this period in Tokyo, most of it in Renaissance style, includes the first building of the Bank of Japan, constructed by Tatsuno in brick and stone between 1890 and 1896; the Akasaka palace, completed in 1909, and the Hyōkeikan of the Tokyo National Museum, built in 1908, both designed by Katayama Tōyu (1854–1917); Tokyo Central Station, in brick with a steel frame, completed in 1914 on Tatsuno's plans; and the Imperial Theater built in 1911 after the plans of Yokogawa Tamisuke (1864–1945). Japanese architecture owed its sudden flowering in Western-style building to capitalism, which developed in Japan following the Sino-Japanese War (1894–95) and the Russo-Japanese War (1904–05).

Japan is subject to frequent earthquakes, and it was found that the brick and stone structures in Western style built during the first half of the Meiji period were not safe so they were replaced by earthquake-proof buildings. Steel-frame structures appeared in 1895, followed 14 years later by reinforced-concrete buildings.

Western-style buildings constructed in the Taisho period (1912–26) were chiefly large public buildings, and reinforced-concrete buildings gradually increased in number. Some American-style skyscrapers were erected. Early in the 1920's the Vienna Sezession style was introduced in Japan. The principal extant buildings of this period, all in Tokyo, are the Kaijō building, erected after designs by Tatsuno in 1919; the Marunouchi building, designed by the Mitsubishi Real Estate Department, 1923; the art gallery of the Meiji Shrine, built in the same year; Frank Lloyd Wright's (1869–1959) Imperial Hotel, completed in 1922; and the Department of Technology of Tokyo University buildings, completed in 1923 after plans of Uchida Shōzō (b. 1885), where steel window sashes were used for the first time in Japan.

Shinto shrines, Buddhist temples, and domestic architecture continued in the Meiji period to be built of wood in the tradi-

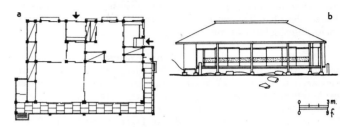

Ground plan and elevation of a typical house.

tional manner. Two examples of wooden structures of this period are various buildings of the Higashi Honganji in Kyoto, rebuilt between 1880 and 1895, and the Heian Shrine in Kyoto, built in 1895. The residences of the nobility and the wealthy class were mainly of *shoin* style, with some rooms in a semi-European style.

In the Meiji period the construction of gardens of traditional design and taste was discontinued; after 1873 many gardens were turned into public parks. In the Showa period (after 1926) Western-style gardens were imitated, and some Japanese gardens were built.

Sculpture. In the Meiji period Buddhist sculpture was no longer made owing to the anti-Buddhism of the government, and Japanese sculpture was at a low ebb in this period. Only the miniature art of the netsuke, made of wood, bone, and ivory for the export trade, was produced. Western-style sculpture was studied in the early part of the Meiji period (when European culture was absorbed with little understanding or criticism on the part of the Japanese). In 1876 the government ordered a school of art to be built at Kōbu University. Vincenzo Ragusa (1841–1928), an Italian, was invited to the university to give lessons on Western art; he introduced the art of plaster modeling, and gave instructions on architectural decoration, such as marble statues and plaster busts. Before this new type of sculpture was fully assimilated, however, a nationalistic current arose, which led to a revival of interest in traditional wood carving. When the Tokyo Academy of Fine Arts was founded in 1888, two professional sculptors of the traditional school were appointed professors in the sculpture department: Takeuchi Kyūichi (1857–1916) and Takamura Kōun (1852–1934).

Japanese sculptors specializing in Western-style carving, however, continued to find favor. Ōkuma Ujihirō (1856–1934) was a pupil of Ragusa; Sano Akira (b. 1866) and Naganuma Moriyoshi (1857–1942) studied in Italy. The latter was appointed professor in the sculpture department of the Tokyo Academy of Fine Arts in 1899, when sculpture was included as an independent subject in the curriculum. In 1902 he was awarded the gold medal at the international exhibition in Paris for a work in Western style. Two years later, Shinkai Taketarō (1868–1927) returned from Germany after completing his studies there. Thus the new Western-style school flourished at the same time as traditional sculpture in wood.

In 1907 the Ministry of Education held for the first time an over-all exhibition of fine arts under government management; both Japanese sculpture and Western-style carvings were exhibited. Western-style sculpture gradually came to be understood and appreciated by the general public. Prominent among

the sculptors of this school are Asakura Fumio (b. 1883) and Ogiwara Morie (1879–1910). In 1914 the Nippon Bijutsuin, or Japanese Academy of Fine Arts, was reestablished in opposition to the government-operated exhibition; among the members of this organization are Hiragushi Denchū (b. 1872), Ishii Tsuruzō (b. 1887), and Tobari Kogan (1882–1927). Also in 1914 a group of Western-style painters organized the Nika-kai. In 1919 a Western sculpture department was created in the Nika-kai, with Fujikawa Yūzō (1883–1935) a leading member. He had been an assistant of Rodin, and when he introduced some of the master's works to Japan the influence on Japanese sculpture was considerable. The Teikoku Bijutsuin, or Imperial Academy of Fine Arts, was established by the Ministry of Education in 1919; among the sculptor members were Takamura Kōun, Shinkai Taketarō, and several Western-style sculptors including Asakura Fumio.

Painting. The policy of extreme Europeanization adopted by the Meiji government in an effort to modernize Japan and elevate it to the level of Western nations stimulated an interest in Western oil painting and woodcuts, with the result that these became more influential than traditional Japanese painting. This trend of the Meiji period led Japanese artists to follow traditional Japanese and Western styles (treated separately below) without being able to fuse the two. When the imperial palace and the government were established in Tokyo in 1869, Tokyo became the artistic center of the nation.

a. Traditional-style painting. Toward the end of the Edo period the Maruyama-Shijō school was the center of artistic life in Kyoto; many of the artists of this school were active in the first 20 years of the Meiji period and were strongly influenced by Western realism. Among them were Mori Kansai (1814–94), Kishi Chikudō (1826–97), and Kōno Bairei (1844–95). In these first 20 years, some pupils of Kōno Bairei were active: Kikuchi Hōbun (1862–1918), Takeuchi Seihō (1864–1942), and Tsuji Kakō (1870–1931). At this time a reaction against extreme Europeanization set in, and a movement to reevaluate traditional Japanese painting was started. Young artists, including Takeuchi Seihō (PL. 330), after various experiments successfully introduced a new style of Japanese painting, adapting traditional elements to modern requirements. Thus in the latter part of the Meiji period the traditional style was revitalized.

The principal painters active in the Taisho period were Uemura Shōen (1875–1949), a woman painter, Nishiyama Suishō (1879–1958), Hashimoto Kansetsu (1883–1945), Tsuchida Bakusen (1887–1936), Kikuchi Keigetsu (1879–1955), Tomida Keisen (1879–1936), and Murakami Kagaku (1888–1939). They assimilated the spirit of Western painting and fused it with the classical style of Japanese painting, deriving their modern Japanese style from that of Takeuchi Seihō. Entirely independent of the main group of Kyoto painters was Tomioka Tessai (1836–1924), an exponent of the Nanga school who developed a unique style. In the latter half of the Edo period the Nanga painters had lost their originality and become coarse, but Tessai breathed new life into the old forms. He successfully expressed an unworldly spirit in his painting, combining with it his Chinese classical culture. His works were the last glory of Nanga painting.

Unlike the Kyoto school, several groups, led by the Kanō school, made up the artistic world of Tokyo. In the first half of the Meiji era, the following artists were outstanding: Kikuchi Yōsai (1788–1878) in Nanga painting, Taki Katei (1830–1901) of the realist group, Tsukioka Yoshitoshi (1839–92) of Ukiyo-e, and Kanō Hōgai (1828–88; PL. 356) and Hashimoto Gahō (1835–1908) of the Kanō school. Ernest Fenollosa (1853–1908), an American scholar who went to Japan in 1878 to teach philosophy at the university in Tokyo, was instrumental in arousing the interest of the Japanese in their ancient arts just at the time they tended to reject them for European styles. The movement for the revival of traditional Japanese arts which arose about 1882 became more concrete with the training of artists and research into ancient works of art conserved in old Buddhist temples and Shinto shrines. Vigorous advocates

of this movement were Fenollosa and Okakura Tenshin (also called Okakura Kakuzō, 1862–1913). Okakura Tenshin became the president of the Academy of Fine Arts in Tokyo, founded in 1888, and Hashimoto Gahō and Kawabata Gyokushō (1842–1913) were appointed professors of Japanese painting.

In 1898 Okakura Tenshin resigned because his views on the administration of the school were rejected, and set up the Nippon Bijutsuin in opposition to the governmental organization with Hashimoto Gahō and some of the first graduates of the Academy of Fine Arts, including Yokoyama Taikan (1868–1958; PL. 330), Shimomura Kanzan (1873–1930), and Hishida Shunsō (1874–1911). In their new, romantic Japanese painting emphasis was laid not on line, as in the Kanō school, but on the choice of subject matter according to interpretations derived from modern thought. Some critics contemptuously called this new style the Mōrō school or ultraimpressionism. Thus the first part of the Meiji period was a time of antagonism between the Academy of Fine Arts and the Nippon Bijutsuin.

At the first art exhibition held in 1907 painters of the Nippon Geijutsuin group took part; however, in 1914 Yokoyama Taikan severed his connection with the government-managed exhibition and together with Shimomura Kanzan, Imamura Shikō (1880–1916), and Yasuda Yukihiko (b. 1884) he reestablished the Nippon Bijutsuin, which is still a private circle of artists in opposition to the official group.

Prominent among the faculty members of the Tokyo Academy of Fine Arts were Kobori Tomone (1864–1931), Terasaki Kōgyō (1866–1919), Kawai Gyokudō (1873–1957), and Matsuoka Eikyū (1881–1938). Kaburagi Kiyokata (b. 1878), Kikkawa Reika (1875–1929), Hirafuku Hyakusui (1877–1933), and Matsubayashi Keigetsu (b. 1876) were among painters who, without belonging to any group, displayed their works at the government-managed exhibitions. Among the newly enlisted members of the Nippon Geijutsuin were Kobayashi Kokei (1883–1957), Maeda Seison (b. 1885), Ogawa Usen (1868–1938), Kawabata Ryūshi (b. 1885), and Hayami Gyoshū (1894–1935). The Kanten circle or the Tokyo Academy of Fine Arts group was academic and conservative in style, whereas the Nippon Bijutsuin group was progressive, always ready to improve and undertake new experiments. Various techniques, styles, and designs of different schools existing in the first half of the Meiji period were now brought together: the Kanō school and the Maruyama-Shijō school were entirely consolidated in the Taisho period, the Yamato-e and Nanga painters became small branches, and the Ukiyo-e died out. Nevertheless, the problem of how much of Western artistic culture to incorporate into Japanese art remained unsolved.

b. Western-style painting. The history of Western painting in Japan may be divided into three stages: the *namban-ga* of the Momoyama period, the *kōmō-ga* of the latter half of the Edo period, and the Western painting introduced at the beginning of the Meiji period.

Charles Wirgman (1832–91), who went to Yokohama as special correspondent of the *Illustrated London News* at the end of the Edo period, introduced regular Western painting, or oil painting, into Japan. Among the earlier oil painters were two pupils of Wirgman's, Takahashi Yuichi (1828–94) and Goseda Yoshimatsu (1855–1915). Later, two Italians, Edoardo Chiossone, a painter (1832–98) who went in 1875, and Antonio Fontanesi (1818–82) who went the following year and taught painting at the Academy of Fine Arts, helped to spread the techniques of oil painting. Among the painters who had studied abroad were Kunizawa Shinkurō (1847–77), who returned to Japan from England in 1875, and Kawamura Kiyoo (1852–84), who came back from Europe and America in 1881. In 1888 Asai Chū (1856–1907), who had studied under Fontanesi, and Kawamura Kiyoo set up the Meiji Bijutsu-kai, the first of its kind in Japan, and held an exhibition. Kuroda Kiyoteru (1866–1924), who had studied plein-air painting under Raphaël Collin (1850–1917), and Kume Keiichirō (1866–1934) returned to Japan in 1893 and joined the Meiji Bijutsu-kai. Three years later these two artists set up a separate group of painters called Hakuba-kai and simultaneously were appointed professors of

Western painting, a new subject added to the curriculum of the Tokyo Academy of Fine Arts. The Meiji Bijutsu-kai was renamed the Taiheiyō Gaka in 1902 and lasted into the Showa period; this association, together with the Hakuba-kai (renamed the Kōfū-kai in 1909), supported the Kanten group and represented Western painting in Japan during the latter half of the Meiji period. The Hakuba-kai, led by Kuroda Kiyoteru, was the chief force behind the art exhibition held in 1907; consequently, their plein-air style came to be identified with academism in Japanese Western painting.

Dissatisfied with the academism of the Kanten group, in 1912 Takamura Kōtarō (1883–1956) and some other artists organized a private association, inspired by their admiration of the Fauves, called the Fusain Society. Two years later another private organization called the Nika-kai was set up by Ishii Hakutei (1882–1958), Sakamoto Hanjirō (b. 1882), Kishida Ryūsei (1891–1929), and others, followed eight years later by the Shunyō-kai founded by Umehara Ryūzaburō (b. 1888) and others. Efforts were made by all these painters to absorb as best they could the various European movements after the Fauves, such as cubism, futurism, Dadaism, surrealism, and expressionism. The Kanten group, on the other hand, showed signs of deterioration in this period; its principal artists were Fujishima Takeji (1867–1943), Okada Saburōsuke (1869–1939), and Wada Eisaku (1874–1959), all professors at the Tokyo Academy of Fine Arts.

Minor arts. Following the restoration of imperial rule in 1868 there was a decline in the minor arts for a short period. In 1873 some Japanese products were displayed at the World's Fair in Vienna; the exhibit created a demand for Japanese works, thus stimulating the production of works of art for export. The first exhibition held in Japan in 1877 testified to the gradual revival of the crafts in the country, and much credit must be given to the German craftsman Gottfried Wagner (1830–92), who went to Japan in 1868. It was he who taught Japanese artisans the true worth of the crafts, at the same time introducing new techniques of Western industrial arts.

With the national development, the growth of capitalism, the establishment of crafts departments in newly founded schools of fine arts, public and private, and the success of Japanese craftsmen at the World's Columbian Exhibition in Chicago (1893) and at the Exposition Universelle in Paris (1900), Japanese crafts were gradually recognized as being on the same level as other branches of fine arts such as painting and sculpture. In the Taisho era, under the influence of the new Western art movements, Japanese craftsmen were faced with the question of how their traditional crafts were to adapt themselves to the Western style.

Most of the creations in metal in the Edo period had been small pieces requiring elaborate workmanship and skill, objects mainly for the decoration of swords. The metalworkers were hard hit by the decree abolishing the wearing of swords, but new techniques and designs were devised to make up for the loss, both in the production of articles for export and for home consumption. Leading craftsmen in the art of metal-chasing were Kanō Natsuo (1828–98), Unno Shōmin (1844–1915), and Tsukada Shūkyō. Hata Zōroku (1823–90) and Katori Hozuma (1874–1954) were outstanding in casting techniques. In the field of wrought gold Suzuki Chōō (1848–1919), a traditional master artisan, and Eiichi (b. 1876), who adapted the traditional technique to the new spirit of the age, were distinguished craftsmen.

Lacquerwork also, after a period of decline similar to that of metalwork, revived. Shibata Zeshin (1807–91), a painter and master lacquerer, produced beautiful lacquerwork in the early part of the Meiji period; Ogawa Shōmin (1847–91) of the Kōrin school and Kawanobe Itchō (1830–1910) of the Kōami school were noted artisans in the traditional style. Other lacquerers added new tones of colors and applied lacquer to objects that had not hitherto been included in *maki-e* production; among these Umezawa Ryūshin (1874–1955) and Rokkaku Shisui were prominent.

Japanese ceramics were displayed for the first time at the World's Fair in Vienna in 1873, and from then on ceramics were represented at exhibitions abroad. Artisans introduced Western techniques and designs, thus stimulating the production of new types of ceramics. Prominent among the potters of this period were Itō Tōzan (1846–1920) and Mashimizu Zōroku (1822–77) of Kyoto and Miura Ken-ya (1821–89) of Tokyo, who worked in the traditional style, and Takemoto Hayata (1848–92) and Suwa Sozan (1852–1922) of Tokyo, who originated a new style by combining Western design with traditional Japanese techniques. These types tended to become formalized in the Taisho period. Numata Kazumasa (1873–1954) introduced sculpture in ceramic, which he had learned to make in the Sèvres works in France; Itaya Hazan (b. 1872), after studying European enamels, succeeded in creating a new color.

The true cloisonné (*shippō*) enamel, which had appeared in the Edo period, achieved a remarkable development, stimulated by large demands from overseas. Kaji Tsunekichi (1803–83) of Aichi prefecture created a lined cloisonné enamel. Namikawa Yasuyuki (1845–1927) of Kyoto created a translucent type. Namikawa Sōsuke (1847–1910) opened a new cloisonné enamel factory in Tokyo.

The dyeing and weaving industries also developed gradually under the influence of Western designs and practices. Date Yasuke (1844–92) of Kyoto went to the 1873 World's Fair, and also studied the chemical dyeing processes in Germany and France. He brought a Jacquard apparatus from France to Japan. In 1887 Kawashima Jinbei (1853–1910) of Kyoto went to France to study at the Gobelin tapestry works. The Nishijin weavers of Kyoto began to produce large tapestries, adopting Western techniques, with embroidered figures in traditional Japanese style.

Small ivory and bone carvings were made by Ishikawa Kōmei (1852–1913) and Asahi Gyokuzan (1841–1923), among others. The demand for netsuke by foreigners declined, and netsuke production ceased in the Taisho period. Bamboo vessels and utensils used in arranging flowers and in the tea ceremony continued to be produced in the Meiji period; the style was like that of the Edo period.

SHOWA PERIOD (1926). *Architecture.* The great earthquake disaster that occurred in the Kantō district in 1923 destroyed practically all the buildings in and around Tokyo. It was after this catastrophe that the true worth of Western earthquake-proof and fireproof buildings was widely recognized and European architecture was adopted on a grand scale in the Showa period. After 1926 the influence of Walter Gropius, Le Corbusier, and Otto Wagner was felt in Japan. Antonin Raymond (b. 1889) of Czechoslovakia accompanied Frank Lloyd Wright to Japan, and in 1921 he opened his own office; he has exerted a deep influence on contemporary Japanese architecture. Buildings of this time in Tokyo are the Yasuda Assembly Hall and the library of Tokyo University by Uchida Shōzō (1925) and the Kiyosu and Eitai bridges, designed by the Bureau of Reconstruction (1928). Attempts were also made to combine the styles of Japanese and other Oriental architecture with that of the West. The Kabuki Theater (1922) by Okada Shin-ichirō and the Tsukiji Honganji (1934) by Itō Chūta, both in Tokyo, are two examples of this.

In the 1930s the following buildings were erected in Tokyo: Central Post Office by Tetsurō Yoshida (1931); National Diet Building (completed 1936); Communications Hospital by Mamoru Yamada (1937), built of concrete with large windows and projecting verandas on the sides; the chapel of the Women's University by Antonin Raymond (1938); and the Daiichi Sōgo Building by Watanabe Hitoshi and Sugimoto Kōsaku (1938). In Osaka the Sogō Department Store by Tōgo Murano (1936) and the Central Post Office by Tetsurō Yoshida (1939) are notable.

Soon, however, the spirit of nationalism reasserted itself, and official architecture became massively solid and martial in appearance, with the buildings statically juxtaposed. The Army Palace in Tokyo is an example of this style.

Very few buildings were erected on a large scale during the Sino-Japanese conflict of 1937 and World War II. Owing

to the almost complete destruction of many cities during the war, the need for organic and radical town planning arose. New materials, such as cement, metal, and glass, and new techniques were employed. Numerous large public buildings were constructed, generally inspired by American architecture. Outstanding examples of the use of traditional forms and Western techniques are the exhibition building for the Kobe Trade Fair (1950) and the Hiroshima Memorial Peace Center (begun 1951; X, PL. 428), both designed by Kenzō Tange. The Japanese style, since the end of World War II, has been adopted only for a limited number of small private houses, and an increasing number of private dwellings, in wood or reinforced concrete, are being built in the Western style.

Sculpture. In 1927 the Kōzōsha, a new art group made up solely of sculptors, was founded, and in 1928 the Kokuga-kai was established with a sculpture department. The influence of the French sculptors Emile-Antoine Bourdelle and Aristide Maillol made itself felt in Japan about this time. There has been an increase in the use of sculpture in monuments and as architectural decoration, but ornamental sculpture, displayed mainly at exhibitions, still occupies the better part of the field.

Painting. Most of the Taisho artists survived into the Showa period and attempted to modernize the "new" Japanese painting of the Taisho period. The Sino-Japanese conflict of 1937 and World War II paralyzed practically every activity of Japanese artists; after Japan's surrender in 1945, however, the painters resumed their work. French and American influence is strong. Many artists imitate the Western style even in their Japanese paintings or use Western materials and paint brushes. The works thus created are hard to distinguish at a glance from Western paintings; these extremists ignore even the traditional Japanese emphasis on line and color. The present confusion prevailing in Japan, however, may be looked on as a state of transition in which artists are experimenting to produce an absolutely new school of Japanese painting.

Besides those painters already mentioned, the following masters are still active: of the Kanten group, Yamaguchi Hōshun (b. 1895) and Itō Shinsui (b. 1898), both of Tokyo, and Dōmoto Inshō (b. 1891), Fukuda Heihachirō, Tokuoka Shinsen, and Nakamura Gakuryō (b. 1890), all of Kyoto; of the Nippon Geijutsuin group, Okumura Dogyū (b. 1889).

Western painting had flourished in the Taisho period as vigorously as Japanese painting. In 1926 a department of Western painting was established in the Kokuga Sōsaku Kyōkai; in 1928 this department organized a separate group called the Kokuga-kai. Among its members were Umehara Ryūzaburō, Onchi Kōshirō (1891–1955), and Aoyama Yoshio (b. 1894). In 1931 Satomi Katsuzō (b. 1895), who had studied in France under Maurice de Vlaminck, and Saeki Yūzō (1898–1928) broke away from the Nika-kai and founded the Dokuritsu Bijutsu Kyōkai. The Issui-kai was established in 1936 by Yasui Sōtarō (1888–1955) and others, and the Shin Seisaku-ha Kyōkai was founded the same year by Ogisu Takanori (b. 1901) and Inokuma Gen-ichirō (b. 1902). A year later Hasegawa Saburō formed the Jiyū Bijutsu Kyōkai.

The increase in the number of private groups weakened the influence of the Kanten group, which continues to practice academic realism. The various European movements that the private circles follow are surrealism (Nika-kai), neoimpressionism (Shunyō-kai and Kokuga-kai), Fauvism (Dokuritsu Bijutsu Kyōkai), sensitive modernism (Shin Seisaku-ha Kyōkai), and nonobjectivism (Jiyū Bijutsu Kyōkai). After World War II other organizations were formed, whose members painted in the Western style: the Kōdō Bijutsu Kyōkai in 1945 and the Dainiki-kai in 1947, both founded by former Nika-kai members. Although at present all these independent groups are intent on copying Western styles, the creation of a unique Japanese style of oil painting must be their ultimate aim.

Since 1951, when several Japanese painters exhibited at the biennial in Saõ Paulo, Brazil, Japanese works of art have appeared in many international exhibitions in Europe and America. Many of the artists reside in Europe and appear to be open to the most modern tendencies.

Minor arts. During the Meiji-Taisho period, Japanese crafts had achieved a marked development, stimulated by demands from the nobles and rich merchants in Japan and from art lovers abroad. The craftsmen gradually were accorded the same social position as painters and sculptors. In 1927 several master craftsmen were chosen as members of the government-organized Teikoku Bijutsuin. The Secessionist and Art Nouveau movements, which had been introduced to Japan in the Taisho period, stimulated the development of new crafts, and the handicraft production advocated by John Ruskin and William Morris in England inspired the development of *mingei* or folk arts. In adapting Western styles, however, Japanese artists copied the external form and did not comprehend the spirit.

BIBLIOG. *General*: S. Tajima, Tōyō Bijutsu Taikan (Selected Masterpieces of Far Eastern Art), 15 vols., Tokyo, 1908–18; G. Ono, Bukkyō no Bijutsu Oyobi Rekishi (Buddhist Art and a History of Buddhism), Tokyo, 1916; Seika-dō Kanshō (Appreciation of the Seika-dō Art Collection), 3 vols., Tokyo, 1921; Tōyō Bijutsu Bunken Mokuroku Zokuhen (Sequel to the Bibliography of Far Eastern Art Publications), Tokyo, 1922–45; Dai Nihon Kokuhō Zenshū (Catalogue of the National Treasures of Japan), 84 vols., Tokyo, 1924–39; S. Ōmura, Tōyō Bijutsu-shi (Outline History of Far Eastern Art), Tokyo, 1926; Shōsōin Gomotsu Zuroku (Catalogue of the Imperial Treasures in the Shōsōin), 18 vols., Tokyo, 1928–55; S. Taki and K. Kume, Nihon Kobijutsu Annai (Guide to Ancient Japanese Works of Art), Tokyo, 1931; Ōkagami Sōsho (Series of Illustrated Catalogues of Art Treasures), 32 vols., Tokyo, 1932–42; Seizansō Seishō (Illustrated Catalogue of the Nezu Collection), 10 vols., Tokyo, 1939–51; Minamoto-no-Toyomune, Nippon Bijutsu-shi Nempyō (Chronological Table of Japanese Art History), Kyoto, 1940; Tōyō Bijutsu Bunken Mokuroku (Bibliography of Far Eastern Art Publications), Tokyo, 1941; Y. Yashiro, Nihon Bijutsu no Tokushitsu (Characteristics of Japanese Art), Tokyo, 1943; S. Tani, Nippon Bijutsu-shi Gaisetsu (Outline History of Japanese Art), Tokyo, 1948; Sekai Bijutsu Zenshū (Arts of the World), IX, XV, XXI, XXV, and XXVIII, Tokyo, 1950–55; S. Tani and S. Noma, Nippon Bijutsu Jiten (Dictionary of Japanese Art), Tokyo, 1952; Nihon Bijutsu Ryakushi (Brief History of Japanese Art), Tokyo, 1952; Pageant of Japanese Art, 6 vols., Tokyo, 1952–54; A. Imaizumi et al., Kindai Nippon Bijutsu Zenshū (Catalogue of Contemporary Japanese Art), 6 vols., Tokyo, 1952–55; T. Moriguchi, Bijutsu Hachijūnen-shi (Eighty Years of Japanese Art), Tokyo, 1954; R. T. Paine and A. Soper, The Art and Architecture of Japan, Harmondsworth, 1955; R. Sawa, Mikkyō Bijutsu Ron (Essays on Esoteric Buddhist Art), Kyoto, 1955; Kokka Sakuin (Index to The Kokka), Tokyo, 1956; Y. Tazawa and M. Ōoka, Zusetsu Nihon Bijutsu-shi (Illustrated History of Japanese Art), 2 vols., Tokyo, 1957; Shitei Bunkazai Sōgō Mokuroku (Brief Catalogue of Registered Cultural Properties), 3 vols., Tokyo, 1958.

Architecture: S. Amanuma, Nippon Kenchiku-shi Zuroku (Historical Album of Japanese Architecture), 5 vols., Kyoto, 1933–38; E. Toyama, Muromachi Jidai Teien-shi (History of Gardens in the Muromachi Period), Tokyo, 1934; K. Ishiwara, Nippon Nōmin Kenchiku (Peasant Architecture in Japan), 12 vols., Tokyo, 1934–39; H. Kitao, Sukiya Shūsei (Illustrated Catalogue of Architectural Works of *sukiya* Style), 20 vols., Tokyo, 1935–37; T. Sekino, Nihon Kenchiku-shi Kōwa (Lectures on the History of Japanese Architecture), Tokyo, 1936; M. Toba, Nippon Jōkaku-shi (History of Japanese Castles and Forts), Tokyo, 1936; C. Itō, Nihon Kenchiku-shi no Kenkyū (Studies in the History of Japanese Architecture), 2 vols., Tokyo, 1936–37; M. Fujita, Nippon Minka-shi (History of Dwelling Houses in Japan), Tokyo, 1937; M. Shigemori, Nippon Teien-shi Zukan (Historical Album of Japanese Gardens), 24 vols., Tokyo, 1939; M. Sekino, Nihon Jūtaku Shōshi (Brief History of Japanese Residential Architecture), Tokyo, 1942; T. Fukuyama, Nihon Kenchiku-shi no Kenkyū (Studies in the History of Japanese Architecture), Kyoto, 1943; S. Horiguchi, Katsura Rikyū (Katsura Detached Palace), Tokyo, 1952; H. Ōta, Nippon no Kenchiku (Architecture of Japan), Tokyo, 1954; H. Ōta, Chūsei no Kenchiku (Medieval Architecture), Tokyo, 1957.

Sculpture: Zōzō Meiki (Inscriptions on Sculpture), Tokyo, 1926; Kamakura Chōkoku Zuroku (Pictorial Record of Sculpture of the Kamakura Period), Kyoto, 1932; T. Myōchin, Butsuzō Chōkoku (Buddhist Sculpture), Kyoto, 1935; Nippon Kogaku-men (Japanese Classical Masks), Tokyo, 1935; K. Adachi, Nihon Chōkoku-shi no Kenkyū (Studies in the History of Japanese Sculpture), Tokyo, 1944; T. Kobayashi, Nihon Chōkoku-shi Kenkyū (Studies in the History of Japanese Sculpture), Tenri-city, 1947; S. Noma, Gomotsu Kondō Butsu (Gilt-bronze Statues in the Imperial Collection), Kyoto, 1952; F. Miki, Haniwa (The *haniwa*), Tokyo, 1958; S. Noma, Chōkoku (Japanese Sculpture), Tokyo, 1959.

Painting: S. Fujioka, Kinsei Kaiga-shi (History of Modern Japanese Painting), Tokyo, 1903; S. Tajima, Kōrin-ha Gashū (Masterpieces Selected from the Kōrin School), 5 vols., Tokyo, 1903–06; K. Ōta, Zōtei Koga Bikō (Handbook of Classical Painting), 4 vols., Tokyo, 1905; S. Tajima, Ukiyo-e-ha Gashū (Masterpieces Selected from the Ukiyo-e School), 5 vols., Tokyo, 1906–09; S. Tajima, Maruyama-ha Gashū (Masterpieces Selected from the Maruyama School), 2 vols., Tokyo, 1908; W. Umezawa, Nippon Nanga-shi (History of Nanga Painting in Japan), Tokyo, 1919; M. Kurokawa, Teisei Zōho Kōko Gafu (Catalogue of Ancient Painting in Japan), Tokyo, 1924;

S. Sakasaki, Nippon Garon Taikan (Collection of Classical Essays on Japanese Painting), 2 vols., Tokyo, 1926–28; K. Tanaka, Shoki Ukiyo-e Shūhō (Collection of Early Ukiyo-e Masterpieces), Tokyo, 1927; K. Tanaka, Ukiyo-e Gaisetsu (Introduction to Ukiyo-e), Tokyo, 1928; I. Tanaka, Nihon Emakimono Shūsei (Collection of Japanese Scroll Paintings), 29 vols., Tokyo, 1929-43; S. Sawamura, Nihon Kaiga-shi no Kenkyū (Studies in the History of Japanese Painting), Kyoto, 1931; H. Ikenaga, Kōsai Banka Dai-hōkan (Illustrated Catalogue of the Ikenaga Collection), 2 vols., Osaka, 1932; K. Takahashi, Nippon Genshi Kaiga (Primitive Japanese Painting), Tokyo, 1933; Momoyama Jidai Kimpeki Shōheki-ga (Wall and Screen Paintings of the Momoyama Period), 2 vols., Tokyo, 1937; Nippon Shōzōga Zuroku (Album of Japanese Portrait Painting), Kyoto, 1938; S. Fujioka, Kinsei Kaiga-shi (History of Modern Japanese Painting), Tokyo, 1941; S. Tani, Muromachi Jidai Bijutsu-shi Ron (Essays on the Art of the Muromachi Period), Tokyo, 1942; S. Shimomise, Kara-e to Yamato-e (Kara and Yamato Painting), Osaka, 1944; S. Ienaga, Jōdai Yamato-e Zenshi (Complete History of Yamato-e), Kyoto, 1946; I. Kobayashi, Yamato-e-shi Ron (Essays on the History of Yamato-e), Kyoto, 1946; S. Ōmura, Kō Nippon Kaiga-shi (Complete History of Japanese Painting), Tokyo, 1948; H. Watanabe, Higashiyama Suiboku-ga no Kenkyū (Studies of Ink Paintings of the Higashiyama Period), Tokyo, 1948; Ukiyo-e Zenshū (Illustrated Catalogue of Ukiyo-e), 6 vols., Tokyo, 1957–58; S. Tani, Chūsei Kaiga (History of Medieval Japanese Painting), Tokyo, 1960.

Calligraphy: J. Iki, Nippon Shodō no Hensen (Development of Calligraphy in Japan), Tokyo, 1935; Shodō Zenshū (Album of Calligraphic Writings), 25 vols., Tokyo, 1954–56.

Minor arts: Y. Kuwabara, Chōkin-ka Nempyō (Chronology of Japanese Metalworkers), Tokyo, 1909; T. Hirose, Wa-kyō Shūei (Masterpieces of Japanese-style Mirrors), Kyoto, 1919; T. Hirose, Zoku Wa-hyō Shūei (Sequel to Masterpieces of Japanese-style Mirrors), Kyoto, 1921; Y. Takahashi, Taishō Meiki-kan (Plates of Rare Tea Wares Selected in the Taisho Era), 9 vols., 1921–27; Mon'yō Shūsei (Collection of Patterns), Tokyo, 1923–25; Saika, Illustrated Catalogue of Patterns, Tokyo, 1924–29; S. Akashi, Nippon Senshoku-shi (History of Japanese Dyed Textiles), Tokyo, 1928; S. Sugiyama, Nippon Genshi Kōgei Gaisetsu (Introduction to the Handicrafts of Ancient Japan), Tokyo, 1928; Senshoku Meihin Zuroku (Album of Famous Works of Dyeing and Weaving), Kyoto, 1930; S. Okuda, Nippon Kōgei-shi Gaisetsu (Outline History of Japanese Handicrafts), Tokyo, 1931; H. Katori, Nippon Kinkō-shi (History of Japanese Metalwork), Tokyo, 1932; S. Rokkaku, Tōyō Shikkō-shi (History of Oriental Lacquer), Tokyo, 1932; G. Sawaguchi, Nihon Shikkō no Kenkyū (Studies in Japanese Lacquer), Tokyo, 1933; K. Ono, Tōki Daijiten (Encyclopedia of Ceramics), 6 vols., Tokyo, 1934–36; T. Yoshino, Jidai Makie Kyūshū Shūsei (Collection of Masterpieces of Japanese Lacquer), 16 folders, Tokyo, 1934–40; M. Ōkōchi and S. Okuda, Tōki Kōza (Lectures on Ceramics), 25 vols., 1935–39; J. Homma, Kokuhō Tōken Zufu (Illustrated Catalogue of Swords Registered as National Treasures), 16 vols., Tokyo, 1936–38; S. Sasaki, Nihon Jōdai Shokugi no Kenkyū (Studies in the Ancient Japanese Textile Arts), Kyoto, 1951; J. Okada, Nippon Kōgei Zuroku (Illustrated History of Japanese Handicrafts), Tokyo, 1952; F. Koyama, Tōki Zenshū (Ceramics Library), 18 vols., Tokyo, 1957–58; F. Koyama, Tōgei (Japanese Ceramics), Tokyo, 1960.

Western-style contemporary art: H. Munsterberg, Art in Tokyo 1953, College Art J., XII, 1953, pp. 217–22; W. Baldinger, Westernization and Tradition in Japanese Art Today, College Art J., XIII, 1954, pp. 125–31; V. Takachiyo, Conflicts of Art in Postwar Japan, The Studio, Aug., 1954; pp. 33–48; Y. Harada, Japanese Contemporary Art: Another Aspect, The Studio, July, 1955, pp. 9–17; H. Munsterberg, East and West in Contemporary Japanese Art, College Art J., XVIII, 1958, pp. 36–41.

Shin'ichi TANI

Illustrations: PLS. 259–330; 6 figs. in text.

JEFFERSON, THOMAS. Author of the Declaration of Independence and third President of the United States, statesman, philosopher, and architect (b. Virginia, Apr. 13, 1743; d. Virginia, July 4, 1826). Jefferson was graduated from the College of William and Mary in 1762. When in 1769 he began serious proposals to build at Monticello, his knowledge of architecture must have been derived almost entirely from reading and from conversations. The development of Monticello from a simple Virginia country house to a structure with articulate massing of central and end pavilions joined by arcaded passages shows Jefferson's increasing grasp and assimilation of Palladian principles and reveals his individuality as an architect imbued with the ideal of classical monumentality. By the time he departed for Europe in 1784, Monticello was completed in its first form.

Finding the civil architecture of Virginia inadequate, he planned the remodeling of the Governor's Palace at Williamsburg and designed a statehouse for the new capital at Richmond. His wide European travel from 1784–89 sharpened his interest in classical architecture. "I am immersed in antiquities from morning to night," he wrote; and he found in the Maison Carrée at Nîmes the model which he adopted for his statehouse, the first public building to utilize the temple form and the first work of the classical revival in America (I, PL. 78). As Secretary of State, Jefferson made sketches and offered suggestions to Pierre Charles L'Enfant for the plan of the city of Washington which show his vital interest in city planning and his conviction that classical formalism provided the only worthy setting for the capital of the new republic. He made two designs for the President's house, one of which, a variation of Palladio's Villa Rotonda, he actually submitted anonymously in competition. At the same time he was also deeply involved in the selection and evolution of the Capitol design.

In 1794 he resigned from the Cabinet and returned to Monticello to continue (largely between 1796 and 1809) the remodeling he had been contemplating for some years. He also designed Edgehill (1798–1800) for his son-in-law, Thomas Mann Randolph, and Farmington (finished in 1803) for George Divers. As President he appointed Benjamin Henry Latrobe (q.v.) surveyor of the public buildings and assisted in the many changes in William Thornton's Capitol scheme. The design of the central mass of the building with its freestanding colonnade (I, PL. 79), embodied in Latrobe's drawings of 1807, seems to have been Jefferson's idea.

Poplar Forest, its plan based on a regular octagon, related to that of Monticello, was started on his farm of Pantops in 1806 and finally completed about 1822. In 1815 he designed Ampthill in Cumberland County for Randolph Harrison and, in 1817, Barboursville in Orange County for James Barbour. Bremo, planned during the same period for John H. Corley, with its ingenious use of different levels and of a semicircular ha-ha to unite outlying pavilions to the main block, its sober classical detail, and its bold simplicity of design, is one of Jefferson's most successful buildings.

The University of Virginia, planned as "an academical village" and virtually completed by 1824, crowned Jefferson's career. The design provided a rising perspective between facing colonnaded pavilions (each exemplifying the proper use of one of the classical orders) toward the dominating form of the library, a rotunda inspired by the Pantheon (I, PL. 80).

Inspired by the idea that only forms expressing the ideals of Roman republicanism were proper for new building in America, and powerfully influenced by Palladianism as an antidote to the Georgian baroque he deplored and by his admiration for contemporary French planning, Jefferson was a pioneer of the classical revival. His own work during this vital, formative period in America and his influence upon the work of others decisively directed the course of American classicism.

BIBLIOG. F. S. Kimball, Thomas Jefferson and the First Monument of the Classical Revival in America, Harrisburg, Pa., Washington, D.C., 1915; F. S. Kimball, Thomas Jefferson, Architect, Boston, 1916; I. T. Frary, Thomas Jefferson, Architect and Builder, Richmond, 1931; K. Lehmann, Thomas Jefferson, American Humanist, New York, 1947; E. D. Berman, Thomas Jefferson among the Arts, New York, 1947.

Richard B. K. McLANATHAN

JEWELRY. See GEMS AND GLYPTICS; GOLD- AND SILVERWORK.

JEWISH ART. The exceptional historical vicissitudes of the Jewish people have affected their art possibly more than any other manifestation of their national life. On the one hand, the origins of the Hebrew nation are closely bound up with a religious covenant that involved a repudiation of the beliefs and rituals of the neighboring nations, including the expression of such elements in painting and sculpture. On the other hand, the dispersion of the Jews among other nations and their continuous wanderings for over two millenniums have rendered them highly receptive to the artistic influences of their host cultures. Consequently Jewish art acquired a great richness and variety; occasionally, however, this very fact makes the definition of the specific Jewish element a matter of considerable difficulty. Moreover, at least until the 19th century, the Jewish artist labored under the specific restrictions

of a nomocracy. These restrictions varied in severity but required even in the most liberal times a compromise between the prescriptions of a God-given law and the natural freedom of artistic expression. The existence of such restrictions in matters of sacral art — and until fairly recent times almost all art was sacral among the Jews — was not an unmixed disadvantage. It often rendered Jewish art more subtle and more adept in expressing esoteric meanings by the use of symbols. The customary disapproval of a considerable part — if not the majority — of the rabbinic leaders brought the Jewish artist closer to the simple people. His art may have lost something in formal perfection, but it gained in spontaneity and freshness of expression.

SUMMARY. Art and law (col. 899). Ancient Israel (col. 901). Hellenistic and early Roman periods: the Diaspora (col. 903). The later Roman period (col. 908). The Middle Ages (col. 911): *Byzantium; Islamic countries; The European West.* The modern era (col. 920).

ART AND LAW. Any discussion of the art of the Hebrew nation, any evaluation of its standing in universal art must start from the laws, both Biblical and rabbinical, that governed representational art. The origins of the Hebrew tribes and the historical circumstances which forged them into a nation are still obscure; however, there can be no doubt of the fundamental character of the henotheistic revolution that accompanied the birth of Israel. Nor can there be any doubt that it involved a violent denial of the religions of the ancient Orient in all their aspects. The worship of the forces of nature in their multiplicity found expression in the polytheistic variety of representations of the divine, which ranged from the anthropomorphic image to the floral and faunal, and included even the sacred stone, or baetyl. All these representations had in common the element of the immanent or the symbolic. This religious environment explains the violence and the sweeping character of the Second Commandment: "Thou shalt not make unto thee any graven image, or any likeness of any thing that is in heaven above, or that is in the earth beneath, or that is in the water under the earth: Thou shalt not bow down thyself to them, nor serve them" (Exod. 20:4-5). This is amplified in Deuteronomy 4:16-18, and in Deuteronomy 27:15 the man who makes any graven or molten image is solemnly cursed. Two points should be noted in connection with these passages: first, they seem directed in particular against the conception of the Babylonian pantheon, with its cosmos graded into a heaven above, an earth below, and a watery abyss beneath the earth; second, the prohibition specifically envisages a "graven" or "molten" (cast) image. Later interpreters were quick to exploit these verbal limitations, thus rendering lawful two-dimensional representations that could not reasonably be described as "graven." By stressing rather the additional prohibition of bowing to such images or of serving them, the original injunction could be further limited to representations actually serving, or likely to serve, some idolatrous purposes. (See IMAGES AND ICONOCLASM.)

Other passages indicate that the prohibitions were construed with much latitude even in Biblical times. Exodus 25-27 contains detailed descriptions of the tabernacle with its cherubim in the holy of holies and its candlestick with knops and flowers. Numbers 21:9 gives an account of the making of a brazen serpent by Moses, an image which was apparently kept in a high place until it was destroyed by the zealous king Hezekiah (Num. 18:4). The Bible also gives details of the Temple of Solomon (I Kings 7) and of Solomon's throne, with lions standing on its steps (I Kings 10:18-20). These examples indicate too that the works of art referred to received the approval of the author or the editor of the canonical Bible. The popular practice can be surmised from stories such as that of Micah (Judg. 17) and from the archaeological finds mentioned below.

In the post-Biblical periods of antiquity and the Middle Ages, the same ambivalent attitude is exhibited. Whenever there seemed to be some danger of idolatry involved in making works of art, opposition became violent. The violence often increased in proportion to the political or social dangers threatening the moral or economic existence of the Jewish nation. Whenever there was a lessening of the external danger, the popular attitude changed and great latitude was allowed in practice. Even the rabbinic authorities of such laxer times had to adapt themselves, to some extent, to the popular trend. In the Persian period (536-332 B.C.), for example, since the danger of idolatry was insignificant, the high priestly authorities of the province of Yehud (Judea) did not hesitate to strike coins in their own name, imitating the Athenian tetradrachma with its owl and human faces in relief. With the advent of Hellenism, this tolerant attitude gained still more ground among the Hellenized aristocracy, as is evidenced by the lion frieze in the castle of the Tobiads in 'Arāq el-Emīr, east of the Jordan. It was possibly at this time that Hellenized Jewish circles in Alexandria evolved a narrative cycle of Biblical scenes intended to illustrate the Greek translation of the Old Testament in the manner in which Homer and the other Greek classics were illustrated. Somewhat later, however, the clash of the Greek and Jewish cultures and religions that resulted in the Hasmonean revolt caused a complete reversal of this attitude. Hasmonean coinage was aniconic (PL. 333). Most of the Jewish tombs of the Hellenistic and Roman periods are ornamented with geometric and floral motifs exclusively. When Herod the Great struck coins with such pagan symbols as the caduceus of Hermes and the tripod of Apollo, these were introduced as if by stealth, and when he dared to place a golden eagle on the façade of the Temple, two young Zealots, instigated by their rabbinical preceptor, removed it in broad daylight (Josephus, *Antiquities*, XVII, 151; *War*, I, 650). The statues in the palace of Herod Antipas in Tiberias were smashed by order of the Sanhedrin (Josephus, *Vita*, 65). Roman troops passing through Judea were even ordered to remove images from their standards.

There are evidences of a change in the Jewish attitude toward art in the 1st century of the Christian Era. Herod Agrippa I, although he minted coins bearing his own image as well as that of the emperor, remained one of the most popular of the Jewish kings. According to one Talmudic source, all kinds of images were to be found in Jerusalem toward the end of the period of the Second Temple. After the destruction of the Temple, the Jewish leaders, particularly the patriarchal house of Hillel, continued this tolerant attitude. They used seals with images and entered freely into buildings such as public baths decorated with the statues of gods, reasoning that since the purpose of the bath was not idolatrous the statues used to decorate it should not be regarded as idols (Mishnah, *Avodah Zarah* III, 4). As the danger of relapse into paganism became more remote, in the 3d and 4th centuries, the rabbinical rulings became even less severe. The Jewish leaders in Babylonia had always been less strict, for there the Jews lived under the rule of the Parthian kings, who, like their Persian predecessors, were Zoroastrian dualists. In the late Roman Empire, since Christianity, the great rival of Judaism, did not practice image worship, rabbinical precautions could be relaxed without danger. Rabbi Johanan (3d cent.) smashed the idols in the public bath of Tiberias, but allowed two-dimensional art on the walls (Jerusalem Talmud, *Avodah Zarah*, 42d). In the 4th century, mosaic pavements were allowed by Rabbi Abun. From the extant synagogue decorations of the 3d and 4th centuries it is apparent that sculptured reliefs (and occasionally sculpture in the round) were freely used in Palestine. The synagogue frescoes of Dura-Europos, a Mesopotamian city located on the upper Euphrates, near the Parthian border, show the freedom allowed to artists in the Diaspora (PL. 335). In the 6th century, mosaic pavements of synagogues show scenes from the Bible, including even a symbolic hand of God, and images of such pagan deities as Helios and Selene. The reaction that set in during the 7th century must have been due in large part to the influence of Islam, in which the traditional desert-nourished aversion to figural art again found forceful expression.

Jewish art in the Middle Ages was influenced by Islamic aniconism on the one hand and by the artistic freedom of Christian Europe on the other. The resultant split can best be observed in book illumination: In the East, Hebrew books

are found which are devoid of all ornament except the arabesque, while in the West there is a spate of illuminated manuscripts in which Biblical scenes are represented figurally in the rich landscape and architectural setting of Gothic art. (Here too there are occasional evidences of restriction, however. One of the strangest appears in a manuscript haggadah which depicts the Jews and angels with the beaks of birds, but does not deny human likeness to the Gentiles. It is the divergence between East and West, together with the subtle way in which they occasionally converge, that lends its peculiar fascination to the Jewish art of this period.

ANCIENT ISRAEL (ca. 1200–300 B.C.). The nomadic way of life of the Hebrews during the period of the Patriarchs and during their wanderings in the desert has naturally precluded the survival of any tangible remains of their artistic activities, other than the literary evidence referred to above. The conquest of Canaan under Joshua was marked by destruction of the sacral arts of the Canaanites and by a general decline of material culture rather than by fresh artistic activity on the part of the invaders. Not until the period of the Monarchy (Iron Age I and II, ca. 1000–586 B.C.) are we able to judge the character and qualities of Israelite art on a factual basis.

Situated on the narrow strip of fertile territory between the Mediterranean Sea and the Arabian Desert, and forming a connecting bridge between Egypt and Mesopotamia, ancient Israel was at the crossroads of four cultures (see SYRO-PALESTINIAN ART); the strongest influence in matters of art was exercised by the neighboring Phoenicians, with whom Israel maintained close cultural and political relations. It was through the medium of their eclectic art that the Hebrews found their way into the artistic traditions of the ancient Orient. It should be noted at the same time that the remains found so far, whether in the more cosmopolitan Israel or in traditionalistic Judah, show absolutely no aniconic tendencies. There are, to be sure, few traces of sculpture in the round, but there is no evidence whatever of reluctance to represent human and animal forms in the relief decoration of ivories and seals or in the hundreds of pottery figurines, vessels, and plaques. Most of the finds — which could be related to all classes of society, from the royal court and the aristocratic houses to the dwellings of the poor — display a pronounced pagan character, showing only too well how justified were the prophetic strictures against the backslidings of Israel, its ritual art included, into pagan worship.

An assessment of the artistic influences that dominate Hebrew art in the period of the Monarchy may well begin with architecture. The description of the Temple of Solomon in the Bible recalls in plan and detail the Syrian temple excavated at Tell Ta'inat and ascribed to the 8th century B.C. There is the same tripartite arrangement: an anteroom with two columns is followed by a cult hall and a cella, the holy of holies

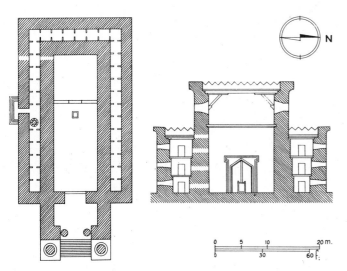

Jerusalem, hypothetical plan and section of the Temple of Solomon (*from A. Jirku, Die Welt der Bibel, Stuttgart, 1957, pl. 82*).

(FIG. 901). Similarly, northern (Hittite?) influences can perhaps be traced in the fortified acropolis of Samaria, with its casemate wall (FIG. 902). The palace structures of kings Omri and Ahab were built on the plan of an open space enclosed by rooms. Each unit was integrated into the general scheme of the palace, with its central court and halls of ceremony. The origin of this plan is obviously the North Syrian palace, which for some time dominated the palace architecture of the ancient

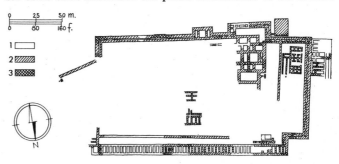

Samaria, fortified acropolis with plan of the palace complex of the Kings of Israel. (1) Standing walls; (2) remains; (3) unexcavated areas.

East, including Assyria. More original are the dwelling houses found in the Israelite levels of such excavated sites as Megiddo and Lachish, consisting of an open court flanked by two elongated rooms, with a third room set crosswise behind the court.

Phoenician influence on Israelite architecture is strongly apparent in the typical treatment of ashlar in Samaria: each stone is drafted on its outer face with a margin on three sides. Precisely the same kind of stone dressing has been observed in the constructed parts of contemporaneous Phoenician tombs found at Achzib.

The architectural ornament of the Israelite period consists mainly of volute capitals, usually termed "proto-Aeolic," having a triangular leaf in the center and two curling leaves (shaped like spirals) on the sides. Though ultimately derived from the lotus capital of Egypt, the Israelite capitals were copied not directly from the Egyptian models but from Cypro-Phoenician imitations; they are consequently much more formalized. Capitals of this kind, some of them of considerable size, have been found at Megiddo (I, PL. 526), Samaria, and Ramat Rahel, south of Jerusalem. At the last-named site there was found also a frieze decorated with lotus flowers shaped like fleurs-de-lis. Capitals with double volutes are represented on pottery models of shrines discovered in Sharuhen (Tell el-Fara) and sites east of the Jordan.

Because it was transmitted by way of Phoenicia, the basic Egyptian influence on Israelite architecture is often camouflaged (see PHOENICIAN-PUNIC ART). However, it is plainly evident in some rock-cut tombs in the Valley of the Kidron, east of Jerusalem, which date from the time of the Judean Monarchy (PL. 331). The pyramidal shape of the roof and the molded cavetto and cornice are close imitations of features of Egyptian funerary shrines.

The extant metalwork is almost entirely utilitarian. There are some fine incense stands and tripod bases, the stands bearing openwork representations of priests making offerings or praying to images of seated deities, the tripods with a garland of leaves as their sole ornament. Much more numerous than the metal objects are pottery figurines and plaques, in particular those of Astarte; these represent nude women holding flowers, tambourines, or doves, or playing the flute. The number and the variety of types indicate that despite Biblical prohibitions the popular worship of Cannaanite gods continued in Israel. Other Israelite work in the round includes figurines of riders and chariots, miniature representations of tables, beds, and chairs, and models of shrines.

Among the finest works of art of the Israelite period are the ivory plaques found in Samaria (PL. 332), probably in the ruins of the "ivory house" (I Kings 22:39) of Ahab, king of Israel (875-850 B.C.); these are clearly of Phoenician origin. Comparable objects, probably Assyrian spoils of war, have

been found at Nimrud and Arslan Tash (I, PL. 526). The ivories from Samaria show a mixture of styles characteristic of Phoenician art: Egyptian, Mesopotamian, and Hittite influences are evident, Egyptian predominating. Thus images of the Egyptian deities Ra, Horus, Isis, and Nephthys are found, along with a representation, clearly of Mesopotamian inspiration, of a lion attacking a bull. The plaques, some of which were made of black (smoked) ivory, were carved in low relief on thin pieces of the material; others had traces of inlay ornamentation in gold, lapis lazuli, stones, and so on.

The numerous Israelite seals that have been preserved (PL. 332) date from the period of the 8th to the 6th century B.C. They fall into three groups on the basis of type of decoration. Some, derived from the Egyptian, are ornamented with griffins or shaped like scarabs; the names, however, are invariably in Hebrew script. Another group comprises figural representations of men engaged in various ritual functions; two of the finest of these are the seal of Shema, the servant of Jeroboam II (ca. 785–745 B.C.), which shows a roaring lion, and that of Jaazaniah, "servant of the king" (cf. II Kings 25:23), on which a cock is represented. In the latter days of Judah, especially after the reforms of Hezekiah and Josiah, even such modest representations were apparently frowned upon; in consequence, the latest seals — the third group — revert to the purely aniconic type of decoration, the artistic effect being achieved by the use of a finely spaced alphabetical script. The jar-handle stamps marked with a "flying scarab" and the words *lammelekh* ("belonging to the king"), followed by a place name, belong to this group.

Thus Israelite art, which at first gave evidence of reluctance to adopt the rich imagery of the nations surrounding Israel and subsequently for a time borrowed freely from its neighbors, reverted finally to its original strictness. Only by returning to its basic traditions could the Hebrew nation hope to preserve its identity during the long Babylonian exile.

HELLENISTIC AND EARLY ROMAN PERIODS: THE DIASPORA (333 B.C.–A.D. 70). Greek influences had begun to penetrate into the East soon after the victory of the Greeks over the Persians in the middle of the 5th century B.C. In the Persian period, however, such influences remained restricted to the coastal area, leaving Judea almost untouched. The only evidence of Attic influence there are the coins bearing the image of the owl of Athena and the heads of deities struck by the Jewish autonomous authorities.

Alexander the Great conquered Judea along with the rest of the Persian empire. During the period of his successors, the Ptolemies (312–198 B.C.) and the Seleucids (198–141 B.C.), Hellenic influences broadened and deepened, affecting all spheres of Oriental life. The ultimate result was the creation of a cosmopolitan Hellenistic culture.

In Judea, the scope of Hellenistic influence was restricted by the essentially aniconic — or rather anti-iconic — character of the Jewish religion. Thus it was only in secular life that Hellenism was to find scope for expression. When the Hellenizing Jewish circles attempted to carry the dominant Greek culture into the realm of religion, they provoked the Maccabean revolt. After the victory, however, and after the reestablishment of an independent Jewish state (141–63 B.C.), the need to integrate this state into the framework of contemporary civilization resulted in a cultural compromise whose effects were apparent in the domain of art. A Jewish art developed which, while keeping aloof from images, took over some elements of Greek architecture and ornament on a highly selective basis; on the whole it favored contemporaneous Oriental elements and techniques.

Among the architectural remains of the Hellenistic period, first note should be taken of the Tobiad castle at 'Arāq el-Emīr, which dates from the early 2d century B.C. Its architectural ornament is a blend of Hellenistic and Oriental motifs. The façade displays an entranceway combining a Doric lintel frieze with Corinthian columns; a clerestory above this is flanked by a frieze of lions, facing toward the center, in high relief — a feature that reflects Babylonian and Persian prototypes.

The development of the plans of Hasmonean buildings can be followed by comparing the typical Oriental constructions at Beth-zur and Gezer with the commander's residence at Tell el-Judeida, probably late Maccabean, which is divided into two parts, one a Hellenistic house, peristyle, with Doric columns, and the other a gynaeceum of Oriental type with a narrow protected entrance and a congeries of small rooms round a second courtyard. This plan reflects the dual aspect of Hebrew culture of the period.

The greater freedom allowed the arts in the early Maccabean period is evidenced by the family tomb constructed by Simon (ca. 142–135 B.C.) at Modin; it had marble pyramids and sculpture in the round representing ships and trophies. Of the tombs found in Jerusalem and its vicinity two have been assigned to the Maccabean period: the tomb of the priestly family of the Beni Hezir, the so-called "Tomb of St. James," in the Valley of the Kidron (PL. 331), and the tomb discovered in 1956 in Alfasi Street in the Rehavia section of Jerusalem. Both have in front of the tomb cave proper a pillared façade which is combined with a pyramidal monument (*nefesh*). The façades and the loculi inside the burial caves are clearly derived from Hellenistic prototypes. In the Alfasi Street tomb the pyramid surmounted an entrance divided into two by a single pillar; the stuccoed walls of the antechamber were decorated with crude drawings representing a naval battle. The Beni Hezir tomb has a rock-cut Doric façade with two columns in the center and two flanking pillars.

The Hasmonean reaction against Hellenistic civilization is also evidenced by coins; yet here too a characteristic compromise with the world around Judea can be noted. The earliest Hasmonean coins, now generally attributed to John Hyrcanus I (135–104 B.C.), adapted the cornucopias found on the reverse of Seleucid coins by replacing the accompanying caduceus with the pomegranate, a fertility symbol not overtly connected with any pagan god. The image of the king on the obverse is replaced by an inscription enclosed in a wreath — an equating of the written word with the image that is characteristically Jewish. Alexander Jannaeus (103–76 B.C.) assumed the title of king and struck coins with bilingual (Greek and Hebrew) legends. He used such symbols of good fortune as stars, wheels, and flowers, but he did not dare to coin in his own image. The symbols of Hasmonean numismatics thus generally remained neutral; only on coins of the last king of the dynasty, Antigonos Mattathias (40–37 B.C.) — which bore the table of the shewbread and the seven-branched candlestick, or Menorah (PL. 333) — do sacred Jewish symbols appear.

The Herodian period in Judea begins with the conquest by Pompey in 63 B.C.; the destruction of Jerusalem, A.D. 70, can be taken as the *terminus ad quem* for the ancient Jewish monuments of that city and its environs. This period is characterized by great economic prosperity and by the growth of influence, increasingly felt in the Jewish homeland, of the Jewish Diaspora in Egypt, Asia Minor, and Italy. The Herodian dynasty was profoundly conscious of the need to bridge the gulf between the Jewish people — seething at that period with a deep Messianic ferment — and the Greco-Roman world. The political clash of Rome and Judea could not be avoided, but on the cultural plane there was a gradual absorption of Greco-Roman forms into Jewish art. By a process paralleled elsewhere in the Hellenistic world, Greek elements were integrated into the Judeo-Greek art of the Roman period.

The greatest monuments of Herodian architecture were the Temple and the Palace of Herod in Jerusalem. Unfortunately there are only scant remains in both cases. In judging the Temple of Herod, the three limitations under which his architects labored should be kept in mind: (1) the measurements and the layout of the buildings, as well as of their component parts, were dictated by tradition, both oral and written, and were considered immutable; (2) besides their avowed aim, whether sacred or profane, all the buildings of Herod had another purpose: they served as fortresses buttressing the king's imposition of his will upon a rebellious nation; (3) the buildings had to be strictly aniconic while conforming to the current taste in ornament, in particular to that of the multitude of pilgrims

from the Diaspora who were familiar with the prevailing styles of Greco-Roman architecture. Despite these limitations, the saying was that he who had never seen Herod's Temple had never seen a fine building in his life. According to Josephus, the whole structure, of marble and gold, appeared at a distance like a mountain covered with snow glittering in the sun.

In order to create an appropriate setting for the Temple, Herod had constructed a vast rectangular esplanade (about 600 × 1,000 ft.). The Temple mount was entirely surrounded by a retaining and curtain wall of monumental masonry — smooth up to a certain height, and above this point molded in projecting flat pillars. This type of revetment can be studied in the wall encircling Abraham's tomb at Hebron, which also dates from the time of Herod. The general effect recalls Oriental temenos walls; the treatment is ultimately derived from the ornamentation of the brick walls of early Mesopotamian sanctuaries. Inside the wall the esplanade was surrounded with porticoes in the Hellenistic style. Of special interest was the southern portico, the "royal stoa," which was a basilican building (one of the earliest of this type), with a heightened nave

topmost part of the palace was a small dwelling house (about 70 × 40 ft.), facing a semicircular terrace. It consisted of three small rooms, protected by a II-shaped corridor extending around them, and two wings of three rooms each. Some of the rooms were paved in black and white mosaics in the geometric patterns common in Italy at the time of Augustus. From this house a staircase led down to the middle terrace, occupied by a circular structure of unknown purpose, comprising two concentric walls, about 50 ft. in diameter. Another staircase led to the lower terrace, most of which was taken up by a square structure, about 55 ft. across, comprising an open court surrounded on all four sides by an ambulatory. Each of the two walls of the ambulatory — the interior one, forming the boundary between it and the court, and the exterior one, constituting the perimeter of the structure — had an inner and an outer order of engaged Corinthian columns separated by windows. The inner order of columns of the interior wall stood on high pedestals; the other three orders of columns were full-length. The inner face of the exterior wall of the south wing of the ambulatory, as well as the inner and outer faces of the entire interior wall, were

a
b

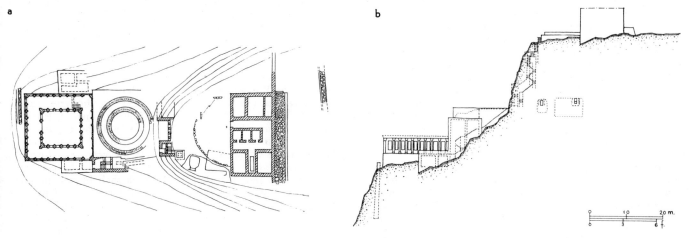

Masada, Herod's palace. (a) Plan; (b) east flank showing sections of structures on several levels (*from M. Avi-Yonah et al., Masada: Survey and Excavations, 1955–1956, Jerusalem, 1957*).

and two aisles; it had clerestory lighting. The inner sanctuary consisted of a rectangle divided into two parts: a women's court to the east preceded the sanctuary court proper; inside the latter court stood the altar of sacrifices, before the sanctuary itself. The entire structure conformed to Greco-Roman style in its accessories but preserved the ritual traditions. Thus the gate of the women's court and the Gate of Nicanor, both donated by Jews of the Diaspora, were presumably adorned in the Hellenistic style favored by the donors. The Nicanor gate was preceded by a portico; this as well as the porticoes surrounding the women's court and the inner court probably had Corinthian columns, the order that was certainly used in the four huge columns that decorated the façade of the sanctuary proper, as can be determined from the representations of the façade of the Temple on the coins of Bar Kokhba (PL. 332) and in the synagogue frescoes from Dura-Europos (PL. 333). On the other hand, the characteristic overhang of the lintel over the central gate of the Temple was copied in the doors of tombs and of later synagogues.

The objects in the Temple seem to have preserved the style transmitted from the Persian period. Only the base of the candelabrum (at least as represented on the Arch of Titus in Rome; IX, PL. 161) bears the imprint of the Hellenistic style of the Herodian period: it shows images of dolphins, hippocampi, and so forth.

Important remains of Herodian architecture have come to light in the remote fortress of Masada on the shores of the Dead Sea (FIG. 905). Masada is built on an isolated flat rock about 1,000 ft. above sea level. The principal building there was Herod's palace, built on three terraces overhanging the abyss below the northern point of the fortress plateau. The

covered with multicolored semigeometric paintings. The column shafts, built of masonry, were stuccoed over to give the effect of fluting. The palace at Masada, constructed at so great a cost in labor and means, illustrates not only the daring engineering enterprise of Herodian architecture but also the overbearing and inhuman character of the king. The whole complex was planned to function as a unit for Herod and a small entourage.

The other buildings at Masada included vast storehouses and barracks, built on the usual Hellenistic plan as exemplified at Pergamon, and another palace, probably intended for the royal suite. The principal parts of this palace were two groups of rooms, centered on an open court; one group seems to have had a *prostas*. The walls were stuccoed and molded, and traces of paint were observed on them. The whole fortress was provided with a casemate wall and a system of immense rock-cut cisterns fed by an aqueduct.

Herodian tomb architecture is exemplified by scores of tombs in the Kidron and Hinnom valleys. Among these are a number of large tombs; these include the so-called "Tomb of Zechariah" (second half of 1st cent. B.C.), "Tomb of Absalom," and "Tomb of Jehoshaphat," as well as the tomb of Herod's family, the tombs of the kings of Adiabene ("Tombs of the Kings"), and the tombs of the Sanhedrin ("Tombs of the Judges"). These rock-cut tombs are principally of symmetrical plan based on an axis that passes through a central hall and the main burial chamber; the hall is flanked by other halls, each with its loculi fanning out into the rock. The characteristic sepulcher of the period had an entrance cut in a perpendicular rock face and was preceded by a courtyard, often provided with benches. If the entrance was wide enough, it was subdivided by columns or pillars. The antechamber behind the

portico led to the main burial hall; the entrance to the latter was occasionally protected by a removable stone.

Above the façade of the more ornate tombs is a gable or lintel, cut in low relief and surmounted by an acroterium formed of acanthus cups or wreaths. The surface of the gable is covered with a low-cut, dense scroll of acanthus leaves evolving from a central group of leaves; grapes, pomegranates, and citrus fruits are occasionally added. The carving of the leaves is sharp and dry. The lintel over the tomb entrance is usually of the Doric type, its frieze having triglyphs and metopes, the latter filled either with a classical round shield or wreaths or rosettes. The frieze itself is used without much appreciation of its architectural value, often being interrupted by symbolic representations of vessels, wreaths, and fruits (in particular the vine, with leaves, tendrils, and bunches of grapes). Occasionally a band of vegetation is added to the lintel.

The same disregard of the classical orders is evident in the monuments sometimes placed before tomb entrances in this period. The best-preserved of these are the "Tomb of Zechariah" and "Tomb of Absalom." The former is a rock-cut cube with pilasters in the corners and Ionic columns on its faces, the columns surmounted by an Egyptian concave groove (cavetto) and a pyramidal roof. The "Tomb of Absalom" (PL. 331) is more complicated in pattern. The lower cube has pilasters, Ionic columns, and a Doric frieze with metopes and shields, and is surmounted by a cavetto. Over this rises a constructed part consisting of a square base supporting a drum, the whole capped by a tapering cone with rope ornaments above and below, and (originally) a flower at the top. The whole appears as a kind of tholos on a high pedestal, the space usually left for columns and statues being filled in with solid masonry so as to avoid the use, common in the prototypes, of images.

In the tomb façades of the Herodian period several features characteristic of Jewish art of that period can be observed: it is based on classical Greek art but employs its elements in an eclectic manner, adding symbolic or decorative features derived from Oriental sources. In its peculiarly dry and flat style the ornament foreshadows the ultimate replacement of the glyptic principle of classical relief by the optic principle, based on the contrast of light and shade; it also prefigures the stylization of naturalistic details and the characteristic Oriental *horror vacui*. The use of specific Jewish symbols, such as the Menorah, is avoided.

The ossuaries which are a characteristic feature of Jewish burials in Jerusalem in the last century before and the first century of our era are important because they occur in quantity and because they represent a popular art. These stone boxes, intended to hold the bones of the dead after the decay of the flesh, are for the most part about 20–30 in. long, 8–12 in. wide, and 12–15 in. high (PL. 332; V, PL. 338). The lids vary in shape, being flat, arched, or gabled. The basic pattern of ossuary ornament consists of two six-petaled rosettes within a framework of straight and wavy lines; in many cases this is interrupted by the addition of other elements — for example, representations of buildings, columns, doors, objects such as cups, vessels, and weapons, and a variety of plants and plant ornaments (these last occasionally stylized or shown in section). The rosettes and the rest of the ornament are executed in the chip-carving technique, probably derived from working in wood. The incised portions are deeply gauged, with sharp arrises, thus giving the same effect of sharply contrasted light and shade as is seen on the tomb façades. Undoubtedly this type of ornament reflects a type of local craftsmanship based on Oriental (in this case Israelite) traditions of the pre-Hellenistic period. The ossuaries are thus very early representatives of a specific artistic style that appears at a later date in Coptic art and in Byzantine ornament in general.

As opposed to the popular art of the ossuaries, the sarcophagi found in the "Tombs of the Kings" and in the tomb of Herod's family obviously represent the type of ornament acceptable to the aristocracy. This consists in the main of floral motifs, rosettes, and scrolls similar in style to the tomb pediments described above.

The artistic influence of the Jewish communities scattered abroad — and especially numerous in Egypt, Asia Minor, and Greece — first made itself felt in the Hellenistic period, increasing considerably in the times of the Augustan peace and under the Julio-Claudian dynasty. The isolated groups of Jews living among Gentiles were naturally more exposed to the dominant Greco-Roman culture. In the domain of thought they reacted by developing the Neoplatonic philosophy of Philo; in the domain of art they reacted by adjusting their needs to the formal aspect of Hellenistic ornament, at the same time dissociating themselves from anything pronouncedly pagan. It was as part of their endeavor to propagate Judaism that the Hellenized Jews of Alexandria seem to have evolved their narrative cycle of Biblical scenes illustrating the Septuagint. No direct evidence of this illustrated Bible has been found, but its influence is evident in the early catacomb paintings and is still felt in the frescoes of the Synagogue of Dura-Europos (PL. 335) and the illuminated miniatures of Byzantine manuscripts. The extant Jewish paintings and reliefs in Roman catacombs such as those of Monteverde, Vigna Rondanini (III, PLS. 101, 103), and Villa Torlonia (VII, PL. 405) show a tendency to integrate the symbols of Judaism (the seven-branched candlestick in particular) with the common vocabulary of popular art in the Rome of their day: cupids, personifications of the seasons, dolphins, birds, and flowers.

THE LATER ROMAN PERIOD (70–324). The latent conflict between the Roman Empire and the Hebrew nation finally led to two revolts (A.D. 66–70 and A.D. 132–35, the latter called, after its leader, the War of Bar Kokhba), which ended with the destruction of Jerusalem by Titus and the expulsion of the Jews from Judea by order of Hadrian. In such times of conflict there could be very little artistic activity. However, twice during these revolts coins in silver and bronze were struck by the Jewish authorities to mark their liberation, albeit temporary, from the Roman yoke, and these expressed in their designs and legends the political and religious aspirations of the people. The silver coins of the first revolt (shekels and half shekels) show the sacrificial cup, symbolizing the Temple, and on the reverse, three pomegranates on a stalk, possibly the arms of Jerusalem. The symbols appearing on the bronze coins are the palm tree, a well-known mark of Judea, the citrus fruit (ethrog) used during the Feast of Tabernacles, and the symbolic vine leaf and amphora. The coins of Bar Kokhba are inferior in execution but somewhat superior in design (PL. 332). They repeat the amphora and vine leaf, the palm tree, and so forth, but these are represented with more feeling for decoration and better spacing. They also show the Temple façade and a series of musical instruments used in divine services (trumpets, harps, and lyres). This double series of coins gives us an indication of the craftsmanship and artistry of the Jewish engravers, who worked independently of — and even in opposition to — the tendencies current in contemporary numismatic art.

The suppression of the two revolts caused Palestinian Jewry to concentrate in Galilee, and it is there that the principal monuments of Jewish art from the 3d and later centuries must be sought. The *modus vivendi* that was achieved between the Roman government and Palestinian Jewry from the 2d century onward made possible the construction of a series of monumental stone synagogues in Galilee. These buildings, among them the Synagogue of Capernaum (PL. 334; FIGS. 909, 910), were erected with the façade looking toward Jerusalem; the wall facing toward the Holy City was made particularly ornate, with a triple entrance imitating Syrian temple façades. The central door was made higher and was surmounted by a large semicircular window, with a smaller window flanked by colonnettes and curved above in a shell-like arch.

In plan these synagogues were basilican, with a central nave surrounded by three aisles, two lateral and the other transverse. The roof was supported by columns placed on high pedestals. The columns were for the most part of the Corinthian order but with simplified detail; the leaves of the capitals in particular are sharply cut and present a pattern of light and shade that seems both to recall ossuary ornament and to anticipate By-

zantine capitals of the 5th and 6th centuries. The main hall of the synagogue had a gallery, probably for the women; the richest part of the architectural ornament was reserved for this feature of the building. The gallery was thus in contrast with the plain interior of the hall, which had bare walls with benches running round them. The door jambs, lintels, and especially the great frieze of the gallery were decorated in high relief. Besides geometric and floral motifs and representations of the palm tree, the vine, the pomegranate, and other characteristic fruits of the Holy Land, there occur magic symbols such as the type of hexagram later called the "Shield of David" and the type known as the pentacle ("Seal of Solomon"). The Jewish sacral symbols that appear are not numerous: they include the seven-branched candlestick and its accessories and the Ark of the Law (in one case the Ark of the Covenant shown on wheels, as it was supposed to have traveled in the desert). Architectural ornament also included representations in relief of eagles, hippocampi, griffins, and even angels in the form of winged Victories. In one synagogue (Chorazin) the frieze shows a figure of Hercules, a Gorgon's head, and vintage scenes with human figures. Other places have yielded fragmentary remains of sculpture in the round, in particular of lions that flanked the Torah shrine.

The relative artistic freedom apparent in the decoration of the early group of Galilean synagogues is an indication of the latitude allowed the architect and the sculptor. The decay of the old polytheistic religions, which was manifest in the 3d century, made the danger of idolatry seem much less acute in the eyes of the rabbinical authorities, and they therefore permitted a much freer use of figural ornament. It is quite possible that they were forced to this by the attitude of the Jewish laity, whose views had by that time drawn much nearer to Greco-Roman culture. This liberal position was only temporary, however, for at a later date the images of men and animals in these synagogues were smashed by Jewish iconoclasts, who refrained from damaging the inscriptions and floral symbols.

After the early Galilean synagogues, the second main source of our knowledge of ancient Jewish art in Palestine in the late Roman period is the necropolis of Beth Shearim. This small Galilean town was chosen by the patriarch Judah I (135-ca.

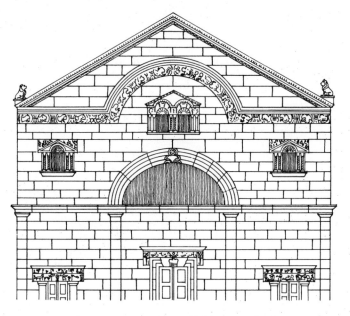

Capernaum, reconstruction of Synagogue façade.

212) as his burial place and thus became in the 3d century the central necropolis of world Jewry. The catacombs continued to be made until the year 351.

The tombs at Beth Shearim, which were cut in the hillsides below the town, are of three principal types: small cata-

combs consisting of a court with several burial halls branching off; large catacombs with several systems of halls and burial chambers, often connected by a corridor and arranged one above another (in this type of catacomb would be entombed the dead from a single vicinity, grouped in family vaults); and monumental burial caves surmounted by mausoleums. Burial

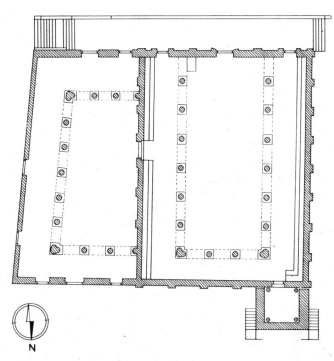

Capernaum, plan of Synagogue.

was usually in loculi or under arcosolia, and the tombs are marked by inscriptions, 80 per cent of which are in Greek, the remainder in Hebrew and Aramaic. The decoration of the usual catacomb consisted of designs painted or scratched on the surface of the wall or of low reliefs cut into the rock. The motifs include about twenty different variations of the Menorah, which had become by that time the central symbol of Judaism. Somewhat rarer are representations of the Ark of the Law, usually surmounted by a shrine, flanked by columns and approached by steps. This seems to have reproduced fairly accurately the contemporary architectural arrangement of the synagogue. The Jewish sacred symbols are accompanied by representations of lions, rosettes, ships, and a number of figures of human beings (one of whom supports a Menorah on his head; PL. 333). There were also secular figures such as cavalrymen, either mounted or leading their horses, and Roman soldiers and gladiators. The workmanship, usually very crude, exhibits the typical Oriental combination of conceptual composition and realistic detail.

Outstanding among the catacombs at Beth Shearim is a group of burial caves of monumental character. One of these (No. 14) is supposed to have contained the burials of Judah I himself and of his three sons, and of numerous other rabbis. It has an ornamental façade of three arches, surmounted by steps leading to a niche, probably a place of prayer, facing toward Jerusalem. The interior is severely aniconic. Nearby is a similar triple-arched façade, leading to another large catacomb (No. 20; FIGS. 911, 912), which contained over a hundred sarcophagi, some of them decorated with figures. The decorations include a bearded human face, lions affronted over a bull's head or a vase, a lion attacking a gazelle, eagles, fish, and rosettes of many varieties. The reliefs, presumably executed by Jewish artisans, are worked in a provincial style. On the whole they show a tendency to imitate Roman funerary symbols, combined with an Oriental stress on details (which are emphasized to the detriment of the general proportion); the composition is in the main heraldic. A third catacomb (No. 11), surmounted

by a mausoleum, had in the forecourt a mosaic with a design of fish; the mausoleum itself was decorated with eagles and an arched frieze with fighting wolves, a motif possibly showing the influence of the art of Central Asia.

The use of figural elements in burials closely associated with the chief rabbinical authorities of the time, as seen in the great necropolis of Beth Shearim, has gone far to dispel the

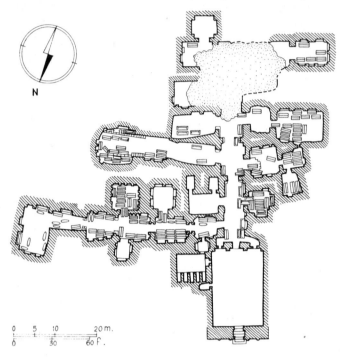

Beth Shearim, plan of Catacomb 20.

myth of the antipathy to art of normative Judaism, at least in its creative period.

No survey of Jewish art in late Roman times would be complete that did not include the minor arts. In this category what has been preserved comprises chiefly a few ivory reliefs showing sacred objects, some glass vessels, and a number of lamps, mostly of pottery but some of bronze. The decorative motifs used are the Menorah — sometimes mistaken for the tree of life but easily identifiable when it appears in conjunction with the four other symbols, the ethrog, the lulab, the shofar (ram's horn), and the shovel (for incense?) — the Ark of the Law, the cluster of grapes, and the shrine. In their general development these examples of the minor arts follow the stylistic evolution of the late Roman period, gradually abandoning the classical freedom of design in favor of Orientalizing stylization, richness of detail, and severity of outline.

THE MIDDLE AGES. *Byzantium.* It is agreed among historians of art that the tendencies generally referred to as Byzantine appeared at a much earlier date than the beginning of the Byzantine period (4th–6th cent.), in the art of the Roman Empire. Here again Jewish art is in a special position. Since the Jews alone, of all the nations composing the Roman Empire, retained their religious identity in the Middle Ages, they might have been expected to maintain the traditions of antiquity longer than the nations which underwent a transformation on the ethnic or religious plane. The contrary is the case. Because of the closer contact of the Jews with the Oriental nations and cultures and their resistant attitude toward Greco-Roman culture, the typical transition to a medieval setting occurred earlier in Jewish art than in the art of the other peoples of antiquity. Evidence of this is furnished by the frescoes of the Synagogue of Dura-Europos (PL. 335). The synagogue and its paintings can be dated with reasonable certainty to the middle of the 3d century.

By a fortunate incident in the siege that led to the capture

and destruction of Dura-Europos by the Sassanians in 256, the synagogue has been preserved in large measure. Almost the whole of its western wall, about half of the northern and southern walls, and a considerable portion of the eastern wall remain. The fact that the building was apparently used by an orthodox Jewish community lends particular interest to the way in which its walls were decorated: they contain depictions, in three registers, of Biblical scenes and personages, which draw upon the human image almost to the exclusion of other motifs. These pictorial representations form a most important link connecting the presumed Alexandrine cycle of Biblical illustrations and the later representations of the same scenes on mosaic pavements and in illuminated manuscripts. A connection of sorts had already been established between these disjointed phases of Jewish artistic tradition with the help of the Christian catacomb paintings and sarcophagus reliefs of the 3d and 4th centuries, but this connection was of necessity tenuous until the discovery of the Synagogue of Dura-Europos in 1931.

The community of Dura-Europos seems to have been one of the first to take advantage of the liberal decision of Rabbi Johanan of Tiberias in regard to the painting of figures on walls. The content of the paintings was selected from three points of view, or at least is divisible into three distinct types. The representations are in part symbolic, reproducing such motifs of the Jewish religion as the Temple façade, the seven-branched candlestick, the Ark of the Tabernacle, the Temple, and the high priest in his glory (PLS. 333, 336). A second group includes scenes that illustrate the salvation — through divine intervention — of Israel as a whole, or of individual persons: the Sacrifice of Abraham, the finding of Moses, the Exodus, the Waters of Marah, the liberation of the Ark from Philistine hands, David and Saul, Elijah and the Widow, the triumph of Mordecai (PL. 337). The third type can be said to reflect the hope of a national rebirth, as associated with the Messianic expectation: the tree of life, the blessing of Jacob, the anointing of David, Ezekiel's vision of the dry bones, and the Messiah in his glory. Thus the paintings of Dura-Europos represent a cross section so to speak, of the spiritual aspirations — both in Palestine and in the Diaspora — of the Jewish nation in the 3d century.

The form of these frescoes is hardly less interesting, from the point of view of art history, than their content. On the one hand, they anticipate several of the aspects characteristic of Byzantine art; on the other, they revive various elements obviously derived from the art of the ancient Orient. The composition features the grouping of images in well-defined units, or compartments, separated by strongly emphasized borders. These units hark back to the well-defined individual

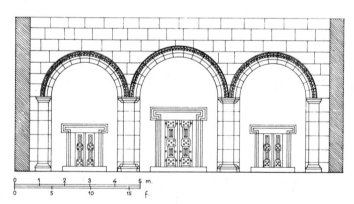

Beth Shearim, reconstruction of façade of Catacomb 20.

pictures of manuscript illumination. Within the compartments the artists of Dura-Europos employed the method typical of the strip narrative, which is prominent in Assyrian reliefs and occurs again in Roman art of the 2d century (columns of Trajan and Marcus Aurelius). The figures are placed against a uniform background, with only a hint of such landscape elements as are essential to the narrative (e.g., the Nile in the story of

Moses, the rocks and trees in the vision of Ezekiel). The personages themselves are either juxtaposed or massed in large groups. Where necessary, a narrow strip in the foreground provides a kind of "downstage" area. The nearer figures are placed lower, the farther ones higher, with no other indication of spatial relations — a typically Oriental nonperspective organization of space. Another typical Eastern (more specifically Egyptian) feature is the exaggerated size of the principal personages: the relative proportions of Moses at the Red Sea are like those of the Pharaoh in Egyptian reliefs. The drawing is strictly linear, and isocephalism and frontality are observed throughout. It is the frontality — which seems to detach each of the actors from the scene in which he appears — that especially gives the frescoes of Dura-Europos their "Byzantine" character. Nevertheless, it should be noted that, along with the mannerisms of later art, these frescoes exhibit its characteristic strong points: directness and forcefulness of representation and narrative; freedom from distracting accretions; and intense spirituality of the figures, especially evident in the concentrated gaze. It is this spirituality that endows the four figures of Moses enclosing the central tableau with a force and a nobility that lift them into the sphere of genuine works of art.

The authorship of the Dura-Europos frescoes is still being ardently debated both as to the number of artists and as to their nationality. The theory that more than one artist was involved is based on a difference in dress. Two distinct types of male attire are seen: the Hellenistic chiton, himation, and sandals are worn by Moses, Elijah, and the Jews in general, whereas Pharaoh and Ahasuerus, Mordecai and Ezekiel as well as their entourage, wear belted tunics, trousers, and soft white boots — in short, Parthian riding dress. Most of the soldiers appear in scale armor, a few in Roman accouterments. It has been deduced from this evidence that there was at Dura-Europos one artist who followed the Hellenistic tradition and another who was influenced by Parthian art. However, since on closer study the details of the frescoes seem to be the work of one hand — or possibly of several closely related hands — it is a reasonable assumption that the paintings are the work of a master and several helpers. The master, who was especially meticulous in painting details, probably executed the Exodus and the crossing of the Red Sea and designed the other pictures, which were then completed by his assistants. There is a bare possibility that the paintings above the Torah shrine and the "tree of life" were executed by an earlier painter (PL. 333).

The frescoes of Dura-Europos seem to have established the following facts: (1) that there was a Jewish cycle of Biblical illustration, which was freely used even in orthodox circles; (2) that this cycle, while retaining some of the features of its presumably Hellenistic original, followed on the whole the rules of composition and arrangement of Oriental art; (3) that the cycle may have strongly influenced the development of the art of later periods, constituting — to use J. H. Breasted's telling phrase — an "Oriental forerunner of Byzantine art."

The continuation of the same tradition is to be observed in the mosaic pavements that have been preserved in various synagogues in Palestine and at least one in North Africa. This later group of pictorial representations should be examined, however, in the light of the general development of synagogue architecture during the 4th and 5th centuries of the current era. As has been noted, in the earlier synagogue the façade looked toward Jerusalem and the Ark of the Law was apparently transportable. This arrangement, emphasizing the direction toward Jerusalem by means of the large windows and the generally ornamental character of the wall facing toward the Holy City, had, however, the functional flaw that it obliged the worshiper to face about before beginning to pray. In succeeding periods, various experiments were made which led finally to the general adoption of the basilican plan, with a nave and two aisles, culminating in an apse directed toward Jerusalem. This new type of plan, based on a longitudinal axis, had the advantage of proper direction and of concentration on the focal point of synagogue worship, the Ark of the Law; it is the only type represented among the Palestinian synagogues of the 6th and later centuries.

Paralleling this change of plan was a change in the decorative elements used. It is true that we have no later counterparts of the wall painting of Dura-Europos — although to be sure the extant synagogue remains consist only of foundations and pavements, and some ornament seems to have been applied to the wall of the synagogue at Beth Shearim. As noted previously, mosaic decoration using images was allowed by Rabbi Abun in the 4th century. Actually there seems to have been some reluctance to take advantage of this permission, or a tendency to limit the images to symbolic ones or representations of the seasons, which had no religious connotation. Thus the synagogue at Naro (Hammam Lif) in Tunisia contained a mosaic pavement — parts of which are in New York (Brooklyn Mus.) — with a series of representations of symbolic import: a cantharus flanked by peacocks and palm trees, fish (an allusion to the story of Jonah?), and vine trellises (perhaps signifying paradise) enclosing a lion, birds, and baskets of fruit. In Palestine, too, the earlier pavements — for example, the one found at Isfaya — show images of the zodiac and the seasons, combined with a seven-branched candlestick, and a symbolic vine trellis. Soon, however, Biblical imagery found its way into mosaic representations. There developed in the 6th century a well-defined cycle of synagogue decoration, examples of which have been found at Naʻaran ('Ain Duq) near Jericho, at Beth Alpha in the Valley of Jezreel (FIG. 915), and in Jerash, east of the Jordan. These pavements contain three main elements. There is a Biblical scene, usually taken from the same salvation cycle that served as the basis of the Dura-Europos paintings and that occurs also in the Roman catacombs. It is based on a liturgical setting, both Jewish and Christian, in which the various miraculous deeds of salvation are recorded (for the Hebrew version reference may be made to the Mishnah Taanith IV, 2). Thus at Naʻaran the story of Daniel and the lion is depicted, at Beth Alpha the Sacrifice of Abraham (PL. 337), and at Jerash the story of Noah's ark. The second element, occurring at Isfaya, Beth Alpha, and Naʻaran, is the zodiac, with representations of the seasons in the corners and images of the sun and moon in their chariots in the center. The third element is representation of the Ark of the Law, of the seven-branched candlestick, and of other ritual objects, flanked by lions, birds, curtains, and so on. So far as can be ascertained, the mosaic pavements follow closely the Biblical cycle as preserved in miniatures; for example, the Sacrifice of Abraham at Beth Alpha resembles in detail the presentation of the subject in the manuscripts of Cosmas Indicopleustes — both probably derived from the same Alexandrine tradition.

In the late 6th and the 7th century a significant change can be noted in the mosaic pavements of synagogues. The figural subjects tend to disappear, and the images are restricted to representations of the Ark of the Law (as in the late synagogue of Jericho), of the seven-branched candlestick [as at Jericho and Maon (Nirim)], and to images of lions or other beasts or birds [as at Hammath Gader (el-Hammeh) and Maon]. Whether this aniconic tendency is attributable to internal Jewish development or to the Islamic invasion has been much debated. It is noteworthy that at Naʻaran the zodiac images were carefully removed, whereas the Hebrew inscriptions accompanying them were left intact. This fact, taken together with the apparent destruction of the reliefs in the earlier synagogues by iconoclasts, since no damage was done to the buildings themselves, would seem to indicate that a wave of orthodoxy, directed particularly against images of human beings, swept over the Jewish communities in Palestine in the 7th century.

The style in which the mosaic pavements were executed is no less interesting than their subjects. Of course the mosaics vary exceedingly in quality, in accordance with the means of the local community and the capacities of the particular artist. Thus at one extreme are pavements such as that in Jerash, which was an important city of the Decapolis and probably had a wealthy Jewish community; the mosaics executed there compare favorably with the contemporaneous work of provincial Byzantine artists, although they are naturally much inferior to the work of the mosaicists at Constantinople. At the other extreme is the rustic work — probably by local artists,

who proudly sign their names, Ananias and Marinus — at Beth Alpha, a small and insignificant village in Galilee. The Jerash mosaics have various characteristics typical of Byzantine art: frontality, a strip arrangement of the animals waiting to enter the ark, and so forth. The image of Daniel in the mosaic at Na'aran seems to have been executed in the typical orant pose. But in respect to style it is the better-preserved pavement at Beth Alpha that is the most interesting. Here are found, besides isocephaly and frontality, such characteristically Oriental elements as arrangement of the component parts of an image

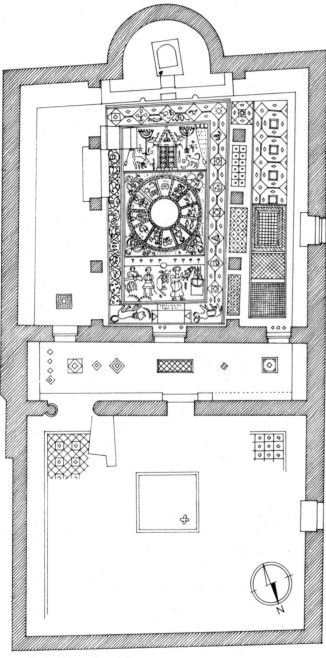

Beth Alpha, plan of Synagogue showing mosaic pavement.

side by side without regard to their true position, in an effort to render the image as complete as possible; exaggeration of the parts of the body especially important for conveying expression (e.g., head and eyes); uniform background; combination of several episodes of a story into one picture; the abbreviated character of various elements. Nevertheless, what has been said of the sculptures at Beth Shearim can be said without hesitation of the Beth Alpha mosaics; they represent the same vital, if somewhat naïve, trend of Jewish popular art. The

synagogue pavement discovered in 1957 in Maon is interesting for another reason: in general composition and details it closely resembles a church pavement found at Shellal in the Gaza region, and dating from the second half of the 6th century. The Jewish pavement, which seems to have been somewhat later, shows the same arrangement in outline, with a trellis issuing from a crater flanked by peacocks, and various animals grouped symmetrically around a central axis; the main difference is the introduction of a seven-branched candlestick flanked by lions and palm trees, in the top center. The way in which the Jewish artist transformed and simplified his prototype, while bringing it nearer to the Byzantine style of later works, exemplifies the generally prevalent trend of Jewish art toward the Orient.

Islamic countries. At the beginning of the Middle Ages, with the Islamic conquest, which extended from Spain to India, the Jewish communities were split into two groups. One, in which the Spanish Jews soon assumed a preeminent position, was strongly influenced in its art by Islam, while the other, which remained under Christian rule, followed European developments through the Romanesque and Gothic periods. Because of the catastrophe that befell Spanish Jewry at the end of the 15th century and the general decline of the Moslem countries, less information is available on the artistic activities of the Jewish communities under Islam than on those of Germany, France, and England. In Italy both Islamic and Christian influences were strongly felt.

It was only natural that Islamic rule should reinforce among the Jews the anti-iconic tendencies always latent in their religion. Since they lived dispersed in small groups, they were more amenable to external influences (as were also the Jews dispersed in Christian countries) than the comparatively densely settled Jewry of Byzantine Palestine. Thus the artistic traditions handed down in the Jewish communities under Islam were expurgated of all representations of living beings, and even of plants, and tended more and more toward the geometric arabesque as the sole source of ornament.

The divergence in artistic development between Jewry under Islam and Jewry under Christian rule was manifest in the planning of the synagogues, the only buildings of a specifically Jewish character and hence the sole representatives of Jewish architecture of the period. Spanish — and, in general, Eastern — Jews followed the late Palestinian tradition, in which the focal point of the synagogue was the Ark of the Law firmly set up in the wall facing toward Jerusalem, that is, they favored the basilican type, with several rows of columns perpendicular to the wall opposite the entrance. This tradition predominates in the two Spanish synagogues of Toledo. Although erected under Christian rule — one in the second half of the 12th century and the other in 1356 — they nevertheless reflect Arab influence, Spanish Gothic appearing only in minor details. The earlier synagogue has a flat roof and four arcades with horseshoe arches dividing it into five aisles. Its simple exterior contrasts strongly with the rich decoration inside, in particular the carved capitals and the glazed tiles at the base of the pillars. The later synagogue (which has since become a church, El Tránsito) is similar in plan; especially remarkable are the walls, embellished with rich arabesques cleverly blended with decorative Hebrew inscriptions, and the latticed partition between the main hall and the women's gallery.

In the minor arts, Jewish (as well as Christian) craftsmen played a most important part under Islam; however, since they succeeded in adapting themselves to the rules of Islamic art to a remarkable extent, their work can be distinguished with certainty only when it bears a Hebrew inscription. Noteworthy in the field of the minor arts is the granulated and filigree work of the Yemenite Jews, who continue to this day the traditions of medieval craftsmanship. A few examples of carvings in wood, on which Hebrew inscriptions remain, survive from Fatimid Cairo (10th–11th cent.). The glass industry was from its beginnings largely in Jewish hands, but only a few objects marked with Hebrew lettering furnish a clue to their provenance.

Jewish artistic activity under Islam in the Middle Ages must

ultimately be judged, therefore, by the illuminated Hebrew manuscripts that have come down to us from the Orient and from Spain. In these the decoration is strictly aniconic, continuing and strengthening tendencies which had already appeared, as has been noted, toward the end of the Byzantine period. However, there is an interesting exception to be noted: a group of Persian-Jewish miniatures that illustrate the Biblical narrative with extremely vivid and colorful representations in which figural images play the principal part. The artists have adapted Persian costumes, arms, and ways of fighting to the Biblical story, adding the Hebrew explanation underneath.

But aside from these exceptional Persian manuscripts, the Hebrew manuscripts produced in Islamic countries either are not illuminated at all — and here the influence of the Pentateuch manuscripts, used for worship, in which any kind of ornament was strictly forbidden, is apparent — or, at the utmost, have only a decorated title page, in which the ornament is based almost exlusively on arabesques. One such title page, from a Pentateuch completed in Yemen in 1469 (London, Br. Mus., Ms. Or. 2348), combines with the usual arabesques stylized representations of mountains formed by a scale pattern, a six-petaled rosette, and what seem to be vestigial images of fish — all these forms made up of minutely written texts. The only exception to the strict eschewal of figural art is the representation of objects used in worship in the Temple, the synagogue, or the Jewish home found in manuscripts that seem to be the work of Karaites (members of a heretical sect that separated from Judaism in the early Middle Ages). Thus in a Pentateuch in Leningrad dated 930 (State Lib., Cod. II. Firk. 17) the Temple gate (or the Gate of the Tabernacle) is shown below a seven-branched candlestick, above which is an Ark of the Covenant; it should be noted, however, that the images of the cherubim above the ark are replaced by two little golden leaves. The other objects represented (vessels, lavers, a table) are placed, according to the canons of Oriental art, in full profile, one above the other, against a neutral background. In another Karaite manuscript similar objects appear against a background curtain with a geometrical pattern enclosed in an ornamental border formed by a Hebrew inscription.

Islamic influences manifest themselves with special clarity in the manuscripts produced in Spain; this country having passed from Moslem to Christian rule, the development of its art as reflected by Jewish artists makes possible the isolation of the various elements with particular exactness. On the whole, Spanish manuscripts repeat the Islamic pattern of arabesque in complicated designs occasionally resembling those on woven carpets. The appearance of what seem to be Gothic windows in a Spanish haggadah of the 14th century (London, Br. Mus., Ms. Or. 2884) shows a certain degree of penetration by other influences. But even when the representation of objects is allowed (as in the Pentateuch known as the "Farchi Bible," completed 1382; Letchworth, Coll. D. S. Sassoon), the use of images of human beings is still strictly prohibited. This sometimes leads to paradoxical results: we see the tents of Jacob and his wives, but not the patriarch or his womenfolk; in the story of the men sent to spy out the land of Canaan, the giant cluster of grapes is reproduced, but not the men who carry it; the scarlet thread marking the window through which the messengers enter Jericho is shown, but not the messengers; and so on.

The evaluation of Jewish elements in the art of Islamic countries is especially difficult precisely on account of the fundamental agreement between the two religions. Because Islam pressed to finality tenets latent in Judaism, it is far from easy to arrive at a clear-cut distinction between the two cultural forces. It can therefore be seen why Jewish art, as an identifiable entity, vegetated in Islamic countries, whereas in contemporary Europe it was strongly stimulated — by the very contrast between church and synagogue.

The European West. In the Middle Ages the Jewish artists of the West were drawn in two directions: they felt, on the one hand, a strong attraction to the splendid examples of Romanesque and Gothic art which were being created before their eyes; on the other hand, they were bound by restrictions imposed on them partly by a hostile church and state and partly by the community leaders who were their patrons. It is this polarity that lends medieval Jewish art its particular interest. In judging its products we do well to keep in mind the external circumstances under which they were produced. The Jewish communities in the Middle Ages were small and scattered; their means were therefore for the most part limited, and they did not need large and expensive rooms for worship. The Jewish tradition of the Diaspora, as exemplified at Dura-Europos, obliged the communities to keep the synagogues as inconspicuous as possible (in direct contrast to the Palestinian synagogues, which were erected — as the Law commanded — in the most prominent place in the town). The church edicts also ordered that synagogues be built low, their existence being simply tolerated; the Jews' acceptance of this circumstance was based on the Psalmist's worship of the Lord "out of the depths" (Psalms 130:1).

Jewish architecture in medieval Europe was limited almost exclusively to synagogue building. In contrast to Spanish usage, which focused the ritual on the Ark of the Law, placed at one end of the building, the custom adopted by the French and German Jews was in the older, Palestinian tradition of a movable Ark; the focal point was a raised platform (almemar, or bema), placed in the middle of the hall, around which the worshipers were grouped. Another architectural problem was the situation of the women's section; since the synagogue building had to be kept low, there was no place for the high gallery of the earlier synagogues. In consequence, the women's section was placed either on the same level as the main prayer room or, in two-storied synagogues (such as that of Carpentras, near Avignon; 1396), below it.

Medieval synagogues are in general of two types: those in which the vaults are supported by central columns, usually two, dividing the synagogue into two aisles, and those in which the vaulting is not supported centrally. The two-aisled type, which imitated the town halls and refectories of medieval Europe, apparently had two advantages: it made possible the avoidance of the basilican plan, which was associated with churches; and it afforded an opportunity for the felicitous placing of the bema between the two central columns of the hall. This type of building must have recommended itself to the Jewish architect as well as his patrons for its small proportions. The earliest extant two-aisled synagogues belong to the Romanesque period and have rounded vaults on piers; the later ones date from the 13th or 14th century, and have the pointed ribbed arches and other features of well-developed Gothic architecture.

To the earlier group belongs the Synagogue of Worms, in Germany, founded in 1034 (PL. 335). It has a main hall with six cross vaults resting on two columns; the capitals, doors, and other architectural ornament closely resemble those of the contemporary Cathedral of Worms. The women's section, added on the same level in 1213, has a single central column and four cross vaults. In the same complex there is also a ritual bath, built in the customary way, deep into the ground. Two other examples of the two-aisled type are the Regensburg Synagogue (late 13th cent.), with three central columns, built in a style transitional between Romanesque and Gothic, and the smaller synagogue in Eger in northern Bohemia, in which the vault was supported by one pillar in the center of the hall. The most remarkable of these buildings is the legendary synagogue of Prague, the Altneuschul (Old-New Synagogue), erected at the end of the 13th or the beginning of the 14th century. Situated in the center of an extensive ghetto, the Altneuschul could be less inconspicuous than other contemporaneous synagogues; it rises to a prominent height, and its exterior as well as its interior is ornamented. It is typically Gothic in style; heavy buttresses take the stress of the arches on the outside. The entrance is on one side. In the interior, two piers support pointed vaults with five ribs. The fifth rib is thought by some to have been added as a means of avoiding the Christian associations of the four cross ribs, but this is speculative: the unusual five-rib arrangement occurs again in the small 14th-century Gothic synagogue of Miltenberg (Germany), but the

Old Synagogue in Kraków (Poland), erected in 1364 on the same plan as the Altneuschul, has the normal Gothic four-ribbed vault. The wide range of occurrence of the same type of building — from Worms near the Rhine to Kraków, by way of Germany and Bohemia — is an indication of the cosmopolitan character of Jewish medieval architecture. This is not surprising, considering the close bonds that existed between the widely dispersed Jewish communities; it is, moreover, quite in accord with the generally unified character of medieval culture.

The second type of medieval synagogue, in which the vaulting covers an undivided hall, is chronologically concurrent with the two-aisled type. Selection of one type in preference to the other probably depended upon the relative size of the community concerned. In any case, the unitary type afforded a simpler setting for the ritual — that is, the two focuses (the Ark of the Law and the bema) did not have to be separated as in the two-aisled synagogue. The unitary vaulted hall appears in both Romanesque and Gothic styles. Two noteworthy examples are the Synagogue of Miltenberg, already metioned, and the one in Bamberg. The latter is slightly earlier (13th cent.), but has, nevertheless, a Gothic type of vaulting; it is also remarkable for its elongated proportions and because the women's section adjoins the main hall longitudinally.

Illuminated manuscripts of all kinds (prayer books, ethical treatises, haggadahs, etc.), commonly found in richer households, constitute another main aspect of Jewish art. Here too occurs the eternal struggle between the iconic and the aniconic. Spanish-Islamic influence, particularly strong in Provence and in Italy, was allied, of course, with the traditional Jewish aversion to images. In Italy, however, the aniconic tendency came into conflict with the general trend of medieval art, which, in the end, proved too strong for the Jewish illuminators to resist. But at least they made a brave attempt to keep as close as possible to the letter of the law. Thus in a prayer book (mahzor) of 1272 (Jerusalem, Jewish Nat. and Univ. Lib.; formerly Worms Synagogue) there is a representation of a hunt in which the hunter is dog-faced; in another prayer book, of the 13th century (Oxford, Bodleian Lib.), a bird-faced Abraham sacrifices an Isaac bound on the altar in the guise of a ram. In certain cases the artists applied their principles selectively; for example, in a haggadah in Jerusalem (Bezalel Nat. Mus.) all the Jews are represented with heads of birds, whereas the Gentiles appear in normal human form. Traces of this tendency are still visible in the Sarajevo Haggadah (14th-cent.; Sarajevo, Nat. Mus.), one of the best examples of medieval Jewish miniature art, in which all the figures have the usual human appearance, but the angels on Jacob's ladder cover their faces with their wings. This haggadah contains clear evidences of the dependence of its artist on French miniature art. Similar influences can be detected in a manuscript dated 1277–78 in the British Museum, in which the slender figures, delicately bending forward, and the exquisite drawing are obviously derived from French Gothic art. German manuscripts are generally more robust in style and are often characterized by the introduction of elements of the grotesque. The title page of the Worms prayer book of 1272 shows the image of Jerusalem restored (modeled after a typical Gothic city) and, below, two wolves, their tails bound together in a knot, gazing with symbolic rage at the Holy City above. Another particularity of the medieval manuscripts is the outlining of figures of animals (lions, etc.) by means of minutely written textual commentaries on the Bible (Masorah). These point to a dominant desire for some kind of figural decoration; at the same time, the transforming of these commentaries into ornament seems to indicate the neglect into which their study had fallen at the time. The finest of the medieval manuscripts is the so-called "Kennicott Bible" of 1476 (Oxford, Bodleian Lib., Cod. Kennicott 1), written and illuminated in northern Spain; it represents both lines of Jewish manuscript tradition, containing, as it does, both elaborate arabesques, including the Shield of David, and marginal representations, such as that of King David in his glory, shown in the guise of a medieval monarch, and Jonah being thrown into the sea from a typical caravel. Rich manuscripts of this type were also produced in Italy; such examples as the Rothschild manuscript from the end of the 15th century (Jerusalem, Bezalel Nat. Mus.), show the clear and abiding influence of Renaissance art.

Michael AVI-YONAH

THE MODERN ERA. Until the 19th century, Jewish art was created primarily to serve the synagogue and the Jewish community and was limited mainly to illuminated manuscripts and ceremonial objects. While always employing the prevailing art styles of their countries of residence, Jewish artists adapted these styles to conform to the specific religious purposes of their works.

The relatively favored status that Jews enjoyed as loan bankers in 15th-century Italy — which had enabled them to acquire and to commission some of the finest illuminated Hebrew manuscripts — gradually deteriorated with the steady decline of the economic and political foundations of many of the Italian city-states, particularly in the late 16th century. At the same time, Venice was achieving preeminence as a center of wealth, culture, and learning, and its Jews, though residing in ghettos, participated in the flourishing cultural life. This participation was reflected in the Jewish art and architecture of 16th- and 17th-century Venice.

A superb example of the many baroque synagogues built in the Venetian Republic during this time is the Tempio Israelitico Spagnolo (Scuola Spagnola) of the Ghetto Vecchio in Venice, in the section where the aristocratic Spanish-Portuguese Jews resided. Constructed toward the end of the 16th century, it was enlarged and rebuilt in 1665 by Baldassarre Longhena. Its plain exterior encloses a lavish, grandiloquently baroque interior, with marble Corinthian pillars, flamboyant chandeliers, and a gilt and stucco-incrusted ceiling; it is rectangular in shape with an oval-shaped women's gallery.

In addition to building richly adorned synagogues, many prosperous Jewish communities in the Venetian Republic commissioned rich ceremonial objects for use in the home and in the synagogue (PL. 338). These objects are highly valued because of the dearth of earlier examples. Particularly attractive are the gold and enamel betrothal rings, the brass Hanukkah lamps decorated with standard Renaissance motifs such as putti, centaurs, and nymphs, and the illuminated marriage contracts.

In 17th- and 18th-century Germany there emerged a small group of privileged individuals — the Court Jews — who functioned as provisioners of the princes' armies and as suppliers of luxury goods for the nobility. Their special status, with its accompanying privileges, enabled the Court Jews and their immediate circles to donate elaborately embroidered Torah curtains, mantles, and ceremonial objects in precious metals to their synagogues and to commission ceremonial objects for their own private use. Since Jewish craftsmen were excluded from the guilds, most of the ceremonial objects were executed by Christian silver- and goldsmiths; the foremost craftsmen of Augsburg, Nuremberg, and Frankfort are represented. The pompous, heavy baroque style of the 17th century and the more elaborate, delicate rococo style of the 18th century are apparent in these works. Among the typical pieces are silver spice boxes (used in the habdalah ceremony at the conclusion of the Sabbath) in the form of town-hall towers with large clocks and weather vanes, and graceful wine goblets for the holidays. Other legacies from these communities are exquisite silver Torah breastplates with intricate floral and animal decoration, produced by the master craftsmen of Nuremberg and Augsburg, and 18th-century Torah crowns, in graceful three-tiered, hexagonal turret form, with bells set in arches within each tier, made by such masters as Jeremias Zobel of Frankfort on the Main.

Eastern Europe, and especially Poland, is a significant area in the history of Jewish art. During the 16th and the early 17th century, Poland contained the greatest concentration of Jews in Europe and was one of the main cultural and religious centers of European Jewry. The Jews of Poland were intimately involved in the rise of its prosperous feudal towns; they functioned as merchants and as managers of vast estates for the nobility; they levied customs duties and collected road tolls. Jewish culture flourished, and with it the development of synagogue architecture. During this period some of the larger

towns of Poland saw the construction of many synagogues. Usually of stone and brick, these were often privately endowed by wealthy Jews, and many of them had fortresslike exteriors with thick, heavily buttressed walls and high parapets with embrasures and loopholes for defense purposes. During the 16th century, when the influence of Italy was strong in Poland, some of the stone synagogues were built by Italian architects; for example, the Taz Synagogue of Lvov (1582), a nearly square vaulted structure, was designed by Paolo Romano. The Maharshal Synagogue, built in 1567 in the important commercial city and Jewish center of Lublin, was especially significant in the development of later Polish synagogue architecture. Unlike the Italian synagogues, where the bema was characteristically placed next to the western wall, the Maharshal Synagogue had the bema in the center of its spacious hall, thus constituting its dominating element. The bema was enclosed in a vaulted tabernacle with four supports, of three clustered columns each, which carried the vaulting of the entire synagogue. Most of these synagogues were razed during the uprising and invasion of 1648 and the ensuing massacres and persecutions of the Jews, events symptomatic of the general breakdown of Poland's feudal economy.

The destruction of Poland's major centers of Jewish settlement and the Jewish exodus from the cities had a marked effect on the artistic output of the Jews. Relocating in Polish towns and villages in the late 17th and the 18th century, many Jews turned to employment in local trades and crafts. Finding an abundance of timber, these local Jewish craftsmen, whose names have occasionally come down to us, built synagogues of wood, with the aid of the Jewish population of the villages. Most of these fine examples of Jewish folk art were destroyed during World War II.

The exteriors of these wooden synagogues, with their many-tiered, hipped roofs are scarcely less interesting than their interiors. As in the masonry synagogues, the bema was placed in the center of the synagogue, but it was not required, since the lightness of wood allows for greater freedom of construction, to support the ceiling. Thus the bema had no functional part in the architectural construction, and the ceilings of the square rooms were imaginatively vaulted with tentlike structures and cupolas. The decorative effect was further heightened by polychrome paintings in which floral and arabesque designs were entwined with signs of the zodiac, musical instruments, animals, naïve visions of Jerusalem, and tablets with Hebrew inscriptions taken from the liturgy and rabbinic literature. All this produced the effect of a richly woven fabric. In the 18th century, the bema, and, more especially, the shrine for the Torah were intricately carved. Large wooden structures with wings and columns, the Torah shrines sometimes featured two rampant lions flanking the tablets inscribed with the Ten Commandments; often the entire Ark was covered with an intricately carved labyrinth of animals and tendrils in interlaced designs similar to those used in paper cutout work. Of the Polish Jewish folk artists who produced the decoration of these houses of worship, Eliezer Sussmann (18th cent.) is particularly noteworthy; he painted the interiors of wooden synagogues not only in Poland but in southern Germany as well.

The ceremonial objects produced by Jewish gold- and silversmiths who flourished in such cities as Lvov are also notable for their floral decoration and whimsical naturalistic ornament (e.g., a bear climbing a tree to reach a honey pot). The spice boxes for the habdalah ceremony appear in a great variety of forms: birds, trees, flowers, fish, and fruits.

Although this period was marked by a gradual decline, beginning with the mid-17th century, in the status of Polish Jewry, it produced some of the finest examples of Jewish folk art.

In the Netherlands in the 17th century and in England in the late 17th and 18th centuries, Jews were encouraged to engage in international trade and commerce. The thriving Jewish communities soon built synagogues; notable among these is Amsterdam's Portuguese (Sephardic) Synagogue, built in 1675 by the Dutch architect Elias Bouman. Dignified and austere in design, like the neighboring Calvinist churches, the synagogue is divided into a nave and two aisles by the high Ionic columns that support the barrel vaultings. In this synagogue the focal point shifts from the bema in the center to the Ark — on the eastern wall — which is of the cupboard type, with doors resembling the reredos of northern baroque church altars. A women's gallery upheld by 12 low Ionic columns projects from the three other walls, partly filling the outside aisles. The design of this Sephardic synagogue influenced London's Bevis Marks Synagogue, built in 1701, though the London structure mainly followed the dominant style of English meetinghouses.

In the realm of painting, portraits, which were popular among both Jews and non-Jews in the Netherlands and England, were occasionally commissioned of Jewish artists; two portraitists of some ability were Salom Italia, an Italian Jew who engraved portraits in Holland in the middle of the 17th century, and David Estevens, a Danish Jew who worked in 18th-century England.

Elegant ceremonial ornaments in silver, especially those for the adornment of the Scroll of the Law (Torah), were fashioned in the Netherlands in the 17th-century. These ornaments, with their baroque turret form, were often modeled after Dutch church towers. It was unusual at this time to find skilled Jewish silversmiths outside eastern Europe. An exception is the Dutch Jew Abraham de Oliveyra, who, working in England in the early 1700s, fashioned some delicate ceremonial objects based on Dutch models. Carved tombstones, unusual for Jewish cemeteries, were produced in the Netherlands in the 17th and 18th centuries for the Sephardic Jewish cemetery in Ouderkerk, near Amsterdam. These elegant horizontal tombstones, probably carved on commission by Christians, have Biblical scenes sculptured on them. Thus the tombstone of one Rachel Teixeira, who died in childbirth, depicts the Biblical Rachel on her deathbed, being mourned by her family (a scene probably influenced by representations of the Death of the Virgin) and uses such Humanistic symbols as the putto with the death's head, signifying the transitoriness of life.

Any brief treatment of Jewish art in Europe from the 16th to the 19th century is essentially a review of European art as adapted to Jewish life, since, with the notable exception of eastern Europe, this art was for the most part created by non-Jewish artists. The few Jewish artists of western Europe who appear on the record hardly ranked above the average.

With the beginning of the 19th century, the term "Jewish art" becomes ambiguous. The French Revolution had encouraged both Jews and non-Jews to adopt a national identity in addition to a religious one. Moreover, the abolition of medieval guild restrictions enabled the Jew to study art, while his status as a citizen motivated him to contribute his artistic talents to his nation rather than to his particular religious community. Although, as previously noted, portraiture had manifested itself among Jews prior to the French Revolution, it was not until the 19th century that the artist of Jewish origin could free himself from strict subservience to Jewish religious needs and pursue art as an independent discipline. Hence, the record of Jewish participation in the art of the 19th and 20th centuries becomes the history of the contributions of professional German, French, Dutch, and American artists of Jewish origin to the general development of Western art. Few of them have been particularly concerned with Jewish subject matter.

In Germany, early in the 19th century, Moritz Oppenheim (1800-82), one of the first successful Jewish painters, produced a series of genre scenes called "Pictures of Traditional Jewish Family Life," which were somewhat saccharine and shallow. Later in the century, in eastern Europe, artists of Jewish origin — such as Samuel Hirszenberg (1865-1908) and Isidor Kaufmann (1853-1921), who had received their training in the academies of Germany and Austria — also attempted to give visual expression to the Jewish scene. Their minutely realistic narrative renditions of Jewish life in eastern Europe, full of pathos and sentiment, were popular in their day despite their lack of genuine depth of feeling or sincerity. Out of this eastern European school came Baruch (Boris) Schatz (1866-1932), who in 1906 voluntarily left his post as the head of the Bulgarian Academy of Fine Arts in Sofia to help establish the Bezalel School of Arts and Crafts in Jerusalem, which had as its primary

aim the fostering of a Jewish art. This aim, although in consonance with the emerging Jewish nationalism, proved unrealizable because western European art was already severing its ties with nationalistic goals.

Nonetheless, several modern artists have succeeded in refracting in their art their specific Jewish religious and cultural background. Foremost among them is Marc Chagall (q.v.), a painter influenced by the cubist school, whose imaginative poetic flights of fancy, drawing heavily on his early childhood experiences in Russia, are firmly rooted in the Yiddish folk idiom. Max Weber (q.v.), one of the outstanding pioneers of modern art in America, conveys, in the elongated, distorted figures and faces of his Talmudists and Hasidim (whom he portrays with poignant lyricism and vibrant color) some of the ecstatic and spiritual intensity of these scholars. These artists, in a genuine rather than an artificial response to a resurgence of ethnicism, attempted to strengthen their ethnic identity by seeking out Jewish motifs.

In modern Israel art is little influenced by such European Jewish experiences as ghetto life and worship; religious subject matter, in fact, is rarely treated. Many prominent Israeli artists paint the picturesque sights of the country and its people, using postimpressionist, Fauvist, and expressionist styles; especially among the younger generation there is evidence of great interest in the nonobjective idiom.

Joseph GUTMANN

BIBLIOG. *General*: V. Stasov and D. Günzburg, L'ornement hébreu, St. Petersburg, 1905; E. Cohn-Wiener, Die jüdische Kunst, Berlin, 1929; F. Landsberger, History of Jewish Art, Cincinnati, 1946; G. Schoenberger, The Essence of Jewish Art, H. Judaica, VIII, 1946, pp. 191-98; E. Naményi, L'esprit de l'art juif, Paris, 1957 (Eng. trans., E. Roditi, The Essence of Jewish Art, New York, 1960); C. Roth, ed., Jewish Art, New York, 1961.

Antiquity: N. Müller, Die jüdische Katakombe am Monteverde zu Rom, Leipzig, 1912; H. Kohl and C. Watzinger, Antike Synagogen in Galiläa, Leipzig, 1916; H. C. Butler, American Expedition to Syria, I(A), Leiden, 1922; H. W. Beyer and H. Lietzmann, Die jüdische Katakombe der Villa Torlonia in Rom, Berlin, Leipzig, 1930; C. Watzinger, Denkmäler Palästinas, 2 vols., Leipzig, 1933-35; E. L. Sukenik, Ancient Synagogues in Palestine and Greece, London, 1934; M. Rostovtsev, Dura Europos and Its Art, Oxford, 1938; M. Avi-Yonah, Oriental Elements in the Art of Palestine in the Roman and Byzantine Periods PEQ, X, 1940, pp. 105-51, XIII, 1947-49, pp. 128-65, XIV, 1950, pp. 49-80; B. Maisler, Beth She'arim, I: Catacombs I-IV, Jerusalem, 1940; M. Kohn, The Tombs of the Kings, Jerusalem, 1947; A. Reifenberg, Ancient Jewish Coins, 2d ed., Jerusalem, 1947; A. Reifenberg, Ancient Hebrew Arts, New York, 1950; A. Reifenberg, Ancient Hebrew Seals, London, 1950; E. R. Goodenough, Jewish Symbols in the Greco-Roman Period, 8 vols., New York, 1953-58; N. Avigad, Ancient Monuments in the Kidron Valley, Jerusalem, 1954; N. Avigad, Excavations at Beth She'arim: Preliminary Report, Israel Exploration J., V, 1955, pp. 205-39, VII, 1957, pp. 73-92, 239-55; M. Avi-Yonah and others, Masada: Report on the Archaeological Survey, Jerusalem, 1956; C. H. Kraeling, Excavations at Dura Europos: The Synagogue (Final Rep., VIII, 1), New Haven, 1956; N. Glueck, Rivers in the Desert: A History of the Negev, Philadelphia, 1959; M. Schapiro and M. Avi-Yonah, Israel: Ancient Mosaics, Greenwich, Conn., 1960; M. Avi-Yonah, Oriental Art in Roman Palestine, Rome, 1961; B. Kanael, Die Kunst der antiken Synagoge, Munich, Frankfort on the Main, 1961. See also bibliogs. for ISRAEL; JORDAN.

Medieval and modern era: D. H. DeCastro, Auswahl von Grabsteinen auf dem niederländisch-portugiesisch-israelistischen Begräbnissplatze zu Ouderkerk am den Amstel, Leiden, 1883; D. Kaufmann, Sens et origine des symboles tumulaires, Rev. des ét. juives, XIV, 1887, pp. 33-48, 217-53; D. Kaufmann, Art in the Synagogue, Jewish Q. Rev., IX, 1897, pp. 254-69; D. H. Müller and J. von Schlosser, Die Haggadah von Sarajevo, Vienna, 1898; B. Italiener, Die Darmstädter Pessach-Haggadah, Leipzig, 1927; R. Krautheimer, Mittelalterliche Synagogen, Berlin, 1927; R. Wischnitzer, Symbole und Gestalten der jüdischen Kunst, Berlin, 1935; M. Diamant, Jüdische Volkskunst, Vienna, 1937; M. Narkiss, The Hanukkah Lamp, Jerusalem, 1939 (Heb., Eng. summary); F. Landsberger, Jewish Artists Before the Period of Emancipation, Hebrew Union Coll. Ann., XVI, 1941, pp. 321-414; J. Leveen, The Hebrew Bible in Art, London, 1944; G. Loukomski, Jewish Art in European Synagogues, London, New York, 1947; K. Schwarz, Jewish Artists of the 19th and 20th Centuries, New York, 1949; H. Volavková, The Synagogue Treasures of Bohemia and Moravia, Prague, 1949; J. Gutmann, The Jewish Origin of the Ashburnham Pentateuch Miniatures, Jewish Q. Rev., XLIV, 1953, pp. 55-72; J. Pinkerfeld, The Synagogues of Italy, Jerusalem, 1954 (in Heb.); A. Rubens, A Jewish Iconography, London, 1954; F. Cantera, Sinagogas españolas, Madrid, 1955; A. G. Grimwade, Anglo-Jewish Silver, London, 1955; R. Wischnitzer, Synagogue Architecture in the United States, Philadelphia, 1955; F. Landsberger, The Origin of the Ritual Implements for the Sabbath, Hebrew Union Coll. Ann., XXVII, 1956, pp. 387-415; A. Scheiber, The Kaufmann Haggadah, Budapest, 1957; S. S. Kayser, Jewish Ceremonial Art, Philadelphia, 1959; L. A. Mayer, L'art juif en terre de l'Islam, Geneva, 1959; M. and K. Piechotka, Wooden Synagogues, Warsaw, 1959; J. Gutmann, The Haggadic Motif in Jewish Iconography, Eretz Israel, VI, 1960, pp. 16-22.

Illustrations: PLS. 331-338; 8 figs. in text.

JONES, INIGO. The English architect and scenographer Inigo Jones was born in London in 1573 and died there June 21, 1652. According to his pupil John Webb (the chief authority for the architect's early life), Jones early visited Italy, including Venice, whence he was called to work for Christian IV of Denmark. The earliest documentation of Jones in a capacity connected with the arts is a mention of him as a "picture maker," dated June, 1603, in the household accounts of the Earl of Rutland, who was about to leave England as ambassador to the Danish court. For Anne of Denmark, the wife of James I of England and sister of Christian IV, Jones designed a masque that was presented in January, 1605. There survives a continuous series of designs that he executed from 1605 until the 1640s, when, after the outbreak of the English Civil Wars, the masques were no longer performed.

Between 1605 and 1613 Jones was responsible for the staging of nine court masques, a series of entertainments in the hall at Christ Church College, Oxford, and a presentation for the Earl of Salisbury on the occasion of the opening of the Earl's newly built "Britain's Burse" (New Exchange) in London's Strand. There is little sign that Jones was engaged in architectural activity during this period, although he was concerned in the design of Lord Salisbury's building in London and was responsible for some change in the design of the south front of the Earl's new house at Hatfield in 1609-10. In January, 1611, Jones was appointed surveyor to Prince Henry, the eldest son of the King, but the only buildings known to have been carried out in that capacity are a number of small works for the gardens at Richmond. Nevertheless, this appointment marked the recognition by the court of Jones's suitability for purely architectural employment. A notation in Jones's copy of Vitruvius' *De Architectura* (conserved at Chatsworth, Derbyshire) mentions a visit to Paris in 1609.

Drawings in various quantities survive for seven of the masques and entertainments presented before 1613; the others of this period are known only from descriptions in the printed text published by the authors of the masques. The most famous of these poets were George Chapman and Ben Jonson. Jones's association with the latter was to be a long and stormy one. There is other evidence of Jones's circle of acquaintance at this time (1610-11), which included the poet John Donne and Lionel Cranfield, later Earl of Middlesex, for whom Jones designed a gateway (1621) that still survives.

Jones made a second visit to Italy in the suite of the Earl and Countess of Arundel. They visited Milan, Parma, and Padua and arrived in Venice on July 20, 1613. They proceeded to Vicenza, Bologna, Florence, Siena, Rome, and Naples. Jones left his companions in Genoa and made a further visit to Venice in July and August, 1614, when he met the Italian architect Vincenzo Scamozzi (1552-1616). From Venice Jones went again to Vicenza, and he was back in London by January, 1615.

A sketchbook preserved at Chatsworth and notes in his copy of Palladio's *I Quattro Libri dell'Architettura* (Oxford, Worcester College) indicate Jones's concerns during this Italian visit. They were of two kinds: a predilection for the antique that took precedence over his interest in more recent or even contemporary Italian architecture and an interest in the work of Guercino (q.v.). Indeed, the sketchbook contains a portrait of the Italian painter and a Guercino-like drawing (dated May, 1614) of the Castel S. Angelo in Rome.

In September, 1615, Jones succeeded to the office of Surveyor to the Crown. This appointment determined all the architect's later career. The office, which made him the architect of any important new building project undertaken by the Crown, also made him responsible for much minor work of maintenance and alteration to royal residences and entailed a considerable amount of administrative work. But his new position allowed him to work for distinguished courtiers in a private capacity.

There is abundant documentary evidence of Jones's activities in various fields during the three and a half years from his appointment as Surveyor and the beginning of the best-known of his large surviving works, the Banqueting House at Whitehall (II, PL. 147). In 1618 he again designed the scenery and costumes for a masque by Ben Jonson. A close connection with Lord

Arundel continued; Jones was associated with the Earl's activities as a collector of pictures and sculpture, and the architect did some work at Arundel House in the Strand.

An architectural work of great importance was undertaken by Jones in this period — the Queen's House at Greenwich (begun 1616; FIG. 925; PL. 340). This was a large pavilion about 120 ft. square contrived in two rectangular parts, one on either side of the Woolrich-Deptford road. The two buildings were designed as one and linked by a bridge across the road. (The position of the road, which was later filled in, is marked by the two 19th-century colonnades flanking the house). The work continued until 1618 and seems to have reached the top of the ground floor when it was abandoned for ten years. It is clear that the general conception of the building, both in plan and construction, belongs to the early period and only the internal finishing to the years 1629–35. It has been noted that the plan bears a marked resemblance to that of the villa (1480–85) Giuliano da Sangallo designed for Lorenzo the Magnificent at Poggio a Caiano, Italy, and that the long, comparatively low proportions of the Sangallo villa may have served as a precedent for the proportions of Jones's work. Another Italian precedent, one acknowledged by Jones himself, was the Villa Dondi dell'Orologio (near Padua), which Scamozzi designed (1597) for Niccolò Molini. From this structure Jones derived several features in addition to the relation of the pilasters to the columns, which he mentioned. Apart from its situation over a public road, the plan of the Queen's House, in which the relations and proportions of the rooms are based on definite arithmetical ratios (the result of Jones's study of Palladio), was something new in England.

The death of Queen Anne (1619) postponed indefinitely any hope of completing the building at Greenwich, and Jones turned to the rebuilding of the Banqueting House at Whitehall, which had been destroyed by fire that year. The rebuilding was begun in June, 1619, and completed by 1622. The building consists of a single great hall (in the form of a double cube), 110 by 55 ft. and 55 ft. high, that was raised on a low undercroft. The predominant Italian influence in the building is that of Palladio, and a Palladian precedent can be found for almost all the motifs employed in its design. For all their importance, the Palladian influences in the Banqueting House design have been assimilated and subtly transformed. The mannerist elements in Palladio

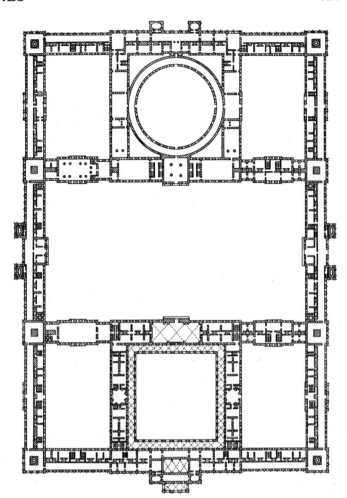

London, Whitehall Palace, according to the original design (from M. Whinney and O. Millar, English Art 1625-1714, Oxford, 1957).

have been minimized, and the broader proportions of the building in relation to its height give a more classical, almost High Renaissance calm to the structure.

Two other buildings survive from the 1620s, the Queen's Chapel at Marlborough Gate (1623–27; London, St. James's Palace) and the entrance front of Castle Ashby, Northamptonshire. The Queen's Chapel is a small building with a coffered barrel vault of wood that gives the interior an air of antique gravity (PL. 339). This is the only interior in which Jones's lifelong preoccupation with antiquity can be fully appreciated. This predilection is also reflected in the building's exterior. The entrance front to Castle Ashby must, on the evidence of its heraldry, date from before 1631. This is not a documented work, but its date, technical accomplishment, and resemblance to other Jones designs of a few years later make Jones's authorship reasonably sure. The entrance front comprises a screen and arcaded loggia surmounted by a long gallery and closes the fourth side of an earlier courtyard. This structure closely resembles Jones's designs for Whitehall and Somerset House that are known from drawings of the late 1630s.

The 1620s was a period of varying activity for Jones, both in architecture and theatrical designing. He made designs for five masques between 1622 and 1626, and the drawings for them include some striking examples of his new Guercinesque manner of drawing.

During the 1630s he undertook many projects. In 1631 he was employed by the Earl of Bedford to lay out the grounds to the north of the garden of the Earl's house in the Strand. There Jones built the piazza of Covent Garden, of which little remains of the original. The piazza was surrounded on two sides by buildings that had arcaded walks at ground level. The third side was occupied by the east front of the church, which was flanked on either side by symmetrical pavilions. The front of

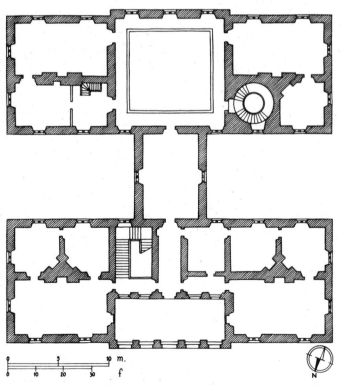

Greenwich, Queen's House, plan according to the original design (from M. Whinney and O. Millar, English Art 1625-1714, Oxford, 1957).

the church is treated with a portico on two Tuscan columns *in antis*. The Tuscan order, as described by Vitruvius, and the Tuscan motif are employed with consistency throughout.

After the design of the Queen's Chapel at Marlborough Gate and the Vitruvian exercise at Covent Garden, the most interesting evidence of Jones's preoccupation with the antique is a series of drawings, executed for the most part by Jones's pupil John Webb, for a complete reconstruction of Whitehall Palace (FIG. 926). In these studies there is a marked attempt to achieve an antique gravity of effect, above all to recapture the internal space forms of imperial Roman architecture. This element seems to be lost sight of in drawings that appear to be later versions of the reconstruction scheme, for they are more purely Italianate in the truest Renaissance sense. These later schemes seem to date, at least in part, from the period immediately preceding the English Civil Wars and are related to some elevations for the treatment of Somerset House.

In 1634 Jones was appointed architect for the restoration of St. Paul's Cathedral in London. The restoration of St. Paul's consisted of refacing the exterior of the transepts and nave and of building a colossal octastyle Corinthian portico across the west end. The portico was about 115 ft. long and projected 40 ft. from the west face of the building; the columns were 50 ft. high. The portico had no pediment and was finished with a balustrade, a treatment for which Jones found precedent in Palladio's illustration for the portico of the Temple of the Sun and Moon. The great surviving monument from the 1630s is the interior treatment of the Queen's House at Greenwich, work on which was resumed for Queen Henrietta Maria in 1629. These interiors, for which a number of drawings survive, as well as much of the work itself, are the best surviving examples of Jones's more intimate work for the royal family and the court. The interiors give some idea of the type of decoration used in his other royal works, notably at Somerset House.

The 1630s was also a productive period in theatrical design. Designs exist for 14 important masques that were performed between 1631 and 1640 (PL. 342). In the earlier part of this period the differences between Jones and his great collaborator Ben Jonson reached a climax. The quarrel eventually attained the character of a public scandal, and Jonson ceased to be employed to write the masques at court. The quarrel was more than a mere clash of personalities and fundamentally reflected Jonson's refusal to accept the Italian ideas of Jones regarding the dignity of the visual arts as compared with literature.

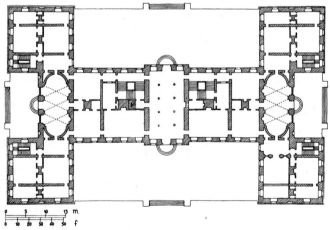

Belvoir Castle, plan of the lower floor (*from The Designs of Inigo Jones, London 1727*).

Inigo Jones's work, both for the court entertainments and as Surveyor to the Crown, continued into the early 1640s. His last court masque, *Salamacida Spolia*, was produced in January, 1640, and in 1642 Jones left London, handing over his office to John Webb as deputy. Jones is lost to sight from that time until he was taken prisoner at the sack of Basing House in 1645.

In 1647 a fire at the Earl of Pembroke's house at Wilton, near Salisbury, provided the occasion of Jones's last important employment as an architect. This work consisted of the building and interior finishing of a range of state apartments fronting on the gardens (PL. 341). There is evidence that Jones's exterior may in some degree have been conditioned by an earlier scheme by the architect Isaac de Caux. Internally the work seems to

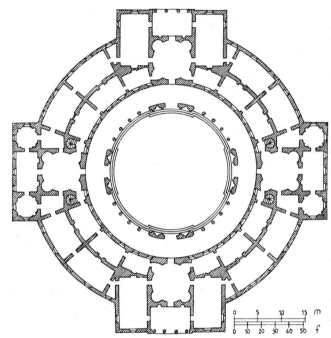

Design for a central-plan structure (*from The Designs of Inigo Jones, London, 1727*).

be entirely by Jones and Webb. These interiors comprise the great "Double" and "Single Cube Rooms," the former designed to contain a series of portraits by Van Dyck (PL. 341). The decorations are markedly French in character and are derived from Jean Barbet's *Livre d'Architecture* and Pierre Le Muet's *Traicté des cinq ordres d'Architecture*. Inigo Jones died the same year that Wilton House was finished.

The posthumous reputation of Inigo Jones reached its height in the period 1710–60. His drawings and buildings and those of John Webb were engraved and published, and Jones's name was associated by English critics with Rubens and Fiammingo (François Duquesnoy) as one of the three greatest northern Europeans to follow in the tradition of the Italian masters of the 16th century. Two contemporary portraits of Jones are known, a drawing by himself and the portrait by Van Dyck (Leningrad, The Hermitage).

BIBLIOG. C. F. Bell, P. Simpson, The Masque Designs of Inigo Jones, Oxford, 1924; E. Welsford, The Court Masque, Cambridge, 1927; J. A. Gotch, Inigo Jones, London, 1928; G. H. Chettle, The Queen's House, Greenwich, London, n.d.; M. Whinney, John Webb's Drawings for Whitehall Palace, Oxford, 1943; D. J. Gordon, Poet and Architect, The Intellectual Setting of the Quarrel Between Ben Jonson and I. Jones, Warburg, XII, 1949, p. 152; J. Summer-Smith, The Italian Sources of Inigo Jones's Style, BM, XCIV, 1952, p. 200; R. Wittkower, Inigo Jones, Architect and Man of Letters, J. of the Royal Inst. of Br. Arch., LX, 1953; J. Summerson, Architecture in Britain, 1530–1830, London, 1953 (2d ed., 1955); L. Stone, The Building of Hatfield House, Archaeol. J., CXII, 1955; M. Whinney and O. Millar, English Art 1625–1714, Oxford, 1957.

Geoffrey WEBB

Illustrations: PLS. 339–342; 4 figs. in text.

JORDAENS, JACOB. Flemish painter of religious, mythological, and genre subjects (b. Antwerp, May 19, 1593; d. Antwerp, Oct. 18, 1678). Jordaens, the oldest of 11 children, was the son of a prosperous linen merchant. At an early age he was apprenticed to Adam van Noort, a painter who had also taught Rubens. In 1616 he married Van Noort's daughter Cath-

arina, by whom he had three children. The artist remained in close contact with his father-in-law, whose jovial face appears in many of his paintings. In 1641 he built for himself a palatial house, parts of which are still preserved in Antwerp (II, PL. 147). Jordaens appears to have embraced Calvinism soon thereafter; he was once fined for writing Calvinist pamphlets, but apparently he was not seriously molested for his heresy, and he in turn had no qualms about painting altarpieces for Catholic churches. Jordaens was buried in a Calvinist cemetery in Putte, a village near the Dutch border.

Jordaens's career was as uneventful as it was long. He traveled little and appears to have had none of the social ambitions of Rubens or Van Dyck. Only rarely was he charged with large decorative projects, the best known being two huge allegories glorifying Frederick Henry of Orange (1652), which are located in the royal villa of Huis ten Bosch outside The Hague. Most of his work was done for the *bourgeoisie* and for the churches and charitable institutions of Antwerp.

Although never a pupil of Rubens, from the beginning Jordaens showed the influence of that master; he must have been familiar also with the ideas of Caravaggio, yet Jordaens possessed a vigorous and highly personal idiom, characterized by an earthy optimism and frank sensuousness (V, PL. 298). His pictures often lack restraint and tend to be crowded, but they compensate for their faults in the glowing beauty of their colors and in the sheer animal strength and happiness of their figures. Jordaens revived some of the ideas of the elder Bruegel, translating them into the opulent language of the baroque; like Bruegel he used the wisdom of popular proverbs to point a moral, but he avoided the pessimism of the older artist. He borrowed many of his themes from the Dutch poet Jakob Cats, who himself was representative of a simple and somewhat shallow middle-class morality.

Jordaens's long career can be divided into several periods, but his art changed very gradually. His first period (ca. 1612–25) is the most interesting, owing to the forceful contrasts of light and shade and the unaffected simplicity of his types. Characteristic works of this period are two paintings, both titled *Adoration of the Shepherds* (Stockholm, Nationalmus.; Grenoble, Mus. de Peinture et Sculpture), *The Satyr and the Peasant* (Brussels, Mus. Royaux des B. A.; V, PL. 323), *Family Portrait* (Leningrad, The Hermitage), *The Artist's Family* (Madrid, Prado; II, PL. 206), and *The Ferryboat of Antwerp*, also called *The Tribute* (Copenhagen, Nationalmuseet). The paintings of his middle years (1625–50) are outstanding for coloristic subtlety and harmoniousness. Most of his pictures of happy family gatherings and of the *Adoration* belong to this period. During the 1640s Jordaens designed several series of tapestries which were woven in Brussels. After 1650 his art declined, and he repeated (not to their advantage) many of his earlier designs. Jordaens was one of the most prolific draftsmen of his age. He preferred pen and ink in his earlier years, black and red chalk later on. His Calvinist leanings show most clearly in the subjects of his later drawings. He also made a small number of etchings.

BIBLIOG. M. Rooses, Jordaens, sa vie et ses œuvres, Antwerp, 1906; L. van Puyvelde, Jordaens, Paris, New York, 1953; R.-A. d'Hulst, De Tekeningen van Jakob Jordaens, Brussels, 1956.

Julius S. HELD

JORDAN. State of the Near East, established in 1950 (formerly Transjordan) as the Hashemite Kingdom of Jordan. It is bordered on the west by Israel, on the north by Syria, on the east by Iraq, and on the southeast by Saudi Arabia.

SUMMARY. Historical-artistic background (col. 929). Western Jordan (col. 932). Eastern Jordan (col. 938).

HISTORICAL-ARTISTIC BACKGROUND. The historical and artistic development of Jordan is closely connected to that of Israel (q.v.); in fact, the two states divide, by an extremely irregular border, the Palestine geographical area, which is relatively homogeneous in its nature and in its history. Archaeological discoveries have established that human beings inhabited western Jordan, specifically the caves of the desert of Judah, as far back as the Mesolithic period,

and that their culture was well developed, as indicated by the different types of grain found. Western Jordan was also the site of the oldest urban culture yet known, that of Jericho, whose origins go back to the first half of the 8th millennium B.C. Even in this period the city was fortified by a circle of defensive walls, and by a sturdy stone tower equipped with stairs inside and with an underground passageway. To the Neolithic period (6000–4000 B.C.) belong the first works of sculpture: a mask of painted clay (or marl) and a series of human skulls, covered with clay and with traces of paint (IX, PL. 414). In the Chalcolithic period (4000–3000 B.C.), the first earthenware products appear, together with crude statuettes of animals. Particularly interesting, because of its age, is a pictorial composition, discovered at Teleilat Ghassul, showing a large multicolored star and remains of human figures, animals, and demons. The lifelike figure of a bird is especially striking.

In the Bronze Age (3000–1200 B.C.) western Jordan was in the cultural sphere of the Palestine region and thus under the prevailing Egyptian influence, while in the eastern part, inhabited by seminomadic peoples, there appeared numerous megalithic monuments. The quality of clay statuettes does not exceed the average level for objects of this nature, the more advanced techniques of neolithic Jericho having been forgotten by this time, whereas the toreutics and ivory carving reveal marked technical skill (assuming that the objects found in Jordan were locally produced and not imported); examples are a cow's head in ivory from Jericho, in a markedly Geometric style, and a statuette of silver-plated bronze from Tell el-Far'ah representing a female divinity in a notably realistic manner. The pottery making of the 2d millennium represents a local variation of the Syrian school known as "Mitannian," which is characterized by geometric designs, figures of animals — especially birds — and stylized trees; the Mycenaean influence on these works is readily seen. The theriomorphic and anthropomorphic vases belong to the same cultural climate.

In the Iron Age, corresponding to the period of Hebrew political domination (see JEWISH ART), the production of crude religious stat-

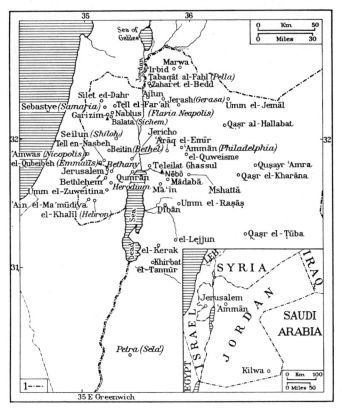

Jordan. Principal sites of archaeological and artistic interest. (Inset: the territory and its boundaries.) *Key:* (1) Modern national boundaries.

uettes, mostly of women, continued; recent discoveries at Amman point to the existence of a local school of sculpture which was characterized by reduced dimensions of the human figure, the relief on a stele found at Balu'ah being stylistically quite different. Notable in the field of minor arts is the series of ivories found in Samaria (PL. 332); their style links them to those of the Phoenicians found in various parts of Palestine, Syria, and Mesopotamia. In architecture use is made, as in Israel, of the proto-Aeolic capital, an archi-

tectural adaptation of a decorative motif, the palmette. The defensive walls of Samaria, distinguished by their strong towers with round bases, date from the period of Persian and Greek domination, as does the castle of the Tobiads at 'Arāq el-Emīr, adorned by a frieze of lions. In this period and in the following ones, there is a strong Greek influence on the country, especially in the arts; naturally, however, the works are still markedly provincial in character, and utilize local iconographic and stylistic themes. Thus, while the influence of the city-planning theories of Hippodamos of Miletos is seen in the large cities of the Roman era, in other sites, such as Petra, far from the urban centers and in the midst of the rocks, another style — theatrical, imposing, and completely alien to the Greek concept — is revealed; the latter trend is also present, to a lesser degree, in the tombs of Jerusalem. Stylistically more independent are the Nabataean works found in neighboring areas, such as the statues of the temple at Khirbat el-Tannūr, which seem to foreshadow Byzantine features. Nabataean pottery is notable for the refinement of its decoration, characterized by graceful plant motifs. The imprint of Byzantine rule is seen throughout Jordan; in addition to several basilicas, there are numerous fortresses along the edge of the desert.

A new artistic flowering took place in Jordan in the Arabic period immediately following the conquest (637 A.D.); there appeared in the desert new fortresses and rich buildings often decorated with stuccowork and mosaics, a striking example being the great palace at Khirbat al-Mafjar, which also included a mosque (see OMMIAD SCHOOLS). The arrival of the Crusaders (1099–1250) brought to Jordan the influence of the religious and military architecture of Europe, as well as construction techniques which endure to this day.

Elements of the Ottoman tradition, introduced by the Turkish occupation at the beginning of the 16th century, spread throughout the land in the four centuries that followed, during which time the territory of Jordan was a part of the Ottoman Empire. However, the monuments of this period, some of which reveal an Ottoman-baroque style, are rare and poorly preserved. On the other hand, both religious and civil building flourished during the 19th century, leaving a definite stamp on the towns of Jordan. There was a marked development of civil buildings, such as asylums, colleges, centers of the foreign colonies, schools, and private houses.

In the early 20th century, tastes with regard to the building of churches, monasteries, and seminaries became noticeably eclectic. A further step forward in building took place in 1920, when the Transjordan districts of 'Ajlun, Belqa, and el-Kerak formed an emirate, to which Ma'an and 'Aqaba were annexed in 1925 under the British mandate. In this period there prevailed an eclectic tendency toward an imitation of the classical European styles fused with elements of the local tradition. In more recent times, after the country's many vicissitudes as well as the Arab-Jewish conflict, there has been a great renewal of construction throughout the country, following the latest international trends but retaining elements of the local tradition, especially in ornamentation. All city-planning schemes follow modern Westernized criteria. There are numerous hotels and housing units, such as the Dead Sea Hotel (1959) on the Dead Sea and the facilities of such health resorts as Ramallah and Beit Jala. There are port facilities in 'Aqaba.

BIBLIOG. *a. Geography*: H. C. Luke and E. Keith-Roach, The Handbook of Palestine and Trans-Jordan, 2d ed., London, 1930; F. M. Abel, Géographie de la Palestine, 2 vols., Paris, 1933–38; N. Glueck, The River Jordan, London, 1946; D. Baly, The Geography of the Bible, New York, 1957; F. De Agostini, C. Sommadossi, and B. Del Boca, Imago mundi: Enciclopedia dell'Istituto per ricerche geografiche e studi cartografici, Milan, 1958, s.v.; M. Du Buit, Géographie de la Terre Sainte, Paris, 1958. *b. Atlases*: G. E. Wright, The Westminster Historical Atlas of the Bible, Philadelphia, 1945; P. Lemaire and D. Baldi, Atlante storico della Bibbia, Turin, 1955; L. H. Grollenberg, Atlas of the Bible, trans. J. M. B. Reid and H. H. Rowley, London, 1956. *c. Maps*: Jordan, Department of Lands and Surveys, Geological Map of Jordan, 3 sheets, [Amman?], 1954 (scale 1:250,000); Jordan, Department of Lands and Surveys, The Hashemite Kingdom of Jordan, Road Map, [Amman?], 1955 (scale 1:750,000). *d. History*: F. M. Abel, Histoire de la Palestine depuis la conquête d'Alexandre jusqu'à l'invasion arabe, Paris, 1932; R. Devresse, Les anciens évêchés de Palestine, in Mémorial Lagrange, Paris, 1940, pp. 217–27; R. Devresse, Le patriarcat d'Antioche, depuis la paix de l'Église jusqu'à la conquête arabe, Paris, 1945; G. Ricciotti, Storia di Israele, 4th ed., Turin, 1949; P. K. Hitti, History of Syria, London, 1951; R. Dussaud, La pénétration des Arabes en Syrie avant l'Islam (Inst. fr. d'archaeol., Beirut, Bib. archéol. et historique, LIX), Paris, 1955; J. Starcky, The Nabataeans, a Historical Sketch, Bib. Archaeologist, XVIII, 1955, pp. 84–106; S. Moscati, I predecessori d'Israele, Rome, 1956; M. Noth, Geschichte Israels, 3d ed., Göttingen, 1956. *e. Archaeology and art*: R. E. Brünnow and A. von Domaszewski, Die Provincia Arabia, 3 vols., Strasbourg, 1904–09; C. Enlart, Les monuments des croisés dans le royaume de Jérusalem, 2 vols., Paris, 1925–28; C. Watzinger, Denkmäler Palästinas, 2 vols., Leipzig, 1933–35; N. Glueck, Explorations in Eastern Palestine (Am. Schools of O. Research, Ann., XIV, XV, XXV–XXVIII), (4) vols., Philadelphia, 1934–(51); N. Glueck, The Other Side of the Jordan, New Haven, Conn., 1940; W. F. Albright, The Archaeology of Palestine, Harmondsworth, 1949; Jordan,

Department of Antiquities, Ann., 1951 ff.; G. L. Harding, Recent Discoveries in Jordan, PEQ, XC, 1958, pp. 7–18; N. Glueck, Rivers in the Desert, New York, 1959; G. L. Harding, The Antiquities of Jordan, London, 1959; K. M. Kenyon, Archaeology in the Holy Land, New York, 1960; Moyen-Orient (Les guides bleues), Paris, 1960.

WESTERN JORDAN. The description of places of interest proceeds from west to east, and from north to south.

Silet ed-Dahr. A burial cave, enlarged in the Roman period, it contained a great number of Roman and Byzantine earthenware oil lamps, and a bust in Oriental style.

Bibliog. O. R. Sellers and D. C. Baramki, A Roman-Byzantine Burial Cave in Northern Palestine (BAmSOR, Sup. Studies, 15–16), New Haven, Conn., 1953.

Samaria (Shomeron, Σαμάρεια, Σεβαστή, Sebastye). Former capital of the kingdom of Israel, founded by Omri, it underwent a radical transformation at the hands of Herod the Great; in the Roman period, and especially between A.D. 180 and 230, it covered a considerable expanse, as a result of the large buildings erected at that time. Archaeological campaigns have brought to light the remains of the palace structures of Omri and of Ahab on the acropolis, with their distinctive proto-Aeolic capitals placed on pilasters set against the sides of the enclosure walls and the sides of a gate. Belonging to the same Israelite period are numerous ivory plaques in pseudo-Egyptian style, and the inscriptions on vases regarding the wine and oil industries. The citadel and the circular towers belong to the Hellenistic era. Of the constructions of Herod, there are: the remains of the great temple dedicated to Augustus (Gr., Sebastos), in whose honor the city assumed the name of Sebaste; ruins of another temple which was dedicated to Kore; as well as the remains of a stadium later reconstructed with large colonnades. To the period of the city's prosperity in the 2d and 3d centuries belong a basilica, the great

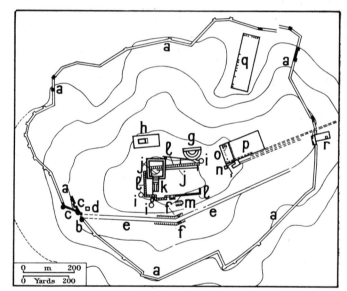

Samaria, archaeological plan of the city; (*a*) Walls of the Roman city; (*b*) west gate; (*c*) Hellenistic tower and walls; (*d*) Roman shrine; (*e*) street with columns; (*f*) shops; (*g*) theater; (*h*) temple of Kore; (*i*) Hellenistic towers; (*j*) Israelite internal wall; (*k*) Temple of Augustus; (*l*) Israelite casemate walls; (*m*) Greek church; (*n*) Roman shrine; (*o*) basilica; (*p*) forum; (*q*) stadium; (*r*) mosque and Latin church over tomb of St. John the Baptist (*from J. W. Crowfoot, K. M. Kenyon, and E. L. Sukenik, The Buildings at Samaria, London, 1942, pl. 1*).

stadium, and a mausoleum with a dome supported in a manner that was to be further developed in St. Sophia in Constantinople. A 12th-century cruciform basilica (now a mosque) covers the tomb of St. John the Baptist, venerated here as early as the 4th century.

BIBLIOG. G. A. Reisner, C. S. Fisher, and D. G. Lyon, Harvard Excavations at Samaria, 1908–1910 (Harvard Semitic Ser.), 2 vols., Cambridge, Mass., 1924; J. W. Crowfoot, Churches at Bosra and Samaria-Sebaste, London, 1937; J. W. and G. M. Crowfoot, Early Ivories from Samaria, London, 1938; R. Hamilton, The Domed Tomb at Sebastya, Palestine, Department of Antiquities, Q., VIII, 1939, pp. 64–71; J. W. Crowfoot, K. M. Kenyon, and E. L. Sukenik, The Buildings at Samaria, London, 1942; R. Hamilton, A Guide to Samaria-Sebaste, Jerusalem, 1944; A. Parrot, Samarie capitale du royaume d'Israël, Neuchâtel, 1955; J. W. Crowfoot, G. M. Crowfoot, and K. M. Kenyon, The Objects from Samaria, London, 1957.

Tell el-Far'ah (Tirzah). A locality inhabited from the chalcolithic era until about 600 B.C., with an interruption from approximately 2500 to about 1900 B.C. The first walls were erected about 2800 B.C.; a building with a colonnade belongs to the middle of the 2d millennium; there are numerous houses from the Israelite period. Cult statues of terra cotta have been found in the neighborhood, as has a small statue in silver-plated bronze, perhaps representing the goddess Hathor.

BIBLIOG. R. de Vaux, [Les fouilles à Tell el-Far'ah, près Naplouse], RBib, LIV, 1947, pp. 394-433, 573-89, LV, 1948, pp. 544-80, LVI, 1949, pp. 102-38, LVII, 1951, pp. 393-430, 566-90, LIX, 1952, pp. 551-83, LXIV, 1957, pp. 552-80; R. de Vaux, The Excavations at Tell el-Far'ah and the Site of Ancient Tirzah, PEQ, LXXXVIII, 1956, pp. 125-40.

Nablus (Flavia Neapolis). City founded by Titus in A.D. 72 of which there remain some underground Jewish tombs and the ruins of a Roman villa.

BIBLIOG. L. H. Vincent, Un hypogée antique à Naplouse, RBib, XXIX, 1920, pp. 126-35; F. M. Abel, Naplouse: Essai de topographie, RBib, XXXII, 1923, pp. 120-32.

Mount Garizim (Gerizim). Formerly a renowned shrine of the kingdom of Israel, believed to be the location of Abraham's sacrifice and an altar built by Joshua; today there remains only the massive rectangular enclosure wall, in rusticated ashlar, which surrounds the octagonal basilica erected by the emperor Zeno in 484. This is flanked by four small chapels, one of which, with a hexagonal font, served as a baptistery.

BIBLIOG. A. M. Schneider, Garizim, Z. des D. Palästina-Vereins, LXVIII, 1951, pp. 211-34.

Sichem (Shechem, Σίχιμα, Balata). Continuous excavations conducted in the city have revealed the cyclopean walls of the middle Bronze Age and the great expansion in construction that took place in the late Bronze Age. To the latter period belong two monumental gates, destroyed by the Egyptians in the 16th century B.C. In addition to the scanty remains of the Israelite and Hellenistic periods, mention must be made of the so-called "Well of Jacob" with the ruins of the two churches that were later constructed on top of it.

BIBLIOG. E. Sellin, Die Ausgrabung von Sichem, Z. des D. Palästina-Vereins, XL, 1926, pp. 229-36, 304-20, L, 1927, pp. 205-11, 265-74; F. M. T. Böhl, De Opgraving van Sichem, Zeist, 1927; G. Welter, Stand der Ausgrabungen in Sichen, AAnz, 1932, cols. 289-316; F. M. Abel, Le puits de Jacob et l'église Saint-Sauveur, RBib, XLII, 1933, pp. 384-402; G. E. Wright, The First Campaign at Tell Balâṭah (Shechem), BAmSOR, 144, 1956, pp. 9-20, The Second Campaign at Tell Balâṭah (Shechem), BAmSOR, 148, 1957, pp. 11-28; L. H. Vincent, Puits de Jacob ou de la Samaritaine, RBib, LXV, 1958, pp. 547-67.

Shiloh (Σηλώ, Seilun). On this site Israelite and Roman walls are preserved, as well as the remains of houses of the Bronze Age and the Israelite period. There are also two churches (5th-6th cent.), in one of which is a mosaic composition of two facing animals separated by a plant. Coming from nearby Turmus 'Aya is a Roman sarcophagus with representations of Dionysus, the seasons, the earth, and the ocean.

BIBLIOG. R. Savignac and E. Michon, Découverts à Tourmous 'Aya, RBib, X, 1913, pp. 106-18; H. Kjaer, The Excavation of Shiloh 1929, Palestine O. Soc. J., X, 1930, pp. 87-174.

Bethel (Beitin). On this site, inhabited from the early Bronze Age, there remain ruins of the walls and of a fortress of the Hyksos period, as well as traces of Roman and Byzantine buildings; a mosque rises over the ruins of a Byzantine church.

BIBLIOG. W. F. Albright, The Kyle Memorial Excavations at Bethel, BAmSOR, 56, 1934, pp. 2-15, 57, 1935, pp. 27-30; J. L. Kelso, The Second Campaign at Bethel, BAmSOR, 137, 1955, pp. 5-10, The Third Campaign at Bethel, BAmSOR, 151, 1958, pp. 3-8.

Tell en-Nasbeh (Mizpah). Of this city there remain parts of the walls of various periods (from the early Bronze Age to the Israelite period), many houses from Israelite times, and the remains of a temple dedicated to Astarte.

BIBLIOG. C. C. McCown and J. C. Wampler, eds., Tell en-Nasbeh..., (2) vols., Berkeley, Calif., 1947 ff.

'Amwas (Νικόπολις, Nicopolis, Emmaus of the Maccabees). Found here is an imposing ruin with three apses, of large dressed stones, thought to be the remains of a church dating from the 2d-4th century. The mosaic pavement has scenes with animals against a background of papyrus plants. In the 12th century a church was built against the three apses; part of it is still preserved.

BIBLIOG. J. Lassus, Sanctuaires chrétiens de Syrie, Paris, 1932, pp. 80-87; L. H. Vincent and F. M. Abel, Emmaüs, sa basilique et son histoire, Paris, 1932; C. Cecchelli, Il problema della basilica cristiana precostantiniana, Palladio, VII, 1943, pp. 1-13.

Ramallah. A small city of recent origin, which became a well-known and well-equipped health resort after the Arab-Jewish conflict (1949). The city is laid out in modern fashion, with wide streets, houses, hotels, and office buildings which reflect international influences.

el-Qubeibeh (according to later tradition, the Emmaus of the Gospels). Here are preserved the remains of a village dating from the period of the Crusades, with a wide artery lined with shops, a church with nave and side aisles, and a castle. The church and the monastery of the Franciscans are of the early 20th century.

BIBLIOG. B. Begatti, I monumenti di Emmaus el-Qubeibeh e dei dintorni, Jerusalem, 1947.

Jericho (Eriha, Ϝεριχώ). This city was founded during the Mesolithic period, and by the Neolithic period had acquired walls and a tower (a neolithic dwelling is illustrated in IX, PL. 413). Some

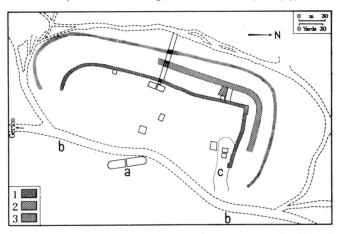

Jericho, plan of the city in the early and middle Bronze Age. *Key*: (1) Walls of the city of the early Bronze Age; (2) embankment from the middle Bronze Age; (3) ditch from the middle Bronze Age. (*a*) Reservoir; (*b*) modern street; (*c*) area excavated by Garstang [*from A. D. Tushingham, The Joint Excavations at Tell el-Sultan (Jericho), BAmSOR, 127, 1952*].

tombs which have yielded rich archaeological finds date back to the Bronze Age, as do the mighty encircling walls. After violent destruction in the 16th century B.C., there were minor settlements on the tell until the city rose again, through the efforts of Herod, near the Qilt River. Belonging to the Roman period are remains of a palace with large niches for statues, in *opus reticulatum*, the only one of its kind in Jordan. There are some mosaics from the Christian period. A little to the north lie the imposing ruins of Khirbat al-Mafjar (see OMMIAD SCHOOLS).. This is a large palace with a rectangular ground plan, with an adjacent mosque and bathhouse, as well as a courtyard in front with a basin and a pavilion, the whole complex encircled by a large wall. Both the palace and bathhouse were richly decorated with paintings, sculptures, and mosaics, many of which have survived to this day, in varying states of preservation. Among the most sensational discoveries are some stucco figures in full relief, which represent an eminent personage or ruler (X, PL. 382), dancing girls, and horsemen, and rich relief decorations in gesso, stucco, and stone. Less original, but no less admirable, is the mosaic part of the bath and of the palace, with iconographic and decorative motifs in Hellenistic-Oriental style (X, PL. 383). Khirbat al-Mafjar dates from the time of the Ommiad caliph Hishâm (724-43). Nearby is the 19th-century Monastery of the Forty Days (or Sarandarion).

BIBLIOG. D. C. Baramki, Excavations at Khirbet el Mefjer, Palestine, Department of Antiquities, Q., V, 1935-36, pp. 132-38, VI, 1937, pp. 157-68, VIII, 1938, pp. 51-53, X, 1942, pp. 153-59; D. C. Baramki, The Pottery from Kh. el Mefjer, Palestine, Department of Antiquities, Q., X, 1942, pp. 65-103; R. W. Hamilton, [Khirbat Mafjar: Stone Sculpture], Palestine, Department of Antiquities, Q., XI, 1944, pp. 47-66, XII, 1945, pp. 1-19, XIII, 1947, pp. 1-58, XIV, 1950, pp. 100-19; R. W. Hamilton, The Baths at Khirbat Mafjar, PEQ, 1949, pp. 40-51; A. Augustinovič, Gerico e dintorni, Jerusalem, 1951; Joint Expedition of the Pittsburgh Xenia Theological Seminary and the American School of Oriental Research in Jerusalem, 1950, Excavations at New Testament Jericho and Khirbet En-Nitla, ed. J. L. Kelso and D. C. Baramki (Am. Schools of O. Research, Ann., XXIX-XXX, 1949-51), New Haven, Conn., 1955; K. M. Kenyon, Digging up Jericho, London, 1957; R. Hamilton, Khirbat al-Mafjar, an Arabian Mansion in the Jordan Valley, Oxford, 1959; K. M. Kenyon, Excavations at Jericho, (I), London, (1960).

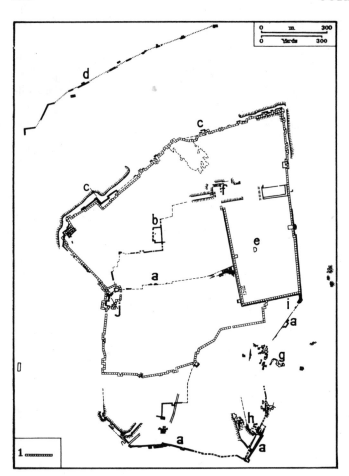

Jerusalem, general plan of the archaeological remains. *Key*: (1) Modern walls. Monuments: (*a*) First wall, from the period of Solomon; (*b*) second wall, from the period of Hezekiah (?); (*c*) third wall, from the period of Herod Agrippa; (*d*) fourth wall, from the period of Aelia Capitolina; (*e*) area of the Temple; (*f*) remains of the Antonia Fortress; (*g*) aqueduct of Hezekiah; (*h*) steps of the City of David; (*i*) Ophel; (*j*) citadel and Tower of David.

Jerusalem (Urusalim, Hierosolyma, Aelia Capitolina, el-Quds). The boundary established by the armistice in 1949 divided the city into two parts; Jordan has retained almost all of the more ancient part of the city, surrounded by medieval walls, while Mount Zion was assigned to Israel (q.v.). On the Mount of Olives there is a tomb dating from the end of the 2d millennium. The Temple and the Palace of Solomon having disappeared, all that remains from the period of the Monarchy is the underground aqueduct of Hezekiah (FIG. 935). A considerable amount remains of the temple which was reconstructed by Herod in place of the one destroyed by Pompey in 63 B.C., including the great walls of the open space between the city and the citadel, and the huge entrances with their domed gates. Dating from the same period are the ruins of the Antonia Fortress and the base of the Tower of David; parts of the Hasmonean walls have also been preserved. Also belonging to the Hellenistic-Roman period are some huge tombs dug out of the rock on the outskirts of the city, among them: the tomb of Herod's family and tombs of the kings of Adiabene ("Tombs of the Kings"), which consist of a courtyard with an atrium leading to the burial chambers, and the tombs situated in the Valley of the Kidron — the Tomb of the Beni Hezir (so-called "Tomb of St. James"), with a façade in Doric style and once having had a pyramidal roof, now missing (PL. 331); the so-called "Tomb of Zechariah," a monolithic construction in Egyptianizing style with Ionic columns on the outside; and finally the so-called "Tomb of Absalom" (PL. 331) and "Tomb of Jehoshaphat." Of the Aelia Capitolina reconstructed by Hadrian, there remains only the outline, still followed in the Old City, and a triumphal arch called the Ecce Homo Arch.

Among the few remaining churches of the many built during the period from the time of Constantine to that of Justinian are the Church of the Tomb of the Virgin, which was extensively restored by Crusaders, and the Church of St. John the Baptist, both dating from the 5th century. In addition, many mosaic pavements have been preserved. Dating from the early Islamic period is the Mosque of 'Omar, called the Dome of the Rock (Qubbat al-Sakhrā), built

on the site of the Temple of Solomon. Completed in 691 under the caliph 'Abd al-Malik, this octagonal building is both one of the most venerated Islamic shrines and one of the most notable monuments of Moslem architecture (PL. 146). The exterior, formerly embellished with mosaics, is now covered by a ceramic decoration dating from the era of the Ottoman sultan Sulaymān (16th cent.). The interior, to which four doors at the cardinal points give access, is comprised of two concentric ambulatories and a center room that contains the rock which, according to Islamic belief, was the starting point of Mohammed's miraculous voyage to heaven. Above this central area is a two-story drum, covered with 11th-century mosaics, and on top of this is a dome which was restored and paneled with wood in the late 19th century. On the inner arches of the eight walls are some very precious mosaics — representing date palms, rinceaux, and garlands — that date from the end of the 7th century, the period of the foundation itself, although the dedicatory inscription in Kufic characters bears the name of the 9th-century caliph, al-Ma'mūn. (See X, PLS. 182, 377, 385.) Some of the handsome stained-glass windows also date from the time of the sultan Sulaymān. In 1960, sheets of gilded aluminum were placed on the roof of the monument.

The period of the Crusades has left several churches — such as the Church of the Holy Sepulcher (restored in 1810), the Church of St. Anne, and the Church of the Ascension — as well as traces of Latin taste in later mosques, such as the Aqsā Mosque. Built by the Moslems during the Ommiad age, and continued during the Abbasside age, the Aqsā Mosque has undergone, over the centuries, a series of remodelings and modifications (colonnade and ceiling restored, 1939), which makes it almost impossible to reconstruct its original appearance. It now consists of seven pillared aisles with a rich mihrab from the era of Ṣalāh ad-Dīn and a mimbar which Nūr ad-Dīn had built as a votive offering for the reconquest of Jerusalem by the Moslems. The region was the capital of the Latin kings of Jerusalem, and, from 1128, the seat of the Order of Templars.

Dating from the 15th century are the Qāit Bey Fountain (1482) and the portal of the Ashrafiya Madrasah. Occupied by the Turks in 1517, the city remained under Ottoman rule for four centuries. It flourished in the 16th century under Sulaymān the Magnificent; notable constructions of this era, especially remarkable for the materials utilized, are the fountain of the Bāb el-Silsileh (1537) and the fortifications of the citadel with the Damascus Gate (1532). Following

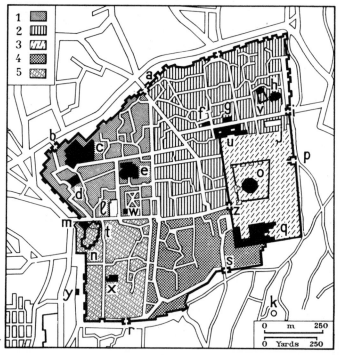

Jerusalem. *Key*: (1) Greek and Latin quarter; (2) Moslem quarter; (3) Ḥaram el-Sherīf (area of the Temple); (4) former Hebrew quarter; (5) Armenian quarter. Principal monuments: (*a*) Damascus Gate; (*b*) New Gate; (*c*) Church of the Saviour; (*d*) Casa Nova hospice; (*e*) Church of the Holy Sepulcher; (*f*) Ecce Homo Arch; (*g*) Chapel of the Scourging of Christ; (*h*) Church of St. Anne; (*i*) St. Stephen's Gate; (*j*) Birket Isra'il; (*k*) Gihon; (*l*) Birket Ḥammām el-Batrak; (*m*) Jaffa Gate; (*n*) citadel; (*o*) Dome of the Rock; (*p*) Golden Gate; (*q*) Aqsā Mosque; (*r*) Zion Gate; (*s*) Gate of the Maghribi; (*t*) Tower of David; (*u*) Antonia Fortress; (*v*) Pool of Bethesda; (*w*) Church of St. John the Baptist; (*x*) Church of St. James; (*y*) tomb of Herod's family (Israeli zone); (*z*) Bāb el-Silsileh (*from M. Join-Lambert, Jérusalem israélite, chrétienne, musulmane, Paris, 1957, with modifications*).

this period there was a gradual decline. In the Ottoman period, the Church of St. James was restored and enlarged (the portico dating from 1712), as was the Dome of the Rock (the east portico dating from 1780), and the Coptic monastery was built.

With the 19th century there was a significant increase in construction, and, in addition to important restorations of many monuments, new religious buildings were constructed, such as the German Lutheran Church of the Saviour (1898; built over the old Church of St. Mary the Latin, 10th–11th cent.), the Church of the Sisters of Zion (1868; architects, Daumiet and Mauss), the Church of the

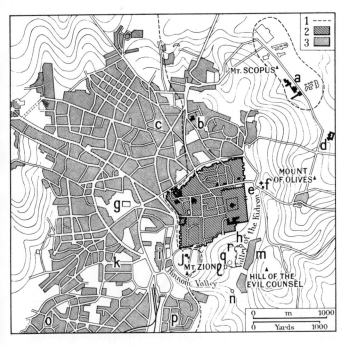

Jerusalem, development of the city in its topographic setting. *Key*: (1) Modern national boundary between Jordan and Israel; (2) the old city within the walls; (3) extent of the present inhabited district. Principal monuments and buildings: (*a*) Hebrew University; (*b*) "Tombs of Kings"; (*c*) Mandelbaum Gate; (*d*) Church of the Ascension; (*e*) Church of the Tomb of the Virgin; (*f*) Gethsemane; (*g*) Birket Mamilla; (*h*) Gihon; (*i*) Birket el-Sulṭān; (*j*) "Tomb of David" and the Cenacle; (*k*) Talbieh; (*l*) Pool of Siloam; (*m*) village of Silwan; (*n*) ʿain Rogel; (*o*) Katamon; (*p*) Abū-Tor; (*q*) royal tombs; (*r*) aqueduct of Hezekiah.

Pater Noster (1875), the Chapel of the Holy Sepulcher, as well as the Alexandra hospice of the Russian Orthodox community, the hospice of the Johannites (1855), the German Catholic hospice of St. Paul, the headquarters of the Dominican Colony (1881), and the el-Maʿmūniya College (1892; built over the old Church of St. Magdalene of the Jacobites). Dating from the early part of the 20th century are the Basilica of St. Stephen (ca. 1900; built over the 5th-cent. original), the Palestine Archeological Museum (1927), the Greek Catholic Seminary of St. Anne, the Oratory of the Chapel of Golgotha (1937), and the Roman Catholic Church of All Nations (1924). Other museums are the Archaeological Museum of the Studium Biblicum Franciscanum and the Museum of the White Fathers.

BIBLIOG. H. T. F. Duckworth, The Church of the Holy Sepulchre, London, 1922; E. T. Richmond, The Dome of the Rock in Jerusalem, Oxford, 1924; H. Kendall, Jerusalem: The City Plan, London, 1948, R. Hamilton, The Structural History of the Aqsa Mosque, Jerusalem, 1949, J. Simons, Jerusalem in the Old Testament, Leiden, 1952; E. Wistrand, Konstantins Kirche am heiligen Grab in Jerusalem nach den ältesten literarischen Zeugnissen, Göteborg, 1952; L. H. Vincent and P. M.-A. Stève, Jérusalem de l'Ancien Testament, (3) vols., Paris, 1954–(56); M. A. de Sion, La forteresse Antonia à Jérusalem et la question du Prétoire, Jerusalem, 1955; M. Join-Lambert, Jérusalem israélite, chrétienne, musulmane, Paris, 1957; B. Bagatti and J. T. Milik, Gli scavi al "Dominus Flevit," I, Jerusalem, 1958; O. Grabar, The Umayyad Dome of the Rock in Jerusalem, Ars Orientalis, III, 1959, pp. 33–62; E. A. Moore, The Ancient Churches of Old Jerusalem: The Evidence of the Pilgrims, Beirut, 1961.

Bethany (Βηθανία, el-ʿAzariya). Preserved here are the ruins of a church built in the 4th century near the traditional tomb of Lazarus, of a later church built on the same spot, and of the abbey built by Queen Melisande in the 12th century.

BIBLIOG. S. J. Saller, Excavations at Bethany (1949–1953) (Studium Biblicum Franciscanum, Pubs., 12), Jerusalem, 1957.

Qumran. A region which has become famous since the finding of the Dead Sea Scrolls; it contains the ruins of an Essene "monastery" (ca. 100 B.C.–ca. A.D. 66), a settlement established for communal activities — such as eating, praying, and studying — by a religious sect who lived in nearby tents and caves. The complex includes conference rooms, a flour mill, a pottery, a scriptorium, and a two-story tower, as well as a network of canals and water tanks.

BIBLIOG. R. de Vaux, Fouilles au Khirbet Qumrân, RBib, LX, 1953, pp. 340–61, LXI, 1954, pp. 206–36, LXIII, 1956, pp. 533–77.

Bethlehem (Bēt Lehem, Beit Lahm, Βηθλεέμ). Preserved here in fairly good state is a rare church specimen: the Church of the Nativity, with five aisles and a triconch at its eastern end, built by Justinian over a Constantinian church, of which only parts of mosaics remain. A number of mosaic fragments have survived from additions made to the church by the Crusaders in the 12th century. The church was restored in 1671 and again in 1842. Nearby, at Bīr el-Qūtt and Khirbat Siyār el-Ghanam, two monasteries dating back to the period between the 5th and 7th centuries have been uncovered, yielding mosaic floors and liturgical objects. Also nearby is the Monastery of St. Sabas (5th cent.), which was destroyed by an earthquake and reconstructed in 1834. The Basilica of St. Theodore (5th cent.; reconstructed in 1952) is at Deir Dosi. In complete decline throughout the late Middle Ages and the first centuries of the modern era, the city has been given a new impetus by the religious groups which settled there during the 19th and 20th centuries.

BIBLIOG. W. Harvey, W. R. Lethaby, and O. M. Dalton, The Church of the Nativity at Bethlehem, London, 1910; L. H. Vincent and F. M. Abel, Bethléem, Paris, 1914; E. T. Richmond, Basilica of the Nativity: Discovery of the Remains of an Earlier Church, Palestine, Department of Antiquities, Q., V, 1936, pp. 75–81; L. H. Vincent, Bethléem, RBib, XLV, 1936, pp. 544–74, XLVI, 1937, pp. 93–121; B. Bagatti, Gli antichi edifici sacri di Betlemme, Jerusalem, 1952; V. Corbo, Gli scavi di Khirbat Siyar el-Ghanam e i monasteri dei dintorni, Jerusalem, 1955.

Herodium (Ἡρῳδίων). Tomb of Herod the Great, rising forth from a hill. The wall that circles the top has three apses and a circular room with an unusual plan resembling that of a fortress.

BIBLIOG. C. R. Conder and H. H. Kitchener, The Survey of Western Palestine, ed. E. H. Palmer and W. Besant (Palestine Exploration Fund, The Survey of Western Palestine), III, London, 1883, pp. 330–32.

Umm el-Zuweitina. Site of a prehistoric settlement; excavations have uncovered, among other things, a statuette of gray stone from the Natufian culture depicting a ruminant.

BIBLIOG. R. Neuville, Le paléolithique et le mésolithique du désert de Judée, Paris, 1951, p. 124.

Hebron (Χεβρών, Kiryat Arba, el-Khalīl). The colossal wall of rusticated ashlar which encloses the tombs of the patriarchs was the work of Herod the Great, who also constructed underground tombs next to the ancient ones, now inaccessible. More modest and less well preserved is the nearby wall of Ḥaram Rāmat el-Khalīl (Mambre), which commemorates Abraham's vision of the three angels. Constantine had constructed an undistinguished church there, the foundation of which still remains. The well, which was restored at that time, is still in use. Partly destroyed in the repression of the revolt against Ibrāhīm Pasha (1834), the city contains but a few vestiges of monuments of the modern age. Today it flourishes once again, expanding in the valley and along the eastern slopes of the hill.

BIBLIOG. L. H. Vincent, E. J. Mackay, and F. M. Abel, Le Haram el-Khalil, Paris, 1923; A. Dupont-Sommer, Les fouilles du Ramet-el-Khalil près d'Hébron, Syria, XI, 1930, pp. 16–32; E. Mader, Mambre, Freiburg im Breisgau, 1957.

ʿAin el-Maʿmūdiya. A spring near which was erected a little church dedicated to St. John the Baptist and used as a baptistery. Dating from the 6th century is a small fortification, now excavated, that safeguarded the church.

BIBLIOG. C. Kopp and A. M. Stève, Le désert de Saint-Jean près d'Hébron, RBib, LIII, 1946, pp. 547–75.

EASTERN JORDAN. Irbid. Traces remain of the walls of this city of the early Bronze Age — perhaps the ancient city of Arbila (Arbela); not until the Roman era was it inhabited again. The modern city has recently obliterated the remains of the Roman era.

BIBLIOG. G. L. Harding, The Antiquities of Jordan, London, 1959, pp. 54–56.

Marwa. On this site near Irbid, preserved in a Roman tomb, is a painting of mythological scenes.

BIBLIOG. C. C. McCown, A Painted Tomb at Marwa, Palestine, Department of Antiquities, Q., IX, 1942, pp. 3–10.

Pella (Πέλλα, Tabaqat al-Fahl). A city which was a refuge of Christians in the year A.D. 70, it contains the remains of a theater, the Temple of Zeus Areios, and a Christian basilica. It has not yet been excavated.

BIBLIOG. J. Richmond, Khirbet Fahil, Palestine Exploration Fund Q. Statement, 1934, pp. 18–31.

Zaharet el-Bedd. There is a Nabataean relief here depicting a serpent killing an eagle.

BIBLIOG. N. Glueck, Explorations in Eastern Palestine (Am. Schools of O. Research, Ann., XXV–XXVIII), IV, Part 1, Text, Philadelphia, 1951, pp. 202–03.

Umm el-Jemāl. City founded by the Nabataeans in the 1st century B.C., and very well preserved. Within its great Roman wall are a temple attributed to the Nabataean period, tombs, cisterns, and 15 Christian churches. The churches display two roofing techniques — one using transverse arches, the other utilizing columns to support a pitched roof. Two of the churches are dated: the Church of St. Jul-

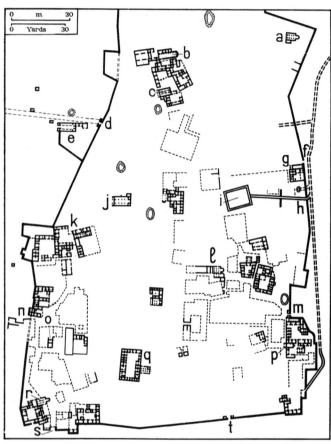

Umm el-Jemāl: (a) northeast church; (b) Church of St. Julian; (c) Church of St. Claudian; (d) Gate of Commodus; (e) west church; (f) northeast gate; (g) east church; (h) water gate; (i) Roman reservoir; (j) Cathedral; (k) praetorium; (l) double church; (m) east gate; (n) west gate; (o) Nabataean temple; (p) southeast church (q) barracks and tower; (r) southwest church; (s) southwest gate; (t) south gate (from G. L. Harding, The Antiquities of Jordan, London, 1959, fig. 8).

ian (346) and the Cathedral (557). The Gate of Commodus and the praetorium remain from the Roman period.

BIBLIOG. H. C. Butler, Architecture, Section A, Southern Syria (Syria: Pubs. of the Princeton Univ. Arch. Expeditions to Syria in 1904–5 and 1909, Division II), Leiden, 1919, pp. 149–213. G. L. Harding, The Antiquities of Jordan, London, 1959, pp. 146–50.

'Ajlun. A medieval Arab castle called Qal'at el-Rabadh is preserved here; constructed in 1184 and enlarged in 1214–15, it has towers, huge halls, and such sculptures as the stylized figures of birds in the entrance arch. In the surrounding territory there are Roman and Byzantine remains, including sarcophagi and mosaics. At Umm el-Manabya there are ruins of a small church with a Nilometer.

BIBLIOG. C. N. Johns, Medieval 'Ajlūn, Palestine, Department of Antiquities, Q., I, 1932, pp. 21–33; A. Augustinovič and B. Bagatti, Escursioni nei dintorni di 'Ağlūn, Studium Biblicum Franciscanum, Liber annus, 1952, pp. 227–314.

Jerash (Γέρασα, Gerasa). The best-preserved Roman city in the Near East. Everything is enclosed within Roman and Byzantine walls, except for the hippodrome and the triumphal arch, which are

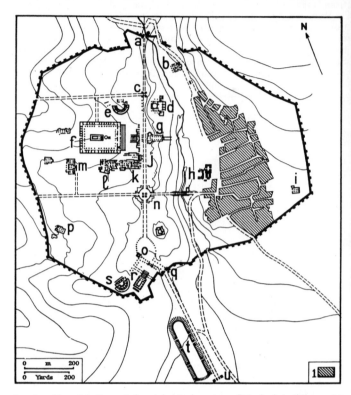

Jerash. Key: (1) Present-day inhabited sector. Principal buildings: (a) North gate; (b) Church of the Prophets, Apostles, and Martyrs; (c) north tetrapylon; (d) west baths; (e) north theater; (f) Temple of Artemis; (g) Viaduct church; (h) east baths; (i) Procopius Church; (j) nymphaeum; (k) Cathedral; (l) Church of St. Theodore; (m) Churches of SS. Cosmas and Damian, of St. John, and of St. George; (n) south tetrapylon; (o) forum; (p) Church of SS. Peter and Paul; (q) south gate; (r) Temple of Zeus; (s) south theater; (t) hippodrome; (u) triumphal arch (from G. L. Harding, The Antiquities of Jordan, London, 1959, fig. 4).

situated a little outside the south gate. It constitutes a typical example of a provincial Roman city; constructed around the cardo and two decumani maximi, and with two tetrapylons at their intersections, the city has a forum with a characteristically elliptical ground plan, a large temple dedicated to Artemis and another to Zeus, two theaters, and two thermae. The Roman remains date from the 2d and 3d centuries of the Christian Era, a period in which the city flourished economically. Especially significant among the 13 known churches are: the Cathedral, with its "miraculous fountain" in the courtyard; the Church of St. Theodore; the Church of St. John, with a central ground plan and with considerably advanced architectural motifs; and the Church of SS. Cosmas and Damian and that of St. George, with notable mosaics preserved in situ. The mosaics from the Church of St. John, finest of all because of their inventiveness and technique, have been in part transferred to the small local museum. A synagogue, some architectural traces of which remain, was transformed into a church in 531. Abandoned since 1131, Jerash was occupied at the end of the 19th century by a colony of Circassians, who built a village, using materials taken from the ancient city.

BIBLIOG. C. H. Kraeling, Gerasa, City of the Decapolis, New Haven, Conn., 1938; A. L. Detweiler, Some Early Jewish Architectural Vestiges from Jerash, BAmSOR, 87, 1942, pp. 10–17; J. H. Iliffe, Imperial Art in Trans-Jordan, Palestine, Department of Antiquities, Q., XI, 1945, pp. 1–26; G. L. Harding, Recent Work on the Jerash Forum, PEQ, 1949, pp. 12–20; S. J. Saller and B. Bagatti, The Town of Nebo, Jerusalem, 1949, pp. 269–89.

Qasr al-Hallābāt. In addition to Nabataean architectural remains, this site contains a Roman building dating from the time of Caracalla, which was later used as a monastery, and a 12th-century mosque; both structures are in ruins.

BIBLIOG. G. L. Harding, The Antiquities of Jordan, London, 1959, pp. 151–52.

Amman (Rabbath Ammon, Φλαδέλφεια, Philadelphia). The present-day capital of Jordan has yielded archaeological remains from

as far back as Paleolithic times, but except for some tombs (such as that of Adoni Nūr with its interesting furnishings) from the middle of the 7th century B.C. and a few statuettes of the 1st millennium B.C., there are no monumental remains prior to the Roman period. On the west bank of the river there is a large triapsidal nymphaeum, from which a great deal of material has been taken and reused in modern constructions; there is a well-preserved theater, with an odeum nearby; part of the colonnade of the *cardo maximus* has also survived. The most important remains are on the citadel: parts of a wall of the 1st millennium B.C.; a Roman temple, dedicated to Hercules, containing a colossal statue of the god, fragments of which have been found; a small church of the 6th or 7th century; a rectangular building, called the "Tomb of Uriah," originally covered by a dome dating from the period A.D. 600–800, with the remains of reliefs on its walls; and, finally, a Byzantine gate.

Having declined in the earlier Middle Ages, it remained a poor village throughout most of the modern era. Ceded by the Turks to a colony of Circassians, it rose again, and material taken from Greco-Roman structures was used in the construction of its buildings. The capital of Transjordan since 1922, it has undergone a complete transformation, becoming the scene of an exceptional urban development, which was further increased after 1950, when it became the capital of the Hashemite Kingdom of Jordan. Of special interest are the palaces of Basman and Raghdan, dating from the end of the 19th

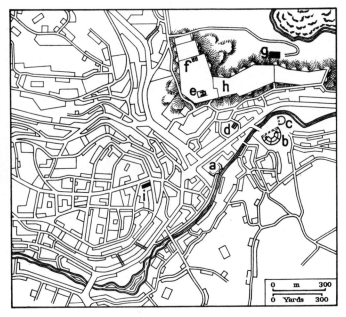

Amman, map of the city showing location of the remains of the ancient Philadelphia; (*a*) nymphaeum; (*b*) theater; (*c*) odeum; (*d*) propylaeum; (*e*) temple from the period of Marcus Aurelius; (*f*) "Tomb of Uriah" and temple area; (*g*) museum; (*h*) citadel; (*i*) el-Ḥusayn Mosque.

century. Of more recent date are the el-Ḥusayn Mosque (1924), the mausoleum of King 'Abdullāh (1952), and many public improvements, as well as hotels and housing developments.

Bibliog. H. C. Butler, Architecture, Section A, Southern Syria (Syria: Pubs. of the Princeton Univ. Arch. Expeditions to Syria in 1904–5 and 1909, Division II), Leiden, 1919, pp. 34–62; R. Bartoccini, Scavi ad 'Amman, Rome, Associazione internazionale degli studi mediterranei, B., III, 1932, pp. 16–23, IV, 1933, pp. 10–15; R. Bartoccini, La roccia sacra degli Ammoniti, Atti del IV congr. naz. di studi romani, Rome, 1938, pp. 103–08; A. Bartoccini, Un decennio di ricerche e di scavi italiani in Transgiordania, Ist. di archeol. e storia dell'arte, B., 1941, pp. 75–84; G. L. Harding, Two Iron Age Tombs from 'Amman, Palestine, Department of Antiquities, Q., XI, 1944, pp. 67–74; R. D. Barnett, Four Sculptures from Amman, Jordan, Department of Antiquities, Ann., I, 1951, pp. 34–36; G. L. Harding, Excavations on the Citadel, Amman, Jordan, Department of Antiquities, Ann., I, 1951, pp. 7–16; G. L. Harding, A Roman Tomb in Amman, Jordan, Department of Antiquities, Ann., I, 1951, pp. 30–33; G. L. Harding, Two Iron-Age Tombs in Amman, Jordan, Department of Antiquities, Ann., I, 1951, pp. 37–40; G. L. Harding, A Middle Bronze Age Tomb at 'Amman, Palestine Exploration Fund, VI, 1953, pp. 14–18; G. L. Harding, The Tomb of Adoni Nur in 'Amman, Jordan, Department of Antiquities, Ann., VI, 1953, pp. 48–65.

'Arāq el-Emīr. Preserved here are the ruins of a castle, variously dated from the 3d century B.C. to the 1st century of the Christian Era, that is associated with the name of the Tobiads. Its capitals, similar to those found in Petra, and a damaged frieze with lions in bas-relief are especially noteworthy.

Bibliog. H. C. Butler, Architecture, Section A, Southern Syria (Syria: Pubs. of the Princeton Univ. Arch. Expeditions to Syria in 1904–5 and 1909, Division II), Leiden, 1919, pp. 1–25; C. C. McCown, The 'Araq el-Emir and the Tobiads, Bib. Archaeologist, XX, 1957, pp. 63–76.

el-Quweisme. A village near Amman, somewhat to the south, with a Roman mausoleum of cruciform plan; nearby is a mosaic depicting two churches, with an inscription stating that the priest T. Khobeos reconstructed the sacred edifice in 717–18.

Bibliog. R. E. Brünnow and A. Domaszewski, Die Provincia Arabia, II, Strasbourg, 1905, pp. 207–11; S. J. Saller and B. Bagatti, The Town of Nebo, Jerusalem, 1949, pp. 251–68.

Teleilat Ghassul. Excavations here have brought to light chalcolithic wall paintings (4th millennium B.C.). Despite their extremely poor state of preservation, it is possible to discern a complex composition, with human figures, animals, and demons. Superimposed layers of paintings testify to the existence of a fairly long-established school of painting.

Bibliog. A. Mallon, R. Köppel, and R. Neuville, Teleilat Ghassûl, I, Rome, 1934.

Mount Nebo. At the summit of nearby Ras Siyagha excavations have brought to light a triapsidal building and a large monastery. The structures date from the 2d and 3d centuries through the 7th. Notable are a mosaic of an imaginary temple of Jerusalem and the original capitals of a 5th-century church. Probings in the hill at Khirbat el-Mukhayyat have revealed remains dating from the Bronze Age to the 7th century of the Christian Era. The mosaics in the three churches are clearly visible and the one in the Church of SS. Lot and Procopius is especially interesting for its allegorical compositions (6th cent.).

Bibliog. B. Bagatti, Edifici cristiani nella regione del Nebo, RACr, XIII, 1936, pp. 101–42; S. J. Saller, The Memorial of Moses on Mount Nebo, Jerusalem, 1941; B. Bagatti, Il monastero del Nebo e gli antichi monasteri della Palestina, Atti del IV congr. int. di archeol. cristiana, II, Rome, 1948, pp. 89–110; S. J. Saller and B. Bagatti, The Town of Nebo, Jerusalem, 1949; H. Schneider, The Memorial of Moses on Mount Nebo, Jerusalem, 1950.

Quṣayr 'Amra. A well-preserved castle, completed ca. 715 by the caliph al-Walīd I; it contains many frescoes (X, PL. 384), outstanding among them being portraits of such contemporary sovereigns as the emperor of Persia, the emperor of Byzantium, the Negus of Ethiopa, and the Visigoth Roderick.

Bibliog. A. Musil, Arabia Petraea, I, Moab, Vienna, 1907, pp. 275–85; K. A. C. Creswell, Early Muslim Architecture, I, Oxford, 1932.

Mshattā. The palace probably belongs to the Ommiad period. Never completed, it had a façade with luxurious decoration in bas-relief, most of which is now in Berlin (X, PL. 381). The central part of the vast building has a trefoil ground plan, with vaulted ceilings.

Bibliog. R. E. Brünnow and A. Domaszewski, Die Provincia Arabia, II, Strasbourg, 1905, pp. 104–70; S. Bettini, Il castello di Mschâttâ: Transgiordania nell'ambito dell' "arte di potenza" tardoantica, in Anthemon: Scritti di archeologia e di antichità classica in onore di Carlo Anti, Florence, 1955, pp. 321–66; O. Grabar, Al-Mushatta, Baghdâd, and Wâsiṭ, in J. Kritzeck and R. B. Winder, eds., The World of Islam (Studies in Honor of P. K. Hitti), London, New York, 1959, pp. 99–108; L. Trümpelmann, Mschatta: Ein Beitrag zur Bestimmung des Kunstkreises, zur Datierung und zum Stil der Ornamentik, Tübingen, 1962.

Qaṣr al-Kharāna. An imposing Ommiad defensive construction, with a Kufic inscription dating it 711, built on Hellenistic-Roman ruins. The two-story building has an almost perfectly square ground plan, and semicircular bastions along the perimeter. The rooms, which open off the sides of a large central hall, have vaulted ceilings.

Bibliog. G. L. Harding, The Antiquities of Jordan, London, 1959, pp. 157–59.

Madaba (Μαίδαβα, Μύδαβα). Repopulated in the 19th century, the city has not been excavated, but a tomb — with vases, bracelets, rings, arms, and scarabs — has been found here dating from the beginning of the 1st millennium B.C., as well as various Roman and Byzantine remains. The latter consist primarily of mosaic floors from churches of the second half of the 6th century that have been partly uncovered, with hunting and farming scenes, figures of bacchantes, and depictions of the myth of Achilles. Exceptionally interesting is the mosaic map of Palestine (III, PL. 494), still preserved in the Greek Orthodox church reconstructed in 1880 over the previous Early Christian building.

Bibliog. C. Manfredi, Piano generale delle antichità di Madaba, NBACr, V, 1899, pp. 149–70; G. L. Harding, An Early Iron Age Tomb at Madaba,

Palestine Exploration Fund, VI, 1953, pp. 27–33; M. Avi-Yonah, The Madaba Mosaic Map, Jerusalem, 1954.

Ma'in (Baal Meon). A mosaic, originally in a church, has been found here, with depictions of ecclesiastical structures representing various cities of Palestine and an allegorical composition.

BIBLIOG. R. de Vaux, Une mosaïque byzantine à Ma'in (Transjordanie), RBib, XLVII, 1938, pp. 227–58.

Diban (Dibon). Inhabited since the 3d millennium B.C., it was the capital of the kingdom of Moab. In 1868 the famous stele (ca. 830 B.C.) of King Mesha, who rebuilt the city, was found; it is now in the Louvre. Recent excavations have brought to light remains of walls of various periods, with a huge gate which was used from 3000 to 500 B.C., several tombs and a temple of the Moabitic period, Nabataean structures, a Roman *caldarium* and two Byzantine churches.

BIBLIOG. D. Mackenzie, Dibon: The City of King Mesa and of the Moabite Stone, Palestine Exploration Fund Q. Statement, XLV, 1913, pp. 57–79; S. J. Saller, Un'antica chiesa a Diban, RACr, XV, 1938, pp. 160–61; F. V. Winnett, Excavations at Dibon in Moab, 1950–51, BAmSOR, 125, 1952, pp. 7–20; A. D. Tushingham, Excavations at Dibon in Moab, 1952–53, BAmSOR, 133, 1954, pp. 6–26.

Umm el-Raṣāṣ. Numerous ruins, including those of churches, are enclosed within a surrounding wall; outside the wall, toward the north, there are fragments of architectural decorations with geometric motifs. A tower, elegant in form and of careful workmanship, situated so as to defend the reservoir, is well preserved.

BIBLIOG. S. J. Saller and B. Bagatti, The Town of Nebo, Jerusalem, 1949, pp. 245–51.

Qaṣr el-Ṭūba. An Ommiad castle located about 30 miles south of Umm el-Raṣāṣ, it is the southernmost and most remote of these structures. Never completed, it is distinctive in being constructed partly in stone, partly in brick. The central part is covered by a wide barrel vault.

BIBLIOG. G. L. Harding, The Antiquities of Jordan, London, 1959, pp. 159–60.

el-Lejjun (Legio). A fortified camp of about 800 × 625 ft., with towers at the corners of the walls, situated near a spring. Nearby, to the northwest, is another small camp. This site is one of the best-preserved Roman fortifications.

BIBLIOG. R. E. Brünnow and A. Domaszewski, Die Provincia Arabia, II, Strasbourg, 1905, pp. 24–38.

el-Karek (Le Crac, Kir Moab, Kir Haraseth). One of the principal Moabitic cities, it has no architectural remains anterior to the period of the Crusades, although fragments of Nabataean sculptures were reused in more recent walls. The citadel, on a mountain ridge, is typical of the period, containing long galleries with vaulted ceilings and arched passageways in other rooms. Notable for its decorations

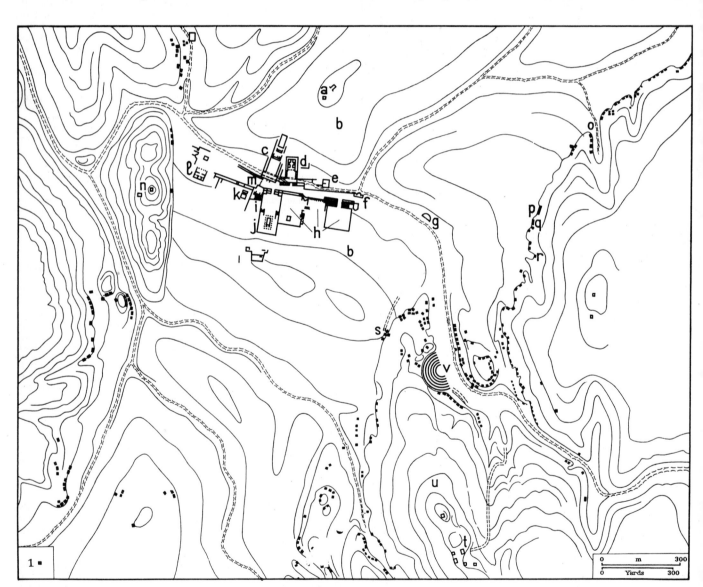

Petra, archaeological map of the city and its surroundings. *Key*: (1) Tombs. Individual monuments and architectural ruins: (*a*) Byzantine church and ruins of a tower; (*b*) remains of houses; (*c*) gymnasium; (*d*) palace; (*e*) Byzantine structure; (*f*) nymphaeum; (*g*) little theater; (*h*) upper market, central market and cisterns, and lower market; (*i*) thermae; (*j*) large temple; (*k*) small temple; (*l*) "Qaṣr Fir'ūn" or "Qaṣr Bint-Fir'ūn"; (*m*) large gate; (*n*) citadel and sacrificial spot; (*o*) Tomb of Sextus Florentinus; (*p*) three-story tomb; (*q*) Tomb of the Corinthian Order; (*r*) Tomb of the Urn; (*s*) gate of the city with the ancient road; (*t*) Tomb of the Obelisks and citadel; (*u*) sacred mountain; (*v*) theater (*from A. Kammerer, Pétra et la Nabatène, I, Paris, 1929, supplemented by M. Rostovtzeff, Caravan Cities, Oxford, 1932*).

is a circular room, which originally had a domed ceiling, with ample openings all around. Largely destroyed in 1840 by Ibrāhīm Pasha, el-Kerak fell under Turkish domination in 1893. Dating from this period are the madrasah and the present mosque (built over a previous church and mosque), both constructed with material taken from medieval buildings. Among recent structures is the Italian hospital.

BIBLIOG. R. Canova, Monumenti protocristiani del paese di Moab, Vatican City, 1954.

Khirbat el-Tannūr. Here is the only Nabataean temple ever to have been excavated. Dating from about the beginning of the Christian Era, it has an outer courtyard with an altar and small surrounding rooms, an imposing façade with columns and pillars, an inner courtyard with a true shrine, and a large altar. A large number of sculptures, some with architectural functions, were removed from the temple and are now in the Museum in Amman, outstanding among them being a statue of Zeus-Hadad, busts of the goddess Atargatis (one encircled by a band of the zodiac), Nikai, and floral subjects. The style of these works reveals a strong local reaction to Hellenistic norms. Also of interest are the fine Nabataean ceramics, with their characteristic decorations of stylized flowers.

BIBLIOG. N. Glueck, The Nabataean Temple of Khirbet et-Tannûr, BAmSOR, 67, 1937, pp. 6-16; N. Glueck, Explorations in Eastern Palestine (Am. Schools of O. Research, Ann., XXV-XXVIII), IV, Part I, Text, Philadelphia, 1951, pp. 87, 203, 207, 209; N. Glueck, The Zodiac of Khirbet-el-Tannûr, BAmSOR, 126, 1952, pp. 5-10.

Petra (Sela, Πέτρα). The city was situated inside a rocky area, the only means of entrance being a narrow passageway called the Sīq. At the entrance to the city there are older four-sided tombs and, a little farther on, the Tomb of the Obelisks, so called because there are four obelisks on its upper story. Almost all of what remains of the city from the Roman era is carved in the rock itself, which gives it a singular appearance. The ground plan of the city, dating from the same period, was patterned after the Roman model; parts of the principal road, which was lined with columns, have been excavated recently. In addition to ruins of houses — particularly numerous in the zone of Mughār al-Naṣāra, where Nabataean inscriptions and pottery have been found — Petra also contains various public buildings of a Roman character: a theater, a temple (known as "Qaṣr Firʿūn" or "Qaṣr Bint-Firʿūn"), a triumphal arch, and portions of the walls. The sacrificial site, with two pillars and ruins of the priests' houses, is situated on a high, open plain. The most distinctive structures of Petra, however, are the huge façades cut from the rock, behind which are rooms serving as tombs, or, as is probable in the case of "el-Khazna" ("the treasury") and "el-Dair" ("the monastery"), actual temples (VII, FIGS. 308, 309). The most important of these structures are the tombs of the Urn, of the Corinthian Order, of Sextus Florentinus, of the Garden, of the Statue, of the Nabataean Inscription, of the Palace, of the Roman Soldier, of the Three Stories, of the Lions, and of el-Khazna and el-Dair, mentioned above. They are usually divided into two floors, with columns in the lower floor and a circular kiosk in the center of the upper floor. A notable Hellenistic influence prevails in these works. On the outskirts of the city there are also ruins of castles from the period of the Crusades.

BIBLIOG. R. E. Brünnow and A. Domaszewski, Die Provincia Arabia, I, Strasbourg, 1904, pp. 125-428; W. Bachmann, G. Watzinger, and T. Wiegand, Petra, Berlin, 1921; A. Kennedy, Petra, Its History and Monuments, London, 1925; A. Kammerer, Pétra et la Nabatène, 2 vols., Paris, 1929-30; M. Rostovtzeff, Caravan Cities, Oxford, 1932; G. and A. Horsfield, Sela-Petra, The Rock of Edom and Nabatene, Palestine, Department of Antiquities, Q., VII, 1938, pp. 1-42, VIII, 1939, pp. 87-115, IX, 1942, pp. 105-204; D. Kirkbride, A Short Account of the Excavations at Petra in 1955-56, Jordan, Department of Antiquities, Ann., IV-V, 1960, pp. 117-22; P. C. Hammond, Petra: The Excavation of the Main Theater, The American Scholar, XXXII, 1962-63, pp. 93-106.

Kilwa. This site was occupied by a monastery from the 6th to the 8th century; nearby are rock carvings dating from the prehistoric period (XI, PL. 298).

BIBLIOG. G. L. Harding, The Antiquities of Jordan, London, 1959, pp. 162-63.

Bellarmino BAGATTI

Illustrations: 10 figs. in text.

JUGENDSTIL. See ART NOUVEAU.

JUPÉON (or Ju Péon—French forms for Hsü Pei-hung). Chinese painter (b. I-hsing, in Kiangsu, 1895; d. Peking, Sept. 26, 1953). His father, Hsü Ta-tsang, who was also a painter,

taught Jupéon the fundamentals of painting and schooled him in the traditions of Chinese art. Jupéon went to France on a scholarship granted by the Chinese government, and his long stays in Paris (1921-26) and Berlin (1927-28) decisively influenced his artistic development. In Paris, under F. Cormon, P.-A.-J. Dagnan-Bouveret, L. Flameng, and P. A. Besnard, Jupéon completed his study of European painting, both Renaissance and modern. With this experience as a basis, he sought to unite in his works the traditions of Chinese painting and the realistic tendencies of Western art, exploiting even the technical advances of the impressionists. He thus created a new, characteristic, and personal style. Upon his return to China he lived for a long period in Peking, where he divided his time between his own work and teaching. In 1949 he was named director of the Central Institute of Fine Arts in Peking, an office which he occupied until his death.

Jupéon's role in the history of modern Chinese art is an important one because he was the first Chinese artist to break the bonds of tradition while, at the same time, creating works in an unmistakable individual style. Contrary to traditional practice, he did not imitate earlier classical Chinese works but developed animal themes (PLS. 343, 344) treated by earlier painters [e.g. Han Kan, Li Kung-lin (q.v.), and Chao Mêng-fu (q.v.)] in an entirely new and personal manner. Indeed, his pictures of wild horses — his most famous works — seem in their almost infinite variety of ever new and vital poses to have come from the hand of a master who, with merely a few meaningful strokes of the ink-laden brush, has instilled in these forms his great admiration for free, untrammeled nature (PL. 343). A new technique evident in these works is the use of very wide brushes, at times tied together in order to produce special spray effects. Thus, the apparent simplicity of his drawing hides a perfection of technique which is the result of the surmounting of many difficulties (III, PL. 296). Although for Jupéon wild horses were the preferred theme, landscape also interested him, and his impressionistic paintings of the Kuei-lin Mountains and of the O-mei and Cheng-cheng Mountains in Szechwan are noteworthy. Furthermore, such allegorical paintings as Awaiting the Liberator (1930-33; a title derived from a passage in the Shu-ching, a classic work of Chinese history), The Crowing of the Cock Before the Coming Storm (1937), and Angry Looks (1939) show that he was not indifferent to the political and social history of China.

After the foundation of the People's Republic of China and his nomination to the directorship of the Central Institute of Fine Arts, Jupéon treated more explicitly political themes. He began work on two paintings — one portraying Mao Tse-tung among the people, the other representing the writer Lu Hsün with the young revolutionary author Chu Chiu-pai — but died leaving them incomplete. Thus it is impossible to judge the works of his last period, especially since he devoted himself primarily to teaching in his later years.

Most of Jupéon's works are now in the Jupéon Museum, founded in 1954 in Peking, near the artist's home. The publishing by the Jung Pao Chai Studio in Peking of many excellent reproductions of these works (especially of the paintings of wild horses) has done much to further knowledge of Jupéon's art in the Western world.

BIBLIOG. Chou Ling, Exposition des artistes chinois en France (exhib. cat.), Paris, 1946; R. Grousset, La Chine et son art, Paris, 1951; Ai Chung-hsin, Un grande pittore realista: Hsu Pei hung (Ju Péon), B. del Centro studi per lo sviluppo delle relazioni economiche e culturali con la Cina, 7, May, 1954, pp. 17-19; A. Giuganino, La pittura cinese, Rome, 1959, pp. 270-71, pls. 544-47; M. Sullivan, Chinese Art in the Twentieth Century, London, 1959.

Piero CORRADINI

Illustrations: PLS. 343-344.

JUSTUS OF GHENT (Joos van Gent; to his Italian contemporaries Giusto da Guanto). The only documented work by this artist is the Communion of the Apostles in Urbino (Gall. Naz. delle Marche), which was painted in 1473-74 for the Confraternity of Corpus Domini in that city. In 1475 he agreed to paint a banner for the same confraternity, but after this there

is no mention of him in the documents of Urbino. Federigo da Montefeltro's librarian, Vespasiano da Bisticci, asserted that because the duke could not find an Italian artist to his taste who knew how to paint in oil, he had summoned a talented Fleming. It is therefore likely that Justus of Ghent is identical with a Flemish artist named Joos van Wassenhove, who is mentioned in several Netherlandish documents between 1460 and 1468. The artist joined the painters' guild in Antwerp in 1460 and four years later was admitted to the guild in Ghent. When Hugo van der Goes sought admission to the latter body in 1467, Joos van Wassenhove was his guarantor. The last mention of him occurs in a text of 1475 that records how Hugo advanced him money when Joos set out on a journey to Rome.

Three works have been ascribed to Justus of Ghent in the years before he went to Italy: the large triptych with the Crucifixion (V, PL. 280), another Crucifixion (Brussels, Coll. Baron Descamps), and the *Adoration of the Magi* (New York, Met. Mus.). These works show a considerable resemblance in style to the paintings of Hugo van der Goes. There is also, however, a strong reflection in them of Dirk Bouts, especially of his characteristic isolation of figures in space.

The *Communion of the Apostles*, though clearly related in types and handling to the works ascribed to Joos's earlier Netherlandish period, shows a distinct advance over them in technical mastery. It contains portraits of Federigo and his court which are impressive statements of personality, the composition is much more unified, and there is a new ability to render movement. The subject is highly original, picturing Christ not in the act of instituting the Eucharist by breaking bread, but as a priest delivering to each communicant the consecrated wafer.

Twenty-eight paintings that once decorated Federigo's *studiolo*, of famous men of the past, are the most important of the works generally attributed to Joos after the *Communion*. They are now divided equally between Urbino and the Louvre. There are also a portrait of Federigo reading (Urbino, Gall. Naz. delle Marche), a painting of him with his court attending a lecture (Windsor, Royal Colls.), and a pair of allegorical pictures representing Rhetoric and Music (London, Nat. Gall.) which, like two others destroyed in Berlin during World War II, may have formed part of a series of the Liberal Arts. In an unconvincing attempt to account for the striking development of his style under the influence of Italian art and Humanism, the names of the Italian painter Melozzo da Forlì and the Spaniard Pedro Berruguete have been proposed as collaborators of Justus in his later paintings at Urbino, and some scholars have even ascribed the works to one or the other of these artists.

BIBLIOG. Friedländer, III, 1925; J. Lavalleye, Juste de Gand, peintre de Fédéric de Montefeltre, Louvain, Rome, 1936; Musée des Beaux-Arts, Juste de Gand, Berruguete et la Cour d'Urbino, Ghent, 1957 (exhib. cat.).

Margaretta M. SALINGER

JUVARA (JUVARRA), FILIPPO. The leading Italian architect of the 18th century (b. Messina, Mar. 27, 1678; d. Madrid, Jan. 31 or Feb. 1, 1736). At an early period he was doubtless influenced by the works of Guarino Guarini (q.v.) in Messina, but his real training took place in Rome under Carlo Fontana, the most eminent practitioner of an academic late-baroque style. Fontana is said to have told Juvara to forget all he had previously learned and to start again, perhaps in order to discipline the riotous fantasy inherent in Juvara's Guarinesque background. His surviving drawings (e.g., the sketchbook in London, Vict. and Alb.) for the theater and for other ceremonial occasions from the period of ten years he spent in Rome (1703/04–14) as a designer are evidence of his fantasy and powers of invention. The classical discipline imposed by Fontana helped him to become a learned and eclectic architect, and his later buildings are characterized by sophistication and restraint.

In 1714 he returned to Messina and began a royal palace for the new king of Sicily, Victor Amadeus II, but by the end of the year he had settled in Turin as the King's First Architect. During the next twenty years he was responsible for a vast amount of work in Turin, including his three masterpieces, — the Palazzo Madama; the royal hunting lodge at Stupinigi, near Turin; and the church and monastery of the Superga also just outside Turin.

The Palazzo Madama was an older building refronted by Juvara (1718–21; PL. 226) with a screen façade leading directly into a very large and grand staircase hall. The façade shows an awareness of Versailles but is a summary of the classic Italian palace type. It has a rusticated basement with *piano nobile* and mezzanine above and is distinguished by an order of pilasters (here, columns in the three central bays). The vast hunting lodge at Stupinigi (1729–33) is based on a cross plan with two arms extended to form an enormous seven-sided court and with a great central, oval, domed hall as the focal point (I, PLS. 389, 407; II, PL. 141). The rich decoration recalls Juvara's practice as a stage designer. His most important church — the huge basilica of the Superga (1717–31 and later), located on the top of a 2000-ft. hill near Turin — combines a church and a monastery, the entire structure dominated by the very high dome above the entrance portico (II, PL. 140). The church is built into the monastery in a way that indicates knowledge of contemporary Austrian buildings.

Juvara's firsthand acquaintance with buildings outside Italy was considerable: in 1719–20 he went to Portugal and designed a royal palace, and in 1720 he traveled to Paris and then to London. In 1735 he went to Madrid to design a palace (II, PL. 160) for Philip V (the model still exists), but died soon thereafter.

BIBLIOG. L. Rovere, V. Viale, and A. E. Brinckmann, Filippo Juvarra, Milan, 1937; R. Wittkower, Art and Architecture in Italy, 1600 to 1750, Baltimore, 1958, pp. 275–82.

Peter MURRAY

KAIKEI. Japanese sculptor of the early Kamakura period, active ca. 1189–1221.

The two most famous sculptors of the Kamakura period (1185–1392) were Unkei and Kaikei, respectively the son and pupil of Kōkei. They worked in the same atelier and sometimes on the same commissions, notably the *Kongōrikishi* (1203) or "Guardians" of the Tōdaiji monastery in Nara. Their workshop, the Shichijō Bussho at Nara, was the most popular one of the time. Despite Kaikei's fame, however, comparatively little is known about his life.

The civil wars preceding the establishment of the militaristic regime which governed Japan from its headquarters at Kamakura had resulted in much damage to the temples of the old capitals of Nara and Kyoto and to the treasures they contained. The restorations, inspired by priests such as Chōgen of the Tōdaiji, were often entrusted to the workshop of Unkei and Kaikei. Kakei was even accorded ecclesiastical rank for his services.

At that time Buddhism was developing into a universal religion rather than one reserved for the upper classes. The work of the period thus shows a preference for straightforward, comparatively unesoteric interpretations of religious images. Artistic activity was centered in Nara, amid the sculptural masterpieces of the ancient capital, and contributed to their restoration. It was natural that this new activity should inherit the traditions and techniques not only of the preceding late Heian (Fujiwara) period but also reflect the simple faith of earlier centuries rather than the later, more complicated forms of Buddhism. The Kamakura period is thus considered by most historians as a renaissance of Nara ideals, lacking something of the nobility of earlier work, but surpassing it in power, intensity, and vigorous naturalism.

Diplomatic relations with China, interrupted during the Fujiwara period, were reestablished. Priests and workmen traveled between the two countries and, as a result, Chinese art once again exerted a strong influence on the products of Japanese artists and craftsmen. The images of the period also reflect the newly imported styles of Sung China — especially in the full, soft faces with their gentle expressions, and in the delicate flowing drapery. The complicated effects demanded in sculpture were achieved by the perfection of such artists

as Unkei and Kaikei, with the aid of newly introduced techniques, such as the use of numerous roughly carved pieces of wood which were then assembled for the finishing touches of the master.

The *Miroku* (Maitreya), Kaikei's earliest surviving work (1189; formerly in the Kōfukuji, Nara, and now in Boston, Mus. of Fine Arts), follows the Sung norms — a gentle softness of body and a pretty face, with elegant, natural drapery, harmoniously arranged — to produce a vision of transcendent beauty. The figure of the god Hachiman as a Buddhist priest (1201; PL. 295) in the Tōdaiji is in the popular tradition of realistic priest portraits, but, although the surface is beautifully decorated, the figure is somewhat uninspired. The standing *Jizō Bosatsu* (Kṣitigargbha), also in the Tōdaiji, was made between 1201 and 1211; its decoration includes crystal eyes, painted floral designs, and lavish use of cut gold leaf. The *Kongōrikishi* (*Niō*; PL. 291) of the Great South Gate (Nandaimon) of the Tōdaiji, were made by Unkei, Kaikei, and pupils in about two months of 1203. They are about 27 ft. high, the largest wooden sculptures in Japan. Figures of terrifying grandeur, they faithfully reflect traditions which can be traced to the Chinese guardians of early T'ang dynasty cave temples (see CHINESE ART). Kaikei's last known work, the *Amida* (Amitābha) in the Kōdaiin (Wakayama prefecture), dates from 1221. Like a number of sculptors of the period, he sometimes copied earlier works, and his *Shūkongōjin* ("Menacing Guardians of Buddhism") in the Kongōin (Kyoto prefecture) are copies of originals in the Tōdaiji.

WORKS: *a. Works by Kaikei alone*: Standing *Miroku*, 1189, Boston, Mus. of Fine Arts. – Seated *Miroku*, 1192, Kyoto, Sambōin. – Standing *Amida*, ca. 1194, Kyoto prefecture, Kongōin. – Seated *Shaka*, 1197, Otsu, Shiga prefecture, Empukuin. – *Kujaku Myōō*, 1200, Kōyasan, Wakayama prefecture, Kongōbuji (PL. 345). – *Sōgyō Hachiman* (the god Hachiman as a Buddhist priest), 1201, Nara, Tōdaiji (PL. 295). – Standing *Jizō*, 1201–11, Nara, Tōdaiji (PL. 345). – Seated *Amida*, 1202, Awa, Mie prefecture, Shin-Daibutsuji (some scholars hold that only the head is original). – Seated *Fudo Myōō*, 1203, Kyoto, Sambōin (PL. 345). – Standing *Amida*, 1208, Nara, Tōdaiji. – Standing *Miroku*, Nara, Tōdaiji (PL. 345). *b. Works in collaboration with Unkei*: Standing *Amida*, before 1203, Kyoto, Saihōji. – *Shinsha Taishō*, Kyoto prefecture, Kongōin. – Standing *Amida*, before 1203, Kōyasan, Wakayama prefecture, Henjōkōin. – *Dainichi*, before 1203, Nara, Enjōji (PL. 292). – *Kongōrikishi* (*Niō*), 1203, Nara, Tōdaiji, Nandaimon (PL. 291). – Standing *Amida*, 1204, Okayama prefecture, Tōjuin. – Standing *Amida*, 1221, Nara prefecture, Korinji. – *Amida*, 1221, Kōyasan, Wakayama prefecture, Kōdaiin. – *Jūdai Deshi* (*Ten Great Disciples*), Kyoto, Daihōonji. – Standing *Amida*, Nara, Saihōin. – Standing *Amida*, Kyoto, Daigoji. – *Shūkongōjin*, Kyoto prefecture, Kongōin.

BIBLIOG. Nara Museum, Kamakura Chōkoku Zufu (The Sculpture of the Kamakura Period), Kyoto, 1933; T. Kobayashi, Nihon Bijutsu Taikei, Chōkoku (Summary of the History of Japanese Art: Sculpture), Tokyo, 1941; L. Warner, The Enduring Art of Japan, New York, 1952; Tokyo Kokuristu Hakubutsukan (Tokyo National Museum), Pageant of Japanese Art, III. Sculpture, Tokyo, 1952; R. T. Paine and A. Soper, The Art And Architecture of Japan, Harmondsworth, 1955; P. C. Swann, Introduction to the Arts of Japan, Oxford, 1958.

Peter C. SWANN

Illustrations: PL. 345.

KALAMIS (Κάλαμις, CALAMIS). Greek sculptor who seems to have been active in the late-archaic and early classical periods (ca. 480–450 B.C.). Nothing is known of his origins or artistic training. His connections with Pindar and Boeotia have led many to suppose that he was a Boeotian. On the other hand, many scholars have held him to be an artist of Attica, while still others have emphasized the Peloponnesian elements of the works commonly ascribed to him.

Kalamis is generally mentioned among the major artists of the classical period, on the same plane as Onatas, Myron (q.v.), Phidias, and Polykleitos (qq.v.); the fact that his name is customarily cited in the line of development as traditionally summarized in ancient sources is undoubtedly owing not so much to the preeminence of his work in itself as that it was a milestone marking the achievement of triumphs over obstacles, an important turning-point.

Ancient references to Kalamis, aside from occasional mention of him in connection with a specific work, seem to fall into two groups which various scholars have felt to be incompatible. Cicero (*Brutus*, xviii, 70) and Quintilian (*Institutiones oratoriae*, XII, x, 7) place him in a middle ground between the archaic rigidity of Kallon or of Kanachos and Myron's greater freedom of form. A statement by Dionysios of Halikarnassos (*On Isokrates*, 3) has been held to be in opposition to this chronology; here Kalamis is connected with Kallimachos and praised along with him for his subtlety and grace (χάρις καὶ λεπτότης). Such a characterization, considered by many to be inconsistent with the statements of Cicero and Quintilian, has been related instead to references which describe Kalamis as the teacher of Praxias (Pausanias, *Description of Greece*, X, xix, 4) and as "collaborator" with Skopas and Praxiteles (Scholia to Aischines, *Against Timarchus*; Pliny, *Naturalis historia*, xxxiv, 71). In addition, since Pliny twice mentions a Kalamis as an engraver or "caelator" as though in opposition to the bronzeworker, various scholars have presumed the existence of a second Kalamis, active perhaps in the beginning of the 4th century and in every respect the opposite of his archaic predecessor.

Actually, the fact that the ancient authors speak freely of a great sculptor named Kalamis and never once refer to the existence of a minor artist of the same name who might be confused with him seems to prove that, as far as they were concerned, there was only one Kalamis. Pliny's apparent distinction may be discounted as an artificial separation by which the same artist is placed in different categories according to the various types of artistic activity under discussion. At the same time, the supposed collaboration with Skopas and Praxiteles may be understood to mean that works by Kalamis were completed by more recent sculptors decades or even more than a century later. The placement of Kalamis precisely between the late-archaic and the classical periods agrees with ancient accounts that Kalamis was commissioned to execute statues for Hieron I, for Pindar, and for Kallias, Kimon's son-in-law; he therefore belongs in the second quarter of the 5th century.

Kalamis was famous for his sculptures of horses (Propertius, III, ix, 10; Ovid, *Ex Ponto*, IV, i, 33). Besides various other unspecified two- and four-horse chariots, he fashioned race horses with boys riding on them for a chariot group, the work of Onatas, dedicated by Hieron at Olympia (Pausanias, VI, xii, 1). The ex-voto of the people of Akragas (Agrigento), also at Olympia, must have been just as splendid with its *choros* of boys in bronze. Other works of Kalamis mentioned in literature are the statue of Apollo Alexikakos that was in Athens; a colossal statue of Apollo made for Apollonia on the Pontos Euxeinos (Black Sea), taken to Rome by Lucullus; and a third Apollo "in hortis servilianis" (Pliny, *op. cit.*, xxxvi, 36). There are also references to a Dionysos and a Hermes Kriophoros for Tanagra, a Zeus Ammon dedicated by Pindar in Thebes, and a bearded chryselephantine statue of Asklepios in Sikyon. Many scholars identify the statue of an unnamed divinity, the so-called "Sosandra" from the Acropolis, as the Aphrodite that was recorded in sources as having been dedicated by Kallias on the Acropolis (PL. 346). Kalamis has also been credited with a Semne (Erinys) that was placed between two others, executed by Skopas, which were evidently not so old nor so imposing as the first one; a Nike Apteros (Wingless Victory) made for Olympia; and a statue of Hermione, an ex-voto of the Spartans in Delphi. The attribution of a statue of Alkmene is less certain, since it is based on a corrupt passage in Pliny (*op. cit.*, xxxiv, 71). There also remained in the Villa Celimontana (Mattei), Rome, at one time, the transcription of an inscription, now lost, of still another sculpture, possibly a statue representing Iphitos.

This relative wealth of documentation would seem to present the image of an attractive and well-defined artistic personality — as seen, particularly, from the interesting allusions of Lucian, himself a sculptor (*Eikones*, 4, 6; *Dialogues of the Hetairai*, III, 2) — or, in any case, one famous enough for works of his to be presumed to have survived at least in Roman copy. It is therefore not surprising that art historians have tried for

a century and a half to reconstruct the real artistic personality of Kalamis and to recognize his works from the vague references found in the authors of antiquity. But the rather discouraging results produced by this evidence are confusion and contradictory hypotheses. Sometimes a refined and archaizing Kalamis emerges, at other times a more rigid Kalamis working in the traditions of the Peloponnesos, or, if the emphasis is shifted to a "collaboration" with Skopas and Praxiteles, a Kalamis of the mature classical period who must be placed at the end of the 5th or in the first half of the 4th century.

At one time or another almost all the famous statues of the late-archaic period and many from the mature phase of classical art were ascribed to this elusive artist. The *Apollo Belvedere* (III, PL. 383) has been proposed for the Apollo Alexikakos; so have the *Apollo* from the Tiber and the *Apollo* from the Omphalos at Delphi (III, PL. 353). The statuettes in the Pembroke Coll. (Wilton) and in the Museo Barracco (Rome), the original of an archaizing altar on the Acropolis, and various terra cottas and small bronzes have all been put forward as representing his Hermes Kriophoros. The Sosandra with veiled head has been recognized in the *Hestia* Giustiniani, in the so-called "Aspasia Amelung" — another copy of which was recently discovered at Baia (PL. 346) — in a veiled dancer known especially through reliefs, in the Cherchel *Demeter* (or Venus) in Algiers, and in the *Aphrodite* of Fréjus. Others assert that the Aspasia represents his Semne, and the Barberini *Suppliant* has been identified as either the Nike Apteros of Olympia or as the Semne. The Hermione has been tentatively associated with a running figure of a *peplophoros* in the Ny Carlsberg Glyptotek (Copenhagen) and with an Atalanta once in the Holland Collection. During the past fifty years, all the important sculptures in the severe style have been linked to Kalamis at one time or another. Occasionally, as in the case of the *Penelope* in the Vatican that has been connected with the so-called "Alkmene," they have been identified with works mentioned in sources, but at times even such vague evidence has been lacking. Thus the so-called "Ludovisi Throne" (VII, PL. 63), the *Atalanta* in the Galleria dei Candelabri (Vat. Mus.), the *Eros* Soranzo, the "Humphry Ward head" in the Louvre, the archaizing *Amazon* in Vienna, the *Boy Removing a Thorn* (Conserv.) the *Charioteer* of Delphi (III, PL. 346), the *Charioteer* (Conserv.), the Esquiline *Aphrodite* (VII, PL. 365), the severe *Athena* wearing the peplos (Rome, Mus. Naz.) — all have been ascribed to Kalamis. The two sculptures on which there is most agreement are the *Apollo* from the Omphalos which is identified with the Apollo Alexikakos, and the "Aspasia" in which many see either the veiled Aphrodite dedicated by Kallias or a Demeter, Europa, or some other divinity. The attribution to Kalamis of the *Apollo* from the Omphalos, on the other hand, brings with it that of the *Zeus* (or Poseidon) from Artemision (III, PL. 356), which has been judged by many to be inseparable from the Apollo. Others have instead assigned these two statues to Myron or to a Peloponnesian school.

In the most recent and authoritative history of Greek sculpture, G. Lippold limits his treatment of Kalamis to an analysis of the literary sources and of some coins presumably representing the colossal Apollo of Apollonia and the Dionysos and the Hermes of Tanagra; he only points out certain elements which the Apollo on the coins and the *Apollo* from the Tiber have in common. Following the lead of the greatest scholar of Kalamis, F. Studniczka, it must be admitted that in the case of this fascinating and mysterious figure there is absolutely no proof for any certain attribution.

BIBLIOG. Brunn, GGK, pp. 89–94; F. Hauser, Die neuattische Reliefs, Stuttgart, 1889, pp. 130, 168; Furtwängler, MW, pp. 38, 115, 737; E. Sellers, Greek Head in the Possession of T. Humphry Ward, Esq., JHS, XIV, 1894, pp. 198–205; E. Strong, On an Apollo of the Kalamidian School, Strena Helbigiana, Leipzig, 1900, pp. 293–98; E. Reisch, Kalamis, ÖJh, IX, 1906, pp. 199–268; W. Furtwängler, Zu Pythagoras und Kalamis, Sb-München, 1907, pp. 157–69; F. Studniczka, Kalamis, Leipzig, 1907; G. Lippold, BrBr, 1909, p. 800; J. Six, Kalamis, JdI, XXX, 1915, pp. 74–95; C. Anti, Calamide, Atti R. Ist. veneto, LXXXII, 1922–23, pp. 1105–20; W. Amelung, Der Meister des Apollon auf dem Omphalos und seine Schule, JdI, XLI, 1926, pp. 247–87; E. Langlotz, Frühgriechische Bildhauerschulen, Nürnberg, 1927, p. 174; C. Karouzos, Ὁ Ποσειδῶν τοῦ Ἀρτεμισίον, Ἀρχαιολογικὸν Δελτίον, XIII, 1930–31, pp. 41–104; V. H. Poulsen, Der strenge Stil, Copenhagen, 1937; L. Curtius, Die antike Kunst, II, Berlin, 1938, p. 252; E. Homann-Wedeking, Zu Meisterwerken des strengen Stils, RM, LV, 1940, pp. 196–218; A. E. Raubitscheck, Greek Inscriptions: The Aphrodite Statue of Kalamis, Hesperia, XII, 1943, pp. 18–19; H. G. Beyen and W. Vollgraff, Argos et Sicyone, The Hague, 1947, pp. 61–95; Lippold, GP, pp. 110–12; P. Orlandini, Calamide, Bologna, 1950 (bibliog.); J. Marcadé, Recueil des signatures de sculpteurs grecs, I, Paris, 1953, pp. 39–42; M. Napoli, Una nuova replica della Sosandra di Calamide, BArte, XXXIX, 1954, pp. 1–10.

Enrico PARIBENI

Illustration: PL. 346.

KANDINSKY, WASSILY. Painter and graphic artist (b. Moscow, Dec. 4, 1866; d. Paris, Dec. 13, 1944). Kandinsky began his studies at the Gymnasium in Odessa in 1876, and in 1886 entered the University of Moscow to study law. In 1889 he traveled to the province of Vólogda as a member of an ethnographic expedition and visited The Hermitage in St. Petersburg, where he was particularly impressed by the Rembrandts. In 1892 he passed his law examination, and the following year he accepted a position on the law faculty. He was greatly affected by a large exhibition of French impressionism — and especially by Monet — held in Moscow in 1895. In 1896 he refused an invitation to join the faculty of the University of Dorpat (Tartu) and instead left for Munich to study painting. There he studied first at the Azbé School, where he met his compatriot Alexej von Jawlensky (b. 1864). In 1900 he attended the classes of Franz von Stuck at the Munich Academy, in which Paul Klee (q.v.) was also enrolled.

In Germany Kandinsky came under the influence of the then dominant Jugendstil. Beginning in 1902, he executed numerous woodcuts, painted landscapes and romantic subjects in oil and tempera, and in 1905 began to paint scenes of Russian life, such as the *Troika*, in a broad-dot technique. Many of these early works are preserved in the Münter bequest in the Städtische Galerie in Munich. Between 1903 and 1908 Kandinsky made several trips. In 1903 he visited Venice and in 1904, Holland. From December, 1904, until April, 1905, he traveled in Tunisia, and from December, 1905, until April, 1906, he was in Rapallo. He was in Sèvres near Paris from June, 1906, to June, 1907, and in 1908 returned to Munich. From 1909, when he and the painter Gabriele Münter acquired a house in Murnau, until the beginning of World War I in 1914, he lived and worked in Murnau and Munich. Gabriele Münter was with him from 1902 until 1914.

Kandinsky's landscapes of Murnau are his first original works (cf. V, PL. 264). In 1909 he began his series of *Improvisations* (PL. 349); in 1910, his series of *Compositions*; and in 1911, his *Impressions*. By "impressions" Kandinsky meant paintings which retain an impression of exterior nature, by "improvisations," paintings which arise from an inner emotion, and by "compositions," paintings which are built up from preliminary studies and into whose construction the painter's consciousness enters. Kandinsky painted six *Impressions*, all in 1911; thirty-five numbered *Improvisations*, between 1909 and 1914, in addition to three which bear A-numbers and five not numbered; seven *Compositions* between 1910 and 1913 and three more dated 1923, 1936, and 1939, making a total of ten *Compositions* in all. His first abstract water color dates from the end of 1910.

In 1909 Kandinsky helped found the Neue Künstlervereinigung, out of which the Blaue Reiter was formed in 1911 (V, PL. 211). The first Blaue Reiter exhibition was held from Dec. 18, 1911, to Jan. 1, 1912; the second, an exhibition of graphic works, in February, 1912. Kandinsky's two principal writings also appeared in 1912. They are *Über das Geistige in der Kunst*, completed in 1910, and the important article, "Über die Formfrage," which was published in *Der Blaue Reiter* along with his poetic drama, "Der gelbe Klang." In 1913 he published the *Klänge*, a series of prose poems with accompanying woodcuts, and the *Rückblicke*, his autobiography. The years 1910–1914 are perhaps Kandinsky's best period. His paintings of this time open up a new chapter in art history. In them objects gradually lose their optical reality in favor of an absolute reality (V, PL. 126); representation of nature is replaced by a "spiritual" image whose laws depend upon an "inner necessity." Kandinsky was

not doctrinaire; until 1914 he did not completely abandon representation. Although he had no rigid principles about form, he developed a theory of harmony similar to that proposed by the composer Arnold Schönberg in 1911. Particularly interesting for artists are Kandinsky's detailed investigations of form and color and their interrelationships.

Kandinsky's most productive period was that of the Blaue Reiter. It was at this time that he created the paintings upon which his reputation rests. To these belong the *Compositions*, *Improvisations 10* (1910), *20* (1911), *30* (1913), and *35* (1914), *Painting with White Forms* (1913), *Painting with Red Spot* (1914), and *Fugue* (1914). A large number of his major works are now in the Guggenheim Museum in New York (PLS. 349, 350). His *Compositions VI* and *VII* (1913) are in the Tretyakov Gallery in Moscow.

At the start of the World War in 1914 Kandinsky returned to Russia. He lived in Moscow until the end of 1921, working little during the war and revolution. In 1917 he married Nina Andreevsky and in 1918 became a member of the Fine Arts Division of the Commissariat for Public Instruction and a professor in the Government Art Workshops. While in Russia he published his *Rückblicke* in Russian with addenda. Kandinsky left Russia in 1921 for Berlin. In the summer of 1922 he went as an instructor to the Bauhaus in Weimar, where he once again met Klee and Lyonel Feininger (q.v.), whom he had known earlier. Along with Klee, Feininger, and Jawlensky he founded the Blaue Vier (Blue Four), in 1924, a group which showed both in Europe and America. In 1925 he moved with the Bauhaus to Dessau. The following year his book on the theory of art, *Punkt und Linie zu Fläche*, appeared in the Bauhaus book series. He acquired German citizenship in 1928, and in the same year he staged Mussorgsky's *Pictures at an Exibition* at the Dessau Theater. His first Paris exhibition took place in 1929, and in 1933 with the suppression of the Bauhaus he moved to France, going to live in the Paris suburb of Neuilly-sur-Seine. He remained in France, becoming a French citizen, until his death on Dec. 13, 1944.

Kandinsky himself described his years spent at the Bauhaus as a "cold period" and his years in Paris as a time of synthesis. *Composition VIII* (1923) is typical of his geometric constructions: geometry becomes number and number is transformed into magic. Kandinsky's development was undoubtedly affected by his years in Moscow. His compositional technique became more apparent at that time, but without weakening the picture's inner expression. *Punkt und Linie zu Fläche* contains the start of Kandinsky's theories on harmony, which he was unfortunately never able to complete because of his teaching duties and the disruptive effect of his move to Paris. The scope of the book is stated in his description of the goals of research: "precise investigation of each individual phenomenon — in isolation; the reciprocal effect of phenomena upon each other — in combinations; general conclusions to be drawn from the preceding sections."

A certain naturalism of forms appears in Kandinsky's pictures of the Bauhaus period. Instead of forms, one may speak rather of figures which conform, as in nature, to a structural law of "inner necessity." Kandinsky's Munich paintings had had a romantic quality; his work now took on a classicistic note. Among the major works of this period are the *Composition VIII* (1923), *Through-going Line* (1923), *Black Accompaniment* (1924), *Yellow-Red-Blue* (1925), *Several Circles* (1926), *On Points* (1928), and *Slowly Out* (1931). Prior to 1922 Kandinsky's titles are in Russian, from 1922 to 1934, in German, and from 1934 on, in French.

Kandinsky's Paris period is marked by a great serenity and fullness. In the 144 canvases and 209 water colors produced during these 11 years, Kandinsky summed up his experiences of three decades (PL. 350). In articles he wrote in Paris he placed emphasis on the synthesis of mind and heart, of compositional technique and intuition. Now he also preferred the expression "concrete" to the concept "abstract."

As often happens in old age, memories of Kandinsky's youth and of his stay in Moscow appear in the works of his last years. His late paintings take on a richness of color that is more Asiatic than European and a passionate rhythm of movement; in their sensuous unreality, they seem baroque. The composition may lead the viewer at first to imagine that he sees actual objects, but Kandinsky's achievement is, rather, the creation of a new figural mythology. Kandinsky's most important works of the Paris period are: *Compositions IX* and *X* (1936 and 1939), *Movement I* (1935), *Dominant Curve* (1936), *Center with Accompaniment* (1937), *Red Circle* (1939), *Various Parts* (1940), *Reciprocal Accord* (1942), and *Tempered Elan* (1944, his last painting).

BIBLIOG. *Writings of Kandinsky*: a. *Principal works*: Black and White (2 unpub. stage compositions in Rus.), 1909; Violett (unpub. stage composition), 1911; Der Blaue Reiter (ed. by Kandinsky and F. Marc), Munich, 1912 (includes: Über die Formfrage, Der gelbe Klang); Über das Geistige in der Kunst, insbesondere in der Malerei, Munich, 1912 (Eng. trans., F. Golffing and others, Concerning the Spiritual in Art, and Painting in Particular, New York, 1947); Klänge, Munich, 1913; Rückblicke, 1901-1913 (Autobiography), Berlin, 1913 (Eng. trans., New York, 1945); Punkt und Linie zu Fläche, Munich, 1926 (3d ed., Bern-Bümplitz, 1955: Eng. trans., New York, 1947). b. *Graphic works*: Stikhi bez slov (Songs without Words), Moscow, 1904: Xylographies, Paris, 1909; Kleine Welten (12 sheets), Berlin, 1922. c. *Other works (selected)*: Pis'mo iz München (Letter from Munich), Apollon (St. Petersburg), II, 1909, pp. 17-20, IV, 1910, pp. 28-30, VI, 1910, pp. 12-15, VIII, 1910, pp. 4-7, XI, 1910, pp. 13-17 (repr. in Zwiebelturm, V, 1950, pp. 24-44); Über Kunstverstehen, Der Sturm, III, 1912, pp. 157-58; Malerei als reine Kunst, Der Sturm, IV, 1913, pp. 98-99; Selbstcharakteristik, Das Kunstblatt, III, 1919, pp. 172-74; Ein neuer Naturalismus, Das Kunstblatt, VI, 1922, pp. 384-87; Grundelemente der Form, Farbkurs, Seminar: Über die abstrakte Bühnensynthese, in Staatliches Bauhaus Weimar, 1919-23, Weimar, Munich, 1923, pp. 26-28, 142-44, 186-87; Gestern-Heute-Morgen (ed. P. Westheim), Weimar, 1923, pp. 164-65; Der Wert des theoretischen Unterrichts, Bauhaus, I, Dec. 1926, p. 4; Kunstpädagogik, Bauhaus, II-III, Apr. 1928, pp. 8-9; P. Plaut, Psychologie der produktiven Persönlichkeit, Stuttgart, 1929, pp. 306-08 (reply of Kandinsky to three questions in 1928); Der Blaue Reiter: Rückblick, Das Kunstblatt, XIV, 1930, pp. 57-60; Réflexions sur l'art abstrait, CahArt, VI, 1931, pp. 350-53; L'art concret: la valeur d'une œuvre concrète, XXᵉ siècle, I, 1938, pp. 9-16; C. Giedion-Welcker, ed., Poètes à l'écart, Bern, 1946, pp. 53-60 (poems); M. Bill, ed., Essays über Kunst und Künstler, Stuttgart, 1955 (repr. of numerous studies). d. *Contributions to exhibition catalogues*: Neue Künstlervereinigung, Munich, 1910; Der Blaue Reiter (1st and 2d exhibitions), Munich, 1911-12; Der Sturm, Berlin, 1912; These, Antithese, Synthese, Lucerne, 1935, pp. 15-16.

Writings about Kandinsky: a. *General works*: F. Marc, Kandinsky, Der Sturm, IV, 1913, p. 130; K. Umansky, Kandinskys Rolle im russischen Kunstleben, Der Ararat, II, 1920, pp. 28-30; W. Grohmann, Wassily Kandinsky, Leipzig, 1924; C. Einstein, Kandinsky zum 60. Geburtstag, Das Kunstblatt, X, 1926, pp. 372-73; W. Grohmann, Wassily Kandinsky, Paris, 1930; Sélection, 14, Antwerp, 1933 (special no.); Gaceta de arte, 38, Teneriffe, 1936 (special no.); C. Zervos, Wassily Kandinsky (1866-1944), CahArt, XX-XXI, 1945-46, pp. 114-27; H. Debrunner, Wir entdecken Kandinsky, Zürich, 1947; C. Giedion-Welcker, Kandinskys Malerei als Ausdruck eines geistigen Universalismus, Werk, XXXVII, 1950, pp. 117-23; M. Bill and others, Wassily Kandinsky, Boston, Paris, 1951; Derrière le miroir, 42, 1951, 60-61, 1953, 77-78, 1955, 118, 1960 (special nos.); K. C. Lindsay, An Examination of the Fundamental Theories of Wassily Kandinsky, Madison, Wis., 1951 (unpub. dissertation); C. Estienne, Kandinsky ou la liberté de l'esprit, Les arts plastiques, IV, 1952, pp. 267-70; K. C. Lindsay, Genesis and Meaning of the Cover Design for the First Blue Rider Exhibition Catalog, AB, XXXV, 1953, pp. 47-52; W. Grohmann, Zu den Anfängen W. Kandinsky, Quadrum, I, 1956, pp. 62-68; J. Eichner, Kandinsky und Gabriele Münter, Munich, 1957; P. Selz, The Aesthetic Theories of Wassily Kandinsky, AB, XXXIX, 1957, pp. 127-36; W. Grohmann, Wassily Kandinsky, Cologne, 1958 (Eng. trans., N. Guterman, New York, 1958: bibliog. and catalogue of works); P. Volboudt, Wassily Kandinsky, CahArt, XXXI-XXXII, 1958, pp. 177-215; L. D. Ettlinger, Kandinsky's "At Rest," London, 1961. b. *Selected exhibition catalogues*: Oakland Art Gallery, The Blue Four (text by H. Clapp and G. E. Scheyer), Oakland, 1926; Galerie de France (text by E. Tériade, C. Zervos, F. Halle, and M. Raynal), Paris, 1930; Biblioteca Nacional, Cuatro Azules (text by D. Rivera), Mexico City, 1931; Museum of Non-objective Art, Paintings in Memory of Wassily Kandinsky (ed. H. Rebay), New York, 1945; Galerie E. Drouin, Époque parisienne 1934-1944 (text by C. Estienne and H. P. Roché), Paris, 1949; Gimpel fils, Kandinsky (text by D. Sutton), London, 1950.

Will GROHMANN

Illustrations: PLS. 347-350.

KANŌ SCHOOL.

The Kanō school was founded by Kanō Motonobu (1476-1559), whose style represents the fusion of the Chinese technique of ink painting with the color and vivacity of the Tosa school (q.v.), which, to some extent, was related to the traditions of Yamato-e (q.v.). The Kanō school was active for several centuries. It flourished first in Kyoto, the imperial capital in the Muromachi and Momoyama periods (see JAPANESE ART). In the Edo period (1615-1867) members of the Kanō family began to move to Edo (mod. Tokyo), the new capital of the military dictators, where they became the official artists of the shogunate regime. The provincial adminis-

trators, in imitation of the central government, also called Kanō artists to work for them, with the result that the style was diffused over almost the entire Japanese territory. The official position reached by the Kanō painters lowered the quality of their art, which hardened into academicism and inertia, while the vitality of Japanese art found its expression more and more in Ukiyo-e (q.v.).

SUMMARY. Introduction (col. 955). Kanō Masanobu and Kanō Motonobu (col. 955). Kanō Eitoku (col. 956). Kanō Tanyū (col. 958). The Edo-Kanō school (col. 959). The Kyō-Kanō school (col. 960). The Kanō school and modern Japanese painting (col. 960).

INTRODUCTION. Both secular court painting and religious painting of Buddhist inspiration were introduced into Japan from China. During the Heian period (794–1185) the way of life of the court nobles became more purely Japanese, a change that is reflected in the paintings of the time. That is to say, artists depicted both the natural beauties of Japan and Japanese life as they themselves saw and experienced them. These works, which began to appear in the 10th century, were quite different in form and style from Chinese paintings and are called Yamato-e (Japanese painting) in contrast to Kara-e (Chinese-style painting), which continued to be practiced at the same time.

In the Kamakura period (1185–1333) the two styles continued to exist together, but the introduction of sumi-e (India-ink drawing) revolutionized Kara-e. The sumi-e works, brought to Japan from China by Ch'an (Jap., Zen) priests and returning Japanese Zen priests, were collected and preserved in Zen temples in Japan. Sumi-e had originally developed in China as a type of secular painting and had little to do with Zen, but since the sumi-e works in Japan were introduced by Zen priests, they naturally had some relation to the Zen sect, and the appreciation of sumi-e was primarily from the standpoint of Zen Buddhism. Early in the Muromachi period (1334–1573) Zen priests began to produce sumi-e whose subject matter was the Zen ideal of spiritual awakening. Thus was born the Japanese sumi-e. At this time also landscape paintings were introduced from China, and the most important development in sumi-e was the growth of Kara-e landscapes. Numerous sumi-e landscapes were produced; Shūbun (active 1st half of 15th cent.) and Sesshū (q.v.; 1420–1506) were the outstanding exponents of this type of painting. The 15th century was the golden age of sumi-e. Sumi-e, born and developed in the Zen temples, was also studied and practiced by lay painters, and the first great sumi-e artist who was not a priest was Kanō Masanobu.

KANŌ MASANOBU AND KANŌ MOTONOBU. The Zen priests of the Muromachi period were not only priests but also distinguished men of letters, who held literary meetings at which they composed poems or wrote essays in Chinese, chiefly in appreciation of the beauty of nature. They had artists draw sumi-e of the scenes that had inspired their poetry, giving rise to the custom of the priests of adding poems of their own composition on the upper space of the picture. Picture and poem therefore formed an artistic whole; this type of production was named shigajiku ("poem-picture roll"). Landscape sumi-e, an expression of the poetic state of mind, were also drawn on the fusuma (sliding doors) and byōbu (sliding panels) of Zen monasteries.

The ruling Ashikaga family and the military class were much influenced by the way of life and the ideals of the Zen priests. Shūbun, the acknowledged master of the Zen priest-artists, occupied the post of official government artist. After his death the post was given to Sōtan, another Zen priest-artist, who was in turn succeeded, in 1481, by Kanō Masanobu (1434–1530?). The ancestors of Masanobu belonged to the warrior class, and his father seems to have become an artist. Masanobu had gone to Kyoto to learn sumi-e under Shūbun and had been a fellow student of Sōtan.

The fact that a layman such as Masanobu could study sumi-e and finally come to occupy the highest position in that field shows that sumi-e, developed by the priesthood, had by then spread among the military and other secular classes. Three of Masanobu's works are in Tokyo (Nat. Mus.), one of which is titled Chou Mao-shu (Jap., Shūmoshuku) Admiring Lotus Flowers (PL. 351). So few are his extant works that critical judgment is difficult. His first work is known to have been paintings on the fusuma of a Zen temple in 1463. In 1483 he painted the fusuma in the Higashiyama Mansion (later Jishōji, popularly known as the Ginkakuji) of Ashikaga Yoshimasa, and he also painted many other fusuma in temples and in the residences of the military lords.

The sumi-e Masanobu made for his military patrons were naturally different from those painted by the Zen priests for their temples, and it may be said that his works were held in high esteem because of the difference. In these sumi-e the character and ideals of Zen began to be replaced by motifs of secular inspiration. Kanō Motonobu (1476–1559), the eldest son of Masanobu, developed the secular aspect of his father's style into an independent school of painting and consequently established sumi-e as the painting of the military classes. Motonobu studied sumi-e under his father, after whose death he was named official government artist by the Ashikaga shogunate. He was given the ecclesiastical rank of hōgen in his later days. Of the many fusuma paintings he executed in temples and in the mansions of the warriors, his best works were those in the original Nishi Honganji (at that time in Ishiyama, Osaka) of the Jōdo-Shinshū sect, on which he worked for several years beginning in 1539. His extant works include a group of 8 paintings of flowers and birds (PL. 313) in the Daisenin of the Daitokuji and another group of 49 paintings of flowers and birds (PL. 357) and of landscapes in the Reiunin of the Myōshinji. These were originally fusuma paintings, but they have been made into hanging scrolls to preserve them.

The sumi-e landscape before Motonobu represented an ideal landscape, combining the Zen view of nature with the view of nature as seen by the Japanese poets who composed Chinese poems. Motonobu's landscapes, however, represented the breadth and vitality of real nature. His flowers and birds expressed the beauty and variety of forms and colors. In short, he attempted to reproduce in his work, as realistically as possible, the object itself. His technique consisted chiefly in the use of bold lines and thick ink, with the addition of suitable gradations of color. This vigorous style could no longer be called pure sumi-e, differing as it did from both that of previous priest-artists and from the mixed style in which sumi (India ink) and colors were employed.

In the original sumi-e the use of color was generally avoided, and the rare times when it was used (usually red ocher and indigo) were only to accentuate the image. Therefore the fact that Motonobu habitually used thick sumi and strong colors represented a new departure in the field of sumi-e. His color technique was that of Yamato-e, and his use of the sumi of Kara-e together with the colors of Yamato-e resulted in a new style and technique. In other words, he combined Chinese and Japanese styles and methods. The poetic character, inspired by Zen ideals, which had marked the earlier sumi-e almost disappeared, and there emerged an art which emphasized magnificent effects. The new decorative style was well suited to the tastes of the military aristocracy and can therefore be called the painting of the warrior class. Motonobu's descendants and the many disciples who followed his manner are generally known as the Kanō school.

KANŌ EITOKU. Among Motonobu's children, his third son Kanō Tadanobu (Shōei; 1519–92) faithfully carried on his father's style and assisted him in commissions for many temples and mansions. During Shōei's life the power of the Ashikagas was already declining, and the government could not afford to have an artist in service after the death of Motonobu.

Kanō Eitoku (1543–90), the eldest son of Shōei, maintained the traditional style. His youth was passed during a time in which the struggle for power among the military lords was destroying the Ashikaga government. In 1573, when Eitoku was thirty, Oda Nobunaga seized the reins of government from the Ashikagas. In 1589 Toyotomi Hideyoshi became master of the entire country.

Oda Nobunaga built a castle at Azuchi, which was the center of military affairs and administration. This castle contained both Nobunaga's residence and government buildings. The pillars, ceilings, *ramma* (frieze between pillars and ceiling), fusuma, and *byōbu* were decorated with paintings and carvings, and Eitoku supervised the work. Nothing remains of the castle. It is known only that the pillars were lacquered and were decorated with gold, silver, and polychrome paintings and that, to harmonize with them, the fusuma were decorated with magnificent pictures in thick colors on a gold ground. There were also fusuma paintings in only black and white, which were no less decorative. The subjects of these fusuma paintings were the same Buddhist and Confucian themes used in the Kara-e and Yamato-e of the Muromachi period, as well as traditional subjects such as landscapes and flowers and birds (PLS. 318, 353). Eitoku's ancestors Masanobu, Motonobu, and Shōei had painted many fusuma, but none of them surpassed his work at Azuchi castle. Eitoku broadened and developed the style created by his grandfather Motonobu, making it more heroic, well suited to the military spirit of the age.

A few years later Eitoku was asked to work for Toyotomi Hideyoshi, and it is believed that he executed the paintings in Osaka castle (built 1583) and in the Jurakudai Mansion in Kyoto (built 1585). The *shoin* and Hiunkaku of the Nishi Honganji in Kyoto are said to have come from these two buildings.

Although the period during which Oda Nobunaga and Toyotomi Hideyoshi held political power was brief (1573–98), the two rulers succeeded in establishing a solid feudal regime. The age of Nobunaga and Hideyoshi was characterized by a heroic and luxurious culture, reflecting the life and spirit of these two rulers. Another of Hideyoshi's fortresses was Fushimi castle, erected on Momoyama in Kyoto, in 1594, which gives its name to the Momoyama period during which Nobunaga and Hideyoshi lived. The greatest representative of the art of the Momoyama period was Eitoku, whose pictorial style was followed also in the next period, the Edo.

Besides Shōei and Eitoku, many other members of the Kanō family contributed to the development of the Kanō school after the style of Eitoku. Among them were Yukinobu (d. 1575), younger brother of Motonobu; Munenobu (d. 1562), eldest son of Motonobu; Sōshū (d. 1601), younger brother of Eitoku; Mitsunobu (1565–1608), eldest son of Eitoku; and Takanobu (1571–1618), second son of Eitoku. Hideyori, who was a contemporary of Shōei, Motohide (d. 1601), Naganobu (1577–1654), Soyu (1566–1617), Naizen Shigesato (1570–1616), Sanraku (1559–1635), and others, since they bore the name of Kanō, must have come from the same family.

After Eitoku's death in 1590 his eldest son, Kanō Mitsunobu, worked for Hideyoshi. The paintings in Fushimi castle were by Mitsunobu, and he is supposed to have been assisted in this work by his uncle Sōshū, his younger brother Takanobu, his father's disciple Sanraku, and others. Mitsunobu and his disciples painted many fusuma for the mansions of the court nobles, for Nagoya castle (built 1612), for the residences of local daimios, and for various temples.

The extant authentic works of all these artists are not numerous. Among these the following are representative: *Ploughing*, 8 fusuma by Yukinobu, Daisenin of the Daitokuji, Kyoto; *Nehan* (*Parinirvāṇa*), by Shōei, Daitokuji, Kyoto; *Maple Viewing at Takao*, *byōbu* by Hideyori, National Museum, Tokyo; *Chinese Lions* (X, PL. 140), six-panel *byōbu* by Eitoku, Imperial Collection, Tokyo; 16 flowers and birds, fusuma (PL. 318), presumed to have been painted about 1566, and 12 landscapes, fusuma, all by Eitoku, Jūkōin of the Saitokuji, Kyoto; *In and Around Kyoto*, screen by Eitoku, Uesugi Takanori Collection, Yamagata prefecture; portrait of Oda Nobunaga, by Motohide (PL. 352), Chōkoji, Ōsato; *Hōkoku Festival*, screen by Naizen Shigesato, Hōkoku Shrine, Kyoto; *Feasting under Cherry Blossoms*, screen by Naganobu, National Museum, Tokyo; *Flowers and Birds*, fusuma by Mitsunobu, Kangakuin, Otsu; portrait of Emperor Goyōzei, by Takanobu, Senyūji, Kyoto; *Eagles and Pines*, screen by Sanraku, Nishamura Jurobei Collection, Shiga prefecture; and a figure painting, screen by Sanraku, National Museum, Tokyo.

The Kanō artists belonging to various branches of the family and their disciples were numerous and they dominated the world of painting during the Momoyama period.

KANŌ TANYŪ. Tokugawa Ieyasu came to power in 1603 and established his Bakufu (Shogunal Government) in Edo (mod. Tokyo). He remodeled the administrative systems and the institutions that Hideyoshi had established. The Tokugawa regime lasted until 1867, and the period from 1615 to 1867 is generally called the Edo period.

In 1590 Hideyoshi gave Kanto district to Ieyasu as his fief, and when the Bakufu was established in Edo in 1603, the city began to develop rapidly; it very soon became the cultural center of eastern Japan, just as Kyoto was of western Japan.

Among the painters invited by Ieyasu from Kyoto to decorate Edo castle were Kanō Mitsunobu, of the original Kanō family, and two painters of new branches of the same house, Naganobu and Yoshinobu (1552–1640). Mitsunobu returned to Kyoto on the completion of his commission, while Naganobu stayed on in Edo, the first of the Kanō family to settle in the new metropolis. As the Tokugawa regime became more firmly established, a need was felt for painters who would work exclusively for the government, and in 1621 an official-painter system was established. Kanō Sadanobu (1597–1623), the eldest son of Mitsunobu, was the head of the original Kanō family in Kyoto; Morinobu (Tanyū; 1602–74), the eldest son of Takanobu, was the head of a new branch of the house. When Tanyū was employed by Ieyasu as official painter, he transferred the headship of the house to his younger brother Naonobu (1607–50) and moved to Edo, where he was offered a residence near the Kajibashi Gate of Edo castle. For this reason Tanyū and his descendants are usually called the Kajibashi-Kanō. About 1630, when the number of the official painters in the service of the government was increased, Naonobu was sent for. His family later moved to Kobikichō and is usually referred to as the Kobikichō-Kanō. When Sadanobu, the head of the original Kanō family in Kyoto, died in 1623, Yasunobu (1613–85), the younger brother of Naonobu, inherited the house. Yasunobu also moved to Edo, before 1641, settling at Nakabashi, and this branch of the family is known as the Nakabashi-Kanō. Thus the Kanō school of Edo increased its power and influence, while the Kanō school in Kyoto declined.

Takanobu, the father of Tanyū and his teacher, died when his son was seventeen. In the absence of an expert artist to study under in the Kanō family in Kyoto, Kanō Kōi (1569–1636), one of the disciples of Mitsunobu, became Tanyū's guardian and teacher. Since Tanyū was employed by the Tokugawas as official painter at the age of nineteen, however, it is to be presumed that he studied under the guidance of Kanō Naganobu, who had been in Edo. His first great works were the paintings he did for Edo castle when it was reconstructed (1622). He became the most influential painter of his era. In 1638 he was given the ecclesiastical rank of *hokyō*, and this was when he changed his name from Morinobu to Tanyū; thus the works of art bearing the signature of Tanyū were produced after this date. He was promoted to the rank of *hōin* in 1662. Tanyū painted many works for the government, for the warriors employed by the government, and for the daimios who regularly came to Edo from their fiefs.

Tanyū paid three visits to Kyoto, in 1626, 1636, and 1641. On the third and last trip he was accompanied by his brothers Naonobu and Yasunobu. The first of the three journeys was made when he was ordered to decorate Nijō castle on the occasion of the interview between Emperor Gomizuno-o and the second shogun, Tokugawa Hidetada. The multicolored fusuma paintings on a gold ground, still in the *ninomaru* in Nijō castle, must have been done by Tanyū and his followers. During these three journeys he produced pictures, at the request of the imperial court, of various temples in Kyoto, and of the court nobles. The magnificent painted fusuma and screens that still survive in the Daitokuji, Chionin, Tokuzenji, Gyokurinin, Ryūkōin, Kohōan, Konchiin, and Nanzenji are believed to be by the hand of Tanyū himself. Some of the fusuma paintings in

Nagoya castle, attributed to Tanyū, must have been painted on one of this trips to Kyoto.

Tanyū's surviving works include, in addition to the large-scale fusuma paintings referred to above, scrolls such as the *Tōshōgū Engi*, an illustrated biography of Tokugawa Ieyasu in five rolls, produced in 1640 and kept in the Tōshōgū Shrine at Nikkō; portraits, including one of Ieyasu in the Rinnōji at Nikkō; and Buddhist paintings, such as the *Shaka Triad* in the Kōtōin at Kyoto. These works show that Tanyū was a versatile artist who could paint almost any subject in a variety of styles. A good many of his miniature paintings and sketch-books (Tokyo, Nat. Mus.) reveal that Tanyū improved his skill by his ardent and assiduous study both of nature (PLS. 353, 354) and of classical masterpieces. His genius is most evident in his larger works, in which he deftly expressed the spirit of the early Edo period.

Edo society was strictly feudal in structure, but Ieyasu's civil administration was based on Confucian philosophy and ethics. Tanyū reorientated the old Kanō school and adapted its style to the needs of a new society under a new regime. The features of the traditional Kanō school — magnificent design, bold lines, rich colors, less spiritual themes, and decorative emphasis — were replaced by a harmonious and gentle style; this new Kanō style expressed the Confucian spirit and conservative character of the regime. Tanyū was held in great esteem and promoted to the highest rank. He represents the academic school of painting in the Edo period.

THE EDO-KANŌ SCHOOL. The three masters of the Kanō family, Tanyū and his brothers Naonobu and Yasunobu, were appointed court artists in the service of the Tokugawa regime in 1621, 1630, and before 1641 respectively. The subsequent heads of the three Kanō families succeeded to the post until the Tokugawa regime fell in 1867. The three families are usually distinguished from one another by the names of the places in which they lived: Kajibashi-Kanō, Kobikichō-Kanō, and Na-kabashi-Kanō.

Kanō Minenobu (1662–1708), the second son of Tsunenobu of the Kobikichō-Kanō, founded a new family and was also appointed court painter with the same rank as those of the three other Kanō houses. He lived at Hamachō, and his family for this reason came to be called the Hamachō-Kanō. Later on the branches of the four Kanō houses were also employed by the Tokugawa Bakufu as court artists of a lower rank; the four main branches were called *oku-eshi*, or senior court artists, to distinguish them from the lesser branches. The four *oku-eshi* on certain fixed days of the month worked in the office called the *o-e-beya* (painters' room) in Edo castle, where they painted, gave opinions on the classical paintings collected by the government, and restored paintings in the collections.

Several younger members of the four *oku-eshi* families and other disciples of superior skill — 15 in number altogether — were also employed as court artists. These 15 families, called *omote-eshi*, were on the same footing as warriors of lower rank.

The *oku-eshi* and the *omote-eshi* made up the Kanō school proper in Edo. In addition, there were hundreds of other Kanō painters who are considered part of this school. These minor artists were either distant relations or sons-in-law of the Kanō family or disciples granted the surname of Kanō; they were not in the service of the Tokugawa regime, but produced paintings in the Kanō style to satisfy the demands of the *chōnin* (townsfolk). These artists are generally known as Machi-Kanō. The three divisions are called the Edo-Kanō school to distinguish them from the Kanō school in Kyoto.

The painters of the Edo school generally followed the styles and techniques originated by Tanyū, the founder of this school, and no painter surpassed him. There were a few, however, who were nearly as good as Tanyū: Tanyū's brother Naonobu (1607–50), Naonobu's eldest son Tsunenobu (1636–1713), and Tanyū's adopted son Masunobu (Toun; 1625–94), for example.

In spite of his undeniable limits, Naonobu mastered the classical style through study of the simple and pure style of *sumi-e* painting. Among his extant works is a pair of landscape screens in Tokyo (PL. 355). Tsunenobu studied the classical works of art produced from the Muromachi period on. During his life-time, the stable government and the rise of the wealthy classes made it possible for the ruling class to enjoy a life of peace and luxury. Tsunenobu emphasized the decorative elements of Tanyū's style and adjusted it even more to the spirit of the times (PL. 355). The Edo-Kanō school from then on followed Tsunenobu's style. Masunobu was an artist of outstanding skill whose designs and style were similar to those of Tsunenobu.

In this conservative age the Kanō painters found it safer to adhere to the styles and designs originated by Tanyū and Tsunenobu; the whole Kanō school in Edo had built up a little feudal society of its own, the center being the four *oku-eshi*. Some Kanō painters, however, departed from this conservative formalism and were expelled from the school; among them were Kusumi Morikage (ca. 1680), Hanabusa Itchō (1652–1724), and Tani Bunchō (1763–1842).

Morikage was a pupil of Tanyū, but being too eager to adopt the time-honored technique of *sumi-e* and to portray the life of the common people, he was not approved of by the Kanō school and he moved to Kanazawa. A good many of his works survive, including two screens: *Enjoying the Evening Cool* (Yoshida Shigeru Coll.) and *The Kamo Horse Race* (Tokyo, Ōkura Mus.). Itchō was at first a disciple of Yasunobu, but was expelled because he dealt with the life of ordinary citizens; the rest of his life was spent as a private painter. Bunchō also belonged to the Kanō school at the outset, but established a new style of his own, availing himself of the techniques and designs of other schools. In the eyes of the Kanō school he was a traitor, inordinately critical of their traditions.

THE KYŌ-KANŌ SCHOOL. Most of the Kanō families had moved from Kyoto to Edo before 1641. Among those painters who remained in Kyoto, Kanō Sansetsu (1589–1651), son-in-law of Kanō Sanraku, deserves special mention. Sansetsu was no less gifted than his father-in-law, and the Kanō school continued to flourish during his lifetime. Besides the *Plum Trees and Birds* fusuma in the Tenkyūin, Kyoto, which is now ascribed to Sansetsu rather than Sanraku, some *sumi-e* and large polychrome paintings survive, which testify to his mastery of the gorgeous decorative Momoyama style. After his death the Kanō school of Kyoto decayed rapidly, as the Kanō painters after Sansetsu were all mediocre.

The Kanō artists and painters who lived in Kyoto and followed the Kanō style are usually called the Kyō-Kanō school. The Kyō-Kanō school had their own traditions, uninfluenced by the Edo-Kanō school.

It was the employment of Kanō painters as court artists in the imperial court that gave the official seal of approval to the Kyō-Kanō school. From the Heian period on, the artists in the service of the imperial court had belonged to the Yamato-e school; since the Muromachi period artists of the Tosa family had succeeded to this position of honor. The custom changed, however, in the Genroku era (1688–1703), when, in addition to a Tosa painter, Kanō Tanzan (1655–1729) was appointed court artist. Tanzan, a disciple of Tanyū, moved from Edo to Kyoto, where his family was in the service of the court throughout this period.

Following the example set by the central government, many local daimios employed Kanō artists as their "court artists." Among these were Kanō Kōi, teacher of Tanyū and his brother, who was employed by the Tokugawas at Kishū (Wakayama prefecture), and various disciples of Tanyū who worked in other prefectures. This custom among the local daimios of employing Kanō painters helped to spread and popularize the school all over the country, so that by the middle of this period painting and the Kanō school were synonymous.

THE KANŌ SCHOOL AND MODERN JAPANESE PAINTING. The spread of the Kanō school in the Edo period was due not only to the patronage of the shogunate and the local daimios but also to the fact that the school had completely transformed itself into what might be called the art of the warrior class, fully adjusted to the tastes and needs of this class. However, other schools were active. The court nobles patronized the Tosa school, the

principal exponent of Yamato-e. In addition, the new importance of the *chōnin* gave rise to such schools as the Kōrin, the Maruyama, and the Ukiyo-e. Each school had its masters and masterpieces, but the Kanō school led in prestige.

When the Tokugawa shogunate was overthrown in 1867, ushering in the Meiji period, the warrior class collapsed and the Kanō school as a result declined rapidly. Only two representatives of the orthodox Kanō school remained in Tokyo: Kanō Hōgai (1828–88; PL. 356) and Hashimoto Gahō (1835–1908). In the Taisho period (1912–26) all the Kanō artists had disappeared, and their place was taken by the neo-Japanese school, founded in Kyoto and based on the Maruyama-Shijō school. Modern Japanese painting is a modification of the neo-Japanese school. The Kanō school is now extinct, and the few remaining traces may be discerned in the technique and the use of the brush in certain *sumi-e* works. Two masters who have conserved in their work this characteristic manner of the Kanō school are Yokoyama Taikan (1868–1958; PL. 330) and Kawai Gyokudō (1873–1957).

BIBLIOG. Shiichi Tajima, Motonobu Gashū (Album of Paintings by Motonobu Kanō), 3 vols., Tokyo, 1903–07; Okisada Asaoka, Koga Bikō (Handbook of Classical Painting), rev. ed. by Kin Ōta, 4 vols., Tokyo, 1905; Kanō-ha Taikan (General View of Works by the Kanō School of Painters), 3 vols., Tokyo, 1912–14; Sakutaro Fujioka, Kinsei Nippon Kaigashi (History of Modern Japanese Painting), 2d ed., Kinkōdō, 1926; Bijutsu Kenkyūjo (Institute of Art Research), Momoyama-jidai Kimpeki Shōheki-ga (Album of Momoyama Style Paintings on Sliding Doors), 2 vols., Tokyo, 1937; Shin'ichi Tani, Kinsei Nippon Kaiga-shi Ron (Essays on the History of Modern Japanese Painting), Tokyo, 1941; Tsuguyoshi Doi, Nippon Kinsei Kaiga-kō (Studies of Modern Japanese Painting), Kyoto, 1944; Sekai Bijutsu Zenshū (Catalogue of World's Art), Tokyo, XV, XXI, 1950–55.

Shin'ichi TANI

Illustrations: PLS. 351-357.

KASHMIR ART.

Kashmir is situated in the western part of the Himalaya range (see INDIA), and its position as a frontier region is reflected in its art and culture. Basically Kashmir art falls within the orbit of Indian cultural and religious traditions, but actually it is the composite product of classic (see GANDHARA; KUSHAN ART), Iranian (see INDO-IRANIAN ART), Central Asian (see ASIA, CENTRAL), and, in a few cases, Chinese art. Grafted onto the traditional local forms, these external but, to a greater or lesser extent, dominating influences resulted in an original local idiom, exemplified in the monumental Kārkoṭa and elegant Utpāla styles.

SUMMARY. *The development of ancient art in Kashmir* (col. 961). *The great phases of medieval Kashmir art* (col. 965): *The Kārkoṭa style; The Utpāla style; The last phase. The Islamic conquest and the later phases* (col. 970).

THE DEVELOPMENT OF ANCIENT ART IN KASHMIR. Paleolithic points and flake blades, mainly of the Levallois type, were discovered by H. de Terra in the sediment terraces of the Sohan and Jhelum rivers and in Kashmir proper; they are the oldest discoveries in this region. At Burzahom near Harwan there is a megalithic circle consisting of a group of 11 megaliths, the only one in northwest India. There is one in Asota in Pakistan. Trial excavations have unearthed well-polished stone axes and painted gray (P.G.) ware beneath a later layer of northern black polished (N.B.P.) ware. On this evidence, which needs further corroboration, these megaliths have been dated about 1100–400 B.C. Cave paintings at Sassir Pass (Nubra Valley) may belong to the same period. Rock pictures (animals, hunting scenes) in Dardistan (Kargil and Kalatse), though still belonging to the same level of civilization, are, however, of a later period, as Brahmi and Kharoshthi inscriptions and pictures on Buddhist chortens prove.

Kashmir was part of the empire founded by the Maurya dynasty (324–181 B.C.). Srinagar, the capital of Kashmir, was founded under the name of Srinagari by Aśoka (r. ca. 273–ca. 236 B.C.) at what is now Pandrethan. When the capital was transferred to Pravapura (Old Srinagar) about 460, the original location was called Puranadhishthana, the "old capital." After

the third Buddhist council at Palatiputra (mod. Patna), Aśoka sent Buddhist missionaries to Srinagar and erected the first stupa there, of which no traces are left.

To Jalauka, one of Aśoka's sons, is attributed the founding of the most famous Śiva temples: Jyeṣṭharudra or Jyeṣṭheśa behind the former maharaja palace at Gupkar, Vijayeśvara or Aśokeśvara at Bijbehara (anc. Vijabror), and Jyeṣṭharudra at Wangath. Jalauka's mother is said to have founded several Mātṛcakra (round temples of the "Mothers"). These temples were later rebuilt several times on a more magnificent scale. The huge Mātṛkā images found at Gupkar (now in Srinagar, Sri Pratap Singh Mus.) may go back to an 8th-century rebuilding of one of these Mātṛcakra.

The history of the subsequent centuries, the so-called "first Gonandiya dynasty," is obscure; as presented in Kalhaṇa's *Rājataraṅgiṇī*, written in the 12th century, it is a hotchpotch of disarranged historical facts, legends, and romances. However, we know from other sources that the Turuṣka kings Kaniṣka, Juṣka, and Huviṣka were the most prominent rulers of the Kushan empire, which from the end of the 1st century to the middle of the 3d century comprised Afghanistan, large parts of western and eastern Turkistan, and northern India up to Bihar, Gujarat, and Sind (see KUSHAN ART). Kaniṣka held a Buddhist council in Kashmir, which is mentioned by all Mahayana scriptures and historians as being of decisive dogmatic importance. Kaniṣka founded Kanishkapura (mod. Kanispor), his successor Juṣka (Vāsiṣka or Vajhiṣka) founded Jushkapura (mod. Zukur), and Huviṣka founded Huvishkapura (mod. Ushkur). Only Huvishkapura became a town of importance; its Buddhist monasteries were grouped around the great stupa erected by the emperor. In the 8th century it was filled with Hindu temples and was the residential suburb of the famous Viṣṇu temple dedicated to Varāha. (The cult became popular in the 6th cent.) Huviṣka's stupa was almost entirely rebuilt in the 8th century, but only the foundations remain. Contemporary Gandhara reliefs have not been discovered. However, the fragment of a statue of a Kushan emperor (Srinagar, Sri Pratap Singh Mus.) is reminiscent of the statues in Parthian style found in the chapel (*devakūla*) of the Kushans at Mat near Mathura, especially that of Huviṣka (see VI, cols. 29–30). But, as with a number of Gandhara statues, the emperor is represented in the guise of a god (probably the Buddhist yaksha Pāñcika) wearing a flower garland (*vanamālā*) and sitting on a crouching lion on a lotus socle.

Almost all the sculpture or fragments of sculpture in the Gandharan style found in Kashmir belong to the final phase of this artistic current, which received new impetus and new energy from the work of Parthian and Hellenistic artists, who moved to northwest India following the collapse of the Parthian empire in 227, and from a revival of the national Iranian art, which resumed, to some degree, the Achaemenian traditions (see SASSANIAN ART).

Shortly after this the Kushan empire was conquered by the Sassanians, but was restored a century later by the Kidaras after a period of struggle, during which time apparently the "second Gonandiya dynasty" came into power in Kashmir (ca. 345). Although this dynasty was soon the vassal alternately of the Kidaras, the Gupta emperors of India, the Ephthalites (White Huns), and the Maukharis (or Guptas of Malwa), it became the focal point of a local art tradition in which purely Parthian elements were fused with Hellenistic-Gandharan and Indo-Gupta elements.

The Parthian style proper is represented by the ruins of the Buddhist monastery at Harwan (anc. Shadarhadvana). Of the badly constructed stupas, apsidal chaitya hall, and cells for monks only the foundations survive. The floor of the court was covered with molded tiles decorated with bas-reliefs (PL. 359): Parthian horseman, heads, busts, and full figures of people in Indian costume (interpreted, though, in an utterly un-Indian manner), Brahmanical ascetics, wreath-bearing Erotes, stupas, floral ornaments, etc. The stupas depicted (probably of the same type as those once standing at Harwan) have a rather small body (*aṇḍa*), crowned by a set of honorary umbrellas surrounded by flags. The floral ornaments and other decorations are rem-

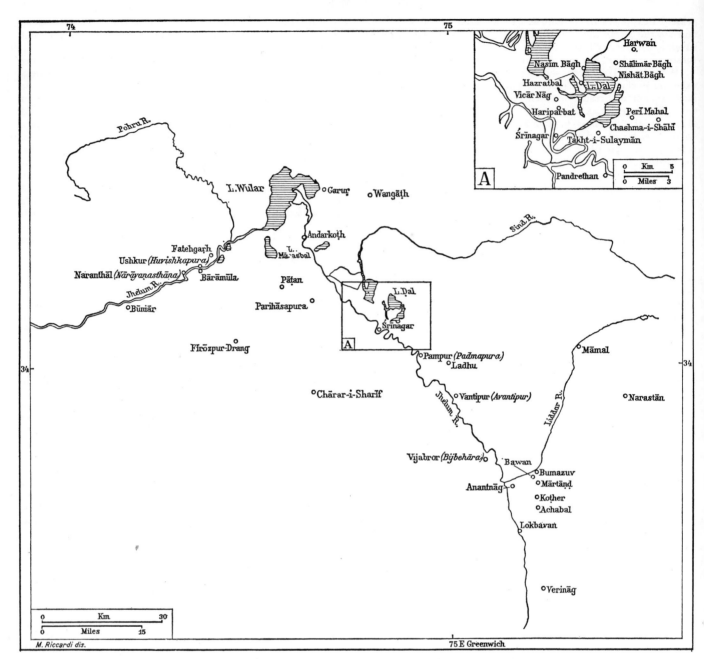

Principal centers of historic and artistic interest of Kashmir.

iniscent of those discovered at Mirpur Khas in Sind and Sam-laji in Gujarat; they have a certain affinity with early Gupta art, but are probably prototypes of this rather than works of direct Gupta influence. The monastery had been founded by the Kushans, but the floor tiles are of the 4th century. Terra-cotta fragments of a related type have also been discovered at Pan-drethan (now in Srinagar, Sri Pratap Singh Mus.).

The late Gandharan-Hellenistic figure style, as we know it from the stucco figurines of Hadda in Afghanistan and Jau-lian and Mohra Moradu at Taxila, is represented by terra-cotta heads and fragments of figures from Ushkur and Akhnur. Those from Ushkur, of the same time as the Hadda finds, must have been executed on the occasion of the renovation of the Jayendra Vihara during the reign of Pravārasena I (ca. 379–ca. 410). The Akhnur terra cottas represent a later, "baroque" style, with round faces and rather heavy features, with a tendency toward formal mannerism (the first stage of the style develop-ment later found in the Tarim Basin; see ASIA, CENTRAL), very far from the fragile rococo elegance of the Fondukistan stuccoes (see INDO-IRANIAN ART). They may be of the time of Rāṇāditya

(ca. 506–86). Probably belonging to the same era is a bronze Buddha in Srinagar (Sri Pratap Singh Mus.), of a decadent style but very well executed. Even later are the stone images of Hindu deities (Śrī-Lakṣmī, Gaja-Lakṣmī, and perhaps also Kārtti-keya) and a number of stucco figures in a very decadent style from Bijbehara, also in Srinagar (Sri Pratap Singh Mus.), which are mostly of late Gandharan type but with some Gupta elements. It is tempting to connect these sculptures with a renovation of the Śiva temple of Vijayeśvara at Bijbehara when the Ephtha-lite king Mihiragula, a fanatical persecutor of the Buddhists and champion of the Hindu religion, settled Brahmans from Gandhara in the city about 520–30.

Gupta influence set in under Pravārasena II (ca. 410–70), who in his early reign seems to have been the ward of the great Candragupta II (see GUPTA, SCHOOL OF). After the first Tungus invasion the new capital Pravarapura was founded (ca. 460); this is now Old Srinagar. The city was destroyed and rebuilt many times, and the stones of the earlier buildings were used to strengthen the river dams. Though the sites of Pravārasena II's Pravāreśvara temple (today cemetery of Bahā-ud-Dīn) and of

Rāṇāditya's Rāṇāsvāmin temple (now cemetery of Pīr Hājj Muḥammad Sahib) have been identified, the ruins there belong to renovations of the 8th century.

THE GREAT PHASES OF MEDIEVAL KASHMIR ART. *The Kārkoṭa style.*

The last Gonandiyas were reduced to utter impotence as a result of the Hun occupation. In 622 they were overthrown by Durlabhavardhana, the founder of the Kārkoṭa dynasty; under this dynasty Kashmir became one of the great powers of India. Originally probably supported by Harṣavardhana of Thanesar (606–47), the Kārkoṭas conquered the Punjab and the western Himalaya after the fall of Harṣavardhana's empire. Early in the 8th century they became the suzerains of the Turkish Śāhīs of Afghanistan, who were hard pressed by the Moslems. In 713 and 720 the Kārkoṭas appealed to the T'ang emperors for aid against the Moslem advance from Sind into the southern Punjab and reorganized their army and administration with the help of experts sent from China. Lalitāditya Muktāpīḍa (ca. 725–56) conquered India from the Bay of Bengal to Mysore, Ladakh, and a good part of the Tarim Basin but clashed with the rising power of the kings of Tibet and at last committed suicide in the snows of Central Asia. Jayāpīḍa (ca. 768–99) attempted to hold northern India, but failed. Under the last Kārkoṭas, tools in the hands of unscrupulous court factions, the kingdom was again reduced to the Jhelum Valley.

The war booty and an immense labor force were at Lalitāditya's disposal, and he engaged in a megalomaniac building activity. In this short period most Buddist and Hindu monuments in Kashmir, as well as a number of temples in the Punjab and even in Afghanistan, were erected, and these represent but a fraction of those mentioned in Kalhaṇa's *Rājataraṅgiṇī*. For almost half a millennium the later Hindu kings of Kashmir looted these temples and monasteries, especially of their costly images (some of gigantic size), to fill their depleted treasury. They also pulled down many temples and towns of this period to obtain cheap building materials. Later the Moslem sultans, especially Sikandar Būtshikān (the "idol breaker," ca. 1390–1416), the Moghul emperors, and the Afghans systematically destroyed many more temples. Even so, the largest and most impressive temple ruins, indeed the overwhelming majority of those surviving, belong to the reign of Lalitāditya.

Of the early monuments of the Kārkoṭa dynasty, when Pravarapura (now completely destroyed) was still the capital, we know hardly anything. Possibly the Śaṅkarācārya (Jyeṣṭheśa) temple proper on the Takht-i-Sulaymān may date from this time, for this perplexing monument is an almost fully developed shikhara of the central Indian type (and therefore cannot be older than the 7th cent.) but of very crude workmanship, with triangular gables that appear to be a transition from the Indian *upaśṛṅga*. It stands in complete contrast to the simple but perfect Gupta platform and to the octagonal exterior platform with its arcaded balustrade and staircase that was evidently constructed during Lalitāditya's reign around the original sanctuary.

The temples of Ladhu (Loduv), 6 miles from Pampur, and Norwa also look rather archaic. Ladhu is probably identical with Lalitapura, which was founded by one of Lalitāditya's architects. The temple, with its horseshoe arch entrance, simple torus course at the base, cornice, and domed round cella, is perhaps an example of the still undeveloped early Lalitāditya style. It may be of approximately the same time as the platforms of the Jyeṣṭheśa temple on the Takht-i-Sulaymān and the ruins in the Zainakadal quarter of Srinagar (which were reused for the cemetery of Pīr Hājj Muḥammad Sahib and the mausoleum of Sultan Zain-ul-'Ābidīn's mother), for here we find the same plinth moldings, the same round arch tending toward the horseshoe, and the same balustrade of small, round-arched niches. Dating from this period is a bronze Buddha (Berlin, Mus. für Völkerkunde), which is a clumsy attempt at transforming a Buddha of Gandharan type into a three-headed Viṣṇu.

The new artistic current set in with the monuments erected by Lalitāditya's Tocharian prime minister Caṅkuṇa, a fervent Buddhist originally in the Chinese service. The earliest ones seem to have been some small stupas of late Gupta type, decorated with Gupta Buddhas and with semi-Chinese bodhisattva statues whose style evokes associations with Wei, Six Dynasties, and T'ang prototypes. These were followed by the repair of Huviṣka's great stupa and monasteries at Huvishkapura. When Lalitāditya founded a new capital at Parihasapura (mod. Paraspor), Caṅkuṇa created a Buddhist establishment there, consisting of the Rāj Vihara (royal monastery), a chaitya, and a great stupa. The stupa, a copy of the one at Huvishkapura, has a double platform with a stairway on each side; the trefoil arches contained images of the Buddha, in a decadent Gupta style, and of bodhisattvas, inspired by T'ang Chinese prototypes. The chaitya was a towerlike building, open in front, in which a huge Buddha of embossed and gilded copper was surrounded by a gallery of several stories. A similar Bṛhadbuddha was erected by Caṅkuṇa at Pravarapura. Both were evidently inspired by the colossi of Bamian (PL. 10), and it is thus not surprising that Gandharan motifs were prominent in the decoration of the chaitya. Probably all these monuments were completed before Lalitāditya's conquest of India in 733–47.

In the next buildings two new stylistic tendencies appear: late Syro-Roman and Byzantine stylistic elements on the one hand and late Gupta (Kanauj and Bengal) on the other. The first (round arch and niches) become apparent in the Jyeṣṭheśa temple on the Takht-i-Sulaymān and the mausoleum of Sultan Zain-ul-'Ābidīn's mother, of later date. In the temple at Malot in the Salt Range both styles appear, unassimilated, side by side.

In the great Sun (Sūrya) Temple of Martand the Syro-Roman traits predominate (PLS. 360, 361). It is a tower construction with a rather short cult hall (mandapa), which stands on a platform and is flanked by two double chapels. Many details are Roman: use of mortar and dowels; genuine round arches (rarely used in India); a ceiling of superimposed intersecting squares; engaged Doric columns, Corinthian pilasters with small rectangular panels and niches, helical columns; vast Syrian windows with heavy lintels; and Byzantine imposts, triangular panels (as at Mshattā) enclosing projecting heads, and harpies (*kinnaras*) in the corners of the gables. This type of temple had already developed in Gandhara and in the Gupta empire under Parthian and Roman influence. The capped and superimposed gables and trefoil arches were common in Gandhara. (At this time they also began to be used in the Mediterranean.) The column bases are Gupta, and their capitals represent that transitional stage from the Parthian (i.e., Gandharan-Hellenistic) acanthus capital to the Gupta pot-and-foliage capital, which we know from Mirpur Khas, Samlaji, and Bhitargaon. The sculpture is purely Indo-Gupta in style, although the costumes and jewelry are characteristic of northwest India (derived from the Gandharan tradition).

Although there had been some mixture of western and Indian artistic elements from about the 2d century, it appears that the immense artistic activity under Lalitāditya required more artists than were available locally, necessitating the importation both of Syrian architects, who were far superior to the Indians as engineers and who were unemployed after the conquest of Syria and the invasion of Asia Minor by the Arabs, and of Indo-Gupta masons and sculptors, whose work was superior to that of the westerners.

Roman influence is also evident in the ruins of the Hindu temples in Parihasapura. The other temples that can be attributed to Lalitāditya's time — Wangath, Pandrethan, Buniar, Naoshera, Narastan, and Amb (where Bengali features predominate) and Katas in the Salt Range — reveal a progressive simplification of the architectural forms and a parallel barbarization of the sculpture. These ruins are still impressive because of their size and the strength of their construction. Only a few stones remain of monuments in the following places: Wular Lake dams, Lokbavan, Fatehgarh, the Dhathamandir temple near Uri, and Firozpur-Drang, all in Kashmir; Saydabad, Panjmara, and Thana, in Bhimbar; Rajaori, Chatrarhi, and Brahmor, in Chamba; Bhavan in the Kangra Valley; Manali in Kulu; Maylang and Triloknath, in Lahul; Pasupatinatha (Yamunā statue) in Nepal; the Chomos of Dras on the route to Ladakh; the Swat Valley; and eastern Afghanistan. To

complete these architectural works in less than three decades it was necessary to employ insufficiently trained artisans. Thus most of these temples had very few sculptures. Also, in constructing the temples a few standardized forms were employed, such as the Gupta plinth, pseudo-Doric and pseudo-Corinthian columns and pilasters, trefoil arch under a steep gable, and double pyramidal roof; these are the typical elements of the medieval Kashmir style. The most grandiose, somewhat barbaric sculptures are those excavated during the construction of the maharaja's palace at Gupkar; they probably belonged to the Jyeṣṭheśa temple at Gupkar. The style of these statues, now in Srinagar (Sri Pratap Singh Mus.), is a mixture of Indian, Gandharan, and late Roman elements.

Jayāpīḍa founded his capital, Jayapura, on the Jhelum north of Srinagar; it consisted of the royal "palace which equaled heaven in beauty" (Abhyantarakotta), on an island in the Sambal swamp, and the town proper (Dvaravati, mod. Andarkoth), between the swamp and the river. The ruins of numerous temples can still be seen; although they are in very poor condition, they reveal a powerful but much more refined taste than in Lalitāditya's time. Of the monuments of the last decades of the Kārkoṭa dynasty, all that remain are some huge fragments of the foundations of the Padmasvāmin temple at Padmapura (mod. Pampur), built by the minister Padma, regent for King Ajītāpīḍa (ca. 812–50) in his childhood, and a temple ruin at Utpalapura (mod. Kakapur, between Pampur and Vantipur), built by another minister.

The Utpāla style. With the descendants of Utpāla, brother-in-law of the twelfth Kārkoṭa king Lalitāpīḍa, another strong dynasty came to the throne; they brought prosperity again to the country and restored the suzerainty of Kashmir over the western Punjab and eastern Afghanistan (then under the Hindu Śāhīs). King Avantivarman (856–83), who was principally responsible for this recovery, founded Avantipur (mod. Vantipur). While still heir apparent he erected the Avantisvāmi temple (FIG. 967) dedicated to Viṣṇu, a copy on a smaller scale of the Martand temple. When he became the ruler, he built the Avantiśvara temple dedicated to Śiva; set on a broad platform with projecting chapels at the four corners, it is of the *pañcāyatana* type. The architectural forms are much more elegant than in Lalitāditya's time. The temples were richly decorated, and many of the ornaments were of Sassanian origin. The sculptures are better modeled than the earlier ones, though

often very mannered; the idols possess a suppressed vitality (PL. 362; VII, PLS. 228, 463). The better reliefs (Viṣṇu with his consorts, the king, queen, high priests, etc.; PL. 363) are dignified; the others look somewhat bloated.

With Avantivarman's successor, the clever but cynical Śaṅkaravarman (883–902), another period of decadence set in. He was the first monarch to loot the earlier temples systematically. He demolished most of Parihasapura in order to build another capital, Sankarapura (mod. Patan), 3 miles further west. There were three principal temples in this city, but only ruins of the Śaṅkaragaurīśvara (built by the king; PL. 364) and the Sugandheśa (built by his queen Sugandhā) are left. In size the temple compares with those at Avantipur; the ornamentation is even more elegant, but the figural decoration is simpler. A bronze frame unearthed at Divsar (anc. Devasarasa in the southern Kashmir Valley; PL. 364) sheds a revealing light both on Śaṅkaravarman's policy and on the art encouraged by him. The frame, beautifully made, was designed for a Buddha image apparently belonging to one of Caṅkuṇa's buildings. In the frame is a series of figures representing the 10 avatars within flower scrolls, and at the top is a 4-headed Paravāsudeva (in Pāñcarātra theology); by this means the image was transformed into Viṣṇu's Buddha avatar. In other words, a Buddhist monastery had apparently been looted, but the sordid transaction was concealed by its official transformation into a Viṣṇu temple, with beautiful, but not especially precious, equipment. On this frame the king, his queens Sugandhā and Surendrāvatī, and two other persons, probably the minister Nāyaka and Sukharāja, are represented as donors. Its style is analogous to the Rashtrakuta cave sculptures at Ellora; its iconography anticipates much of later Tibetan Buddhist art. The 35 years after the assassination of Sugandhā in 904 were an uninterrupted series of debaucheries and murders; the throne was sold by the royal guards to the highest bidder; the provinces were fleeced and in revolt. During this period building activity was continued, but the constructions were mainly in wood.

The Utpāla dynasty left its mark on the art of the surrounding areas: in the north, at Navapura in Gilgit; in the southeastern Himalaya, with the lovely Kālī temple at Thalora-Babbaur and in Jammu with the Kāladhera, besides minor works of sculpture at Akhnur, Chamba, Mulkihar, Nagar in Kulu, Kangra, etc.; in the Punjab plains and North-West Frontier, with the temples at Bilot, Kafirkot, Sassi-da Kallar, and Baghanwala, in a mixed Pratīhāra-Kashmir style, as well as individual sculp-

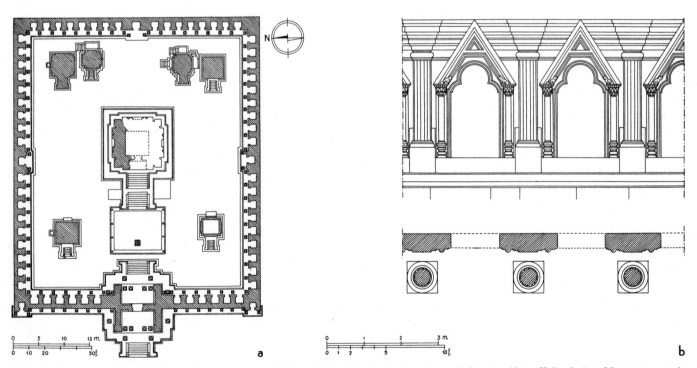

Vantipur, Avantisvāmi temple, second half of 9th cent. (*a*) Plan: (*b*) detail of peristyle, plan and elevation (*from Kak, Ancient Monuments, 1933*).

tures from the Yusufzai district (London, Br. Mus.), Peshawar, Kaithal, Hansi, and others of unknown origin (London, Br. Mus.) executed under the Hindu Śāhī kings, who were at first vassals of the Utpālas and later became independent.

The last phase. The final phase of medieval Kashmir art was the work of the Rajput princes of Lohara (in the mountains between Kashmir and the Punjab), first through Diddā (958–1003), queen of the weak Kṣemagupta (950–58), then through her nephew Saṅgrāmarāja (1003–28) and his descendants Ananta

carvings in the Buddhist temples of Tsaparang in Guge (western Tibet), Toling and Lha-lun in Spiti, and Alchi in Ladakh. Even more than in the stone structures, the colonnettes and screens were covered with fine filigree filled with figures set in complicated niches or resting on lotuses emerging from a rich scrollwork. The old royal palace of Srinagar at Rajadhani near the Second Bridge, 12 stories high and famous for its luxury, was built of wood and was destroyed by fire when Harṣa was besieged by the revolutionaries.

The sculpture of Diddā's time, known to us from a stone

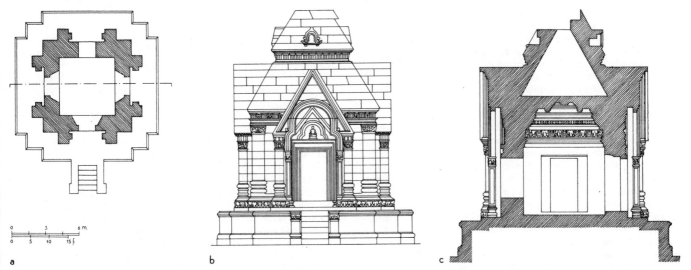

Pandrethan, Rilhaneśvara temple dedicated to Śiva, 12th cent. (*a*) Plan; (*b*) elevation; (*c*) section (*from Kak, Ancient Monuments, 1933*).

(1028–63), Kalaśa (1063–89), and Harṣa (1089–1101), and finally through the descendants of Diddā's brother Kāntirāja, Uchchala (1101–11), Sussala (1112–28), and Jayasiṃha (1128–55). Under the first Lohara kings Kashmir again became a power, at least in the Himalaya, although the ruling dynasty could not hinder the overthrow of the Hindu Śāhīs by the sultans of Ghazni. Art and culture flourished again. But under Harṣa's extravagant rule the long-festering social discontent erupted in a terrible revolution that weakened the royal power so much that the following rulers, although they were very capable, had great difficulty with the practically independent nobility. The subsequent Hindu dynasties were almost without power. The country again became impoverished, and there was no artistic activity worth mentioning.

The stone temples of this last period (Bumazuv, Pandrethan, Zadibal, Kother, Payar, Mamal, Naranthal, Garur) became smaller and smaller, and their forms, highly integrated, were increasingly simplified. The decoration, restricted to the socles, capitals, cornices, etc., made use of small figures, if any, and tended more and more toward filigree. The best known temple is the Rilhaneśvara, dedicated to Śiva, in Pandrethan (FIG. 969). Erected about 1135 by Rilhana, a minister of Jayasiṃha, it is similar to the Bhīmakeśava temple in Bumazuv, founded by Diddā's grandfather, Bhīma Śāhī (940–65), which is now the ziara of the Moslem saint Bābā Bamudīn Sahib, and also to the Hindu temple upon which the ziara of Mādīn Shah in the Zadibal quarter of Srinagar was erected. The Mammeśvara was built by Jayasiṃha at Mamal, opposite Pahlgam. Kashmir influence spread outside the Jhelum Valley, as the temples in Nainsukh and Ballaur show.

In this period the wooden temple became much more important. Though all these monuments have been destroyed in Kashmir, the type seems to survive in the characteristic wooden mosques (blockhouses with a low pyramidal roof, enclosing a huge hall) and also in the monastic architecture of western Tibet. Examples of the interior decoration still exist in the Kālī (originally Sūrya) temple of Mirkula-Udaipur in Chamba (probably restored by Sūryamatī, Ananta's queen) and also in the

Birth of the Buddha from Pandrethan (PL. 363) and a bronze Avalokiteśvara group (PL. 364), represents the decadent phase of the Utpāla style; the modeling is still careful but the proportions are bad, and the faces are soft, tired, and unhealthily bloated. This last characteristic was taken over by the Lamaistic art of Tibet, where the Buddhist reformers Rin-c'en bzaṅ-po and Atīśa summoned some hundreds of masters from Kashmir. The 11th-century style again became tense and energetic; examples are the idols from Verinag (now in Srinagar, Sri Pratap Singh Mus.), the reliefs at Mirkula-Udaipur in Chamba, and the two Buddha reliefs at Tabo in Spiti. Later the modeling and plasticity disappeared; the figures were no more than lifeless dolls, at first elegant but in the 13th century grotesque.

Painting of the 8th and 9th centuries is perhaps represented by the "late Gandharan" murals in the cave temples at Kizil and Ming-oi in eastern Turkistan (see ASIA, CENTRAL; KUCHA). Painting of the 10th and 11th centuries survives in the Tibetan murals in Man-nan and, in part, in Tsaparang, as well as in illustrated manuscripts from Toling and Kulu; their draftmanship is more delicate and lively than in the Pala paintings of Bengal, the colors are brighter, the halos iridescent, and the background sometimes golden. Shawl weaving was introduced from Central Asia by Suhadeva (1301–20).

THE ISLAMIC CONQUEST AND THE LATER PHASES. Islam was introduced in 1339, when the Moslem adventurer Shah Mīr, who was the powerful minister of the last Hindu queen Koṭā Devī, married and then assassinated her; he then took the title of Sultan Shams-ud-Dīn. The cultural transition was rather slow, mainly by conversion (chief missionary Shah Hāmādan, d. 1384). Only later, during the reign of Sultan Sikandar Būtshikān (ca. 1393–1416), at the instigation of the Moslem immigrants, were the Hindus systematically persecuted and their temples destroyed. His successor Zain-ul-'Ābidīn (1420–70) did much to restore harmony between Hindus and Moslems.

The early Islamic architecture of Kashmir was therefore an adaptation of the indigenous wooden style into which genuine Islamic forms penetrated only gradually. The characteristic

building was a huge blockhouse of square ground plan; the interior consisted of a hall of one or two floors, sometimes supported by four pillars; in other words, it was a variation of the type first known to us in Caṅkuṇa's chaitya at Parihasapura. Also characteristic of this style were the "storerooms" along the walls of the hall (originally cells of the Buddhist monks) and the slightly sloping turf roof with wooden "bells" suspended from the flower (originally dragon) decoration at the corners; in the center of the roof was a conical *maʿzīna* (low minaret), reminiscent of the *chattrāvalī* (shikara) of Buddhist stupas and Hindu temples. None of the original monuments still exist, because these wooden buildings caught fire easily. The ziara and mosque of Shah Hāmadān and the Jāmiʿ Masjid in Srinagar and the mosque in Pampur have been rebuilt more or less in the original style, with only slight concessions to the taste of later times. The Jāmiʿ Masjid was erected on the place where the royal Cakradhāra temple, dedicated to Viṣṇu, originally stood; this temple was moved to the Hariparbat. The Jāmiʿ Masjid was originally built by Sikandar Būtshikān and was reconstructed in 1503, 1620–37, 1674, at the end of the 18th century, and again in 1913. In the Jāmiʿ Masjid, partly constructed of brick, the blockhouse construction was adapted to a Persian mosque with four aiwans (vaulted halls), with the hall and peristyle resting on huge wooden columns. In most of the ziaras in Srinagar and the Kashmir Valley, however, the influence of Moghul and Sikh (i.e., late Moghul) art is visible; the columns, arches, mirror mosaics, and decoration of the ceiling are all in the Moghul style (see MOGHUL SCHOOL).

In several cases the ziaras were erected on Hindu ruins, for example, the Bhīmakeśava temple in Bumazuv, the Mādin Shah in Zadibal (1444 and 1483), and the mausoleum of the mother of Sultan Zain-ul-ʿĀbidīn in Srinagar. The mausoleum is a brick building decorated with blue-enameled molded tiles, and is crowned by five fluted domes on drums; the ground plan is unusual and is based on the cruciform layout of the original Hindu temple of the early 8th century. Zain-ul-ʿĀbidīn was a great patron of the arts. He constructed the pleasure islands of Sonā Laṅkā and Rūpa Laṅkā in Dal Lake, Zaina Laṅkā in Wular Lake, and a network of irrigation canals nearby. When the sultan constructed the Zainakadal quarter of Srinagar he built six wooden bridges over the Jhelum, which were only recently modernized. He introduced from Timurid Samarkand most of the industries for which Kashmir has become famous: wood carving, lacquer, papier-mâché, etc. No buildings remain from the last years of the sultanate — a period of civil wars and of invasions.

The Moghul emperor Akbar (1556–1605) conquered Kashmir in 1585. When he visited the valley in 1589, he had a strong fortress constructed on the Hariparbat, which was completed in 1599. It was his successor Shah Jahāngīr (1605–27) who first appreciated the beauty of the country; he made it his imperial summer residence in 1619. A good road, provided with caravansaries (at Nur Mahal, Saydabad, Naushahra), was constructed over the Pir Panjal Pass. The Shālimār Bāgh on Dal Lake and the bathing pool at Verinag (source of the Jhelum) were erected in 1619/20, and the gardens at Achabal, Manasbal Lake, and Gandarbal were laid out during Jahāngīr's reign. The empress Nūr Jahān seems to have been especially fond of Kashmir; the Paṭṭhar Masjid in Srinagar was built on her orders in 1623 and the Jāmiʿ Masjid was reconstructed in 1620–37. Shah Jahān (1628–58) spent many summers in Kashmir, and the Chashma-i-Shāhī on Dal Lake was built by him in 1632/33. His minister Āṣaf Khan laid out the Nishāt Bāgh on Dal Lake in 1633. Prince Dārā Shikōh, viceroy of northwestern India, erected the Parī Mahal overlooking the lake in 1644 and a mosque for his former tutor Mullā Akhūn Shah on the slopes of the Hariparbat in 1649. After the new imperial residence at Shahjahanabad (Delhi) was completed in 1638 and the Tāj Mahal in Agra in 1648, Shah Jahān ceased visiting Kashmir regularly. And after Aurangzēb (1658–1707) the emperors came no more. The last genuine Moghul work was the decoration of the ziara of Shah Hāmadān during Aurangzēb's reign. However, the frequent imperial visits had made Srinagar an important artistic and industrial center, and the city was particularly noted for the production of Kashmir (Cashmere) shawls.

All the Moghul gardens (see LANDSCAPE ARCHITECTURE; MOGHUL SCHOOL) were laid out in terraces, each one corresponding to a palace section: the first terrace, sometimes touching the lake, for general receptions; the next one for the men; the last one for the women. Some gardens (e.g., at Achabal and Verinag) were on a single level; others rose in terraces, with the highest reserved for the women, who were able to enjoy the view without being seen. Along the central axis of the garden ran a channel interspersed with basins and fountains; the water fell in front of colored lamps and ran along ramps decorated with fish scales (*pusht-i-māhī*), creating waves; across the channel were bridges with pavilions and platforms of various shapes. On both sides there were multicolored flower beds watered by secondary channels, cypresses and chinars, and orchards. Along the walls of the enclosure were situated the hammams (hot baths), quarters for the ladies in waiting, etc. Most of the inhabitants lived in tents; the principal buildings' alone were executed in brick and wood on stone substructures. Only the substructures and some brick buildings go back to the 17th century; all the other constructions were renovated in the 19th century. The Parī Mahal, high up on a hill, now deserted because the water supply dried up, preserved the original Moghul brick structures. In the Shālimār Bāgh, the principal imperial residence, Persian columns of black marble with Rajput brackets were used.

The Paṭṭhar (Stone) Masjid — the largest in Kashmir, with 9 front arches and 27 domes, which was never used because of a quarrel between Nūr Jahān and the local Moslem clergy — and the mosque of Mullā Akhūn Shah are built of a fine gray limestone and are in a pure Persian style characteristic of the transitional phase between the early Moghul style and the classical style of Shah Jahān. In other buildings in Kashmir in this style, the domes were often replaced by a low pyramidal roof. In the Paṭṭhar Masjid the cusped arch was used for the first time. The much-renovated mosque of Hazratbal on Dal Lake, built by Shah Jahān for a hair of the Prophet, followed the traditional local design but was of Persian construction. The stay of the emperors in Kashmir also influenced Moghul art. Copies of the Shālimār Bāgh were executed in Delhi (1632) and Lahore (1637; PL. 446), and the flower patterns of Kashmir became the favorite decoration of panels on palaces, textiles, weapons, etc.

In 1739 Kashmir passed into the control of the Persian Nādir Shah, and in 1752–53 it was ceded, together with the Punjab, to Aḥmad Shāh Durrānī. The Afghans exploited the country. However, they erected most of the present fort on the Hariparbat, built the Shēr Gaṛhī in Srinagar, repaired the Jāmiʿ Masjid and a number of ziaras, and decorated the entrance to the shrine of Mādin with encaustic tiles, most of which have disappeared. The Parī Mahal was repaired by Malik Sābir Munshī, assistant to the cruel governor Āzād Khān Pathān, in 1784–85. The Afghans introduced a new style of Moghul-Persian painting (which originated in Persia) and new techniques for papier-mâché and lacquer; flower designs derived from Persian art were woven into the shawls.

Under Sikh rule (1819–46) the Jāmiʿ Masjid was closed and the central dome was removed from the Paṭṭhar Masjid. However, it was also during this time that textile arts flourished and Kashmir shawls were exported in large quantities to Europe and America. Illustrated Persian manuscripts found a market in Delhi and beyond. Under the Ḍogrā maharajas of Jammu, expecially under Gulāb Siṅgh and Ranbīr Siṅgh, Kashmir began to recover. In the Shēr Gaṛhī a summer palace in European style was built. All the Moghul gardens were renovated, and the present flimsy, but charming, buildings date from this time. The art of this period was a synthesis of Indo-Afghan, Sikh, and Kangra-Rajput elements. The Kangra style of painting was introduced from Jammu, from which the late Hindu-Kashmir miniatures developed. Generally 1 1/2 to 2 3/4 inches in size and depicting Tantric figures in vermilion and gold, these miniatures are found in numerous manuscripts, usually small, and in scrolls. The textile industry continued to flourish, as did lacquer work and wood carving. As a result of the annexation of Ladakh, art objects from China were diffused in Kashmir; the Chinese influence is mainly seen in wood carving.

Kashmir painting is no longer practiced, except in painted lacquer ware, and the Kashmir shawl has become an antique. Traditional wooden architecture is still being produced, although it has been adapted to the modern taste.

SOURCES. Kalhana, Rājataraṅginī (Chronicle of the Kings of Kashmir), Eng. trans., M. A. Stein, 2 vols., Westminster, 1900.

BIBLIOG. A. Cunningham, Essay on the Aryan Order of Architecture, J. Asiatic Soc. of Bengal, XVII, 2, 1848, pp. 241-327; W. G. Cowie, Notes on Some of the Temples of Kashmir, J. Asiatic Soc. of Bengal, XXXV, 1866, pp. 91-123; H. H. Cole, Illustrations of Ancient Buildings in Kashmir, London, 1869; C. E. de Ujfalvy, Les cuivres anciens de Cachemire, Paris, 1883; W. S. Talbot, An Ancient Hindu Temple in the Panjāb, JRAS, 1903, pp. 335-38; G. Watt and P. Brown, Indian Art at Delhi, Calcutta, 1903; W. H. Nicholls, Muhammedan Architecture in Kashmir, Ann. Rep. Archaeol. Survey of India, 1906-07, pp. 161-70; W. H. Nicholls, Report of the Mughal Gardens at Srinagar, Shalimar Bagh, Atthibal and Chasma Shahi, Allahabad, 1906; J. P. Vogel, Antiquities of Chamba State. I, Calcutta, 1911; D. R. Sahni, Excavations at Avantipur, Ann. Rep. Archaeol. Survey of India, 1913-14, pp. 40-62; C. M. Villiers Stuart, Gardens of the Great Mughals, London, 1913; D. R. Sahni, Pre-Muhammedan Monuments of Kashmir, Ann. Rep. Archaeol. Survey of India, 1915-16, pp. 49-78; R. C. Kak, Antiquities of Bhimbar and Rajauri, Calcutta, 1923; R. C. Kak, Handbook of the Srī Pratāp Museum, Srinagar, Calcutta, 1923; R. C. Kak, Antiquities of Marev-Wadwan, Srinagar, 1924; M. S. Vats, The Salt Range, Ann. Rep. Archaeol. Survey of India, 1927-28, pp. 89-90; H. L. Shuttleworth, Lha-lun Temple, Spyi-ti, Calcutta, 1929; K. M. Panikkar, Gulab Singh: Founder of Kashmir, London, 1930; G. Dainelli, Buddhists and Glaciers of Western Tibet, London, 1933; R. C. Kak, Antiquities of Basohli and Ramnagar, Indian Art and Letters, VII, 1933, pp. 65-91; R. C. Kak, Ancient Monuments of Kashmir, London, 1933; H. de Terra and T. T. Paterson, Studies on the Ice Age in India, Washington, 1933; G. Tucci, I templi del Tibet occidentale e il loro simbolismo artistico, I-II, Rome, 1935-36; G. Tucci, Indian Painting in Western Tibetan Temples, AAs, VII, 1937, pp. 191-204; C. L. Fabri, Buddhist Baroque in Kashmir, Asia, XXXIX, 1939, pp. 593-98; N. S. Kaul Shastri, Gilgit Excavation, 1938, Bangalore, 1940; G. Tucci, Tibetan Painted Scrolls, 2 vols., Rome, 1948; H. Goetz, The Conquest of Western India by Lalitāditya-Muktāpīḍa of Kashmir, J. Bombay Branch of the RAS, N.S., XXVII, 1951, pp. 43-59; S. C. Ray, A Note on an Unpublished Vishnu Image from Kāśmīra, J. Asiatic Soc. of Bengal, Letters, N.S., XVII, 1951, pp. 251-53; H. Goetz, Beginnings of Mediaeval Art in Kashmir, J. Univ. of Bombay, XXI, 2, 1952, pp. 63-106; J. Irwin, The Kashmir Shawl, Marg, VI, 1, 1952, pp. 43-50, VIII, 2, 1955, pp. 121-36; H. Goetz, A Masterpiece of Mediaeval Kāshmīrī Metal Art, J. Asiatic Society of Bengal, Letters, N.S., XIX, 1953, pp. 45-55; H. Goetz, The Sun Temple of Mārtānd and the Art of Lalitāditya-Muktāpīḍa, Indian Art and Letters, XXVII, 1953, pp. 1-11; H. Goetz, Two Early Hindu Sāhī Sculptures, Sarūpa-Bhāratī, Hoshiarpur, 1954, p. 216 ff.; P. Brown, The Architecture of Kashmir, Mārg, VIII, 2, 1955, pp. 40-52; H. Goetz, Early Indian Sculpture in Nepal, AAs, XVIII, 1955, pp. 61-74; H. Goetz, The Early Wooden Temples of Chamba, Leiden, 1955; H. Goetz, Mediaeval Sculpture of Kashmir, Mārg, VIII, 2, 1955, pp. 65-74; J. Irwin, Shawls, London, 1955; D. Schlumberger, Le marbre Scorretti, Arts asiatiques, II, 1955, pp. 112-19; D. Barrett, Sculptures of the Shāhī Period, O. Art, N.S., III, 1957, pp. 54-59; H. Goetz, Late Gupta Sculpture in Afghanistan, Arts asiatiques, IV, 1957, pp. 13-19; D. H. Gordon, The Prehistoric Background of Indian Culture, Bombay, 1958; S. C. Ray, Early History and Culture of Kashmir, Calcutta, 1958; M. Hasan, Kashmir under the Sultanate, Calcutta, 1959; H. Härtel, Zur Datierung einer alten Viṣṇubronze, Indologentagung Essen 1959 (ed. E. Waldschmidt), Göttingen, 1960, pp. 165-78; H. Goetz, A Reconstruction of the Later Gonandīya Dynasty of Kashmir, J. Bihar Res. Soc. (Prof. Altekar Issue), 1961.

Hermann GOETZ

Illustrations: PLS. 358-364; 3 figs. in text.

KENT, WILLIAM. English architect, landscape gardener, and painter (b. Bridlington, Yorkshire, probably 1685; d. London, 1748). It is said that he was first apprenticed to a coach painter. In 1709 he was sent by three patrons to Rome, where he collected works of art for their country houses and studied painting under Benedetto Luti. In 1719 he returned to England with Richard Boyle, third Earl of Burlington, whom he had met in Rome in the winter of 1714-15 and who lodged Kent in his own house in Piccadilly, where the artist completed Sebastiano Ricci's Cupid and Psyche cycle. Burlington obtained for Kent a commission to decorate the interiors at Kensington Palace (1722-25), and in 1726, through Burlington's influence, the artist became Master Carpenter of the King's Works. About 1725 Kent designed the interiors of Burlington's house at Chiswick, Middlesex (VI, PL. 441). In 1735 he was appointed Master Mason and Deputy Surveyor of the King's Works.

Kent's chief public buildings in London were the Royal Mews (1732, demolished 1830; Charing Cross), the Treasury (1734; Whitehall), and the Horse Guards (built 1750-58, after his death; Whitehall). Private works included the Stone Hall at Houghton Hall (VI, PL. 442), Devonshire House (1734, demolished 1924-25; Piccadilly), Holkham Hall (1734; Norfolk), 44 Berkeley Square (1742; London), Worcester Lodge and Badminton House (before 1745; Gloucestershire), and Wakefield Lodge (ca. 1748; Northamptonshire). Among his unexecuted designs for major public buildings were those drawn for new houses of Parliament. In his architecture Kent enlivened the austere classicism of Burlington with baroque touches and essentially painterly effects of massing and texture. At Esher Place (ca. 1730; Surrey) he was responsible for the earliest English example of Gothic rococo.

In garden design he was the leader of the landscape school, which substituted for the symmetry of the baroque a studied informality, which was justified by the Earl of Shaftesbury's concept of "nature's genuine order" and was thought to represent "the taste of the ancients." Gardens designed by Kent, wholly or in part, included Burlington's, at Chiswick; those at Esher Place and Claremont, Surrey; Euston, Suffolk; Stowe, Buckinghamshire (PL. 444); and Rousham, Oxfordshire, which is the best preserved.

BIBLIOG. S. F. Kimball, William Kent's Designs for the Houses of Parliament, J. Royal Inst. Br. Architects, XXXIX, 1932; R. Wittkower, Lord Burlington and William Kent, Arch. J., CII, 1945; M. Jourdain, The Work of William Kent, London, 1948; R. Wittkower, The Earl of Burlington and William Kent, York Georgian Soc. Occasional Pap., no. 5, 1948; H. M. Colvin, A Biographical Dictionary of English Architects 1660-1840, London, 1954.

Marcus WHIFFEN

KHMER ART. The art that flourished in ancient Cambodia (q.v.) from the end of the 6th to the end of the 14th century is designated as Khmer. Though it was an offshoot of Indian art (q.v.), the distinctive qualities of the Khmer people and the wealth at the disposal of their rulers during the period in which they dominated the Indochinese peninsula combined to give their art a highly individual cast. An account of the political factors that determined the several changes of capital and the contingent division of the country's history into successive periods is to be found in the article devoted to Cambodia, along with a description of the principal monuments found within the confines of modern Cambodia. The present article deals with the chronology and development of Khmer art, the various styles of which are named after the sites or monuments most characteristic of each. Architecture and sculpture will be treated jointly, not only because in function they were closely interdependent but also because subjection to the same currents of influence produced a parallel evolution.

SUMMARY. History of the research relating to Khmer art (col. 974). Chronology of Khmer art (col. 975). Building techniques, materials, and ground plans (col. 976). Pre-Angkorian art (col. 977): *Funan; Sambor-Prei Kuk; Prei Khmeng and Kompong Prah.* Styles of Angkorian art, first phase (col. 979): *Kulên; Prah Kô; Bakheng; Koh Ker; Banteay Srei; The Kleangs.* Styles of Angkorian art, second phase (col. 983): *The Baphuon; Angkor Wat; The Bayon.* Main trends in the development of Khmer art (col. 988). Minor arts (col. 991).

HISTORY OF THE RESEARCH RELATING TO KHMER ART. Khmer art has been the object of copious study ever since its imposing monuments were first drawn to public attention by Henri Mouhot, who had visited the ruins of Angkor in 1860. The work of the Commission d'Exploration du Mékong (1866-68), led by Doudart de Lagrée and Francis Garnier, and the Delaporte mission (1871-77) constituted a first phase of research, which resulted in the drawing up of a list of the principal monuments and the founding of a collection of Khmer antiquities in Paris.

A second phase was introduced with the work of Etienne Aymonier, who, as representative of the French protectorate in Cambodia, spent the years 1879-84 journeying about the country to make an inventory of its ancient monuments. The 340 impressions of Sanskrit and Khmer inscriptions he subsequently took back to France enabled the Sanskrit specialists Auguste

Barth and Abel Bergaigne to establish, between 1882 and 1885, a chronology of the Khmer rulers and to distinguish the characteristics of the ancient civilization of Cambodia. Etienne Aymonier's work *Le Cambodge*, published in three volumes between 1900 and 1904, presents the sum of what was known of Khmer art up to the founding of the Ecole Française d'Extrême-Orient.

The first task of this institute, whose creation in 1898 marked the beginning of a third phase of research, was to catalogue and describe the ancient monuments of French Indochina. Upon Siam's restitution of the ancient Cambodian provinces of Siem Reap and Battambang to Cambodia (treaty of March 23, 1907), the Ecole set up the Conservation d'Angkor, whose first duty was to free the most important monuments, Angkor Wat and the Bayon, of the jungle that had overgrown them. This body subsequently extended its work to other monuments, not attempting to restore them but merely seeking to halt the slow disintegration of the ruins. Since 1931, however, new methods of anastylosis, or reconstruction from scattered parts, based on those which the Archaeological Service of the Netherlands Indies was following in Java, have been applied wherever possible.

CHRONOLOGY OF KHMER ART. It is essential that study of Khmer art and of the various stages in its development be preceded by a brief account of the vicissitudes which have attended the chronological ordering of its monuments, for the chronology adopted in works on Khmer art written before 1929 is likely to be completely erroneous.

Until 1923 it had been accepted unquestionably that the Bayon and the enclosure of Angkor Thom were initiated by King Yaśovarman (889–900). Epigraphical evidence had revealed that he had founded a capital, Yaśodharapura, in the middle of which, according to a text of the 11th century, he had raised the "central mount." Since this city was firmly believed to correspond to the known Angkor Thom, the identification of the "central mount" with the Bayon temple, which stands in the exact center of Angkor Thom, seemed unavoidable. In 1924, however, the discovery of an effigy of the Bodhisattva Lokeśvara (Avalokiteśvara) carved on a pediment of the Bayon showed that this and other monuments of the same style (e.g., Banteay Kedei, Ta Prohm, Prah Khan, Banteay Chmar) had originally been Buddhist shrines, whose Buddhist decoration had subsequently been erased and replaced by a profusion of Saiva motifs. Since this group of monuments could therefore no longer be attributed to the time of the Saiva ruler Yaśovarman, Louis Finot, in the belief that there were valid grounds for assuming that King Jayavarman II (802–50) was a Buddhist, suggested attributing this monumental ensemble to his reign. This hypothesis — which, for legion historical and stylistic reasons, was in any case untenable — had scarcely been proposed when Philippe Stern put forward another, based on analysis of the decoration on the monuments, primarily because its development was perceptibly more rapid than that of either their ground plans or their structure.

Applying his method to the study of Khmer art, Stern (1927) succeeded in demonstrating not only the impossibility, stylistically, of assigning the Bayon to the same period as the brick towers of the 9th century but also the necessity of recognizing that the Angkor monuments belonged to two different periods and of attributing the Bayon and Angkor Wat to the second. King Yaśovarman had indeed founded a new capital, Yaśodharapura, and had raised a temple at its center, but the mistake had been to associate this capital of the late 9th century with the ruins of Angkor Thom as they are today. Stern deserves great credit for having refuted this long-accepted identification; but he did not go so far as to challenge the prevalent belief in the anteriority of the Bayon to Angkor Wat, which he continued to regard as the last great monument of Khmer art. Then, because of the Bodhisattva discovery of 1924, indicating that the decoration of the Bayon had originally been of Buddhist inspiration, he proceeded to search for a Buddhist ruler in the second half of the Angkorian era, and it was thus that he came to attribute the building of the Bayon to Sūryavarman I, who reigned during the first half of the 11th century and posthumously received the Buddhist name of Nirvāṇāpada.

This dating merely complicated matters further; subsequent study (Cœdès) of the Sanskrit inscriptions on the steles at each of the four corners of the enclosure of Angkor Thom showed that they commemorated both the building of this enclosure and the digging of the moats around the city by King Jayavarman VII (last twenty years of the 12th, first twenty years of the 13th century). Citing the fact that the ringwalls and reservoirs of the city of Angkor Thom are inseparable from and form the enclosure of its central temple, the Bayon, the author proposed a chronology (adopted in 1929) which ascribed the building of Angkor Thom, the Bayon, and other monuments of the same style to the late 12th century and accordingly attributed their realization to the great Buddhist ruler Jayavarman VII. Thereafter, the site of the first Yaśodharapura, built by Yaśovarman at the end of the 9th century, and the identification of its "central mount" with Phnom Bakheng were established by Victor Goloubew (1931–32).

BUILDING TECHNIQUES, MATERIALS, AND GROUND PLANS. The Cambodian climate has destroyed all the lightweight wooden structures of the Khmers and has spared only the edifices built of durable materials, which were reserved exclusively for the gods and the deified dead. Thus, almost nothing is, or can be, known of their secular architecture and their houses, apart from what little can be learned through study of the relief carvings in which these are represented. The durable building materials of the Khmers were brick, laterite, and sandstone, used either in combination or separately. Sparse fragments of the wooden roofing of minor buildings have been found, together with odd bits of iron shaped like double T"s and used as cramps.

Brick had been used almost exclusively for the tower sanctuaries from the 7th century to the 9th, after which it gradually fell into disuse; and even from earliest times the door frames had always been fashioned of schistose stone, and the architraves and colonnettes of sandstone. The bricks were smoothed by friction — one was rubbed against another — and then they were cemented together with a substance which ensured so perfect an adhesion that the blocks thus constructed could be carved like stone. Laterite, a reddish oxide of iron, which subsists in large quantities in the Cambodian soil, was used for foundations, annexes, enclosures, and the substructure of pyramids. Sandstone, which was quarried from Phnom Kulên, about 25 miles north of Angkor, is usually rather soft and tends to crumble in the process of extraction. Assembled without any adhesive substance, the blocks were smoothed, as they were laid, by means of an apparatus that is represented in a relief carving of the Bayon. The fabrication of these sandstone blocks had become very faulty by the time the Bayon was built, at the end of the 12th century; through haste or carelessness the masons neglected to alternate the vertical joints, a failure that accelerated the ruin of the structures. These edifices were raised on laterite foundations laid over a base of crushed stones. The solid structures, such as the stepped pyramids, were built of laterite and faced with sandstone.

Two features of the Khmer construction methods are noteworthy: first, since they did not know the principle of the keystone and used the corbeled vault instead, they could span only halls or galleries of limited width; second, they applied the methods of timber construction to stone architecture. According to Henri Parmentier, the second characteristic involved two illogical devices: fashioning stone blocks with the wood techniques of tongue-and-groove joints, slots, tenons, and mortises in order to hold them together and introducing wooden beams into the masonry. In the tropical climate the beams slowly disintegrated and finally crumbled to dust, leaving cavities that proved fatal to the stability of the walls.

In the decoration of the surfaces, the fundamental principle governing disposition of the stringcourse was symmetry, which dictated a harmonious balancing of the upper and lower moldings. The diversity of the moldings derived from their carved ornamentation.

This brief review of Khmer building techniques would be incomplete without passing mention of the "second thoughts,"

the revamping and the modifications carried out after a building had been completed, and sometimes even during its initial construction. It should also be noted that the builders did not hesitate to reuse elements salvaged from ancient monuments which had been demolished and that many buildings were never completed.

The typical ground plan of the temple evolved from very simple beginnings and became more complicated as time went on. Its essential element was the square or rectangular tower sanctuary, generally oriented toward the east and raised in three superimposed stages: podium, main structure, and superstructure, the latter composed of a varying number of nonfunctional stories, which were of decreasing height and constituted small-scale replicas of the main structure.

As in examples from the 10th century, the entrance to the tower was generally preceded by a porch; the door was set in a stone frame surmounted by an architrave that, supported on colonnettes, was in turn surmounted by a pediment. Blind doorways, of the same general design as the actual doorway, adorned the other sides (X, PL. 435), and the exterior decoration was completed by pilasters. The windows, framed in the same way as the doors, were spanned with more or less closely spaced stone bars or colonnettes in place of shutters. Because all the elements here enumerated were decorated, architectural decoration has proved of great value in the study of the development of Khmer art.

As noted earlier, all the monuments built of durable materials — the only ones that have survived — are of a religious character. The layout of the capital was determined by an intent to harmonize the world of men with that of the gods. Thus, the city that lodged the king, who was the supreme expression of the state, was designed as a replica of the universe. Square in plan, the city was surrounded by a water-filled moat, symbolizing the ocean, and was contained within a fortified wall representing the chain of mountains surrounding the world. The pyramidal temple that rose in its center constituted an embodiment of the cosmic mountain marking the center of the great world.

In the building program undertaken by the king, priority was given to hydraulic works for the benefit of agriculture (great reservoirs in the vicinity of the capital) and to other works of public utility (roads, inns, hospices). The second most important item was the raising of temples to accommodate the funerary cult of the royal ancestors and to display the deified images commemorating the deceased. It was only after he had fulfilled these social and familial obligations that the king could turn to the building of his pyramid, atop which was a cella to receive the image of the god-king and meant perhaps eventually to serve as the royal mausoleum. About ten such pyramid temples, built by as many kings, still exist: Bakong (881), Phnom Bakheng (end of 9th cent.), Baksei Chamkrong (beginning of 10th cent.), Koh Ker (921), the East Mebon (952), Prè Rup (961), Takeo and Phimeanakas (end of 10th, early 11th cent.), the Baphuon (third quarter of 11th cent.), Angkor Wat (first half of 12th cent.) and the Bayon (beginning of 13th cent.). In contrast to such permanent religious monuments, secular public buildings, royal palaces, and private houses were built of perishable materials and none survives.

PRE-ANGKORIAN ART. The oldest surviving examples of Khmer art appear to date from the 6th century, that is, from the last years of the Funan era. The art produced during the period that lasted from the Funan era until the end of the 8th century — known to history as the pre-Angkorian period — is quite distinct from Angkorian art, which developed about the beginning of the 9th century. This pre-Angkorian period comprises three different phases, named for the archaeological sites most characteristic of each: Funan, Sambor–Prei Kuk, and the phase of Prei Khmeng and Kompong Prah.

Funan (end of 6th, beginning of 7th cent.). It is not certain whether any of the monuments of southern Cambodia dates from the Funan era. However, it should be noted that for some time after the union of their country with Chenla at the beginning of the 7th century, the Funan kings continued to reign at Angkor Borei; therefore, a number of monuments and statues found in this region may well reflect the last phase of Funan art. Furthermore, according to a theory advanced by Parmentier, those edifices of the pre-Angkorian period with roofs comprising a large number of low stories of diminishing height and with niches reminiscent of the *kūḍu* of southern Indian architecture (see INDIAN ART) probably reproduce the characteristics of Funan architecture. Among the structures of this type is one of exceptional interest, the Asram Maharosei (see CAMBODIA), which belongs to the Angkor Borei group.

The statuary of Angkor Borei, which P. Dupont is inclined to attribute, if not directly to the Funan period, then at least to a school that was heir to its artistic traditions, includes both Hindu idols (see HINDUISM) and images of the Buddha (see BUDDHISM). Although some of these works already show a marked tendency toward the frontality that was to prevail in Khmer statuary, most of them remain faithful to the Indian canon of the triple flexion (*tribhanga*). The faces are flat, with elongated eyes and aquiline noses, and the hair is treated either in large flat curls or in long ringlets covering the nape of the neck. The only headdress represented is a cylindrical tiara; in general, jewelry is practically nonexistent. The statues of this period manifest the striving of the sculptor to realize statuary in the round through progressive liberation of the high-relief image or the engaged statue. Evidently, however, he was still not secure enough in his technique to disengage the statue completely, for it was provided with either a supporting frame or arm props, and sometimes even a stone wedge set between the ankles and terminating the front panel of its long garment.

The statues of the Funan phase, nearly all of which represent male figures, are of two different but not indisputably contemporaneous types. One class comprises figures dressed in a long garment similar to the Indian dhoti, with a sash round the waist; the other consists of figures of Vishnuite inspiration, of a homogeneous ethnic type (broad shoulders, narrow hips, and short legs), dressed in a short, pleated garment similar to the modern Cambodian *sampot*. The latter type — which includes the Vishnuite triad of Phnom Da, the Harihara of Asram Maharosei, and two images of Kṛṣṇa raising Mount Govardhana — would appear to date from the reign of Rudravarman (6th cent.), the last ruler of greater Funan before the incursions of Chenla.

Sambor–Prei Kuk (first half of 7th cent.). The three groups of edifices constituting the complex of Sambor–Prei Kuk correspond to the religious sector of the first capital of pre-Angkorian Cambodia, Iśānapura, built by King Iśānavarman in the first half of the 7th century. They comprise isolated or grouped (in a double quincunx in the northern group) brick towers of square plan, not unlike the ancient Cham towers, with a superstructure composed of a few stories of diminishing height that repeat the principal features of the main structure. The doorways have stone frames. Originally, the exterior walls were faced with decorated plaster, which has mostly flaked off and crumbled.

The decoration of the architrave was inspired by that of a wooden arch, adorned with garlands and pendants, whose jambs emerge from the jaws of affronted *makara*s supported on consoles. The arch is further ornamented with three medallions in high relief, the central one representing a divinity; below are garlands and pendants separated by small leaves. Infrequently, these foliate motifs adorning the space beneath the arch are replaced by figural scenes. The restrained decoration of the colonnettes consists of a ring with medallions around the middle, a frieze of pendent garlands around the top, and a row of leaves around the base.

Little is known of the decoration of the brick pediments, since it was executed in a layer of plaster which has not survived. From the little that remains of the tympanum decoration, it may be assumed that it consisted of a small-scale representation of an edifice. The frame of the pediment was generally in the form of an inverted U, while that of the small replicas of pediments on the upper stories was inspired

by the horseshoe frame, or *kūḍu*, of ancient Indian temples. The decoration of the blind doors, which were fashioned in brick and faced with a layer of plaster, constituted a detailed reproduction of a wooden door and its leaves. Although the pilaster decoration has almost all disappeared, the "flying palaces" represented in the interpilasters furnish some clue to the aspect of Khmer architecture in light materials.

The meager statuary of this period consists mainly of small, slightly inflected female figures, capped with cylindrical tiaras and dressed in skirts with the folds indicated merely by incisions rather than relief. With the male figures, the majority of which are framed in a supporting arch, the inflection steadily decreases as the tendency toward frontality becomes more pronounced. The most representative of the works in this style are a Harihara from Sambor-Prei Kuk, a Viṣṇu from Toul Dai Buon, and a magnificent Lokeśvara found at Rachgia, in the delta of the Mekong. Sculpture in low relief is represented at Sambor by scenes carved on the lower part of some of the architraves and in the large circular medallions adorning the interpilasters in the enclosing wall of the southern group. The Indian influence manifest throughout probably dates from the first half of the 7th century.

Prei Khmeng and Kompong Prah (second half of 7th, and 8th cent.). To this period, besides the two temples for which it is named, belong the early parts of various monuments of the Roluos group (Svay Pream, Trapeang Phong) and of the Ak Yom pyramid, as well as Prasat Andet, which yielded one of the masterpieces of pre-Angkorian Khmer statuary, and the Phum Prasat, restored in 1928. The architecture of this period shows little change from that of the Sambor-Prei Kuk group. The only new development would seem to be the appearance of the pyramid at Ak Yom — provided, of course, that this pyramid is contemporary with the oldest parts of the monument.

The architraves are characterized by a profusion of foliate motifs that seems to cover their entire surface. The arch has become a heavy foliated scroll whose outward-coiling ends have replaced the *makara* of the preceding style; foliate motifs have also replaced the garlands and pendants. The decoration of colonnettes has become more elaborate: the leaves in the frieze of garlands round the top of the colonnette tend to supplant the garland itself, and clusters of blossoms embellish shafts, forming a series of rings. The pediments, blind doorways, and pilasters continue the Sambor decorative tradition, but representations of isolated figures on the walls perhaps reveal the Javanese influence that was to become pronounced in the following century (see INDONESIA; INDONESIAN CULTURES).

The statuary is somewhat uneven in quality; along with mediocre works that show no sense of either proportion or anatomy, the period produced a late masterpiece in the Harihara of Prasat Andet (PL. 365), in which both the modeling and the sense of anatomy are of exceptional quality. As was the case in the preceding period, inflection at the hips tends to be eliminated in favor of a more rigidly frontal pose. The headdress is still the cylindrical tiara, which curves over the temples and covers the nape of the neck to the apex of the spine. The short garment, draped in concentric folds and gathered into a bunch of supple pleats in front, foreshadows that of the following period. A small mustache appears over the upper lip for the first time and was long to remain one of the principal characteristics of the male faces. The scenes carved in low relief on a few of the architraves show little of the animation of the representations on the architraves of Sambor-Prei Kuk.

STYLES OF ANGKORIAN ART, FIRST PHASE. The Angkorian period, which opened at the beginning of the 9th century, lasted for five centuries; artistically, it falls into two phases. The art of the first phase, which came to an end early in the 11th century, is in turn divided into six different styles, linked by transitional styles: Kulên, Prah Kô, Bakheng, Koh Ker, Banteay Srei, and the style of the Kleangs.

Kulên (first half of 9th cent.). To this style belong not only the monuments of Phnom Kulên but also the main sanc-

tuary of the central group at Sambor-Prei Kuk. As might have been expected, in view of the historical circumstances, this period was characterized by an artistic renascence, whose origins can be traced to the unmistakable influence of both Javanese and Cham art, even — though to a lesser degree — to that of the earliest forms of pre-Angkorian art. The pyramid of Rong Chen on the Kulên, an edifice of small height, undoubtedly dates from the reign of Jayavarman II.

Whereas the architecture of the tower sanctuaries differs but little from that of the preceding centuries, their decoration shows numerous innovations; and symmetrical grouping, hitherto an exceptional device, became the rule from this period.

The decoration of the architraves is greatly varied. The early arch reappears beside the foliate scroll of the Prei Khmeng and Kompong Prah style, its jambs sometimes springing from the jaws of affronted *makara*s, as at Sambor-Prei Kuk, and sometimes terminating in *makara* heads facing outward, as in Java. The medallions also reappear but are of a rather different aspect, and pendent leaves adorn the space beneath the arch. The colonnettes have assumed an entirely new form; their profiles, instead of being circular, are now octagonal or rectangular, and their shafts are expanded at summit and base. The moldings are evenly distributed along the shaft and, following a pattern that was to be observed until the 12th century, steadily decrease in size with their distance from the center. Each facet of the octagonal colonnettes is adorned at intervals with leaves represented in front view. The pediments of certain monuments are of a polylobed form. Many of the tympanums are in ruins; among those whose decoration can still be discerned, some were adorned with a solitary figure or a figure flanked by attendants, as at Champa, and others with representations of edifices, as in the pre-Angkorian period. The decoration of the blind doors and pilasters of the Kulên has worn away.

No female statues of the Kulên period are known. The modeling of the oldest images, such as the Viṣṇu of Rup Arak, remains fairly close to that of the Harihara of Prasat Andet, and the figures show a slight tendency toward plumpness. However, inflection at the hips is less and less noticeable, and the images have a hieratic attitude. The garment, sometimes turned down over a low belt at the top, is characterized by a sort of pocket on the right thigh and a mass of folds falling over the legs in front. The headdress is still the cylindrical tiara, but there also appear the first examples of the diadem that was to become the fashion in the ensuing periods; this is surmounted by a rather low, tiered miter of conical form and is still a very simple headpiece. The supporting arch, already greatly reduced during the preceding period, was definitively abandoned at the beginning of the Kulên period. The first images of crouching lions with huge heads and curled manes date from this period.

Prah Kô (last quarter of 9th cent.). A transitional period, represented by the central sanctuary of Trapeang Phong and two of the edifices of Prasat Kok Po (second half of 9th cent.), heralded the opening of the second period, which witnessed the building of the temples of the Roluos group: Prah Kô (ca. 879), Bakong (881), and Lolei (893).

The architecture of the brick towers presents no striking innovations in relation to that of the earlier towers. The six towers of Prah Kô and the four towers of Lolei are grouped on a terrace. The eight towers of Bakong rise at the foot of the first pyramid the Khmers built of stone. With its highly distinctive features, the decoration of these towers ranks among the most beautiful creations of Khmer art.

The architrave assumed in this period that aspect which, apart from changes of detail, it was to retain until the end of the Khmer period. The arch is represented as a horizontal, foliated scroll, rectilinear or undulating; its jambs are sometimes adorned with divergent *makara* or naga heads, sometimes simply with a plant motif, and beneath it hang large leaves twisted in the form of crosiers and interspersed with pendants. In the Prah Kô style, the central motif of the architrave, representing the head of the monster Kāla, a Garuḍa, or Indra, is set high (cf. VII, FIG. 924). The rectangular colonnette of the

Kulên period does not persist in the Prah Kô style, in which, apart from an infrequent round colonnette, an extremely ornate octagonal colonnette predominates. The splay toward the summit and base is eliminated, together with the rings of molding, but pendants appear among the frontal leaves that decorate each facet.

Although most of the pediment frames are poorly preserved, it has been possible to establish that they were denticulated and that their edges were adorned with makara or naga heads. The tympanums were adorned with deities accompanied by worshipers, and these were framed within replicas of edifices which became more and more simplified. Stone slabs set into the walls flank the real and blind doorways and are carved with large figures. The pilasters are adorned with a variety of motifs, such as rinceaux, chevrons, foliate stalks, and lozenges, summarily executed in the brick and then detailed in a plaster facing. The plaster decoration still intact on the blind doors evidences a progressive increase in the number of moldings framing their leaves; this results in diminution of the central panel, which is adorned with a high-relief mascaron representing a lion's head.

The statuary, from which all props and supporting frames have been discarded, has assumed a hieratic severity. It is "standardized, almost codified, [and] already contains the seeds of all the formulas that were to be exploited for over three centuries" (J. Boisselier). The male figures, softly modeled without indication of musculature, continue to manifest a slight inflection at the hips and tend to be somewhat thickset. Treatment of the facial features is transitional between the preceding period and those to come: to the mustache is added a schematically indicated beard, and the eyebrows are joined in a slightly sinuous line that foreshadows the schematic horizontal ridge of the following century. A pleated garment is characteristic, and the top part of both the male garment and the female skirt is turned down over a belt to form a semicircular flap. The cylindrical tiara is replaced by a jeweled diadem, supporting either a narrow topknot or a tiered, conical miter (mukuṭa). The throat, torso, and arms are bedecked with jewelry.

New forms enriched the repertory of animal sculpture. In addition to the sedent lions with curled manes, there appeared some quite realistic crouching bulls and also some polycephalous nagas, displaying a tiny diadem on each head; the last-mentioned are represented slithering along the ground and form a balustrade on either side of the causeways.

Bakheng (end of 9th, beginning of 10th cent.). The Bakheng period, which marked the definitive establishment of the Khmer rulers at Yaśodharapura, on the site of Angkor, saw the development of stone construction. The three most important monuments of this period are the pyramid of Phnom Bakheng (PL. 368), located in the center of the capital; Phnom Krom, to the south; and Phnom Bok, to the east. All three structures are set atop natural eminences.

The Phnom Bakheng constitutes the first realization of the characteristic plan of the monumental edifices of Angkorian art: a stepped pyramid, with five towers disposed in quincunx on its uppermost terrace. The disposition of additional towers, as well as annexes and galleries, around this central structure varies from one monument to the next. The Bakheng pyramid has twelve turrents on each of its five terraces, and forty-four brick towers round its base.

The three massive stone towers of both Phnom Bok and Phnom Krom, oriented to the east and dedicated to the three gods of the Brahmanic Trimūrti, are aligned along a north–south axis on a single base. The plan of these stone towers is the same as that of the brick towers; they are composed of a base, a main structure, with real and blind doorways, and a tiered superstructure whose diminishing stories and setbacks repeat the form of the main structure.

The architraves are not so richly decorated as were those of the Prah Kô period. The foliated scroll dips in the middle, as if folding under the weight of the central motif (a *kāla* head or some other mythological subject), which has become more prominent. The octagonal colonnette continues the devel-

opment of the preceding styles, and each facet of its shaft is adorned with frontal leaves flanked by two half leaves. The frames of the pediments, carved in stone, are of two different types: one is rather low and denticulated, the other higher and undulating. Both terminate in divergent *makara* heads, whose raised snouts hold pendants. The tympanums, though still adorned with a deity accompanied by lesser figures, begin to show the foliate motifs that were to become increasingly profuse in the subsequent styles. The leaves of the blind doors are no longer adorned with the protruding mascaron of the preceding period.

The statuary of the Bakheng period is the most hieratic of all Khmer sculpture. The human anatomy is completely stylized: there is no longer any trace of inflection at the hips; the faces are severe; the joined eyebrows form a sharp horizontal ridge across the forehead; the hair comes to a point at the temples; and the beard is indicated by a triangle pointing upward on the chin. Both the male and the female garments have narrow and uniform vertical pleats, and they are turned down over a low belt at the top. The headdress is a diadem, which sometimes supports a tiered, conical *mukuṭa* and sometimes a chignon either of horizontal tresses or of pendent ringlets. The sedent lions of the period are fairly naturalistic in proportion, but their manes gradually become stylized.

Koh Ker (second quarter of 10th cent.). After the transitional period represented by the Prasat Kravan (921), which is noted for the relief carvings adorning the interior, and by the small, laterite pyramid of Baksei Chamkrong (900–922), surmounted by a single sanctuary, the transfer of the capital to Chok Gargyar (Koh Ker) in 921 by Jayavarman IV inaugurated a new style characterized by a striving for grandeur, and even for the colossal, in both architecture and sculpture. The architecture, in general, differs only in size from that of the preceding periods. The long, narrow halls roofed with light materials, which formerly extended along the enclosure walls, began to acquire the dimensions of veritable galleries. Their roofs were supported on solid or fenestrated walls, and sometimes even by ranges of pillars.

The decoration of the architraves in the Koh Ker style presents two innovations: first, the very prominent central motif sometimes represents mythological scenes or legends; second, the console, which had served as a sort of capital for colonnettes, disappears. The decoration of the colonnettes remains unchanged otherwise, except for the moldings around the shaft, which are enlarged at the expense of the plain surfaces. Whereas the frame of the pediments — in most cases in ruins — seems to have remained more or less unchanged also, a new type of triangular pediment appears, copied from wooden architecture. The tympanums are increasingly ornamented by foliate motifs.

In addition to works imbued with the rigid hierarchism typical of Angkorian art, the statuary, which is of monumental proportions in keeping with the architecture of the period, includes single figures and groups of images that manifest a powerful dynamic quality and a sense of movement quite unusual in Khmer art: the dancing Śiva, a striding Garuḍa, wrestlers, and fighting monkeys. The faces are less severe than those of the preceding period, and sometimes the expressions are almost smiling; the nose is slightly aquiline, the line of the eyebrows less severe. The figures display the pleated garment of the Bakheng style, but their diadems are richer and their jewelry more lavish. The most striking feature of the animal sculpture is the two-horned diadem adorning the naga heads.

Banteay Srei (second half of 10th cent.). The first ten years of this period witnessed the return of the capital from Koh Ker to Angkor and the building of the temples of East Mebon (952) and Prè Rup (961), under Rājendravarman, and constituted a transitional phase, marked by an endeavor to renew the traditions of the reigns of Yaśovarman and his sons (Bakheng period). A new style, characterized at once by the pursuit of archaism and a search for new formulas, was inaugurated with the building of Banteay Srei (967) and, shortly thereafter, of Prasat Sralau and the monument behind Prasat Kleang North.

The decoration of the architraves, though largely modeled after that of the Prah Kô period, presents a new motif in the form of the floret emerging from a calyx cup. With their notably simple decoration, the colonnettes of Banteay Srei might be said to interrupt the over-all development, a steady tendency toward increasing richness. The moldings, each of which took up an eighth of the shaft height, have been discarded, and the space they occupied has been left blank; the archaic strain is manifest in the reappearance of some round colonnettes. None of the pediments of the transitional period represented by the East Mebon and Prè Rup has survived. Those of Banteay Srei, however, are extremely varied: the edges of the frame terminate in profile *kāla* heads, spewing forth the heads of polycephalous nagas dangling pendants. An important innovation in the decoration of the tympanums (PL. 377) is the introduction, among the foliate motifs, of mythological scenes, which in some cases occupy the entire surface. The exterior wall decoration displays an extravagance more akin to metal engraving than to stone carving. The arches framing the figures flanking the real and blind doorways terminate in naga heads, some of them highly stylized.

The prevailing trend of development can be perceived more readily in the statuary, which continues the tradition of Koh Ker, but in images that are less original than those of Koh Ker reveals a degree of archaism. The figures are smaller, the faces softer, and the eyebrows slightly sinuous. The garments are of two types: one similar to the pleated garment of the preceding periods, the other a reversion to the earlier smooth garment. The diadem is the same as that of the preceding style, but in some cases it is omitted in favor of a tall hairdo alone. The animal sculpture was also enriched with new forms. The major innovation of the Banteay Srei style is the relief carving adorning the tympanums, spacious and singularly harmonious in composition; the figures are disposed with a remarkable sense of balance, and their surroundings are suggested with a few simple details.

The Kleangs (very late 10th, early 11th cent.). The most important monuments of this style, which completes the first phase of Angkorian art, are the pyramid of Takeo (PL. 368), Prasat Kleang North, Phimeanakas, the gopuras (monumental gateways) of the royal palace, and Prasat Kleang South. From an architectural viewpoint, this period is characterized by disappearance of the brick towers, at least from the more important architectural complexes, and the development of the pyramidal structure surmounted by a group of stone sanctuaries with surrounding galleries. The Phimeanakas gallery, the first to be vaulted with sandstone, is very narrow.

The decoration of the architraves, which lacks originality and is somewhat monotonous, retains the *kāla* head as central motif on the strongly dipping scroll. The colonnettes, which initially are as soberly decorated as those of Banteay Srei, gradually become encumbered with moldings, and the small leaves adorning their shafts become stylized to the point of assuming the aspect of sawtooth ornament. The pediment frames maintain the line introduced at Banteay Srei, while the tympanums are adorned with the plant motifs of the styles prior to Banteay Srei.

The sparse statuary remaining from this period, some of which seems to constitute a sort of compromise between the Bakheng style and that of Banteay Srei, is hieratic in its general aspect, though the faces usually have a rather gentle expression. The long, pleated skirt worn by the female figures is characterized by a sort of fishtail drape just above the ankles. In comparison with the animal sculpture of the Prah Kô style, that of the Kleangs is less realistic and somewhat coarse.

STYLES OF ANGKORIAN ART, SECOND PHASE. The reign of Sūryavarman I lasted through the first half of the 11th century and opened the second major period of Angkorian history, which was marked by westward expansion of Cambodian power and by development of the cult of deified royalty that, after Saiva beginnings in the 11th century, became Vishnuite in the first half of the 12th century and, finally, Buddhist at the end

of the 12th. However, in the history of Khmer art the reign of Sūryavarman I, to whom is attributed the completion of Takeo and the building of the gopuras of the royal palace, both of which continue the style of the Kleangs, represents a period of transition from the latter to the Baphuon style, which flourished in the second half of the 11th century and was followed by the styles of Angkor Wat and the Bayon. The new edifices attributable to Sūryavarman I — namely, Phnom Chisor, Chau Srei Vibol, and Prah Vihar — present no changes worthy of note.

In architecture, some hesitation is still noticeable in the construction of stone vaulting. As already noted, the surrounding gallery of Phimeanakas, the first such gallery to be vaulted in stone, is very narrow. The gopuras of the royal palace are built of a combination of brick and stone. At Prah Vihar the arched section of some vaults is of brick, supported on stone foundations, while others there are built entirely of stone and remain very narrow.

The decoration of the architraves, colonnettes, pilasters, and blind doorways contains virtually nothing new. Only the frame of the pediments reflects a degree of evolution, a trend that had in fact begun during the preceding period: the *kāla* heads have been permanently abandoned, and the polylobed arch, which now terminates directly in naga heads on either side, seems to comprise the body of the serpent.

The statuary merely continues the style of the Kleang period, the only innovation worthy of note being that the nagas forming balustrades are mounted on low walls; these foreshadow the dadoes of the 12th century.

The Baphuon (second half of 11th cent.). The monuments most characteristic of this style are the great pyramid temple of the Baphuon itself (PL. 369), with its gopuras, the temple raised in the center of the West Baray (a vast artificial lake), and Prasat Khna Sen Keo. From an architectural viewpoint, the Baphuon is noted for the vaulted stone galleries that surrounded three of its five terraces, interrupted on all four sides by towered gopuras. The top gallery, now in ruins, is the earliest example of an attempt to support stone vaulting on rows of pillars; but the summit of this vault rests on a median wall, so that the gallery is divided into two half galleries, the one opening toward the exterior, the other toward the interior.

Although the decoration of most architraves still consists of foliate motifs, and a foliated scroll that dips strongly in the middle, a few begin to present scenes with figures. The disposition of the moldings about the shafts of the colonnettes continues to follow the traditional order, but the decoration of the crown has been reduced to little more than an accumulation of superimposed projections. The smooth, rounded frame of the pediments seems to echo the undulating body of the two nagas whose heads adorn its ends. Where the architrave below is adorned with a scene, the tympanum decoration consists merely of foliate motifs. The pilasters, with the long notches typical of this period, have a rather original arrangement of rinceaux divided by small leaves.

Whereas the early Baphuon statuary differs little from that of the Kleang period, the later works are characterized by an elongation not altogether free of mannerism. The faces, with small noses, fleshy lips, and dimpled chins, have a gentle expression; the eyes are represented summarily by incisions or blank cavities, and the beard and mustache by bracket-shaped lines. The garment appearing most frequently is high in the back and fairly similar to a type that appeared in the Kleang period; however, a few figures display a garment that may be copied from a type of the Banteay Srei period. Low-relief sculpture figures abundantly in the Baphuon style. Apart from the above-mentioned scenes, those adorning some of the architraves, there should be noted the small carved panels, square and rectangular, which are superimposed from floor to ceiling on both sides of the walls flanking the entrance to the galleries and which represent episodes from mythology and the Indian epics. Each panel contains a small number of figures grouped on a single plane, and scenery is reduced to the bare minimum required for identification of the episode presented. The in-

tervening wall space is filled with representations of birds. Indeed, images of animals of all sorts abound throughout this monument and constitute one of the characteristic features of the Baphuon style. Prasat Khna Sen Keo is also adorned with figural scenes, which correspond closely to those in the Baphuon.

Angkor Wat (first half of 12th cent.). This period, generally regarded as the golden age of Khmer art, encompasses the building of a series of great monuments, beginning with Beng Mealea, Prah Palilay (a sanctuary recently reconstructed by anastylosis), which rises on the summit of the Bakong pyramid, and Phimai (Siam), all of which probably date from the first quarter of the 12th century; these were followed by Prah Pithu, Chausay Tevoda, Thommanon, the central sanctuary of Prah Khan (province of Kompong Thom), Angkor Wat, Athvea, and Banteay Samrè, all built — or at any rate completed — at a later date. Above all, this period is celebrated for its architectural realizations. Because of the skill of a brilliant architect, or of a school of gifted architects, the conception and execution of the building plans attained a degree of perfection never equaled before nor since in Khmer art.

Beng Mealea, a vast complex of buildings that rise from the same ground level, comprises a massive central sanctuary with porticoes, surrounded by a series of wide concentric galleries; on the east side, where the principal entrance is located, the galleries are connected by a system of cruciform arcades. This plan foreshadows that of Angkor Wat (PL. 369), which is oriented toward the west. The triumph of the latter monument lies in the fact that, viewed from the outside, it gives the impression of being a solid pyramid capped with five towers in quincunx, a structure differing only in size from the preceding pyramid temples, whereas it is in fact provided with the same concentric galleries as Beng Mealea; but the galleries of Angkor Wat, increasing progressively in height, rise one above the other like the tiers of a pyramid. The system of cruciform arcades connecting the outer to the median gallery at Beng Mealea, where both are on the same level, reappears on the west side of Angkor Wat. Here, however, in order to solve the problem of connecting galleries on different levels, the architect devised a system of telescopic or superimposed galleries, which constitutes not only one of the most impressive architectural elements of the edifice but also a remarkable independent achievement. With the exception of the two small temples of Chausay Tevoda and Thommanon, where the combination of brick and stone is continued, for the obvious purpose of reducing the weight of the vault, all the galleries of the Angkor Wat period are vaulted entirely in stone. At Beng Mealea, some of the vaults are supported on a wall and a row of pillars, others on two rows of pillars. Both these formulas reappear in a more elaborate form at Angkor Wat, where a second, outer row of pillars, parallel to the first, supports a half vault. The superstructure of the towers is raised, as customary, in a series of receding stories, but many denticulations, having projections adorned with antefixes, modify the recesses created by the passage from one story to the next.

Khmer art offers no more elaborate and involved decoration than that produced by the artists of the Angkor Wat period, who would appear to have been inspired with a veritable horror vacui. Whereas some of the architraves repeat the foliate decoration of those of the preceding period, with the addition of small human figures, others present a new type of decoration consisting merely of rinceaux, which all coil in the same direction on either side of a *kāla* head. The shafts of the profusely decorated colonnettes are divided into as many as ten bands, and some sixteen-sided colonnettes tend to look almost circular in profile. The highly ornate pediment frames are once more adorned with the heads of divergent monsters emitting nagas, while the tympanums display a mythological personage, often placed above several rows of subsidiary figures in attitudes of adoration. The figures adorning the walls may be executed without an enframing arch, as is the case with most of the numerous apsarases at Angkor Wat (PL. 376), but those arches which do appear terminate either in nagas or birds.

The statuary, often works of large scale, is reminiscent of that of the hieratic period. The square faces have contiguous eyebrows, small noses, and full lips. The male garment is shorter than in the preceding periods, and the female garment, known best from relief carvings, faithfully reproduces the appearance of a material embroidered or printed with flowers and has voluminous flounces, or floating panels, on either side. Jewelry becomes of primary importance, and the diadem curving over the temples affects the form of a crown. The apsarases of Angkor Wat display remarkable, excessively ornate jeweled tiaras with high peaks.

The bodies of the nagas forming balustrades are mounted on evenly spaced dadoes or on carved stone blocks, and their polycephalous hoods are framed with an aureole of flamelike motifs that encloses a small representation of a Garuda. The lions have highly stylized manes and are represented standing on all fours, while the bulls have barely perceptible humps and stand with one leg raised. Finally, it was this period which saw the development of the vast relief compositions adorning the walls of the galleries that open outward at Angkor Wat (PL. 370; III, PL. 300; VII, PL. 255). These compositions are executed in very low relief, at times suggesting a large panel painting rather than sculpture, and manifest the same horror vacui prevailing throughout this monument, so that practically no surface remains unadorned.

The Bayon (last quarter of 12th, beginning of 13th cent.). As was noted earlier, the art of the Bayon period, that is, the art produced during the reign of Jayavarman VII (1181–1219), was long subject to erroneous dating. After the great revision of the Khmer chronology, effected between 1927 and 1929, works of this style were attributed wholesale to the reign of Jayavarman VII; albeit certain scholars believed that the oldest monuments in the style might be of an earlier date — notably Gilberte de Coral-Rémusat, who considered the oldest parts of the temple of Ta Prohm as representative of a transition period, datable to the mid-12th century and extending from Angkor Wat to the Bayon. Through rigorous application of his analytic method, and with the help of information provided by the stele discovered at Prah Khan in 1939, Philippe Stern was able to fix quite precisely the date at which the style of the Bayon (PL. 372), whose earliest works do not antedate the reign of Jayavarman VII, underwent important modifications, apparently as a result of the elaboration of the concept of the monarch.

This style departs from those that preceded it in that it was exclusively of Buddhist inspiration and was influenced to a greater extent than any other by the character of the ruler. About 1190 this monarch, who during the first ten years of his reign had conformed, in all except matters of religious belief, to the traditions of his predecessors and had devoted himself, first, to carrying out works of public utility (hospices, roads, inns) and, then, to providing for the funerary cult of his parents (temples of Ta Prohm, dedicated to his mother, and Prah Khan, to his father), established a new concept of the cult of deified royalty adapted to the Mahayana Buddhism he professed and, at the same time, promoted the cult of the Bodhisattva Lokeśvara. This innovation determined the markedly original change in aspect of the towers, which were now ornamented on all four sides with huge smiling faces, unanimously recognized as representations of the royal visage in the aspect of the Bodhisattva (PL. 373). Such towers, connected by galleries, were added to existing monuments and incorporated into those in process of construction as well. At the same time, enormous enclosures were built to delimit the sacred precincts, and surrounding galleries opening inward were added, thereby placing the innermost gallery and the central sanctuaries within a sort of cloister. The structures thus became complicated and cluttered, and this building frenzy, these repeated modifications in the course of construction, allied to a growing scarcity of fine sandstone in the quarries of Phnom Kulên, resulted in hasty and careless construction, arbitrary combination of laterite with sandstone, and often shoddy or unfinished decoration.

A curious result of the premium on speed of construction in this period was the development, shortly before the appearance of the towers with faces, of a new formula for representation of the blind windows with balusters — which, in fact, provided Stern with a major clue to distribution of the monuments of the Bayon style over several successive phases. In the oldest parts of both Ta Prohm (1186) and Prah Khan (1191), the balusters of the blind windows are represented in their entirety; in the later parts of Prah Khan, however, the top two-thirds of the balusters are seemingly hidden behind a lowered blind, suggested by leaving the stone uncarved. Since this time-saving device was not applied at Ta Prohm, it must have been adopted after the completion of this monument but before the building of Prah Khan, and also therefore before the introduction of the towers with faces, which are absent at Prah Khan.

Thus, in the Bayon style there can be distinguished three successive phases — or, more specifically, two early phases and a late phase. To the first of the early phases, prior to 1190, belong the old parts of Banteay Kedei, Ta Prohm, the Prah Khan at Angkor and its annexes (Neak Pean; PL. 374), and the enclosure added to the Prah Khan at Kompong Thom, which was copied from that of the Angkor Prah Khan. The style remains fairly close to that of the Angkor Wat period, and it was toward the end of this phase that the blind windows began to be represented as if with lowered shades. To the second of these early phases, characterized by the appearance of the towers with faces, the pediments framing large figures of Lokeśvara, and the consistent application of the time-saving formula for representation of blind windows, belong the enclosures of Banteay Kedei and Ta Prohm, the gallery passages added to these same temples, the modification of Neak Pean at the Angkor Prah Khan, the Prah Thkol, located near the Prah Khan at Kompong Thom, Wat Nokor at Kompong Cham, Ta Prohm at Bati, the early part of Banteay Chmar, and the city walls of Angkor Thom.

The third phase, which probably dates from the beginning of the 13th century, encompassed the completion of Banteay Chmar, the building of the Bayon (which also underwent numerous alterations in the course of construction, such as the side passages added between the outer and inner galleries, access ways subsequently demolished), and the building of the Terrace of the Elephants and the Terrace of the Leper King, to the east of the royal palace of Angkor Thom.

The decoration of the Bayon period presents no new elements worthy of mention and is generally executed in perfunctory fashion, with the notable exception of that of the central tower of the Bayon, which despite its late date appears to have received particular care from the royal sculptors. In the early Bayon style, the central branch on the architrave is invariably segmented and appears to describe a series of ascending and descending curves; later, the branch is replaced by foliate spirals, alternately opposed and adorned with large pointed leaves. The decoration of tiny sawtooth leaves disappears from the colonnettes, and only heavy torus moldings, disposed without regard for the canons so strictly observed in the past, remain on the shafts. Both the tympanum, with its central figure and rows of subsidiary adorant figures, and the pediment frame continue the traits of the Angkor Wat period. The figures adorning the walls were at first surmounted by an arch terminating in naga heads or birds; later, however, this member was resolved into a series of rinceaux. The surviving decoration of the pilasters is in general rather inferior.

The statuary of this period, in consequence of the importance assumed by the cult of deified persons during the reign of Jayavarman VII, understandably includes many images executed in series and is noted especially for its facial expression, for under the influence of Buddhism it changed radically from that of the preceding periods. Scholars have conjectured the influence of the Buddhist statuary of the Dvaravati kingdom in the characteristic expression, the half-closed eyes and vaguely smiling lips that seem to reflect an inner beatitude and a state of mystic meditation. As the Bayon period progressed, gradually the eyes closed entirely and the smile became more pronounced, so that a few of the later figures suggest efforts to realize recognizable portraits. Although these faces have a singular charm unknown to earlier Khmer art, and though the modeling of the bust occasionally manifests some degree of realism, the proportions of the lower limbs, are more ponderous than even those of the Angkor Wat statuary, and the scale of the feet borders on the monstrous. The male garment, which is very short and edged with a pearl motif, has an anchor-shaped fold in front; the female garment, like that of the Angkor Wat period, reproduces a material adorned with flowers, but instead of having flounces or floating panels at both sides, it now has only one in front. The Buddhist images have no distinctive type of headdress: the Buddha is represented with his traditional cranial protuberance (*uṣṇīṣa*) covered with small curls, and the Bodhisattva Lokeśvara displays a cylindrical chignon, adorned in front at its base with a small image of the seated Buddha. The female images of Prajñāpāramitā are also represented with a conical protuberance, almost identical to the *uṣṇīṣa*; but like the rest of the head, the projection is covered with small, flat tresses, and it is adorned in front with the same figurine as the bodhisattvas. The headdresses of the divinities adorning the wall areas flanking the entrances are much simpler than those of their counterparts at Angkor Wat. The only genuine innovation in animal sculpture is the representation of a Garuḍa straddling the heads of the nagas forming balustrades.

From a historical and iconographic point of view, the reliefs on the gallery walls of the Bayon and Banteay Chmar (PL. 371) are of far greater interest than those of Angkor Wat, but they are vastly inferior in artistic quality. This estimate is especially true of the carvings in the inner gallery of the Bayon, which must have been executed at a later date than the rest and could hardly be of poorer workmanship. On the other hand, the scenes carved on the Terrace of the Elephants (PL. 374) are comparatively realistic, and the figures disposed in registers on the walls of the Terrace of the Leper King, which approach high-relief sculpture, are outstanding in quality.

MAIN TRENDS IN THE DEVELOPMENT OF KHMER ART. It may prove of value to conclude this study of Khmer art with some attempt to define the general trends of its development in the several fields of architecture, decoration, and sculpture and to record the outside influences that affected this development.

From the 7th century, the as yet isolated towers began to be grouped on a single base, and from the 9th century such grouping became the rule. Although the most common disposition was that of three towers on one base, there are also groups of four (double rows of two towers each at Lolei) and of six (double rows of three towers each at Prah Kô). At Bakong, eight towers are symmetrically disposed around a pyramidal structure, from whose top story rises a tall sanctuary surrounded by twelve turrets.

In 881 the building, at Bakong, of the first great pyramid of stone (heralded by the cautious experiments in brick at Ak Yom and Rong Chen on the Kulên) constituted a major step in the development of the Khmer temples and was an innovation directly related to the cult of the god-king (*devarāja*), or the deified royalty. These pyramids are commonly known as "temple-mountains." This was the designation used by the Khmers themselves, because the edifices symbolized the cosmic mountain and were raised in the center of the royal city, which itself constituted a miniature reproduction of the universe. Between 881 and the beginning of the 13th century, the Khmer rulers built about ten such temple-mountains.

The pyramid of Phnom Bakheng (PL. 368) has twelve towers on each of its five stories and is crowned with five towers disposed in quincunx; the latter arrangement was to remain characteristic of the greatest monuments of Khmer architecture. The East Mebon (952), whose central group consists of a quincunx arrangement of sanctuaries surrounded by eight other towers, is provided with long halls on the first story of its pyramid. The inner enclosure at Prè Rup (961), a three-storied pyramid, with the twelve turrets of its first story surrounding a quincunx of towers on its summit, is flanked by separate corridors that were roofed with perishable materials. Takeo

(PL. 368), another five-storied pyramid also surmounted by a quincunx of sanctuaries, has a brick-roofed surrounding gallery on its second story and two other corridors, also roofed in brick, extending from either side of the eastern gopura on its first story. The narrow surrounding gallery on the summit of the three-storied pyramid of the Phimeanakas was the first to be vaulted with sandstone. Continuous and concentric stone-vaulted galleries surround the first, third, and fifth stories of the five-storied Baphuon (PL. 369), and three concentric galleries enclose the central sanctuaries at Beng Mealea and Angkor Wat. Both of the latter temples are provided, on the principal flank, with a system of cruciform cloisters connecting the outer and median galleries.

Thus, it is evident that the elements properly termed "surrounding galleries" did not appear until about the end of the 10th or the beginning of the 11th century. Undoubtedly because of the inexperience and caution of the builder, the first gallery vaulted with sandstone was very narrow, but subsequent ones became steadily wider. A gallery supported on rows of pillars appeared about the middle of the 11th century, and the 12th century developed a gallery supported on one side by a row of pillars and on the other by a blank wall. This disposition encouraged the adornment of the wall, illuminated by the light entering between the pillars, with vast compositions in low relief (Angkor Wat, the Bayon, Banteay Chmar; PLS. 370, 371, 375). The various types of edifices briefly described include, in addition to the characteristic elements already mentioned, one or more concentric enclosures interrupted — sometimes on all four sides, sometimes only in front — by gopuras, as well as annexes (minor sanctuaries, libraries, storerooms) variously disposed among the several enclosures.

Despite their almost certain lack of surveying instruments and their rudimentary technical methods, the Khmers were able to realize with great accuracy plans that were often very complex. It seems likely that the builders worked from a model, all dimensions of which were multiplied by the same coefficient. Since the Khmers did not have scaffolding adequate to raise heavy blocks of stone to great heights, it is probable that they used the inclined plane, a technical device which, like the use of models, was also employed in Siam before the adoption of European methods.

As to the time required for construction of the monuments, the known dates and the changes of style from one reign to the next would seem to indicate that it was much shorter than might be supposed on the basis of techniques and scale. It has been roughly calculated that a brick tower about 40 ft. high and 16 ft. on a side at the base could probably have been built in a month, and that a maximum of thirty years must have sufficed to erect the vast complex of Angkor Wat, which is the work of a single interval and shows no sign of any change of style in the course of construction. It must be added that the monuments were raised entirely of rough-hewn blocks, for no carving had been done before their placement. Although the masons and sculptors worked independently of each other, they were able to proceed simultaneously soon after the building was begun, since the sculptors began decoration of the lower courses of the edifice as soon as they were in place.

Generally speaking, the decoration, which developed in the 7th century from formulas very close to Indian models, gradually departed from these sources and yet retained the essential elements of the Indian tradition, into which it incorporated new plant, animal, and other motifs treated in a distinctive manner. For example, throughout the history of Khmer art, except in the last phase of the Bayon style, the central motif of the architrave decoration remained an arc, which probably symbolized the rainbow as the link between the world of men and the world of the gods, for like the rainbow this member constituted a link between the profane outside world and the sacred precincts of the temple. This arc might subsequently assume the form of a foliated branch, might curve unbroken or be segmented, and might even change in decorative motif; but the basic scheme, of Indian origin, always remained the same — though the inventive genius of the Khmer sculptors often transformed it beyond recognition.

The underlying tendency in the evolution of the colonnette was toward an increase in the number and size of the horizontal moldings about its shaft; these bands gradually encroached upon the bare surface areas and reduced the rows of small leaves bordering them to minor sawtooth ornament. Nevertheless, through all these transformations the colonnette remained what it had been originally, namely, a translation into stone of the Indian wooden column, as is represented in a fresco at Ajanta (q.v.). The pediment, initially in the form of an inverted U like its Indian counterpart, evolved finally into a polylobed arch. The ends of these members were first adorned with makara heads and then with kāla heads each spewing forth a naga. The latter motif, with wide variation, remained the essential element of the frame. The tympanum decoration, at first a representation of a miniature edifice and then of a divinity framed within such a structure, eventually became schematic and dissolved into foliate motifs, which persisted on some tympanums even after the introduction of figural scenes.

Stylistic analysis of the statuary reveals certain general trends in its development. During the period lasting from the end of the 6th to the end of the 9th century, familiarly known as the "period of youth and vitality," the Indian sculptural canon was gradually abandoned, though a vestige of the Indian tribhaṅga subsisted in the slight inflection at the hips. At the same time, the sculptors overcame their early uncertainty and progressively eliminated the framing arch and the other props they had relied upon to bolster the limbs of their statues. The modeling of the anatomy evidences some striving for naturalism; the garments are smooth and cling to the body contours, and the male figures are crowned with tall cylindrical tiaras.

With the onset of the 10th century, there began a period in which the sculptors sought to impart to their images an aura of hieratic majesty. The inflection at the hips disappeared, and there was no longer any attempt at realistic modeling of the anatomy. The massive forms achieve an effect of vigor and power, and the features are set in a severe expression. These figures are clothed with a pleated garment and display a jeweled miter. The ensuing period, a somewhat archaizing phase, lasted from the end of the 10th through the 11th century and was characterized by a degree of relaxation in the whole figure, as well as a softening of the facial expression. Finally, after the return to a hieratic style in the first half of the 12th century, the second half of this same century brought an entirely new type of statuary, in which only the face, with its half-closed eyes and smiling features expressing Buddhist gentleness and mysticism, seemed to merit artistic attention.

Relief sculpture, used in architectural decoration for the architraves and tympanums, calls for separate treatment. During the pre-Angkorian period, compositions in low relief were incorporated in the architraves over the entrances to the sanctuaries and in the medallions adorning the exterior walls. At the beginning of the Angkorian period, this decoration came to include human figures, which were represented under the arcature flanking the doorways, as well as on the tympanums and the interior walls of the cellas. Episodes with figures appeared for the first time in the tympanums at Banteay Srei (PL. 377); in the Baphuon, mythological and epic scenes represented in small panels covered the gopura walls both inside and out. Finally, at Angkor Wat, the Bayon, and Banteay Chmar, the galleries half-supported by pillars have their walls adorned with linear mythological, epic, or historical scenes, extending uninterruptedly along the entire length of the panel. The purely decorative ornament abounding throughout these edifices was of a consistent richness that in many cases resembled metal engraving rather than stone carving in effect.

External influences affecting Khmer art in the course of its evolution have already been stressed in the description of the styles of the successive periods. Indian influence dominated the initial stages and left its mark on the 7th-century complex of Sambor–Prei Kuk. Circumstances of history determined the influence that both Champa and Java exerted on Khmer artistic development in the 9th century; and the advent of Buddhism, which became the official religion at the end of the 12th century, caused Khmer sculpture to be influenced by that

of the old Buddhist kingdom of Dvāravatī. Besides these outside influences affecting its development there was the marked tendency of Khmer art to archaize, a tendency repeatedly manifest in the revival of certain motifs of its artistic past. Thus, the Kulên style borrowed from that of Sambor–Prei Kuk, the style of Banteay Srei revived motifs of Prah Kô, and the artists of the Angkor Wat period did not disdain to turn for inspiration to the styles of Banteay Srei and the Kleangs.

MINOR ARTS. Of the surviving examples of the minor arts of ancient Cambodia, only the bronzework and ceramics are numerous enough to encourage any judgment of artistic value. Most of the ancient bronzes presently known are statuettes of divinities, probably from private houses and also from temples, where they served as *utsavamūrti* (ceremonial images) and were carried in processions in lieu of the great stone idols (obviously far too heavy to be moved), whose aspect these small bronze images faithfully reproduced. The remaining bronzework consists of an assortment of ritual objects, such as bells, the vajra (thunderbolt), and vessels for lustral water, domestic utensils, and fragments of furniture, whose chief interest perhaps lies in the fact that they are the models for the utensils represented in the relief carvings.

The ceramic ware, sober and almost classical in form, was coated with a brown or blackish slip and adorned simply with a few incisions in the paste. In contrast to the austerity of the ceramics, the gold and silver objects — to judge from the rare surviving examples — were of a decorative richness approaching that of the ornamental stone carvings. The proficiency the Cambodians continue to display in reproducing, in precious metals, the motifs carved on their ancient stone monuments proves to how great an extent this decorative art is an inherent expression of their artistic genius.

BIBLIOG. G. Cœdès, Bronzes Khmèrs (Ars Asiatica, V), Paris, Brussels, 1923; G. Groslier, Les collections khmères du Musée Albert Sarraut à Phnom Penh (Ars Asiatica, XVI), Paris, Brussels, 1927; H. Parmentier, L'art khmèr primitif, Paris, 1927; P. Stern, Le Bayon d'Angkor Thom et l'évolution de l'art khmèr, Paris, 1927; Catalogue des collections indochinoises du Musée Guimet, B. de la Commission archéologique de l'Indochine, 1931–34; H. Parmentier, L'art khmèr classique, Paris, 1939; G. de Coral-Rémusat, L'art khmèr, Paris, 1940; G. Cœdès, Pour mieux comprendre Angkor, 2d ed., Paris, 1947; J. Boisselier, La statuaire khmère et son évolution, Saigon, 1955; B. P. Groslier, Angkor, hommes et pierres, Paris, 1956 (Eng. trans., The Arts and Civilization of Angkor, New York, 1957); P. Dupont, L'archéologie Môn de Dvāravatī, Paris, 1959; G. Cœdès, Le portrait dans l'art khmèr, Ars Asiatiques, VI, 1960, pp. 179–99; G. Montgomery, ed., Khmer Sculpture, New York, 1961 (exhib. cat.); B. P. Groslier, The Art of Indochina, New York, 1962.
 See also the bibliography for CAMBODIA.

 George Cœdès

Illustrations: PLS. 365–377.

KHOTANESE ART. Khotan (Chin., Yü-t'ien) was not only a small kingdom playing a conspicuous role in Central Asian history, but also a region with its own important culture and religion. Artistically the region received a variety of influences, some coming from northwest India via either the valley of Swat or other routes, others clearly Iranian, Chinese, or Chorasmian, all of which were soon reinterpreted. Generally speaking, popular work, such as the terra-cotta figurines, exists side by side with a higher level of production, exemplified by the Buddhist monuments. Khotanese Buddhist art had great influence at Tun-huang (q.v.) and especially in Tibetan Buddhist art (see TIBET; TIBETAN ART), where one of the more ancient styles is specifically called "Khotanese."

SUMMARY. Name and culture of the region (col. 991). Historical sources and modern exploration: Basis of the dating system (col. 992). Typology and value of the Khotanese finds (col. 994). Rawak (col. 995). Dandan-uilik (col. 996). Niya (col. 998). Endere (col. 998).

NAME AND CULTURE OF THE REGION. The region of Khotan developed an important civilization as a result of its location south of present-day Chinese Turkistan: it was an important stage on both the Silk Route and the roads from India and was

particularly important in transmitting culture currents from eastern Iran and Sogdiana (q.v.) to the Far East. These currents, in turn, had been subjected to strong classical influences from the eastern Mediterranean and India, by way of Kashmir (see KASHMIR ART), and were at some periods influenced by the art of Gandhara (q.v.), as well as that of eastern Iran. This helps to explain the complex picture presented by the region, where Chinese influences also were at work at the end of the Han period (about the beginning of the Christian Era). These reached Khotan either by way of the Chinese colonies situated along the southern Silk Route from Lou-lan or by way of Niya and Keriya. Underlying these various influences and cultures was an ancient indigenous civilization, traces of which have been discovered at Yōtkan.

The various names given to the administrative center in different periods reflect the complexity of the culture. The royal city was first called "Yü-t'ien" by the Chinese, presumably from the original "Odan." Later, in the 7th century, Hsüan-tsang, speaking of this region, calls it "Ch'ü-sa-tan-na," which corresponds to the Khotanese "Gaustamä" (according to Sylvain Lévi, the transcription of the Indian form "Gostana"). Hsüan-tsang adds that in the native language it is the kingdom of Huan-na," which the Hsiung-nu (a Turkic tribe) call "Yü-tun," the Iranians "Ho-tan," and the Indians "Ch'ü-tan" (S. Beal, *Hsüan-tsang's Si-yu-ki, Buddhist Records of the Western World*, London, 1884). Leaving aside the indigenous name, which must have been something like "Hvanna," the Turkic name evidently represents a variation of the form "Odan" and probably corresponds to "Odon," while the former two transcriptions represent the two forms "Hwatan" and "Khutan," which lead to the name "Khotan." The ancient name "Odan" ("Odon") reappears in the Mongol period. The form with guttural continued to be used by the Iranians and the Indians, while the Chinese used both forms at various times.

HISTORICAL SOURCES AND MODERN EXPLORATION: BASIS OF THE DATING SYSTEM. This little kingdom, whose rulers apparently had names of Indian origin, soon took an active role in the diffusion of Buddhism (q.v.). As early as the end of the 2d century there is a reference in the *Mou-tsŭ* (a Buddhist polemic) to a person who is said to have visited Khotan and to have found an existing Buddhist community. Chou Shih-hsing, the first Chinese Buddhist pilgrim of whose travels beyond China there is no doubt, left for Khotan in 259 and died there at the beginning of the 4th century. In spite of the promising titles of certain texts, among them Abel Rémusat's *Histoire de la ville de Khotan* (Paris, 1820) and the Tibetan chronicle entitled "The History of the Kings of Li-yul" (see F. W. Thomas, *Tibetan Literary Texts and Documents concerning Chinese Turkestan*, I, London, 1935), as well as other works published on the subject, little is actually known about the history of Khotan or of Buddhism there. The ancient royal city was probably abandoned during the 11th century, following the destruction of the temples and palaces during the Moslem invasions that had been described by Hsüan-tsang in the 7th century. The site about five miles northwest of the new Chinese city of Khotan (Ho-t'ien), where numerous archaeological vestiges have been found, was probably the ancient royal city. However, Buddhism must have survived in the region for several centuries longer, at first during the Moslem Ilkhan rule, later under the Kara-Khitai, and lastly under the Mongols, who favored the older religion. Marco Polo (late-13th cent.) speaks of "idolaters" — Buddhists — in the city, but, aside from the Moslems, he does not mention representatives of other religions. However, Gardīzī, writing in the 11th century, had reported two Christian churches. In the following centuries Islam was imposed upon the last members of non-Moslem communities, and the culture of this region declined and was forgotten.

Khotanese culture belongs to a complex formed by all the sites on the southern Silk Route and can be interpreted only in context with such sites as Niya, Endere, and those of the Kashgar region; the area includes various sites, of which the most important are Yōtkan, the ancient pre-Islamic royal city, and Rawak and Dandan-uilik, which were monastic cities. Yōt-

kan supplies only fragmentary documentation, because no systematic excavation has as yet been carried out there. Rawak and Dandan-uilik are architectural complexes which have been examined with some care by Aurel Stein. These complexes date from different periods. They can be compared to the westerly Kashgar sites, which have suffered great destruction, and to the better-preserved sites of Niya and Endere to the east.

During a visit in Khotan, F. Grenard bought fragments of pottery and other objects which were the first to arrive in Europe; their provenance, he was told, was a site called "Yār" or "Yōtkan." He visited this site and identified it as the ancient capital of the region. After Aurel Stein visited the same location, he said that the site consisted of a depression enclosed by steep sides cut into what first seemed to be natural loess, but on closer examination was seen to be layers of pottery, ashes, and pure soil. He concluded that the depression had been excavated by the local population in their search for gold and precious objects, and learned that the site had been discovered about 1870, when tiny flakes and fragments of gold leaf had been found after a flood had eroded a ditch through the loosely packed soil. The natives then began to exploit the site and each year at flood time washed the soil for gold and small objects of value. Unfortunately Stein went there during the dry season when work was not in progress; he could not therefore obtain *in situ* objects which could be related to each other according to the strata in which they had lain.

The depth of the deposit of debris showed that the site had been occupied over a long period of time. There is neither any extant architecture nor evidence of suitable stone for building; judging from excavations, construction materials seem to have been sun-dried bricks and clay with reinforcing timbers. When covered by cultivated soil wet by irrigation, these materials gradually disintegrated. Only works in lasting materials — ceramic, stone and metal — survived.

Since all the pieces known were acquired by purchase and their stratigraphic position is unknown, there is no clear historical record of Yōtkan from artifacts. The site must have been continuously occupied from an early date until the 11th-century Moslem invasion and perhaps even slightly longer; it is impossible to tell at what moment and for what reason it was abandoned.

Descriptions of the royal city and its monuments were left by Chinese pilgrims. Fa-hsien (see H. A. Giles, *The Travels of Fa-hsien . . .* , 2d ed., London, 1956) reports, at the end of the 4th century, that he visited a magnificent stupa, located slightly west of the city, part of which was richly covered with gold. Sung-yün (see E. Chavannes, *BEFEO*, III, 1903, pp. 379–441) visited the city in the 6th century and mentioned that there were temples and pagodas and that one temple contained frescoes representing Rāhula, who had appeared as Buddha at a nearby site. Hsüan-tsang writes that the oldest sanctuary in the city was a wooden tower with seven stories, and he marvels at the richness of the temple existing in his day. The report of a mission sent in the 10th century notes that the royal palace structures faced the east and that among them was the so-called "Pavilion of the Seven Phoenixes." The annals of the Later Liang dynasty (907–22) record that the king's palace was decorated with frescoes and that the city was surrounded by fairly low walls. Only a few ruins and fragments of decomposed wood remain, a fact proving that all building was done in perishable materials.

However, the complex can be approximately dated by the numerous coins on the site. Since their level has not yet been established, they cannot be directly related in date to the other objects. It can only be stated that a rather important city existed from the beginning of the Christian Era until about the 11th century. Numerous copper coins were found and classed as Sino-Kharoshthi since they bear Chinese inscriptions on one side and, on the other, Prakrit legends in Kharoshthi characters. Representations of a camel and a horse on these coins seem to relate to those of a similar type on coins of the Scythian princes of northwest India. These coins must have been minted by the rulers after A.D. 73, the year in which Khotan fell under Chinese domination for the first time. The oldest pieces found, all of foreign origin, include a coin of Kujūla Kadphises (see KUSHAN ART) from about the beginning of the Christian Era, numerous

coins of Kaniṣka, and Chinese coins, perhaps of the Han dynasty (206 B.C.–A.D. 321). Stein also obtained coins of the emperor Valens (A.D. 364–78) and was able to acquire coins from Yōtkan dating from the T'ang (618–907) and Sung (960–1279) dynasties, proving that by the beginning of the 12th century commerce with China had been reopened. A few Islamic coins were found; they may prove that the ancient royal city survived for a while after its Moslem conquest.

Thus, while it is relatively easy to determine the period of the city's development, it is practically impossible to assign

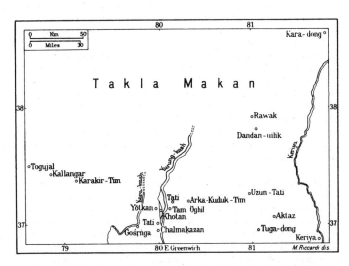

Area of Khotanese culture showing principal archaeological sites.

a precise date to the fragments acquired by Stein, Grenard, and others, because all come from chance finds, with no exact provenance. However, it is possible to attempt some classification of the objects by dividing them into categories and relating some of the fragments to dated materials from neighboring regions.

TYPOLOGY AND VALUE OF THE KHOTANESE FINDS. The first category consists of numerous terra-cotta figurines of animals in the round, almost all of which are decorated with incising representing their coats. There are camels, horses, felines, and, most often, monkeys. The monkeys constitute a separate group, because they reflect human expressions; they often play musical instruments — such as the syrinx, sitar, rabat, and various kinds of drums — or form groups in amorous embrace.

The monkey images appear to be an isolated type, corresponding only to objects found in Sogdiana, and to the rare and undated finds of the Indus civilization (see INDUS VALLEY ART). This remarkable skill in representing animals not found in the Khotan region suggests that the sculptures relate to a much earlier period, when Khotan was in touch with the protohistoric civilizations of northwest India, eastern Iran, Sogdiana, and Chorasmia (Khwarizm).

The second and more common category of finds consists of numerous fragments of plain and decorated pottery vessels. Some are in good condition, among them a little vase resembling an oinochoe and another with a handle in the form of a monkey playing a sitar, a motif also found in the terra cottas. A large jar of amphora type is decorated on its neck with figures of women holding a garland, a popular motif, found on numerous terra cottas and on the Dandan-uilik stuccoes, which seems to have been borrowed from Gandhara. There is also a vase with a male head on one side and a female head on the other, recalling bifrontal Greek vases.

The molded ornaments on vases were made separately and attached before firing. Many of these ornaments were found unattached. Some are grotesque or grimacing masks which reflect either the diffusion, often by means of coins, of the barbarian types throughout Central Asia or the final stylization of barbarian types found in Taxila during the 4th and 5th centuries. A satyr head, adorning a handle, has been treated naturalis-

tically and is classical in appearance. The neck of another vase is decorated on one side with two haloed figures seated on lotus pedestals with an elephant *vāhana* (vehicle); on the other side are two parrots above a grape cluster, a motif reminiscent of ornaments used in Gandharan sculpture, as well as in the Ajanta (q.v.) frescoes and even in Coptic embroideries (see COPTIC ART). Another appliqué shows a buddha within a lotus flower. There are also heads, many in the round, that may have been vase decorations. The head of a woman, apparently modeled on a regional type, is like those found among the worshipers in the Dandan-uilik frescoes. The pottery and terra cottas of this local art clearly employ models of every provenance.

The third category consists of fragments which seem to have been imported from different regions. Many little stone reliefs, probably from Gandhara, are carved in schist and soapstone, materials found in the Peshawar region. Some show scenes from the life of the Buddha and probably adorned miniature stupas. Intaglios have been found, some of which seem to be the work of engravers from the Greco-Roman world; two in particular — one showing Eros and the other a quadriga — certainly are Roman works of the first centuries of the Christian Era. Others come from Iran or India; one represents a warrior of the Indo-Scythian type.

RAWAK (Ravaq). The most important site, after the ancient royal city, is the monastery of Rawak, a large complex consisting of a stupa (FIG. 995) in a rectangular court surrounded by a wall which is decorated inside and out with colossal stucco statues. The arrangement of the stupa within the four walls corresponds to the courts with chapels of the monasteries of Gandhara and elsewhere in northwest India and Central Asia.

The stupa has a three-storied base with a centered staircase on each side leading directly to the foot of the dome, so that the base plan is shaped like a Greek cross. The stupa was completely encased in stucco painted white. The greatest interest of the site lies in the decorations of the encircling wall, consisting

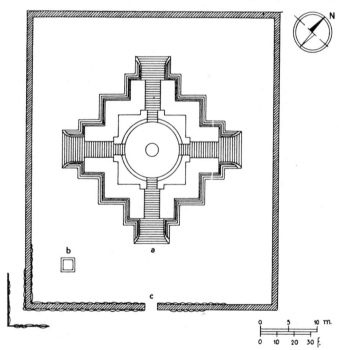

Rawak, plan of stupa. (*a*) Stairway; (*b*) base of a small stupa; (*c*) entrance (*from A. Stein, Ancient Khotan, Oxford, 1907*).

of rows of stucco statues. They form a frieze of colossal statues representing buddhas and bodhisattvas in various poses arranged in groups; smaller statues of divinities and arhats fill the leftover spaces. Remains of frescoes on the surfaces not covered by statuary were visible at the time of the excavation. All the statues were originally painted, but no color remains except on parts protected by drapery.

The reliefs were supported by a strong wooden framework fastened to beams thrust into the wall behind. The statues showed no trace of willful destruction; it seems that the site, which had been abandoned quite early, suffered only the slow action of weather before being covered by sand. Moreover, the decorations were probably protected by a wooden roof. Stein recovered only the southeast and southwest portions of the wall, which was paralleled inside by a thinner wall that was probably continuous and decorated on both faces by reliefs, of which practically nothing remains. The passage formed by the inner and outer walls was probably roofed and served as another circumambulatory.

The sculptured frieze shows a close relationship to Gandharan sculpture in the handling of drapery, but with an important difference in that some statues emphasize the form of the body under the garment, while in others the conventional treatment of drapery in waves is similar to the style of Chinese art. Many of the individual statues are reproduced in several examples.

Some statues are individualized, such as that of a seated and apparently nude buddha with a resigned smile, a work like no other at the site. In some heads (PL. 380) there is a similarity, in the modeling of the face, to those found at Tumshuk (I, PL. 477), and a little buddha with crossed legs also resembles the seated buddhas of Tumshuk, in spite of differences in costume and nimbus. A female bust still reflects ancient Hellenistic models. The statuary of Rawak consists mostly of buddhas, bodhisattvas, and arhats, but the gate in the center of the south side is flanked on the inside by two pairs of *dvārapālas* (gate guardians). Almost life size and wearing the local costume, they are preserved from the waist down.

Rawak, therefore, shows similarities to the art of Gandhara, with variations caused, apparently, by local tradition. It is difficult to date this site. The only elements which give any idea about its age are the Chinese *wu-shu* coins placed at the feet of the statues as offerings. These pieces belong to the Later Han period, but were in circulation at least until the end of the 4th century, if not until the end of the period of the domination of Central Asia by the Sui dynasty (581–618). It is necessary to turn to the style of the sculptures to establish an approximate date. They are closer to Gandharan types than are those from Dandan-uilik and Endere, which are of the T'ang period, and not a single figure with multiple arms can be found. The Rawak site therefore can be considered earlier than the T'ang era and is dated approximately between the 4th and the beginning of the 7th century.

DANDAN-UILIK. This site includes many temples assembled in a complex. Dating is quite precise here, since various dwellings, undoubtedly monastic, contained Sanskrit manuscripts: the *Prajñāpāramitā*, written in Gupta characters; the *Vajracchedikā*, written in Brahmi characters; other writings dating from the 7th and 8th centuries; and, especially, numerous Chinese papers from 780 to 790. These dates are further confirmed by the discovery of Chinese coins of the K'ai-yüan (713–42) and Ch'ien-yüan (758–60) dynasties.

Stein has indicated the various structures by a letter followed by a number, since the names are unknown. The stucco reliefs consist of numerous fragments varying in importance, many of which once formed plaques decorating the upper walls. It is possible that, as at Rawak, many of these fragments were part of the decorative aureoles surrounding the principal images; they were made of clay, like the walls, and have completely disintegrated. Among the fragments found in the cella of Sanctuary D I, Stein identified various small figures of standing buddhas, seated bodhisattvas, and gandharvas holding garlands, as well as fragments of a flame design from an aureole and floral ornaments, such as lotus petals and vine scrolls; these decorative elements are clearly related to both Gandhara and eastern Iran (see INDO-IRANIAN ART). Stein also found small fragments of seated bodhisattvas in Sanctuary D II, where each corner of the cella was decorated with a draped stucco figure standing on a lotus pedestal. In a small adjoining room was a large, seated figure, of which the base alone remains, flanked on each side by lions, only fragments of their mane-curls

undestroyed. Fragments of aureoles made up of small buddhas and bodhisattvas were found, some still attached and arranged to follow the curve of a border, the edge of which was formed by series of overlapping lotus petals, alternately red and green. On the east wall there was a stucco statue of a figure dressed in chain mail reaching down to his knees and composed of alternating rows of red and blue and red and green links; he wears soft boots and is trampling upon the twisted figure of a demon. The head was found near the statue, which seems to be one of the four lokapalas adorning the corners of sanctuaries. Sanctuary D XII contained traces of some small reliefs which indicate that the decoration of the upper portion of the walls was composed, like that of D I, of different elements inspired by the art of Gandhara or eastern Iran, although it is impossible to tell how and from where these motifs arrived in Khotan.

While sculpture is poorly represented, murals and painted wood panels are among the most important examples of the art of this region and of all Serindia (PLS. 378, 379, 381, 383). Painting probably decorated all the interior cella walls not covered by the large reliefs of cult images, while the passages surrounding the shrines were decorated with frescoes on the inner walls. The cella of Sanctuary D I was decorated by a much damaged frieze formed by ranks of tiny buddhas and bodhisattvas differing only in color of dress and background. The large cella of Sanctuary D II had a broad frieze with lotuses and small worshipers above the statue. On the outer walls are narrow bands of frescoes with miniature bodhisattvas and arhats seated in meditation. On the south side was pictured a local legend that must have been quite popular, since it also appears on some of the wooden panels: three rows of youths, on horseback or riding camels, each holding in his outstretched right hand a cup toward which a bird is flying. In a small cella on the west side of Sanctuary D II were found the remains of a fresco in which some figures clearly show Indian influence (PL. 381). On the right there is a small image of a seated buddha wearing a dark reddish-brown garment and on the left, a youth seated near an older man whose hand is raised as if he were teaching. A female figure standing in a lotus-filled tank bordered by paving stones forms the most important part of the composition. The lady is nude and bejeweled; she wears four ropes of tiny bells and pearls around her hips and thighs. At her feet a small male figure rises from the water; farther left another male figure seems to be swimming, and in front of the tank is a riderless horse. This is probably a representation of the legend told by Hsüan-tsang about a widowed naga who asked the king of Khotan to provide her with a husband in exchange for her protection. This scene, in which the graceful female figure is treated as in Indian sculpture, must have been inspired by the paintings of Gandhara, none of which have survived, or by Gupta art. Stein also sees classical influences in the Venus-like pose and the leaf covering of the lady.

In Sanctuary D VI, the walls with their frescoes are preserved to a height of about 3 ft. Except for the wall with the door, the cella walls were occupied by three large figures, of which only the feet on lotus cushions and the lower part of the garments remain. Below the feet of the great central figure on the south wall can be distinguished the pedestal, around which is painted a lotus-filled tank with geese swimming in it. Two worshipers appear on each side of the pedestal. At the far right a male figure, dressed in a Chinese garment and with a coiffure like that of certain Yōtkan figurines, offers lotuses. At the far left there is a woman kneeling with hands folded in prayer. Sanctuary D X was decorated with simple murals of little seated buddhas, all alike, whose garments were either dark brown, red, or white. They appear on both the inside and the outside walls. Sanctuary D XII also contained murals that were badly ruined. There must have been on every wall, except the north, three life-size figures standing on lotuses and surrounded by aureoles. In the lower part, between two aureoles, a fully draped female figure, looking up, plays the lyre.

Panel paintings were found in some shrines and monastic dwellings. In Sanctuary D II three panels show, respectively, a dancer drawn in a free and lively manner, a Gaṇeśa (?), and a most unusual bearded figure with four arms, flanked by two figures on each side playing musical instruments. Two panels from Sanctuary D IV survive: one, a bust of a figure with the head of a rat, crowned; and the other, an upright, preaching buddha. There are two panels from Sanctuary D VI the larger of which shows ten seated figures, perhaps bodhisattvas. Three remarkable panels in good condition were preserved in an adjacent room of Sanctuary D VII. One shows two riders, the upper figure holding a cup in his right hand, toward which a wild duck swoops (PL. 383). Both riders have halos, which might indicate that they are holy figures in a local legend unknown at the present time (the legend is repeated in the frescoes of Sanctuary D XII and two panels from D X). The second panel is decorated on both sides. On one side appears a three-headed, four-armed divinity whose attributes suggest that this is a type of Śiva (PL. 379); on the reverse, there is a bearded, long-haired figure with four arms, holding in his hands symbols of unknown significance. The third panel is in very poor condition but shows a well-drawn bodhisattva seated on a low throne.

Other panels were found in Sanctuary D X. The most important recovery illustrates the legend concerning the introduction of sericulture to Khotan (PL. 378): a female figure, probably the princess of the legend, is shown wearing in her abundant black hair a gold diadem to which a maid is pointing. Between them is a kind of basket containing the cocoons which the princess is apparently protecting. Behind her is a loom, beyond which another figure, with a coiffure resembling that of the maid, appears, holding an instrument like a currycomb, similar to one found at Niya.

The stuccoes and frescoes show a mingling of influences difficult to determine or identify because of their complexity; but the problem becomes even more difficult with the painted panels, where later influences coming from India via Kashmir or from eastern Iran join local artistic traditions in which Gandharan and Chinese influences had long been at work.

NIYA. The discoveries from Niya illustrate equally well the joint influences of China and Gandhara, but at a time earlier than at Dandan-uilik, since Niya was abandoned by the end of the 3d century, a date which more or less corresponds to the end of Chinese domination after the reign of Wu-ti. The small structure N XVI must have been a sanctuary of the Dandan-uilik type; it enclosed a square platform with a small semicircular plaster base which probably supported a cult image. Also included were two crude wooden statuettes in very poor condition. The most interesting objects were found within the dwellings. Besides the seals and intaglios mentioned above, of special interest are the furniture and textiles, which, together with the documents written in Chinese and Kharoshthi, show the preponderance of Indian influence. In the dwelling N III was discovered a carved wooden chair that had decorative motifs similar to those on Gandharan reliefs: four-petaled flowers inscribed within squares (PL. 382). The remains of two other carved chairs were found in N IV, the legs of one representing lion-headed monsters with horses' legs and winged bodies, and the legs of the other forming a pair of monsters with the head and shoulders of, respectively, a man and a woman, and with horses' hooves. One of the most distinctive textiles is a fabric that has bands of different colors with geometric decorations reminiscent of Indian models. Stein also discovered on the entrance wall in N III fresco remains in which bands of five-petaled flowers alternate with plain double rings; these two motifs, in red, were joined by a scroll ornament, composed of two crescents back to back, and can be compared to the same kind of motif found in Gandhara.

ENDERE. Farther east are the ruins of Endere which consist of a stupa (FIG. 999), an important temple near the center of a circular enclosure (part of its wall still stands), and housing for monks or for a defending army. In the sanctuary, similar to those of Dandan-uilik, Stein found plaster images almost completely detached from the walls and standing on a base in the shape of a reversed lotus blossom. Three of these images, partly preserved in the corners of the cella, seem to have been lokapalas. The drapery, similar to that used at Dandan-uilik, is clearly related to Gandharan models. The statues were

painted, but only the portions protected by the drapery folds have retained their color. Traces of frescoes that remain on the northeast wall depict a total of 14 buddhas or bodhisattvas seated in two rows. The workmanship on these seems to have been better than that at Dandan-uilik, and the colors are more delicate. The monastic dwellings E II included a small chapel; on its south wall was a fresco with a buddha or bodhisattva in the center (only his feet and the lower part of his garment remain). An oval aureole enclosing him bears little seated buddhas or arhats in red robes on a blue background. In the triangular spaces left at the bottom on each side are a praying figure and a standing figure holding a raised sword. A painted panel found on the floor in another room pictures a seated Gaṇeśa or Vināyaka with four arms, whose details are clearly Indian. Colored sketches on paper were also found; the liveliest shows a camel nursing her calf (PL. 378).

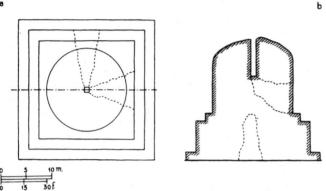

Endere, stupa. (a) Plan; (b) section (from A. Stein, Ancient Khotan, Oxford, 1907).

In addition to these major sites mention should be made of Kara-dong near the Keriya River and, somewhat nearer to Khotan on the east, Uzun-Tati, Tuga-dong, and Aktaz. Near Aksipil, with its fortifications, is Arka-Kuduk-Tim, Tati (1), and Tam-Öghil. All the foregoing sites are east of the Yurung-kash River, on which Khotan lies. West of the river are Tati (2), Chalmakazan and Gośṛṅga, as well as the more distant Kara-döbe, Karakir-Tim, Kallangar, and Togujal. Even further west are Kakshal-Tati and Tōpa-Tim.

The region of Khotan, the king of which was said to have reigned over seven cities during the T'ang dynasty, was an important center of civilization before its final destruction by the Moslem invasion. All its sites prospered for many centuries. Apparently most of the sites were abandoned at different periods: some, like Niya, in the 3d century, after the overthrow of Chinese domination in Central Asia; others, like Dandan-uilik and Endere, at the end of the 8th century, after the Tibetan invasion; and finally, still others, like Yōtkan, for undetermined reasons, the Moslem invasion being the most likely cause. Doubtlessly, after the various devastations, the inhabitants of Khotan could no longer maintain the water systems which were indispensable to life there and had to abandon their lands.

BIBLIOG. A. Stein, Ancient Khotan, 2 vols., Oxford, 1907; A. Stein, Sand-Buried Ruins of Khotan, London, 1907; A. Grünwedel, Alt-Buddhistische Kultstätten in chinesisch Turkistan, Berlin, 1912; P. Pelliot, Les influences iraniennes en Asie Centrale et en Extreme-Orient, Rev. d'histoire et de littérature religieuse, III, 1912, pp. 97–119; A. Stein, Ruins of Desert Cathay, 2 vols., London, 1912; A. Stein, Serindia, 5 vols., Oxford, 1921; A. von Le Coq and E. Waldschmidt, Die buddhistische Spätantike in Mittelasien, 7 vols., Berlin, 1922–33; R. Grousset, L'art de l'Asie Centrale et les influences iraniennes, RAA, I, 1924, pp. 13–16; A. von Le Coq, Bilderatlas zur Kunst und Kulturgeschichte Mittel-Asiens, Berlin, 1925; A. Stein, Innermost Asia, Oxford, 1929; E. Matsumoto, On the Characteristics of the Buddhist Pictures in Khotan in Their Relations to the Far East, Tōhō gakuhō, II, 1931, pp. 227–37 (in Japanese); A. Stein, On Ancient Central-Asian Tracks, London, 1933; F. H. Andrews, Central Asian Wall Painting, Indian Art and Letters, VIII, 1934, pp. 1–21; M. Bussagli, L'influsso classico ed iranico sull'arte dell'Asia Centrale, RIASA, N.S., II, 1953–54, pp. 171–262; L. Hambis and M. Hallade, Sculptures et peintures de l'Asie Centrale: Inédits de la Mission Paul Pelliot, Paris, 1956 (exhib. cat.).

Louis HAMBIS

Illustrations: PLS. 378–384; 3 figs. in text.

KHWARIZM. The Arabic name Khwarizm, found in Islamic sources, is a transcription of the classical forms (Gr., Χοραυμίη; Lat., Chorasmia) derived from the ancient Iranian Huwārazmi (or Hwāirizem) of uncertain etymon. It has become the established custom among specialists to use this name in the sense and with the significance that Russian scholars attribute to the form Khorezm (derived from the Greek form). It thus refers to the successive cultures and civilizations of pre-Islamic times which flourished in the lower Amu Darya (anc. Oxus) basin and in the area of the Syr Darya (anc. Jaxartes) basin. A region traversed by the invaders from the East and already the seat of an organized state by the first half of the 1st millennium B.C., Khwarizm was later incorporated into the Achaemenid empire. By the time of Alexander the Great the region had again become autonomous and seems to have remained so until the Islamic conquest. Although influenced by the classical and Iranian West, Khwarizm developed an independent art culture whose originality lay above all in certain architectural characteristics, which were in turn a reflection of its particular economic and social systems (see ASIA, CENTRAL).

SUMMARY. Historical background (col. 1000). The Amirabad culture and the "culture of the villages with wall dwellings" (col. 1000). The Kangyu period (col. 1002): *The fortresses with rectangular enclosures: Dzhanbas Kale; The fortresses of circular plan: Koy-krylgan Kale.* The monuments contemporary with the Kushan period (col. 1005). The Kushano-Afrigidian period: Toprak Kale (col. 1006). The Afrigidian period (col. 1007). The Afrigid-Samanid period (col. 1008). The period of the Khwarizmshāhs (col. 1009).

HISTORICAL BACKGROUND. During the first half of the 1st millennium B.C., the peoples of central Asia (the regions lying between the Caspian Sea and the chains of mountains bordering northern Asia) constituted a complex population of related tribes speaking a variety of Iranian languages (see ASIA, CENTRAL). Some led a sedentary life based on agriculture; others remained in a nomadic state, deriving their livelihood from cattle breeding supplemented by hunting and fishing. It is difficult to determine the territorial limits of each group, for the nomads probably lived in close contact with the sedentary population.

The nomadic peoples were called Scythians by the Greeks and Śakas by the Indians. In the 2d century B.C. they invaded a part of the Iranian world and, like the Yüeh-chih, or Tocharians, one of whose tribes founded the Kushan empire (see KUSHAN ART), were finally absorbed into the sedentary population. Descended from the same stock as the Indo-Europeans, this population was eventually replaced by the Turks, after the collapse of the Hsiung-nu empire and the gradual advance from the Siberian region of ethnic groups that were ancestors of the Huns and of various tentatively identified peoples called Kidaras and Ephthalites. The arrival of first the Turks and then the Mongols led to the almost total destruction of the sedentary civilizations, which had already lost their distinctive characteristics in the course of their conversion to Islam. The invaders of Khwarizm disrupted not only the culture but also the very way of life, which was oriented to an agriculture based essentially on the irrigation of regions threatened by the progressive drying up of central Asia. Certain regions managed to survive, but most areas, as a result of the systematic destruction of the irrigation network and the massacre of a part of the population, ceased to be cultivated and reverted to desert.

THE AMIRABAD CULTURE AND THE "CULTURE OF THE VILLAGES WITH WALL DWELLINGS." Of those centers of sedentary civilization which were extensions, more or less, of Iran on its borders, the most remarkable was Khwarizm. The population gradually became concentrated in several locations which grew into towns. The development of this region was due essentially to its irrigation; intelligent tapping of the middle course of the Amu Darya and of its delta at Lake Aral made possible the irrigation of considerable areas of land. Research by S. P. Tolstov has shown that the irrigation system in Khwarizm must have been created between the 7th and 6th centuries B.C., though the manner in which it gradually evolved remains a mystery. There can, however, be no doubt that the realization of such an important project took centuries, requiring the determined effort of a large population of considerable means. Archaeological documentation and the Arab geographers furnish no more than legends; only the Achaemenid period (see IRANIAN PRE-SASSANIAN ART CULTURES) provides a firm historical basis on which to study the archaeological data. All that is known of this remote period is that the inhabitants of Khwarizm had a variety of implements at their disposal — agricultural tools, in particular, fashioned mainly of iron — and that they produced a coarse black or gray-black pottery with a herringbone pattern. Ac-

cording to Tolstov, this civilization was akin to that of the Massagetae, who lived in the north, and he has named it the "Amirabad culture." It apparently developed toward the end of the 2d millennium B.C. and lasted about four centuries. It is at this point that Khwarizm enters history and that the civilization called by Tolstov the "culture of the villages with wall dwellings" existed (6th-4th cent.).

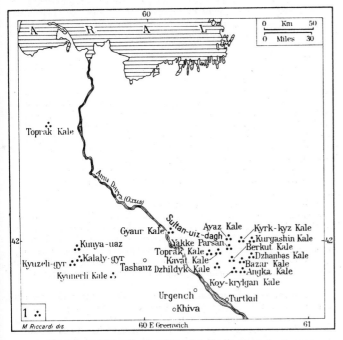

Khwarizm (Uzbekistan). *Key:* (1) Archaeological sites.

The rise of this civilization, which was certainly materially advanced, coincided roughly with the founding of the Achaemenid empire by Cyrus. At this time, the future Khwarizm must have presented a somewhat unusual picture, certain regions having already reached quite a high level of civilization, while others had remained at a rudimentary economic stage (cf. Herodotus, I, 202, on the sedentary population of the lower Oxus basin). The lower Syr Darya was inhabited by a sedentary population with rather important settlements in the Dzhety-Asar region. This seems to have been an original civilization in which cattle breeding and agriculture played major roles, as is attested by the numerous cereal graters and animal bones found in the lower

strata of one of these sites. (Handmade pottery of high quality was also discovered.) Tolstov is inclined to regard this population as the ancestors of the Tocharians, mentioned at a much later date by Ptolemy in his geographic work. Thus, the deltas of both rivers were inhabited by more or less civilized, sedentary people. No important centers of civilization developed in this area, however, since the settlements of the lower Syr Darya were exposed to the attacks of nomads and were isolated from the other cultivated regions by the desert. In contrast, the centers along the lower Amu Darya, well protected and in communication with those of northern Iran, flourished and constituted a remarkable focus of civilization, which finally collapsed only before the onslaught of the Mongols.

The "culture of the villages with wall dwellings," as it was discovered at Kyuzeli-gyr and at Kalaly-gyr (FIG. 1001), is characterized by enormous, generally rectangular edifices, each built around a large empty space resembling a vast courtyard (in which the cattle may have been kept). Massive walls divided each edifice into two or even three passages in which the inhabitants lived. Light and air entered and the smoke from the fires escaped through apertures — pierced at irregular intervals in the vaulted ceilings of the passages — which opened onto a flat terrace roof. The upper part of the much thicker and higher outside wall, which formed a parapet around the terrace, was pierced with loopholes from which the area could be defended; a series of towers flanked the exterior of the complex and four entrances opened from the outside onto zigzag passages.

This type of habitation would appear to derive from those of the Amirabad period. The small number of objects found here includes coarse pottery turned on a wheel and decorated with horizontal fluting (reminiscent of that on Achaemenid metal vases) and vases coated with a red slip. Also found in the excavations were three-bladed arrowheads differing from the leaf-shaped, socketed specimens of the preceding period (8th–6th cent.), when Scythian influence had predominated. To this scanty material must be added the fragmentary remains of a few coarse clay statuettes representing animals and what must have been a female divinity, perhaps a prototype of Anahita.

These vast constructions would appear to be comparable to those described in the Avesta, though our limited knowledge prevents the drawing of any definitive conclusions.

THE KANGYU PERIOD. Tolstov calls the following period (4th cent. B.C.–1st cent. of our era) the "Kangyu period." Kangyu (or Kankju) is the Russian transcription of the Chinese name K'ang-ch'ü, given to a group of nomads who, according to Chinese historians, roamed the territory to the northwest of the Wu-sun; the Chinese transcription apparently corresponds during this period to the theoretical reconstitution *Kangkio (*indicates a hypothetical word form). Tolstov seems to infer that Khwarizm was included in this nomadic state, or, at any rate, came within its sphere of influence; however, that Khwarizm, a stably organized and well-defended center of civilization, should have escaped conquest by Alexander, only to become

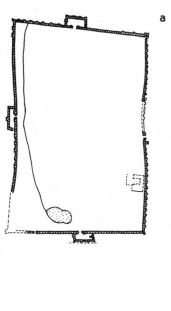
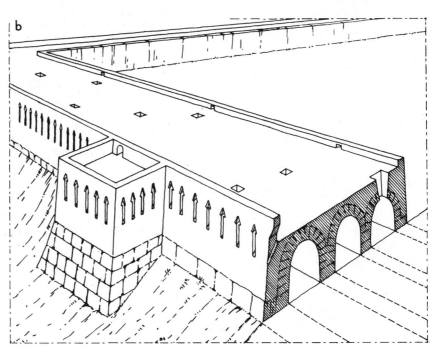

Kalaly-gyr, "village with wall dwellings." (*a*) Plan; (*b*) perspective view of a sector of the wall according to Tolstov's reconstruction (*after S. P. Tolstov, Po sledam drevniekhorezmskoi tsivilizatsii, Moscow, 1948*).

a tributary of a nomadic confederation probably composed of Scythian tribes, hardly seems likely. It is more probable that any relations between the two groups were purely commercial. (The K'ang-ch'ü appear to have occupied the territory between Lake Balkhash and the banks of the middle course of the Syr Darya during the period to which Tolstov attributes their greatest expansion.) With the scanty data available, it is impossible to make any definitive affirmations.

Whatever name may justifiably be given to the period lasting from the 4th century B.C. to the 1st century of our era, Tolstov's discoveries have made it possible to distinguish two groups of monuments from among those he has discovered: the earlier specimens date from the period that preceded the founding of the Kushan empire, the later ones from the beginning of the Kushan epoch, which lasted from the 2d to the 4th century. The excavations carried out at Ayaz Kale, Toprak Kale, Dzhanbas Kale, Gyaur Kale, Kunya-uaz, and Koy-krylgan Kale — to mention only the most important locations — have led to the discovery of abundant documentary material and, in particular, of ceramic ware from which it has been possible to date these sites (PL. 385). Tolstov divides this ceramic ware into four categories. Two groups comprise pieces turned on a foot wheel: the first consists of jars with rolled upper lips decorated mainly with triangular motifs in red or black, goblets with disk-shaped feet, and pitchers covered with a black glaze — all made of a smooth, well-baked red paste and sometimes coated with a red slip or glazed red; the pieces of the second group are covered with a red glaze and closely resemble the pottery discovered at Tali Barzu (south of Samarkand) and at Airtam (near Termez), where coins of Kaniṣka (2d cent. of our era) were also found. The third group consists of pieces adorned with an incised design of triangles and painted red over a yellow foundation, which apparently show a certain affinity with the local pottery of the "villages with wall dwellings." The fourth group comprises handmade gray pottery, which appears to be comparable to that discovered in the necropolises (dating from about the beginning of our era) attributed to the Wu-sun of Kirghizstan and eastern Kazakhstan.

These sites are the first that have been found to contain a considerable number of coins; some have yielded only Khwarizmian coins bearing the royal effigy crowned with a helmet in the form of an eagle. By means of the Kushan coins of the 2d century, which were scattered in large numbers throughout the regions bordering the Kushan empire and recovered at even the most recent sites, it has been possible to date even the latest monuments, certain of which may have existed as late as the 3d or 4th century (since Kushan coins of this date have also been found). These sites have also yielded such objects as beads of polychromed glass, of the same type as those found on the shores of the Black Sea, which date from the 3d century B.C. to the 2d century of our era. In addition, a certain number of rather coarse clay figurines, which, since they are flat, must have been cast in a single mold, have also come to light: at Dzhanbas Kale were found a man's head, the torso of a male figure dressed in a short jacket, a horse's head, a lion's head, and a fragment of an earthenware vessel decorated with animals in relief; and at Kurgashin Kale there was a fragment with a feline in relief. These figurines correspond to those found at various sites in Sogdiana (q.v.) and even in central Asia and northwestern India.

According to Tolstov, the majority of those found at Dzhanbas Kale date from the 4th century B.C. to the 1st century of our era and can be divided into three groups. The first group, from the Achaemenid period, comprises figurines of women dressed in long garments with embroidered edges, holding their left hands against their breasts. A second group, probably dating from approximately the second half of the 3d to about the 1st century B.C., includes numerous male and female figurines reminiscent of the work of Parthian coroplasts: the men are dressed in shirt jackets fitting tightly at the waist, baggy trousers, and headdresses of Phrygian type with ear flaps, the women in gowns over long petticoats with shawls over their shoulders. (This dress resembles not only the costume in which the Khwarizmians are portrayed on Achaemenid relief carvings, but also that known to have been worn by the Scythians and the inhabitants of Asia Minor and Thrace, and even that of certain personages figuring in the frescoes of the Tarim Basin.) A third group, which Tolstov dates no earlier than the 1st century B.C., consists of larger figurines including male and female figures draped in mantles or shawls, female figures either posed like the Medici Venus or riding animals, nude male figures, and a few others seated in a pose reminiscent of certain examples of Gandharan art (see GANDHARA). A few intaglios which seem to show Hellenistic influence may be added to this assortment of documents, on the basis of which it has been possible to classify sites that are of interest, above all, for their architecture.

The architectural complexes on these sites are of quite considerable dimensions. Tolstov and his collaborators attribute those of Dzhanbas Kale, Kyrk-kyz Kale, Koy-krylgan Kale, and Kyunerli Kale, to mention only the most important, to an early phase, namely to the Kangyu period. He regards these fortified complexes as independent and exclusively Khwarizmian architecture, owing nothing to the ancient East. Whatever their origins, they are of two different types.

The fortresses with rectangular enclosures: Dzhanbas Kale. Dzhanbas Kale is a vast rectangular complex consisting essentially of a double fortified wall measuring about 605 × 525 ft., with two stories of loopholed galleries, within which rose two blocks of buildings separated by a wide street; the entrance, located at one end of the street, was protected by projecting structures measuring about 65 × 170 ft., which formed a staggered passage. Both blocks consisted of adjoining dwellings; the only isolated building was a "house of fire," which stood at the opposite end of the street, facing the entrance way, and contained a sanctuary and a room that served, according to Tolstov, as a communal dining room. Several other sites, of the same plan but, apparently, of later date, are Gyaur Kale, consisting of a vast irregular rectangular complex with several rows of rooms forming a single unit with the wall; Kunya-uaz, where the enclosure is divided in two by a wall that rises opposite the entrance to the sections; and Kyunerli Kale, where an enormous keep stood in the center of a square enclosure.

The fortresses of circular plan: Koy-krylgan Kale. A highly original plan characterizes such other fortified complexes as the little castle of Kyrk-kyz and the fortress of Koy-krylgan Kale. Kyrk-kyz is of an irregular oval shape (determined by the configuration of the ground) and is protected by a second enclosure, which is in the form of a

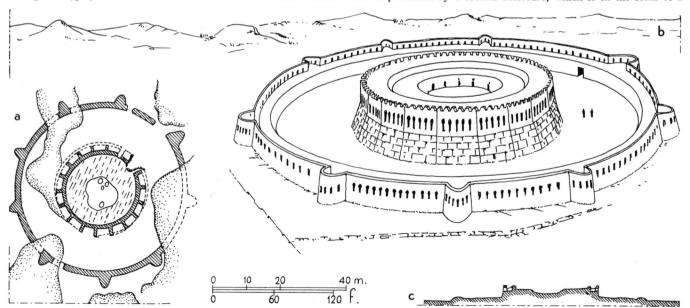

Koy-krylgan Kale, fortress (dynastic and funerary sanctuary). (*a*) Plan; (*b*) perspective view according to Tolstov's reconstruction; (*c*) section (*after S. P. Tolstov, Po sledam drevniekhorezmskoi tsivilizatsii, Moscow, 1948*).

segment of a circle and is linked to the central fortress by two more or less perpendicular walls bordering the platform on which the whole complex is built; the entrance was located in the middle of the outside wall. The same type of circular fortification is found at Koykrylgan Kale (FIG. 1003; III, PL. 484), where a vast circular enclosure surrounds an enormous citadel of the same shape. This complex consists, in effect, of a massive circular wall about 195 ft. in diameter, which is flanked by nine evenly spaced towers, pierced with loopholes all the way around, and provided with a broad rampart walk and a single entrance. The citadel is in the form of a vast regular polygon with 18 sides; the walls, rising considerably above the outer enclosure, are pierced with loopholes near the top and surmounted by serrated crenelation. The outer enclosure is entered by way of a covered gallery, above which runs the rampart walk giving access to the battlements. The interior is taken up by a circular edifice forming a single unit with the inside wall of the fortress, and a courtyard of the same shape is located in the center of the citadel. This completely original complex with its towers foreshadows the fortifications of the Kushan period, when the great fortified sites were to undergo further transformations. These fortresses, which had sheltered entire clans, were gradually replaced by others of lesser dimensions, which were inhabited by families descended from the clans.

THE MONUMENTS CONTEMPORARY WITH THE KUSHAN PERIOD. The architectural monuments that may be regarded as contemporary with the Kushan period, such as Ayaz Kale, Dzhildyk Kale, Angka Kale, Bazar Kale, and Kurgashin Kale, differ markedly from those of the preceding period. Fortress 1 of Ayaz Kale, built on a high cliff, has massive walls which are provided with galleries for archers, reinforced by semicircular towers, and dovetailed at the corners. The fortress, dominating the site on which it stands, is small in comparison with such earlier constructions as Fortress 3 of Ayaz Kale, at the foot of the cliff, the ruins of which show a staggered entrance and spacious courtyards surrounded by baked brick walls, against one of which a few dwellings have remained standing. The difference in size of the two fortresses (Fortress 1 measures about 655 × 490 ft.; Fortress 3 is about 850 × 590 ft.) indicates that during the Kushan period there was a transformation in the way of life paralleled by a profound modification of society. Henceforth, families, instead of clans, inhabited these complexes, in which the fortress represented the families' residence and the outbuildings the dwellings of those whose job it was to look after the families' property. The fortress of Kurgashin Kale, of lesser dimensions (ca. 460 × 330 ft.), has a more elaborate system of defense, including oblique loopholes, two adjacent towers, and even two abutting towers which form a dovetail on the southeast corner. Bazar Kale is a square complex, each side measuring about 1,870 ft., with a thick wall reinforced by more or less evenly spaced towers, two of which guard its entrance, and with a redoubt of modest dimensions on the northeast corner, which has a zigzag entrance. Angka Kale, measuring about 260 × 280 ft., is also a square fortress; it has a double wall pierced with loopholes and reinforced by massive square corner towers reached by narrow passages. The main entrance, guarded by smaller towers of the same type, is located in the middle of one of the sides; this fortress probably also included a central redoubt.

The far more complex fortress of Dzhildyk Kale was built on steeply rising ground and provided with an improved system of defense. As in the other fortresses, the outer wall was reinforced by an inner wall, but, instead of being vertical, the outer wall was erected with sloping sides and reinforced by massive buttresses. The occupants were thus able to dominate any assailants or to defend the place more effectively and with a minimum of risk. Moreover, four corner towers built in the same way provided a further reinforcement for this outer wall, the upper part of which was occupied by a rampart walk protected by serrated crenelation, while a passageway under the terrace enabled the defenders to reach safely any threatened areas. The fortress was entered along a ramp leading to an entrance in one of the corner towers, through which, in turn, led the sole passageway to the interior of this fortified structure. The central redoubt consisted of a keep, provided with casemates and surmounted by a battlemented terrace, which occupied a corner of the inner court and rose above the rampart walk of the outer enclosure.

It has been possible to date the various fortresses from a certain number of objects discovered on these sites. One of the complexes at Ayaz Kale, however, has not been dated definitively, because the coins found here were from the era of Kaniṣka, and the dates of his reign have not been determined. The ceramics recovered here, however, are of the same type as pottery found elsewhere and approximately confirm the dates assigned to Ayaz Kale; other finds, such as necklace beads, provide further confirmation, since they resemble those found in the regions bordering the Black Sea dating from the 1st to the 3d century. A bone stiletto, with a handle shaped like a hand, three-bladed bronze arrowheads with sockets, fragments of alabaster vases with representations of female figures, and bronze

earrings and pendants (perhaps amulets, since they represent animals) have also been brought to light at Ayaz Kale, while a fragmentary torso of a statuette probably representing the Egyptian god Bes was found at Bazar Kale.

Khwarizmian pottery, like that of the other Central Asiatic regions during the centuries prior to and following the dawn of the Christian Era, is often characterized by a red slip, glaze disposed in bands, and a design of undulating lines; the most recurrent types are vessels in the form of jars, wide-necked bottles with feet, and vases with handles in the form of animals. In addition to these, however, Khwarizm produced more distinctive ceramic ware, such as large wine jars and vessels adorned with a painted design of spirals linked by circles; wide use was made of glaze, which was applied not only in bands, but also in crisscross patterns and even over the whole surface.

THE KUSHANO-AFRIGIDIAN PERIOD: TOPRAK KALE. Tolstov has named the following period Kushano-Afrigidian, after the dynasty that ruled independent Khwarizm upon the dissolution of the Kushan empire. This was a period of transition, during which Khwarizm entered upon what may without exaggeration be called its medieval period and developed a feudal system. Society underwent further sweeping transformations, which were expressed through modifications in architecture as well as in the other fields of art and in technique. The most noteworthy of the architectural complexes attributed to this period are Toprak Kale and the less important sites of Yakke Parsan and the small Kavat Kale.

Of all the architectural monuments of Khwarizm, Toprak Kale (PL. 389) is perhaps the most important. It is a princely city and was perhaps the residence of the rulers of Khwarizm. Its discovery by Tolstov has yielded not merely another architectural ensemble and a few archaeological documents which allow an estimate of the degree of civilization attained here, but a city whose successful excavation and reconstitution, carried out with extreme competence by Soviet archaeologists, has yielded remarkable archaeological documentation on the arts of painting and sculpture.

Toprak Kale is a rectangular complex of about 1,910 × 1,380 ft. surrounded by a wide ditch spanned by a bridge leading to a fortalice attached to the fortified outer wall, which constitutes the entrance to the city. The rectangular outer wall is reinforced by evenly spaced square towers and flanked at the corners by larger square towers; the walls and towers, built on inclined foundations, are pierced with elongated loopholes and surmounted by crenelation. The city itself consists of two blocks of houses divided into wards by lateral streets joining at right angles with a central avenue which runs between the entrance and a fortified palace located in the northwest corner of the city. This palace, built on a high platform, comprises a spacious courtyard, terraces, an entrance ramp, and a sizable main building flanked and dominated by three massive square towers (PL. 389). Another group of buildings surrounds a rectangular space filled with ashes which must have been a "house of fire." This space is in the center of a vast rectangular courtyard which, although slightly more to the west, constitutes an extension of the central avenue.

This plan shows the same characteristics as that of the towns of the preceding periods, such as Dzhanbas Kale, with the notable difference that the façades, which had hitherto been plain, are adorned with pilasters separating the loopholes — a feature which persisted throughout the Afrigidian period.

The lowest strata at Toprak Kale contained material of the Kushan epoch, higher strata afforded Afrigidian coins ranging from the beginning of the 3d to the beginning of the 4th century together with coins of Vāsudeva (first half of 3d cent.), while the upper strata have yielded only Afrigidian coins, the most recent of which are of the late 5th and early 6th centuries. The objects found on this site are thus amply dated.

The main part of the palace consisted of two stories of vaulted rooms; those in the center, richly decorated with sculpture and paintings (PLS. 386–388, 390), were the great reception rooms. Cut into the walls of one of these rooms were niches which contained clay statues representing crowned personages; another room was adorned with images of rulers or divinities and dark-skinned warriors, as well as reliefs, probably depicting a hunting scene, of trees, rolled vine leaves, cervine creatures, and griffins. The living quarters, adorned with mural paintings, were located to the south of the central section; the public buildings, including the workshops, were on the west side of the structure.

The pictorial and sculptural remains are of major interest. Both the paintings and the sculpture are closely related to the architecture and, characteristically, the sculpture (whether high or low relief or statuary) was generally polychromed; true statuary was, moreover, a rarity, most statues being left unmodeled at the back.

Most of the pictorial remains, known through Tolstov's publications, consist of no more than fragments, found in the rubble, which had fallen from the walls (PL. 390); the odd fragments still in place

are apparently in very poor condition. M. A. Orlova has made a study of the principles which governed the internal disposition of these pictorial compositions. The first and most widely applied consists in dividing the wall surface into circumscribed decorative panels, each about 3 ft. high, and filling in the space above them with random ornamentation on a smaller scale or with a representational painting. Another procedure is that of alternating decorative motifs and representational paintings at random over the entire wall surface, while a third consists in interspersing an over-all decor of painted garlands and symbolic designs with portraits framed in ornamental motifs.

Judging from the available information, sculpture appears to have predominated in the interior decoration, but always in conjunction with painting; the pieces of sculpture were executed in unbaked clay and coated with a thin layer of plaster (the base of which was powdered alabaster), which constituted the foundation for the paint. This polychrome sculpture stands out clearly from the painted background of the wall surface and, as Tolstov observes, is characterized by the constant repetition of groups of an identical type, emphasizing the internal structure of the room.

Because of their ornamentation, three of the reception rooms have been named, respectively, "Hall of Kings," "Hall of Victories," and "Warriors' Hall." According to Tolstov, the sculpture in the Hall of Kings was placed in niches, each containing a group representing a ruler of Khwarizm surrounded by the members of his family (the latter of comparatively lesser proportions). These groups were evenly distributed around the walls and separated only by thin partitions of brick openwork; the whole resembled a portrait gallery featuring the monarchs who reigned during the first centuries of our era.

The groups executed in high relief in the Hall of Victories were also arranged in niches, and all represented the same female figure (perhaps the goddess of victory) dressed in a thin, billowing gown standing with her face turned toward a seated personage of princely aspect (PL. 387). The Warriors' Hall was decorated with a series of ornamental motifs (resembling those on Ionic capitals) alternated with the repeated representation of a male figure turned to the left, and the remainder of the wall surface above these motifs was occupied by reliefs of dark-skinned warriors executed on a smaller scale (PL. 386).

The secondary halls and chambers, together with the corridors, were adorned with a variety of either purely ornamental or representational paintings. Noteworthy among the fragments of figural painting are a woman picking fruit, two figures adorning a niche in Room 25 on the first floor, and, particularly, a female harpist in Room 25 on the second floor; two fragments of female heads also deserve mention. The female harpist, whose face is partially destroyed, is vaguely reminiscent of the female harpist of the Airtam frieze; the painting is executed in a yellow tone, and the elegance of the drawing and the acanthus leaves seem to reflect distantly the art of Gandhara. In contrast, the fragmentary full-faced portrait of a woman is reminiscent of the style of the Syro-Egyptian paintings of the Roman period, and even of that of the paintings in the catacomb at Kerch, of the same period. These two fragments would seem to reveal that diverse artistic influences probably penetrated Khwarizm, constituting, as it did, one of the junctions on the network of caravan routes linking the eastern Mediterranean and the northern shores of the Black Sea to central Asia and India.

The remaining fragments seem to differ in both color and style from those described above and may perhaps be regarded as the products of an original, local art. In addition to these extremely precious, but rare, fragments, there have been found a certain number of others with decorative geometric or plant motifs, many of which seem to correspond with the contemporaneous popular art of Central Asia (see ASIA, CENTRAL).

Toward the 5th or 6th century, Toprak Kale began to show signs of a decadence that was manifested chiefly in the minor arts (e. g., pottery became coarse and ceased to be turned on a wheel). The town itself was gradually abandoned and, by the 7th century, had become a necropolis.

THE AFRIGIDIAN PERIOD. The sites of the small Kavat Kale and Yakke Parsan already belong to the Afrigidian period and are of an entirely different plan. In each case, the whole complex is laid out in a plan of two or three concentric squares, with the keep in the center instead of in the corner, and the courtyards disposed in terraces; moreover, while the walls of the central redoubt continued to be built of small, baked bricks, the outer walls were henceforth of mud and no longer provided with the loopholes characteristic of the preceding period. (The inhabitants assembled on top of the walls to defend the castle, with only the battlements to protect them.) This was a considerable modification, for, during the Kushan period, large, square, unbaked bricks had constituted, as in the past, the principal building material for both the supporting walls and the vaulted roofs; the Khwarizmians, like the inhabitants of Sogdiana (Transoxiana), rarely had recourse to stone, which was used only for the bases of the columns supporting

the roofs of certain chambers. Though the small Kavat Kale appears to be the earlier of the two complexes, the castle of Yakke Parsan is the more interesting. The central keep with its festooned and battlemented walls is built on a foundation with sloping sides and is linked to the inner enclosure by a bridge leading to the entrance, which is guarded by two massive round towers. This rectangular inner enclosure, reinforced by four massive round corner towers and by two towers along each side, rises above a second enclosure, forming a vast quadrilateral with rounded corners and provided with only two towers guarding its entrance, which in turn dominates and is reinforced by a much larger outer enclosure with an unfortified entrance.

The Afrigid period lasted approximately from the 4th century until the start of the Arab conquest and even until the founding of the Samanid dynasty (which originated near Balkh and ruled Transoxiana and Khwarizm between 875 and 999). It was during this period that feudalism became firmly established, superseding the village system on which the ancient urban civilization of Khwarizm had been based. The region enjoyed a certain economic prosperity in the fields of agriculture and cattle breeding, and castles of varying sizes rose everywhere to house the big and small landowners, each of whom commanded numerous serfs. It was mainly the serious disorder accompanying the evolution to feudalism which prompted the modification of the plan of the castles that were the feudal lords' defense against opponents or invaders. These defenses, however, did not prevent the triumph of the Arab invasion.

The group of monuments most characteristic of this period is that of Berkut Kale, which extends for about 15 miles beside an old canal north of Turtkul. Of the more than 90 archaeological sites in this area, the most important are Teshik Kale, Berkut Kale, and Kumbaskan Kale.

Teshik Kale, a powerfully fortified complex, has an outer enclosure of mud, measuring about 45 × 320 ft., with oval corner towers and a staggered entrance; the inner enclosure has equally high but less massive walls. The wall facing the entrance to the outer enclosure ran through the keep. This keep, reached by a drawbridge, is built on a foundation with sloping sides which are 25 ft. high; its upper structure, built of small bricks, forms a rectangular block of festooned and crenelated walls decorated with a blind arcade with engaged columns, each adorned with three blind loopholes. The interior consisted of rooms opening onto a passageway, of which two on the right were reception rooms. The smaller was adorned with a terra-cotta frieze, the larger with a frieze of unbaked clay of rosettes with eight petals and palmettes with five leaves (PL. 389); a back room contained large jars. The ceramics, very different types from those of the early period, include large jars with incisions around the neck, potbellied pitchers with narrow bases, and vases with two handles and wide necks. Found with the ceramics were three impressions made with seals in clay; one represents a horseman shooting at an ibex and the other two, showing the influence of Greco-Buddhist art, a female divinity with four arms. Pieces of woven materials and such small objects as a double comb have also been brought to light, together with pre-Islamic coins, iron arrowheads with three blades, and rings set with round stones instead of the oval stones of earlier periods.

Berkut Kale consists of only a fortress with a keep in one corner and a square enclosure fortified by towers at the corners and along the sides; the whole, together with the few scattered remains of the town itself, was surrounded by another, irregular enclosure.

At the site of Kumbaskan Kale, which appears to be of later date, there is a fortress with a double enclosure; the outer enclosure, measuring about 490 × 655 ft., is reinforced by oval corner towers and by two towers on one of the shorter sides, and the entrance was flanked by square towers in the form of pylons. The inner enclosure, which takes up a large part of the area protected by the outer enclosure, had in front of it a spacious courtyard, with a few secondary buildings which faced the outer entrance; an inner gateway opening onto the outer entrance was defended by a square tower in the form of a pylon and by the keep. This inner enclosure measures about 410 ft. on each side and is fortified by four oval corner towers and by three towers along three of the sides. (On the side facing the courtyard there is a single tower reinforcing the defenses around the entrance.)

THE AFRIGID-SAMANID PERIOD. The following period (9th–10th. cent.), which Tolstov calls Afrigid-Samanid, was a time of transition. Whereas Moslem influence tended to dominate ornamentation, the architectural principles of the preceding period, with modifications, prevailed. Of the castles of Buran Kale, Castle 2 differs but little from those of the Afrigidian period, while Castle 1, like those of Naib Kale, shows the characteristics of the Moslem medieval period of Khwarizm. These fortresses are far less imposing than those of the Afrigids. Rectangular in plan, they have festooned walls reinforced at the corners by identical square towers and by other towers, one in the middle of each side; the gateway, also located in the middle of one of the sides, is defended by two towers shaped like pylons.

THE PERIOD OF THE KHWARIZMSHĀHS. The following period, that of the Khwarizmshāhs (rulers of Khwarizm), is perhaps best represented by the complex of Kavat Kale, north of Turtkul. The feudal organization of this complex is demonstrated by the existence of a large castle, that of Kavat Kale, the residence of the feudal lord, who also owned several smaller castles inhabited by his vassals and an agglomeration of nearly ninety farm buildings or peasants' dwellings. Moreover, with their scant defenses, slender walls, and towers that look more like turrets, these castles are clearly the architecture of a peaceful period; certain architectural features of the preceding period have been voluntarily preserved, although, since the defense of the region was ensured by the ruler and his army, they no longer served any military purpose. A certain number of nonfigural ornamental motifs recovered on this site show the Moslem influence which gradually came to prevail in Khwarizm. Among the fortresses of this period, mention should be made of that of Kyz Kale, an edifice of imposing dimensions, 1,380 × 590 ft., which dominates the right bank of the Amu Darya upstream from Turtkul. Of irregular plan, its crenelated enclosing wall, though reinforced by round, oval, and triangular towers, is not so high as those of the preceding periods; its defensive value, despite the reinforcement of the gateways, is thus considerably reduced.

The fortress of Dzhanpyk Kale, on the right bank of the Amu Darya between Turtkul and Nukus, presents the same characteristics.

BIBLIOG. A. I. Terenozhkin, Arkheologicheskie razvedki v Khorezme (Archaeological Researches in Khwarizm), SA, VI, 1940, pp. 168–89; A. I. Terenozhkin, O drevnem goncharstve v Khorezme (Regarding the Ancient Ceramics of Khwarizm), Izvestiia Uzbekistanskogo Filiala Akademii Nauk SSSR, VI, 1941; S. P. Tolstov, Khorezmskaia ekspeditsiia 1939 goda (The Expedition to Khwarizm in 1939), KS, VI, 1940, pp. 70–79; S. P. Tolstov, Drevnosti verkhnego Khorezma (Antiquities of Upper Khwarizm), Vestnik Drevnei Istorii, 1941, 1, pp. 155–84; S. P. Tolstov, Toprak-kala: K istorii pozdneantichnogo Khorezmiiskogo goroda (Toprak Kale: On the History of a City of Khwarizm in Late Antiquity), Izvestiia Akademii Nauk, Seriia istorii i filosofii, II, 1945, pp. 275–86; S. P. Tolstov, Novye materialy po istorii kul'tury drevnego Khorezma (New Materials for the History of Ancient Khwarizm's Culture), Vestnik Drevnei Istorii, 1946, 1, pp. 60–100; S.P.Tolstov, Khorezmskaia arkheologo-etnograficheskaia ekspeditsiia Akademii Nauk SSSR (The Archaeological and Ethnographic Expedition of the USSR Academy of Sciences to Khwarizm), Izvestiia Akademii Nauk, Seriia istorii i filosofii, IV, 1947, pp. 177–82, V, 1948, pp. 182–92, VI, 1949, pp. 246–62, VII, 1950, pp. 514–29; I. G. Guliamov, K vozniknoveniiu irrigatsii v Khorezme v svete dannykh arkheologii (Rise of Irrigation in Kkwarizm in the Light of Archaeological Data), Nauchnaia sessiia Akademii Nauk Uzbekskoi SSSR, 1948; S. P. Tolstov, Drevnii Khorezm (Ancient Khwarizm), Moscow, 1948; S. P. Tolstov, Po sledam drevniekhorezmskoi tsivilizatsii (On the Track of the Ancient Civilization of Khwarizm), Moscow, 1948; S. P. Tolstov and M. A. Orlov, Opyt primeneniia aviatsii v arkheologicheskikh rabotakh Khorezmskoi ekspeditsii (Experiment with Aviation in the Archaeological Work of the Khwarizm Expedition), Vestnik Akademii Nauk SSSR, 1948, 6, pp. 54–68; M. A. Orlov, K voprosu o rekonstruktsii dvortsa khorezmshahov III v.n.e.: Toprak-kala (The Problem of Reconstructing a Castle of the Khwarizmshāhs of the 3d Century: Toprak Kale), Izvestiia Akademii Nauk, Seriia istorii i filosofii, VII, 1950, pp. 384–92; S. P. Tolstov, V Khorezmskoi ekspeditsii 1950 goda (On the 1950 Expedition to Khwarizm), Izvestiia Akademii Nauk, Seriia istorii i filosofii, VII, 1950, pp. 577–78; S. P. Tolstov, Arkheologicheskie pamiatniki na trasse glavnogo turkmenskogo kanala (Archaeological Monuments along the Route of the Principal Canal of Turkmenistan), Razvedki Khorezmskoi ekspeditsii v. 1950–51 gg. (Research of the Expedition to Khwarizm in 1950–51), Vestnik Akademii Nauk SSSR, 1952, 4, pp. 46–58; S. P. Tolstov, Arkheologicheskie razvedki po trasse glavnogo turkmenskogo kanala (Archaeological Researches along the Route of the Principal Canal of Turkmenistan), Kratkie soobshcheniia instituta etnografii, XIV, 1952, pp. 3–11; Trudy Khorezmskoi arkheologo-etnograficheskoi ekspeditsii (Work of the Archaeological and Ethnographic Expedition to Khwarizm), 2 vols., Moscow, 1952–58; S. P. Tolstov, Arkheologicheskie issledovaniia Khorezmskoi ekspeditsii 1952 goda (Archaeological Explorations of the Expedition to Khwarizm in 1952), Vestnik Akademii Nauk SSSR, 1953, 8, pp. 34–45; S. P. Tolstov, Arkheologicheskie raboty Khorezmskoi ekspeditsii Akademii Nauk SSSR v 1952 goda (Archaeological Work of the Expedition to Khwarizm of the USSR Academy of Sciences in 1952), Vestnik Drevnei Istorii, 1953, 2, pp. 154–88; S. P. Tolstov, Khorezmskaia arkheologo-etnograficheskaia ekspeditsiia Akademii Nauk SSSR 1950 goda (The Archaeological and Ethnographic Expedition of the USSR Academy of Sciences to Khwarizm in 1950), SA, XVIII, 1953, pp. 301–25; S. P. Tolstov, Raboty Khorezmskoi ekspeditsii Nauk SSSR po raskopkam pamiatnika IV–III vv. do n.e. Koi-Krylgan-Kala, mart–mai 1952 g. (Work of the USSR Academy of Sciences Expedition to Khwarizm for the Excavation of the Monument of 400–300 B.C. at Koy-krylgan Kale, March–May 1952), Vestnik Drevnei Istorii, 1953, 1, pp. 160–73; S. P. Tolstov, Arkheologicheskie raboty Khorezmskoi arkheologo-etnograficheskoi ekspeditsii Akademii Nauk SSSR v 1951 goda (Archaeological Work of the Archaeological and Ethnographic Expedition to Khwarizm of the USSR Academy of Sciences in 1951), SA, XIX, 1954, pp. 241–62; A. L. Mongait, Arkheologiia v SSSR, Moscow, 1955, pp. 261–72 (Eng. trans., D. Skvirsky, Archaeology in the USSR, Moscow, 1959, pp. 263–77); S. P. Tolstov, Itogi rabot Khorezmskoi arkheologo-etnograficheskoi ekspeditsii Akademii Nauk SSSR v 1953 goda (Account of the Work of the Archaeological and Ethnographic Expedition to Khwarizm of the USSR Academy of Sciences in 1953), Vestnik Drevnei Istorii, 1955, 3, pp. 192–206; S. P. Tolstov, Raboty Khorezmskoi arkheologo-etnograficheskoi ekspeditsii 1951–54 gg. (Work of the Archaeological and Ethnographic Expedition to Khwarizm during the years 1951–54), Voprosi Istorii, 1955, 3, pp. 173–80; S. P. Tolstov, Itogi dvadtsati let raboty Khorezmskoi arkheologo-etnograficheskoi ekspeditsii (1937–56) (Account of 20 Years of the Work of the Archaeological and Ethnographic Expedition to Khwarizm), Sovetskaia Etnografiia, 1957, 4, pp. 31–59; S. P. Tolstov, Khorezmskaia arkheologo-etnograficheskaia ekspeditsiia 1955–56 gg. (The Archaeological and Ethnographic Expedition to Khwarizm in 1955–56), SA, 1958, 1, pp. 106–33; M. G. Vorob'eva, Izobrazheniia l'vov na ruchkakh sosudov iz Khorezma (Representations of Lions on Handles of Vessels at Khwarizm), Kratkie soobshcheniia instituta etnografii, XXX, 1958, pp. 40–53.

Louis HAMBIS

Illustrations: PLS. 385–390; 3 figs. in text.

KIRCHNER, ERNST LUDWIG. German expressionist painter and graphic artist (b. Aschaffenburg, May 6, 1880; d. Davos, Switzerland, June 15, 1938). Kirchner was the son of a paper expert. During a study trip to Nürnberg in 1898 he was attracted to the work of Dürer and of other early German woodcut artists. In 1901 he went to Dresden to study architecture. He also painted on his own with another architectural student, Fritz Bleyl, and, in 1902, began to etch. During 1903–04 he attended art school and then went back to architecture school, where he met Erich Heckel, who joined him and Bleyl in the study of art. The three young men worked in a store that Heckel had converted into a studio. In 1904 Kirchner saw a neoimpressionist exhibition and began to work in that style; he was also influenced at this time by medieval German art and Japanese prints. That same year his discovery of African and Oceanic art in the Dresden Ethnological Museum was an important step toward his future primitivistic leanings and those of the Brücke group he was to lead.

Kirchner's earliest works, especially his drawings and graphics, show a high degree of originality but also betray strong Jugendstil elements and the influence of Edvard Munch's cursive linear sweep and flat color areas. These sources, together with the flat brilliant areas of Félix Vallotton, contributed to the generally decorative and two-dimensional character of Kirchner's early art.

In 1905 another architectural student, Karl Schmidt-Rottluff, joined the group, and the Brücke was organized. In 1906 they added the Germans Emil Nolde and Max Pechstein, the Swiss Cuno Amiet, and the Finn Axel Gallén-Kallella and held group shows in Dresden-Löbtau. During the summers of 1907–09 the group worked on the Moritzburger Lakes, studying the nude in nature, and during the winters they worked in the studios of Heckel and Kirchner (V, PL. 211). At this point Kirchner's art was still more postimpressionist than expressionist; as the influence of Van Gogh made itself increasingly felt in the group, Kirchner's color became more spatulated and expressively brilliant. Although his art was so much under French influence, Kirchner and his group, unlike the Fauvist painters, leaned toward a Munch-derived erotomania with symbolic representations of men and women seen together in various circumstances. Kirchner, never content with a "form for form's sake" presentation, preferred to convert the form of visible nature into a symbol of life itself.

In 1910 Kirchner met Otto Müller (Mueller), the final recruit to the Brücke group. That year Kirchner was responsible for the group's annual subscriber's portfolio of graphic works. In 1911 he moved to Berlin with the others, and his drawings began to run in Der Sturm, Germany's leading avant-garde periodical. The following year his works were included in two Blaue Reiter ("Blue Rider") exhibitions, but his own new and personal style was now clear.

The tense, exciting life of the big city gave his art a psychological and dynamic quality. There appeared a whole new series of subjects which reveal him as perhaps the outstanding and the most typical of the figurative expressionists. In his nudes out of doors nature is used as a mirror of the artist's soul, the figures emerging from their background in a state of nature, emotions heightened by conflicting rather than complementary color, by brutalized forms, and by distorted perspective (V, PL. 208). Similarly, the city scenes of Kirchner and his friends

(e.g., his *Street Scene*, 1913; New York, Mus. of Mod. Art) have a philosophical intention as they project anonymous mask-like faces moving aimlessly about the metropolis. Kirchner is more analytical in these scenes than in the representations of nudes seen out of doors, where he was more poetic and universal, but both types of work are part of his interpretive attitude toward art, the basic expressionist quality of searching to find some deeper value beyond the mere physical appearance, which he has destroyed by selfconscious distortions of form, color, and space. His infrequent portraits (for example, *Sick Woman*, 1912; Frankfurt, private coll.) are as probing and subjective as his other works.

Invalided out of the army after a nervous breakdown during World War I, he settled in 1917 in Switzerland near Davos, where he spent the rest of his life in a mountain retreat at Langmatt, the city philosopher becoming the poet of the mountains and peasants. His nervous, graphic Berlin style yielded to a more sculpturesque form and to a new color quality (no longer stressing dissonances, but rather emphasizing an enamellike brilliance that supports the new form interests) which strive toward a monumentality and serenity far removed from his earlier work. His figures convey the feeling of the rough-hewn work of some archaic period, his glorified peasant protagonists revealing another philosophical facet of his creativity.

Following the Nazi purge of modern art in 1937 and because of his failing health, Kirchner took his own life in June, 1938.

BIBLIOG. B. S. Myers, The German Expressionists, New York, London, 1957; W. Grohmann, E. L. Kirchner, Stuttgart, 1958 (Eng. trans., New York, 1960); Kunstverein für die Rheinlande und Westfalen, Düsseldorf, E. L. K., 9 Sept.–30 Oct., 1960 (exhib. cat.).

Bernard S. MYERS

KLEE, PAUL. Painter and graphic artist (b. München-Buchsee near Bern, Switzerland, Dec. 18, 1879; d. near Locarno, June 29, 1940). Klee was the son of Hans Klee, a German musician (1849–1940), and Ida Maria Frick of Basel (1855–1921). In 1880 the family moved to Bern, where the young Paul attended primary school and in 1898 was graduated from the Literarschule. From 1898 to 1901 he studied in Munich, first at the painting school of E. Knirr and later with Franz von Stuck at the Munich Academy. Kandinsky (q.v.) was attending the Academy at the same time, but the two artists did not meet until 1911. In Munich Klee took courses in anatomy and the history of art, learned etching, and experimented with sculpture. At the same time contact with the active musical life of Munich strengthened the interest in music which he had inherited from his family. For a long time Klee was undecided whether to take up painting or music, for both of which he was gifted; in fact, his theories of painting were to a large extent formed by analogies with musical theory. In 1901 Klee, together with the Swiss sculptor Hermann Haller, traveled to Italy, visiting Milan, Genoa, Rome, and Naples. On May 7, 1902, he returned to Bern, where for financial reasons he was forced to remain with his parents until 1906. At first he devoted himself more to drawing and graphic arts than to painting, perhaps in the hope that as an illustrator he could earn enough to keep alive. From 1903 to 1905 Klee etched his ten *Inventions*, which he showed at the Munich Sezession in 1906. These were his first original works. The *Inventions*, which were satirical in intent, grew out of a particularly bitter and pessimistic period in Klee's youth. In 1905 Klee began a series of drawings and water colors on glass. In 1906 he visited the Centenary Exhibition in Berlin and saw the Rembrandts at Kassel and the Grünewalds at Karlsruhe. A series of shows held in Munich allowed Klee to study the work of Van Gogh (1908) and of Cézanne (1909), whom he called the master par excellence. In addition he studied works of Blake, Goya, and Ensor in the print room of the Munich Pinakothek. In September, 1906, Klee married the pianist Lily Stumpf and settled in the Munich suburb of Schwabing, where they lived until 1920. Their only child, Felix, was born in 1907. Klee's sole source of income during these early Munich years — until the start of the war — was the music lessons given by Lily;

he was not able to sell his paintings. During this time music continued to attract him. He attended the concerts of Felix Mottl and, beginning in 1911, those of Bruno Walter. Recollections of his musical life appear in some of his later water colors, such as *The Vocal Fabric of the Singer Rosa Silber* (IX, PL. 397) and *Fiordiligi* (1923). His favorite composer was Mozart, but he also expressed appreciation in his letters for Debussy's *Pelléas and Mélisande*, calling it the most beautiful opera since Wagner, and for Schönberg's *Pierrot Lunaire*. The first exhibition of Klee's collected works took place at the Bern Kunstmuseum in 1910; the exhibition was shown subsequently in Zurich and in 1911 at Basel. In 1911 Klee exhibited 30 drawings at the Galerie Thannhauser in Munich and in the same year began a catalogue of his own works extending back to 1899. This catalogue is one of the most important sources for our knowledge of Klee's early works. Between 1911 and 1912 Klee also did 26 illustrations in pen for Voltaire's *Candide*, which were published in 1920. In 1912 Klee took part in the second Blaue Reiter ("Blue Rider") exhibition in Munich and the Sonderbund exhibition in Cologne, and in 1913 he showed at the Erste Deutsche Herbstsalon in Berlin, sponsored by the periodical *Der Sturm* and directed by Herwarth Walden. In 1911 Klee's circle of friends began to enlarge. A. Kubin visited him, and his old school companion from Bern, L. Moilliet, introduced him to August Macke, through whom he came to know Kandinsky and Franz Marc (qq.v.). He also became friends with A. von Jawlensky, M. von Werefkin, G. Münter, and Jean (Hans) Arp (q.v.; see also EUROPEAN MODERN MOVEMENTS). In the spring of 1912 Klee visited Paris, where he saw and admired the cubists' paintings and met Delaunay. His admiration for the latter led him to translate Delaunay's essay on light for the January, 1913, issue of *Der Sturm*.

In April of 1914 Klee traveled to Tunisia with Moilliet and Macke. It was this trip that fully opened his eyes to color. He noted in his diary: "That is the significance of this blessed moment. Color and I are one. I am a painter." In the weeks immediately following his return to Munich, Klee painted his Kairouan water colors. The outbreak of the war on Aug. 1, 1914, however, prevented public recognition of the paintings, and they succeeded in arousing the interest of his friends only. Klee's journey to Tunisia and a later one (1928–29) to Egypt may also help explain the close resemblances in his work to art of the Near East, especially Islamic art, in the use of arabesques — the interweaving of figures, plants, and animals, and the interchangeability of figure and ground.

With the war Klee's circle of friends broke up. Macke was killed in 1914, Marc in 1916. On March 11, one week after Marc's death, Klee too was called up. He was not sent to the front, however, but was assigned to garrison duty and escorting convoys to the front, so that to some extent he was able to continue painting. In 1918 he wrote an essay on the elements of graphic arts, which appeared in 1920 as a part of his *Schöpferische Konfession* (Creative Credo). Also in 1918 *Der Sturm* published a volume of Klee drawings, and two important essays on the artist appeared, one by W. Hausenstein, the other by T. Däubler. These publications mark the beginning of Klee's fame. On Christmas of 1918 Klee was demobilized and thus was able to return exclusively to his artistic activities. In 1920 he exhibited 38 canvases, 212 water colors, and 79 drawings at Goltz's in Munich. That same year both L. Zahn and H. von Wedderkop published monographs on the artist, and in 1921 one by Hausenstein appeared. The years immediately after the war were extremely productive for Klee. He painted numerous oils, including the well-known *Villa R* (1919; PL. 391), and executed a number of water colors, illustrating various themes, such as *Greeks and Barbarians* (1920). The range of his activities was increasing. On Nov. 25, 1920, he was called by Walter Gropius (q.v.) to teach in Weimar at the Bauhaus, which Gropius had founded in 1919. In January, 1921, Klee began his career as a teacher. The strict collaboration that Gropius required of Bauhaus instructors brought Klee into close association with Kandinsky and Feininger, both of whom remained with the institute until its closing by the Nazis in 1933.

Klee remained with the Bauhaus in Weimar until 1924; in 1926 he moved to its new location in Dessau. In 1931 he

resigned his position at the Bauhaus and accepted a professorship at the Düsseldorf Academy of Fine Arts. He remained there until 1933, when, as a modern artist, he fell under the suspicion of the Nazis and was forced to resign. In December, 1933, he left Germany for good and moved to Bern, where he resided until his death.

Klee's Bauhaus and Düsseldorf periods were particularly fertile. He developed a close relationship between his teaching and his creative activities, for he felt a strong need to define that which he had formerly done intuitively. His conscientiousness as a teacher led him to prepare his lessons in advance and carefully set them down in writing. These were published, together with a group of essays, in 1956. His *Pedagogical Sketchbook* was published in 1925 in the Bauhausbücher series. As a result of the 1923 Bauhaus Exhibition, which was attended by prominent figures from all over the world, Klee had an opportunity to meet and talk with Stravinsky, Busoni, and Hindemith among others. Through his association with the Bauhaus he also came to know Adolf Busch, Edwin Fischer, Driesch, Ostwald, Ozenfant, Gleizes, Kurt Schwitters, and the poet Léon-Paul Fargue. In 1924 Klee, with Kandinsky, Feininger, and Jawlensky, helped found the group called "the Blue Four" (Der Blaue Vier). In 1925 he participated in the first surrealist exhibition in Paris and organized a one-man show at the Galerie Vavin-Raspail. The mid-twenties were also the beginning of frequent travels for Klee. In 1923 he vacationed on the island of Baltrum in the North Sea; in 1924 he was in Sicily; in 1925, in Italy and the island of Elba; in 1927, Corsica and the island of Porquerolles; in 1928, Brittany; from December, 1928, to January, 1929, in Egypt; in the summer of 1929, in southern France; in 1930, the Engadine Valley in Switzerland; in 1931, again in Sicily; in 1932, in northern Italy and Venice; and in 1933, the French Riviera.

By 1929 Klee had become an artist of international renown. His fiftieth birthday was marked by a one-man show at the Galerie Flechtheim in Berlin, and the following year the show was transferred to the Museum of Modern Art in New York. In 1934 Klee organized his first one-man show in England. It was held at the Mayor Gallery in London. In 1935 the Bern Kunsthalle held a large Klee retrospective. That same year Klee felt the first signs of the illness that was to cause his death. He nevertheless continued to work steadily except for 1936, when he was too ill to produce more than a few pieces. The last few years of his life, in fact, were especially productive. During this time in Bern he also took a few short trips, spending the summer of 1936 in Tarasp and Montana in Switzerland, the next two summers respectively at Ascona and Beatenburg, and the autumn of 1939 on the Murtensee. In 1939 he also visited the Prado Exhibition at Geneva. Picasso, Braque, and Kandinsky visited Klee in Bern in 1937. In the same year 17 of Klee's pictures were exhibited in Munich in the Nazi exhibition of "Degenerate Art," and his work was removed from German museums. In 1938 a large Bauhaus exhibit was held at the Museum of Modern Art in New York, in which some of Klee's paintings were shown. That same year saw the creation of seven large oils, which are among Klee's most important. The paintings of 1939 and 1940 may be said to be Klee's own requiem; they are filled with images of angels and the presentiment of death (PL. 394). In February, 1940, a large Klee exhibition was held at the Kunsthaus in Zurich. On May 10 Klee entered a hospital near Locarno. On June 29 he died. Large retrospectives of his work were held soon after his death: in Bern and New York in 1940, in Basel and Zurich in 1941. In 1947 the Klee Foundation (Paul-Klee-Stiftung) was established at the Bern Kunstmuseum.

Klee began his career as a draftsman and etcher. Of his almost 9,000 works, about 5,000 are drawings. Much of his œuvre is now in the Klee Foundation, which comprises 2,571 items, of which 2,250 are drawings. Another important group of 1,324 works, including 689 drawings, is owned by the artist's son, Felix Klee, in Bern. The rest are scattered in various public and private collections, principally in the United States.

Klee's fame as an artist is due in large part to his ability to transcend abstract pictorial invention to achieve a "rebirth of creation," and partly also to the wide range of allusions to music, poetry, and Eastern philosophy that he was able to incorporate in his art. Klee's work always began "with the smallest things," that is, with a pictorial motif, which he developed into a theme as a composer develops a musical motif (PL. 391). His point of departure was not the finished forms of nature but the process of creation itself. In his *Schöpferische Konfession* Klee wrote that "art does not render the visible; rather, it makes visible." He wanted, he said, to make evident "the reality of visible things," since "the visible realm is no more than a 'special case' in relation to the cosmos" and other truths may predominate. It was necessary, he wrote, to strive for "the essence that lies behind the fortuitous." From abstract elements could be built up a universe of form which would correspond to the macrocosm. In 1923 Klee published, as a Bauhaus teacher, his *Ways of Studying Nature*. In it he outlined the multiple ways of analyzing an object according to its anatomical, physiological, and biological aspects and its terrestrial (static) and cosmic (dynamic) relationships. The purpose of such an analysis, according to Klee, was to aim at a total correspondence between the "I" (the painter) and the universe, and to create pictures which differ from optical reality without contradicting it.

In 1924, at a conference held at the Jena Kunstverein, Klee delivered a lecture in which he compared the relation of art to nature with that of the crown to the root of a tree: as the crown cannot mirror the roots that feed it, because "different functions operating in different elements lead to vivid divergencies," so art must transform and not merely imitate nature. He asserted that the artist must concern himself with the dimensions of mass (line), weight (tonality), and quality (color), not with resemblance. If a formal motif is developed into a pictorial structure, "it is easily joined by an association which acts as an enticement toward an objective meaning." These associations may lead to misunderstandings if the viewer tries to compare them with the given forms of nature, but for the artist they are merely a fortuitous encounter in the course of his creative activity. The artist must aim not at representation but at creating his own archetypes; he must seek "the primary ground of creation where the secret key to all is kept." For Klee, art, like nature, is a generative force; the artist works as nature does, except that in the end "the picture looks at him"; something identifiable and meaningful results, because, as Goethe had observed, "to an unknown law of the object there corresponds an unknown law of the subject."

As a painter who was also a musician, Klee sought to find in painting a theory of harmony that could be of use to both students and teachers. He composed with pictorial elements the way a musician works with notes, motifs, themes, and modulations; and although he believed in a clear separation of the arts, his work has definite points of contact with music. His *Fugue in Red* of 1921 is, to be sure, a pictorial fugue; nevertheless, like a musical fugue, its structure is based on the principle of imitation. Among Klee's works can be found pictures which have a clear polyphonic or homophonic character, pictures with continuous melodic line, with ascending and descending rhythms, with tonal and atonal relationships, and so on (V, PL. 137).

Klee was a poet as well, and the associational titles he gave to his pictures, such as *Lomolarm* ("L'homme aux larmes" or "man of tears") and *Stuhltier* ("chair-animal"), show a highly inventive use of language. His *A Light and Dry Poem* is a poem in pictorial signs and its title a poetic metaphor. In such titles may be read the measure of Klee's poetic sensitivity (PL. 393).

Klee's work evolved slowly until 1914, and he produced little in color up to that time. After 1914, however, the range of his pictorial devices and motifs expanded considerably. His Kairouan water colors were based upon Delaunay's principle of building up a subject by means of rhythmically active color contrasts, but they were entirely original schemes. From 1914 on Klee created in all about 30 different compositional schemes in which formal inventions were developed into a wide variety of pictorial conceptions. He created paintings and drawings arranged as rigidly as notes on a musical staff; screenlike pictures with intersecting vertical and horizontal lines; pictures with

fanciful perspectives; compositions formed by succeeding parallels or with small squares of different colors (PL. 393); some with volumetric shapes which seem like animated pieces of cut and folded paper; and finally others with dark and heavy bars which seem to have as their subject matter ultimate questions of life and the world (PL. 392). Klee's methods enabled him to create images of an originality such as had never before been achieved in painting, as for example *The Fateful Hour: 11:45* (1922); *Pastoral* (1927); *Before the Snow* (1929); *Drum Organ* (1930); *Heroic Fiddling* (1938), a homage to the violinist Adolf Busch; or *Forgetful Angel* (1939). From 1930 on Klee succeeded in realizing to an increasing extent the "multidimensional simultaneity" he was seeking in painting and which, for him, had spiritual implications.

To select a certain number of masterpieces from Klee's work is impossible, for almost everything he did is on the same high level. The catalogue of his work comprises 733 canvases, 3,197 paintings on paper (water colors and mixed media), 4,877 drawings, 54 etchings, 38 lithographs, 3 woodcuts, and 16 small sculptures. The literature on Klee has become so enormous that only a selected bibliography can be given here. The list of Klee's own writings is complete.

PRINCIPAL EXHIBITIONS TO 1940: 1906: Munich Sezession. – 1910: Kunsthaus, Zurich. – 1911: Galerie Thannhauser, Munich. – 1912: Blaue Reiter exhibition, Munich. – 1912: Sonderbund exhibition, Cologne. – 1913: Der Sturm, Berlin. – 1917: Galerie Dada, Zurich. – 1919: Zinglers Kabinett, Frankfurt am Main. – 1919: Galerie Gurlitt, Berlin. – 1919: Kestner-Gesellschaft, Hannover. – 1920: Galerie Flechtheim, Düsseldorf. – 1920: Galerie Goltz, Munich. – 1921: Kunstverein, Cologne. – 1921: Neue Sezession, Munich. – 1923: Kronprinzenpalais, Berlin. – 1923: Galerie Thannhauser, Munich. – 1924: Galerie Fides, Dresden. – 1924: Société Anonyme, New York. – 1925: Galerie Goltz, Munich. – 1925: Galerie Vavin-Raspail, Paris. – 1926: Galerie Fides, Dresden. – 1926: Kunsthaus, Zurich. – 1927: Galerie Flechtheim, Düsseldorf. – 1928: Galerie Le Centaure, Brussels. – 1929: Galerie Flechtheim, Berlin. – 1929: Galerie Bernheim, Paris. – 1930: Nationalgalerie, Berlin. – 1930: Museum of Modern Art, New York. – 1931: Kunstverein für die Rheinlande und Westfalen, Düsseldorf. – 1934: Mayor Gallery, London. – 1935: Kunsthalle, Bern. – 1938: Buchholz Gallery, Curt Valentin, New York. – 1938: Ballay et Carré, Paris. – 1938: Nierendorf Gallery, New York. – 1938: Museum of Modern Art Bauhaus exhibition, New York. – 1940: Nierendorf Gallery, New York. – 1940: Germanic Museum, Harvard University, Cambridge, Mass. – 1940: Kunsthaus, Zurich.

BIBLIOG. *Writings and graphic work of Klee*: Die Ausstellung des Modernen Bundes im Kunsthaus Zürich, Die Alpen, VI, 1912, pp. 696–704; Über das Licht (trans. of an essay by Delaunay), Der Sturm, III, 1913, pp. 255–56; C. Corrinth, Potsdamer Platz, oder Die Nächte des neuen Messias, Munich, 1920 (10 lithographs); Schöpferische Konfession (Tribüne der Kunst und Zeit, XIII), Berlin, 1920, pp. 28–40; Voltaire, Kandide oder Die beste Welt, Munich, 1920 (26 ink drawings); Neue europäische Graphik, erste Mappe: Meister des Staatlichen Bauhauses in Weimar, Weimar, 1921; Über den Wert der Kritik, Der Ararat, II, 1921, p. 130; Wege des Naturstudiums, in Staatliches Bauhaus in Weimar, 1919–1923, Weimar, Munich, 1923, pp. 24–25 (repr. for the exhibition of Klee at the Haus der Kunst, Munich, 1950); Pädagogisches Skizzenbuch (Bauhausbücher, 2), Munich, 1925 (Eng. trans., S. Peech, New York, 1944); Katalog Jubiläumsausstellung zum 60. Geburtstag Kandinsky, Dresden, 1926; Festschrift für Emil Nolde anlässlich seines 60. Geburtstages, Dresden, 1927; Exakter Versuch im Bereich der Kunst, Bauhaus-Z. für Gestaltung, Dessau, II–III, 1928, p. 17; Über die moderne Kunst, Bern-Bümplitz, 1945 (Eng. trans., P. Findlay, On Modern Art, London, 1947); C. Giedion-Welcker, ed., Poètes à l'écart, Bern-Bümplitz, 1946, pp. 105–10 (8 poems); J. Spiller, ed., Das bildnerische Denken, Basel, Stuttgart, 1956 (Eng. trans., R. Manheim, New York, 1961); Im Zwischenreich: Aquarelle und Zeichnungen, Cologne, 1957 (Eng. trans., N. Guterman, The Inward Vision, New York, 1959); Tagebücher 1898–1918, Cologne, 1957. *Works on Klee*: A. Behne, Paul Klee, Die weissen Blätter, IV, 1917, pp. 167–69; T. Däubler, Paul Klee, Das Kunstblatt, II, 1918, pp. 24–27; W. Grohmann, Handzeichnungen von Paul Klee, Mnh. für Bücherfreunde und Graphik-Sammler, I, 1925, pp. 216–26; A. Schardt, Das Übersinnliche bei Paul Klee, Mus. der Gegenwart, I, 1930, pp. 36–46; R. Vitrac, A propos des œuvres récentes de Paul Klee, CahArt, V, 1930, pp. 300–06; Sondernummer Paul Klee, Bauhaus-Z. für Gestaltung, Dessau, Dec. 1931; R. Bernoulli, Mein Weg zu Klee, Bern, 1940; W. Grohmann, The Drawings by Paul Klee, New York, 1944; CahArt, XX, XXI, 1945–46 (series of articles dedicated to Klee); S. W. Hayter, Paul Klee: Apostle of Empathy, Mag. of Art, XXXIX, 1946, pp. 127–31; H. Read, Paul Klee, 2 vols., London, 1948; Klee-Gesellschaft Bern, ed., Paul Klee, 2 vols., Bern, 1949–60; M. Pulver, Erinnerungen an Paul Klee, Das Kunstwerk, III, 4, 1949, pp. 28–32; M. Armitage and others, Five Essays on Klee, New York, 1950; W. Haftmann, Paul Klee, Munich, 1950 (Eng. trans., The Mind and Work of Paul Klee, London, New York, 1954); A. D. B. Sylvester, Paul Klee: La période de Berne, Les Temps Modernes, VI, 1951, pp. 1297–1307; C. Giedion-Welcker, Paul Klee, New York, 1952; W. Grohmann, Paul Klee, Stuttgart, 1954 (Eng. trans., London, New York, 1954; bibliog.); G. di San Lazzaro, Paul Klee, Paris, 1957 (Eng. trans., New York, 1959); W. Grohmann, Paul Klee: Handzeichnungen, I, Cologne, 1959; L. Grote, ed., Erinnerungen an Paul Klee, Munich, 1959; F. Klee, Paul Klee: Leben und Werk in Dokumenten, Zürich, 1960; N. Ponente, Klee, Geneva, 1960.

Will GROHMANN

Illustrations: PLS. 391–394.

KNELLER, SIR GODFREY. English painter (b. Lübeck, 1646 or 1649; d. London, Oct. 19, 1723). Kneller studied under Ferdinand Bol, and possibly Rembrandt, in Amsterdam in the 1660s and went to Italy late in that decade or in the 1670s. During his stay in Rome, Naples, and Venice he came to know Carlo Maratti and Bacciccio (G. B. Gaulli), the leading Italian portrait painters of their period. In 1674 Kneller settled in England. Little is known of his activity between 1678 and 1682, during which time he may have made several trips abroad. Knighted on March 3, 1692, and created a baronet on May 24, 1715, he was raised by these honors to a position of social eminence unequaled by other English artists until the reign of Queen Victoria, and from this time was the dominant artistic figure of his age in England. In 1711 he became the first Governor of the Academy of Painting, a position that he held until 1716.

Kneller was one of the first English artists to regard the portrait, rather than as purely a work of art, as a document concerned with the likeness of a historical personality. His first known work, *The Philosopher* (1668; Lübeck), is similar to the work of other pupils of Bol. No paintings dating from his sojourn in Italy are known. *Admiral Tromp* (1675; Devon, Antony House), the first known painting of his post-Italian period, is still within the spirit of Bol. There was no marked change in his work until about the time he was introduced to the court; the style of his *Mr. Vernon* (1677; London, Nat. Portrait Gall.), for instance, recalls the paintings of Maratti. The portrait of the Duke of Monmouth (ca. 1677; Sussex, Goodwood House), traditionally attributed to Kneller, is considered his first outstanding achievement. It was possibly this portrait which led to his introduction to the King, as well as to his sudden rise in popularity. About 1683 Kneller attained his mature style, a manner which reflects that of Peter Lely (q.v.). His studio housed a multitude of assistants, who specialized in rendering parts of costumes or backgrounds, and frequently Kneller was responsible only for the face of the sitter; yet, though his extremely large output was often indifferently composed and executed because of this atelier system, he was himself capable of doing exceptional work. The best of his later work, created after 1700, reveals Kneller's interest in the perception and communication of character, qualities especially apparent in the "Kit Cat" series (1702–18; London, Nat. Portrait Gall.).

REPRESENTATIVE WORKS. *Sir Charles Cottrell* (1683; Oxfordshire, Rousham House, T. Cottrell-Dormer Coll.). – *Duchess of Portsmouth* (1684; Sussex, Goodwood House). – *Philip, Earl of Leicester* (1685; Kent, Penshurst Place, Viscount De L'Isle Coll.). – *Chinese Convert* (1687; London, Kensington Palace). – *Mrs. Dunch* (1689; Sussex, Parham, C. Pearson Coll.). – *Anthony Leigh as "The Spanish Friar"* (1689; London, Nat. Portrait Gall.). – *Duchess of Marlborough and Lady Fitzhardinge* (1691; Oxfordshire, Blenheim Palace, Duke of Marlborough Coll.). – *Dr. Burnet* (1691; Surrey, Charterhouse). – *Matthew Prior* (1700; Cambridge, Trinity Coll.; VI, PL. 438). – *Jacob Tonson* (1717; London, Nat. Portrait Gall.).

BIBLIOG. C. H. Collins Baker, Lely and the Stuart Portrait Painters, London, 1912, II, pp. 75–94; A. C. Sewter, Kneller and the English Augustan Portrait, BM, LXXVII, 1940, pp. 106–15; M. Davies, National Gallery Catalogues: British School, London, 1946, pp. 89–90; E. K. Waterhouse, Painting in Britain, Harmondsworth, 1953, pp. 97–100.

* *

KOKOSCHKA, Oskar. Bohemian-born Austrian painter, graphic artist, illustrator, and author (b. Pöchlarn, Mar. 1, 1886), outstanding and highly influential expressionist who carried the movement on to an international plane. While still a child, Kokoschka was drawn to African and Oceanic art (cf. Kirchner, Pechstein, Derain, Picasso). In 1905 he was given a scholarship to the Vienna School of Arts and Crafts, where he disliked the conventional approach but derived the beginnings of a decorative attitude which emerged in his early Art Nouveau linearism; he was also influenced by the Austrian Gustav Klimt and by Oriental art. His book of illustrated poetry, *The Dreaming Boys* (1908), reveals the mystical eroticism typical of his work as a whole.

Kokoschka shows a partly Fauve, partly expressionist reaction to the prewar decadence of Vienna in such paintings of the 1907–12 period as *Auguste Forel* (Mannheim, Städt. Kunsthalle) and *Hans and Erica Tietze* (New York, Mus. of Mod. Art), where a fragile, nervous line embedded in a yellow-gold background animates the always significant hands. All the portrait studies of this period show a kind of clinical analysis, a probing for the inner person beneath the outward physical appearance.

Through both his art and his writing — dramas which project with outspoken sex and violence the conflict between man and woman — Kokoschka became a *cause célèbre* (1908–09). The term "degenerate artist," later made famous by the Nazis in Germany, was already being applied to Kokoschka in 1909 by the Austria that was to produce Hitler himself. In 1910 Kokoschka went on to Berlin, where he found himself among many like-minded artists, especially the Brücke members who had come from Dresden (see KIRCHNER), progressive dealers like Paul Cassirer, and avant-garde editors like Herwarth Walden, for whose *Der Sturm* Kokoschka immediately became an illustrator. It seems fairly clear that at this point Kokoschka exercised a strong influence on the Brücke painters, who were just turning from a Fauve-oriented type of painting.

In 1911 the "public terror" of Vienna returned there for an exhibition, and it was then that he produced his drama *The Burning Thornbush* and his two famous lithographic series, *Bach Cantata* and *The Fettered Columbus*. He also began his tempestuous relationship with Alma Mahler, who was immortalized in his painting *Bride of the Winds* (or *The Tempest*, 1914; Basel, Kunstmus.), which, like other works of this period, shows a shift from the earlier involuted Freudian approach and presents a freer, looser handling of paint and a bolder, more assertive, romantic style appealing directly to the spectator. In this depiction of two lovers lying side by side in their cockleshell whirling through space, Kokoschka mingles the real and the unreal, the material and the unearthly.

Severely wounded in the head during World War I in the Russian campaign of 1916, Kokoschka was invalided to Dresden. At this time he was a miserable, even irrational being who was, however, recognized by a professorship in the Dresden Academy. From the end of the war through the revolutionary and inflationary period, Kokoschka turned to a more vividly coloristic but compact type of paint application, influenced by such French postimpressionists as Seurat and Cézanne. In 1924 he left Dresden and began his long travel period (1924–31), during which he portrayed the great cities of the world in an inherently emotional but very broad and spatial manner, evoking in each case the spirit of a city (London, Marseilles, Algiers, Jerusalem, Paris, etc.).

Kokoschka's landscape paintings parallel in a general way his other works but with less passion and, by and large, with more decorative quality in an impressionist sense (e.g., *Courmayeur et les Dents des Géants*, 1927; Washington. D.C., Phillips Coll.). This lyrical reaction to nature has remained fairly constant, persisting into the 1940s and 1950s. Kokoschka returned to Vienna in 1931 and during the next three years became increasingly active in politics against the rising Nazi tide, moving on to Prague in 1934 for a four-year stay in his native land. His *Self-Portrait of a Degenerate Artist* (1937; coll. of the painter) underlines both his preoccupations of the moment and the state of art in central Europe at that point.

He fled to England in 1938 and spent the next ten years at Polperro in Cornwall (V, PL. 213). In 1947 he went to Switzerland, where his pent-up energies were released in a new se-ries of lambent landscapes in which the old subjects of a previous generation were treated with a new sensitive emotionalism showing as great a grandeur and sweep as ever (e.g., *Montana*, 1947; IX, PL. 25). In addition, the humanist and politically oriented Kokoschka still persists in such paintings as the *Thermopylae* (1954; Villeneuve, private coll.), a projection of the conflict between East and West in the ancient story of the war between the Greeks and the Persians (see also I, PL. 410; V, PLS. 141, 206; XI, PL. 228).

BIBLIOG. E. Hoffmann, Kokoschka: Life and Work, London, 1947; H. M. Wingler, Oskar Kokoschka, The Work of the Painter, New York, 1957; B. Bultmann, Oskar Kokoschka, New York, 1961.

Bernard S. MYERS

KOLLWITZ, Käthe. German graphic artist (b. Königsberg, 1867; d. Moritzburg, 1945). Although her favored technique was etching, sometimes in combination with the aquatint process, Käthe Kollwitz also produced many lithographs and in her later life did woodcuts, all of which were the outcome of many preliminary drawings. Without failing to become deeply involved psychologically in whatever work at hand, she nonetheless demanded of herself the most rigorous technical standards. Throughout her career a preoccupation with realistic portrayal of the poorer classes made her work a strong social and political document of her time.

After settling permanently in Berlin in 1891, Kollwitz was inspired by the initial performance of Gerhart Hauptmann's *The Weavers* (1893) and made her first great print cycle, *Der Weberaufstand* (1894–98). In 1902 she began another great series, *Peasant War*, which was not finished until 1908. Her son Peter was killed in World War I, and her next major work, *War* (1923), reflects the artist's personal tragedy and reaction to war. Thereafter, another cycle, *Proletariat* (1925), demonstrated her continuing concern with social problems. Single plates and woodcuts that are widely known include *La Carmagnole* (1901), an etching inspired by *A Tale of Two Cities*; *Mother and Child* and *Death and the Woman* (1910); and a woodcut with strong political connotations that commemorated Karl Liebknecht, as well as various propaganda posters.

A noteworthy characteristic of Käthe Kollwitz was her life-long interest in the self-portrait, manifesting a deep psychological insight reminiscent of Rembrandt, Callot, and Goya. She was also strongly interested in sculpture and admired Barlach in particular. His remarkable equilibrium between naturalism and stylization finds its counterpart in the monumental realism of her graphic creations, whose suggestion of volume frequently approaches the sculptural. Her one important sculptural project was a monument for her son, erected in Diksmuide cemetery (Flanders; 1924–32). Important late works include her last cycle of lithographs, *Death* (1935), and the touching final self-portrait, a lithograph of 1938 that depicts her as a worn old woman.

In 1919 Käthe Kollwitz became the first woman member of the Prussian Academy of Arts (Berlin), and in 1928 she became director of the academy's master classes for graphic arts, a post from which the Nazis dismissed her in 1933. From 1936, exhibitions of her work were prohibited in Germany, but despite such official opposition she remained there throughout World War II; she died in Moritzburg Castle, near Dresden. Her internationally acclaimed work first appeared in New York in a print show of 1912. Major Kollwitz exhibitions include: New York, 1925; Moscow, 1927, 1932; Basel, 1929; Berlin, 1945 (memorial exhibit); Bern, 1946; Rotterdam, 1947; Moscow, 1954; New York, 1962.

BIBLIOG. M. Lehrs, Käthe Kollwitz, Die graphischen Künste, XXVI, 1903, XLVI, 1924; A. Bonus, Das Käthe Kollwitz–Werk, Dresden, 1925; C. Zigrosser, Kaethe Kollwitz, New York, 1946; C. G. Heise, Käthe Kollwitz, Einundzwanzig Zeichnungen der späten Jahre, Berlin, 1948; K. Kollwitz, Tagebuchblätter und Briefe, ed. Hans Kollwitz, Berlin, 1948; A. Heilborn, Käthe Kollwitz, 4th ed., Berlin, 1949; K. Kollwitz, "Ich will wirken in dieser Zeit": Auswahl aus den Tagebüchern und Briefen, aus Graphik, Zeichnungen und Plastik, ed. Hans Kollwitz, Berlin, 1952; A. Klipstein, The Graphic Work of Käthe Kollwitz, New York, 1955; The Diary and Letters of Kaethe Kollwitz, ed. H. Kollwitz (trans. R. and C. Winston), Chicago, 1955; R. J. Fanning, Kaethe Kollwitz, Karlsruhe, 1956.

Guido SCHOENBERGER

KOREA (Chosen). Korea possesses a noteworthy artistic heritage, although wars and invasions have destroyed many works of art and monuments and even caused the disappearance of entire cities. Not all the surviving monuments of Korean art are to be found in Korean territory, since for a long time the kingdom of Koguryo had its capital in what is now Manchuria. The present survey of surviving artistic material will also consider remains existing outside the Korean peninsula and indicate the area of Korean artistic influence irrespective of the fluctuations of political boundaries.

SUMMARY. Historical background (col. 1019). Art centers and groups of monuments (col. 1021).

HISTORICAL BACKGROUND. Korea (which is divided into the Korean People's Republic, north of the 38th parallel, and the Republic of Korea, south of the same parallel) is a peninsula projecting from the Asian continent but separated from it by mountains, forests, and two great rivers, the Yalu and the Tumen. A range of mountains runs down the east coast of Korea and the general slope of the land is toward the southwest, where there are large rivers, broad plains, and a much-indented coastline. Communications are thus easier by sea than by land, particularly with the provinces of China that face Korea across the Yellow Sea. Korea has long maintained contact with Japan via the islands of the Tsushima Strait and transmitted to Japan the advanced culture that it received from China, thus acting as a bridge between the two countries. But this intermediate position caused Korea to suffer devastating wars and repeated invasion — from China during each of the main historical periods and from Japan at the end of the 16th century.

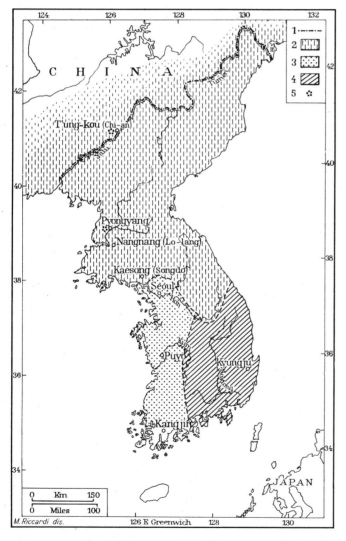

Korea: principal centers of artistic interest. *Key:* (1) National boundaries; (2) area of expansion of the kingdom of Koguryo; (3) area of expansion of the kingdom of Paekche; (4) area of expansion of the kingdom of Silla; (5) necropolises.

Korea is essentially a mountainous country, and its population is contained for the most part in small, relatively isolated villages distributed in countless valleys. There are few large towns, and since the end of the 14th century the city of Seoul has been the capital and almost the only important center. Because of the destructive invasions already mentioned, little would have remained of Korea's ancient arts, but many great works were made of stone (a material that abounds in Korea), while other, more perishable articles were buried in tombs, the inner walls of which were sometimes decorated with paintings. The practice of interring funerary articles with the dead, however, was discontinued after the suppression of Buddhism and the rise of Confucianism early in the 15th century.

It follows that — apart from a number of stone monuments, especially memorial pagodas, lanterns, and sculptures, which are found at Buddhist monasteries and other sites throughout the country — virtually no important relics from the earlier historical periods have survived aboveground. Prehistoric artifacts of stone, bronze, and pottery have been found in many parts of the country, and a number of dolmens have been located, but the earliest cultural period of which details are known began with the establishment of a Chinese colony, Lo-lang (Kor., Nangnang), in northern Korea in 108 B.C. This settlement lasted for about four hundred years, and important discoveries of Han lacquerware, bronze and iron vessels, weapons, and so on (see CHINESE ART) have been made at the Lo-lang graveyard in the vicinity of Pyongyang. These remains, however, are entirely Chinese and identical with similar finds in China itself; their significance for Korea lies mainly in their influence on the native arts. This can be traced in relics of the period of the Three Kingdoms, which followed the collapse of Lo-lang (see KOREAN ART). The northern kingdom of Koguryo existed side by side with Lo-lang, which it finally absorbed, and for many years its capital was T'ung-kou, Manchuria, beside the Yalu River. At T'ung-kou are the first important Korean monuments — several hundred tumuli, some of imposing size and many built of stone. The capital of Koguryo was later transferred to Pyongyang, and some tombs in this region as well as at T'ung-kou were found to contain stone chambers decorated with magnificent mural paintings, constituting the earliest great art of authentic Korean origin.

Virtually nothing has remained on Korean soil of the southwestern kingdom of Paekche, whose capital at Puyo was destroyed by a Chinese army in the year 660. It was Paekche that transmitted Buddhist civilization and art to Japan (see BUDDHISM). Paekche left its imprint on the 7th-century monastery of Hōryūji (near Nara, Japan), whose treasures undoubtedly include many works by Korean artists (see JAPAN). By far the most important ancient center in Korea, however, is Kyungju (near the southeast coast), where the third kingdom, Silla, established its capital. In 668 the greater part of the peninsula was unified under the rule of Silla, and in the Great Silla period which followed, Korean art attained its zenith, not merely as a result of importations from China but by its own individual creations. The scenic valley where Kyungju is situated forms an attractive setting for the vestiges of this ancient civilization, which escaped destruction by the Japanese in the invasion of 1592–98; but these remains are few and fragmentary in proportion to the fame of the Korean capital in the 8th and 9th centuries, with its wealth of palaces, temples, and works of art. There remain only some royal tombs (guarded by stone figures and encircled with groves), scattered stone monuments, foundations of buildings, rock-hewn Buddhist sculptures, and many large tumuli, from which gold crowns (VI, PL. 283) and ornaments, weapons, horse trappings, and a vast amount of pottery have been excavated.

About 8 miles from Kyungju lie the ruins of Pulguk-sa, the oldest Korean temple of which there are recognizable traces (PL. 397); near it, a half-hour's walk in the hills, stands the unique cave temple of Sukkulam (Sŏkkuram; II, PL. 394), whose Buddhist stone carvings are the sole worthy monument to this supreme period of Korean art. Some other 8th-century statues found in the same region have been placed in the small museum at Kyungju.

After the founding of the Koryo dynasty in 918, the capital was moved to Songdo (Kaesong), but nothing remains of the original city. The only surviving Koryo buildings are a few structures at Buddhist monasteries, notably at Pusok-sa (PL. 397), in southeast Korea. In this period, however, Korean porcelain, especially celadon, attained great fame and rivaled the products of Sung China. Many fine specimens of Koryo celadon have been recovered from the tombs of kings and noblemen in the vicinity of Songdo, and the two principal potteries have been located: one south of Kangjin, near the southwest tip of the peninsula, and the other some 80 miles to the north, near Ch'ulp'o-ri on the west coast. Many minor works of bronze, some inlaid with silver, and lacquerware with mother-of-pearl inlay have survived from the Koryo period; nearly all come from tombs.

After the establishment of the Yi dynasty in 1392, the capital was moved to Seoul, where it has since remained. The city walls and imposing gates that have survived in Seoul and other towns, together with palaces and government buildings built in the traditional style, are relics of this period, which ended in 1910 with the Japanese annexation of Korea. So widespread, however, was the destruction wrought by the Japanese invasion of 1592-98 — as well as by natural calamities since that time — that the majority of the buildings of the Yi period have required partial or complete restoration, with the result that very few of the remaining structures date from the early part of the period; some, such as the main palace buildings in Seoul, were constructed as recently as the 19th century. Yi period architecture is perhaps better represented in the Buddhist monasteries scattered throughout the country, though here also fires and storms have necessitated a great deal of reconstruction. The monastic center in the Diamond Mountains is believed to have suffered grave damage during the Korean War (1950–53).

Many paintings on silk and paper and a large amount of pottery, especially blue-and-white, have survived from the Yi period. The most important collections, as in the case of all other Korean art works, are those of the National Museum and the Prince Yi Museum in Seoul; but there are also many fine examples of pottery and handicrafts at the Folk Art Museum in Tokyo.

ART CENTERS AND GROUPS OF MONUMENTS. T'ung-kou. Several hundred tumuli on the Yalu River, made of granite blocks in pyramid form or earthen mounds, at the site of the early capital of the kingdom of Koguryo, on the Yalu, dating from the 1st to the 4th century.

Pyongyang. Necropolis of the Chinese colony of Lo-lang, comprising hundreds of brick or wooden graves, dating from 108 B.C. to A.D. 313; individual tombs or groups of tombs, dating from the later years of the kingdom of Koguryo, that is, from the 5th to the 7th century. Some of the tomb chambers contain exceptionally fine mural paintings.

Kyungju. Sculptures, royal tombs, sites and foundations of buildings, stone monuments, ruins of Pulguk-sa, and the Sukkulam cave temple, all dating from the 5th to the early 10th century, when the kingdom of Silla reached its zenith.

Seoul. Walls, gates, and palace buildings dating from the Yi period (from the 15th century on), but mostly reconstructed during the past three centuries.

Diamond Mountains. Buddhist sanctuary: five monasteries founded in the first few centuries of our era, but reconstructed many times since then. Most of the present buildings date from the last three centuries.

BIBLIOG. a. Prehistoric: R. Torii, Les Dolmens de la Corée, Mem. of the Research Dept., Toyo Bunko, No. 1, 1926, pp. 93–100; Han Hŭng-su, Chosŏn ŭi Kŏsŏk Munhwa Yŏn-gu (Studies on Megalithic Culture of Korea), Chindan Hakpo, III, 1935, p. 132 ff., resumé in J. Hoyt, Some Points of Interest from Han Hŭng-su's "Studies on Megalithic Culture of Korea," AmA, L, 1948, pp. 573–74. For articles appearing in Japanese publications, see G. W. Hewes, Archaeology of Korea: A Selected Bibliography, Research Monographs on Korea, Ser. F., No. 1, 1947. b. Lo-lang: T. Sekino et al., in Koseki Chōsa Tokubetsu Hōkoku (Special Report of Investigation of Ancient Remains), I, Seoul, 1919, IV, Rakurō-gun Jidai no Iseki (Remains of the Lo-lang Period), 4 parts, Seoul, 1927; Y. Harada and K. Tazawa, Rakurō (Lo-lang), Tokyo, 1930; H. Ikeuchi, A Study on Lo-lang and Tai-fang, Ancient Chinese Prefectures in the Korean Peninsula, Mem. of the Research Dept., Toyo Bunko, Ser. B., No. 5, 1930, pp. 76–96; A. Koizumi, Rakurō Sailkyō-zuka (Tomb of the Painted Basket of Lo-lang), Seoul, 1934; Koseki Chōsa Gaiho (Brief Report of Investigation of Ancient Remains), Ann. Rep. of the Soc. for the Study of Korean Antiquities (1933–35), 3 vols., Seoul, 1934–36; T. Nomori, K. Kayamoto, and S. Kanda, in Koseki Chōsa Hōkoku (Report of Investigation of Ancient Remains), Ann. Rep. of the Service of Antiquities for the Government-General (1930), Seoul, 1935; T. Oba and K. Kayamoto, Rakurō Ōkō-bo (Tomb of Wang-Kuang of Lo-lang), Seoul, 1935; S. Umehara and R. Fujita, Chōsen Kobunka Sōkan (A Survey of the Ancient Culture of Korea), II, Rakurō (Lo-lang), Kyoto, 1948; S. Umehara, Two Remarkable Lo-lang Tombs of Wooden Construction Excavated in Pyongyang, Korea, Arch. of the Chinese Art Soc. of Am., VIII, 1954, pp. 10–20. c. Remains of Koguryo: M. Courant, Stèle chinoise du royaume du Ko Kou Rye, JA, IX, 1899, pp. 210–39; E. Chavannes, Rapport sur les monuments de l'ancien royaume coréen de Kao-keou-li, Compte rendus des séances de l'Acad. des Inscriptions et Belles-lettres, 1906, p. 549; Chōsen Kofun Hekiga-shū (Collection of Old Korean Tomb Wall Paintings), with introd. in English, Seoul, 1917; T. Sekino et al., Kōkuri Jidai no Iseki (Remains of Koguryo Period), in Koseki Chōsa Tokubetsu Hōkoku (Special Report of Investigation of Ancient Remains), V, part 2, Seoul, 1927; H. Ikeuchi and S. Umehara, Tsūkō (Tungkou), with resumés in English and Chinese, 2 vols., Tokyo, 1940; B. Szczesiniak, The Kōtaiō Monument, Monumenta Nipponica, VII, 1951, pp. 242–68; S. Umehara, The Newly Discovered Tombs with Wall Paintings of the Kao-kou-li Dynasty, Arch. of the Chinese Art Soc. of Am., VI, 1952,

pp. 5–17. d. Remains of Paekche: J. Karube, Kudara Bijutsu (Art of Paekche), Tokyo, 1946; H. B. Chapin, Pu Yo, One of Korea's Ancient Capitals, Tr. of the Korea Branch of the Royal Asiatic Soc., XXXII, 1951, pp. 51–61; Koseki Chōsa Hōkoku (Report of Investigation of Ancient Remains), Ann. Rep. of the Service of Antiquities for the Government-General (1927), II, Seoul, 1935. e. Remains of Silla: K. Hamada and S. Umehara, Keishū Kinkan-tsuka to Sono Ihō (The Gold Crown Tomb at Kyungju and Its Treasures), with English titles and resumé, in Koseki Chōsa Tokubetsu Hōkoku (Special Report of Investigation of Ancient Remains), III, 2 parts, Seoul, 1924–27; K. Hamada and S. Umehara, Shiragi Koga no Kenkyū (Study on the Ancient Tiles of Silla), Kyōto Teikoku Daigaku Bungaku-bu Kōkogaku Kenkyū Hōkoku (Report on Archaeological Research in the Department of Literature, Kyoto Imperial University), XIII, Tokyo, 1934; K. Arimitsu, in Koseki Chōsa Hōkoku (1931), Seoul, 1935 (1932), Seoul, 1937; Chōsen Hōbutsu Koseki Zuroku (Illustrated Catalogue of Korean Treasures and Relics), 2 vols., Kyoto, 1938–40; H. B. Chapin, Kyŏngju, Ancient Capital of Silla, Asian Horizon, I, 1948, pp. 36–45; C. Kim, Two Old Silla Tombs, Seoul, 1948; H. B. Chapin, A Hitherto Unpublished Great Silla Pagoda, AAs, XII, 1-2, 1949, pp. 84–88; C. and W. Y. Kim, Excavation of Three Silla Tombs, Seoul, 1955.

Godfrey St. G. M. GOMPERTZ

Illustration: 1 fig. in text.

KOREAN ART. Korea, throughout its history, has been profoundly affected by Chinese culture, but the importance of this external influence should not be overestimated, for native characteristics invariably developed after an initial stage of borrowing and assimilation, with the result that Korea has made distinctive contributions in the arts and crafts. In addition the transmission of Chinese culture to Japan by way of Korea had a deep and lasting influence on Japanese art.

SUMMARY. Lo-lang (col. 1022). Period of the Three Kingdoms (col. 1022): Koguryo; Paekche; Silla. Great Silla period (col. 1025). Koryo period (col. 1026). Yi period (col. 1027).

LO-LANG. Probably there is some truth in the legend that a kingdom was set up in Korea in 1122 B.C. by a Chinese refugee, Chi-tzŭ (Kor., Ki Ja) and his five thousand followers, but no trace has been found of this early culture. Neolithic remains discovered in Korea are believed to be of later date and do not as a rule show marked Chinese influence. However, there is archaeological proof to support the historical records that the emperor Wu-ti of the Han dynasty invaded northern Korea in 108 B.C. and established a military colony under Chinese governors. The colony was divided into four provinces, the chief of which was called Lo-lang (Kor., Nangnang), and it is by this name that it is now known.

Numerous Chinese merchants and artisans migrated to this new outpost of the Han, and during the four centuries of its existence its influence extended far into southern Korea and even reached Japan. Considerable wealth and luxury evidently prevailed in the settlement, and excavations carried out by the Japanese authorities from 1910 to 1945, principally at the extensive graveyard not far from the Taedong River, have brought to light artistic treasures, chiefly of decorated lacquerware, but including also bronze and iron implements, horse trappings, jewelry, pottery, and fragments of silk and leather. Some of these discoveries, such as the celebrated "Painted Basket" (PL. 413), with its delicate figure paintings on lacquered surfaces, are finer than any similar relics found in China itself. The abundance and high quality of the relics are such as to make Lo-lang perhaps the most notable repository of Han art yet discovered.

PERIOD OF THE THREE KINGDOMS. Koguryo. The disappearance of Lo-lang was followed by the period of the Three Kingdoms (Koguryo in the north, Paekche in the southwest, and Silla in the southeast). Koguryo had come into existence during the 1st century B.C. and comprised a large part of what is now Manchuria as well as northern Korea. Its capital was at

first situated north of the Yalu River; the original location has not been determined, but it was later moved to T'ung-kou, near Chi-an, on the Yalu itself. This site is marked by several hundred tumuli, about half of which are made of granite blocks built up in pyramid form, while the others are rounded earthen mounds. Some of the tombs are of imposing size; the "General's Tomb," investigated by E. Chavannes in 1907, is one of the best preserved, although not the largest, measuring about 30 yd. square by 13 high. Funerary articles and other signs of identity had long since been removed, and it is not certain whether this is the tomb of King Kwanggaet'o (r. 391–412) — whose monument, an inscribed stele, stands about a mile away — or that of another, earlier king. In A.D. 427 King Changsu trans-

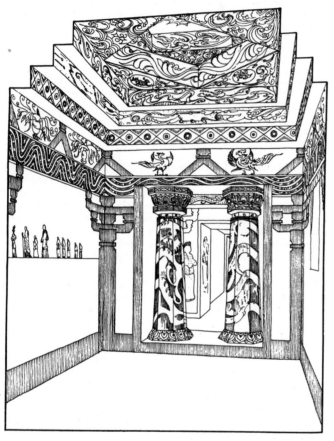

"The Tomb of the Two Columns," near Pyongyang, Koguryo period, 6th cent.

ferred the capital to Pyongyang, where it remained until the final overthrow of the kingdom by the combined forces of Silla and T'ang China in 668.

Although the more important tombs so far investigated had been looted by tomb robbers, some magnificent mural paintings have been found in the tomb chambers, which are usually single but sometimes double or triple and connected by short passages. This applies not only to the tombs beside the Yalu but also to several others near Pyongyang, which date from the later years of the kingdom and are mostly of earthen construction, although with stone chambers inside. The paintings sometimes represent the deities of the four cardinal points: Red Phoenix, Green Dragon, dragonlike White Tiger, and Tortoise entwined by a Snake (PL. 395). They are in the style that was doubtless current in China during the Six Dynasties period — indeed, there are records of early contacts with Chinese states and of artists being sent to Korea. However, nothing similar has been found in China itself, and the treatment of the imported symbols may be regarded as authentically Korean. Perhaps the finest examples are to be seen in the principal tomb (possibly that of King P'yong-won; r. 559-90) at U-hyonni, where three great tumuli of granite construction rise above the broad plain some 20 miles west of Pyongyang.

While the murals at U-hyonni are essentially stylized designs based on Chinese originals, many other paintings found in tombs at T'ung-kou and near Pyongyang show more individuality and vividly portray the costumes and way of life of the Koguryo people. A rather formal painting shows a king and queen seated in their palace with attendants grouped around them; there are sketches of serving maids bearing trays of food, and long-sleeved dancing girls giving a display. Some spirited hunting scenes show mounted huntsmen pursuing tigers and deer and shooting arrows. In addition, there are numerous decorative motifs along the friezes and cornices within the tomb chambers. Most of these are lotuses and other floral or geometric figures, but others show flying phoenixes and Buddhist themes. The paintings are in the style of the Han or Six Dynasties period and recall such Chinese examples as the painted Han tiles in Boston (III, PL. 234) and mural paintings in several Han tombs excavated near Port Arthur; the Koguryo murals, however, display a freshness, vitality, and naïveté which may justly be regarded as characteristic of Korean art.

Apart from the tomb paintings, little has remained of Koguryo art. Some small bronze images, together with their molds, and fragments of pottery bearing Buddhist figures, show the influence of the Northern Wei. A large number of tiles, decorated in relief with floral and animal motifs, have also been found near tombs and at castle and citadel sites; these tiles differ from those of other parts of Korea in the freedom and vigor of the style.

Paekche. Little enough is known of the art of Koguryo; still less would have survived of that of Paekche if this had not been the state which transmitted Buddhist culture from the continent to Japan. Very few remains have been unearthed at Puyo, the capital of Paekche which was destroyed by an army from T'ang China in 660; the sole surviving monument of any note is a stone pagoda erected by the Chinese general to commemorate his victory. Excavated relics are confined mainly to bronze images and vessels, often of superior workmanship, and ornamented tiles, of which some unique examples bear landscape designs of tree-clad mountains and valleys in relief; but some of the most celebrated Buddhist sculptures of the 7th century, preserved in the Hōryūji (Nara, Japan), are without doubt of Korean make and afford a glimpse of the mystical beauty which pervaded the religious art of Paekche. It is clear that the style itself did not originate in Korea but was derived from the Northern Wei; there can be no question, however, that its expression was distinctively Korean and that it provided the strong initial impulse in Japanese art of the Asuka period (see JAPANESE ART). Perhaps the most impressive of these early Korean sculptures, many of which are of wood, is the "Kudara Kwannon," traditionally ascribed to Paekche (Jap., Kudara), and unequalled for its archaic grace (PL. 396), but the "Yumedono Kwannon" (PL. 262), called by its discoverer E. Fenollosa, "the greatest monument of Korean art that has come down to us," is less aloof and of a more gracious expression.

There are two other masterpieces of 7th-century sculpture, also of carved wood, in Japan, which may be singled out as exemplifying the Korean style. The Maitreya in the Kōryūji (Kyoto) closely resembles a gilded-bronze statue (Seoul, Prince Yi Museum) which was found near Kyungju in Korea; the similar but far more impressive Maitreya known as the "Chūgūji Miroku" (PL. 266) may have been carved in Japan, but if so was undoubtedly the work of Korean craftsmen or their Japanese pupils. Historical records show that hundreds of skilled artists came from Paekche at this time and settled in the region of Hōryūji and Nara, and the classical beauty of Hōryūji Monastery itself is a monument to their genius.

Hōryūji Monastery (PL. 282) was originally built by architects from Paekche in 607, but there is evidence that a disastrous fire in 670 destroyed all but the Golden Hall (Kondō), around which the monastery was immediately reconstructed in the same style. This traditional "Kudara plan," as it is now called by Japanese historians, was followed after subsequent, less devastating fires. Here, therefore, may be seen the simplicity and restraint that marked the early Buddhist architecture of

Korea, for no similar structure has survived in Korea itself. Among the artistic treasures preserved at the Hōryūji is the famous reliquary known as the "Tamamushi Shrine," which is decorated with archaic Buddhist paintings (PL. 418) and exhibits the same architectonic elegance. Although the origin of this shrine is unknown, the fact that it is ornamented with the iridescent wings of beetles suggests that it may also be of Korean make, for the same technique has been found only in objects excavated in southern Korea.

Silla. The third state during the period of the Three Kingdoms was Silla, known to contemporary Arab traders and described as "a mountainous land rich in gold," whose capital, Kyungju, was set in a valley of great scenic charm not far from the southeast coast. The most conspicuous feature of this region at the present time is the large number of tumuli which rise on all sides from the paddy fields and among the scattered villages. Many of these tombs have been opened in this century and, despite the depredations of robbers, have yielded a vast store of relics from the early Silla period, before the kingdom extended its territory over the whole of Korea. The most striking finds are the gold crowns (VI, PL. 283), consisting of broad bands surmounted by conventionalized trees with numerous gold spangles and jade *magatama* (crescent jades) attached. The tombs also contained ornaments; weapons, including swords, axes, daggers and halberds, sometimes with elaborately ornamented pommels; horse trappings; bronze mirrors; and iron or bronze cooking vessels. Some Chinese influence is evident in these articles, but the gold crowns and the ear pendants are distinctively Korean. A great quantity of unglazed earthenware has also been collected from the tombs, the characteristic type being brittle pottery of bluish-gray color with crudely incised or stamped ornament — mainly cups, jars, and vases on tall stands with openings in the sides, no doubt intended to be placed directly on the cooking fires. While most of the shapes are utilitarian, some crude but vigorous clay figurines have been found, and a vessel in the form of a mounted warrior must be classed with the major achievements of representational art (PL. 398).

Some of these relics, especially the pottery and *magatama*, show an affinity to similar articles excavated in Japan, which may be taken as evidence of close cultural relations between the two countries.

A gilded-bronze Maitreya (PL. 396), considered to date from this period, demonstrates the high artistic level attained and indicates that the artisans and bronze casters of Silla were no less accomplished than those of Paekche.

GREAT SILLA PERIOD. The unification of Korea under the rule of Silla took place in 668, after the successive overthrow of Paekche and Koguryo. This marks the beginning of that supreme era of Korean art and culture called the Great Silla period which lasted for 250 years. Unfortunately, the Japanese invasion of 1592–98 wrought such widespread destruction as far north as Pyongyang that few important relics from this time have survived. The most impressive remains are the ruins of Pulguk-sa, a temple near Kyungju, and the unique cave temple of Sukkulam in the hills nearby.

Pulguk-sa was founded in the early 6th century and rebuilt in grand style in 751; the cave temple of Sukkulam was probably constructed at that time. Both, according to tradition, were built under the direction of the prime minister, Kim Taisung. Of Pulguk-sa only an arched stone stairway and balustrade remain, together with stone pagodas, lanterns, and two bronze images, but even these few traces give some idea of the classic beauty of the original structure (PL. 397). The cave temple of Sukkulam, however, was discovered almost complete, although in a ruined state, and has been restored to something like its original condition. It is an artificial cave, consisting of a small antechamber with an unroofed passage leading to the main rotunda, which is faced with granite and has a domed roof; the entire structure is covered with earth and appears to form part of the hillside. In the center of the rotunda is a statue of the seated Buddha on a pedestal, remarkable for its massive

proportions and great dignity. The granite-lined walls of both entrances and rotunda are decorated with 27 reliefs of bodhisattvas, lohans (Skr., *arhat*), heavenly kings, and guardians, above which eight smaller seated figures occupy arched niches. The extraordinary grace and beauty of the bodhisattvas, the nobility and vigor of the kings and guardians, and the stark realism of the lohans, some of whom have Caucasian or Semitic features, are unequalled in the surviving art of T'ang China, by which they were plainly inspired. There is a legend that Chinese artists were employed on the work, but evidence of the high quality of stonecarving in Silla indicates that more likely the artists were predominantly Korean (II, PL. 394).

There are also many stone monuments at royal tombs, such as the massive and lifelike tortoise marking the tomb of King Muryol (dating from 662, preceding the Great Silla period by a few years), and effigies of men and beasts in a double line guarding the approaches. The pagoda of Hoaom-sa Monastery, with its supporting lions, is one of the finest examples among a large number of stone memorials and lanterns. Many fine tiles, plaques, and paving stones, bearing elaborate relief ornament of Buddhist subjects or floral rosettes and arabesques, have been found at the sites of important buildings.

The bronze casters of Silla attained great proficiency in making large temple bells, which became famous throughout the East. Probably the finest extant example is the great bell at Kyungju, dating from 770, with delicate relief ornament of Buddhist celestial figures and floral designs that shows the Korean feeling for graceful, flowing linework (PL. 396). Another famous bronze bell, made in 725, was lost in the destruction of Wolchong-sa Monastery during the Korean War. A number of small Buddhist images in gilded bronze have been recovered; the refined taste and classicism of the period are evident in their serene countenances and elegant forms. Pottery continued in the tradition of the earlier Silla wares, but the stamped or incised decoration became more elaborate (PL. 398), and attempts were made to produce a colored glaze.

KORYO PERIOD. A revolt against the degenerate royal house brought the Great Silla period to an end in 918, a new dynasty was established, and the capital was moved to Songdo (or Kaesong). The kingdom was renamed "Koryo" ("High Hills and Sparkling Waters") and a brilliant new epoch began, marked by the rise of Buddhism to unprecedented power and the building of numerous temples or monasteries. Because of natural calamities and invasions, only three original structures are known to have survived from the Koryo period, apart from stone monuments and pagodas. The two most important structures are located at Pusok-sa Monastery, in a remote part of southeastern Korea.

The "Hall of Eternal Life" at Pusok-sa is a large wooden building of great simplicity and charm, constructed in the late 13th century (PL. 397); it contains perhaps the finest remaining Koryo sculpture, a wooden image of Amitābha. The smaller "Founder's Hall," built in the last years of the dynasty, is less archaic and transitional in style, giving a foretaste of the architecture of the Yi period; this building contains the earliest wall paintings (bodhisattvas and heavenly kings) which have been found in Korea outside tombs.

Other than the Amitābha at Pusok-sa, relatively little sculpture has survived from the Koryo period. A colossal stone Maitreya at Nonsan in southwestern Korea, dating from the late 10th century, possesses littles artistic merit. Some carved wooden or lacquered figures of Kwannon exhibit the plump worldliness and elaborate dress ornaments which characterize 12th- and 13th-century Buddhist sculpture in China: there could hardly be a more marked decline from the dignified classicism of Great Silla.

A new standard, however, was set by the bronze mirrors and ornaments, while the ceramic products of the Koryo period have made Korean art famous throughout the world. Koryo celadon in particular has come to be regarded as among the most beautiful pottery ever made (PL. 399).

Recent research has made it clear that the Koryo potters learned the art of making high-fired porcelaneous wares from

the Yüeh factories of Chekiang province in southern China, probably during the latter part of the 11th century. At first the Koreans were content to imitate the more famous Chinese wares, but by the early 12th century they had developed their own native style and were producing distinctively Korean porcelains, which are unsurpassed for beauty of form and exhibit an effortless grace and serenity.

In 1123 a Chinese scholar, Hsü Ching, accompanied an envoy from the Sung court on a visit to Korea; his vivid account of the country has fortunately survived. He noted that the Koryo potters had made great advances in recent years and was greatly impressed by the novelty of some of their designs and the beauty of the "king-fisher-colored" or bluish-green celadon glaze. Specimens of the identical types he described have been excavated from royal tombs near Songdo. Soon afterwards the Koreans developed the unique device of inlaying different clays to produce striking black-and-white decoration. This innovation may have had its antecedents in the stamped or incised pottery of the Silla period and the inlaid metalwares of T'ang China, but it became a distinctively Korean style and was exploited to great effect. Nowhere is the Korean spirit expressed with more charm and naïveté than on celadon pots and vases of the Koryo period, with their quiet country scenes of birds, trees, and flowers traced in long flowing lines and graceful curves. The same method was used for decorating metalwares and lacquered chests and boxes; an outstanding example, one of the chief treasures of Koryo art, is a bronze sprinkler vase inlaid with silver.

In 1231 Korea was invaded by the Mongols, and the arts suffered a severe blow, from which they took many years to recover. Mongol influence is apparent in a tendency toward excessive ornament during the latter part of the Koryo period, but some bronze bells and incense vessels show that creative ability was maintained to the end of the dynasty.

YI PERIOD. With the founding of the Yi dynasty in 1392 by the strong but moderate Yi Taejo, the capital was moved to Seoul and the entire culture underwent a transformation. Buddhism fell into disfavor and was replaced by a rigid Confucian formalism, which imparted masculine strength to the arts but brought about their steady decline. Elaborate palaces were built in the new capital, but none of the original structures remain: the Kyungbok Palace was rebuilt in grandiose style as recently as 1867, and its ornate features and coffered ceilings should not be taken as representing the best in Yi period architecture, although the building as a whole is not without dignity. However, it was in painting, pottery, and handicrafts that the Korean artistic genius found a new and vital expression, though its development was arrested and impaired by the Japanese invasion of 1592-98.

Korean paintings now in existence with few exceptions date from the Yi period and follow the tradition of Chinese Ming paintings, from which they are not easily distinguished (II, PL. 394). A native Korean style is evident in some attractive studies of domestic animals, especially cats, kittens, and puppies, which are painted with great verve and fidelity, and also in paintings of birds, flowers, and insects. Some vivid genre sketches date from the late 18th century and after, while the portraits commissioned by noblemen and scholars in the same period show remarkable power of characterization. One of the most prolific artists of this time was Kim Hong-do (VI, PL. 81), also known as Tanwon, whose versatile genius found expression in traditional landscapes and figures as well as in the contemporary portraits, genre scenes, and fan paintings.

The pottery of the Yi period was at first rough and crude, showing in its robust forms and vigorous iron-brown painting the unself-conscious artistry of the peasant potter. Later in the period an official factory was set up near Seoul and followed the Chinese trend by producing white and blue-and-white porcelain but the Korean blue decoration was sparingly applied. By the late 18th century, however, the decoration had become over-profuse, losing its former significance.

Many Korean potters were taken captive during the Japanese invasion of 1592-98 and were resettled on the island of Kyushu, where they laid the foundations of the Japanese porcelain industry. Some Korean porcelains brought back by the invaders became famous under the name of "Ido bowls"; they were used in the tea ceremony by some of its most famous devotees and have been preserved as part of the Japanese national heritage. In modern times Yi period pottery has inspired leading potters in Japan and England.

Among the noteworthy productions of the latter part of the Yi period were such minor works of art and handicrafts as chests and caskets of coarse red or black lacquer inlaid with mother-of-pearl and many types of brassware, wood carving, and furniture. Folk arts continued to show surprising vigor even after the annexation by Japan in 1910 and have won high praise from scholars and artists.

BIBLIOG.: a. General: C. Dallet, Histoire de l'église de Corée, 2 vols., Paris, 1874; M. Courant, Bibliographie Coréenne, 3 vols. and Sup., Paris, 1894-97; H. B. Hulbert, The History of Korea, 2 vols., Seoul, 1905; F. A. McKenzie, The Tragedy of Korea, London, 1908; Chōsen Bijutsu Taikan (Survey of Korean Art), Seoul, 1910; W. E. Griffis, Corea, the Hermit Kingdom, 9th ed., New York, 1911; J. H. Longford, The Story of Korea, London, 1911; S. Sugihara, Chōsen Kokuhō Taikan (Survey of the National Treasures of Korea), Tokyo, 1911; Chōsen Koseki Zufu (Album of Korean Antiquities), 15 vols. of plates and 5 vols. of commentary, Seoul, 1915-35; Koseki Chōsa Hōkoku (Report of Investigation of Ancient Remains), Ann. Rep. of the Service of Antiquities for the Government-General (1916-34) and of the Soc. for the Study of Korean Antiquities (1936-38), 16 vols., Seoul, 1917-40; Chōsen Sōtokufu Hakubutsukan Chinretsuhin Zukan (Exhibits in the Museum of the Government-General of Chosen), 17 vols., (plates), Seoul, 1918-43; Koseki Chōsa Tokubetsu Hōkoku (Special Report of Investigation of Ancient Remains), 6 vols., Seoul, 1919-29; J. S. Gale, A History of the Korean People, Seoul, 1927; A. Eckhardt, A History of Korean Art, trans. from German by J. M. Kindersley, London, 1929; Ri-ō-ke Hakubutsukan Shozō Shashin-chō (Albums of Photographs of Art Objects Held by the Museum of the Yi Royal House), Seoul, 3 vols., 1929; H. E. Fernald, Rediscovered Glories of Korean Art, Asia, Dec., 1931, pp. 788-95, 799-902; C. A. Clark, Religions of Old Korea, New York, 1932; T. Sekino, Chōsen Bijutsu-shi (History of Korean Art), Kyoto, 1932; Y. Kang, The Grass Roof, New York, 1934; S. Katsuragi, Chōsen Kinseki-kō, (Notes on Korean Stone Monuments), Seoul, 1935; Y. S. Kuno, Japanese Expansion on the Asiatic Continent, 2 vols., Berkeley, 1937-40; S. Bergman, In Korean Wilds and Villages, London, 1938; L. E.-S. Youn, Le Confucianism en Corée, Paris, 1939; T. Sekino, Chōsen no Kenchiku to Geijutsu (Korean Architecture and Art), Tokyo, 1941; T. Saitō, Chōsen Kodai Bunka no Kenkyū (Study of Korean Ancient Culture), Tokyo, 1943; R. Fugita, Sugihara Chōtarō-shi Shūshū Kōkohin Zuroku (Illustrated List of Sugihara Chōtarō's Collection of Archaeological Articles), Kyoto, 1944; A. J. Grajdanzey, Modern Korea, New York, 1944; E. Keith and E. K. Robertson Scott, Old Korea, London, 1946; M. F. Nelson, Korea and the Old Orders in Eastern Asia, Baton Rouge, 1946; S. Umehara, Chōsen Kodai no Bunka, (Ancient Culture of Korea), Kyoto, 1946; Yun Hui-sun, Chosōn Misul-sa Yōn-gu (Research on the History of Korean Art), Seoul, 1946; Kim Yōng-gi, Chosōn Misul-sa (History of Korean Art), Seoul, 1947; S. Umehara and R. Fujita, Chōsen Kobunka Sōkan (A Survey of the Ancient Culture of Korea), I, II, Kyoto, 1947-48; S. Umehara, Chōsen Kodai no Bosei (Funerary Practices of Ancient Korea), Tokyo, 1947; R. Fujita, Chōsen Kōkogaku Kenkyū (Studies in Korean Archaeology), Kyoto, 1948; H. Lautensach, Korea: Land, Volk, Schicksal, Stuttgart, 1950; G. M. McCune and A. L. Grey, Korea Today, Cambridge, Mass., 1950; C. Osgood, The Koreans and Their Culture, New York, 1951; I.-S. Zong, Folk Tales from Korea, London, 1952; C. Dallet, Traditional Korea (trans. of introd. to Histoire de l'église de Corée), New Haven, 1954; M. Li, The Yalu Flows, London, 1954; S. Yanagi, Chōsen to Sono Geijutsu (Korea and Her Art), in Collected Works, IV, Tokyo, 1954; S. McCune, Korea's Heritage: A Regional and Social Geography, Tokyo, 1956; E. McCune, The Arts of Korea, London, 1962. See also the following periodicals: The Korean Repository, 1892, 1895-98; The Korea Review, 1901-06; Transactions of the Korean Branch of the Royal Asiatic Society, 1900-41, 1948. b. Architecture: T. Sekino, Kankoku Kenchiku Chōsa Hōkoku (Report of Research on Architecture in Korea), Tokyo, 1904; F. Starr, Korean Buddhism: History, Condition, Art, Boston, 1918; T. Sekino, Chōsen no Kenchiku to Geijutsu (Korean Art and Architecture), Tokyo, 1941; S. Sugiyama, Nippon Chōsen Hikaku Kenchiku-shi (A History of the Comparative Architecture of Japan and Korea), Kyoto, 1946; H. B. Chapin, A Little-known Temple in South Korea and Its Treasures, AAs, XI, 3, 1948, pp. 189-95; Ko Yu-sōp, Chosōn T'app'a ŭi Yōn-gu (Study of Korean Stupas), Seoul, 1948; H. B. Chapin, Palaces in Seoul, Tr. of the Korea Branch of the Royal Asiatic Soc., XXXII, 1951, pp. 3-46. c. Ceramics: L. d'O. Warner, Korai Celadon in America, EArt, II, 1930, pp. 37-126; W. B. Honey, Corean Wares of the Yi Dynasty, Tr. O. Ceramic Soc., XX, 1944-45, pp. 11-24; T. Nomori, Kōrai Tōji no Kenkyū (Research on Koryō Pottery), Tokyo, 1944; W. B. Honey, Corean Pottery, London, 1947; G. St. G. M. Gompertz, The Development of Koryo Wares, Tr. O. Ceramic Soc., XXVI, 1950-51, pp. 11-26; G. St. G. M. Gompertz, Koryo Inlaid Celadon Ware, Tr. O. Ceramic Soc., XXVIII, 1953-54, pp. 37-40; Sekai Tōji Zenshu (Catalogue of World's Ceramics), vol. 13 (Koryo pottery) and 14 (Yi pottery), Tokyo, 1955-56; C. Kim and G. St. G. M. Gompertz, The Ceramic Art of Korea, London, 1961. d. Painting and Minor Arts: E. Yoshida, Chōsen Shogaka Retsuden (Biographies of Korean Painters and Calligraphers), Seoul, 1915; M. DuPont, Décoration Coréenne, Paris, 1927; C. Hunt, Some Pictures and Painters of Corea, Tr. of the Korea Branch of the Royal Asiatic Soc., XIX, 1930, pp. 1-34.

Godfrey St. G. M. GOMPERTZ

Illustrations: PLS. 395-400; 1 fig. in text.

KUCHA. In the field of Central Asian art (see ASIA, CENTRAL), the products of the city and oasis of Kucha (in Chinese, Ku-chich, but called "Küsän" and "Kujā" by al-Kāshghārī) can be recognized as having a particular character of their own. Kucha was one of the most important caravan stops of the Tarim Basin and was the capital of the small state of Kucha and the seat of a sophisticated culture particularly inspired by Buddhism (q.v.). Although the most salient aspects of the art of Kucha is the reinterpretation of elements drawn from other cultures, original features do exist, mingling with influences from Gandhara (q.v.), India (see INDIAN ART), and Sassanian Iran (see SASSANIAN ART).

SUMMARY. Introduction (col. 1029). Relation to Tumshuk (col. 1029). Relation to Karashahr and Shorchuk (col. 1031). Temple architecture: Duldur-akhur and Su-bashi (col. 1034). Rock sanctuaries: Kizil and Kumtura (col. 1035). Styles of painting (col. 1037).

INTRODUCTION. The oasis of Kucha fostered a notable artistic culture of which only the most significant part has been studied: the rock-cut temples of Kizil and Kumtura and the temple buildings of Duldur-akhur and Su-bashi, as well as those of Kizil-Karga (or Kizil-shahr), Hisar, Sim-Sim, Kirish, Ačiǵ-Ilāk, and in other less important areas. Sites of less interest, such as Tonguz-bash, have been noted by Pelliot and other archaeologists, but these have been neither studied nor excavated satisfactorily. This complex, certainly one of the most remarkable archaeological finds of innermost Asia, cannot be studied nor its artistic discoveries properly interpreted without considering it in relation to two other sites: Tumshuk to the west and, to the east, Karashahr (Qara Shahr) with its adjoining sites, the most important of which is Shorchuk (also called Shikshim).

Greco-Buddhist influences came to Kucha through Tumshuk from Taxila, as well as from Hadda and Fondukistan, and probably passed through Gilgit to reach the northern Silk Route through the Tarim Basin, no doubt like the Greco-Buddhist influences that came from Bamian by way of a more northerly route. Unfortunately, only fragments of wall paintings are preserved at Tumshuk, and although these paintings most likely represent a distinct stage of development, the fragments are too incomplete for sufficient evidence. Chinese influences, on the other hand, came to Kucha through Shorchuk; Kumtura represents the extreme western limit of the advance of Chinese culture along the north Tarim route. The influences active at Kucha in various periods and places were indeed complex; the mark of Sassanian Iran and India is especially noticeable in the earlier works, while Chinese influence predominates in the later period, corresponding more or less to the political conditions of the Tarim Basin, which periodically was subjected to Chinese rule. A brief description of Tumshuk and Shorchuk will explain how the art currents of Kucha arrived there.

RELATION TO TUMSHUK. Tumshuk, located between Maralbashi and Aksu, is a vast monastic complex established in the northwestern section of the Tarim Basin at the base of a rocky spur, from which the Turkish name Tumshuk ("beak" or "promontory") is taken, replacing the now unknown ancient name. Long after the destruction of the monastery, a Moslem village, later moved east of the pass, was established here; a cemetery, the ruins of a house, and a mazār (tomb of a Moslem saint) remain on the site. The Buddhist center is quite complex, comprising three settlements, two of which were originally discovered and excavated by Pelliot and the third by Von Le Coq. The first two are situated on either side of the pass through which the road from Maral-bashi to Aksu crosses the chain of peaks. One of the two centers, Tokuz-saray, is the most important site; it rises on a plateau that dominates a valley which can be reached from only one side by a gentle slope. The other two centers were built on sheer cliffs, one of them even having been cut into the rock at the southwest end of Tokuz-saray. For lack of a better name, Pelliot also called the second site Tumshuk; it consists of ruins of a complex of sanctuaries located south of the pass at the northern end of Tumshuk-tagh (the Tumshuk oasis), which lies somewhat east of the pass on

the Aksu road. The third site, explored by Von Le Coq, is located at the southern end of Tumshuk-tagh, and bears the name Tumshuk-tagh-shahri (the city of the Tumshuk-tagh).

At the time of the Pelliot–Von Le Coq explorations only ruins buried under mounds of debris remained at the three sites. At Tokuz-saray, buildings had been erected during the Moslem period — that is, beginning in the 10th or 11th century at the earliest — and a Moslem cemetery established in the midst of the ruins, with the graves adjoining the remains of the destroyed buildings. (The sanctuaries and monastic buildings had been demolished and burned, a fact that led the archaeologist Sven Hedin to suggest that the site dated from a late period.) Apparently a very important center existed in this region, since numerous ruins stretch over a large area east of Tokuz-saray. The ancient irrigation canals which watered the fallow sand-covered lands show how large a population once lived in this region, but there is nothing left from which it might have been possible to tell when the population disappeared — whether it was decimated in the course of the many wars which

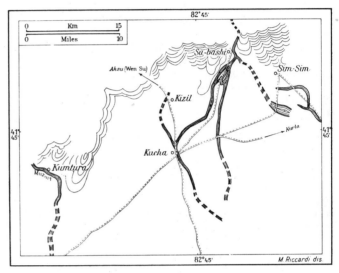

Kucha region, showing chief sites of archaeological and artistic interest.

took place in the Tarim Basin, especially in the time of Tamerlane, or whether it was dispersed for reasons yet unknown.

The Buddhist period seems to have lasted a long time, but the destruction of the buildings of that era was so thorough that only the foundations of religious monuments and monastic structures remain. Important archaeological material was discovered here, finds which help to establish the dates of the period when the religious communities flourished. Chinese texts studied up to now have yielded no information about the site, for — unless it was called by another name — it is not even mentioned. Only one Tibetan document from Tunhuang (q.v.) apparently mentions Tumshuk under the form t'um-c'u, although it seems unlikely that the name Tumshuk existed at so early a period, since that is actually the Turkish name of the site. It must have had an Indo-European name before its occupation by the Uigurs or by the Oghuz (Ghuz). Perhaps a study of the documents written in Brahmi script discovered at Tumshuk may indicate a more exact date. However, the objects discovered in different sections of the ruins vary so in style that it must be concluded that they belong to different periods.

According to Pelliot's excavation notes, "the terra cottas of Greek type from the little Temple I do not belong to the same period as the purely Indian bas-reliefs on the earthworks; they are even less contemporary with the statues of torchis [or cob, a mixture of vegetable fibers and clay or gesso], so typically Chinese, decorating the central stupa, and mark a step backward, an artistic decadence." There are many important archaeological remains, including several panels from a relief series decorating the principal sanctuary, which seem to represent Bud-

dhist scenes that are still unidentified. One depicts an emaciated figure with a Brahman; another shows a seated divinity above whose head are flying two devas or apsarases (I, PL. 472). On a third, a divinity with a nimbus is shown with a young woman on his left and an old woman on his right, both women with nimbi. To the right of the old woman, a figure carries on his shoulders a burden which is difficult to identify, and a young woman attendant is seated at his feet. Aside from these panels, which constitute the major documents, numerous fragments of statues which had adorned different portions of the sanctuary and the stupa were discovered. In the complex of buildings where these remains were found, several temples can be distinguished, as well as altars decorated with bas-reliefs, of which only fragments remain. A low balustrade with elephant heads was found north of the stupa, while other elephants from reliefs were found inside the buildings.

Except for fragments of arms and torsos, most of the material consists of heads from large statues or from bas-reliefs broken by the Moslems and scattered about (I, PLS. 476, 477). According to Pelliot, the statues must have been painted or covered with gold leaf; they show a considerable amount of variation. The cult images, which represent the Buddha or bodhisattvas, were very large, some actually larger than life. They reveal the influence of a highly evolved sculpture and must date from the T'ang period — between the 7th and 8th centuries. The figures from the broken bas-reliefs, which were doubtless similar to those few reliefs that luckily survived in entirety, depict figures of all types: monks, divinities, lay figures, barbarians, and demons. The stylistic sources for these figures seem to be numerous and problematic. Some show the influence of the Greco-Buddhist art of Gandhara, although resembling the terra-cotta sculpture of Taxila and Hadda; these pieces come mostly from Temple I and are clearly the earliest, probably dating from about the 4th century of the Christian Era. Other heads and busts show the influence of Gupta (q.v.) and Sassanian art (q.v.). One head, of a barbarian or a yaksha, may reflect a still more distant influence, since it is remarkably similar to the silenus heads on the coins of Panticapaeum (mod. Kerch). Still another head, draped in a lion skin, distinctly shows a Hellenistic heritage. Other materials recovered include fresco fragments and wooden statuettes, but since these are in poor condition and relatively scarce, definitive conclusions concerning them cannot be drawn.

At Tumshuk the most varied influences were brought together during the long period before its destruction, a fact which makes this site an especially rich source of knowledge. Pelliot's discoveries there are of great importance, since this site provides the link connecting Kucha and the other eastern Serindia centers to India and the West. The work done by Von Le Coq, in the course of which complete objects as well as fragments were discovered, confirms these relationships.

RELATION TO KARASHAHR AND SHORCHUK. Karashahr, which includes the important complex of temples and monastic establishments called "Shorchuk" by German archaeologists and "Shikshim" by the Russians, was originally the seat of an Indo-European state and was known as "Yen-ch'i" (Yenki; or "A-chini", Agni). It later became Uigurian and was called Karashahr, meaning "the Black City." Chinese influences penetrated into Kucha via Karashahr. At the same time, Western influences traveled to eastern Serindia through Karashahr and entered China (q.v.) during the T'ang era. While the city of Karashahr has yielded few archaeological remains, Shorchuk, located 16 miles south-southwest of the city on the rolling heights above the loess plain, contains a considerable complex of Buddhist ruins, near which are located rock sanctuaries. The ruins include over a hundred sanctuaries, ranging in type from a miniature cella, from 4 ft. to 6 ft. square, to massive rectangular buildings with an 80-ft. side built of sun-dried bricks reinforced by wooden beams.

The influence of Khotanese architecture (see KHOTANESE ART), particularly that of Dandan-uilik, is reflected in the sanctuaries of Shorchuk. Some of the buildings are similar to stupas with cylindrical domes, except that they are hollow;

they resemble the buildings of the cemetery in Kosh-gumbaz (Qosh-gumbaz) near Khocho (Kara Khōja) and served as tombs or shrines, as is indicated by the cinerary urns and boxes found inside. The most common type is a sanctuary of medium size formed by a cella with a small, narrow vaulted chamber behind the wall facing the entrance. Low vaulted entries into this space permitted circumambulation around the principal image, which faced the main entrance. This little room or passage may have been decorated with frescoes or stuccoes. Such a plan is strikingly similar to the cellas of the rock sanctuaries of the second style in Kizil (Qizil). The monuments in Shorchuk, mostly derived from types found more toward the west, provide a new architectural link between the Turfan and Kansu ruins and the Tarim Basin sites.

The same is true, in part, of the decoration, which also derived most of its motifs from the more westerly sites, but which nevertheless absorbed considerable Chinese influence through Turfan and through the Kansu centers. Among the paintings that survive, those on a section of the vault and on the walls of a corridor in Sanctuary XIII, as well as those in several caves, deserve special mention. The paintings in the passageway in Sanctuary XIII depict a group of monks around their master, or writing in caves surrounded by trees, or teaching their disciples, while genii fly about scattering blossoms or gandharvas float above them on clouds, Other scenes show monks ascending on clouds, as disciples and divinities kneel in adoration, or descending on clouds, as seated or kneeling monks watch the approaching arhat. These paintings seem to be quite late, undoubtedly belonging to the Uigur period; they are completely Chinese in their general appearance.

Cella VII yielded a painted wooden panel, similar to those from Khotan, portraying a bodhisattva seated in European fashion (i.e., with his feet hanging) below a flattened horseshoe arch. Like the paintings of other bodhisattvas, this panel clearly shows Indian influence. On the other hand, a fresco fragment discovered in Sanctuary XVIII depicts a typically Chinese subject: a dragon similar to those in the Bezeklik and Khocho sites is shown emerging from the water to attack a man who is about to cross the water, which barely reaches above his bare feet.

The cave paintings show the same mixture of influences; they can be considered as a transition between the second and third style of the Kucha region, with variations in thematic representations. The scene of the bodhisattva feeding himself to the hungry tiger and her young, a subject also found at Kizil, can be seen in Cave III. The *Parinirvāṇa* in Cave IX shows a change in the representation of Vajrapāṇi, who is shown flinging himself face down upon the ground and releasing his thunderbolt. More important differences are evident in other paintings. The Indian princes assisting at the division of the relics wear different clothes, and architectural details such as doors, windows, and walls are no longer the same. The soldiers of Māra, participating in the Assault on the Buddha, are dressed in a kind of coat of mail formed by rows of plaquettes, examples of which are found in the statuary of Shorchuk, as well as that of Dandan-uilik (Sanctuary D II); it is similar to the lacquered leather armor found in the Tibetan fortress of Miran, which lies east of Khotan on the southern Silk Route. The arrangement of the plaquettes is like that on the armor of a soldier of Māra in a Gandharan relief (Lahore, Central Mus.), a distant reminder of Greek armor. The donors depicted do not resemble those at Kizil but are similar to those of the Kumtura caves XIV and XXXIII; many are of Uigur type and their costumes are somewhat like those of donors found in Turfan paintings.

Such examples point to the complexity of influences on the paintings found in these sanctuaries, representative of the art of Kucha but often with significant variations derived from Chinese influences brought from Turfan. While Kizil paintings have light, brilliant colors, those at Shorchuk are rich and deep in color, with yellows, browns, roses, and greens predominating. The decorations on the vaults of rock sanctuaries recall the arrangement of Cave III in Kizil, with its large band of floral decoration surrounding bodhisattva medallions. The latter is Chinese in inspiration and similar to that of the caves of Kumtura's third style.

The statuary in Shorchuk is as rich and varied as its painting. Besides the many examples of stuccowork, there are also numerous fragments of carved wood. Many clay molds were found, which show how various parts of the statues — heads, torsos, and limbs — were first molded in clay and fitted on a crude skeleton. They were then attached to the wall and finished by hand with a chisel, and finally painted and gilded. Since similar molds were found in Tumshuk and Kucha, it is obvious that this process was commonly used at least on the sites in the north Tarim Basin.

The site of Shorchuk may be divided into two sectors, the southern zone, known as Ming-oi, and the northern zone. Many stucco reliefs were found in Ming-oi. A colossal arm of a lokapala decorated with the head of a monster was discovered in the cella of Group I (Stein's classification). There are other similar examples. Cellas I and II of Group II contained various fragments, which included a well-modeled head of a buddha, a terra-cotta plaque with bead decoration, and a beautiful head of a bodhisattva wearing a flowered diadem and earrings of the Tumshuk and Kucha style. The remains of a flowered stucco frieze, attached to the wall by wooden pegs, were found in the corridor of Cella XXVI of Group II. There were also excavated numerous urns containing the remains of human bones and two crudely made little boxes in which there were cloth-wrapped bone fragments.

In the northern zone, especially in the northwest, excavation was even more rewarding, for the central terrace is occupied by several important temples, of which buildings X, XI, and XII yielded the richest finds. Cella XI contained numerous stucco fragments of varying importance. These had been preserved by a fire which hardened them but which, unfortunately, destroyed most of the colors. Decorative friezes must have been attached to the walls throughout the building. Large statues apparently did not exist, for no traces of them were found. The surviving fragments, consisting of numerous bodhisattvas of varying types and sizes, are in poor condition but show considerable artistic skill. A marked Gandharan influence is evident in the portrayal of genii and other celestial beings and of emaciated figures clothed in rich garments. Other less important fragments were also found; heads of statues — the bodies gone — were probably preserved because they had been hardened more quickly by the fire. Many of these heads are freely treated in a naturalistic style very different from the hieratic and conventional influences found elsewhere. This style is especially evident in some bearded heads, based on classical models transmitted through Gandhara. Often heads from the same mold were varied by modifying the hair style or by adding a different turban, diadem, beard, or mustache. The shape of the eye was altered to produce a great variety of expressions. These methods allowed expressions of emotion — rarely found in Gandharan art — to show in the faces, as seen, for example, in the head of an old woman laughing, in that of a weeping man, and in a grotesque half-man and half-animal vomiting forth a skull.

The fragments of sculpture decoration found in the chamber behind building XII consisted of groups of richly draped, nearly life-size statues in high relief, arranged on low platforms along the exterior walls at the northwest and northeast corners; small reliefs that had fallen from a stucco frieze attached to the north wall; and statuettes, found at the feet of one of the statues of the northeast group, which undoubtedly represented donors.

In buildings X, XI, and XII other statue fragments were found, some of warriors, of which only the heads remained (covered with scale armor like the statues in the Tibetan fortress of Miran and in the region of Khotan), others representing a Gandharan type of bodhisattva. Near these human figures were found stucco fragments of animals skillfully modeled in a naturalistic style, among them the head of a camel and the legs and body of a horse reminiscent of the horses in T'ang sculpture. In other sanctuaries pieces of carved wood were found, including a fragment of a round box — similar to those found in Kucha — which may have contained relics; a fragment of the border of a large aureole, like examples discovered in Kucha and Rawak; and a lokapala in the T'ang style. The influence of the art of Gupta and Gandhara predominates in most of these fragments; the small statuary recalls that of Hadda and Taxila but is more stylized than the Tumshuk sculpture, while the elegance of the bodies and the anatomical details visible through the garments, derived from Gupta art, at times contrast with the painted decoration, which is frequently Chinese in style.

Shorchuk and Tumshuk are the connecting links between Kucha and the great cultures of northwest India and China. In the course of almost ten centuries an eclectic art evolved in Kucha which, while not great, is important, especially in the context of the area in which it developed, a region continually menaced by nomads.

Since it is impossible to examine all the sites which make up the complex of Kucha, only the most important are discussed below: Duldur-akhur and Su-bashi for examples of temple construction, and Kizil and Kumtura for their rock-cut temples.

TEMPLE ARCHITECTURE: DULDUR-AKHUR AND SU-BASHI. Duldur-akhur, on the right bank of the Kucha River, is essentially a monastery complex, with its buildings arranged around a central court. Su-bashi forms a complex at the point at which the Kucha River exits from the Chöl-tagh; it consists of rock sanctuaries and of several monasteries on both banks of the river.

Besides the monastery buildings, the site of Duldur-akhur also includes isolated stupas. Unfortunately, the complex of buildings has been burned, and the stupas have been partially destroyed by treasure hunters. It is likely that the monastery was pillaged before it was burned; this is indicated by spots on the frescoes from which the gilding has been scratched. Much archaeological material was recovered by the various missions working in the ruins: fragments of murals and of statues made of cob, pieces of carved wood, and some examples of sculpture still classical in appearance (I, PL. 473). It is not possible to reconstruct the architecture of this monastery, but it seems that on the whole it resembled the monasteries of Gandhara.

Among the fresco fragments several can be considered characteristic in spite of their small size. One fragment includes a pair of forearms and the palms of the hands, apparently clasped against the chest; the garment is patterned with multicolored flowers, and the figure wears bracelets and a necklace. The same bright colors, rosy ochre and light green, were also used on another fragment which shows two feet close together below the lower border of a garment. The colors and the variety of the styles indicate that these paintings — like those on other fragments, including one with an ascetic or a Brahman — were part of a group formed over several centuries; perhaps some are quite late. Some are close to the first style at Kizil, while others are touched by the Chinese influences present in the Tarim Basin from about the 8th century on.

The statuary includes many more examples with classical overtones. Several beautiful pieces of sculpture found within the ruins of one isolated stupa include: the head of a life-size stucco bodhisattva, classical in appearance, wearing a laurel crown over a coiffure of thick curls; and another slightly smaller head, also with a laurel crown and with hair arranged in more formalized waves, its face covered with a white coating which remains in some spots, while traces of black paint emphasize the hair, eyebrows, eyelids, and mustache. The wooden sculptures — which include statuettes, fragments of aureoles, and decorative objects — must have been painted and gilded, as indicated by the traces of gilding and paint that remain on a buddha's raised hand. The aureole fragments clearly show Chinese influence. Other statues, very skillfully carved, show the influence of Gandhara and perhaps even of the art of the Steppes (see STEPPE CULTURES), as can be seen, for example, in the figure of an open-jawed griffin of a menacing appearance. On the other hand, a vase fragment with a dark green glaze, decorated with a grotesque mask within a circle of beading, shows Western influences; the mask derives from the Gorgon motif and the beading is also of Western derivation.

Su-bashi absorbed even more varied influences, judging from the art found there, including frescoes in many styles, photographed in situ by Pelliot and studied by Hackin. One of these frescoes, in a good state of preservation at the time it

was photographed, demonstrates how highly developed this art had become, as well as the influences at work in its formation. The fresco shows a bodhisattva surrounded by musicians and other figures, the entire scene framed by a frieze formed by a row of rosettes. Both Indian and Sassanian influences are clearly evident, suggesting that this fresco dates from a period no earlier than the end of the 4th or from the 5th century, the date of the first Kizil style. The stuccoes show distant influences, harking back to Greek prototypes, perhaps transmitted via Hadda. To these influences were added those of Gupta art, as is suggested by the elegance of the forms and by the *tribhaṅga* ("three-bends") pose of some of the figures. This pose may be seen in certain thin figures — actually made in molds, but nevertheless giving the impression of having been freely modeled — which appear to have been executed with great spontaneity and may even have been left unfinished intentionally. The rhythm of the drapery and the slenderness of the forms are especially remarkable in a dancing female figure with arms and legs akimbo, in a female torso with hips slightly outthrust, and in a fragment of a nude torso partly covered with a supple, free drapery. This art is extremely refined and complex, but since extant examples of it are so scarce, it cannot be analyzed with any degree of certainty (I, PL. 476).

ROCK SANCTUARIES: KIZIL AND KUMTURA. The rock sanctuaries of Kizil and Kumtura afford much rich material for the study of their art and architecture. The sanctuaries are particularly remarkable for the number of frescoes that survived (PLS. 401, 402, 404, 405; I, PLS. 471, 474, 475, 478–481, 483, 484); statuary is represented only by a limited number of painted mold-made pieces. As with the Romanesque churches of the West, the purpose of painting was not only to decorate the walls but also to instruct the faithful. Also as in the West, sculpture was painted, as is proven by certain statuettes from Kumtura (PL. 403) and by many stuccoes from Shorchuk.

Three architectural types are represented in the rock sanctuaries of Kizil and, in different proportions, in Kumtura, where the only free-standing temple structure was found (see ASIA, CENTRAL). Two sanctuaries at Kizil and one at Kumtura, where the influence of Chinese T'ang painting (see CHINESE ART) prevailed, can serve as examples of the three most characteristic styles in Kucha art, which developed approximately during the period from the second half of the 4th century to the end of the 8th century. After absorbing the influence of India and Iran, this art seems to have undergone considerable change,

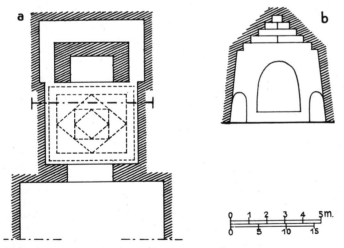

Kizil, Cave of the Painter. (*a*) Plan; (*b*) section (*from A. von Le Coq and E. Waldschmidt, 1922–33*).

developing elements characteristic of the art of the entire Tarim Basin. Beginning with the 8th century, tremendous waves of Chinese influence arrived, profoundly changing the art until the time of its disappearance.

Among the sanctuaries containing paintings in the first style (mid-4th cent.–mid-5th cent.) one of the most character-

istic is the Cave of the Peacocks. It includes a main hall, wider than it is deep, the portal of which must have formed a vestibule, and a second hall entered by a rather deep doorway, of which a portion of the frame still survives. Three steps lead to the second hall. The main cella is rectangular, with a flat ceiling in the midst of which arises a cupola about 5 ft. high. At the back

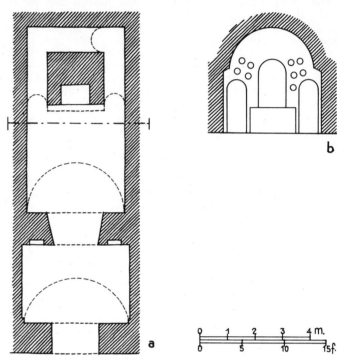

Kizil, Cave of Māyā. (*a*) Plan; (*b*) section looking toward the rear wall (*from A. von Le Coq and E. Waldschmidt, 1922–33*).

is a base that must have supported the cult image. On the wall adjoining the front entrance, there is a painting of a divinity holding a club, behind whom are shown only the feet of a figure and a horse. Nothing remains on the other wall. On the side of the main hall, to the left of the entrance, there is a large scene with figures larger than life size representing the Assault of Māra. The image of the Buddha is well preserved; there are three animal-headed demons in front, while on one side are shown demons attacking the Buddha, and, on the other, demons fleeing or being hurled to earth. Below the Buddha, Vasundharā is depicted in the form of four little figures emerging from a lotus blossom. On the opposite wall and in the same scale the Sermon at Sarnath was represented, but this fresco has almost totally disintegrated.

The cella is decorated on the ceiling and in the dome as well as on all the walls. The dome is painted with peacock feathers at the base, and a rosette, which later fell, was once attached by three pegs at its center. This rosette has a border and is divided into six segments, on each of which a putto is painted. The putti wear aureoles and a rather unusual hair style, partly shaven, and are shown flying downward, holding a necklace. *Devaputra*s, with arms uplifted as if supporting the cupola, are painted above the door and on the other three sides of the ceiling. Each corner has a bodhisattva with a large *parivāra* (retinue). Wherever the paint is preserved on the walls of the cella, it can be seen that the upper portion had a border — representing a balustrade — with a seated bodhisattva in the middle and a *parivāra* composed of delightful figures of devatas with musical instruments and flowers, and of *devaputra*s. On the balustrade extend three bands representing, in a series of pictures as wide as they are high, scenes from the Life of the Buddha according to Indian iconography (see BUDDHISM; BUDDHIST PRIMITIVE SCHOOLS).

The second style (6th–8th cent.) of the art of Kucha is exemplified by the Cave of the Sixteen Sheaths, which contains well-preserved typical paintings with harsh green and lapis

lazuli as dominant colors. Its architecture is simple, consisting of a single rectangular hall with a barrel vault. In the back, the sanctuary was carved out around a pedestal hollowed out like a niche for the cult image; an ambulatory was formed around the pedestal by hollowing out the wall behind it. There was a row of stucco figures on the upper part of the wall, above a wooden balcony, of which traces of the supports remain.

The vault is decorated with alternating series of Buddhas and bodhisattvas against a stylized mountain background, with more or less recognizable representations of the Jātakas and the Avadānas. The paintings on the top are characteristic of Kizil. In the center is a two-headed Garuḍa holding serpents in his beak. Buddhas, surrounded by flames, are shown on each side, and at either end, the sun and the moon — the sun as a brownish-red disk with a blue and white border, the moon as a white disk with a brownish-red semicircle surrounded by little circles representing stars. Near an isolated pillar in the rear passage, the Distribution of the Relics of the Buddha is depicted. The Brahmanic Droṇa, a legendary ruler, is pictured according to Indian tradition; he is shown distributing the relics to representatives of the various Malla tribes, here portrayed as Central Asian warriors in armor riding stirrupless on horseback, their feet pointing downward. The paintings in the back part of the cella were destroyed, but those on the sides of the corridors represent richly dressed donors. The walls at the end of the cella are covered with paintings of the Preaching of the Buddha, and the lunette over the door preserves a portion of a scene depicting flying figures, bearing offerings or playing lutes.

At Kumtura, in the Cave of Nirvana, both painting style and architectural type are different. The shrine is formed by a rectangular cella with a base bearing the cult image and a passage hollowed out around it. Rows of monks and lay figures are painted on each side of the door. On the cella vault there are pictures of Buddhas, surrounded by devatas, looking toward the back of the cave. The intervals are richly decorated with clouds and floral ornaments. Corridor vaults are treated as a continuation of the cella vault and have the same floral motifs. The front of the niche shows the Assault of the Buddha, in the Chinese manner. Each of the side walls of the cella had two niches with relief groups of bodhisattvas, probably surrounded by other figures. The walls of the niche were also decorated, and the back of the cella, behind the cult image, was adorned with wavy superimposed stripes, a characteristic decoration of this period. The walls of the passage show images of bodhisattvas, some of which, according to Grünwedel, show elements of the best types of ancient Japanese art.

STYLES OF PAINTING. The paintings of Kizil and Kumtura represent a composite art. The first style shows signs of uncertainty or, rather, of experimentation; its subjects and arrangement of details seem to have followed certain rules, unless a ritual order had to be used. The influence of Gupta art and of the Irano-Buddhist art of Bamian, quite distinct at first, gradually fused into a more individual art which found full expression in the second style. In the first style, the colors are soft and lack contrast, and the modeling gives an appearance of depth because of the shading, which follows the contours and underlines certain details, thus creating an effect of roundness. In the second style, colors are often contrasting and violent, and a sharper linear style finally resolves itself in a cursive, summary treatment in which the effect is gained by means of line rather than volume. The second style often sacrifices quality to dramatic effects, but the composition remains balanced. At this point, an art peculiar to the Tarim Basin was in the process of being formed; it depicts an ethnic type characteristic of the region, the figure slightly stocky but preserving the rhythms and grace of its Indian prototype (PL. 405), and there is a characteristic arrangement of the decorative elements. This development took place during the period when Serindia was free from Chinese rule — from the fall of the later Han protectorate until the T'ang conquest in the 7th century. Then the Chinese invasion carried into the region its own strong influences, the importance of which decreases from east to west. This influence, which flourished at Kumtura, pervaded Khotan on

the southern Silk Route and lasted until the fall of the T'ang dynasty in the 10th century. It was then too late for the art of the Tarim Basin to regain its unique personality. The Moslem conquest gradually brought about its end, but it remained for a time among the Uigurs, who had already been strongly influenced by China.

BIBLIOG. P. Pelliot, Rapport de M. Paul Pelliot sur sa mission en Asie Centrale (1906–1909), CRAI, 1910, pp. 58–68; A. Grünwedel, Alt-Kutscha: Archäologische und religionsgeschichtliche Forschungen an Tempera-Gemälden aus buddhistischen Höhlen der ersten acht Jahrhunderte nach Christi Geburt, Berlin, 1920; A. Stein, Serindia, 5 vols., Oxford, 1921; A. von Le Coq and E. Waldschmidt, Die buddhistische Spätantike in Mittelasien, 7 vols., Berlin, 1922–33; R. Grousset, L'art de l'Asie Centrale et les influences iraniennes, RAA, I, 1924, pp. 13–16; A. von Le Coq, Bilderatlas zur Kunst und Kulturgeschichte Mittel-Asiens, Berlin, 1925; E. Waldschmidt, Gandhāra, Kutscha, Turfān: Eine Einführung in die frühmittelalterliche Kunst Zentralasiens, Leipzig, 1925; J. Hackin, Buddhist Art in Central Asia: Indian, Iranian and Chinese Influences from Bāmiyān to Turfān, Studies in Chinese Art and Some Indian Influences, London, 1937, pp. 1–14; M. Bussagli, L'influsso classico ed iranico sull'arte dell'Asia centrale, RIASA, N.S., II, 1953–54, pp. 171–262.

Louis HAMBIS

Illustrations: PLS. 401–405; 3 figs. in text.

KU K'AI-CHIH.

Chinese painter (ca. 344–ca. 405) born at Wu-hsi in the province of Kiangsu. Although history records the names of various Chinese artists who attained prominence during the early centuries of our era, Ku K'ai-chih is the first concerning whose life and work anything of consequence is known. Later generations enthroned him as one of the chief patriarchs of the Chinese school; as a painter of the human figure, he seems to have been the forerunner of the great masters of the T'ang period (618–906).

Ku painted at least one work for a Buddhist temple, but was especially noted for his secular portraits; his recorded hand-scroll compositions, commonly executed in Chinese ink and color, include historical subjects as well as Taoist legends represented in a landscape setting. Early accounts praise the dramatic force of his conceptions, his fluent, linear brushwork and telling use of color, and above all the singular skill with which he portrayed human character — perhaps his most original contribution to the progress of the art. The authenticity of the works long attributed to Ku is extremely questionable, but there are in existence several ancient scrolls which have long been associated with his name and which certainly preserve the spirit of a strongly individual style. The most important of these, The Admonitions of the Instructress to the Court Ladies (PLS. 406, 407; III, PL. 235), may be among the oldest Chinese scrolls extant. In execution it comes close to the supposed conventions of the pre-T'ang period, but there has been much subsequent restoration, and opinion remains divided concerning its actual date.

According to the Chin-shu, the official history of the Chin dynasty — which, although compiled only at the beginning of the 7th century, incorporates records dating back almost to the painter's lifetime — Ku K'ai-chih was born at Wu-hsi and lived to the age of 62. Early in life he served as military secretary to the Grand Marshal Huan Wên (312–73), and since a further appointment is recorded for the year 405, his life span must correspond roughly to the years 344–406. He was subsequently on terms of intimate friendship with Huan Wên and also with Yin Chung-k'an, prefect at Ching-chou in Hupeh.

Ku was a popular figure of the day, and his reputation as a wit is reflected in various telling anecdotes. Someone commented of him that as a young man he was "composed half of real madness, half of conscious buffoonery: one cannot understand him properly without making allowances for both." At the same time he is credited with wide erudition and no small opinion of his own literary talents.

Ku K'ai-chih's place in the history of Chinese art is clearly affected by these indications of his lively personality, but account must also be taken of the novel intellectual climate in which he lived. By this time the formerly powerful Chin state had become confined to the region of the lower Yangtze River valley, and the northern provinces were torn repeatedly

by feudal rivalries and barbarian invasions. For several centuries, therefore, this enlightened southern court at Nanking was to serve as the chief repository for the traditions and culture of the preceding Han dynasty (206 B.C.–A.D. 221). Already, however, the rigid system of Confucianism (q.v.) established in that era, which laid down strict rules for the conduct of affairs of state and society alike, had undergone a marked mollification at the hands of scholars influenced by mystical Taoism (q.v.).

One effect of this on literature and art was a considerable broadening of the individual imagination. Ku's participation in this trend was reflected in many aspects of his life and work, not only in his belief in magic and the Taoist cosmology but also in his keen interest in natural phenomena and the human emotions. He was, in effect, the first exemplar of that observant philosophical and literary approach which has ever since directed the main course of Chinese painting.

Ku K'ai-chih's earliest known work is a remarkable picture of the Buddhist hermit-saint Vimalkīrti, painted in his youth for the Tile-Coffin Temple at Nanking, and this, it is said, laid the foundations of his later reputation. The 9th-century critic Chang Yen-yüan, in his famous Li-tai ming-hua chi comments as follows: "In the painting of the wise old men of ancient times only master Ku mastered its vital principles He was the first to make a picture of Vimalakīrti which has well-defined and emaciated features that plainly show his illness. Lu and Chang both tried to equal this portrait but never did so." [Lu T'an-wei (5th cent.) and Chang Sêng-yü (see CHINESE ART) were the two foremost pre-T'ang painters whom critics ranked with Ku.] But Ku was no less noted for the verisimilitude of his secular portraits; and among various fragmentary writings attributed to the artist, which are incorporated in Chang Yen-yüan's work, the following remarks on his approach to the art of portraiture are especially revealing: "Once you have arranged the accessories on which the sitter's gaze is directed, you must not move them. Men do not wave a friendly hand or look interested when there is nothing in front of them." This passage implies psychological insight as well as the study of gesture and movement.

The same characteristics may be noted in Ku's more ambitious works, among which were a variety of compositions on themes already traditional. The subject of the Admonitions scroll, like that of the Heroines or Illustrious Women, was one of moral instruction with a strong Confucian flavor, yet its interpretation was apparently distinguished by a keen, almost cynical personal observation. It seems highly probable that the Seven Sages of the Bamboo Grove, a coterie of eccentric scholars prominent in the advancement of Taoist philosophies during the post-Han era, provided a motive more sympathetic to his own ideals.

Another painting of Taoist inspiration is described in an essay entitled Hua yün t'ai shan chi ("On Painting the Cloud Terrace Mountain"), the most lengthy of Ku's writings preserved by Chang Yen-yüan and the most valuable for the appreciation of his artistic aims and methods. This mountain was the scene of the legendary activities of the Taoist magician Chang Tao-ling, who came to be regarded as the first Taoist t'ien-shih, or patriarch. It was the setting therefore for a dramatic illustration of scripture rather than a landscape composition of the type which was to appear later in Chinese art under the influence of poetry. The scene chosen for illustration is that of the ordeal of the disciple Chao Sheng, who is commanded to gather the fruit of immortality from a tree growing high on an inaccessible cliff face. Ku describes how the faces of the participants are to be charged with deep emotion, while each feature of the mountain landscape is disposed to accentuate the atmosphere of awe and dizzy terror. The prominence given to such purely symbolic elements as the mythical phoenix and tiger, the peach tree and pine, and the "felicitous clouds" which attract spirits underlines the essentially mystical nature of his conception.

In conjunction with other passages in Chang Yen-yüan's critical work, Ku's vivid essay provides not a few indications of the conventions and technicalities of painting in the period of the Six Dynasties. It describes, for example, various composi-

tional devices designed to heighten the illusion of space and distance and speaks of realism in the presentation of details.

To represent the whole mountain within the picture space required, however, a tacit disregard for scale in the figures. The way in which such problems was resolved may usefully be studied in certain sections of the Admonitions scroll. Ku's use of colors, of which blue, cinnabar red, and purple are specifically indicated in his essay, appears well calculated for dramatic effect. His brushwork was predominantly linear and achieved life through its rhythmic movement, tracing a contour within which color could be applied flatly, while shading was kept to a minimum. Such an interpretation, at least, seems to be supported by comparison with tomb murals and other works of the period. According to Chang Yen-yüan, "his strokes are firm and tense and connect with one another uninterruptedly; they circle back upon themselves in sudden rushes. His tone and style are evanescent and variable, his atmosphere and interest lightning and sudden." The 6th-century critic Hsieh Ho, however, who formulated the renowned "Six Principles" of painting in his Ku-hua p'in-lu, thought Ku K'ai-chih famed beyond his merits; "His style and execution were refined and minute and he never used his brush haphazardly. But his works did not come up to his conceptions." From this, Ku's brush technique may be suspected of lacking that superior vitality which was the critic's highest canon of excellence.

Numerous other pictures have at various times been attributed to Ku K'ai-chih; nine are listed in the 12th-century imperial catalogue Hsüan-ho hua-p'u, but very few have survived and only the Admonitions hand scroll lays claim to be considered a pre-Sung version. Its attribution in fact dates back to this 12th-century work, but Pelliot (1933) has traced the history of its ownership to the 11th century. Of considerable length (11 ft., 4 1/2 in. × 9 3/4 in.), it is executed in ink and red and brown color, and shows signs of repeated restoration. The work comprises nine distinct illustrations to a moralistic tract of the same title by the poet Chang Hua (232–300), each accompanied by a descriptive text apparently added later. Two preceding sections and an introductory text are missing. The surviving themes (PLS. 406, 407; III, PL. 235) are: (1) Lady Feng rescues her Emperor from a bear. (2) Lady Pan refuses to ride in the Emperor's litter "lest she should distract him from state affairs." (3) A hunter in a mountain landscape ("In nature is nothing high that is not soon brought low"). (4) A lady adorning her person ("Few know how to embellish their souls"). (5) A lady in bed conversing with a bearded man ("If the words you utter are not good, even your bedfellow will distrust you"). (6) A large family ("Your race shall multiply"). (7) A lady reproached by her husband ("No one can endlessly please"). (8) A lady kneeling ("Fulfill your duties calmly and respectfully"). (9) The Instructress. Lively and harmonious, the figure compositions are executed with a sinuous, rhythmic line that, while it allows little emphasis of structure or mass, is nevertheless richly expressive in its rendering of the hands, face, and bodily movement. Undoubtedly, these are the work of a master of very early date.

Nevertheless Binyon's (1912) championing of the attribution to Ku K'ai-chih himself has not been widely accepted. Much of the subsequent discussion is conveniently summarized by Sullivan (1954), whose claim to have identified details characteristic of a 10th–11th-century execution may be contested on the ground that these are restorations. Not a few authorities (e.g., Sirén, 1956) favor an early T'ang date, although in Sickman's view no adequate evidence has yet been produced to support any of these comparatively late attributions.

Several other pictures connected with Ku's name show in their conception unmistakable affinities to the Admonitions scroll, the most important being two (probably Sung) versions of a scroll entitled The Nymph of the Lo River now in the Hui-hua-kuan, Peking and in Washington (PL. 408). The subject, which is again based on a 3d-century Taoist poem, depicts a host of heavenly creatures disposed in an ethereal landscape. (The order of the episodes should be viewed from bottom to top, in the reading order of Chinese.) In each case the somewhat still rendering has an archaistic, rather than

merely archaic, flavor. The *Illustrious Women* scroll, likewise in Peking, is a composition in many respects close to the *Admonitions* in its grouping of figures, but in execution belonging essentially to the Sung period. So is the rather free version of *The Making of the Lute*, a work that perhaps deserves closer study than it has yet received, since its subject is recorded among the artist's œuvre.

SOURCES: Ku K'ai-chih, Hua yün t'ai shan chi (On Painting the Cloud Terrace Mountain), Eng. trans. in S. Sakanishi, The Spirit of the Brush, London, 1939, pp. 30-33, and in M. Sullivan, On Painting; the Yün-t'ai-shan, AAs, XVII, 1954, pp. 87-102; Hsieh Ho (6th cent.), Ku-hua p'in-lu (Old Records of the Classification of Painters), in W. R. B. Acker, Some T'ang and Pre-T'ang Texts on Chinese Painting, Leiden, 1954, pp. 1-32; Chang Yen-yüan (9th cent.), Li-tai ming-hua chi (A Record of the Famous Painters of All the Dynasties), in W. R. B. Acker, Some T'ang and Pre-T'ang Texts on Chinese Painting, Leiden, 1954, pp. 59-382; Chin-shu (History of the Chin Dinasty), 92: 21a-22a, Biography of Ku K'ai-chih, Eng. trans. Chen Shih-hsiang (Chinese Dynastic Histories, 2), Berkeley, Los Angeles, 1900.

BIBLIOG. L. Binyon, A Chinese Painting of the 4th Century, BM, IV, 1904, pp. 39-44; E. Chavannes, Ku K'ai-tche, TP, V, 1904, pp. 325-31; E. Chavannes, Note sur la peinture de Ku K'ai-tche conservée au British Museum, TP, X, 1909, pp. 76-86; Sei-ichi Taki, Ku K'ai-chih's Illustrations of the Poem of Lo Shên, Kokka, XXI, 1911, pp. 349-54; L. Binyon, Admonitions of the Instructress in the Palace: A Painting by Ku K'ai-chih, with Complete Chromoxylograph Reproduction, London, 1912; A. Waley, Introduction to the Study of Chinese Painting, London, 1923, pp. 45-66; T. Naito, History of Chinese Painting, II, Bukkyō Bijutsu, VII, 1926, pp. 12-16 (in Japanese); O. Sirén, Chinese Painting in American Collections, I, Paris, 1927, pls. 1-2; P. Pelliot, Le plus ancien possesseur connu du Kou K'ai-tche du British Museum, TP, XXX, 1933, pp. 453-55; S. Sakanishi, The Spirit of the Brush, London, 1939; W. R. B. Acker, Some T'ang and Pre-T'ang Texts on Chinese Painting, Leiden, 1954; M. Sullivan, A Further Note on the Date of the Admonition Scroll, BM, XCVI, 1954, pp. 307-09; M. Sullivan, On Painting the Yün-t'ai-shan, AAs, XVII, 1954, pp. 87-102; Wei ta te i shu fu t'ung t'u lu (The Great Heritage of Chinese Art), II, 7, Shanghai, 1955, pl. XII; L. Sickman and A. Soper, The Art and Architecture of China, Harmondsworth, 1956, pp. 63-64; O. Sirén, Chinese Painting: Leading Masters and Principles, I, London, New York, 1956, pp. 26-35, III, 1956, pls. 9-15; P'an T'ien-shou, Ku K'ai-chih, Shanghai, 1957 (in Chinese); A. Giuganino, La pittura cinese, Rome, 1959, pp. 35-41, pls. 40-50.

John AYERS

Illustrations: PLS. 406-408.

KUSHAN ART.

The name Kushan refers to an ethnic group of controversial origin and make-up (see GANDHARA). In the early centuries of the Christian Era this group gave rise to a great empire in whose area there arose various schools of art (see BACTRIAN ART; GANDHARA; INDO-IRANIAN ART; KHWARIZM; MATHURA, SCHOOL OF) inspired primarily by Buddhism (q.v.). The present article deals with the traits common to these schools and those formal and stylistic characteristics which the Kushans themselves contributed to the flowering of the various schools; in addition, by typological analysis of the art, it attempts to reconstruct the tastes of these peoples, which were in part responsible for the spread and continuation of both Hellenistic-Roman art (q.v.) and of anticlassical (Iranian and Central Asian) forms in the area of Indo-Iranian contacts and on the borders of Central Asia.

SUMMARY. The culture of the Kushan empire (col. 1041). Civil engineering (col. 1044). Architecture (col. 1045): *Fortifications; Urban centers; Dynastic sanctuaries.* Sculpture and religious monuments (col. 1047). Jewelry (col. 1048). Pottery and figurines (col. 1048).

THE CULTURE OF THE KUSHAN EMPIRE. The Kushans, perhaps one of the five principal seminomadic Iranian Yüeh-chih tribes that reached Bactria from the west during the 2d and 1st centuries B.C., became the leading political power in central Asia in the 1st century of our era. Further excavation may throw fresh light on the chronology of the Kushan rulers, but on the basis of current knowledge the first dynasty of Kujūla Kadphises (Kadphises I) and Wima Kadphises (Kadphises II) is dated to the 1st century of our era, and the second dynasty of Kaniṣka I, Huviṣka, and Vasudeva to the 2d century. Under Kaniṣka I the Kushan empire reached its zenith, covering an area limited by Mathura on the Jamuna River, the country of Turfan (q.v.), the oasis cities to the south of the Aral Sea, and

the lower Indus Valley. After the Sassanian conquest (see SASSANIAN ART), the Kidara Kushans ruled semi-independently over a diminished area in the 3d and 4th centuries, until their defeat by the Ephthalites (White Huns). The Kushans not only sponsored great intellectual and artistic achievements in their dominions but were also in contact with the leading cultural centers of the ancient world, protecting the important overland route from Rome to China.

The Kushan civilization originated among peoples of mixed cultures. Their neighbors in the northern Eurasian steppes led a nomadic life and produced an art enriched by contacts with the Mediterranean world. In the Parthian borderland, ancient Iranian elements of the Achaemenid empire felt the impact of both the later Iranian nomadic cultures and of classic art (see IRANIAN PRE-SASSANIAN ART CULTURES). The southern neighbors of the Kushans on the Indian peninsula in the kingdoms of Magadha and Andhra (q.v.) had a mastery of architectural and sculptural techniques and an art which blended original and typically Indian features with elements of ancient Iranian, Mesopotamian, and possibly Mediterranean origin. Finally, land traffic and sea trade brought the Kushan empire into contact with the Hellenized civilization in the eastern provinces of the Roman Empire that reflected various art trends of western Asian (see ASIA, WEST: ANCIENT ART), Greek, and Roman origin.

The cosmopolitanism of the Kushan rulers favored an active exchange of all these esthetic ideas within the boundaries of its vast empire. The Begram hoard may symbolize the cultural aspects under which the Kushan empire flourished: in a deposit were discovered Indian ivories in the Mathura style (see IVORY AND BONE CARVING; PL. 241), Chinese lacquers, and bronze, glass, and plaster from eastern Mediterranean workshops (VI, PL. 220; VII, PL. 195). This material probably belonged to a customs post on the road from Bactria to India that branched off the east-west Silk Route. Foreign and indigenous artists, partly following older Asiatic traditions and partly inspired by Western models, were encouraged by tolerant rulers of syncretistic religion to create complex architecture, sculpture, and painting that united the content and form of past and contemporary arts of East and West. A great deal of this artistic achievement is ascribed to the individual energy of Kaniṣka I, who might be called a politician and Maecenas. In respect to Oriental cultures and those of the steppes, the Kushans represent the advance of a strong nomadic clan into Central Asia, bearing the art elements of the equestrian peoples. In relation to the West they represent the farthest descendant of Mediterranean culture. The developments of their art — sometimes similar and sometimes differing widely among the territories of Khwarizm (q.v.), Bactria (see BACTRIAN ART), Gandhara, and Mathura (qq.v.) — are all included by D. Schlumberger in the term "Greco-Iranian." More specifically, however, Kushan art is a part of early Indian architecture and sculpture, known for the famous workshops in Gandhara and Mathura; the foreign Western elements prevail in Gandhara, and the indigenous Asian ones in Mathura (PLS. 410, 412).

The Kushan artists enriched the Buddhist sculpture of India by the most important innovation of the period: the rendering of the Buddha in human form as a cult image or as a slightly oversized figure in the narrative reliefs (see BUDDHISM; BUDDHIST PRIMITIVE SCHOOLS; IMAGES AND ICONOCLASM). The contact of the Kushan empire with the Greco-Roman world and its anthropomorphic deities may have accelerated the Indian evolution toward the use of the male figure rather than the earlier aniconic symbols (VII, PL. 412) to interpret the central cultic personality. (Lavish exemplification of the Buddha in human form is to be seen in the reliefs of Bharhut and Sanchi.) Probably at the same time the Gandhara Apollonian type and the Mathura Kapardin types of Buddha image were originated.

Two other phenomena of Kushan sculpture were not continued in later Indian art: the dynastic portrait and the colossal cult image. The portrayal of the individual was never a subject of Indian art, but the influence of Greco-Bactrian coins and Roman portrait sculpture seems to have inspired magnificent statues of Kushan rulers in the dynastic sanctuaries of Khwarizm,

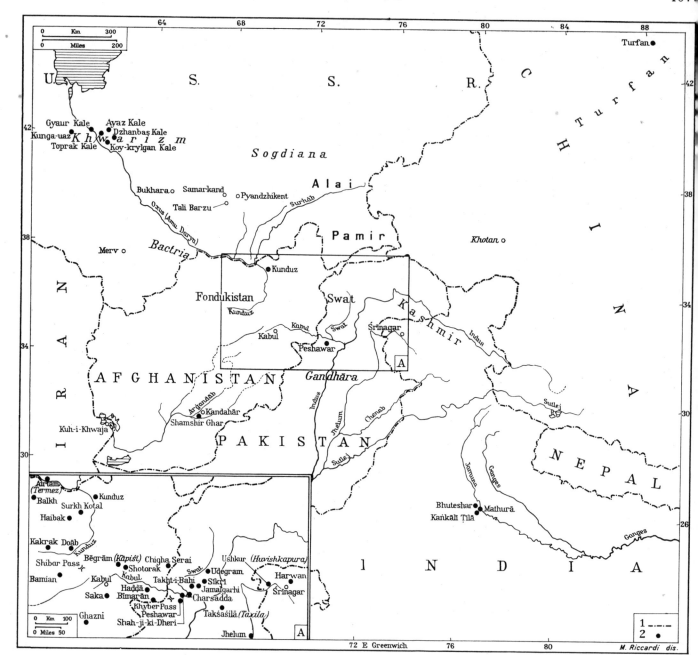

Principal centers of Kushan culture. (1) Modern national boundaries; (2) remains from the Kushan period.

Surkh Kotal, and Mathura. This branch of sculpture was later without interest for Indian sculptors. The gigantic Buddha statues of Bamian, Kakrak, Ghazni, and Surkh Kotal may have been shaped after models of the late-antique period, but colossal cult images are unknown on Indian soil after the Kushan period, with the exception of the reclining Buddhas in Ajanta (q.v.) and Polonnaruva (Ceylon; see CEYLONESE ART; III, PL. 175) and the colossal standing images of medieval Jain art (see JAINISM).

The monuments of Kushan arts and crafts are a focal point between ancient Asian tradition and later Indian development. Patterns of prehistoric Indus Valley pottery (see INDUS VALLEY ART) survive in Kushan works found at Rang Mahal (Bikaner dist., Rajasthan). On the very site of Mohenjo-daro a Kushan stupa was erected. In Toprak Kale and in Kashmir, wall paintings and stuccoes were executed in the Gandharan style long after the downfall of the Kushan empire. The Kushan capital of Mathura was erected over early historic settlements and later provided the basis for the planning of the modern town. At Toprak Kale, Tali Barzu, and Kandahar the Kushan layers represent just one chapter in a long historic record.

The sculpture of Mathura (PLS. 410, 412; IX, PLS. 379–384) preserves esthetic qualities of the Maurya, Śuṅga, and Early Andhra periods; enriched by Gandharan motifs, this art became the basis of Gupta art (see GUPTA, SCHOOL OF), with its manifold medieval derivations. After the Kushan dynasty Hindus and Moslems settled at Surkh Kotal. The diaper schist masonry known from Gandharan stupas and monasteries was used, toward the end of the 1st millennium of our era, by Hindu kings — who boasted of being successors of the Kushans — and by Islamic builders in the Kunar Valley and the Hindu Kush area.

The jewelry of Scythian character from Begram II is even nowadays in use among the central Asian and Indian populations. The Greek alphabet introduced by the Kushans in coin legends and epigraphs was transformed into a Greek cursive by the Ephthalites who finally conquered the Kidara Kushans.

CIVIL ENGINEERING. The greater part of the Kushan empire consisted of arid country, the cultivation of which was dependent on irrigation. Throughout Khwarizm during all periods of strong central government there flourished a well-developed

system of canals. It is surmised that the Kushans maintained the large canals existing in their dominions from the middle of the 1st millennium B.C., some of which lasted to about the 11th century of our era. In Bactria also, in the environs of Balkh and near the Kunduz and Khanabad rivers, there are the remains of a traditional canal system.

In the mountains of Swat the population had to face another problem: protection of the villages against floods and the collection of monsoon waters by barrages. A rare example at Tokar Dara of such a hydrological structure is especially interesting because of its diaper schist masonry.

Monuments of daily life from very remote times are scarce. The excavations by S. P. Tolstov supply at least one specimen of a rural settlement from the Kushan period: in the plain beneath the fortress of Ayaz Kale is a series of unfortified farmhouses. Mud-brick walls enclosed a very large court (perhaps a garden), and a small dwelling house consisting of 10 to 15 rooms was attached to one of the walls.

ARCHITECTURE. *Fortifications.* Fortified posts protecting economic centers and roads between the capital cities are found especially in the northern part of the Kushan empire. They were erected in the vicinity of the villages and the unfortified isolated farms. Together with the caravansaries they were placed along the overland communications to safeguard caravan trade. The mud-brick ruins of Ayaz Kale 1–3, Gyaur Kale, and Kunya-uaz represent the various types of fortifications that defended the northern border. One striking feature is the vast court behind huge mud walls, where the garrison was probably housed. The bulwark consisted of semicircular towers, vaulted corridors, and arrowlike loopholes. As far as present observations allow, it can be concluded that a system of fortified posts protected the traditional silk road along the route Shibarghan–Balkh–Tashkurghan–Kunduz–Khanabad–Taliqan and farther east. These posts were either rectangular structures in the open plain or polygonal walls in the curves of rivers and canals. The *tepes* (hills) are now of different sizes; common to all is a slight elevation in the center or at one corner — probably the watch tower of the garrison. Of extraordinary interest is the fortification of the south wall of Balkh, where Le Berre excavated earthen walls and profusely decorated mud-brick towers of the Kushan period, giving the outline of the Timurid fortress.

In the plains the type of small buildings was continued, while in mountain regions such as Doab imposing fortresses in diaper stone masonry dominated. In the Kabul plain and in the Logar Valley the unexcavated mound of Shahr-i-Sikandri and the small fortress of Saka indicate a similar defensive system. The mountains of the northwestern Indian frontier supplied abundant stone for the strongholds in the Kunar Valley and Swat, where fortified posts such as those on the cliffs of Chigha-Serai and Udegram remained in use long after the Kushan period. During the long history of ancient Kandahar, represented by extensive ruins, the Kushans seem to have played an important part. Dupree's excavations have demonstrated that during the Kushan period refugees from cities and villages in the Kandahar area several times found shelter in the Shamshir Ghar caves.

Urban centers. The vast Kushan empire was administered from large capital cities. In the northern part Begram (anc. Kapisi) was the summer capital and Peshawar the winter residency; in the south Mathura served as the royal seat. Ruins of Kushan cities are preserved at Udegram and Begram as the upper layers of older towns, and at Sirsukh (Taxila) as fresh foundations.

Everywhere can be seen the combination of the type of Central Asian nomadic camp with various forms of Mediterranean town planning. In the last period of Begram I the rulers of the first Kushan dynasty adapted their cities to the character of a regularly planned town with walls like those of the Hellenized Greco-Bactrian kings.

The second Kushan dynasty of Begram II continued to use the town, enlarging the stone houses with mud-brick con-

structions and introducing a new technique of stone socles serving as bases for pisé walls. In the mud-brick houses of Begram III of the third and fourth dynasties there appear innovations of banquettes and niches such as are known in contemporary south Russian and Chorasmian dwelling houses (see KHWARIZM). Other striking affinities with Transoxianian types of architecture are to be seen in the square structure with four bastions in the form of a three-quarter circle, a fortress within a fortified town. At the same time walls with semicircular bastions and corner buttresses are the dominating feature of the stone structures of Sirsukh (Taxila). In the form of a parallelogram, the Kushan city lies in an open plain protected by a small river near the eastern part of the south wall. An original Central Asian system seems to be combined with methods of the Roman castrum.

Mathura of the Kushans was protected to the north by the broad Jamuna River. Depending on the geographical situation, an earthen wall and a mud-brick fortification surrounded the city area. In the western part of this fortified city a mud-brick fortress with corner bastions was situated at the crossing point of two main streets. The plan of this city has influenced all later stages of Mathura. Accordingly we might find in present Central Asian cities or ruined sites such as Airtam (near Termez), Afrasiyab, Tali Barzu, and Toprak Kale the remains of a city system introduced by the Kushans.

No superstructures are preserved from the Kushan period. Architectural representations on narrative reliefs from Gandhara

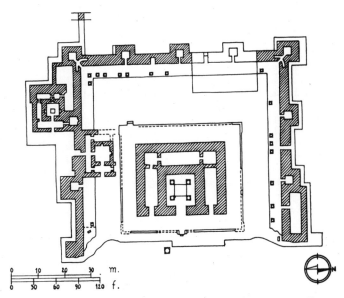

Surkh Kotal, dynastic sanctuary of the Kushan kings, plan according to the excavations of 1953 (*from D. Schlumberger*).

and Mathura give an idea of city walls with pavilions, towers, and streets between two-storied houses with wooden balconies. At present it is uncertain whether there really existed vaulted rooms with coffered ceilings, as depicted in some reliefs.

Dynastic sanctuaries. Three ruins and find sites — in the south Russian steppes, on the northern slope of the Hindu Kush, and in the Jamuna-Ganges plain — represent a special kind of dynastic and cult monument and, in spite of many local variations, all belong to the area of Greco-Iranian art. In the Kushan stratum of Toprak Kale the royal palace (PL. 389) and fire temple are the spiritual centers of the town; the Kushan style — best known in Gandharan and Mathuran stone sculpture — is evident in wall paintings of the post-Kushan palaces glorifying the ruling dynasty and in stuccoes and colorful figural representations.

The acropolis on the hill of Surkh Kotal (FIG. 1046), accessible by a flight of well-dressed limestone stairs, is crowned by a fortress with square towers and a great peribolos. The Attic bases of the four columns of the fire altar are preserved (II,

PL. 86). From three male statues in Scythian dress and the great inscription on the outer wall of the structure, it appears that Kaniṣka I himself represented the deity worshiped in this sanctuary. The fragment of a male head excavated in 1953 at Surkh Kotal is of value for the study of individual expression in Greco-Iranian art.

A monumental figure from Mathura, of the same Scythian style, is named by an inscription as Kaniṣka (PL. 1). This rare work of art belonged, together with other sculptures, to the sanctuary at Mat, near Mathura, which was probably a kind of portrait gallery for worship of the ancestors of the dynasty.

SCULPTURE AND RELIGIOUS MONUMENTS. Architectural fragments of pseudoclassic Attic bases, Corinthian capitals, and stone decoration with vine leaves, stepped pinnacles, and rows of beading or rosettes derive from cult buildings, mainly Buddhist. Remains of this Greco-Iranian style [known also in Parthian buildings of Palmyra and Nysa (Nisa)] stretch from Toprak Kale to Termez, Balkh, Kunduz, Surkh Kotal, Shotorak, Hadda, Jandial (Taxila), Jhelum, and Mathura. Within this huge area are distinguished several regional varieties.

The fragments of capitals from Airtam, the plan of the Buddhist monastery and of the underground chambers of Kara Tappa, and the remains of wall paintings in the Bamian style are examples of the Kushan art that was dominant in several religious communities in Khwarizm, Uzbekistan, and Sogdiana for some centuries after the Kushan rule had ceased.

Bactria and Gandhara were the main Buddhist countries whose artists freely adopted inspirations of the Greco-Roman world. Center of the cult was the stupa, represented by the gigantic mud-brick structures of Balkh, the Kaniṣka stupa of Shah-ji-ki-Dheri near Peshawar (about whose gilded towers the Chinese pilgrims wrote), and the unique, large stone stupa in the Ghazni plain, where remains of the ancient wooden superstructure have been recognized. The innumerable votive stupas of schist in the monasteries during the Kushan period followed a general tendency of Indian art: the evolution toward pronounced slenderness. In some stupas were discovered caskets with jewelry, inscriptions, and Kushan coins; especially valuable are the gold reliquaries from Bimaran (VII, PL. 465) and Peshawar. The freestanding stupa was at the center of the monastery courtyard. (The monks were housed in square cells.) The stupas were decorated with Persepolitan capitals, winged lions, chaitya arches, columns supported by elephants, atlantes, Tritons, garland-bearing Erotes, and fantastic compositions of ancient Near Eastern, Mediterranean, and Indian origin. Those of Shotorak, Takht-i-Bahi, Jamalgarhi, and Sikri are among the best-known examples. In these sanctuaries the Buddha was worshiped in the form of a seated or standing cult image in stone or stucco. Auspicious marks such as the ūrṇā and the uṣṇīṣa were conceived by Gandharan and Mathuran artists according to the Buddhist holy scriptures (see BUDDHISM). In well-balanced artistic contrast to the serene face of the Buddha, the Indian sculptors represented the surrounding figures — men, women, and demons — with individual and even ethnographic characteristics.

The stuccoes from Kunduz (II, PL. 88), Hadda (VI, PL. 20), and Taxila in particular display a beautiful combination of the Asian with the Mediterranean mind. Friezes around the stupas illustrated continuous legendary scenes from the Jātakas and the Buddha's life, the traditional Indian style enriched by Greco-Roman imagery; but the Greco-Roman elements are constantly set off by anticlassic Oriental forms of linearity and rigidity. Three-quarter relief fills the friezes, and empty space is rarely left. The scenes are often symmetrically grouped, and the action takes place mainly in the foreground; background figures appear on a higher level. Scanty details suggest the locality. Figures and groups are rendered frontally, and, according to the rules of hieratic art, usually the main figures — the bodhisattva or the Buddha — are larger than the other figures.

Architecture and sculpture also display local variations in Bactria, southern Afghanistan, the Kunar Valley, Swat, and the environs of Peshawar and Taxila. Unique monuments are the monolithic stupa at Haibak (see AFGHANISTAN); the "platform of statues" in the plain beneath Surkh Kotal, with the remains of a more than life-size earthen figure; the row of votive stupas added to the city gate site of Begram III; and the towers Minār-i-Cakri and Surkh Minār, in schist diaper work, on mountain peaks near Kabul, in the vicinity of the Logar Valley stupas. The towers probably displayed the Buddhist symbol of the Wheel of the Law. In addition, the cave monasteries and colossal rock-cut figures of the Buddha (ca. 115 ft. and ca. 175 ft. high) in the Bamian valley (see INDO-IRANIAN ART; PL. 10) show Central Asian, Iranian, Indian, and Mediterranean features side by side in architecture, sculpture, and painting. Traces of Buddhist painting in the Kushan style, enriched by motifs from Sassanian and Gupta art (qq.v.), also survive in the Foladi and Kakrak valleys near Bamian (PL. 12) and in the buildings at Hadda.

Kaniṣka I and Huviṣka extended their rule over Kashmir (see KASHMIR ART). The Buddhist site of Harwan dates from Kaniṣka's reign; its apsidal temple in diaper pebble style is surrounded by a tiled courtyard with patterns that reveal Chinese, north Indian, Near Eastern, and Mediterranean influences (PL. 359). The name of Huviṣka is preserved in the name of the sanctuary at Ushkur (Huvishkapura), where beautiful terracotta heads were produced in late Kushan style up to the middle of the 1st millennium of our era (see INDIAN ART).

At Mathura the Buddhists and the Jains built stupas surrounded by stone railings like those at Bharhut and Sanchi. The Kushan style is obvious in the decoration — Near Eastern and Mediterranean palmettes, animal friezes, and astragals — intermingled with Indian toranas (Skr., toraṇa) and arches. Legendary scenes from the life of the Buddha are rendered in an abstraction of the Gandharan relief style. Female figures decorating the railings of Bhuteshar (VII, PL. 450; IX, PLS 381-383) and Kaṅkālī Tīlā are of purely Indian origin in their sensuality and expressiveness. The same Indian style was also used for one subject of the classical world: Hercules strangling the Nemean lion. A female figure perhaps representing Hāritī, however, shows the adaptation of the typical Gandharan style to a monumental sculpture of a type unknown in Gandhara itself. Various Eastern and Western patterns decorate the āyāgapaṭṭas (votive tablets) of the Jains (PL. 258). Illustrative reliefs found in various places near Mathura, the Kumrahar plaque, and replicas of the Vajrāsana (or Mahābodhi) temple at Bodhgaya (VII, PL. 133) indicate that priests and architects of Mathura created, during the Kushan period, the first form of a towerlike structure as the upper finial of a sanctuary. This innovation thenceforth marked the evolution of the Indian temple. Possibly the Hindus of Mathura worshiped their cult images in such structures.

Artists of the Kushan period originated both the forms and the iconography of anthropomorphic representation of the Hindu gods that were passed on to Gupta, medieval, and even modern times as elements of Indian art. The expressive, hieratic, frontal figure of the traditional Indian yaksha in high relief became the model for images of Sūrya, Śiva, Brahmā, and Viṣṇu.

JEWELRY. Various finds of jewelry from Khwarizm and Taxila are comparable to the treasures of the Kushan city of Begram II. The wealthy population favored gold ornaments enriched with polychrome stones among which red stones — probably rubies from Badakhshan — predominated. This art belongs to the style of the steppe nomads and is known in Sarmatian jewelry from the ancient home of the Kushan tribes. Small gold disks have been found in excavations of Kushan sites; such pieces are also represented as decoration of the Scythian riding costumes on statues from Surkh Kotal and Mathura.

POTTERY AND FIGURINES. Small clay figurines have been discovered in Kushan layers, notably at Begram, Balkh, Airtam, Dzhanbas Kale, and Koy-krylgan Kale. These figurines reflect two artistic inspirations. In the beginning of the Kushan period Western models can clearly be recognized by the at-

titude, proportions, costume, and facial expressions of the figures. Later on, purely Indian influence appeared in the sensual, yakshi-like female figures with heavy ornaments and in male figures that display the Scythian equestrian costume known from the royal statues of Surkh Kotal and Mathura and from the coin images (PL. 409).

Simple utensils of daily life, such as the various forms of pottery, derived totally from local workshops and do not reveal any foreign influence. Detailed classifications of jars, bowls, cups, and dishes are based on the Begram (FIG. 1049) material, but types from Rang Mahal, Balkh, Shamshir Ghar, Airtam, Ayaz Kale, and Gyaur Kale can generally be fitted into the same categories.

Gray-black ware was no longer produced after the early Kushan period, but a fine, thin red pottery was made occasion-

of Early Buddhist Art in India, AB, XL, 1958, pp. 95-104; K. Fischer, Schöpfungen indischer Kunst, Cologne, 1959, pp. 127-45, 376-78; H. Goetz, Imperial Rome and the Genesis of Classic Indian Art, East and West, X, 1959, pp. 153-81, 261-68; E. Roberts, Greek Deities in the Buddhist Art of India, O. Art, N.S., V, 1959, pp. 114-19; D. Ahrens, Die römischen Grundlagen der Gandhara-Kunst (diss.), Münster, 1960; D. Schlumberger, Descendants non-méditerranéens de l'art grecque, Syria, XXXVII, 1960, pp. 131-66, 253-318.

b. Excavations and finds. H. Field and E. Prostov, Excavations in Uzbekistan, Ars Islamica, IX, 1942, pp. 147-49; S. Piggott, Some Ancient Cities of India, London, 1945; R. Ghirshman, Begram; Recherches archéologiques et historiques sur les Kouchans, Paris, Cairo, 1946; S. P. Tolstov, Po sledam drevnekhorezmiiskoi tsivilizatsii (On the Trail of the Ancient Civilization of Khwarizm), Moscow, 1948, Ger. trans., O. Mehlitz, Auf den Spuren der altchoresmischen Kultur, Berlin, 1953, pp. 163-78, 234; J. Marshall, Taxila, Cambridge, 1951, I, pp. 66-73, 212, 217-21, II, pp. 785-90; Arkheologicheskie i etnograficheskie raboty khorezmskoi ekspeditsii (Archaeological and Ethnographic Work of the Expedition to Khwarizm),

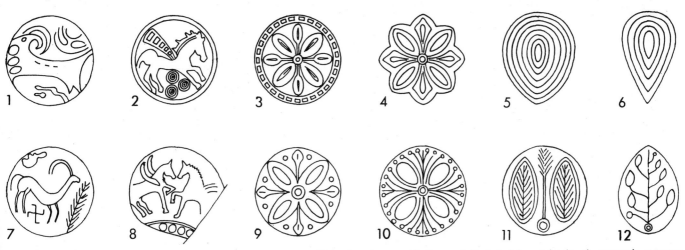

Decorative motifs of Kushan ceramics from Shotorak and Begram. Shotorak: (1) goat; (2) horse of Central Asian style; (3, 4) geometric rosettes; (5, 6) meander designs. Begram: (7) goat; (8) winged affronted horses; (9, 10) geometric rosettes; (11, 12) plant motifs (*drawings from the Délégation archéologique française en Afghanistan*).

ally. The greater part of pottery during the first two dynasties was a coarse red ware of poor quality. Decoration consists of incised circles, wavy lines, and fishbone patterns; relief ornaments on the shoulders or handles of the vessels are rare. In Begram III a new type appeared: a stamped ware of the traditional form, decorated with rich geometrical, floral, and animal patterns, in which sometimes old Iranian heraldic motifs seem to survive. During this period Shamshir Ghar supplied a metallic black pottery which, like other ceramics too, may have been produced after a model in metal. Some rare glazed and painted shards also occur.

BIBLIOG. *a. General*: A. Foucher, L'art greco-bouddhique du Gandhara, 2 vols. in 4, Paris, 1905-51; J. P. Vogel, La sculpture de Mathura, Brussels, 1930; A. C. Kak, Ancient Monuments of Kashmir, London, 1933, p. 105; G. Combaz, L'Inde et l'Orient classique, 2 vols., Paris, 1937; K. Trever, Pamiatniki greko-baktriiskogo iskusstva (Monuments of Greco-Bactrian Art), Moscow, 1940; H. Seyrig, Ornamenta palmyrena antiquiora, in Antiquités syriennes, III, Paris, 1946, pp. 64-115; V. S. Agrawala, Catalogue of the Mathura Museum, J. United Prov. H. Soc., XXI, 1948, pp. 42-98 (part 1), XXIV-XXV, 1951-52, pp. 1-160 (part 4); J. Auboyer, Ancient Indian Ivories from Begram, JISOA, XVI, 1948, pp. 34-46; J. E. van Lohuizen de Leeuw, The "Scythian" Period, Leiden, 1949; B. Rowland, The Hellenistic Tradition in Northwest India, AB, XXXI, 1949, pp. 1-10; M. Wheeler, Romano-Buddhist Art; An Old Problem Restated, Antiquity, XXIII, 1949, pp. 4-18; H. Deydier, Contribution à l'étude de l'art du Gandhâra: Essai de bibliographie analytique et critique des ouvrages parus de 1922 à 1949, Paris, 1950; A. C. Soper, The Roman Style in Gandhara, AJA, LV, 1951, pp. 301-19; M. Bussagli, L'irrigidimento formale nei bassorilievi del Gandhara in rapporto all'estetica indiana, AC, V, 1953, pp. 67-83; J. Hackin and others, Nouvelles recherches archéologiques à Begram, Paris, 1954; M. Bussagli, Osservazioni sulla persistenza delle forme ellenistiche nell'arte del Gandhara, RIASA, N.S., V-VI, 1956-57, pp. 149-247 at 157 and note 9; H. W. van der Osten, Die Welt der Perser, 3d ed., Stuttgart, 1956; B. Rowland, The Art and Architecture of India, 2d ed., Harmondsworth, 1956, pp. 75-122; B. Rowland, Gandhara, Rome, and Mathura: The Early Relief Style, Arch. Chinese Art Soc. of Am., X, 1956, pp. 8-17; O. Takata, On the Dated Buddha Images in the Kushān Art of Mathurā, Bijutsu Kenkyu, CLXXXIV, 1956, pp. 223-40; R. Ghirshman, Le problème de la chronologie des Kouchans, Cah. d'h. mondiale, III, 1957, pp. 689-722; K. Fischer, Gandhāran Sculpture from Kunduz and Environs, AAs, XXI, 1958, pp. 231-53; W. Spink, On the Development

2 vols., Moscow, 1952-58; K. Fischer, Kandahar in Arachosien, Wissenschaftliche Z. der Martin-Luther-Univ. Halle-Wittenberg, VII, 1958, pp. 1151-63; G. Tucci, Preliminary Report on an Archaeological Survey in Swat, East and West, IX, 1958, pp. 279-328; J. Hackin and others, Diverses recherches archéologiques en Afghanistan, Paris, 1959; H. Rydh, Rang Mahal, Lund, 1959; K. Fischer, Pre-Islamic Fortifications, Habitations, and Religious Monuments in the Kunar Valley, Afghanistan, XV, 3, 1960, pp. 8-9. *c. Irrigation works.* A. Stein, An Archaeological Tour in Upper Swat and Adjacent Hill Tracks, Calcutta, 1930, figs. 10, 11; E. Barger and P. H. Wright, Excavations in Swat and Explorations in the Oxus Territories of Afghanistan, Delhi, 1941, fig. ix, 2. *d. Pottery.* A. Stein, A Survey of Ancient Sites along the "Lost" Sarasvati River, Geog. J., XCIX, 1942, pp. 173-82; J.-C. Gardin, Céramiques de Bactres, Paris, 1957, p. 93; L. Dupree, Shamshir-Ghar; Historic Cave Site in Kandahar Province, New York, 1958; L. Courtois, Note sur le cruchon no. 72 de Bégram-Kāpiçi (conservé au Musée de Kabul), Arts asiatiques, VI, 1959, pp. 135-40. *e. Numismatics.* U. Monneret de Villard, Le monete dei Kushāna e l'impero romano, Orientalia, N.S., XVII, 1948, pp. 205-45; R. Göbl, Die Münzprägung der Kusān, in F. Altheim, ed., Finanzgeschichte der Spätantike, Frankfurt am Main, 1957, pp. 173-256. *f. Epigraphy.* A. Maricq, Inscriptions de Surkh Kotal (Baghlan), JA, CCXLVI, 1958, pp. 345-49; C. Kieffer, La grande découverte épigraphique de Surkh-Kotal et la langue de la Bactriane, Afghanistan, XV, 2, 1960, pp. 1-40. *g. Dynastic sanctuaries.* D. Schlumberger, Surkh Kotal, Antiquity, XXXIII, 1959, pp. 81-86; D. Schlumberger, Les fouilles de Surkh Kotal et l'histoire ancienne de l'Afghanistan, Afghanistan, XV, 3, 1960, pp. 26-47.

Klaus FISCHER

Illustrations: PLS. 409-12; 3 figs. in text.

LABROUSTE, HENRI. French architect and professor of architecture (b. Paris, May 11, 1801; d. Fontainebleau, June 24, 1875). In 1819 Labrouste entered the Ecole des Beaux-Arts in Paris, where he was a pupil first of A. L. T. Vaudoyer and then of L. H. Lebas. In 1824 he won the Prix de Rome and spent five years (1825-30) in Rome, where he produced a controversial restoration of the temples at Paestum (1828-29). Labrouste's conclusions concerning the Greek use of polychromy gained him a certain notoriety in Paris, and upon his return in 1830 he opened an atelier at the Ecole. Although he was dissatisfied with the Ecole and had earned a considerable rep-

utation as a rationalist, Labrouste neither crusaded for changes nor published his views. Appointed inspector of works for the new buildings of the Ecole itself (1832, under Jacques-Félix Duban), he was soon named architect of the Bibliothèque Ste-Geneviève (1838), and constructed its new quarters (1843–50). While the interior is admired for the bold and sensitive use of cast iron in its frame, the masonry exterior is also of great merit, recalling certain aspects of contemporary German architecture and the revolutionary classicism of J. N. L. Durand.

Named architect of the Bibliothèque Nationale in 1854, Labrouste subsequently constructed its cast-iron domed reading room (1861–69) and stacks (1862–67), works which show his continuing desire to reconcile the new material with traditional modes of design. In this, as in his failure to expound his doctrines emphatically, Labrouste appears as a typical revolutionary *manqué* of the mid-19th century. His election to the Institut de France at the age of sixty-six (1867) was a tardy yet appropriate recognition of his accomplishments as an academic designer of uncommon ability and penetration.

OTHER WORKS, POSTS, AND PRIZES. 1837, Lausanne, First prize, competition for asylum. – 1838, Architecte des Monuments Historiques. – 1840, Decorations for the return of Napoleon's ashes (with L. T. J. Visconti). – 1840, Alessandria, Italy, First prize, competition for prison. – 1842, Gold medal, competition for the tomb of Napoleon. – 1848, Member of Commission des Monuments Historiques. – 1852, Paris and Fontenay-aux-Roses, Architect of the Collège Ste-Barbe. – 1854, Rennes, reconstruction, Grand Séminaire. – 1856–58, Paris, Hôtel Louis-Fould, Rue de Berry. – 1860, Neuilly, Hôtel Thouret. – 1861, Neuilly, Hôtel Rouvenat. – 1862, Paris, Hôtel de l'administration du Chemin de Fer PLM, Rue Neuve-des-Mathurins. – 1865, Paris, Hôtel Vilgruy, Place François Iᵉʳ. – 1873, President, Société Centrale des Architects.

BIBLIOG. E. Millet, Henri Labrouste..., Paris, 1879–80; Souvenirs d'Henri Labrouste: Notes recueilliés et classées par ses enfants, Fontainebleau, 1928; J. Vallery-Radot and R. A. Weigert, Exposition Labrouste, Bib. Nat., Paris, 1953 (exhib. cat.).

John M. JACOBUS, Ir.

LACE. See TEXTILES, EMBROIDERY, AND LACE.

LACHAISE, GASTON. Sculptor (b. Paris, Mar. 19, 1882; d. New York, Oct. 19, 1935), son of an Auvergnat cabinetmaker. He received his early training at the Ecole Bernard Palissy, and later attended the Ecole des Beaux-Arts. In 1904 he left school to work with René Lalique. He met his future wife, Isabel Nagle, in 1905, and followed her to America, arriving in Boston, January, 1906. There he worked as an assistant to Henry Hudson Kitson, an academic sculptor, whom he followed in 1912 to New York, where he began his first large nude figure, *Standing Woman*. His wife posed for this figure, as she did for many others. Although she was a large woman, the amplification of the form came from his imagination, conditioned by the Art Nouveau style of Lalique.

Lachaise worked for a time as an assistant to Paul Manship, but his ideas for his own creative forms departed sharply from the academic norm. He began a series of statuettes, the earliest of which show the influence of Rodin in their rough surfaces and dynamic poses. Others reveal the emphasis upon large breasts and hips which was to prevail in much of his later work. In 1913 he began carving in stone *La Montagne* (Worcester, Mass., Art Mus.), a reclining woman of truly mountainous proportions (the stone figurine and several later bronzes of it are small; a later version in concrete is 9 ft. long).

One of Lachaise's exaggerated figures was included in the Armory Show (1913). The Bourgeois Galleries offered him his first one-man exhibit in 1918. His work was praised by critic Henry McBride and two of his pieces were sold, but the large *Standing Woman* (68 in. high, in plaster) was ridiculed by conservative critics. In 1920 he held a second show at the Bourgeois Galleries, but sold nothing.

The art dealer, C. W. Kraushaar, began to buy his work regularly. James Sibley Watson and Scofield Thayer, editors of *The Dial*, publicized his sculpture and sat for portraits. He

also did portraits of Marianne Moore, E. E. Cummings, Gilbert Seldes, Edgar Varèse, and Henry McBride.

His decorative work continued to be his main source of income. Alfred Stieglitz gave him a one-man show in 1927 which established him firmly as one of the avant-garde. The head of John Marin (New York, Mus. of Mod. Art), one of his best-known portraits of this period, was modeled in a craggy impressionistic manner, unlike the smoothly rounded forms of his female heads. In the following year, the art dealer Joseph Brummer arranged an impressive exhibition including his stylized drawings. In addition to a bronze of the *Standing Woman* (one is owned by the Whitney Mus., New York), the exhibit included a large plaster figure entitled \ *Floating Figure* (a bronze of the latter is today in the Mus. of Mod. Art, New York; I, PL. 130).

Lachaise was commissioned in 1931 to do a frieze on the RCA building in New York's Rockefeller Center, and, in 1932, a portal (since destroyed) for the Electricity Building of the Century of Progress Exposition in Chicago. He later did two large reliefs of construction workers for the International Building of Rockefeller Center. The monumental plan for his first sculptural commission at Fairmount Park, Philadelphia, the *Memorial to the Peoples of America*, was left unfinished at his death. During his last years, Lachaise executed a few more large figures, including a *Standing Woman* (bronze, New York, Mus. of Mod. Art) and a *Man* (bronze, New York, Coll. Nelson Rockefeller). He also did a number of half-length nudes, full-figure portraits of his friends, and some remarkable semiabstract compositions based on acrobats, dancers, and female torsos.

Developing from the modern classical tradition of the early 20th century, like Maillol and Despiau, and, like them, under the pervasive influence of Rodin, Lachaise, although transplanted to American soil, forged a strong individual style based on lyrical accentuation of female forms, while still clinging to the European tradition of the contemporaries he admired: Lehmbruck, Epstein, and Brancusi. Working in New York after the Armory Show, he became a pioneer in modern American sculpture, a position shared in those years only with William Zorach and Robert Laurent.

BIBLIOG. A. E. Gallatin, Gaston Lachaise, New York, 1924; Museum of Modern Art, L. Kirstein, Gaston Lachaise, Retrospective Exhibition, New York, 1935; Knoedler Galleries, L. Kirstein, Gaston Lachaise, New York, 1947 (exhib. cat.).

Henry R. Hope

LACQUER. The use of lacquer as an art medium originated in China, whence it spread to other Oriental countries, Japan, Korea, Iran, and the Islamic world. A form of lacquer work was also produced in Europe. Although the origins of this medium are obscure, they must be found within the zone where the lac tree, *Rhus vernicifera*, is indigenous, for its sap is the prime component of lacquer. This zone is believed to have been more extended than it is now, including in the past certain areas of northern and western China. Used chiefly for the beautification of utilitarian objects, lacquer is characterized by the hardness and unalterability which it confers on even such impermanent materials as vegetable fiber, textiles, and paper. These special qualities have given rise to numerous individual techniques for its use. Esthetically, the use of lacquer is a manifestation of a taste for varied and brilliant colors and for glossy surfaces. It is from these qualities, and their almost universal appeal, that the art of the lacquerer derives its importance and wide diffusion.

SUMMARY. China (col. 1052). Korea (col. 1056). Japan (col. 1056): *Historical and stylistic development; Techniques.* Iran and the Islamic world (col. 1061). The West (col. 1061).

CHINA. In the preparation of Chinese, Korean, and Japanese lacquer, the sap of the *Rhus vernicifera* (Chin., *ch'i shu*) is strained, slowly heated to remove impurities and excess moisture, and stored in airtight vessels until it is ready for use. Lacquer,

being very resistant to water, heat, and acids, constitutes an excellent protective covering, especially for wooden objects. Moreover, its glossy surface is eminently suited to decorative uses. The majority of lacquered objects are made of wood, but lacquer can also be applied to bronze, iron, pottery, porcelain, leather, basketwork, and even to cloth. In pre-Han times, black lacquer was used as a writing material. From the earliest times, lacquer was applied with a brush either directly on the surface of the article or over a priming or undercoat which often included a piece of cloth. In the dry-lacquer technique (*chia chu*), a piece of cloth saturated with lacquer was spread over a form or model of the article. After the lacquer had dried and stiffened, the form was removed and further lacquer coatings were applied. Lacquer dries best in darkness and in warm and humid air. Black and red are the colors most frequently found, black being derived probably from iron sulphate, and red from cinnabar; brown, green, yellow, blue, gold, and silver lacquers are also found. For decorative purposes, lacquer could be painted, carved in relief, engraved, inlaid with gold, silver, mother-of-pearl, and other materials, and used in combinations of various colors. Relief and marbled effects were achieved by molding the priming. (The various techniques of decoration are described in greater detail in the section on Japanese lacquers.)

Although there is a tradition to the effect that lacquer was first used during the reign of the legendary emperor Shun, no definite data are available earlier than the Warring States period (480–221 B.C.). It is possible that the black inlay found on some Shang (1523–1028 B.C.) bronzes is lacquer, but this has not been established with any certainty. Most of the late Eastern Chou lacquered objects known today were found in tombs near Ch'ang-sha (Hunan), which at that period was an important city in the state of Ch'u. Others came from Ku-wei-ts'un, Hui-hsien, and from Chin-ts'un (all in Honan). Some large lacquered wooden guardian figures from a tomb at Hsin-yang in southern Honan have been discovered in China. These finds include boxes, bowls, plates, sword scabbards, shields, coffins, pottery vessels, wood sculptures, and bronze fittings. The provenance of the lacquers is, however, unknown. Reports as to the sites often appear to be reliable, but only a few pieces have been excavated under archaeological supervision. Lacquers with wooden bodies usually have been found in a waterlogged condition, since the tombs had often been flooded and water had penetrated through cracks or other flaws in the lacquer coating. Evaporation of the water after excavation often causes the wood of such pieces to shrink, and the lacquer is consequently damaged beyond repair. A large number of lacquered objects appear to have been lost in this way.

The decoration is usually painted. Occasionally the wood was first carved in relief and then lacquered; such pieces may also carry additional painted decoration. One plaque, presumed to have decorated a sword pommel, appears to be carved lacquer. The repertory of decorative motifs consists largely of a combination of more or less stylized animals, especially birds, and geometrical patterns of lines and forms. Frequently animals or parts of animals are reduced to unrecognizable shapes; sometimes as many as four stages of animal stylization occur on a single piece. The style of the decoration is related to that of mirrors and gold- and silver-inlaid bronzes.

Chinese records mention three state factories which produced lacquers during the Han dynasty (206 B.C.–A.D. 221). One was in the Ho-nei district in northern Honan; the other two were in the Shu and Kuang-han districts in Szechwan. Many private factories must also have existed. Some vessels carry inscriptions giving the size, place and date of manufacture, the names of the artisans, and those of the manager of the factory, his assistant, the clerk, and the officer of the guard. Inscribed specimens from the Shu and Kuang-han factories have also come to light. These inscriptions indicate a highly developed division of labor, with as many as six artisans engaged in the manufacture of a single piece. The inscriptions are found either on plain specimens or on those which have relatively simple decorations, usually of birds and scrolls. The most richly decorated

lacquers are not inscribed; they may therefore have been privately produced. The finest pieces made by the state factories were probably reserved for the imperial court. Most of the known specimens have been excavated by Japanese archaeologists from tombs near Lo-lang in northern Korea (PL. 413). During the Han period, Lo-lang was a Chinese colony; the majority of the lacquers found there appear to date from the 1st and 2d centuries. Other pieces have been excavated in Yang-kao-hsien (Shansi), in Noin-ula (northern Mongolia), and even as far west as Begram in Afghanistan. As there is no clear-cut dividing line between late Eastern Chou and Han lacquers, it is often difficult to give definite attributions to the artifacts of these two periods. Some of the pieces found at Ch'ang-sha may, however, be attributed to the Han period on stylistic grounds. No guardian figures or other fantastic sculptures of the Han period have been found, but, in general, lacquer was put to the same uses in both periods. The finds include crossbows, tables, and table tops.

Painting was still the favorite decorative technique in the Han period (PL. 415); engraving, however, was also used, sometimes in combination with painting. Silver and gold were used as inlays, but very few pieces of such work have been found. The "cloud-scroll" ornament dominates the repertory of decorative motifs; frequently interspersed with animals, the cloud scrolls probably symbolize Taoist mountain landscapes (see TAOISM). Dragons began to assume the shape which they were to maintain for centuries with only slight variations. Geometric ornamentation was generally confined to narrow borders. A few specimens have figured decoration. The most famous of these, the "Painted Basket" (PL. 413) found in a Lo-lang tomb, also shows a floral tendril as a border ornament; it is one of the earliest known examples of formalized floral decoration and probably dates from the 2d century.

Almost nothing is known of the lacquers produced between the Han and T'ang periods. Excavations in Korea have yielded a lacquered mask and some fragments. A few bronze mirrors in which elaborate figural decoration cut from a thin sheet of gold is laid into a lacquer background may be attributed to this interim period.

Our knowledge of T'ang (618–906) lacquer work is based almost entirely on the numerous pieces preserved in the Shōsōin in Nara, Japan, where among the lacquered objects are boxes, sword scabbards, musical instruments (PL. 414), mirrors, iron stirrups, and a ewer. Gold and silver foil inlay (Chin., *p'ing t'o*; Jap., *heidatsu*) was the favorite decorative technique; mother-of-pearl, tortoise shell, and other materials were also used as inlays. Painted specimens occur less frequently. The Shōsōin does not seem to have contained any carved or engraved lacquers, but this collection probably represented the taste of the 8th-century Japanese court. T'ang decorative art was strongly influenced by Persia and by India, and the style of lacquer decoration is closely related to that of silver vessels, undoubtedly because of the wide use of silver inlay. Occasionally, however, the design of *p'ing t'o* pieces seems to have been derived from silks.

Apart from the objects preserved in the Shōsōin, a few Buddhist sculptures made by the dry-lacquer technique may be tentatively attributed to the T'ang period for reasons of style.

Very little is known about Sung (960–1279) lacquers. The few pieces attributed to that period are believed to have been found in Chü-lu-hsien, a city in southern Hopei destroyed by flood in 1108. These include dishes, bowls, and boxes lacquered in black, brown, or red and entirely devoid of decoration. Most of them are made in the dry-lacquer technique in shapes resembling the contemporaneous ceramics. The same technique was used for Buddhist sculptures; these, however, are very rare. Chinese records of the 16th century describe beautiful lacquers carved down to a background of gold or silver (lacquer?), but none appear to have survived.

The same 16th-century records mention two famous lacquer artists, Chang Ch'êng and Yang Mao, who lived at the end of the Yüan dynasty (1260–1368). Specimens bearing the incised mark of both these artists exist but are of doubtful authenticity. Chinese archaeologists have discovered a carved lacquer

box with figural and landscape decoration in a 14th-century tomb. This is the only piece which can be definitely attributed to the Yüan period.

Our knowledge of Ming (1368–1644) lacquer is based on a series of pieces with reliable reign marks. Specimens exist which bear the marks of the emperors Yung-lo (1403–24), Hsüan-tê (1426–35; PL. 420), Hung-chih (1488–1505), Chia-ching (1522–66), Lung-ch'ing (1567–72), Wan-li (1573–1619), and Ch'ung-chêng (1628–43). Most of these marked pieces were produced in the imperial factories. The Yung-lo marks were incised with a needle and may be apocryphal; they are usually found on early-15th-century specimens. With the reign of Hsüan-tê the marks on imperial pieces began to be cut with a knife and filled with gold lacquer. The reign of Hung-chih is represented by a single specimen, a finely carved plate dated 1489 in the Percival David Collection, London; it was undoubtedly privately produced. Only two pieces with Lung-ch'ing marks are known; both are imperial products. There are no reliably dated pieces from the important reigns of Ch'êng-hua (1465–87) and Chêng-tê (1506–21) nor any undated specimens which might be attributed to either reign; it has not yet been possible to explain these gaps. Wan-li pieces, often with cyclical marks giving the exact year of manufacture, comprise boxes, plates, dishes, bowls, cups, cupstands, chalices, vases, jars, ewers (which are very rare), tables, chairs, footstools, cabinets, and chests.

Carving was a favorite technique, particularly in the imperial workshops. The pieces are usually cinnabar red, but such colors as buff, black, green, and yellow appear also. Another technique used by the imperial workshops is one similar to the Japanese zonsei. Painted, inlaid, carved, and marbled pieces were produced mainly by private artisans. Mother-of-pearl, metal, bone, and hard stones were used as inlays.

In the first half of the 15th century, the best pieces were produced by the imperial factories. Production, however, seems to have been small and specimens of that period are quite rare. Although private workshops certainly existed at that time, it has not been possible to identify any of their products. The decoration of the early-15th-century imperial pieces is boldly conceived and beautifully executed. These works can be classified into three groups, according to the principal decorative motifs: flowers and foliage; figural and landscape scenes; dragons or phoenixes (or both) in conjunction with flowers or clouds (PL. 416). Borders and other small surfaces usually carry floral decoration. The design of the carved specimens in the first and third groups is arranged in a close-knit manner, showing very little of the generally smooth, yellow background. Obviously this style could not be used for the second group, where specific, finely carved background patterns indicate earth, water, and air. The carving is sensitively modeled and the edges of individual details are slightly rounded. Such pieces give the impression of having been modeled in wax. These "zonsei" examples are extremely rare. They are always polychrome, although sometimes details of the design are outlined in gold lacquer.

During the 16th century production seems to have increased. In addition to many imperial Chia-ching and Wan-li pieces, a large number of other lacquers can be attributed to the 16th century, usually on stylistic grounds. Some of them are also dated and are apparently products of private artisans. The style of the decoration is less bold; individual details such as flowers, leaves, and figures are smaller in relation to the decorated surface. The repertory of decorative motifs was enlarged; characters and symbols of longevity, happiness, and other felicitations occur frequently. It is no longer possible to classify the imperial pieces, as numerous decorative motifs are frequently found on a single piece. Dragons, rarely used in the early 15th century, occur very frequently on 16th-century examples. Carved specimens often have sharp edges and abrupt transitions from one level of relief to the next. Such pieces give the impression of wood carvings; this is particularly true of imperial Chia-ching products.

Very little is known about lacquers of the early Ch'ing period. Imperial specimens with either K'ang-hsi (1662–1722) or Yung-chêng (1723–35) marks do not seem to exist. The so-called "Coromandel" lacquers were apparently an innovation of the K'ang-hsi period; several large Coromandel screens carry K'ang-hsi dates. The Nationalmuseet in Copenhagen owns some provincial pieces which are known to have reached Denmark during the second half of the 17th century. There are also a few other provincial pieces with painted decoration marked either K'ang-hsi or Yung-chêng. The emperor Ch'ien-lung (1736–95) had a preference for carved lacquers and much was produced during his reign, including the usual boxes, plates, and bowls, as well as thrones, screens, and other furniture. Large panels (sometimes depicting battle scenes), figurines, small chests on wheels, and toy horses with carts are characteristic of the period. The best 18th-century pieces are masterworks of craftsmanship. The designs, however, are usually too crowded, the details too small for real artistic quality. Private artisans favored the burgautée technique of a very fine mother-of-pearl inlay.

Occasionally during the 19th century simple vessels, either with or without discreetly engraved decoration, were made for Chinese connoisseurs. Various articles, usually lacquered black with painted gold decoration, were made for export to Europe and America. Carved pieces are generally coarse.

KOREA. Korean lacquer has never been adequately studied. On the basis of present knowledge, it is often difficult or impossible to differentiate between Chinese and Korean pieces. Korean lacquer artisans seem to have specialized in mother-of-pearl inlay. This was first commented upon in 1123 by the Chinese ambassador Hsü Ching, who wrote that Koreans "are not very good at lacquer work, but their [lacquer work with] inlaid mother-of-pearl, which is minutely executed, should be valued." A few boxes decorated in that technique were excavated in Korea; several others are in Japanese and Western collections. Some of them were made to contain Sūtras (sacred Buddhist texts). One of these boxes is decorated with a landscape; the others show tight floral scrolls with petals and leaves of mother-of-pearl and stems inlaid with twisted wire. Colored tortoise shell was occasionally used for certain details. The style of decoration is related to that of the celadons with slip decoration of black, white, and sometimes red. These lacquers date from the 12th–14th centuries and are the only pieces for which a Korean origin is reasonably certain.

Lacquers were also produced in Burma, but almost nothing is known about them. The few boxes and bowls in Western collections do not seem to antedate the 18th century.

Fritz Low-BEER

JAPAN. *Historical and stylistic development.* Even though concrete evidence is lacking, it can be assumed that Japanese lacquerers learned their craft from the Chinese during the early centuries of the Christian Era. There is, however, a semilegendary tradition which tells of a 2d-century prince named Yamatotakeru who broke a branch off a certain tree and noticed that the sap in his hand turned a lustrous black. He thereupon ordered his vassal Tokoba-no-Sikune to paint utensils with this juice. The story might indicate that the lac tree grew in Japan during the archaic period, which lasted until the mid-6th century. A few specimens from this period have been excavated in the northern part of Japan.

The first historical record of Japanese lacquer is an edict of the year 645 establishing the Imperial Lacquer Works. In 701, in the full flowering of the Nara period (645–793), the works employed 30 workmen. From the same year is an edict which encouraged the growing of lac trees by granting lands for this purpose in exchange for an annual tribute of the sap. The oldest existing example of lacquer work of any artistic value is a splendid miniature Buddhist temple known as the Tamamushi Zushi in Hōryūji, Nara (PL. 418). This shrine, over 7 ft. high, is built of wood finished with black lacquer and ornamented with gilt metal and iridescent beetle (*tamamushi*) wings. The painted lacquer decoration represents Buddhist deities and scenes from previous incarnations of the Buddha; one of the four panels of the base shows the Buddha

sacrificing his body to feed a hungry tiger. These decorations are executed with remarkable dexterity in red, yellow, and green — a color scheme reminiscent of Chinese lacquer of the Han dynasty. The Tamamushi Zushi is attributed to Korean artists active in Japan about 646–708 (see JAPANESE ART).

The most specifically Japanese lacquer is *maki-e* (see the discussion of the various techniques below). The earliest type of *maki-e* is known as *makkinru*. An example is the decoration of a sword scabbard belonging to the emperor Shōmu (d. 756), now in the Shōsōin at Nara. The design, consisting of animals flying among clouds, is carried out in gold filings processed by the *togidashi* (revealed-by-grinding) method. Two other types of lacquer work, *heidatsu* (using gold and silver foil) and *raden* (with mother-of-pearl) are found in the Shōsōin. These represent two important steps in the development of *maki-e*. It is not yet known whether the *makkinru* technique originated in Japan; *heidatsu* and *raden* are found in Chinese lacquer objects of the T'ang dynasty, but so far no examples of *makkinru* have been discovered outside Japan. During the latter part of the Nara period images made by the *kanshitsu* (dry-lacquer) process were very popular. This process, however, belongs more properly in the realm of sculpture, since the lacquer is used only as a binder.

The Fujiwara or late Heian period (895–1185) is marked by a steady progress in *maki-e*, the term appearing in Japanese literature in the mid-9th century. The luxury-loving nobility demanded more and more gold lacquer, taking advantage of the increasing output of the gold mines. The lacquerers' art thus was applied not only to movable articles but also to the interior decoration of large buildings.

In the first half of the period, the only technique used appears to have been the *togidashi*, as attested by several extant pieces. Typical of this technique is a box ordered by the Emperor in 919 to hold the manuscripts on an esoteric form of Buddhism brought to Japan by Kūkai (Kōbō Daishi). The design is composed of *karyo-binga* (mythical birds) surrounded by sacred flowers and clouds, executed in gold and silver filings (PL. 417). The decorative motifs on this box reflect T'ang influences. This Chinese influence was, however, soon replaced by a more pictorial Japanese style.

By the middle of the period, the *chiriji* and *ikakeji* techniques, employing gold-dust grounds were developed. This indicates an abundant supply of gold as well as improvement in the techniques for smoothing and sifting the metal particles. Mother-of-pearl inlays were also used to embellish the otherwise simple *chiriji* and *ikakeji* grounds. One of the most extravagant decorations in this gold-lacquer and mother-of-pearl technique is found in the interior of the Konjikidō in Hiraizumi, built in 1124. Although this temple has suffered greatly from the ravages of time, enough of the decoration remains to attest its original splendor.

The flat gold *hira-maki-e*, the simplest of all gold-lacquer techniques, was developed not earlier than the second half of the 12th century. It was probably made possible by the production of a very fine type of gold powder. The oldest existing specimens of *hira-maki-e* are the drawings of Buddhist groups, in gold and red, on a number of boxes made in 1176 for the storage of sutras.

It is interesting to note that Chinese historical records of the Sung dynasty state that in the year 987 the Chinese court received as a gift lacquer objects of many kinds, decorated with gold, silver, and mother-of-pearl. This would indicate that these specimens of Japanese lacquer were considered characteristic of the arts of Japan and worthy of presentation to the Chinese emperors.

During the Kamakura period (1185–1333) the raised-gold *taka-maki-e* was developed. This enabled lacquerers to follow the general trend toward the freer, more pictorial decoration that characterizes this period. A notable example of *taka-maki-e* is the early-13th-century box for toilet articles believed to have belonged to Lady Taira-no-Masako (1156–1224; PL. 419). Here the birds and trees are slightly raised by means of double layers of lacquer under the gold. The waves, rocks, and land are in *hira-maki-e*, while the Chinese

characters and the single-petaled flowers are in silver foil — all on a gold ground. This box not only represents the first attempt to use the raised-gold technique, but it is also an early example of the use of patterned metal foils, applied in combination with different lacquering techniques. Although *tsuishu* (carved red lacquer) was imported to Japan from China during the Kamakura period, no attempt seems to have been made by the Japanese lacquerers to adopt the technique until a later period. Even the Kamakura *bori* (lacquered, carved wood), which may have originated in the Kamakura period, does not seem to have been in general use until later.

During the Muromachi (Ashikaga) period (1334–1573) the *taka-maki-e* technique was further developed. Greater thickness was obtained by the use of a mixture of powdered ocher and lacquer. An early specimen of this technique is the set of boxes (PL. 420) presented to the Kumano-Hayatama Jinja shrine at Wakayama by the shogun Ashikaga Yoshimitsu in 1390. These boxes have a raised design finished in gold and silver dust and foils; some also have mother-of-pearl and carved metal. Minute pieces of gold or silver foil known as *kirikane* (cut metal-foil decoration) are used in the rocks which form part of the design. These boxes have the two kinds of gold-particle-strewn grounds, *hirame* (literally "flat eyes") and *nashiji* (literally "pear-skin" or aventurine ground). Both forms were developed from the older *chiriji* technique. During the second half of the Muromachi period, under the shogun Ashikaga Yoshimasa (1435–90), two families of *maki-e* artists, Kōami and Igarashi, were active under the direct patronage of the shoguns. Many of the ceremonial objects and utensils traditionally presented by the shoguns for use in imperial coronations came from the workshops of these two families. Japanese gold lacquer became well known in China, and during the reign of the Chinese emperor Hsüan-tê (1426–35) a Chinese lacquerer was sent to Japan in order to learn this Japanese technique. On the other hand, the importation of Chinese carved lacquer stimulated the Japanese to produce imitations of this type.

Although the Momoyama period lasted less than half a century (1573–1615), it is distinguished by a number of notable artists. Under the patronage of the military dictator Toyotomi Hideyoshi, they produced numerous masterpieces. Kōami Chōan (1569–1610), made an inkstone box which represents the height of the perfection reached in this medium. Landscapes in *taka-maki-e* reproduce a number of paintings which had been prized since the time of the 14th-century Ashikaga shoguns. One type of lacquer decoration is peculiar to the Momoyama period. This is known as Kōdaiji *maki-e* and is found on architecture as well as on movable objects. The decorative motifs generally represent autumn foliage and flowers, especially chrysanthemums, in a natural manner executed by the *hira-maki-e* method. The most striking characteristic of Kōdaiji *maki-e* is the use of *nashiji* as a part of the design rather than as a background, in combination with other parts executed in flat gold. This is found in a reading stand (ca. 1605; VII, PL. 339). Other lacquer decoration of this type covered the woodwork of the interior and the furniture of Momoyama castles. Although the structure has perished, some of the woodwork may still be seen in the Kōdaiji, hence the name Kōdaiji *maki-e*. The great artistic genius Kōetsu was active at the end of the Momoyama period. The various fields and media in which he worked include lacquer, in which his treatment of pictorial subjects is bold and imaginative. In lacquer decoration (VII, PL. 336), he used thick sheets of lead, mother-of-pearl, and gold dust. This style is better known under the name of the Kōrin school.

For approximately the first two decades of the Edo (Tokugawa) period (1615–1867), lacquer surpassed even the finest work of the preceding period. Every possible *maki-e* technique was used in the decoration of an inkstone box attributed to Ryōsei (1597–1665) as well as a new form of *taka-maki-e* known as *shishiai-togidashi*. New elements were also introduced, including the inlaid ceramic frog, coral representing citrons, and a crystal disk over a cavity in which a water wheel cut in metal foil is suspended and filled with mercury. This box is representative of the golden age of *maki-e* art (ca. 1585–1630). In the *hirame* background, *gyōbu* (large gold flakes) are also used.

The artists of the middle Edo period were unrivaled in technical skill. Encouraged by the patronage of the shoguns and daimios, and in many cases enjoying the position of official lacquerer, they produced superb pieces. Nevertheless, when their work is compared with that of the preceding half century it shows a lack of freedom in artistic expression. This is undoubtedly a reflection of the strict regimentation of every aspect of life under the Edo regime. An exception seems to be the work of Ogata Kōrin (1658–1716; q.v.), who worked independently and was not confined by an official position. In his famous inkstone box, he followed the technique of Kōetsu, with flowers in mother-of-pearl, leaves of gold dust, and a leaden bridge, creating a strong design that contrasts, for example, with the decoration on an inkstone box (PL. 289) by Shunshō II (1615–1707), who also lived and worked independently in Kyoto. This decoration, illustrating a passage from the Ise Monogatari, shows ivy leaves in various shades of gold and red and a traveler's trunk in fine take-maki-e with gold foil and mother-of-pearl. The box is an example of togidashi technique at the peak of its perfection.

Many other fine artists were active during the Edo period. A number of particularly fine signed pieces are inro (medicine boxes). It is, however, not known to what extent the maki-e artists designed their own decorations or copied in lacquer designs previously prepared on paper by other artists. There seems to be little doubt that the majority of maki-e artists relied on painters or designers for their sketches. An album containing some fifty drawings for inro decorations by Sakai Hōitsu (1761–1828) and other painters, made specially for the maki-e master Hara Yōyūsai (1772–1845), is in the Museum of Fine Arts in Boston.

The later Edo period (ca. 1750–1867) was, on the whole, an age of decadence in which maki-e artists merely imitated the work of their predecessors. After the overthrow of the shoguns in 1868, artists such as Zeshin and Shōmin originated new and free ideas. Today, contemporary lacquerers are striving to create new forms, but although many of them are skilled workers, they have perhaps less incentive than their predecessors under the patronage of the shoguns and daimios.

Techniques. For the sake of clarity, the term *urushi* will be used to designate the liquid material derived from the sap of the lac tree with which the lacquerer works. The term "lacquer" is used whenever possible to indicate the finished product of the lacquerer's art.

A lacquer object is generally built upon a core or matrix of wood fashioned into the form determined for the finished object. Upon this form, strengthened at the joints with *urushi* paste and overlaid with hemp, linen cloth, silk, or paper, soaked in *urushi*, a number of successive coats of *urushi* mixed with stone powder are applied, followed by many more coats of transparent or black *urushi*. Each coat, including the soaked cloth, is allowed to harden in a very damp and entirely dust-free atmosphere and is ground smooth before the succeeding coat is applied. The number of coats varies with the quality of the object and the intentions of the lacquerer. Good black lacquer is built up of thirteen or more coats, while carved lacquer may be coated a hundred times before it is ready for the carver's hand.

Comparatively few pieces made of gold lacquer (except for the sculptured varieties) are finished by means of one process only. Indeed, more elaborate pieces not only include most of the varieties mentioned below but also employ additional elements such as inlays of various materials.

1. *Maki-e* (sprinkled picture). As the name implies, the art of *maki-e* is fundamentally a decoration produced by sprinkling gold particles on a design painted with adhesive *urushi*. This basic principle is applicable to most of the techniques described below. The general process may be given briefly here. The design is first prepared in black ink on thin, translucent paper. The outlines of the various figures or patterns are traced on the back in iron-red lacquer. Then the paper bearing the design is placed right side up with the design against the black-lacquered object; under pressure the outline in red lacquer is transferred to the black surface. A yellowish powder is then dusted over the wet transferred lines to provide an accurate guide. The *maki-e* artist, following the guidelines, then draws or paints with red lacquer the area which is to be covered with gold dust. Gold dust of fine grain is brushed on from one side with a brush of soft hair; coarse dust is strewn from above through a tiny sieve. When the lacquer has hardened, the gold design is coated either with thin transparent *urushi* or with thick black *urushi*, preparatory to burnishing or grinding.

The term *maki-e* is often used to include all kinds of gold, and even colored, lacquer.

2. *Makkinru* (gold-filing decoration). This is the earliest form of *maki-e* in which gold is used in coarse filings and finished in the *togidashi* method (see below).

3. *Togidashi* (revealed by grinding). The gold-dust sprinkled design is carried out on the ground immediately preceding the application of a final layer of black *urushi*. When the last coat, covering the entire surface, is dry, it is ground evenly with charcoal until the gold design is revealed. Polishing follows.

4. *Heidatsu* (literally, "leveled off") or *heimon* (flat pattern). This is carried out in the *togidashi* technique. Gold and silver foils cut into patterns are used in place of gold and silver dust.

5. *Raden* (mother-of-pearl inlay). A flat piece of mother-of-pearl is shaped to a desired pattern and imbedded in a lacquer ground before the final opaque *urushi* coating is applied. The piece is then finished in the *togidashi* method. In the later periods, mother-of-pearl cut almost as thin as paper was used.

6. *Chiriji* (gold-dust ground). The ground is produced by a layer of coarse gold dust flattened under pressure; the particles are brought out in the *togidashi* method. A ground thickly covered with gold dust is called *heijin* (flat-dusted).

7. *Ikakeji* (richly sprinkled gold ground). Gold dust, sieved to a uniform size, is thickly applied on a wet *urushi* surface. When hard, it is coated with translucent *urushi* and burnished.

8. *Hira-maki-e* (flat sprinkled picture). In this technique, the design is painted in *urushi* on a polished lacquer surface and gold powder is brushed over it. When dry, the adhering gold is given a very thin coating of clear *urushi*. When this has hardened, it is burnished.

9. *Taka-maki-e* (raised sprinkled picture). The principal difference between this and the preceding technique is that here the design is in relief rather than flat. The relief is obtained in various ways: (a) by repeating *urushi* layers; (b) by modeling with a combination of *urushi* and whetstone powder; (c) by covering the wet *urushi* design with charcoal or pewter dust to increase the height. After the raised design is smoothed with thickened *urushi*, the gold is applied.

10. *Tsuishu* (carved red lacquer). The ground for carving is usually formed on a wooden base by building up many layers (80–250) of *urushi*. In addition to red, there are carved lacquers in black, yellow, and green, and still others comprising layers of different colors. In *kōka-ryokuyō* (red flowers and green leaves) the ground is built up by repeating red layers for flowers and green layers for leaves according to a prearranged plan. *Guri* (curves and rings) is the variety which shows spiral patterns gouged through many layers of various colors. Imitation carved lacquer is usually made on a wood or composition ground and coated with colored *urushi*. Kamakura *bori* has a wood ground.

11. *Kirikane* (cut metal foil). Gold or silver foil is cut into tiny rectangles, then used individually or in combination with gold dust. This process is similar to *heidatsu*.

12. *Hirame* (literally, "flat eyes"). Grains of gold filings are flattened by pressure, forming irregular flakes which are strewn either sparsely or densely as a background. It is an advanced type of *chiriji*. In *oki-hirame*, large *hirame* flakes are laid on one by one.

13. *Nashiji* (literally, "pear-skin" ground). Because of its appearance, *nashiji* ground has been called "aventurine" in the West. The *nashiji* flakes are smaller and thinner than those of *hirame*; they are sprinkled densely and coated with clear *urushi* which then receives the usual polishing.

14. *Shishiai-togidashi* (literally, "robust flesh," with *togi-*

dashi). The term suggests modeled relief gradually diminishing into the *togidashi* method; it represents a combination of almost all the known techniques.

15. *Gyōbu* (a personal name). Flakes are made by tearing gold foil and are applied in the same manner as *oki-hirame*.

Kojiro TOMITA

IRAN AND THE ISLAMIC WORLD. The technique of lacquer painting was introduced into Iran from China in the 15th century, during the rule of the Timurids (see TIMURID ART). Herat, the Timurid capital, was a great center of learning and of the arts, where miniature painting, book illustration, illumination, and binding thrived. In Iran, lacquer painting was the product of a close cooperation between miniaturists, illuminators, and binders. One of the earliest examples of Persian lacquer is the binding of a *Mathnavī* manuscript by Jalāl ad-Dīn Rūmī, completed in the year A.H. 887/A.D. 1483, in Herat. The title page of this manuscript, now in the Museum of Turkish and Islamic Art, Istanbul, bears the *ex libris* of the last Timurid sultan, Ḥusayn Bayqarā, whose vizier Mīr 'Alī Shīr Navā'ī, a poet, musician, and painter, was known as a patron of the arts. The exteriors of the front and back covers of the binding are decorated with delicate floral scrolls, tendrils bearing composite palmettes, and leaves painted in liquid gold on a black background. In addition to lacquer painting, each cover has a central medallion with two pendants, corner pieces, and inner borders with a stamped and gilded decoration.

Lacquer technique was fully developed in Iran and was only later adopted in Turkey and India. Bindings were made by first overlaying the pasteboard cover with a foundation of chalk, on which a thin coat of lacquer was spread to form the ground for the painting; this was finally covered with several layers of transparent lacquer. On the top coat of lacquer, liquid gold, silver, and mother-of-pearl dust were painted and stippled.

Lacquer painting was widespread in the 16th and 17th centuries under the Safavids and continued to be popular under the Qajars (see QAJAR SCHOOL) in the 18th and 19th centuries. It was used not only for bookbinding but also for objects of daily use such as mirrors, pen boxes, and wooden doors. In the Safavid period, two types of lacquer painting existed: polychrome and monochrome. The painted decoration usually followed the styles of contemporary miniature painting and illumination, and there is no doubt that some of the finest lacquer painting was the work of great artists. According to the Turkish historian 'Alī, the famous painter Ustād Muḥammadī painted lacquered book covers. A number of 16th-century bookbindings with polychrome lacquer painting of landscapes and figure subjects have been preserved in museums and private collections. The finest examples are those in the Musée des Arts Décoratifs, Paris; the British Museum, London; the Louis Cartier Collection, Paris; the Royal Asiatic Society, London; and the Metropolitan Museum of Art, New York.

A number of wooden doors of the 17th century and later periods are decorated with lacquer painting similar in technique to that of bookbinding. A pair of door panels in the Metropolitan Museum of Art, New York, and another in the Victoria and Albert Museum, London, from the Hall of Forty Columns (Chihīl Sutūn) are richly decorated with landscapes and garden scenes in the style of Riẓā-i-'Abbāsī (PL. 421). Iranian lacquered bookbindings of the 17th and 18th centuries frequently show an over-all seminaturalistic floral pattern in polychrome on a brownish-red or gold background.

In Turkey, the Persian style continued with the introduction of typical Turkish motifs. Turkish book covers of the 18th and 19th centuries have rich designs of flowering tendrils with large leaves and palmettes in gold or polychrome on a black or pale-yellow ground.

In India, during the 18th and 19th centuries, book covers, mirrors, and boxes were of lacquer painted in Persian style with the addition of Indian floral designs.

M. S. DIMAND

THE WEST. The western term "lacquer" is derived from the Persian *lak*. Lacquer was brought to the West by Venetian, Portuguese, and Dutch travelers and by Jesuit missionaries. In the 15th and 16th centuries, the type of lacquer called "Coromandel," produced in India, Korea, and Japan, was widely exported. The best examples of European lacquer were produced in Italy, France, England, Holland, and Portugal, although this work was by no means up to the Chinese or Japanese standards of perfection. The period in which most European lacquers were produced coincided with the fashion for exotic objects (the so-called *chinoiserie*) from the late 17th to the mid-18th century.

The European lacquer technique differs from the Oriental, although superficial comparison may reveal certain similarities in the brilliance of the colors and in the motifs (PL. 422). The difference is due primarily to the materials used. Real lacquer, or resin, was unknown in the West. Moreover, Western artisans did not exercise the extreme care employed by the Oriental lacquer workers; consequently, European cabinetmakers and painters were seldom able to achieve the perfection of the models they attempted to follow. Another factor was the greater freedom in imagination of the European artist; when he became tired of imitating Oriental models, he developed new designs more in keeping with his own nature and environment. At a certain point this occurred throughout Europe; the fashion for the exotic, for *chinoiserie*, gave way to a more spontaneous taste for new subjects: landscape, figures, flowers, birds, and still life. This change in taste became progressively more marked by the mid-18th century.

The Venetians were the first artisans in Italy, and perhaps in Europe, to achieve fine imitations of Oriental lacquer, and their production soon surpassed all others in both quality and quantity. At first they remained faithful to the models which reached them from China and Japan; they painted the wood with red, black, or dark-green lacquer, adding gilded decorations (either applied, alloyed with silver, or sprayed on in the form of dust) or lozenges in low relief. The decorative motifs were copied from, or at least inspired by, Oriental models; thus frequently there are figures in Chinese costume, mandarins, ladies with parasols and fans, pagodas, exotic architectural details, and plants and other natural motifs. These designs were barely indicated against a monochrome background. The lacquer object was decorated after it had been prepared with a well-polished sizing of chalk stucco, then covered with various layers of transparent resin. This, however, was not real lacquer but a type of varnish prepared from sandarac (powdered resin of the *Tetraclinis articulata*), which produced a remarkably brilliant polish. It was used in Venice from the end of the 17th century, but the period of greatest splendor was the early part of the 18th century, when it was employed to decorate not only furniture but also small objects for daily use: trays, bowls, boxes (PL. 422), candlesticks, mirror frames, inlaid statuettes, and toilet sets. The wood most often used, especially for small pieces, was the very light *Annona cherimolia* (Peruvian custard apple). Lacquer decoration was used not only on various articles of furniture, such as wardrobes, tables, spinets, chests, beds, and cradles, but also on details of interior decoration: panels, wainscoting, window shutters, listels, cornices, and door panels. A very fine example of this style is an inner door in the Ca' Rezzonico, Venice, on which the figured decoration stands out in light relief on a yellow background with gilded details. It is somewhat Oriental in subject matter, but the wreaths of flowers are definitely European in taste. The high artistic quality of this door has given rise to the hypothesis, perhaps not wholly erroneous, that no less an artist than Tiepolo had a direct or indirect hand in its design. He is known to have been at work on the ceilings in this palace in 1758–60.

From the *chinoiserie* of the two Tiepolos (father and son) and other Venetian painters of the period, it was an easy step to the domestic subjects found on the sides and panels of bureaus, on the covers of spinets, and on the doors of wardrobes. Rustic or Arcadian scenes, landscapes with mythical and allegorical figures, often recall the work of Zuccarelli, Marco Ricci, and Guardi. Smaller pieces are decorated with floral, leaf, and plant motifs, sometimes with small animals, butterflies, and birds. This change of style became more noticeable

about 1750. Venice competed with France in the export of such articles; while the French were superior in the perfection of finishing and in their technical abilities, the Venetians excelled in the variety of subjects, in freedom of design, and in brilliance of color.

By the end of the 18th century, color had become more uniform and decoration heavier. Moreover, a quick and economical method was devised to lacquer furniture. Printed paper was hastily painted and then varnished with sandarac. The effect achieved was brilliant but unrefined. This is the so-called "poor lacquer" very similar to the prints of the Remondini brothers of Bassano and other prints of this period. In some cases, the decorations of the Venetian Albrizzi's publications were cut out and used for lacquering purposes. The lacquerers worked with the illuminators who colored the prints used as a base for this type of decoration.

Other Italian centers followed the Venetian example. In Rome, in the mid-17th century, Father Eustache Jannart discovered a formula for a type of varnish similar to the Oriental lacquers. The painter Mario de' Fiori (Mario Nuzzi) developed this technique and decorated furniture for the Borghese family. Lacquered furniture was also produced in Parma, Ferrara, Lucca, and even in the Marches, although there it was of a more modest character ("poor lacquer"). In Sicily, lacquerers used vivid colors to achieve brilliant effects, and a Spanish influence is evident in the abundant use of gold and silver. In Piedmont, motifs of chinoiserie were favored; later these were combined with French styles. The lacquers of Turin compared well with the Venetian in quality. Light colors — white, yellow, pale blue — were used for backgrounds of figured scenes in the prevailing style of painting. Milanese lacquer reveals a preference for strong colors, gold illumination, and sometimes a direct imitation of Oriental models. Genoese lacquer is generally applied thinly more or less directly on the surface with very little sizing. Decorative motifs are mainly flowers, birds, and chinoiserie (rarely landscapes), generally in monochrome on a blue background.

Lacquered furniture was produced in France, England, and Holland. Paris was a center for lacquering, especially between 1735 and 1765. Lacquerers and other artisans worked under the patronage first of Cardinal Mazarin and Louis XIV and then of Madame de Pompadour. They decorated all types of furniture in a style of chinoiserie that differed from the Venetian in its wider use of metal. The French preferred dark tones — reddish-brown, blues, and greys; sometimes white was used together with gilded relief. Miniature work was done with extreme care. Guillaume and Étienne Simon Martin, in 1730, obtained a patent for a type of lacquer called vernis Martin and their establishments became, in 1748, members of the Manufacture Royale des Meubles de la Couronne. The Martins were very active until the end of the 18th century and were especially noted for their imitation of Coromandel lacquer. Voltaire praised the cabinetmakers and lacquerers of his time, and it is possible that great painters, including Watteau, provided designs for the decoration of furniture and the boiserie of the period. During the reign of Louis XVI, lacquer went out of fashion; other styles of decoration, particularly marquetry, were preferred.

English lacquerers had less imagination than their continental rivals and generally followed Oriental models. Dutch influence became prevalent in the reign of William and Mary, in the last years of the 17th century. The style of William and Mary is characterized by simplicity of line and decoration with monochrome backgrounds, either dark red or black with gold in the Chinese manner, a style inspired by the lacquers imported by the East India Company. English lacquer of the early 18th century followed the Oriental fashion seen also in the furniture of the period. Exotic motifs appear in the Queen Anne and George I periods, while in the Chippendale work of the second half of the 18th century the Chinese style was in high favor. Venetian influence is seen in the chests of drawers, cabinet desks, small framed mirrors, and toilet sets. During the reign of George IV, there was a fashion for exotic furniture, but in the 19th century this gave way to the neoclassical revival. The bright, polychrome, varnished decorative objects of the Art Nouveau style cannot be classified as lacquer. In the

Orient, however, real lacquer continued to be produced, often on an industrial basis for export.

In recent years, a revival of the lacquerer's art has taken place in France, Belgium, and Korea, based on new techniques. In Italy, lacquerers are still active in Venice, either restoring antique pieces or producing commercial imitations of 18th-century models. An interesting attempt is now being made to return to a purely esthetic revival of this art in line with contemporary currents in the figural arts.

Giovanni MARIACHER

BIBLIOG. a. China: E. F. Strange, Catalogue of Chinese Lacquer, Victoria and Albert Museum, London, 1925; E. F. Strange, Chinese Lacquer, London, New York, 1926; T. Sekino and others, Archaeological Researches on the Ancient Lolang District (Service of Ant. of Korea, Special Rep., IV), 3 vols., Tokyo, 1927–28 (text in Jap.); Shōsōin gyobutsu zuroku (Catalogue of the Treasure of the Shōsōin), Tokyo, 1928 ff., particularly II, pls. 3–9, 26, 28, 34–36, VIII, pls. 10, 34–39, 46–53; Y. Harada, Lolang: A Report on the Excavations of Wang Hsü's Tomb, Tokyo, 1930; A. Koizumi, The Tomb of the Painted Basket of Lolang, Seoul, 1934; S. Umehara, Kandai shikki kinen meibun shuroku (An Annotated List of the Lacquer-Vessels with Dated Inscriptions of the Han Dynasty), Tōhō Gakuhō, V, 1934, pp. 207–22, VI, 1936, pp. 315–18; T. Oba and K. Kayamoto, The Tomb of Wang Kuang of Lolang, Seoul, 1935; F. Low-Beer, Zum Dekor der Han Lacke, Wiener Beiträge zur Kunst- und Kulturgeschichte Asiens, XI, 1937, pp. 65–73; O. Maenchen-Helfen, Zur Geschichte der Lackkunst in China, Wiener Beiträge zur Kunst- und Kulturgeschichte Asiens, XI, 1937, pp. 32–64; O. Maenchen-Helfen, Materialen zur Geschichte des chinesischen Lacks, OAZ, N.S., XIII, 1938, pp. 215–22; F. Low-Beer, Two Lacquered Boxes from Ch'ang-sha, AAs, X, 1947, pp. 266–73, XI, 1948, pp. 302–11; Chiang Yüan-yi, Ch'ang sha Ch'u min tsu ch'i i shu (Ch'ang-sha: The Chu Tribe and Its Art), 2 vols., Shanghai, 1949–50; F. Low-Beer, A Carved Lacquer Plaque of the Late Chou Period, BMFEA, XXI, 1949, pp. 27–29; F. Low-Beer, Chinese Lacquer of the Early 15th Century, BMFEA, XXII, 1950, pp. 145–67; F. Low-Beer, Chinese Lacquer of the Middle and Late Ming Period, BMFEA, XXIV, 1952, pp. 27–49; Ch'ang sha ch'u t'u ku tai ch'i ch'i t'u an hsüan chi (Illustrated Selection of Lacquer Objects Found at Ch'ang-sha), Peking, 1954; Chung kuo tai ch'i ch'i t'u an hsüan (An Illustrated Selection of Ancient Chinese Lacquer Objects), Peking, 1955; Shang Ch'eng-tso, Ch'ang sha t'u lu ch'u ch'i ch'i t'u lu (Illustrated Catalogue of Lacquered Objects from Ch'u found at Ch'ang-sha), Shanghai, 1955; Wen wu ts'an kao tzŭ liao pien chi wei yüan hui, 1956, 10, 1957, 7, 9, 1958, 1; W. Willetts, Chinese Art, I, Harmondsworth, 1958, pp. 188–206, 253–92; M. Feddersen, Chinese Decorative Art, London, New York, 1961 (trans. A. Lane), pp. 184–207 (bibliog.); K. Stephan, Chinesische und japanische Lackmalerei, Munich, 1962; Rokkaku Shisui, Shina Kogei Zukan, III, 1, Tokyo, n.d. b. Korea: Chosen Koseki Zufu (Illustrated Korean Antiquities), IX, Seoul, 1923; J. Fontein, Notes on Korean Lacquer, B. Vereeniging van Vrienden der Aziatische Kunst, 3d ser., VI, 1956, pp. 88–93; E. McCune, The Arts of Korea, Rutland, Vt., Tokyo, 1962, passim. c. Japan: J. J. Rein, The Industries of Japan, New York, 1889; Nihon Shikkō Kai (Varia on Japanese Lacquer), Nihon Shikkō Zasshi (Review of Japanese Lacquer), 1–319, Nihon Shikkō Kai Kaihō (B. of Japanese Lacquer), 320–34, Urushi to Kōgei (Lacquer and Decorative Art), 335–459, Tokyo, 1900–39; O. Kümmel, Das Kunstgewerbe in Japan, 3d ed., Berlin, 1922, pp. 11–52; E. F. Strange, Catalogue of Japanese Lacquer, Victoria and Albert Museum, 2 vols., London, 1924–25; S. Rokkaku, Tōyō Shikkō Shi (History of Far Eastern Lacquer), Tokyo, 1932; G. Sawaguchi, Nihon Shikkō no Kenkyū (Summary of Japanese Lacquer), Tokyo, 1933; J. Okada, History of Japanese Textiles and Lacquer, Pageant of Japanese Art, V, Tokyo, 1954; M. H. Boyer, Japanese Export Lacquers from the 17th Century in the National Museum of Denmark, Copenhagen, 1959; M. Feddersen, Japanisches Kunstgewerbe, Brunswick, 1960, pp. 150–209 (bibliog.). d. The West: M. Martini, Novus Atlas Sinensis, Amsterdam, 1655; A. Kircher, China monumentis, qua sacris qua profanis, Amsterdam, 1667; F. M. Misson, Nouveau voyage d'Italie, 4th ed., III, The Hague, 1702; F. Bonanni, Trattato sopra la vernice comunemente detta cinese, II, Rome, 1720; A. Guidotti, Metodo facile per formare qualunque sorta di vernici della Cina e del Giappone, Rimini, 1748; J. F. Watin, L'art du peintre, doreur et vernisseur, Paris, 1773 (with sup. by P. d'Incarville, Mémoire sur le vernis de la Chine); F. Agricola, Trattenimenti sulle vernici ed altre materie utili, Ravenna, 1788; P. Jaubert, Dictionnaire raisonné des arts et métiers, I, Paris, 1793; A. Sagredo, Sulle consorterie delle arti edificatorie in Venezia, Venice, 1856, p. 124 ff.; E. Dilke, French Furniture and Decoration in the 18th Century, London, 1901; F. Luthmer, Deutsche Möbel der Vergangenheit, Leipzig, 1902; G. Morazzoni, Lacche veneziane del secolo XVIII, Dedalo, IV, 1924–25, pp. 643–64; G. Morazzoni, Il mobile veneziano del '700, Milan, 1927; P. Molmenti, La storia di Venezia nella vità privata, III, Bergamo, 1929, p. 154; N. Barbantini, Il mobile, in Il settecento italiano (ed. N. Barbantini and others), II, Milan, Rome, 1932, pp. 1–6; F. Pasqui, L'arte della laccatura, Rass. della Istruzione Artistica, Urbino, V, 3–4, 1934; G. Lorenzetti, Lacche veneziane del Settecento (exhibition cat.), Venice, 1938; G. Morazzoni, Il mobile italiano, Florence, 1940; C. E. Rava, Il mobile d'arte dal '400 all' '800, Milan, 1950; N. Truman, Historic Furnishing, London, 1950; G. Morazzoni, Il mobile genovese, Milan, 1951; H. Huth, Europäische Lackarbeiten, 1600–1850, Darmstadt, 1955; O. Kuéant and A. Marie, Style de France: Meubles et ensembles de 1610 à 1920, Paris, 1956; G. Morazzoni, Il mobile veneziano del '700, 2 vols., Milan, 1958; W. Holzhausen, Lackkunst in Europa, Brunswick, 1959; G. V. Yalovenko, Fedoskino, Moscow, 1959.

 * *

Illustrations: PLS. 413–422.

LA FRESNAYE, Roger de. French painter (b. Le Mans, July 11, 1885; d. Grasse, Nov. 27, 1925). Between 1903 and 1908 he studied at the Académie Julian, at the Ecole des Beaux-Arts, and, most significantly, with Maurice Denis and Paul Sérusier at the Académie Ranson. After painting in Brittany (1908–09), La Fresnaye traveled in Italy and Germany (1910–11). Beginning in 1912, when he was affiliated with the Artistes de Passy, he was closely connected with the cubists and exhibited with them at the *Salon des Indépendants,* the *Salon d'Automne,* and the *Section d'Or.* La Fresnaye served with the infantry from 1914 to 1918 and, after 1919, spent the remainder of his life as an invalid in Grasse. His last oil painting was executed in 1921, but he continued to draw until his death. In 1925 he exhibited at the Exposition des Arts Décoratifs. Characteristic paintings include *The Cuirassier* (1910; Paris, Mus. d'Art Mod.), *The Artillery* (1911–12; Chicago, Coll. Mr. and Mrs. Samuel A. Marx), and *Conquest of the Air* (1913; New York, Mus. of Mod. Art). La Fresnaye's work also includes sculpture, mainly of cubist inflection, and book illustrations, some published posthumously (Gide, *Paludes,* 1921; Rimbaud, *Les Illuminations,* 1949; and Claudel, *Tête d'or,* 1950).

About 1911, having first submitted to the influence of Gauguin and Cézanne, La Fresnaye began to evolve a more personal idiom dependent on cubism. Generally his cubist work does not reach so complex a fragmentation as Picasso's and Braque's but retains a more traditional sense of French classical order in its legible geometric stylizations and lucid structure (IV, PL. 78). While he usually adhered to the familiar themes of still life and landscape, La Fresnaye occasionally celebrated such contemporary motifs as aeronautics and military mechanization. About 1914, following the evolution of cubism in general and the style of Léger in particular, he experimented with compositions of flatter, simpler planes, and after about 1920, he began to restore the unfragmented integrity of objects in his portrait drawings and scenes of peasant life.

Bibliog. R. Allard, Roger de La Fresnaye, Paris, 1922; E. Nebelthau, Roger de La Fresnaye, Paris, 1935; G. Seligman, Roger de La Fresnaye, New York, 1945; R. Cogniat and W. George, Roger de La Fresnaye: Oeuvre complète, Paris, 1950; Musée d'Art Moderne, Paris, Roger de La Fresnaye, 1950 (exhib. cat.).

Robert Rosenblum

LANCRET, Nicolas. French painter (b. Paris, Jan. 22, 1690; d. Paris, Sept. 14, 1743). Lancret first studied under the history painter Pierre Dulin and at the Royal Academy, but after a failure in 1711 in a competition for history painters, in 1712 he entered the studio of Claude Gillot, whose *fêtes galantes* were then coming into vogue. During the years spent with Gillot (1712–17), Lancret met Jean Antoine Watteau, another of Gillot's pupils. Watteau profoundly influenced Lancret, persuading him to set out on his own and to turn directly to nature for inspiration. In 1719 Lancret was admitted to the Academy. Within a short time his works became extremely popular and remained so throughout his career. He enjoyed the patronage of Pierre Crozat, the Duc d'Antin, and other leading amateurs and received official commissions as well. Engravings after his works were also extremely popular and, with the aid of a royal patent which protected reproduction rights to many of his paintings, he was provided with a steady source of income. With Lancret's death the vogue for the *fête galante* died out.

In his chosen genre Lancret was overshadowed by Watteau, but after the latter's death in 1721 and that of Gillot the following year, he and Jean-Baptiste Pater were the leading painters of "modern subjects." Although Lancret did some portraiture and occasionally such series as the seasons (VI, PL. 76) and the ages of man (V, PL. 411), the bulk of his output — rustic scenes or courtly amusements — falls under the classification of *fête galante.* Unlike his more famous contemporary Watteau, Lancret painted no religious or mythological subjects. Toward the end of his career, however, when he became interested in the theater, subjects from the *commedia dell'arte* and others reflecting the comedies of Dancourt and Marivaux at the Théâtre Français became common themes for his paintings.

Like Watteau, Lancret frequently drew from the model, incorporating and often repeating the drawings in his finished paintings. His work is characterized by extreme delicacy in the grouping of figures, gentle color harmonies, and suffused, silvery lighting. His touch is broader than Watteau's, his brush more heavily loaded with pigment, and the mood of his paintings somewhat less ethereal. Representative of his work are *The Four Seasons* (1738; Paris, Louvre), *The Pleasure Party* (1735; Chantilly, Mus. Condé), *Dance in a Park* (1738; London, Wallace Coll.), and *The Dancer La Camargo* (1730; Washington, D.C., Nat. Gall.; V, PL. 413).

Bibliog. G. Wildenstein, Lancret, Paris, 1924.

John W. McCoubrey

LANDSCAPE ARCHITECTURE. The artificial arrangement of cultivated areas into geometric or free patterns to achieve a purely esthetic result has always been considered a creative art form. It may also be regarded as an extension of architecture into its surroundings. Landscape architecture as a branch of the architectural discipline has been at times the determining factor in the design of specialized architectural forms such as terraced gardens, porticoes, and pavilions for the enhancement of the existing landscape.

In the figural arts, particularly in certain ornamental forms such as tapestry and carpets (q.v.), gardens appear as iconographic elements of great importance. Their use may be either decorative or symbolic. In literature, gardens appear as both subjects and settings. These artistic and literary sources provide a basis for a historical and documentary survey of the development of landscape architecture in several cultures over a period of more than three millenniums.

Summary. General considerations (col. 1066). Antiquity (col. 1070): *The ancient Near East; The classical world.* The Orient (col. 1074): *Islam; Pre-Islamic India and southeast Asia; China; Japan.* Primitive civilizations and pre-Columbian America (col. 1084). The West (col. 1084): *The Middle Ages; Renaissance and baroque periods; The 19th and 20th centuries.*

General considerations. As an enclosed area cultivated with special care, the garden in its primitive form is an expression of the concept of individual possession of natural resources. It represents a qualitative and esthetic maximum that can be achieved in the practice of agriculture. Landscape architecture has the same significance and esthetic values as other specialized handicrafts such as ceramics, glassmaking, and the working of precious metals. In common with these, landscape architecture has a utilitarian origin: the most ancient descriptions of gardens indicate that they were orchards or kitchen gardens, such as the garden of Alcinous in the *Odyssey.* The fact that landscape architecture is based on a natural element with fixed formal configurations to which we already attribute esthetic values (even though it may subsequently be improved) does not limit its esthetic possibilities any more than certain other arts are limited by such a basis. The fundamental element of the dance is also natural, but its esthetic legitimacy is not questioned.

The character of landscape architecture of the most ancient times appears to have been twofold, based on the choice of plant species (and consequently the selection of the best type of the species) and the distribution of cultivated plants. The choice of species and selection of varieties represent an agricultural phase in the development of gardens, since the quality of plants depends in large measure on the care taken in their cultivation. Plant distribution is also determined to a large extent by agricultural considerations, such as exposure to sun and proximity to irrigation sources; but the over-all design of the garden, geometrical patterning, and division into symmetrical areas of vegetation can be seen as an architectural phase in garden development. Landscape architecture was originally determined by principles derived from horticultural practices. Most sources agree that the basic criteria of plant distribution were conditioned by the most favorable location for the several

species of plants, the distance required between each tree, the available sources of water, and the means of regulating its flow. Another fundamental criterion was the necessity to organize plant distribution so as to ensure a crop production for every season and a flourishing appearance to the garden.

The formal aspect of the garden changes with each season, and its appearance throughout history is that of a miniature of nature itself. Natural phenomena are brought to a level of perfection depending on the effectiveness of human activity in attenuating the excesses of nature and in stimulating those qualities most suited to the interests and requirements of man. Landscape architecture expresses the concept of nature as beautiful and propitious for human existence, implying that natural beauty can be perfected by the agency of man and that it can be isolated and put to use by a choice of the best among natural values.

Because of certain common roots, the physical evolution of landscape architecture and the development of religious practices are closely related. Fundamental to concepts of landscape architecture is the myth, common to all known historical civilizations, of a terrestrial paradise or a lost perfect harmony between man and nature. It is known that in ancient times there was a direct relation between gardens and certain agrestal and domestic cults: particular sections of gardens were dedicated to a *genius loci*; certain trees and springs were considered sacred; and small temples and votive steles were erected within the precincts. Christianity retains this ancient symbolism: the resurrected Christ appears to Mary Magdalene in an orchard or garden, as if to emphasize the state of purity to which nature has returned after the divine sacrifice. Fra Angelico represents paradise as a flowering garden, and Botticelli conceives of "ideal nature" as cultivated and controlled.

The concept of an "ideal nature" was spontaneously associated with a further concept wherein its enjoyment was not vouchsafed to all men but was granted only to the educated and sensitive, an elite easily identifiable as the more cultured and wealthier social strata. Religious considerations in the composition of the garden thus gave way to sociological considerations. These are easily documented. Less emphasis was placed on the formal structure of the garden and more on its delimitation and enclosure. (The etymological root of the word "garden" is related in meaning to "enclosure"; Old High Ger. *gard*, to surround.) A typical example of the convergence of religious and sociological elements is found in the *hortus conclusus* (enclosed garden), which in later Gothic painting served as a background for both sacred and courtly profane subjects. A gradual shift of emphasis from enclosure to ground plan appeared with the decline of the feudal hierarchical social structure.

During the Renaissance the interest of the landscape architect was focused more and more on geometric and perspective considerations, which made it possible to extend the garden to a much larger area; the enclosure became necessary only for practical purposes. These geometric, structural, and perspective aspects of the garden coincided with a new and radical concept of a direct relationship between the architecture of the garden and that of the villa or palace with which it was associated. Architecture, conceived as an absolute representation of space, could not fail to influence beneficially the surrounding space of the main structure. And perspective, as the structural rule of spatial vision, became the connecting link between architecture and nature, realized by means of the space and the "ideal" aspect of the garden. The progressive architectural evolution of the villa to open planimetric and freely articulated designs paralleled the development of the garden both dimensionally and in the search for more vast and varied perspectives. This was achieved not so much by the linear distribution of single elements as by the use of large masses of trees, fountains, and water courses. The garden was conceived as an ordering and formal rectification of a natural landscape, which led to the use of architectural elements and of small secondary structures within the garden. The form and disposition of these structures was determined exclusively by the possibility of placing in the garden area new architectural nuclei such as nymphaea and porticoes, designed expressly for landscaping purposes.

A further development in landscape architecture is seen in the progression of the garden from a scenic setting for the villa into an element of fusion between the architectural space of the edifice and the natural space of its setting. The garden came to be considered as a link between areas devoted to the civilized life of the owner and areas devoted to the rustic life of ordinary agricultural pursuits. This distinction between "civilized" and "rustic" is especially noticeable in French parks and gardens of the 17th and 18th centuries. The distinction represents the great abyss which by that time had developed between the wealthy urban dwellers, who sought distraction and rest in the country, and the peasants, who tilled the soil for a living. The landscape architect had to take into account not only this fact but also the specific pastimes of the garden owners, such as hunting and fishing, which required extensive spaces. Viability within the garden necessitated wide avenues, walks, alleys, and footpaths, and reproduced on a smaller scale the topography of the open country.

The conceptual divergence between the urban dweller and the rural peasant, in their relation to nature, conferred on the latter an importance he had never previously enjoyed. Rural life became more and more regarded by the urbanite as the authentic and "real" mode of living; and the urban dweller felt that he must in some way come closer to rural life and establish a relationship with nature appropriate to one who lives in daily contact with it. This naturalism, characteristic of the age of Enlightenment, together with a growing acquaintance with Oriental landscape architecture and a related poetic concept of the picturesque (q.v.), was responsible for the development of the "English" garden of the 18th century. Here we find an attempt to eliminate the distinction between wild and cultivated nature by reproducing a condition of the former and emphasizing its uncorrupted beauty. Thus the traditional development became reversed, to all appearances. Man was no longer trying to "educate" nature according to the precepts of his own reason and sentiment; rather nature, which in its primeval state was assumed to possess inherently all values of beauty and goodness by sweeping away social prejudice, was now educating man to find again the ethical and esthetic values of his natural origins. This enlightened philosophical concept, fundamentally sociological and pedagogical, subsequently developed into romanticism, with its contrived reproductions of the wildest and most fearsome aspects of nature. Thus the garden, understood as pure nature or as a return to nature (supposedly made convincing by human artifice), was liberated from its boundaries and its geometric and perspective formulas. In the present era, however, the garden exists only as a restricted area of transition between architecture and its ambient space or as an extended green area within the urban layout of the modern city.

The development of landscape architecture on a purely esthetic plane is rendered complex as a result of the numerous external figural and literary influences to which it has been subjected. The basis of landscape architecture, fundamentally naturalistic, lends itself directly or indirectly to poetic considerations inspired by nature.

Landscape architecture as an art, in the Latin sense of the expression *opus topiarum* (topiary work), began in the late republican era in Rome, during the 1st century B.C. The earliest examples are found in the *horti* of the urban villas, which were complexes of wooded areas and architectural elements such as nymphaea, exedrae, and porticoes. These were often of a sacred nature, either as objects of worship or through mythological association. All Roman gardens were reflections of a mythological concept of nature, especially manifested in the transformations to which certain plants were subjected. Trunks and branches of trees were trained and leaves were pruned so as to suggest either geometric patterns of idealized or enhanced natural forms, or human and animal figures alluding to historical, mythological, or allegorical subjects. Perhaps the most interesting aspect of this figured landscape architecture is the fact that the natural elements not only were used as media but also retained their natural appearance while assuming a contrived form. Fable, history, and allegory were thus considered latent in nature itself. Man's handiwork only revealed the world

of images which nature carried within itself *ab aeterno*. Thus by the distribution of certain types of plants and the attribution to them of allegorical significance, the garden became an allegorical representation of nature. The search for exotic and rare species turned the area into an idealized place where every living thing found the best conditions for its existence.

The Middle Ages viewed landscape architecture as an arrangement of an enclosed space, inaccessible to the outsider, where supposedly nature could once again find the original purity of creation. The medieval garden type was the monastery cloister — a place for withdrawal and meditation, girt by walls and surrounded by an arcade (PL. 426). It was cultivated as an orchard and filled with flowers. The well in the center was symbolic of the *fons salutis*; in secular gardens the well was replaced by a fountain as a symbol of eternal youth (PL. 427). There is an apparent thematic analogy here between ascetic literature and monastery gardens on one hand, and romance narrative and secular gardens on the other.

During the Renaissance, landscape architecture became closely related to the figural arts. Common ground was the interest in problems of perspective; the formal relation between gardens and buildings, which tended more and more to assume the forms of sumptuous mansions; and the typically Humanistic tendency to consider the garden as a type of arboreal architecture. In Renaissance treatises, especially those of L. B. Alberti and Francesco di Giorgio, the garden is represented as "ideal nature," the agricultural parallel and complement to the geometrically planned "ideal city."

In the second half of the 16th century, the spread of mannerism added many new elements to the figural and perspective forms of landscape architecture. The garden, which had hitherto been an idealized natural site, became a place where the art of ancient times could find a most appropriate environment. Statues, ruins, architectural fragments, and sarcophagi became the typical decoration in an age with a passion for the "discovery" of antique art. It was believed that the beauty of the art object, whether ancient or not, would return to its original and profound significance if placed in a natural setting. Gardens were gradually filled with small edifices such as nymphaea, exedrae, and small temples, all made to look ancient and sometimes even in the form of ruins. A new art came into being: a form of garden sculpture representing mythological subjects, often drawn from theatrical scenes. The intentionally unrefined but vividly pictorial workmanship was aimed at enhancing the material by placing it in the open air and at blending the plastic forms with the natural elements, fountains, and water displays of its surroundings. A new concept of a "capricious" nature, filled with unexpected and contrived details, took the place of a "regulated" nature. The landscape architect joined forces with the building architect and the hydraulic engineer; together they devised bizarre perspective effects, water displays, springs, and labyrinths. The prevailing fashion for open-air theatrical performances and the descriptive literature of this period (especially the works of Torquato Tasso), in which the miraculous was a dominating element, also brought a close collaboration between landscape architect and scenic designer. In gardens conceived as miraculous, fantastic, even enchanted places, all the formal limitations were cast aside. The garden thus became an area of natural setting for the expression of human sentiments.

The taste for the picturesque (q.v.) and Sir William Chambers' description (1774) of Chinese landscape architecture strongly influenced the 18th-century English garden. Here nature was allowed to retain its primitive character, and the only limitation was the "correction" of lines and forms in accordance with an ideal concept of nature. The philosophic basis of English landscape architecture was strongly influenced by the writings of Pope, the esthetics of Shaftesbury, the artistic theories of Alexander Cozens and Uvedale Price, and the social functions of the gardens themselves. Gardens were places not only for rest and conviviality but also for sports, especially hunting. The first real theories and principles of landscape architecture as such were formulated in England by men like Thomas Girtin (q.v.) and were placed on an equal

footing with the theories and principles of the figural arts and architecture. Wide knowledge of distant lands — India, China, and America — enriched the European gardens, especially English gardens, with many exotic plant species. At first regarded as curiosities, these plants were gradually cultivated, acclimatized, and diffused.

In the 19th century the gardens of the wealthier classes tended to disappear or to become public parks, and their character became more and more determined by scientific interests. The botanical garden may be considered the last expression of a formal philosophic basis to landscape architecture. The esthetic does not differ substantially from the scientific philosophy that flourished in the 19th century.

Giulio Carlo ARGAN

ANTIQUITY. *The ancient Near East.* Our knowledge of the landscape architecture of the ancient Near East is limited to the two major civilizations: Egyptian and Mesopotamian. For other civilizations both literary and archaeological data are lacking, with the partial exception of Elam, for which some fragmentary information has reached us through Assyrian reliefs.

In Egypt the most salient characteristic of landscape architecture was the widespread use of flowers for decorative purposes in the gardens of private dwellings and public buildings. Flowers were also used generally on ceremonial occasions, both sacred and profane. Most widely used was the lotus, in two varieties: blue (*Nymphaea coerulea*) and white (*Nymphaea lotus*). Among other flowers that appear as decorative elements in the figural arts are the chrysanthemum, jasmine, and oleander, arranged in wreaths or bunches. In the New Kingdom, extensive gardens were laid out to constitute an organic unit with the great lordly dwellings. Generally these gardens were plantations of fruit trees providing cool and agreeable places where the inhabitants of the residential complexes could rest and amuse themselves. Other elements found in Egyptian landscape architecture were artificial pools and kiosks built of light materials. Networks of canals provided water for irrigation. In the houses at Tell el 'Amarna, capital of the pharaoh Akhenaten, a number of gardens with all the characteristic elements of the period have come to light. These gardens were enclosed within the walled perimeter of the dwelling unit. The principal species of trees, planted in rows, were the date palm (*Phoenix dactylifera*), doom palm (*Hyphaene thebatica*), sycamore fig (*Ficus sycomorus*), acacia (*Acacia nilotica*), bito (*Balanites aegyptica*), and tamarisk (*Tamarix nilotica*).

The Theban tomb of Rekhmira (No. 100), reign of Thutmosis III, contains an image of a garden of a private house (IV, PL. 371), shown in perspective. At the focal center is a quadrangular pool surrounded on all sides by rows of trees planted on three levels, one above the other, the trunks converging toward the center. The tree species represented are the sycamore fig, doom palm, and date palm. On one side of the garden is a small kiosk. The owner is seated in a small light craft floating in the pool, towed by two ropes on the shore. Two gardeners are watering the plants. Each carries two buckets attached by a rope to a wooden pole carried across the shoulder. Other representations of gardens are found in the tomb of Amenemheb (No. 85), reign of Thutmosis III, and in the tomb of Sebekhotep (No. 63), reign of Thutmosis IV. In both these Theban tombs a pool is shown surrounded by trees in parallel rows. The gardens are all depicted longitudinally. In the tomb of Ipi (No. 217), 19th dynasty (PL. 423), there is a remarkable painting of a garden with all the characteristic Egyptian elements. Four gardeners are seen drawing water from a pond by means of an elevator similar to the *shādūf*, still in use today in the less advanced agricultural areas of Egypt. The water is poured into small irrigation ditches, which carry it to the trees and flowering plants of the garden. In a number of grave paintings we find images of landed proprietors seated under arbors of grape vines.

Landscaped areas are shown in the funeral complexes of Mentuhotep II Nebhepetra (11th dynasty) and of Hatshepsut (18th dynasty). In the former, the main approach was flanked by sycamore fig trees under which stood statues of the King;

rows of tamarisks were planted laterally. The avenue of the Temple of Queen Hatshepsut was decorated with a row of sphinxes, and a note of color was provided by groups of trees. Two great bitos stood at the entrance, the trunks of which have been found *in situ* planted in great brick tubs containing silt from the Nile. A palm tree and a grape vine grew on the south side of the lower portico. The expedition sent by the Queen to the land of Punt (probably on the Somali coast) brought back 30 aromatic trees from whose resin incense and balms were obtained. These trees are mentioned and depicted in the reliefs commemorating the expedition (IX, PL. 1). They were transplanted into great vats in order that they might survive the journey. A study of the characteristics of these trees, as

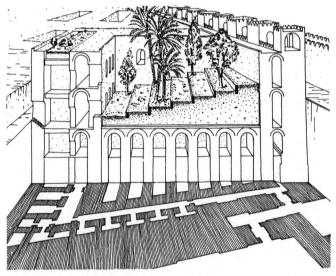

Hypothetical reconstruction of the Hanging Gardens of Babylon, perspective section (*from R. Koldewey and F. Wetzel, Die Königsburgen von Babylon, I, Leipzig, 1931*).

depicted on the reliefs, shows them to be of the species *Boswellia thurifera*.

Literary sources furnish ample data on the flora cultivated in ancient Mesopotamia. A good example of this documentation is the inventory of plants grown in the kitchen garden of Mardukapaliddina II. These data, however, are of more botanical or horticultural than artistic interest. Further information from literary sources regarding Mesopotamian landscape architecture is generic and does not furnish any description of the actual appearance or design of the gardens. A text of Sennacherib states that this Assyrian king imported exotic species, which he planted in his garden in order to acclimatize them.

Some interesting information, although limited, can be derived from figural depictions in Mesopotamian art. The narrative character of the great Neo-Assyrian reliefs is illustrated in scenes and landscapes of the conquered cities as well as the playgrounds of the Assyrian court. These scenes have provided fairly precise information regarding the green zones of the cities. The existence of a definitely urbanistic function of gardens can be deduced from a relief of Ashurbanipal of Nineveh, which illustrates a detail of the conquest of the Elamite city of Susa (VII, PL. 253). Beyond the walls of the city proper a less thickly built zone, in which the houses were scattered under trees, extended to the banks of the river. It is difficult to determine whether this was a residential quarter or an agricultural suburb. In any case, the separation between this green zone and the walled city is very clearly depicted. Another relief of Ashurbanipal, from the same series on the wars against the Elamites, shows the enemy fleeing against the background of a hilly, thickly wooded landscape crossed by water courses. An altar stands in the middle of a road, at the end of which are several shrines. It has generally been assumed that this relief illustrates a natural landscape; but the presence of these small places of worship (similar to another relief of Ashurbanipal depicting a shrine on the summit of a hill and the King hunting

in a chariot) and of some arcades holding up trees, like those in Babylon which supported the famous Hanging Gardens (FIG. 1071), suggest a royal park, elaborate in plan and filled with architectural elements.

From a study of the texts of this period we know that palaces and temples within the cities might have had their own gardens. Excavations have proved the existence of trees both within and without the Bīt Akītu of Ashur. But it cannot be established whether these were planted in a garden. The royal parks, however, must have been very large and rich in vegetation, as is suggested in the relief of Ashurbanipal (PL. 423). The famous hunting expeditions of this king took place in a park within an area surrounded by a cordon of men at arms. The absence of a landscape element in this relief is not due to a lack of vegetation but to the spatial concept of the artist, who isolated the figures in order to give them greater prominence. One relief of a royal hunting scene shows a tree-covered hill peopled with spectators, who stand behind the cordon of soldiers. In other reliefs of the period animals are shown wandering beneath the trees of the royal park, and trees form a background for a convivial royal garden scene.

The architectural function of trees can be seen not only in the above-mentioned Bīt Akītu of Ashur but also in the Hanging Gardens of Babylon, numbered in antiquity among the Seven Wonders of the World. Robert Koldewey's excavations near the Ishtar Gate have revealed traces of these gardens in a series of 14 vaulted rooms that seem to have supported a terrace planted with trees.

Sergio BOSTICCO and Giovanni GARBINI

Level or terraced gardens of the Islamic types described below existed in Mesopotamia. The royal palaces of the Achaemenian and Sassanian emperors of Persia were surrounded by immense gardens and parks. The palace at Ctesiphon, the Ṭāq-i-Kisrā, opened on such an area. During the winter an immense carpet set with costly precious stones was used as a substitute for the natural garden. This carpet was lost during the Arab conquest, but garden carpets have remained in fashion in Persia to the present day. A good example of these Persian parks and hunting preserves may be seen in the rock reliefs at Ṭāq-i-Bustān. The Persian garden became the prototype of the classical Greek *paradeisos* (paradise; see below).

Hermann GOETZ

The classical world. The art of landscape architecture was introduced into the Greco-Roman world from the Orient at the beginning of the 3d century B.C. The earliest examples appeared in Hellenistic Greece and later in Italy, particularly in Campania and in the immediate environs of Rome. Preclassic and classic Greece do not seem to have known the garden as a place for pleasure and relaxation. The Homeric period, however, had a tradition of sacred gardens surrounding sanctuaries and groves which were the dwelling places of the gods (*Odyssey*, V, 57–74, 291–93); but these were situated far from Greece proper. It is possible that the most remote origins of this Homeric tradition go back to the Aegean world and are related to pre-Greek vegetation cults. Sacred orchards containing pomegranates and vines were planted around the shrine of Herakles at Thasos and in Athens, near the Theseion. The gardens of the hero Akademos were a sacred enclosure built by Kimon; later they became a public walk.

The first purely voluptuary gardens in the West of which we have record were the celebrated Horn of Amalthea, built by Gelon in Syracuse (early 5th cent. B.C.; Athenaeus, *Deipnosophists*, xii), and the miniature gardens laid out by Hieron II on his great ship (3d cent. B.C.; Athenaeus, op. cit., v). It is probable that from this period onward the influence of the royal parks of the Persian world, especially the *paradeisos* of Cyrus at Sardis (Xenophon, *Oeconomicus*, iv, 20 ff.; cf. Pollux, *Onomasticon*, s.v. Παράδεισος), greatly stimulated the Greek imagination. The successors of Alexander adopted the idea of the "royal paradise" — parks laid out in geometric patterns, which were also the scenes of royal hunts. These parks followed a tradition that went back to pre-Persian times. The

fashion spread throughout the Hellenistic world, arousing the indignation of the philosophers, and lasted until the end of classical antiquity. Descriptions of the royal gardens constituted one of the favorite subjects of the Greek writers of the Hellenistic period.

In Rome the art of landscape architecture was introduced from two sources: the example of the "paradises" of the Sicilian tyrants and the walks that surrounded south Italian sanctuaries; and the discovery by the Romans in the 2d century B.C. of the royal gardens of the Orient. The tradition of sacred gardens is found in the Italic *luci*. The persistence of the Dionysian cults in Italy and especially in Alexandria, despite official repression, contributed to the fashion for rock gardens and sacred landscapes in private gardens. The Romans' love of luxury, their systematic imitation of Oriental magnificence, and their inborn delight in all the manifestations of nature contributed to the spread of landscape architecture. From the last years of the republic to the end of the Western empire gardens had an important place in daily life.

The earliest voluptuary gardens in Rome of which we have a record were those of Scipio Aemilianus (Cicero, *De amicitia*, vii, 25; *De republica*, i, 9) and of the general D. Junius Brutus (Cicero, *De amicitia*, i, 7). Both of these gardens were probably located near the Campus Martius. During the Sullan period in Latium there was a great increase in the number of villas with gymnasiums, promenades (ambulationes), and porticoes, inspired by the Academy and the Lyceum. An essential characteristic of these gardens was the architectural use of terraces, which was increasing. This use initiated a style from which later was to spring the style of landscape architecture of the Italian Renaissance and baroque periods. The immediate suburbs of Rome gradually became covered with gardens.

By the middle of the 1st century B.C., the Domus Tampiliana on the Quirinal contained a then ancient grove (silva; Cicero, *Ad Atticum*, iii, 20). And by the end of the republic, there were gardens on the right bank of the Tiber. Here Julius Caesar created the Horti Caesaris, the great park which at his death he willed to the Roman people. The Horti Clodiae were in the same quarter. Within the city itself the most important gardens were the Horti Pompeiani, probably situated near the present-day location of Piazza di Spagna; the Horti Lucculliani, near Trinità dei Monti; and the Horti Sallustiani, between Via Vittorio Veneto and Via Venti Settembre.

Under the empire the number of gardens in the city increased steadily. Those of Agrippina Major (the elder), or Vipsania, were on the right bank of the Tiber. The Garden of Domitia on the Vatican hill later became the Horti Neronis. On the Esquiline hill, Maecenas began the creation of the famous Horti Maecenatiani on the ramparts of the Servian Wall. In order to build these gardens, Maecenas covered the ancient burial grounds with a thick layer of earth. In the same zone were the Horti Lamiani (near modern Piazza Dante) and the Horti Maiani, which soon became imperial property, as did the gardens of Maecenas. In the neighborhood of Porta Maggiore, T. Statilius Taurus created the Horti Tauriani, which were confiscated after he had been condemned to death in A.D. 53. Large parks also existed in other parts of the city, especially at the foot of the Aventine hill.

In A.D. 64, with the creation of the gardens of Nero's Domus Aurea (Golden House), the green zone of the Esquiline was gradually extended as far as the Caelian hill and became property of the *fiscus*, a branch of the public treasury. These gardens lasted until the Antonine period, after which they were gradually parceled. The Horti Sallustiani and the garden on the Pincian hill, which had both become the Horti Aciliani, were still in existence when the Aurelian walls were built (A.D. 270-75).

The first public garden was the promenade of the Theater of Pompey (55 B.C.), adorned with groves of trees and fountains. Augustus built porticoes around other gardens of the same type: the Portico of Livia on the Esquiline (7 B.C.), the Area Apollinis on the Palatine, and the Portico of Vipsania and the Campus Agrippae in the Campus Martius. Later, the thermae included avenues bordered with gardens.

Cicero (*Ad Quintilianum*, fr. iii, 1, 55) called the art of landscape architecture *ars topiaria*. This term, derived from the Greek, does not indicate the pruning of leaves and branches to give them an artificial shape, as is commonly believed; rather it refers to the arrangement of landscaped compositions in which plants such as ivy, periwinkle, and maidenhair were used as ornamental covers for walls and grottoes, and in which shrubs and trees (especially cypresses) bordered walks and avenues. Topiary art was an attempt to reproduce, within the landscape, landscapes such as those seen in paintings. The landscape architect achieved this by means of rustic sanctuaries, shrines, tombs, statues, bridges, towers, streams, rock work (e.g., the grotto in the form of a nymphaeum; PL. 424) — all elements which figure in the painted landscape of the "sacred idyl" and in the huge wall paintings of mythological subjects. An attempt was made to reproduce the image of the countryside as seen by the painter, the idyllic poet, and the epigrammatist. The novelty of Roman landscape architecture was particularly evident in this attempt to express sentiments proper to nature, in which, as the Romans viewed it, the gods were always present.

While the expressive media of Roman landscape architecture were derived from Hellenistic models, the choice of themes and subjects remained unmistakably Ro.nan. Thus a large number of statues were used and a strong Dionysian element was present, represented by the spirits of the most ancient Roman religion: Priapus, who replaced the ancient *fascinus*, and the satyrs, assimilated to Sylvanus and Faunus. The most perfect example of this type of composition is to be found in the park of the Domus Aurea of Nero (Suetonius, *Nero*, xxxi, 1–2), where villages, woods, fields, and an entire rural landscape were set on the shores of a lake. The Pompeian peristyles and the simpler gardens, like the one belonging to the House of Loreius Tiburtinus (PL. 425), were adorned with scenes representing a hunt or a design surrounding a shrine to the household god.

Even at a very early period the general outline of the Roman garden followed certain architectural principles. The paintings in the Auditorium of Maecenas, whose dates have not been definitely established (but which cannot be later than the end of the 1st century B.C.), show two gardens divided into a number of compartments separated by pergolas, picket fences, and arbors built of reed trellis. Similar gardens are found in the paintings of the Pompeian Style IV (PL. 424). The vistas, the contrasts of light and shadow, the quiet recesses and nooks give the garden a definitively architectural character and make it an integral part of the house. Pliny the Younger (*Letters*, ii, 7; v, 6) describes such gardens as "servants of architecture." They took various forms: a stadium or hippodrome (Palace of Domitian on the Palatine), a gymnasium, a terrace surrounded by a dense thicket (represented in the paintings of the Villa of Livia at Prima Porta, now Rome, Mus. Naz.; VII, PL. 208), a terrace enclosed within a peristyle (House of the Black Anchor, Pompeii; lower peristyle of the Domus Flavia on the Palatine). Often, as in the House of Loreius Tiburtinus at Pompeii, the median line is marked by a series of pools connected by small waterfalls, called *euripi*. The grounds of Hadrian's Villa at Tivoli are a good example of a garden broken into small units around a number of buildings (III, PL. 386).

The Roman garden was at the same time a sacred site, an idyllic landscape, and a place dedicated to leisure. Its Hellenistic and "royal" origins gave it an undeniably grandiose character, but Roman taste required the enrichment of the model. The practical genius of the Roman architects enabled them to integrate gardens and private dwellings and to make them a part of the new urban complex, which was one of the most original aspects of imperial Rome.

Pierre GRIMAL

THE ORIENT. *Islam.* In southwest Asia, North Africa, and parts of the Mediterranean, the ground destined to be made into a garden (*jannat* or *bāgh*) must be wrested from the desert. Water is brought from afar — from the mountains, from a wadi, or from an artificial reservoir, through an open or an underground canal (*qanāt* or *kārez*), aqueduct, or clay pipe; in some places it is drawn from deep wells. The water is dis-

tributed to the flower beds, which are divided into square or oblong plots through a system of clay or stone-faced irrigation canals. High walls, trees, and shrubs protect the garden from the drifting sand. While complex, this system of landscape architecture produces exuberant plant growth and flowers of exceptionally brilliant color. It is not surprising, therefore, that the inhabitants of the desert belt consider such gardens an image of heavenly bliss; and that the Oriental parks or game preserves, a simpler variant, became the prototype of the Western concept of paradise.

If the garden is on sloping terrain, it is laid out in a series of terraces. At the wall of each terrace the water flows beneath a pavilion or a stone seat, either forming a waterfall, behind which are niches for colored lamps, or running down a ribbed duct into a basin on the next level. The water pressure thus generated is used for additional fountains. The lowest terraces are the setting for public receptions, and the middle and upper terraces are reserved for the male and female members of the household, respectively.

If the garden is situated on flat terrain, the water must be lifted to a high storage tank, from which it flows to the garden pavilions built along the enclosure and to the pavilion in the center. The water courses either converge on, or radiate from, a central pool and divide the garden into four compartments (*chār-bāgh*). The banks of the canals are paved and bordered with cypresses and grape vines. The compartments, which are on a slightly lower level, are planted with fruit trees and flowers such as tulips, narcissuses, and roses.

The Balkuwāra Palace at Samarra, capital of the Abbasside caliphate (see ABBASSIDE ART) in the 9th century, has been excavated by Ernst Herzfeld. It had a vast forecourt and a similar garden in the rear. Under the Fatimid caliphate (10th–12th cent.) Egypt was filled with gardens of astonishing luxury. Among the famous garden palaces were the Western, or Golden, Palace in the Garden of Kāfūr, built by al-ʿAziz (975–96), and the golden al-Lūlua, west of Cairo, on the Nile Canal. Both gardens contained lakes, golden trees, extensive greenhouses for roses, silver gondolas with golden awnings, and so forth. The later caliphs were wont to spend their days in these gardens, dallying with singing and dancing maidens.

Islamic gardens are found as far west as Morocco and, in Europe, Sicily and Spain. At Palermo, Arab landscape architects designed the Favara, the Zisa, and the Cuba for the Norman kings of Sicily (12th cent.). In Morocco there were gardens at Fez and Meknes. In Spain the summer residence of the Ommiad caliphs (see MOORISH STYLE) at Medina az-Zahra, near Cordova, was built along the slopes of a mountain on three terraced levels, one containing the palace, one the gardens, and the third the town and great mosque. At Granada, capital of the Nasrid dynasty (1232–1492), three palaces have been preserved: the Alhambra (al-Ḥamrā, or "Red Castle"), the Generalife (Jannat al-ʿAraf, or "Garden of the Architect"), and the Alcazar Genil (now part of a modern mansion). The Alhambra, begun by Muḥammad I Ibn-al-Aḥmar (1232–73), opens on various courts and gardens (Court of the Myrtles, Court of the Lions, etc.; X, PLS. 166, 167) with water courses and fountains. The Generalife, a summer residence, is much simpler: it is crossed by one canal, into which a series of fountains on both sides scatter their waters. The splendor of these Islamic gardens, filled with beautiful maidens, fired the imagination of Frankish travelers and crusaders and inspired the medieval legends of the magic gardens of Armida and Klingsor.

The Islamic garden is celebrated in Persian painting and literature, especially in the works of the 12th-century poet Niẓāmī. The only extant gardens of this type, however, are those dating from two dynasties — the Safavid (16th–18th cent.; q.v.) and Qajar (19th cent.; q.v.). Among these gardens are the palace gardens at Isfahan built by Shah ʿAbbās I (1587–1629) and Shah Ḥusayn (1694–1722); the gardens of the Palace of Ashraf near Asterabad (now in ruins) begun by Shah ʿAbbās I in 1612, where seven gardens are decorated with fountains, pavilions, baths, stables, and murals in the Persian and European styles; the gardens at Safiabad and Farahabad (also in ruins); the Gulistan Palace at Teheran; and the Bāgh-i-Takht at Shiraz.

In Istanbul, the Topkapı Saray (15th–18th cent.), the palace of the Ottoman Turkish sultans, has canals, basins, fountains, and garden buildings (Chīnīlī Kōshk, Throne Hall, and the Baghdad Kōshk) in an eclectic Persian-Egyptian-Byzantine style. The landscape architecture does not adhere strictly to the Islamic style, since the climate of the northeastern Mediterranean coast renders irrigation unnecessary.

The largest number of well-preserved gardens in the Persian style can be found in northern India and the Deccan. From the pre-Moghul period (before 1550) there are vestiges in Kotila-i-Fīrūz Shah in Delhi of a 14th-century garden around a deep well. There are also vestiges in the Bahmanī palaces at Bidar (15th cent.), between the Takht Mahal, Chīnī Mahal, and the Sōlakhamba Mosque (the principal pavilion, known as the "Commandant's House"). The gardens of Maḥmūd I and Ghiyās-ud-Dīn at Mandu (15th and early 16th cent.) around Lake Munja and the Kapur Talao had many fountains, sluices, and water courses. Other examples in the area were the water palace of Kumatgi near Bijapur (late 16th cent.) and the gardens and deer park at Mahmudabad in Gujarat (early 16th century, once flanked by four halls with high wooden pillars behind which were four harems; the ruins of only one harem are extant).

From the period of the Moghul empire (1526–1857), the earliest extant Persian-style gardens — all early 16th to early 17th century — are the Ārām Bāgh at Agra, the tombs of Bā-Halīma and Humāyūn at Delhi, the mausoleum of Akbar at Sikandra, and the mausoleum of Āṣaf Khan at Shahdara (Lahore), the last in pure Safavid-Persian style. The imperial type of garden developed under Shah Jahān (1628–58) was on the Persian plan but with costly pavilions of white marble. In the forts at Agra, Delhi, and Lahore, there were garden courts of this type surrounded by open sleeping and living quarters. The Angūrī Bāgh (Grape Garden) at Agra had a women's bath and curved marble ledges between the flower beds (PL. 446). There are other imperial gardens in the Red Fort at Delhi: the small gardens in front of the Dīwān-i Khās, — the Rang Mahal, and the Mumtaz Mahal; and the larger gardens of the Mahtāb and the Hayāt Bakhsh, with the Shāh Burj, Bhādon and Sāvan pavilions, and the Ẓafar Mahal (bath), all framed with costly marbles. Outside the cities imperial summer retreats and pleasure gardens (Shalimar Gardens) are located near Delhi; near Lahore, Pakistan (PL. 446); and on Lake Dal in Kashmir. Others include those on the lake called the Ana Sagar near Ajmer, the Chashma-i-Shāhī in Kashmir, and the one at Achabal, also in Kashmir, with its many pavilions divided by walls. Princes and nobles also built gardens, such as those of the Raushānārā Begam near Delhi, the Zēbinda Begam near Lahore, Nishāt Bāgh and Parī Mahal in Kashmir, Pinjaur in the Punjab, and several near Rauza (Khuldabad) in the Deccan. Gardens were also laid out around mausoleums, such as the Tāj Mahal at Agra, those in Shahdara near Lahore, and the Bībī-kā Maqbara at Aurangabad.

In the 18th century there flourished a sort of Moghul "rococo" style, of which two examples are the Qudsiā Bāgh, comprising a huge enclosure filled with a mosque, pleasure houses several stories high, and a complex system of basins, fountains, and water courses, at the end of which is a view over the Yamuna River; and the mausoleum of Nawab Sāfdar Jaṅg of Oudh at Delhi (PL. 169). The latter was originally used as a palace and had living quarters around the vast area surrounding the central tomb.

Rajput gardens in the Moghul style are found at Amber, Jaipur, Jodhpur, Bikaner, Udaipur, Bundi, Alampur, and Nadaun (Himalaya); those at Dig, between Delhi and Bharatpur, are among the finest. The Rajput gardens were often situated on or below the dikes of irrigation lakes. Today the taste for this refined art has been lost. The "Moghul" garden of the Rashtrapati Bhawan (former Government House) at New Delhi is actually of the Italian type.

Gardens in a semi-European, or semi-Chinese, style, built in the 19th century, include that of Mubārak Shah at Delhi and the Kaisar Bāgh and Sikandar Bāgh, both in Lucknow.

Pre-Islamic India and southeast Asia. In the hot climates of India and southeast Asia, gardens are natural habitats, save during the hottest months, when people seek shelter indoors. Most houses are built around a courtyard garden; larger mansions are surrounded by extensive parks and gardens, and palaces consist of many buildings spread over a vast landscaped area of courts, gardens, and groves of trees. The towns are ringed about with large green areas.

The Indian hermitage, or ashram, the modern math, is generally situated in a grove or forest. The Buddha was born in a garden; he preached his first sermon in a garden and died in another. The sites of Buddhist monasteries were either in a garden (*ārāma*) or on the side of a mountain in a setting of natural beauty. Almost all the Hindu temples rise in the midst of gardens or on the banks of a river or lake. In the zone of the wet monsoons (eastern and southern India, Ceylon, and southeast Asia) the garden, with its exuberant vegetation, ponds, and hills, where wild animals were sometimes kept, was a stylization of nature. In the dry desert belt of southwest Asia (including northern India, Pakistan, and the Deccan), it was an artificial product made possible by complex and laborious methods of irrigation.

None of the ancient Indian gardens has survived, although literary works are filled with references to them. The Ajanta murals depict gardens with lightly constructed pavilions of wood and brick. These were copied from the royal gardens of Ceylon, of which an example is found at Anuradhapura below the Tisaveva dike. These gardens have rectangular lotus ponds, a central lake with a pleasure island, rock cliffs decorated with reliefs of elephants swimming in lotus pools, underground rooms, bathing pools, and wooden pleasure houses. Parts date from the time of Mahāsena the Great (A.D. 334–61). At the southern end is 5th- to 6th-century Isurumuniya, with a rock temple, rock reliefs, and a beautiful temple terrace. A further example in Ceylon is the royal garden town at Sigiriya (late 5th cent.), a fortified quadrangle in which the palace proper is arranged around four square basins. The palace is connected with the rock fortress to the east by an oblong garden with stone embankments; these embankments are flanked by pavilions built on artificial round hills that are set in the center of square ponds.

At Polonnaruva, Ceylon, the fortified palace square is north of the Topaveva (12th–13th cent.). The principal edifice (Vaijayanta Prasāda) rises from a special court to a height of seven stories. In its vast garden area there are richly decorated stone terraces and numerous ponds. The great monasteries Ālāhana Parivena (to the west) and Potgul Vehera (to the east) are set in the midst of extensive gardens with underground chapels and rock sculpture; the great Buddha images at Gal Vihara are noteworthy examples of rock carving (see CEYLON; CEYLONESE ART).

In India we can interpret the two great 7th-century reliefs inspired by the Kirātārjuna story (commonly known as "the Descent of the Ganges" or "Arjuna's Penance") at Mamallapuram (IV, PL. 256) and the adjoining Kṛṣṇa Mandapa as the last remnants of a royal pleasure garden laid out beneath the ramparts of a one-time fortress. The unexcavated palaces of the Chola emperors of southern India at Uraiyur (near Tanjore), at Gangaikondacholapuram, and at Kumbakonam (11th–12th cent.) consisted of vast areas covered with mounds and pools. The palace of the Rāyas of Vijayanagar (16th cent.; see DRAVIDIAN ART) had great terraces supporting wooden superstructures surrounded by vast courts, one of which stood in the middle of a lake. The Hindu style of a square lake with one or more islands in the middle and palaces on the banks was adopted by Moslem landscape architects. Examples of this type of garden are in the harem of the Jahānpanāh citadel (15th–16th cent.) at Champaner, Gujarat; Bijay Mandal (part of Hazār Sutūn; mid-14th cent.) at Siri, Delhi; Hauz-i Khās (late 14th cent.), Delhi; and the Rūpa Laṅkā and Sona Laṅkā islands of Sultan Zain-ul-'Ābidīn (15th cent.) in Lake Dal, Kashmir.

Examples of gardens outside India are, in Nepal, those of Budha Nīlakaṇṭha and Bālajī, with many fountains along the terraces; in Burma (at Mandalay), the fort gardens and the royal pleasure gardens southeast of the fort (19th cent.), both oblong rectangles of canals and ponds; in Java, the *kraton* (palace complex) of the kings of Majapahit described in the *Nāgarakṛtāgama* (1365) of Prapañca, the ruins at Mojokerto, the *kraton* of Jogjakarta, that of Sūrakarta, and those of the princes on Bali. In Cambodia, the ruins of the royal palace at Angkor Thom consist of a series of relief-covered platforms facing the public square and a system of pools, shrines, and stone platforms behind the square (PL. 374).

Today this highly refined form of landscape architecture of pre-Islamic India and southeast Asia has degenerated, subject to Persian influences in India and to Chinese influences in southeast Asia.

Hermann GOETZ

China. Chinese landscape architecture, with its asymmetric and indeterminate character, attempts to create an atmosphere of solitude and isolation. In China it was the great painters who created the typical Chinese garden, following the principles of their pictorial art; particularly important was the *shan-shui* (mountain and water) school of landscape painting. Gardens were composed of fairly isolated sections which, although part of a homogeneous composition, were intended to be observed gradually as the visitor walked along the paths.

The Chinese belief that water is an indispensable element in landscape architecture has its origins in the Taoist theory that water courses are the arteries of the earth, through which flows the universal life spirit. The most common use of water in Chinese landscape architecture is an island-studded pool surrounded by buildings (PL. 447). Mountains represent, in Taoist thought, the earth's skeleton. Perforated and grooved stone blocks (called "mountains"), which are placed around the pool or scattered among the flower beds, constitute the most original element of Chinese landscape architecture and occur in no other type of garden (PL. 447). These stone blocks assume all sorts of shapes but fall generally into the two formal categories of horizontal (rocks of small size usually set in layers and held together with mortar to form miniature mountains, grottoes, and tunnels) and vertical (rocks of any size with the long axis placed vertically). Some of the largest are considered monuments and are set on pedestals in open spaces. They are analogous to the obelisks found in Western gardens. Most highly prized are limestone blocks, naturally formed, from T'ai-hu and other lakes in southern China. Stones and rocks from the mountains, modified by the hand of man, are also used.

In addition to these "permanent" elements, trees and flowering plants are grown, which complete the beauty of the garden when they blossom. Many plants have a symbolic character. Bamboo, because of its flexibility, resistance, hardness, and pliancy, is a symbol of lasting friendship, of vigorous age, and, above all, of the *chü-jên* (gentleman) who bows beneath the weight of adversity but rises again after every storm. The pine is a symbol of a strong and firm character and, because of its height, of silence and solitude. The plum tree, as popular in China as the cherry in Japan, is regarded as the herald of spring and bringer of life. Among the flowers the orchid symbolizes feminine grace, the chrysanthemum longevity, and the peony wealth and happiness. The lotus is considered the supreme element of beauty. Because of the peculiar luminosity of its flower, and because it rises from the muddy bottom of a pool to the surface of the water, where the light of the sun enhances its beauty, the lotus is a symbol of the desire to rise above the material world toward the enlightened spheres of the spirit; it is the symbol of pure Buddhist doctrine and the central theme of Buddhist artistic symbolism (see BUDDHISM).

Pavilions in Chinese gardens are open or completely enclosed and occur in various shapes: square, rectangular, round, polygonal, and crescent; they may also be built in the shape of a plum blossom or a Greek cross. The pavilion is used as a place in which to study and meditate or as an observation point for the garden. Open galleries (*lang-fang* or *lang-tzu*), which follow the sinuous contours of the garden and edges of the pools and connect the various buildings, may take the form of a veranda, corridor, or portico in front of the main room

(ta-t'ing) of the house. Emphasizing the architectural character of the garden, with its pavilions and galleries, is the ch'êng, or garden wall, which follows the contours of the terrain; only on rare occasions is a wall built on a straight line, as in the Garden of the Jade Fountain near Peking and in the New Summer Palace of that city. Openings in the walls give access to the garden and are generally octagonal or circular, without doors or gates; rarely are they rectangular. One of the most famous of the circular type is the so-called "moon opening," in which the garden appears to be reflected, as in a mirror. Particularly decorative elements in Chinese landscape architecture are the bridges that connect the mainland to the islands and rocks in the lakes. A typical bridge is built of stone in the form of an arc that is decorated with a balustrade surmonted by small pillars. Other types are level, following a zigzag course that breaks the straight line of the walks. Wading stones are placed in shallow water and along the towpaths.

The traditions of Chinese landscape architecture are so ancient that it is almost impossible to make an adequate historical survey of the subject. The Shih-ching ("Book of Odes or Songs") contains vague references to terraces, pools, and gardens but gives no details as to their design or type. From the Ch'in (221–206 B.C.) and Han (206 B.C.–A.D. 221) dynasties we have references to pavilions, bridges, and galleries built around the palace-cities, but these references are not sufficiently detailed to convey any clear idea of the principles of landscape architecture of these periods. Under the Liu Sung dynasty in Nanking (420–79), the first formal elements of landscape architecture (e.g., pavilions, stone blocks, pools, and trees) seem to have made their earliest appearance. They correspond to the Taoist philosophical principles that attempted to lead man back to a deeper spiritual and material contact with nature. These theories were more clearly expressed in 4th- and 5th-century Buddhism, especially in the pantheistic philosphy of Ch'an Buddhism.

Toward the end of the T'ang dynasty (618–906), many gardens were laid out according to Taoist theories regarding the achievement of immortality. During the Five Dynasties (907–60) gardening activity was concentrated in the cultivation of flowers. During the Sung dynasty (960–1279) Chinese landscape architecture reached a peak of natural perfection that was never equaled in any other era. In the period of the Yüan

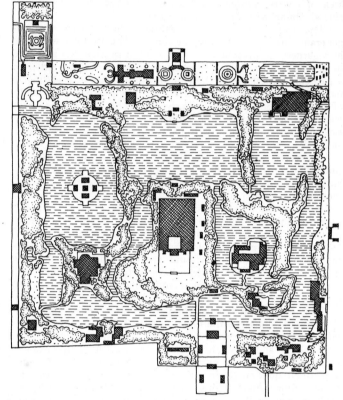

Peking, Ch'ang-ch'un-yüan ("Garden of the Long Spring"), ground plan (from Sirén).

dynasty (1260–1368) the representation of nature lost the formal perfection of the previous period and assumed romantic aspects. From the Ming dynasty (1368–1644) to the present day, the relationship of the garden to nature has been manifested in highly realistic scenic representation (FIGS. 1079, 1080).

Japan. Japanese landscape architecture is an expression of a profound love of nature and the desire to be in constant synthesis with nature in all its living aspects. The Japanese call this mono-no-aware. The peculiar characteristics of Japanese gardens set them completely apart from all other types of gardens. The landscape architecture of Japan differs even from that of China, which contributed the first compositional elements, subsequently adapted according to Japanese taste and national character. In Japan there is no attempt to create a faithful reproduction of nature. The landscape architect is an artist who tries to express his own personality, discarding what he considers useless and emphasizing those elements that he believes will find favor with the spectator.

The observance of conventional rules in this art is intended to evoke the feeling of living in the midst of natural surroundings. The aim of the architect is to create a weathered and antique look (sabi), achieved by covering stones and tree trunks with moss, allowing wood and stone to become corroded, and permitting all metal work to become oxidized (PLS. 448, 449). Water, in the form of pools, lakes, streams, or waterfalls, is an essential element for the achievement of a natural aspect to the garden. It evokes the landscape of the seashore or mountains, where turbulent streams and waterfalls abound. The two Japanese terms that denote a garden are sensui (pool and water) and rinsen (water and wood). The latter term refers to trees, another essential element in Japanese gardens.

The cycle of seasons is symbolized by numerous plants

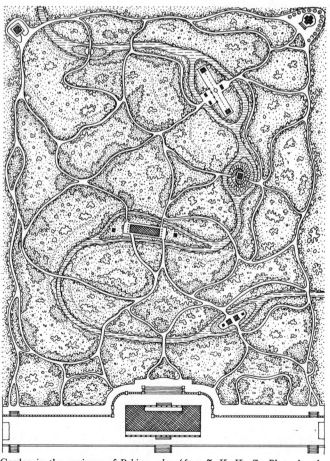

Garden in the environs of Peking, plan (from J. K. Krafft, Plans des plus beaux jardins pittoresques . . . , Paris, 1809).

and trees such as conifers, broad-leaved evergreens, and deciduous species. Among the conifers the *akamatsu* (*Pinus densiflora*) is preferred. The most admired broad-leaved evergreens are the *mochi* (*Ilex integra*) and *mokkoku* (*Ternstroemia japonica*). Deciduous trees are not so highly regarded; they are considered beautiful only in the spring, when they come into leaf and blossom, and in the autumn, when their leaves turn (*momiji*, autumn leaves). Shrubs, either evergreen or deciduous, complete the botanical element of the garden. Among these the conifers are preferred, but flowering bushes such as azaleas and bushes with yellow or reddish leaves are also planted.

A further indispensable element to complete the natural aspect of the garden is stone. Stones are placed along the water courses, which represent streams, or on the banks of the artificial pools, which represent either lakes or oceans. They are placed so as to suggest a natural landscape. Traditionally rocks or stones used in connection with water are gathered from the seacoast; stones used for "mountain" effects are obtained from the mountains.

No trace of affectation is allowed to appear in Japanese gardens. This has led to the creation of precise rules governing landscape architecture and to esthetic principles regarding the forms and proportions of the decorative elements. A pool or lake is the most common form of the water element. Its source must always be within sight, either as a waterfall or a fountain. In terrains that do not permit the building of a pool, the water is made to flow as a stream. Lakes must have an irregular outline with bays, promontories, and small tortoise-shaped islets planted with trees, preferably dwarf pines. The islets are often connected to the mainland by bridges. The lake or pool must always be at the center of the garden, surrounded by a circle of trees and "mountains." Waterfalls must be placed in the hilly part of the garden, to the left of the viewing point, so that the water flows from left to right. This left-right movement is required for esthetic reasons and is also derived from very ancient Chinese beliefs based on occult directional principles. The directional emphasis on the left also governs the placement of the other scenic elements such as trees and rocks. As a rule, the dominating elements are placed at the apexes of a scalene triangle whose shortest side is on the left and longest side faces the main house. The most important scenic element (such as a waterfall) is placed at the apex farthest from the base. This plan provides the greatest possible perspective depth to the whole design.

The stones are placed according to three systems of grouping: artificial (*ishi-gumi*), Chinese, and freely scattered (*suteishi*). In the first system the stones are used to complete the scenic elements of the landscape — lake, brook, hill, and so forth. The second, or Chinese, system involves the cementing together of various stones into a desired shape; this method is not highly regarded. The third system tends to avoid any possible trace of stiffness that could be detrimental to the natural outlines of the garden, the stones being scattered singly and at random on the ground.

Special techniques apply to the placing of trees as well as stones. These techniques govern the choice of species, the manner of planting, and — since Japanese gardens represent a miniature of nature — the special cultivation of dwarf types. Dwarf trees are obtained by a process called *zundo*: the top of the tree is repeatedly pruned, preventing it from growing vertically and forcing it to spread laterally. This system, not unique by any means, originated during the Edo (or Tokugawa) period. It is used most frequently in gardens where the tea ceremony is held.

A cardinal principle of Japanese landscape architecture is that every garden must be delineated and isolated from the surrounding countryside by a wall. Often, however, a line of trees or a grove of bamboos is considered sufficient for this purpose. One characteristic peculiar to Japanese gardens, and one which is most striking to Western eyes, is the complete absence of lawn in the empty spaces of the terrain. In keeping with the concept of a representation of nature, these spaces are covered with azalea bushes or dwarf plants. Moss is used in shaded areas. In classic gardens, especially where the terrain is flat, it was the custom to spread white sand mixed with pebbles on the ground. This was then raked with the greatest care, leaving the traces of the raking tool on the surface (PL. 448).

Special techniques have also been devised for the stone lanterns (*tōrō*; PL. 448) and for the small bridges connecting the islets to the mainland. The bridges are made either from a single stone slab or in curved sections joined together. Special methods are also used to trace the footpaths that run between the various buildings so that visitors can walk around the lake.

Japanese gardens are generally classified as hill gardens (*tsukiyama*) or level gardens (*hiraniwa*). The former contain hills and a lake; the latter are built on flat terrain with sand, stones, trees, lanterns, and wells. Both garden types can be laid out in three different styles: *shin*, *gyō*, and *sō*. The first requires a large space and must contain all the prescribed scenic elements. It is the most elaborate style, ceremonial and severe in aspect. In the *gyō* style, details are less important and the design is not so formal; the rigid symmetry of the *shin* style is lacking. The third style allows free rein to the fantasy of the landscape architect. In aspect it is asymmetric and restful.

Hill or level gardens in any of the three styles can assume three different forms: simple, continuous, or composite. For gardens of small area the simple form is preferred. The composition is arranged as in a painting, so that the whole garden can be seen from a single viewpoint. If the plot is long and narrow, a continuous landscape is constructed (*roji-niwa*, transitional garden), and the visitor must traverse the entire length of the garden in order to appreciate it. A changing series of views is obtained by dividing the garden into two sections, outer and inner; the connecting path is bordered with stone lamps and ornamental stones. The tea garden is a typical examples of the continuous garden form. For large gardens the composite form is used. A succession of panoramas is constructed, each with a different landscape, in the manner of the painted scrolls (*emakimono*); the pictorial story is unfolded, scene by scene, to the end of the tale.

There are also certain specialized forms of gardens, including miniature gardens on trays (*bonkei*), which are made of mud, peat, and sand of various colors; landscapes of stone and sand on black lacquered trays (*bonseki*); and miniature trees in pots (*bonsai*).

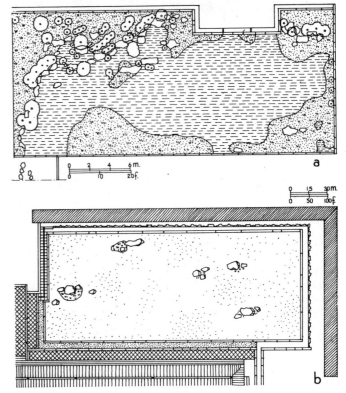

Kyoto, plans of small Japanese gardens: (*a*) Daitokuji, south garden of the Hōjō (abbot's quarters); (*b*) sand garden of the Ryūanji.

The art of landscape architecture was introduced into Japan about the middle of the 6th century, but it has not been possible to determine the precise date. The first notions of landscape architecture in Japan were a result of the introduction of Buddhism, which reached the country from China, via Korea. The style was that of China of the Han and Six Dynasties (3d cent. B.C.–6th cent. of our era), a style which flourished through the Asuka (552–644) and Nara (645–793) periods, when the capital was at Nara. In the period that followed the transfer of the capital to Kyoto (794), a smaller type of garden (*senzai*, cultivated courtyard), purely Japanese in style, was developed alongside the larger Chinese garden.

When the feudal wars broke out, the Buddhist priests preserved the art of landscape architecture by constructing splendid gardens in their monasteries. At the beginning of the 13th century the Chinese Buddhist Zen philosophy (Chin., Ch'an) was introduced into Japan. Zen aimed at the union of the individual

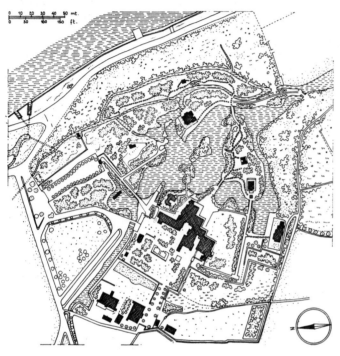

Kyoto, Katsura palace, plan of the garden.

with nature, inspiring a taste for simplicity and serenity. This caused a revolution in landscape architecture and led to the creation of the ceremonial tea garden (*cha-no-yu*). Even today it is possible to admire the vestiges of the gardens of this period (FIG. 1082) in the Shōmyōji at Kanazawa, near Yokohama, and in the Kenchōji at Kamakura.

During the Muromachi (or Aṣhikaga) period (1334–1573), gardens began to take on the characteristics of the lake-island and level garden types. Good examples of this period still visible today are the Tenryūji garden in the suburbs of Kyoto, creation of the Buddhist priest and calligrapher Soseki (Musō Kokushi; 1275–1351); the Kitayama garden near Kyoto, laid out by the shogun Yoshimitsu (1397), which forms part of the Rokuonji (better known as Kinkakuji); and the level garden of the Ryūanji, designed by Sōami (q.v.; PL. 448; FIG. 1082).

During the Momoyama period (1573–1615) the tea garden was further developed, as were the two garden types of the previous period. Momoyama landscape architecture avoided every trace of artificiality. Characteristic of this period are the paths made of stones laid down at a certain distance from one another (*tobiishi*), as in the Myōkian garden near Kyoto, built in 1582 by Sen-no-Rikyū. After the rise of the Tokugawa shoguns in 1603 and the transfer of the capital to Edo (now Tokyo), gardens of the lake-island type were built in ever-increasing numbers and size and assumed the character of composite landscapes. A famous example from this period is the

garden of Katsura palace, southwest of Kyoto, created by Kobori Enshū (1579–1647; FIG. 1083).

When Japan was opened to Western contacts in 1868, landscape architecture was subjected to new influences. This state of affairs lasted but a short time, since these influences were contrary to Japanese taste. During the 19th century, however, a new type of garden was developed, known as the *bunjin-shiki* (garden of the man of letters). The design of the *bunjin-shiki* allows the landscape architect to express his ideas in a very free and independent manner.

 Antonio PRIORI

PRIMITIVE CIVILIZATIONS AND PRE-COLUMBIAN AMERICA. The cultivation of plants and flowers for ornamental purposes is rare in primitive cultures. In only a few places (Tahiti, Benin, the interior of New Guinea) are sacred areas, communal houses, and dwellings of chiefs surrounded by ornamental plantations. Detailed information on this subject is very limited.

Better documentary evidence exists, however, concerning gardens in the Aztec civilization of pre-Columbian Mexico and the Inca empire in Peru, contained in the descriptions of ancient chroniclers and early travelers. In the Aztec cities every house had an inner courtyard where flowering plants were cultivated. Suburban houses were surrounded by gardens planted with flowers and vegetables. Terraced gardens with flowers and green plants decorated the palaces of chiefs and high dignitaries. The love of flowers among the Aztecs is documented in their art. Three of the deities of their pantheon — Xochiquetzal, Xochipilli, and Macuilxochitl — presided over the cultivation of flowers. At Oaxtepec there was a nursery garden for tropical plants, and at Xochimilco, on the outskirts of modern Mexico City, there was a magnificent public garden.

King Nezahualcoyotl is remembered for his beautiful gardens. The most remarkable were those at Texcoco and Tezcotzinco, which contained numerous fountains, pools, and water courses, filled with many varieties of fish. Multicolored birds nested on the branches of the trees; the records speak of more than two thousand pines. A section of these gardens was laid out as a labyrinth in the center of which, carved in the living rock, was the sovereign's bath, where he received and entertained important guests. Statues, kiosks, and temples of beautiful design filled all these grandiose Aztec parks. At Tezcotzinco the structures were laid out in terraces. A great variety of plants and flowers were cultivated, some brought from far-off places.

In ancient Peru the chronicles tell of a "golden garden" near the Coricancha (golden enclosure, or Temple of the Sun), the greatest sanctuary in Cuzco. This garden was said to contain golden plants among which grazed herds of llamas all of gold, tended by shepherds of gold and silver — a sculptural representation possibly inspired by a royal garden. On the island of Titicaca in Lake Titicaca, E. G. Squier noted that the so-called "Palace of the Incas" was surrounded by an architectural garden built on terraces connected by stairs.

 Ernesta CERULLI

THE WEST. *The Middle Ages.* The gardens and monuments of the Roman Empire, including its distant provinces, were destroyed by repeated barbarian invasions. By the early Middle Ages, gardens were probably restricted to narrow confines such as those of a monastery cloister (PL. 426). Medieval gardens consisted of small walks and flower beds radiating from the edge of a central well, around which grew stately cypresses. Secular gardens, within castle enclosures, cannot have been very different.

Considerable source material is available on Gothic landscape architecture. Miniatures, paintings (VI, PL. 345), tapestries, and to a lesser extent frescoes (PL. 427) enable us to reconstruct partially the main outlines of the Gothic garden. Two literary documents contain descriptions of gardens of this period: the eighth chapter of the *Liber ruralium commodorum* by Pietro de' Crescenzi of Bologna (ca. 1305), translated into Italian, English, French, and German in the 14th and 15th centuries; and the "Proem to the Third Day" from Boccaccio's *Decameron*. The *Amorosa Visione* by Boccaccio also describes

the great garden of the Castel Nuovo in Naples, which lay between the palace of King Charles of Anjou and the sea. Describing life in the 14th century, Folgore da San Gimignano wrote in his sonnet "Domenica Die": "Youths dance, knights joust — seeking adventure in every district — in the squares, gardens, and orchards." Boccaccio furnishes us with a detailed description of a garden-orchard, stating that the layout was geometric; spacious and straight walks radiated outward from the center. The walks were covered with arbors of grape vines, and their sides were almost completely enclosed with hedges of jasmine and white and red roses. Rectangular and triangular beds, formed by intersecting walks running parallel to the perimeter and diagonally across the garden, were filled with so many fragrant plants that "to describe them all would take too long." In the center of the garden was a closely mown lawn of fine grass, of such a dark green it seemed almost black. The lawn was colored by nearly a thousand different varieties of flowers and was enclosed by a border of bright green and brilliantly hued oranges and citrons. In the middle of the lawn stood a magnificently carved white marble fountain. A figure supported by a column in the center of the basin threw a jet of clear water high into the air, which fell back into the pool with a pleasant sound. The water then flowed through a hidden conduit under the lawn and reemerged to flow through skillfully constructed canals all around the garden.

Pietro de' Crescenzi noted the indigenous varieties of flowers in 14th-century gardens: flag irises, lilies, roses, and violets, as well as lilacs, hyacinths, and jasmine — the species brought to the West by crusaders and merchants. Next to the garden was a grove of ornamental trees: laurels, cedars, olives, pines, and cypresses; and beyond this an orchard laid out on a strictly geometric but simple plan. A typically Gothic detail, often depicted in miniatures, was an aviary large enough to contain one or more trees where birds could roost. An illustration in the 15th-century *Liber de sphaera* (Modena, Bib. Estense) and representations of the fountains of youth (PL. 427) are excellent examples of the types of fountains that were obligatory in every garden. The *Madonna in the Rose Garden* by Stefano da Zevio (I, PL. 380; VI, PL. 372) faithfully depicts an arbor-covered walk which surrounds the garden. Similar walks can be seen in the miniature of *St. Anne and the Three Marys* in Fouquet's *Heures d'Étienne Chevalier* (Chantilly, Mus. Condé). The clear-cut division of the landscape by a high enclosing wall is a very typical characteristic of Gothic landscape architecture, and more than one example of this can be found in the famous miniatures of the *Très Riches Heures* of the Duc de Berry (Chantilly, Mus. Condé). In the later Middle Ages gardens became richer, softer in outline, and more sensuous, although they maintained the layout and spirit of the cloister.

Roberto CARITÀ

Material evidence of Byzantine landscape architecture is lacking. However, it is possible to reconstruct in general outline the appearance of Byzantine gardens on the basis of miniatures, historical documents, and a few mosaics (PL. 426). Close contacts between the eastern Roman Empire and Persia during the Sassanian period (ca. 300–650) undoubtedly contributed to the spread within the Byzantine world of a Persian style of landscape architecture particularly well suited to a terrain and climate requiring shelter during the hot season. Large plants and fountains must have been fundamental elements. A mosaic in the Great Palace of the Emperors at Constantinople — probably 5th or 6th century — depicts trees and a pool fed by running water, set among architectural constructions. According to Theophanes (K. de Boor, ed., *Theophanes chronographia*, Leipzig, 1883–85), the walls of Constantinople were bordered with gardens. The *Chronicon paschale* tells us that the summer palace of the Emperors was set amid gardens and terraces and was connected to the imperial palace by galleries and groves of trees.

From Theophanes we also learn that Emperor Basil the Macedonian (d. 886) ordered the Tzykanisterion (playing field for a ball game on horseback similar to polo, derived from the Persians) to be demolished in order to build a larger one. In its place there rose the Nea Moni (New Church), connected with the new Tzykanisterion by two galleries; between them a shaded garden with trees and fountains was constructed.

Private dwellings were provided with gardens of varying sizes. Generally a house was fronted by a courtyard with a well; baths sometimes opened onto the garden.

One of the last descriptions of Byzantine landscape architecture was written by Theodore Metochites, lieutenant of the emperor Andronicus II Palaeologus (1282–1328). He described his own palace, unfortunately destroyed in 1328, and the delightful gardens and ornamental water works surrounding it.

Byzantine art — religious and nonrealistic in character — can only offer an approximate idea of the actual appearance of Byzantine gardens. The illuminations found in the homily books and a few mosaics (e.g., late 11th cent., *The Annunciation to Joachim and Anna*, Catholicon, Daphne, Greece; II, PL. 449) depict fountains in the form of "fountains of life," which have a Christian significance. Such fountains, probably traditional in Byzantine gardens, consisted of several superimposed basins surmounted by a cone-shaped urn from which flowed the water; a structure of this type is known to have existed in the Great Palace.

* *

Renaissance and baroque periods. During the 15th century the naturalistic character of medieval landscape architecture made way for a new architectonic concept. This concept had a tenuous and indirect link with the classical Roman period based on literary sources (often fanciful) and a few figural sources that were rarely more than backgrounds for pictorial representations. Certain ancient elements were revived, however, particularly the *opus topiarium* and the planting of trees in quincuncial arrangement. These and other elements gave the 15th-century garden an antinaturalistic, rational, and geometric character. The arboreal arrangement was not the only one subjected to mathematical treatment; every form was given an artificial shape — cube, sphere, pyramid, and so forth. The spatial aspect of the garden resulted from a series of calculated linear and volumetric effects.

The transition from a Gothic to a Humanistic concept of landscape architecture was slow and gradual. To a certain extent it was determined by the change in the character of the urban centers. When the fortress city, dominated by the strongholds of the nobles, was freed from the limitations of its encircling walls, residential villas were erected in the surrounding open countryside. Whereas previously a garden had been considered a necessary but circumscribed ornament, now in the spacious surroundings of these suburban villas, landscape architecture assumed new forms; in the succeeding century they were to develop in a very striking fashion. Although it is difficult to establish precise chronology, the specific style of 15th-century landscape architecture probably lasted for only a few decades, reaching a high point of perfection in the second half of the century. The new forms were developed first in Tuscany and central Italy (where Alberti and Francesco di Giorgio laid down the constructional norms) and almost contemporaneously in parts of northern Italy (Ferrara, Bologna, Mantua, Pavia) and in the south (Naples). These new forms were seen in the great villas of the Medici, Montefeltro, Este, and Visconti families and in the villas of the Aragonese kings of Naples.

Many of the greatest architects of the period turned to landscape architecture: Alberti, Rossellino, Giuliano da Maiano, Michelozzo [the Medici villas in Careggi (1433), Cafaggiolo (1451), and Fiesole (1458–61); Castello di Trebbio, ca. 1461], and Giuliano da Sangallo (Villa of Poggio a Caiano, 1480–85; PL. 428). None of these 15th-century gardens now exists in its original form; all were subsequently redesigned and altered by mannerist and baroque architects. We can form an idea of the actual appearance of the gardens of this period only from literary sources and from a number of paintings. The *Hypnerotomachia Poliphili* (Venice, 1499) is a very important documentary source, containing an imaginary description of the Garden of Venus on the island of Cythera. All the elements

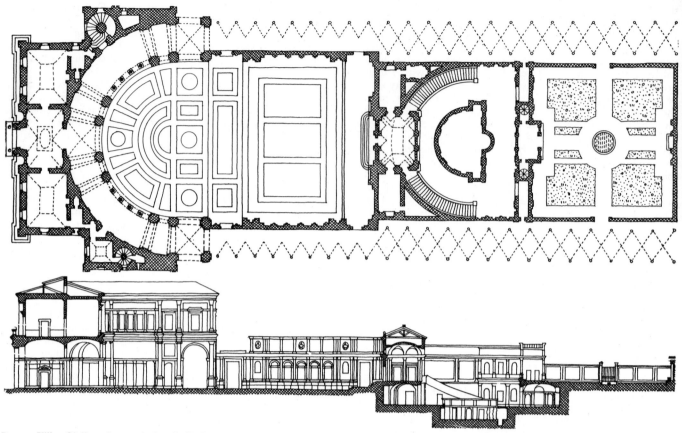

Rome, Villa Giulia, plan and longitudinal section of the original layout (*from P. Letarouilly, Edifices de Rome moderne, Paris, 1868–74*).

which other writers of treatises had only indicated fragmentarily, or which artists had used as backgrounds for their paintings and frescoes, are dealt with here in considerable detail. This mythical garden is laid out on a circular plan radiating from the fountain of Venus, which rises in the center of an amphitheater surrounded by a mosaic walk. The garden spreads out in ever-widening concentric circles of canals, topiary work of shrubs, flower beds, and lawns. The arboreal element, such as box trees trimmed in geometric patterns and even sculptural groups, alternates with the architectural element, represented by peristyles and marble gates, which are rendered live with creeping plants. The entire garden is enclosed by a ring of cypresses and of myrtle trees pruned to imitate a wall.

The *Zibaldone* of G. Rucellai describes a 15th-century garden that actually existed at Quaracchi, near Peretola, Tuscany. It is believed that Alberti may have collaborated in its design. The quantity and variety of trees with which the garden was adorned were remarkable; some — the sycamore, for example — were very rare at that time. More important, however, was the essentially architectonic character of the design, achieved by a geometric treatment of the various elements and by a logical layout which deepened the perspectives. Fanciful effects were also obtained, such as labyrinths, which set a fashion so widely followed in the gardens of the 16th century. Less importance seems to have been attached to the spatial relation between the buildings and the gardens, and between the gardens and the natural surroundings. A study of the literary and figural sources of the period shows that much stress was placed on the enclosure of the garden by a wall or by a screen of trees. This suggests that the 15th-century landscape architects, although opening the way for the magnificent and elaborate gardens of the 16th century, had not yet completely abandoned the medieval concept of the *hortus conclusus*.

The earliest important example of 16th-century landscape architecture was the grandiose project of Bramante (begun 1505) to connect the Vatican Palace with the small villa on the Belvedere hill, commissioned by Pope Julius II. The distance between the two buildings was approximately 950 ft., with a

rise of about 65 ft. (The slope, however, was not even; there was a slight depression running across the ground that had to be filled in before the work could begin.) Little of Bramante's original design exists today; only the general outlines survived the alterations made by later architects. During the pontificate of Sixtus V (1585–90), Domenico Fontana divided the area in two with the wing of the library; and in 1817–22 the upper half was further divided by the construction of the Braccio Nuovo. Other portions were also substantially modified, especially the great exedra at the upper (Belvedere) end, over which Pirro Ligorio added a half-bowl-shaped vault and a loggia.

The best illustrations now extant of Bramante's original plan can be found in a rare drawing by G. A. Dosio (Uffizi, Florence) and in a painting by an unknown artist in the Kunsthistorisches Museum in Vienna. Bramante planned an absolutely new type of garden in which the architectural element clearly predominated over the arboreal. The latter element, however, was important in providing color. Bramante overcame the unevenness of the terrain by means of a geometric progression of three levels, the lowest of which is now the Cortile del Belvedere (not to be confused with the small octagonal internal courtyard of the same name in the Belvedere pavilion at the north end, built by Innocent VIII). Bramante's middle terrace is now mostly occupied by Fontana's library and the Braccio Nuovo; the space between them is known as the Cortile della Biblioteca. The upper level is the present Cortile della Pigna. The horizontal terraces were laid out with grass and flower beds, their mass articulated by the steep flights of steps between levels (each approximately 30 ft. high) and by the shadows cast by the surrounding buildings. (The longitudinal axis of the garden ran from south to north.) Despite strong contrasts of light and shade, the whole design must have achieved a feeling of continuity by means of a succession of ascending stairways, a series of connecting fountains along the central longitudinal axis, and, above all, by two niches, or exedrae — a smaller one in the center and the other, at the far upper end, very large and incorporated into an impressive edifice with a double order of columns (II, FIG. 605). By these

means the strongly defined dividing line created a perspective effect (as seen from the lower, or Vatican, end) of yet another terrace based on what was actually the second story of the upper building. Such an architectonic solution seemed to use the very arch of the sky as its logical conclusion. Perspective was heightened by the fact that the flanking buildings had a diminishing series of orders — the lowest with three, the middle with two, and the upper with a single order.

Bramante's conception, integrated with the original creations of other great architects (Raphael; A. da Sangallo; Vignola; Ligorio and Peruzzi, PL. 429; and Tribolo), became the basis of Italian landscape architecture. Raphael designed the plans (ca. 1516–17) for a villa (now Villa Madama) for Cardinal Giulio de Medici, later modified by A. da Sangallo. Although the villa was never completed, what remains of it today is fascinating, even if a feature considered fundamental by Raphael — its ideal relationship to the melancholy solitude of the surrounding countryside — no longer exists. While Bramante had conceived a purely architectonic garden, Raphael, the better to be in harmony with the georgic peace of the Roman countryside, surrounded the building with spacious planted gardens carefully laid out along geometric lines. Sangallo added a nymphaeum, elaborating with great originality an architectural theme derived from classical antiquity. The nymphaeum was destined to become an almost obligatory decoration in later gardens, since by this means water could be used ornamentally in the most fanciful ways. The two small rustic grottoes in the nymphaeum of the Villa Madama already existed in 1522 and are probably the first of this kind of architectural detail. (The one designed by Niccolò Tribolo for the Villa Medici in Castello, near Florence, formerly believed to have been the first example, dates only from about 1545; PL. 431.)

Garden design rapidly became one of the most diffused and significant expressions of 16th-century architecture, and many famous architects followed in the footsteps of Bramante and Raphael. Among the first was Peruzzi, who laid out the Villa Farnesina in 1508–11. Vignola designed the Villa Giulia in 1551–53 (FIG. 1087), the gardens of the Palazzo Farnese in Caprarola in 1559 (FIG. 1090), and the Villa Lante at Bagnaia, famous for its ornamental water works, finished in 1588 (PL. 433; FIG. 1090). On the Palatine, Vignola also built the Orti Farnesiani, now vanished save for the gate, which has recently been reerected at the eastern base of the hill. In 1544 Giovanni Lippi designed the Villa Medici in Rome (formerly attributed to his son Annibale). Between 1500 and 1600 the town

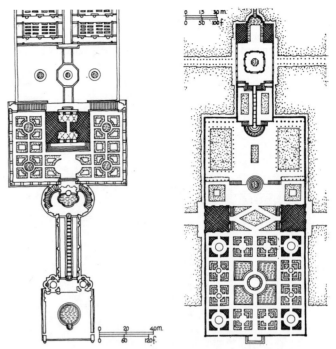

Sixteenth-century gardens near Viterbo, Italy, plans. *Left*: Caprarola, Casino and garden of Palazzo Farnese. *Right*: Bagnaia, Villa Lante, after an 18th-century engraving.

of Frascati became a center of princely villas and gardens: The magnificent Villa Falconieri was begun in 1545, followed by the Villa Mondragone, the Villa Aldobrandini (laid out by Giacomo della Porta; PL. 433), and others in 1598–1609. The series culminates in Maderno's masterpiece, the 17th-century water theater of the Villa Ludovisi (later Conti, now Torlonia). Great Imperial ruins, particularly in Rome, sometimes became the curious and majestic foundations for gardens, as did the Mausoleum of Augustus.

The vast complex of the Villa d'Este at Tivoli, built with amazing speed by Ligorio between 1550 and 1569, has fortunately come down to us without substantial modification, as can be seen from an aerial view engraved by Etienne du Pérac in 1573 (PL. 432). Ligorio basically followed Bramante's scheme,

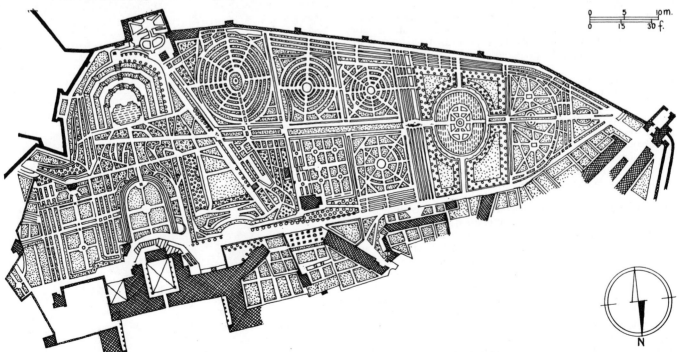

Florence, Boboli Gardens in the 18th century, plan (*from an engraving by Soldini*).

laying out a series of terraces along a clearly defined central axis leading to the monumental mass of the villa. Though it may not be apparent at first glance, Ligorio also followed Raphael's concept for the Villa Madama in the relation between

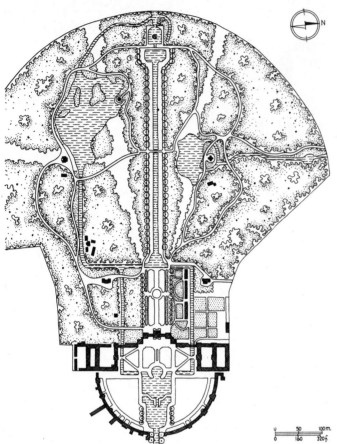

Nymphenburg, near Munich, plan of the castle gardens.

the architecture of the villa and the planted landscaped garden. At the Villa d'Este a very plentiful water supply was used for decorative purposes as much as were trees, plants, and flowers (IX, PL. 313).

A worthy Tuscan version of the Villa d'Este was the series of gardens laid out on the Boboli hill in Florence, at the base of which stood Brunelleschi's Palazzo Pitti (PLS. 429, 430, 431; FIG. 1089). Tribolo prepared the designs and began the work before his death in 1550. He was probably succeeded by Ammanati. Buontalenti, sometimes mentioned as Tribolo's successor, built only the Grotto where Michelangelo's figures of the prisoners were to have been placed in 1576 (PL. 430). The sculpture which Ammanati grouped around the fountains and in the grottoes assumed fantastic forms that blended with the surrounding landscape, as is also the case with the *Appennino* of Giambologna in the Villa Demidoff at Pratolino (PL. 430) and in the park of the Palazzo Orsini at Bomarzo (X, PL. 137).

Mannerist landscape architects devised a number of admirable gardens in other parts of Italy, and their character varied from place to place, depending on the individual tastes of the owners (and the architect) and the nature of the terrain. The immense Royal Garden in Turin, built between 1560 and 1630, was the first of a series in a beautiful belt of castles and villas built by the dukes of Savoy, who were determined to turn the city into a baroque capital. It was the Royal Garden that inspired Torquato Tasso's description of the Garden of Armida in his *Gerusalemme Liberata* and was the site of a battle in 1706 during the War of the Spanish Succession; today only its memory remains in the form of the etchings in the *Theatrum Sabaudiae*. In Venice, gardens assumed special characteristics. Two different types were devised, depending on whether they were laid out within the confined spaces of the city on the

lagoon, or in the unlimited areas surrounding the villas on the mainland. The layout of the mainland villas followed a pattern that remained in use until the 18th century. Here the natural elements predominated over the architectural, even though the general plan followed the Italian style based on a central axis of stairways or avenues (PLS. 434, 435). Among the other noteworthy Renaissance gardens in Italy were the Castello Imperiale at Pesaro, commissioned by Alessandro Sforza shortly after 1450, and the Palazzo del Te at Mantua, built by Giulio Romano in 1525–35 (PL. 428).

During the 17th century landscape architecture all over Europe remained under the influence of the Italian style. It is as difficult to arrive at exact chronological or stylistic dividing lines between mannerist and baroque landscape architecture as it is for the other arts. Until the great creations of Le Nôtre (q.v.), landscape architects continued to develop and expand 16th-century Italian models. Nevertheless, the landscape architecture of the late 17th century differs considerably from that of the early part of the century and is the forerunner of the architectonic style of the 18th century. A predominant characteristic of the baroque garden was the stress placed on the size and extent of the arboreal element. A tendency toward the picturesque developed during the 17th century and was expressed by an increasing use of large numbers of plants and a greater complexity and variety of structural details. There was also a growing use of color and light, and architects sought to create smoother transitions from one area of the garden to another. Sculpture, often in the form of monumental masses that were surrounded by water, was frequently employed to heighten the architectural effects of the earlier forms.

The 17th century brought many changes to the great villas at Frascati (see above) and added to their number the previously mentioned Villa Ludovisi. A complete list of 17th-century gardens in Europe would be long indeed. Rome, however, maintained a lead, with the new (or renovated) Vatican Gardens and the gardens of the princely palaces and villas. It is not easy to attribute a definite architect or date to every garden,

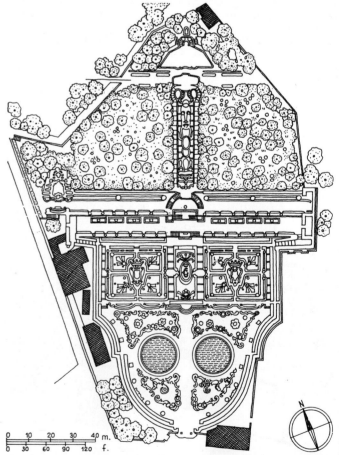

Collodi, Italy, garden of Villa Garzoni (*from R. Beretta, Giardini, Milan, 1959*).

since landscape architecture, of all the forms of architecture, is most easily subjected to stylistic changes. The aspect of a garden hardly ever remains faithful to its original design, and its date can only be approximately set within the span of a century. Certain gardens, in fact, can be cited as examples of the evolution of landscape architecture through three centuries, from the Renaissance through the mannerist, baroque, and rococo, graphic documentation being fairly plentiful for the more important gardens. The gardens of the Palazzo Colonna on the Quirinal illustrate this evolution. They are mentioned by Francesco Albertini in 1510, and were repeatedly altered until the middle of the 18th century. The garden of the Palazzo Barberini, on the other hand, is definitely known to have been laid out in the middle of the 17th century. The powerful and ambitious Barberinis also laid out another garden around their villa on the Janiculum. The gardens of the Altieri palace and villa, as well as those of the Villa Aldobrandini (PL. 433), were famous for their wealth of antique sculptures and obelisks. Other important Roman villas included the Rospigliosi villa on the Quirinal; the Giustiniani villas, one near the Lateran and another on the Via Flaminia, the latter now incorporated in the Borghese Gardens; and the Odescalchi villa on the Via Flaminia. The garden of the Villa del Vascello (originally Villa

was the work of A. di Castellamonte. Construction continued for several decades, until the French army of Marshall Catinat destroyed everything beyond repair in 1693, during the War of the Spanish Succession. Few great gardens existed in Liguria,

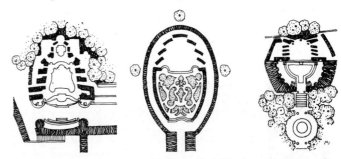

Examples of arboreal theaters in Tuscan villas of the baroque period, plans. *From left to right*: Garzoni; Gori; Marlia.

although that of the Villa Durazzo at Zerbino, designed by B. B. del Bianco, is notable. In the Veneto, landscape architects were active, especially in the Treviso district and along the Brenta River, between Venice and Padua. Longhena's Villa Lezze at Rovarè, now no longer in existence, was by all accounts a masterpiece. But the fame of the Venetian villas lies more in the buildings than their gardens. The main focal centers of mannerist and baroque landscape architecture were in Latium and Tuscany, where the greatest and most typical examples of the Italian style are found.

In the rest of Europe, the garden in the Italian style found the widest favor until Le Nôtre introduced a new style, which was to make the 18th an essentially French century. But the fundamentals of this transalpine landscape architecture had Italian roots. The gardens of Fontainebleau (PL. 436; FIG. 1093),

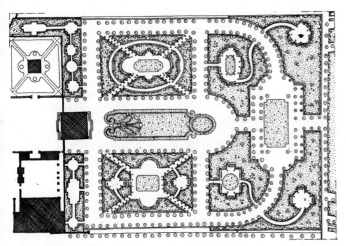

France, park of the Château of Fontainebleau, plan of the garden of the Marquise de Pompadour.

Benedetta) was the only known creation of two architects, Basilio and Plautilla Bricci. It was the scene of a furious battle and was totally destroyed in 1849. Also on the Janiculum was the splendid garden of Villa Doria-Pamphili, designed by Algardi after 1650. The original layout has been altered beyond recognition. Only its enormous area (a circumference of more than 8 miles) remains unchanged as the largest of all Roman gardens from the days of Innocent X.

In Florence, A. Novelli and L. Fantini created a baroque garden in the Orti Oricellari, while G. Silvani designed several villas, of which the Villa Corsini was the most important. Other fine gardens were those of the Villa Garzoni at Collodi, near Lucca (FIG. 1092), laid out in 1650; Poggio Imperiale, the masterpiece of G. Parigi, in 1622; and several near Siena. Splendid villas and fine gardens were designed in other parts of Italy, both north and south, during the 17th century. In Lombardy, Palazzo Borromeo (begun 1622 by Carlo Borromeo, finished 1671) on Isola Bella in Lake Maggiore was the creation of a group of collaborating artists including A. Crivelli, F. M. Ricchino, and C. Fontana (PL. 440). In Piedmont the dukes of Savoy, followed by almost all the nobility, owned splendid gardens. Emmanuel Philibert commissioned the Royal Garden and the small but graceful garden of the Old Royal Palace (enlarged and altered by Le Nôtre, 1698–1700). The *vigna* of Cardinal Maurizio (later Villa della Regina) was designed and laid out by Ascanio Vitozzi in 1616; the *vigna* of Madama Reale (Marie Christine) in 1648–63 by A. Costaguta. A magnificent garden was built at Venaria Reale, near Turin; the design

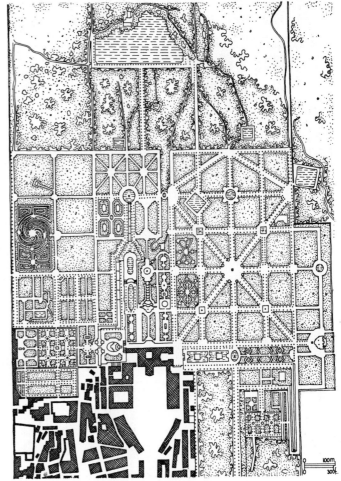

Segovia, Spain, gardens of La Granja, plan.

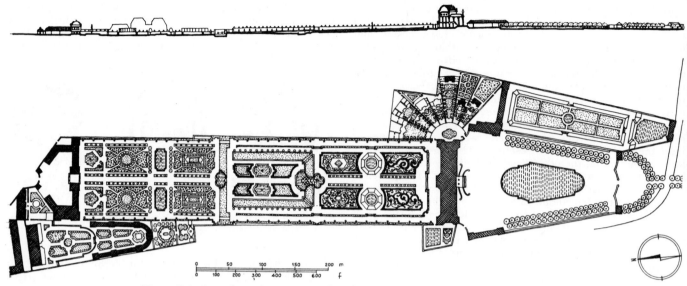

Vienna, Belvedere, plan and transverse section of the garden, from contemporaneous sources.

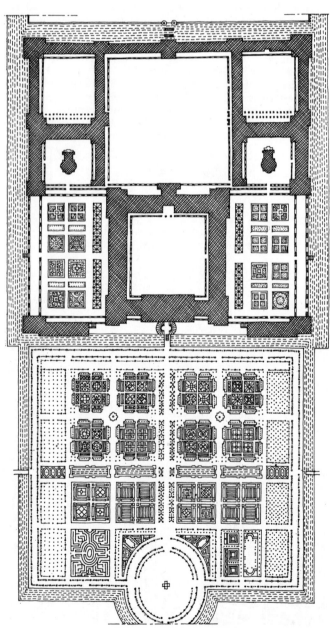

France, Château de Charleval, project of J. Ducerceau the Elder, general plan.

the Tuileries (PL. 438), and the Luxembourg were designed along Italian lines. Du Pérac, who designed Fontainebleau, studied for several years in Italy, and the Florentine Marie de Médicis, queen to Henry IV, was influential in introducing the Italian style, especially in the Luxembourg. It was from these models that Claude Mollet and Jacques Boyceau drew their inspiration. The Italian style was also successfully introduced into England; Hampton Court is the finest example of Italian landscape architecture in England (PL. 444). In Spain, the Italian style appears in the Royal Palace gardens of Aranjuez (PL. 443) and Buen Retiro in Madrid and in La Granja at Segovia (PL. 443; FIG. 1094); in Austria, in the Belvedere, Vienna (FIG. 1095); and in Russia, in the 18th-century Peterhof Gardens. Today, unfortunately, we know many gardens of this type only from figural sources.

André Le Nôtre, whom Louis XIV called "grand dans l'esprit," was a man of uncommonly wide culture. Born in 1613 of a family of gardeners, he studied painting with Vouet and architecture probably with Mansart. At the age of twenty-four he became general superintendent of the royal buildings. Le Nôtre's art had a decisive influence on landscape architecture in 18th-century Europe. Because of his contribution the garden in the French style became something more than a style; it became a fashion that lasted to the end of the *ancien régime*, a century after his death.

The cardinal points of Le Nôtre's landscape architecture are found in the Italian baroque. It could hardly have been otherwise, for the style of the great villas of Latium and Tuscany had established deep roots on French soil (although the style was noticeably altered owing to the flat terrain around the villas and châteaux of France). Le Nôtre realized, as had Bramante before him, that if a garden is not to appear lost in its surrounding space, it must be laid out along a well-defined axis. And, like Raphael, Le Nôtre understood that the main edifice must always be the central pivot of the design and the logical justification for the natural elements of the surrounding garden. On these 16th-century fundamentals, to which the 17th century had added a wealth of picturesque detail (sometimes even bizarre in character but always elegant in form), the French landscape architects based their style. Le Nôtre extended the composition and simplified it. His layout was arranged along well-defined contours and achieved carefully calculated effects. (It should always be borne in mind that, in order to study the ground plan of a garden, a mental reference to its perspective planes is necessary.) In Le Nôtre's style there are always two main points of view: looking from the main building to the farthest ends of the garden, and looking from the farthest point toward the building. Both these prospects must be free, yet at the same time the eye must be led toward interruptions

planned by the architect in the form of parterres of flowers or low shrubs planted along sinuous lines and enclosed within long rectangles. In some cases the straight lines of these rectangles may be broken by short and gentle curves. The geometric pattern of the parterres is emphasized by narrow strips of lawn placed along the sides. Yews and other trimmed shrubs, placed at stated intervals, align and articulate the line of sight, which with the help of carefully calculated perspective effects creates an illusion of space. The outer boundaries of the composition are denoted by masses of large trees, generally planes of great size, which further provide a transition to the surrounding landscape. Le Nôtre also used these trees to create mysterious shaded avenues, the *allées* of which he was so fond.

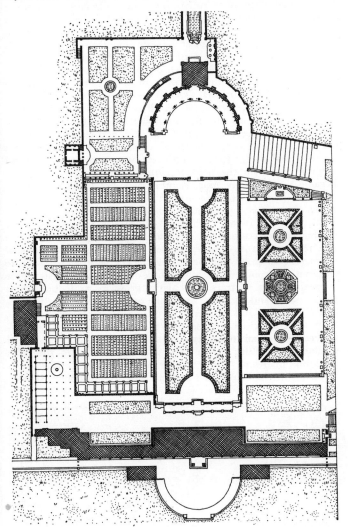

Rome, Villa Albani. Reconstruction of the plan, after an 18th-century engraving.

Water was another very important element; it had to be motionless, in vast expanses that reflected the changing lights of the sky, except for a few fountains where it gushed in short jets.

Le Nôtre's creations, from the gardens of Vaux (ca. 1655–61) to Versailles (FIG. 1098) and the Tuileries (PLS. 437, 438), constitute a series of masterpieces. In 1698 he was called to Turin to redesign the garden of the Royal Palace. Completed in 1700, the year of his death, this last creation of Le Nôtre's has, like Versailles, come down to us intact in its essential outlines.

From France, Le Nôtre's style soon spread to the rest of Europe. In Vienna, Schönbrunn Castle, begun by Fischer von Erlach in 1696 and finished by Paccassi in 1744, was surrounded by a vast and magnificent garden designed by Steckhoven and Von Hohenberg and laid out between 1753 and 1775. The design is based on the contraposition of two edifices, the castle and the Gloriette, separated by an enormous open space that

slopes gently upward toward the latter building, filled with a series of parterres, terraces, and stairways. The style of Le Nôtre (who had been dead for half a century) was subjected

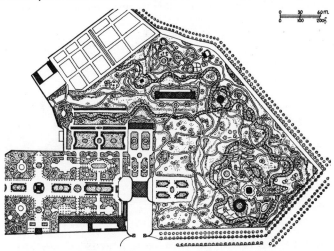

Versailles, France, English-Chinese garden of the Petit Trianon, plan (*from a project of C. Richard, 1774*).

to a good many modifications in Schönbrunn Castle, but it is still in evidence in the geometric layout of the parterres, in the relatively small number of trimmed shrubs, and in the great development of the arboreal frame that makes Schönbrunn more than a garden — rather an almost limitless park with a clearly defined transition from the luminous open spaces to the shadows of the forest. Schönbrunn represents a turning point in landscape architecture, not a single phenomenon; the stylistic change is complete and definitely established.

Decorative water works such as those of Vanvitelli's park of Caserta (PL. 441) constitute the main difference between the royal gardens of the Neapolitan Bourbons and of the Austrian Hapsburgs, which are contemporaneous. In Caserta there is also a close connection between natural elements (water, trees, lawns) and man-made elements (sculpture, hydraulics) — a fundamental characteristic of 18th-century landscape architecture.

A third type of 18th-century landscape architecture influenced by the French style is represented by the Villa Albani, on Via Salaria in Rome. The building was designed by C. Marchionni, who collaborated with A. Nelli in the plans for the garden. (PLS. 442, 445; FIG. 1097).

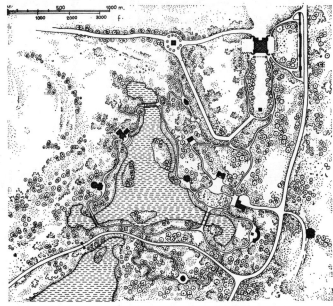

Wiltshire, England, Stourhead, plan of the garden (*from the project of F. M. Piper, 1779*).

In England, the French style met with little success, although Charles II commissioned Le Nôtre to design the gardens at Greenwich and St. James Park. A new style of landscape architecture had its origins in this country, devised by William

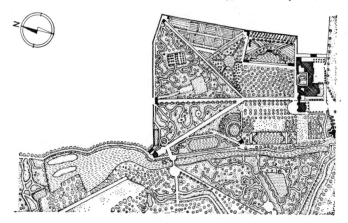

Chiswick, near London, plan of the garden in its 18th-century state.

Kent (q.v.) and inspired by the writings of Alexander Pope. The principles were codified by a school of "landscape gardeners" headed by Capability Brown, who created the English garden that was so typical of the 19th century (FIGS. 1C98, 1099). Essentially romantic in character, the English garden actually had origins that antedated the romantic movement, with which it was associated for almost half a century. By the last quarter of the 18th century the English garden had become a European phenomenon; a garden in this style was laid out by J. A. Graeffer in 1782 adjoining the park at Caserta, a stronghold of the baroque. Many new gardens were constructed in the English and neoclassic styles, and older gardens were adapted according to English dictates (PL. 444).

The basic tenet of English landscape architecture was a return to nature. But this was really an illusion, for never in the history of landscape architecture had gardens become so contrived, based on a spurious naturalism. Small lakes, temples, kiosks, and imitation ruins were hidden beneath the discreet shadows of great trees. The willow, because of its lonely and

melancholy character, was a universal favorite. Twisting walks crossed elaborately laid-out lawns that were veritable carpets of mown grass of an intense green. The romantic garden went far beyond its technical premises, but precisely because of this it achieved a dreamlike beauty and a picturesque scenery of muted colors, shadows, and silence.

Roberto CARITÀ

The 19th and 20th centuries. In Europe, the English reaction against the formal garden brought a new style of landscape architecture in its wake. Gardens were no longer laid out along rigid geometric lines; they became places where man could be brought back to a love of nature free and unfettered by artificial decorative rules. This new direction was, to a great extent, stimulated by the principles of Oriental landscape architecture found in China and Japan. In these two countries, with their age-old traditions and innate enjoyment of the beauties of nature, gardens were conceived as a reflection of natural beauty, on a small scale and necessarily stylized.

The new style rapidly spread from England to the European and American continents. It can be seen in the "romantic" parks and gardens where the dominant note is complete freedom in the use of all the traditional elements of landscape architecture. Trees, lawns, hedges, lakes, and waterfalls assume a casual and, to all appearances, unplanned aspect. The aim of the English landscape architects was to create a natural environment with the help of nature itself — a tendency that became progressively more complicated, especially during the romantic period. New decorative details typical of this period made their appearance more and more frequently; artificial ruins, pagodas in an "Oriental" style, classic temples, Neo-Gothic constructions, and tropical and exotic plants gave the late 18th- and 19th-century garden a picturesque and unusual character (PL. 445). Landscape architects attempted to re-create the free and spontaneous atmosphere of a tropical forest, where a great variety of trees and plants grow in wild abundance. Great parks and gardens were laid out also in the expanding cities. Planned and planted with the greatest care and artifice, they were designed to resemble tracts of rural landscape enhanced by human ingenuity but always suited to the original geological structure of the site, as may be seen in the Villa Torlonia in Rome and at Ashridge Park in Hertfordshire, England, the latter planned and laid out by Humphry Repton.

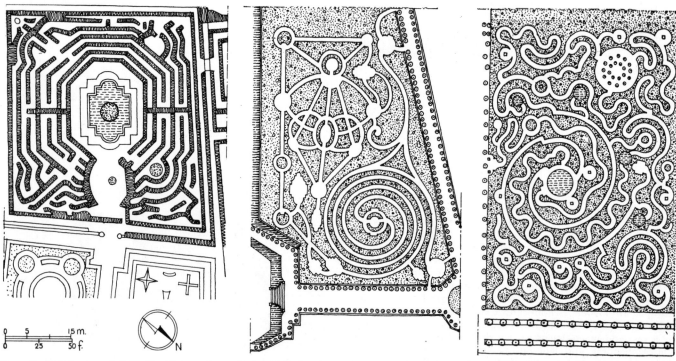

Plans of arboreal mazes. *Left*: Seville, Alcázar. *Center*: Project by F. Blondel for Choisy-le-Roi, France. *Right*: Project by Batty Langley (*from B. Langley, New Principles of Gardening, London, 1728*).

By the end of the 19th century, however, three factors had spelled the end of this form of landscape architecture: movement of the population into urban areas, uncontrolled expansion of the cities, and the growth of great industrial areas. More-

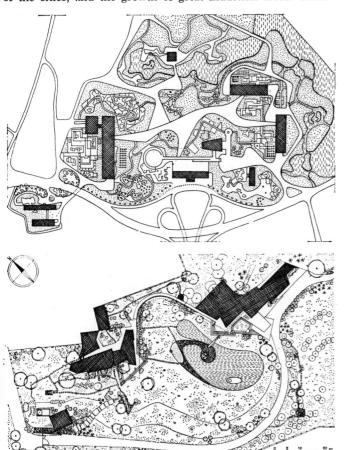

Contemporary gardens. *Above*: São Paolo, Brazil, plan for the Exposition garden (*from the project of R. Burle Marx, 1953?*). *Below*: Camaiore, near Lucca, Italy, garden of a private villa, plan by A. Mazzoni (*from Domus, no. 326, 1957*).

over, many areas of ancient gardens were sacrificed to satisfy the exigencies of a mechanized and industrial age. In some cases they became public gardens. Today the concept of the private garden as the natural complement to structural architecture has all but vanished; overcrowded cities encroach more and more upon the few remaining green zones within the city limits, and only new legislation can halt the slow but inexorable disappearance of these zones. Apart from public gardens, often the remains of former private properties, only a few airless spaces between the great cement buildings are left. In Europe — particularly England, Sweden, and Holland — a movement has arisen that would enable man to live once again in contact with nature in so-called "garden cities" on the peripheries of the great metropolises. In the attempt to resolve the problem of incorporating green zones within modern urban areas, a radical and significant change in the spatial concepts of modern urban architecture has led to a search for a new, balanced relationship between man-made buildings and their natural ambience. These trends can be seen in the rational architecture recently developed in Sweden, Norway, Denmark, and Holland where influences of Oriental landscape-architectural principles are evident in the attempted fusion of the green of the surrounding external space with the internal spaces of the edifice by means of open architectural forms directly related to their natural environment. Terraces, inner courtyards, flower beds, and pools are among the means employed to bring nature into the dwellings of man. This unity between architecture and landscaping has freed the latter from every trace of traditional formalism. Gone are the avenues, the hedges and en-

closures, fountains, statues, sculptural groups, and decorative constructions. An effect of natural wildness is created by pebbled walks, irregularly shaped pools evoking Oriental gardens, large aquatic plants, rocks, and exotic vegetation. Verandas and covered terraces open directly onto lawns, and trees and plants are surrounded by, and at times even inserted into, the buildings to emphasize the articulation and delimitation of the various areas and underline the spatial continuity inherent in modern architectural concepts. Among the most significant examples of this new style are the Savoye house at Poissy, designed by Le Corbusier; the apartment of Count Carlos de Beistegui on the Champs Elysées, Paris; and the garden of the UNESCO building in Paris, laid out by Isamu Noguchi.

In the past few years a new impulse in landscape architecture toward a style less apparently dependent on the architectural setting has come from R. Burle Marx (FIG. 1101; PL. 450), the chief exponent of the new tendencies. His work has aroused world-wide interest and drawn universal attention to the problems of modern landscape architecture. It is almost entirely confined to South America: Brazil (Hospital Sul America, Rio de Janeiro; Kronsfoth house, Teresopolis) and Venezuela (Parque del Este and Palacios house in Caracas). Burle Marx has achieved a very high degree of originality, particularly in the establishment of a chromatic relationship between the various zones of the garden. Somewhat influenced by Oriental concepts, especially in his use of isolated plants and the placement of stones, he has by careful selection and location of plants given new values to the various compositional elements of landscape architecture.

Marco CHIARINI

BIBLIOG. *The ancient Near East. a. Mesopotamia*: R. Koldewey, Das wieder erstehende Babylon, 3d ed., Leipzig, 1913, pp. 90–100; B. Meissner, Babylonien und Assyrien, I, Heidelberg, 1920, pp. 200–02; G. Contenau, La civilisation d'Assur et de Babylone, Paris, 1937; M. Rutten, Babylone, 2d ed., Paris, 1958, pp. 68–71. *b. Egypt*: F. Hartmann, L'agriculture dans l'ancienne Égypte, Paris, 1923, pp. 17–70; L. Keimer, Die Gardenpflanzen im alten Ägypten, 2 vols., Hamburg, Berlin, 1924. *c. Iran*: F. Sarre, Denkmäler persischer Baukunst, 7 parts in 3 vols., Berlin, 1901–10; A. U. Pope and P. Ackerman, Persian Gardens, SPA, II, 1939, pp. 1427–45.

The Greco-Roman world: O. Comes, Illustrazione delle piante rappresentate nei dipinti pompeiani, Naples, 1879, pp. 177–240; F. Marx, Das sogennante Stadium auf dem Palatin, JdI, X, 1895, pp. 129–43; O. E. Schmidt, Cicero's Villen, Neue Jahrbücher, III, 1899, pp. 328–55, 466–97; G. Lafaye, Hortus, DA, III, 1900, cols. 276–93; M. L. Gothein, Das griechische Garten, AM, XXXIV, 1909, pp. 103–44; L. Jacono, Osservazioni sui viridari pompeiani, Pompeii, 1910; Olck, Gartenbau, RE, VII, 1910, cols. 768–841; P. Rostovtsev, Die hellenistisch-römische Architekturlandschaft RM, XXVI, 1911, pp. 1–185; M. L. Gothein, Geschichte der Gartenkunst, 2 vols., Jena, 1914 (Eng. trans., L. Archer-Hind, 2 vols., New York, London, 1928); G. Luglio L'arte dei giardini presso i Romani, Assoc. Archeol. Rom., VIII, 1918, pp. 27–80; T. Ashby, The So-called Stadium of Domitian and the Caracalla Frigidarium, Arch. Rev., XLVI, 1919, pp. 79–81; F. Krischen, Das hellenistische Gymnasium von Priene, JdI, 1923–24, pp. 133–50; H. Tanser, The Villas of Pliny the Younger, New York, 1924; C. Picard, Dans les jardins du Héros Academos, Paris, 1934; A. Brock-Utne, Der Göttergarten, Oslo, 1935; M. Launey, Le verger d'Héraclès à Thasos, BCH, LXI, 1937, pp. 380–409; D. H. Thompson, The Garden of Hephaistos, Hesperia, VI, 1937, pp. 396–425; C. Picard, Jardins sacrés, RA, XII, 1938, pp. 245–47; C. Picard, Les prétendus "Jardins d'Héphaïstos" à Athènes, RA, XI, 1938, pp. 102–05; P. Grimal, Les jardins romains à la fin de la République et aux deux premiers siècles de l'Empire, Paris, 1943; A. Rutten and J. Lacam, Les jardins suspendus de Babylone, Rev. horticole, 1949, pp. 88–92, 123–27; M. A. Gabriel, Livia's Garden Room at Prima Porta, New York, 1953; P. Grimal, L'art des jardins, Paris, 1954; J. André, Lexique des termes de botanique en Latin, Paris, 1956.

The Orient. a. Islam: A. F. Calvert, The Alhambra, 2d ed., New York, London, 1907; R. Velázquez Bosco, Medina Azzahra y Alamiriya, Madrid, 1912; C. M. Villiers-Stuart, Gardens of the Great Mughals, London, 1913; D. N. Wilber, Persian Gardens and Garden Pavilions, Rutland, Vt., 1962. *b. Pre-Islamic India and southeast Asia*: O. Reuther, Indische Paläste und Wohnhäuser, Berlin, 1925; M. L. Gothein, Indische Gärten, Munich, 1926; R. Grousset, L'Inde, Paris, 1930; R. C. Kak, Ancient Monuments of Kashmir, London, 1933. *c. China*: R. Grousset, La Chine, Paris, 1930; Chi ch'êng, Yüan Yeh (On Gardens), mod. ed., Peking, 1933; Ch'ên Chin, Tsao yüan hsüeh kai lun (Profile of the Study of Garden Construction), Shanghai, 1935; H. Inn and Shao Chang Lu, Chinese Houses and Gardens, Honolulu, 1940; O. Sirén, Gardens of China, New York, 1949 (bibliog.). *d. Japan*: R. Grousset, Le Japon, Paris, 1931; M. Tatsin, Gardens of Japan, Tokyo, 1935; T. Tamura, Art of the Landscape Garden in Japan, Tokyo, 1936; J. Harada, Japanese Gardens, Boston, 1956; S. Newsom, A Thousand Years of Japanese Gardens, 3d ed., Tokyo, 1957; K. Shigemori, The Artistic Gardens of Japan, 3 vols., Tokyo, 1957; T. Yoshida, Gardens of Japan, New York, 1957.

Primitive and Pre-Columbian America: Garcilaso de la Vega, Primera parte de los Commentarios reales, II, Madrid, 1723 (Eng. trans., M. Jolas, New York, 1961); P. de Cieza de León, La Crónica del Perù, 2 vols., Madrid, 1862 (Eng. trans., H. de Onis, Norman, Okla., 1959); A. de Tapia, Relación sobra la conquista de México, Documentos para la historia de México (ed. J. García Icazbalceta), II, Mexico City, 1866, pp. 554-94; E. G. Squier, Peru: Incidents of Travel and Exploration in the Land of the Incas, New York, London, 1877; F. Alvarado Tezozomoc, Cronica méxicana, Mexico City, 1878; F. de Alva Ixtlilxochitl, Historia Chichimeca, Mexico City, 1892; H. L. Roth, Great Benin: Its Customs, Art and Horrors, Halifax, 1903; R. H. K. Marett, Archaeological Tours from Mexico City, New York, Oxford, 1933; B. Díaz del Castillo, Historia verdadera de la Conquista de la Nueva España, Mexico City, 1950 (Eng. trans., A. P. Maudslay, New York, 1956. J. Soustelle, La vie quotidienne des Aztèques à la veille de la conquête espagnole, Paris, 1955.

The West: The Middle Ages, Renaissance and baroque periods, 19th and 20th centuries: A. J. Dezallier d'Argenville, La théorie et la practique du iardinage, 4th ed., Paris, 1747 (2d Eng. ed. trans. by J. James, London, 1728); W. Chambers, Dissertation on Oriental Gardening, 2d ed., London, 1774; C. Watelet, Essai sur les jardins, Paris, 1774; H. Walpole, Essay on Modern Gardening, Strawberry Hill, 1785; J. C. Loudon, An Encyclopaedia of Gardening, London, 1822; G. W. Johnson, A History of English Gardening, London, 1829; J. C. A. Alphand, Les promenades de Paris, Paris, 1867-73; R. Blomfield and F. I. Thomas, The Formal Garden in England, 3d ed., London, 1901; H. I. Triggs, Formal Gardens in England and Scotland, London, 1902; F. Benoît, L'art des jardins, Paris, 1903; C. Holme, The Gardens of England, 2 vols., London, Paris, New York, 1907-11; C. Ranck, Geschichte der Gartenkunst, Leipzig, 1909; A. Grisebach, Der Garten, Leipzig, 1910; M. Fouquier, De l'art des jardins du XVᵉ au XXᵉ siècle, Paris, 1911; J. Cartwright, Italian Gardens of the Renaissance, London, 1914; A. Duchêne and M. Fouquier, Des divers styles des jardins, Paris, 1914; M. L. Gothein, Geschichte der Gartenkunst, 2 vols., Jena, 1914 (Eng. trans., L. Archer-Hind, 2 vols., New York, London, 1928); E. M. Phillips and A. T. Bolton, Gardens of Italy, London, 1919; H. D. Eberlein, Villas of Florence and Tuscany, Philadelphia, London, 1922; G. Gromort, Jardins d'Italie, 3 vols., Paris, 1922-31; L. Dami, Il giardino italiano, Milan, 1924; A. E. Brinckmann, Schöne Gärten, Villen und Schlösser aus fünf Jahrhunderten, Munich, 1925; P. Pean, Jardins de France, Paris, 1925; J. C. Shepherd and G. A. Jellicoe, Italian Gardens of the Renaissance, London, 1925; G. Gromort, Jardins d'Espagne, Paris, 1926; L. Einstein, The Tuscan Garden, London, 1927; A. and M. S. Byne, Spanish Gardens and Patios, Philadelphia, 1928; R. Standish Nichols, Italian Pleasure Gardens, New York, 1928; C. M. Villiers-Stuart, Spanish Gardens, London, 1929; G. Damerini, Giardini di Venezia, Bologna, 1931; U. Ojetti, Catalogo della Mostra del Giardino Italiano, Florence, 1931; E. Erdberg, Chinese Influence on European Garden Structures, Cambridge, Mass., 1936; L. Callari, Le ville di Roma, 2d ed., Rome, 1942; J. Tyrwhitt and B. Colvin, Trees from Town and Country, London, 1947; H. F. Clark, The English Landscape Garden, London, 1948; R. W. Kennedy, The Renaissance Painter's Garden, New York, 1948; C. Tunnard, Gardens in the Modern Landscape, London, 1948; E. de Ganay, Les jardins de France, Paris, 1949; G. Eckbo, Landscape for Living, New York, 1950; G. Hellinger, Der deutsche Garten, Munich, 1950; A. Seifert, Italienische Gärten, Munich, 1950; O. Sirén, China and the Gardens of Europe of the 18th Century, New York, 1950; P. O. Rave, Gärten der Barockzeit, Stuttgart, 1951; G. Sitwell, On the Making of Gardens, 2d ed., London, 1951; D. F. Iñiguez Almech, Casas reales y jardines de Felipe II, Madrid, 1952; E. Prieto-Moreno, Los jardines de Granada, Madrid, 1952; J. F. Watkins, Gardens of the Antilles, Gainesville, Fla., 1952; G. Gromort, L'art des jardins, 2d ed., Paris, 1953; B. Jones, Follies and Grottoes, London, 1953; H. Kreisel, Der Rokokogarten zu Veithöchsheim, Munich, 1953; G. Taylor, Old London Gardens, London, 1953; J. S. Ackerman, The Cortile del Belvedere, Vatican City, 1954; R. Cevese, Le ville vicentine, Treviso, 1954 (Eng. trans., J. Walters); J. A. and C. L. Grant, Garden Design Illustrated, Seattle, 1954; P. Grimal, L'arte des jardins, Paris, 1954; G. Mazzotti, Le ville venete, 3d ed., Treviso, 1954 (exhib. cat.); P. Shepheard, Modern Gardens, London, 1954; E. Baumann, Neue Gärten, Zürich, 1955 (Eng. trans., J. Hull); T. D. Church, Gardens Are for People, New York, 1955; A. Marie, Jardins français créés à la renaissance, Paris, 1955; F. E. Carl, Kleinarchitekturen in der deutschen Gartenkunst, Berlin, 1956; G. Eckbo, The Art of Home Landscaping, New York, 1956; F. Fariello, Arte dei giardini, Rome, 1956; C. Franck, Die Barockvillen in Frascati, Munich, 1956; D. Green, Gardener to Queen Anne: Henry Wise (1653-1738) and the Formal Garden, London, 1956; K. Hoffmann, Garten und Haus, 4th ed., Stuttgart, 1956; G. Gollwitzer, Kinderspielplätze, Munich, 1957; G. Lippold-Hälssig, Deutsche Gärten, Dresden, 1957; D. Stroud, Capability Brown, rev. ed., London, 1957: S. Crowe, Garden Design, London, 1958; G. Mazzotti, Palladian and Other Venetian Villas, Rome, 1958 (also Ital. ed.); O. Valentien, Mauern und Wege im Garten, Munich, 1958; G. Bascapè, Mostra storica dei giardini di Lombardia, Milan, 1959; L. Hautecœur, Les jardins des dieux et des hommes, Paris, 1959; D. R. Coffin, The Villa d'Este at Tivoli, Princeton, 1960; C. Fiorani, Giardini d'Italia, Rome, 1960; P. Porcinai, Roberto Burle Marx, pittore di giardini, Zodiac, VI, 1960, pp. 118-27; G. Masson, Italian Gardens, London, New York, 1961 (bibliog.); J. O. Simonds, Landscape Architecture, New York, 1961.

Illustrations: PLS. 423-450; 21 figs. in text.

PLATES

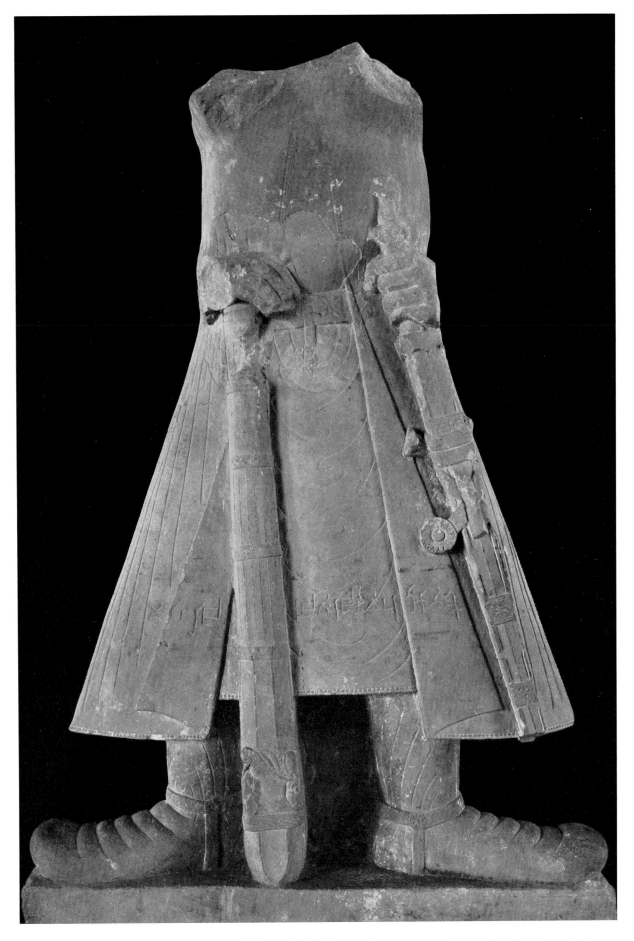

Pl. 1. The Kushan emperor Kaniṣka, from Mathura, India, 2d cent. Red sandstone, ht., 5 ft., 4 in. Mathura, Archaeological Museum.

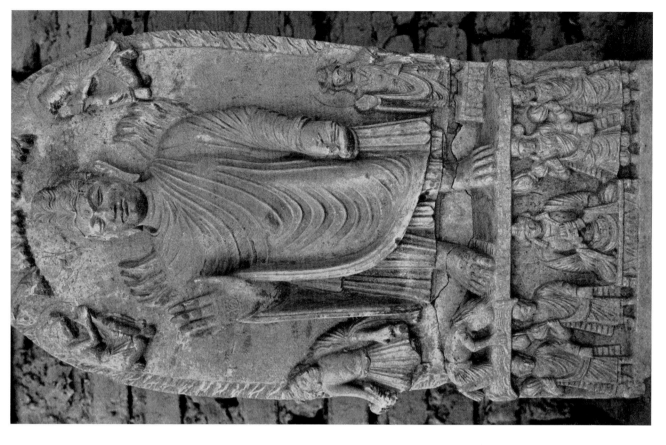

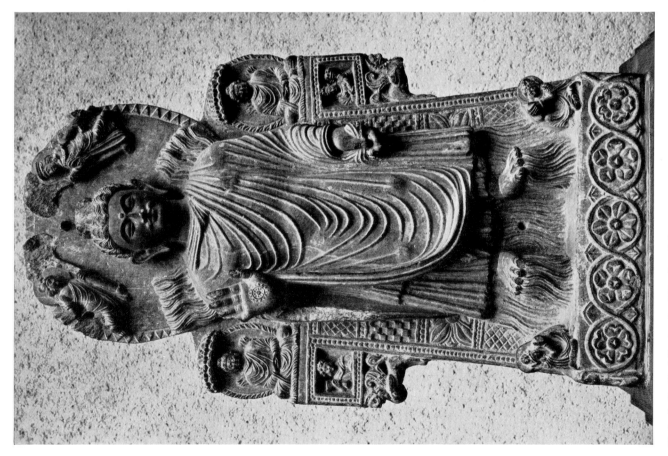

Pl. 2. *Left:* Buddha in the Miracle of Śrāvastī, from Paitava, Afghanistan, 3d cent. Stone. Paris, Musée Guimet. *Right:* Buddha Dīpaṅkara, from Shotorak, Afghanistan, 3d cent. Stone. Kabul, Afghanistan, Museum.

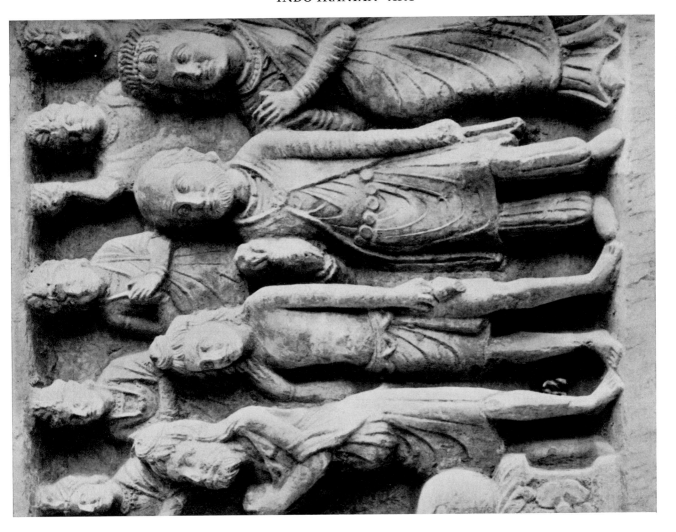

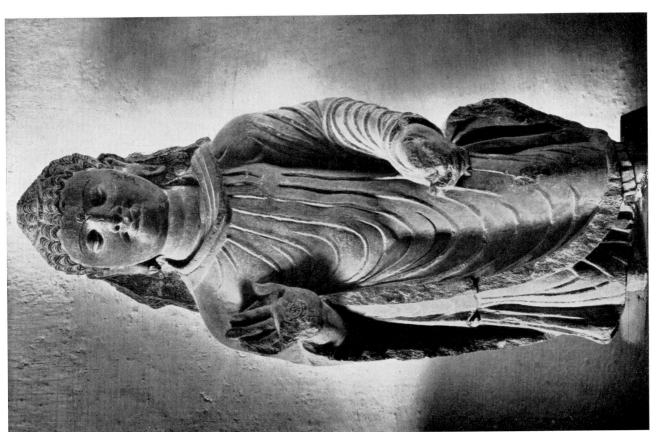

Pl. 3. *Left*: Standing Buddha, from Hadda, Afghanistan, 3d–4th cent. Stone. *Right*: Donors, detail, from Shotorak, Afghanistan, 3d–4th cent. Stone. Both, Kabul, Afghanistan, Museum.

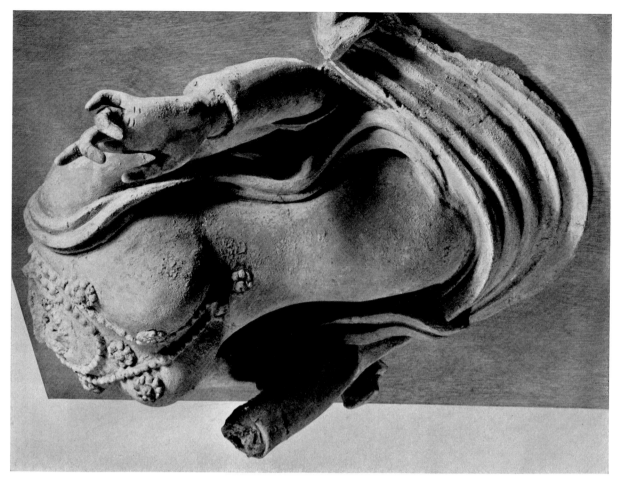

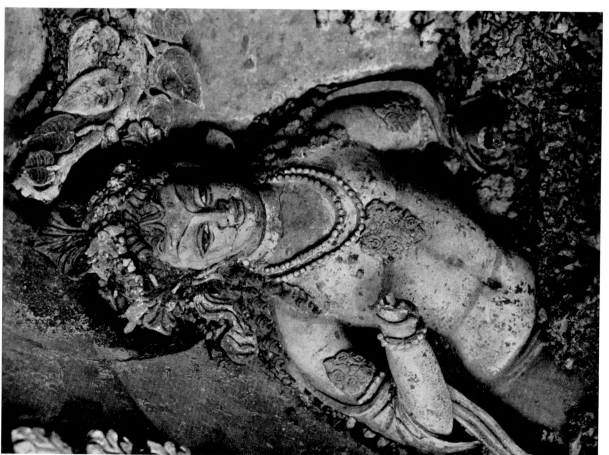

Pl. 4. Stucco figures, from Fondukistan, Afghanistan, 7th-8th cent. *Left*: A divinity. Kabul, Afghanistan, Museum. *Right*: Female torso. Paris, Musée Guimet.

Pl. 5. Winged figures, detail of wall painting, from Hadda, Afghanistan, 3d–5th cent. (?). Paris, Musée Guimet.

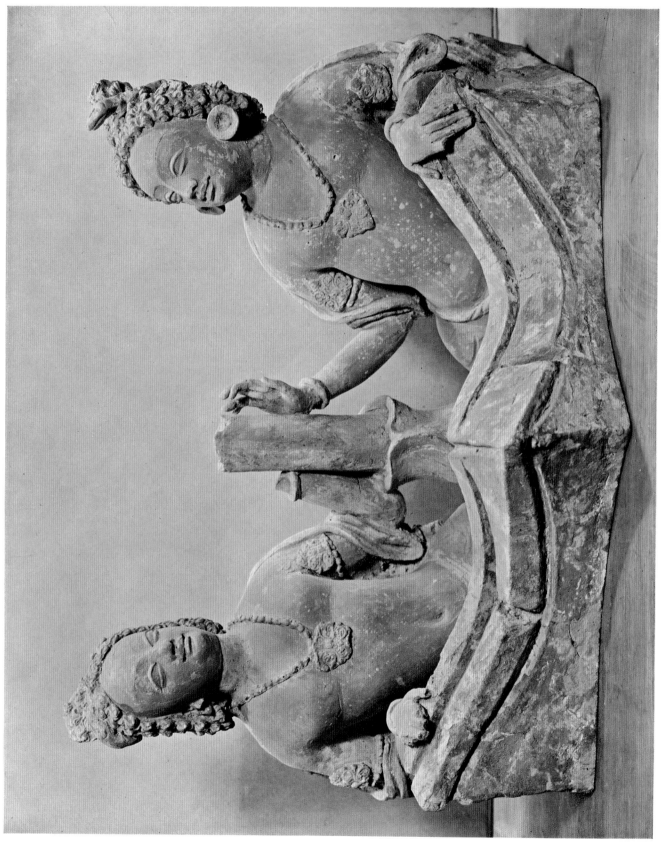

Pl. 6. Two Nāga kings, from Fondukistan, Afghanistan, early 7th cent. Stucco. Paris, Musée Guimet.

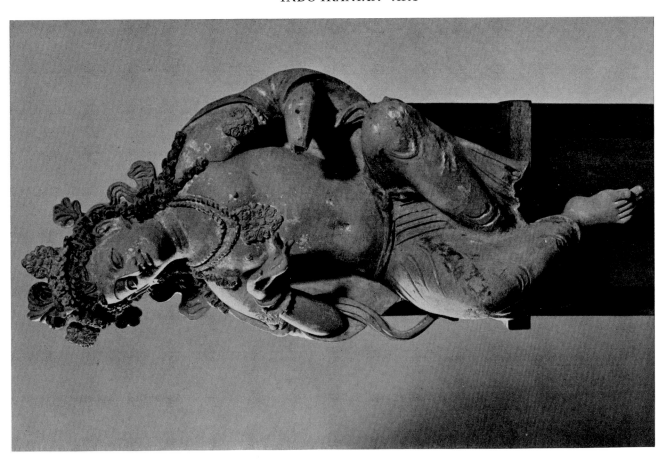

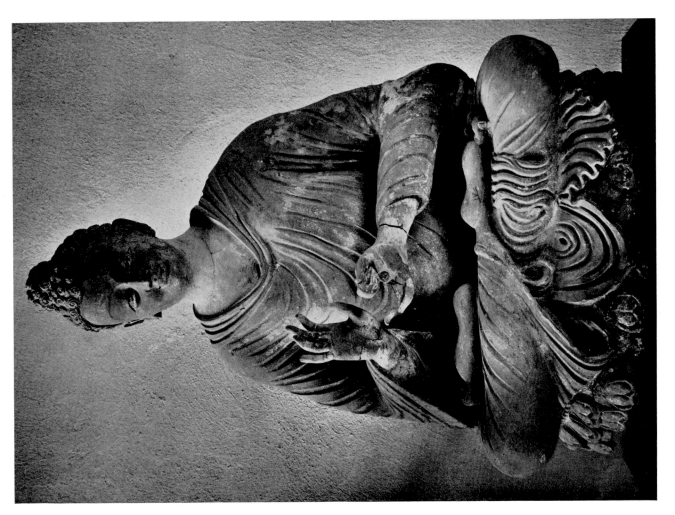

Pl. 7. Stucco figures, from Fondukistan, Afghanistan, 7th–8th cent. *Left*: Seated Buddha. Kabul, Afghanistan, Museum. *Right*: Bodhisattva. Paris, Musée Guimet.

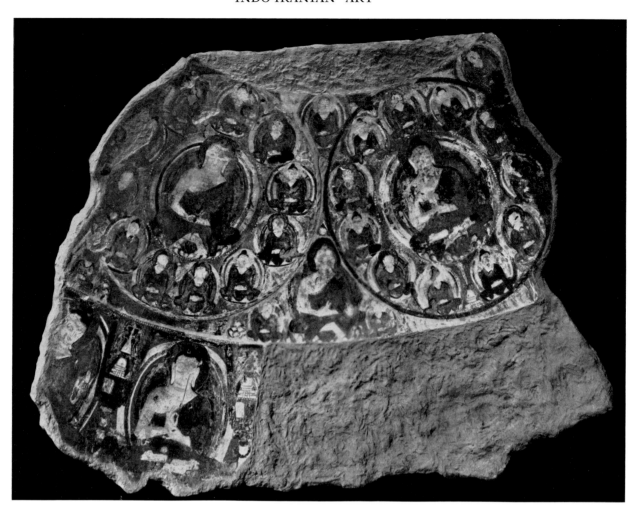

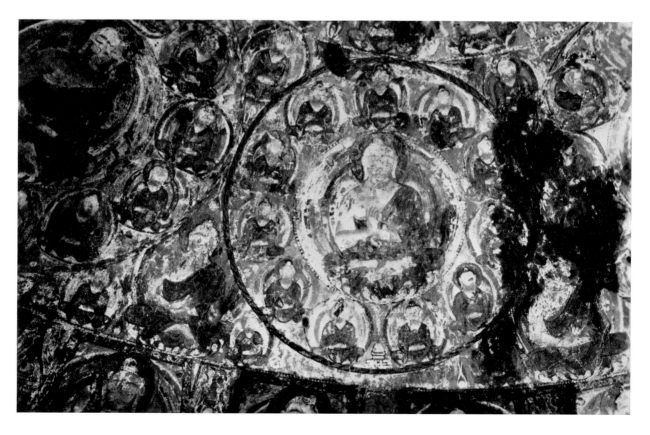

Pl. 8. Kakrak, near Bamian, Afghanistan, fragment and detail of sanctuary dome, ca. 6th cent.

Pl. 9. Ceiling decoration, fragment, from Bamian, Afghanistan, ca. 6th cent. Terra cotta. Paris, Musée Guimet.

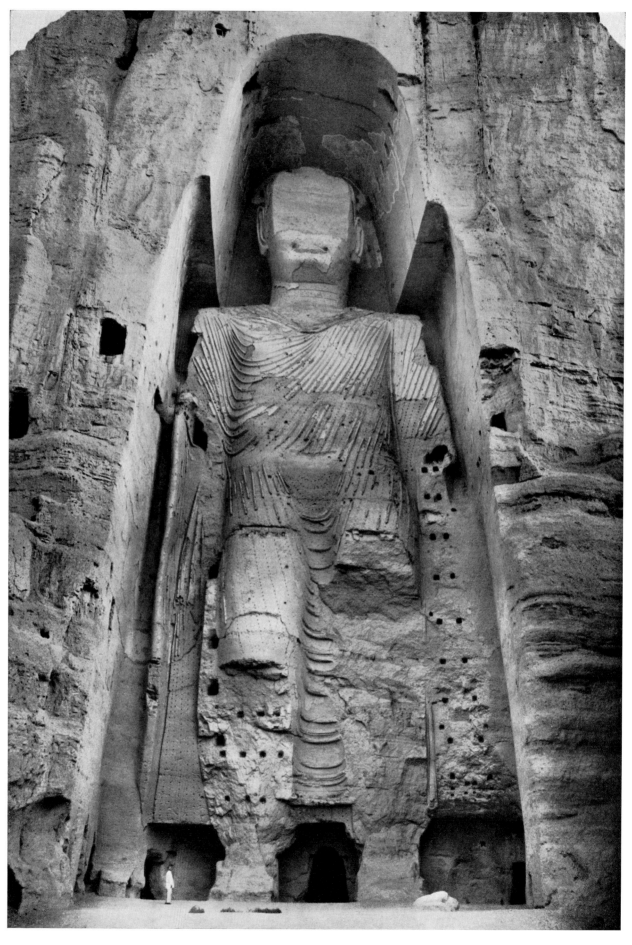

Pl. 10. Bamian, Afghanistan, colossal Buddha, 6th–7th cent. Ht., 175 ft.

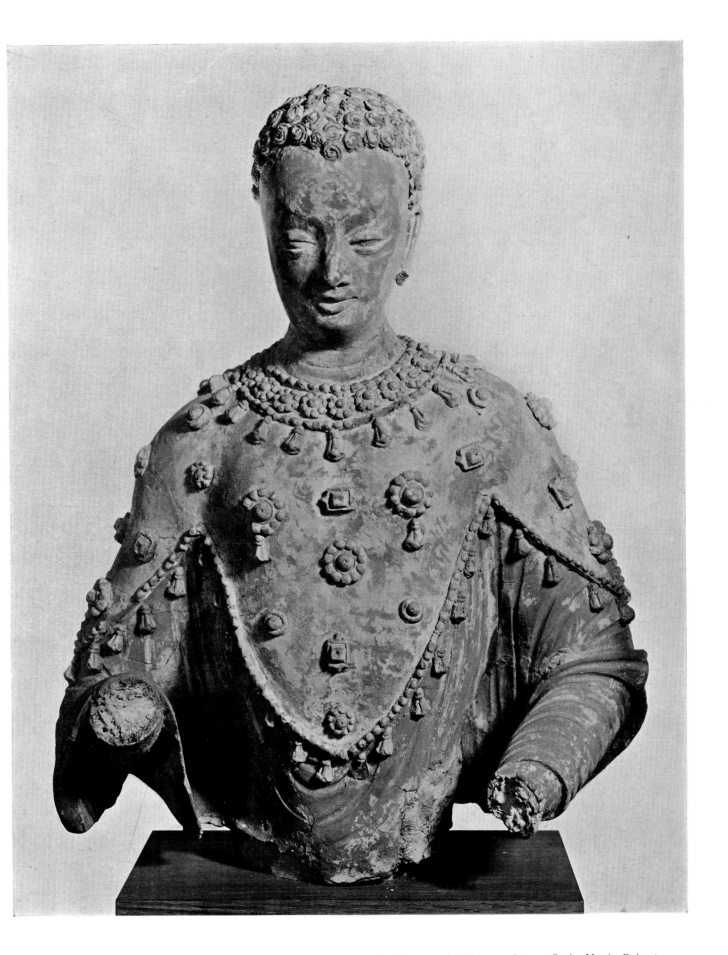

Pl. 11 Fragmentary figure of Buddha adorned, from Fondukistan, Afghanistan, early 7th cent. Stucco. Paris, Musée Guimet.

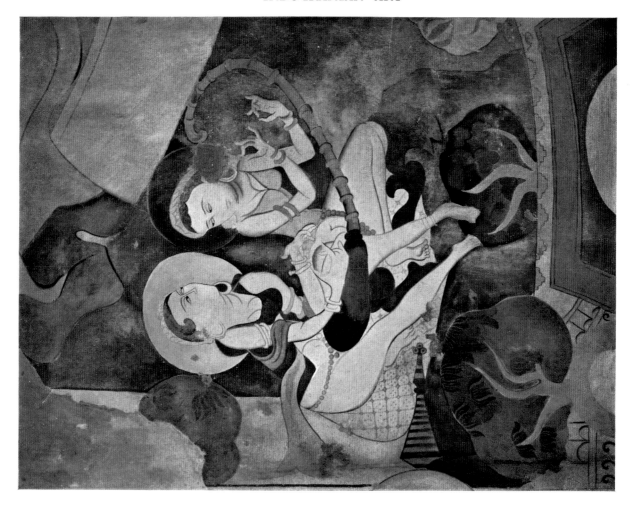

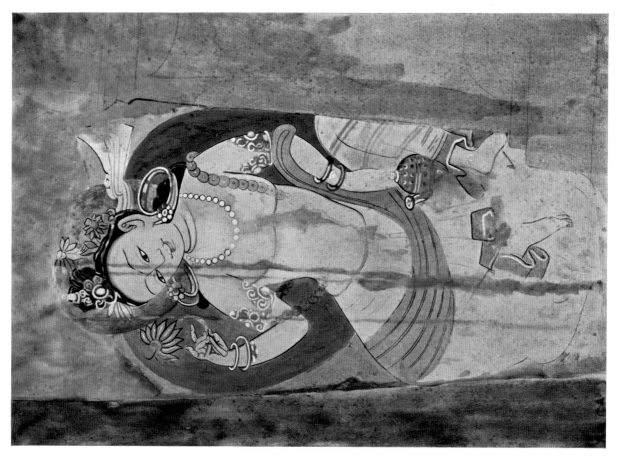

Pl. 12. Wall paintings, Bamian, Afghanistan, 6th–7th cent. (From water-color copies in Paris, Musée Guimet.) *Left*: Avalokiteśvara. *Right*: Musicians.

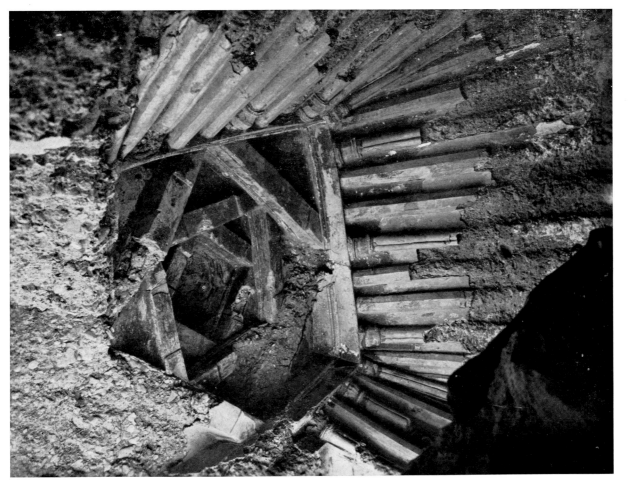

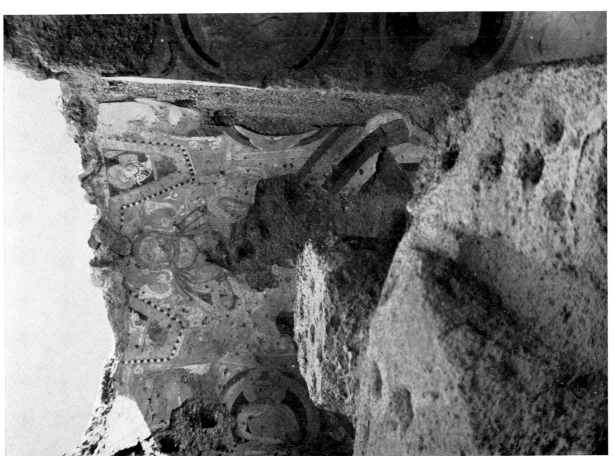

Pl. 13. Bamian, Afghanistan, 6th–7th cent. *Left*: Group E, bodhisattva in Iranian style. Wall painting. *Right*: Cave XV, detail of ceiling.

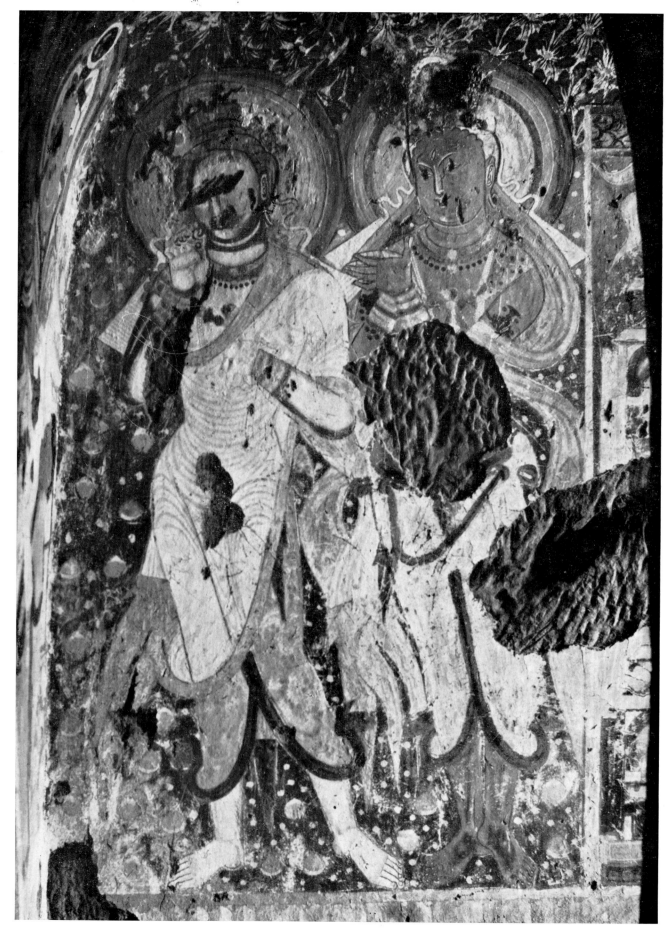

Pl. 14. Buddhist figures, Kizil, China, ca. 6th cent. Wall painting.

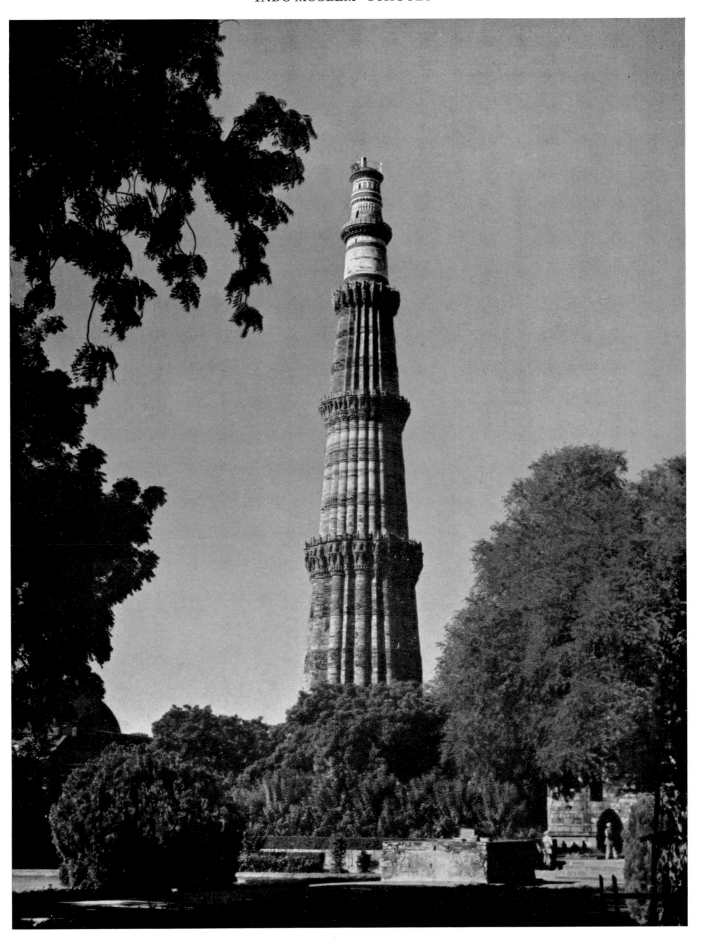

Pl. 15. Delhi, the Quṭb Minār, begun 1199, two upper stories rebuilt at later date. (Cf. PL. 164.)

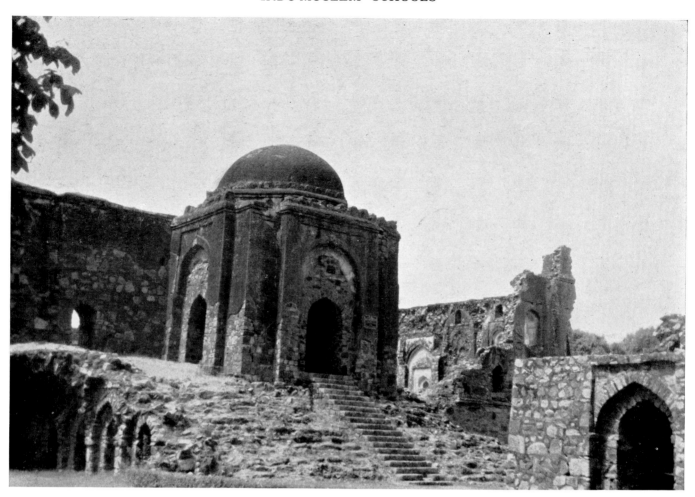

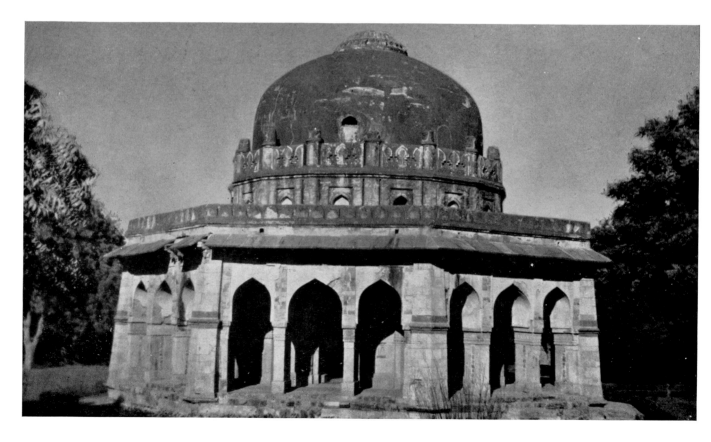

Pl. 16. Delhi. *Above*: Mosque of the Kotila-i Fīrūz Shah, 1354. *Below*: Mausoleum of Sultan Sikandar Lōdī, died 1517.

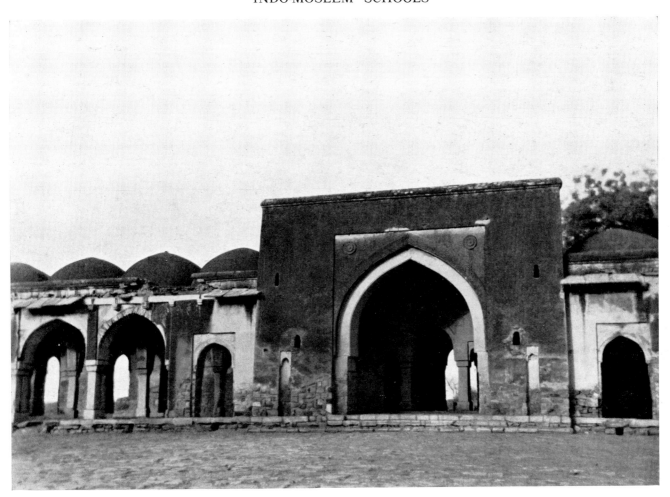

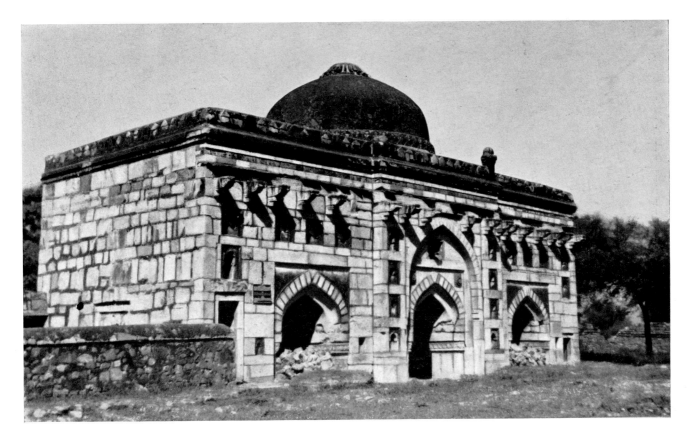

Pl. 17. Delhi. *Above*: Begampur Mosque, built by Khan Jahān, entrance, second half of 14th cent. *Below*: Siri, Muḥammadī Mosque, first half of 15th cent.

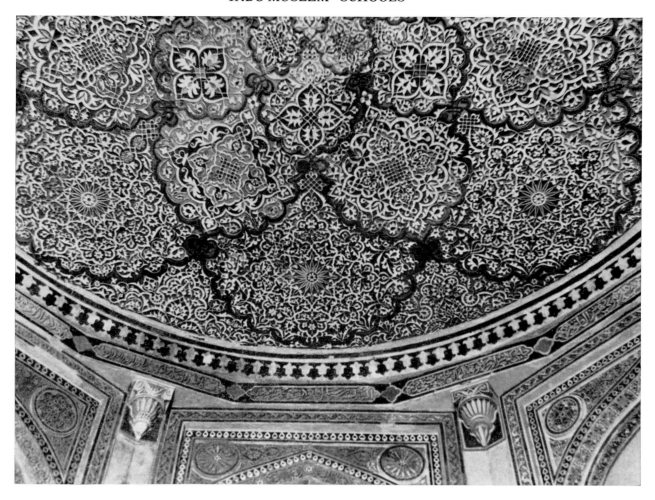

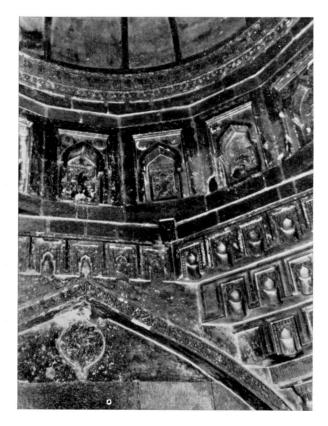

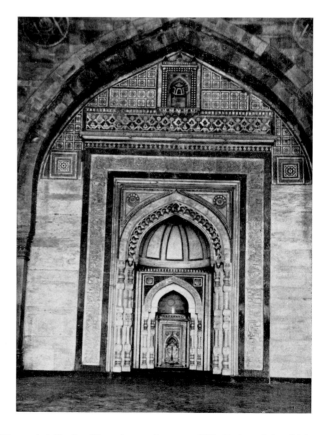

Pl. 18. Delhi. *Above*: Mahrauli, Mausoleum of Maulānā Jamāl Khan, detail of ceiling decoration, ca. 1530. *Below, left*: Siri, Mōth-kā Masjid, interior, detail of central dome, 1489. *Right*: Purana Qila, Qila-i Kohna Masjid, the main mihrab, 16th cent.

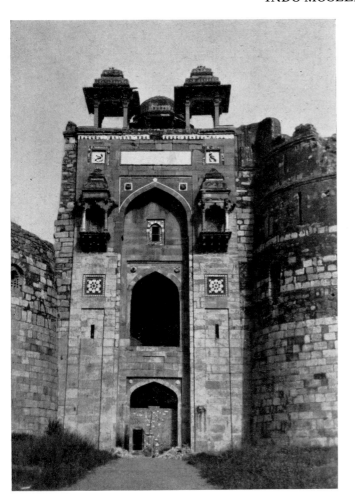
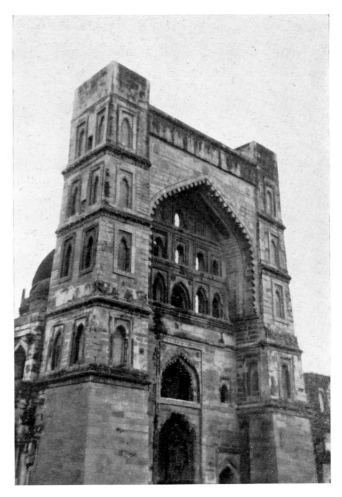
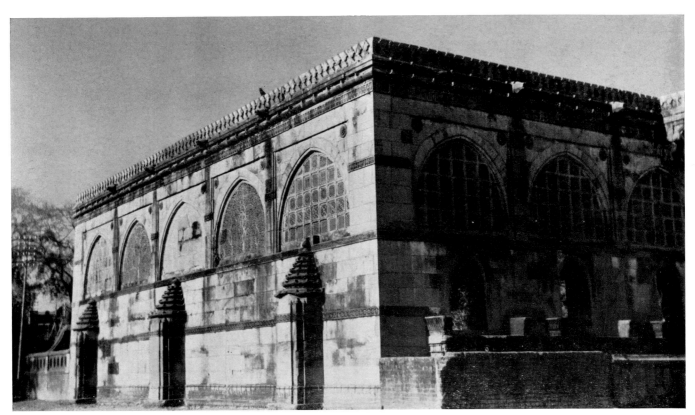

Pl. 19. *Above, left*: Delhi, Purana Qila, north gate, 1540. *Right*: Jaunpur, Uttar Pradesh, the Ātala Masjid, 1376–1408. *Below*: Ahmadabad, Gujerat, Mosque of Sīdī Sayyid, 1572.

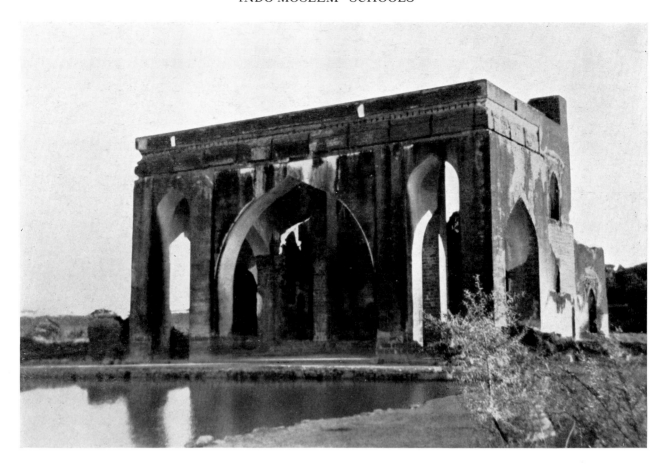

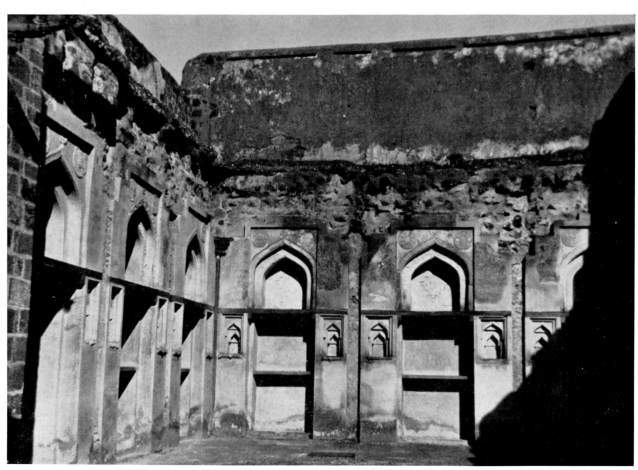

Pl. 20. *Above*: Torwa (Nauraspur), near Bijapur, Mysore, the Sangīt Mahal, 1610. *Below*: Daulatabad, Andhra Pradesh, the Fort, hall in the residence of the Niẓāmshāhs, first half of 17th cent.

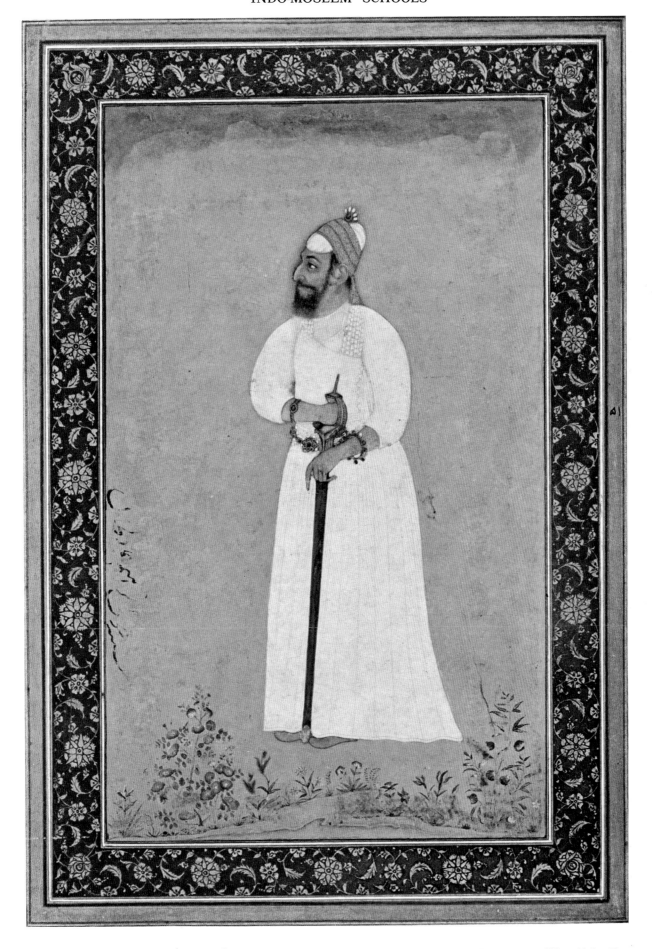

Pl. 21. Hāshim, portrait of Ibrāhīm ʿĀdilshāh II, first half of 17th cent. Color and gold on paper; 15⁵/₁₆×10 in. New
York, Metropolitan Museum.

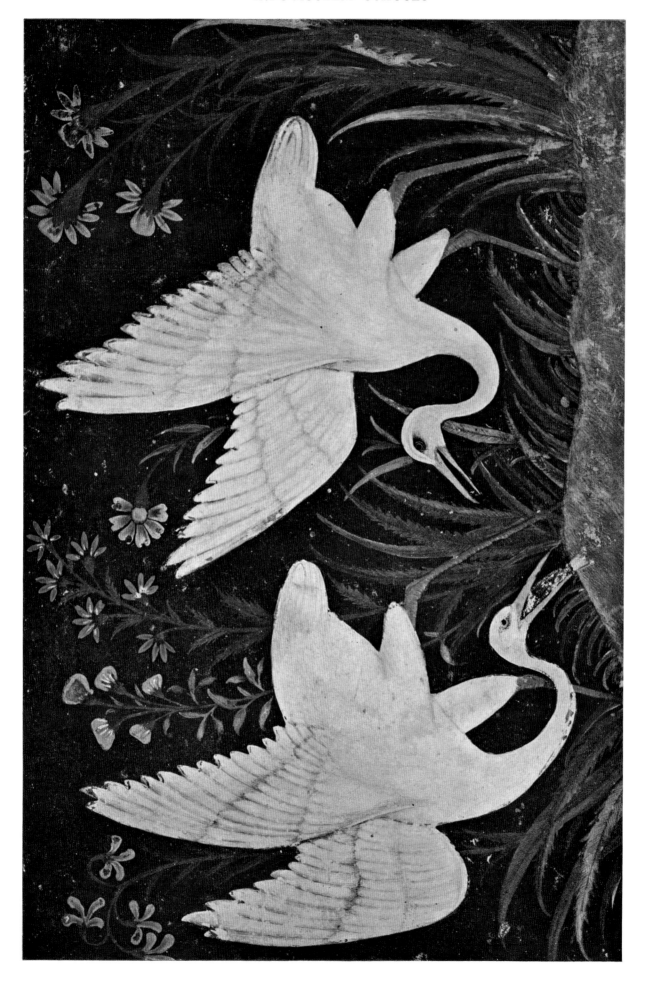

Pl. 22. Two cranes at the edge of a pond, Deccan school, early 17th cent. Gouache and water color on paper; $4^7/_8 \times 7^1/_4$ in. Paris, Musée Guimet.

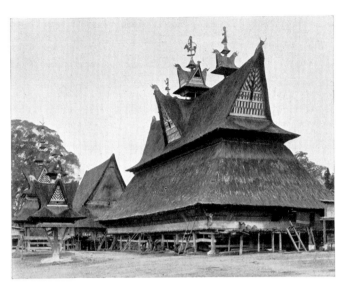

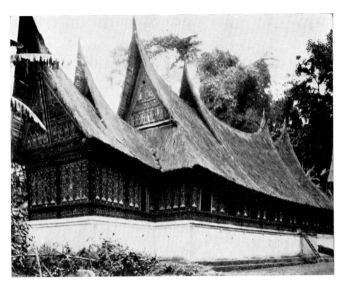

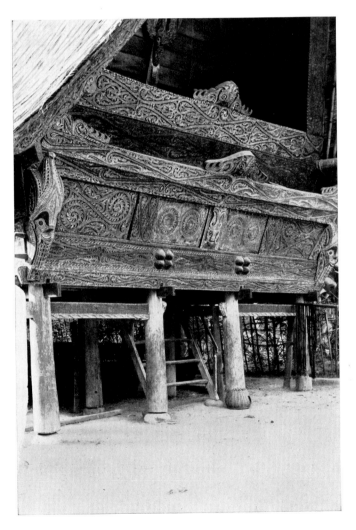

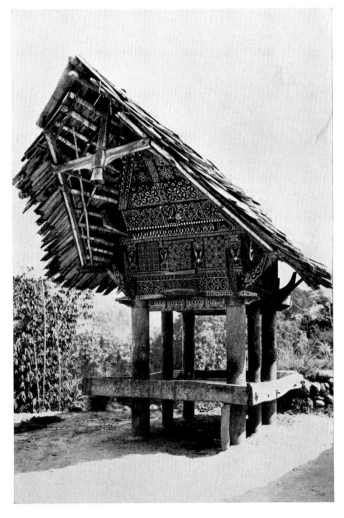

Pl. 23. *Above, left*: Karo Batak dwelling near Kabau Djahe, Sumatra. *Right*: Menangkabau dwelling, Sumatra, west coast. *Below, left*: Carved wooden façade of Toba Batak dwelling, Sumatra. *Right*: Rice shed, Saadang Toradja group, central-western Celebes.

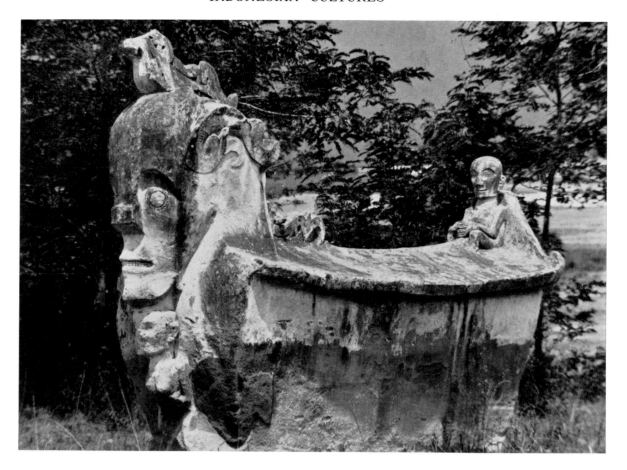

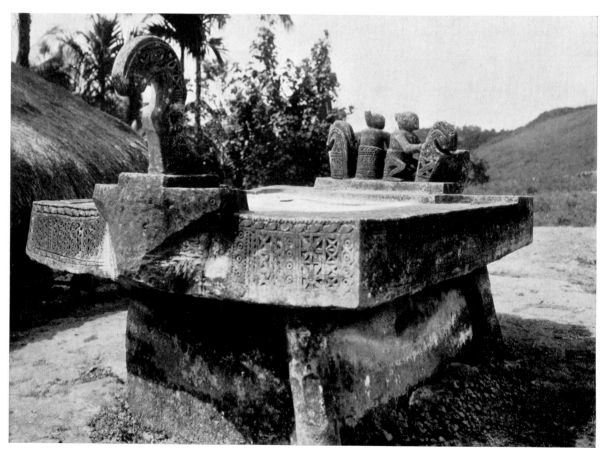

Pl. 24. *Above*: Toba Batak sculptured sarcophagus, Tapanuli, Sumatra. Stone. *Below*: Sarcophagus in the form of a buffalo (back view), Tabelara, Sumba. Stone.

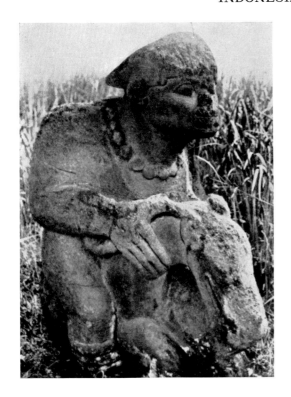

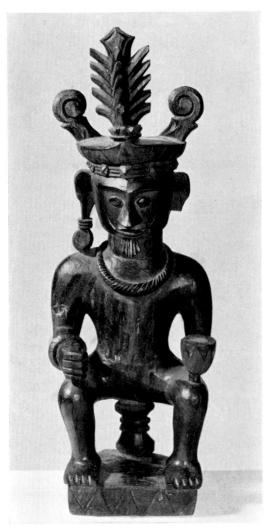

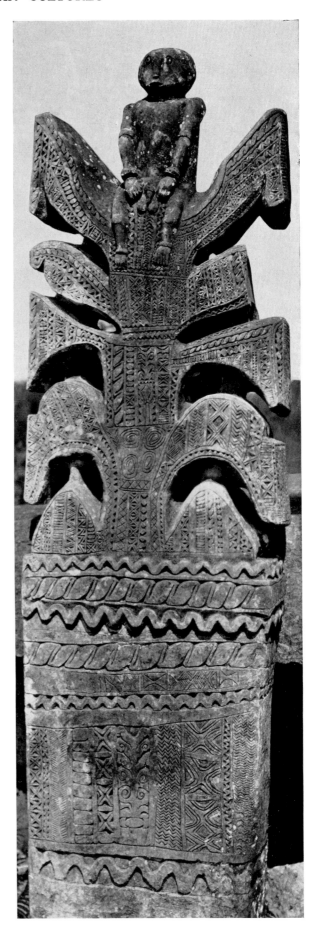

Pl. 25. *Left, above*: Man riding a buffalo, Pasemah plateau, Sumatra. Stone. *Below*: Ancestor figure, from Nias. Wood. Amsterdam, Koninklijk Instituut voor de Tropen. *Right*: Tombstone, Sumba.

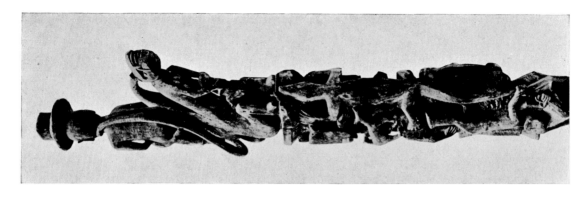

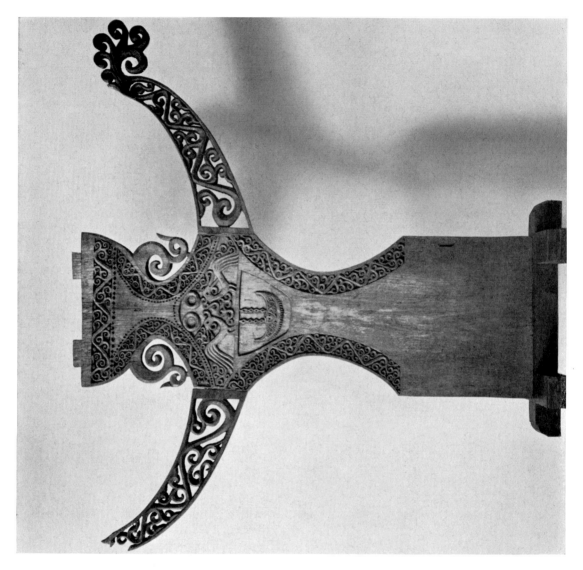

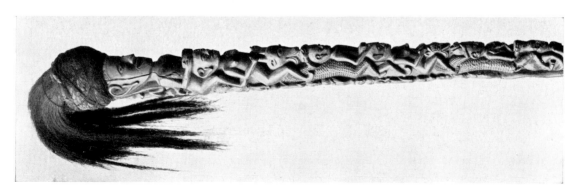

Pl. 26. *Left*: Toba Batak priest's staff, Sumatra. Wood. *Center*: Carved element from above an ancestor altar, from Tanimbar Islands, Malay Archipelago. Wood. Both, Amsterdam, Koninklijk Instituut voor de Tropen. *Right*: Commemorative monument for the dead, Ngadju group, Borneo. Wood. Djakarta, Museum.

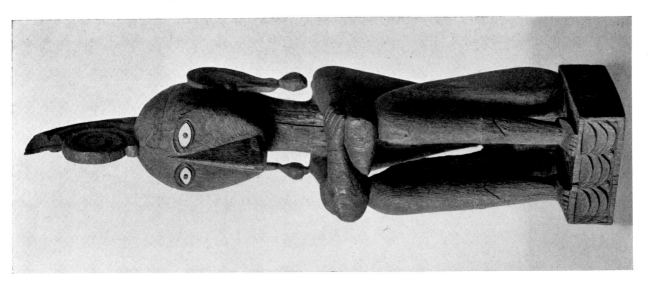

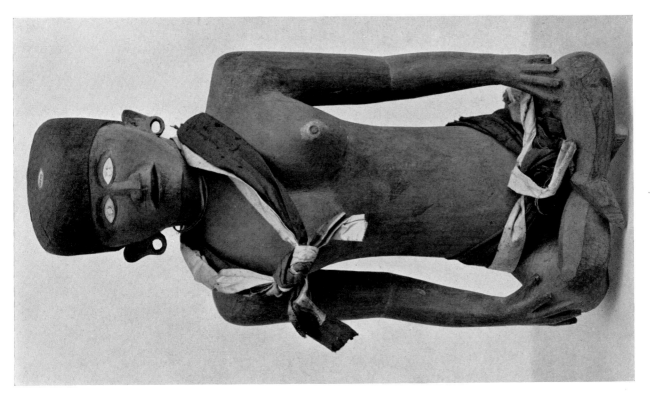

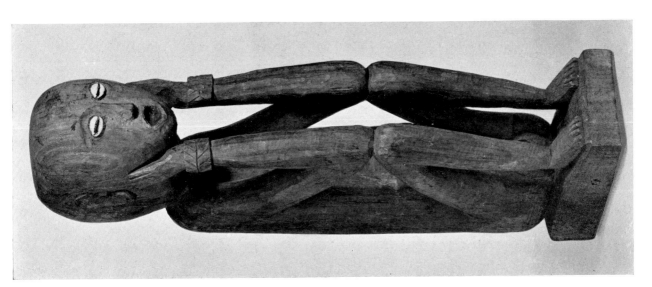

Pl. 27. *Left*: Ancestor figure, from northern Luzon, Philippine Islands. Wood. Florence, Museo Nazionale di Antropologia e Etnologia. *Center*: Female figure, from Nicobar Islands. Wood. Leiden, Rijksmuseum voor Volkenkunde. *Right*: Ancestor figure, from Leti, Moluccas. Wood. Amsterdam, Koninklijk Instituut voor de Tropen.

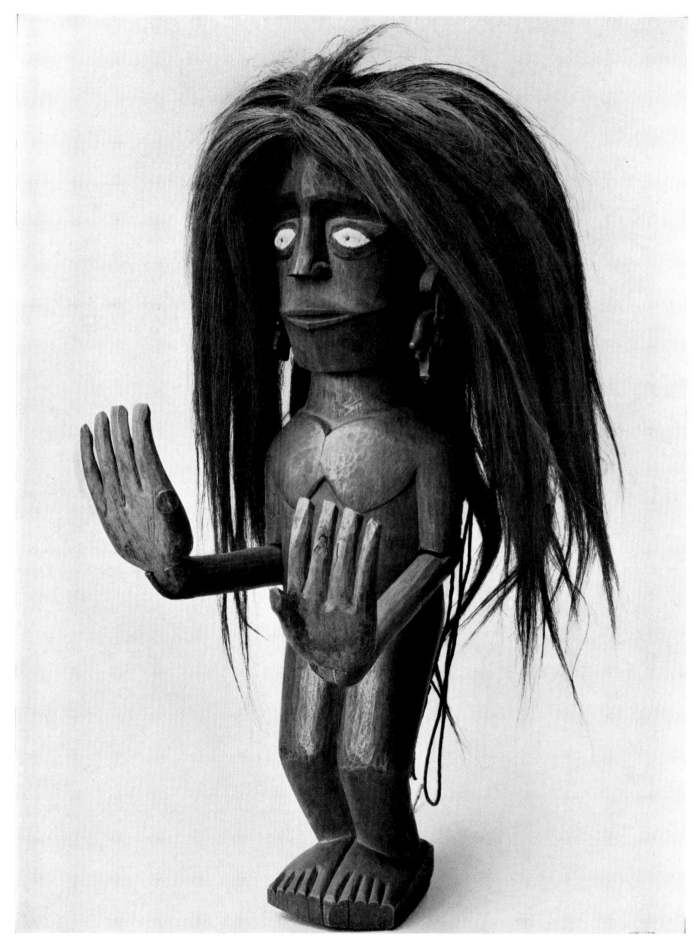

Pl. 28. Ancestor figure, Batak group, Sumatra. Wood. Copenhagen, Nationalmuseet.

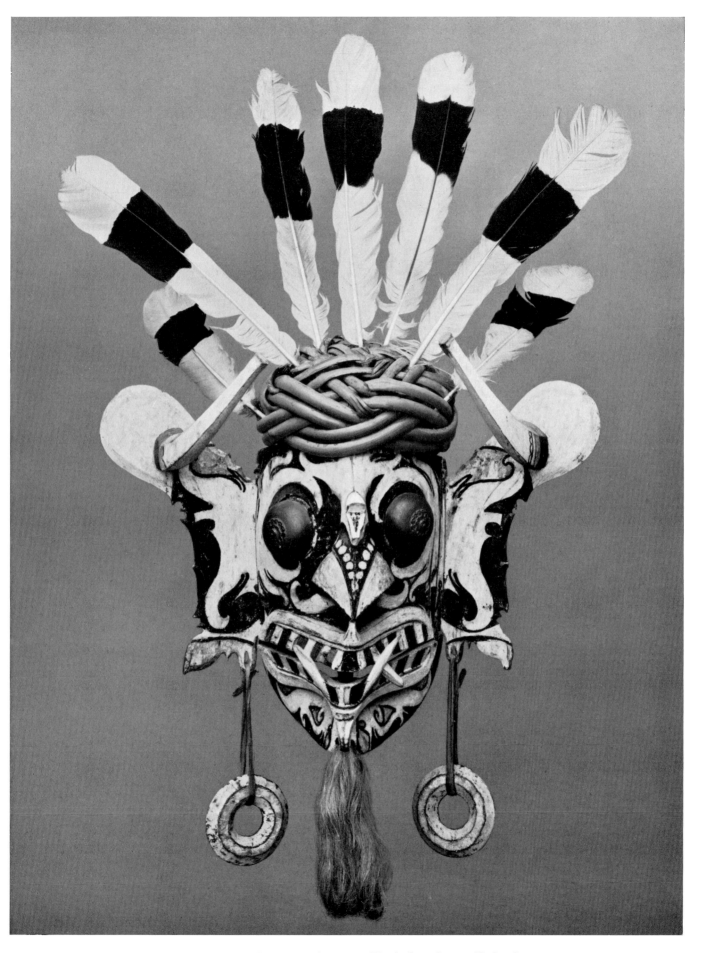

Pl. 29. Painted mask with feather appendages, from central Borneo. Wood. Copenhagen, Nationalmuseet.

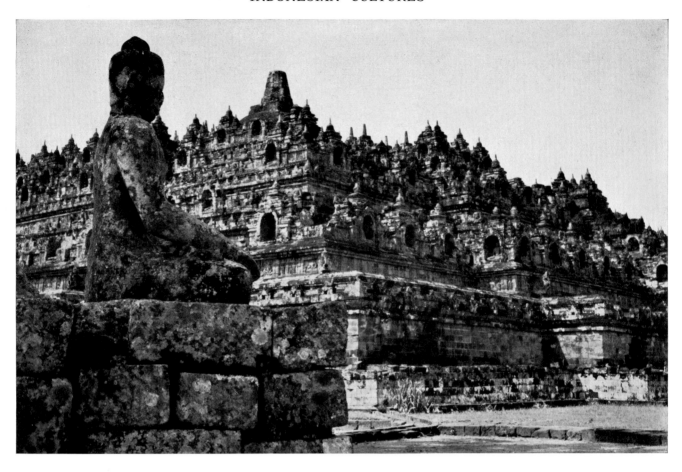

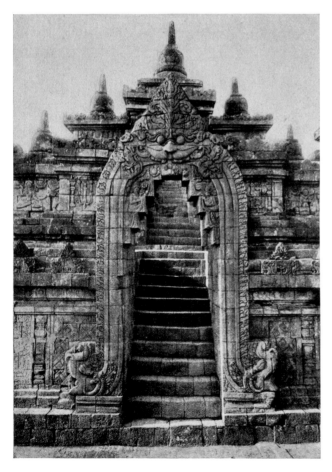

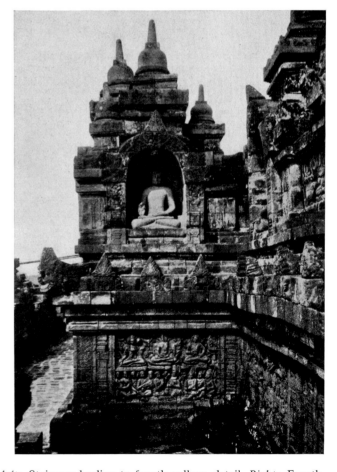

Pl. 30. Borobudur, Java, 8th cent. *Above*: Partial view. *Below, left*: Staircase leading to fourth gallery, detail. *Right*: Fourth gallery, detail showing Buddha Amoghasiddhi and reliefs of the Samantabhadra.

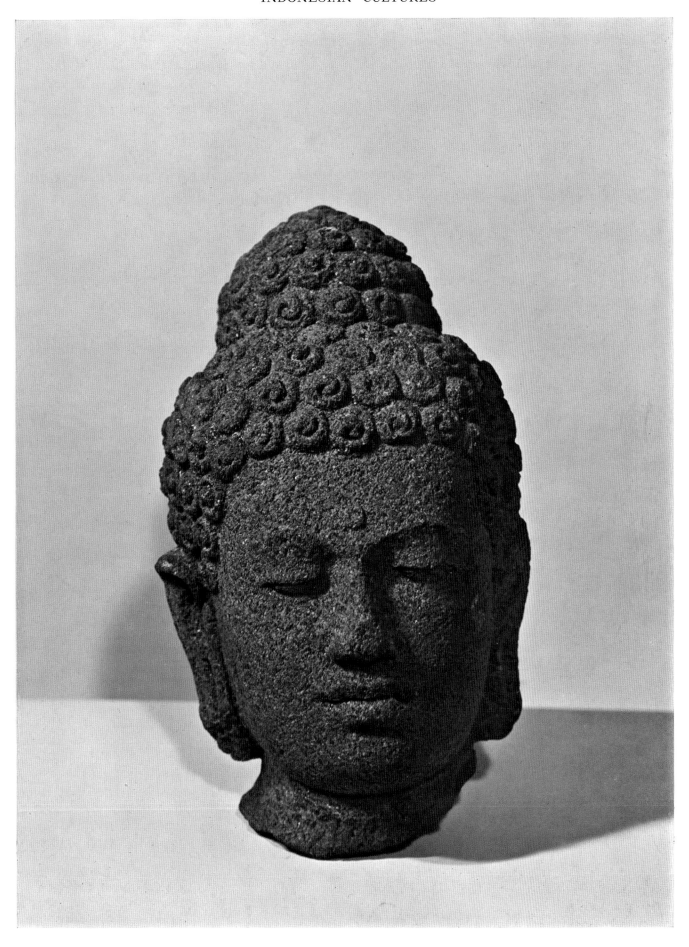

Pl. 31. Head of the Buddha, from Java, 8th–9th cent. Stone. Leiden, Rijksmuseum voor Volkenkunde.

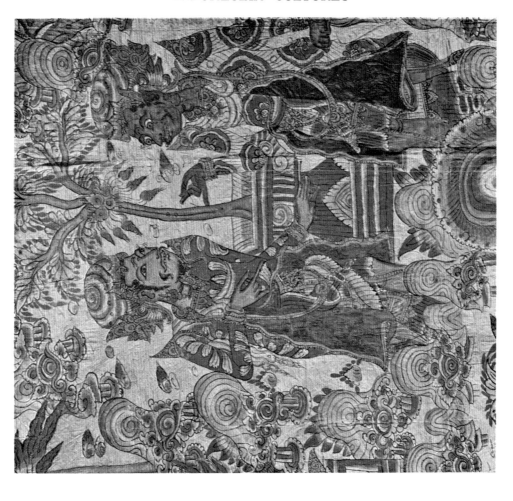

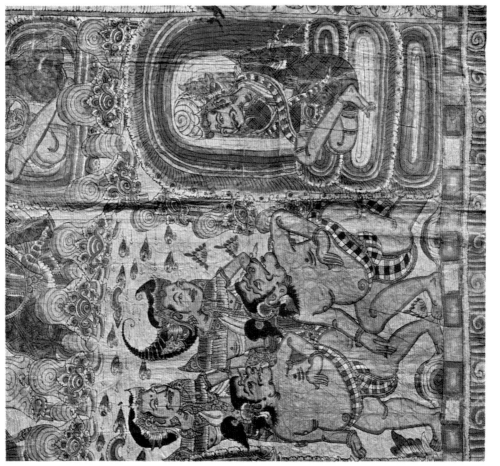

Pl. 32. King Pariksit meeting the hermit Chagawān Samīti, two details, from Bali. Painting on bark cloth. Amsterdam, Koninklijk Instituut voor de Tropen (Inv. 809/161).

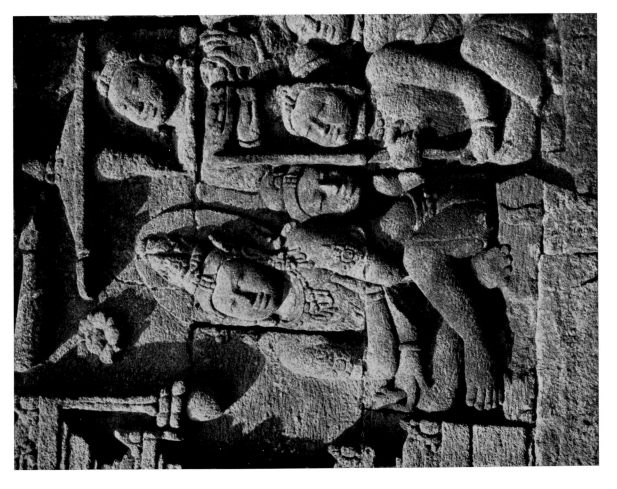

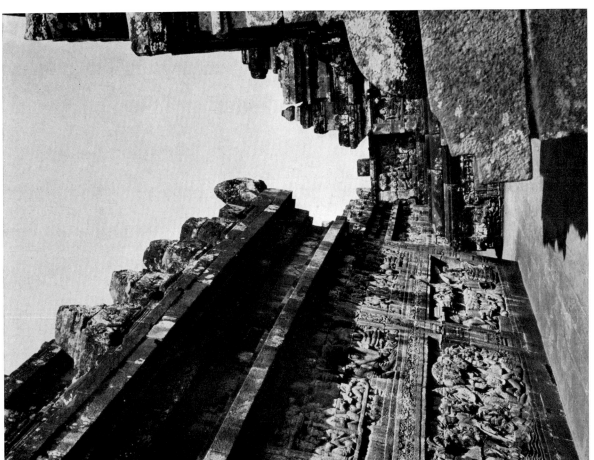

Pl. 33. Borobudur, Java, 8th cent. *Left*: First gallery, detail. *Right*: Detail of relief series showing scenes from the life of the Buddha.

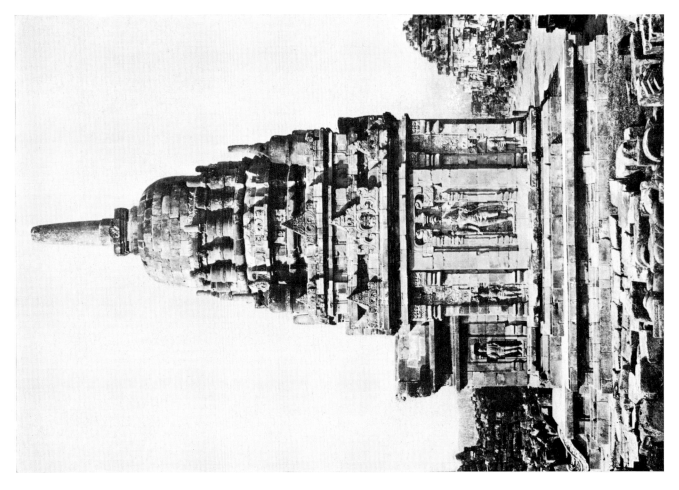

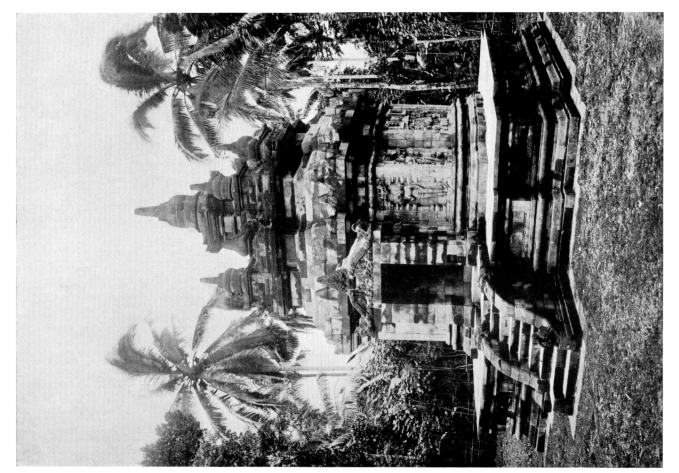

Pl. 34. *Left*: Candi Pawon, Kedu plain, Java, 8th–9th cent. *Right*: Candi Sewu, Prambanam plain, Java, one of the shrines, 9th cent.

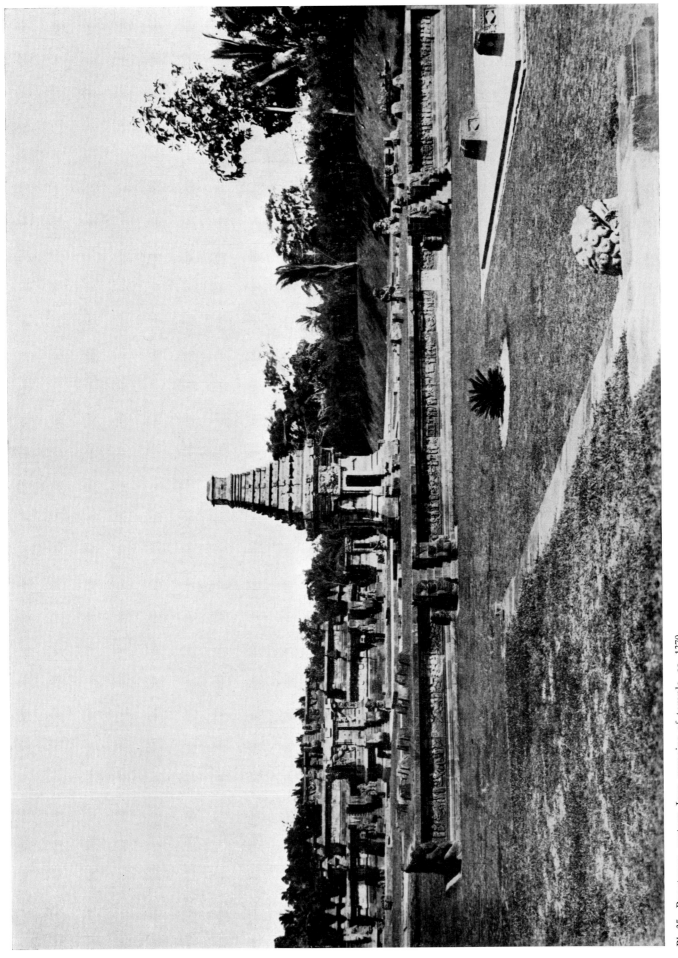

Pl. 35. Panataran, eastern Java, remains of temple, ca. 1370.

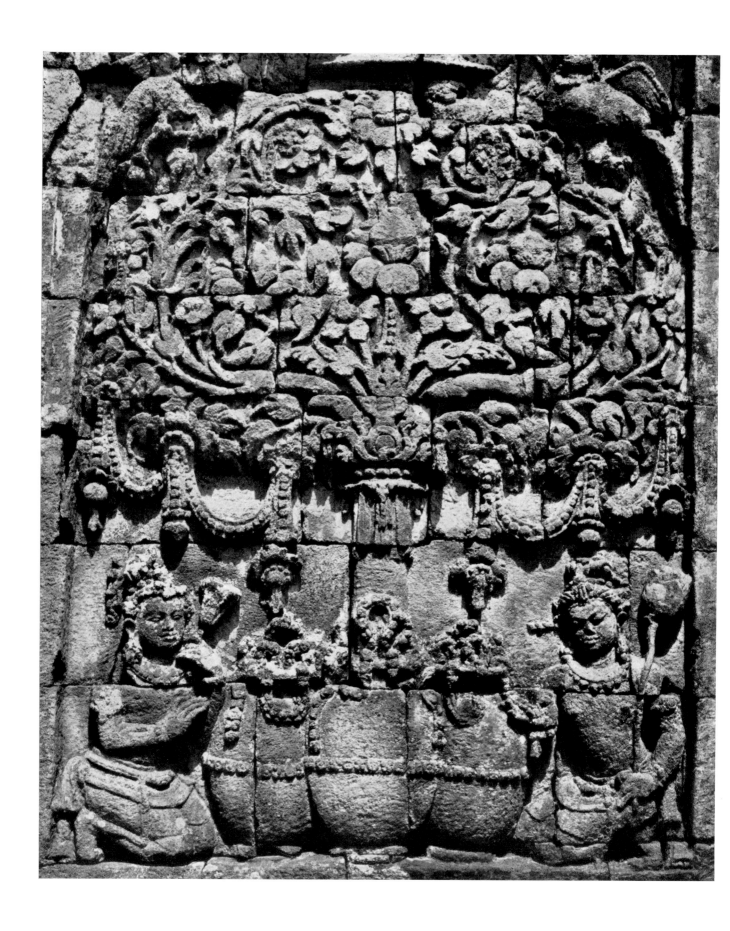

Pl. 36. Borobudur, Java, detail of the decoration, 8th cent.

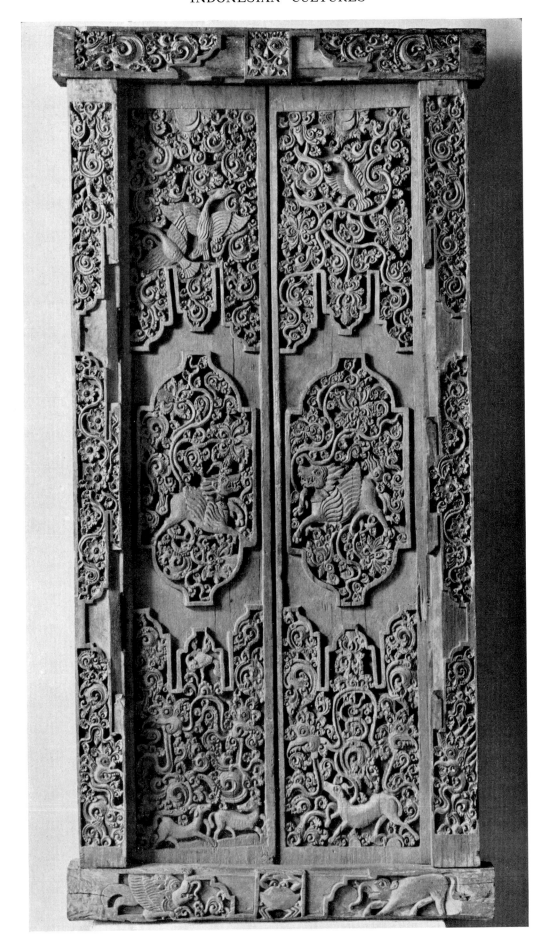

Pl. 37. Carved door of a royal palace, from Bali. Wood. Munich, Museum für Völkerkunde.

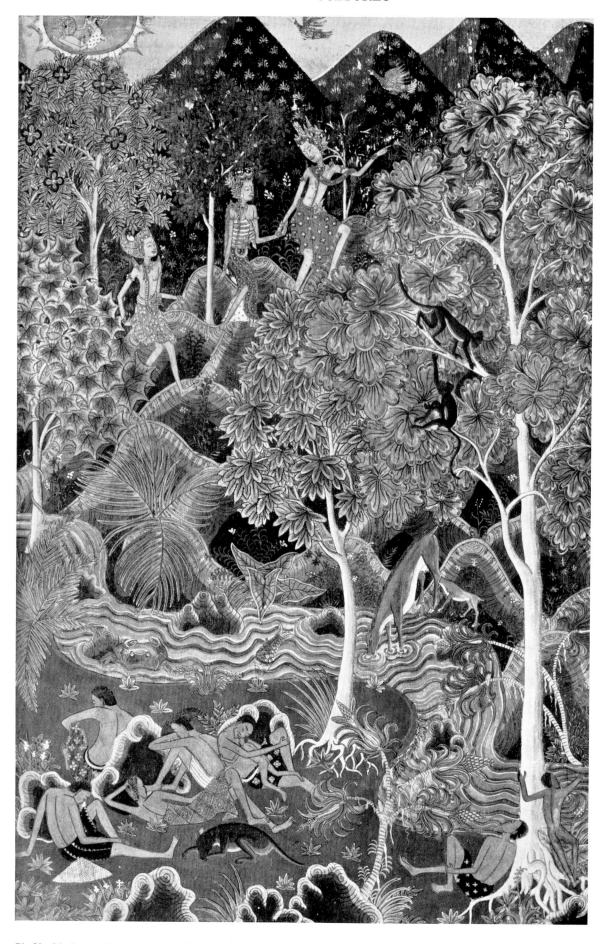

Pl. 38. Modern painting representing Rāma, Sītā, and Lakṣmaṇa walking in the woods in the moonlight, from
Bali. Canvas. Amsterdam, Koninklijk Instituut voor de Tropen.

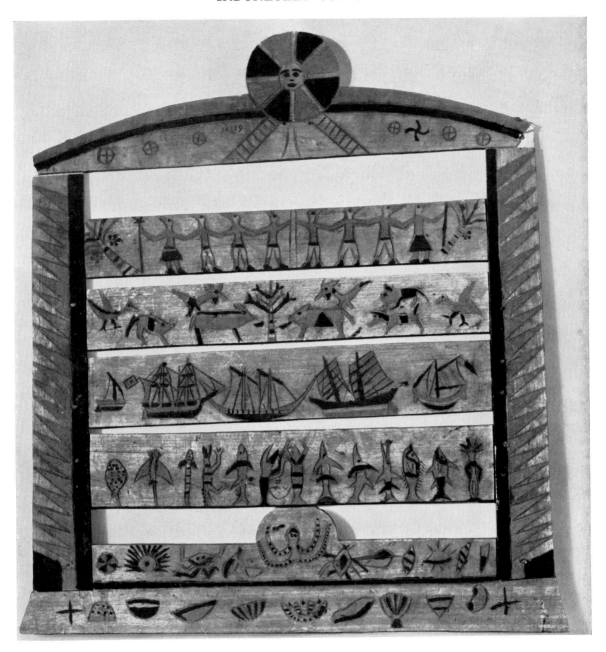

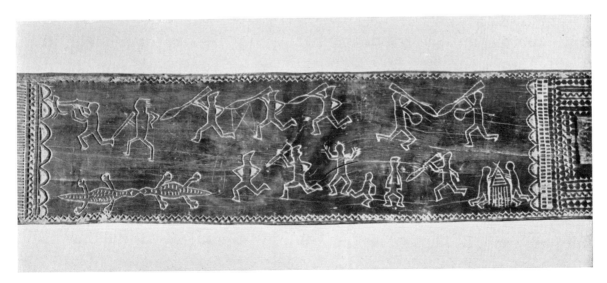

Pl. 39. *Above*: Painting, from Nicobar Islands. Wood. Vienna, Museum für Völkerkunde. *Below*: Part of a bed, Merina group, Malagasy Republic. Wood. Paris, Musée de l'Homme.

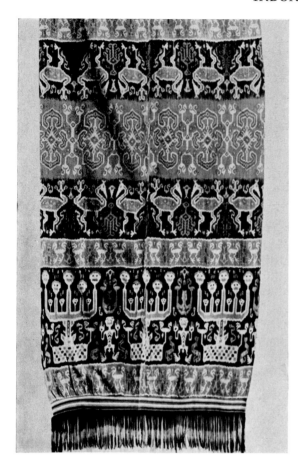

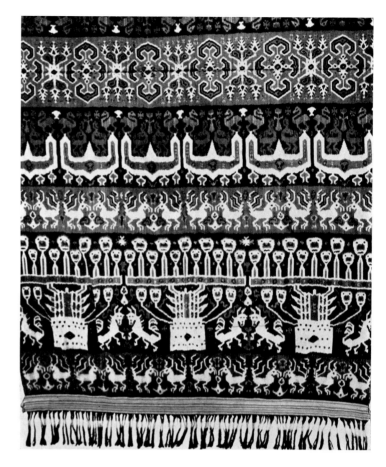

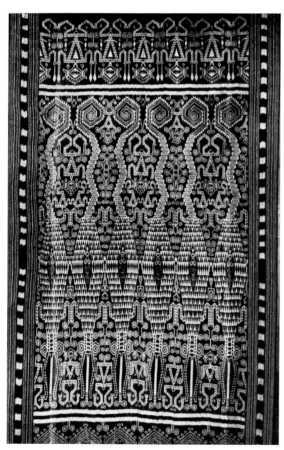

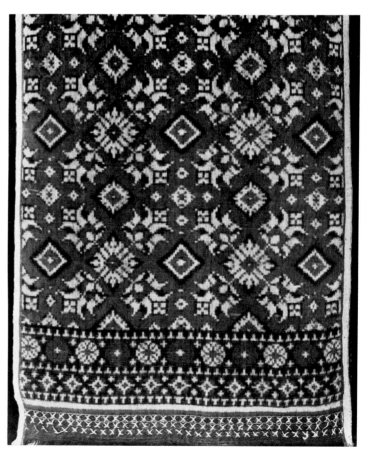

Pl. 40. *Above, left and right*: Examples of *ikat* cloth, from Sumba. New York, private coll., and Amsterdam, Koninklijk Instituut voor de Tropen. *Below, left*: *Pilih* cloth, Iban group, Borneo. *Right*: Cloth with *ikat* decoration of warp and weft, from Tenganan, Bali. Last two, Amsterdam, Koninklijk Instituut voor de Tropen.

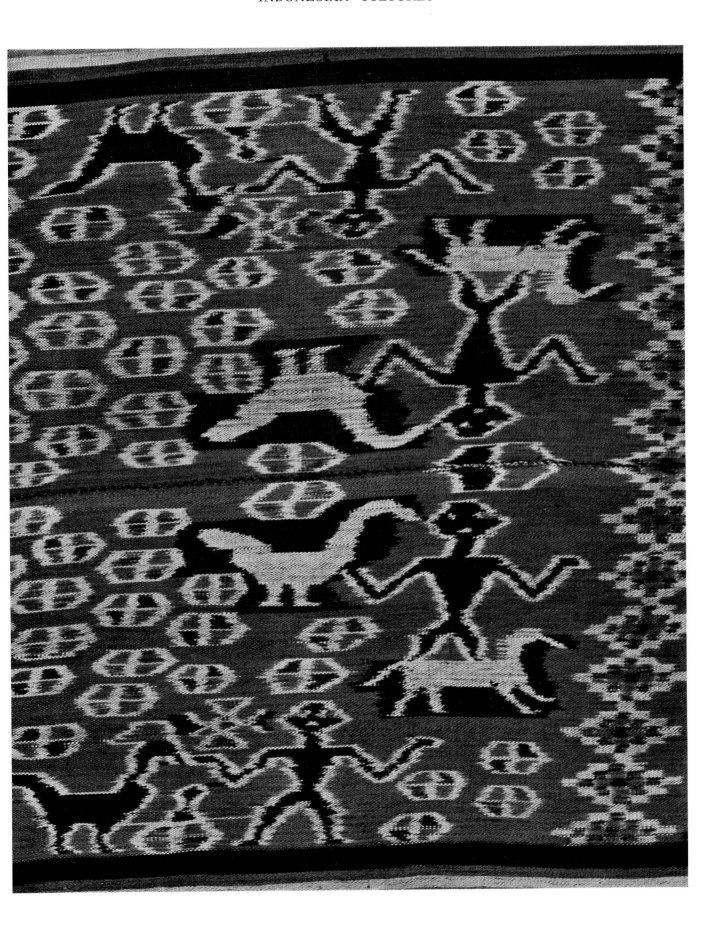

Pl. 41. *Ikat* cloth, Saadang Toradja group, central Celebes. Cotton. Leiden, Rijksmuseum voor Volkenkunde.

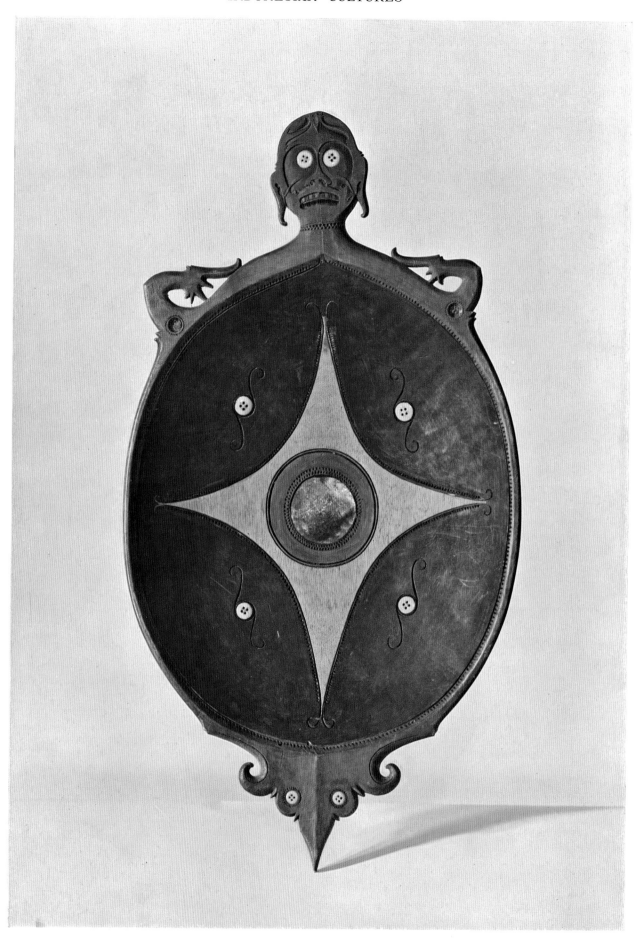

Pl. 42. Bowl, from central Borneo. Carved and inlaid wood. Leiden, Rijksmuseum voor Volkenkunde.

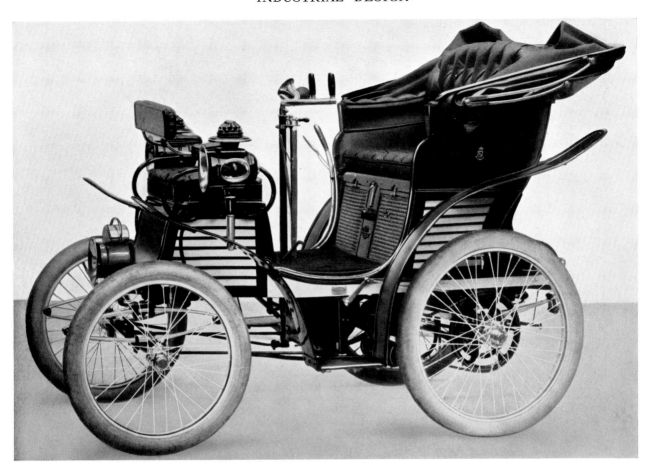

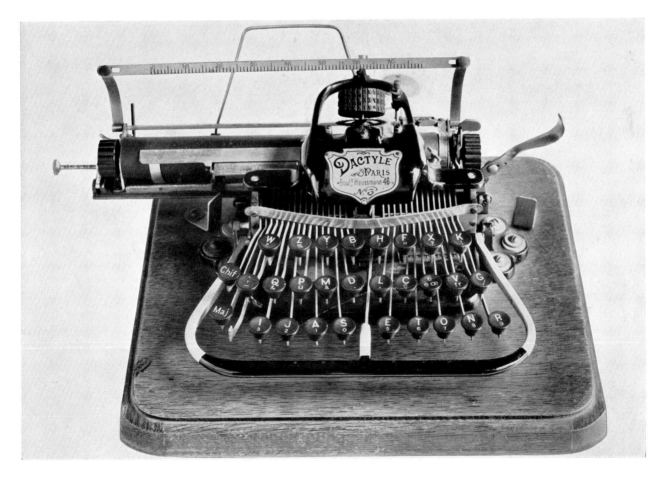

Pl. 43. *Above*: The first FIAT automobile, Italy, 1899. *Below*: Dactyle typewriter, No. 3, France.

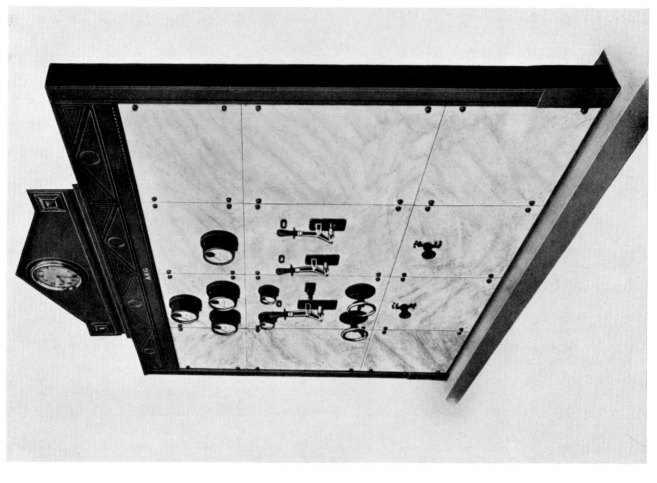

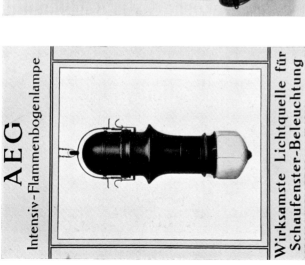

Pl. 44. P. Behrens, designs for Allgemeine Elektricitäts-Gesellschaft (AEG), Germany. *Above, left*: Arc lamp, 1906–1910. *Above, center, and below*: Four types of electric kettles, 1908. *Right*: Switchboard for a low-voltage three-phase a-c generator, with framing, clock top, and clock, 1911.

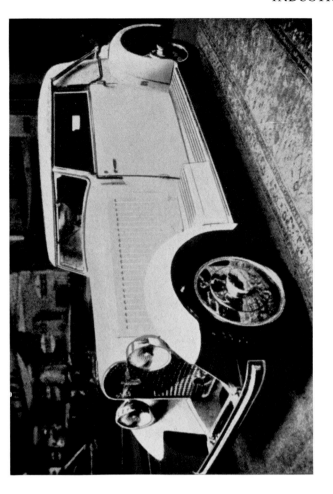

Pl. 45. *Above, left*: H. Earl, Cadillac, U.S.A., 1930. *Right*: W. Gropius, Adler, Germany, 1929–31. *Below, left*: R. B. Fuller, dymaxion three-wheeled, eleven-passenger automobile, not mass-produced, U.S.A., 1927–32. *Right*: G. Bertone, Citroën DS 19, France, 1956.

Pl. 46. *Above, left*: Dodge station wagon, Chrysler Corp., U.S.A., 1959. *Right*: Ferrari 212 "Inter" with body by Pininfarina, Italy. *Center, left*: Tractor, one of the D8 series originated in 1935, Caterpillar Tractor Co., U.S.A. *Right*: C. D'Ascanio and E. Piaggio, Vespa 98-CC model, Piaggio & Co., Italy, 1946. *Below*: M. Breuer & Assoc., Rail Diesel Car, The Budd Co., U.S.A., 1955.

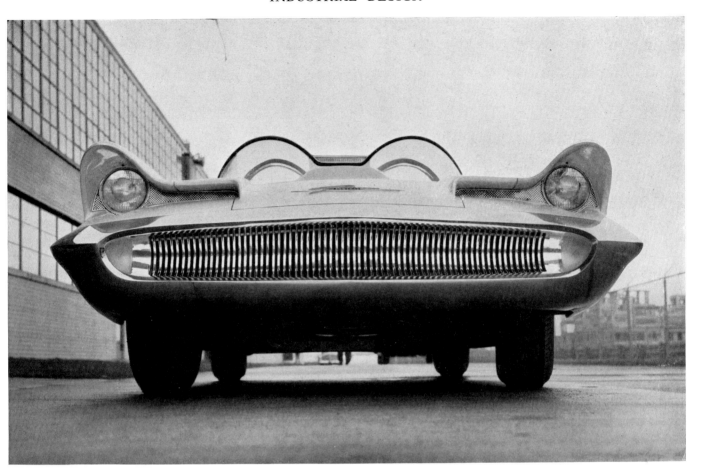

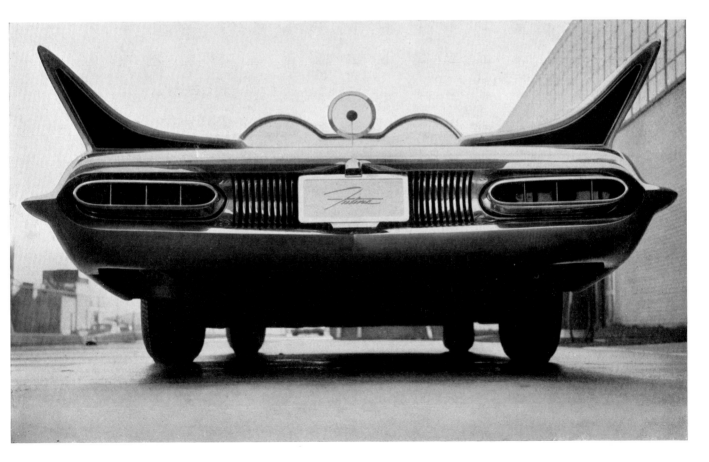

Pl. 47. Experimental design, utilizing a shark motif, for Lincoln "Futura," Ford Motor Co., U.S.A., 1955.

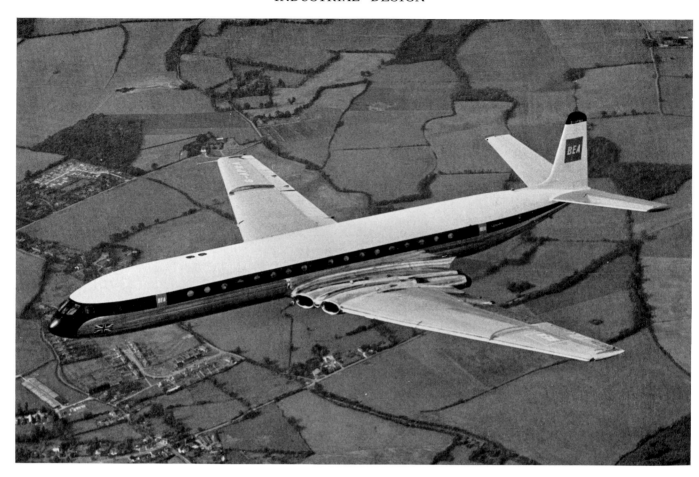

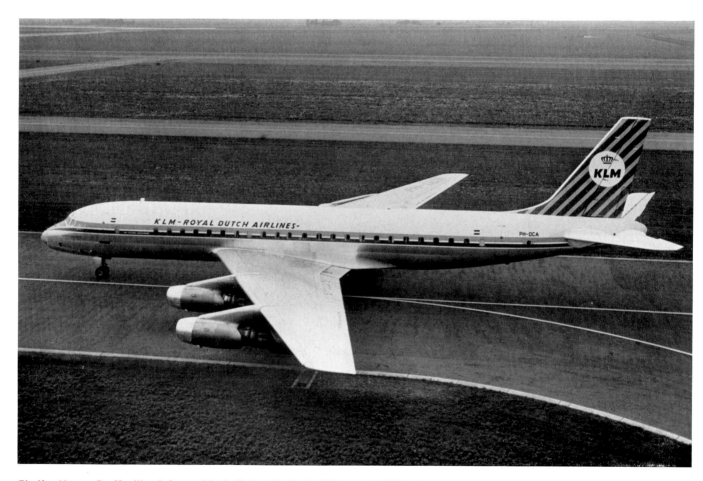

Pl. 48. *Above*: De Havilland Comet Mark 4B jet, England, flight-tested 1958. *Below*: Douglas DC-8 U.S.A., flight-tested 1956.

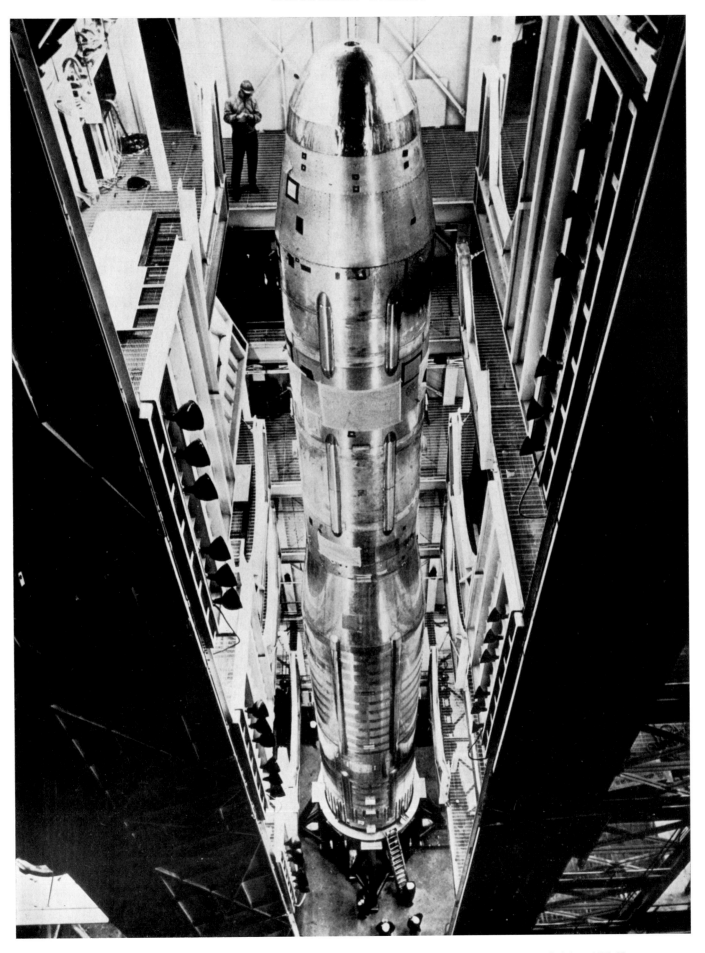

Pl. 49. "Titan" intercontinental ballistic missile, U.S.A., developed by the Glenn L. Martin Co , Denver division, 1955–59.

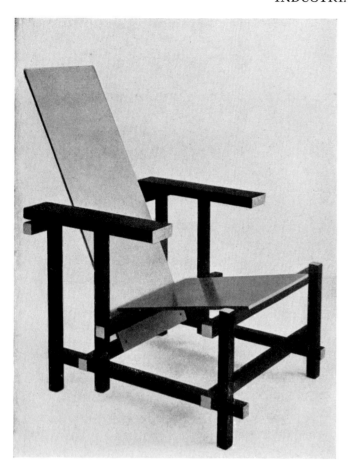
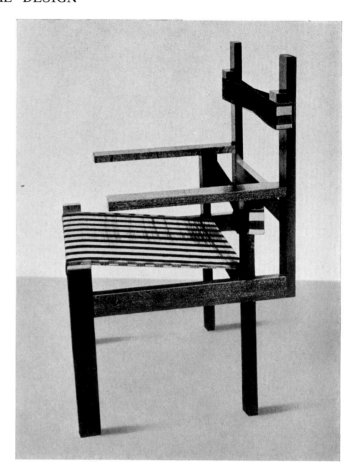
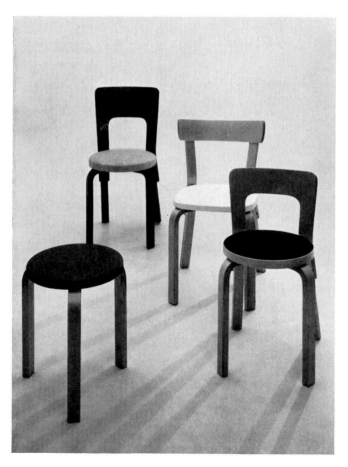
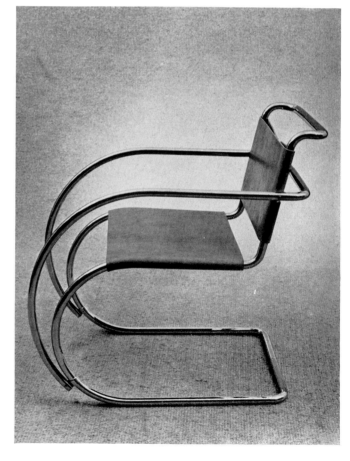

Pl. 50. *Above, left*: G. T. Rietveld, armchair, 1917. *Right*: M. Breuer, armchair, 1922. *Below, left*: A. Aalto, stool and chairs, ARTEK, Finland, 1933. *Right*: L. Mies van der Rohe, armchair, 1926. New York, Museum of Modern Art.

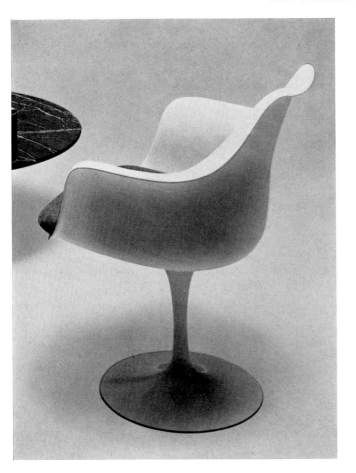
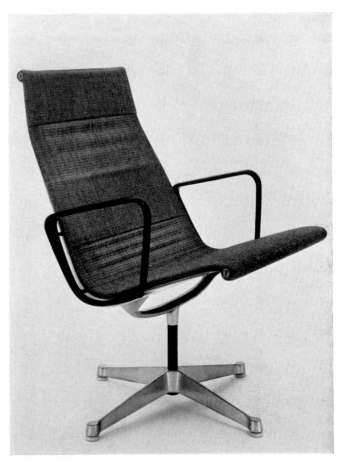

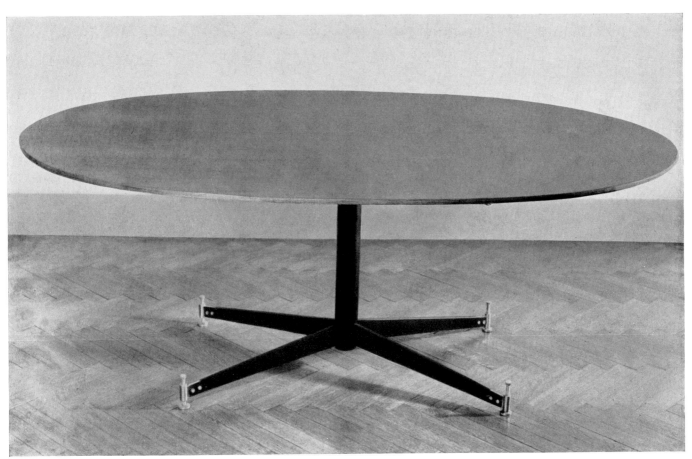

Pl. 51. *Above, left*: Eero Saarinen, single-pedestal armchair, Knoll Associates, Inc., U.S.A., 1958. *Right*: C. Eames, lounge chair of the "Aluminum Group," Herman Miller, Inc., U.S.A., 1958. *Below*: I. Gardella, oval table, Italy, 1948.

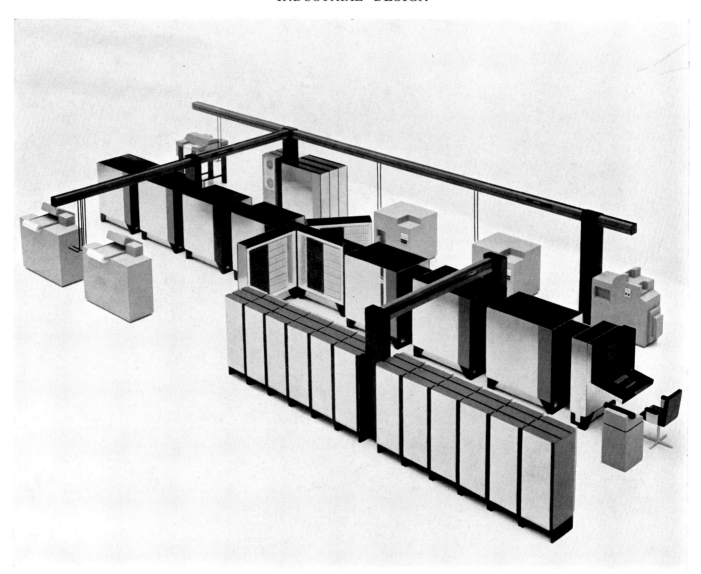

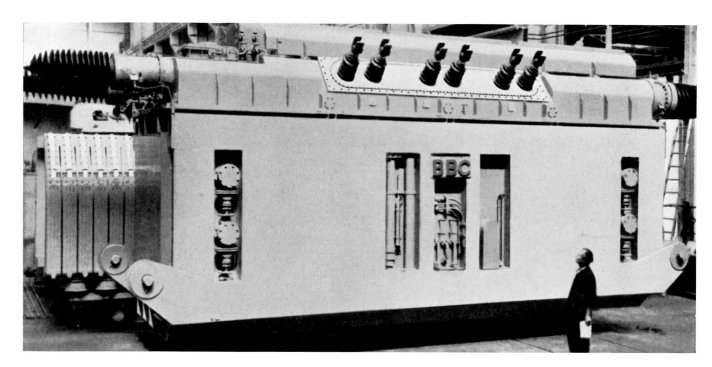

Pl. 52. *Above*: E. Sottsass, Jr., design for electronic computer, Olivetti "Elea 9003," Italy, 1960. *Below*: Three-phase traveling transformer, Brown, Boveri & Cie, AG, Germany, 1957.

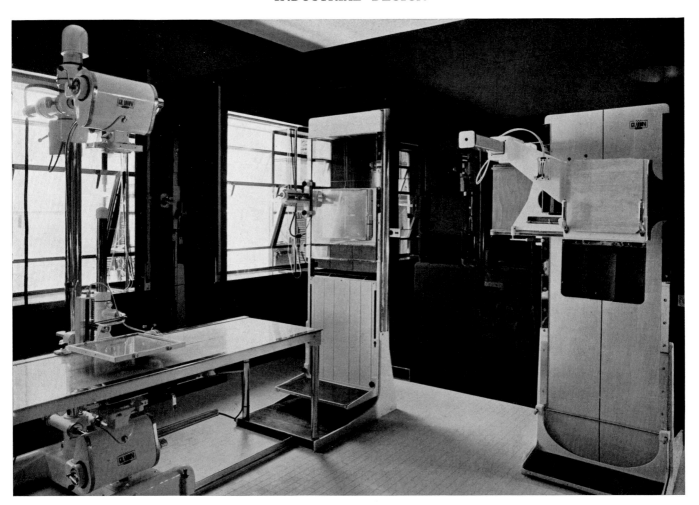

Pl. 53. *Above*: Radiological apparatus, Gilardoni, S.p.A., Italy, 1949–50. *Below, left*: W. Wagenfeld, opal glass lamp with porcelain fixture, Germany, 1959. *Right*: Silent electric-light switch, Adolf Feller AG, Switzerland, ca. 1945.

Pl. 54. *Left, above*: G. and N. Valle, J. R. Myer, and M. Provinciali, electromechanical clock, "Cifra Cinque," R. Solari & Co., Italy, 1956. *Center*: S. Bernadotte and A. Bjørn, toaster, Elektro Helios A. B., Sweden, 1955. *Below*: H. Dreyfuss, model "500" telephone set, Bell Telephone Laboratories, U.S.A., 1950. *Right, above*: P. Sieber, electric razor, "President," Allgemeine Elektricitäts-Gesellschaft (AEG), Germany, 1958. *Below*: C. Eames, speaker cabinet, model E-4, Stephens Trusonic, Inc., U.S.A., 1957.

Pl. 55. *Above*: C. Eames, loudspeaker cabinet, model E-2, Stephens Trusonic, Inc., U.S.A., 1957. *Below*: Pocket-size all-transistor radio, model 292, Bulova Watch Co., U.S.A.

Pl. 56. M. Nizzoli. *Above*: Typewriter, Olivetti "Lettera 22," Italy, 1950. *Below*: "Mirella" sewing machine, Necchi, S.p.A., Italy, 1956.

Pl. 57. *Above, left*: S. Bernadotte and A. Bjørn, electric pot, Elektro Helios A. B., Sweden, 1957. *Right*: R. Sambonet, covered steel skillet, Italy, 1957. *Below*: J. and S. Reid, enameled cast-iron casseroles, Izons & Co., Ltd., England, 1960.

Pl. 58. *Above*: W. Wagenfeld, flameproof glass tea service, Jenaer Glaswerke Schott & Gen., Germany, 1931–34. *Below, left*: N. Landberg, glassware. *Right*: S. Palmquist, cut vase and vase in the Ravenna technique. Last two, Orrefors Glasbruk, Sweden, 1958.

Pl. 59. *Above, left*: Outside caliper, Brown & Sharp, Inc., U.S.A., 1934. *Right*: W. Kennedy, tripod, "Professional KI," Ilford, Ltd., England, 1955. *Below*: E. Sottsass, Jr., ceramics, Italy.

Pl. 60. *Left*: H. Löffelhardt, chemists' bottles, Gral-Glas, Germany. *Right*: O. Colombini, plastic pitchers, Kartell, s.r.l., Italy, 1954.

Pl. 61. A. Steiner, packaging, Pierrel products, Italy, 1957.

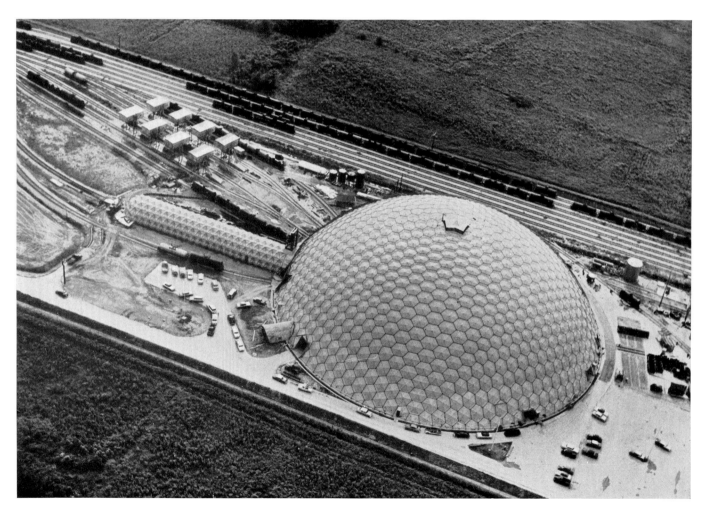

Pl. 62. *Above*: Exhibit at 12th Triennale, Milan, 1960, exemplifying prefabricated construction of elementary schools under the Consortium of Local Authorities Special Program, England, post-World War II. *Below*: Railroad-car repair and maintenance shop, 1958, utilizing the geodesic dome design of R. B. Fuller, Union Tank Car Co., Alsen, La.

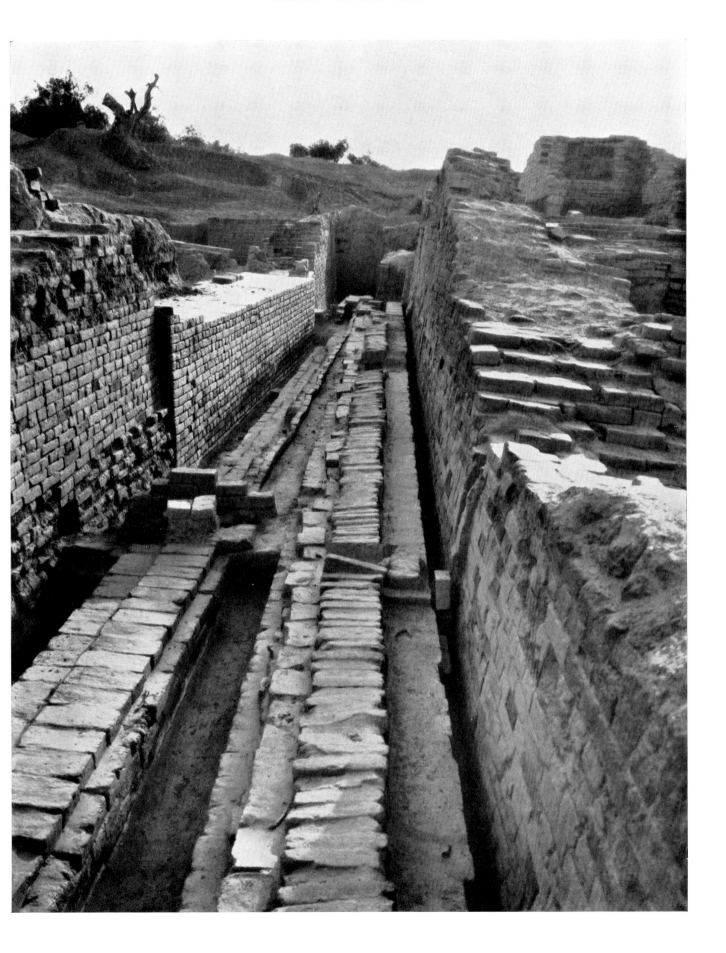

Pl. 63. Mohenjo-daro, Pakistan, remains of constructions and drainage system, ca. 3d millennium B.C.

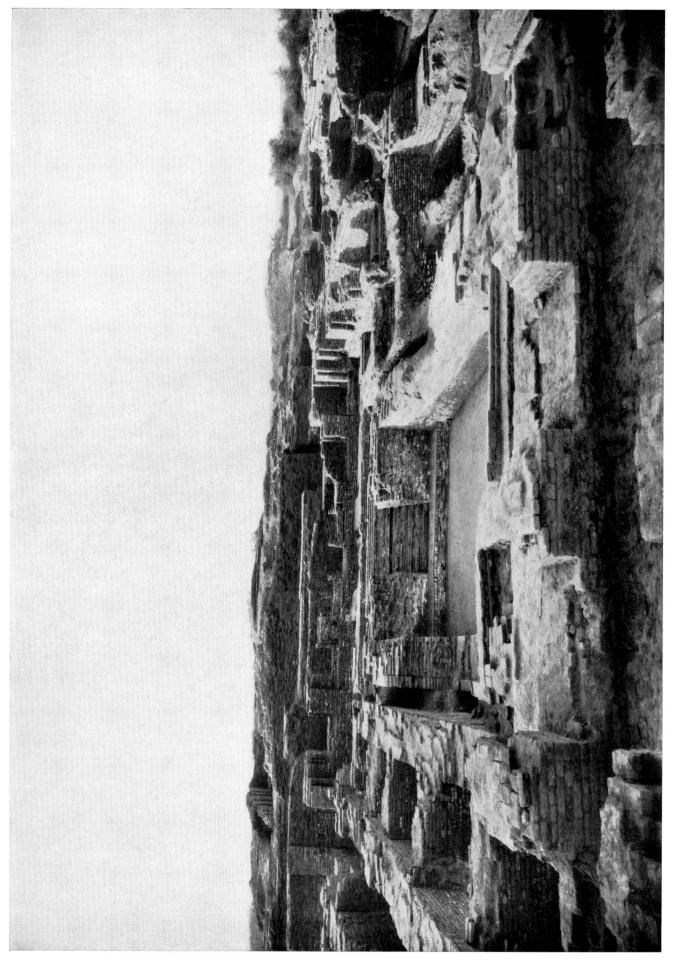

Pl. 64. Mohenjo-daro, Pakistan, view of the Great Bath, ca. 3d millennium B.C.

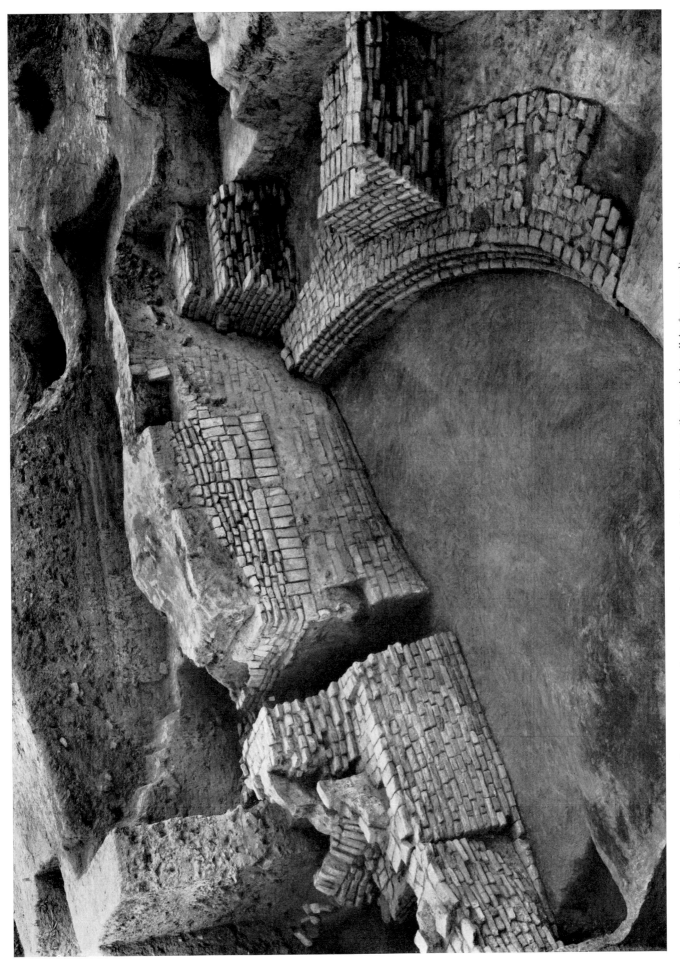

Pl. 65. Harappa, Pakistan, remains of structures near the western outer gate, ca. 3d millennium B.C. (late-period wall in foreground).

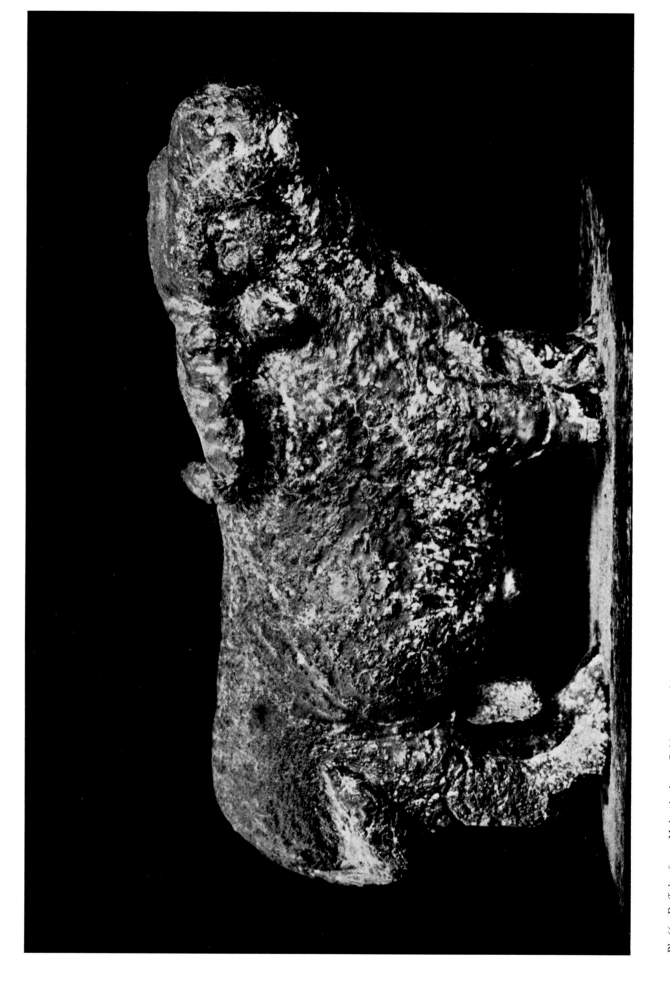

Pl. 66. Buffalo, from Mohenjo-daro, Pakistan, ca. 3d millennium B.C. Stone, l., 3 1/8 in. New Delhi, National Museum.

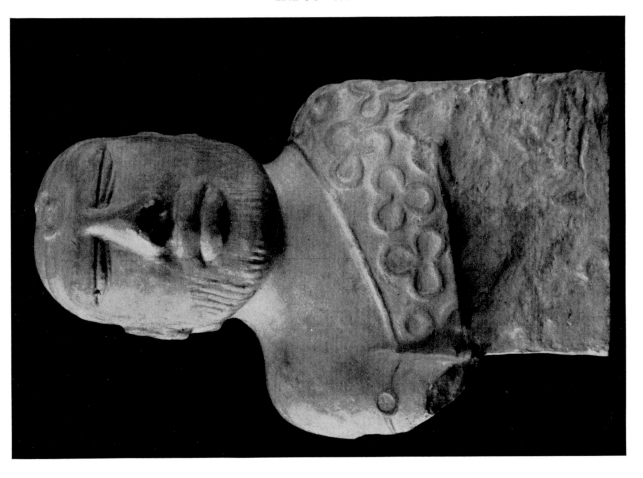

Pl. 67. *Left*: Seated figure, from Harappa, Pakistan, ca. 3d millennium B.C. Stone, ht., 11³/₈ in. *Right*: Male bust, from Mohenjo-daro, Pakistan, ca. 3d millennium B.C. Stone, ht., 7 in. Both, New Delhi, National Museum.

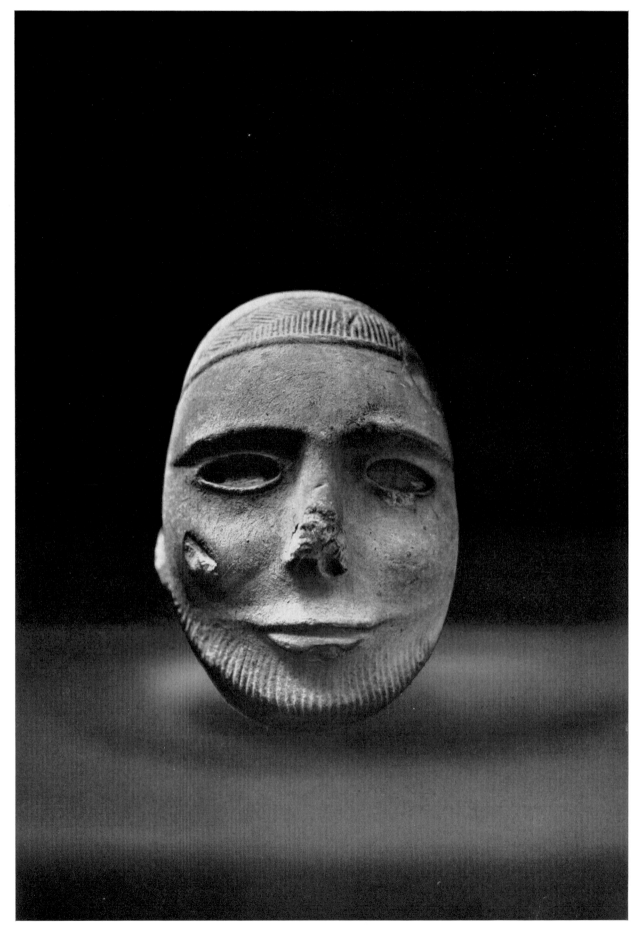

Pl. 68. Male head, from Mohenjo-daro, Pakistan, ca. 3d millennium B.C. Limestone, ht., 6⁷/₈ in. New Delhi, National Museum.

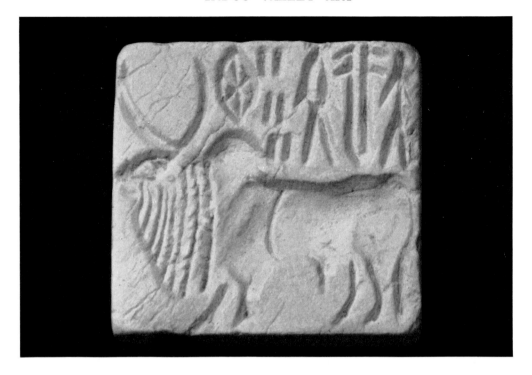

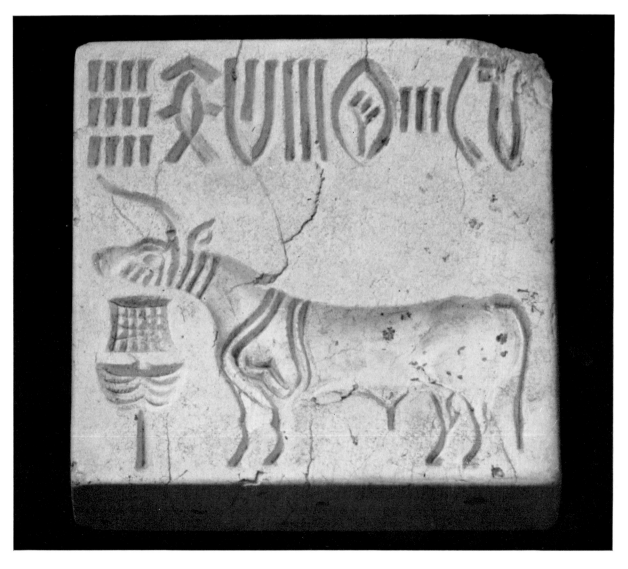

Pl. 69. Seals, from Mohenjo-daro, Pakistan, ca. 3d millennium B.C. Steatite. New Delhi, National Museum.

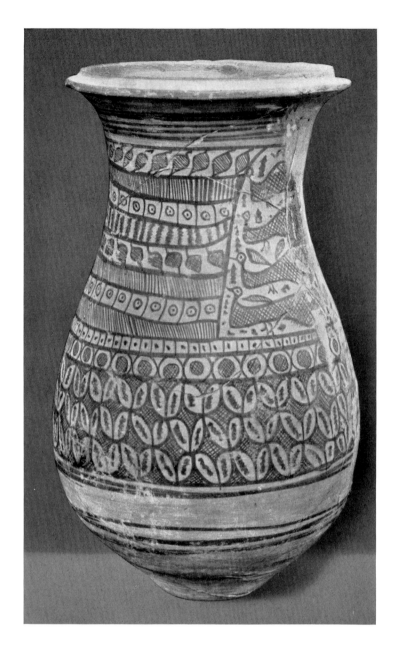

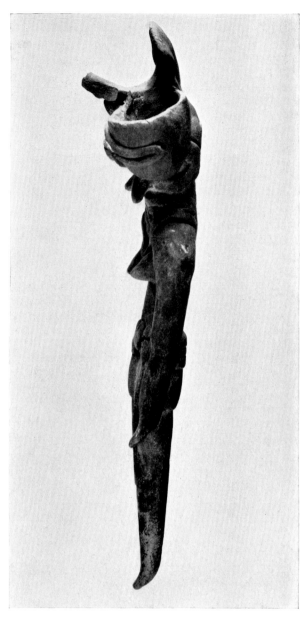

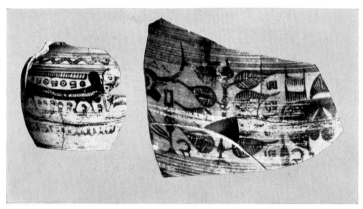

Pl. 70. *Left, above*: Painted vase, from Harappa, Pakistan, ca. 3d millennium B.C. Ht., 11³/₄ in. *Below*: Fragments of painted pottery, from Mohenjo-daro, Pakistan, ca. 3d millennium B.C. *Right*: Clay figurines, from Mohenjo-daro, ca. 3d millennium B.C. All, New Delhi, National Museum.

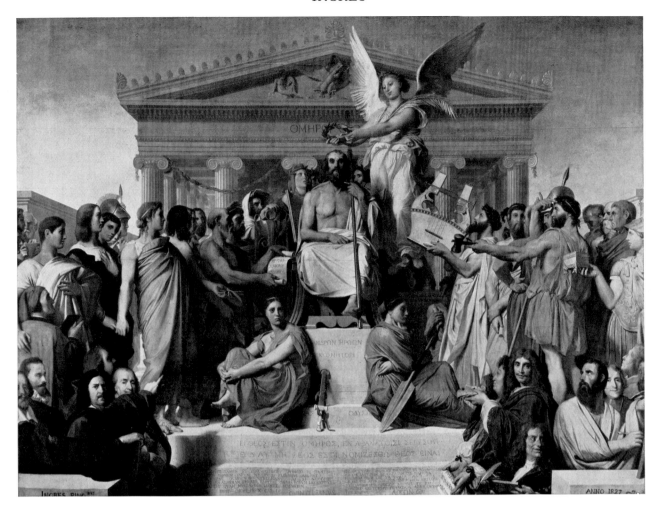

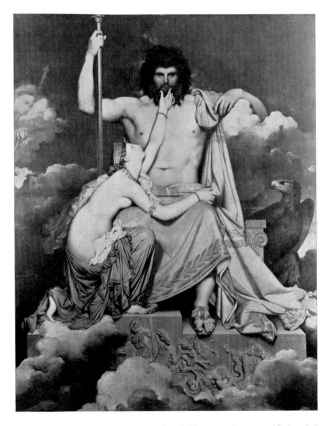

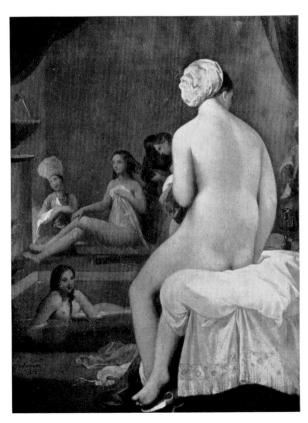

Pl. 71. *Above*: The Apotheosis of Homer. Canvas, 12 ft., 8 in. × 16 ft., 11 in. Paris, Louvre. *Below, left*: Jupiter and Thetis. Canvas, 10 ft., 10⅝ in. × 8 ft., 5¼ in. Aix-en-Provence, France, Musée Granet. *Right*: Interior of a Harem (La petite baigneuse). Canvas, 1 ft., 1¾ in. × 10⅝ in. Paris, Louvre.

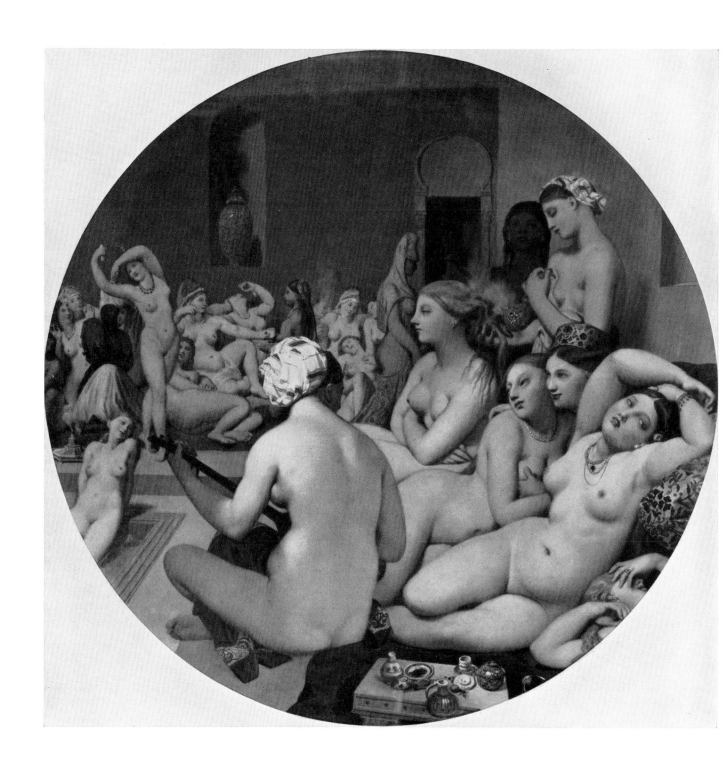

Pl. 72. The Turkish Bath. Canvas, diam., 3 ft., 6$^1/_2$ in. Paris, Louvre.

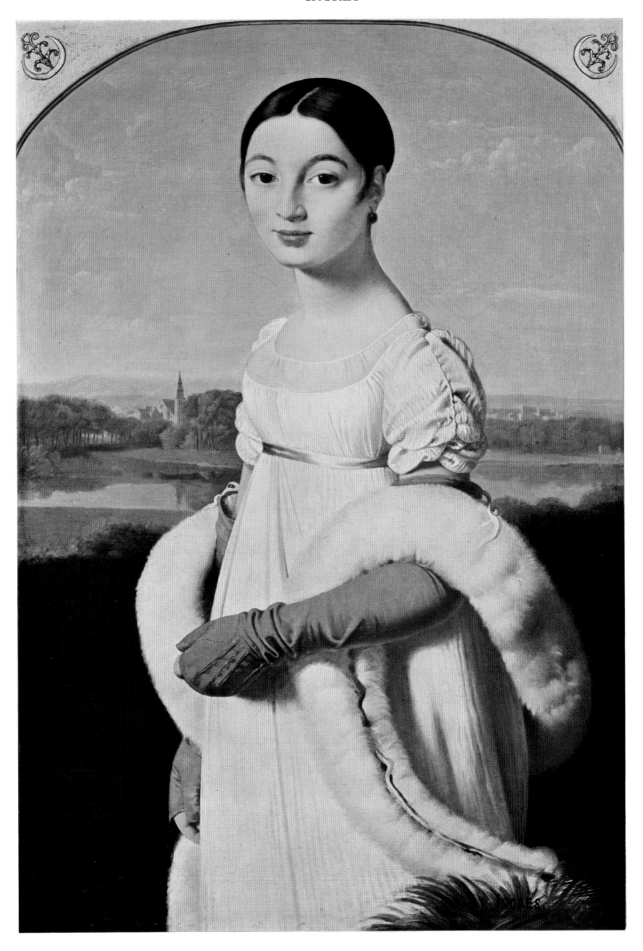

Pl. 73. Mademoiselle Rivière. Canvas, 3 ft., $3^3/_8$ in. × 2 ft., $3^1/_2$ in. Paris, Louvre.

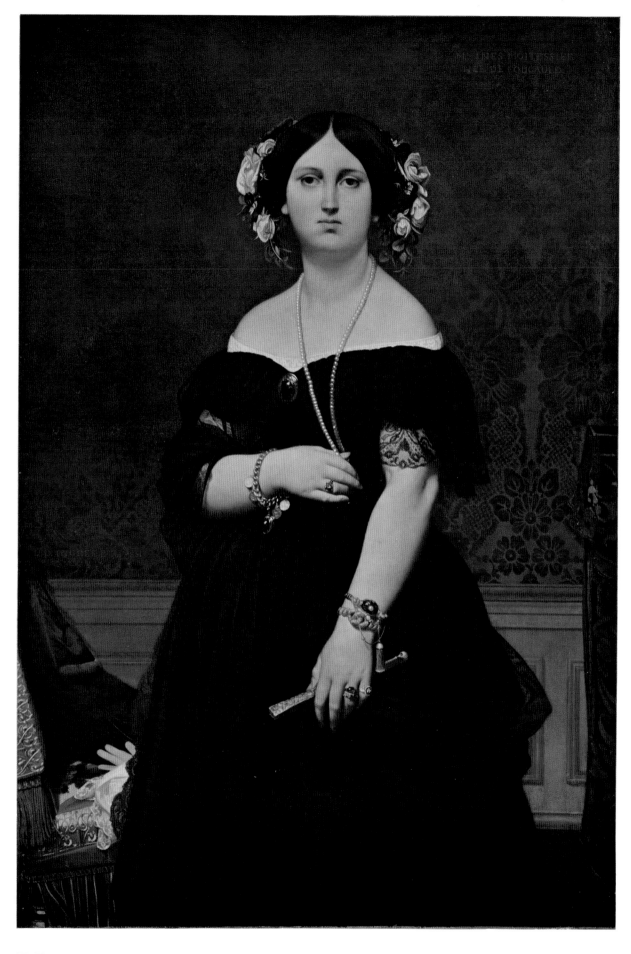

Pl. 74. Mme Inès Moitessier. Canvas, 4 ft., 10¼ in. × 3 ft., 5⅜ in. Washington, D.C., National Gallery.

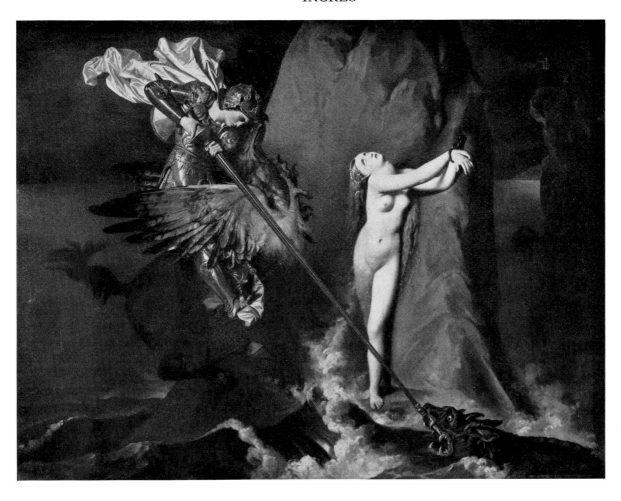

Pl. 75. Roger Freeing Angelica, whole and detail. Canvas, 4 ft., 9⅞ in. × 6 ft., 2¾ in. Paris, Louvre.

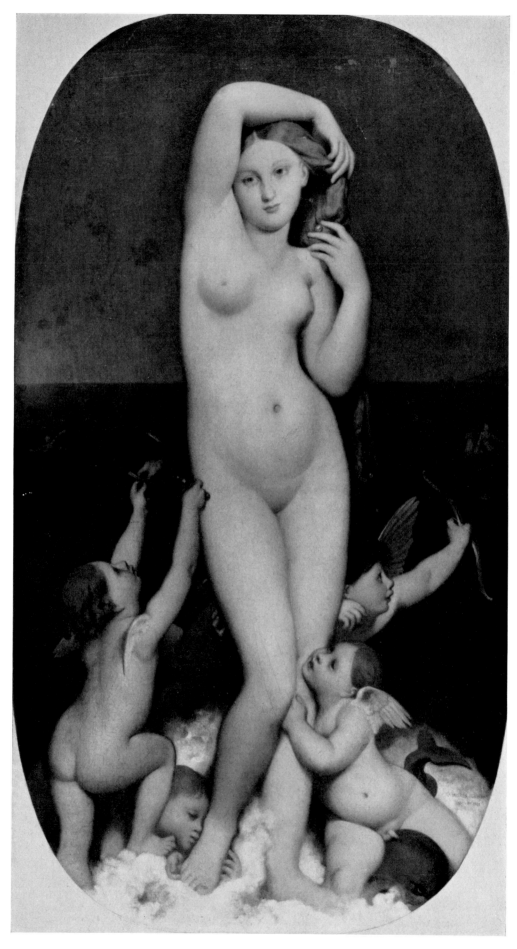

Pl. 76. Venus Anadyomene. Canvas, 5 ft., 4⅛ in. × 3 ft., ¼ in. Chantilly, France, Musée Condé.

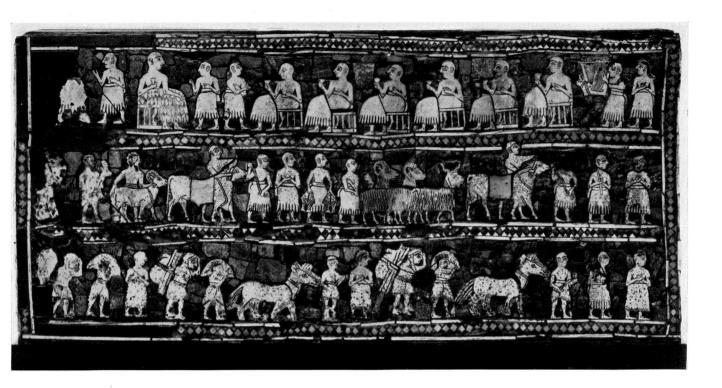

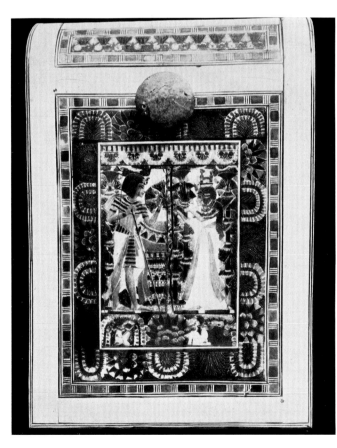

Pl. 77. *Above*: So-called "Standard" of Ur, showing a victory celebration, mid-3d millennium B.C. Panel inlaid with shell, lapis lazuli, and red limestone, 8×19 in. London, British Museum. *Below, left*: Lid of a chest, from the tomb of Tutankhamen, Thebes, showing the king and queen, mid-14th cent. B.C. Wood inlaid with ivory, 12⁵/₈×8³/₄ in. Cairo, Egyptian Museum. *Right*: Inlay from a wooden box, Jericho, ca. 18th cent. B.C. Bone, 6¹/₂×5¹/₂ in. Lund, Sweden, Antikmuseet.

Pl. 78. *Above*: Dionysiac scene, from Pompeii, Augustan age. Polychrome marble on slate, 8^1/$_4$×25^3/$_4$ in. *Below, left*: Egyptian mythological scene, detail of a bowl, from Castellammare di Stabia (anc. Stabiae), Italy, Augustan age. *Pietra dura* and gold on obsidian; full ht., 4^7/$_8$ in. Both, Naples, Museo Nazionale. *Right*: Allegory of the origin of Rome, from Bovillae near Rome, ca. mid-4th cent. Polychrome marble on porphyry, 23^1/$_4$×29^1/$_8$ in. Rome, Palazzo Colonna.

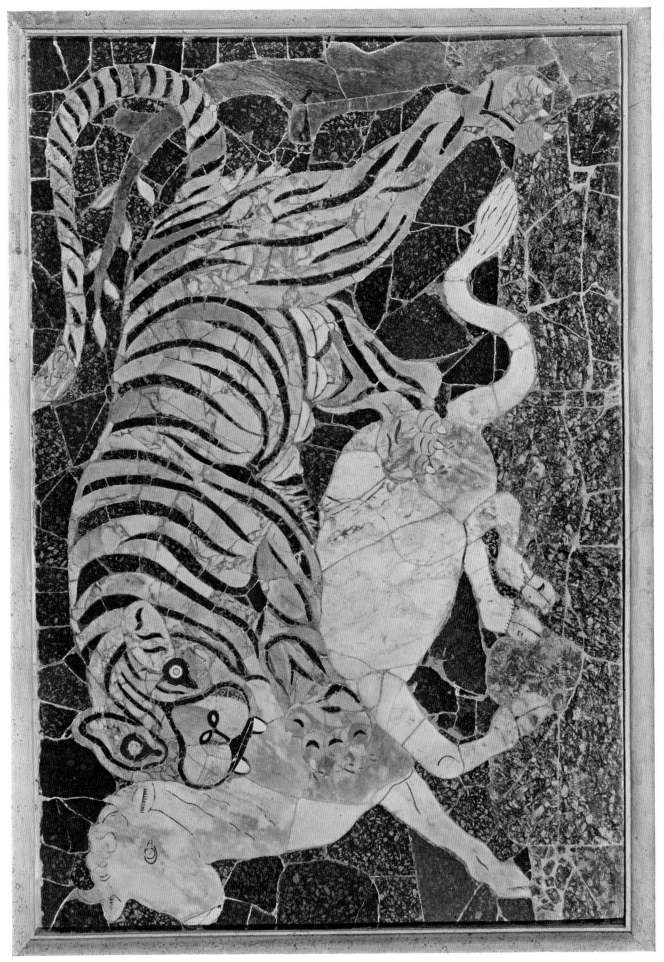

Pl. 79. Tiger attacking a calf, detail of wall facing in *opus sectile*, from the Basilica of Junius Bassus in Rome, 4th cent. (?). Marble, ca. 4×6 ft. Rome, Palazzo dei Conservatori, Museo Nuovo.

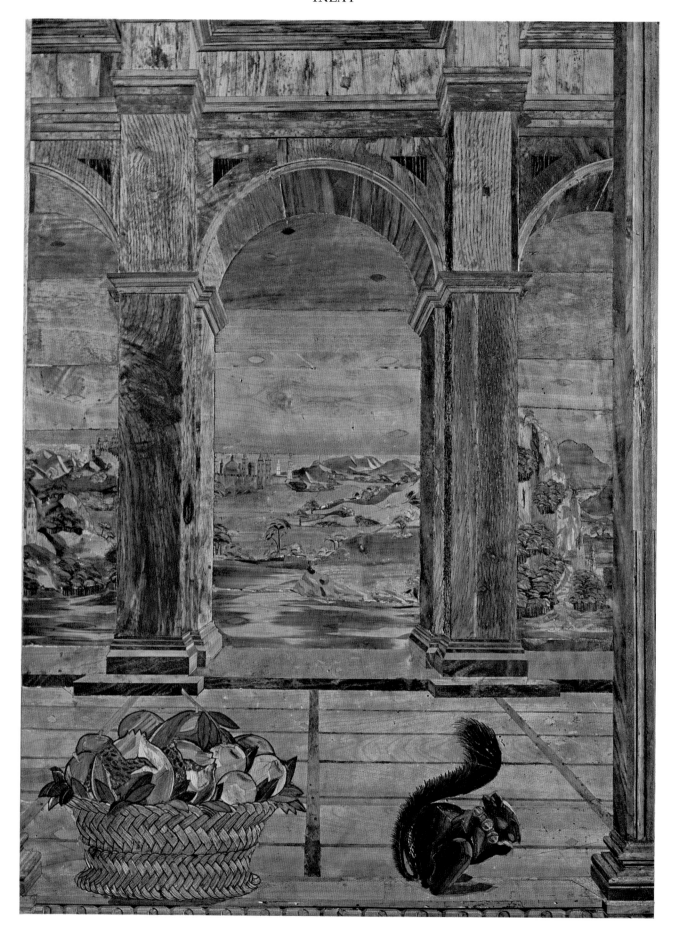

Pl. 80. Francesco di Giorgio and B. Pontelli, marquetry paneling, detail, in the *studiolo* (PL. 100) of Federigo da Montefeltro, Palazzo Ducale, Urbino, Italy, ca. 1470. Wood.

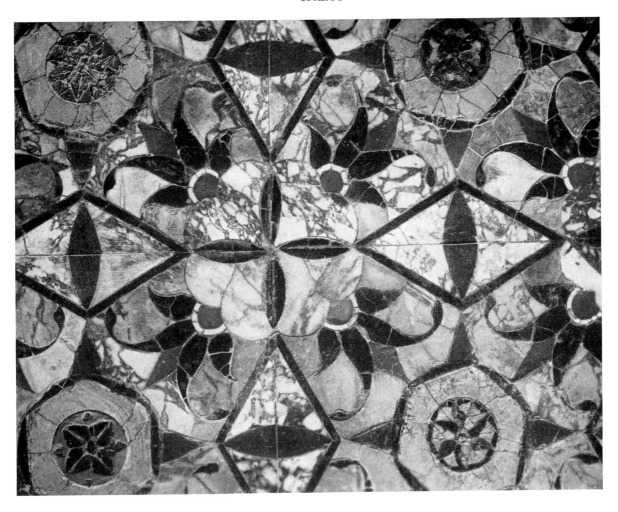

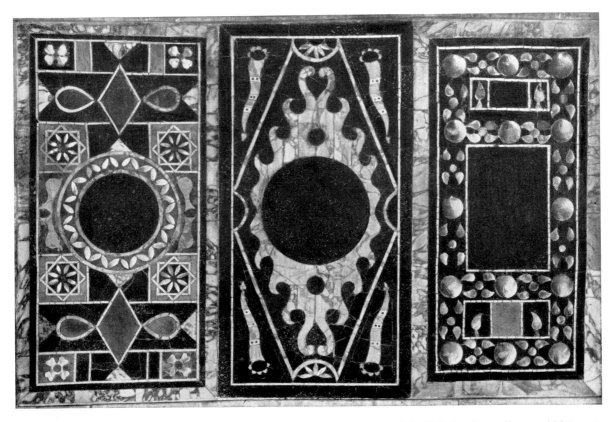

Pl. 81. *Above*: Pavement in *opus sectile*, detail, in the triclinium, House of the Ephebe, Pompeii, ca. mid-1st cent. Polychrome marble. *Below*: Polychrome facing, detail, in the apse of the Basilica Eufrasiana, Parenzo (now Poreč), Yugoslavia, 6th cent. Marble, glass paste, and mother-of-pearl.

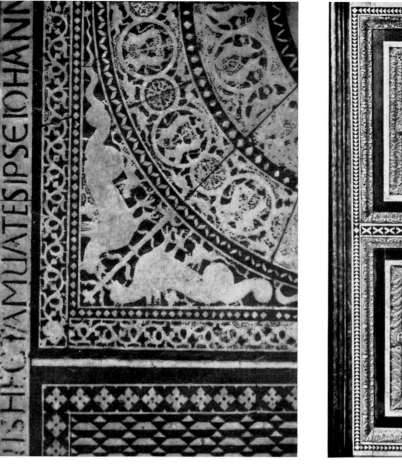

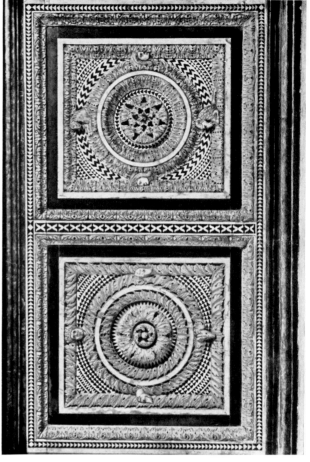

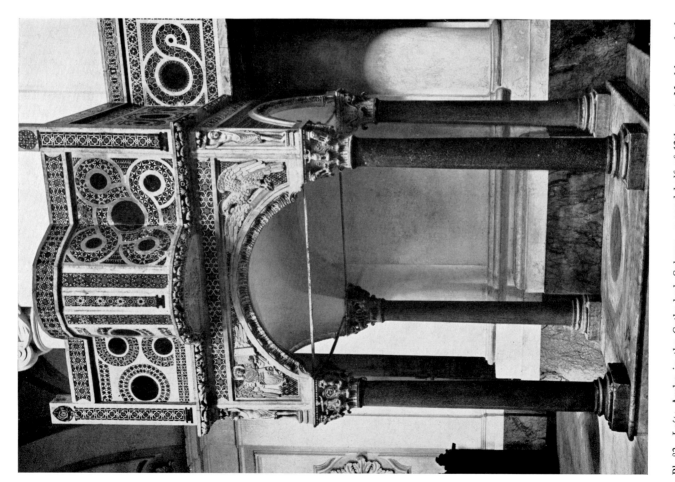

Pl. 82. *Left:* Ambo in the Cathedral, Salerno, second half of 12th cent. Marble and glass paste. *Right, above:* Pavement, detail, in the Baptistery, Florence, 13th cent. Marble. *Below:* Guido Bigarelli da Como, baptismal font, detail, in the Baptistery, Pisa, 1246. Marble.

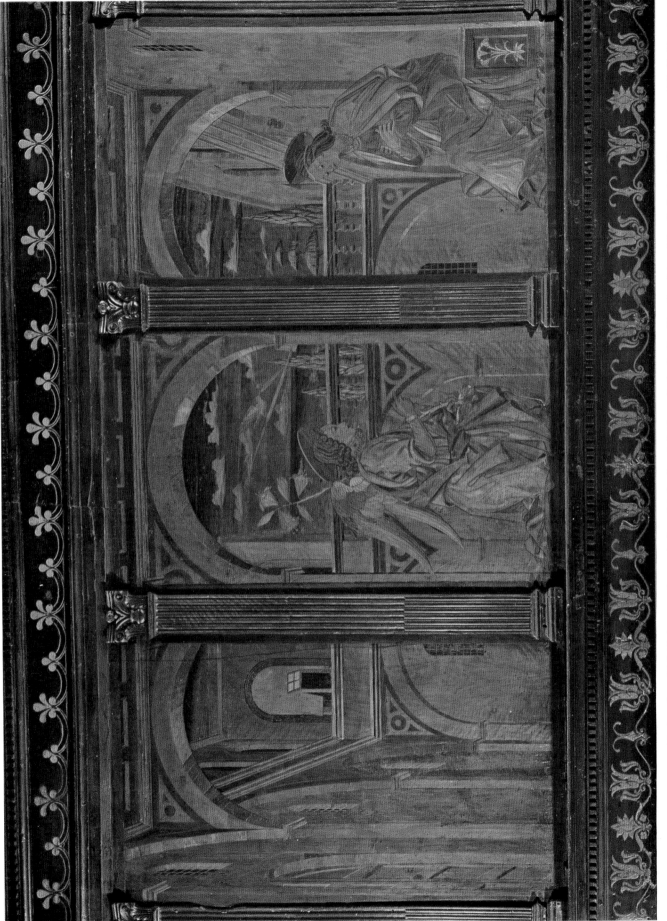

Pl. 83. Giuliano da Maiano, A. Baldovinetti, and M. Finiguerra, Annunciation, detail of an inlaid wardrobe in the New Sacristy of the Cathedral, Florence, ca. 1463–65. Wood.

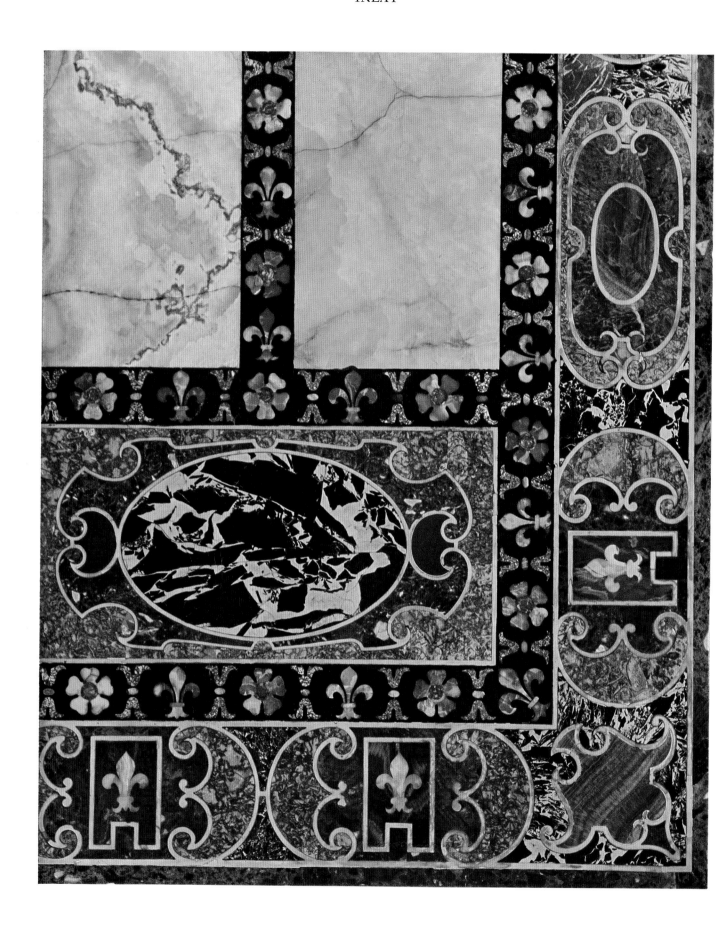

Pl. 84. Table top, detail, from Palazzo Farnese, Rome, ca. 1570. Marble and rare stones. New York, Metropolitan Museum.

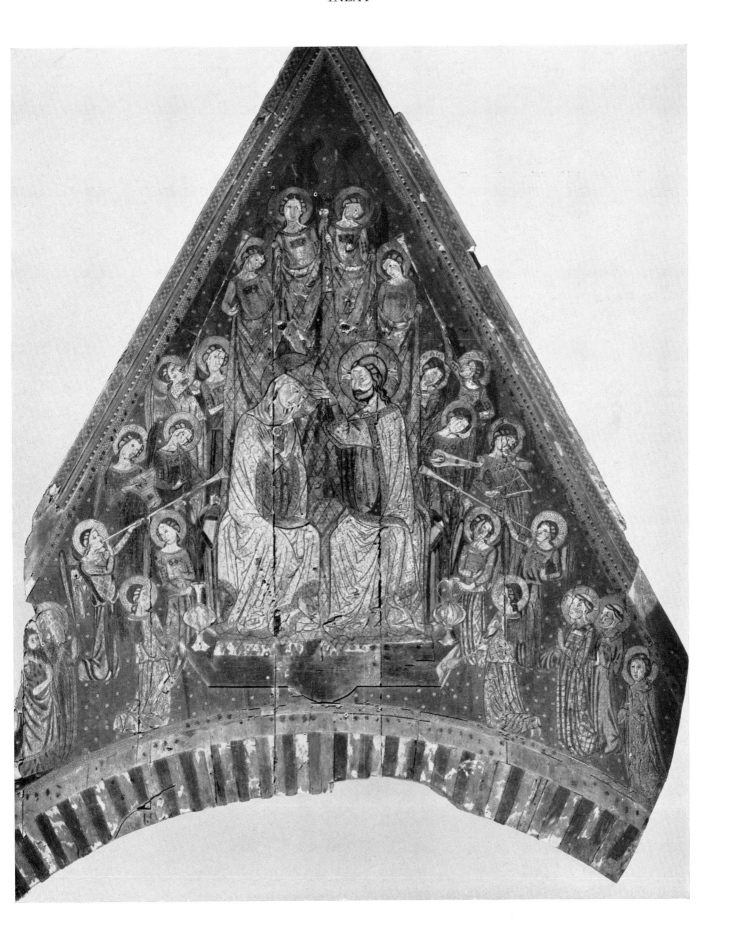

Pl. 85. Tympanum with Coronation of the Virgin, fragment of the old choir of the Cathedral, Orvieto, Italy, Sienese school, first half of 14th cent. Wood. Orvieto, Museo dell'Opera del Duomo.

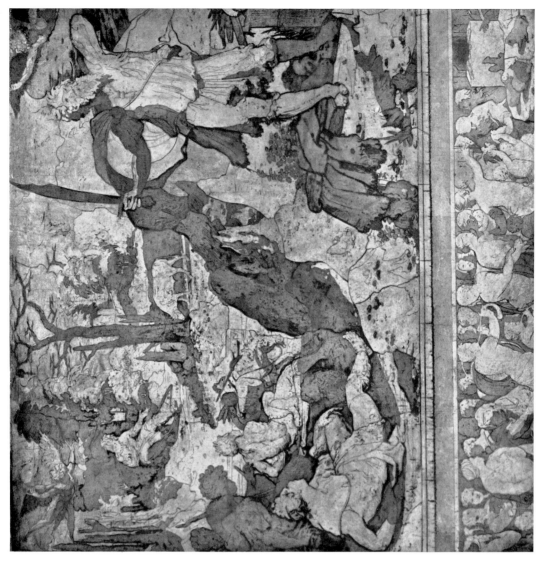

Pl. 86. *Left*: Cristoforo da Lendinara, St. Mark, 1477. Wood. Modena, Cathedral. *Right*: D. Beccafumi, Sacrifice of Isaac, detail of floor in the Cathedral, Siena, 1544-46. Marble.

Pl. 87. *Left*: C. Fanzago, marble inlay, 17th cent. Naples, Certosa di S. Martino, Church. *Right*: Cabinet door, detail of marquetry, from the workshop of A. C. Boulle (?), 17th-18th cent. Wood. London, Wallace Coll.

Pl. 88. *Left*: Marble mihrab and mimbar of inlaid wood, Mosque of al-Mu'ayyad, Cairo, second half of 15th cent. *Right*: Wooden mimbar, detail, Madrasah of Abū-Bakr ibn-Muzhir, Cairo, first half of 15th cent.

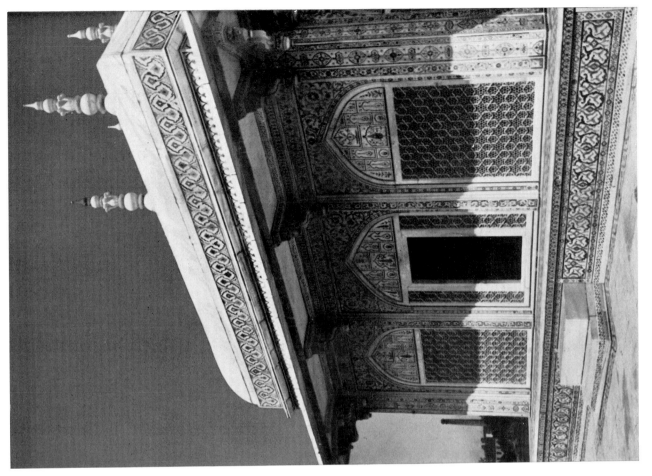

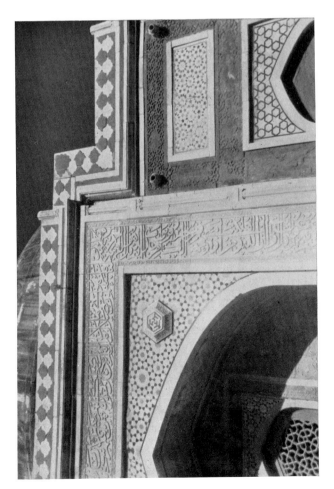

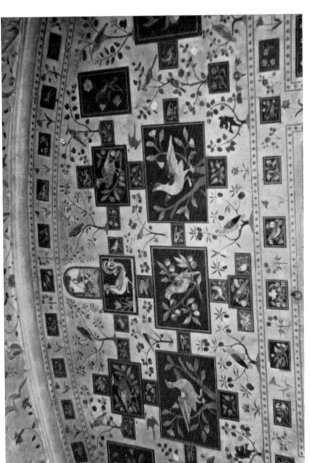

Pl. 89. *Left, above*: Delhi, Tomb of Ātga (Ataga) Khan, detail, 17th cent. Marble. *Below*: Delhi, the Fort, Hall of Public Audience, detail of decoration in the throne recess, 17th cent. *Pietra dura* and marble. *Right*: Agra, upper pavilion of the Tomb of I'timād-ud-Daula, ca. 1628. *Pietra dura* and marble.

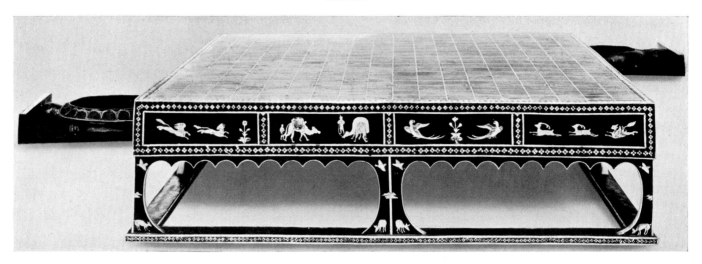

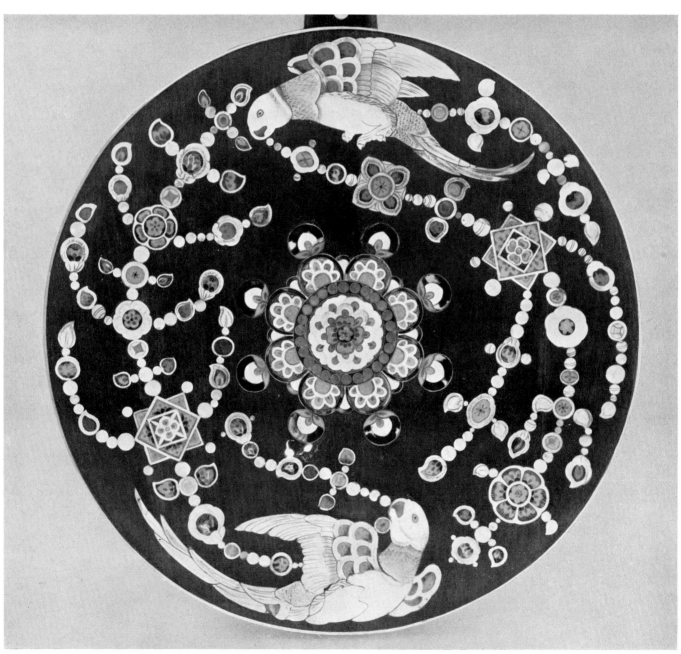

Pl. 99. *Above*: Go game board, Japan, Nara period. Sandalwood inlaid with wood, bamboo, ivory, etc. *Below*: Soundboard of flat lute (*gekkin*), Japan, Nara period. Red sandalwood inlaid with mother-of-pearl, tortoise shell, and amber. Both, Nara, Shōsōin.

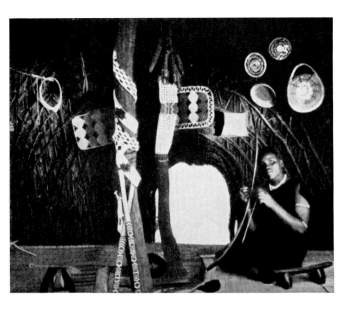 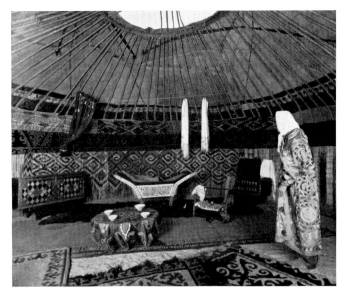

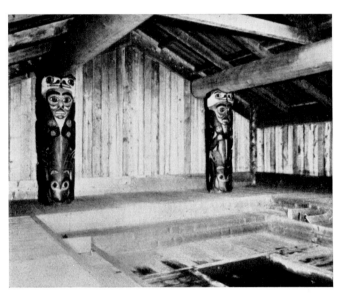 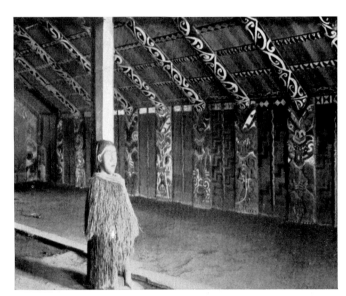

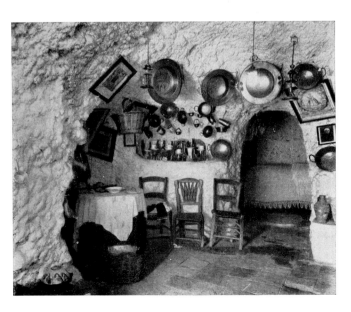 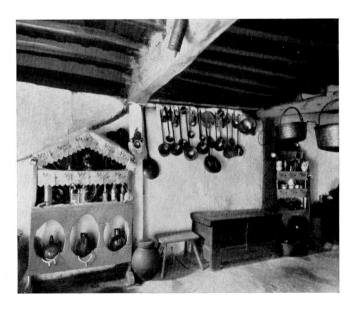

Pl. 91. *Above, left*: Zulu hut, South Africa. *Right*: Kirghiz tent, Central Asia. Hamburg, Museum für Völkerkunde. *Center, left*: Tlingit community house, Mud Bight, near Ketchikan, Alaska. *Right*: Maori assembly or guest house, Te Kuiti, New Zealand. *Below, left*: Gypsy *cueva* (cave), Sacro Monte, Granada, Spain. *Right*: Kitchen, La Alberca, Salamanca, Spain.

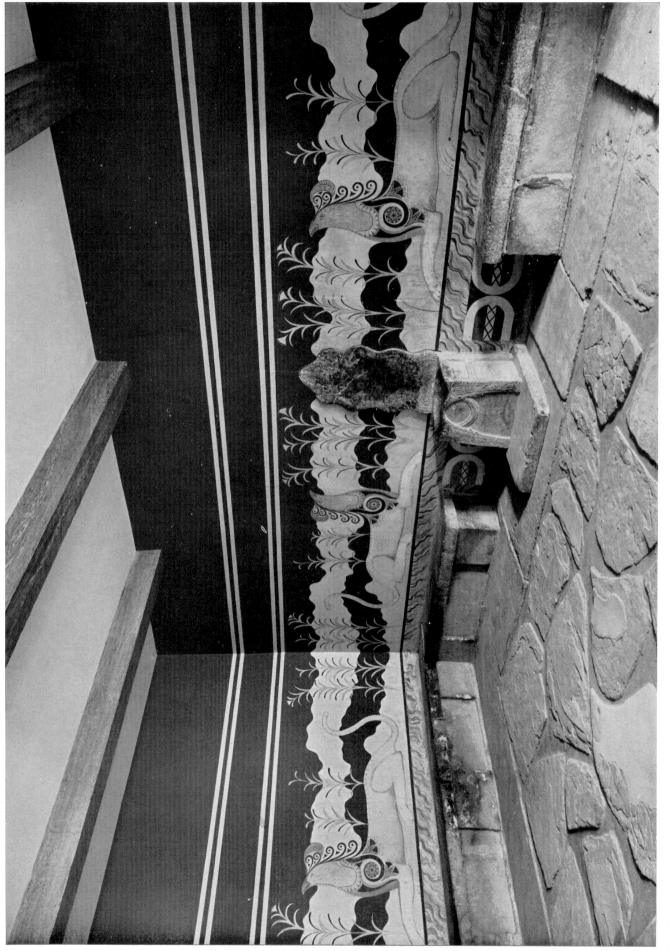

Pl. 92. The so-called "Throne Room," in the second palace, Knossos, Crete, 1700–1400 B.C. (reconstructed around original stone elements).

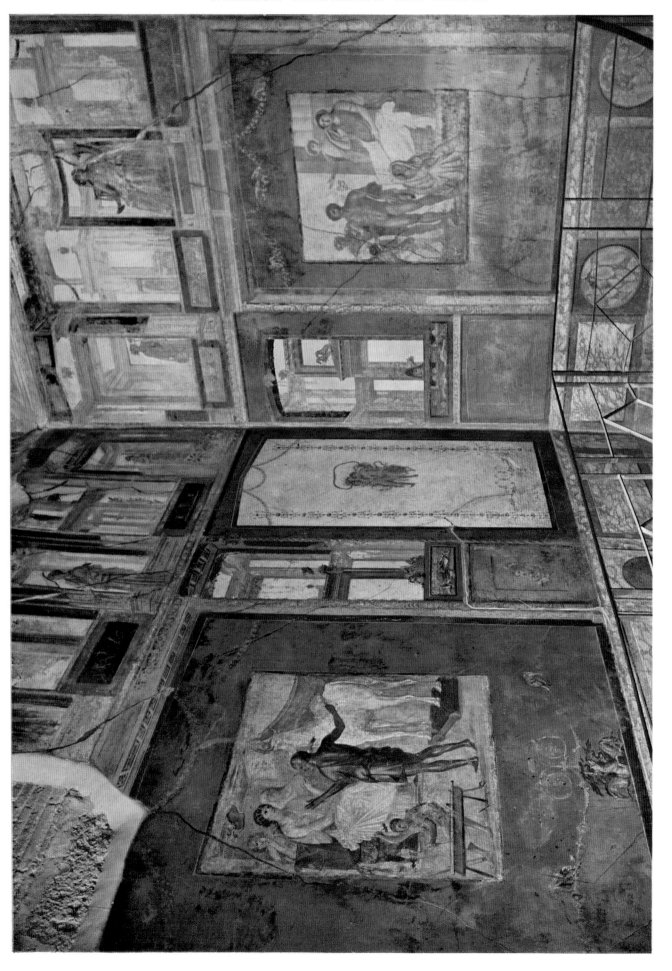

Pl. 93. House of the Vettii, Pompeii, with painted decorations in Style IV and mythological scenes, A.D. 63-79.

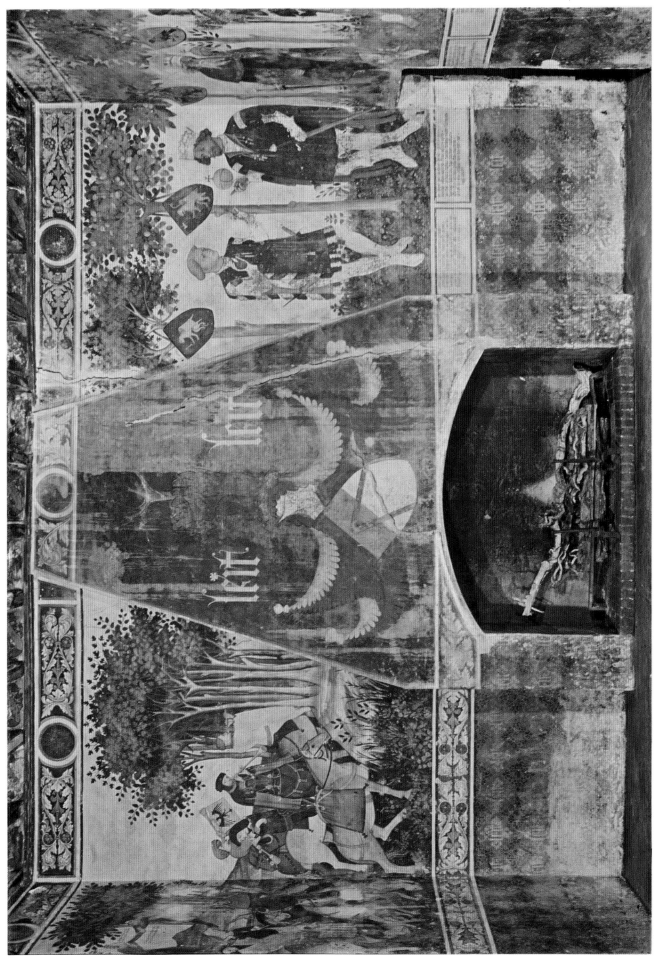

Pl. 94. Frescoed hall, Castello della Manta, Piedmont, Italy, 15th cent.

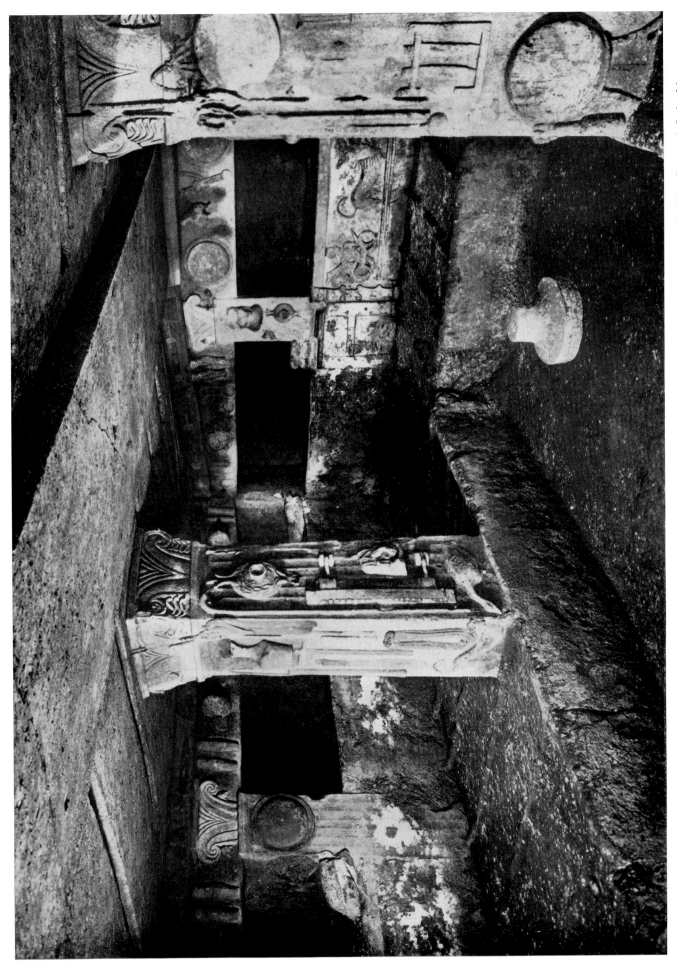

Pl. 95. Etruscan tomb modeled on a house interior, decorated with painted stucco reliefs showing domestic objects and arms, Tomb of the Reliefs, Cerveteri, Italy, 3d cent. B.C.

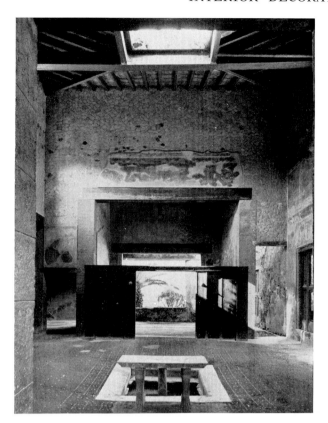

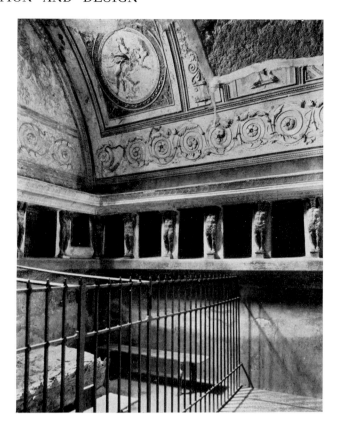

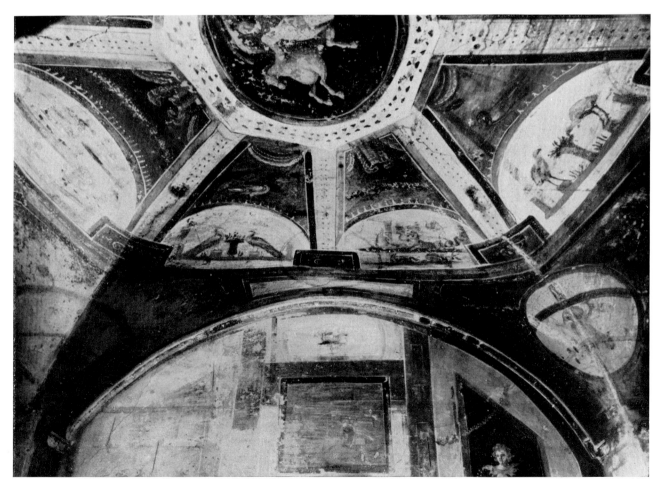

Pl. 96. *Above, left*: Tuscan atrium with impluvium and tablinum, House of the Wooden Partition, Herculaneum, late 1st cent. B.C.–early 1st cent. *Right*: Tepidarium, Baths of the Forum, Pompeii, 1st cent. B.C. *Below*: House of the Painted Vaults, Ostia Antica, Italy, ca. A.D. 120.

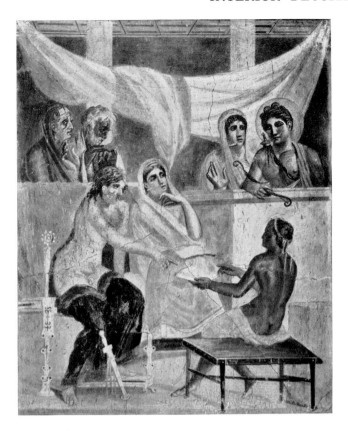

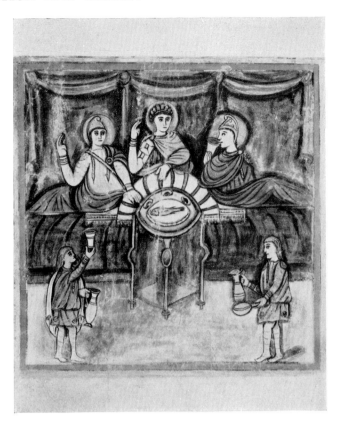

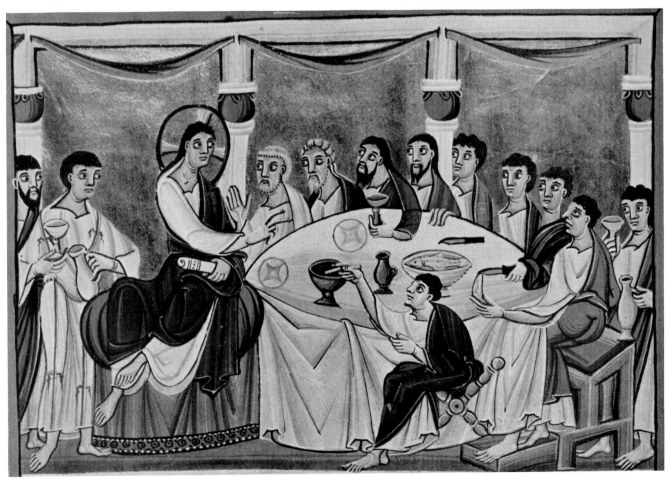

Pl. 97. *Above, left*: Hellenistic-Roman interior, wall painting from Pompeii. Naples, Museo Nazionale. *Right*: Late Roman interior, illumination in *Vergilius Romanus*, late 5th–early 6th cent. Rome, Vatican Library (Cod. Vat. lat. 3867, fol. 100v). *Below*: Pre-Romanesque medieval interior, illumination in the Book of Pericopes of Henry II, from Reichenau, Germany, 1007–14. Munich, Bayerische Staatsbibliothek (Ms. lat. 4452, fol. 105v, detail).

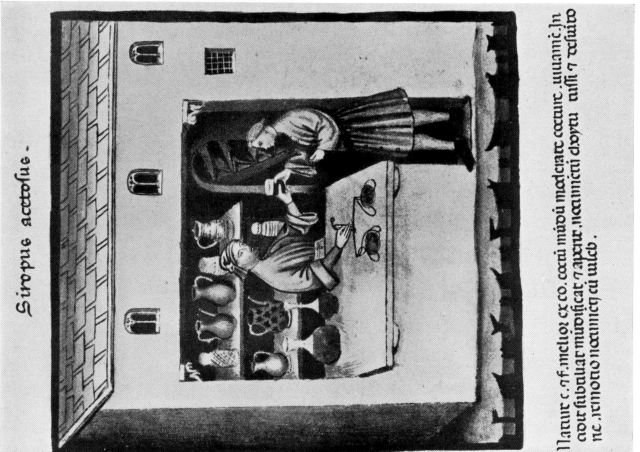

Pl. 98. *Left*: Pharmacy, illumination in *Theatrum Sanitatis*, late 14th cent. Rome, Biblioteca Casanatense (Ms. 4182, fol. 183v). *Right*: Bedroom, detail of a panel painting by Paolo di Giovanni Fei, active 1372–1410, the Birth of the Virgin. Siena, Italy, Pinacoteca.

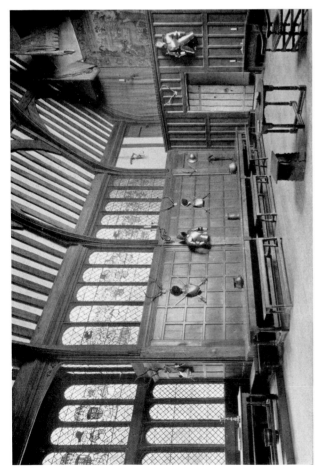

Pl. 99. *Above, left*: The Hall, Ockwells Manor, Berkshire, England, ca. 1450. *Right*: Room of the Abbess Cecilia von Stelfenstein, from the convent of Fraumünster, Zurich, 1489, with furniture of the 15th–16th cent. Zurich, Schweizerisches Landesmuseum. *Below, left*: Bishop Russell's Hall, Bede House, Lyddington, England, late 15th cent. (Copyright, *Country Life*.) *Right*: St. Johannser-Stube, from Villanders, Tirol, ca. 1500. Innsbruck, Tiroler Volkskunstmuseum.

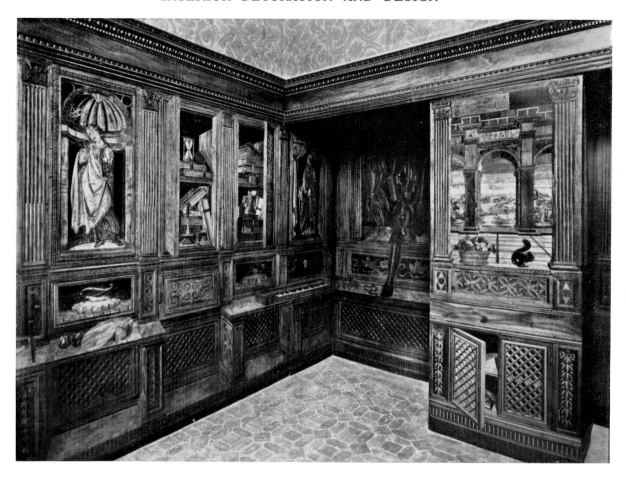

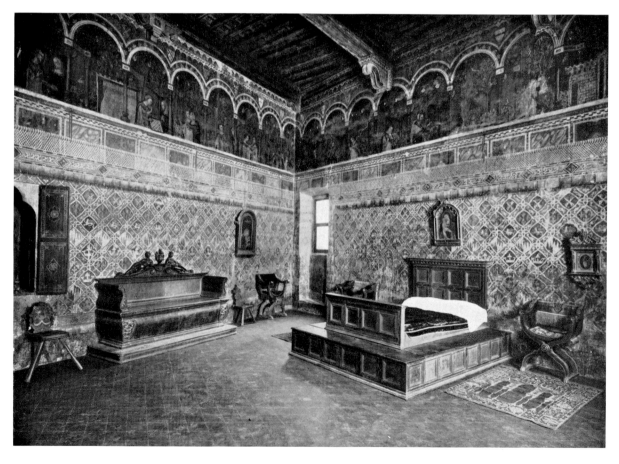

Pl. 100. *Above*: *Studiolo* of Federigo da Montefeltro, Palazzo Ducale, Urbino, Italy, ca. 1470. (See detail, PL. 80.)
Below: Bedroom (as previously furnished), Palazzo Davanzati, Florence, second half of 15th cent.

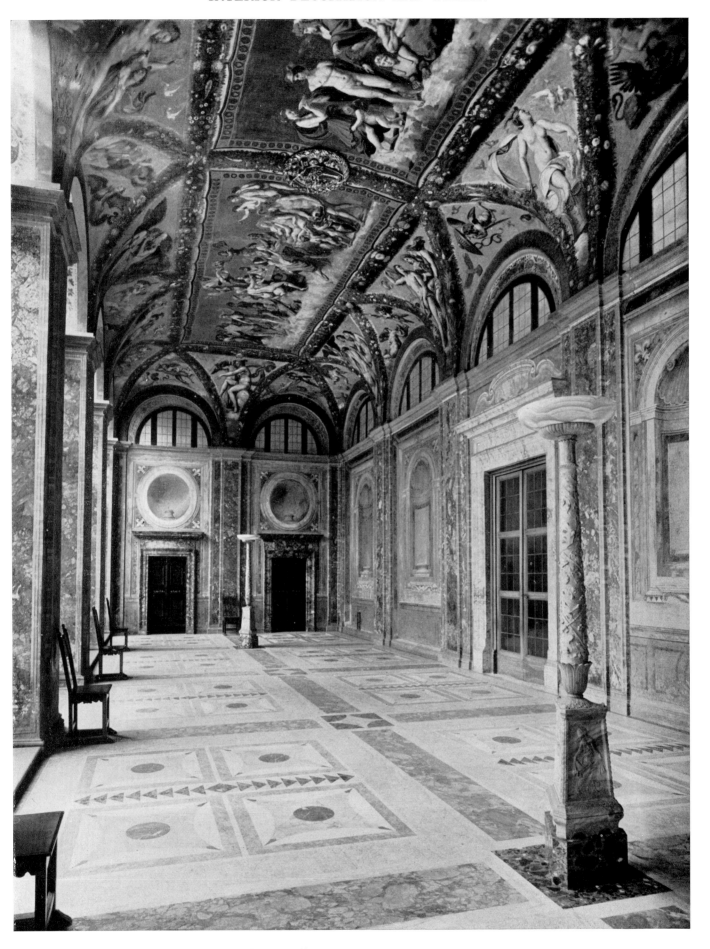

Pl. 101. Loggia, with frescoes by Raphael and assistants, Farnesina, Rome, early 16th cent.

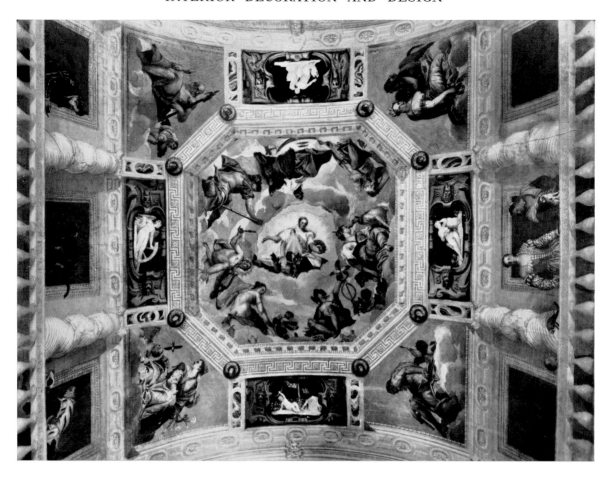

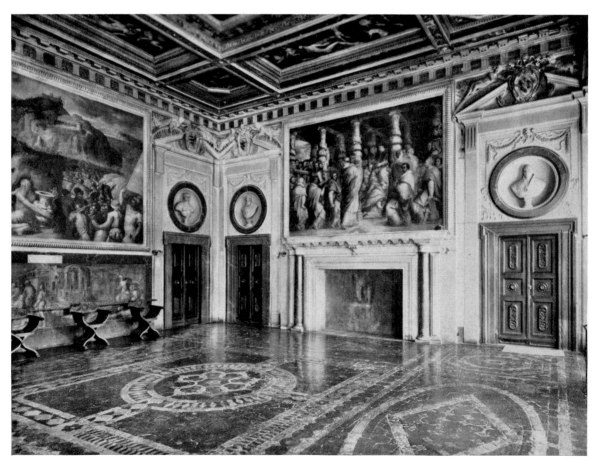

Pl. 102. *Above*: Sale dell'Olimpo, with frescoes by P. Veronese, Villa Barbaro, Maser, Treviso, Italy, second half of 16th cent. *Below*: Hall of Leo X, decorated (1560) by G. Vasari and assistants, Palazzo Vecchio, Florence.

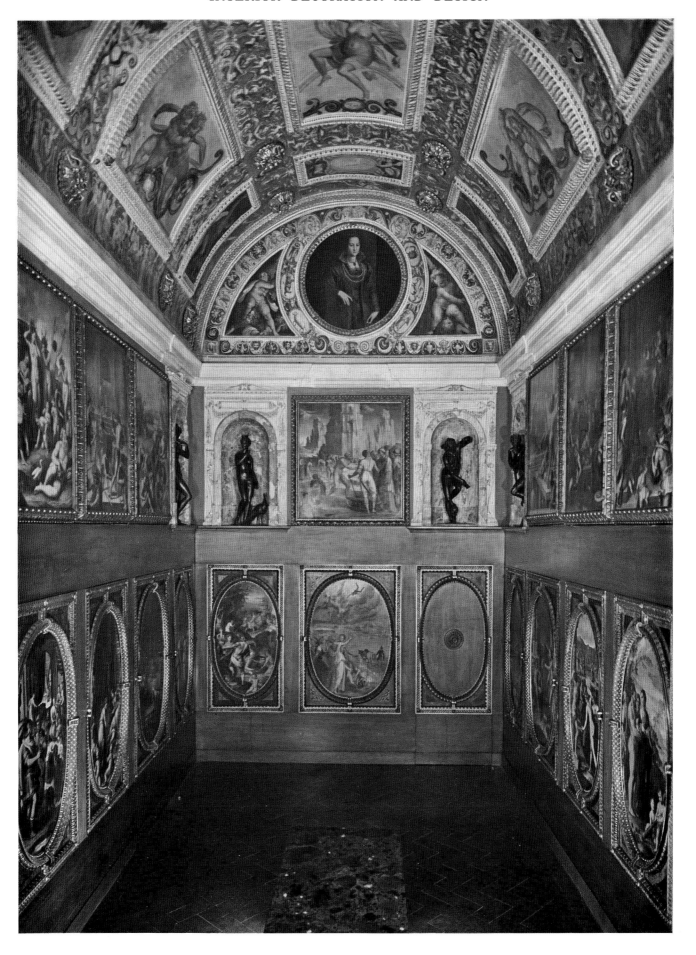

Pl. 103. *Studiolo* of Francesco I de' Medici, decorated (ca. 1570) by G. Vasari, Palazzo Vecchio, Florence.

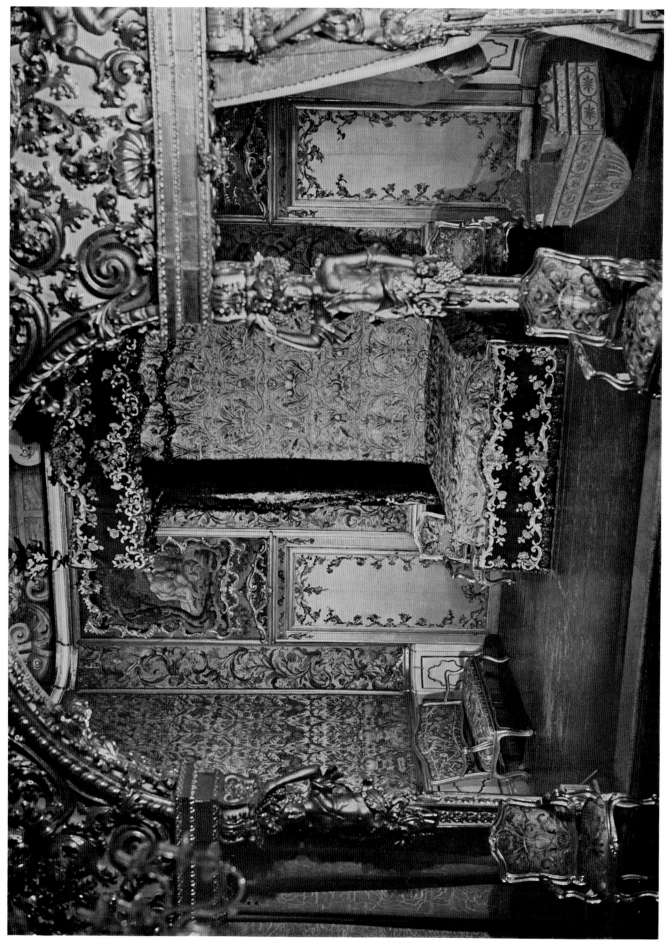

Pl. 104. Camera dell'Alcova, Palazzo Mansi, Lucca, Italy, 17th cent.

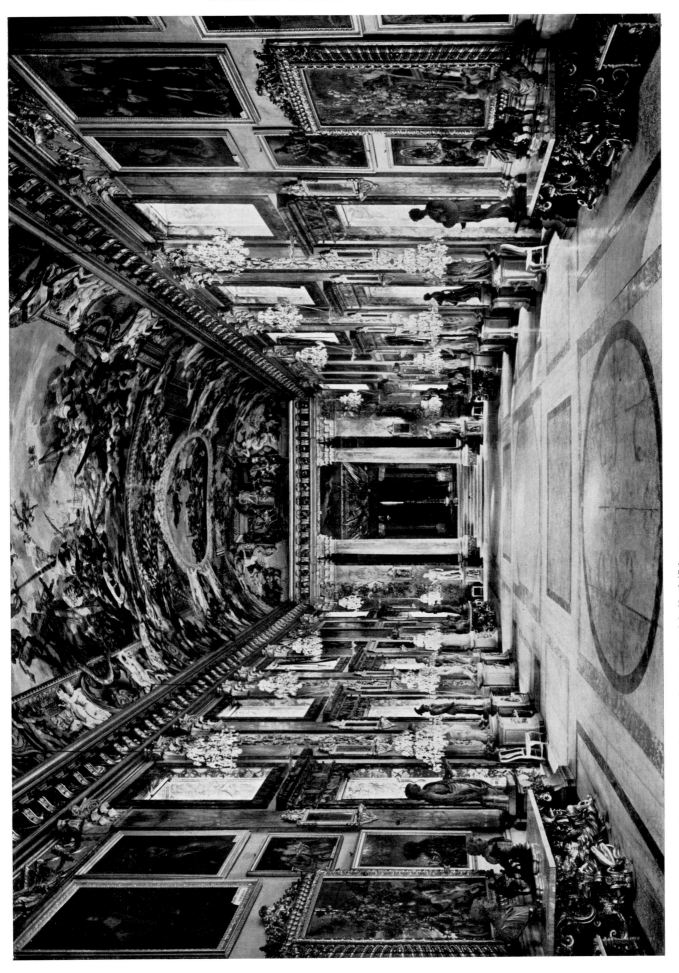

Pl. 105. *Salone* of the Galleria, Palazzo Colonna, Rome, second half of 17th cent.

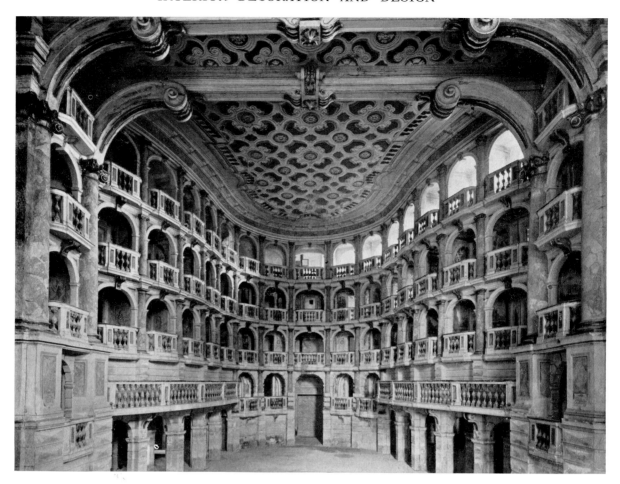

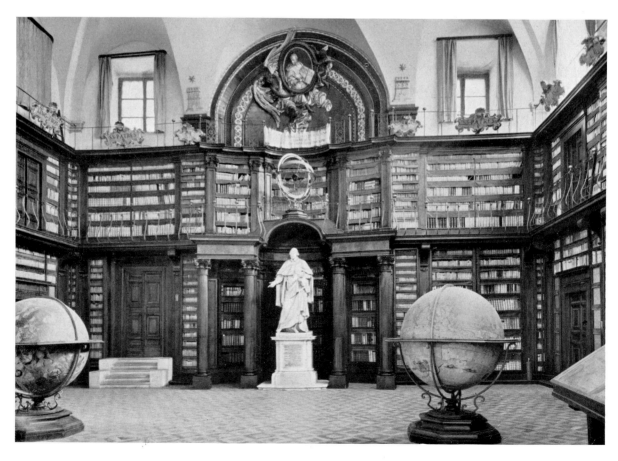

Pl. 106. *Above*: A. Galli Bibiena, Teatro Scientifico, Accademia Virgiliana, Mantua, Italy, first half of 18th cent.
Below: *Salone* of the Biblioteca Casanatense, Rome, with 18th-cent. shelving.

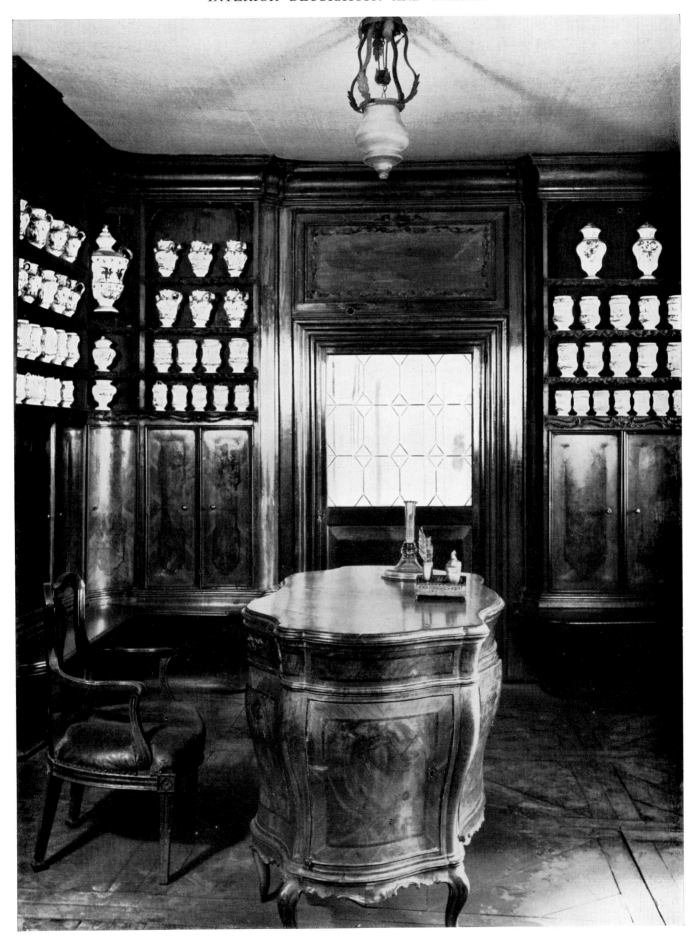

Pl. 107. Reconstruction of pharmacy "Ai due San Marchi," formerly in Campo San Stin, Venice, 18th cent. Venice, Ca' Rezzonico.

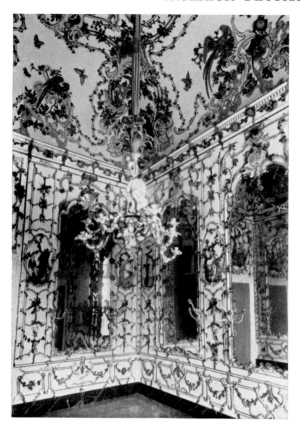

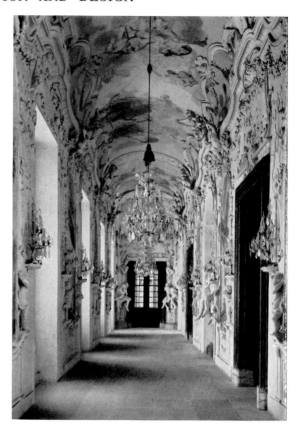

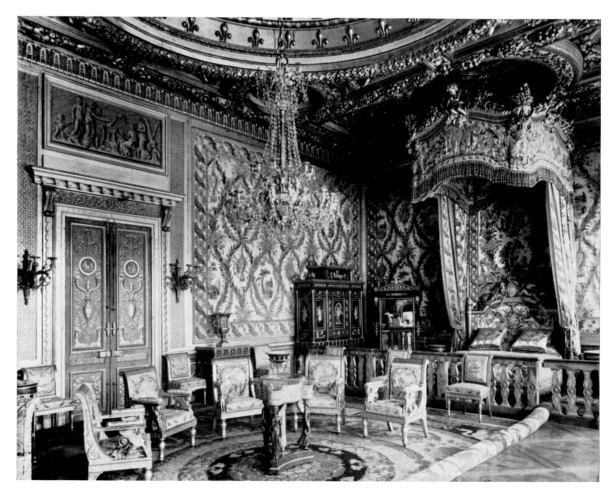

Pl. 108. *Above, left*: Porcelain Room, Palazzo di Capodimonte, Naples, 1757–59. *Right*: D. G. Frisoni, Hall of Mirrors, in the palace at Ludwigsburg, Germany, first half of 18th cent. *Below*: Bedroom, redecorated for Marie Antoinette, in the palace at Fontainebleau, France, 1770–90.

INTERIOR DECORATION AND DESIGN

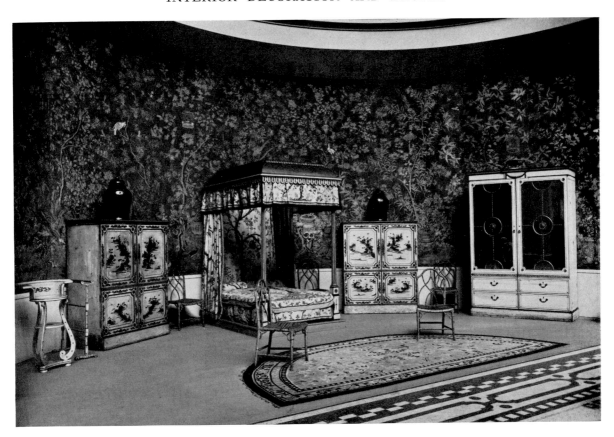

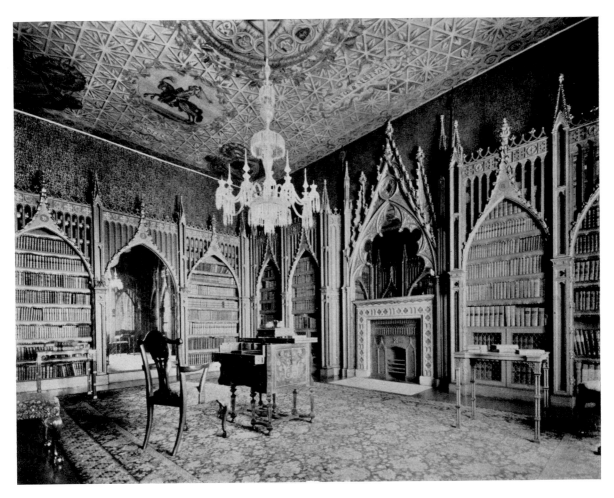

Pl. 109. *Above*: Bedroom in Chinese taste, ca. 1750. London, Victoria and Albert Museum. *Below*: J. Chute, library of Strawberry Hill (home of Walpole), Twickenham Middlesex, England, 1754. (Copyright, *Country Life.*)

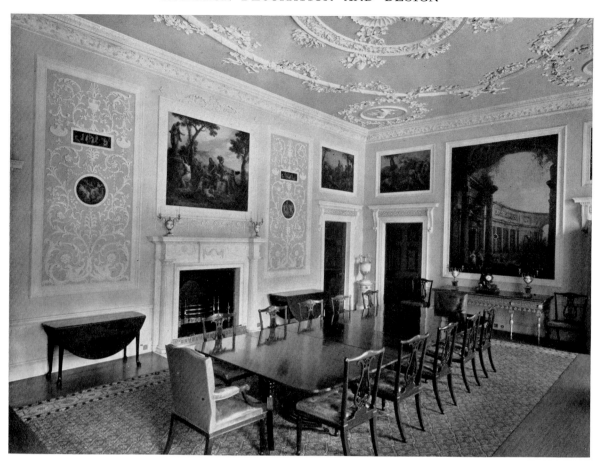

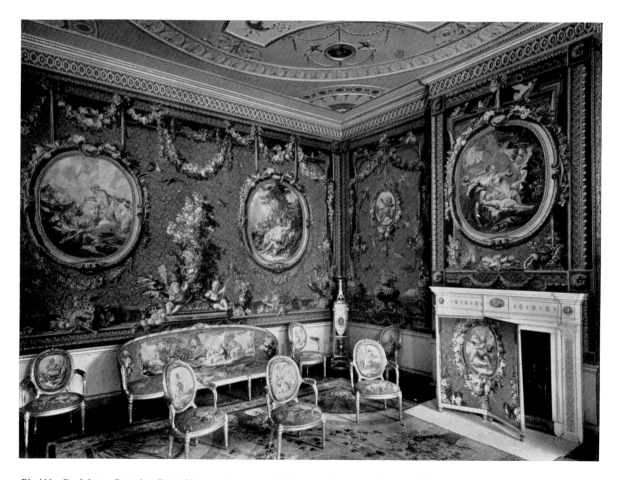

Pl. 110. R. Adam, Osterley Park House, Osterley, Middlesex, England. *Above*: Dining Room, ca. 1765. *Below*: Tapestry Room, ca. 1775.

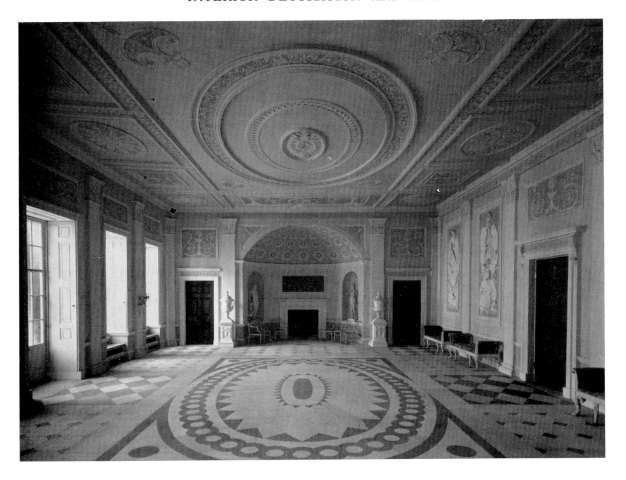

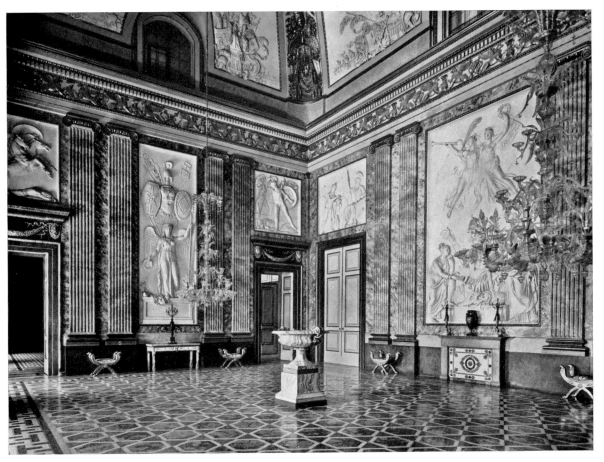

Pl. 111. *Above*: R. Adam, vestibule of Osterley Park House, Osterley, Middlesex, England, ca. 1765. *Below*: Room of Mars (Sala di Marte), in the palace at Caserta, Italy, ca. 1810.

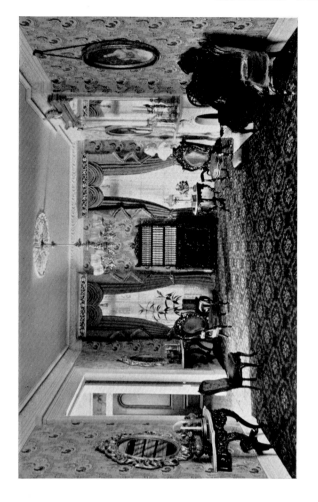

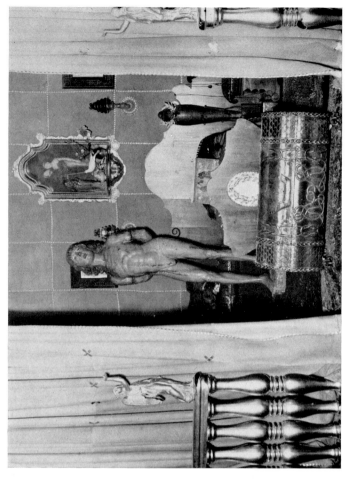

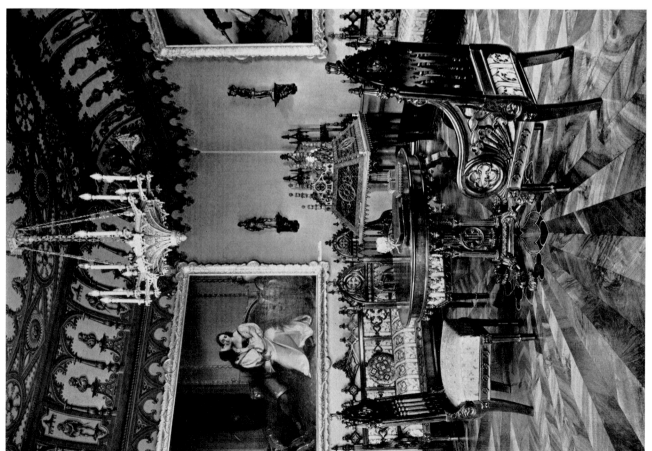

Pl. 112. *Left*: Neo-Gothic interior, Italy, second half of 19th cent. Triestre, Museo Sartorio. *Right, above*: Scale reproduction of the parlor of the Theodore Roosevelt House, New York City, 1850–75. Chicago, Art Institute. *Below*: The so-called "Room of the Leper," in Vittoriale (home of d'Annunzio), Gardone Riviera, Italy, 3d decade of 20th cent.

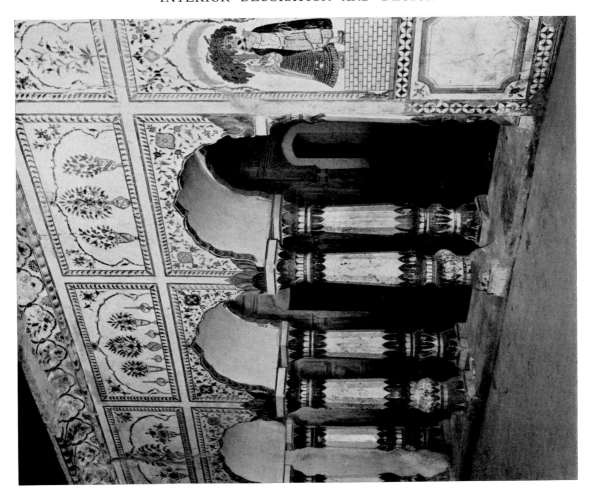

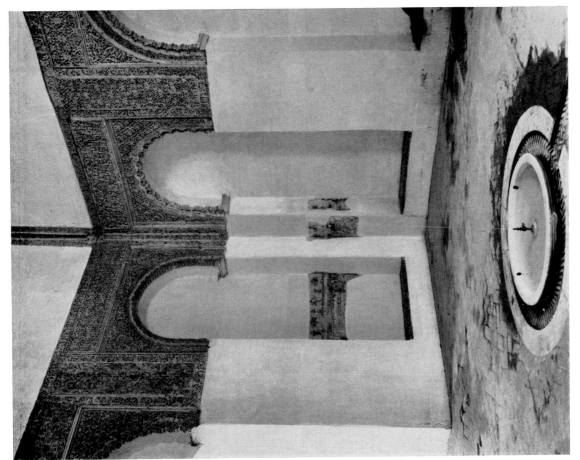

Pl. 113. *Left*: Hall of Justice, Yeso Apartments, Alcázar, Seville, 14th cent. *Right*: Painted corridor in the women's quarters, Ramnagar palace, Jammu, Kashmir, 18th cent.

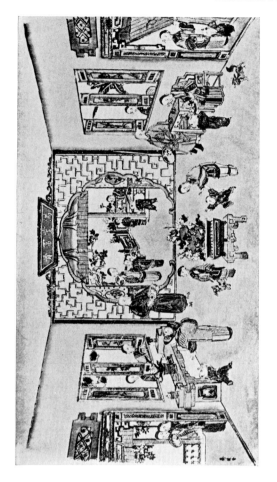

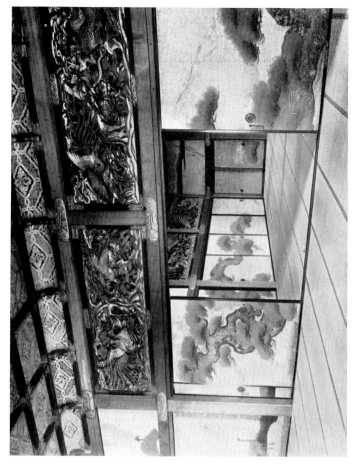

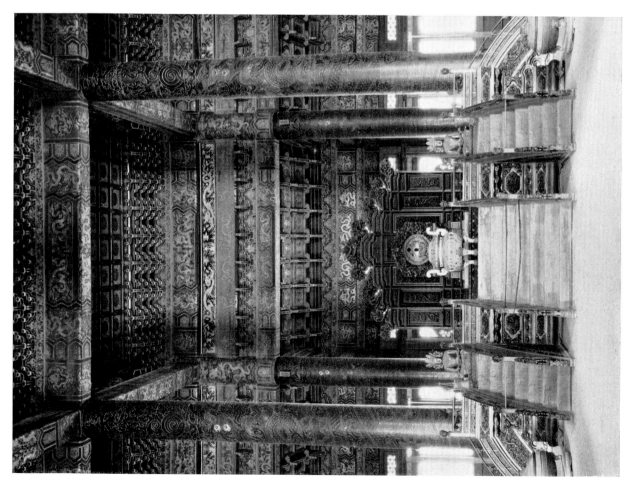

Pl. 114. *Left*: Throne room of the T'ai-ho-tien, Peking, Ch'ing dynasty. *Right, above*: Chinese 19th-cent. interior, depicted in a print called "Family Reunion," 1851–75. *Below*: Reception hall of Nijō castle, Kyoto, 17th cent.

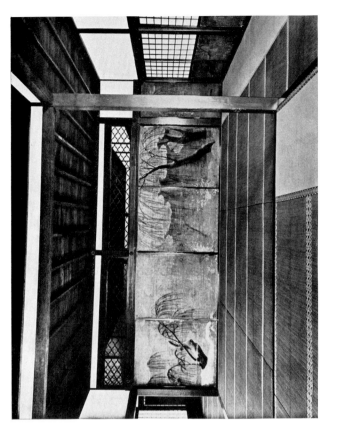

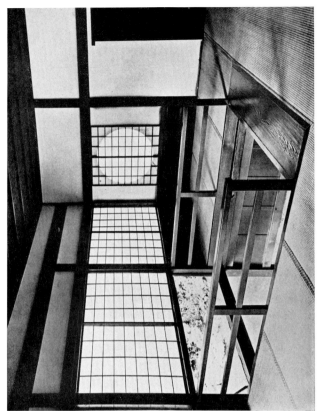

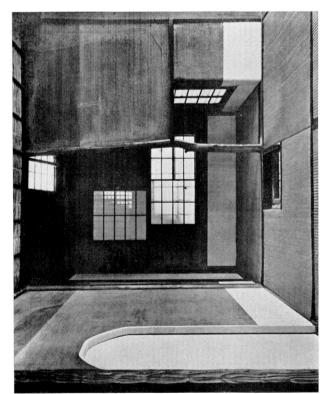

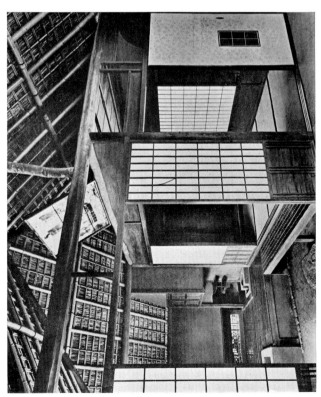

Pl. 115. *Left*: Tea-ceremony houses, Katsura palace, Kyoto, 17th cent. *Above*: The Shōkintei. *Below*: The Gepparō. *Right*: Two interiors of the Hiunkaku, Kyoto, late 16th cent.

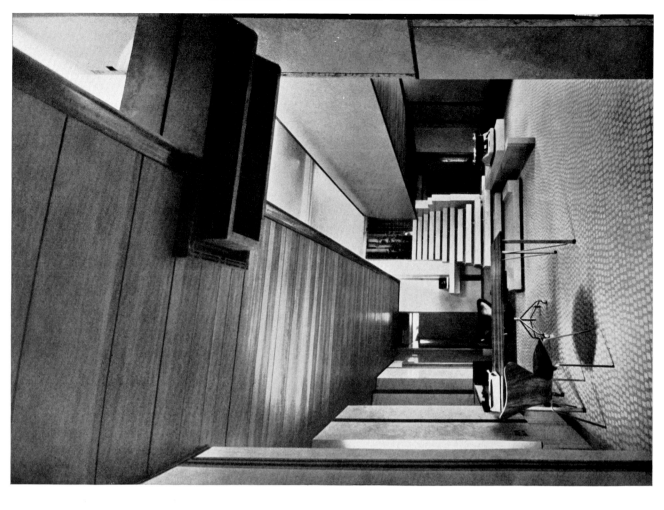

Pl. 116. *Left, above:* F. L. Wright, living room of Taliesin West (the architect's home), Scottsdale, Ariz., begun 1938. *Below:* R. Neutra, room in the Von Sternberg house, Santa Monica, Calif., 1935. *Right:* C. Scarpa, the Olivetti premises in Piazza San Marco, Venice, 1958.

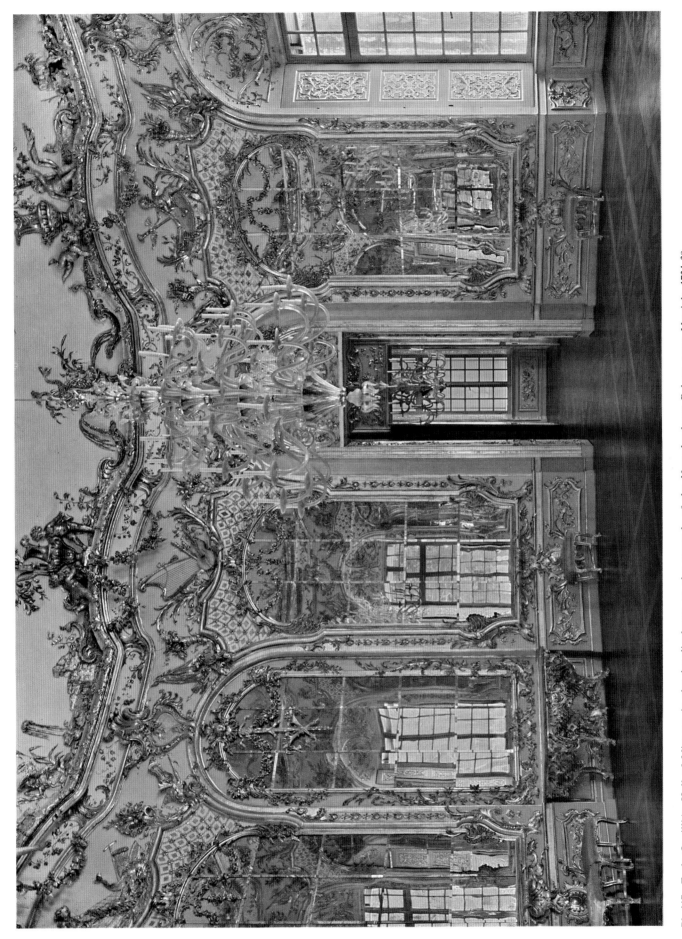

Pl. 117. F. de Cuvilliés, Hall of Mirrors, in the Amalienburg, on the grounds of the Nymphenburg Palace, near Munich, 1734-39.

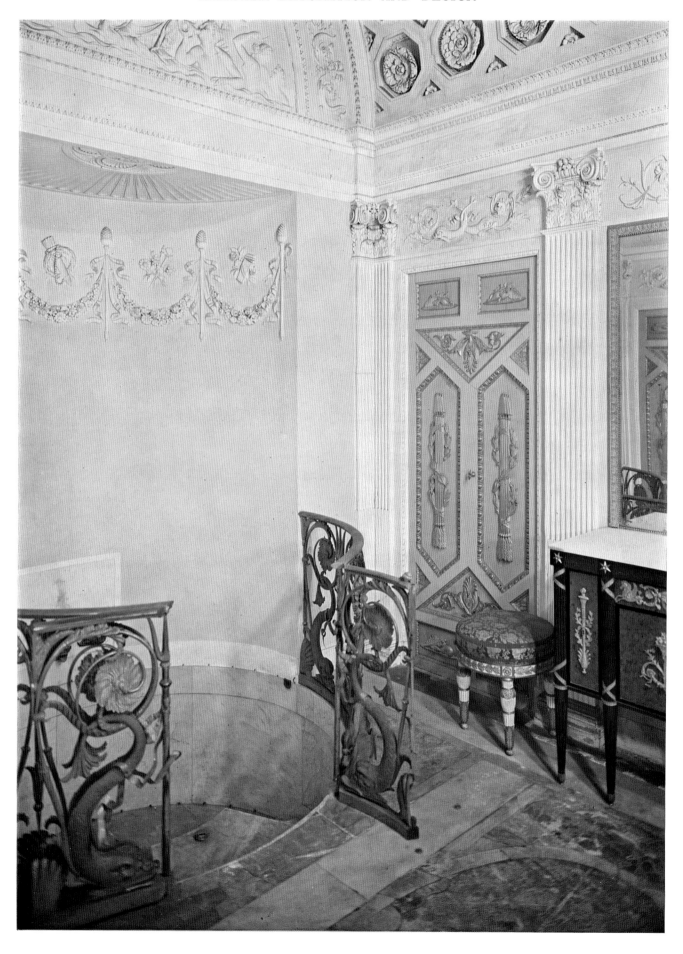

Pl. 118. Bathroom of Maria Luisa, in the Pitti Palace, Florence, second half of 18th cent.

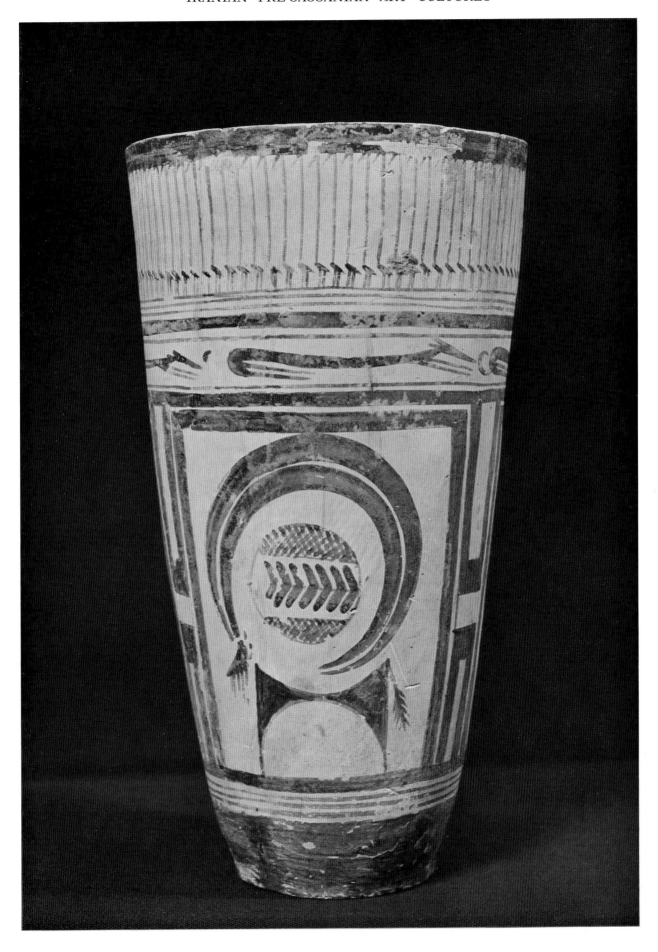

Pl. 119. Goblet of Style I, from Susa, Khuzistan, second half of 4th millennium B.C. Terra cotta, ht., 11 3/8 in. Paris, Louvre.

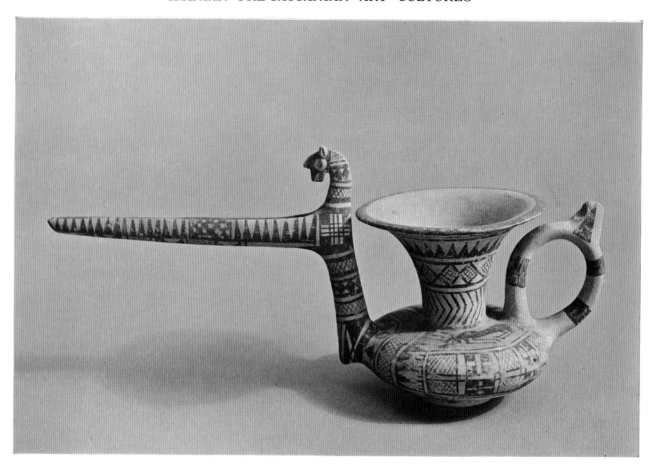

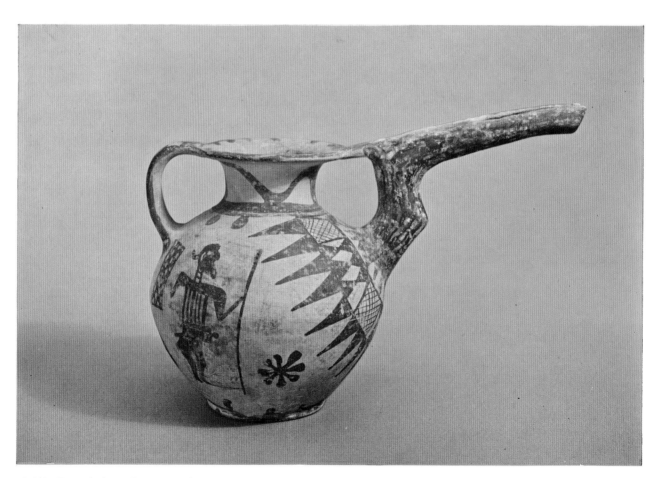

Pl. 120. Two pitchers, from Tepe Sialk, near Kashan, ca. 11th cent. B.C. Terra cotta; l., *above*, 15³/₄ in.; *below*, 11³/₄ in. Lucerne, Switzerland, Kofler-Truniger Coll.

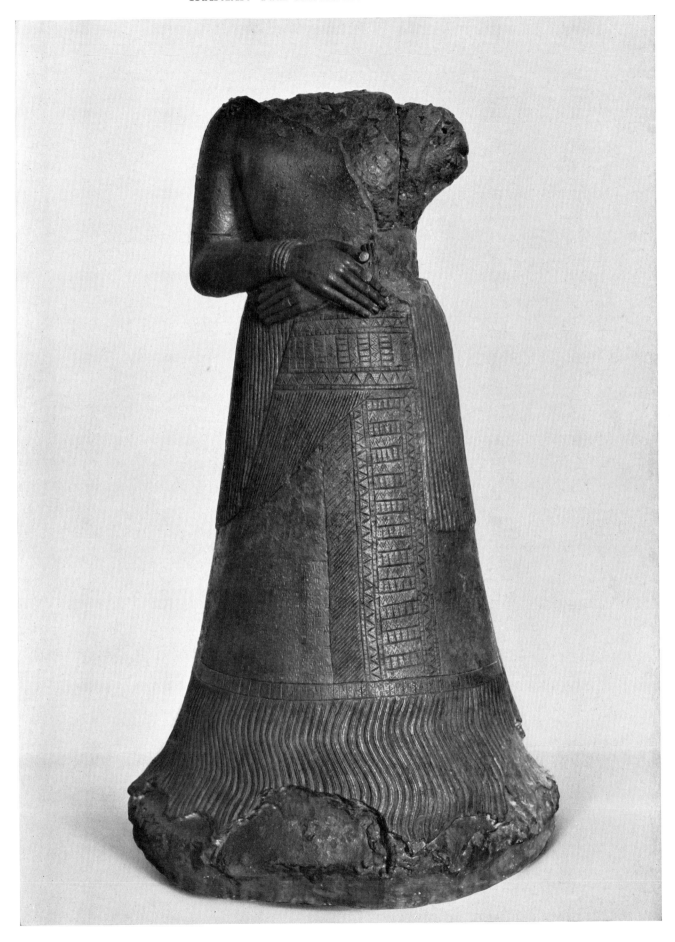

Pl. 121. Statue of Queen Napirasu, from Susa, Khuzistan, 13th cent. B.C. Bronze, ht., 4 ft., 3 in. Paris, Louvre.

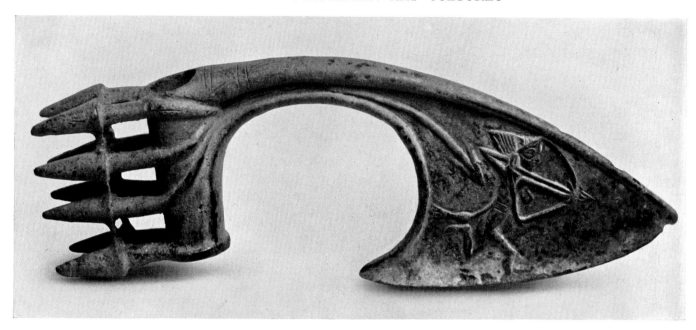

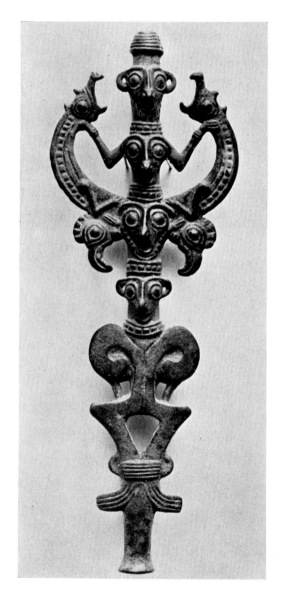

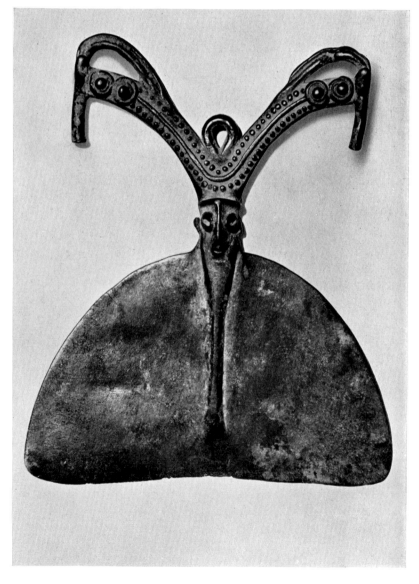

Pl. 122. Luristan bronzes, 14th–9th cent. B.C. *Above*: Axhead. L., 10 in. Paris, Coll. David-Weill. *Below, left*: Finial. *Right*: So-called "razor blade." Last two, New York, N. Heeramaneck Coll.

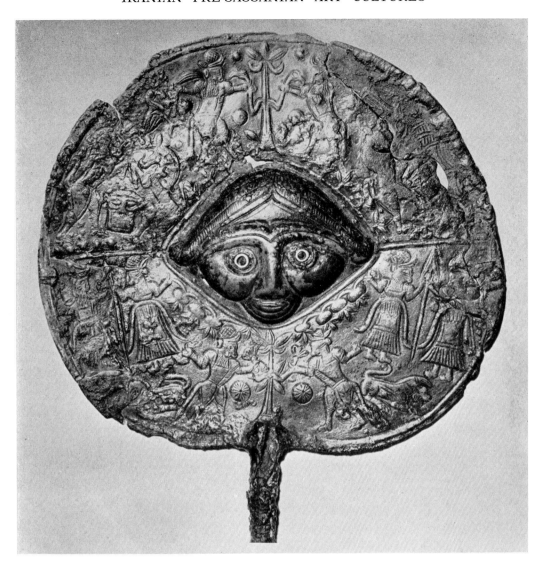

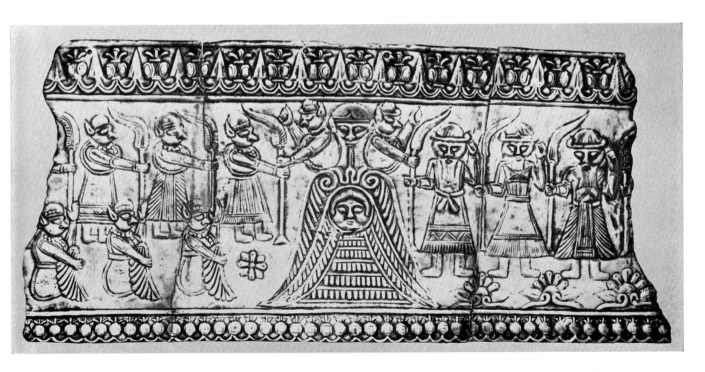

Pl. 123. Luristan, 14th–9th cent. B.C. *Above*: Head of a pin. Bronze, diam., 6¼ in. New York, N. Heeramaneck Coll. *Below*: Plaque representing Eternity in androgynous form, with his sons Ormazd and Ahriman receiving the barsom. Silver. Cincinnati, Art Museum.

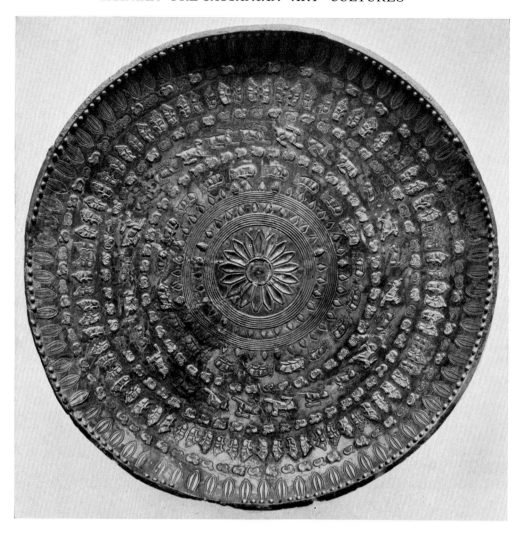

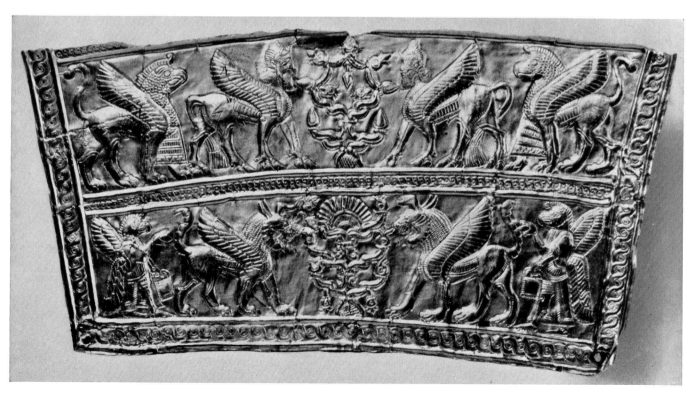

Pl. 124. Hoard of Zawiyeh, Azerbaijan, 7th cent. B.C. *Above*: Engraved dish. Silver with gold studs along rim; diam., ca. 15 in. Teheran,
Archaeological Museum. *Below*: Fragment of overlay. Gold, $3^9/_{16} \times 7$ in. Toronto, Royal Ontario Museum, J. H. Hirshhorn loan.

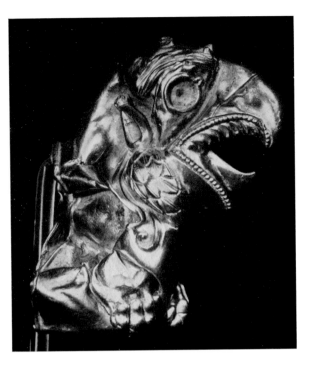

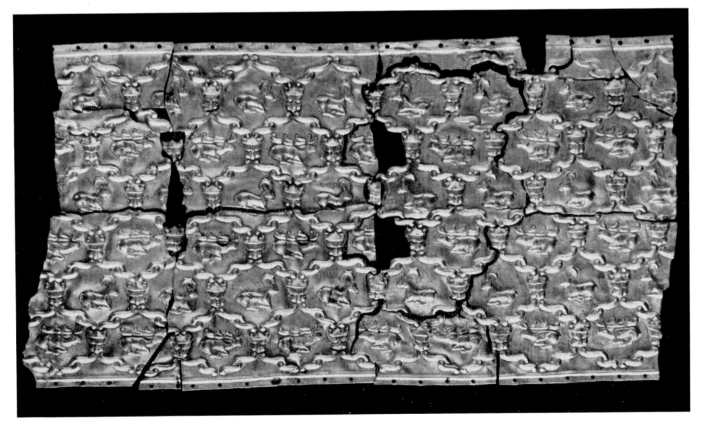

Pl. 125. Hoard of Zawiyeh, Azerbaijan, 7th cent. B.C. Gold. *Above, left*: Terminal representing a griffin. *Right*: Bracelet. *Below*: Plaque, from a belt (?). All, Teheran, Archaeological Museum.

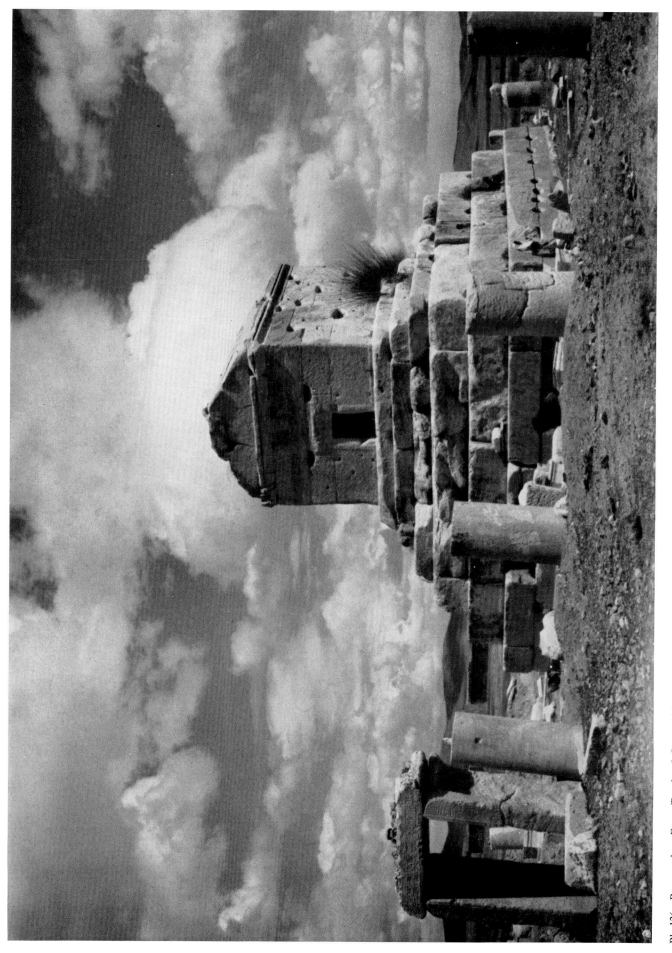

Pl. 126. Pasargadae, Fars, Tomb of Cyrus, 6th cent. B.C.

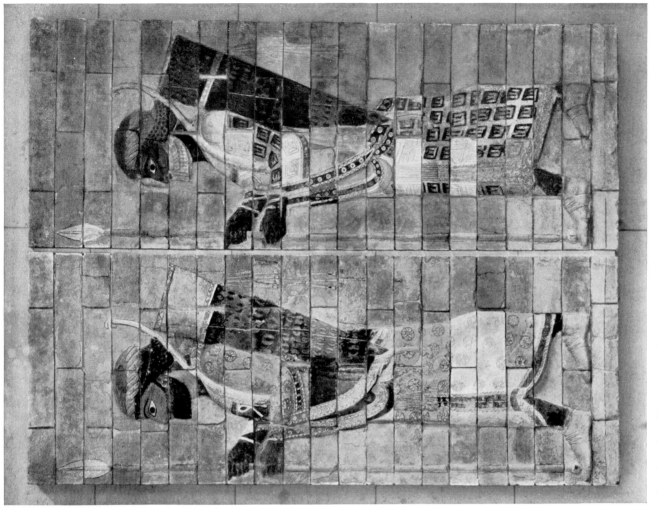

Pl. 127. *Left*: Pasargadae, Fars, doorjamb of the Palace of Cyrus, with relief of a winged genius, 6th cent. B.C. Stone. *Right*: Archers, detail of wall decoration from the Palace of Darius, Susa, Khuzistan, early 5th cent. B.C. Glazed brick. Paris, Louvre. (Cf. IV, Pl. 21.)

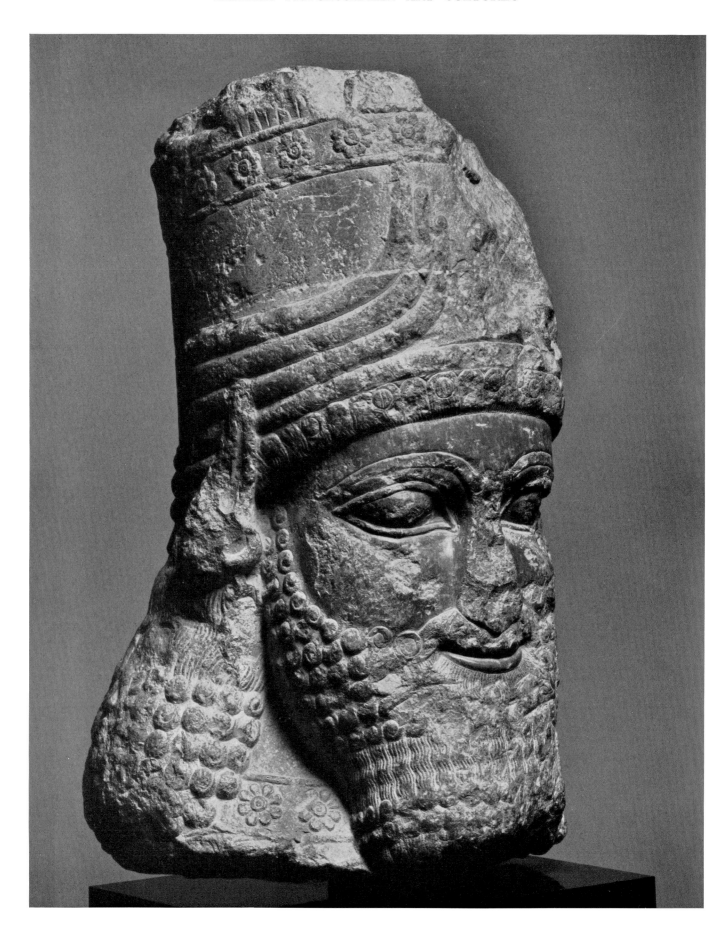

Pl. 128. Head, from a human-headed bull capital (?), Ecbatana (mod. Hamadan), 6th–5th cent. B.C. Ht., 19³/₄ in. Kansas City, Mo.,
Nelson Gallery of Art and Atkins Museum.

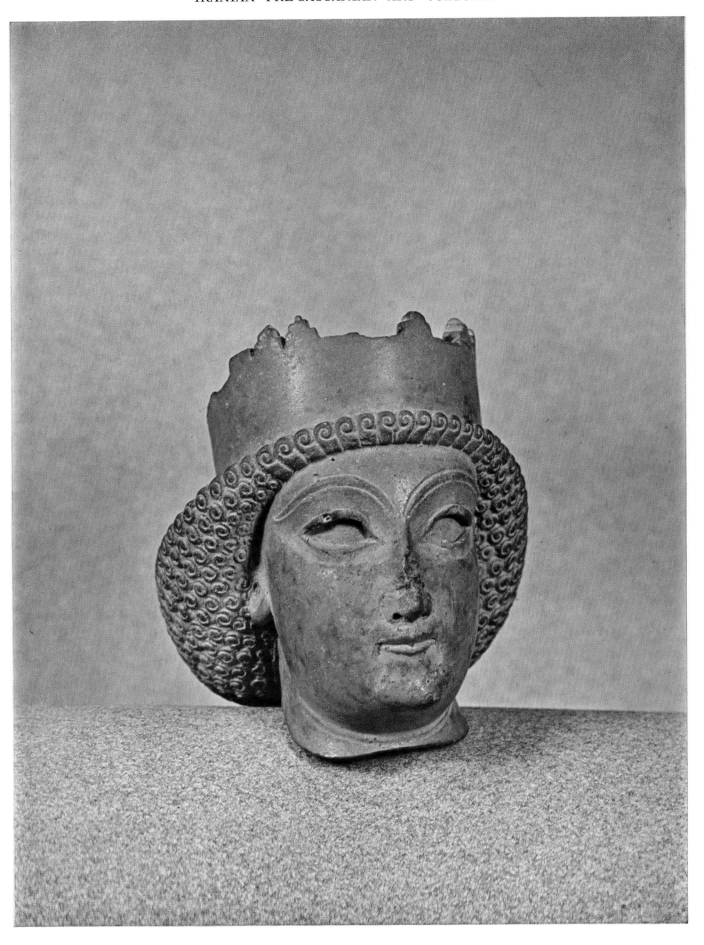

Pl. 129. Head of a prince, from Persepolis, 5th cent. B.C. Lapis-lazuli paste, ht., 2³/₄ in. Teheran, Archaeological Museum.

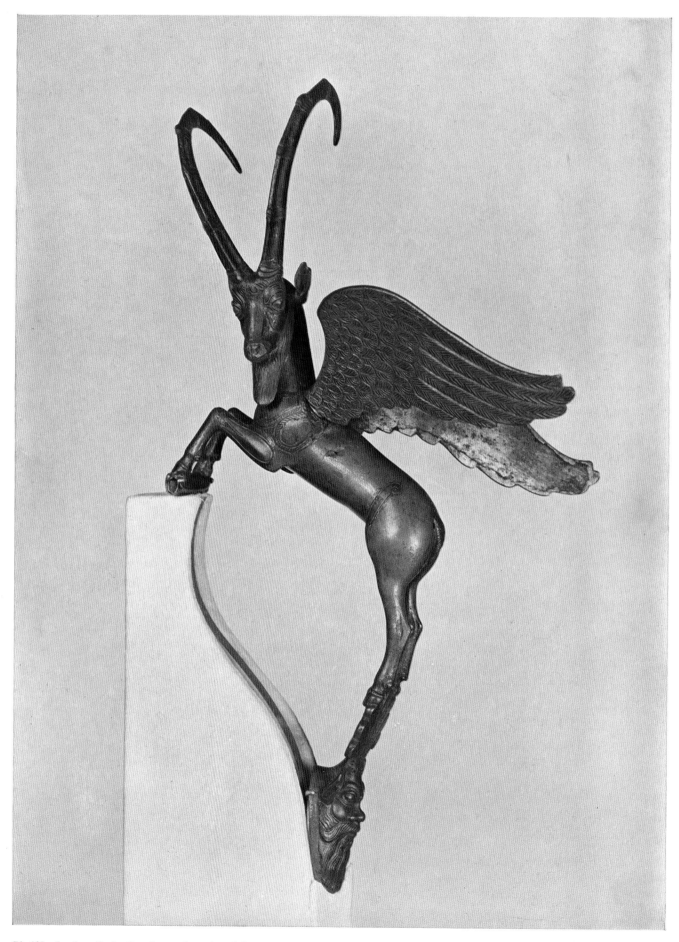

Pl. 130. Jar handle in the shape of a winged ibex upon a satyr's head, Achaemenid period. Bronze with silver and gold; ht., ca. 10³/₄ in. Paris, Louvre.

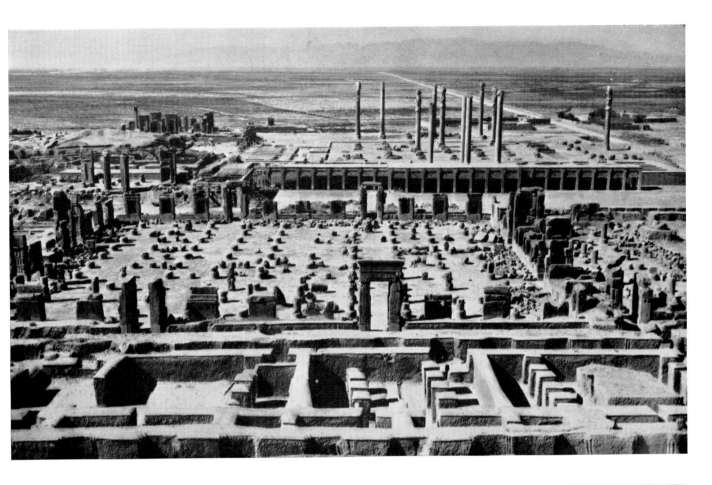

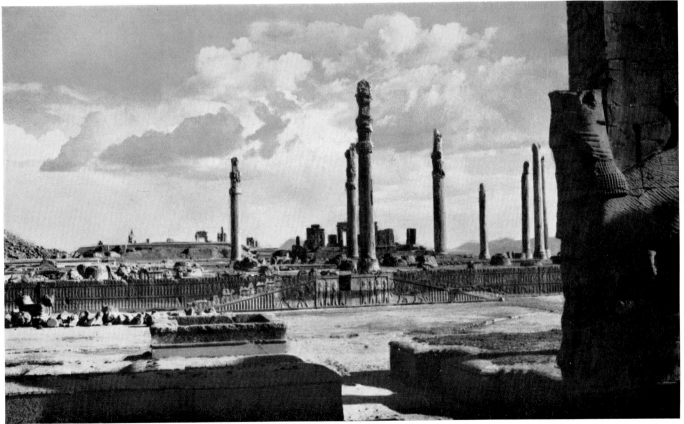

Pl. 131. Persepolis. *Above*: Panorama of the ruins. *Below*: View showing the Apadana (Audience Hall), late 6th–early 5th cent. B.C.

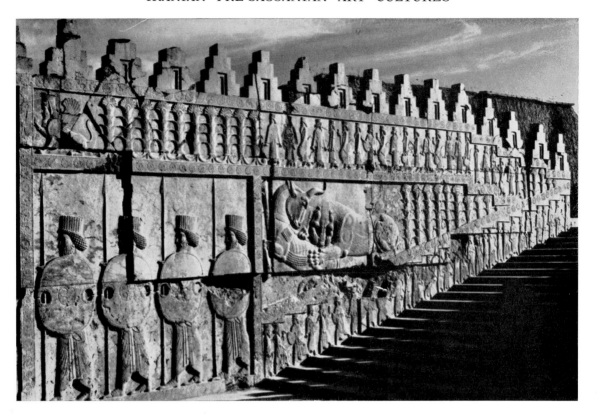

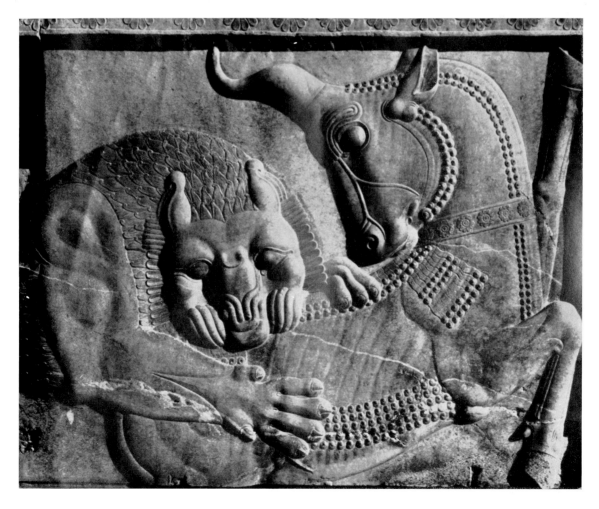

Pl. 132. Persepolis, reliefs of the main stairway leading to the Tripylon (Council Hall), late 6th–early 5th cent. B.C. *Above*: West wing, with procession of Persian guards and dignitaries. *Below*: Lion attacking bull, on the east wing.

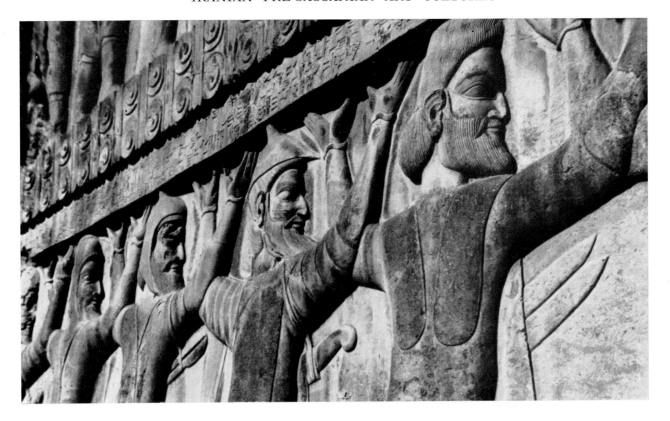

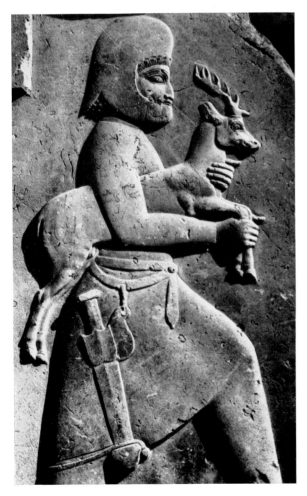
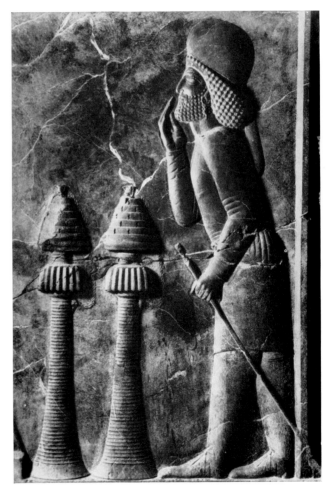

Pl. 133. Persepolis, reliefs. *Above*: The nations of the empire supporting the throne, detail, façade of southern royal tomb above the Terrace, usually assigned to Artaxerxes II, d. 359 B.C. *Below, left*: Servitor, southern stairway, Palace of Darius, late 6th–early 5th cent. B.C. *Right*: Official received by Darius, detail of audience scene, southern portico, court of the Treasury, late 6th–early 5th cent. B.C.

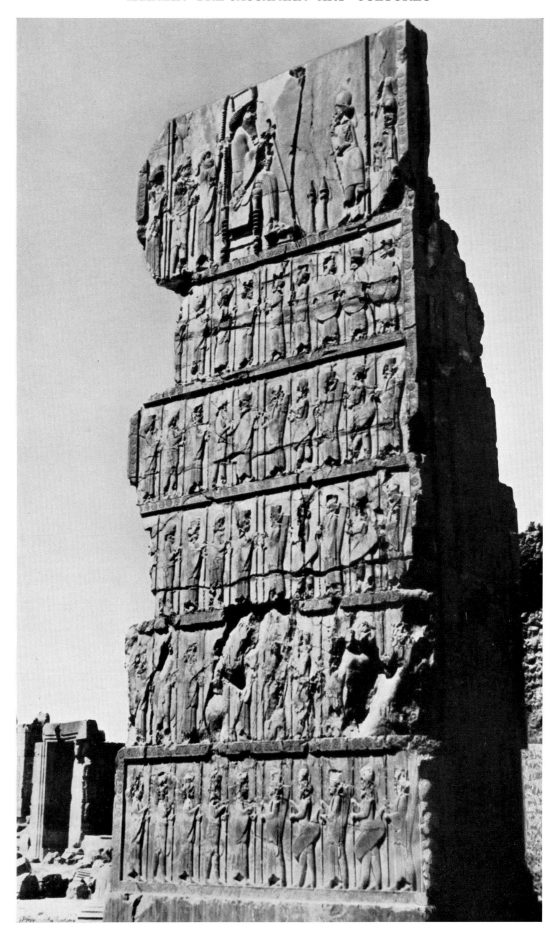

Pl. 134. Persepolis, doorjamb in the Throne Hall of Xerxes ("Hundred Column Hall"), with audience scene surmounting rows of guards, 5th cent. B.C.

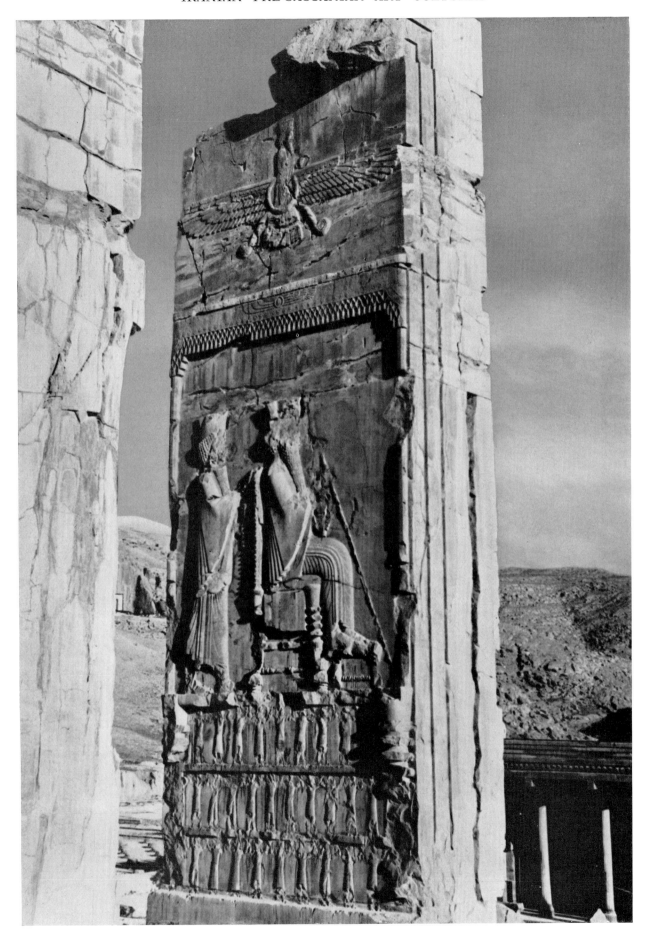

Pl. 135. Persepolis, doorjamb in the Tripylon (Council Hall), showing Darius enthroned beneath a baldachin, late 6th–
early 5th cent. B.C.

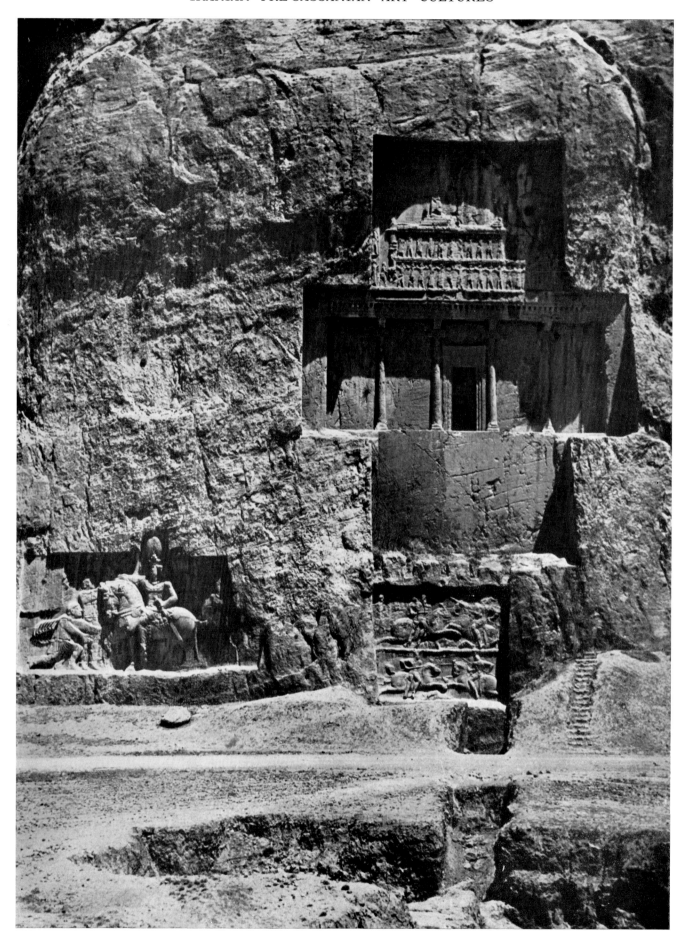

Pl. 136. Naqsh-i-Rustam, Fars, Tomb of Darius I, 5th cent. B.C. (See IV, PL. 457.)

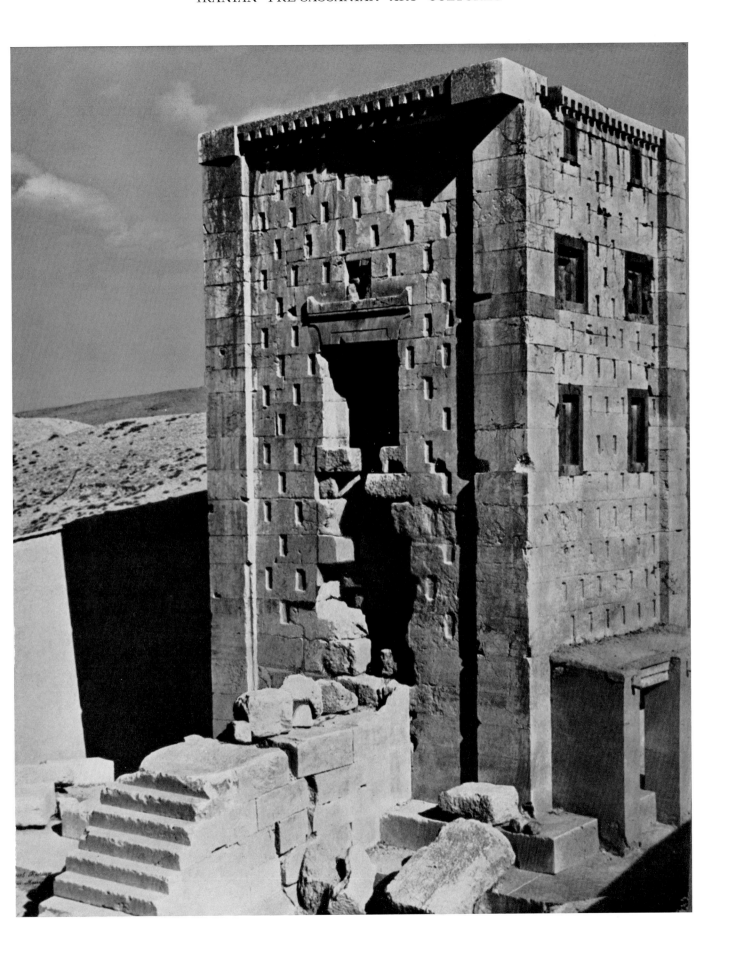

Pl. 137. Naqsh-i-Rustam, Fars, tower, probably a temple for conservation of the sacred fire, 5th cent. B.C.

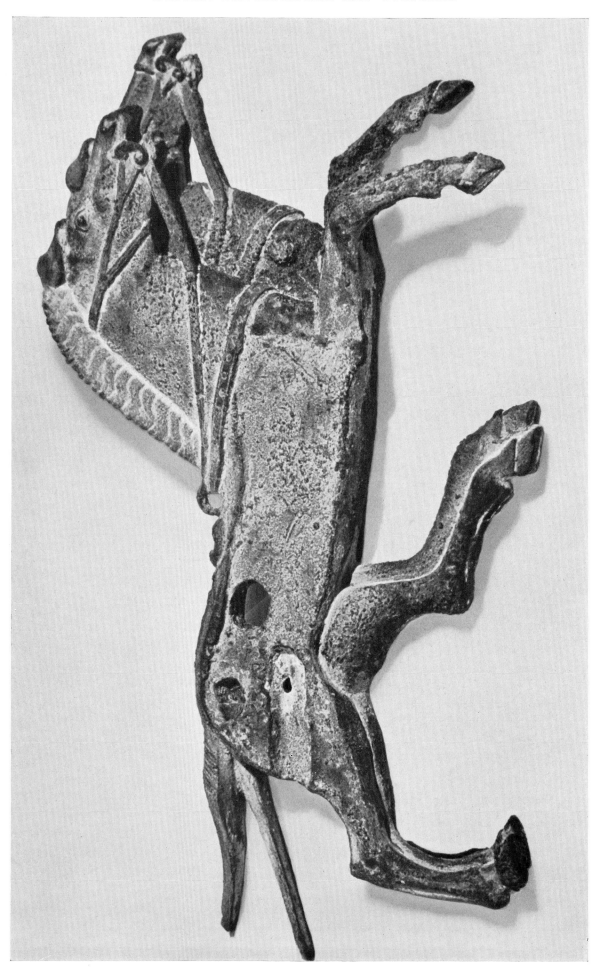

Pl. 138. Pair of horses, plaque from Persepolis, Achaemenid period. Bronze, l., 5⁷/₈ in. Teheran, Archaeological Museum.

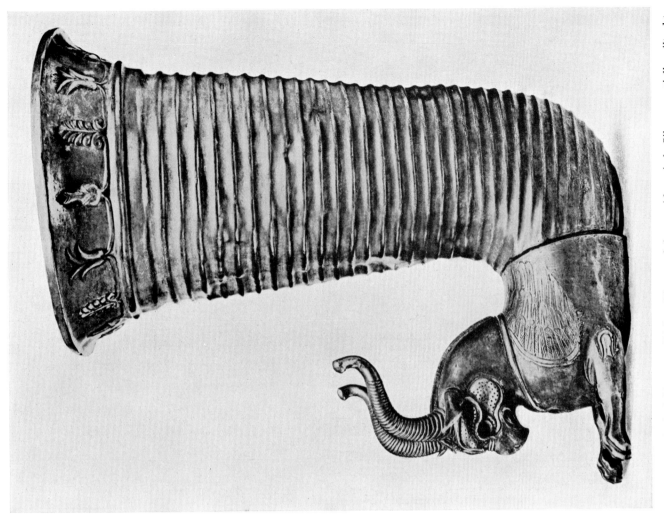

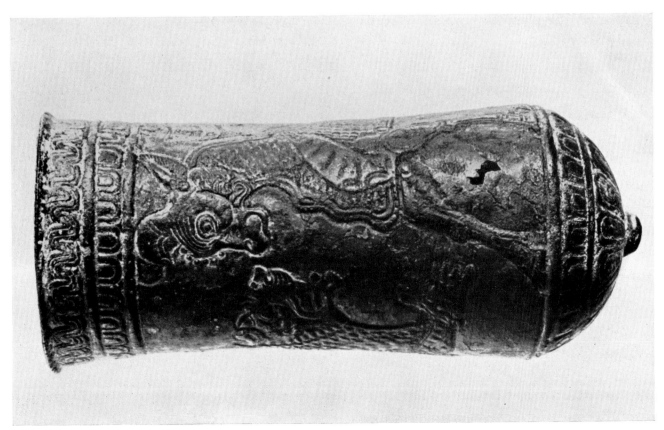

Pl. 139. *Left*: Situla, from Luristan, ca. 8th–7th cent. B.C. Bronze, ht., 6¼ in. Teheran, Archaeological Museum. *Right*: Rhyton, Achaemenid period. Silver, partially gilt; ht., 9¹³/₁₆ in. London, British Museum.

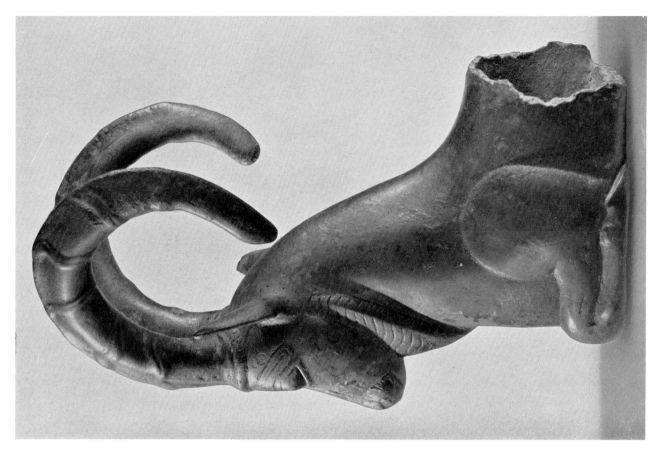

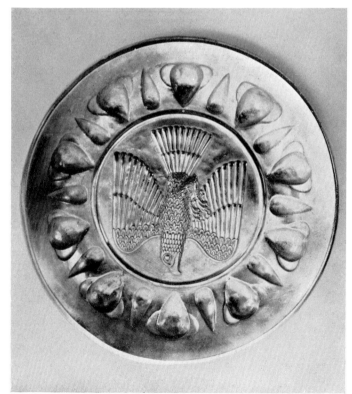

Pl. 140. *Left, above:* Sword hilt, Achaemenid period. Gold. Teheran, Archaeological Museum. *Below:* Plate with eagle, Achaemenid period. Gold. Teheran, private coll. *Right:* Fragment of a ram, Achaemenid period. Bronze, ht., ca. 11³/₄ in. Boston, Museum of Fine Arts.

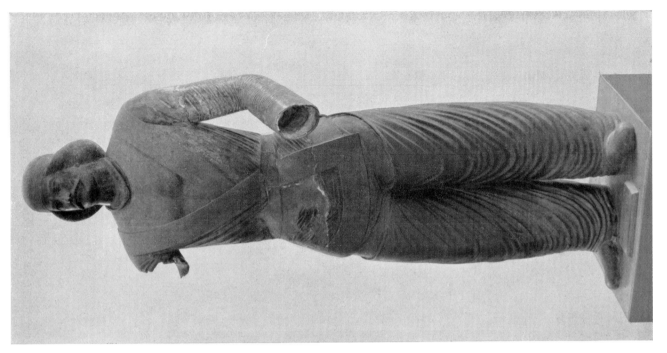

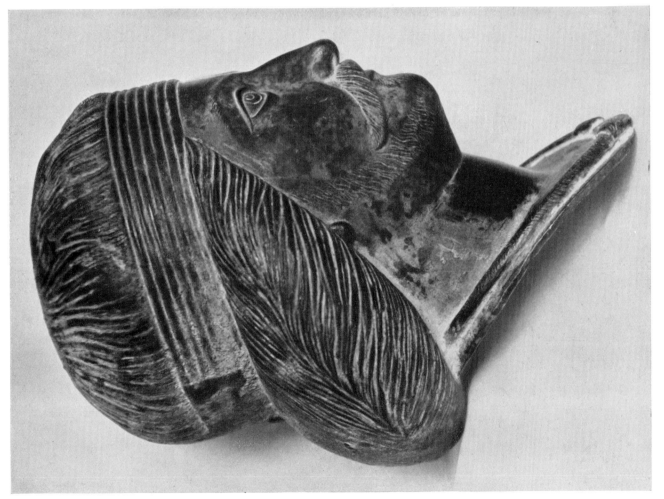

Pl. 141. Parthian statue, from Shami, Khuzistan, with profile view of the head (separately cast), 3d–2d cent. B.C. Bronze, over life size. Teheran, Archaeological Museum.

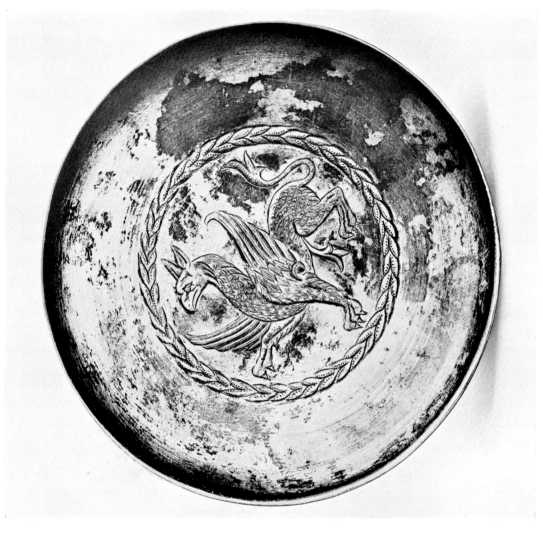

Pl. 142. *Left*: Emblema, representing a fertility goddess, from Susa, Khuzistan, 2d cent. B.C.–2d cent. Terra cotta. Paris, Louvre. *Right*: Patera with griffin, Parthian period. Repoussé and engraved silver, partially gilt; diam., 7 in. Berlin, Staatliche Museen.

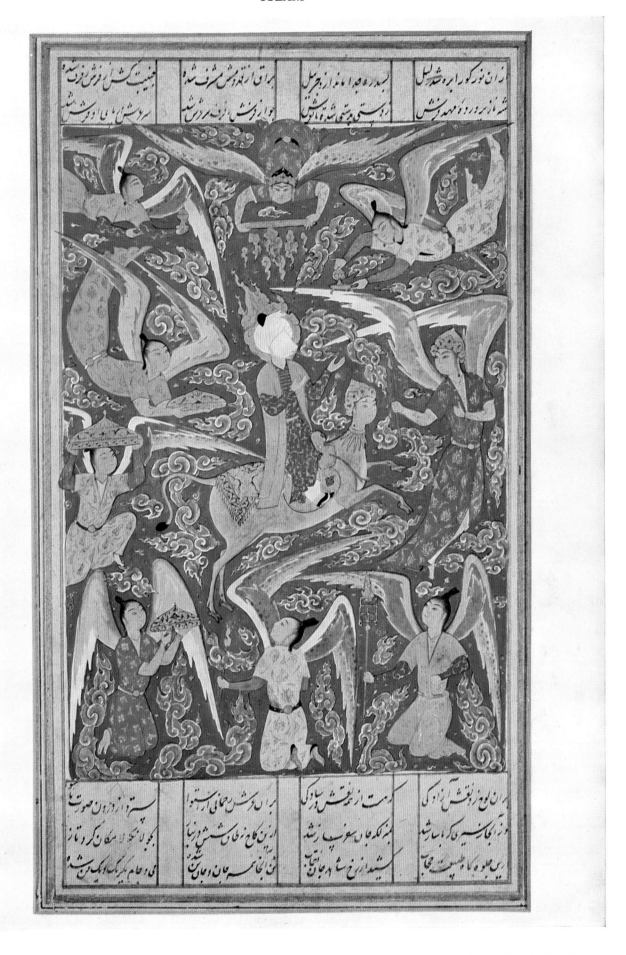

Pl. 143. Mohammed, mounted on Burāq, ascends to Paradise, Tabriz school (?), Iran, 16th cent. Miniature. Seattle, Art Museum.

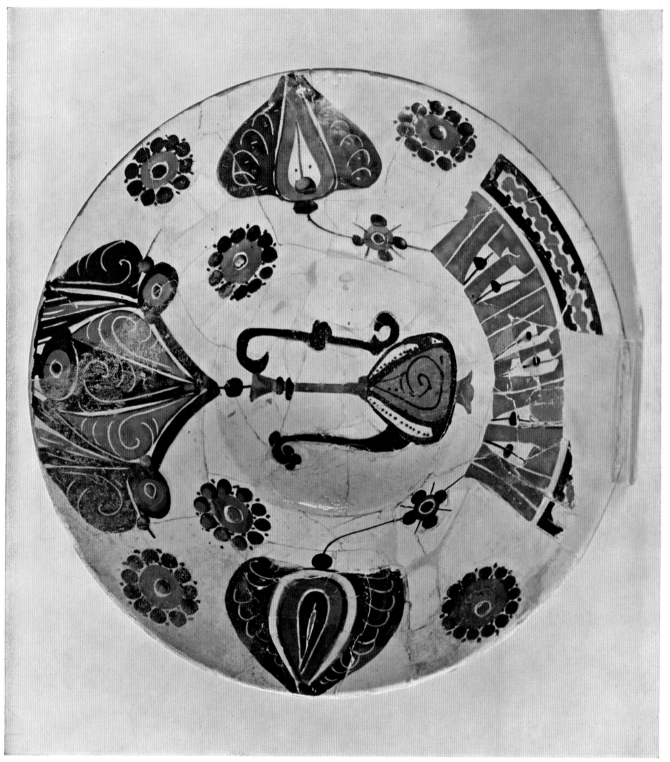

Pl. 144. Ceramic plate, Nishapur, Iran, 9th–10th cent. Diam., 10¹/₈ in. London, British Museum.

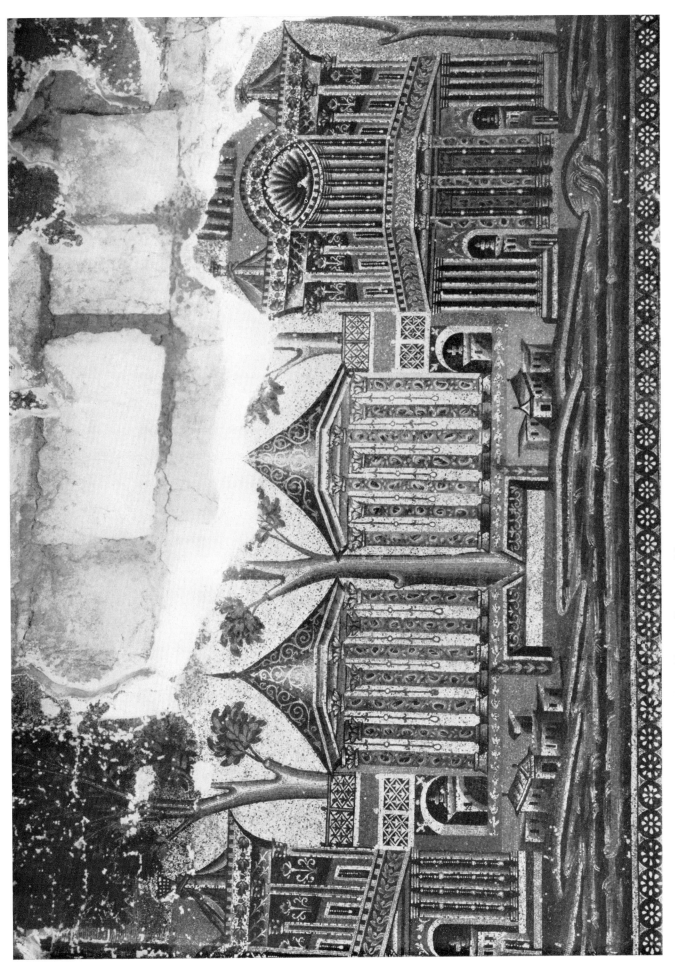

Pl. 145. Detail of mosaic in the western portico, Great Mosque, Damascus, 8th cent.

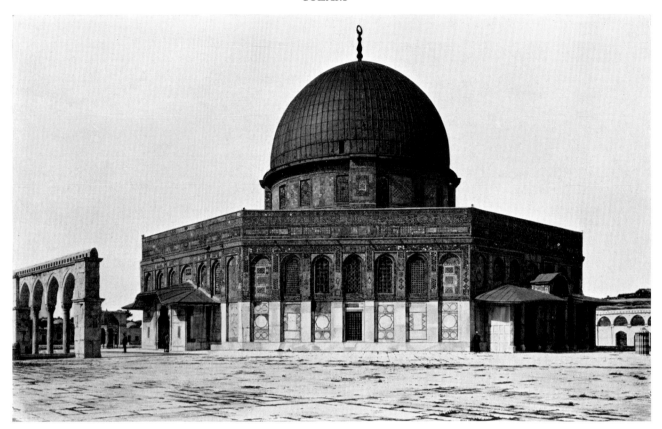

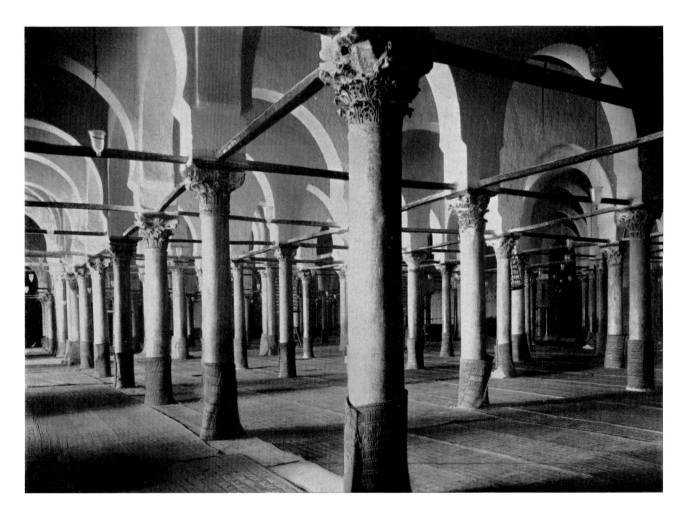

Pl. 146. *Above*: Jerusalem, Dome of the Rock, seen from the west, late 7th cent. *Below*: Kairouan, Tunisia, Great Mosque, 9th cent. (originally built in 670).

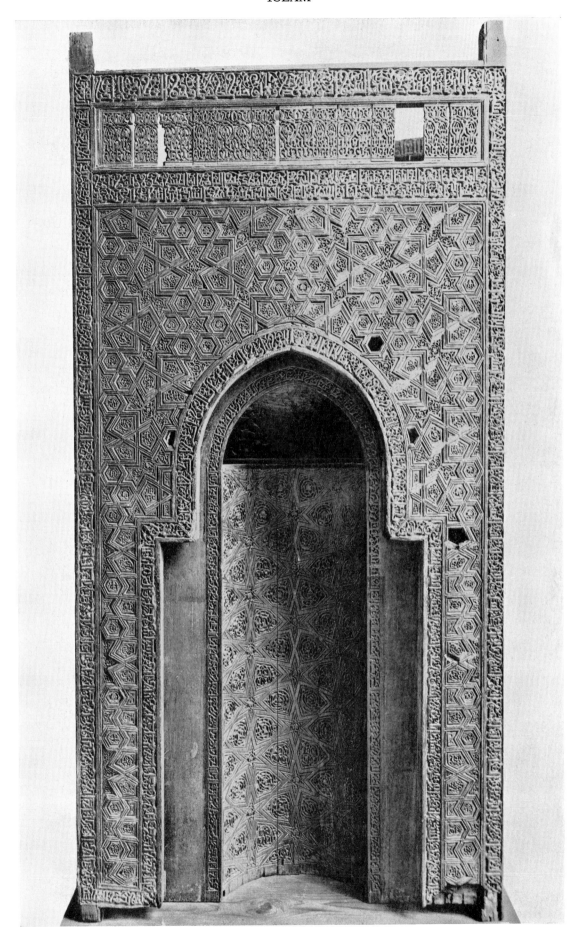

Pl. 147. Portable wooden mihrab, from the Mashhad of Sayyida Ruqayya, Cairo, 1154–60. Cairo, Museum of Islamic Art.

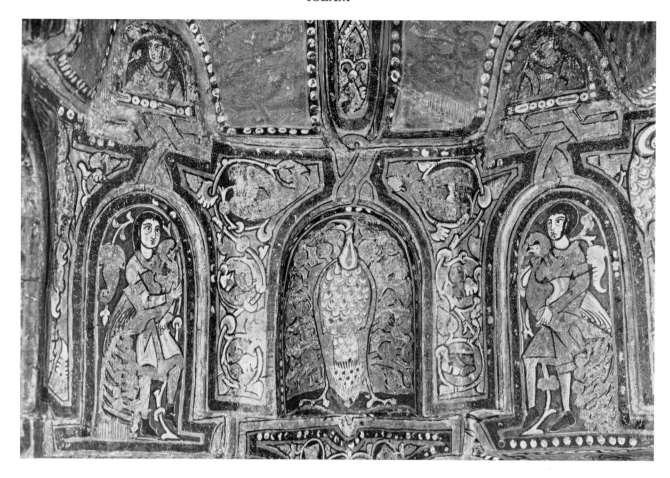

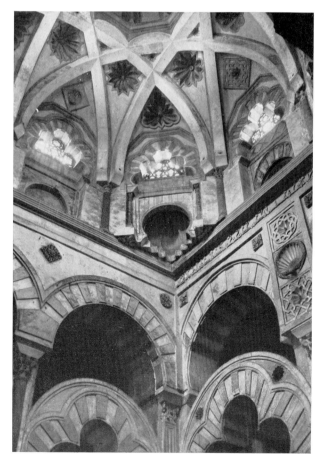
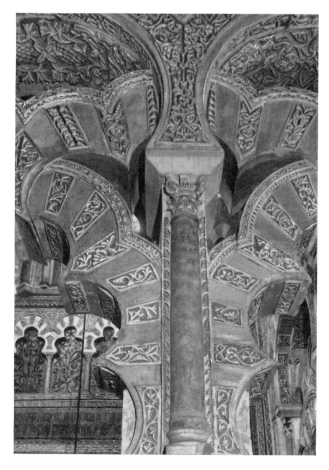

Pl. 148. *Above*: Palermo, Sicily, Cappella Palatina, detail of wall decoration, 12th cent. *Below*: Córdoba, Spain, Mosque, begun 785. *Left*: Mihrab, view of cupola. *Right*: Supporting arches, mihrab by Ḥākim II, 961.

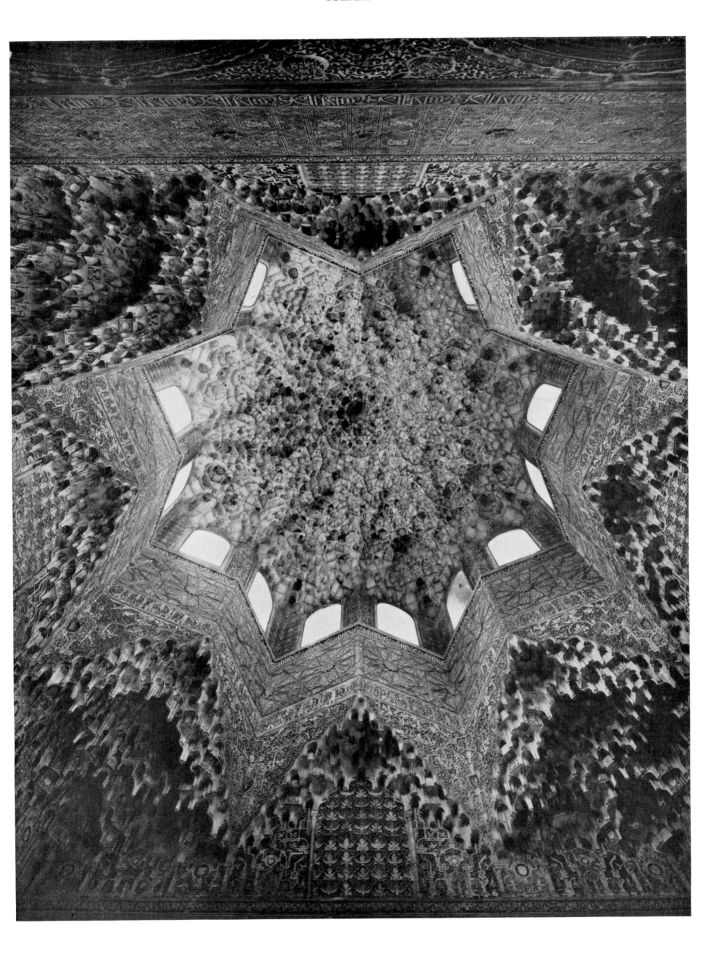

Pl. 149. Granada, the Alhambra, so-called "stalactite" cupola in the Sala de los Abencerrajes, 14th cent.

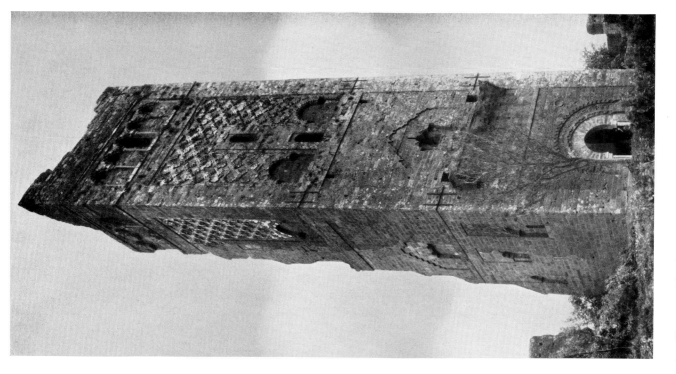

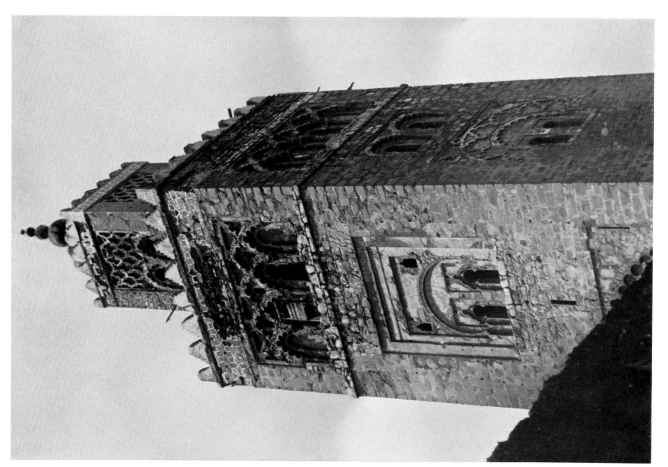

Pl. 150. *Left*: Marrakech, Morocco, minaret of the Mosque of the Kutubīya, 12th cent. *Right*: Mansura, Algeria, minaret of mosque, 14th cent.

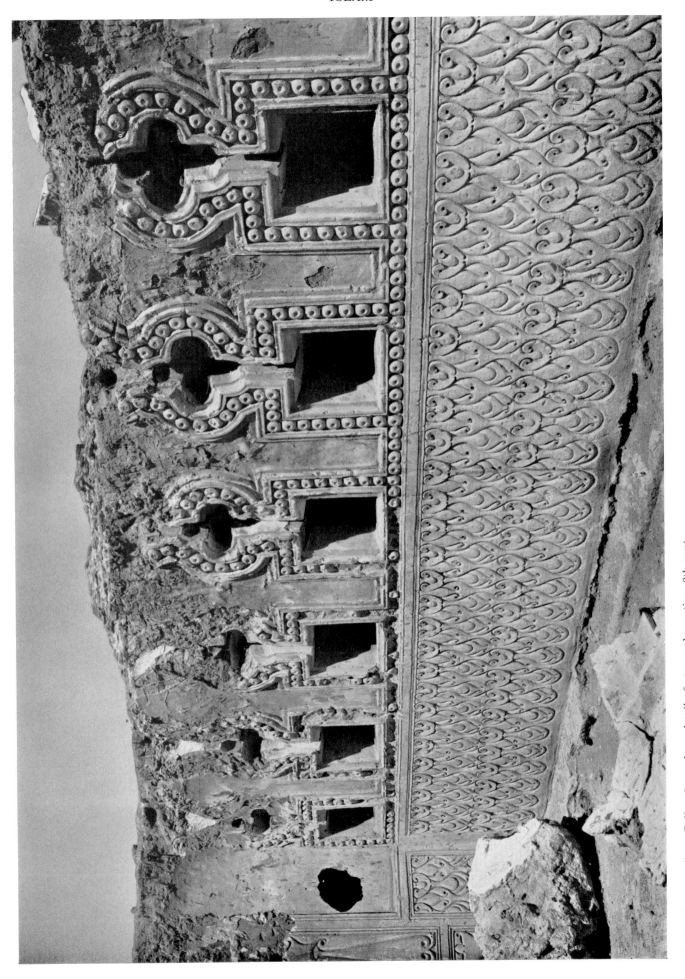

Pl. 151. Samarra, Iraq, Balkuwāra palace, detail of stucco decoration, 9th cent.

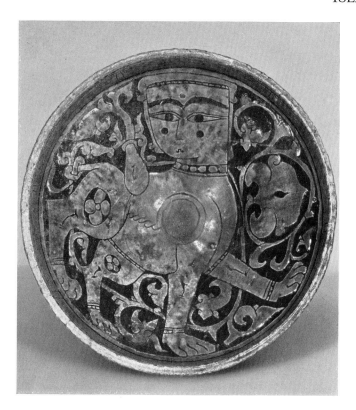

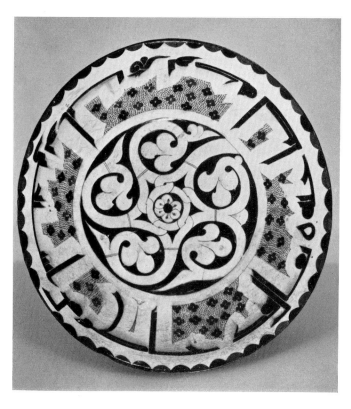

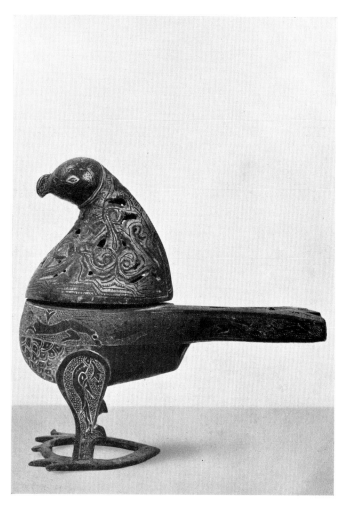

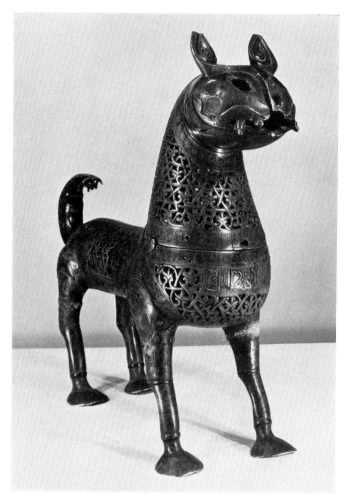

Pl. 152. *Above, left*: "Gabry"-ware dish with Sassanian characteristics, western Iran, 9th cent. Cambridge, England, Fitzwilliam Museum. *Right*: Ceramic bowl, Iran, 10th cent. Diam., 15⁹/₁₆ in. Washington, D.C., Freer Gallery of Art. *Below, left*: Incense burner, Khorasan, Iran, 9th cent. Bronze, ht., 8¹/₄ in. Teheran, Archaeological Museum. *Right*: Incense burner, Iran, 12th cent. Bronze. Leningrad, The Hermitage.

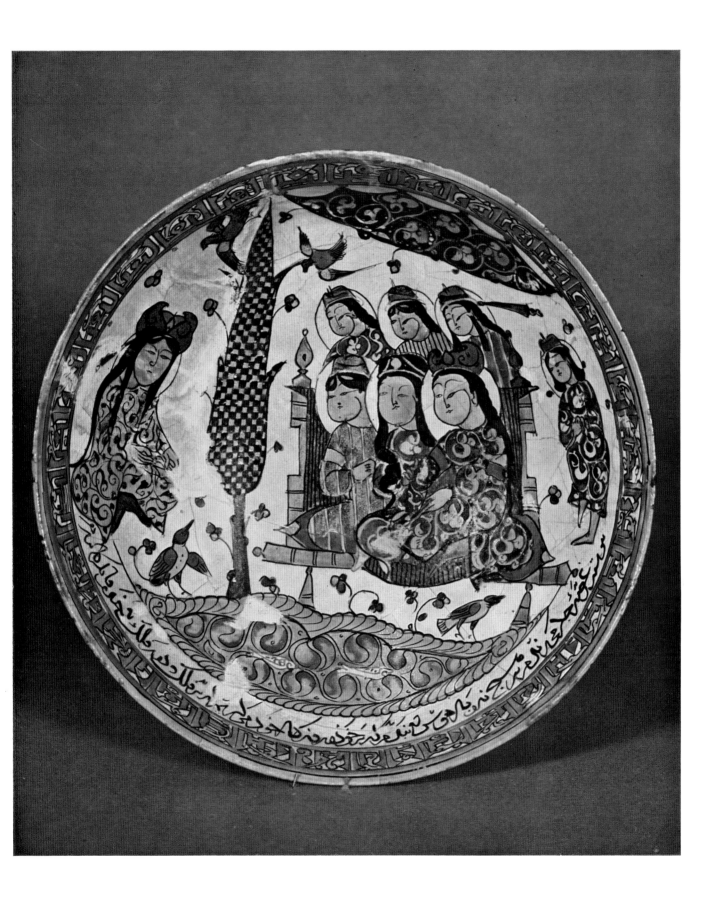

Pl. 153. Ceramic bowl in Sāva style, Iran, late 12th cent. Diam., 8¹/₂ in. Los Angeles, County Museum.

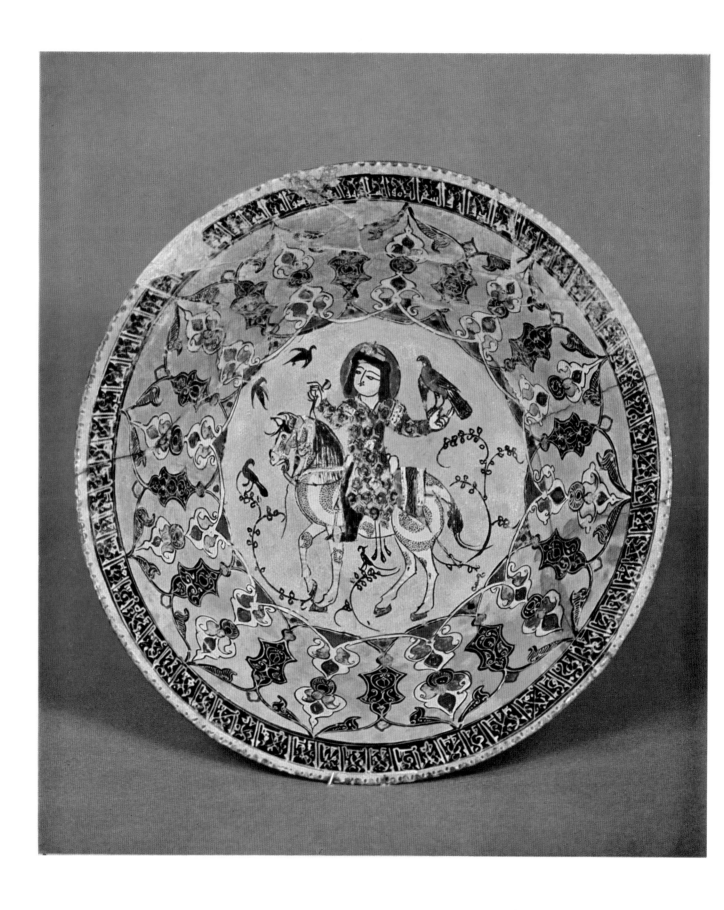

Pl. 154. Ceramic bowl, Rhages (Rayy), Iran, 11th–12th cent. Diam., 7$^{7}/_{8}$ in. Teheran, Archaeological Museum.

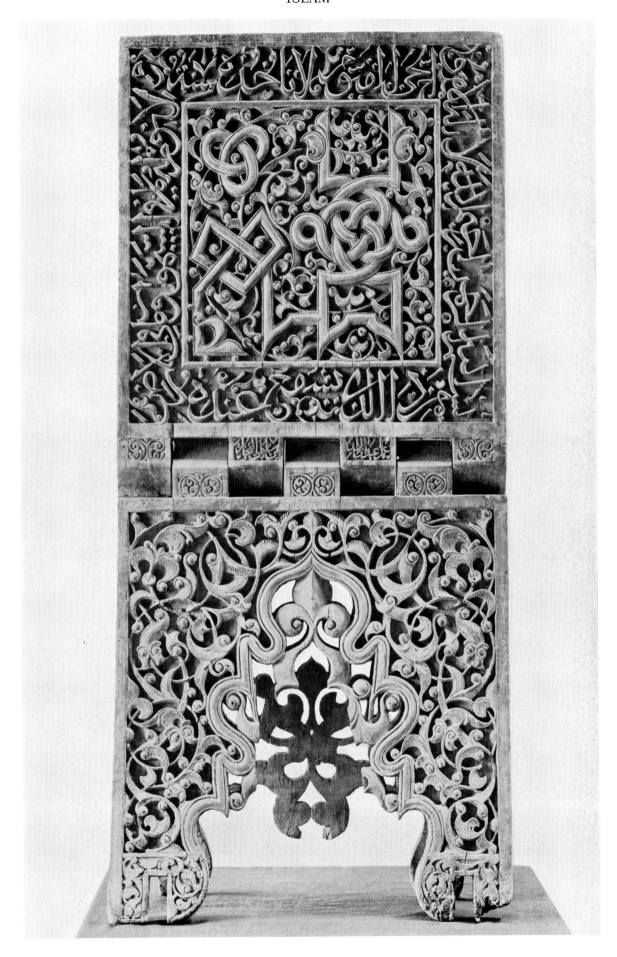

Pl. 155. Wooden Koran stand, with inscriptions and arabesques, Anatolia, 13th cent. Berlin, Staatliche Museen.

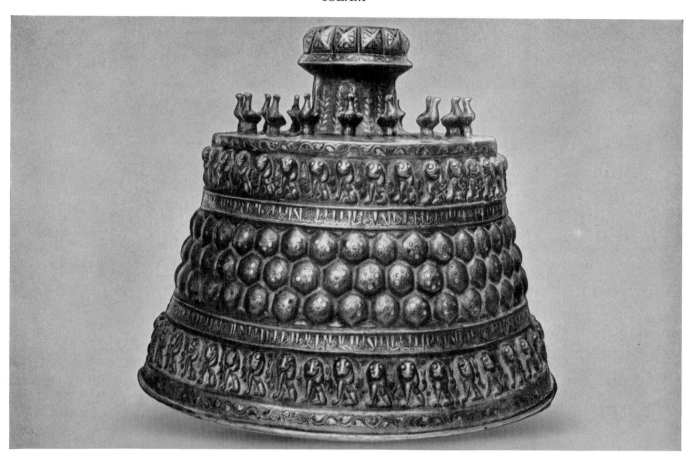

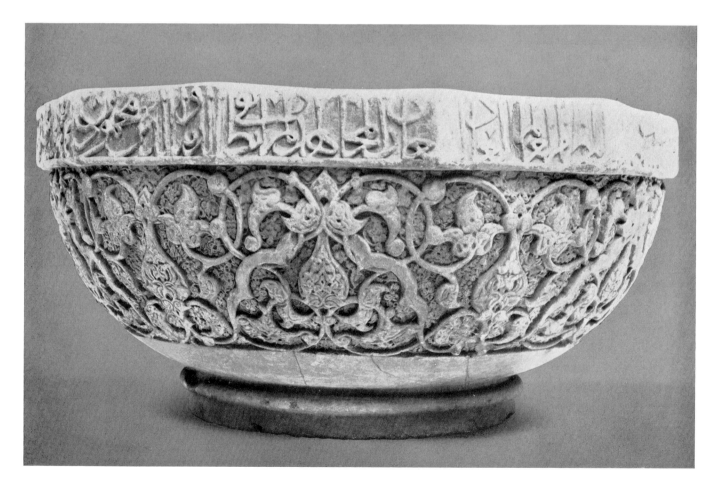

Pl. 156. *Above*: Candlestick, Iran, 12th cent. Bronze incrusted with silver. Cairo, Museum of Islamic Art. *Below*: Marble basin, Syria, 13th cent. London, Victoria and Albert Museum.

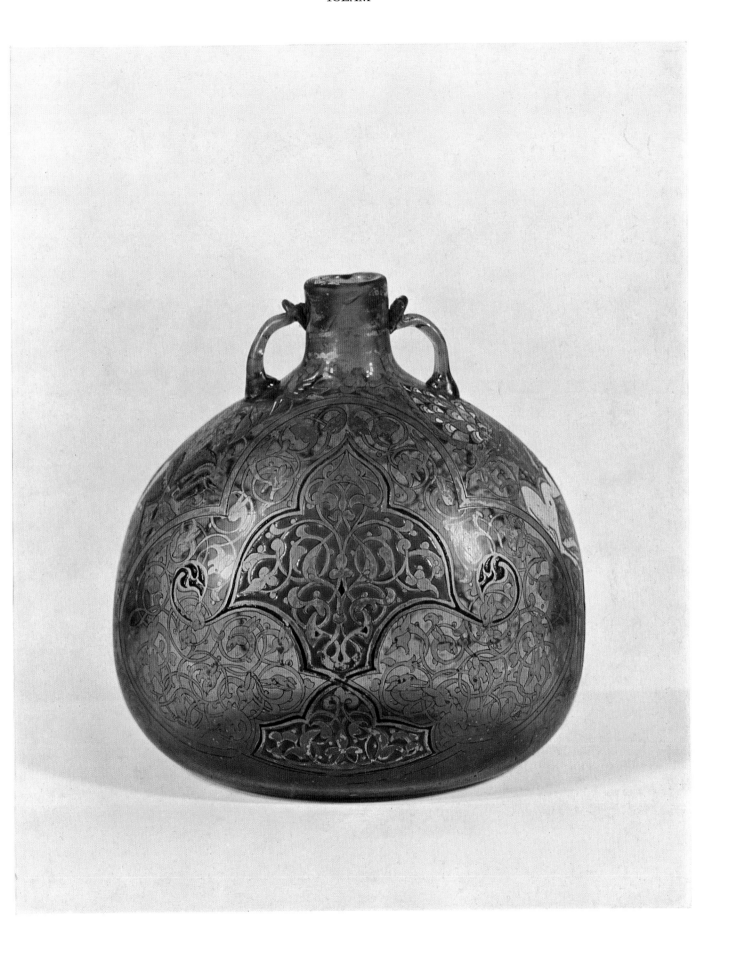

Pl. 157. Pilgrim bottle, Syria, ca. 1300. Enameled glass, ht., ca. 8 in. London, British Museum.

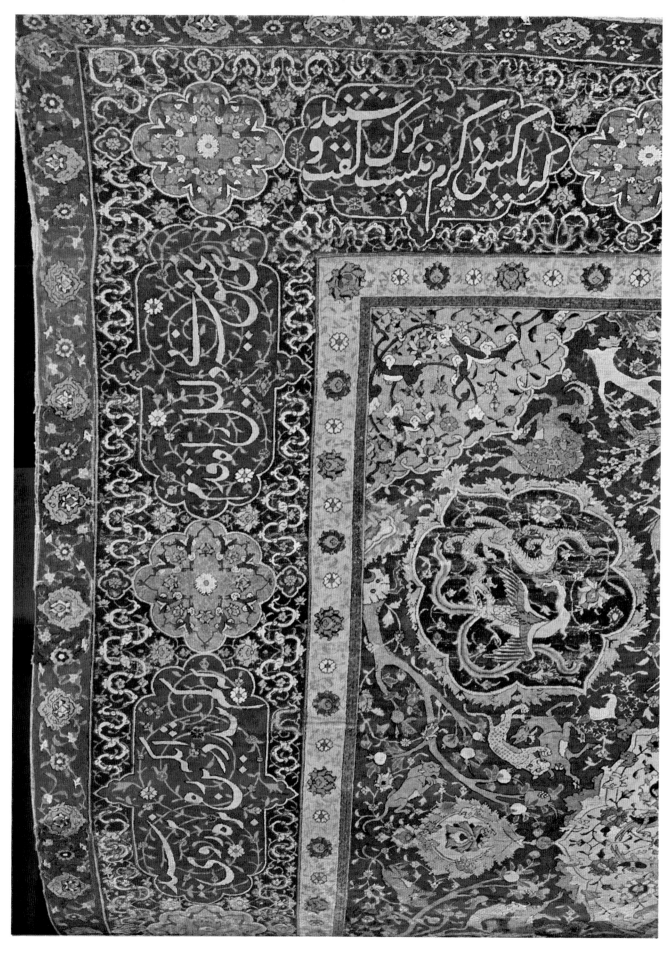

Pl. 158. Detail of a rug from Karabagh, Iran, 16th cent. Wool with gold. Florence, Museo Bardini.

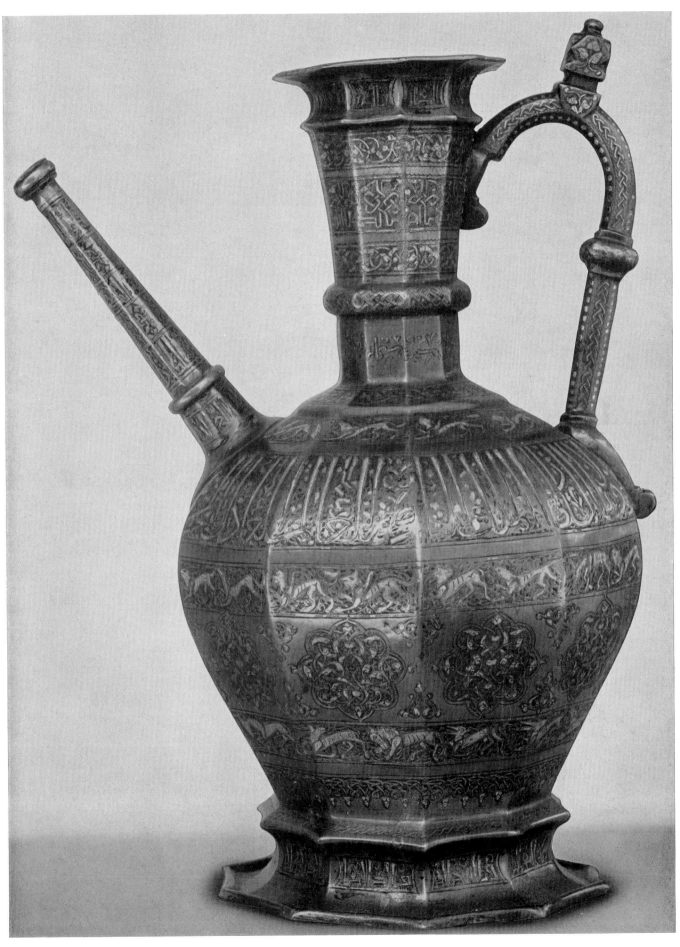

Pl. 159. Ewer by an artist from Mosul, Iraq, signed and dated, 1260. Bronze incrusted with silver. Paris, Louvre.

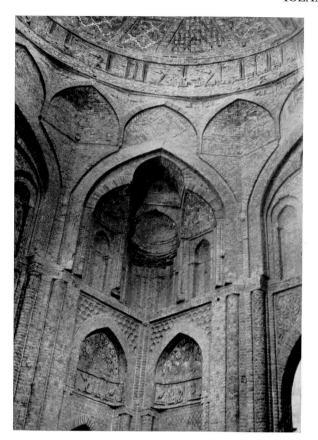

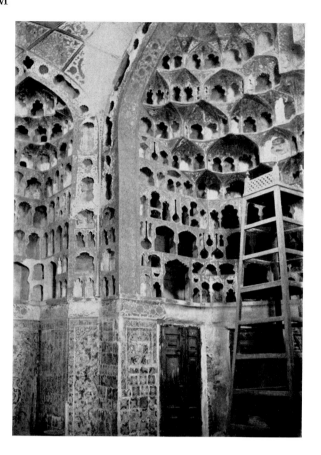

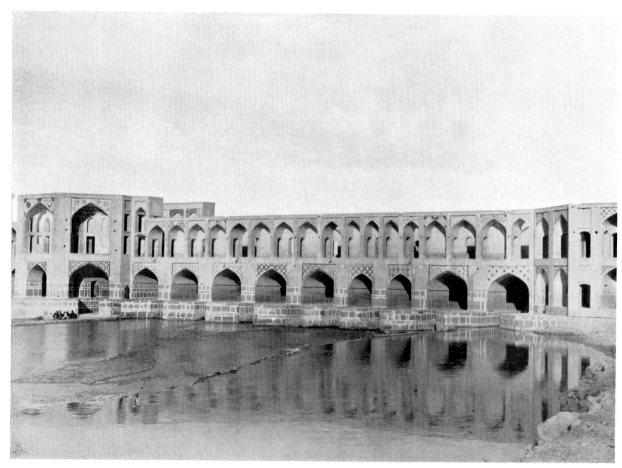

Pl. 160. *Above, left*: Isfahan, Iran, "Friday Mosque," interior detail of earliest part, 13th cent. *Right*: Ardebil, Iran, Porcelain Room, 17th cent., in the shrine of Sheik Ṣafī. *Below*: Isfahan, bridge over the Zayinda River, erected by Shah ʿAbbās I, early 17th cent.

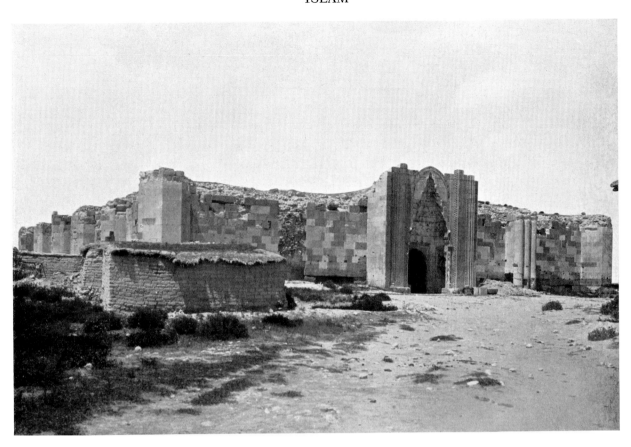

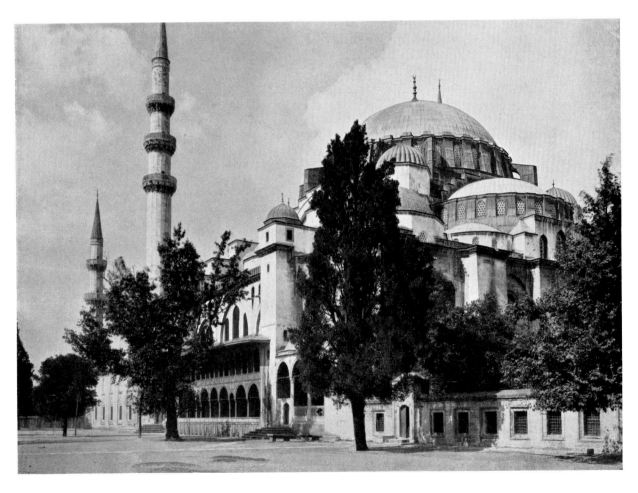

Pl. 161. *Above*: Sultanhanı, near Konya, Turkey, the caravansary, 13th cent. *Below*: Istanbul, Mosque of Sultan Süleyman, 16th cent.

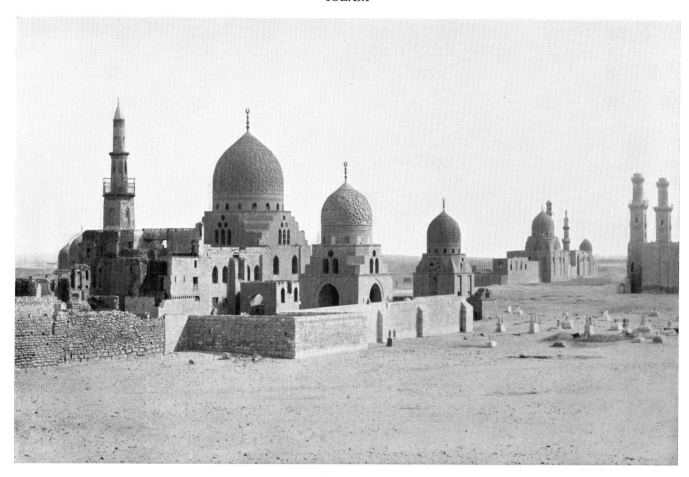

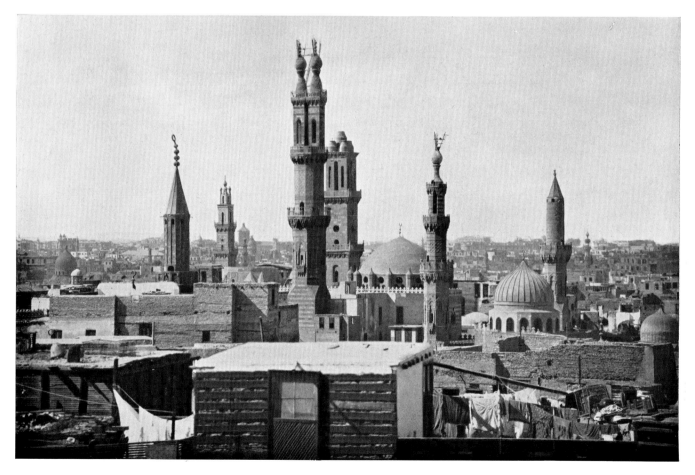

Pl. 162. Cairo, 14th–15th cent. *Above*: Tombs of the Mamelukes, partial view. *Below*: Mameluke minarets.

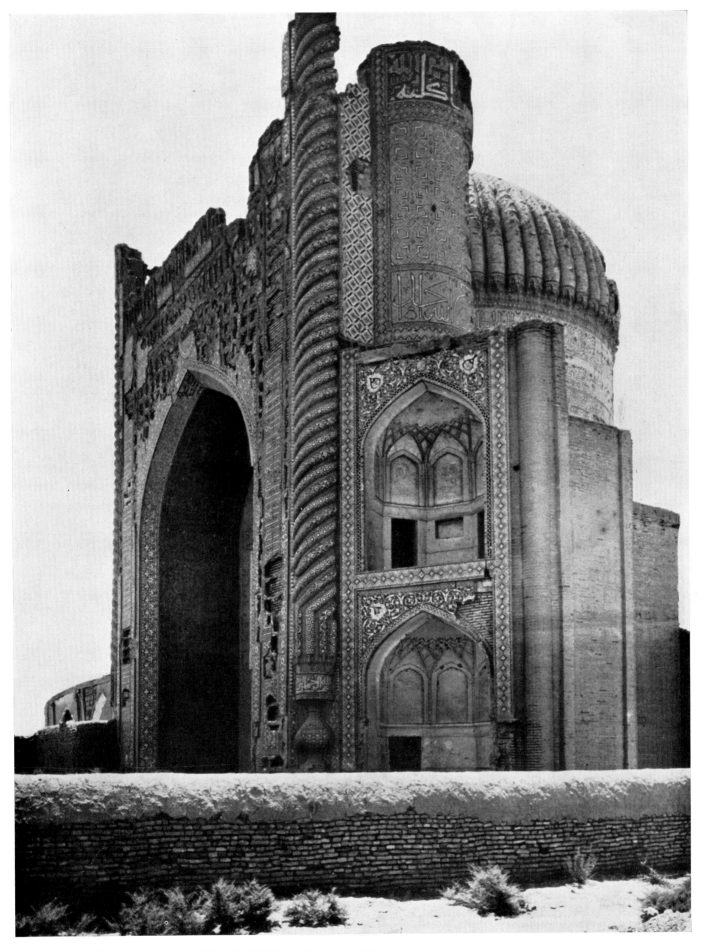

Pl. 163. Balkh, Afghanistan, shrine of Khwāja Abū-Naṣr Pārsā, late 15th cent.

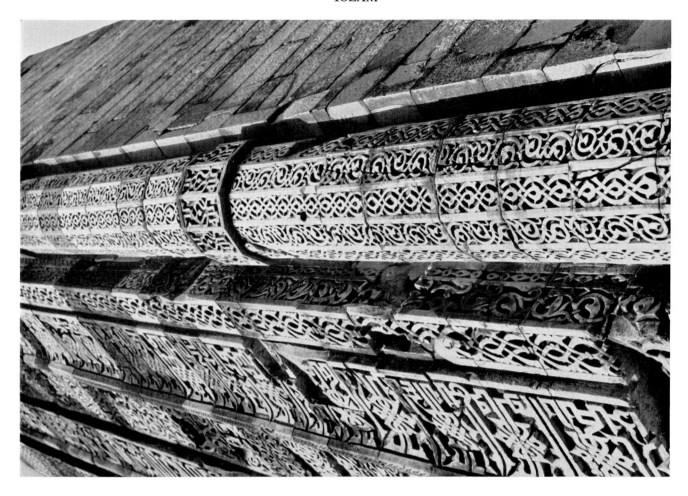

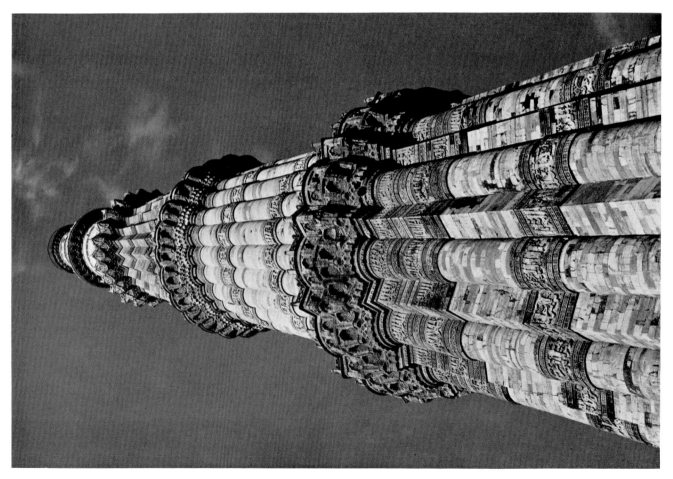

Pl. 164. Delhi, the Quṭb Minār, begun 1199, upper portion and detail. (Cf. pl. 15.)

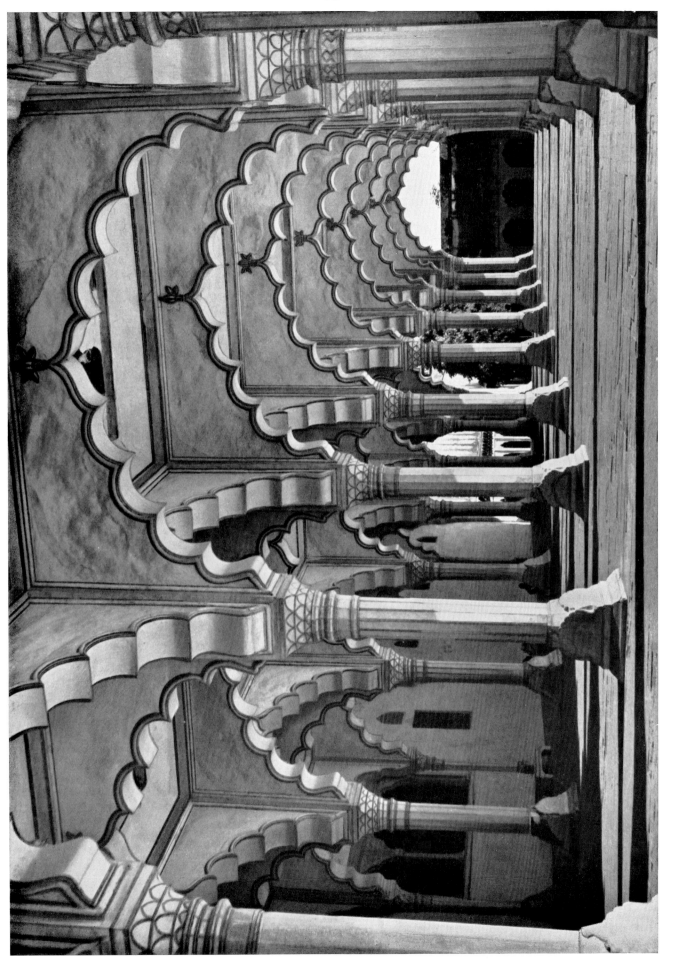

Pl. 165. Agra, Fort, the Hall of Public Audience, first half of 17th cent.

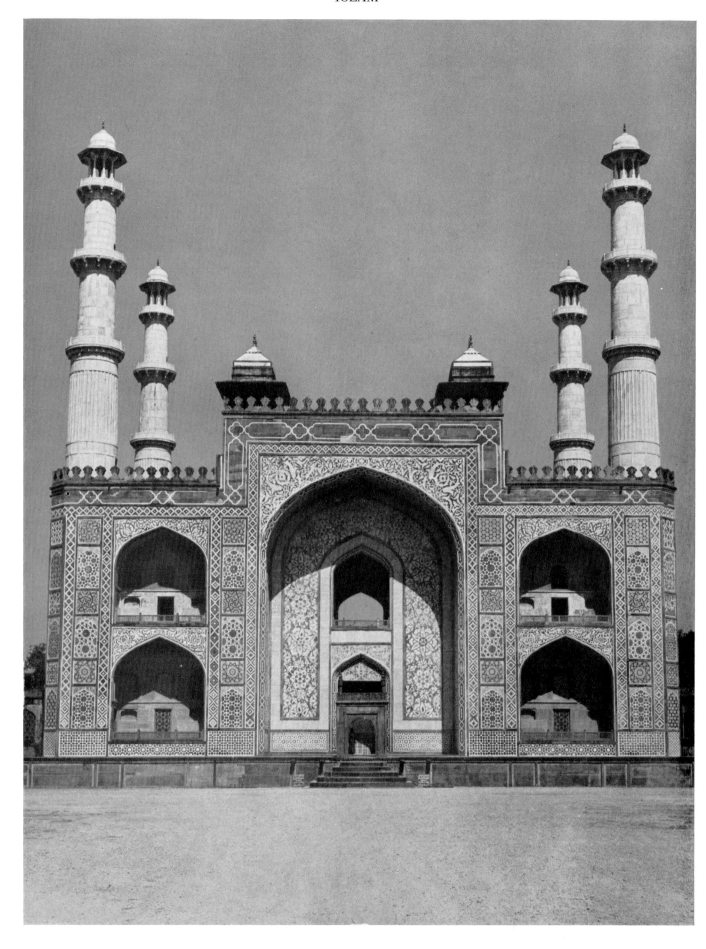

Pl. 166. Sikandra, near Agra, Tomb of Akbar, main gateway of the enclosure, completed ca. 1613.

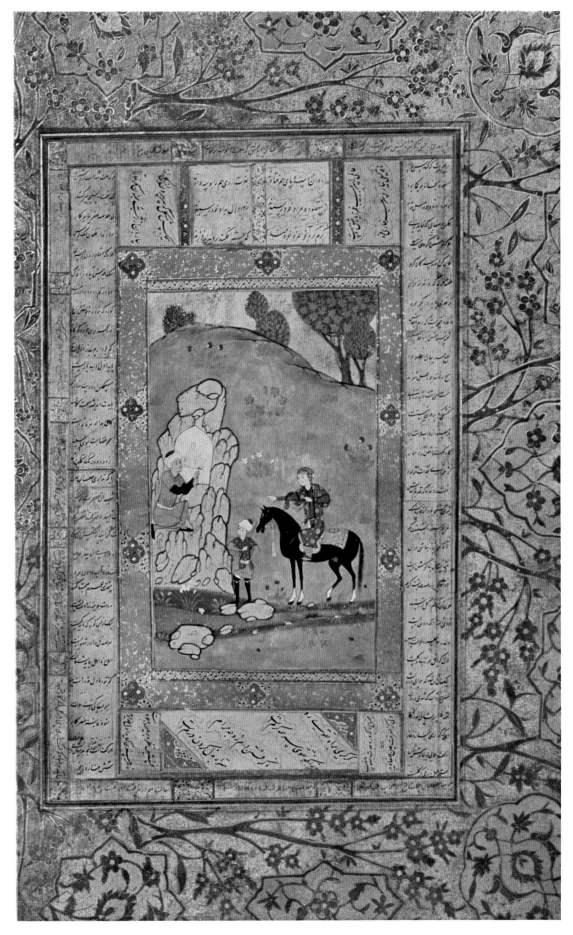

Pl. 167. Episode in the story of Shīrīn and Farhād, Iran, 16th cent. Miniature. Teheran, Gulistan Palace, Imperial Library.

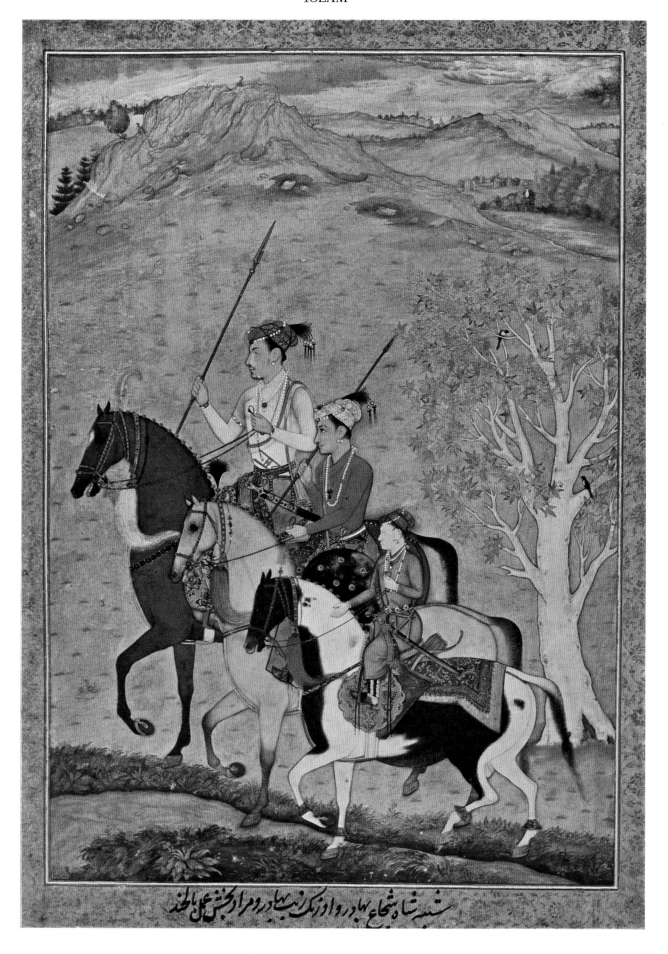

شبیه شاه شجاع بهادر و اورنک زیب بهادر و مراد بخش علی بالخذ

Pl. 168. Three sons of Shah Jahān, Moghul school, first half of 17th cent. Tempera. London, Victoria and Albert Museum.

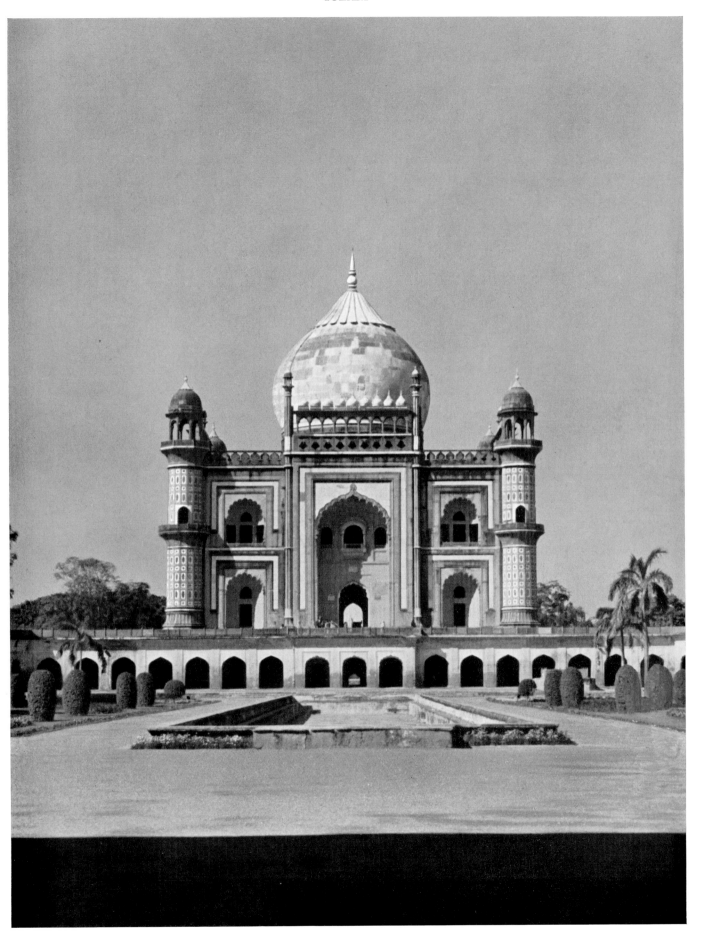

Pl. 169. Delhi, Mausoleum of Nawab Safdar Jang, ca. 1753.

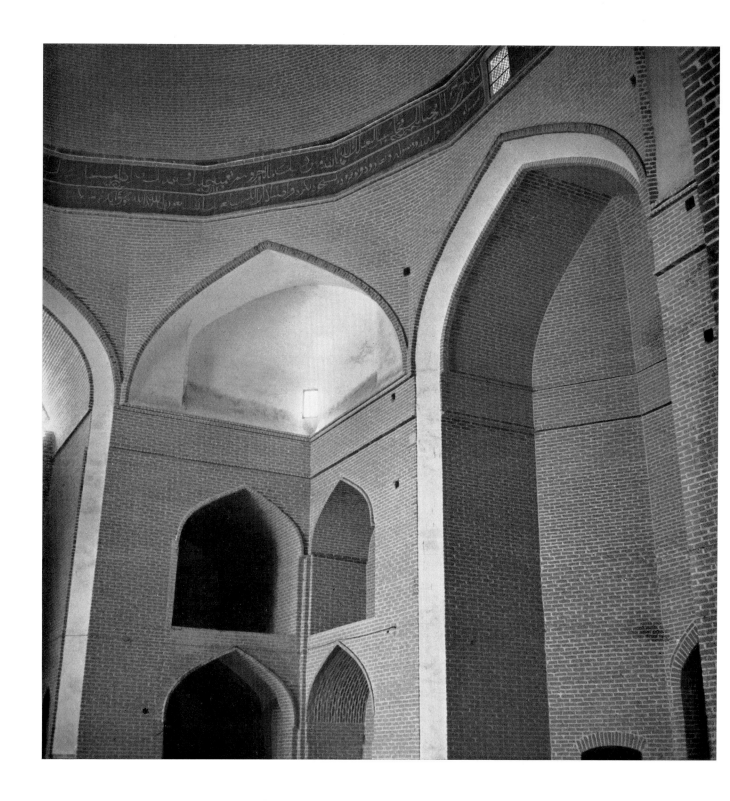

Pl. 170. Yezd, Iran, Mosque, detail of the interior, 20th cent.

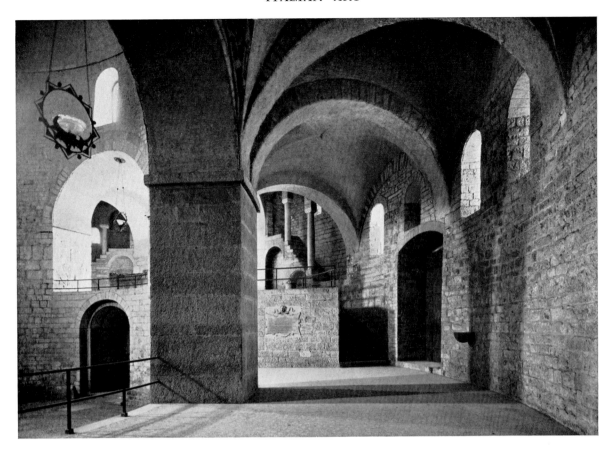

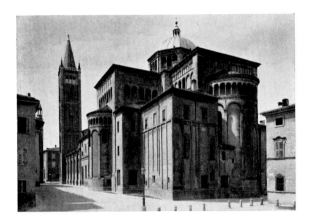

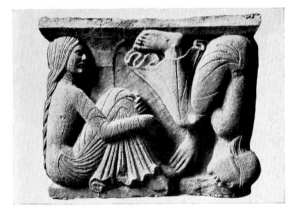

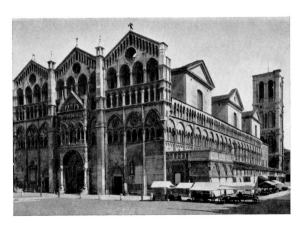

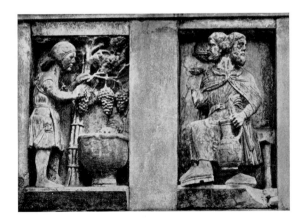

Pl. 171. Lombardy and Emilia. *Above*: Brescia, Rotonda or Old Cathedral, early 12th cent. *Center, left*: Parma, Cathedral, view of apse, 12th cent. *Right*: Relief with girl and acrobat, from Cathedral of Modena, 12th cent. Stone. Modena, Museo del Duomo. *Below*: Ferrara, Cathedral. *Left*: Façade and south side, 12th–15th cent. *Right*: September and January, reliefs from the Porta dei Mesi, late 12th cent. Marble. Ferrara, Museo dell'Opera del Duomo.

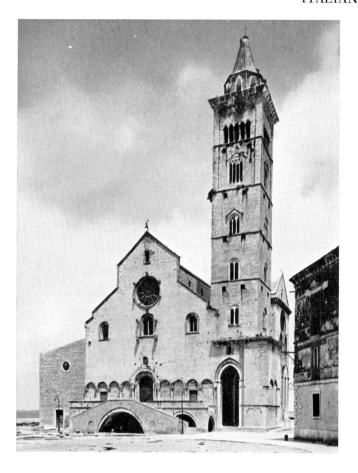

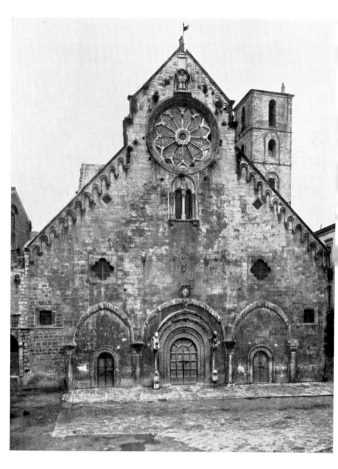

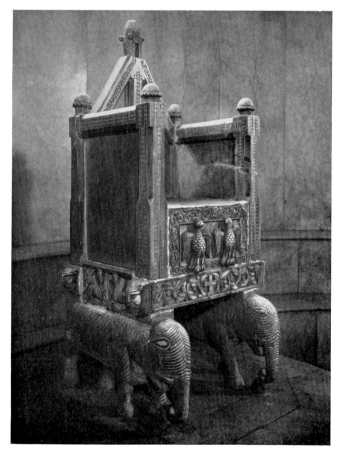

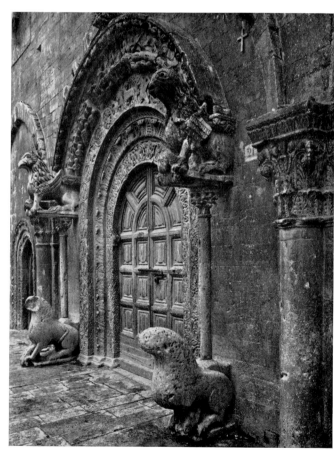

Pl. 172. Apulia. *Left, above*: Trani, Cathedral, façade, 11th–13th cent., and campanile, 13th–14th cent. *Below*: Romualdus, cathedra, 1078–89. Marble. Canosa di Puglia, Cathedral. *Right*: Ruvo di Puglia, Cathedral, façade and central portal, early 13th cent.

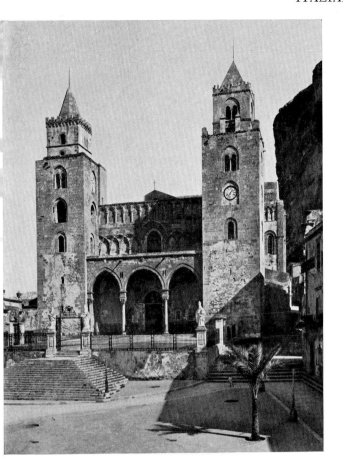

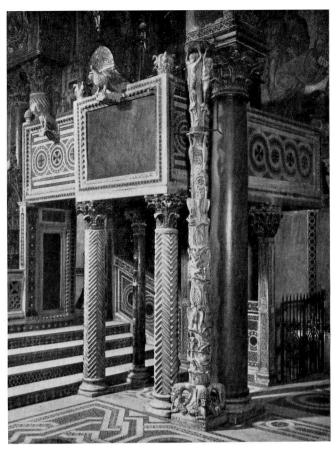

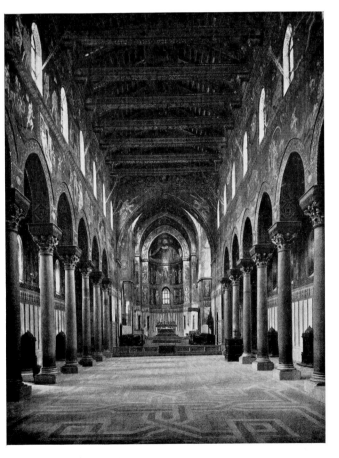

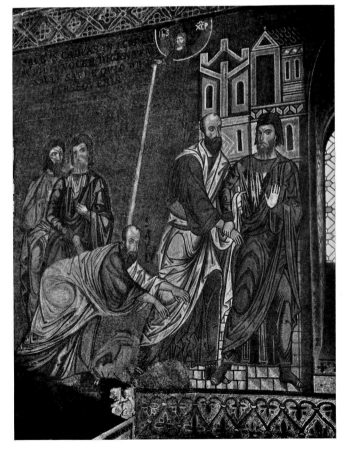

Pl. 173. Sicily. *Left, above*: Cefalù, Cathedral, façade of 1240 with 15th-cent. porch. *Below*: Monreale, Cathedral, nave, second half of 12th cent. *Right*: Palermo, Cappella Palatina. *Above*: Pulpit and Easter candlestick, 12th cent. Marble. *Below*: Saul receiving the order to persecute the Christians, late 12th cent. Mosaic.

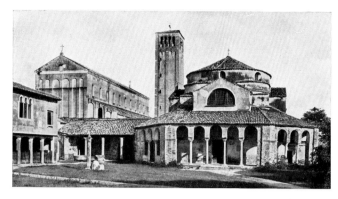

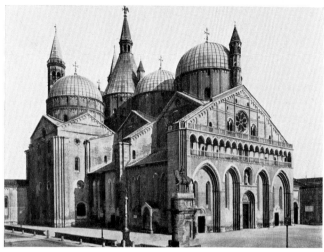

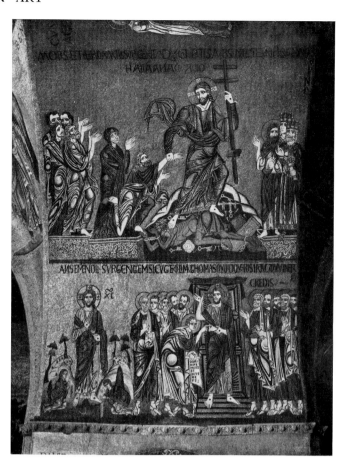

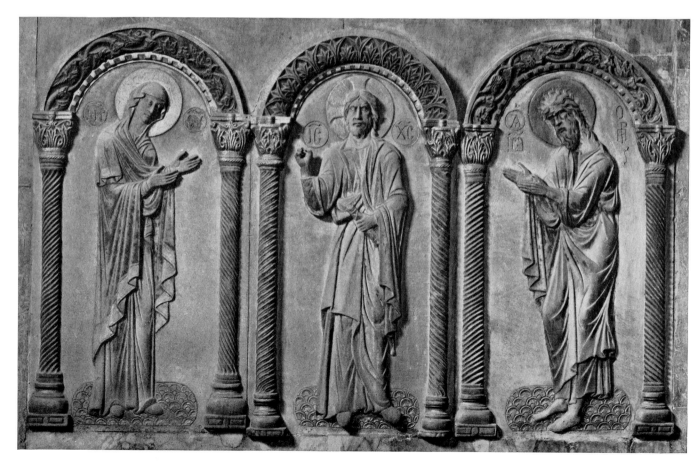

Pl. 174. Veneto. *Left, above*: Torcello, Cathedral and S. Fosca, 11th cent. *Center*: Padua, S. Antonio, 13th–14th cent. *Right*: Episodes from the life of Christ, detail, 12th cent. Mosaic. Venice, S. Marco. *Below*: Deësis, 12th cent. Marble. Venice, S. Marco.

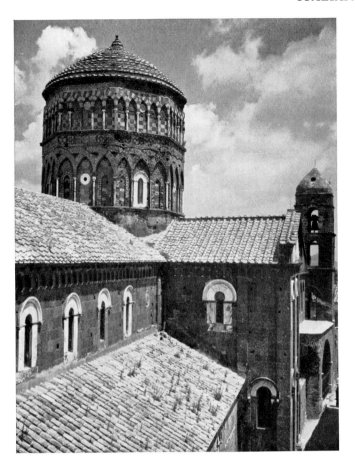

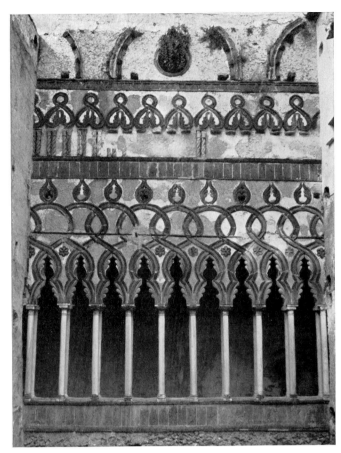

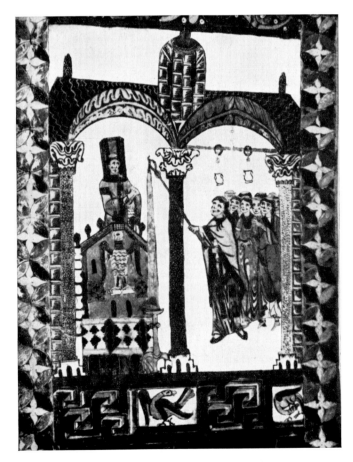

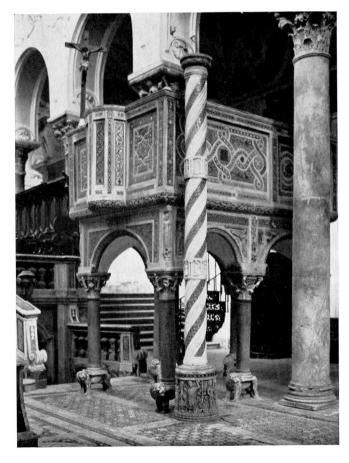

Pl. 175. Campania. *Above, left*: Caserta Vecchia, Cathedral, 12th cent. *Right*: Ravello, Palazzo Rufolo, detail of the courtyard, 12th–13th cent. *Below, left*: Exultet, detail, from Benevento, 12th cent. Illumination. Rome, Biblioteca Casanatense (Ms. 724). *Right*: Sessa Aurunca, Cathedral, pulpit and Easter candlestick, 13th cent. Marble.

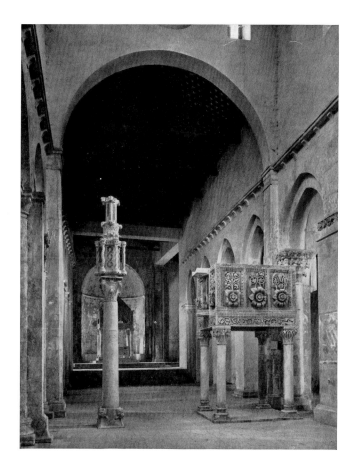

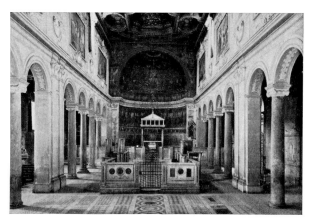

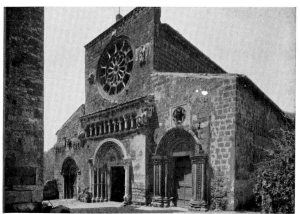

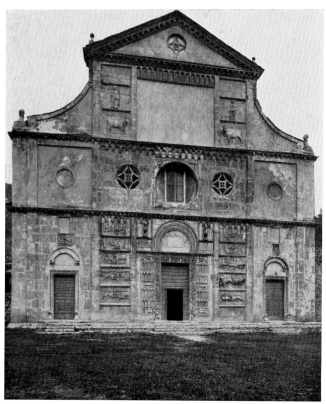

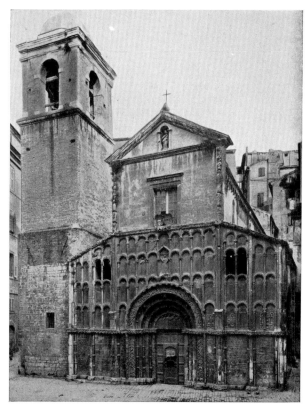

Pl. 176. Abruzzi, Umbria, Latium, the Marches. *Left, above*: Torre dei Passeri, S. Clemente a Casauria, second half of 12th cent. *Below*: Spoleto, S. Pietro, façade, 13th cent., with reliefs of 12th cent. *Right, above*: Rome, S. Clemente, nave, 11th–12th cent. (Cf. III, PL. 477.) *Center*: Tuscania, S. Maria Maggiore, façade, second half of 12th cent. *Below*: Ancona, S. Maria della Piazza, façade, 1210.

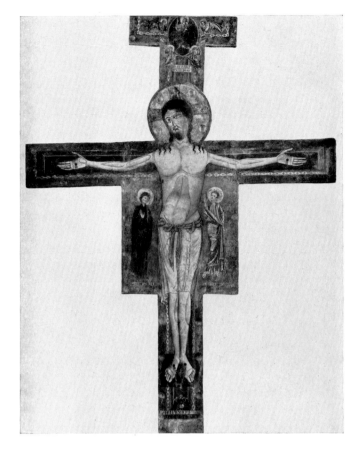

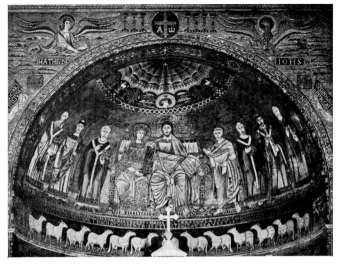

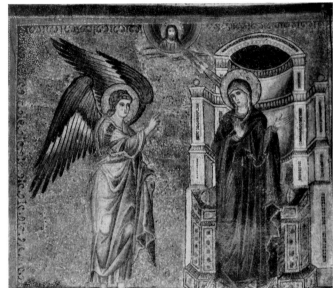

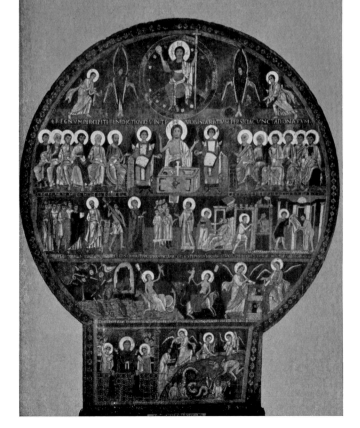

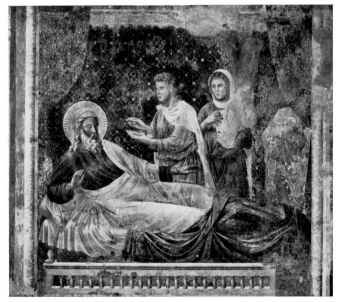

Pl. 177. *Left, above*: Alberto Sotio, Crucifix, 1187. Panel, ht., 9 ft., 1¹/₂ in. Spoleto, Cathedral. *Below*: Last Judgment, ca. 1080. Canvas on wood, 9 ft., 5³/₄ in. × 7 ft., 11¹/₄ in. Rome, Vatican Museums. *Right, above*: Christ and the Virgin Enthroned, ca. 1140. Mosaic. Rome, S. Maria in Trastevere, apse. *Center*: J. Torriti, Annunciation, 1295. Mosaic. Rome, S. Maria Maggiore, apse. *Below*: The Isaac Master, Esau and Isaac, 13th cent. Fresco. Assisi, S. Francesco, Upper Church.

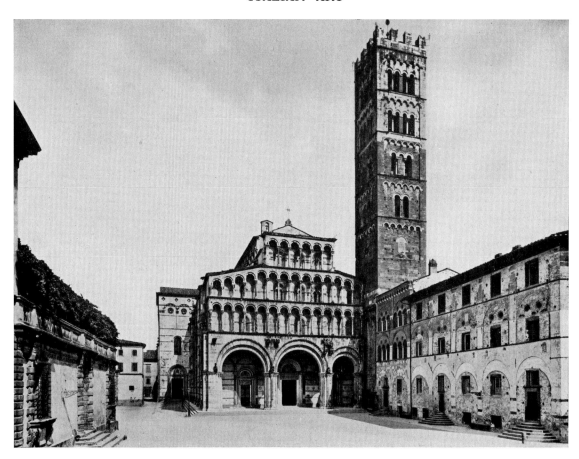

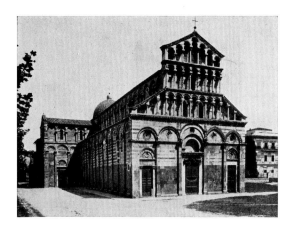

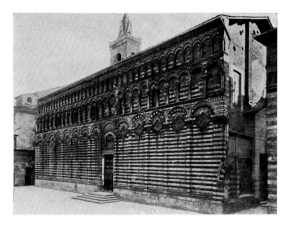

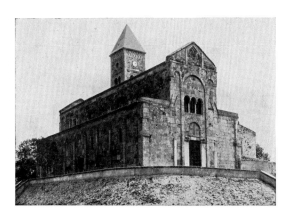

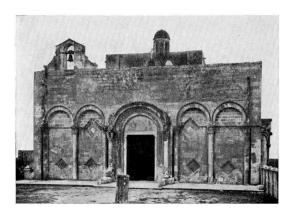

Pl. 178. Pisan-Luccan architecture and its diffusion. *Above*: Lucca, Cathedral, façade and campanile, 13th cent. *Center, left*: Pisa, S. Paolo a Ripa d'Arno, façade, 13th cent. *Right*: Pistoia, S. Giovanni Fuorcivitas, lateral façade, 12th–14th cent. *Below, left*: Oristano, Sardinia, S. Giusta, 1135–45. *Right*: Siponto, Apulia, S. Maria, façade; consecrated, 1117.

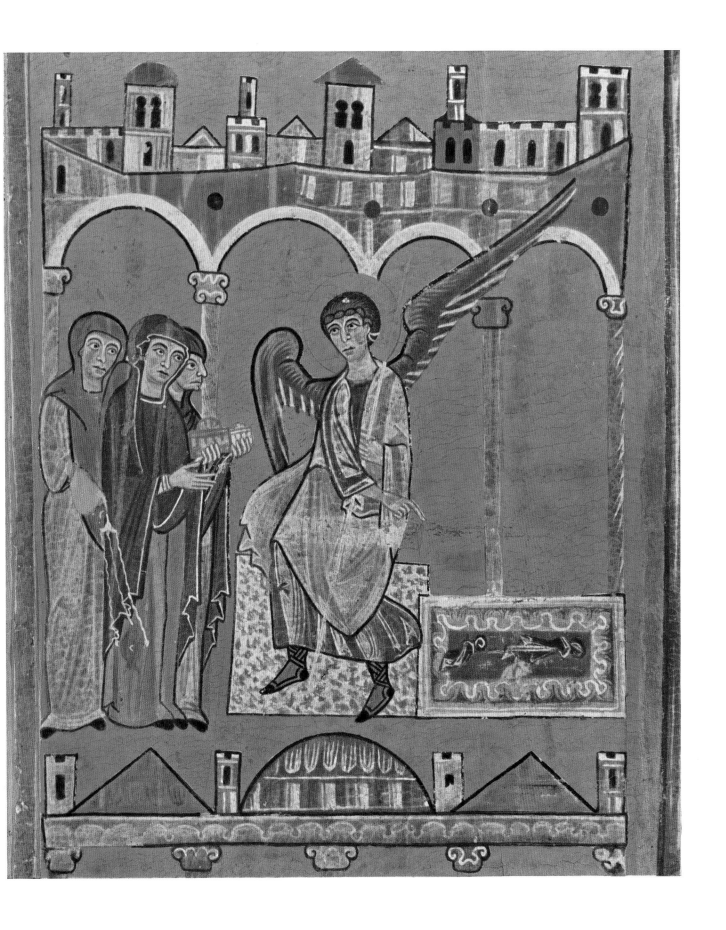

Pl. 179. The Marys at the Sepulcher, detail of the great panel of the painted cross from the Priory of Sto Sepolcro, Pisa, late 12th cent. Panel; full size, 9 ft., 3 in. × 7 ft., 10 in. Pisa, Museo Nazionale.

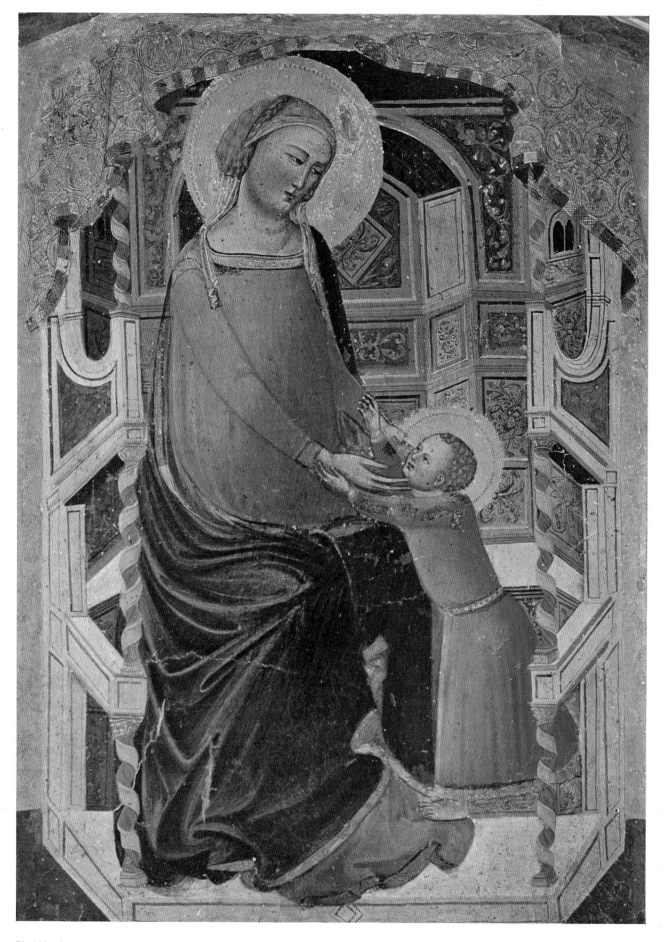

Pl. 180. G. Baronzio, polyptych with the Virgin and Child and saints, detail, 1345. Panel; full size, 4 ft., 8 ¼ in. × 7 ft., 3 in.
Urbino, Galleria Nazionale delle Marche.

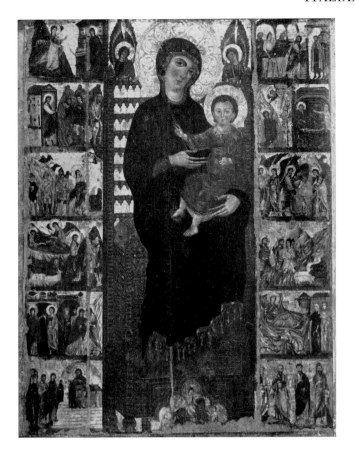
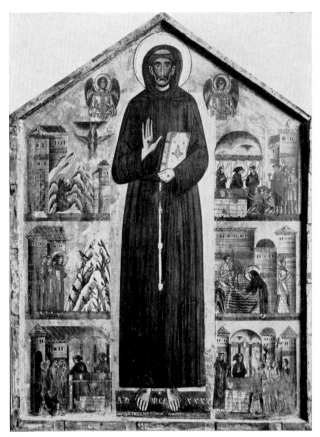
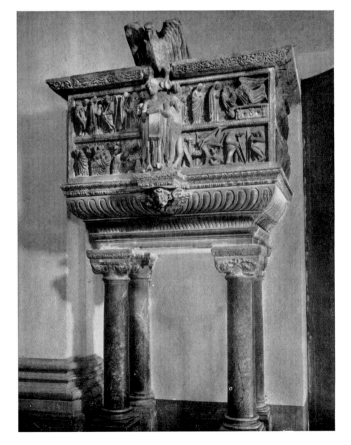
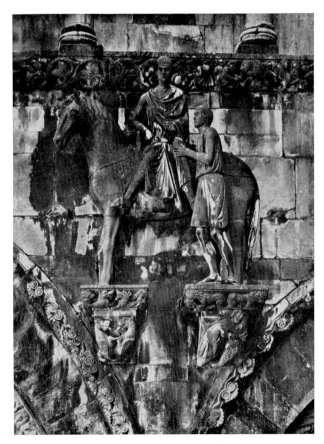

Pl. 181. Painting and sculpture in Pisa and Lucca. *Above, left*: Master of S. Martino, Virgin and Child and stories of the Virgin, late 13th cent. Panel, 5 ft., 3 in. × 4 ft., ¹/₂ in. Pisa, Museo Nazionale. *Right*: Bonaventura Berlinghieri, St. Francis and episodes from his life, 1235. Panel, ca. 5 ft. × 3 ft., 9³/₄ in. Pescia, S. Francesco. *Below, left*: Guglielmo, pulpit, from the Cathedral of Pisa, 1159–62. Marble. Cagliari, Cathedral. *Right*: St. Martin and the beggar, 13th cent. Stone. Lucca, Cathedral, façade.

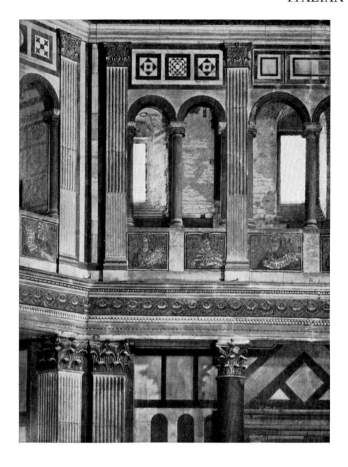

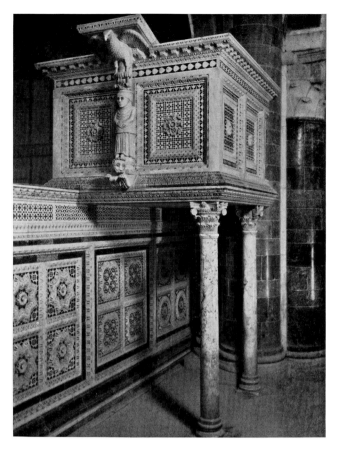

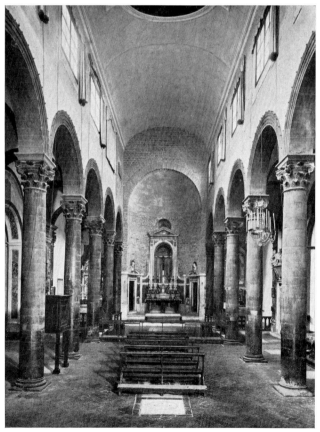

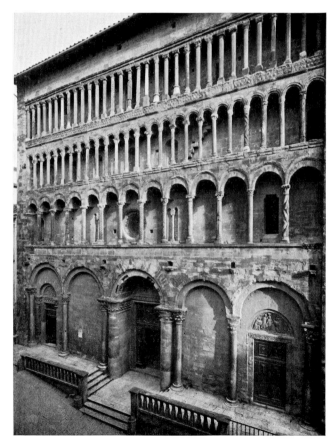

Pl. 182. Florence and Arezzo. *Above, left*: Florence, Baptistery, interior, detail of the polychrome decoration, 11th cent. *Right*: Florence, S. Miniato al Monte, pulpit, 1207. Marble. *Below, left*: Florence, SS. Apostoli, nave, prior to 1075. *Right*: Arezzo, Pieve di S. Maria, façade, 13th cent.

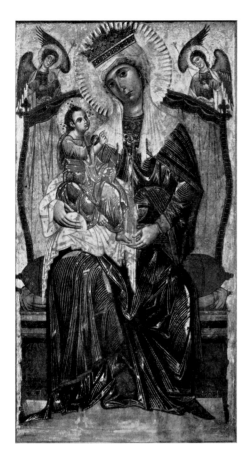

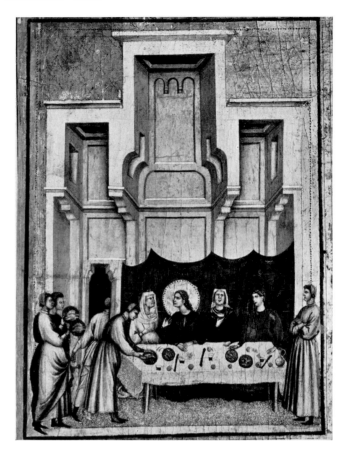

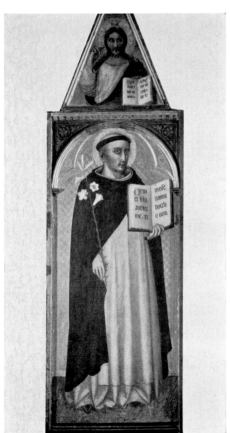

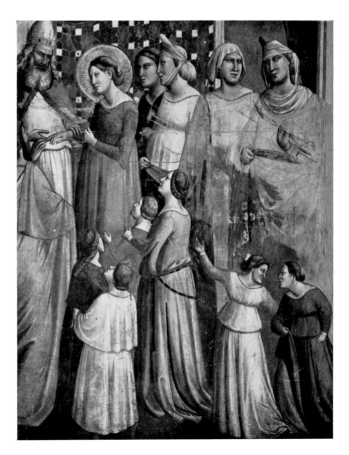

Pl. 183. Painting in Florence and Pisa. *Above, left*: Coppo di Marcovaldo, Madonna and Child Enthroned, 1265–70. Panel, 7 ft., 9³/₄ in. × 4 ft., 5 in. Orvieto, S. Maria dei Servi. *Right*: Master of S. Cecilia, Wedding feast of St. Cecilia and St. Valerian, early 14th cent. Panel, ca. 6 ft. × 2 ft., 9¹/₂ in. Florence, Uffizi. *Below, left*: F. Traini, St. Dominic, ca. 1345. Panel, 5 ft., 9 in. × 2 ft., 5 in. Pisa, Museo Nazionale. *Right*: T. Gaddi, Marriage of the Virgin, detail, 1332–38. Fresco. Florence, Sta Croce, Baroncelli Chapel.

Pl. 184. Gothic architecture in Florence and Siena. *Above, left*: Florence, Palazzo del Podestà, or Bargello, 1254–1346. *Right*: Castello delle Quattro Torri, near Siena, 14th–15th cent. *Below, left*: Florence, Cathedral, Porta della Mandorla, early 15th cent. *Right*: Giovanni di Agostino, Siena, New Cathedral, portal, ca. 1345.

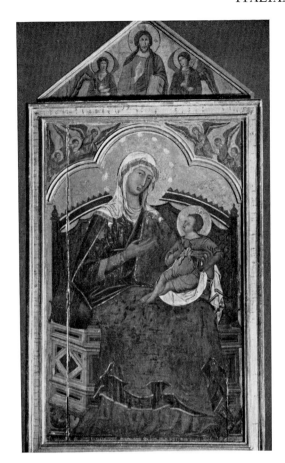

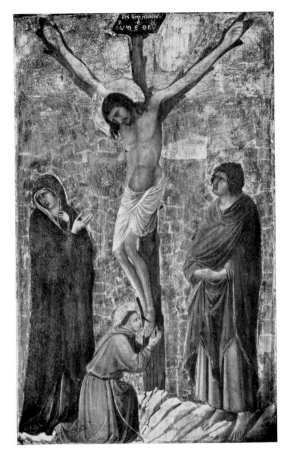

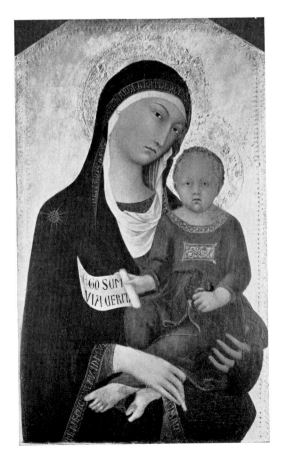

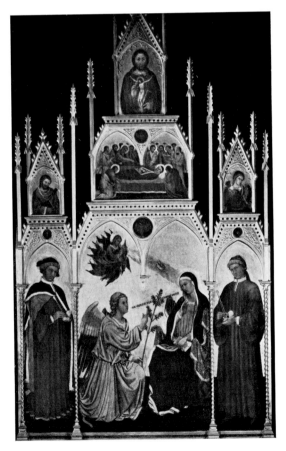

Pl. 185. Sienese painting. *Left, above*: Guido da Siena, Madonna and Child Enthroned, 13th cent. Panel, 9 ft., 4¹/₂ in. × 6 ft., 4 in. Siena, Palazzo Pubblico. *Below*: Lippo Memmi, Virgin and Child ("Madonna del Popolo"), ca. 1317. Panel, 20×30³/₄ in. Siena, S. Maria dei Servi. *Right, above*: Ugolino da Siena (di Neri or Nerio), Crucifixion, 14th cent. Panel, 24³/₄×15³/₄ in. *Below*: Taddeo di Bartolo, Annunciation and saints, 1409. Panel, 10 ft., 6 in. × 6 ft., 10¹/₂ in. Last two, Siena, Pinacoteca.

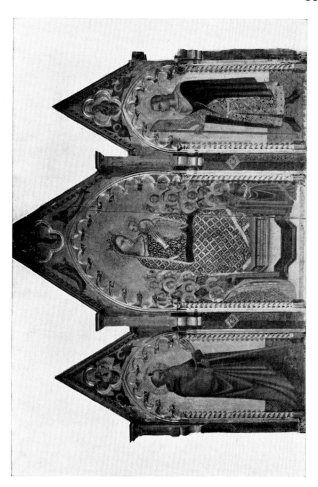

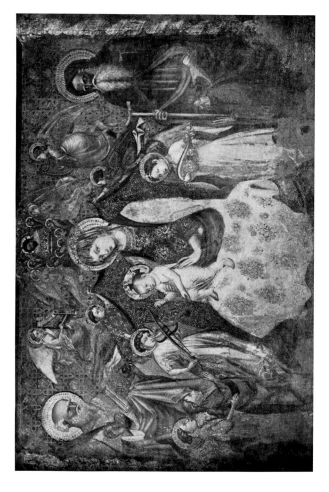

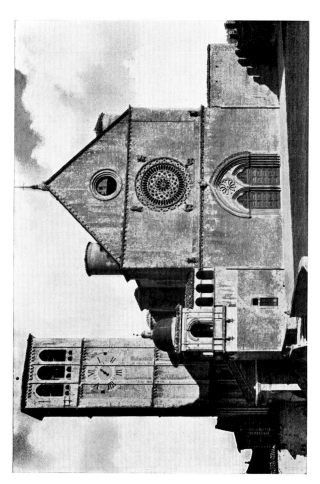

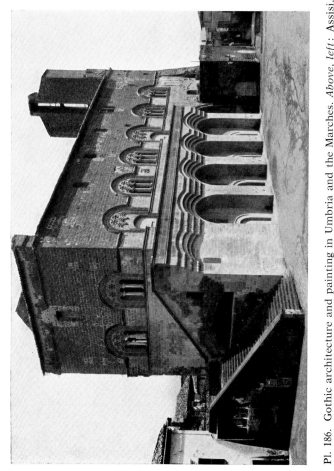

Pl. 186. Gothic architecture and painting in Umbria and the Marches. *Above, left*: Assisi, S. Francesco, Upper Church, façade, 13th cent. *Right*: Allegretto Nuzi, triptych with the Virgin and Child and saints, 1369. Panel. Macerata, Cathedral. *Below, left*: Orvieto, Palazzo del Popolo, 13th cent. *Right*: O. Nelli, Virgin and Child and saints, 1403. Fresco. Gubbio, S. Maria Nuova.

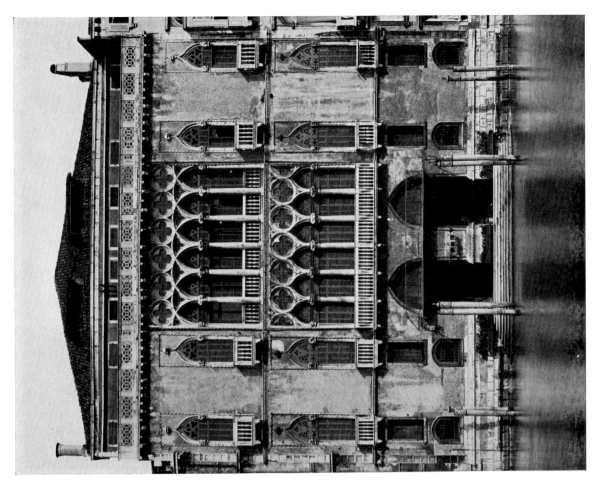

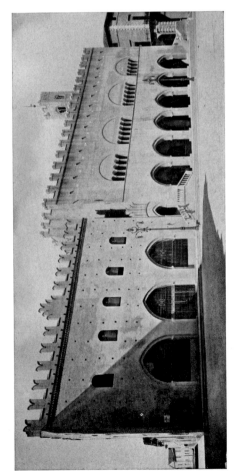

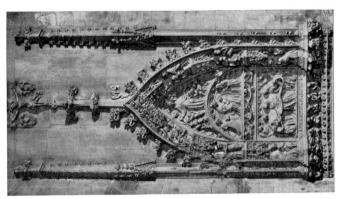

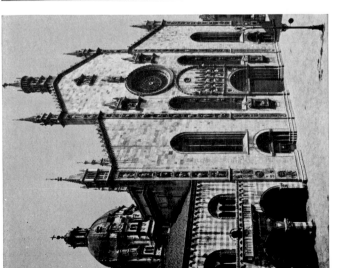

Pl. 187. Gothic architecture in northern Italy. *Left, above*: Rimini, Palazzo dell'Arengo, 1204. *Below*: Como, Cathedral, façade, 15th cent. *Center*: Giovanni di Fernach, decoration above South Sacristy door, Milan, Cathedral, 1393. *Right*: Venice, Palazzo Pisani Moretta, façade, mid-15th cent.

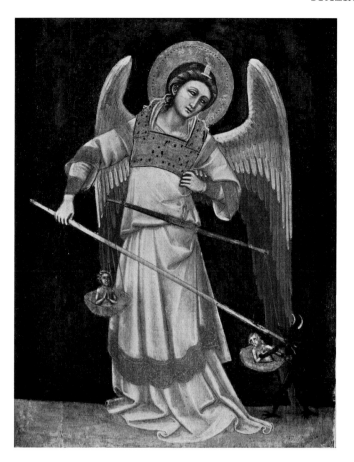

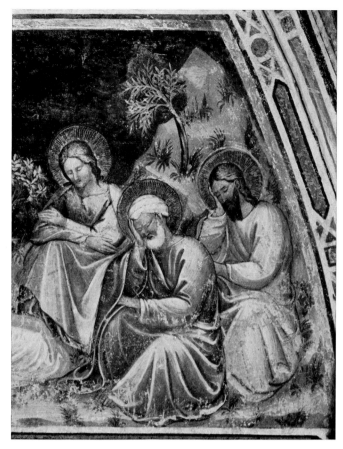

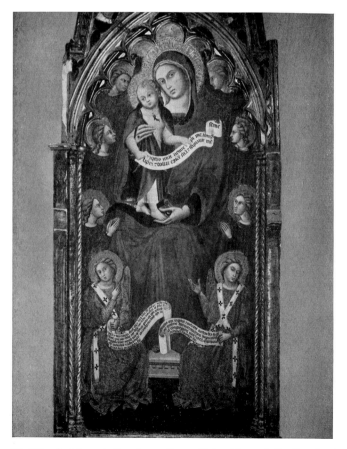

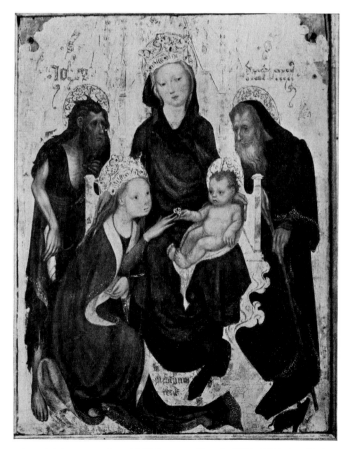

Pl. 188. Gothic painting in northern Italy. *Above, left*: Guariento, angel weighing a soul, mid-14th cent. Panel, $30^3/_4 \times 22^7/_8$ in. Padua, Museo Civico. *Right*: Deposition, detail, second half of 14th cent. Fresco. Viboldone, near Milan, Abbey. *Below, left*: Barnaba da Modena, Virgin and Child with angels, second half of 14th cent. Panel, 5 ft., 11 in. × 2 ft., $7^1/_2$ in. Pisa, Museo Nazionale. *Right*: Michelino da Besozzo, Mystical Marriage of St. Catherine, late 14th–early 15th cent. Panel, $29^1/_2 \times 22^1/_2$ in. Siena, Pinacoteca.

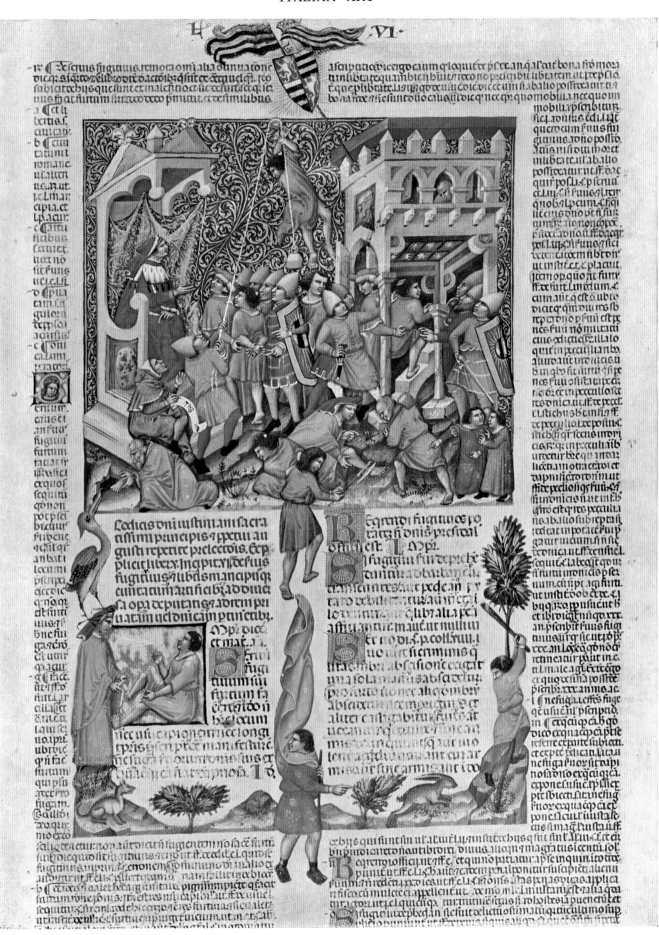

Pl. 189. Nicolò da Bologna, Torture, from the Pandects, second half of 14th cent. Illumination. Rome, Vatican Library (Ms. Vat. lat., fol. 179).

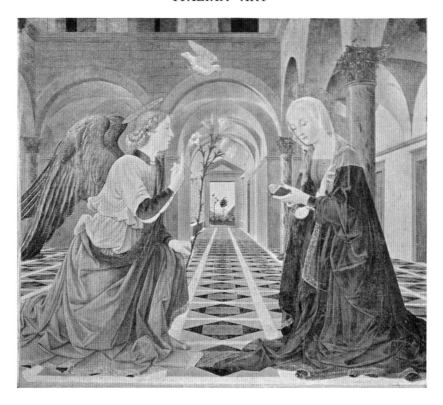

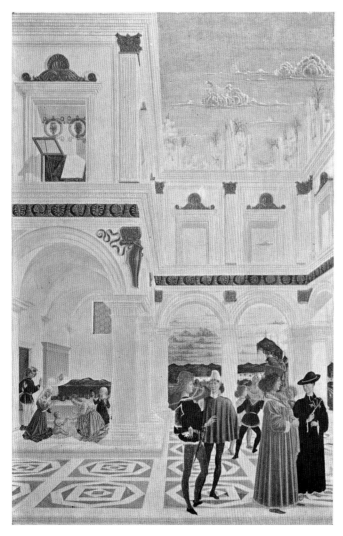

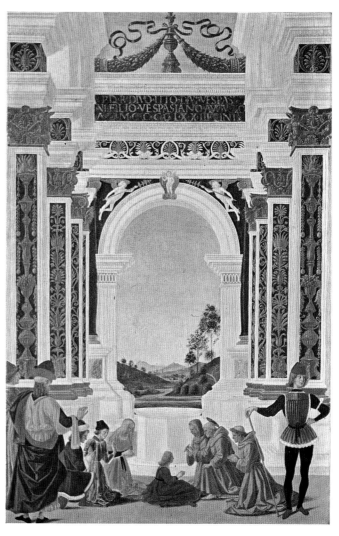

Pl. 190. *Above*: Master of the Gardner Annunciation (Antoniazzo Romano?), Annunciation, ca. 1480. Panel, 39³/₄×45 in. Boston, Isabella Stewart Gardner Museum. *Below*: Miracles of St. Bernardino of Siena, second half of 15th cent. Panel. Perugia, Galleria Nazionale dell'Umbria. *Left*: Anonymous, 28⁷/₈×22 in. *Right*: Perugino (?), 31¹/₈×22¹/₂ in.

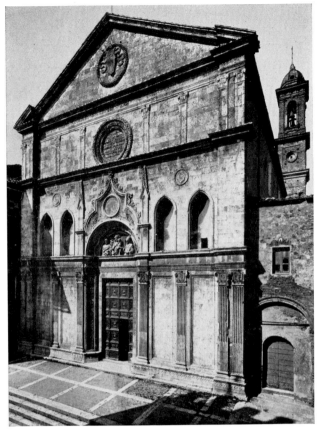

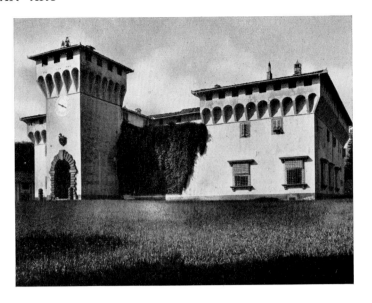

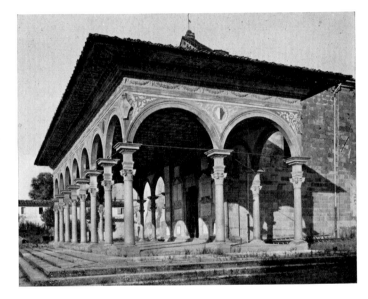

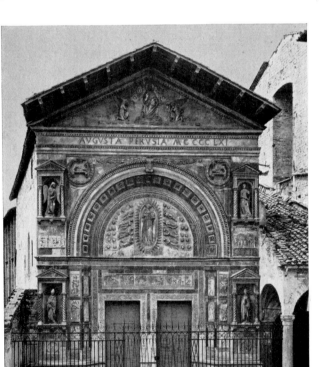

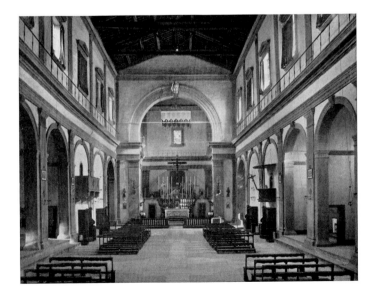

Pl. 191. Florentine architecture, 15th cent. *Left, above*: Michelozzo, Montepulciano, S. Agostino, façade. *Below*: Agostino di Duccio, Perugia, Oratory of S. Bernardino, façade. *Right, above*: Michelozzo, Cafaggiolo, Villa Medici. *Center*: Benedetto da Maiano, Arezzo, S. Maria delle Grazie, loggia. *Below*: Il Cronaca (Simone del Pollaiuolo), Florence, S. Salvatore al Monte, nave.

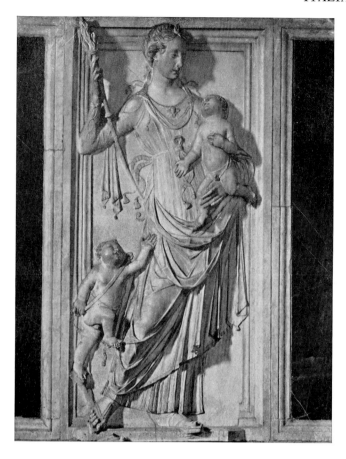

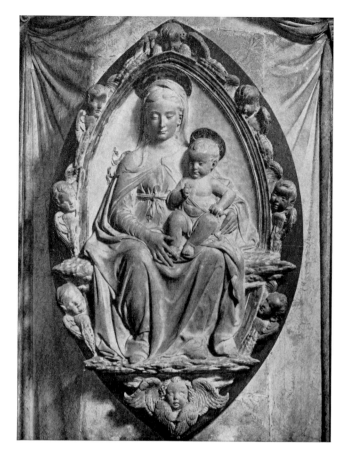

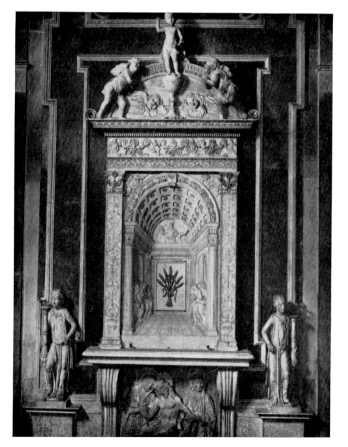

Pl. 192. Florentine sculpture, 15th cent. *Above, left*: Mino da Fiesole, tomb of Count Hugo, Charity. Marble. Florence, Church of the Badia. *Right*: A. Rossellino, tomb of Francesco Nori, Madonna and Child. Marble. Florence, Sta Croce. *Below, left*: Desiderio da Settignano, tabernacle. Marble. Florence, S. Lorenzo. *Right*: Giuliano and Benedetto da Maiano, portal of the Sala dell'Udienza. Florence, Palazzo Vecchio.

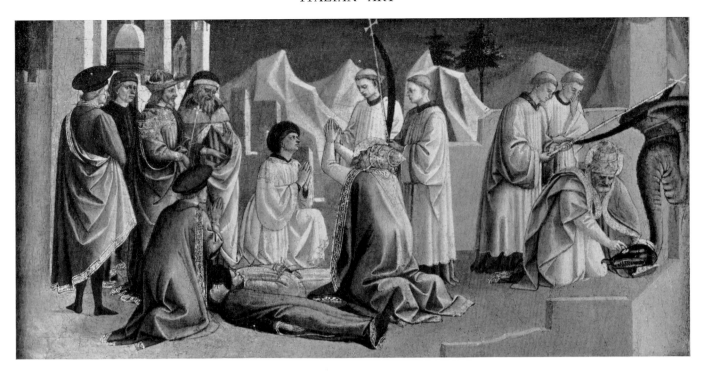

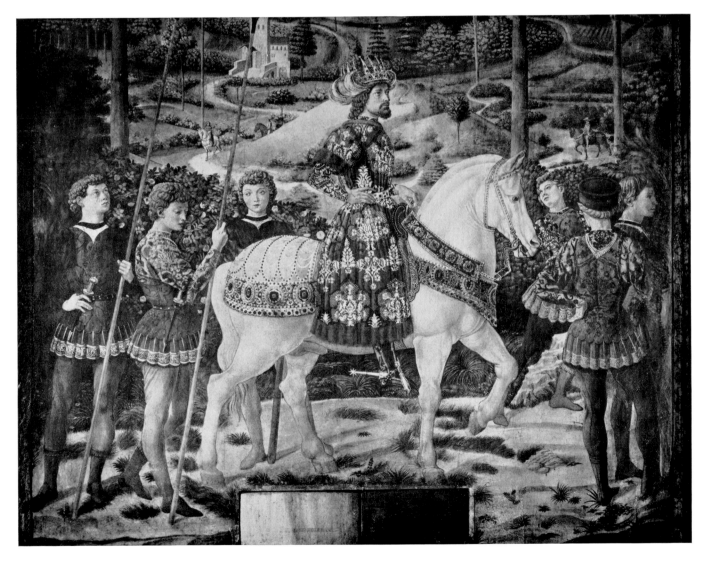

Pl. 193. Florentine painting, 15th cent. *Above*: Pesellino, St. Sylvester subduing a dragon. Panel, 11½×23 in. Rome, Galleria Doria Pamphili. *Below*: B. Gozzoli, The Procession of the Magi, detail. Fresco. Florence, Palazzo Medici-Riccardi, Chapel.

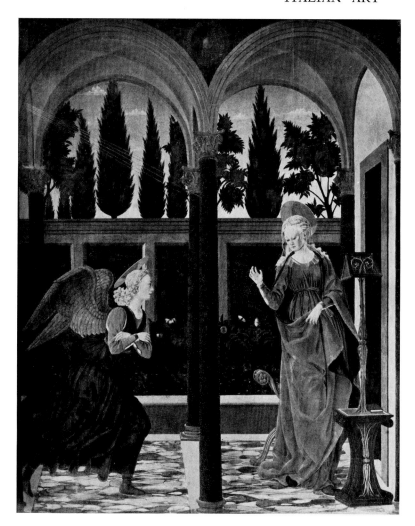
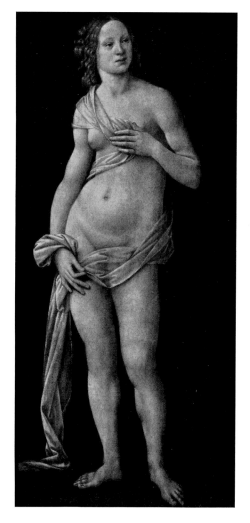
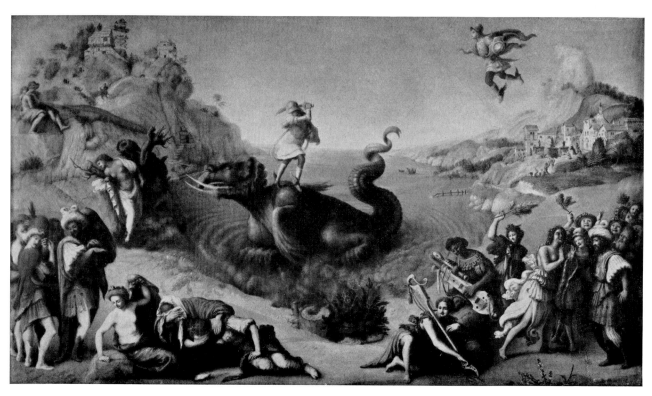

Pl. 194. Florentine Renaissance painting. *Above, left*: A. Baldovinetti, Annunciation. Panel, 5 ft., 5³/₄ in. × 4 ft., 6 in. *Right*: Lorenzo di Credi, Venus. Canvas, 4 ft., 11¹/₂ in. × 2 ft., 3 in. *Below*: Piero di Cosimo, Perseus freeing Andromeda. Panel, 2 ft., 4 in. × 4 ft., ¹/₂ in. All, Florence, Uffizi.

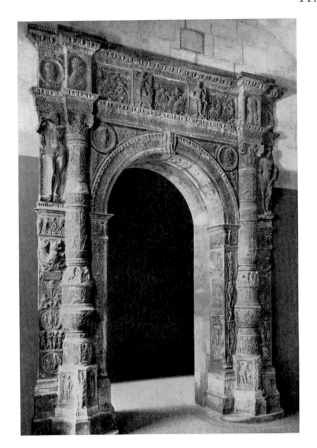

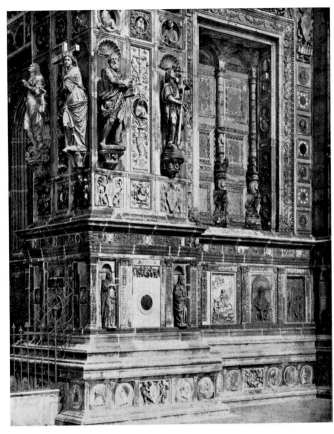

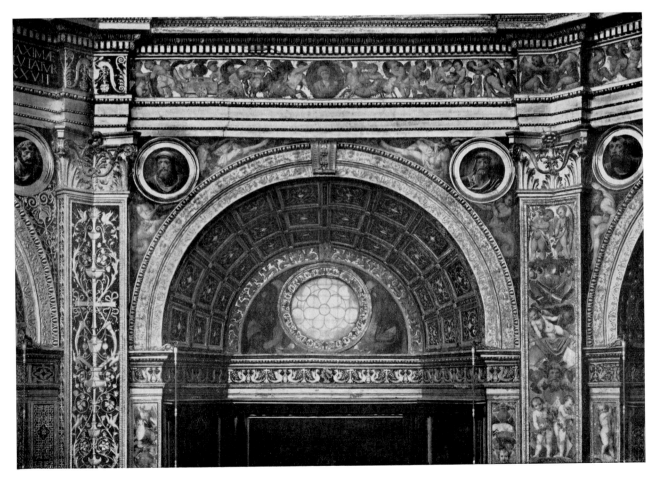

Pl. 195. Lombard Renaissance architecture. *Above, left*: Portal, from Palazzo Stanga in Cremona. Marble. Paris, Louvre. *Right*: C. and A. Mantegazza and G. A. Amadeo, Pavia, Certosa, detail of the façade. *Below*: Callisto, Cesare, and Scipione Piazza, Lodi, Church of the Incoronata, interior, detail of the decoration.

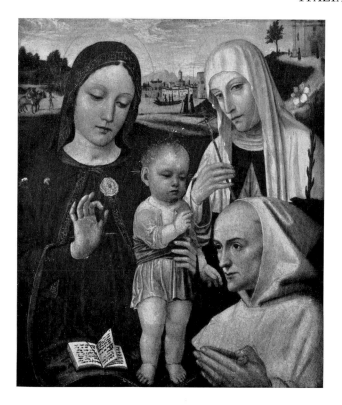

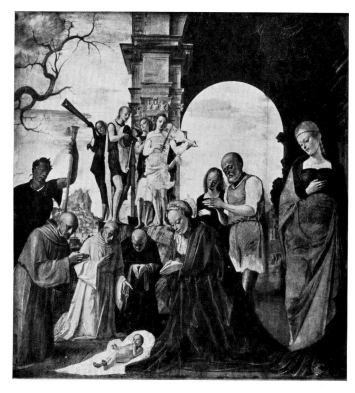

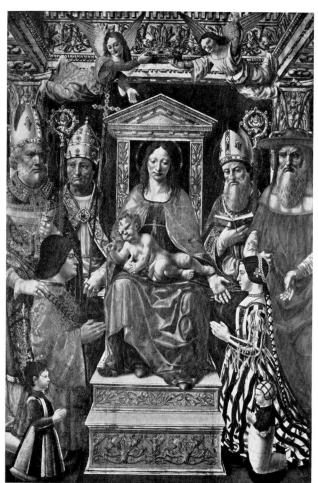

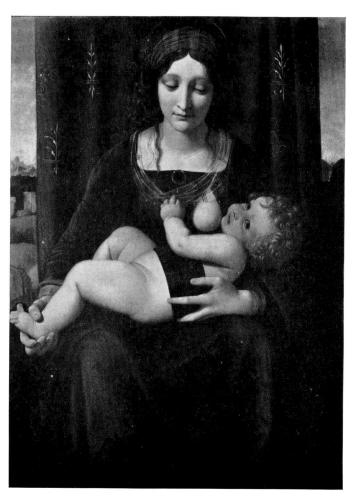

Pl. 196. Lombard Renaissance painting. *Left, above*: Il Bergognone (Ambrogio da Fossano), Madonna and Child with St. Catherine of Siena and a Carthusian. Panel, 17³/₄×15¹/₂ in. *Below*: Master of the Pala Sforzesca, the Sforzesca altarpiece. Panel, 7 ft., 6¹/₂ in. × 5 ft., 5 in. Both, Milan, Brera. *Right, above*: Bramantino, Nativity. Panel, 34¹/₄×33¹/₂ in. Milan, Pinacoteca Ambrosiana. *Below*: G. A. Boltraffio, Madonna and Child. Panel, 36¹/₂×26¹/₂ in. London, National Gallery.

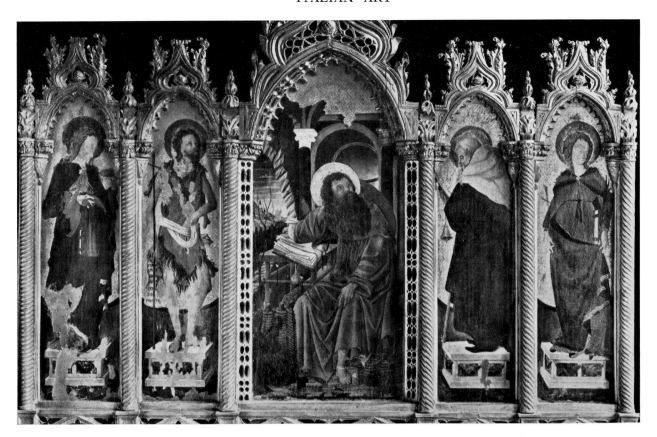

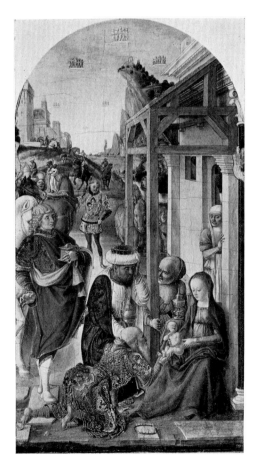

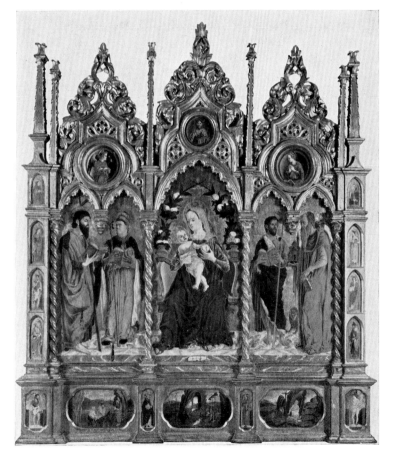

Pl. 197. Squarcione in Padua and his school, 15th cent. *Above*: F. Squarcione, polyptych with St. Jerome and other saints. Panel, 5 ft., 9 in. × 7 ft., 2³/₄ in. Padua, Museo Civico. *Below, left*: B. Vivarini, Adoration of the Magi. Panel, 21¹/₂ ×12³/₄ in. New York, Frick Coll. *Right*: M. Zoppo, triptych with the Madonna and Child and saints. Panel, 7 ft., 8¹/₂ in. × 6 ft., 10 in. Bologna, Collegio di Spagna, S. Clemente.

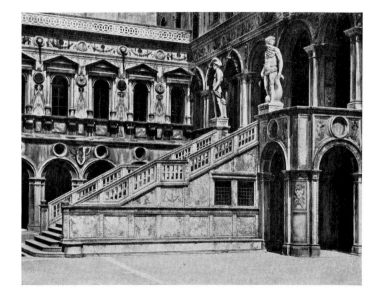

Pl. 198. Early Renaissance architecture and sculpture in Venice. *Left, above*: P. Lombardo (attrib.), Palazzo Dario, façade. *Below*: A. Rizzo, tomb of Doge Nicolò Tron, S. Maria Gloriosa dei Frari. *Right, above*: M. Coducci, S. Michele all'Isola, façade. *Center*: P. Lombardo and others, Scuola Grande di S. Marco, façade. *Below*: A. Rizzo and others, Doges' Palace, Scala dei Giganti.

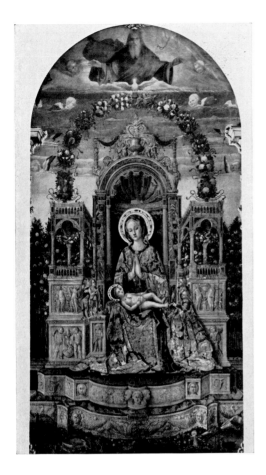

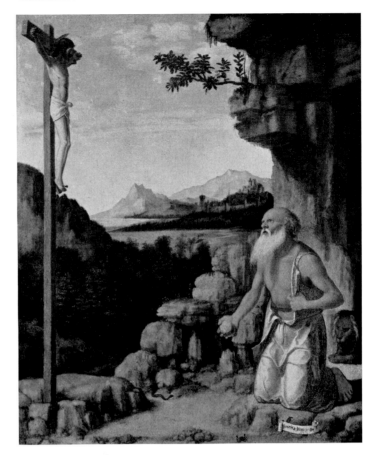

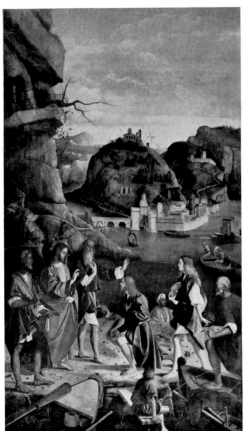

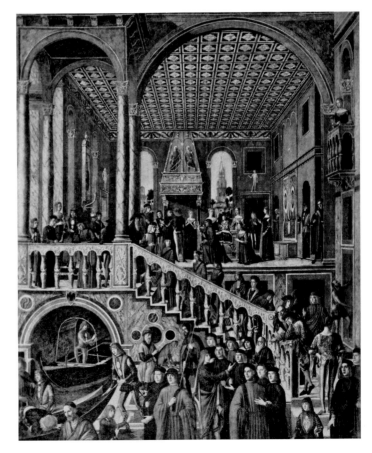

Pl. 199. Venetian Renaissance painting. *Above, left*: Antonio da Negroponte, Madonna Enthroned. Panel, 12 ft., 1$^1/_2$ in. × 7 ft., 6$^1/_2$ in. Venice, S. Francesco della Vigna. *Right*: Cima da Conegliano, St. Jerome in the Wilderness. Canvas, 19×15$^3/_4$ in. Washington, D.C., National Gallery. *Below, left*: M. Basaiti, Calling of the Sons of Zebedee. Panel, 12 ft., 8 in. × 8 ft., 9$^1/_2$ in. *Right*: G. Mansueti, Miracle of the True Cross. Canvas, 11 ft., 9$^1/_2$ in. × 9 ft., 8$^1/_2$ in. Last two, Venice, Accademia.

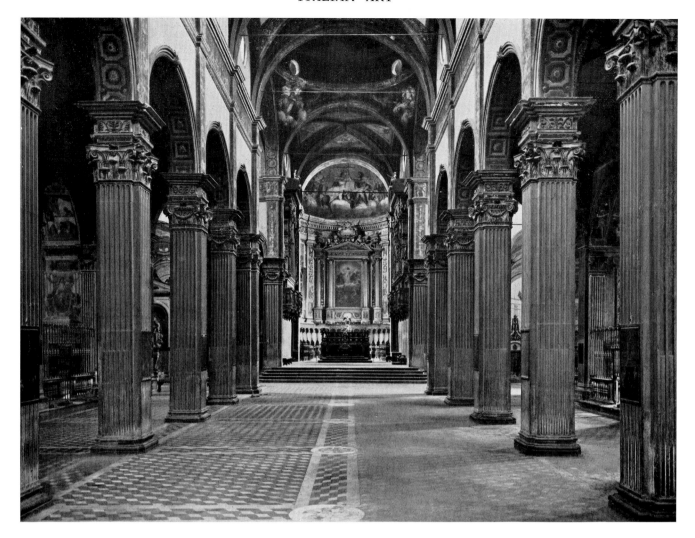

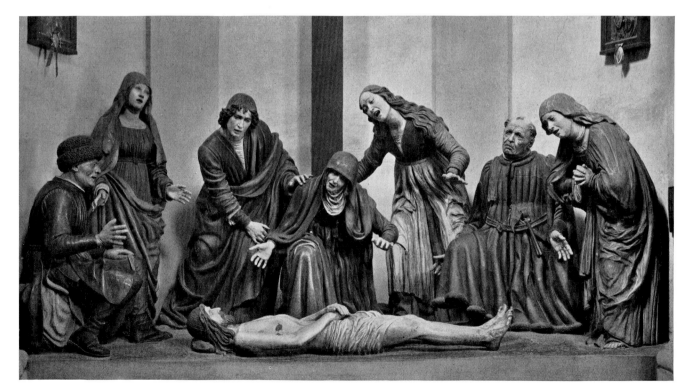

Pl. 200. Renaissance architecture and sculpture in Emilia. *Above*: B. Zaccagni the Elder, Parma, S. Giovanni Evangelista, nave.
Below: Guido Mazzoni, Lamentation over the Dead Christ. Painted terra cotta, life size. Modena, S. Giovanni Battista.

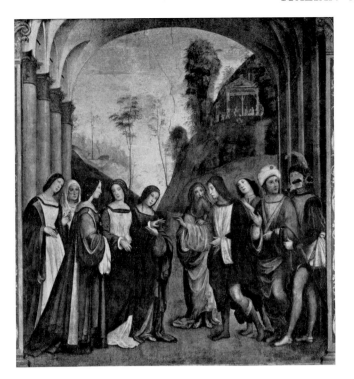

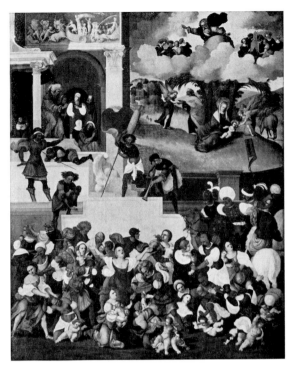

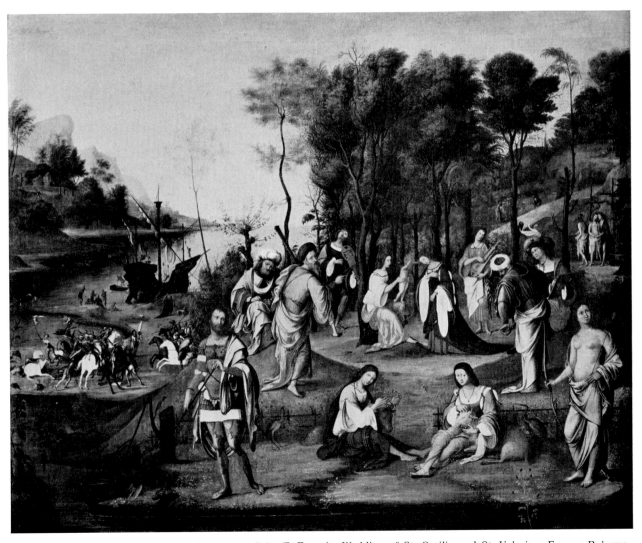

Pl. 201. Renaissance painting in Emilia. *Above, left*: F. Francia, Wedding of St. Cecilia and St. Valerian. Fresco. Bologna, S. Giacomo Maggiore, Oratory of S. Cecilia. *Right*: L. Mazzolino, Slaughter of the Innocents. Canvas, 4 ft., 5 in. × 3 ft., 8 in. Rome, Galleria Doria Pamphili. *Below*: Lorenzo Costa, The Court of Isabella d'Este. Canvas, 5 ft., 2¹/₄ in. × 6 ft., 4 in. Paris, Louvre.

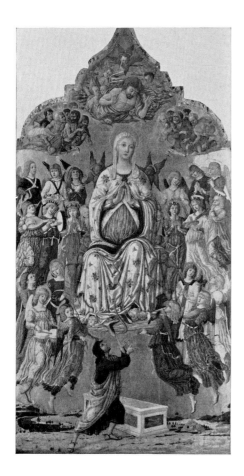

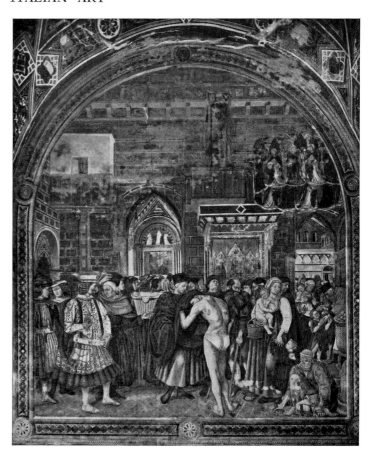

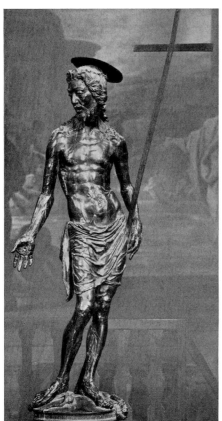

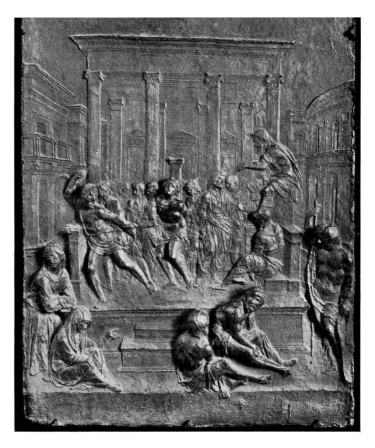

Pl. 202. Sienese painting and sculpture, 15th cent. *Above, left*: Matteo di Giovanni (da Siena), The Assumption of the Virgin. Panel, 10 ft., 10$\frac{1}{2}$ in. × 5 ft., 8$\frac{1}{2}$ in. London, National Gallery. *Right*: Domenico di Bartolo, Distribution of Alms. Fresco. Siena, Hospital of S. Maria della Scala. *Below, left*: Il Vecchietta, Risen Christ. Bronze. Siena, S. Maria della Scala. *Right*: Francesco di Giorgio, Flagellation. Bronze, 22×16 in. Perugia, Galleria Nazionale dell'Umbria.

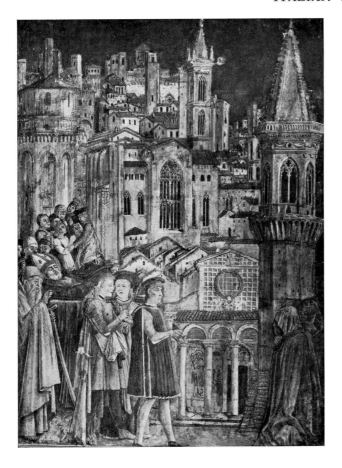 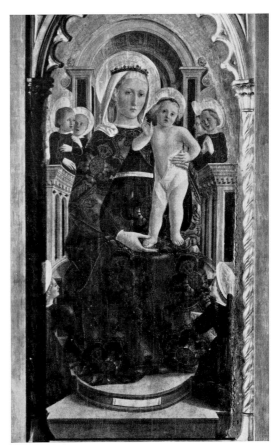

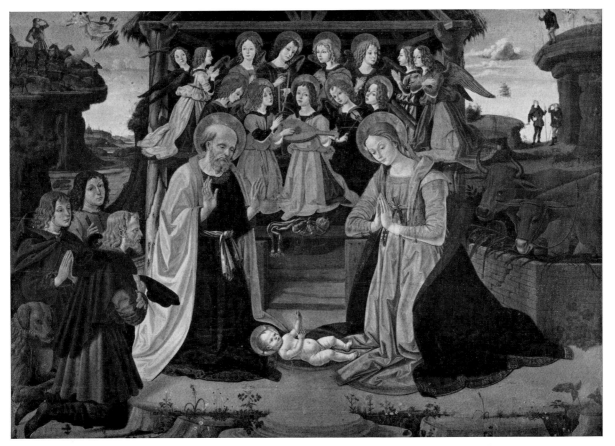

Pl. 203. Renaissance painting in Umbria and the Marches. *Above, left*: B. Bonfigli, First Transferral of the Body of St. Herculanus to St. Peter's. Fresco. Perugia, Galleria Nazionale dell'Umbria. *Right*: Girolamo di Giovanni da Camerino, Madonna and Child with angels, detail of a triptych. Panel, 4 ft., 4 in. × 2 ft. Milan, Brera. *Below*: Fiorenzo di Lorenzo, Adoration of the Shepherds. Panel, 6 ft., 4 in. × 7 ft., 3 in. Perugia, Galleria Nazionale dell'Umbria.

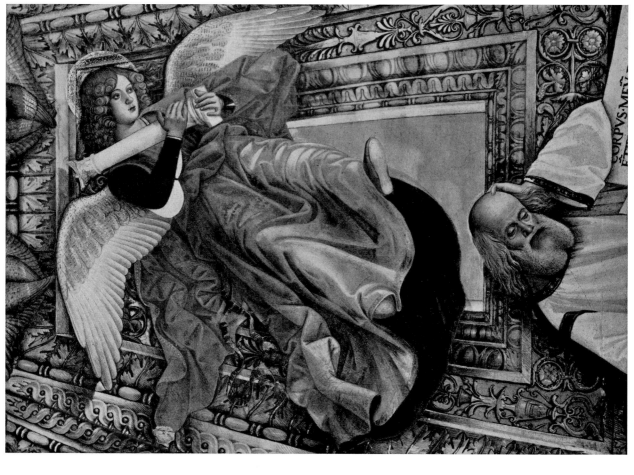

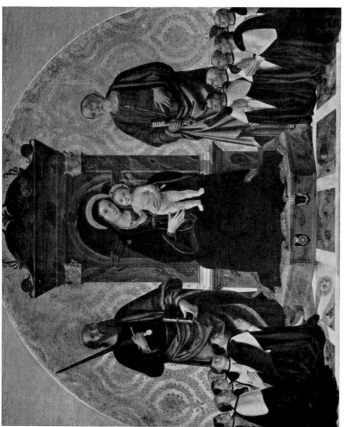

Pl. 204. Early Renaissance painters under Roman influence. *Left, above*: Antoniazzo Romano, Madonna and saints with members of the Rota. Panel, 6 ft., 1 3/4 in. × 6 ft., 11 1/2 in. Rome, Vatican Museums. *Below*: Lorenzo da Viterbo, Nativity. Fresco. Viterbo, S. Maria della Verità, Mazzatosta Chapel. *Right*: Melozzo da Forlì and assistants, Angel with Symbol of the Passion. Fresco. Loreto, Sanctuary of the Holy House, Sacristy of St. Mark.

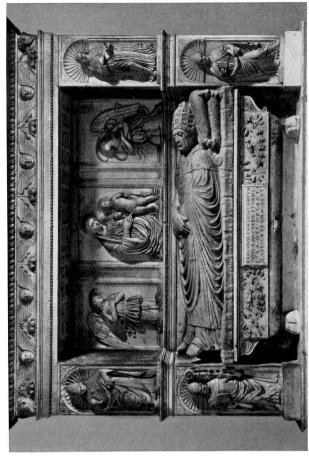

Pl. 205. Early Renaissance architecture and sculpture in Rome. *Left*: Palazzo Venezia, courtyard. *Right, above*: S. Maria del Popolo, façade. *Below*: Isaia da Pisa (attrib.). tomb of Pope Eugenius IV. Marble. S. Salvatore in Lauro.

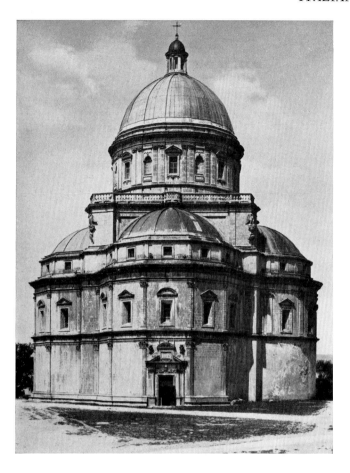

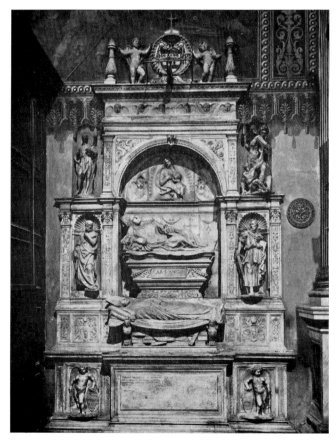

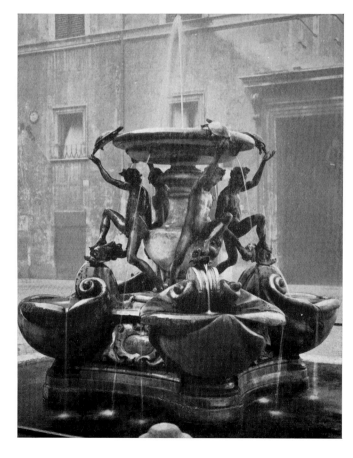

Pl. 206. Roman architecture and sculpture, 16th cent. *Above, left*: Todi, S. Maria della Consolazione. *Right*: Raphael with A. da San-gallo the Younger, Rome, Villa Madama, loggia, decoration executed by Giulio Romano and Giovanni da Udine. *Below, left*: J. Sansovino and others, tomb of Antonio Orso and Giovanni Michiel. Marble. Rome, S. Marcello. *Right*: T. Landini and Giacomo della Porta (?), Rome, Fontana delle Tartarughe. Marble and bronze.

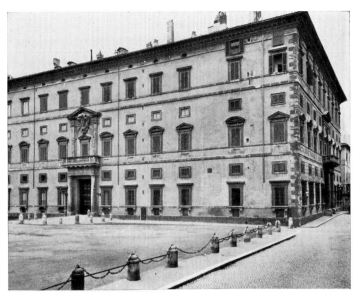

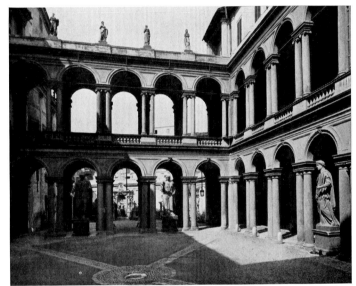

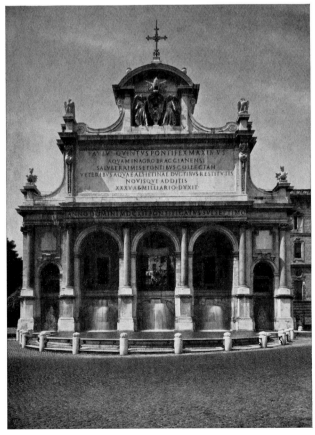

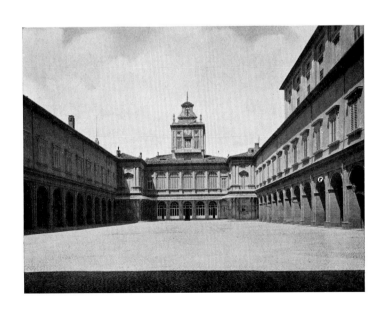

Pl. 207. Architecture in Rome, late 16th–early 17th cent. *Left, above*: M. Longhi the Elder, S. Girolamo degli Schiavoni, façade. *Below*: Acqua Paola fountain. *Right, above and center*: M. Longhi the Elder, Palazzo Borghese, façade and detail of the courtyard. *Below*: O. Mascherino, Palazzo del Quirinale, courtyard.

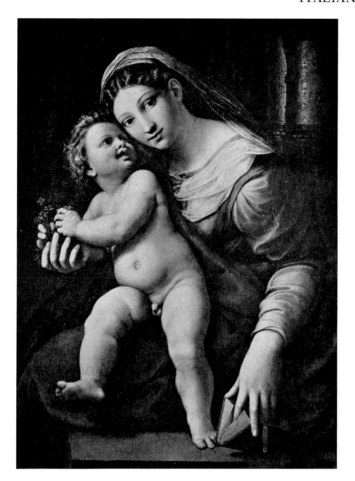

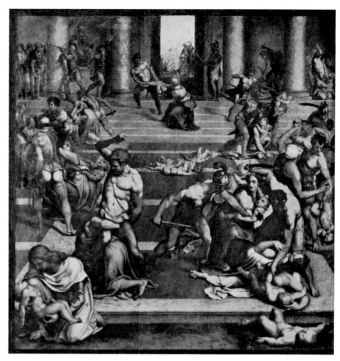

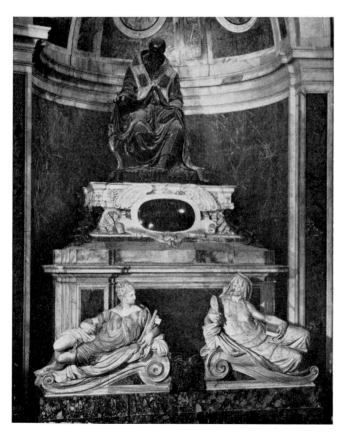

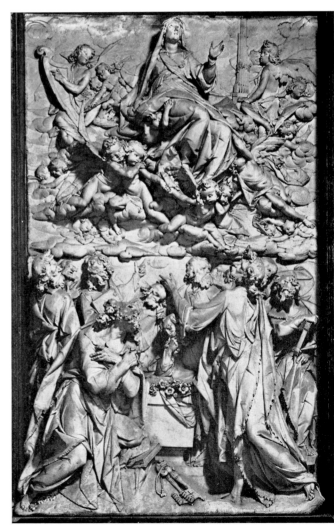

Pl. 208. Mannerist painting and sculpture in Rome. *Above, left*: Giulio Romano, Madonna and Child. Panel, 41$^1/_4$×30$^3/_4$ in. *Right*: Daniele da Volterra, Slaughter of the Innocents. Panel, 4 ft., 10 in. × 4 ft., 8$^3/_4$ in. Both, Florence, Uffizi. *Below, left*: Guglielmo della Porta, tomb of Pope Paul III. Bronze and marble. Rome, St. Peter's. *Right*: P. Bernini, Assumption. Marble relief. Rome, S. Maria Maggiore, Baptistery.

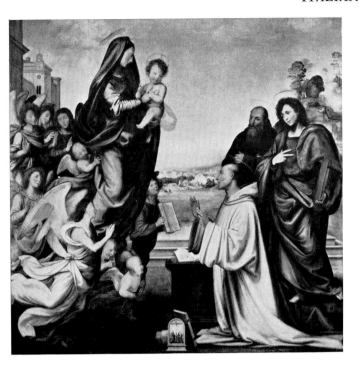

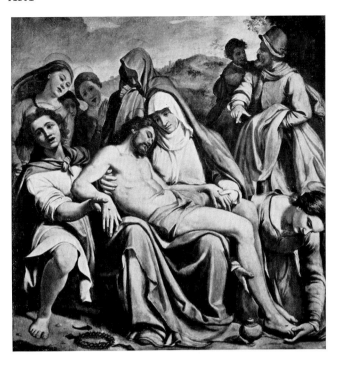

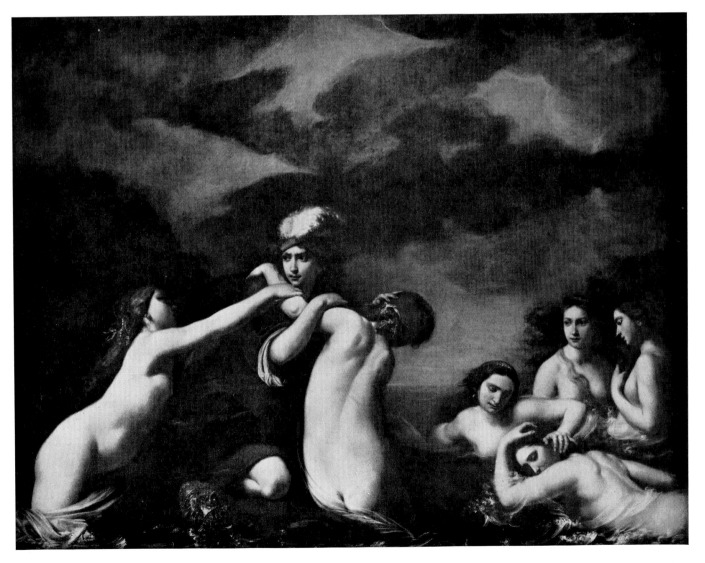

Pl. 209. Florentine painters, 16th–17th cent. *Above, left*: Fra Bartolommeo, The Vision of St. Bernard. Panel, 7 ft. × 7 ft., 2³/₄ in.
Right: Santi di Tito, Pietà. Panel, 4 ft., 11 in. × 4 ft., 11 in. Both, Florence, Accademia. *Below*: F. Furini, Hylas and the
Nymphs. Canvas, 7 ft., 6¹/₂ in. × 8 ft., 6³/₄ in. Florence, Pitti.

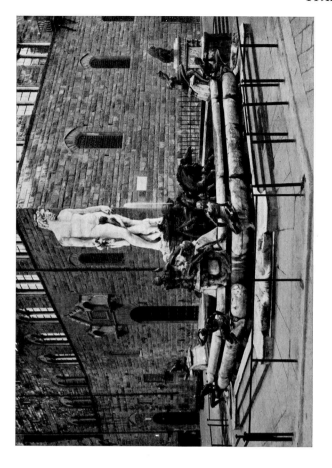

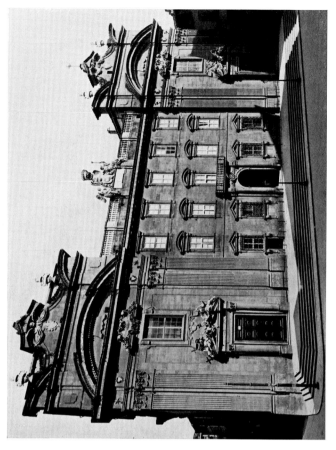

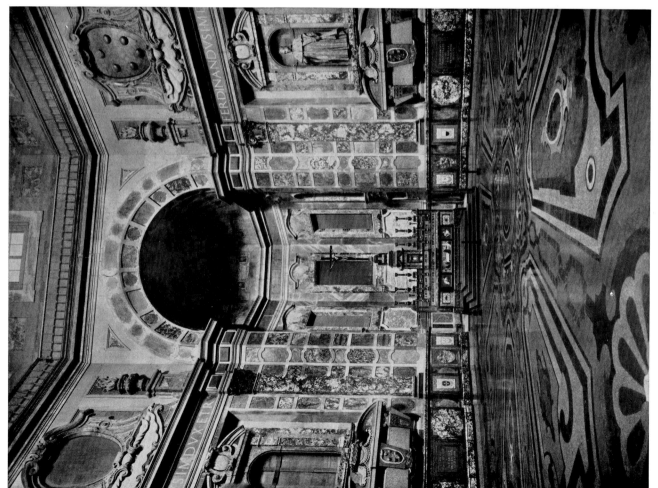

Pl. 210. Sculpture and architecture in Florence. *Left*: M. Nigetti, S. Lorenzo, Cappella dei Principi, begun 1604. *Right, above*: B. Ammanati and others, Piazza della Signoria, Fountain of Neptune, 1575. Marble and bronze. *Below*: S. Firenze, façade, 18th cent.

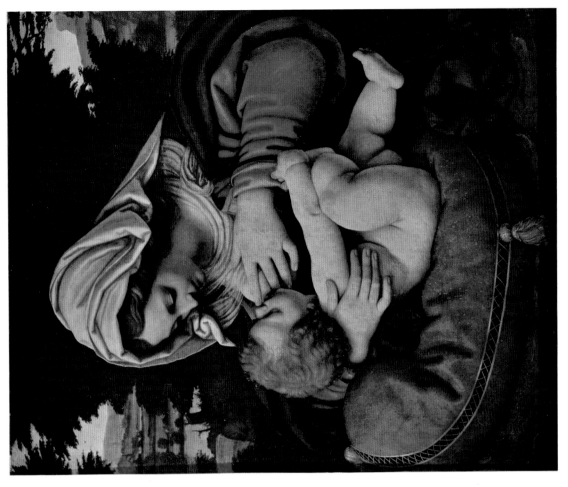

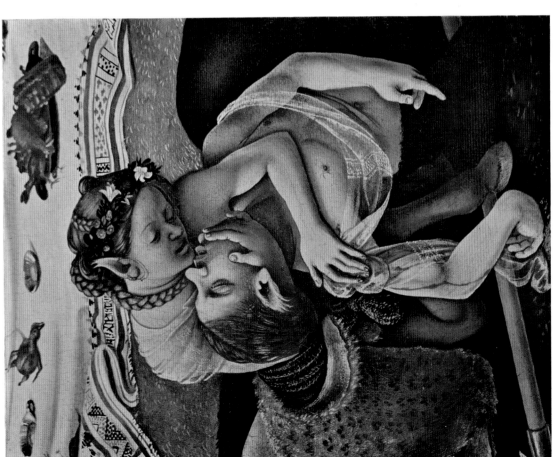

Pl. 211. *Left*: Piero di Cosimo (1462–1521), The Fight between the Lapiths and the Centaurs, detail. Panel; full size, 2 ft., 4 in. × 8 ft., 6½ in. London, National Gallery. *Right*: Andrea Solari, The Virgin with the Green Cushion, ca. 1500. Panel, 23⅝×19¾ in. Paris, Louvre.

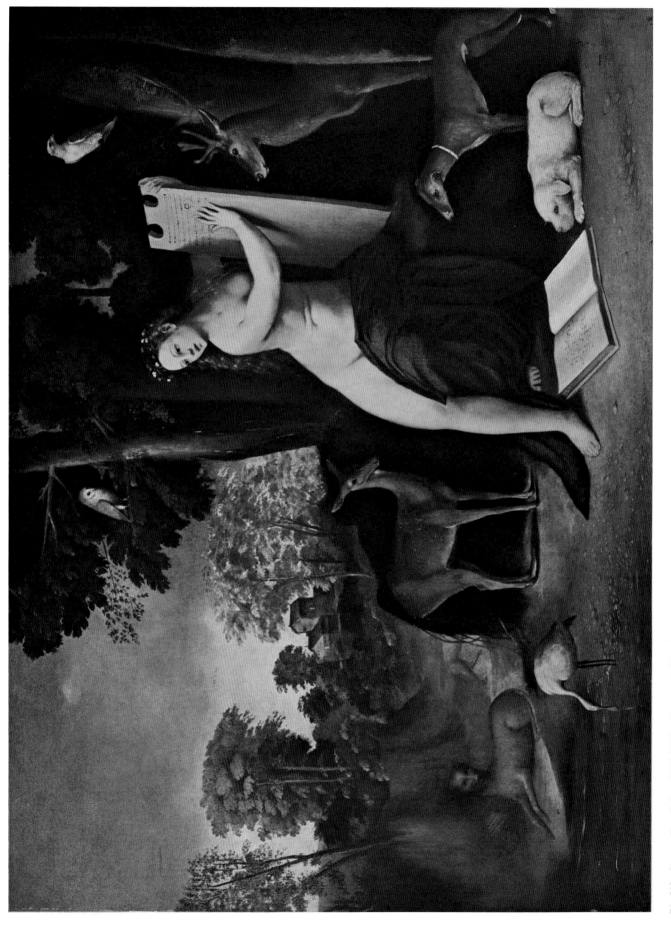

Pl. 212. Dosso Dossi (ca. 1479–1542), Circe and Her Lovers in a Landscape. Canvas, 3 ft., 3½ in. × 4 ft., 5½ in. Washington, D.C., National Gallery.

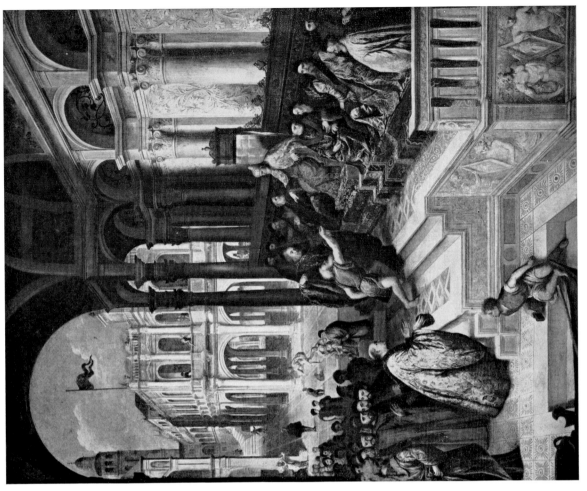

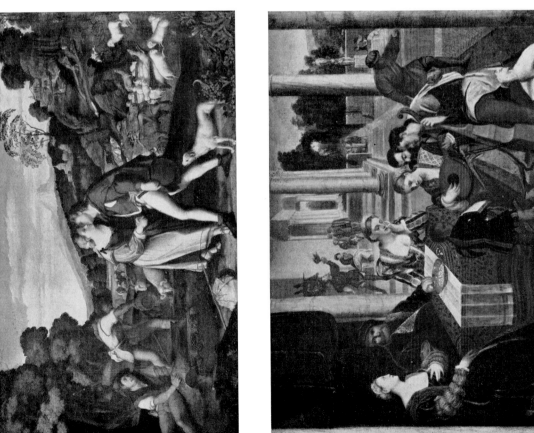

Pl. 213. Venetian painters, 16th cent. *Left, above*: Palma Vecchio, Jacob and Rachel. Canvas, 4 ft., 9¹/₂ in. × 8 ft., 2¹/₂ in. Dresden, Gemäldegalerie. *Below*: Bonifazio Veronese, The Rich Man's Feast, detail. Canvas; full size, 6 ft., 6³/₄ in. × 14 ft., 3¹/₂ in. *Right*: P. Bordone, The Presentation of St. Mark's Ring to the Doge. Canvas, 12 ft., 1¹/₂ in. × 9 ft., 10 in. Last two, Venice, Accademia.

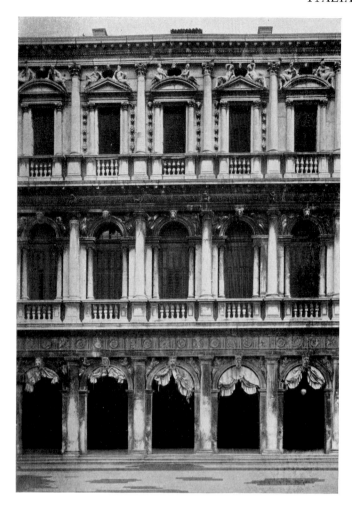

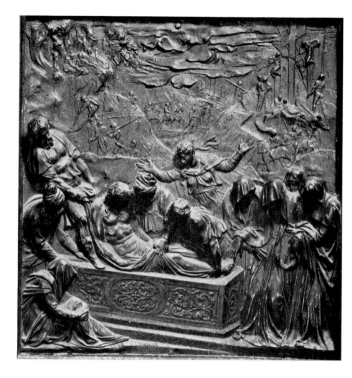

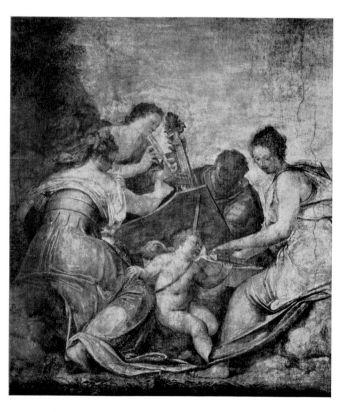

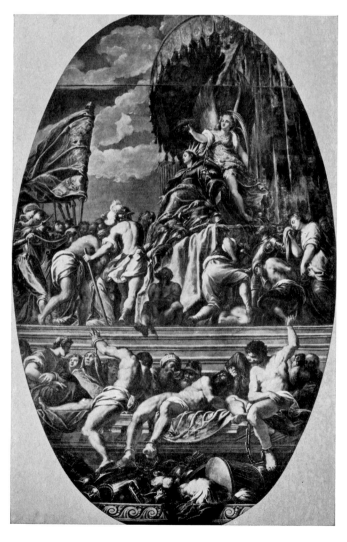

Pl. 214. Venetian architecture, sculpture, and painting. *Above, left*: V. Scamozzi and B. Longhena, Venice, the Procuratie Nuove, 1584–1640. *Right*: J. Sansovino, Deposition, panel of door, 1546–69. Bronze. Venice, S. Marco, sacristy. *Below, left*: G. B. Zelotti (1526–78), Concert. Detached fresco. Verona, Museo di Castelvecchio. *Right*: Palma Giovane, Venice Crowned, 1578/84. Canvas. Venice, Doges' Palace.

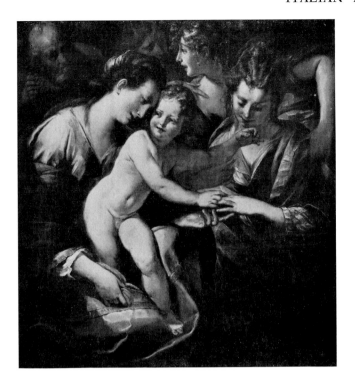

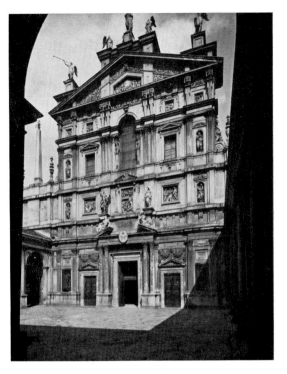

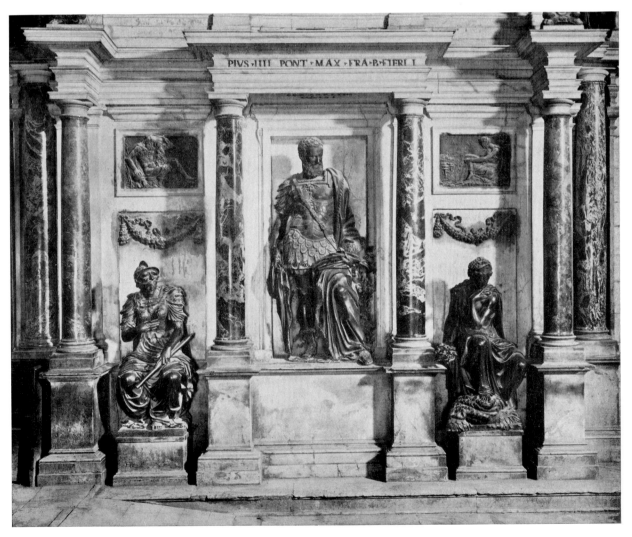

Pl. 215. Mannerist architecture, sculpture, and painting in Milan. *Above, left*: G. C. Procaccini, Mystical Marriage of St. Catherine. Canvas, 5 ft., 2½ in. × 4 ft., 9 in. Milan, Brera. *Right*: G. Alessi and M. Bassi, Milan, S. Maria presso S. Celso, façade. *Below*: L. Leoni, tomb of Gian Giacomo Medici, lower part. Marble and bronze. Milan, Cathedral.

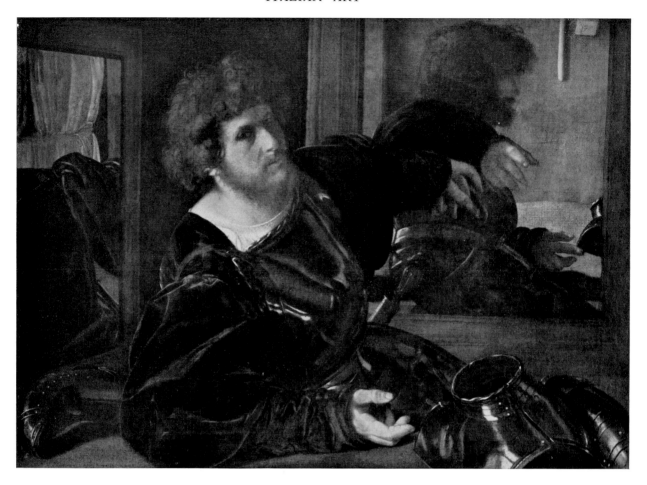

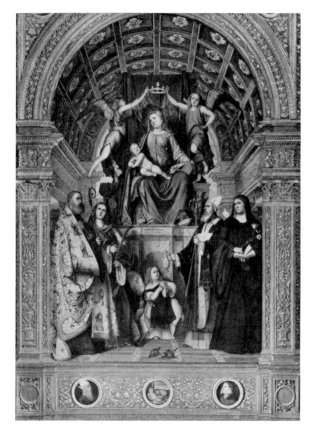

Pl. 216. Painting of Bergamo and Brescia, 16th cent. *Above*: G. G. Savoldo, portrait (Gaston de Foix?). Canvas, 3 ft. × 4 ft., ¹/₂ in. Paris, Louvre. *Below, left*: Il Romanino (G. Romani), Madonna Enthroned with angels and saints. Panel, 12 ft., 6 in. × 8 ft. Padua, Museo Civico. *Right*: Moretto da Brescia, St. Nicholas of Bari presents three children to the Virgin. Canvas, 7 ft., 11¹/₄ in. × 5 ft., 11 in. Brescia, Pinacoteca Civica Tosio-Martinengo.

Pl. 217. Emilian painting, 16th cent. *Above, left*: Garofalo (B. Tisi), Adoration of the Magi. Panel, 11 ft. × 6 ft., 5 in. Ferrara, Pinacoteca Nazionale. *Right*: Scarsellino (I. Scarsella), Madonna and Child with St. John. Panel, 14³/₄× 10¹/₄ in. Rome, Galleria Borghese. *Below*: N. dell'Abate, Concert. Fresco. Bologna, University.

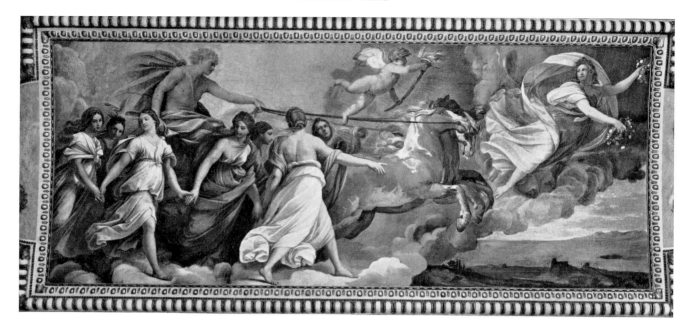

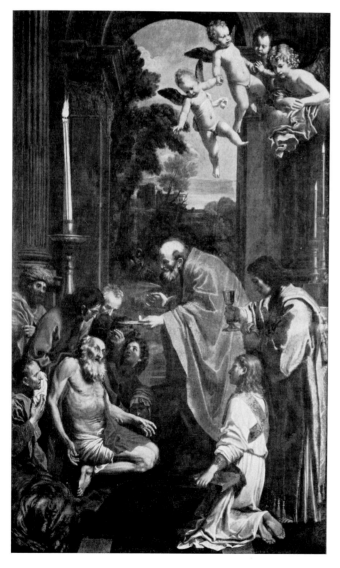

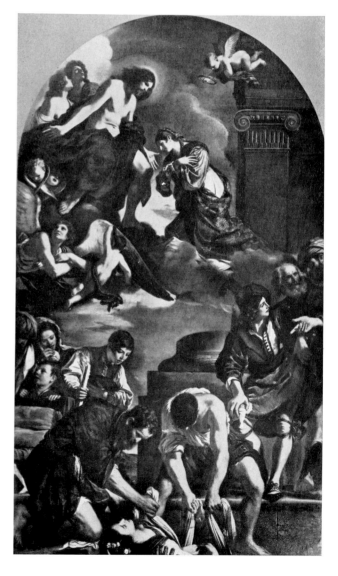

Pl. 218. Emilian painters in Rome, early 17th cent. *Above*: G. Reni, Aurora. Fresco. Rome, Palazzo Pallavicini-Rospigliosi, Casino. *Below, left*: Domenichino, Last Communion of St. Jerome. Canvas, 13 ft., 9 in. × 8 ft., 4¹/₂ in. Rome, Vatican Museums. *Right*: Guercino, Burial and Reception into Heaven of St. Petronilla. Canvas, 23 ft., 7¹/₂ in. × 13 ft., 9 in. Rome, Palazzo dei Conservatori, Pinacoteca Capitolina.

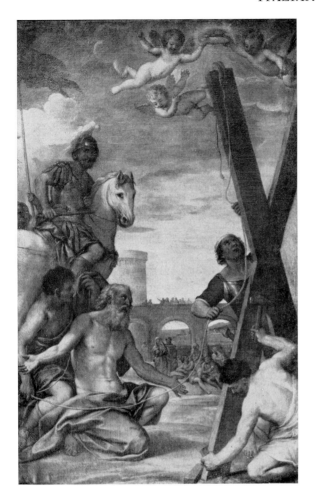

Pl. 219. Painters of the Carracci school in Rome and Emilia, 17th cent. *Above, left*: F. Albani, Martyrdom of St. Andrew. Canvas, 11 ft., 2 in. × 7 ft., 2³/₄ in. Bologna, S. Maria dei Servi. *Right*: G. Cavedone, Virgin and Child with SS. Alò and Petronius. Canvas, 12 ft., 10³/₄ in. × 7 ft., 3¹/₂ in. Bologna, Pinacoteca Nazionale. *Below, left*: Sassoferrato (G. B. Salvi), Nativity. Canvas, 4 ft., 4³/₄ in. × 3 ft., 3 in. Naples, Museo di Capodimonte. *Right*: A. Tiarini, St. Dorothy. Canvas, 5 ft. × 3 ft., 8¹/₂ in. Rome, Galleria Doria Pamphili.

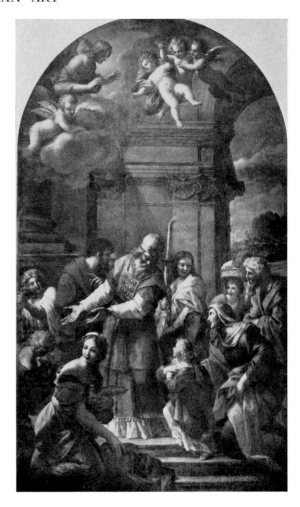

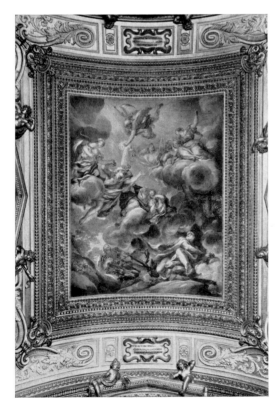

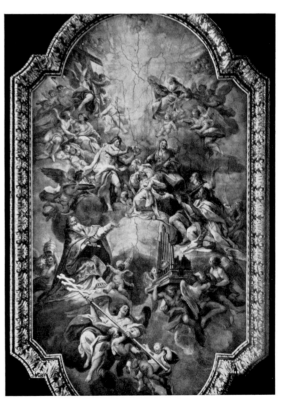

Pl. 220. Roman baroque painting. *Above, left*: A. Sacchi, Vision of St. Romuald. Canvas, 10 ft., 2 in. × 5 ft., 9 in. Rome, Vatican Museums. *Right*: G. F. Romanelli, Presentation of the Virgin in the Temple. Canvas. Rome, S. Maria degli Angeli. *Below, left*: C. Ferri, ceiling. Sala di Saturno, Palazzo Pitti, Florence. Fresco. *Right*: S. Conca, Crowning of St. Cecilia. Fresco. Rome, S. Cecilia in Trastevere.

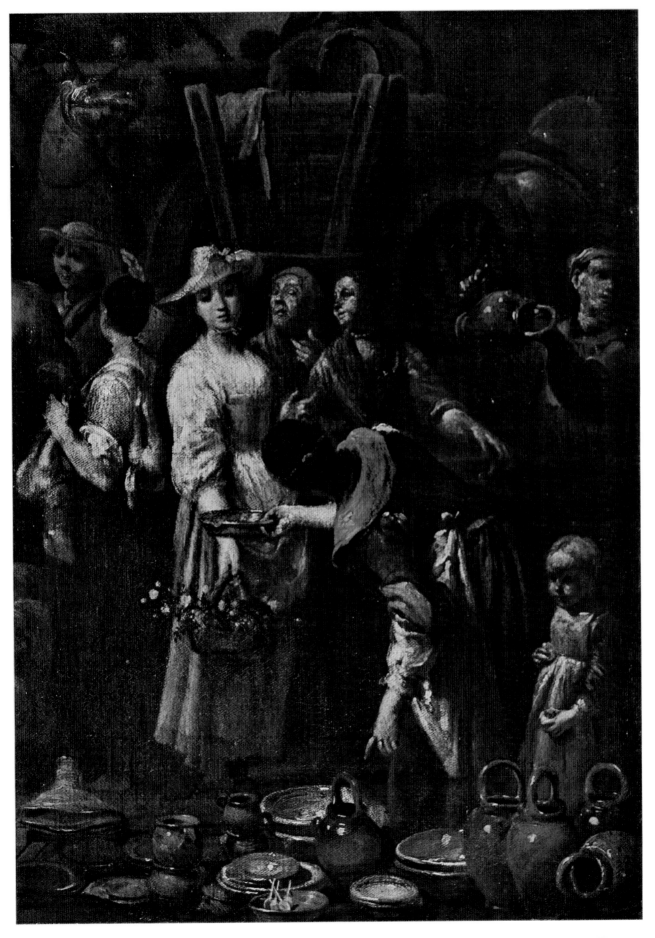

Pl. 221. G. M. Crespi, The Fair at Poggio a Caiano, detail, 1708–09. Canvas; full size, 3 ft., 10^1/$_2$ in. × 6 ft., 4^1/$_4$ in. Florence, Uffizi.

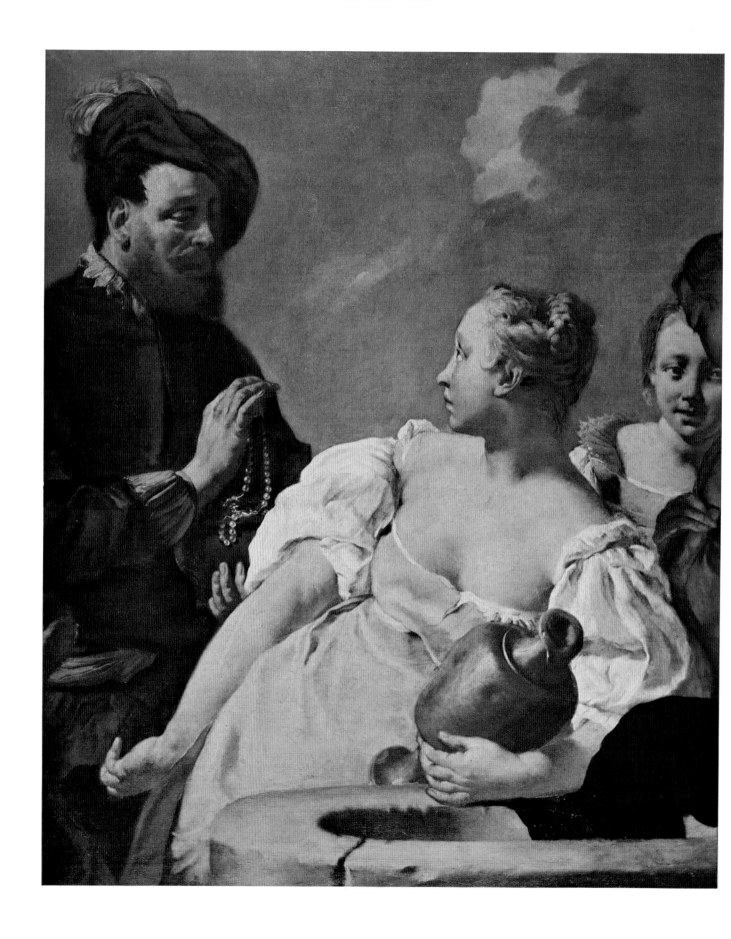

Pl. 222. G. B. Piazzetta, Rebecca at the Well, detail, ca. 1735–40. Canvas; full size, 3 ft., 3¹/₄ in. × 4 ft., 6 in. Milan, Brera.

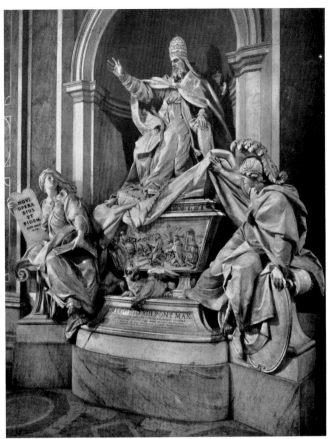

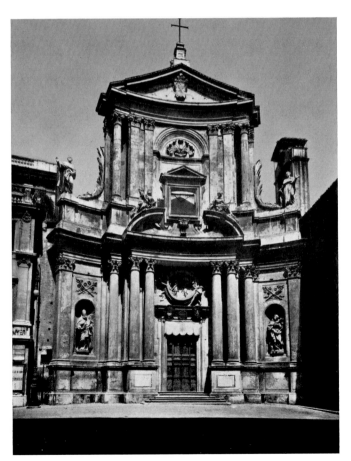

Pl. 223. Baroque sculpture and architecture in Rome. *Above, left*: P. Bracci and others, tomb of Maria Clementina Sobieski. Marble.
Right: C. Rusconi, tomb of Pope Gregory XIII. Marble. Both, St. Peter's. *Below, left*: C. Fontana, S. Marcello, façade. *Right*:
F. Fuga, S. Maria Maggiore, detail of façade.

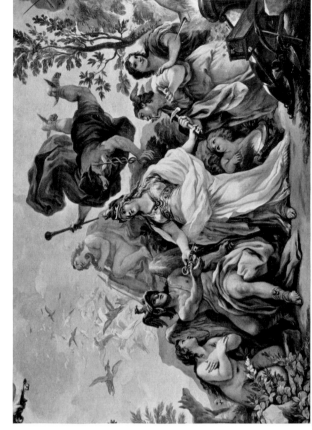

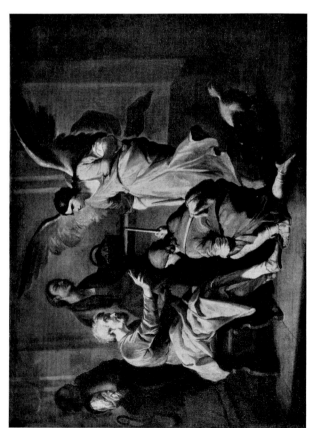

Pl. 224. Neapolitan painting, 17th cent. *Above, left*: G. B. Caracciolo, Christ Washing the Disciples' Feet. Canvas. *Right*: M. Stanzione, Descent from the Cross. Canvas, 7 ft., 11½ in. × 10 ft., 6 in. Both, Naples, Certosa di S. Martino, Church. *Below, left*: B. Cavallino, Tobias taking leave of his father. Canvas, 29½×39½ in. Rome, Galleria Nazionale. *Right*: L. Giordano, Minerva offering a golden key to Intellect, detail of frescoes in the gallery, Palazzo Medici-Riccardi, Florence.

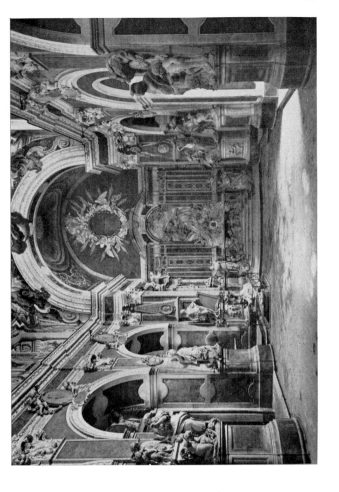

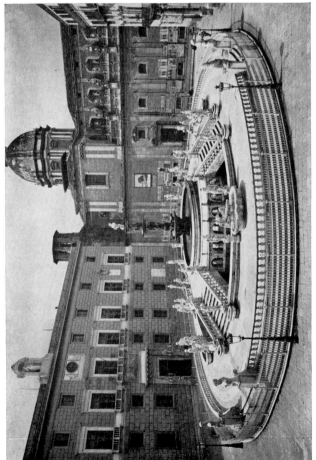

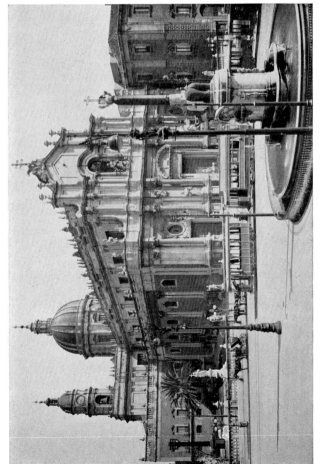

Pl. 225. Architecture in Sicily and Naples. *Left, above:* Palermo, view of Piazza Pretoria, with the fountain by F. Camilliani and M. Naccherino, 1554–75. *Below:* G. Palazzotto and G. B. Vaccarini, Catania, Cathedral, 1709–58. *Right, above:* Naples, S. Maria della Pietà dei Sangro, Chapel with 18th-cent. decoration. *Below:* C. Fanzago, Naples, Certosa di S. Martino, Great Cloister, 17th cent.

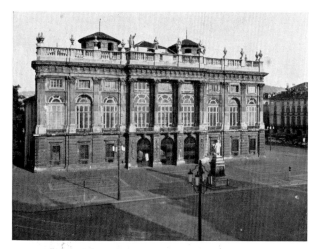
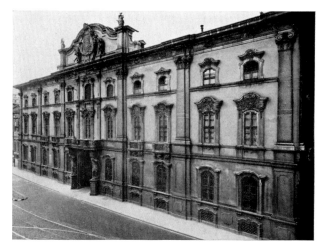
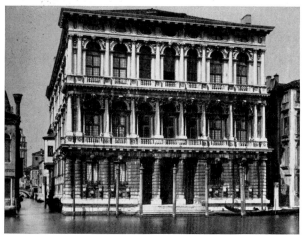
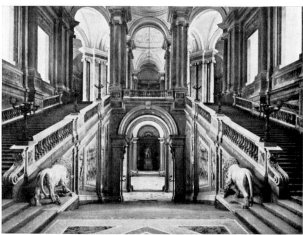
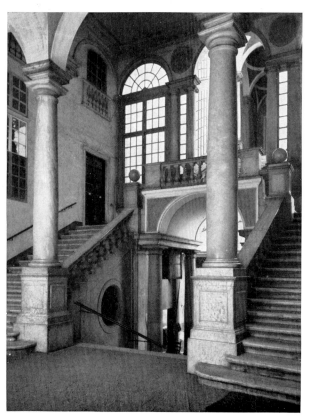
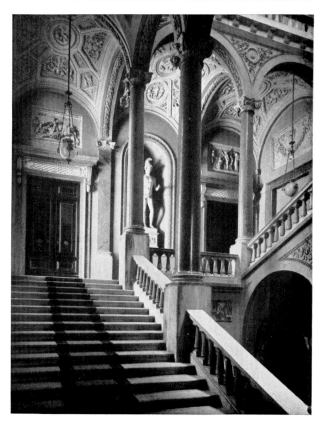

Pl. 226. Architecture, late 17th–18th cent. *Left, above*: F. Juvara, Turin, Palazzo Madama, façade. *Center*: B. Longhena and G. Massari, Venice, Ca' Rezzonico, façade. *Below*: G. Petondi, Genoa, Palazzo Balbi, staircase. *Right, above*: B. Bolli, Milan, Palazzo Litta, façade. *Center*: L. Vanvitelli, Caserta, Royal Palace, staircase. *Below*: C. Morelli, Rome, Palazzo Braschi, staircase.

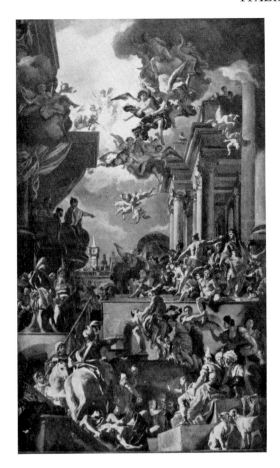

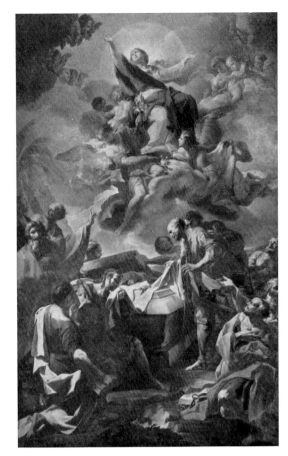

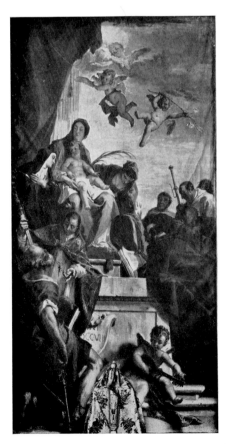

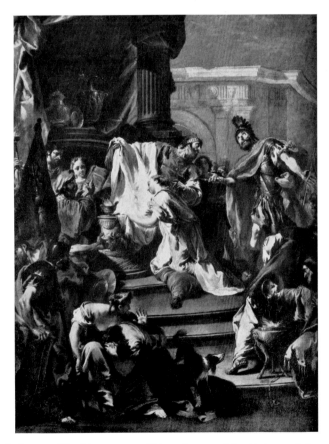

Pl. 227. Painting, 18th cent. *Above, left*: F. Solimena, The Massacre at Chios. Canvas, 9 ft., $^{1}/_{4}$ in. × 5 ft., 4$^{1}/_{4}$ in. Naples, Museo di Capodimonte. *Right*: C. Giaquinto, Assumption. Canvas, 14 ft., 9 in. × 9 ft., 2$^{1}/_{4}$ in. Rocca di Papa, S. Maria Assunta. *Below, left*: S. Ricci, Madonna Enthroned with angels and saints. Canvas, 13 ft., 1$^{1}/_{2}$ in. × 6 ft., 6$^{3}/_{4}$ in. Venice, S. Giorgio Maggiore. *Right*: G. B. Pittoni, The Sacrifice of Jephthah. Canvas, 6 ft., 9 in. × 5 ft., $^{1}/_{4}$ in. Genoa, Palazzo Reale.

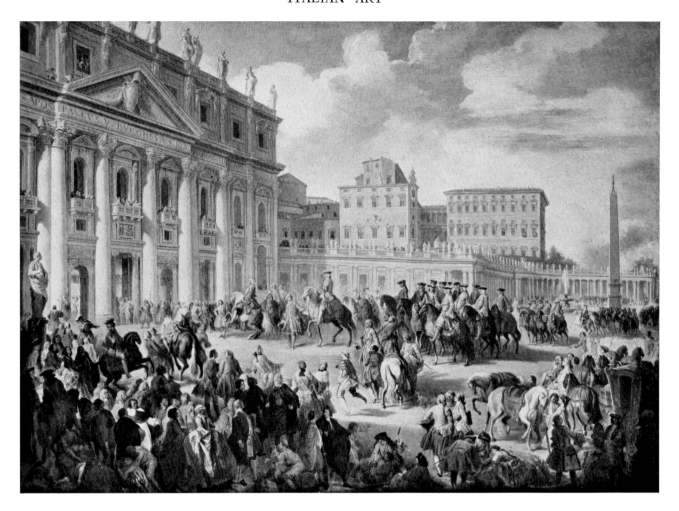

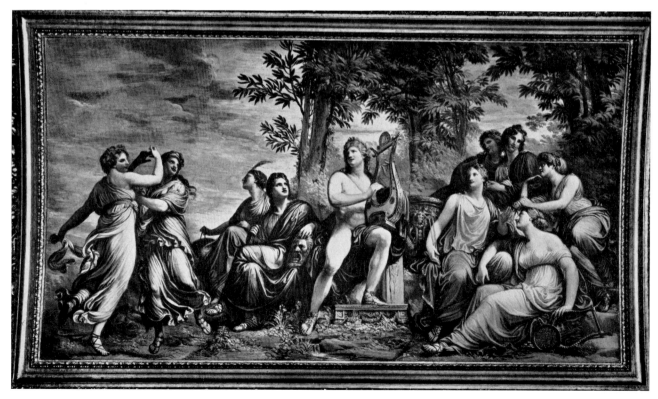

Pl. 228. *Above*: G. P. Pannini, Charles III visits the Basilica of St. Peter's in Rome, 1745. Canvas, 4 ft., $\frac{1}{2}$ in. × 5 ft., 8 in. Naples, Museo di Capodimonte. *Below*: A. Appiani, Apollo and the Muses, 1811. Fresco. Milan, Villa Reale.

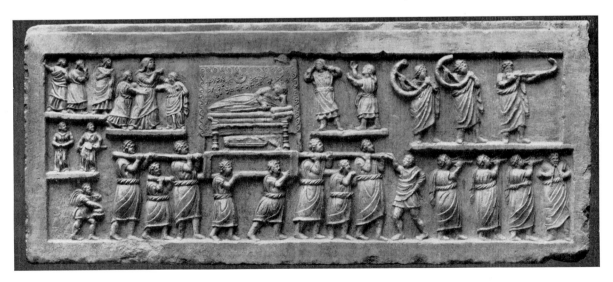

Pl. 229. *Above, left*: Grave stele, from Santa Maria Capua Vetere, 1st cent. B.C. Stone. Capua, Museo Provinciale Campano. *Right*: Grave stele of the Longidienus family, from Ravenna, detail, late 1st cent. B.C. Limestone, full ht., 8 ft., 6³/₄ in. Ravenna, Museo Nazionale. *Center*: Bakery scene, detail of frieze on the tomb of the baker M. Vergilius Eurysaces, Rome, late 1st cent. B.C. *Below*: Funeral procession on sarcophagus, from Preturo, near Aquila, second half of 1st cent. B.C. Marble, ht., 26³/₄ in. Aquila, Museo Nazionale d'Arte Abruzzese.

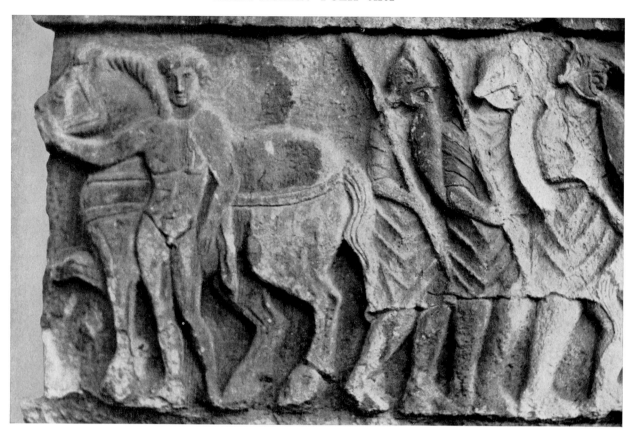

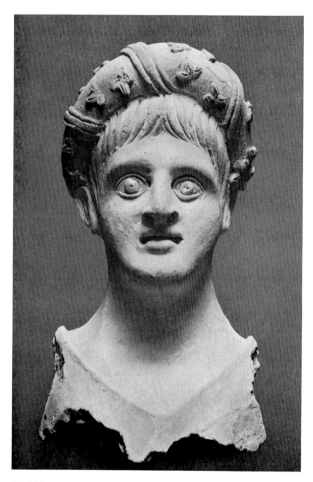

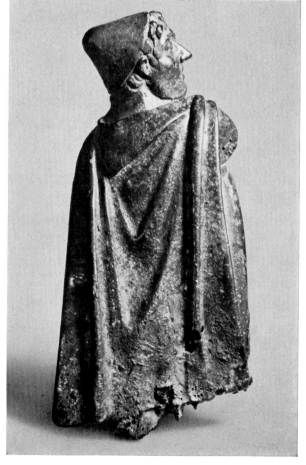

Pl. 230. *Above*: Horseman and soldiers, detail of frieze on the Arch of Augustus, Susa, province of Torino, 12 B.C. *Below, left*: Bust of a youth crowned with a wreath, early 1st cent. B.C. Terra cotta, ht., 12³/₄ in. Rome, Museo Nazionale Romano. *Right*: Figurine (one of a group?) of mountaineer wearing the cucullus, from Aosta, 1st cent. Bronze, ht., ca. 4³/₄ in. Aosta, Museo Archeologico.

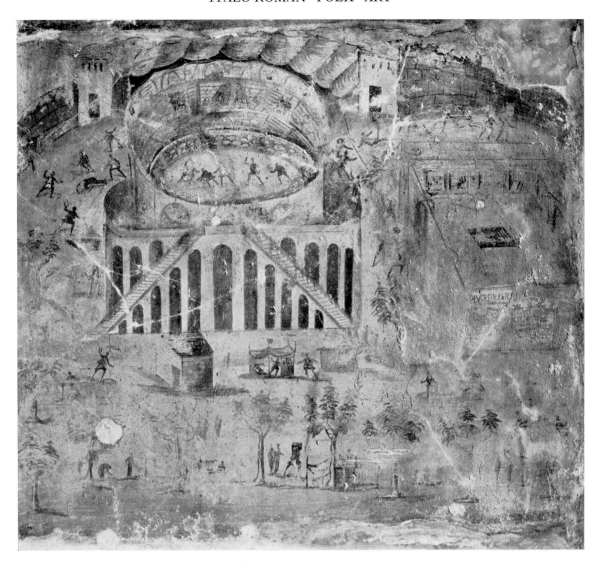

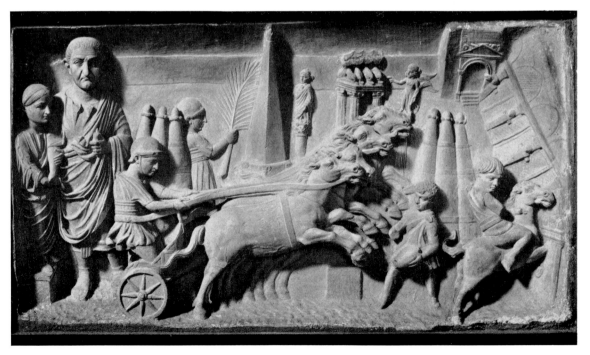

Pl. 231. *Above*: Brawl between Pompeians and Nucerines in the amphitheater of Pompeii, A.D. 59. Wall painting, from Pompeii, 5 ft., 6$^7/_8$ in. × 6 ft., $^7/_8$ in. Naples, Museo Nazionale. *Below*: Funerary relief with chariot race, first half of 2d cent. Marble, 19$^3/_4$×38$^1/_4$ in. Rome, Lateran Museums.

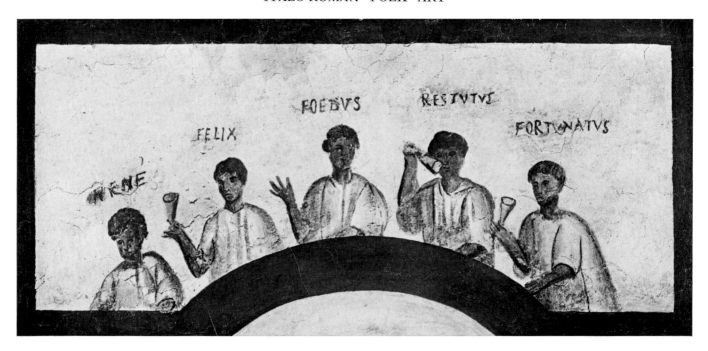

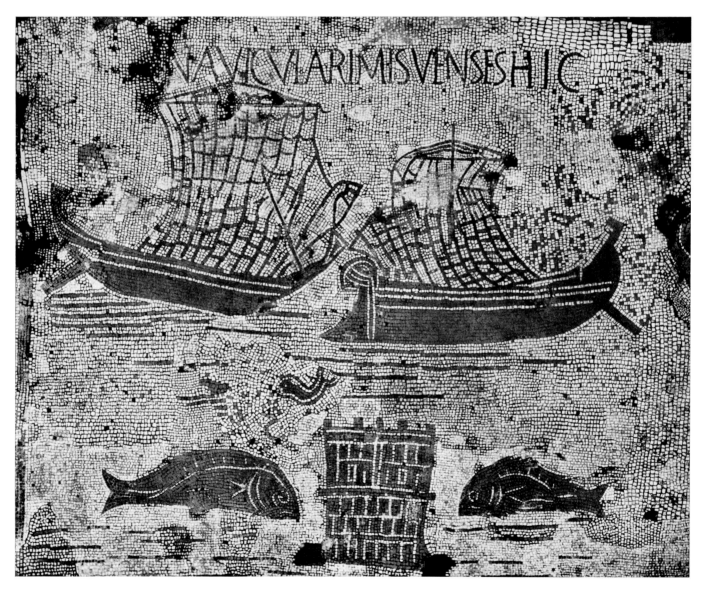

Pl. 232. *Above*: Banquet scene, from Ostia Antica, 2d cent. Wall painting, 12⅝×29⅛ in. Rome, Lateran Museums. *Below*: Trademark of the *Naviculari Misuenses*, 2d cent. Mosaic. Ostia Antica, Piazzale delle Corporazioni.

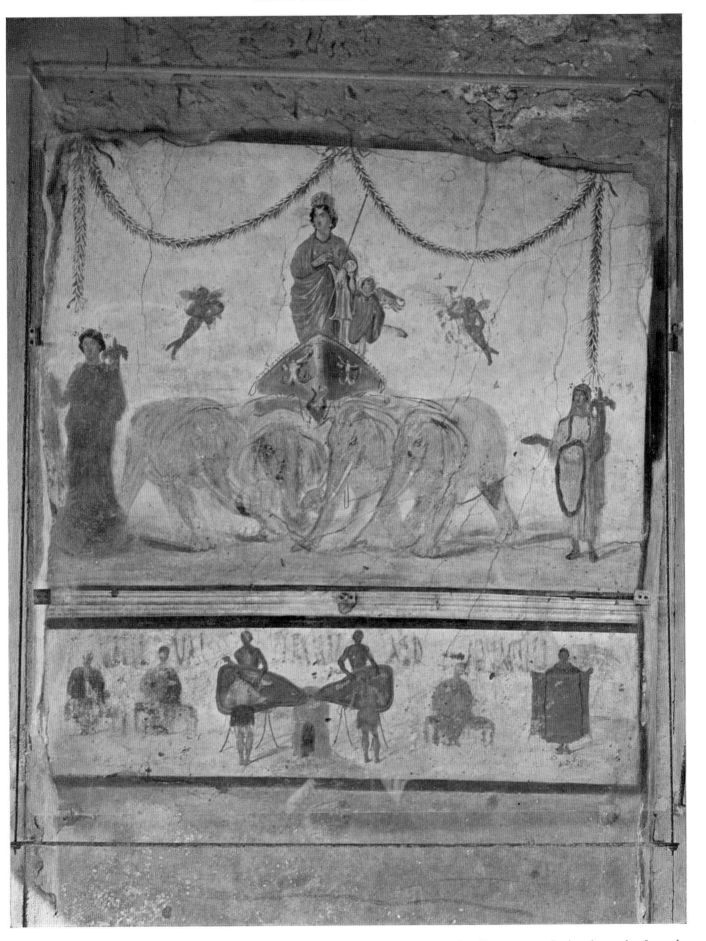

Pl. 233. Wall painting in the shop of M. Vecilius Verecundus, Pompeii, showing Pompeian Venus on a chariot drawn by four elephants, and textile workers, 3d quarter of 1st cent. (Cf. VI, PL. 61.)

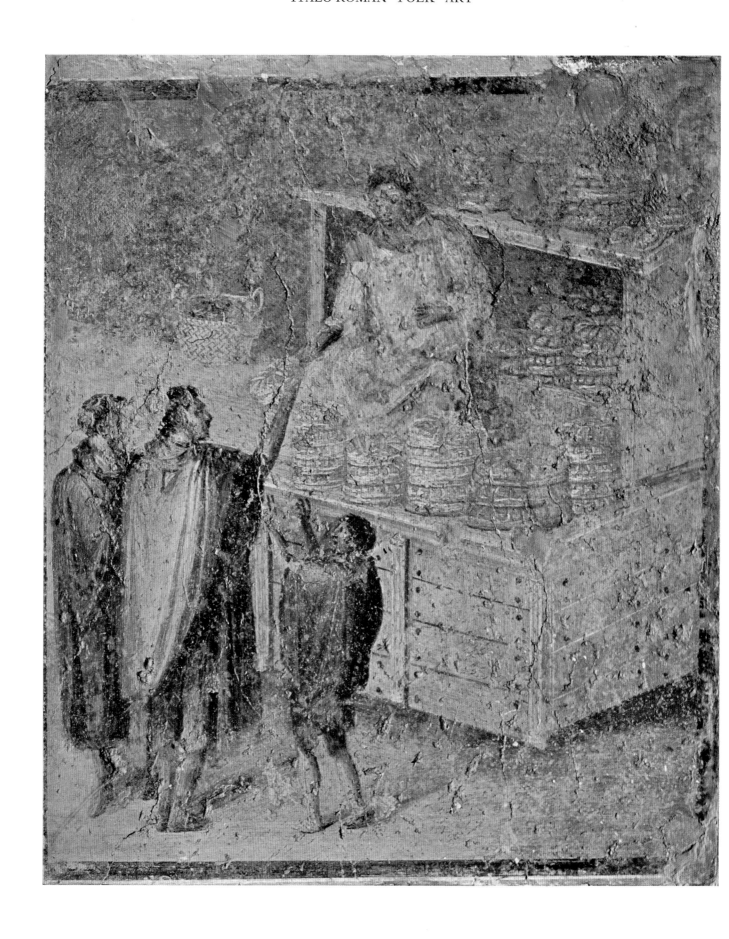

Pl. 234. Bread seller, from Pompeii, third quarter of 1st cent. Wall painting, 22×19³/₄ in. Naples, Museo Nazionale.

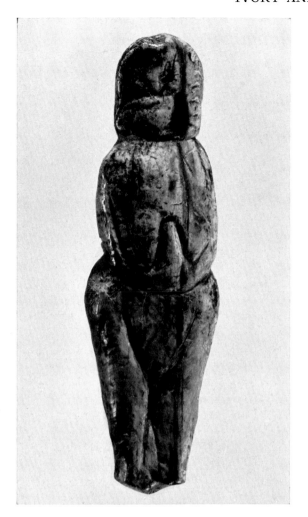

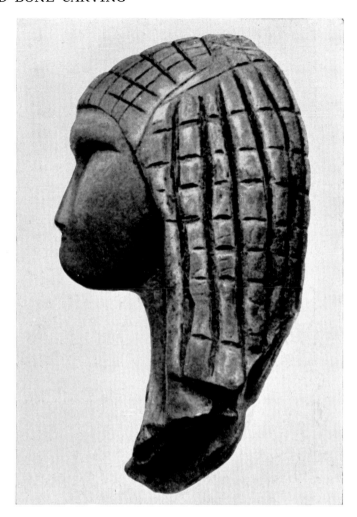

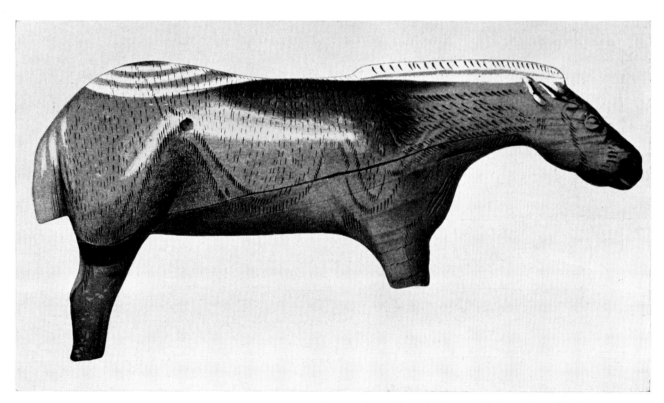

Pl. 235. Sculpture of the Upper Paleolithic era. *Above, left*: Female figure, from Malta, near Lake Baikal, Siberia, Aurignacio-Périgordian period. Ivory, ht., $3^7/_8$ in. Leningrad, The Hermitage. *Right*: Head of a woman, from the Grotte du Pape, Brassempouy, Landes, France, Aurignacio-Périgordian period. Ivory, ht., $1^3/_8$ in. *Below*: Horse, from the cave of Les Espélugues, near Lourdes, Hautes-Pyrénées, France, Magdalenian period. Ivory, l., ca. 3 in. Last two, Saint-Germain-en-Laye, France, Musée des Antiquités Nationales.

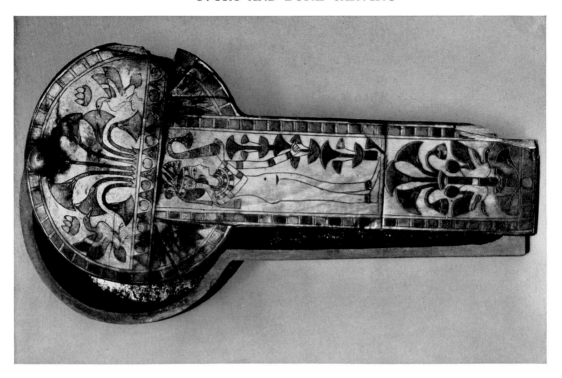

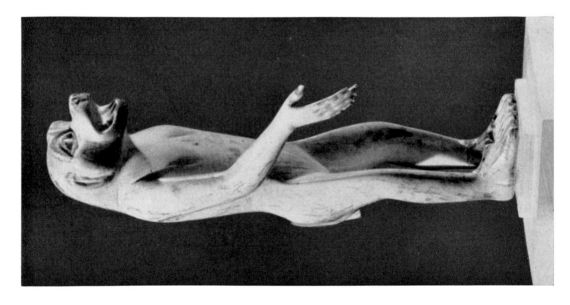

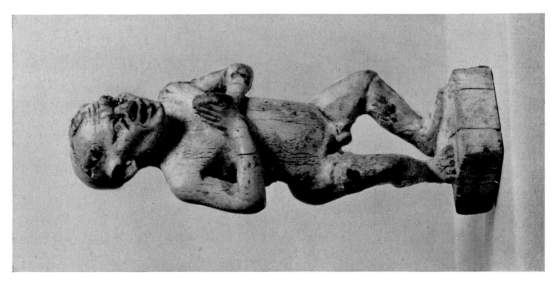

Pl. 236. Egyptian ivories. *Left:* Pygmy, part of a mechanical toy, from a tomb at Lisht, 12th dynasty. *Center:* Monkey, 18th dynasty. New York, Brooklyn Museum. *Right:* Mirror case, from a tomb at Deir el Bahri, 21st dynasty. Ivory with wood, l., ca. 11 in. Cairo, Egyptian Museum. Ht., 2½ in. New York, Metropolitan Museum.

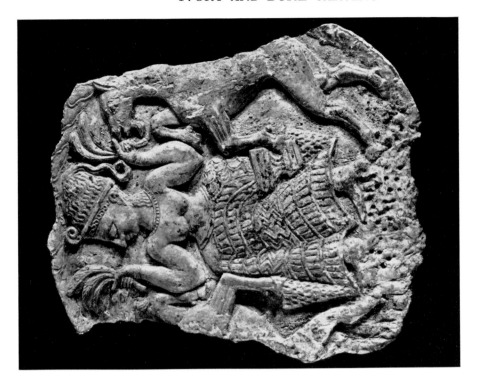

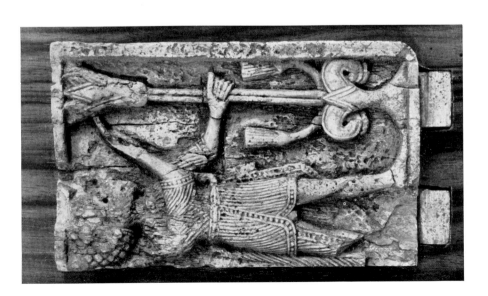

Pl. 237. *Left*: King holding a sacred tree, Assyrian plaquette from Nimrud, 8th cent. B.C. (?). Ivory, ht., 3⅝ in. Princeton, N.J., University Art Museum. *Center*: Head of a man, from a tomb at Mycenae, ca. 1500 B.C. Ivory, ht., 3⅞ in. Athens, National Museum. *Right*: Seated goddess flanked by two goats, lid of a box, from Minet el-Beida, Syria, first half of 14th cent. B.C. Ivory, ht., 5⅞ in. Paris, Louvre.

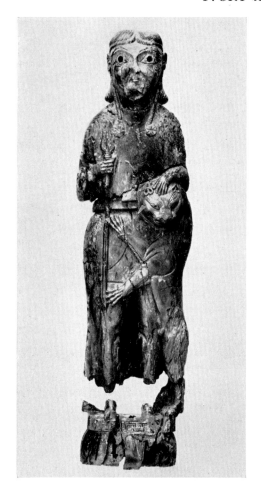
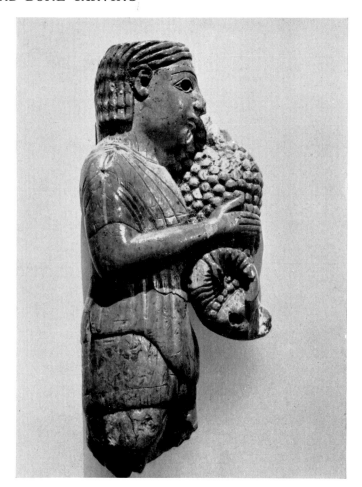
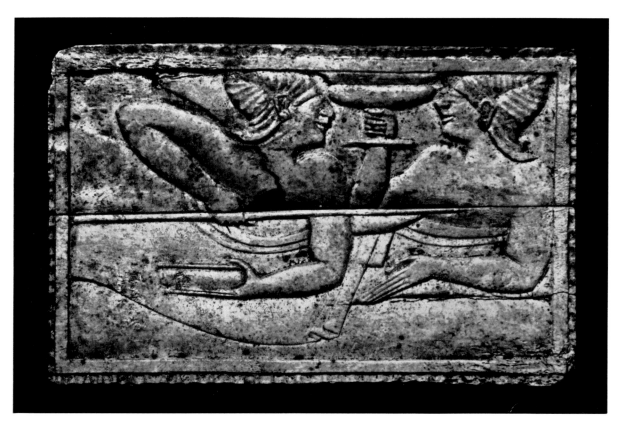

Pl. 238. *Above, left*: Hero vanquishing a lion, appliqué, from the Sanctuary of Apollo at Delphi, second half of 7th cent. B.C. Ivory, ht., 7¹/₄ in. Delphi, Greece, Archaeological Museum. *Right*: Figure of a man bearing a ram, from Castel San Mariano, near Perugia, Italy, ca. 540 B.C. Bone, ht., 3³/₈ in. Perugia, Musei Civici. *Below*: Banqueters, plaquette, from Orvieto, Italy, late 6th cent. B.C. Bone, 2¹/₂×4¹/₈ in. Florence, Museo Archeologico.

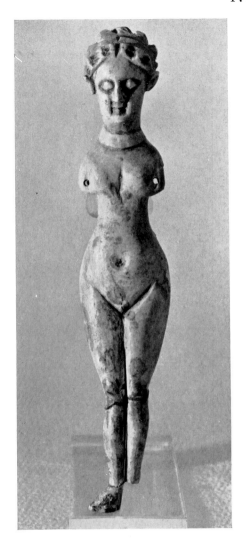

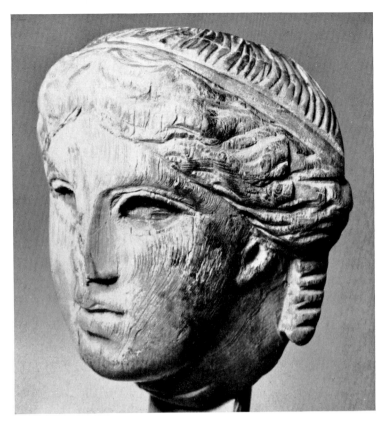

Pl. 239. *Above, left*: Female figure, from Susa, Iran, Parthian period, 2d–3d cent. (?). Bone, ht., 4³/₈ in. Teheran, Archaeological Museum. *Right*: Head of a woman, from Fos, Provence, France, 1st cent. B.C. Ivory, ht., ca. 2 in. Marseilles, Musée Archéologique. *Below, left*: Pygmy, late Hellenistic period. Ivory, ht., 5¹/₈ in. Florence, Museo Archeologico. *Right*: Head of a woman, 4th cent. Bone, ht., 2¹/₂ in. Rome, Museo Nazionale Romano.

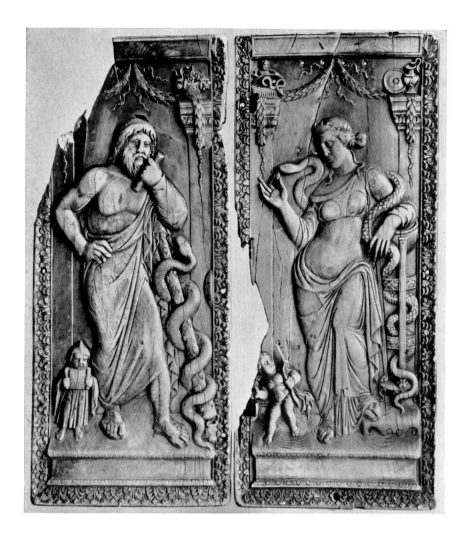

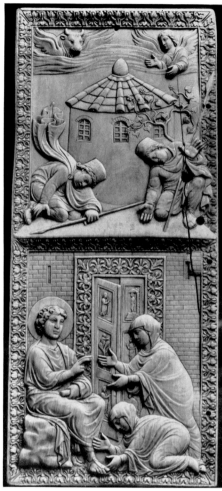

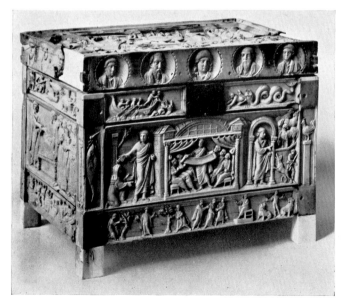

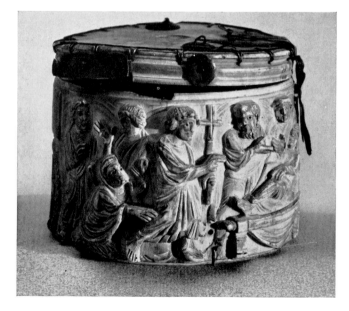

Pl. 240. *Above, left*: Asklepios and Hygieia, diptych, 4th–5th cent. Ivory, each panel, $12^3/_8 \times 5^1/_2$ in. Liverpool, Public Museums. *Right*: The Marys at the Sepulcher, leaf from a diptych, 5th cent. Ivory, $12^1/_8 \times 5^1/_4$ in. Milan, Castello Sforzesco. *Below, left*: Reliquary, 4th cent. Ivory, l., $12^7/_8$ in. Brescia, Italy, Museo Cristiano. *Right*: Box with scenes of the miracles of Christ, 6th cent. Ivory, diam., $4^1/_8$ in. Pesaro, Italy, Cathedral Treasury.

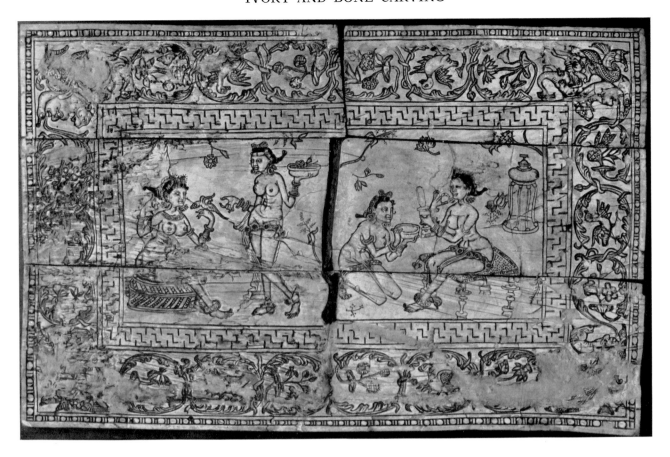

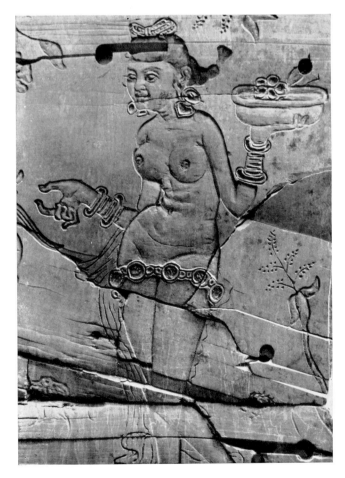

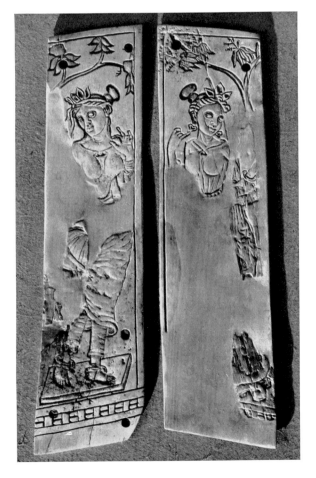

Pl. 241. Ivories from Begram, Afghanistan, 1st cent. *Above, and below, left*: Plaque with toilette scene, whole and detail. *Right*: Diptych with female figures. Both, Kabul, Afghanistan, Museum.

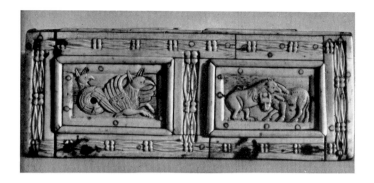

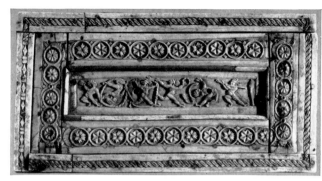

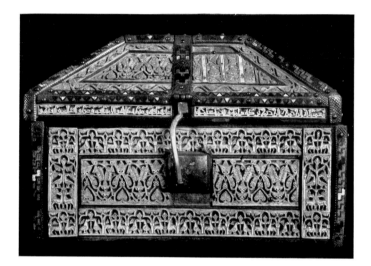

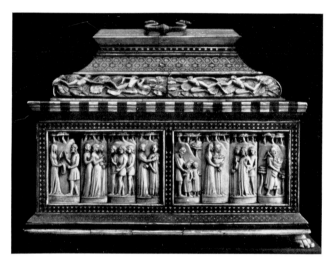

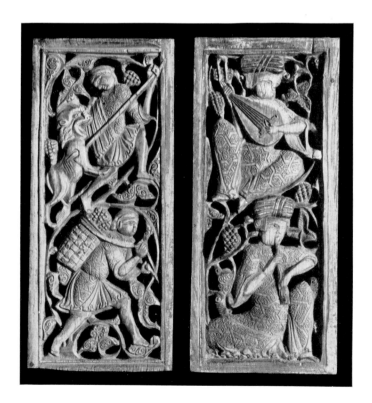

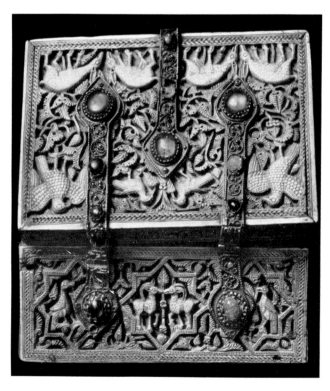

Pl. 242. *Left, above*: Casket with fantastic animals, 10th–12th cent. (?). Ivory. Ravenna, Italy, Museo Nazionale. *Center*: Islamic casket, originally in the Cathedral of Palencia, Spain, 11th cent. Ivory, leather, and wood. Madrid, Museo Arqueológico Nacional. *Below*: Plaques from a casket, from Mesopotamia, 12th cent. Ivory. Florence, Museo Nazionale. *Right, above*: Casket with acrobats, 12th cent. Ivory. Ravenna, Italy, Museo Nazionale. *Center*: Casket, by the Embriachi, 14th cent. Ivory. Paris, Musée de Cluny. *Below*: Moorish casket, from Córdoba, Spain, 11th cent. Florence, Museo Nazionale.

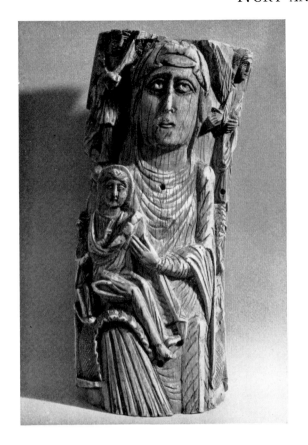

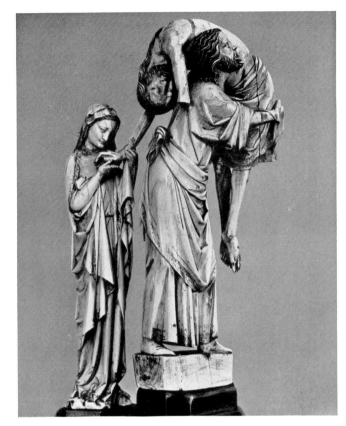

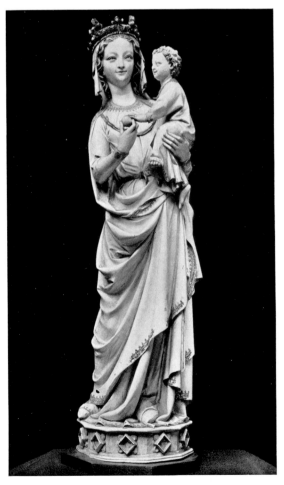

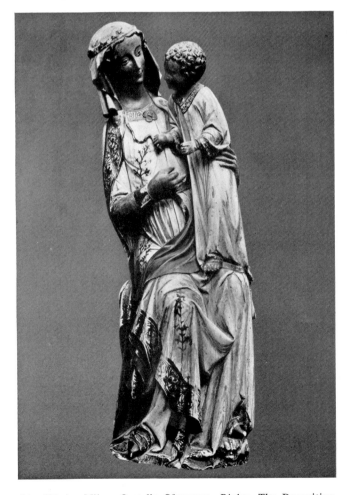

Pl. 243. *Above, left*: Virgin and Child, 8th–9th cent. Ivory, ht., 6⅛ in. Milan, Castello Sforzesco. *Right*: The Deposition, French, 14th cent. Ivory. *Below, left*: Virgin and Child, French, 14th cent. Ivory. Last two, Paris, Louvre. *Right*: Virgin and Child, French, 14th cent. Ivory. Villeneuve-lès-Avignon, France, Notre-Dame.

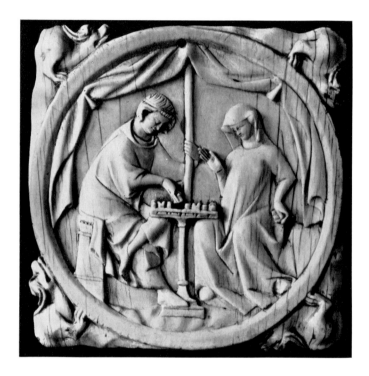
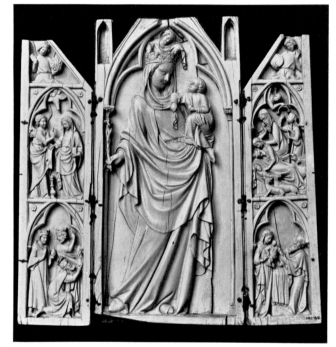

Pl. 244. *Above, left*: Rabbit, Fatimid, 10th–11th cent. Ivory. Athens, Benaki Museum. *Above, center and right*: Game pieces, 11th–12th cent. Ivory. Lucerne, Switzerland, Kofler-Truniger Coll. *Center, left*: Back of a setting for a mirror, French, 14th cent. Ivory. *Right*: Triptych, French, 14th cent. Last two, London, Victoria and Albert Museum. *Below, left*: Comb, Franco-Flemish, 16th cent. Ivory. *Center*: Chess piece, German, 16th cent. Last two, Paris, Louvre. *Right*: Rosary, Franco-Flemish, 16th cent. Ivory. London, Victoria and Albert Museum.

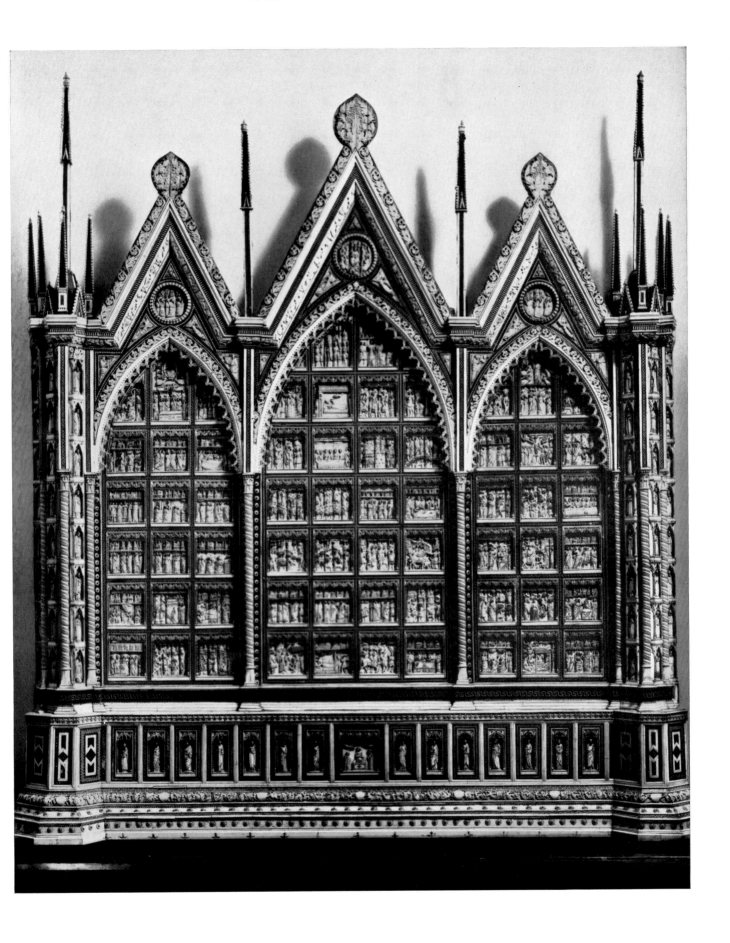

Pl. 245. Baldassare degli Embriachi, triptych, 1400–09. Wood, ivory, and hippopotamus teeth. Pavia, Italy, Certosa.

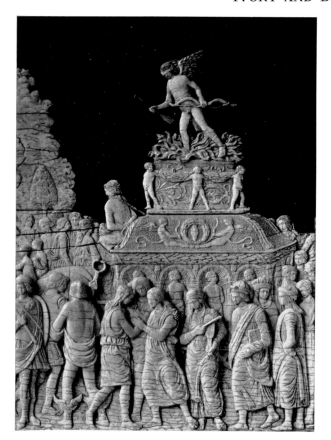 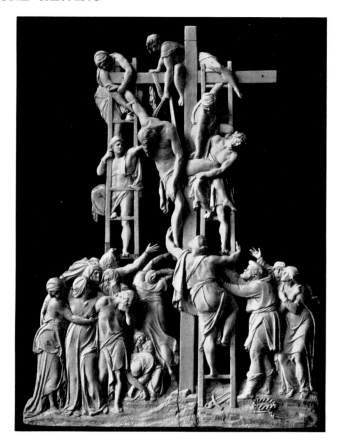

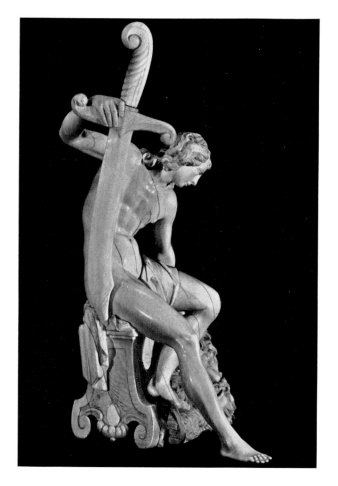 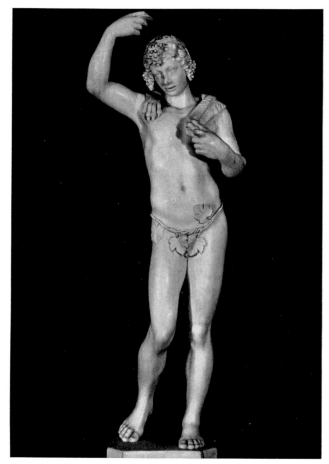

Pl. 246. Italian ivories. *Above, left*: The Triumph of Love, from Mantua, 15th cent. Florence, Museo Nazionale. *Right*: The Deposition, 16th cent. *Below, left*: David, 16th cent. *Right*: Bacchus, 16th cent. Last three, Florence, Pitti, Museo degli Argenti.

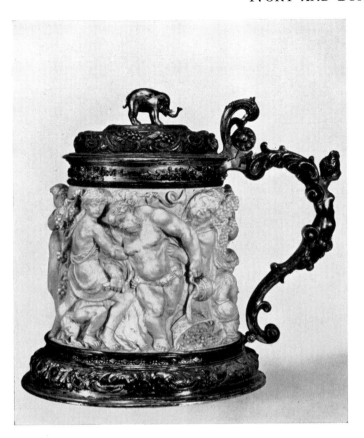
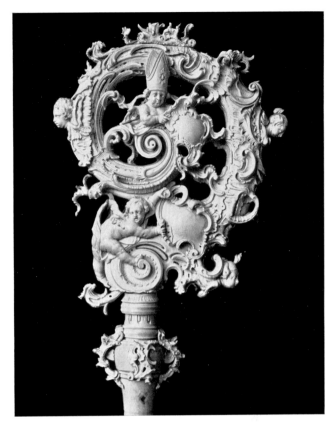
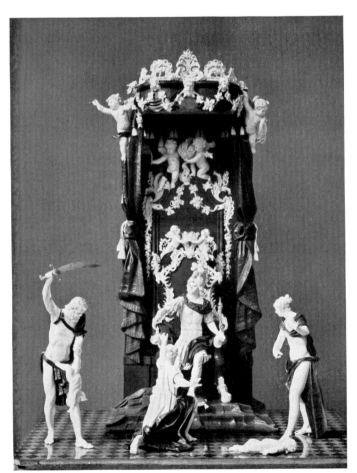
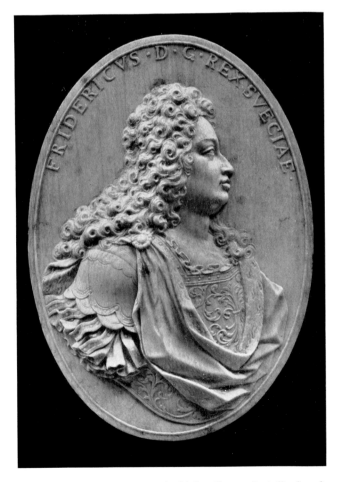

Pl. 247. *Above, left*: Tankard, from Flanders, 17th cent. Ivory. Florence, Pitti, Museo degli Argenti. *Right*: Pastoral staff, signed "I.T.," 18th cent. Ivory. Munich, Bayerisches Nationalmuseum. *Below, left*: S. Troger, The Judgment of Solomon. Ebony and ivory. London, Victoria and Albert Museum. *Right*: J. Dobbermann, portrait of King Frederick I of Sweden. Ivory. Kassel, Germany, Staatliche Kunstsammlungen.

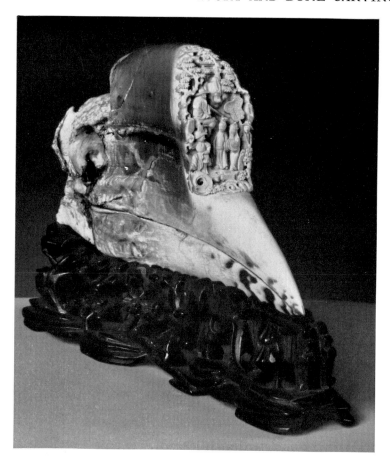

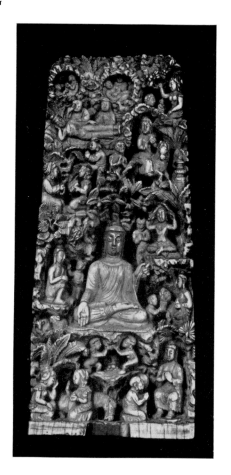

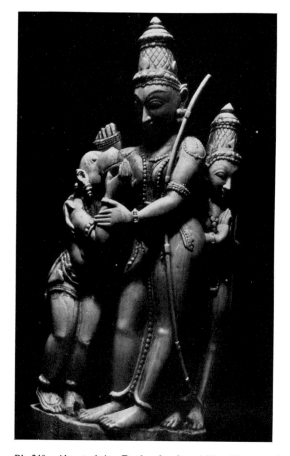

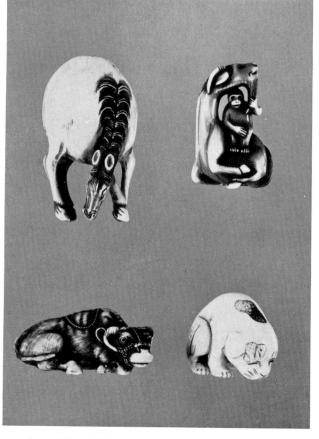

Pl. 248. *Above, left*: Beak of a hornbill with carved casque, from China, Ch'ing period. *Right*: Section of elephant tusk with scenes from the life of the Buddha, from China, Ming period. Both, Philadelphia, University Museum. *Below, left*: Rāma, Sītā, and Hanuman, contemporary craft art of India. Ivory. *Right*: Japanese netsukes, 17th–18th cent. Ivory. Philadelphia, University Museum.

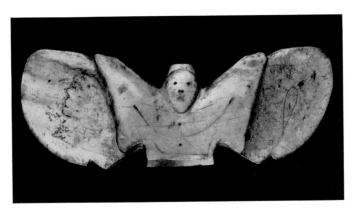

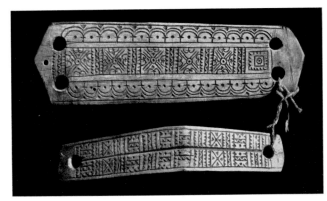

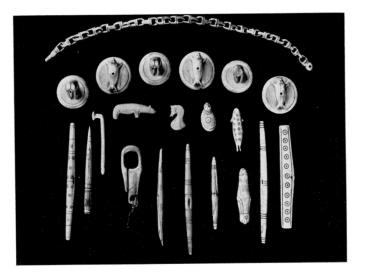

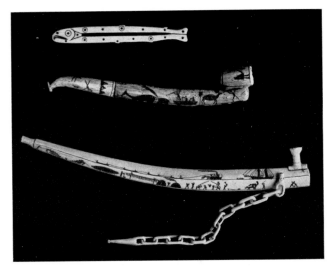

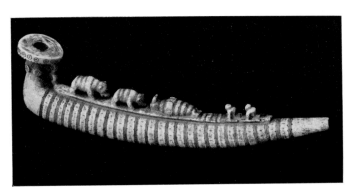

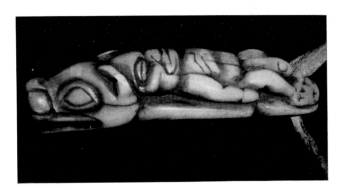

Pl. 249. *Above, left*: Siberian carving. Old Bering Sea culture. Ivory. *Right*: Pieces of a headstall from reindeer harness of the Dolgan people, Siberia. Reindeer antler and mammoth ivory. *Center, left*: Buttons and other small objects of the Alaskan Eskimos. Ivory. All three, Philadelphia, University Museum. *Right*: Harness ornament and pipes of the Alaskan Eskimos. Ivory. Rome, Museo Pigorini. *Below, left*: Carved pipe of the Kamchadals, Kamchatka, northeastern Siberia. Ivory. Copenhagen, Nationalmuseet. *Right*: Amulet of the Northwest Coast Indians, North America. Bone. Seattle, Thomas Burke Memorial Washington State Museum.

IVORY AND BONE CARVING

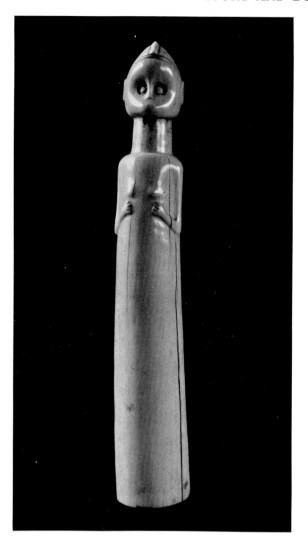 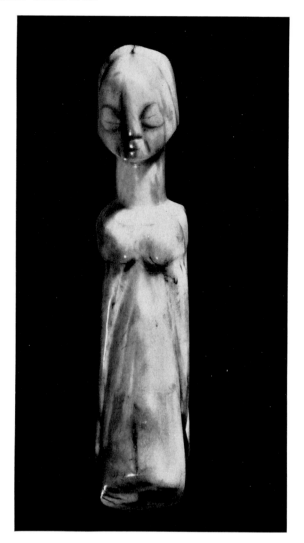

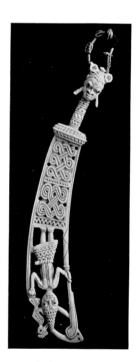 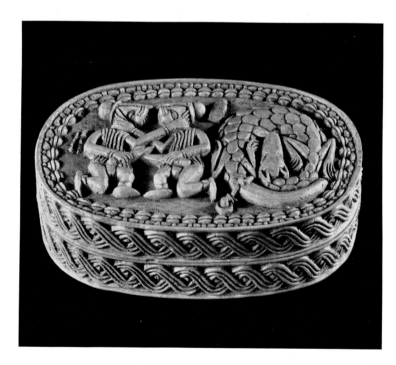 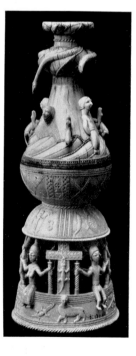

Pl. 250. African ivories. *Above, left*: Anthropomorphic figure, region of the upper Congo. Philadelphia, University Museum. *Right*: Female figure, Baluba tribe, Kasai region, Congo. Tervueren, Belgium, Musée Royal de l'Afrique Centrale. *Below, left*: Hilt and scabbard of a ceremonial saber of the Owo-Yoruba people, western Nigeria. London, British Museum. *Center*: Carved box, from Benin, Nigeria. Philadelphia, University Museum. *Right*: Cup with cover, from Benin. Copenhagen, Nationalmuseet.

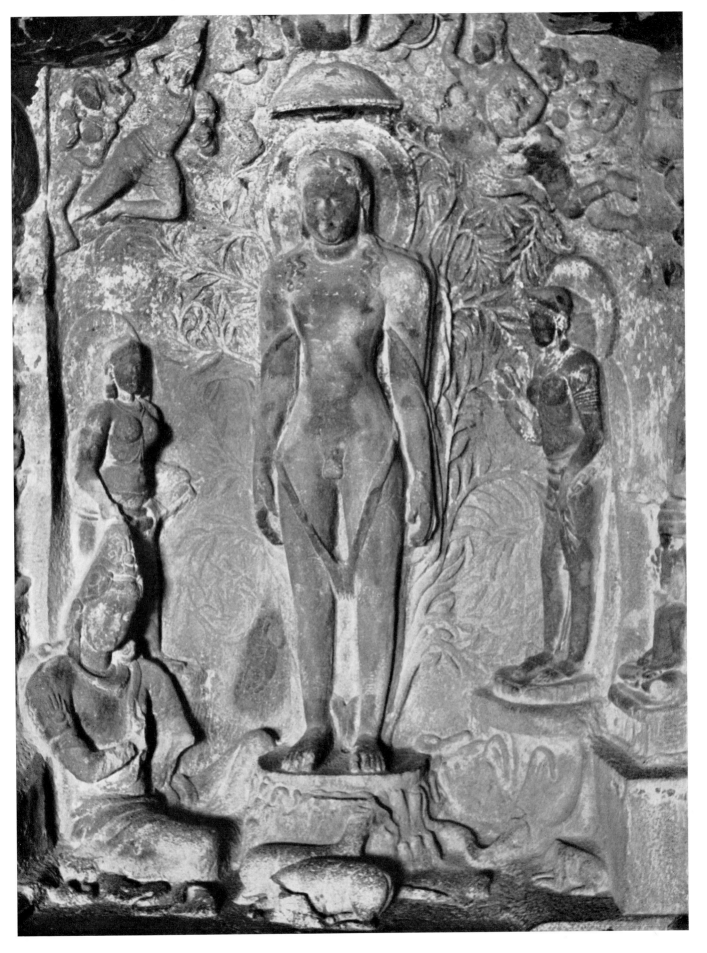

Pl. 251. Ellora, Maharashtra, tirthankara, in Cave XXXII, 5th–8th cent.

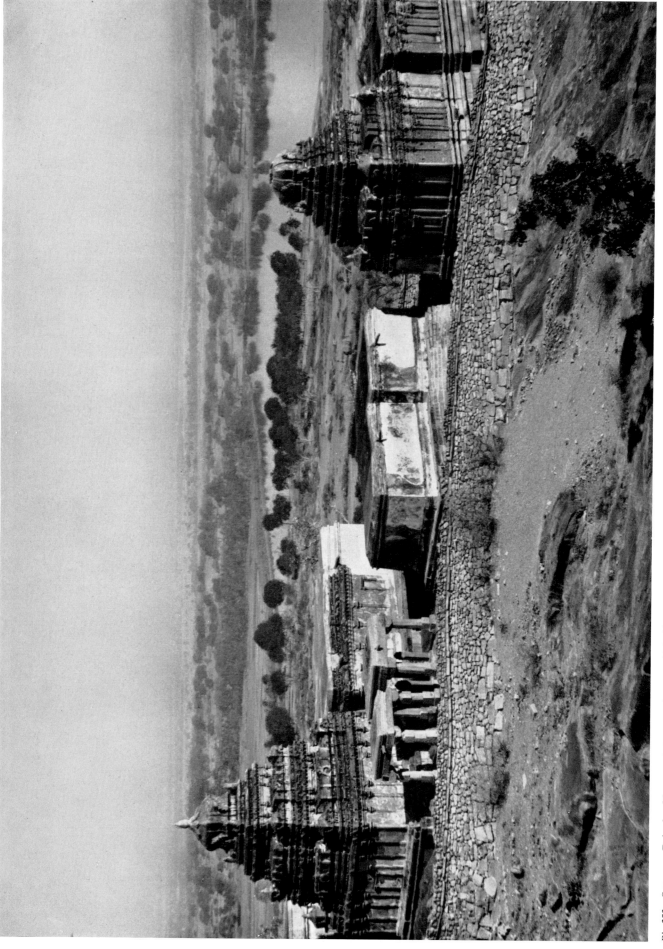

Pl. 252. Sravana Belgola, Mysore state, temples, ca. 10th–13th cent.

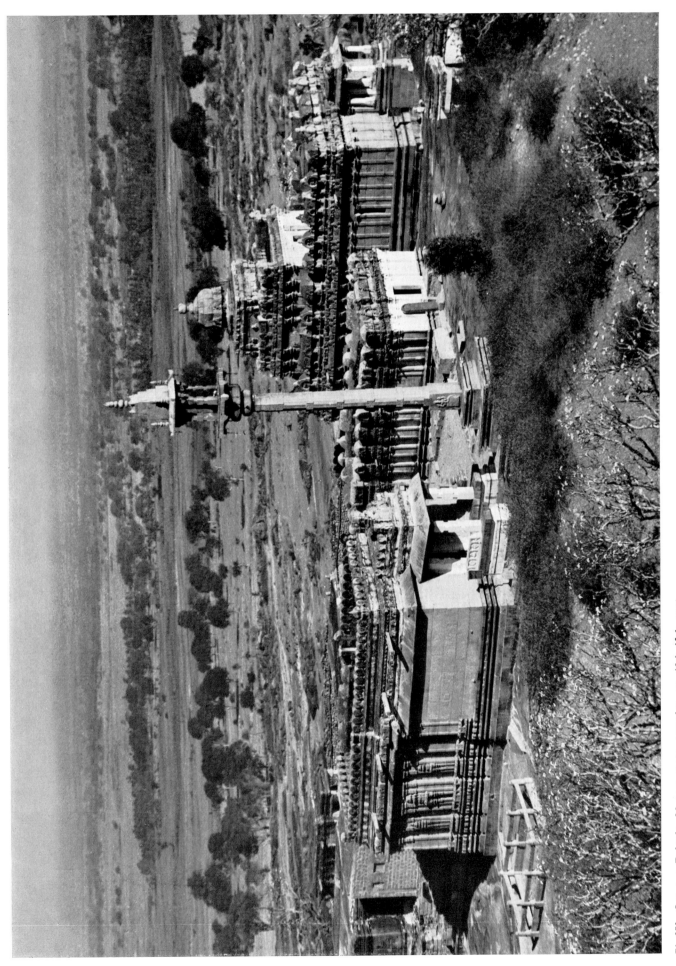

Pl. 253. Sravana Belgola, Mysore state, temples, ca. 10th–13th cent.

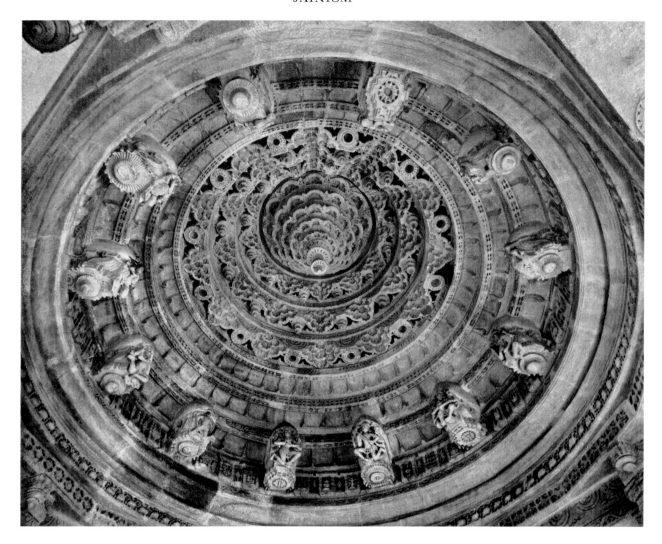

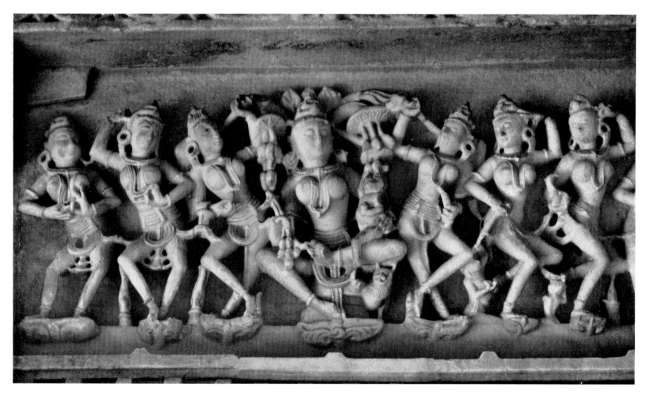

Pl. 254. Mount Abu, Rajasthan. *Above*: Ceiling of one of the Dilwara temples, 11th cent. *Below*: Tejapāla's temple, detail of interior decoration, 13th cent.

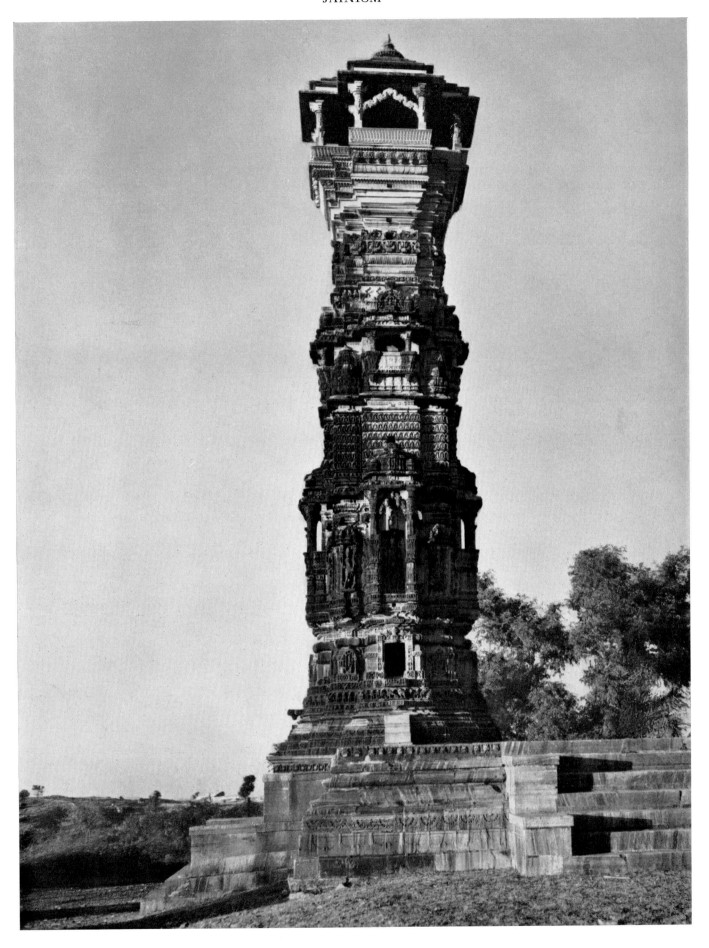

Pl. 255. Chitorgarh, Rajasthan, one of the so-called towers of fame (*kīrtistambha*), ca. 12th cent.

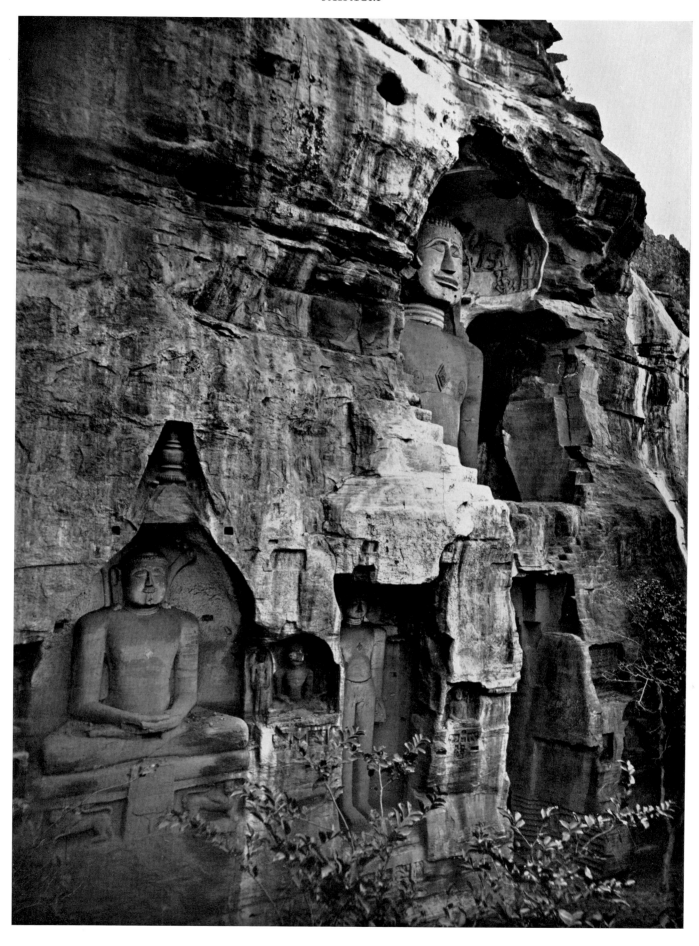

Pl. 256. Gwalior, Madhya Pradesh, tirthankaras carved in Arvahi cliffs, ca. 15th cent.

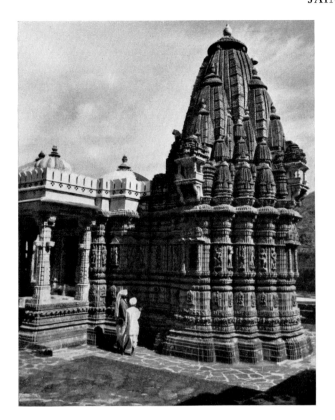 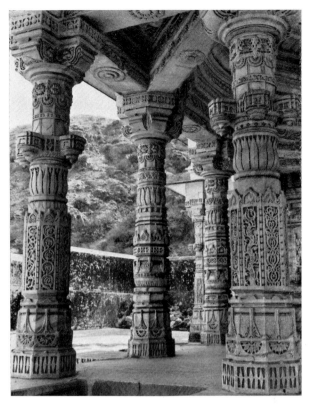

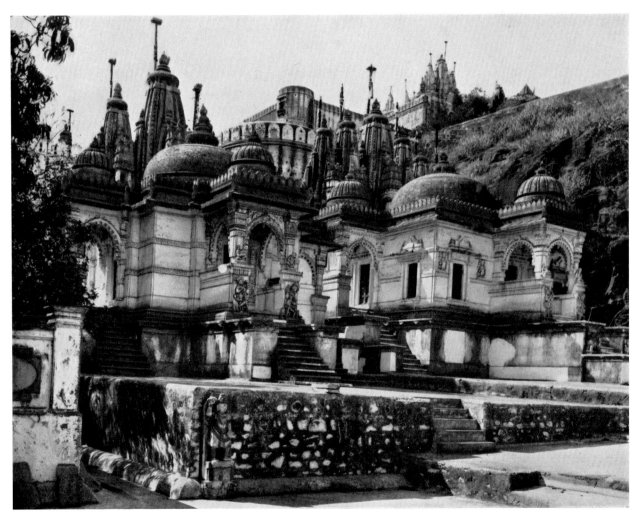

Pl. 257. *Above*: Mirpur, Rajasthan, two details of temple, ca. 15th cent. *Below*: Mount Satrunjaya, near Palitana, Maharashtra, temple, partially rebuilt in 19th cent.

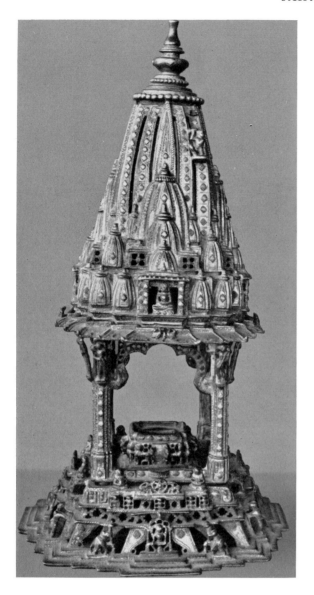

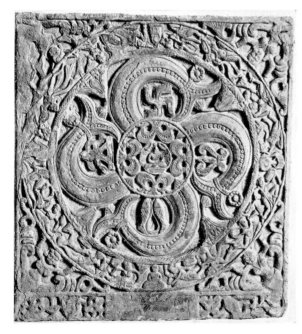

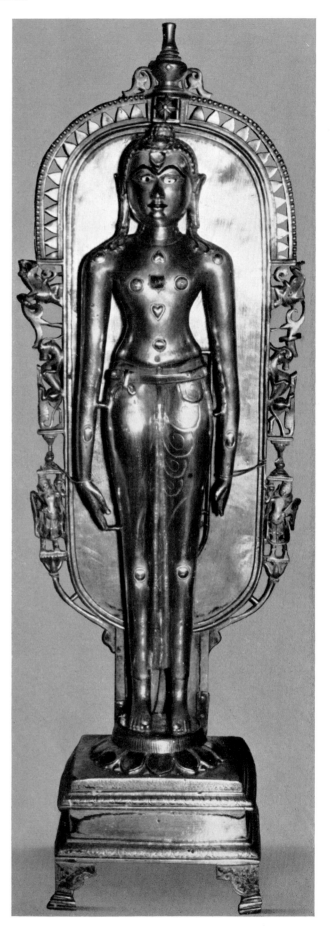

Pl. 258. *Left, above*: Miniature temple. Bronze. Bombay, Prince of Wales Museum. *Below*: Votive relief (*āyāgapaṭṭa*). Clay. Lucknow, Provincial Museum. *Right*: Tirthankara in temple, Gujarat, ca. 9th cent. (halo, 14th–15th cent.). Bronze.

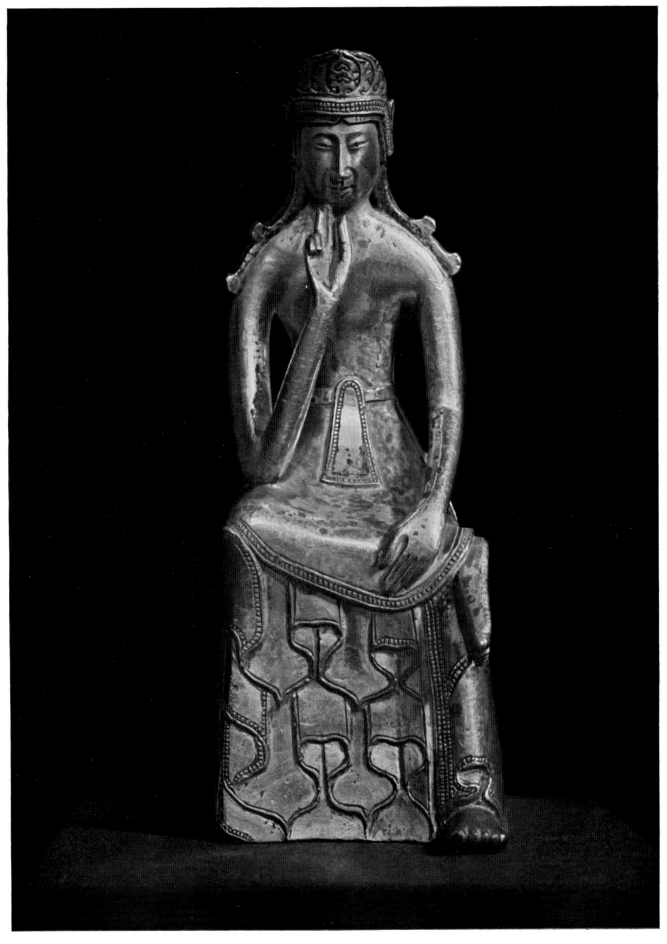

Pl. 259. Bodhisattva, Asuka period. Gilded bronze, ht., 8¹/₈ in. Tokyo, National Museum.

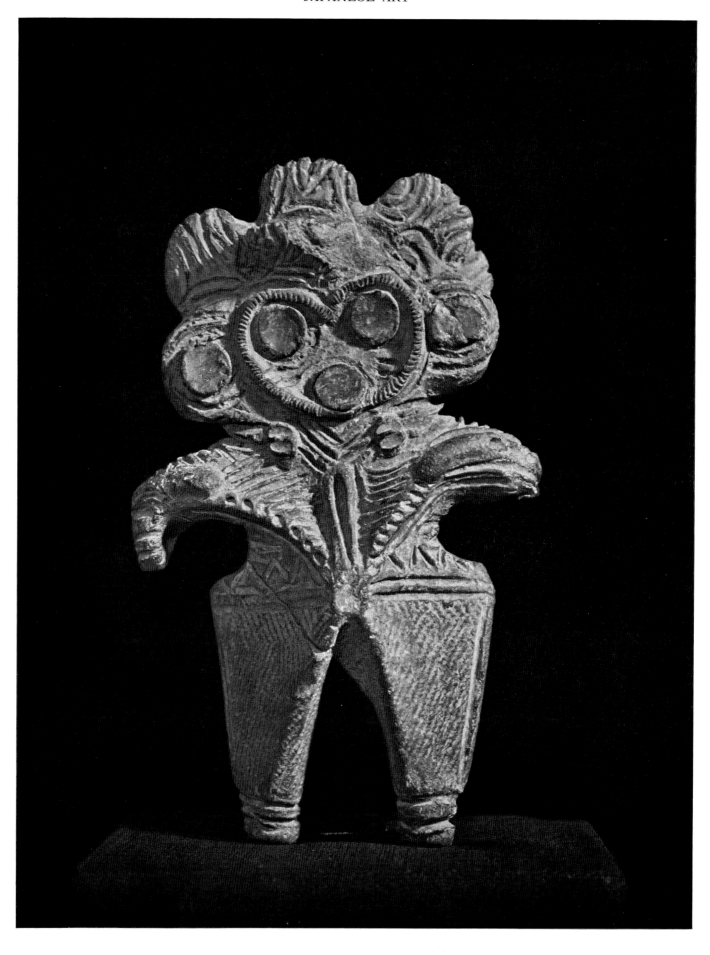

Pl. 260. Figurine from Iwatsuki, Saitama prefecture, Shimpukiji, late Jōmon period. Clay, ht., 9¹⁄₄ in. Tokyo, Takeo Nakazawa Coll.

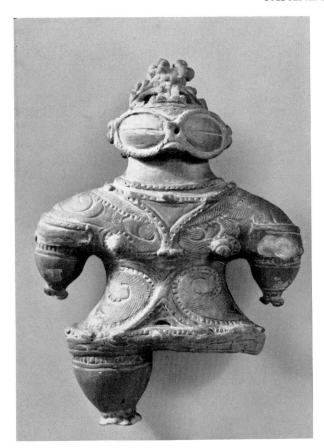

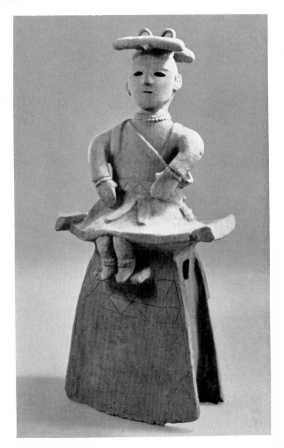

Pl. 261. *Above, left*: Figurine, from the village of Kizukuri, Aomori prefecture, Kamegaoka temple, Jōmon period. Clay, ht., 13⁵/₈ in. Aomori, Gengo Echigoya Coll. *Right*: Seated woman, from the village of Okawa, Gumma prefecture, Great Burial period. Clay, ht., 27³/₈ in. Tokyo, National Museum. *Below*: Head of a deer, from Ibaraki prefecture, Great Burial period. Clay, ht., ca. 7 in. Tokyo, Keiji Takakuma Coll.

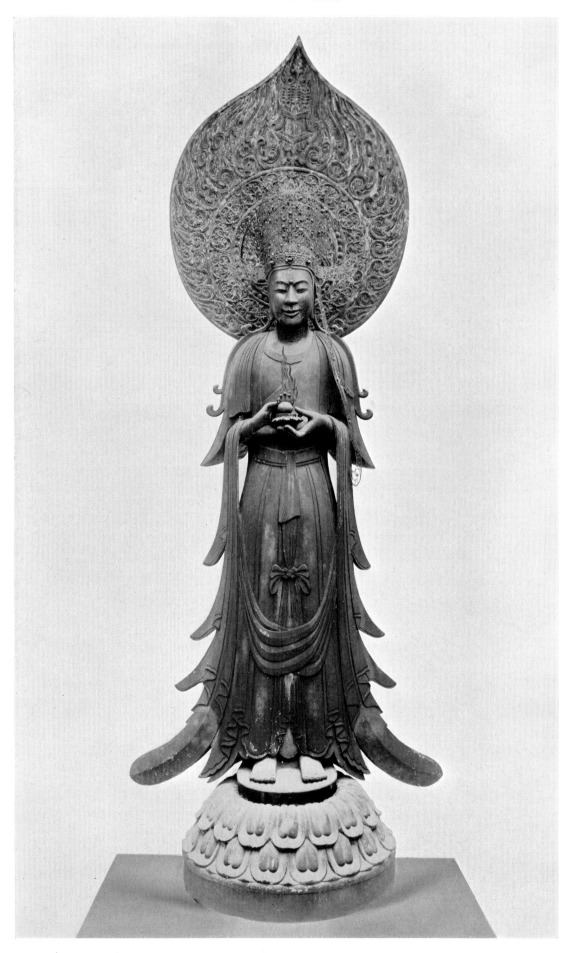

Pl. 262. Yumedono Kwannon, Asuka period. Gilded wood, ht., 6 ft., 5¹/₂ in. Nara, Hōryūji.

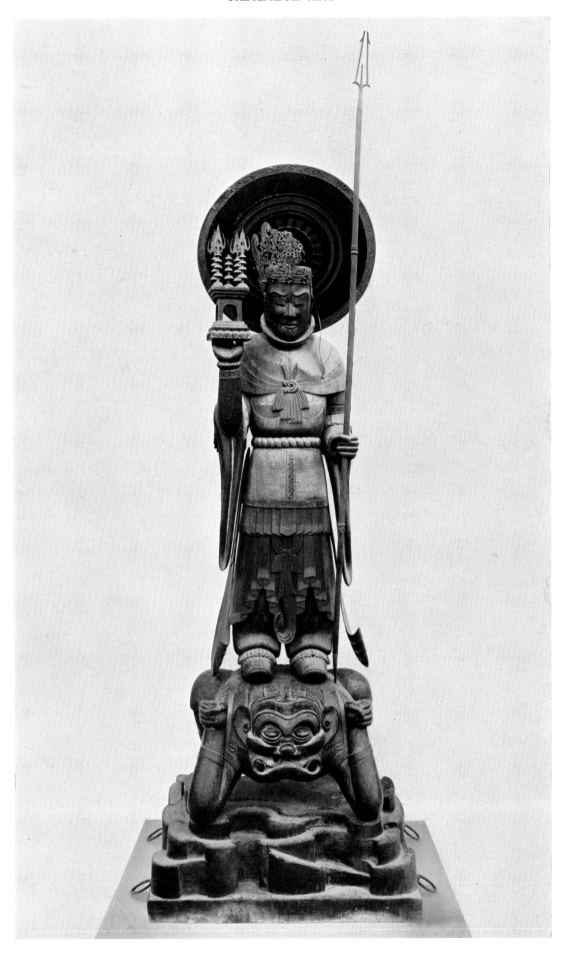

Pl. 263. Bishamonten, Asuka period. Wood, ht., 4 ft., 4³/₈ in. Nara, Hōryūji.

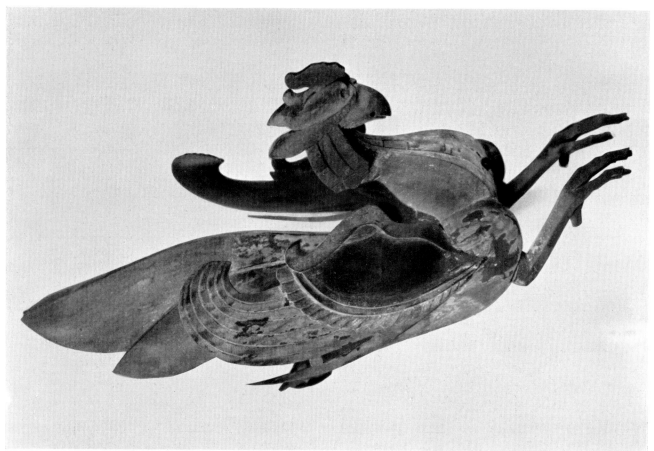

Pl. 264. *Left*: Phoenix, Asuka period. Wood. *Right*: Celestial being, Asuka period. Wood. Both, Nara, Hōryūji.

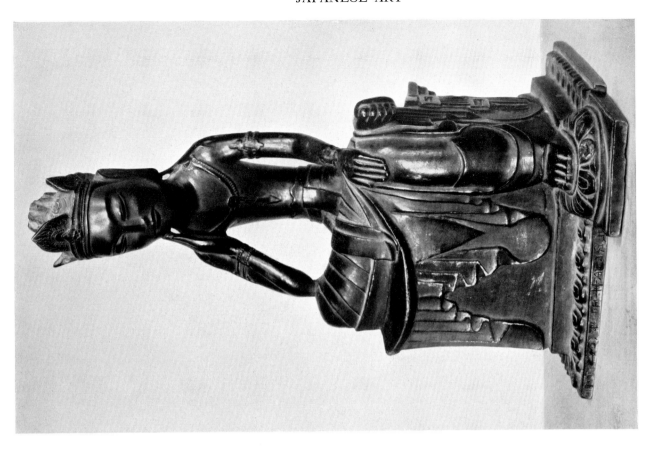

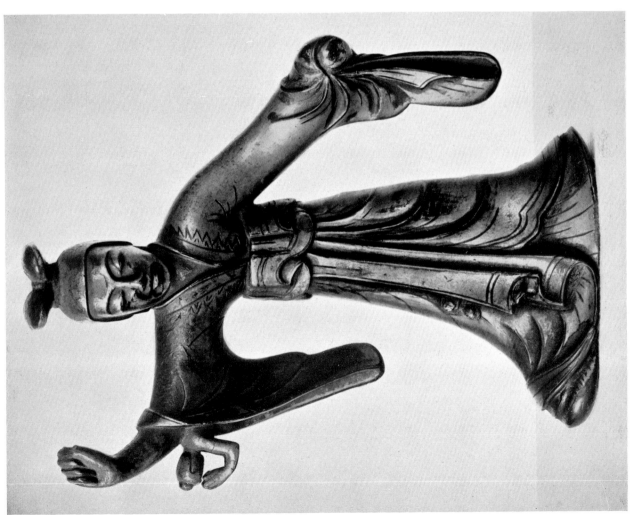

Pl. 265. *Left*: Queen Māyā and the birth of the Buddha, Asuka period. Bronze, ht., 49 in. *Right*: Miroku (Maitreya), Asuka period, 606. Gilded bronze, ht., 16¹/₈ in. Both, Tokyo, National Museum.

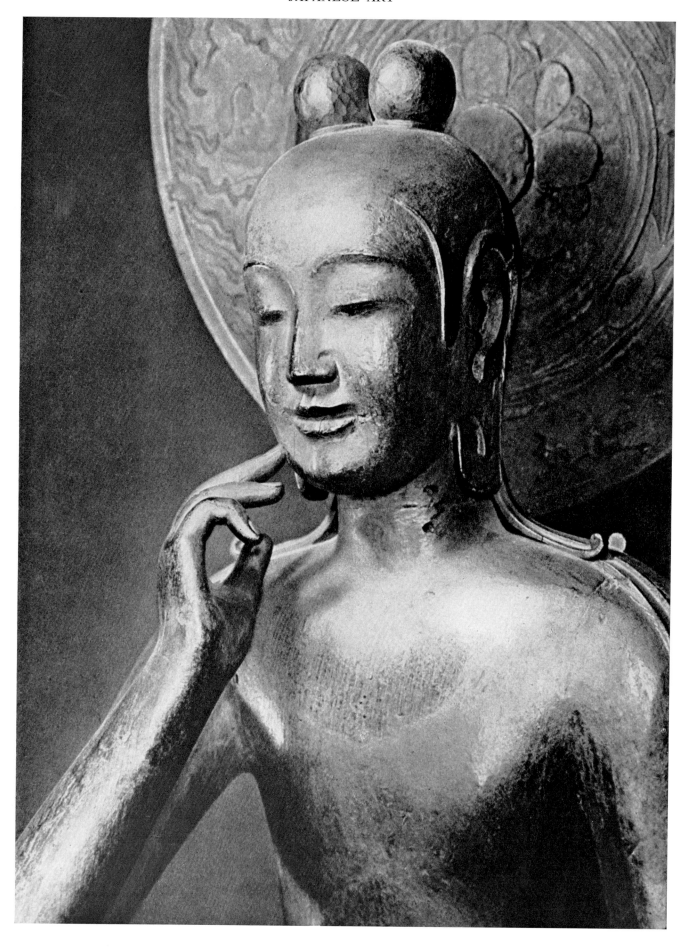

Pl. 266. Miroku (Maitreya), detail, Asuka period. Polished camphor wood, ht., ca. 5 ft. Nara, Chūgūji.

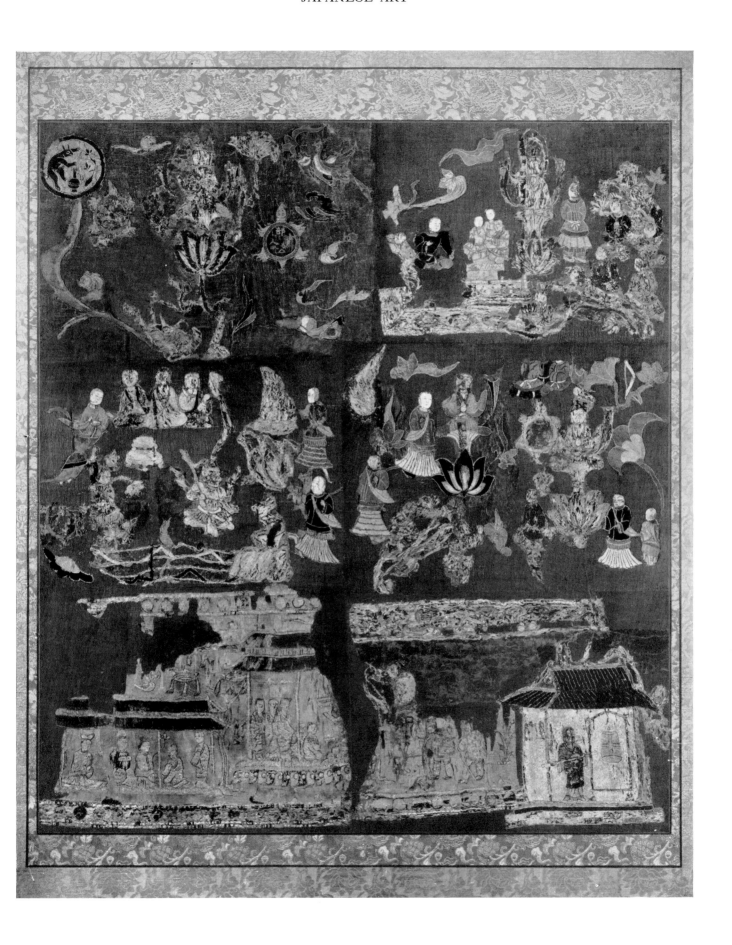

Pl. 267. Buddhist paradise, Asuka period. Embroidery on silk. Nara, Chūgūji.

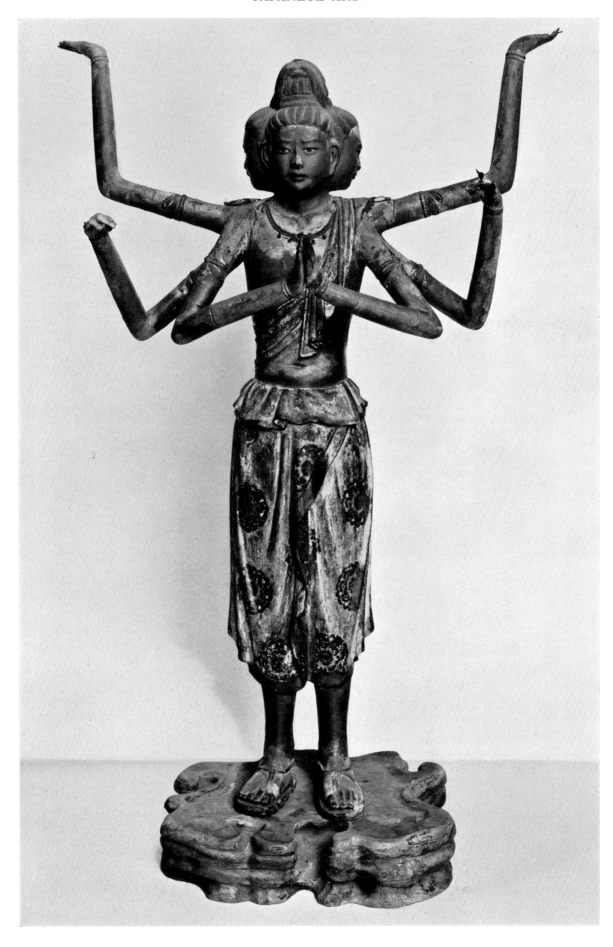

Pl. 268. Statue of Asura, Nara period. Dry lacquer, ht., 4 ft., 11 in. Nara, Kōfukuji.

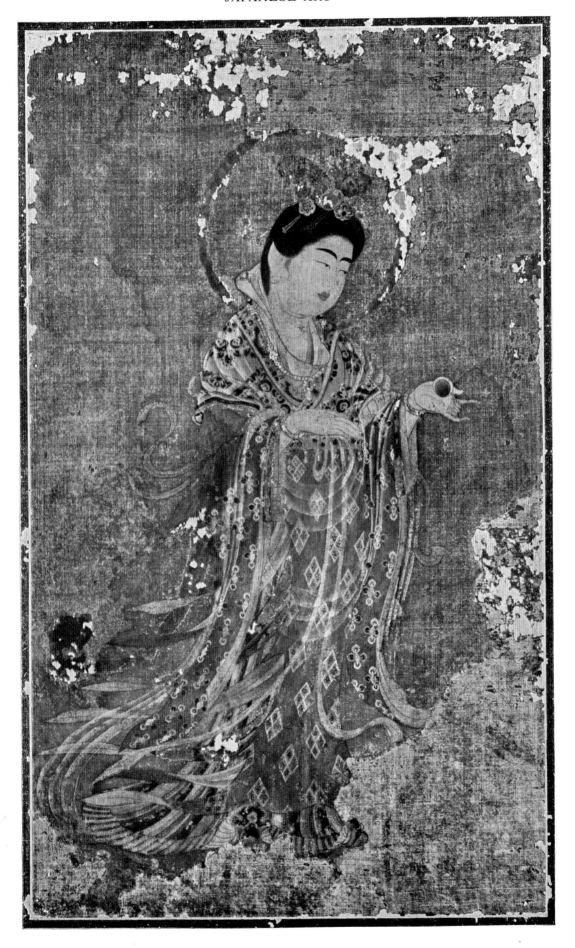

Pl. 269. Kichijōten (Mahāśrī), Nara period. Color on hemp cloth, 20¹/₂×11³/₄ in. Nara, Yakushiji.

Pl. 270. Suiten, early Heian period. Color on silk, 5 ft., 1 in. × 4 ft., 5¹/₈ in. Nara, Saidaiji.

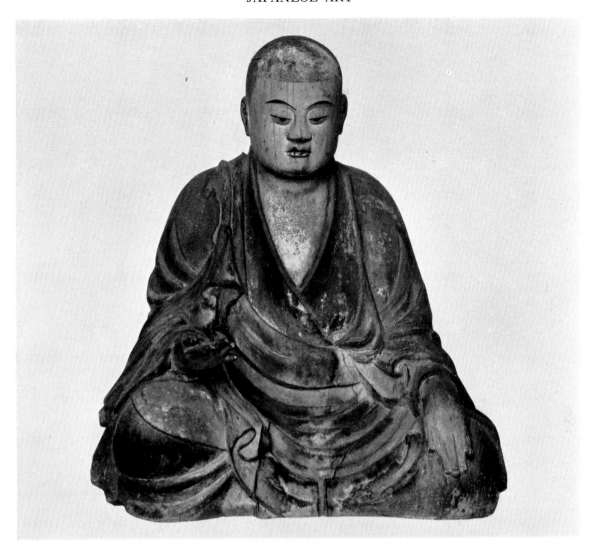

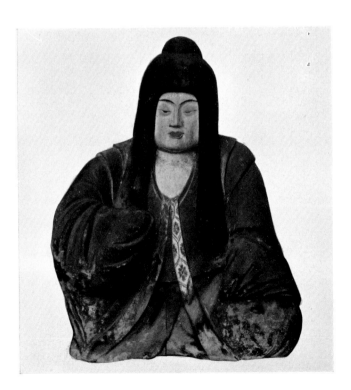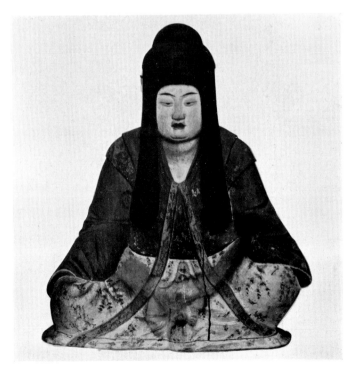

Pl. 271. Shinto divinities, early Heian period. Painted wood, ht., ca. 15³/₄ in. Nara, Yakushiji.

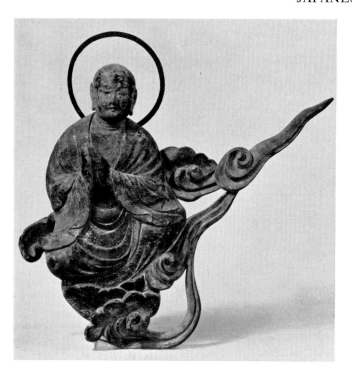

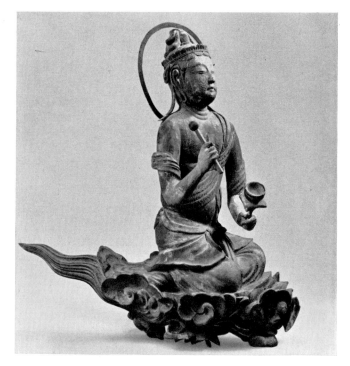

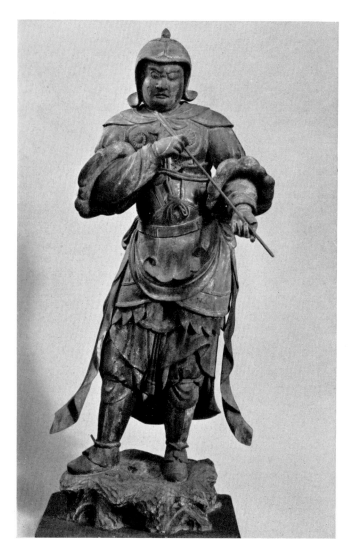

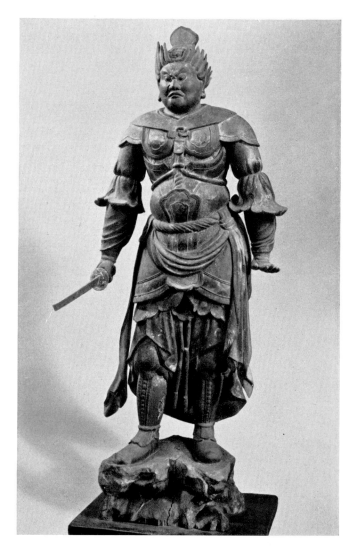

Pl. 272. *Above*: Celestial worshipers, Heian period, 11th cent. Wood, ht., ca. 27¹/₂ in. Uji, near Kyoto, Byōdōin. *Below*: Chōsei, two of the Twelve Celestial Guardians of Yakushi (Bhaiṣajyaguru), Heian period, dated 1064. Wood, ht., ca. 5 ft., 3 in. Kyoto, Kōryūji.

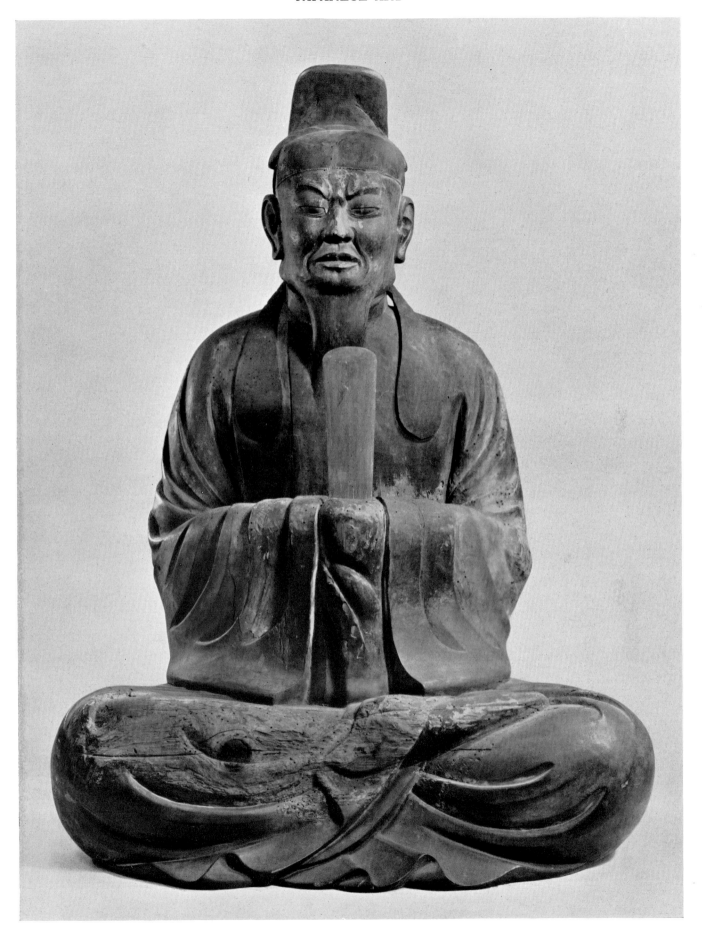

Pl. 273. Shinto divinity, Heian period, 9th–10th cent. Painted wood, ht., 38¹/₄ in. Kyoto, Matsunoo Jinja.

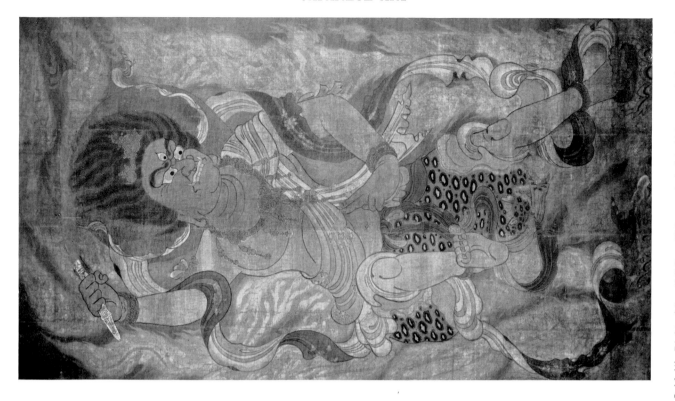

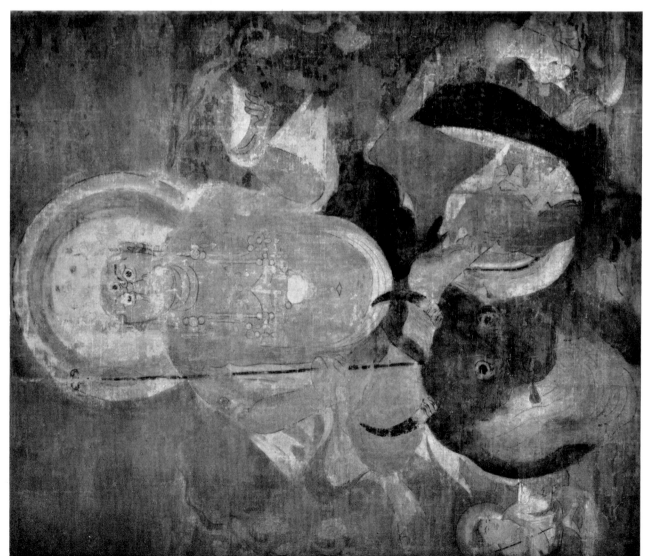

Pl. 274. *Left*: Ishanaten (Īśāna), Heian period, 9th cent. Color on silk, 5 ft., 2⁵/₈ in. × 4 ft., 4³/₄ in. Nara, Saidaiji. *Right*: Muryōriku, Heian period, 9th–10th cent. Color on silk, 10 ft., 8³/₈ in. × 3 ft., 6¹/₂ in. Wakayama, property of the 18 monasteries of the Junji Hachimankō group.

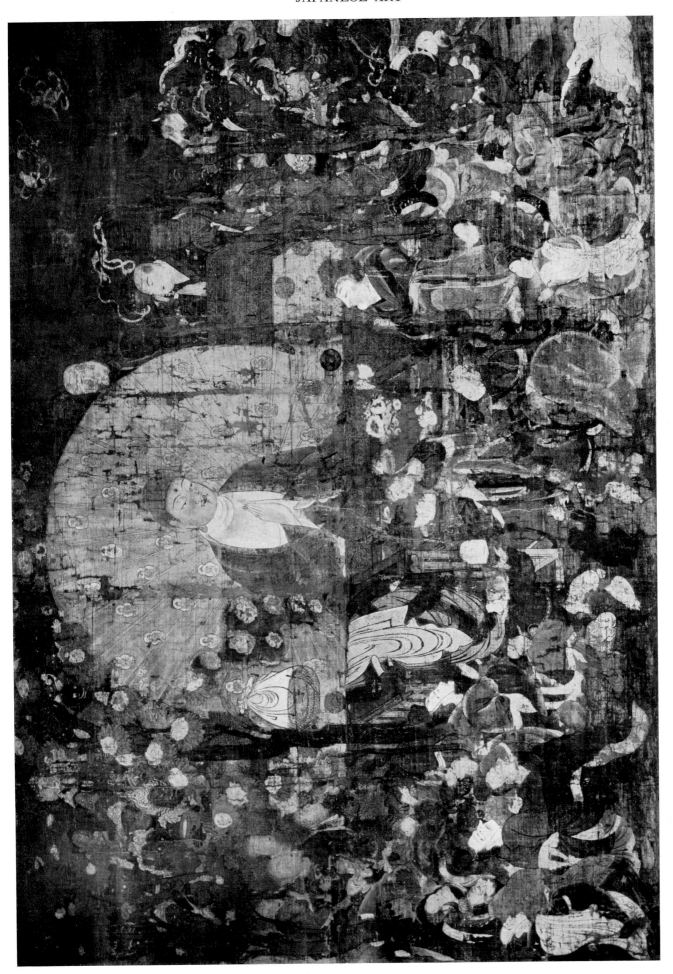

Pl. 275. Resurrection of the Buddha, Heian period, ca. 1086. Color on silk. Kyoto, Chōhōji.

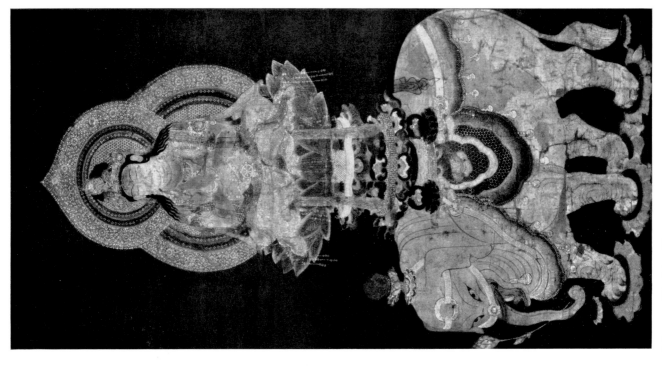

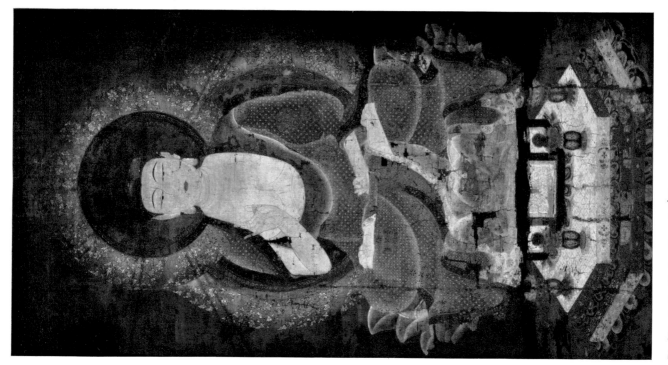

Pl. 276. *Left*: Shaka Nyorai (Śākyamuni), Heian period, 11th–12th cent. Color on silk, 5 ft., 2⁵/₈ in. × 2 ft., 9¹/₂ in. Kyoto, Jingoji. *Right*: Fūgen Bosatsu (Samantabhadra), Heian period, 12th cent. Color on silk, 40¹/₂×20¹/₂ in. Tottori, Bujōji.

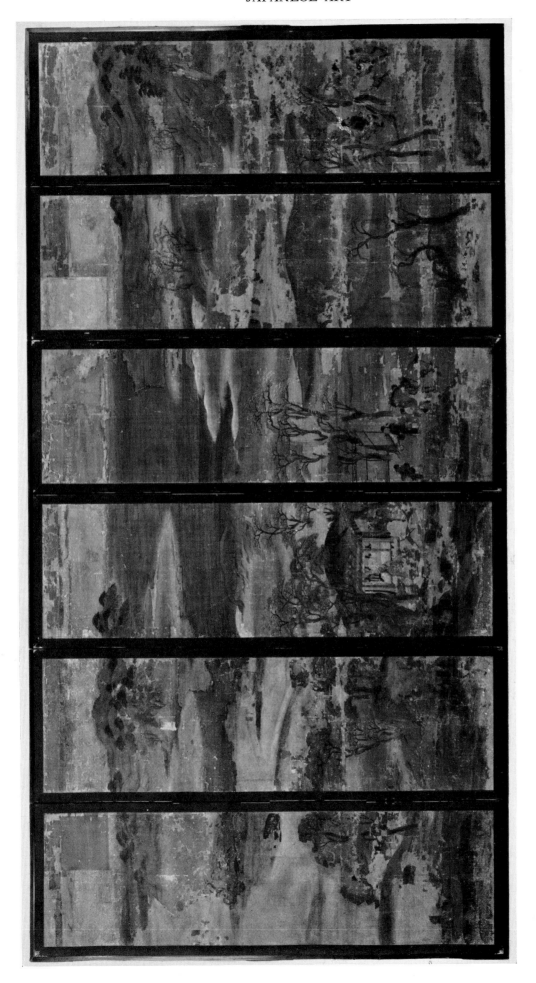

Pl. 277. Screen with landscape, Heian period. Silk, ht., 4 ft., 9⅞ in. Kyoto, Tōji.

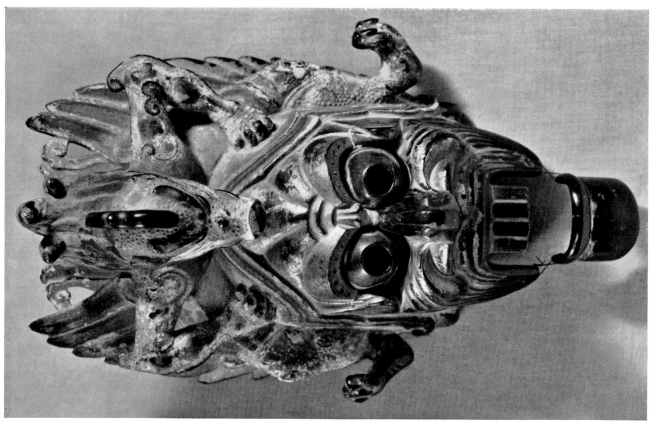

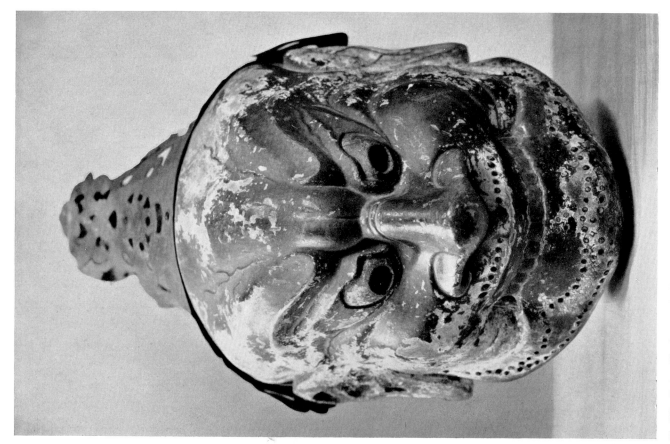

Pl. 278. *Left*: Gigaku mask, Nara period. Wood, ht., 16¼ in. Tokyo, National Museum. *Right*: Bugaku mask, Heian period, 12th cent. Wood, ht., 15 in. Mizuki, Fukuoka, Kanzeonji.

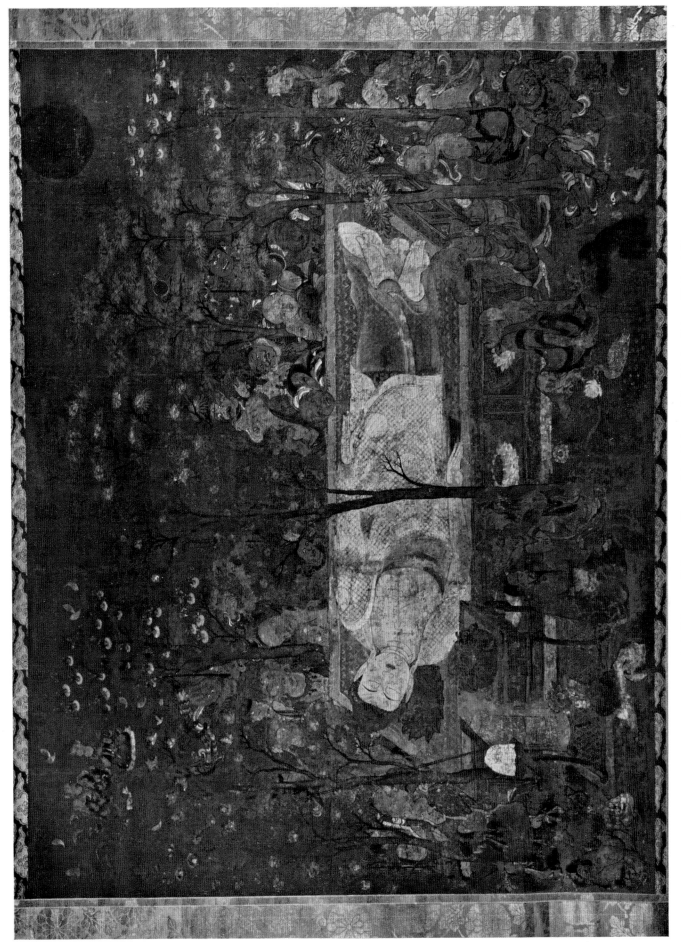

Pl. 279. Death of the Buddha (*parinirvāṇa*). Heian period, 12th cent. Color on silk, ca. 4 ft., 11 in. × 6 ft., 7¹/₂ in. Tokyo, National Museum.

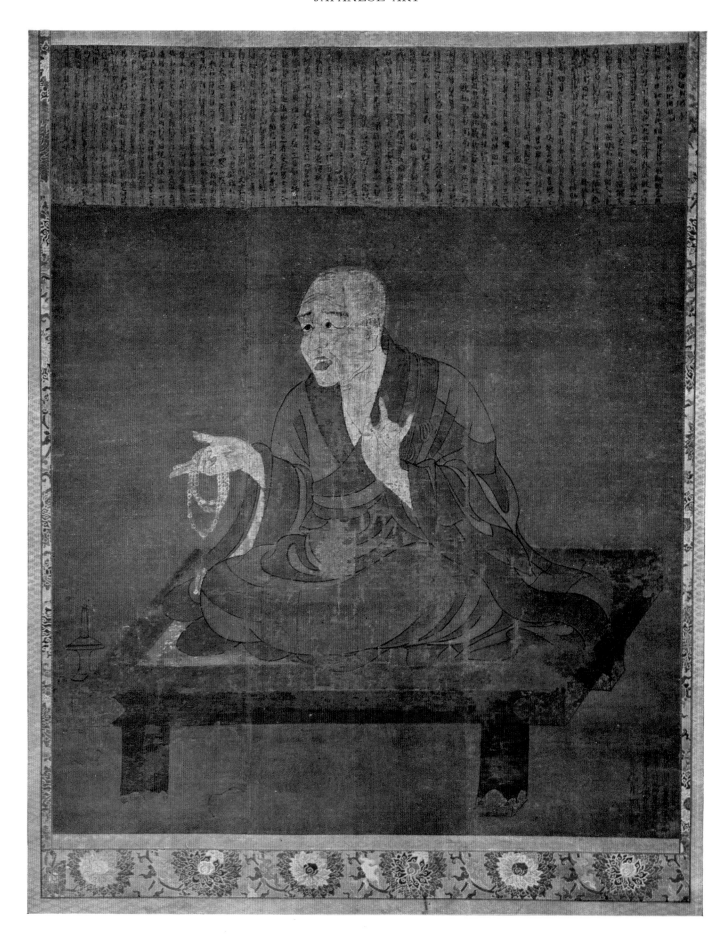

Pl. 280. The monk Gonzō, Heian period, 12th cent. Color on silk, 5 ft., 4⅝ in. × 4 ft., 5⅛ in. Kōyasan, Wakayama prefecture, Fumonin.

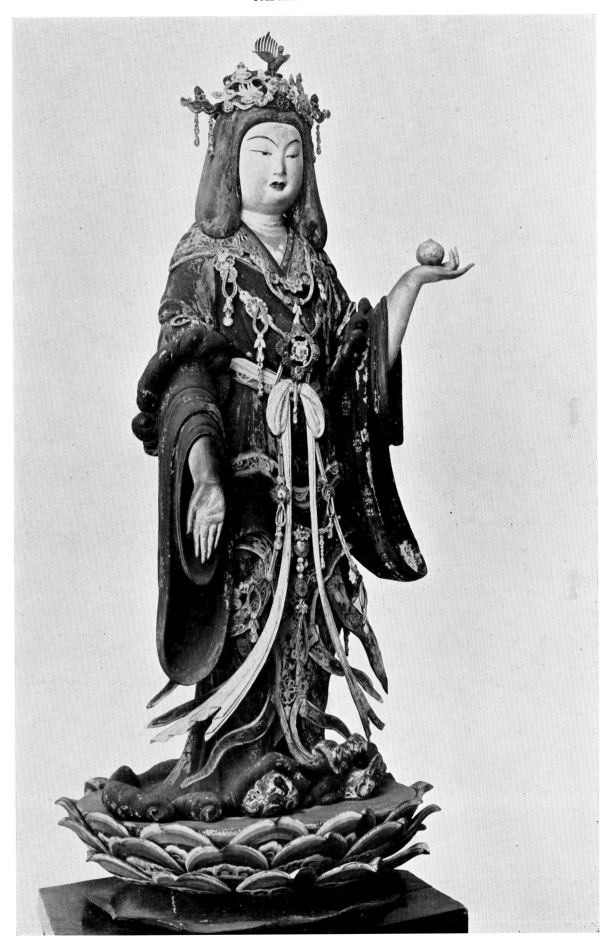

Pl. 281. Kichijōten (Mahāśrī), Heian period, late 12th cent. Wood, ht., 35 in. Kyoto, Jōruriji.

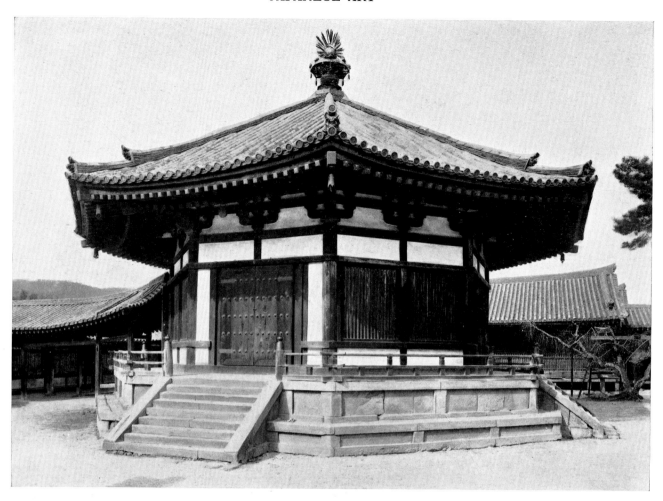

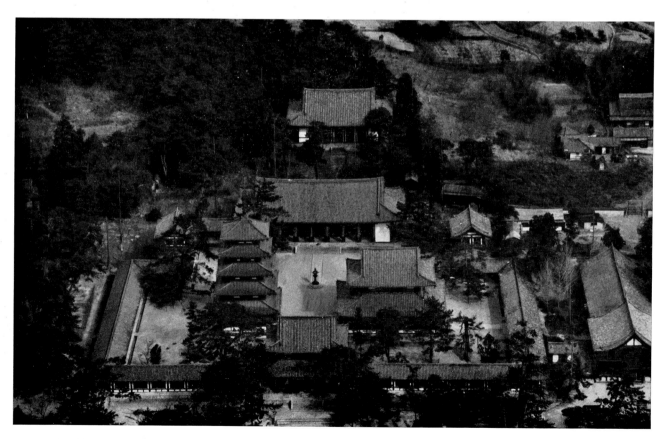

Pl. 282. Nara, Hōryūji, 7th–10th cent. *Above*: The Yumedono (Dream Hall), 8th cent. *Below*: General view.

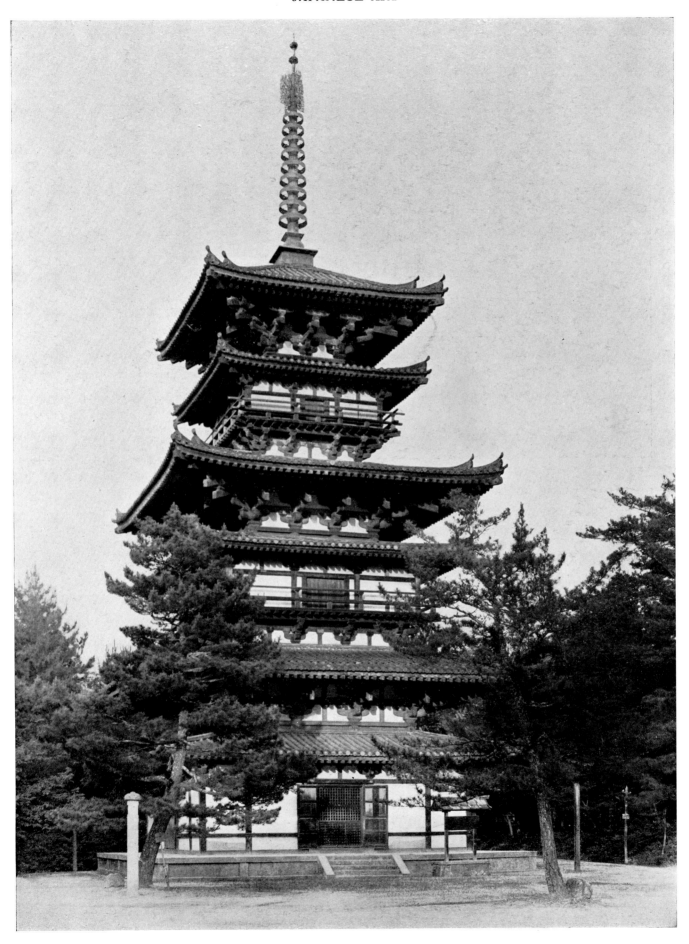

Pl. 283. Nara, Yakushiji, the east pagoda, 7th–8th cent.

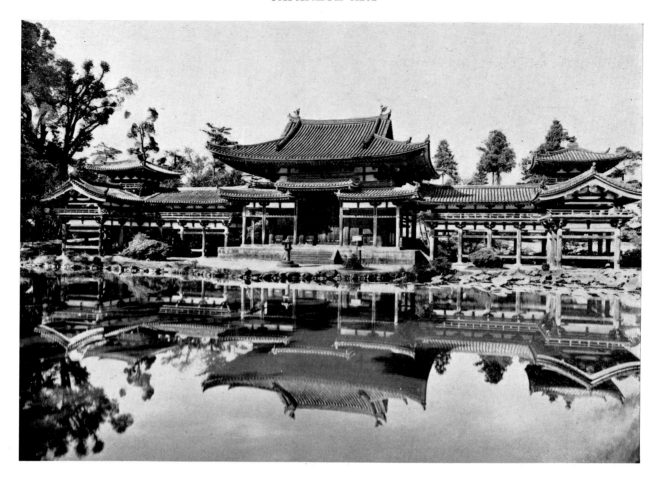

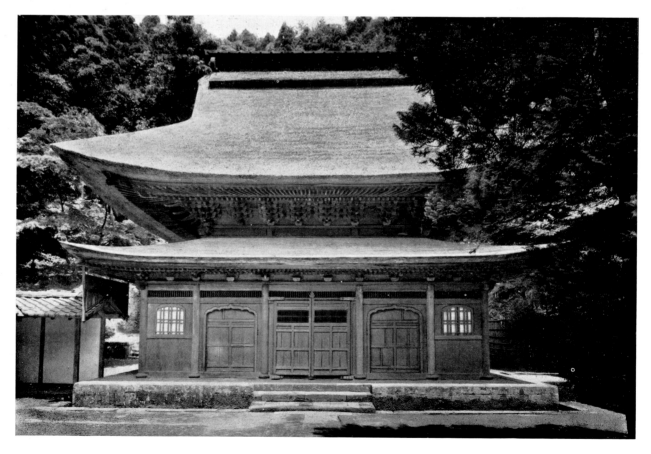

Pl. 284. *Above*: Uji, near Kyoto, Byōdōin, the Hōōdō (Phoenix Hall), Heian period. *Below*: Kamakura, Kanagawa prefecture, Engakuji, relic hall (*shariden*), Kamakura period, 13th cent.

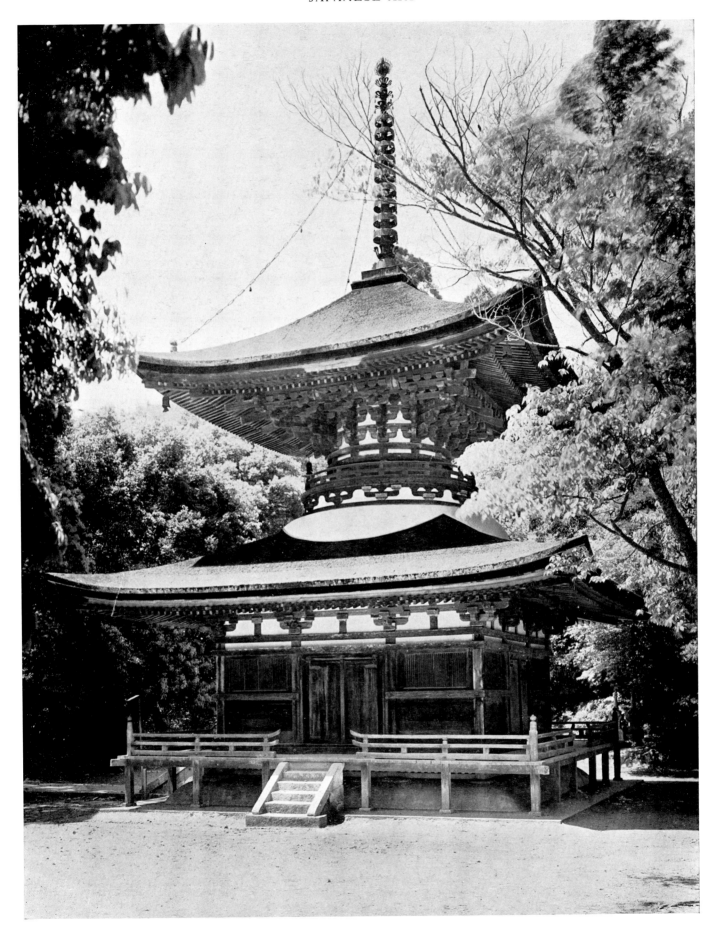

Pl. 285. Ishiyamadera, Shiga prefecture, the Tahōtō, Kamakura period, late 12th cent.

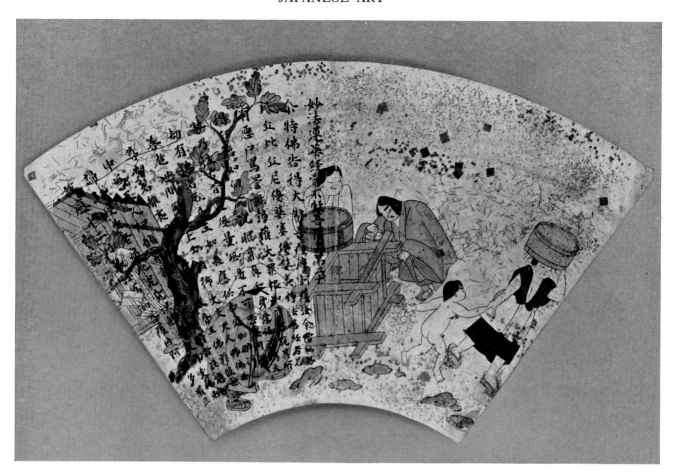

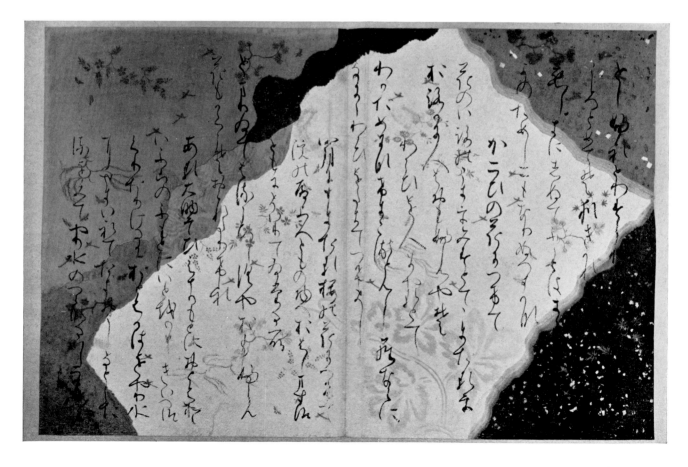

Pl. 286. *Above*: Buddhist sutra on fan, Heian period. Color on paper. Osaka, Shitennōji. *Below*: Poetry by Ise, from the Sanjū-roku-nin-shū, Heian period. Ink and color on paper. Kyoto, Nishi Honganji.

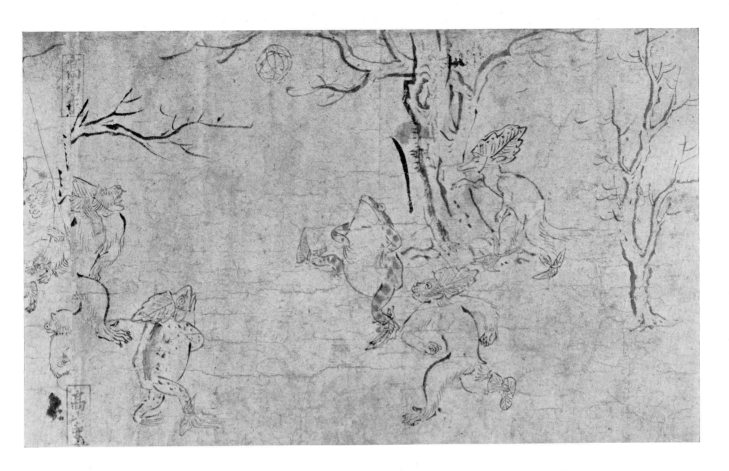

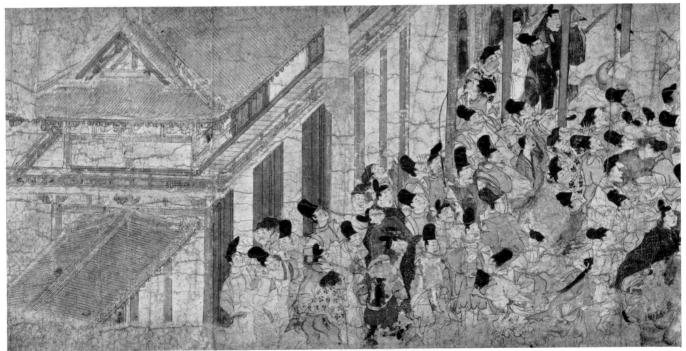

Pl. 287. *Above*: Kakuyū (Toba Sōjō; attrib.), Animal Caricatures Scroll, Heian or early Kamakura period. Ink on paper, ht., 12 in. Kyoto, Kōzanji. *Below*: Tokiwa Mitsunaga (attrib.), Story of Ban Dainagon, detail of scroll, late Heian–early Kamakura period. Color on paper, ht., 12 in. Tokyo, Sakai Coll.

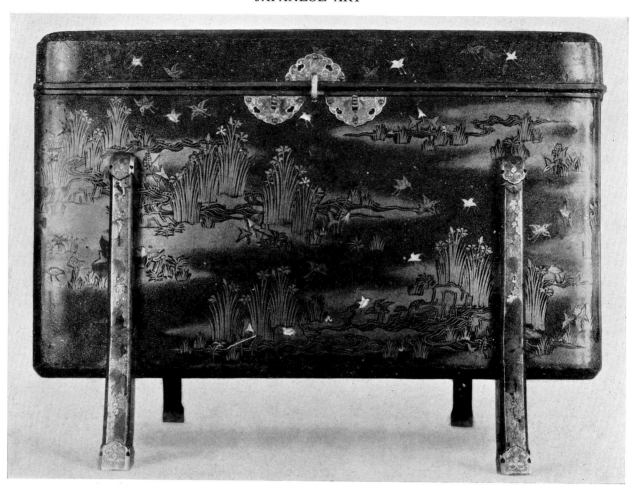

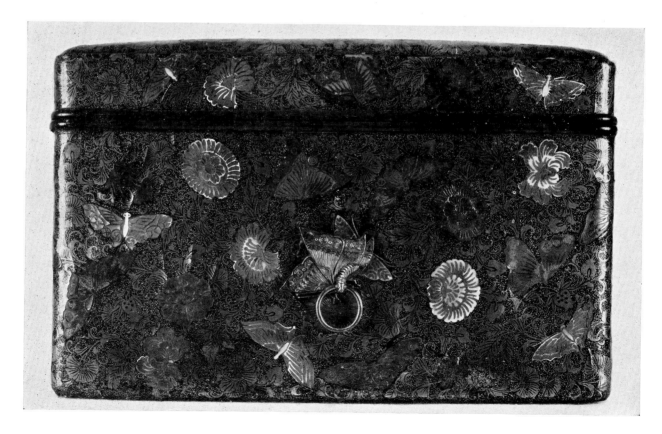

Pl. 288. *Above*: Box, Heian period. Lacquer with mother-of-pearl inlay. Wakayama, Kongōbuji. *Below*: Cosmetic box, Kamakura period. Lacquer with mother-of-pearl inlay. Tokyo, Matsudaira Coll.

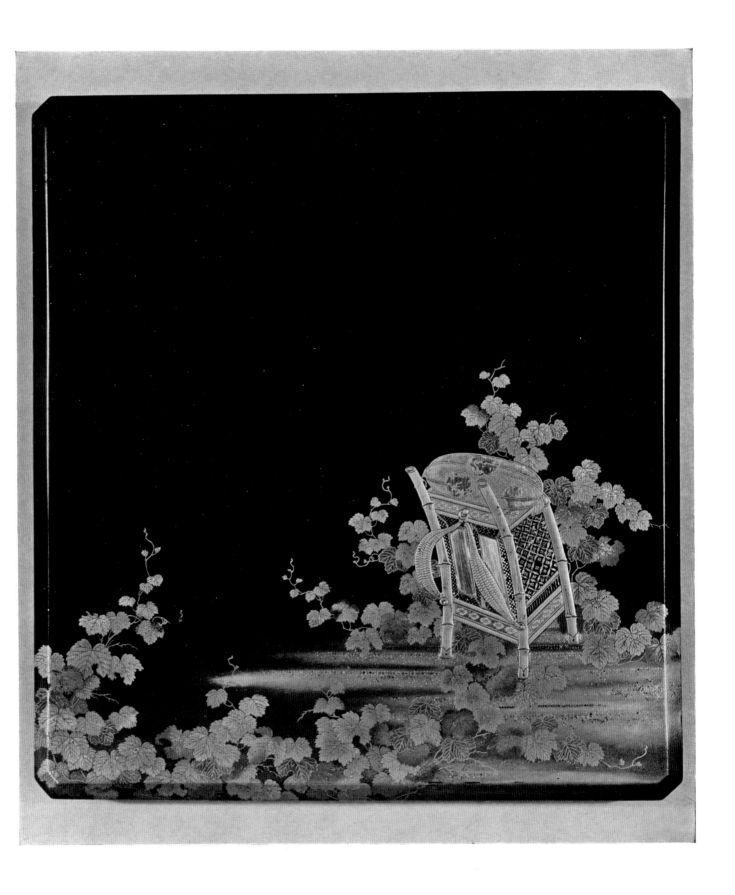

Pl. 289. Shunshō II, box for inkstones, 18th cent. Lacquer. Boston, Museum of Fine Arts.

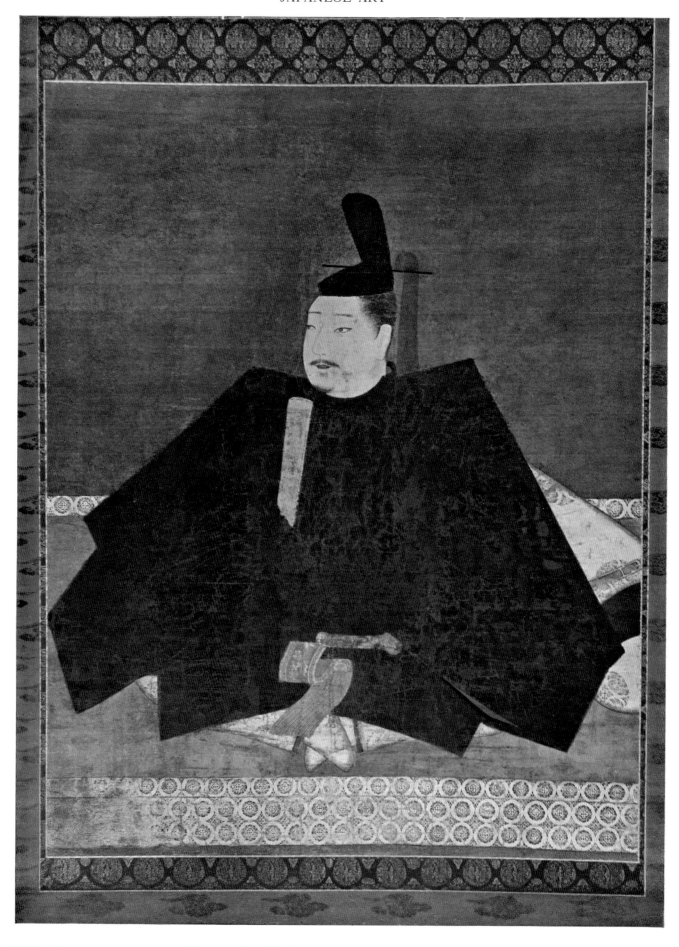

Pl. 290. Fujiwara-no-Takanobu (attrib.), portrait of Fujiwara Mitsuyoshi (?), Fujiwara period, late 12th cent. Color on silk, 4 ft., 7¹/₈ in. × 3 ft., 7¹/₄ in. Kyoto, Jingoji.

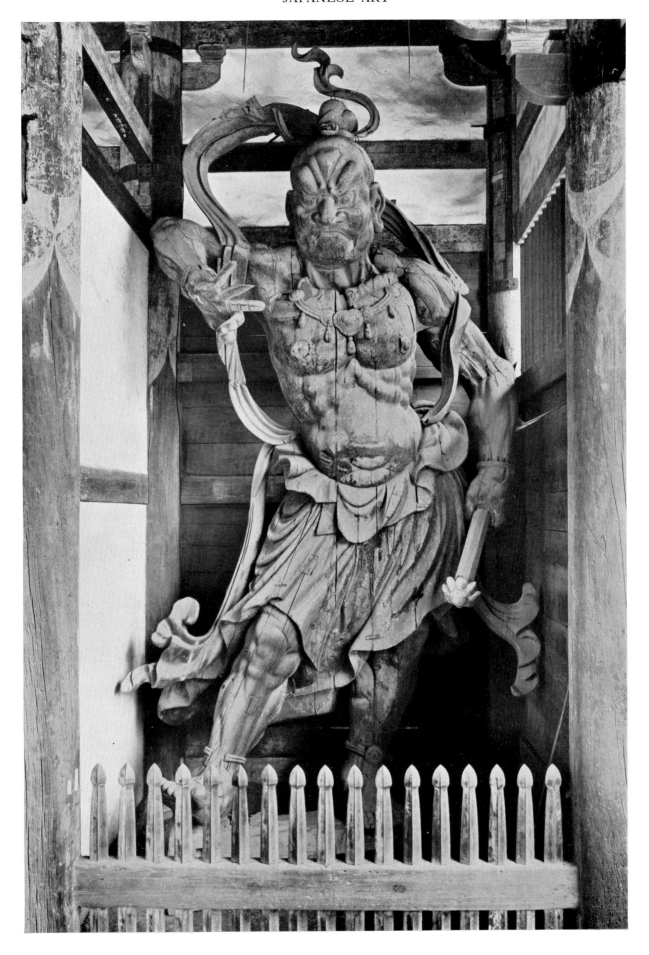

Pl. 291. Unkei and Kaikei, one of the celestial guardians, Kamakura period, dated 1203. Wood, ht., 27 ft. Nara, Tōdaiji.

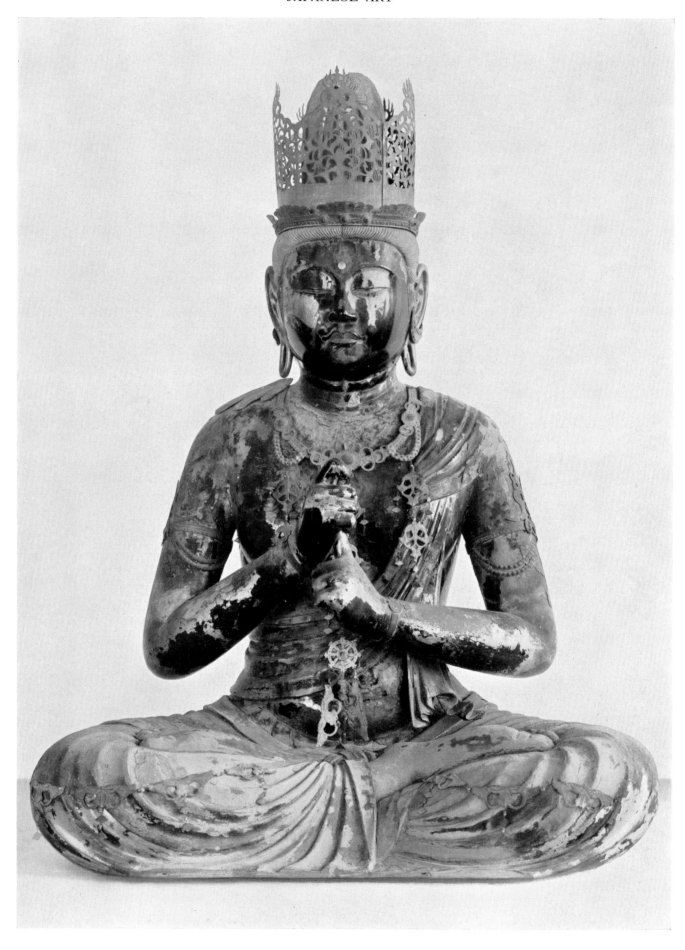

Pl. 292. Unkei, the Dainichi Nyorai (Vairocana Tathāgata), Kamakura period, 12th cent. Wood. Nara, Enjōji.

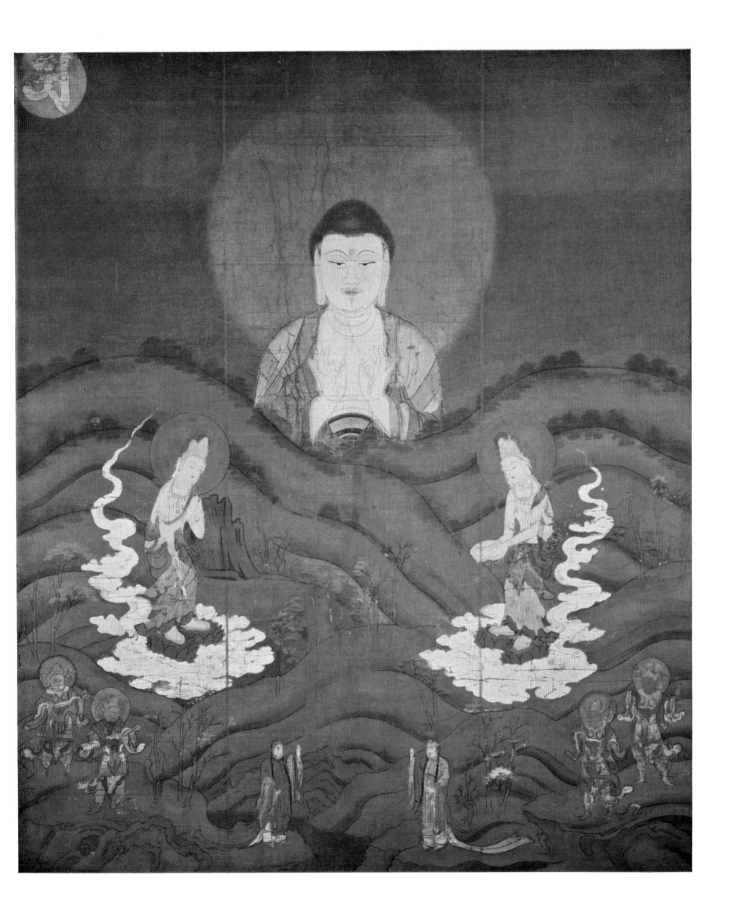

Pl. 293. The descent of Amida (Amitābha), Kamakura period, 13th cent. Color on silk, 4 ft., 6³/₈ in. × 3 ft., 10¹/₆ in. Kyoto, Zenrinji.

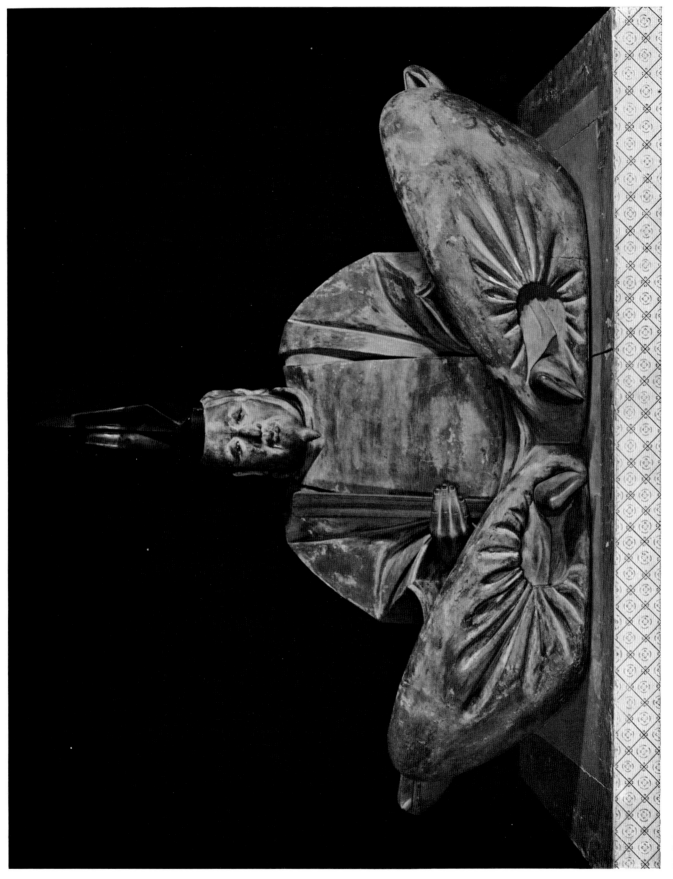

Pl. 294. Portrait of Uesugi Shigefusa, Kamakura period, 13th cent. Painted wood, ht., 27½ in. Kamakura, Kanagawa prefecture, Meigetsuin.

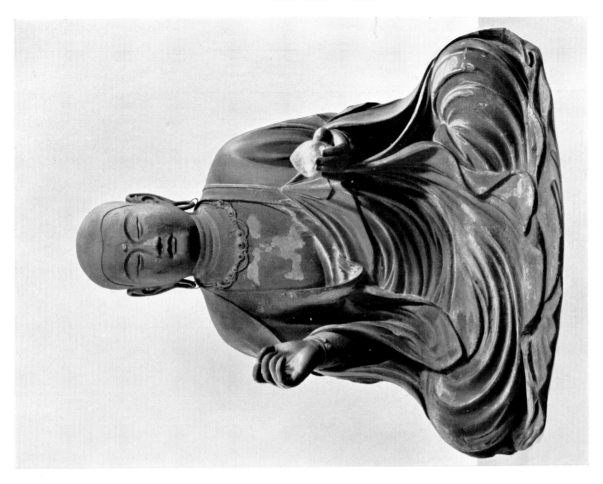

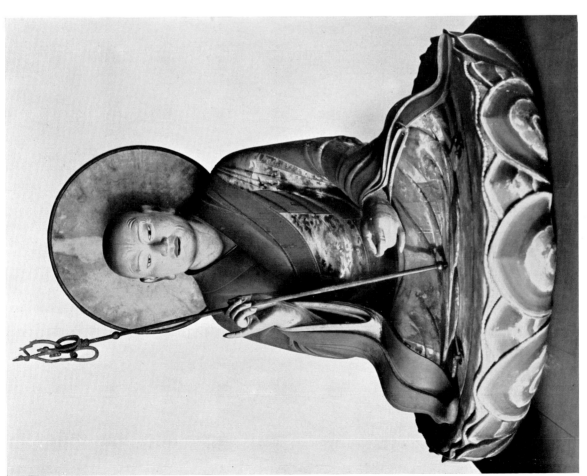

Pl. 295. *Left*: Kaikei, the god Hachiman as a priest, Kamakura period, 1201. Painted wood. Nara, Tōdaiji. *Right*: School of Unkei, Jizō Bosatsu (Kṣitigarbha), Kamakura period, late 12th cent. Painted wood, ht., 35³/₈ in. Kyoto, Rokuharamitsuji.

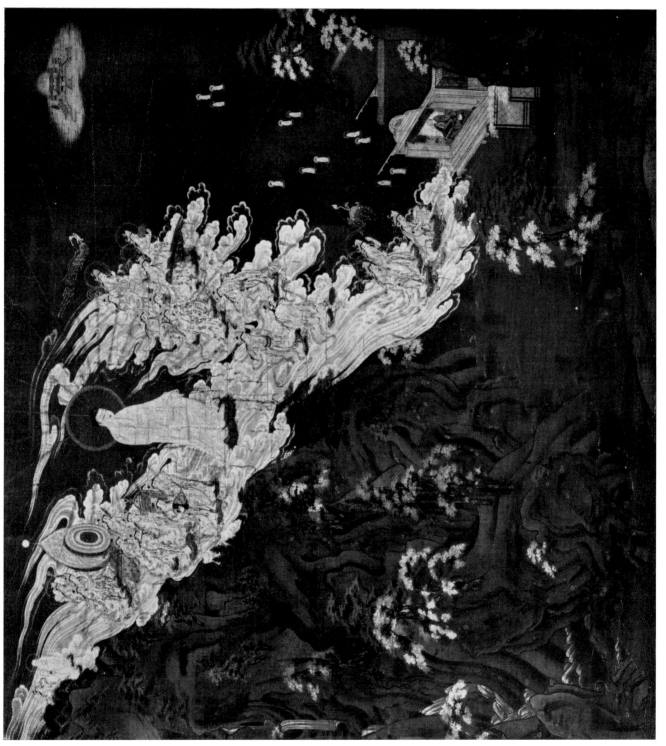

Pl. 296. The descent of Amida (Amitābha), Kamakura period. Color on silk. Kyoto, Chionin.

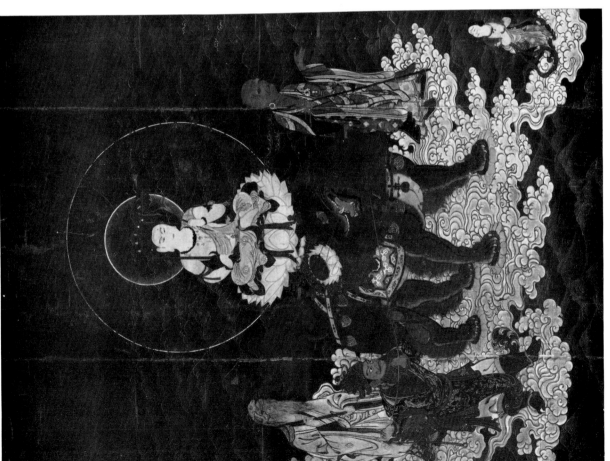

Pl. 297. *Left*: Monju (Mañjuśrī) crossing the ocean, Kamakura period. Color on silk, 13th cent. Color on silk, 29¹/₂×21¹/₄ in. Nara, Yamato Bunkakan. *Right*: Kasagi mandara, Kamakura period, 4 ft., 8¹/₄ in. × 3 ft., 3³/₈ in. Kyoto, Kōdaiin, Daigoji.

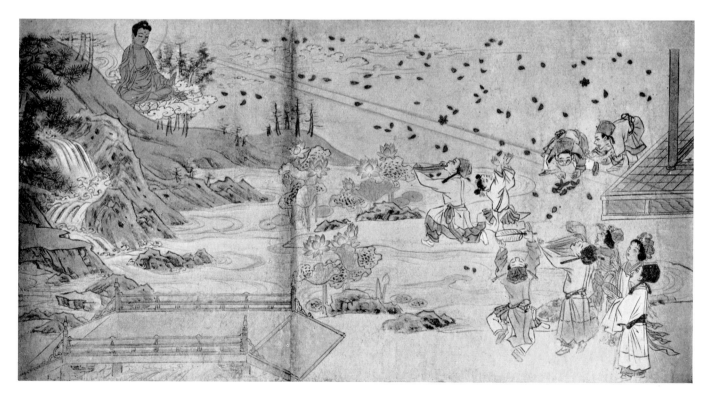

Pl. 298. *Above*: Eni, The Life of Ippen, detail, Kamakura period, early 14th cent. Ink and faint color on silk. Kyoto, Kankikōji. *Below*: The Story of Jōdō, detail, Kamakura period. Ink and faint color on paper. Kamakura, Kanagawa prefecture, Kōmyōji.

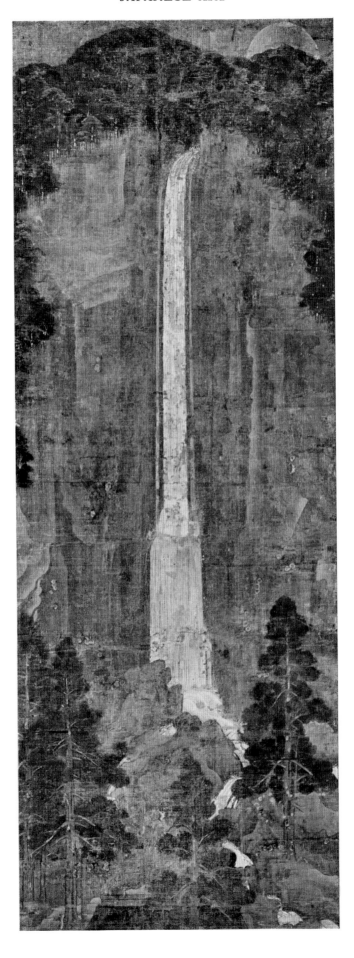

Pl. 299. Nachi Waterfall, Kamakura period, 14th cent. Color on silk, 5 ft., 1³/₄ in. × 22¹/₂ in. Tokyo, Nezu Museum.

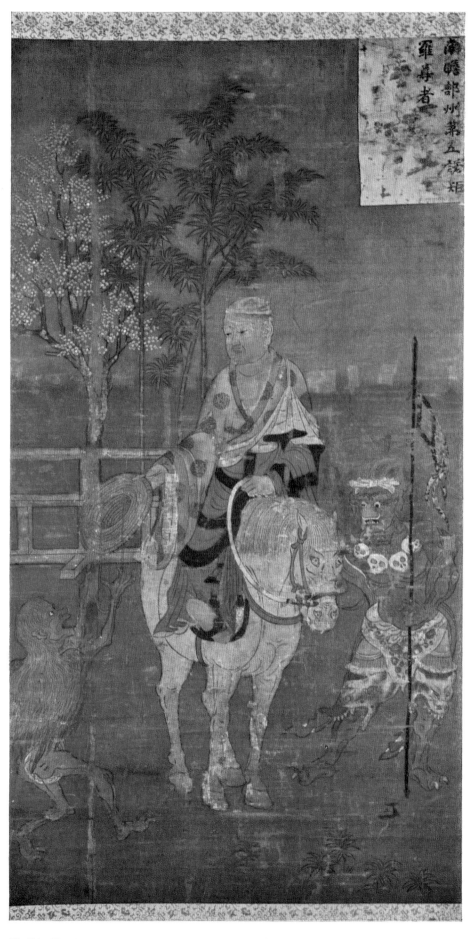

Pl. 300. The holy Buddhist Nakura, Heian period, 12th cent. Color on silk, $37^3/_4 \times 20^1/_2$ in. Tokyo, National Museum.

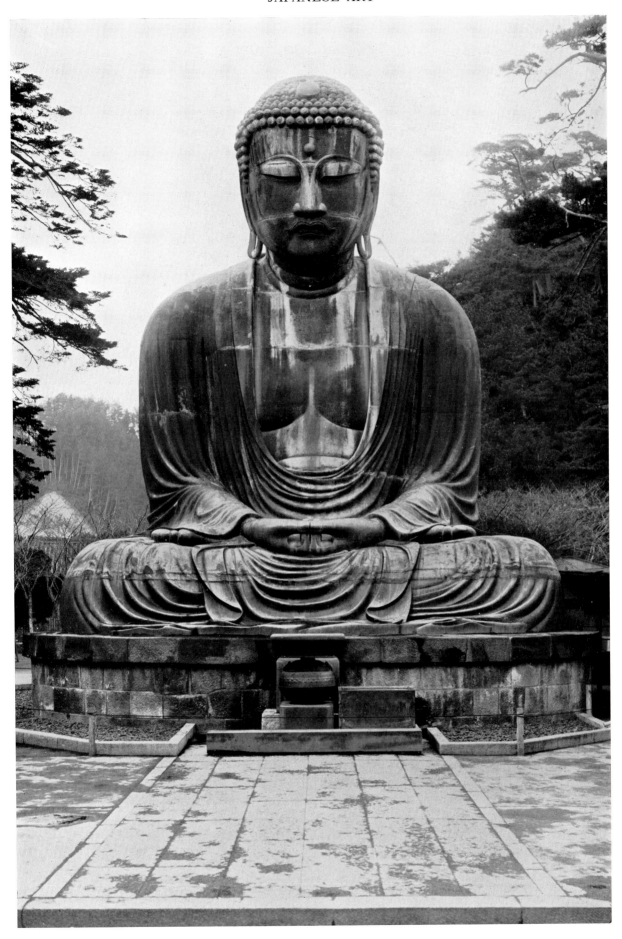

Pl. 301. Colossal statue of the buddha Amitābha. Kamakura period. Bronze, ht., 49 ft., including dais. Kamakura, Kanagawa prefecture, Kōtokuin.

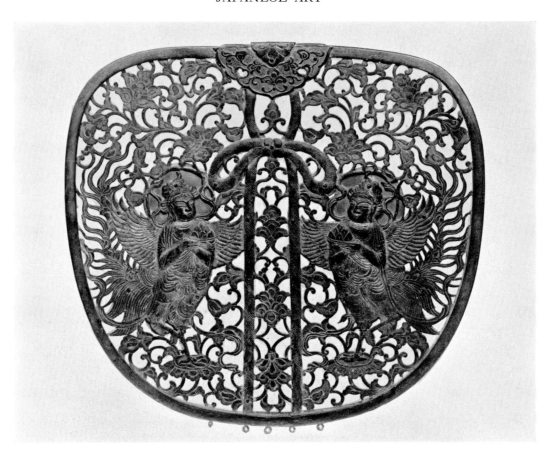

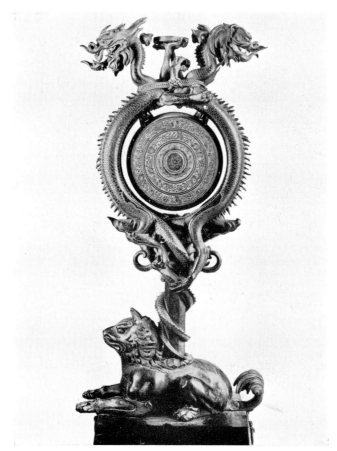

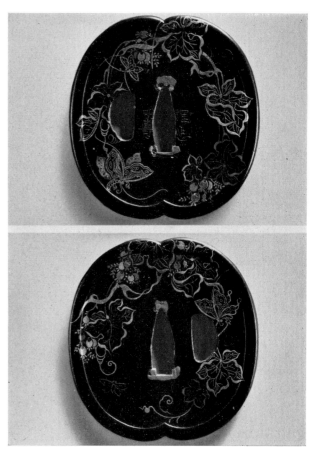

Pl. 302. *Above*: Ornamental plaque with Buddhist motifs, Heian period. Bronze. Hiraizumi, Iwate prefecture, Konjikidō, Chū-
sonji. *Below, left*: Gong, Kamakura period, in gong rack of Nara period. Bronze. Nara, Kōfukuji. *Right*: Umetada Myōju,
sword guard (tsuba), front and back, Edo period, 17th cent. Copper and gold alloy. Tokyo, Yamanouchi Coll.

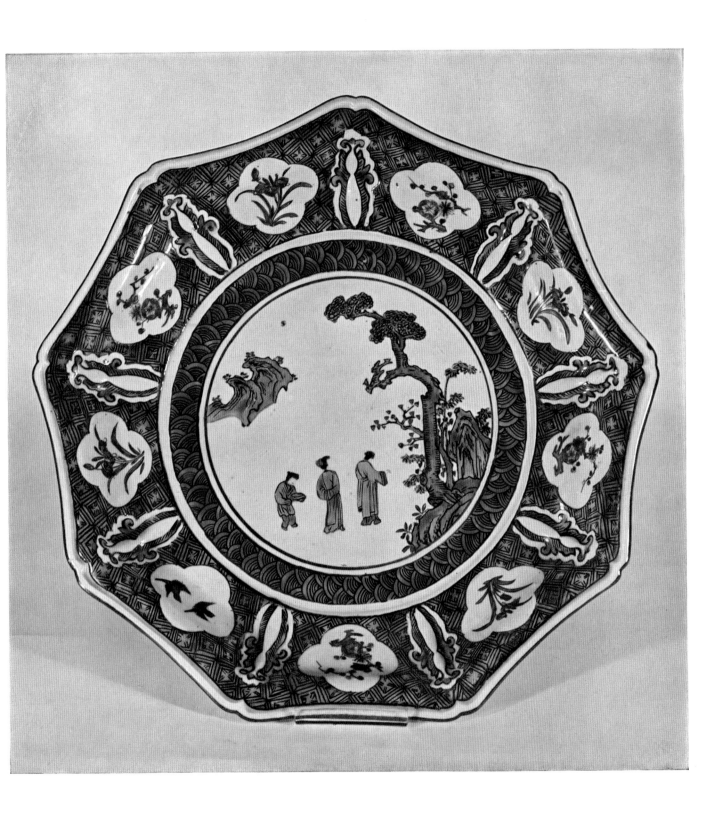

Pl. 303. Plate of Kutani type, 17th cent. Porcelain. London, British Museum.

Pl. 304. Fujiwara-no-Nobuzane (attrib.), portrait of Ko-ōgimi, Kamakura period, 13th cent. Color on paper; including calligraphy, 13³/₄×22¹/₂ in. Nara, Yamato Bunkakan.

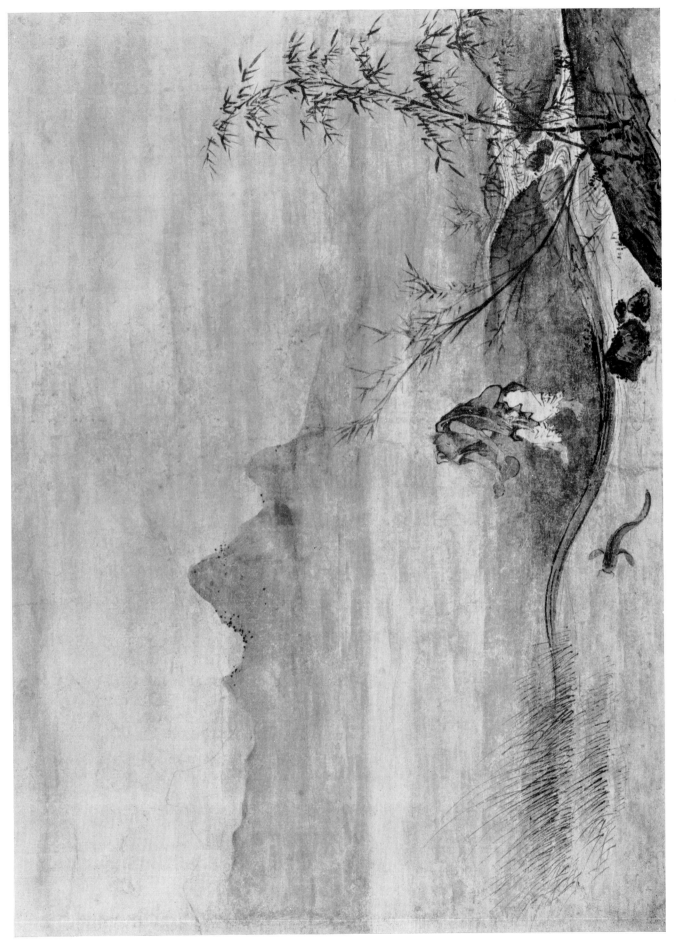

Pl. 305. Josetsu, Catching a Catfish with a Gourd, Muromachi period, early 15th cent. Ink and faint color on paper, $29^1/_2 \times 39^3/_8$ in. Kyoto, Taizōin, Myōshinji.

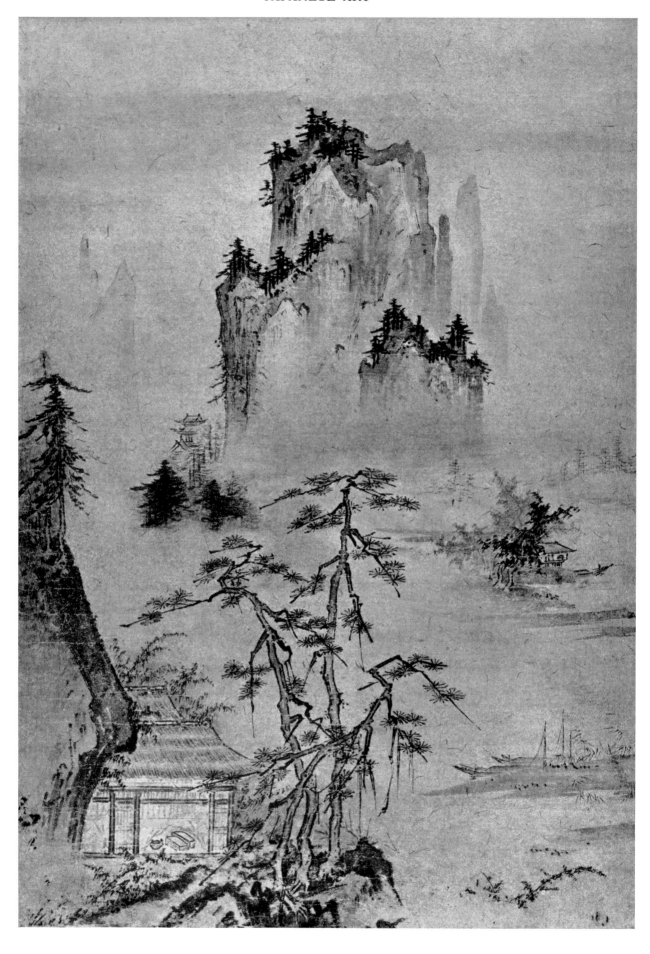

Pl. 306. Shūbun (attrib.), landscape, Muromachi period, 15th cent. Ink and faint color on paper. Tokyo, Fujiwara Coll.

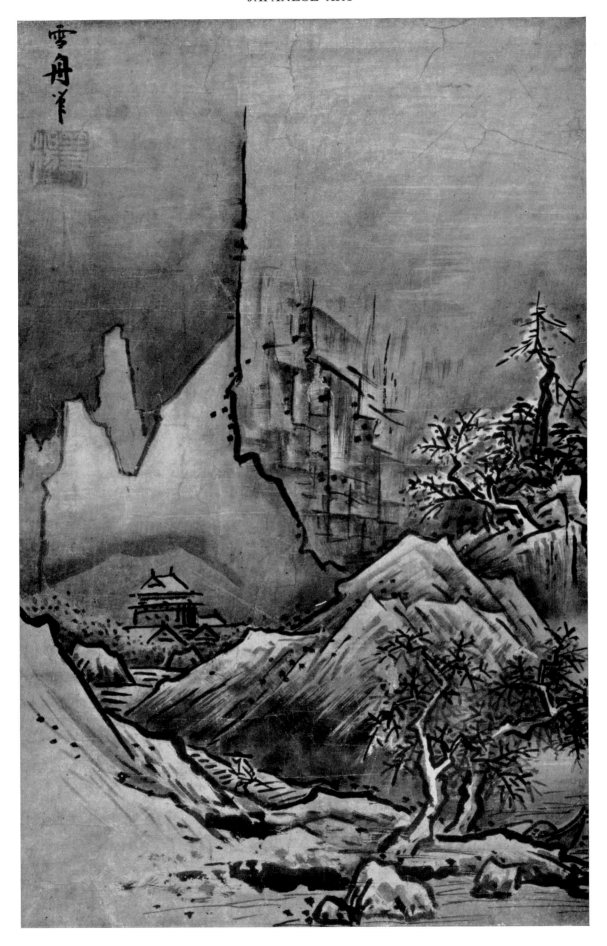

Pl. 307. Sesshū, Winter Landscape, Muromachi period, 15th cent. Ink and faint color on paper, $17^3/_4 \times 10^5/_8$ in. Tokyo, National Museum.

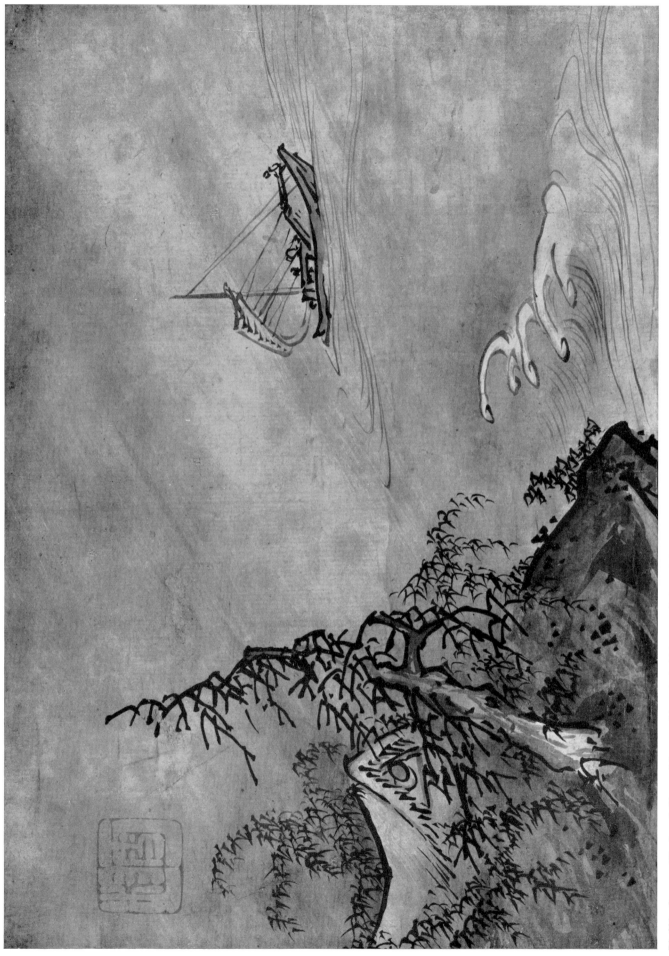

Pl. 308. Sesson, Wind and Waves, Muromachi period, 16th cent. Ink and faint color on paper, $8^5/_8 \times 11^3/_4$ in. Kyoto, Nomura Coll.

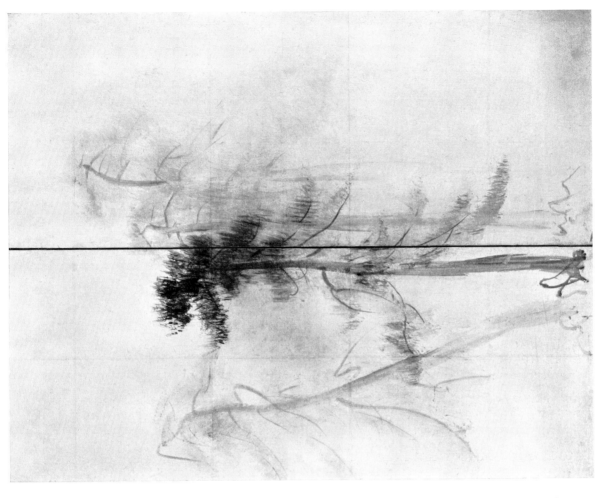

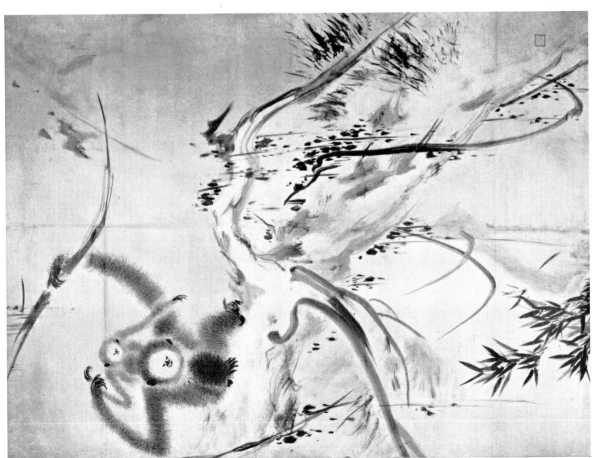

Pl. 309. Hasegawa Tōhaku, Momoyama period. *Left*: Monkeys. Ink on paper, 5 ft., ⁵/₈ in. × 4 ft., 8¹/₄ in. Kyoto, Ryūsenan, Myōshinji. *Right*: Pines, detail of a screen. Ink on paper; full size, 5 ft., 1 in. × 11 ft., 4⁵/₈ in. Tokyo, National Museum.

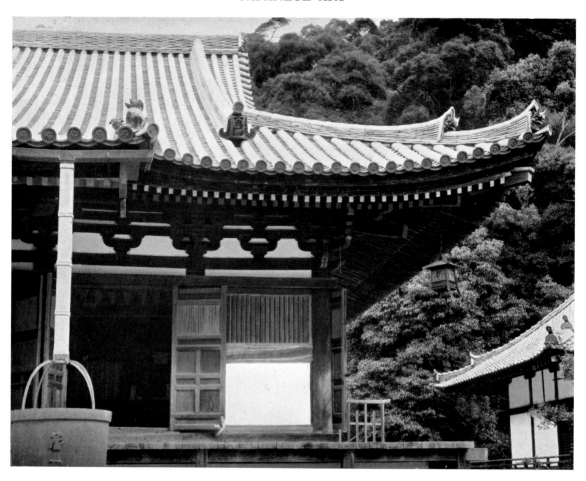

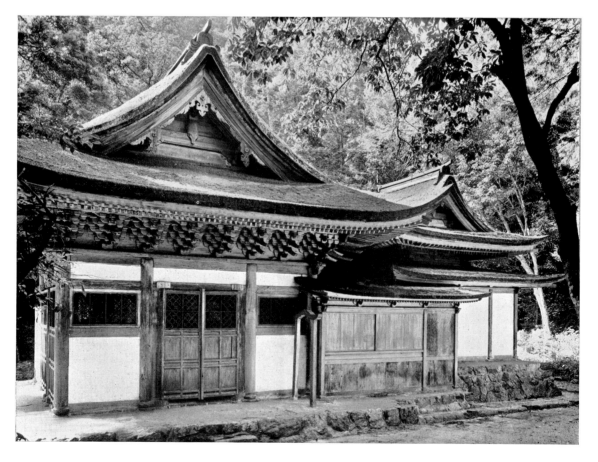

Pl. 310. *Above*: Osaka, Kanshinji, main hall, Muromachi period, 14th cent. *Below*: Tajimi, Gifu prefecture, Eihōji, the Kaisandō, Muromachi period, 1352.

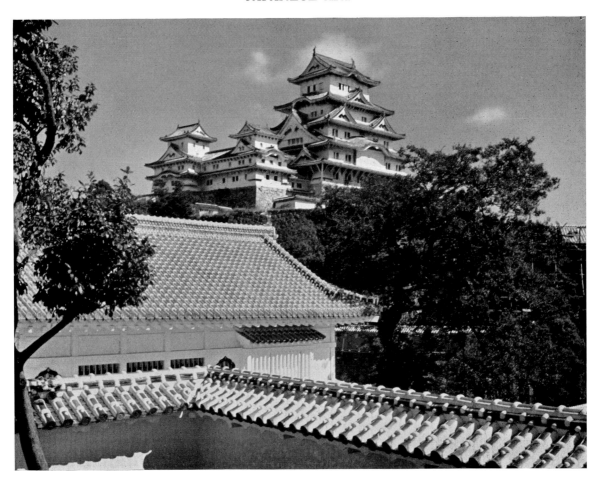

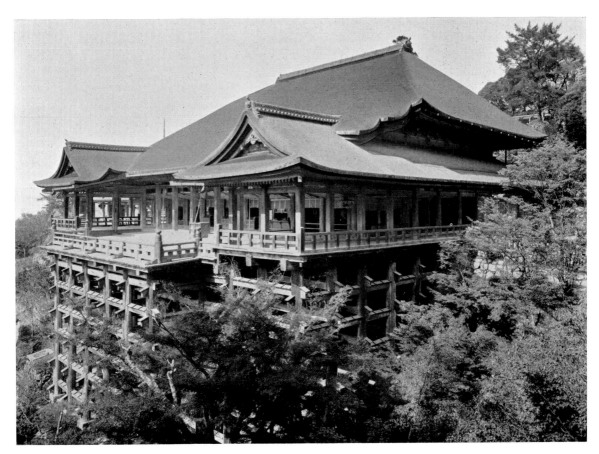

Pl. 311. *Above*: Himeji castle, Hyogo prefecture, Momoyama period, late 16th cent. *Below*: Kyoto, Kiyomizu-dera, Edo period, 1633.

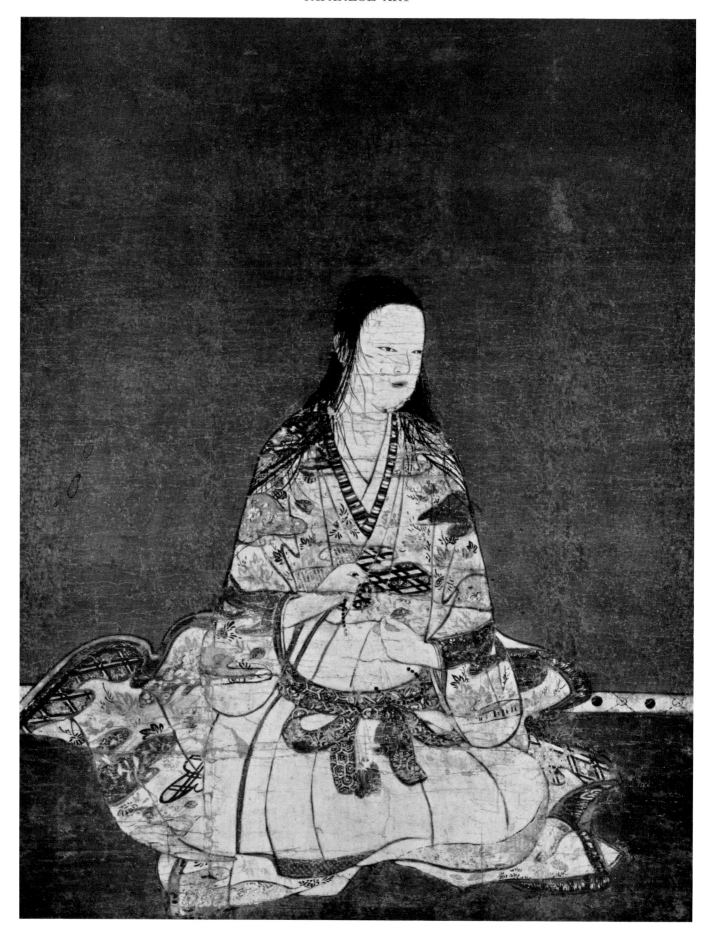

Pl. 312. Portrait of a lady, Momoyama period, 16th cent. Color on paper, 19³/₄×15 in. Nara, Yamato Bunkakan.

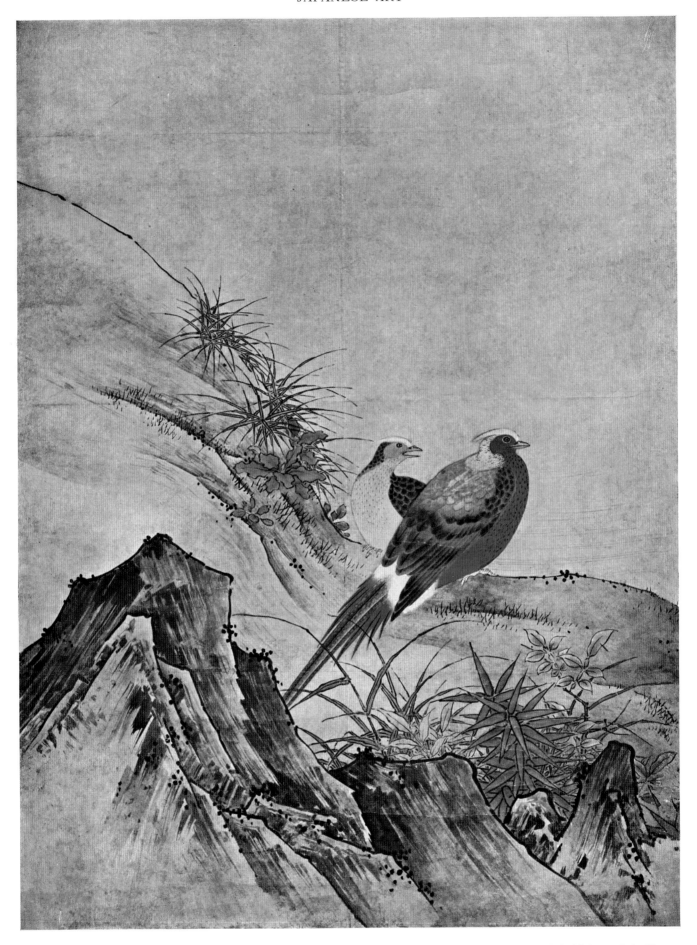

Pl. 313. Kanō Motonobu (attrib.), Flowers and Birds, Muromachi period, dated 1509. Color on paper, 5 ft., 8 in. × 3 ft. Kyoto, Daisenin.

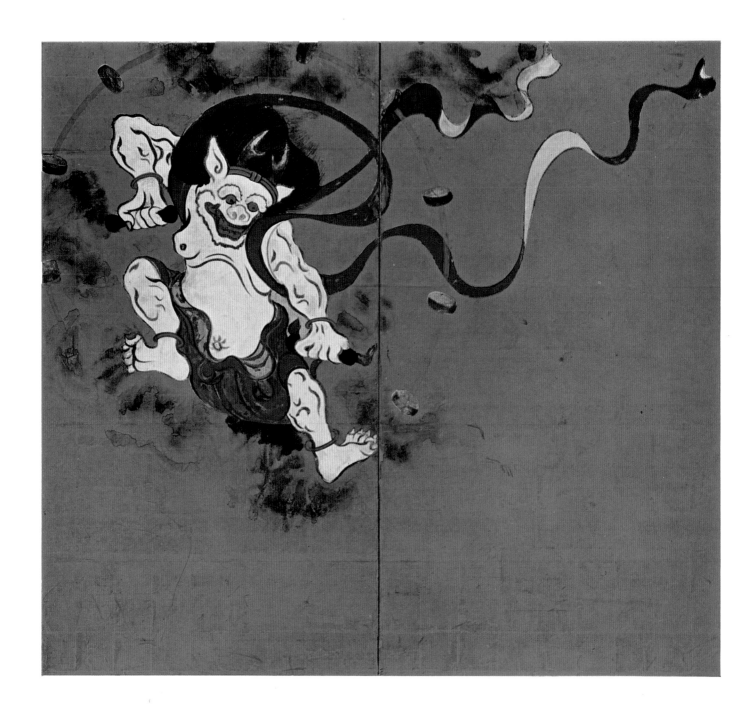

Pl. 314. Tawaraya Sōtatsu, Thunder God, screen, Edo period, early 17th cent. Color on gold paper, ht., 4 ft., 11¹/₈ in. Kyoto, Kenninji.

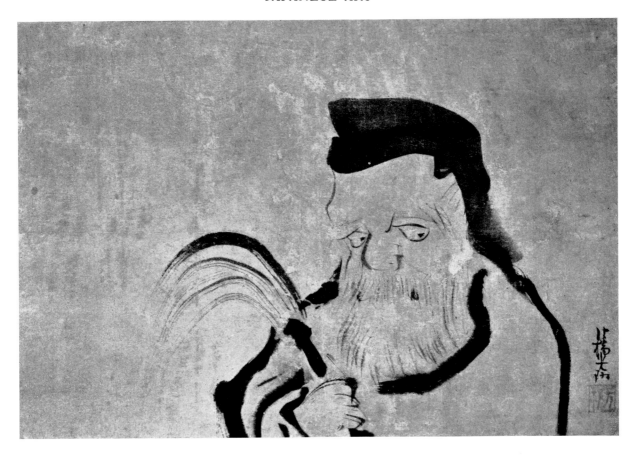

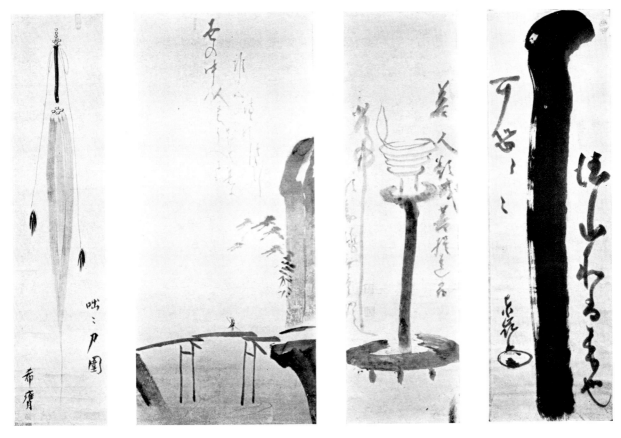

Pl. 315. Paintings of Zen Buddhist inspiration, Edo period. Ink on paper. *Above*: Ogata Kōrin, imaginary portrait of Yuima (Vimalakīrti). late 17th–early 18th cent., 14⁵/₈×20¹/₂ in. Tokyo, Mosaku Sorimachi Coll. *Below, left*: Takuan, The Fly Whisk, early 17th cent., 48⁷/₈×11¹/₈ in. Tokyo, Brasch Coll. *Two at center*: Hakuin, Landscape with Bridge (46³/₄×20⁵/₈ in.), and Oil Lamp (38¹/₂×11¹/₂ in.), 18th cent. Tokyo, Hosokawa and Hara Coll., and Shōinji. *Right*: Tōrei, The Walking Stick of Master Tē-shan, second half of 18th cent., 32⁵/₈×9⁷/₈ in. Numazu, Tanaka Coll.

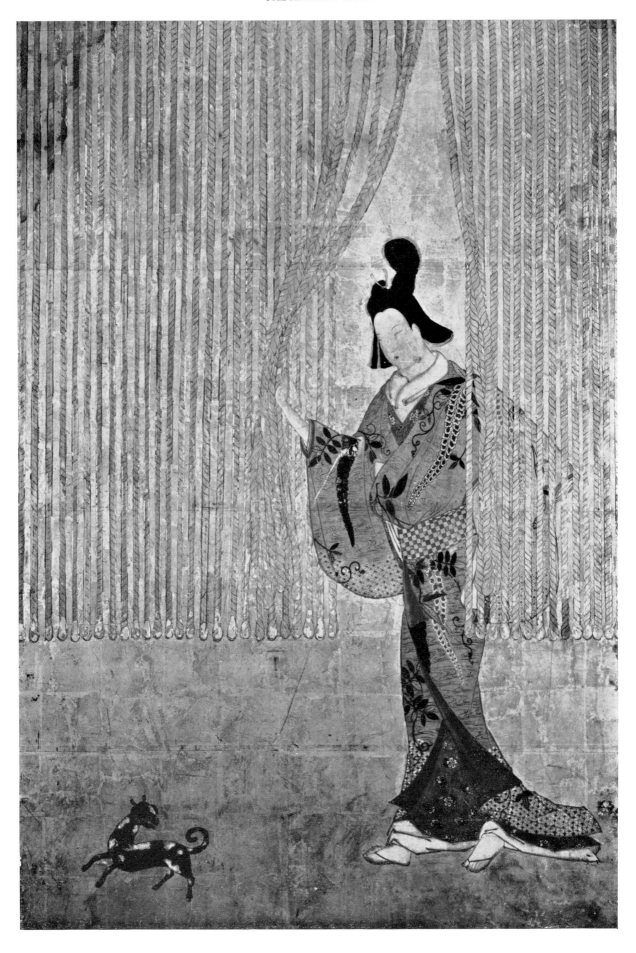

Pl. 316. The Rope Curtain, Edo period, 17th cent. Color on gold paper, 5 ft., 3³/₄ in. × 2 ft., 10¹/₄ in. Tokyo, Hara Coll.

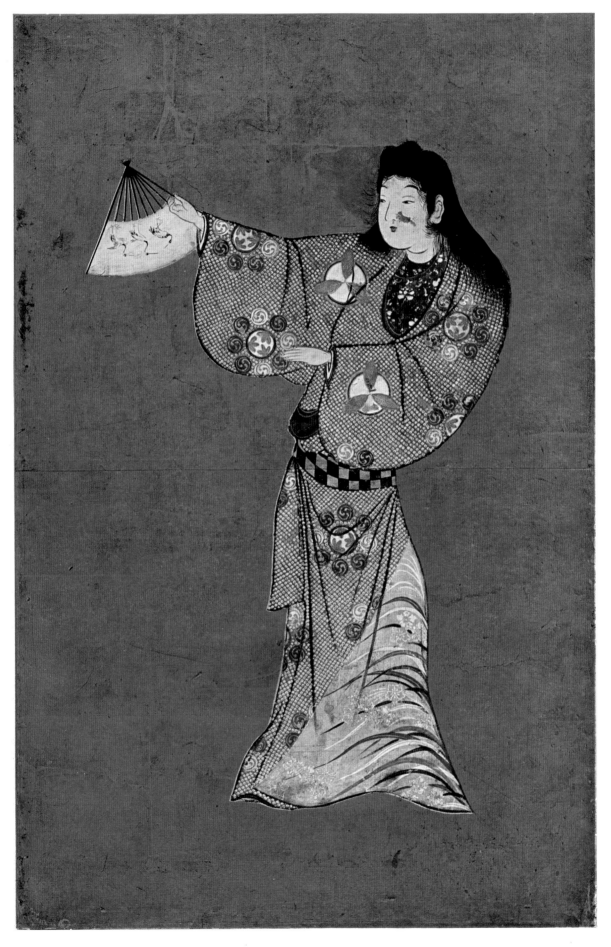

Pl. 317. Dancing girl, panel of a screen, Edo period, 17th cent. Color on gold paper, ht., 24³/₈ in. Kyoto, National Museum.

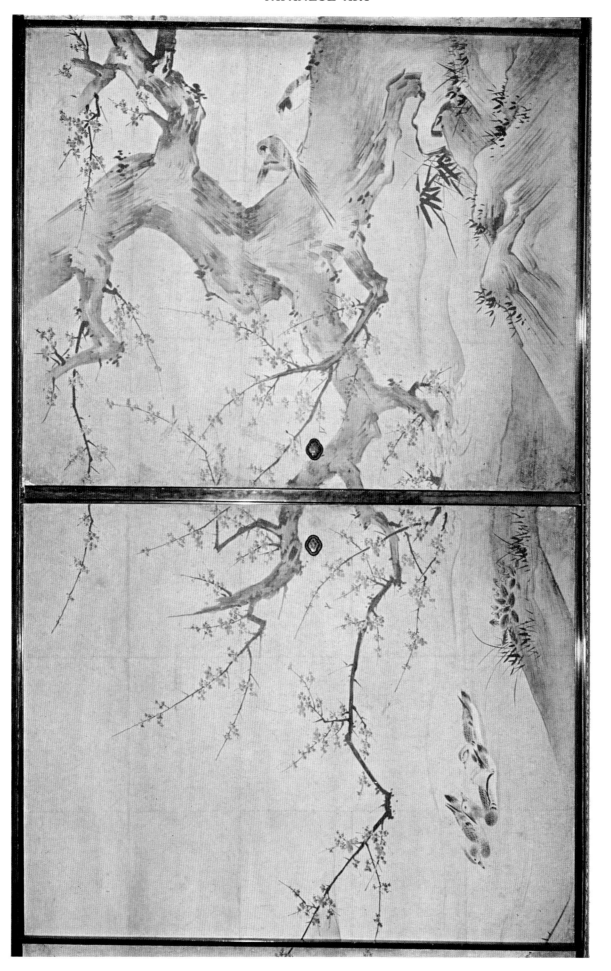

Pl. 318. Kanō Eitoku, plum tree by a stream, central panels of a sliding wall, Momoyama period, second half of 16th cent. Ink and faint color on paper, ht., 5 ft., 6⅞ in. Kyoto, Daitokuji, Jūkōin.

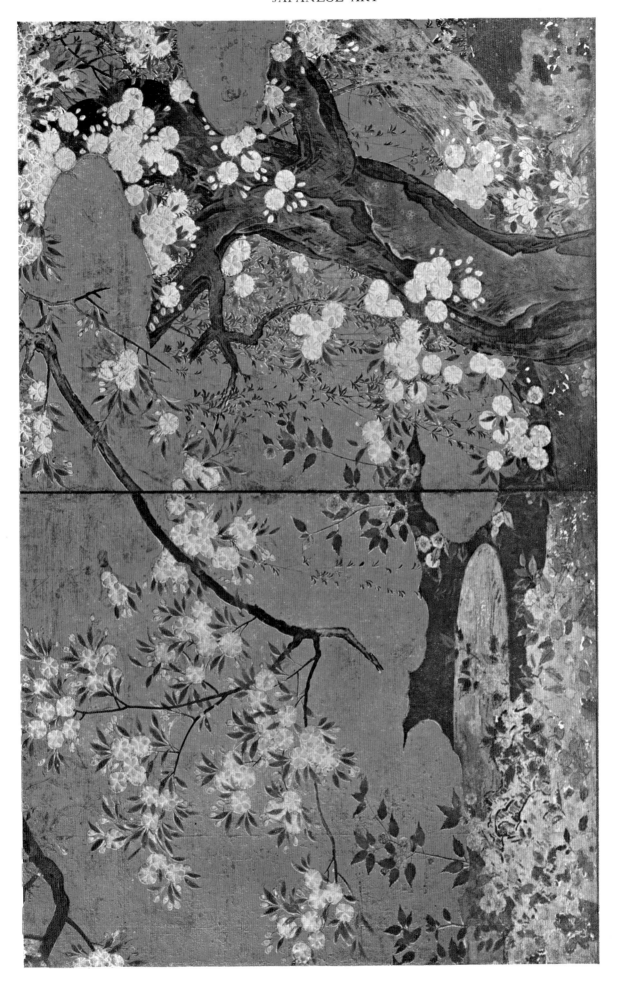

Pl. 319. Cherry blossoms, sliding wall panels, Momoyama period, ca. 1591. Color on gold paper, ht., 5 ft., 7³/₄ in. Kyoto, Chishakuin.

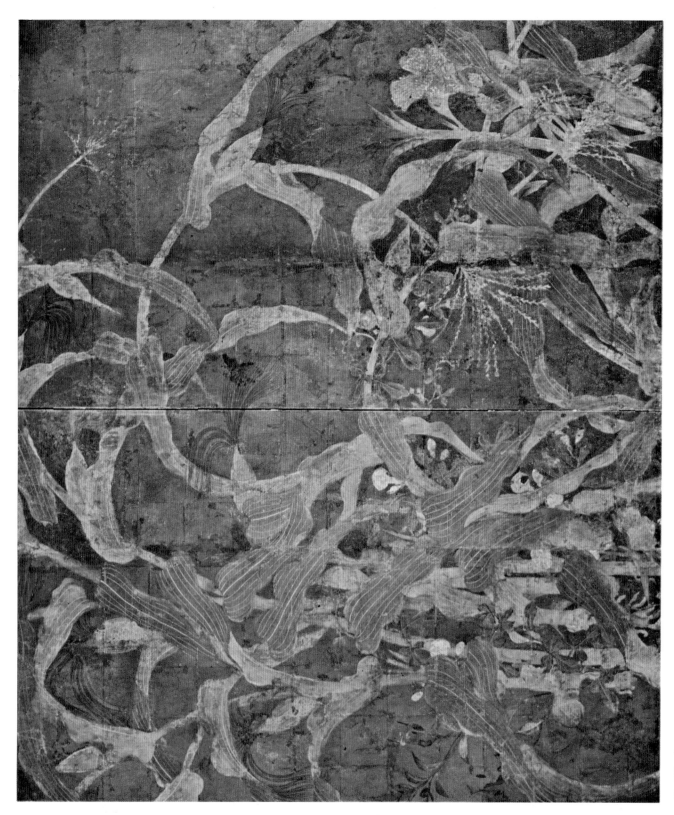

Pl. 320. Coxcombs, maize, and morning glories, screen. Momoyama period. Color on silver paper, 4 ft., 6 in. × 5 ft., 1¼ in. Washington, D.C., Freer Gallery of Art

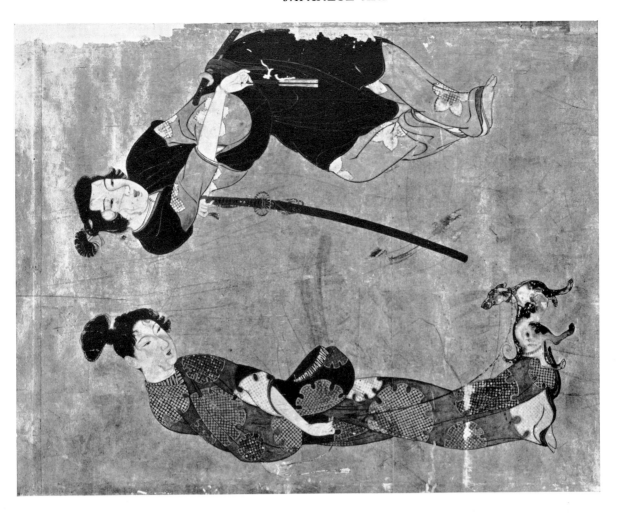

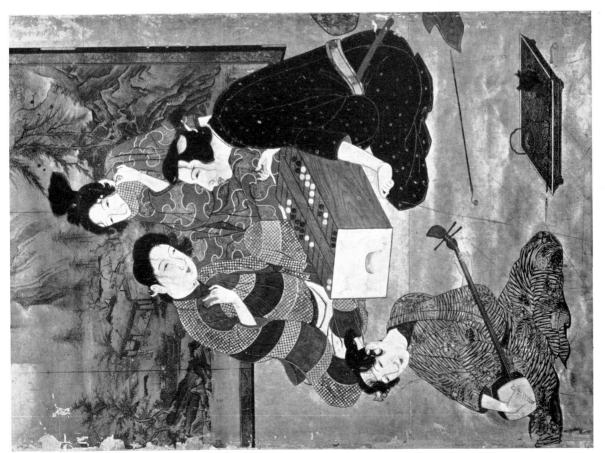

Pl. 321. Two panels of the Hikone screen, Edo period, first half of 17th cent. Color on gold paper; full size, 3 ft., 1/4 in. × 8 ft., 3 1/4 in. Hikone, Naosuke Ii Coll.

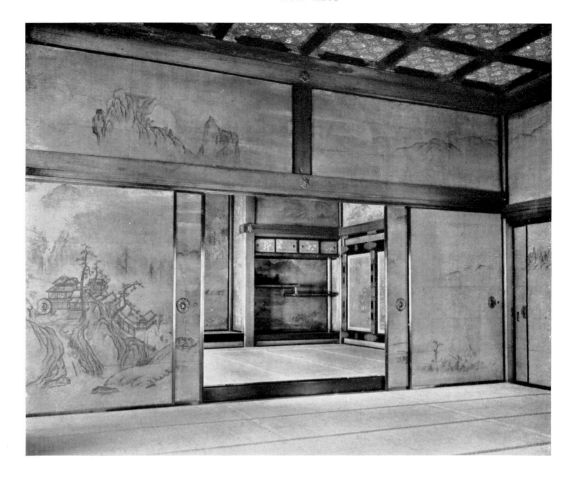

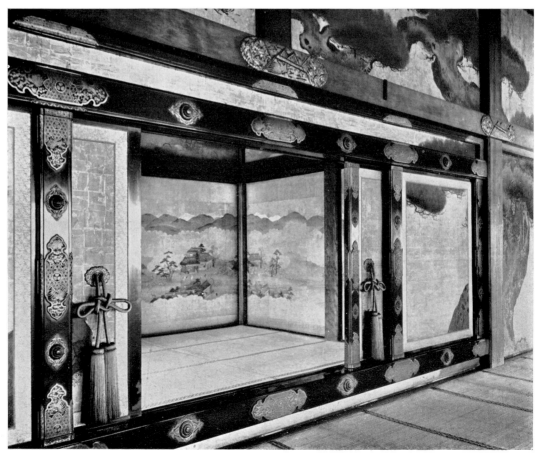

Pl. 322. Kyoto, Nijō castle, Edo period, 17th cent. *Above*: Detail of a room. *Below*: Room of the Shogun's guards.

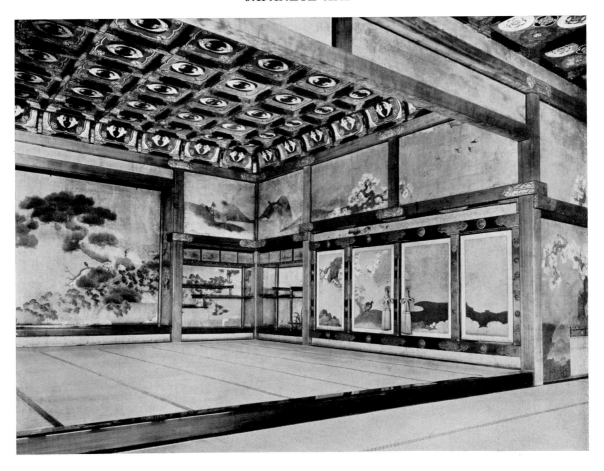

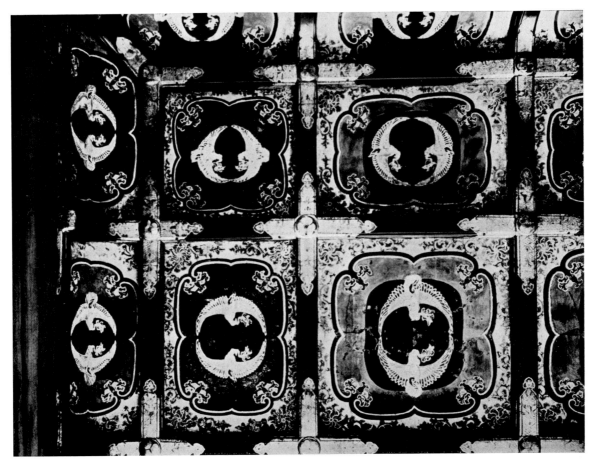

Pl. 323. Kyoto, Nijō castle, a room and detail of the ceiling, Edo period, 17th cent.

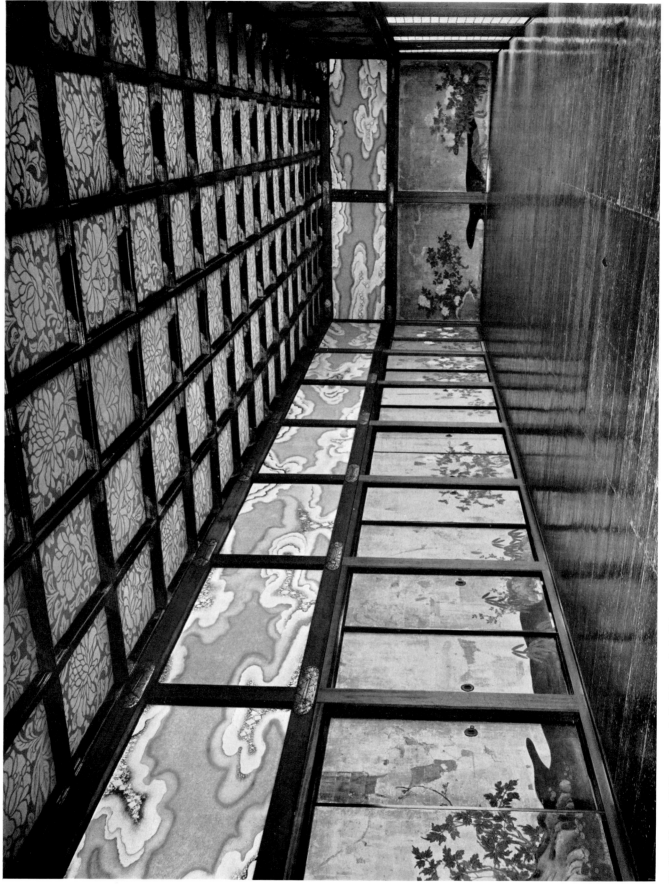

Pl. 324. Kyoto, Nijō castle, a hall, Edo period, 17th cent.

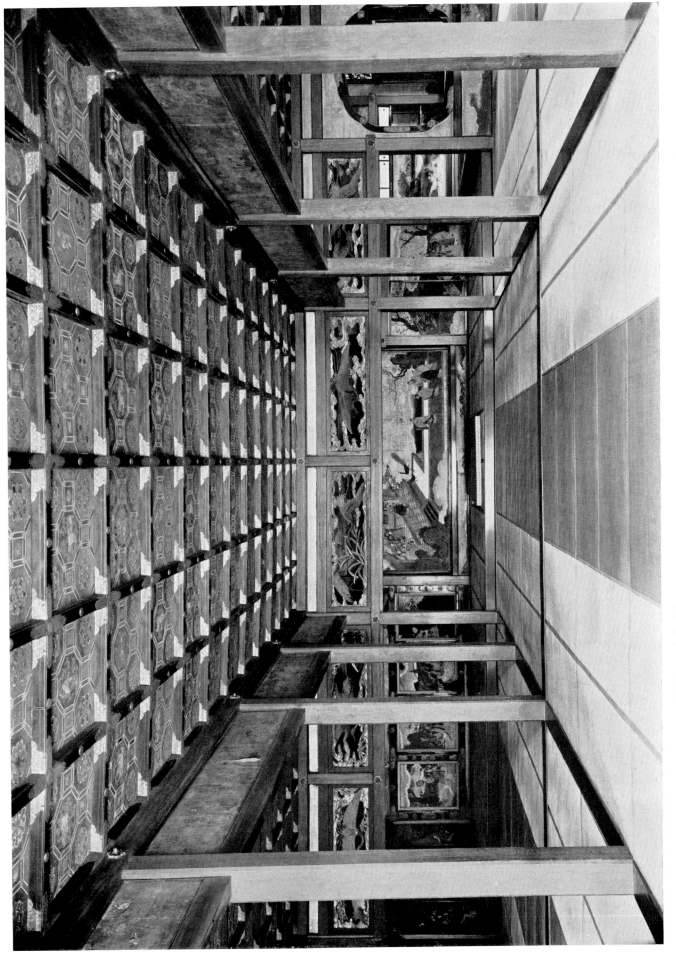

Pl. 325. Kyoto, Nishi Honganji, the Grand Hall, Edo period, 18th cent.

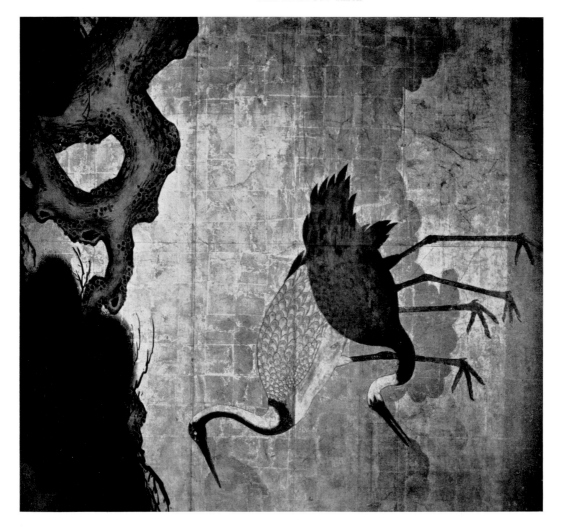

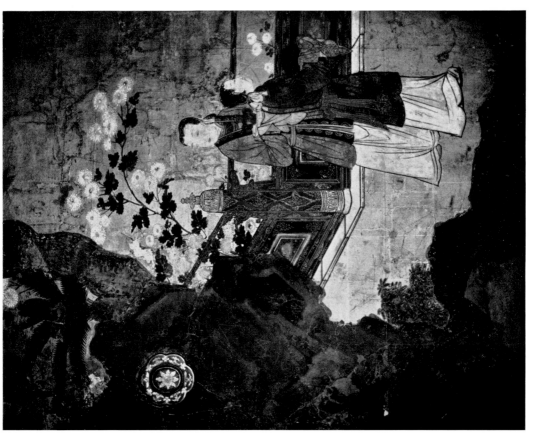

Pl. 326. Kyoto, Nishi Honganji, door panels, Edo period, 18th cent. Color on gold paper.

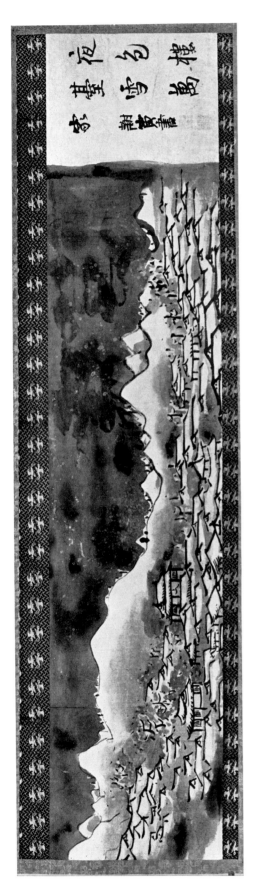

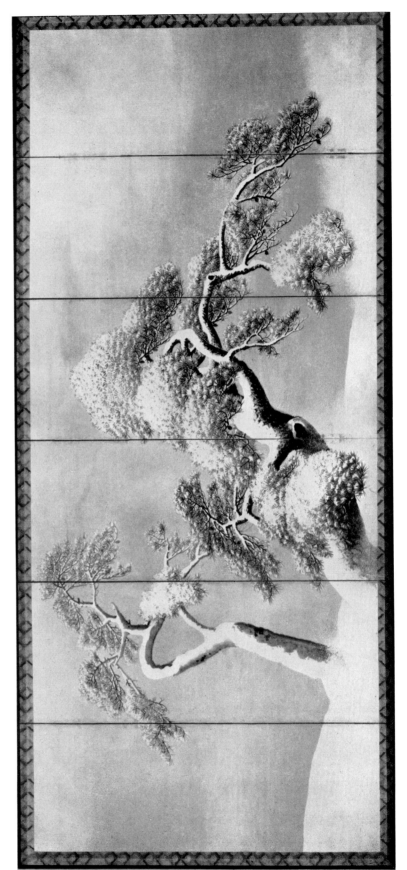

Pl. 327. *Above:* Yosa Buson, Snow Landscape, Edo period, second half of 18th cent. Ink and faint color on paper. Tokyo, Muto Coll. *Below:* Maruyama Ōkyo, Pine Trees in Snow, screen, Edo period, second half of 18th cent. Color on paper, 4 ft., 11 ft., 5¾ in. Tokyo, Mitsui Coll.

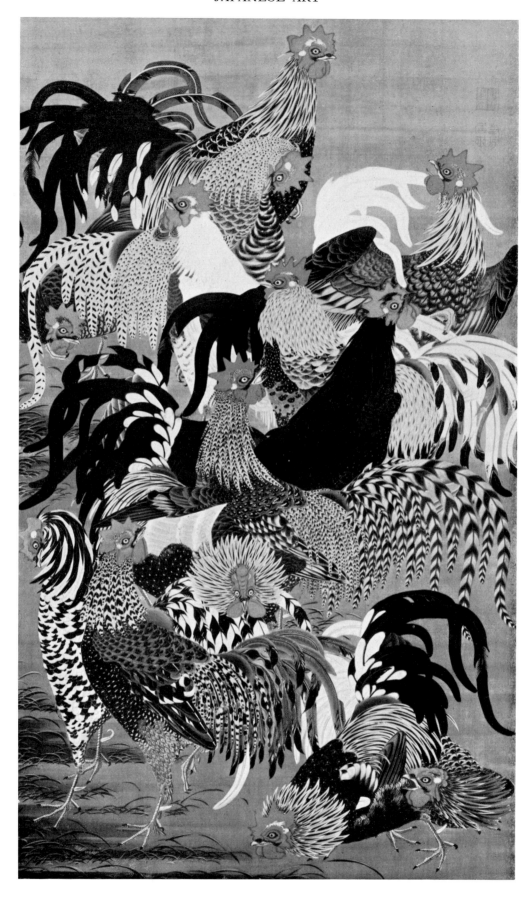

Pl. 328. Itō Jakuchū, Roosters, Edo period, second half of 18th cent. Color on silk. Tokyo, National Museum.

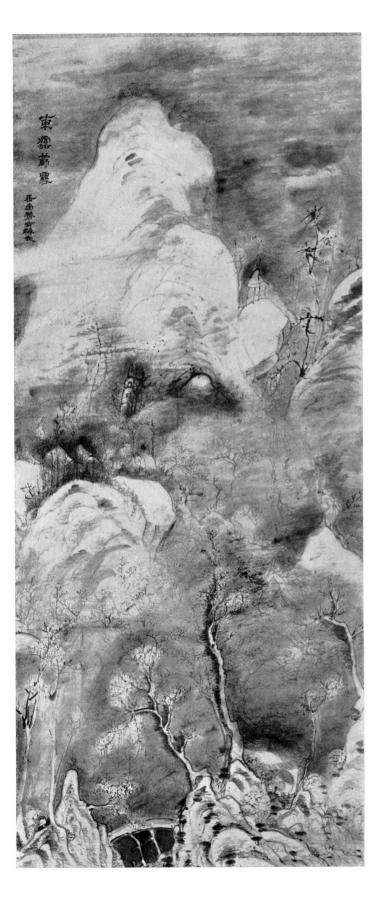 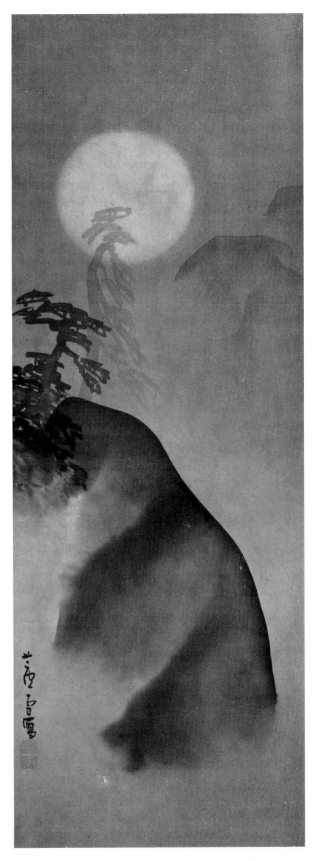

Pl. 329. *Left*: Uragami Gyokudō, Icy Clouds Sift Floury Snow, Edo period, late 18th–early 19th cent. Ink and faint color on paper. Kamakura, Kanagawa prefecture, Kawabata Coll. *Right*: Nagasawa Rosetsu, Moonlit Landscape, Edo period, late 18th cent. Ink and faint color on paper. Tokyo, Nagao Museum.

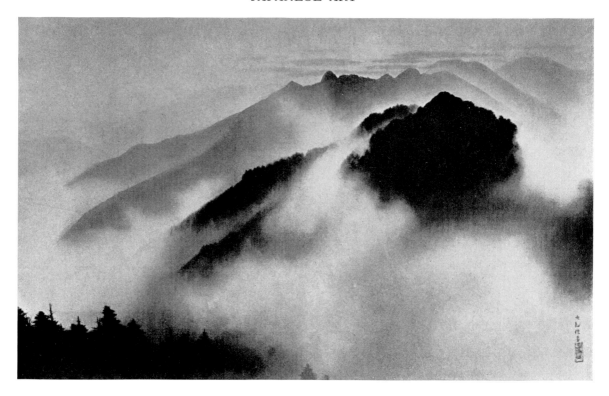

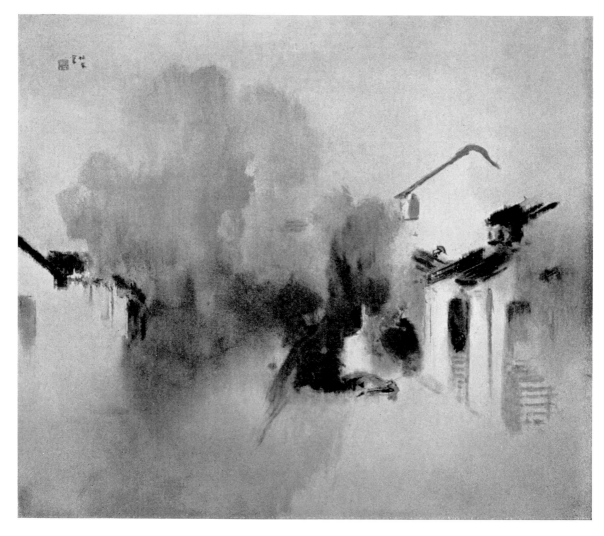

Pl. 330. *Above*: Yokoyama Taikan, The Chichibu Mountains at Dawn in Spring, 19th–20th cent. Ink and gold on silk, 25⁵/₈×43¹/₄ in. Tokyo, Princess Chichibu Coll. *Below*: Takeuchi Seihō, Rain at Soshu, 19th–20th cent. Ink on silk, 4 ft., 6 in. × 6 ft., 1⁵/₈ in. Paris, Musée d'Art Moderne.

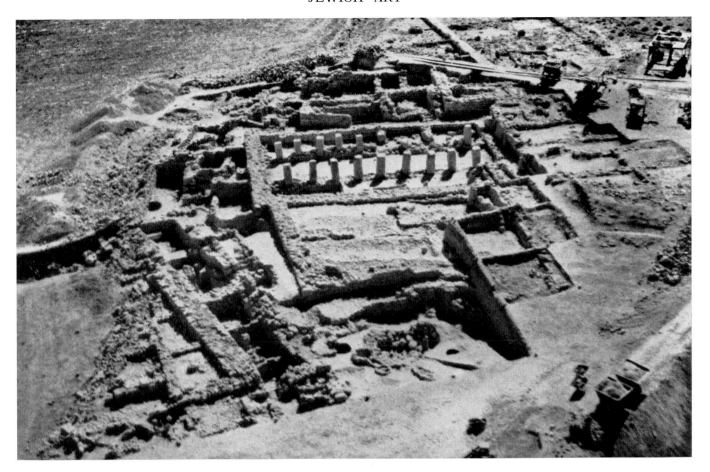

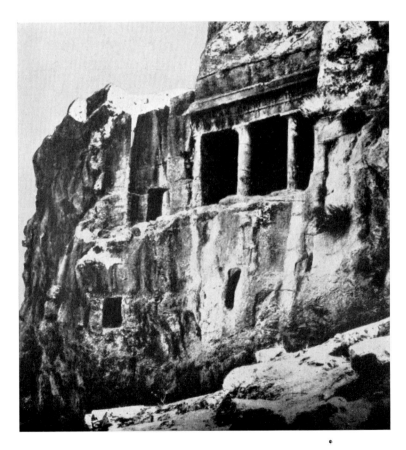

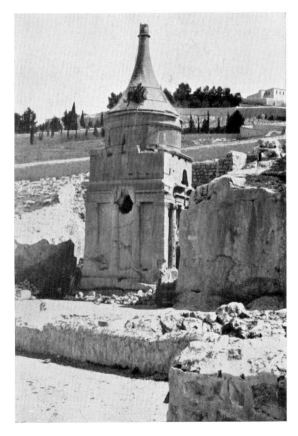

Pl. 331. *Above*: Hazor, Israel, remains of columned hall, 9th cent. B.C. *Below*: Valley of the Kidron, near Jerusalem. *Left*: Tomb of the Beni Hezir, 100–50 B.C. *Right*: "Tomb of Absalom," early 1st cent.

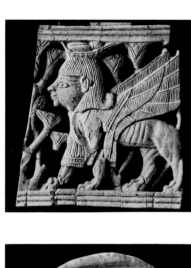 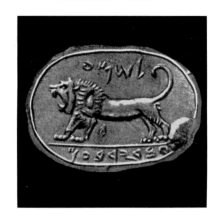

 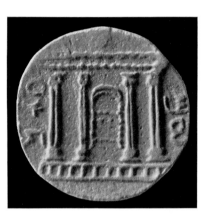 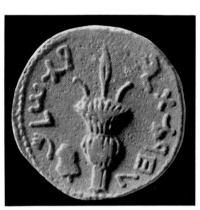

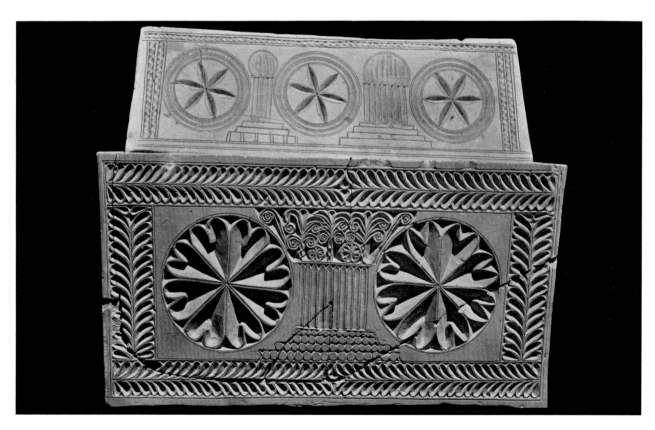

Pl. 332. *Above, left*: Ivory plaque with sphinx, from Samaria, 9th cent. B.C. Jerusalem, Palestine Archaeological Museum. *Center and right*: Two impressions from Palestinian seals, 8th–7th cent. B.C. Roaring lion (*center*). Formerly, Istanbul, Archaeological Museums. Sacrificial scene (*right*). Jerusalem, Reifenberg Coll. *Center, left*: Judean coin from Beth-zur, Jordan, late 4th cent. B.C. Silver, diam., ca. ¹/₄ in. Jerusalem, Palestine Archaeological Museum. *Middle and right*: Tetradrachma of Bar Kokhba, reverse and obverse. Silver, diam., 1¹/₈ in. A.D. 132–35. *Below*: Ossuary, from a tomb near Jerusalem, 1st cent. B.C.–1st cent. Limestone, l., 23⁵/₈ in. Last two objects, Jerusalem, Hebrew University Coll.

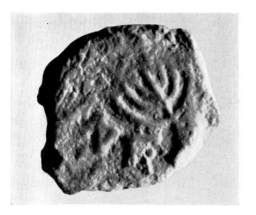
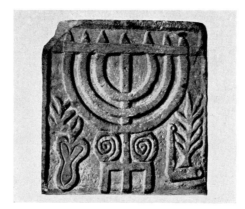
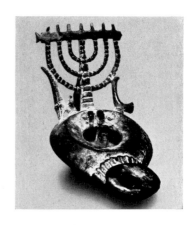

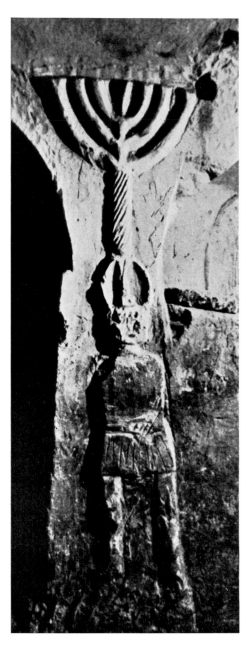
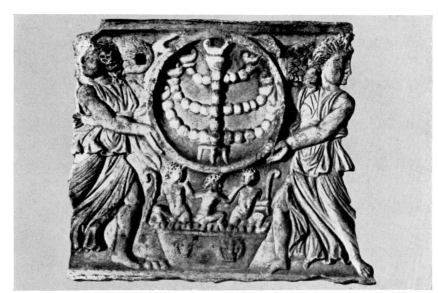

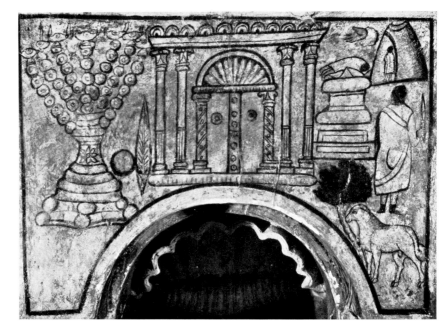

Pl. 333. Representations of the seven-branched candlestick (Menorah). *Above, left*: Hasmonean coin of Antigonos Mattathias, 40–37 B.C. Bronze, diam., ⁵/₈ in. Jerusalem, Hebrew University Coll. *Center*: Relief, from Priene, 3d–4th cent. Marble, ht., 24¹/₄ in. Berlin, Staatliche Museen. *Right*: Oil lamp, from Syria, 4th cent. Bronze. Beirut, Lebanon, American University, Museum of Archaeology. *Below, left*: Figure holding the candlestick, 1st–2d cent. Rock relief. Catacomb at Beth Shearim, Israel. *Right, center*: Fragment of a sarcophagus from the Vigna Rondanini, Rome. Marble, ht., 28³/₈ in. Rome, Museo Nazionale Romano. *Right, below*: Decorative panel from above the niche of the Torah shrine in the Synagogue at Dura-Europos, Syria, ca. 250. Wall painting. Damascus, National Museum.

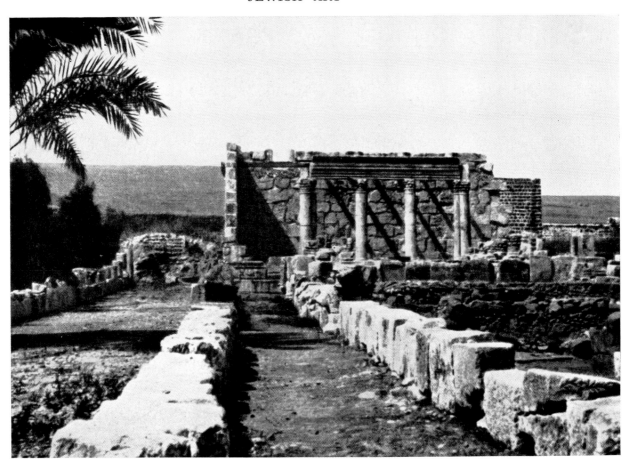

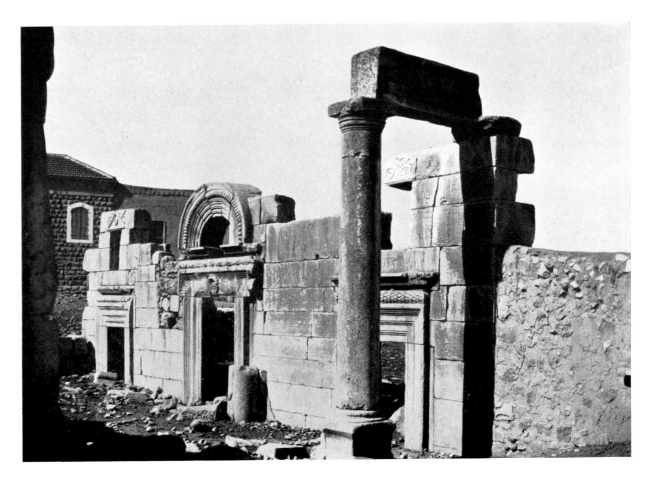

Pl. 334. *Above*: Capernaum, Israel, ruins of the Synagogue, 2d–3d cent. *Below*: Kfar Birim, Israel, façade of the Synagogue, 3d cent.

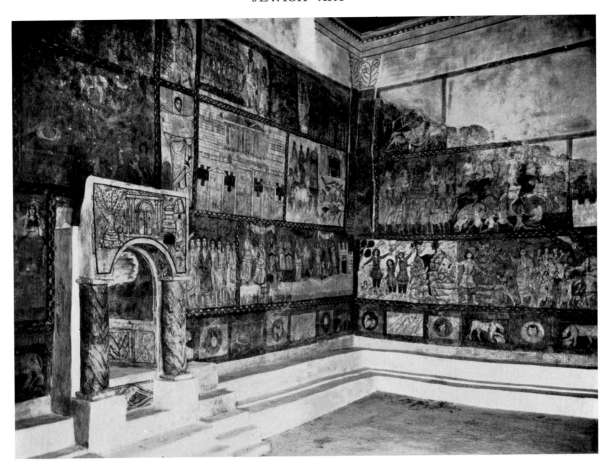

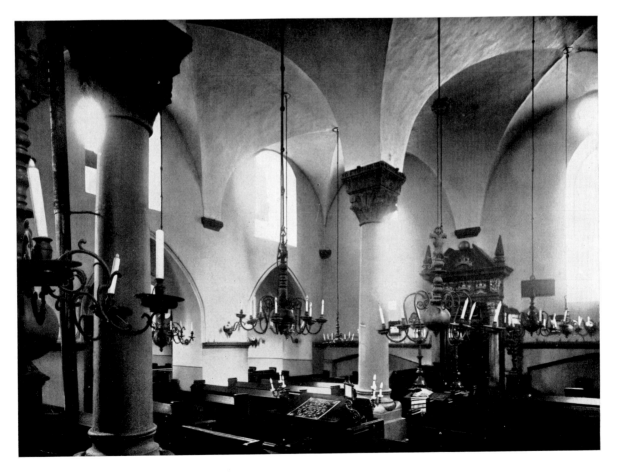

Pl. 335. *Above*: Detail of reconstruction of the interior of the Synagogue at Dura-Europos, Syria, ca. 250. Damascus, National Museum. *Below*: Worms, Germany, interior of the Synagogue, 1034 with 13th-cent. additions.

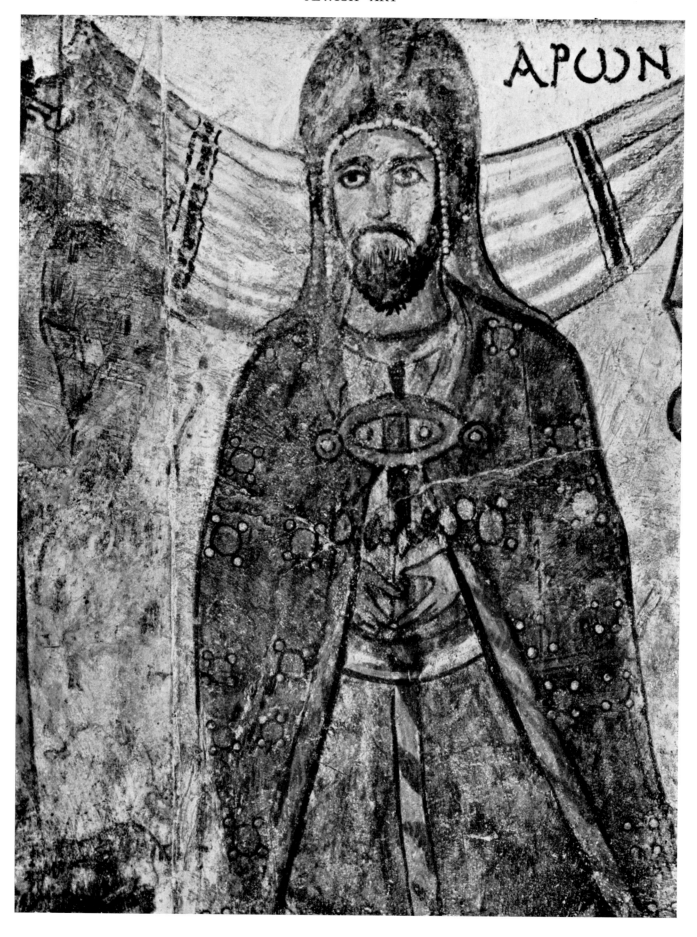

Pl. 336. Consecration of the Tabernacle, detail of wall painting from the Synagogue at Dura-Europos, Syria, ca. 250. Damascus, National Museum.

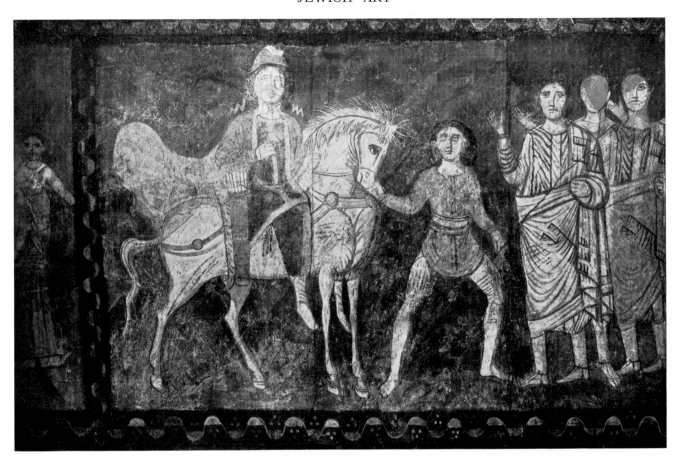

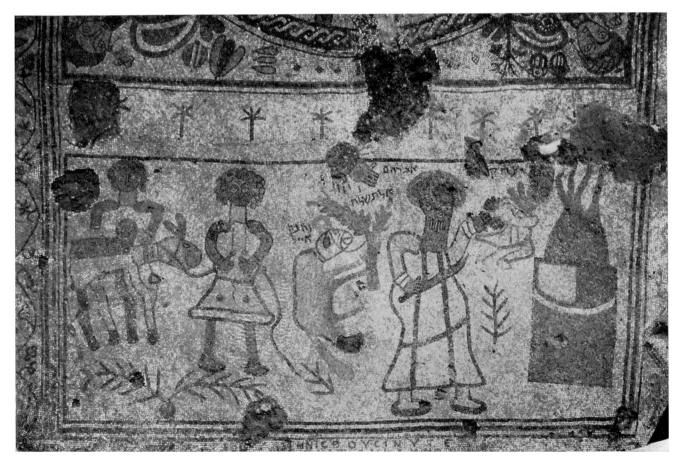

Pl. 337. *Above*: Haman and Mordecai, detail of wall painting from the Synagogue at Dura-Europos, Syria, ca. 250. Damascus, National Museum. *Below*: Sacrifice of Abraham, detail of floor mosaic from the Synagogue at Beth Alpha, Israel, 6th cent.

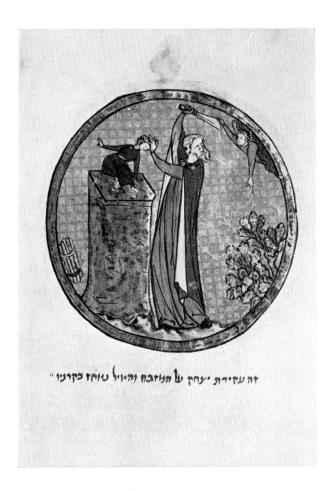

זה עקידת יצחק על המזבח והיול טואוד בקרויו "

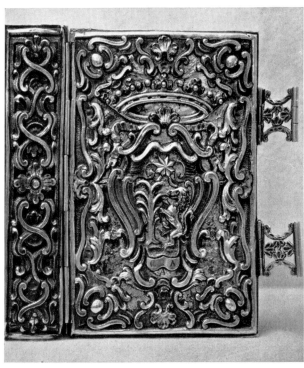

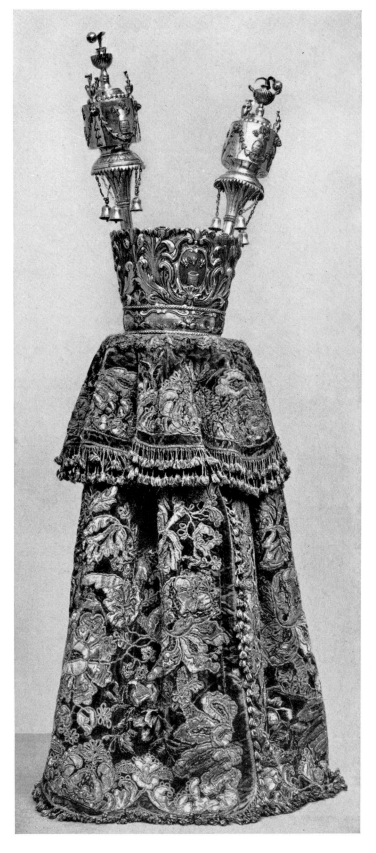

Pl. 338. *Left, above*: Sacrifice of Abraham, 14th cent. Miniature. London, British Museum (Ms. Add. 11639, fol. 521v). *Below*: L. Rota, spine and front cover of a Jewish Bible, 18th cent. Silver. Rome, Museo di Palazzo Venezia. *Right*: *Rimmonim, Keter*, and *Mappah* (ornaments and case for the Scroll of the Law), from Rome, 18th cent. Silver and embroidered velvet. Rome, private collection.

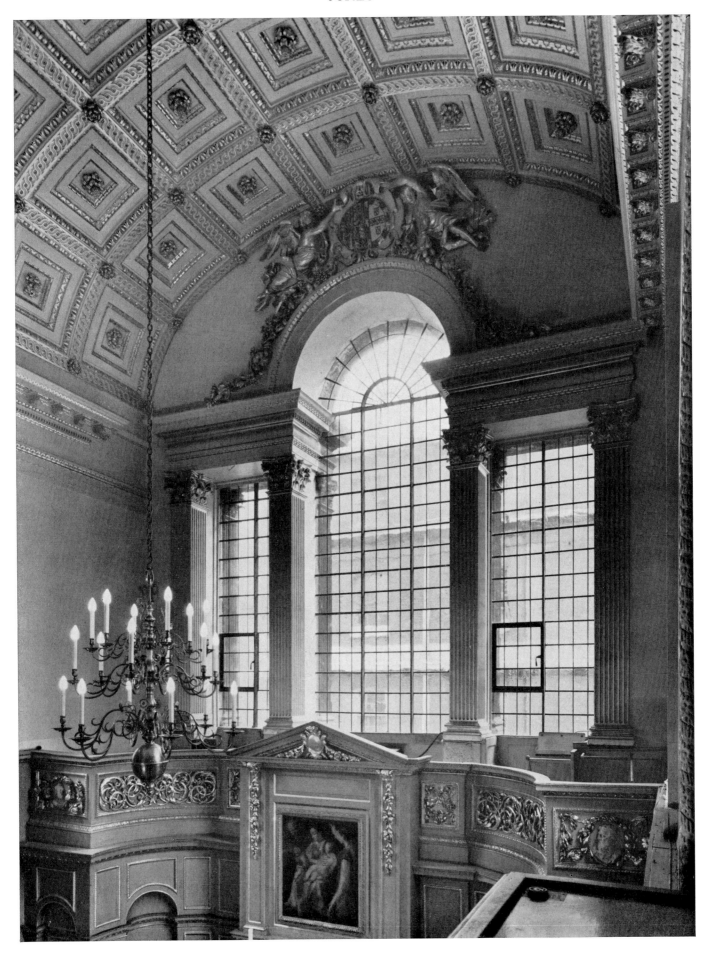

Pl. 339. London, St. James's Palace, interior detail of the Queen's Chapel.

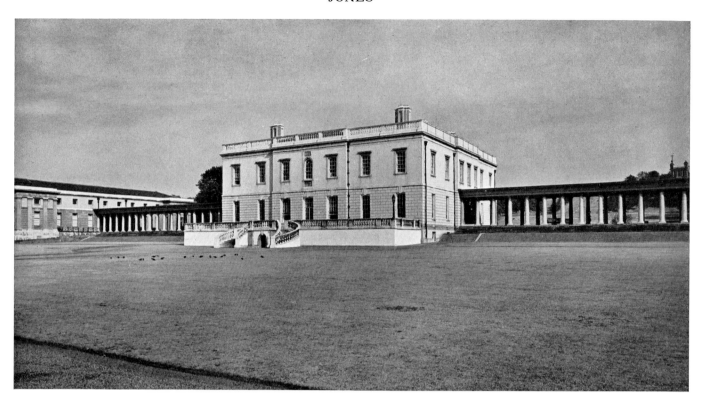

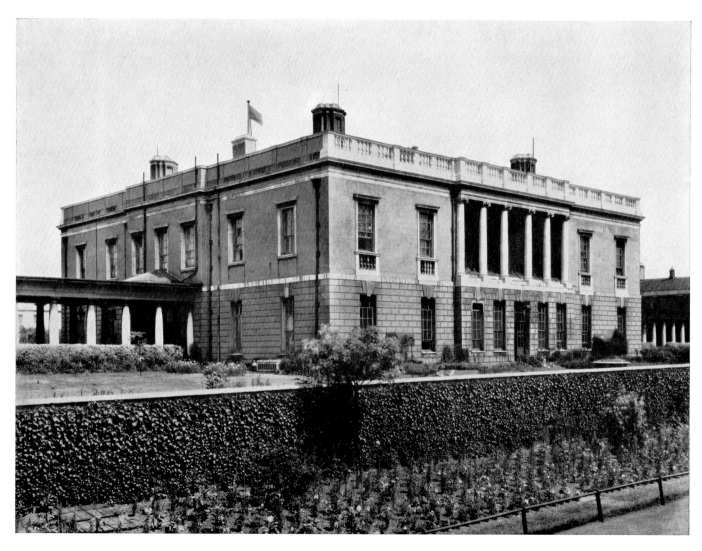

Pl. 340. London, the Queen's House, Greenwich. *Above*: North front. *Below*: South front.

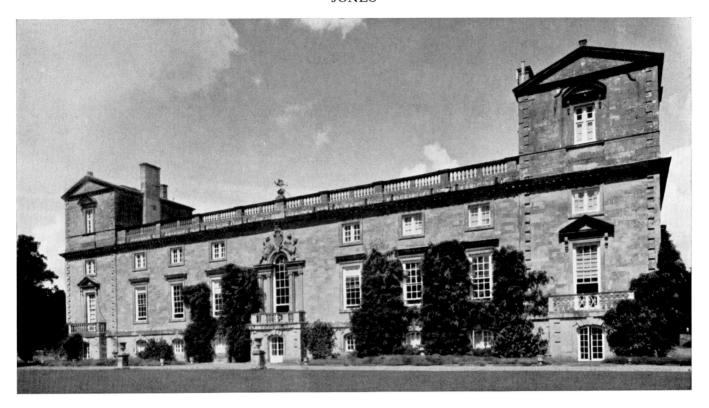

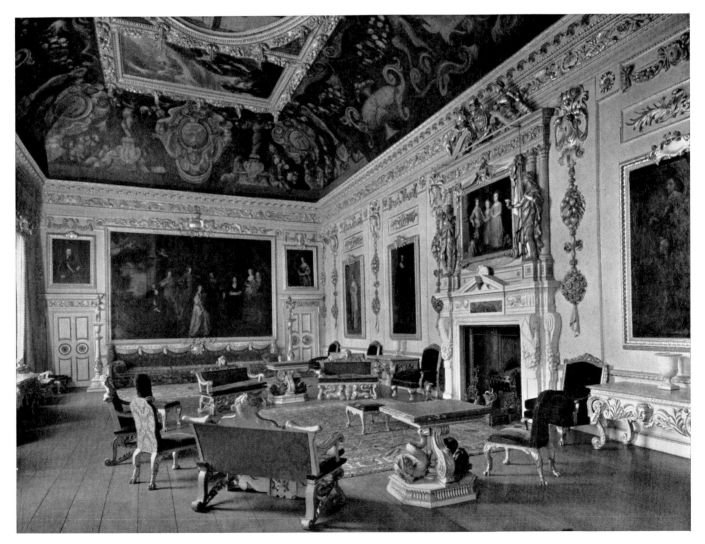

Pl. 341. Wilton House, Wilton, Wiltshire. *Above*: South front. *Below*: "Double Cube Room."

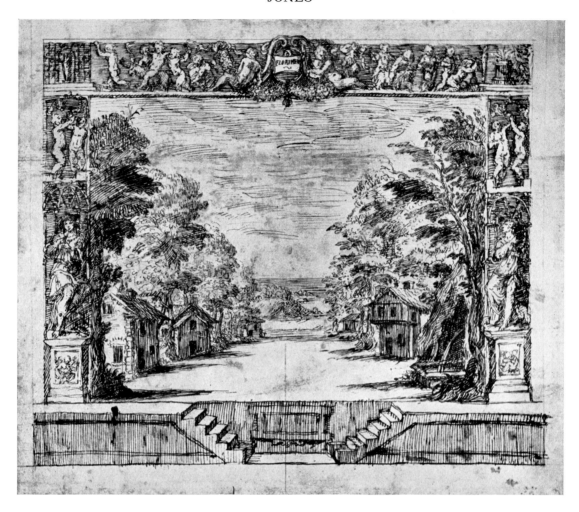

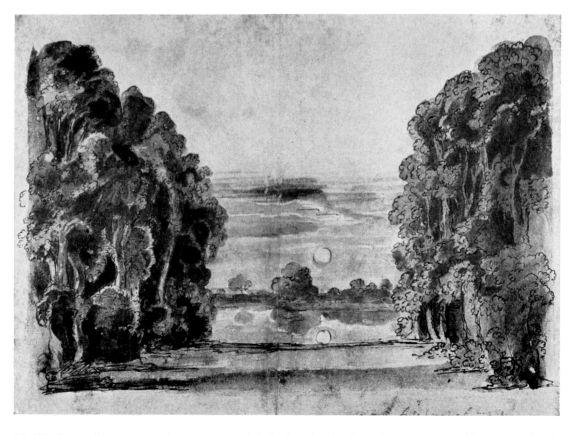

Pl. 342. Scenes for masques. Pen and brown ink. Derbyshire, England, Trustees of the Chatsworth Settlement. *Above*: *Florimene*, 1635, 11³/₄×13⁷/₈ in. *Below*: *Luminalia*, Scene 1, Night, 1638, 10³/₈×14¹/₂ in.

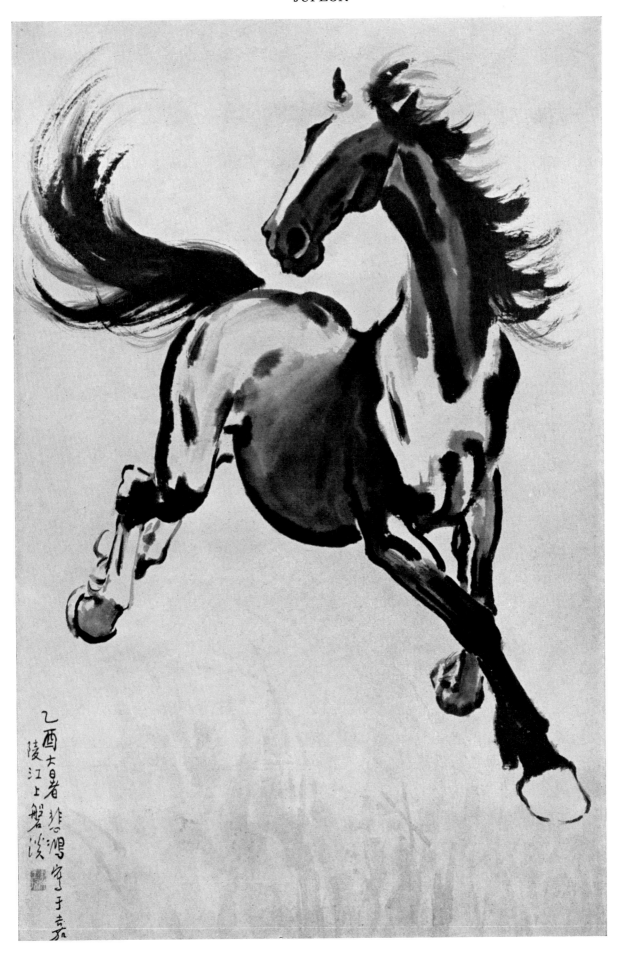

Pl. 343. Horse. Ink on paper. Peking, Jupéon Museum.

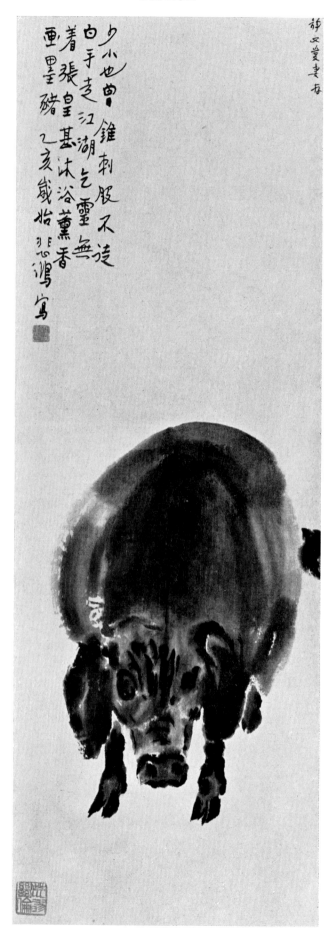

少小也曾錐刺股不逡
白手走江湖乞靈無
著張皇其沐浴薰香
亞墨豬
乙亥歲始悲鴻寫

Pl. 344. Pig. Ink on paper. Peking, Jupéon Museum.

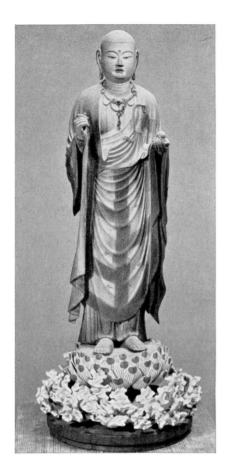

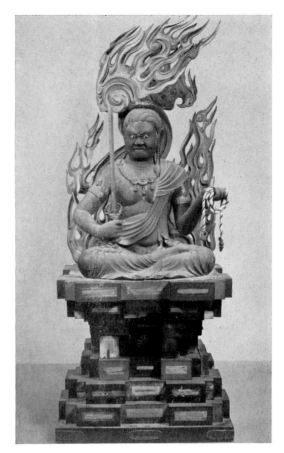

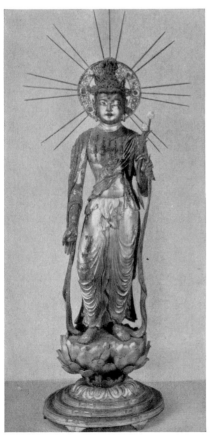

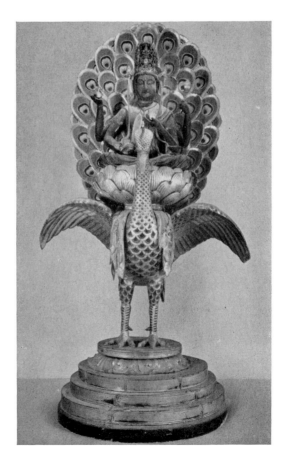

Pl. 345. *Left, above*: Jizō Bosatsu. Painted wood, ht., 37³/₈ in. *Below*: Miroku Bosatsu. Painted wood, ht., 4 ft., 3¹/₈ in. Both, Nara, Tōdaiji. *Right, above*: Fudō Myōō. Painted wood, ht., 4 ft., 2 in. Kyoto, Sambōin. *Below*: Kujaku Myōō. Painted wood, ht., 7 ft., 8¹/₂ in. Kōyasan, Wakayama prefecture, Kongōbuji.

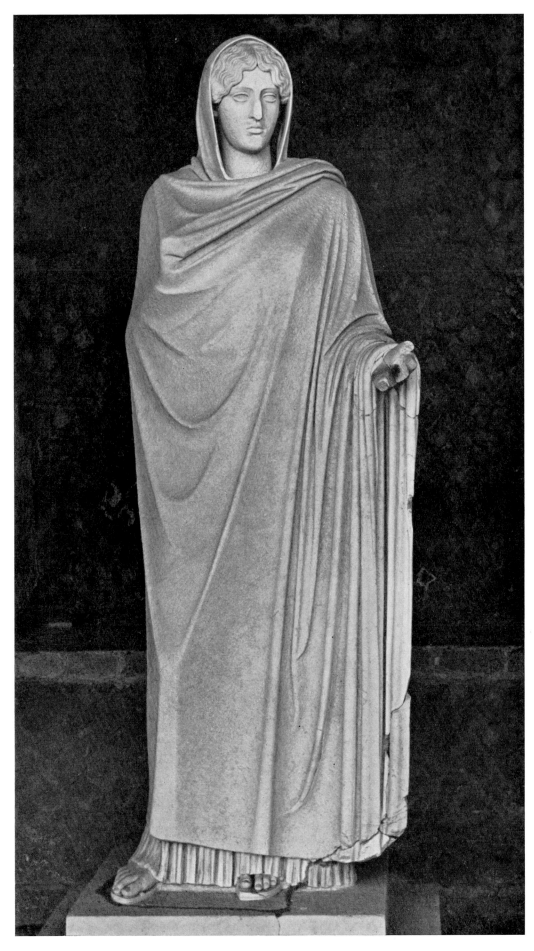

Pl. 346. So-called "Sosandra," Roman copy, early 3d cent. B.C. Marble, ht., ca. 6 ft. Baia, Italy, Terme Romane.

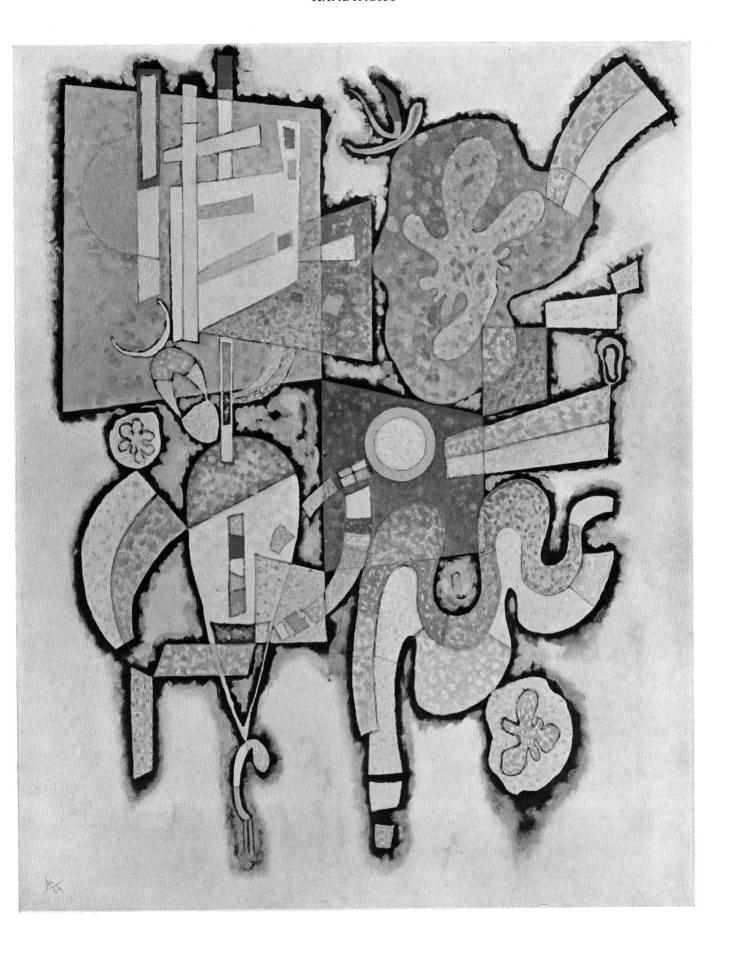

Pl. 347. Ambiguity (Complex-Simple). Canvas, $39\,^3/_8 \times 31\,^7/_8$ in. Paris, Musée d'Art Moderne.

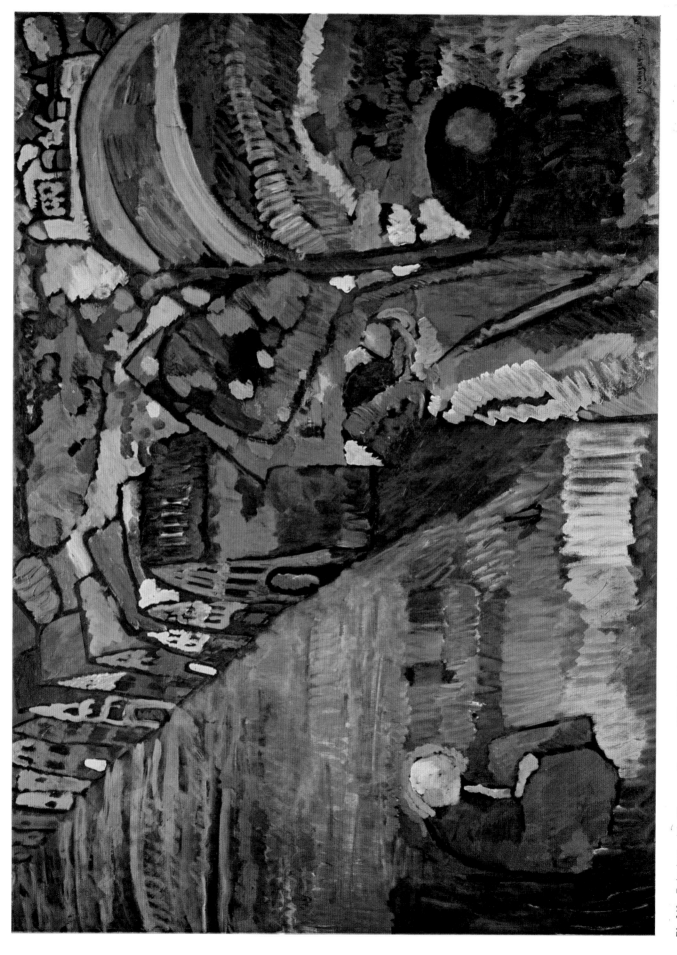

Pl. 348. Painting with Houses. Canvas, 38$^{1}/_{4}$×51$^{5}/_{8}$ in. Amsterdam, Stedelijk Museum.

KANDINSKY

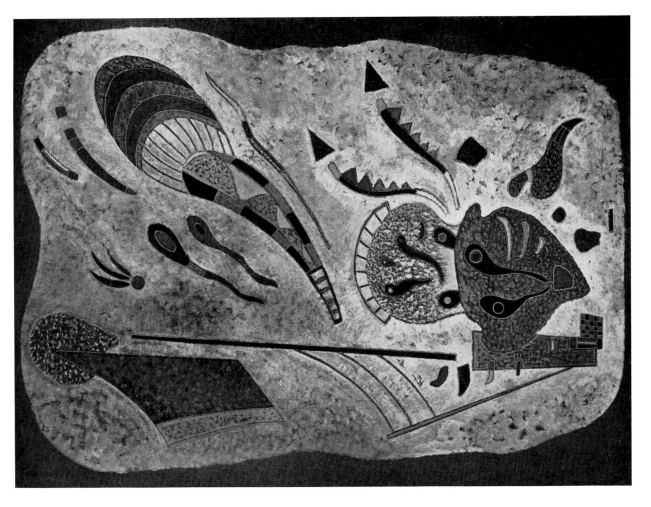

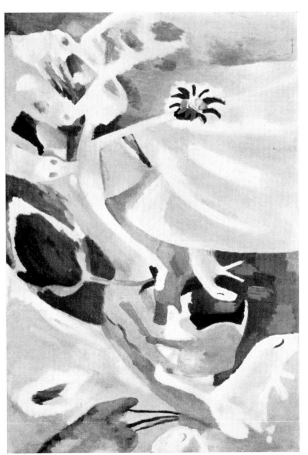

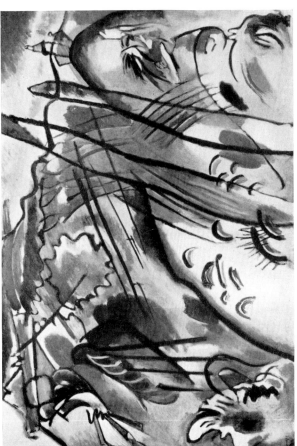

Pl. 349. *Left, above:* Pastorale. Canvas, 41⁷/₈×61³/₄ in. *Below:* Improvisation 28. Canvas, 44×63³/₄ in. *Right:* Twilight. Oil on cardboard, 22³/₄×16¹/₂ in. All, New York, Solomon R. Guggenheim Museum.

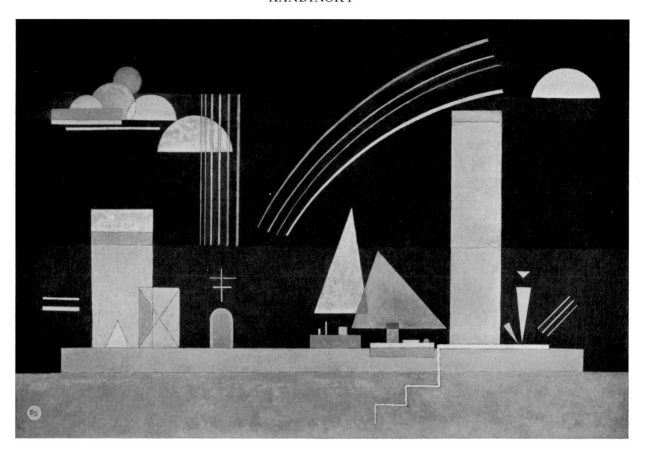

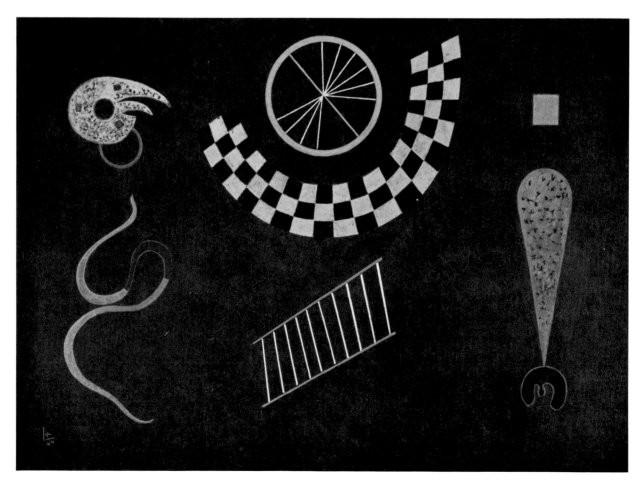

Pl. 350. *Above*: Calm. Canvas, $20^1/_2 \times 30^7/_8$ in. *Below*: Ribbon with Squares. Gouache and oil on cardboard, $16^1/_2 \times 22^3/_4$ in. Both, New York, Solomon R. Guggenheim Museum.

KANŌ SCHOOL

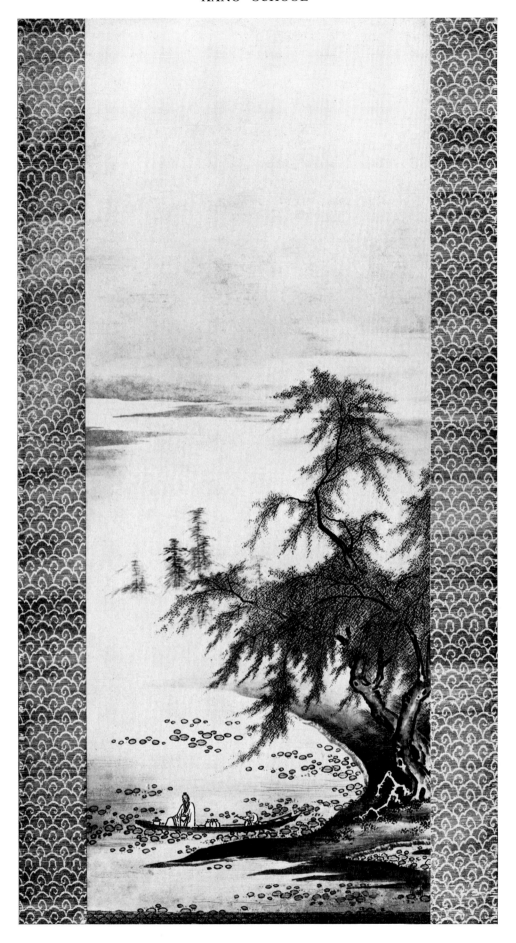

Pl. 351. Kanō Masanobu (1434–1530?), Chou Mao-shu Admiring Lotus Flowers. Ink and faint
color on paper, 35³/₈×12⁵/₈ in. Tokyo, National Museum.

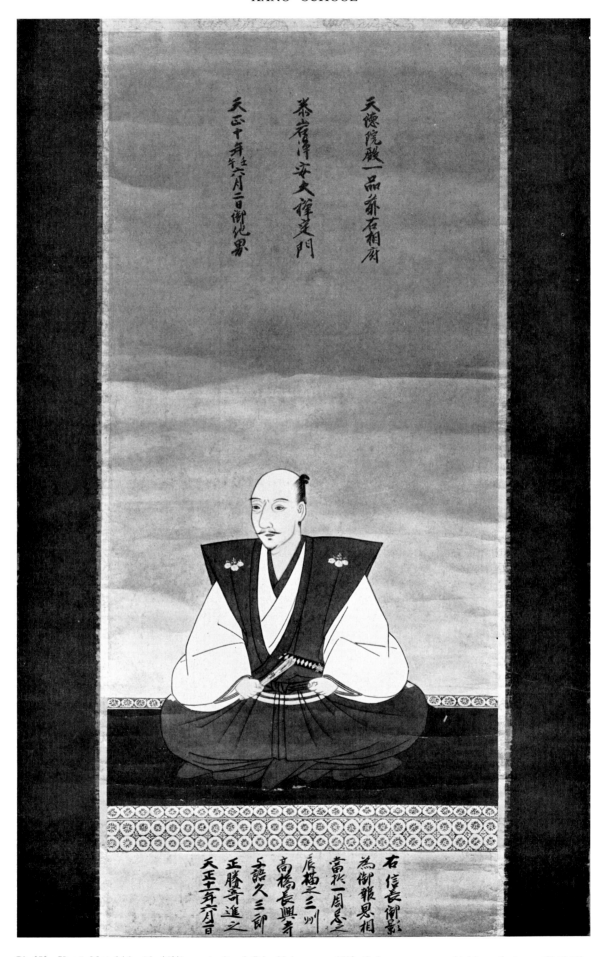

Pl. 352. Kanō Motohide (d. 1601), portrait of Oda Nobunaga, 1583. Color on paper. Aichi prefecture, Chōkōji.

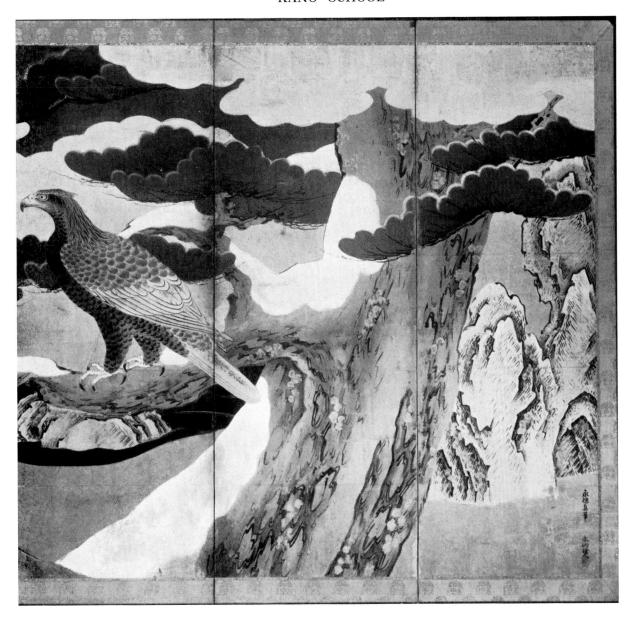

Pl. 353. *Above*: Kanō Eitoku (1543–90), Hawk on a Pine Tree, half of a six-panel folding screen. Color on paper. Tokyo, University of Arts. *Below*: Kanō Tanyū (1602–74), Peonies. Ink on paper. Tokyo, National Museum.

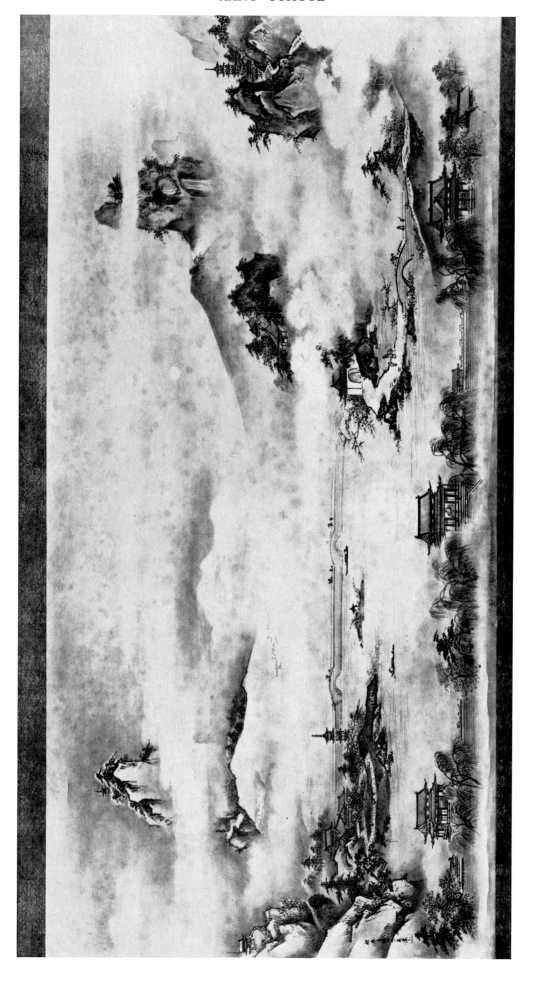

Pl. 354. Kanō Tanyū (1602–74), Lake of Zihu. Color on paper. Tokyo, Hatakeyama Hazukiyo Coll.

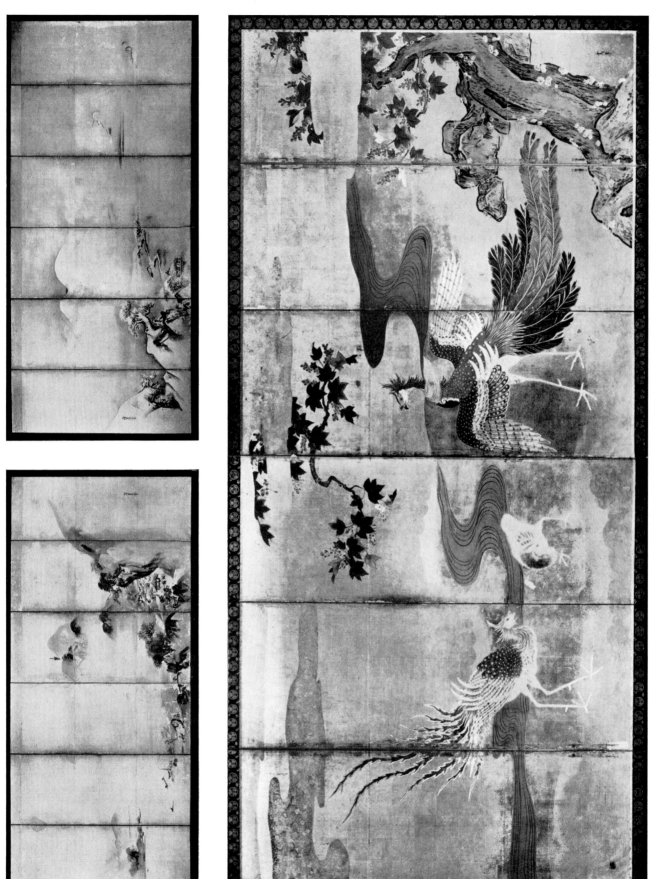

Pl. 355. *Above:* Kanō Naonobu (1607–50), Landscape, pair of folding screens. Ink on paper. Tokyo, National Museum. *Below:* Kanō Tsunenobu (1636–1713), A Paulownia and Chinese Phoenixes. Folding screen. Color on paper. Tokyo, University of Arts.

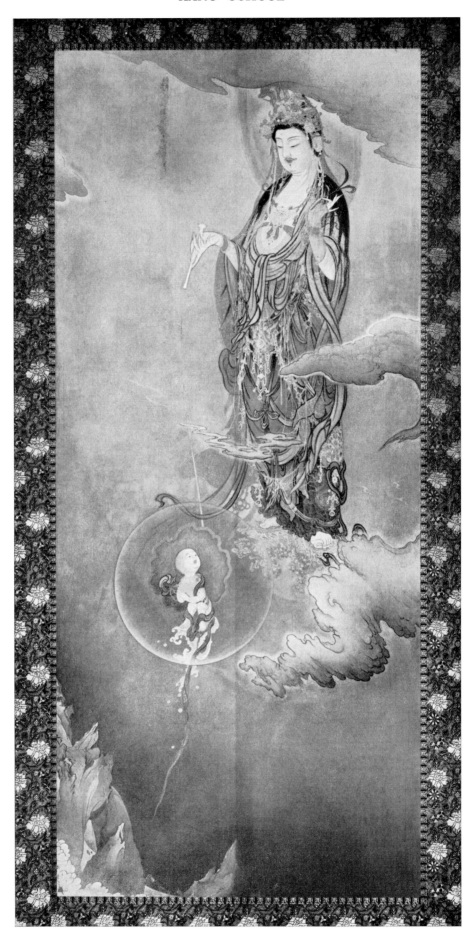

Pl. 356. Kanō Hōgai (1828–88), Kwannon. Color on silk, 6 ft., 3½ in. × 2 ft., 10 in. Tokyo, University of Arts

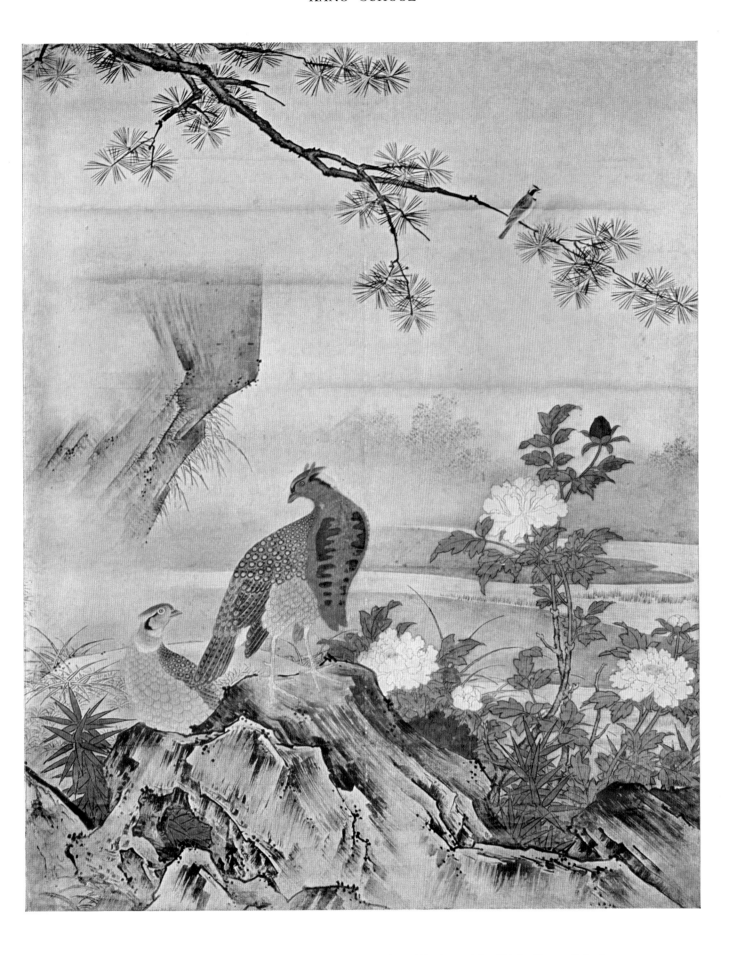

Pl. 357. Kanō Motonobu (1476–1559), Flowers and Birds. Sliding door, 5 ft., $10^{1}/_{8}$ in. × 4 ft., $8^{1}/_{4}$ in. Kyoto, Reiunin.

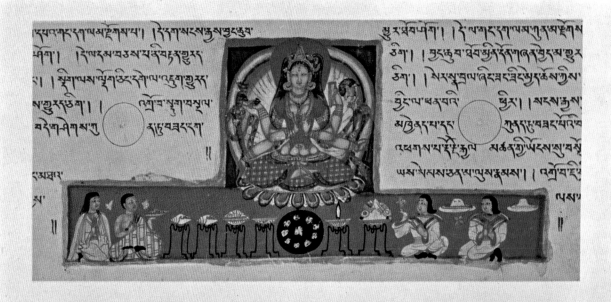

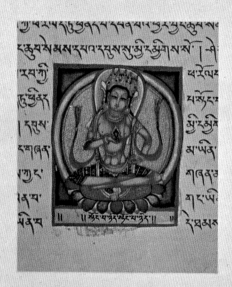

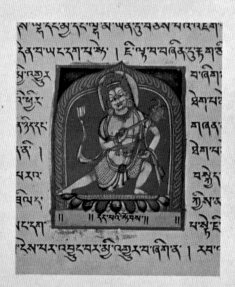

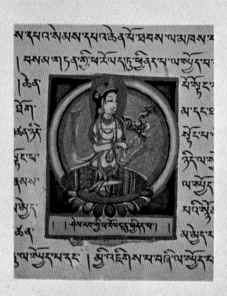

Pl. 358. Tibetan Buddhist illuminations, of Kashmirian influence, 10th–11th cent. Rome, private coll.

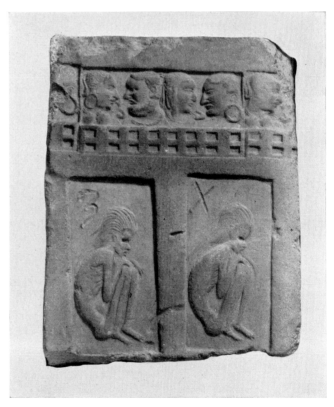

Pl. 359. Molded floor tiles, from the Buddhist monastery of Harwan, ca. 4th–5th cent. Terra cotta, ht., ca. 20 in. Paris, Musée Guimet.

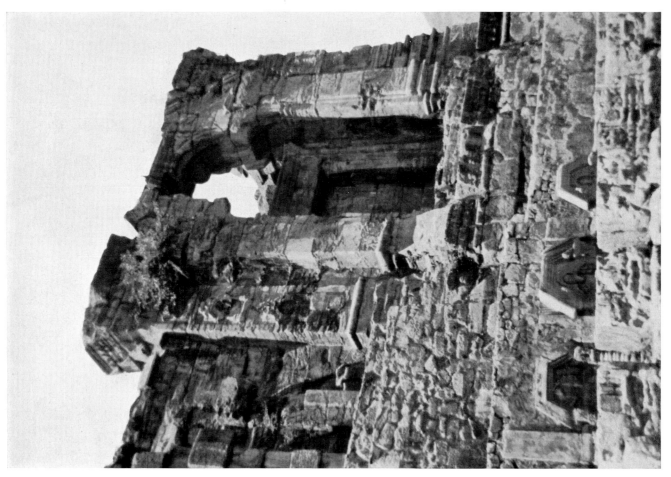

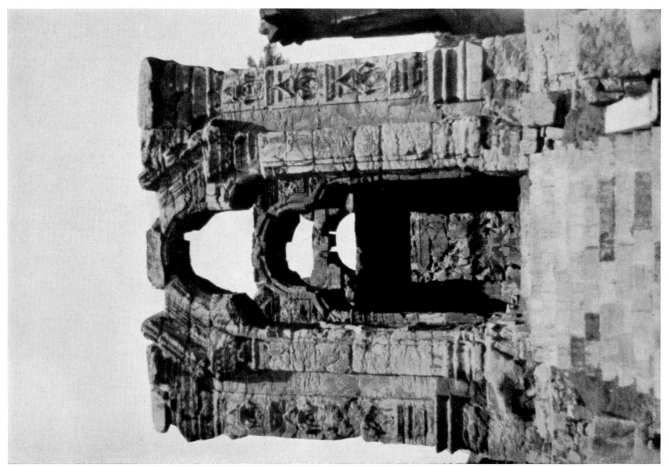

Pl. 360. Martand, Sun Temple, ca. 735-50. *Left:* Entrance to central sanctuary. *Right:* Arch and portal of south side.

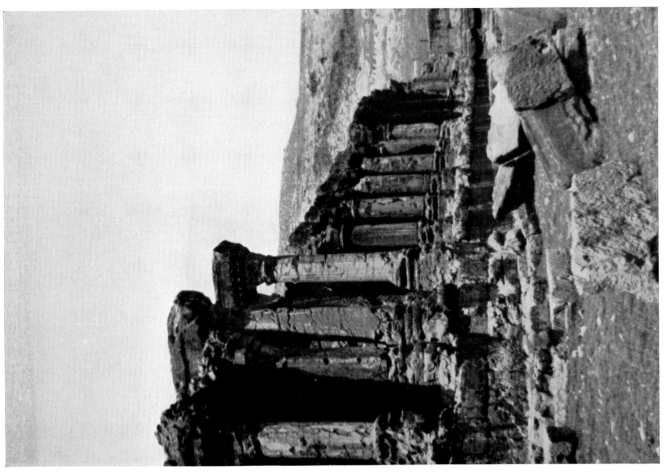

Pl. 361. Martand, Sun Temple, ca. 735–50. *Left*: Relief representing the sun god Sūrya. *Right*: Colonnade of the court.

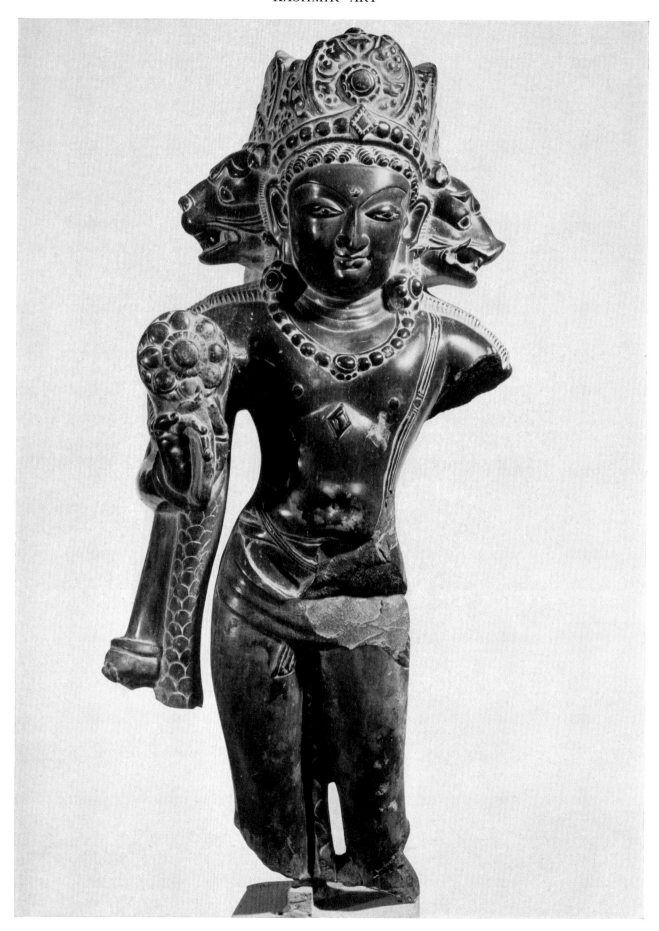

Pl. 362. The god Viṣṇu, from the Avantisvāmi temple, Avantipur, near Srinagar, second half of 9th cent. Black basalt, ht., 19³/₄ in. Srinagar, Sri Pratap Singh Museum.

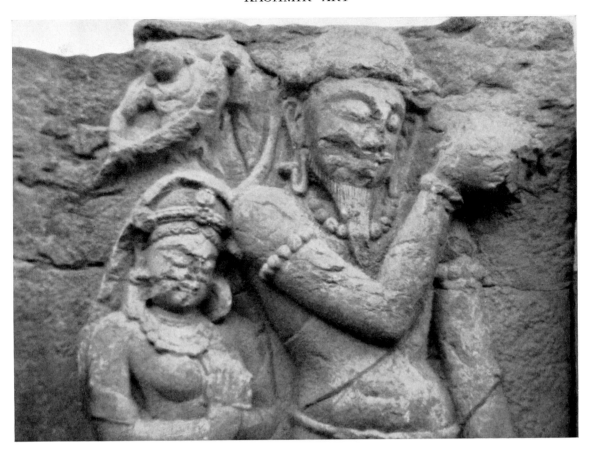

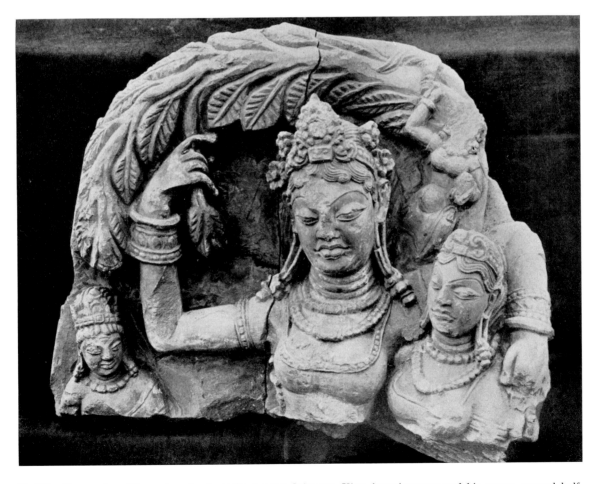

Pl. 363. *Above*: Avantiśvara temple, Avantipur, near Srinagar, King Avantivarman and his queen, second half of 9th cent. Stone. *Below*: Birth of the Buddha, from Pandrethan, late 10th cent. Stone. Srinagar, Sri Pratap Singh Museum.

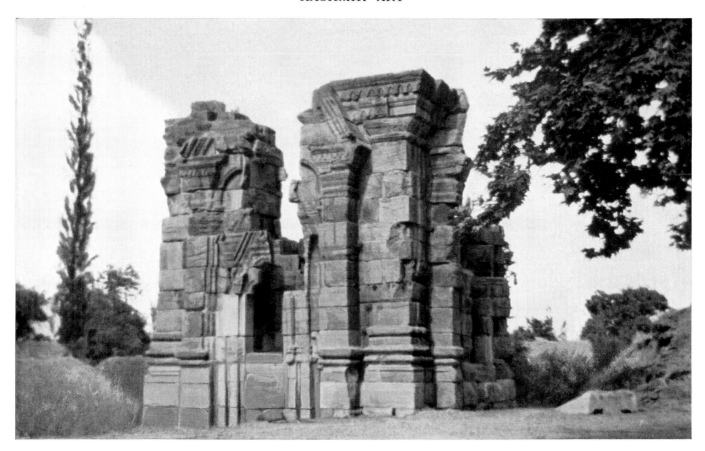

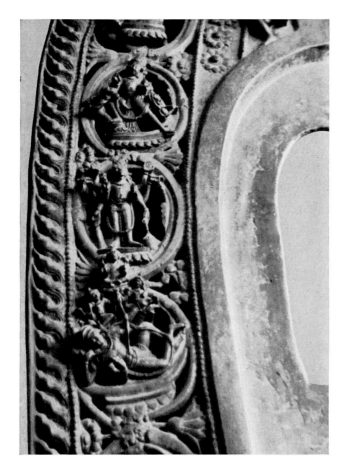

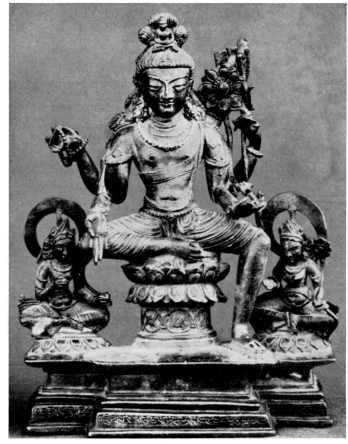

Pl. 364. *Above*: Patan, near Srinagar, the Śaṅkaragaurīśvara temple, late 9th–early 10th cent. *Below, left*: Frame of a Buddha image transformed by King Śaṅkaravarman into Viṣṇu's Buddha avatar, from Divsar, detail, late 9th–early 10th cent. Bronze. *Right*: Avalokiteśvara, late 10th cent. Bronze. Both, Srinagar, Sri Pratap Singh Museum.

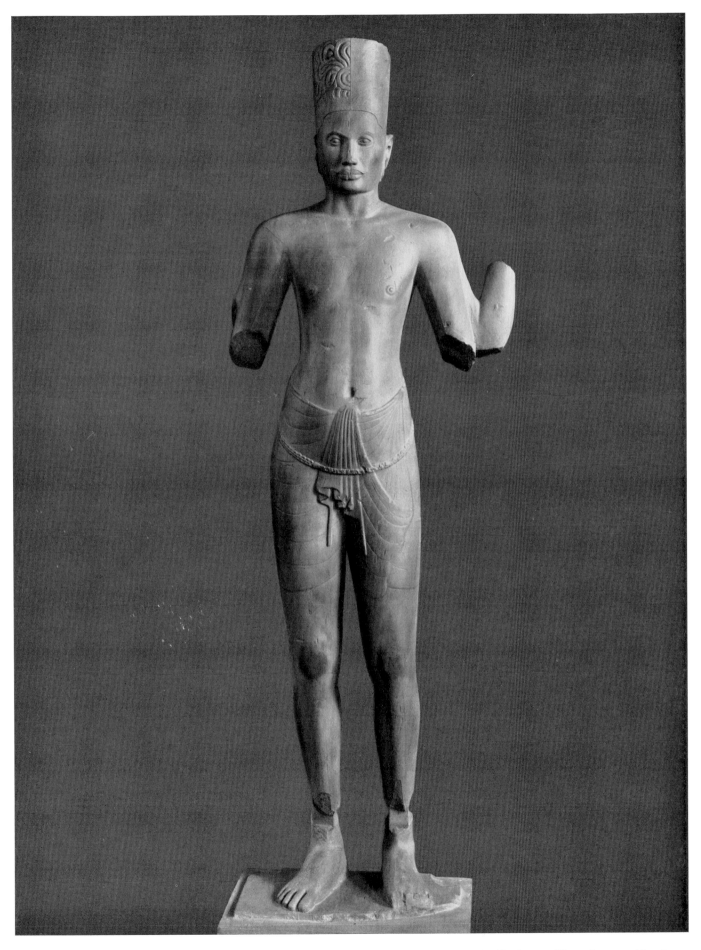

Pl. 365. Harihara, from Prasāt Andet, ca. 7th cent. Stone, ht., 6 ft., 3 in. Phnom Penh, Cambodia, Musée Albert Sarraut. (Cast.)

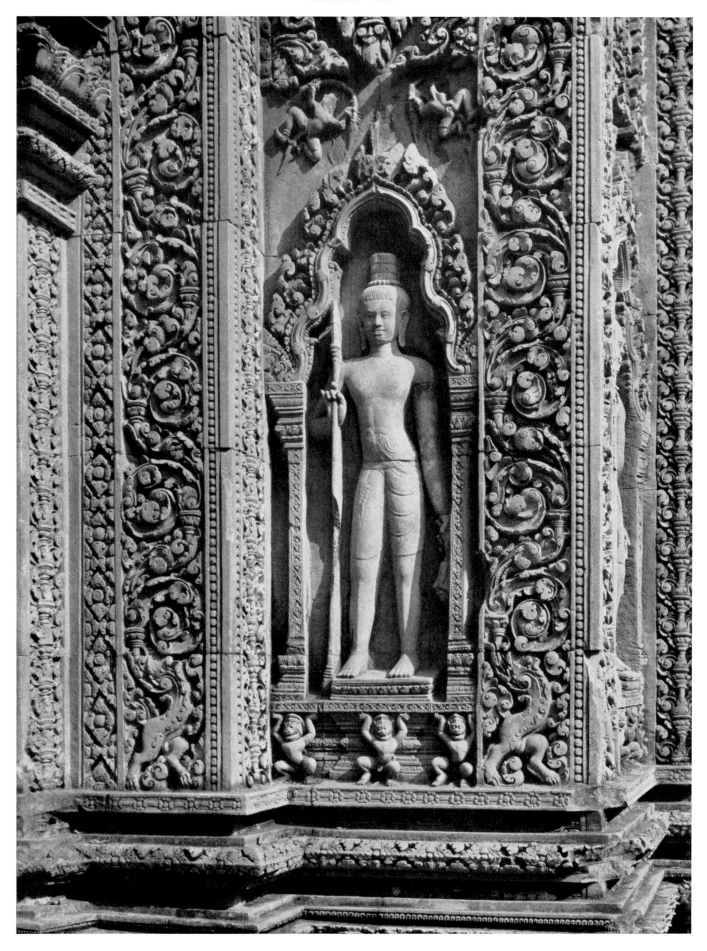

Pl. 366. Banteay Srei, central sanctuary, early 14th cent., detail of the decoration.

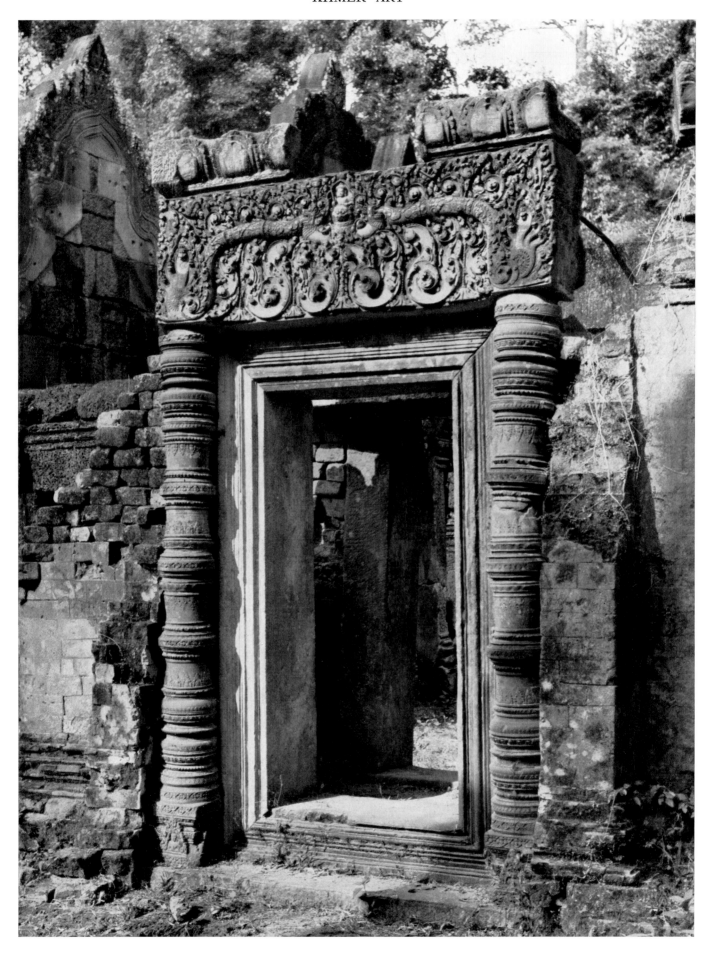

Pl. 367. Banteay Srei, early 14th cent., a portal.

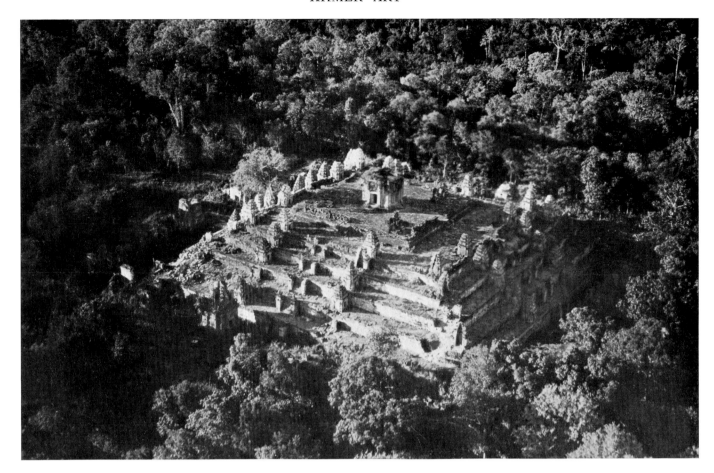

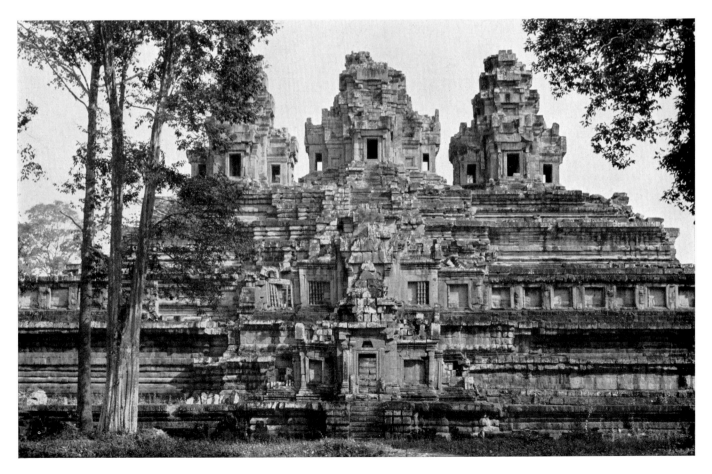

Pl. 368. *Above*: Phnom Bakheng, ca. 10th cent., aerial view. *Below*: Angkor, Takeo, ca. 10th cent.

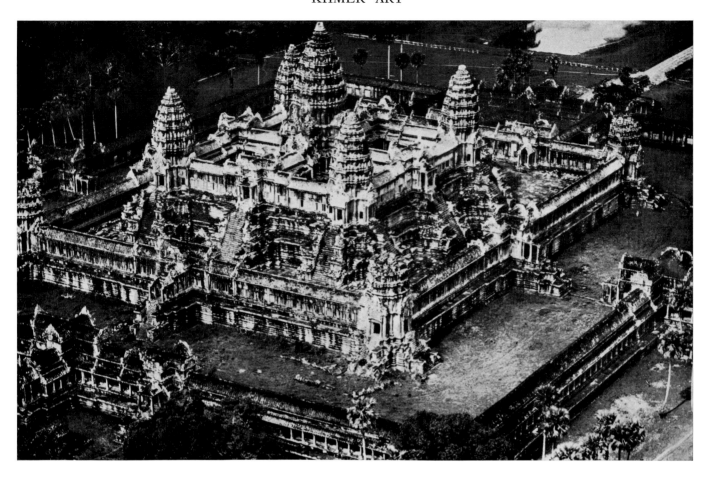

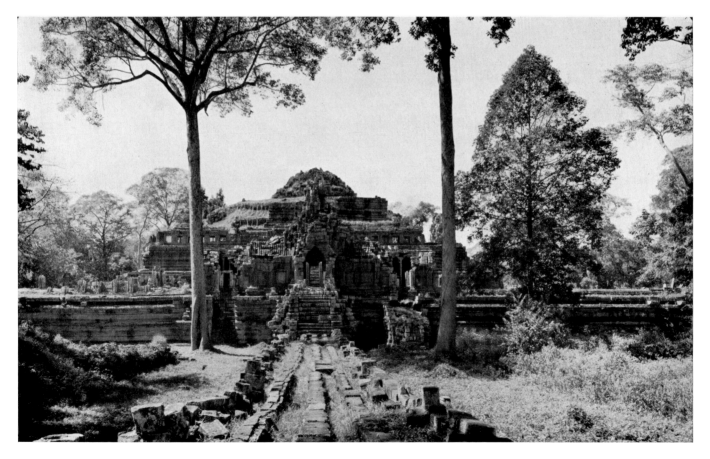

Pl. 369. *Above*: Angkor Wat, ca. 12th cent., aerial view. *Below*: Angkor Thom, the Baphuon, second half of 11th cent.

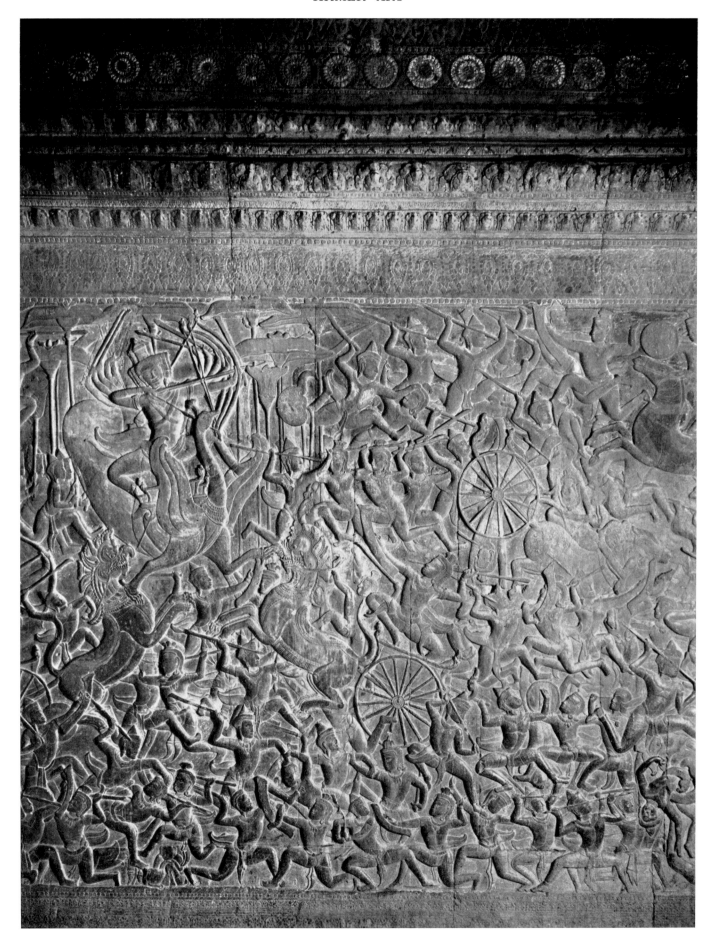

Pl. 370. Angkor Wat, west gallery, battle scenes from the *Mahābhārata*, early 12th cent. Stone.

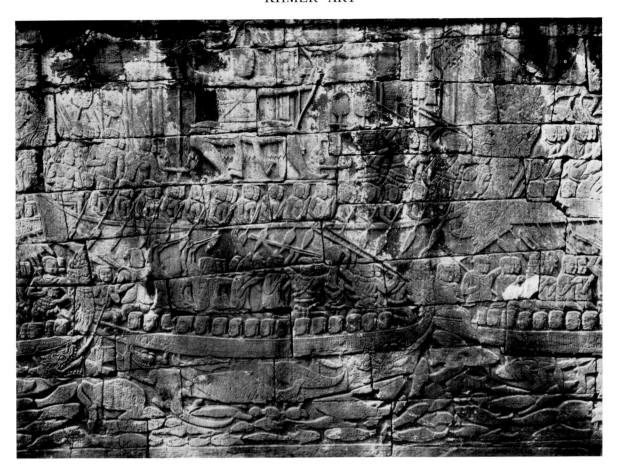

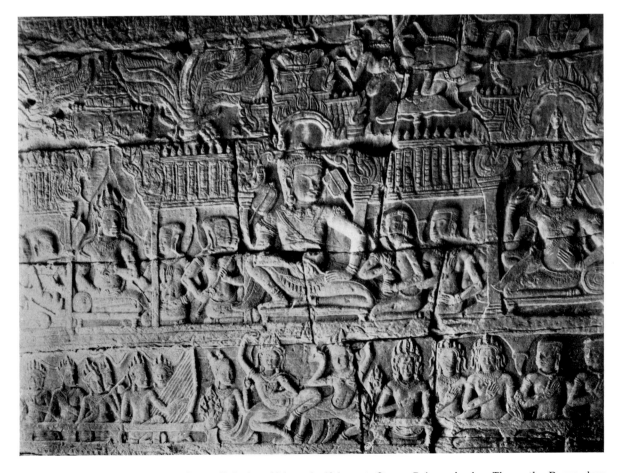

Pl. 371. *Above*: Banteay Chmar, low reliefs, late 12th–early 13th cent. Stone. *Below*: Angkor Thom, the Bayon, low reliefs, late 12th–early 13th cent. Stone.

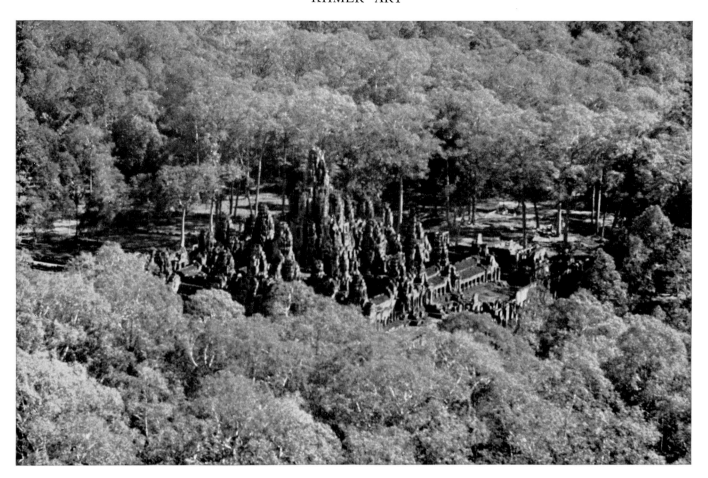

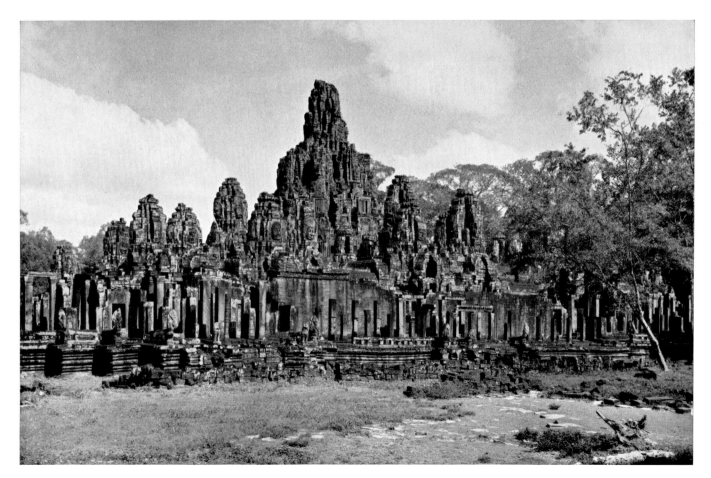

Pl. 372. Angkor Thom, two views of the Bayon, late 12th–early 13th cent.

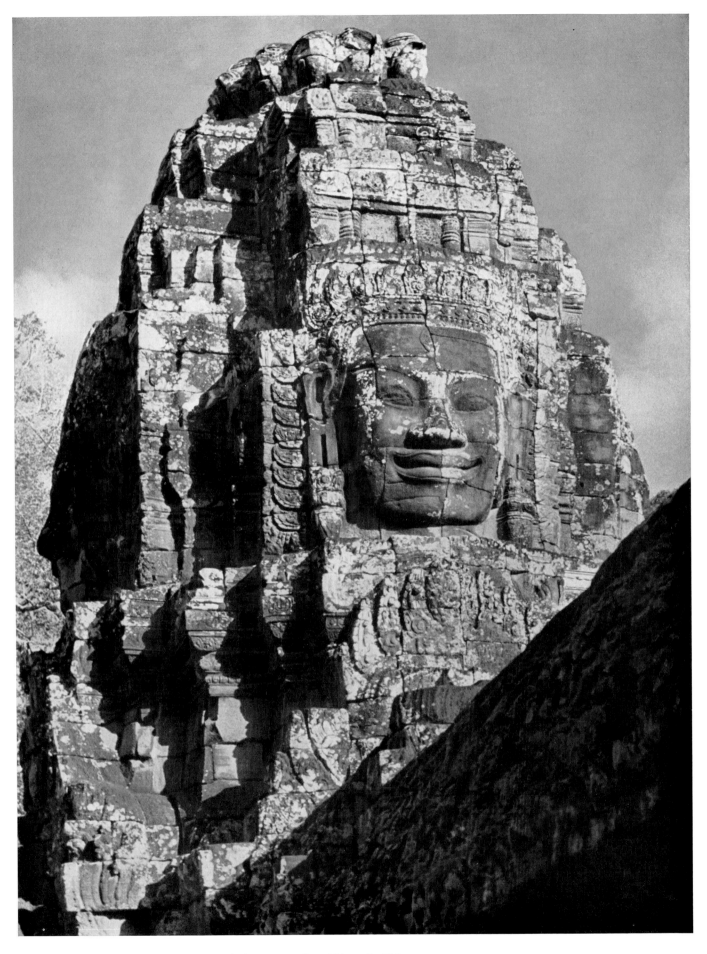

Pl. 373. Angkor Thom, the Bayon, one of the towers, late 12th–early 13th cent.

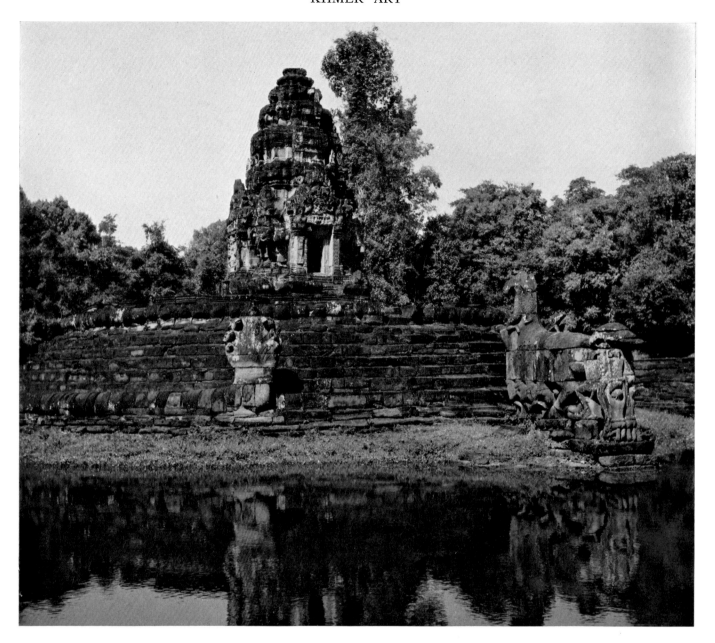

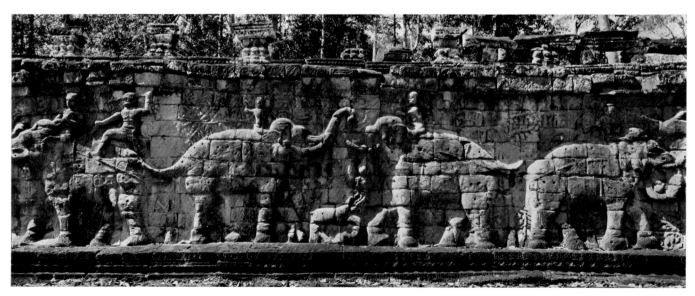

Pl. 374. Angkor Thom. *Above*: Neak Pean, late 13th cent. *Below*: Detail of the decoration of the Terrace of the Elephants, 13th cent.

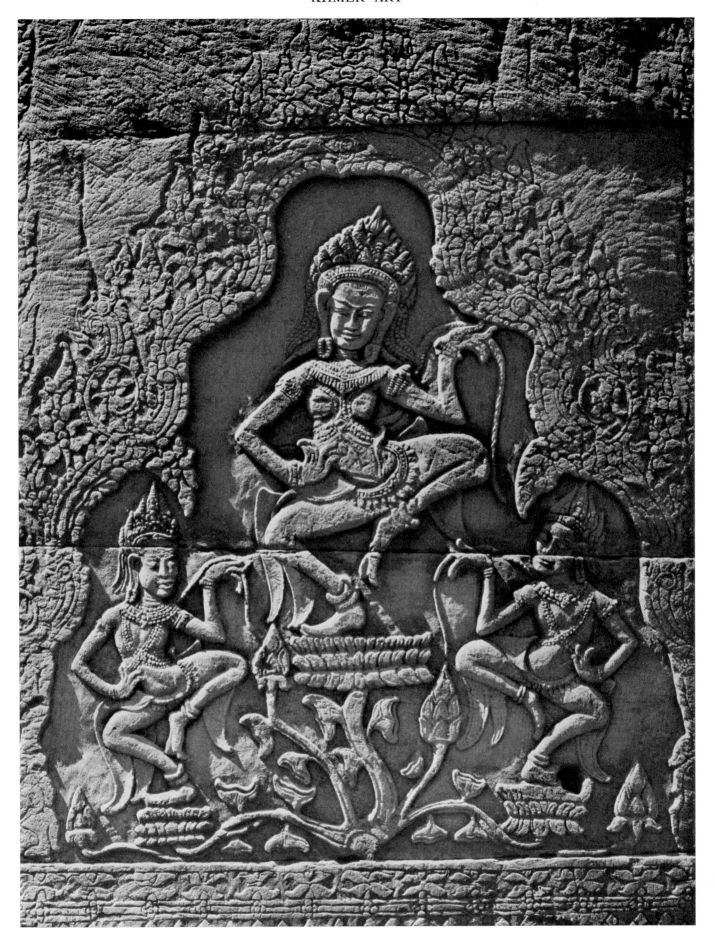

Pl. 375. Angkor Thom, the Bayon, dancing apsarases, early 13th cent. Stone.

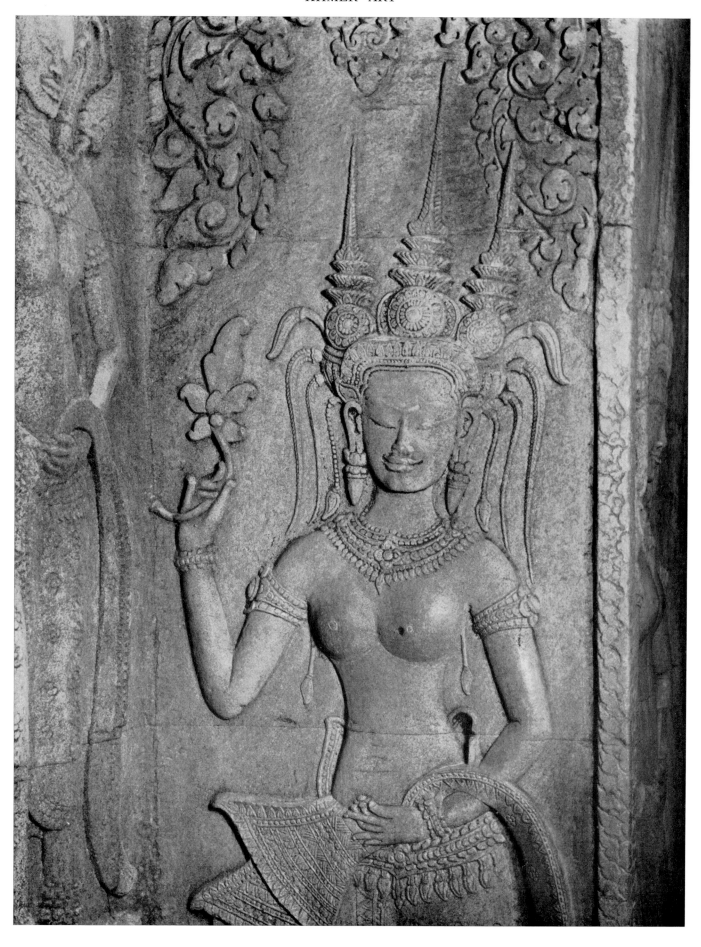

Pl. 376. Angkor Wat, an apsaras, ca. 12th cent. Stone.

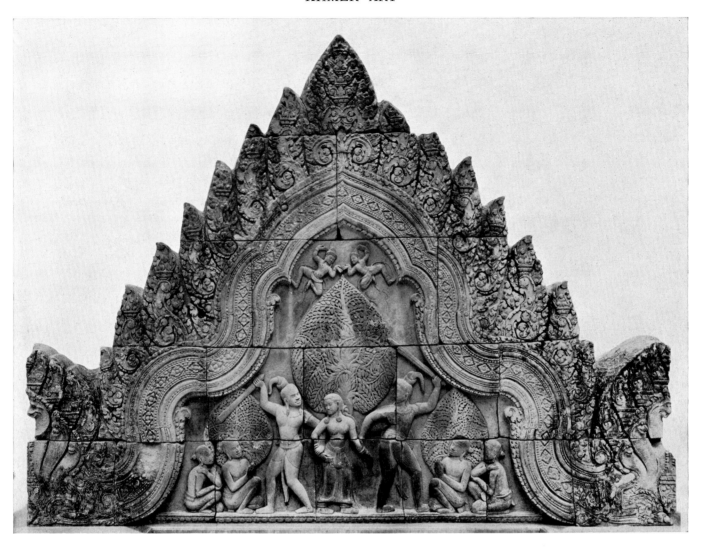

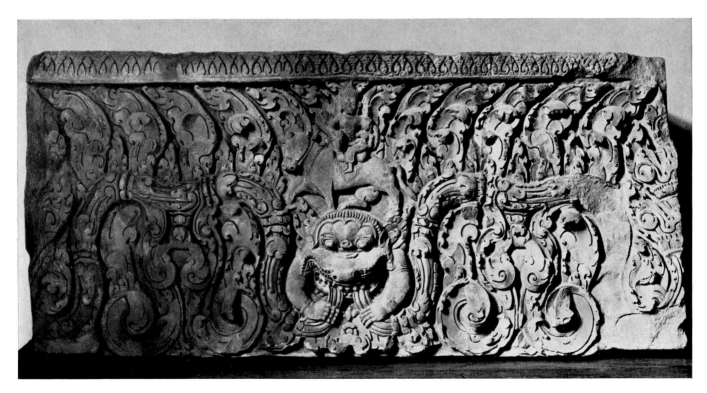

Pl. 377. *Above*: A tympanum, from Banteay Srei, late 10th–early 14th cent. *Below*: Fragment of decoration, from Roluos, ca. 10th cent. Stone. Both, Paris, Musée Guimet.

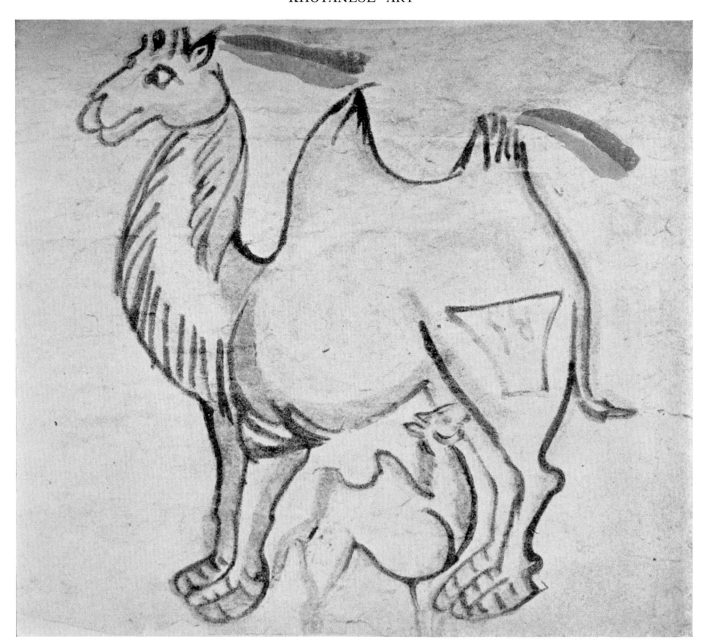

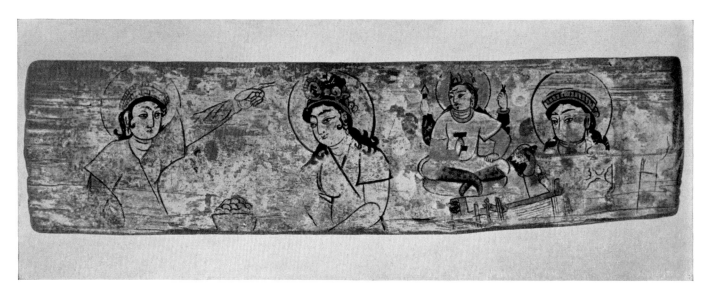

Pl. 378. *Above*: Camel, from the temple at Endere, 2d–4th cent. Ink and faint color on paper, $5^1/_4 \times 4^1/_2$ in. *Below*: Painted panel from sanctuary D X, Dandan-uilik, 4th–8th cent. Wood, l., ca. 18 in. Both, London, British Museum.

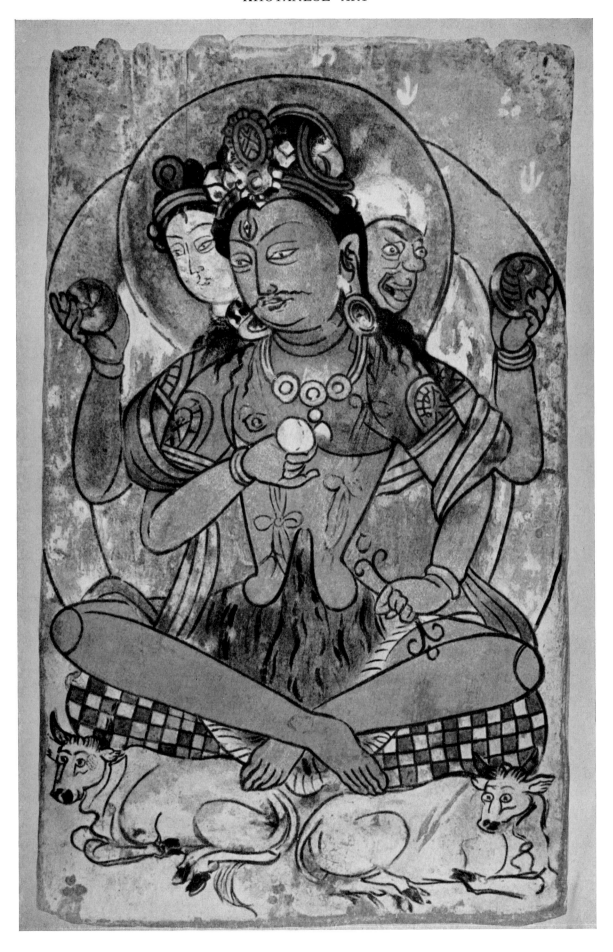

Pl. 379. Painted panel from dwelling, Dandan-uilik, 6th–8th cent. Wood, ht., 13³/₄ in. London, British Museum.

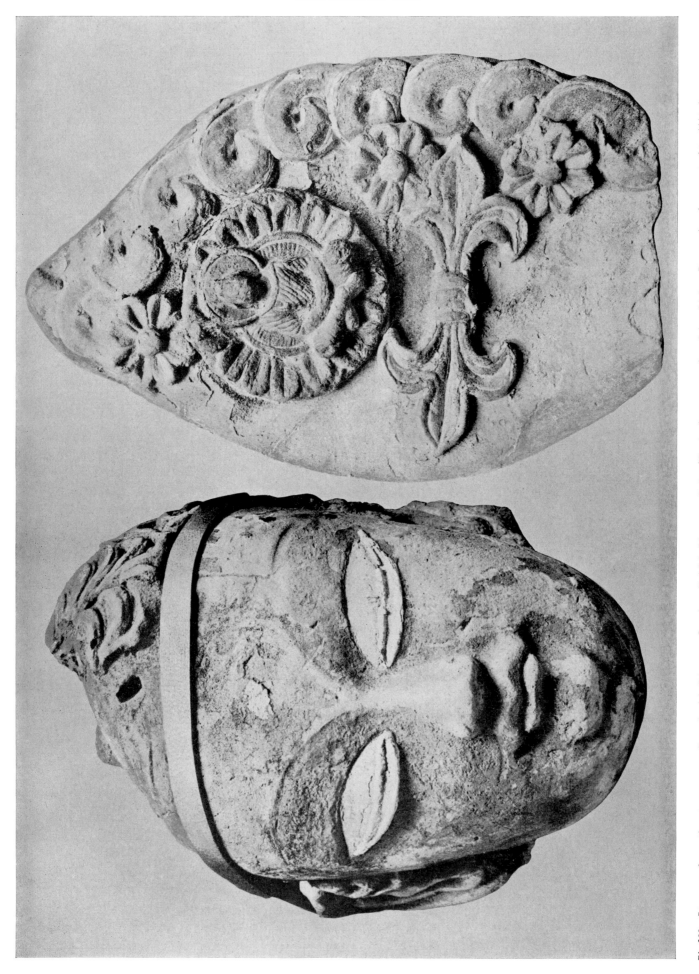

Pl. 380. Stuccoes from the stupa court, Rawak, 4th–5th cent. London, British Museum. *Left*: Head of a statue; ht., 9 in. *Right*: Decorative fragment; ht., 11½ in.

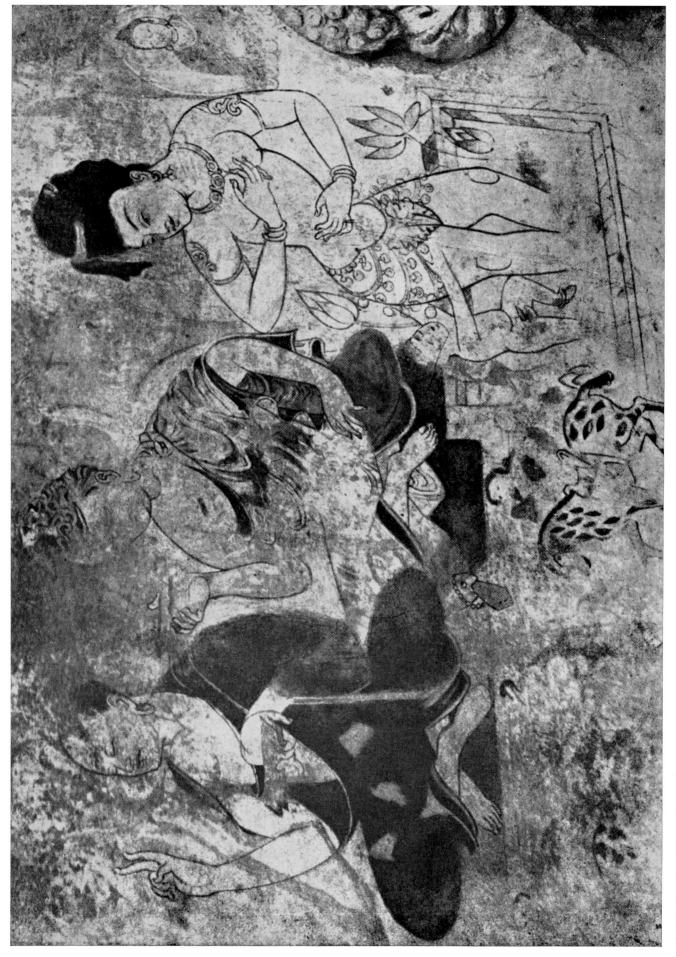

Pl. 381. Dandan-uilik, wall painting in small cella of a Buddhist shrine, 7th–8th cent. Ht. of bather, 18 in.

Pl. 382. Carved double brackets (l., 22 and 24 in.) and chair (ht. of legs, 23 in.), from dwellings, Niya, 7th–8th cent. (?). Wood. All, London, British Museum.

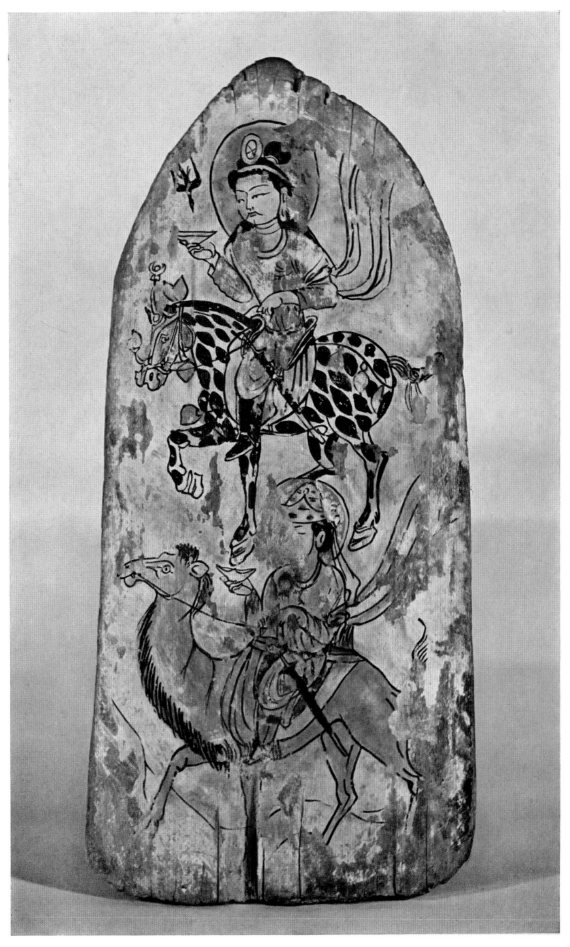

Pl. 383. Painted panel, from dwelling, Dandan-uilik, 6th–8th cent. Wood, ht., 15 in. London, British Museum.

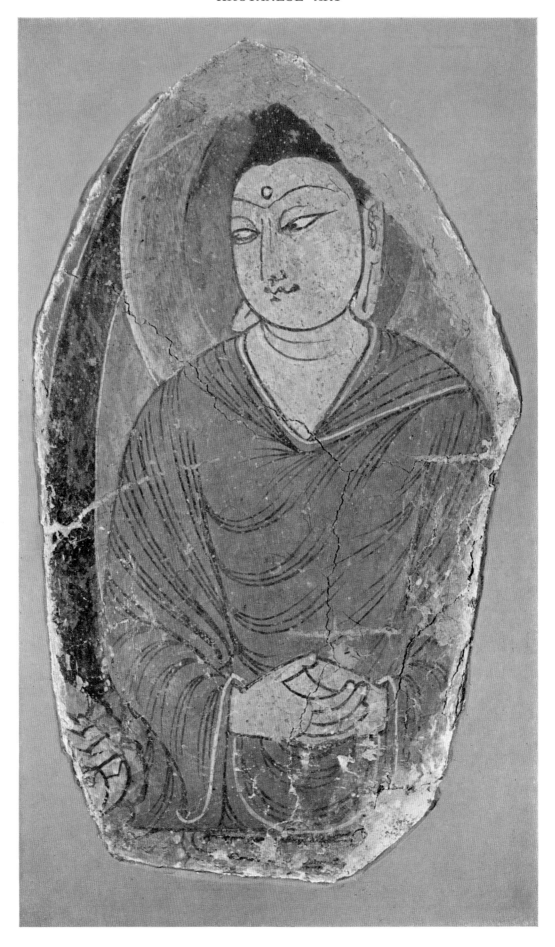

Pl. 384. Buddha, Khotan, ca. 9th cent. Painting on stucco. London, British Museum.

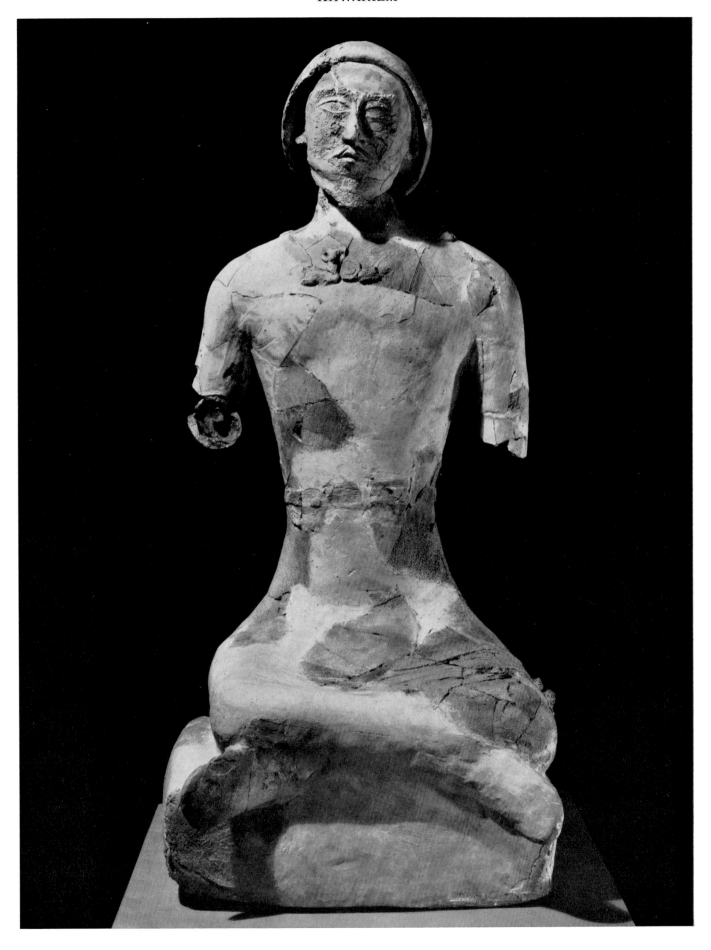

Pl. 385. Statue from a funerary urn, from Koy-krylgan Kale, 1st cent. Clay.

Pl. 386. *Left*: Head of a prince of Khwarizm, from Toprak Kale, palace, 3d–early 4th cent. Painted clay. *Right*: Head of a warrior, from Toprak Kale, palace, "Warriors' Hall," 3d–early 4th cent.

Pl. 387. *Left:* Fragment of a male figure, from Toprak Kale, palace, 3d–early 4th cent. Painted clay. *Right:* Fragment of a figure from Toprak Kale, palace, "Hall of Victories," 3d–early 4th cent. Clay.

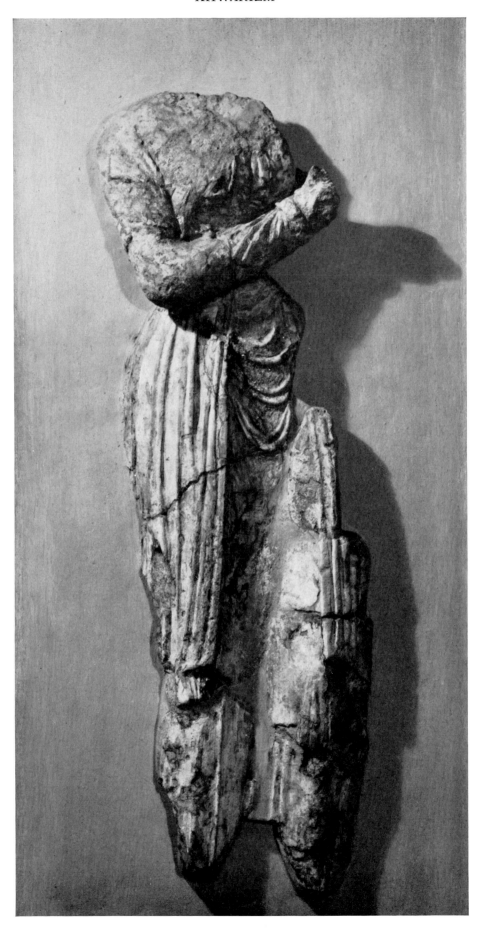

Pl. 388. Female figure, from Toprak Kale, palace, 3d–early 4th cent. Painted clay.

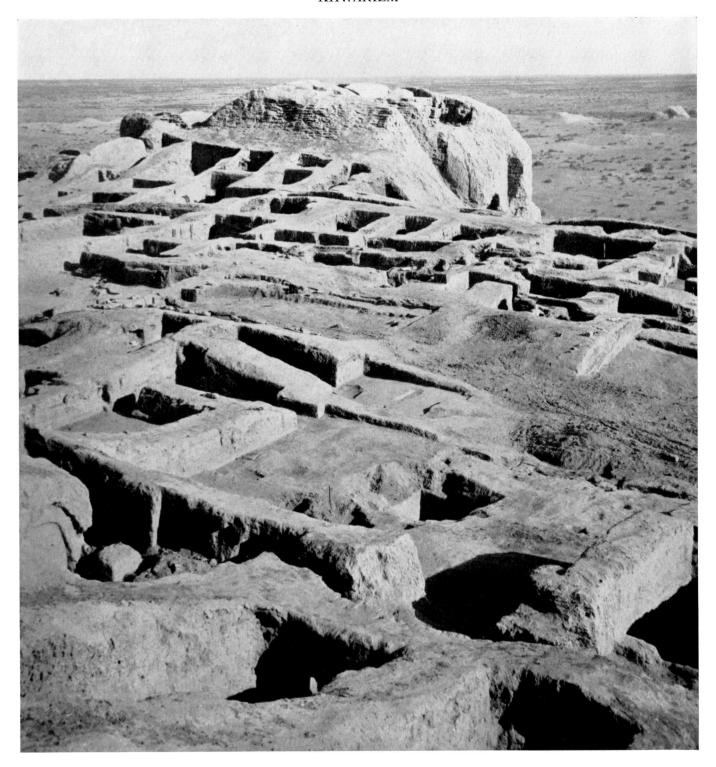

Pl. 389. *Above*: Toprak Kale, general view of excavations of the palace, 3d–early 4th cent. *Below*: Relief, from the castle wall of Teshik Kale, 2d–3d cent. Clay.

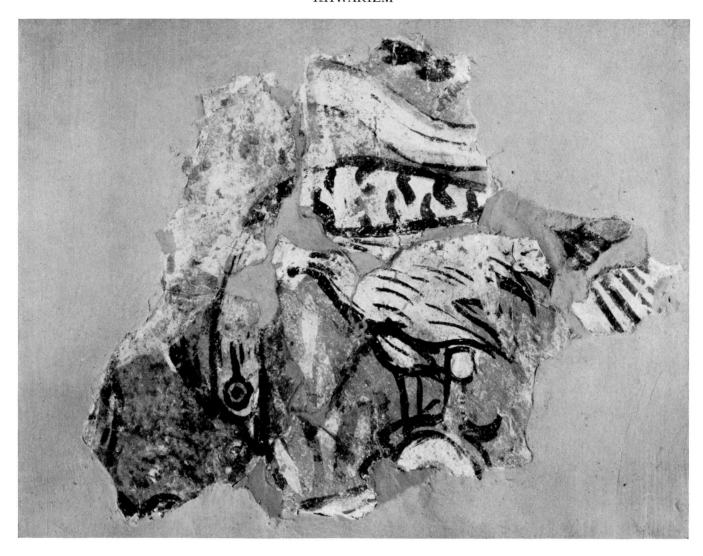

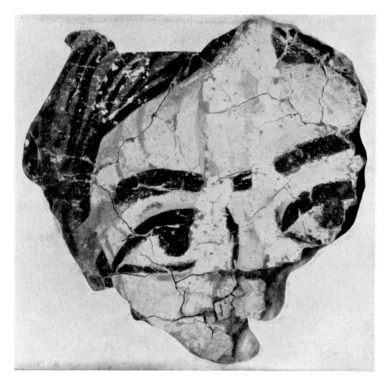 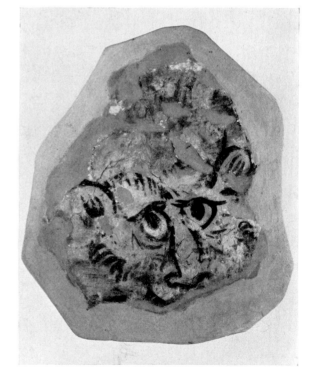

Pl. 390. Fragments of wall painting, from Toprak Kale, palace, 3d–early 4th cent. *Above*: Bird. *Below, left*: Face of a woman. *Right*: Head of a tiger.

KLEE

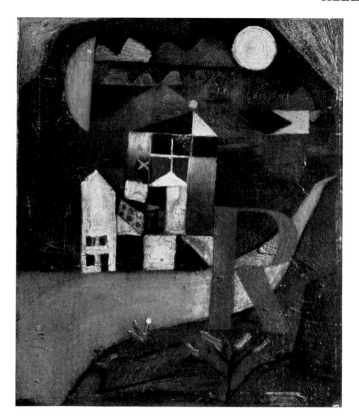

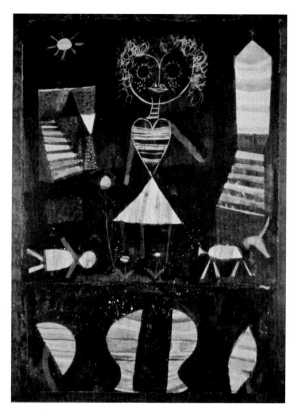

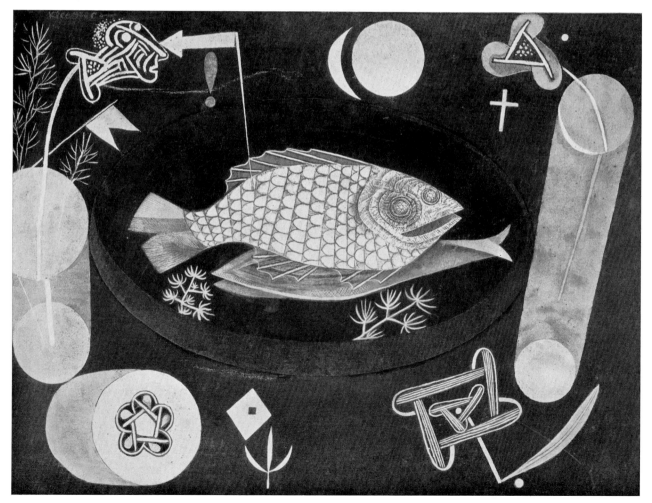

Pl. 391. *Above, left*: Villa R, 1919. Oil on cardboard, $10^1/_2 \times 8^5/_8$ in Basel, Kunstmuseum. *Right*: Puppet Show, 1923. Water color on chalk ground, $20^1/_4 \times 14^5/_8$ in. Bern, Kunstmuseum, Paul-Klee-Stiftung. *Below*: Around the Fish, 1926. Canvas, $18^3/_8 \times 25^1/_8$ in. New York, Museum of Modern Art.

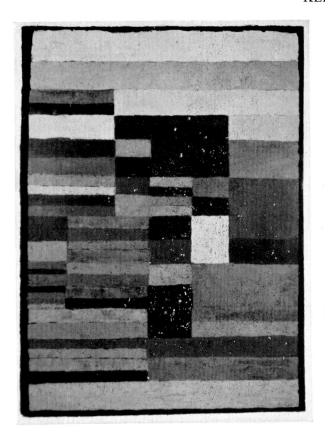

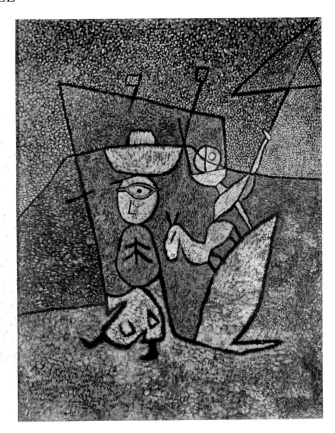

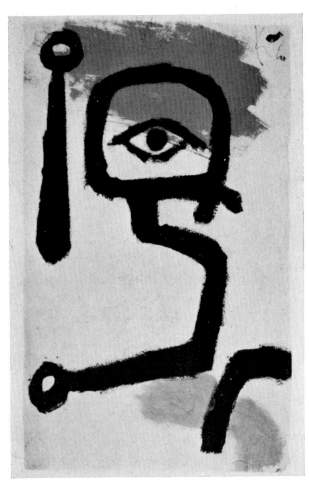

Pl. 392. *Above, left*: Individualisierte Höhenmessung der Lagen, 1930. Pastel with paste on paper, 19×14¹/₈ in. Bern, Kunstmuseum, Paul-Klee-Stiftung. *Right*: Traveling Circus, 1937. Canvas, 25¹/₂×19³/₄ in. Baltimore, Museum of Art. *Below, left*: Kettledrummer, 1940. Paste tempera on paper, ca. 13³/₄×9 in. *Right*: Double, 1940. Paste tempera on paper, ca. 21×14 in. Last two, Bern, Kunstmuseum, Paul-Klee-Stiftung.

KLEE

Pl. 393. "Einst dem Grau der Nacht enttaucht . . . ," 1918. Water color, $9^{7}/_{8} \times 6^{1}/_{8}$ in. Bern, Kunstmuseum, Paul-Klee-Stiftung.

Pl. 394. Death and Fire, 1940. Tempera on burlap, $18\,^1/_8 \times 17\,^3/_8$ in. Bern, Kunstmuseum, Paul-Klee-Stiftung.

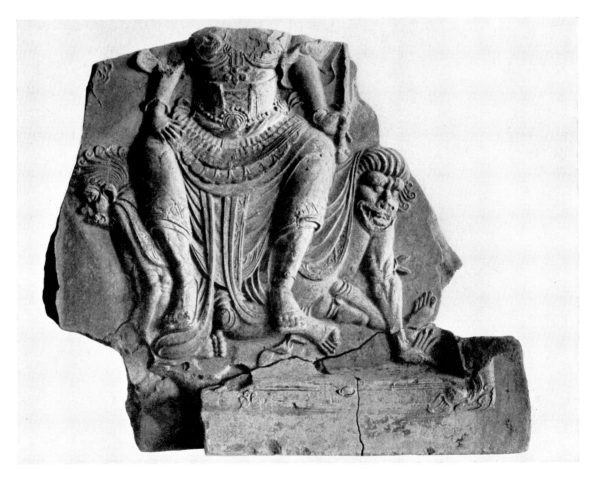

Pl. 395. *Above*: Tortoise and serpent, wall painting in the principal tomb at U-hyonni, near Pyongyang, Korea, Koguryo dynasty (ca. 37 B.C.–A.D. 668), 6th cent. (Water-color rendering.) *Below*: Fragment of a relief, showing a heavenly king, from the temple of Sach'onwang-sa, near Kyungju, Korea, Great Silla period (668–918), 7th cent. Terra cotta, ht., 21 in. Seoul, National Museum of Korea.

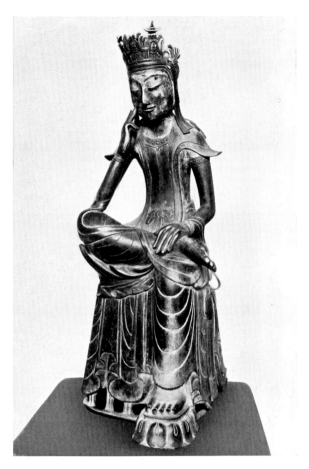

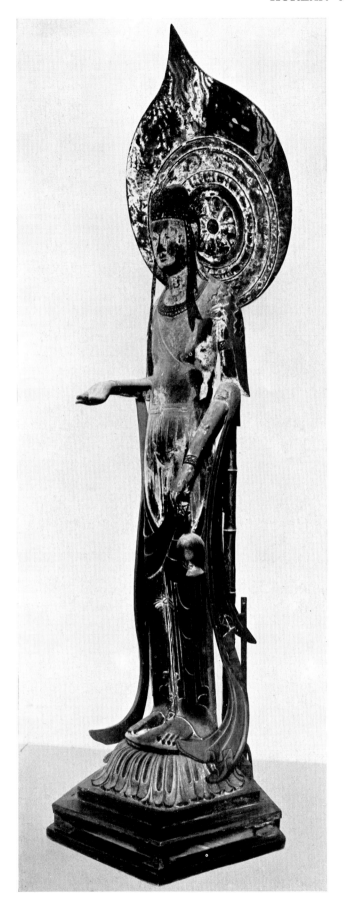

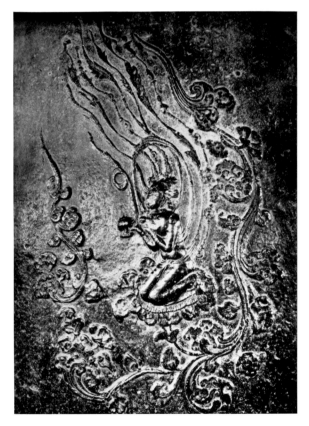

Pl. 396. *Left*: Statue of Avalokiteśvara, called the "Kudara Kwannon," Paekche dynasty (ca. 18 B.C.–A.D. 663), 7th cent. Wood, ht., 6 ft., 8⅝ in. Nara, Japan, Hōryūji. *Right, above*: The Buddha Maitreya, said to be from the Andong area, Korea, Old Silla dynasty (ca. 57 B.C.–A.D. 668), 6th-7th cent. Gilded bronze, ht., 31¹¹/₁₆ in. Seoul, National Museum of Korea. *Below*: Relief on a bronze bell, with a Buddhist celestial figure, Kyungju, Korea, Great Silla period (668–918), 770.

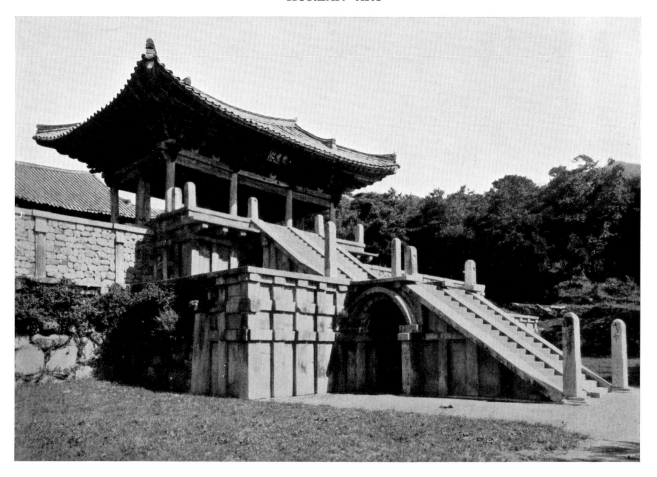

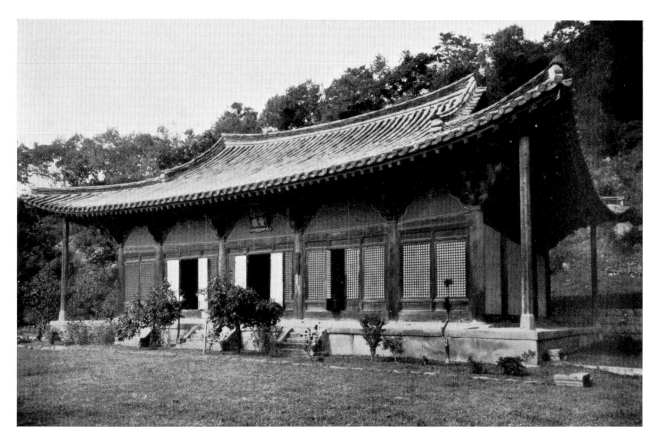

Pl. 397. *Above*: Steps of the temple of Pulguk-sa, near Kyungju, Korea, Great Silla period (668–918), 8th cent. *Below*: "Hall of Eternal Life," Pusok-sa Monastery, southeastern Korea, Koryo period (918–1392), 13th–14th cent.

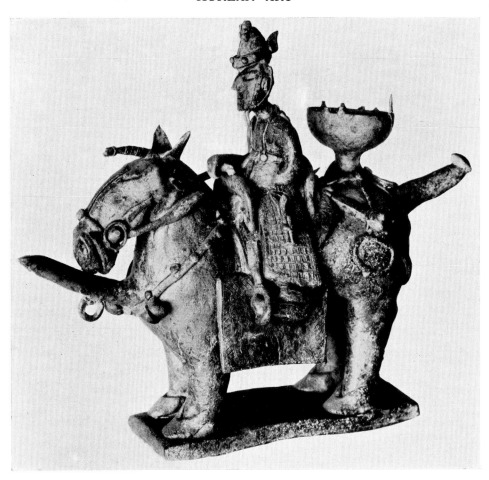

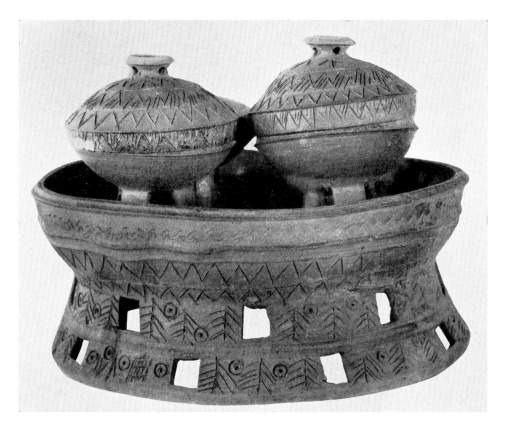

Pl. 398. *Above*: Vessel in the shape of a mounted horseman, from the Gold Bell Tomb at Kyungju, Korea, Old Silla dynasty (ca. 57 B.C.–A.D. 668), 5th–6th cent. Gray stoneware, ht., 9³/₈ in. *Below*: Set of ceramic vessels, from Kyungju, Great Silla period (668–918), 8th–10th cent. Ht., 10⁷/₈ in. Both, Seoul, National Museum of Korea.

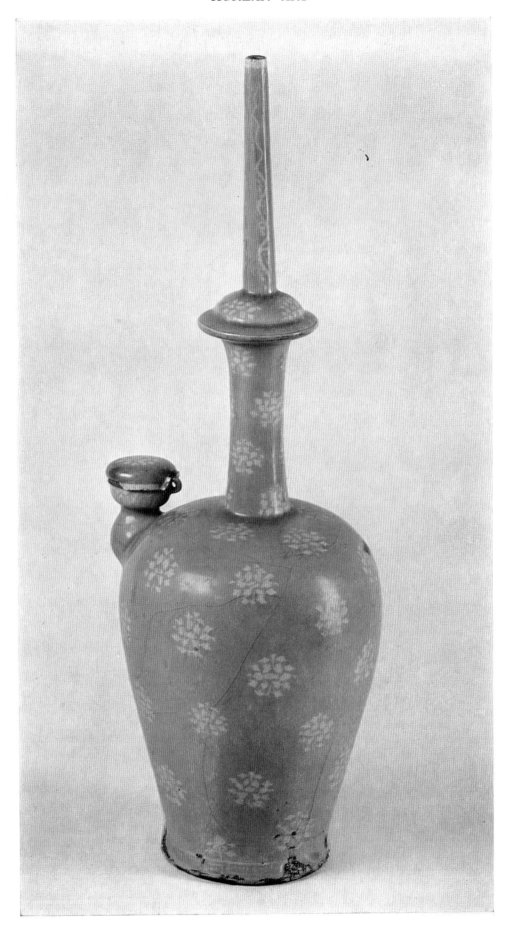

Pl. 399. Lustral vessel, Koryo period (918–1392), 12th cent. Porcelain, ht., 17³/₈ in. London, British Museum.

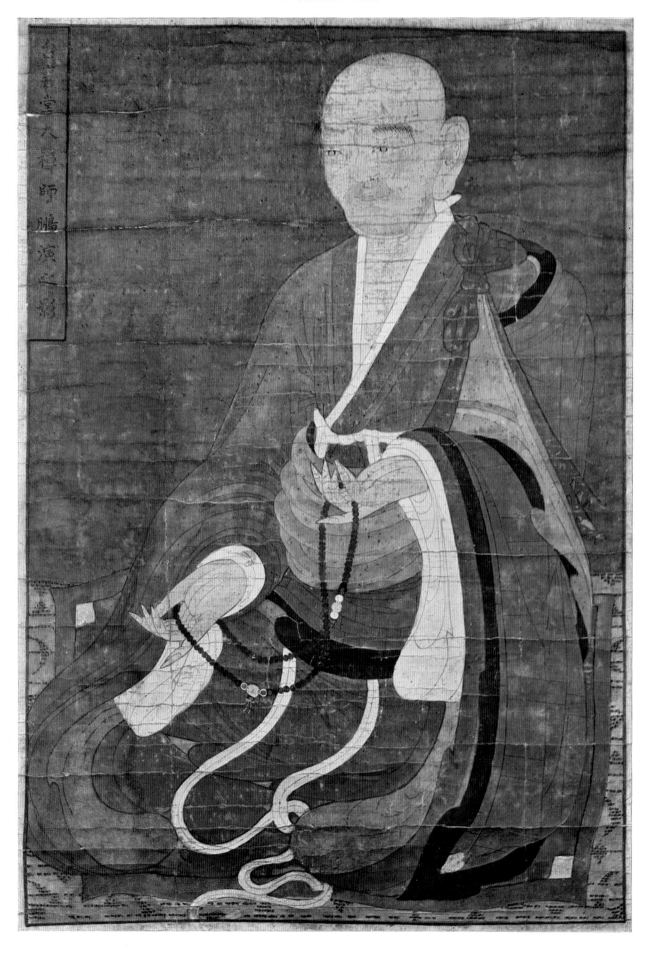

Pl. 400. Portrait of a monk, 14th cent. Painting on silk, 40 1/8×27 1/2 in. London, British Museum.

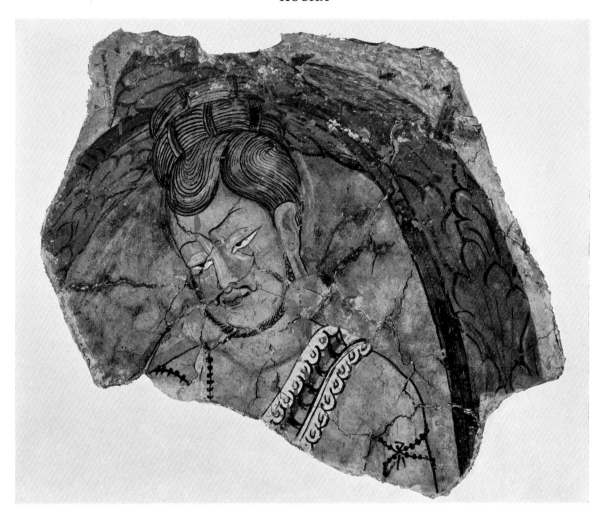

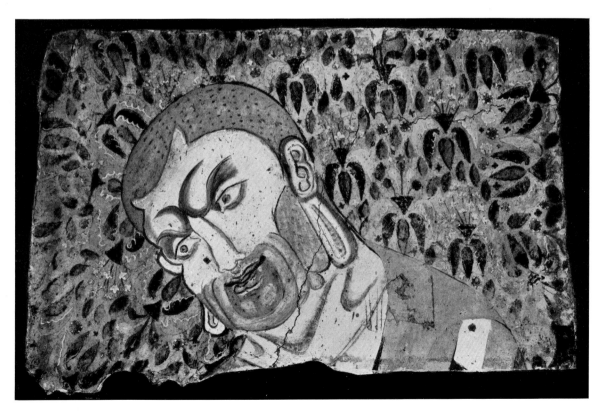

Pl. 401. *Above*: Young ascetic in a leaf hut, fragment of a wall painting, from the Cave of the Navigator, Kizil (Qyzyl), China, ca. 6th cent. *Below*: Head of Mahākāśyapa, fragment of a wall painting, from the Main Cave, Kizil, ca. 7th cent. Ht., 17³/₈ in. Both, Berlin, Museum für Völkerkunde.

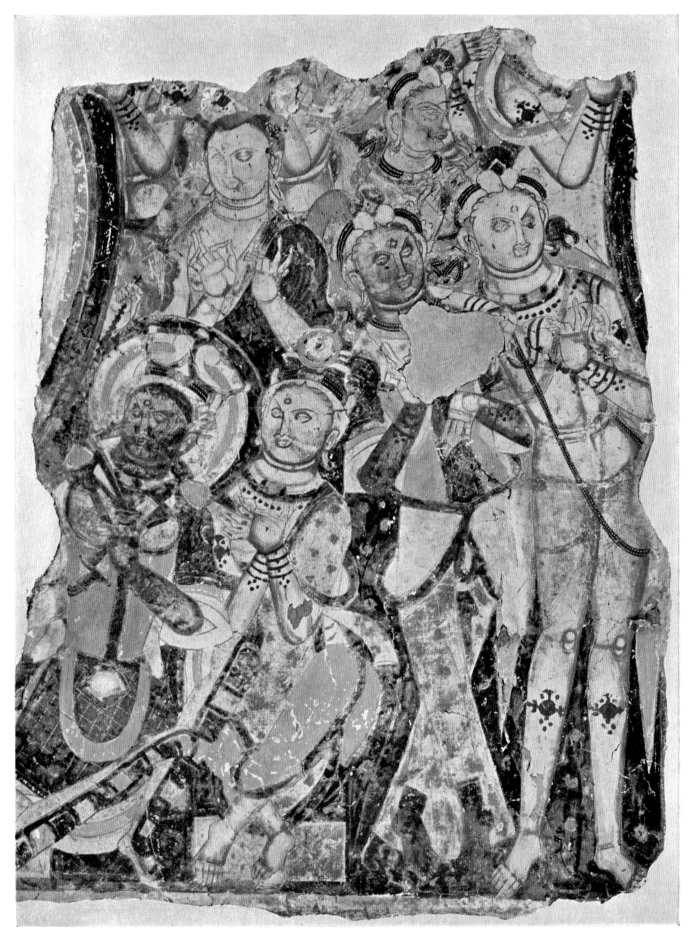

Pl. 402. Scene of worship, fragment of a wall painting, from the Cave of the Temptations, Kizil (Qyzyl), China, ca. A.D. 700. Ht., 26 3/8 in. Berlin, Museum für Völkerkunde.

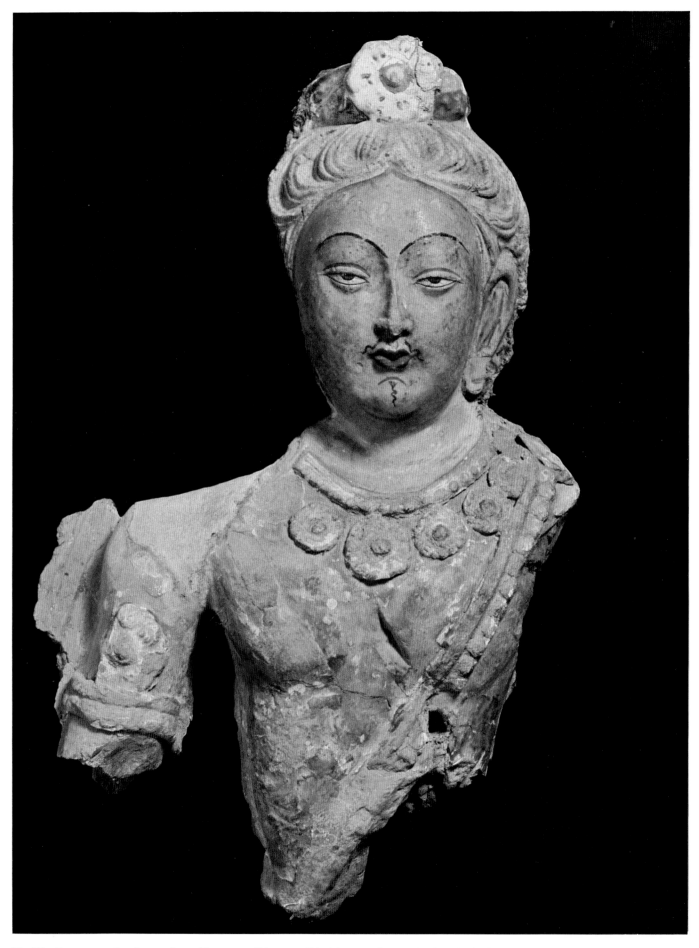

Pl. 403. Fragment of a figure, from Kumtura. China, ca. 7th–8th cent. Stucco. Paris, Musée Guimet.

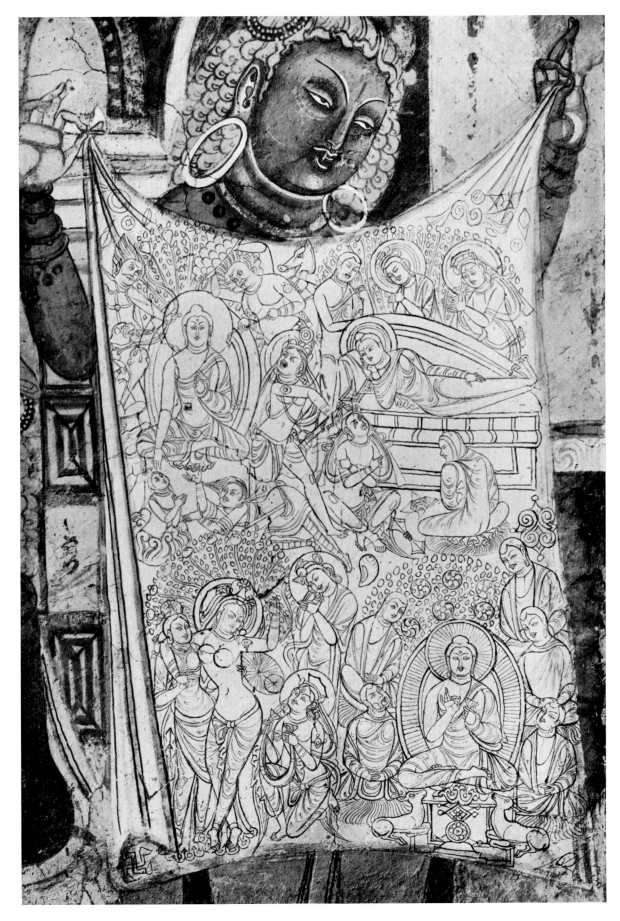

Pl. 404. King Ajātaśatru learns of the Buddha's *Parinirvāṇa*, detail showing the cloth with representations of events from the life of the Buddha (*left, below*: Birth; *above*: Victory over Māra; *right, below*: First Sermon; *above*: *Parinirvāṇa*, "death"), from the Cave of Māyā, Kizil (Qyzyl), China, ca. 7th cent. Wall painting; full size, 3 ft., 7¹/₄ in. × 5 ft., 3³/₄ in. Berlin, Museum für Völkerkunde.

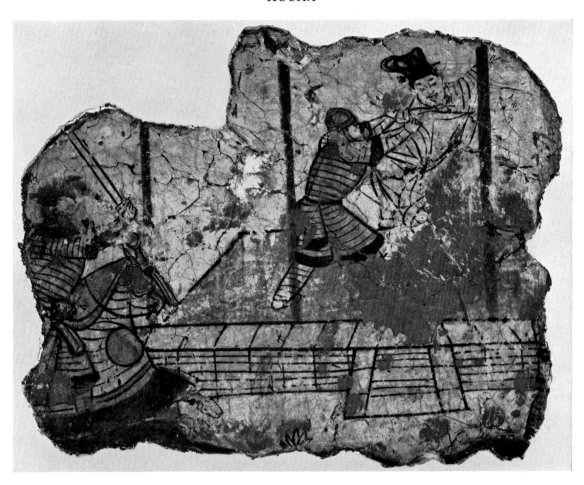

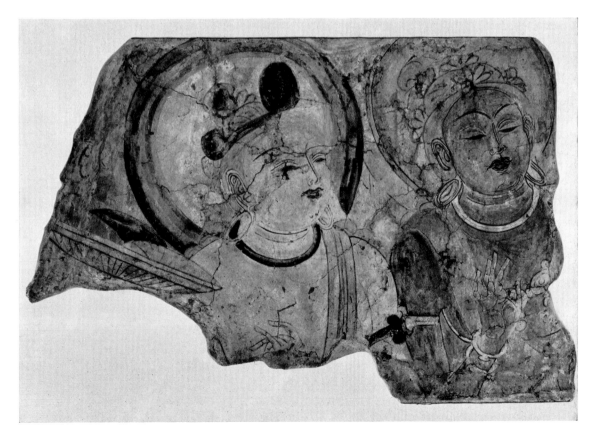

Pl. 405. *Above*: Soldiers capturing a dignitary, fragment of a wall painting, from the Ming-oi, Kumtura, China, 7th–9th cent. *Below*: Divinities of the Tushita heaven, fragment of a wall painting, from the Cave of the Apsaras, Kumtura, ca. 8th cent. Both, Berlin, Museum für Völkerkunde.

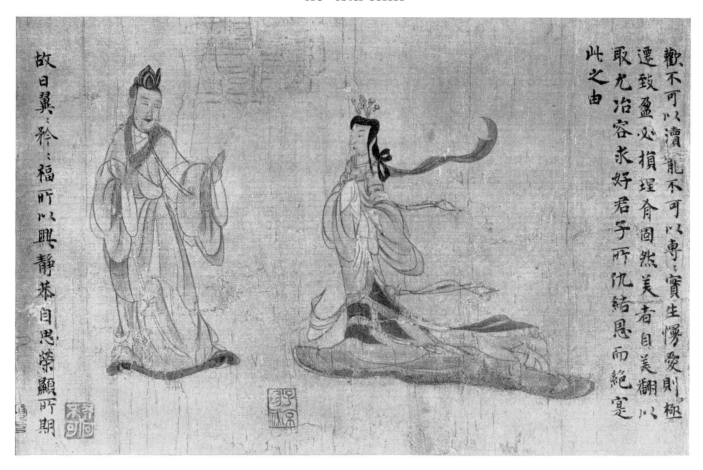

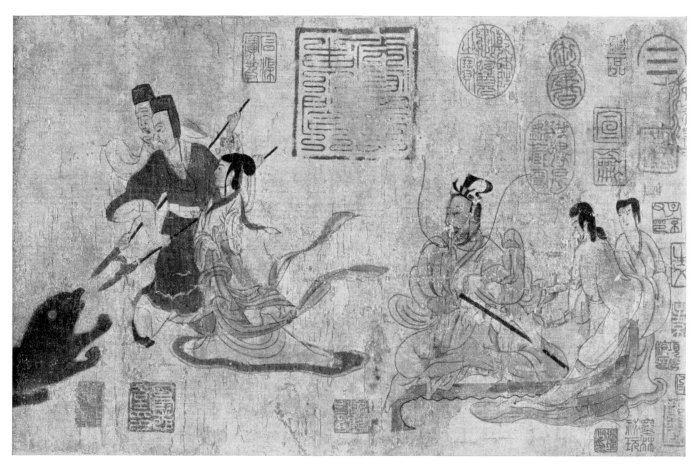

Pl. 406. Details of hand scroll, "The Admonitions of the Instructress to the Court Ladies," (cf. III, PL. 235). Ink and color on silk, ht., 9³/₄ in. *Above*: Sage and Lady. *Below*: Lady and the Bear. London, British Museum.

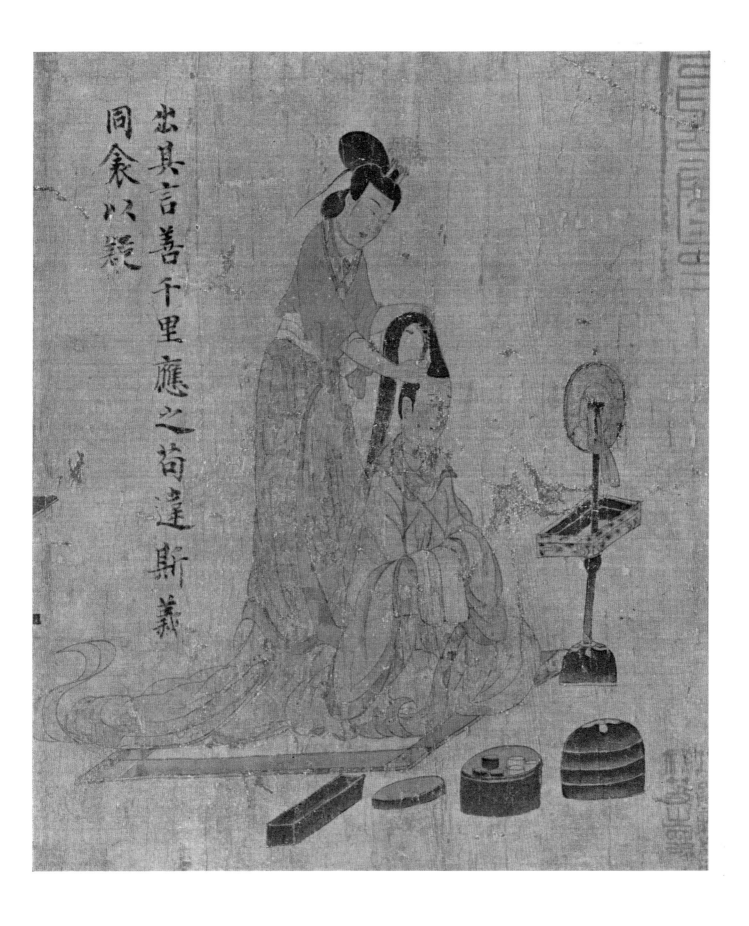

出其言善千里應之苟違斯義
同衾以疑

Pl. 407. Lady at Her Toilet, detail of hand scroll, "The Admonitions of the Instructress to the Court Ladies." Ink and color on silk, ht., 9³/₄ in. London, British Museum.

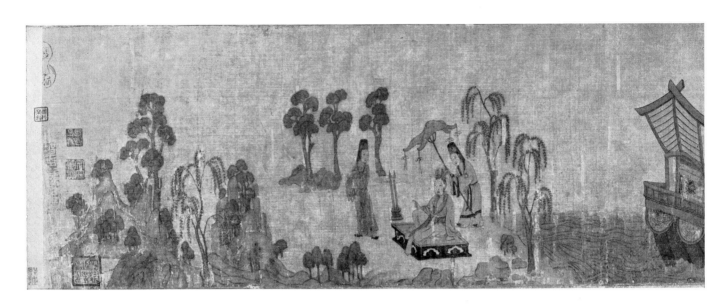

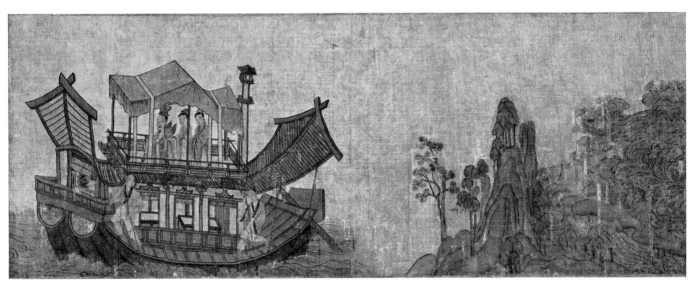

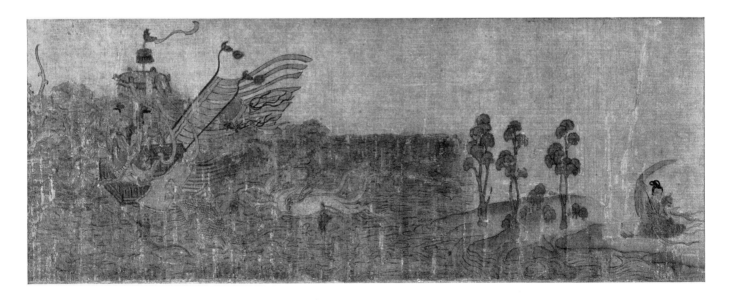

Pl. 408. Details of hand scroll, "The Nymph of the Lo River," 12th-cent. copy after Ku K'ai-chih (attrib.). Ink and color on silk, ht., 9½ in. Washington, D.C., Freer Gallery of Art.

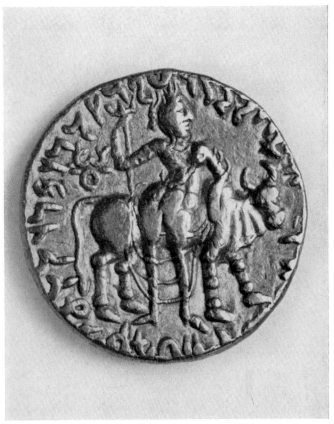

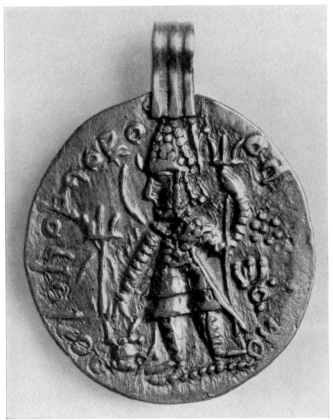

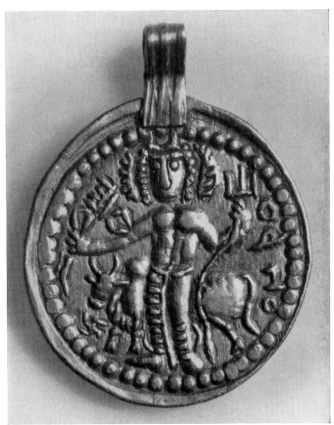

Pl. 409. *Above*: Coin of King Wima Kadphises, obv., rev., 1st cent. Gold, diam., 24 mm. *Below*: Coin of King Vasudeva III, obv., rev., 3d–4th cent. Gold, max. diam., 25 mm. Both, Rome, Museo d'Arte Orientale.

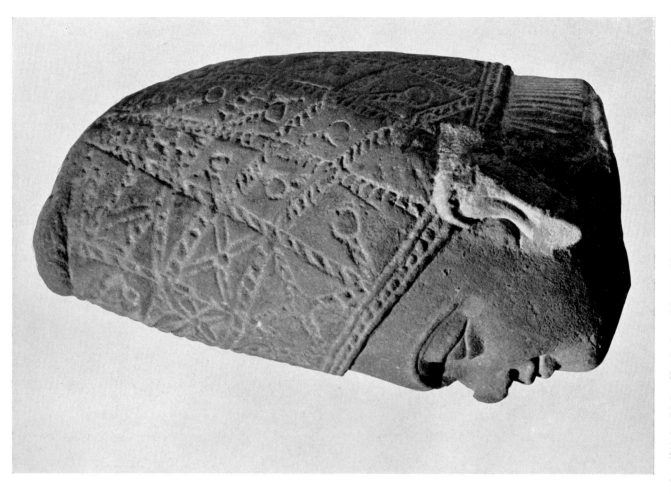

Pl. 410. *Left*: Torso of a nobleman, Mathura, Uttar Pradesh, 1st–3d cent. Red sandstone, ht., 42¹⁄₈ in. *Right*: Head of a nobleman, Mathura, ca. 1st cent. Red sandstone, ht., 9⁷⁄₈ in. Both, Mathura, Archaeological Museum.

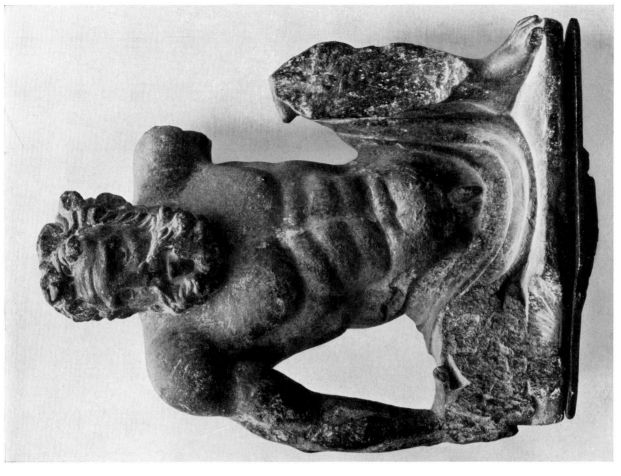

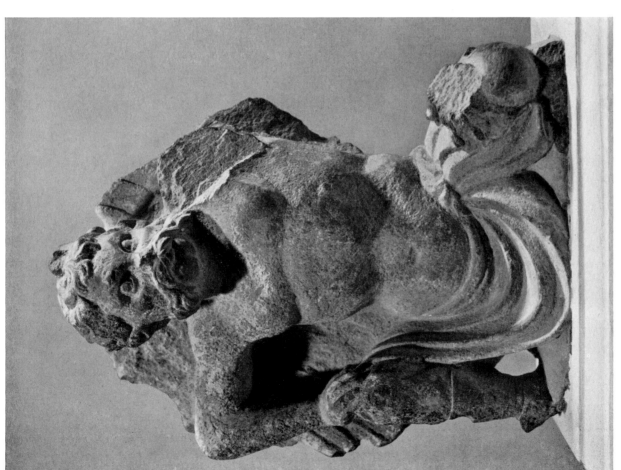

Pl. 411. *Left*: Yaksha, from Jamalgarhi, Pakistan, ca. 2d cent. Stone, ht., 7¹/₂ in. Patna, India, Archaeological Museum. *Right*: Yaksha, from Jamalgarhi, ca. 2d cent. Basalt, ht., 10⁷/₈ in. Calcutta, Indian Museum.

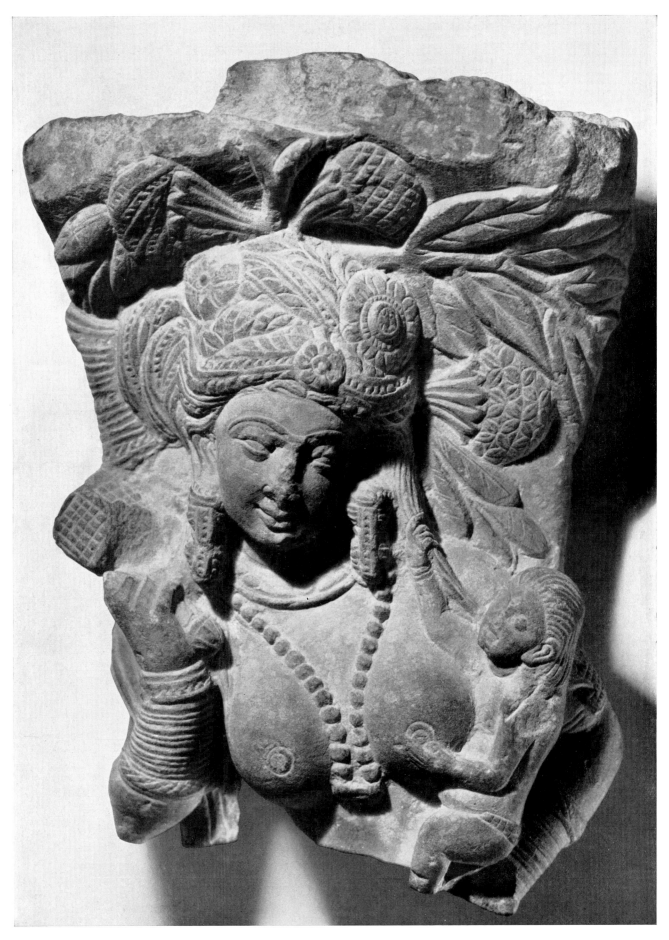

Pl. 412. Architectural fragment with mother and child under the Aśoka tree, Mathura, Uttar Pradesh, 1st–3d cent. Red sandstone, ht., 12⁵/₈ in. Mathura, Archaeological Museum.

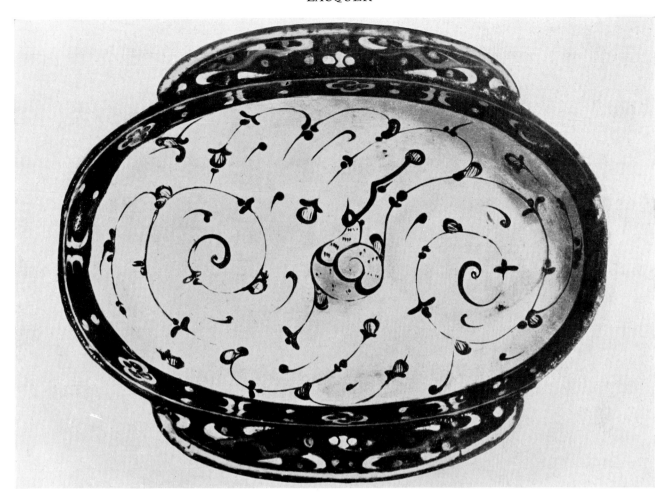

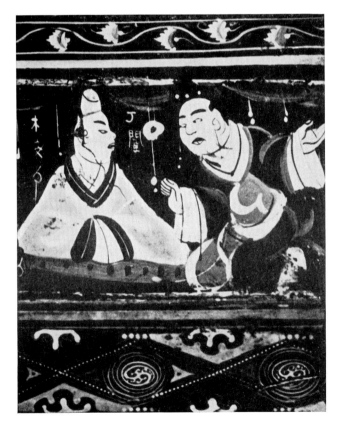

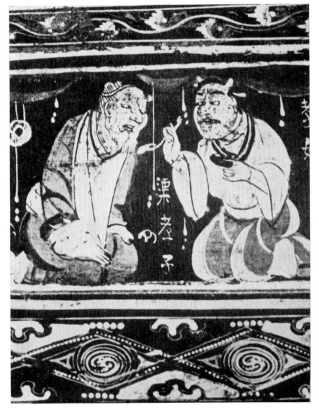

Pl. 413. *Above*: Wine cup, from a tomb in Mt. Tso-chiang-kung, Ch'and-sha (mod. Changsha), Hunan, China; Warring States period (Chan Kuo; 480–221 B.C.). L., 6¹/₂ in. Property of the Chinese Government. *Below*: Two details of the "Painted Basket," from Lo-lang, Korea, Han dynasty (206 B.C.–A.D. 221), ca. 2d cent. Formerly, Seoul, National Museum of Korea.

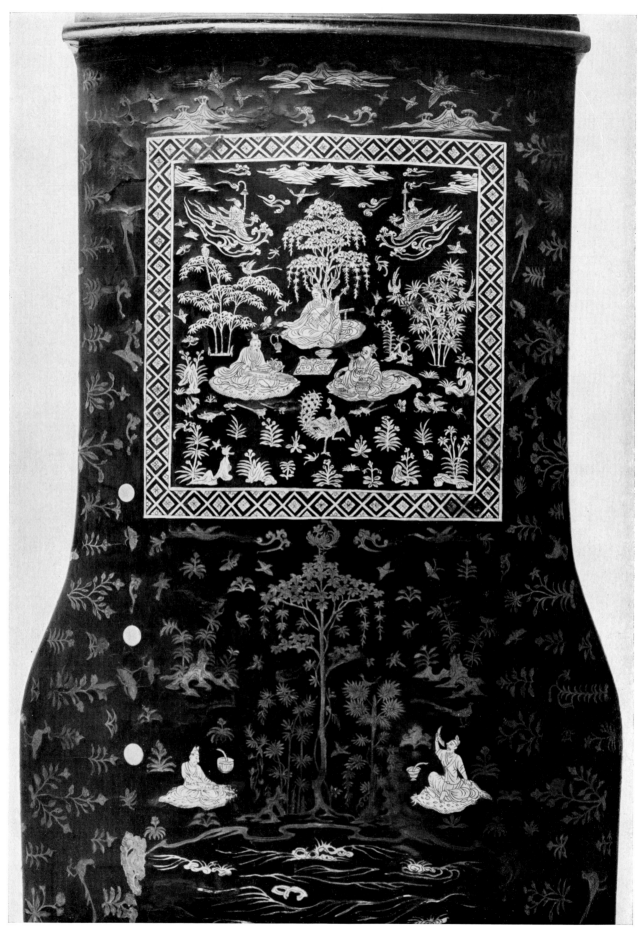

Pl. 414. Detail of musical instrument (*ch'in*), from China, T'ang dynasty (618–906). Lacquered wood with inlays of sheet gold and silver. Nara, Japan, Shōsōin.

Pl. 415. *Above*: Box for toilet articles, from Haichow (mod. Tunghai), Kiangsu, China, Han dynasty (206 B.C.–A.D. 221). Lacquered wood, painted and engraved; ht., 5¹/₂ in. London, British Museum. *Below*: Box, from China, Ming dynasty (1368–1644), early 15th cent. Diam., ca. 9 in. Philadelphia, Museum of Art.

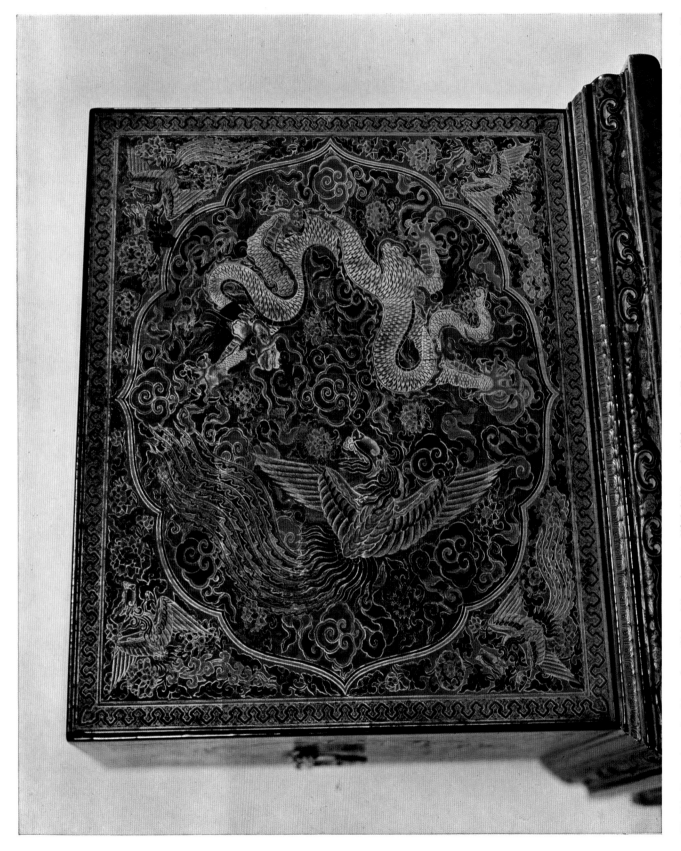

Pl. 416. Rear view of cabinet, from China, Ming dynasty (1368–1644), early 15th cent. "Zonsei" technique; ht., 19¼ in., l., 22¼ in. New York, F. Low-Beer Coll.

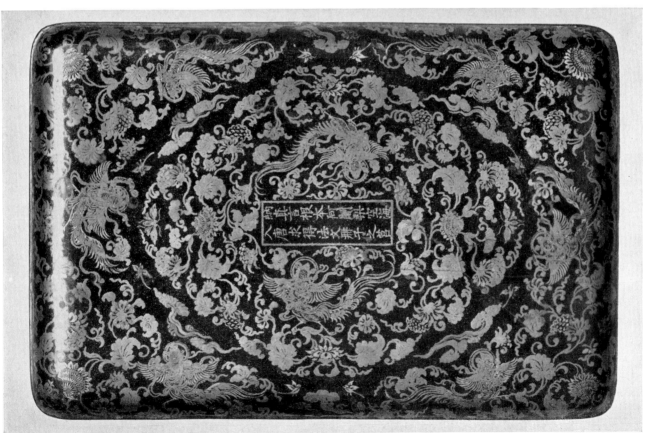

Pl. 417. *Left*: Box for Buddhist writings, Japan, 919. Kyoto, Ninnaji. *Right*: Cover of a box for Buddhist writings, Japan, 1124. Hiraizumi, Japan, Chūsonji, Konjikidō.

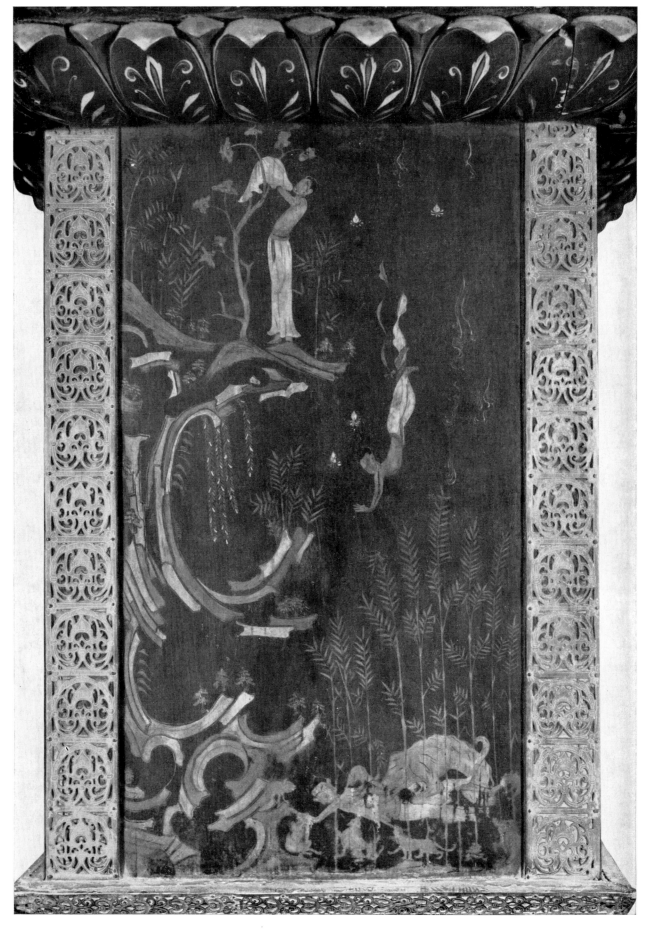

Pl. 418. Tamamushi Zushi (Beetle Wing Shrine), Sacrifice to a Hungry Tigress, detail, Japan, 7th cent. Full ht., 7 ft., 6¹/₂ in. Nara, Japan, Hōryūji.

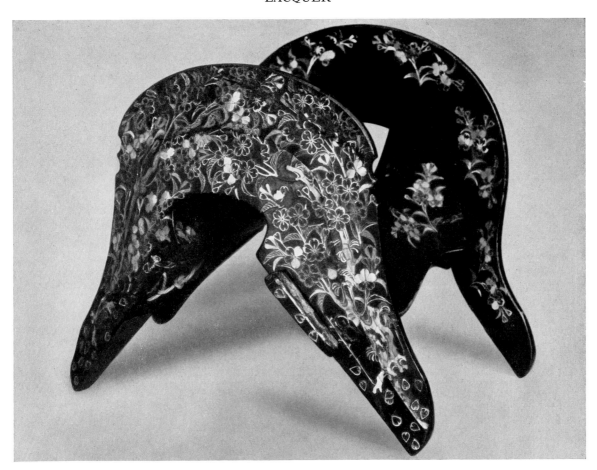

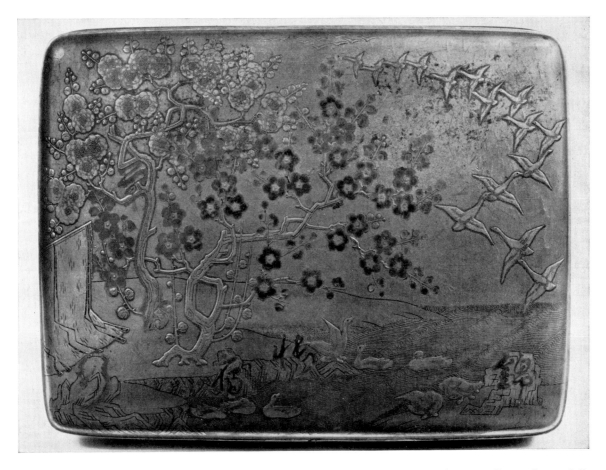

Pl. 419. *Above*: Saddle, Japan, ca. 13th cent. Lacquer with mother-of-pearl inlay. Odawara, Japan, Asano Coll.
Below: Cover of box for toilet articles, Japan, early 13th cent. Shizuoka, Japan, Mishima Jinja.

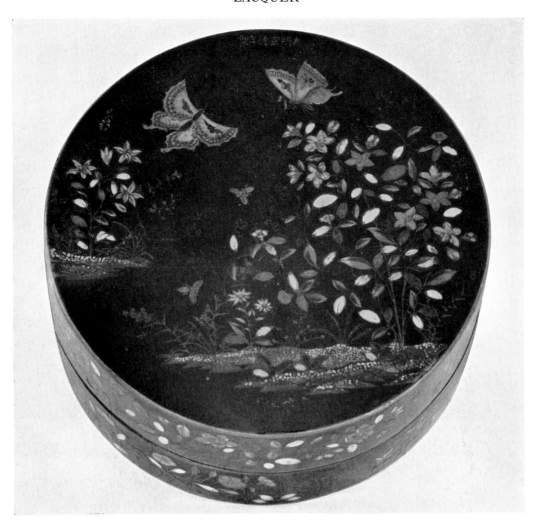

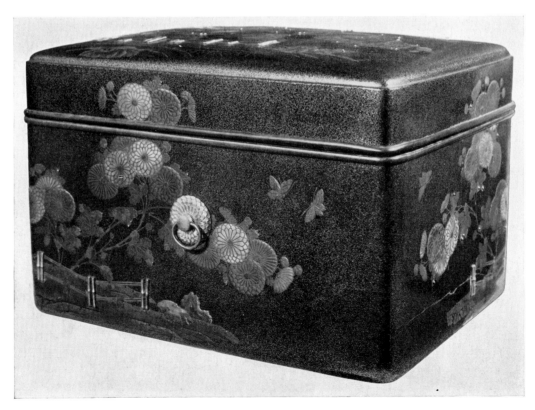

Pl. 420. *Above*: Box, China, Hsüan-tê period (1426–35). Diam., 8¼ in. Boston, Museum of Fine Arts.
Below: Box, Japan, 1390. Shingu, Wakayama, Japan, Kumano-Hayatama Jinja.

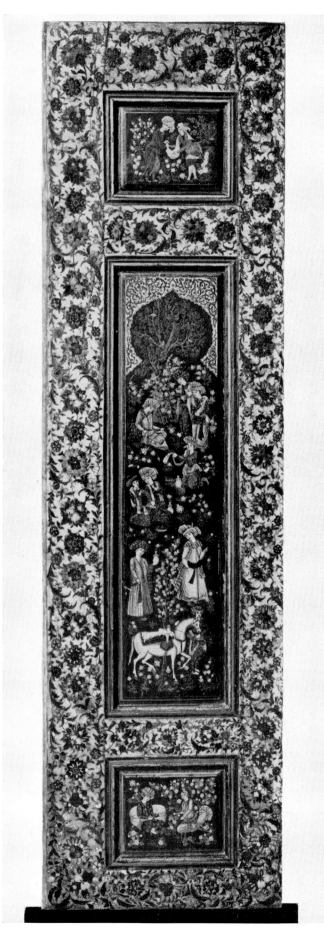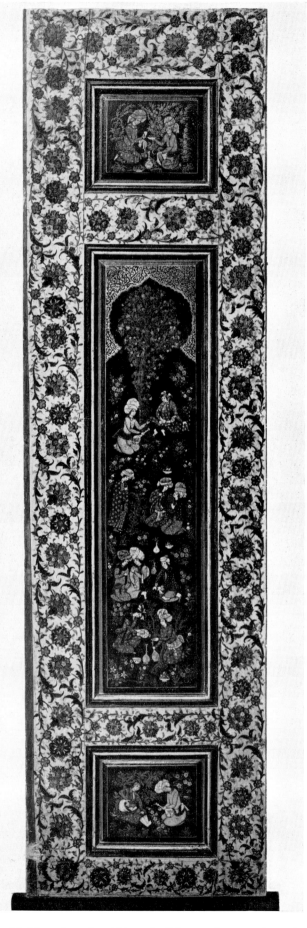

Pl. 421. Two door panels, from the Hall of Forty Columns, royal palace of Isfahan, Iran, late 16th–early 17th cent. Lacquered wood, painted and gilded; ht., 6 ft., 4³/₄ in. London, Victoria and Albert Museum.

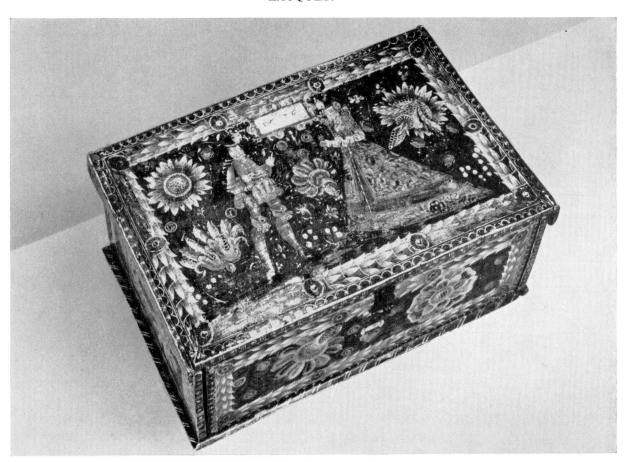

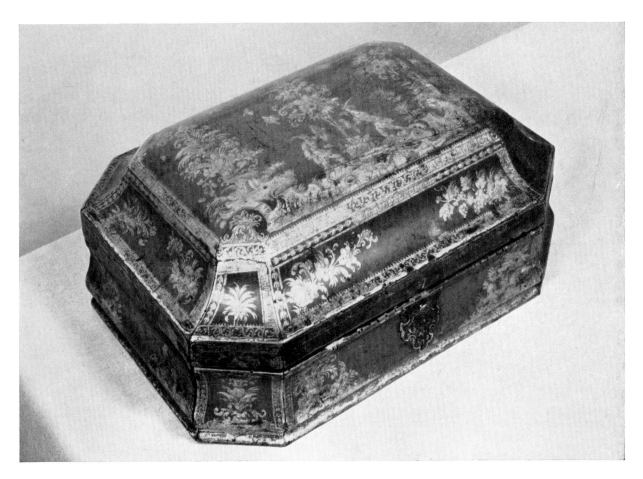

Pl. 422. *Above*: Wedding box, from Nürnberg, 1576. Ht., 5⅞ in. *Below*: Box, from Venice, ca. 1710. Red lacquer and gold, ht., 5⅛ in. Both, Cologne, Lackmuseum Herbig-Haarhaus.

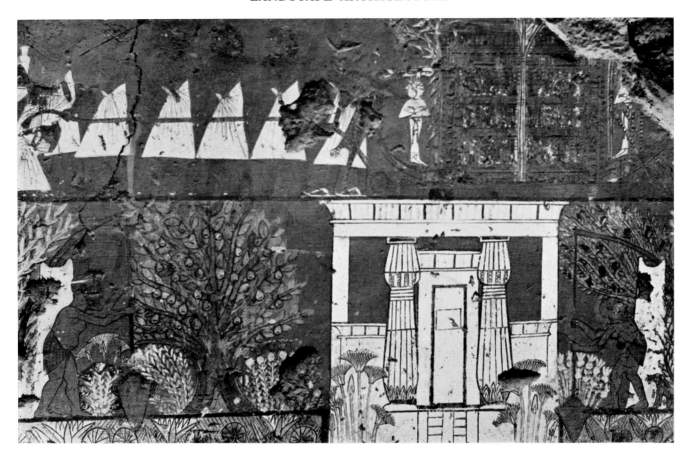

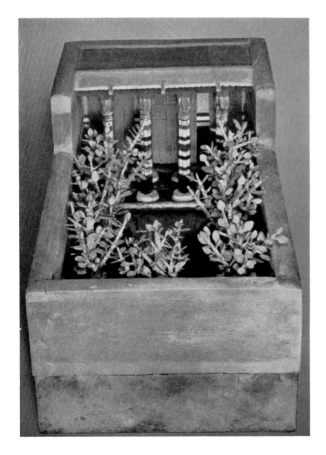

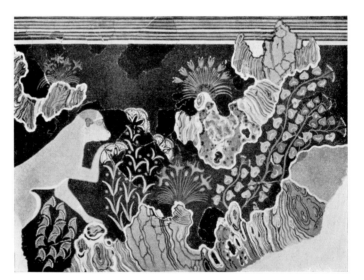

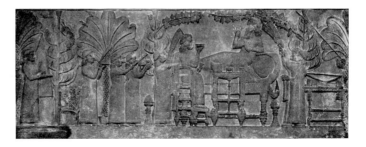

Pl. 423. *Above*: Garden shrine, detail of wall painting in the tomb of the sculptor Ipi, Deir el-Medineh, Egypt, ca. 1250 B.C. *Below, left*: Model of house and garden, from the tomb of Meket-ra, Thebes, Egypt, 11th dynasty. Wood. New York, Metropolitan Museum. *Right, center*: Garden scene, fragment of wall painting, 2d millennium B.C. Knossos, Crete, Palace. *Below*: Ashurbanipal and his queen feasting in their garden, relief from Nineveh, 668–626 B.C. Stone, ht., 20⅞ in. London, British Museum.

LANDSCAPE ARCHITECTURE

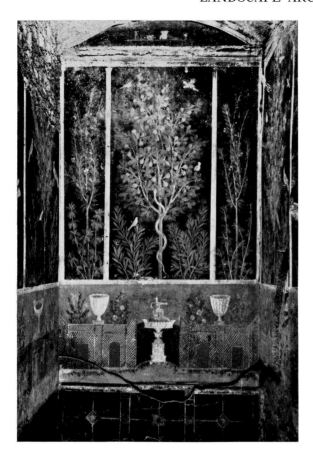
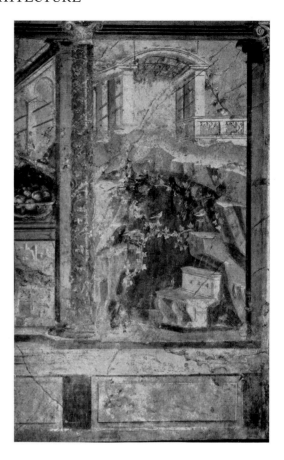

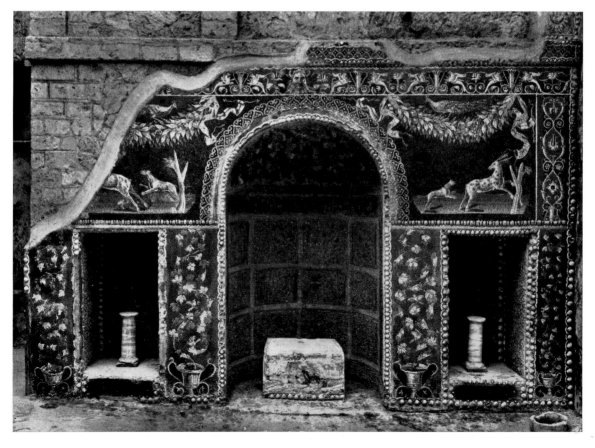

Pl. 424. *Above, left*: Representation of garden, ca. mid-1st cent. Wall painting. Pompeii, House of the Fruit Orchard. *Right*: Garden scene with grotto and fountain, wall painting, from Villa di Boscoreale, Italy, ca. 40 B.C. New York, Metropolitan Museum. *Below*: Nymphaeum with mosaic decorations, 1st cent. Herculaneum, House of Neptune and Amphitrite.

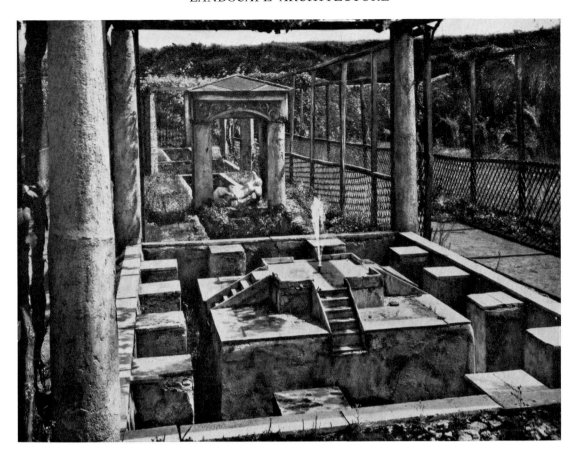

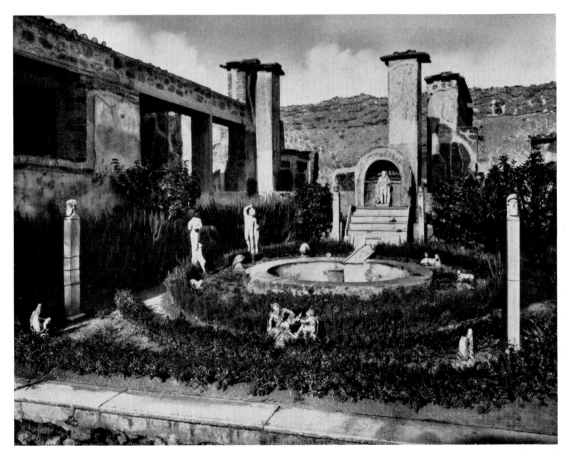

Pl. 425. Pompeii. *Above*: Garden with connecting pools and covered walks. House of Loreius Tiburtinus. *Below*: Nymphaeum of garden. House of Marcus Lucretius.

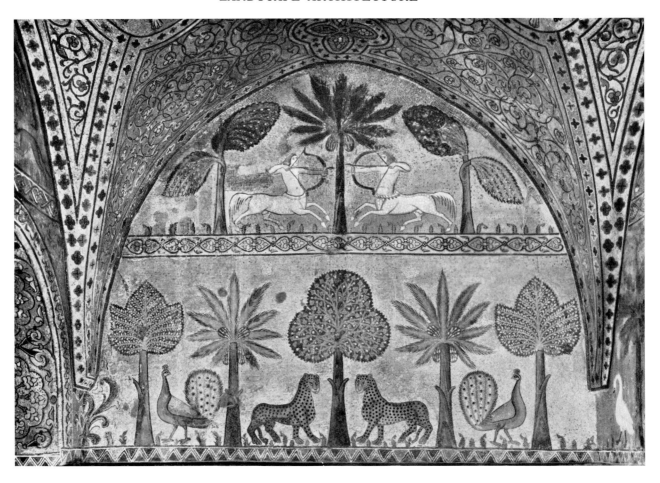

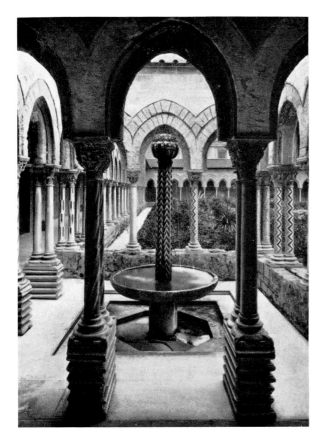

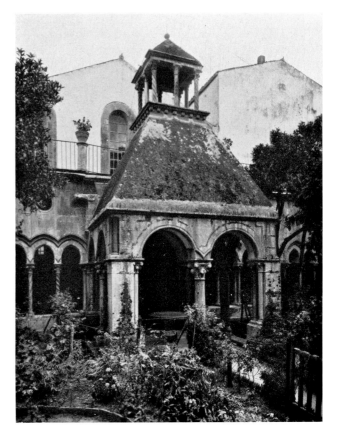

Pl. 426. *Above*: Stylized plants, animals, and centaurs, detail of wall decoration, 12th cent. Mosaic. Palermo, Palazzo Reale, room of Roger II. *Below, left*: Monreale, Sicily, Cathedral, detail of cloister, 12th cent. *Right*: Fossanova, Italy, Abbey, detail of cloister, 12th–13th cent.

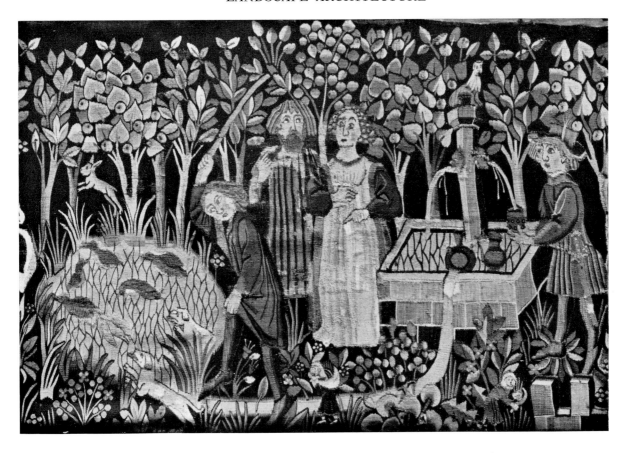

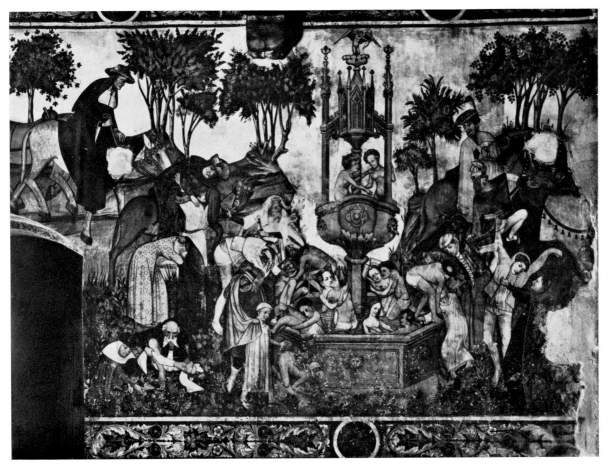

Pl. 427. *Above*: Garden with fountain of love, from Franconia, ca. 1450–60. Tapestry. Munich, Bayerisches National-museum. *Below*: The fountain of youth, 15th cent. Fresco. Castello della Manta, Piedmont, Italy.

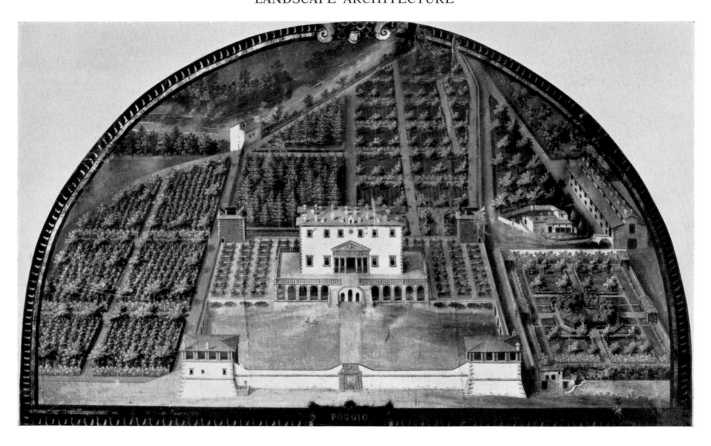

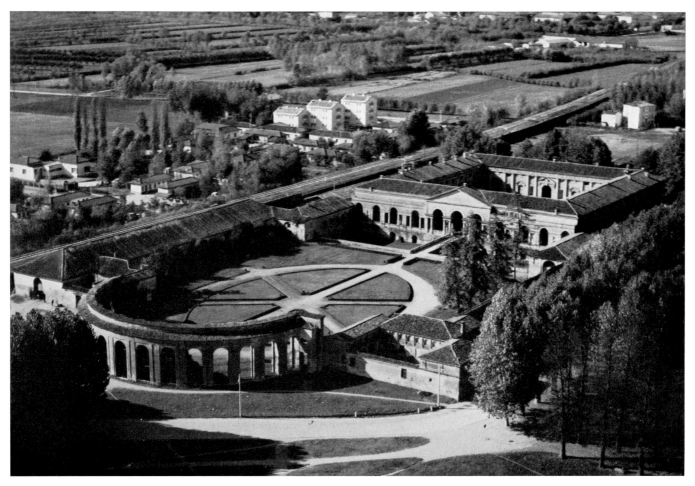

Pl. 428. *Above*: View of the Villa of Poggio a Caiano, near Florence, 15th cent. Canvas. Florence, Museo Storico e Topografico. *Below*: Giulio Romano, Palazzo del Te, Mantua, Italy, first half of 16th cent., aerial view.

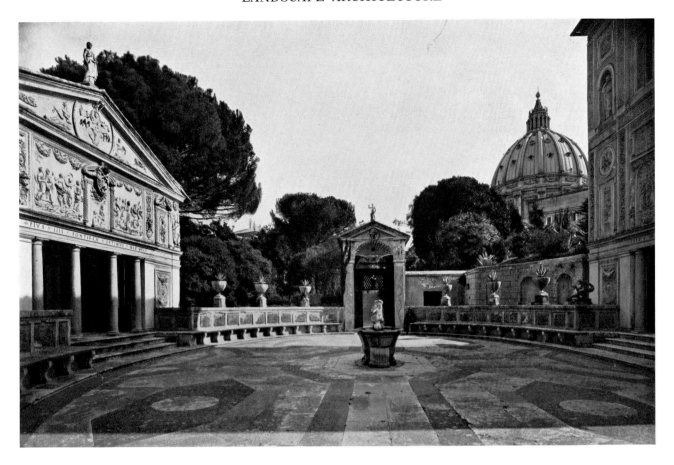

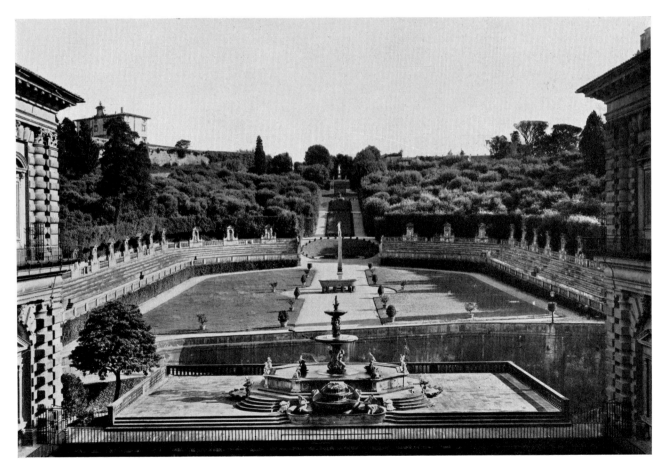

Pl. 429. Italian gardens, second half of 16th cent. *Above*: P. Ligorio and S. Peruzzi, the Rotunda and the Casino of Pius IV in the Vatican Gardens, Rome. *Below*: Boboli Gardens, Florence, from the courtyard of Palazzo Pitti.

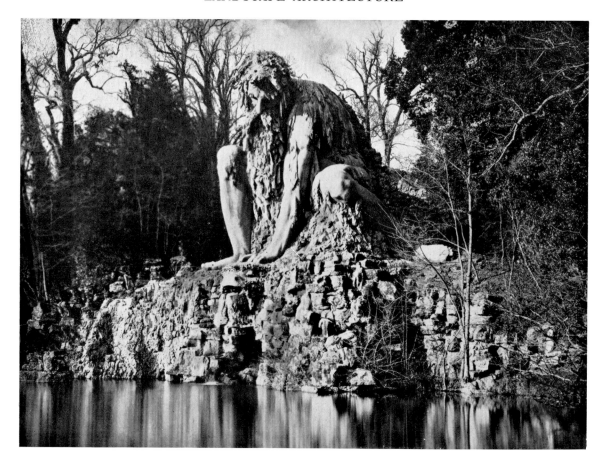

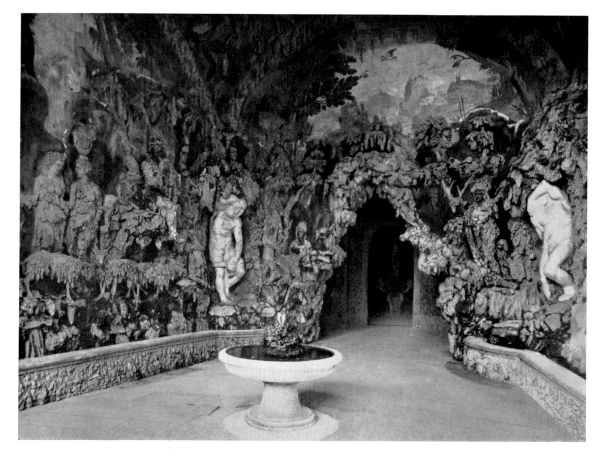

Pl. 430. *Above*: Giambologna, the "Apennine," second half of 16th cent. Villa Demidoff, Pratolino, near Florence.
Below: B. Buontalenti, interior of the Grotto, 1583–88, Boboli Gardens, Florence.

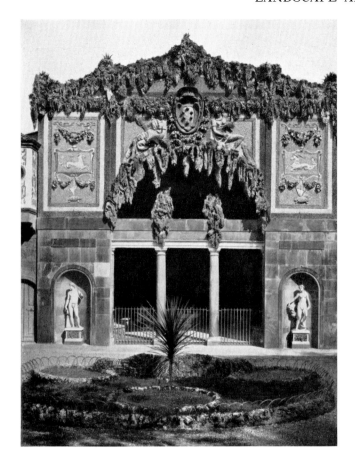

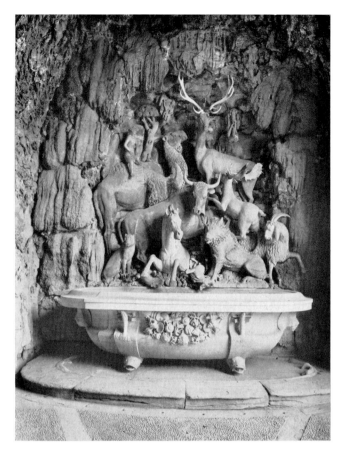

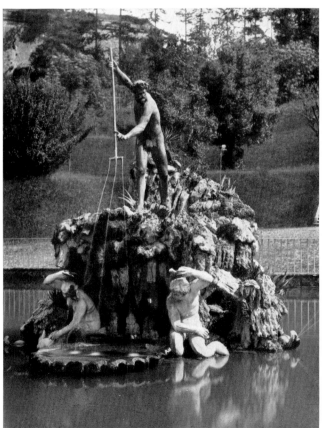

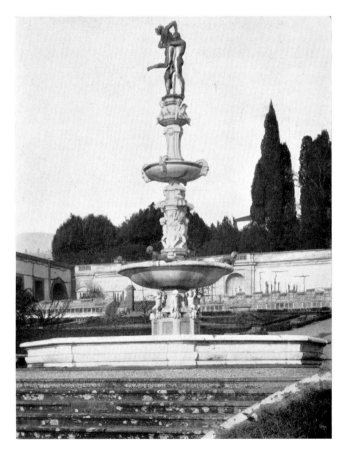

Pl. 431. *Left*: Boboli Gardens, Florence. *Above*: B. Buontalenti, exterior of the Grotto, 1583–88. *Below*: Stoldo Lorenzi, fountain of Neptune, 1565. *Right*: Castello, near Florence, Villa Medici, second half of 16th cent. *Above*: N. Tribolo, sculpture in grotto. *Below*: N. Tribolo and B. Ammanati, fountain of Hercules and Cacus.

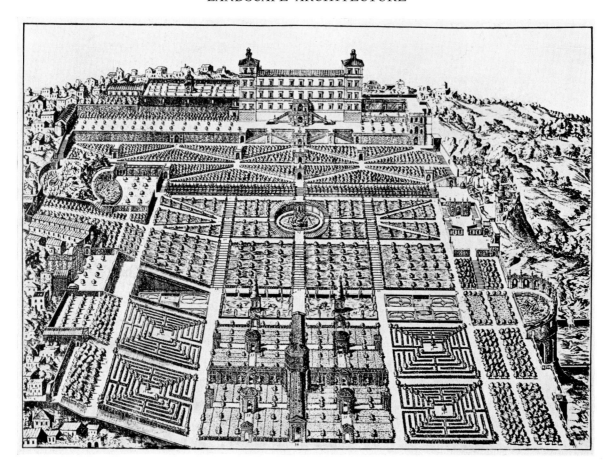

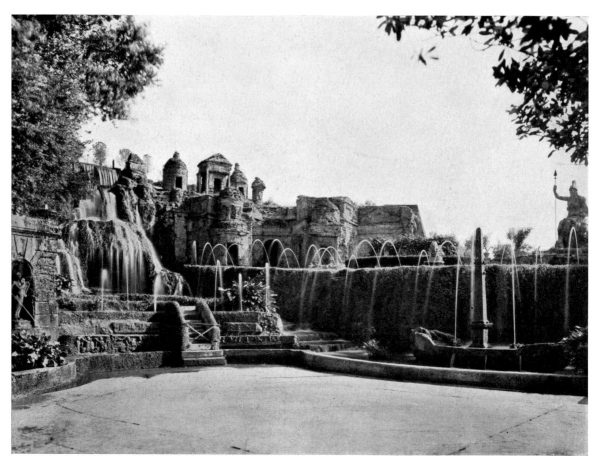

Pl. 432. P. Ligorio, Villa d'Este, Tivoli, Italy, second half of 16th cent. *Above*: The villa and gardens. Etching by E. du Pérac. *Below*: Ruins of "Rometta" (little Rome).

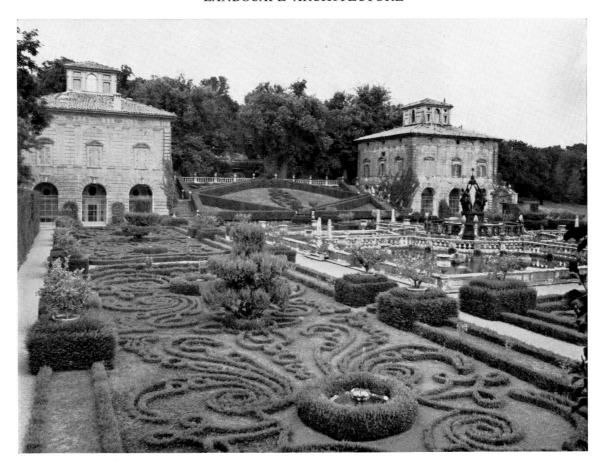

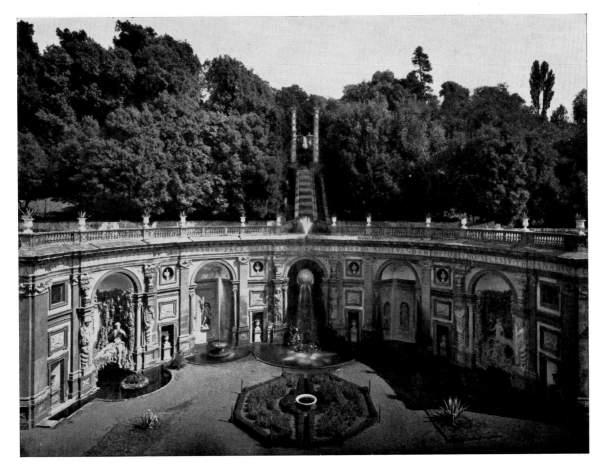

Pl. 433. Italian gardens, second half of 16th cent. *Above*: Garden of Villa Lante, Bagnaia, near Viterbo. *Below*: Water theater of Villa Aldobrandini, Frascati.

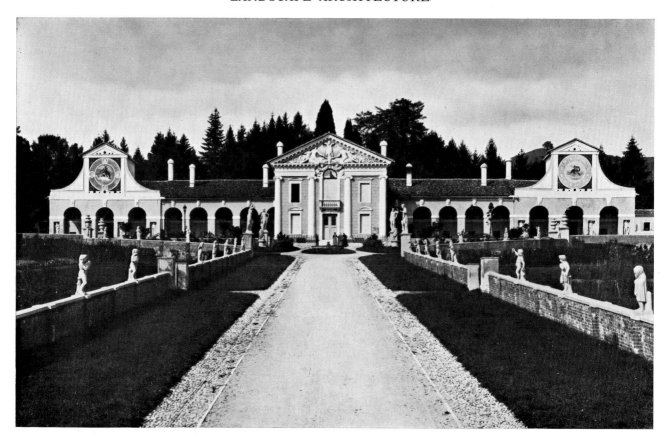

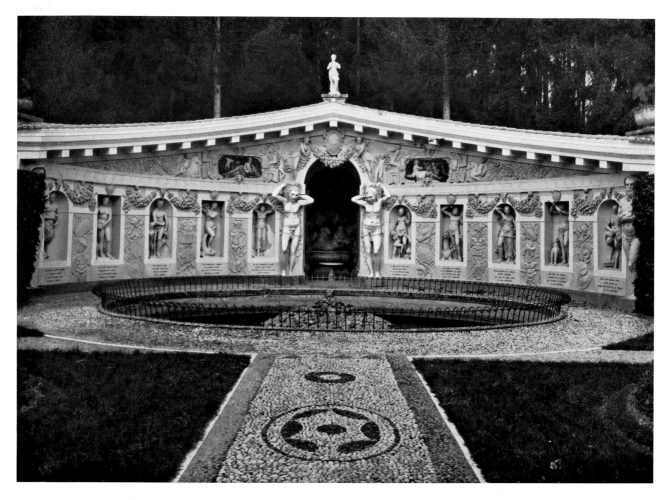

Pl. 434. A. Palladio, Villa Barbaro, second half of 16th cent. Maser, near Treviso, Italy. *Above*: Façade of main building. *Below*: Grotto with stucco decoration by A. Vittoria.

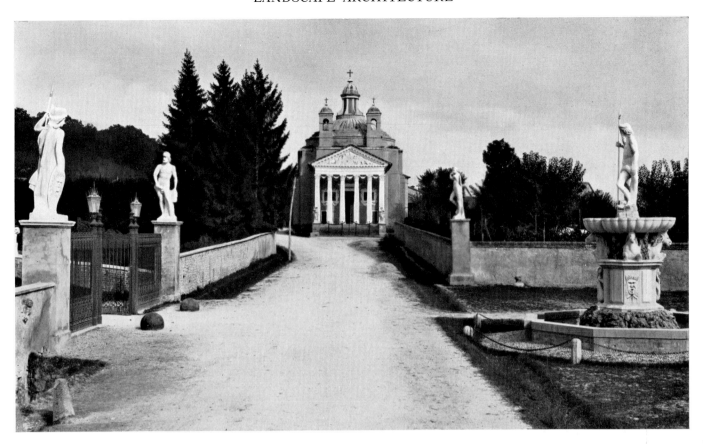

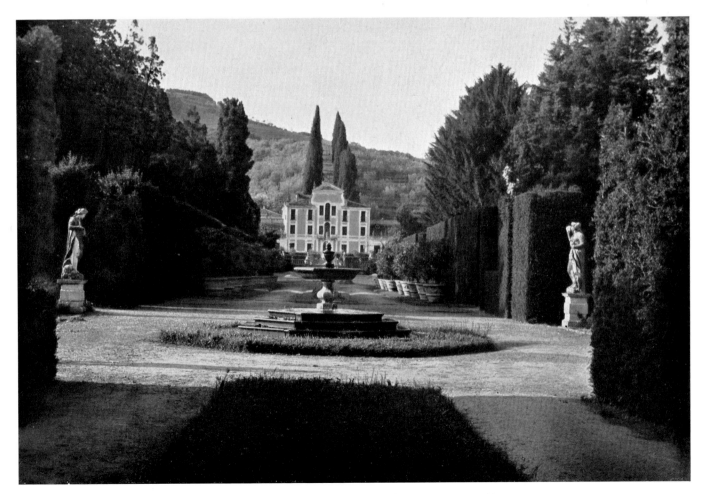

Pl. 435. *Above*: A. Palladio, Villa Barbaro, entrance with fountain and *tempietto*, second half of 16th cent. Maser, near Treviso, Italy.
Below: Villa Barbarigo, near Padua, 17th cent.

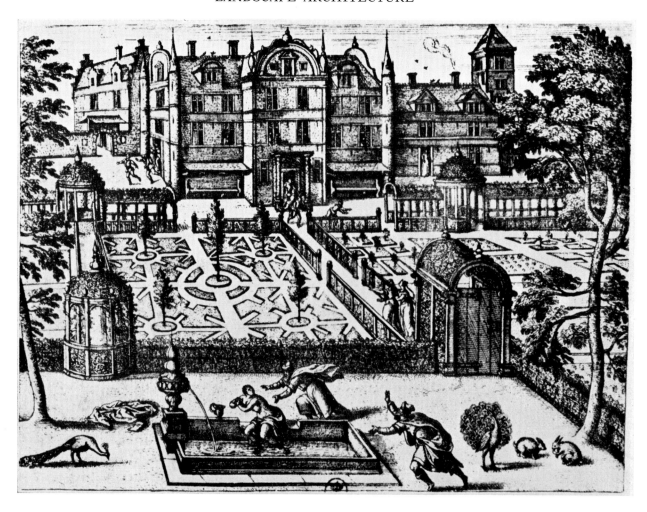

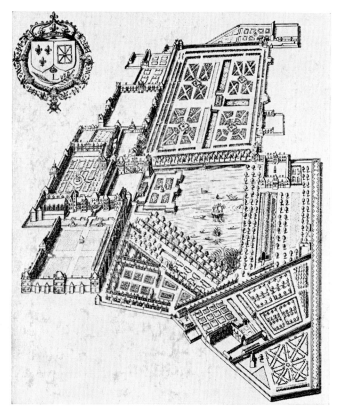

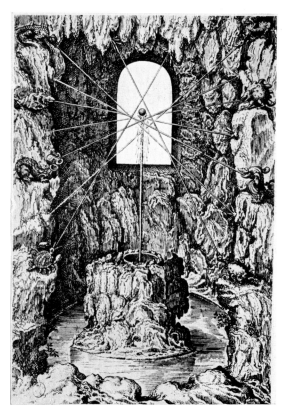

Pl. 436. *Above*: Dutch garden. Etching by H. Vredeman de Vries, *Hortorum Viridariorumque. . .* , Antwerp, 1583. *Below, left*: Fontainebleau, Palace and park at the time of Henry IV (1589–1610). Etching by Furttenbach. *Right*: Water works. Etching by S. de Caus, *Les raisons des forces mouvantes*, Frankfurt, 1615.

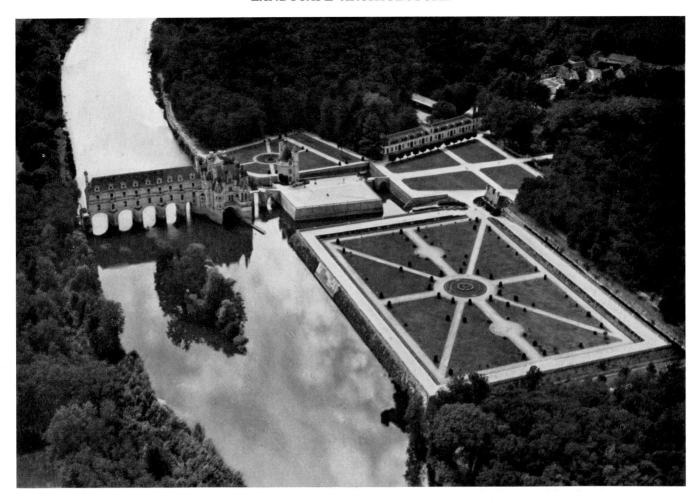

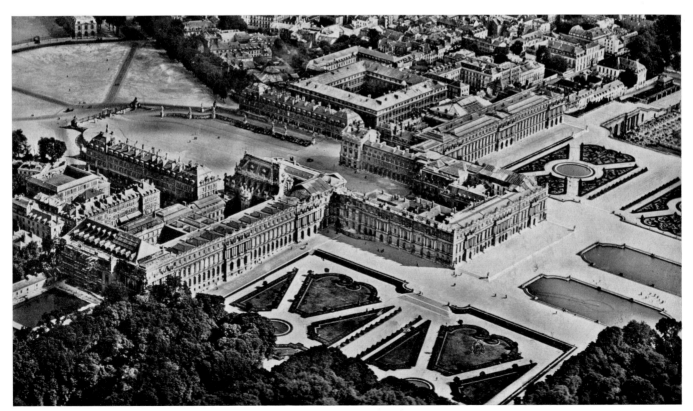

Pl. 437. *Above*: Chenonceau, Château and park, 16th cent., aerial view. *Below*: Versailles, 17th cent., aerial view.

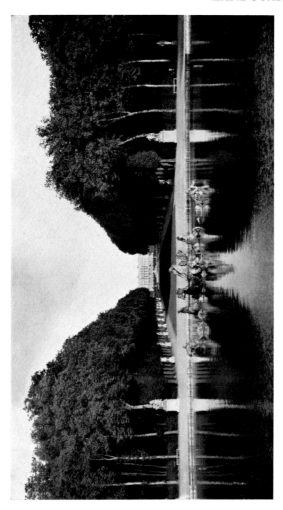

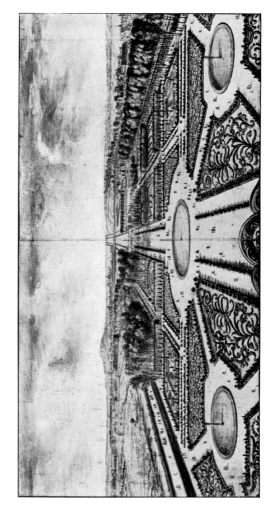

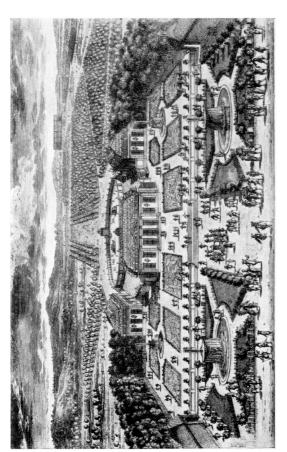

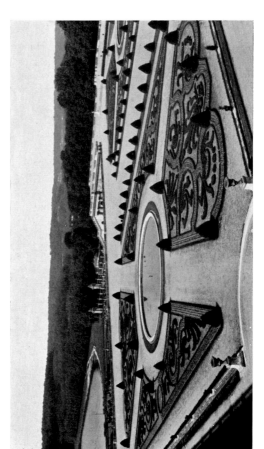

Pl. 438. *Above*: Versailles. *Left*: Perspective view of the Grand Trianon, with gardens by A. Le Nôtre, ca. 1660–70. Engraving by Mariette after a drawing by Perelle. *Right*: *Tapis vert* from the *Bassin d'Apollon*. *Below, left*: Versailles, *Parterres du Midi*. *Right*: A. Le Nôtre, gardens of the Tuileries, Paris, in the 17th cent. Engraving by I. Silvestre. Paris, Louvre.

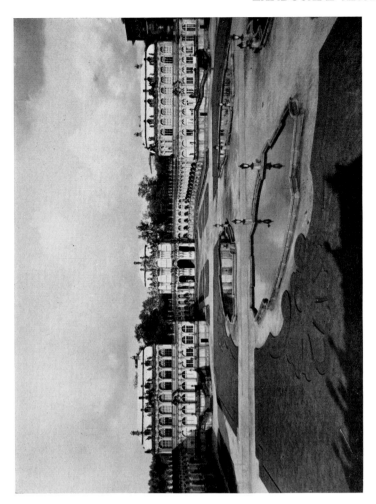

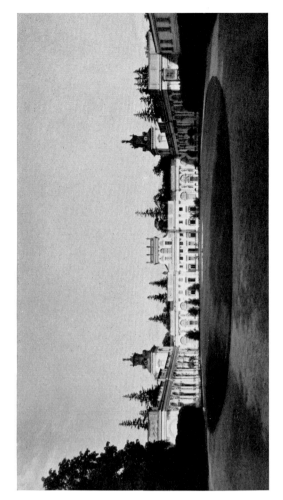

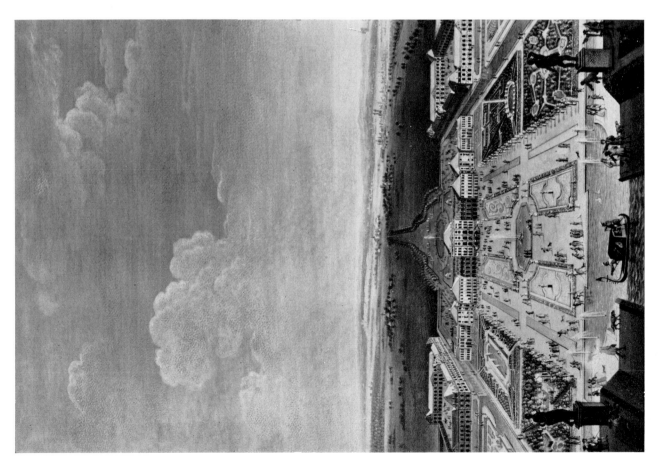

Pl. 439. *Left*: Palace and park of Nymphenburg, near Munich, in the 18th cent. Canvas. *Right, above*: Dresden, Zwinger, 18th cent. (Restored after severe damage in World War II.) *Below*: Wilanów, near Warsaw, Palace, 18th cent.

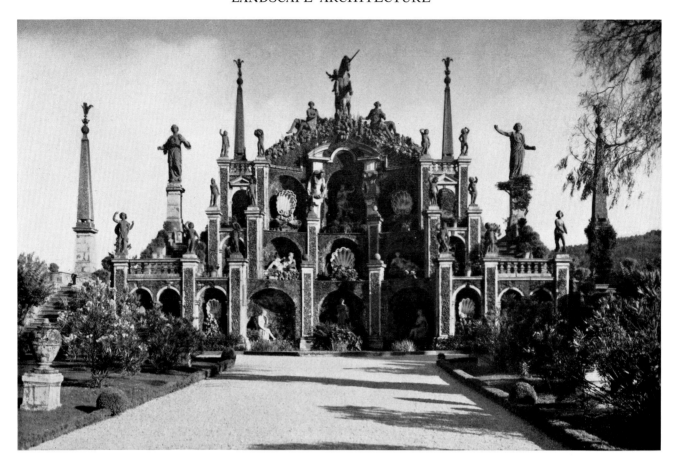

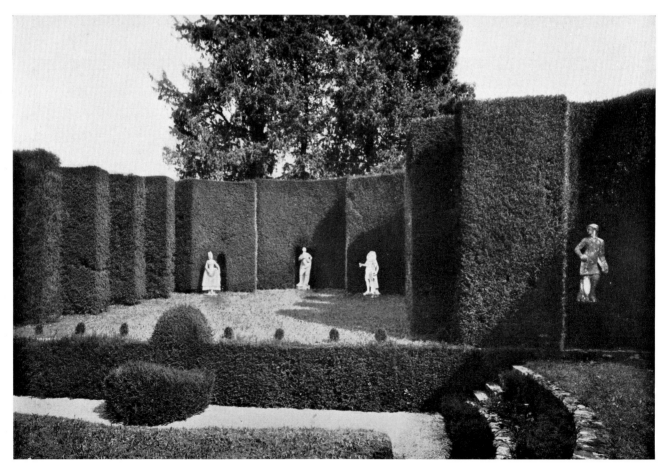

Pl. 440. *Above*: Great unicorn terrace of Palazzo Borromeo, 17th cent. Isola Bella in Lake Maggiore, Italy. *Below*: Villa Reale of Marlia, 18th cent. Lucca, Italy.

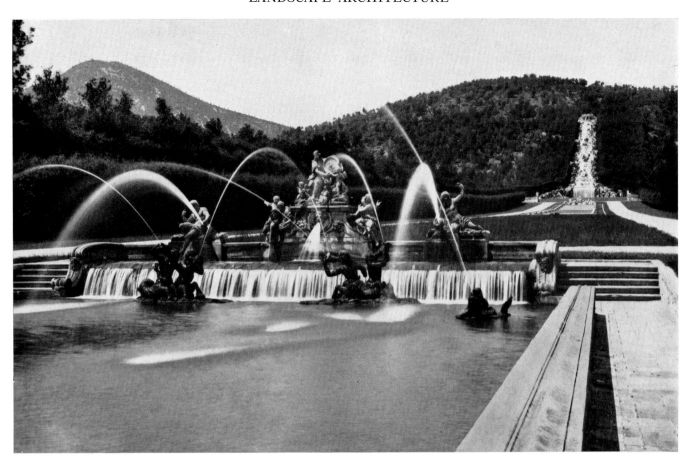

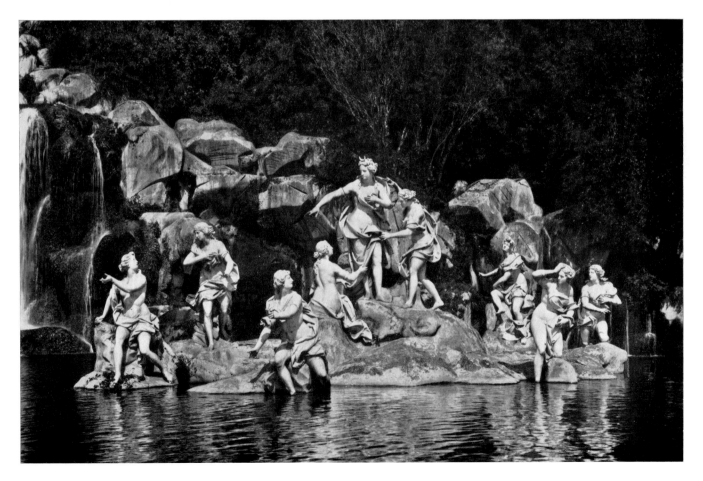

Pl. 441. Caserta, Italy, park of the Royal Palace, 18th cent. *Above*: Great cascade from the fountain of Ceres. *Below*: Detail of the great cascade, with sculpture group of Diana and Actaeon.

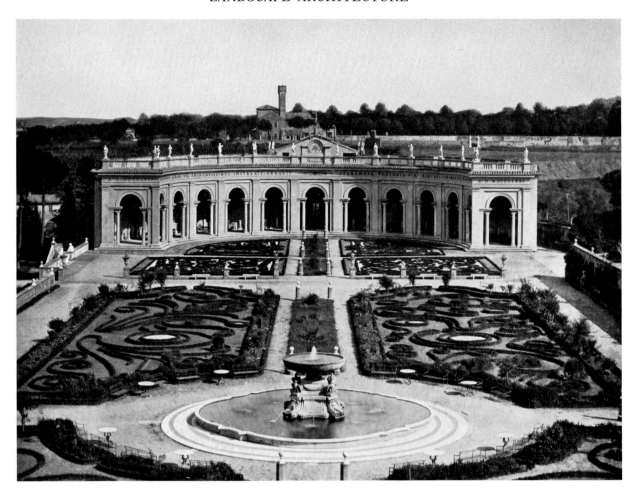

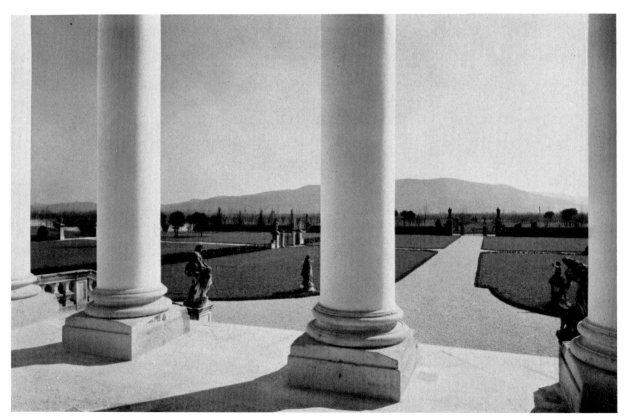

Pl. 442. *Above*: C. Marchionni, Villa Albani, Rome, ca. 1760. *Below*: Villa Cordellina, Montecchio Maggiore, Italy, 18th cent.

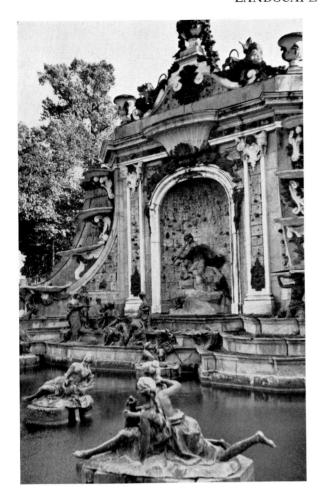

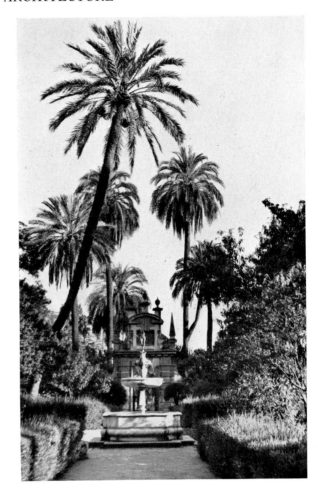

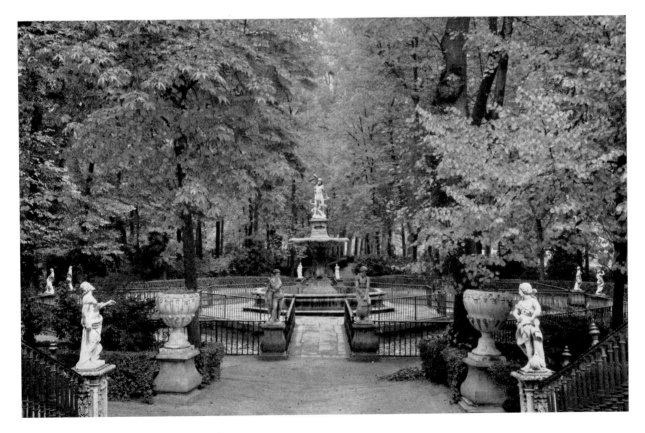

Pl. 443. Spanish landscape architecture, 17th cent. *Above, left*: Fountain of Diana's Baths, La Granja, Segovia. *Right*: Gardens of the Alcázar, Seville. *Below*: Fountain of Hercules, Royal Palace gardens, Aranjuez.

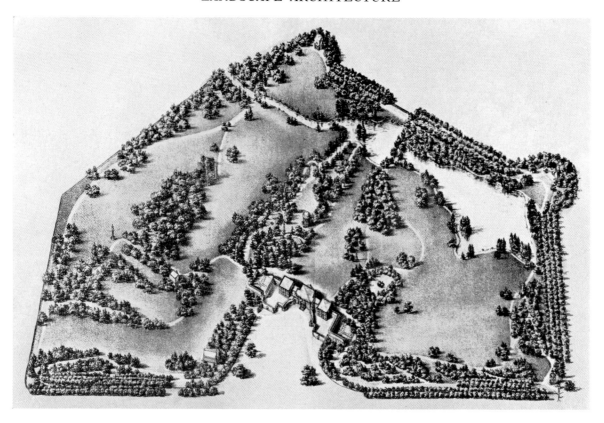

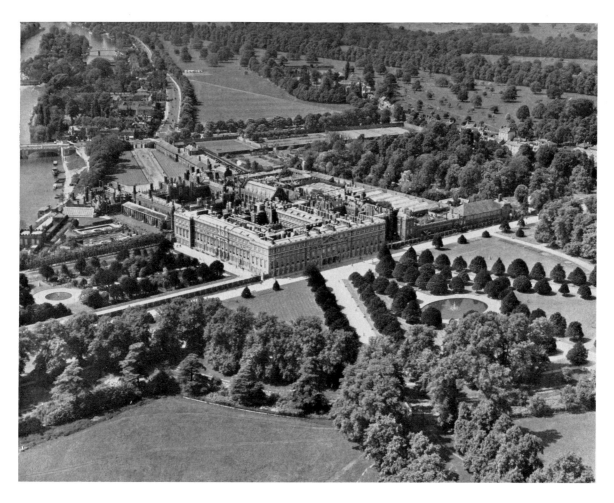

Pl. 444. *Above*: Stowe, England, the house and park, 18th cent. Lithograph by N. E. J. Desmadryl, Bernard, and Bichebois l'aîné. *Below*: Hampton Court, England, aerial view.

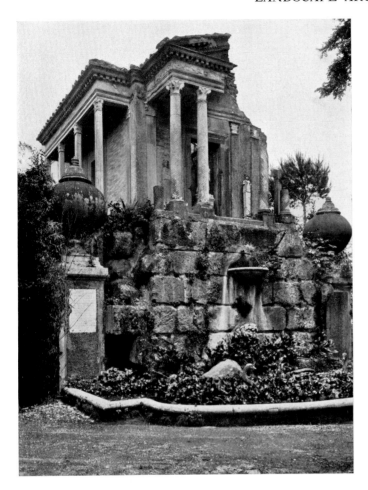

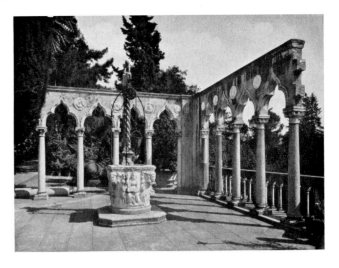

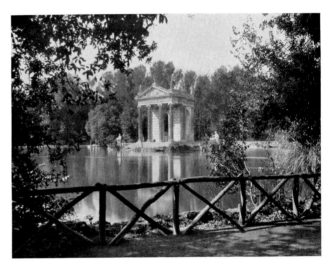

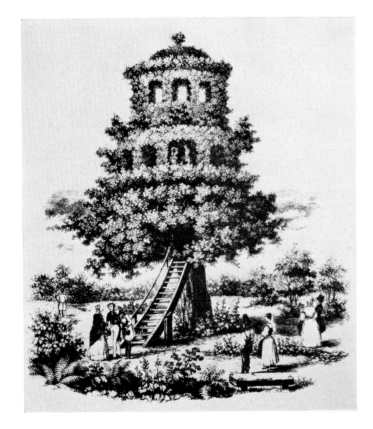

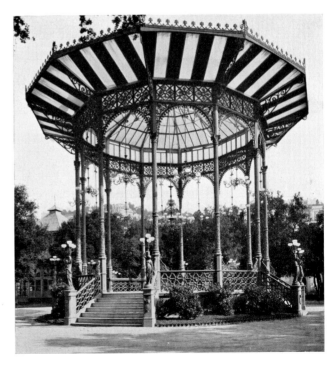

Pl. 445. *Left, above*: Artificial ruin, 18th cent. Rome, Villa Albani. *Below*: Albero Belvedere (tree gazebo). Matibo farm near Savigliano, Italy. Etching by F. Wiesener, *Magasin Pittoresque*, 1841. *Right, above*: Arcade and well in Venetian Gothic style, 19th cent. Florence, Villa Stibbert. *Center*: Lake garden, 18th cent. Rome, Villa Borghese. *Below*: Bandstand, 19th cent. Naples, Villa Nazionale of Via Caracciolo.

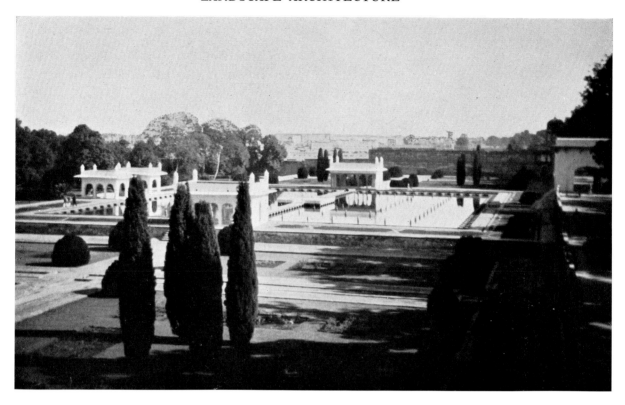

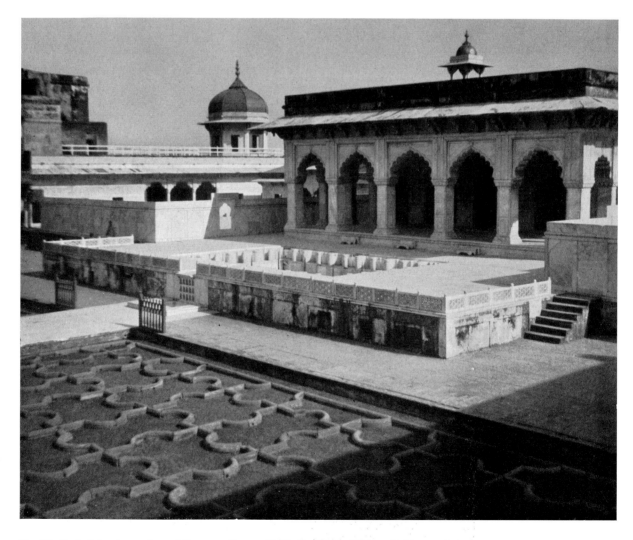

Pl. 446. Indo-Islamic gardens, 17th cent. *Above*: Shālimār Bāgh, Lahore, Pakistan. *Below*: Angūrī Bāgh (Grape Garden), Agra, India.

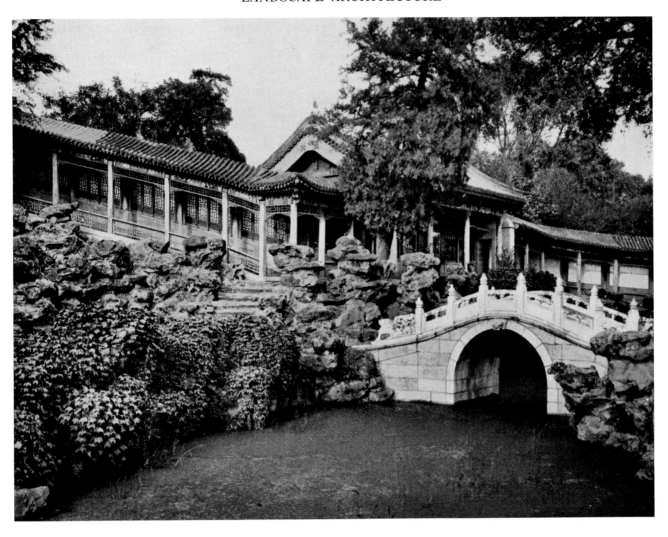

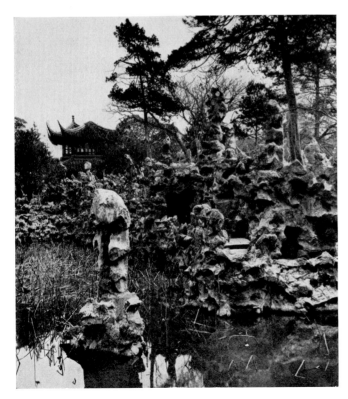

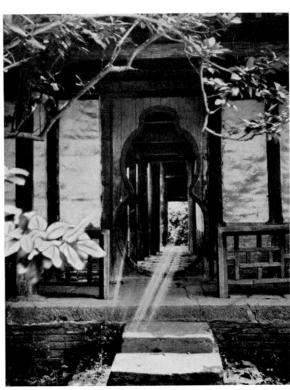

Pl. 447. Chinese gardens, 17th–18th cent. *Above*: Partial view of the Ching-hsin-chai, Pei-hai, Peking. *Below, left*: Pool and rocks in the Shih-tzŭ-lin, Soochow. *Right*: Garden gateway in the Ch'eng Wang Fu, Peking.

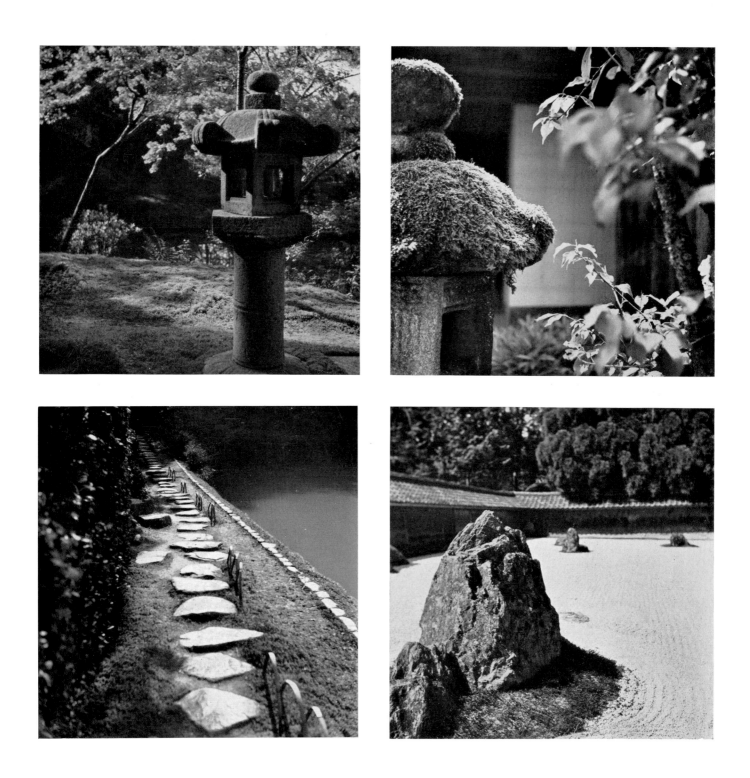

Pl. 448. Details of Japanese gardens. *Left, above and below*: Lantern and stepping stones, early 17th cent. Kyoto, Katsura palace. *Right, above*: Moss-covered stone lantern, mid-16th cent. Zanazawa. *Below*: Garden of the Ryūanji, Kyoto, 16th cent.

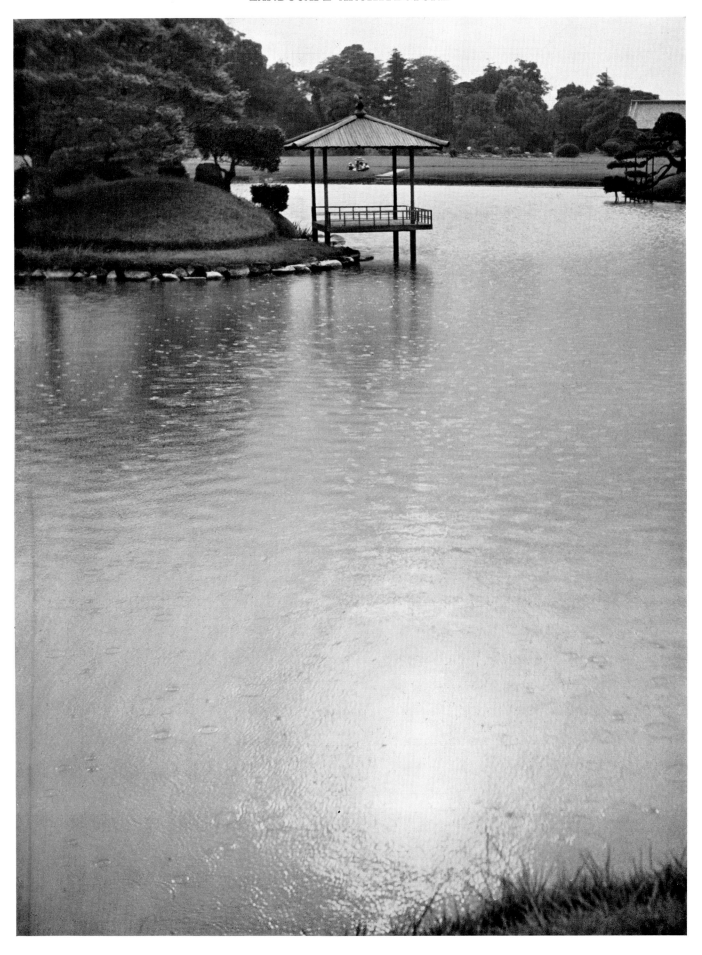

Pl. 449. Garden of the Gorakuen, Kanazawa, Japan, 18th cent.

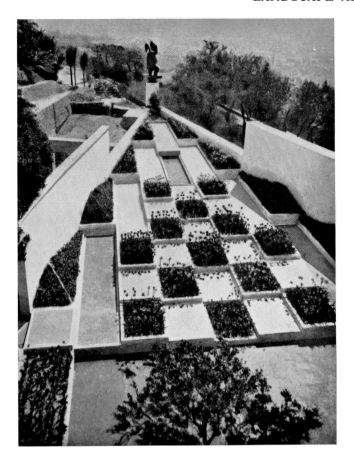

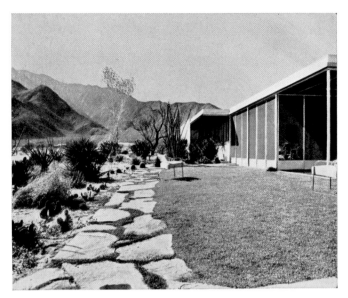

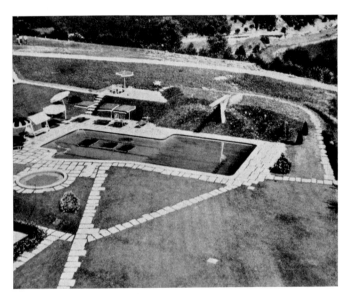

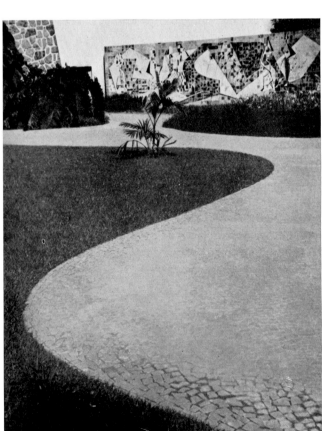

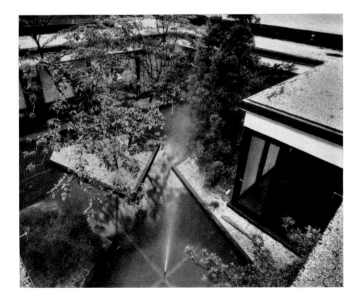

Pl. 450. *Left, above*: G. Guevrekian, Villa de Noailles, Hyères, France, terrace garden, 1926. *Below*: R. Burle Marx, Villa R. de Campos, Brazil, partial view of garden with panel of *azulejos*. *Right, above*: R. J. Neutra, Mensendieck country house, garden, Palm Springs, Calif., 1937. *Center*: F. Clerici, swimming pool in park of a mountain villa, Italy. *Below*: H. Hebbeln and J. Rose, landscape architect, Phillip Macht house, patio, Baltimore, Md., 1957.